Grove Encyclopedias of the
Arts of the Americas

Encyclopedia of Latin American
& Caribbean Art

Grove Encyclopedias of the
Arts of the Americas

Encyclopedia of

LATIN AMERICAN
& CARIBBEAN ART

Edited by
JANE TURNER

Grove Encyclopedias of the Arts of the Americas
Encyclopedia of Latin American & Caribbean Art
Edited by Jane Turner

Published in the United Kingdom by

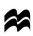

MACMILLAN REFERENCE LIMITED, 2000
25 Eccleston Place, London, SW1W 9NF, UK
Basingstoke and Oxford
ISBN: 0–333–76466–8
Associated companies throughout the world
http://www.macmillan-reference.co.uk

British Library Cataloguing in Publication Data
Encyclopedia of Latin American and Caribbean Art
 1. Art, Latin American—Encyclopedias
 2. Art, Caribbean—Encyclopedias
 I. Turner, Jane, 1956—
709.7'29'03
ISBN 0-333-76466-8

Published in the United States and Canada by

GROVE'S DICTIONARIES, INC
345 Park Avenue South, New York, NY 10010-1707, USA
ISBN: 1–884446–04–3
http://www.grovereference.com

Library of Congress Cataloging-in-Publication Data

Encyclopedia of Latin American and Caribbean Art / editor, Jane Turner
 p. cm – (Grove library of world art)
Includes bibliographical references and index.
ISBN 1–884446–04–3 (alk. paper)
 1. Art, Latin American Encyclopedias.
 2. Art, Caribbean Encyclopedias.
 I. Turner, Jane Shoaf. II. Series
N6502 .E53 1999
709'.8'03–dc21

 99–41595
 CIP

Typeset in the UK by William Clowes, Beccles, Suffolk
Printed and bound in the UK by Bath Press Ltd, Bath

Jacket illustration: Antonio Ruiz: *The New Rich*, oil on canvas, 321x422 mm, 1941 (New York,
Museum of Modern Art/Photo: Museum of Modern Art)

Contents

Preface

The *Encyclopedia of Latin American and Caribbean Art* is the second publication in the Grove Library of World Art, an exciting new publishing programme devoted to specialist topics, offering the award-winning scholarship of the 34-volume *Dictionary of Art* (London and New York, 1996) in more accessible and affordable one- to three-volume encyclopedias.

The Grove Library of World Art will initially be organized in six separate series:

Grove Encyclopedias of Ancient Art
Grove Encyclopedias of Asian Art
Grove Encyclopedias of African Art
Grove Encyclopedias of Australasian Art
Grove Encyclopedias of European Art
Grove Encyclopedias of the Arts of the Americas

This volume is the second title in the last series, the *Encyclopedias of the Arts of the Americas*. The first volume in this series, the *Encyclopedia American Art before 1914*, has also appeared this year. There are plans to follow these two volumes in due course with the *Encyclopedia of American Art since 1914*, the *Encyclopedia of North American Indian Art*, the *Encyclopedia of Pre-Columbian Art* and the *Encyclopedia of Canadian Art*.

For each of these spin-off volumes, we have gone back to the original specialist authors and invited them to update their entries. In some cases, the entries have been substantially rewritten by their contributors to reflect recent research and new interpretations. In addition, our own in-house editorial staff have researched each heading for new bibliographical items.

Readers will also find completely new entries, for instance 25 biographies of contemporary Latin American artists, since it was felt that a number of artists active today deserved inclusion. The number of illustrations has also been greatly increased. With the addition of some 200 new black-and-white illustrations and nearly 100 colour plates, there are now almost 500 illustrations, in addition to maps of every country in the region.

This alphabetically arranged encyclopedia covers the arts and culture of every country in the Western Hemisphere except Canada and the United States, from the European conquest to the present day, with introductory articles on the arts of indigenous peoples where appropriate. Country surveys chart the evolution of artistic traditions and the melding of European and native art forms not only in architecture and the fine arts but also in interior design, metalwork, textiles and other decorative arts, and include discussions of art patronage and training in each nation. The artistic discovery of South and Central America and the Caribbean islands by Europeans can be traced in biographies ranging from Miguel Cabrera and Alexander von Humboldt to 20th-century artists such as Pablo O'Higgins. The coverage of native artists begins with one of the earliest named craftsmen, Juan Tomás Tuyru Tupac Inca, a descendent of the Inca nobility, and stretches to the youngest artist profiled, Jac Lierner.

However, as in the *Dictionary of Art*, information is not limited to artist biographies and country surveys. Articles covering such issues as Latin American art in the USA, the role of the Jesuits in the establishment of Christian artistic traditions, and women artists in Latin America are intended to accommodate a wide range of art historical interests. Influential national and international art movements are discussed, and background information is covered in articles that explore such topics as the Currigueresque style and the Athens Charter propounded by CIAM, both of which were influential at different times on the architecture of much of Latin America.

Jane Turner
Diane Fortenberry
London, 1999

Introduction

I. Alphabetization and identical headings. II. Article headings and structures. III. Standard usages. IV. Cross-references. V. Locations of works of art. VI. Illustrations. VII. Bibliographies and other sources. VIII. Authors. IX. Appendices. X. Index.

I. Alphabetization and identical headings.

All main headings in this encyclopedia are distinguished by bold typeface. Headings of more than one word are alphabetized letter by letter as if continuous, up to the first true mark of punctuation, and again thereafter: the comma in **Torres, Martin de** therefore breaks the alphabetization, and his biography precedes the article on **Torres García, Joaquin**. Parenthesized letters or words and square-bracketed matter are also ignored in alphabetization: for example, the article **Hernández (Navarro), Agustín** precedes that on **Hernández, Daniel**. The reader who searches in the wrong place for a prefixed or double surname will be led to the correct location by a cross-reference. The prefixes Mc and Mac where occurring as the first two or three letters of a name are alphabetized under Mac. Acronyms are alphabetized by initial, as if words, rather than by the full name (**CIAM** follows **Churrigueresque**, rather than **Concha, Andrés de la**). Accented letters are treated like unaccented ones, although for headings identical except for the accents the unaccented form appears first. Article headings that are truly identical are distinguished by the use of parenthesized small roman numerals.

II. Article headings and structures.

1. BIOGRAPHICAL. All biographies in this encyclopedia start with the subject's name and, where known, the places and dates of birth and death and a statement of nationality and occupation. In the citation of a name in a heading, the use of parentheses indicates parts of the name that are not commonly used, while square brackets enclose variant names or spellings:

> **Castro, Carlos (Luis)**: full name Carlos Luis Castro, referred to as Carlos Castro
> **Castro, C(arlos) L(uis)**: full name Carlos Luis Castro, referred to as C. L. Castro
> **Echave** [Chávez]: the family name Echave has the alternative version of Chávez
> **López** [neé García], **María**: López is María García's married name, by which she is generally known
> **Martínez, Antonio** [Soto, Arturo]: Arturo Soto is known chiefly by his pseudonym of Antonio Martínez
> **Soto, Arturo** [pseud. Martínez, Antonio]: Arturo Soto is referred to as such and is also known by the pseudonym of Antonio Martínez

Places of birth and death are cited according to the name current during the subject's lifetime, followed by the modern name, where that is different:

> (*b* La Plata [now Sucre], . . .)

Statements of places and dates of birth and death are given with as much precision as the evidence allows and may be replaced or supplemented by dates of baptism (*bapt*) or burial (*bur*). Where information is conjectural, a question mark is placed directly before the statement that it qualifies. Where dates of birth and death are unrecorded, but there is documentary evidence for the subject's activity between certain fixed dates, *floruit* (*fl*) dates are given; when such evidence is circumstantial, this is cited as '*fl c.*'.

If a subject changed nationality or country of activity, this is stated where significant, as may also be the subject's ancestry; otherwise this information is evident from the parenthesized matter after the heading or is conveyed in the text. The subject's nationality is followed by a definition of occupation, that is to say the activity (or activities) of art-historical significance that justified inclusion in the encyclopedia.

Biographies are generally structured to present information in chronological order. Longer biographies usually begin with a brief statement of the subject's significance and are then divided into sections, under such headings as 1. LIFE AND WORK. 2. STYLE AND IMAGERY. The biographies of two or more related artists or patrons and collectors are gathered in 'family' entries, alphabetized under the main form of the surname. Within a family article, individual members of significance have their own entries, beginning with an indented, numbered bold heading; for the second and subsequent members of the family, a statement of relationship to a previous member of the family is included wherever possible:

> **Lisboa**. Portuguese family of artists, active in Brazil.
> (1) **Manoel Francisca Lisboa** (*b*. . .; *d* . . .). Architect.
> (2) **Antônio Francisco Lisboa** (*b* . . .; *d* . . .). Architect and sculptor, son of (1) Manoel Francisco Lisboa.

The numbers allocated to family members are used in cross-references from other articles:

> 'He commissioned the architect Antônio Francisco Lisboa (see LISBOA, (2)) . . .' .

2. NON-BIOGRAPHICAL. As with biographies, the headings of all non-biographical articles provide variant spellings, transliterations etc. in square brackets, where relevant, followed by a definition. Longer articles are divided as appropriate for the topic and are provided with contents lists after the heading, introductory paragraph or each new major subheading. In all articles the hierarchy of subdivisions, from largest to smallest, is indicated by large roman numerals (I), arabic numerals (1), small roman numerals (i) and letters (a). A cross-reference within a long survey to another of its sections takes the form '*see* §I, 2(iii)(b) above'.

III. *Standard usages.*

For the sake of consistent presentation in this encyclopedia, certain standard usages, particularly in spelling and terminology, have been imposed throughout. In general, the rules of British orthography and punctuation have been applied, except that wherever possible original sources are followed for quoted matter and for specific names and titles. Many of the conventions adopted in this encyclopedia will become evident through use, for example the general abbreviations (which are listed on pp. xv-xx); some of the other editorial practices are explained below.

1. WORKS OF ART. Titles of works of art are generally cited in italics and by their English names. Some subjects, religious and mythological in particular, have been given standard titles throughout. The use of 'left' and 'right' in describing a work of art corresponds to the spectator's left and right. For locations of works of art *see* §V below.

2. FOREIGN TERMS AND TRANSLITERATION SYSTEMS. For citations of foreign language material, a basic reading knowledge of art historical terms in French, German, Italian and

Spanish has been assumed (although wherever there is an exact English equivalent of a foreign term this has been used). Foreign words that have gained currency in English are cited in roman type, whereas those that have not are italicized and are qualified with a brief definition, unless this is clear from the context. The conventions of capitalization in foreign languages are generally adhered to within italicized matter (e.g. book titles) but not in running, roman text for job titles, for names of institutions, professional bodies and associations and for recurring exhibitions. Abbreviations for foreign periodical titles cited in bibliographies (see §VII below) are capitalized, despite the relevant foreign language conventions.

3. MEASUREMENTS AND DIMENSIONS. All measurements are cited in metric, unless within quoted matter or if the archaic form is of particular historical interest. Where two dimensions are cited, height precedes width; for three dimensions, the order is height by width by depth. If only one dimension is given, it is qualified by the appropriate abbreviation for height, width, length, diameter etc.

IV. Cross-references.

This encyclopedia has been compiled in the spirit of creating an integrated and interactive whole, so that readers may gain the widest perspective on the topics in which they are interested. The cross-referencing system has been designed and implemented to guide the reader easily to the information required, as well as to complementary discussions of related material, and in some cases even to alternative views. External cross-references (i.e. those to a different heading) take several forms, all of which are distinguished by the use of small capital letters, with a large capital to indicate the initial letter of the entry to which the reader is directed. External cross-references appear exactly as the bold headings (excluding parenthesized matter) of the entries to which they refer, though in running text they are not inverted (e.g. 'He collaborated on the project with ROBERTO BURLE MARX...'). The phrases 'see', 'see under' and 'see also' are always italicized when referring to another entry or another section of a multipartite article in the encyclopedia; where the word 'see' appears in roman type, the reference is to an illustration within the article or to another publication).

Cross-references are used sparingly between articles to guide readers to further discussions or to articles they may not have considered consulting; thus within a phrase such as 'He was influenced by Orozco' there is not a cross-reference to OROZCO, whereas 'The French artistic commission organized by the Prince Regent... included the painters NICHOLAS-ANTOINE TAUNAY (for illustration *see* RIO DE JANEIRO) and JEAN-BAPTISTE DEBRET...' alerts the reader to useful discussions in the biographical entries and an illustration in the city article. Cross-references have also been used to direct the reader to additional bibliography.

Another type of cross-reference appears as a main bold heading, to direct the reader to the place in the dictionary where the subject is treated:

> **Escobar, Marisol.** *See* MARISOL.
> **Soler, Ignacio Nuñez.** *See* NUÑEZ SOLER, IGNACIO.
> **Oropesa.** *See* COCHABAMBA.
> **Aflalo, Roberto.** *See under* CROCE, AFLALO AND GASPERINI.
> **Guadeloupe.** *See under* ANTILLES, LESSER.

Some cross-references of this type include a short definition and guide the reader to a fuller discussion or illustration:

> **Carib.** One of several groups of Amerindian peoples inhabiting pockets of the Caribbean and northern countries of South America. They were particularly dominant

in the Lesser Antilles until the European colonies began to be established in the late 15th century.

For main discussion *see* ANTILLES, LESSER, §II, 1.

V. Locations of works of art.

For each work of art mentioned specifically, every attempt has been made to cite its correct present location. In general this information appears in an abbreviated form, in parentheses, directly after the first mention of the work. The standard abbreviations used for locations are readily understandable in their short forms and appear in full in Appendix A. Pieces that are on loan or on deposit are duly noted as such, as are works that are *in situ*. Works in private collections are usually followed by the citation of a published illustration or a catalogue raisonné number to assist in identification. Works for which the locations are unknown are cited as untraced or are supplied with the last known location or, in the case of pieces that appeared on the art market, are given the city, auction house or gallery name and, when known, the date of sale and lot number or a reference to a published illustration; works that are known to have been destroyed are so noted.

VI. Illustrations.

As often as possible, pictures have been integrated into the text of the article that they illustrate, and the wording of captions has been designed to emphasize the subject to which the picture is related. For an article with a single illustration, the textual reference appears as '(see fig.)'; multiple illustrations are numbered. References to colour plates are in the form '(see colour pl. XII, fig. 2)'. There are frequent cross-references to relevant illustrations appearing in other articles, and all captions have been indexed.

VII. Bibliographies and other sources.

All but the shortest of entries in the encyclopedia are followed by bibliographies and may also have sections on unpublished sources, writings, photographic publications or prints, and video recordings or films. These function both as guides to selected further reading and viewing and as acknowledgements of the sources consulted by authors. In some family entries and in longer surveys, bibliographies may be located directly after the introduction and/or at the end of each section. All bibliographies are chronologically arranged by the date of first edition (thus providing an abstract of the topic's historiography); longer bibliographies are divided into categories, in which the items are also in chronological order. Items published in the same year are listed alphabetically by authors' names and, where by the same author, alphabetically by title; items with named authors or editors take precedence over exhibition catalogues, which are cited by title first.

For books that have appeared in several editions, generally the earliest and the most recent have been cited (unless there was a particular reason to include an intermediate edition), and where page numbers are provided these refer to the most recent edition. Revisions are indicated by the abbreviation 'rev.', reprints with '*R*' and translations with 'trans.' prefaced by an abbreviation to indicate the language of the translation. Where the place or date of publication does not appear in a book this is rendered as 'n.p.' or 'n.d.' as appropriate; where this information can be surmised it appears in square brackets. Volume numbers usually appear in small roman numerals, both for citations from multi-volume publications and for periodicals; issue numbers of periodicals are in arabic numerals. The titles of periodicals are cited in abbreviated forms, a full list of which appears in Appendix B. Exhibition catalogues are provided with the name of the host location (not the place of publication) according to

the list of location abbreviations (*see* Appendix A). Collected papers from conferences and congresses are arranged chronologically by date of their oral presentation rather than by the date of their publication in hard copy. Dissertations are included in the bibliography sections (rather than as unpublished sources), with an abbreviated form of the degree (diss., MA, MPhil) and awarding institution; if available on microfilm, this is noted.

Lists of unpublished sources, apart from dissertations, include such material as manuscripts, inventories and diaries. They are organized alphabetically by the location of the holdings, with an indication of the contents given in square brackets. Lists of selected writings are included in biographies of subjects who wrote on art; these are ordered according to the same principles as the bibliographies. Sections of photographic publications and prints list published books or collections of work by the subject of the article.

Throughout the production time of this encyclopedia authors were asked to submit important new bibliography for addition to their articles. Some contributors did so, while others left updating to be done by the editors. For the additions that were made by the editorial staff, this may have resulted in the text of an article apparently failing to take into consideration the discoveries or opinions of the new publications; it was nevertheless felt useful to draw readers' attention to significant recent literature that has appeared since *The Dictionary of Art* was published in 1996.

VIII. Authors.

Signatures of authors, in the form of their choice, appear at the end of the article or subsection of an article that they contributed. Where two authors have jointly written an article, their names appear in alphabetical order:

CHARLES JONES, BETTY SMITH

If, however, Smith was the main author and was assisted or had her text amended by Jones, their signatures appear as:

BETTY SMITH, with CHARLES JONES

In the event that Jones assisted with only the bibliography to Smith's text, this would be acknowledged as:

BETTY SMITH (bibliography with CHARLES JONES)

Where an article or introduction was compiled by the editors or in the few cases where an author has wished to remain anonymous, this is indicated by a square box (☐) instead of a signature.

IX. Appendices.

Readers' attention is directed to the Appendices at the back of this volume. These comprise full lists of: abbreviated locations of works of art (A); abbreviated periodical titles (B); authors' names (C).

X. Index.

All articles and illustration captions in this encyclopedia have been indexed not only to provide page numbers of the main headings but also to pinpoint variant names and spellings and specific information within articles and captions.

Acknowledgements

The preparation of the 34 volumes of the *Dictionary of Art* (London and New York, 1996) represented an enormous collective effort, one that took over 14 years and involved literally a cast of thousands. By contrast, the *Encyclopedia of Latin American and Caribbean Art* has taken less than 14 months to prepare. To a large extent, however, we continue to be indebted to the same cast of thousands. We are particularly grateful to those former *TDA* contributors who updated their entries and approved their proofs within the very tight deadlines for this single volume.

Further formal acknowledgements are divided into three sections: outside advisers, in-house staff and other outside sources. Although, for reasons of space, we are unable to mention everyone who participated in the creation of the *Encyclopedia of Latin American and Caribbean Art* (whether before 1996 or during the past twelve months), we should like to express our thanks to all for their role in making this prize-winning scholarship available to an even wider public.

1. OUTSIDE ADVISERS AND CONSULTANTS.
Our first debt of gratitude must again go to the members of the distinguished Editorial Advisory Board to the *Dictionary of Art* for the guidance they provided on matters of general concept and approach. The editorial policy that they helped to shape will continue to inform all of the subsequent reference works that are derived from the *Dictionary*:

Prof. Emeritus Terukazu Akiyama (formerly of the University of Tokyo)
Prof. Carlo Bertelli (Université de Lausanne)
Prof. Whitney Chadwick (San Francisco State University)
Prof. André Chastel (formerly of the Collège de France) †
Prof. Oleg Grabar (Institute for Advanced Study, Princeton)
Prof. Francis Haskell (University of Oxford)
Prof. Alfonso E. Pérez Sánchez (formerly of the Museo del Prado, Madrid)
Prof. Robert Rosenblum (Institute of Fine Arts, New York University)
Dr Jessica Rawson (University of Oxford and formerly of the British Museum, London)
Prof. Willibald Sauerländer (formerly of the Zentralinstitut für Kunstgeschichte, Munich)
Mr Peter Thornton (formerly of the Sir John Soane's Museum, London)
Prof. Irene Winter (Harvard University, Cambridge, Massachusetts)

In addition, Mr John Bury offered guidance on our coverage of Latin American art.

2. EDITORIAL AND ADMINISTRATIVE STAFF. Among my editorial colleagues, I should like first to express my gratitude to my Deputy Editor, Diane Fortenberry, who has shared with me the responsibility of devising the Grove Library of World Art publishing programme

† deceased

and was solely responsible for the preparation of the *Encyclopedia of Latin American and Caribbean Art*. We are particularly indebted to Pauline Antrobus, who helped select the illustrations and who searched for bibliographical updates for each article. The task of implementing the editorial changes and updates was shared by Anya Serota, Octavia Nicholson and Gillian Northcott. Gillian, who supervised the creation of the original index of some three quarters of a million references for the *Dictionary of Art*, also expanded and updated the index for the present volume.

Although one volume is certainly easier to prepare than thirty-four, the administration of a project of even this size—with some 1200 entries, almost 500 illustrations and over 200 authors—is a formidable task. The entire *Dictionary of Art* text database is now stored electronically under the watchful eye of Richard Padley, who directed its conversion into an online product (the *Grove Dictionary of Art*, www.groveart.com), and we are grateful for his help in extracting the relevant articles for this volume. The illustrations database has been maintained by Veronica Gustavsson; for this volume, she was ably assisted on matters of sizing and electronic digitization by Fiona Moffat, who oversaw the early production stages before returning to her native New Zealand earlier this year. Following Fiona's departure, Sophie Durlacher, a former *Dictionary of Art* staff member, returned as Editorial Manager, once again applying her excellent project management skills. On the production side, we were fortunate to have the expert guidance and support of Publishing Services Manager Jeremy Macdonald, who was assisted in final stages by Senior Production Controller Claire Pearson. For the page makeup, it was a pleasure to work again with John Catchpole and his colleagues at William Clowes Ltd.

3. OTHER OUTSIDE SOURCES. Many people and organizations outside of the Macmillan editorial offices have provided generous help to us and to our contributors. We are grateful to the library staff of the University of Essex who provided excellent resources to Pauline Antrobus throughout her work on the project. Special thanks are owed to Matthew Gould, Acting Curator of the University of Essex Collection of Latin American Art, who provided access to works of art and arranged for them to be photographed by Ferdy Carabott. We are also grateful to several other photographic sources and copyright-holders who processed especially large orders from us, especially Art Resource, New York; the Art Museum of the Americas, Washington, DC; and the Jack S. Blanton Museum of Art, University of Texas, Austin. The colour plates were designed by Alison Nick and the book jacket cover by Lawrence Kneath; the maps were produced by Oxford Illustrators Ltd, who were also responsible for some of the line drawings. The specific sources for all images in the encyclopedia, both black-and-white and colour, are acknowledged in the list of picture credits.

General Abbreviations

The abbreviations employed throughout this encyclopedia, most of which are listed below, do not vary, except for capitalization, regardless of the context in which they are used, including bibliographical citations and for locations of works of art. The principle used to arrive at these abbreviations is that their full form should be easily deducible, and for this reason acronyms have generally been avoided (e.g. Los Angeles Co. Mus. A. instead of LACMA). The same abbreviation is adopted for cognate forms in foreign languages and in most cases for plural and adjectival forms (e.g. A.=Art, Arts. Arte, Arti etc.); not all related forms are listed below. For the reader's convenience, separate full lists of abbreviations for locations and periodical titles are included as Appendices A and B at the back of this volume.

A.	Art, Arts	ARA	Associate of the Royal Academy	BC	Before Christ
A.C.	Arts Council			BC	British Columbia (Canada)
Acad.	Academy	Arab.	Arabic	BE	Buddhist era
AD	Anno Domini	Archaeol.	Archaeology	Beds	Bedfordshire (GB)
Add.	Additional, Addendum	Archit.	Architecture, Architectural	Behav.	Behavioural
addn	addition	Archv, Archvs	Archive(s)	Belarus.	Belarusian
Admin.	Administration			Belg.	Belgian
Adv.	Advances, Advanced	Arg.	Argentine	Berks	Berkshire (GB)
Aesth.	Aesthetic(s)	ARHA	Associate of the Royal Hibernian Academy	Berwicks	Berwickshire (GB; old)
Afr.	African			BFA	Bachelor of Fine Arts
Afrik.	Afrikaans, Afrikaner	ARIBA	Associate of the Royal Institute of British Architects	Bibl.	Bible, Biblical
A.G.	Art Gallery			Bibliog.	Bibliography, Bibliographical
Agrar.	Agrarian	Armen.	Armenian	Biblioph.	Bibliophile
Agric.	Agriculture	ARSA	Associate of the Royal Scottish Academy	Biog.	Biography, Biographical
Agron.	Agronomy			Biol.	Biology, Biological
Agy	Agency	Asiat.	Asiatic	bk, bks	book(s)
AH	Anno Hegirae	Assist.	Assistance	Bkbinder	Bookbinder
A. Inst.	Art Institute	Assoc.	Association	Bklore	Booklore
AK	Alaska (USA)	Astron.	Astronomy	Bkshop	Bookshop
AL	Alabama (USA)	AT&T	American Telephone & Telegraph Company	BL	British Library
Alb.	Albanian			Bld	Build
Alg.	Algerian	attrib.	attribution, attributed to	Bldg	Building
Alta	Alberta (Canada)	Aug	August	Bldr	Builder
Altern.	Alternative	Aust.	Austrian	BLitt	Bachelor of Letters/Literature
a.m.	ante meridiem [before noon]	Austral.	Australian	BM	British Museum
Amat.	Amateur	Auth.	Author(s)	Boh.	Bohemian
Amer.	American	Auton.	Autonomous	Boliv.	Bolivian
An.	Annals	Aux.	Auxiliary	Botan.	Botany, Botanical
Anatol.	Anatolian	Ave.	Avenue	BP	Before present (1950)
Anc.	Ancient	AZ	Arizona (USA)	Braz.	Brazilian
Annu.	Annual	Azerbaij.	Azerbaijani	BRD	Bundesrepublik Deutschland [Federal Republic of Germany (West Germany)]
Anon.	Anonymous(ly)	B.	Bartsch [catalogue of Old Master prints]		
Ant.	Antique	b	born	Brecons	Breconshire (GB; old)
Anthol.	Anthology	BA	Bachelor of Arts	Brez.	Brezonek [lang. of Brittany]
Anthropol.	Anthropology	Balt.	Baltic	Brit.	British
Antiqua.	Antiquarian, Antiquaries	bapt	baptized	Bros	Brothers
app.	appendix	BArch	Bachelor of Architecture	BSc	Bachelor of Science
approx.	approximately	Bart	Baronet	Bucks	Buckinghamshire (GB)
AR	Arkansas (USA)	Bask.	Basketry	Bulg.	Bulgarian
		BBC	British Broadcasting Corporation		

Bull.	Bulletin	Colloq.	Colloquies	DE	Delaware (USA)
bur	buried	Colomb.	Colombian	Dec	December
Burm.	Burmese	Colon.	Colonies, Colonial	Dec.	Decorative
Byz.	Byzantine	Colr	Collector	ded.	dedication, dedicated to
C	Celsius	Comm.	Commission; Community	Democ.	Democracy, Democratic
C.	Century	Commerc.	Commercial	Demog.	Demography, Demographic
c.	*circa* [about]	Communic.	Communications	Denbs	Denbighshire (GB; old)
CA	California	Comp.	Comparative; compiled by, compiler	dep.	deposited at
Cab.	Cabinet			Dept	Department
Caerns	Caernarvonshire (GB; old)	Concent.	Concentration	Dept.	Departmental, Departments
C.A.G.	City Art Gallery	Concr.	Concrete	Derbys	Derbyshire (GB)
Cal.	Calendar	Confed.	Confederation	Des.	Design
Callig.	Calligraphy	Confer.	Conference	destr.	destroyed
Cam.	Camera	Congol.	Congolese	Dev.	Development
Cambs	Cambridgeshire (GB)	Congr.	Congress	Devon	Devonshire (GB)
can	canonized	Conserv.	Conservation; Conservatory	Dial.	Dialogue
Can.	Canadian	Constr.	Construction(al)	diam.	diameter
Cant.	Canton(s), Cantonal	cont.	continued	Diff.	Diffusion
Capt.	Captain	Contemp.	Contemporary	Dig.	Digest
Cards	Cardiganshire (GB; old)	Contrib.	Contributions, Contributor(s)	Dip. Eng.	Diploma in Engineering
Carib.	Caribbean	Convalesc.	Convalescence	Dir.	Direction, Directed
Carms	Carmarthenshire (GB; old)	Convent.	Convention	Directrt	Directorate
Cartog.	Cartography	Coop.	Cooperation	Disc.	Discussion
Cat.	Catalan	Coord.	Coordination	diss.	dissertation
cat.	catalogue	Copt.	Coptic	Distr.	District
Cath.	Catholic	Corp.	Corporation, Corpus	Div.	Division
CBE	Commander of the Order of the British Empire	Corr.	Correspondence	DLitt	Doctor of Letters/Literature
		Cors.	Corsican	DM	Deutsche Mark
Celeb.	Celebration	Cost.	Costume	Doc.	Document(s)
Celt.	Celtic	Cret.	Cretan	Doss.	Dossier
Cent.	Centre, Central	Crim.	Criminal	DPhil	Doctor of Philosophy
Centen.	Centennial	Crit.	Critical, Criticism	Dr	Doctor
Cer.	Ceramic	Croat.	Croatian	Drg, Drgs	Drawing(s)
cf.	confer [compare]	CT	Connecticut (USA)	DSc	Doctor of Science/Historical Sciences
Chap., Chaps	Chapter(s)	Cttee	Committee		
		Cub.	Cuban	Dut.	Dutch
Chem.	Chemistry	Cult.	Cultural, Culture	Dwell.	Dwelling
Ches	Cheshire (GB)	Cumb.	Cumberland (GB; old)	E.	East(ern)
Chil.	Chilean	Cur.	Curator, Curatorial, Curatorship	EC	European (Economic) Community
Chin.	Chinese				
Christ.	Christian, Christianity	Curr.	Current(s)	Eccles.	Ecclesiastical
Chron.	Chronicle	CVO	Commander of the [Royal] Victorian Order	Econ.	Economic, Economies
Cie	Compagnie [French]			Ecuad.	Ecuadorean
Cinema.	Cinematography	Cyclad.	Cycladic	ed.	editor, edited (by)
Circ.	Circle	Cyp.	Cypriot	edn	edition
Civ.	Civil, Civic	Czech.	Czechoslovak	eds	editors
Civiliz.	Civilization(s)	$	dollars	Educ.	Education
Class.	Classic, Classical	*d*	died	e.g.	*exempli gratia* [for example]
Clin.	Clinical	d.	denarius, denarii [penny, pence]	Egyp.	Egyptian
CO	Colorado (USA)			Elem.	Element(s), Elementary
Co.	Company; County	Dalmat.	Dalmatian	Emp.	Empirical
Cod.	Codex, Codices	Dan.	Danish	Emul.	Emulation
Col., Cols	Collection(s); Column(s)	DBE	Dame Commander of the Order of the British Empire	Enc.	Encyclopedia
Coll.	College			Encour.	Encouragement
collab.	in collaboration with, collaborated, collaborative	DC	District of Columbia (USA)	Eng.	English
		DDR	Deutsche Demokratische Republik [German Democratic Republic (East Germany)]	Engin.	Engineer, Engineering
Collct.	Collecting				

Engr., Engrs	Engraving(s)	ft	foot, feet	Human.	Humanities, Humanism
Envmt	Environment	Furn.	Furniture	Hung.	Hungarian
Epig.	Epigraphy	Futur.	Futurist, Futurism	Hunts	Huntingdonshire (GB; old)
Episc.	Episcopal	g	gram(s)	IA	Iowa
Esp.	Especially	GA	Georgia (USA)	ibid.	*ibidem* [in the same place]
Ess.	Essays	Gael.	Gaelic	ICA	Institute of Contemporary Arts
est.	established	Gal., Gals	Gallery, Galleries		
etc	*etcetera* [and so on]	Gaz.	Gazette	Ice.	Icelandic
Ethnog.	Ethnography	GB	Great Britain	Iconog.	Iconography
Ethnol.	Ethnology	Gdn, Gdns	Garden(s)	Iconol.	Iconology
Etrus.	Etruscan	Gdnr(s)	Gardener(s)	ID	Idaho (USA)
Eur.	European	Gen.	General	i.e.	*id est* [that is]
Evangel.	Evangelical	Geneal.	Genealogy, Genealogist	IL	Illinois (USA)
Exam.	Examination	Gent.	Gentleman, Gentlemen	Illum.	Illumination
Excav.	Excavation, Excavated	Geog.	Geography	illus.	illustrated, illustration
Exch.	Exchange	Geol.	Geology	Imp.	Imperial
Excurs.	Excursion	Geom.	Geometry	IN	Indiana (USA)
exh.	exhibition	Georg.	Georgian	in., ins	inch(es)
Exp.	Exposition	Geosci.	Geoscience	Inc.	Incorporated
Expermntl	Experimental	Ger.	German, Germanic	inc.	incomplete
Explor.	Exploration	G.I.	Government/General Issue (USA)	incl.	includes, including, inclusive
Expn	Expansion			Incorp.	Incorporation
Ext.	External	Glams	Glamorganshire (GB; old)	Ind.	Indian
Extn	Extension	Glos	Gloucestershire (GB)	Indep.	Independent
f, ff	following page, following pages	Govt	Government	Indig.	Indigenous
		Gr.	Greek	Indol.	Indology
F.A.	Fine Art(s)	Grad.	Graduate	Indon.	Indonesian
Fac.	Faculty	Graph.	Graphic	Indust.	Industrial
facs.	facsimile	Green.	Greenlandic	Inf.	Information
Fam.	Family	Gr.-Roman	Greco-Roman	Inq.	Inquiry
fasc.	fascicle	Gt	Great	Inscr.	Inscribed, Inscription
fd	feastday (of a saint)	Gtr	Greater	Inst.	Institute(s)
Feb	February	Guat.	Guatemalan	Inst. A.	Institute of Art
Fed.	Federation, Federal	Gym.	Gymnasium	Instr.	Instrument, Instrumental
Fem.	Feminist	h.	height	Int.	International
Fest.	Festival	ha	hectare	Intell.	Intelligence
fig.	figure (illustration)	Hait.	Haitian	Inter.	Interior(s), Internal
Fig.	Figurative	Hants	Hampshire (GB)	Interdiscip.	Interdisciplinary
figs	figures	Hb.	Handbook	intro.	introduced by, introduction
Filip.	Filipina(s), Filipino(s)	Heb.	Hebrew	inv.	inventory
Fin.	Finnish	Hell.	Hellenic	Inven.	Invention
FL	Florida (USA)	Her.	Heritage	Invest.	Investigation(s)
fl	*floruit* [he/she flourished]	Herald.	Heraldry, Heraldic	Iran.	Iranian
Flem.	Flemish	Hereford & Worcs	Hereford & Worcester (GB)	irreg.	irregular(ly)
Flints	Flintshire (GB; old)			Islam.	Islamic
Flk	Folk	Herts	Hertfordshire (GB)	Isr.	Israeli
Flklore	Folklore	HI	Hawaii (USA)	It.	Italian
fol., fols	folio(s)	Hib.	Hibernia	J.	Journal
Found.	Foundation	Hisp.	Hispanic	Jam.	Jamaican
Fr.	French	Hist.	History, Historical	Jan	January
frag.	fragment	HMS	His/Her Majesty's Ship	Jap.	Japanese
Fri.	Friday	Hon.	Honorary, Honourable	Jav.	Javanese
FRIBA	Fellow of the Royal Institute of British Architects	Horiz.	Horizon	Jew.	Jewish
		Hort.	Horticulture	Jewel.	Jewellery
FRS	Fellow of the Royal Society, London	Hosp.	Hospital(s)	Jord.	Jordanian
		HRH	His/Her Royal Highness	jr	junior

Juris.	Jurisdiction	MD	Doctor of Medicine; Maryland (USA)	Mt	Mount	
KBE	Knight Commander of the Order of the British Empire	ME	Maine (USA)	Mthly	Monthly	
		Mech.	Mechanical	Mun.	Municipal	
KCVO	Knight Commander of the Royal Victorian Order	Med.	Medieval; Medium, Media	Mus.	Museum(s)	
		Medic.	Medical, Medicine	Mus. A.	Museum of Art	
kg	kilogram(s)	Medit.	Mediterranean	Mus. F.A.	Museum of Fine Art(s)	
kHz	kilohertz	Mem.	Memorial(s); Memoir(s)	Music.	Musicology	
km	kilometre(s)	Merions	Merionethshire (GB; old)	N.	North(ern); National	
Knowl.	Knowledge	Meso-Amer.	Meso-American	n	refractive index of a medium	
Kor.	Korean			n.	note	
KS	Kansas (USA)	Mesop.	Mesopotamian	N.A.G.	National Art Gallery	
KY	Kentucky (USA)	Met.	Metropolitan	Nat.	Natural, Nature	
Kyrgyz.	Kyrgyzstani	Metal.	Metallurgy	Naut.	Nautical	
£	libra, librae [pound, pounds sterling]	Mex.	Mexican	NB	New Brunswick (Canada)	
		MFA	Master of Fine Arts	NC	North Carolina (USA)	
l.	length	mg	milligram(s)	ND	North Dakota (USA)	
LA	Louisiana (USA)	Mgmt	Management	n.d.	no date	
Lab.	Laboratory	Mgr	Monsignor	NE	Nebraska; Northeast(ern)	
Lancs	Lancashire (GB)	MI	Michigan	Neth.	Netherlandish	
Lang.	Language(s)	Micrones.	Micronesian	Newslett.	Newsletter	
Lat.	Latin	Mid. Amer.	Middle American	Nfld	Newfoundland (Canada)	
Latv.	Latvian	Middx	Middlesex (GB; old)	N.G.	National Gallery	
lb, lbs	pound(s) weight	Mid. E.	Middle Eastern	N.G.A.	National Gallery of Art	
Leb.	Lebanese	Mid. Eng.	Middle English	NH	New Hampshire (USA)	
Lect.	Lecture	Mid Glam.	Mid Glamorgan (GB)	Niger.	Nigerian	
Legis.	Legislative	Mil.	Military	NJ	New Jersey (USA)	
Leics	Leicestershire (GB)	Mill.	Millennium	NM	New Mexico (USA)	
Lex.	Lexicon	Min.	Ministry; Minutes	nm	nanometre (10^{-9} metre)	
Lg.	Large	Misc.	Miscellaneous	nn.	notes	
Lib., Libs	Library, Libraries	Miss.	Mission(s)	no., nos	number(s)	
Liber.	Liberian	Mlle	Mademoiselle	Nord.	Nordic	
Libsp	Librarianship	mm	millimetre(s)	Norm.	Normal	
Lincs	Lincolnshire (GB)	Mme	Madame	Northants	Northamptonshire (GB)	
Lit.	Literature	MN	Minnesota	Northumb.	Northumberland (GB)	
Lith.	Lithuanian	Mnmt, Mnmts	Monument(s)	Norw.	Norwegian	
Liturg.	Liturgical			Notts	Nottinghamshire (GB)	
LLB	Bachelor of Laws	Mnmtl	Monumental	Nov	November	
LLD	Doctor of Laws	MO	Missouri (USA)	n.p.	no place (of publication)	
Lt	Lieutenant	Mod.	Modern, Modernist	N.P.G.	National Portrait Gallery	
Lt-Col.	Lieutenant-Colonel	Moldav.	Moldavian	nr	near	
Ltd	Limited	Moldov.	Moldovan	Nr E.	Near Eastern	
m	metre(s)	MOMA	Museum of Modern Art	NS	New Style; Nova Scotia (Canada)	
m.	married	Mon.	Monday			
M.	Monsieur	Mongol.	Mongolian	n. s.	new series	
MA	Master of Arts; Massachusetts (USA)	Mons	Monmouthshire (GB; old)	NSW	New South Wales (Australia)	
		Montgoms	Montgomeryshire (GB; old)	NT	National Trust	
Mag.	Magazine	Mor.	Moral	Ntbk	Notebook	
Maint.	Maintenance	Morav.	Moravian	Numi.	Numismatic(s)	
Malay.	Malaysian	Moroc.	Moroccan	NV	Nevada (USA)	
Man.	Manitoba (Canada); Manual	Movt	Movement	NW	Northwest(ern)	
Manuf.	Manufactures	MP	Member of Parliament	NWT	Northwest Territories (Canada)	
Mar.	Marine, Maritime	MPhil	Master of Philosophy			
Mason.	Masonic	MS	Mississippi (USA)	NY	New York (USA)	
Mat.	Material(s)	MS., MSS	manuscript(s)	NZ	New Zealand	
Math.	Mathematic	MSc	Master of Science	OBE	Officer of the Order of the British Empire	
MBE	Member of the Order of the British Empire	MT	Montana (USA)			
				Obj.	Object(s), Objective	

Occas.	Occasional	Physiol.	Physiology	red.	reduction, reduced for
Occident.	Occidental	Pict.	Picture(s), Pictorial	Ref.	Reference
Ocean.	Oceania	pl.	plate; plural	Refurb.	Refurbishment
Oct	October	Plan.	Planning	*reg*	*regit* [ruled]
8vo	octavo	Planet.	Planetarium	Reg.	Regional
OFM	Order of Friars Minor	Plast.	Plastic	Relig.	Religion, Religious
OH	Ohio (USA)	pls	plates	remod.	remodelled
OK	Oklahoma (USA)	p.m.	post meridiem [after noon]	Ren.	Renaissance
Olymp.	Olympic	Polit.	Political	Rep.	Report(s)
OM	Order of Merit	Poly.	Polytechnic	repr.	reprint(ed); reproduced, reproduction
Ont.	Ontario (Canada)	Polynes.	Polynesian	Represent.	Representation, Representative
op.	opus	Pop.	Popular	Res.	Research
opp.	opposite; opera [pl. of opus]	Port.	Portuguese	rest.	restored, restoration
OR	Oregon (USA)	Port.	Portfolio	Retro.	Retrospective
Org.	Organization	Posth.	Posthumous(ly)	rev.	revision, revised (by/for)
Orient.	Oriental	Pott.	Pottery	Rev.	Reverend; Review
Orthdx	Orthodox	POW	prisoner of war	RHA	Royal Hibernian Academician
OSB	Order of St Benedict	PRA	President of the Royal Academy	RI	Rhode Island (USA)
Ott.	Ottoman	Pract.	Practical	RIBA	Royal Institute of British Architects
Oxon	Oxfordshire (GB)	Prefect.	Prefecture, Prefectural	RJ	Rio de Janeiro State
oz.	ounce(s)	Preserv.	Preservation	Rlwy	Railway
p	pence	prev.	previous(ly)	RSA	Royal Scottish Academy
p., pp.	page(s)	priv.	private	RSFSR	Russian Soviet Federated Socialist Republic
PA	Pennsylvania (USA)	PRO	Public Record Office	Rt Hon.	Right Honourable
p.a.	per annum	Prob.	Problem(s)	Rur.	Rural
Pak.	Pakistani	Proc.	Proceedings	Rus.	Russian
Palaeontol.	Palaeontology, Palaeontological	Prod.	Production	S	San, Santa, Santo, Sant', São [Saint]
Palest.	Palestinian	Prog.	Progress	S.	South(ern)
Pap.	Paper(s)	Proj.	Project(s)	s.	solidus, solidi [shilling(s)]
para.	paragraph	Promot.	Promotion	Sask.	Saskatchewan (Canada)
Parag.	Paraguayan	Prop.	Property, Properties	Sat.	Saturday
Parl.	Parliament	Prov.	Province(s), Provincial	SC	South Carolina (USA)
Paroch.	Parochial	Proven.	Provenance	Scand.	Scandinavian
Patriarch.	Patriarchate	Prt, Prts	Print(s)	Sch.	School
Patriot.	Patriotic	Prtg	Printing	Sci.	Science(s), Scientific
Patrm.	Patrimony	pseud.	pseudonym	Scot.	Scottish
Pav.	Pavilion	Psych.	Psychiatry, Psychiatric	Sculp.	Sculpture
PEI	Prince Edward Island (Canada)	Psychol.	Psychology, Psychological	SD	South Dakota (USA)
Pembs	Pembrokeshire (GB; old)	pt	part	SE	Southeast(ern)
Per.	Period	Ptg(s)	Painting(s)	Sect.	Section
Percep.	Perceptions	Pub.	Public	Sel.	Selected
Perf.	Performance, Performing, Performed	pubd	published	Semin.	Seminar(s), Seminary
Period.	Periodical(s)	Publ.	Publicity	Semiot.	Semiotic
Pers.	Persian	pubn(s)	publication(s)	Semit.	Semitic
Persp.	Perspectives	PVA	polyvinyl acetate	Sept	September
Peru.	Peruvian	PVC	polyvinyl chloride	Ser.	Series
PhD	Doctor of Philosophy	Q.	quarterly	Serb.	Serbian
Philol.	Philology	4to	quarto	Serv.	Service(s)
Philos.	Philosophy	Qué.	Québec (Canada)	Sess.	Session, Sessional
Phoen.	Phoenician	*R*	reprint	Settmt(s)	Settlement(s)
Phot.	Photograph, Photography, Photographic	*r*	*recto*	S. Glam.	South Glamorgan (GB)
Phys.	Physician(s), Physics, Physique, Physical	RA	Royal Academician	Siber.	Siberian
		Radnors	Radnorshire (GB; old)		
Physiog.	Physiognomy	RAF	Royal Air Force	Sig.	Signature
		Rec.	Record(s)		

Sil.	Silesian	Tech.	Technical, Technique	USA	United States of America
Sin.	Singhala	Technol.	Technology	USSR	Union of Soviet Socialist Republics
sing.	singular	Territ.	Territory		
SJ	Societas Jesu [Society of Jesus]	Theat.	Theatre	UT	Utah
Skt	Sanskrit	Theol.	Theology, Theological	*v*	*verso*
Slav.	Slavic, Slavonic	Theor.	Theory, Theoretical	VA	Virginia (USA)
Slov.	Slovene, Slovenian	Thurs.	Thursday	V&A	Victoria and Albert Museum
Soc.	Society	Tib.	Tibetan	Var.	Various
Social.	Socialism, Socialist	TN	Tennessee (USA)	Venez.	Venezuelan
Sociol.	Sociology	Top.	Topography	Vern.	Vernacular
Sov.	Soviet	Trad.	Tradition(s), Traditional	Vict.	Victorian
SP	São Paulo State	trans.	translation, translated by; transactions	Vid.	Video
Sp.	Spanish			Viet.	Vietnamese
sq.	square	Transafr.	Transafrican	viz.	*videlicet* [namely]
sr	senior	Transatlant.	Transatlantic	vol., vols	volume(s)
Sri L.	Sri Lankan	Transcarpath.	Transcarpathian	vs.	versus
SS	Saints, Santi, Santissima, Santissimo, Santissimi; Steam ship	transcr.	transcribed by/for	VT	Vermont (USA)
		Triq.	Triquarterly	Vulg.	Vulgarisation
		Tropic.	Tropical	W.	West(ern)
SSR	Soviet Socialist Republic	Tues.	Tuesday	w.	width
St	Saint, Sankt, Sint, Szent	Turk.	Turkish	WA	Washington (USA)
Staffs	Staffordshire (GB)	Turkmen.	Turkmenistani	Warwicks	Warwickshire (GB)
Ste	Sainte	TV	Television	Wed.	Wednesday
Stud.	Study, Studies	TX	Texas (USA)	W. Glam.	West Glamorgan (GB)
Subalp.	Subalpine	U.	University	WI	Wisconsin (USA)
Sum.	Sumerian	UK	United Kingdom of Great Britain and Northern Ireland	Wilts	Wiltshire (GB)
Sun.	Sunday			Wkly	Weekly
Sup.	Superior			W. Midlands	West Midlands (GB)
suppl., suppls	supplement(s), supplementary	Ukrain.	Ukrainian		
		Un.	Union	Worcs	Worcestershire (GB; old)
Surv.	Survey	Underwtr	Underwater	Wtrcol.	Watercolour
SW	Southwest(ern)	UNESCO	United Nations Educational, Scientific and Cultural Organization	WV	West Virginia (USA)
Swed.	Swedish			WY	Wyoming (USA)
Swi.	Swiss			Yb., Y.-b.	Yearbook, Year-book
Symp.	Symposium	Univl	Universal	Yem.	Yemeni
Syr.	Syrian	unpubd	unpublished	Yorks	Yorkshire (GB; old)
Tap.	Tapestry	Urb.	Urban	Yug.	Yugoslavian
Tas.	Tasmanian	Urug.	Uruguayan	Zamb.	Zambian
		US	United States	Zimb.	Zimbabwean

A Note on the Use of the Encyclopedia

This note is intended as a short guide to the basic editorial conventions adopted in this encyclopedia. For a fuller explanation, please refer to the Introduction.

Abbreviations in general use in the encyclopedia are listed on pp. xv–xx; those used in bibliographies and for locations of works of art or exhibition venues are listed in the Appendices.

Alphabetization of headings, which are distinguished in bold typeface, is letter by letter up to the first comma (ignoring spaces, hyphens, accents, and any parenthetized or bracketed matter); the same principle applies thereafter. Headings with the prefix 'Mc' appear under 'Mac'.

Authors' signatures appear at the end of the article or section of an article that the authors have contributed. Where the article was compiled by the editors or in the few cases where an author has wished to remain anonymous, this is indicated by a square box (□) instead of a signature.

Bibliographies are arranged chronologically (within section, where divided) by order of the year first publication and, within years, alphabetically by authors' names. Abbreviations have been used for some periodical titles (Appendix B).

Cross-references are distinguished by the use of small capital letters, with a large capital to indicate the initial letter of the entry to which the reader is directed; for example . 'He commissioned JOSÉ CLEMENTE OROZCO . . .' means that the entry is alphabetized under 'O'.

A

Abela, Eduardo (*b* San Antonio de los Baños, nr Güines, 1889; *d* Havana, 1965). Cuban painter and caricaturist. He graduated from the Academia de S Alejandro in Havana in 1920 and lived in Paris from 1927 to 1929. There he studied at the Académie de la Grande Chaumière and abandoned academicism, developing a modernist 'Cuban' style, in which folkloric scenes of peasant life were depicted in a colourful, energetic, pseudo-naive manner reminiscent of Jules Pascin and Amedeo Modigliani. An outstanding work of this period is *Triumph of the Rumba* (*c.* 1928; Havana, Mus. N. B.A.). After a trip to Italy in the early 1930s, Abela began to paint canvases such as *Guajiros* ('Peasants'; 1938; Havana, Mus. N. B.A.), in which the Classical sobriety and order is the result of his contact with Italian medieval and Renaissance art. His style underwent a radical change in the early 1950s, and from this time until his death he painted small works that recall in their use of fantasy the drawings of children as well as the works of Marc Chagall.

Abela was a noted caricaturist early in his career, which contributed to the informal, whimsical quality of his painting. His most famous cartoon series, *The Fool*, helped bring about the overthrow of the Machado regime in Cuba in 1933.

BIBLIOGRAPHY

L. de la Torriente: 'El mundo ensoñado de Abela', *Rev. Inst. N. Cult.*, i/1 (1956), pp. 41–56

O. Hurtado and others: *Pintores cubanos* (Havana, 1962)

Abela: Magic and Fable (exh. cat., ed. C. Luis; Miami, FL, Cub. Mus. A. & Cult., 1983)

L. Camnitzer: *New Art of Cuba* (Austin, 1994)

J. A. Martínez: *Cuban Art and National Identity: The Vanguardia Painters, 1927–1950* (Gainsville, 1994)

N. G. Menocal: 'An Overriding Passion: The Quest for a National Identity in Painting', *J. Dec. & Propaganda A.*, xxii (1996), pp. 187–219

GIULIO V. BLANC

Abrahams, Carl (*b* St Andrew, 1913). Jamaican painter. He began his career as a cartoonist for various local periodicals. In 1937 Augustus John, then working in Jamaica, encouraged him to begin painting. Unlike the majority of his contemporaries, he eschewed the 'official' classes of the Institute of Jamaica and virtually taught himself to paint through self-study courses and manuals and by copying masterpieces from art books. His cartoonist's wit and a sardonic humour became the most important ingredients in work that drew on numerous stylistic sources, from Renaissance painting to Cubism. He was a devout Christian, and produced a host of religious works of an undeniable sincerity, although he transformed many

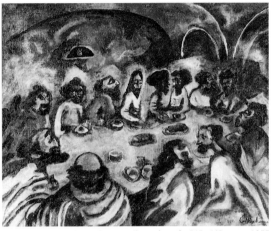

Carl Abrahams: *Last Supper*, oil on board, 545×665 mm, 1955 (Kingston, National Gallery)

traditional Christian themes into witty contemporary parables. His *Last Supper* (see fig.) is the best known of these. Some of his finest work consists of ironic transformations of the great mythological themes of the past and intensely personal fantasies based on contemporary events. He was also one of the few painters to treat successfully historical Jamaican subjects, for example in paintings of the imagined daily lives of the extinct Arawaks, the landing of Columbus, and a series depicting the riotous living of 17th-century buccaneers in Port Royal. His *Destruction of Port Royal* (*c.* 1970; Kingston, N.G.) is a dramatic portrayal of that cataclysmic event. In 1985 he won a competition to create two murals for the Norman Manley Airport in Kingston. The murals successfully combine many of his thematic interests into a montage celebrating Jamaican life and history.

BIBLIOGRAPHY

Carl Abrahams: A Retrospective (exh. cat. by D. Boxer, Kingston, Inst. Jamaica, N.G., 1975)

D. Boxer and V. Poupeye: *Modern Jamaican Art* (Kingston, 1998)

V. Poupeye: *Caribbean Art* (London, 1998)

DAVID BOXER

Abramo, Livio (*b* Araraquara, 1903). Brazilian printmaker and teacher. He worked initially as a printmaker and painter until 1933 when, influenced by Lasar Segall's expressionism, he abandoned painting for wood-engraving, which he had first practised in São Paulo *c.* 1926. He initially treated social themes such as the São Paulo working

class. Between 1935 and 1938 he produced a series of wood-engravings, *Spain*, based on the Spanish Civil War, for example *War* (1937; U. São Paulo, Inst. Estud. Bras.). In 1950 he won a trip abroad from the Salão Nacional de Belas Artes, Rio de Janeiro, and visited Italy, Switzerland, France and the Netherlands. On his return he made the series of wood-engravings, *Rio*, with scenes and landscapes characterized by a frank lyricism. This lyricism can be seen also in works such as *Untitled* (1955; see fig.). He was named best national engraver in the first São Paulo Bienal in 1951. His constant activity as a teacher influenced many younger engravers. In 1957 he founded the Julian de la Herreria engraving workshop in Asunción, Paraguay, and in 1960 the Estúdio Gravura in São Paulo. From 1962 he lived in Asunción, where he became director of the Centro de Estudos Brasileiros. In later years his work tended towards a geometrization of space as in the series on rain and on groups of Paraguayan houses, for instance *Paraguay* (1962; São Paulo, E. Wolf priv. col.; see exh. cat., pl. 112). He had a large retrospective in 1977 in the Museu de Arte Moderna in São Paulo.

BIBLIOGRAPHY
S. Milliet: *Pintores e pinturas* (São Paulo, 1940)
J. R. Teixeira Leite: *A gravura brasileira contemporânea* (Rio de Janeiro, 1965)

Livio Abramo: *Untitled*, woodcut, 300×225 mm, 1955 (Colchester, University of Essex, Collection of Latin American Art)

Art of Latin America since Independence (exh. cat. by S. L. Catlin and T. Grieder, New Haven, CT, Yale U. A.G.; Austin, U. TX, A. Mus.; San Francisco, CA, Mus. A.; La Jolla, CA, A. Cent.; 1966)
ROBERTO PONTUAL

Abreu, Mario (*b* Turmero, nr Maracay, 22 Aug 1919; *d* Caracas, 20 Feb 1993). Venezuelan painter and sculptor. From 1943 to 1947 he studied drawing and painting in the Escuela de Artes Plásticas y Aplicadas, Caracas. He was a founder-member of the Taller Libre de Arte, taking part in its activities from 1949 to 1952. His paintings, always within a figurative framework, are marked by a pursuit of the magical and of indigenous roots. In his early work he was interested in the themes of roosters and flowers, using the surrounding environment as a source of inspiration. He expressed human, animal and vegetable existence in strong, warm colours (e.g. *The Rooster*, 1951; Caracas, Gal. A. N.). In 1952 Abreu moved to Europe, visiting Spain and Italy and living in Paris until 1962, when he returned to Venezuela. In Europe his contact with the Musée de l'Homme in Paris and with Surrealism produced a profound transformation in his work. He created his first *Magical Objects* in 1960, and he continued to make these throughout the 1960s, in circular and rectangular forms and with varied subject-matter made out of domestic and industrial materials, including refuse. The best known of these objects are *Souvenir of Hiroshima* (*c.* 1965) and *I, Mario, the Planet Hopper* (1966; both Caracas, Gal. A. N.).

BIBLIOGRAPHY
A. Boulton: *Historia de la pintura en Venezuela*, ii (Caracas, 1972)
J. Calzadilla: *Pintura venezolana de los siglos XIX y XX* (Caracas, 1975)
Pinturas y objetos: Mario Abreu (exh. cat., ed. Binev; Maracay, Gal. Mun. A., 1990)
Mario Arbeu (exh. cat., Caracas, Mus. Arturo Michelana, 1994)
MARÍA ANTONIA GONZÁLEZ-ARNAL

Abularach, Rodolfo (*b* Guatemala, 7 Jan 1933). Guatemalan painter and printmaker. From 1954 to 1957 he studied at the Escuela Nacional de Artes Plásticas in Guatemala City while researching folk art for the Dirección de Bellas Artes, but he was virtually self-taught and began as a draughtsman and painter of bullfighting scenes. In 1958 he travelled to New York on a Guatemalan government grant, prolonging his stay there with further grants, studying at the Arts Students League and Graphic Art Center and finally settling there permanently. He was influential in Guatemala until *c.* 1960, but because of his long residence abroad his work did not fit easily in the context of Central American art. Before leaving Guatemala he had painted landscapes and nudes in a naturalistic style, but he soon adopted a more modern idiom partly inspired by aboriginal Guatemalan subjects. After moving to New York, and especially from 1958 to 1961, his art underwent a profound transformation as he sought to bring together elements of abstract art and Surrealism and experimented with textures, for example in cross-hatched pen-and-ink drawings such as *Fugitive from a Maya Lintel* (see fig.). Later he simplified his art and turned his attention to light as a substance emanating from within his works. In the 1980s he began to paint large landscapes characterized by a magical symbolism.

BIBLIOGRAPHY
R. González-Goyri: 'El arte guatemalteco en el Museo de Arte Moderno de Nueva York: III. Rodolfo Abularach', *Salón 13*, i/3 (Aug 1960), pp. 43–56

Rodolfo Abularach: *Fugitive from a Maya Lintel*, pen and ink, 685×965 mm, 1958 (Washington, DC, Art Museum of the Americas)

L. Méndez Dávila: *Arte vanguardia Guatemala* (Guatemala City, 1969), pp. vii–viii
R. Cabrera: *Rodolfo Abularach: Artista testimonial* (Guatemala City, 1971)
A. Pizarro: 'Rodolfo Abularach: Ojos primordiales', *Rev. Pensam. Centroamer.*, xxxi/152 (1976), pp. 120–33
R. Díaz Castillo: *Visión del arte contemporáneo en Guatemala*, ii (Guatemala City, 1995)
D. Quiñónez de Tock: 'Rodolfo Abularach', *Banca Cent.*, xxvii (1995), pp. 137–54
Guatemala: Arte Contemporáneo (Antigua, 1997), pp. 21–4

JORGE LUJÁN-MUÑOZ

Aceves Navarro, Gilberto (*b* Mexico City, 24 Sept 1931). Mexican painter. He studied at the Escuela Nacional de Pintura y Escultura 'La Esmeralda' under Enrique Assad Lara and Carlos Orozco Romero. His work reflects a concern for the negative effects of industrialization and modernization on cities and displays a nostalgia for more humane urban conditions. His large-scale paintings, for example the *Boots of the Gran Solar* (oil on canvas, 1.60×1.80 m, 1982; artist's col.), convey a sense of urgency through the use of light and colour, with broad lines and chromatic tones creating dynamic forms that show the influence of Abstract Expressionism.

BIBLIOGRAPHY
Siete pintores contemporáneos: Gilberto Aceves Navarro, Luis López Loza, Rodolfo Nieto, Brian Nissen, Tomás Parra, Vlady, Roger von Gunten (exh. cat., Mexico City, Pal. B.A., 1977)
R. Tibol: *Aceves Navarro, Durero y las variaciones* (Mexico City, 1978)
M. Idalia: 'Más libertad y menos barroquismo en la nueva pintura de Aceves Navarro' [Greater freedom and less extravagance in the new painting of Aceves Navarro], *Excelsior* (13 Sept 1979), p. 1B

S. Alatriste: *La intuición primitiva* (Mexico City, 1986)
Pintura mexicana, 1950–1980: Gilberto Aceves Navarro, Raúl Anguiano... (exh. cat. by T. del Conde and others, Mexico City, Mus. José Luis Cuevas, 1990)

JULIETA ORTIZ GAITÁN

Acosta, Wladimiro [Konstantinovsky, Wladimir] (*b* Odessa, Russia, 23 June 1900; *d* Buenos Aires, 11 July 1967). Argentine architect. He studied architecture at the Istituto di Belle Arti in Rome, graduating in 1919. From 1922 he worked in Germany, gaining experience in building engineering and urban design, before moving to Argentina in 1928. He worked in Chile, Uruguay, Brazil, Venezuela, Guatemala and, from 1954 to 1957, in the USA, where he taught (1956) at Cornell University, Ithaca, NY. On his return to Argentina he was appointed Professor of Architectural Composition (1957–66) at the Universidad de Buenos Aires. Acosta was an early exponent of an approach to architecture through environmental design and engineering, which he promoted through his book *Vivienda y clima* (1937) and his 'Helios' buildings. These were based upon correct orientation, cross-ventilation, and the control of solar radiation by means of *brises-soleil*, with minimal mechanical intervention. Like the architects of the Modern Movement in Europe, he saw architecture as a social phenomenon and became dedicated to the provision of mass housing for rapidly growing urban populations. His early work included individual houses in Buenos Aires, for example the Casa Stern, Ramos Mejía (1939), the 'Helios' villa (1943) at La Falda, and others

elsewhere in Argentina, at Rosario, Córdoba, Bahia Bianca and Bariloche. He also designed a psychiatric hospital (1942) at Santa Fé, but he is principally known for his multi-storey 'Helios' building: Departamentos de Figueroa Alcorta y Tagle (1942–3) and Co-operativa El Hogar Obrero workers' housing (1954; with Fermin Bereterbide and A. Felici), Avenida Rivadavia y Riglos, Buenos Aires, a slim, 24-storey slab block on a two-storey podium. Acosta's buildings are simple and astylar in the early Modern Movement genre, although expressive of the principles of solar control.

WRITINGS

Vivienda y clima (Buenos Aires, 1937)
Vivienda y ciudad (Buenos Aires, 1947)
'Villa à La Falda', *Archit. Aujourd'hui* (Sept 1948), pp. 62–3

BIBLIOGRAPHY

F. Bullrich: *Arquitectura Argentina contemporánea* (Buenos Aires, 1963)
S. Borghini, H. Salama and J. Solsona: *1930–1950: Arquitectura moderna en Buenos Aires* (Buenos Aires, 1987), pp. 30–37, 99–101

LUDOVICO C. KOPPMANN

Aflalo, Roberto. *See under* CROCE, AFLALO AND GASPERINI.

African diaspora. The African diaspora is principally a result of the slave trade, in the course of which millions of Africans were deported to the Americas and elsewhere. On a smaller scale, many other factors have contributed to the presence of active African cultural traditions outside Africa itself.

1. Historical introduction. 2. Architecture. 3. Sculpture. 4. Mask and masquerade. 5. Textiles. 6. Other arts.

1. HISTORICAL INTRODUCTION. Because African cultures have been misrepresented, many people, including many African Americans, believe that the slaves came from cultures so 'primitive' that they had nothing worth bringing to the New World and even welcomed Western technology as superior. Scholars have attempted to remedy this situation by showing the strength, beauty and complexity of African cultures so long denigrated in order to justify slavery. Anthropological and historical research has brought to light ample evidence of just how much of their intellectual and aesthetic traditions the enslaved Africans were able to preserve and transport intact and to re-establish in the New World. With little privacy and less power, the Africans managed to retain both those aspects of their cultures that their masters did not know or care about (i.e. religious beliefs, medical practices and folklore) and those which their masters needed or enjoyed (i.e. tool- and weapon-making, woodworking, weaving and other textile arts, narrative, music, dance and cuisine). Furthermore, it has become apparent that some of the slaves knew more about tropical agriculture than did their masters, while others possessed technical and artistic skills comparable to or surpassing those of their European counterparts.

In evaluating the evidence, M. J. Herskovits (1941) suggested that the Africans were able to retain fully some African traits, while many other traits were reinterpreted or modified, and a few were blended or syncretized with local practices. All cultures, even the most conservative, are open to innovation, and the enslaved Africans, facing up to one of the cruellest displacements in human history, were eager to grasp any appropriate practice, object or opportunity, from whatever source, that might alleviate their predicament. Thus while preserving the best, most beloved and most useful from Africa, they were far from conservative and adapted more or less willingly not only many Western culture traits, notably in language and religion, but also a considerable number from Native Americans.

Sub-Saharan African slaves were known in ancient Egypt, Classical Greece (Aesop the fable-teller is thought to have been an African slave) and Rome. With the rise of Islam in the 8th century AD they spread across North Africa and the Near East and from there were taken with the Mughals into India, where some, such as the Siddis of Janjira and the Habshis of Gujarat, became mercenaries and established states (Harris, 1982). Domestic slavery through debt, crime or capture was widespread within African societies, and after the arrival of the Europeans in the mid-15th century Africans were again brought in significant numbers to Europe; this explains the presence of African faces in Spanish and other European paintings. The Atlantic slave trade began early in the 17th century, transporting Africans first to the Atlantic and Indian Ocean islands and then widely throughout the Americas until as late as 1888, when slavery was finally outlawed in Brazil.

The extensive documents of the slave trade analysed by P. D. Curtin demonstrate that virtually all Africans in the New World came either from West Africa (from Senegal to Nigeria) or from west Central Africa (present-day Congo, Zaïre and Angola), nearly always from within 300 km of the coast; only a few were brought from Southern or East Africa. For Europeans, slavery was a means of servicing a huge new market. The burgeoning plantations of the New World required cheap labour to produce sugar, cotton and other valuable crops. Although Europeans sometimes raided the coast for slaves themselves, it was easier and cheaper for them to encourage the local African states, some (such as Asante, Dahomey and Benin) built on slavery, to war among themselves in order to capture prisoners to be traded for guns, ammunition, liquor, cloth and other European trade goods. Thus most of the New World Africans came from those parts of Africa with the heaviest populations and the most developed technology. They can claim kinship with the Asante, Fanti, Baule and other Akan-speaking peoples, with the Ewe of Togo, the Fon, the Manding, Serer and Wolof of the western Sahel, the Kongo of Zaïre and especially the Yoruba and Igbo of Nigeria. By the time slavery ended in the New World in the late 19th century an estimated 12 million Africans had been transported (42% to the Caribbean, 38% to Brazil and 6.8% to the USA), and they and their descendants, already much mixed with both European and Native American ancestry, could be found in every nation from Argentina to Canada.

Herskovits's system of retention, reinterpretation and syncretism works well for the arts, especially when they are combined with equally beloved religious and secular ritual. Indeed, the most African characteristic of the diasporic aesthetic is that all the arts combine in vibrant

public displays, both religious and secular, which are quite different from the contemplative 'shrine' art central to much European and Asian religious artistic expression.

The widespread and increasingly popular New World religion that syncretizes Yoruba *orisa* and Fon *loa* (gods or spirits) with Catholic saints, termed Candomblé or Macumba in Brazil, Shango in Trinidad, Vodoun in Haiti and Santeria in Cuba, is a leading vehicle bringing African arts to the New World. Sculptures, costumes, ritual objects (rarely masks) and finely embellished musical instruments, as well as songs, chants, prayers and incantations sometimes sung in the Yoruba language, are coming directly out of Africa. With the increasing ease of intercontinental travel, Yoruba priests can be found teaching their language and faith in Brazil, London and Miami, while prosperous West Indian faithful visit the shrines in Nigeria. There has been intermittent contact via Brazilian sailors between West Africa and Brazil for the past several centuries at least, and sizeable communities still exist in Cotonou, Accra and elsewhere that are descended from freed Brazilian slaves who returned to Africa.

2. ARCHITECTURE. As Stuckey and other revisionist historians have pointed out, some slaves arrived from Africa possessing advanced skills in such areas as tropical agriculture, metalwork and woodwork. In building construction they shared a knowledge of the two-room gabled house, thatching and wattle-and-daub. These skills were immediately employed in every kind of building, both Europeans and Africans needing to adapt the buildings they knew to the new climates, materials, techniques and requirements of New World plantation societies.

While African artisans undoubtedly quickly learnt the architectural methods and styles of the transplanted Europeans, they also constructed truly African-inspired buildings. On the Costa Chica on the Pacific coast of Mexico, circular houses with conical thatched roofs introduced by the Mande of Mali and Senegal were still being built in the 1990s. More important, the Africans discovered that their oblong 'shotgun house' (see fig. 1), which derived from the basic unit of the common traditional compound architecture, served well in both rural and urban settings. Unlike European-derived folk buildings, such as the classic American log cabin with its long side facing the street and gables at right angles to the street, the shotgun house has one gable-side facing the street, with the rooms of the house extending one behind the other and opening one into the next, so that a shotgun could be fired through the successive doorways without hitting anything. (The Yoruba word *to-gun*, 'place of assembly', is another possible derivation.) These houses, sometimes double or with a second floor at the back, can be found throughout the Caribbean, often with porches and/or Georgian or Victorian façades. The relatively small size of the rooms, rarely more than 4×4 m, and the widespread use of the front porch reflect African practice.

African artisans and their descendants left their mark also on churches, theatres and public buildings throughout the New World. Perhaps the most famous of these was Antônio Francisco Lisboa (see LISBOA, (2)), a physically disabled mulatto freedman in late 18th-century Brazil, better known as Aleijadinho ('little cripple'). His spectac-

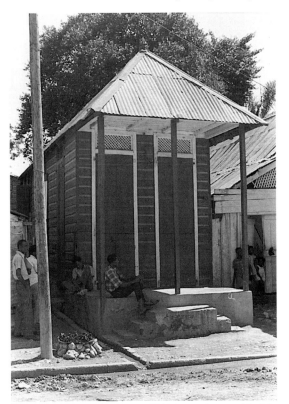

1. 'Shotgun house', Port-au-Prince, Haiti; from a photograph by John Michael Vlach, 1973

ular Late Baroque churches and the monumental sculptures in wood and stone that surround them have made the old mining towns around Ouro Preto world-famous. His astonishing originality and unique ability to manipulate an otherwise drab and worked-out provincial style bear witness to his African roots.

3. SCULPTURE. In contrast to architectural ironwork, wood sculpture of African inspiration is richly preserved throughout the Americas, the most spectacular examples being the religious figures of Yoruba *orishas* (spirits or gods) found in north-eastern Brazil (see Verger). A sculpture of the popular goddess of the sea—Yemoja in Yoruba, Yemanja in Brazil—has been found in use in Afro-Brazilian Candomblé ceremonies in the old slaving port of Salvador da Bahia, so completely in Yoruba style that it is uncertain whether it was carved in Nigeria or in Brazil. Other sculptures of Candomblé divinities in wood, clay and wrought-iron with obvious African antecedents abound wherever the cult is found.

The African maroons who escaped from coastal plantations into the interior of Surinam (former Dutch Guiana) and French Guiana in northern South America from the late 16th century onwards set up what many consider to be the most 'African' societies in the Americas, having developed religious and political institutions. A complex pierced style of wood-carving, which may have carried arcane, multi-level, possibly erotic symbolism, was used to decorate superb combs (see fig. 2), stools, clothes-beaters,

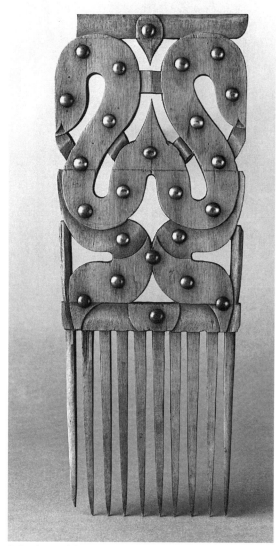

2. Comb, wood, h. 336 mm, from a village of the Djuka maroons on the Tapanahoni River, Surinam, collected late 1920s (New York, American Museum of Natural History)

peanut-pounding boards, paddles and doorframes that suggest but do not duplicate the finest Asante and Fon sculpture (*see* SURINAM, §III; FRENCH GUIANA, §III).

4. MASK AND MASQUERADE. As the most popular sculptural expression in Africa, masks have managed to retain their central position in the secular carnival complex of theatrical arts throughout the New World, although they occur only rarely in religious art. Carnivals or carnival-like street parades exist widely, in virtually every Caribbean island and every Latin American city (*see* CARNIVAL).

In the mid-19th century, particularly in Brazil, Cuba and Trinidad, freed Africans recognized the possibilities of the European colonial carnival for their own individual and group self-expression and gradually took over the street parades previously dominated by the planter class (at which time they had been allowed to provide only music). With their brilliant masks and costumes, controversial and often witty themes, throbbing drum *baterías*, ecstatic dancing and huge, extravagant floats pulled by horses, humans and nowadays giant trucks, New World carnivals are quite distinct from their European antecedents. The choosing and development of an often historical or topical theme and the designing of the costumes and floats require the full- or part-time work of theme researchers, designers, sketch-artists, seamstresses, embroiderers, wire-workers, styrofoam-carvers, shoe- and bootmakers, tinsmiths (for armour and chain-mail), electricians and welders (for the immense floats and decorated double-decker trucks carrying maskers, musicians and literally earth-shaking sound equipment). Artistic innovation and creativity are expected and indeed required in all these crafts, some of them otherwise rarely considered as art forms.

Masks and masquerades are not associated, however, with secular ritual alone. A remarkable example of full retention of an African art form in the New World is in the cloth masks and richly embroidered costumes representing female ancestors of the Yoruba Egungun cult, still made near Salvador da Bahia in north-eastern Brazil. Their panels of cloth swinging around the dancing wearer and symbolic objects decorated with cowrie shells and glass beads are indistinguishable from their African antecedents. Some of the Candomblé divinities today wear nylon and spandex held on by velcro and carry chromium-plated staffs, while finely detailed oil paintings on canvas delineate the ritual details of their costumes.

5. TEXTILES. West African weavers long ago invented a distinctive horizontal loom, between 50 and 100 mm wide but with a warp that can extend many metres, producing with considerable speed and minimum effort a long, narrow strip of cloth, plain or intricately designed, which can be cut and stitched together to produce superbly complex textiles. Once slavery began, male and female slave weavers were brought to the previously unpopulated Cape Verde Islands some 500 km off the coast of Senegal in West Africa and put to work producing the finest possible narrow-strip-weave textiles. Their products were then used to trade for more slaves with the African élites who gloried in the rich clothing made from these intricately designed textiles. Modern Caboverdianas and the Manjaco in nearby coastal Guinea-Bissau still make these superb weavings, among the finest in Africa, and some are displayed as part of the carnival costumes of the urban creoles in Guinea-Bissau.

The maroons of Surinam and French Guiana have probably managed the cleverest variant on the African narrow-strip-weave aesthetic. More than a century ago, in their South American jungle homes, they cut European trade cloth of several contrasting designs into narrow strips and sewed them combined together in the African manner to make capes and covers of surprisingly traditional beauty and style (see fig. 3). Today similar print-cloth strip-design clothing can be found in West African markets.

6. OTHER ARTS. Traditionally, African pottery is made by the built-up method of attaching one flattened piece of

and then encouraged them to experiment, using their own local folklore and history as subject-matter. Besides the colourful street life, the rituals of Vodoun, the local religion syncretizing Catholicism with Fon cosmology (*see* HAITI, §II, 2), became the subject of many paintings and the source of national pride and much-needed income from avid collectors and tourists. Later, wood-carving and pierced sheet-iron panels (made from flattened steel oil drums) on the same subjects continued the tradition in sculpture as well. Although some painted wall decoration is known in Africa among the Mangbetu of Zaïre and the Ndebele of South Africa, Haitian mural and easel paintings on canvas or board using acrylic or oil paints have a Western form and a content paralleling that of other 'naive' (i.e. not academically trained) genre painters, including modern African sign-painters, whose work is now similarly appreciated abroad.

See also ANTILLES, LESSER, §II, 2; BAHAMAS, THE, §II, 2; BRAZIL, §III; CARIBBEAN ISLANDS, §II, 3; CUBA, §II, 2; DOMINICAN REPUBLIC, §II, 2; JAMAICA, §II, 2; TRINIDAD AND TOBAGO, §II, 2.

BIBLIOGRAPHY
M. J. Herskovits and F. S. Herskovits: *Rebel Destiny: Among the Bush Negroes of Dutch Guiana* (New York and London, 1934)
M. J. Herskovits: *The Myth of the Negro Past* (Boston, MA, 1941)
P. Dark: *Bush Negro Art: An African Art in the Americas* (London and New York, 1954)
P. Verger: *Dieux d'Afrique: Culte des Orishas et Vodouns à l'ancienne Côte des Esclaves en Afrique et à Bahia, la Baie de tous les Saints au Brésil* (Paris, 1954)
J. H. Rodrigues: *Brazil and Africa* (Berkeley, 1965)
P. D. Curtin: *The Atlantic Slave Trade: A Census* (Madison, 1969)
R. F. Thompson: *Black Gods and Kings: Yoruba Art at UCLA* (Los Angeles, 1971/R Bloomington and London, 1976)
African Art in Motion: Icon and Act (exh. cat. by R. F. Thompson; Washington, DC, N.G.A.; Los Angeles, UCLA, Wight A.G.; 1974/R 1979)
J. Drachler: *Black Homeland, Black Diaspora: Cross-Currents in the African Relationship* (Port Washington, 1975)
J. M. Vlach: 'The Shotgun House: An African Architectural Legacy', *Pioneer America*, viii (1976), pp. 47–80; also in *Afro-American Folk Art and Crafts*, ed. W. Ferris (Boston, MA, 1983) and *By the Work of their Hands: Studies in Afro-American Folklife*, by J. M. Vlach (Charlottesville and London, 1991), pp. 185–213
A. M. Pescatello: *Old Roots in New Lands: Historical and Anthropological Perspectives on Black Experiences in the Americas* (Westport, 1977)
S. Rodman: *Genius in the Backlands: Popular Artists of Brazil* (Old Greenwich, CT, 1977)
Haitian Art (exh. cat. by J. Stebich; New York, Brooklyn Mus.; Milwaukee, WI, A. Cent.; New Orleans, LA, Mus. A.; 1978–9)
The Afro-American Tradition in Decorative Arts (exh. cat. by J. M. Vlach; Cleveland, OH, Mus. A.; Milwaukee, WI, A. Cent.; Birmingham, AL, Mus. A.; and elsewhere; 1978–9)
Carybé: *Iconografia dos Deuses Africanos no Candomble da Bahia* (São Paulo, 1980)
Afro-American Arts in the Surinam Rain-Forest (exh. cat. by S. Price and R. Price; Los Angeles, UCLA, Wight A.G.; Dallas, TX, Mus. F.A.; Baltimore, MD, Walters A.G.; New York, Amer. Mus. Nat. Hist.; 1980–82)
The Four Moments of the Sun: Kongo Art in Two Worlds (exh. cat. by R. F. Thompson and J. A. Cornet, Washington, DC, N.G.A., 1981–2)
J. H. Harris: *Global Dimensions of the African Diaspora* (Washington, DC, 1982)
W. Ferris, ed.: *Afro-American Folk Art and Crafts* (Boston, MA, 1983)
R. F. Thompson: *Flash of the Spirit: African and Afro-American Art and Philosophy* (New York, 1983)
D. J. Crowley: *African Myth and Black Reality in Bahian Carnival* (Los Angeles, 1984)
Carib. Q., xxxvi/3&4 (1990) [issue dedicated to Konnut Carnival, Caribbean Festival Arts]
Free within Ourselves: African-American Artists in the Collection of the National Museum of American Art (exh. cat. by R. A. Perry; Hartford,

3. Shoulder-cape, cotton, l. 1 m, Saramaka maroons, Surinam, collected 1960s (Los Angeles, CA, University of California, Fowler Museum of Cultural History)

clay to another to form the desired shape rather than by coiling or by the potter's wheel. Women usually make pottery for their own use, but in areas where good clay produces superior pots, valuable for sale or barter, men are also potters. No built-up pottery has been found in the Americas, but, as in the other arts, African potters quickly adapted their traditional skills to the new methods, materials and forms needed in the plantation societies. African potters are known to have produced fine pottery in Brazil and the Caribbean

The existence of other long-hidden or misunderstood African religious expression from the Mande, Fon, Yoruba, Ejagham and Kongo peoples, among others, has been revealed by the research of Robert Farris Thompson (1983) and his students. African form and colour symbols or cosmograms, somewhat modified or creolized, still exist throughout the New World, examples being the Haitian *vèvè* ground designs (*see* HAITI, fig. 3); protective charms made of cloth, leather and other materials; grave ornaments featuring shells, crosses and arrow-forms; and even one or more writing 'scripts', such as the *nsibidi* of the Ejagham (Ekoi) of south-central Nigeria. These different expressions suggest that many more persisting African beliefs and practices remain to be discovered in the New World.

Possibly the most 'African' people in the New World after the maroons, the Haitians have developed a strong painting tradition initiated in 1944 by an American teacher, De Witt Peters (1902–66), who exposed a number of young, uneducated men to a wide range of foreign arts

CT, Wadsworth Atheneum; New York, IBM Gal. Sci. & A.; Sacramento, CA, Crocker A. Mus.; Memphis, TN, Brooks Mus. A.; Columbus, GA, Mus.; 1992–4)

M. Azevedo: *Africana Studies: A Survey of Africa and the African Diaspora* (Durham, NC, 1993)

R. F. Thompson: *Divine Inspiration from Benin to Bahia* (Albuquerque, 1993)

Face of the Gods: Art and Altars of Africa and the African Americas (exh. cat. by R. F. Thompson, New York, Mus. Afr. A., 1993)

M. D. Harris: 'From Double Consciousness to Double Vision: The Africentric Artist', *Afr. A.*, xxvii (1994), pp. 44–53

Carib. Q., xxxix/3&4 (1994) [issue dedicated to Spiritual Baptists, Shango and other African derived religions in the Caribbean]

L. L. Martínez Montiel, ed.: *Presencia africana en el Caribe* (Mexico City, 1995)

Sacred Arts of Haitian Vodou (exh. cat., Los Angeles, CA, Fowler Mus. Cult. Hist., 1995)

A. Lindsay: *Santería Aesthetics in Contemporary Latin American Art* (Washington, DC, and London, c.1996)

DANIEL J. CROWLEY

Aguilar Ponce, Luis (*b* Panama City, 6 Nov 1943). Panamanian painter. He studied painting from 1960 to 1962 at the Escuela Nacional de Artes Plásticas in Panama City and from 1964 to 1970 at the Universidad Autónoma, Mexico. From 1971 he taught at the Escuela Nacional de Artes Plásticas, Panama City, of which he was director from 1980 to 1982. Under the influence of Pop art he produced semi-abstract paintings that combined geometric shapes and lines with sensuous parts of human anatomy painted with an airbrush and set in vaporous spaces of flowing colours. A typical example is *Profiles of Attraction* (1976; Panama City, Mus. A. Contemp.). In later works such as *Attack II* (1987; Panama City, Mus. A. Contemp.) he added expressionist brushstrokes for visual contrast.

BIBLIOGRAPHY

M. Gasteazoro: *Homenaje* (exh. cat., Panama City, Gal. Etcétera, 1982)

R. Oviero: 'Luis Aguilar Ponce: Ahora mi pintura se une a la humanidad', *La Prensa* [Panama City] (19 Oct 1984), p. 1B

B. Ramón: *Aguilar Ponce: Otro contexto, otros criterios* (exh. cat., Panama City, Mus. A. Contemp.)

MONICA E. KUPFER

Aguilera Silva, Gerardo (*b* Barcelona, Venezuela, 22 April 1907; *d* 13 Oct 1976). Venezuelan painter. He was self-taught and painted his first portraits and self-portraits *c.* 1930. In 1965 his first exhibition was held at the Museo de Bellas Artes, Caracas. His paintings, which later included nudes, possess a very particular atmosphere, developing from a small focal point, to which successive layers of paper or card are added, creating the effect of a collage; heavily and energetically worked, the works are small scale, which lends a further intensity to their expressiveness. Aguilera Silva had exhibitions throughout Venezuela, and examples of his work are held in the Galería de Arte Nacional, Caracas.

BIBLIOGRAPHY

Gerardo Aguilera Silva (exh. cat. by L. Luksic and J. Jordán, Caracas, Mus. B.A., 1965)

Gerardo Aguilera Silva (exh. cat. by J. Calzadilla, L. Luksic and J. Jordán, Caracas, Gal. A. N., 1978)

Based on information supplied by LELIA DELGADO

Aire Libre, Escuelas de Pintura al. *See* ESCUELAS DE PINTURA AL AIRE LIBRE.

Aizenberg, Roberto (*b* Federal, Entre Ríos, 22 Aug 1928). Argentine painter, draughtsman and collagist. He studied under Juan Batlle Planas from 1950 to 1953 and quickly established the terms of his work, rooted ideologically in Surrealism and indebted in particular to the work of René Magritte and Giorgio de Chirico. All the elements of his mature art are evident in an early painting, *Burning of the Hasidic School in Minsk in 1713* (1954; artist's col.): architecture, space, light and ordered series. He developed an essentially intellectual approach, working in a variety of media (paintings, drawings, gouaches and collages) in rigorous sequences and picturing objects in cold impersonal light that confers on them a sense of distant majesty. The most common motif is that of a geometric, almost abstract structure, often in the form of a tower pierced by rows of large plain windows. Aizenberg's work, while far removed from the Surrealist presumption of achieving a synthesis of wakefulness and dream, acquires its strength through the ordering of the unreal and the strange in the search for a transcendent essence capable of perturbing and jolting the viewer by bringing into play the archetypes of silence and solitude.

BIBLIOGRAPHY

Aizenberg: Obras, 1947/1968 (exh. cat. by A. Pellegrini, Buenos Aires, Inst. Torcuato Tella, 1969)

H. Safons: 'Los poderes de lo imaginario', *Periscopio*, 47 (1970), pp. 57–8

HORACIO SAFONS

Albert, Tótila (*b* 1892; *d* 1967). Chilean sculptor. From 1902 to 1939 he lived in Germany; he studied under Franz Metzner in Berlin. On his return to Chile, he taught at a private school and then taught sculpture in the Academia Particular of the Universidad de Chile in Santiago, also executing important works such as the tomb of President Pedro Aguirre Cerda (1941; Cementerio General de Santiago) and a large relief, *La naturaleza*, in Parque Cousiño (1945; Santiago, Escuela Jard. Parque Cousiño).

Albert's training in Germany, when Expressionism was at its height, led him to use distortion of form as the sign of vehement emotion. In his *Ariel and Caliban* (bronze, h. 8 m, 1960; Santiago, Parque Forestal), limbs are lengthened, muscles swell, tendons are visible beneath the skin, and one body yields and droops while the other rises imposingly into space. These traits are found in all his other sculptures, with the stress on subjectivity impelling him towards the metaphysical notion that the 'real' materials with which he works are his own feelings. Yet there is also a meditative depth in his work and a calming effect arising from an idealized geometry of forms. Albert's concern with mass, which brought out the sensual qualities of his materials, was part of a profound examination of the specific problems of sculptural language: rhythm, movement and tension of surfaces.

BIBLIOGRAPHY

M. Ivelič: *La escultura chilena* (Santiago, 1979)

V. Carvacho: *Historia de la escultura chilena* (Santiago, 1983)

CARLOS LASTARRIA HERMOSILLA

Alesio, Mateo Pérez de. *See* PÉREZ DE ALESIO, MATEO.

Alfaro, Brooke (*b* Panama City, 5 Sept 1949). Panamanian painter. A graduate of the University of Panama's Architecture School, he became a full time painter following his first solo exhibition in 1979. From 1980 to 1983 he studied

at the Art Students League in New York, his only formal training as an artist. Alfaro is best known for his beautifully rendered oil paintings but has also produced drawings, pastels and three-dimensional pieces. His first images were portraits of young women surrounded by surreal elements or in dream settings. From 1983 he painted humorous images of traditional or religious subjects such as church processions, as well as portraits of imaginary ecclesiastical figures and war heroes; capitalizing on Panama's strong Catholic tradition. Alfaro even invented his own saints, including the *Virgin of All Secrets* (1986; see colour pl. I, fig. 1). By 1990, his compositions became increasingly baroque, crowded with human figures in often menacing natural environments that suggest abundant iconographic, literary and historical interpretations. Towards the end of the decade, Alfaro began to isolate and increasingly distort his models, achieving an expressive deformation characteristic of his disturbing view of humanity and personal vision of surrealism.

BIBLIOGRAPHY
V. Gould Stoddart: 'The Magical Realism of Brooke Alfaro', *Américas*, xxxviii/4 (1986), p. 59
P. Heilbron: 'Brooke Alfaro: Profile of an Artist', *Cordialidad*, iii (May–June 1988), pp. 30–32
Brooke Alfaro: Cuando nuestros mundos se cruzan (exh. cat. by R. Pau Llosa, Monterrey, Gal. Ramís Barquet, 1997)
Crosscurrents: Contemporary Painting from Panama, 1968–98 (exh. cat. by M. Kupfer and E. Sullivan, New York, Americas Soc. A.G., 1998)
MONICA E. KUPFER

Almeida, Belmiro (Barbosa) de (*b* Cerro, 1858; *d* Paris, 1935). Brazilian painter and caricaturist. Brought as a child from the interior of the state of Minas Gerais to Rio de Janeiro, he graduated in 1877 from the Academia Imperial das Belas Artes. By then he had already published his first caricatures in the Rio press, and he continued to be a frequent contributor to such humorous periodicals as *O Binóculo*, *O Rataplan* (which he founded in 1886), *O Mercúrio*, *A Bruxa*, *O Malho*, *Fon-Fon!* and *Don Quixote*. He first went to Europe in 1888, where he finished his studies with Jules Lefebvre in Paris and travelled to Italy. On his return to Brazil at the beginning of the 1890s, he taught drawing at the Escola Nacional de Belas Artes in Rio de Janeiro, but he spent most of the latter part of his life in Paris. There, despite the underlying academicism from which his work was never entirely free and unlike the majority of Brazilian artists of the time, he showed genuine interest in the avant-garde developments of modernist art.

Almeida was essentially a realist who, with a healthy dose of mordacity and humour, tried to capture the life that went on around him in pictures such as *Lovers' Tiffs* (1887), *Chatterbox* (1893) and *Fine Weather* (1893; all Rio de Janeiro, Mus. N. B.A.). His *Landscape at Dampierre* (1912; Rio de Janeiro, priv. col., see Pontual, p. 66) makes slightly dated use of Georges Seurat's pointillism but blends it with the angular and geometrically precise composition characteristic of Cubism. Similarly, *Woman in Circles* (1921; Rio de Janeiro, priv. col., see Pontual, p. 67) illustrates his cautious assimilation of Futurist energy, fusing it with a basically Art Nouveau atmosphere. Such a synthesis of progressive styles places him among the precursors of modernism in Brazil.

BIBLIOGRAPHY
L. Gonzaga Duque: *A arte brasileira* (Rio de Janeiro, 1888)
J. M. dos Reis Júnior: *História de pintura no Brasil* (São Paulo, 1944)
A. Galvão: *Subsídios para a história da Academia Imperial e da Escola Nacional de Belas Artes* (Rio de Janeiro, 1954)
H. Lima: *História da caricatura no Brasil* (Rio de Janeiro, 1963)
R. Pontual: *Dicionário des artes plásticos no Brasil* (Rio de Janeiro, 1969)
J. M. dos Reis Júnior: *Belmiro de Almeida, 1858–1935* (Rio de Janeiro, 1984)
ROBERTO PONTUAL

Almeida Júnior, José Ferraz de (*b* Itu, 1850; *d* Piracicaba, 1899). Brazilian painter. Deeply attached to the interior of the state of São Paulo, where he was born, Almeida Júnior returned there as soon as he had finished his studies with, among others, Victor Meirelles de Lima at the Academia Imperial das Belas Artes in Rio de Janeiro. Under the patronage of the Emperor Peter II (*reg* 1831–89) he travelled to Europe in 1876 to complete his studies with Alexandre Cabanel in Paris. There from 1879 to 1882 he took part in the annual Salon of French Artists. The influence of Courbet's realism on works produced during his stay in France, such as *Brazilian Woodchopper* (1879; Rio de Janeiro, Mus. N. B.A.), remained in evidence on his return to Brazil in 1882, especially in his more picturesque paintings.

Although Almeida Júnior worked in many different genres, his most original paintings were those done late in life on rural themes vividly capturing the types and customs of life in the interior of the state of São Paulo. Such pictures as *São Paulo Woodsman Chopping Tobacco*, *Knife-sharpening Interrupted* (both 1893; São Paulo, Pin. Estado) and *The Viol-player* (1899; see fig.), in spite of their relatively conventional technique, capture the essence of daily life in Brazil. His nationalism led him also to paint historical works such as the large canvas *Leaving Monção* (U. São Paulo, Mus. Paulista). Although he remained faithful to European styles, his genuine enthusiasm for rural everyday life in Brazil was untainted by academic pretentions and linked him to the Brazilianist tendency, which from the middle of the 1910s emerged in its maturity with the modernist revolution.

BIBLIOGRAPHY
S. Millet: *Pintores e pinturas* (São Paulo, 1940)
F. Acquarone: *Primores da pintura no Brasil* (Rio de Janeiro, 1941)

José Ferraz de Almeida Júnior: *The Viol-player*, oil on canvas, 1.41×1.72 m, 1899 (São Paulo, Pinacoteca do Estado de São Paulo)

Art of Latin America since Independence (exh. cat. by S. L. Catlin and T. Grieder, New Haven, CT, Yale U. A.G.; Austin, U. TX, A. Mus.; San Francisco, CA, Mus. A.; La Jolla, CA, A. Cent.; 1966)
A. Amaral: *Pinacoteca do Estado de São Paulo* (São Paulo, 1982)
Q. Campofiorito: *História da pintura brasileira no século XIX* (Rio de Janeiro, 1983)
Almeida Jr (São Paulo, 1985)
A. Amaral: 'Stages in the Formation of Brazil's Cultural Profile', *J. Dec. & Propaganda A.*, xxi (1995), p. 13

ROBERTO PONTUAL

Alonso, Raúl (*b* Buenos Aires, 25 Jan 1923; *d* 31 July 1993). Argentine draughtsman, painter and printmaker. He was self-taught and in 1943 began to illustrate publications throughout Latin America, continuing to do so for more than 20 years. His early work consisted of highly emotive ink drawings marked by an intricacy of design and lack of idealization, for example *Vacuum II* (1976; see fig.). He later worked in both pastels and oils to create spectral images of love, death, eroticism and the obscure world of nightmares, fears and terrors. Critics sometimes spoke of these in terms of Magic Realism, although he did not subscribe to any specific stylistic tendency. He often treated human heads and figures in fragmentary form, as if they were the victims of violent torture, and with a veiled but sarcastic humour.

With time Alonso gradually simplified his drawings and replaced his invented characters with fictional objects and childhood memories, moving towards more intimate and abstract work, for example in the pastel *The Sideboard* (1983; Rio de Janeiro, Mus. A. Mod.). His other series included *The Seven Deadly Sins*, *Martín Fierro*, *The Circus* and *Childhood Toys*, and he collaborated with the Argentinian poet Alberto Girri on three illustrated books, published in Buenos Aires: *Los 10 mandamientos* (1981), *Borradores* (1982) and *Amatoria* (1985).

BIBLIOGRAPHY
Arte argentino actual (Buenos Aires, 1979)
R. Squirru: *Arte argentino hoy* (Buenos Aires, 1983), p. 10

NELLY PERAZZO

Alva de la Canal, Ramón (*b* Mexico City, 29 Aug 1892; *d* Mexico City, 4 April 1985). Mexican painter and draughtsman. He studied at the Academia de San Carlos in Mexico City from 1910. In 1917 he was employed as a draughtsman by the Ministry of Agriculture and began to attend the Escuela de Pintura al Aire Libre de Santa Anita under Alfredo Ramos Martínez, his palette gradually lightening. In 1920 he was appointed assistant draughtsman in the Ministry of Education and then tutor at the Academia de San Carlos. In 1922 he was commissioned by the Ministry of Education to paint a mural, the *Landing of the Cross* (fresco, 7×8 m; Mexico City, Escuela N. Prep.), an allegorical depiction of the implantation of Catholicism in New Spain in the 16th century, with large classical figures set in a steeply inclined composition. Over the next 40 years, Alva de la Canal painted six public murals with allegorical and historical themes, such as the *Life of Morelos* (encaustic and fresco, 1937; Janitzio, nr Pátzcuaro). This is a sculptural monument to Morelos, into which the painting is inserted, and which depicts scenes from the life of the Independence figure arranged in an ascending spiral form around the interior of the monument.

Raúl Alonso: *Vacuum II*, pen and ink, 724×1022 mm, 1976 (New York, Bronx Museum of the Arts)

During the 1920s Alva de la Canal was associated with ESTRIDENTISMO. He lived in Jalapa, near Villahermosa, in 1925–6, when the movement was patronized by the governor of the state of Veracruz, and he provided illustrations for Estridentista books and reviews such as *Horizonte*. During this period he depicted scenes of contemporary working life in bold black-and-white pencil and ink drawings, using geometric forms and rounded outlines. In 1928 he helped found the ¡30–30! group in Mexico City, which advocated the use of open-air teaching methods instead of academic ones; his drawings were used as illustrations in the *¡30–30!* magazine, and he participated in exhibitions mounted by the group in cafés and theatre-halls in Mexico City.

Between 1928 and 1932, Alva de la Canal worked on the 'cultural missions' organized by the Ministry of Education, travelling to states in the north and south of Mexico, painting murals and teaching in primary schools. On his return to Mexico City in 1932 he became involved with the Teatro Guiñol sponsored by the Instituto Nacional de Bellas Artes, providing puppets, costumes and scenery, an activity that he continued throughout his life. He painted portraits, numerous local landscapes and scenes with Indian figures, using soft contours and large areas of single colours. From 1953 to 1977 he taught painting at the Centro Universitario de Artes Plásticas in Jalapa, of which he became the director on its inauguration in 1953. On his return to Mexico City he became involved with the TALLER DE GRÁFICA POPULAR, and in 1981 he was named a member of the Academia Mexicana de Artes.

BIBLIOGRAPHY

Homenaje: Ramón Alva de la Canal, 1892–1985 (exh. cat., Jalapa, U. Veracruzana, Gal. Ramón Alva de la Canal, 1986)

L. Basilio: *Ramón Alva de la Canal* (Xalapa, 1992)

NICOLA COLEBY

Alvarado, Antonio (*b* Le Havre, 19 Oct 1938). Panamanian painter and printmaker of French birth. He first studied with the figurative painter Alberto Dutary but established himself in the 1960s as one of the few abstract artists in Panama with paintings such as *Green Force* (Panama City, Mus. A. Contemp.), which attest to the influence of American Abstract Expressionism; in other works he was also influenced by Post-painterly Abstraction. During a visit to Japan in 1969 he came into contact with Japanese art and Zen Buddhism, after which he sought to achieve the maximum impact of form and colour through reduction to essentials. The techniques used in his acrylic paintings and drawings were well suited also to screenprints such as the series *Form and Space* (1975; Panama City, Gal. Etcétera). Alvarado was also active in organizing exhibitions for others and promoting the arts in Panama as director from 1970 to 1975 of the Departamento de Artes Plásticas of the Instituto Nacional de Cultura y Deportes.

BIBLIOGRAPHY

R. de Henestrosa: 'Antonio Alvarado', *Vanidades México*, xvi/18 (1976)

R. Ros: 'La pintura de Antonio Alvarado', *Rev. N. Cult.*, 7–8 (1977), pp. 151–60

Crosscurrents: Contemporary Painting from Panama, 1968–98 (exh. cat. by M. Kupfer and E. Sullivan, New York, Americas Soc. A.G., 1998)

MONICA E. KUPFER

Alvarado Lang, Carlos (*b* La Piedad Cabadas, Michoacán, 1905; *d* Mexico City, 1981). Mexican printmaker. His skill as a printmaker became apparent at an early age when he was employed as an assistant metal-engraver by Francisco Díaz de Léon at the Academia de San Carlos in Mexico City. In 1929 he succeeded his teacher Emilio Valadés as professor of printmaking and subsequently became Director of the Escuela Nacional de Artes Plásticas and of the Escuela Nacional de Pintura y Escultura La Esmeralda, both in Mexico City. He was influential both as a teacher and for his virtuoso handling of traditional printmaking techniques, including line-engraving, drypoint, aquatint, mezzotint, wood-engraving and linocut. His prints, mainly of Mexican landscapes, combine technical skill with affective expressiveness. He experimented constantly with methods of improving procedures, especially with mezzotint, with the modification of printing presses and with the introduction of new acids. Alvarado Lang also did much to popularize 19th-century Mexican prints as a collector and writer.

WRITINGS

El grabado a la manera negra (Mexico City, 1938)

39 estampas populares (Mexico City, 1947)

'La obra de José Guadalupe Posada', *El Centavo*, 136 (1988), pp. 30–31

BIBLIOGRAPHY

A. Rodríguez: *Carlos Alvarado Lang, baluarte del grabado mexicano* (Mexico City, 1990)

JULIETA ORTIZ GAITÁN

Alvarez, Augusto H. (*b* Mérida, 24 Dec 1914; *d* Mexico City, 29 Nov 1995). Mexican architect. He graduated from the Universidad Nacional de México, Mexico City, in 1939. In his early works he was influenced by the theories of José Villagrán García and later by those of Le Corbusier, Mies van der Rohe and Gropius. He is notable in Mexican architecture for his adherence to Rationalism throughout his long career. In construction he used steel and concrete, prefabricated units and glass, and there is an evident unity in his works, especially in the high quality of his finishes. A notable example of his buildings is a small bank branch (1958; destr.), Mexico City, in which the International Style is clearly visible in the cleverly composed structure and in the neon illumination of the exterior, recalling Mondrian. The Jaysour Building (1961), Mexico City, is the clearest example of his assimilation of the International Style, evident in the ground-plan, structure and even the glass cladding. Also in Mexico City are the IBM Building (1971–2), an innovative and flexible design adapted to different functions on each of its six levels, and the La Mitra offices (1972–3), in which he managed to blend the exposed concrete structure with a system of metal mezzanines, the use of space being fundamental.

WRITINGS

Augusto H. Alvarez: Historia oral de la ciudad de México: Testimonios de sus arquitectos, 1940–1990 (Mexico City, 1994)

Augusto H. Alvarez: Arquitecto y asociados S.C. (Mexico City and Barcelona, 1996) [intro. by A. Creixell]

BIBLIOGRAPHY

T. G. Salgado: *Augusto H. Alvarez* (Mexico City, 1984)

L. Noelle: *Arquitectos contemporáneos de México* (Mexico City, 1988)

F. González Gortázar: *La arquitectura mexicana del siglo XX* (Mexico City, 1994)

XAVIER MOYSSÉN

Alvarez, Mario Roberto (*b* Buenos Aires, 14 Nov 1913). Argentine architect. He studied architecture at the Univer-

sity of Buenos Aires, graduating in 1937 with two gold medals and the Ader Scholarship, which enabled him to spend a year studying architecture in Europe. He joined the Ministry of Public Works and then became Municipal Architect at Avellaneda (1942–7); he established his own office in Buenos Aires in 1947. Alvarez became one of the most prolific and successful architects in Latin America, winning first prize in a large number of competitions and building a great number of works. His designs were based on a rationalist approach, developing consciously simple structural form in the manner of Mies van der Rohe; his goal was to produce functional buildings utilizing modern technology and efficient workmanship, allowing for flexibility and change and contributing to the quality of the environment. Important works include the Medical Centre (1936–7) at San Martín; the Roncatti Restaurant (1938), Pergamino; the San Martin Cultural Centre (1953–60), Corrientes; the IBM building (1979–83), Catalinas Norte; the Alto Palermo flats and shopping centre (1983–6), Buenos Aires; and many other health centres, stadia, multistorey blocks of flats and office buildings. His persistent hard work over several years resulted in the extension of the Municipal Theatre (1953) at San Martín into the most important cultural centre of Buenos Aires. His interest in technology was revealed in his work on the Santa Fé–Paraná River Tunnel (1965), Entre Rios Province, which experiments with prefabricated construction techniques, and his design for the Somisa Headquarters (1966), Buenos Aires, was the first building in Argentina to be built entirely of steel and the first in the world to be entirely welded.

WRITINGS
Mario Roberto Alvarez y Asociados: Obras, 1937–1993 (c. 1993)

BIBLIOGRAPHY
M. A. Trabucco: *Mario Roberto Alvarez* (Buenos Aires, 1965)
'Mario Roberto Alvarez: 50 años de arquitectura', *Summa*, 233–4 (1987), pp. 35–100 [issue dedicated to Alvarez]
'Casa de Campo. Mario Roberto Alvarez', *Casas Internacionales* (Buenos Aires, 1996), pp. 12–17

LUDOVICO C. KOPPMANN

Alvarez Bravo, Manuel (*b* Mexico City, 4 Feb 1902). Mexican photographer. He studied painting and music at the Academia Nacional de Bellas Artes in Mexico City in 1918. In 1922, after training as an office worker, he began to take an interest in photography, and in 1923 he met Hugo Brehme shortly before buying his first camera. In 1929, through his friendship with Tina Modotti, he got to know Diego Rivera. In 1930, when Modotti left Mexico, he provided illustrations for Francis Toor's book *Mexican Folkways*. From 1930 to 1931 he was cameraman for Eisenstein's film *Viva Mexico*. Subsequently he met Paul Strand and Cartier-Bresson and became friendly with Mexico's leading painters and writers. In 1938 he met André Breton, who was visiting Mexico and who was deeply impressed by the mysterious and suggestive nature of his photographs. Breton was keen to enlist him for the Surrealist cause and published some of his photographs in *Minotaure*.

In his photographs Alvarez Bravo captured the essential spirit of Mexico by a process of reconstruction, not reproduction. As a young man he encountered the revolutionary Muralist movement, the first embodiment of an individual and indigenous artistic movement in Mexico, and this, together with childhood experience of the Mexican Revolution, was to have a considerable influence on his development. Though he travelled for short periods to Europe and the USA and was in contact with photographers such as Strand and Edward Weston, his images were drawn almost exclusively from Mexico, capturing unnoticed details that encapsulated the mysterious in the everyday. When not derived from his personal domestic life, his subjects were drawn from those of the indigenous Indian peoples, whether urban or rural, whose roots in deeper non-European culture and tradition are suggested by unexpected juxtapositions of objects and activities. Often his photographs give a vivid impression of the political and social problems faced by Mexico in the 20th century, for example in *Striking Worker, Assassinated* (1934; see 1978 exh. cat., fig. 45), in which the worker's sprawling corpse is seen in close-up, its head lying in a pool of blood. A less dark side of Mexican life is featured in *The Daydream* (1931; see fig.), which shows a contemplative young girl leaning on a balustrade in the half-light of a city courtyard.

Alvarez Bravo rarely strove for dramatic effect; like Walker Evans and Dorothea Lange he never monumentalized his subjects. He depicted human beings reduced to their existential presence. His influence on the younger generation of photographers in Latin America has been decisive, not only because of his subject-matter, but also because in his work he combined awareness of current trends in international photography with an appreciation of his own country's traditions.

WRITINGS
Mucho sol (Mexico, 1989)

Manuel Alvarez Bravo: *The Daydream*, photograph, 1931 (Pasadena, CA, Norton Simon Museum)

PHOTOGRAPHIC PUBLICATIONS
Manuel Alvarez Bravo: Fotografías (Mexico City, 1945)
Photographs by Manuel Alvarez Bravo (Geneva, 1977)
Sol (Mexico City, 1989)
Luz y tiempo: Catálogo de la colección fotográfica formada por Manuel Alvarez Bravo para la Fundación Cultura Televisa, 3 vols (Mexico City, 1995)

BIBLIOGRAPHY
F. Toor: *Mexican Folkways* (Mexico, 1930)
D. Rivera: *Manuel Alvarez Bravo* (Mexico, 1945)
Manuel Alvarez Bravo (exh. cat. by F. Parker, Pasadena, A. Mus., 1971)
C. Beaton and G. Buckland: 'Manuel Alvarez Bravo', *The Magic Image* (Boston and London, 1975)
Manuel Alvarez Bravo (exh. cat. by J. Livingston, Washington, DC, Corcoran Gal. A., 1978)
E. C. Garcia: 'Manuel Alvarez Bravo', *Photo-Vision* (April–June 1982)
E. Poniatowska: *Manuel Alvarez Bravo: El artista, su obra y su tiempo* (Mexico City, 1991)
J. A. Rodríguez: *Manuel Alvarez Bravo: Los años decisivos, 1925–1945* (Mexico City, 1992)
M. Ortíz and R. Torres Sánchez: *El Ojo de vidrio: Cien años de fotografía del México indio* (Mexico City, 1993)
Manuel Alvarez Bravo: Variaciones 1995–1997 (exh cat., Mexico City, Cent. Imagen, 1997)
Manuel Alvarez Bravo: A Retrospective (exh. cat., New York, MOMA, and Mexico City, Cent. Cult. A. Contemp., 1997)
 ERIKA BILLETER

Alvarez Ijjasz Murcia. Architectural partnership in Bogotá, Colombia, established in 1972 by Cecilia Alvarez Pereira (*b* Manizales, 23 July 1934) and Emese Ijjasz de Murcia (*b* Budapest, 18 May 1936). Alvarez studied at the University of Javeriana School of Architecture in Colombia from 1953 to 1958. Before establishing her own firm she worked with the firms Guillermo González Zueleta and Pizano Pradilla & Caro between 1957 and 1964. Between 1964 and 1979 she worked in the Department of Works, Special Projects and Urban Politics at the Instituto Crédito Territorial. De Murcia studied at the National University of Argentina from 1956 to 1958, Catholic University, Santiago, Chile, from 1958 to 1961, and the National University of Colombia at Medellín in 1962. De Murcia also worked for the Instituto Crédito Territorial from 1964 to 1971 and designed more than 17,000 dwellings during this time. From 1970 she taught at the University of the Andes, Bogotá, becoming Vice-Dean in 1978.

While they have built or renovated offices, medical centres and private housing, Alvarez and de Murcia have been primarily involved with large-scale, high-density social housing. One of their largest such projects is NIZA VIII (won in competition in 1979; built 1982–3), a housing estate of 684 apartments in the Niza area, on the outskirts of Bogotá. While the housing units are only six storeys high, their modernist-inspired geometry is uninviting. The architects have been concerned, however, with softening the buildings' impact on the environment. Extensive landscaping has been incorporated, and water for the apartments is heated with solar energy. Both Alvarez and de Murcia worked on projects with other organizations in addition to their joint work.

BIBLIOGRAPHY
Proa, 287 (1979), pp. 9–53 [competition for residential area in the north of Bogotá]
C. Lorenz: *Women in Architecture: A Contemporary Perspective* (New York, 1990)
 □

Amador, Manuel E(ncarnación) (*b* Santiago de Veraguas, 25 March 1869; *d* Panama City, 12 Nov 1952).

Panamanian painter, draughtsman and printmaker. He is known chiefly as the designer of the national flag (1903) of Panama. He studied business administration and had a long career in public office. When Panama became independent in 1903, he became Secretario de Hacienda and in 1904 Consul-General *ad-honorem* to Hamburg. In 1908 he moved to New York, where he studied with Robert Henri, who strongly influenced his style of vigorous drawing, loose brushwork, distorted expressionist images and sombre colours, as in *Head Study* (1910; Panama City, R. Miró priv. col.; see Miró). He produced most of his work between 1910 and 1914 and again after the late 1930s; his main subject was the human figure, but he also painted portraits, landscapes and still-lifes. On his return to Panama in the 1930s he worked as an auditor in the Contraloría General. After his retirement he resumed painting and produced some of his most passionate works, such as *Flowers* (*c.* 1939; Panama City, R. Ozores priv. col.; see E. Wolfschoon: *Las manifestaciones artísticas en Panamá*, Panama City, 1983, p. 447), receiving recognition as an artist only late in life. Nine days after his death, his first one-man show opened at the Universidad de Panamá, which holds the largest collection of his drawings, watercolours and etchings.

BIBLIOGRAPHY
R. Miró: *Manuel E. Amador: Un espíritu sin fronteras* (Panama City, 1966) [unpaginated]
Maestros de la plástica panameña: Manuel E. Amador (exh. cat., essay A. Herrerabarría; Panama City, U. Panama and Inst. N. Cult., 1979)
 MONICA E. KUPFER

Amaral, Antonio Henrique (*b* São Paulo, 1935). Brazilian painter and printmaker. After studying engraving in São Paulo, he moved to New York in 1959 to complete his studies at the Pratt Graphic Center, where his contact with international Pop art merged with his own interest in Brazilian popular imagery, for example in the portfolio of woodcuts *Mine and Yours* (1967). Immediately afterwards he began painting ambiguous and ironic still-lifes collectively titled *Brasíliana*, which use bananas as symbols of underdevelopment and exploitation, for example *BR-1 SP* (1970; São Paulo, Pin. Estado) and *Bananas* (1971; see fig.). In 1971 he won a trip abroad in the National Salon of Modern Art (Rio de Janeiro), which took him again to New York between 1972 and 1973. On his return to São Paulo he began the series *Battlegrounds* (see colour pl. I, fig. 2), in which he submitted the previously reclining bananas to slashing, torture and putrefaction. Subsequently shapes were reorganized into configurations of an undramatic Surrealism, playful, colourful, tumescent and as firmly rooted as ever in his native Brazil and Latin America.

BIBLIOGRAPHY
F. Gullar: 'Antonio Henrique Amaral', *Visão da terra* (exh. cat., Rio de Janeiro, Mus. A. Mod., 1977)
Antonio Henrique Amaral—Obra em processo, 1956–1986 [Antonio Henrique Amaral—work in progress, 1956–1986] (exh. cat. by F. Morais, São Paulo, Mus. A. Mod., 1986)
Art of the Fantastic: Latin America, 1920–1987 (exh. cat. by H. Day and H. Sturges, Indianapolis, IN, Mus. A., 1987)
Antonio Henrique Amaral (exh. cat., Coral Gables, FL, Elite F.A. José Martínez-Cañas, 1994)
Antonio Henrique Amaral: Obra reciente (exh. cat., São Paulo, M. A. Assis Châteaubriand, 1997)
Antonio Henrique Amaral: Da gravura à pintura (exh. cat., São Paulo, Inst. Moreira Salas, 1997)
 ROBERTO PONTUAL

Antonio Henrique Amaral: *Bananas*, oil on canvas, 1.69×1.28 m, 1971 (Washington, DC, Art Museum of the Americas)

Amaral, Tarsila do. *See* TARSILA.

Amat (y Junyent), Manuel (de) (*b* Barcelona, 1704; *d* 1782). Spanish architect, engineer and administrator, active in Peru. He was the second son of the Marquis de Castellbell and received military training at an early age. He served as Spanish governor in Chile (1755–61), acquiring a reputation there as a fortifications expert. In 1761 he was appointed Viceroy of Peru, where he launched a vast campaign of public works (*see* PERU, §III, 1). During his administrative term, which lasted until 1776, the city of Lima enjoyed a period of prosperity and splendour marked by the French Baroque taste favoured by the Spanish Court. The evidence strongly suggests that Amat was the designer of several monuments in Lima that were executed by the *alarife* (surveyor and inspector of works) Juan de la Roca, who may have also collaborated in the elaboration of some of the plans. Amat's masterpiece was the church of Las Nazarenas (consecrated 1771; *see* PERU, §III, 1), with a scenographic interior influenced by Ferdinando Galli Bibiena, who had worked in Barcelona. Other major works attributed to him include the *camarín* or chapel of the Virgin (1774) behind the main altar of the church of La Merced, the belfry tower (1775) of the church of S Domingo and a chapel (*c.* 1775) in the convent of Las Mercedarias, all in Lima. In addition, the Paseo de Aguas (begun 1770; formerly La Navona), Lima, which was a rare example of Baroque urban design in the district of Rímac, may have been conceived by Amat himself. He sent designs for the Palacio de la Virreina (begun 1772),

Barcelona, back to Spain. It is distinguished by a restrained façade articulated by colossal pilasters over a rusticated base set off by a balustraded roof-line borne on consoles and punctuated by heavy stone vases.

BIBLIOGRAPHY
E. Harth-Terré: '¿Dibujó realmente el Virrey Amat lo que se le atribuye?', *Cult. Peru.*, i (1941), pp. 17–18
V. Rodríguez Casado and F. Pérez Embid, eds: *Memoria de gobierno del Virrey Amat* (Seville, 1947)
V. Rodríguez Casado and F. Pérez Embid: *Construcciones militares del Virrey Amat* (Seville, 1949)
A. Sáenz-Rico Urbina: *El Virrey Amat*, 2 vols (Barcelona, 1967)
J. García Bryce: 'Observaciones sobre cuatro obras atribuídas al Virrey Amant', *Arquit. & Urb.*, i/4 (1988), pp. 12–29
HUMBERTO RODRÍGUEZ-CAMILLONI

Américo de (Figueiredo e) Melo, Pedro (*b* Areia, 1843; *d* Florence, 1905). Brazilian painter. His precocious talent as a draughtsman was recognized as early as 1853, when he accompanied the expedition led by the French naturalist Louis Jacques Brunet to the north-east of Brazil. He then went to Rio de Janeiro, where he entered the Academia Imperial das Belas Artes in 1855. Under the patronage of Emperor Peter II he lived in France from 1859 to 1864, studying with Jean-Auguste-Dominique Ingres and Horace Vernet at the Ecole des Beaux-Arts in Paris. His interests also included physics, philosophy and literature. His essay 'Refutation of the Life of Jesus by Renan' won him the decoration of the papal order of the Holy Sepulchre. He also painted one of his first important pictures at this time, *Carioca* ('Woman from Rio de Janeiro'; 1862; Rio de Janeiro, Mus. N. B.A.). On his return to Brazil he taught drawing (and, later, art history, aesthetics and archaeology) at the Academia Imperial. When the Republic was proclaimed in 1889, he became a member of the constituent assembly.

Américo de Melo's paintings were firmly rooted in the Neo-classical tradition, later modified by Romantic elements. He produced biblical scenes, allegories, portraits and even caricatures, but he specialized in historical scenes, notably the *Battle of Avaí* (5×10 m; 1872–7; Rio de Janeiro, Mus. N. B.A.), commissioned by the Brazilian government to commemorate the famous episode in the war against Paraguay (1865–70) and completed in Florence, where he lived from 1873 to the late 1880s. In Florence he painted another of his historical works, the *Cry of Ipiranga* (1886–8; U. São Paulo, Mus. Paulista), depicting the proclamation of Brazilian independence in 1822.

BIBLIOGRAPHY
Pontual
L. Gonzaga Duque: *A arte brasileira* (Rio de Janeiro, 1888)
Pedro Américo no Museu Nacional de Belas Artes, cat. (Rio de Janeiro, 1965)
Q. Campofiorito: *História da pintura brasileira no século XIX* (Rio de Janeiro, 1983)
D. Mello Júnior: *Pedro Américo de Figueiredo e Melo, 1843–1905: Algumas singularidades de sua vida e de sua obra* (Rio de Janeiro, 1983)
J. M. Cardoso de Oliveira: *Pedro Américo: Sua vida e suas obras* (Rio de Janeiro, 1943/R Brasília, 1993)
ROBERTO PONTUAL

Amighetti, Francisco (*b* San José, 1 June 1907). Costa Rican engraver, painter, illustrator, draughtsman, writer and critic. He studied for a year from 1931 at the Escuela

Nacional de Bellas Artes but was otherwise initially self-taught, using Louis Gonse's *L'Art japonais* (Paris, 1883) as a source. He produced a series of caricature drawings, influenced by Cubism, in the *Album de dibujos de 1926*. During 1929 he met the sculptors Juan Manuel Sánchez and Francisco Zúñiga (the latter was also a printmaker), and through his interest in German and Mexican Expressionist printmakers, he developed a passion for wood-engraving. His first wood-engravings were published in the periodical *Repertorio Americano* (1929). He went on to contribute wood-engravings and drawings to collections of short stories and poetry, educational books, periodicals and newspapers. In 1931 he taught drawing and wood-engraving at the Escuela Normal in Heredia. He exhibited at the Salones Anuales de Artes Plásticas in San José (1931–6). His subject-matter was largely Regionalist, but unlike his peers in the group Círculo de Amigos del Arte, he was able to go beyond a mirror-like reflection of peasant life (e.g. *Burial at Heredia*, 1938; see 1989 exh. cat., p. 21). The dominance of black in his images of this period was especially suited to interiors and night scenes. He visited Argentina, Bolivia and Peru in 1932 and exhibited at the second Sala de Amigos del Arte in Buenos Aires with Raúl Soldi and Antonio Berni.

In 1934, in collaboration with several artists belonging to the Nueva Sensibilidad, including Francisco Zúñiga, Manuel de la Cruz González, Carlos Salazar Herrera, Gilbert Laporte, Teodorico Quirós and Adolfo Sáenz, Amighetti produced a series of engravings collected in the *Album de grabados*, which was to become a valuable art-historical document. From 1936 Amighetti wrote poetry, which he published from time to time. He also taught at the Liceo de Costa Rica. In 1943 he went to the USA to study art at the University of New Mexico in Albuquerque, and from there he went to Taos to study watercolour painting. He taught at the fine arts faculty of the Universidad de Costa Rica in San José in 1944. In 1947 he studied mural painting at the Escuela de Talla Directa 'La Esmeralda' in Mexico with Federico Cantú, a pupil of Diego Rivera. He painted the mural *Agriculture* (1948) in the Casa Presidencial in Costa Rica (now San José, Mus. A. Costarricense) in collaboration with Margarita Bertheau. Two years later he went to Argentina to study engraving. In 1952 he painted murals in the Banco Nacional in Alajuela and the library of the Policlínico de la Caja Costarricense del Seguro Social, San José; in 1954 he completed two murals for the Colegio Lincoln, San José. Amighetti often had one-man shows of oils and watercolours, as well as wood-engravings, until 1968 when he dedicated himself to chromoxylography. After 1970 his works often featured a child as an innocent witness of adult conflict (e.g. *Large Window*, 1981; see 1989 exh. cat., p. 104), and themes of old age and death became more frequent. This later work is characterized by brighter colours and more expressionistic style and abstract composition. Amighetti also published articles on the work of his peers, including Max Jiménez.

WRITINGS

Album de dibujos de 1926 (San José, 1926)
Francisco en Costa Rica (San José, 1966)
La exhibición personal de grabado de Francisco Amighetti (exh. cat., Taipei, Taiwan Mus., 1989)

BIBLIOGRAPHY

Repert. Amer., xi/470 (1929)
R. Ulloa Barrenechea: *Pintores de Costa Rica* (San José, 1975), pp. 81–8
R. A. Herra: *El desorden del espíritu: Conversaciones con Amighetti* (San José, 1987)

JOSÉ MIGUEL ROJAS

Anaya, Gustavo Medeiros. *See* MEDEIROS, GUSTAVO.

Andrade (Moscoso), Jaime (*b* Quito, 10 Sept 1913; *d* Quito, 11 April 1990). Ecuadorean sculptor and engraver. He studied sculpture at the Escuela de Bellas Artes in Quito, graduating in 1932. He was a pupil of Luigi Cassadio (*fl* 1915–33), an Italian sculptor who stimulated sculptural activity in the school and whom Andrade succeeded as professor. With his *Mother Earth* (Quito, Mus. Mun. Alberto Mena Caamaño), Andrade won the Mariano Aguilera national prize in 1940. His early work was realist and academic, but in 1941 he studied mural composition with the Ecuadorean artist Camilo Egas at the New School for Social Research in New York. His previous low reliefs in stone and wood were transformed into vast murals depicting stylized and geometric human scenes (e.g. the untitled mural, 18×9 m, at the Universidad Central del Ecuador in Quito, 1949–54). In the late 1960s he used hammered steel sheeting in his sculptures, and in the 1970s he executed what he called his 'flying sculptures' (e.g. *Flight*, 1979; Quito, priv. col.), in which expanses of spiralling pebbles wrapped in brightly coloured sheets produced sounds generated by the wind. He continued also to execute large-format public murals, in which he experimented continually with materials, creating for example a mosaic landscape in 1976–7 for the Municipio de Quito building. In 1982 the Banco Central del Ecuador held a large retrospective of Andrade's work, affirming his reputation as the greatest Ecuadorean sculptor of the 20th century.

BIBLIOGRAPHY

Jaime Andrade: Obra escultórica y gráfica (Quito, 1977)
Retrospectiva de Jaime Andrade (exh. cat., Quito, Banco Cent. del Ecuador, 1982)
El siglo XX de las artes visuales en Ecuador (exh. cat. by H. R. Castello, Guayaquil, Mus. Antropol. & Mus. A. Banco Cent., 1988), pp. 39–40
E. J. Sullivan, ed.: *Latin American Art in the Twentieth Century* (London, 1996)

ALEXANDRA KENNEDY

Angel Card, Abraham (*b* El Oro, nr Acambaro, 7 March 1905; *d* Mexico City, 27 Oct 1924). Mexican painter and teacher of Scottish descent. He studied briefly at the Escuela Nacional de Bellas Artes, Mexico City, where in 1921 he met the painter Manuel Rodríguez Lozano, who introduced him to Mexican avant-garde artists. Under Rodríguez Lozano's tutelage he joined the 'brigade' of teachers who trained primary and secondary school students using Adolfo Best Maugard's method of teaching drawing based on the motifs of popular art. Angel developed a pictorial style characterized by a deliberately naive drawing technique and vivid, unnaturalistic colours; he typically made portraits of friends and relatives superimposed on backdrops of village scenes or simplified rural landscapes. A commemorative book published shortly after his death featured texts by major artistic and literary figures of the period, including Rodríguez Lozano, Diego Rivera, José Juan Tablada and Xavier Villaurrutia, and

revealed the process of romantic mythification of Angel, characterizing him as a 'pure popular painter' and even inventing for him exotic Argentinian origins.

BIBLIOGRAPHY
M. Rodríguez Lozano and others: *Abraham Angel* (Mexico City, 1924)
M. Moreno Sánchez: *Notas desde Abraham Angel*, Monografías de arte (Toluca, 1976)
Abraham Angel y su tiempo (exh. cat. by O. Debroise, Coahuila, Mus. Bib. Pape, 1984)
L. M. Schneider: *Abraham Angel* (Mexico City, 1995)

KAREN CORDERO REIMAN

Angrand, Léonce(-Marie-François) (*b* Paris, 8 Aug 1808; *d* Paris, 11 Jan 1886). French painter and draughtsman, active in Peru. He served as the French Vice-Consul in Lima from 1834 to 1838 and while there produced albums of watercolours and drawings of cities such as Arica, Arequipa, Lima, Cuzco, Ollantaytambo, Urubamba and Tacna. His romantic spirit inclined him to the exotic, and he documented street scenes, the characters of city life, groups of buildings and archaeological monuments. Taken as a whole, these pictures bear witness to everyday life in Peru at that time.

BIBLIOGRAPHY
C. Milla Batres, ed.: *Léonce Angrand: Imagen del Perú* (Lima, 1972)
L. E. Tord: 'Historia de las artes plásticas en el Perú', *Historia del Perú*, ix (Lima, 1980)

LUIS ENRIQUE TORD

Anguiano, Raúl (*b* Guadalajara, 26 Feb 1915). Mexican painter, printmaker and teacher. He studied painting from 1927 at the Escuela Libre de Pintura in Guadalajara. He moved to Mexico City in 1934 and entered the Escuela de Pintura Escultura y Grabado 'La Esmeralda' in 1935. He was also a founder-member in that year of the TALLER DE GRÁFICA POPULAR in Mexico City, where he was able to develop his interest in engraving and lithography. He produced a vast body of work. His subject-matter, both in his prints and his paintings, focused on people's dramas, labours and fiestas (e.g. *The Circus*, 1937; artist's col.; see Crespo, fig. 14), the resignation and stoicism of Mexican women and popular myths and folk wisdom, for example *Popular Sayings*, an album of 18 engravings. He also painted numerous portraits and produced a number of murals that expressed a typical local ideology (e.g. *Fascism and Clericalism, Enemies of Civilization*, fresco, 1937; Mexico City, Cent. Escul. Revol.). Later murals portray Pre-Columbian historical events (e.g. *Creation of Man in the Mayan World*, 1964; Mexico City, Sala Maya, Mus. N. Antropol.). He began to produce his series of ceramic items in the late 1950s. An example of his work is *La Llorona* (1942; see fig.).

WRITINGS
Dichos populares (Mexico City, 1944)
Raúl Anguiano: Remembranzas (Toluca, 1995)

Raúl Anguiano: *La Llorona*, oil on canvas, 597×750 mm, 1942 (New York, Museum of Modern Art)

BIBLIOGRAPHY
Exposición retrospectiva 1930–1982 Raúl Anguiano (exh. cat., Mexico City, Inst. N. B.A., 1982)
J. J. Crespo de la Serna and others: *Raúl Anguiano* (Mexico City, 1985)
En la pintura de Raúl Anguiano (Mexico City, 1986)
Pintura mexicana, 1950–1980: Gilberto Aceves Navarro, Raúl Anguiano... (exh. cat. by T. del Conde and others, Mexico City, Mus. José Luis Cuevas, 1990)
Raúl Anguiano: Monotipos (exh. cat. by A. Rodríguez, Mexico City, Inst. N. B.A., 1992)
J. Fernández and others: *Raúl Anguiano: Obra gráfica* (Mexico City, 1995)
ELISA GARCÍA BARRAGÁN

Antequera. *See* OAXACA.

Antigua (i) [formerly Santiago de Guatemala]. Guatemalan city. It is located in a valley at the foot of the Agua volcano, 1500 m above sea-level, and has a population of *c.* 30,000. It was founded in 1527 as Santiago de Guatemala, but following a landslide in 1541 it was relocated in 1543 to the Panchoy Valley. It was the capital of the Audiencia de Guatemala, which included the present Mexican state of Chiapas and the five Central American countries (excluding Panama), until 1773, when the last in a series of devastating earthquakes led to its abandonment as the capital; GUATEMALA CITY became the new capital in 1776. The old city quickly began to grow again and gained the status of capital of the Sacatepéquez department, acquiring its present name in 1790.

Antigua was originally laid out on the typical Spanish grid plan centred around a main square; the plan is believed to have been executed by Juan Bautista Antonelli the elder (*see* ANTONELLI). Before its demise in 1773, the city had *c.* 30,000 inhabitants. As capital of an area of *c.* 500,000 sq. km and the main city between Mexico and Peru, it was a centre of economic, political and cultural life for a wide region. The finest artists were based there, with new artistic styles reaching it first from Spain before spreading out over the territory of the kingdom. One of the most notable painters of the early 18th century was TOMÁS DE MERLO. The architecture of the city possessed several striking aspects: there was minimal use of stone, with most buildings being made first from rubble and later from brick, with a stucco surfacing; a second feature was the limited height of the buildings, with towers barely rising higher than the central elements of the façades. This feature, in addition to the thick walls and columns and groined vaults, among other things, was the result of the efforts of architects to make buildings withstand the earthquakes that periodically struck the city. Although they were not totally successful, they persisted in their search for solutions to the problem, producing the heavy dimensions that came to be termed 'earthquake baroque' by Pál Keleman.

Repeated earthquakes between 1600 and 1773 destroyed most 16th-century and 17th-century buildings. The original cathedral, destroyed in 1541, was replaced (inaugurated 1680, completed 1686; see fig.) largely by Joseph de Porres (*see under* PORRES) with a vaulted three-nave church; damaged in 1717, it was restored by his son Diego de Porres in 1720–21 but was again damaged in 1773. Joseph de Porres was appointed Arquitecto Mayor in 1687 and began to adopt early Baroque forms in such buildings as the churches of S Francisco (1690) and La Compañía de Jesús (1698). A notable achievement of the

Antigua, S José (formerly the cathedral) by Joseph de Porres, completed 1686

Baroque architecture of the late 17th century and the 18th was the development of a series of new forms of pilaster, such as the frequently used bolster pilaster (*almohadillada*), seen, for example, in La Merced (1767) on the third storeys of the towers. Notable civil architecture of the mid-18th century included the Real Cabildo (1740–43), probably by José Manuel Ramírez, the Real Palacio, built by Luis Díez Navarro, and the Casa de Chamorro (1762), also by Díez Navarro, in a Baroque style with an arcaded patio. The polychromed wood-carvings of Santiago de Guatemala were renowned for their high quality, and major sculptors in the 18th century included members of the GÁLVEZ family.

Although in the 20th century artistic activity tended to be concentrated in Guatemala City, three important museums were founded in Antigua: the Museo de Arte Colonial (founded 1936), housing work by such artists as Tomás de Merlo, the Museo de Santiago (founded 1957) and the Museo del Libro Antiguo (1960). The city has retained its colonial appearance, with the ruins of churches and monasteries still present. In 1943, on the 400th anniversary of the city's foundation, Antigua was declared a national monument. Its main buildings were cleaned and a process of conservation was begun, with legislation establishing regulations for new buildings in the city. In 1965 it was declared a 'Monument of America' in the Congress of the Panamerican Institute of Geography and History, and in 1985 a 'Heritage of Humanity' by UNESCO. Its preservation is entrusted to a specific autonomous council. By the late 20th century the city was an important centre of traditional craftwork, with maiolica, glazed pottery, carpentry, ironwork and textiles widely available. A number of commercial art galleries were also established.

BIBLIOGRAPHY
P. Keleman: *Baroque and Rococo in Latin America* (New York, 1951), pp. 122–5
S. D. Markman: *Colonial Architecture of Antigua Guatemala* (Philadelphia, 1966)
V. L. Annis: *La arquitectura de la Antigua Guatemala, 1543–1773* (Guatemala City, 1968)
M. Rubio Sánchez: *Monografía de la ciudad de Antigua* (Guatemala, 1989)
J. Luján-Muñoz and L. Luján-Muñoz: 'Arquitectura', *Historia general de Guatemala*, ii (Guatemala City, 1993) , pp. 704–16; iii (Guatemala City, 1994), pp. 473–84
C. H. Quitanilla Meza: *Breve relación histórico-geográfia de Sacatepequez* (Guatemala City, 1994)

J. Luján-Muñoz: 'Guatemala: Arquitectura colonial del Reino de Guate-
mala', *Arquitectura colonial iberoamericana*, ed. G. Gasparini (Caracas,
1997), pp. 145–78

JORGE LUJÁN-MUÑOZ

Antigua (ii). *See under* ANTILLES, LESSER.

Antilles, Greater. Group of CARIBBEAN ISLANDS com-
prising CUBA, JAMAICA, PUERTO RICO and Hispaniola, the
last divided into HAITI and the DOMINICAN REPUBLIC.
Prior to contact with the Spanish colonists, the art of the
Greater Antilles was relatively unified. However, after
colonization traditions soon separated.

☐

Antilles, Lesser. Group of CARIBBEAN ISLANDS com-
prising TRINIDAD AND TOBAGO, Barbados, the Nether-
lands Antilles and the Leeward and Windward Islands.
These last include the French Overseas Departments of
Martinique and Guadeloupe with their dependencies of St
Martin, St Barthélémy, and the Saintes Islands; the Amer-
ican and British Virgin Islands; Dominica; Grenada; St
Lucia; St Vincent and the Netherlands possessions of
Saba, St Eustatius and St Maarten, among numerous
smaller islands. The westernmost islands of Aruba, Bonaire
and Curaçao were all formerly Dutch colonies, but Aruba
withdrew from the Netherlands Antilles in 1986. (For
map, *see* CARIBBEAN ISLANDS, fig. 1.)

I. Introduction. II. Cultures. III. Architecture. IV. Painting, graphic arts
and sculpture. V. Decorative arts. VI. Patronage. VII. Museums. VIII. Art
education.

I. Introduction.

In geological terms the Virgin Islands form an eastern
extension of the faultblock geology of the Greater Antilles,
while the outer islands, such as Anguilla, Antigua and
Barbuda in the Leeward Islands, Barbados, eastern Gua-
deloupe and the Aruba, Bonaire and Curaçao group are
of coral limestone formation. The latter are generally low-
lying and surrounded by white sand beaches and coral
reefs. Rainfall is low, *c.* 0.5–1.15 m a year, and there is little
surface water; the coastal areas are particularly arid. The
inner islands are of volcanic origin and are more rugged:
there are active volcanoes on St Vincent, St Lucia, Marti-
nique, Guadeloupe, Dominica, Montserrat, and St Kitts
and Nevis. Some two-thirds of Montserrat became unin-
habitable following several volcanic eruptions beginning
in July 1995. The highest points are Soufrière on Guade-
loupe (1467 m), Morne Diablotin on Dominica (1447 m)
and Mont Pelée, Martinique (1397 m). These well-watered
islands have lush vegetation, especially on the upper slopes
of the central hills, and support several rare indigenous
species of birds. The sugar industry was established by the
mid-17th century, and as a result, Caribbean life was at its
most affluent between 1750 and 1840. However, the
waning of the industry in the 19th century also had a great
impact. Cotton was grown as an export crop from the
17th century and peaked during the late 18th century,
stimulated by the demands of the English textile industry.
Bananas became the dominant export of the Windward
Islands after World War II, but by the late 1990s produc-

tion was threatened by loss of preferential prices in the
European market.

The earliest known inhabitants of the islands were the
Arawaks. These were subsequently displaced by the Carib
people (*see* §II, 1 below), who were in occupation at the
time of the first European contact at the end of the 15th
century AD. Traces of Carib and Arawak culture can be
seen in the rock-carvings and pottery found on many
islands. The earliest British colonists established principal
permanent settlements on Barbados and St Kitts (1625),
Nevis (1628), Antigua and Montserrat (1632), Anguilla
(1650) and the British Virgin Islands a little later (e.g. the
largest, Tortola, 1666). The French settled on Dominica
(1632), Martinique and Guadeloupe (both 1635), St Bar-
thélémy (1648) and Grenada (*c.* 1650). The Dutch estab-
lished settlements at St Eustatius (1632), Saba (1640) and
St Maarten (1648), and Curaçao, Bonaire and Aruba (1634).
The Danish West India Company established itself on St
Thomas in 1671 and occupied St John and St Croix in the
Virgin Islands until the USA bought them in 1917. Several
islands changed hands many times in the 17th and 18th
centuries, but colonial control was finally settled in the
early 19th century. A multi-cultural history has left its mark
on the islands. Colonial architecture gives a distinctive
appearance to many islands, and *patois* based on various
European languages with some African and Indian influ-
ences is widely spoken.

For bibliography *see* CARIBBEAN ISLANDS and individual island
surveys.

JANET HENSHALL MOMSEN

II. Cultures.

1. AMERINDIAN. Most islands in the Lesser Antilles
have small collections of prehistoric artefacts in their
museums and libraries, but the majority of the large
collections are overseas (e.g. London, BM; New York,
Amer. Mus. Nat. Hist. and Mus. Amer. Ind.; Cambridge,
MA, Harvard U., Peabody Mus.). The artefacts chiefly
predate the Amerindian Caribs, who inhabited most of
the Lesser Antilles at the end of the 15th century, when
Columbus first explored the area. The only substantial
surviving group of Amerindians live on the Carib reserve
in Dominica. The Caribs' predecessors were said to have
been the Arawaks, an Amerindian people originating in
central South America, who by the 16th century occupied
the Greater Antilles. Linguistic and, to a lesser degree,
biological data suggest that the Island Caribs and Arawaks
were virtually identical, but despite this, various attempts
have been made to attribute different pottery styles to
these two peoples. For example, because 'Suazey' ceramic
figurines depicted people with flattened heads and pierced
ears they were linked with early European descriptions of
Caribs, which included comments on their habit of dis-
torting the skull in infancy. The earlier 'Insular Saladoid'
pottery had complicated decoration, frequently including
lugs representing animal heads. Zoomorphic stone figures
were roughly contemporary with these, while anthropo-
morphic stone figures (see fig. 1) coincided with later
Saladoid ceramics.

The prehistoric art of the Lesser Antilles is characterized
by numerous rock drawings or petroglyphs. Because of

1. Stone pestle, 130×75 mm, from the Antilles, *c.* AD 800–1500 (London, British Museum)

in the late 20th century. Outside the region, the descendants of Vincentian Caribs deported to Central America in 1795/6, known as the Garifuna (*see* BELIZE, §I, HONDURAS and GUATEMALA, §II), have retained some of their ancestors' basketwork styles.

The Caquetios (also known as Caiquetios and Caiquetias) who inhabited Aruba, Bonaire and Curaçao also dwelt on the mainland in what is now Venezuela. They were Arawak speakers, and the records of early settlers also mention their body painting, pearl bracelets and calabash penis sheaths. Archaeologists have seen many parallels between their artefacts and those of other Amerindian populations of Venezuela and Colombia (*see* VENEZUELA, §II and COLOMBIA, §II). The Caquetios appear to have succeeded a fishing, hunting and gathering people who have sometimes been identified as Ciboney (*see* CUBA, §II, 1 and HAITI, §II, 1). Cave and rock drawings exist on all three islands, and local prehistoric artefacts are displayed in the Curaçao Museum in Willemstad.

See also CARIBBEAN ISLANDS, §II, 1.

BIBLIOGRAPHY
Proceedings of the International Congress for the Study of Pre-Columbian Cultures of the Lesser Antilles (1961–)
H. Huth: 'Agostino Brunias, Romano: Robert Adam's "Bread Painter"', *Connoisseur*, cli (Dec 1962), pp. 264–9
A. Bullen and R. Bullen: *Archaeological Investigations on St Vincent and the Grenadines West Indies*, William Bryant Foundation, American Studies Report, viii (Orlando, 1972)
The European Vision of America (exh. cat. by H. Honour, Washington, DC, N.G.A.; Cleveland, OH, Mus. A.; Paris, Grand Pal.; 1975–7)
F. Chiappelli and others, eds: *First Images of America* (Berkeley, 1976)
L. Allair: *Later Prehistory in Martinique and the Island Caribs: Problems in Ethnic Identification* (diss., New Haven, CT, Yale U., 1977; microfilm, Ann Arbor, 1977)
A. Boomert: 'The Cayo Complex of St Vincent', *Anthropológica*, lxvi (1986), pp. 3–68
P. Hulme: *Colonial Encounters: Europe and the Native Caribbean* (London, 1986)
I. Rouse: *The Taino* (New Haven, 1992)

C. J. M. R. GULLICK

their location, these are difficult to date stratigraphically, but stylistic analysis suggests that they are pre-Carib or at least pre-Suazey. However, this attribution is inconclusive, as the use of different media can produce different styles, particularly when they are employed by different individuals. The most typical Lesser Antillean petroglyphs represent anthropomorphic figures with rayed heads and/or swaddled bodies. Similar rayed heads are depicted in rock drawings in the Greater Antilles, although swaddled bodies are virtually absent except in Puerto Rico, which lies closest to the Lesser Antilles. As the major artistic heritage of Caribbean prehistory, these petroglyphs have had an impact on the vernacular arts of the Lesser Antilles and some 'Carib' themes derived from them appear in tourist art.

Historical accounts of the Caribs and illustrations of their artefacts show that their art forms included wooden clubs decorated with geometric designs, painted hammocks, basketwork with black, brown and yellow geometric designs, ceramics, featherwork, body painting (mainly using red pigment with black for rays and moustaches), singing and dancing. Their metal jewellery was thought to have been produced outside the area, but Carib-style basketry was still produced in Dominica and Martinique

2. AFRO-CARIBBEAN. From the beginning of the 16th century African slaves were imported into the Lesser Antilles to work on plantations (*see* AFRICAN DIASPORA). They came mainly from West Africa, where the major arts included dance, wood-carving, bronze- and brass-casting, goldwork, textiles and architecture. Metalworkers frequently belonged to a separate caste, and good carvers, potters and weavers could become full-time specialists. Others came from Western Central Africa, where fewer specialists were found, although the region was famous for raffia cloth and carvings in wood and ivory. Slaves who brought their craft skills with them from Africa practised those permitted by their masters; the most commonly reported were basketwork, used to make containers and chairs; straw plaiting for ropes and bed mats; and leatherworking and pottery. Dance, which initially survived as a part of slave celebrations at Christmas and carnivals, also required costumes and accoutrements. Many Antillean slaves were later transferred to North America, and some of their arts and crafts travelled with them: for example, North American Afro-American pottery was influenced by Caribbean ceramics. Full emancipation of slaves in the British Caribbean took place in 1834.

Whether the slaves were generally permitted to build their own design of huts in the Caribbean is debated, but there appears to have been less African architectural input than in the Greater Antilles. Rural housing can be seen as the result either of a mixture of African and European influences or of modifications of European architecture. A major problem with such debates is the fact that the historical and archaeological study of the artefacts produced by Black Caribbeans in the Lesser Antilles is in its infancy. Early descriptions of items rarely give sufficient data, and there are problems with interpreting illustrations owing to the artists' stylistic and aesthetic conventions. As a consequence of this lack of hard data, African connections are frequently proposed to explain parallels between contemporary African and Caribbean crafts and designs. However, studies of 'Bush Negro' arts in Surinam have shown how inaccurate such arguments can be (see SURINAM, §III).

Afro-Caribbean craftwork in the Antilles is the work of both full-time specialists and part-time craftspeople, whose products cover a wide range of household, tourist and ritual items. Household products sometimes continue the traditions of the slave period, although many have been replaced by mass-produced or European-style products. For example, contemporary ceramics range from the highly African-influenced wares of Antigua to the uninfluenced pottery of Barbados. However, whereas in North America and Haiti some African traits persisted in Afro-American metalwork, little has survived in the Lesser Antilles. A minor art form of the region is the decoration of vehicles, especially vans, buses, trucks and hearses. Tourist arts include shell, straw and fibre works. Carved wood, bamboo products, cloth, ceramics and seed (bead) work are produced in most islands, and embroidery is sold in Trinidad and the French islands. Leatherwork is sold in the French islands and beaten metal products in Trinidad. Few, if any, of these artefacts can be seen as representing a continuation of slave traditions, and some types have recently been introduced from Africa. For example, Black Power-orientated cooperatives use 'African' themes to produce works emphasizing the Black population's African origins. As with the use of Amerindian themes in tourist art (see §1 above), this stresses the fact that Afro-Caribbean people were not the indigenous inhabitants of the region.

Antillean ritual arts include drawings used by various Pentecostal Christian sects to assist initiates on spiritual pilgrimages. However, these are of minor import when compared to the arts associated with Christmas and carnival celebrations. In general, those islands with a predominantly British and Protestant history celebrate Christmas, while those with a French and Roman Catholic past hold pre-Lenten carnivals. Islands with significant influences from both colonial powers tend to celebrate both occasions, and the Dutch islands celebrate both carnival and New Year, although the former is the more significant. Most of the performing arts featured at these festivals can be traced back to local slave events and sometimes to Africa: the Martiniquan carnival, for example, includes performances and costumes very similar to those found in West Africa. However, in St Vincent the British suppressed most of the French-style carnival during the 19th century, and the modern version in Kingstown, the capital, is the result of a reintroduction of the event from Trinidad (see TRINIDAD AND TOBAGO, §II, 2). The Trinidadian influence similarly modified many of the carnivals in the southern Windward Islands. Before World War II, carnivals held on the islands to the north of Trinidad were generally performed by individuals and small groups using traditional costumes and dances. However, after the war they imitated the larger carnival bands of Trinidad. Such bands have costume designers who ensure that the costumes of their 'king', 'queen', 'prince', 'princess' and supporting players illustrate a common theme; the queen is usually the dominant figure. The topic changes annually, and the costumes and their relationship to the overall theme are judged on artistic grounds.

The islanders of St Kitts and Nevis similarly influenced the Christmas celebrations of their northern neighbours: for example, evidence suggests that the traditional St Kitts and Nevis Christmas dances involving 'Indians' were exported to the Dominican Republic and Bermuda along with labour migrants. The Indian masqueraders wear tall feather headdresses with trousers, shirts, aprons and capes decorated with beads and mirrors (see fig. 2). The costumes and dances changed little during the 20th century, although early masqueraders frequently wore European masks (made of wire mesh and imported from the Tyrol in the early 19th century) to make them appear white. The costumes are influenced by the dress of Native North Americans, but not to the extent of those worn by Indian

2. 'Indian' carnival costume, St Kitts, Lesser Antilles, 1992

3. Chattel house, Barbados, Lesser Antilles

carnival bands in Trinidad and actors in the Christmas cowboy play performed in Nevis. There are also similarities between the Christmas performances of the Lesser Antilles (especially the northern islands) with the Jamaican, Bahamian and Belizean Jonkonnu or Junkanoo (John Canoe) performances (*see* BAHAMAS, THE, §II, 2) and the Gombey celebrations of Bermuda, all of which are normally held at Christmas.

BIBLIOGRAPHY
R. D. Abrahams: *The Man-of-words in the West Indies* (Baltimore, 1956)
Carib. Q., iv/3–4 (1956) [special issue on carnival]
C. J. M. R. Gullick: 'West Indian Artefacts: A Bibliographical Essay', *Mus. Ethnographers Grp Newslett.*, xix (1985), pp. 26–53
J. W. Nunley and J. Bettelheim: *Caribbean Festival Arts* (Seattle, 1988)

C. J. M. R. GULLICK

III. Architecture.

1. PRE-COLONIAL AND VERNACULAR FORMS. Before the arrival of the Europeans the Amerindians built circular or oval thatched huts, typically with walls of timber staves spaced to allow ventilation: none of these now survives on the islands, but a characteristic pre-colonial Arawak dwelling has been reconstructed at the Arawak Indian Museum, St Catherine, Jamaica. After the largest islands were settled by the rival European powers, the Amerindian dwelling was subsequently developed in rectangular form for plantation-workers and slaves; it was probably the prototype of the chattel house (originally so called as a movable possession of transient workers in Barbados) or *casa*, in which many islanders live. The houses were usually built of timber, raised off the ground

on stone (or later concrete) 'pillar trees'. Characteristically the chattel house had exposed timber corner-posts, weatherboarded walls and a steeply pitched roof covered in wood shingles. The weatherboarding was usually inset between the vertical frames, allowing each to be articulated by painting in a different colour, traditionally yellow ochre panels between dark red structural frames and door and window surrounds. Island preferences, however, have produced other colour combinations (e.g. blues and greens in Grenada, brown with yellow ochre in St Lucia). A timber-framed chattel house has been restored on the Welches plantation, north of Bridgetown, Barbados (see fig. 3). On islands where there was a shortage of timber, plantation houses were also built with stone walls, and in Curaçao (Netherlands Antilles), for example, thatch rather than shingles was common, but both were increasingly displaced by corrugated iron after it became available in the 19th century.

2. COLONIAL SETTLEMENT: 17TH AND 18TH CENTURIES. Though much influenced by the vernacular and the available local craft skills, urban architectural character in the Lesser Antilles was largely derived from Europe. In the century and a half after the arrival of colonists, some of the islands were shared and others changed hands by conquest or political manoeuvre. Their architecture, therefore, shows evidence of mixed cultures: examples are British and French in St Lucia, Grenada, Dominica and St Kitts and French and Dutch in St Martin. Early building was concerned with defence: bastion-trace

fortifications were small in scale. Examples include Fort Amsterdam (begun 1634) at Willemstad, Curaçao; Fort St Louis (Fort Royal; begun 1670s), Martinique; Fort St George (1680s), Grenada; and Fort Christian (begun 1671), Charlotte Amalie, St Thomas, US Virgin Islands. Fortifications were extended when nearly a hundred years of conflict between the British and French began in the second quarter of the 18th century. Examples include Fort Berkeley (1740s), Antigua, protecting the naval installations of English Harbour (1726–94), and the technically and architecturally sophisticated Prince of Wales bastion on Brimstone Hill, St Kitts, with its classicizing details.

Little survived the hurricanes and fires of the prosperous 17th century. St Nicholas Abbey (probably 1660s), Barbados, with its triple ogee gables, and Drax Hall, Barbados, built by Thomas Shettenden Drax (d 1702) in the last quarter of the century, are among the few surviving great houses that can be dated to the 17th century with any degree of certainty. A few examples from the 18th century remain: plantation houses, such as Romney Manor, or Rawlins above Dieppe Bay at the foot of Mt Misery, both in St Kitts; Château Murat, the severely classical French country house on Marie Galante, Guadeloupe; and the Danish Baroque Whin Plantation Museum on St Croix, US Virgin Islands. Characteristic Dutch-gabled urban houses were built at Punda (from 1706), Willemstad, Curaçao, where there are also merchants' houses, such as the Five Senses (begun 1750), neither of which types makes any concession to local climate or conditions. Smaller British and French estate houses, on the other hand, were carefully adapted to climate: metal- and timber-framed verandahs surrounded the houses at each floor level, and jalousies and louvred shutters gave protection from the sun and facilitated through-ventilation. Byde Mill, Barbados, is a fine mid-18th-century example, with a delicately framed and balustraded verandah at ground-level only; French examples with elegantly framed verandahs survive in both Guadeloupe and Dominica. Military housing also gives expression to both national and local factors: the barracks at Fort St George (before c. 1750), St George's, Grenada, is characteristic of French provincial buildings of the period, with simple stone surrounds to segmental window- and door-heads; British examples from later in the century, such as the ruined buildings on Shirley Heights, Antigua, and the garrison, Bridgetown, Barbados, reflect European academic classicism and recall contemporary British military buildings in South-east Asia.

Churches have been especially prone to hurricane damage and therefore much restored and altered. They were usually single-naved with a single square west tower. The ruined Dutch Reformed Church on St Eustatius is squat and forceful; towers are castellated (e.g. St Mary's, Bridgetown, Barbados), or have characteristic finials (St George's on the island of the same name); all have foundations of the late 17th century and early 18th. The fine Fort Church (1766–9; cupola, 1903), Willemstad, Curaçao, has Dutch Rococo overtones. The English architect Sir Thomas Robinson went to Barbados as Governor (1742–7), and the refining influence of his mid-Georgian Palladianism upon the design of government and public buildings is widely apparent on the islands: Government House, Bridgetown, has been attributed to

him, as well as an armoury and arsenal. Jackson-Stops (1986) suggests that his influence extends to the mid-18th-century parts of such great houses as Clifton Hall, Barbados. Influences of this kind are widespread, ranging well into the 19th century, from such elegant classicizing urban façades as the western waterfront of St George's, Grenada (built after the arrival of the British in 1762), to the arcaded façades of Kingstown, St Vincent, and Charlotte Amalie, St Thomas.

3. Neo-classical to modern: 19th and 20th centuries. There are interesting 19th-century churches in both British and French traditions. The church at Parham (1840), Antigua, is an octagonal Neo-classical building of simple dignity; the cathedral of Fort-de-France (after c. 1875), Martinique, is built in iron to the design of Gustave Eiffel. The Roman Catholic cathedral at Castries, St Lucia, is another iron church of the same period, and Basseterre, St Kitts, has a 19th-century iron clock-tower in its main square. Among the finest domestic buildings of the 19th century and early 20th are those of the Netherlands Antilles, mostly in the academic classical manner. Examples include Belvédère House (1864–5), Otrabanda, Willemstad, Curaçao, built for the Governor by Lt W. F. H. van Riemedijk, an army engineer; imposing urban mansions in the Scharloo district, such as that built for David Senior in 1875, with a fine two-storey portico with coupled Doric columns; and, also at Willemstad, the elegant classical octagonal house, Groot Davelar (1873), by the Curaçoan architect Antoine Martis and the unique Bolo de Bruid (wedding-cake) house (begun 1916), built by Henry da Costa Gomez and a local amateur architect, Maurice Cardoze.

In the Netherlands Antilles during the 1930s developments parallel with those in Europe took place: for example, a form of Art Deco appeared in such buildings as P. A. Stuyvenburg's streamlined cinemas, Cinelandia (1936) and West End (c. 1940), both Willemstad. Despite substantial development programmes, however, the unrest of the 1930s led to mass emigration to the UK after World War II. The growth of tourism in the 1950s created a demand for hotels, including Sandy Lane Hotel, Barbados, and La Toc, St Lucia, both by Robinson Ward of Barbados, reminiscent of the Georgian style associated with the colonial past. By the late 20th century many major buildings were still being designed by American or European consultants, although local practices were also active in many of the islands, including such major firms as Gillespie and Steel and such distinguished, small practices as that of Colin Laird (b 1924). Laird's work includes a number of major hotels, for example the Spice Islands Hotel (1960), Grande Anse, Grenada, and such public buildings as the Government Administration Building (1961), St Kitts, and the five-storey Government Headquarters (1968), Dominica, both sophisticated Modernist buildings designed to respond to climate. Details of Ian Morrison's Barbadian vernacular houses of the mid-1980s were published internationally.

BIBLIOGRAPHY
A. W. Acworth: *Buildings of Architectural or Historic Interest in the British West Indies* (London, 1951)

M. D. Ozinga: *De monumenten van Curaçao in voord en beeld* (The Hague, 1959)

P. W. Gosner: *Plantation and Town: Historic Architecture in the US Virgin Islands* (Durham, NC, 1971)

R. Devaux: *Saint Lucia Historic Sites* (Castries, 1975)

Y. Attema: *St Eustatius: A Short History of the Island and its Monuments* (Zutphen, 1976)

V. Radcliffe: *The Caribbean Heritage* (New York, 1976)

G. Tyson: *An Inventory of the Historical Landmarks of St Kitts-Nevis* (Saint Thomas, 1976)

D. Buisseret: *Historic Architecture of the Caribbean* (London, 1980)

B. Hill: *Historic Churches of Barbados* (Barbados, 1984)

V. Hitchcock: 'Sun, Sieges and Sugar Cane', *Country Life*, clxxviii/4597 (26 Sept 1985), pp. 704–9

G. Jackson-Stops: 'A Future for a Colonial Past', *Country Life*, clxxx/4649 (25 Sept 1986), pp. 936–41

R. Marcorelles: 'Guadeloupe–Martinique', *Archit. Medit.*, 33 (Oct 1989), pp. 157–82

H. E. Coomans, M. A. Newton and M. Coomans Eustatia: *Building up the Future from the Past: Studies on the Architecture and Historic Monuments of the Dutch Caribbean* (Zutphen, 1990)

K. Howes: 'Barbadian Palladian', *House & Gdn*, xlvi/7 (July 1991), pp. 84–91

C. L. Temminck Groll and others: *Curaçao: Willemstad: City of Monuments* (Amsterdam, 1992)

P. Gosner: *Caribbean Baroque: HIstoric Architecture of the Spanish Antilles* (Pueblo, CO, 1996)

JOHN NEWEL LEWIS

IV. Painting, graphic arts and sculpture.

The Lesser Antilles and their Carib inhabitants appeared or were described with varying degrees of accuracy in minor European illustrations, travel books, stage costumes and paintings from the 15th century onwards. Until the mid-20th century the majority of these were produced by Europeans: many early depictions were executed in Europe and were based on the descriptions and sketches of travellers and sometimes on artefacts. Most early prints accompanied sensational travellers' tales. Amerindians became equated with nakedness or exotic costumes comprising feather headdresses and imaginary feather skirts, as in the work of Albrecht Dürer (e.g. the illustration to Psalm 24 in the *Book of Hours of the Emperor Maximilian I*, fol. 41*r*; Munich, Bayer. Staatsbib.), and were mainly portrayed either as noble savages living a pastoral life or as inhuman cannibals. The Caquetios who inhabited Aruba, Bonaire and Curaçao were initially described as giants and tended to be depicted as towering noble savages. From the 17th century naturalists illustrated their accounts of the Lesser Antilles with depictions of tropical plants, crops and animals. This artistic theme reached its apex in the 19th century with, for example, the watercolours of Caribbean molluscs and plants by Hendrik van Rijgersma (1835–77).

The European artists who visited the region in the 18th and 19th centuries included both amateurs (mainly sailors, soldiers, priests and clerks) and itinerant professional artists. Significant among the latter was Agostino Brunias [Augustin Brunais] (1730–96), who painted Caribs in St Vincent and plantation life in Dominica; some of these works were reproduced in volume 3 of Bryan Edwards's *The History of the British Colonies in the West Indies* (1801). In general, professional artists were employed to show the grandeur of their patrons' plantations and other possessions; the amateurs tended to illustrate other aspects of island life. While some of the works of the itinerant

European artists were hung in the plantation houses, the majority of art on display in such mansions was imported from Europe. The collections are hinted at in the holdings of the Curaçao Museum, Willemstad, Sam Lord's Castle, St Philip, Barbados, and the Musée de la Pagerie, Trois Ilets, Martinique. Reports of slave life in both pictures and documents around the time of the abolition of slavery in the mid-19th century tend to be biased towards either the planters or the slaves. The arduous transatlantic passage and the plantation system had extirpated virtually all African graphic arts. However, the ritual drawings of such Pentecostal Christian sects as the Vincentian Shakers and Trinidadian Shouters may have African antecedents. Slavery and colonialism became a topic of the Afro-Caribbean art of the late 20th century.

Indigenous fine arts in the region began only during the late colonial period with art classes begun by expatriate teachers. This instruction was reinforced by further training for promising students in the colonial homeland, with consequent Dutch influences on the arts of Aruba, Bonaire and Curaçao, and French influences on those of Guadeloupe and Martinique. Conversely, Paul Gauguin's discovery of the tropics in Martinique in 1887 influenced French perceptions of the Caribbean. The Musée Gauguin, Le Carbet, Martinique, documents his visit but displays only reproductions of the paintings he produced there. Following independence, American influences replaced the British colonial influence in the majority of Caribbean Commonwealth states. As a result, early exhibitions of Caribbean art tended to include examples of most mainstream schools with little, except occasionally the subject-matter, to distinguish them as Caribbean. Local naive artists, however, were far more centred within their own cultural milieux. In the late 20th century artists from the Lesser Antilles were educated at the Jamaica School of Art (*see* JAMAICA, §XI), and distinctive Caribbean styles developed from the merging of local and foreign art traditions. Noteworthy naive artists of the area included Ivan Payne (1922–77) of Barbados, Canute Caliste (*b* 1916) from Carriacou (see fig. 4) and Hipólito Max Ocalia (1916–84) from Curaçao.

All the states of the Lesser Antilles experienced a flowering of indigenous naive and fine arts in the late 20th century, each island expressing its own individuality. For example, St Lucia has produced many sculptors as the consequence of Joseph Eudovic's tutorage. During its revolutionary phase Grenada developed, partially as a consequence of Cuban influences, a politicized version of its own naive school of art; in contrast, the presence of a large community of expatriate artists in Barbados may have swamped local talent. In St Vincent during the 1970s there was a trend to develop local 'Carib' themes, while Trinidadian artists, perhaps influenced by their island's carnival, have concentrated upon abstract paintings.

BIBLIOGRAPHY
B. Edwards: *The History, Civil and Commercial, of the British Colonies in the West Indies*, 3 vols (London, 1793–1801)

N. Connell: 'Caribbean Artists, Paint, Action and Colour', *Studio Int.*, cliii/770 (1957), pp. 129–35

H. Huth: 'Agostino Brunias, Romano: Robert Adam's "Bread Painter"', *Connoisseur*, cli (1962), pp. 264–9

M. L. Vincent: 'Two Painters of the Tropics: Lafacio Hearn and Paul Gauguin in Martinique', *Carib. Stud.* (March 1970), pp. 177–9

4. Canute Caliste: *Fisher Man Selling Fish*, acrylic on hardboard, 241×305 mm, *c.* 1985 (Grenada, Yellow Poni Gallery)

F. Lewisohn, W. Lewisohn and B. Meadows: *The Living Arts and Crafts of the West Indies* (Christiansted, St Croix, 1973)

F. Chiapelli, ed.: *First Images of America: The Impact of the New World on the Old* (Los Angeles, 1976)

B. L. Duke: 'Women, Art and Culture in the New Grenada', *Lat. Amer. Persp.*, xi/3 (1984), pp. 37–52

Caribbean Art Now: Europe's First Exhibition of Contemporary Caribbean Art (exh. cat. by E. Wallace, London, Commonwealth Inst., 1986)

H. E. Coomans and M. Coomans Eustatia: *Flowers from St Martin: The 19th Century Watercolours of West Indian Plants by Hendrik van Rijgersma* (Zutphen, 1988)

H. E. Coomans: *Antillean Seashells: The 19th Century Watercolours of Caribbean Molluscs Painted by Hendrik van Rijgersma* (Zutphen, 1989)

Gala di Arte (exh. cat., Curaçao, International Trade Cent., 1991)

N. Henriques and J. Römer-de Vreese: *Ocalia: Schildert Curaçao* (Zutphen, 1992)

R. Eckmeyer, ed.: *Carib Art: Contemporary Art of the Caribbean* (Curaçao, 1993)

H. Frubis: *Die Wirklichkeit des Fremden: die Darstellung de Neuen Weld im 16 Jahrhundert* (Berlin, 1995)

K Drayton: 'Art, Culture and National Heritage', *Barbados: Thirty Years of Independence*, ed. T. A. Carmichael (Kingston, 1996)

C. J. M. R. GULLICK

V. Decorative arts.

1. Interior design and furniture. 2. Textiles. 3. Ceramics. 4. Metalwork and jewellery.

1. INTERIOR DESIGN AND FURNITURE. Apart from written observations, inventories and wills, a few paintings from the late 18th century survive as documentation of the West Indian interior. The furnishings of the homes of the earliest settlers comprised woven cotton hammocks slung from eaves and crudely constructed stools, storage chests, tables and benches. By the 1640s small tobacco farmers had simple, undecorated wooden cabins furnished with the merest essentials. Roger Mills's deed of 1642 (Barbados) revealed that the lower of the two storeys was furnished with only a long table and two benches, and the upper bedchamber contained a bed, brass lamp, table and bench.

The introduction of stone structures in the mid-17th century influenced interior design, as did English Jacobean style. Drax Hall (*c.* 1655), St George, Barbados, is dominated by a fine mastic wood staircase and a broad elliptical arch, ornately carved with bold pendants of leaves. St Nicholas's Abbey (*c.* 1650) at St Peter, Barbados, has wooden floors throughout, and intricately carved mouldings enhance the cornices, main beams and arched doorways. A Chippendale-style staircase was installed in 1746, and Georgian-style sash windows and cedar panelling were added by the plantation carpenter in 1898. The Caribbean Georgian style became popular between *c.* 1750 and 1840, and importation of furniture from England (mahogany from Lancaster and Cork) and the USA (particularly

Boston and Salem, MA) increased during the 18th century. Nevertheless, late 18th-century newspaper advertisements for Barbados reveal a growing number of local craftsmen. John Mottley's notice (1783) identifying his runaway slave, Grigg, as 'an excellent good hand at the carpenter's and joiner's trade' is evidence of another source of furniture production before emancipation. Slaves were trained to produce copies of European furniture for the plantations. The introduction of mahogany to Barbados *c.* 1780 provided joiners with an excellent source of raw material. An example of the Caribbean Georgian style was the Olovaze Plantation near Basseterre, which had a hall panelled in mahogany and finished with mirrors. Both drawing room and bedroom were typically 'entirely fitted up and furnished in the English taste'. The Villa on Calliaqua Estate, St George, St Vincent (destr. 1795), was unusually sumptuous in its décor, boasting a large ballroom and a painting by Agostino Brunias. In St Philip, Barbados, Samuel Hall Lord built Long Bay Castle (1831; later known as Sam Lord's Castle). The ground-floor rooms were decorated with late Georgian woodwork and fine plaster ceilings, the latter the work of Charles Rutter and two Italian assistants; many of the original furnishings remain, including elaborate crystal chandeliers, massive gilt-framed mirrors and several pieces of Sheraton-style mahogany furniture.

After the devastation caused by a hurricane in 1831, many houses were reconstructed or built in quite modest fashion. In furniture a distinctive local style developed, adapted from European pattern books for a middle-class market and characterized by heavier proportions, coarse yet exuberant carving and a heavily lacquered dark finish. Tub chairs and 'berbice' or 'planter' chairs (a type of chair with broad arms and an extended leg-rest) were particularly popular, as were double- and single-ended couches with caned backs and seats. Reflecting the local practice of rum-drinking, the Barbadian cellaret (drinks cabinet) was a unique design, featuring a large tray-top, resting on a semicircular drawer section cradled in a curved X-frame (see fig. 5). Apart from the introduction in the 1920s of the popular Morris chair (with an adjustable backrest), this repertory remained virtually unchanged for over a century. In the 1940s industry was mechanized and new opportunities created for exporting furniture to neighbouring islands. By the 1950s and 1960s, however, Caribbean style had significantly changed, due in part to the introduction of American-influenced metal furniture and influenced by the British stage designer Oliver Messel. Through such projects as Maddox, Cockade House, and Mango Bay, St James, Barbados, he popularized an indoor–outdoor lifestyle, using open-plan rooms extending on to verandahs, loggias and terraces, and trelliswork, and the use of sage green walls, floors and shutters with white contrasting elements. After his death his associates Heather Aquilar, Arne Hasselqvist and Robert Thompson continued to create luxurious interiors, primarily for expatriates in Mustique and Barbados. The Barbados-based architect Ian Morrison combined pastel-coloured pickled pine floors and ceilings with curving coral walls, while Andrew Steel and Merwyn Awon have in different ways explored the texture, colour and versatility of indigenous wood. Awon's work also incorporates traditional jalousie shutters

5. Barbadian cellaret, mahogany, *c.* 1830 (St Michael, Barbados Museum)

and 'gingerbread' decorative touches reminiscent of 19th-century Caribbean vernacular architecture. Barbados furniture manufacturers produce styles ranging from dark, polished mahogany and pastel pickled pine pieces for interior use, to wrought iron and aluminium furniture for the garden and beach.

2. TEXTILES. In spite of the Caribbean cotton industry, imported coarse linens and woollen and other textiles formed the bulk of material available for domestic use and clothing until the late 18th century. Sir Joshua Steele, founder of the Barbados Society of Arts, first encouraged the development and promotion of the local textile industry. He imported equipment for spinning, reeling, weaving and frame-knitting and brought over a Lancashire weaver and his wife to give public demonstrations of the newly invented engine for spinning on 20 spindles. Following the decline of the sugar industry, in the 19th century cotton cultivation first waned and was then revived in the latter half of the century, leading to the introduction of Sea Island cotton, remarkable for its length, lustre and fineness. Throughout the 20th century the industry experienced many vicissitudes so that a textile industry remained in a formative stage. During the 1960s a growing tourist industry encouraged the development of successful batik production, studios for which included Caribelle Batiks (St Kitts), Bagshaws (St Lucia) and Stella St John's Studio Gallery (Barbados), all of which based their designs on Amerindian motifs. In the 1970s the Spencer Cameron Gallery (St Kitts) established a successful silkscreen workshop, producing textiles printed with floral and tropical

designs. Hilary Armstrong's lyrical silkscreened Caribbean scenes and Judy Layne's colourful tie-dyed renderings of traditional culture have also attracted attention.

3. CERAMICS. Archaeological evidence from mid-17th-to 18th-century sites reveals widespread importation of primarily English tin-glazed and earthenware and Delft-ware. By the 17th century some plantations already had 'pot houses' to provide the conical sugar moulds used for the draining and storage of freshly refined sugar. Slave potters also produced red, African-inspired earthenware for domestic use on the plantation and possibly for barter. These early wares were often painted with a red slip, and multi-directional striations were occasionally incised below the rim on the exterior. Emancipation of slaves gave impetus to the development of a cottage-based industry in all the islands. In general this was characterized by a predominantly female workforce producing handmade, open-fired pottery, which provided a secondary family income. There was no formal apprenticeship system, but skills were passed on through families.

In most islands the industry became localized around areas with a ready supply of clay, which have remained the production centres. Traditional pottery from Morne Sion, Pointe Caraibe and Fiette (St Lucia) is handcoiled and includes cooking vessels, flower pots and 'coal pots' (ceramic stoves). At Seaview Farm, Antigua, a traditional vessel with a flat bottom and handles is called variously 'pepper pot', 'mud pot' or 'jar pot'; a red-slipped earthen-ware griddle (*yabba*) was also produced. Newcastle and Brick Kiln (Nevis) produce hand-built 'monkey jars', cooking vessels, coal pots and large storage jars, usually painted and burnished. The same forms are produced at Chalky Mount and Turners Hall (Barbados), along with 'guglets' or 'goglets' and *conarees* with an interior glaze. These vessels were usually unadorned except for an incised line below the rim. By the 20th century large storage jars, flower pots with saucers and 'crimp pots' with indented rims and extended shoulders were also produced, as were small zoomorphic figures. Folk potters shifted their emphasis to more decorative pieces including ashtrays, vases, candlesticks, miniature monkeys and coal pots, primarily for the growing souvenir market.

During the late 1940s and 1950s island governments introduced gas-fired kilns and factory structures in an effort to industrialize and commercialize handicraft production. The pottery industry was revolutionized by the British ceramicist Christopher Russell's establishment, near Bridgetown, Barbados, of his potteries (1962–4) which produced a range of tableware, lamps, tiled tables and trays with tropical motifs. With the Jamaican Denis Bell, Russell developed a technique of fusing coloured glass to a glazed ground to enhance his large-scale ceramic panels, such as *Mother and Child* (1962). Other ceramicists include Lionel Laville (Dominica), the best-known exponent of traditional forms, Helena Jones (Nevis) and Wilbert Harding (Barbados). Annie Kinsella (Antigua) produced popular glazed figurines, while Bill Grace (Barbados) expressed his fascination with music through ceramics; Ras Akyem Ramsey (Barbados) interpreted his symbiotic relationship with the natural environment, and Stanley Greaves reinterpreted traditional Amerindian imagery in

his work. The potteries that have achieved some commercial success include the Marinica (Dominica), the Nevis near Newcastle (Nevis) and the Fairfield, Earthworks and Courtney Devonish (Barbados; later Anguilla). Sarah Fuller Arawak Pottery is known for blue-and-white wares, and Cockleshell Pottery run by Ken Derrick for floral ceramic art in non-local clay.

4. METALWORK AND JEWELLERY. Despite the paucity of mineral resources in the region, 17th-century accounts mention jewellers and goldsmiths in the islands. By the 18th century gold jewellery had become an essential part of the costume of both Creole (native-born white) and mulatto (mixed-race) women. The Creole gold jewellery produced in Martinique was particularly popular, and the paintings of Agostino Brunias offer convincing evidence of a considerable trade in such metalwork. By the 19th century, most silverware and jewellery was imported from Europe. However, by the first half of the 20th century pewter, copper and iron were worked by a number of itinerant artisans, supplying basic domestic wares and construction services to the local community; these have since been overtaken by the ready availability of modern commodities, and only those expert artisans who cut and work metal drums for the thriving steel-pan music industry have gained significant recognition for their work. The Barbados Foundry, established during this period, was the only one of its kind in the Lesser Antilles, but its focus was on servicing industry, not on the creation of products. In the late 20th century Caribbean metalwork remained primarily confined to jewellery making, and professional metalworkers were few. In 1965 William Bertalan began to cast sculptures in bronze, aluminium and brass using the lost-wax process. In Antigua during the 1960s the metalsmith Frank Agard (1911–91) gained popular recognition for his carnival costumes, musical instruments and scale models in copper and brass; in the 1970s the Dutch goldsmith Hans Smit used the same technique to create his marine-inspired pieces. The silversmith Patricia Byer-Dunphy moved from Jamaica to Barbados to establish the Pat Byer Studio, producing starkly lyrical pieces inspired by the rhythms of Caribbean music, and the Barbadian goldsmith Disa Allsopp produced jewellery incorporating such local materials as black coral.

BIBLIOGRAPHY
N. Connell: 'Furniture and Furnishings in Barbados during the 17th century', *J. Barbados Mus. & Hist. Soc.*, xxiv (1957), pp. 102–21
E. M. Shilstone: 'Books and Pocket Almanacs', *J. Barbados Mus. & Hist. Soc.*, xxviii (1961), pp. 78–84
R. S. Dunn: *Sugar and Slaves: The Rise of the Planter Class in the English West Indies, 1624–1713* (Chapel Hill, 1972, 2/London, 1973)
J. S. Handler: 'A Historical Sketch of Pottery Manufacture in Barbados', *J. Barbados Mus. & Hist. Soc.*, xxx (1973), pp. 129–53
F. Lewisohn, W. Lewisohn and B. Meadows: *The Living Arts and Crafts of the West Indies* (Christiansted, St Croix, 1973)
L. Honychurch: *Our Island Culture* (Dominica, 1982)
K. R. Wernhart: 'Report of Ethno-technological Research', *Research in Ethnography and Ethnohistory of St Lucia: A Preliminary Report*, iii (1986), pp. 122–38
J. B. Petersen and D. R. Watters: 'Afro-Montserratian Ceramics from the Harney Site Cemetery, Montserrat, West Indies', *An. Carnegie Mus.*, lvii/1 (1988), pp. 167–87

ALISSANDRA CUMMINS

VI. Patronage.

Patronage has changed from European commissions for illustrations of the area to encouragement of the arts within

the islands themselves. Partly as a result of these changes, the art of the region has become international. While the early European illustrators of the Lesser Antilles were employed to embellish travel books, few of them visited the area; they and their art remained in Europe, where Caribbean themes commonly featured in élite commissions, such as views of the Four Continents. In France, the Gobelins produced variations on this theme from 1687, with major revisions in 1735 (example in Valletta, Pal. Grand Masters, Tapestry Room). Planters were early patrons, at first importing European art and design but later using their slaves to copy European models for their housing, furniture and furnishings (*see* §V above). Sir William Young, for example, a landowner in St Vincent, employed itinerant European artists such as Agostino Brunias to paint local personalities and scenes. Sir William edited the third volume of Bryan Edwards's *The History, Civil and Commercial, of the British Colonies in the West Indies* (1801) and included several engravings after Brunias's paintings. The majority of illustrations appear to have been designed to display patrons' status and wealth. In the debate over emancipation planters also used art to defend slavery, while their opponents encouraged illustrations of the barbarity of the transatlantic 'Middle Passage' and the life of the slaves.

The role of planters as patrons declined in the 19th century with emancipation and the collapse of the Lesser Antillean sugar industry. Items from planters' collections were sometimes preserved in local museums (e.g. Willemstad, Curaçao Mus., and Bridgetown, Barbados Mus.) and libraries, although some are still held by the companies that took over the plantations. During the last three decades of the 20th century local museums began to exhibit items produced by local artists, while the development of tourist art produced new patrons and galleries throughout the region. The owners of these frequently short-lived institutions found suitcase-sized pictures of sun, sea, palm trees and local festivals easiest to sell, and it was generally immaterial whether these were produced by locals or by expatriate artists. However, in the 1950s Barbados had a large influx of expatriate artists who encouraged and patronized local craftspeople and artists, even though they often overshadowed them. Because of their higher status expatriates tended to dominate local shows and collections. It was not until the 1980s that exhibitions of local artists began to be sponsored by institutions in Grenada and Barbados (e.g. Bridgetown, Barbados Mus.; Bridgetown, Queen's Park Gal.; Barbados A. Council). Another form of patronage involves the organization of cultural events such as carnivals. Such bodies as Carnival Development Committees comprise artists and members of the local élite, who set the rules for major events and give prizes for artistic displays.

As many contemporary institutions for the distribution of the art of the Lesser Antilles are aimed at visitors, most locally produced art has been dispersed throughout the world. It is either in small, private collections, or part of major holdings of Caribbean art in the USA and Europe (e.g. London, BM; London, N. Mar. Mus.; Washington, DC, Lib. Congress; Leiden, Kon. Inst. Taal-, Land- & Vlkenknd.). Despite the widespread exportation of art, most islands maintain collections of local scenes and other

works by local artists in their museums and public libraries (*see* §VII below), as do some commercial organizations (e.g. St John's, Montserrat, Mellon Col., Barclays Bank). Local art is sold at local markets or tourist shops or direct from studio-workshops. Galleries aimed primarily at tourists tend to have relatively short lifespans, but most are rapidly replaced. Some galleries, particularly in Antigua (e.g. Nonsuch Bay, Harmony Hall; St John's, Island A.; Falmouth, Seahorse Studios), Martinique (e.g. Fort de France, Carib. A. Cent. (Métiers A.)) and Barbados (e.g. Christchurch, Guardhouse Gal.; Christchurch, Coffee & Cream), sell pieces of higher quality. Most concentrate on local scenes by both expatriates and local artists, and some on the work of the latter.

BIBLIOGRAPHY
B. Edwards: *The History, Civil and Commercial, of the British Colonies in the West Indies*, 3 vols (London, 1793–1801)
C. Hampshire: *The British in the Caribbean* (London, 1972)
D. Devenish: 'On Collecting Caribbean Material', *Mus. Ethnographers' Grp Newslett.*, xix (1985), pp. 58–67
C. J. M. R. Gullick: 'West Indian Artefacts: A Bibliographical Essay', *Mus. Ethnographers' Grp Newslett.*, xix (1985), pp. 26–53
Caribbean Art Now: Europe's First Exhibition of Contemporary Caribbean Art (exh. cat. by E. Wallace, London, Commonwealth Inst., 1986)
C. J. M. R. GULLICK

VII. Museums.

Between 1847 and 1848 the Governor-in-Chief of the Windward Islands, Lt-Col. (later Sir) William Reid, initiated the development of legislation to establish museums 'to which everyone may have access' in St Lucia, Barbados and Grenada. Although he was convinced that 'their establishment will at once give a great forward movement to general education', until the first decades of the 20th century they remained for the most part case collections housed in local libraries. The expansion of American archaeological activities within the region stimulated the rapid growth of 'museum' collections in even the smallest of islands, and by the 1920s libraries in St Vincent, St Kitts, Grenada, Guadeloupe, St Lucia and Antigua all held small collections. In 1933 a Museums Association survey of museums in the British Empire included a study of the Caribbean institutions in which Bather and Sheppard undertook to ascertain 'the status of museums in general in the West Indies and also to make suggestions as to the methods by which they could be improved'. The survey revealed very little Caribbean museum development. The only new museums were the Victoria Memorial Museum (1911) at Roseau in Dominica, Brimstone Hill on St Kitts and a historical museum at the Naval Dockyard at English Harbour in Antigua; the last was the first historic site museum in the region. The visit of the surveyors also gave impetus to the establishment of the Barbados Museum and Historical Society at St Michael, Barbados, in 1933.

A proposal for a Federal Museum in 1956 did not come to fruition. However, in the 1960s local historical and archaeological societies proliferated, and national trusts were established in most of the islands; all had plans to open new museums. This, combined with the fact that during the 1970s most of the islands achieved independence, triggered the establishment of several new institutions. These include the Grenada National Museum (1976)

at St George's, Grenada; the Carriacou Museum (1976) at Carriacou, Grenada; the Montserrat National Museum (1976); the Brimstone Hill Museum (1982) on St Kitts; the Fort Shirley Museum (1982) at Portsmouth, Dominica; the Hamilton House Museum (1983) on Nevis; the St Vincent Archaeological Museum (1979); the Eco Museum (1979), Marie-Galante, Guadeloupe; and the Museum of Antigua and Barbuda (1985), St John's, Antigua. In 1989 the Museums Association of the Caribbean (MAC) was founded. Museums that opened their doors in the 1990s include the Cayman Islands National Museum, Grand Cayman; the Turks and Caicos Museum, Grand Turk; and in Barbados the Barbados Gallery of Art, the Folkstone Marine Museum and the Sir Frank Hudson Sugar Museum.

BIBLIOGRAPHY

F. A. Bather and T. Sheppard: 'The Museums of the British West Indies', *Report on the Museums of Ceylon, British Malaya, the West Indies, etc to the Carnegie Corporation of New York*, Museums Association Report (London, 1933), pp. 27–58

Caribbean Community: *Report of Workshop on Museums, Monuments and Historic Sites* (Kingston, Jamaica, 1979)

J. Whiting: *Museum Focussed Heritage in the English-speaking Caribbean*, UNESCO Report (New York, 1983)

J. Cannizzo: 'How Sweet it Is: Cultural Politics in Barbados', *Muse* (Winter 1987), pp. 22–7

A. Cummins: *The History and Development of Museums in the English-speaking Caribbean* (diss., U. Leicester, 1989)

A. Cummins: 'The Caribbeanization of the West Indies: The Museum's Role in the Development of National Identity', *Museums and the Making of Ourselves*, ed. F. Kaplan (Leicester, 1994), pp. 192–221

A. Cummins: 'Making Histories for Afro-Caribbeans', *Making Histories in Museums*, ed. G. Kavanagh (Leicester, 1995)

ALISSANDRA CUMMINS

VIII. Art education.

Following emancipation in 1834, an apprenticeship system was introduced to train ex-slaves in various manual skills; it lasted until 1838, but art did not form part of any curriculum for apprenticeship or basic education. During the first quarter of the 20th century a few institutions were established to provide technical and vocational training, and some craft unions emerged, though with only sporadic success. In 1932 the Marriot-Mayhew Commission, a West India Royal Commission to consider problems of primary and secondary education in Trinidad, Barbados, Leeward Islands and Windward Islands, carried out a comprehensive survey of educational services and recommended necessary changes in both curricula and teacher training. The Moyne Commission of 1945, a West India Royal Commission established to investigate thoroughly the social and economic conditions of the Caribbean labouring classes, recommended the organization of a handicraft industry. At the same time the British government established a colonial office of the British Council in Barbados to serve Jamaica and the eastern Caribbean. Art classes sponsored by the Council encouraged the development of an aesthetic consciousness and contributed to the establishment of Art Societies in most islands. In Barbados the plans of Neville Connell (1906–73) for an Art Education department at the Barbados Museum, St Michael, received a supporting grant. During the 1950s and 1960s moves towards independence in the islands triggered the realization that education would play a key role in the development of cultural identity. In 1963 the Barbados

government appointed Hector Whistler (1905–78), from Britain, as the first Government Adviser on Art Teaching, and for the first time art education was fully incorporated into secondary school curricula. The provision of scholarships provided opportunities for student training overseas, especially in Britain. From 1950 the Jamaica School of Arts and Craft, later the Edna Manley School for the Visual Arts (*see* JAMAICA, §XI), was the major regional training institution for Caribbean students of Fine and Applied Arts. During the 1960s and 1970s technical colleges were established in most of the islands, including the Barbados Community College (1969) and the Samuel Jackman Prescod Polytechnic (1970), Wildey, St Michael, Barbados.

BIBLIOGRAPHY

C. Brock: 'Education and Multiculturalism in the Caribbean Region', *Education in Multicultural Societies*, ed. T. Corner (1978, 2/London, 1984), pp. 157–97

Hector Whistler (exh. cat. by A. Cummins, Bridgetown, Barbados Mus., 1988)

P. Ellis: *Adult Education in Barbados* (1991)

ALISSANDRA CUMMINS

Antonelli. Italian family of engineers and architects. They were active in Spain and Spanish America in the service of the Spanish Habsburgs from 1559 to 1650. The most prominent member of the family was Juan Bautista Antonelli the elder (*b* Gaeteo, Italy, *c.* 1530; *d* Madrid, 17 March 1588), who settled in Spain from 1559 while working in the employ of Charles V, Holy Roman Emperor. Most of his fortification works were carried out in the coastal south-east of Spain, where several members of his family settled, although he also worked in Oran and particularly in Portugal as a strategist and engineer. Many of his projects were not realized, including the creation of a navigable river network throughout the Iberian peninsula to facilitate the transport of merchandise from the ports to the interior. Several fortification plans for the Magellan Straits also failed to materialize.

Bautista Antonelli (*b* Rimini, 1547; *d* Madrid, 22 Feb 1616), brother of Juan Bautista Antonelli (with whom he is often confused), began working in Spain from 1570, participating in the fortification of Cartagena, Peñíscola and Alicante as well as various sites in Navarre, Catalonia and Portugal. In 1581 he travelled to the Americas for the first time, planning the fortification of the Cape Verde Islands, but soon returned from his main destination, the Magellan Straits, after an unproductive visit. In 1586 he went to Colombia, where he worked on the fortification of Cartagena de Indias, subsequently moving on to Tierra Firme (the provinces of Panama, Darien and Veraguas) and Cuba (*see* CUBA, §III, 1) with the intention of studying how best to defend it against continuous attacks by pirates. On returning to Spain, he submitted a general plan of fortification for all Spain's overseas possessions to Philip II, who accepted it and charged Antonelli with putting his scheme into practice. With this objective he travelled again to the Americas in 1589, settling first in Puerto Rico, then moving on to Santo Domingo and Havana (Cuba), which had become the chief port of Spanish America after the sack of Santo Domingo by Sir Francis Drake in 1586. Here Antonelli began building the fortress of Los Tres Reyes del Morro. Later he went to Mexico and Tierra

Firme to write reports on work in progress there to protect communication routes and the transport of merchandise. In San Juan de Ulúa (Mexico) and along the Pacific coast, he analysed the problems inherent in shipping products out of Peru. He remained in Cuba until 1593, when he gave up directing the schemes he had in hand, moving on the next year to Cartagena de Indias, Portobelo and Panama, where he proposed various protective measures. In 1599 he returned to Spain to work on the fortification of Gibraltar and Larache. Other members of the Antonelli family who worked as military engineers include his son Juan Bautista Antonelli the younger (*c.* 1585–1649), his nephews CRISTÓBAL DE RODA and Cristóbal Garavelli Antonelli and the latter's son, Juan Bautista Garavelli Torres, who became known as Juan Bautista Antonelli on assuming control of the estate founded by the first Juan Bautista Antonelli.

BIBLIOGRAPHY
D. Angulo: *Bautista Antonelli: Las fortificaciones americanas del siglo XVI* (Madrid, 1942)
J. A. Calderón Quijano: *Fortificaciones de Nueva España* (Seville, 1953)
R. Segre: 'Significación de Cuba en la evolución tipológica de las fortificaciones coloniales de América', *Bol. Inst. Invest. Hist. & Estét.*, 13 (1972)
L. Toro Bariza: 'Juan Bautista Antonelli el Mayor', *Bol. Real Acad. B. Let.*, vii/7 (1979), pp. 41–56
J. M. Zapatero: *Historia de las fortificaciones de Cartagena de Indias* (Madrid, 1980)
J. Porres Martín-Cleto: *Toledo, puerto de Castilla* (Toledo, 1982)
S. Sebastián López, J. de Mesa and T. Gisbert: *Summa Artis: Historia general del arte xxviii Arte desde colonización a la Independencia (primera parte)* (Madrid, 4/1992)

MARIA CONCEPCIÓN GARCÍA SÁIZ

Antunes Ribeiro, Paulo (*b* Rio de Janeiro, 1 Sept 1905; *d* Rio de Janeiro, 8 March 1978). Brazilian architect. He graduated in 1926 from the Escola Nacional de Belas Artes, Rio de Janeiro, where he won the gold medal; his contemporaries there included Lúcio Costa and Diógenes Rebouças. He then studied urban planning at the Institut d'Urbanisme, University of Paris (1928–9). Initially, like Costa and other contemporaries, he supported the neo-colonial movement in Brazil in the wide-ranging debate on the development of national art that dominated Latin America from the beginning of the century. Later, influenced by the tremendous growth taking place in American cities, he based his work on the rationalist modernism of Le Corbusier and CIAM, and its Brazilian adaptations, specializing in urban planning. An early example is the plan he drew up for the city of Goiânia (1933; with Attilio Corrêa Lima). Other important works include the Prudência office building (1946; also known as the Caramurú building), Salvador, covered with *brises-soleil* on panels arranged in a chequered fashion and with a roof garden and curved service towers and windbreaks on the roof, for which he won an honourable mention at the first São Paulo Bienniale (1951); and the Hotel da Bahia (1949–51; with Diógenes Rebouças), Salvador, a long, rectangular block of rooms above two floors of public rooms that curve out beyond the plan form in an exuberant manner. He was a versatile architect, designing houses, blocks of flats, public buildings and hospitals, and he made a significant contribution to the development of Brazilian architecture immediately after World War II. He was President of the Instituto de Arquitetos do Brasil (1953–

6) and was its representative on the selection jury for the national competition to design the master plan for the new capital city of Brasília.

BIBLIOGRAPHY
'Edifice Caramurú A Bahia: Paulo Antunes Ribeiro Architecte', *Archit. Aujourd'hui*, xxiii/42–3 (1952), pp. 24–5
D. Paglia, ed.: *Arquitetura na Bienal de São Paulo* (São Paulo, *c.* 1952)
H. E. Mindlin: *Modern Architecture in Brazil* (Amsterdam and Rio de Janeiro, 1956)
Y. Bruand: *Arquitetura contemporânea no Brasil* (São Paulo, 1981)

JULIO ROBERTO KATINSKY

Antúnez, Nemesio (*b* Santiago, 1918; *d* June 1993). Chilean painter and printmaker. After studying architecture at the Universidad Católica de Chile in Santiago he won a scholarship that enabled him to continue his studies at Columbia University, New York, from 1943 to 1945. Having painted sensitive watercolours from nature while living in Chile, his journey to New York had a disquieting effect on him: he translated his experience of the concrete city, with its massive buildings dwarfing the anonymous inhabitants wandering the streets, into nearly abstract geometric compositions. He remained in New York to work with Stanley William Hayter from 1948 to 1950 and later travelled to Spain.

On his return to Chile in 1953 Antúnez founded Taller 99, a workshop modelled on Hayter's Atelier 17, which had far-reaching effects on the development of printmaking in Chile. His renewed contact in Chile with the natural landscape and its fields, beaches and mountains allowed him to return to intimate, sensitively coloured scenes, as in the *Fishing-lines* and *Bicycles* series. He returned to the USA from 1964 to 1969, this time as cultural attaché in the Chilean Embassy in Washington, DC, which brought him back into contact with crowds; his paintings again featured volumes in perspective and geometric structures based on his vision of the modern city (e.g. *Valparaiso*, 1968; see fig.). He went back to Chile to work as Director

Nemesio Antúnez: *Valparaiso*, oil on canvas, 255×255 mm, 1968 (Austin, TX, University of Texas, Jack S. Blanton Museum of Art)

of the Museo Nacional de Bellas Artes in Santiago, vigorously promoting the visual arts and extending the exhibition space by building the Sala Matta, but he went into voluntary exile in Europe after the military coup of 1973, spending time in England, Spain and Italy. From 1975 he painted a series entitled the *Black Stadium* (see colour pl. II, fig. 1), an allusion to the football stadium that served as a massive prison for political detainees under the military junta, in which he expressed his anguish at the dramatic events that had taken place in Chile after the fall of President Allende's government. He decided to settle again in Chile only in 1985.

Antúnez's work stems in general from a sensitive and emotionally detached contemplation of daily life, even when dealing with dramatic events. Within the apparent restrictions of line and colour he found all the expressive possibilities he needed, superimposing images of female figures, beds and tablecloths in intimate, natural surroundings on to highly formal structures.

BIBLIOGRAPHY

E. Lihn: 'Antúnez', *Rev. A.* [Santiago], 3 (March–April 1956)

M. Ivelić and G. Galaz: *Chile: Arte actual* (Santiago, 1988)

Antúnez (exh. cat., Santiago, Gal. Praxis, 1988)

E. Meissner: 'Semblanza de Nemesio Antúnez', *Atenea*, cdlxix (1994), pp. 11–27

Nemesio Antúnez: Exposición retrospectiva (exh. cat., Santiago, Mus. N. B.A., 1997)

MILAN IVELIĆ

Arai, Alberto T. (*b* Mexico City, 29 March 1915; *d* Mexico City, 25 May 1959). Mexican architect, theorist and writer, of Japanese descent. The son of a Japanese ambassador in Mexico, he studied philosophy, espousing neo-Kantianism and becoming politically a socialist. He became a supporter of Functionalism, with its emphasis on the social applications of architecture, and was a founder, with Enrique Yañez, of the Unión de Arquitectos Socialistas (1938), helping to draw up a socialist theory of architecture. He was one of the most active participants in the Unión and attempted to put his socialist theory into practice on two unexecuted projects in the same year: the building for the Confederación de Trabajadores de México and the Ciudad Obrera de México, both with Enrique Guerrero and Raúl Cacho. Later, when Mexico opted for a developmental policy, Arai became a standard-bearer for nationalism in architecture. He re-evaluated traditional building materials, such as tree trunks, bamboo, palm leaves and lianas, using them in a plan for a country house that was adapted to the warm, damp climate of the Papaloapan region. The building of the Ciudad Universitaria, Mexico City, gave him his greatest architectural opportunity when he designed the Frontones (1952). In these he used the volcanic stone of the area to great effect in truncated pyramid shapes inspired by Pre-Columbian pyramids. His numerous books and articles addressed conceptual problems in Mexican architecture.

WRITINGS

La nueva arquitectura y la técnica (Mexico City, 1938)

Nuevo urbanismo (Mexico City, 1940)

Filosofia de la arquitectura (Mexico City, 1944)

Caminos para una arquitectura mexicana (Mexico City, 1952)

¿Qué orientaciones fundamentales debe seguir la arquitectura en México? (Mexico City, 1956)

BIBLIOGRAPHY

M. L. Cetto: *Moderne Architektur in Mexico* (Stuttgart, 1960; Eng. trans., New York, 1961)

E. X. de Anda: *Evolución de la arquitectura de México* (Mexico City, 1987)

F. González Gortázar, ed.: *La arquitectura Mexicana del siglo XX* (Mexico City, 1994)

RAMÓN VARGAS

Arango, Débora (*b* Medellín, Antioquia, 1910). Colombian painter. From 1933 to 1938 she studied at the Instituto de Bellas Artes de Medellín and under Eladio Veles and Pedro Nel Gómez ; her early still-lifes and portraits reflect contemporary studio practices, while her expressive, provocative female nudes reveal the influence of Nel Gómez. Other early works are concerned with religious life, autobiographical subject-matter that stemmed from her childhood (e.g. *First Communion* and *Sisters of Charity*, both 1942, Medellín, Mus. A. Mod.). From 1938 her paintings reflected a growing concern with social issues. In 1944 Arango was part of a group of artists that published the *Manifiesto de los Independientes*, asserting the regionalist values of art and emphasizing the importance of mural painting as a public educational medium. Her subject-matter became openly feminist, exploring both private feminine life (e.g. *Adolescence*, 1944, Medellín, Mus. A. Mod.) and the social and political status of women. In *Justice* (1944, Medellín, Mus. A. Mod.), she employed grotesque characters to allude to such situations of exploitation and injustice as prostitution. Works such as *The Massacre of April the 9th* (*c.* 1950), *The Students Strike* and *Military Junta* (both 1957; all Medellín, Mus. A. Mod.) comment on turbulent national political events of the period. But her works also transcend the local and anecdotal, expressing violence and degradation of power in universal terms. In allegorical works such as *The Republic* (1950, Medellín, Mus A. Mod.), the influence of the Mexican muralists, especially Orozco, is evident.

From the beginning of her career, Arango's paintings provoked controversy, resulting in her withdrawal from public life. In 1939 she won first prize in the Exhibition of Professional Artists of the Union Club of Medellín, though her female nudes were considered obscene. In 1940 her first one-person show at the Colon Theater of Bogotá, mounted at the invitation of the Ministry of Education, closed the day after opening following criticism on moral and religious grounds; the situation was repeated in 1955 at the Instituto de Cultura Historica in Madrid. Her work was marginalized not only because of its content and discordant expressionistic rendering, but also because it was figurative in a period when abstraction was dominant in Colombia, synonymous with modernism. Despite criticism, Arango continued her figurative expressionism throughout the 1950s. In 1974 her participation in the exhibition *Arte y Politica* (Bogotá, Mus. A. Mod.) and donation of work to the Museo de Arte Moderno de Medellín prompted intense re-examination of her work, and many exhibitions followed; she came to be considered a pioneering social and feminist artist in Latin America.

BIBLIOGRAPHY

Débora Arango, (exh. cat., Medellín, Mus. A. Mod., 1986)

M. González: 'Débora Arango', *America, Bride of the Sun* (exh. cat., Antwerp, Kon. Mus. S. Kst., 1992)

Débora Arango: Exposición retrospectiva (exh. cat., Bogatá, Bib. Luis-Angel Arango, 1996)

Colombia en el umbral de la modernidad (exh. cat. by A. Medina, Bogotá, Mus. A. Mod., 1997)

NATALIA VEGA

Arboleda, Carlos (*b* Chilibre, 16 Jan 1929). Panamanian sculptor and painter. He studied at the Accademia di Belle Arti in Florence (1949–54) and at the Real Academia Catalana de Bellas Artes de San Jorge in Barcelona (1955–60). On his return to Panama City he became the first professor of sculpture at the Escuela Nacional de Artes Plásticas from 1961 to 1964, and in 1964 he founded the Casa de la Escultura, a government-supported centre for the teaching and promotion of the fine arts which he continued to direct after it was renamed the Centro de Arte y Cultura. Arboleda exhibited often and established his reputation as a young man with academic works such as *Serenity* (marble, 1950; Panama City, Mus. A. Contemp.). Most of his work was figurative, but he later developed a more symbolic style and produced his most original sculptures on indigenous themes, as with the bronze head of a Chocó Indian entitled *Under the Skin* (1961; Panama City, R. Durán priv. col., see E. Wolfschoon: *Las manifestaciones artísticas en Panamá*, Panama City, 1983, p. 286), with which he won the Prix Georges Roudier at the Paris Biennale of 1961. Unlike his sculptures, Arboleda's paintings tend to be mild, with light colours and diffused images of human figures or birds.

BIBLIOGRAPHY

M. Martínez de Lahidalga: *Carlos Arboleda: Pintor y escultor panameño* (Madrid, 1974)
Encuentro de escultura (exh. cat., ed. M. E. Kupfer; Panama City, Mus. A. Contemp., 1987), pp. 4–5

MONICA E. KUPFER

Arburo [Arburu] **(y) Morell, José** (*b* ?Havana, 1864; *d* Paris, 17 Aug 1889). Cuban painter. He was one of the most prominent students of Miguel Melero (1836–1907), the first Cuban-born director of the Academia de S Alejandro in Havana (founded 1818). Morell also studied at the Academia de S Fernando in Madrid. Morell's portraits, with their natural poses in domestic settings, reflect an ease with effects of light and texture not seen in the work of his Cuban contemporaries, with the exception of Guillermo Collazo. One of his most significant works is *In the Garden* (1888; Havana, Mus. N. B.A.), in which the use of light is reminiscent of the naturalism of *plein-air*, with which Morell would almost certainly have come into contact in Spain. His promising career was cut short by typhus when he was 25.

BIBLIOGRAPHY

J. Mañach: 'La pintura en Cuba: Desde sus orígenes hasta 1900', *Las bellas artes en Cuba*, xviii of *La evolución de la cultura cubana (1608–1927)*, ed. J. M. Carbonell y Rivero (Havana, 1928), pp. 239–40
Enciclopedia del arte en América, iii (Buenos Aires, 1968)

RICARDO PAU-LLOSA

Arciniega [Arziniega], **Claudio de** (*b* Burgos, 1526–7; *d* Mexico City, 1593). Mexican architect and sculptor of Spanish birth. In 1541 he moved from his native city to Madrid, where he served as an apprentice to Luis de Vega, one of the architects working in the High Renaissance style for Emperor Charles V. Arciniega worked with Vega in the remodelling of the Alcázar at Madrid. At intervals between 1542 and 1548 he worked under the direction of Rodrigo Gil de Hontañón as a sculptor on the plateresque façade of the university at Alcalá de Henares. He was

possibly also responsible for the main retable in the church of Santiago at Guadalajara.

In 1554 Arciniega arrived in New Spain (now Mexico) with his brother Luis de Arciniega (1537–99), who was also an architect. He settled in Puebla de los Angeles (now Puebla) and worked there between 1554 and 1558, primarily engaged in a large number of public works as master mason. He established his reputation with the fountain that he constructed (1556–7) in the centre of the city's main plaza. After seeing the fountain, the viceroy engaged Arciniega to work for him in México (now Mexico City). Arciniega's career in the viceregal capital began in 1558, and a year later he designed the *Túmulo Imperial*, a temporary monument for the obsequies of Charles V (an engraving of 1560 of the design is preserved in Seville, Archv Gen. Indias). In the harmonic proportions, structural use of Classical orders and simplicity of ornamentation, the design displays a genuine High Renaissance style. Arciniega was thus one of the earliest exponents of the mature Renaissance in New Spain. In 1559 the viceroy appointed him Maestro Mayor for the viceregal capital, and 19 years later King Philip II bestowed on him the title of Obrero Mayor for New Spain. This was the highest honorific title to which an architect could then aspire. In 1578 Arciniega had reached the peak of professional glory.

As chief architect for México, Arciniega was involved, in one way or another, in all of the major projects of the city, which comprised at least five churches, two convents, three hospitals and one school for girls. He was the main architect for the construction of the Viceregal Palace (1563–76, destr. 1692). Outside México, he may have designed the Franciscan church at Tecali, near Puebla (1568–9). In 1591 he made the plans for the church of S Mateo, Atenco, near México. He was also involved in 1576 in the design of the fortress of S Juan de Ulúa (Veracruz) and made recommendations concerning a projected relocation and new urban plan for the city of Veracruz. Arciniega also made assessments and recommendations on the project to construct the cathedral at Pátzcuaro (1560) and for rebuilding Puebla Cathedral (1564).

Arciniega's greatest architectural achievement, however, was his contribution to the cathedral of México, the largest church building in the western hemisphere until the 20th century (*see* MEXICO, fig. 3). In his capacity as Maestro Mayor, Arciniega was entrusted with designing the cathedral. By 1563 he had completed the ground-plan and elevation, based on those of various Spanish cathedrals, especially of Segovia and Salamanca. Serious problems relating to the stabilization of the building site delayed construction, but by 1570 the ground was consolidated; construction began in 1573, and by 1585 the foundations and boundary walls were well advanced. At the time of Arciniega's death, most of the exterior walls had been completed. Also concluded were the buttresses forming the peripheral chapels, some of the niches serving as altars for the latter, many of the interior piers and a few of the rib vaults on the eastern end of the building. Construction came almost to a halt after Arciniega's death. Between *c.* 1600 and 1610 Arciniega's scheme for the vaults was modified, possibly by Juan Miguel de Agüero (*fl* 1574–?1613). This was a more modern design, calling for saucer

vaults and dome instead of the original rib vaulting scheme. The interior of the building was completed incorporating these modifications by 1667.

BIBLIOGRAPHY
H. Berlin: 'Artífices de la Catedral de México', *An. Inst. Invest. Estét.*, xi (1944), pp. 19–39
D. Angulo Iñiguez: *Historia del arte hispanoamericano*, i (Barcelona, 1945)
E. Marco Dorta: *Fuentes para la historia del arte hispanoamericano*, i (Seville, 1951)
M. Toussaint: *Claudio de Arciniega: Arquitecto de la Nueva España* (Mexico, 1981)

FRANÇOIS-AUGUSTE DE MONTÊQUIN

Arellano, Francisco Chávez y. *See* CHÁVEZ Y ARELLANO, FRANCISCO.

Arequipa. Peruvian city and capital of the department of Arequipa. The city (population in 1996 *c.* 680,600) is situated on the River Chili in a fertile valley in the foothills of the Andes and on the slopes of a volcanic range. Earliest settlement dates back to the Early Horizon (*c.* 900–*c.* 200 BC), and there have been archaeological finds at San Juan de Siguas, Santa Isabel de Siguas (to the north), and in the Vítor Valley (to the west of Arequipa). The Lupaca people first settled in the area around what is now Arequipa *c.* AD 800–1200. The site of Churajon lies about 30 km from Arequipa; substantial agricultural systems and terracing characterize the region. In drier areas there are numerous petroglyphs, notably at Toro Muerto. By the 1350s provincial Inca settlements had been established near the present-day city. Arequipa would have been a *tambo* (Quechua: 'road-side inn') on the route between the highlands and the coast. The Spaniards founded the city of Villahermosa de Arequipa (or Villa Hermosa de la Asunción) on 15 August 1540. The proximity of the volcanic range has ensured a supply of easily dressed but strong, white volcanic tufa, or sillar; however, it has also led to disastrous earthquakes (in particular, 1582, 1600, 1687, 1715, 1784 and 1868), which have defined the phases of the city's architectural development. These may be referred to generally as rural development (1540–82), Baroque (1582–1784), Rococo and Neo-classical (1784–1868), and Colonial Revival and modern (1868–1960). In efforts to withstand earthquakes, architects used wide-based, buttressed and supported walls; these give a sense of volume, bulk and static mass, broken only by the vitality of the carvings. Unfortunately, few early colonial buildings survive; many are 18th-century reconstructions. Arequipa does, however, retain its characteristically colonial grid plan.

The present church of La Compañía (1650–98; tower rebuilt 1919 and 1966) represents the Mestizo Baroque style that developed in the 1600s. It has a characteristic Arequipeño relief, carved by incising the surface rather than by working in the round, creating a tapestry-like effect. The main façade (1698; see fig.) was initially planned by Gaspar Báez (*fl* 1569–73) in 1573, and in 1590 Diego Felipe (*fl* 1590–95) planned the main entrance following the 1584 earthquake. The portal has two registers crowned by a trilobate arch, with indigenous decorative elements. A number of church and house façades feature Hispanicized forms of such Pre-Columbian motifs as cantuta flowers, maize, leaves, birds, fish and masks. The design

Arequipa, façade and main portal of the church of La Compañía, 1698

of the portal is ascribed to Agustín de Costa, and it was probably executed by the mason Agustín de Adrián. The side portal (1654) and other parts of the church were by Simón de Barrientos (*fl* 1654–90). The importance of this church lies in its incorporation of Creole and Mestizo traditions, as in the side portal, where the Hispanic saint Santiago Matamoros is supported by winged mermaids, who had a symbolic value in Pre-Columbian times. The main cloisters have arches supported on substantial square columns, crowned by pediments containing medallions displaying the Jesuit monogram. They were begun at the end of the 17th century by Lorenzo de Pantigoso and Juan de Ordoñez and completed in 1738; the style and ornamentation are the same as those on the façade. Similar traditions of masonry and decoration were also used on La Merced (rebuilt 1657; rest.), S Agustín (early 18th century) and the suburban churches of S Miguel (*c.* 1719–30), Cayma, by Pérez del Cuadro (*fl c.* 1719), with a dome (1782) by Carlos Aranchi, and S Juan Bautista (1750; partly destr.), Yanahuara. Polychrome paint was sometimes applied, for example on the façade of S Juan Bautista.

S Domingo (1677-80) is another of the city's oldest churches and follows the scheme of La Compañía. The façade of two registers was finished in 1647 and the polygonal tower in 1649, both under Juan de Aldana (*fl* 1643–56). The nave was remodelled in 1784, and the vaults were rebuilt in 1873. Earthquakes in 1958 and 1960 destroyed a large section of the main portal, but the lateral portal remains as a good example of the contribution of local carvers, who combined images of the human form

and geometric, floral designs. Damaged sections, including the tower, have been restored in sillar and brick. Viceregal Arequipeño architecture can also be found in the townships of Ayaviri, Asillo, Lampa, Juli, Pomata, Juliaca, Puno and Zepita. Additionally, there are at least 16 parish churches in the Colca Valley along the main route to the Collao that reveal its influence (e.g. churches of Yanque and Maca).

The first convent in Arequipa was S Catalina (1576), officially founded in September 1579. The plans were drawn up by Juan de la Torre, Gómez de Hernández and Francisco Espinoza. It was built within huge, fortress-like, buttressed walls and still occupies nearly 2.5 ha (20,426 sq. m), an area equivalent to a whole block on the city's grid plan. In 1582 the convent was badly damaged by an earthquake; it was rebuilt in 1662 and restored in 1758. Following the earthquake of 1784 large sections were reconstructed following the old ground-plans, and further restoration took place in 1874. The miniature citadel of arcaded galleries, small squares and individual houses was opened to the public in 1970, a small section being retained for the remaining nuns. The walls within are washed in crimson, red, orange, golden-yellow and cobalt-blue, and such architectural details as cornices are picked out in natural sillar. The convent of S Teresa (1700–c. 1784) retains its original character, although the associated church and its façade have been altered. The convent of S Rosa (founded 1747) likewise retains its original design, despite a total reconstruction following the earthquake of 1868.

Construction of the cathedral (founded 1612) began in 1621 following plans by Andrés de Espinoza and continued for several decades under the architect Moscoso; it was completed under Juan de Aldana in 1656. Following a fire in 1844 and the 1868 earthquake it was rebuilt by Lucas Poblete, and it retains much of the original plan. It is a long, low building, with a façade occupying the entire north end of the city's main square, the Plaza de Armas. It is divided into three largely undecorated registers, each incorporating a series of 70 columns. Surrounding the Plaza de Armas are two-storey Neo-classical arcades built in *sillar* (a white, porous volcanic stone), which complement the cathedral and give the square a sense of architectural unity. The second storey (post-1900) was added in the Republican period.

Secular architecture in Arequipa includes the multiple-arch Puente Bolognesi (1577–1608), which was built in sillar and spans the Chili. Fine Mestizo carving was applied to the portals, windows, cornices, gargoyles and lintels of seigneurial houses and mansions. These are usually of one storey with thick walls supporting vaulting and a small patio. In the Casa del Moral (mid-18th century; formerly owned by Arthur Williams, now by Banco Industrial) elements of Arequipeño mestizo Plateresque are combined with aspects of religious architectural design. The original owner's coat of arms fills the central ground of the portal tympanum. The protruding bay-like windows resemble those found in coastal towns, although they have much more decorative detailing. Heraldic elements include keys, lions, towers, cocks and crowns, which are complemented by puma gargoyles, cantuta flowers, drums and indigenous elements. The Casa Ugarteche (1738; originally Seminario de San Jerónimo, now Casa Gibbs-Ricketts, offices of Banco Continental) has similar proportions to the Casa del Moral, although its decoration is more formal and complex. Other seigneurial houses include the Casona Irriberry (1793; restored by the Universidad Nacional de S Augustín, it includes an art gallery and the Chárez de la Rosa Culture Centre), Casa de la Moneda (1794 or 1798) and Casa Goyeneche. It has been suggested that such single-storey houses in Arequipa are closer to the civilian architecture of the Canary Islands than to that of mainland Spain (Keleman). Furthermore, Juan de Mesa y Lugo (1605–65), Governor of Arequipa, had been a member of the council of Santa Cruz de Tenerife, Canary Islands.

From the Republican period onwards there has been an urge to conserve the city's characteristic architecture and even to replicate it using Baroque and Rococo Revival styles, for example in the late 1950s Teatro Municipal, various public buildings and the Hotel de Turistas. In the 1960s purely functional, modernist structures were built, such as the Beneficencia Pública, Hospital del Empleado and American-style housing associations; sillar facing was sometimes used. In the 1970s and 1980s, following a massive influx of peoples from the Altiplano (Juliaca, Puno, Cuzco), the suburbs expanded rapidly, resulting in large shanty towns and some houses built of brick, cane, matting and sillar blocks. Substantial new sections were added to the University of S Agustín campus (1990s).

BIBLIOGRAPHY

H. E. Wethey: *Colonial Architecture and Sculpture in Peru* (Cambridge, MA, 1949), pp. 140–75
P. Keleman: *Baroque and Rococo in Latin America* (New York, 1951)
E. Harth-Terré: *Perú: Monumentos históricos y arqueológicos* (Mexico City, 1975), pp. 69–87
Prehistoria de Arequipa (exh. cat. by E. Linares Málaga, Arequipa, Casa Ricketts, 1983)
J. B. Ballesteros: *Historia del arte hispanoamericano: Siglos XVI a XVIII*, ii (Madrid, 1987), pp. 277–81
J. A. de Lavalle and others: *Arequipa* (Rio de Janeiro, 1988)
R. Gutiérrez: *Evolución histórica urbana de Arequipa (1540–1990)* (Lima, 1992)
E. Quiroz Paz-Soldán: *Visión histórica de Arequipa, 1540–1990* (Arequipa, 1991)
Gran enciclopedia del Perú (Barcelona, 1998), pp. 177–221
W. IAIN MACKAY

Argentina, Republic of [República Argentina]. South American country. It is bordered to the north by Bolivia and Paraguay, to the north-east by Brazil and Uruguay, to the east by the Atlantic Ocean and to the west by Chile (see fig. 1). Buenos Aires is the capital city, and the country is divided administratively into several areas. The mild and fertile Pampa region in the centre accounts for the country's agricultural wealth; the Andes in the west range from dry, hot, northern peaks to sub-Antarctic Patagonia; the arid north-west is rich in mineral reserves. The north is covered by subtropical forest, known as the Chaco. Mesopotamia, to the north-east, is enclosed by two great rivers, the Paraná and the Uruguay, which the Spanish expeditioners followed in search of the gold and silver that they believed Argentina ('the land of silver') concealed. This varied hinterland has, nevertheless, remained underdeveloped at the expense of the over-populated capital; around a third of the total population of 32,609,000 lives there and in the surrounding province. The majority of

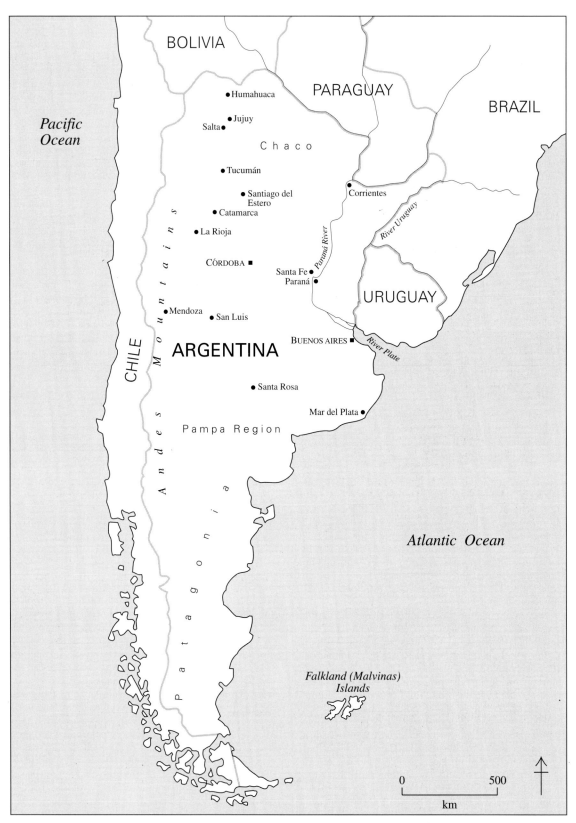

1. Map of Argentina; those sites with separate entries in this encyclopedia are distinguished by CROSS-REFERENCE TYPE

the population is of European, particularly Spanish and Italian, origin, although there are also communities of East Asian immigrants. The population of African descent that was introduced through slavery during colonial rule has all but disappeared, not least as a result of an epidemic of yellow fever in 1871.

I. Introduction. II. Architecture. III. Painting, graphic arts and sculpture. IV. Gold and silver. V. Textiles. VI. Patronage and art institutions. VII. Art education. VIII. Art libraries.

I. Introduction.

The settlement of Argentina by the Spanish conquistadors was a gradual and faltering process: Juan Díaz de Solís first set foot on Argentine territory in 1516; after Díaz's death at the hands of the indigenous peoples, Sebastian Cabot followed in his trail in 1526, but only in 1536 was BUENOS AIRES founded by Pedro de Mendoza (only to be abandoned and refounded in 1580 by Juan de Garay). Little evidence remains of the indigenous population, which probably numbered *c.* 300,000 at the time of the Spaniards' arrival. The most prolific people in terms of surviving indigenous art were the north-western Diaguita people, who were able potters and basket-makers and who were acquainted with basic metalwork and stone-carving techniques. Their stone fortresses or *pucará* still stand on the old Inca road that the Spanish later followed on their way to the Atlantic. The Guaraní people in the north-east were taken in by the missionaries once the Jesuits became established in Paraguay in 1585. The ruins of San Ignacio Miní mission in the province of Misiones testify to their technical and artistic abilities.

The Viceroyalty of Peru was given control of all Spanish possessions south of Lima in 1543, and in that year expeditions were sent from both Peru and the Captaincy of Chile to those territories. The oldest Argentinian towns were therefore founded along the expeditions' routes: along the north route these were Santiago del Estero (1551), Tucumán (1565), CÓRDOBA (1573), Salta (1582), La Rioja (1591) and Jujuy (1592); while expeditions from the west founded Mendoza (1561), San Juan (1562) and San Luis (1598). Settlers followed, as well as the religious orders of the Merced, Jesuits (*see* JESUIT ORDER, §3), Dominicans and Franciscans. Settlements grew into cities, and a local Baroque style developed in architecture, painting and devotional sculpture that was to prevail throughout the 17th and 18th centuries.

In the 19th century the growing weakness of the Spanish crown under Napoleonic control and two attempted British invasions (1806, 1807) strengthened local independence movements. A revolt in 1810 established a locally elected government in Buenos Aires, leading to a formal declaration of independence in 1816 by the Congress of Tucumán. In 1853 the national constitution was drawn up, settling the civil war between Buenos Aires and the provinces that had raged since independence and abolishing the slave trade. Visual records of this period survive in the paintings and etchings of contemporary foreign artists such as EMERIC ESSEX VIDAL, exploring the newly independent South American countries. Art education was furthered by the formation of drawing and painting schools. In the second half of the 19th century

the arrival of European immigrants, mainly from Italy and Spain, heralded a period of stability. Painting and architecture flourished with the adoption of European trends. The indigenous community, however, suffered a final blow when the nomadic peoples of Araucanos, Querandíes, Tehuelches, Onas and Yaganes were systematically exterminated and all their crafts destroyed during the Conquista del Desierto campaign (1877–81). The remaining population began to increase again only in the 20th century.

With the two world wars and the economic depressions of the 1930s another wave of immigrants arrived from Europe. At the same time developments in European and North American art and architectural styles attracted a new generation of young Argentinians. The Instituto Torcuato di Tella (founded 1958; *see* §VI below) played a significant role in focusing interest on the modernization of Argentine art. Cultural development was hindered by a series of military dictatorships from the 1930s to the early 1980s; democracy was finally restored in 1983.

BIBLIOGRAPHY
J. León Pagano: *Historia del arte argentino* (Buenos Aires, 1944)
W. Parish: *Buenos Aires y las provincias del Río de la Plata desde su descubrimiento y conquista por los españoles* (Buenos Aires, 1957)
J. Luis Romero: *Breve historia de la Argentina* (Buenos Aires, 1979)
N. Shumway: *The Invention of Argentina* (Berkeley, CA, *c.* 1991)
T. di Tella: *Historia Argentina desde los orígenes hasta 1830* (Buenos Aires, 1994)

IRENE FANNING, with MARIO TESLER

II. Architecture.

1. Colonial period, before *c.* 1810. 2. *c.* 1810–*c.* 1920. 3. After *c.* 1920.

1. COLONIAL PERIOD, BEFORE *c.* 1810. In 1536 Pedro de Mendoza founded the first settlement of Buenos Aires, but it was demolished in 1541. In 1580 it was refounded permanently on the River Plate by Juan de Garay. By 1617 the importance of Buenos Aires had been recognized by Spain, who made it the capital of a new province of the same name within the Viceroyalty of Peru. By 1776 the city was declared the capital of the newly created Viceroyalty of the River Plate, the last of Spain in America. Other new establishments were made between 1553 and 1594 when Spanish expeditions out of Lima and Santiago, Chile, established a series of cities in Argentine territory, including Santiago del Estero, Mendoza, San Juan, Tucumán, CÓRDOBA, Salta, La Rioja, Jujuy, San Luis, Concepción del Bermejo and Corrientes. The cities founded by the Spaniards were characterized by their grid-plans, with a *plaza mayor* in the centre surrounded by the government house, the town hall and the principal church. The relative poverty of Argentinians until the 18th century prevented the construction of great places of worship or sumptuous residences, however. In Salta and Jujuy the first houses were of rough stone with timber roofs; in Santiago del Estero and Córdoba they were of adobe and thatch, as in the eastern zone and Buenos Aires; in their north-eastern missions the Jesuits made use of a more solid system, *pisé*, earth construction within a wooden framework. An early 18th-century temple at Molinos in Salta is typical; it has an adobe and brick church and cloister. Squat twin towers are crowned with simple cupolas and bridged by a deep barrel vault.

2. Thomas Prosper Catelin and Pierre Benoit: portico of Buenos Aires Cathedral, 1822–7

Numerous chapels with Hispanic influence were constructed in Salta and Jujuy, including the Yaví Chapel (1690), Jujuy. Other notable buildings include the church of S Francisco (1657–80), Santa Fe, attributed to Fray Francisco Arias, and the later S Pedro de Fiambalá (1770, Catamarca). The front of the *posta* (rest-house) at Sinsacate, near Córdoba City (18th century), is shaded by a verandah with closely spaced piers flanking a small adobe chapel with a freestanding bell tower. By comparison the *estancia* of S Catalina, also near Córdoba, is more sophisticated. The church has a Baroque façade and a dome with much simplified scroll buttresses. It was completed in 1763 with the help of the German architect–priest Anton Harls but may also show the influence of Jesuit architects ANDREA BIANCHI and GIOVANNI BATTISTA PRIMOLI, who both arrived in 1717.

Córdoba City was the most outstanding centre of colonial architecture, a position that it owed to the Jesuits, among whom there was an abundance of good architects. The Society's first chapel was established there *c.* 1596, and La Compañía (1645–74) was the mother church of the town. Its vaulting, constructed in Paraguayan cedar, is due to the Belgian Jesuit Felipe Lemer; it was partially damaged by fire in 1965. The cathedral (1697–1787) was inspired by Jacopo Vignola's Il Gesù in Rome. It was begun by José González Merguete of Granada who came to Córdoba from Bolivia in 1697; and Bianchi took over *c.* 1729. The curious dome (1752) attributed to the Franciscan Fray VICENTE MUÑOZ refers to the Late Romanesque cupolas of the Old Cathedral at Salamanca and the cathedrals at Zamora and Toro in Spain. A good

example of the architecture of Jesuit *reducciones* (hamlets for converted Indians) in north-eastern Argentina is offered by the ruins of San Ignacio Miní (Misiones prov.), the constructions of which were designed by fathers Giuseppe Brasanelli and Angelo Petragrassa (*c.* 1700–24). The splendid church of San Ignacio Miní shows the presence of Indian artisans in the elaborate ornament of its Baroque façade of red stone.

In Buenos Aires the Jesuit church of S Ignacio was begun in 1712 by the architect–priest Johann Kraus, of Pilsen, Bohemia. Bianchi worked in a number of churches in Buenos Aires, including El Pilar (1716–32), La Merced (1721–33) and S Francisco (1730–54). The cathedral (1755–1791) is a three-aisled church with chapels along both sides, a dome at the crossing and a three-bay choir designed by Antonio Masella. The town hall by Bianchi was inaugurated in 1740, although building work finished only in 1786. Domestic architecture was built of brick and tiles until sometime in the second half of the 18th century. At this time the first flat-roofed dwellings of Hispanic origin were constructed. A turn-of-the-century example is the villa of Gen. Juan Martín de Pueyrredón at San Isidro (near Buenos Aires), with an elegant verandah with a simple Tuscan order. By 1944 it had opened as a museum, following restoration.

2. *c.* 1810–*c.* 1920. Little new building took place in the period of the War of Independence (1810–19). The government then recruited European architects to work in Argentina. The French architects Thomas Prosper Catelin (1764–1842) and Pierre Benoit designed the great

Neo-classical Corinthian dodecastyle portico of Buenos Aires Cathedral (1822–7; see fig. 2) with reference to the Palais Bourbon, Paris. With the hexastyle portico of S José de Flores (1830–33; destr. 1879), Buenos Aires, by the Catalan Felipe Senillosa (1783–1858), it marks the wider acceptance of Neo-classicism, which had already taken in Córdoba, Mendoza and Santa Fe before the end of the 18th century. Senillosa's Palermo de San Benito, the villa of Juan Manuel de Rosas (1838; destr. 1899), however, reintroduced nostalgic references to the colonial tradition eschewed since independence.

Other architects and engineers who came to Buenos Aires in the 1820s included James (Santiago) Bevans, Edward Taylor, Richard Adams and Charles Rann from Britain, CARLOS ENRIQUE PELLEGRINI from France, and Carlo Zucchi and Paolo Caccianiga from Italy. The Neo-classical Presbyterian church of St Andrew (1829–30) and the Anglican cathedral of St John the Baptist (1830–31), both in Buenos Aires, were built by Adams. Renewed confidence was symbolized by the enhancement (1856–7) by PRILIDIANO PUEYRREDÓN of the Pirámide de Mayo, an obelisk 15 m high, made in 1811 to commemorate the first anniversary of the Revolution, and since then placed in the Plaza de Mayo. Other buildings in Buenos Aires include Edward Taylor's Gothic Revival German Evangelical Church (1850–51), his somewhat Mannerist Customs House (1855–7; destr. 1894) and the Club del Progreso (1856; destr. 1971); and Henry Hunt's and Hans Schroeder's Stock Exchange (1861), which now belongs to the Central Bank of Argentina.

The building of the suburb of Adrogué by Nicolá Canale (1807–74) and his son Giuseppe (1833–83)—who came from Genoa in 1855—was part of the development of Buenos Aires. They designed the churches of La Inmaculada Concepción (1865–78), which has a circular plan, and La Piedad (1866–95), both in Buenos Aires. Juan Antonio Buschiazzo (1846–1917) was the first architect to graduate in architecture from the Universidad de Buenos Aires (1878). He designed the town hall (1869–72), Belgrano, now a museum, and completed La Piedad. Pietro Fossati from Lombardy made the Palacio San José (1848–59) in Entre Ríos as a Renaissance Revival palace for the Urquiza family, and built the mother church at Concepción del Uruguay (1856–9) and the Palladian residence of Santa Cándida (1858–61). Cathedrals were built at Tucumán (1845–56) by Pierre Dalgare Etcheverry, at Salta (1876–86) by Francesco Righetti; and at Corrientes (1854–64) by master mason Nicola Grosso. Increased building activity in Paraná during the seven years that it remained capital (1854–60) included new government buildings, mainly by the Italian Salvatore Danuzio in a Renaissance Revival style: the Chamber of Deputies (1855), the Senate (1859) and the Government House (1854–6). Before architectural education began at the Universidad de Buenos Aires, the few Argentinian architects included Jonás Larguía (1832–91) of Córdoba, who studied in Rome and designed the first Congreso Nacional (1864) in the Plaza de Mayo, and Ernesto Bunge (1839–1903), educated in Germany, who built the church of S Felicitas (1879) in Buenos Aires.

In 1880 Buenos Aires was federalized as capital. During a period of the greatest and most sustained economic growth in its history, it became transformed into the overwhelming image of the new Argentina, which increased its powers on all levels, to the point that it almost became the Nation itself. Architecturally it rushed to emulate Haussmann's Paris, and a Beaux-Arts classicism first took root. Buschiazzo opened up the Avenida de Mayo (1888–94) and demolished older buildings. Spacious vistas were opened up and gave credence to the cognomen 'Paris of South America'. The Italian Vittorio Meano (1854–1904) designed the Congreso Nacional (1898–1906), and, until his untimely death, was responsible for the building of the Teatro Colón (completed 1908; for illustration *see* BUENOS AIRES). It was designed by the Italian Francesco Tamburini (*d* 1891), who also built the Casa de Gobierno (Casa Rosada, 1885–98; see fig. 3), and finished by the Belgian architect Jules Dormal (1846–1924).

Characteristic of *fin-de-siècle* eclecticism is much of the work of ALEJANDRO CHRISTOPHERSEN. It includes the elegant Palacio Anchorena (1909; now the Foreign Office), in the Plaza San Martín and the Stock Exchange (1916), Avenida Alem, and the two-storey *petit hôtel* (1903), Calle Libertad 1264. Among architects working in the Art Nouveau idiom were Mario Palanti; Francesco Gianotti; Enrique Rodríguez Ortega, who designed the four-storey façade of Calle Rivadavia 2031 (1905); and Emile Hugé (1863–1918), whose Casa Moussion (1908; now Fundación Banco Patricios) features a highly decorated giant order and shop-front canopies reminiscent of Hector Guimard's work. Julián Jaime García Núñez (1875–1944) was educated in Barcelona and worked under Luis Domènech i Montaner. He designed many buildings in Buenos Aires, including Calle Chacabuco 78 (1910) and Calle Luis Sáenz Peña 274 (1913). His Hospital Español (1908; partly destr.) has suggestions of Moorish influence and a central dome with Gaudíesque fish-scale tiles.

3. AFTER *c*. 1920. A Neo-colonial movement flourished during the 1920s with such works as the Museo de Arte Isaac Fernández Blanco (1924) in Buenos Aires, by Martín Noel (1888–1963). But the outstanding personality of the period is ALEJANDRO VIRASORO, a forerunner of Art Deco and a bridge to early Modernism. Le Corbusier visited Argentina in 1929 to give a series of ten lectures later published in *Précisions sur un état présent de l'architecture et de l'urbanisme* (1930). These had little immediate effect, but his influence grew over the next 20 years. The local pioneer of the Modern Movement was Alberto Prebisch, whose Gran Rex cinema (1937), Calle Corrientes 857, Buenos Aires, is one of the most significant buildings of Modernist architecture. Other rationalists include ANTONIO UBALDO VILAR, designer of the multistorey flats of Avenida del Libertador 3590 and the office building of Calles Florida and M. T. de Alvear (both 1935; Buenos Aires); Jorge Kalnay (1894–1957); and Léon Dourge (1890–1969). Mention is due to the first skyscrapers of Buenos Aires—the Comega (1932), Safico (1933) and Kavanagh (1936), all of them Modernist. In June 1939 the Austral group published their manifesto 'Voluntad y acción' [Will and action] in Buenos Aires's *Nuestra arquitectura*, in which they assumed the defence of Rationalism against what they denounced as the dehumanization and

3. Francesco Tamburini: Casa de Gobierno (Casa Rosada), Buenos Aires, 1885–98; finished by Juan Antonio Buschiazzo and Vittorio Meano

lack of social engagement of the International Style. The group included ANTONIO BONET, Juan Kurchan (1913–72) and Jorge Ferrari Hardoy (1914–77). The three had met a year before at Le Corbusier's studio in Paris, where they helped Le Corbusier with his far-reaching masterplan for Buenos Aires (completed by 1940 but made known only in 1947), which was never brought to fruition. The principles of the 1939 manifesto were realized, however, in such works as the apartment house at Calle Virrey del Pino 2446 (1943). Amancio Williams exhibited in Paris in 1947 under the auspices of Le Corbusier and was later patronized by Walter Gropius and Ludwig Mies van der Rohe. The principle of his work was to make optimum use of air, light and space, which was realized in the House over the Brook designed for his father at Mar del Plata (1943–5; for illustration see WILLIAMS, AMANCIO). Eduardo Sacriste (b 1905) employed a rationalist language to create an architecture responsive to Argentina's social and aesthetic demands. Sacriste's Critical Regionalism is evident above all in a dozen one-family residences he built (1939–83) in the province of Tucumán.

Rationalism was also the starting-point of three distinguished practices founded in Buenos Aires in the 1930s. The first, chronologically, was that of José Aslán and Héctor de Ezcurra, whose work includes the apartment house (1968) at Calle M. T. de Alvear 534 in Buenos Aires and the Lever factory (1978–82) in Pilar, north of Buenos Aires. The second, SEPRA, founded by Santiago Sánchez Elía, Federico Peralta Ramos and Alfredo Agostini, designed the Telephone building (1951–64) in Buenos Aires and the town hall (1954–61) and the football stadium (1977) in Córdoba City. The third was that of MARIO ROBERTO ALVAREZ, whose extensive work ranges from the elegant Teatro General San Martín (1956) and the IBM offices (1983), to the Galería Jardín (1974) and the Le Parc apartment tower (1993), all in Buenos Aires. SEPRA was associated with Clorindo Testa in one of the most notable contemporary buildings of Buenos Aires, the Banco de Londres y América del Sur (1959–66; now Banco Hipotecario; see TESTA, CLORINDO, fig. 1). Testa was also responsible for the civic centre (Government House, ministries and legislature; 1958–63 and 1972–6), Santa Rosa, province of La Pampa, and the Biblioteca Nacional (1962–92), Buenos Aires.

Claudio Caveri designed the church of Our Lady of Fatima (1957, with Eduardo Ellis) in Martínez and two one-family residences, Casa Caveri (1962), his own house in San Miguel, and Casa Moores (1963), San Isidro. Located near Buenos Aires, these are examples of an architecture concerned with local traditions and materials. Among the important buildings of the practice of Flora Manteola, Javier Sánchez Gómez, Josefina Santos and Justo Solsona is the ATC (the State Television Network) headquarters (1978) and the Prourban office circular tower (1982), both in Buenos Aires. Other innovative practices include those of: Juan Manuel Bortagaray, Mario Gastellu and Carlos Marré (Escuela Carlos della Penna, 1971; apartment house in Avenida del Libertador and Calle Blanco Encalada, 1981); José Urgell, Augusto Penedo and Juan Urgell (Hospital Regional S Vicente de Paul, Orán, Salta prov., 1963; Villa Argentina Permanente of Yacyretá, Corrientes prov., 1982); Antonio Antonini, Gerardo Schon, Eduardo Zemborain and Associates (football stadium and multi-sports complex in Mar del Plata, 1977; Club Hotel DUT, nr Nahuel Huapi Lake, Neuquén prov., 1981; Miguel Baudizzone, Jorge Erbin and Alberto Varas (Estuario building, 1979; 25 de Mayo tower, 1981, both in Buenos Aires, with Jorge Lestard and Antonio Díaz); Angela Bielus, Jorge Goldemberg and Olga Wainstein-Krasuk (social housing quarters in Florencio Varela, 1978, nr Buenos Aires, and Formosa, 1985, Formosa prov.); and Miguel Ángel Roca (Paseo Azul, 1980; Office Centre, 1993, both in Córdoba City).

The members of the 'Generation of 1970', developed under the aegis of rationalist teaching, followed the architectural paths of the preceding decades. They included

the practices of Rosina Gramática, Juan Carlos Guerrero, Jorge Morini, José Gregorio and Juan Ricardo Pisani and Eduardo Urtubey (Nuevocentro shopping centre, 1991, Córdoba City); Berardo Dujovne and Silvia Hirsch (apartment building at Calle Salguero 2450, 1983, Buenos Aires); Raúl Lier and Alberto Tonconogy (Paseo Alcorta shopping centre, 1992, Buenos Aires); Juan Carlos López (Alto Palermo, 1990, and Galerías Pacífico, 1992, both shopping centres, Buenos Aires). They indicate the range of late 20th-century trends.

BIBLIOGRAPHY

J. A. Pillado: *Buenos Aires colonial* (Buenos Aires, 1910)
A. Christophersen: 'Nuevos rumbos', *Rev. Arquit.* (July 1915), p. 7
M. J. Buschiazzo: *Las viejas iglesias y conventos de Buenos Aires* (Buenos Aires, 1937)
J. Giuria: *Apuntes de arquitectura colonial argentina* (Montevideo, 1941)
A. Lascan González: *Monumentos religiosos de Córdoba colonial* (Buenos Aires, 1941)
D. Angulo Iñiguez, E. Marco Dorta and M. J. Buschiazzo: *Historia del arte hispanoamericano*, 3 vols (Barcelona, 1945–56)
P. Keleman: *Baroque and Rococo in Latin America* (New York, 1951), pp. 126–64
C. Sanz: *Relación histórico-bibliográfica de la conquista del Río de la Plata y fundación de Buenos Aires* (Madrid, 1958)
F. Bullrich: *Arquitectura argentina contemporánea* (Buenos Aires, 1963)
——: *Arquitectura latinoamericana, 1930–1970* (Barcelona, 1969)
——: *New Directions in Latin American Architecture* (London, 1969), pp. 15–17, 30–35, 104–17
D. Bayón and P. Gasparini: *The Changing Shape of Latin American Architecture* (Chichester and New York, 1979), pp. 10–37, 234–7
J. Glusberg, ed.: *Arquitectos de Buenos Aires* (Buenos Aires, 1979)
M. J. Buschiazzo: *Arquitectura en Argentina* (Buenos Aires, 1982)
T. Dagnino: *Manteola, Sánchez Gómez, Santos, Solsona* (Buenos Aires, 1984)
S. Borghini, H. Salama and J. Solsona: *1930–1950: Arquitectura moderna en Buenos Aires* (Buenos Aires, 1987)
R. Gutiérrez, M. Martín and A. Petrina: *Otra arquitectura argentina* (Bogotá, 1989)
A. Irigoyen and R. Gutiérrez: *Nueva arquitectura argentina: Pluralidad y coincidencia* (Bogotá, 1990)
J. Glusberg: *Breve historia de la arquitectura argentina*, 2 vols (Buenos Aires, 1991)
R. Gutiérrez: *Buenos Aires: Evolución histórica* (Bogotá, 1992)
E. Katzenstein: 'Argentine Architecture of the Thirties', *J. Dec. & Propaganda A.*, xviii (1992), pp. 54–75
R. Gutiérrez: 'Una entusiasta introspección: El neocolonial en el Río de la Plata', *Arquitectura neocolonial: América Latina, Caribe, Estados Unidos*, ed. A. Amaral (São Paulo, 1994), pp. 61–78
P. de la Riestra: 'Arquitectura del período colonial en la Argentina', *Arquitectura colonial Iberoamericana*, ed. G. Gasparini (Caracas, 1997), pp. 409–42
R. Gutiérrez, ed.: *Barroco iberoamericano* (Barcelona and Madrid, 1997)

JORGE GLUSBERG

III. Painting, graphic arts and sculpture.

1. Colonial period, 1536–1816. 2. After 1816.

1. COLONIAL PERIOD, 1536–1816. Despite the fact that Buenos Aires and a number of other cities were founded on Argentinian territory during the 16th century, no art of any consequence was produced during this period; indeed, throughout the entire colonial period artistic activity in Argentina was less significant than in other parts of Latin America. Nevertheless, the country did come to conform with the general Latin American trend of forming regional styles. These were centred in the north on Jesuit schools in Buenos Aires, Santa Fe and Córdoba, where workshops produced paintings that were essentially religious in theme. However, rather than encouraging a production with purely local characteristics, models were sought in Peru and Europe, and European styles, subjects and techniques were adopted. It was also commonplace to import paintings from Spain, Italy, Flanders, Peru and Upper Peru (now Bolivia); those from Upper Peru were produced in the workshops of Cuzco and Potosí and went on to enjoy wide dissemination in the 18th century. Of particular interest were highly imaginative paintings of arquebus angels, probably executed in Cuzco, for which there was no known European prototype.

Notable local artists included Fray Luis Berger, who painted the *Virgin of the Miracles* (1636) in the church of La Compañía in Sante Fe; Juan Bautista Daniel painted foliage and figurative decorations in the interior of the church of La Compañía (1645–71) in Córdoba. Although there must have been painters at the Jesuit missions in addition to the sculptors, gilders and wood-carvers, only written documentation survives. The first examples of engraving in Argentina came from the Jesuit missions. The earliest preserved book, *Diferencia entre lo temporal y lo eterno* by Fray Nieremberg, was illustrated with woodcuts by indigenous artists, one of which was signed by the Indian Joan Yapaí. The second Argentinian printing press reached Buenos Aires in 1780, when the first engravings were made in the city (e.g. *Holy Trinity*, 1781; Buenos Aires, Mus. Saavedra). In Buenos Aires, Spaniards and Italians were the most active artists. They included José de Salas, who painted the portrait of *Canon Riglos* (Luján, Mus. B.A.), Martino di Pietro, who painted the earliest miniature (1794) in Buenos Aires, and Angelo María Camponeschi, perhaps the most important painter of the colonial period, who executed the portrait of *Fray Zemboraín* (1804; Buenos Aires, Conv. S Domingo; see fig. 4). Camponeschi's achievements earned him the praise of the Cabildo, which proclaimed him as 'the best artist of his time'.

Retables and pulpits were an important complement to religious architecture; *retablos mayores* in particular, as the focal point at the high altar, were a fundamental element of church interiors, although in Argentina their style was simpler than the Baroque theatricality of those in other Latin American countries. Outstanding examples in the north are found in the Jujuy, Quebrada and Altipiano regions, in churches at Humahuaca, Yavi and Uquía; also noteworthy is the *retablo mayor* of the church of La Compañía in Córdoba. In Buenos Aires, where the old Baroque retables were later replaced by Rococo and Neoclassical ones, those in the cathedral and the churches of S Ignacio and La Merced are of interest. Some Argentinian pulpits are among the best examples in Latin America, and include those of Jujuy Cathedral, which was carved by Indians and gilded, and La Merced in Córdoba, also in gilded wood. Figurative carvings were often imported from Spain, Portugal, Italy, Peru, Quito and Brazil; local production was in the north and north-east, the Jesuit missions, Buenos Aires and Córdoba. Each region had special characteristics, but the most original sculpture was produced by indigenous artists at the Jesuit missions. Sculptures from Peru and Upper Peru pre-date the European imports and were carved in wood or made of maguey, glued cloth and paste. Some of those created by mestizo and creole craftsmen using wood or stone are remarkably

4. Angelo María Camponeschi: *Fray Zemboraín*, 1804 (Buenos Aires, Convento de S Domingo)

expressive. The oldest surviving Spanish statues are from the 17th century, and Italian examples arrived in the 18th century, generally carved in wood and painted in the exaggerated style of Italian academic Baroque. A fine example of an 18th-century work from Quito is a group in the Convento de Clarisas, intended to be clothed, with brilliantly painted lead faces. One of the most striking features is the predominance of sculptured mass, as in the 18th-century *Archangel Gabriel* (priv. col.) carved in wood with traces of original polychrome.

2. AFTER 1816. As in other parts of Latin America, in the first half of the 19th century a number of foreign artists visited Argentina, attracted by the possibility of exploring the newly independent republic. One of the first to arrive, in 1817, was the Swiss artist Josef Guth, who settled in Buenos Aires. Within a year he had set up a drawing school, and he went on to teach drawing at the Universidad de Buenos Aires from 1822 to 1828. Many became known as 'traveller–reporter' artists, recording in oil, watercolour, drawing and engraving what they perceived as the characteristic and picturesque qualities in the people and landscapes of the Río de la Plata area. Foremost

among them were EMERIC ESSEX VIDAL and JOHAN MORITZ RUGENDAS; CARLOS ENRIQUE PELLEGRINI, also an architect, settled in Argentina and expanded the typical subject-matter of the traveller–reporter–landscapes, exotic fruit and Amerindians—in his depictions of daily life in Buenos Aires, which he included with letters to friends in Europe. In the second half of the 19th century these artists were instrumental in forging a new sense of national identity following independence from Spanish rule and after centuries of emulation of European iconography.

In the mid-19th century Argentinian-born artists began to gain in stature. Among the leading figures were PRILIDIANO PUEYRREDÓN, who produced portraits and nudes, as well as landscapes and street scenes; CARLOS MOREL, a painter, miniaturist and lithographer who had studied under Josef Guth; and CÁNDIDO LÓPEZ, who portrayed the War of the Triple Alliance (1865–70) against Paraguay with great detail and spontaneity. From the 1870s the art life in Buenos Aires gained momentum, firstly with the creation of the Sociedad Estímulo de Bellas Artes by, among others, Eduardo Sívori. Then in 1878 the Escuela Nacional de Bellas Artes 'Prilidiano Pueyrredón' was founded, followed in 1895–6 by the Museo Nacional de Bellas Artes. This period was a cultural and economic highpoint in the country's history, and the work of such artists as ERNESTO DE LA CÁRCOVA, EDUARDO SÍVORI and ANGEL DELLA VALLE combined European training with local vernacular subjects. At the turn of the century a number of artists began to adopt Impressionism, including Martín Malharro (1865–1911) and Fernando Fader (1882–1935), who had studied in Munich. Prominent sculptors in the late 19th century included FRANCISCO CAFFERATA, who began to break with academic style in his depictions of the African descendants in Argentina. Lucio Correa Morales (1852–1923) taught, among others, Pedro Zonza Briano (1866–1941) and ROGELIO YRURTIA, the first great Argentine sculptor, who, while influenced by European trends, avoided copying them. In the early 20th century Lola Mora (1867–1936) became the first successful woman sculptor in Argentina, with such works as the Nereidas Fountain.

Pío Collivadino (1869–1945), who was director of the Escuela Nacional de Bellas Artes in Buenos Aires from 1908, set up the first workshop for the teaching of engraving. In 1915 the Sociedad de Acuarelistas, Pastelistas y Grabadores was founded and held its first salon, and in 1916 the engraver Mario Canale (1890–1951) founded the first specialist engraving periodical, *El grabado*. The medium was boosted in the 1920s by the appearance of the so-called Artistas del Pueblo, who treated social themes; as well as writers, painters and sculptors, the group included such printmakers as Guillermo Facio Hébequer, José Arato, Antonio Vigo and Adolfo Bellocq, who formed what came to be known as the Grupo de Boedo. Their approach was one of merciless realism and sharp social criticism, expressing through lithographs, etchings and woodcuts the more sombre aspects of the world of the working and disadvantaged classes. Similar subjects were taken up in the woodcuts of Víctor Rebuffo (1903–83), while the Expressionism of Pompeyo Audivert (1900–77) and the imaginative and formal invention of Fernando López Anaya (1903–88) displayed different responses to

the medium. Printmakers working in the provinces included Víctor Delhez (1901–85) and Sergio Sergi (1896–1973) in Mendoza, Gustavo Cochet (1904–79), Juan Grela (*b* 1914), Agustín Zapata Gollán (1895–1986) in Santa Fe and Alberto Nicasio (1902–80) and Oscar Meyer in Córdoba.

AGUSTÍN RIGANELLI and Luis Falcini (1889–1973) were among the sculptors who depicted working-class subjects in a Social Realist style in the 1920s. PABLO CURATELLA MANES, meanwhile, moved from Cubist sculpture to totally abstract works, and SESOSTRIS VITULLO depicted gauchos and Argentinian landscapes using blocks of stone or wood; both spent periods living in Europe. The work of their contemporaries José Fioravanti (1896–1977) and Alfredo Bigatti (1898–1964) was monumental, while ANTONIO SIBELLINO was one of the first Latin American sculptors to use abstract forms.

Painting took on new forms with the generation active during the 1920s and 1930s, who had been influenced by Cubism and Fauvism from France. Perhaps the first important figure was EMILIO PETTORUTI, who first introduced Cubism to the country to an initially bemused public, and who remained with the style for some time (e.g. *Argentinian Sun*; Buenos Aires, Mus. N. B.A.; see fig. 5). Other figures experimenting with avant-garde styles were Ramón Gómez Cornet (1898–1964), LINO ENEAS SPILIMBERGO, RAQUEL FORNER, HORACIO BUTLER, HÉCTOR BASALDÚA, JUAN DEL PRETE, who worked

successively with abstraction and *Art informel* styles, and EMILIO CENTURIÓN. The periodical *Martín Fierro* was launched in 1924, and its manifesto, published in the fourth issue in May, in many ways reflected Marinetti's views on Futurism; in addition, it acknowledged the paradoxical situation whereby, in spite of the need to assert Latin American independence, artistic influence from Europe was unavoidable. A leading contributor to the periodical was Argentina's celebrated writer Jorge Luis Borges, and among the artists that grouped themselves around it was XUL SOLAR, whose abstract and mythical paintings prefigured Surrealism and broke new ground in Argentina; Solar also translated Dadaist poetry and illustrated a number of books by Borges. This cosmopolitan generation of artists was known collectively as the Grupo de Florida; aside from their interest in the European avant-garde, they were also united by a concern for social issues, a subject that was to become more prominent as the century progressed. Some painters concentrated on aspects of life in Buenos Aires, among them Onofrio Pacenza and Horacio March, who gave a metaphysical view of some districts. MIGUEL DIOMEDE, Leónidas Gambartes (1909–63), Juan Grela (*b* 1914) and, in Córdoba, LUIS SEOANE were all influenced by European trends.

In 1928 the Argentinian critic Aldo Pellegrini formally introduced Surrealism to the country through the poetry review *Qué*. JUAN BATLLE PLANAS was quick to identify with the movement (e.g. in *The Message*), and he remained with it for many years. He was followed in 1939 by Grupo Orión, whose members included Orlando Pierri, Luis Barragán and Leopoldo Presas. Batlle Planas's student ROBERTO AIZENBERG achieved considerable success with paintings that combined Surrealism, Symbolism and geometric abstraction; it was this lack of clear definition in his work and that of countless Latin American artists that contributed in a fundamental way to the richness of their art, free as it was from the categorizations imposed on European art. Other artists who used elements of Surrealism in their work included RAÚL ALONSO, MILDRED BURTON and VÍCTOR CHAB; a member of the group Siete Pintores Abstractos, Chab oscillated between geometric abstraction and Surrealism. In the 1940s a strong Constructivist trend developed, initially through the group calling themselves the ASOCIACIÓN ARTE CONCRETO INVENCIÓN. Its members included Tomás Maldonado (*b* 1922), GYULA KOŠICE, the rigorously logical and rational sculptor ENNIO IOMMI, Raúl Lozza (*b* 1911), Claudio Girola (*b* 1923) and the Uruguayan artists Rhod Rothfuss (*b* 1920) and Joaquín Torres García. The last contributed a text to the only issue of the periodical *Arturo* (1944) enunciating the group's commitment to abstract art; Rothfuss in turn advocated the use of irregularly shaped canvases, expressing the desire to break away from what was seen as the restrictive tradition of the rectangular format. The Asociación's membership increased, and the original members broke away, coining the name ARTE MADÍ for their new grouping. Principal among them was Košice, who wrote the Arte Madí manifesto in 1946 (see 1989 exh. cat., p. 330) and whose irregularly shaped canvases displayed ideological similarities with the Asociación. Also of prime importance to the group were the involvement of the spectator, movement and articulation

5. Emilio Pettoruti: *Argentinian Sun*, oil on canvas, 995×650 mm, 1941 (Buenos Aires, Museo Nacional de Bellas Artes)

and the use of new materials and technology, seen in Košice's *Madí Aluminium Structure No. 3* (neon, 1946; artist's col.; see fig. 6): these were significant elements in the inventiveness and playfulness that the movement had in common with Dada. Another break occurred in 1947 when Raúl Lozza separated from the Asociación Arte Concreto Invención to form the group PERCEPTISMO; still concerned with promoting Constructivism, Lozza typically used large backgrounds on which he placed dynamically shaped planes of colour. Another line of development was represented by the *Manifiesto blanco* (1946) of LUCIO FONTANA and his followers, which set out the concept of SPAZIALISMO; Fontana's work in steel and mixed media explored the boundaries between painting and sculpture.

Argentina increasingly synchronized with developments in European art, and in the 1950s various groups and trends emerged. In 1952 four semi-abstract painters, José Antonio Fernández Muro, Sarah Grilo, Miguel Ocampo (*b* 1922) and Hans Aebi (*b* 1923), formed the group Artistas Modernos de Argentina, and in 1959 *Art informel* arose in opposition to the rationality of Arte Concreto, led by such artists as KENNETH KEMBLE and ALBERTO GRECO, whose work included gestural painting, assemblage and performance art, which had no local precedents. Prominent sculptors in the 1950s included NOEMÍ GERSTEIN, who used welded metal and later bronze tubes, and LÍBERO BADII. Badii's works ranged from rounded forms symbolizing fecundity to specifically Argentinian themes and portraits and, from the late 1960s, polychromed wooden doll figures; the Museo Badii was opened in

6. Gyula Košice: *Madí Aluminium Structure No. 3*, neon, 560×410×180 mm, 1946 (artist's collection)

Buenos Aires in 1988. Geometric abstraction continued to be favoured by a number of artists. The term ARTE GENERATIVO was coined in 1959 by EDUARDO MACENTYRE and MIGUEL ANGEL VIDAL, and in 1960 they published a manifesto to support their aims. Other artists associated with the style included the painter and sculptor Ary Brizzi, the painters CARLOS SILVA, MARÍA MARTOREL, and ROGELIO POLESELLO and the painter, draughtswoman and printmaker ANA KOZEL. Most Argentinians interested in kinetic and Op art were working in Paris, and in 1960 the Groupe de Recherche d'Art Visuel was formed around JULIO LE PARC; among those associating with Le Parc was the Minimalist GABRIEL MESSIL. During the same period ALEJANDRO PUENTE used unconventional shaped canvases, and César Paternosto used geometric symbols from Pre-Columbian cultures in a constructivist spirit.

In the 1960s many avant-garde activities were centred on the Centro de Artes Visuales di Tella at the Instituto Torcuato Di Tella (founded 1958) in Buenos Aires, which promoted, among other things, the Argentinian equivalent of Pop art. Among those who exhibited their work at the Instituto were Carlos Squirru, the performance artist and sculptor MARTA MINUJÍN, and MARTHA PELUFFO; as a result of political pressure and financial problems the centre closed in 1970. In 1962, also in Buenos Aires, the Nueva Figuración group emerged, comprising RÓMULO MACCIÓ, LUIS FELIPE NOÉ, JORGE DE LA VEGA and ERNESTO DEIRA; they worked in a variety of media with a combination of neo-Expressionism, gestural and geometric painting, Pop art and *Art informel*. The last was also used by the painter and printmaker ANTONIO SEGUÍ, whose work contained elements of humour, and JOSEFINA ROBIROSA, who was part of an *Art informel* group centred on the periodical *Boa*; Robirosa later turned to Op art and figuration and, eventually, abstraction in her paintings and drawings. Another group formed round the Centro de Arte y Comunicación in Buenos Aires, taking its name from the centre founded in 1969 by Jorge Glusberg, Grupo CAYC was made up of artists working in a variety of media. They included the painter and sculptor LUIS BENEDIT, the sculptors JACQUES BEDEL and VÍCTOR GRIPPO and the architect and painter Clorindo Testa. Happenings publicizing ecological concern were organized by, among others, the conceptual artist and architect Nicolás García Uriburu.

By the late 20th century an abundance of artistic styles was being simultaneously expressed. Worthy of note are Guillermo Kuitca, the abstract painter Eduardo Médici, Jean Lecuona, Alfredo Prior, who produced neo-figurative landscapes, the Expressionist Duilio Pierri, Fernando Fazzolari, ANA ECKELL and the painter, draughtsman and graphic designer Juan Pablo Renzi. Initially involved with Nueva Figuración, Renzi combined figurative and Abstract Expressionist elements in his work before developing a more rational style; he also worked with other artists from Rosario on *Tucumán arde*, a multimedia event using image, sound and movement, which expressed the desire for an alternative to institutionalized culture. JUAN CARLOS DÍSTÉFANO, one of the major figures in painting and sculpture in the late 20th century in Argentina, projected his profound humanism through the use of man-made

materials and strong colours; JORGE MICHEL produced both modern and archaicizing combinations of carved wood or stone and bronze, iron or steel; and HERNÁN DOMPÉ pursued a regional identity with his evocations of Aztec, Inca and Maya civilizations.

BIBLIOGRAPHY
E. Schiaffino: *La pintura y la escultura en la Argentina, 1783–1894* (Buenos Aires, 1933)
El grabado en la Argentina, 1705–1942 (exh. cat., Rosario, Mus. Mun. B.A., 1942)
J. L. Pagano: *Historia del arte argentino desde los aborígenes hasta el momento actual* (Buenos Aires, 1944)
A. Pellegrini: *Panorama de la pintura argentina contemporánea* (Buenos Aires, 1967)
C. Córdoba Iturburu: *80 años de pintura argentina* (Buenos Aires, 1978)
Cien años de pintura y escultura en la Argentina, 1878–1978 (exh. cat. by A. Ribera, N. Perazzo and G. Whitelow, Buenos Aires, Banco Ciudad, 1978)
H. Schenone and A. L. Ribera: *Historia general del arte en la Argentina*, 2 vols (Buenos Aires, 1982–3)
Arte argentina: Dalla indipendenza ad oggi, 1810–1987 (exh. cat., Rome, Ist. It.–Lat. Amer., 1987)
N. Perazzo: 'Constructivism and Geometric Abstraction', *The Latin American Spirit: Art and Artists in the United States, 1920–1970* (exh. cat., New York, Bronx Mus. A., 1988–9)
Art in Latin America: The Modern Era, 1820–1980 (exh. cat., ed. D. Ades; London, Hayward Gal., 1989)
R. Brughetti: *Nueva historia de la pintura y escultura en la Argentina* (Buenos Aires, 1991)
120 años de pintura en Córdoba, 1871–1991 (exh. cat., foreword by N. Perazzo; Córdoba, Argentina, Mus. Prov. B.A. 'Emilio A. Caraffa', 1991–2)
R. Gutiérrez, ed.: *Barroco Iberoamericano* (Barcelona and Madrid, 1997)
L. Buccellato: 'Argentina 1910–1960', *Voces de Ultramar: Arte en América Latina, 1910–1960* (exh. cat., Madrid, Casa América; Las Palmas de Gran Canaria, Cent. Atlántic. A. Mod., 1992), pp. 23–32
Art from Argentina, 1920–1994 (exh. cat. by D. Elliott and others, Oxford, MOMA, 1994)
Historia crítica del art Argentino, Asociación Argentina de Críticos de Arte (Buenos Aires, 1995)
Historia general del arte en la Argentina, Academia Nacional de Bellas Artes, 7 vols (Buenos Aires, 1982–95)
M. Pachecho: 'Argentina', *Latin American Art in the Twentieth Century*, ed. E. Sullivan (London, 1996), pp. 283–99
J. López Anaya: *Historia del arte Argentino* (Buenos Aires, 1997)
NELLY PERAZZO

IV. Gold and silver.

Silversmiths were among the earliest settlers in the River Plate region, but they discovered that the gold and silver deposits of the region were limited compared to the riches of Peru and Mexico. Some mines were established in the Mendoza region, but the sparse indigenous population meant that, unlike in Potosí (now in Bolivia), there was little slave labour available to make large-scale mining of gold and silver viable. Nevertheless, there was considerable demand for both ecclesiastical and domestic gold- and silverwork in wealthy Buenos Aires on account of its position on the trade routes, and by the mid-17th century the city supported a thriving colony of silversmiths. Unlike their counterparts in Peru and Mexico, however, they were subjected to few regulations. Periodic attempts were made to force them to use a maker's mark and to submit their work for assay, but an almost total lack of surviving marked pieces shows how unsuccessful these attempts were. A small group of silver pieces, which appear to date from the early 19th century, survive stamped with a town mark consisting of the conjoined initials BsAs within the

'Pillars of Hercules' (similar to the official and more widespread marks used in Mexico). Such official hallmarks should not be confused with stamps bearing owners' names, which sometimes appear on 19th-century domestic articles.

A rare survival from the mid-17th century is a pair of silver lanterns (Buenos Aires, Mus. Hist. N. Cabildo Ciudad) made in Buenos Aires and dated 1642. They are chased with strapwork and foliage, but 17th- and 18th-century silver produced in the River Plate region is generally plainer than that produced in Peru, with a distinct emphasis on line rather than ornament, even when the piece is highly decorated. A good example is a candelabrum of 1796 (Orán Parish Church), on which exotic foliage enclosing cartouches and coats of arms is contained within severe, plain borders. As in Peru, Baroque ornament continued to be used throughout the 18th century with the occasional addition, late in the century, of such Rococo motifs as rocaille. Unlike contemporary Peruvian work, however, the ornament on pieces made in the River Plate region never dominates the form: a silver altar-frame (*c.* 1760; Buenos Aires, S Ignacio), though elaborately chased with Baroque and Rococo motifs, lacks the exuberance of contemporary Peruvian examples.

Work produced in the central regions and the north in the 17th and 18th centuries generally shows Peruvian influence in its more forceful decoration, while perfectly plain pieces, for example a cylindrical ciborium of *c.* 1680 (Córdoba, Convento de S Francisco), were inspired by the work of River Plate silversmiths. An architectonic tabernacle (*c.* 1800; Córdoba Cathedral) by Cayetano Albares is virtually unique in Argentinian silverwork on account of its scale; it follows the form of 17th-century Spanish examples.

Argentinian metalwork of the 18th century was often influenced by the work of European silversmiths, some of whom worked in South America. In the early 18th century the Jesuits brought with them skilled workers from Germany, as well as quantities of tools, but little of the silverwork produced in their missions to the Guaraní tribe has survived, although an altar-frame of *c.* 1750 (Buenos Aires Cathedral) shows the assured use of such Baroque elements as twisted pilasters, baluster columns and roundels incorporating sacred scenes, which are typical of their work. Another important influence was that of the Portuguese silversmiths who had settled in Brazil. After 1766, when the manufacture of gold and silver in Brazil was prohibited, many emigrated to the River Plate area, bringing with them superior techniques and new forms and designs. The work of Francisco da Silva Lemos (*fl c.* 1770–1810) from Rio de Janeiro, for example, shows assured use of Rococo forms and ornament (e.g. chalice, *c.* 1790; Buenos Aires Cathedral).

Neo-classicism was introduced at the beginning of the 19th century, largely due to works imported from Antonio Martínez Barrio's Real Fábrica de Platería in Madrid and mass-produced plated articles, such as candlesticks, from Sheffield and Birmingham. A monumental inkstand showing the vertical fluting typical of Martínez's work is in the Complejo Museo Gráfico 'Enrique Udaondo', Luján. A series of columnar candlesticks (Buenos Aires, S Francisco), decorated with a mixture of classical motifs, is

marked with the Buenos Aires town mark. In the 1820s a more ponderous style was introduced in domestic silver, often utilizing castings of fauna and foliage evidently imported from Europe; the silversmith from Buenos Aires who marked his work CONEH appears to have specialized in domestic articles of this kind, such as a perfume burner (Buenos Aires, Mus. Saavedra) in the form of a tree surrounded by deer. Jeronimo Martínez (*fl* 1790–1826) also worked in this monumental style, illustrated by his perfume burner surmounted by an eagle (*c.* 1825; Buenos Aires, Mus. N. B.A.).

Typical vessels produced in the 19th century include the silver cups used to drink *mate*, often formed of gourds or polished nuts mounted in silver. At the beginning of the 19th century they became much more elaborate, often supported on a circular dish and accompanied by a silver tube (*bombilla*). Rectangular kettles with compartments to hold coal, used for infusing the *mate* leaves, were also popular; some were made in the form of animals, while others are circular and raised on three legs. Silver boxes in the form of shells, their interiors fitted with vials and spoons, are often described as chrysmatories; they may have been used, however, for storing coca leaves, on account of the lack of religious motifs in their decoration.

Such plain, utilitarian domestic objects as mugs and platters were made in large quantities, while articles for the horse and rider were especially important. Throughout the 19th century great wealth was expended on silver and even gold horse trappings, for example stirrups, saddles, reins and bridles were often mounted with precious metal. Gauchos carried a dagger in an elaborately decorated silver sheath, as well as a similarly ornamented whip, a silver-mounted drinking horn (*chifle*) and a gold or silver *yesquero* or flint-striker, profusely chased with decoration often incorporating nationalist symbols. Silver spurs, which became larger during the 19th century, are usually characterized by large rowels and decoration of foliate scrolls.

BIBLIOGRAPHY

A. Taullard: *Platería sudamericana* (Buenos Aires, 1941)
J. Torre Revello: *La orfebrera colonial en Hispanoamerica y particularmente en Buenos Aires* (Buenos Aires, 1945)
A. Perez-Valiente de Monctezuma: *Platería colonial* (Buenos Aires, 1960)
El arte luso brisileno en el Río de la Plata (exh. cat., Buenos Aires, 1966)
A. L. Ribera and H. H. Schenone: *Platería sudamericana de los siglos XVII–XX* (Munich, 1981)
H. Schenone and A. L. Ribera: *Historía general del arte en la Argentina,* 2 vols (Buenos Aires, n.d.)
Platería americana (exh. cat. by A. L. Ribera and others, Rosario, 1986)
G. de Urgell and others: *El mate de plata* (Buenos Aires, 1988)
A. L. Ribera: *Diccionario de orfebres rioplatenses, siglos XVI al XX* (Buenos Aires, 1996)

CHRISTOPHER HARTOP

V. Textiles.

The sources of Argentinian textile production are both pre-Hispanic (with corresponding ethnic diversities) and Spanish; styles and techniques therefore reflect these influences. In the rural zones of the northern province of Jujuy a style displaying native influences is common, which is a feature repeated only among some weavers of the Calchaqui valleys and in Patagonia. In other regions there is evidence of a markedly Hispanic tradition.

In the period of the Viceroyalty of Peru, Santiago del Estero was an important centre for textile production. At the end of the 16th century the cotton and wool industry became increasingly important in Santiago, and such items as tapestries, quilts and blankets, some of which were exported to Brazil by the bishop of Victoria in 1587, were woven. From the end of the 18th century textiles were also manufactured in Córdoba (examples in Córdoba, Argentina, Convent of Sta Catalina; Mus. Teresas). During the Viceroyalty, tapestry hangings or very heavily embroidered carpets were made, which generally depicted local flora (e.g. Buenos Aires, Cabildo). Domestic textiles with bold designs and motifs representing local plants and flowers were also made, particularly in Santiago del Estero, Córdoba and San Luis.

The *caranchado* from Santiago del Estero is a checked fabric made using contrasting techniques and colours and is a characteristic late-20th century textile. The quilts made in central and north-western Argentina featuring shaggy, uncut pile are produced using a technique called *caracolillo*, which made use of extra wefts. In the Chaco area plant fibres are employed to make fabrics. The geometric designs in *chahua* textiles refer to mythical animals. In the northeast, cotton is woven. The manufacture of *ñanduty* (a filmy lace) links it to production in Paraguay. In Tucumán a Spanish technique is used to manufacture cotton *randas* (lace borders); the most important centre of production for this type of weaving is Monteros. Manually produced braidwork or 'semi-fabrics' is a traditional craft in Argentina and continued to be used in the manufacture of rough blankets for horses and saddle padding.

In the northwest the hair of the indigenous vicuña is woven into fabrics, and the best weavers are in the area around Catamarca. In addition to the 'wool' of cameloids, which continued to be very prestigious in the late 20th century, wool from sheep, goat hair, cotton and other indigenous vegetable fibres were more extensively used.

The poncho is very much associated with Argentina. This garment first became popular during the colonial era: the first references to it date from the 17th century (1983 exh. cat.). In the 18th century it became popular as an outer garment for riders on long journeys. In Upper Peru (now Bolivia) during the 18th century striped ponchos already featured mestizo elements. At the beginning of the 19th century the poncho was an indispensable garment during the War of Independence, forming part of the 'uniform' of the soldiers. There are different styles of poncho depending on the region from which they come and what materials, colours and designs are used; the Catamarcan vicuña poncho, for example, was left undyed, and if it was embroidered, the thread was of the same colour and occasionally combined with silk. The ponchos made in Salta are red with a black border, which according to tradition is a mark of respect for the death of the regional chief Guemes.

During the 18th century, when the Araucanians ruled vast regions of Argentina from Patagonia to Buenos Aires, the use of the ikat Pampa poncho (see fig. 7), made of sheep's wool dyed in indigo and decorated with pre-Hispanic designs, became increasingly extensive. At the beginning of the 19th century industrially made ponchos, which reproduced traditional Argentine designs, were imported from England. In the late 20th century the hair of the vicuña was being replaced by that of the alpaca; the

7. Pampa poncho, warp ikat technique, wool, natural and dyed blue, 1.66×1.54 m, 19th century (Buenos Aires, Museo de Motivor Populares Argentinos José Hernandez)

ikat design continued to be popular in the north-west. Since the end of the 19th century the modernization of Argentina has resulted in a decline of the traditional textile industry. Some contemporary tapestry artists, however, among them Antoinette Galland (*b* 1926), Beatriz Bodigliani (*b* 1933), Gracia Cutulli (*b* 1937) and Carola Segura (*b* 1944), derive inspiration from traditional Argentinian textiles.

BIBLIOGRAPHY

F. L. May: *Hispanic Lace and Lace Making* (New York, 1939)
D. Millán de Palavecino: *El tejido en la Argentina* (Buenos Aires, 1981)
A. Geijer: *A History of Textile Art* (London, 1982)
Aymara Weavings: Ceremonial Textiles of Colonial and 19th Century Bolivia (exh. cat. by L. Adelson and A. Tracht, Washington, DC, Smithsonian Inst. Traveling Exh. Serv., 1983)
R. Faccaro: *Arte textil argentino hoy* (Buenos Aires, 1986)
R. de Corcuera: *Herencia textil andina* (Buenos Aires, 1987)

RUTH CORCUERA

VI. Patronage and art institutions.

In the years following the Spaniards' arrival, artistic activity in Argentina was centred on the missions, where the Indians learnt from European priests to build churches and to engrave religious images; it was a long time before the educated and wealthy classes began to patronize any form of art. When they did start collecting art in the 19th century, they sought only European art, in particular French, to adorn their houses, estates or small palaces. The first exhibition in Argentina is believed to have been one that took place at the Colegio de Ciencias Morales, Buenos Aires, in March 1829. It was organized by the Spanish businessman and collector José Mauroner, who risked his fortune to bring works over from Europe. These included paintings by Titian, Tintoretto, Rubens and Murillo—more than 300 paintings in all, representing French, Spanish, Flemish and Italian schools. They were probably not all authentic, but Mauroner intended to sell them to the state to found a museum; this never took place, however and, partly as a result of unstable political

and economic conditions in the country, he returned to Europe in 1830 with his cargo.

The first Argentinian collector was probably Manuel J. de Guerrico of Buenos Aires, whose collection of paintings was later increased by his son José Prudencio de Guerrico and later became part of the collection of the Museo Nacional de Bellas Artes, Buenos Aires. A large part of this collection comprised 19th-century Spanish paintings, which were very popular with Argentinians at the time. Public interest in the arts continued to be stimulated by various exhibitions in the 1870s and 1880s, such as the one organized in 1878 in the former Teatro Opera, Buenos Aires, by the Sociedad Damas de Caridad, at which indigenous pottery, fabrics, arms, drawings, portraits, coins and medals, among other things, were exhibited to raise money for charity. In September 1888 an exhibition of 326 paintings by Spanish artists was held in Buenos Aires, organized under the auspices of the Spanish Chamber of Commerce; in the same year an exhibition of French paintings was held at the Jardin Florida in the capital, although this was unsuccessful. The Galería Witcomb, established in 1868, went on to hold important exhibitions of French and Italian painting, and in the early 20th century Argentinian artists began to gain recognition as they returned from Europe, versed in the latest artistic movements and styles.

The Museo Nacional de Bellas Artes was created by decree in 1895 during the presidency of José E. Uriburu; it was officially inaugurated in 1896, in the Bon Marché building at Calle Florida 783 in Buenos Aires. Its first collection comprised 40 pictures donated by Aristóbulo del Valle, pictures from the Biblioteca Nacional and acquisitions made by Eduardo Schiaffino. On the top floor of the building the Sociedad Estímulo de Bellas Artes held classes in drawing and painting. In 1910 the directorship of the museum was entrusted to Carlos Zuberbühler, and it began to operate from the Argentinian pavilion in the Retiro. Various collections were donated to the museum, including those of Adriano Rossi and José Prudencio de Guerrico, who had specified that the legacies they left to the State should serve solely as the basis for a national art museum. Further donations of works were made by Emilio Furst and his wife, Antonio and Mercedes Santamarina, the di Tella family, Alfredo and Elizabeth Hirsch and Simón Scheinberg. By 1914 there were 3000 works in the museum, a level that was maintained for 20 years until the move was made to the permanent site, for which the former Casa de Bombas de la Recoleta was converted. By the late 20th century the museum housed an important collection of 2500 paintings, over 1000 drawings and engravings, 2590 coins and medals, 300 sculptures and a number of singularly valuable Flemish tapestries from the 17th century. The collection is fundamentally orientated towards modern art, and although not as rich as some, it was the first major collection in Latin America and is perhaps one of the most complete. Ribera, Manet and Goya are among the most important artists represented, and of particular interest is the collection of French Impressionist works. There is also an annexed workshop and a specialist library. Important group and one-man shows are periodically organized by the museum. The important work of art lovers and collectors such as José

Prudencio de Guerrico, Andrés Lamas, Adriano Rossi and Aristóbulo del Valle was later supplemented by such groups as El Ateneo (*fl* 1893–8), which supported, disseminated and promoted the work of Argentinian artists. Between *c.* 1910 and 1929 the Cooperativa Artística operated in Buenos Aires with the aim of helping young artists. The Boliche de Arte was set up in 1927 under direction of the critic Leonardo Estarico to provide financial assistance for avant-garde artists.

The Museo de Calcos y Escultura Comparada shares a site in Buenos Aires with the Escuela Superior de Bellas Artes 'Ernesto de la Cárcova'. Housed in a former veterinary quarantine site converted by the school's founder, Ernesto de la Cárcova, the museum and the various workshops of the school were officially established by decree in 1921, and activities began in 1923. The museum is one of only two of its kind in Latin America (the other is in Mexico City), and its importance stems from the fact that the casts contained in it were taken with moulds directly from the originals, thus faithfully preserving their markings. The casts were brought to Buenos Aires from such places as the Musée du Louvre and Musée Guimet, Paris, the British Museum, London, the National Archaeological Museum in Athens and the Glyptothek in Munich between 1923 and 1930, and the Comisión Nacional de Bellas Artes combined them with another group of casts that had arrived between 1911 and 1913, sent from the Königliche Museum, Berlin. The collection was distributed between various schools, with the largest number remaining in the Escuela Superior de Bellas Artes.

The Museo Provincial de Bellas Artes 'Rosa Galisteo de Rodríguez' in Sante Fe was built in 1922 and donated to the province by Martín Rodríguez, who also donated his rich private collection of art to provide the basis for the museum; its long-standing director was Horacio Caille Bois. The institution grew to contain more than 1000 works by Argentinian artists, and it is committed to the development and cultivation of all art forms: its 22 rooms hold paintings, sculpture, engravings and numismatics, and it also has a print room, a restoration workshop, a photographic laboratory and a public library specializing in both antiquarian and new books on art; there is also a large concert hall. Acting under the auspices of the provincial Dirección General de Bellas Artes, Museos y Archivos, the museum is the focus of all the main artistic activities in the province, and every year since 1922 the Salón de Pintura, Escultura, Dibujo y Grabado de Santa Fe, one of the most important national art exhibitions in the country, has been held there. Among the most valued collections on display is a group of paintings by Cesáreo Bernaldo de Quirós, which depict the region of Entre Ríos in the second half of the last century.

In Buenos Aires, the Museo Municipal de Arte Colonial was initially operated from a site at Calle Suipacha 1422, in the private residence of Carlos and Martín Noél. In 1937 the Buenos Aires City Council acquired the museum, and it was opened to the public in 1938. It is the only museum in the country dedicated to Latin American colonial art. In its original form the building attempted to revive an ideal Peruvian palace from the viceregal period; the distribution of the rooms was therefore planned so as to respect the original residential structure, and the mu-

seum's Chilean ironwork, Spanish tiles and ceramics, numerous pieces of furniture and items from Peru, Ecuador, Colombia, Bolivia, Chile and northern Argentina were distributed on this criterion when the site was organized, under the honorary direction of Rómulo Zabala and the secretary Enrique de Gandía. In 1942, under the municipal leader Carlos A. Pueyrredón, a part of this museum was moved to the Saavedra park and combined with the collections of the Museo de Arte Colonial to form the Museo Municipal Brigadier General Cornelio de Saavedra. The task of organizing this museum was given, in an honorary capacity, to Silvia de Pueyrredón, and its first director was José Marco del Pont. The collections of religious, silver and numismatic pieces are distributed between 11 rooms.

In 1911 the architect René Sergent, with the collaboration of the landscape painter Achille Duchesne, built a palace on Avenida Alvear (later Avenida Libertador) for Matías Errázuriz and his wife Josefina de Alvear. The building contains a gothic chapel that is an important example of French-inspired, 20th-century Neo-classical architecture; the chapel façade was inspired by that of the Petit Trianon in the palace of Versailles. In 1937 the building was turned into the Museo Nacional de Arte Decorativo, containing the collections of the Errázuriz family in addition to various other collections, comprising paintings, sculpture, furniture, porcelain, tapestries, glass, musical instruments and silverware. The Museo de Arte Moderno was founded in Buenos Aires in 1956; its collection of Latin American paintings focuses especially on the work of Argentinian artists. The collection of Ignacio Pirovano was donated to the museum.

A large number of galleries was established from the 1950s onwards, and such groups as Ver y Estimar, made up of artists and critics, continued the work of investigation and dissemination of the arts; of particular importance was the Centro de Artes Visuales di Tella at the Instituto Torcuato di Tella, which provided space for all new forms of artistic expression. Founded in 1958, the centre was led from 1963 by Jorge Romero Brest, and it became critically important to the development of Argentinian art, not least by trying to overcome the confines on artistic production imposed by military dictatorship. Brest championed the work of young Argentinians, as well as popularizing international art and increasing public awareness through exhibitions and discussion. At a national level the State operated the Fondo Nacional de las Artes in the late 20th century, which encouraged in particular the work of young artists through grants, loans for exhibitions, study trips, research work, the purchase of materials etc. On the whole, however, the State has rarely been a benefactor of the arts in Argentina, with the result that institutions and cultural groups have had to seek private finance. Nevertheless, an active art market is supported by a fair number of galleries in the country's major cities, and museums stimulating public interest in the arts are widespread; most museums have established foundations or associations of friends that support their growth.

BIBLIOGRAPHY

J. L. Pagano: *El arte de los argentinos*, i (Buenos Aires, 1937)

J. Mantovani: *La cultura, el arte y el estado* (Santa Fe, 1939)

E. Maglione: 'Las galerías de arte bonaerenses', *Lyra*, xv/171–3 (1958) [whole issue]

F. Palomar: 'Primeros salones de arte de Buenos Aires: Reseña histórica de algunas exposiciones desde 1829', *Cuad. Buenos Aires*, xviii (1962)

Los 15 años del Fondo nacional de las artes (Buenos Aires, 1973)

R. Squirru: *Arte argentino hoy* (Buenos Aires, 1983)

Colección Ignacio Pirovano (exh. cat., Buenos Aires, Mus. A. Mod., 1983)

M. de Riglos, G. Whitelaw and M. Mújica Lainez: *Colección Ignacio Pirovano: Donación Sra Josefina Pirovano de Mihura* (Buenos Aires, 1983 and 1992)

Argentina y sus museos (Buenos Aires, 1986)

L. de Oliveira Cézar: *Los Guerrico: Coleccionista argentinos* (Buenos Aires, 1988)

J. Bérchez: *Arquitectura Mexicana de los siglos XVII y XVIII* ([Mexico City], 1992), pp. 149-59

La colección Costantini en el Museo Nacional de Bellas Artes (Buenos Aires, 1996)

J. Glusberg: *Guía Rápida del Museo Nacional de Bellas Artes* (Buenos Aires, 1996)

M. Insausti: *Museos de Buenos Aires: Patrimonio de la Ciudad* (Buenos Aires, 1996)

Museo Histórico Nacional (Buenos Aires, 1997)

NELLY PERAZZO, MARTA ARCIPRETE DE REYES, JULIETA ZUNILDA VAQUERO

VII. Art education.

With European art as the model, various religious orders, and the Jesuits in particular, offered the indigenous Argentinians the opportunity to produce their own architecture, sculpture and painting; this activity ceased, however, when the Jesuits were expelled in 1767. The earliest formal attempts to foster art education include the plan of Manuel Belgrano (1770–1820), Secretary to the Consulate of Buenos Aires, to establish the Academia de Dibujo in 1799, but this had barely started to operate when it was closed by the Court in the same year. In 1815 Fray Castañeda opened two small academies in the Monastery of La Recoleta, with 'the purpose of propagating . . . the custom of graphic arts', and *c.* 1818 Josef Guth ran a drawing school in the capital, as well as teaching drawing at the Universidad de Buenos Aires in the 1820s. There was considerable activity in the 1870s: in 1876 the Sociedad Estímulo de Bellas Artes was created through the efforts of Carlos Gutiérrez, Eduardo Schiaffino and Eduardo Sívori; it was a further 30 years, however, before the society, effectively a forerunner of art education, was officially recognized by the government. At that time it had more than 600 pupils. Formal education was stimulated in 1878 by the foundation in Buenos Aires of the Escuela Nacional de Bellas Artes 'Prilidiano Pueyrredón', with departments of painting, sculpture and engraving. The first faculty of architecture was also opened in the Universidad de Buenos Aires in the 1870s, and this meant that students no longer had to go to Europe to study.

Various initiatives were taken in the early 20th century to increase the availability of training in the arts, notably with the foundation in 1904 of the Escuela Nacional de Bellas Artes 'Manuel Belgrano', the Escuela Superior de Bellas Artes 'Ernesto de la Cárcova' in 1923 and the Academia Nacional de Bellas Artes in 1936, all in Buenos Aires. In the 1950s an interest in the possibilities of educating through art led to the establishment in 1958 of the Instituto Vocacional de Arte (IVA) in Buenos Aires, under the leadership of Blanca González. La Escuelita, a private kindergarten founded in 1959, provided new tools for creative development and expression by way of daily workshops. The La Escuelita technique was adopted by the IVA in 1979, incorporating the methodology into an official programme. By the late 20th century the Dirección General de Enseñanza Artística had been established under the Ministerio de Educación y Justicia, and a three-tier system of training was created, with a basic level, teacher training and advanced specialization. Political instability in the country, however, prevented the development of a more specific programme. Nevertheless, in 13 universities throughout the country courses are offered in ceramics and other decorative arts, drawing, design, stage design, sculpture, graphic arts, history of art and painting, and architecture is taught at 18 universities.

BIBLIOGRAPHY

I. Córdoba Iturburu: *80 años de pintura argentina* (Buenos Aires, 1978)

J. Cáceres Freyre, M. J. Buschiazzo and H. H. Schenone: *Historia general del arte en la Argentina* (Buenos Aires, 1982)

MARTA CALVO

VIII. Art libraries.

The creation of libraries that specialized in the visual arts and architecture followed the establishment of educational institutions and art museums. The library of the Museo Nacional de Bellas Artes was created together with the museum in 1895–6, and by 1911 it had 2253 books. By 1931 it had 2560 books and a further 2500 exhibition catalogues and periodicals. It was enriched in 1944 by the donation of Antonio Santamarina's valuable collection of books. A new site was inaugurated in 1983, with specially constructed and refurbished rooms, and the collection grew to 40,000 books, 600 periodical titles, 400 bulletin titles and *c.* 120,000 leaflets and catalogues from major museums, private institutions and galleries throughout the world, making it one of the most important specialist art libraries in Latin America. Many other art museums in Argentina have specialist libraries, including the Museo de Arte Moderno in Buenos Aires, which has 2000 items, the Museo Nacional de Arte Decorativo, also in Buenos Aires, with 2000, and the Museo Provincial de Bellas Artes 'Rosa Galisteo de Rodríguez' in Santa Fe, with over 30,000.

The library of the Escuela Nacional de Bellas Artes 'Prilidiano Pueyrredón' initially comprised almost entirely those books donated by the architect Pío Collivadino, who directed the Escuela Nacional de Bellas Artes from 1908. The collection grew to *c.* 11,000 books, covering all aspects of the arts, aesthetics, history of art and architecture. The first inventory of the library of the Escuela Superior de Bellas Artes 'Ernesto de la Cárcova' (as the Escuela Superior de Bellas Artes came to be known) dates from 1929. It was formed with the donations of lecturers, the greater contribution being made after 1944. The collection was later increased by acquisitions made by the Ministerio de Educación, as well as through donations from institutions. Aside from books the library also houses collections of French, English and German periodicals, as well as a substantial collection of prints and reproductions, an archive of work by pupils in the engraving workshop and a cabinet of engravings.

BIBLIOGRAPHY

Repertorio de bibliotecas especializadas y centros de información (Buenos Aires, 1979)

JULIETA ZUNILDA VAQUERO

Armas, Ricardo (*b* Caracas, 1952). Venezuelan photographer. He was self-taught and dedicated himself to photography from 1972, first working for the magazine *Escena* (1974–6) and then for the Galería de Arte Nacional in Caracas (1976–8). His first exhibition, *Acercamiento a Zitman*, was held at the Museo de Arte Contemporáneo Sofía Imber, Caracas, in 1976. He lived in New York from 1979 to 1983 and studied at the International Center of Photography; from then on technical and formal growth and transformation became evident in his work, demonstrating a particular taste for the dramatic effects of the medium and for the narrative power of black-and-white photography. He went on to work as a photographer for the Museo de Arte Contemporáneo Sofía Imber in Caracas.

BIBLIOGRAPHY
Caracas, Fond. Gal. A. N., Archvs [File A-71]

GUSTAVO NAVARRO-CASTRO

Arnal, Enrique (*b* Catavi, Potosí, 1932). Bolivian painter. He was self-taught as a painter and had his first one-man show in Cuzco in 1954, which was followed by 25 one-man shows in La Paz and by exhibitions in North American cities and in Paris. Arnal was the principal exponent of the Generación del 52. In the 1950s he painted still-lifes with subjects drawn from open-air markets that included potatoes, roosters and dogs, as in *The Inn* (1960; La Paz, Mus. N. A.). In the early 1960s he painted towns of earth and stone, and at the end of the 1960s he painted *Aparapitas*, the stevedores of La Paz, as well as condors and recumbent female nudes, which in the 1980s became *Mountains*, especially during the period 1985 to 1988. He then portrayed the galleries of *Mines* with a progressive stylization and abstraction, and repeated all the themes he had treated throughout his career in a number of series under the overall title the *World of My Memory* (1989; La Paz, Banco Hipotecario N.). His paintings, with their nervous brushstrokes, are in sober colours: greys, earthen shades and especially black. Arnal won seven national prizes for painting, including that of the Salón Municipal de Pintura in 1955, the Salón Nacional de Artes prize in 1960 and the first INBO (Inversiones Bolivianas) Biennale prize in 1975. He worked as a painting instructor in the Faculty of Plastic Arts in the Universidad Católica Boliviana in La Paz.

BIBLIOGRAPHY
Museum of Modern Art of Latin America: Selections from the Permanent Collection (exh. cat., Washington, DC, Mus. Mod. A. Latin America, 1985)
P. Querejazu: *La pintura boliviana del siglo XX* (Milan, 1989)

PEDRO QUEREJAZU

Arrieta, (José) Agustín (*b* Santa Ana Chiautempan, near Tlaxcala, 28 Aug 1803; *d* Puebla, 22 Dec 1874). Mexican painter. He was one of the first students at the Escuela de Dibujo de la Real Casa de la Academia y Junta de Caridad para la Buena Educación de la Juventud, founded in Puebla in 1813, which eventually became the local Academia de Bellas Artes. He is the most representative artist of the Puebla school in the mid-19th century.

Arrieta concentrated at first on portraits, but *c.* 1840 he began to specialize in *costumbrista* paintings and still-lifes, for which he acquired a large local clientele. He exhibited paintings of both kinds from 1851 at the academies in Puebla and Mexico City. His genre paintings, like the Flemish and Dutch works from which they are derived, often have a moralizing intention. There are scenes of flirtation and seduction in kitchens, taverns and markets, in which he avoids sentimentality and condescension in the treatment of his predominantly lower-class subjects. His still-lifes are hybrid compositions in which he combined a variety of luxurious and ordinary Mexican and European foods, including fruits and vegetables, live and dead animals, and regional and foreign dishes. The best public collections of his work are held by the Museo Nacional de Historia in Mexico City and the Museo Bello and Galerías Bello in Puebla.

BIBLIOGRAPHY
F. J. Cabrera: *Agustín Arrieta: Pintor costumbrista* (Mexico City, 1963)
F. Pérez Salazar: *Historia de la pintura en Puebla* (Mexico City, 1963), pp. 105–8
F. Ramírez: *La plástica del siglo de la Independencia* (Mexico City, 1985), pp. 46, 58–9
F. J. Cabrera: *Puebla y los poblanos* (Mexico City, 1987), pp. 91–115
B. Olivares Iriarte: *Album artístico: 1874* (Puebla, 1987), pp. 51–4 [notes by E. Castro Morales]
E. Castro and X. Moyssén: *José Agustín Arrieta* (Mexico City, 1994)

FAUSTO RAMÍREZ

Arrieta, Pedro de (*b* Real de Pachuca, *c.* 1670; *d* Mexico City, 1738). Mexican architect. He qualified as an architect in 1691. Between 1695 and 1709 he worked on the Basílica of Guadalupe, Mexico, which is mainly interesting for its broken lines and for the octagonal form used in the dome, in the section of the towers and the lintels of the doors. His activities were concentrated mainly in Mexico City, where he worked as Maestro Mayor for the Inquisition and the cathedral. He was responsible for the churches of S Gregorio and S Bernardo, the church and convent of S Teresa la Nueva, the monastery of S José de los Carmelitas Descalzos, the church of El Amor de Dios and the church, sacristy and sacristy entrance hall of S Domingo, as well as the Palace of the Inquisition and Customs, all in Mexico City. He also collaborated on the churches of S Clara, Jesús Nazareno, S Francisco, S Miguel and La Profesa, all in Mexico City, and worked on the Colegio Seminario of the cathedral. His non-ecclesiastical works include the S Juan del Río, Mariscala and Alhóndiga bridges. He used a white stone from Chiluca and *tezontle* (dark red volcanic rock), polychromy being fundamental to his work. In 1736 he was among the Mexican architects who drew up new regulations for the guild.

BIBLIOGRAPHY
H. Berlin: 'El arquitecto Pedro de Arrieta', *Bol. Archv Gen. Nación*, xvi (1945), pp. 73–94
D. Angulo Iñiguez, E. Marco Dorta and J. y Buschiazzo: *Historia del arte hispanoamericano*, 3 vols (Barcelona, 1945–56)
H. Berlin: 'Three Master Architects in New Spain', *Hisp. Amer. Hist. Rev.*, xxvii (1947), pp. 375–83
M. Toussaint: *Arte colonial en México* (Mexico City, 1962; Eng. trans., 1967)
G. Gasparini: *América, barroco y arquitectura* (Caracas, 1972)
C. Amerlinck: 'Pedro de Arrieta', *Bol. Mnmts Hist.*, vi (1981), pp. 27–40
G. Tovar de Teresa: *El barroco en México* (Mexico City, 1981)
R. Gutiérrez: *Arquitectura y urbanismo en Iberoamérica* (Madrid, 1983)
M. Fernández: *Arquitectura y gobierno virreinal: Los maestros mayores de la ciudad de México, siglo XVII* (Mexico, 1985)
J. Bérchez: *Arquitectura Mexicana de los siglos XVII y XVIII* ([Mexico City], 1992), pp. 149–59

MARIA CONCEPCIÓN GARCÍA SÁIZ

Arteaga, Sebastian López de. *See* LÓPEZ DE ARTEAGA, SEBASTIAN.

Arte generativo. Style of Argentine painting named in 1959 by EDUARDO MACENTYRE and MIGUEL ANGEL VIDAL to describe their work, with its power to generate optical sequences by circular, vertical and horizontal displacement, and based on their studies of Georges Vantongerloo. Developing the tradition of geometric abstraction that had emerged in Argentina in the 1940s with groups such as Arte Concreto Invención, Movimiento Madí and Perceptismo, the aim of these artists was to extol the beauty and perfection of geometry through line and colour. They and the collector Ignacio Pirovano (1919–80), who acted as their theorist, were soon joined by the engineer and painter Baudes Gorlero (1912–59), who as well as creating his own work also analysed its development mathematically. All three artists were awarded prizes in 1959 in the Argentine competition *Plástica con plásticos* by a jury that consisted of the French critic Michel Ragon, the American museum director Thomas Messer (*b* 1920), the French painter Germaine Derbecq (1899–1973) and the Argentine critic Aldo Pellegrini (1903–75), shortly after which Gorlero died. MacEntyre and Vidal produced the *Arte generativo* manifesto in 1960, not as a theoretical statement but as a 'clarification of ideas'. They distinguished the adjective 'generative' ('able to produce or engender') from the verb 'to engender' ('to procreate, to propagate the same species, to cause, occasion, form') and from the noun 'generatrix' ('a point, line or surface whose motion generates a line, surface or solid'). After exploring these ideas more fully they suggested that shapes 'produce *power* through the sensation of breaking free from and wishing to penetrate the basic plane and *energy* from the displacements and vibrations that they produce'. Both MacEntyre and Vidal relied on an analytical process, organizing basic units (curved lines for MacEntyre, straight lines in Vidal's case) in accordance with constant laws and subjecting them to inventive variations characterized by an impeccable technique, splendid colour and surprising power.

WRITINGS
E. MacEntyre and M. A. Vidal: *El arte generativo* (Buenos Aires, 1960)
I. Pirovano: 'Arte generativo: Eduardo MacEntyre, Miguel Angel Vidal', *Arte argentino contemporáneo* (Madrid, 1979)

NELLY PERAZZO

Arte Madí. Argentine movement of the 1940s based in Buenos Aires and led by GYULA KOŠICE and the Uruguayan artists Carmelo Arden Quin (*b* 1913) and Rhod Rothfuss (*b* 1920). Together with Joaquín Torres García and the Argentine poet Edgar Bayley (*b* 1919), they were responsible for the publication in early 1944 of a single issue of a magazine, *Arturo*, which heralded the development of the Constructivist movement in Argentina, stressing the importance of pure invention and of interdisciplinary links. Tomás Maldonado, who designed the cover, and Lidy Prati (*b* 1921), who was responsible for most of the vignettes, then dissociated themselves from their colleagues to help set up the ASOCIACIÓN ARTE CONCRETO INVENCIÓN; the editorial content of the magazine, however, suggested a coherent aesthetic that was also promoted in booklets published by Košice and Bayley in 1945 and in two exhibitions, *Art Concret Invention* (which opened on 8 Oct 1945 in the house of the doctor and patron Enrique Pichon Rivière) and *Movimiento de Arte Concreto Invención* (from 2 Dec 1945 in the house of the photographer Grete Stern). Articles by Arden Quin and Košice stressed the pure quality of plastic images free of naturalistic or symbolic connotations, whose radical character was distinguished by Bayley from what he termed the falsity of such movements as Expressionism, Realism and Romanticism. Rothfuss's exposition of his ideas about shaped canvases, prefiguring by more than a decade devices taken up by American abstract painters, proved particularly influential.

An exhibition of manifestos, paintings, sculptures, poems and architectural maquettes, together with recitals of music and dance performances, titled simply *Madí*, was held in August 1946 (Buenos Aires, Inst. Fr. Estud. Sup.). It was followed by further group exhibitions entitled *Arte Madí* in October 1946 (Buenos Aires, Salón Altamira, and Buenos Aires, Bohemien Club, Gal. Pacífico) and 1948 (Paris, Salon Realités Nouv.) and by Košice's *Manifiesto Madí* of February–March 1947, which refers to drawing, painting, sculpture, architecture, music, poetry, theatre, novels, stories and dance. A journal, *Arte Madí Universal*, was also published from 1947 until June 1954. Košice's work, particularly his use of shaped canvases, light and movement, typified Arte Madí's emphasis on spectator participation and on new technologies and materials.

WRITINGS
E. Bayley: *Invención 2* (Buenos Aires, 1945)
G. Košice: *Invención 1* (Buenos Aires, 1945)
——: *Arte Madí* (Buenos Aires, 1982)

BIBLIOGRAPHY
Vanguardias de la década del 40, Arte Concreto–Invención, Arte Madí, Perceptismo (exh. cat., intro. N. Perazzo, Buenos Aires, Mus. Mun. A. Plást. Sívori, 1980)
G. Pérez-Barreiro: 'The Negation of All Melancholy: Arte Madí/Concreto-Invención, 1944–1950', *Art from Argentina, 1920–1994* (exh. cat. by D. Elliot and others, Oxford, MOMA, 1994)
——: *The Argentine Avante-Garde, 1944–1950* (diss., Colchester, U. Essex, 1996)
Arte Madí (exh. cat., Madrid, Mus. N. Cent. A. Reina Sofía, 1997)

NELLY PERAZZO

Artigas, João B(atista) Vilanova (*b* Curitiba, 23 June 1915; *d* São Paulo, 6 Jan 1985). Brazilian architect, teacher and writer. He graduated as an engineer–architect from the Escola Politécnica of the University of São Paulo (1937) and became a partner in the design and construction firm Marone & Artigas. In his earliest projects he sought to move away from the academic eclecticism that dominated São Paulo at the time, and his first projects were influenced by the work of Frank Lloyd Wright; for example, the Rio Branco Paranhos house (1943) was clearly inspired by Wright's prairie houses. In 1944 he opened his own design office in São Paulo; he was increasingly influenced by the rationalist modernism of Le Corbusier that began to spread from Rio de Janeiro and often used pilotis, *brises-soleil* and roof gardens at this time, as in the Louveira block of flats (1948) and the Mario Bittencourt house (1949), São Paulo, and the bus station (1950), Londrina.

During this period Artigas was also heavily involved in cultural and political activities; he became a professor of

architecture at the Escola Politécnica, São Paulo (1940–56), where he was a pioneer of modern teaching, and in 1943 he helped form the São Paulo division of the Instituto de Arquitetos do Brasil and was one of its first directors. In 1945 he joined the Brazilian Communist Party and was one of the principal organizers of the first Brazilian Congress of Architects. He travelled in the USA for a year (1946–7) on a grant from the Guggenheim Foundation, and in 1948 he helped to establish the Faculty of Architecture and Urbanism at the University of São Paulo (FAU/USP). He then published his two most important critical essays on architecture: 'Le Corbusier e o imperialismo' (1951) and 'Os caminhos da arquitetura moderna' (1952); both are pioneering analyses of the ideology behind modernist architectural thinking.

In 1953 Artigas won a competition for the São Paulo Football Club stadium, his first large-scale work. After this project, he began to develop an architectural style of his own; in buildings in São Paulo such as the Olga Baeta house (1956), the José Mario Taques Bittencourt house (1959), the boat-house for the Santapaula Yacht Club (1960) and his most influential work, the new FAU/USP building (1961; see fig.), he searched for the dissociation of the building from its surrounding site, emphasized monumentality and used heavy construction elements both as means of architectural expression and as ethical metaphors for social conflict. This resulted in a brutalist approach, but it was based more on Wright's spatial experiments as seen in the Larkin Building (1904), Buffalo, NY, than on Le Corbusier's *manière brute*. In the 1960s and 1970s the rather limited vocabulary of this language, characterized by the extensive use of *béton brut* (Fr.: 'raw concrete') to define compact, regular volumes, blank walls supported by irregularly shaped pillars, and rectangular roofs covering a series of spaces, became the definitive model for architecture in São Paulo, adopted by many architects for a wide variety of buildings.

Artigas produced some of his most significant projects in the late 1960s, for example the Elza Berquó house (1967), a poetic work in which he used tree trunks as supports, and the housing complex Parque Cecap (1967), a plan for 10,000 low-cost flats based on the idea of the neighbourhood unit. He also presented his influential essay 'O desenho' in the opening lecture at FAU/USP in 1967. However, this was also the most troubled period of his political life. His influence on the architectural students of São Paulo had been growing since the mid-1950s, and he was involved in new proposals to reform the teaching of architecture at the FAU/USP (1962), which became the model followed by most schools in Brazil. After the military coup in 1964, however, the persecution of communists intensified, and in 1969 he was compulsorily retired from the university.

The only official commissions Artigas subsequently received were those for the Território Federal do Amapá in the far north, including a school and the territorial guard barracks (both 1971). From 1972 he designed a series of elevated pedestrian walkways for the Empresa Municipal de Urbanização de São Paulo, using a composite structure of reinforced concrete and steel, and in 1973 he designed the bus station for the Prefecture of Jaú, with an immense reinforced concrete roof resting on huge columns like tree trunks. In his design for the Conceiçãozinha state school (1976), Guarujá, he returned to his earlier interest in materials and textures; the unusual combination of brick arcades, concrete block walls, wood latticework and tiled roofs make this his most creative project of the period. In 1979 Artigas returned to the University of São Paulo and

João B. Vilanova Artigas: Faculty of Architecture and Urbanism building, University of São Paulo, 1961

was awarded a special doctorate from the FAU/USP in 1984. He received many other honours and awards during his career, including the Jean Tschumi Award (1972) and the Auguste Perret Award (1984), both from the Union Internationale des Architectes. His architecture and his teaching both had an enormous influence on a generation of architects in Brazil.

WRITINGS

'Le Corbusier e o imperialismo', *Fundamentos*, 18 (1951), pp. 8–9, 27
'Os caminhos da arquitetura moderna', *Fundamentos*, 24 (1952), pp. 20–25
O desenho (São Paulo, 1967)
Caminhos da arquitetura (São Paulo, 1981)
Memorial, 2 vols (São Paulo, 1981)

BIBLIOGRAPHY

H. E. Mindlin: *Modern Architecture in Brazil* (Amsterdam and Rio de Janeiro, 1956)
'Rapporto Brasile', *Zodiac*, 6 (1960), pp. 97–107
S. Ficher and M. M. Acayaba: *Arquitetura moderna brasileira* (São Paulo, 1982)
A. Xavier, C. Lemos and E. Corona: *Arquitetura moderna paulistana* (São Paulo, 1983)
A. Xavier: *Arquitetura moderna em Curitiba* (São Paulo, 1986)
M. C. Ferraz: *Vilanova Artigas* (São Paulo, 1997)

SYLVIA FICHER

Artistas Modernos de la Argentina. Argentine group of artists formed in 1952 and active until 1954. It was founded on the initiative of the art critic Aldo Pellegrini (1903–75) as a union of Constructivist painters belonging to the Asociación arte concreto invención—Tomás Maldonado, Alfredo Hlito, Lidy Prati (*b* 1921), Ennio Iommi and Claudio Girola (*b* 1923)—and four independent semi-abstract artists: José Antonio Fernández Muro, Sarah Grilo, Miguel Ocampo and Hans Aebi (*b* 1923). Pellegrini's main concern was with the quality of the artists' work rather than with a shared programme. They were the first abstract artists in Argentina to exhibit together as a group abroad: in 1953 they showed both at the Museu de Arte Moderna in Rio de Janeiro and at the Stedelijk Museum in Amsterdam.

Pelligrini was pleased with the genuine interaction within the group. The work of the independent artists became more rigorous and economical, inclining progressively towards geometric abstraction, and their lack of dogmatism in turn led the Constructivists to adopt a more flexible approach. The group disbanded on Maldonado's move to Germany in 1954, but the former associates continued to work separately with great success.

BIBLIOGRAPHY

A. Pellegrini: *Panorama de la pintura argentina contemporánea* (Buenos Aires, 1967), pp. 60–61
N. Perazzo: *El arte concreto en la Argentina* (Buenos Aires, 1983), p. 106

NELLY PERAZZO

Arturo. Argentine art magazine published as a single issue in Buenos Aires in early 1944. Its avant-garde stance proved influential on the development of Constructivism in Argentina, leading directly to Arte madí and to Asociación arte concreto invención.

☐

Arziniega, Claudio de. *See* Arciniega, Claudio de.

Ascher (Oved), Daisy (*b* Mexico City, 25 April 1944). Mexican photographer. She studied art at the Universidad

Motolinía and at the Universidad Anáhuac, both in Mexico City, and undertook specialist studies at the Club Fotográfico de México. Ascher's work showed the influence of such photographers as Yousuf Karsh, Sam Haskins (*b* 1926) and Richard Avedon, but it was also more generally stimulated by the work of Eugène Atget, Alfred Stieglitz, Paul Strand, Manuel Alvarez Bravo and Henri Cartier-Bresson. She made frequent trips to New York, where she acquired experience from photographers and artists that not only enriched her own visual concepts but also the technical aspects of her work. Ascher consolidated her position in Mexican photography through her work, particularly in the acute sensitivity of her many portraits of personalities from the artistic and cultural world. Her series of José Luis Cuevas and Juan Rulfo are among her most outstanding works. After several years of work she collected the material that was published as *Revelando a Cuevas*.

BIBLIOGRAPHY

J. Rulfo and others: *Cien retratos por Daisy Ascher* (Mexico City, 1981)
Daisy Ascher: De todo corazón: Homenaje a Teodoro Césarman (exh. cat., Mexico City, Gal. Tenatitla, 1996)

JULIETA ORTIZ GAITÁN

Asociación Arte Concreto Invención. Argentine group formed in November 1945 by Tomás Maldonado and other Constructivist artists and active until *c.* 1964. Its other original members were Lidy Prati (*b* 1921), Alfredo Hlito, Manuel Espinosa, Raúl Lozza (*b* 1911), Alberto Molenberg (*b* 1921), Ennio Iommi, Claudio Girola (*b* 1923), Jorge Souza (*b* 1919), Primaldo Mónaco (*b* 1921), Oscar Núñez (*b* 1919), Antonio Caraduje (*b* 1920) and the poet Edgar Bayley (*b* 1919). Maldonado and Prati were prominent among the artists involved in the publication of the single issue of the magazine *Arturo* in early 1944, in which the image–invention was proposed as an alternative to representational, naturalistic or symbolic imagery, but they did not take part in two exhibitions of associated artists in 1945 that led to the establishment of Arte madí. In fact, their central role in setting up the Asociación Arte Concreto Invención was a way of declaring their independence from the other group.

The first exhibition of the Asociación opened on 18 March 1946. It was accompanied by the publication of the *Manifiesto invencionista*, which affirmed the values of concrete art over figurative art and stressed the importance of a social role for art. Works exhibited by group members later that year, together with the theories espoused by them in two issues of their magazine (the first, *Revista Arte concreto invención*, published in August 1946 and the second, *Boletín de la Asociación arte concreto invención*, following in December 1946), were concerned largely with investigating the shaped canvas in a variety of ways that anticipated the work of American painters in the 1960s. After exploring with great inventiveness the relationship between the painted surface and its shape or supporting wall, they concluded that these formal concerns were too limiting and returned to more conventional rectangular formats, leaving it to painters associated with Arte Madí and Perceptismo to continue with these experiments. While the painters concerned themselves with clear and harmonious structures of form and colour, the group's

sculptors used new materials in constructions that replaced solid mass with transparencies and intersecting planes. From 1952 to 1954 Maldonado and other members of the group banded together with four independent painters working in a semi-abstract style as ARTISTAS MODERNOS DE LA ARGENTINA. Although group members gradually went their own way, their common aesthetic remained influential not only on painting and sculpture but also on theories of architecture and design.

BIBLIOGRAPHY

N. Perazzo: *El arte concreto en la Argentina* (Buenos Aires, 1983), pp. 87–108

M. H. Gradowczyk: *Argentina: Arte Concreto-Invención 1945/Grupo Madí 1946* (exh. cat., New York, Rachel Adler Gal., 1990)

G. Pérez-Barreiro: 'The Negation of All Melancholy: Arte Madí/Concreto-Invención, 1944–1950', *Art from Argentina, 1920–1994* (exh. cat. by D. Elliott and others, Oxford, MOMA, 1994), pp. 54–65

——: *The Argentine Avante-Garde, 1944–1950* (diss., Colchester, U. Essex, 1996)

NELLY PERAZZO

Astete y Concha, Luis (*b* Lima, 1866; *d* Lima, 12 Jan 1914). Peruvian painter. He studied at the Academia de S Fernando in Madrid, where he lived from 1883 to 1893; his friends there included Joaquín Sorolla y Bastida, a fellow student. On his return to Lima in 1893 he painted portraits and for 14 years taught drawing at the Academia Concha. He also worked as an illustrator for the review *Prisma*. In 1897 he was awarded first prize at the Exposición de Lima and was commissioned to execute a series of portraits of Peruvian personalities; these were later destroyed in a fire at the Biblioteca Nacional in Lima. In addition to landscapes and portraits he executed genre scenes and allegorical paintings.

BIBLIOGRAPHY

T. Núñez Ureta: *Pintura contemporánea: Primera parte, 1820–1920* (Lima, 1975)

C. Milla Batres, ed.: *Diccionario histórico y biográfico del Perú: Siglos XV–XX*, i (Lima, 1986)

LUIS ENRIQUE TORD

Asúnsolo, Ignacio (*b* Hacienda de San Juan Bautista, Durango, 15 March 1890; *d* Mexico City, 21 Dec 1965). Mexican sculptor. He served in the Mexican Revolution before enrolling in the Academia de S Carlos, continuing his studies from 1919 at the Ecole des Beaux-Arts in Paris. On his return to Mexico in 1921, he began a fruitful career as teacher and artist, applying an academic naturalism to official public monuments of nationalist inspiration such as monument to the *Fatherland* (1924; Mexico City, Mus. N. Hist.). His most ambitious works relating to the revolution are the monument to *Obregón* (1933; Mexico City, Avenida Insurgentes), *Proletarian Family* (1934; Mexico City, Inst. Poli. N.) and the monument to *Francisco Villa* (1957; Chihuahua, Avenida División del Norte). He also treated other subjects, such as female nudes and portraits, sometimes in wood or cast bronze, which contain reference to Pre-Columbian art. Essentially he was an artist resistant to change, a staunch and honourable traditionalist.

BIBLIOGRAPHY

M. Nelken: *Ignacio Asúnsolo* (Mexico City, 1957)

Ignacio Asúnsolo, escultor (exh. cat. by R. Tibol, Mexico City, Mus. N. A., 1985)

L. Kassner: *Diccionario de escultores mexicanos del siglo XX* (Mexico City, 1997)

XAVIER MOYSSÉN

Ataíde [Athaide], **Manoel da Costa** (*b* Mariana, Minas Gerais, *bapt* 18 Oct 1762; *d* Mariana, 2 Feb 1830). Brazilian painter. He was the most important painter active in the province of Minas Gerais during the Colonial period. He learnt his craft in the workshop with other artists and from such theoretical treatises as Andrea Pozzo's *Perspectivae pictorum atque architectorum* (1693–1700) and such technical manuals as the *Segredos necessarios para os officcios, artes e manufaturas* (Lisbon, 1794), which was recorded in the inventory of his possessions. He was also strongly influenced by engravings of religious subjects in bibles and missals. He had a great influence on the development of religious painting in the region, especially through his numerous pupils and followers, who until the middle of the 19th century continued to make use of his compositional methods, particularly in the perspective ceilings of churches. Often referred to in documents as 'professor de pintura', in 1818 he unsuccessfully petitioned for official permission to found an art school in his native city. He left an extensive body of work, which includes decorative painting of architecture, single pictures and the painting of religious statues (gilding and flesh-colouring). Especially famous are the vast perspective paintings such as the *Glorification of the Virgin* (1801–10; *see* BRAZIL, fig. 8) on the vaulted ceilings of the church of São Francisco de Assis in Ouro Preto and similar compositions for the parish churches of Sta Bárbara and Itaverava; in these he transforms the overweight Baroque schemes derived from Andrea Pozzo into light and graceful compositions of the purest Rococo, giving rise to an important regional tradition that has no equal elsewhere in colonial Brazil.

BIBLIOGRAPHY

S. de Vasconcellos: *Ataíde: Pintor mineiro do século XVIII* (Belo Horizonte, 1941)

C. del Negro: *Contribução ao estudo da pintura mineira* (Rio de Janeiro, 1958)

I. Porto de Menezes: *Manoel da Costa Athaide* (Belo Horizonte, 1965)

J. Martins: *Dicionário de artistas e artífices dos séculos XVIII e XIX em Minas Gerais*, i (Rio de Janeiro, 1974), pp. 79–87

L. C. Frota: *Ataíde: Vida e obra de Manoel da Costa Ataíde* (Rio de Janeiro, 1982)

MYRIAM A. RIBEIRO DE OLIVEIRA

Athaide, Manoel da Costa. *See* ATAÍDE, MANOEL DA COSTA.

Athens Charter. *See under* CIAM.

Atkins, Roy. *See* ROY, NAMBA.

Atl, Dr [Murillo, Gerardo] (*b* Guadalajara, 3 Oct 1875; *d* Mexico City, 14 Aug 1964). Mexican painter, printmaker, writer, theorist, vulcanologist and politician. Better known by his pseudonym, which signifies 'Doctor Water' in Náhuatl and which he adopted in 1902, Murillo first studied art in Guadalajara and from 1890 to 1896 at the Academia de San Carlos in Mexico City, where his vocation became clear. In 1899 he travelled to Europe and settled in Rome, where the work of Michelangelo had a profound impact on him. He travelled to other countries to study

and to learn about avant-garde painting. He went back to Mexico in 1904 and seven years later returned to Europe, only to rush back when the Revolution broke out in Mexico. He joined the revolutionary movement, taking an active role in its various activities, including the muralist movement, through which he was associated with Diego Rivera, José Clemente Orozco and David Alfaro Siqueiros. Although he practised portrait painting, his passion was for landscape in a variety of techniques and materials, some of them invented by him; for example, he used 'atlcolours', which were simply crayons made of wax, resins and pigment with which he could obtain textures not obtainable with oil paint. His favoured supports were rigid surfaces such as wood or hardboard.

The different formative influences that set the parameters for Dr Atl's mature style are visible in his early works. *Seated Woman* (pastel, 1903; Mexico City, Fomento Cult. Banamex) is Impressionist in treatment, while the Post-Impressionism of Giovanni Segantini served as the model for his *Bathers* (Guadalajara, Mus. Reg. Antropol. & Hist.). Another Italian source, the Futurist work of Luigi Russolo, lay behind the style of paintings such as *Lightning on the Waves* (Guadalajara, Mus. Reg. Antropol. & Hist.). Japanese woodcuts left an unmistakable mark on his work as a printmaker, particularly on his experiments with stencils, for example *Landscape with Volcano* (Mexico City, Luis Felipe del Valle Prieto priv. col.).

Dr Atl's first landscapes fluctuate between bad academic habits and modernist techniques. The Valley of Mexico and its volcanoes soon made an appearance and became a frequent theme in his extensive production. As he was a mountaineer he chose his sites in the high mountain ranges, thus emphasizing the monumentality of the Mexican landscape. The vision he gained from the heights was not that of man but of the birds, space being one of his constant preoccupations. Until 1933 he used conventional perspective and a straight line to represent the horizon. After that date, inspired by the theories of the Mexican painter Luis G. Serrano (1894–1972), he made use of a curvilinear horizon in the large landscapes that form the most significant part of his work, such as the *Valley of Mexico* (Mexico City, A. Luna Arroyo priv. col.). In *Clouds over the Valley* (1933; Mexico City, Mus. N.A.) he took the theory to extremes, with the movement of the clouds obeying the guiding line of the earthly horizon.

An enthusiasm for innovation led Atl around 1957 to the practice of 'aerolandscape', which involved taking the essential sketches for a picture from the cockpit of a plane or helicopter. He concentrated on the peaks of the volcanoes, for example *Popocatepetl Seen from an Aeroplane* (1948; Mexico City, Octavio Barocio priv. col.). A natural event, the eruption of the volcano Paricutín in 1942, gave a new dimension to his art. He made a meticulous record of the volcano's development in a long series of drawings in charcoal, and in works such as *Volcano in the Starry Night* (Mexico City, Mus. N.A.) also painted the impressive eruptions by day and night.

WRITINGS
El paisaje. Un ensayo (Mexico City, 1933)

BIBLIOGRAPHY
A. Luna Arroyo: *El Dr Atl: Sinopsis de su vida y su pintura* (Mexico City, 1952)

C. Pellicer: *Dr Atl: Pinturas y dibujos* (Mexico City, 1954)
A. Casado Navarro: *Gerardo Murillo, el Dr Atl* (Mexico City, 1984)
J. Hernández Campos and others: *Dr Atl, 1875–1964: Conciencia y paisaje* (Mexico City and Monterrey, 2/1986)
B. Espejo: *Dr Atl: El paisaje como pasión* (Mexico City, 1994)

XAVIER MOYSSÉN

Audivert, Eduardo (*b* Buenos Aires, 2 Aug 1931; *d* 1998). Argentine draughtsman and printmaker. He studied under the Argentine painter Demetrio Urruchúa (1902–78) and later at the Instituto Superior de Artes of the Universidad Nacional in Tucumán, under his father, Pompeyo Audivert (1900–77), and Lino Eneas Spilimbergo, who encouraged him to take up printmaking. After working in a realist style from 1954 to 1960 and in a linear style from 1960 to 1965 he began to produce technically accomplished drawings and prints in an idiom strongly influenced by Surrealism. Architectural supports such as plinths, pedestals, staircases and doors were among his favoured images, dominated by an atmosphere of anguish.

BIBLIOGRAPHY
J. Glusberg: *Del Pop-art a la Nueva Imagen* (Buenos Aires, 1985), pp. 235–40

JORGE GLUSBERG

Azevedo, Francisco de Paula Ramos de (*b* São Paulo, 8 Dec 1851; *d* Guarujá, 13 June 1928). Brazilian architect. He studied at the Escola Militar in Rio de Janeiro (1869–72) and then trained as an engineer–architect, graduating in 1878 from the University of Ghent, Belgium, under the patronage of the Visconde de Parnaíba, who subsequently provided him with his first commissions in Rio. His architectural education was based on the classicism of the Beaux-Arts tradition, and one of his designs represented his school at the Exposition Internationale (1878) in Paris. He began his career in 1883 in Campinas, where his family had originated, when he completed some unfinished work on the 18th-century parish church; this project became well known for his use of the *taipa de pilão* (Port.: 'pounded gravel wall') construction techniques of the earlier builders, a considerable engineering feat.

In 1886 Azevedo began to work in São Paulo and designed for the government two neo-Renaissance buildings, the Tesouraria da Fazenda Nacional (1891) and the Secretaria da Agricultura (1896); these were the first scholarly works in what was then a provincial city, but one expanding rapidly in size and wealth owing to its coffee-producing industry and large-scale immigration, mainly from Italy. These two factors stimulated a revival of eclecticism in architecture, and Azevedo's academically correct buildings received great acclaim and marked the beginning of a prosperous career; he subsequently became the leading architect and builder in Brazil, employing the best practitioners in his profession. He also established companies concerned with the production of building materials of all kinds, including a comprehensive import business, and after the closure of the Banco União he became president of a substantial property development company. A founder-member of the Escola Politécnica, São Paulo, at the turn of the century, he combined business activities with the role of professor of architecture there, becoming director from 1917 to 1928. He strongly encouraged the expansion of the Liceu de Artes e Ofícios,

the craft and trade school at which joiners, ironworkers, sculptors, artists and other craftsmen connected with the building trade received a rigorous training.

Azevedo continued to design in the classical style, for example the Secretaria da Justiça, the new wing of the Palacio do Governo, the Escola Normal (1894) and several primary schools. Impressed by the ornate Second Empire architecture of Paris after its replanning in the 1860s, having seen the folios of buildings in Paris published by César-Denis Daly, he found the Paris Opéra (1861–75) the obvious model for the Municipal Theatre (1911), São Paulo, his most important work. It was based on a project devised by the Italian scenographer Claudio Rossi (*b* 1850), for which the Italian architect Domiziano Rossi (1865–1920) made the plans and drawings; Azevedo directed the building work and determined the final design. In 1907 Azevedo was joined by the Portuguese engineer Ricardo Severo (1869–1940), who through his lectures launched the neo-colonial style in Brazil, a nationalist style based on the Baroque ornament of 18th-century buildings. From 1915 the Escritório Técnico F. P. Ramos de Azevedo, by then a large organization of architects, draughtsmen, engineers and artists, was responsible for the diffusion of this new style through the design of many houses, including one for Numa de Oliveira (1916–17), Avenida Paulista, São Paulo; the style became very popular in the 1920s. Azevedo was an important architect in São Paulo at a time when it was said to be the fastest-growing city in the world. His office remained active until the 1960s.

BIBLIOGRAPHY

J. F. da Silveira: *Ramos de Azevedo e sua atividade* (São Paulo, 1941)

A. Salmoni and E. Debenedetti: *Arquitectura italiana em São Paulo* (São Paulo, 1981), pp. 75–95

C. A. C. Lemos: *Alvenaria burguesa* (São Paulo, 1985)

A. Fabris, ed.: *O ecletismo na arquitectura brasileira* (São Paulo, 1987), pp. 79–96

C. A. C. Lemos: *História da casa brasileira* (São Paulo, 1989), pp. 48–53

C. A. C. Lemos: *Ramos de Azevedo e seu escritório* (São Paulo, 1993)

B. Lima de Toledo: 'Opera Houses', *J. Dec. & Propaganda A.*, xxi (1995), pp. 43–59

CARLOS A. C. LEMOS

B

Baca Flor, Carlos (*b* Islay, Arequipa, 1867; *d* Neuilly-sur-Seine, 20 Feb 1941). Peruvian painter and draughtsman. His family moved to Chile when he was four, and in 1882 he entered the Escuela de Bellas Artes de Santiago. In recognition of his rejection of an offer of Chilean nationality, the Peruvian government invited him to Lima in 1887 to assist him with his studies. In 1890 he went to Paris, continuing on to Rome where he studied under Francisco Pradilla at the Academia Española de Bellas Artes and again in Paris under Jean-Paul Laurens and Benjamin Constant at the Académie Julien in 1893. In Paris he was commissioned to paint important society and government figures; in 1908 the American banker and collector J. Pierpont Morgan summoned him to New York, where he lived for 20 years, painting 120 portraits. In 1926 he became a member of the Académie des Beaux-Arts in Paris and three years later he settled in Paris again. His painting was academically accomplished and realist in style, influenced by Leonardo, Rembrandt and Hans Holbein. He was a careful observer of detail, and he achieved astonishing physical resemblance to his subjects. The prominent figures he portrayed include *Cardinal Bonzano* and the future Irish prime minister *Eamon de Valera* (both *c.* 1909; Lima, Mus. A.). Some works show a more impressionistic style, such as *Girl with Chrysanthemums* (Lima, Mus. A.). He painted some religious scenes and landscapes and was also an accomplished draughtsman, as shown by *Female Nude* and *John Morgan* (Lima, Mus. A.).

BIBLIOGRAPHY

J. Villacorta Paredes: *Pintores peruanos de la República* (Lima, 1971), pp. 38–41

J. A. de Lavalle and W. Lang: *Pintura contemporánea, I: 1820–1920*, Col. A. Tesoros Perú (Lima, 1975), pp. 152–67

W. IAIN MACKAY

Badii, Líbero (*b* Arezzo, 2 Feb 1916). Argentine sculptor, painter, printmaker and draughtsman of Italian birth. After completing his studies at the Escuela Superior de Bellas Artes in Buenos Aires in 1945, he went on study trips around Latin America (1945–6) and Europe (1949). He became a naturalized citizen of Argentina in 1947 and from 1949 he participated in the Salones Nacionales, winning various awards. He soon won a reputation as one of Argentina's most outstanding sculptors, working in marble, bronze, wood, cement and clay. *Torrent* (marble, 1953; Buenos Aires, Mus. N. B.A.), a semi-abstract female nude composed of smooth curved planes, typifies one aspect of his work: his treatment of themes of fecundity,

motherhood and the family, using rounded forms to which he attached a symbolic value. The titles associated with some of these material forms, such as *Time* (bronze, 1959; Buenos Aires, Mus. A. Mod.), indicate the way they are meant to be read.

His equation of art with life, represented by such works, centred on a theme that he termed 'sinister knowledge', a deliberately vague concept linked to irrationality, mystery, the inexplicable and the unforeseeable, which he proposed as a metaphor for understanding the universe. The application of this theme can be seen, for example, in *The Sacrifice* (polychromed wood, h. 2.2 m, 1971; Buenos Aires, Mus. Badii), a monumental work in five parts representing revelation, primordial existence, communication with the mysterious and a couple resembling Pre-Columbian gods. Badii also produced portraits, for example of the writers Macedonio Fernández (*Homage to Macedonio Fernández*, bronze, h. 3 m), two bronze busts of Antonio Porchia (*Physical Portrait* and *Spiritual Portrait*) and Ema de Cartosio (version, head, polychromed plaster; Buenos Aires, Mus. Badii), and works on Argentine themes such as *The Tango* (bronze, h. 1.9 m, 1963, priv. col., see Merlín) and *Martín Fierro* (marble, h. 2.1 m; Buenos Aires, Bib. N.). In 1968 he made a surprising departure in his sculpture with a series of monumental *Dolls* made of polychromed wood, for which he was awarded the international sculpture prize at the São Paulo Biennale in 1971. These vivid works, full of vitality, were constructed from contrasting elements painted in combinations of strident colours. Badii also produced paintings (from 1975), prints and series of drawings (e.g. *The Tango, The Pampas and the Andes* and *Sinister Forces*, all Buenos Aires, Mus. Badii). The Museo Badii, supported by the Fundación Banco de Crédito Argentino, was inaugurated in Buenos Aires in September 1988.

WRITINGS

Arte siniestro (Buenos Aires, 1979)

Almataller, Líbero Badii (Buenos Aires, 1996)

Comunicación de Líbero Badii (Buenos Aires, 1996)

Conocimiento siniestro, Líbero Badii (Buenos Aires, 1996)

Escritura de Líbero Badii (Buenos Aires, 1996)

Comunicándome (Buenos Aires, 1997)

BIBLIOGRAPHY

A. Burnet Merlín: *Líbero Badii* (Buenos Aires, 1965)

J. López Anaya: *Historia del arte argentino* (Buenos Aires, 1997)

NELLY PERAZZO

Báez, Myrna (*b* San Juan, 18 Aug 1931). Puerto Rican painter and printmaker. She studied painting for six years

at the Real Academia de San Fernando in Madrid, woodcut and screenprinting with Lorenzo Homar at the Graphics Workshop of the Instituto de Cultura Puertorriqueña (1959–63), and printmaking techniques at Pratt Graphic Center in New York (1969–70). From the early 1970s she was actively involved in the development of art education in Puerto Rico, teaching at the Art Students League of San Juan and at Sacred Heart University. She was also a founding member of the Hermandad de Artistas Gráficos, president of the Fine Arts Section of the Ateneo Puertorriqueño, adviser to the National Endowment for the Arts and one of the principal advocates of the Puerto Rican women artists' movement.

Báez's early work was influenced by the social realism current in the 1950s and focused on nationalist, social and political subject-matter. Gradually she developed a personal iconography based on the human figure in solitary interiors and environments, through which she criticized the pretensions and manners of Puerto Rican middle-class society. In her early work she explored the painterly potential of the woodcut, later adapting other techniques to equally expressive ends, achieving rich, textural effects. Her tendency as a printmaker to find equivalents for her concerns as a painter was evident also in her screenprints, in which she used transparent layers, spatial planes and luminous colours to reinforce the psychological space in which her characters exist.

BIBLIOGRAPHY

Myrna Báez: Diez años de gráfica y pintura, 1971–1981 (exh. cat. by M. Traba and M. Benítez, New York, Mus. Barrio, 1982)

Tres décadas gráficas de Myrna Báez, 1958–1988 (exh. cat. by M. Fernández Zavala, M. García Fonteboa, R. Tibol and J. A. Torres Martinó, San Juan, Inst. Cult. Puertorriqueña, 1988)

MARI CARMEN RAMÍREZ

Bahamas, the [Commonwealth of]. Group of islands between the northern Caribbean Sea and the Atlantic Ocean. They comprise *c.* 2000 cays (low coral banks) and 700 larger islands, which stretch southwards in an arc of 1200 km, *c.* 80 km off the Florida peninsula (see fig. 1). The capital, Nassau, is on the main island, New Providence, where 67% of the population of 284,000 live. The Bahamas became fully independent of Britain in 1973.

I. Introduction. II. Cultures. III. Architecture. IV. Painting, graphic arts and sculpture. V. Interior decoration and furniture. VI. Patronage, collecting and dealing. VII. Museums. VIII. Art education.

I. Introduction.

According to some scholars the Bahamian island of San Salvador was Christopher Columbus's first landing-place in the New World in 1492. The Spaniards did not settle the islands, however, and in 1629 the British decided to administer them as part of their North American colonies. The first European settlers arrived about 20 years later. Cultivable land was turned over to the production of such

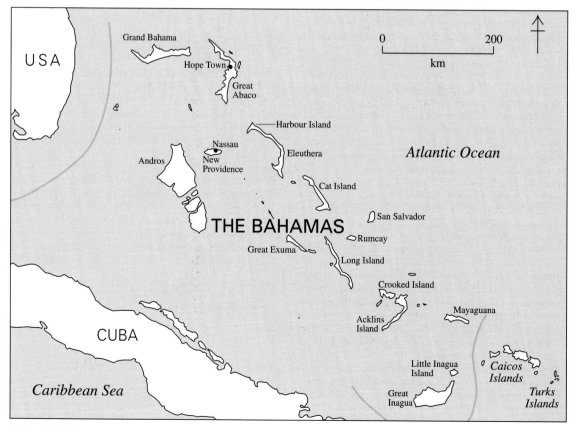

1. Map of the Bahamas

cash crops as sugar, and slaves were imported, mainly from West Africa, to work the plantations. In consequence, 80% of Bahamians are of African descent. Emancipation of the slave population took place in 1834. After 1691 the Bahamas became a centre of piracy, which was followed by wrecking, illegal slave-trading and blockade-running during the American Civil War (1861–5). During American Prohibition (1920–33) smuggling of alcohol was common. Universal adult suffrage was introduced in 1962, followed by independence 11 years later.

See also CARIBBEAN ISLANDS.

BIBLIOGRAPHY
M. Craton: *A History of the Bahamas* (Ontario, 1986)
M. Cratan and G. Saunders: *From Aboriginal Times to the End of Slavery*, i of *Islanders in the Stream: A History of the Bahamian People* (Georgia, 1992)
R. Douglas: *Island Heritage: Architecture of the Bahamas* (Nassau, 1992)
P. Glinton, C. Higgins and C. Smith: *Bahamian Art, 1492–1992* (Nassau, 1992)
V. Poupeye: *Caribbean Art* (London, 1998)
JANET HENSHALL MOMSEN

II. Cultures.

1. AMERINDIAN. When Christopher Columbus landed on the Bahamas during his first voyage to the New World, the archipelago was inhabited by Amerindians, whom the Spaniards called Lucayos, naming the islands themselves Lucayas. These Amerindians, migrants from Cuba and Hispaniola, had arrived in the islands by the middle of the 8th century AD and spoke an Arawak language common throughout the Greater Antilles. Since the Lucayos' culture was less advanced than that of the Taino Indians of Hispaniola, Puerto Rico or eastern Cuba, archaeologists have classified it as Sub-Tainan, along with that of the Amerindians of central Cuba and Jamaica. Although the Spaniards did not colonize the Bahamas, since the islands lacked gold and were therefore of no interest, they captured and enslaved the inhabitants to work in the Greater Antilles. As a result, historical information on the aboriginal culture is scarce.

It is known, however, that the Lucayos were agriculturalists who lived in small villages under a chief known by the Spaniards as a *cacique*. Their pottery was crude and its decoration limited to red paint, geometric designs incised on the borders and roughly modelled lugs representing mythological beings; in this respect it resembles the Meillac pottery found in Hispaniola and Cuba. Research by Sullivan has uncovered the distinctive pottery called Palmetto ware, which is decorated by fine-line incision and punctation, incised appliqué strips, loop and strap handles, red slip and modelled lugs. Some examples are decorated with broad lines or curvilinear incisions. Besides pottery, archaeologists have found characteristic Taino petaloid stone celts, conch-shell artefacts and ornaments. Loven described a monolithic stone-axe (Brussels, Musées Royaux A. & Hist.) from the area.

There is no evidence of wood-working, but time and climate would have destroyed most wooden artefacts. Several *dujos*, low, wooden four-legged ceremonial seats, sometimes anthropomorphic in shape, used by Tainos throughout the islands, have been found (see fig. 2). Although they represent the best examples of Lucayan

2. Bahamian Taino *dujo*, anthropomorphic ceremonial seat, wood with gold inlay, 222 x 432 mm, 15th century (London, British Museum)

artistry, there is doubt as to whether these and other wooden artefacts found in the Bahamas were made by the Lucayos or obtained by barter from the Tainos of Hispaniola or eastern Cuba, who visited the islands to trade for the abundant salt there.

The practice of ceremonial ball games by Tainos of the Greater Antilles was also present in the Bahamas, where Sullivan found evidence of a plaza and a simple ballcourt at Middle Caicos Island.

BIBLIOGRAPHY
S. Loven: *Origins of the Tainan Culture, West Indies* (Göteborg, 1935)
I. Rouse: 'Prehistory of the West Indies', *Science*, cxliv (1964), pp. 499–513
C. Hoffman: 'The Palmetto Grove Site on San Salvador, Bahamas', *Contrib. FL Site Mus.*, xvi (1970)
J. Granberry: 'A Brief History of Bahamian Archaeology', *FL Anthropol.*, xxxiii/3 (1980)
S. D. Sullivan: 'Archaeological Investigation in the Caicos Islands', *FL Anthropol.*, xxxiii/3 (1980), pp. 120–51
W. F. Keagan: *The People Who Discovered Columbus: The Prehistory of the Bahamas* (Gainesville, 1992)
RICARDO E. ALEGRÍA, MELA PONS-ALEGRÍA

2. AFRO-CARIBBEAN. By the beginning of the 18th century the slavery system had been established in most of the British Caribbean colonies: slaves, taken mainly from West Africa, were considered essential to the plantation system and the British Empire, which depended on commerce (*see* AFRICAN DIASPORA). As a part of the British Empire, the Bahamas, although small and relatively

insignificant, had their own slave society. Slaves arrived in the islands in 1648 with English and Bermudian Puritans who were seeking religious freedom. In 1672 the population numbered 500; by 1773 it had increased to 4293, half of which was of African origin, mostly slaves. Between 1783 and 1785 there was an influx of Loyalists (former North American colonists who remained loyal to the British Crown) following the War of Independence. This doubled the population of the Bahamas and put the black population in the majority. The arrival of liberated Africans (or recaptives) between 1808 and 1860 also profoundly affected the population and reinforced the practice of African traditions. The consensus among most American scholars of slavery is that slaves had lives independent from those of their masters and maintained many of their African customs, despite their dilution by the new environment and tribal dispersal. Slaves of the Loyalists from the USA also brought their own beliefs and practices with them. Much of the slaves' folklore, shaped by the local environment, was passed from generation to generation and in the late 20th century continued to affect Bahamian culture. Especially significant are the use of bush or herb medicine, the Junkanoo festival, the adoption of the Baptist religion, traditional story-telling, music and dance, the practice of obeah and food and games derived from Africa.

Junkanoo (Jonkonnu [John Canoe] elsewhere in the Caribbean), a national festival held in the early hours of Boxing Day and New Year's Day, originated in West Africa. During slavery some type of dance was held by the slaves at Christmas and, although there are many theories as to its origin, by 1801 Junkanoo had become a regular fixture in the Bahamas. The imagery of Junkanoo reappears throughout the Caribbean in CARNIVAL (see fig. 3). Instruments used in the festival and costume parade include cowbells, goatskin drums and whistles. The slaves, whose religious customs were different from those of their white masters, identified with the early Baptist and Methodist missionaries, the first of whom were black. Slaves were allowed to congregate for worship and were particularly attracted to the Baptist Church with its emphasis on freedom, the rousing music, emotional sermons, lively singing, hand-clapping and spirit possession. They enjoyed both religious and secular music; the latter, with a strong emphasis on drumming and dancing, was undoubtedly of African origin. The Ring Play, Fire Dance and Jumping Dance were the most popular and were performed to the accompaniment of the goatskin drum. Obeah, a combination of superstitions, medicine and worship, is most certainly of African origin. It is found under different names in other parts of the Caribbean. McCartney (1976) saw Bahamian obeah as the phenomenon of the supernatural rendering of good or evil and believed that it can cause or cure illnesses and even cause death.

BIBLIOGRAPHY

A. D. Peggs, ed.: *A Mission to the West India Islands: Dowson's Journal for 1810–1817* (Nassau, 1960)
E. Brathwaite: *The Development of Creole Society in Jamaica, 1770–1820* (Oxford, 1971)
T. McCartney: *Ten, Ten the Bible Ten, Obeah in the Bahamas* (Nassau, 1976)
G. Saunders: *Bahamian Loyalists and their Slaves* (London, 1983)
——: *Slavery in the Bahamas, 1648–1838* (Nassau, 1985)
C. E. Bethel: *Junkanoo: Festival of the Bahamas* (Hong Kong, 1991)

D. GAIL SAUNDERS

3. Bahamian Junkanoo costume; photograph from the *Nassau Magazine*, 1935

III. Architecture.

The capital city, Nassau, was founded in 1666. In 1729 it was laid out on a grid plan based on Bay Street, which skirted the waterfront. Early buildings were impermanent palm-thatched huts; little survives from this period other than fortifications, such as Fort Montague, built in 1741 by the official engineer of the day, Peter Henry Bruce. The twin circular bastions of Fort Charlotte and the great stone prow of Fort Fincastle came later (both 1780s). The architectural character of the colony began to develop with the arrival of Loyalist refugees and their slaves from the USA (1783–5). They introduced the characteristic Bahamian Georgian style based on North American colonial models, although North American characteristics other than Neo-Georgian can be distinguished at, for example, Dunmore Town, Harbour Island, where high-pitched roofs and barge boards are similar in style to architecture at Cape Cod, according to Verey (1971). A number of civic and ecclesiastical examples of Bahamian Georgian survive. In Nassau the Public Library (1798–9), until 1879 a panopticon gaol, is an octagonal three-storey building with an elegant timber arcaded gallery at the third level, covered by a pitched roof, rising to an ogee dome. Another colonial building is Government House (1803–6). The two-storey Neo-Georgian Legislative Council Chamber, Government Offices and Post Office (all completed 1812) are said to be reminiscent of local government buildings at New Bern, NC. All are built in the local coral

limestone with the heavily emphasized quoins so typical of the islands: the Legislative building boasts a tetrastyle Tuscan portico with a giant order. Contemporary churches in Nassau include the Anglican St Matthew's (1800–04) by Joseph Eve, a Neo-Georgian barrel-vaulted church with an Ionic nave colonnade, a Palladian window to the apse and a spire that recalls Wren's city churches. St Andrew's Presbyterian Kirk (1810) is similar in style but with a simple castellated tower.

The most characteristic examples of Bahamian Georgian are in Nassau and include Balcony House (c. 1790), Market Street, a clapboard house built in imported American cedar and one of the few surviving examples showing the influence of shipwright's art in its curved timber balcony brackets. Larger houses, however, were usually built in stuccoed rubble with accentuated ashlar quoins and Georgian sliding sash or Demerara windows (with top-hung opening shutters to provide shade with ventilation during the day) and steeply pitched roofs with dormers. Timber-framed balconies or verandahs at each floor are often continuously clothed on the south side with louvred jalousies. Oakes House, Queen Street, its dignified Georgian doorway flanked by Ionic pilasters, has open galleries to the street at both ground- and first-floor levels; a solid two-storey stone house in West Hill Street has miniature Greek Doric columns on pedestals at each floor with classical balustrading and a full entablature between floors; the three-storey Jacaranda House (mid-1840s; see fig. 4) at the corner of Parliament Street and East Hill Street was built for the Chief Justice of the day, Sir George Anderson, using ballast stone from Georgia, USA. It boasts a chimney-stack with a curved terminal of a kind more common on small houses and kitchens at the other end of the island chain of the Turks and Caicos Islands. Attempts were made here in the second half of the 19th century to provide housing for the emancipated slaves in villages such as Fox Hill and Sandilands, although workers' and slaves' houses followed a pattern similar to the chattel houses of the Lesser Antilles (see ANTILLES, LESSER, fig. 3), built in local timber from the forests of Andros, Abaco and Grand Bahama.

4. Jacaranda House, Nassau, the Bahamas, mid-1840s

Throughout the period of prosperity after the American Civil War (1861–5) and the depression that followed, which ended in the first half of the 20th century, the Neo-Georgian tradition was largely maintained in public buildings, such as the Supreme Court (1921), Nassau. Despite the growth in tourism, the character of the islands has been maintained, although some International Style commercial buildings have been erected, for example the National Insurance Board Headquarters Building (1986) by the Architects Partnership, as well as large hotels, such as the Paradise Grand Hotel (1982) on Paradise Island by Mitchell Carson Associates.

BIBLIOGRAPHY

S. Toy: 'Old Houses in Nassau, Bahamas', *Builder*, clxxxi (1951), pp. 884–7

D. Verey: 'The Georgian Buildings of Nassau', *Country Life*, cl/3825 (28 Oct 1971), pp. 1134–40

D. Cartwright and G. Saunders: *Historic Nassau* (London, 1979)

D. J. Buisseret: *Historic Architecture of the Caribbean* (London, 1980)

S. Russell: *Nassau's Historic Buildings* (Nassau, 1980)

R. Douglas: *Island Heritage: Architecture of the Bahamas* (Nassau, 1992)

JACKSON L. BURNSIDE III, PATRICK RAHMING

IV. Painting, graphic arts and sculpture.

The earliest art to be produced in the Bahamas was that of the Lucayan Indians, who inhabited the islands until *c*. 1513 (*see* §II, 1 above). The colonizing Spaniards who annihilated the Lucayans left scant evidence of their own occupation. Bahamian art of the 1700s and 1800s is primarily the work of itinerant artists and British colonials: watercolours by the British colonialist John Irving (*fl* 1790–1802), a landscape painter, are in the collection of the Central Bank of the Bahamas, Nassau; and the Public Library, Nassau, holds an oil painting of *Nassau Harbour* by the Englishman Thomas Luny (1759–1837). In the 19th century visiting journalists illustrated scenes of Nassau for *Leslie's Illustrated Newspaper* and other publications. In the late 1800s two American artists based in Nassau were Albert Bierstadt and Winslow Homer, both of whom painted seascapes (e.g. Bierstadt's *On the Shore of the Turquoise Sea*, 1887; Michigan, Richard Manoogian priv. col.). Homer visited twice (1884–5, 1898–9), producing sensual watercolour sea- and landscapes, for example *Under the Coco Palm* (see colour pl. XV, fig. 2).

Recognition of indigenous artists began only in the second half of the 20th century. Two painters are considered to be 'fathers of modern Bahamian art': Don Russell (1921–62), who painted mostly land- and seascapes in oil and in *c*. 1950 opened Russell's Academy of Fine Arts, Nassau, one of the first schools offering formal art classes; and Horace Wright (1915–76), a watercolourist, who often used a very muted palette to depict the landscape and scenes of life among the common people in the older communities of Nassau, and who was the only art teacher in the public school system (1951–60). Improvements in education and economic growth in the 1960s and national independence in 1973 sparked an explosion of Bahamian art. The First Annual Bahama Island Exhibition, the largest of its kind to date, was held in Nassau in 1961; unfortunately the principal organizer, the Haitian Olaf Froen, left the Bahamas shortly afterwards.

Since independence Bahamians have attempted to define a national idiom in art. Bahamian iconography reflects

the Junkanoo masquerade tradition found in carnival, the African heritage and the brilliant light and colours of the natural environment of the Bahamas. In the late 20th century most Bahamian painters had polarized into two groups, broadly defined as either Expressionists with surrealistic tendencies or those aligned to a European-type of naturalism (mostly landscape painters, who took impressionistic approaches). The Expressionists were dominated by members of the group B.-C.A.U.S.E. (Bahamian Creative Artists United for Serious Expression), dedicated to highlighting the culture and African heritage of the Bahamas and to protesting against social inequities. The father of Bahamian Expressionism, Max Taylor (b 1939), espoused cubistic forms and the use of chromatic colour (including vivid blues, oranges, greens and ochres). In its stylized elongation of figures his work is allied to African art. Also highly skilled in woodcut, linocut and ceramics, he drew on themes from the lives of Afro-Caribbeans and of the downtrodden, infusing their images with great poignancy and dignity. A founder of B.-C.A.U.S.E., Stan Burnside (b 1947) was a dedicated Africanist and nationalist. Steeped in the Junkanoo and African mysticism, Burnside's paintings are often jewelled metaphors, saturated in rich colours, increasingly depicted with reference to Surrealism in stylistic elements and imagery; his work has been shown in the USA, Dominican Republic, Brazil and France.

The 30-year retrospective of Brent Malone (b 1941) in 1992 showed him to be a versatile artist, whose style evolved from realist portraiture to abstracted natural forms reminiscent of the Art Nouveau two-dimensional work of Henry Van de Velde. Antonius Roberts (b 1958) mastered style from a decorative realism, reminiscent of the work of Gauguin, to Abstract Expressionism. The figuration of his work of the 1990s recalls Matisse. Jackson Burnside (b 1949), Stan's brother, also a noted architect, demonstrated the influence of his designs in his painted works in planar intricacies, created by fragmentation of distinct lines and the superimposition of multiple images, separated by glazed and unglazed areas. John Beadle (b 1962) is generally classed with the Generation of '80 (of artists born after 1960), but his cerebral paintings, laden with African symbolism, gained him a berth with B.-C.A.U.S.E. The collaborative work *Breakfast in Somalia* (1993; see fig. 5) by Beadle, the Burnside brothers, Malone and Roberts reflects Bahamian Expressionist ideals.

Leading artists working in the naturalistic mode include Rolfe Harris (b 1942), known for photorealist underwater scenes; Alton Lowe (b 1945), who drew inspiration from his native-island group, the Abacos; and Eddie Minnis (b 1946), adept in using the palette knife and in rendering the Bahamian landscape in the manner of Renoir. Amos Ferguson (b 1921) is considered the premier naive artist of the Bahamas, whose religious piety, love of nature and Bahamian traditions inspired his housepaint-on-cardboard works. In the 1990s younger artists were led by the group Opus 5 (all disciples of Stan Burnside), photorealist Nicole Minnis (b 1970), and Dorman Stubbs (b 1962) and Ricardo Knowles, two brilliant colourists influenced by French Impressionism. Of the younger artists who emerged in the 1990s, four are noteworthy for having held major exhibitions: John Edward Cox (b. 1973), Toby Lunn (b.

5. John Beadle, Stan Burnside, Jackson Burnside, Brent Malone and Antonius Roberts: *Breakfast in Somalia*, mixed media on rag paper, 620×480 mm, 1993 (Nassau, B.-C.A.U.S.E. private collection)

1972), Nadine Seymour and Jessica Maycock. By the end of the 20th century graphic design and illustration, often for books, journals or advertising, were beginning to emerge as major forms of expression, the principal exponents being John Beadle, Dionne Benjamin (b 1970), P. Neko Meicholas (b 1965), Jolyon Smith (b 1964) and Sue Bennett Williams (b 1947).

There is no great sculptural tradition in the Bahamas, although wood-carvers have always been active. Monumental sculpture, which is scarce, was imported from Britain. In 1950 Canadian-born sculptor Randolph Wardell Johnston (1904–92) settled in Little Harbour, Abaco, setting up a bronze foundry there; the Bahamian government commissioned several works from him, for example the bust of the national hero *Sir Milo Butler* (Rawson's Square, Nassau). In the 1960s the work of indigenous sculptors began to appear. Exponents include Denis Knight (b 1926), Stephen Burrows (b 1937) and Malcolm Rae (b 1941). Burrows, a naive artist, created mild-steel works representing indigenous animals, which punctuate the landscape in Nassau. Rae worked in concrete, fashioning friezes on buildings and small intimate pieces, taking humans and marine creatures as his subjects. Knight created decorative tiles and sculptures of small realist figures in clay and bronze. His student Sabrina Glinton (b 1966) produced some totemic structures and masks. By the mid-1990s, painter Antonius Roberts had begun to carve powerful figurative pieces in indigenous woods such as mahogany, sapodilla and gumelemi.

BIBLIOGRAPHY
Match me If you Can: Mr Amos Ferguson (exh. cat., Nassau, Cent. Bank Gal., 1991)

C. Huggins, P. Glinton and B. Smith: *Bahamian Art, 1492–1992* (Nassau, 1992)

Brent Malone: Retrospective, 1962–1992 (exh. cat. by R. B. Malone, Nassau, Cent. Bank Gal., 1992)

'Faces': Stan Burnside (exh. cat., Santo Domingo, Gal., 1992)

First Biennial of Painting of the Caribbean and Central America: B.-C.A.U.S.E. (exh. cat., Santo Domingo, Gal. A. Mod., 1992)

'Jammin': An Exhibition of Paintings by Stan Burnside, Jackson Burnside and John Beadle in Collaboration (exh. cat., Nassau, Bahamian A.G., 1992)

P. Glinton: *An Evening in Guanima* (Nassau, 1993) [incl. *c.* 28 illustrations by Beadle, Smith, Meicholas and others]

B.-C.A.U.S.E. (exh. cat., Nassau, Bahamian A.G., 1993)

P. Glinton-Meicholas: *Flight of the Spirit* (Nassau, 1997)

PATRICIA GLINTON-MEICHOLAS

V. Interior decoration and furniture.

The furnishing of early dwellings of the 18th century included simple wooden stools, benches and tables made of local woods. In one of the surviving houses of this period, the Deanery (*c.* 1710), Nassau, the doors, dados and cornices are typical of the Queen Anne period in England. Interior walls were probably plastered and left undecorated. By 1748 Governor John Tinker noted that the island of New Providence had 'increased most surprisingly in strength and wealth' and that the new homes were furnished with such grandeur as to be regarded as 'sumptuous in the Indies'. The American War of Independence had a significant impact on the Bahamian lifestyle during the 1780s. Nassau increased in prosperity as a result of the immigration of loyalists from Carolina and Georgia. Plantations were established during the prosperous period following the American War of Independence, during which Loyalist immigrants arrived from Carolina and Georgia, and interior decoration reflected the influence of Charleston, SC, and Georgia, as did the architecture. Neill (1949) described the interiors of Bahamian great houses as 'lofty and cool . . . large rhythmically spaced openings invite the breeze. Smooth plastered walls and ceilings are enlivened by simple plaster cornices, delicately moulded, and central ornamentation overhead . . . from which were suspended chandeliers . . . richly polished floors of dense native pine and moulded wooden trim around openings.' Balcony House (1790), Nassau, built of imported American cedar, is remarkable for its carved wooden staircase, said to have been built according to shipwrights' construction techniques. The pine-panelled tray ceilings were probably influenced by Bermudian interiors of an earlier period.

During the period of greatest construction, which extended from the last quarter of the 18th century to the first quarter of the 19th and was primarily limited to New Providence, most of the houses were built in local coral limestone, sometimes finished in stucco in the popular Neo-Georgian style. In Abaco and Eleuthera islands, however, New England timber and shipbuilding traditions influenced the creation of rather more austere timber constructions with simple, sparsely furnished, white-painted interiors. MacIntosh (1984) documented the high level of skilled slave labour available at this time. As in other parts of the region, slave carpenters and joiners reproduced imported furniture. Trade links with the USA and Bermuda so heavily influenced local craftsmen that no identifiable Bahamian style developed. In addition,

slave-owners often hired out their skilled labourers, including plasterers and masons, as another source of income. By the time of Emancipation (1834) a significant body of skilled craftsmen were capable of supplying goods to the local community. It should be noted, however, that the failure of the Bahamian economy in the 19th century ensured a high level of absentee ownership, which in turn limited the development potential of the furniture industry. Instead, a dependence on American-made products emerged, which remained throughout the 20th century.

From the mid-1930s, the influx of wealthy Americans and other expatriates had a significant influence on Bahamian lifestyles. The demand for exotic informality ensured the popularity of raffia, rattan and bamboo furniture. The Dolley House, designed by its owner with a distinctly Eastern opulence and spaciousness combining white stucco walls with tiled floors, was particularly characteristic of this style. Aimee Crane gave expression to this lifestyle in her article 'Nassau Pink' (1941). She praised the work of local craftsmen in making reproduction Chippendale as well as bamboo furniture, produced by the Bahamas Woodwork Company and the Mosko Company, the tiles turned out, for example, by the Nassau Tile Factory and the palm straw mats produced by Home Industries, which together with local art created the epitome of the Nassau interior. Throughout the 1950s and 1960s Bahamian houses echoed Florida design. In the latter part of the 20th century interior decoration reflected the overwhelming influence of the southern USA.

BIBLIOGRAPHY

A. Crane: 'Nassau Pink', *Nassau Mag.*, viii/2 (1941), pp. 9, 26, 29

S. Neill: 'Some Notes on Bahamian Architecture', *Nassau Mag.* (1949), pp. 16–19, 43

D. Cartwright and G. Saunders: *Historic Nassau* (London, 1979)

R. J. MacIntosh: 'Trades and Occupations of Runaway Slaves in the Bahamas, 1784–1834', *J. Bahamas Hist. Soc.*, vi/1 (1984), pp. 7–9

M. Craton: *A History of the Bahamas* (Ontario, 1986)

R. Douglas: *Island Heritage: Architecture of the Bahamas* (Nassau, 1992)

E. E. Crain: *Historic Houses in the Caribbean* (Gainesville, FL, 1994)

ALISSANDRA CUMMINS

VI. Patronage, collecting and dealing.

Church and State patronage of art has been limited in the Bahamas. Royal governors commissioned portraits, landscapes and statuary; for example, the English artist William Hogarth painted a group portrait of the first royal governor, *Woodes Rogers and his Family*. In the following century Governor James Carmichael Smyth commissioned a statue of *Christopher Columbus* (*c.* 1833); the design of the statue, which was sculpted in London, is attributed to Washington Irving. In 1938 Sir Bede Clifford commissioned Hildegarde Hamilton (*b c.* 1900) to execute a painting of *Government House*. Brent Malone, Alton Lowe and Chan Pratt were some of the artists to receive commissions from the Bahamian government after independence. Since the 1950s wealthy individuals and commercial interests have been the major sources of patronage. Sir Harold Christie, a parliamentarian and estate agent, sponsored the establishment in *c.* 1954 of the Nassau branch of the Chelsea Pottery. In 1973 Shell Bahamas Ltd commissioned Brent Malone to create a collection of paintings depicting Junkanoo. In the 1990s the Finance Corporation of

Bahamas Ltd (FinCo) commissioned two series of paintings for its important collection of mainly landscapes and sponsored an annual summer art workshop and the book *Bahamian Art, 1492–1992*, the first published on the subject. The State's principal involvement in collecting is realized through the Central Bank of the Bahamas, which operates a non-profit gallery and underwrites an important art competition. In 1992 the Bahamian government funded the establishment of the Pompey Museum in Nassau; the collection includes 25 paintings by Amos Ferguson, donated by the Ministry of Tourism.

By the 1990s there was still no national gallery in the Bahamas, and most of the leading collections of art were private. Small collections of pre-20th-century woodcuts, other prints and watercolours are held by the National Archives, the Public Library and the Bahamas Historical Museum, all in Nassau. Coutts & Co., Nassau, holds an important collection of Bahamian works, among them 10 major oil paintings by Dorman Stubbs, landscapes of the island of Eleuthera. Outstanding private collections of Bahamian art include those of Vincent d'Aguilar, Allyson Gibson, Campbell Cleare, Winston Saunders and Gail Saunders and members of B.-C.A.U.S.E. D'Aguilar collected in particular works by Bahamian naive artists Amos Ferguson and Exuma (Tony MacKay). In the mid-1990s Ricardo Knowles (*b* 1962) completed a collection of around 50 paintings for the Nassau estate of the French filmmaker Jean Chalopin. A number of dealers ran privately owned galleries: the Bahamian Art Gallery played an important part in stimulating the development of Bahamian art before closing in 1993 due to lack of funds, and the Caripelago Mezzanine had to curtail its activities; the Lyford Cay Gallery dealt principally in modern Bahamian painting, as well as promoting the work of foreign artists; Pink'un and Brent Malone's Upstairs Gallery were the most active galleries later in the decade.

PATRICIA GLINTON-MEICHOLAS

VII. Museums.

The first museum in the Bahamas was established in 1847, concurrently with the Nassau Public Library. The governor had the power to nominate four of the seven trustees appointed annually; the other three were elected from among the subscribers to the institution. These trustees were given authority to appoint a keeper and to purchase 'such books, maps, prints, philosophical and other instruments and apparatus as they shall deem proper from time to time to place therein'. In 1873 the Nassau Public Library and Museum was transferred to an 18th-century prison and opened free to the public. Little effort was made, however, to staff the museum properly, and it remained under the nominal supervision of the librarian well into the 20th century. In 1933 a survey of Caribbean museums by the Museums Association revealed that little progress had been made in almost 100 years. The library staff maintained a small miscellaneous collection of historical, geological and archaeological material and a few marine specimens; the surveyors noted that these 'were not properly labelled and no educational use is made of them . . .it is obvious that little time or money is spent on it [the museum]'. The care of the collection was later transferred

to the National Archives, which contained a strong documentary collection.

The Bahamia Museum was a short-lived private venture started in Nassau in 1971 with a miscellaneous collection, including 19th-century domestic wares, traditional woodworking and fishing equipment, folk costume, a shell collection, slave artefacts, coins, stamps and photographs. In 1975 the collection was acquired by the Bahamian government and housed in the Jumbey Village (a craft and cultural centre) under the supervision of the Ministry of Education and Culture. The Bahamas Historical Society Museum was founded in 1978, with military and naval artefacts forming the bulk of its collection. By the 1990s a plan to form a national museum incorporating all these collections had yet to come to fruition. The Wyannie Malone Historical Museum, a private historic house museum, was founded in 1978 by the local community of Hope Town (Abaco) in commemoration of the fifth anniversary of independence. The Pompey Museum at Vendue House was opened in 1992 as part of the country's Columbus commemorations; it houses a collection of folk art. Since then, traditional Bahamian life and vernacular architecture have been documented in exhibits at Balcony House.

BIBLIOGRAPHY
'An Act for Establishing and Supporting a Public Library and Museum in the City of Nassau', *Laws of the Bahamas Chapter 20, Act 35* (Nassau, 1847)
S. Wilson: *The Role of the National Museum in the Bahamas* (diss., U. Leicester, 1981)
J. Whiting: *Museums Focused Heritage in the English-speaking Caribbean* (UNESCO Report, 1983)
A. Cummins: *The History and Development of Museums in the English-speaking Caribbean* (diss., U. Leicester, 1989)
A. Cummins: 'Making Histories for Afro-Caribbeans', *Making Histories in Museums*, ed. G. Kavanagh (Leicester, 1995)
ALISSANDRA CUMMINS

VIII. Art education.

The first Board of Education in the Bahamas was created by the colonial legislature in 1836, in an effort to make provision for the education of newly emancipated slaves. Apart from providing the rudiments of formal education, government schools stressed vocational training in agriculture, mechanics and handicrafts. As Secretary Inspector and later as Inspector and General Superintendent of Schools, George Cole (1866–1913) made a highly important contribution to the development of the Bahamian school system between 1882 and 1911; his background in blacksmithing, mechanics and carpentry probably influenced the concentration on vocational training for the Bahamian masses. This system remained virtually unchanged until the late 1950s, with no formal arts programme available until that time. Rudimentary training and prevailing attitudes served to reinforce the indifferent performance of the educational system. Training in arts and crafts was available only through rare apprenticeships or private classes. From the late 1940s, for example, the American portrait painter Vuc Vuchinich offered popular annual art classes at the British Colonial Hotel in Nassau, but the conservative social mores of the time ensured that such opportunities were effectively closed to the Afro-Caribbean population.

During 1950s the Bahamian artist Don Russell founded the Russell's Academy of Fine Arts, Nassau, where many other Bahamian artists, including Maxwell Taylor and Brent Malone, received their first formal training. At Queen's College sixth-form school in Nassau influential art teachers included Maureen Liddle, John Beadle (a graduate of the Slade School of Art, London) and David Gill (a graduate of Beckenham School of Art, Kent). The Chelsea Pottery, founded in 1957 by the Briton David Rawnsley, the owner of Chelsea Pottery, London, offered the first opportunity of apprenticeships for a number of young Bahamians. Sir Harold Christie encouraged such developments where they led to the creation of new crafts to support the budding tourist industry. The Bahamas' attainment of internal self-rule (1962) led to the establishment of the Ministry of Education in 1964. Affiliation was soon established with the University of the West Indies, and particularly the Jamaica School of Art (later the Edna Manley School for the Visual Arts; *see* JAMAICA, §XI), and an increased number of scholarships for study abroad became available. Full independence (1973) was soon followed by the institution of the College of the Bahamas, which officially undertook the provision of technical education, teacher-training and associate degree courses in Fine Arts. Bahamian Stanley Burnside served as lecturer and coordinator of art at the college from 1981.

BIBLIOGRAPHY
J. M. Trainor: 'George Cole and his Influence on Bahamian Education: 1866–1913', *J. Bahamas Hist. Soc.*, vi/1 (1985), pp. 3–8
——: 'Public Education in the Bahamas', *Modern Bahamian Society*, ed. D. W. Collingwood and S. Dodge (Indiana, 1989), pp. 172–98
Brent Malone: Retrospective, 1962–1992 (exh. cat. by R. B. Malone, Nassau, Cent. Bank Gal., 1992)
ALISSANDRA CUMMINS

Bahia. *See* SALVADOR.

Bahiana, Elisiário (Antonio da Cunha) (*b* Rio de Janeiro, 4 Dec 1891; *d* São Paulo, Aug 1980). Brazilian architect and teacher. He studied architecture at the Escuola Nacional de Belas Artes, Rio de Janeiro (1908–10, 1918–20) and carried out his major work in the 1920s and 1930s, during the transition from eclecticism to Modernism in Brazil. He was strongly influenced by the work of the Perret brothers, the potential of reinforced concrete and Art Deco, and he became a pioneer of the rational use of reinforced concrete in the Art Deco style. His first major work was the 30-storey headquarters of the newspaper *A Noite* (1927; with Joseph Gire), Rio de Janeiro. It was the tallest reinforced concrete building in Brazil at that time, pioneering in its use of a rational structural design worked out by Emilio Baungart, the engineer who was later responsible for the structure of the Ministry of Education and Health building (1937) in Rio by Le Corbusier. In 1928 Bahiana came second in the competition for the Argentine embassy in Rio de Janeiro with a design (unexecuted) that was Modernist in its use of reinforced concrete, emphasis on geometry and the discreet use of ornament. First prize was awarded to an eclectic design by Lúcio Costa. Bahiana's Pirapitingui building (destr.) and the elegant Saldanha Marinho building, São Paulo, both designed in 1929, were inspired by Art Deco, in contrast to the eclectic Martinelli building

that dominated the city. In 1930 Bahiana moved to São Paulo and began the most productive phase of his career. In 1935 he won the public competition for the construction of the new Chá viaduct, designed the adjoining Anhangabaú Park, which forms the functional and symbolic centre of the city, and also designed the Mappin Stores building and the extension of the Hotel Esplanada at the junction of the viaduct and the park. Other works included the Jockey Club (1935) of São Paulo. From 1943 he taught at the Mackenzie School of Engineering, later the Mackenzie Faculty of Architecture at the University of São Paulo.

BIBLIOGRAPHY
H. Segawa: 'Elisiário Bahiana e a arquitetura art deco', *Projeto*, 67 (1984), pp. 14–22
REGINA MARIA PROSPERI MEYER

Balbás, Jerónimo de (*b* Zamora, *c.* 1680; *d* Mexico City, 1748). Spanish architect and sculptor, active in Mexico. Between 1702 and 1703 he worked in Madrid as a designer of stage machinery, later moving to Andalusia, where he produced the principal altar of the sacristy of Seville Cathedral in the Rococo style, completed in 1709 (destr. 1824). Ceán Bermúdez described it as having 'four large *estípites*, pilasters, lots of angels prankishly tumbling about and a cornice broken and interrupted in a thousand places with tortuous projections and recessions, the whole topped by a huge arch'. In 1714 Balbás also carried out the plan for the choir-stalls of the church of S Juan in Marchena, carved by Juan de Valencia, equally playful in style and similarly using *estípites*. The same year he designed the lectern in the same church, though this was not constructed until 1735.

Around 1718 Balbás went to Mexico City to take charge of the 'retablo del Perdón' in the Chapel of the Kings at the Metropolitan Cathedral, using the *estípite* as a fundamental element of his artistic language and thereby introducing to Mexico the style that had become popular throughout Spain. In 1726 he made the three retables in the Capilla del Consulado of the church of S Francisco, Mexico City, and the high altar in the church of the Third Order of St Francis. In 1741 Balbás installed the high altar of the cathedral, known as the 'cypress', and in 1747 he made the main retable for the church of the Conception. From 1726 he worked as an architect in Mexico City, supervising work on the Hospital Real de Indios. In 1733 he presented a plan for the Casa de la Moneda (Mint), which was not, however, accepted. He also drew up the plans for the church of S Fernando, although he did not direct the work in its entirety.

From the moment Balbás introduced the *estípite*, it became a favourite feature with Mexican Baroque architects, to the extent of its being referred to as a specific style, the '*Estípite* Baroque', with its use spreading from retables to external façades (*see also* MEXICO, §III, 1). His adopted son, Isidoro Vicente Balbás, continued his work as architect and sculptor.

BIBLIOGRAPHY
J. A. Ceán Bermúdez: *Descripción artística de la catedral de Sevilla* (Seville, 1804)
H. Berlín: 'Three Master Architects in New Spain', *Hisp. Amer. Hist. Rev.*, xxvii (1947), pp. 375–83
V. M. Villegas: *El gran signo formal del barroco* (Mexico City, 1956)
F. de la Maza: *El churrigueresco en la ciudad de México* (Mexico City, 1969)

J. Fernández: *El retablo de los reyes: Estética del arte de la Nueva España* (Mexico City, 1972)

C. Amerlinck: 'Jerónimo de Balbás, artista de vanguardia, y el retablo de la Concepción de la ciudad de México', *Bol. Mnmts Hist.*, ii (1979), pp. 25–34

G. Tovar de Teresa: 'La muerte de Don Jerónimo de Balbás', *Bol. Mnmts Hist.*, iv (1980), pp. 25–34

E. Vargas Lugo: 'Nuevos documentos sobre Jerónimo, Isidoro y Luis de Balbás', *An. Inst. Invest. Estét.*, xliii (1985)

G. Tovar y Tovar: *Gerónimo de Balbás en la catedral de México* (Mexico City, 1990)

J. Bérchez: *Arquitectura Mexicana de los siglos XVII y XVIII* ([Mexico City], 1992), pp. 247–73

MARIA CONCEPCIÓN GARCÍA SÁIZ

Balmes, José (*b* Montesquiú, nr Barcelona, 20 Jan 1927). Chilean painter of Spanish birth. He arrived in Chile at the age of 12 with his family, who had gone into exile following Franco's victory in the Spanish Civil War. He studied at the Escuela de Bellas Artes of the Universidad de Chile in Santiago from 1945 to 1949. While still a student there he joined groups seeking to reform both the teaching and practice of painting, and in the early 1960s he was a member of the short-lived Signo group, together with Gracia Barrios, Alberto Pérez and Eduardo Martínez. By rejecting representation, specifically by adopting the principles of *Art informel*, they provoked a crisis in Chilean artistic circles. By 1962, however, Balmes had returned to a figurative idiom in order to address himself to contemporary events and especially to the political situation in Latin America and abroad. His subject-matter included references to Santo Domingo in 1964–5, to Vietnam in 1966–8, to Che Guevara in 1968–9, and more generally in the early 1970s to Fascism and Repression.

Gradually Balmes arrived at a visual language combining colour and graphic linear elements with spontaneous and dynamic gestures derived from his involvement with *Art informel*. He also exploited the pictorial and semantic possibilities offered by newspaper and magazine photographs or other objects collaged on to the surface; the presence of written texts, signs and numerals as a sort of clandestine graffiti turned the support into a semblance of a wall carrying the anonymous writing of the people. Balmes, who was a professor and later Dean of the fine arts faculty at the Universidad de Chile, went into exile after the military coup of 1973 and taught at the University of Paris. He returned to Chile in 1984, later becoming professor of painting in the Escuela de Arte of the Universidad Católica de Chile in Santiago.

BIBLIOGRAPHY

José Balmes (exh. cat., Santiago, Inst. Chil.–Fr. Cult., 1985)

José Balmes: Desechos (de olvido y de memoria) (exh. cat. by A. Pérez, Santiago, Gal. Carmen Waugh, 1986)

Balmes: *Tiempo presente* (exh. cat., Buenos Aires, Cent. Cult. Borges, 1996)

MILAN IVELIĆ

Bandeira, Antonio (*b* Fortaleza, 26 May 1922; *d* Paris, 6 Oct 1967). Brazilian painter. In the first half of the 1940s, while still in his native state of Ceará, he was very active in the introduction of modernist ideas. In 1945 he moved to Rio de Janeiro and in 1946 to Paris, where he spent most of the rest of his life. In Paris, where he studied at the Ecole Supérieure de Beaux-Arts and at the Académie de la Grande Chaumière, he first painted landscapes and portraits (e.g. *Self-portrait*, 1947; Rio de Janeiro, Gilberto Chateaubriand priv. col.) that combined elements from Surrealism and Expressionism. He later adopted a gestural abstraction that maintained its links with the outside world through analogies established in poetic titles (e.g. *Flowing like a Waterfall*, 1964; Rio de Janeiro, Roberto Marinho priv. col.). At the beginning of his stay in France he was briefly part of an informal association with two other artists sharing a similar artistic language, Camille Bryen and Wols; Banbryols, their chosen name, was formed from their three surnames. On one of his return visits to Brazil, Bandeira executed a mural for the headquarters of the Instituto dos Arquitetos do Brasil in São Paulo; in 1958 he made a panel for the Palais des Beaux-Arts in Brussels; and in 1961 he also painted a vast triptych for the University of Ceará. In large-scale paintings, such as *Big City Illuminated* (1953; Rio de Janeiro, Mus. N. B.A.), and in his equally characteristic tiny gouaches he directed the dynamic energy of dots, lines, blots and drops of colour with a centripetal force, which organized what might otherwise have been random gestures into webs of regular and sometimes geometrically based structures.

BIBLIOGRAPHY

C. Valladares: 'Antonio Bandeira, pintor', *GAM*, 13 (1969)

Antonio Bandeira (exh. cat., ed. R. Pontual; Rio de Janeiro, Mus. A. Mod., 1969)

C. Levy: 'Vieira da Silva & Bandeira', *Seis décades de arte moderna na Coleção Roberto Marinho* (Rio de Janeiro, 1985), pp. 402–19

V. Novis: *Antonio Bandeira, um raro* (Rio de Janeiro, *c*. 1996)

ROBERTO PONTUAL

Bandurek, Wolf (*b* Dobrzyn, 1906; *d* Buenos Aires, Argentina, 1972). Paraguayan painter and engraver of Polish birth. He studied at the National Academy of Fine Arts in Poznań and the Hochschule für Bildende Künste in Düsseldorf. As a result of Nazi persecution he settled in Paraguay in 1936, where his work was particularly influential on the development of late 20th-century art. Although he was not an innovator from the point of view of form, he introduced into painting a dramatic content drawn from Paraguayan history and comment on social injustice and recent wars, thus giving new life to a school of painting that until then had been bucolic. His sombre and moving oil paintings had vitality and an impassioned expressiveness. In the late 1930s and early 1940s this intensity of expression in his work provided a useful complement to the formal clarity of Jaime Bestard; both helped to undermine the prevailing academicism of art in Paraguay. Bandurek's black-and-white wood engravings confirm the drama in his work and his persisting social concern. They were published in Buenos Aires in 1945 in a series entitled *Guaraní Land*.

BIBLIOGRAPHY

V. Díaz Pérez: *De arte* (Palma de Mallorca, 1982)

T. Escobar: *Una interpretación de las artes visuales en el Paraguay* (Asunción, 1984)

TICIO ESCOBAR

Barbados. *See under* ANTILLES, LESSER.

Barboza, Diego (*b* Maracaibo, 4 Feb 1945). Venezuelan painter and performance artist. He studied painting at the Escuela de Artes Plásticas in Maracaibo and at the Escuela de Artes Plásticas in Caracas. In 1970, after holding several

one-man shows at the Galería Polo y Bot in Caracas, he moved to England to study at the London College of Printing. In London and Paris he performed his *acontecimientos* (events) or *acciones poéticas* (poetic actions) on streets and in parks; these were a form of happening that stressed the poetic with ludic and festive elements and had no social content. In 1986 he reverted to Neo-Expressionistic painting, although still with the intention of demystifying art. Works by Barboza are in the most important museums of Venezuela as well as in the Museu de Arte Moderno do São Paulo, Brazil, and the gallery of the Midland Group, Nottingham.

BIBLIOGRAPHY
E. Viloria Vera: *Diego Barboza (compilación 1985–1995)* (Caracas, 1995)
CRUZ BARCELÓ CEDEÑO

Barcala, Washington (*b* Montevideo, 3 July 1920; *d* Montevideo, 8 Dec 1993). Uruguayan painter. He studied at the Círculo de Bellas Artes in Montevideo (1934–41) under the direction of Professor Guillermo Laborde (1886–1940) and in 1942 came into contact with Joaquín Torres García. In the early 1950s he continued his studies in Europe, primarily at the Real Academia de Bellas Artes de San Fernando in Madrid. In his work, which has been termed Organic Constructivism, he juxtaposed, sewed or glued together fragments of humble materials such as wood, string, cardboard and tracing paper, subjecting them to various systems (e.g. *Historia 3 WH*, Montevideo, Casa de Gobierno). His cryptically titled works suggestive of narrative, such as *Story X.Z.A.* (1982; see 1989 exh. cat.), are all conceived in terms of such mixed media techniques rather than as conventional paintings. Barcala exhibited widely in Europe and Latin America, particularly in the 1970s.

BIBLIOGRAPHY
J. P. Argul: *Proceso de las artes plásticas del Uruguay* (Montevideo, 1975), pp. 231, 235-6
Arte contemporáneo en el Uruguay (exh. cat., ed. A. Kalenberg; Montevideo, Mus. N.A. Plást., 1982)
Arte dell'Uruguay nel novecento (exh. cat., Rome, Ist. It.–Lat. Amer., 1989)
Uruguay: *XXII Biennale de San Pablo* (exh. cat., ed. M. L. Torrens; Montevideo, Ministerio de Educación y Cultura, 1994)
Washington Barcala (1920–1993): Un homenaje (exh. cat., Madrid, Gal. Jorge Mara; Montevideo, Mus. Torres García; 1995)
Washington Barcala (1920–1993) (exh. cat., Santiago de Compostela, Casa Parra, 1996)
ANGEL KALENBERG

Bardi [neé Bo], **Lina** (*b* Rome, 5 Dec 1914; *d* São Paulo, 29 March 1992). Brazilian architect of Italian birth. She graduated in architecture (1942) from the University of Rome and in 1943 was editor of the magazine *Domus*. In 1947 she moved to Brazil when her husband, Pietro Maria Bardi (*b* 1901), was invited to establish and direct the Museu de Arte de São Paulo; Lina Bardi was involved in planning the interior and designing the fittings of the museum. In 1949 she founded the art and architecture journal *Habitat* and was its editor until 1953, a period when it was the most influential architecture magazine in Brazil. With her husband and the architect Giancarlo Palanti (1906–77), she set up the Studio d'Arte Palma, making modern furniture that had a great impact in Brazil (for example, *see* BRAZIL, fig. 11). She also set up the first industrial design course in Brazil (1948–51) and taught

at the University of São Paulo (1954–5). In 1952 she was naturalized, and during the 1950s she designed her own house (1952) in São Paulo, an enormous new building for the Museu de Arte de São Paulo (1958; for illustration *see* SÃO PAULO) and the Museu de Arte Popular do Unhão (1963), Salvador, Bahia, where she restored a 19th-century building and worked on the collections. Following a period in Rome in the 1970s during the military dictatorship in Brazil, Bardi worked on a large cultural centre (1980–85) in São Paulo, renovating an old drum factory to create areas for leisure activities and including new sports facilities. In 1987 she was invited to plan the restoration of the historic centre of SALVADOR, listed as national heritage by UNESCO. Bardi's buildings were influenced by Mies van der Rohe, particularly in the fluid articulation of spaces, and by 16th-century Portuguese military architecture in Brazil; she used materials austerely and in their natural state, whether modern or traditional. Her work is also strongly linked to that of other modern Brazilian architects by its desire to place technology at the service of architecture as a whole.

BIBLIOGRAPHY
'Museum of Art, São Paulo', *Archit. Rev.* [London], cxii/669 (1952), pp. 160–63
C. A. C. Lemos: *Arquitetura brasileira* (São Paulo, 1979)
Y. Bruand: *Arquitetura contemporânea no Brasil* (São Paulo, 1981)
W. Zanini, ed.: *Historia geral da arte no Brasil* (São Paulo, 1983)
P. A. M. Rocha: 'Para entender Lina Bo Bardi', *Rev. Mus. A. Sao Paulo*, ii/2 (1993), p. 36
Lina Bo Bardi (São Paulo, 1993)
Lina Bardi Bo (exh. cat. ed. M. Carvalho Ferraz; São Paulo, Mus. A. Assis Chateaubriand and elsewhere; 1993)
E. Andreoli: 'Lina Bo Bardi: The Anthropological Gaze', *Third Text*, xxviii–xxix (1994), pp. 87–100
Tempos de grossura: o design no impasse (São Paulo, 1994)
M. M. M. Azevedo: *A experiência de Lina Bo Bardi no Brasil (1947–1992)* (diss., U. São Paulo, 1995)
M. A. Roca, ed.: *The Architecture of Latin America* (London, 1995)
Lina Bo Bardi: Museu de Arte de São Paulo, 1957–1968 (São Paulo, 1996)
JULIO ROBERTO KATINSKY

Barradas, Rafael (Pérez) (*b* Montevideo, 7 Jan 1890; *d* Montevideo, 12 Feb 1929). Uruguayan painter and stage designer. He was encouraged to pursue his interest in art by his father, the Spanish painter Antonio Pérez Barradas (1862–99), and appears to have been taught drawing by the Spanish artist Vicente Casanova y Ramos (1870–1920). He became involved with the bohemian intellectual life of Montevideo while exhibiting his drawings and working as an illustrator for newspapers and magazines such as *La Semana, Bohemia, El Tiempo, La Razón* and *Ultima hora* in Montevideo and Buenos Aires. In 1913 he founded the publication *El Monigote*.

At the end of 1914 Barradas settled in Spain, where he began to produce work influenced by the Italian avant-garde art he had seen on his travels through Europe, introducing the avant-garde in Spain. In response to Futurism he painted pictures such as *Apartment House* (1919), *Everything on 65* (1919) and *Vibrationist* (1918; all Montevideo, Mus. N.A. Visuales), in a style that he termed *vibracionismo* because of the shimmering quality of the surface. He also produced picturesque scenes set in Madrid, as well as generic and archetypal portraits of Spanish peasant men and women, such as *Aragon Miller* (*c*. 1924) and *Man in the Café* (1925; both Montevideo,

Mus. N.A. Visuales), as part of a series entitled *The Magnificent Ones*.

Barradas exhibited his work in Barcelona (at the Galerías Dalmau in 1917), where he befriended Joaquín Torres García, and in Madrid at the Salón de los Humoristas in 1917. He moved to Madrid *c.* 1918, becoming more closely involved with the artistic community through his illustrations, posters and stage and costume designs for the Teatro de Arte. Salvador Dalí, the writers Gregorio Martínez Sierra, Sebastián Gasch and Federico García Lorca, and the film maker Luis Buñuel were among the most renowned of his circle. He was awarded the Grand Prize in the theatre category at the Exposition Internationale des Arts Décoratifs et Industriels held in 1924 in Paris. He returned to Uruguay, gravely ill, in 1928.

BIBLIOGRAPHY

J. Torres García: *Universalismo constructivo* (Buenos Aires, 1944), pp. 551–9

J. Romero Brest: *Pintores y grabadores rioplatenses* (Buenos Aires, 1951), pp. 183–9

C. Rolleri López: 'Rafael Pérez Barradas', *Rev. Mus. Juan Manuel Blanes*, 1/i (1956), pp. 56–8

Seis maestros de la pintura uruguaya (exh. cat., ed. A. Kalenberg; Buenos Aires, Mus. N. B.A., 1985), pp. 113–38

R. Pereda: *Barradas* (Montevideo, 1989)

Barradas (exh. cat., ed. J. Brihuega and others; Mus. Aragones A. Contemp., 1992)

Barradas/Torres García (exh. cat., Buenos Aires, Mus. N. B.A., 1995)

A vanguardia no Uruguai: Barradas e Torres-García (exh. cat., Rio de Janeiro, Cent. Cult. Banco Bras., 1996)

ANGEL KALENBERG

Barragán, Luis (*b* Guadalajara, 9 March 1902; *d* Mexico City, 22 Nov 1988). Mexican architect. As no architectural course was offered in Guadalajara, he entered the city's Escuela Libre de Ingenieros, graduating in 1924. He then undertook complementary studies to qualify as an architect, but these were cut short by a trip to Europe (1925–6), which included a visit to southern Spain; here he was able to study Spain's Moorish architectural heritage and to become familiar with the theories of the French writer, painter and landscape architect Ferdinand Bac (1859–*c.* 1940). On his return to Mexico, he worked on a series of houses in Guadalajara (e.g. Casa Cristo, 1929), preserving in them the spirit of the local colonial vernacular architecture. In 1932 he visited Europe again and attended Le Corbusier's lectures in Paris, assimilating the teachings advocated by the latter in his *L'Esprit nouveau*. In 1936 he settled in Mexico City, but the Corbusian influences became apparent in a number of residential buildings ranging from a group of houses in the Parque México (1936), Mexico City, to a series of apartment buildings (1936–40) in the Cuauhtémoc development, Mexico City, all of which were constructed with great economy of means and with a clearly commercial goal.

In the early 1940s Barragán concentrated on the creation of gardens. First came four comparatively small private gardens on the Calle Francisco Ramírez at Tacubaya, Mexico City. These were followed in 1944 by three others on the Avenida San Jerónimo, San Angel, adjacent to the river and bordering the fantastic volcanic landscape of the Pedregal district. He next produced his celebrated layout and landscaping of the Parque Residencial Jardines del Pedregal de San Angel (1945–50). Here Barragán's love of nature found expression in public spaces of generous dimensions, with fountains set against horizontal and vertical planes in the landscape. By the time his own house was built in 1948–9 at Calle Francisco Ramírez 14, incorporating one of the Tacubaya gardens, Barragán had returned to the spiritually based, locally inspired style of nearly 20 years earlier. Here his mastery of composition and of definition of space were fully developed in a building of almost ascetic simplicity.

Although the ideals represented by the house—the search for vernacular roots, the affirmation of the spiritual, the exaltation of beauty and the integration of artefact with nature—were dear not only to Barragán, it was he who pursued them most rigorously in the period that followed, for example in the Casa Prieto López (1950), as well as in the Jardines Pedregal and in two other houses near by, designed in collaboration with Max Cetto. Linked with Barragán's religious mysticism, the style came to be known as *arquitectura emocional*, a term derived from a manifesto written by Mathias Goeritz for the inauguration of the Museo Experimental El Eco (on which Barragán collaborated) in 1953. The style was also influenced, though, by the teachings of Ferdinand Bac, Frederick Kiesler and Jesús Reyes Ferreira and realized in simple constructions with small windows and thick walls in daringly coloured and textured local materials. It culminated in such works as the chapel of the Capuchinas Sacramentarias del Purísimo Corazón (1953–5), Tlalpan, and the Casa Gálvez (1955), San Angel, both in suburbs of Mexico City. This period of Barragán's career includes the sculptural towers, ranging from 30 to 50 m in height, of the Ciudad Satélite, executed in 1957 in collaboration with Goeritz.

In his subsequent work, Barragán returned to his interest in suburban layouts and landscape schemes, for example at Las Arboledas (1959) and Los Clubes (1963–4), both in the suburbs of the capital and both sadly vandalized or neglected in subsequent years. The San Cristóbal estate and riding stables (see fig.) at Los Clubes, for the Folke Egerstrom family, is the best known of the buildings associated with these projects, offsetting pure rectilinear forms against horizontal and vertical water movement to

Luis Barragán (with Andrés Casillas): San Cristóbal estate and riding stables, Los Clubes, Mexico City, 1967–8

produce spectacularly evocative images. In the Casa Giraldi (1976; with Raúl Ferrera) Barragán again evoked Mexico's indigenous architectural character through a unique understanding of colour and texture, set around the natural forms of a tree. By the late 20th century his work had taken on an almost mythical importance both nationally and internationally, in spite of his limited output. A retrospective exhibition was held at the Museum of Modern Art, New York, in 1976, and in 1980 Barragán was awarded the Pritzker Prize for Architecture.

BIBLIOGRAPHY
C. Bamford Smith: 'Luis Barragán', *Builders in the Sun: Five Mexican Architects* (New York, 1967)
The Architecture of Luis Barragán (exh. cat., ed. E. Ambasz; New York, MOMA, 1976)
Luis Barragán: Ensayos y apuntes para un bosquejo crítico (exh. cat., Mexico City, Rufino Tamayo, 1985)
L. Noelle: 'Luis Barragán', *Arquitectos contemporáneos de México* (Mexico City, 1988)
E. X. de Anda Alanis: *Luis Barragán: Clásico del silencio* (Bogotá, 1989)
A. S. Portugal: *Barragán* (New York, 1992)
Barragán, obra completa (exh. cat. Madrid, Min. Obras Púb. & Urb., 1995)
A. Alfaro: *Voces de tinta dormida: Itinerarios espirituales de Luis Barragán* (Mexico City, 1996)
J. Palomar, J. M. Buendía and G. Eguiarte: *Luis Barragán* (Mexico City, 1996)
L. Noelle: *Luis Barragán: Búsqueda y creatividad* (Mexico City, 1996)
A. Riggen Martínez: *Luis Barragán: Mexico's Modern Master, 1902–1988* (New York, 1996)
R. Rispa, ed.: *Luis Barragán: The Complete Works* (London, 1996)
LOUISE NOELLE

Barrios, Alvaro (*b* Cartagena, 27 Oct 1945). Colombian painter, sculptor and conceptual artist. He studied at the Escuela de Bellas Artes of the University of Atlántico in Barranquilla, Colombia, from 1958 to 1960, and in Italy from 1966 to 1967 at the University of Perugia. In 1966, under the influence of Pop art, he made the first of a series of collages combining cut-outs of well-known individuals and comic strips with drawn elements. Two years later he added frosty effects and velvet flowers to his interpretations in black and red ink of figures with distorted bodies and the faces of film stars. In 1969 he began to present these in increasingly three-dimensional boxes or glass cases, accompanied by clouds of cotton wool, plastic figures and other additions that combined to make up fantastic or nostalgic scenes, dream-like and surrealist in appearance and tone.

Barrios was among those who introduced conceptual art to Colombia, for example by publishing in newspapers a series of *Grabados populares*, which he signed and numbered for anyone who asked. Later he devoted himself to an exhaustive study on Marcel Duchamp; his extensive production in this respect included some sensitive watercolours, which depicted the arrival of Duchamp's works in Venice in a triumphal and fantastic procession of gondolas, as well as decidedly literary works in which he narrated his dreams about these works. He went so far as to shave his head in the shape of a star, as Duchamp had done. Barrios's drawings of the 1980s, based as usual on the history of art, reiterate the refinement and overflowing imagination present in all his work.

BIBLIOGRAPHY
E. Serrano: *Un lustro visual* (Bogotá, 1976)
Cien años de arte colombiano (exh. cat. by E. Serrano, Bogotá, Mus. A. Mod., 1985)

Los cincuenta caminos de la vida (exh. cat., Cali, Mus. A. Mod. La Tertulia, 1997)
EDUARDO SERRANO

Barrios, Moisés (*b* San Marcos, 1 Jan 1946). Guatemalan painter and printmaker. He began his art studies at the Escuela Nacional de Artes Plásticas in Guatemala City, then studied painting at the Facultad de Bellas Artes of the Universidad de Costa Rica (1968–9) and printmaking at the Real Academia de Bellas Artes de San Fernando in Madrid (1974–5). His first works were expressionist woodcuts influenced by Munch, but after studying in Madrid he changed his style, emphasizing the role of drawing and texture and taking his subjects from Latin American literature.

On his return to Guatemala in 1979, Barrios addressed himself to the magic realism that held sway there in literature as well as in the visual arts. From *c.* 1980 he devoted himself increasingly to watercolour (e.g. *Bosch's Garden*, Guatemala City, Mus. A. Contemp.) and to oil painting. His brother César Barrios (*b* 1945) was also active as a painter and printmaker.

WRITINGS
'Xilografías', *Alero*, ii/6 (1972), pp. 38–50

BIBLIOGRAPHY
R. Cabrera: 'La obra gráfica de Moisés Barrios y César Barrios', *Cuad. U.*, n.s. (May–June 1979), pp. 26–45
J. B. Juárez: *Pintura viva de Guatemala* (Guatemala, 1984), pp. 73–89
Tierra de tempestades/Land of Tempests: New Art from Guatemala, El Salvador and Nicaragua (exh. cat. by J. Bernstein and others, Preston, Harris Mus. & A.G., 1994)
Visión del arte contemporáneo en Guatemala, iii (Guatemala City, 1996)
JORGE LUJÁN-MUÑOZ

Basaldúa, Héctor (*b* Pergamino, Buenos Aires, 22 Sept 1894; *d* Buenos Aires, 21 Feb 1976). Argentine painter, stage designer and illustrator. He studied drawing in Buenos Aires under the Italian painter Augusto Bolognini (*b* 1870) and at the Academia Nacional before moving in 1923 to Paris, where he worked in Charles Guérin's studio and at the Académie Colarossi. He also studied in the studios of André Lhote and Othon Friesz and became associated with other Argentine artists based in Paris. Like others of his generation and nationality, he sought in the 1920s to escape from pictorial provincialism by rejecting academic norms, as in *Still-life* (1926; Rosario, Mus. Mun. B.A.). He learnt how to paint while living in France and developed a range of imagery typical of Argentine art without showing any great originality.

More than any other painter, Basaldúa depicted life in the suburbs of Buenos Aires, concentrating humorously and without sentimentality on the wide boys, dance-hall girls, loose women and handsome, dangerous men of the tango in such pictures as the *Man in the Bar* (1951), *The Dance* (1964) and *The Dream* (1967; all E. Basaldúa priv. col., see Whitelow, pp. 30–31). He was also successful as an illustrator and as a stage designer; in 1933 he was appointed director of stage design at the Teatro Colón in Buenos Aires. He became a member of the Academia Nacional de Bellas Artes in 1956 and in 1958 was appointed Director of the Fondo Nacional de las Artes.

BIBLIOGRAPHY
C. Córdova Hurburu: *80 años de pintura argentina* (Buenos Aires, 1978), pp. 50–51

G. Whitelow: *Basaldúa* (Buenos Aires, 1980)
E. Basaldúa: 'Héctor Basaldúa and the Colón Theater: Thirty Years of Stage Design', *J. Dec. & Propaganda A.*, xviii (1992), pp. 32–53
J. López Anaya: *Historia del arte argentino* (Buenos Aires, 1997)
NELLY PERAZZO

Batlle Planas, Juan (*b* Torroella de Montgri, Catalonia, 3 March 1911; *d* Buenos Aires, 8 Oct 1966). Argentine painter, printmaker, illustrator, sculptor and stage designer of Spanish Catalan birth. He arrived in Buenos Aires in 1913. Although his uncle, José Planas Casas (*b* Catalonia, 1900; *d* Argentina, 1960), taught him the rudiments of art, he was basically self-taught and began to exhibit his work

Juan Batlle Planas: *Figura*, tempera on card, 1010×450 mm, 1952 (Buenos Aires, Museo de Arte Moderno)

in 1934. Synthesizing ideas from Zen philosophy, psycho-analysis and the theories on cosmic energy espoused by the Austrian psychologist Wilhelm Reich with his interests in automatism, poetry and painting, he found a creative sense of direction from an early age. He applied his methods not only to paintings but to stage designs, illustrations, collages, prints, polychrome sculptures and boxlike constructions; as a painter he worked both in tempera and in oil, and he also produced 72 murals.

In 1936 Batlle Planas inaugurated a Surrealist phase with a series entitled *Paranoiac X-rays*, followed by another group of pictures, *Tibetan Series*, populated by spectral figures related to works by Yves Tanguy. Between 1939 and 1943 he developed the theme of communication between occult powers, relating such concerns also to Carl Gustav Jung's theory of the collective unconscious. Submerging the spectator in mysterious and fantastic landscapes, he created stylized and spiritual pictures, such as *Figura* (1952; see fig.) and *The Wait* (1959; Buenos Aires, Mus. Mun. A. Plást. Sívori), that in some cases appear to depict unreal figures moving on the surface of the moon. His work became increasingly ascetic and spiritual, and from 1965 moved closer to abstraction, with attention concentrated on the support and on the material quality of the paint and scraped textures.

BIBLIOGRAPHY
A. Pellegrini: *Panorama de la pintura argentina contemporánea* (Buenos Aires, 1967), pp. 41, 121
S. Sulic: *Batlle Planas* (Buenos Aires, 1980)
J. López Anaya: *Historia del arte argentino* (Buenos Aires, 1997)
NELLY PERAZZO

Bazile, Castera (*b* Jacmel, 26 Nov 1923; *d* Port-au-Prince, 1966). Haitian painter. Orphaned at an early age and no stranger to deprivation, Bazile was forced to seek work rather than attend school. He moved to Port-au-Prince and found employment as a houseboy with the American Dewitt Peters (1901–66). Witnessing gatherings of artists at the Centre d'Art, he soon expressed a desire to try his hand at painting and became a full-time painter in 1945. He began producing compositions of the life he knew, powerful volumetric images with strong contrasts of light and dark and a firm contour.

Bazile's figures were monumental in their solidity, and his colours were strong; he had a sense of the dramatic and he exploited value contrasts to emphasize it. He painted from a compassionate social conscience, favouring themes such as mother with child, birth and the desperation of poverty. He was a serious person and was described as having little sense of humour. He favoured religious subjects, and although a devout Catholic his knowledge of and sympathy for Vodoun is apparent in his representations of ceremonies. He was chosen in 1950 to paint three important murals for the Ste-Trinité Episcopal Cathedral in Port-au-Prince: the *Ascension*, the *Baptism* and *Christ Driving the Money-changers from the Temple*. They are among the most successful of his oeuvre and have been compared in their classic monumentality to the frescoes of Piero della Francesca. He died of tuberculosis at the age of 42.

BIBLIOGRAPHY
Haitian Art (exh. cat. by U. Stebich, New York, Brooklyn Mus., 1978)
S. Rodman: *Where Art Is Joy* (New York, 1988)

Haïti: Art naïf–art vaudou (exh. cat., Paris, Grand Pal., 1988)
M. P. Lerrebours: *Haïti et ses peintres*, i (Port-au-Prince, 1989), pp. 332–8
DOLORES M. YONKER

Becerra, Francisco (*b* Herguijuela, Extremadura, 1545; *d* 1605). Spanish architect, active in South America. Both his father, Alonso (*d* ?1570), and his grandfather, Domingo, were architects; the latter was *maestro mayor* for Toledo Cathedral (completed 1493). Francisco was considered one of the finest architects in Extremadura, where he was active on a wide range of schemes including the church of S Maria and the chapel of S Isabel (both Trujillo), patrician houses in Guevara and a chapel between the cloisters in Guadalupe Monastery. In 1573 he left for America, one of the few architects permitted to do so by the Spanish government, which restricted the emigration of qualified personnel. The fact that Becerra was immediately associated with works of magnitude confirms his importance. In 1575 he became *maestro mayor* for Puebla Cathedral in Mexico, assisted by Francisco Gutiérrez Cabello. By his own account his activity on this assignment lasted for five years and probably included the design and laying of the foundations; however, the plan was amended after 1585 (as were those of the cathedrals of Mexico City and Lima).

Becerra cited his involvement in Puebla in building the churches of S Francisco, S Domingo, S Agustín and S Luis. Other Mexican projects may have included the church of S Domingo in Mexico City and the parish churches of Cuautinchán, Tepoztlán, Cuernavaca and Temoguacán. By 1581 he had arrived in Quito, Ecuador, where he constructed three bridges and planned the church of S Agustín, employing Gothic groined vaulting as in S Agustín, Mexico City. He probably also took part in the work on S Domingo in Quito.

Both churches in Quito had been designed and their foundations laid when Becerra was summoned to Lima in 1582 by Martín Enríquez de Almansa, Viceroy of Peru (*d* 1583), to draw up a new plan for the cathedral there. Enormous expense had already been incurred in connection with an existing plan, for which adequate resources were lacking. While he was engaged on this commission, Becerra also designed the new Cuzco Cathedral (*see* PERU, fig. 4). Both cathedrals are rectangular in plan, with aisles and naves of equal height. The interior of Lima Cathedral is unornamented, while that of Cuzco has round arches; Lima has compound Ionic piers and Cuzco Tuscan, its entablature blocks recalling Diego de Siloë's usage at Granada Cathedral (begun 1528). Above the Renaissance features of both Lima and Cuzco springs Gothic rib-vaulting, possibly chosen for its supposed resistance to earthquakes. In 1584 Becerra was confirmed as *maestro mayor* on these projects and was also commissioned to design the Palace of the Viceroys, Lima, and the fortification of the port of Callao. Budgetary limitations unfortunately restricted these works to the planning stage and in 1598 also affected plans for Lima Cathedral itself, although Becerra managed to complete half of the project (1604). Work on Cuzco Cathedral ceased when the Viceroy died, but restarted in 1598 to new plans (substantially influenced by Becerra's designs), first under the direction of Bartolomé Carrión (1604–16) and, for 30 years, under that of

Miguel Gutiérrez Sencio. Francisco Becerra belongs to the category of talented, mobile architects who brought their indigenous styles to major projects in cities separated by great distances.

BIBLIOGRAPHY
D. Angulo Iñiguez: 'Las catedrales mexicanas del siglo XVI', *Bol. Acad. N. Hist.* (1943)
E. Marco Dorta: 'Arquitectura colonial: Francisco Becerra', *Archv Esp. A.* (1943)
H. Wethey: *Colonial Architecture and Sculpture in Peru* (Cambridge, MA, 1949)
G. Kubler and M. Soria: *Art and Architecture in Spain and Portugal and their American Dominions, 1580 to 1800* (Harmondsworth, 1959), pp. 89–98
E. Harth-Terré: *La obra de Francisco Becerra en las catedrales de Lima y Cuzco* (Buenos Aires, 1962)
S. Sebastián López, J. de Mesa Figueroa and T. Gisbert de Mesa: *Summa artis: Historia general del arte*, xxviii (Madrid, 4/1992)
RAMÓN GUTIÉRREZ

Bedel, Jacques (*b* Buenos Aires, 7 Aug 1947). Argentine sculptor and architect. After studying architecture he began in 1967 to make multiple colour projections of shadows, continuing in 1968 to work with light apparatuses. He then travelled on a French Government scholarship to Paris, where he began to create multiple superimposed images using acrylic shapes laid on top of flat mirrors. He became involved with the Groupe d'Art Constructif et Mouvement and turned to spheres within cubes or other spheres. After this he experimented with inflatable sculptures and back projections of photographs, and later with *Books* (e.g. *Summa geometrica*, 1979, see Glusberg, p. 133) and *Megacubes*, which consist generally of ruins or landscapes rendered unfamiliar. As an architect he worked on the Recoleta Cultural Centre (1972–9; with Clorindo Testa and Luis Benedit) in Buenos Aires. He was a founder-member of Grupo CAYC.

BIBLIOGRAPHY
J. Glusberg: *Del Pop-art a la Nueva Imagen* (Buenos Aires, 1985), pp. 133–8
A. Tager: 'Jacques Bedel', *Art of the Americas: The Argentine Project*, ed. S. Baker (New York, 1992), pp. 117–31
Fin del siglo (exh. cat., Buenos Aires, Fund. Banco Patricios, 1995), pp. 5, 8
JORGE GLUSBERG

Bedia Valdés, José (*b* Havana, 1959). Cuban painter and installation artist. He graduated from the Escuela de Artes Plásticas 'San Alejandro' in Havana in 1976, and in 1981 from the city's Instituto Superior de Arte. Later in 1981 Bedia participated in the groundbreaking exhibition Volumen I, the aim of which was to create a more open, outward-looking art, free from official constraints. Liberalization of Cuban society allowed Bedia to visit many countries throughout Africa, Europe and the Americas, eventually returning to his country's own Afro-Cuban culture and religion. Bedia's early archaeological and ethnographical interests resulted in the creation and documentation of fictious finds and in the use of photographs of Amazonian Indians, such as those on *amate* (native bark) paper in the untitled work from the series *Crónicas Americanas* (1982, Havana, Mus. N. B.A.). This perspective gradually developed into anti-colonialist paintings, drawings and installations. Bedia's initiation into the Afro-Cuban Palo de Monte religion in 1983 and his time on a Dakota Sioux reservation in 1985 reaffirmed his belief in

the need to revitalize and work within the framework of non-Western traditions rather than merely quoting from them; from the Sioux, Lakota, Navajo and Nahuas, Bedia developed artisic conventions such as his outline drawing style. On his return to Cuba, however, the content of his work was increasingly influenced by Palo de Monte and Santería Afro-Cuban religions. Since 1988, these have also inspired Bedia's use of unorthodox materials and techniques in works that challenge traditonal notions of genres.

BIBLIOGRAPHY
L. Camnitzer: *New Art of Cuba* (Austin, 1994)
Art of the Fantastic: Latin America, 1920–1987 (exh. cat. by H. T. Day and H. Sturges; Indianapolis, IN, Mus. A., 1987)
E. J. Sullivan, ed.: *Latin American Art in the Twentieth Century* (London, 1996)

J. HARWOOD

Belém. Brazilian city, capital of Pará state. Built *c.* 130 km from the Atlantic Ocean on the Baia de Marajó, the southern estuary of the Amazon delta, the city (1994 population 1,244,688) is the chief port and commercial centre of northern Brazil and has several fine Neo-classical buildings. Founded by the Portuguese in 1616 as a defensive outpost for the Amazon region, its remote location and difficulty of access left it largely isolated from the rest of Brazil until the end of the 18th century, although it developed a prosperous spice trade with Europe during this period. Early buildings include the Jesuit church of S Francisco Xavier (1719), which replaced two earlier buildings on the site and has an interior with rich gilt woodcarving. Significant urban development took place in Belém in the 1750s and after, when a mission of scientists, architects and draughtsmen arrived in the region to demarcate the Portuguese–Spanish frontier established by the Treaty of Madrid (1750). Among them was the Bolognese architect ANTONIO GIUSEPPE LANDI, who settled in Belém in 1759 and received many commissions from the government, the Church and the local élite, several of which were documented by Alexandre Rodrigues Ferreira. Landi's style was new to the country: without abandoning Rococo, he introduced elements of Neo-classicism, then spreading through Europe. His chief work on these lines was the Palácio de Governo (completed 1771; rest. 1971–5), a monumental building with little decoration. Landi designed or modified various religious buildings in the city, such as the chapel of S João Batista (consecrated 1777), which has a neo-Palladian façade with a hint of Rococo in the pediment of the portal; the church of Nossa Senhora das Mercês (1777), with an innovative curved pediment; and the parish church of Santana (1782).

The city's greatest expansion took place in the second half of the 19th century following the exploitation of rubber from the Amazon, when the population grew from 18,000 in 1851 to 192,000 in 1907. Notable buildings of this period include the Teatro da Paz (1868–75), designed in an austere Neo-classical style by José Tiburcio Pereira de Magalhães; another Neo-classical building is the Palácio da Câmara Municipal e Prefeitura (1868). A picturesque aspect of the city is provided by the glazed tiles (*azulejos*) of semi-industrial production that face many of the buildings, for example the Serviço de Proteção do Patrimonio. The Museu Paraense Emílio Goeldi (founded 1866) is an important centre for archaeological and ethnological studies.

BIBLIOGRAPHY
A. R. Ferreira: *Viagem filosófica pelas capitanias do Grão-Pará, Rio Negro, Mato Grosso e Cuiabá, 1783–1792* (Rio de Janeiro, 1971)
D. Mello jr: *Antonio José Landi, arquiteto de Belém* (Belém, 1974)
Museu Paraense Emílio Goeldi (Rio de Janeiro, 1981)
D. Bayón and M. Marx: *Historia del arte colonial sudamericano* (Barcelona, 1989)

ROBERTO PONTUAL

Belize [formerly British Honduras]. Central American country. Bordered by Mexico on the north, Guatemala on the west and south and the Caribbean Sea on the east (see fig. 1), its total land area is *c.* 23,300 sq. km. Its population of *c.* 250,000 (1999) contains a vast variety of ethnic groups. There are three types of Maya: the Mopan, Kekchi and Yucatec, each with its own unique language. The largest group are the Mestizos (43.6%), of mixed Spanish and Maya descent. There are also Creoles (29.8%), of mixed European and African ancestry, whose language, derived from English, is widely spoken by all, and Garifuna (6.6%), descended from Amerindian Caribs, Arawaks and

1. Map of Belize

Africans. The population also includes Chinese, Lebanese, Europeans, Hindu and Mennonite communities. In 1970 Belmopan became the capital in place of the coastal Belize City, which had been devastated by a hurricane in 1961. The terrain in the north of the country is mostly flat, as is the whole of the coastal area, while the south contains the Maya Mountains. There is thick rainforest in the interior, while the coast has the largest barrier reef in the western hemisphere; the Belize Barrier Reef has been named a World Heritage Site.

1. Introduction. 2. Architecture. 3. Painting, graphic arts and sculpture. 4. Patronage and institutions.

1. INTRODUCTION. Before European colonization, the country was occupied by the Maya from as far back as *c*. 1000 BC. They constructed magnificent buildings at such sites as Lamanai, Altun ha and Caracol. By the mid-10th century this culture had declined, although the Maya were still living in Belize as subsistence farmers in the late 20th century and still preserving certain of their customs and religious rites. In the 15th century most of northern Belize belonged to the principality of Chetumal (now the northern Belize town of Corozal). Spanish incursions into Belize began in 1513 when an expedition set out from the Yucatán to Chetumal, supposedly to 'pacify' the Maya, exact tribute from them and convert them to Christianity. After an unsuccessful 18-month siege the Spanish departed for Honduras. They intermittently invaded Belize unsuccessfully, however, until the early 18th century.

Occupancy of Belize by British logwood-cutters began around the 1650s after the arrival of an ex-buccaneer, Bartholomew Sharpe. From the mid-17th century the Spanish made several attempts to dislodge the British, culminating in 1798 in the Spanish failure to capture St George's Caye, a British island base and Belize's first capital. After this, the British settlers began to consolidate their control with permanent buildings and a stronger presence of the British church and state. In 1862 the colony of British Honduras was established, becoming in 1871 a Crown Colony with more direct rule from Great Britain through governors.

In the 18th and early 19th centuries the British moved further into the interior of the country in search of mahogany, driving the Maya deeper into the forests. The switch from logwood to mahogany, a highly lucrative export, required more labour, supplied from 1724 by slaves brought from West Africa via Bermuda and Jamaica; by 1745 they made up *c*. 71% of the settlement's population. There were four main slave revolts in Belize, in 1765, 1768, 1773 and 1820. In the late 18th century, Caribs from Caribbean islands were also brought to the country. Although they mixed with the African slaves, becoming known as Garifuna, they did preserve aspects of their original culture, including language, music, dance, foods and such crafts as basketry. Other customs resemble those of Caribbean African-American culture, such as the Jonkonnu or Junkanoo (John Canoe) performances at Christmas, Boxing Day and New Year' Day.

After the abolition of slavery in 1834, timber and merchant interests still controlled the country's economy by using a system of labour control to keep the workers in line. Large landowners increased their holdings, and the freedmen became more dependent on them for survival. This oppression, together with economic crises, resulted in disturbances in 1894, 1919 and the mid-1930s. In 1950 the People's United Party was formed to campaign for independence. The country achieved self-government in 1964, and in 1973 its name was changed to Belize. In 1977 more British troops were sent there as a result of the threat from Guatemala, which was pressing a long-standing claim to the territory. Belize eventually obtained independence in 1981.

2. ARCHITECTURE. In Belize City and Dangriga, the predominant architectural style is known as 'Creole colonial'. Buildings have weatherboard-clad frames with corrugated iron roofs. Such buildings are liable to destruction by both hurricanes and fire and therefore have been constantly rebuilt. The law requires that the lowest storey is raised or protected by a covered verandah or porch, away from swampy land and insects. External staircases provide entry to the main living quarters. The roofs are steeply pitched to contend with the humid Caribbean climate, the rain being collected in huge water cisterns or vats.

Belize City also contains much public colonial architecture. The mid-19th-century Government House is a white framed structure with a hipped roof and a colonnaded portico at its entrance. St John's Cathedral, with a traditional Anglican design, was consecrated in 1826 and is one of the few brick buildings in Belize City (see fig. 2). The bricks are laid in a Flemish Bond pattern, with alternating headers and stretchers on each course. The roof line is stepped with a gable at the end of each wing. The windows are headed by a round stone arch over a rounded glass fanlight window. The bell-tower is square, topped by battlements. Bricks, imported from Britain, were also used for several colonial homes in Regent Street. The Court House, reconstructed in 1923–6, is a two-storey white stucco building with a gabled roof and faces the mouth of the Belize River. Late 20th-century architecture in Belmopan is based on classical Mayan architecture, apparently combined with British styles. The result is not especially attractive. Modern commercial buildings and residential structures have mainly stark, boxlike shapes, with either flat or pitched roofs and smooth finishing. The main material used is concrete, which is resistant to fires and hurricanes. The houses of the modern Maya, which can be seen in San Pedro Columbia and San Antonio in the Toledo district, are very similar to those of their ancestors, attractive and utilitarian.

3. PAINTING, GRAPHIC ARTS AND SCULPTURE. Throughout the colonial period, the various ethnic groups in Belize were educated by the British to consider their own cultures as inferior and the art produced copied British examples. Art education was limited. Even as late as the 1960s, besides the work of a few art teachers at primary and secondary schools, the only art instruction was given by Louis Belisle at the Bliss Institute in Belize City as part of the University of the West Indies Extra-Mural Department. He taught a handful of students, giving

2. Belize City, St John's Cathedral, consecrated 1826

a basic training in perspective, shading and much free-style sketching of sailing boats on the Belize River, market scenes and Creole and Maya female figures; nude and semi-nude.

In 1974 a group of Belizean artists headed by Philip Lewis formed Soul to Art in order to exhibit their own and others' works. Overcoming the problems of lack of materials, artistic contacts and public support, in the late 20th century artists became considerably more serious about their work. They held regular exhibitions, were interviewed for radio and television, appeared in the local newspapers, sold works and approached painting and sculpture as a serious, creative business. Particularly after independence, there was a slow, steady increase in the numbers of Belizean painters.

One of the most significant influences on Belizean painting was exerted by Michelle Perdomo, who moved to Belize from the USA c. 1970 and became the country's most important art instructor, teaching drawing and painting at the Jesuit St John's College High School and Sixth Form. In the late 1980s a distinct change occurred in the work of Perdomo's students. Instead of imitating British, European or North American subjects and models, as in the 1970s, they depicted Belizean subjects, including flora, fauna, landscapes, seascapes and the various ethnic groups. The diverse backgrounds of Belizean artists were reflected in the variety of their styles, and many of Perdomo's students became significant figures in Belizean art. Rachel Heusner painted Belizean faces and localities, developing her own technique of using acrylic on mirrors. Reneth

Oliver designed various government calendars, greetings cards and a logo for the Belize Arts Council, as well as showing work in exhibitions. Terryl Godoy became a highly individual painter of street scenes, as well as sketching and painting such little documented subjects as the canals and the (now dismantled) market of Belize City. Other significant painters included two artists from Dangriga, Pen Cayetano and Benjamin Nicholas, who produced numerous depictions of Garifuna history, folklore, customs and domestic scenes (e.g. Cayetano's *Braiding Hair*, 1983; L. Curry priv. col., on dep. Pass Christian, LA, USA). Cayetano's often large-scale paintings are realistic, perspectival and detailed. They depict scenes, with many people, from earlier times in Dangriga, when rural life centred around the cultivation and preparation of cassava. Nicholas, who studied for three years at the Minneapolis College of Art and Design in the USA, has a primitive style, without natural perspective, using bright colours and stylized figures. Nelson Young (*b* 1958) was also inspired by his Belizean roots, in his case his experience of the skills of local craftsmen. Manuel Villamor Reyes, active in Mexico, is another Belizean painter and muralist, whose works range from biblical and liturgical themes to Mayan abstracts in what critics called a 'peculiar' abstract style; his paintings retain a sense of impressionistic landscape.

The many wood-carvers and sculptors in Belize mainly used hardwood such as ziricote or mahogany, although sometimes also rosewood. Most of the wood-carvers mass-produced images of local animals, birds and sailing ships, as well as abstract works, for the ever-growing tourist

industry. Ignatius Peyrefitte jr, who came from a family of wood-carvers, developed his own unique style of Madonnas, family scenes and abstract sculptures. George Gabb, perhaps Belize's best-known wood-carver, produced such works as *Sleeping Giant* (1983; Belmopan, House of Culture; see fig. 3). His works entered important British collections and were displayed in the Belize booth at the New Orleans World Fair of 1984. David Magaña from Succotz in Cayo used slate to carve ancestral forms inspired by his Mayan roots. The four García sisters (*b* 1960–70) of San Antonio, Cayo, have also re-created their Mayan heritage by carving altar-stones, stelae and figurines on slate. Public sculpture includes a work by the Mexican Enrique Carbajal Sebastián in Belmopan (painted steel): it was presented to the country in 1991, on the tenth anniversary of independence. Another statue (cement, h. *c.* 15 m), dedicated to the political leader Antonio Soberanis, is in Battlefield Park, Belize City.

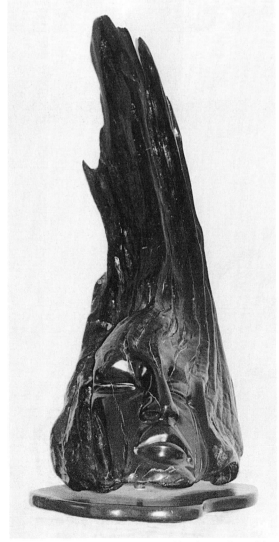

3. Sculpture from Belize by George Gabb: *Sleeping Giant*, ziricote hardwood, h. 760 mm, 1983 (Belmopan, House of Culture)

4. PATRONAGE AND INSTITUTIONS. Until the second half of the 20th century there was no patronage, collecting or dealing on a sophisticated level. An important private collector and patron of Belizean arts was Vernon Leslie, resident tutor at the University of the West Indies. In Belize City the Atlantic Bank was one of the main patrons during the 1970s of such artists as Pen Cayetano and Benjamin Nicholas, buying and selling many of their works. In 1981 the Atlantic Bank Exhibition displayed thirty-six paintings and drawings by nine artists. Although Belizean artists basically handle their own sales, various galleries display and sell works. The first to be inaugurated (1984) was the Bliss National Gallery (renamed the Belisle Art Gallery), run by the Ministry of Culture and the venue of numerous exhibitions designed to promote Belizean artists. The Bliss Institute in Belize City, officially opened in 1954, houses a public library, the Belisle Art Gallery and the offices of the Belize Arts Council, which runs the institution. The art gallery offers an attractive, central, inexpensive place for artists to show their work and is in almost constant use. Although foreign artists do exhibit here, the gallery concentrates on Belizean artists from all the ethnic groups.

Other galleries in Belize City include the Gabbay Art Gallery, owned by Belize's foremost wood-carver, George Gabb. Lindy Ward established a gallery, Belizean Arts, at San Pedro on Ambergris Caye, with a branch at the Great House, Belize City. Also at San Pedro is the Iguana Jack Gallery, specializing in ceramics. Small informal art galleries are set up periodically on the nearby island of Caye Caulker, including a group calling itself the Caye Caulker Academy of Arts, made up of such Belizean artists as Philip Lewis, with members from Canada, the USA and Europe. The young novelist David Ruiz also opened a gallery, the El Balum Art Gallery, in Benque Viejo, Cayo District. The Image Factory, opened in Belize City in June 1995, is a non-profit institution dedicated to the promotion, exhibition and documentation of Belizean art and culture.

In the late 1990s plans were formulated to replace the existing Ministry of Culture with a National Institute of Culture and History, a statutory body supported by the government but independent of it, which would assist in a wide range of cultural activies emphasizing freedom and diversity. Through cultural agreements with Mexico and Cuba, the teaching of music, dance and visual arts is envisaged in Houses of Culture to be established in every district in Belize. The first House of Culture is at the former Government House in Belize City.

BIBLIOGRAPHY

J. E. Thompson: *The Maya of Belize: Historical Chapters since Columbus* (Belize, 1972)
Brukdown, iii/6–7 (1979) [issues entitled 'In Search of History']
G. Nichols: 'Art Alive and Well in Belize', *Brukdown*, v/5 (1981)
H. L. Meredith: 'An Architectural History of Belize', *Beliz. Stud.*, xiii/2 (1985)
L. Hunter Krohn, ed.: *Readings in Belizean History*, 2nd edn (Belize City, 1987)
'Belize Experiences a Cultural Renaissance', *Belize Today* (Feb 1990)
'Garments without Pockets', *Caricom Persp.*, 48 (April–June 1990)
T. Barry: *Inside Belize: The Essential Guide to its Society, Economy, and Environment* (Albuquerque, 1992)

LITA HUNTER KROHN

Arnold Belkin: *Modular Hero*, acrylic on canvas, 1.37×1.22 m, 1970 (Austin, TX, University of Texas, Jack S. Blanton Museum of Art)

Belkin, Arnold (*b* Calgary, 9 Dec 1930; *d* Mexico City, 12 July 1992). Canadian painter, draughtsman and sculptor, active in Mexico. After studying in Canada at the Vancouver School of Art (1944–5) and Banff School of Fine Arts (1947–8) he moved to Mexico City, where he continued his training at the Escuela de Pintura y Escultura La Esmeralda (1948–9) and from 1950 worked as one of a team of assistants to David Alfaro Siqueiros. He began soon after to produce murals, such as *The People Don't Want War* (acrylic, 2×2.5 m, 1952; Mexico City, Inst. Poli. N.) and *Scenes from Don Quixote* (acrylic on concrete, 1957; Cuernavaca), following these with many others in Mexico, the USA, Canada, Cuba and Nicaragua. He was also prolific as a draughtsman and easel painter, often working on a large scale, and to a lesser extent as a sculptor. Working in an Expressionist style and concentrating his attention on the human figure (see fig.)—sometimes contorted, flayed or treated in a robot-like manner—he treated biblical themes as well as more contemporary subjects such as the victims of Nazism or of the bombing of Hiroshima. In 1961 he and Francisco Icaza (*b* 1930) founded the group Nueva Presencia, which until 1963 published five issues of a magazine under the same name.

BIBLIOGRAPHY
A. de Luna: *Arnold Belkin: Los creadores y las artes* (Mexico City, 1987)
A. de Luna: *35 años de presencia gráfica de Arnold Belkin* (exh. cat., Mexico City, Inst. N. B.A., 1990)
Arnold Belkin: A través del recuerdo a dos años de su partida: Homenaje (exh. cat., Mexico City, Mus. N. Est., 1994)
MARGARITA GONZÁLEZ ARREDONDO

Beltrán, Alberto (*b* Mexico City, 22 March 1923). Mexican painter, printmaker and illustrator. He studied at the Escuela Nacional de Artes Plásticas and with Carlos Alvarado Lang. Although he painted some murals and a good number of easel pictures, he was active primarily as a printmaker and as an illustrator of books, magazines and journals. He founded the satirical newspapers *Ahí va el golpe* (1958) and *El coyote emplumado* (1960) and from its inception in 1962 acted as art director and illustrator for the newspaper *El día*. From 1945 to 1959 Beltrán was associated with the TALLER DE GRÁFICA POPULAR in Mexico City, acting as its president for several years and sharing its populist, political and nationalist principles. Placing his art at the service of social concerns and using protest as his main weapon, he expressed himself with particular force in his prolific production of drawings and in masterful linocuts such as *Exodus* (1955; Mexico City, Mus. N. Est.).

For illustration of Beltrán's work, *see* MEXICO, fig. 11.

BIBLIOGRAPHY
A. Haab: *Mexican Graphic Art* (New York, 1975), p. 110
H. Covantes: *El grabado mexicano en el siglo XX* (Mexico City, 1982), pp. 124–5
LOUISE NOELLE

Bencomo, Mario. *See* DÍAZ BENCOMO, MARIO.

Benedit, Luis (*b* Buenos Aires, 12 July 1937). Argentine sculptor, painter and architect. As an artist he was self-taught. Making reference to biological and chemical experiments to construct metaphors of the relationships between science and art, he began in 1968 to analyse the

Luis Benedit: *Water Drop*, plexiglass, plastic tubing, water and cotton, 479×250×250 mm, 1971 (Austin, TX, University of Texas, Jack S. Blanton Museum of Art)

role of the individual in society through his first *Animal Habitat*, consisting of glass objects with water and fish, and *Microzoos* of ants, lizards, fish, tortoises, vegetables and honeycombs. At the Venice Biennale in 1970 he showed *The Biotron* (see Glusberg, p. 142), a cage for bees containing an artificial meadowland with 24 flowers that supplied a sugary solution; the bees could choose between the artificial device and the gardens that surrounded the Biennale. In later works he designed mazes for rats, ants, cockroaches and fish, as well as contraptions displaying the behaviour of plants (e.g. *Fitotron*, 1972, see Glusberg, p. 141), not to encourage scientific observation but to suggest to the spectator possible applications of the experiment; another work from this period is *Water Drop* (1971; see fig.).

Benedit shared the international grand prize at the São Paulo Biennale in 1977 with the Grupo CAYC, of which he was a founder member. In the same year he began the series *Thomas's Toys*, made of wood, acrylic, iron and enamel, for example *King Kong in Chains I* and *King Kong in Chains II* (both 1980; see Glusberg, p. 132), three-dimensional figures based on children's drawings. In the early 1980s he began addressing Latin American themes in representational pictures painted in a childlike style. He was also active as an architect, working on the Recoleta Cultural Centre (1972–9), Buenos Aires, with Clorindo Testa and Jacques Bedel, as well as designing rural buildings.

BIBLIOGRAPHY

Luis Benedit (exh. cat., Los Angeles, CA, ICA, 1981)
J. Glusberg: *Del Pop-art a la Nueva Imagen* (Buenos Aires, 1985), pp. 139–58
A. Tager: 'Luis Benedit', *Art of the Americas: The Argentine Project*, ed. S. Baker (New York, 1992), pp. 83–103
D. Cameron: 'Luis Benedit: Field Work', *Art from Argentina, 1920–1994* (exh. cat. by D. Elliott and others, Oxford, MOMA, 1994), pp. 94–9
Luis F. Benedit (exh. cat., Buenos Aires, Mus. N. B.A., 1996)
Un altre mirar arte contemporani argentini/Otro mirar arte contemporáneo argentino (exh. cat., Barcelona, Generalitat Catalunya, 1997)

JORGE GLUSBERG

Benítez, Isaac Leonardo (*b* Panama City, 5 Sept 1927; *d* Panama City, 6 Nov 1968). Panamanian painter and draughtsman. He studied under Humberto Ivaldi in the 1940s. In 1950 he won a scholarship to the Accademia di Belle Arti in Florence, but he returned to Panama after only a year and a half because of health problems. There he painted constantly until his death, but he remained a marginal figure in Panamanian art circles. He specialized in portrait drawings rendered with sparse but expressive ink lines and dramatic semi-abstract landscapes in tempera. In his oil paintings he favoured strong contrasts, sombre colours and dynamic brushwork.

BIBLIOGRAPHY

Benítez (exh. cat., essays B. Pereira Jiménez and A. Herrerabarría; Panama City, Escuela N.A. Plást., 1968)
E. Wolfschoon: *Las manifestaciones artísticas en Panamá* (Panama City, 1983), pp. 77–8, 187–202, 451–3

MONICA E. KUPFER

Benoit, Rigaud (*b* Port-au-Prince, 1 Nov 1911; *d* Port-au-Prince, 29 Oct 1986). Haitian painter. A painter of particularly lyrical gifts, he entered the Centre d'Art in Port-au-Prince as the driver of its jeep, having earlier exercised his talents as a musician and painter of china. He was so shy about his first efforts at panel painting that he attributed them to a friend. He admired Hector Hippolyte's art while he was courting his daughter, whom he later married. His genre pictures, although anecdotal, are tinged with a subtle mystery. From the beginning, his work was meticulously executed. His polished surfaces, often obtained by repeated overpainting, are reminiscent of medieval manuscript illuminations. Details of faces, hands and feet are delicate but expressive and individualistic. Scenes of everyday events or of Vodoun ceremonies are usually situated in an architectural framework, giving scope to his fascination with perspective. His paintings of Vodoun scenes incorporate the mystical appearances of the spirits in wildly imaginative forms. In *Baptism of the Assotor Drum* (1950–53; New Jersey, Mrs Angela Gross priv. col., *see* HAITI, fig. 5) he represented one of the most sacred ceremonies of Vodoun. His *Nativity*, one of three major panels in the apse of Ste-Trinité Episcopal Cathedral in Port-au-Prince, is as expressive of his admiration for beautiful women as for the sacred personage of the Virgin. Never acceding to the growing demand for his pictures, Benoit produced only two or three finished works a year. An element of fantasy and satire became more marked as his style matured, and his colours became paler and more nuanced. The beings he painted, florid hybrids of human, animal and plant forms, took on a Surrealist flavour as well as erotic overtones.

BIBLIOGRAPHY

Haitian Art (exh. cat. by U. Stebich, New York, Brooklyn Mus., 1978)
Haïti: Art naïf—art vaudou (exh. cat., Paris, Grand Pal., 1988)
M. P. Lerrebours: *Haïti et ses peintres*, i (Port-au-Prince, 1989), pp. 320–24; ii, pp. 381–2

DOLORES M. YONKER

Bermúdez, Cundo (*b* Havana, 3 Sept 1914). Cuban painter, ceramicist and printmaker. He studied at the Academia de S Alejandro in Havana (early 1930s) and at the Academia de S Carlos in Mexico City (1938), where he also became familiar with the work of the muralists. He had his first one-man exhibition at the Lyceum in Havana in 1942.

Bermúdez shared with many of his contemporaries an interest in Cuban realities and themes painted in a manner that was in keeping with 20th-century art movements. His work from the 1940s is characterized by popular Cuban scenes and types depicted in an almost caricatural, naive style with loud tropical colours (e.g. *The Balcony*, 1941; see colour pl. II, fig. 2).

In the 1950s Bermúdez abandoned the folkloric themes and tropical voluptuousness of his earlier paintings, instead depicting elongated, barely human, Byzantine-like figures. The most accessible of these paintings are of acrobats and musicians. In 1967 Bermúdez left Cuba for political reasons and settled in San Juan, Puerto Rico. There he continued to evolve metallic colour harmonies and surrealistic imagery including clocks, ladders and turbaned figures in his paintings. He also produced murals and lithographs, and his best-known print is the silkscreen entitled *Virgin of Charity* (1970; *Segunda Bienal de San Juan del Grabado Latinoamericano*, exh. cat., San Juan, Inst. Cult. Puertorriqueña, 1972, P. 111, no. 91a) depicting the patron saint of Cuba.

BIBLIOGRAPHY

A. Barr: 'Modern Cuban painters', *MOMA Bull.*, xi (1944), pp. 1–14

O. Hurtado and others: *Pintores cubanos* (Havana, 1962)

Cundo Bermúdez (exh. cat., ed. C. Luis; Miami, FL, Cub. Mus. A. & Cult., 1987)

N. G. Menocal: 'An Overriding Passion: The Quest for a National Identity in Painting', *J. Dec. & Propaganda A.*, xxii (1996), pp. 187–219

GIULIO V. BLANC

Bernardelli, Rodolfo (*b* Guadalajara, 1852; *d* Rio de Janeiro, 1931). Brazilian sculptor. The son of Italian musicians, he spent his childhood in Mexico and Chile before coming to Brazil with his family. In 1870 he was already enrolled in the course on statuary sculpture in the Academia Imperial das Belas Artes in Rio de Janeiro, from where he was awarded a trip to Europe in 1876. He remained abroad until 1885, living briefly in Paris from 1878 to 1879 but staying mainly in Rome, where he finished his studies with Achille Monteverdi. During that time he executed one of his best-known works, the marble *Christ and the Adulteress* (1884; Rio de Janeiro, Mus. N. B.A.), which bears witness to the persistence in Brazil of a Neo-classically based naturalism throughout the 19th century and beyond. He taught in the Academia Imperial, and when this was renamed the Escola Nacional de Belas Artes with the establishment of the Republic, he became its director from 1890 to 1915. In his day he was one of the country's most sought-after sculptors, and several Brazilian cities have works by him in their public parks, such as the *Monument to the Discovery of Brazil* in the Jardim da Glória, Rio de Janeiro, and the mausoleum of *Emperor Peter II* in Petrópolis Cemetery.

BIBLIOGRAPHY

A. Costa: *A inquietação das abelhas* (Rio de Janeiro, 1927) [account of contemp. artistic life in Rio de Janeiro incl. interviews with Bernardelli and other artists]

E. R. Peixoto: *Rodolfo Bernardelli no Museu Nacional de Belas Artes* (Rio de Janeiro, 1958)

A. Fontainha: *História dos monumentos do Rio de Janeiro* (Rio de Janeiro, 1963)

ROBERTO PONTUAL

Bernardes, Sérgio (Vladimir) (*b* Rio de Janeiro, 9 April 1919). Brazilian architect and industrial designer. He graduated as an architect in 1948 at the Federal University of Rio de Janeiro, where he subsequently taught architectural composition. He went into private practice in Rio de Janeiro in 1948, and his early residential work was in the elegant, rationalist style of modernism then dominant in Rio. Examples include the M. G. Brandi house (1952), near Petrópolis, where a stone wall resolves the uneven terrain and the angular volume of the main building, and the L. de Macedo Soares house (1953), Rio, where the most frequent elements of his later work first appear: very light structures of bare steel painted black on tubular pillars, reflecting a growing interest in structural and constructional techniques. This treatment was used in a series of non-residential works, such as the administrative headquarters and workshops (1956) of the CCBE Company in São Paulo and several exhibition pavilions, including the prize-winning Brazilian Pavilion at the Exposition Universelle (1958) in Brussels. In his own house (1960), Rio de Janeiro, Bernades developed an experimental architecture that was both contemporary and traditional. Built on a promontory above the sea, the house is set on a solid base of stone walls, which shelter the rooms; the interior rises as a pavilion, a light structure of concrete and wood at the level of the main entrance. Modern materials are used, such as sawn asbestos cement tubes forming a wide-eaved roof raised well above the ceiling to admit sea breezes, but the connection with the Luso-Brazilian colonial tradition is visible in the use of sloping stone walls, heavy masonry, glazed tiles and antique furniture.

From 1960 Bernades developed a prolific and multi-faceted practice. Restless by temperament and driven by a passion for experiment, he designed and patented a large number of industrial components, including coachwork for cars, and he organized large exhibitions of his work. He also founded an inter-disciplinary research institute, the Laboratório de Investigacões Conceituais (LIC), in Rio de Janeiro to assist his studies in technology. Outstanding examples of his later, often highly technological designs include the Hotel Tambaú (1966), João Pessoa; the IBC building (1968) and IBM headquarters (1974), both in Rio; the Naval Ministry (1977), Brasília; the Corintias stadium (1981), São Paulo; and the Clube Atlántico Boa Vista (1983), Rio. He also became increasingly involved in utopian planning ideas, producing highly innovative experimental urban plans for places such as Rio de Janeiro, the heart of the Amazon forest and Alaska.

WRITINGS

City: The Survival of Power (Rio de Janeiro, 1975)

BIBLIOGRAPHY

H. E. Mindlin: *Modern Architecture in Brazil* (Amsterdam and Rio de Janeiro, 1956)

'Sergio Bernades House in Rio', *Zodiac*, 11 (1962), pp. 48–55

'São Paulo Biennale Exhibition', *Acrópole*, 301 (1963), pp. 1–19

J. Maurício: 'Tambú: Sérgio Bernardes', *VIDA das Artes*, i/4 (1975)

PAULO J. V. BRUNA

Berni, Antonio (*b* Rosario, 14 May 1905; *d* Buenos Aires, 13 Oct 1981). Argentine painter, sculptor and printmaker. He trained at the stained-glass window workshop of Buxadera & Compañía, Rosario, province of Santa Fé, and with Eugenio Fornels and Enrique Munné. He held his first exhibition in 1920. At the age of 20 he won a scholarship for study in Europe awarded by the Jockey Club of Rosario, which enabled him to study in Paris under André Lhote and with Othon Friesz at the Académie de la Grande Chaumière. After showing his European works in Buenos Aires in 1927 he obtained another scholarship, this time from the government of the province of Santa Fé, as a result of which he established contact with the Surrealists in 1928; in particular he befriended Louis Aragon and the French philosopher Henri Lefebvre.

Berni returned to Argentina in 1930. In 1933 he established an artistic–literary group, Nuevo Realismo, and began to depict Argentina's social reality. From the 1960s, through two characters he created (Juanito Laguna and Ramona Montiel) he began to create works from pieces of metal and wood, buttons, burlap, wires and other debris gathered by him in the shantytowns surrounding Buenos Aires. Combining in these works commonplace materials and a brutal realism (e.g. *Noontime*, 1976; see fig.), he strengthened a form of political art that gave him the courage to experiment in various directions, including

Antonio Berni: *Noontime*, photograph and paper on canvas, 1.98×1.98 m, 1976 (Austin, TX, University of Texas, Jack S. Blanton Museum of Art)

Surrealism and Neo-expressionism. In spite of these variations of style, however, he remained committed to the plebeian. He was awarded the grand prize for prints at the Venice Biennale in 1962.

BIBLIOGRAPHY

M. Troche: *La caverna de Ramona o el mismo mundo* (Paris, 1971)
J. Viñals: *Berni: Palabra e imagen* (Buenos Aires, 1976)
C. Córdova Iturburu: *80 años de pintura argentina* (Buenos Aires, 1978)
D. Elliott: 'Antonio Berni: Art and Politics in the Avant-Garde', *Art from Argentina, 1920–1994* (exh. cat. by D. Elliott and others, Oxford, MOMA, 1994), pp. 40–49
J. Glusberg: *Antonio Berni* (Buenos Aires, 1997)
J. López Anaya: *Historia del arte argentino* (Buenos Aires, 1997), pp. 165–81
N. Perazzo: 'Berni's Objects from the 1960s', *A. Nexus*, xxv (1997), pp. 60–64
M. E. Pacheco: *Antonio Berni*, (Buenos Aires, 1997)

JORGE GLUSBERG

Bestard, Jaime (*b* Asunción, 26 June 1892; *d* Asunción, 1965). Paraguayan painter. He trained in Paris, where he lived from 1924 until 1933, attending studios and private academies. His landscapes from the period are constructed solidly with vigorous modelling, massive forms and clear outlines. The result is an image made up of compressed bodies and dense colours regulated by strict composition, as in the oil painting *My Mother's Patio* (1934; Asunción, Paraguay, Mus. N. B. A.). His tendency to emphasize the structure of a work had great importance during the 1930s and 1940s as a forerunner of the revival of Paraguayan art, which until then had been dominated by a 19th-century type of naturalism. The paintings of Bestard and those of Wolf Bandurek prepared the ground for the break with academicism that took place in the 1950s. While Bandurek drew attention to the expressive content of paintings, Bestard's contribution was to formal values. After 1950 he produced small-format sketches in oil, tempera, pencil, pastel and watercolour, for example *The Football Match* (*c.* 1950; priv. col., see Escobar, 1984, p. 74); these show great boldness of expression and a strong sense of humour, a mood which until then had rarely been introduced into Paraguayan painting.

BIBLIOGRAPHY

J. Plá: *Treinta y tres nombres en las artes plásticas paraguayas* (Asunción, 1973), pp. 16–17
T. Escobar: *Una interpretación de las artes visuales en el Paraguay* (Asunción, 1984), pp. 65, 70–74, 86, 97–9

TICIO ESCOBAR

Bianchi, Andrea (*b* nr Rome, 1677; *d* Córdoba, Argentina, 25 Dec 1740). Italian architect, active in Argentina. Having studied architecture in Rome, in 1716 he joined the Jesuit Order. In 1717 he travelled with GIOVANNI BATTISTA PRIMOLI to Buenos Aires, subsequently settling in Córdoba. He was an able designer with a considerable theoretical knowledge of architecture and often worked in collaboration with Primoli, who completed many of his designs. Bianchi's purified, classical style contained some Mannerist tendencies, and its implementation helped to increase the level of craftsmanship in architecture in the region. In 1719 he set up the lime kilns at La Calera, near Córdoba, so enabling an improvement in the building techniques of the region. In 1720 he moved to Buenos Aires, where he directed work on the Jesuit Colegio and later completed the construction of their church. Other important projects in Buenos Aires were his designs for the churches of Nuestra Señora del Pilar (Recoletos), Belén, S Catalina, La Merced, and S Francisco as well as the façade of the cathedral (all 1721–8), in several of which he was assisted by Primoli. Bianchi then returned to Córdoba in 1728, working there until 1739 on the rebuilding of the cathedral. During the same period, he also worked on the Colegio Máximo of the university with Primoli and on the Colegio de Montserrat, both in Córdoba, as well as on the Jesuit properties (*estancias*) in Alta Gracia, Jésus María, Santa Catalina, Caroya and Santa Ana. The plans for the churches of S Roque and S Teresa in Córdoba, unfinished at his death, are also attributed to him.

BIBLIOGRAPHY

M. J. Buschiazzo: *La catedral de Buenos Aires* (Buenos Aires, 1943)
G. Furlong: *Arquitectos argentinos durante la dominación hispánica* (Buenos Aires, 1946)
——: *Historia social y cultural del Río de la Plata*, 3 vols (Buenos Aires, 1969)
D. H. Sobrón: *Giovanni Andrea Bianchi: Un arquitecto italiano en los albores de la arquitectura colonial argentina* (Buenos Aires, 1997)

RAMÓN GUTIÉRREZ

Bigaud, Wilson (*b* Port-au-Prince, 29 Jan 1931). Haitian painter and draughtsman. He was introduced to the Centre d'Art in Port-au-Prince by Hector Hippolyte, his neighbour at the time, when he was only 15; his seriousness and tenacity were already apparent. From the first his drawings were densely detailed. Working towards a mastery of colour as well as an illusion of volume modelled in light and dark, Bigaud demonstrated a mature command of his art in the great *Terrestrial Paradise* (1952; Port-au-Prince, Mus. A. Haït.), painted when he was just 21. He has been called a popular realist, as he delighted in the festivals of carnival and Rara, representing them in full action and colourful detail. His *Self-portrait in the Carnival Costume of the Fancy Indian* (WI, Flagg priv. col.) demonstrates his

love for lush detail and the golden colours that suffuse many of his paintings. His genre scenes are material rather than dreamlike, solid and respectful of the limitations of naturalism. The ritual and mystery of Vodoun are presented as he observed them in reality. His masterpiece in Ste Trinité Episcopal Cathedral in Port-au-Prince, the *Marriage at Cana*, anthologizes many of the themes he had treated previously and introduces numerous details of Vodoun ritual into the Christian subject. Between 1957 and 1961 Bigaud suffered a series of breakdowns that affected his work, but he continued to paint in his little house in Petit-Goâve.

BIBLIOGRAPHY
Haitian Art (exh. cat. by U. Stebich, New York, Brooklyn Mus., 1978)
S. Rodman: *Where Art is Joy* (New York, 1988), pp. 113–21
M. P. Lerrebours: *Haïti et ses peintres*, ii (Port-au-Prince, 1989), pp. 79–90, 382

DOLORES M. YONKER

Bisilliat, Maureen (*b* Surrey, 16 Feb 1931). Brazilian photographer and film maker of English birth. Having moved to Brazil, she studied painting with André Lhote in Paris (1953–4) and with the American painter Morris Kantor (*b* 1896) at the Art Students' League in New York (1954–6), before deciding to become a photographer; after 1962 she worked as a freelance photojournalist and film maker. In 1970 a Guggenheim Fellowship enabled her to go to Brazil, where she settled. She began to take an interest in the Indian inhabitants, and as a result spent years working with the Xingu in the Amazon region, creating an important visual record of the Amazon Indians at a time when their culture was increasingly threatened. In 1975 this work brought her the Critics' Prize at the São Paulo Biennale. In 1979 her illustrated book *Xingu Tribal Territory* appeared. Among her films were *A João Guimarães Rosa* (1986) and *Xingu Terra* (1980).

PHOTOGRAPHIC PUBLICATIONS
Xingu Tribal Territory (London, 1979) [texts by O. and C. Villas-Bôas]
Maureen Bisilliat: Terras do rio de São Francisco (Belo Horizonte, 1986)
with J. Amado: *Bahia amada amado ou o amor a liberdade y aliberadade no amor* (São Paulo, 1996)

ERIKA BILLETER

Bitti, Bernardo (*b* Camerino, the Marches, 1548; *d* Lima, 1610). Italian painter, active in South America. He joined the Society of Jesus in Rome in 1568. The origins of his style lie in late Roman Mannerism, which was influenced by Giorgio Vasari and Francesco Salviati, while his figures are indebted to Raphael. The Jesuits in Peru sent a request to the General of the Order for a painter, which resulted in Bitti travelling first to Lima (1571) and later to America (1575). His journey took him through Seville, where he saw the work of Luis Morales, whose influence is also evident in his paintings. In Peru, Bitti worked in Lima and Cuzco, where he executed some wall paintings in the Capilla de Indios in La Campaña (damaged in 1650 earthquake), and he also executed several commissions for the city of Arequipa. From there he went to the Bolivian cities of La Paz, Potosí and Chuquisaca. He established his reputation in 1600 in Chuquisaca with his painted retable for the church of S Miguel (Chuquisaca, Mus. Cat.), of which the canvas of the *Investiture of St Ildefonsus* is outstanding. The *Virgin and Child with the Young St John* (Chuquisaca, Mus. Cat.) is probably not part of the same retable. His great canvas of the *Coronation of the Virgin* and the painting of *Candlemas* (Purification of the Virgin), characterized by the elegant and elongated figures typical of Roman Mannerism, are also preserved (Lima, S Pedro).

Bitti was sent to Juli, the town of Aymara Indians on the shores of Lake Titicaca, where the Jesuits had a missionary centre. Most of the work he painted there (1585–91, 1601–4) was produced in the large workshop he ran for the indigenous population, and this brought him numerous followers. Among his collaborators were the Andalusian Jesuit Pedro de Vargas (*b* 1533), who worked with him in Lima, and the Ecuadorean Dominican friar Pedro Bedón, who founded a painting school for the native inhabitants of the city of Quito.

BIBLIOGRAPHY
R. Vargas Ugarte: *Ensayo de un diccionario de artífices coloniales de la América Meridional* (Lima, 1947)
M. Soría: *La pintura del siglo XVI en Sudamérica* (Buenos Aires, 1956)
J. Mesa and T. Gisbert: *Bitti, un pintor manerista en Sudamérica* (La Paz, 1974)
P. Querejazu: 'Cinco tablas de Bitti y Vargas en el Museo Regional del Cuzco', *A. & Arqueol.*, v–vi (1978)
R. Gutiérrez, ed.: *Pintura y escultura y artes útiles en Iberoamérica, 1500–1825* (Madrid, 1995)

TERESA GISBERT

Blanes, Juan Manuel (*b* Montevideo, 8 June 1830; *d* Pisa, 15 April 1901). Uruguayan painter and draughtsman. He came from a humble background and as a child suffered the separation of his parents, a disrupted schooling, poverty and the social upheavals of Montevideo under siege by General Manuel Oribe during Uruguay's *Guerra grande* of 1839–51. From an early age he showed talent as a draughtsman, making life drawings and oil paintings while working as a typographer for *El defensor de la independencia americana*, a daily newspaper run by the besieging army.

The work produced by Blanes from 1850 to 1860 established him as one of the outstanding portraitists in South America as well as a distinguished painter of murals on historical themes. He supported himself through commissions while living in Montevideo with his wife and children and by teaching painting at the Colegio de Humanidades in Salto after settling there in 1855. His own formal training was limited to that of local artists and to the basic guidelines established by foreign academic and naturalist portrait painters. During these years he did eight paintings of the military victories of the Argentine General Justo José de Urquiza, some paintings on religious themes for the chapel at Urquiza's palace and *Yellow Fever* (1857; untraced), in which he commemorated the epidemic that struck Montevideo.

Thanks to a study grant he was able to move with his family to Paris in 1860 and to Florence in 1861, where he was taught painting by Antonio Ciseri, who introduced him to academic disciplines of rigorous drawing, perspective, composition, local colour and tonal modelling. A group of drawings sent as his first shipment to Uruguay in 1862 was lost in a shipwreck, but when he returned to Montevideo in 1864 he was in great demand as a portraitist; the President of Paraguay, Francisco Solano López, was among his eminent sitters. Following the failure of his

proposal in 1866 to the Uruguayan government to create an Escuela de Bellas Artes, he travelled to Argentina and Chile, where he treated such episodes of Latin American history as the *Review at Rancagua* (1871; Buenos Aires, Primer Mus. Hist. Argentina) and *Last Moments of General José Miguel Carrera* (1873; Montevideo, Mus. N.A. Visuales). Through such works and related portraits, including the *Oath of the Thirty-three Uruguayan Patriots* (1878; Montevideo, Mus. N.A. Visuales), he confirmed his reputation in Latin America.

From 1879 to 1883 Blanes again lived in Florence, where he continued to paint scenes of South America (see colour pl. II, fig. 3); his two sons, Juan Luis Blanes (1856–95) and Nicanor Blanes (*b* 1857), received their training as painters in Florence. On his return to Montevideo in 1883 he painted the *1885 Review* (Montevideo, Mus. Mun. Blanes) on commission from the President of Uruguay, Máximo Santos, and portraits of *General José G. Artigas* (Montevideo, Casa Gobierno) and *Carlota Ferreira* (Montevideo, Mus. N. A. Visuales): the latter, one of his most successful works, depicts the woman whose marriage to Nicanor did much to disrupt the relationship between father and son. In 1890 Blanes travelled to Europe and the Far East with his sons, returning to Argentina in order to undertake his most important commission, the *Rio Negro Review* (3.53×7.04 m, 1891; Buenos Aires, Mus. Hist. N.). After the death of Juan Luis in a road accident, he returned to Europe to look for Nicanor, who had disappeared mysteriously. He was unsuccessful in his search but established himself in Pisa, where he remained until his death.

BIBLIOGRAPHY
E. de Salterain y Herrera: *Blanes: El hombre, su obra y su época* (Montevideo, 1950)
J. P. Argul: *Proceso de las artes plásticas del Uruguay* (Montevideo, 1975)
F. García Esteban: *El pintor Juan Manuel Blanes* (Montevideo, 1977)
Seis maestros de la pintura uruguaya (exh. cat., ed. A. Kalenberg; Buenos Aires, Mus. N. B.A., 1985), pp. 21–42
G. Peluffo Linari: *Historia de la pintura Uruguayana: De Blanes a Figari* (Montevideo, 1993)
K. E. Manthorne: 'Juan Manuel Blanes and the Artists of the American West', *Review*, l (1995), pp. 100–106
The Art of Juan Manuel Blanes (exh. cat., Buenos Aires, Bunge & Born Found.; New York, Americas Soc. A.G.; 1994)

ANGEL KALENBERG

Blanes Viale, Pedro (*b* Mercedes, 19 May 1878; *d* Montevideo, 22 June 1926). Uruguayan painter. He first studied painting and drawing as a child with the Catalan painter Miguel Jaume i Bosch. As an adolescent he moved with his family to Spain, where he studied at the Real Academia de Bellas Artes de San Fernando in Madrid and frequented the workshop of Santiago Rusiñol. After studying in Paris with Benjamin Constant, he visited Italy and Mallorca, where he first developed his talents as a landscape painter before returning briefly to Uruguay in 1899. During another prolonged visit to Europe from 1902 to 1907 he enthusiastically studied the work of Pierre Puvis de Chavannes, Lucien Simon, Henri Martin, Claude Monet and James Abbott McNeill Whistler. After his return to Montevideo in 1907 he painted shimmering Impressionist-influenced landscapes such as *Palma de Mallorca* (1915; Montevideo, Mus. N. A. Visuales) and treated local rural and urban scenes in which he established himself as a

remarkable colourist. He also commemorated subjects from Latin American history in works such as *Artigas Dictating to his Secretary Don José G. Monterroso* (*c.* 1920; Montevideo, Mus. Hist. N.), the equestrian portrait of *General Galarza* (1909; Durazno, Mus. Mun.) and *Artigas in el Hervidero* (Palacio Legislativo, Montevideo). He exhibited at the Paris Salons and in 1910 was awarded the Gold Medal at the *Exposición Internacional del Centenario de la Independencia Argentina* in Buenos Aires for his portrait of Galarza.

BIBLIOGRAPHY
J. P. Argul: 'Pedro Blanes Viale', *Rev. Mus. Juan Manuel Blanes* (1958)
G. Peluffo: *Historia de la pintura uruguaya* (Montevideo, 1988–9), iii, pp. 43–57
R. Pereda: *Blanes Viale* (Montevideo, 1990)
Pedro Blanes Viale (exh. cat., ed. A. Kalenberg; Buenos Aires, Mus. N. B. A., 1991)

ANGEL KALENBERG

Blinder, Olga (*b* Asunción, 1921). Paraguayan painter and engraver. She studied under the painters Ofelia Echagüe, João Rossi and Lívio Abramo, and her work contributed fundamentally to the revival of Paraguayan art in the 1950s. Until then representational art was still tied to 19th-century Naturalism, but in 1954 the Arte Nuevo group, founded by Blinder, Josefina Plá, Lilí del Mónico and José Laterza Parodi, organized the Primera Semana de Arte Moderna, which helped bring to a head the struggle with entrenched academicism. She began by painting still-lifes and landscapes that emphasized structure, but she soon turned to thematic and expressive content centred on the human condition; later her work was concerned as much with intensity of meaning as with

Olga Blinder: *Nanduti III*, linoprint, 320×410 mm, 1961 (Colchester, University of Essex, Collection of Latin American Art)

the severity of formal arrangement. Sensitive and intellectual, subjective and socially aware, her work turned into an individual lyrical expressionism, enlivened by tension but carefully formal. This complexity can be seen in the techniques she used at different stages: the severe images that she developed in paintings and wood-engravings during the 1960s (see fig.); the engravings made with zincograph blocks in the 1970s that incorporate conceptual analysis based on her existential and social preoccupations; and finally painting, which she resumed in the 1980s.

BIBLIOGRAPHY
Guggiari, Blinder, Colombino (exh. cat. by L. Abramo, Asunción, Paraguay, Mis. Cult. Bras., 1969)
J. Plá: *Treinta y tres nombres en las artes plásticas paraguayas* (Asunción, 1973)
T. Escobar: *Una interpretación de las artes visuales en el Paraguay* (Asunción, 1984)

TICIO ESCOBAR

Bo, Lina Bardi. *See* BARDI, LINA.

Boari (Dandini), Adamo (*b* Ferrara, 1863; *d* Rome, 1928). Italian architect and engineer, active in Mexico. He graduated as an engineer at the Università di Bologna in 1886 and completed his architectural training in the USA in 1899. He was then appointed to design and oversee the building of the Teatro Nacional (now Palacio de Bellas Artes; *see* MEXICO, fig. 5) in Mexico City. During the preparatory stages he travelled widely to study current ideas of theatre architecture and made an urban study of the streets and open spaces around the site. His original plans show the influence of Art Nouveau derived from the Exposition Universelle of 1900 in Paris and incorporate Mexican national features, such as mascarons of coyotes, monkeys and eagles. The design included a glass-enclosed garden instead of a foyer, a dome over the garden rather than the auditorium and a safety curtain of opalescent glass; the structure was of iron. Construction began in 1904 and lasted several years. Meanwhile Boari also undertook the construction of the Edificio Central de Correos (1902–7), Mexico City, the first building in Mexico to use reinforced concrete. The exterior was faced in white stone, and the decorative details show a hybrid revival of Italian Renaissance and Hispano-Flemish style. It is an early example in Mexico of a large project given a specific functional role. Work on the Teatro Nacional was eventually halted by financial problems, and in 1916 Boari returned to Italy. The building was completed in 1934 under other architects, including Géza Maróti, who modified the original plan.

WRITINGS
with F. Mariscal and X. Moyssén: *Palacio de Bellas Artes, México* (Mexico City and Milan, 1993)

BIBLIOGRAPHY
El Palacio de Bellas Artes: Album histórico (Mexico City, 1934)
J. Urquiaga and V. Jiménez: *La construcción del Palacio de Bellas Artes* (Mexico City, 1984)
A. Farinelli Toselli and L. Scardino: *Adamo e Sesto Boari: Architetti Ferraresi del primo novecento* (Ferrara, *c.* 1995)

MÓNICA MARTÍ COTARELO

Boggio, Emilio (*b* Caracas, 21 May 1857; *d* Auvers-sur-Oise, 7 May 1920). Venezuelan painter, active in France. He travelled to France in 1864 and studied at the Lycée Michelet in Paris until 1870. He returned to Caracas in 1873 but made a second journey to Paris in 1877, where he was a student of Jean-Paul Laurens at the Académie Julian. In 1889 Boggio was awarded the bronze medal at the Exposition Universelle in Paris. Between 1907 and 1909 he lived in Italy, where he painted seascapes. Boggio excelled in landscape painting, and Claude Monet and Camille Pissarro were decisive influences on the Impressionist style of his work. In 1919 he stayed briefly in Caracas and held an exhibition at the Academia de Bellas Artes, which greatly influenced local artistic circles. Notable among his works was *End of the Day* (1912; Caracas, Gal. A. N.).

BIBLIOGRAPHY
J. Calzadilla: *Emilio Boggio* (Caracas, 1968)
A. Junyent: *Boggio* (Caracas, 1970)
Donación Miguel Otero Silva: Arte venezolano en las colecciones de la Galería de Arte Nacional y el Museo de Anzoátegui, Fundación Galería de Arte Nacional (Caracas, 1993)

MARÍA ANTONIA GONZÁLEZ-ARNAL

Bogotá, Santa Fe de. Capital of Colombia. The largest city in Colombia, it is located in the centre of the country on the Sabana, a plateau in the Andes 2600 m above sea level. The population in the late 20th century was *c.* 6 million. The city's name probably derives from that of the village of Bacatá, the seat of El Zipa, chief of a group of Muisca tribes that populated the region at the time of the Spaniards' arrival.

1. TO 1819. In 1536 Gonzalo Jiménez de Quesada was commissioned to undertake an expedition to discover the mouth of the Magdalena River and to search for an alternative route to Peru. After an arduous year-long journey, he arrived in the Zipa lands; in 1538 he officially founded the city and proceeded to build a church and straw houses, followed by Spanish-style constructions in more permanent materials. The city spread out on a grid, characteristic of Spanish rules of urban planning for the New World colonies, interrupted only by the San Francisco and San Agustín rivers. The central district of La Candelaria was developed around the Plaza Real and Calle Real (now the Plaza de Bolívar and Carrera 7). Of the houses, constructed around central patios and with hallways connecting the public and private spaces, a notable example is the home of the Marqués de San Jorge (now the Museo Arqueológico del Banco Popular); built on two storeys, it was one of the most complex houses in its adaptation to the uneven land.

Various religious orders established cloisters, including the Augustinians (1575; destr.), the Dominicans (1577; destr.) and the Jesuits (San Ignacio, 1604; now the Museo de Arte Colonial). Their churches were characterized by exquisite *Mudéjar* panelling on the ceilings and rich Baroque ornamentation, as in S Clara, decorated (1630) by Matías de Santiago; the altarpiece (1623) of S Francisco (1569–1622) by Ignacio García de Asucha (1580–1629); and the exuberant woodwork of the church of the Veracruz, which was left in its natural colour and highlights the beauty of the local woods. The Jesuit brick-built church of S Ignacio (1625–41; see fig.) by Giovanni Battista Coluccini (1569–1641) introduced such innovations as the Latin-cross plan, barrel-vaulted central nave and cupola. The wealth of architectural decoration was complemented

Bogotá, S Ignacio, by Giovanni Battista Coluccini, 1625–41

by the painting and sculpture produced in local workshops, which inherited the traditions of Seville. The most prestigious painting of the so-called Santa Fe school was undertaken in the workshops of the families of Gáspar de Figueroa (*d* 1658) and Gregorio Vázquez de Arce y Ceballos (1638–1711), the latter being the most prolific artist of the period; his realistic treatment of mystical themes is exemplified in *Holy Family* (Bogotá, S Ignacio).

In 1717 Santa Fe de Bogotá became capital of the viceroyalty of Nueva Granada. Baroque gradually gave way to Mannerist and Rococo tendencies in painting, these coinciding with the move away from religious topics in the 18th century. In architecture Fray DOMINGO DE PETRÉS, with his Neo-classical style a representative of the Enlightenment, arrived from Spain in 1792 to undertake both civil works and plans for the cathedral (begun 1807; incomplete on Petrés's death in 1811).

2. 1819 AND AFTER. Following independence in 1819, English and French Neo-classicism appeared increasingly, as did Romanticism; the new styles came to be known as 'republican' architecture. New materials such as steel were introduced, although brick retained its popularity. Important exponents of these eclectic trends included the British architect Thomas Reed (1810–78), who built the Capitolio Nacional (1847) and the Panóptico (1851, now the Museo Nacional), and Pietro Cantini (1850–1929), who designed the Teatro Colón (1885).

For the exhibition of 1910 celebrating the centenary of the struggle for independence, the city underwent significant transformations in appearance as electric light was introduced and tree-lined avenues and parks with railings were created. The city also grew in density, with new construction backing on to former colonial sites. Among the most significant works of the period is the Palacio Echeverry (1905) by the Frenchman Gaston Lelarge

(1852–1934). In the 1930s international Functionalism became popular in Colombia. Among those who played a major role in the transition from historicism to Modernism were Karl Brunner, who planned the Universidad Nacional, Leopoldo Rother (1894–1978) and Bruno Violi (1909–71), who designed the Faculty of Engineering (1938–42) at the Ciudad Universitaria. The embracing of these new trends resulted from various factors, including the need to meet the massive demands on housing made by the growing immigrant population, the creation of a faculty of architecture at the Universidad Nacional, the enthusiasm surrounding Le Corbusier's visit (1947) and his elaboration of the regulating plan (unrealized) for the city, and the need to rebuild areas destroyed by fire in the revolt of 1948.

In the 1950s, while the first International-style skyscrapers were being built, an organic style was developing, with the use of such traditional local materials as brick. An early example of this was the government-built multi-level Centro Antonio Nariño (1950–53; by Violi, Pablo Lanzetta (1933–85) and Gabriel Serrano Camargo (1909–82)). One of the first successful solutions to mass-housing, the scheme is notable for the way green areas are integrated and the buildings are adapted to the topography.

In the late 20th century a local architecture of formal richness was created from a versatile use of brick and occasionally masonry and wood, along with adaptation to the uneven land and to the landscape. Examples of this are the works of Rogelio Salmona (*b* 1929), such as the Residencias El Parque (1965–70; *see* COLOMBIA, fig. 4), the brickwork of which interprets the changing light of the Sabane and the mountains. Housing complexes such as the Santa Theresa Complex at Usaquén (1977–8) by Jorge Rueda, Enrique Gómez Grau and Carlos Morales also followed the organicist trend and with commercial centres contributed to raising the profile of other parts of the rapidly spreading city.

Sculpture and painting at the end of the 19th century were dominated by Academicism, due to the establishment of schools of art such as the Academia Gutiérrez (1883) and the Instituto de Bellas Artes (1882). This art of the schools, which fulfilled the demand of local patrons for portraiture and landscape painting—the most popular genre in the early 20th century—evolved to produce the intimate and realistic renderings of the artists of the Escuela de la Sabana, who concentrated on the changing light and quiet landscapes surrounding Bogotá.

In the 1940s Bogotá came under the influence of international modernism, and the sculptures of Constructivists Edgar Negret and Eduardo Ramírez exemplify the abstract and rational tendencies that since then have characterized the city, in contrast to the figurative or popular art that prevailed elsewhere in Colombia.

The importance of Bogotá as an artistic centre is reflected in a number of major museums, including the Museo del Oro, the Museo Nacional, the Museo de Arte Colonial and the Museo de Arte Moderno. The Escuela de Conservación y Restauración de Colcultura has played an important part in salvaging the country's artistic heritage. There are a number of institutions teaching art and architecture, including the Universidad Nacional de Colombia, the Universidad de los Andes, the Pontificia

Universidad Javeriana and the Universidad Jorge Tadeo Lozano. The city hosts the Salón Nacional for Colombian artists (although this has also twice been held in Cartagena) and the Bienal de Bogotá.

BIBLIOGRAPHY

C. Martínez: *Bogotá: Sinopsis sobre su evolución urbana* (Bogotá, 1976)
M. Traba: *Mirar en Bogotá* (Bogotá, 1976)
G. Tellez: *Aspectos de la arquitectura contemporánea en Colombia* (Bogotá, 1977)
S. Arango de Jaramillo: *Historia de la arquitectura de Colombia* (Bogotá, 1980)
G. Franco Salamanca: *Templo de Santa Clara de Bogotá* (Bogotá, 1987)
B. Villegas, ed.: *Historia de Bogotá*, 3 vols (Bogotá, 1988)
E. Pulecio Marino: *Museos de Bogotá* (Bogotá, 1989)

NATALIA VEGA

Bolivia, Republic of. South American country. It shares borders with Brazil to the north and east, with Paraguay and Argentina to the south, and with Chile and Peru to the west (see fig. 1). The Spanish arrived in Bolivia in 1534. During colonization, as part of the Viceroyalty of Peru, the territory of Bolivia was called Charcas or Upper Peru. The name derives from the Charcas Indians who lived to the north of Potosí, where the Spanish established the main political and administrative body of the region, the Audencia de Charcas. The region remained under the control of Lima until 1776, when it became the most northerly region of the Viceroyalty of Rio de la Plata. The Republic of Bolivia (founded 6 August 1825) was named after the Venezuelan revolutionary Simón Bolívar. It is divided into nine departments, which are further divided into provinces and cantons. Each department has a canton, usually the largest city. Sucre is the legal capital, and La Paz is the administrative capital.

Although the nation is identified with the Andean *meseta* (high tablelands or plains), more than half of its territory consists of low-lying tropical lands, largely unpopulated

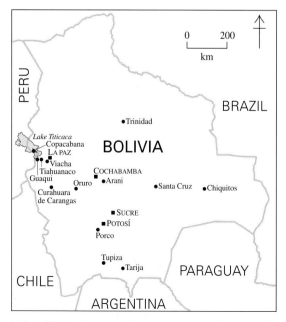

1. Map of Bolivia; those sites with separate entries in this encyclopedia are distinguished by CROSS-REFERENCE TYPE

because of the rugged terrain and the difference in level (*c.* 3400 m) between high- and low-lands. After the 19th century Bolivia lost large tracts of territory through international wars and diplomatic agreements. The climatic variety of the country allows for a great diversity of plant and animal types. Some species, including pumas, condors, jaguars and caymans, have been the subject of myths and blends of religions. Animal skins were used ritually, and the multicoloured plumes of tropical birds are still used for festive decoration. Cattle, horses and sheep, some imported by the Spanish, have aided in the cultivation of land, in transport and in providing fine wools. The harsh nature of the topography, however, has also been one of the factors that has most forcefully limited development because of the difficulty of establishing and maintaining communication routes. Bolivia's mineral wealth led to the development of metallurgy in copper and bronze in Pre-Columbian times, a decisive factor in the supremacy of Tiahuanaco, an ancient city state on the southern shores of Lake Titicaca. In the colonial period exploitation of these minerals and metals continued for craft products of daily use, silver for minting and the creation of works of art. The wooded valleys and plains provided materials, particularly cedar and pine, for the construction of the missions and for architectural wood-carving, wooden sculptures and the production of altarpieces and furniture. In the 20th century new access to more humid zones, previously unexploited, facilitated the use by artists of various precious woods.

I. Introduction. II. Architecture. III. Painting and graphic arts. IV. Sculpture. V. Gold and silver. VI. Textiles. VII. Patronage, collecting and dealing. VIII. Museums and photographic collections. IX. Art education.

I. Introduction.

Within a short period after their arrival, the Spaniards took over the whole country, concentrating on the occupation of the highlands and attracted by the availability of cheap labour and mineral wealth. At this time the indigenous population's economic basis lay in farming and cattle-breeding. Pre-Columbian practices of food storage and distribution of goods and services persisted despite their lack of recognition by the Spanish, and other Pre-Columbian cultural features continued with the influence of mestizos (people of mixed Indian and European ancestry), of which the textile art of the Andes is especially noteworthy (*see* §VI below). The city of POTOSÍ was founded officially in 1572, although it had been established unofficially in 1545; other 16th-century cities were La Plata (founded in 1540; now SUCRE), COCHABAMBA (1542), LA PAZ (1548), Santa Cruz (1560) and Tarija (1574). Oruro was founded in 1606, following the discovery of silver mines there. The low tropical and jungle lands were colonized in the 17th and 18th centuries through the Jesuit and Franciscan missions. The ecclesiastic hierarchy was based mainly in La Plata, where the episcopate (established in 1565) was elevated to an archbishopric in 1605. (For discussion of the role of religious missionaries in Bolivia *see* JESUIT ORDER, §3.)

Charcas was divided up among Spanish *encomenderos* (colonists granted Indian labourers by royal decree), some of the lands remaining in the hands of native Indians in

the form of *reducciones* (settlements of native Indians). The *reducciones* obliged the Indians to gather together in towns and better facilitated control of the Indians who lived in the countryside but did not belong to any *encomienda*. The discovery of silver mines in Porco, Potosí and Oruro enhanced Charcas's importance, and the subsequent need for a large labour force was met by a system of forced labour on a rotating basis for all Indians, known as *mitá*.

On its foundation the Republic proclaimed the abolition of the *mitá*, the *encomienda*, taxes on the natives and enslavement. It favoured the élites of landholders, businessmen and creole (people of European ancestry born in the New World) bureaucrats. With the economic decline in the 19th century, the government had to face the harsh reality that the Spanish administration had created no industries, basing its hopes solely on agricultural development and on mineral wealth. In 1879 Bolivia was engaged in a war with Chile, as a result of which it lost its outlet to the sea. In the late 19th century there was a revival of silver mining, and in the early 20th century a boom in tin mining created a new Bolivian aristocracy, perhaps more attached to foreign interests. In the 1940s the oil industry began to develop and became one of the most important sources of foreign currency. The most significant historical event of the 20th century was the National Revolution of April 1952, which led to nationalization of the mines, land reform and universal suffrage. It also brought the Indians and mestizos into the economic, political and cultural activity of the nation.

BIBLIOGRAPHY

J. E. Fagg: *Latin America: A General History* (London and New York, 1963, rev. 3/1977), pp. 426–30, 679–90
R. Villaroel Claure: *Bolivia* (Washington, DC, 1963)
A. Arguedas: *Historia general de Bolivia: El proceso de la nacionalidad, 1809–1921* (La Paz, 1967)
W. E. Carter: *Bolivia: A Profile* (New York, 1971)
J. Fellman Velarde: *Historia de la cultura boliviana* (La Paz, 1976)
H. Klein: *Historia general de Bolivia* (La Paz, 1980)
J. de Mesa and T. Gisbert: *Manual de historia de Bolivia* (La Paz, 1983)
H. Vázquez Machicado and others: *Manual de historia de Bolivia* (La Paz, 4/1994)
J. de Mesa and T. Gisbert: *Historia de Bolivia* (La Paz, 1997)

LAURA ESCOBARI

II. Architecture.

1. 1534–1825. 2. After 1825.

1. 1534–1825. When the Spanish arrived in the region that became Bolivia, they found traditions of planning, building and architecture that dated back to pre-Inca cultures, such as that at Tiahuanaco (*c.* AD 500 onward). The grid plan, for example, existed here long before it was reintroduced from Spain, and other architectural elements had been rigidly formalized and related to location and climate.

(i) Urban planning and building techniques. (ii) Historical survey.

(i) Urban planning and building techniques. Only rarely did the Indians of the Pre-Columbian period settle in great urban centres. Their concept of a city was in reality a ceremonial site; for all other purposes they lived in rural communities. All the towns and cities of modern Bolivia, therefore, date from after the arrival of the Spanish, who forced the Indians to gather in *reducciones* and new towns.

The latter were laid out in grid plans with precise specifications for street blocks, width of the streets and water courses, and assigned spaces for places of worship, monasteries and hospitals. The Pre-Columbian tradition of building open-air temples was influential in determining the standard layout of churches. Typically, these consist of large, walled atria or courtyards on to which usually face an open chapel (*capilla abierta*) and small open shrines (*posas*) as well as an enclosed church.

Traditional Indian building methods continued under the Spanish throughout the colonial period and after, especially for residential buildings. Wattle, adobe and thatch, for example, were used to construct enclosures for everyday use, including churches at first. However, local skills also included the more sophisticated rubble and fieldstone methods handed down from the Pre-Columbian Chavín period and the accurately fitted dry-stone masonry of the Incas. These techniques were combined by the Spanish with the stylistic complexities in structure and decoration that were common in Spain. There the transition from Gothic to Renaissance in the last quarter of the 15th century coincided with the introduction of the Plateresque manner of overall low-relief surface decoration (*see* PLATERESQUE STYLE) and was further complicated by continuing use of MUDÉJAR references. Consequently, colonial architecture shows putative Renaissance forms, Gothic vaulting and other medieval remnants, together with *Mudéjar* building in brick and timber, including coffered ceilings. Once absorbed by tradition-bound local craftsmen, these new forms tended to persist longer than in Spain: for example, Gothic vaulting continued well into the 18th century. Architecture with European pretensions was in the hands of the architects and engineers who came from Europe, while construction was executed by masons assisted by both Indian and mestizo craftsmen.

(ii) Historical survey.

(a) Renaissance, Plateresque and early Baroque, 1534–1690. (b) Mestizo Baroque to Neo-classicism, 1690–1825.

(a) Renaissance, Plateresque and early Baroque, 1534–1690. Buildings of this period, of which churches are the best examples, mirror the contemporary stylistic transition from Gothic to Renaissance architecture in Spain. Exteriors are simple, and imported styles affected principally the design of portals. These are Plateresque in character in early examples and more purist after the mid-16th century, when the so-called classical period had begun in Spain. Ground-plans are elongated rectangles with apsidal-ended single naves and usually octagonal chancels. Walls were reinforced with thick buttresses, and roofs were coffered or rib-vaulted in timber. Examples include the early church (1560) at Caquiaviri, which helped to set the trend for rich interior decoration, the adobe church (1590) at Corque, with a brick and ceramic tiled portal, and the simple stone church (1612) at Tiahuanaco, its classicizing portal framed in a delightful, locally devised Ionic order. All have characteristic atria, with four small open shrines and, unique to Bolivia and Peru, centrally placed miserere chapels. At Copacabana, near Lake Titicaca, which was a place of pilgrimage in Pre-Columbian times, the first Christian sanctuary was built by the Augustinians (warrant

issued in the mid-1580s), and a chapel followed (1614–18). From this period dates the unusual, *Mudéjar*-influenced cloister (see fig. 2), which is roofed with flat domes concealed from the courtyard by a narrow entablature above the piers of the arcade. A larger new church was begun by the architect Francisco Jiménez de Singüenza in 1668. It is built mainly in brick and, like some other Augustian foundations, has crenellated walls around an atrium with four open shrines: here the open chapel also has an open dome. *Mudéjar* influence is apparent in the local jade-green tiling of the main dome and cupolas. Building continued into the 18th century.

At La Plata (now Sucre), the cathedral was begun in 1561 by Juan Miguel de Veramendi, and the earliest phase of building was completed in 1572. The vaulted nave and side aisles (1683–92) of the present building are by José González Merguelte; although the cathedral was not completed until 1712, it remained unaffected by the regional Mestizo Baroque style that was developing around it. The flat roof emphasizes the horizontality: above the smooth stone walls is a continuous balustrade, broken only by terminal urnlike features on pedestals above each buttress. Unusually, one of the long sides of the cathedral faces the main square, providing the spacious background for a magnificent retable portal. Other significant churches built in La Plata include S Lázaro (already in use by 1544, though it continued to develop well into the 17th century)

and S Francisco (1581–1619), the latter by Martín de Oviedo, both of which were closely based on Andalusian models; the *Mudéjar*-style brick and timber church of S Miguel (1612), its tower later painted to resemble stonework; and the groin-vaulted churches of S Domingo (1583–1628) and S Augustín (1590–1632). Among civil buildings constructed in La Plata are the famed Casa de Moneda (1592), the spacious Casa Consistorial (*c*. 1600), the Casa del Gran Poder (1630) and some early buildings of the Universidad Boliviana Mayor, Real y Pontificia de S Francisco Xavier, founded in 1624.

The influence of the Baroque was apparent from *c*. 1630 in Latin-cross ground-plans, frequently with timber domes at the crossing. Building methods remained largely unchanged, although adobe churches became less frequent. Single Roman barrel-vaulted naves, Gothic cross-vaulting (especially for subsidiary naves of three-naved churches) and *Mudéjar* coffered roofs all continued but with less inventiveness from the middle of the century. Surfaces other than stone were whitewashed or painted in earthen colours, but from the beginning simplicity of construction or spatial expression was accompanied by highly decorated interiors, with altarpieces, panels, framed pictures and pedestals, all in painted and gilded timber often enriched with precious metals. Such exuberant expression of evangelical success is heralded but rarely matched by the exterior splendours of the portal ensem-

2. Cloister in the sanctuary at Copacabana, early 17th century

bles, which became increasingly expressive of the Baroque spirit. The most notable examples were also in La Plata, including the transitional monastery churches of S Clara (1639) and S Teresa (1665), the latter by the architect–friar Pedro de Peñaloza, and the church of the Hospital de S Bárbara (c. 1663), perhaps the finest regional example in the early Spanish Baroque tradition. The Universidad de S Francisco Xavier retains its two-storey cloister of 1697 with typical Doric and Ionic orders, in which the rhythm of the upper-storey arcade is doubled, a lightness of touch not seen in earlier buildings. Spandrel panels show the persistence of *Mudéjar* influence on Spanish models. Civil buildings built in La Plata at the end of the 17th century include the Palacio Torre Tagle and the Palacio Arzobispal, both with two-storey stone portals with sculptural decoration.

(b) Mestizo Baroque to Neo-classicism, 1690–1825. By the late 17th century regional culture and techniques had so overlaid the imported early Baroque trends as to produce, along a strip from Arequipa in Peru to Lake Titicaca and right across the Bolivian highlands, a recognizable regional style, the MESTIZO Baroque, which was derived from the synthesis of European, particularly Spanish, culture with resurgent indigenous traditions. Towards the end of the 17th century the indigenous taste for low-relief decoration received greater impetus through the influence of the CHURRIGUERESQUE style from Spain. Largely disposed in surface decoration, the motifs of Mestizo Baroque combine elements of the Christian pre-Renaissance and Mannerist traditions with the non-figural geometrical patterns of *Mudéjar* origin and images of tropical flora and fauna. Unlike European Baroque, there is no concern with innovative ground-plans nor any attempt at chiaroscuro effects in the decoration, which is archaizing in character and largely planiform. Rather, it is the *horror vacui* of the Baroque that makes for the near filigree effects of the characteristic style.

Bolivian Mestizo Baroque developed and reached its apogee in the silver-mining town of Potosí. At the height of its prosperity the town boasted some 30 churches and monastic establishments. The Carmelite church of S Teresa (founded 1685), Potosí, is one of the earliest of the Mestizo Baroque churches: the archaic pedimented tympanum above the door to its nunnery is dated 1692, although the brick and stone whitewashed façade of the church is probably a little later. It is a fine example of a 'flying façade', in which a two-storey belfry with three arches, framed by single twisted columns, stands atop the façade of the church itself. In the same category is the church of La Compañía (1700–07), Potosí, by the Indian stonecutter Sebastián de la Cruz, one of the most notable of Bolivian colonial buildings. The vigorous decoration of the portal and coupled spiral columns flanking the niche above it stands boldly against the plain surface of rose-coloured stone. A finely hewn façade with a bold two-storey belfry surmounting it together rise to 35 m above street-level. The works of de la Cruz, who also began the church of S Francisco (1704–14), Potosí, were completed after his death by Indian craftsmen colleagues Joseph Augustín and Felipe Chavarria. S Bernardo (1725–31) and El Belén (1725–50), both in Potosí, are by the local

architect Fernando de Rojas Luna, who also influenced the design of S Benito (1711–44), one of many Latin American buildings of the period inexplicably decorated with classical figures. S Lorenzo (1728–44), Potosí, by an anonymous architect, has been acclaimed as the ultimate expression of the Mestizo Baroque: cruciform in plan, it has a dome at the crossing and half-domes over transepts and apse. Its façade consists of two towers and a central pediment (restored late 19th century), below which the portal (see fig. 3) is sheltered under an arch of great depth that spans the area between the towers, seeming to continue the vault of the nave. The highly original portal decoration includes 'Indiatids' and mermaids playing the *charango*, a mestizo stringed instrument, on either side of a niche above the entablature.

Notable contemporary and somewhat later churches remain in La Paz: S Francisco (1744–84) is similar to churches in some of the nearby Titicaca settlements but, unlike them, is on a rectangular (three-aisled basilican) plan: plates of alabaster used in the original windows are still preserved in the church; slightly earlier, mid-18th century S Domingo served throughout the 19th century as the city's cathedral. In Sucre (formerly La Plata) the only extant portal in the Mestizo Baroque style is that of the church of Las Monicas (c. 1740). Elsewhere, well-known examples include the church at Arani (1745) in the Cochabamba Valley, designed by Lucas Cabral, and churches at Sicasica (1725) and Guaqui (1784) in the highlands.

With the notable exception of the early Casa Vicaria (1615), Potosí, distinguished civil architecture is mainly

3. Portal of S Lorenzo, Potosí, 1728–44

later in date. The monumental Casa de Moneda (1759–72), Potosí, by Salvador Villa and Luis Cabello, has domes, high-arching roofs, three large courtyards and many outbuildings. The many fine mansions and houses are usually of two storeys and intimate in scale; they form a continuous streetscape but have spacious patios behind. Notable examples of secular architecture in Potosí, all from the last quarter of the 18th century, include the portal and bold decoration of the Casa de Otavi (1750–85; now the Banco Nacional de Bolivia); the filigree surface decoration matching the dignity of its official occupant of the Casa del Corregidor; and the lacelike carving around the neo-*Mudéjar* portal of the Casa de Herrera (now part of the university). The manorial houses of La Paz, such as the Casa Villaverde (*c.* 1755), built for the marquis of the same name, and the three-storey Palacio de Diez de Medina (1775), have particularly fine courtyards.

The mid-18th-century architecture of the Jesuit *reducciones* in the regions inhabited by the Moxos and Chiquitanos Indians, in the eastern and north-eastern plains respectively, was much influenced by the designs of the corresponding missions to the Guarani Indians in Paraguay and Argentina, where Giovanni Battista Primoli worked in the 1730s. The principal buildings, typically a church with free-standing belfry, a college and a miserere chapel, face on to a square with a monumental central cross and a subsidiary cross or open shrine at each corner. Churches follow the Jesuit rectangular plan and here have a nave and two aisles with adobe walls set back inside the outer rows of timber columns, which support the wide eaves necessary in areas of heavy rainfall. The most important of these are the mission buildings of the Chiquitanos group, designed by the Jesuit architect–priest MARTIN SCHMID, who came to Bolivia in 1730, including S Javier (1749–53), Concepción (1768) and S Rafael (1749–53), all showing the influence of Schmid's native Bavarian Rococo.

By the late 18th century, there were signs of a move away from the exuberance of the regional style in churches such as S Teresa, Cochabamba, and S Felipe Neri, Sucre, both of transitional Neo-classical design. The Mestizo Baroque disappeared from the cities, but classicizing designs were still much affected by the strong Baroque tradition, and portals and other features retained their Baroque character in both form and decoration well into the 19th century. Under the influence of France, however, there was a return in the new century to the High Renaissance models of Jacopo Vignola and Palladio, precisely coinciding with the turbulent events surrounding Bolivian independence.

BIBLIOGRAPHY

Fernández: *Relación historial de las misiones de Indios Chiquitos* (Madrid, 1726)
A. Ramos and R. Sans: *Historia de Copacabana* (La Paz, 1860)
V. Martinez: *Anales de Potosí* (Potosí, 1925)
J. Rosquellas: 'La arquitectura en el Alto Perú', *Bol. Soc. Geog. & Hist. Sucre*, xii (1925)
G. Angel: 'El estilo mestizo o criollo en el arte de la colonia', *Congreso internacional de historia de América: Buenos Aires, 1938*, iii, pp. 474–94
M. J. Buschiazzo: *Impresiones sobre Bolivia* (Buenos Aires, 1939)
E. Harth-Terré: 'La obra de la Compañía de Jesús en la arquitectura virreinal peruana', *Mercurio Perú*, xxx (1942), pp. 57–8
M. de Castro: 'La arquitectura barroca del virreinato del Perú', *Rev., U. La Habana*, xvi–xviii (1943–4) [special issues]
P. J. Vignale: *La Casa Real de Moneda de Potosí* (Buenos Aires, 1944)
E. Harth-Terré: *Artífices en el virreinato del Perú* (Lima, 1945)
H. Velarde: *Arquitectura peruana* (Mexico City, 1946)
A. Neumeyer: 'The Indian Contribution to Architectural Decoration in Spanish Colonial America', *A. Bull.*, xxx (1948), pp. 104–21
P. Kelemen: *Baroque and Rococo in Latin America* (New York, 1951), pp. 186–91
H. E. Wethey: 'Hispanic Colonial Architecture in Bolivia', *Gaz. B.A.*, n. s. 5, xxxix (1952), pp. 47–60
——: 'La última fase de la arquitectura colonial en Cochabamba, Sucre y Potosí', *A. América & Filipinas*, ii/4 (1952), pp. 21–42
D. Angulo Iñiguez and others: *Historia del arte hispano-americano* (Barcelona, 1956), iii, pp. 471–574
H. E. Wethey: *Arquitectura virreinal en Bolivia* (La Paz, 1960)
L. Castedo: *A History of Latin American Art and Architecture* (New York and London, 1969)
T. Gisbert and J. de Mesa: *Monumentos de Bolivia* (La Paz, 1978)
L. Castedo: *Precolombino: El arte colonial* (1988), i of *Historia del arte iberoamericano* (Madrid, 1988), pp. 271–80
J. de Mesa and T. Gisbert: 'La arquitectura virreinal en Bolivia', *Arquitectura colonial iberoamericana*, ed. G. Gasparini (Caracas, 1997), pp. 319–54
R. Gutiérrez, ed.: *Barroco iberoamericano* (Barcelona and Madrid, 1997)

PEDRO QUEREJAZU

2. AFTER 1825.

(i) Neo-classicism to Eclecticism, 1826–1952. (ii) Modern to Post-modern, after 1952.

(i) Neo-classicism to Eclecticism, 1826–1952. Development in Bolivia was set against an unstable political background for more than half a century after independence (1825). Neo-classicism came relatively late and by the early 19th century had developed characteristics more typical of 17th-century Italian Baroque: plain surfaces remained, though sometimes touched with an element of the Rococo in the style and distribution of decoration. This is well exemplified in the early work of MANUEL DE SANAHUJA, the Franciscan architect–friar who went to Bolivia in 1808 to design Potosí Cathedral, which was completed in 1838 after his death. Although Sanahuja's name is associated with Neo-classicism, the façade owes little to classical principles. Severe square towers are drawn up into tall octagonal towers with ogee cupolas of neo-Gothic origin and are linked by a Rococo gable. The plain surface of the gable is pierced by three deeply arched portals, each with a simple lunette above it. In 1830 Sanahuja was in La Paz working on a new retable for the church of La Merced and was commissioned to design the city's new cathedral (for illustration *see* LA PAZ). This is in a purer Neo-classical style, though still reminiscent of Baroque: only the first storey of the façade was completed before his death. Santa Cruz Cathedral was begun in 1832 under the direction of the French engineer Philippe Bertrés, in local bricks with a timber vault. Within the limits of the materials it is Neo-classical in form, but it retains vestiges of Mestizo Baroque in the cutting of stone and the decoration, as do a number of contemporaneous churches built near cities in that decade, such as that at Viacha, near La Paz. The monastery of the Tercera Orden Franciscana (1833), La Paz, by Vicente Loayza has been described as *arquitectura crucista*, after Andrés de Santa Cruz, who was the Bolivian leader between 1829 and 1839. It is an elegant Neo-classical design, with more stylistic interest than later, more academicist buildings. The period of the 1830s is also rich in civil buildings, for example the Casa del Mariscal Andrés de Santa Cruz (now the S Calixto College), the Casa del Repositorio Nacional and the triumphal arches dedicated

to Santa Cruz, all in La Paz, and the commemorative column at Potosí. In 1832 Bertrés with José Núñez del Prado established the first school of architecture in La Paz, disseminating a somewhat sober French Neo-classicism. Among its early manifestations are Núñez del Prado's Teatro Municipal (1834–45) and the three-storey Palacio del Gobierno (1845–52), both in La Paz. Both architects also continued work on La Paz Cathedral.

The Neo-classical style persisted up to and beyond the middle of the century: the commemorative Capilla Redonda (1850), Sucre, for example, is firmly based on Palladian models. Thereafter Bolivian architecture slowly began to mirror the eclecticism of the European architecture, as is evident in the Banco Nacional, Sucre, by the Swiss-born ANTONIO CAMPONOVO, who came to Sucre from Argentina in 1872 to carry out the project: it is in the manner of the early Renaissance though with Gothic overtones. A little later Eulalio Morales introduced a full-blown Gothic Revival style in La Paz in the churches of S Calixto (1882) and La Recoleta (1884–94). Camponovo worked on the Palacio de Gobierno (begun 1892), Sucre, one of the more successful revivals of French urban Louis XV style. As in Paris, the neo-Baroque style was used in Sucre for its opera and *zarzuela* (musical comedy) house, the Teatro Gran Mariscal Sucre; a scaled-down version of the Eiffel Tower was erected in the capital's Alameda pleasure gardens as tribute to French engineering, alongside the obelisks, triumphal arches and artificial lakes. The century ended with the French academic style in the ascendancy: it is exemplified by Eduardo Doynel's Banco Argandoña, Sucre, and in country houses (*quintas*) outside the capital, such as La Florida, Ñucchu and Camponovo's El Guereo, all with their formal landscaped gardens. Throughout the 19th century Franciscans from Potosí and Tarija continued to build missions among the Chiriguano Indians in the southern and eastern plains.

By 1900 Camponovo had completed the Palacio de la Glorieta, the finest residence in Sucre and a virtuoso demonstration of eclectic design with elements of the Romanesque, Renaissance and *Mudéjar* as well as Neo-classical. At La Paz Cathedral he was appointed as Eulalio Morales's successor; he reverted to the spirit of Sanahuja's original design: he added the second storey to the façade and finished the interior, using a Corinthian order, and he constructed the cupola over the crossing, completing the cathedral but for the upper parts of the towers by 1905. At the same time he built the Palacio Legislativo (1900–08), La Paz, a work of academic Neo-classicism elegantly articulating the principal elements of Senate and Chamber of Deputies. In 1909 he redesigned the façade and interior of the Teatro Municipal, La Paz. The first manifestation of the search for a national architecture also dates from this time, the La Paz house (1909) built by the archaeologist Arturo Posnansky (1878–1946) for himself in the style of the Pre-Columbian site of Tiahuanaco (now Museo Nacional de Arqueología). At this time also the earliest architectural uses of iron occurred: wrought-iron balconies and windows appeared in houses in La Paz, as did iron-framed glazing over inner circulation areas in residential blocks. Prefabricated iron buildings, such as the Aduana Nacional (1915–20), La Paz, erected by Miguel Nogué, and the modular Colegio Militar, La Paz, were imported

from abroad, the former from Philadelphia, the latter from France.

French academicism continued in La Paz and elsewhere in such buildings as Adán Sánchez's Palacio de Justicia (1919), in the Palais Concert theatre (1930), Oruro, and, perhaps more importantly, in the earlier work of EMILIO VILLANUEVA, the most distinguished mid-20th-century Bolivian architect. In La Paz, Villanueva designed the Banco Central de Bolivia, the Hospital General (late 1920s and early 1930s) and the Alcaldía Municipal, with its mansard roofs and towers of 17th-century French influence. Although Villanueva's spatial design displays an incipient mid-century European rationalism, his continuing eclectic attitude led him also to seek a national style in the culture of Tiahuanaco, seen in such buildings as the Universidad Boliviana Mayor de 'S Andrés' (1940–48), La Paz, for which he adopted a sculpturesque concept based on the monoliths of Tiahuanaco. Villanueva founded the first Faculty of Architecture in the country, at the University of La Paz in 1943. A nostalgic return to neo-colonial and Hispanic models is revealed in such buildings as the Estación de Ferrocarril (1947) by Mariaca Pando and Mario del Carpio's contemporary Caja Nacional de Seguro Social, both in La Paz.

(ii) Modern to Post-modern, after 1952. There was a hiatus in architectural activity following the successful left-wing revolution in 1952. Industries were nationalized, and rural migrants settled in self-built *ranchos* around the expanding cities, Santa Cruz in particular. The consequent need for extensive building programmes created a growing economic dependence on North America. The result was rapid urban development with anonymous international Modernist buildings designed outside Bolivia. Triumphal revolutionary zeal eventually found expression in the Monument to the National Revolution (1960), La Paz, an impressive work by the sculptor–architect Hugo Almaraz, inspired by Pre-Columbian architecture. Design in the 1960s, however, followed European Rationalist ideals in buildings such as La Papelera and the headquarters of Yacimentos Petrolíferos Fiscales Bolivianos, both in La Paz and both by Luis Perrin and Luis Iturralde. By 1970 a more contextual organic architecture had been developed by graduates of the post-revolutionary years; one such was Marco Quiroga, whose Casa Kyllman, La Paz, is an early example; another was the American-trained Juan Carlos Calderón, who has designed many major buildings: the HANSA headquarters building (1975), the Plaza Hotel (1976), the Illimani and S Teresa residential blocks (1979 and 1980) and such major government buildings as the Edificio Nacional de Correos (1983) and the Ministerio de Transportes y Comunicaciones (1975–90), all in La Paz.

The best-known member of this school is GUSTAVO MEDEIROS, although his work leans towards a late Brutalist expression in brick and board-marked concrete. It began with his own highly original house (1970), La Paz, and other unique houses, such as the Casa Buitrago (1982; see fig. 4), La Paz, a double-coded, almost Post-modernist design, in response to his client's wish for a neo-Georgian house. The commission is brilliantly interpreted in a multi-layered angular composition, in brick and concrete with

4. Gustavo Medeiros: Casa Buitrago, La Paz, 1982, view from the north-west

steep, tiled roofs, backing almost directly on to a canyon wall above La Paz. His most widely discussed work is the Ciudad Universitaria (begun 1970; Faculty of Engineering completed 1982), Oruro, on a flat riverside site near Lake Poopo. Here Medeiros's aim was to combine innovation with tradition while subscribing to a clear contextualist relationship between the low brick and concrete buildings, with their oblique references to Pre-Columbian models, and the view across the river to the city. Post-modernism tinges the later work of both Calderón and Medeiros and was also more self-consciously adopted in the 1980s by such younger architects as Roberto Valcárcel (*b* 1951), for example in his Casa Morales (1985), La Paz.

BIBLIOGRAPHY
E. Villanueva: *Urbanística: Práctica y técnica* (La Paz, 1967)
L. Castedo: *A History of Latin American Art and Architecture* (New York, 1969), pp. 202–16
G. Medeiros: *Oruro: Su ciudad universitaria como factor del desarollo regional y urbano* (La Paz, 1975)
T. Gisbert and J. de Mesa: *Monumentos de Bolivia* (La Paz, 1978)
R. Gutierrez: *Arquitectura y urbanismo en Iberoamerica* (Madrid, 1983)
C. D. Mesa: *Emilio Villanueva: Hacia una arquitectura nacional* (La Paz, 1984)
G. Medeiros: 'Bolivia: Inovación y adaptación', *Summa*, 232 (1986), pp. 334–9
L. Castedo: *Siglo xix, siglo xx* (1988), ii of *Historia del Arte iberoamericano* (Madrid, 1988), pp. 37–9, 219–21
M. Cuadra: *Arquitectura y proyecto nacional: Los siglos XIX y XX en los paises andinos* (Buenos Aires, 1989)
Cien años de arquitectura Paceña, Colegio de Arquitectos (La Paz, 1990)
L. Iturralde: *Medio siglo de obra arquitectónica, 1931–1981: Historia ilustrada del inicio y desarrollo de la arquitectura contemporánea en Bolivia* (La Paz, 1994)
P. Querejazu: 'El estilo neocolonial en Bolivia', *Arquitectura neocolonial: América Latina, Caribe, Estados Unidos*, ed. A. Amaral (São Paulo, 1994), pp. 193–204

PEDRO QUEREJAZU

III. Painting and graphic arts.

1. 1534–1825. 2. After 1825.

1. 1534–1825. During the Viceroyalty (1572–1825) there were three major influences on painting in Bolivia: the Italian, which was very intensive during the 16th century and the early 17th and which regained strength in the late 18th century through Neo-classicism; the Flemish, an enduring influence from the beginning through the importation of paintings and drawings; and the Spanish, in the 17th-century Baroque period, through the school of Seville and in particular the school of Potosí. This period can be divided stylistically into the following stages:

Renaissance to Mannerism (*c.* 1534–*c.* 1630); Baroque (*c.* 1630–*c.* 1700); Mestizo Baroque (*c.* 1700–*c.* 1790); and Neo-classicism (*c.* 1790–*c.* 1825). This division does not mean, however, that particular features did not survive and develop from one period to another. In the first stage Spanish, Italian and Flemish paintings and such materials as canvas, panel and copper-sheeting were imported in substantial quantities. Graphic art, imported in the form of large series of European and especially Flemish prints and illustrated books, circulated throughout the country and was important in the dissemination of subject-matter. No local workshops are known in the Audiencia de Charcas however, although there is a painting on a printing plate in Potosí by the Italian MATEO PÉREZ DE ALESIO, who was active in Lima. The characteristics of Mannerism, such as elongated, elegant figures, bright, cool colours and centralized compositions, can be seen in such works as the *Adoration of the Shepherds* (*c.* 1590; Sucre Cathedral) by BERNARDO BITTI and the *Magdalene* (1582; Sucre, Charcas Mus.) by Antonio Bermejo (*b* 1588) and in the works of Gregorio Gamarra and Montufar (both *fl* 1601–42).

The Baroque period was characterized by the enduring Flemish influence in its rich colouring, refined pictorial technique, large compositions and grandiose settings. The Spanish influence, however, as defined by Zurbarán's work, was also evident in the choice of subject-matter and in such stylistic features as the introduction of tenebrism and realism, the interest in the figure and the sobriety and warm chromatic range of the school of Seville, a tendency evident, for example, in the *St Michael* (1634; La Paz, Mus. N.A.) by Diego de la Puente (1586–1663). The schools formed during this period defined the particular spirit of each region and town: they included the school of Cuzco, which had a great influence on Bolivian Mestizo Baroque; the school of Lake Titicaca (also known as the school of Collao), which encompassed La Paz, the surrounding towns and the shores of Lake Titicaca; the school of La Plata, in what is now Sucre; and the school of Potosí. There was also the religious art of the Jesuit missions of Moxos and Chiquitos. Wall painting underwent a great development in the MESTIZO Baroque period, featuring decorative themes and religious and pagan history. Examples of this are in the churches in Callapa and Carabuco, in the department of La Paz, in Curahuara de Carangas, department of Oruro, and the church of SS Michael and Raphael in Chiquitos, department of Santa Cruz. Mestizo Baroque was a conceptual style full of symbolism, which did not treat space and perspective realistically. In the school of Lake Titicaca, South American originality became prominent for the first time. Its main exponents included Leonardo Flores (*fl* 1665–83), José López de los Ríos (*fl* 1670) and the Master of Calamarca (*fl* 1670–1700), all of whom painted large-scale works and treated their subjects in an individualistic manner. In the *Last Stages of Man* in the church in Carabuco, López de los Ríos drew inspiration from Baroque allegorical religious plays (*autos sacramentales*). In *Archangels Armed with Arquebus* in the church at Calamarca, the Master of Calamarca presented the forces of nature in the form of angels, dressed as army officers and knights of the period.

The work of the school of Potosí, with its characteristic tenebrism and realism and themes centering on the human figure, shows the marked influence of Spanish art. Important 17th-century painters there included Francisco de Herrera Velarde (*fl* 1650–70), who painted *St Francis Solano* (Potosí, S Francisco), and Francisco López de Castro (*fl* 1674–84), known for the *Immaculate Virgin* (Sucre, Charcas Mus.). Melchor Pérez de Holguín was a major figure during the late 17th century and the first third of the 18th, painting such works as the *Nativity* in the church of S Teresa, Potosí. Exponents of the Mestizo Baroque in Potosí included Gaspar Miguel de Berrio (1706–62) and Luis Niño (*fl c.* 1720), to whom is sometimes attributed the *Virgin of the Hill* (see fig. 5), in which the Virgin's spreading skirts are depicted both as a hill of silver mines and as the fertile land of Pachamama. There was a simultaneous interest in the depiction of cities, as in *Potosí* (1758; Sucre, Charcas Mus.) by Berrio and *La Paz* (1781; La Paz, Alcaldía) by Olivares. Although there are no known prints from this period, at Potosí copperplates survive from members of the school of Lake Titicaca at Juli, where the Jesuits had a press. These, however, have been re-engraved and used as supports for painting. The only copperplate to have been preserved from this period is the *Virgin of Cocharcas* (*c.* 1700; La Paz, Mus. N. A.), by an anonymous indigenous local artist.

Neo-classicism in Bolivia mixed elements of metropolitan Baroque with Rococo, especially in the centres of La Plata (now Sucre), Cochabamba, Potosí and La Paz, but this did not reach rural areas. The important painters of this period were Manuel Gumiel, Oquendo, the Master of Moxos and La Plata, Balcera in Potosí and Diego del Carpio in La Paz.

5. Luis Niño (attrib.): *Virgin of the Hill*, oil on canvas, 1.37×1.05 m, *c.* 1720 (Potosí, Museo Nacional de la Casa de Moneda)

2. AFTER 1825. The quality of artistic production in Bolivia declined following independence. In official quarters attempts were made to deny the past of the Viceroyalty, and French academic art was taken as a model. This soon led to a cultural division between those in positions of social or economic power and the middle and lower classes, who maintained a cultural tradition linked to the Baroque period of the Viceroyalty with which they identified. The academic painters included MANUEL UGALDE, ANTONIO VILLAVICENCIO and JOSÉ GARCÍA MESA. Popular art took the form of small-scale images, votive offerings and domestic items, made by such artists as Joaquín Castañón (*fl* 1853). In this period MELCHOR MARÍA MERCADO was exceptional. A self-taught painter, he produced more than 100 watercolours depicting his environment, in particular the customs of the Indians and mestizos.

Little change occurred in the first decade of the 20th century. When La Paz became the capital and the seat of government it was, like Sucre, the location for urban and cultural renewal. Mural paintings of romantic scenes drawn from European photographic prints became a fashionable feature of interior decoration. Angel Dávalos (1871–1953) and ARTURO BORDA were active in this bohemian atmosphere, and AVELINO NOGALES worked for a period in Potosí and Cochabamba, where the same kind of activity was taking place as in Sucre and La Paz but on a smaller scale. Landscape as subject-matter was gradually introduced into Bolivian painting, as in the urban scenes of José García Mesa and the colourful patios full of flowers and rural scenes of Nogales. The reinterpretation of history and the depiction of moralistic allegories were other recurrent subjects from the end of the 19th century, particularly in the work of Dávalos, who painted portraits of all the national heroes and liberators. Dávalos also designed the emblems of Bolivia and all its departments, which were then lithographed and officially adopted. His other works included urban landscapes and delightful still-lifes, in which he was influenced by contemporary literature. In the early 20th century Borda was an influential figure; although self-taught, he achieved great success as a painter of technical accomplishment and stylistic versatility. While his portraits of members of his family show affinities with Hyperrealism and Surrealism, and while he also depicted native and social themes, another of his great concerns was landscape, in particular Illimani, the snow-covered mountain of La Paz, which he painted many times (see fig. 6).

In the 1920s and 1930s local artists were influenced by the many foreign painters who went to Bolivia, notably JUAN RIMSA, a Lithuanian who arrived there in 1937 and stayed until 1950 (when he went to Mexico, before settling in California, USA). He helped to introduce Expressionism, and he was prolific in his dramatic depictions of the Andean landscape and people. He also trained a whole generation of painters in Sucre, Potosí and La Paz. There were also developments in the graphic arts in the 1930s, although the only outstanding figure was the engraver Genaro Ibáñez. The Bolivian artist whose work best represents the first half of the century was CECILIO GUZMÁN DE ROJAS, who studied painting first under Nogales and then in Europe, where under the influence

6. Arturo Borda: *Illimani*, 1932 (La Paz, Museo Tambo Quirquincho)

of Julio Romero Torres (1880–1930) he began depicting Bolivian native themes in a style that combined Art Nouveau, Art Deco and indigenous Bolivian realism. After returning to Bolivia, Guzmán de Rojas held several official positions, through which he helped to establish Indigenism as the official style of Bolivian art. Indigenism became popular among high society and the wealthy classes, who ignored the social and economic problems that lay behind it. It nevertheless played a part in the slow process of national awareness that characterized Bolivian art in the 20th century. ARMANDO JORDÁN, a self-taught painter active in Santa Cruz, painted landscapes and depicted the customs and people of the region in the 1940s and 1950s, when it was comparatively isolated. He invented a technique of retouching photographs of his paintings to produce *fotoleos* (oil-photos), which he valued more highly than the original paintings.

In the 1950s a period of renewal began, heralded by the deaths of Guzmán de Rojas and Borda in 1950 and 1953 respectively and by political and economic changes instigated by the National Revolution. The generation of artists that began working in this decade is known as the Generación del '52. This grew out of the Anteo group, formed in 1950 in Sucre, which comprised artists, writers and intellectuals under the overall sponsorship of the Universidad de Chuquisaca, where many of the young artists of the new generation received their training. Another influence was the work of Rimsa. The group's aesthetic and ideological postulates were embodied in the

1950s and 1960s in government programmes promoting the fine arts as well as representing their personal artistic principles. A vigorous mural-painting movement arose that had undeniable connections with the Mexican movement (*see* MURAL) and expressed Marxist political doctrines. Allegorical murals of moral, pedagogical content, which depicted the Pre-Columbian period as an era of untroubled peace and happiness, were painted on the walls of public buildings, universities and schools. The leading proponents were members of the Anteo group: Solón Romero (*b* 1925), GIL IMANÁ, Lorgio Vaca Durán (*b* 1930) and other independent artists in La Paz, such as Miguel Alandia (1914–75). Their principal subject-matter was the social and economic defence of the factory worker, the miner and the Indian, and they depicted figures en masse with grandiloquent gestures, using distorted perspective to emphasize the historical, revolutionary message, as in Lorgio Vaca Durán's triptych *Public Demonstration* (1963; La Paz, Mus. N. A.).

At the same time another group of artists sought to achieve a more universal language for Bolivian art, trying to open it up to international trends, notably the Abstract Expressionism of the New York school. They became known as 'abstract' painters despite their wide range of responses and varying degrees of abstraction. Artists associated with this movement include Armando Pacheco (*b* 1913) and MARÍA LUISA PACHECO, who was greatly influenced by her period of study in Europe but whose gradual evolution towards stylization and abstraction were

reaffirmed in her participation in the São Paulo Biennales and, later, in her move to New York. The first exhibition of abstract art was held in La Paz in 1956. Most Bolivian artists, however, including those termed 'abstract', showed a strong feeling for their native land, which was incorporated into their paintings with varying degrees of subjectivity. María Luisa Pacheco created a lyricism of colour, structure and material that recalls the light and landscape of the Andes, while Oscar Pantoja (*b* 1925) pursued a poetic use of subtle colours in abstract, mystical works that often include reminiscences of ancestral Andean cultures.

A third tendency sought to deal with characteristic national themes such as the Bolivian landscape, the urban dweller and the Indian in a style that was not ideologically committed to the revolution nor sufficiently unconventional or stylized to be considered abstract. Its adherents included numerous artists of very different aesthetic and ideological positions who wanted to find points of contact with other Latin American art. Many of them oscillated between the polarized trends of abstraction and social realism. Although apparently stifled at first by the vigorous activity and production of the followers of these other movements, this third trend slowly gained ground, especially in the late 1960s, and gradually became dominant. Artists associated with it include Fernando Montes (*b* 1930), Luis Calderón Zilveti (*b* 1941) and ENRIQUE ARNAL, whose subject-matter included the stony landscape of the Andes, mines, the inns and markets of La Paz, condors and, later, female nudes. In La Paz a large group of artists depicted the landscape of the towns of the highlands, distant mountains and displaced people, while in such cities as Cochabamba, Sucre and Potosí landscape painting became rather bucolic. Herminio Pedraza (*b* 1935), working in Santa Cruz, made expressive use of colour in his paintings, while other artists idealized the landscape, and still others used signs and symbols in interesting reformulations of the spatial concepts implicit in indigenous textiles and of the symbolism of the *munachis*, the magic amulets with which the Indians sought to secure good fortune. A little later, within the same movement, an interest in mestizo cultural expressions, popular traditions and folklore developed, resulting in portrayals of a fantastically distorted reality in which ordinary people were suddenly transformed into the heroes of a magical, dramatic universe.

In the 1980s there was a sense of exhaustion at the diatribes of the social realists and at the proposals of the abstract painters, most of whom had turned to figurative art or disappeared from view. Changes in the social and economic situation gradually led to economic depression; cities increased dramatically in size while rural areas were depopulated. New industries arose, and previously remote areas such as Santa Cruz rose to prominence. In this context art also sought new directions. There was a feeling of disillusionment with the annual art competitions, while art galleries increased in number. The biennial exhibitions organized from the second half of the 1970s by INBO (Inversiones Bolivianas) gave encouragement and impetus to those seeking new artistic ideas. Many artists of this new generation trained outside Bolivia and gained a fresh inspiration for their work, and there was a great development in techniques and materials as artists worked with new processes to produce experimental art using *objets trouvés* and other non-traditional materials. Forms of conceptual art and Arte Povera developed alongside happenings and performances, drawing was re-evaluated as a medium in its own right, and photography developed significantly. However, because of limited access to advanced technical means, artists were somewhat timid in making use of modern technology. The generation that succeeded the Generación del '52 took as its subject-matter everyday urban themes, such as passengers on public transport, seated mestizos selling their wares in the markets, the despair of the Indian who had moved to the city and lost a sense of identity, victims of political persecution, students, prostitutes, cocaine sellers and their victims. The aim was still a criticism of society but more subtle than in the work of the Generación del '52. A notable artist of this period was Roberto Valcárcel (*b* 1951), whose social analysis and criticism were deeply probing. Gastón Ugalde (*b* 1946) reformulated Indigenism, while Fernando Rodríguez-Casas (*b* 1946) was concerned with the third and fourth dimensions and problems of perspective.

For bibliography *see* §IV below.

IV. Sculpture.

The three main stylistic periods of sculpture are Mannerism (*c.* 1534–*c.* 1630), Realism (*c.* 1630–*c.* 1680) and Hyperrealism (*c.* 1680–*c.* 1790), the last two originating in Seville and being roughly contemporaneous with the Baroque and Mestizo Baroque periods in painting and architecture. With the arrival of Neo-classicism, sculpture declined and became comparatively undistinguished. The importation during the Viceregal period of Spanish carved, polychromed works such as the *Virgin of La Paz* (1550; La Paz Cathedral), by an unknown artist, or the *Immaculate Virgin* (*c.* 1620; Oruro Cathedral), by Juan Martínez Montañés, provided models, especially for Indian sculptors. Sculpture workshops were formed, in which artists worked on techniques that became characteristic of each region, such as the pasteboard made of agave fibre combined with cloth and glue that was used in the workshops of Copacabana and La Plata (now Sucre). The majority of master craftsmen in the Mannerist period were Spanish, such as the Galván brothers, who executed the main retable (1582) of the church of La Merced in Sucre, and Diego Ortiz, the sculptor of *Christ of La Recoleta* (1580) in Cochabamba. Italian artists such as BERNARDO BITTI and ANGELINO MEDORO were also active in this period, as were the Copacabana sculptors Francisco Tito Yupanqui, who carved the *Virgin of Copacabana* (1582) in the shrine there, and Sebastián Acosta Tupac Inca, who made the retable of Copacabana (1618).

The two principal centres of Realism were La Plata and, in particular, Potosí, where the Sevillian sculptor Gaspar de la Cueva produced such works as the *Christ of S Lorenzo*, still in Potosí, and another Spaniard, Luis de Espíndola, made the retable of St Anthony (Potosí, S Francisco). After their deaths, sculpture remained entirely the work of anonymous indigenous and mestizo artists,

one of whom made the *St Michael of Chiquitos* (*c.* 1760; Santa Cruz). They formed semi-industrial workshops, which in the Hyperrealist period produced numerous articulated works with clothing, glass eyes, natural wigs and other details. These works included the images of St James that are found in many churches. During the Mestizo Baroque period Hyperrealist sculptures of groups or scenes were common, for example the Christmas crèches with miniature figures and those representing the events of Holy Week. The same period also featured the development of large-scale retables, richly decorated in gilt or polychrome, which covered the main walls of churches and which at times were extended laterally, forming an ensemble with the pulpits and the frames of the large canvases on the side walls. Examples of this are the main retable (*c.* 1700) at Copacabana, the *Calvary* retable (*c.* 1765; Sucre, S Miguel) by the Indian Juan de la Cruz and the main retable (*c.* 1775) in Arani (Cochabamba) by the Master of Arani.

In the 19th century mainly popular sculpture was produced. By the early 20th century French and Italian works in marble and bronze were imported for the decoration of public buildings, residences and offices. The establishment in 1926 of the Academia de Bellas Artes in La Paz was of major importance in the development of modern Bolivian sculpture. Such sculptors as Alejandro Guardia (*b* 1897), Emiliano Luján (1910–74) and MARINA NÚÑEZ DEL PRADO all studied there and trained in the style of Indigenism. They later developed personal idioms, for example the traditional realism of Luján, who executed some of the most important monumental sculptures in Bolivian art and some of the most notable portrayals of the condor and of death. Marina Núñez del Prado developed from Indigenism to abstraction, working in a great variety of materials, most notably precious tropical wood from the Amazon region and Andean stones. Her subject-matter centred on the female figure (see fig. 7) and symbolic animals and birds. TED CARRASCO, an artist of the Generación del '52, was greatly inspired in his choice of subject-matter by ancestral cultural expressions, imbuing his portrayals with a totemic character. Marcelo Callaú (*b* 1946), active in Santa Cruz, was of the generation that succeeded the Generación del '52. His sculptures in precious tropical wood portray the human figure in harmony with the tropical environment and incorporate geometric optical illusions. These sculptors were all inspired by a feeling for their native soil, by ancestral and mestizo Bolivian cultures and their myths, the mountains, condors, the mystery of life and death and the exuberant and luxuriant world of the tropics.

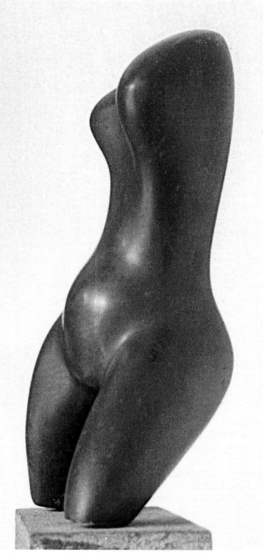

7. Marina Núñez del Prado: *Black Venus*, basalt, 1958 (La Paz, Museo Nacional de Arte)

BIBLIOGRAPHY

P. Kelemen: *Baroque and Rococo in Latin America* (New York, 1951)
R. Villarroel Claure: *Arte contemporáneo: Pintores, escultores y grabadores bolivianos* (La Paz, 1952)
R. Carpani: *Arte y revolución en América Latina* (Buenos Aires, 1960)
T. Gisbert and J. de Mesa: *Pintura contemporánea, 1952–1962* (La Paz, 1962)
M. Chacón Torres: *Pintores del siglo XIX* (La Paz, 1963)
T. Gisbert and J. de Mesa: *El arte en Perú y Bolivia, 1800–1840* (La Paz, 1966)
Art in Latin America since Independence (exh. cat. by S. L. Catlin and T. Grieder, New Haven, CT, Yale U. A.G.; San Francisco, CA, Mus. A.; New Orleans, LA, Mus. A.; and elsewhere; 1966)
G. Chase: *Contemporary Art in Latin America: Painting, Graphic Art, Sculpture, Architecture* (New York, 1970), pp. 115–20
T. Gisbert and J. de Mesa: *Escultura virreinal en Bolivia* (La Paz, 1972)
M. Chacón Torres: *Arte virreinal en Potosí: Fuentes para su historia* (Seville, 1973)
M. Traba: *Dos décadas vulnerables en las artes plásticas latinoamericanas, 1950–1970* (Mexico City, 1973)
D. Bayón: *Aventura plástica de Hispanoamérica: Pintura, cinetismo, artes de la acción, 1940–1972* (Mexico City, 1974), pp. 172–91
T. Gisbert and J. de Mesa: *Holguín y la pintura virreinal en Bolivia* (La Paz, 1978)
D. Bayón, ed.: *Arte moderno en América Latina* (Madrid, 1985), pp. 330–31
G. G. Palmer: *Sculpture in the Kingdom of Quito* (Albuquerque, 1987)
L. Castedo: *Historia del arte iberoamericano*, 2 vols (Madrid, 1988), i, pp. 315–17, 346–50; ii, pp. 221–4
P. Querejazu: *La pintura boliviana del siglo XX* (Milan, 1989)
D. Bayón and R. Pontual: *La Peinture de l'Amérique latine au XXe siècle* (Paris, 1990)
T. Gisbert, J. de Mesa and others: *Bolivian Masterpieces: Colonial Painting* (La Paz, 1994)

P. Querejazu: 'La escultura en el Virreinato de Perú y la Audiencia de Charcas', *Pintura, escultura y artes útiles en Iberoamérica, 1500–1825*, ed. R. Gutiérrez (Madrid, 1995), pp. 257–70
Potosí: Colonial Treasures and the Bolivian City of Silver (exh. cat., New York, Americas Soc. A. Gal., 1997)
R. Gutiérrez, ed.: *Barroco Iberoamericano* (Barcelona and Madrid, 1997)
P. Querejazu: 'El arte en Bolivia entre 1920 y 1960', *Voces de Ultramar. Arte en América Latina: 1910–1960* (exh. cat., Madrid, Casa de América; Las Palmas de Gran Canaria, Cent. Atlántic. A. Mod., 1992), pp. 33–42
——: 'Bolivia', *Latin American Art in the Twentieth Century*, ed. E. Sullivan (London, 1996), pp. 233–47
Arcángeles actuales de Bolivia (exh. cat., London, Mall Gals, 1996)
Entre el pasado y el presente: Tendencias nacionalistas en el arte boliviano, 1925–1950 (exh. cat., Washington, DC, Int.-Amer. Dev. Bank, 1996)

PEDRO QUEREJAZU

V. Gold and silver.

The wealth of silver and gold that was extracted from Bolivian mines from the 16th century, most significantly those at Porco and Potosí, is difficult to quantify, although a study of historical documents in 1971 indicated that between 1556 and 1800 over 22,000 tonnes of silver were mined at Potosí alone. The extravagant displays of the rich merchants and mine operators of the region are legendary: the streets of Potosí were paved with silver bullion in 1658 to celebrate the birth of a Habsburg prince, while as late as 1813, when mining was in decline, the Argentine general Manuel Belgrano (1770–1820) found that the fronts of the houses of Potosí were decorated with gold and silver. In 1737 Juan de Santelices gave the city of Potosí a great silver *carro* (cart) to carry the Host through the streets on the feast of Corpus Christi; it was surmounted by an architectonic canopy and flanked by statues of saints and angels.

Surviving 18th- and 19th-century objects, while not on this scale, are evidence of the great wealth of the region. Baroque foliage and scrolls, often combined with Indian motifs, cover the surfaces of altar fronts and tabernacles, for example those of *c.* 1700 in the church of the Carmine, La Paz, and of *c.* 1700–40 in the parish church at Calamarca. Arrangements of liturgical furnishings such as that in Calamarca, when seen with its statues in place, show the splendour that was intended to impress the visitor. The elaborate foliage decoration of these works is compartmentalized yet nevertheless presents a continuous pattern, broken only by roundels containing figures of saints. As in the silverwork of coastal Peru, Baroque elements continued to be used throughout the 18th century, and the only Rococo influence tended to be the addition of bold rocaille scrolls, based on German printed sources, during the fourth quarter of the 18th century (e.g. altar plaque depicting the *Last Supper, c.* 1780; Sucre, Mus. Catedral). On the other hand, silverwork produced in the 18th century for the Jesuits shows much greater influence of European fashions in design and craftsmanship: an early 18th-century tabernacle, which was acquired by Sucre Cathedral after the Jesuits' expulsion in 1767, has cast and applied figures of clambering putti and winged horses that show little Indian influence.

BIBLIOGRAPHY
A. Taullard: *Platería sudamericana* (Buenos Aires, 1941)
J. A. de Lavalle and W. Lang: *Platería virreinal* (Lima, 1974)
A. L. Ribera and H. H. Schenone: *Platería sudamericana de los siglos XVII–XX* (Munich, 1981)

Temples of Gold, Crowns of Silver: Reflections of Majesty in the Viceregal Americas (exh. cat., Washington, DC, A. Mus. Americas and George Washington U., Dimock Gal., 1991)
J. de Mesa: *La Plata en Bolivia: Introducción a la platería civil* (exh. cat., La Plaz, Mun. de La Plaz, 1992)
Potosí: Colonial Treasures and the Bolivian City of Silver (exh. cat., New York, Americas Soc. A. Gal., 1997)
R. Gutiérrez, ed.: *Barroco iberoamericano* (Barcelona and Madrid, 1997)

CHRISTOPHER HARTOP

VI. Textiles.

Bolivian textiles remain firmly linked to the traditions of Bolivia's past, both Pre-Columbian and the period of the Viceroyalty (1534–1825). Dyes were traditionally obtained from vegetable, animal and mineral sources, and cochineal dye, *magnum*, still enjoys the greatest prestige. The looms used are those that were known before the arrival of the Spanish (e.g. backstrap looms and vertical looms). To these were added, among others, the wooden, foot-operated pedal loom. During the Viceroyalty woven tapestries and carpets were produced, while liturgical embroidery, festive clothing and knitted fabrics underwent significant developments. These last two types of textiles were highly popular in the late 20th century because of their fine quality. Although it is difficult to distinguish between Bolivian and Peruvian tapestries produced in the Viceroyalty, from the 19th century onwards republican themes make it possible to identify a specific area of origin. Until the late 20th century woven tapestries were produced in Villa Rivero for quilting and carpeting.

The finest expression of textile art in Bolivia is to be found in dress. Native dress still derives, for the most part, from the Pre-Columbian period. Clothing worn by men comprises the *llacota* (cloak), the poncho, the *uncu* (a short shirt or tunic, fast disappearing from common use), the *chullu* (woven hood) and the *chuspa* (a bag or pouch worn by both men and women; see fig. 8). Women's dress consists of the *lliclla* (cloak), the *acsu* (a rectangular piece of fabric wrapped around the body like a dress) and the *ahuayo* (a quadrangular piece of fabric used for carrying

8. Pouch (*chuspa*) for holding coca, Bolívar style, alpaca wool, 180×170 mm, from Cochabamba, 19th century (Buenos Aires, private collection)

children). In the cities of Bolivia, the clothing worn by the *cholas* (mestizo women) draws its inspiration from the period of the Viceroyalty: skirts, blouses and various forms of hat are worn, especially the embroidered silk shawl (*mantón de Manila*).

Decoration on native dress is divided into two main areas: the *pallai* (the area filled with decoration) and the *pampa* (the area left plain). Decorative motifs comprise those from the pre-Inca traditions—hooks, s motifs and zigzags that refer to the snake, and fantastic animals in the Paracas style (see fig. 9); those from the Inca traditions——such geometric motifs as rectangles or squares and eight-pointed stars; Christian motifs and motifs used in the period of the Viceroyalty, including crosses, double-headed eagles, floral ornament and the portrayal of European breeds of cattle; contemporary motifs reflecting the industrial age—trucks, aeroplanes and helicopters; and dedications and inscriptions common to all Andean textiles.

The production of textiles in Bolivia can be classified according to eight ethnographical areas: Charazani, Ay-maras, Oruro, Charcas, Central Area, area of Incaic influence, Tarabulo, Potosí. In the Charazani area three substyles are found: the *Charazani*, the *Ulla-ulla* and the *Amarete*. The *Charazani* style is produced by a group of weavers living to the north-west of Lake Titicaca, who maintain Pre-Columbian traditions that bear testimony to the relationship between artefacts and belief systems. The Callahuayas, ancestral herbalists of the Aymara Indians, transport their medicinal herbs in bags on which the s motif refers to ancient myths, and their clothing still marks their social status. Women's cloaks indicate the place of origin and the resources of their lands: green identifies those who reside in the corn belt, reddish backgrounds indicate those residing in areas where red potatoes are cultivated, and brown indicates those residing in the *punas*, the high Andean plateaus. Crops do not, however, appear in the decoration of the textiles, although such symbolic motifs as condors, birds and dancers do. In the *Ulla-ulla* substyle, textiles are decorated by warp ikat weaving, in which groups of threads are bound in a pattern sequence, dyed, and untied again before weaving. The basic effect when woven is a light pattern with a characteristic blurred edge on a darked ground. In the *Amarete* substyle, textiles are predominantly red in colour with the decoration in white. The distinct style produced by the Aymara Indians in the environs of Lake Titicaca includes the Juli, *Pacaje* and *Omasuyos* substyles. Until the mid-20th century fine-quality fabrics similar to shot silk were made in Juli, and the fabrics produced there are still considered to be the finest examples of spinning and workmanship. The Aymara cloaks display a range of black and brown shades with thin strips of geometric designs that make up a sober *pallai*. In the Oruro area, the archaic *chipaya* weavers are deemed among the best spinners of the high plateaux, producing work in the little-known Oruro style. One of the most attractive substyles of the Charcas area is produced north of Potosí in Llallagua, a mining area, and reflects the surrounding contemporary technology, incorporating such motifs as trucks and motorcycles.

In the Central area, a number of different styles are produced around Cochabamba. One of the most distinct is the Bolívar style (see fig. 8), with its prevalent colours of pinks and sky-blues. The lace edging that borders the stripes and lace designs are notable, as are the *lymi linku* flowers. This style is thought to have disappeared in the 19th century. The *Kurti* style is based on four motifs: condors with spread wings, snakes, *intis* (suns) and rhombuses, which represent lagoons. Pre-Inca ornament, rhombuses, birds and mythological animals are predominant in the *Leque* style. The Tapacarí substyle found in Cochabamba itself reflects the movement of displaced peoples in the Inca period. In colour and design the textiles are similar to some produced in Cuzco. To the south-east, the Tarabuco style is found in the environs of Sucre. The Yamparaes Indians make ponchos with Spanish motifs and, to a lesser degree, Pre-Columbian designs. The ceremonial textiles are highly coloured, with a predominance of reds, oranges and yellows. The mourning fabric is predominantly black in colour.

Textiles from the Potosí area are produced in a number of different substyles. The *Macha* style is characterized by its marked Pre-Columbian heritage. The *pampa* is black or

9. Mummy turban, alpaca, 910×90 mm, from Paracas Necropolis, south coast of Peru, *c.* 200 BC–*c.* AD 600; detail in simple overhand knot techniques, showing cat demon holding trophyhead (Basle, Museum der Kulturen)

brown, and the *pallai* yellow, red, pink, burgundy or white. The designs are abstract in nature. In the *Pocoata* substyle, the *pallai* consists of linear designs ranging in colour from red to yellow to purple, while the *pampa* is reddish. The *Potolo* substyle produces *acsus* with fantastic animals, generally in purple tones. The *pampa* is usually black or brown. A characteristic of this style is that the colour of the design does not contrast with that of the background. The designs are loose, irregular and asymmetrical, the motifs zoomorphic. The Calcha substyle is characterized by ponchos with decoration of coloured stripes, achieved by the ikat technique.

BIBLIOGRAPHY
L. Girault: *Textiles boliviens: Région de Charanazi* (exh. cat., Paris, Mus. Homme, series H: Amérique, 1969)
A. P. Rowe: *Warp-patterned Weaves of the Andes* (Washington, DC, 1977)
T. Waserman and J. S. Hill: *Bolivian Indian Textiles: Traditional Designs and Costumes* (New York, 1981)
L. Adelson and A. Tracht: *Aymara Weavings: Ceremonial Textiles of Colonial and 19th-century Bolivia* (Washington, DC, 1983)
T. Gisbert, S. Arce and M. Cajías: *Arte textil y mundo andino* (La Paz, 1987)
C. Gravelle Le Count: *Andean Folk Knitting: Traditions and Techniques from Peru and Bolivia* (St Paul, 1990)
Traditional Textiles of the Andes: Life and Cloth in the Highlands (exh. cat., San Francisco, CA. F.A. Museums, 1997)
RUTH CORCUERA

VII. Patronage, collecting and dealing.

During the Viceroyalty artistic patronage was essentially provided by the Crown and the Church. Wealthy and powerful mining industrialists and landowners also acted as patrons and financed the construction of some religious buildings, retables and paintings, in which the portraits of the donors were frequently included. Often there was recourse to alms to contribute towards the costs of construction and maintenance or alterations of buildings. Collecting in the period of the Viceroyalty was mainly the pursuit of these industrialists and landowners, some of whom managed to assemble substantial collections, which were dispersed by the 20th century. A few bishops had important collections, which they passed on to their respective churches and which were later housed in the museums of the cathedrals of Sucre, Potosí, La Paz and Santa Cruz. Other important collections are in convents such as S Teresa and S Monica in Potosí, S Teresa and S Clara in Sucre and S Teresa in Cochabamba; in monasteries such as La Recoleta and those of S Francisco in Potosí and La Paz; and in country churches in the highlands and in valley and mission churches, especially in Chiquitos.

The period between 1825 and 1900 was marked by a cultural dichotomy between the upper classes and ruling political and economic groups on the one hand, who were partisans of European and especially French culture, and the middle and lower classes on the other, who continued the aesthetic tradition of the 18th-century Mestizo Baroque. Patronage was reduced to the commissioning of portraits of the ruling class and officials. Of the few public buildings constructed, all were in the academic style, which did not allow for artistic innovation. Moreover, because the Church lacked political power, few religious buildings were erected. The cultural division between the upper classes, with their admiration for European art, and the middle and lower classes meant there were few important

developments in collecting during this period, even in the last 20 years of the 19th century, when an economic boom brought increased prosperity. The wealthy classes travelled to Paris and other European cities, where they acquired paintings, sculptures and other works of official, academic art and bought imitation Baroque or Neo-classical furniture and mass-produced *objets d'art* of little artistic value.

In the early 20th century liberal governments concentrated on such works as road and railway construction rather than on local culture. In their attraction to European ideals, however, they did seek to transform Bolivian cities, especially La Paz, through the Modernist urban-planning ideas embodied in Le Corbusier's concept of the *ville radieuse*. By the 1940s the art of the Viceroyalty had been rediscovered in Potosí, where, due largely to Cecilio Guzmán de Rojas and the Indigenist movement, the population began to be aware of its own cultural values: small collections of Baroque art appeared, while at the same time people started collecting works by such contemporary Bolivian artists as Juan Rimsa, Arturo Borda, Jorge de la Reza, Genaro Ibáñez and Guzmán de Rojas himself. The formation of several private collections gave rise to the first museums (*see* §VIII below).

It was not until the National Revolution of 1952 and the government that followed it, however, that there was substantial official art patronage, channelled through such national institutions as the Ministry of Education, offering a national prize for culture and national art awards, and through the various municipalities and universities. The Mayoralty of La Paz was particularly notable for establishing the Salón Anual de Artes Plásticas and other artistic awards. During the same period impetus was given to all the arts, from public building and increased production in the visual arts to collecting, with government and national organizations commissioning and acquiring works by contemporary artists and colonial and Republican items, now housed mainly in public museums. Prize-winning entries in the Salón Anual de Artes Plásticas in La Paz began to be collected and are now in the Museo Tambo Quirquincho.

In the late 1960s the economic and political situation changed drastically, and public patronage dwindled. The Church now saw its role as being the spiritual and material care of the dispossessed, and with almost no tradition of artistic patronage by individuals, it was only in the 1970s that private patronage developed, above all in La Paz and especially through the banks. Particularly noteworthy was Inversiones Bolivianas (INBO), which in 1975, 1977 and 1980 organized important biennales of Bolivian art, with large prizes and international juries. These exhibitions were suspended, however, after the last one was censored by the military government. Thereafter patronage was applied to rescuing works of the art heritage of the country, helping art museums, publishing the first complete history of Bolivian art and establishing the Fundación BHN, a foundation dedicated to the propagation and dissemination of Bolivian art. The difficult economic and political circumstances after the 1960s also militated against the development of private collections. Another important factor has been the Law of Artistic Patrimony, which states that any Pre-Columbian material or object is state property, the private collection of which is prohibited.

Moreover, the same law decrees that any cultural item dating from before 1900 is national patrimony and cannot be exported. While recognizing the right to private ownership of some types of art objects, the law has discouraged private collecting, which is considered intrinsically contrary to the interests of the state. Zealous state control has led, moreover, to the break-up and looting of a large number of those private collections of art that had been kept in churches and monasteries over the previous 400 years, resulting in much smuggling of the national art heritage into Brazil, Argentina, Paraguay, the USA and elsewhere. Special mention should be made, however, of the collection of the Banco Central de Bolivia, which has important works of Viceregal and contemporary art in its offices and on loan to museums.

For the same historical reasons, there has been very little art dealing in Bolivia, what little there has been occurring since the 1960s, when the Galería ARCA played an important role in promoting the new trends and the artists of the Generación del '52, who could not rely on official support. By the 1990s the Galería Empressa Minera Unificada Sociedad Anonima (EMUSA) was the oldest and most consistent in dealing in contemporary *objets d'art*. Its rivals included Arte Unico in La Paz and the Galería de la Casa de la Cultura in Santa Cruz. There have been many others at different times, most of which were short-lived.

BIBLIOGRAPHY
P. Querejazu: *La pintura boliviana del siglo XX* (Milan, 1989)

PEDRO QUEREJAZU

VIII. Museums and photographic collections.

The first museum of artistic and cultural objects (including natural history items) was established in 1845 by Melchor María Mercado, although the collection was dispersed soon after the artist's death. Others followed in the 20th century, including those associated with, or part of, religious buildings. A Museo Público was established in La Paz in 1911, with natural history, ethnographical and archaeological objects. In time this developed into what is now the Museo Nacional de Arqueología. Another public museum, the Casa de la Libertad in Sucre, was founded in 1925 under the sponsorship of the Banco Central de Bolivia. This is a historical museum in a former Jesuit college, the chapel of which was used in 1825 for the ceremony of the founding of the Republic and thereafter as the seat of the National Congress. The museum houses the largest collection of portraits of Bolivian presidents and many paintings of important battles among its more than 1000 works of art from the Viceroyalty and the Republican periods. The Museo Charcas was founded in 1939 as part of the Universidad Boliviana Mayor, Real y Pontificia de S Francisco Xavier in Sucre. Located in the old Casa del Gran Poder (1630), where the Tribunal of the Inquisition performed its functions in the 17th century, it is Bolivia's most wide-ranging museum, with works of art from the early Renaissance to the present day, including a collection of 16th- and 17th-century Flemish works, examples by the school of Potosí and an important collection of popular and official 19th-century portraits. It also has a notable collection of furniture and musical instruments. The Museo Casa de Murillo, La Paz, another public museum that is under the auspices of the mayoralty of the city, was founded in October 1948. It is principally a historical museum, with more than 2000 works of art from before and after independence.

The Pinacoteca Colonial, which Cecilio Guzmán de Rojas organized in 1945, later became the art collection of the Museo Nacional de la Casa de Moneda in Potosí, while the collection formed by him in 1948 grew into the Museo Nacional de Arte, La Paz. The building (1759–72) housing the Museo de la Casa de Moneda was constructed as the Mint. Implements used for casting, testing and minting are exhibited along with examples of coins. The modern museum, which is financed by the Banco Central de Bolivia, was founded in April 1942. Works originally in the Pinacoteca Colonial were added later; as well as over 4000 paintings and sculptures dating from the Viceroyalty onwards, the museum has assembled a diverse collection of minerals, fossils, furniture and silverware. The Museo Nacional de Arte is housed in an old Mestizo Baroque mansion in La Paz, built in 1775. After restoration, it was established as a public museum in 1964 and is financed by the Instituto Boliviana de Cultura. Although it includes interesting works of art from the 19th and 20th centuries in its collection, its most important works date from the period of the Viceroyalty, in particular paintings by Melchor Pérez de Holguín and artists of the school of Lake Titicaca. Two other museums were set up in the 1960s: the Museo Catedralicio (1962), Sucre, a private foundation dependent on the Church and designated for religious art, with 400 items of Viceregal and Republican painting, sculpture, metalwork and ecclesiastical vestments; and the Pinacoteca de Arte Colonial (1967), Cochabamba, a public museum financed by the Casa de la Cultura of the mayoralty of Cochabamba, which has a collection of contemporary art and paintings from the Viceroyalty.

Among the museums established in the 1970s are the Museo Ricardo Bohorquez (1974), for art and archaeology and attached to the Universidad Autónoma 'Tómas Frías' in Potosí, with a collection of local contemporary art, and the Museo de la Casa de la Cultura (1975), Oruro, attached to the Universidad Técnica de Oruro, with an interesting collection of regional art. The Museo Costumbrista Juan de Vargas and the Museo del Litoral Boliviano in La Paz (both 1978) were founded as museums of local history, although they also have small art collections.

More significant, however, was the establishment of a number of privately funded museums. Institutions financed by the Church include the Museo de S Clara (1971) and the Museo de La Recoleta (1972), both in Sucre, the Museo del Convento de S Teresa (1976) and the Museo S Francisco (1979) in Potosí and the Museo S Francisco (1978), Tarija. All have collections of work from the period of the Viceroyalty, and the Museo S Francisco in Potosí and its namesake in Tarija also have collections from the period after independence. The Museo Sacro (1982), La Paz, and the Museo de Arte Sacro S Lorenzo Mártir (1983), Santa Cruz, are among later examples of Church-funded museums of religious art, the former having a collection of fine art, metalwork and ecclesiastical vestments. The Casa Museo Núñez del Prado (1982) in La Paz, was founded by the Fundación Marina Núñez del Prado in

1982, and it has a fine collection of the sculptor's work from 1925 to 1971 as well as works by other artists, including some in gold and silver by Nilda Núñez del Prado, Marina's sister. In addition, public finances continued to be used to establish new institutions, such as the Museo de la Casa Dorada (1985), Tarija, a historical museum with over 400 works of contemporary art, and the Museo de Arte Contemporáneo (1991) in Santa Cruz. In 1992 there were 49 museums in Bolivia.

Although there are no museums in Bolivia devoted exclusively to photography, there are some notable collections, the largest of which is in the Biblioteca y Archivo Nacional in Sucre, which has a good-sized archive of photographs taken between 1860 and 1940. The Archivo Histórico of Potosí in the Museo de la Casa de Moneda has another important collection of photographs relating to local history, and the archives of La Paz in the Universidad Boliviana Mayor de 'San Andrés' in La Paz has a photographic section, most of it relating to the period between 1900 and 1940. The only notable private photographic collection is that of Núñez del Arco in La Paz, which is important for its 19th-century Bolivian photographs. The Mesa–Gisbert collection has negatives and photographs of the art of the Viceroyalty and Republic in Bolivia and of the Andean region.

BIBLIOGRAPHY

M. Giménez Carrazana: *Museo Charcas* (La Paz, 1962)
T. Gisbert and J. de Mesa: *Museos de Bolivia* (La Paz, 1969)
Diagnóstico de los museos de Bolivia (La Paz, 1989)
P. Querejazu: '150 años de fotografía en Bolivia', *La Presencia* [La Paz] (3 July 1990)
T. Gisbert and J. de Mesa: *La pintura en los museos de Bolivia* (La Paz, 1991)

PEDRO QUEREJAZU

IX. Art education.

During the Viceroyalty artists were trained in guilds based on medieval European prototypes, which were brought to the Audiencia de Charcas by the Spanish. Evidence of apprenticeship in workshops under this system includes numerous teacher–apprentice contracts and other testimonies, such as the autobiography of the sculptor Francisco Tito Yupanqui. There followed an academic type of training, in which the participants were no longer treated as master craftsman and workshop apprentice but as teacher and pupil. The first academy was founded in San Pedro de Moxos, where the painter Oquendo was appointed Master Painter of the Province of Moxos in 1790 in order to 'direct an Academy' in which he 'taught drawing and painting to a group of Indians', with the aid of a drawing book by Charles Lebrun. There was another school in Concepción de Moxos and still others in the Chiquitos region that were very active until 1820. After the foundation of the Republic, various attempts were made to offer a firm academic training, but they were all short-lived. In 1848 there was a Chair of Drawing in the Colegio de Ciencias in La Paz. In the early 1850s the Prefect of Potosí created a Sala de Dibujo Popular, and in 1858 President Linares established in La Paz the Escuela Popular de Dibujo Lineal. Some years later the painter José García Mesa founded the Academia de Dibujo y Pintura as part of the Instituto Nacional de Ciencias y Letras in La Paz. In the early 20th century a further attempt was made to establish schools that would endure. Many artists taught privately, and in 1905 a privately run Academia Particular de Pintura was established in La Paz, while other organizations set out to encourage the visual arts. These included the Círculo de Bellas Artes of La Paz (active from 1910), the Atheneum in Sucre, the Círculo de Bellas Artes in Potosí and the Sociedad de Artistas Plásticos in Cochabamba.

A third period of development began in 1926, when the Academia de Bellas Artes was founded in La Paz, with regular five-year programmes and courses. It has functioned continuously since then, although it subsequently changed its name to the Escuela Superior de Bellas Artes. In 1939 schools were established in Sucre and Potosí. The Atheneum in Sucre sponsored the school there and the Museo Colonial Charcas, both of which became subsidiaries of the Universidad Boliviana Mayor, Real y Pontificia de S Francisco Xavier in Sucre in 1950. The school operated until 1972. The school in Potosí was established in 1939 as the Academia Man Césped, teaching music and the visual arts. In 1948 it was separated from the music academy and remained as the Escuela de Artes Plásticas before being incorporated into the Universidad Autónoma 'Tomás Frías' in Potosí. In 1948 the schools of Oruro and Cochabamba were founded, and in 1960 two other important schools were established: the Escuela de Artes Plásticas of the Universidad Boliviana Mayor de 'S Andrés' in La Paz, in which architecture was taught from 1969, and the Escuela de Bellas Artes of Santa Cruz, which closed and reopened several times but continued to be active as a Taller de Artes Visuales. In the 1960s other schools were founded in Tarija and Tupiza and later in the city of Trinidad. These schools offered training in drawing, painting, especially in watercolours and oil, engraving, modelling, sculpture, ceramics and such subjects as the history of art, aesthetics and anatomy. The schools of La Paz, Sucre, Potosí and Cochabamba played an important role in the training of the artists of the Generación del '52 and their followers. In the late 20th century difficulty in obtaining good, affordable materials and the scarcity of large, well-equipped premises, combined with problems in the teaching programmes and systems connected with low teachers' salaries, meant that many of the best-known contemporary artists received their training outside the country. Attempts began to be made to establish private schools with modern pedagogical systems and an emphasis on creativity.

Although there are no specialist art libraries in Bolivia, there are sections on art in major libraries such as the Biblioteca Nacional de Bolivia in Sucre, although this essentially deals only with Bolivian art. The central library of the Universidad Boliviana Mayor de 'S Andrés' in La Paz contains a good section on world art, and the university also has a small arts section in the library of the Faculty of the Humanities. A similar situation exists in the libraries of the universities in Sucre, Cochabamba, Oruro, Potosí and Santa Cruz. The art museums lack libraries of note, and although there are some small private libraries with books on world art, public access to them is limited. The most important library in the art field in Bolivia is the Biblioteca Mesa–Gisbert, established by the art historians

José de Mesa and Teresa Gisbert. It has the most complete series of essays on architecture and art of the colonial and republican periods. The recently established Fundación BHN has a bibliographic and documentary centre for Bolivian art.

BIBLIOGRAPHY
P. Querejazu: *La pintura boliviana del siglo XX* (Milan, 1989)

PEDRO QUEREJAZU

Bonet, Antonio (*b* Barcelona, 2 June 1913; *d* Barcelona, 13 Sept 1989). Spanish architect, urban planner and designer, also active in Argentina and Uruguay. He graduated from the Escuela Superior de Arquitectura, Barcelona, in 1936, having also worked during 1932–6 in the offices of Josep Lluís Sert and, in Paris, of Le Corbusier. In 1938 he went to Buenos Aires and there became a founder member of Grupo Austral, together with (among others) Jorge Hardoy (*b* 1914) and Juan Kurchan, with whom he had worked in Paris. Bonet applied the rationalist principles of the group's manifesto *Voluntad y acción* (1939) in a wide range of architectural and urban-design projects in Argentina and Uruguay over the next two decades. He is perhaps most widely known for his individual houses, and especially for the Casa Berlingieri (1946) at Punta Ballena, Uruguay, and (with Jorge Vivanco and Valera Peluffo) for the four pavilions at Martínez, Buenos Aires, in a manner reminiscent of Le Corbusier's work of a decade or so earlier, although quite original in expression. As a planner Bonet was involved in the master-plans for Mendoza (1940) and the Casa Amarilla housing development (1943), Buenos Aires; he was a member of the San Juan reconstruction committee in 1944 and worked on the South Buenos Aires Urban Development Plan (1956). He was also a noted furniture designer, and he taught architecture as a visiting professor (1950) at Tucumán National University. Among many buildings in the 1950s, Bonet designed the Casa Oks (1955), part of a larger housing development at Martínez, the Galería Rivadavia and Terraza Flats (1957–9) and the Galería de las Américas (1958–62), all in Mar del Plata. In 1963 he returned to Spain to practise in Girona and Barcelona; his best-known building of this later period is the Urquinaona Tower (1971), Barcelona. He nevertheless continued periodic visits to Argentina, where he established the Bonet award for Argentine students of architecture.

BIBLIOGRAPHY
'Groupe de quatre pavillons à Martínez', *Archit. Aujourd'hui*, 18–19 (1948), pp. 64–5
F. Bullrich: *New Directions in Latin American Architecture* (London, 1969), pp. 13–14

1. Marcelo Bonevardi: *Supreme Astrolabe*, painted construction, 1.78×2.21 m, 1973 (New York, Solomon R. Guggenheim Museum)

F. Ortiz and M. Baldellon: *La obra de Antonio Bonet* (Buenos Aires, 1978)
E. Katzenstein and others: *Antonio Bonet* (Buenos Aires, 1985)

LUDOVICO C. KOPPMANN

Bonevardi, Marcelo (*b* Buenos Aires, 13 May 1929; *d* 1994). Argentine painter, sculptor and draughtsman. He studied architecture at the University of Córdoba in Argentina from 1948 to 1951 but later decided to devote himself to painting, in which he was self-taught. Like other artists working in New York, where he settled in 1958 on being awarded a Guggenheim Fellowship, he reacted against Abstract Expressionism, in his case by developing a highly personal vocabulary and by incorporating sculptural elements within spaces hollowed out from the canvas support. These geometrical or enigmatic objects are presented as agents of revelation, emblems resonant with ancient significance, bringing together geometry, mathematics and astronomy in order to penetrate the secret labyrinths of the unconscious. *Supreme Astrolabe* (1973; see fig. 1) is a good example of his extraordinarily rich work, as minutely detailed as that of a goldsmith. In other

2. Marcelo Bonevardi: *Trapped Angel III*, acrylic on canvas and wood, 2.47×1.22 m, 1980 (Buenos Aires, Museo Nacional de Bellas Artes)

constructions he explored a psychologically intimate sense of space, as in *Trapped Angel III* (1980; see fig. 2).

In his drawings Bonevardi abandoned the frontality of his reliefs, foreshortening images of disconcerting exteriors or useless, refined machinery, which he treated in a combination of graphic methods and techniques of dripping. Through his treatment of space and time he created irrational, enigmatic and dreamlike atmospheres.

BIBLIOGRAPHY
Marcelo Bonevardi Retrospective Exhibition (exh. cat., intro. D. Ashton; New York, Cent. Inter-Amer. Relations, 1980–81)
N. Perazzo: 'Constructivism and Geometric Art', *Latin American Presence in the United States, 1920–1970* (exh. cat., New York, Bronx Mus. A., 1988), pp. 106–7
Tiempo y espacio de lo sagrado: Pinturas, construcciones, 1963–1989 (exh. cat., Caracas, Mus. B.A., 1990)
'Arco '97: El envío Argentino del FNA', *Cultura* (Buenos Aires, 1997), pp. 18, 23–4

NELLY PERAZZO

Bonnafé, A. A. (*fl* mid-19th century). ?French draughtsman and lithographer active in the USA and Peru. He lived briefly in the USA, where in 1852 he published a book containing 32 woodcuts depicting American working-class figures. Later he moved to Lima, the capital of Peru, where he published two albums of hand-coloured lithographs, *Recuerdos de Lima* (1856–7), depicting the city's people, clothing and customs.

PRINTS
Recuerdos de Lima (Lima, 1856–7)

BIBLIOGRAPHY
L. E. Tord: 'Historia de las artes plásticas en el Perú', *Historia del Perú*, ix (Lima, 1980)
C. Milla Batres, ed.: *Diccionario histórico y biográfico del Perú: Siglos XV–XX*, ii (Lima, 1986)

LUIS ENRIQUE TORD

Borda, Arturo (*b* La Paz, 14 Oct 1883; *d* La Paz, 1953). Bolivian painter and writer. He began painting in 1899 and was self-taught. He was a civil servant in various departments, and with his brother Héctor Borda he was a union organizer; together they founded the first workers' federation in Bolivia. His paintings contain a substantial modernist literary element and were largely done as illustrations to his autobiographical work *El loco*. He exhibited his work in La Paz on 14 occasions and twice in Buenos Aires (1920, 1950). From 1899 to 1920 he developed his style and technique in portraits of family members, such as *Héctor* (1915), *My Two Sisters* and *Yatiri* (1918; all La Paz, priv. cols); the last was one of the first Bolivian paintings in which an Indian appeared as the main subject.

Between 1920 and 1940 Borda concentrated on literature, politics, public service and union activity and completed very few paintings. The works he did produce included landscapes, jungles and mountains, such as *Illimani* (1932; La Paz, Mus. Tambo Quirquincho; *see* BOLIVIA, fig. 6). From 1940 he began an intensive new period of painting, consisting of allegorical scenes with a strong content of social criticism, as in *Portrait of My Parents* (1943), which has Surrealistic elements, and the *Criticism of -isms and the Triumph of Classical Art* (1948; both La Paz, priv. cols). From 1950 to 1953 he executed

several *Studies I, II* and *III*, full of light and colour, precursors of Op art.

BIBLIOGRAPHY

Borda (exh. cat., La Paz, 1966)

P. Querejazu: *La pintura Boliviana del siglo XX* (Milan, 1989)

Entre el pasado y el presente: Tendencias nacionalistas en el arte boliviano, 1925 a 1950 (exh. cat., Washington, DC, Inter-Amer. Development Bank, 1996)

PEDRO QUEREJAZU

Borges, Jacobo (*b* Caracas, 28 Nov 1931). Venezuelan painter. He studied at the Escuela de Artes Plásticas in Caracas from 1949 to 1951. In 1951 he was awarded a scholarship and moved to Paris, where he remained for four years, employing bright colours in a series of stylistic experiments that culminated in the Cubist-influenced *Fishing* (1956; Caracas, priv. col., see Ashton, pl. 3). In 1957 this painting won a prize at the Biennale in São Paulo. This success provoked a crisis of content and direction in Borges's work, from which emerged his first figurative paintings in an expressionist style and with a strong element of social criticism. In 1963 he won the national prize for painting, for the *Coronation of Napoleon* (Caracas, Gal. A. N.). The work of the mid-1960s, using bright colour, strong brushwork and grotesque distortions of the figure, bears comparison with that of de Kooning and Bacon. A retrospective of his work was held in 1976 at the Museo de Arte Moderno in Mexico City, and his reputation spread further when in 1983 he had his first one-man show in the USA, at the CDS Gallery in New York. In 1985 Borges was awarded a Guggenheim Fellowship, and the following year he was invited to work and exhibit in West Berlin by the Deutscher Akademischer Austauschdienst. By this stage his work had become more dramatic, with more realistic figures and a greater fluidity in the brushwork (e.g. *Swimmers in the Landscape*, 1986; New York, CDS Gal., see 1987–8 exh. cat., pl. 52).

BIBLIOGRAPHY

Jacobo Borges: Magia de un realismo crítico (exh. cat. by J. Cortázar and R. Guevara, Mexico City, Mus. A. Mod., 1976)

D. Ashton: *Jacobo Borges* (Caracas, 1982)

Jacobo Borges: De la pesca . . . al espejo de aguas, 1956–1986 (exh. cat. by S. Imber and C. Ratcliff, Monterrey, Mus. Reg. Nue. León; Mexico City, Mus. A. Contemp. Int. Rufino Tamayo; W. Berlin, Staatl. Ksthalle; and elsewhere; 1987–8)

Itinerario de viaje, 1987/1990 (exh. cat. by D. Ashton and others, Caracas, Cent. Cult. Consolidado, 1991)

Jacobo Borges: Pinturas (exh. cat., Santa Fe, Granada, Inst. América, Cent. Damián Bayón, 1993)

11 artistas venezolanos representados por Galería Freites (exh. cat., Caracas, Gal. Freites, 1994), pp. 4–5

Lo humano: En Jacobo Borges y en la pintura venezolana (exh. cat., Caracas, Mus. Jacobo Borges, 1995)

A. Alifano: *El humor de Borges* (Buenos Aires, 1996)

D. Balderston: *¿Fuera de contexto? Referencialidad histórica y expresión de la realidad en Borges* (Rosario, 1996)

MELANÍA MONTEVERDE-PENSÓ

Fernando Botero: *House of Raquel Vega*, oil on canvas, 1.95×2.46 m, 1975 (Vienna, Museum Moderner Kunst, Stiftung Ludwig)

Botero, Fernando (*b* Medellín, 19 April 1932). Colombian painter and sculptor. After attending a Jesuit school in Medellín he was sent to a school for matadors in 1944 for two years. He first exhibited in 1948 in Medellín with other artists from the region and provided illustrations for the Sunday supplement of the daily paper *El Colombiano* at this time. His discovery of the works of Diego Rivera, David Alfaro Siqueiros and José Clemente Orozco inspired paintings such as *Woman Crying* (1949; artist's priv. col., see 1979 exh. cat., p. 25). After studying at the San José high school in Marinilla, near Medellín, from 1949 to 1950 and then working as a set designer, he moved to Bogotá in 1951. A few months after his arrival he had his first one-man show there at the Galería Leo Matiz in 1951, at which time he was working under the influence of Gauguin and Picasso's work of the 'blue' and 'rose' periods. In 1952 Botero travelled with a group of artists to Barcelona, where he stayed briefly before moving to Madrid. From 1952 to 1953 he studied at the Academia de San Fernando in Madrid, although he was more interested in the paintings by Goya and Velázquez in the Prado. In 1953 he moved to Paris, where he lost his earlier fascination with the modern French masters and spent most of his time in the Louvre. He then travelled to Florence, where he stayed from 1953 to 1954 studying the works of Renaissance masters such as Giotto, Uccello and Piero della Francesca.

Botero first visited the USA in 1957, buying a studio in New York in 1960. A number of works executed between 1959 and 1961, such as *Mona Lisa, Age Twelve* (1961; see colour pl. III, fig. 1), though figurative, showed the influence of Abstract Expressionism through the energetic handling of the paint. After a long period of development under the influence of various styles and artists, by about 1964 Botero had arrived at his mature style, characterized by the use of rotund figures and inflated forms, as in the *Presidential Family* (1967; see colour pl. III, fig. 2), in which he made allusion to the official portraits of Goya and Velázquez. Throughout his career Botero often made reference to past masters, sometimes to the point of caricature.

In 1973 Botero moved his studio from New York to Paris and began making sculptures. He concentrated exclusively on these between 1976 and 1977, extending his painting style and principles into three dimensions in works such as *Big Hand* (*see* COLOMBIA, fig. 8), which was inspired by a detail of the *Victory of Samothrace* (Paris, Louvre). His paintings of the 1970s, such as the *House of Raquel Vega* (1975; see fig.), were a continuation of his mature style of the 1960s. In the 1980s he turned to subjects taken from bullfighting, for example in *Bull* (1987; priv. col., see 1987 exh. cat., pl. 13). One of his largest public sculptures in bronze, *Broadgate Venus* (London, Exchange Square), was unveiled in 1990.

BIBLIOGRAPHY
K. Gallwitz: *Fernando Botero* (London, 1976)
G. Arciniegas: *Fernando Botero* (New York, 1977)
Fernando Botero (exh. cat. by C. J. McCabe, Washington, DC, Hirshhorn, 1979)
C. Ratcliff: *Botero* (New York, 1980)
La Corrida: Fernando Botero (exh. cat. by M. Mafai, Milan, Castello Sforzesco, 1987)
W. Spies, ed.: *Fernando Botero: Paintings and Drawings* (Munich, 1992)
Fernando Botero: Esculturas (exh. cat., Caracas, Gal. Mus., 1994)
Fernando Botero (exh. cat., New York, Marlborough Gal., 1996)
Botero in Washington (exh. cat., Washington, DC, A. Mus. Americas, 1996)

☐

Boxer, David (*b* St Andrew, Jamaica, 17 March 1946). Jamaican artist and art historian. He studied at Cornell University, Ithaca, NY, and at Johns Hopkins University, Baltimore, MD, where he was awarded a PhD in 1975. He studied briefly under the American painter Fred Mitchell (*b* 1903) while at Cornell, although he was essentially self-taught as an artist. He developed a coherent but continuously evolving iconography consisting of complex and often highly personal metaphors that commented on the human condition and the anguish of modern existence. Although he also produced non-figurative works, he usually concentrated on the human figure (e.g. *Pietà in Memory of Philip Hart*, 1986; see fig.). He often worked with 'appropriated images' borrowed from myth, religion, music, history, archaeology and art history. These images, often mechanical reproductions of his sources, were transformed, cruelly assaulted sometimes, through a surrealist method of association.

The major multi-media installation *Headpiece. The Riefenstahl Requiem* (1986; Kingston, N.G.) summarized some of Boxer's major thematic concerns, namely the self-destructive forces in the individual as well as in society, through references to war, genocide and natural catastro-

David Boxer: *Pietà in Memory of Philip Hart*, mixed media, 1.83×1.22 m, 1986 (Kingston, National Gallery)

phe; the juxtaposition of Classical Apollonian and Dionysiac motives; and mythological figures such as Icarus, Narcissus and the Three Graces. Boxer worked in a wide variety of media, ranging from experimental painting techniques to collage and assemblage, photography and video. In 1975 he became Director/Curator of the National Gallery of Jamaica in Kingston. He resigned from the post of director in 1991 to become Director Emeritus/ Chief Curator of the Gallery.

BIBLIOGRAPHY

In Situ II: Some Persistent Themes (exh. cat. by V. Poupeye-Rammelaere, artist's studio, Kingston, 1988)
New World Imagery: Contemporary Jamaican Art (exh. cat., London, Hayward Gal., 1995)
D. Boxer and V. Poupeye: *Modern Jamaican Art* (Kingston, 1998)
V. Poupeye: *Caribbean Art* (London, 1998)

VEERLE POUPEYE

Brandt, Federico (*b* Caracas, 17 May 1878; *d* Caracas, 25 July 1932). Venezuelan painter. In 1896 he began studying at the Academia de Bellas Artes, Caracas, under Emilio Mauri (1855–1908) and Antonio Herrera Toro. In 1902 Brandt travelled to Paris, where he attended the Académie Colarossi and the Académie de la Grande Chaumière, as well as the studios of the painters Jean-Paul Laurens and Antonio de La Gandara. He then moved to the Netherlands to study Dutch painting, which had a permanent influence on his work, although his output at this stage was still sporadic. At the end of 1903 he returned to Venezuela. Between 1904 and 1907 Brandt regularly attended the workshops at the Academia de Bellas Artes, Caracas. From 1912, coinciding with the creation of the anti-academic Círculo de Bellas Artes in Caracas, he painted with greater regularity and enthusiasm, motivated in part by the innovations of the painters Samys Mützner, Nicolas Ferdinandov and Emilio Boggio; Mützner was particularly influential to him. His appreciation of Dutch painting, antique objects and architectural space led him to produce intimate still-lifes, interiors, landscapes and portraits (e.g. *Interior with Dolls*, 1927; Caracas, Gal. A. N.).

BIBLIOGRAPHY

A. Boulton: *Historia de la pintura en Venezuela*, 3 vols (Caracas, 1968, rev. 1973)
J. Calzadilla: *Federico Brandt* (Caracas, 1972)

YASMINY PÉREZ SILVA

Brasília. Capital city of Brazil. Founded on the central plateau *c.* 1000 km from the Atlantic coast, within a federal district in Goiás state, the city (population *c.* 400,000) was inaugurated in 1960. The establishment of a new federal capital was part of a series of modernization measures drawn up by Juscelino Kubitschek when he became President of Brazil in 1956; the city was intended to be the urban and architectural expression of those measures, symbolizing the national reconstruction of Brazil. A national competition for the master-plan (*plano piloto*) was held in 1957 and won by Lúcio Costa. His proposal (for illustration *see* COSTA, LÚCIO) was inspired by the urban planning principles of CIAM and its Athens Charter (1933), which included functional zoning and the use of isolated, single-function buildings; these principles were realized for the first and only time at Brasília.

Brasília, cathedral, by Oscar Niemeyer, 1958–87

In his manifesto Costa explained the guiding principle behind his aeroplane-shaped plan, partly enclosed by an artificial lake, as the gesture of possession: two axes that form a cross. It also incorporated advanced principles of highway technology, fulfilling Kubitschek's explicit intention of building a city for the motor car. Thus the curved north–south axis (the 'wings' of the aeroplane) was designed as a linear traffic artery, with the main residential sectors, framed by a dense belt of trees, spread along it in superblocks: areas 350 m square in which six-storey blocks of flats built on pilotis were placed. The superblocks are grouped in neighbourhood units together with local businesses and schools. At the junction of the two axes are the commercial and entertainment sectors, with the campus of the University of Brasília in open ground beyond. The monumental east–west axis contains the cultural sector, with the Museum of Brasília, library, theatre and cathedral (see fig.), and the administrative sector. Here the Esplanada dos Ministérios, lined with identical government blocks, terminates at the triangular Praça dos 3 Poderes, where the buildings for the three branches of government are placed: the Palácio de Alvorado (presidential palace), the Supreme Court and the Congresso Nacional complex at the apex. Oscar Niemeyer, who was Chief Architect at Brasília for the first five years of construction, achieved a logistic miracle in completing most of the main public buildings in time for inauguration in 1960, and his elegant and original designs provide an appropriate architectural expression of Costa's lucid and integrated plan (for further discussion and illustration *see* NIEMEYER, OSCAR). Much of the landscaping was carried out by ROBERTO BURLE MARX.

In practice, however, the plan for Brasília created several problems, the most crucial being the lack of provision for

low-cost housing, which developed instead in unplanned satellite settlements between 13 and 43 km from the centre. The census of 1985 recorded only 25% of the total population of the Federal District of Brasília as living in the city inscribed by the pilot plan. In 1987 Costa produced a plan for the extension of Brasília with new wings for low-cost housing, which was faithful to the intent of the original. This proposal was widely criticized, however, a reflection of changing views on urban planning.

BIBLIOGRAPHY

L. Costa: 'Relatório sobre o plano piloto de Brasília', *Leituras de planejamento e urbanismo*, IBAM (Rio de Janeiro, 1965)
——: 'O urbanista defende a sua capital', *Acrópole*, xxxii/375–6 (1970), pp. 7–8
M. Gorowitz: *Brasília: Uma questão de escala* (São Paulo, 1985)
A. Paviani, ed.: *Brasília: Espaço urbano em questão* (São Paulo, 1985)
E. Holston, ed.: *The Modernist City: An Anthropological Critique of Brasília* (Chicago, 1989)
M. da Silva Pereira: 'L'Utopie et l'historie. Brasília: Entre la certitude de la forme et le doute de l'image', *Art d'Amérique latine, 1911–1968* (exh. cat., Paris, Pompidou, 1992), pp. 462–71
L. Fernando Tamanini: *Brasília: Memória da construção* (Brasília, 1994)
B. Schvasberg and others: *Brasília, moradia e exclusão* (Brasília, c. 1996)

REGINA MARIA PROSPERI MEYER

Bratke. Brazilian family of architects. Oswaldo Arthur [Carlos] Bratke (*b* Botucatú, São Paulo, 24 Aug 1907; *d* São Paulo, 6 July 1997) graduated as an engineer–architect from the Mackenzie School of Engineering, São Paulo, in 1931, when he also won first prize in an open competition for an urban viaduct in São Paulo, with an Art Deco design. About 1934 he set up a design and construction firm with Carlos Botti (1906–42), building mainly private houses in original versions of styles such as neo-colonial, California mission and Spanish Renaissance.

After Botti's death, Bratke concentrated on architectural projects and made a transition to modernism by fitting the traditional features of neo-colonial buildings, such as tiled roofs, overhanging eaves and verandahs, into the modern vocabulary. He was a highly practical architect with an interest in technical solutions, for example waterproofing and insulating flat roofs, and he designed construction components such as windows, doors and prefabricated kitchens and bathrooms. He was one of the few people in his generation not to be influenced directly by Le Corbusier, preferring the work of Mies van der Rohe and Richard Neutra.

Bratke designed some of the most beautiful houses in São Paulo, one of the best being his own house (1953) with a simple, Miesian rectangular plan and with all interior spaces opening on to a wide garden through a covered walkway built along the sunny, north-facing façade. In the adjoining guest pavilion, a timber deck and sliding timber wall panels are reminiscent of traditional Japanese houses. As well as several hundred private houses, Bratke's most important works include the ABC office buildings (1952), the Morumbi Children's Hospital (1953), the Bom-Bril factory (1958) and the Matarazzo Metallurgical Industries building (1960), all in São Paulo. He also produced urban plans for the Morumbi district of São Paulo (1950) and Ilha Porchat (1964) in São Vicente, S.P. In 1966 he prepared a master plan for housing at the ICOMI manganese mines in the Amapá Territory; using local materials, he designed buildings to function in the hot, humid jungle climate, with overhanging eaves, double roofs and movable and fixed louvres.

Oswaldo Bratke retired from professional activity in 1967 when his son, Carlos Bratke (*b* 1942), graduated as an architect. As a formalist working in a Brutalist idiom, Carlos Bratke produced buildings that differ profoundly from his father's. The most important example of his work is the group of 36 office buildings (1976–84) carried out for his family's construction company in the southern part of São Paulo; while each retains individual characteristics, all of these conform to a single overall formal approach.

WRITINGS
'Núcleos habitacionais no Amapá', *Acrópole*, 326 (1966), pp. 17–38

BIBLIOGRAPHY
H. E. Mindlin: *Modern Architecture in Brazil* (Amsterdam and Rio de Janeiro, 1956)
S. Ficher and M. M. Acayaba: *Arquitetura moderna brasileira* (São Paulo, 1982)
B. Adiron Ribeiro: *Vila Serra do Navio: Comunidade urbana na selva amazônica: Projecto do eng. arquitector Oswaldo A. Bratke* (São Paulo, 1993)
H. Segawa and G. M. Mazza: *Oswaldo Arthur Bratke* (São Paulo, 1997)

SYLVIA FICHER

Bravo, Claudio (*b* Valparaíso, 8 Nov 1936). Chilean painter and draughtsman. He studied painting in Santiago in 1947–8 with the Chilean painter Miguel Venegas, then lived in Spain from 1961 to 1972 before moving to Tangiers. His entire artistic career has been conducted outside his native country.

Bravo initially worked as a portrait painter, supporting himself in Spain through commissions, which also introduced him into Spanish high society. His sitters included General Franco and his family. Later, while still in Spain, he began painting packages and wrapped objects in a polished, highly detailed realist style bordering on Photorealism but consciously related to the Spanish still-life tradition represented by Zurbarán and Velázquez, whose work he greatly admired. He remarked that he hoped to be regarded as one of the few 20th-century painters to have respected the work of the Old Masters and learnt from it.

Working with both oil paints and pastels, after moving to Morocco, Bravo combined objects with human figures in interior spaces, displaying perfect control of the luminous atmosphere and the strict perspective. While his technical facility was undeniable, the ambiguity of his subject-matter and the mysteriousness of his settings, tempering the clarity of the figures and objects, led him beyond the mere reproduction of appearances. Unlike the Photorealists, who tended to present their images as straightforward visual evidence, Bravo used his motifs as a way of dealing with obsessions such as narcissism or the random meeting of figures unconnected in time. An illusory and confusing interplay between reality and representation is central to Bravo's work, leaving the spectator unsure whether what he is seeing lies inside or outside the painting.

BIBLIOGRAPHY
Claudio Bravo (exh. cat., Madrid, Gal. Vandrés, 1974)
M. Ivelić and G. Galaz: *La pintura en Chile desde la colonia hasta 1981* (Santiago, 1981)
Claudio Bravo (exh. cat., Hamburg, Gal. Levy, 1981)
M. Colle Corcuera: *Artistas latinoamericanos en su estudio* (Mexico City, 1994)
Claudio Bravo: Visionario de la realidad (exh. cat. by E. Sullivan, Santiago, Mus. N. B.A., 1994)

P. Bowles and others: *Claudio Bravo: Paintings and Drawings* (New York, 1997)
Claudio Bravo: Wrapped Packages (Miami, Bass Mus. A., 1997)
MILAN IVELIĆ

Brazil [Brasil], Federal Republic of. South American country. It is in the centre of the eastern side of the continent, bounded by all other South American countries except Chile and Ecuador. Geographic regions of Brazil include the equatorial north, containing the Amazon basin, extensive and scantily populated; the north-east, with a semi-arid interior reaching to the coast and a relatively dense but poor population; the south-east, populous and highly developed, with the main cities of São Paulo and Rio de Janeiro; the southern plateaux, occupied mainly by landowners of European origin; and the central plateaux, the western part of which contains the swampy depression of the Mato Grosso irrigated by the basin of the River Paraguay. The vegetation is essentially tropical, with rainforests in the north, pine forests in the south, *caatinga* (brushwood) in the arid north-east interior and savanna grasslands in the centre and south. Although its area of *c.* 8,512,000 sq. km takes up almost half the continent (see fig. 1), about 75% of the population live in urban centres, mostly in eastern Brazil along the coastline or on the major rivers. São Paulo, the largest centre of production in Latin America, is Brazil's financial capital and Rio de Janeiro its cultural capital. Brazil was colonized by Portugal after 1500, but the culture of the indigenous peoples survived (see §II below). Brazil became a kingdom in 1815, an independent constitutional empire in 1822 and a republic in 1889. Its federal capital, Brasília, was inaugurated in 1960.

I. Introduction. II. Indigenous culture. III. Afro-American culture. IV. Architecture. V. Painting, graphic arts and sculpture. VI. Furniture. VII. Ceramics and glass. VIII. Gold, silver and jewellery. IX. Textiles. X. Patronage, collecting and dealing. XI. Museums. XII. Art education. XIII. Art libraries and photographic collections.

I. Introduction.

The territory that became Brazil was discovered by Europeans at the end of the 15th century, and under the Treaty of Tordesillas, which divided the lands in the New World between Spain and Portugal, it was claimed for Portugal by Pedro Alvarez Cabral (1467–1520) after he landed there in 1500. However, it was only after the institution in 1534 of hereditary captains, each granted an area of coast and nominal hinterland together with political and economic privileges, that Brazil began to be populated by Europeans. In 1549 the first governor-general, Tomé de Souza, arrived to organize the administration of the colony, prompting more substantial development particularly in SALVADOR in the state of Bahia, which became the first capital. Jesuit, Benedictine and Franciscan missionaries also arrived to undertake the conversion of the indigenous population, and they provided the main stimulus for the arts in the 16th and 17th centuries, based on European styles, notably Portuguese and Spanish Baroque and Rococo.

Sugar production in the north-east dominated the first stage of Brazil's economy, becoming increasingly dependent on imported slave labour from Africa after 1560, which introduced another distinct ethnic contribution to Brazilian culture (see §III below). The wealth generated by sugar production led to a short-lived Dutch invasion and occupation (1630–54) of RECIFE in the state of Pernambuco and part of the north-east coast, where Johan Maurits, Count of Nassau-Siegen, was governor-general in 1637–43 (see NASSAU-SIEGEN, JOHAN MAURITS OF). The Dutch introduced new urban planning techniques, brought scientists and artists to document their conquest and produced the first examples of secular art in Brazil.

This trend was reinforced after the end of the 17th century by the second phase of economic development, the mining of gold, which was centred on Minas Gerais. Although most of the gold was exported to Portugal, considerable wealth went to the mining towns, notably OURO PRÊTO (formerly Vila Rica), providing funds for building and the arts and stimulating the development of the Rococo style, which spread to Salvador, Recife and OLINDA. RIO DE JANEIRO, the port from which the gold was exported, came into prominence in 1763 when the capital was transferred there from Salvador, and again in 1808 when the Portuguese court moved from Lisbon to Rio as a result of the Napoleonic Wars. The city became the capital of the entire kingdom, and Dom João, the Prince Regent (later John VI, King of Portugal), set about improving its physical and cultural environment to suit its new status. Particular impetus to the arts was provided by the organization of a French artistic mission to Brazil (1816), whose purpose was the encouragement of the fine arts and architecture through practice and formal training and the foundation of such institutions as the Academia Imperial das Belas Artes, through which the academic European Neo-classical style was brought to the country.

At the same time, the development of coffee production opened up a new economic phase, accelerating the process of Brazilian emancipation. After the King returned to Portugal, his son declared independence (1822) and became Emperor, ruling as Peter I (*reg* 1822–31). The long reign of Peter II (*reg* 1831–89), a cultivated patron of the arts and sciences, generated considerable economic development marked by the expansion of the coffee trade, the arrival of many immigrants from Europe, the abolition of slavery and the building of railways and other technological innovations. However, the war with Paraguay (1865–70) brought about a serious financial and economic crisis, which led to the proclamation of the republic in 1889, and new social and political divisions involving military and civil factions emerged from the break-up of the centralized imperial system.

Between 1889 and 1930 SÃO PAULO increasingly replaced Rio de Janeiro as the economic and political centre of Brazil. Enormous urban growth was experienced after World War I, and a wave of modernization swept the country, accompanied by a preoccupation with the roots of national identity. The collision of progressive and conservative ideas culminated in the revolution of 1930 and the new government of Getúlio Vargas, which was followed by official acceptance and consolidation of the Modern Movement in the arts and the development of Brazil's highly original, lyrical version of the International Style, particularly in architecture. Repression and censorship during the dictatorship of Vargas (1937–45) were

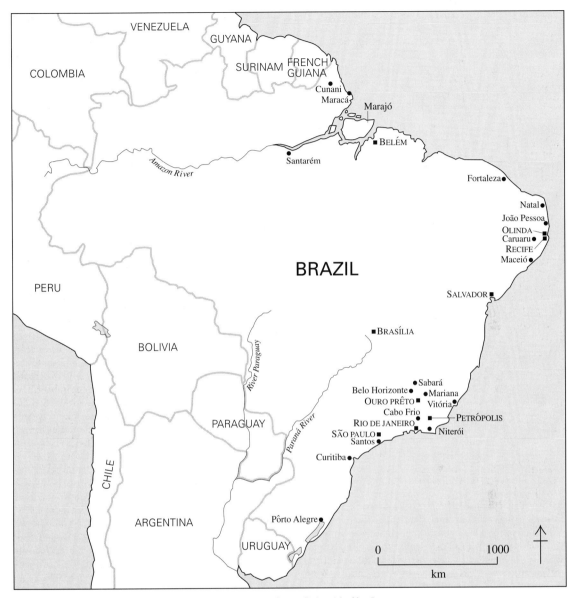

1. Map of Brazil; those sites with separate entries in this encyclopedia are distinguished by CROSS-REFERENCE TYPE

offset by the encouragement of industrial progress. Confidence increased with the presidency (1956–61) of Juscelino Kubitschek, who produced a major plan for the development of infrastructure and industry and initiated the construction of a new federal capital, BRASÍLIA, in the central highlands, stimulating avant-garde movements in the arts. The military coup of 1964 and the authoritarian governments that followed produced an economic boom but also a profound crisis due to external debts and inflation. Democracy was restored with the election by direct vote of Fernando Collor de Mello (President, 1989–94).

GENERAL BIBLIOGRAPHY

P. Calmon: *História do Brasil*, 7 vols (Rio de Janeiro, 1959)
S. Buarque de Hollanda, ed.: *História geral da civilização brasileira, 1500–1889*, 7 vols (Rio de Janeiro, 1960–72)
L. Castedo: *A History of Latin American Art and Architecture* (London, 1969), pp. 181–200, 266–92
P. M. Bardi: *História da arte brasileira: Pintura, escultura, outras artes* (São Paulo, 1975)
C. A. C. Lemos: *The Art of Brazil*, intro. P. M. Bardi (New York, 1983)
W. Zanini, ed.: *História geral da arte no Brasil*, 2 vols (São Paulo, 1983)
D. Ribeiro: *Aos trancos e barrancos: Como o Brasil deu no que deu* (Rio de Janeiro, 1985)

ROBERTO PONTUAL

II. Indigenous culture.

Before the arrival of the Portuguese in 1500, the population of indigenous Amerindian peoples living in the territory that became Brazil totalled about three million. Their culture was still based on stone-tool technology, a factor partly explaining the difference in the process of colonization in Brazil compared to that of other Latin American

countries where more sophisticated Pre-Columbian civilizations made a greater contribution to the new national identity: in all cases, however, the destruction of the indigenous culture was the norm—only about 200,000 Indians remained in Brazil at the end of the 20th century. Although the culture of the indigenous peoples of Brazil survived colonization, European and colonial interest in its art forms long remained marginal as remaining exotic traits were never really integrated into the mainstream of local artistic development. Between the 16th century and the 19th, more or less fanciful descriptions of indigenous art were given in verbal or visual accounts by foreign and Brazilian travellers and artists, for example Pero Vaz de Caminha, Jean de Léry, Hans Staden, André Thevet, ALBERT ECKHOUT, JEAN-BAPTISTE DEBRET, Alexandre Rodrigues Ferreira and JOHANN MORITZ RUGENDAS. Scientific expeditions, which began to study Brazil in 1870, acquired a vast quantity of examples—almost always the best—of indigenous art, especially pottery from the island of Marajó, and this heritage forms part of the collections of the Museu Nacional and the Museu do Índio in Rio de Janeiro, the Museu Paulista at the Universidade de São Paulo and the Museu Paraense Emílio Goeldi in Belém.

The artistic activity of Brazilian Indians must be considered in the context of their culture and daily life. All works are intended for immediate practical purposes and are derived from a homogeneous culture, in which each element is a component in harmony with all others. The desire to perfect each work in accordance with tradition produces a formal severity and beauty, in which care is the basis of the aesthetic. Traditional indigenous art was based on three important types of production: weaving, pottery and body arts; all three continued to be produced after colonization. The abundance of plant materials resulted in the predominance of weaving and plaiting as art forms among Brazilian tribes, both in the past and present: leaves, palm fronds, lianas and a variety of fibres are used for baskets, sieves, fans, mats, belts, sleeping-nets, ceremonial masks and vestments, all decorated with ingenious and strictly geometric patterns. Outstanding examples are found in the work of the Timbira, Kayabi, Xavante, Desana, Tukuna and Paresi peoples, although the last three no longer produce ceremonial vestments and masks.

Pottery, more easily made and preserved, flourished in the Pre-Columbian period in four principal areas: Marajó, Cunani, Maracá and Santarém, all in the north of Brazil, and production continued after the European discovery and conquest of the territory. Traditional funerary urns from the island of Marajó, painted in two or three colours, reveal stylized geometric and non-figurative decorative designs that are extraordinarily well executed. Vases and *caretas* (modelled decoration) produced by the Tapajós from Santarém constitute an exception to the general rule of indifference to naturalistic human representation among the indigenous Brazilian peoples: for decoration they used zoomorphic and anthropomorphic elements that are often carefully realistic and concerned with individuality—unlike the peoples of the Andes, they did not have moulds. Other fine work includes the pottery of the Kadiwéu, decorated with incised designs, the zoomorphic panels of the Waurá and, above all, the *licocós* of the Karajá—small figures, single or in groups, and scenes portraying human beings and their immediate environment. These continued to be produced in the 20th century, although profoundly altered as a result of tourism, which created a new market.

In spite of the repressive effects of religious indoctrination, the body arts of indigenous Brazilians also continued to be practised in the 20th century as body painting, the wearing of feather ornaments and dramatic masked dances. The tribes of the Xingu, for example, use pigments from natural sources, such as vermilion from the urucu plant, black from the genipap tree and white from clay, to cover their bodies—at all ages—with a careful sense of fantasy. Equally splendid are the abstract patterns common among the Kadiwéu, who use them not on their bodies but on skins and woven fibre cloth. The body is also used for other aesthetic devices, especially on the face where such devices are intended to give a special shape: examples include the perforated earlobes of the Kaapor, Xavante and Timbira peoples, and lips perforated for the insertion of such decorative elements as rings, discs and pierced stone, sometimes of impressive size. The nose ornaments of the Yanomani and the parrot-tail feathers linking the nasal septum to the earlobe among the Tiriyo peoples are other examples of body arts that exploit the face. Necklaces made from feathers, teeth, claws, seeds, circles of mother-of-pearl and a range of other materials are frequently worn; outstanding examples include those made from feathers by the Kaapor and the rows of black zoomorphic figures incised in tucum palm-nut shells by the Tukuna. The male and female genitals are also given aesthetic treatment, for enhancement in the case of the men and for protection in that of the women. For all the body arts, each tribe had a particular decorative model that governed the items worn, which were also controlled by a sense of harmony of line and colour.

The use of feathers, in which the Kaapor peoples in particular but also the Mundurucú and Bororo excelled, is one of the most refined indigenous art forms in Brazil (see fig. 2). It is characterized by the purely decorative nature of each piece, involving a search for beauty through the extraordinary range of multicoloured tropical feathers used to create crests, diadems, coifs, garlands, belts, bracelets, armbands, anklets and *cache-sexes*. Many of these items, especially the fantastic masks used by men among the Tukano, Karajá, Bororo and Timbira peoples, remained an integral part of the tribal ceremonies that were essential to the preservation of their culture. An outstanding example, in the continuation of which the various forms of indigenous arts are powerfully integrated, is the Kuarup ritual in the Xingu region.

BIBLIOGRAPHY

K. von den Steinen: *Unter den Naturvölkern Zentral-Brasiliens* (Berlin, 1894)
C. M. Rondon: *Índios do Brasil*, 3 vols (Rio de Janeiro, 1946–58)
C. Lévi-Strauss: *Tristes tropiques* (Paris, 1955), pp. 95–105
D. Ribeiro and B. Ribeiro: *A arte plumária dos índios Kaapor* (Rio de Janeiro, 1957)
J. H. Steward, ed.: *Handbook of South American Indians*, i and iii (New York, 1963)
A. R. Ferreira: *Viagem filosófica pelas capitanias do Grão-Pará, Rio Negro, Mato Grosso e Cuiabá, 1783–1792* (Rio de Janeiro, 1971)
C. Andujar and D. Ribeiro: *Yanomani* (São Paulo, 1978)
M. Bisilliat: *Xingu* (São Paulo, 1978)
A. Bento de Araújo Lima: *Abstração na arte dos índios brasileiros* (Rio de Janeiro, 1979)

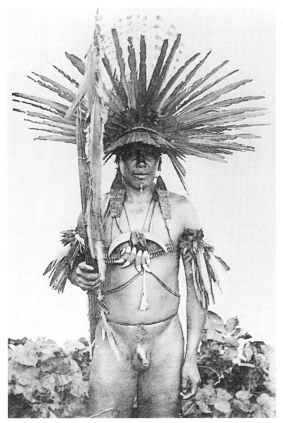

2. Featherwork of Bororo headman, Brazil; photograph by Karl von den Steinen, 1887–8

Arte plumaria del Brasil (exh. cat. by S. F. Dorta and L. H. Velthem, Mexico City, Mus. N. Antropol., 1982)
D. Ribeiro: 'Arte índia', *História geral da arte no Brasil*, ed. W. Zanini (São Paulo, 1983), i, pp. 46–87
R. E. Reina and K. M. Kensinger: *The Gift of Birds: Featherwork of Native South American Peoples* (Philadelphia, 1991)

ROBERTO PONTUAL

III. Afro-American culture.

The traffic in slaves between 1560 and 1850 brought Africans to Brazil in numbers that must have totalled between four and six million. Most were put to work in the sugar mills of the north-east, the gold mines of Minas Gerais and the coffee plantations of Rio de Janeiro and the southern provinces. Some were subsequently employed by religious orders: by the second half of the 16th century both Africans and mulattos were engaged in carving and gilding work for the churches being constructed throughout the country. The Africans brought to Brazil came from an area between the Gulf of Guinea and the Congo basin and thus, in general, from technically sophisticated cultures, skilled in metallurgy and accustomed to sculpture. To some extent, therefore, they were more willing to undertake work for the churches because it had parallels in their native community art. Contact with the dominant Catholic religion also led to a process of eclecticism in their own art, but while they were obliged to change the outward appearance of their religions,

artefacts and ceremonies, they could preserve their inner essence. Thus ritual Afro-Brazilian statuary developed basically from such West African plastic traditions as those of the Nago, Yoruba and other peoples, good examples being the Oxum (river goddess) figures of the Xangó religion of Pernambuco and the iron or wooden *exus* ('devil') figures and Gueledé masks of the Candomblé religion in Bahia (*see also* AFRICAN DIASPORA).

The high point of the African contribution to mainstream Brazilian art was between the end of the 17th century and the beginning of the 19th, when the building activity of the religious institutions was increasingly enriched by gold-generated wealth (*see* §IV, 1(i) below). The African slaves could not express themselves in accordance with their original cultural heritage but were expected to reproduce in local terms the patterns of European Baroque that were adopted in Brazil. This process, however, produced an interesting phenomenon: in the painted or carved figures required by the Catholic liturgy, the African physical type appeared with increasing frequency. Some of the greatest artists of the period were Africans or mulattos, including Antônio Francisco Lisboa (O Aleijadinho; *see* LISBOA, (2)), an architect–sculptor who worked in Minas Gerais; VALENTIM DA FONSECA E SILVA and Francisco das Chagas, sculptors working in Rio de Janeiro and Bahia; and José Teófilo de Jesus, a painter who worked between Bahia and Sergipe. MANOEL DA COSTA ATAÍDE is also thought to be of African descent. European models predominated in these artists' works (*see also* §§IV, 1 and V, 1 below), but the traces of their African background cannot be ignored.

As Neo-classicism became established in the 19th century, however, the role of Africans in the development of the visual arts in Brazil diminished sharply and was transferred to music, dance and sport—activities in which the hereditary community spirit was more apparent. There were several reasons for this. The Neo-classical concept of beauty was based on the Greco-Roman model and rejected negroid or mulatto features: even at the end of the century Oscar Pereira da Silva (1867–1939) portrayed the theme of slavery using an anachronistic white Roman slave rather than a black African. The absence of Africans from the visual arts was reinforced by the changing role of the artist, increasingly less often a craftsman working under the aegis of the Church than a trained professional dependent on state patronage, and by the social and economic conditions of Africans in Brazil at this time that constituted a radical hindrance to their admission to the official practice of art. Between 1840 and 1889 there was also a renewed policy of persecution of the 'barbaric fetishism' of African cults in Brazil: their ceremonial centres were closed, their statues and cult objects destroyed, and the free expression of their creativity curtailed. Almost the sole appearance of the African in Brazilian art in the 19th century was as a lay figure in the vast series of documentary and pictorial records made by foreign artists visiting Brazil, notably JEAN-BAPTISTE DEBRET and JOHANN MORITZ RUGENDAS (*see also* §V, 2(i) below).

In the last three decades of the century, however, the activities leading to the abolition of slavery resulted in a new awareness of African values, although at first only as the object of study. The first Afro-Brazilian collections

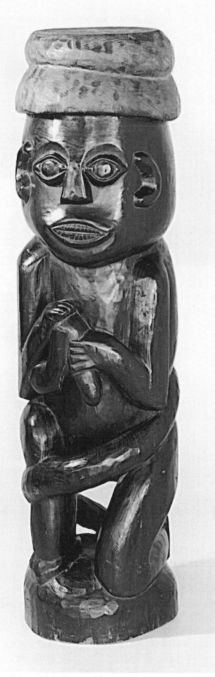

3. Agnaldo Manoel dos Santos: *Totem*, wood, h. 1 m, *c.* 1950 (São Paulo, João Marinho private collection)

were started at this time, beginning with that made by the ethnographer Nina Rodrigues between 1890 and 1904, part of which is now in the Museu Artur Ramos in Fortaleza. Other institutions continued the discovery and preservation of material that earlier had invariably been despised, for example carvings, utensils, jewellery, ceramics, basketry and clothing; collections are found in the Museu da Fundação Carlos Costa Pinto, Salvador; Museu

da Polícia, Maceió; Museu Folclórico da Divisão de Discoteca, São Paulo; Museu de Arqueologia e Etnologia, Universidade de São Paulo; and the Museu Paraense Emílio Goeldi in Belém. However, the systematic rehabilitation of the African contribution to Brazilian culture dates only from the 1920s. It was a principal interest of the modernist revolution in Brazilian art, which broke with academicism, sought a return to national roots and affirmed the regenerating power of the archaic, and one of the first truly modern works in Brazilian art was *The Negress* (1923; U. São Paulo, Mus. A. Contemp.; *see* TARSILA, fig. 1) by Tarsila do Amaral. The work of the sociologist Gilberto Freyre (1900–89) was of considerable importance in evaluating the role of Africans in the formation of the Brazilian family of races and culture, and he also organized the first Afro-Brazilian Congress (1934) in Recife.

Although artists of African origin whose work was orientated towards African sources contributed to the development of Brazilian art in the 20th century, their numbers bore no relation to the size of their racial element in Brazilian society. Many of the principal artists came from Bahia, the state in which African roots were strongest and continued to flourish. Of these, Deoscóredes Maximiliano dos Santos (Mestre Didi; *b* 1917) remained closest to his ancestral culture, of which he was also a practising high priest. His para-ritual objects—sculptures of leather, shells and vegetable fibres, such as palm-ribs—relate to the forces of nature and the divinities that represent them in the Afro-Brazilian pantheon of Yoruba origin. Agnaldo Manoel dos Santos (1926–62), part-African and part-Indian, produced hieratic and archaic wooden carvings combining archetypes from African tribal culture and medieval Catholic iconography (see fig. 3). Another fusion of cultures is seen in the totemic–emblematic painting of Rubem Valentim (*b* 1922): the figurative geometry of the 'implements' identifying each divinity of the cult (the *orixás do candomblé* or voodoo idols) are combined with the strict non-referential discipline of European Constructivism. Geometry also underlies the work of Emanoel Araújo (*b* 1940) in engravings, reliefs and sculptures reflecting the multiple totemic expression that suffuses the art of black Africa.

BIBLIOGRAPHY

G. Freyre: *Casa-Grande e Senzala: Formação da família brasileira sob o regime da economia patriarcal* (Rio de Janeiro, 1933)
A. Ramos: 'Arte negra no Brasil', *Cultura*, i/2 (1949), pp. 188–212
M. Barata: 'The Negro in the Plastic Arts of Brazil', *The African Contribution to Brazil* (Rio de Janeiro, 1966)
C. P. Valladares: 'O negro brasileiro nas artes plásticas', *Cad. Brasil.*, 47 (1968), pp. 97–109
N. Rodrigues: *Os africanos no Brasil* (São Paulo, 1976)
C. P. Valladares: *The Impact of African Culture in Brazil* (Rio de Janeiro, 1977)
M. Carneiro da Cunha: 'Arte afro-brasileira', *História geral da arte no Brasil*, ed. W. Zanini (São Paulo, 1983), ii, pp. 973–1033
M. S. Omari: *From the Inside to the Outside: The Art and Ritual of Bahian Candomblé*, Los Angeles, UCLA, Mus. Cult. Hist., Monograph 24 (Los Angeles, 1984)
——: 'The Role of the Gods in Afro-Brazilian Ancestral Ritual', *Afr. A.*, xxiii/1 (1989), pp. 54–61, 103–4

ROBERTO PONTUAL

IV. Architecture.

1. Before *c.* 1850. 2. After *c.* 1850

1. BEFORE *c.* 1850.

(i) Early colonial, Baroque and Rococo, c. 1500–c. 1760. (ii) Neo-classicism, c. 1760–c. 1850.

(i) Early colonial, Baroque and Rococo, c. 1500–c. 1760. In the years immediately following its possession of Brazil and the introduction of hereditary captains (*see* §I above), Portugal was primarily concerned with the defence of the long coastline, and architectural activity was limited to uncomplicated fortifications and dwellings built with the techniques and materials at hand. Only with the arrival in 1549 of the first governor-general, Tomé de Souza, and with him the mason Luís Dias, were more substantial buildings constructed. In Salvador, the capital until 1763, Dias was responsible for the customs buildings and the first council chamber and jail, in addition to the defensive system. Other fortifications were built along the coast by the Portuguese engineer FRANCISCO DE FRIAS DA MESQUITA, who worked in Brazil from 1603 to 1635; these included the forts of Lage (1606), Recife, Reis Magos (begun 1614), Natal, and S Marcelo (enlarged and completed in 1728 by the French brigadier Jean-Baptiste Massé), Salvador, in the north-east and S Mateus (begun 1617) at Cabo Frio in the south. The Casa da Torre at Garcia d'Ávila, north of Salvador, is the only surviving example of the civil buildings of a pioneer settlement of this period.

The most important stimulus to colonial architecture in Brazil, however, was provided by the religious orders. Members of the JESUIT ORDER, who also came with de Souza in 1549, brought architects, masons, building materials and even complete sets of components for churches to replace the primitive mud and thatch chapels built by the pioneers. Francisco Dias (1538–1623), who arrived in 1577 and was involved in the development of the early 'Missionary style' in Brazil, designed and built solid, rather grandiose Jesuit colleges and churches at OLINDA (1584) and Rio de Janeiro (1585). He also began the great collegiate church (completed 1672; now the cathedral) at SALVADOR, which is typical of the early churches designed on Portuguese models. Baroque characteristics became more evident in later works of the Jesuits, which spread as far north as Belém, Pará, on the delta of the Amazon, where important examples include the college of S Alexandre (begun 1670) and the adjacent church of S Francisco Xavier (1719/20). Although indigenous building skills were not available in Brazil to the extent that they were in other areas of Latin America with a more complex pre-Hispanic culture, in both of these buildings local Indians participated in the construction and interior decoration.

The Benedictine Order was also active in Brazil, particularly in the 17th century, and it commissioned work from three outstanding architects: Frei Macário de São João (*d* 1676) from Spain, who designed the ground-plans and original façades of the church of the Misericórdia (1659), the monastery of S Bento and the convent and church of S Teresa, Salvador; Gregório de Magalhães (1603–67), who planned the monastery (1649) at Santos; and Frei Bernardo de São Bento (1624–93) from Portugal, who modified and carried out (1670–80) Frias da Mesquita's original design for the Benedictine church in Rio de Janeiro. Although the Baroque architecture of the last is sober, echoing the Portuguese tradition, it has exuberant interior decoration incorporating gilded carvings (*talhas*), polychrome statues, silver candlesticks and paintings.

The contribution of the Franciscan Order reached its high point in the convent of S Antonio (begun early 18th century, completed 1783) at João Pessoa, north of Recife, which has a tower coping faced with *azulejos* (glazed tiles). Other notable Franciscan buildings include the church of S Francisco da Penitência, Rio de Janeiro, built during the 17th and 18th centuries with a unity of conception and style not found again until the late 18th-century churches of Minas Gerais, at the end of the Baroque period; the church of the Third Order of S Francisco da Penitência (begun 1702), Salvador, planned by Gabriel Ribeiro (*d* 1719), which has a richly carved stone façade rare among Brazilian colonial churches that usually conceal behind somewhat solemn façades their exuberant interiors; and the adjoining convent and church of S Francisco, the church (begun 1708) being one of the most richly decorated in Brazil, with gilded carvings, sculpture and *azulejos*.

Remarkable developments also took place in civic and domestic architecture during the 17th century, particularly in the area between Salvador and, to the north-east, Recife and Olinda, where sugar production expanded. The Dutch occupation (1630–54; *see* §I above) in the north-east introduced the first attempts at urban planning, with RECIFE being planned on the basis of the new European rationalist models. New buildings in Salvador included the Casa de Câmara and prison building (begun 1660), designed in a Renaissance style, with Tuscan columns and an elegant staircase to a central courtyard. Large town houses built for wealthy landowners, though simple in design, were often complemented by elaborate portals, as in those built for the Saldanha, the Unhão, the Sete Candeeiros and the Conde dos Arcos, all in Salvador.

Other important examples of the monumental Baroque style (*c*. 1655–1760) in religious architecture include the basilica of Nossa Senhora da Conceição da Praia, Salvador, designed in 1736 by the military engineer Manuel Cardoso de Saldanha, which took over a century to complete, using stone imported from Lisbon. It is a reproduction of Italianate Portuguese Baroque and is considered one of the best examples of Brazilian colonial architecture . The church of Nossa Senhora da Glória do Outeiro (1717–39; see fig. 4), Rio de Janeiro, was the first religious building in Brazil with a polygonal plan, a form rarely used in Portugal but later adopted enthusiastically in Minas Gerais. Further north, the 'Pernambuco school', which began to flourish in Recife before the end of the 17th century, produced several notable buildings, including the convent of S Antonio (1697) by Fernandes de Matos; the magnificent Golden Chapel in the church of the Third Order of S Francisco da Penitência (dedicated 1703); and the church of S Pedro dos Clérigos (1731–82) by Manuel Ferreira Jácome, which took up the polygonal theme, with a dodecagonal interior set in a rectangular external form, and which has twin square towers topped by octagonal ogee cupolas above a three-storey façade.

The discovery of gold in Minas Gerais at the end of the 17th century enabled the Baroque spirit to reach its apogee in Brazil. Religious orders flourished in the gold-mining centres, and much wealth went into church building. The golden age of 'arquitetura mineira' began with the chapel

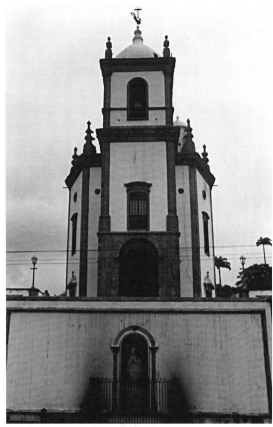

4. Nossa Senhora da Glória do Outeiro, Rio de Janeiro, 1717–39

of Nossa Senhora do Ó (begun 1719), Sabará, and the three-nave church of Nossa Senhora da Ascensão (now the cathedral), Mariana. In OURO PRÊTO (formerly Vila Rica), which became the administrative centre of the region, the church of Nossa Senhora do Pilar was built in only two years (1731–3), with a polygonal nave within the rectangular plan designed by the military engineer Pedro Gomes Chaves. Other churches in Ouro Prêto include Nossa Senhora do Rosário dos Pretos (1725–85), completed by José Pereira Arouca but said to have been designed by Manuel Francisco de Araújo; it has a unique double-oval plan with a flowing, convex façade topped by an ornate coronet pediment accentuated by circular towers. This church is seen variously as the culmination of Baroque three-dimensional movement and as one of the finest expressions of Rococo in Brazil. The pilgrimage church of Bom Jesus de Matozinhos (begun 1757), on a hilltop overlooking Congonhas do Campo, represents the dramatic fantasy of the final flowering of Brazilian Baroque. It was designed by the craftsmen Antonio Gonçalves de Rosa and Antonio Rodrigues Falcate and dominates an atrium in which stand 12 great figures of biblical prophets carved in soapstone (1800–05) by Antonio Francisco Lisboa (O Aleijadinho; for illustration *see* LISBOA, (2); *see also* §V, 1 below), an architect and sculptor who was one of the most remarkable figures of the colonial period.

(ii) Neo-classicism, c. 1760–c. 1850. The wealth produced by gold stimulated the construction of impressive secular buildings, although Portuguese models were necessarily simplified by the limitations of local technical resources. The most important residential building of the period in Ouro Prêto is the Casa dos Contos (1787) built for João Rodrigues de Macedo, the collector of taxes. Important civic buildings in the city include the Casa de Câmara and prison (now the Museu da Inconfidência), designed in 1745 by the military engineer José Fernandes Pinto Alpoim (1700–70) but not built until 1784 after modifications by the provincial governor of Minas Gerais, Luiz da Cunha Menezes; its symmetrical façade heralds Neo-classicism.

RIO DE JANEIRO was the centre of architectural development after 1763, when it became the capital. A single-storey residence for the governor, designed by Alpoim and completed in 1743, was raised to two storeys (1778–90) by the viceroy Luiz de Vasconcelos e Souza, who also redesigned its surroundings (now the Largo do Paço or Praça XV de Novembro) and installed a magnificent stone fountain attributed to the sculptor VALENTIM DA FONSECA E SILVA. The latter is also associated with the formation on reclaimed land of the Passeio Público (1779–83), with paths traversing gardens in the French manner, complete with fountains and statuary.

Just as the Baroque and Rococo reached their peak in Minas Gerais, the Italian architect ANTONIO GIUSEPPE LANDI was introducing the first signs of Neo-classicism to Brazil. Landi lived and worked in Belém after 1759, employing a style halfway between Baroque theatricality and Neo-classical restraint (*see* BELÉM (ii)). As well as working extensively on church interiors, he designed the octagonal chapel of S João Batista and the elegant Nossa Senhora das Mercês; more significantly, perhaps, he also designed the headquarters of the Companhia do Grão-Pará and the governors' palace (1771), Belém, which, despite its sober air—perhaps reflecting the influence of the Pombaline style in Lisbon—is among the finest buildings of the colonial period. The acceptance of Neo-classicism was assured when the Portuguese court moved to Brazil in 1808. The French artistic commission that arrived in Rio in 1816 to develop the fine arts and architecture (*see* §I above) included the architect Auguste-Henri-Victor Grandjean de Montigny, who had studied and worked in Paris and Rome and who became the first professor of architecture at the new Academia Imperial das Belas Artes.

By the time of independence in 1822, Brazilian architecture was already under the foreign influences that dominated it for most of the 19th century. The Neo-classicism that prevailed, particularly in Rio de Janeiro, was strongly influenced by the work of Grandjean de Montigny. Educated in the cultured, rational, urban classicism of Charles Percier and Pierre-François-Léonard Fontaine, he developed a style characterized by the sobriety of the Tuscan order, which transposed well into the Brazilian context and the austerity of the Pombaline stylistic tradition inherited from Lisbon. His first design in Rio was the building (1826; destr. 1939; façade re-erected in the Botanical Gardens) for the new Academia Imperial das Belas Artes. He also designed the Bolsa de Comércio (now the Casa França-Brasil) and customs house (both c. 1830) and some houses in Rio, including his own (now administrative offices on the campus of the Pontifícia

Universidade Católica; for illustration *see* GRANDJEAN DE MONTIGNY, AUGUSTE-HENRI-VICTOR). His influence and that of his pupils at the Academia on the architecture and urban planning of Rio combined to give the city a more elegant and modern appearance.

Other European architects who moved to Brazil also contributed to the development of the academic Neo-classical style. PIERRE JOSEPH PEZERAT arrived in Rio in 1825, soon after graduating in Paris, and worked as private architect to Peter I until the Emperor's abdication in 1831. Pezerat completed the Palácio da Quinta da Boa Vista (1827 and after; now the Museu Nacional), the Academia Militar (later the Escola de Engenharia) and several houses, including that of the Marquesa de Santos, all in Rio. Another Frenchman, Louis Vauthier (1815–1901), was active in Recife from 1840 to 1846, where he designed the Teatro S Isabel (*c.* 1845), the Hospital Dom Pedro II (begun 1847), the Ginásio Pernambucano (1855) and the Assembléia Provincial (1876).

Julius Friedrich Köller (1804–47), a military officer from Germany who came to Brazil in 1828 to build roads, also designed a number of buildings, including the Casa de Câmara in Itaboraí and in the nearby town of Maricá (both 1835), as well as the white church of the Glória (1842; with Philippe Garçon Rivière), a landmark in Rio, with neo-Gothic elements. Köller organized a colony of immigrants and founded the city of PETRÓPOLIS, where he designed the Palácio Rio Negro, the Emperor's summer residence (now the Museu Imperial), completed after Köller's death by one of Grandjean de Montigny's Portuguese students, José Maria Jacinto Rebelo (1821–71). Rebelo also designed the Hospital Dom Pedro II (completed 1852) at Petrópolis and the Palácio do Itamarati (1851–4; restored 1928–30), Rio, which became the seat of government for a period after 1889 and later the Ministry of Foreign Affairs.

BIBLIOGRAPHY
E. C. Falcão: *Relíquias da Bahia* (São Paulo, 1940)
A. Morales de los Ríos: *Grandjean de Montigny e a evolução da arte brasileira* (Rio de Janeiro, 1941)
C. M. da Silva-Nigra: *Construtores e artistas do mosteiro de São Bento do Rio de Janeiro* (Salvador, 1950)
P. Kelemen: *Baroque and Rococo in Latin America*, 2 vols (New York, 1951)
P. F. Santos: *O barroco e o jesuítico na arquitetura do Brasil* (Rio de Janeiro, 1951)
R. C. Smith: *Arquitetura colonial* (Salvador, 1955)
G. Bazin: *L'Architecture religieuse baroque au Brésil* (Paris, 1956; Port. trans., Rio de Janeiro, 1983)
L. Saia: *Arquitetura paulista* (São Paulo, 1960)
L. Castedo: *The Baroque Prevalence in Brazilian Art* (New York, 1964)
L. G. Machado: *Barroco mineiro* (São Paulo, 1969)
C. P. Valladares: *Análise iconográfica do barroco e neoclássico remanescentes no Rio de Janeiro*, 2 vols (Rio de Janeiro, 1978)
J. W. Rodrigues: *Documentário arquitetônico relativo à antiga construção civil no Brasil* (São Paulo, 1979)
C. P. Valladares: *Aspectos da arte religiosa no Brasil* (Rio de Janeiro, 1981)
D. Bayón and M. Marx: *L'Art colonial sud-américain* (Paris, 1990), pp. 293–343, 407–20
J. Bury: *Arquitetura e arte no Brasil colonial* (São Paulo, 1991)
P. de la Riesta: 'Arquitectura Lusobrasileña', *Arquitectura colonial iberoamericana*, ed. G. Gasparini (Caracas, 1997), pp. 493–552
R. Gutiérrez, ed.: *Barroco iberoamericano* (Barcelona and Madrid, 1997)
ROBERTO PONTUAL

2. AFTER *c.* 1850.

(i) Eclecticism, Art Nouveau and Neo-colonial, *c.* 1850–1920. (ii) Modernism, 1920–60. (iii) After 1960.

(i) Eclecticism, Art Nouveau and Neo-colonial, c. 1850–1920. As in Europe, by the middle of the 19th century French academic Neo-classicism in Brazil had begun to give way to more eclectic attitudes and the use of various foreign styles, including Gothic Revival and Moorish; a prime example of this tendency is the Palácio do Catete (1858–67; now the Museu da República), Rio de Janeiro, built by the German Gustav Wähneldt in Venetian Renaissance style as a residence and later used as the seat of central government in Brazil until the inauguration of Brasília. There was also a return to colonial models, including the late 18th- and early 19th-century *fazendas* (ranches) of the coffee and cattle estates. This was encouraged by the painter Manuel de Araújo Pôrto Alegre (1806–79), Director of the Academia Imperial das Belas Artes (1854–7), who questioned whether recent urban buildings were suited to the Brazilian climate and way of life and recommended the use of local motifs rather than Classical ones for their decoration. Examples of this approach include *solars* (summer residences), enhanced with such local elements as *azulejos* (glazed tiles), and Neo-colonial *fazendas* such as that at Vassouras (1870s) in the state of Rio de Janeiro, where a simple appearance is belied by a florid Second Empire interior. Another influence was the iron and glass architecture of such designers as Joseph Paxton in England and Gustave Eiffel and Victor Baltard in France, made possible by industrial developments there. The pioneering building of this type in Brazil is the San José market, Recife, imported from France in 1873.

Towards the end of the 19th century, far-reaching urban developments began in São Paulo and Rio de Janeiro. In SÃO PAULO the Avenida Paulista was opened up and garden districts initiated, and in central Rio the creation of Avenida Rio Branco (1903–6) was followed by intensive building activity there: the Escola (now Museu) Nacional de Belas Artes (1908), with a façade inspired by the Louvre in Paris, was designed by the Spanish-born architect ADOLFO MORALES DE LOS RÍOS, the outstanding figure of the period, who also designed the Moorish-style Instituto de Pesquisas Oswaldo Cruz on the outskirts of Rio; the Teatro Municipal (1909), inspired by the Paris Opéra, was designed by the engineer Francisco de Oliveira Passos; and the Biblioteca Nacional (1910) was designed by Francisco Marcelino de Souza Aguiar (1855–1935).

Art Nouveau also flourished for a time in the work of the Swedish architect Carl Eckman (1866–1940), for example the Vila Penteado (1902), São Paulo, and the French architect VICTOR DUBUGRAS, for example the Mairinque Railway Station (1907), São Paulo. However, Dubugras soon began to follow the neo-colonial tenets expressed in 1914 by Ricardo Severo (1869–1940), a partner of the important eclectic architect FRANCISCO DE PAULA RAMOS DE AZEVEDO; in his search for national roots Severo turned again to the robust buildings of the colonial *fazendas*. Others, including José Mariano Filho (1875–1946), who designed his own house, the Solar do Monjope (destr. 1974), Rio de Janeiro, as an essay in early 19th-century Portuguese colonial domestic style, were

adopting formal simplifications that heralded ready acceptance of the European Modern Movement.

(ii) Modernism, 1920–60. After World War I the enormous urban expansion in Brazil, particularly in São Paulo and Rio de Janeiro, made necessary the adoption of new building techniques for the construction of public buildings, offices and flats. The groundswell against the plethora of eccentric styles and crumbling academicism in favour of Modernism was first felt in the plastic arts, literature and music, exemplified in the SEMANA DE ARTE MODERNA in São Paulo (1922). Two architects, Antonio García Moya (1891–1956) of Spanish origin and Georg Przyrembel (1885–1956) from Poland, took part but neither was involved with real innovation, and Brazil's earliest Modernist buildings were built later in the pioneering work of GREGORI WARCHAVCHIK, who moved to São Paulo in 1923 after studying in his native Odessa and in Rome. In 1925 he published his manifesto, *Acerca de arquitetura moderna*, in São Paulo and Rio de Janeiro, in which he quoted from Le Corbusier's writings, and he built the first Modernist houses in Brazil, both in São Paulo: his own house (1927–8; altered 1935) and the Modernistic House (1927–30), Rua Itápolis, Pacaembú, which was exhibited to the public on its completion together with a collection of paintings, drawings and sculptures by rising modern artists. These and his other early houses were all typical rationalist designs in concrete reminiscent of early work by Le Corbusier.

The move towards Modernism, stimulated by Le Corbusier's lectures in São Paulo and Rio de Janeiro in 1929, culminated in the appointment of Lúcio Costa as Director of the Escola Nacional de Belas Artes in Rio de Janeiro following the revolution of 1930. Costa introduced Modernist teachers, including Warchavchik, and established a radical new curriculum, which the students continued to support even after he was forced to resign in 1931. A brief partnership between Costa and Warchavchik (1931–3) produced some more Modernist houses, including the Alfredo Schwarz House (1932), Rio, which gave ROBERTO BURLE MARX his first landscape commission. Frank Lloyd Wright gave encouragement to the new generation of Brazilian architects at the first Salão de Arquitetura Tropical (1933) in Rio, where he was the president of honour.

In 1935 a series of large architectural competitions was held, including one for a new building to house the Ministry of Education and Health in Rio de Janeiro. This was won by a traditionalist design, but on the advice of a number of art critics and architects the Minister awarded the commission to LÚCIO COSTA, who assembled a team of young Modernists, including AFFONSO EDUARDO REIDY, Carlos Azevedo Leão and JORGE MOREIRA, joined later by Hernani Mendes de Vasconcelos and also OSCAR NIEMEYER (who assumed its leadership in 1939). At Costa's suggestion, Le Corbusier was invited back to Rio as adviser to the project; he stayed for a month in 1936, working with the team and leaving an outline plan. Le Corbusier's basic ideas were modified to suit local conditions, and the Ministry Building (1937–43; now the Palácio da Cultura; see fig. 5) became the prototype of modern architecture in Brazil, characterized by slender pilotis, glazed walls with *brises-soleil* in the form of horizontal louvres on the exposed façade and sculptural rooftop

elements. The building brought together paintings by CÂNDIDO PORTINARI, sculpture by BRUNO GIORGI and gardens by Burle Marx, who all later collaborated on several other important buildings.

Another competition, for the Associação Brasileira de Imprensa (ABI) Building (1936), Rio, was won by the brothers Marcelo and Mílton Roberto; this building was among the earliest to have the design of façades wholly determined by fixed louvres, here arranged vertically (for illustration *see* ROBERTO, M. M. M.). Niemeyer's first independent work, the simple, white, rectilinear Obra do Berço day nursery (1937), Rio, also used vertical louvres on the exposed façade, but they were adjustable. In São Paulo the early work of Rino Levi, who studied in Rome, had a hint of Expressionism, for example in the residential Columbus Building (1932) and the entrance of the UFA Palácio cinema (1936). Other notable buildings of this period include the residential Esther Building (1938), São Paulo, by ALVARO VITAL BRASIL, the Santos Dumont Airport buildings (1937–44), Rio, by the Roberto brothers and the seaplane station (1938), also Rio, by ATTILIO CORRÊA LIMA. The new architecture of Brazil was brought to worldwide attention by the Brazilian Pavilion (1939; destr.; see fig. 6) at the World's Fair in New York, a commission won in competition by Lúcio Costa, who invited Niemeyer to participate in the design (with Paul Lester Wiener in New York); this was followed by the exhibition *Brazil Builds* (1942) at MOMA, New York.

The Modern Movement became fully established in Brazil in the 1940s and 1950s. Reidy, who was chief municipal architect and planner for Rio de Janeiro, prepared a master-plan for the development on the Santo Antonio hill and also designed the elegant, serpentine, seven-storey residential block in Pedregulho (1947–52; for illustration *see* REIDY, AFFONSO EDUARDO), as well as the technically sophisticated Museu de Arte Moderna (1952–60), which was destroyed in a fire in 1978. It was rebuilt in 1980 by Mindlin Associates, whose founder, HENRIQUE

5. Lúcio Costa, Oscar Niemeyer and others (with Le Corbusier as adviser): Ministry of Education and Health, Rio de Janeiro, 1937–43; now the Palácio da Cultura

6. Lúcio Costa and Oscar Niemeyer (with Paul Lester Wiener): Brazilian Pavilion, New York World's Fair, 1939 (destr.)

E. MINDLIN, specialized in the construction of large industrial and commercial complexes in the 1950s and 1960s. Mindlin's book (1956) became an important record of much of the 'heroic' period of modern architecture in Brazil. Later work by the pioneers included the Instituto Central do Cancer (1949–54) by RINO LEVI, the Roberto brothers' Marquês do Herval Building (1955) in Rio, its façade enlivened with patterns of *brises-soleil*, and the purist buildings of Jorge Moreira, for example at the Cidade Universitária (1949–62; with Aldary Henriques Toledo), Rio de Janeiro, for which he also produced the master-plan.

Early in the 1950s a different approach was developed by SÉRGIO BERNARDES, based on the direct expression of structure and materials; examples include the Macedo Soares House (1953) at the Samambáia estate, Rio, and the brilliant exhibition building (1953) for the Companhia Siderúrgica in Ibirapuera Park, São Paulo, an early tension structure. JOÃO B. VILANOVA ARTIGAS, who built the residential Louveira Building (1948) in São Paulo, an often-quoted example of the influence of Le Corbusier in Brazil, later became an influential teacher at the Universidade de São Paulo. Oswaldo Arthur Bratke (*see* BRATKE) was also active in São Paulo in the 1940s and 1950s, as were FRANZ HEEP, Icaro de Castro Mello (*b* 1913), Helio Queiroz Duarte (1906–74), Xenon Lotufo (*b* 1911) and Flaminio Saldanha (*b* 1905).

The outstanding figure of the period, however, was undoubtedly Niemeyer, whose lyrical work, mostly in reinforced concrete, developed a refined aesthetic formalism that seems to distil the essence of Brazilian art and culture and provides many of the popular images of Latin American architecture, for example the group of four minor masterpieces around the lake at Pampulha (1942–7), near Belo Horizonte (*see* NIEMEYER, OSCAR, fig. 1). When Costa won the competition in 1957 for the master-plan for a new capital city, BRASÍLIA (for illustration *see* COSTA, LÚCIO), it was Niemeyer as Chief Architect who

made possible the artistic realization of a logistic miracle: the major public buildings, including the sculptural Congresso Nacional complex (*see* NIEMEYER, OSCAR, fig. 2), were all ready for the inauguration ceremonies in 1960. Despite its many shortcomings, it was at Brasília that images of Corbusian urbanism of the 1930s became reality, presenting one of the most memorable visions of 20th-century architecture.

(iii) After 1960. Niemeyer continued to work in Brasília after 1960, a well-known later building being that for the Ministry of Foreign Affairs, the elegant Palácio dos Arcos (1965), with landscaping by Burle Marx (for illustration *see* BURLE MARX, ROBERTO) and sculpture by Giorgi (see fig. 10 below). Other architects began to investigate different approaches. Some developed a Brutalist style in the mid-1960s and 1970s, although in a more refined form than in Europe. The São Paulo 'school' led by Vilanova Artigas, who designed the Faculty of Architecture Building (1961; for illustration *see* ARTIGAS, JOÃO B. VILANOVA) at the university there, developed an architecture of powerful forms, extensive use of raw concrete and simple, often monumental envelopes covering lighter-weight structures housing the building functions; the work of Ruy Ohtake (*b* 1939) is another good example. PAULO MENDES DA ROCHA's work was also influenced by Vilanova Artigas; he built the Museu de Arte Contemporânea (1975; with Jorge Wilheim) at the Universidade de São Paulo. Bernardes, who worked extensively in urban planning and prepared a master-plan (1964) for the development of Rio de Janeiro, made the study of industrialized building an integral part of his commission and set up a research centre to carry out economic and technical studies, the results of which are seen in much of his later work. João Toscano (*b* 1933) in his Araraquara University (1974) and MARCELO FRAGELLI in his Piraquê Industry Building (1977), Rio de Janeiro, also adopted the constructionalist ethic, initiated by Bernardes in the 1950s, and JOÃO

FILGUEIRAS LIMA's clarity of structural expression, as in the ascending helicoidal design of the Central Administration of Bahia (CAB) Chapel (1974; see fig. 7), Salvador, is reminiscent of this approach.

As Modernism lost ground, other names came to the fore with a variety of different approaches. For example, José Zanine Caldas (*b* 1918), a brilliant model-maker and self-taught architect, developed an original craft-based neo-vernacular style of building in and around Rio de Janeiro, which is reminiscent of early 19th-century colonial *fazendas*. SEVERIANO PORTO, who worked in the Amazon region, was concerned with regional, environmentally appropriate design and construction techniques. Joaquim Guedes, whose individual constructionalism was developed in a series of private houses in São Paulo in the 1960s and 1970s (for illustration *see* GUEDES, JOAQUIM), designed the new town of Caraíba (1976–80), where he based his plans on traditional village patterns and built simple, economic houses in environmentally appropriate forms and materials.

Many of the younger architects received their education in the provinces, and more diverse groups began to form in the 1980s. Well-known examples include Luiz Forte Netto (*b* 1935), a graduate of the Universidade Mackenzie, São Paulo, who worked with a group of younger architects: Vicente Ferreira de Castro Neto (*b* 1943), Orlando Busarello (*b* 1947), Silva Cândida Busarello (*b* 1947) and Adolfo Sakaguti (*b* 1954), all graduates of the Universidade Federal do Paraná, producing a number of commercial buildings in the fast-developing city of Curitiba, the state capital of Paraná; and Joel Ramalho Júnior (*b* 1934), another graduate of Mackenzie, who worked with Leonardo Toshiaki Oba (*b* 1950) and Guilhermo Zamoner Neto (*b* 1950), both

graduates of Paraná, and designed the Expo Centre (1980), Recife, and the confidently Post-modern Legislative Assembly building (1982), Curitiba. Another Post-modern building, the Citibank Building (1983–6), São Paulo, by the partnership of CROCE, AFLALO AND GASPERINI, resulted from an internationalist approach, their later style reflecting contemporary overseas aesthetic developments.

BIBLIOGRAPHY
G. Warchavchik: 'Acerca de arquitetura moderna', *Il Piccolo* (15 June 1925)
P. L. Goodwin and G. E. Kidder Smith: *Brazil Builds: Architecture New and Old, 1652–1942* (New York, 1943)
Archit. Forum, lxxxvii/5 (1947) [whole issue on Brazil]
Archit. Aujourd'hui, xxiii (1952) [whole issue on Brazil]
H.-R. Hitchcock: *Latin American Architecture since 1945* (New York, 1955)
H. E. Mindlin: *Modern Architecture in Brazil* (Rio de Janeiro, 1956)
'Rapporto Brasile', *Zodiac*, 6 (1960) [special feature], pp. 56–139
O. Niemeyer: *Minha experiência em Brasília* (Rio de Janeiro, 1961)
G. Ferraz: *Warchavchik e a introdução da nova arquitetura no Brasil, 1925–1940* (São Paulo, 1965)
F. Bullrich: *New Directions in Latin American Architecture* (London, 1969), pp. 22–7, 96–105
Y. Bruand: *L'Architecture contemporaine au Brésil* (Lille, 1973; Port. trans., São Paulo, 1981)
D. Bayón and P. Gasparini: *Panorámica de la arquitectura latino-americana* (Barcelona, 1977; Eng. trans., New York, 1979), pp. 39–61, 237–40
A. Amaral, ed.: *Arte y arquitectura del modernismo brasileño, 1917–1930* (Caracas, 1978)
C. A. C. Lemos: *Arquitetura brasileira* (São Paulo, 1979)
'Modern Brazilian Architecture', *Process: Archit.*, 17 (1980) [whole issue]
G. Ferrez and P. F. Santos: *Marc Ferrez: Álbum fotográfico da construção da Avenida Rio Branco, 1903–1906* (Rio de Janeiro, 1982)
S. Ficher and M. M. Acayaba: *Arquitetura moderna brasileira* (São Paulo, 1982)
G. Rosso del Brenna: *O Rio de Janeiro de Pereira Passos* (Rio de Janeiro, 1985)
M. M. dos Santos Camisassa: *Modern Architecture and the Modernist Movement in Brazil during the 1920s and 1930s* (diss., Colchester, U. Essex, 1994)

7. João Filgueiras Lima: Central Administration of Bahia (CAB) Chapel, Salvador, Brazil, 1974

A. Brant, ed.: *Arquitetos do Brasil/Architects from Brazil* (Rio de Janeiro, 1995)

J. Dec. & Propaganda A., xxi (1995) [issue dedicated to Brazil]

P. Meurs and E. Agricola: *Brazilië: Laboratorium van architectuur en Stedenbouw* (Rotterdam, 1997)

ROBERTO PONTUAL

V. Painting, graphic arts and sculpture.

1. Before *c*. 1822. 2. After *c*. 1822.

1. BEFORE *c*. 1822. Artistic activity in colonial Brazil was almost exclusively linked to the work of religious orders throughout the country for the first century after Portuguese settlement. The Jesuits were the most active in building, particularly colleges and churches, and this led to a need for wood-carvers and sculptors capable of supplying the demand for statues, crucifixes and retables. The first of these artists came from outside Brazil; in the first half of the 17th century, for example, the Portuguese João Correia worked in the states of Rio de Janeiro and Bahia, and Johann Xavier Traer (1668–1737), a carver and painter from the Tyrol, worked in the states of Maranhão and Pará. Traer, together with indigenous assistants, was responsible for the pulpits in the collegiate church of S Alexandre, Belém, the canopies of which are reminiscent of Central European Baroque design. The main Jesuit contribution to painting dates from the arrival in 1587 of Belchior Paulo, a Portuguese member of the order who worked until 1619 in the Jesuit colleges of Olinda, Salvador, Vitória, Rio de Janeiro and São Paulo. He was followed by several other Jesuit painters, chiefly from Portugal, France and the Netherlands, including Fernão Cardim, active in Olinda; João de Almeida (*c*. 1635–79), who was responsible for the decoration of the side altars (1668) in the church of S Francisco Xavier, Belém; and Francisco Coelho, who executed 16 paintings (1740) for the refectory of the college in Salvador. Jesuit carvers and painters also produced the magnificent gilded carvings (1665–70) that cover the classical-style altar of the collegiate church (now the cathedral) in Salvador.

The Benedictines produced works in Salvador, Olinda and São Paulo, but their finest artistic production was concentrated on the monastery of S Bento in Rio de Janeiro. In the 17th century, for example, this work included sculpture by the Brazilian-born Frei Agostinho de Jesus (*b c*. 1600), who was also a painter and potter, and by the Portuguese Frei Domingos de Conceicão (*c*. 1643–1718), who produced carvings for the monastery church, including the two portals and most of the high altar retable (1693–4). Frei Ricardo do Pilar (*d* 1700), who arrived in Brazil from Germany in 1660, was perhaps the most significant artist working at the monastery; his surviving works include ten panels painted for the chancel of the church and the large canvas of *Our Lord of the Martyrs*, painted in 1690 for the sacristy.

The Dutch occupation in north-east Brazil (1630–54; *see* §I above) produced important changes in artistic production, in particular by introducing secular subjects. When Johan Maurits, Count of Nassau-Siegen (*see* NASSAU-SIEGEN, JOHAN MAURITS OF), came to Brazil in 1637 as governor-general, he brought with him several scientists, architects and artists, including the painters Frans Post and ALBERT ECKHOUT and the draughtsman Zacharias Wagener II (1614–68); they produced important records of landscapes, genre scenes, costumes, fauna and flora (*see also* §§II above and X below). The exoticism of the surroundings helped to develop the sensitivity of Post's landscapes, in particular the intensity of detail characteristic of tropical colours (e.g. a painting of the *Island of Itamaracá*, 29 km north-east of Recife, 1637; Amsterdam, Rijksmus., on loan to The Hague, Mauritshuis; for illustration *see* POST, (2)). Although less vigorous than Post's, Eckhout's work—mainly still-lifes and representations of local scenes and customs—also showed a skill that raised it above mere documentation. Wagener, who was a soldier and Nassau's steward, made drawings in his free time that are early examples of simple observation of the reality of Brazil. He also produced a manuscript, *Thierbuch Zoobiblion* (Dresden, Kupferstichkab.), consisting of drawings and picturesque descriptions of native animals.

During the second half of the 18th century the best colonial art in Brazil was produced by artists in the three centres of Rio de Janeiro, Bahia and Minas Gerais and by the more isolated painters Padre Jesuíno do Monte Carmelo (1764–1819) in São Paulo and João de Deus Sepúlveda in Pernambuco. The Baroque style began to appear at the beginning of the 18th century with the adoption of the illusionist perspective introduced by Andrea Pozzo in Rome. Between 1733 and 1743 Caetano de Costa Coelho painted an illusionistic architectural composition in the church of S Francisco da Penitência, Rio de Janeiro. Bahia was dominated by the work of José Joaquim da Rocha (1737–1807), a Brazilian trained in Europe who introduced Italian influences and whose religious works included the painting (1772–3) of the nave vault of the church of the Conceição da Praia, Salvador, and two panels (1777–92) for the church of the Misericórdia, Salvador.

In the state of Minas Gerais, the wealth produced by gold-mining in the 18th century was reflected in the exuberance of the painting, wood-carving and sculpture there. The Portuguese Antônio Rodrigues Belo (*b* 1702) introduced new techniques of ceiling painting, executing the chancel vault in the parish church of Cachoeira do Campo in 1755. Two of the most significant Brazilian artists during the transition from the Baroque to the Rococo style worked in Minas Gerais: MANOEL DA COSTA ATAÍDE, who executed one of the most important paintings of the colonial period in Brazil, the ceiling (1801–10; see fig. 8) of S Francisco de Assis da Penitência in Ouro Prêto; and the sculptor and architect Antônio Francisco Lisboa (O Aleijadinho), who worked there for more than 50 years after 1760. At a time when the colony was beginning to assert its own identity, Lisboa's prolific, varied work (for example, *see* RETABLE, fig. 2) fused conventional religious imagery with elements of Brazilian experience, including the use of local materials such as soapstone. His statues of *Prophets* (1800–05; for illustration *see* LISBOA, (2)), carved for the pilgrimage sanctuary of Bom Jesus at Matozinhos, near Congonhas do Campo, together with 64 painted wood figures of the Via Crucis in chapels along the hillside path leading to the sanctuary, provided a formal model for Brazilian sculpture (*see also* §IV, 1(i) above).

8. Manoel da Costa Ataíde: *Glorification of the Virgin*, painted ceiling (1801–10) of S Francisco de Assis da Penitência, Ouro Prêto

In Rio de Janeiro, which became the capital in 1763, important work was done by VALENTIM DA FONSECA E SILVA, a sculptor and carver who was also responsible for the design and landscaping of the Passeio Público (1779–83), Rio, including pine-cone ornaments, obelisks, statues, a fountain and pavilions decorated by the painter Leandro Joaquim (1738–98). The move to Rio of the Portuguese royal court in 1808 (*see* §I above), however, resulted in a transformation of the visual arts in Brazil. The French artistic commission organized by the Prince Regent (later John VI, King of Portugal) was led by Joachin Lebreton (1760–1819) and included the painters NICOLAS-ANTOINE TAUNAY (for illustration *see* RIO DE JANEIRO) and JEAN-BAPTISTE DEBRET, the sculptor Auguste-Marie Taunay (1768–1824) and the engraver Charles-Simon Pradier (1783–1847); they were joined in 1817 by the sculptors Marc Ferrez (1788–1850) and Zéphirin Ferrez (1797–1851). One of its main achievements was the founding of the Academia Imperial das Belas Artes in Rio de Janeiro (1826), from which the academic ideas of Neo-classicism began to spread throughout Brazil (*see* §2(i) below).

BIBLIOGRAPHY

T. Thomsen: *Albert Eckhout: Ein niederlaendischer Maler und sein Goenne Moritz der Brasilianer* (Copenhagen, 1938)
C. M. da Silva-Nigra: *Construtores e artistas do mosteiro de São Bento do Rio de Janeiro* (Salvador, 1950)
S. Leite: *Artes e ofícios dos Jesuítas no Brasil* (Rio de Janeiro, 1953)
L. Castedo: *The Baroque Prevalence in Brazilian Art* (New York, 1954)
A. Taunay: *A missão artística de 1816* (Rio de Janeiro, 1956)
E. Larsen: *Frans Post: Interprète du Brésil* (Amsterdam, 1962)
G. Bazin: *Aleijadinho et la sculpture baroque au Brésil* (Paris, 1963)
Z. Wagener: *Zoobiblion: Livro de animais do Brasil* (São Paulo, 1964)
J. R. Teixeira Leite: *A pintura no Brasil holandês* (Rio de Janeiro, 1967)
L. G. Machado: *Barroco mineiro* (São Paulo, 1973)
C. P. Valladares: *Rio barroco* (Rio de Janeiro, 1978)
——: *Aspectos da arte religiosa no Brasil* (Rio de Janeiro, 1981)

ROBERTO PONTUAL

2. AFTER *c.* 1822.

(i) Neo-classicism to Romanticism, *c.* 1822–88. (ii) Early modernism, 1889–1930. (iii) Developments in modernism, 1931–60. (iv) After 1960.

(i) Neo-classicism to Romanticism, c. 1822–88. For many years after independence from Portugal in 1822, artistic activity in Brazil was dominated by France, due largely to the influence of the Academia Imperial das Belas Artes (founded 1826; *see* §§1 above and XII below). The Baroque and Rococo models that had been handed on by the system of apprenticeship were replaced by Neo-classicism, an understanding of which could only be acquired by academic training. At the same time, the domination of art patronage passed from the Church to the State, and secular subjects replaced religious ones (*see* §X below). The many aspects of Brazilian life in the 19th century were best documented by foreign travellers, both professional artists and amateurs, who recorded the flora, fauna, landscape and people of the country. Particularly important was a series of paintings executed between 1816 and 1831 by JEAN-BAPTISTE DEBRET, who was Professor of History Painting at the Academia, and the work of JOHAN MORITZ RUGENDAS, who visited Brazil in 1821 as draughtsman to the scientific expedition of the Russian diplomat Baron de Langsdorff. Other artist–travellers of the time, some of whom settled permanently in Brazil, included Emeric Essex Vidal, Louis Buvelot and Thomas Ender. Few Brazilian artists recorded the actual appearance of their country until later in the century, although Manuel de Araújo Pôrto Alegre (1806–79), Director of the Academia from 1854 to 1857, encouraged interest in the local environment, and himself produced Romantic landscapes (e.g. *Brazilian Forest*, 1853; Rio de Janeiro, Mus. N. B.A.). Graphic artists also depicted Brazilian subjects. The first important lithographer in Brazil was the Swiss Johann Steinmann (1800–44), who worked in Rio (1825–33) and produced maps and popular prints. In 1839 Frederico Guilherme Briggs printed the first caricatures, a series of political attacks attributed to Pôrto Alegre. The first wood-engraving workshop was opened in Rio in 1870 by the Portuguese Alfredo Pinheiro; the technique was practised particularly expressively by Modesto Brocos y Gomez (1852–1936), who was also a painter.

Academic influences continued to prevail, however, and Brazilian painting and sculpture continued to be dominated by Neo-classicism throughout most of the 19th century. This can be seen in the paintings of VICTOR MEIRELLES DE LIMA and PEDRO AMÉRICO DE MELO (e.g. the *Battle of Avaí*, 5×10 m, 1872–7; Rio de Janeiro, Mus. N. B.A.) and the sculpture of Francisco Manuel Chaves Pinheiro (1822–84), for example the *Goddess Ceres* (Rio de Janeiro, Mus. N. B.A.), which was predominantly historical, religious and allegorical. Only in the last quarter of the century did Romantic, natural and nationalistic subjects become more popular. Under the influence of

GEORG GRIMM, who arrived in Brazil from Germany in 1874 as professor at the Academia, many artists began to take up *plein-air* painting, for example JOÃO BATISTA CASTAGNETO and ANTONIO PARREIRAS. Brazilian themes that had occasionally appeared in rhetorical history scenes or idealizations of national types, such as those by Meirelles de Lima, Américo de Melo, Rodolfo Amoedo (1857–1941) and Henrique Bernardelli (1857–1936), also became more common during the period of economic growth in the last two decades of the 19th century; JOSÉ FERRAZ DE ALMEIDA JÚNIOR, in particular, introduced popular types and costumes of the interior of the state of São Paulo into his increasingly Realist paintings (e.g. *Brazilian Woodchopper*, 1879; Rio de Janeiro, Mus. N. B.A.).

(ii) Early modernism, 1889–1930. The proclamation of the republic in 1889, rapid industrialization and increasing popular interest in the visual arts in Brazil brought a desire for change, challenging conventional approaches. Teaching at the Academia, renamed Escola Nacional de Belas Artes, was partially reformed (*see* §XII below), and innovative young artists were encouraged by those who had undergone an academic training but had later become acquainted with the most recent European movements. The new approach was exemplified by the opening of the Atelier Livre in Rio de Janeiro, which was modelled on the Académie Julian in Paris at the instigation of Rodolfo Amoedo, Henrique and RODOLFO BERNARDELLI and ELISEU VISCONTI. Visconti in particular overcame a narrow academic training through his work with Eugène-Samuel Grasset (1841–1917) in Paris. He returned to Brazil imbued with a mixture of Impressionism and Art Nouveau that informed his work for nearly 60 years (e.g. decorations for the Teatro Municipal in Rio de Janeiro, 1906–7; *in situ*). Contemporary styles and subject-matter were also reflected in the illustrations and caricatures of such draughtsmen as BELMIRO DE ALMEIDA.

Brazilian art as a whole, however, was marked by a persistent conservatism. The poet Oswald de Andrade from São Paulo, who had first-hand experience of Futurism in Europe, returned to Brazil in 1912 and worked hard for a radical reformulation of Brazilian culture. In particular he attacked Brazilian artists for their lack of interest in the landscape and people of their country. During this period São Paulo began to replace Rio as the centre of artistic activity in Brazil: the wealth generated by coffee production in the state enriched an élite who travelled regularly to Europe, bringing back avant-garde works and ideas. The Lithuanian-born LASAR SEGALL, trained in German Expressionism, first exhibited modern art in Rio de Janeiro and São Paulo in 1913, although this had little immediate impact. The real break came four years later with the work of Anita Malfatti (1896–1964) in São Paulo (e.g. *The Fool*, 1917; U. São Paulo, Mus. A. Contemp.). She had studied in Berlin and New York (1914–16), and her experience of Cubism and Expressionism made her exhibition of 1917 crucial for the development of Brazilian Modernism. This took firm hold after the SEMANA DE ARTE MODERNA in São Paulo (1922), which included an exhibition championed by leading writers, with paintings by Malfatti and EMILIANO DI CAVALCANTI, VICENTE DO REGO MONTEIRO and John

Graz (1895–1980), drawings by OSWALDO GOELDI and sculptures by VICTOR BRECHERET (e.g. *Guitar-player*, 1923; São Paulo, Pin. Estado). Their approach to modernism drew on both international developments and Brazilian experience. Their enthusiasm was particularly stimulated by encounters in Europe with Futurism, Cubism, *L'Esprit nouveau* and Surrealism.

TARSILA, a pupil of Fernand Léger (1881–1985) and André Lhote (1885–1962) in Paris from 1920 to 1923, became the principal figure in Brazilian Modernism on her return to São Paulo; her work effectively combined elements of geometric stylization, primitivism and Surrealism to convey a deep native lyricism. This style of painting inspired Oswald de Andrade to issue the *Manifesto antropófago* (1928) in São Paulo, aiming at the reconciliation of external influences with local traditions. Surrealism also influenced two other painters: ISMAEL NERY of Pará, who met Marc Chagall in Paris in 1927, and CÍCERO DIAS from Pernambuco, whose watercolours recaptured in dreamlike scenes his childhood experiences in the sugar mills. Pernambuco also succeeded in establishing itself as an important centre through a regionalist movement led by the sociologist Gilberto Freyre after 1926. The heroic phase of Modernism ended in 1930, when an exhibition of the work of artists of the Ecole de Paris was brought to Recife, Rio de Janeiro and São Paulo by Rego Monteiro, who had lived in France. It was the first time that the Brazilian public was able to see at first hand a collection of works by some of the great modern artists of Europe.

(iii) Developments in Modernism, 1931–60. Conditions for the modernization of Brazil changed at the beginning of the 1930s. The repercussions of the international financial crisis of 1929 and the Brazilian revolution of 1930 and subsequent rise to power of Getúlio Vargas ended the ideological turbulence of the preceding decade and began a long period of state intervention and patronage of the arts. Modernism was officially accepted and was marked by two new concerns: social issues and professionalism. The determined audacity typical of early Modernism was replaced by a more sober approach, which is clearly seen in the work of Tarsila, Cavalcanti and Segall, who moved to São Paulo in 1923, and also in the work of CÂNDIDO PORTINARI a little later. In the 1930s Portinari began a series of murals and large easel paintings, many commissioned by the State, on historical and social themes, in which he was influenced by Mexican Social Realism (e.g. *Coffee*, see fig. 9; for further illustrations of his work *see* PORTINARI, CÂNDIDO and NIEMEYER, OSCAR, fig. 1).

In parallel with this ideological approach, other groups of artists between 1931 and 1945 were concerned with improving the status of their profession, for example the Núcleo Bernardelli, formed in Rio in 1931, from whose ranks emerged at least two important painters: MÍLTON DACOSTA and JOSÉ GIANINI PANCETTI. In São Paulo, groups such as the Sociedade Pró-Arte Moderna, the Clube dos Artistas Modernos, the Salão de Maio and the Família Artística Paulista were formed in the 1930s, in which the first generation of modernists were joined by such rising artists as FLÁVIO DE CARVALHO, ALBERTO DA VEIGA GUIGNARD, ALFREDO VOLPI and CARLOS SCLIAR. Of these, it was Flávio de Carvalho who did most to

9. Cândido Portinari: *Coffee*, oil on canvas, 1.31×1.97 m, 1935 (Rio de Janeiro, Museu Nacional de Belas Artes)

promote the adventurous spirit of Brazilian Modernism through this cautious period. His work (e.g. the *Final Ascension of Christ*, 1932; São Paulo, Pin. Estado) was enigmatic and violent and, although rooted in Viennese Expressionism, was responsible for the pioneering debate between Surrealism and abstract art in Brazil. Sculpture of this period included the Surrealist work of Maria Martins (1900–73), for example the *Great Serpent* (1942; Rio de Janeiro, Dalal Achcar priv. col., see 1987 exh. cat., p. 205), and the eclecticism of BRUNO GIORGI and Ernesto de Fiori (1884–1945), some of it commissioned in conjunction with the new architecture that was beginning to emerge in Brazil (*see* §IV, 2(ii) above). The work of the landscape architect and painter ROBERTO BURLE MARX was also important in this context.

Only in the middle of the 1940s did modernist art extend outside São Paulo and Rio de Janeiro, and this was followed by new developments after the end of World War II. The art world in Brazil underwent a structural change with the appearance of the first museums of modern art between 1947 and 1949 (*see* §XI below) and the establishment of an art market, in which the first São Paulo Biennale (1951) was a vital factor. Subsequent exhibitions increased the availability of information about international movements to the art world and the general public, as did the arrival in Brazil of such foreign artists as Maria Elena Vieira da Silva (1908–92), Arpad Szenes (1897–1984), Samson Flexor (1907–71), Heinrich Boese (1897–1982), Laszlo Meitner (1900–68) and Emeric Marcier (*b* 1916). The chief result of this process of fertilization was the development of abstract art in Brazil. Cícero Dias,

who had lived in Paris since 1937, and ANTONIO BANDEIRA, who had moved there in 1946, were the pioneers, the former producing geometric abstraction (e.g. a mural in the Ministry of Finance in Recife, 1948) and the latter *Art informel* (e.g. *Big City Illuminated*, 1953; Rio de Janeiro, Mus. N. B.A.). Many artists gradually became associated with *Art informel*, including such Japanese–Brazilians as MANABU MABE and Tomie Ohtake (*b* 1913), together with IBERÊ CAMARGO, Yolanda Mohalyi (1909–78) and FRANS KRAJCBERG, who later dedicated himself to engraving, photography and sculpture with natural materials. However, it was geometric abstraction that became dominant during the 1950s. At the head of this movement were Abraham Palatnik (*b* 1928), Almir Mavignier (*b* 1925), Vieira da Silva and IVAN SERPA in Rio de Janeiro and Samson Flexor, Waldemar Cordeiro (1925–73) and Geraldo de Barros (*b* 1923) in São Paulo. They were encouraged by Max Bill's visit to Brazil in 1941, the first two São Paulo Biennales and the support of the critic Mário Pedrosa (1900–81).

In the second half of the 1950s, in the optimistic climate of the government of Juscelino Kubitschek, Concrete art became the spearhead of abstract art. This movement, in which poets and artists were again united, was centred on São Paulo, and the best-known artists were Cordeiro, Luís Sacilotto (*b* 1924), Lothar Charoux (1912–87) and Hermelindo Fiaminghi (*b* 1920). The Neo-Concrete group was formed in reaction to the mathematic certainty of Concrete art. It consisted mainly of artists working in Rio de Janeiro, who introduced subjective, symbolic and organic dimensions to their work. In the work of LYGIA

CLARK (e.g. *Rubber Grubs*, 1964, remade by artist, 1986; Rio de Janeiro, Mus. A. Mod.), HÉLIO OITICICA, Aluísio Carvão (*b* 1918), Willys de Castro (1926–88), Lygia Pape (*b* 1929), Franz Weissman (*b* 1914) and AMÍLCAR DE CASTRO, the group's chief members, Constructivism and Dadaism were often combined; their ideas were supported by the writings of the poet and critic Ferreira Gullar (*b* 1930). There were many artists of this time who, without associating themselves with the Concrete or Neo-Concrete groups, submitted in varying degrees to the rigours of geometric abstraction, including such painters as Volpi (e.g. *Night Façade*, 1955; U. São Paulo, Mus. A. Contemp.; for illustration *see* VOLPI, ALFREDO), Mílton Dacosta (e.g. *On a Brown Background*, 1955; U. São Paulo, Mus. A. Contemp.), Rubem Valentim (*b* 1922), Dionísio del Santo (*b* 1925) and Mira Schendel (1919–88) and the sculptor SÉRGIO DE CAMARGO.

However, the dominance of geometric abstraction met some intransigent opposition, even in the 1950s, for example from older artists such as Emiliano di Cavalcanti. Groups of graphic artists interested in Realism and Expressionism also formed in the 1950s, impelled by the Cold War and by the examples of Oswaldo Goeldi and LÍVIO ABRAMO; the most consistent of these was the Clube de Gravura in Pôrto Alegre (1950–56) led by Carlos Scliar, but other artists included the Magic Realist Marcello Grassman (*b* 1925) of São Paulo and the group of engravers centred on the studio of the Museu de Arte Moderna do Rio de Janeiro, which remained on the fringe of *Art informel*.

(iv) After 1960. All these initiatives were stifled by the political disturbances in Brazil in 1961 and after, and by the wave of figurative art that directly confronted social realities and was combined with the influence of Pop art. This new phase was exemplified by the *popcret* assemblages of Waldemar Cordeiro; the *Negress* and *Animals* series of Ivan Serpa (e.g. *Head*, 1964; U. São Paulo, Mus. A. Contemp.); the 'happenings' of WESLEY DUKE LEE and Nelson Leirner (*b* 1932); and the painting and graphic art of such artists as GLAUCO RODRIGUES, ANTÔNIO HENRIQUE AMARAL and ANTÔNIO DIAS. These developments were publicized by exhibitions, for example *Opinião-65* and *Nova objetividade brasileira* (1967), both at the Museu de Arte Moderna do Rio de Janeiro. The latter was particularly important because it was simultaneously a résumé of the avant-garde movements of São Paulo and Rio de Janeiro and also marked a new battle between the geometric abstraction prevalent in the 1950s, especially Neo-Concrete art, and the new trends. The gap between them was bridged by Hélio Oiticica, whose work showed a new neo-Dadaist dimension. Notable sculpture was produced in this period by Bruno Giorgi (see fig. 10) for the new federal capital of Brasília.

This activity took place under the repressive military regime installed in 1964; however, the anti-cultural spirit that prevailed made avant-garde manifestations possible. Many of these went beyond traditional limits, for example the series of *Domingos da Criação* (1971) in Rio de Janeiro—events that called on everyone, artist or not, to participate in creative action. There was also a decentralization of art, with the appearance of museums and

10. Bruno Giorgi: *Meteor*, marble, h. 4 m, 1965, outside the Palácio dos Arcos (Ministry of Foreign Affairs), Brasília

contemporary exhibitions throughout the country. Pernambuco was one of the most active centres at this time, with the work of the potter and painter FRANCISCO BRENNAND, the painter and engraver João Câmara Filho (*b* 1944) and the wood-engraver Gilvan Samico (*b* 1928), for example, drawing inspiration from popular art of the region. The interest in popular art also stimulated such artists as the sculptor Agnaldo Manoel dos Santos (for illustration of his earlier work see fig. 3 above) and the painters José Antônio da Silva (*b* 1909), DJANIRA, Raimundo de Oliveira (1930–66) and ANTÔNIO MAIA.

In the 1970s an ideology was imposed on Brazilian art by the dictatorship in power. However, individual artists could provide lively opposition to the official approach, as shown by events organized at the time by the Museu de Arte Contemporânea of the Universidade de São Paulo and the Museu de Arte Moderna do Rio de Janeiro. Conceptual art, in particular, was adopted by the avant-garde. The most interesting artists of the period included CILDO MEIRELES, Artur Alípio Barrio (*b* 1945), Antônio Manuel de Oliveira (*b* 1947), Carlos Zílio (*b* 1944), Waltércio Caldas Júnior (*b* 1946) and José Resende (*b* 1945). However, with the process of democratization that began in 1978, the Conceptual movement was soon completely extinguished. A new generation, concerned with a more humorous depiction of the reality of their country, was inspired by the expressive possibilities of such new international movements as the Italian *Transavanguardia* and German Neo-Expressionism. Its vitality was made evident in the exhibition *Como vai você, geração 80?* in the Escola de Artes Visuais, Rio de Janeiro, in 1984.

BIBLIOGRAPHY
J.-B. Debret: *Voyage pittoresque et historique au Brésil* (Paris, 1834–9)
J. M. dos Reis Júnior: *História da pintura no Brasil* (Rio de Janeiro, 1944)
G. Ferrez: *A mui leal e heróica cidade de São Sebastião do Rio de Janeiro* (Rio de Janeiro, 1965)
J. R. Teixeira Leite: *A gravura brasileira contemporânea* (Rio de Janeiro, 1966)

Art in Latin America since Independence (exh. cat. by S. L. Catlin and T. Grieder, New Haven, CT, Yale U. A.G.; San Francisco, CA, Mus. A.; New Orleans, LA, Mus. A.; and elsewhere; 1966)

R. Pontual: *Dicionário das artes plásticas no Brasil* (Rio de Janeiro, 1969)

A. Amaral: *Artes plásticas na semana de 22* (São Paulo, 1970)

P. M. Bardi: *Profile of the New Brazilian Art* (Rio de Janeiro, 1970)

——: *História da arte brasileira* (São Paulo, 1975)

A. Amaral, ed.: *Arte y arquitectura del modernismo brasileño, 1917–1930* (Caracas, 1978)

J. R. Teixeira Leite: *Pintura moderna brasileira* (Rio de Janeiro, 1978)

C. P. Valladares: *Rio neoclássico* (Rio de Janeiro, 1978)

N. Carneiro: *Rugendas no Brasil* (Rio de Janeiro, 1979)

J. Fekete: *Dicionário universal de artistas plásticos* (Rio de Janeiro, 1979)

R. Brito and P. V. Filho: *O moderno e o contemporâneo: O novo e o outro novo* (Rio de Janeiro, 1980)

M. J. Harrison and S. de Sá Rego: *Modern Brazilian Painting* (Albuquerque, 1980)

Grabadores brasileños contemporáneos (exh. cat. by E. von Lauenstein Massarani, Mexico City, Mus. A. Carrillo Gil, 1980)

J. Feinstein: *Feitura das artes* (São Paulo, 1981)

F. Morais: *Núcleo Bernardelli: Arte brasileira nos anos 30 e 40* (Rio de Janeiro, 1982)

C. Zilio: *Querela do Brasil: A questão da identidade da arte brasileira: A obra de Tarsila, Di Cavalcanti e Portinari, 1922–1945* (Rio de Janeiro, 1982, 2/1997)

Do modernismo à Bienal (exh. cat. by R. Abramo, F. Magalhães and M. B. Rosseti, São Paulo, Mus. A. Mod., 1982)

Q. Campofiorito: *História da pintura brasileira no século XIX* (Rio de Janeiro, 1983)

A. Trevisan: *Escultores contemporâneos do Rio Grande do Sul* (Pôrto Alegre, 1983)

'Arte contemporânea', *História geral da arte no Brasil*, ed. W. Zanini (São Paulo, 1983), ii, pp. 499–820

J. Marino, ed.: *Tradição e ruptura: Síntese de arte e cultura brasileiras* (São Paulo, 1984)

R. Brito: *Neoconcretismo: Vértice e ruptura do projeto construtivo brasileiro* (Rio de Janeiro, 1985)

R. Pontual: *Entre dois séculos: Arte brasileira do século XX na coleção Gilberto Châteaubriand* (Rio de Janeiro, 1987)

Modernidade: Art brésilien du 20e siècle (exh. cat. by A. Amaral and others, Paris, Mus. A. Mod. Ville Paris, 1987)

Art in Latin America: The Modern Era, 1820–1980 (exh. cat. by D. Ades, London, Hayward Gal., 1989)

A. Amaral: 'Límites y oscilaciones entre el arte y la realidad: El caso brasileño', *Voces de Ultramar: Arte en América Latina, 1910–1960* (exh. cat., Madrid, Casa América; Las Palmas de Gran Canaria, Cent. Atlántic. A. Mod.; 1992), pp. 43–8

F. Morais: *Cronología das artes plásticas no Rio de Janeiro, 1816–1995* (Rio de Janeiro, 1995)

J. Dec. & Propaganda A., xxi (1995) [issue dedicated to Brazil]

I. Mesquita: 'Brazil', *Latin American Art in the Twentieth Century*, ed. E. Sullivan (London, 1996), pp. 201–32

Escultura brasileña de 1920–1990: Perfil de una identidad (exh. cat., New York, Cult. Cent. Inter-Amer. Dev. Bank, 1997)

ROBERTO PONTUAL

VI. Furniture.

Furniture used in Brazil during the colonial period (from *c.* 1535) was basically Portuguese in origin. It reflected the various European influences—Spanish, Dutch, French and English—that had entered Portugal in the 15th century at the start of the Portuguese success in navigation, discovery and conquest. At the beginning of this period the import of furniture followed the settlement of the religious orders, which established themselves in Brazil at an early stage, and the expansion of sugar production, which was then the principal source of wealth (for further discussion *see* §I above). Furniture destined for churches, administrative buildings and houses was almost all imported from Europe (except for rare and ephemeral pieces produced at village level) and was characterized by simplicity and robustness, with straight lines and little deco-

ration. From the second half of the 17th century and especially throughout the 18th, gold production was at its height. During this period furniture became more complex and exuberant, with Baroque ornamentation and generous curved lines; examples can be seen in the monumental chests, altar credences, sacristy benches and cupboards and carved chairs that still exist in innumerable Brazilian churches and in the collections of the Museu de Arte Sacra de Universidade Federal Bahia, Salvador, and the Museu de Arte Sacra, São Paulo. The wood used most frequently was jacaranda. It was elegantly carved with a profusion of detail into a kind of lacework, which, by the end of the period, used as motifs the flora and fauna of the country.

The transfer of the Portuguese court to Brazil in 1808 changed the way of life in the isolated colony. Helped by a new economic cycle based on coffee production, the primitive living conditions and the basic accessories of daily life began to improve. In 1822 Brazil became independent, and the establishment of modern infrastructures accelerated urban development and created new standards of comfort. From this time a strong French influence could be seen in a succession of refined styles—Louis XVI style, Empire style and Restoration—in materials and decoration. It was only at the turn of the century, under the auspices of Art Nouveau, that the idea of truly Brazilian furniture began to be accepted. Furniture was mass-produced for the first time, a reflection of the new impetus in industry. A further stimulus to furniture production were the Liceus de Artes e Ofícios (Crafts and Trades Schools), especially those of Rio de Janeiro and São Paulo, which had been founded in the middle of the 19th century and were places both of learning and of production. The established middle class, which had become richer as a result of the coffee industry, still preferred to import furniture, for example the European Art Nouveau furniture for Villa Penteado (1920), one of the finest houses of the period in São Paulo. The emerging middle class, however, was ready to absorb nascent local production. The industrialist Alvaro Auler designed and made his own furniture and also designed the interior fittings of the Confeitaria Colombo, Rio de Janeiro.

Constructivist models from the Bauhaus dominated in the wave of modernization that swept the country from the beginning of the 1920s. The first Brazilian example is the wooden furniture and glass light-fittings in a pure and functional style created by Gregori Warchavchik for his Modernistic House (1930) in São Paulo. The influence of the more sensual Art Deco style can be seen in the furniture in Brazilian woods made in the 1930s by the factory of Federico Opfido in São Paulo. The overtly Modernist architecture from the 1930s, influenced by Le Corbusier and Mies van der Rohe, and the interest in the synthesis of the arts meant that contemporary Brazilian architects were concerned to create furniture that suited the pure and functional lines of their buildings. An example is the pioneering series of pieces in wood, leather and metal designed by the team led by Lúcio Costa and Oscar Niemeyer for the Ministry of Education and Health in Rio de Janeiro (*see* §IV, 2(ii) above). At the same time, the Modernist involvement in the preservation of the national art heritage led to a rediscovery and reappraisal of vernac-

ular furniture of the colonial period, in particular the rural furniture produced in Minas Gerais. This comprised chests, strongboxes for valuables or alms, tables, commodes, chairs, benches and cupboards (often painted inside with cheerful naïve floral patterns), which were made of such rare woods as jacaranda, cedar, mulberry and Brazilian mahogany. LINA BARDI, who designed the Museu de Arte Popular do União, Salvador, in the 1960s and the interior and fittings for the Museu de Arte de São Paulo (from 1947), also set up the Studio d'Arte Palma to make modern furniture and designed a chair inspired by the native sleeping-net (1948; see fig. 11). Joaquim Tenreiro (*b* 1906) settled in Rio de Janeiro in 1928. After working with such furniture firms as Laubisch and Hirth and Leandro Martins, in 1942 he began to design and produce his own furniture, opening a shop for interior furnishings in Rio de Janeiro in 1947 and another in São Paulo in 1953. In 1967 he created the furniture for the Banqueting Room in the Palácio dos Arcos (Ministry of Foreign Affairs) in Brasília. His pieces are usually of jacaranda-wood and are characterized by the use of traditional seats and backs in plaited straw. Sérgio Rodrigues (*b* 1927) enjoyed international success with his design 'Poltrona Mole' (1961), an armchair in wood and leather. José Zanine Caldas (*b* 1919) designed Z-line furniture in wood veneers that were mass-produced in the 1950s. He also designed strong, bold wooden furniture using traditional techniques for the interiors of the houses he had designed

for wealthy clients throughout the country (e.g. for Roberto Pontual in Buzios, near Rio de Janeiro, 1971–3; altered).

BIBLIOGRAPHY

T. Canti: *O móvel no Brasil: Origens, evolução e características* (Rio de Janeiro, 1980)
J. Marino: *Coleção de arte brasileira* (São Paulo, 1983)
J. R. Katinsky: 'Desenho industrial', *História geral da arte no Brasil*, ed. W. Zanini (São Paulo, 1983), ii, pp. 915–51
J. Marino, ed.: *Tradição e ruptura: Síntese de arte e cultura brasileiras* (São Paulo, 1984)
A. M. M. Monteiro and R. R. Macedo: *Joaquim Tenreiro: Madeira, arte e design* (Rio de Janeiro, 1985)
S. F. da Silva: *Zanine, sentir e fazer* (Rio de Janeiro, 1988)

ROBERTO PONTUAL

VII. Ceramics and glass.

Before the arrival of the Portuguese in Brazil in the 16th century, there were four areas of ceramic production: Marajó, Cunani, Maracá and Santarém, all in the north of Brazil (for further discussion *see* §II above). Vernacular pottery developed throughout Brazilian territory, and production included such utilitarian objects as pitchers, cooling-jars, teapots, bowls, dishes, pots, skillets and plates, which were usually made by women. The chief centres of production were the Jequitinhonha Valley in Minas Gerais and the area of Vitória in the state of Espírito Santo; in the latter, wares were characterized by an intense, black colour. Figurative pottery was a family activity, which was

11. Lina Bardi : chairs inspired by the native sleeping-net, wood and canvas, 1948 (São Paulo, Museu de Arte de São Paulo)

particularly prevalent during the periods between harvests. The main production centres were in the north-east, in the interior of Bahia, the Paraíba Valley in São Paulo and São José in Santa Catarina. A wide variety of decorated wares were made from plain clay or were glazed with red lead.

The religious orders working in Brazil after the conquest often made ceramic figures for religious purposes. Two outstanding Benedictine potters during the colonial period were the Portuguese Frei Agostinho da Piedade (d 1661) and the Brazilian Frei Agostinho de Jesus (1600/10–1661). Although the former produced prolifically in the monastery of S Bento in Salvador, less than 50 pieces have been definitely attributed to him. There are three signed pieces, including the *Nossa Senhora de Monteserrate* (1636; Salvador, Inst. Geog. & Hist.), which shows a synthesis of Gothic, Renaissance and East Asian influences; *St Peter Weeping* (Salvador, Nossa Senhora de Monteserrate) and *St Amaro* (São Paulo, Mus. A. Sacra) are executed in a similar style. Frei Agostinho de Jesus visited Portugal in 1628 and acquired a taste for the Baroque, which is evident in the exuberant form and colour of such pieces as *Nossa Senhora do Rosário* (São Paulo, Basilica de S Bento) and *Nossa Senhora dos Prazeres* (São Paulo, Mus. A. Sacra). Another type of ceramic production during the colonial period was the tin-glazed *azulejo* (tile). These were decorated with blue and sometimes yellow designs and were used on the exteriors of religious, civic and residential buildings.

The most interesting potter working at the beginning of the 20th century was the painter ELISEU VISCONTI. From 1893 he spent some time in Paris as a pupil of Eugène-Samuel Grasset (1841–1917) and became interested in the decorative arts through the influence of the Pont-Aven group and the Nabis. He created stained-glass windows, glass and ceramic vases, and he was concerned with the application of industry to art. Inspired by Art Nouveau he focused his designs on flowers, including the tropical maracujá (passion-flower) and the female figure. The painter Teodoro Braga (1872–1953) also experimented with the decorative arts, producing *c.* 1930 Art Deco ceramics that were inspired by the geometric Marajó patterns. These designs were also influential in stained-glass windows, which were frequently made for middle-class houses in São Paulo and Rio de Janeiro during the 1930s. In 1929 there was an exhibition of German decorative arts at the Escola Nacional de Belas Artes in Rio de Janeiro; it included pieces from the Deutscher Werkbund and led to a surge of interest in decorative arts. Shortly afterwards, the painter Paulo Rossi Osir (1890–1959) and other artists founded Osirarte for the industrial production of art pottery. Among Osir's products were tiles with designs by the painter Candido Portinari for the Ministry of Education and Health in Rio de Janeiro and for Niemeyer's church in the suburb of Pampulha, Belo Horizonte (*see* NIEMEYER, OSCAR, fig. 1). In the late 20th century the most important potter was FRANCISCO BRENNAND. He set up a museum-workshop near Recife in an old ceramics factory that belonged to his family. Here he produced and exhibited small and monumental works, which included fantastic flowers and animals. He also created the ceramic murals for Guarapes Airport in

Recife. Important non-figurative potters included Celeide Tostes (b 1935) in Rio de Janeiro and Megumi Yuasa (b 1937) in São Paulo.

Urban development and improved forms of communication after 1940 enabled a number of producers in rural areas to sell their work throughout the country. Vitalino Pereira dos Santos (1909–63), known as 'O Mestre Vitalino', was an active potter in Caruaru in Pernambuco and produced figures of bandits, soldiers, students and politicians. Largely due to his fame, Caruaru became the main centre for this type of figurative pottery; innumerable *bonequeiros* (dollmakers) began working full-time and supplied a predominantly tourist market.

BIBLIOGRAPHY
G. Cruls: 'Arte indígena', *As artes plásticas no Brasil*, ed. R. M. F. de Andrade (Rio de Janeiro, 1952), i, pp. 75–110
H. Borba Filho and A. Rodrigues: *Cerâmica popular do nordeste* (Rio de Janeiro, 1969)
C. P. Valladares and V. J. Salles: *Artesanato brasileiro* (Rio de Janeiro, 1978)
A. Bento de Araújo Lima: *Abstração na arte dos índios brasileiros* (Rio de Janeiro, 1979)
P. Herkenhoff: 'The Jungle in Brazilian Modern Design', *J. Dec. & Propaganda A.*, xxi (1995), pp. 239–59
D. Alcantara, ed.: *Azulejos na cultura Luso-Brasileira* (Rio de Janeiro, 1997)
ROBERTO PONTUAL

VIII. Gold, silver and jewellery.

According to Antonio Blasquez, a contemporary chronicler, the first Portuguese goldsmith arrived in Brazil in 1561. Unlike their counterparts in Peru (*see* PERU, §V) and Mexico (*see* MEXICO, §VII), however, the earliest gold- and silversmiths in colonial Brazil relied on imported silver (usually from Peru) in exchange for slaves. The gold-mines in Minas Gerais, Goias, Mato Grosso, Bahia and São Paulo subsequently provided craftsmen with plentiful raw material for the production of gold jewellery and domestic objects. Most of the surviving silver from the 16th and 17th centuries is ecclesiastical. In addition to antependia, candlesticks, lamps and liturgical vessels, chased incense boats in the form of ships were popular (see fig. 12; examples in Rio de Janeiro, Cathedral; Salvador, Mus. A. Sacra U. Fed. Bahia; São Paulo, Mus. A. Assis Châteaubriand). One distinctly Brazilian form is the large, goblet-shaped holy water stoup.

In the 17th century the main centres of production of silver and jewellery were Salvador and Olinda, and the number of silversmiths in Salvador rose from 25 at the

12. Silver incense boat, h. 85 mm, l. 170 mm, from São Paulo, second half of the 17th century (São Paulo, Museu de Arte de São Paulo)

end of the 17th century to 150 in 1750. The craft was not necessarily restricted to workers of European origin: Jews, Africans, native Americans and mulattos made and sold gold- and silverware, although a series of decrees issued from 1621 sought to prevent these groups of craftsmen from working. One of the earliest known extant Brazilian pieces is the reliquary bust of *St Lucia*, made about 1630 by Frei Agostinho da Piedade (*d* 1661) for the monastery of S Bento in Salvador. It is often difficult to differentiate between Brazilian and Portuguese silverwork, although certain characteristics, largely derived from African and native American art, can be detected in many Brazilian pieces. A lantern in the treasury of Rio de Janeiro Cathedral, dating from the second half of the 17th century, is a typical Brazilian combination of exotic figures and native vegetal motifs combined with European elements. In contrast, a gold ciborium made for the church of S Teresa in São Paulo during the same period shows no Brazilian features and is obviously the work of a Portuguese-trained goldsmith with a full knowledge of the most fashionable European Baroque ornament. During this period considerable quantities of silverware were imported from Portugal, and periodic attempts were made by the guilds of Lisbon and Oporto to limit the activities of Brazilian craftsmen; a decree of 1678, reissued in 1703, for example, limited the number of goldsmiths working in Rio to three.

Extravagant Baroque forms were used throughout the 18th century, although certain elements of the Rococo style, for example rocaille motifs, were adopted. One of the most accomplished exponents of the Baroque style was Lourenco Ribeiro da Rocha, who was appointed assaymaster in Salvador in 1725. During the first half of the 18th century, native American craftsmen working under Jesuit supervision in the missions of Paraguay produced liturgical silver of astonishing richness. In 1766, however, a decree was issued, in force until 1815, prohibiting the manufacture of all gold and silver articles in Brazil. Its purpose, ostensibly to protect the interests of Portuguese craftsmen, was effectively to curtail the trade in contraband wares, on which the *quinto* or 'King's fifth' had not been paid. Many workers moved to Buenos Aires in Argentina, and the trade in silverware with that city, as well as with those in Peru, continued unchecked in Brazil. Yet this law appears to have been generally ignored; many craftsmen continued to work clandestinely in Brazil and struck their works with imitation Portuguese hallmarks. Most surviving 18th-century domestic silver pieces are either ewers, basins or salvers, although some *farinheiras* (bowls for manioc flour) are extant, sometimes made of gold and elaborately chased with Baroque ornament.

Neo-classical motifs appeared at the end of the 18th century and are often combined with other styles in the same piece. Good examples of this combination of styles include the antependium and tabernacle from the chapel of the Blessed Sacrament of Salvador Cathedral by Joao da Costa Campos (1791–8; Salvador, Mus. A. Sacra U. Fed. Bahia). Swags of husks, beading and other classical motifs are combined with a background of horizontal bands, but the overall effect is Baroque in style.

Towards the end of the 18th century Rio de Janeiro became an important centre of production where, in the 19th century, immigrant Italian, French and German craftsmen brought new techniques and to a certain extent developed the mechanized production of silverware. In the 19th century large quantities of candlesticks, snuffers and inkstands, often decorated with exotic foliage, were produced in Rio de Janeiro, together with *paliteiros* (toothpick holders) in the form of animals, mythological figures or plants. Large sums of money were spent on silver, as well as gold, horse trappings. Typical silver items from southern Brazil include a type of silver beaker with a swing handle and chain, known as a *guampa*, that was hung from the saddle and used to collect water without dismounting. In Rio Grande do Sul, where the herbal infusion *mate* was especially popular, a distinctive form of *chimarrao* (*mate* cup) and accompanying *bombilha* (sucking tube) was produced.

In the 20th century, workers in Bahia continued to produce jewellery incorporating African and Vodoun motifs, the most popular being the *balanganda*, a pendant comprising numerous amulets that was worn on the belt by slaves and made of silver and occasionally of gold, depending on the wealth of their owner. African elements are also found in the *joias de coco* (gold-mounted coconut jewellery) produced in Minas Gerais.

Only a small proportion of surviving Brazilian gold- and silverwork is hallmarked, although a system of assaying had been established in Bahia as early as 1689. Some surviving 18th-century pieces are marked with a crowned B for Bahia, sometimes found in conjunction with a maker's mark. The marks of a crowned M, for Minas, and a crowned R, for Rio, were also used; 19th-century silver made in Rio is marked with a 10 (denoting the silver standard of 10 dineiros) and a maker's mark. The conjoined letters SP appear on a small group of mid-19th-century silver and probably denote that the piece was made in São Paulo.

BIBLIOGRAPHY

J. Valladares and G. Valladares: 'A ourivesaria no Brasil', *As artes plasticas no Brasil*, ed. R. M. F. de Andrade (Rio de Janeiro, 1952), i, pp. 203–63
P. A. Carvalho Machado: *Ourivesaria Baiana* (Rio de Janeiro, 1973)
M. Rosa: *A prata da casa* (Salvador, 1980)
H. M. Franceschi: *O oficio da prata no Brasil: Rio de Janeiro* (Rio de Janeiro, 1988)
R. Lody: *Pencas balangandas da Bahia* (Rio de Janeiro, 1988)

CHRISTOPHER HARTOP

IX. Textiles.

The indigenous peoples of Brazil had developed an established and productive tradition of weaving and plaiting with leaves, palm fronds and other vegetable fibres well before the arrival of the Portuguese in 1500. They created objects for domestic and ceremonial use, among the most striking of which are the robes and painted masks used by the Tukuna for ritual purposes, the sleeping-nets from the Rio Negro made from palm fibre and the cotton garments of the Paresi, which have elaborately woven geometrical patterns in yellow, red and black (*see also* §II above). Although increasing contact with white civilization resulted in the decline of this activity, some continuity was guaranteed by the transmission of these techniques and forms to village weaving and cloth production. The indigenous Indians in religious missions or in rural enter-

prises came into contact with European spinning and weaving equipment—the spindle, the cotton gin and the shaft loom—and incorporated them in their own tradition. The Brazilian textile tradition is the result of these three traditions. The principal fibre used is cotton, which is widely available, as well as wool and various vegetable fibres.

Spinning and the related tasks of producing and dyeing thread are traditionally associated with women, who learn them in early childhood. For dyeing they use aniline extracted from some other textile, or natural ingredients from such plants as anil (indigo), *urucu* (annatto) and *quaresmeira* (Brazilian spider-flower), which, by maceration, fermentation and boiling, produce respectively a basic blue, red and yellow, from which a wide range of other colours can be obtained. The cloth is woven on two types of handloom: vertical (of disputed origin), which is widely used by the Amazonian Indians to make their sleeping-nets; and horizontal (of Portuguese origin), used in most other regions. Geometrical patterns predominate, based on straight lines. Figurative subjects are rare, although they do appear in the 'coast cloth', which the Negro *tercelões* of Bahia continued to produce in the African tradition. Blankets, bedcovers and towels are produced, as well as vividly coloured sleeping-nets, which are very common in Ceará and are also found in Maranhão and Mato Grosso. The bobbin-lace work, produced from native cotton thread, usually by women and especially in the north-east of Brazil, is used to decorate trousseaus, babies' layettes, towels, pillow-cases and sheets and sacristy towels or altar cloths.

Weaving as an art form developed in Brazil only at the beginning of the 20th century. The pioneer figure was the painter ELISEU VISCONTI, who, after studying in Paris with Eugène-Samuel Grasset (1841–1917), returned to Brazil with a profound interest in applied arts. His designs for silk textiles exhibited in Rio de Janeiro in 1901 have foliage motifs inspired by Art Nouveau. The influence of modernism is apparent in the work of Regina Gomide Graz (1897–1973), who trained from 1913 to 1920 at the Ecole des Beaux-Arts et des Arts Décoratifs in Geneva and produced designs for cushions, blankets and tapestries with geometrical patterns influenced by Cubism and Art Deco. Some of her pieces featured in the inaugural exhibition of the Modernistic House of GREGORI WARCHAVCHIK in São Paulo in 1930. After this period, the development of tapestry as *obra tecida* ('woven work') was rapid and widespread in Brazil. The principal practitioners were Madeleine Colaço (*b* 1907) in Rio de Janeiro, who used motifs from national folklore; Genaro de Carvalho (1926–71) in Salvador, whose designs reflect the exuberance of tropical vegetation; and Jacques Douchez (*b* 1921) and Norberto Nicola (*b* 1930) in São Paulo, both of whom used abstract forms.

BIBLIOGRAPHY
A. Ramos and L. Ramos: *A renda de bilros e sua aculturação no Brasil* (Rio de Janeiro, 1948)

G. E. de Andrade: *Aspectos da tapeçaria brasileira* (Rio de Janeiro, 1977)

C. P. Valladares and V. J. Salles: *Artesanato brasileiro* (Rio de Janeiro, 1978)

P. M. Bardi: *O modernismo no Brasil* (São Paulo, 1982)

D. Ribeiro: 'Arte india', *História geral da arte no Brasil* (São Paulo, 1983), i, pp. 46–87

E. Kac and A. F. Fagundes: *Madeleine Colaço* (Rio de Janeiro, 1988)

ROBERTO PONTUAL

X. Patronage, collecting and dealing.

For almost three centuries after colonization until the transfer of the Portuguese court to Rio de Janeiro (1808), artistic activity in Brazil depended primarily on the missions and religious orders that established themselves in the country. The undisputed strength of the Church came to a large extent from the administrative role it exercised in the colony, including responsibility for education. Countless sculptors, carvers and painters were employed by the Jesuits, Benedictines and Franciscans to work on their churches and colleges (*see* §V, 1 above). Much of this production and an important part of the vast cultural wealth of Baroque and Rococo paintings, *azulejos* (glazed tiles), gold- and silverwork, furniture and carvings owned by the religious orders, some of it imported from Europe, is still to be found in churches, convents and religious colleges throughout Brazil. During this period, apart from the work produced by foreign travellers and artists, the only secular element in Brazilian art was the documentary work of artists who came to Brazil with Johan Maurits, Count of Nassau-Siegen (*see* NASSAU-SIEGEN, JOHAN MAURITS OF), in 1637. The Brazilian work of such artists as Frans Post, Albert Eckhout and Zacharias Wagener II was taken back to the Netherlands in 1644, but in the 20th century some of it was returned to Brazilian collections; for example, the Museu Nacional de Belas Artes in Rio de Janeiro acquired eight paintings by Post.

After the second half of the 18th century, when the mining of gold and diamonds led to the concentration of wealth and urbanization, especially in Minas Gerais, state intervention in culture and the arts increased considerably. Expansion of the religious orders in the gold-producing region was under the control of royal authority, which encouraged the construction of public buildings and the employment of artists to carry out their ornamentation. This climate promoted the development of a number of major artists, including the sculptor Antônio Francisco Lisboa (O Aleijadinho) and the painter Manoel da Costa Ataíde, although most of their work was still the result of ecclesiastical commissions. The secularization of art was stimulated by the introduction of art education in 1800 with the opening of the Aula Pública de Desenho e Figura in Rio de Janeiro but more particularly by the steps taken by the Prince Regent (later John VI, King of Portugal) after his arrival in 1808, in an attempt to develop the cultural life of the colony; this led to the encouragement of artistic creation passing more directly to the state and away from the Church. His initiatives, particularly the organization of a French artistic commission (1816; *see* §§I, IV, 1(ii) and V, 1 above), resulted in the foundation of some of Brazil's most important institutions, including the Academia Imperial das Belas Artes, Rio de Janeiro, as well as the first import of secular works of art from Europe: for teaching purposes, the commission brought with them 50 paintings, originals or copies, by European artists, including Eustache Le Sueur, Charles Le Brun, Poussin, Canaletto and Guercino. Several of these later disappeared, but the remainder ultimately formed the basis of the collection of foreign paintings in the Museu Nacional de Belas Artes in Rio de Janeiro. This museum, together with the Museu Imperial in Petrópolis, also

received the collections of the emperor Peter II (*reg* 1831–89), who was a decisive influence in the development of the arts, constantly involved both officially and personally in encouraging their production and dissemination. The seeds of collecting, of an art market and of art criticism were planted during his reign, although restricted to a narrow circle centred on the court in Rio. Even after the proclamation of the republic (1889), the absolute hegemony of the capital as the artistic centre persisted until the first decades of the 20th century. Regular annual exhibitions were organized by the Academia Imperial das Belas Artes, official commissions for portraits and decorative or commemorative paintings increased, and private premises were opened to exhibit the work of individual artists then in vogue. The most systematic collections were begun at this time, such as that of Jonathas Abbot (*d* 1868) in Salvador, which was purchased by the provincial government in 1871 and later formed the basis of the Museu de Arte da Bahia. Outstanding collectors at the end of the 19th century included the Viscondessa de Cavalcanti and the Barão de São Joaquim; the Viscondessa was the first collector to bring back to Brazil a painting by Post, which is now in the Instituto Histórico e Geográfico Brasileiro, Rio de Janeiro, and the Barão acquired several works by Eugène Boudin that later passed to the Museu Nacional de Belas Artes.

Rapid industrialization and economic development after the end of the 19th century brought another change to the art world as private patrons began to appear, especially in São Paulo, which gradually succeeded Rio as the largest urban centre. The Semana de Arte Moderna (1922), which established modernism in Brazil (*see* §V, 2(ii) above), was the result of patronage by some of the most important individuals in economic and political circles of São Paulo. Private art collecting also began in earnest in the 20th century, beginning with such pioneers as Domingos de Góes and Gastão Penalva in Rio de Janeiro, and Carlos Costa Pinto and Francisco Góes Calmon in Salvador. They made a point of collecting paintings that were both old and Brazilian at a time when such works were being dispersed because of a general preference then for 19th-century French art. Other important collections of the colonial and imperial periods were made by José Mariano Filho, a historian and critic; Raymundo Ottoni de Castro Maya (1894–1968), an industrialist; the diplomat Joaquim de Souza Leão; and the antiquarian Francisco Marques dos Santos, all in Rio; and the entrepreneur João Marino (*b* 1929) in São Paulo. The collection of religious and folk art made by Abelardo Rodrigues of Pernambuco was acquired by the provincial government of Bahia and housed in the Solar do Ferrão in Salvador, while the collection of Brazilian and foreign modernist paintings and drawings of writer and critic Mário de Andrade (1893–1945) was absorbed into the collection of the Instituto de Estudos Brasileiros of the Universidade de São Paulo. State involvement in the arts continued, particularly in the direction of institutions such as schools, museums and foundations; for example the Vargas government initiated the modernization of teaching at the Escola Nacional de Belas Artes in 1930 (*see* §IV, 2(ii) above). Government patronage was also extended to individual artists, including Cândido Portinari in the 1930s and 1940s, and to many other artists with the construction of the new capital of Brasília in the 1950s and 1960s.

After 1945, with the establishment of the first museums devoted to modern art, the succession of international Biennales in São Paulo and the more consistent functioning of the art market, collectors in Brazil began to concentrate more on contemporary art. The largest of these collections, covering developments from the beginning of modernism in the 1910s to the late 20th century, was that of the former diplomat Gilberto Châteaubriand (*b* 1925) in Rio de Janeiro. Other collections of modern and contemporary art were formed by João Sattamini (*b* 1940) and Sérgio Sahione Fadel (who also collected a significant group of 19th-century works) in Rio; and by Adolfo Leirner, Ladi Biezus (*b* 1932), Ernesto Wolf and Rodolpho Ortenblad Filho in São Paulo. Some dealers, for example Jean Boghici (*b* 1930) and Max Perlingeiro (*b* 1945) in Rio, also collected on a considerable scale. For the most part these collections consisted almost entirely of Brazilian works, largely because of the strength of the internal market, which over-valued Brazilian artists, while protective legislation by import duties and the lack of international opportunities ensured that foreign works appeared on the market only rarely.

Many important collections later contributed to the foundation of new museums: the private collection of the industrialist Francisco Matarazzo Sobrinho (1898–1977), who was also the creator of the São Paulo International Biennale in 1951, was the basis of the Museu de Arte Moderna in São Paulo in 1948, and the collection of Assis Châteaubriand (1891–1968), the senator and journalist, formed the foundation of the Museu de Arte de São Paulo in 1947. The industrialist Raymundo Ottoni de Castro Maya, who helped found the Museu de Arte Moderna do Rio de Janeiro in 1949, also opened two museums in the Santa Teresa and Alto da Boa Vista districts of Rio to house his collections of Brazilian art; and the Fundação Roberto Marinho, created in 1983, includes the Marinho collection of contemporary art.

Private patronage and other private initiatives continued to expand in the latter part of the 20th century, for example through sponsorship of competitions, exhibitions, prizes and publications. Important newspapers such as the *Jornal do Brasil*, *Rede Globo* and *Manchete*—which established the Museu Manchete in Rio, founded on the 20th-century Brazilian art collection of its president, Adolpho Bloch (*b* 1908)—stood out among firms supporting artistic activities in Brazil.

See also §§XI, XII and XIII below.

BIBLIOGRAPHY

C. M. da Silva Nigra: *Construtores e artistas do mosteiro de S Bento do Rio de Janeiro* (Salvador, 1950)

S. Leite: *Artes e ofícios dos jesuítas no Brasil* (Rio de Janeiro, 1953)

A. Amaral: *Artes plásticas na Semana de 22* (São Paulo, 1970)

A. C. da Silva Telles: *Atlas dos monumentos históricos e artísticos do Brasil* (Rio de Janeiro, 1975)

C. P. Valladares: *Aspectos da arte religiosa no Brasil* (Rio de Janeiro, 1981)

Q. Campofiorito: *História da pintura brasileira no século XIX* (Rio de Janeiro, 1983)

J. Marino: *Coleção de arte brasileira* (São Paulo, 1983)

M. R. Batista and Y. S. de Lima: *Coleção Mário de Andrade* (São Paulo, 1984)

J. R. Teixeira Leite and others: *Seis décadas de arte moderna na coleção Roberto Marinho* (Rio de Janeiro, 1985)

R. Pontual: *Entre dois séculos: Arte brasileira do século XX na coleção Gilberto Châteaubriand* (Rio de Janeiro, 1987)

F. Gullar and others: *150 anos de arte brasileira: Coleção Sérgio Sabione Fadel* (Rio de Janeiro, 1989)

C. Martins: 'The Legacy of Raymundo Ottoni de Castro Maya', *J. Dec. & Propaganda A.*, xxi (1995), pp. 127–37

ROBERTO PONTUAL

XI. Museums.

The first museums in Brazil, including the Museu Nacional, Rio de Janeiro (founded 1818), the Museu Paraense Emílio Goeldi, Belém (1866), and the Museu Paulista da Universidade de São Paulo (1892), were all concerned with archaeology, history, anthropology and ethnography; not until the 20th century were museums established for the collection, conservation and exhibition of works of art. The first of these was the Pinacoteca do Estado in São Paulo, initially housed in the Liceu de Artes e Ofícios in 1905. Its foundation was due largely to José de Freitas Valle, a poet, patron and senator who did much to introduce modernism into Brazil in the 1910s. By the late 20th century it contained a very large collection of 19th-century Brazilian paintings, especially works by José Ferraz de Almeida Júnior, Pedro Alexandrino Borges (1864–1942) and Henrique Bernardelli (1857–1936). After 1969 its collections of contemporary art were enriched by automatic annual acquisitions from the Salão de Arte Contemporânea in São Paulo. The second art museum was founded in 1918: the Museu de Arte da Bahia, Salvador, originated in a purchase by the state in 1871 of paintings by local artists collected by Jonathas Abbot (*d* 1868). The collection, rich in porcelain, colonial art from Bahia and Luso-Brazilian furniture, was moved in 1982 to the Palácio da Vitória, built in 1924 with traditional architectural features.

Brazil's principal gallery for painting and sculpture, with works dating from the 13th century, is the Museu Nacional de Belas Artes, founded in Rio de Janeiro in 1937 and located in the building designed by Adolfo Morales de los Ríos for the Escola Nacional de Belas Artes, which operated there from 1908 to 1976. The basis of its collections came from the Escola Real das Ciências, Artes e Ofícios, instituted in 1816 on the arrival of the French artistic commission organized by the Prince Regent (*see* §X above), which brought paintings and prints from Europe for teaching purposes. Later acquisitions came from the royal collections, particularly of Emperor Peter II (*reg* 1831–89). Among its most important European paintings are works by Jacopo Bassano, Giambattista Tiepolo, Francesco Guardi, Frans Post and Eugène Boudin, but its great strength lay in its collection of Brazilian painting and sculpture from the mid-19th century to the early 20th, especially its patriotic scenes by Victor Meirelles de Lima and Pedro Américo de Melo and a comprehensive collection of works by Eliseu Visconti.

Museums concerned primarily with modern art were founded after World War II, when modernism had become well entrenched throughout Brazil. The first of these, the Museu de Arte de São Paulo, was established through the efforts of the senator and journalist Assis Châteaubriand (1891–1968) and the technical guidance of Pietro Maria Bardi (*b* 1900), its director. Its first assets included works by Mantegna, Giovanni Bellini, Tintoretto, Memling, Bosch, Frans Hals, El Greco, Goya, van Gogh, Gauguin, Degas and Picasso, but the museum at once turned towards new movements in art, especially through the educational activity of its Instituto de Arte Contemporânea. After 1967 it occupied a new building designed by Lina Bardi. The second such museum was the Museu de Arte Moderna (1948), also in São Paulo, the original holdings of which consisted of works by European artists presented by the industrialist Francisco Matarazzo Sobrinho (1898–1977). The first São Paulo International Biennale was held there in 1951, but subsequent Biennales were moved to one of the pavilions designed by Oscar Niemeyer in the Parque Ibirapuera. In addition to retrospective exhibitions devoted to Brazilian artists, annual surveys of painting, drawing, engraving and sculpture were also held there, substantially enriching the museum's collection.

In 1949 the Museu de Arte Moderna do Rio de Janeiro was founded, modelled on MOMA in New York. Although it had no foundation collection and no building of its own until Affonso Eduardo Reidy's two-stage design was completed (1957 and 1967), its director during the 1950s and 1960s, Niomar Muniz Sodré (*b* 1922), acquired important donations from international and national sources, especially of abstract works. The museum was well known for its exhibitions of avant-garde movements (*see* §V, 2(iv) above) and for its introductory courses for children and adults run by the painter Ivan Serpa. In 1978 a fire destroyed more than 80% of the collections, and although the building was reconstructed in 1980, the museum's work was interrupted for many years.

For the wealth of its holdings, however, the Museu de Arte Contemporânea of the Universidade de São Paulo, founded in 1963 and occupying buildings in the Parque Ibirapuera and the university campus, outshines its fellow institutions. Its collections were based on a gift to the university of the holdings of the Museu de Arte Moderna de São Paulo, which was then passing through a crisis, together with the private collections of Matarazzo Sobrinho and Yolanda Penteado. These were rapidly increased by acquisitions made at each São Paulo Biennale, so that the museum holds perhaps the most important collection of international contemporary art in Latin America, from Cubism onwards. It is also rich in 20th-century Brazilian art, including, for example, a donation by Emiliano di Cavalcanti of 564 drawings made by him between the 1920s and 1950s. From its inception the museum favoured experimental art and exhibitions of the work of young artists, which then travelled to other provincial capitals.

Brazilian modernist works are also found in the Instituto de Estudos Brasileiros of the Universidade de São Paulo, which created a special section in 1968 to house works donated by Mário de Andrade (1893–1945), a writer and critic who was a pioneer supporter of Modernism and throughout his life collected works by the principal modernists of Brazil as well as some foreign artists. Galleries devoted to the work of single artists are rare in Brazil. Exceptions include the Museu Lasar Segall, created in 1970 in the house in São Paulo where the artist lived and worked and containing a large part of his work and related documents; the Museu Antônio Parreiras in Niterói; and

the Casa-Museu Portinari at Brodósqui. Museums of 20th-century art in other cities include the Museu de Arte do Rio Grande do Sul, Pôrto Alegre; the Museu de Arte Contemporânea, Curitiba; the Museu de Arte Moderna, Belo Horizonte; the Museu de Arte Moderna da Bahia, Salvador; and the Museu de Arte Contemporânea de Pernambuco, Olinda.

Two museums were founded in Rio by the industrialist and patron Raymundo Ottoni de Castro Maya (1894–1968): the Museu de Tijuca (1964), which houses a fine collection from the colonial and imperial periods in Brazil, including work by foreign artists who visited the country, with a particularly good group of watercolours by Jean-Baptiste Debret; and the Museu Chácara do Céu (1972), which houses his collections of 20th-century Brazilian art and French Realism, Impressionism and Fauvism. In Salvador the Museu da Fundação Carlos Costa Pinto, inaugurated in 1969, specializes in Portuguese and Brazilian furniture and silverware, including the finest existing collection of sets of jewellery from Bahia, as well as Chinese and European porcelain of the 17th, 18th and 19th centuries.

Three museums have outstanding collections of religious art, including wooden and terracotta statues and gold and silver liturgical objects: the Museu de Arte Sacra da Bahia (founded in 1959) in the Benedictine convent of S Teresa, Salvador; the Museu Arquidiocesano in Mariana (1961); and the Museu de Arte Sacra (1970) in the Franciscan monastery of Luz, São Paulo. Other important museums include the Museu da Inconfidência, Ouro Prêto (1938), which contains relics of the miners' rebellion as well as sculptures by Antônio Francisco Lisboa and paintings by Manoel da Costa Ataíde; the Museu Imperial, Petrópolis (founded 1945), which received part of the collections of Emperor Peter II and has the fullest archive of historical and artistic documents of the Brazilian monarchy, together with an excellent gallery of 19th-century art; the Museu de Arte Técnica Popular e Folclore in São Paulo (founded 1947); the Museu da Coleção Abelardo Rodrigues, Salvador (1984); and the Museu do Pontal (Coleção Jacques van de Beuque), established in Rio in 1984.

For information on museum architecture in Brazil, see §IV, 1(ii) and 2(i) above.

BIBLIOGRAPHY
A. Sodré: *Museu imperial* (Rio de Janeiro, 1950)
P. M. Bardi: *The Arts in Brazil: A New Museum at São Paulo* (Milan, 1956)
F. de Camargo e Almeida: *Guia dos museus no Brasil* (Rio de Janeiro, 1972)
M. Pedrosa, ed.: *Museu de imagens do inconsciente* (Rio de Janeiro, 1980)
A. Amaral: *Pinacoteca do estado de São Paulo* (Rio de Janeiro, 1982)
A. de Oliveira Godinho, ed.: *O Museu de arte sacra de São Paulo* (São Paulo, 1983)
M. R. Batista and Y. S. de Lima: *Coleção Mário de Andrade* (São Paulo, 1984)
O. Marques de Paiva: *O Museu paulista da Universidade de São Paulo* (São Paulo, 1984)
A. Amaral: *Desenhos de di Cavalcanti na coleção do MAC* (São Paulo, 1985)
A. Mafra de Souza, ed.: *O Museu nacional de belas artes* (Rio de Janeiro, 1985)
O modernismo no Museum de Arte Brasileira: Pintura (exh. cat., São Paulo, Mus. A. Brasileira, 1993)
J. Bitran Trindade and others: *Pinacoteca do estado de São Paulo: Um olhar crítico sobre o acervo do século XIX* (São Paulo, 1994)
M. C. Barbosa de Almeida and others: *Guía de museus brasileiros* (São Paulo, 1997)
 ROBERTO PONTUAL

XII. Art education.

Three centuries of colonial rule passed before formal institutions of art education were established in Brazil. From 1500 to 1800 artistic knowledge was transmitted by personal contact between masters and their apprentices. Even at the height of artistic production in the Baroque and Rococo periods, the teaching of art in Brazil continued to lack organization; moreover, very few Brazilian artists were able to study in European academies. This situation began to change in 1800 with the foundation by Portuguese royal decree of the Aula Pública de Desenho e Figura in Rio de Janeiro, which established regular teaching under the command of a master painter, Manuel Dias de Oliveira (1764–1837), an exception among local artists in that he trained in Lisbon and with Pompeo Batoni in the Accademia di S Luca in Rome. His most important innovation in art education was to replace the copying of imported prints with life drawing.

The French art commission organized by the Prince Regent that arrived in Rio in 1816 led to the establishment of the Academia Imperial das Belas Artes (1826) and the provision of an academic art education based on the canons of Neo-classicism. The Academia was dominated initially by the Professor of History Painting, Jean-Baptiste Debret, who organized the first art exhibitions in Brazil (1829 and 1830), and by the French Neo-classical painter Félix-Emile Taunay (1795–1881), who became director in 1834. Exhibitions modelled on the salons in Paris were begun in 1840, and many future teachers studied in Europe, either through travel grants established in 1845 or the personal patronage of the emperor Peter II. Under the directorship of Manuel de Araújo Pôrto Alegre (1806–79) from 1854 to 1857, the Academia, although still élitist, became more receptive to national and contemporary trends: a pupil of French masters, Pôrto Alegre encouraged a Romantic depiction of the reality of life in Brazil and a reform in teaching towards the integration of art and industry.

The creation of the Liceu de Artes e Ofícios in Rio de Janeiro in 1856 marked the first effective move towards the democratization of art training, and during the imperial period (1822–89), perhaps in imitation of the education of the royal family, the rudiments of art were taught in both boys' and girls' schools in Brazil. Art education in schools increased most dramatically with the wave of liberalism that accompanied the industrial expansion of the country after 1870. The ideas of Walter Smith, a British educator working in Massachusetts, in particular his emphasis on the importance of drawing in the classroom, were highly influential on the reform of primary and secondary education proposed by the legal expert Rui Barbosa in 1882 and 1883.

In 1889 the Academia Imperial das Belas Artes, renamed as the Escola Nacional de Belas Artes, was partially reformed, although it continued to promote historical models. In 1930, however, under the aegis of the Vargas government, Lúcio Costa's short but influential directorship revolutionized its teaching and introduced European avant-garde ideas. Other educational reforms beginning in 1929 were based on the ideas of John Dewey, which stimulated the natural impulse of children to draw; in the

following decades the first children's schools specializing in art were established, in particular the Escolinha de Arte do Brasil (1948), founded in Rio by the painter Augusto Rodrigues (*b* 1913), and rapidly expanded to other cities.

The educational function of museums and art galleries began to be exploited in Brazil at the end of the 1940s, especially at the Instituto de Arte Contemporânea of the Museu de Arte de São Paulo and the Setor de Cursos of the Museu de Arte Moderna in Rio de Janeiro. The latter was renowned for the teaching of art to children and adolescents in the years 1950–60 by Ivan Serpa and for the engraving workshop founded there in 1959 by Johnny Friedlaender. Other influential schools in Brazil include the Escola Brasil, set up in São Paulo (1970) under the direction of four young local artists, all disciples of Wesley Duke Lee: Luís Paulo Baravelli (*b* 1942), José Resende (*b* 1945), Carlos Fajardo (*b* 1941) and Frederico Nasser (*b* 1945). At the end of the 20th century most states in Brazil had official art schools, generally administered by universities. The most important remained the Escola de Belas Artes of the Universidade Federal do Rio de Janeiro, the former Escola Nacional de Belas Artes. Important work was also done by the official but progressive Escola de Artes Visuais do Parque Lage in Rio, which organized important avant-garde events in the 1980s.

BIBLIOGRAPHY

A. Morales de los Ríos: *O ensigno artístico: Subsídio para a sua história* (Rio de Janeiro, 1942)
A. Galvão: *Subsídios para a história da academia imperial e da escola nacional de belas artes* (Rio de Janeiro, 1954)
M. Pedrosa: *Crescimento e criação* (Rio de Janeiro, 1954)
A. F. Taunay: *A missão artística de 1816* (Rio de Janeiro, 1956)
A. Mafra de Souza: *Artes plásticas na escola* (Rio de Janeiro, 1968)
A. M. Barbosa: *Teoria e prática da educação artística* (São Paulo, 1975)
——: *Arte-educação no Brasil: Das origens ao modernismo* (São Paulo, 1978)
F. Ostrower: *Criatividade e processo de criação* (Rio de Janeiro, 1986)

ROBERTO PONTUAL

XIII. Art libraries and photographic collections.

Very few libraries existed in Brazil before the beginning of the 19th century; as a result, there was no tradition of conserving either written or visual records of the nation's heritage during the first 300 years of Portuguese colonization. The only exceptions were the Jesuit, Benedictine and Franciscan convents founded in the 16th century. The libraries of the Benedictine monasteries of S Bento in Rio de Janeiro and Salvador kept valuable artistic records, including documents relating to the construction and decoration of their respective churches. Religious art in Brazil from the 16th century to the 18th still forms an important part of the conservation work begun in museums of sacred art, particularly the convent of S Teresa, Salvador, and the Franciscan monastery of Luz, São Paulo.

When the Portuguese court moved to Brazil in 1808, it brought equipment for the first printing plant in the country and in 1810 founded the Biblioteca Real in Rio de Janeiro, which became the Biblioteca Nacional in 1878. Gradually this library assembled the most complete collection in Brazil of documents relating to artistic production (including many foreign works) and of rare books, drawings and engravings. These collections were the subject of a series of studies and exhibitions in the 1950s held under the direction of Lygia da Fonseca Fernandes da Cunha (*b*

1922). Historical documents, books, drawings and engravings relating to Brazilian art of the colonial and imperial periods (from the 16th to the 19th century) were also collected by many of Brazil's principal museums, including the Museu Paulista, Universidade de São Paulo; Museu Imperial, Petrópolis; Museu da Inconfidência, Ouro Prêto; Museu Paraense Emílio Goeldi, Belém; and Museu da Imagem e do Som, São Paulo. Important collections are also held in such institutions as the Escola de Belas Artes of the Universidade Federal do Rio de Janeiro (formerly the Academia Imperial Escola Nacional); the Secretaria do Patrimônio Histórico e Artístico Nacional (SPHAN) in Rio; the Fundação Pró-Memória in Brasília; and the Instituto Histórico e Geográfico Brasileiro, based in Rio. The Fundação Raymundo Ottoni de Castro Maya in Rio is particularly rich in collections of the work of foreign travellers in Brazil during the first half of the 19th century. Some private libraries and collections, such as those of Gilberto Ferrez (*b* 1908) in Rio de Janeiro, were also created. In spite of the wealth and importance of these collections, however, economic constraints and the difficulty of training specialist personnel created problems in developing new, technological methods of conservation and presentation.

Documents relating to the republican period (after 1889) are found in the Instituto de Estudos Brasileiros of the Universidade de São Paulo, which was based on the library, archives and collections of photographs, paintings, drawings and engravings of the modernist writer and critic Mário de Andrade (1893–1945). Donations of archives and libraries of other artists and art critics are found in the Sector de Documentação of the Fundação Nacional de Arte in Rio. In addition to museum archives, several other libraries in São Paulo also specialize in this period, including the Departamento de Documentação e Informação Artística of the Secretaria Municipal de Cultura; the Departamento de Pesquisa e Documentação de Arte Brasileira of the Fundação Armando Alvares Penteado; the architecture faculty of the Universidade de São Paulo; and the Arquivos Históricos Wanda Svevo of the Fundação Bienal. Another important library, in the Museu de Arte Moderna, Rio, was seriously damaged by fire in 1978.

Fewer photographic collections developed in Brazil, largely due to the difficulties of conservation in the humid, tropical climate. Growing interest in the cultural heritage of Brazil in the last decades of the 20th century, however, led to improvements in the storage and restoration of local photographic collections. Outstanding photographic archives include those of SPHAN in Rio, which pioneered the photographic documentation of Brazilian art and architecture; the Fundação Joaquim Nabuco de Pesquisas Sociais in Recife; the Seção de Iconografia of the Divisão de Documentação Social e Estatística, São Paulo; and the Instituto Nacional da Fotografia of the Fundação Nacional de Arte in Rio. The art historian and critic Clarival do Prado Valladares (1918–83) also created a valuable private photographic archive in Rio de Janeiro that covered the whole history of Brazilian art and architecture of all kinds, including popular art, which he used in his publications, such as *Arte e sociedade nos cemitérios brasileiros* (1972), *Análise iconográ e neoclássico remanescentes no Rio de Janeiro* (1978) and *Nordeste histórico e monumental* (1983).

BIBLIOGRAPHY
L. F. F. da Cunha: 'A seção de iconografia da biblioteca nacional', *J. Comérc.* (22 May 1966)
Guia das bibliotecas brasileiras (Rio de Janeiro, 1969)
B. Kossoy: 'Fotografia', *História geral da arte no Brasil*, ed. W. Zanini (São Paulo, 1983), ii, pp. 867–913
G. Ferrez: *A fotografia no Brasil, 1840–1900* (Rio de Janeiro, 1985)
R. de Henriques Medeiros, ed.: *Arquivos y coleções fotograficas da Fundaçao Joaquim Nabuco* (Recife, 1995)
P. Vasquez: *Mestres da fotografia no Brasil: Coleção Gilberto Ferrez* (Rio de Janeiro, 1995)

ROBERTO PONTUAL

Brecheret, Victor (*b* São Paulo, 22 Feb 1894; *d* São Paulo, 18 Dec 1955). Brazilian sculptor. He first studied at the São Paulo Liceu de Artes e Ofícios and in 1913 left for Rome, where he stayed for six years and completed his studies with Arturo Dazzi (1881–1966). During this period he fell under the influence of Emile-Antoine Bourdelle (1861–1929) and especially of the Symbolist sculpture of Ivan Meštrović (1883–1962). On his return to São Paulo in 1919 the innovative force of his work immediately caught the interest of the young intellectuals and artists who shortly afterwards brought Modernism into being in Brazil with the SEMANA DE ARTE MODERNA in 1922 in São Paulo. Although he returned to Europe in 1921, before this took place, Brecheret contributed several works to the event, including some on a religious theme such as *Head of Christ* (bronze, 1920; U. São Paulo, Inst. Estud. Bras.), characterized by an extreme simplification of the figure and by a geometric stylization that prefigured Art Deco. In 1920 he created the commemorative medal for the centenary of Brazil's independence and was commissioned by the government of São Paulo to create a vast monument to the *Pioneers* for the Parque Ibirapuera in São Paulo; Brecheret finally executed the granite sculpture between 1936 and 1953.

When Brecheret returned to Paris he discovered the work of Constantin Brancusi and won a prize in the Autumn Salon of 1921 with his sculpture *Temple of My Race* (untraced). After some time in Rome he returned to São Paulo, where during the 1930s in particular he was active in modernist events. In the latter part of his life he temporarily abandoned his preferred medium, marble, to carry out a series of works in bronze or in other types of stone, in which he tried to transmute indigenous Brazilian folklore into a deeply telluric, organic abstraction. The bronze *Indian and Suaçuapara* (1951; U. São Paulo, Mus. A. Contemp.; see fig.) is one of the most important pieces in the series. At the first São Paulo biennale in 1951 he was awarded first prize for sculpture in the national section.

BIBLIOGRAPHY
S. Milliet: *Pintores e pinturas* (São Paulo, 1940)
M. da Silva Brito: *História do modernismo brasileiro* (Rio de Janeiro, 1958)
P. M. de Almeida: *De Anita ao Museu* (São Paulo, 1961)
R. Pontual: *Arte brasileira contemporânea* (Rio de Janeiro, 1976)
W. Zanini, ed.: *História geral da arte no Brasil*, ii (São Paulo, 1983)
Victor Brecheret, modernista brasileiro (exh. cat. by J. Klintowitz, São Paulo, Mus. Brasileiro Escultura, [?1994])
Escultura Brasileña de 1920–1990: Perfil de una identidad (exh. cat., New York, Cent. Cult. Banco Interamer. Desarrollo, 1997)

ROBERTO PONTUAL

Brehme, Hugo (*b* Eisenach, 1882; *d* Mexico City, 1954). German photographer, active in Mexico. As a young man he travelled through Africa, taking photographs; an archive of some of these glass plates survives. He reached Mexico by way of Panama, Costa Rica, El Salvador and Guatemala, and took his first Mexican photographs in the Yucatán peninsula. He then opened a studio in Mexico City and, together with Agustín Victor Casasola, became one of the most important photographers of the Revolution (1910–17). What he loved most, however, was the beauty of the Mexican landscape. His book *Malerisches Mexico* was published by Ernst Wachsmuth in Germany in 1923, the same year in which he collaborated with Manuel Alvarez Bravo, later to become Mexico's leading photographer. Brehme's photography was not merely reportage. He sought to capture the spirit of the country rather than isolated events as, for example, in his photograph of Pancho Villa's horsemen, each in direct eye-contact with the photographer. In this he was inspired by José Guadalupe Posada, who was one of the first artists to capture the Mexican temperament in his woodcuts. Occasionally, indeed, Posada worked from photographs by Brehme and by Casasola. More than most foreigners, Brehme was able to feel real empathy with Mexico, and he became an impressive interpreter not only of its customs and traditions, but also of its historical monuments and festivals.

PHOTOGRAPHIC PUBLICATIONS
Pueblos y paisajes de México (Mexico City, 1992)
México pintoresco (Mexico City, 1992) [text by E. Poniatowska]

BIBLIOGRAPHY
Fotografie Lateinamerika (Zurich and Berne, 1981)
H. Brehme: *Mexico pintoresco* (Mexico City, 1990)
D. Brehme and others: *Hugo Brehme: Su vida, su obra y sus tiempos* (Mexico City, 1992)
México, 1910–1960: Brehme, Casasola, Kahlo, López, Modotti (exh. cat. by J. Mraz and others, Berlin, Andere Amer. Archv., 1992)
E. Billeter: *Canto a la realidad: Fotográfia latinoamericana, 1860–1993* (Barcelona and Berne, 1993–4) [Sp. and Ger. text]
México una nación persistente: Hugo Brehme fotografías (exh. cat., Mexico City, Mus. Diego Rivera, 1995)

ERIKA BILLETER

Victor Brecheret: *Indian and Suaçuapara*, bronze, 795×1018×476 mm, 1951 (São Paulo, Universidade de São Paulo, Museu de Arte Contemporânea)

Brennand, Francisco (*b* Recife, 11 June 1927). Brazilian painter and ceramicist. He made an extended visit to Europe from 1949 to 1952, living mainly in Paris, where he studied with André Lhote (1885–1962) and Fernand Léger (1881–1955), whose tumescent forms had a lasting influence on his work. On his return to Recife, where his family had long been responsible for a vast output of industrial ceramics, he dedicated himself increasingly to his work with art pottery. He carried out ceramic murals in several Brazilian cities and abroad, the most outstanding being the *Battle of the Guararapes* (completed 1962; Recife, façade of the Banco Bandeirantes do Comércio), commemorating the war between the Portuguese and the Dutch in Brazil in the 17th century. For both his ceramics and his painting he drew inspiration mainly from popular art, blurring the distinction between the real and the imaginary, seeking an epic quality in simple acts of heroism and reinventing nature in fantastic flora and fauna. In later years he created monumental ceramic works in which eroticism is linked to powerful primitive forces. He transformed his studio–factory in Recife into a museum of his work but still used it as a studio.

BIBLIOGRAPHY

F. Morais: *Francisco Brennand* (exh. cat., Rio de Janeiro, Petite Gal., 1969)
R. Pontual: *Arte brasileira contemporânea* (Rio de Janeiro, 1976)
C. Leal: 'Francisco Brennand', *Visão da terra* (exh. cat., Rio de Janeiro, Mus. A. Mod., 1977), pp. 46–57
Expressionismo no Brasil: Heranças e afinidades [Expressionism in Brazil: legacies and affinities] (exh. cat. by S. T. Barros and I. Mesquita, São Paulo Bienal, 1985], pp. 51, 100, 116

ROBERTO PONTUAL

Briceño, Trixie [Beatrix; Beatriz] (*b* London, 16 Sept, 1911; *d* Sun City, AZ, 4 Nov 1985). Panamanian painter of English birth. She was one of the first women to make an important contribution to art in Panama, where she arrived in the 1950s. She began her studies in Panama under Juan Manuel Cedeño and continued in Brazil from 1958 to 1960. Her naive style, characterized by a strong sense of geometry and flat, bright colours, was unique in Panamanian art. Giving free rein to her imagination, she painted magical and humorous compositions that bordered on Surrealism, such as *Adam's Fruit Shop* (1977; Panama City, Mus. A. Contemp.), at times showing the influence of European artists such as Paul Klee, Joan Miró and René Magritte.

BIBLIOGRAPHY

Beatriz Briceño of Panama (exh. cat. by J. Gómez Sicre, Washington, DC, Pan Amer. Un., 1969)
Homenaje a Trixie Briceño (exh. cat. by A. Dutary, Panama City, Mus. A. Contemp., 1982)
E. Wolfschoon: *Las manifestaciones artísticas en Panamá* (Panama City, 1983), pp. 87, 322–33, 481–4

MONICA E. KUPFER

British Guiana. *See* GUYANA.

Brito, Luis (*b* Río, Sucre, 20 March 1945). Venezuelan photographer. He took courses in cinema at the Ateneo in Caracas, where his interest in photography began. After winning second prize in the National Salon of Photography, he went to Rome on a scholarship to study at the Centro de Adiestramiento Profesional 'Don Orione'. His black-and-white photographic work is distinctive in its capturing of physical details and gestures of people in the street, such as their hands, feet and faces, obliging the spectator to complete the figure with his imagination; examples include *The Exiles, Level with the Ground, The Mask* and *Parallel Relations*. He exhibited in Rome, Cairo, Bilbao, London, Barcelona, New York and Lyon.

BIBLIOGRAPHY

V. Guédez: *La poética de lo humano en 5 fotográfos venezolanos* (Caracas, 1997)

CRUZ BARCELÓ CEDEÑO

Brito (Avellana), María (*b* Havana, 10 Oct 1947). Cuban sculptor, active in the USA. She arrived in the USA during the 1960s and in 1979 obtained an MFA at the University of Miami. She worked primarily in three formats: wall-hanging constructions, free-standing sculpture and installations situated in corners like stage props. Using mixed media, often wood and found objects, she focused on the objective representation of personal dreamed images, reminiscent of the assemblages of Joseph Cornell and Marisol (e.g. *Next Room (Homage to R.B.)*, mixed media, 1986; see 1987–8 exh. cat., p. 259). Brito exhibited widely throughout the USA, in both one-woman and group exhibitions.

BIBLIOGRAPHY

P. Plagens: 'Report from Florida: Miami Slice', *A. America*, lxxiv/11 (Nov 1986), pp. 26–39
R. Pau-Llosa: 'The Dreamt Objectivities of María Brito Avellana', *Dreamworks*, v/2 (1986–7), pp. 98–104
Outside Cuba (exh. cat. by I. Fuentes-Pérez, G. Cruz-Taura and R. Pau-Llosa, New Brunswick, NJ, Rutgers U., Zimmerli A. Mus.; New York, Mus. Contemp. Hisp. A.; Oxford, OH, Miami U., A. Mus.; and elsewhere; 1987–9), pp. 258–61
C. S. Rubenstein: *American Women Sculptors: History of Women Working in Three Dimensions* (Boston, 1990), pp. 564–5
L. M. Bosch: 'Metonomy and Metaphor: María Brito', *Lat. Amer. A.*, v/3 (1993), pp. 20–23
Islands in the Stream: Seven Cuban American Artists (exh. cat. by L. Bosch, Cortland, SUNY, Dowd F.A. Gal., *c.*1993)

RICARDO PAU-LLOSA

Brizzi, Ary (*b* Avellaneda, nr Buenos Aires, 11 May 1930). Argentine painter and sculptor. He studied in Buenos Aires at the Escuela Nacional de Bellas Artes Manuel Belgrano and at the Escuela Superior de Bellas Artes Ernesto de la Cárcova, leaving in 1951, and then worked as a researcher for the Centro de Investigaciones de Comunicación Masiva, Arte y Tecnología in Buenos Aires. He played a leading role in the second wave of artists using geometric abstraction in Argentina, painting asymmetric compositions from 1957 and later making reliefs of plastic, painted wood and aluminium. As a sculptor he often worked with repeated elements, such as plastic or metal rods with which he created a continuous rhythm describing an apparently curved space. He also used sheets of transparent acrylic to make monumental parallelepipeds and boxes, over which he placed bands of colour to create superpositions, coincidences and dissonances that produce an effect of criss-crossing forces in movement as the observer changes his or her position, as in *Kinetic Expansion* (1967; Buenos Aires, Mus. A. Mod.). In other works he explored the possibilities of bending or moulding plastic by heating it, or used its transparency to create ambiguous spaces.

Ary Brizzi: *Gran tensión No. 2*, acrylic on canvas, 1.50×1.49 m, 1970 (Austin, TX, University of Texas, Jack S. Blanton Museum of Art)

Brizzi returned to painting in order to explore the unlimited possibilities of imaginary space, using progressively gradated bands of colour in dynamic serial formations whose energy and impact create an almost mystical effect, as in *Krypton III* (1978; Buenos Aires, Mus. N. B.A.) and *Gran tensión No. 2* (1970; see fig.). He was made a full member of the Academia Nacional de Bellas Artes in 1976 and won numerous prizes, including the first prize for painting at the Salón Nacional de Artes Plásticas in 1970 and the Premio Rosario of the Academia Nacional de Bellas Artes in 1980.

BIBLIOGRAPHY
Ary Brizzi: Retrospectiva (exh. cat. by N. Perazzo, Buenos Aires, Fund. S Telmo, 1986)
J. López Anaya: *Historia del arte argentino* (Buenos Aires, 1997)
NELLY PERAZZO

Brown, Everald (*b* St Ann, 1917). Jamaican painter and sculptor. A self-taught mystic and visionary, unknown until the late 1960s, he drew his artistic inspiration from a very personal interpretation of two Afro-Christian Jamaican cults, Rastafarianism and Revivalism. His imagery developed through meditation and techniques similar to the automatism of the Surrealists. The curious limestone formations found in Jamaica frequently served as a source of inspiration, as in *Bush Have Ears* (1976; Kingston, N.G.). He also made ritual objects, such as carved wooden staffs and decorated musical instruments. During the 1970s he worked in close collaboration with his son Clinton Brown (*b* 1954), who also received substantial critical acclaim.

BIBLIOGRAPHY
V. Poupeye-Rammelaere: 'The Rainbow Valley: The Life and Work of Brother Everald Brown', *Jamaica J.*, xxi/2 (May–June 1988), pp. 2–14
G. Mosquera: 'Everald Brown', *Ante América* (exh. cat. by G. Mosquera and others, Bogotá, Banco de la República, 1992), pp. 25–30
V. Poupeye: *Caribbean Art* (London, 1998)
VEERLE POUPEYE

Bueno, Mauricio (*b* Quito, 8 Sept 1939). Ecuadorean painter, graphic designer, sculptor, installation artist, ar-

chitect and teacher. He studied architecture at the Universidad Nacional de Bogotá, Colombia. He worked for the Graham Foundation and the National Endowment for the Arts, Washington, DC, and received a grant to attend the Center for Advanced Visual Studies at Massachusetts Institute of Technology, Cambridge, MA, where he worked with Gyorgy Kepes. Later he became a professor at the arts faculty of the Universidad Central, Quito. Bueno worked first in graphic design before going on to experiment with the incorporation of technology into art, using laser beams, mechanical pumps, plastic, glass and such elements as water, fire and air, for example in *49 Tubes*, exhibited at the Bienal de Arte Coltejer in Medellín in 1972. He also combined visual art with music in such works as *Flame Orchards*, with music by Paul Earls, which won joint first prize with Kepes in the same exhibition. Exploration into ecological and environmental art led him to experiment with the idea of an aerial view of the urban landscape incorporating military camouflage sheets.

BIBLIOGRAPHY
H. Rodríguez Castelo: 'Mauricio Bueno', *Rev. Diners*, 6 (1981), pp. 36–44
Mauricio Bueno (exh. cat., Caracas, Cent. A. Eur.-Amer., 1994)
CECILIA SUÁREZ

Buenos Aires. Capital and largest city of Argentina. Located on the south-western bank of the River Plate estuary, it has a metropolitan population of 11 million, almost entirely of European (especially Italian) descent; indeed, the cultural development of the city was largely influenced by the wave of Italian immigrants who arrived in the 1870s. Buenos Aires was first founded by Spanish colonizers in 1536, but it was not until 1580 that a lasting settlement was established. During the first two centuries of colonial occupation, the city of CÓRDOBA was of greater importance, but in 1776 Buenos Aires became the centre of the new Viceroyalty of the River Plate, and since then it has grown continually in size and importance. The few remaining buildings from the colonial period display a range of influences, including Spanish Baroque, Portuguese Manueline style and the Rococo style of Lima (*see also* ARGENTINA, §II, 1). One of the most notable early structures was the cathedral (1593), subsequently rebuilt (1689–1791) by Antonio Masella and others (Andrea Bianchi and Giovanni Battista Primoli executed the façade) as a three-aisled church with a dome at the crossing. The Cabildo, first built in 1608 but rebuilt from 1719 by Primoli, is also notable. The Jesuit church of S Ignacio, La Compañía, was built from 1710 by Juan Kraus of Bohemia, while La Merced and S Francisco (completed 1754) were both worked on by Bianchi.

Planning initiatives in the late 19th century led to Buenos Aires taking on the Beaux-Arts classicism of Paris. Giovanni Antonio Buschiazzo (1846–1917), notably, opened up the Avenida de Mayo in 1880. The opera house, the Teatro Colón (see fig.), was rebuilt in 1908; it plays a central role in the cultural life of Buenos Aires. Designed by Vittorio Meano and completed after his death by Jules Dormal (1846–1924), it is Neo-classical in style, using Ionic and Corinthian orders. It combines the effective planning and solidity of German architecture with French decorative charm and variety; with a capacity of 3570, the theatre is well known for its perfect acoustics. ALEJANDRO

Buenos Aires, Teatro Colón, by Vittorio Meano and Jules Dormal, 1908

BUSTILLO, reflecting a 20th-century revivalist tendency, also created many notable Neo-classical buildings in Buenos Aires, including La Continental hotel (1927), the Chade Volta building (1930) and the Banco de la Nación (1944), but the city has felt other progressive influences, such as Art Nouveau and, more importantly, Modernism itself. Le Corbusier visited the city in 1929 and drew up a plan envisaging skyscrapers set in green areas. While this was not implemented *per se*, a 1936 project created plazas along the Avenida de Mayo (which runs from the Palacio del Congreso to the Casa Rosada; for an illustration of the latter, *see* ARGENTINA, fig. 3), dramatically widening the street; in 1990, however, renovation work began to return the avenue to its Neo-classical splendour.

Several structures built in the late 20th century greatly enhanced the architectural environment of Buenos Aires. In 1987 Eduardo Leston designed a gymnasium and swimming pool complex as part of the Parque Deportivo Jorge Newbery: the building is ideally suited to the surrounding flora, with the strong horizontal lines contrasting with the verticality of the trees. Aldo Rossi and Gianni Braghieri designed the office building Techint (1984) in the city centre and combined the city's European traditions with Modernism to form a uniquely Argentine style. The first floor is raised by over 4 m on each of the lateral sections to allow viewing of the church and convent of S Catalina and to allow space for public gatherings.

Buenos Aires has many notable museums (*see also* ARGENTINA, §VI), of which the Museo Nacional de Bellas Artes is the largest and most important, with some galleries devoted to Argentine painting of the 19th and 20th centuries. The Museo Nacional de Arte Decorativo, housed in an elegant Neo-classical mansion designed by

Tené Sergent and Achille Duchesne, has an impressive collection of antique furnishings, musical instruments, silver and weapons from the 16th to 19th centuries, as well as a collection of Oriental art. Specialist museums of colonial gold- and silverware include the Museo de Arte Issac Fernandez Blanco. Buenos Aires has a strong tradition as a centre of activity for artists, and various avant-garde groups have been based there in the 20th century. Notable among the artists working in the city at the end of the century were the painter and sculptor Juan Carlos Distéfano and the sculptors Jorge Michel and Hernán Dompé (*see also* ARGENTINA, §III, 2).

BIBLIOGRAPHY

J. A. Pillado: *Buenos Aires colonial* (Buenos Aires, 1910)

J. Glusberg, ed.: *Arquitectos de Buenos Aires* (Buenos Aires, 1979)

A. R. Williams: 'Eighty Years of Elegance and Excellence', *Américas* (Sept–Oct 1987), pp. 14–19

'The Friends of Museums of Argentina Make the Arts and Collections of their Country Known', *Museum*, xxxix/2 (1987), pp. 120–21

J. Goldman: 'Argentine Renaissance', *Archit. Rec.*, clxxxi (Jan 1993), pp. 44–6

R. Gutiérrez and I. Gutiérrez Zaldívar: *Buenos Aires: Obras Monumentales* (Buenos Aires, 1997)

A. Varas: *Buenos Aires metropolis* (Buenos Aires, 1997)

ANN McKEIGHAN LEE

Burchard, Pablo (*b* Santiago, 1875; *d* Santiago, 1964). Chilean painter. He studied at the Escuela de Bellas Artes in Santiago under Pedro Lira and Miguel Campos (1844–99) and under the influence of Juan Francisco González developed an Impressionistic approach to painting that was rational in its emphasis on technique and precise drawing, but also romantic in the poetry animating his landscapes and in its delicate range of enveloping colour. His approach was one of humility, befitting his personality,

and it took shape, mainly from the example of Cézanne, in clear patches of colour: light, evocative and with their own unique poetic spirit. Nevertheless, his tendency to synthesize different elements placed him in the avant-garde as a young man, and he had a profound influence on the Grupo Montparnasse a short time later (*see* MORI, CAMILO). Rightly considered one of the founders of modern Chilean art, he influenced later generations both through his teaching at the Escuela de Bellas Artes (of which he was director from 1932 to 1935) and through the expressive and abstract qualities of his painting. He won various awards including the Premio Nacional de Arte in 1944. His son, Pablo Burchard Aguayo (*b* 1919), also established his reputation as a painter, especially with several large murals in Santiago (e.g. for the Banco Central) and on the basis of his later abstract work.

BIBLIOGRAPHY
Art of Latin America since Independence (exh. cat. by S. L. Catlin and T. Grieder, New Haven, CT, Yale U. A.G.; Austin, U. TX, A. Mus.; San Francisco, CA, Mus. A.; and elsewhere; 1966), pp. 91, 143, 157, 163–4, 222
Burchard/Balmes/Barrios (exh. cat. by F. González Vera, Santiago, Tres Manchas, Exp. Gabinete, 1995)
Pablo Burchard (1875–1964): Un pintor fundamental (exh. cat. by P. Gema Swinburn, and V. Francisco González, Santiago, Corp. Cult. Condes, [1996])

CARLOS LASTARRIA HERMOSILLA

Burle Marx, Roberto (*b* São Paulo, 4 Aug 1909). Brazilian landscape architect, painter and designer. He studied painting at a private school in Berlin from 1928 to 1929, and during this time he frequently went to the Botanical Gardens at Dahlem to study the collections of plants that were arranged in geographical groupings, providing useful lessons in botany and ecology. He thus learnt to appreciate many examples of Brazilian flora that were rarely used in Brazilian gardens, an experience that had a lasting effect on him. In 1930 he entered the Escola Nacional de Belas Artes in Rio de Janeiro to study painting; he also took a course in ecology at the Botanical Gardens in Rio. From 1934 to 1937 he was Director of Parks and Gardens at Recife, leaving when he established his own practice as a landscape architect in Rio de Janeiro. To this period belong the gardens of the Casa do Forte, where aquatic plants predominate, and the gardens he designed for the Praça Euclides da Cunha, where his studies of the *caatinga*, the low, open, sandy forests of Brazil, led him to make extensive use of species from arid climates.

In 1938 Burle Marx came into contact with the Modernist architects who led the revival of Brazilian architecture from the 1930s when, working in association with Lúcio Costa and his team, he was commissioned to design the gardens for the Le Corbusier Ministry of Education and Health building (now the Palácio da Cultura) in Rio de Janeiro. He was associated with another Modernist architectural group, M. M. M. ROBERTO, when he designed the roof garden for the Brazilian Press Association (ABI) building and the gardens for Praça Salgado Filho at Santos Dumont Airport (both 1938; Rio de Janeiro). The gardens for the airport and for the Roberto Marinho house (1938) in Rio were works that greatly impressed OSCAR NIEMEYER, and from 1941 Burle Marx worked on the design of the park at Niemeyer's Pampulha complex at

Belo Horizonte, Minas Gerais, producing a work of great beauty and international renown.

In 1943 Burle Marx created a park at Araxá, Minas Gerais. Divided into 25 sections, each demonstrating different ecological systems, this work was inspired by the botanist Henrique L. de Mello Barreto, who taught Burle Marx to appreciate that plants do not live in isolation but in associations, and to be aware of the natural habitats of plants before attempting to use them in gardens. With Mello Barreto he visited many parts of Brazil to study the flora of the different geological regions—ferriferous clay, sandstone, quartzite, calcareous rocks—and of such areas as *cerrado*, or open pastureland with stunted vegetation. Another garden based on this principle was the park, designed in 1948, attached to the Odette Monteiro house at Correas, Rio de Janeiro; situated near the Serra dos Orgãos, the gardens were planned in accordance with their mountain environment and were integrated with the native vegetation of the region.

In 1949 Burle Marx acquired the S Antônio da Bica site in Campo Grande, Rio de Janeiro, where he gradually built up one of the greatest collections of living plants in the world. During years of patient work, he gathered together classified groups of plants collected on systematic journeys throughout Brazil in the company of botanists from whom he acquired a profound knowledge of tropical plants. This extensive study formed the basis of several landscaping projects of considerable complexity and size, such as the 70-ha Parque del Este (1956) in Caracas and a series of works in Brasília, in collaboration with Oscar Niemeyer. These included the Parque Zoobotánico (1961), in which Burle Marx demonstrated the relationship between animals, plants and rocks of the same region in a sequence of ecological settings; the garden of the Ministry of Foreign Affairs building (1965; see fig.), in which a large lake with waterlilies surrounds the Palácio dos Arcos, providing reflections and creating a lush microclimate within the arid environment of the new capital; the Army and Justice Ministries (1970) and the Rogério Pithon Serejo Farias Recreation Park (1974).

Burle Marx was a prolific designer. Other notable works include gardens for the Civic Centre of Santo André (1967; design Rino Levi), São Paulo, in which Portuguese tiles are used to unify squares, terraces and parks in a restrained plan of curved and straight lines; features include three

Roberto Burle Marx: garden of the Ministry of Foreign Affairs building, Brasília, 1965

large concrete bas-reliefs at the theatre entrance and a tapestry 26 m long. From 1954 he collaborated with the architect AFFONSO EDUARDO REIDY on the design for a 1.2 million sq. m area of the Flamengo waterfront in Rio de Janeiro, in which the gardens for the Museu de Arte Moderna and the Monument to the Dead of World War II are outstanding.

The magnificent promenades (1970) of the Copacabana beach embankment in Rio, where abstract, flowing mosaic designs in white, black and brown Portuguese tiles establish a dialogue between the paving, the sea and the groups of trees growing along the foreshore, are typical of Burle Marx's painterly approach. In these large-scale works it is clear that he is preoccupied with questions of form, colour, geometry and rhythm. He continued to paint with intensity, and just as he treated plants and gardens with a painter's vision, so his studies of flora enriched his work as a painter. However, he made a clear distinction between the two activities, recognizing the effect on a garden of a complex range of environmental factors and the variability of colour under different conditions of light and weather. Burle Marx was outspoken in defence of flora and fauna threatened with destruction and pollution, using his position to advise the government on more effective legislation to protect the environment. His work, including sculpture and tapestry design as well as painting and landscape design, was exhibited in galleries and museums around the world on numerous occasions, and he received many awards and honours during his career.

Mildred Burton: *Made in France*, pencil, 495×348 mm, 1974 (Colchester, University of Essex, Collection of Latin American Art)

WRITINGS
Arte & paisagem: Conferéncas escolhidas [Art & landscape: selected lectures] (São Paulo, 1987)

BIBLIOGRAPHY
C. Vincent: 'The Modern Garden in Brazil', *Archit. Rev.* [London], ci/605 (1947), pp. 165–72
H. R. Hitchcock: *Latin American Architecture since 1945* (New York, 1955)
H. E. Mindlin: *Modern Architecture in Brazil* (Rio de Janeiro, 1956)
'Rapporto Brasile', *Zodiac*, 6 (1960), pp. 118–27
P. M. Bardi: *The Tropical Gardens of Burle Marx* (Amsterdam, 1964)
D. Bayón and P. Gasparini: *Panorámica de la arquitectura latino-americana* (Barcelona, 1977; Eng. trans., New York, 1979)
F. L. Motta, ed.: *Roberto Burle Marx e a nova visão da paisagem* (São Paulo, 1984)
E. Eliovson: *The Gardens of Roberto Burle Marx* (London, 1991)
Roberto Burle Marx: The Unnatural Art of the Garden (exh. cat. by W. Howard Adams, New York, MOMA, 1991)
L. C. Frota: *Burle Marx: Landschaftgestaltung in Brasilein/Burle Marx: Landscape Design in Brazil/Burle Marx: Paisagismo no Brasil* (São Paulo, 1994)
C. Hamerman: 'Roberto Burle Marx: The Last Interview', *J. Dec. & Propaganda A.*, xxi (1995), pp. 156–79
L. Fleming: *Roberto Burle Marx: A Portrait* (Rio de Janeiro, 1996)
Arte e paisagem: A estética de Roberto Burle Marx (exh. cat. by J. Leenhardt and L. Coelho Frota, São Paulo, Mus. A. Contemp. USP, 1997)
Roberto Burle Marx: El Parque del Este de la ciudad de Caracas (exh. cat., Caracas, Sala Mendoza, 1997)

PAULO J. V. BRUNA

Burton, Mildred (*b* Paraná, Entre Ríos, 28 Dec 1942). Argentine painter, draughtsman and collagist. She studied at the Escuela Provincial de Artes Visuales in Paraná and at the Escuela Superior de Bellas Artes 'Ernesto de la Cárcova' in Buenos Aires. Taking the cue for her well-crafted works from Surrealism but concentrating her attention on fortuitous encounters in everyday life, she fluctuated between a meticulously detailed photographic realism and an artificial imagery of old porcelain dolls and turn-of-the-century postcards, posters and advertising handbills (e.g. *Made in France*, 1974; see fig.). Generally working in series, she combined the sinister and the humorous, sometimes in a single work, as in *Sublime Portrait of my Mother* (1978; see Glusberg, p. 455), a frontal view of a masked woman with a vacant and enigmatic smile. An early triptych, the *Family of the Condemned* (1974), is in the national collection in Buenos Aires (Mus. N. B.A.).

BIBLIOGRAPHY
J. Glusberg: *Del Pop-art a la Nueva Imagen* (Buenos Aires, 1985), pp. 455–8
Mildred Burton: Sutilezas, pinturas (exh. cat. by J. Glusberg, Buenos Aires, Gal. Rubbers, 1986)
Premios Fortabat en el Museo Nacional de Bellas Artes (exh. cat., intro. by J. Glusberg, Buenos Aires, Mus. N. B.A., 1997)

JORGE GLUSBERG

Bustillo, Alejandro (*b* Buenos Aires, 18 March 1889; *d* ?Buenos Aires, ?1982). Argentine architect. He won a national award for painting (1912) while still a student of architecture at the Universidad de Buenos Aires, where he graduated in 1913. He visited Europe in 1920. A classicist, he favoured the Greek Revival (he went to Greece as a guest of honour in 1970), but he worked in many styles in his vast oeuvre of more than 200 buildings. Bustillo's declared aim of producing original designs within traditional styles brought him a wide range of commissions. In Buenos Aires, as well as many apartment buildings constructed both before and after World War II, he designed offices, hotels and banks, including the Banco de la Nación

(1944), which boasts a central glass-covered banking hall with a span of 50 m. Elsewhere he designed the Casino and Hotel Provincial (1936), Mar del Plata; Bariloche Cathedral (begun 1932) and the Llao Llao Hotel (1939), also in Bariloche, South Andes; and numerous rural *estancias* in the colonial manner. He was also responsible for two buildings in Paris and a hotel in Brussels.

WRITINGS
Alejandro Bustillo (Buenos Aires, 1944)

BIBLIOGRAPHY
F. Bullrich: *Arquitectura latino-americana, 1930–1970* (Barcelona, 1969)
M. Levisman de Clusellas: 'The Bariloche Style', *J. Dec. & Propaganda A.*, xviii (1992), pp. 10–31

LUDOVICO C. KOPPMANN

Bustos, Hermenegildo (*b* Purísima del Rincón, Guanajuato, 13 April 1832; *d* Purísima del Rincón, 28 June 1907). Mexican painter. He was mainly self-taught, painting small-format portraits, still-lifes, ex-votos and retables. His portraits were realistic and closely observed; he generally portrayed villagers, but his *Self-portrait* (1891; Mexico City, Inst. N. B.A.) makes skilful use of light and shade to construct and highlight shapes. His still-lifes are distinguished by their presentation of Mexican fruit and objects, laid out as if for a botanical illustration (e.g. *Still-life with Fruit and Frog*, 1847; see fig.). The small ex-votos show wit, spontaneity and fantasy, and constitute valuable historical records of the faith and customs of the period. Bustos was one of the most popular artists of his time, and his work is notable for its precision of line, sensitivity, skill and sobriety of colour.

BIBLIOGRAPHY
P. Aceves Barajas: *Hermenegildo Bustos* (Guanjuato, 1956, rev. 1996)
R. Tibol: *Hermenegildo Bustos: Pintor del pueblo* (Guanajuato, 1981/R Mexico City, 1992)

Hermenegildo Bustos: *Still-life with Fruit and Frog*, oil on canvas, 410 x 355 mm, 1874 (Guanajuato, Museo de Granaditas)

Art in Latin America: The Modern Era, 1820–1980 (exh. cat. by D. Ades and others, London, Hayward Gal., 1989), pp. 91–2
Hermenegildo Bustos (1832–1907) (exh. cat., Mexico City, Mus. N. A.; Monterrey, Mus. A. Contemp; [1993])

ELISA GARCÍA BARRAGÁN

Butler, Horacio (*b* Buenos Aires, 28 Aug 1897; *d* Buenos Aires, 17 March 1983). Argentine painter, tapestry designer and stage designer. From 1922 to 1933 he lived in Europe, where he studied first in Germany at the artistic colony in Worpswede and then in Paris under André Lhote (1885–1962) and Othon Friesz (1879–1949). He was untouched by the violence of German Expressionism, but he assimilated various influences in France, structuring forms in the manner of Cézanne, and combining these with the audacious colouring of Fauvism and the strict sense of order in Cubism, as in *The Siesta* (1926; see fig.).

On his return to Argentina, Butler applied these European influences to lyrical landscapes of the islands in the Parana Delta of the Tigre region near Buenos Aires, selecting unusual scenes into which he incorporated childhood reminiscences in the figures. Using arabesques to

Horacio Butler: *The Siesta*, oil on canvas, 765×970 mm, 1926 (Buenos Aires, Museo Nacional de Bellas Artes)

link nature and people in his essentially flat pictures, he projected himself on to the scenery of which he was so fond in pictures such as the *House of the Trees* (1960) and *Nocturne* (1972; both Buenos Aires, Mus. Mun. A. Plást. Sívori). He also designed tapestries, notably one of monumental size (12×8 m), an *Allegory of St Francis*, for the wall behind the altar in the church of S Francisco in Buenos Aires, as well as stage sets for the Teatro Colón in Buenos Aires, the Teatro Solís in Montevideo and La Scala in Milan.

WRITINGS
La pintura y mi tiempo (Buenos Aires, 1966)

BIBLIOGRAPHY
C. Córdoba Iturburu: *80 años de pintura argentina* (Buenos Aires, 1978), p. 38
Horacio Butler: Diez años después (1897–1983) (exh. cat., Buenos Aires, Mus. N. B.A., 1993)
J. López Anaya: *Historia del arte argentino* (Buenos Aires, 1997)

NELLY PERAZZO

Buvelot, Abram-Louis (*b* Morges, Vaud, 3 March 1814; *d* Melbourne, Victoria, 30 May 1888). Swiss painter,

lithographer and photographer, active in Brazil and Australia. He attended a drawing school in Lausanne, where his teacher may have been Marc-Louis Arlaud (1772–1845), and is thought to have spent some time with the landscape painter Camille Flers (1802–68) in Paris *c.* 1836 *en route* to Bahia (Salvador), Brazil. In 1840 he moved to Rio de Janeiro, where he established himself as a painter of local views and exhibited with the Imperial Academy of Fine Arts, Rio. His Brazilian landscapes, of which the *View of Gamboa* (1852; Rio de Janeiro, Mus. N. B.A.) is an example, received critical acclaim for their vivacious lighting. As a photographer he fulfilled commissions in daguerreotype for Emperor Peter II, and with the figure painter Auguste Moreau he produced a set of 18 lithographs, *Picturesque Rio de Janeiro*, published in 1843–4. From 1852 to 1864 he worked as a portrait photographer in Switzerland and from 1855 to 1864 as a teacher of art in La Chaux de Fonds, Neuchâtel, associating and exhibiting his landscapes with the Swiss followers of Corot. In 1865 Buvelot settled in Melbourne, Victoria, and worked for a year as a portrait photographer. From 1866 to *c.* 1884, painting both in oils and watercolours, he depicted sunny and peaceful landscapes, creating images of the countryside that were familiar and domesticated, as in *St Kilda Park* (*c.* 1878; Adelaide, A.G. S. Australia). His manner was identified as French because of its relative freedom of touch. He was accorded the highest respect by Australian patrons and critics and by younger artists, in particular those of the Heidelberg school.

BIBLIOGRAPHY

Louis Buvelot: Landscape and Portrait Photographer (exh. cat. by J. Gray, Melbourne, Gal. E. Hill, 1970)

J. Gray: *Louis Buvelot: His Life and Work* (MA thesis, U. Melbourne, 1977)

——: 'Abram-Louis Buvelot and the Art of the French Painters of Barbizon', *A. & Australia*, xvi/12 (1978), pp. 152–8

F. Ansermoz-Dubois and V. Ansermoz-Dubois: *Louis Buvelot* (Lausanne, 1984)

JOCELYN FRAILLON GRAY

C

Caballero, Luis (*b* Bogotá, 1943). Colombian painter. His earliest paintings, executed in oil on paper in the late 1960s, represent large and energetic nudes—influenced by the work of Francis Bacon—among gestural splashes of intense colour. He subsequently toned down his use of colour and began to work from life, showing the human body in varied postures indicative of emotion and energy. He used sexuality and his own erotic pleasure as a means of heightening the impact of his nude figures, which he described as painted 'with semen, not turpentine'. His exclusive subjects in later paintings were athletic young men in recumbent positions, their expressions suggestive of a state of sexual trance or death. Violence, blood and suffering dominate images of figures piled together in dramatic orgies and states of sadness and desire, projecting an intensity of emotion rooted in Romanticism.

WRITINGS
Me tocó ser así (Bogotá, 1986)
with others: *Luis Caballero* (Bogatá, 1995)

BIBLIOGRAPHY
Cien años de arte colombiano (exh. cat. by E. Serrano, Bogotá, Mus. A. Mod., 1985)
Luis Caballero (exh. cat., Paris, Gal. Albert Loeb, 1996)
Re-Aligning Vision: Alternative Currents in South American Drawing (exh. cat., New York, Mus. Barrio; Little Rock, AR A. Cent.; Austin, U. TX, Huntington A. G.; and Caracas, Mus. B.A.; 1997–8)

EDUARDO SERRANO

Cabré, Manuel (*b* Barcelona, 25 Jan 1890; *d* Caracas, 5 Feb 1984). Venezuelan painter of Spanish birth. From 1896 he lived in Venezuela and studied at the Academia de Bellas Artes, Caracas (1904–9) under Emilio Mauri (1855–1908) and Antonio Herrera Toro. In 1912 he was a founder-member with Antonio Edmundo Monsanto and others of the Círculo de Bellas Artes in Caracas, a group that made landscape painting the leading genre in Venezuelan art in the first half of the 20th century. Between 1916 and 1919 the influence of Samys Mützner, Nicolas Ferdinandov and Emilio Boggio had a marked effect on his palette and composition. He travelled to France in 1920 to consolidate his artistic training, attending the Académie Colarossi and the Académie de la Grande Chaumière and executing several works. In 1931 he returned to Venezuela and held an exhibition of his French paintings. From then on he dedicated himself fully to studying the Venezuelan landscape, in particular the mountain El Avila. In 1951 he was awarded the national painting prize, which confirmed his position as a leading representative of Venezuelan landscape painting and as the origi-

nator of a school of painting. An example of his work from this period is *La Silla Seen from La Urbina* (1955; Caracas, Mus. A. Contemp. Sofía Imber).

WRITINGS
Cabré por Cabré (Caracas, 1980)

BIBLIOGRAPHY
A. Amengual: *Cabré, el niño* (Caracas, 1980)
J. Calzadilla: *Cabré* (Caracas, 1980)
A. Boulton: *Cabré* (Caracas, 1989)
Cabré y Monsanto: Hacia la reinvención del paisaje, Galería de Arte Nacional (Caracas, [1990])
J. Calzadilla: 'Manuel Cabré o cómo rehace la naturaleza en el taller', *Rev. N. Cult.*, cclxxxv (1992), pp. 212–23

YASMINY PÉREZ SILVA

Cabrera, Francisco (*b* Guatemala City, 16 Sept 1781; *d* Guatemala City, 21 Nov 1845). Guatemalan painter, printmaker and medallist. He entered the mint in 1795 as an apprentice engraver but on the recommendation of its director, Pedro Garci-Aguirre, also became Master Corrector at the Escuela de Dibujo de la Sociedad Económica de Amigos del País, Guatemala City, in 1796, holding the post until 1804. He continued working at the mint until 1809 and demonstrated outstanding skill both as a medallist and engraver of coins and as an engraver and etcher. He returned to the mint in 1823 as second engraver, remaining in the post until his death.

Despite the quality of his work as a printmaker and medallist, Cabrera gained artistic recognition especially as a miniature painter, working mostly in watercolour on ivory in a meticulous technique. He produced some miniatures on religious themes and others of birds, but the majority, measuring no more than 50 mm in height or width, were portraits of members of the Guatemalan aristocracy and bourgeoisie. It is not known exactly how many he produced, but from the middle of the 1830s he began to number them, starting from 500; the highest known number of the approximately 200 authenticated miniatures is 745. Although he suffered some illness, he was most productive during the last five years of his life. An evolution can be discerned from his earliest works, dating from *c.* 1810, in which he painted in compact and smooth vertical strokes on grey backgrounds tinged with green, through to the extraordinarily fine quality of anatomical drawing in his final works, with pale blue backgrounds. He had several students, including Justo Letona, José Letona, Delfina Luna and Leocadia Santa Cruz, but none rivalled him in quality. As a miniature painter he

remained an essentially solitary figure, following no local precedents and leaving no substantial legacy.

BIBLIOGRAPHY
H. Garavito: *Francisco Cabrera: Miniaturista guatemalteco* (Guatemala City, 1945)
Francisco Cabrera (1781–1845) (exh. cat. by J. Luján-Muñoz, Guatemala City, Bib. N., 1984)

JORGE LUJÁN-MUÑOZ

Cabrera, Geles (*b* Mexico City, 2 Aug 1929). Mexican sculptor. She studied at the Academia de Bellas Artes de San Carlos, Mexico City, from 1944 to 1946, and in 1947 at the Academia de San Alejandro in Havana, Cuba, where she received a number of awards. She held her first one-woman exhibition in 1950. Her sensitive sculpture addressed human emotions and situations, including motherhood, love and solitude. Taking inspiration for her sculptures from prehistoric art, she worked first in terracotta and then in bronze and with direct carving in stone, using clean contours to stress the curves and sensuality of the human form. Later she used newspapers as a sculptural material. From 1975, in association with other Mexican sculptors such as Angela Gurría, Mathias Goeritz, Juan Luis Díaz (*b* 1939) and Sebastián, she began also to conceive sculptures for urban settings.

BIBLIOGRAPHY
Geles Cabrera (Mexico City, 1977)
L. Kassner: *Diccionario de escultura mexicana* (Mexico City, 1983; rev. 1997), p. 55
A. M. Saavedra: 'Geles Cabrera y el principio de otra actitud en la escultura', *Cuad. Amer.*, ccxxvi/3 (1986), pp. 119–24
Imaginación de la materia: Geles Cabrera, Asociación de Artistas Plásticos de México (Mexico City, [1988])
A. M. Saavedra: *Cabrera Geles: Otra actitud en la escultura* (Toluca, 1990) [intro.]

LOUISE NOELLE

Cabrera, Germán (*b* Las Piedras, nr Montevideo, 2 May 1903; *d* Montevideo, 30 May 1990). Uruguayan sculptor. He studied under the Argentinian sculptor Luis Falcini (1899–1973) from 1918 to 1926 at the Círculo de Bellas Artes in Montevideo, and in Paris from 1926 to 1928 under Charles Despiau (1874–1946) at the Académie Colarossi and under Emile-Antoine Bourdelle (1861–1929) at the Académie de la Grande Chaumière. He lived again in Uruguay (1928–36), and in Paris (1936–8) before moving to Caracas (1938–44). After travelling extensively in Europe, Mexico and the USA, he settled in Madrid from 1975 to the end of the decade.

Cabrera's sculptures, such as *Untitled* (1963; Montevideo, Estación Goes), depend on a dramatic tension between spatial, geometrical and mechanical elements and biomorphic and organic forms suggestive of the human body. He used a great variety of materials, including scrap iron, concrete, marble and combinations of wood and metal, sometimes left in their natural state and sometimes modified, painted or assembled. In Montevideo many of his works are displayed in architectural settings. He took part in a number of exhibitions, including the São Paulo Biennale in 1961 and the Venice Biennale in 1962.

BIBLIOGRAPHY
R. Huyghe: *El arte y el hombre*, iii (1967/*R* Madrid, 1975), p. 549
F. García Esteban: *Artes plásticas del Uruguay del siglo XX* (Montevideo, 1970)

A. Kalenberg: *Reencuentro y recuperación de lo monstruoso* (Montevideo, 1976)
Germán Cabrera: Una visión retrospectiva (1956-86) (exh. cat., ed. A. Haber; Montevideo, Salón Mun. Exp., 1992)

ANGEL KALENBERG

Cabrera, Miguel (*b* Antequera [now Oaxaca], 27 Feb 1695; *d* Mexico City, 16 May 1768). Mexican painter. He studied under Juan Correa and made indiscriminate use in his paintings of old engravings from different European schools. He is known to have painted a number of pictures during the 1740s, but it was after 1750 that he received his most important commissions, including the series dedicated to the life of St Ignatius Loyola for the Colegio de San Ignacio y San Francisco Javier in Querétaro, for the Templo de La Profesa in Mexico City and for the Jesuit college at Tepotzotlán near Mexico City. In the 1760s Cabrera painted a *Virgin of the Apocalypse* (Mexico City, Pin. Virreinal), basing the image on an engraving after a work by Rubens that was very popular in Mexico during the colonial period. He also designed funerary pyres commemorating the deaths of Maria Amalia of Saxony (1761), the Archbishop Rubio y Salinas (1765) and Isabel Farnese (1767). In addition he explored genres known as 'castes' and 'half-castes', representations of family groups comprising individuals with ethnic differences (see colour pl. III, figs 3 and 4).

Cabrera was among the painters who in 1754 participated in the formation of a society or academy of art in Mexico City. In his book *Maravilla americana y conjunto de raras maravillas* (1756) he described one of his paintings, a representation of the *Virgin of Guadalupe*, and the opinions of contemporary artists on that subject. His prolific production and reliance on stereotypical models had considerable influence on his contemporaries.

WRITINGS
Maravilla americana y conjunto de raras maravillas (1756, rev. Madrid/1785)

BIBLIOGRAPHY
J. Castro Mantecón: *Miguel Cabrera, pintor oaxaqueño del siglo XVIII* (Mexico City, 1958)
A. Carrillo y Gariel: *El pintor Miguel Cabrera* (Mexico City, 1966)
M. C. García Sáiz: *Las castas Mexicanas: Un género pictórico americano* (Milan, 1989)
M. Burke: *Arte Novohispano. Pintura y escultura en Nueva España: El barroco* (Mexico City, 1992), pp. 158–74
R. Cruz Aguillón: *El maestro Miguel Cabrera* (Mexico, 1993)
R. Gutiérrez, ed.: *Pintura, escultura y artes útiles en Iberoamérica, 1500–1825* (Madrid, 1995)

MARIA CONCEPCIÓN GARCÍA SÁIZ

Cabrera, Roberto (*b* Guatemala City, 11 Dec 1937). Guatemalan painter, printmaker and teacher . He studied at the Escuela Nacional de Artes Plásticas in Guatemala City from 1953 to 1958 and displayed great originality from an early age, mixing styles as diverse as Expressionism and Surrealism and ranging from a traditional figuration to avant-garde modes in a variety of media, including drawing, printmaking, painting and collage. His interest in archaic styles led him to use Pre-Columbian sources as well as their modern popular and indigenous counterparts. He also addressed himself, both personally and artistically, to political and social problems on both a national and an international level. Together with Marco Augusto Quiroa and Elmar René Rojas he founded the Vértebra group,

which held a number of exhibitions from 1965 to 1968. In the early 1980s he settled in Costa Rica, where he devoted himself primarily to teaching and aesthetic theory; in the early 1990s he returned to Guatemala and later took up the position of director of the Escuela de Bellas Artes, Guatemala City.

WRITINGS

El grabado guatemalteco (Guatemala City, 1973)
'Contribución a la valoración retrospectiva del arte integrado a la arquitectura: Guatemala, 1950–1980', *Escultura 80* (Guatemala City, 1980)
'De la tradición a lo nuevo reencontrado: 50 años de arte en Guatemala', *Guatemala: Arte contemporáneo* (Antigua Guatemala, 1997), pp. 10–70

BIBLIOGRAPHY

L. Méndez Dávila: *Arte vanguardia Guatemala* (Guatemala City, 1969), pp.v–vi
Roberto Cabrera: Su producción artística (exh. cat., Guatemala City, Escuela N.A. Plást., 1976)
R. Díaz Castillo: *Visión del arte contemporáneo en Guatemala*, ii (Guatemala City, 1995)
Roberto Cabrera, maestro de la plástica guatemalteca (exh. cat. by S. Goldman, Guatemala City, Fundación Paiz, 1996)
Guatemala: Arte contemporáneo (Antigua Guatemala, 1997), pp. 29–32

JORGE LUJÁN-MUÑOZ

Cadena, Luis (*b* Machachi, Pichincha, 12 Jan 1830; *d* Quito, 1889). Ecuadorean painter and teacher. He studied under Antonio Salas (1780–1860) and lived in Santiago de Chile from 1852 to 1856, painting lavish, sentimental portraits under the tutelage of the French painter Raymond Monvoisin (1809–70). In 1857 he went to Rome on a government grant to attend the Accademia Nazionale di S Luca; he worked with the painter Alejandro Marini and made a series of academic studies of nudes and typical Italian characters. His interest in establishing greater academic training in Ecuador, which was still the centre of a prolonged colonial Baroque style in the arts, led him in 1861 to become Director of the Academia de Dibujo y Pintura in Quito. Between 1872 and 1875 he directed the Escuela de Bellas Artes, also in Quito. Cadena dedicated much of his prolific career to executing portraits of leading figures of the period, such as *Nicolás Martínez* (late 19th century; Quito, Mus. Aurelio Espinosa Pólit). His academic style and accuracy of draughtsmanship and composition are evident in the numerous works executed for the Roman Catholic Church. Outstanding are the series on the *Life of St Augustine* (1864; Quito, Convento S Agustín) and the *Mysteries of the Virgin of the Rosary* (1888; Quito, Convent of S Domingo).

BIBLIOGRAPHY

J. M. Vargas: *Los pintores quiteños del siglo XIX* (Quito, 1971), pp. 24–7
J. G. Navarro: *La pintura en el Ecuador del XVI al XIX* (Quito, 1991), pp. 190–92
C. Hartup: *Artists and the New Nation: Academic Painting in Quito during the Presidency of Gabriel García Moreno (1861–1875)* (MA thesis, Austin, U. Texas, 1997)

ALEXANDRA KENNEDY

Cafferata, Francisco (*b* Buenos Aires, 28 Feb 1861; *d* Buenos Aires, 28 Nov 1890). Argentine sculptor. He studied in Buenos Aires under Julio Laguens before travelling in 1877 to Florence, where he studied sculpture under the Italian sculptors Urbano Lucchesi (1844–1906) and Augusto Passaglia (1838–1918). His bronze *Slave*, now in the Jardines del Parque 3 de Febrero in Buenos Aires, was awarded a gold medal at the Exposición Continental,

Buenos Aires, in 1882. In 1885 he returned to Argentina with his monument to *Admiral Guillermo Brown* (bronze; Adrogué, Plaza Almirante Brown), unveiled in 1886; as the first monument by a native artist to be erected in Argentina it received an enthusiastic reception.

Cafferata also produced busts of his father, of the revolutionary Spanish ideologist Mariano Moreno and of the poet José de Espronceda, and he was one of the few 19th-century artists in Argentina to recognize the role of the negro in his society, for example in a monument to the popular hero *Falucho*, which was unfinished when he committed suicide; the conception was taken over by Lucio Correa Morales in his bronze sculpture *Falucho* (Buenos Aires, Plazoleta Falucho). Cafferata's sculpture is characterized by powerful modelling and a dramatic expressiveness that places him beyond the bounds of academic sculpture.

BIBLIOGRAPHY

J. M. Taverna Irigoyen: *Escultura argentina de este siglo* (Santa Fé, 1977), p. 10
E. B. Rodríguez: *Visiones de la escultura argentina* (Buenos Aires, 1983), pp. 13–14

NELLY PERAZZO

Cajahuaringa, José Milner (*b* Huarochirí, nr Lima, 29 Feb 1932). Peruvian painter. He graduated from the Escuela Nacional Superior de Bellas Artes in Lima in 1959, winning a gold medal, and taught there from 1972. In his paintings he played with the complementary colours, trapezoidal images and geometrical forms that typify the architecture of ancient Tahuantinsuyu and with the warm tonalities used in native weaving. He maintained a steady balance in his work between abstraction and figuration, although the representational aspect became more dominant in later years.

BIBLIOGRAPHY

J. M. Ugarte Eléspuru: *Pintura y escultura en el Perú contemporáneo* (Lima, 1970)
L. E. Tord: 'Historia de las artes plásticas en el Perú', *Historia del Perú*, ix (Lima, 1980)

LUIS ENRIQUE TORD

Cajamarca. Peruvian city and capital of the department of Cajamarca in northern Peru. It is also notable for being the site of a Pre-Columbian culture represented primarily by a localized pottery style dated *c.* AD 400–*c.* 1000. It is situated at an altitude of *c.* 2750 m in a fertile Andean valley and has a population of *c.* 70,000. Settlements dating back to the Early Horizon or Chavín period (*c.* 900–*c.* 200 BC), such as Huaca Loma and Layzón, have been discovered on the outskirts of the town. In the hills above the town, 14 km to the south-west, the Cumbe Mayo aqueduct, which is 7.8 km long and probably contemporary with Chavín culture, feeds the fertile Cajamarca valley. Also in the vicinity is the site of Otuzco, with its Middle Horizon cemetery, comprising mainly niches carved into the stone and an associated fortress. The modern city is a popular holiday destination for Peruvians.

The town was built around the hill known as Ingaconga in Quechua (later San Francisco de Monte Alberna; now Santa Apolonia), which is crowned by a shrine that is probably Early Horizon. After its capture *c.* 1460 by the Inca, the town served as a base for the conquest of the Chimú kingdom. Under the Inca, the shrine was fortified

and the town below enlarged. Inca remains include the polygonal-style stonework at the so-called Incas' Palace on Jirón Amalia Puga. Some sources suggest that Cajamarca had a triangular main square (although trapezoidal is more likely), with a ceremonial dais (*usnu* or *ushnu*) surrounded by assembly halls (*kallankas*) with an associated Temple of the Sun and *Akllawasi* (Quechua: House of the Chosen Women). After Pizarro's arrival (1532) and the ambush and execution of the Inca Atahuallpa (1533), a grid plan of streets was laid out around a central Plaza de Armas, largely obliterating evidence of the Inca settlement. In colonial times the city's wealth was generated by silverworking, rich farmlands and textile factories.

The modern city retains many of its colonial buildings dating from the 17th century, when Cajamarca was in its heyday, with 362 Spanish families. In the centre are mansions, churches and the cathedral, which developed from an earlier adobe chapel, said to have been constructed in three days. A royal decree (1665) ordered the construction of a more substantial, stone building (1682–1762; *see* Peru, §III, 1), with a barrel vault over the nave. The plan is simple, but there is rich decoration spiralling up the columns, including figures and vines, grapes and clusters of fruit. The church became a cathedral in 1908. S Francisco (or S Antonio de Padua) was built from 1699 on the site of the Temple of the Sun; Matías Pérez Palomino began the project, which was completed by José Manuel and Francisco de Tapia. It has an unusually tall Baroque Plateresque façade, and the central portal is richly carved. A belfry was added in 1941, and the towers were completed in the 1960s. The adjacent Capilla de la Virgen de los Dolores contains some fine stonework and catacombs.

The church of El Belén (or Belém; 1684–1744) has a tall, narrow retable façade flanked by an expanse of undecorated stone. Inside, the large, stone cupola is punctuated by windows and a ring of sculpted and painted winged angels that appear to support the roof. The upper portion of the cupola is decorated with multicoloured, intricate, chainlike garlands on a pale blue background. It was financed by the corregidor Francisco de Espinoza. Alongside the church is an attractive courtyard and two hospitals, one for men (1763) and the other for women (1774), known as Nuestra Señora de la Piedad and built by Juan de Belém. This now serves as a museum of archeological and ethnographic material. The Colegio de Belém (1672–1767), on the opposite side of the street from the church, has a small belfry and a richly ornamented façade. Other colonial churches include La Recoleta (1668–78), La Inmaculada (1747–1806) and S José (1681–3). Cajamarca has at least 104 decorated stone portals, notable examples of which include those of the Casona de los Condes de Uceda (now a bank), Toribio Casanova, Santisteban, the Palacio de Espinache and the Casa de los Castañeda. Colonial architecture in Cajamarca incorporates both interesting features from the coastal area and fine stone ornamentation typical of the Central and Southern Andes. In 1802 the king of Spain raised its status to regional capital, resulting in a number of architectural projects. The city has few outstanding examples of early republican architecture; styles are essentially local and functional or, in a few cases, refer to North American

examples. In 1986 the Organization of American States declared Cajamarca an American Heritage and Cultural Site.

BIBLIOGRAPHY

P. F. Cortázar: *Cajamarca* (1971), vi of *Documental del Perú* (Lima, 1966)
J. Dammert Bellido: 'Trabajo indígena bajo el Virreinato', *La Prensa* [Lima] (29 Oct 1976), p. 19
R. Ravines: *Cajamarca: Arquitectura religiosa y civil* (Lima, 1983)
R. Ravines: *Cajamarca prehispánica* (Lima, 1985)
F. Silva Santisteban and others, ed.: *Historia de Cajamarca*, iv (Cajamarca, 1989)
A. Mires Ortiz, ed.: *Iconografía de Cajamarca* (Cajamarca, 1992)
Gran enciclopedia del Perú (Barcelona, 1998), pp. 280–317

W. IAIN MACKAY

Calderón, Coqui [Constancia] (*b* Panama City, 17 Jan 1937). Panamanian painter and printmaker. She studied from 1955 to 1959 at Rosemont College in Philadelphia, PA, and in Paris at the Académie de la Grande Chaumière (1959–61) and from 1960 to 1961 at the Académie Julien and the Sorbonne. Her early paintings were figurative, with sombre colours and textured surfaces. She held her first solo exhibition in Panama in 1960, followed by others in Munich and Paris, and established her reputation with an international art prize in San Salvador in 1967. In the 1960s she lived in New York, where she came under the influence of Pop art in paintings such as *555–1212* (1967; Panama City, Mus. A. Contemp.), which depict positive/negative images in strident, fluorescent colours. In the 1970s she produced paintings, drawings, screenprints and embossed prints based on patterns created through the repetition of an image, often a part of the body. There was humour in acrylic paintings such as *Tribute to the Letter A, No. 2* (1976; see colour pl. IV, fig. 1), in which the lines of the letters were softened and curved until they looked like shapely human torsos.

The smooth surfaces of Calderón's abstract paintings were often airbrushed with acrylic paint; shapes could be sharp and stencilled in appearance or soft and diffused. This technique is apparent even in her sometimes politically inspired later works and in her sensuous and colourful landscapes and still-lifes of the 1980s. Calderón was an important promoter of the arts in Panama. In 1983 she was awarded the Order of Vasco Nuñez de Balboa for her work with the Instituto Panameño de Arte.

BIBLIOGRAPHY

Coqui Calderón: Protesta '84 (exh. cat. by G. Guardia, Panama City, Gal. Etcétera, 1984)
Calderón, 1985–1986 (exh. cat., ed. M. E. Kupfer; Panama City, Mus. A. Contemp., 1986)
Panama Series: Winds of Rage, 1987-1989: Coqui Calderón (exh. cat., Washington, DC, A. Mus. Americas, 1992)
Crosscurrents: Contemporary Painting from Panama, 1968–98 (exh. cat. by M. Kupfer and E. Sullivan, New York, Americas Soc. A.G., 1998)

MONICA E. KUPFER

Calderón, Juan Carlos (*b* La Paz, 2 June 1932). Bolivian architect. He studied architecture at Oklahoma State University, Stillwater, and lectured in the architecture faculties of the University of Utah, Salt Lake City, and Florida State University, Tallahassee, in the 1960s. Unlike his slightly younger contemporary Gustavo Medeiros, Calderón was educated in the USA during the period of American influence immediately after the revolution of 1952, but he returned to do his main work in La Paz in

the 1970s and 1980s. He designed a number of important buildings that tend towards an organic style sensitive to context. Among his best-known private commissions are the multi-storey HANSA headquarters (1975), the Plaza Hotel (1976) and the Illimani and S Teresa apartment blocks (1979–80), all in La Paz. Major government buildings followed, for example the Edificio Nacional de Correos (1983) and the Ministerio de Transportes y Comunicaciones (1975–90) in La Paz. There are suggestions of Post-modernism in Calderón's later work in the 1980s.

WRITINGS
Juan Carlos Calderón, arquitecto (Mexico City, 1986)

TERESA GISBERT

Calle, Benjamín de la (*b* Yarumal, 1869; *d* Medellín, 1934). Colombian photographer. After studying photography with Emiliano Mejía, he established a photographic studio in Yarumal in 1898, working there until his move in 1903 to Medellín. He added the prefixes to his surname, Calle, to declare his identification with other people 'of the street': nonconformists, bohemians and those marginalized by society. He openly aligned himself with the underprivileged social classes in his photographs, stating his opposition to the arbitrary and vengeful aspects of his society by recording some of the most moving events of his day, including the last executions by firing squad to take place in Colombia. This series included photographs of prisoners awaiting their deaths while facing their coffins and as bullet-ridden corpses.

De la Calle was also an exceptional portraitist, usually of anonymous and unsophisticated people to whom he gave great dignity, such as proudly barefooted peasants who boldly displayed the instruments and tools of their work. He sometimes presented his figures with elements such as revolvers and cartridge belts to indicate his political and social rebellion. Through such perceptive images he recorded the urban, industrial and commercial development of Medellín.

BIBLIOGRAPHY
Historia de la fotografía en Colombia (exh. cat. by E. Serrano, Bogotá, Mus. A. Mod., 1983)
W. Watriss and L. Parkinson, ed.: *Image and Memory: Photography from Latin America, 1866–1994* (Austin, TX, 1998)

EDUARDO SERRANO

Calvit, Mario (*b* Panama City, 29 Jan 1933). Panamanian sculptor and painter. He studied at the Escuela Nacional de Artes Plásticas in Panama City (1950–53) and established his reputation with abstract or semi-abstract sculptural constructions of soldered unfinished iron. Although the metal surface is sometimes painted, most pieces have a rusty finish, for example *Marine Flight* (1972; Panama City, Mus. A. Contemp.). The lyrical realism of his paintings, such as *Mythical Trainers of a Lipizzaner Horse* (1982; Panama City, artist's col., see E. Wolfschoon: *Las manifestaciones artísticas en Panamá*, Panama City, 1983, p. 401), is comparable to that of the Mexicans Francisco Corzas and Pedro Coronel, often with poetic or literary associations.

BIBLIOGRAPHY
R. Oviero: 'Calvit del otro lado del lienzo', *A. Visual*, i/2 (1985), pp. 17–20

Encuentro de escultura (exh. cat., ed. M. E. Kupfer; Panama City, Mus. A. Contemp., 1987), pp. 22–3

MONICA E. KUPFER

Calzada, Humberto (*b* Havana, 25 May 1944). Cuban painter, active in the USA. He moved to the USA in 1960, settling in Miami. Self-taught as an artist, he had his first one-man show at the Bacardi Art Gallery in Miami in 1975. He is known principally for acrylic paintings showing architectural images or themes of the infinite in a hard-edge style, as in his series of the 1980s *A World Within* (e.g. *No. 14*, 1984; see 1988–9 exh. cat., p. 27), which employs a 'painting-within-a-painting' technique. In his works he drew upon Renaissance perspective; the spaces of Giorgio De Chirico and Luis Barragán; the stained-glass images of Amelia Peláez; and colonial Caribbean architecture. The buildings that Calzada depicted are non-functional; they comprise detached façades and windows, labyrinthine walls and stairs, and portions of columns arranged in courtyards, with projections of shadow and perspective. Calzada exhibited throughout the Americas, and his work is held in a number of North American museums and in the Museo de Arte de Ponce, Puerto Rico.

For illustration *see* LATIN AMERICAN ARTISTS OF THE USA, fig. 3.

BIBLIOGRAPHY
R. Pau-Llosa: 'Calzada's Architecture of Memory', *Carib. Rev.*, xiii/2 (1984), pp. 38–9
——: 'Image du bâti', *Conn. A.*, 384 (1984), pp. 52–7
Outside Cuba (exh. cat. by I. Fuentes Pérez and others, New York, Mus. Contemp. Hisp. A.; Oxford, OH, Miami U., A. Mus.; Ponce, Mus. A.; and elsewhere; 1987–9), pp. 212–17
¡Mira! Canadian Club Hispanic Art Tour (exh. cat. by R. Pau-Llosa, S. Torruella Leval and I. Lockpez, Dallas, TX, S. Methodist U., Meadows Mus. & Gal.; and elsewhere; 1988–9)

RICARDO PAU-LLOSA

Camacho, Jorge (*b* Havana, 5 Jan 1934). Cuban painter. A self-taught artist, he forsook law studies in 1952 to dedicate himself to painting and held his first individual exhibition in the Galería Cubana in Havana in 1955. In 1959 he settled in Paris, where he became an important figure in the circle of Latin American émigré artists. In 1961 he met André Breton and joined what was left of the Surrealist group.

Camacho derived his stylized organic forms from the quasi-abstract Surrealism of Yves Tanguy, and his totemistic images from Wifredo Lam. Gradually he integrated into his complex and enigmatic art other interests such as alchemy, jazz and flamenco, as well as the bird life of French Guiana and Venezuela (which he studied at first hand in 1974 and 1975), as in, for example, *Bird, Night* (1980; Mario Amignet priv. col., see 1987 exh. cat.). His subtle tropes and allusions had a particularly strong appeal to poets such as Joyce Mansour and Reinaldo Arenas, with whom he collaborated on numerous projects.

BIBLIOGRAPHY
A. Breton: *Le Surréalisme et la peinture* (Paris, 1928, rev. 1965; Eng. trans., London and New York, 1972)
Outside Cuba/Fuera de Cuba (exh. cat., New Brunswick, NJ, Rutgers U., Zimmerli A. Mus., 1987), p. 125

RICARDO PAU-LLOSA

Camagüey [formerly Santa María del Puerto Príncipe]. Cuban city situated between the Tinima and Hatibonico

rivers. The original settlement of Santa María del Puerto Príncipe, one of the first seven towns founded by the Spaniards in Cuba, was established in 1514 at Punta del Guincho on the central north coast of the island. The vulnerability of this location led to the settlement being transferred in 1516 to Caonao, where it was subsequently destroyed by a native uprising. It was finally relocated at the inland site, later renamed Camagüey, in 1528. The population was sparse in the 16th century, and the town comprised a line of buildings stretching between its first two churches, the monastery of San Francisco de Paula (rebuilt 1720) and La Merced. In the 17th century the number of inhabitants grew to 3000, but the town was destroyed by Henry Morgan, the English pirate, in 1668. During the 18th century the population expanded to almost 30,000 as a result of new prosperity from cattle-rearing, smuggling and the growing sugar industry. Significant monuments of this period include the church of Santo Cristo del Buen Viaje (1723), the monastery and hospital of S Juan de Dios (1728), the sanctuary of La Caridad (1734) and the hermitage and hospital of S Lázaro (1737). The district of La Caridad was the first area to apply the grid system of urban planning, in contrast to the winding streets and irregular squares of the old town centre. When the Spanish Royal Tribunal was transferred from Santo Domingo (now in the Dominican Republic) to Puerto Príncipe in 1800, the population increased yet again: by the end of the 19th century it had reached 60,000. In 1817 Ferdinand VII made the town a city; following Cuban independence in 1898 it was renamed Camagüey in 1903 and became the capital of a province of the same name.

The emergence of a rich landholding middle class created new residential districts, such as La Vigía, La Zambrana and Garrido; from the 1940s these were joined by Vista Hermosa, Puerto Príncipe and Montecarlo. Following the Revolution of 1959 the growth of the capital Havana was restricted and provincial development encouraged, leading to further growth in the population; by 1990 there were 300,000 inhabitants. Peripheral expansion in the city has allowed the protection of the historical centre, which is undergoing restoration.

BIBLIOGRAPHY

J. Juárez Cano: *Apuntes de Camagüey* (Camagüey, 1929)
A. Pérez: *El Camagüey legendario* (Camagüey, 1944)
'Camagüey, otra carga al machete', *Cuba Int.*, vi/56 (1974) [special issue]
L. Gómez Consuegra and others: *Centro histórico de Camagüey* (Camagüey, 1989)
L.Gómez Consuegra and others: *Centro histórico de Camagüey: Compendio de resultados/autores* (Camagüey, 1992)

ROBERTO SEGRE

Camarena, Jorge González (*b* Guadalajara, 24 March 1908; *d* Mexico City, 24 May 1980). Mexican painter and sculptor. He studied painting at the Academia de San Carlos, Mexico City (1922–30), and later devoted himself to illustrating advertisements and especially to painting murals. In 1932–3 he worked on the restoration of a 16th-century fresco in the monastery at Huejotzingo, which allowed him to study earlier techniques in detail. After various mural experiments in the 1940s he was commissioned in 1950 to decorate the main building of the Instituto Mexicano del Seguro Social in the Paseo de la

Reforma, Mexico City; here his mural painting and the sculptural groups on either side of the door were perfectly integrated with the architecture of the building. Camarena developed his own technique based on 'harmonizing geometry' (*geométrica armónica*), a term applied by a critic, but based on the artist's own words, in which the whole composition and construction of figures derives from the laws of elementary geometry. This, together with the singular colouring inspired by the work of Rufino Tamayo, gave a freshness and originality to his murals. His use of dramatic foreshortening and stylized realism are sometimes reminiscent of the work of David Alfaro Siqueiros, while the mural of *The Fight against Tyranny: Tribute to Belisario Domínguez* (1958) in the Senate in Mexico City has more anguish and strength.

BIBLIOGRAPHY

A. Luna Arroyo: *Jorge González Camarena en la plástica mexicana* (Mexico City, 1981)
E. Acevedo and others: *Guía de murales del centro historico de la ciudad de México* (Mexico City, 1984), p. 49
A. Luna Arroyo: *González Camarena* (Mexico City, 1995)
R. Tovar and others: *Jorge González Camarena: Antología* (Mexico City, 1996)

ESPERANZA GARRIDO

Camargo, Iberê (*b* Restinga Seca, 18 Nov 1914). Brazilian painter and engraver. He settled in Rio de Janeiro in 1943, travelling to Europe in 1947 to complete his painting studies in Paris and Rome with André Lhote and Giorgio De Chirico and his engraving studies with Carlo Petrucci (*b* 1881). Camargo resisted changing fashions, continuing to produce figurative works such as *Riacho Landscape* (1946; Pôrto Alegre, Mus. A. Rio Grande do Sul) and *Lapa* (1947; Rio de Janeiro, Mus. N. B.A.) long after abstraction took hold in Brazil in the late 1940s. Conversely, he practised abstraction, for example in *Structure* (1961; Rio de Janeiro, Mus. N. B.A.), when figurative art was in the ascendancy in the 1960s. In 1966 he painted an abstract panel (7.0×7.0 m) for the headquarters of the World Health Organization in Geneva. His interpretation of Neo-Expressionism in the 1980s was likewise a highly personal one. Throughout these changes his painting retained an atmosphere of violence conveyed through colour and convulsive shapes. In 1982 he resettled in Pôrto Alegre in southern Brazil while still making frequent visits to Rio de Janeiro.

BIBLIOGRAPHY

J. Teixeira Leite: *A gravura brasileira contemporânea* [Contemporary Brazilian engraving] (Rio de Janeiro, 1965)
E. Berg and others: *Iberê Camargo* (Rio de Janeiro, 1985)
J. Maurício: 'Abstração', *Seis décadas de arte moderna na Coleção Roberto Marinho* (Rio de Janeiro, 1985), pp. 332–9
Iberê Camargo (exh. cat., São Paulo, Gal. Camargo Vilaça, 1993)
L. Lagnado: *Conversaçoes com Iberê Camargo* (São Paulo, 1994)
R. Naves: *Iberê Camargo, mestre moderno* (Rio de Janeiro and Porto Alegre, 1994)

ROBERTO PONTUAL

Camargo, Sérgio de (*b* Rio de Janeiro, 8 April 1930; *d* Rio de Janeiro, 10 Jan 1991). Brazilian sculptor. He studied with Emilio Petorutti (1892–1971) and Lucio Fontana in the Academia Altamira in Buenos Aires and in 1948 left for Paris. There he saw the work of Constantin Brancusi, Arp and Georges Vantongerloo, who became important influences on his work. From 1953 to 1961 he lived in

Brazil, where at the São Paulo Biennale in 1965 he won the prize for best national sculptor, before settling again in Paris. His active participation in the Parisian milieu, extended through exhibitions in Europe and the USA, led to his recognition, with Jesús Rafael Soto, Julio le Parc and Carlos Cruz-Diez, as a leading figure within the Latin American Constructivist movement. His brand of Kinetic art, however, was never concerned purely with optical effects. At first his rigorously non-figurative route led him to carry out a reductive exercise of variations on the same problem and subject. But in the long series of reliefs begun in 1963 with wooden modules, usually cylindrical and painted white (e.g. *Large Split Relief No. 34/4/74*, 1964–5; see fig.), and in the wood and marble sculptures that he produced after his return to Brazil in 1974 (*Relevo 351*, 1974; Rio de Janeiro, Col. Gilberto Chateaubriand), he demonstrated the inexhaustible diversity of solutions aris-

Sérgio Camargo: *Large Split Relief No. 34/4/74*, split limewood cylinders on plywood, 1964–5, (London, Tate Gallery)

ing out of an exclusive, restricted nucleus of research. In 1968 he finished a vast concrete panel (untitled) for the interior of the Palácio dos Arcos in Brasília.

BIBLIOGRAPHY
P. Chevalier: 'Sérgio de Camargo', *Aujourd'hui*, 46 (1964)
Sérgio de Camargo (exh. cat. by J. Clay, Caracas, Estud. Actual, 1972)
R. Pontual: *Entre dois séculos—Arte brasileira do século XX na Coleção Gilberto Chateaubriand* [Between two centuries—Brazilian art of the 20th century in the Gilberto Chateaubriand collection] (Rio de Janeiro, 1987)
R. Brito: *Sérgio Camargo* (São Paulo, 1990)
O clássico no contemporâneo (exh. cat., São Paulo, Paço A., 1991)
ROBERTO PONTUAL

Camino Brent, Enrique (*b* Lima, 22 July 1909; *d* Lima, 15 July 1960). Peruvian painter and teacher. He attended the Escuela Nacional de Bellas Artes in Lima from the age of 12 or 13, studying under José Sabogal, Daniel Hernández and Manuel Piqueras Cotoli. In 1930 in Lima he exhibited Indigenist-style paintings inspired by his travels in Cuzco, Puno and Ayacucho, and he finally completed his studies in 1932 and began teaching at the Escuela Nacional. He began to exhibit outside Peru in the late 1930s, and in 1941 he set up the Galería de Lima. Over the next two decades he travelled extensively, including to the USA, Europe and North Africa. Notable among the commissions Camino Brent received was that for the Corporación Nacional de Turismo for its chain of hotels throughout Peru. In these and other paintings he displayed his distinctive form of Indigenism, characterized by distorted figures and architecture—often dilapidated buildings in remote villages—full of movement and contrast (e.g. *Herod's Balcony* and *Church of S Sebastián at Huancavelica*, both 1937; both Lima, Mus. Banco Central de Reserva).

BIBLIOGRAPHY
J. Villacorta Paredes: *Pintores peruanos de la República* (Lima, 1971), pp. 51–3
J. A. de Lavalle and W. Lang: *Pintura contemporánea II: 1920–1960*, Col. A. & Tesoros Perú (Lima, 1976), pp. 88–97
J. Falcón: *Enrique Camino Brent* (Lima, 1989)
E. Moll: *Enrique Camino Brent* (Lima, 1989)
W. IAIN MACKAY

Camnitzer, Luis (*b* Lübeck, 1937). Uruguayan conceptual artist and teacher, of German birth. Of Jewish ancestry, he fled with his family to Uruguay in 1939. He studied at the University of Uruguay between 1953–57 and 1959–62 before a Guggenheim fellowship took him to New York in 1961 to study printmaking. Although he settled in the USA, he retained his Uruguayan citizenship. From the 1970s, Uruguay and Latin America in general inspired a series of conceptual installations that addressed such issues as language, identity, freedom, repression and the role of art. Politics is a dominant element in Camnitzer's work, expressed in ethical and artistic debate rather than in rhetoric. For Camnitzer, the task of the artist was to be aware of and express the problems that surround him, an attitude that challenged a perceived lack of meaning prevalent in much contemporary work. His questioning of traditional values applied not only to the theme of his work, but to its material form: employing objects of little intrinsic value, he rejected traditional notions of art as beautiful and of commercial worth. Through the use of

texts, images and objects, such as those employed in *El libro de los muros* (1993, collection of the artist), Camnitzer encouraged the viewer to fill in the blank spaces, thereby actively participating in the meaning of the work. He became Professor of Art at the State University of New York in 1969.

WRITINGS
New Art of Cuba (Austin, 1994)

BIBLIOGRAPHY
E. J. Sullivan, ed.: *Latin American Art in the Twentieth Century* (London, 1996)
<div align="right">J. HARWOOD</div>

Campbell, Ralph (*b* Kingston, 13 March 1921; *d* Kingston, 26 Nov 1985). Jamaican painter and teacher. He received his early artistic training under Edna Manley at the Junior Centre of the Institute of Jamaica and at the Jamaica School of Art and Crafts, both in Kingston. He later attended Goldsmiths' College, London, and the Chicago School of Interior Decoration. He taught intermittently at the Jamaica School of Art and at several high schools in Kingston. Although he is best known for his expressionist religious works and his atmospheric landscapes, his work is characterized by variety in terms of subject-matter, styles and techniques. His many experiments were not always equally successful, and the quality of his work is somewhat uneven, although his best works, such as *Sea of Galilee* (1975; Kingston, N.G.), are among the finest of the early Jamaican Art Movement.

BIBLIOGRAPHY
D. Boxer and V. Poupeye: *Modern Jamaican Art* (Kingston, 1998)
<div align="right">VEERLE POUPEYE</div>

Camponovo, Antonio (*b* Medrissio, Ticino, 1850; *d* Buenos Aires, 1938). Swiss architect, active in Bolivia. He studied at the Politecnico, Turin. At the end of the 1860s he emigrated to Argentina and later moved to Sucre, Bolivia, where with his brother Miguel Camponovo he planned and built the Banco Nacional (begun 1872). Its style is derived from early Renaissance forms, with characteristic mullioned windows, and it is among the first examples in Bolivia of Eclecticism, which was then in fashion in the European academies. He also worked on the Palacio de Gobierno (begun 1892), Sucre (*see* BOLIVIA, §II, 2(i)), and designed private houses, such as the country house (*quinta*) El Guereo, outside Sucre, and the Palacio de la Glorieta (*c*. 1900), Sucre, for the Argandoña family, which combines elements of the Romanesque, Renaissance, Arabic and Neo-classical styles in one of the most richly eclectic buildings in Bolivia. In 1900 he went to La Paz, which had been made the capital of Bolivia in the previous year, to oversee the completion of the cathedral (for illustration *see* LA PAZ), begun *c*. 1830 by Manuel de Sanahuja. After disputes with the Jesuit architect Eulalio Morales, Camponovo's Neo-classical design, which conformed with that of Sanahuja, was accepted. By 1905 he had completed the interior decoration (using a Corinthian order), the second storey of the main façade and the dome above the transept. He also built the Palacio Legislativo (1900–08), La Paz, a Neo-classical structure focused on two main debating halls. His other works in La Paz include his own house in El Prado, a building of elegant eclecticism,

and a new façade and the interior decoration (1909) for the Teatro Municipal.

WRITINGS
La catedral de La Paz (La Paz, 1900)

BIBLIOGRAPHY
T. Gisbert and J. de Mesa: *Monumentos de Bolivia* (La Paz, 1978), pp. 128, 132–3, 150–52
<div align="right">TERESA GISBERT</div>

Canal, Ramón Alva de la. *See* ALVA DE LA CANAL, RAMÓN.

Canales, Alejandro (*b* Managua, 1945; *d* Managua, Oct 1990). Nicaraguan painter. He studied drawing, painting and sculpture at the Escuela Nacional de Bellas Artes, Managua, from 1961 to 1970. Throughout the 1970s he struggled to make a living by selling his art and in 1977 joined the revolutionary movement that overthrew the dictatorship of General Somoza in 1979. He was commissioned in 1980 by the newly established Ministerio de Cultura to paint a mural, *Homage to Woman: The Literacy Crusade* (see colour pl. IV, fig. 3), about the highly successful national literary crusade that took place in that year, deftly synthesizing elements from European modernism, Mexican muralism and Pre-Columbian art.

Canales executed two more murals near Velásquez Park: *Coffee Harvest* (2×7 m, 1982) and the huge, boldly-coloured *Communication Past and Present* (1984–5; see colour pl. IV, fig. 2), a synthesis of Nicaraguan history that extended several stories in height on the side of the Telcor Building, which dominates downtown Managua near the lake front. There was also a mural by Canales in the Instituto Nacional de Securidad Social, Managua. His growing international reputation led to further invitations to paint murals in other countries, including Mozambique and the USA, and was an important factor in establishing Nicaragua's influential role in the revitalization of mural painting.

Nicaragua's mural movement ended in 1990, when the new government ordered the destruction of many Sandinista-era murals. Canales died of a heart attack in early October 1990, and on 25 October his mural at Velásquez Park was painted over.

BIBLIOGRAPHY
E. Cockcroft and D. Kunzle: 'Report from Nicaragua', *A. Amer.*, lxx/5 (1982), pp. 51–9
D. Craven and J. Ryder: 'Nicaragua's Revolution in Culture', *A. Mag.*, lviii/5 (1984), pp. 83–6
J. Weber: 'Sandinista Arts', *New A. Examiner* (Oct 1985), pp. 42–4
L. Morales Alonso: 'Reflexiones sobre el muralismo', *Ventana* (23 Nov 1985), p. 2
D. Craven: *The New Concept of Art and Popular Culture in Nicaragua Since the Revolution in 1979* (Lewiston, 1989), pp. 189–207
J. Rosenberger: 'Nicaragua's Vanishing Sandinista Murals', *A. Amer.* lxxxi/7 (1993), p. 27
D. Kunzle: *The Murals of Revolutionary Nicaragua* (Berkeley, 1995)
<div align="right">DAVID CRAVEN</div>

Candela (Outeriño), Félix (*b* Madrid, 27 Jan 1910; *d* Raleigh, NC, 7 Dec 1998). American architect of Spanish birth, active mainly in Mexico. He trained at the Escuela Superior de Arquitectura, Madrid. After graduating in 1935, Candela opened a small studio and applied to the Real Academia de Bellas Artes de S Fernando for a travel scholarship to Germany, where he intended to study the

theory of shell structures. The Civil War in Spain (1936–9), however, shattered these plans. Candela joined the Republican forces, fleeing across the frontier into France after the Nationalist victory in 1939. Briefly interned in a camp in Perpignan, he then emigrated to Mexico, where, with his younger brother Antonio Candela, he opened a construction company.

At the beginning of his professional career Candela yielded to the conservative tastes of his clients, setting aside his passion for thin-shell structures until 1951, when he was commissioned to build the cosmic ray laboratory at the University of Mexico. The laboratory's two hyperbolic paraboloid concrete vaults, 15 mm thick and spanning over 10 m, brought instant recognition and led to many building commissions and lecture invitations. More importantly, however, Candela was finally able to pursue his own particular interests. Over the period that followed, he broke the monopoly of academic science in thin shells that had been held hitherto by German and British theoreticians. In this he was strongly influenced by such architects as Antoni Gaudí (1852–1926) and Eduardo Torroja y Miret (1889–1961), whose experiments with vault designs differed from conventional solutions used by Italian and German architects, emphasizing formal variety and exploring the possibilities for slender, ribless structures. The *c.* 1000 structures erected by Candela ranged from simple 'umbrella' roofs to the most sophisticated shells. Examples from the early 1950s include the Florería Ras Martín (1951; with Cayetano de la Jara), Chapultepec, and the Escuela Hidalgo (1953; with Luis Rivadaneyra) in Mexico City, and the umbrella structure (1953–4; with Alejandro Prieto) at the entrance to the Laboratorios CIBA, Churubusco.

Perhaps Candela's best-known work from the 1950s, however, is the church of the Miraculous Virgin (1955; see fig. 1) in Mexico City. The beauty of the church's interior is reinforced by warped columns integrated with the hyperbolic paraboloid roof vaulting. This was followed a year later by the church of S Antonio de las Huertas (with Enrique de la Mora and Fernando López Carmona), which exemplifies Candela's characteristic use of shells with free edges (without reinforcing arches to support their outer edges). Here light penetrates to the interior through clerestories between the vaults to give splendid architectural effects. There were also a number of commercial and industrial buildings built by Candela during this period, including such multiple umbrella structures as the Mercado de Coyoacán (1956; with Pedro Ramírez Vázquez and Rafael Mijares) and single or multiple shells, as in the vast twin vaults of Las Aduanas (1954), Vallejo, Mexico City. His own favourite structure, however, was the restaurant at Xochimilco (1957–8; with Joaquin Alvárez Ordóñez and Fernando Alvárez Ordóñez; see fig. 2). This consists of eight groin vaults formed by four intersecting hypars; the undulating outside edges of the shells, apparently unsupported, allow for the full appreciation of the slenderness of the roof, which is only 40 mm thick, despite spanning a distance of 42.5 m. Another important building of the late 1950s was the open chapel (1959; with Guillermo Rossell and Manuel de la Rosa) on the top of a hill near the Lomas de Cuernavaca Valley. This is planned in the tradition of a Classical Greek theatre and has an asymmetrical saddle roof that spans 31 m, rises to 22 m at its crown and is a mere 40 mm in thickness.

During the 1950s and early 1960s Candela benefited from the oil boom that stimulated the Mexican economy. Apart from the impetus it naturally gave to local building activity, the oil boom led to considerable migration by the rural poor into large cities, and this provided Candela with the cheap labour necessary for shell construction. He continued to produce important work, however, even as the effects of the boom faded throughout the 1960s. In 1963 he built the Bacardi Bottling Plant in Cuatitlán, and in 1966 the church of S Monica, Mexico City. In 1968 he won first prize in the competition for the Palacio de Deportes for the Olympic Games, which were held in Mexico City that year. The palace has an impressive roof, built with intersecting steel arches 135 m long and covered with copper. In the 1970s Candela settled in the USA, establishing a practice in Chicago in 1971 and becoming an American citizen in 1978. He was also professor of architecture at the University of Illinois at Chicago Circle until 1978. In 1980 he left for Madrid but after several years returned to the USA and settled in Raleigh, NC, where he was active as a consultant and visiting lecturer. His international reputation brought him several honorary doctorates.

Candela considered creativity in art and in science to be close, if not identical. He strongly objected to the indiscriminate application of the theory of elasticity for shell design, and the pedantic requirements of local building codes based on this theory. He also never lost sight of aesthetic criteria or allowed his intuitive feel for structure to be outweighed by other factors. Thus, while his projects were masterpieces of logic, blending skills of construction, economy and function, this logic was inseparable from an appreciation of the architectural merits of a structure, and all Candela's collaborations bear the stamp of his personality and style.

WRITINGS

D. Billington and others: *New Architecture; Maillart Papers* (Princeton, 1973)
En defensa del formalismo y otros exitos (1985)
Félix Candela, arquitecto (Madrid, 1994)

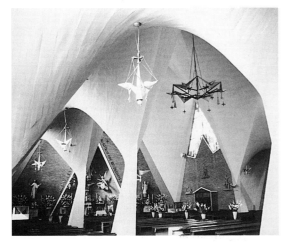

1. Félix Candela: church of the Miraculous Virgin, Mexico City, 1955

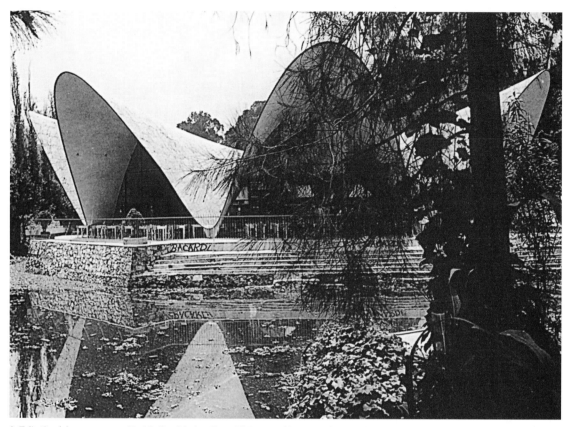

2. Felix Candela: restaurant at Xochimilco, Mexico City, with Joaquín Alvárez Ordóñez and Fernando Alvárez Ordóñez, 1957–8

BIBLIOGRAPHY

C. Faber: *Candela: The Shell Builder* (New York, 1963)

C. Bamford Smith: *Builders in the Sun: Four Mexican Architects* (New York, 1967), pp. 93–130

J. A. Starczewski: 'Spotkanie z Felixem Candelą: Twórcą konstrukcji łupinowych', *Inzyn. & Budownictwo*, xl/5 (1984), pp. 161–6

——: *Félix Candela: The Structure and Form of Reinforced Concrete Shells* (Atlanta, 1992)

H. Ursula, ed.: *Zum Werk von Félix Candela: Die Kunst der leichten Schalen* (Cologne, 1992)

Félix Candela, arquitecto (exh. cat., Madrid, 1994)

JERZY ANDRZEJ STARCZEWSKI

Cantú, Federico (*b* Cadereyta, nr Monterrey, 3 March 1908; *d* Mexico City, 29 Jan 1989). Mexican painter, sculptor and printmaker. He studied at the Escuela de Pintura al Aire Libre at Coyoacán in the early 1920s and independently with Spanish sculptor Mateo Hernández (1884–1949) and the Catalan José de Creeft (1884–1982). Although younger than the major figures of post-revolutionary Mexican art, his work reflected their influence in the use of Pre-Columbian themes in his mural and sculptural work and in occasional references to indigenous types. In general, however, it was distinguished by the ephemeral, melancholic, linear quality of his figures, clearly influenced by Botticelli and by Picasso's Blue Period; harlequins, romantic poets and women with flowing hair were common subjects in his paintings, which were primarily portraits, religious scenes and allegorical compositions. In 1945 he began an association with the printmaker Carlos Alvarado Lang (1905–81), and the resulting engravings showed fine linear elegance (e.g. the *Communion Rail*, 1945–6; Monterrey, La Purísima). Throughout the 1960s he produced sculpted reliefs and free-standing sculptures for the buildings of the Instituto Mexicano del Seguro Social; in these works Cantú came close to the massive qualities associated with the Mexican school, but his figures' volume was still tempered by linear detailing.

BIBLIOGRAPHY

Eduardo P. Blackaller: *Federico Cantú: Seis décadas de trabajo* (Mexico City, 1980)

Federico Cantú: Ciclos y reencuentros (exh. cat., Mexico City, Mus. Pal. B.A., 1986)

A. Arteaga: *Federico Cantú: Una nueva visión* (Mexico City, 1989)

Federico Cantú: Exposición homenaje (exh. cat. by M. Kaiser, Mexico City, Mus. Franz Mayer, 1991)

Federico Cantú: Los látigos de tus líneas (exh. cat., Puebla, Mus. Amparo, 1994)

Obras de Federico Cantú: Retrospectiva (exh. cat., Mexico City, Mus. A. Sinaloa, 1997)

KAREN CORDERO REIMAN

Caracas [Santiago de Leon de los Caracas]. Capital of Venezuela. It was founded in 1567 by Diego de Losada in a strategic location on fertile land in the foothills of the Cordillera, about 11 km from the coast. It was laid out by Diego de Henares on a grid-plan, as was characteristic of most of the cities founded by the colonizing Spaniards in the Americas and in general accordance with the 'Leyes de Indias' (1573) of Philip II, King of Spain. In the first plan (1578) houses were located around a central square,

and each city block was divided into four parts. Throughout the period of colonial rule (until 1821) Caracas developed slowly, the result of limited economic activity, recurrent earthquakes and devastating epidemics. No buildings survive from the 16th century. In the mid-17th century, however, Caracas took on the role of civic and religious authority that had previously rested with the city of Coro. The most significant building from this period is the cathedral, begun in the mid-1660s to replace an earlier cathedral destroyed by earthquake. It has five naves and owes much to Coro Cathedral (1583–1617). The façade (see VENEZUELA, fig. 3) was executed by Francisco Andrés Meneses in 1711. The architecture of southern Spain, particularly of Andalusia, influenced colonial dwellings, few examples of which survive. Houses were usually single storey with plain exteriors and grilled windows. Decorative features were generally confined to sculptural details above windows and doors. All rooms connected with a central patio; some dwellings had secondary patios and gardens. Red-tile roofs projected deeply over exterior walls.

In the 18th century, cultivation of cacao made Venezuela a prosperous agricultural dominion of Spain and stimulated the creation of the Real Compañía Guipuzcoana. In 1728 the company made an agreement with the Crown by which the colony would be sent two warships a year in return for the company's sole right to import European goods to Venezuela. Since the port of La Guaira was of more importance to the Real Compañía Guipuzcoana, they erected no notable building in Caracas. At the instigation of Governor Felipe Ricardos, stores were constructed around the Plaza Mayor in 1755, but these were demolished by President Guzmán Blanco in the mid-19th century when the Plaza Mayor was converted into the Plaza Bolívar. A number of goldsmiths operated in Caracas at this time, and a silversmiths' guild was also established in the 18th century. Works were generally Hispanic in character, and there were some notable ecclesiastical commissions (see VENEZUELA, §V).

A powerful earthquake devastated Caracas in 1812, killing some 12,000 people; the wars of independence and subsequent civil unrest also detracted from any impetus for urban development and architectural planning. The portrait painter JUAN LOVERA was based in Caracas in this unstable period. The city was recorded in oil sketches by Ferdinand Bellermann (1814–89) and in drawings by Camille Pissarro, who visited in 1852–4, establishing a studio in the city. Bellermann emphasized the melancholy majesty of the ruined churches of Santísima Trinidad (c. 1720; now the site of the Pantéon Nacional) and Las Mercedes (1698), set among tropical vegetation and against the impressive Cordillera.

The first art institution in Caracas was established in 1835, and painters were greatly influenced by developments and teaching in Paris (see VENEZUELA, §IX). A cholera epidemic struck the city in 1855, resulting in the building of the Neo-classical Hijos de Dios cemetery by Olegario Meneses (c. 1810–60). From the late 19th century Caracas began to spread along the east–west axis of its valley. Guzmán Blanco (President, 1870–90) was responsible for the first sustained programme of public building and did much to develop the arts. He commissioned the European-trained architect Juan Hurtado Manrique

(1837–96) for such projects as the Palacio del Gobierno (1856–60), the Universidad façade (1876), the Museo Nacional (1883; now the Museo de Bellas Artes), the Masonic temple, the church of the Calvario and the Plaza Bolívar (1886–90). Manrique's most important religious work was the Neo-classical church of S Teresa (1876; see fig.). By the late 19th century Caracas's once uniform skyline of red roofs was punctuated by a number of stately Neo-classical buildings.

A marked eclecticism appeared in public building works in the early 20th century, notably by Alejandro Chataing (1874–1928), while a simplified version of colonial architecture also prevailed. Another building boom began in 1936, when the International Style was established in Venezuela under the leadership of the French urban planner Maurice Rotival. Although not accepted in its entirety, elements survived of Rotival's design for a modern Caracas. Carlos Raúl Villanueva, who had trained in Paris and was a member of the Rotival team, was responsible for El Silencio (completed 1943), Caracas's first multi-functional urban complex. This ambitious project replaced slum dwellings with six-storey blocks of flats joined by an unbroken street-level arcade. Villanueva was also involved in the nearby Avenida Bolívar project (1946–7) and in the construction of the Centro Simón Bolívar (1952–4), which, with its two 30-storey towers providing office and commercial space and separate levels for pedestrians and vehicles, became symbolic of a dynamic, future-orientated Caracas. Works for the Ciudad Universitaria (1944–59) were probably Villanueva's greatest achievement. These buildings exhibit a fusion of architectural styles based on colonial, local and modern European aesthetics, and the design of the complex was likened by

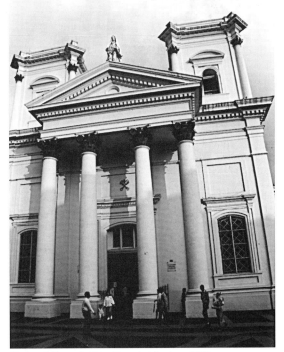

Caracas, S Teresa by Juan Hurtado Manrique, 1876

Villanueva to musical movements (for illustration *see* VILLANUEVA, CARLOS RAÚL). In addition, the university was conceived as an open-air museum and adorned with sculptures in open spaces and murals on exterior walls by such 20th-century artists as Fernand Léger, Hans Arp and Alexander Calder. Projects of superblocks for urban workers by Villanueva and others in the mid-20th century were intended to be independent, self-contained units making the most of sculptural forms and vibrant colours.

In the second half of the 20th century a new generation of architects produced a range of complexes, parks and buildings such as the Museo de Arte Contemporáneo (1974–82; *see* VENEZUELA, §VIII) and the Teatro Teresa Carreño (*see* VENEZUELA, fig. 5), while the Metro train system, with its two routes across the city, was opened in 1983, with ongoing plans for expansion. By the 1990s Caracas's population numbered some four million, and in conjunction with an oil boom and land speculation, a rather chaotic urban sprawl developed.

BIBLIOGRAPHY

C. R. Villanueva: *La Caracas de ayer y de hoy, su arquitectura colonial y la reurbanización de El Silencio* (Paris, 1950)
G. Gasparini and J. P. Posani: *Caracas a través de su arquitectura* (Caracas, 1969)
G. Gasparini: *Caracas: La ciudad colonial y guzmancista* (Caracas, 1978)
J.-P. Cousin and others: 'Caracas, Venezuela', *Archit. Aujourd'hui*, 247 (1986), pp. 70–95 [Fr. and Eng. text]
F. Irace: 'Caracas, un dramma urbano', *Abitare*, 253 (1987), pp. 206–31 [It. and Eng. text]
E. Cruz: *Templos de Caracas* (Caracas, 1995)

ANTHONY PAEZ MULLAN

Cárcova, Ernesto de la (*b* Buenos Aires, 3 March 1867; *d* Buenos Aires, 28 Dec 1927). Argentine painter. He studied painting in the mid-1880s at the Academia de la Sociedad Estímulo de Bellas Artes in Buenos Aires, and then in Turin and Rome. On his return to Buenos Aires in 1893 he showed one of his most representative works, *Without Bread and without Work* (1893: see colour pl. V, fig. 1), which in its application of a naturalistic style to subjects drawn from the lives of ordinary people revealed the influence of contemporary Italian art and of his socialist convictions; although painted in Italy it related to the desperate situation in which many found themselves in Argentina. He also produced portraits and still-lifes in oils and pastels, and he became preoccupied with problems of light and atmosphere that led him to adopt an increasingly light palette and linked him to the Impressionist aesthetic, as in *Silent Nature* (1927; Buenos Aires, Mus. N. B.A.).

Cárcova was outstanding among Argentine painters working at the turn of the century. He was also influential on many artists who later became prominent in Argentina: in Buenos Aires in 1921 he co-founded and directed the Escuela Superior de Bellas Artes (later renamed the Escuela Superior de Bellas Artes Ernesto de la Cárcova); he was also Director of the Patronato de Becarios en Europa (which awarded scholarships for study in Europe), president of the Sociedad Estímulo de Bellas Artes and Director of the Museo de Calcos y Escultura Comparada. He was awarded the gold medal at the International Exhibition held in St Louis, MO, in 1904.

BIBLIOGRAPHY

C. Córdova Iturburu: *La pintura argentina del siglo veinte* (Buenos Aires, 1958), p. 20

Arte Argentina dalla Independenza ad oggi, 1810–1987 (exh. cat., Rome, Ist. It.-Lat. Amer., 1987), p. 54
J. E. Payró: 'La pintura', *Historia general del arte en la Argentina*, vi (1988), pp. 162–4

NELLY PERAZZO

Cárdenas, Agustín (*b* Matanzas, 10 April 1927). Cuban sculptor, active in France. He studied under Juan José Sicre, and at the Escuela Nacional de Bellas Artes 'San Alejandro' in Havana (1943–9). He settled in Paris in 1955 and became involved with the Surrealists. He also started to consider his African heritage and to incorporate Dogon totems in his work (e.g. *Sanedrac*, 1957; bronze cast, 1974; see exh. cat., p. 5). Brancusi and Arp were significant influences, and affinities can also be traced between Cárdenas's use of line to evoke magical transformations and the works of two other Cubans based in Paris, Wifredo Lam and Jorge Camacho. Working in marble, bronze and stone, he often used familiar images such as birds, flowers or the female nude as the bases for his lyrical abstractions (e.g. *Engraved Torso*, marble, 1976; see exh. cat., p. 22). The combination of these images of life with patterns suggesting infinite repetition became a central element in his work and constitute a synthesis of abstraction and reference. He undertook monumental commissions in France, Israel, Austria, Japan and Canada, and his works are housed in collections worldwide, including the Museo de Arte Contemporáneo, Caracas, the Musée d'Ixelles, Bruxelles, and the Musée d'Art et d'Industrie, St Etienne, France.

BIBLIOGRAPHY

A. Breton: *Le Surréalisme et la peinture* (Paris, 1928, rev. 1965; Eng. trans., London and New York, 1972), pp. 322–3
J. Pierre: *La Sculpture de Cárdenas* (Brussels, 1971)
Cárdenas: Trente ans de sculpture (exh. cat. by J. Pierre, Paris, JGM Gal., 1988)
M. Colle Corcuera: *Artistas latinoamericanos en su estudio* (Mexico City, 1994)

RICARDO PAU-LLOSA

Careaga, Enrique (*b* Asunción, 30 Aug 1944). Paraguayan painter. He studied in Asunción in the studio of the painter and teacher Cira Moscarda, who helped to reform the artistic values of the younger generation in the 1960s. In 1964 Careaga helped found Los Novísimos, a group concerned with revitalizing Paraguayan art and introducing into it a more cosmopolitan style. He began in his paintings to develop geometrical arrangements that showed a debt to Constructivism (e.g. *Structures III*, 1979; Maldonado, Mus. Amer. A.) and to Op art (e.g. *Diagonal Progression*, 1968–70; Asunción, Mus. Parag. A. Contemp.; and *Chromatic Transparencies*, 1971–2; Paris, Bib. N.). In 1964 he won a scholarship to go to Paris, where he was strongly influenced by Victor Vasarely (1908–97) and the Groupe de Recherche d'Art Visuel, which confirmed his interest in using optical effects to generate the image, as in *Spatial–Temporal Spheres BS 7523* (1975; see colour pl. V, fig. 2). The first stage of this work was based on the representation of two-dimensional fields in which effects of vibration and instability were created by the interreaction of strongly contrasting colours. Towards 1972 Careaga introduced three-dimensionality in spatial projects: the structure of a work no longer depended on oscillatory effects that play on perception through light and colour, but it was defined by the presence of weightless volumetric

bodies shifting in space, which in their final stage explode and disintegrate. He also used metal in constructions based on geometric shapes (e.g. *Revolving Structure Zama 7916*, 1978–9, using stainless steel).

BIBLIOGRAPHY
O. González Real: 'La abstracción geométrica en la plástica paraguaya', *Anticipación y reflexión* (Asunción, 1980), pp. 83–6
O. Blinder and others: *Arte actual en el Paraguay* (Asunción, 1983)

TICIO ESCOBAR

Carib. One of several groups of Amerindian peoples inhabiting pockets of the Caribbean and northern countries of South America. They were particularly dominant in the Lesser Antilles until the European colonies began to be established in the late 15th century.

For main discussion *see* ANTILLES, LESSER, §II, 1.

□

Caribbean Islands. Archipelago in the Caribbean Sea, comprising numerous islands scattered in a wide arc stretching from Cuba to Aruba. The islands may be divided into three groups: the Greater Antilles, consisting of CUBA, Hispaniola (divided into HAITI and the DOMINICAN REPUBLIC), PUERTO RICO and JAMAICA; the chain of small islands from the Virgin Islands to Aruba known as the LESSER ANTILLES; and the islands to the north of the Greater Antilles that form THE BAHAMAS (see fig. 1). This article discusses the major cultures found throughout the Caribbean Islands and their influence and importance within the region. For more detailed surveys of specific arts and artists, *see* the individual islands' surveys.

I. Geography and history. II. Cultures. III. Exhibitions.

I. Geography and history.

The islands cover a total land area of 234,000 sq. km, and their geology falls into three areas: the faultblock mountains of the Greater Antilles, Trinidad and Tobago and the islands close to the north coast of South America; the volcanic peaks of the inner arc of the Lesser Antilles; and the limestone plateaux of parts of Cuba, the Bahamas and the outer arc of the Lesser Antilles. The climate is marine tropical, with local variations based on wind direction and altitude. There is a risk of hurricanes in summer months. Rainfall largely determines vegetation, but most of the original forest has been cleared for cultivation.

The population of the islands (35.8 million in 1996) is predominantly Afro-Caribbean, but it also includes people

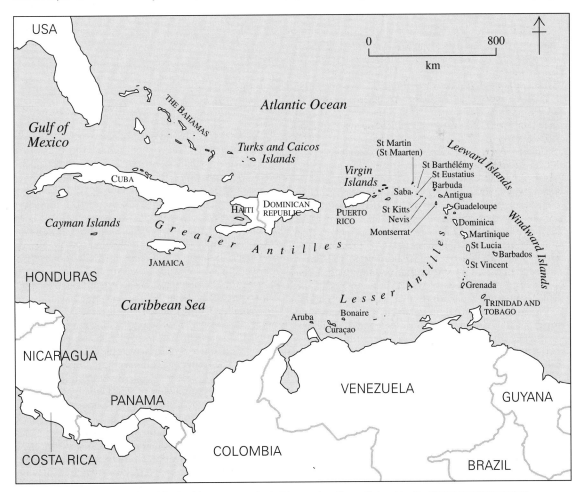

1. Map of the Caribbean area; those islands with separate entries in this encyclopedia are distinguished by CROSS-REFERENCE TYPE

of Amerindian, European, Indian, and Chinese origin. The diversity of religions in the Caribbean Islands reflects the variety of the region's settlers. The influences that have come to bear on Caribbean art and architecture include the shamanism of the Amerindians; Christianity and Judaism of the European colonists; the West African religions of imported slaves; and the Hinduism and Islam of indentured labourers from south Asia.

The Spaniards concentrated on mainland spoils and neglected the islands themselves, which came to be used in the 16th century as trading and raiding posts from which the Dutch, French and English harassed the passage of Spanish treasure fleets. Permanent agricultural settlements followed, but it was the Dutch-led transition to sugar production in the middle of the 17th century that provided the real foundations of the Caribbean experience. The plantation system under which sugar was produced determined not only the physical landscape but also Caribbean social structure and patterns of life, including attitudes towards race and colour. The white plantation owners satisfied the need for manual labour through the large-scale importation of African slaves, and, after emancipation in the 19th century, by various forms of contract labour from Asia and Portugal. This accounts for the diverse character of Caribbean populations. When great fortunes were possible, as in the period up to 1800, men of substance and taste chose to live in the metropolis, where they spent their money and educated their children. This absentee tradition influenced the development of Caribbean ideas. Those among the élite who stayed had to contend with the ever-present threat of slave uprisings, and they regarded the Caribbean as a place of transitory exile. This may explain why European visitors to the plantation 'Great Houses' often found them bereft of style and adornment.

A major process of localization nevertheless took place, which affected every group in the Caribbean. This was known as creolization: 'creole' was originally applied to black slaves born in the Caribbean but was later used to refer to anyone born locally, and was then extended to local things, habits and ideas. A major role in this process was played by the so-called free people of colour, the mixed offspring of white masters and their slaves. Although they suffered from a series of legal and other disabilities and they were distrusted by the black slaves, they formed the group that provided the leadership for the constitutional struggles of the post-slavery period. Generally, in the Caribbean the ending of slavery was associated with the rise of the peasantry, and in villages off the plantations some scope was found for a revitalization of African cultural traits. Creolization had, however, made great progress, and the emerging middle class was more likely to be the product of Western, often missionary, education. This group gradually demanded a greater say in the process of administration. After World War I, and particularly following the depression of the 1930s, a rising labour movement added fuel and mass support to these claims. The scene was set for a process of constitutional devolution, which, after a brief flirtation with the notion of a Caribbean federation, lead to the independence of the small territories of the Caribbean in the 1960s and 1970s. American economic, political and cultural influence has expanded, though the establishment of NAFTA and the European Union has created greater interest in a pan-Caribbean regional identity.

BIBLIOGRAPHY

E. V. Govela: *Slave Society in the British Leeward Islands at the End of the 18th Century* (New Haven, 1965)
E. Williams: *From Columbus to Castro: A History of the Caribbean, 1492–1969* (London, 1970)
E. Brathwaite: *The Development of Creole Society in Jamaica* (Oxford, 1971)
D. Lowenthal: *West Indian Societies* (London, 1972)
H. Blume: *The Caribbean Islands* (London, 1974)
M. Cross: *Urbanization and Urban Growth in the Caribbean* (Cambridge, 1979)
D. Watts: *The West Indies: Patterns of Development, Culture and Environmental Change Since 1942* (Cambridge, 1987)
J. M. Carrion, ed.: *Ethnicity, Race and Nationality in the Caribbean* (Rio Piedras, 1997)

JANET HENSHALL MOMSEN, C. J. M. R. GULLICK, KUSHA HARAKSINGH

II. Cultures.

1. Native American. 2. Western. 3. Afro-Caribbean. 4. Indo-Caribbean.

1. NATIVE AMERICAN. The Greater Antilles and the Bahamas were inhabited by Taino Native Americans when they were the first lands visited by Columbus during his early voyages of discovery. The Lesser Antilles were inhabited at the time by the fierce Carib Native Americans, who had migrated a few centuries before from the coast of South America, displacing the earlier inhabitants, Saladoids of Arawak stock. These comprise the three main groups of Pre-Columbian Native Americans in the Caribbean Islands.

(i) Saladoid. (ii) Carib. (iii) Taino.

(i) Saladoid. The finest Pre-Columbian artefacts of the Lesser Antilles are the pottery, amulets and personal ornaments of the Saladoids (also known as Igneris) who inhabited the islands *c.* AD 1200, having migrated from the north-eastern coast of South America *c.* 400 BC. The Saladoids were the best potters of the ancient Caribbean. Their ceramic tradition, imported from South America, enabled them to produce a fine, high-fired, thin-walled ware usually decorated with white-on-red designs of exceptional beauty. Typical forms included bell-shaped bowls, sometimes ornamented with modelled zoomorphic and anthropomorphic lugs and D-shaped strap-handles. Exotic pieces shaped as fishes, crabs, birds, turtles and humanoid heads were also produced; these were ceremonial wares dedicated to spirits or mythological beings believed to be essential to their subsistence. Some of the most elaborate vessels were covered with red paint and decorated with thin, incised lines filled with white paint; others were adorned with small, delicately modelled lugs. Paints, made from mineral oxides, kaolin and charcoal, were used to create mostly geometric ornamental designs; these were generally restricted to borders, although the inner surfaces of plates and bowls were totally decorated. When the background colour of the vessel was incorporated into the red-and-white painted decoration, beautiful polychromeware resulted. Fine crosshatched incision, sometimes filled with red or white paint, and modelled lugs on the flaring rims of unpainted bowls are common

and are considered a characteristic trait of early Saladoid pottery.

Personal ornaments and amulets made from polished hardstones such as amethyst, cornelian and quartz, as well as marble and granite, are among the finer examples of Saladoid art. Miniature silhouettes of frogs, birds, fishes and humanoid figures were also carved from mother-of-pearl, conch-shell or bone and perforated for attachment to cotton clothing; *naguas* (short, apron-like garments), belts and bindings are also common. The finest examples of early Saladoid pottery and personal ornaments in the Lesser Antilles (examples San Juan, U. Puerto Rico Mus.; New Haven, CT, Yale U., Peabody Mus. Nat. Hist.; and Fort de France, Musée d'Archéologie) have been found in Martinique, Guadaloupe and Monserrat, but with the conquest of the Lesser Antilles by the Caribs, the production of pottery and other expressions of Saladoid culture ceased.

(ii) Carib. The Caribs, a warlike people who used large, powerful bows and poisoned arrows, were the best navigators of the Caribbean, which they travelled in large canoes (*piraguas* or *pirogues*) made from tree trunks and propelled by oars. They practised ritual cannibalism, believing, in common with other American aborigines, that by eating human flesh they would be endowed with the victims' strength and courage. Because of this practice and their hostility towards the colonists, the Spaniards punished them with slavery. From their islands in the Lesser Antilles—especially their strongholds of Guadeloupe, Martinique, Dominica and St Vincent—the Caribs organized war parties of 15–20 canoes to raid the Greater Antilles, robbing the Taino inhabitants of food and women. The Spaniards were not interested in colonizing the Lesser Antilles, mainly because the islands lacked gold, but they were also deterred by the Caribs' poisoned arrows. The Caribs continued their attacks on the Greater Antilles during the early phase of Spanish colonization, sacking coastal settlements, burning plantations and capturing Spaniards, Tainos and African slaves. During the second decade of the 17th century, French and English corsairs and pirates established settlements in the islands, sometimes warring and sometimes making peace with the Caribs. Gradually the Carib populations of most of the islands were exterminated by the Europeans. In St Vincent and Dominica, however, many Caribs survived and intermixed with African slaves captured during attacks on Spanish settlements or rescued from sunk slave ships. These people were called Black Caribs, and in 1797 the English made a treaty by which they were resettled in the island of Routan, off the coast of Honduras; they later expanded into inland Honduras and Guatemala, where they are known as Garifunas.

From the discovery of the islands in 1493, Spanish chroniclers described aspects of Carib art and culture, noting the Caribs' excellence as weavers. Woven cotton, produced by women (both Caribs and captured Tainos) was used for *naguas*, and cotton bindings were used as arm and leg decoration. Basketry was also produced by women. Personal ornaments—mostly amulets—and ceremonial objects were made by men from stone, conch-shell, bone and clay. Special value was assigned to the

caracoli, a greenstone ornament resembling a batlike creature that was worn as a pendant over the chest. This ornament was also sometimes made from *guanin*, a gold and copper alloy obtained by trade from Colombia. The pottery, made by women, was crude and more functional and domestic in character. Both cooking pots and the large *ouicu* vessels, used in the fermentation of a manioc beverage, were simple, unadorned, low-fired ware with a grainy texture; some archaeologists have identified it with the Swazey culture. The best description of Carib culture is found in the writings of such French missionaries as Dutertre, J. B. Labat (*Nouveau Voyage aux isles de l'Amérique*, 6 vols (Paris, 1722)), Charles de Rochefort (*Natuurlijke en zedelyke historie van d'eylanden de voor-eylanden van Amerika* (Rotterdam, 1662; Eng. trans., London, 1666)) and others, who describe the Caribs' excellent basketry, woven cloth and personal ornaments.

(iii) Taino. The Tainos were Arawak-speaking Native Americans, whose ancestors were the Saladoids (*see* §(i) above). The Tainos were agriculturalists, cultivating yucca (manioc; from which they made cassava bread), maize and various edible roots. Their complex political system was based on powerful hereditary chiefs called *caciques*, who exercised political and religious power over a number of villages. The Tainos believed in the existence of a creator god, Yocahu, and a goddess of fecundity, Atabey. They also had other gods associated with rain, storms and other inexplicable natural phenomena. Ancestor cults were common, and some deceased *caciques* or other extraordinary individuals were considered demi-gods, to be embodied in myths. Their remains, especially the skulls, were encased in woven cotton or put inside sacred wooden idols (*zemis*). When the Spaniards arrived Taino culture was flourishing, as can be seen from the centralization of chieftainship, the hierarchically structured society, organized worship and the construction of impressive ceremonial centres with multiple plazas, in which ball-games, ceremonies and ritual practices were held. However, within a century of the Spanish Conquest the Tainos had disappeared from the Greater Antilles and the Bahamas. Wars and forced labour, together with new illnesses brought to the islands by Africans and Europeans, were among the causes of their demise.

Taino art was mostly linked to religious belief and ceremonial practice, personal ornament and the decoration of tools and implements. The most striking artefacts are associated with the esoteric *cohoba* ritual, in which the practising *cacique* or shaman attained a hypnotic state through the inhalation of the sacred *cohoba* powder (*Anadenanthera peregrina*). The *cohoba* idols, mostly made from wood, represent Yocahu, squatting nude in what seems to be a ceremonial posture; a round, slightly concave dish on the idol's head held the hallucinogenic powder. Among the many beautiful examples of these idols is a dark, highly polished piece, 1.03 m high, from Jamaica, in the British Museum, London (see fig. 2). Another large example from the Dominican Republic and held by the Smithsonian Institution, Washington, DC, represents two squatting figures on a low ceremonial stool (*dujo*) with a vertical, rodlike projection supporting the round *cohoba* dish. The two figures seem to allude to twins, a common theme in

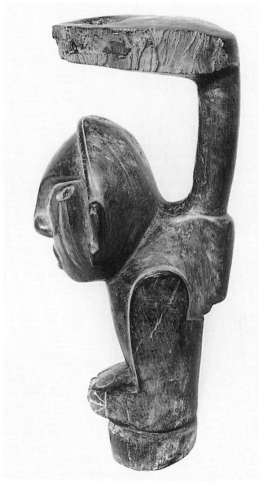

2. Taino wooden *cohoba* idol representing the god Yocahu, h. 1.03 m, from Jamaica (London, British Museum)

Taino mythology; gold-leaf or conch-shell inlays were probably set in the concave eyes and mouths, as was common in Taino sculpture. The Metropolitan Museum of Art in New York has a fine specimen from Hispaniola, carved, like other *cohoba* idols, from *guayacan* wood, which still retains its inlaid teeth of conch-shell. There are only a few carved stone *cohoba* idols. Other elaborate and decorated artefacts, such as inhaling tubes, vessels and sticks used to induce vomiting were also associated with the *cohoba* ceremony.

The Tainos wore hardly any clothing, although they decorated their bodies with ornaments and paint, and married women wore a *nagua*, sometimes painted with red and black geometric designs or decorated with applied bone, conch-shell or stone beads. Red, white and black vegetable pigments were also used as body paint. The typical Taino designs used in personal art were also applied to ceramics, wooden implements, rock drawings and sculpture. Tubes of bone, pierced stones and conch-shells and ceramic beads of various sizes were strung on fibre cords to create elaborate and striking necklaces and pendants, while woven cotton and feathers were used to make beautiful head ornaments. Small anthropomorphic

or zoomorphic amulets of coloured stones, conch-shell, bone or modelled clay were also worn, and lips and ears were perforated to take ornaments.

The Tainos had not learnt the art of casting metals, but they pounded gold nuggets found in riverbeds into thin sheets to create amulets and other ornaments or inlays for sculptures. The technique of stone-carving and polishing reached a climax with the manufacture of monolithic stone belts and 'elbowstones' used during the ceremonial ballgame. Stone belts have a convex decorative field, generally decorated with carved human, animal or geometric designs. The elbowstones are similar but smaller, representing only the main section or boss, which was protective and also served for hitting the rubber ball (*c.* 9 lbs) used in the ceremonial game. They have carved grooves at either end, where curved wood branches were attached with twigs to complete the belt. *Bateyes* or ballcourts were lined with monoliths, sometimes carved with elaborate petroglyphs, delimiting the long sides of the rectangular fields (*see* BALLCOURT, §1). In Puerto Rico and the Dominican Republic, the Tainos carved their petroglyphs not only in the *bateyes* but also on rocks in rivers, creeks, caves and other isolated places, where they seem to mark important or sacred events. They usually represent human or animal figures, large anthropomorphic heads or mythical figures with combined human and animal features. Ovoid anthropomorphic stone masks with open mouths and large eyes seem to represent a ritual expression and are another important manifestation of Taino sculpture. They are carved from stone nodules and are slightly hollowed and unpolished on the reverse, suggesting that they were made to attach to other objects. The occurrence of small figurines with similar masks attached to their forearms has led scholars to believe that they formed part of the ballplayer's ceremonial paraphernalia. The original masks probably had inlaid eyes and mouths.

Dujos, ceremonial stools carved from wood or stone, represent another important category of Taino sculpture. Zoomorphic *dujos*, probably of mythic or totemic significance, have the animal's head projecting from between the front legs of the stool, while the narrow and slightly concave seat extends upwards and backwards, simulating its tail and forming the backrest. The faces have deep-set eyes and expressive open mouths, occasionally inlaid with gold, as in the case of one example from the Dominican Republic conserved in the British Museum, London. The backrests of *dujos* were sometimes carved with central decorative panels composed of concentric circles, triangles and chevrons. Anthropomorphic *dujos* usually have the head protruding from the back; some also have arms incised along the borders of the seat. The most sculptural, interesting and abundant objects of magico-religious paraphernalia are *zemis*, three-pointed idols of diverse types: archaeologists have associated their various forms with mountains, germinating yucca and women's breasts as well as with gods or tutelary spirits. Sculptural *zemis* represent anthropomorphic, zoomorphic or anthropozoomorphic figures. The head is usually carved on the front projection, while the back cone represents the posterior extremities, generally in the form of a frog's hindquarters.

Areytos were ceremonial celebrations held to mark noteworthy events such as the inauguration or death of a

cacique or other important figure, a military victory or a significant birth, initiation or marriage. Songs, dances and recitals of myths were employed as means of narrating communal history. Participants in these events decorated themselves with personal ornaments (headdresses, earrings, necklaces, lip-ornaments, rings and bracelets) and with body paint and elaborate hairstyles. The *areytos* represent the union of all the arts practiced by the Tainos: narrative, song, dance, costume, paint, personal ornament and ritual sculpture.

BIBLIOGRAPHY

Père R. Breton: *Relations de l'isle de la Guadaloupe* (1647)
C. de Rochefort: *Histoire naturelle et morale des Iles Antilles de l'Amérique* (Rotterdam, 1658, 2/1665)
J. B. Du Tertre: *Histoire générale des Antilles* (Paris, 1667–71)
T. A. Joyce: *Central American and West Indian Archaeology* (London, 1916)
J. W. Fewkes: *A Prehistoric Island Culture Area of America* (Washington, DC, 1922)
S. Loven: *Origins of the Tainan Culture, West Indies* (Göteborg, 1935)
M. MacKusick: *Distribution of Ceramic Styles in the Lesser Antilles* (microfilm, Ann Arbor, 1960)
Proceedings of the International Congresses for the Study of Pre-Columbian Cultures of the Lesser Antilles: Montreal (1961–)
E. Tabio and E. R. Tabio: *Prehistoria de Cuba* (Havana, 1966)
G. Willey: *An Introduction to American Archaeology*, i: *North and Middle America* (Englewood Cliffs, 1966)
E. Fernández Méndez: *Art and Mythology of the Taino Indians of the Greater West Indies* (San Juan, 1972)
M. Veloz Maggiolo: *Arqueología prehistórica de Santo Domingo* (Singapore, 1972)
L. Allaire: *Vers une préhistoire des Petites Antilles* (Montreal, 1973)
M. García Arévalo: *El arte Taíno de la República Dominicana* (Santo Domingo, 1977)
M. Pons-Alegría: 'Taino Indian Art', *Archaeology*, xxxiii/4 (1980), pp. 8–15
Crónicas francesas de los indios caribes, Sp. trans., abridged, by M. Cárdenas Ruiz, intro. R. E. Alegría, Centro de Estudios Avanzados de Puerto Rico y el Caribe (San Juan, 1981)
R. E. Alegría: *Ball Courts and Ceremonial Plazas in the West Indies*, Yale U., Pubns Anthropol., lxxix (New Haven, 1983)
I. Rouse: *The Tainos: Rise and Fall of the People who Greeted Columbus* (New Haven, 1992)
R. Cassá: *Los indios de las Antillas* (Quito, 2/1995)

RICARDO E. ALEGRÍA, MELA PONS-ALEGRÍA

2. WESTERN.

(i) Architecture. (ii) Painting, graphic arts and sculpture. (iii) Decorative arts.

(i) Architecture. The first European colony in the Caribbean region was Santo Domingo (now Dominican Republic), founded in 1496. Within 50 years the settlement had acquired the appearance of a Spanish city. The architecture owed nothing to antecedent Amerindian tradition; rather, its principal buildings were the work of Castilian and Sevillian designers. The Alcazar del Almirante (1510–14; partly ruined, partly restored), Santo Domingo, was a primary example of early Caribbean architecture. Although Amerindians and, later, Africans formed a major part of the workforce, they did not significantly influence the stylistic approach to the design. The use of local cut stone for the façades of these buildings was perhaps the most important contribution of the West Indian environment.

Elsewhere in the Caribbean, by the mid-17th century the Leeward Islands were extensively settled by the French and English. Simple one-room wooden or wattled cottages gave way to more palatial stone buildings as the wealth of the plantation class increased. Richard Ligon, in *A True*

and Exact History of the Island of Barbados (London, 1657), was critical of the hot, stuffy, low-ceilinged rooms that he encountered; however, his ideas for using shuttered windows to enhance ventilation found little response at this time among the conservative planters. By the 1650s, Nicholas Abbey and Drax Hall in Barbados were constructed along the lines of Jacobean country houses. These were among the first to be built in local limestone, since brick was not widely available and the local hardwoods were disappearing rapidly. In Jamaica, Stokes Hall, (*c.* 1710), St Thomas, and Colbeck Castle (*c.* 1748), St Catherine, were clearly influenced by military design. On Curaçao the Brievengat Land House, with its tiled roof, dormer windows and massive shutters, showed little evidence of tropical adaptation. Château Murat on Marie-Galante, Guadeloupe, resembled a typical 18th-century French country house, while Whim Great House (now Estate Whim Plantation Museum) on St Croix, with its extended oval shape, was an elegant late 18th-century architectural fantasy. In Jamaica, great houses such as Rose Hall, St James, bore little evidence of adaptation but reflected the style of the English 18th-century country mansion; built between 1770 and 1780, Marlborough, Manchester, was clearly designed in the Palladian style, while Bellevue, St Andrew, with its colonnaded entrance and row of sash windows, was unmistakably Georgian in style. In general, by the late 18th century English style had become the model for much of the region, except on the Spanish islands. From the 18th century the single most important influence on Caribbean architecture was probably the *Book of Architecture* (1728) by James Gibbs, and Caribbean Georgian (incorporating corner quoins, pediments and engaged pilasters) became the accepted style. After 1760 a new prosperity in the Spanish islands brought an influx of architects from Cádiz. Havana became the centre for this later flowering of Spanish colonial architecture. Such late 18th-century buildings as the Casa de Correos (*c.* 1770–92) and the Casa de Gobierno (*c.* 1776–92), both in Havana, are characteristic of the severity of Spanish Neo-classicism.

By the end of the 18th century smaller Caribbean houses showed more evidence of creolization and modification. In most cases the whole structure was raised off the ground to allow for circulation; a double entrance staircase, often with a vaulted area under the central section (used as a hurricane shelter), was a characteristic feature. Multiple hipped roofs (occasionally with dormer windows in the French and Dutch islands) protected the buildings during hurricanes. The ground-floor often had many apertures, some filled with jalousies (louvres), and often incorporated a verandah with intricately carved rail and bargeboard; this gingerbread fretwork often formed the most attractive feature of the house. At the turn of the 19th century the vogue for the styles of European Gothic Revival and Italianate villas found expression in Caribbean architecture. In Haiti, local architects, trained in Paris, embellished these styles, using multicoloured wood and brick to create the airy confection of the gingerbread style embodied in the Grand Hotel Oloffson (1887), Port-au-Prince. In Trinidad, the migration of European merchants at the end of the 19th century led to the creation in the early 1900s of the 'Magnificent Nine' in St Clair, Port of

Spain. The expansion of such provincial cities as Santiago and Puerto Plata in the Dominican Republic easily lent itself to a similar process of transculturation. The influx of workers from the English and Dutch islands were reflected in the construction of Victorian gingerbread style wooden houses, their exteriors painted in bright colours with the balconies, columns, doors and windows painted in contrasting tones. These features came to be regarded as elements of a quintessentially Caribbean style.

ALISSANDRA CUMMINS

(ii) Painting, graphic arts and sculpture. The earliest form of Western culture to appear in the Caribbean was religious art: the Spaniards who arrived in the Greater Antilles brought with them Spanish and Flemish religious paintings. Sculpture as an art form appeared in churches and official buildings; the New Seville Carvings (*c.* 1530; Kingston, Inst. Jamaica, N.G.) are among the earliest-known examples of European craftsmen incorporating specifically Caribbean themes into their work. Most of the Christian art came via Seville at first, but there was some input from Mexico in the 17th century. In the Roman Catholic areas of the Caribbean, religious forms of folk art, santos, were produced. These were small wooden carvings of saints and other holy figures (see fig. 3). The earliest ones were in a style reminiscent of Spanish Baroque and were probably imitations of imported icons and may

3. Wooden santos carved by Pedro Rinaldi, Ponce, Puerto Rico

have been carved by priests. These were replaced by indigenous styles, which in Puerto Rico were similar to European Gothic, and finally by so-called 'primitive' santos. The tradition of producing these figures survived longest in Puerto Rico, and their production flourished between 1750 and 1950. After the 1950s santos declined in quality and were mainly replaced by plaster casts or plastic figures. There were fewer flowerings of religious art in the Protestant areas of the Caribbean. As there were no saints to merge with African and Native American spirits, little religious syncretism occurred. Hardly any religious art from before the late 18th century has survived hurricanes, wars and religious conflicts in the region.

Between the late 15th century and the 17th, artists in the Caribbean were for the most part anonymous recorders of the exotic landscape. Prints of the Caribbean area were produced as part of the first European books and albums on the region, following Columbus's arrival in the New World. In the 16th century the growing popular interest and investment in commercial ventures in the region fuelled a profitable industry in the production of illustrative maps and prints. By the 1590s the engraver and publisher Jean Theodor de Bry, based in Frankfurt am Main, was firmly established as one of the most important suppliers of 'Caribbeana'; his copperplate engravings for Girolamo Benzoni's *Americae pars quinta . . . secundae sectionis hispanorum* (Frankfurt, 1595) seem to have attracted popular attention. During the 17th century European engravers, particularly the Dutch, exploited the popularity of exotic Caribbean scenes, borrowing freely from every source. The *Prospect of Bridge Town in Barbados* (1695; St Michael, Barbados Mus.; see fig. 4) by Samuel Copen (*c.* 1663–1717) is a fine example of this type of typographical engraving. It was not, however, until the 18th century that printing presses were introduced into most of the islands. Even then these remained limited for the most part to letterpress printing. The interest in rational and scientific discipline gave rise to a more formal development in the graphic arts to aid the systematic recording of the flora and fauna of the West Indies. The book of *The Natural History of Barbados* (1750; St Michael, Barbados Mus.) by the Rev. Griffith Hughes was illustrated by the celebrated Georg Dionysius Ehret (1708–70).

Also during this period some wealthy plantation owners in the larger islands began to commission large numbers of works of art both at home and abroad. The Spanish court painter Luis Paret (1746–99) stimulated the development of art in Puerto Rico, where he had been banished in 1775; he was one of the few professional artists known to have been active in that country. The emergence of José Campeche (1751–1809) as a major portrait painter owes a debt to Paret's presence. His *Lady on Horseback* (1785; Ponce, Mus. A.) is considered to be his first masterpiece. Campeche was the first major Caribbean artist to turn from religious to secular topics. His father had produced altar frontals in Puerto Rico, with which he assisted. In the Lesser Antilles, Italian artist Agostino Brunias, active in the region from 1770, concentrated his attention on the lower echelons of society, including slaves and mulattos. From the 1770s there developed an interest in panoramic landscapes favoured by travelling artists from Europe. Minor English painters Philip Wickstead

4. Samuel Copen: *Prospect of Bridge Town in Barbados*; topographical engraving by Johannes Kip, 189×511 mm, 1695 (St Michael, Barbados Museum)

(*d* 1790s) and George Robertson (1748–88), who travelled to Jamaica in 1773 under the patronage of Jamaican historian William Beckford, concentrated their attention on painted topographical scenes, while Robertson, James Hakewill (1778–1843) and Joseph Bartholomew Kidd (1808–89) all produced albums of prints of Jamaican views. The first prints known to have been published in Jamaica were the lithographs, by Adolph Duperly sr, of sketches by Jamaican artist Isaac Mendes Belisario (?1795–1849), for example *Koo Koo, or the Actor Boy* (St Michael, Barbados Mus.; *see* JAMAICA, fig. 3).

Between the 17th and 19th centuries sculpture came primarily from European sources, commissioned by the wealthy classes and by government. Several churches in Jamaica and Barbados boast superb examples of English commemorative sculpture. The many memorials that were executed include the monument to *James Lawes* (*c.* 1740; Jamaica, St Andrew) by John Cheere (1709–87), the memorial to *Sir Walter Rodney* (1789; Jamaica, Spanish Town) by John Bacon (1740–99) and the Brathwaite Memorial (1800; Barbados, St Michael's Cathedral) by John Flaxman (1755–1826). Other sculptors whose work is represented in the Caribbean include Joseph Wilton (1722–1803), John Steell (1804–91), Edward Hodges Bailey (1788–1867), Joseph Nollekens (1737–1823) and John Gibson (1790–1866), firmly establishing the Neo-classical image of the English colonies of the period. The bronze of *Horatio Nelson* (*c.* 1812–13; Bridgetown, Trafalgar Square) by Sir Richard Westmacott (1747–1808) and the bust of *Augustus Frederick Ellis* (1824; Kingston, N.G.) by Francis Chantrey (1781–1841) are among the examples of portrait sculpture that are still extant.

The impact of growing independence movements in the Spanish colonies and in Haiti encouraged the search for national identities, which greatly influenced the development of art in those islands. In addition, the printing press became a powerful instrument for social and political reform, and in the 1930s a number of Spanish engravers escaping the Spanish Civil War (1936–9) arrived in the Caribbean, including Joaquin de Alba and Blas, who made their protests from the Dominican Republic. The founding of art academies in Cuba and Haiti during this period was a part of the process of seeking Caribbean identities. In the Lesser Antilles, minor European artists such as Percy William Justyne, William Carpenter and Lionel Grimstone Fawkes gained popular patronage for their literal renderings of Caribbean scenes. It was, however, only in the latter part of the 19th century that local artists began to establish themselves, though typically under the influence of European academic training.

During the first decades of the 20th century, art continued to be influenced by European culture, and, for the most part, landscapes, portraits and genre painting continued to form the main themes, rendered in a Realist or Neo-Impressionist style. Nevertheless the radical artistic tendencies developing in Europe did enter Caribbean expression, adapted by avant-garde artists who, returning home in the 1920s, became involved with the anti-colonialist movements developing in the islands. Also during the 1920s, Caribbean sculpture began to emerge from the shadow of European domination. In 1937 Caribbean nationalist fervour reached its peak, expressed by extensive rioting among the islands' working classes. From the 1940s, Caribbean artists focused deliberately on

the establishment of an authentic national identity. Foreign artists continued to influence Caribbean artistic development as they settled in the islands, often playing a teacher–mentor role to local artists. In Haiti, the American De Witt Peters (1901–66) established the Centre d'Art in Port-au-Prince, thus becoming a catalyst for the development of Haitian art from 1943. In Barbados, Englishman John Harrison played a similar role through the British Council office there.

From the early 1950s Caribbean art developed rapidly, as artists were brought into contact with various trends in European and American art through either visits and training abroad or the Western-orientated training systems adopted in local art schools, which debated the balance of power between dependency and identity. By the late 20th century, art schools and museums had been largely responsible for the creation of an environment more receptive to art, particularly as an expression of national identity and multiculturalism, in islands that more often than not were newly independent. Throughout the Caribbean, artists continued to explore and adapt a multiplicity of styles that bear witness to the diversity of Caribbean culture and its synthesism in the consciousness of its people.

ALISSANDRA CUMMINS, C. J. M. R. GULLICK

(iii) *Decorative arts.* From the establishment of the first Spanish colonies *c.* 1493 until the late 16th century, the majority of manufactured goods in the New World came from Europe rather than local sources. From the late 16th century ceramic production of unglazed and lead-glazed utilitarian earthenware had begun on the island of Hispaniola, while in the other islands such production was started only in the latter half of the 17th century in response to the rapid development of the sugar industry and continued until well into the 20th century. There is no evidence of glass production in the Caribbean Islands; glassware remained an imported item throughout the history of the region, the primary sources being England and the Netherlands until the 19th century, when North American products were favoured.

From the 16th century, jewellery and tableware made in Mexico and Peru were probably distributed to the Spanish-speaking islands. Blacksmiths in the Spanish settlements worked with imported raw iron, producing domestic and military hardware and developing an exuberant creole style by the 19th century, reflected in the fashionable house balconies of wrought-iron. Accounts of the 16th and 17th centuries, from both Barbados and Jamaica, reveal a large number of jewellers and goldsmiths working with imported material, despite the scarcity of mineral resources in the islands. In the French islands by the 18th century a thriving goldsmithing industry had developed, which serviced the other smaller English and Dutch islands; this trade existed into the 20th century. In the Dominican Republic the existence of significant sources of hardstones, such as amber and larimar, led to the development of a prosperous jewellery-making industry by the 19th century, which continued to be popular in the late 20th century. In the English islands a small but significant metalworking industry emerged in the early 20th century.

Little remains of the furniture used in the early island settlements before the 18th century. From the simple, crudely constructed joint-stools, plank-tables and forms that were constructed during the 16th century, the local craftsmen progressed to deft reproductions of European-made furniture, while the wealthy landowners continued to import large quantities of furniture in the popular styles of the day. It was only during the 19th century that a true Caribbean style may be said to have emerged, utilizing the excellent local hardwoods available. The creolization of European 19th-century styles took the form of a broader, more exuberantly carved design, less graceful and heavier proportions, the incorporation of Caribbean floral elements to replace the European, a preponderance of native woods (including the popularization of mahogany), caned backs and seats and a heavy, dark finish, which contrasted well with the pale, plastered walls of Caribbean interiors. In the 20th century, Caribbean furniture design continued to be influenced primarily by European and American sources, although traditional domestic styles remained popular.

BIBLIOGRAPHY
R. S. Dunn: *Sugar and Slaves: The Rise of the Planter Class in the English West Indies, 1624–1713* (Chapel Hill, 1972)
Five Centuries of Art in Jamaica (exh. cat. by D. Boxer, Kingston, Inst. Jamaica, N.G., 1976)
D. Buisseret: *Historic Architecture of the Caribbean* (London, 1980)
P. Gosner: *Caribbean Georgian: The Great and Small Houses of the Caribbean* (Washington, DC, 1982)
E. Perez Montas: *Colonial Houses of Santo Domingo* (Santo Domingo, 1984)
R. Taylor: *José Campeche and his Time* (New York, 1988)
P. Archer-Shaw and K. Morrison: *Jamaican Art* (Kingston, 1990)
V. Poupeye-Ramelaar: *1940–1990: Jamaica School of Art* (Kingston, 1990)
A. Cummins: 'European Prints and Paintings as Markers in Ethnohistorical Research on the Caribbean', *Proceedings of the 14th Congress of the International Association for Caribbean Archaeology: Barbados, 1991*
L. Mezin: 'Portrayals of West Indian Carib and the Amerindian of the Guyanas', *Proceedings of the 14th Congress of the International Association for Caribbean Archaeology: Barbados, 1991*
E. E. Crain: *Historic Architecture in the Caribbean Islands* (Gainesville, 1994)
R. Segre: 'Preludio a la modernidad: Convergencias y divergencias en el contexto caribeño (1900–1950)', *Arquitectura neocolonial: América Latina, Caribe, Estados Unidos*, ed. A. Amaral (São Paulo, 1994), pp. 95–112
R. Gutiérrez, ed.: *Pintura y escultura y artes útiles en Iberoamérica, 1500–1825* (Madrid, 1995)
P. Gosner: *Caribbean Baroque: Historic Architecture of the Spanish Antilles* (Pueblo, CO, 1996)
V. Poupeye: *Caribbean Art* (London, 1998)

ALISSANDRA CUMMINS

3. AFRO-CARIBBEAN. The term Afro-Caribbean is applied in a number of ways, such that the boundaries of its meaning have become blurred. Usage tends to differ between discussions of the period of slavery and post-emancipation. With reference to the period of slavery it includes free persons of colour; in Cuba, the Dominican Republic and Puerto Rico, slaves were more readily freed than in other islands. Those freed in Spanish colonies tended to be more hispanicized, and some of their arts and crafts relate to European vernacular arts. The slaves of subsequent importations to Cuba and Puerto Rico in the 19th century were less often freed and less acculturated. Even within the more racially segregated British Caribbean, not all the free people of colour were brought up within a cultural tradition rooted in African heritage. For example,

the illegitimate sons of wealthy plantation owners in the British Caribbean could be brought up within an élite European tradition. As élite free persons of colour have been marginalized in discussions of Afro-Caribbean culture of the pre-emancipation period, the complications of the role of ancestry and culture in the definition of Afro-Caribbean is generally ignored; rather, discussions concentrate on the arts and crafts produced by the slaves and maroon (runaway slave) population.

Abolition of the slave trade and emancipation occurred at different times throughout the Caribbean Islands. Following emancipation, acculturation continued throughout the region. This merging of traditions has contributed to the problems of the use of the term Afro-Caribbean to describe peoples and artefacts of the late 19th century and the 20th. A narrow definition considers cultural items within an African tradition that are produced in the Caribbean by people of African descent. A wide-ranging use of the term includes people and their products, with at least one African ancestor, whose descendants live or once lived in the Caribbean; such people form the majority on all the Caribbean islands except Puerto Rico.

The African slaves imported to the Caribbean came mainly from West Africa initially, passing through ports on the coast of the area that now comprises Guinea, Sierra Leone, Ghana and Nigeria. The African origins frequently mentioned in West Indian slave lists include Asante, Efik, Dahomey, Moco, Fante and Yoruba. The major arts of these peoples included wood-carving, bronze- and brass-casting, goldwork, textiles and architecture. Metalworkers often belonged to a separate group or caste, and skilled carvers, potters and weavers could become full-time specialists. Other slaves came from further south along the West African coast, where fewer specialists were found; raffiawork, cloth and carvings in wood and ivory were the major arts of this area (*see also* AFRICAN DIASPORA).

Despite the fact that the British, French and Dutch planters in the Caribbean systematically split groups of peoples in an attempt to reduce chances of rebellions, their specific cultural traditions survived. Haiti retained many African traits as a partial consequence of its slave revolution; similarly, maroon settlements in Jamaica and Surinam also preserved some elements of African culture. Slaves brought their skills with them from Africa and practised those that their masters permitted; more African traditions survived in areas where there was a larger proportion of Africans to Europeans. Commonly reported crafts were basketwork chairs and containers; straw plaiting for ropes and bed mats; leatherwork and pottery. Little African-style metalwork survives, except in Haiti, nor sculpture, except in some religious cults. Slave housing appears to have had some African input, but the amount is debated; Haitian examples have arguably more. Dance and the accompanying costumes survived and developed as part of performances in the period leading up to Christmas and New Year as precursors of CARNIVAL; after emancipation, many celebrations in the Catholic areas of the Caribbean moved from the Christmas period to being pre-Lenten. The continuity of African traditions was not always consistent in a given area. Some pre-Lenten carnival celebrations in the southern Caribbean have come indirectly via Trinidad. The emphasis on artistic designers

for a set of related costumes is particularly Trinidadian. The carnival of St Kitts and Nevis similarly influenced the Christmas celebrations of the Dominican Republic; Jamaican Jonkonnu is thought to have influenced the celebrations of the same name in the Bahamas and elsewhere, held at Christmas.

Many aspects of Afro-Caribbean culture are associated with religion and ritual, and African religious practices frequently combined with Catholicism. Similarities in iconography resulted in visual puns equating Roman Catholic saints with African gods; for example, St Patrick became equated with Damballah-wedo, the serpent spirit in Haitian Vodoun, and some crosses are dedicated to Baron Samedi. Other Haitian religious art is less multivocal; the *vévé* or ritual ground drawings from Vodoun ceremonies for Damballah clearly illustrate a serpent. *Vévé* have in turn influenced Haitian secular art. Many of the works of HECTOR HYPPOLITE, who was a Vodoun functionary, make reference to them. Indeed, it could be argued that Vodoun and its images and symbols were the most common topic of the naive school of Haitian painting. There are some similarities between the *vévé* and the artefacts of Pentecostal sects, for example the drawings used by Vincentian shakers in mourning rituals and the similar diagrams of Trinidadian shouters. Once in the Caribbean, African religious carvers appear to have been put to work carving furniture for their masters. Only a few slaves seem to have found time to carve ancestor figures, but drums were produced and some other musical instruments. The more artistic examples tend to be the most African-influenced. Traditional Cuban carving and masks and traditional Haitian sculpture have African parallels and probably ancestry, as do some of the drums and occasionally other musical instruments used in rituals in Cuba and Haiti.

In the Protestant islands, those Afro-Caribbeans who were the most successful at retaining their African beliefs and related art forms were the descendants of maroons. The major maroon communities of the Caribbean Islands were in Jamaica and St Vincent. The descendants of the Jamaican maroons have a syncretic Protestant belief system. The majority of Vincentian maroons inter-married with Carib Indians, and they were deported to the Bay Islands of Central America in 1797; their descendants, the Garifuna, have merged shamanism, ancestor worship and Roman Catholicism. The major Jamaican maroon art forms are performing arts and involve few aesthetic artefacts other than costumes and drums.

In the 20th century Afro-Caribbean art became much harder to define precisely. Throughout the history of the region professional Caribbean artists (with the partial exception of the naive arts of Haiti) were influenced by Western fine arts. Materials other than wood tend to be non-traditional, as are the tools used, and the ideas behind much art are 'Westernized', even when the artist attempts to reach back to African roots. Some major 20th-century Afro-Caribbean artists, such as RONALD MOODY (see fig. 5), received some of their training in Europe, while others, such as Dennis Williams (*b* 1923), were academics with Westernized education. The Jamaican sculptor EDNA MANLEY, wife of one prime minister and mother of

5. Ronald Moody: *The Mother*, concrete, h. 1.6 m, 1958–9 (Leicester, New Walk Museum)

another, produced many sculptures affirming the Afro-Caribbean way of life and encouraging the development of the arts in Jamaica.

Since the majority of Afro-Caribbeans are Christian, Christian themes are frequently represented in 20th-century painting and sculpture. Black Power-orientated cooperatives have used African religious themes in items of tourist art, but these rarely have religious significance, since their purpose is to emphasize the enslavement of their ancestors. Other tourist art, which need not be considered as strictly Afro-Caribbean, includes work in shell, straw and fibre. Carved wood, bamboo products, cloth, ceramic and seed works are also produced in most islands, while embroidery and leatherwork are sold on some islands. Vehicle decoration is another form of 20th-century art in the Caribbean (see fig. 6); vehicles decorated with the most African stylization are produced by or for Rastafarians and reggae musicians.

BIBLIOGRAPHY
Carib. Q., iv/3 (1956); iv/4 (1956) [special issues on carnival]
The Art Heritage of Puerto Rico (exh. cat., New York, Met., 1974)
Haitian Art (exh. cat. by U. Stebich, New York, Brooklyn Mus., 1978)
C. J. M. R. Gullick: 'West Indian Artefacts: A Bibliographical Essay', *Mus. Ethnographers' Grp Newslett.*, 19 (1985), pp. 26–53
J. W. Nunley and J. Bettelheim: *Caribbean Festival Arts* (St Louis, 1988)
Carib. Q. xxxvi/3 and 4 (1990) [issues dedicated to the Konnut Carnival]
Faces of the Gods: Art and Altars of Africa and the African Americas (exh. cat. by R. F. Thompson, New York, Mus. Afr. A., *c.*1993)
Carib. Q., xxxix/3 and 4 (1994) [issues dedicated to Spiritual Baptists, Shango and other African derived religions in the Caribbean]
P. Mason: *Bacchanal! The Carnival Culture of Trinidad* (Philiadelphia, 1998)
V. Poupeye: *Caribbean Art* (London, 1998)

C. J. M. R. GULLICK

4. INDO-CARIBBEAN. The Asian population of the Caribbean Islands are descendants of the indentured labour force of the 19th century. They are more heavily represented in the south than in the northern population, and in Trinidad they constitute the largest ethnic group. The workers came mainly from the rural areas of the eastern Gangetic plain, with smaller numbers from the south of the Indian Subcontinent; the legacy of the latter is especially noticeable in the French territory of Guadeloupe. Until the 1940s a sizeable proportion of the Caribbean Indian population was born in India, but indenture was terminated in 1917, and in the late 20th century it was rare to find an Indian who was not born locally. Until the 1940s, also, the majority of Asians lived in rural districts and were engaged in agriculture, which was natural considering their introduction to the Caribbean Islands to work on sugar plantations; thereafter, however, there was a significant move into new occupations, and some residential drift to the towns.

The rural origins of the Asian population and their adherence to Hinduism and Islam help to account for the features of Indian art and culture in the Caribbean. Though a variety of traditions defined by locality and caste categories were evident in the original population of migrants, on the plantations of the Caribbean these were telescoped into a small space. Initially, there was some jostling for status and pre-eminence, but before long a process of homogenization was underway, in which the Bhojpuri tradition of eastern India was to emerge as dominant. This was characterized in language by Bhojpur (a variant of Hindi) and in religion by devotional Hinduism, based particularly on the *Rāmāyana* epic and the myths of the Puranas. These provided the basis not only for the view of the ideal life but also for folk songs, stories and dramatic presentations, and a range of icons and imagery available for replication in folk art. Homogenization was further fuelled by the exodus from plantation or estate residence

6. Afro-Caribbean decorated vehicle, late 20th century

to village life in the later 19th century, as Asians exchanged their guaranteed return passage to India and their savings for land, and by ethnic competition in the 20th century, both of which further minimized regional or other peculiarities and precipitated the formation of an Indo-Caribbean identity.

Although those recruiting in India had sought to concentrate on agricultural labour, they in fact took in a fair cross-section of the catchment area; accordingly, a variety of caste-specific skills, such as those of the potter and the jeweller, crossed the seas and have been handed down in the Caribbean Islands. Domestic and ritual occasions provided the early field of practice and remain significant. Especially important, for example, is the decoration of the altar for ritual observances, and the platform on which the priest sits. Folk artists decorate the marriage tent and other spaces that are consecrated for ritual performances, such as annual celebrations of the *Ramlīlā* and *Krṣnālīlā* village theatre based on the exploits of Rama and Krishna as recorded in the epics. The materials used are coloured rice and paper. Cheap prints imported from India, with framed images of the deities of the Hindu pantheon, have been supplemented by local paintings in oils, which are highly stylized and sometimes include motifs from films produced in Bombay. Much folk art is functional and destroyed after the event. Indeed, Hindu religious paraphernalia is destroyed in flowing water courses after the occasion, and so too are the elaborate replicas of Muslim tombs constructed in bamboo and paper for the annual celebration of the Shi'ite Muharram festival known locally as Hosay, which takes place in Trinidad and Jamaica. The festival commemorates the martyrdom on 10 Muharram 680 of Muhammad's grandson Husayn. Gold and silver jewellery were routinely and repeatedly melted down to make new or more pieces as gifts to keep up with additions to the family.

The more permanent arts include the temples and mosques that are a common feature of the landscape of the southern Caribbean (see fig. 7). These betray a variety of styles and materials, from early crude and makeshift structures in mud and wood to elaborate and spacious concrete buildings, particularly those erected since the 1970s. In some of the earlier temples representations of gods and goddesses were roughly carved in stone. In modern structures, it is more common to find icons brought from India and installed after due ceremony. The characteristic type of mosque structure is hypostyle, with symbolic domes and minarets attached after completion of the central building. Ancillary features include arches, cupolas, façades, towers and representations of a star and moon.

BIBLIOGRAPHY
A. Niehoff and J. Niehoff: *East Indians in the West Indies* (Milwaukee, 1960)
M. Klass: *East Indians in Trinidad* (New York, 1961)
V. S. Naipaul: *A House for Mr Biswas* (London, 1961)
D. Lowenthal: *West Indian Societies* (London, 1972)
Singaravelou: *Les Indiens de la Guadeloupe* (Bordeaux, 1975)
I. J. Bahadur Singh, ed.: *Indians in the Caribbean* (London, 1987)
S. Vertovec: *Hindu Trinidad: Religion, Ethnicity and Socio-economic Change* (London, 1992)
Carib. Q., xli/1 (1995) [issue dedicated to the Indian presence]
KUSHA HARAKSINGH

7. Hindu temple, Reform Village, Trinidad, 1940s

III. Exhibitions.

Major exhibitions of Caribbean art took place from the second half of the 19th century, triggered by the enthusiastic response of the Caribbean Islands when they participated in the Great Exhibition of the Industry of All Nations at the Crystal Palace in London in 1851. They included the Trinidad Exhibition (1868) and the Jamaica International Exhibition (1891), which incorporated exhibits of local artwork. From the 1890s museums played a central role in establishing the importance of national exhibitions as a tool for development in the arts. In 1890 in the Dominican Republic the establishment of the Salon Artistique provided the first opportunity for artists to exhibit their work locally.

During the 20th century Caribbean exhibitions began to gain a popular audience. The development of schools of fine arts in the Spanish islands influenced the creation of national exhibitions as a forum for exchange. During the 1920s the Salon of the Association of Painters and Sculptors of Havana created a regular schedule of shows. In 1927 the Exhibition of New Art in Havana established the impact of modernism on the visual arts in the Spanish islands. In Jamaica the *All Island Exhibition* (1938) was organized in Kingston to exhibit the best in local art and craft, and many unknown Jamaican artists emerged for the first time.

During the 1940s and 1950s the surge of nationalist sentiment found a response among the visual artists of the Caribbean; in the Dominican Republic the first National Biennial of the Plastic Arts was held in 1942. In Barbados the local Arts and Craft Society initiated an annual exhibition, which included artists invited from other islands. In 1944–5 the British Council assisted in the organization of an exhibition of work from the larger countries of the English-speaking Caribbean. In 1955 an exhibition of *Fine Art from the Caribbean*, sponsored by the Alcoa Steam Ship Company of New York, was the first show to represent the region's artistic expression. The

paintings were drawn from the Dutch, Spanish, English and French Caribbean territories, and they focused primarily on naive artists. The Riverside Museum in New York organized the first recorded exhibition of Puerto Rican art in 1956 to almost universal criticism, the works exhibited being rejected as mediocre copies of European art. By this date the São Paulo Biennale in Brazil had become the mecca for all artists from the Spanish islands. By the 1960s exhibitions of Caribbean art contributed to expressions of radicalism in local culture. The *Backyard Exhibition* in Trinidad and the *Sidewalk Exhibition* in Barbados were examples of this activity in the English-speaking Caribbean. In 1970 the Instituto de Cultura Puertorriqueña established the first Biennial Exhibition of Graphic Art of Latin America. Its impact can be clearly defined in the subsequent flowering of graphic arts in the Spanish-speaking islands. Since 1976 the Carifesta Exhibition has been the single most important agent for exchange among the visual artists of the Caribbean.

In the late 20th century the art of the Caribbean Islands became the subject for a number of international exhibitions. In 1983 an exhibition on 19th-century Cuban art was held at the Museo del Prado in Madrid; in the same year *Jamaican Art, 1922–1982* was the subject of a Smithsonian Institution travelling exhibition; and *Caribbean Art Now*, organized by the Commonwealth Institute of London in 1986, attempted to bring the work of English-speaking Caribbean artists into focus. As a counter-balance the Caribbean turned its attention on itself, attempting to reconstruct its national art histories for the first time through well-documented, penetrating retrospectives and national exhibitions. Jamaica led the way with the exhibition *Five Centuries of Jamaica Art*, organized in 1976 by the National Gallery. A number of retrospectives of individual artists were held by the Museo de Arte, Ponce (*Francisco Oller*, 1984; *José Campeche*, 1988), and by the Barbados Museum, St Michael (*Golde White*, 1987; *Hector Whistler*, 1988; *Ivan Payne*, 1990). In 1991 the *Gala di arte* brought together important artists of the Dutch Antilles for the first time. In the Dominican Republic in 1992 the first Biennial of Painting of the Caribbean and Central America was held in Santo Domingo, at the Galería de Arte Moderno.

BIBLIOGRAPHY

N. Connell: 'Artists of the Caribbean', *The Studio*, cliii/770 (1957)
D. Boxer: *Jamaican Art, 1922–1982* (Washington, DC, 1983)
A. Cummins: *The History and Development of Museums in the English-speaking Caribbean* (diss., U. Leicester, 1989)
Art in Latin America: The Modern Era, 1820–1980 (exh. cat. by D. Ades, London, Hayward Gal., 1989)
Gala di Arte: An Exhibition of Works by Antillean and Aruban Artists (exh. cat. by H. Block-Storm, Curaçao, 1991)
A. Cummins: 'Exhibiting Culture: Museums and National Identity in the Caribbean', *Carib. Q.*, xxxviii/2–3 (1992), pp. 33–53
A. Moss: 'Art Publishing in the Contemporary Caribbean', *Artistic Representations of Latin American Diversity: Papers of the 34th Annual Meeting of the Seminar of the Acquisition of Latin American Library Materials: Albuquerque, 1993*, pp. 269–74
R. L. Paquette and S. L. Engerman, eds: *The Lesser Antilles in the Age of European Expansion* (Gainesville, *c*.1996)
Taino: Pre-Columbian Art and Culture from the Carribean (exh. cat., New York, Mus. Barrio, 1997)

ALISSANDRA CUMMINS

Carnival. Term used to describe public revelling that includes music, dance or performance. It is characterized mainly by the elaborate costumes that are created specifically for it. In countries where the Roman Catholic tradition is dominant, carnival denotes a period of variable duration that ends at midnight before Ash Wednesday, although in some localities the latter day can also be included. In these contexts, therefore, it is a specific calendrical event generally associated with forthcoming Lent. The term has, however, become used more generally; it may entail demonstrating, occasionally with explicit, if satirical, political overtones. It also denotes indoor partying and feasting of the kind arranged by community organizations or private individuals.

1. Origins. 2. Symbolism. 3. Modern development.

1. ORIGINS. The etymology of the term has long been debated, but consensus concentrates on a root *carnem levare* (Lat. 'to put away the flesh [as food]'), from which derive *carnis levamen, carnelevarium, carnilevaria* and other terms. This makes 'carnival' an inverted metonymy of Lent and its fasting connotations. In considering carnival not as an isolated event but as part of the wider cycle of Christmas and Easter celebrations, there appears to be continuity between it and the winter masquerades that in Europe mark the Christmas season; the relation of opposition between carnival and Lent is crucial to the definition of both. The opinion widely held by folklorists is that carnival is a historical and structural transformation of pre-Christian winter festivals, such as the Roman Saturnalia (kalends of January), Lupercalia (15 and 16 February), Brumalia (late February) and Matronalia (kalends of March). The overall symbolism of Saturnalia, for example, is considered by many to be the most probable historical model of carnival-like behaviour. One hypothesis is that carnival is also linked etymologically with *carrus navalis*, a boat-shaped wagon drawn by horses, which carried the revellers. Livy (*History of Rome* II.xxi) tells of how the Saturnalia were officially established in 495 BC, although some authorities maintain that the festival must have been older. Tacitus (*Annals* XIII.xv) mentions the custom of electing a King of the Saturnalia, a feature of carnival celebrations throughout Europe. The Saturnalia fell in the last days of December through to the beginning of January, and it was characterized by the inversion or disregard of normal social rules. According to Virgil (*Georgics* II.387), the earliest masks were made of bark; other materials were introduced later, while mask types multiplied into a wide range of characters. Lupercalia was explicitly linked to women's fertility, a theme recurrent in Matronalia, while at Brumalia men and women revelled in the streets, wearing animal skins and ivy garlands and hailing the end of winter. Some historians, on the other hand, claim that carnival is a specific development of the Christian era, dating only to the Middle Ages. Carnival as such is probably a medieval development that became increasingly influenced by Lent in both its timing and symbolism, growing out of a pan-European complex system of winter masquerading related to the seasonal passages still recognizable in European folklore.

2. MODERN DEVELOPMENT. The birth of a distinctly urban, modern tradition of carnival was due largely to

transformations in the symbolism of masks introduced by the Renaissance development of the Italian *commedia dell'arte*. The masks shed both their wider symbolic connotations and their mythological references and came to embody individual psychological types. The chthonic underpinnings of such masks as Pulcinella (Punch), Arlecchino (Harlequin) and Zanni turned into definite comic characters (hence 'zany'). In the 16th century Harlequin wore a black mask and a patched costume and carried a bat, but by the 18th century he wore the more familiar diamond-patterned costume. Carnival became all the more an expression of individual creativity. The traditions of the Venice, Rome, Nice, Basle, Binche, Viareggio and other major historical and contemporary carnivals acquired their present structures mainly in the second half of the 19th century.

Parallel to that process, the confrontation of the colonizing powers of Portugal and Spain with the cultural traditions of the indigenous and slave populations in the American colonies paved the way to the development of what has become a carnivalesque tradition unparalleled in participation and magnificence. In Mexican popular culture, elements of the yearly, pre-Conquest ritual cycle merged with the popular traditions introduced by Spanish missionaries and lay colonizers. In the late 20th century the variety of Mexican masquerades reflected the highly diversified patterns of both native and Spanish influences. In Brazil and the Caribbean the early disappearance of Amerindian culture fostered a pattern of development of urban masquerades in which the African element has become predominant. In Rio de Janeiro the Samba schools, although rooted in the culture of the underclasses, draw to their carnival parades large numbers of middle- and upper-class revellers in what has been analysed by sociologists as a phenomenon underpinned by strong ideological and nationalistic overtones. In Haiti, carnival, mainly attended by the middle and the upper classes, is not particularly structured, focusing on individual masquerading. It is followed during Lent by the Rara festival celebrated by the Maroon population. The symbolism of Rara is rooted in the Haitian revolution of 1791 and in elements of Vodoun, in turn derived from the articulation of Yoruba and Kongo religious traditions with popular Roman Catholicism (*see* HAITI, §II, 2).

Elements of British and continental European folklore, such as the Mummers' Plays and the Hobby Horse, merged in the Christmas Jonkonnu (John Canoe) masquerades with African motifs introduced by the plantation workforce in Jamaica, Belize and the Bahamas (*see* JAMAICA, fig. 3). As well as John Canoe, characters include Pitchy Patchy, Horsehead and Amerindian. Masks are generally of decorated wire mesh. Variations of the Jonkonnu-type of celebration take place at Christmas and in the New Year in St Kitts and Nevis, the Dominican Republic and Bermuda. Costumes for these include capes decorated with mirrors, ribbons, or beads. Wire-screen masks are often attached to the sides of headdresses. Elements derived from the secret societies of Kongo as well as from the Ekoi and Efik societies of the Cross River area of Eastern Nigeria were at the roots of the Cabilda associations, which form the core of the *comparsas* of Cuban carnival. The *comparsas* are formed from groups of musi-

cians, families or neighbourhoods. In Cuba and elsewhere throughout the Caribbean carnival traditions are strictly linked with the fight for emancipation from slavery and the subsequent struggle to impose the legitimacy of Black West Indian cultural expressions. The myriad symbolic costumes, motifs and music documented in Trinidad and Tobago over two centuries constitutes such an example (*see* TRINIDAD AND TOBAGO, §II, 2). The heart of this carnival is the period of two days and nights before Ash Wednesday. In 1983 the characters included Roman Centurions wearing copper armour and masks that drew upon African forms (see fig.).

The specific dynamics and complexities of the history of Caribbean carnival have developed its contemporary political significance as a fundamental (if disputed and contested) symbol of cultural and national identity. The late 20th-century carnivals of Toronto, Paris and Notting Hill in London are modelled on the carnival Mas ('mask') celebrations of Trinidad and Antigua (and to a lesser extent Rio); in their complex interplay of revivalist pan-African and militant symbolism, they articulate issues of ethnicity and cultural identity also detectable in the New Orleans Mardi Gras and in the Brooklyn Carnival in New York. Having borrowed symbolic and cultural elements from imported African traditions, by the end of the 20th century carnival had come almost full-circle back to the African continent: the Ode-lay masquerades of Freetown in Sierra Leone, although originating in the secret societies of the freed Yoruba slaves, came to be advertised as 'carnivals'.

For further illustration *see* ANTILLES, LESSER, fig. 2; *see also* JAMAICA, §II, 2.

BIBLIOGRAPHY
D. J. Crowley: 'The Traditional Masques of Carnival', *Carib. Q.*, iv/3 & 4 (March & June 1956), pp. 194–223 [double issue]
J. Caro Baroja: *El carnaval: Análisis historico-cultural* (Madrid, 1965)
E. Hill: *The Trinidad Carnival: Mandate for a National Theatre* (Austin, 1972)
A. Cohen: 'Drama and Politics in the Development of a London Carnival', *Man*, i (1980), pp. 65–87
R. da Matta: *Carnavais, malandros e heróis* (Rio de Janeiro, 1981)
F. Manning, ed: *The Celebration of Society: Perspectives on Contemporary Cultural Performance* (Bowling Green, 1983)

Carnival parade in Trinidad, showing Roman centurion costumes designed and made by Ken Morris, 1983

D. J. Crowley: *African Myth and Black Reality in Bahian Carnival* (Los Angeles, 1985)

J. Nunley: *Moving with the Face of the Devil: Art and Politics in Urban West Africa* (Urbana, 1986)

J. Nunley and J. Bettelheim, eds: *Caribbean Festival Arts* (Seattle, 1988)

J. Cowley: *Carnival and Other Seasonal Festivals in the West Indies, USA and Britain: A Selected Bibliographical Index* (Coventry, 1991)

M. I. Pereira de Queiroz: *Carnaval brasileiro: O vivido e o mito* (Sao Paulo, 1992)

A. Cohen: *Masquerade Politics: Exploration in the Structure of Urban Cultural Movements* (Oxford, 1993)

R. Mitchell: *All on a Mardi Gras Day: Episodes in the History of the New Orleans Carnival* (Cambridge, MA, 1995)

J. Cowley: *Carnival, Canboulay and Calypso: Traditions in the Making* (Cambridge, 1996)

CESARE POPPI

Carrasco, Ted (*b* La Paz, 1933). Bolivian sculptor. He taught himself to sculpt by studying Pre-Columbian sculpture and ceramics. Between 1959 and 1961 he travelled in several Latin-American countries; he then lived in Europe for 12 years, working in Holland, Belgium, France and Switzerland. While in Europe he married the Swiss sculptor Francine Secretan, with whom he returned to Bolivia in 1974, settling in La Paz. In 1964 he was awarded the first 'Queen Elizabeth' prize in the 10th International Sculpture Biennale in Brussels. Carrasco's preferred materials were stone and bronze. His subject-matter was based on the knowledge of the age-old traditions of native peoples and on their relation to nature, although his work is modernist in appearance. His earliest works represent seated women and later the *munachis*, or love and fertility amulets. In the early 1970s his art became more synthetic, more cryptic and abstract. During this period his interpretation of the genesis of life was notable, conveyed in enormous spheres that were split open to reveal magical interior worlds. After returning to Bolivia his art became more figurative, as in *Pachamama*, the Andean goddess of the earth, *Andes* (1988; Seoul, Olymp. Village, Sculp. Gdn), and the monument to *Marshal Andrés de Santa Cruz* (1990; La Paz).

WRITINGS
with P. Querejazu: *Ted Carrasco* (La Paz, 1988)

BIBLIOGRAPHY
P. Querejazu: *La pintura boliviana del siglo XX* (Milan, 1989)

PEDRO QUEREJAZU

Carreño, Mario (*b* Havana, 24 June 1913). Cuban painter. He studied at the Academia de S Alejandro in Havana (1925–*c*. 1930), at the Academia de S Fernando in Madrid (1932–5) and at the Ecole des Arts Appliqués in Paris (1937–9). He subsequently lived in New York from 1944 to 1950. During the 1940s he was part of the Caribbean avant-garde that applied Cubist and Surrealist approaches to regional themes, producing paintings such as *Caribbean*

Mario Carreño: *Caribbean Enchantment*, oil on canvas, 610×760 mm, 1949 (Washington, DC, Art Museum of the Americas)

Enchantment (1949; see fig.) and *Cuba Libre* in the United Nations series (1945; see colour pl. V, fig. 3). Widely travelled and stylistically diverse, in the 1950s he worked primarily in geometric abstraction, but after settling permanently in Santiago, Chile, in 1957, he integrated these Constructivist forms into dreamlike settings influenced by the Andean landscape and by the poetry of his friend, Pablo Neruda (1904–73), as in *Land of Volcanoes* (1974; Santiago, Manuel Agosín priv. col., see 1976 exh. cat., p. 26). In the 1960s and early 1970s he treated the threat of nuclear war in paintings such as *20th-century Totem* (1973; priv. col., see 1976 exh. cat., p. 41), which depicts a column of mannequin fragments over a desolate terrain. In 1948–9, and again in the early 1980s, Carreño worked on the *Antillanas* series, which celebrates the lore and colours of the Caribbean. In 1982 he received the National Prize for Art in Santiago, Chile.

BIBLIOGRAPHY

J. Gómez-Sicre: *Pintura cubana de hoy* (Havana, 1944)

E. Ellena: *Mario Carreño: 24 dibujos* (Santiago, 1973)

Carreño (exh. cat., Santiago, Gal. Imagen, 1976)

R. Pau-Llosa: 'Contemporary Central American and Caribbean Painting', *A. Int.*, xxvii (1984), pp. 28–33

Outside Cuba/Fuera de Cuba (exh. cat., New Brunswick, NJ, Rutgers U., Zimmerli A. Mus., 1987)

Four Cuban Modernists: Mario Carreño, Amelia Peláez, Fidelio Ponce, René Portocarrero (exh. cat., Coral Gables, Javier Lumbreras F.A., 1993)

RICARDO PAU-LLOSA

Carreño, Omar (*b* Porlamar, 7 Feb 1927). Venezuelan painter and sculptor. He studied at the Escuela de Artes Plásticas y Aplicadas in Caracas (1942–50). He lived for over 12 years in Europe from 1951, studying at the Académie de la Grande Chaumière and at the Ecole du Louvre in Paris, where he was a member of the group Los Disidentes (1951). He also studied conservation and restoration in Rome. In Caracas he was a member of the influential Taller Libre de Arte (from 1948), and in 1966 he began promoting the expansionist movement in Venezuela. After briefly working in an *Art informel* style, Carreño adopted geometric abstraction from the late 1960s until the mid-1980s, at which point he turned to figuration. In 1972 he received the Premio Nacional de Artes Plásticas in Caracas.

BIBLIOGRAPHY

F. Paz Castillo and P. Rojas Guardia: *Diccionario de las artes plásticas en Venezuela* (Caracas, 1973), pp. 61–3

ELIDA SALAZAR

Carrillo, Lilia (*b* Mexico City, 2 Nov 1930; *d* Mexico City, 6 June 1974). Mexican painter and stage designer. She studied at the Escuela de Pintura y Escultura la Esmeralda in Mexico City and later in Paris at the Académie de la Grande Chaumière. One of the pioneers of *Art informel* in Mexico, like her husband, Manuel Felguérez (whom she married in 1960), she formed part of a group of young painters who rebelled against the Mexican art establishment in the 1950s. Exhibiting her work widely during the 1960s, she aroused controversy by winning second prize with an abstract work at the Salón Esso (1965; Mexico City, Pal. B.A.). In 1968 she also helped set up the Salón Independiente as a protest against the government-subsidized Salón Solar on the occasion of the Olympic Games in Mexico City. She made several murals, but her most important works were her abstract easel paintings, displaying a fine use of colour. In the 1960s she also worked as a stage designer.

BIBLIOGRAPHY

Homenaje a Lilia Carrillo (exh. cat., Monterrey, Nue. Léon, Promoc. A., 1979)

Lilia Carrillo (exh. cat. by J. Moreno Villarreal, Monterrey, Mus. A. Contemp., 1992)

Regards de femmes (exh. cat., Liège, Mus. A. Mod., 1993), pp. 90–93

J. Moreno Villareal: *Lilia Carrillo: La constelación secreta* (Mexico City, 1994)

LEONOR MORALES

Carrington, Leonora (*b* Clayten Green, nr Chorley, Lancs, 6 April 1917). Mexican painter, sculptor and writer of English birth. In 1936 she travelled to London, where she studied under Amédée Ozenfant (1886–1966) and in 1937 met Max Ernst (1891–1976), with whom she became involved artistically and romantically, leading to her association with Surrealism. They moved to Paris together in 1937. At the outbreak of World War II, Ernst was interned as an enemy alien, and Carrington escaped to Spain, where she was admitted to a private clinic after having a nervous breakdown; she later recounted the experience in her book *En bas* (1943). After marrying the Mexican poet Renato Leduc in 1941 (a marriage of convenience), she spent time in New York before settling in Mexico in 1942, devoting herself to painting. There she and Remedios Varo developed an illusionistic Surrealism combining autobiographical and occult symbolism. Having divorced Leduc in 1942, in 1946 she married the Hungarian photographer Imre Weisz.

Carrington remained committed to Surrealism throughout her career, filling her pictures with strange or fantastic creatures in surprising situations, notably horses, which appear in *Self-portrait* (1938; priv. col., see Chadwick, p. 77), as well as unicorns, owls, dogs and lizards; she sometimes also combined features of animals and human beings. Her references were wide-ranging, whether to ancient Babylonian, Assyrian and Egyptian mythology (e.g. *Palatine Predella*, 1946; priv. col., see Chadwick, pl. XIX) or to visions reminiscent of the Middle Ages. The strange, enigmatic and subtly humorous anecdotes that appear in her work were the expression of a profound inner world, a mythology of her own making, which although terrifying protected her from the aggressive banality of the external world. A prolific painter, she combined technical refinement with a careful but at the same time extremely free design, as in *The Chrysopeia of María de Jesús* (1964; priv. col., see Rodríguez Prampolini, pl. XIII).

From the late 1990s Carrington divided her time between New York and Mexico City, where exhibitions of her work were held (New York, Bruster Gal.; Mexico City, Gal. A. Mex.; both 1997) and where she began to sculpt in bronze.

WRITINGS

En bas (Paris, 1943), xviii of *L'Age d'or*, ed. H. Parisot; Eng. trans. as *Down Under* (New York, 1944, Paris, 2/1973)

BIBLIOGRAPHY

I. Rodríguez Prampolini: *El surrealismo y el arte fantástico de México* (Mexico City, 1969), pp. 73–5

J. García Ponce: *Leonora Carrington* (Mexico City, 1974)

T. del Conde: 'Pintura fantástica y nueva figuración' (1982), xv of *El arte mexicano*, ed. J. A. Manrique, pp. 2276–98

W. Chadwick: *Women Artists and the Surrealist Movement* (London, 1985), pp. 67–8, 74–86, 191–201

Leonora Carrington: Paintings, Drawings and Sculptures, 1900–1990 (exh. cat., London, Serpentine Gal., 1991)

Leonora Carrington: The Mexican Years, 1943–1985 (exh. cat., San Francisco, CA, Mex. Mus., 1991)

S. M. Rubin: 'The Bird Superior Meets the Bride of the Wind: Leonora Carrington and Max Ernst', *Significant Others: Creativity and Intimate Partnership*, ed. W. Chadwick and I. de Courtivron (London, 1993), pp. 97–117

C. Whitney: *Leonora Carrington: La realidad de la imaginación* (Mexico City, 1994)

Leonora Carrington: Una retrospectiva (exh. cat. by L. C. Emerich and L. Andrade, Monterrey, Mus. A. Contemp., 1994)

JORGE ALBERTO MANRIQUE

Cartagena (de Indias). City in northern Colombia. It is located on the Caribbean coast in northern Colombia, in the department of Bolívar, with a population in the late 20th century of *c.* 500,000. Founded in 1533 on a strategically important bay, throughout the colonial period it was the principal port for trade with Spain and the importation of slaves from Africa. This commercial activity and the immediate need to fortify the city from attack were reflected in a rapid consolidation that made it the first well-established site on Colombian territory. It achieved city status in 1575, and ground-floor trading arcades and religious buildings were almost complete by the early 17th century. The cathedral (begun 1575, damaged 1586, restored and completed 1600–21 by Simón Gonzáles (*d* 1627)) was one of the most influential religious buildings in the Spanish viceroyalty of Nueva Granada. The church of S Pedro Claver (1695–1736), designed by Jesuit architects and the most monumental church in the city, was inspired by Il Gesù in Rome. Opposite it, Palacio de la Inquisición (1770) has a massively arched portal that is perhaps the most elaborate example of Baroque in Colombia.

Surviving examples of domestic colonial architecture are usually of two or three storeys, some with *Mudéjar* ceilings and towers facing the sea (e.g. the 17th-century house of the Marqués de Valdehoyos in Calle de la Factoria); others are single-storey (e.g. in the San Diego district and the Getsemani suburb). Cartagena's houses were notable throughout Nueva Granada for their elegance and often had large bay windows; the appearance from the end of the 16th century of overhanging balconies (see fig.) shows the influence of craftsmen from the Canary Islands. The Spanish wars with France and England paralysed much Caribbean trade, with repeated attacks continuing until the mid-18th century. It was only in the late 18th century that renewed prosperity made possible the completion of the modern defensive system. The military engineer appointed to the task, Antonio de Arévalo (*b* 1715), like his predecessors Juan Bautista Antonelli the younger, Juan Bautista McEvan (*d* 1715) and Juan de Herrera y Sotomayor (*d* 1732), made use of the abundant supply of slave labour and the nearby quarries to restore the old forts of S José (dating from 1698) and S Fernando de Bocachica (1759), the impressive castle of S Felipe de Barajas (1657) and the city wall, with its vaults for supplies and munitions and its elegant Neo-classical gateway.

In the early 19th century epidemics and social and economic unrest during the struggle for independence

Cartagena, colonial houses with overhanging balconies, 17th–18th century

dramatically reduced the population and growth of Cartagena, and the city only began to recover towards the end of the century. Traditional architectural crafts using wood and bamboo provided an economical alternative for builders, as exemplified in the houses of El Cabrero and Torices, districts near the city walls; ranches (*quintas*) on Manga island were eclectically designed by their socially aspiring owners and foreign builders in predominantly French Neo-classical, Moorish or Caribbean styles, incorporating tiles and shutters as well as grilles, attics, pediments and gardens. One of the most significant 20th-century buildings is the Casa de Huéspedes Ilustres de Colombia, built in 1980–81 by Rogelio Salmona (*b* 1929). It combines Salmona's contemporary design with the restoration by German Tellez (*b* 1931) of the arsenal of the fort (built 1741) of S Juan de Manzanillo. The modern city has numerous museums, many of them housed in historic buildings. The Museo de Arte Religioso, for example, is housed in the Casa S Pedro Claver, while the Palacio de la Inquisición now houses the Museo Colonial, the Museo Antropológico and the Museo Histórico. The Museo de Arte Moderno and the Museo Naval del Caribe are located in the Claustro de S Juan de Dios, and the Bartolomé Calvo Library is located in a former Republican bank. In addition, the Museo del Oro y Arqueológico specializes in Precolumbian Sinú culture.

BIBLIOGRAPHY

E. Marco Dorta: *Cartagena de Indias, puerto y plaza fuerte* (Madrid, 1960)

J. M. Zapatero: *Historia de las fortificaciones de Cartagena de Indias* (Madrid, 1979)

E. Lemaitre: *Breve historia de Cartagena de Indias, 1501–1901* (Bogotá, 1986)

F. Lucarelli: *Cartagena de Indias: Città patrimonio del mondo* (Naples, 1988)

FERNANDO CARRASCO ZALDÚA

Carvalho, Flávio de (Resende) (*b* Barra Mansa, 10 Aug 1899; *d* Valinhos, 4 June 1973). Brazilian painter, draughtsman, architect and sculptor. He was in Europe from 1910 to 1922 and lived first in Paris and then in London; he studied civil engineering at Armstrong College, University of Durham, and painting in the evening at the King Edward VII School of Fine Arts. On his return to Brazil he settled in São Paulo. His design of 1927 for the headquarters of the government of São Paulo state, although never realized, made him one of the pioneers of modern Brazilian architecture (Dahler, pp. 130–31). During the 1930s in particular he was one of the liveliest figures in the cultural life of the country, responsible for radicalizing the initial successes of Modernism. In 1931 his interest in the psychology of the masses led him to put on the performance *Experience No. 2* in São Paulo. In the same city in 1932 he founded the Clube dos Artistas Modernos and the Teatro de Experiência, where he mounted, to great public scandal, his *Bailado do Deus morto*, later publishing a text related to it, *A origem animal de Deus e O bailado do Deus morto* (São Paulo, 1973). From 1937 to 1939 he also led the May Salon group. In 1947 he executed the *Tragic Series*, drawings of his mother on her deathbed (U. São Paulo, Mus. A. Contemp.). His varied production was recognized at the São Paulo Biennale with a gold medal for ballet design in 1953, the international prize for drawing in 1967 and the posthumous tribute of a retrospective in 1983.

Carvalho was consistently in step with the international movements of his time, especially between the 1920s and 1940s, but his work is essentially rooted in Viennese Expressionism with a Surrealist inflection. Among his best-known works are *Final Ascension of Christ* (1932; São Paulo, Pin. Estado) and the portrait of the poet Ungaretti (1941; Rome, G. N. A. Mod.). His sculpture included a monument to the Spanish poet *Federico García Lorca* in São Paulo. In painting and drawing he focused on the human figure, especially the female body, treating it with a violence and brutality rare in Brazilian art at any time, for example *Despised Woman Curls into a Foetal Position* (1932; São Paulo, Mus. A. Assis Châteaubriand).

BIBLIOGRAPHY

P. M. Almeida: *De Anita ao museu* (São Paulo, 1961)

P. M. Bardi: *Profile of the New Brazilian Art* (Rio de Janeiro, 1970)

Flávio de Carvalho (exh. cat. by W. Zanini and others, São Paulo, XVII Biennale, 1983)

L. C. Dahler: *Flávio de Carvalho e a volúpia da forma* (São Paulo, 1984)

Expressionismo no Brasil: Heranças e afinidades (exh. cat. by S. T. Barros and I. Mesquita, São Paulo, XVIII Biennale, 1985)

C. Rodríguez dos Santos: 'L'autre phare de Colomb: Origènes de l'architecture moderne au Brésil', *Art d'Amérique latine, 1911–1968* (exh. cat., Paris, Pompidou, 1992), pp. 116–27

M. M. dos Santos Camisassa: *Modern Architecture and the Modernist Movement in Brazil during the 1920s and 1930s* (diss., Colchester, U. Essex, 1994)

J. Toledo: *Flávio de Carvalho: O comedor de emoções* (São Paulo, [1994])

R. Moreira Leite: 'Flávio de Carvalho: Modernism and the Avant-Garde in São Paulo, 1927–1939', *J. Dec. & Propaganda A.*, xxi (1995), pp. 196–217

ROBERTO PONTUAL

Carvalho Mange, Ernest Robert de. *See* MANGE, ERNEST.

Carvallo, Feliciano (*b* Naiguatá, Vargas, 11 Nov 1920). Venezuelan painter. A self-taught artist, his naive painting first prompted public attention in 1949, in a one-man show at the Taller Libre de Arte in Caracas. Carvallo's appearance on the art scene marked the beginning of the boom in naive painting in Venezuela. His main subject was the various Venezuelan folk festivals, which he depicted in fabulous jungles populated by numerous native animals. His detailed technique was based on the elaborate intertwining of different elements in the painting, achieving attractive decorative effects. He exhibited at an international level, and in 1966 he was awarded the Premio Nacional de Pintura and the Premio Armando Reverón at the Salón Oficial Anual de Arte Venezolano.

BIBLIOGRAPHY

Feliciano Carvallo (exh. cat. by G. Diehl, Paris, Gal. Villand & Galanis, 1966)

ELIDA SALAZAR

Casasola, Agustín Víctor (*b* Mexico City, 1874; *d* Mexico City, 1938). Mexican photographer and collector. He worked as a reporter for the Catholic newspaper *El tiempo* during the 1890s, becoming a staff photographer by 1900. He not only recorded the official functions and daily life in Mexico City under President Porfirio Díaz but also began to take an interest in social conditions, despite strict government censorship preventing publication of anything other than the most anodyne of images. He also began to collect the work of other photographers, which with his own work provide an invaluable record of Mexican life before, during and after the Revolution (1910–17). Few of the photographs in the Casasola archive are credited, making it almost impossible to attribute images to him. The subjects included political demonstrations, insurrections, the poor, factories, executions (see 1985 exh. cat., pp. 24–5) and music-hall performers (see 1985 exh. cat., pp. 78–9). Casasola did not, however, comment on events or display the passion for social improvement found in the work of Jacob A. Riis (1849–1914) and Lewis W. Hine (1874–1940).

After working on a freelance basis as a photographer for *El imparcial* and *El mundo ilustrado* during the first decade of the 20th century, Casasola established the Society of Press Photographers (1911). While Díaz's dictatorship was beginning to crumble, the Society documented Francisco Madero's 'No Re-election' presidential campaigns throughout the country, resulting in many striking photographs of the bloody uprising in the north led by Pascual Orozco and Francisco (Pancho) Villa (see 1985 exh. cat., pp. 32–3). At the end of 1911 Casasola organized an exhibition of this material in Mexico City, to which the newly elected President Madero was invited. In 1914 Casasola founded the Photographers' Information Agency, which both commissioned and bought news photographs from other photographers.

Following the Revolution, Casasola received many official commissions from the Obregón and Calles governments. In 1921 his son, Gustavo Casasola, became the archivist of the family firm and published the *Album histórico gráfico*, which set out to provide a visual record of the Mexican Revolution; the album was expanded and published as the *Historia gráfica de la Revolución Mexicana* and in more comprehensive form as *Seis siglos de historia gráfica de México*. Few of the photographs in the archive

document the battles of the Revolution but rather are records of leading personalities and of the context of the struggles. During the 1920s and 1930s they were valuable reference material for the Mexican muralist painters. In the early 1970s the archive was purchased by the Mexican government and went into the custodianship of the National Institute of Anthropology and History (INAH), housed at the Fototeca of the Ex-Convento de San Francisco, Pachuca, Hidalgo.

PHOTOGRAPHIC PUBLICATIONS

G. Casasola, ed.: *Historia gráfica de la Revolución Mexicana, 1900–1960*, 10 vols (Mexico City, 1964)
——: *Seis siglos de historia gráfica de México, 1925–1970*, 7 vols (Mexico City, 1976)

BIBLIOGRAPHY

The World of Agustín Víctor Casasola, 1900–1938 (exh. cat., ed. M. Zuver; Washington, DC, Fondo del Sol Visual A. Media, 1984)
Tierra y libertad: Photographs of Mexico, 1900–1935, from the Casasola Archive (exh. cat., ed. D. Elliott; Oxford, MOMA, 1985)
F. Lara Klahr: *Fotografía y prisión, 1990-1936* (Mexico City, 1991)
——: *Jefes, héroes y caudillos* (R Mexico City, 1996)

DAVID ELLIOTT

Casé, Paulo Hamilton (*b* Rio de Janeiro, 1931). Brazilian architect. He graduated in 1957 from the Faculty of Architecture at the National University of Brazil and in 1958 went into partnership in Rio de Janeiro with Luiz Acioli (*b* 1933). In 1964 he began to teach architecture at the Federal University of Rio de Janeiro. He belonged to a new generation of Brazilian architects, whose intention was to go beyond the formalism and functionalism of international styles and to promote, through their teaching, an authentically Brazilian character in architecture. In his design for the Hotel Porto do Sino (1966), his planning and use of local materials and building techniques countered both the aesthetic ideas of Le Corbusier, which dominated the Rio de Janeiro school, and the Brutalism seen in the obsessive use of reinforced concrete that dominated architecture in São Paulo. Other hotel designs were also characterized by a wealth of space and use of local materials and building techniques, as in the Porto do Sol hotel (1973–6) at Guarapari, a horizontal building formed by groups of white-walled blocks with balconies and mud-tiled roofs, stretching out rhythmically along a rocky point overlooking the sea. His most characteristically Brazilian works were private houses, such as the Manga Larga house (1968) at Itaipava and the João Dalmacio house (1978) at Vitória. In his commercial work, a great inventiveness of form and use of reinforced concrete was allied to complex planning: examples include the Banco Mercantil do Brasil (1969) and the Bank of Tokyo (1972) in São Paulo, and the Fininvest headquarters (1983) in Rio de Janeiro, in which a 12-storey lightwell organizes the internal space, protecting it from noise and sun. Several of his buildings won prizes from the Institute of Architects of Rio de Janeiro.

BIBLIOGRAPHY

'Brazilian Hotels with International Standards', *Constr. São Paulo*, 1391 (1974), pp. 13–15
'Projects for Hotels in Brazil', *Arquit. Brasil*, 10 (1977–8), pp. 39–48
'Fininvest, Rio de Janeiro', *Projeto*, 63 (1984), pp. 39–42

PAULO J. V. BRUNA

Caspicara [Chili, Manuel] (*fl* Quito, 18th century). Ecuadorian sculptor. An Indian nicknamed *Caspicara*

(wooden face), he lived in Quito, and his name and work were discovered in 1791 by the doctor and journalist Eugenio Espejo. He was a pupil of Bernardo de Legarda. He is considered the outstanding sculptor of religious images in polychromed wood of the colonial period in Quito, a result of the delicacy, grace and feeling that he gave to human expressions and his attention to the details of anatomy and the movement of his figures. The elegant but natural carving of the drapery adds a Baroque quality to his sculptures. The most outstanding of his works in Quito, all of unknown date, include the *Four Virtues* and the *Holy Shroud* in Quito Cathedral; *St Francis*, the *Twelve Apostles* and the *Assumption of the Virgin* in S Francisco; and *La Virgen del Carmen*, *St Joseph* and the *Coronation of the Virgin* in the Museo Franciscano in Quito. In certain of his works he grouped the figures as if in a painting, as in the *Holy Shroud* and the *Assumption of the Virgin* mentioned above.

RICARDO DESCALZI

Castagneto, João Batista [Castagnetto, Giovanni Battista] (*b* Genoa, 27 Nov 1851; *d* Rio de Janeiro, 29 Dec 1900). Brazilian painter of Italian birth. He went to Brazil in 1875 and in 1877 entered the Academia Imperial das Belas Artes in Rio de Janeiro. He completed his education there between 1882 and 1884 under the German painter Georg Grimm, who encouraged his *plein-air* painting, as in *Port of Rio de Janeiro* (1884; Rio de Janeiro, Mus. N. B.A.). In 1884 Castagneto and Grimm shared the main prize of the Exposição Geral de Belas Artes in Rio de Janeiro. From 1890 to 1893 Castagneto lived in France, mainly in Toulon, where he confirmed his interest in seascapes, as in *Afternoon in Toulon* (1893; São Paulo, Pin. Estado). In his later years, back in Rio de Janeiro, he used to paint in a boat converted into a studio, often on the small surface of cigar box covers. His best works, which balance Romantic emotion with rationalism, date from this period.

BIBLIOGRAPHY

J. M. dos Reis Júnior: *História da pintura no Brasil* (São Paulo, 1944)
C. R. M. Levy: *O grupo Grimm: paisagismo brasileiro no século XIX* (Rio de Janeiro, 1980)
——: *Giovanni Battista Castagnetto: O pintor do mar* (Rio de Janeiro, 1982)

ROBERTO PONTUAL

Castagnino, Juan Carlos (*b* Mar del Plata, 19 Nov 1908; *d* Buenos Aires, 21 April 1972). Argentine painter and draughtsman. He studied at the Escuela Superior de Bellas Artes in Buenos Aires and worked from 1932 to 1938 in the studios of the Argentine painters Lino Eneas Spilimbergo, Miguel Carlos Victorica and Ramón Gómez Cornet (1898–1964). In 1933 he worked as an assistant to David Alfaro Siqueiros, who was in Buenos Aires to paint a mural in Natalio Botana's villa, and from 1939 to 1940 he attended the studios of the artists André Lhote (1885–1962) and Marcel Gromaire (1892–1971) in Paris.

In his early work Castagnino revealed a deep concern for the problems of his day, for people and their relations with their surroundings. A visit to China in 1952 enriched his pictorial vocabulary and led him to incorporate direct observation and rapid execution into his working methods; he also directed the Escuela de Arte Pópular del Oeste,

where he proved influential as a teacher. From 1962, when he illustrated a classic of Argentine gaucho literature, *Martín Fierro* by José Hernández (Buenos Aires, 1962), two main strands emerged in his art: on the one hand a reworking of the visual investigations instituted in Cubism and Futurism, and on the other an expression of his political commitments, sometimes combined in the same pictures. This combination of social and pictorial concerns was especially evident in his watercolours and ink drawings, for which he was much admired. While living in Mexico in 1960 he received the Premio Especial de Dibujo at the second Bienal Interamericana de México.

Castagnino's work as a muralist, for example for the Sociedad Hebraica Argentina, the Galería Flores, the Galería Caballito and the Galería del Centro, all in Buenos Aires, was of particular importance. He was one of a group of artists who worked on the finest example of the Mexican mural tradition to be found in Argentina, a mural depicting subjects from domestic life on the cupola of the Galería Pacífico in Buenos Aires. His preferred subjects as an easel painter included images of the mother and child, the simple untamed nature of the Argentine countryside (e.g. *Burning*, 1961; Buenos Aires, Mus. N. B.A.), for which he won the Premio de Honor at the Salón Nacional in 1961, the vitality of horses in movement and the local workers and native Indians with whom he aligned himself in their harsh struggle for existence.

BIBLIOGRAPHY

R. Irurtia: *Juan Carlos Castagnino. Argentinos en las artes* (Buenos Aires, 1962)

A. Pellegrini: *Panorama de la pintura argentina contemporánea* (Buenos Aires, 1967), pp. 43–4, 98

J. López Anaya: *Historia del arte argentino* (Buenos Aires, 1997)

NELLY PERAZZO

Castellanos, Julio (*b* Mexico City, 3 Oct 1905; *d* Mexico City, 16 July 1947). Mexican painter. At the age of 13 he entered the Academia de San Carlos in Mexico City, where he was taught by Saturnino Herrán and Leandró Izaguirre. At the end of a short stay in the USA he met Manuel Rodríguez Lozano, who decisively influenced his work. After holding his first exhibition in Buenos Aires, Argentina, in 1925, he moved to Paris, where he continued his studies and was exposed to the sources of great Western art. On his return to Mexico he took part in an exhibition organized by the group Los Contemporáneos, showing six works that displayed his departure from his earlier influences. He began at this time to stress volumetric form, almost sculptural in appearance, by means of colour and fluid line.

Although he was primarily an easel painter, Castellanos also experimented with murals. In 1933 and 1934 he painted frescoes in two schools in Mexico City—the Escuela Melchor Ocampo in Coyoacán and the Escuela Gabriela Mistral in Peralvillo—in which he treated children's themes far removed from the grandiloquent, epic tone of the social realism of that period. In his best works Castellanos captured simple, everyday themes that also form an essential part of a country's history. Castellanos's development had just reached maturity when it was cut short by his premature death.

BIBLIOGRAPHY

S. Toscano and C. Pellicer: *Julio Castellanos: Monografía de su obra* (Mexico City, 1952)

R. Flores Guerrero: *Cinco pintores mexicanos: Frida Kahlo, Guillermo Meza, Juan O'Gorman, Julio Castellanos y Jesús Reyes Ferreira* (Mexico City, 1957)

J. Fernández: *La pintura moderna mexicana* (Mexico City, 1964)

JULIETA ORTIZ GAITÁN

Castillo, Marcos (*b* Caracas, 5 April 1897; *d* Caracas, 19 March 1966). Venezuelan painter. He began studying in 1917 at the Academia de Bellas Artes, Caracas, where from 1922 he taught painting and composition. In 1926 Castillo held his first one-man show at the Club Central, Caracas, after which he made a brief journey to Paris. During the following years he studied the work of Paul Cézanne, which permanently influenced his own work. In 1940 he was awarded the Venezuelan national painting prize. Also influenced by such Venezuelan painters as Federico Brandt, Manuel Cabré, Armando Reverón and, in particular, Emilio Boggio, his output boldly crossed all genres of painting, including realistic portraiture, but his greatest achievement was with still-lifes, the compositional strength of which enabled him to express freely his passion for colour (e.g. *Still-life*, 1930; Caracas, Gal. A. N.).

BIBLIOGRAPHY

J. Calzadilla: *Marcos Castillo, una muestra de sus pinturas* (Caracas, 1967)

M. Quintana Castillo: *Marcos Castillo* (Caracas, 1967)

A. Boulton: *Historia de la pintura en Venezuela*, 3 vols (Caracas, 1968, rev. 1973)

Marcos Castillo: El color y el espíritu. Obra antológica, 1915–1966 (exh. cat. by J. J. Mayz Lyon, Caracas, Gal. A. N., 1986)

J. Calzadilla: 'Marcos Castillo o cómo rehace la naturaleza en el Taller', *Rev. N. Cult.*, cclxxxv (1992), pp. 215–23

C. Silva: *La obra pictórica de Marcos Castillo* (Caracas, 1992)

YASMINY PÉREZ SILVA

Castillo (Guash), Teófilo (*b* Carhuás, Ancash, 2 Oct 1857; *d* San Miguel de Tucumán, Dec 1922). Peruvian painter, photographer, teacher and critic. At the age of four he was brought to Lima, where he began to take lessons in art. From 1885 he travelled through France, Italy and Belgium, and on returning to Latin America he settled in Buenos Aires, where he took up photography. In 1905 he returned to Lima, where he set up a workshop and art college at the Quinta Heeren, introducing the latest photographic techniques. On visiting Spain in 1908 Castillo discovered the historical genre paintings of Mariano Fortuny y Marsal, and once back in Lima worked as a painter and as art critic for the magazines *Prisma*, *Variedades*, *Actualidades* and *Ilustración peruana*. He later supported DANIEL HERNÁNDEZ in founding (1919) the Escuela Nacional de Bellas Artes in Lima (*see also* PERU, §XI). In parallel with the writer Ricardo Palma, Castillo was concerned with recording the traditions of Lima's colonial past, and such paintings as the *Funeral of Santa Rosa* (1918; see colour pl. VI, fig. 1) evoke that period in an exuberant fashion, with sketchily outlined figures executed with impressionistic brushstrokes full of movement, anticipating later anti-academic styles in Peru; his portraits and landscapes were often more subdued, although his native Ancash was depicted with romanticized opulence. Castillo moved in 1920 to San Miguel in Tucumán, Argentina, where he taught at the Escuela de Bellas Artes.

BIBLIOGRAPHY

J. Villacorta Paredes: *Pintores peruanos de la República* (Lima, 1971), pp. 36–7

J. A. de Lavalle and W. Lang: *Pintura contemporánea, I: 1820–1920*, Col. A. & Tesoros Perú (Lima, 1975), pp. 128–37

C. Aitor Castillo: 'Teófilo Castillo', *Kantú, Rev. A.*, 8 (July 1990), pp. 5–8

W. IAIN MACKAY

Castro, Amílcar de (*b* Paraisópolis, 1920). Brazilian sculptor, draughtsman and printmaker. Moving from the interior to the capital of Minas Gerais, he studied drawing and painting with Alberto da Veiga Guignard in Belo Horizonte from 1942 to 1950. He then went to Rio de Janeiro, where he began to show preference for sculpture and worked extensively as a graphic designer, making his name by redesigning the daily newspaper *Jornal do Brasil*. Already a Constructivist, in 1959 he signed the Neo-Concrete Manifesto, participating in exhibitions of the Grupo Neoconcreto until 1961 and in the international exhibition of Concrete art in Zurich (1960). Awarded a trip abroad by the Salão Nacional de Arte Moderna, Rio de Janeiro, from 1967 to 1969 he lived in New Jersey, where in 1968 he was granted a Guggenheim Fellowship. On his return to Brazil he settled in Belo Horizonte. In his sculpture, mainly in sheet iron, he continued to use a language of extreme economy (*Escultura*, 1967; Rio de Janeiro, Mus. N. B.A. and *Cavalo*, 1972; São Paulo, Pin. Estado). The drawings and etchings (e.g. *Untitled*, 1993; see fig.) to which he devoted increasing attention are much more gestural, conceived as records of feverish activity.

BIBLIOGRAPHY

A. Amaral, ed.: *Projeto construtivo brasileiro na arte, 1950–1962* [The Brazilian Constructivist project in art, 1950–1962] (São Paulo, 1977), pp. 240–45

América Latina: Geometria sensível [Latin America: sensitive geometry] (exh. cat., ed. R. Pontual; Rio de Janeiro, Mus. A. Mod., 1978), pp. 16, 63, 142–5

R. Brito: *Neoconcretismo: Vértice e ruptura do projeto construtivo brasileiro* [Neo-Concretism: apex and breaking point of the Brazilian Constructivist project] (Rio de Janeiro, 1985), pp. 51, 65–70, 76

P. S. Duarte: 'Amílcar de Castro ou a aventura da coerência', *Novos Estudos*, xxviii (1990), pp. 15–28

A. Tassinari, R. Naves and R. Brito: *Amílcar de Castro* (São Paulo, 1991)

R. Naves: 'Amílcar de Castro: Matéria de risco', *A forma difícil: Ensaios sobre arte brasileira* (São Paulo, 1996), pp. 225–59

ROBERTO PONTUAL

Castro, Casimiro (*b* Mexico City, 24 April 1826; *d* Mexico City, 8 Jan 1889). Mexican lithographer, draughtsman and painter. He may have studied at the Academia de San Carlos, Mexico City, but it seems more likely that he trained professionally with the Italian lithographer, painter and stage designer Pedro Gualdi (*fl* 1838–*c*. 1851). He subsequently worked with another stage designer, the Frenchman Eduardo Rivière, producing lithographs of Rivière's illustrations to his novel *Antonio y Anita o los nuevos misterios de México* (1851). Castro made drawings and *c*. 30 lithographs (with the help of J. Campilo among others) for the album *México y sus alrededores* (1855–6),

Amílcar de Castro: *Untitled*, etching, 300×365 mm, 1993 (Colchester, University of Essex, Collection of Latin American Art)

published by Decaen, of which he became director in 1880. Copies of the album are housed in the Museo de la Ciudad and the Museo Nacional de Historia, Castillo de Chapultepec, Mexico City. It offers a characteristic, contemporary view of the capital, including depictions of buildings, squares and streets embellished with figures representative of all social classes, professions and occupations. In 1877, shortly after the opening of the railway, he illustrated the *Album del ferrocarril mexicano* (Mexico City; copies in Mexico City, Mus. Ciudad) with a series of colour lithographs. They reveal a highly developed cartographic sense; some appear to have influenced José María Velasco in the composition of landscapes in which the railway appears, for example the *Volcano Citlaltépetl* (1891; Mexico City, Mus. N. A.). In addition, Castro produced architectural drawings during a visit to Spain and Italy (1885), depictions of other Mexican towns (including Puebla, Jalapa and Orizaba), designs for the decoration of façades and elegant shop interiors, posters for fairs, landscapes and fashion designs. Some of his drawings reveal an incipient tendency to Art Nouveau.

<center>PRINTS</center>

Album del ferrocarril mexicano/Album of the Mexican Railway (Mexico City, 1977); *R* with additional English text (Mexico City, 1981)

<center>BIBLIOGRAPHY</center>

Casimiro Castro (1826–1889) (exh. cat. by J. G. Ponce, M. R. Gómez and A. de Neuvillate, Mexico City, Inst. N. B.A., 1968)
Casimiro Castro y su taller (exh. cat. by C. Monsiváis and others, Mexico City, Pal. Iturbide, 1996)

<div align="right">FAUSTO RAMÍREZ</div>

Castro (y Morales), José Gil de (*b* Lima, 1785; *d* Lima, 1841). Peruvian painter, also active in Chile. He was self-taught. He spent many of his early years in Chile (*see also* CHILE, §III, 2), during which he worked in the army as, among other things, a topographer. He also painted a number of religious works during this period, including *Our Lady of Mercy* (1815; Lima, Irene Eyzaguirre Col.) and portraits of prominent society figures (e.g. *Isabel Rodríguez Riquelme*, 1819; Santiago, Mus. Hist. N.; *see* CHILE, fig. 4). In 1822 he returned to Peru, where he designed the army uniform and painted portraits of leaders of the Independence movement, including the *Martyr Olaya* (1823; Lima, Mus. N. Hist.) and various paintings of *Simón Bolívar* (e.g. 1822; Lima, Mus. A.). While vestiges of colonial art can be seen in de Castro's work, his subject-matter and his skilled treatment of perspective, colour and composition singled him out as the most important painter of the early Republican era, and his work constitutes an invaluable historical record.

<center>BIBLIOGRAPHY</center>

A. R. Romero: *Historia de la pintura chilena* (Santiago, 1951, rev. 1980), pp. 19–25
J. Villacorta Paredes: *Pintores peruanos de la República* (Lima, 1971), pp. 10–11
J. A. de Lavalle and W. Lang: *Pintura contemporánea, I: 1820–1920*, Col. A. & Tesoros Perú (Lima, 1975), pp. 42–51
R. Mariátegui Oliva: *José Gil de Castro* (Lima, 1981)
E. Pereira Salas: *Estudios sobre la historia del arte en Chile republicano* (Santiago, 1992)
José Gil de Castro en Chile: Exposición retrospectiva (exh. cat., Santiago, Mus. N. B.A., 1994)

<div align="right">W. IAIN MACKAY</div>

Catherwood, Frederick (*b* London, 1799; *d* at sea nr Liverpool, 1854). English draughtsman and printmaker active in Mexico. He studied architecture at the Royal Academy of Fine Arts in London and continued his studies in Rome. He accompanied the American archaeologist John Lloyd Stephens (1805–52) on two trips to Mexico. On the first, in 1839–40, he undertook to draw the archaeological ruins of Palenque, Uxmal, Copán and other places or monuments specified by Stephens. Under the terms of the contract Stephens became the owner of the originals, with the right to reproduce them. On the second trip, in 1841–2, Stephens bought Copán with the intention of exporting archaeological pieces from Mexico.

Catherwood employed both the camera lucida and daguerreotypes in the production of drawings, from which more than 200 engravings were made; these were published in two books, *Incidents of Travel in Central America, Chiapas and Yucatan* (New York, 1841) and *Incidents of Travel in Yucatan* (New York, 1843). These were followed by an album of 25 lithographs, *Views of Ancient Monuments in Central America, Chiapas and Yucatan* (London, 1844), which featured not only Mayan architecture but also the jungle landscape, to which he gave eloquent expression. He died in an accident at sea.

<center>BIBLIOGRAPHY</center>

F. Ramírez: 'La visión europea de la América tropical: Los artistas viajeros', *Hist. A. Mex.*, 67–8, pp. 138–63
K. Robinson: *The Archaeological Image of Mexico in the Nineteenth-century: Verbal and Visual Discourses in the Works of Stephens and Catherwood, Charnay and Maudslay* (diss., Colchester, U. Essex, 1993)

<div align="right">ESTHER ACEVEDO</div>

Cavalcanti, Emiliano (de Albuquerque e Mello) di (*b* Rio de Janeiro, 6 Sept 1897; *d* Rio de Janeiro, 26 Oct 1976). Brazilian painter and draughtsman. His first exhibited works were caricatures shown in Rio de Janeiro and São Paulo between 1916 and 1917. In 1921, already deeply involved in the movement for the renewal of Brazilian art, he published a collection of drawings, *Fantoches da meia-noite* ('Midnight puppets'), accompanied by a text by Ribeiro Couto in São Paulo. He was one of the leaders of the SEMANA DE ARTE MODERNA in São Paulo in 1922. From 1923 to 1925 he lived in Paris, where he produced numerous book and magazine illustrations as well as articles on European events for Brazilian newspapers. Apart from a second period in Paris from 1935 to 1940 he lived in Rio de Janeiro.

Completely self-taught, Cavalcanti borrowed elements from a mixture of sources, including Art Nouveau, Post-Impressionism, Expressionism, Cubism and Surrealism, eventually arriving at a vividly figurative style of painting with a marked national flavour. He relied heavily on the female form, especially that of the mulatto woman, as a source of frank sensuality—erotic, dreamlike, lyrical and fantastic. He depicted women in the guise of virgin, Venus, lover or mother, in an atmosphere of domestic celebration, in hot, luminous landscapes or in scenes reminiscent of the popular *bas-fond* suburbs of Rio. Typical works include *The Kiss* (1921; U. São Paulo, Mus. A. Contemp.), *Five Girls from Guaratinguetá* (1930; see colour pl. VII, fig. 1), *Gypsies* (1940; Rio de Janeiro, Mus. N. B.A.) and *Brazilian Scene* (1938; Paris, Pompidou); 564 of his drawings from the 1920s to the 1950s are housed at the Museu de Arte Contemporânea at the Universidade de São Paulo.

WRITINGS

O testamento da alvorada (1955), i of *Viagem dà minha vida* (Rio de Janeiro, 1955)
Reminiscências líricas de um perfeito carioca (Rio de Janeiro, 1964)

BIBLIOGRAPHY

E. Di Cavalcanti (exh. cat., São Paulo, Mus. A. Mod., 1971)
L. Martins: *Di Cavalcanti* (São Paulo, 1983)
A. Amaral, ed.: *Desenhos de Di Cavalcanti no Museu de Arte Contemporânea da Universidade de São Paulo* (São Paulo, 1985)

ROBERTO PONTUAL

Cedeño, Juan Manuel (*b* La Villa, Los Santos, 28 Dec 1914; *d* Panama City, 11 Aug 1997). Panamanian painter. After studying in Panama under Roberto Lewis and in the 1940s at the School of the Art Institute of Chicago, he sustained a reputation from the 1950s to the 1970s as his country's leading portraitist, with paintings such as *Octavio Méndez Pereira* (1950; Panama City, U. Panamá). He also painted landscapes, still-lifes and scenes representing local folkloric traditions, a subject to which he was drawn because of his rural background. Cedeño was one of the first artists in Panama to experiment with non-academic international styles, in particular subjecting his imagery to a process of geometrization. The composition of *Talco en sombra* (1950; Panama City, artist's priv. col., see 1987 exh. cat., p. 9), for instance, is based on a pattern of swirling geometric planes influenced by Cubism; the title refers to a sewing technique used in the making of the intricate national costume in which the two women in the picture are clothed. Cedeño was director of the Escuela Nacional de Pintura (later renamed Escuela Nacional de Artes Plásticas) from 1948 to 1967 and taught at the Faculty of Architecture of the Universidad de Panamá from 1967 to 1978. His role as an educator was of great importance for art in Panama.

BIBLIOGRAPHY

Exposición retrospectiva de Juan Manuel Cedeño (exh. cat., ed. M. E. Kupfer; Panama City, Mus. A. Contemp., 1983)
Exposición maestros-maestros (exh. cat. by A. Prados, Panama City, U. Panamá, 1987), pp. 9–10
Crosscurrents: Contemporary Painting from Panama, 1968–1998 (exh. cat., New York, Americas Soc. A.G., 1998)

MONICA E. KUPFER

Centurión, Emilio (*b* Buenos Aires, 14 July 1894; *d* Buenos Aires, 26 Dec 1970). Argentine painter. He trained in Buenos Aires under the Italian professor Gino Moretti and in the open studio which ran in the Salas de la Comisión Nacional de Bellas Artes. He went on study trips to Salta and Jujuy in northern Argentina, to Brazil and to Italy, Spain and France. From 1931 he was head of the painting workshop at the Escuela Superior de Bellas Artes Ernesto de la Cárcova in Buenos Aires, and in 1936 he became an academician of the Academia Nacional de Bellas Artes. He produced murals, sculptures and drawings but worked above all as an easel painter, in which medium he was both technically accomplished and severe and rigorous in his working methods, e.g. *Portrait* (1934; Buenos Aires, Mus. Mun. A. Plást. Sívori). In spite of his traditional training, he was receptive to modernist trends and was able to strike a balance between the two in works characterized by their carefully judged colour and skilful modelling, for example *Creole Venus* (see fig.) and *Cliffs* (1955; Buenos Aires, Mus. Mun. A. Plást. Sívori). He

Emilio Centurión: *Creole Venus*, oil on canvas, 1.85×1.30 m, 1955 (Buenos Aires, Museo Nacional de Bellas Artes)

received the most distinguished prizes awarded in Argentina, beginning in 1920 with first prize in the Salón Nacional and the Jockey Club Prize and including, among others, the Gran Premio de Honor at the Salón Nacional in 1935. Centurión's loyalties during the rule of Juan Perón caused him to be imprisoned for his participation in a showing of the Salón de Independientes and stripped of his teaching posts.

BIBLIOGRAPHY

E. González Lanuza: *Emilo Centurión* (Buenos Aires, 1972)
C. Córdoba Iturburu: *80 años de pintura argentina* (Buenos Aires, 1978)

NELLY PERAZZO

Cervera, Andrés Campos. *See* HERRERÍA, JULIÁN DE LA.

Cetto, Max (L.) (*b* Koblenz, 20 Feb 1903; *d* Mexico City, 5 April 1980). Mexican architect, architectural historian and teacher, of German birth. He studied at the technical universities of Darmstadt, Munich and Berlin. At the latter he studied with Hans Poelzig, graduating as an engineer–architect in 1926. In 1927 he took part in the plan for the headquarters of the League of Nations in Geneva, and he was a founder-member of CIAM. He moved to San Francisco, CA, in 1938, where he worked in the studio of Richard Neutra. He settled in Mexico in 1939 and became a naturalized Mexican in 1947. As well as having a natural affinity with Mexico, he was able to incorporate his European experiences into what he built there. The respect for nature he had learnt from Neutra is evident in his

handling of the volcanic terrain of the Jardines del Pedregal, Mexico City, where he collaborated with Luis Barragán, constructing various houses amid the impressive scenery of the place without disturbing the volcanic lava or the vegetation. He also showed skill and great sensitivity in using the materials and techniques of the region. Notable examples of his work there are his own house (1949) and that built in 1951 for the painter Roberto Berdecio (*b* 1910). These and other houses elsewhere, where he combined a Modernist approach with a respect for ecology, were highly influential in Mexican domestic architecture. In 1966 he won second prize in the international competition for a museum of art in West Berlin. He was Professor of Architecture at the Universidad Nacional Autónoma de México, Mexico City, from 1965 to 1979.

WRITINGS
Moderne Architektur in Mexico (Stuttgart, 1960; Eng. trans., New York, 1961)

BIBLIOGRAPHY
Contemp. Architects
L. Noelle: *Arquitectos contemporáneos de México* (Mexico City, 1988)
F. González Gortázar: *La arquitectura mexicana del siglo XX* (Mexico City, 1994)
S. Dussel Peters: *Max Cetto (1903–1980): Arquitecto mexicano-alemán* (Mexico City, 1995)

XAVIER MOYSSÉN

Chab, Víctor (*b* Buenos Aires, 6 Sept 1930). Argentine painter. A self-taught artist, in 1952 he began working in a Surrealist style, finding in it a profound impetus that decisively affected the later direction of his work. In 1957 he became a member of the Siete Pintores Abstractos, hinting at the oscillations in his art between geometric

Victor Chab: *A Thousand Teardrops (Suite of the Fourth Song)*, acrylic on canvas, 995×800 mm, 1994 (Colchester, University of Essex, Collection of Latin American Art)

abstraction on the one hand and subconscious, fantastic and irrational imagery on the other. In 1962 he painted the first of his *Bestiaries*, in which he created a world of hallucinatory creatures such as *Ghelderade* (1963; Buenos Aires, Mus. N. B.A.).

From 1972 Chab painted apparently abstract pictures in which one can discern suggestions of objects and organic forms (e.g. a later work, *A Thousand Teardrops (Suite of the Fourth Song)*; see fig.). By 1977 his works again tended more to the geometric, with a suggestively poetic atmosphere, as in *Axial Figure* (1975; Buenos Aires, Mus. A. Contemp.). In the series of *Landscapes* that he exhibited in 1984 he returned to a pictorial language reminiscent of *Art informel*, using fine textures and transparencies in oils and collage to create fantastic spaces of metaphysical suggestiveness. Chab took part in the Venice Biennale in 1956 and 1964 and won a silver medal at the Exposition Universelle in Brussels in 1958.

BIBLIOGRAPHY
V. P. Caride: 'Constantes en el universo poético–plástico de Víctor Chab', *Ars*, xx/88 (1960)
C. Dukelski: *Chab* (Buenos Aires, 1981)
Víctor Chab (exh. cat., Coral Gables, FL, Gary Nader F.A., 1993)
Víctor Chab mujeres (exh. cat. by J. Villacorta Chávez, Buenos Aires, Gal. Rubbers, 1995)
J. López Anaya: *Historia del arte argentino* (Buenos Aires, 1997)
Víctor Chab (exh. cat., Buenos Aires, Cent. Mun. Exp. S Martín, 1998)

NELLY PERAZZO

Chambi [de Coaza], **Martín** (*b* Coaza, nr Puno, 1891; *d* Cuzco, 1973). Peruvian photographer. The only major photographer of Latin American Indian origin in his time, he gained international recognition only after his death. As a boy he was fascinated by photography, about which he learnt in the studio of Max T. Vargas in Arequipa in 1908. In 1920 he opened a studio in Cuzco, which became the base for his examination of Inca culture. Like the radical intellectuals of the 'indigenous' movement with which he was associated, he believed that his country's true spirit lay with the Indian population. He was motivated, however, not just by documentary concerns but by pictorial ones; his experimentation with light sources can be directly related to his interest in Rembrandt's paintings. His growing posthumous reputation is largely due to the work of his son, Victor Chambi (*b* 1917), who on his father's death began printing some of his 18,000 glass negatives.

PHOTOGRAPHIC PUBLICATIONS
Documental del Perú (Cuzco, 1968)

BIBLIOGRAPHY
S. Facio, ed.: *Martín Chambi* (Buenos Aires, 1985)
M. Vargas Llosa and P. López Mondejar: *Martín Chambi, 1920–50* (Barcelona, 1990)
Martín Chambi: Photographer, 1920–50 (exh. cat. by E. Ranney and P. López Mondejar, foreword by M. Vargas Llosa; Madrid, Circ. B.A.; Washington, DC, Smithsonian Inst.; 1990–93)

ERIKA BILLETER

Charcas. *See* BOLIVIA.

Charlot, Jean (*b* Paris, 1898; *d* Honolulu, 1979). French painter and printmaker, active in Mexico and the USA. As a child he was surrounded by the nostalgic presence of Mexico, as one of his great-grandmothers was Mexican,

and one of his grandfathers had collected Pre-Columbian art. He specialized in murals, painting his first for the Exposition Saint Jean, an exhibition of liturgical art at the Louvre in 1920. In 1921 he settled in Mexico to take up an offer of work from Alfredo Ramos Martínez at the open-air school in Coyoacán. He worked in Mexico City as one of Diego Rivera's assistants on the mural *The Creation* (1923), executing two important murals of his own in the city during the same period: the *Conquest of Tenochtitlán* (1922–3) in the Escuela Nacional Preparatoria, and *Porters and Washerwomen* (1923) in the building of the Secretaría de Educación Pública. Charlot collaborated on the magazine *Mexican Folkways* and from 1922 to 1927 worked with Sylvanus Morley (1883–1948) in reproducing the Maya paintings from Chichen-Itza. He later settled in Hawaii and painted some murals in the USA.

WRITINGS
The Mexican Mural Renaissance, 1920–1925 (New York, 1979)

BIBLIOGRAPHY
O. S. Suárez: *Inventario del muralismo mexicano, siglo VII a.c.–1968* (Mexico City, 1972), pp. 120–21
P. Morse: *Jean Charlot's Prints: A Catalogue Raisonné* (Honolulu, 1976)
Jean Charlot y el renacimiento del grabado mexicano (exh. cat., Mexico City, Mus. N. Est., 1990)
México en la obra de Jean Charlot (exh. cat. by G. Estrada and others, Mexico City, Colegio Ildefonso and elsewhere, 1996)

ESTHER ACEVEDO

Chartrand, Esteban (*b* Limonar, Matanzas, 1840; *d* New York, 1884). Cuban painter. He and his brother Phillipe (*d* 1889) were trained in France. He was the most fashionable Cuban landscape painter of the late 19th century, especially among the landowners of Matanzas. Under the influence of Corot he painted Cuba's landscape and flora in great detail but in dark tones that do not correspond to tropical colours and light, rendering light and form in terms of tonal values rather than by colour and drawings. *Landscape* (1880; Havana, Mus. N. B.A.) typically represents the peasant *bohío* ('hut'), royal palms and a brook against a pastel-shaded sky highly uncharacteristic of the tropics.

BIBLIOGRAPHY
D. Ramos: 'Tres maestros del paisaje: E. Chartrand, V. Sanz Carta, y A. Rodríguez Morey', *An. Acad. N. A. & Let.* (June 1940–Sept 1941)
M. L. Nuñez: 'Retratos de Fayum, pintura europea', *Museo Nacional de Cuba: Pintura* (Havana and Leningrad, 1978), pp. 8–13
J. Rigol: 'Pintura cubana' *Museo Nacional de Cuba: Pintura* (Havana and Leningrad, 1978), pp. 14–22
R. R. Ruiz: *Esteban Chartrand: Nuestro Romántico* (Havana, 1987)

RICARDO PAU-LLOSA

Chávez. *See* ECHAVE.

Chávez, Gerardo (*b* Trujillo, 16 Nov 1937). Peruvian painter and printmaker. He studied at the Escuela Nacional Superior de Bellas Artes in Lima, graduating in 1959 with a gold medal. After painting figurative pictures in a realist style, he developed a richly imaginative and powerfully erotic Surrealistic imagery. While showing the marked influence of Roberto Matta and Wifredo Lam, his work also recalled the fantastic subjects painted by Pieter Bruegel I and Hieronymus Bosch.

BIBLIOGRAPHY
A. Bosquet: *Chávez* (Paris, 1972)
M. Scorza: *Chávez* (Lima, 1982)
Chávez: Peru. Utopia versus Reality (Lima, 1987)

LUIS ENRIQUE TORD

Chávez Morado, José (*b* Silao, Guanajuato, 4 Jan 1909). Mexican painter and printmaker. His artistic vocation was evident from an early age, and in 1925 he attended the Chouinard School of Arts in Los Angeles, CA. Returning to Mexico City he completed a course at the Escuela Nacional de Artes Plásticas, met the painter OLGA COSTA, whom he later married, and began his untiring work for the arts and for better working conditions for artists. Despite his official appointments and his preoccupation with social causes, he produced some vigorous mural work, in particular the murals in Mexico City for the Faculty of Sciences of the Universidad Nacional Autónoma (1952); the Secretaría de Comunicaciones y Obras Públicas (1954); and the Centro Médico Nacional (1960). He made easel paintings, prints and mosaics, as well as a bronze relief (1964) for the column in the central courtyard of the Museo Nacional de Antropología, Mexico City. Chávez's style is characterized by an expressionistic treatment of his subjects, at times bordering on caricature. He was a member of LEAR (Liga de Escritores y Artistas Revolucionarios; 1934–7) and of the TALLER DE GRÁFICA POPULAR, which were both centres of social militancy in the 1930s, and he established such important venues for the arts as the Salón de la Plástica Mexicana and the Taller de Integración Plástica. As a draughtsman and printmaker he displayed great technical skill, especially in the 1930s and 1940s, when, in his prolific graphic work, he dealt critically with themes that revealed great social concern for humanitarian ideals. He later concentrated on the art and culture of Guanajuato.

WRITINGS
Apuntes de mi libreta (Mexico City, 1979)
José Chávez Morado: Su tiempo, su país; obra plástica (Guanajuato, 1988)

BIBLIOGRAPHY
C. Graef Fernández: *La ciencia en la Ciudad Universitaria* (Mexico City, 1952)
J. J. Crespo de la Serna: *José Chávez Morado en la Alhóndiga de Granaditas* (Mexico City, 1955)
R. Tibol: *José Chávez Morado: Imágenes de identidad mexicana* (Mexico City, 1980)
José Chávez Morado, Olga Costa: Mano a mano (exh. cat. by J. Prieto and others, Coahuila, Mus. Bib. Pape, 1991)
Muestra de la colección pago en especie: José Chávez Morado, Raúl Anguiano, Rafael Coronel, Luis Nishizawa, Ricardo Martínez, Roger von Gunten, Manuel Felguérez, Vicente Rojo (exh. cat. by R. Tibol and others, Mexico City, Secretaría de Hacienda y Crédito Público, 1992)

JULIETA ORTIZ GAITÁN

Chávez y Arellano [Orellana; Arellana]**, Francisco (Domínguez)** (*fl* 1648–69). Spanish architect, active in Peru. On 23 March 1648 he signed a contract with the Franciscans to build rib vaults over the transept and apse of the church of S Francisco in Cuzco. These vaults, which were built in brickwork, withstood the earthquake of 1650 and are evidence of the survival of Gothic building techniques in the New World. Another contract dated 16 August 1649 indicates that he was also responsible for the construction of similar rib vaulting in Cuzco Cathedral, begun to plans by Francisco Becerra in 1582. There he built 17 vaults over the nave and aisles of the cathedral, leading to the piers of the choir, all of brick masonry. Other major works by Chávez y Arellano in Cuzco included the construction of the chapel (1652) of the Jesuit School next to the church of La Compañía on the Plaza

de Armas and the choir (1663) of the church of S Domingo, as well as private houses in the city of Cuzco. He also built the parish church (1663) in the nearby town of Paucartambo.

UNPUBLISHED SOURCES

Cuzco, U. N. S Antonio Abad [documents relating to the career of Chávez y Arellano]

BIBLIOGRAPHY

H. E. Wethey: *Colonial Architecture and Sculpture in Peru* (Cambridge, MA, 1949, 2/1969), p. vi

J. Cornejo Bouroncle: *Derroteros de arte cuzqueño* (Cuzco, 1960), pp. 47–50, 63–4, 74, 152–7, 197–201, 203

HUMBERTO RODRÍGUEZ-CAMILLONI

Chile, Republic of. South American country. It is in the south-west of the continent, bordered to the north by Peru, to the north-east by Bolivia and to the east by Argentina. The country occupies a narrow strip of land running for 4200 km from north to south, with an area of 756,947 sq. km (see fig. 1). Further territory includes Easter island, the Juan Fernandez Islands, various other Pacific islands and an area of the Pacific known as the Mar Chileno. The country is physically distinguished by the Andes Mountains and by coastal mountain ranges, a central valley and coastal plains. The climate is predominantly temperate, except in the extreme south, which is cold, and the extreme north, which has a hot desert climate. The population of 12 million is mostly mestizo (of mixed race), although in the late 20th century *c.* 5% were Native Americans, principally Mapuche from the southern region of Arauco; it is also mostly urban, based predominantly in and around VALPARAÍSO and the capital and largest city, SANTIAGO, which has a population of over 4 million. The northern and southern extremes of Chile are almost uninhabited. Spanish settlers began to arrive in the 16th century, and subsequently the colonized region was integrated into the Viceroyalty of Peru. Independence was eventually achieved in 1818.

I. Introduction. II. Architecture. III. Painting, graphic arts and sculpture. IV. Gold, silver and jewellery. V. Textiles. VI. Ceramics. VII. Patronage, museums and art libraries. VIII. Art education.

I. Introduction.

The first Spanish exploration of the present north-central and central areas of Chile was made in 1535 by Diego de Almagro, but his advance south was halted by the tenacious resistance of the tribes of Mapuche Indians. Several settlements, including Santiago, were made in 1541 by Pedro de Valdivia, who was killed by the Mapuche at Tucapel (1553); another governor, Martín de Loyola, was killed at Curalaba in 1598. Although dogged by continuing Native American resistance (resulting in Spanish recognition of the 'state' of Arauco as an independently organized entity), the Spanish established the colony as part of the Viceroyalty of Peru and imported their own styles of art and architecture, although most of the latter was destroyed in earthquakes in the 17th and 18th centuries. The Spanish also founded the first university in Chile, the Universidad de S Felipe, in Santiago, in 1747. Eventually the Creole population declared autonomy from Spain in 1810; Spanish military opposition was finally defeated under Bernardo O'Higgins and José de San Martín, and independence was

proclaimed in 1818 under the leadership of O'Higgins. Centralized government by wealthy conservative merchants and landowners followed, and a constitution was established in 1833, lasting until 1925.

After independence, Chile entered a phase of greater development, becoming involved in international commerce. Valparaíso became an entrepôt port for the South Pacific, and many British and French trading companies set up there, forming extensive networks with other ports in Chile, Peru and Central America. Settlers arrived from Europe, and together with 'reporter-artists' they helped introduce new artistic styles such as Neo-classicism and Romanticism. A Biblioteca Nacional and an Instituto Nacional were established in Santiago (both 1813), and the Universidad de Chile, Santiago, inaugurated in 1843 and directed by Andrés Bello, became a strong force in the cultural life of the country, together with its Academia de Pintura (founded 1849) and architectural department. The young republic made gradual but sustained advances towards the extremes of the territory. The southern region of Arauco was finally occupied when the Mapuche tribes were defeated in 1881, and after Chile's victory in the War of the Pacific (1879–83) against Peru and Bolivia the new northern territories of Antofagasta and Tarapacá were incorporated. A period of prosperity followed, during which the rich nitrate deposits in the northern deserts were exploited.

In 1925 a new constitution, providing a popularly elected president and the separation of Church and State, was established by Arturo Alessandri. The period of democratic rule that followed, lasting until 1973, was unprecedented in the political life of Latin America. Manufacturing industry developed faster following the creation in 1939 of the Corporación de Fomento de la Producción, which initiated a vast plan for the industrialization of the whole country. There was a corresponding cultural renaissance during this period, with strong interest in French art.

Inflation dogged Chilean governments for most of the 20th century, together with problems of dependency on the USA (which owned most of the copper mines) and unequal land distribution. Attempts to remedy the latter two situations in the 1960s met with much opposition. In 1970, socialist Salvador Allende became president of Chile, elected by a group of moderate and leftist parties; he was replaced in 1973 by the military régime of Augusto Pinochet, which succeeded in reducing inflation but was widely accused of human rights violations. When Pinochet fell from power in 1990, hopes were raised for a less oppressive form of government.

BIBLIOGRAPHY

E. Pereira: *Historia del arte en el reino de Chile* (Buenos Aires, 1965)

A. Romera: *Historia de la pintura chilena* (Santiago, 1980)

D. Bayón and M. Marx: *A History of South American Colonial Art and Architecture* (New York, 1989)

JORGE ORTIZ ÁVILA, ARMANDO DE RAMÓN

II. Architecture.

1. Before *c.* 1780. 2. Neo-classicism, *c.* 1780–*c.* 1855. 3. Further European influences, *c.* 1855–*c.* 1925. 4. After *c.* 1925.

1. BEFORE *c.* 1780. At the time of the Spanish arrival in Chile (1535), indigenous peoples in the northern desert

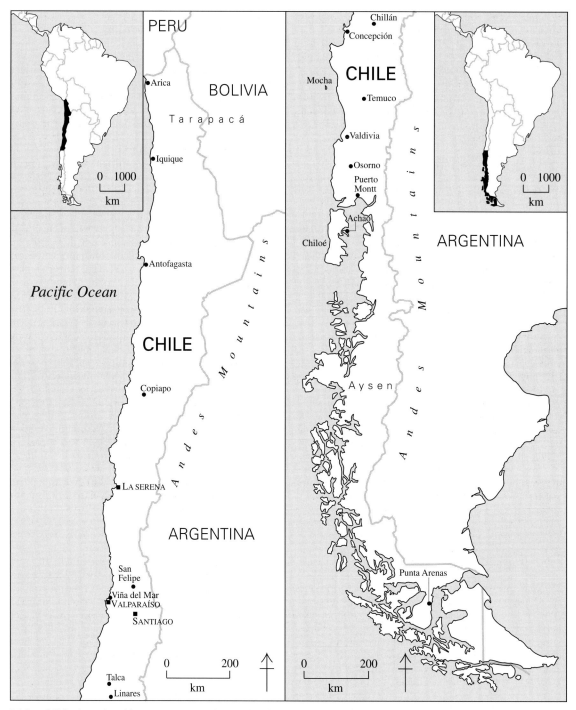

1. Map of Chile; those sites with separate entries in this encyclopedia are distinguished by CROSS-REFERENCE TYPE

had developed an architecture of rough stone with roofs of cactus fibres; these buildings, used for dwellings and storage, were defensively grouped in hill villages known as *pukaras*. Further south, in the Valle Central, some tribes built their dwellings to a simple rectangular plan of one or two rooms with vertical walls of *quincha* (wattle and daub), a plant-fibre roof and earth floor; their villages were called

ayllus. When Pedro de Valdivia founded Santiago (Santiago del Nuevo Extremo) in 1541 on the Río Mapocho at the northern end of the Valle Central, in Chile's heartland, the first buildings followed indigenous models with *quincha* walls and thatched roofs. The settlement was destroyed by the Native American Indians in 1542, when most of the conquistadors had moved southward to Arauco, but

rebuilding in more permanent materials soon followed. Valparaíso, the port for Santiago, and La Serena to the north were both founded in 1544; Concepción (1550), Valdivia (1552), Osorno (1558) and others were founded in quick succession at the fertile southern end of the Valle Central in support of Valdivia's policy of developing a temperate-climate agriculture. The first mendicant orders (Franciscan, Mercedarian and Dominican) arrived in the 1550s and began to establish their monasteries and churches; the Jesuits and Augustinians followed in the 1590s.

In 1552 an adobe church with a triumphal arch entrance in stone set in lime mortar was built by Bartolomé Flores. As a pro-cathedral it was poorly constructed, and a new one was commissioned by the governor in 1561. The church and monastery of S Francisco was begun in 1572, dedicated in 1597 and completed in 1618 (part of the monastery, including the refectory, was demolished to make way for urban development in 1923). The massively built stone church, on a Latin-cross plan, had a single nave; the roof was supported on timber beams carried on triple corbelled timber brackets or hammerbeams with Renaissance profiles—unique in America—made by the master carpenter Mateo de Lepe.

Burnt clay tiles were developed for protection against incendiary arrows and were used increasingly as the city grew. Progress was hindered, however, by the cost of the continuing war with the Mapuche Indians. Notable among the adobe and tile houses of this early period were those of Francisco de Aguirre and Alonso Escobar. As elsewhere in Latin America, architectural interest in Chile was in splendid street portals, their pediments carrying family escutcheons where appropriate. Nothing remains of these buildings, however, or of the foundation establishments of the mendicant orders, most of which were demolished in a major earthquake in 1647. The church of S Francisco survived, however, saved by its massive construction, and enough of the cathedral remained to enable rebuilding to start at once; it was restored to use by the middle of the century. Seismic resistance became a vital consideration in subsequent building design, with, for example, the windows of houses being carefully spaced to avoid weakening the walls.

The 17th-century Jesuit church of La Compañía, Santiago, was destroyed in 1647, but rebuilding started in 1670 under the direction of the Jesuit brothers Francisco Ferreyra and Gonzalo Ferreyra, who studied Jesuit buildings in Lima, an influential example for Chilean architecture at this time. The new church proved to be sufficiently well built to withstand another major earthquake in 1730, which again flattened Chilean cities. Its twin towers had to be demolished in 1751, however, and were replaced with a single central tower. During the contingent renovation the building took on a Bavarian character under the hands of an active group of Bavarian Jesuits, artists and craftsmen, whose first members arrived in 1723 and included the sculptor–architect Fray Juan Bieterich. La Compañía is now known only from engravings and early photographs taken in the 1860s, as it was demolished following fires in 1841 and 1863.

The Bavarian group became known as the Calera de Tango school (taking the name from the hacienda near Santiago in which they worked); they were led by Fray Carlos Haymhaussen, who arrived in Chile in 1748, and they continued until the expulsion of the Jesuits in 1767. Bavarian influence in architecture was less widespread than that of Liman Baroque, however, judging from the drawings (preserved in the Archivo General de Indias, Seville) of buildings no longer extant, such as the cathedral (1744) at Concepción, with its squat twin towers and characteristic cupolas, or the Carmelite convent of La Cañadilla, Santiago, founded by Luis Manuel de Zañartu in 1773. In the valleys of the north, however, more important influences came from other regions. The church of S Pedro, Atacama, for example, with its long narrow nave, polygonal apse and cruciform chapels (typical of many northern churches), is reminiscent of the Bolivian churches around Lake Titicaca; portals of churches such as those at Chiapa and Mocha show in their planar decoration the hands of the Baroque master masons of Collao. In the southern regions an abundance of timber encouraged the creation of a different style of architecture. The simple Jesuit timber churches on the island of Chiloé and in neighbouring areas are typical 18th-century examples, some of which indicate Bavarian involvement. The church at Achao (1730–50) is perhaps the best known: it has a rare five-lobed timber vault, longitudinally boarded, with carved timber ribs outlining mock vault intersections.

The church of S Francisco, Santiago, survived another earthquake in 1730, although the tower, damaged in 1647, had to be replaced in 1756. The Dominicans, whose earlier churches in Santiago were destroyed, began a complete reconstruction, which they entrusted to the Portuguese master mason Juan de los Santos Vasconcellos, and this became the basilican church of S Domingo (1747–71; towers modified in early 19th-century repairs). A heavy structure with massively buttressed walls, its sober but dignified façade anticipates the arrival of Neo-classicism, although there is a suggestion of Bavarian Baroque influence in the convex profiles of the cupolas to the towers. Various examples of larger 18th-century urban houses also survive in Santiago, including that built for the Condes de la Conquista, known as the Casa Colorada, and the Posada de Corregidor (1750): both have characteristic Baroque stone portals wide enough to admit carriages into the first patio, their pediments sheltered by overhanging double-pitched tile roofs. The Posada del Corregidor is partly two-storey and has an overhanging timber balcony with latticed balustrades.

2. NEO-CLASSICISM, *c.* 1780–*c.* 1855. From his arrival in 1778, JOAQUÍN TOESCA Y RICCI, sent by Charles III to work on the cathedral of Santiago, was a dominant figure in Chilean architecture. Although again rebuilt after 1730, the cathedral had been burnt down in 1769; using the same foundations, Toesca worked on it from 1780 until his death in 1799. Photographs of 1886 show elevations with vestiges of late Baroque in a fine Neo-classical composition, subsequently obscured in alterations in the late 19th century. Toesca's most distinguished work, however, is the Real Casa de Moneda (see fig. 2), a large government building mainly of two storeys built around a number of courtyards. Often said to be the finest Neo-classical building in Latin America, its manner is creatively

2. Joaquín Toesca y Ricci: Real Casa de Moneda, Santiago, late 18th century

suited to local materials and conditions. The coupled columns of the giant order applied to the three-storey entrance pavilion, the massively scaled classical balustrade and the recessed wall planes in which the windows are set are especially notable features. Toesca also rebuilt the severely damaged church of La Merced (completed 1795), the Hospital de S Juan de Dios (1797–1801; destr.), new river-walls for the Mapocho and a number of local parish churches. His legacy also includes notable Neo-classical works by his collaborators and pupils: for example the Real Audiencia (1804–7) by Juan José de Goicoles y Zañartu and the Real Aduana (1805–7) by Miguel María Atero.

During his brief period as president (1818–22) immediately after independence, Bernardo O'Higgins effected major urban changes in Santiago; he himself planned the city's principal avenue, La Alameda de las Delicias, and he also created numerous squares and ordered the construction of the Real Canal de San Carlos de Maypu to irrigate land to the south of the city. In the early years of independence the style established by Toesca and his disciples was continued by such architects as Juan Herbage, who worked on the cathedrals at Concepción and La Serena (inaugurated *c.* 1830), and Francisco Reclus, a Frenchman who arrived in Chile *c.* 1828 and built the Portal de Sierrabella (1830; destr.), which occupied the entire south side of the Plaza de Armas, Santiago.

Another French architect, Claude François Brunet-Debaines (1788–1855), from Vannes in Brittany, was appointed as the first *arquitecto de gobierno* in 1845 and

commissioned to build the Congreso Nacional in Santiago, but his most widely recognized work, also in Santiago, is the Teatro Municipal (1853; altered). The theatre was built on part of the site of the former Universidad de S Felipe, and although renovated following several fires over the years, it remains in use. The fly-tower is concealed within a two-storey lateral façade on Calle S Antonio, to harmonize with the adjacent convent of S Augustín. The sober French Neo-classical façade has a first-floor gallery to the street with a balustraded Ionic order. Brunet-Debaines carried out many other projects in Santiago, including the Iglesia de la Veracruz (1852), the interiors of the Casa de Moneda (which he equipped for use as the Palacio Presidencial) and residences commissioned by a growing local plutocracy. His restrained Neo-classical style to a large extent established the character of the central area of mid-19th-century Santiago. In addition, the Clase de Arquitectura that he set up in 1850, although it ran only irregularly, produced such architects as FERMÍN VIVACETA RUPIO, to whom Brunet-Debaines assigned the completion of his outstanding works before his death.

3. FURTHER EUROPEAN INFLUENCES, *c.* 1855–*c.* 1925. Following the death of Brunet-Debaines, another Frenchman, Lucien Ambrose Hénault (1790–1880), was appointed *arquitecto de gobierno*. Hénault took up his post in 1857 and was commissioned to design the Universidad de Chile (1863). The plan is bold and simple, based around two patios with the Salón de Honor between them. The mainly two-storey façade differs from earlier Neo-classical

architecture in Chile in being more horizontal in feeling, with a cornice dividing the storeys and three Italianate doorways. Hénault also continued the work begun by Brunet-Debaines on the Congreso Nacional as well as building numerous residences. Among the latter are the Palacio Pereira (1872) and the Palacio Edwards (1872; destr.), a notable urban residence built around a central patio. He returned to Europe in 1872, and again Vivaceta completed the unfinished works.

In addition to those given official appointments, other European architects were also attracted to Chile and executed important works there in the late 19th century. An Italian, Eusebio Chelli (*d* 1890), was the most notable of these, introducing a more robust academic classicism into Chilean architecture in the Iglesia de la Recoleta Domínica (1853), where the traditional portal was replaced by a classical portico. Similar buildings by Chelli include the churches of S Augustín (1857), S Ignacio (1867–72) and the Preciosa Sangre (1875) and the Palacio Errázuriz (1872; now the Brazilian Embassy), all in Santiago. His influence can also be seen in the continuation of the work on the Congreso Nacional (completed 1883) by Hénault and Vivaceta, especially in the overscaled hexastyle Corinthian portico. Another Italian, Eduardo Provasoli, was renowned for his refined interiors, examples of which are in the vigorously classical church of the Divina Providencia (1881–5) and the Palacio Rivas (*c.* 1890; destr.), both in Santiago. Among French migrant architects, Paul Lathoud (*b* 1818) was responsible for the Palacio Cousiño (1871), the Palacio Arrieta (destr.) and the Palacio para la Exposición Internacional (1875; now the Museo de Historia Natural) in Santiago, and Victor Villeneuve built the Escuela Militar (1878), also in Santiago, in a neo-Baroque style characteristic of the Second Empire in France. Elements of this style are also evident in the renovation after a fire in 1870 of the Teatro Nacional, on which Lathoud and Chelli collaborated with Hénault. French influence is also evident in the major urban development of Santiago in the 1870s under the direction of Benjamín Vicuña Mackenna, who adopted the principles followed by Georges-Eugène Haussmann in Paris. In 1872, a Chilean, Manuel Aldunate Avaria, who had built the highly eclectic Palacio de la Alhambra (1862), Santiago, for an affluent mining family, was appointed *arquitecto de gobierno* in succession to Hénault. He revived the Clase de Arquitectura, and this led in 1894 to the establishment of a Corso de Arquitectura in the Universidad Católica de Chile (founded 1888). Chilean eclecticism, however, reached its apotheosis in the work of Teodoro Burchard, a versatile German who arrived in Valparaíso in 1855. His Palacio Díaz Gana (1876; destr.), Santiago, was a *Mudéjar* extravaganza with Moghul *chatrīs* and quasi-minarets; he also built the brick Gothic Revival Basilica del Salvador (1870–90), Santiago.

The War of the Pacific established Chilean control of the nitrate deposits in the northern deserts, and this was followed by the initiation of a programme of public works during the presidency of José Manuel Balmaceda (1886–91). Again, architects were invited from France. Eugène Joannon, who continued Chelli's vigorous classical style, was also responsible for the first building in Chile with a steel frame, the Edificio Commercial Edwards (1892) in

Santiago, and he also experimented with reinforced concrete in the floor slabs of the building he designed (1898) for the Petites Soeurs des Pauvres, also in Santiago. Emile Jecquier designed a number of large buildings in the capital, including new facilities for the Universidad Católica (1907–17) and the Palacio de Bellas Artes (1910). The latter boasts an elliptical glazed roof-vault supported on long-span latticed steel arches with a public gallery at the springing line. Emile Doyère's Tribunales de Justicia (1907; with Jecquier) has a two-storey glass-covered public arcade and is an early example of Art Nouveau in Chile, a trend continued in the work of the Chilean architects Alberto Cruz Montt (*b* 1874) and Ricardo Larraín Bravo (1879–1945) in Santiago and Valparaíso. In Chile, Art Nouveau continued well into the 1920s, often enhanced with indigenous motifs in the decorative elements.

4. AFTER *c.* 1925. The influence of the European Modern Movement was first apparent in Chile in the work of SERGIO LARRAÍN GARCÍA-MORENO, who had visited Europe in the early 1920s. His Edificio Oberpaur (1929) is a six-storey commercial building on a corner site in Santiago; continuous banded windows sweep around the angle and suggest the influence in particular of Erich Mendelsohn's much larger Schocken department store in Stuttgart, completed three years earlier. There were also a number of other parallel developments during the 1920s and 1930s, including a productive Neo-colonial nostalgia, derived more from Californian than Chilean models; Art Deco was popular—suburban developments to the north of Santiago in that style remain—and even Sergio Larraín designed buildings that combined a stripped-down classical framework with typical streamline Art Deco characteristics into the 1930s (e.g. the Edificio S Lucia, Santiago, 1932; with Jorge Arteaga). By the mid-1930s, however, Rationalism was being established by a school of Chilean architects who had studied abroad: it included Rodulfo Oyarzún and Roberto Dávila Carson, as well as Larraín, Héctor Mardones and JUAN MARTÍNEZ GUTIÉRREZ, whose Facultad de Derecho (1936–8), Universidad de Chile, Santiago, combines curving façades with unadorned profiles.

A devastating earthquake in the central region of Chile in 1939 caused much loss of life and, combined with the economic privations of World War II, inhibited architectural development until the post-war period. Emilio Duhart Harosteguy, who returned to Chile in 1943 after postgraduate studies at Harvard under Walter Gropius, designed the two-storey terraces on the Avenida Pocura and the Casa Marta de Duhart on the Avenida Vaticano (1946), both Santiago: both suggest Bauhaus origins modified by local conditions. Duhart joined Larraín, Mario Pérez de Arce and Alberto Piwonka in the winning entry of a national competition (1947) for the Colegio del Verbo Divino, a functional two- and three-storey white building in the International Style. The collaboration was continued until 1952, when Duhart went to Paris to work with Le Corbusier. Martínez Gutiérrez was an early exponent of exposed concrete on both exteriors and interiors, for example in the Escuela de Medicina (1951) for the Universidad de Chile, Santiago. Precisely contemporary is Fernando Castillo Velasco (*b* 1918), who formed a part-

nership in 1942 with Héctor Valdés Phillips and Carlos García Huidobro. They were joined by Carlos Bresciani in 1953 to form a partnership that became synonymous with major housing developments of the 1950s and 1960s, such as the mixed medium- and low-rise scheme (1954–60) in the Portales neighbourhood of Santiago, an imaginative spatial solution using elevated walkways with a Brutalist air conveyed by the use of exposed board-concrete.

Theoretical developments and design trends in Europe after the late style of Le Corbusier were accented in two important buildings in the 1960s: the church (1964) of the Benedictine monastery at Las Condes, near Santiago, by the architect–clerics Gabriel Guarda and Martín Correa; and Duhart's headquarters (1966) for the Comisión Económica para América Latina (CEPAL), a United Nations agency, on the Mapocho at Vitacura, again near Santiago. Both are highly original buildings in *béton brut*, but whereas the intersecting cubes of the former, whitewashed inside and out, refer to North American formalism, the latter (see fig. 3) is neo-Expressionist in character and unerringly related to its cultural background and spectacular location. Also important in this context of changing theoretical values was the foundation of the Ciudad Abierta at Ritoque, near Viña del Mar, a decade after the formation in 1952 of a group of architects at the Universidad Católica de Valparaíso, who sought to promote the merging of professional and practical aspects of training in urban planning and architecture.

After a major earthquake in 1971, a number of notable buildings were built, such as the Torres de Miramar (1973–5) at Viña del Mar by Sergio Larraín, Jorge Swinburn and Ignacio Covarrubias. The political and economic upheavals of the 1970s, however, from Communism under Salvador Allende to authoritarian military government under Augusto Pinochet, impeded significant develop-

ment. Architectural discussion was nevertheless stimulated in the 1970s by the foundation in 1976 of the Centro de Estudios de la Arquitectura (CEDLA) and the inauguration in 1977 of a Bienale de Arquitectura, as well as through the foundation of a number of architectural journals. As a result, much subsequent architecture is characterized by contextualism and a cultural, historical attitude to design. Pedro Murtinho Larraín (*b* 1933), closely associated with the foundation of CEDLA, designed the Conjunto Plaza Lyon (1982) on a corner site in Santiago. It has a turret boldly projected ten storeys above the angle of the wings of the building, which themselves enclose a circular plaza. Other works by Murtinho, including his Fundación Mi Casa (1986), display an entirely original Post-modernism closely linked to its context. Other notable works produced in the 1980s included the Casa Peña (1980) by Miguel Eyquem, the Edificio Fundación (1982) by Cristián Boza with Jorge Luhrs and José Muzard, and the Torre S Ramón (1986), Santiago, by Hernan Flaño, Max Núñez and José Tuca. All these architects worked within the context of an appropriate urban typology. Cristián Valdés (*b* 1932) is one of the leading exponents of the Valparaíso school, developing, in such works as the Casa García Huidobro (1983), Santo Domingo, a geometric, constructive style that began to evolve in the early 1970s. The work of Cristián de Groote (*b* 1931) reflects all these trends, displaying in the contextual brilliance of the Casa Edwards (1980) and the elegant purism of the Casa Fuenzalinda (1982), both near Santiago, a constructional realism and an aesthetic purity that blends a Post-modern historical and formal context with an abstraction that comes close to that of Luis Barragán.

BIBLIOGRAPHY
R. Dávila: *Apuntes sobre arquitectura colonial chilena: La portada colonial* (Santiago, 1927)

3. Emilio Duhart Harosteguy: headquarters of the Comisión Económica para América Latina (CEPAL), Vitacura, near Santiago, 1966

D. Angulo Iñiguez, E. Marco Dorta and M. J. Buschiazzo: *Historia del arte hispano-americano* (Barcelona, 1945–56), iii, pp. 583–608

A. Benavides Rodríguez: 'The Art of Chile: Architecture in the Colonial Period', *The Studio*, cxxxix (1950), pp. 134–50

E. Secchi: *La casa chilena hasta el siglo XIX* (Santiago, 1952)

F. A. Plattner: *Deutsche Meister des Barock in Südamerika* (Freiburg im Breisgau, 1960)

J. Borchers: *Institución arquitectónica* (Santiago, 1968)

G. Garda: *La ciudad chilena del siglo XVII* (Buenos Aires, 1968)

J. R. Morales: *Arquitectónica*, 2 vols (Santiago, 1968)

F. Bullrich: *New Directions in Latin American Architecture* (London, 1969)

M. Palmer: *50 años de arquitectura metálica en Chile, 1920–1970* (Santiago, 1971)

E. Marco Dorta: *Arte en América y Filipinas*, A. Hisp., xxi (1973), pp. 296–300

S. Pirotte: *Palacio de la Moneda* (Santiago, 1974)

Guía de la arquitectura en Santiago (Santiago, 1976)

R. Martínez Lemoine: *El modelo clásico de la ciudad colonial hispanoamericana* (Santiago, 1977)

G. Guarda: *Historia del urbanismo en el reino de Chile* (Santiago, 1978)

R. A. Méndez Brignardello: 'Chile', *International Handbook of Contemporary Developments in Architecture*, ed. W. Sanderson (Westport, 1981), pp. 211–26

——: *La construcción de la arquitectura: Chile, 1500–1970* (Santiago, 1983)

E. Brown: *Otra arquitectura en América Latina* (Mexico City, 1988)

L. Castedo: *Historia del arte ibero-americano*, 2 vols (Madrid, 1988), ii, pp. 39–43, 224–30

E. Brown: *Casas y escritos* (Santiago, 1989)

H. Eliash and M. Moreno: *Arquitectura y modernidad en Chile, 1925–1965* (Santiago, 1989)

C. Fernández Cox: *Arquitectura y modernidad apropiada* (Santiago, 1990)

C. Ferrari: 'Arquitectura neocolonial en Chile (1915–1945)', *Arquitectura neocolonial: América Latina, Caribe, Estados Unidos*, ed. A. Amaral (São Paulo, 1994), pp. 165–78

F. J. Pezarro Gómez: 'Arquitectura colonial chilena', *Arquitectura colonial iberoamericana*, ed. G. Gasparini (Caracas, 1997), pp. 443–62

R. Gutiérrez, ed.: *Barroco iberoamericano* (Barcelona and Madrid, 1997)

E. Pereira Salas: *La arquitectura chilena en el siglo XIX* (Santiago, n.d.)

RAMÓN ALFONSO MÉNDEZ

III. Painting, graphic arts and sculpture.

1. The colonial period, before 1818. 2. Early developments after independence, 1818–1910. 3. Modernist influences, 1910–60. 4. After 1960.

1. THE COLONIAL PERIOD, BEFORE 1818. During the three centuries of Spanish colonial rule, art in Chile, as in much of Latin America, was largely dependent on European models. The increasing influences of local Indian and mestizo artists, however, resulted in the late colonial period in an identifiable style, sometimes called 'viceregal' or 'mestizo' art. The immediate and direct primary sources of colonial art came from Europe—particularly Spain, Italy, the Netherlands, Portugal and Germany—and took the form of imported paintings and prints or works produced by artists who settled in the New World. European engravings, drawings and paintings by established artists often entered South America as illustrations in the many devotional books produced from the mid-16th century in response to the successful development of printing, especially in Antwerp. Philip II, King of Spain, granted the monopoly of the sale of religious books there to the Plantin Moretus press of Antwerp; they were illustrated by such draughtsmen as Marten de Vos and such engravers as Hieronymous Cock and the Wierix brothers. These were prominent among the sources used by artists working in Chile, who reinterpreted the originals in their own way while respecting the standard Christian iconography so zealously guarded by the church authorities.

Imported works and original engravings were rare, however, and it seems likely that the few artists active in Chile during the colonial period worked from Latin American copies of engravings or paintings, produced in the artistic centres of Cuzco and Quito, whose workshops produced a large part of the colonial art still extant in convents and churches in the country. It is nevertheless technically possible to speak of a local school of artistic production, however modest; notarial documents of the time allude to commissions of works.

The essential function of colonial art was religious. Carved and painted images were a visual means of teaching Christian doctrine and values through the iconography of the Roman Catholic faith, with the objective of converting native communities. The new faith introduced by missionaries required sculptors and painters to decorate places of worship with illustrations of the Christian message. As evangelization spread, particular techniques and iconographic models were taught to the native population, undergoing modification in the process.

Sculpture in Chile during the colonial period was characteristically produced as a collaborative work, carved from wood and polychromed by a colourist and dressed by an embroiderer (e.g. the *May Christ* by Pedro de Figueroa, 1640; Santiago, S Agustín). The size of the sculpture generally depended on whether it was intended for a church or for private devotional use, and figures were also made specially for public processions that took place as part of religious festivals.

As part of its mission to describe, explain and instruct, colonial painting typically represented the symbols of the Christian faith or the dangers to which humanity was subject when departing from the path to eternal salvation. An important example is the largest and best-preserved group of paintings of this period, describing the *Life of St Francis of Assisi* (1668–84; Santiago, Mus. A. Colon. S Francisco). These were probably executed in Cuzco by a group of painters that included Basilio Santa Cruz, Juan Zapaca Inga and Pedro Lozano. Colonial painters arranged scenes hierarchically, in that the figures were positioned according to their identity and function within the scheme of the Creation. The need to relay a clear narrative encouraged artists to divide the picture into separate spaces, clearly distinguished from each other in size and imagery, each representing a different moment in a sequence of events. In this sense they largely dispensed with the homogeneous concept of space developed in the Renaissance and in particular with one-point perspective. This spatial logic was deeply rooted in the colonial painters, who represented the world primarily in symbolic rather than rational terms.

2. EARLY DEVELOPMENTS AFTER INDEPENDENCE, 1818–1910. In the period immediately after independence the old craft workshops disappeared as the church ceased to be the chief patron of the arts. A gradual process of secularization began, influenced by the American Enlightenment. As art acquired new function and orientation the influence of foreign artists who had settled in Chile was fundamental. The arrival from Peru of JOSÉ GIL DE CASTRO during the military campaign that led to independence in Chile marked the beginning of the

4. José Gil de Castro: *Isabel Rodríguez Riquelme*, oil on canvas, early 19th century (Santiago, Museo Historico Nacional de Chile)

transition from the colonial to the early modern period. Although de Castro's techniques were derived from colonial tradition, he treated new subject-matter, most notably in his portraits of important figures in the country's political, military and social life, such as Isabel Rodríguez Riquelme, the mother of Bernardo O'Higgins (see fig. 4). These helped to establish the country's national identity in the public consciousness. The arrival of such European

artists as Charles Wood (1793–1856), an English sailor with artistic talent who reached the country in 1819, the German Romantic painter Johann Moritz Rugendas (*see* RUGENDAS, (2)), who settled in Chile in 1834, and the French artists Ernest Charton de Tréville (1818–78) and the Neo-classical painter Raymond Monvoisin (1809–70) helped introduce new artistic styles. In addition, a group of European visitors of various nationalities who recorded the geography and customs of the inhabitants in sketches helped to disseminate these new European influences.

The links with France were extended and consolidated by the foundation in 1849 of the Academia de Pintura, which was modelled on the Académie Française. The Chilean government also appointed European artists to direct this institution, and the successive appointments of the Italian Alessandro Cicarelli (1811–79), the German Ernst Kirchbach (1832–80) and the Italian Giovanni Mochi (1831–92) took the academy to the end of the century. When the sculpture section was created, another Frenchman, Auguste François (*fl* 1859–71), was appointed. The strict academic precepts that marked the academy's tuition provoked strong dissension among students who wanted more freedom. Those who opted at the end of the century for the abolition of academic standards did not, however, make a complete break but introduced modifications of technique and theme into academic models: the rigidity of mythology, history and portraiture was relaxed by the introduction of landscape as subject-matter. This helped to liberate the work of a group of artists that included PEDRO LIRA, JUAN FRANCISCO GONZÁLEZ, Alberto Orrego (1853–1933), ALFREDO HELSBY and Alberto Valenzuela (1869–1925); Valenzuela's *Flowering Apple Trees* (1901; Santiago, Mus. N. B.A., see fig. 5) is a good example of this liberation.

Sculpture remained far more fixed in the Neo-classical tradition, as in the work of Nicanor Plaza (1844–1918), Virginio Arias (1855–1941) and REBECA MATTE, who immortalized in bronze the heroic personalities and events of the War of the Pacific. Other formally classical works

5. Alberto Valenzuela: *Flowering Apple Trees*, oil on canvas, 900×2000 mm, 1901 (Santiago, Museo Nacional de Bellas Artes)

included those of Simón González (1856–1919), Carlos Lagarrigue (1858–1927), José Miguel Blanco (1839–97) and Ernesto Concha (1874–1911).

3. MODERNIST INFLUENCES, 1910–60. An important landmark in the history of painting and sculpture in Chile was the Exposición Internacional of 1910, organized to celebrate the centenary of Chilean independence and held in a building that is now the principal museum of the country, the Museo Nacional de Bellas Artes in Santiago; the works exhibited were mainly by officially supported academic artists. The significance of the exhibition was stressed in the preface to the catalogue by the Frenchman Richard Richon-Brunet (1866–1946), professor at the Academia de Pintura. He began by ignoring the art of the 16th, 17th and 18th centuries, declaring that Chilean art began in the middle of the 19th century. He went on to celebrate the importance of Monvoisin's arrival for the artistic aspirations of the country and the creation of the Academia de Pintura. Despite his enthusiastic apologia for the academic art of Europe, Richon-Brunet argued that painting in Chile did not merely passively assimilate well-worn formulae, and it is significant that the works presented for exhibition by Juan Francisco González were rejected by the organizing committee.

The first symptoms of a break with academic tradition appeared with a group of young painters trained in the Academia by the Spanish artist Fernando Alvarez de Sotomayor (1875–1960), known as the Generación del Trece from the date of their first collective exhibition (1913). They included Agustín Abarca (1882–1953), Alfredo Lobos (1890–1917), Exequiel Plaza (1892–1947), Enrique Bertrix (1895–1915), Jerónimo Costa (1895–1967), ARTURO GORDON and Pedro Luna (1896–1956). These mostly middle-class painters took landscapes and the daily life of humble people as their main subject-matter. From Alvarez de Sotomayor they learnt to convey the luminosity of the Impressionists' work. At the same time they were also influenced by the work and independent attitude of González. The Generación del Trece constituted an important development from the officially sanctioned painting, which nevertheless continued to be produced in the well-polished style upheld by academic training and accepted by the most Europeanized and cultured social groups.

In the 1920s the Grupo Montparnasse, which included Luis Vargas (1897–1976), Manuel Ortiz de Zárate (1887–1946), Henriette Petit (1894–1982) and CAMILO MORI, accentuated the break with naturalism and the late arrival of modernism through their study of the work of Paul Cézanne. Their intellectual approach towards the essentials of painting opened the way for abstract art in Chile. Polemic and controversy reached a climax at the end of the 1920s. Some progressive artists presented their work in the Salón Oficial of 1928, provoking angry protests at their alleged abuse of a long academic tradition. The controversy was ended by the closure of the Academia de Bellas Artes by the Ministerio de Educación and the decision to send some 30 artists to Europe on scholarships to continue their artistic training. A key figure of these years was PABLO BURCHARD, an outstanding teacher of several generations of Chilean artists, whose modernist work showed no trace of the conflicts then raging. His pupils included Carlos Pedraza (b 1913), Sergio Montecino (b 1916), Ximena Cristi (b 1920) and Renaldo Villaseñor (b 1925), all of whom extended techniques derived from Impressionism and Fauvism.

A group of abstract artists, the Grupo Rectángulo, was formed in 1955. Led by Ramón Vergara (b 1923) and including Gustavo Poblete (b 1915), Waldo Vila (1894–1979), Matilde Pérez (b 1920), Elsa Bolívar (b 1930) and James Smith (b 1925), they were the first artists in Chile systematically to promote Constructivism and geometric abstraction; among their Latin American forerunners were the Uruguayan Joaquín Torres García and the Argentine Emilio Pettoruti. The position of the Grupo Rectángulo was seriously called into question in 1960 because of the dominance at that time of *Art informel*, which in its emphasis on paint textures and on the expression of emotion was in open conflict with Constructivism.

4. AFTER 1960. The 1960s were a time of profound artistic change that coincided with a strong desire for political and social change. Many artists felt unable to continue using a language confined by the aesthetic limitations of pictures or sculptures and began to reflect on a connection between the language of art and the problems of historical reality in Chile and the rest of Latin America. Their artistic language was enlarged by the use of elements drawn from social reality, especially the life of the extremely poor. Artists such as Francisco Brugnoli (b 1935) and Hugo Marín (b 1930) were among those who developed an aesthetic of waste by using discarded objects as symbols of social destitution, thus making a break with fine art traditions. Members of the Grupo Signo, founded by Gracia Barrios (b 1929), JOSÉ BALMES, Eduardo M. Bonati (b 1930) and Alberto Pérez (b 1926), likewise linked the aesthetics of *Art informel* with the specific problems of Chile and Latin America.

A central feature of art in Chile in the 1960s was the critical attitude taken by artists not only towards the language of art but also towards the art market system, the role of art in society and its relationship with everyday life. While some artists sought to break free from traditional definitions of painting and sculpture, others set an important example by adapting those traditions to a new sense of purpose. ROBERTO MATTA, in spite of having left Chile for Europe in his youth, was the most distinguished of these artists, who also included NEMESIO ANTÚNEZ, Enrique Zañartu (b 1921), MARIO CARREÑO, RODOLFO OPAZO, MARIO TORAL and RICARDO YRARRÁZAVAL. Among the most influential sculptors were Lorenzo Domínguez (1901–62), SAMUEL ROMÁN, Lily Garafulic (b 1914) and MARTA COLVIN, with such works as her *Great Sign* (see fig. 6), and a new generation of sculptors taught by them at the Escuela de Bellas Artes of the Universidad de Chile in the 1950s; among their students were JUAN EGENAU and MARIO IRARRÁZABAL. Printmaking also underwent an important development in the 1960s through the creation of Taller 99 by Nemesio Antúnez, who had studied with S. W. Hayter in New York from 1948 to 1952. Such workshops had long been active in university art departments for training artists in particular techniques; for example Julio Palazuelos (b 1931) and

6. Marta Colvin: *Great Sign*, bronze, h. 2.2 m, 1968 (Paris, Musée de Sculpture en Plein Air)

Eduardo Garreaud (*b* 1942) taught at the Universidad de Chile in Santiago, and Jaime Cruz (*b* 1934), Eduardo Vilches (*b* 1932) and Pedro Millar (*b* 1930) at the Universidad Católica, also in Santiago.

During the 1970s artists continued to reject established artistic codes, but given the authoritarian political atmosphere that resulted from the military coup of 1973, many strategies were devised to conceal the critical and often subversive content of their work. Renouncing conventional materials and the very idea of the art object, artists became involved in other forms: for example, Carlos Leppe presented himself as the work of art; others, such as EUGENIO DITTBORN, turned their attention to the manipulation of space and of relationships among objects in temporary installations. A group called Colectivo Acciones de Arte (CADA) aimed to realize works of art in a collective form and to work outside art galleries, favouring open and public spaces; they used the city as the context of their performances in order to deprive urban signs of their restrictive meanings. In the early 1980s young artists in Chile responded to the international trends in figurative painting, in particular that emanating from Italy and Germany with a strong neo-expressionist current. While constrained by the lack of cultural growth in their country and lacking the certainty of purpose and ideology that had characterized Chilean artists in the preceding decades, they returned to a personal and subjective basis for art.

Separated from the mainstream of Chilean art, indigenous people such as the Mapuche meanwhile continued to produce various sculptural objects, including the *rehue* (sacred tree trunk) and carved posts that presided over ceremonial areas (*pampas de ngillatún*).

BIBLIOGRAPHY

A. R. Romera: *Historia de la pintura chilena* (Santiago, 1951; rev. 1980)
E. Pereira: *Historia del arte en el reino de Chile* (Buenos Aires, 1965)
J. González: *Arte colonial en Chile* (Santiago, 1978)
M. Ivelic: *La escultura chilena* (Santiago, 1979)
M. Ivelic and G. Galaz: *La pintura en Chile: Desde la colonia hasta 1981* (Santiago, 1981)
E. Pereira: *Historia de la pintura en Chile* (Santiago, 1981)
L. Mebold: *Catálogo de pintura colonial en Chile* (Santiago, 1985)
R. Nelly: *Margins and Institutions* (Melbourne, 1986)
M. Ivelic and G. Galaz: *Chile: Arte actual* (Santiago, 1988)
N. Richard: 'Neovanguardia y postvanguardia: El filo de la sospecha', *Modernidade: Vanguardas artísticas na América Latina*, ed. A. M. de Moraes Belluzo (São Paulo, 1990), pp. 185–99
Pintura chilena, i , Universidad de Concepción (Concepción, 1991)
Recovering Histories: Aspects of Contemporary Art in Chile since 1982/ Historias recuperadas: Aspectos del arte contemporáneo en Chile desde 1982 (exh. cat., New Brunswick, NJ, Rutgers U., Zimmerli A. Mus. and elsewhere, 1993)
I. Cruz de Amenabar: *Arte: Lo mejor en la historia de la pintura y escultura en Chile* (Santiago, *c.* 1995)
——: 'La pintura en Chile y en el virreinato del Rio de la Plata', *Pintura y escultura y artes útiles en Iberoamérica, 1500–1825*, ed. R. Gutiérrez (Madrid, 1995), pp. 177–88
M. Ivelic: 'Chile', *Latin American Art in the Twentieth Century*, ed. E. Sullivan (London, 1996), pp. 301–13

MILAN IVELIĆ

IV. Gold, silver and jewellery.

A guild of silversmiths was recorded in Santiago as early as in 1556, but it is likely that these craftsmen made only rudimentary objects. Important pieces, both ecclesiastical and domestic, were brought from the large workshops of Lima or Cuzco (*see* PERU, §V, 1) or from Spain. A rare example of elaborate silverware from this period, bearing a *quinto* (tax) stamp and probably made in Chile, is a helmet-shaped ewer (Santiago, Carlos Alberto Cruz priv. col.) excavated at Ercilla at the end of the 19th century. It can be dated to before 1599, the year in which the settlement at Ercilla was destroyed by the Araucan tribes.

Silver with definite Chilean characteristics dates only from the second half of the 18th century, although the absence of hallmarks or makers' marks makes it difficult to date pieces accurately. In 1755 Bavarian craftsmen were brought by Fray Carlos Haimbhausen to the Jesuit settlement at Calera de Tango. These workers taught the Spanish and mestizo silversmiths superior chasing and casting techniques, as well as introducing central European Rococo elements to Chilean silver. This is well illustrated by the magnificent silver antependia of the church of S Domingo, Santiago, and of Santiago Cathedral. A monstrance in the convent of S Francisco, Santiago, also made in the workshops at Calera de Tango, has a compact design and restrained decoration quite different from the more flamboyant and exotic Rococo decoration prevalent in Peru during this period.

After the expulsion of the Jesuits in 1767 and the dissolution of their workshop, silversmithing in Chile appears to have been confined to the production of utilitarian objects and horse trappings. A distinctly Chilean type of object from the end of the 18th century is the *mate* kettle in the form of a lion, known as a *pave de hornillo* ('kettle with oven'), which incorporates a chamber for hot coals. The source of the design is probably a Portuguese print published in 1751 depicting a monster, half lion and half dragon, that features in Chilean folklore. The distinctive Chilean silver spur, known as a 'Nazarene' because of its long, spiked rowels reminiscent of Christ's Crown of Thorns, was produced in large quantities during the 19th

century. In the 20th century the Araucan native peoples continued their tradition of making elaborate silver jewellery, often incorporating Spanish or Republican coins, and the distinctive *topo* (cloak pin).

BIBLIOGRAPHY

D. Ovalle Castillo: *La platería colonial en Chile* (Santiago, 1936)
R. M. von Bonnewitz: *Mapuche Silver* (Santiago, 1992)
F. de la Lastra: *Platería colonial* (Santiago, 1985)

CHRISTOPHER HARTOP

V. Textiles.

Chilean textiles were clearly influenced by Pre-Columbian tradition even as late as the 20th century. A great variety of textile types is made, and it is women who have been responsible for keeping the art alive. In Región I (Tarapacá) and Región II (Antofagasta), in the north of the country, textiles reveal Aymara, Quechua and Atacamen influences. Further south, Región VI (Liberador General Bernardo O'Higgins), especially in the town of Doñihue, is an important centre of textile production, where the finest Chilean rugs and jackets are made. These woven garments are multicoloured and make up part of the dress particular to a *huaso* (an inhabitant of rural central Chile). The Mapuche of southern Chile, one of the indigenous groups with the largest numbers surviving, have a strong textile tradition that is clearly reflected in their famous rugs, called *trarican macuñ*, and their woven ikat-dyed fabrics (see fig. 7).

In the mid-20th century, textile weaving in Chile was recognised as a contemporary art form combining the cultural heritage of Chile with European tapestry traditions, mixing the influences of anonymous past Andean masters and of such contemporary textile masters as Hilda Icarte and Margarita Johow. In the 1970s the group 20 Artesanos Contemporáneos was formed, to which the textile artists Paulina Brugnoli, Inge Dusi, Marta Miranda and Rosa Lloret belonged; they produced printed and dyed fabrics. In 1983 the exhibition *Arte textil contemporáneo chileno* took place in Santiago; among the most outstanding artists represented were Tatiana Alamos, Isabel Baixas, María Eugenia Cañas, Andrea Fisher, Dora Matta, Lorena Lemunguier, Dina Medvinsky and Rosa Lloret.

For bibliography *see* §VI below.

ISABEL BAIXAS FIGUERAS

VI. Ceramics.

The pottery traditions of Pre-Columbian Chile have had an important influence on ceramic production since the beginning of the colonial period. The Mapuche Indian women of southern Chile, for example, still make such asymmetric wares as duck-jugs, or *ketrumetawe*, a form believed to have originated *c.* AD 500 and which has a symbolism relating directly to the Mapuche family structure. The Mapuche ceramic type called *pitrén* is characterized by a monogram and often shows resist-painted decoration or negative-painted designs. Traditional ceramics are produced in Pomaire, in central Chile. The pottery tradition in this important centre of production pre-dates the arrival of the Spanish; the local potters thereafter made themselves indispensable to the colonists, ensuring the survival of this craft tradition. Such utensils as cooking-pots, containers and jugs are made in a reddish clay and decorated with a paste called *colo*, which imparts colour, smoothness and shine.

In the 1960s two excellent ceramicists, Fernando Mandiola and María Rosa Cominetti, popularized contemporary Chilean ceramics. Of the group 20 Artesanos Contemporáneos, formed in the 1970s, Rita Grob was particularly outstanding for her everyday wares, while Lautaro Valenzuela, Jaime Yver, Paulina Valdivieso and Waltraud Petersen all made high-quality decorative and utilitarian ceramics. In the 1990s a huge variety of ceramic types was produced in Chile, as witnessed by the work of such accomplished ceramicists as Isabel Izquierdo, Enrique Zamudio, Lize Moller, Odette Sansott, Oscar Capece, Simone Racz and Elsa Pfeninger, among others.

7. Ikat-dyed poncho, wool, whole garment 1.18×1.26 m, made by the Mapuche (London, British Museum)

BIBLIOGRAPHY
T. Lago: *Arte popular chileno* (Santiago, 1971)
A. Wilson: *Textilería mapuche: Arte de mujeres* (Santiago, 1992)
Identity and Prestige in the Andes: Caps, Turbans and Diadems, Museo Chileno de Arte Precolombino (Santiago, 1993)

ISABEL BAIXAS FIGUERAS

VII. Patronage, museums and art libraries.

After the demise of the Church as principal patron of the arts at the end of the colonial period, educational institutions did much to encourage artistic development in Chile in the 19th and 20th centuries. Museums were established under the aegis of universities and other institutions, as well as through the efforts of private collectors; these were financially dependent partly on private investment and partly on state budget allocations. From *c.* 1960, however, the state ceased to provide finance for acquisitions, and approaches were increasingly made to institutions and commercial enterprises in the private sector. Donations of this kind aided the purchase of works, the sponsorship of art competitions and the hosting of exhibitions of foreign work. A biennial exhibition of architecture was also established under the patronage of the Colegio de Arquitectos de Chile, providing, among other things, design competitions for students and practising architects.

Legislation introduced in 1986 was aimed at encouraging the creation, investigation and diffusion of the arts and sciences, including support for the Dirección de Bibliotecas, Archivos y Museos del Ministerio de Educación. The legislation allowed donations to be tax-deductible; applicable principally to company donations, the exemption was conditional upon a two-year period of implementation of regular public programmes in accordance with the law's objectives. This led to the creation of foundations and other bodies with private subscribers aimed at collaborating in artistic and cultural activities and supporting the needs of the institutions they sponsored.

Although private collections do exist in Chile, legislation does not provide for the easy importation of works of art, as duty is payable on their entry into the country. In response to continued requests for loans from the collection of the Museo Nacional de Bellas Artes, the Ministerio de Relaciones Exteriores in the latter part of the 20th century purchased some works by Chilean artists to decorate Chile's foreign embassies and a number of government departments. A law was subsequently passed to prevent the borrowing of works from museums without approval from the government and the Consejo de Monumentos Nacionales. The collecting of Chilean works by foreign collectors was also made difficult by legislation introduced in 1969, preventing the export of works considered part of the national heritage; in 1976 a decree introduced a system of payment of duty for export, except for those works being used in exhibitions. The law of 1969 also stated that Chilean commercial banks could use 3.5% of their reserve funds for purchasing works of art, of which 30% could be used for offices and 70% for works to be exhibited in state museums; this provision was only partially successful, however.

The first museum devoted to the visual arts in Chile was the Museo de Pinturas, Santiago, founded in 1880 in the building of the Congreso Nacional. From 1887 it became known as the Museo Nacional de Bellas Artes and was housed in a building known as the Partenón in the Quinta Normal Park. The idea for establishing the museum was promoted by the sculptor José Miguel Blanco (1839–97) on his return from Europe in 1875. Works were drawn from various government bodies and as gifts from artists and private collectors, supplemented later by official purchases and further gifts and bequests with the encouragement of laws that facilitated such donations. The collection was later moved to a purpose-built museum designed by the French-born architect Emile Jecquier and built between 1906 and 1910. The collection of the Museo Nacional de Bellas Artes comprises *c.* 5000 paintings, sculptures, prints, drawings and photographs, concentrating on Chilean art from the colonial period but also including Dutch, Spanish, Italian and French painting from the 16th century. In 1940 a collection of 1500 reproductions of prints by Albrecht Dürer and other artists of the 16th and 17th centuries was donated by the German government, and in 1951 a group of Italian Renaissance drawings (including works by Raphael, Andrea del Castagno, Andrea del Sarto and Jacopo da Pontormo) was acquired. The museum also contains an art library run by the Dirección de Bibliotecas, Archivos y Museos del Ministerio de Educación. Following damage to the building in the earthquake of 1985, a foundation was inaugurated in 1988 to promote the activities of the museum.

Other major museums in Santiago are the Palacio de la Alhambra, founded in 1934 and run by the Sociedad Nacional de Bellas Artes; the Museo de Arte Contemporáneo, founded in 1947 and administered by the fine arts faculty of the Universidad de Chile; the Museo Abierto, founded in 1979 and operated by the Dirección de Bibliotecas, Archivos y Museos del Ministerio de Educación in the stations of the city's underground public transport system; and the Museo del Alba Arturo Pacheco Altamirano, founded in 1982, with a private collection devoted exclusively to the work of that Chilean artist. One of the most important museums outside Santiago is the Pinacoteca in Concepción, with its comprehensive collection of Chilean art; founded in 1958 on the initiative of the Chilean painter Tole Peralta and administered by the Universidad de Concepción, the museum also houses an art library and publishes the bi-monthly magazine *Atenea*. Others include the Museo Municipal de Bellas Artes in Viña del Mar, founded in 1941; the Museo de Bellas Artes in Chillán, administered by the Universidad de Chile; the Museo de Arte y Artesanía in Linares, founded in 1966, and the Museo O'Higginiano y de Bellas Artes at Talca, founded in 1925, both run by the Dirección de Bibliotecas, Archivos y Museos del Ministerio de Educación; and the privately run Galería Manoly at Puerto Montt.

There are two museums in Chile that specialize in decorative arts: the Palacio la Rioja in Valparaíso, founded in 1970, and the Museo de Artes Decorativas in Santiago, established in 1983 under the Dirección de Bibliotecas, Archivos y Museos del Ministerio de Educación. Concern for the preservation of collections grew during the 20th century, and the Centro Nacional de Conservación y Restauración, staffed by specialists trained abroad, was set up in 1982 under the Dirección de Bibliotecas, Archivos

y Museos del Ministerio de Educación. Other Chilean museums incorporate art with their general collections. Examples include the Museo Histórico Nacional, the Museo de la Escuela Militar and the Museo Colonial de San Francisco, all in Santiago. The last mentioned and the Museo de la Catedral in Copiapo, the Museo de San Francisco in La Serena and the Museo San Francisco de Curimón in San Felipe all belong to religious communities and possess the finest examples of colonial art gathered from churches, monasteries, convents and private donations.

The first general library in Chile was founded in 1813, but libraries that specialized in art and architecture only began to appear following the establishment of the Universidad de Chile and other universities with their libraries. The most important museum library is that of the Museo Nacional de Bellas Artes, but the Biblioteca Nacional and the library of the Colegio de Arquitectos de Chile, both in Santiago, have comprehensive collections. The best collections of slides, videos and other audio-visual material are in the libraries of the Universidad de Chile and the Universidad Católica in Santiago, and in the Universidad de Concepción. Photographic collections are held by the Departamento de Extensión Cultural del Ministerio de Educación, the Museo Nacional de Bellas Artes and the Biblioteca Nacional.

BIBLIOGRAPHY
I. Cruz: *Museo colonial de San Francisco* (Santiago, 1978)
Los museos de Chile, Colección Chile y su cultura: Serie museos (Santiago, 1984)
L. Balmaceda: *Museo Nacional de Bellas Artes, 1880–1988* (Santiago, 1989)
LISSETTE BALMACEDA

VIII. Art education.

From the 18th century, art in Chile was promoted through workshops specializing in the production of religious images, such as that of the Jesuit Fray Carlos Haymhaussen in Calera de Tango, near Santiago. A more systematic training was provided with the establishment in 1849 of the Academia de Pintura in Santiago, later known as the Escuela Nacional de Bellas Artes, under the aegis of the Universidad de Chile. Its first directors were European, and their strict adherence to academic conventions prompted a reaction among students towards the end of the 19th century (*see* §III, 2 above). Specialist training in sculpture was provided there from 1854 with the establishment of the Escuela de Escultura Ornamental y Dibujo en Relieve, with the French sculptor Auguste François (*fl* 1859–71) as its first director; the teaching was based mainly on European models of the time, with an emphasis on Classical Greek models and on historical and mythological subject-matter.

Institutions established subsequently also made provision for the teaching of art, notably the Universidad Católica de Chile (founded in Santiago in 1888), the Universidad de Concepción (founded in 1919) and the Universidad Católica in Valparaíso (founded in 1928). Schools of painting were also established at the Universidad Austral in Valdivia and at the Universidad Metropolitana de Ciencias de la Educación in Santiago, and sculpture was also taught at such private institutes as Arcis and the Instituto de Arte Contemporáneo, both in Santiago.

Architecture was taught in Chile from 1797 at the Academia de San Luis in Santiago by the Italian architect Joaquín Toesca y Ricci, who was professor there of mathematics and design. It was only with the establishment in 1849 of the department of architecture at the Academia de Pintura, however, that architectural training was systematically provided in the country. The first director of this department, the French architect Claude François Brunet-Debaines (1788–1855), was succeeded by another French architect, Lucien Ambrose Hénault (1790–1880); both were prominent as practising architects in their own right (*see* §II, 2 and 3 above). During the 20th century architecture was also taught at various state and private universities, notably in Santiago at the Universidad de Chile and at the Universidad Católica de Chile.

BIBLIOGRAPHY
Memoria histórica de la Escuela de Bellas Artes (Santiago, 1910)
M. Palmer Trías: *50 años de arquitectura* (Santiago, 1976)
E. Pereira Salas: *Estudios sobre la historia del arte en Chile republicano* (Santiago, 1992)
L. H. Errazúriz: *Historia de un arte marginal: La enseñanza artística en Chile, 1797–1993* (Santiago, 1994)
LISSETTE BALMACEDA

Chili, Manuel. *See* CASPICARA.

Chong Neto, Manuel (*b* Panama City, 16 Nov 1927). Panamanian painter and printmaker. He studied at the Escuela Nacional de Artes Plásticas in Panama City in 1952 and from 1963 to 1965 at the Academia San Carlos in Mexico City. He held his first exhibition in 1959. Always a figurative artist, in his early work he painted children, old women or beggars in dramatic chiaroscuro under the influence of social themes favoured in Mexican art. Upon returning to Panama, he turned to desolate visions of wooden houses and yards, as in *Urban Landscape* (1966; Panama City, Mus. A. Contemp.), and also painted many still-lifes.

At the end of the 1960s Chong Neto developed his characteristic motif, a voluptuous woman with large eyes, an unusually wide neck and large breasts. For the rest of his career, this sensuous figure appeared in most of his works, alone or accompanied by men, voyeurs, clowns, birds or owls, as in *Grey Lady—Torn Prejudice* (1978; Panama City, Mus. A. Contemp.). Nude or dressed, often erotic, she became his symbol for humanity and the vehicle for his depiction of the different aspects of life, including the more pessimistic and humorous sides, especially in his dramatic drawings and prints. He concentrated almost obsessively on the same themes in a variety of media, including oil paintings, pastels, crayon and pen-and-ink drawings and prints. Underlying the sensuous, symbolic and at times satirical overtones of his images there is a strong geometric order and a dramatic use of light that defines the volumes and features of his subjects.

BIBLIOGRAPHY
Manuel Chong Neto: Visión retrospectiva, 1955–1985 (exh. cat., ed. M. E. Kupfer; Panama City, Mus. A. Contemp., 1986)
MONICA E. KUPFER

Christophersen, Alejandro (*b* Cádiz, 30 Aug 1866; *d* Buenos Aires, 5 Jan 1945). Argentine architect and teacher of Norwegian and Spanish descent. He graduated in

architecture (1886) at the Académie Royale des Beaux-Arts, Brussels, and studied at the Ecole des Beaux-Arts, Paris, before moving to Argentina in 1888. He became an honorary professor of architecture in the Facultad de Ciencias Exactas, Universidad de Buenos Aires, where he subsequently set up and became head of the country's first school of architecture (1901). Through this role he was influential in introducing Beaux-Arts classicism to Argentina, as seen in his competition project for the Palacio del Congreso Nacional (1895; unexecuted), Buenos Aires. He then began to develop an individual academic manner, combining a *fin-de-siècle* Baroque style with elements of Art Nouveau. Examples include the Second Empire grandeur of the Palacio Anchorena (1909; now Ministerio de Relaciones Exteriores), with a high, convex-hipped roof and oval dormers, the Hotel Antonio Leloir (now offices of the Circolo Italiano) and a *petit hôtel* on Avenida Alvear (both 1915), which have Art Nouveau elements. In 1915 Christophersen founded and became the first president of the Sociedad Central de Arquitectos; he also directed its *Revista de arquitectura*, in which he published (July 1915, p. 7) a brief credo, 'Nuevos rumbos', suggesting that architects should 'explore new directions inspired by the traditions of the country, thus creating an art that would reflect the climate, morals and building materials of Argentina' (see Bullrich, p. 16). He nevertheless adopted a reactionary attitude towards incipient Modernism in the 1920s in opposition to such architects as Alberto Prebisch, and in his Bolsa de Comercio (1916) and the church of the Colectividad Noruega (1920; destr.) Christophersen adopted an increasing classicist style. He was also a versatile painter and noted watercolourist, serving in the 1930s as honorary president of the Sociedad de Acuarelistas, Pastelistas y Grabadores de Argentina.

See also ARGENTINA, §II.

BIBLIOGRAPHY

C. Eggers-Lecour: *Christophersen: Un maestro del arte argentino* (Buenos Aires, 1946)
R. W. Algier and A. Williams: 'Homage to Alejandro Christophersen', *Rev. Arquit.* [Arg.] (June 1947), pp. 197–235 and cover
'30 años de arquitectura en el Rio de la Plata', *Rev. Arquit.* [Arg.], 378 (Dec 1960), pp. 17–22
F. Ortiz and others: *La arquitectura del liberalismo en la Argentina* (Buenos Aires, 1968)
F. Bullrich: *New Directions in Latin American Architecture* (London, 1969)
V. Carreño: 'Alejandro Christophersen: Fundador de la facultad de arquitectura', *Nueva Prov.* (23 Nov 1980)
J. Cacciatore: 'Alejandro Christophersen', *Summa* [Buenos Aires], 191 (1983), pp. 16–17

LUDOVICO C. KOPPMANN

Churrigueresque. Term used from the late 18th century to denote the most exuberantly ornamental phase of Spanish architectural decoration, lasting from *c.* 1675 to *c.* 1750. The term derives from the Churriguera family, the principal exponents of the style, who worked mostly in Salamanca. The origins of the style, however, can be traced back to the painter and sculptor Alonso Cano, who was a pioneering exponent of a highly ornamental style that began to characterize much Spanish art at the end of the 17th century. Most important in the propagation of the style were a number of sculptors, wood-carvers, cabinet-makers and carpenters who began to be highly influential in the field of architecture at this time, much to the chagrin of the more classically-minded specialist architects, such as Juan de Herrera. These sculptors and other craftsmen were chiefly responsible for the design and construction of the ephemeral structures built for coronations and other celebrations around this time. These were generally made of wood or cloth, allowing all manner of capricious and bizarre experiments with ornamentation. Some of these Baroque experiments were later taken up and applied in stucco or brick to such architectural elements as façades, walls, vaults, doors and cupolas and in sculptural ensembles such as retables.

In the early 18th century the Churriguera family, together with such other artists as Pedro de Ribera (1681–1742) in Madrid and Narciso Tomé (?1694–1742) in Toledo, took up this ornamental style and brought it to its logical conclusion, adding such new decorative elements as the *estípite* (a tapering pilaster, shaped like an inverted pyramid and derived from Mannerist architecture) and solomonic (or spiral) columns. The *estípite* was to become the dominant form. Tomé's designs were particularly ornamental and laden with sculptural decoration, including fluffy clouds and angels' heads on column shafts, entablatures and cornices. The style also had its followers outside the central region of Spain. These included Leonardo de Figueroa (?1650–1730) and his son Ambrosio de Figueroa (1700–50) in Seville (see fig.), Francisco Hurtado Izquierdo (1669–1725) and his group of followers in Córdoba and Granada, and Domingo Antonio de Andrade (1639–1712) and Fernando de Casas y Novoa (both of

Churrigueresque architectural decoration by Leonardo de Figueroa: façade of the Colegio (now Palacio) de San Telmo, Seville, 1724–34

whom worked on the cathedral of Santiago de Compostela) in Galicia. It was also subsequently introduced into Latin America, especially Mexico, by JERÓNIMO DE BALBÁS, LORENZO RODRÍGUEZ and others. Although the late phase of the Churrigueresque coincided with the Rococo movement in Spain, the two styles should not be confused: while both styles were essentially decorative, using ornamentation to disguise weak architectural structure, Churrigueresque consisted in heavy, contorted decoration whereas Rococo was lighter and more curvaceous.

The Churrigueresque style was heavily criticized in the second half of the 18th century, particularly by the leading figures in the Spanish Enlightenment, many of them members of the Real Academica de Bellas Artes de S Francisco, founded in Madrid in 1752. These critics, who included Antonio Ponz and Juan Agustin Céan Bermudez, ridiculed and opposed the style through their writings and worked to eliminate it by exercising control over all public, state, ecclesiastical and private building. Permission for building was often withheld until revisions were made, and the academy also reserved the right to bestow the titles of Architect and Master of Works, which had previously been granted by the council of Castile, the various city councils and the guilds. The arts were considered to have fallen into a state of degeneration and to be a symbol of political, economic and cultural decadence. The main target of attack was the Churriguera family, the poor taste of whose architecture was reflected in the neglect of the Classical principles of harmony, solidity and utility, in their incorrect use of Vitruvius' canonic orders and in their absurd ornamentation. According to the theorists of the Enlightenment, the abuses and infringements of the established rules that the Currigueresque represented had originated in the architecture of Borromini, whose style—they believed—had been assimilated by such artists of José Jiménez Donoso and Francisco de Herrera, who probably trained in Rome c. 1650. They also criticized such painters as Sebastián de Herrera Barnuevo and Alonso Cano, who had introduced a new decorative approach into their painting, even if they had never been to Italy. In fact, however, the influence of Borromini on Churrigueresque was minimal. His work appears to have been virtually unknown to the members of the Churriguera family: his name appears only once in their writings, in a passing reference made by José Benito de Churriguera in a letter to Bernini.

BIBLIOGRAPHY

EWA: 'Churrigueresque Style'

G. Kubler: *Arquitectura de los siglos XVII y XVIII*, A. Hisp., xiv (Madrid, 1957)

A. R. Ceballos: *Los Churriguera* (Madrid, 1971)

——: 'L'Architecture baroque espagnole vue à travers le débat entre peintres et architectes', *Rev. A.*, lxx (1985), pp. 41–52

ALFONSO RODRÍGUEZ CEBALLOS

CIAM [Congrès Internationaux d'Architecture Moderne]. International organization of modern architects founded in June 1928 at the château of La Sarraz, Switzerland. It was instigated by Hélène de Mandrot (who had offered her château as a venue for a meeting of architects interested in discussing developments in modern architecture), Le Corbusier and Sigfried Giedion. Its foundation was stimulated by the campaign in defence of Le Corbusier's unexecuted competition entry (1927) for the League of Nations Building, Geneva, as well as the success of the Weissenhofsiedlung (1927) in Stuttgart—a permanent, model exhibition of social housing in which several noted European Modernists had participated. The creation of CIAM established the Modern Movement in architecture as an organized body, with a manifesto, statutes, a committee and an address in Zurich: that of Giedion, who became its first secretary-general. Karl Moser was its first president, followed by Cornelis van Eesteren (1930–47) and Josep Lluís Sert (1947–56).

The first meeting at La Sarraz, afterwards known as CIAM I, produced a declaration of principles on which future discussions would be based. These were concerned with the establishment of an autonomous architecture rooted in the social and economic needs of the times (including the adoption of industrialized production techniques) and freed from domination by tradition and the academies. A functional approach to urban planning based on dwelling, work and recreation was also specified, to be achieved through land organization, traffic regulation and legislation. At CIAM II (Frankfurt am Main, 1929) the organization's statutes were adopted, establishing a system of membership through national groups and stating its aims: to 'establish and represent the demands of modern architecture, to introduce the ideas of modern architecture into technical, economic and social circles, and to resolve contemporary building problems'. Discussions were centred on low-cost housing, an important preoccupation of the period, with visits to notable housing developments of this type by Ernst May, city architect of Frankfurt. The resulting publication, *Die Wohnung für das Existenzminimum* (1930), included plans of low-cost dwellings that were also exhibited by the group. CIAM III was held in 1930 in Brussels, where several new housing estates had been completed (e.g. the Cité Moderne by Victor Bourgeois). It discussed the efficiency of low-, medium- and high-rise housing, and the rational organization of land for housing. National groups again prepared plans and reports; these were exhibited and published as *Rationelle Bebauungsweisen* (1931).

At the next meeting, intended as the first in a series on 'The Functional City', the 'existing chaos' of 33 large cities was to be analysed. The study was carried out in accordance with the four principal functions of the city: dwelling, work, transportation and recreation. Reviews of existing conditions were followed by 'requirements' within each function: for example, housing should be sited in the most favourable parts of the city; high-rise buildings could free space for recreation areas; green open spaces should be distributed over and around the city; work-places should be sited at the shortest possible distance from residential areas, the latter containing only local services; industry should be isolated by a green belt; and different kinds of traffic should have separate routes, with crossings at different levels.

CIAM IV was the most successful congress to date in terms of its collective discussions, but its results, summed up at the end of the congress as 'Statements', were very generalized. Although the official publications proposed did not appear, the results of CIAM IV formed the basis of two books published much later: Sert's *Can Our Cities*

Survive? (1942) and Le Corbusier's *La Charte d'Athènes* (1943). In the latter Le Corbusier revised the Statements, presenting them in far stronger and more definitive terms than the original, thus depriving them of their suggestive nature. This particularly applied to his 'point de doctrine' on urban planning: it was *La Charte d'Athènes* that embodied the concept of 'autonomous sectors' for the four major functions of the city, thus enshrining the notion of rigid zoning in modern urban planning that was adopted in much urban reconstruction after World War II and later heavily criticized. CIAM V (Paris, 1937) considered proposals on the theme of 'Dwelling and Recreation'. The results, including Le Corbusier's renewed call for high-rise blocks of flats in green open spaces, were published in *Logis et Loisirs* (1938).

The first congress after the war, CIAM VI (Bridgewater, CT, 1947), was a reunion meeting, intended to review work carried out and to consider the future function of CIAM in the context of post-war politics and urban reconstruction. The Declaration of Bridgewater reformulated the aims of CIAM as the creation of a physical environment that 'will satisfy man's emotional and material needs and stimulate his spiritual growth'; its task included ensuring that 'technical developments are controlled by a sense of human values' (see exh. cat., p. 84). At CIAM VII (Bergamo, 1949) Le Corbusier's Grid ('Grille-CIAM') was introduced. This had been developed with the research group ASCORAL as a tool for depicting and comparing urban planning proposals, and there was a presentation of plans entitled 'The Applications of the Athens Charter by means of the CIAM Grid'. At this congress the influence of the Italian members was more apparent, as was the growing student body. Important reference points for the international organization were also being provided by such countries as Brazil and Venezuela, which in the 1940s and 1950s had begun to overtake Europe in their virtuosity in the new architecture; indeed, it was at BRASÍLIA that the planning concepts of the Athens Charter were subsequently realized for the first and only time (for illustration of urban plan, 1957, *see* COSTA, LÚCIO).

CIAM VIII (Hoddesdon, 1951) was entitled 'The Heart of the City'. Its subject, 'the core', was suggested by the English group and reflected increasing concern with social and individual issues, together with a recognition of inadequacies in the Athens Charter. The subject was particularly relevant to contemporary reconstruction work and design of new towns, both in Europe and in the developing countries. Because of its connotations of community centre and city centre, 'the core' became the key term in bringing together separate architectural functions in a composite environment. The conclusions included various generalizations about the nature of 'the core', including the demand that all motorized traffic should be banned.

Discussion of 'the core' continued at CIAM IX (Aix-en-Provence, 1953) under the wider theme of 'Habitat', the environment for human society, with the aim of producing a 'Charte de l'Habitat'. CIAM IX is renowned for the student party held on the roof of Le Corbusier's Unité d'Habitation, Marseille. In a sense this symbolized the end of unanimity in the interpretation and expectations of CIAM's theories and marked the split between the 'old

guard' and the younger generation, who were concerned with ideas of individual architectural identity, scale and meaning, in marked contrast to the original aims of CIAM to formulate an autonomous, universally applicable system of architecture and planning.

In 1954, following CIAM IX, a number of younger members from England and the Netherlands met at Doorn and produced the Doorn Manifesto, which rejected the mechanized functionalism of the Athens Charter and emphasized instead the primacy of human association in urban planning. The younger group, slightly enlarged, was subsequently established as the CIAM X Committee and adopted the Doorn Manifesto in its draft proposals, approved by Le Corbusier in 1955. At CIAM X (Dubrovnik, 1956), the challenge presented by the new approach of the younger generation, who were supported by Le Corbusier, confirmed the split in the organization, and at the end of the meeting it was decided to abolish the federation of groups in more than 30 countries and to reorganize the statutes and congresses. CIAM XI (Otterlo, 1959) was attended by 43 individual participants; most of the leaders of the 'old guard', including Le Corbusier, Giedion, Gropius, Sert and J. Tyrwhitt, were conspicuous by their absence, and it was made plain that the work of the old CIAM was no longer considered relevant. The projects presented were examined and later published as *CIAM '59 in Otterlo* (1959), but clear differences in approach were apparent, and the meeting terminated with the decision to discontinue the name of CIAM.

WRITINGS
Die Wohnung für das Existenzminimum (Stuttgart, 1930)
Rationelle Bebauungsweisen (Stuttgart, 1931)
Logis et loisirs (Paris, 1938)
J. L. Sert, ed.: *Can Our Cities Survive?* (Cambridge, MA, and London, 1942)
Le Corbusier, ed.: *Urbanisme de CIAM: La Charte d'Athènes* (Paris, 1943; Eng. trans., New York, 1973)
J. Tyrwhitt, J. L. Sert and E. N. Rogers, eds: *The Heart of the City: Towards the Humanisation of Urban Life* (London, 1952)
O. Newmann, ed.: *CIAM '59 in Otterlo* (Stuttgart, 1961)

BIBLIOGRAPHY
S. Giedion, ed.: *A Decade of New Architecture* (Zurich, 1951)
S. Giedion: 'Les CIAM', *Archit. Aujourd'hui*, 113–14 (1964), pp. 36–7
M. Steinmann, ed.: *CIAM: Dokumente, 1928–1939* (Basle, 1979)
CIAM: Internationale Kongresse für Neues Bauen (Nendeln, 1979)
A. Smithson, ed.: *The Emergence of Team 10 out of CIAM* (London, 1982) [facsimiles of contemp. doc. incl. Doorn Manifesto]
Het nieuwe bouwen internationaal: CIAM: Volkshuisvesting, Stedebouw [CIAM: Housing, Town Planning] (exh. cat., ed. A. van der Woud; Otterlo, Rijksmus. Kröller-Müller, 1983) [incl. Declaration of La Sarraz, Statutes, Statements of the Athens congress, 1933]

JOS BOSMAN

Clark, Lygia (*b* Belo Horizonte, 23 Oct 1920; *d* Rio de Janeiro, 26 April 1988). Brazilian painter, sculptor and performance artist. She first studied painting with Roberto Burle Marx in Rio de Janeiro and in 1950 moved to Paris, where she completed her studies with Fernand Léger (1881–1955) and Arpad Szènes (*b* 1900). Under the influence of Soviet Constructivism, the Bauhaus and Neoplasticism, she abandoned her early figurative style for geometric abstraction, joining the Frente group on her return to Rio de Janeiro in 1954. Between 1954 and 1958 she produced two series of radical experiments in concrete art, *Modulated Surfaces* and *Counter-reliefs*. These were

followed between 1959 and 1961 by *Animals*, metal sculptures which the spectator was free to rearrange. Her move to Europe in 1968, marked by a retrospective at the Venice Biennale, where she also showed her installation *The House is the Body*, confirmed her growing reputation in Europe. Before returning to Rio de Janeiro she taught a course at the Sorbonne, Paris, from 1970 to 1975, entitled *Imagery of the Body*. In her work she substituted flat surface with unrestricted space so as to invite the physical participation of the spectator, thereby encouraging the spontaneous rediscovery of the body and the transformation of behaviour in art.

BIBLIOGRAPHY

A. Amaral, ed.: *Projeto construtivo brasileiro na arte, 1950–1962* [The Brazilian Constructivist movement in art, 1950–62] (São Paulo, 1977)

F. Gullar and M. Pedrosa: *Lygia Clark* (Rio de Janeiro, 1980)

R. Brito: *Neoconcretismo: Vértice e ruptura do projeto construtivo brasileiro* [Neoconcrete art: climax and breaking point of the Brazilian Constructivist movement] (Rio de Janeiro, 1985)

G. Brett: 'Lygia Clark: The Borderline between Art and Life', *Third Text*, i (1987), pp. 65–94

G. Ferreira and I. de Araújo: 'De Tarsila a Lygia Clark: Influence of Fernand Léger et d'André Lhote', *Cah. Brésil Contemp.*, xii (1990), pp. 125–37

M. A. Millet: *Lygia Clark: Obra—trajeto* (São Paulo, 1992)

G. Brett: 'Lygia Clark: In Search of the Body', *A. Amer.*, lxxxii (1994), pp. 56–63

R. N. Fabrini: *O espaço de Lygia Clark* (São Paulo, 1994)

P. C. Terra Cabo: *Resignifying Modernity: Clark, Oiticica and Categories of the Modern in Brazil* (diss., Colchester, U. Essex, 1996)

Escultura brasileña de 1920–1990: Perfil de una identidad (exh. cat., New York, Cent. Cult. Inter-Amer. Dev. Bank, 1997)

ROBERTO PONTUAL

Clausell, Joaquín (*b* Campeche, 16 July 1866; *d* Lagunas de Zempoala, Morelos, 28 Nov 1935). Mexican painter. He studied law but led a picturesque life, free of responsibilities, mainly given over to his art. He attended the Academia de San Carlos in Mexico City and is thought to have assimilated the techniques of Impressionism in Paris towards the end of the 19th century. He represents an unusual case in the history of Mexican art in establishing his reputation as an Impressionist in the early 20th century.

The evolution of Clausell's work is difficult to disentangle, since he was a prolific painter working in a variety of formats and only rarely signed and dated his pictures. His highly individual Impressionist technique, with its vigorous use of the brush and palette knife, is nevertheless unmistakable, and his use of colour is far removed from the delicate tones of the French masters. He did not care for urban subjects and rarely represented the human figure, all his creativity being centred on landscapes and seascapes. He was an innovator in Mexico in painting the sea, with its stormy waves (e.g. *Rocks in the Sea*, Mexico City, Mus. N.A.) and peaceful beaches. His landscapes, often set near Mexico City (e.g. *Gushing Springs at Tlálpan*, Mexico City, Mus. N.A.), were of hills, the inevitable volcanoes, woods and clouds.

BIBLIOGRAPHY

J. Fernández: *El arte del siglo XIX en México* (Mexico City, 1967), pp. 157–60

J. García Ponce: *Joaquín Clausell* (Mexico City, 1973)

Joaquín Clausell, 1866–1935 (Mexico City, 1988)

X. Moyssén: *Joaquín Clausell: Una introducción al estudio de su obra* (Mexico City, 1992)

——: *Joaquín Clausell: La casa de las mil ventanas* (Mexico City, 1995)

Joaquín Clausell y los ecos del impresionismos en México (exh. cat., Mexico City, 1995)

A. Saborit: *Los exilios de Joaquín Clausell* (Mexico City, 1996)

XAVIER MOYSSÉN

Clavé (y Roqué), Pelegrín (*b* Barcelona, 1810; *d* Barcelona, 13 Sept 1880). Catalan painter and teacher, active in Mexico. He studied in Madrid and Barcelona and at the Accademia Nazionale di San Luca in Rome under Tommaso Minardi, where he learnt the principles of classicism. He was an admirer of Friedrich Overbeck, the leader of the Nazarenes, and was also influenced by Ingres. He was appointed Director of Painting at the Academia de San Carlos, Mexico City, and moved there in 1846 with the Catalan sculptor Manuel Vilar. Together they reorganized the Academia and its syllabus to provide more adequate training, including drawing from nature, anatomy, landscape, perspective and the use of live models. They also held regular exhibitions at the Academia. The purist and classical European approach of the course, which was initiated in January 1847, greatly impressed Mexican critics. Clavé was an excellent portraitist, depicting many leading political and society figures (e.g. *Andrés Quintana Roó*, 1851; priv. col.), and he encouraged his students to follow his example of technical skill, conviction of form and line, harmonious composition, elegance, simplicity and nobility of subject.

BIBLIOGRAPHY

Thieme–Becker

S. Moreno: *El pintor Pelegrín Clavé* (Mexico City, 1966)

J. Fernández: *El arte del siglo XIX en México* (Mexico City, 1967)

E. García Barragán: 'El arte académico en el extranjero', *México en el mundo de las colecciones de arte*, v (Mexico City, 1994), pp. 191–238

ELISA GARCÍA BARRAGÁN

Coaza, Martín de. *See* CHAMBI, MARTÍN.

Cochabamba [formerly Oropesa]. Bolivian city. It is located on the banks of the River Rocha in the central Andean region of the country; in the late 20th century its population was *c.* 300,000. The name derives from a Quechua word meaning 'marsh land'. The city was founded with the name Oropesa by Jerónimo de Osorio on the orders of viceroy Francisco de Toledo in 1571, although it had been inhabited by Spanish settlers since 1542. The city's founding purpose was to supply farming products to the highlands and mining centres of Potosí and Oruro, and its success, particularly in grain cultivation, brought considerable wealth to the landowners. In regard to painting, in the early 18th century Cochabamba experienced a situation similar to that in other cities, where Neo-classicism mixed elements of Rococo with metropolitan Baroque. In architecture Neo-classicism began to appear in the second half of the 18th century in such churches as S Teresa (1753; partly destr.), built by Pedro Nogales to an unusual lobed ovaloid plan. Little remains, however, of the art and architecture of the colonial period in Cochabamba, although some houses from the late 18th century period have been preserved, together with some portals, such as the Mestizo Baroque portal of the main square, decorated with crosses and a crown. The modern civil architecture of the city is distinctive and peculiar to the area, with wooden structures a particular feature and wide eaves giving protection from the elements.

An interest in encouraging artistic activity in various Bolivian cities in the early 20th century was reflected in Cochabamba by the formation of the Sociedad de Artistas Plásticos. Landscapes became a popular subject for painters in the early to mid-20th century, through such exponents as AVELINO NOGALES, who ran a painting workshop in the city from 1905 to 1920. The Escuela de Bellas Artes, founded in 1948, was responsible for training a number of Bolivia's 'Generación del '52' (*see* BOLIVIA, §III, 1); the Universidad Mayor de 'San Simón' has a faculty of architecture. In 1967 the Pinacoteca de Arte Colonial was founded, with a collection of colonial paintings and contemporary art.

BIBLIOGRAPHY

A. Fernández: 'Cochabamba', *Monografía de Bolivia*, ii (La Paz, 1975)

J. de Mesa and T. Gisbert: *Monumentos de Bolivia* (La Paz, 1978)

G. Bryne de Caballero and R. Mercado Mercado: *Monumentos coloniales: Inventario de los monumentos coloniales, civiles y religiosos del Departamento de Cochabamba* (Cochabamba, 1986)

G. Rodríguez Ostria: *La construcción de una región: Cochabamba y su historia, siglos XIX á XX* (Cochabamba, 1995)

LAURA ESCOBARI

Coen, Arnaldo (*b* Mexico City, 10 June 1940). Mexican painter, sculptor, illustrator and stage designer. He was self-taught when he took up painting in 1956 with the encouragement of Diego Rivera, but from 1956 to 1960 he studied graphic design with Gordon Jones. During those years he worked in an Abstract Expressionist manner, although he soon incorporated figurative elements and, from *c.* 1963, elements of fantasy. In 1967 he went to Paris on a French government grant. In the following year he was a founder-member of the Salón Independiente, where he began to exhibit acrylic sculptures of the female torso. These were followed between 1974 and 1976 by a series entitled *Mutations*, in which he explored the possibilities of the cube and which opened the way to later sculptures and paintings in which geometry is balanced with sensuality.

Venus and Mars (Mexico City, U. N. Autónoma) is one of the best of his public sculptures. He also worked as a stage designer, for example on a production in 1964 of *Víctimas del deber* by the French playwright Eugène Ionesco, and he illustrated *Carta de creencia* (Mexico City, 1987) by the Mexican writer Octavio Paz. From 1977 to 1978 he was involved in the plan for Dodoma, the recently created capital of Tanzania.

BIBLIOGRAPHY

L. Cardoza y Aragón: *Pintura contemporánea de México* (Mexico City, 1974)

J. A. Manrique and others: *El geometrismo mexicano* (Mexico City, 1977)

S. L. Catlin and O. Paz: *Artes gráficas latinoamericanas* (Mexico City, 1979)

Arnaldo Coen: A la Orilla del Tiempo (exh. cat. by S. Elizondo, Mexico City, Mus. A. Mod., 1986)

MARGARITA GONZÁLEZ ARREDONDO

Collazo, Guillermo (Enrique) (*b* Santiago de Cuba, 5 July 1850; *d* Paris, 26 Sept 1896). Cuban painter. During Cuba's first war of independence (1868–78) he moved to New York, where he studied with Federico Martínez (1835–1912), and later to Paris, where he lived as an exile until his death. Politically a Cuban separatist and stylistically a conservative influenced by the Rococo, Collazo captured Cuba's luminous vegetation and realized many portraits of its upper classes, for example that of *Susanita de* *Cárdenas* (1880; Havana, Mus. N. B.A.). *The Siesta* (Havana, Mus. N. B.A.) depicts a young woman reclining wistfully on a tropical hammock. Collazo's work achieved its first recognition in Cuba with an exhibition in 1940 at the Universidad de La Habana. Married to an heiress, he lived in a museum-like home which was a meeting place for exiled Cuban nationalists.

BIBLIOGRAPHY

M. de Castro: *El arte en Cuba* (Miami, 1970), p. 46

R. Fernández Villa-Urrutia: 'Las artes plasticas hasta el comienzo de la República', *La Enciclopedia de Cuba* (San Juan and Madrid, 1974), vii, pp. 151–3

RICARDO PAU-LLOSA

Colombia, Republic of. Country in the north-west of South America. It is bordered to the north-west by Panama and the Caribbean, to the east by Venezuela and Brazil, to the south by Peru and Ecuador, and to the west by the Pacific Ocean. The region was colonized by the Spanish in the 16th century under the name of Nuevo Reino de Granada. The area of 1,141,748 sq. km that makes up modern Colombia was established in the years following independence from Spain (1819).

I. Introduction. II. Indigenous culture. III. Architecture. IV. Painting, graphic arts and sculpture. V. Gold and silver. VI. Patronage, collecting and dealing. VII. Museums, art libraries and photographic collections. VIII. Art education.

I. Introduction.

Colombia is divided into 23 departments, with a total population of *c.* 35 million. The capital city, SANTA FE DE BOGOTÁ, has a population of 6 million. The country has an extremely varied topography. Three ranges of mountains running from south-west to north-east divide it into five regions: the Caribbean (with the islands of San Andrés and Providencia) and Pacific coastal regions, the Andean zone, the eastern plains, and the Amazon region in the south-east (see fig. 1). The country is equatorial and has no seasons, but the climate varies greatly according to altitude, the highest point being Cristóbal Colón Mountain (5775 m) at the Sierra Nevada de Santa Marta. Colombia is rich in natural resources, producing gold, silver, emeralds (all three of which have traditionally been used to make works of art), platinum, copper, uranium, oil, salt and coal, as well as numerous agricultural products, principally coffee, flowers and tropical fruits. The country also boasts a great variety of animal life. The longest river, the Magdalena (1400 km), running south to north, and its numerous tributaries have provided routes of communication, and their banks have been the site of settlements since Pre-Columbian times.

The first Spanish conquistadores arrived in 1499 and founded their first settlements on American soil in 1509 at Santa María la Antigua del Darién and San Sebastián de Urabá. These were destroyed some months later, and in 1525 they founded the port of Santa Marta. In the same period, three expeditions reached the Sabana de Bogotá, a plateau of the Andes. One expedition sailed up the Magdalena River and climbed up the Andes, drawn on by information about a chief who covered his body with gold and originating the legend of El Dorado, a mythical land of gold. Gonzalo Jiménez de Quesada (1496–1579), the

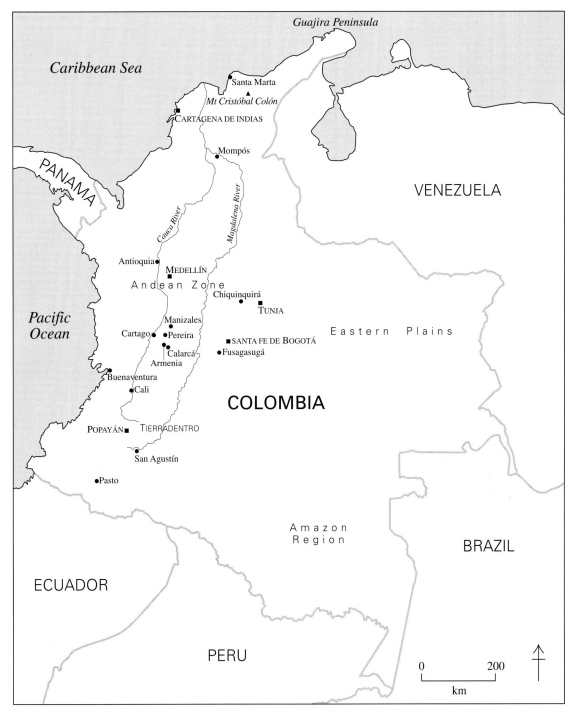

1. Map of Colombia; those areas with separate entries in this encyclopedia are distinguished by CROSS-REFERENCE TYPE

leader of the expedition, named the region Nuevo Reino de Granada and in 1538 founded the capital, Santa Fe de Bogotá. The process of colonization entailed the adoption of Spanish culture and a mixing of the Spanish, Native American and African populations (the latter brought as slaves from western Africa). The Spaniards transplanted their own artistic traditions, while the indigenous popula-

tion, despite Spanish suppression, continued some of their own (*see* §II below). Both cultures mixed directly, and European designs were executed anonymously by native craftsmen. The religious orders carried out extensive construction of churches, and the city of Santa Fe de Bogotá grew considerably, attracting many foreign artists and architects. In 1717 the region became a viceroyalty.

In 1781 the first independence movement in Latin America broke out with the rebellion of the landowners (*Comuneros*). In 1784 the Expedición Botánica, a major expedition inspired by the Enlightenment, coordinated by José Celestino Mutis (1732–1808), assembled a group of Creole scientists and illustrators with the aim of recording all the native plant species not known in Europe. Apart from its scientific and artistic importance, the project, which lasted until 1817, also helped to consolidate the growing Latin American identity. The independence movement was further strengthened by creole discontent with Spanish rule, which denied them equal power in government, by the influence of the French Revolution and the crisis over French domination in Spain. Independence was declared on 20 July 1810 and was followed by nine years of military campaigns under the leadership of Simón Bolívar (1783–1830). These culminated in the withdrawal of Spanish rule in 1819 and the formation of the Republic of Gran Colombia, which included the present territories of Colombia, Venezuela, Ecuador and Panama.

The following decades were marked by political instability between centralist and federalist factions. In 1830 Venezuela and Ecuador separated from the Republic; slavery was abolished soon after, and a new Constitution was proclaimed in 1886. More direct relations were established with other powers, including France and Great Britain. The country underwent considerable modernization, including the building of transport routes and the initiation of the construction of the Panama Canal. After the War of a Thousand Days (1899–1903) between rival Liberal and Conservative factions, Panama, with the support of the USA, separated from Colombia. During the 20th century, as a result of improved transport, integration between the regions increased, giving rise to industrialization and large building programmes in the major cities. However, the conflict between the Liberal and Conservative parties continued, most notably between 1948 and 1957, and resulted in a military coup. There was massive migration to the cities, generating a need for extensive house-building. From 1958 to 1974 a Liberal–Conservative pact, the Frente Nacional, operated a system of power-sharing. Despite continuing democracy and very active economic and cultural development, violence remained a constant presence.

BIBLIOGRAPHY

M. Traba: *Colombia* (Washington, DC, 1959)
J. Friede: *Descubrimiento del Nuevo Reino de Granada y fundación de Bogotá* (Bogotá, 1960)
E. Gostautas: *Arte colombiano* (Bogotá, 1960)
S. Arango de Jaramillo: *Historia de la arquitectura en Colombia* (Bogotá, 1989)
J. Ocampo López: *Historia básica de Colombia* (Bogotá, 4/1994)
N. Vega: *Cien obras maestras del arte colombiano* (in preparation)

NATALIA VEGA

II. Indigenous culture.

The arrival of the Spanish initiated a process of harsh suppression of the indigenous population, particularly during the 16th century. Massacres, the introduction of new diseases and the destruction of the indigenous economy and social order through the enforcement of *encom-*

ienda status on indigenous villages (whereby labour and produce were granted to colonists by royal decree) all contributed to a notable reduction in population. As a result, African slaves were imported from the 17th century to bolster the workforce. Despite their dwindling numbers, and the inter-breeding and acculturation following the Spanish Conquest, some groups have survived, although they have been marginalized and have little sense of continuity with the cultures of their ancestors. They have gradually withdrawn to remote mountain or jungle areas, which have been organized into reserves or protected zones.

In the last decade of the 20th century over half a million indigenous people belong to groups still speaking more than 50 Chibcha- or Carib-based dialects. Their cultural diversity reflects the geographic variety of the territories they have occupied, as well as their degree of contact with non-indigenous cultures. The native groups in the Caribbean coastal area include the Guajiros (or Wayu) in the desert of the Guajira peninsula, the Arhuacos (Kogui and Ica) in the Sierra Nevada Mountains near Santa Marta and the Tunebos and Motilones on the Venezuelan border. Those in the Pacific area include the Noanamas, the Emberas, the Chamis, the Catios and the Kunas, who live near the border with Panama. The Paez, the Guambianos, the Paniquita, Coconuco and Ambalo live in the Andean regions, principally the central range, and the Quillacinga are located near the Ecuadorian border. Many groups speaking Tukano, Arawak and Carib, such as the Desana, the Cubeos, the Huitoto and Sibundoy, are located in the Amazon region. The Guajibos, the Cuiba, the Yuco and the Carare live on the broad eastern plains.

After colonization some forms of native art production, such as sculpture in stone, disappeared, while others (e.g. metallurgy) blended with Spanish traditions. However, a wide range of artefacts that maintains contact with indigenous traditions continues to be made. The traditional daily or ritual function of these objects has diminished, however, and new materials and iconography have been introduced. Production is largely limited to supplying basic clothing and domestic utensils or items for the tourist market.

Some groups continue the Pre-Columbian textile tradition praised by the conquistadores, who collected cotton blankets as tributes. The Arhuacos continue to wear traditional cotton garments such as the *tutsoma* (conical fibre cap); they also make *mochilas* or *tutus* (bags) from pita fibre, cotton or wool, patterned with rhythmic horizontal lines. The Guambianos wear striking skirts and square ponchos, formerly with straw berets (replaced in the mid-20th century by felt hats introduced by non-indigenous markets), and the Paez produce *chumbes*, decorated cotton sashes for carrying babies on their backs. The Guajiros, who adopted a European sheep- and cattle-rearing economy, produce shawls and cotton or wool *chinchorros*, or hammocks, both characterized by their generous size and vivid colours. The Kuna group makes *molas* (see MOLA), rectangles of brightly coloured cloth used as two-panelled blouses with geometric anthropomorphic or zoomorphic designs in reverse appliqué, or patchwork. Basketry forms an integral part of the economic production of many groups. Those of the Amazon

region allude, with their geometrical designs, to their mythology and their concepts of order in the universe. They use traditional forms and materials, including esparto grass, palm leaves and reeds, for utensils such as those used in the processing of such plants as cassava or manioc and for other items characterized by intricate geometric designs. The Embera and Noanama women also produce beautiful baskets in varied colours, in contrasting geometric designs.

The Emberas and Noanamas have also excelled in wood-carving, a craft related to the activities of the local shamans (*jaibanas*). During their period of initiation the shamans were trained in the medicinal use of plants and the control of the spirits, powers that they invoked through finely polished hardwood canes carved with anthropomorphic or zoomorphic figures with bended knees. The carvings in balsa or other soft wood of boats with figures carrying cudgels or shotguns (e.g. *Boat of the Spirits*; Bogotá, Mus. N.) symbolized the vehicle for the arrival of spiritual powers. The groups of the Amazon region carved wooden masks, ceremonial canes for festive dances such as the *yurupari*, or harvest of the *chontaduro* palm, and a stool originally used by the shaman in tobacco healing and other ceremonies. In the 1990s such craftsmen as Eduardo Muñoz Lora, working in Pasto, continue to make stools and other wooden objects decorated with *barniz de Pasto* (see fig. 2), a varnish made from the resin of the mopa-mopa tree, common in the region. The continued evolution of this traditional technique in the 20th century is largely due to the tourist market; in the colonial period, however, the vividly coloured varnish, dyed before use, was employed to decorate *queros* (wooden vessels of Inca origin) as well as furniture of European style. This typically bore European floral iconography mixed with such indigenous motifs as the sun, revealing the characteristic tendency to synthesize motifs in schematic and geometric forms (e.g. *barqueño* (cabinet); Bogotá, Mus. A. Colon.).

Other traditional arts that have survived in the Amazon region include featherwork (such as the Putumayos' ceremonial headdresses); the painting of geometric or zoomorphic figures on stripped tree bark with vegetable dyes; and body-painting with vegetable and mineral dyes. In the southern Andes the *cruzeros*, silver or nickel jewels produced by the Guambianos, are reminiscent of Pre-Columbian silverwork, despite their use of Christian iconography. Centres of pottery production continued in La Chamba (Tolima) and in Ráquira (Boyacá), where a yellow and green glaze was made for pottery, using a solution of copper oxide, burnt copper, lead, sulphur and ground marble.

The population of African descent, introduced during the 17th and 18th centuries as slave labour, remained on both coasts, some liberated groups settling in towns called *palenques* (palisades), such as San Basilio, near Cartagena. Although these people have not preserved their languages, they have retained visual art forms related to music and dance and produce carved wooden masks and disguises used for fiestas and carnivals in which African traditions are reflected.

BIBLIOGRAPHY

G. Abadia Morales: *Compendio general de folclore colombiano* (Bogotá, 1970)
Y. Mora de Jaramillo: *Cerámica y ceramistas de Ráquira* (Bogotá, 1974)
M. L. C. Salvador: *Molas of the Cuna Indians: A Case Study of Artistic Criticism and Ethno-aesthetics* (1976)
N. S. de Friedemann: 'Escultores de espíritus', *Rev. Lámpara*, xix (Dec 1981)
N. S. de Friedemann and J. Arocha: *Herederos del jaguar y la anaconda* (Bogotá, 1982)
L. Villegas and A. Rivera: *Iwouya, como las estrellas que anuncian la llegada de las lluvias: La Guajira a través del tejido* (Bogotá, 1982)
N. S. de Friedemann: 'El barniz de Pasto: Arte y rito milenario', *Rev. Lámpara*, xxiii (1985)
——: *De sol a sol: Génesis, transformación y presencia de los negros en Colombia* (Bogotá, 1986)
G. Reichel-Dolmatoff: *Shamanism and Art of the Eastern Tukanoan Indians: Colombia, North-west Amazon* (New York, 1987)
L. G. Vasco: *Semejantes a los dioses: Cerámica y cestería Embera-Chami* (Bogotá, 1987)
N. S. de Friedemann: *Criele criele, son del Pacífico negro: Arte, religión y cultura en el litoral pacífico* (Bogotá, 1989)
L. Villegas and B. Villegas: *Artefactos: Colombian Crafts from the Andes to the Amazon* (New York, 1992)
Arte indígena en Colombia: Cultures del món (exh. cat., Palma de Mallorca, Castell Bellver, 1992)
L. Davies and M. Fini: *Arts and Crafts of South America* (Bath, 1994)

NATALIA VEGA

III. Architecture.

1. The colonial period, c. 1500–1819. 2. After independence, from 1819.

1. THE COLONIAL PERIOD, c. 1500–1819. Following the first Spanish landings, the building of forts and stockades preceded the foundation in 1509 of the earliest coastal towns: San Sebastián de Urabá and Santa María la Antigua del Darién, both of which no longer exist, and Santa Marta (1525) and CARTAGENA (1533). The foundation of SANTA FE DE BOGOTÁ in 1538 by Gonzalo Jiménez de Quesada (1496–1579) was followed by that of TUNJA (1539), Cartago and Mompox (now Mompós; both 1540) and Antioquia (Santa Fe de Antioquia, 1541), while Pasto, POPAYÁN and Cali (all 1536) were established by other groups moving northward from Quito. These first

2. Eduardo Muñoz Lora: wooden stool, decorated with *barniz de Pasto*, c. 1990

towns were laid out on the standard Spanish grid plan around a central *plaza mayor*, on which were located the most important religious and civil buildings. The first structures, all of which have disappeared, used native craft skills and local materials: *bahareque* (mud-covered woven reeds) for walls and palm leaves for roofs. These were gradually replaced in the mid-16th century by external walls of brick-reinforced rubble masonry, unburnt bricks (*adobes*) or compressed mud (*tapiales*), with stonework for the façades of important buildings, and tiled roofs and ceilings of *Mudéjar* carpentry. Most walls were stuccoed and whitewashed. However, traditional materials and techniques remained in use in remote villages.

In the late 16th century and the 17th the considerable activity in the areas of domestic and religious architecture was based almost entirely on southern European models. Following Spanish tradition, houses were built around arcaded patios and approached through often splendid entrance halls (*zaguánes*). Urban façades were continuous, and from the street houses were distinguishable only by escutcheons above the doorways. A few late 16th-century houses survive, for example the Casa del Fundador (the house of the city's founder, Gonzalo Suárez Rendón) and the Casa de Juan de Vargas, both in Tunja; the latter has decorative frescoes on ceilings and walls (*see* §IV, 1 below).

Tunja Cathedral (originally the basilican parish church), begun in 1569 and inaugurated in 1574, is typical of the larger three-naved churches of the period, some of which had transepts or side chapels giving the effect of a cruciform plan. The red stone façade (see fig. 3) has a

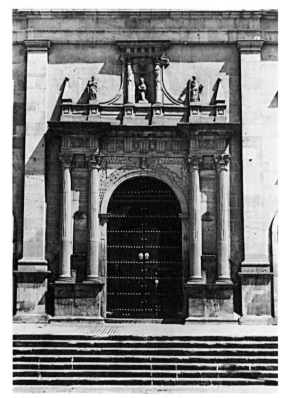

3. Tunja Cathedral, begun 1569; portal by Bartolomé Carrión, 1591–1600; 19th-century additions include the balustrade

central pediment carried on Tuscan pilasters and a Corinthian portal (1591–1600) by the Castilian Bartolomé Carrión, with Plateresque and Herreran elements. The almost featureless sturdy single tower is in a darker, rougher stone. It is an outstanding Renaissance work and expresses well the restrained external face of Colombian colonial architecture that persisted in the harsh climate (nearly 3000 m above sea level) of Tunja and elsewhere throughout the 17th century and beyond. Even in the simpler conventional churches, however, sober exteriors were belied by the extent and exuberance of the interior decoration, exemplified in both the Dominican and Franciscan churches of Tunja. S Domingo (founded 1551) is noted for the Capilla Rosario, which has a peculiarly Colombian form of oriel window (*camarín*) illuminating the figure of the Virgin from behind the altar. S Francisco (founded 1550; rebuilt by 1625) has an extraordinary blend of gilding and painting using local motifs, and a troughed *Mudéjar* ceiling.

In Bogotá the church of S Francisco (1569–c. 1620), one of the city's few remaining buildings from the first century of the Spanish period, also has a restrained stone façade with a scalloped bell chamber (*espadaña*) and a single tower (rebuilt immediately after the earthquake of 1785). S Ignacio, Bogotá (begun 1625; dedicated 1635 before completion; for illustration *see* BOGOTÁ, SANTA FE DE), is spatially more complex and marks the beginning of the transition from Renaissance to Baroque in Colombia. It was designed by the Italian Jesuit Giovanni Battista Coluccini (1569–1641) on a Latin-cross plan with a barrel-vaulted nave and was the first church of Nueva Granada to have a dome at the crossing. Although built in brickwork, the façade is thought to have been inspired by the Jesuit church of Il Gesù, Rome. Of similar importance are the churches of the first half of the 18th century in Cartagena de Indias, where the severe Renaissance façade of the Jesuit church of S Pedro Claver (1695–1716) is given a slight Baroque movement by the horizontality conveyed by deep cornices. The later church of the Third Order (1735) has a single-storey façade with classical overtones, although swept upward to a high two-bell *espadaña*.

The religious teaching centres (*reducciones*) established by the evangelizing orders were often built over many years and usually consisted of a church with an atrium or antechapel and four small open chapels (*capillas posas*); residential accommodation for converted Native Americans was provided around them. In Colombia these were mainly on the Cundi-Boyacá plateau near Tunja, the area assigned to the Franciscan Order, and centred on the village of Monguí, where a chapel and resthouse for the friars was established in 1630. A monastery was founded in 1702, and a very large church was begun under the architect Martín Polo Caballero in 1733 (completed 1760). Twin towers have lower storeys of stone rising to heavy square Baroque belfries, while the lower (stone) portion of the façade recalls the Romanesque. The church is approached via a spacious platform, a feature of various local churches, such as the single-towered parish church of Leíva (established 1573), also in the Boyacá district.

The Bourbons came to power in Spain in 1700, and the reforms that followed encouraged trade between the colonies and produced a boom in construction, including

the erection of the first civic and administrative buildings. The city of Cartagena de Indias continued to build fortifications against attacks from the sea. Perhaps the best-known is the section called La Tenaza (1765–71), designed by the military engineer Antonio de Arévalo (*b* 1715). Behind the turreted redoubts, the grille-covered windows of the patio houses grew larger and were projected into the street as oriels or bays with informal seats between them. Two-storey houses had graceful, overhanging open balconies (for illustration *see* CARTAGENA), such as those of the Casa del Marqués de Valdehoyos in the Calle de la Factoria. Portals became increasingly elaborate. The Palacio de la Inquisición (completed early 18th century), which occupied a typical two-storey house, has an impressive, boldly modelled Baroque stone portal dated 1770. Similar 18th-century houses survive in Bogotá, Mompós and the gold- and silver-mining city of Popayán. After a devastating earthquake in 1736, Popayán was rapidly redeveloped. Among the Baroque buildings that characterize it are S Domingo (1750) and the Dominican convent (now part of the Universidad del Cauca) by the Bogotá master Gregorio Causí (*b* 1696), noted for its archaizing stone portal (dated 1741) with a broken double pediment carried on attached columns influenced by Plateresque decoration. The church of S Francisco (1775–95), by the Spanish regional architect Antonio García, has an impressive three-storey façade, Rococo in spirit, in which coupled columns through the two lower storeys carry obelisks and the second cornice follows the line of the central arched window. The historic buildings of Popayán were restored after an earthquake in 1885 but were damaged by yet another in 1983.

Elsewhere in the 18th century *Mudéjar* influence was apparent, for example at Cali in the church of S Francisco (*c.* 1765) by Pérez de Arroyo (1747–92), where the multifoil windows of the tower are set against a background pattern of blue and green tiles. In Cartago, *Mudéjar* influence was visible in the framed arches and unadorned surfaces in the church of Guadalupe (completed 1810) by Mariano Ormuza y Matute, which has a triple *espadaña*. Plain surfaces also marked the late Baroque façade of the Jesuit church of S Barbara (1780s), Antioquia. In MEDELLIN the church of Veracruz (1791–1802), by the Bogotá architect José Ortiz, also has a notable triple *espadaña* above a sober Baroque façade without towers. The archaizing Baroque of the octagonal tower and balcony of S Barbara (1795–1808), Mompós, is remarkable and, as Marco Dorta points out, coincided in date with the introduction of the Neo-classical style into Colombia by the Spanish Capuchin architect Fray DOMINGO DE PETRES, who arrived in Bogotá in 1792. The colonial period in Colombia closed with Petrés's elegant interpretations in the cathedrals of Chiquinquirá (completed 1796; then the church of the Virgin) and Zipaquirá (completed 1805; then the parish church), the observatory in Bogotá (1803–4) and Bogotá Cathedral (begun 1807, incomplete on Petrés's death), with its simple application of Roman Doric and Tuscan orders.

BIBLIOGRAPHY

D. Angulo Iñíguez, E. Marco Dorta and M. J. Buschiazzo: *Historia del arte hispanoamericano* (Barcelona, 1945–56), iii, pp. 231–63
P. Kelemen: *Baroque and Rococo in Latin America* (New York, 1951), pp. 27, 59–71
A. Corradine Angulo: *Manual de historia de Colombia*, i (Bogotá, 1981)
R. Gutiérrez: *Arquitectura y urbanismo en Iberoamérica* (Madrid, 1983)
M. C. Plazas: 'Reconstrucción de Popayán', *Proa*, 341 (May 1985), pp. 15–37
N. Tobón Botero: *Arquitectura de la colonización antioqueña*, 3 vols (Bogotá, 1985–7)
T. Uriba Forero, ed.: 'Patrimonio, reutilización y restauración', *Proa*, 352 (July 1986) [whole issue]
S. Arango de Jaramillo: *Historia de la arquitectura en Colombia* (Bogotá, 1989)
F. J. Mejía Guinand, ed.: 'Centros históricos: Bogotá', *Proa*, 388 (Feb 1990) [whole issue]
G. Tellez: *Casa colonial: Arquitectura domestíca neogranadina* (Bogotá, 1995)
G. Gutiérrez, ed.: *Barroco iberoamericano* (Barcelona and Madrid, 1997)
S. Sebastián: 'Arquitectura virreinal en Colombia', *Arquitectura colonial iberoamericana*, ed. G. Gasparini (Caracas, 1997), pp. 193–222

FERNANDO CARRASCO ZALDUA

2. AFTER INDEPENDENCE, FROM 1819.

(i) 1819–1930. Independence from Spain resulted in the loss of Spanish master builders and architects. Few buildings were commissioned in the early years of independence during Bolívar's campaigns and the subsequent unrest. There was a brief period of progress in the 1830s, but civil wars throughout the rest of the 19th century severely curtailed architectural achievement. Nevertheless, demographic growth and the expanding coffee industry brought a significant increase in construction in new towns founded in the west of the country by the state of Antioquia: Jérico (1851), Pereira (1863), Manizales (1864), Jardín (1864), Calarcá (1886) and Armenia (1889). There was a return to traditional local crafts: timber, mud-covered woven reeds (*bahareque*) and the large local bamboo (*guadúa*) were readily available and offered the quickest and most economical means of building. They were adapted to the popular styles inherited from early 19th-century churches and sumptuously decorated. Indigenous people continued to use their traditional techniques: the Tulkano in the Amazon region worked wood and plant fibres together, incorporating cosmological symbols.

The Romantic spirit of the second half of the 19th century was characterized by the Capitolio Nacional (1860s) on the Plaza Bolívar, Bogotá, by the Danish architect Thomas Reed (1810–78). Reed introduced an original mix of Neo-classical and Beaux-Arts academic styles with *Mudéjar* overtones, and this became the basis for the 'republican' style of architecture that persisted into the 1930s and beyond. The Capitolio also provided the model for numerous buildings initiated during the 1880s and 1890s. Although new building techniques using imported steel and concrete were introduced throughout Latin America in the last quarter of the century, more notable was the highly skilled use of brickwork, a feature that continued to distinguish Colombian architecture into the late 20th century. Three academically trained architects were principally responsible for introducing the 'republican' style, which often had Italian or French decorative detail, into towns that were still largely colonial in character. The French architect Charles Carré (1863–1923) was responsible for the academic classicism of Villa Nueva Cathedral (1880), Medellín; the Italian Pietro Cantini (1850–1929) designed the Teatro Colón (1885), Bogotá, with clear references to the Neo-classical La Scala, Milan, as well as to the neo-Baroque Paris Opéra; and the

Colombian Mariano Santamaría (1857–1915) built the smaller Neo-classical Teatro Municipal (1887; destr. 1950), Bogotá. In urban houses such as those in Antioquia, grilled windows became larger, reaching almost to street level, and upper floors were set back to provide deep verandahs; oriel windows and enclosed balconies (*gabinetas*) appeared.

Reparations for the loss of Panama after the War of a Thousand Days (1899–1903) were not received until 1922, when an improving economy again encouraged investment in building. Public and large private commissions favoured the new 'republican' architecture, although urban houses and villas (*quintas*) continued to be built in many styles, and most churches continued to be based on Gothic models. As early as 1913 local architects, trained abroad, were helping to change the appearance of the colonial cities. Perhaps the best-known is Alberto Manrique Martín (1890–1968), whose earliest houses had distinctly French classical features: the three-storey *quinta* Pubenza (1913) and the single-storey house in the Avenida Chile (1914) (both Bogotá) had Art Nouveau details, as did his Fiat Garages (1918), Bogotá, where the large openings in the street façade and the attic centrepiece also prefigured 1930s Art Deco garden-city factories and commercial buildings. Other manifestations of Art Nouveau include a late reminiscence of Raimondo D'Aronco's *Stile Liberty* in the entrance gates to the Hipodromo Antiguo (1928), Bogotá, by Vicente Nasi (1906–91) in the year he arrived in Colombia from Turin. Local architects working in Medellín in this period were Pablo de la Cruz (1884–1954), who designed the Instituto Pedagógico (1925; destr. 1972), and Marino Rodríguez (1897–1947), responsible for the Banco de la República (1919). Government commissions for official buildings such as the Gobernación (1918), Bogotá, by the French architect Gaston Lelarge (1852–1934), the Palacio de Justicia (1924) at Cali by the Belgian Joseph Martens (1895–1950), and the Gobernación de Antioquia and Palacio Nacional (1925), both in Medellín, by the Belgian Augustin Goovaertz (1891–1940), favoured a conservative simplified neo-Baroque with French Second Empire elements.

(ii) After 1930. A Liberal government came to power in 1930, and the transition began towards a new aesthetic derived from the Modern Movement in Europe and the USA. Solutions for larger suburban houses continued to be widely eclectic well into the 1930s: for example, hybrid styles from Neo-classical to Art Deco were used by Alberto Manrique Martín at Santa Teresita (1931), Teusaquillo (1932) and Chapinero (1932; all Bogotá suburbs). Vicente Nasi, however, combined Modernist forms with a monumentality reminiscent of Pio Piacentini in the railway station (1930) at Buenaventura. He also designed many white flat-roofed rectilinear houses during the 1930s, this work culminating in the *quinta* Fernando Mazuera (1941), Fusagasugá, Cundinamarca, with a smoother character approaching the International Style. The distinguished Faculty of Engineering (1938–42) in the Ciudad Universitaria, Bogotá, by the German engineer Leopold Rother (1894–1978) and the Italian architect Bruno Violi (1909–71), is a simple three-storey white building with a series of identical open verandah-pavilions influenced by contemporary northern Italian *Razionalismo*. Early Modernist

buildings of note in Bogotá by local architects include the important David Restrepo housing development (1933–9) by Gabriel Serrano Camargo (1909–82) in three-storey multi-family blocks, with formally sophisticated plain brick surfaces more characteristic of Europe than Latin America. The baseball stadium (1947) in Cartagena de Indias, by the Colombian engineer Guillermo González Zuleta (1906–91) in collaboration with a team headed by Mesa Gabriel Solano (*b* 1916), was the first Colombian building to attract worldwide attention.

In 1947 Le Corbusier visited Bogotá to prepare its master-plan, and this provided the basis for development in the 1950s by the American architect and planner Paul Lester Wiener (1895–1967) and Josep Lluís Sert (1902–83), who also prepared plans for Medellín, Tucumán and Cali. A decade of political unrest and violence inhibited building, however, well into the 1950s, when migration to the cities and rapid growth of shanty towns demanded urgent provision of mass housing. The government experimented with high-density housing on Corbusian principles with the Centro Antonio Nariño (1950–53), and it was mainly in housing that the Colombian contextualist school of design, responding to the specific conditions of each site and using local materials, made its mark. The three- to eight-storey apartment blocks (1957–62) on the outskirts of Bogotá by Fernando Martínez (1925–92) have complex forms defined in high-quality brickwork that recall Aalto's work in Säynätsalo, and careful integration with their (similar) pine-clad setting completes the effect.

Colombia's best-known 20th-century architect, Rogelio Salmona (*b* 1929), a Colombian born in Paris and an apprentice with Le Corbusier, also worked in this contextualist genre, although his first building, the El Polo apartment building (1959–60), Bogotá, which he executed with Guillermo Bermúdez (*b* 1924), indicated a more rational approach to planning as well as a strong Corbusian influence in the continuous strip windows on the three upper floors and the open ground floor. His international reputation was established by the wedge-shaped low-cost housing blocks of San Cristóbal (1963), Bogotá, arranged radially on the site; each apartment, with a terrace on the roof of that below, looked out over the countryside between great triangular brick cross-walls. The spectacular Residencias El Parque (1965–70; see fig. 4) consist of three irregular multifaceted towers (up to 35 storeys); the pastel pinks of their brickwork are emphasized by Bogotá's blue-green mountainous backdrop, and their angular forms contrast with the form of the adjacent bull-ring.

Meanwhile, the plan for Bogotá encouraged rapid urban development, and before the end of the 1950s the major Colombian practices had espoused the International Style for city-centre projects. Notable examples were the work of the practice of Camilo Cuéllar Tamayo (*b* 1909), Gabriel Serrano Camargo and José Gómez Pinzón (*b* 1909), ranging from the 12-storey curtain walling of the Ecopetrol Centre (1958) to the 44-storey Centro de las Américas (1976). Educational buildings tended to be modernist–monumental in character, exemplified by the work of Anibal Moreno (*b* 1927) in Bogotá, such as the elegant Facultad de Enfermería in the Universidad Javeriana (completed 1968).

4. Rogelio Salmona: Residencias El Parque, Bogotá, 1965–70

In the 1970s and 1980s speculative comprehensive development on a large scale also included a great deal of middle- and upper-income housing, such as the S Teresa complex at Usaquen (1977–8) and that at Catalejo (1979–80), both in Bogotá, by Jorge Rueda, Enrique Gómez Grau and Carlos Morales, and the highly original five-storey apartments at La Esmeralda (1974–9), Bogotá, by Alvaro Botero and Luis Enrique Reyes. Later trends were towards a combination of Post-modernist models with those drawn from late Italian *Razionalismo*, exemplified in Salmona's atmospheric Casa de Huéspedes Ilustres (1980–81), Cartagena. High-quality brickwork meanwhile remained a constant and distinguishing feature in Colombian architecture throughout the 1980s, setting it apart from the rest of Latin America.

BIBLIOGRAPHY

H.-R. Hitchcock: *Latin American Architecture Since 1945* (New York, 1966), pp. 37–8, 98–107, 192–3
E. Moure Erazo: *Estudio de la expresión urbanística y arquitectónica de la época de la República, 1840–1910* (diss., Bogotá, U. Andes, 1976)
G. Tellez Castañeda: *Manual de la historia de Colombia*, ii–iii (Bogotá, 1979–80)
Architectures colombiennes: Alternatives aux modèles internationaux (exh. cat. by A. Berty, Paris, Pompidou, 1980–81)
C. Namer: 'Arquitectura colombiana presente en París', *A. Colombia* (1981), no. 15
R. Serrano Camargo: *Semblanza de Gabriel Serrano Camargo, arquitecto* (Bogotá, 1983)
'The Recent Work of Rogelio Salmona', *Proa* (1983), no. 317, pp. 16–53; no. 318, pp. 13–55
V. Nasi: *Vicente Nasi: Arquitectura* (Bogotá, 1984)
H. Rother: *Arquitecto Leopold Rother: Vida y obra* (Bogotá, 1984)
Semblanza de Alberto Manrique Martín (Bogotá, 1985)
J. F. Liernur: *America Latina: Architettura, gli ultimi vent'anni* (Milan, 1990)
G. Telléz: *Rogelio Salmona: Arquitectura y poética del lugar* (Bogotá, 1991)
——: 'Arquitectura neocolonial en Colombia', *Arquitectura neocolonial: América Latina, Caribe, Estados Unidos*, ed. A. Amaral (São Paulo, 1994), pp. 21–34

FERNANDO CARRASCO ZALDÚA

IV. Painting, graphic arts and sculpture.

1. The colonial period, c. 1500–1819. 2. After independence, from 1819.

1. THE COLONIAL PERIOD, C. 1500–1819. During the colonial period in Colombia, as elsewhere in Latin America, the fine arts were predominantly religious in character. Following the confirmation by the Council of Trent (1545–63) of the usefulness of Christian iconography in religious education, various communities imported religious images, especially sculptures, during the 16th and 17th centuries. Some paintings produced in Colombia during the early colonial period also survive. Significant examples include the *Virgin of Chiquinquirá* (Chiquinquirá Cathedral) by the Sevillian Alonso de Narváez (d 1583), who settled in Tunja and was the first known significant painter in Colombia. The Dominican friar Pedro Bedón (1556–c. 1621) executed paintings (c. 1595) on the walls of the church of S Clara, Tunja. Born in Quito, Bedón started what came to be known as the Quito school. During the 16th century some non-Christian themes were treated, in the spirit of the Renaissance, and Classical mythology inspired some of the decorations on the walls and ceilings of colonial residences. Anonymous murals depicting naturalistic hunting scenes in the house in Tunja of the city's founder, Captain Gonzalo Suárez Rendón, have been preserved, as have the frescoes in the house of the chronicler Juan de Castellanos, and those in the house of the clerk Juan de Vargas, attributed to the Italian mannerist ANGELINO MEDORO, who lived in Tunja between 1587 and 1589. These combine Christian symbols, grotesques and mythological characters with animals representing Vice and Virtue, groups of figures taken mostly from European prints, and local elements such as tropical fruits, a characteristic of later mestizo art.

As a continuation of the Sevillian workshop tradition, family workshops with apprentices were organized in Bogotá, and these contributed to the diffusion and popularization of Spanish imagery and techniques. They worked principally to commissions from religious communities, and the iconography was usually copied from European books of engravings. The incorporation of local characteristics and the use of local materials allowed the Santa Fe school to establish a distinct identity. The most important painters of the period were attached to the workshop of the Figueroa family, which defined the character of art in Bogotá between 1615 and 1738. Outstanding members of the family were Gaspar de Figueroa (d 1658), who painted biblical scenes using a marked chiaroscuro (e.g. *Virgin of the Rosary*, c. 1615; Tunja, Convento Concepcionista El Topo), and his son Baltasar de Figueroa (d 1667), whose work was characterized by warm colours and careful observation of nature (e.g. *Adoration of the Magi*; Bogotá, Mus. A. Colon.). The colonial attempt to assimilate European art reached its highpoint in the work of Gregorio Vázquez de Arce y Ceballos (1638–1711), who created more than 500 paintings and was the most prolific artist of the Viceroyalty. The quality of his draughtsmanship is evident in the collection of his sketches in the Museo de Arte Colonial, Bogotá.

In the 18th century sculptural decoration assumed Rococo characteristics, particularly in Popayán, which was influenced by work in nearby Quito. The stairway to the pulpit (c. 1775) of the church of S Francisco, attributed to the 18th-century artist Sebastián Usina (fl 1750s; d 1785), is decorated exotically with a female canephor of mestizo appearance, representing the tradition whereby indigenous

people paid tribute in kind to local chiefs and later to the Church. Sculptors made religious images from fine woods such as cedar and walnut. To achieve greater realism, the wood was given a flesh colour with a shiny finish; the figures were then decorated with wigs, clothing and accessories. The gilding of figures and altarpieces was achieved by first covering the wood with a layer of *bolo* (reddish clay) and then applying gold while the clay was still wet. The techniques of quilting and *sgraffito* were used for decoration, and locally produced colours such as ultramarine, crimson (cochineal) and vermilion (mineral) were used. Occasionally anonymous Native American craftsmen took part in creating religious sculpture, their work being notable for a tendency to flatten the Baroque forms and for the introduction of such iconography as the solar symbol.

The works of Pedro de Lugo Albarracín (*fl* 1629; *d c.* 1666) (e.g. *Christ Bleeding*; Bogotá, Santuario Monserrate) and of Miguel de Acuña (*fl* 1690) include outstanding examples of harsh, dramatic sculptural realism. The most important sculptor of the 18th century in Colombia, however, was the Andalusian Pedro Laborio (*b* 1700; *d* after 1750), who settled in Bogotá. The triumph of Baroque forms is evident in his work, though his dynamic, graceful figures are intimate and unsentimental. His pair of statues *St Joachim and the Young Virgin* (Bogotá, Mus. A. Colon.) depicts a playful and tender psychological relationship between its characters.

During the last 50 years of colonial rule a Rococo style of painting developed in Bogotá after acceptance of the style at the Madrid court. This was intended to satisfy the demands of a political and social élite, and its exponents included Joaquín Gutiérrez (*fl* 1750–80), known as 'the painter of Viceroys', who was noted for the decorative and refined quality of his portraits. His portrait of the *Marquis of S Jorge* (1775; Bogotá, Mus. A. Colon.; see fig. 5) is distinctive for the way in which the face is painted in layers, reminiscent of the contemporary colouring of statues; the highly stylized figure is flat in colour, simple in design and full of elegance and grace.

The Expedición Botánica (1784–1817; *see* §I above), although scientific in its aim of recording all the native botanical species unknown in Europe, also had great artistic significance. Under the patronage of the Spanish crown a workshop was set up to teach illustrators, who were paid an official salary; research and the use of indigenous colouring materials were fostered, and for the first time paintings of national subjects from a direct observation of nature were produced. Nearly 5400 illustrations from the expedition are preserved in the Jardín Botánico, Madrid. Although bound by a common scientific purpose, the illustrators developed their own styles of colouring and composition. The works of Pablo Antonio García (1744–1814; a pupil of Joaquín Gutiérrez), the botanist and doctor Francisco Javier Matiz (1783–1816) and Salvador Rizo (1784–1814), an exceptional painter of flowers, were particularly noteworthy; these artists formed part of a creole cultural élite that played a decisive role in the fight for independence, to which many of them were martyrs.

BIBLIOGRAPHY

G. Giraldo Jaramillo: *La pintura en Colombia* (Mexico City, 1948)
L. A. Acuña: *Diccionario biográfico de artistas que trabajaron en el Nuevo Reino de Granada* (Bogotá, 1964)

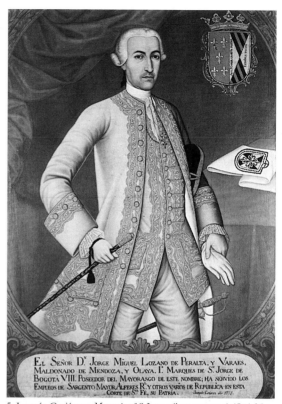

5. Joaquín Gutiérrez: *Marquis of S Jorge*, oil on canvas, 1.45×1.06 m, 1775 (Bogotá, Museo de Arte Colonial)

S. Sebastián: *Itinerarios artísticos de la Nueva Granada* (Cali, 1965)
F. Gil Tovar and C. Arbelaez: *Arte colonial de Colombia* (Bogotá, 1968)
L. A. Acuña: *Siete ensayos sobre el arte colonial en la Nueva Granada* (Bogotá, 1973)
Enciclopedia de historia de arte colombiano, iv–v (Barcelona and Bogotá, 1977)
Barroco de la Nueva Granada: Colonial Art from Colombia and Ecuador (exh. cat. by M. Fajardo and others, New York, Americas Soc. A.G., 1992)
R. Gutierrez, ed.: *Pintura, escultura y artes utiles en Iberoamérica, 1500–1825* (Madrid, 1995)

NATALIA VEGA

2. After independence, from 1819.

(i) 1819–1930. In the years immediately after independence there was a greater change in artistic subject-matter than in the dominant style, as attention focused on the new national heroes: for example, the workshop of PEDRO JOSÉ FIGUEROA executed the portrait of *Simón Bolívar, Liberator and Father of the Nation* (1819; Bogotá, Quinta Bolívar). When Gran Colombia broke up in the 1830s, artists started to look to European countries other than Spain for models, and conventional Neo-classical portraits became fashionable. Artists such as José María Espinosa (1796–1883), who was one of the most influential artists in Colombia in the 19th century, cultivated other genres and developed more personal styles. He had joined the advanced revolutionary forces in the struggle for independence, sketching scenes of soldiers with humour and spontaneity. He was later commissioned to paint scenes of the battles he had witnessed, as in *Action at Tacines* (*c.* 1860; Bogotá, Mus. N.). He painted some of the most

faithful portraits of Bolívar, which were later taken as models for numerous paintings and engravings, and excelled in the technique of portrait miniature on ivory, which was very popular in Bogotá.

José Gabriel Tatís (1813–?1885) executed drawings with a fresh, ingenuous vision, and in his *115 Portraits* (1853; Bogotá, Mus. N.), watercolours of contemporary Colombian personalities shown in stiff group profiles and numbered like specimens, he left an anecdotal documentary bordering on caricature. Outstanding in the work of Luis García Hevia (1816–87), an apprentice in Figueroa's studio, is the painting of the *Death of Santander* (1841; Bogotá, Mus. N.), notable for its elegance of line, austere colours and clarity of composition. García Hevia is also credited with the introduction into Colombia of the daguerreotype.

The first important representative of the regionalist *costumbrista* genre in Colombia was Ramón Torres Méndez (1808–85), who from 1848 executed more than 300 works. He depicted popular anecdotal episodes and portrayed the rural and the village landscape. His works were collected in the album *Costumbres neogranadinas*. Around the same period a number of foreign travellers recorded their impressions of Latin America in sketchbooks and watercolours; between 1843 and 1887 the British Consul Edward Walhous Mark (1817–95) made 53 watercolours of customs and landscapes (Bogotá, Banco de la República).

From 1850 to 1859 the Comisión Corográfica conducted a scientific study comparable to the earlier Expedición Botánica. Its aim was to define the new Colombian identity by making maps and studying the cultural and ethnic diversity of the regions. The commission was directed by Augustín Codazzi, who had successfully completed a similar project in Venezuela; he included three illustrators in the venture: the Venezuelan Carmelo Fernández (1810–87), who was noted for his detailed watercolours recording people (e.g. *Mestizo Farmers of Anís, Ocaña Province, Colombia*, 1850–59; Bogotá, Bib. N. Colombia); the British artist Enrique Price (1819–63), who distinguished himself as a landscape painter and by his humorous touches; and Manuel María de la Paz (1820–1902), whose 96 illustrations favoured a panoramic vision of the landscape. The commission's illustrations (Bogotá, Bib. N. Colombia) gave a complete, authentic and varied picture of the diversity of the new nation.

An important figure in the late 19th century was the humanist Alberto Urdaneta (1845–87), who established the *Papel periódico ilustrado* (1881–6) and founded, in 1886, the first national academy, the Escuela Nacional de Bellas Artes, Bogotá. He also organized the Gran Exhibición (1886), in which 1200 works, including contemporary drawings and photographs, were exhibited as well as, for the first time, Pre-Columbian and colonial art. This unprecedented event received much publicity and stimulated interest in art history in the country. The Escuela became the focal point for artistic learning in Colombia and went on to revive the art of sculpture, which had almost disappeared after the colonial period. A significant exponent of the academic painting style was EPIFANIO GARAY, who painted portraits of the affluent classes of Bogotá, with theatrical settings and sharp psychological characterization. ANDRÉS DE SANTA MARÍA, who had developed

most of his career in Belgium, was influential in art education at the beginning of the 20th century, and played a very important role in the transition to modernism. His *Annunciation* (c. 1922; Bogotá, Mus. N.), with thick visible brushstrokes and arbitrary colours, shows his familiarity with *fin-de-siècle* tendencies. MARCO TOBÓN MEJÍA played a similar role among the sculptors of Antioquia.

In the early 20th century, landscape, painting was widely cultivated by Colombian artists who had been imbued by the academy with a great admiration for the treatment of atmosphere by the English Romantics, for Spanish Realism and for the *plein-air* painting of the Barbizon school. The inspiring variety of the Colombian landscape contributed to the acceptance of this genre in the country; many painters did their sketches on the Sabana de Bogotá, attracted by the serenity of its landscape, light and colour. These artists became known as the Escuela de la Sabana, and they included Jésus María Zamora (1875–1949), Eugenio Peña (1860–1944) and Roberto Páramo (1841–1915) as well as Ricardo Borrero Alvarez (1874–1931), who was notable for his controlled handling of colours and rich treatment of light, as in the *Convent 'La Enseñanza'* (Bogotá, Mus. N.). Meanwhile, the *costumbrista* painter Miguel Díaz Vargas (1886–1956), who depicted country life, using precise outlines and almost photographic colours, served as a bridge between the academic style and the nationalist subject-matter that was to follow.

(ii) After 1930. In 1930 the Bachué group (active until 1950), named in honour of the goddess of Chibcha mythology, reacted against academicism and sought to move away from foreign topics and to look within Colombia for inspiration, dealing in some cases with indigenous mythology. Some members worked on murals, in a manner similar to that of their Mexican contemporaries, in an attempt to direct their art at the community. PEDRO NEL GÓMEZ combined social themes with allusions to universal human values in his murals and included popular mythical figures from western Colombia in such series as *Death of the Miner* (1934–9; Medellín, Pal. Mun.). In expressive female nudes with mestizo features he explored such themes as exploitation and suffering (e.g. *Violence*, 1955; Bogotá, Mus. N.). Other artists associated with the group included Ignacio Gómez Jaramillo (1910–70), Luis Alberto Acuña (*b* 1904) and Gonzalo Ariza (*b* 1912). The expressionist painter Débora Arango (*b* 1910) meanwhile treated provocative social themes, such as the status of women, religion and politics; her work was rejected until the 1980s on grounds of immorality and obscenity and because of her allusions to the political milieu.

Abstract art was introduced into Colombia with exhibitions of paintings by Marco Ospina (1912–83) in 1949 and of works by the Constructivist painter, sculptor and printmaker Eduardo Ramírez Villamizar (*b* 1923) in 1952. The experimental German-born GUILLERMO WIEDEMANN also played a decisive role, however, in its introduction, with works inspired by the tropical landscape and the inhabitants of the Pacific coast of Colombia (e.g. *In the Corral*, 1940; Bogotá, Mus. N.). Significant Abstract Expressionist painters included ARMANDO VILLEGAS, with such works as *Electric Panorama* (1958; Washington,

DC, A. Mus. Americas). The Constructivist sculptor EDGAR NEGRET, best known for his painted metal sculptures (e.g. *Magic Gadget*, 1959; see fig. 6), became one of the most important abstract sculptors in Latin America, with a museum dedicated to his work (*see* §VII below).

In the 1950s, however, many artists continued to produce figurative work. The painter and printmaker ALEJANDRO OBREGÓN explored with vitality and dynamism the Latin American landscape and identity, using a contrasting language of colour and brushwork. He also explored political themes, as in *The Wake* (1956; see fig. 7), painted in reaction to a massacre (led by the military dictatorship) of students in the 1950s. FERNANDO BOTERO achieved international renown with figurative paintings full of sensual monumentality, humour and ironic commentary. The arbitrary or distorted scale of his inflated figures and objects is reminiscent of Pre-Columbian Quimbayan pottery. He also experimented with sculpture in the 1970s (e.g. *Big Hand*, 1976–7; see fig. 8). ENRIQUE GRAU depicted his characters in peculiar situations (e.g. *Girl in the Tavern*, 1969; Bogotá, Fond. Cult. Cafetero) in his paintings and bronze sculptures.

In the 1960s geometric abstraction was represented by, among others, Carlos Rojas (*b* 1933), Manuel Hernández (*b* 1928) and Omar Rayo (*b* 1928), who produced engravings using uninked intaglio and painting with strong optical effects (e.g. *Trapped*, 1960–67; see colour pl. XXXII, fig. 1). At the same time women were beginning to assume a leading role in Colombian art. Olga de Amaral (*b* 1936) used textiles to search for new structural and chromatic possibilities. The organic features of her work are evocative of the Andes, while the treatment of wool, horsehair and gold leaf alludes to Pre-Columbian and colonial cultures (e.g. *Flag*, 1984; Bogotá, Mus. N.). The sculptor Felisa Bursztyn (1933–82) was innovative with her installations, which incorporated the rusting junk and debris of indus-

7. Alejandro Obregón: *The Wake*, oil on canvas, 1.75×1.40 m, 1956 (Washington, DC, Art Museum of the Americas)

trial society. Pop art in Colombia was given a sharply regional focus, with unexpected touches of wit and social comment. BERNARDO SALCEDO assembled unrelated objects in boxes and collages, and Hernando Tejada created imaginative items of furniture. Beatriz González (*b* 1939) reinterpreted popular images such as prints, news photographs and pictures of popular heroes or paintings, creating amusing or satirical associations about bourgeois taste or political criticism. Other artists associated with Pop art in Colombia include Santiago Cárdenas (*b* 1937) and Ana Mercedes Hoyos (*b* 1942).

In contrast to the predominance of abstract art in the 1960s, there was a sharp return in the 1970s to figurative art, with an emphasis on technique. This was most evident in printmaking and drawing. Notable in this tendency were LUIS CABALLERO and Dario Morales (1944–88), who both depicted nudes, while Miguel Angel Rojas (*b* 1946) produced experimental combinations of engraving and photography. Some artists, however, such as Antonio Caro (*b* 1950), became interested in conceptual art during this period. In the 1980s the active artistic environment was supported by a flourishing publishing industry, increased promotion by galleries and the organization of important events by the museums of modern art of Bogotá, Medellín and Cali, which provided alternatives to the more traditional Salón Nacional. This more diverse milieu produced an outstanding new generation of artists. Some 400 artists took part in the 33rd Salón Nacional in 1990, representing the diverse developments of the late 20th century.

BIBLIOGRAPHY

R. Torres Méndez: *Costumbres neogranadinas* (Bogotá, 1851)
A. Boulton: *Los retratos de Bolívar* (Caracas, 1964)
Art of Latin America since Independence (exh. cat. by S. L. Catlin and T. Grieder, New Haven, CT, Yale University A.G., and elsewhere, 1966)
D. Bayón: *Aventura plástica en Hispanoamerica* (Mexico City, 1974)

6. Edgar Negret: *Magic Gadget*, polychromed wood, 486×914×533 mm, 1959 (Washington, DC, Art Museum of the Americas)

8. Fernando Botero: *Big Hand*, bronze, 876 x 565 x 460 mm, 1976–7 (Washington, DC, Hirshhorn Museum and Sculpture Garden)

M. Traba: *Historia abierta del arte colombiano* (Cali, 1974)
G. Giraldo Jaramillo: *La miniatura, la pintura y el grabado en Colombia* (Bogotá, 1980)
E. Serrano: *Historia de la fotografía en Colombia* (Bogotá, 1983)
En busca de un país: La Comisión Corográfica (Bogotá, 1984)
E. Serrano: *Cien años de arte colombiano* (Bogotá, 1985)
Museum of Modern Art of Latin America: Selections from the Permanent Collection (exh. cat. by M. Traba, J. C. Baena Soares and R. Novey, Washington, DC, Mus. Mod. A. Latin America, 1985)
Art in Latin America: The Modern Era, 1820–1980 (exh. cat. by D. Ades and others, London, Hayward Gal., and elsewhere, 1989)
C. Calderon, ed.: *50 años-Salón Nacional de Artistas* (Bogotá, 1990)
E. Serrano: *La Escuela de la Sabana* (Bogotá, 1990)
——: *El bodegón en Colombia* (Bogotá, 1992)
——: 'Manifestaciones vernáculas en el arte colombiano', *Voces de Ultramar, Arte en América Latina: 1910–1960* (exh. cat., Madrid, Casa América; Las Palmas de Gran Canaria, Cent. Atlántic. A. Mod.; 1992), pp. 49–56
A. Medina: *El arte colombiano de los años 20 y 30* (Bogotá, 1995)
I. Pini: 'Colombia', *Latin American Art in the Twentieth Century*, ed. E. Sullivan (London, 1996), pp. 159–77
A. Medina: *Colombia en el umbral de la modernidad: Un homenaje a los artistas antioqueños* (Bogotá, 1997)

NATALIA VEGA

V. Gold and silver.

Gold- and silversmiths are recorded in Santa Fe de Bogotá as early as the 1540s, but, despite documentary references to a system of hallmarking, virtually no marked objects have survived. One of the earliest pieces made in Nueva Granada after the arrival of the Spanish is a cross with Native American motifs in the parish church at Pasca in Cundinamarca. It is unmarked, but an inscription records its presentation to the church by a converted *cacique* (Native American chief) in 1550. Silver items salvaged in 1985 from the wreck of *Nuestra Señora de Atocha*, sunk on its way back to Spain in 1622, are struck with a crowned pomegranate (*granada*), which may have been the *quinto* (tax) mark in use at the time. The widespread use of encrustation with gemstones, especially with native emeralds, can be seen in a series of Baroque monstrances, the earliest dating from 1673 (Popayán, Mus. A. Relig.). Other examples include one known colloquially as 'La Lechuga' that belonged to the church of S Ignacio in Bogotá (now in Bogotá, Mus. A. Relig.), made by José de Galaz between 1700 and 1707, and that made for the church of S Clara la Real, Tunja, by Nicolás de Burgos between 1734 and 1737 (Bogotá, Mus. A. Relig.). The last monstrance is 'La Preciosa' (1736) in Bogotá Cathedral, also by Burgos, which is so encrusted with gems that the form of the monstrance is practically hidden. During the 19th century and the early 20th, silversmiths produced mainly functional objects such as plates and mugs, and few great ecclesiastical commissions were carried out.

BIBLIOGRAPHY
C. Arbelaez Camacho: *El arte colonial en Colombia* (Bogotá, 1968)
Oribes y plateros en la Nueva Granada (exh. cat., ed. M. Fajardo de Ruenda; Bogotá, Mus. Oro, 1990)
J. M. Huertas: *El Tesoro de la catedral de Santafe de Bogotá* (Bogotá, 1995)
The Treasures of the Caciques of Malagana (exh. cat., Bogotá, Mus. Oro, 1997)

CHRISTOPHER HARTOP

VI. Patronage, collecting and dealing.

During the colonial period in Colombia, works of art, chiefly painting and wood sculpture, were commissioned almost exclusively by the religious orders working in the country. This is illustrated in the celebrated painting by Gregorio Vázquez de Arce y Ceballos (1638–1711) of the *Painter Handing Two of his Works to the Augustinian Fathers* (c. 1690; Bogotá, Mus. A. Colon.). A smaller proportion of paintings and religious carvings and a few pendent icons were also privately commissioned by wealthy Spaniards and creoles to decorate their private chapels or to donate to churches and convents. Also notable are the allegorical murals depicting fantastic beasts and baskets laden with tropical fruit that were commissioned in the late 16th century and early 17th to decorate the houses in Tunja previously owned by, and named after, Juan de Vargas, Gonzalo Suárez Rendón and Juan de Castellanos (*see* §IV, 1 above).

While paintings were bought and sold privately in the 17th century, there is evidence that the price paid for works of art was not very high: Vázquez de Arce y Ceballos produced some small paintings, for example a *Virgin and Child* (300×210mm, 17th century; Bogotá, Mus. A. Colon.), nicknamed *Almorzaderos* ('diners'), that came into the possession of dining houses, exchanged for food. In the 18th century the first portraits were commissioned, particularly from the Viceroys, as they attempted to bring the customs of the Madrid court to the colony. Many of these were undertaken by Joaquín Gutiérrez (*fl* 1750–80; *see* §IV, 1 above). This trend gradually spread among wealthy families, but as the insurrection began that led to the country's independence from Spain, the commissions also

came from generals, notably Bolívar and Santander, and from other government dignitaries.

In the 19th century several artists, such as Luis García Hevia (1816–87) and EPIFANIO GARAY, maintained workshops where, as well as teaching, they exhibited, promoted and sold their own works. After 1840 photographers, as a means of attracting the public, began to set up art galleries in their studios, where the work of contemporary painters could be acquired. The first art collections were started in Colombia c. 1870 and first became known to the public in 1886, when Alberto Urdaneta (1845–87) included his own collection in the exhibition that he organized for the inauguration of the Escuela Nacional de Bellas Artes, of which he was Director. Urdaneta was an alert and ambitious collector, not only acquiring European works but also for the first time giving many Colombian artists the recognition that they deserved. A permanent exhibition room was established in the Escuela, where the art market was concentrated until the mid-20th century. The most important exhibitions of the period were held there, and through it landscape painters were able to find buyers and stimulate the market, with the result that for the first time some artists were able to live by their work alone.

The example set by Urdaneta was not imitated until the painter and cultural promoter Roberto Pizano (1896–1929) began to collect art; he also reunited Urdaneta's dispersed collection, much of which was later housed in the Museo de Arte Colonial, Bogotá. The first galleries dedicated exclusively to the sale of art opened in 1948, with the market gaining stability and eventually becoming prosperous only from the 1970s. This activity centred on Bogotá, Medellín, Cali and Barranquilla and was focused on art produced primarily by Colombian artists, many of whom were able to establish international reputations. Government commissions included those for murals by Andrés de Santa María (1926), Ignacio Goméz Jaramillo (1938), Manuel Hernández (1981) and Alejandro Obregón (1987) for the buildings of the Congreso Nacional. There developed numerous private collections of works by Colombian artists, although the greatest were those held by the museums and banks (see §VII below).

BIBLIOGRAPHY
E. Mendoza Varela: *Dos siglos de pintura colonial colombiana* (Bogotá, 1966)
Colección Banco Cafetero (exh. cat., Bogotá, Mus. A. Mod., 1976)
C. Ortega Ricaurte: *Diccionario de artistas en Colombia* (Bogotá, 1979)
E. Serrano: *El Museo de Arte Moderno de Bogotá: Recuento de un esfuerzo conjunto* (Bogotá, 1979)

EDUARDO SERRANO

VII. Museums, art libraries and photographic collections.

Colombia's first museum, the Museo Nacional in Bogotá, was founded at the relatively early date of 1823, but it was only in the second half of the 20th century that museums in the country achieved full recognition as important cultural and educational institutions. They were subsequently encouraged to expand their collections, professionalism was achieved in their management, and their activities and numbers of visitors increased considerably. Colombian museums can be divided into three categories according to the origin of their financial resources: state museums, museums attached to such institutions as banks and universities, and museums funded by private foundations.

The Museo Nacional, a state museum, was created as a means of conserving and displaying some of the works produced by the Expedición Botánica (1784–1817). From 1942 to 1948 it was a dependency of the Universidad Nacional, after which it was housed in a building constructed as a prison after plans by the Danish architect Thomas Reed (1810–78). Objects and works of art from all periods of Colombian history are displayed in the Museum. The important archaeological collection includes examples of ceramic and stone works by most of the indigenous groups that inhabited Colombian territory before the arrival of the Spanish; there is also a varied ethnological collection illustrating the work of several surviving indigenous tribes. A major collection of portraits, coins, banknotes, uniforms, documents, arms, furniture, flags and other objects illustrates the history of the Republic, and there is a collection of painting and sculpture dating back to the 17th century, but with particular emphasis on Colombian art from the 19th and early 20th centuries. Another important state museum in Bogotá is the Museo de Arte Colonial (founded 1942), with a collection of painting, sculpture, furniture and silverware from the colonial period as well as much of the collection built up by Alberto Urdaneta (see §VI above); it is housed in a notable building constructed in the early 17th century by the Jesuit Pedro Pérez (1555–1638).

Those museums attached to other institutions include the Banco de la República's Museo del Oro, also in Bogotá, the country's most celebrated museum because of its magnificent collection of Pre-Columbian goldwork (over 35,000 pieces) as well as numerous ceramic and stone objects. The Museum has small regional branches displaying local pieces in Manizales, Pereira, Armenia, Santa Marta, Cartagena, Cali, Pasto and Ipiales. The Museo Arqueológico in Bogotá, attached to the Banco Popular, houses the country's most complete collection of Pre-Columbian ceramics.

Outstanding among the museums funded by private foundations is the Museo de Arte Moderno, Bogotá, which has a collection of over 2500 works of modern and contemporary art; most are by Colombian or other Latin American artists, but there are also a number of fine European and North American pieces. Other important Colombian museums include the Museo de Artes y Tradiciones Populares in Bogotá; the Museo Arqueológico La Merced and the Museo de Arte Moderno La Tertulia in Cali; and the Museo de Arte Moderno and the Museo de Antioquia Francisco Antonio Zea in Medellín. The last-mentioned houses local art, with one wing dedicated to the work of Fernando Botero, while the Museo Negret in Popayán is dedicated to the work of the sculptor Edgar Negret. A total of 117 museums in Colombia are affiliated to the Asociación Colombiana de Museos (ACOM), most of them small regional museums displaying objects related to local history, customs or trades.

The Museo Nacional, the Museo de Arte Moderno in Bogotá and the Museo de Arte Moderno La Tertulia in Cali are also among the few museums to have specialist art libraries, although art books also form a significant part of the collections of such large public libraries as the

Biblioteca Nacional de Colombia and the Biblioteca Luis Angel Arango in Bogotá. The Museo de Arte Moderno in Bogotá also houses Colombia's most important photographic collection, having acquired 45,000 negatives and numerous prints from different periods as the result of extensive research in 1983 into the history of photography in the country. While most of the negatives are portraits, there are also pictures documenting historical events, the changing appearance of cities and everyday life. The entire collection (*c.* 60,000 negatives) of Juan Nepomuceno Gómez (1865–1946) was later donated to the museum. The archive also contains daguerreotypes, ambrotypes and ferrotypes, as well as antique photographic instruments dating from as early as 1840. Other important photographic collections are formed by the archives of the photographers Melitón Rodríguez and Benjamín de la Calle in Medellín and Quintilio Gavassa (1861–1922) in Bucaramanga.

BIBLIOGRAPHY
E. Serrano: *Historia de la fotografía en Colombia* (Bogotá, 1983)
——: *Cien años de arte colombiano* (Bogotá, 1985)
L. Rojas de Perdomo and C. Ortega Ricaurte: *Catálogo del Museo Nacional* (Bogotá, 1986)
Museo Nacional de Colombia: Catálogo de miniaturas: Colecciones del Museo Nacional, i, Instituto Colombiano de Cultura (Bogotá, 1993)
Museo Nacional de Colombia: El monumento y sus colecciones, Ministerio de Cultura, Museo Nacional and Asociación de Amigos del Museo Nacional (Bogota, 1997)
EDUARDO SERRANO

VIII. Art education.

During the 16th to 18th centuries in Colombia, painters were trained as apprentices in local family workshops, receiving instruction and advice about their own work in exchange for collaboration with the workshop trade. The workshop that had the greatest influence on Colombian painting during this period and where the most outstanding artists, including Gregorio Vázquez de Arce y Ceballos (1638–1711), were trained was that of Gaspar de Figueroa (*d* 1658) and his family, operating in Bogotá between 1615 and 1738. At the end of the 18th century the botanist José Celestino Mutis opened a school for drawing the flora of the Expedición Botánica (*see* §§I and IV, 1 above).

Following independence several artists, such as Luis García Hevia (1816–87) and Manuel Dositeo Carvajal (1820–87), opened studios in Bogotá where painting was taught to young artists. This type of private tuition continued throughout the 19th century and to some extent during the 20th. In 1886 the Escuela Nacional de Bellas Artes was established in Bogotá through the efforts of Alberto Urdaneta (1845–87), who also founded a school of design. In the following decades all Colombian artists were trained there. The school went on to operate as the Faculty of Arts of the Universidad Nacional, Bogotá. Other schools of fine arts were established in Bucaramanga (1907) and in Medellín (1911). From 1950 numerous Colombian universities began to open faculties of fine arts, contributing to an active artistic climate in the country. The Escuela de Conservación y Restauración de Cultura (founded 1978), Bogotá, was instrumental in rescuing much of Colombia's artistic heritage.

BIBLIOGRAPHY
F. Gil Tovar: 'Los primeros pintores criollos', *Historia del arte colombiano* (Bogotá, 1977)
M. Fajardo de Rueda: *Presencia de los maestros, 1886–1960* (Bogotá, 1986)
EDUARDO SERRANO

Carlos Colombino: *Forms of a Simulacrum IV*, engraving and mixed media on paper, 780×990 mm, 1995 (Colchester, University of Essex, Collection of Latin American Art)

Colombino, Carlos (*b* Concepción, 20 Oct 1937). Paraguayan painter and engraver. His training was in architecture, and this had a considerable influence on his painting style, but although he also studied art in Madrid (1964–5) and Paris (1969–70), he was basically self-taught as an artist. After the 1950s, when he went through an initial phase oscillating between a rather wildly dramatic style and another that favoured formal organization, he settled on a more stable personal style in the 1960s. His most frequently used technique, *xylopintura*, involved the use of wood-engraving tools to cut into plywood (for an example *see* PARAGUAY, fig. 6); the variations in the layers and the end- and cross-grain absorbed dyes and paints in different ways, and the image emerged from the process, for example in the xilopainting *Icarus* (1966; Washington, DC, A. Mus. Americas). In 1977 he began to develop a series of constructions entitled *Reflections on Dürer*, in which he analysed his own expressive vocabulary and at the same time made a moving statement on human liberty. These works undoubtedly reflected the influence on Colombino of the Paraguayan RE-FIGURACIÓN movement. Both his tormented neo-figurative work of the 1960s, when he had been a proponent of Neofiguración, and these precise and shattered constructions constitute a vigorous indictment of the violation of human rights committed by Latin-American dictatorships, especially that of General Alfredo Stroessner in Paraguay from 1954 to 1989. From the early 1980s Colombino extended his style to an aggressive impressionism in solid constructions such as *The Resurrection* (1988), a mural in Concepción Cathedral. An example of his later work is *Forms of Simulacrum* (1995; see fig.).

BIBLIOGRAPHY
J. Plá: *Colombino: Pintor paraguayo* (Hamburg, 1969)
Guggiari, Blinder, Colombino (exh. cat. by L. Abramo, Asunción, Misión Cult. Bras., 1969)
T. Escobar: *Colombino: La forma y la historia* (Asunción, 1985)
Formas del simulacro, grabados (exh. cat., Buenos Aires, Gal. A. Centoira, 1995)
TICIO ESCOBAR

Colonia del Sacramento. Uruguayan city and capital of Colonia Province. It is situated in south-west Uruguay on

a peninsula jutting out into the River Plate opposite Buenos Aires, Argentina. Founded by the Portuguese in 1680 on land belonging to Spain, it is the most ancient European township and preserves the best and most numerous group of colonial buildings in Uruguay. It was fiercely disputed until 1777, when it finally became Spanish and existed as a stronghold and a centre of commerce that was sited, destroyed and rebuilt several times. Unusually, the old centre conforms to a Portuguese plan of irregularly distributed blocks of buildings; traditionally, towns in Uruguay, as in the rest of the Spanish Americas, were built on a grid plan. The houses of Colonia del Sacramento are generally of one storey, and the constructional elements (doorjambs, stone lintels, curved railings and sloping roofs) indicate their origins in the colonial architecture of Rio de Janeiro through their modest Baroque lines. This is evident even in those buildings, such as the parish church and the municipal museum, that were reconstructed in the austere Neo-classical style prescribed by the Real Academia de S Fernando in Madrid. Among the religious foundations the parent house and ruins of S Francisco (1680) survive, while military buildings include the dilapidated fortresses of S Pedro and of El Carmen, the entrance to the city, part of the city walls and escarpments (all rest.), and numerous remains discovered during excavation.

BIBLIOGRAPHY
J. Giuria: *La arquitectura en el Uruguay*, 2 vols (Montevideo, 1955)
L. Ferrand de Almeida: *A Colonia do Sacramento na época da sucessão de Espanha* (Coimbra, 1973)
F. Assuncão: *La Colonia del Sacramento* (Montevideo, 1987)
F. Assunçao and others: *Colonia del Sacramento: Patrimonio mundial/ World Heritage* (Montevideo, 1996)
MARTA CANESSA DE SANGUINETTI

Colvin, Marta (*b* Chillán, 22 June 1915). Chilean sculptor. She studied at the Escuela de Bellas Artes of the Universidad de Chile in Santiago before travelling in 1948 to Paris on a French government grant, studying at the Sorbonne and at the Ecole du Louvre and frequenting Brancusi's studio. Her teachers included Henri Laurens, Ossip Zadkine and Etienne-Martin. She visited London in 1949 and returned to Chile in 1950. In 1952, at the invitation of the British Council, she went back to London, studying there at the Slade School of Fine Art and receiving advice from Henry Moore. She began working in a realist style, but her interest in deforming volumes for expressive effect and her contact with innovative European art after World War II led her to 'purify' her sculpture of overt representation and to create organic forms suggestive of the living growth of nature. She moved towards a monumental expression of mass, but she was particularly affected by her discovery of Pre-Columbian art.

Colvin's mature work, usually in wood or stone, is rigorously abstract. Her typical sculptures, such as *Great Sign* (bronze, 1968; Paris, Mus. Sculp. Plein Air; *see* CHILE, fig. 6), are characterized by an architectural strength, by unifying clean volumes and by predominantly blocklike rectangular forms. Startling for the severity of their construction and for their inventive arrangements, they have a physical presence comparable to a kind of ancestral Andean and universal sign. Colvin has produced numerous public sculptures in Europe and Chile, including a monument to the *Libeator Sucre* for the Plaza Sucre in Santiago.

She has won several awards, including the international grand prize at the São Paulo Biennale in 1965 and the Premio Nacional de Arte in 1970.

BIBLIOGRAPHY
M. Villalobos: *Marta Colvin* (Santiago, 1957)
Marta Colvin (exh. cat., intro. J. Lassaigne; Paris, Gal. de France, 1967)
R. Bindis: 'Marta Colvin: Medio siglo de pasión artística', *Atenea*, cdlviii (1988), pp. 13á42
C. Larraín Arroyo: *Marta Colvin: El signo ancestral de América en la piedra* (Santiago, 1989)
Marta Colvin (exh. cat. by M. Ivelić and C. Valdés Urrutía, Santiago, Mus. N. B.A., 1993)
CARLOS LASTARRIA HERMOSILLA

Concha, Andrés de la (*fl* 1568–1612; *d* Mexico, 1612). Spanish painter and architect, active in Mexico. In 1568 he went from Spain to Mexico, where he was commissioned to paint the principal retable of the church of the Dominican monastery, Yanhuitlán, Oaxaca State, with the *Annunciation*, the *Adoration of the Shepherds*, the *Adoration of the Magi*, the *Presentation in the Temple*, the *Descent from the Cross*, the *Resurrection*, the *Ascension*, *Pentecost*, the *Last Judgement*, the *Immaculate Conception*, *St Jerome*, *Mary Magdalene*, *St Luke* and *St Dominic* (1570–75). These reflect his style as a Mannerist painter of the Seville school influenced particularly by Luis de Vargas (1505–67).

In 1580–81 Andrés de la Concha collaborated with Simón Pereins on the retable (destr., paintings untraced) of the high altar in the monastery of Teposcolula, Oaxaca State; and in this period he also worked in the church of the Dominican Order of Coixtlahuaca, Oaxaca State, on paintings for the retable, of which eleven panels survive: three dedicated to the *Apostles*; seven to the *Life of Christ* and one to the *Eternal Father* (all *in situ*). Around 1587 he painted the high altar in the church of the monastery of Tamazulapán, Oaxaca State; four panels exist, all dedicated to the *Life of Christ* (*in situ*). Between 1590 and 1596 he painted the high altar (destr.) of the former convent of S Agustín de México, Federal District. He was made Maestro Mayor of the Hospital de Jesús de México, Federal District, in 1597 and until 1607 was involved in its construction.

Andrés de la Concha was commissioned in 1599 to paint the catafalque erected to mark the death of Philip II, and in 1603 he worked on the triumphal arch built for the reception in Mexico City of the Viceroy, the Marqués de Montesclaros, and used in 1604 to receive the Archbishop Fray García de Santa María in the cathedral. His work as an architect included projects for the cathedral in Mexico City (1603–10), and the ground-plan of the church of the Hospital de S Hipólito, Federal District, is attributed to him. In 1611 he built the Alcaicería del Marqués del Valle (the market place for raw silk); his retable for S Domingo, Oaxaca, was left unfinished at his death.

Andrés de la Concha is thought to have been the St Cecilia Master and may have been responsible for the paintings of *St Cecilia*, the *Holy Family* and the *Martyrdom of St Lawrence* (Mexico City, Pin. Virreinal).

BIBLIOGRAPHY
M. Toussaint: 'Tres pintores del siglo XVI: Nuevos datos sobre Andrés de la Concha, Francisco de Zumaya y Simón Pereyns', *An. Inst. Invest. Estét.*, ix (1942), pp. 59–60
D. Angulo, E. Marco Dorta and J. Buschiazzo: *Historia del arte hispanoamericano*, ii (Barcelona, 1945–56), pp. 383–4

G. Kubler and M. S. Soria: *Art and Architecture in Spain and Portugal and their American Dominions, 1500–1800* (London, 1969), p. 306

E. Castro: 'Los maestros mayores de la Catedral de México', *A. México*, xxi/182–3 (1976), p. 140

E. Marco Dorta: 'Noticias sobre el pintor Andrés de la Concha', *Archv Esp. A.*, 1 (1977), 199, p. 343

G. Tovar de Teresa: *Pintura y escultura del renacimiento en México* (Mexico City, 1979), pp. 129–36

M. Fernández: *Arquitectura y gobierno virreinal: Los maestros mayores de la ciudad de México* (Mexico City, 1985), pp. 65–76, 255–6

M. Fernández: 'Andrés de la Concha: Nuevas noticias, nuevas reflexiones', *Anales del Instituto de Investigaciones Estéticas*, xv/59 (1988), pp. 51-68

MARIA CONCEPCIÓN GARCÍA SÁIZ

Coninck, Juan Ramón (*b* Malines, 1623; *d* 1709). Flemish architect, mathematician and cartographer, active in Peru. He left Belgium for Peru in 1655 and presented a project for the fortification of Lima to the viceroy Duque de la Palata in 1682. The plan was sent to the Council of Indies in Spain for approval and subsequently returned to Lima with notations made by the Duque de Bournonville. The famous engraving (1685; Seville, Archv Gen. Indias) by Pedro Nolasco (*fl* 1663–87) depicting a bird's-eye view of the city of Lima shows the fortification walls designed by Coninck. Appointments held by him included Royal Chaplain and Professor of Mathematics at the University of S Marcos. He also earned the prestigious title of Cosmographer of the Kingdom of Peru, as indicated in the inscription of a map of the Rio de la Plata by his hand (Seville, Archv Gen. Indias), and in 1696 he published in Lima an important treatise on geometry entitled *Cubus et Sphaera geometrice duplicata*. Shortly after his death, an inventory of Coninck's personal library recorded 755 volumes, including scientific and architectural treatises.

UNPUBLISHED SOURCES

Seville, Archv Gen. Indias [*Carta geográfica de las provincias de la gobernación del Rio de la Plata, Tucumán y Paraguay . . . delineada por el D. D. Juan Ramón, capellán de S. M. en la real capilla de Lima, cathedrático de matemáticas de la real universidad y cosmógrafo mayor del reyno del Perú: Año de 1685*]

BIBLIOGRAPHY

R. Vargas Ugarte: *Ensayo de un diccionario de artífices de la América meridional* (Buenos Aires, 1947, Burgos 2/1968), pp. 149–52

V. Gesualdo and others: *Enciclopedia del arte en América: Biografías*, i (Buenos Aires, 1969)

E. D. Chamot: 'Juan Ramón Coninck: El Cosmógrafo mayor', *Comercio, Dominical* [Lima] (6 Aug 1989), pp. 13, 16

HUMBERTO RODRÍGUEZ-CAMILLONI

Contreras, Jesús F(ructuoso) (*b* Aguascalientes, 20 January 1866; *d* Mexico City, 13 July 1902). Mexican sculptor. He studied under Miguel Noreña at the Escuela Nacional de Bellas Artes in Mexico City and collaborated with him in 1886–7 on the casting of the bronze statues for the Cuauhtémoc monument. Awarded a fellowship to complete his training in Paris, he pursued his studies there between January 1888 and December 1889, not at the Ecole des Beaux-Arts but in workshops renowned for casting (Gagnot, Thiébaut Frères) and stone cutting (Colibert). While in Paris he completed 12 large bronze reliefs for the Mexican pavilion at the Exposition Universelle held in Paris in 1889, representing gods and kings of the pre-Hispanic period; these were later moved to Aguascalientes (six in Casa Cult.; two integrated into the monument to *J. F. Contreras*) and Mexico City (four integrated into the Monumento a la Raza).

Both as a practising sculptor and as a teacher, Contreras understood clearly the need to incorporate industrial processes into the preparation of sculpture. On his return to Mexico City he conducted classes at both the Escuela de Artes y Oficios and the Escuela Nacional de Bellas Artes, but his new concept of artistic training soon brought him into conflict with the academic authorities, and he was forced to give up teaching. In 1892 he founded the Taller de Fundición Artística Mexicana, whose financial sponsors included the President of Mexico, Porfirio Díaz, and distinguished businessmen. He also established relations with municipal authorities, and in this way was able to assure the creation of an increasing number of monumental projects both in Mexico City and elsewhere in Mexico. In addition he combined the creation of monumental works with small bronzes and decorative clay objects manufactured at the Alfarería Artística Mexicana, a pottery adjoining the Fundición. He thus assumed the role of the typical turn-of-the-century sculptor-entrepreneur, previously sought less successfully by Noreña and Gabriel Guerra.

Among the most noteworthy public monuments executed by Contreras in the 1890s is a series of 20 statues of illustrious figures from Mexican history and culture commissioned by various states for erection along the Paseo de la Reforma in Mexico City. He also produced equestrian monuments to two anti-imperialist generals, *Ignacio Zaragoza* (Puebla and Saltillo) and *González Ortega* (Zacatecas); a monument to *Peace* in Guanajuato; and one dedicated to the poet *Manuel Acuña* in Saltillo. Stylistically they were essentially academic realist works, but in the monument to Acuña, Contreras succeeded in fusing a commemorative spirit with the expression of spiritual conflicts and tortured states of mind characteristic of the Symbolism that predominates in his most personal works, such as *St Joseph Calasanctius* (coloured clay, *c.* 1895; Puebla, Mus. Bello) and *Malgré tout* (1898; see fig.). Iconographically and in formal terms, with the influence of Auguste Rodin, this part of Contreras's production helped initiate modernist sculpture in Mexico.

BIBLIOGRAPHY

S. Moreno: 'Un siglo olvidado de escultura mexicana', *A. México*, 133 (1970), pp. 14–16, 77–80

Jesús F. Contreras: *Malgre tout*, marble, 610 x 1765 x 680 mm, 1898 (Mexico City, Museo Nacional de Arte)

F. Ramírez: *La plástica del siglo de la Independencia* (Mexico City, 1985), pp. 100–01, 112, 123–4

Jesús F. Contreras, 1866–1902: Escultor finisecular (exh. cat. by P. Pérez Walters, Mexico City, Mus. N.A., 1990)

FAUSTO RAMÍREZ

Contri, Silvio (*b* Arcidosso, Grosseto, 1856). Mexican architect of Italian birth. He settled in Mexico in 1892, acquiring American citizenship for a period in 1904, then becoming a Mexican national in 1923. He is chiefly known for a single building, the Palacio de la Secretaria de Comunicaciones y Obras Públicas (1904–11; now Museo Nacional de Arte), Mexico City. In addition to providing for the functions of the ministry, the building was required to show the progressiveness and prestige of the state that had commissioned it in connection with the centenary (1910) of Mexican independence. Contri's version of a Renaissance palace is enhanced by its mural decorations, which express the ideal of an advanced, industrialized country. Particular emphasis is achieved through the large, ground-floor foyer, the monumental staircase and the reception hall. The elegant façade was originally complemented by a vast space, intended as a formal square, in front of the building. Contri's other buildings include the High Life shop (1922), Calle de Gante, Mexico City, which anticipates some aspects of functionalism.

BIBLIOGRAPHY

I. Katzman: *Arquitectura del siglo XIX en México* (Mexico City, 1973)

J. Gutiérrez Haces: *El Palacio de la Secretaria de Comunicaciones y Obras Públicas: Muestra de la arquitectura del Porfiriato* (diss., Mexico City, U. N. Autónoma, 1980)

MÓNICA MARTÍ COTARELO

Coppola, Horacio (*b* Buenos Aires, *c.* 1907). Argentine photographer. Having produced his first photographs in 1928, he studied in 1932 at the Bauhaus, Berlin, under the American photographer Walter Peterhans (1897–1960). There he met the German photographer GRETE STERN, whom he was later to marry and with whom he started a studio for publicity photography in Buenos Aires in 1937. He established his name in 1936 with the publication of his book on Buenos Aires. He preferred to illustrate art books and was particularly interested in the ceramic culture of Peru and the sculpture of Rodin. Among his other publications were monographs on Stonehenge, Paestum and the Wilhelm-Lehmbruck-Museum in Duisburg, and the volume *De Fotografía* (Buenos Aires, 1969).

PHOTOGRAPHIC PUBLICATIONS

Buenos Aires (Buenos Aires, 1936)

Imagema: Antología fotográfica, 1927–1994 (Buenos Aires, [c.1994])

BIBLIOGRAPHY

E. Billeter: *Fotografie Lateinamerika* (Zurich and Berne, 1981)

S. Facio: *La fotografía en la Argentina desde 1840 a nuestros días* (Buenos Aires, 1995)

ERIKA BILLETER

Cordero, Juan (*b* Teziutlán, Puebla, 10 June 1822; *d* Mexico City, 28 May 1884). Mexican painter. He studied painting at the Academia de San Carlos, Mexico City, and in 1844 went to the Accademia di S Luca, Rome, where he was taught by the Sicilian Neo-classical painter Natal di Carta. His earliest works were portraits, for example that of the Mexican sculptors *Pérez and Valera* (1847; Mexico City, Mus. N. A.). He exhibited *Columbus before the Catholic Kings* (1850; Mexico City, Mus. N. A.) in his studio in Florence, to critical acclaim, and the painting made a great impression in Mexico when he returned there in 1853, also taking with him his most ambitious, and highly academic, easel painting, *Christ the Redeemer and the Woman Taken in Adultery* (1853; Guadalupe, Mus. Reg.). In his Romantic portrait of *Doña Dolores Tosta de Santa Anna* (1855; Mexico City, Mus. S. Carlos), wife of the president of the Mexican Republic, Cordero modelled the sitter in a sculptural fashion; the work is remarkable in 19th-century Mexican art in its departure from mild academic aesthetics, notably through its use of strong colour contrasts. In his mural (1857) in the cupola of the Capilla del Señor in the church of S Teresa la Antigua, Mexico City, Cordero's rebellious attitude to colour reveals a distinct Mexican nationalism. His mural for the Escuela Nacional Preparatoria, Mexico City, depicting the *Triumph of Science and Labour over Envy and Ignorance* (1874; destr.; for illustration of copy see Fernández, fig. 77) was a significant philosophical allegory that marked a new direction in Mexican mural painting.

BIBLIOGRAPHY

S. Toscano: *Juan Cordero y la pintura mexicana en el siglo XIX* (Monterrey, 1946)

J. Fernández: *El arte del siglo XIX en México* (Mexico City, 1983), pp. 64–79

E. García Barragán: *El pintor Juan Cordero: Los días y las obras* (Mexico City, 1984)

ELISA GARCÍA BARRAGÁN

Córdoba. Argentine city and capital of Córdoba province. It is situated in the central valley of the sierras that lie north of the Pampas region, north-west of Buenos Aires, and after Buenos Aires is the country's largest city, with a population of almost one and a quarter million. Until 1776, when the Viceroyalty of the River Plate with Buenos Aires at its head was established, Córdoba was one of the most important centres of Spanish colonial rule south of Lima, capital of the Viceroyalty of Peru. Córdoba de la Nueva Andalucía, as it was first called, was founded by Jerónimo Luis Cabrera in 1573. The original site lay at the crossing of trade routes between the Viceroyalty of Peru, the Andean passes to the Captaincy of Chile and the port of Buenos Aires. Its urban development was based on a grid plan as ruled by the Consejo de Indias: a central square surrounded by a main church, a town hall and a customs house. The Jesuit, Franciscan and Dominican orders were granted adjacent plots of land.

The plot awarded to the Jesuits, known as the Manzana de las Luces, is the best example of 18th-century religious architecture in the city. It contained a hermitage dedicated to SS Tiburcio and Valeriano, built by early settlers in 1586 of stones (*in situ*) from the River Suquía cemented using a lime and sand mixture, and with an adobe and thatch roof. The hermitage was extended and later became the sacristy of the church of La Compañía de Jesús, built *c.* 1644–74 (partially damaged by fire in 1965) and attributed to the Belgian Felipe Lemer (*b* 1608). Well-carved stones with pink marble from the neighbouring sierras were used here. The barrel vault, 11 m long, was made from cedar planks imported from Paraguay. The church was probably painted by the Danish-born Juan Bautista Daniel (*d* before 1662), and the whole was protected by a hammer-beam

roof. Inside were a gilded Baroque triptych retable, removed to the cathedral after the expulsion of the Jesuits in 1767, and a lavishly decorated carved pulpit (*in situ*). The self-sufficient compound included a novitiate (1608) and *convictorio* (students' quarters; both attributed to John Kraus (1664–1714); later work by Hernán Bianchi), a school (1613; from 1622 the Universidad Nacional de Córdoba, the oldest on Argentine territory) and workshops run by indigenous Indians, who produced oil paintings copied from Baroque models imported from Spain and the Netherlands, and fine carvings for church interiors. Wealthy farmers donated land on the outskirts of Córdoba for the establishment of the missions of Alta Gracia (1659–1762) and S Catalina (1754); the Jesús María mission was bought in 1618. A central feature of the missions in general was their exquisite Baroque churches (*see also* JESUIT ORDER, §3).

Córdoba Cathedral, on the main square, was begun in 1697 as a single-nave structure by Pedro de Torres and Andrés Jiménez de Lorca. José González Merguelte, a Spanish architect from Peru, took over in 1698, assisting with building the vault, for which two further aisles were added. The Neo-classical portico (1729) is enclosed by two towers added *c*. 1770. ANDREA BIANCHI participated in later plans (1730–35). The dome of 1750–58, resembling that of Zamora Cathedral in Spain, is almost certainly the work of Fray VICENTE MUÑOZ. The completed monumental building was consecrated in 1789, although the façade decoration dates from the 19th century.

Domestic architecture flourished in the 18th century, typified by the two-storey Casa del Virrey (*c*. 1750; now the Museo Histórico Provincial; see fig.). It was probably designed by Andrea Bianchi. The thick brick walls are whitewashed to help keep the interior cool. The hallway, leading to a central patio, is decorated with scallop shell motifs like those on the towers of the cathedral. The red tiled roof and delicate wrought-iron balconies and window bars give it a picturesque Spanish appearance. One of the few remaining colonial public buildings is the Cabildo, originally built in 1598, rebuilt largely by Juan Manuel López (*fl* Córdoba, 1785–1808). Now the Museo Histórico, it has lost many original features such as a double-arcade façade that was later replaced by windows.

Córdoba has been associated with a number of notable artists: Fray Guillermo Butler (*d* 1961) was born in the city in 1880, and Fernando Fader (1882–1935) and Miguel Carlos Victorica both lived there temporarily, Fader painting local landscapes in an Impressionist style, and Victorica depicting the colonial buildings. Emilio Caraffa (1862–1939) established the Academia de Bellas Artes in 1896. A school of drawing had existed since 1857 as part of the Universidad Nacional, but it was not until 1949 that the Escuela Superior de Bellas Artes, founded by Angel Lo Celso, placed Córdoba at the forefront of national artistic education. In addition, the salon of the city of Córdoba, first held in 1977, remains a major event in the Argentine cultural calendar.

BIBLIOGRAPHY

P. Cabrera: *Ciencias y artes en el pretérito cordobés* (Córdoba, 1931)
M. Buschiazzo: *Buenos Aires y Córdoba en 1729: Cartas de los padres Cattaneo y Gervasoni* (Buenos Aires, 1941)
A. Razori: *Historia de la ciudad argentina* (Buenos Aires, 1945)

Córdoba, Casa del Virrey, probably by Andrea Bianchi, *c*. 1750; now the Museo Histórico Provincial

G. Furlong: *Arquitectos argentinos durante la dominación hispánica* (Buenos Aires, 1946)
——: *Artesanos argentinos durante la dominación hispánica* (Buenos Aires, 1946)
M. Buschiazzo: *Argentina: Monumentos históricos y arqueológicos* (Mexico, 1959)
——: *Las estancias jesuíticas de Córdoba* (Buenos Aires, 1969)
A. Lo Celso: *Cincuenta años de arte plástico en Córdoba* (Córdoba, 1973)
F. Ortiz: 'La arquitectura de Córdoba en tiempo de la dominación española', *La arquitectura en Argentina*, ed. M. A. Correa and R. E. J. Iglesia (Buenos Aires, 1980)
N. Perazzo: *Herencia de Italia en el arte de Córdoba* (Córdoba, 1991)
M. Mora Ferrer: *Córdoba en su pintura del siglo XX* (Córdoba, 1992) [extensive bibliog.]

IRENE FANNING

Coronel. Mexican family of artists.

(1) Pedro Coronel (*b* Zacatecas, 25 March 1923; *d* Mexico City, 23 May 1985). Painter and sculptor. After studying at the Escuela de Pintura y Escultura 'La Esmeralda' in Mexico City, he lived from 1946 to 1952 in Europe, where he came into contact with Marcel Breuer and Constantin Brancusi. He returned to Mexico, where his first exhibition in 1954 was favourably received, but continued to travel and exhibit his work internationally. His chromatically rich paintings, while appearing abstract, include recurrent cosmic motifs, recognizable human figures, flora, fauna and symbols of life and death (e.g. *Repose*, 1965; see colour pl. VII, fig. 2). In form and colour his work is distantly related to that of Rufino Tamayo.

Occasionally, the colour becomes brighter and the texture loses its harsh violence, but the shining suns are recurrent central motifs. He received two prizes at exhibitions held at the Instituto Nacional de Bellas Artes in Mexico City: first prize at the Salón Nacional de Pintura in 1959 and the Premio José Clemente Orozco at the second Bienal Interamericana de Pintura y Grabado in 1960. He also assembled an important collection of African art and Japanese prints, housed in the former Jesuit monastery of S Luis Gonzaga in Zacatecas.

BIBLIOGRAPHY

J. Fernández: *Pedro Coronel, pintor y escultor* (Mexico City, 1971)
L. Cardoza y Aragón: *Pintura contemporánea de México* (Mexico City, 1974), pp. 36–8
S. Pitol and L. Cardoza y Aragón: *El universo de Pedro Coronel* (Mexico City, 1981)
J. A. Manrique, S. Balmoria and others: *Pedro Coronel* (Mexico City, 1993)

(2) Rafael Coronel (*b* Zacatecas, 24 Oct 1932). Painter, brother of (1) Pedro Coronel. In 1953 he entered the Escuela Nacional de Pintura y Escultura 'La Esmeralda' in Mexico City. He painted in an expressionistic realist style, depicting frightening figures bearing the scars of their experience of urban low life. His paintings contain echoes of Goya and José Clemente Orozco and achieve dramatic effects through a skilful use of chiaroscuro and tenebrist effects (e.g. *Pilgrims*, 1970; see fig.). The psychology of the characters is captured with accuracy, and their appearance is carefully depicted, but the background in which they appear imbues them with an air of timelessness (e.g. *Rat Eating a Worm*, Mexico City, Mus. A. Mod.). In 1964 he painted two murals at the Museo Nacional de Antropología, Mexico City, the *Magic World of the Yucatán Peninsula* and a decoration with abstract motifs. He also assembled in Zacatecas an important collection of masks from all over Mexico.

BIBLIOGRAPHY

S. Pitol: *Habla la Celestina* (Mexico City, 1959)
A. de Neuvillate: *Rafael Coronel* (Mexico City, 1978)
L. Cardoza y Aragón: *Rafael Coronel: El rostro anónimo* (Mexico City, 1979)
Rafael Coronel: Obra sobre papel (exh. cat. by L. C. Emerich, Monterrey, Pinacoteca Nuevo León, 1997)

JULIETA ORTIZ GAITÁN

Corrales, Raúl (*b* Ciego de Avila, Camaguey, 25 Jan 1925). Cuban photographer. From 1946 he worked as a photojournalist for various newspapers. He accompanied Fidel Castro on a number of journeys and worked as a photographer on Castro's side during the revolution of 1956 to 1959, producing images of an almost monumental character, such as *Cavalcade*. His particular gift was for choosing unusual angles and for bringing out the humour in a situation through the relationship of one object to another. He took part in numerous exhibitions and international colloquia, and in 1964 became head of the Department of Photography and Microfilm at the Oficina de Asuntos Históricos del Consejo del Estado. He produced several works on Cuba, such as *Geografia de Cuba* (Havana, 1959) and *Cuba* (Moscow, 1962).

Rafael Coronel: *Pilgrims*, oil on linen, 1.75×2.50 m, 1970 (Austin, TX, University of Texas, Jack S. Blanton Museum of Art)

WRITINGS
with Constantino Arias: *Cuba dos epocas* (Mexico, 1987)
Playa Girón (Milan, 1990)

BIBLIOGRAPHY
G. Mosquera: *Raúl Corrales: 35 con la 35* (Havana, 1980)
E. Billeter: *Canto a la realidad: Fotografía latinamericana, 1860–1993* (Barcelona and Berne, 1993–4) [Sp. and Ger. text]
ERIKA BILLETER

Correa, Juan (*b* Mexico, *c.* 1646; *d* Mexico, 1716). Mexican painter. He is thought to have been the teacher of such painters as Juan Rodríguez Juarez and José de Ibarra. His many works for the cathedral of Mexico City include (for the sacristy) the large-scale *Assumption* and the *Coronation of the Virgin* (both 1689) and the *Entry into Jerusalem* (1691). For the same cathedral he also painted the *Vision of the Apocalypse*, other versions of the *Assumption* and the *Coronation of the Virgin* (destr. 1967), and the groups of angels for the retables of the *Angel de la Guarda* and *Angel Custodio*. Other religious paintings by Correa are in the chapel of the Rosary in the convent of Azcapotzalco, Mexico City, and Durango Cathedral, which includes works based on models by Rubens. Some interesting works by Correa in Spain include a series of ten canvases dedicated to the *Life of the Virgin* (Antequera, Mus. Mun.) and the *Virgin of Guadalupe* in the church of S Nicolás in Seville, dated 1704. His few known secular paintings are also important historically, especially the two screens with allegorical themes, one on the *Four Elements* and the other on the *Liberal Arts* (Mexico City, Franz Mayer priv. col.), and another screen with the *Four Continents* and the *Meeting Between Cortés and Montezuma* (Mexico City, Banco N. de México). Other members of Correa's family also worked as painters, including his brother José Correa and the latter's sons, Miguel Correa and Diego Correa, and grandsons, also called Miguel Correa and Diego Correa.

BIBLIOGRAPHY
F. Pérez Salazar: *Historia de la pintura en Puebla* (Mexico City, 1963)
M. Toussaint: *Pintura colonial en México* (Mexico City, 1965)
E. Vargas Lugo and J. G. Victoria: *Juan Correa: Su vida y su obra* (Mexico City, 1985)
J. R. Ruiz Gomar: *Las colecciones de pintura del Museo Regional de Querétaro* (Querétaro, 1986)
G. Tovar de Teresa: *Índice de documentos relativos a Juan Correa, Maestro de Pintor* (Mexico City, 1988)
E. Vargas Lugo and others: *Juan Correa: Su vida y su obra*, 5 vols (Mexico City, 1985–93)
MARIA CONCEPCIÓN GARCÍA SÁIZ

Corrêa Lima, Attilio (*b* Rome, 8 April 1901; *d* Rio de Janeiro, 27 Aug 1943). Brazilian architect of Italian birth. He graduated as an architect in 1925 from the Escola Nacional de Belas Artes, Rio de Janeiro, with a prize that enabled him to study urban planning at the University of Paris; his final thesis, a plan of the city of Niterói, Brazil, was published as an award. In 1931 Corrêa Lima returned to Brazil. He established and held the Chair of Urban Planning at the Escola Nacional de Belas Artes at the time of Lúcio Costa's reforms there (1930–31), when Modernist teachers were introduced, and he established an office with Paulo Antunes Ribeiro, who had also studied urban planning in Paris; together they drew up a master plan (1933) for the city of Goiânia, the new capital of the state of Goiás, where Corrêa Lima also designed some public

buildings. Shortly afterwards the partnership broke up, and Corrêa Lima went to work as an architect for the Instituto de Aposentadoria e Pensões dos Industriários (IAPI). As well as his urban planning work, he produced some outstanding house designs, such as that in Rio (1933) for his father, José Octávio Corrêa Lima (1878–1974), a sculpture teacher, which contained a large sculpture studio on the ground-floor. He also worked on landscaping projects, being one of the first to integrate tropical and subtropical plants in private and public gardens, and he won national and international fame for his seaplane station (1938) at Santos Dumont airport, Rio de Janeiro, a simple, clear building on two levels connected by a spiral staircase. Although strongly influenced by Le Corbusier, Corrêa Lima's buildings also foreshadow the work of Oscar Niemeyer at Pampulha (1942–4) in their free spatial organization and search for structural innovation. He was particularly notable for reinforcing the close link between architecture and urban planning, based on studies on the origin and development of Brazilian cities.

BIBLIOGRAPHY
Brazil Builds: Architecture New and Old, 1652–1942 (exh. cat. by P. Goodwin, New York, MOMA, 1943)
Y. Bruand: *Arquitetura contemporânea no Brasil* (São Paulo, 1981)
M. Metran de Mello: *Moderno e modernismo: A arquitetura dos dois primeiros fluxos desenvolvimentistas de Goiânia, 1933 a 1950–1950 a 1964* (diss., U. São Paulo, 1996)
JULIO ROBERTO KATINSKY

Corzas, Francisco (*b* Mexico City, 4 Oct 1936; *d* Mexico City, 15 Sept 1983). Mexican painter. He studied at Escuela de Pintura y Escultura La Esmeralda in Mexico City and then in Rome at the Accademia di San Giacomo and at the Accademia di Belle Arti e Liceo Artistico. Before returning to Mexico he travelled throughout Europe and worked briefly at a lithographic studio in New York. Generally regarded as an exponent of Mexican Expressionism, he concentrated in his paintings on human beings and was a member of Los Interioristas, a group known for its defence of humanistic values in art.

Corzas's pictures are peopled by a whole gallery of characters, drawn from distant memories of Goya, Picasso, Modigliani and Rembrandt and transformed into a timeless context of disturbing unreality. They are substantial pictorial presences, forcefully expressive, dramatic and phantasmagoric, created with a clean, skilful technique. These figures are enveloped in glazes that sometimes heighten the chiaroscuro effect and at other times suffuse the contours. Colour is used soberly to stress the visual effects of the whole.

BIBLIOGRAPHY
J. García Ponce: *Nueve pintores mexicanos* (Mexico City, 1968)
B. Taracena: *Francisco Corzas* (Mexico City, 1973)
M. Saavedra: *Francisco Corzas* (Mexico City, 1987)
Corzas (1936-1983) (exh. cat. by J García Ponce, Mexico City, Gal. Met., 1997)
JULIETA ORTIZ GAITÁN

Corzo, el. *See* RUIZ, ANTONIO.

Costa, Lúcio (*b* Toulon, 27 Feb 1902; *d* Rio de Janeiro, 13 July 1998). Brazilian architect, urban planner, architectural historian, teacher and writer of French birth. Son of Brazilian parents, he moved to Brazil in 1917 and entered

the Escola Nacional de Belas Artes, Rio de Janeiro, graduating as an architect in 1923. From 1922 he worked with Fernando Valentim, adopting the style favoured by the Traditionalist movement, which took its inspiration from 18th-century Brazilian colonial architecture in an attempt to develop a national style. He designed several houses and won two important competitions, both with neo-colonial designs: the Brazilian Pavilion at the International Exhibition (1925) in Philadelphia, and the headquarters of the Argentine Embassy (1928), Rio de Janeiro (neither of which was built).

In December 1930, following the installation of the new revolutionary government in November, Costa was appointed to direct the Escola Nacional de Belas Artes in Rio and to reform its teaching system. At first his nomination was seen as a victory for the supporters of the neo-colonial style over the academics, but Costa broke with both and created a course, given by specially invited Modernist teachers including GREGORI WARCHAVCHIK, which introduced the principles of avant-garde European architecture to Brazil. His actions were denounced by the teaching staff and its Traditionalist leader, and Costa subsequently lost his government support, leaving the directorship in September 1931. At this time he opened an office with Warchavchik, who had just completed his first modern houses in Rio de Janeiro; working together until 1933, they carried out several early Modern Movement projects, including the Alfredo Schwartz House (1932) and the low-cost housing complex (1933) in Gambôa. During this period Costa became the leading proponent of avant-garde architecture in Rio de Janeiro and was increasingly inspired by the Rationalism of Le Corbusier who, he considered, gave due importance to the plastic and artistic dimension of architecture, whereas Functionalism implied a reduction of the architect's work to the mere resolution of technical problems. This stance was asserted in *Razões da nova arquitetura* (1934), his most important writing on Modern architecture.

In 1935 Costa began his involvement with the most influential modern building in Brazil when a competition was held for the headquarters of the Ministry of Education and Health (now the Palácio da Cultura; *see* BRAZIL, fig. 5), Rio de Janeiro. First prize was awarded to a project, with decorative motifs inspired by ceramics from the Ilha de Marajó, by Archimedes Memória (1893–1960), the academic architect who had taken over the directorship of the Escola Nacional de Belas Artes from Costa in 1931, and his associate Francisque Cuchet. Under pressure from Modernist intellectuals on his staff, the Minister awarded the prize to the winning team but then made Costa, whose entry had not been placed, responsible for developing a new design. Costa assembled a team of architects from his immediate circle: Carlos Leão (*b* 1906), Jorge Moreira, Affonso Eduardo Reidy and, later, two new graduates, Ernani Vasconcellos (*b* 1912) and OSCAR NIEMEYER, and he persuaded the Minister to invite Le Corbusier to come to Rio as consultant on the project (*see* BRAZIL, §IV, 2(ii) and fig. 5). It was not finished until 1943, but it achieved immediate success among architects in Rio and guaranteed the predominance of the style and of Le Corbusier's influence in official buildings thereafter.

In 1937 Costa joined the Serviço do Patrimônio Histórico e Artístico Nacional (SPHAN), a federal body for the preservation of art and architecture, where he worked until his retirement in 1972; he carried out a series of studies on the history of Brazilian architecture, the most important being 'Arquitetura Jesuítica no Brasil' (1941). After joining SPHAN he produced relatively few buildings, as he no longer maintained an office, but in 1938 he won the competition for the Brazilian Pavilion at the World's Fair in New York; Niemeyer came second but Costa, believing Niemeyer's design to be better, shared the prize with him and invited him to participate in the development of the project (with Paul Lester Weiner in New York; *see* BRAZIL, fig. 6). In other works of the period, Costa developed a new architectural language; paradoxically, in those projects where monumental considerations were secondary, he employed a synthesis of modern and colonial styles, using such traditional features as verandahs, bay windows and tiled roofs with overhanging eaves. This can be seen in his few house designs, such as the Argemiro Hungria Machado house (1942), in the country houses of Mrs Roberto Marinho (1942) and Barão de Saavedra (1942–4), both in Petrópolis, and in his design for the Hotel do Parque S Clemente (1944), Nova Friburgo, partly inspired by Niemeyer's plan for the Hotel de Ouro Preto (1942). Between 1948 and 1950 Costa worked on a group of three blocks of flats in Guinle Park, Rio de Janeiro, which foreshadowed the superblock solution he was to adopt in Brasília. He then participated in the Commission of Five who were asked to assess designs for the UNESCO headquarters in Paris (1952–3); the others were Walter Gropius, Le Corbusier, Sven Markelius and Ernesto Nathan Rogers. During this period he produced an initial design for the Casa do Brasil at the Cité Universitaire in Paris, which was the basis for Le Corbusier's definitive project. In 1956 he designed buildings for the Jockey Club Brasileiro and the Banco Aliança, both in Rio de Janeiro.

In 1957 Costa won the competition for the master-plan for the new capital of the country, BRASÍLIA (see fig.). In this plan he departed from the usual grid system and designed a linear traffic axis, where the main residential areas are located; at right angles to this is a monumental axis where institutional, government and major public buildings are located. The resulting cross-shaped plan, which Costa likened to the human gesture of possession, clearly expressed the urban planning principles contained in the Athens Charter (1933) of CIAM calling for the separation of different urban activities into zones and the use of isolated, single-function buildings. Low-rent accommodation was provided in rows of single-storey houses, and medium- and high-rent accommodation was provided in superblocks, i.e. areas 350 m square in which blocks of flats, usually six storeys high and built on pilotis, were placed at right angles to each other. These superblocks were built along the traffic axis, on either side of the monumental axis, and local commerce was provided in small streets between them. Costa's plan, dominated by the juxtaposition of motorway technology and urbanism, fulfilled the explicit intention of President Juscelino Kubitschek of building a city for the car; its clarity provided an appropriate framework for the public buildings later designed by Niemeyer. Costa also designed some buildings

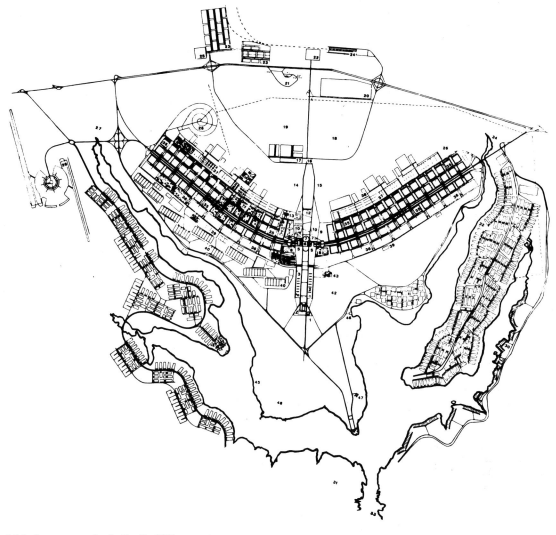

Lúcio Costa: master-plan for Brasília, 1957

at Brasília, including the bus station (1959), the television tower (1959) and a superblock (1961).

Later urban plans prepared by Costa included that for the Barra da Tijuca (1969), an area extending nearly 20 km along the coast south of Rio de Janeiro. He applied the same principles of zoning as in Brasília but included small, separate residential areas or 'urban nuclei' with various types of accommodation including houses and flats, as well as parks and nature reserves to preserve the local ecology. Because of its costs, this plan was never fully implemented. In 1987 he produced a plan for the extension of Brasília, proposing the construction of two new wings for low-cost housing. The proposal was faithful to the plan of 1957 in its functional zoning and segregation of the people in low-cost accommodation into satellite cities, but it was widely criticized, a reflection of changing views on urban planning.

In the latter years of his long and fruitful career, Costa designed residential projects in his personal and elegant reinterpretation of colonial architecture, for example the Thiago de Mello house (1978), Amazon, the Luis Fernando Gabaglia Penna Moreira house (1982) and the Edgard Duvivier house (1988), both Rio de Janeiro. His pivotal role in the introduction and development of modern architecture in Brazil, not only in his buildings but also in his teaching and support of other professionals, was unassailable, and he received many honours and awards during his career.

WRITINGS

'Arquitetura jesuítica no Brasil', *Rev. SPHAN*, 5 (1941)
Arquitetura brasileira (Rio de Janeiro, 1952)
Scientific and Technological Humanism (Cambridge, MA, 1961)
Sôbre arquitetura (Porto Alegre, 1962)
Plano-piloto para a urbanização da baixada compreendida entre a Barra da Tijuca, o Pontal de Sernambetiba e Jacarepaguá (Rio de Janeiro, 1969)
Brasília revisitada (Rio de Janeiro, 1987)
Registro de uma vivencia (São Paulo, 1995)

BIBLIOGRAPHY

H. R. Hitchcock: *Latin American Architecture since 1945* (New York, 1955)

H. E. Mindlin: *Modern Architecture in Brazil* (Amsterdam and Rio de Janeiro, 1956)
J. O. Gazaneo and M. M. Scarone: *Lúcio Costa* (Buenos Aires, 1959)
A. Magalhães and E. Feldman: *Doorway to Brasília* (Philadelphia, 1959)
F. Bullrich: *New Directions in Latin American Architecture* (London and New York, 1969)
P. F. Santos: *Quatro séculos de arquitetura* (Barra do Piraí, 1977)
E. D. Harris: *Le Corbusier and the Headquarters of the Brazilian Ministry of Education and Health, 1936–1945* (diss., U. Chicago, IL, 1984)
C. de Guimareans: *Lúcio Costa: Um certo arquitecto en incerto e secular roteiro* (Rio de Janeiro, 1995)

SYLVIA FICHER

Costa, Olga (*b* Leipzig, 1913; *d* Guanajuato, 28 June 1993). Mexican painter of Russian descent. She went to Mexico in 1925 and attended the Academia de San Carlos, Mexico City (1933–6), where she met the painter JOSÉ CHÁVEZ MORADO, whom she married. In 1941 she co-founded the Galería Espiral, and in 1943 she founded the Sociedad de Arte Moderno, one of the first galleries to promote foreign artists in Mexico. From 1945 she exhibited regularly at the Galería de Arte Mexicano, Mexico City. Costa painted *costumbrista* subjects, depicting regional customs, as well as still-lifes, portraits and landscapes. Her style was traditionalist, without being folkloric in a popular manner. Her best-known work is perhaps the *Fruit Seller* (1951; Mexico City, Mus. A. Mod.). From 1966 she lived in Guanajuato, where she played an active role in local artistic activities. In April 1993 the Museo-Casa Olga Costa-José Chávez Morado was opened in León, Guanajuato.

BIBLIOGRAPHY
Frida Kahlo acompañada de siete pintoras: María Izquierdo, Cordelia Urueta, Olga Costa, Remedios Varo, Alice Rahon, Leonora Carrington y Soffía Bassi (exh. cat. by J. O'Gorman and others, Mexico City, Mus. A. Mod., 1967)
La vida a cuadros (exh. cat., Mexico City, Gal. Tonalli, 1988)
La mujer en México (exh. cat., Mexico City, Cent. Cult. A. Contemp., 1990) [entries by L. Nochlin and E. Sullivan]
Regards de femmes (exh. cat., Liège, Mus. A. Mod., 1993)
Latin American Women Artists, 1915–1995 (exh. cat. by G. Biller and others, Milwaukee, WI, 1995)

JULIETA ORTIZ GAITÁN

Costa Ataíde, Manoel da. *See* ATAÍDE, MANOEL DA COSTA.

Costa e Silva, José da (*b* Povos, nr Lisbon, 25 July 1747; *d* Rio de Janeiro, 21 March 1819). Portuguese architect, active also in Brazil. He studied in Italy under royal patronage, a pattern of artistic education established in Portugal at the beginning of the 18th century. He went first to Bologna, in 1769, becoming a member of the Accademia in 1775. He subsequently went to Rome, making an extensive tour of Italy before returning to Lisbon in 1779. In 1781 he was invited to run the school of architecture at the new Academia do Nu in Lisbon, founded under Mary I. He also became an honorary member of the Accademia di S Luca, Rome. In 1785 he completed the sanctuary of the Italian church of Nossa Senhora do Loreto, Lisbon, the rebuilding of which was started by Manuel Caetano de Sousa (1742–1802).

Costa e Silva's first major work was the opera house, the Teatro S Carlos (1792–3), Lisbon, which was built in six months for a group of wealthy citizens anxious to follow the latest fashions in Italian opera. The design was consciously Neo-classical: the three-bay arcaded *porte-cochère* and severe pilastered façade on a rusticated base were modelled on Giuseppe Piermarini's Teatro della Scala (1776–8), Milan, which Costa e Silva had probably seen in 1779. The interior, a horse-shoe plan with four tiers, was sumptuously decorated with gilt. Also in 1792 Costa e Silva started work on the Royal Palace of Runa, near Lisbon, which incorporated a military hospital and a church. Work was suspended in 1807 owing to the Napoleonic invasion, although parts of the hospital remain.

From 1795 Costa e Silva was occupied with designs for the new royal palace of Ajuda (also called Nossa Senhora da Ajuda), Lisbon, to replace the one destroyed by the earthquake of 1755. The Italian Francesco Saverio Fabri (1761–1807) also presented plans, and work started in 1802 jointly under Fabri and Costa e Silva. The design has been linked to the former royal palace (begun 1752), Caserta, by Luigi Vanvitelli (1700–1773), but the scale is much more intimate and the detailing Neo-classical; the prominent corner towers, however, are essentially Portuguese.

In 1812 Costa e Silva emigrated to Brazil, following John VI, who, fleeing the Napoleonic invasion, had established the court in Rio de Janeiro in 1808. Costa e Silva was the major exponent of Neo-classicism in Brazil until the arrival in 1816 of the French Mission, headed by Auguste-Henri Grandjean de Montigny. The opera house in Rio de Janeiro, the Real Teatro S João (1811–13; destr.), also with a three-bay arcaded *porte-cochère* and pilastered façade, although with a pediment on the central pavilion, resembled Costa e Silva's Teatro S Carlos so closely that he is believed to have been involved in its final design. In 1813 he was appointed Royal Master of Works, advising on the many improvements necessary to various palaces in Rio de Janeiro and Salvador in order to establish the royal court in the somewhat backward conditions then found in Brazil. The large collection of drawings and books on architecture that Costa e Silva brought with him were sold in 1818 to the Royal Library (now the National Library), Rio de Janeiro.

BIBLIOGRAPHY
Viterbo
J. A. França: *Lisboa Pombalina* (Lisbon, 1965)
R. dos Santos: *Oito séculos de arte portuguesa*, ii (Lisbon, 1966)
P. F. Santos: *Quatro séculos de arquitetura* (Rio de Janeiro, 1981)

ZILAH QUEZADO DECKKER

Costa Rica, Republic of [Sp. República de Costa Rica]. Central American country. It is bordered by Nicaragua to the north, by Panama to the south-east, by the Caribbean Sea to the east and by the Pacific Ocean to the south and west (see fig. 1). The Sierra Madre cuts across the country from north-west to south-east, forming a central plateau that is the main centre of population; the capital is San José.

1. Introduction. 2. Architecture. 3. Painting, graphic arts and sculpture. 4. Patronage and institutions.

1. INTRODUCTION. Columbus arrived at the town of Cariari (Puerto Limón) on 18 September 1502, during his fourth voyage. His brother Bartolomé explored the interior

1. Map of Costa Rica

BIBLIOGRAPHY
M. A. Jiménez: *Desarrollo constitucional de Costa Rica* (San José, 1979)
C. Meléndez: *Conquistadores y pobladores: Orígenes histórico-sociales de los costarricenses* (San José, 1982)
E. Fonseca: *Costa Rica colonial: La tierra y el hombre* (San José, 1984, 3/1986)
C. F. Echeverría: *Historia crítica del arte costarricense* (San José, 1986)
O. Fonseca Zamora: *Historia antigua de Costa Rica: Surgimiento y caracterización de la primera civilización costarricense* (San José, 2/1996)

C. GUILLERMO MONTERO

2. ARCHITECTURE. Although Spanish explorations date from 1539, it was not until the early 1560s that the settlements of Real de Ceniza, Garcimuñoz and the colonial capital Cartago (formerly Ciudad del Lodo) were established. The first settlements were mainly on the central plateau, although incursions from the sea and frequent earthquakes led to underpopulation, and few buildings survive from the 16th to 18th centuries. The ruined church at Ujarrás may date from the early 17th century (Marco Dorta) and shows 16th-century Mexican influence. Only part of the three-storey façade remains: it has a wide entrance arch with squat pilasters rising from its springing line to the first horizontal division, and the remains of scrolls rise to a modest bell gable with twin bell arches. The Franciscan sanctuary of Orosi (1766) reflects the Baroque of the first half of the 18th century, perhaps indirectly by way of León, Nicaragua, the seat of the bishopric that controlled the church in Costa Rica, and León's cathedral. The Orosi sanctuary is a low, rectangular church with a shallow-pitched overhanging tile roof, similar in design to the Franciscan churches in Paraguay but without a surrounding colonnade gallery. A sturdy attached two-storey tower is set back slightly from a barely adorned gable and girdled by a balcony with a blind balustrade (as in León Cathedral) overlooking the monastery patio; there are unique, centrally placed pilasters on each exposed face of its lower storey.

Colonial traditions carried over into the 19th century and are evident in churches built in its early decades. The design of the church of Guadalupe (completed 1810, under the direction of Mariano Ormuza y Matute), Cartago, is derived from the *Mudéjar* style. Its three round-arched entrances are set in rectangular architrave frames. The bell gable is divided between two storeys, the upper part of which is roofed and can almost be classed as a central tower. The early 19th-century parish church at Heredia is an example of the use of low, broad-based towers as buttresses in 'earthquake Baroque', though by this date the design is more Neo-classical in feeling. Twin three-storey towers with modest pyramidal cupolas are set back behind the façade, which itself projects either side of a barnlike church. The façade, also buttress-like, is a two-storey, tripartite composition with simple arched entrances on the lower storey and coupled pilasters supporting a pediment above; the pilasters are repeated on the end bays, which themselves have miniature cupolas giving the appearance of secondary towers.

Buildings constructed soon after independence continued the trend towards Neo-classicism. They include the Comandancia (military headquarters) by the Mexican Miguel Velázquez and the Palacio Nacional by the German engineer Franz Kurtze, both in San José; colonial features

of the region but left no settlements. In 1509 the territory of Costa Rica became part of Castilla de Oro and was governed from Panama by Diego de Nicuesa. It was incorporated in the Audiencia de Guatemala, established *c.* 1521. During the government of Pedrarias Dávila, Gaspar Espinosa led an expedition to the Gulf of Nicoya, where the first Spaniards settled. Francisco Fernández de Córdoba, who had founded the town of Bruselas (1524) on the Nicoya Peninsula, was impressed by the wealth of flora and fauna and in 1539 gave the region the name of Costa Rica (rich coast). It was not until 1560 that Juan de Cavallón penetrated into the interior and founded first the city of Castillo de Garcimuñoz (1561) and later Ciudad de los Reyes and the port of Landecho. Juan Vásquez de Coronado, the first Governor of Costa Rica, founded the city of Cartago in 1564 and introduced cattle farming and European plants. The central plateau began to be populated, but the depredations of pirates, attacks by Mosquito Indians and commercial restrictions imposed by Spain made economic progress difficult.

After the kingdom of Guatemala proclaimed independence, without bloodshed, in September 1821, Costa Rica declared its independence. With the other provinces of the former kingdom, in 1822 Costa Rica joined the Mexican Empire of Iturbide; when this broke up in 1823, it joined the Central American Federation. Despite its separation from the Central American Federation in November 1838, Costa Rica did not proclaim absolute independence until August 1848.

In 1948 the Costa Rican Congress declared fraudulent the elections in which the opposition candidate Otilio Ulate Blanco had defeated the official candidate, Rafael Angel Calderón Guardia, and this led to civil war. A rebellion, led by José Figueres, set up a Government junta, and a Constituent Assembly declared the election of Ulate valid. He governed until 1953, when he was succeeded by Figueres. Power then alternated between the National Liberation Party and the opposition Social Christian United Party.

based on local skills reappeared in such buildings as the barracks and the Universidad de S Tomás (both San José). New French and German immigrants helped induce changes: the Caribbean bungalow style began to replace Hispanic domestic models, and *fin-de-siècle* eclecticism ran alongside the established styles. As elsewhere in Latin America, prefabricated iron buildings were imported from Europe, including the Edificio Metálico (mid-1870s), San José, imported from Belgium. The Neo-classical Teatro Nacional (1897), San José, is a small and charming replica of the Paris Opéra. It is among many academicist buildings designed by the engineer Lesmes Jiménez Bonnefill, who studied in Belgium. Jiménez also worked in a neo-Gothic style, as in his church of La Merced (1903–5), San José, an elegant composition finished in stucco though with classical undertones, especially in the central tower, which carries a simple hexagonal spire.

Anti-academicism brought a flowering of *modernismo* c. 1900, for example in the work of Francesco Tenca (*d* 1908), especially in private houses such as that for Jiménez la Guardia (1900), San José. Eclecticism continued during the 20th century. Luis Llach Logostera (*fl* 1900–15; trained in Barcelona) ranged from a mix of Byzantine, Classical and *Mudéjar* elements in the Basílica Nuestra Señora de Los Angeles (1912), Cartago, to a stripped-down classical style in the Edificio Correos y Telegráficos (1914), San José. The Neo-classical and neo-Baroque continued after World War I: José Francisco Salazar Quesada (1892–1968) designed the Club Unión (1921; destr.), San José, and the Basílica S Domingo (1924; with Teodorico Quirós), Heredia. José María Barrantes Monge (1890–1966) produced a number of churches in the 1930s and 1940s, including Nuestra Señora de Desamparados (1935), San José, its portico supported on unique coupled Tuscan columns. On the other hand, Quirós's church S Isidro de Coronado (1935), San José, is a fine late example of Gothic Revival with pinnacled buttresses and a crocketted spire. Art Deco appears in Barrantes's three-storey apartments (1935) on Avenida 6, Calle 1, San José, almost concurrently with Neo-Colonial in a number of houses and La Sabema national airport, San José (1935; now the Museo de Arte Costarricense). The advent of the Modern Movement took place in the 1930s, much influenced by the work of German immigrant Paul Ehrenberg Brinkman (1900–65). His flat-roofed, single-storey dwelling for Dr Gonzala Cubero (1933), and the Almacén Borbón (1935), both San José, are reminiscent of the dynamism of German Expressionism of the mid-1920s; along with a series of cinemas (built well into the 1940s), they retain some Art Deco detailing. The same is true for some of Salazar's buildings of this period, but his three-storey Hospital S Juan de Dios (1934), San José, is a plain-surfaced building with only a touch of Art Deco in the entrance details; the Secretaría de Salubridad Pública (1936–40), San José, is a Rationalist building reminiscent of Auguste and Gustave Perret's work. The Perrets' influence also seems evident in some of Barrantes's later churches, such as Nuestra Señora del Carmen, Cartago (1945). Ehrenberg continued to lead the way, however: his Trejos González building (1954) has fully glazed infill between projecting concrete floors, although there is still an echo of Erich Mendelsohn in the Schyfter building (1954), San José; his pitched-roof

houses, such as the Puci Poli dwellings (1950), San José, and Jane Davidson de Salazar (1956), San José, have elements of the Neo-Colonial style.

Stronger American influence in the 1960s produced many International Style urban developments, followed by a return to deeper consideration for context by such locally trained architects as Jorge Borbón (*b* 1933), Edgar Vargas (*b* 1922) and Hernan Jiménez (*b* 1942). The Chilean Bruno Stagno (*b* 1943) is perhaps the best known of the later generation of architects: his houses in San José (1976) are expressive of the new mood of social and environmental relevance, and his later work, such as the building for Escuela 'Country Day', San Antonio (1983), Escazú, has been labelled *arquitectura mestiza*, reflecting the serious attempts to define a contextual image.

BIBLIOGRAPHY

E. A. de Varona: *Orosi* (San José, 1949)

P. Kelemen: *Baroque and Rococo in Latin America* (New York, 1951), pp. 70–71

D. Angulo Iñiguez and others: *Historia del arte hispano-americano*, iii (Barcelona, 1956), pp. 80–81, 90–92

E. Marco Dorta: *Arte en América y Filipinas*, Ars Hispaniae, xxi (Madrid, 1973), p. 211

C. Altezor Fuentes: *Arquitectura urbana en Costa Rica: Exploración histórica* (San José, 1986)

'Casas en Iberoamerica', *Summa A.*, 235 (March 1987), pp. 51–71

S. Gutiérrez: *Arquitectura caribeña Puerto Limón, Bocas del Toro* (Bogotá, 1991)

R. Segre: 'Bruno Stagno, arquitecto', *Proa*, 407 (Nov 1991), pp. 11–29

E. Tejeira Davis: 'El neocolonial en Centroamérica', *Arquitectura neocolonial: América Latina, Caribe, Estados Unidos*, ed. A. Amaral (São Paulo, 1994), pp. 113–28

JUAN BERNAL PONCE

3. PAINTING, GRAPHIC ARTS AND SCULPTURE. In the period between colonization and independence painting and sculpture in Costa Rica were generally imported from Ecuador, Guatemala and Mexico. In the second half of the 19th century a local sculptural tradition emerged in the work of Fadrique Gutiérrez (1841–97), who created monumental pieces in stone, and Juan Mora González (1862–95), who created a series of portraits and polychrome wood statues. Artistic activity in Costa Rica became more eclectic only in the early 20th century. During the 1920s and 1930s regular exhibitions, including the Salones Anuales de Artes Plásticas, were held in San José. In 1928 the painter and architectural engineer TEODORICO QUIRÓS and the painter and sculptor MAX JIMÉNEZ founded the Círculo de Amigos del Arte; the group, whose members typically depicted rural scenes in an academic manner, held regular exhibitions sponsored by the *Diario de Costa Rica* at Las Arcadas, San José, stimulating artistic production at a national level. In 1935 the Monument to Motherhood competition fuelled the debate between academicists and modernists. Controversy focused on Francisco Zúñiga's sculpture of a woman, for it was deemed that the uneducated masses could understand only realism, not modern art; Zúñiga left for Mexico in 1936. A growing division between academic and more modern styles was embodied in the work of one member of the Círculo de Amigos del Arte, FRANCISCO AMIGHETTI, whose wood-engravings and drawings, although regionalist in subject, were more expressionistic than other members' work; Amighetti was also influential in his creation of mural paintings, a form he had studied

in Mexico and on which he collaborated with such artists as Margarita Bertheau (1913–75).

The painter MANUEL DE LA CRUZ GONZÁLEZ was exiled following the revolution of 1948; in Venezuela his style developed towards geometric abstraction (e.g. *Space-Colour*, *c.* 1962–5; artist's col., see Ulloa, p. 108), and on his return his work was considered avant-garde. González was a member of Grupo Ocho, one of a number of groups that existed throughout the 1960s, whose members were interested in experimenting with non-figurative art while trying to gain popular acceptance for it; they held exhibitions at Las Arcadas, San José, in 1961–2, and organized festivals, increasing contact between Costa Rican artists and the international art world. Other groups included Grupo Taller and Grupo Totem. González himself was included in the first Bienal Centroamericana de Pintura in 1971. The engraver JUAN LUIS RODRÍGUEZ was an important figure in graphic arts, stimulating interest in printmaking by setting up an engraving workshop within the fine arts faculty of the Universidad de Costa Rica, San José, in 1972–3. A number of artists turned to Surrealism in the late 20th century, including Rafael Fernández (*b* 1935). His paintings are somewhat reminiscent of Chagall (see fig. 2).

BIBLIOGRAPHY

El arte religioso en Costa Rica (exh. cat. by F. Amighetti, San José, Mus. N. Costa Rica, 1955)
Modern Artists of Costa Rica: An Exhibition of Paintings and Sculptures Assembled by the Group 8 of San José (exh. cat., Washington, DC, Pan Amer. Un., 1964)
L. Ferrero: *La escultura en Costa Rica* (San José, 1973)
R. Ulloa Barrenechea: *Pintores de Costa Rica* (San José, 1975)
C. F. Echeverría: *Ocho artistas costarricenses y una tradición* (San José, 1977)
L. Ferrero: *Cinco artistas costarricenses: Pintores y escultores* (San José, 1985)
——: *Sociedad y arte en la Costa Rica del siglo 19* (San José, 1986)
E. Zavaleta O.: *Los inicios del arte abstracto en Costa Rica, 1958–1971* (San José, 1994)
E. J. Sullivan, ed.: *Latin American Art in the Twentieth Century* (London, 1996)

C. GUILLERMO MONTERO

4. PATRONAGE AND INSTITUTIONS. The Escuela Nacional de Bellas Artes, San José, was founded in 1897 under the directorship of the Spanish painter Tomás Povedano, whose own academic paintings of rural scenes influenced TEODORICO QUIRÓS and others of his generation who attended the school. The newspaper *Diario de Costa Rica* sponsored exhibitions held regularly between 1928 and 1937 at Las Arcadas, San José, by the group Círculo de Amigos del Arte. In 1940 the Escuela de Bellas Artes was incorporated into the Universidad de Costa Rica, San José, as a faculty of fine arts under Angela Castro Quesada. Quirós was Dean of the faculty from 1942 to 1945, encouraging a revival of the academic style on which it was founded. The Casa del Artista, San José, was founded in 1948 to provide artistic training to poorer students. Also in San José, the Escuela de Arte y Decoración Esempi was founded in 1955 under Francisco Alvarado Abella. At a government level, the Dirección General de Artes y Letras was set up in 1963 to stimulate artistic activity in the country; it initiated the collection that later became the basis of the permanent collection of the Museo de Arte Costarricense, San José. In 1970 the Ministerio de Cultura, Juventud y Deportes was created to promote cultural activities; the Museo de Arte was later attached. The engraver JUAN LUIS RODRÍGUEZ set up an engraving

2. Rafael Fernández: *Flying Figure*, acrylic on hardboard, 500×760 mm, 1972 (Washington, DC, Art Museum of the Americas)

workshop within the fine arts faculty of the university in 1972–3, and this initiative was followed up in 1977 by the foundation of another engraving studio at the Universidad Nacional de Heredia. Upon the conception of the Museo de Arte in 1977 the Dirección General de Artes y Letras ceased to exist. The museum's aim was to preserve, disseminate and stimulate artistic activity and the national artistic heritage and identity. It opened in May 1978 in the former airport building of La Sabema.

BIBLIOGRAPHY

S. Rovinski: *Cultural Policy in Costa Rica* (Paris, 1977)
C. Kandler: *National Museum of Costa Rica: One Hundred Years of History* (San José, 1987)
K. Steinmetz: 'Museum of Contemporary Art and Design, Santa San José de Costa Rica', *A. Nexus* xxi (1996), pp. 34–5
Espíritu de una colección, Mus. A. Diseño cat. (San José, 1996)
J. M. Rojas G.: *Museo de Arte Costariccense* (San José, 1996)
Escuela Nacional de Bellas Artes: Centenario, 1897–1997: Programa revisión de un siglo, i (San José, 1997)

C. GUILLERMO MONTERO

Costigliolo, José Pedro (*b* Montevideo, 6 November 1902; *d* Montevideo, 2 June 1985). Uruguayan painter. Costigliolo studied painting as part of the Bellas Artes group in Montevideo between 1921 and 1925, followed by a period of graphic art production between 1929 and 1946. The period 1946–50 heralded a stage of neo-purist, machinist art and abstraction, following which Costigliolo became a key figure in the development of non-figurative art in Uruguay, co-founding the Grupo de Arte No Figurativo in 1952. In 1953, during a time of economic prosperity and optimism in his country, Costigliolo entered his constructivist phase, revolutionizing and modernizing Uruguayan art along with his wife, Maria Freire (*b* 1917). In the creation of innovative abstract art that embraced both national and international traditions, Costigliolo's constructivism owed a debt to, and expanded on the work of such Uruguayan precursors as the hugely influential Joaquín Torres Garcia. Costigliolo's constructivist art was also close to its Russian counterpart, which just before the 1917 Revolution, was pioneering in its transformation of art into an exploration of such abstract elements as the picture frame, line and colour. Using boldly coloured elements in irregular compositions, as in *Triangles* (1978; see fig.) and *Squares and Rectangles* (1972, both Colchester, U. Essex Coll. Lat. Amer. A.), Costigliolo created complex and visually exciting images of forms in space. An important aspect of his paintings is the constant variation of the size of elements, the latter becoming increasingly simple—squares, triangles and rectangles—after 1964. Costigliolo's artistic output continued until his death in 1985.

BIBLIOGRAPHY

M. Bilke: *Costigliolo* (Montevideo, 1972)
E. J. Sullivan, ed.: *Latin American Art in the Twentieth Century* (London, 1996)

J. HARWOOD

Cotolí, Manuel Piqueras. *See* PIQUERAS COTOLÍ, MANUEL.

Courret, Eugenio (*b* France; *d* ?France). French photographer, active in Peru. He moved to Lima *c.* 1861 where he formed a partnership with the French photographer Eugenio Maunoury. By 1864 he had his own studio, which became the most successful photographic centre in Lima. He was the leading Peruvian portrait photographer of the 19th century, winning a gold medal at the Exposition Universelle in Paris in 1900. As well as carrying out commissions he took photographs of Lima, leaving valuable documentary records not only of its architecture but also of historical events.

BIBLIOGRAPHY

D. McElzoy: *The History of Photography in Peru in the Nineteenth Century, 1836–1876* (diss., Albuquerque, U. NM, 1977)
Memoria de una ciudad: Estudio fotográfico Courret Hnos (1863–1935) (exh. cat. by J. Duestua, Lima, Mus. N., 1994)

ERIKA BILLETER

Covarrubias, Miguel (*b* Mexico City, 22 Nov 1904; *d* Mexico City, 4 Feb 1957). Mexican illustrator and writer. He worked as a draughtsman on maps and street plans in the Secretaría de Comunicaciones, Mexico City, *c.* 1919, and in 1920 made a series of caricatures for a student magazine, *Policromías*. He soon established himself as an illustrator, publishing his work from 1921 to 1923 in large circulation newspapers such as *El Heraldo*, *El Mundo* and the *Universal Ilustrado*.

In 1923 Covarrubias settled in New York, where he began writing about the theatre, writing and drawing for the magazine *Vanity Fair* (1924–36) and drawing for the *New Yorker* (1925–50). In 1925 he published *The Prince of Wales and other Famous Americans*, a shrewd, witty chronicle of his contemporaries. He was particularly interested in non-Western societies and their cultural traditions, about which he wrote extensively with the aim of presenting the history of a region as a continuous process. On his return to Mexico in 1942 he broadened his interests to include museology and dance. He painted in the manner of his caricatures, executing various murals in Mexico City that explored his ethnographic interests.

WRITINGS

The Prince of Wales and other Famous Americans (New York, 1925)
Negro Drawings (New York, 1927)

José Pedro Costigliolo: *Triangles 102*, acrylic on paper, 400×400 mm, 1978 (Colchester, University of Essex, Collection of Latin American Art)

Island of Bali (New York, 1937)
Mexico South: The Isthmus of Tehuantepec (New York, 1946)
The Eagle, the Jaguar and the Serpent (New York, 1954)
The Indigenous Art of Mexico and Central America (New York, 1957)

BIBLIOGRAPHY
L. García Noriega: *Miguel Covarrubias* (Mexico City, 1987)
S. Navarrete: *Miguel Covarrubias: Artista y explorador* (Mexico City, 1993)
A. Williams: *Covarrubias* (Austin, 1994)

ESTHER ACEVEDO

Cravo Neto, Mario (*b* Salvador, Bahia, 1947). Brazilian photographer and sculptor. In 1964 he trained as a photographer in Berlin, returning to Brazil in 1966. He worked with the photographer Hans Mann in Rio de Janeiro, and as assistant to Fulvio Roiter (*b* 1926) on the latter's journey to Bahia. In 1969 he visited New York, and in the 1970s worked as a sculptor and photographer in São Paolo. In 1980 Cravo Neto won the prize for the best photographer of 1980 from the society of Brazilian art critics. This was in recognition of his extraordinary work in portrait studies, which he produced in front of a dramatic black background, as in *Tep, the Indian* (1980; see 1988 exh. cat.).

PHOTOGRAPHIC PUBLICATIONS
La Ciudad de Bahia (Brasília, 1980)
Mario Cravo visto da Mario Cravo Neto (Brasília, 1983)

BIBLIOGRAPHY
Brasil, fotografie di Mario Cravo Neto (exh. cat., intro. J. Amado; Venice, Pal. Fortuny, 1988)
Cartographies: 14 artistas latinamericanos (exh. cat., Winnipeg, A.G., 1993)
P. Weiermair: *Mario Cravo Neto* (Zurich, 1994)
Romperlos: Encuentro de fotografía latinoamericana (exh. cat., Caracas, Mus. A. Visuales Alejandro Otero, 1994)
Mario Cravo Neto (exh. cat., intro. by R. Fernandes Júnior, São Paulo, Mus. A. Assis Châteaubriand; Salvador, Mus. A. Mod. Bahia; Rio de Janeiro, Mus. A. Mod; *c.* 1995)
C. Jímenez Moreno: 'The Lasting Instant: Ruins and Duration in Latin American Photography', *Third Text*, xxxix (1997), pp. 77–86

ERIKA BILLETER

Creole. In the strictest sense the term denotes people of fully European descent born in French, Portuguese and Spanish colonies (or former colonies), mostly in South America, the Caribbean and Africa (for associated art forms *see under* relevant country surveys). The term is applied far more loosely, however, to people of mixed race born in these regions; its usage for people of African descent born in America is now almost obsolete. The designation 'creole' is also applied to the various languages, originally colonial-based, spoken in such regions. ☐

Croce, Aflalo and Gasperini. Brazilian architectural partnership. It was formed in 1962 in São Paulo by Plínio Croce (*b* Tietê, 26 Feb 1921; *d* São Paulo, May 1984), Roberto Aflalo (*b* São Paulo, 18 Sept 1926; *d* São Paulo, 14 Nov 1992) and Gian Carlo Gasperini (*b* Castellamare, Italy, 1926). Croce, the founder of the practice, graduated in architecture in 1946 from the Mackenzie School of Engineering (now Mackenzie University), São Paulo, where the course was extremely conservative; he nevertheless followed the teachings of the modern masters, and the influence of Mies van der Rohe is evident in his early work. He then gained experience in professional practice with Rino Levi in São Paulo. Aflalo graduated in 1950 from the School of Architecture at Mackenzie University, São Paulo, and began to work with Croce on many projects

for blocks of flats. One of these, the João Ramalho Building (1953), São Paulo, on which Salvador Cândia (1924–91) also collaborated, won the International Prize for Collective Housing at the 6th São Paulo Biennale in 1961. It was a work of great formal purity in the style of the European Rationalist masters.

In 1962 Croce and Aflalo were joined by Gasperini, who had trained at the University of Rome and the Federal University of Rio de Janeiro, graduating in 1950; he had already worked in São Paulo, on his own and with the French architect Jacques Pilon (1905–62). The partnership of Croce, Aflalo and Gasperini was very productive, with a wide variety of clients; in the next 25 years more than 500 architectural projects were completed in Brazil, as well as others in the field of regional and urban planning and work outside Brazil. Under the influence of Gasperini and his international experience, including commissions from the Union Internationale des Architectes, they abandoned the severity of extreme Rationalism and began to adopt unconventional formal solutions, often using bold exposed concrete frames articulated with beams and fins. They tended to ignore local trends, particularly the sculptural forms of Oscar Niemeyer, and they were notable for being the first in Brazil to follow an independent internationalist line, open to aesthetic developments in architecture in other countries. While all their projects were thoroughly practical and executed to a high standard, there is no consistent style that gives uniformity to their work, which is characterized by a readiness to vary formal solutions according to the requirements of each individual problem.

Croce, Aflalo and Gasperini won many competitions, including those for the Peugeot Building (1961–2), Buenos Aires, a Miesian glass box; and the headquarters of IBM (1970), on the corner of Avenida 23 de Maio and Rua Tutóia, the constructional solution of which suggested the Parque Iguatemi office building (1971), São Paulo; the latter has a splayed base to accommodate shops and parking on a site that did not permit excavation. In the Tribunal de Contas do Municipio Building (1971), São Paulo, they began to move away from conventional solutions and towards a Post-modernist stance. The Citibank Building (1983–6) in São Paulo, for example, illustrates the international trend in the 1980s towards a sophisticated surface treatment for commercial buildings; its smooth granite cladding, incorporating square windows, is contrasted with a staggered corner section of dark glass and a glazed quadrant vault at roof level.

BIBLIOGRAPHY
F. Bullrich: *New Directions in Latin American Architecture* (London and New York, 1969)
'Modern Brazilian Architecture', *Process: Archit.*, 17 (1980), pp. 116–25 [special issue]
A. Xavier, C. Lemos and E. Corona: *Arquitetura moderna paulistana* (São Paulo, 1983)
'Brésil: Etat des lieux', *Archit. Aujourd'hui*, 251 (1987), pp. 42–4
N. C. Oliveira: 'Citicorp Centre', *Projeto*, 97 (1987), pp. 64–86
Croce, Aflalo e Gasperini: Arquitetos, 25 anos depois, CVS Artistas Asociados (São Paolo, 1989)

CARLOS A. C. LEMOS

Cruz, Luis Hernández. *See* HERNÁNDEZ CRUZ, LUIS.

Cruz Azaceta, Luis (*b* Havana, 5 April 1942). Cuban painter, active in the USA. He left Cuba in 1960 and settled in New York, where from 1966 to 1969 he studied at the

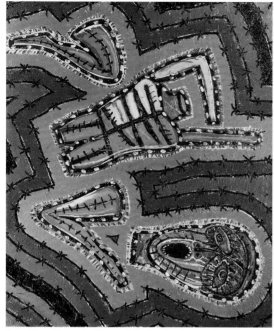

Luis Cruz Azaceta: *Dance of Latin America*, acrylic on canvas, 1.96×2.34 m, 1983 (New York, Metropolitan Museum of Art)

School of Visual Arts. He was a protagonist of the neo-expressionist movement that emerged in New York in the 1970s. His work of this date is characterized by a humour lacking in some of the work by European exponents, for example the *Dance of Latin America* (1983; see fig.). In 1985 he won a Guggenheim Fellowship in painting. Works by Cruz Azaceta are in a number of collections (e.g. *A Question of Colour*, 1989 ; see colour pl. VII, fig. 3) including those of the Metropolitan Museum of Art, New York; Rhode Island School of Design, Providence; Boston Museum of Fine Arts, MA; and the Houston Museum of Fine Arts, TX.

BIBLIOGRAPHY
Azaceta's Tough Ride around the City (exh. cat., New York, Mus. Contemp. Hisp. A., 1986)
The Art of the Fantastic: Latin America, 1920–1987 (exh. cat. by H. T. Day and H. Sturges, Indianapolis, Mus. A., 1987)
C. Damian: 'Cruz Azaceta', *Lat. Amer. A.*, iii/3 (1991), pp. 46–8
J. Yau: *Luis Cruz Azaceta* (exh. cat., New York, Frumkin/Adams Gal., 1991)
Memoria de una ciudad: Estudio fotográfico Courret Hnos, 1863–1935 (exh. cat. by J. Deustua, Lima, Mus. N. Lima, 1994)
RICARDO PAU–LLOSA

Cruz-Diez, Carlos (*b* Caracas, 17 Aug 1923). Venezuelan painter and kinetic artist. He studied in 1940 and 1941 at the Escuela de Artes Plásticas y Aplicadas in Caracas, producing Socialist Realist paintings while working as art director to the McCann Erickson advertising agency in Venezuela, where he became interested in the effect of colour in advertising. In 1955–6 he visited Paris and Barcelona, where his interest was aroused by theories of geometric abstraction, scientific colour theory and Bauhaus ideas on the integration of the arts and crafts. On returning to Caracas he opened the Estudio de Artes Visuales, where he began to investigate the role of colour

in kinetic art. Cruz-Diez's wide experience in advertising, industrial applications of colour, cinema and photographic and photo-mechanical processes, together with his study of work by Georges Seurat and Josef Albers and of Edwin Land's (*b* 1909) scientific ideas on colour perception, led him to produce such constructions as the *Physichromy* series, which was initiated in 1959, immediately after a group of geometric works based on the repetition and serialization of flatly painted trapezoids. The *Physichromies* explored additive, subtractive and reflective colour relationships that could be altered by the relative positions of the light source and viewer (e.g. *Physichromie No. 394*, 1968; see colour pl. VIII, fig. 1). Cruz-Diez continued the series while working on other themes, for example with *Physichromic No. 1270* (1990; see fig.).

In 1964 Cruz-Diez began to create *Chromointerferences*, characterized by mechanically produced movement and by programmed additive colour changes, constructing such works as the *Chromointerference Column* (1971; Paris, U. Paris XIII). In 1965 he introduced *Sensory Deconditioning Rooms*, environments inducing acoustic, visual and tactile perception. The *Chromosaturation* series isolates the

Carlos Cruz-Diez: *Physichromic No. 1270*, aluminium, acrylic and PVC, 800×800 mm, 1990 (Colchester, University of Essex, Collection of Latin American Art)

viewer in an atmosphere of intense colour, as in the *Chromatic Ambience* (1973), constructed for the hydroelectric plant at Santo Domingo in the Barinas State, Venezuela. His *Transchromies* consist of wide sheets of perspex superimposed on a rotating axis to produce different optical mixtures of colour. Cruz-Diez also produced works integrated with architecture, as in the headquarters of the Union de Bancos Suizos (1975–9) and the international airport at Caracas.

BIBLIOGRAPHY
R. Bordier: *Cruz-Diez ou la couleur comme événement* (Paris, 1972)
Carlos Cruz-Diez: Génesis, eclosión y absoluto del color (exh. cat. by R. Guevara, Caracas, Mus. A. Contemp., 1974)
A. Boulton: *Cruz-Diez* (Caracas, 1975)
Carlos Cruz Diez en la arquitectura (exh. cat. by J. M. Salvador, Caracas, Cent. Consolidado, 1991)
G. Rubiano: *Tres maestros del abstracionimso y la proyección internacional* (Caracas, Gal. A. N., 1994)
BÉLGICA RODRÍGUEZ

Cruz González, Manuel de la. *See* GONZÁLEZ, MANUEL DE LA CRUZ.

Cuba, Republic of. Country situated in the Caribbean Sea between North and South America, near the Tropic of

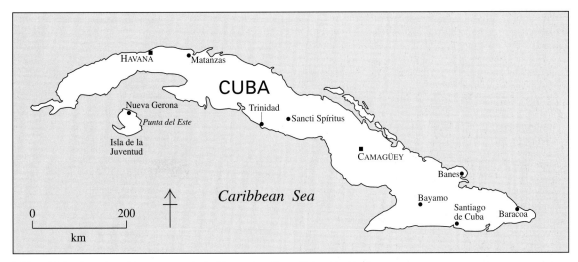

1. Map of Cuba; those sites with separate entries in this encyclopedia are distinguished by CROSS-REFERENCE TYPE

Cancer. It comprises over 1600 cays (low coral banks) and the Isla de la Juventud (see fig. 1), with a total land area of 110,922 sq. km. The capital is HAVANA.

See also CARIBBEAN ISLANDS.

I. Introduction. II. Cultures. III. Architecture. IV. Painting, graphic arts and sculpture. V. Furniture. VI. Ceramics. VII. Metalwork. VIII. Patronage. IX. Art institutions.

I. Introduction.

Cuba is characterized by fertile territory that until the 19th century was covered with forests of valuable timber; these have been replaced by orchards and extensive plantations of sugar cane, tobacco and coffee. The mountains, of moderate height, include the Guaniguanico range, the Sierra de los Organos and the Sierra del Rosario in the west; the Sierra del Escambray in the centre; and the Sierra Maestra in the east. The most important rivers are the Cayagualeje, Almendares, Mayabeque, Hatiguanico, Canimar, Sagua la Grande, Toa and Cauto. The climate is moist and subtropical, and there are two main seasons: dry, from November to April, and rainy, from May to October. The islands are also sporadically swept by hurricanes and cyclones.

When Christopher Columbus landed in 1492 in Cuba, the native population consisted of Ciboney and Taino peoples (*see* §II, 1 below). In 1510 Governor Diego Velázquez took possession of the islands and went on to found the first seven towns: Baracoa, Santiago de Cuba, Bayamo, Puerto Príncipe, Sancti Spíritus, Trinidad and Havana. The *encomienda* system of forced labour exploited the indigenous population, ultimately leading to its extinction.

During the 16th and 17th centuries Cuba's economy had been determined by the direct extraction of natural resources to supply the Spanish fleet, but the rapidly increasing importation of African slaves in the 18th century inaugurated the plantation phase, with the growing of coffee, tobacco and sugar cane. The capture of Havana by the English in 1762, the reforms introduced by the Spanish ruler Charles III (*reg* 1759–88) and the Haitian Revolution

(1804) all made Cuba a prosperous island with a class of educated and refined Creole (native-born white) landowners who fostered the arts and letters. The need to promote exports to neighbouring countries, particularly the USA, and the liberation of Latin America from colonial rule encouraged independence and reform movements led by Félix Varela, José Antonio Saco and Domingo Delmonte. In 1868 Carlos Manuel de Céspedes freed slaves, leading to a ten-year war.

After a truce (the Pact of El Zanjón) in 1878, José Martí created the ideological basis of the movement that culminated in the War of Independence of 1895. In 1898 the USA intervened, ending the war, and occupied Cuba until 1902, marking the beginning of the Republican phase. This was characterized by a new economic and political dependence of the country, maintained by the dictatorships of Gerardo Machado y Morales (1925–33) and of Fulgencio Batista (1952–9). In 1953 Fidel Castro led a revolutionary guerrilla movement that succeeded in ousting the Batista regime in 1959. In 1961 the Socialist character of the Cuban state was established. The country was divided into 14 provinces in 1976, and by 1999 the population approached 11 million. In the 1990s the demise of the USSR led to economic difficulties and an increase in the number of artists leaving the country.

BIBLIOGRAPHY
I. Wright: *The Early History of Cuba, 1492–1586* (New York, 1916)
F. Portuondo: *Historia de Cuba, 1492–1898* (Havana, 1957)
H. Thomas: *Storia di Cuba, 1762–1970* (Turin, 1970)
M. Moreno Fraginals: *El ingenio* (Havana, 1978)
J. M. Macías: *Diccionario cubano* (Havana, 1986)
F. López Segrera: *Sociología de la colonia y la neocolonia cubana, 1510–1959* (Havana, 1989)
F. J. Préstamo y Hernández: *Cuba: Arquitectura y urbanismo* (Miami, 1995)
H. Thomas: *Cuba or the Pursuit of Freedom* (New York, rev. 1998)
ROBERTO SEGRE

II. Cultures.

1. Indigenous. 2. Afro-Caribbean.

1. INDIGENOUS. The small indigenous population of Cuba was exterminated by the colonizing Spaniards as

early as the 17th century. Their contribution to Cuban culture had been limited to rural dwellings, some utensils, crops, eating customs and the use of tobacco, although many place names and other terms are derived from indigenous language. Two groups of people co-existed in Cuba at the time of the arrival of the Europeans. The first group, sometimes known as Ciboney, probably arrived *c.* 4000 BC. Their origin is unknown, although the most commonly accepted hypothesis links them to Central America. They were fishers, hunters and gatherers who lived naked in caves, usually in coastal mangrove swamps; their older sites are characterized by a stone-tool industry, though at later sites shell implements were more commonly used. This group also created a geometric style expressed in carved stone clubs, stone-carvings and extraordinary rock paintings. The most important rock art site is Cave 1 at Punta del Este, Isla de la Juventud, which is painted with hundreds of designs in red and black with a predominance of concentric circles (see fig. 2).

The other group were the Arawak Taínos, who came from the Orinoco Delta *c.* AD 500. These people were farmers who lived in circular or rectangular huts of wood and straw and shared the figurative art style common to the Greater Antilles (*see* individual island surveys). Their ceramics included unpainted bowls modelled with figures on the handles as well as figurines with strongly marked feminine features. Among their wood products were the famous *dujos* (carved anthropomorphic or zoomorphic ceremonial seats), ritual tables and trays, decorated oars and *zemis*, images of gods carved in stone, shell and bone. Some *zemis* have been identified with the myths sung during *areytos*, ceremonies accompanied by dancing and music. Other aesthetic–religious objects include small pendant figures and beads, as well as sticks (made of manatee ribs and carved with faces) used to induce 'purifying' vomiting in *cohoba* ceremonies, at which a hallucinogenic powder was inhaled. Wooden anthropomorphic figures were made to hold the drug before inhalation. The Taínos also made polished stone axes (celts), occasionally carved with anthropomorphic figures. However, no examples of *trigonolitos*, the triangular carved stones typically made by the Arawaks of the Antilles, have been found in Cuba, although petroglyphs and rock paintings are known. The principal collections of indigenous Cuban art are held by the Museo Antropológico Montané, Havana, the Museo de los Indios Cubanos, Banes, the Universidad de Oriente, Santiago de Cuba and the Smithsonian Institution, Washington, DC.

BIBLIOGRAPHY

J. Juan Arrom: *Mitología y artes prehispánicas de las Antillas* (Mexico City, 1975)
A. Núñez Jiménez: *Cuba: Dibujos rupestres* (Lima, 1975)
G. Mosquera: *Exploraciones en la plástica cubana* (Havana, 1983)
R. Dacal Moure and L. Domínguez Gonzáles: 'El arte agroalfarero de Cuba', *Revolución & Cult.*, ii (1988), pp. 32–7
R. Dacal Moure and M. Rivero de la Calle: *Art and Archaeology of Pre-Columbian Cuba* (Pittsburgh, 1996)

GERARDO MOSQUERA

2. AFRO-CARIBBEAN. Cuba's national culture preserves some of the purest and most varied traditions of the entire African diaspora. Africans were first brought to Cuba as slaves in the 16th century and were imported in increasing numbers with the growth of the sugar and coffee plantations in the 19th century (*see also* AFRICAN DIASPORA). It is calculated that *c.* 800,000 Africans from very diverse backgrounds were brought as slaves, although from early times there were also free blacks and mulattos (people of mixed race) who worked as craftspeople in the cities. Despite a process of creolization that helped the slaves adapt to the new milieu, at the peak of sugar production they were exploited at a pace that quickly shortened their lives. Rebellions and flights on the part of the slaves were initially unsuccessful because of the islands' geography and a lack of organization. However, at the end of the 18th century a Cuban national consciousness shared by blacks, mulattos and white creoles began to take shape. Despite the fear of a 'Cuban Haiti' coming into existence—a decisive factor in retarding the Wars of Independence—when these struggles were eventually initiated by the landowners they united all classes and ethnic groups; freed slaves made up 70% of the rebel troops. Such anti-colonial exploits acquired an increasingly popular character and became a crucible in which the national identity was fused. The final abolition of slavery in 1886 contributed further to this identity and helped to forge a culture in which the dominant Western component was conditioned from within by Black African components.

In the fine arts, the African component was expressed in some characteristics of painting at the end of the 1920s when modernism appeared on the Cuban scene. It was not, however, until the 1940s that WIFREDO LAM created a truly Afro-Cuban vision. Lam was followed by Roberto Diago (1920–57), another painter, and in the mid-1950s AGUSTÍN CÁRDENAS put the stamp of African sensibility on abstract sculpture. Around the mid-1960s Manuel Mendive (*b* 1944) began a series of paintings, sculptures, performances and mixed-media works based particularly on myths. From the early 1980s José Bedia (*b* 1959), Juan Francisco Elso (1956–88), Marta María Pérez (*b* 1959), Ricardo Rodríguez Brey (*b* 1955) and Santiago Rodríguez Olazábal (*b* 1955) based their work on an Afro-Cuban world view. Explicit African elements can be discerned in the works of other artists, but from the 1960s a parallel

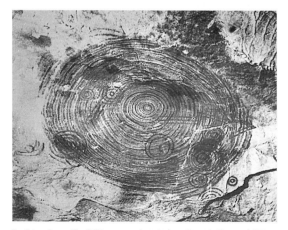

2. Central motif of Ciboney rock painting, Cave 1, Punta del Este, Isla de la Juventud, Cuba, ?*c.* AD 800

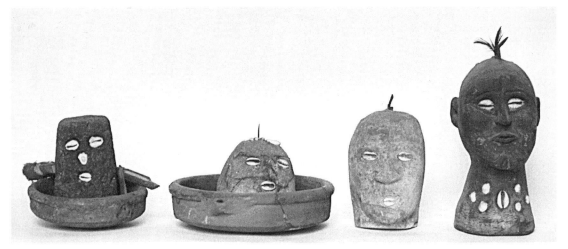

3. Afro-Caribbean Cuban images of Elegguá, cement, stone, cowrie shells, metal, feathers, ceramic bowls, h. *c.* 200–450 mm, early 20th century (Havana, Casa Africa)

'Africanism' of a superficial and often touristic nature also flourished.

The four main Afro-Cuban religious traditions, known as 'Rules', perpetuate African traditions with a certain purity. These groupings arose from the *cabildos de nación*, which had come into being under Spanish colonialism, grouping together Africans of the same ethnic background, but gradually disappeared in the 20th century. Afro-Cuban religions and societies are notable for their popular character, even though all social groups and races take part in them, and they lack a centralized ecclesiastical organization or hierarchy, so that their 'churches' are usually the believers' own houses. Although these cults mingle diverse elements of popular Roman Catholicism and European spiritualism, their essence, structure and ritual remain very close to specific African sources. Thus, the best-known of these religions, the *Santería* (Rule of Ocha), is an adaptation of the religion of the Yoruba people, which is based on the cult of a pantheon of deities known as *orishas*. It is related to the Candomblé, Xango and Batuque religions of Brazil (*see* BRAZIL, §III) and the Shango cult of Trinidad (*see* TRINIDAD AND TOBAGO, §II, 2). Although the deities have been syncretized with Catholic saints and types of the Virgin, they retain their personal mythological features; their cults are performed as in Yoruba culture through the settling of their powers in receptacles, personal initiation, spirit-possession during dances, propitiatory sacrifices and the belief in the intervention of the gods in daily life and their communication with, and advice to, humans. In Cuba, however, the clan, tribal and regional character of the African religion has been lost in the synthesis of the different cults that has taken place. Nonetheless, Cuba is the only country of the African diaspora to have preserved the *babalaos*, high priests of prophecy who operate through the system of Ifá, based on a body of myths. The oral literature, dances, songs and music accumulated and recreated in the ritual of the Santería are extremely rich; in addition, archaic Yoruba has been retained as the ritual language.

The outstanding cult-related artefacts are the altars, complex installations comprising arrangements of the most diverse objects, freely invested with new meanings to create a complex symbolic and aesthetic vocabulary in which religious canons do not obstruct the formation of a new vernacular uniting the traditional and the contemporary. Thus, while various ritual implements and divine attributes retain Yoruba elements, these are often reinterpreted. For the Yoruba, *batá* drums are the drums of Sango, but in Cuba they are used in the rites for all the deities. These hour-glass-shaped, two-membrane instruments are of different sizes, called *ayá*, *atótele* and *okónkolo*, and are struck with the bare hand. Of exclusively religious use, they are inhabited by a power or spirit called Aña. Also of great interest are the bead-embroidered cloths that decorate the drums, images of the gods Elegguá (see fig. 3) and Changó, necklaces, metal objects related to Oggún, Inle, Ochosi and other deities, ritual fly-whisks, garments and initiation thrones. This type of worship is characteristic of the western half of Cuba, from where it spread to the remainder of the island. The widespread nature of this practice has led to the dissemination of 'pure' forms that have spread with Cuban emigration into the USA, Latin America and Spain, as well as to hybridization with popular spiritualism within Cuba.

The Arará Rule is the religion of the Ewe-fon of Benin, Togo and Ghana, practised in Cuba without being structured in 'houses', as it is in Brazil and Trinidad. Proximity and prolonged contact have made the Yoruba and Ewe-fon cultures very similar, and this convergence continued in Cuba, where the Arará Rule and the Rule of Ocha have tended to blend. Fongbé is used as the ritual language, special songs, dances, music and instruments are employed, and a pantheon like that of the Rule of Ocha is worshipped with a similar liturgy. The drums, engraved and painted in the Fon style, are particularly notable. The Rule of Palo Monte originates in the Kongo *minkisi* (spirit) cult of Zaïre, Congo, Angola and other regions, but outside Africa it exists in a fully structured form only in Cuba. The spirit is held by its owner in a receptacle, together with materials that contain and direct it; during songs it enters the owner to counsel him. There is no mythology, but there is a complicated use of magic and herbalism.

Kikongo mixed with Spanish is used as the ritual language, and unique songs, music and instruments are employed. The Rule of Palo Monte is divided into three sects known as Mayombe, Briyumba and Kimbisa: the last, created in the 19th century, combines the spirit worship and Catholicism in the Kongo cult, giving rise to 'Crossed Palo Monte', which spread to other sects. In Crossed Palo Monte, Yoruba-type deities are set into *minkisi* receptacles, with additional borrowings from Catholicism; the liturgy, however, remains Kongo. Some wall paintings in the areas of worship represent curious popular painted versions of the Kongo concept of the universe. Wooden figures are also found, along with 'signatures', abstract ceremonial emblems drawn on the ground and the objects of worship. These symbols derive from writing systems of Kongo origin, developed in Mestizo Baroque style in Latin America, with the incorporation of Western elements. They also form the basis of the Haitian *vèvès* (*see* HAITI, §II, 2), the ground drawings of the Trinidadian Shouters, the 'Pontos riscados' of Brazil and the Ereniyó system of the Abakuás, representing a complete and uniquely Afro-American graphic tradition.

The Abakuá Secret Society is a reconstitution of an African male secret society in the African diaspora. Based on the leopard society of the Ejagham, Efik, Efut and other peoples of the Cross River area of Nigeria and Cameroon, it provides the only true survival of masked dances as the incarnation of spirits; celebrated during funeral and initiation ceremonies, these dances involve predramatic performances. The Abakuá mystery is based on an esoteric power, *Ekue*, and the mythology surrounding the origin and possession of its secret by the society. Terms from Calabar languages form a ritual language, and there are also specific dances, songs and music. From a visual point of view, the clothing of the masked dancers, their sceptres and drums and the numerous stylized designs drawn on the ground, on cloths and on their bodies are the most interesting. These designs probably derive from the Nsibidi ideographic writing of Calabar, with Congolese and Western assimilations and creole inventions. The principal collections of Afro-Cuban artefacts are held at the Casa de Africa, Museo Histórico de Guanabacoa and Museo Municipal de Regla, all in Havana.

BIBLIOGRAPHY

R. Lachatañeré: *El sistema religioso de los lucumís y otras influencias africanas en Cuba* (Havana, 1940)
F. Ortiz: *Los bailes y el teatro de los negros en el folklore de Cuba* (Havana, 1951)
L. Cabrera: *El Monte* (Havana, 1954)
——: *La sociedad secreta Abakuá narrada por viejos adeptos* (Havana, 1958)
R. Bastide: *Les Amériques noires* (Paris, 1967)
L. Cabrera: *Anaforuana* (Madrid, 1975) [reproduces 512 signs of the Ereniyó system and describes the Abakuá initiation ritual]
M. Dornbach: 'Gods in Earthenware Vessels', *Ethnog. Acad. Sci. Hung.*, xxvi (1977), pp. 285–308
L. Cabrera: *Reglas de Congo, Palo Monte, Mayombe* (Miami, 1979)
R. Martínez Furé: *Dialogos imaginarios* (Havana, 1979), pp. 79–238
P. Fatumbí Verger: *Orisha* (Paris, 1982) [text and pict. on the myths and ceremonies of main Yoruba gods in Africa and America]
R. Farris Thompson: *Flash of the Spirit* (New York 1983) [general study of traditional Afro-American art and its underlying religious philosophy]
R. L. López Valdés: *Componentes africanos en el etnos cubano* (Havana, 1985)
G. Mosquera: 'Africa dentro de la plástica caribeña', *Plástica del Caribe: Havana, 1989*
J. Bettelheim: 'Carnaval in Cuba: Another Chapter in the Nationalization of Culture', *Carib. Q.*, xxxvi/3 and 4 (1990), pp. 29–41
——: 'Africa in the Art of Latin America', *A. J.* [New York], li (1992), pp. 30–38
L. Camnitzer: *New Art of Cuba* (Austin, TX, 1994)
L. M. Martínez Montiel, ed.: *Presencia africana en el Caribe* (Mexico City, 1995)
A. Lindsay: *Santería Aesthetics in Contemporary Latin American Art* (Washington, DC, and London, *c.*1996)

GERARDO MOSQUERA

III. Architecture.

1. COLONIAL PERIOD, 1514–1898. HAVANA was founded on its present site in 1519 and became the capital in 1552. By the end of the 16th century it had eclipsed Santo Domingo, on the island of Hispaniola, as the pivot of Spain's Caribbean fortifications. Such early structures as the Fortaleza Vieja (1537; destr.) were replaced by the Real Fuerza (1558–60), designed by Ochoa de Luyando on the model of the ideal Renaissance fort and built by the engineer Bartolomé Sánchez. As foreign incursions grew more serious, King Philip II of Spain employed Bautista ANTONELLI. He worked out a protective system for the entrance to Havana Bay with the large fortified towers of Los Tres Reyes del Morro and San Salvador de la Punta (both *c.* 1590), constructed by local master Juan de la Torre; the same model was subsequently applied to El Morro (1633) in Santiago de Cuba. Sixteenth-century buildings, especially military and naval barracks and service buildings, had heavy masonry walls and roofs of palm thatch. The same is true of the buildings of the religious orders, including the Franciscan Hospital (1544–58), Havana. The town hall and the prison (begun 1580) and the customs house (1582) were among the earliest public buildings in the city. Havana's oldest extant church, Espíritu Santo (dedicated 1638; façade 1674), the S Domingo (1643–4), the Franciscan monastery (1638–44) and the convent of S Clara de Asís (begun 1638) are all noted for their fine MUDÉJAR carpentry, profusely decorated in geometric patterns. Urban houses with enclosed, arcaded courtyards include the house of Don Martín Calvo de la Puerta (1679) on Calle Obrapía, which has an almost Rococo frame to its great portal; a mansion in Calle San Ignacio, also Havana; and the house of Diego Velázquez, Santiago de Cuba (both late 17th century). Bracketed *Mudéjar* timber roofs continued to be built during the 18th century, although there are examples of churches with transverse masonry arches to reinforce the nave arcades, as in the parish church of Guanabacoa (1714–21). The two-storey façade of S Francisco de Asís (1719–38) retains some of the severity of earlier Renaissance models, and the lower storeys of the high central tower, on which the Cuban architect José Arcés worked, is heavy and sober: the church (1730–45) of the hospital of S Francisco de Paula has a more typical Baroque two-storey façade, from which cornices sweep up to a three-bell bellcote (*espadaña*). Although often unadorned, Cuban Baroque church towers are frequently characterized by pyramidal cupolas with an arched aedicula on each face and a pinnacle at each corner.

There were a number of cathedral projects in the 17th century, three of which were by Juan de la Torre. In 1789 the Jesuit church of La Compañía (begun 1748) was accorded cathedral status. Two figures associated with its

development are the Spanish architect Pedro de Medina (1738–96) and a local engineer Antonio Fernández Trevejos (1764–1800). Kubler suggests that the outward-sweeping walls applied to the original centre section of the façade (destr.) may have been the work of de Medina; its character is reminiscent of the work of Borromini and may have been executed in the 1760s. Trevejos and de Medina were also thought to have been responsible for two of Havana's finest colonial civic buildings: the Palacio de los Capitanes Generales (1776–92) and the Palacio del Segundo Cabo (1770–92), both on the Plaza de Armas. They are Neo-classical, with light Baroque ornament and with mezzanines between the ground and principal upper floors, reflecting Andalusian models. Similar houses include the Havana town houses of Don Mateo Pedroso (1780) and the Condesa de Reunión (1785), both of which have tile-roofed timber balconies above their mezzanine floors. The cathedral at Santiago de Cuba (destr. 1770) was rebuilt with a Baroque façade under the direction of Pedro Fernández from 1806; the present Neo-classical façade was remodelled in 1922.

In the 19th century colonial dependence on Spain persisted. However, Neo-classicism came to Cuba via a growth in trade with North America. The French influence is obvious in such buildings as the mid-century Teatro Tacon, Havana, which is built on an elliptical plan. In 1906 a hurricane destroyed many buildings. Notable surviving houses in Havana include the Aldama mansion (1840) by Manuel José Carrerá, Casa-Moré (1872) by Eugenio Rayneri y Piedra (1883–1960) and the Balaguer mansion (1873) by Pedro de Balboa.

2. REPUBLICAN PERIOD, 1898–1959. Peninsular eclecticism persisted with neo-colonial references in such culturally symbolic buildings as the Centro Gallego (1907) by Paul Beleau. There was also a flourishing of Art Nouveau in Havana in the 1910s: typical examples include the house on the Loma del Mazo by Mario Rottland and the Cetro de Oro flats by Eugenio Dediot (1871–1931). More redolent of North American academicism are the Palacio Presidencial (1920) by Beleau and the monumental National Capitol (1929) by Eugenio Rayneri y Sorrentino, Raúl Otero and José María Bens (b 1893), both in Havana. The neo-colonial influence arising from close bonds with the USA is evident in Havana in the Plateresque style tower of the Cuban Telephone Company (1928) by Leonardo Morales (1887–1965) and the Hotel Nacional (1930) by McKim, Mead and White. The Modern Movement made itself felt in Cuba in the 1920s and 1930s, initially through Art Deco, as in the Bacardi offices (1929) by Esteban Rodríguez Castell (b 1887) and the López Serrano flats (1932) by Ricardo Mira (1898–1945) and Miguel Rosich. In the 1940s it was part of the assimilation of the repertory of forms of Rationalism, seen, for example, in Manuel Copado's flats in San Lázaro and houses by Rafael de Cárdenas (1902–57) in Miramar and by Emilio de Soto (1889–1961) on the Avenida de los Presidentes. Eugenio Batista (1900–92) was an influential teacher of architecture in the 1950s. In his Falla Bonet (1938) and Alvarez Tabio (1941) residences he introduced a 'regionalist' aspect to Rationalism, in accordance with the tropical climate and natural materials. Notable experiments in

housing include the Noval house (1949) and the Vidaña house (1955) by Mario Romañach (1917–84). Such architects as Max Borges (b 1918) catered to the booming tourist trade. In Havana, interesting public buildings include the Tribunal de Cuentas (1954) by Aquiles Capablanca (1907–62) and the Retiro Odontológico (1953) and Seguro del Médico (1955) by ANTONIO QUINTANA.

3. POST-REVOLUTIONARY PERIOD, 1959 AND AFTER. The social and economic transformations that followed the Revolution radically changed the direction of architecture. The need for mass housing, schools and hospitals fostered the use of industrialized building techniques. The best-known examples include the large, prefabricated structures built by groups led by FERNANDO SALINAS, such as his four-storey housing at Manicaragua, Las Villas (1963), and the Multiflex housing system. However, despite severely limited resources, Cuban architects of the 1960s produced memorable works in their search for a cultural identity, especially in a series of buildings for the Escuelas Nacionales de Arte (1961–5). Those by RICARDO PORRO are outstanding for their exploitation of short-span domes linked into amorphous clusters by barrel-vaulted corridors, all constructed in economical local materials (see fig. 4). Vittorio Garatti's ballet and music schools and that by ROBERTO GOTTARDI for drama subscribe to the same aesthetic, as does the Casa Cultura de Velasco (1965) by Walter Betancourt (1932–78), all of which are in or near Havana. Serialized components were also used by Salinas in the Oficinas de Mecánica Agrícola (1962) and, to a lesser extent, on José Antonio Echevarria University campus (begun 1960), the Palacio de las Convenciones (1977) by Antonio Quintana and in the Faculty of Farming and Animal Husbandry Sciences (1968) by Juan Tosca (b 1928), as well as the Coppelia ice-cream parlour (1966) by Mario Girona (b 1924). From the 1980s a generation of young professionals followed the path of contextualism in response to the abundant classical vocabulary provided by Havana's historical architecture. In Santiago de Cuba, José Antonio Choy (b 1949) built the Santiago Hotel (1990); in Havana new buildings were designed and constructed in the historical town centre by Eduardo Luis Rodríguez (b 1959), Emma Alvarez Tabio (b 1962), Juan Luis Morales (b 1960), Abel Rodríguez (b 1963) and Francisco Bedoya (b 1959).

BIBLIOGRAPHY
L. de Soto: *The Main Currents in Cuban Architecture* (New York, 1929)
D. Angulo Iñíguez, E. Marco Dorta and M. J. Buschiazzo: *Historia del arte hispano-americano*, 3 vols (Barcelona, 1945–56)
F. Prat Puig: *El prebarroco en Cuba* (Havana, 1947)
J. E. Weiss: *Arquitectura cubana contemporánea* (Havana, 1947)
——: *Medio siglo de arquitectura cubana* (Havana, 1950)
H.-R. Hitchcock: *Latin American Architecture since 1945* (New York, 1955)
G. Kubler and M. Soria: *Art and Architecture in Spain and Portugal and their American Dominions, 1500–1800*, Pelican Hist. A. (Harmondsworth, 1959), pp. 62–8, 165
N. Quintana: 'Evolución histórica de la arquitectura en Cuba', *La enciclopedia de Cuba*, v (Madrid, 1974), pp. 1–115
R. Segre: *Arquitectura, historia y revolución* (Guadalajara, 1981)
E. Tejeira-Davis: *Roots of Modern Latin American Architecture: The Hispano-Caribbean Region from the Late 19th Century to the Recent Past* (Heidelberg, 1987)
L. Castedo: *Historia del arte ibero-americano*, 2 vols (Madrid, 1988)

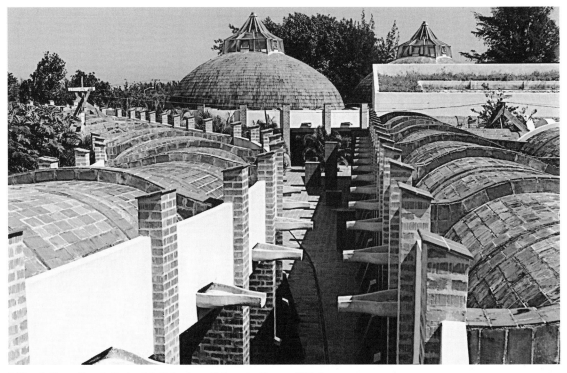

4. Ricardo Porro: Escuela Nacional de Bellas Artes, Cubanacán, Havana, 1961–3

E. Alvarez Tabio: *Vida, mansión y muerte de la burguesía cubana* (Havana, 1989)

R. Segre: *Aquitectura y urbanismo de la revolución cubana* (Havana, 1989)

F. Préstamo y Hernández, ed.: *Cuba: Arquitectura y urbanismo* (Miami, 1995)

P. Gosner: *Caribbean Baroque: Historic Architecture of the Spanish Antilles* (Pueblo, CO, 1996)

J. Weiss: *La arquitectura colonial cubana: Siglos XIV–XIX* (Havana and Seville, 1996)

J. Dec. & Propaganda A., xxii (1996) [issue dedicated to Cuba]

R. Carley and A. Brizzi: *Cuba: 400 Years of Architectural Heritage* (New York, 1997)

C. Venegas Fornias: 'Apreciociones sobre la arquitectura colonial cubana', *Arquitectura colonial iberoamericana*, ed. G. Gasparini (Caracas, 1997), pp. 61–84

ROBERTO SEGRE

IV. Painting, graphic arts and sculpture.

Apart from the rock paintings and carvings of the Native American population (*see* §II, 1 above), the earliest Cuban art works were 16th-century altarpieces and gravestones. Local bronze-casting and graphic art began in the 17th and 18th centuries respectively. Until the early 19th century Cuban art remained basically religious, consisting of altarpieces, paintings of Virgins and saints, all executed in the Baroque style, although there were also popular propaganda murals and decorative architectural paintings; all these forms continued into the 19th century. In the same century a special category of lithographs portraying local customs and other motifs was developed by the tobacco industry for use in packaging, while portrait painting, landscapes and other genres emerged. Academic painting gradually superseded the naive Baroque style, but colonial art remained derivative and imitative of European schools. It rarely achieved a distinctive character, although glimpses

of originality are visible in the paintings of GUILLERMO COLLAZO. Only a few artists (the Spaniard VÍCTOR PATRICIO DE LANDALUZE being the best example) took a direct interest in the human and natural environment.

In the 20th century graphic arts declined, and painting and what little sculpture there was were fettered by the academic style. However, at the end of the 1920s modernism burst on to the Cuban scene as part of the critical movement of national regeneration that arose in opposition to the dictatorship of Gerardo Machado, American neo-colonial control and the consequent economic crisis. Leading figures included EDUARDO ABELA, Rafael Blanco (1885–1955), VÍCTOR MANUEL and Marcelo Pogolotti (1902–88). Their avant-garde activity, although also formally derived from diverse European movements, was driven by an enthusiasm for discovering and expressing qualities uniquely their own: a preoccupation with social issues, an interest in the workings of culture and a will to incorporate the popular into learned discourse. This new consciousness shattered the colonial vision and gave rise to a truly Cuban mode of expression. Among the prominent features of this movement are the expressive use of colour, the importance of the role of light, a quality of sensuality, a baroque style, a deeper exploration of the environment and an imaginative vision of popular origin. The writer Alejo Carpentier was one of the chief promoters of this nationalist modernism, although it was mainly pictorial, with AMELIA PELÁEZ and CARLOS ENRÍQUEZ as its most notable exponents.

A second group of artists with a more internalized aesthetic sense appeared at the end of the 1930s, in keeping with the new intellectual movement formed around the

writer José Lezama Lima and the review *Orígenes*; the most outstanding painters included WIFREDO LAM and RENÉ PORTOCARRERO. In the 1950s this movement became schematized into a sort of manneristic 'School of Havana', which was opposed in turn by the Grupo de los Once, motivated by American Abstract Expressionism. Throughout the decade and until the early 1960s lyrical abstraction was the main movement in Cuban art, although in practice the process of abstraction was often taken as far as a radical form of Concrete art; abstraction brought sculpture, which previously had been unable to free itself of academic mannerisms, into the foreground, notably in the work of AGUSTÍN CÁRDENAS. Graphic arts also gained new impetus in this period with the establishment of the workshop of the Associación de Grabadores de Cuba in 1949.

The Revolution (1959) did not disrupt the artistic process, which continued to develop along its own lines, strengthened by generous government support. Freedom of creativity was guaranteed by cultural policy, and the idea of establishing such an official art style as Socialist Realism was rejected as contradictory to the liberal tradition of Cuban culture, in which modernism united radical social and political positions. The only notable exception in this context was the public art of the 1960s, posters and public bulletin boards combining the political, the aesthetic and the communicative. Some experiments in the integration of the arts were made at the end of the decade. Abstract art gave way to an expressionist, neo-figurative style typified by the work of Antonia Eiriz (*b* 1929; e.g. *The Annunciation*, *c*. 1963–4; Havana, Mus. N. B.A.) and the Pop art of Raúl Martínez (*b* 1927; see fig. 5) and

Umberto Peña (*b* 1937). Other styles included an epic, figurative art inspired by the revolution and exemplified by the work of Servando Cabrera Moreno (1923–81) and the imaginative, mythologizing paintings of Angel Acosta León (1930–64; e.g. *La Nave*, 1961; Havana, Mus. N. B.A.) and Manuel Mendive (*b* 1944). Graphic arts, especially lithography, flourished in new workshops, while photography gave fresh expression to the revolutionary epic with a mixture of journalistic reportage and aesthetic preoccupations. Drawing, too, assumed great importance, which increased in the following decade.

This art boom can be interpreted as a response to the optimistic atmosphere of the 1960s; however, a combination of economic chaos and the collapse of Latin American guerrilla-warfare campaigns over the next decade acted as a restraint. As Cuba entered the orbit of Soviet influence the country's social administration was reorientated in a process of institutionalization. This resulted in a shift in cultural policy in favour of a propagandist art and the superficial proclamation of national identity, leading to a 'dark decade' that stifled existing artistic energy. The only development of note during this period was the burgeoning of the ceramic arts, which had very little local tradition (*see* §VI below). The appearance of Photorealism soon afterwards also testified to an anxious desire for change. This was shortly answered by a new movement that broke through existing forms with an art of conceptual poetics concerned with the Afro-American and Native American vision of the universe as explored in the work of JOSÉ BEDIA VALDEZ and Juan Francisco Els (1956–88; e.g. *The Traveller*, installation, 1986; Mexico City, Cent. Cult. A. Contemp.), the popular kitsch of Flavio Garciandía (*b* 1954; e.g. *Tropicalia*, installation, 1990; Mexico City, Cent. Cult. A. Contemp.) and the philosophical reflection of Arturo Cuenca (*b* 1955); performance art and installations were also popularized. The establishment of the Ministry of Culture in 1976 coincided with a cultural revival: the *Volumen I* exhibition of 1981 was a landmark in the boom of Cuban fine arts. In the 1980s and 1990s trends were numerous and varied, ranging from the appropriation of images seen in the work of Consuelo Castañeda (*b* 1958; e.g. *Lichenstein and the Greeks*, wood, plaster and acrylic on canvas, 1985; Havana, Mus. N. B.A.) to the Neo-expressionism of Tomás Esson (*b* 1963). From the mid-1980s the tone was set by an art of social, cultural and political criticism with a Postmodernist aesthetic derived from the popular and recontextualized, as exemplified by the work of Carlos R. Cárdenas (*b* 1962), Glexis Novoa (*b* 1964; e.g. *Untitled*, installation, 1990; Aachen, Ludwig Forum Int. Kst) and Ciro Quintana (*b* 1964). Utopian attempts to transform art into a direct social activity include the work of Abdel Hernández (*b* 1968). In the 1990s the economic crisis in Cuba led to an exodus of artists.

See also LATIN AMERICAN ARTISTS OF THE USA, §4.

BIBLIOGRAPHY
A. Barr: 'Modern Cuban Painters', *MOMA Bull.*, xi (1944), pp. 1–14
J. Gómez Sicre: *Pintura cubana de hoy* (Havana, 1944)
G. Pérez Cisneros: *Características de la evolución de la pintura en Cuba* (Havana, 1959)
E. Desnoes and O. Hurtado: *Pintores cubanos* (Havana, 1962)
A. de Juan: *Introducción a Cuba: Las artes plásticás* (Havana, 1968)

5. Raúl Martínez: *Fénix*, oil on canvas, 2.0×1.6 m, 1968 (Havana, Museo Nacional de Bellas Artes)

J. Rigol: 'Pintura cubana', *Museo Nacional de Cuba: Pintura* (Leningrad, 1978)
——: *Apuntes sobre la pintura y el grabado en Cuba* (Havana, 1982)
L. de la Torriente: *Imagen de dos tiempos* (Havana, 1982)
G. Mosquera: *Contemporary Art from Havana* (London, 1989)
——: 'Problemas del nueve arte cubano', *Temas*, xx (1990), pp. 57–63
Cuba O.K. (exh. cat. by G. Mosquera and others, Düsseldorf, Städt. Ksthalle, 1990)
Third Text, 20 (Autumn 1992) [special issue on Cuba]
L. Camnitzer: *New Art of Cuba* (Austin, 1994)
Novecento Cubano: La naturaleza, el hombre, los dioses (exh. cat., Havana, Mus. N. 1995)
J. Dec. & Propaganda A., xxii (1996) [issue dedicated to Cuba]
G. Blanc and G. Mosquera: 'Cuba', *Latin American Art in the Twentieth Century*, ed. E. Sullivan (London, 1996), pp. 81–102
Cubo siglo XX: Modernidad y sincretismo (exh. cat. by M. L. Borras and others, Las Palmas de Gran Canaria, Cent. Atlántic A. Mus., 1996)
V. Poupeye: *Caribbean Art* (London, 1998)

GERARDO MOSQUERA

V. Furniture.

Cuban furniture of the 16th, 17th and 18th centuries is strongly indebted to popular Spanish traditions, especially those found in the south of Spain. Spacious interiors contained relatively few pieces of furniture, limited to a small range of chairs, beds and chests. The woods used for furniture were principally cedar and mahogany; jacaranda and Jamaican ebony were also used, particularly for beds. Most surviving 17th-century furniture was commissioned for churches and convents and is therefore conservative in character. While devotional pieces were often very richly styled, objects made for domestic monastic use were simple in form and decoration. Certain pieces of furniture, regarded in the 20th century as primitive—such as Havana chests with step-profiled dovetails, which rely for their effect on plain joinery combined with handsome iron fittings—were highly esteemed at the time and were often exported to South America. Superior examples of these chests (17th-century example, Havana, Mus. N. B.A.) have domed lids and are decorated with flat, geometrical chip-carving, known as *montañesa* or highlander carving, similar to that on furniture from northern Spain. Similar ornament was also used frequently on the backs and rails of chairs (examples in the sacristy of the church at Escolapios, Guanabacoa, Havana), which followed Spanish models closely, except that lavish textiles were normally replaced by leather upholstery. Beds were mostly simple wooden frames with decorative drapes; some featured elaborately turned reel-and-bobbin posts. Limited numbers of tables and wardrobes were made. Surviving examples of the former often have lyre-shaped supports, reflecting the influence of contemporary Spanish prototypes. The design and decoration of the few extant wardrobes is similar to the workmanship found on doors and windows. These pieces, together with documented payments to carpenters, indicate that the Cuban craftsmen who made furniture during this period were the same tradesmen responsible for doors, windows and general home carpentry.

The austerity of traditional 17th-century furniture underwent a dramatic change when mouldings, reliefs and curvilinear impulses began to appear in the mid-18th century, inspired by current European styles. Different styles coexisted and were occasionally combined in single pieces of Cuban furniture. Other pieces were influenced by the English Queen Anne and Chippendale styles or reflected French designs or the Provençal style. Dutch influence is also discernible, but the persistence of Spanish decorative traditions is most obvious. These stylistic trends were partly the result of trade with Europe but may also have been due to immigrant tradesmen. During the 18th century master craftsmen, varnishers and gilders flourished, many of creole or Spanish origin. Foreign craftsmen introduced many new decorative techniques, and furniture inventories of the period describe numerous pieces embellished with inlays, marquetry and gilding. Wickerwork was sometimes used for seat furniture.

Technical developments during the 18th century led to a marked increase in the repertory of available furniture, and this diversity created richer ensembles to equip fashionable interiors. New items recorded in contemporary documents include large mirrors, musical instruments and elaborate lamps. Traditional pieces of furniture were superseded: chests were replaced by chests-of-drawers, and desks and writing tables by bureaux; multi-chairback settees evolved. Cupboards used for both clothes and household goods proliferated. A wide range of tables was produced, such as the folding or console varieties. Chairs multiplied in number and type, while beds increasingly became objects held in high esteem, with delicate carvings and lavish hangings. Elements derived from Cuban architecture are often present in furniture dating from this period; the Baroque Havana jamb was frequently copied on cupboard crestings, cabinets and beds, while the relief work and fine mouldings found on doors and window-frames were used as surface decoration. During the 18th century Cuban furniture, notably chests-of-drawers, gained wide acceptance throughout Hispanic America.

In the first half of the 19th century an increase in trade with North America was directly responsible for the transmission of Neo-classical taste to Cuba. Initially, furniture reflecting the French Empire style co-existed with English Regency-style pieces, as well as items in the American Federal style. These fashions were followed by variations of Biedermeier and French Restoration-style furniture. Many advertisements appeared in Cuban newspapers announcing the arrival of ships from the north with cargoes of furniture. The low price of imported furniture inevitably accelerated demand, and this factor had a powerful influence on Cuban craftsmanship; spectacular items of carved and inlaid furniture were produced as the industry expanded and diversified. Wardrobes, chairs and beds in particular proliferated, and the use of wickerwork instead of textiles became widespread. Comfort, luxurious decoration and ambitious styling came to be highly regarded. An impressive and freely interpreted version of the Louis XVI style, known as the Medallion style, emerged (see fig. 6). Early examples combined a large scale with lavish carving, gilding and often rich textiles. Later decorative schemes were on a more domestic scale and made exclusive use of wickerwork. A simpler, widely popular version of this style, known as *perilla*, was used well into the 20th century.

During the late 19th century the Gothic Revival, the Neo-Romantic and the Spanish style (combining Cuban Renaissance and Baroque elements) became significant. The colonial tradition was effectively terminated by this

6. Drawing-room decorated in the Cuban Medallion style, *c.* 1870 (Santiago de Cuba, Museo de Ambiente Histórico Cubano)

exploration of European revival styles, and by the end of the 19th century many wealthy families were importing furniture from Europe. During the Republican period (1902–59) Art Nouveau furniture was fashionable; this style was widely copied in middle-class homes and marked the modernization of Cuban furnishing schemes. By the 1930s a style known as the 'Modern Line' became widespread and ushered in a period when furniture was dominated by North American design attitudes. The political, economic and social changes that occurred in Cuba as a result of the Revolution of 1959 led to an attempt to create a distinctive national style exemplified by the work of EMPROVA (Empresa de Producciones Varias), which produced furniture using such indigenous materials as fine woods, leather, marble and various fibres, and by the functional furniture developed by the Ministry of Light Industry.

BIBLIOGRAPHY

J. M. F. de Arrate: *Llave del Nuevo Mundo y antemural de las Indias Occidentales* (1761/*R* Mexico, 1949)
E. Pichardo: *Diccionario provincial de voces cubanas* (Havana, 1836)
Directorio de artes, comercio e industrias de La Habana (Havana, 1860)
Directorio criticón de La Habana (Havana, 1883)
Directorio mercantil de la isla de Cuba (Havana, 1888–96)
A. Stapley and M. Byne: *Repertorio de muebles e interiores españoles (siglo XVI–XVIII)* (Mexico City, 1958)
W. C. Briant: 'Cartas de un viajero', *Rev. Bib. N.*, lvi (1965), pp. 35–68
M. Arola: *Historia del mueble* (Barcelona, 1966)
C. F. Duarte: *Muebles venezolanos de los siglos XVI, XVII y XVIII* (Caracas, 1978)
J. Pérez de la Riva: *La isla de Cuba en el siglo XIX vista por los extranjeros* (Havana, 1981)

ERNESTO CARDET

VI. Ceramics.

After the colonization of Cuba in the early 16th century, new influences were introduced by the Spanish and by African slaves; new styles became intertwined and mixed with the vestiges of indigenous ceramics. This gave rise to a new type of pottery that was initially limited to domestic utensils and construction materials. During the 17th century the potter's wheel was introduced into Cuba. No noticeable artistic developments occurred during the Colonial period, as the creoles and Spaniards imported their ceramics from Europe, in particular from Spain and France. National production was limited to the manufacture of cheap earthenware. The only type of ware from this period that can be defined as typically Cuban is the *tinajón* (a large earthenware jar with a narrow base that broadens out and is closed by a narrow neck), which was placed in the inner courtyards of houses to collect rainwater. Ceramic production spread to all the towns; important kilns were established at Santa María del Puerto Príncipe, and in the 18th century a factory was founded by Mateo Santander Pérez, in the town of Trinidad.

There were no great artistic advances during the 19th century, nor did the establishment of the Republic contribute any great ceramic developments. Small factories were set up during this period by such Catalans as Pablo Bergolat in Calabazar (now in Havana) and Mateo Fugarolas in Camagüey. Both factories manufactured earthenwares that lacked any distinctive traits. Similarly, many other kilns proliferated on the island without making any great contributions.

In the early 20th century ceramic production was affected by the move in Cuban art to create designs with national character. The origins of this movement lay in a workshop founded in 1930 by the Catalans Jaime Xart and Castor González Darna in the colony of Santiago de las Vegas (now in Havana). In 1941 they were joined by the Russian Michel Kratchenko. This workshop was converted into a manufacturing centre for industrial earthenware, and José Miguel Rodríguez de la Cruz (1902–90) and Filiberto Ramírez Corría (1902–76) became the central figures in the factory. Rodríguez de la Cruz contributed to the development of ceramic wares through his studies of clay, tin deposits, pastes and pigments and of industrial processes and the construction of kilns.

It was during the 1950s that Cuban ceramics began to develop. The Santiago de las Vegas Workshop became the main centre, where artists who had graduated from the Academia de S Alejandro in Havana and young enthusiasts met to produce and decorate ceramic wares. The work of the painter AMELIA PELÁEZ, for example, includes a *porrón* (1951; Havana, Mus. N. Ceramica Cubana Contemp.; see fig. 7)), which is a drinking vessel traditionally made of glass. Other such painters as Wifredo Lam, RENÉ PORTOCARRERO, Mariano Rodríguez and Luis Martínez Pedro made frequent use of this workshop, together with such young artists as Marta Arjona (*b* 1923), María Elena Jubrías (*b* 1930), Mirta García Buch (*b* 1919) and Rebeca Robés (*b* 1923), who developed new techniques and forms. However, the country's political situation prevented any further development, and the production of ceramics was confined to small, household kilns.

In the 1960s workshops, schools and factories for the industrial manufacture of ceramics were established all over the island. In 1965 the Cubanacán Ceramic Workshop was founded in Havana and attracted such principal potters from the Revolutionary period as Alfredo Sosabravo (*b* 1930), Reinaldo Calvo (*b* 1942), José Rodríguez Fuster (*b* 1943) and Julia González (*b* 1934). The potter Nazario Salazar (*b* 1942) produced thrown wares in the province of Camagüey. In the 1970s several factories producing industrial ceramics were established, and specialist ceramic technology was created and subsequently taught in elementary art schools. These developments led to the

7. Amelia Peláez: glazed ceramic *porrón*, h. 340 mm, 1951 (Havana, Museo Nacional de le Ceramica Cubana Contemporánea)

creation of a movement that culminated in the annual Feria de la Cerámica held at Nueva Gerona, Isla de Pinos. In the 1980s Angel Norniella (*b* 1947), José Ramón González (*b* 1953), Amelia Carballo (*b* 1951) and Agustín Villafaña (*b* 1952) settled on the island and became the leading figures in avant-garde ceramics.

BIBLIOGRAPHY
M. R. Harrington: *Cuba antes de Colón* (Havana, 1935)
B. Tomás: 'Antecedentes e inicios de la cerámica artística en Cuba', *Encuentro de Investigadores de Museos: La Habana, 1976*
Retrospectiva de la cerámica cubana (exh. cat., Havana, Mus. A. Dec., 1976)
L. Romero Estébanez: 'Sobre las evidencias arqueológicas de contacto y transculturación en el ámbito cubano', *Rev. Santiago*, 44 (Dec 1981), p. 71
G. Valdés: *Panorama de la cultura cubana* (Havana, 1983)
REBECA GUTIÉRREZ

VII. Metalwork.

Post-conquest metalwork in Cuba derived little from native traditions, owing to the near extermination of the indigenous peoples. According to records of passengers going to the West Indies, master silversmiths began to settle in the American continent from the earliest years of colonization, and, despite a lack of rich deposits of precious metals, Cuba was one of the first places in which this happened. Under a Spanish royal decree dated 1 June 1513, Cristóbal de Rojas, a silversmith by trade, was allowed to go to Cuba to practise as a founder and hallmarker, and, in order to establish himself on the island, he was given a residence with land, as well as being assigned servants.

In the 16th century Havana supported the activity of about 20 metalworkers. Although there are references before 1550 to the production of such silver objects as vases, pots, small holy-water vessels and jewellery, it was only in that year that the first Havana-based silversmith is

recorded: Juan de Oliver, who was responsible for hall-marking silver. The oldest extant pieces of Cuban metal-work are chapter house maces (1631; Havana City Hall; see fig. 8), made by the master silversmith Juan Díaz Maldonado (*fl* 1631–50). They clearly illustrate the artistic and technical skill that had been achieved by that time. Other surviving examples, although later in date, are the silver filigree cross (*c.* 1662–5; Icod de los Vinos, Canaries, S Marco), crafted by Gerónimo de Espellosa (1613–80) and sent to Icod by the Dean of Santiago de Cuba, Nicolas Estévez Borges, to his native town; and the silver filigree objects (1756) in the cathedrals of Havana and Santiago de Cuba, produced by Antonio Pérez.

In 1665 the Hermandad de S Eloy was constituted in Cuba, and *c.* 1759 the Gremio de Plateros de la Ciudad was founded in Havana, testifying to the number of silversmiths working in that city in the 18th century and

8. Macehead by Juan Díaz Maldonado, silver, 380×240 mm, 1631 (Havana City Hall)

to their artistic drive. The Gremio was subsequently accused by the Governor of not working metals in accordance with the law. It was alleged that, because of Cuba's shortage of rich mineral deposits, the proportion of precious metal included in quality objects was not sufficient. Thus it was decided to import annually a certain quantity of gold and silver from Mexico.

In the 1830s the Gremio was dissolved, which left metalworking open to anyone who had the financial means to establish a shop and withstand local and foreign competition. Competition became fiercer with the importation of gold and silver objects, principally from France, England, the USA and Spain (especially Barcelona); nevertheless, there were around 350 metalworkers in Havana in the later part of the 19th century. Among those whose names have survived were the Misa brothers (Manuel, Juan Ramón and Ricardo; see fig. 9) and workshops such as La Lira and Puño de Oro, all of whom were active in Havana in the mid-19th century.

9. Candelabra by Manuel Misa, silver, h. 230 mm, mid-19th century (Cotovana, Museo de Artes Decorativas)

The largest quantities of surviving pieces of Cuban metalwork date from the 19th, 18th and 17th centuries respectively. They are mainly ecclesiastical examples—little given to changes in fashion, as well as being less subject to economic fluctuations than secular wares—fashioned out of a heavy metal and nearly always worked with a hammer. As demand increased, a marked contrast developed between the pieces that were finely cut and engraved, and others that were extremely simple or on which such industrial techniques as the engraving of borders and other ornamental motifs were used. With the exception of jewellery production, no major contributions to metalwork were made in the 20th century in Cuba.

BIBLIOGRAPHY

H. Hutchinson: 'Spanish and Spanish American Colonial Silver', *Int. Studio*, xcvi (1930), pp. 48–51
J. Torre Revello: *El gremio de plateros en las Indias Occidentales*, U. Buenos Aires, Inst. Invest. Hist., no. 61 (Buenos Aires, 1932)
——: *La orfebrería colonial en hispanoamérica y particularmente en Buenos Aires* (Buenos Aires, 1945)
D. C. Bayón: *América Latina en sus artes*, UNESCO (Paris, 1974)
Raíces antiguas, visiones nuevas/Ancient Roots, New Visions (exh. cat., Tucson, AZ, Mus. A., 1977) [bilingual text]
L. Romero: 'Orfebrería habanera en las Islas Canarias', *Rev., U. La Habana*, 222 (1984), pp. 390–407

MARTA AGUILERA

VIII. Patronage.

From the 16th century local councils and churches commissioned altarpieces and commemorative works; additionally, during the 18th and 19th centuries painters were employed to decorate mansions with wall paintings and to paint advertisements for commercial establishments. Even after the end of the 18th century, when an economic boom led to an increase in the commissioning by businessmen, landowners and other professionals of portraits and other works, the Church and the colonial administration remained the principal patrons of the arts. After independence, however, artists relied chiefly on commissions from the upper class and a few more enlightened patrons, although scarcity of work often obliged them to seek parallel occupations. There was support by some private institutions, but government sponsorship was almost nonexistent until the 1940s and only became meaningful at the beginning of the 1950s with the creation of the Museo Nacional de Bellas Artes, Havana.

Although the first private collections were formed at the end of the 19th century, it was during the 20th century that the most important collections were assembled. These included collections of 17th, 18th and 19th-century European paintings, Classical antiquities, French decorative art and Cuban academic art. Modern fine arts were also collected, particularly by the middle class. The first permanent commercial outlets for paintings emerged in the 20th century as part of luxury stores or art supply shops, but it was not until the beginning of the 1940s that organized galleries appeared. At the same time, the acquisition of Cuban avant-garde painting by MOMA in New York stimulated the market for Cuban art in the USA. Internationally successful artists could survive on the proceeds of their work by working for foreign patrons or by living abroad. In 1954 the 2nd Bienal Hispanoameri-

cano, organized by the Spanish government, was held in the Palacio de Bellas Artes, Havana.

After the Revolution a number of new galleries were set up, among them the Galería Habana and the Centro de Arte Internacional, both in Havana, the Galería Oriente in Santiago de Cuba, and galleries in *casas de cultura* throughout the country; these were for exhibition, rather than commercial, purposes, although the artists could sell the pictures on display. Government institutions such as the Ministries of Foreign Relations and the Sugar Industry, the Cuban Communist Party and the Federación de Mujeres Cubanas also made collections of contemporary paintings, and the state became the principal promoter of art through museums, institutions and public commissions. The Ministry of Culture was established in 1976. However, although support of cultural activities increased considerably, and artists were guaranteed appropriate employment, it was still the case that few were able to make a living from their work. In 1978 the Fondo Cubano de Bienes Culturales, a state organization for commercial art transactions, was created to foster the sale of Cuban art, both in Cuba and abroad, through negotiations with galleries and dealers and its own exhibitions. The numerous new professionals replaced the middle class as patrons, and from the mid-1970s the number of full-time artists increased, thanks to government orders and an increasing international demand for Cuban fine arts.

IX. Art institutions.

The first school of fine arts, the Academia de S Alejandro, Havana, was officially established in 1818; before that, artists either trained in the studios of master painters or were self-taught. The Academia was public and free; its first Director was Jean-Baptiste Vermay (*fl* 1808; *d* 1833), a French pupil of Jacques-Louis David. There were also private art schools in Matanzas and Santiago de Cuba from the 19th century, and in the latter city an official academy was established at the end of the century. Despite changes and interruptions both the Academia (renamed the Escuela Nacional de Bellas Artes S Alejandro) and the Santiago school survive. From 1937–8 avant-garde artists sponsored the Free Studio for Painters and Sculptors in Havana; inspired by the Escuelas de Arte Libre in Mexico, it represented the first anti-academic teaching experiment aimed at establishing a Cuban national form of artistic expression. In 1962 the Escuelas Nacionales de Arte were established in Havana, and subsequently a free, modern, country-wide system of art teaching came into operation; in 1976 the Instituto Superior de Arte opened in the capital. Art training is offered on four levels: three years' study at secondary level in the Escuelas Elementales de Arte is followed by four years at the Escuelas Nacionales de Arte, then five years at the Instituto Superior de Arte to obtain a degree; postgraduate work may then be undertaken at the same institute.

The first public art collection in Cuba was of European paintings. It was originally assembled for teaching purposes in 1842 by the Academia S Alejandro, Havana, and continued to grow throughout the century; however, despite its importance, it did not function as a museum. The first true museums, established in Cárdenas and

Santiago de Cuba at the end of the 19th century, included works of art among their wide-ranging collections, and in 1913 the Museo Nacional in Havana was founded on the same basis. In addition to a permanent exhibition of part of the San Alejandro collection, the Museo Nacional increased its reserves by acquiring modern Cuban artworks. In 1954 the fine arts collections were transferred to the new Palacio de Bellas Artes, inaugurated that year in Havana and renamed the Museo Nacional de Bellas Artes. Some of the best private collections were also exhibited there.

After the Revolution the Museo Nacional was reorganized and enlarged to accommodate collections confiscated from the exiled upper class. Some of these collections formed the nucleus of new museums, such as the Museo de Artes Decorativas, which later enlarged their collections. The Museo Nacional holds the largest and most valuable collection of Cuban art in the world, together with collections of Egyptian antiquities, Greek and Roman artefacts and European paintings from the 17th–19th centuries. It has outstanding holdings of English 18th-century portraits and one of the most noteworthy collections of ancient Greek ceramics in Latin America. There are more than 250 museums in Cuba; some—such as that of Camagüey—specialize in art, others in colonial art and architecture or photography (e.g. the Fototeca de Cuba, Havana). Some multi-purpose galleries also have displays of art.

BIBLIOGRAPHY

Los museos en Cuba, Consejo Nacional de Cultura (Havana, 1972)
J. Rigol: *Museo Nacional de Cuba: Pintura* (Leningrad, 1978)
J. Saruski and G. Mosquera: *La política cultural de Cuba* (Paris, 1979)
J. Rigol: *Apuntes sobre la pintura y el grabado en Cuba* (Havana, 1982)
O. López Núñez: *Escuela San Alejandro: Cronología* (Havana, 1983)
Pintura europea y cubana en las colecciones del Museo Nacional de la Habana (exh. cat., Madrid, 1998)

GERARDO MOSQUERA

Cueto, Germán (*b* Mexico City, 9 Feb 1893; *d* Mexico City, 14 Feb 1975). Mexican sculptor, painter and decorative artist. He studied briefly at the Academia de Bellas Artes de S Carlos in Mexico City but was fundamentally self-taught. In 1925 he was associated with ESTRIDENTISMO, an avant-garde literary and artistic movement with which he exhibited caricature masks painted in strong expressive colours on glossy card, for example *Germán List Arzubide* (1926; Mexico City, priv. col., see List Arzubide, p. 6). Between 1927 and 1932 he lived in France and Spain; he visited the studios of Brancusi, Gargallo and Lipchitz in Paris, but he was especially influenced by his contact there with Joaquín Torres García. It was during this time that he became committed to abstraction, for example in his stone carving *Napoleon* (1931; Mexico City, priv. col., see 1981 exh. cat., no. 1).

Cueto produced not only sculptures in a variety of materials, but also mosaics and puppets. The avant-garde aesthetics of his exclusively abstract art failed to find acceptance, however, on his return to Mexico, and he was likewise unwilling to yield to the ideologically committed art that was then dominant. Instead he continued his experimental work in a variety of techniques and materials, as in the undated *La Tehuana* (see colour pl. VIII, fig. 2), constructed from bronze, aluminium and copper sheets,

and in *Figure* (1967; Mexico City, Acad. A.). From *c.* 1950 he came to be regarded as a precursor of younger Mexican artists dedicated to the avant-garde.

BIBLIOGRAPHY

G. List Arzubide: *El movimiento estridentista* (Jalapa, 1927)
Exposición Germán Cueto (exh. cat. by X. Moyssén, Mexico City, Mus. A. Mod., 1981)

XAVIER MOYSSÉN

Cuevas, José Luis (*b* Mexico City, 26 Feb 1934). Mexican draughtsman, printmaker and painter. He showed early artistic talent and briefly attended the Escuela Nacional de Pintura y Escultura 'La Esmeralda' in Mexico City, which he left because he did not agree with its teaching methods; he was thus essentially self-taught. He studied graphic arts at the Institución de Enseñanza Universitaria in Mexico City *c.* 1948. At the Galería Prisse in Mexico City he joined a group of young artists, including Alberto Gironella, Enrique Echeverría, Pedro Coronel, Manuel Felguérez and Francisco Icaza (*b* 1930), who were opposed to the socialist artists favoured by the Government and whose rebellion against the official mural art was instrumental in modifying the contemporary artistic panorama. Cuevas conducted an aggressive polemic against David Alfaro Siqueiros and his more dogmatic followers, publishing the manifesto 'La cortina de nopal' (*Novedades*, 1957). In 1953 he had his first exhibition at the Galería Prisse; its success led to its being shown the following year at the Pan American Union, Washington, DC, and later to Cuevas's receiving worldwide exposure and recognition as a draughtsman and graphic artist. He was subsequently invited to work in various workshops worldwide, including the Tamarind Workshop in Los Angeles, CA, and Poligrafa in Barcelona in 1981, while in Mexico he worked at the Taller Kyron, among others.

Cuevas produced numerous self-portraits, but he also depicted a variety of characters and scenes in his drawings and prints, some drawn from reality and others from his imagination. His work is satirical, incisive and grotesque in style, and he sometimes visited mental asylums, old people's homes and brothels to seek inspiration in deformity and sordidness (e.g. *Quevedo #3*, 1969; see fig.). His literary sources included Franz Kafka, the Marquis de Sade and Francisco de Quevedo, while his chief artistic influences were Goya, Rembrandt, Picasso and Orozco. He was a skilled draughtsman with both pencil and ink pen, and in his printmaking he experimented constantly with new materials and techniques.

WRITINGS

The World of Kafka and Cuevas (Philadelphia, 1959)
Cuevas por Cuevas (Mexico City, 1965)
Crime by Cuevas (New York, 1968)
Homage to Quevedo (San Francisco, 1969)
Cuevario (Mexico City, 1973)

BIBLIOGRAPHY

M. Traba: *Los cuatro monstruos cardinales: Bacón, Cuevas, Dubuffet y De Kooning* (Mexico City, 1965)
C. Fuentes: *El mundo de José Luis Cuevas* (Mexico City, 1969)
J. Gómez Sicre: *José Luis Cuevas* (Barcelona, 1982)
F. Benítez and others: *José Luis Cuevas: Retrospectiva antológica, 1960–1990* (Santo Domingo, 1993)
José Luis Cuevas: A Retrospective of the Graphic Work, 1948–1990 (exh. cat. by A. Sánchez, Kingston, N.G., 1993)
Homenaje a José Luis Cuevas (Mexico City, 1997)

XAVIER MOYSSÉN

Cúneo (Perinetti), José (*b* Montevideo, 11 Sept 1887; *d* Bonn, 19 July 1977). Uruguayan painter. He first studied art at the Círculo de Bellas Artes in Montevideo under the Uruguayan painter Carlos María Herrera (1875–1914) and the Uruguayan sculptor Felipe Menini (1873–1940). In 1907 he travelled to Europe, and after studying in Turin at the workshops of Leonardo Bistolfi and the Italian painter Anton Maria Mucchi (*b* 1871), and meeting Auguste Rodin in Paris, he returned to Montevideo and had his first show at the Galería Moretti in 1910. He returned to Paris in 1911, studying with Hermen Anglada-Camarasa (1871–1959) and Kees van Dongen (1877–1968) at the Academia Vity.

Around 1914 Cúneo began painting the Uruguayan countryside, an unspectacular landscape of ranches and fields, in an expressionist style, often enlarging the size of the moon and distorting the land and the sky to create a sensation of instability. Typical examples of this highly personal form of perspective include *Moon and Ranch* (1942), *Ranches in the Gully* (1940) and *Outskirts of Florida* (1931; all Montevideo, Mus. N. A. Visuales). He returned in 1938 to Europe, where he painted Venetian canals and exhibited in Paris and Milan, but during World War II went back to Uruguay, where he taught at the Círculo de Bellas Artes and the Escuela Nacional de Bellas Artes. In 1957, after seeing an exhibition of Pablo Picasso's *Guernica* (1937) and related studies, he began to produce abstract paintings, which he signed Perinetti (his maternal surname) and exhibited in Yugoslavia in 1962. His rejection of figuration was decisively demonstrated in the thickly painted and elaborately textured paintings, such as *Serpentine* (1964; Montevideo, Mus. N.A. Visuales), that he began to produce in the mid-1960s, using *José Cúneo Perinetti* as his signature. In 1969 he won the Latin American Grand Prize at the São Paulo Biennale.

BIBLIOGRAPHY

J. P. Argul: *Las artes plásticas del Uruguay* (Montevideo, 1966); rev. as *Proceso de las artes plásticas del Uruguay* (Montevideo, 1975), pp. 148–54, 162–6
Seis maestros de la pintura uruguaya (exh. cat., ed. A. Kalenberg; Buenos Aires, Mus. N. B.A., 1985), pp. 139–56
R. Pereda de Nin: *José Cúneo* (Montevideo, 1988)
Cúneo Perinetti: La lección del maestro (exh. cat., Montevideo, Gal. Latina, 1990)

ANGEL KALENBERG

José Luis Cuevas: *Quevedo #3*, screenprint, 565×764 mm, 1969 (Colchester, University of Essex, Collection of Latin American Art)

Curaçao. *See under* ANTILLES, LESSER.

Curatella Manes, Pablo (*b* La Plata, 14 Dec 1891; *d* Buenos Aires, 14 Nov 1962). Argentine sculptor. He entered the Escuela Nacional de Bellas Artes in Buenos Aires in 1907 and won a scholarship to study in Italy, where he was in the habit of creating and destroying monumental sculptures in a single day. In spite of the prohibition against holders of scholarships absenting themselves from the country to which they were sent, he travelled widely, visiting major museums and galleries and from 1914 to 1926 coming into contact with Aristide Maillol, Emile-Antoine Bourdelle, Maurice Denis, Paul Sérusier, Henri Laurens, Gris, Brancusi and Le Corbusier. Only his seriousness as an artist saved him from being penalized for breaking the terms of his scholarship.

In 1920 Curatella Manes settled in Paris, where he remained until after World War II. Between 1921 and 1923 he produced accomplished sculptures in a Cubist style, concentrating on representations of figures such as *The Guitarist* (1921) and *The Acrobats* (1923). After 1923, in works such as *Dance* (1925) and *Rugby* (1926), he treated mass in a lighter, more rhythmic way, although in works such as *Feminine Torso* (1932) and *The Prophet* (1933) he returned to a heavier expression of mass. His final works, apparently geometrical but with an organic sense of structure, were virtually abstract. In 1949 he gave 31 sculptures to the Museo Nacional de Bellas Artes in Buenos Aires, including all of the works cited above.

BIBLIOGRAPHY

O. Svanascini: *Curatella Manes* (Buenos Aires, 1963)
J. Romero Brest: *Curatella Manes* (Buenos Aires, 1967)
J. López Anaya: *Curatella Manes* (Buenos Aires, 1981)
——: *Historia del arte Argentino* (Buenos Aires, 1997)

HORACIO SAFONS

Cuzco. City in Peru. In the heart of the southern Andes, 3560 m above sea-level, it was the capital of the Inca empire. Cuzco occupies the head of the fertile valley of the Huatanay River, where it is connected by a low pass with the Anta Basin and Valley. The climate is temperate, with a rainy season from December to March. Now a city of over 275,000, a majority of whom are Indians, it is the present-day capital of the department of Cuzco.

Around AD 1200 the Inca tribe established the settlement of Cuzco. The only permanent residents were the rulers and Inca nobility, including priests and important government officials. Temporary residents included some servants and attendants to the shrines, but the majority lived in the outlying districts. Outside the central nucleus, settlements or suburbs were considered parts of the capital. The suburbs were the homes of the native lords of subject provinces. Cuzco's greatness was reflected in the impressive palaces, the primary function of which was royal, although they were also used as administrative, religious and academic centres. The important buildings of the inner city were constructed of finely fitted, dressed masonry, and upper storeys may sometimes have been of adobe; the roofs were always thatched, occasionally decoratively, and interiors could be generously ornamented with gold and silver.

In late 1533 the Spaniards sacked Cuzco, and several periods of destruction were followed by burning and earthquakes. In the mid-16th century the city was rebuilt as a colonial town, preserving the original lines of the streets and reusing the solid masonry foundations of the Inca. In 1650 Spanish Cuzco was destroyed by an earthquake, and the whole town had to be rebuilt; nevertheless, the remains of Inca walls, arches and doorways are still evident throughout the city.

Colonial architecture and painting flourished in Cuzco during the latter half of the 17th century and is partially preserved today. The city contains many colonial churches, monasteries and convents (*see also* PERU, §III, 1). At its heart is the Plaza de Armas, with colonial arcades and four churches situated around it. The cathedral, built on the site of the Inca Temple of Viracocha and completed in the 17th century, exhibits both Renaissance and Baroque elements. It has a solid silver altar and a beautifully carved original wooden altar retable. In the sacristy are paintings of all the bishops of Cuzco. On the east side of the plaza is the twin-towered La Compañia de Jesus, a Jesuit church built on the Inca site of the Amarucancha (Palace of the Serpents) in the late 17th century. Considered by many to be the finest church in Peru, it is filled with exceptional murals, paintings and carved altars. On the south side of the cathedral lies the church of El Triunfo, which contains a Churrigueresque high altar made of granite and gold.

Among Cuzco's many other fine churches, La Merced, founded in 1536 and rebuilt in the late 17th century after an earthquake, contains one of the few existing Platersque choir stalls and many paintings of the CUZCO SCHOOL. In the 17th century S Domingo was built on the walls of the Temple of Coricancha, using its stones. In the convent the ancient temple walls can be seen, and the Baroque cloister has been opened up to disclose four of the original temple chambers. Belen de los Reyes, also dating from the 17th century, has a particularly beautiful main altar with silver embellishments at the centre and goldwashed retables at the sides.

City museums include the Museo de Arte Religioso, a collection of colonial paintings and furniture housed in the Palacio Archiespiscopal, and the Museo Arqueologica, located in the impressive Palacio del Almirante and exhibiting an excellent collection of Pre-Columbian artefacts.

BIBLIOGRAPHY

EWA
G. Kubler: *Cuzco: Reconstruction of the Town and Restoration of its Monuments* (Paris, 1952)
M. Kropp: *Cuzco: Window on Peru* (New York, 1956)
J. de Mesa and T. Gisbert: *Historia de la pintura cuzqueña* (Buenos Aires, 1962)
E. Miranda Iturrino, ed.: *La arquitectura peruana a través de los siglos* (Lima, 1964)
B. Box, ed.: *South American Handbook* (Bath and New York, 1992)
T. Benavente Velarde: *Pintores cusqueños de la colonia* (Lima, 1995)

☐

Cuzco school. Term used to refer to the Peruvian painters of various ethnic origins active in CUZCO from the 16th to the 19th century. When Viceroy Toledo reached Cuzco in 1570, he commissioned a series of paintings (destr.) to be sent to Spain, which included depictions of the conquest and capture of Atahuallpa (*d* 1533) and portraits of the

Inca rulers. These works were painted by Indians who had been taught by such Spanish masters as Loyola. From the beginning of Spanish colonization until the end of the 16th century, two currents existed in painting in Cuzco: that of the Spanish masters, influenced by Netherlandish and Late Gothic art; and the indigenous tradition. Both influences persisted simultaneously until Roman Mannerism reached Peru through the work of three Italian painters based in Lima: MATEO PÉREZ DE ALESIO, BERNARDO BITTI and ANGELINO MEDORO. Bitti, a Jesuit, worked in Cuzco with, among others, two disciples of Medoro: the Indian Loayza and the Lima painter Luis de Riaño (*b* 1596). The influence of Bitti and the popularity of Flemish engravings as inspiration for compositions overwhelmed indigenous art, which was evident only in the drawings in the *Primer nueva crónica y buen gabierno* (*c.* 1580–1613) by Guaman Poma de Ayala. Medieval styles were also perpetuated through the work of such monks as Diego de Ocaña, who popularized the image of the *Virgin of Guadalupe*.

Despite these influential models, the Indian painter DIEGO QUISPE TITO, who took pride in his Inca ancestry, created a personal style in his landscapes embellished with gold leaf and abounding with birds. He lived outside the city itself and maintained a distance from foreign tendencies. His followers included such Indian masters as Chihuantito, Chilli Tupac and the Master of the *Procession of Corpus Christi* (before 1700; Cuzco, Mus. A. Relig.), one of the most important social, historical and artistic documents of Cuzquenian art. Another Indian painter, Basilío de Santa Cruz Pumacallao, produced paintings for Bishop Manuel de Mollinedo y Aungulo (*d* 1699). The latter had seen works by Velázquez and Rubens, and the works of Pumacallao were similar to paintings being produced in Europe at that time. They were also often superior to those of the Spanish and creole artists active in Cuzco, among whom Marcos Ribera is notable for his use of dramatic chiaroscuro.

Wall painting was practised from the 16th century, following the Indian tradition and using Italian influences. It had developed in the poorer towns, where canvases would have been too expensive for church decoration. The most important groups include those by Riaño at the church in Andahuaylillas (1618–26), inspired by the priest Juan Pérez de Bocanegra, and those by Tadeo Escalante at S Juan, Huaro (1802). Escalante also painted portraits of 12 Incas and of noble Indian women at a mill in Acomayo. Pumacahua, the chief of Tinta, commissioned a wall painting on the façade of his village church, which depicted the battle in which he conquered Tupac Amaru, and portraits of him and his family.

Spanish and creole painters were in the same guild as Indian painters until 1684, when the latter group objected to a compulsory examination that required knowledge of the architectural orders and the drawing of a male and a female nude. The Indians began to work independently under the patronage of local leaders, who dedicated themselves to selling their works in other towns, including the mining centres of the Audiencia de Charcas (now Bolivia). Works from this school also reached the north of Argentina, Chile and Lima. The Indian painters abandoned European perspective and returned to characteristically flat compositions filled with figures, birds and trees, which they also gilded.

In the 18th century such Indians as Mauricio García y Delgado (*fl c.* 1760) set up large workshops, which produced up to 100 paintings per month. The quality and colouring of the paintings declined, but their prices also fell, allowing their work to become popular among even the poorest. Marcos Zapata painted *c.* 200 works on the *Litanies of the Virgin* for Cuzco Cathedral (1755) and a series on the *Life of St Ignatius* (*c.* 1762) with Cipriano Toldeo y Gutiérrez (*fl* 1762–73) for the church of La Compañía in Cuzco (both *in situ*). Antonio Vilca, another notable painter, was apprenticed to Zapata. The popular secular theme of portraits of the Inca kings continued until well into the 19th century. They were initially painted alongside those of the Spanish kings until the latter were discontinued, and the Inca dynasty continued from Manco Capar to Atahuallpa. Cueva and Juan y Ulloa made engravings on the theme; Ulloa's was published in *Viaje a la América meridional*.

BIBLIOGRAPHY
C. del Pomar: *Pintura colonial* (Lima, 1928)
R. Vargas Ugarte: *Ensayo de un diccionario de artífices de la América meridional* (Lima, 1947)
Mariategui: *Pintura cuzqueña del siglo XVII* (Lima, 1951)
E. Marco Dorta: *Arte en América y Filipinas* (Madrid, 1973)
P. Macera: 'El arte mural cuzqueño, de los siglos XVI al XX', *Trabajos Hist.*, ii (1977), pp. 343–460
J. Mesa and T. Gisbert: *Historia de la pintura cuzqueña*, 2 vols (Lima, 1982)
J. Bernales Ballesteros: *Historia del arte hispanoamericano: Siglos XVI a XVIII*, ii (Madrid, 1987)
C. Dean: 'Ethnic Conflict and Corpus Christi in Colonial Cuzco', *Colon. Amer. Rev.*, ii/1–2 (1993), pp. 93–120
T. Benavente Velarde: *Pintores cusqueños de la colonia* (Cuzco, 1995)
L. E. Wuffarden: *La procesión del Corpus Domini en el Cuzco* (Seville, 1996)

TERESA GISBERT

D

Dacosta [da Costa], **Mílton (Rodrigues)** (*b* Niterói, 1915; *d* Rio de Janeiro, 1988). Brazilian painter. He entered the Escola Nacional de Belas Artes, Rio de Janeiro, in 1930 and in 1931 was one of the founders of the Núcleo Bernardelli, whose aim was to build on the initial successes of Modernism. After at first being influenced by Cézanne he painted cyclists, bathers and children playing, in compositions of carefully linked rectangles, cubes, cylinders, spheres and pyramids (*At the Swimming-Pool*, 1942; Rio de Janeiro, Roberto Marinho priv. col.). In later works he was briefly influenced by Pittura Metafisica and Surrealism, surrounding ordinary objects with a schematic architecture and mysterious *trompe l'oeil* mannequins and faces. From 1944 to 1946 he lived in the USA and Europe. In the mid-1950s, in constructions such as *On a Brown Background* (1955; U. São Paulo, Mus. A. Contemp.) and *On a Red Background* (1955; Rio de Janeiro, Mus. Manchete), he began to produce austere works close to concrete art. He established his compositions on strict mathematical principles, generally using only two or three colours and precise lines intersected at right angles. In 1963, though retaining the formal economy of his earlier work, he returned to the figure in the series *Venus, Angels and Pageantry*, treated in a manner at once sensual and ascetic (*Venus and the Bird*, 1976; Rio de Janeiro, Gal. Acervo).

BIBLIOGRAPHY
A. Amaral, ed.: *Projeto construtivo brasileiro na arte, 1950–1962* [The Brazilian Constructivist movement in art, 1950–1962] (São Paulo, 1977), pp. 298–9
R. Pontual: *Cinco mestres brasileiros—Pintores construtivistas* (Rio de Janeiro, 1977), pp. 14–15, 23–4, 89–115
T. Spanudis: *Construtivistas brasileiros* (São Paulo, 1978)
A. Bento: *Mílton Dacosta* (São Paulo, 1980)
Mílton Dacosta (exh. cat. by A. Bento, São Paulo, Mus. A. Mod., 1981)
R. Brito: *Miílton Dacosta: Lógica e lírica* (São Paulo, Gal. Raquel Arnaud, 1986)
Morandi no Brasil (exh. cat. by L. Mammí, São Paulo, Cent. Cult., [1994])
ROBERTO PONTUAL

Dangel, Miguel von (*b* Bayreuth, 26 Sept 1946). Venezuelan painter and sculptor of German birth. He arrived in Venezuela in 1948 and in 1963 began his studies at the Escuela de Artes Plásticas 'Cristóbal Rojas' in Caracas. His densely composed work incorporated various objects such as stuffed animals, skins, crucifixes and mirrors, which he used to develop contemplation of the contemporary, with symbolic reference to what is specifically American and to the sacred nature of art. His use of various materials, in conjunction with animal and vegetable forms, reveals the mythological landscape in which Von Dangel ultimately found expression. He represented Venezuela at the São Paulo Biennale in Brazil in 1983, and his work was included in various international touring group exhibitions. He held various one-man shows in Caracas, outstanding among which was the *Batalla de San Romano*, held at the Museo de Arte Contemporáneo in Caracas in 1990.

BIBLIOGRAPHY
Diccionario de artes visuales en Venezuela (Caracas, 1982)
Three Venezuelans in Two Dimensions: Miguel von Dangel, Ernesto León, Carlos Zerpa (exh. cat. by A. Stein, Perth, A.G. W. Australia, 1989), p. 2
La Batalla de San Romano (exh. cat. by S. Imber, Caracas, Mus. A. Contemp., 1990) [incl. texts by M. von Dangel]
Miguel von Dangel (XLV Bienal de Venecia, 1993)
G. Pantin and R. Level, eds: *Miguel von Dangel y La Batalla de San Romano* (Caracas, 1994)
Miguel von Dangel: Exposición antológica, 1963–1993 (exh. cat., Caracas, Gal. A. N., 1994)
ELIDA SALAZAR

Davila, Juan (*b* Santiago, 6 Oct 1946). Australian painter and performance artist of Chilean birth. He studied law and fine arts at the University of Chile. Following the coup of 1973, he arrived in Melbourne as a tourist after meeting an Australian in Buenos Aires, and later took up residence. He exhibited widely in Australia, Europe and South America, returning frequently to Chile, which, thematically and politically, remained a focus for his art. He worked primarily with the quotation of cultural ephemera (e.g. newspaper photographs, advertisements, etc). Originally noted for his adaptations of Pop art in an effort to rewrite the international history of painting from a provincial or Third World perspective, he increasingly developed a hybrid pictorial language that refused the strict confines of Modernism or Post-modernism, seen, for example, in *Fable of Australian Painting* (1982–3; U. Sydney, Power Gal. Contemp. A.). His art deals with fragments, attempting to present a utopia of narrative from another place and time. In canvases such as *Echo* (2.74×8.22 m, 1987; Perth, A.G. W. Australia), he dealt with a 'bastard aesthetic' of Latin-American kitsch. He also achieved some notoriety through film and video performances, and as an editor, writer and curator. He is chiefly known for his attempts to address the problem of the portrayal of a homosexual language.

WRITINGS
with P. Foss: *The Mutilated Pietà* (Melbourne, 1986)

BIBLIOGRAPHY
P. Taylor: 'Juan Davila at the Adelaide Festival', *Studio Int.*, cxcvii/1006 (1984), pp. 20–21
P. Foss: *Juan Davila: The Mutilated Pieta* (Surrey Hills, NSW, 1985)

P. Taylor, ed.: *Juan Davila, Hysterical Tears* (Melbourne, 1985)

A. & Text, xxi (1986), pp. 94–9 [special issue on art in Chile after 1973]

F. Zegers, ed.: *El fulgor de lo obsceno* (Santiago, 1988)

G. Brett: *Transcontinental: Nine Latin American Artists* (London, 1989)

Cartographies: 14 artistas latinamericanos (exh. cat., Winnipeg, A. Gal., 1993)

<div align="right">PAUL FOSS</div>

Debret, Jean-Baptiste (*b* Paris, 18 April 1768; *d* Paris, 28 June 1848). French painter and draughtsman, active in Brazil. When very young he accompanied his cousin, Jacques-Louis David, on a trip to Italy from which he returned in 1785. He then enrolled in the Académie Royale de Peinture et de Sculpture in Paris, initially following parallel studies in civil engineering but soon devoting himself to painting. Between 1798 and 1814 he entered several of the annual Paris Salons with historical or allegorical paintings, Neo-classical in both spirit and form, for instance *Napoleon Decorating a Russian Soldier at Tilsit* (1808; Versailles, Château). He also collaborated at this time with the architects Charles Percier and Pierre-François Fontaine on decorative works. With the fall of Emperor Napoleon Bonaparte I, whom he greatly admired, he agreed to take part in the French artistic mission which left for Brazil in 1816. He stayed there longer than the rest of the group, returning to France only in 1831. During those years spent in Rio de Janeiro and in neighbouring provinces, he was in the vanguard of local artistic life, still in its infancy. He founded and encouraged the Academia Imperial das Belas Artes, of which he became professor of history painting. He painted many historical works such as the *Acclamation of Peter I* (1822; Rio de Janeiro, Mus. N. B.A.). He and two other members of the French mission, the architect Auguste-Henri Grandjean de Montigny and the sculptor Auguste-Marie Taunay (1768–1824), were responsible for preparing the decorations in Rio de Janeiro for the celebrations in 1818 acclaiming John VI as King.

Debret's most important works are the impressive number of drawings and paintings in which documentary exactitude is combined with a certain exoticism to record the most varied aspects of everyday Brazilian life: historic events, ethnic types, scenes, costumes and landscapes. This rich iconographic collection was transposed onto lithographs from which he selected 150 plates, augmented with his own writings, published in three volumes as *Voyage pittoresque et historique au Brésil* (Paris, 1834–9). The Fundaçao Raymundo Castro Maya in Rio de Janeiro has nearly 350 of his paintings and drawings.

<div align="center">BIBLIOGRAPHY</div>

Pontual

A. Taunay: *A missão artistica de 1816* (Rio de Janeiro, 1912)

A. Morales de los Rios Filho: *O ensino artístico: Subsídio para a sua história* (Rio de Janeiro, 1942)

Art of Latin America since Independence (exh. cat. by S. L. Catlin and T. Grieder, New Haven, CT, Yale U. A.G.; Austin, U. TX, A. Mus.; San Francisco, CA, Mus. A.; La Jolla, CA, A. Cent.; 1966)

M. Carelli: 'Jean-Baptiste Debret, um pintor philosphe sous les tropiques', *Cuad. A. Colon.*, v (1989), pp. 35–51

Jean-Baptiste Debret, um pintor de história no Brasil (exh. cat., Rio de Janeiro, Mus. Castro Maya, 1990)

R. Naves: 'Debret, o neoclassicismo e a escravidão', *A forma difícil: Ensaios sobre arte brasileira* (São Paulo, 1996), pp. 40–129

<div align="right">ROBERTO PONTUAL</div>

Deira, Ernesto (*b* Buenos Aires, 26 July 1928; *d* Paris, 1 July 1986). Argentine painter. He studied with the artists Leopoldo Torres Agüero (1924–96) and Leopoldo Presas (*b* 1915), and from the early 1960s he had recourse to elements of *Art informel*, applying the paint with violent gestures and allowing it to drip down the canvas, as in *Grandmother's Stories* (1964; see Glusberg, p. 269). While fervently defending the importance of the human figure, he subjected images of the body to a distortion and Expressionist treatment that almost destroyed their legibility. From the mid-1970s Deira moved towards a more coherent and lyrical but mannered treatment of the figure, as in *Don't Cry for Us Argentina* (1982; see Glusberg, p. 271).

<div align="center">BIBLIOGRAPHY</div>

J. Glusberg: *Del Pop-art a la Nueva Imagen* (Buenos Aires, 1985), pp. 269–72

Deira, Macció, Noé, de la Vega: 1961 Neo Figuración 1991 (Buenos Aires, 1991)

J. López Anaya: *Historia del arte argentino* (Buenos Aires, 1997), pp. 262–3

'Arco '97: El envío Argentino del FNA', *Cultura* (Buenos Aires, 1997), pp. 13, 18–20, 28–29

Re-Aligning Vision: Alternative Currents in South American Drawing (exh. cat., New York, Mus. Barrios; Little Rock, AR A.G.; Austin, U. TX, Huntington A.G.; Caracas, Mus. B.A.; 1997–8)

<div align="right">JORGE GLUSBERG</div>

Della Paolera, Carlos Maria (*b* Buenos Aires, 7 Sept 1890; *d* Buenos Aires, 15 Sept 1960). Argentine urban planner. He was the first South American graduate of the Institut d'Urbanisme, Université de Paris, where he studied from 1921 to 1928 under Marcel Poëte. After World War II Della Paolera founded the Instituto Superior de Urbanismo, Universidad de Buenos Aires (1949). He was an advocate of a beaux-arts 'geometrical' approach to urban planning. One of his particular interests was the provision of open spaces in metropolitan areas, and he became an early advocate of the concept of appropriate environment. His main planning studies were for Buenos Aires, but he also worked on development policy proposals for a number of other Argentine cities, including La Plata, Rosario (Santa Fé), Concepción del Uruguay and Tafí (Tucumán).

<div align="center">WRITINGS</div>

'El símbolo y el día del urbanismo, 1934–1949', *Rev. Arquit.* [Arg.] (1949), no. 347, pp. 326–9

Buenos Aires y sus problemas urbanos, intro. P. Randle (Buenos Aires, 1977)

<div align="right">LUDOVICO C. KOPPMANN</div>

Della Valle, Angel (*b* Buenos Aires, 10 Oct 1852; *d* Buenos Aires, 10 July 1903). Argentine painter. He travelled to Europe, studying for several years in Florence under Antonio Ciseri (1821–91) and undergoing the influence of large-scale evocations of historical scenes. In 1883 he returned to Buenos Aires, where he devoted himself to painting and to teaching at the Escuela Estímulo de Bellas Artes. He was a gifted technician and in his early pictures relied on thinly painted surfaces and muted colours, preferring the impact to arise from the subject-matter. Country scenes, Indians, Indian raids, gaucho musicians and the breaking-in of horses were among his favourite themes, which he depicted in subdued tones or full sunlight, for example *Gauchos on Horseback* (Buenos Aires, Mus. N. B.A.) and *Horse-breaking* (Buenos Aires, Mus. A. Blanco). He painted the gaucho and the Indian without resorting to superficial picturesqueness, and his

Angel Della Valle: *Return of the Indian Raiding Party*, oil on canvas, 1.86×2.92 m, 1892 (Buenos Aires, Museo Nacional de Bellas Artes)

preference for country subjects made him a painter of animals as well as landscapes. He gave a true picture of the limitless Argentinian plains.

Over the years Della Valle's style became more modern, especially in his portraits, for which he began to use a richer palette and looser brushwork; he subsequently incorporated these qualities into his landscapes, which became more luminous and colourful. His work betrays a romantic temperament more evident in his choice of subject than in his technique, which had closer links to Italian realist and academic art of the period, as in his splendid painting *The Return of the Indian Raiding Party* (1892; see fig.).

BIBLIOGRAPHY
J. L. Pagano: *El arte de los argentinos*, i (Buenos Aires, 1937), pp. 339–48
C. Córdova Iturburu: *La pintura argentina del siglo veinte* (Buenos Aires, 1958), p. 25
J. López Anaya: *Historia del arte argentino* (Buenos Aires, 1997)

NELLY PERAZZO

Del Prete, Juan (*b* Vasto, Chietti, 5 Oct 1897; *d* Buenos Aires, 14 Feb 1987). Argentine painter and sculptor of Italian birth. He lived in Argentina from 1909, becoming an Argentine citizen in 1929. In 1925 he began submitting work to national and provincial salons, and in 1926 his first one-man exhibition was held at the Asociación Amigos del Arte in Buenos Aires; the latter also awarded him a scholarship to study in Paris, where he remained until his return to Argentina in 1933.

Del Prete, who exhibited with Abstraction–Création in Paris in 1933 and was in productive contact with Hans Arp (1886–1966), Massimo Campigli (1895–1971), Georges Vantongerloo (1886–1965), Joaquín Torres García and Jean Hélion (1904–87), is generally considered an impor-

tant precursor of abstract art in Argentina. He was self-taught, intuitive, rebellious and independent and had demonstrated a receptiveness to contemporary artistic developments even before travelling to Europe. On his return to Argentina he exhibited a series of abstract plaster carvings as well as works made of wire, maquettes for stage sets and masks.

Convinced that one type of work should not rule out other options, Del Prete produced both abstract and figurative works that registered the impact of the new pictorial languages. Although his pictures of 1944–7 fused Cubist structure and Futurist dynamism, his best works of the 1940s, such as *Bottle of Chianti* (Buenos Aires, Mus. N. B.A.), with their sketchy brushstrokes, testify to his impetuous, lively spirit. Although many of his works are balanced compositions composed of geometrical forms, the evident pleasure in the handling of paint revealed in other paintings (through rough textures, directional brushstrokes or thick impasto) distinguished his art from the rational severity that characterized that of other abstract painters in Argentina. *Tropical Abstraction* (1957; Buenos Aires, Mus. Mun. A. Plást. Sívori) is a clear instance of this more sensual aspect of his art, which in turn led him to investigate the expressive potential of *Art informel* in paintings and in collages of great fantasy made from paper, fabrics and other materials.

BIBLIOGRAPHY
E. C. Yente: *Obras destruídas de Del Prete* (Buenos Aires, 1971)
J. Merli: *Del Prete* (Buenos Aires, 1976)
J. López Anaya: *Historia del arte argentino* (Buenos Aires, 1997)

NELLY PERAZZO

De Simone, Alfredo (*b* Latarico, Cosenza, 29 Oct 1898; *d* Montevideo, 27 Jan 1950). Uruguayan painter of Italian

birth. He studied (1917–20) under the Uruguayan Guillermo Laborde (1886–1940) at the Círculo de Bellas Artes in Montevideo and in 1927 participated in an exhibition at Amigos del Arte in Buenos Aires presented by Teseo, a group of Uruguayan artists. While his paintings of the 1920s were affected to some extent by the romantic currents then dominant in Uruguay, his work soon changed direction because of his passion for the neighbourhoods and streets of the southern zone of Montevideo, its tenement houses and local scenes. In small oil paintings such as *Suburb* (1941), *Street in the Rain* (*c.* 1940) and *City* (*c.* 1940; all Montevideo, Mus. N. A. Visuales), he rejected all concessions to conventional ideas of beauty and culture, rendering large forms in a heavy impasto applied with a palette knife. Noteworthy among the many exhibitions in which he participated were the *Exposición pro víctimas de la guerra civil española*, held in 1938 at the Ateneo of Montevideo, the fifth Salón Nacional (1941), at which he obtained the Banco de la República prize, and *20 pintores uruguayos* at the Salón Kraft in Buenos Aires in 1949.

BIBLIOGRAPHY
J. P. Argul: *Las artes plásticas del Uruguay* (Montevideo, 1966); rev. as *Proceso de las artes plásticas del Uruguay* (Montevideo, 1975)
G. Peluffo: *Historia de la pintura uruguaya* (Montevideo, 1988–9)

ANGEL KALENBERG

Dias, Antônio (*b* Campina Grande, 22 Feb 1944). Brazilian painter. In 1958 he moved to Rio de Janeiro, where he soon began to produce works influenced by the symbolic Constructivism of Joaquín Torres García. From 1964 he moved away from flat surfaces towards a greater use of space in emotionally charged montages that make aggressive use of images and materials. After winning a prize at the Paris Biennale of 1965, he went to Europe and from 1968 lived in Milan. There he adopted a conceptual approach in paintings, videos, films, records and artist's books, using each medium to question the meaning of art. After a visit to Nepal in 1977 and under the influence of Jung, a reassessment of his work led to the incorporation of a symbolic dimension, in pictures often drawn on handmade Nepalese paper (*Song of the Axe*, ferrous oxide, shellac, graphite, metallic pigment, 1982; São Paulo, Robert Blocker priv. col.). An example of his later work is *Untitled* (1994; see fig.)

Antônio Dias: *Untitled*, etching, 215×145 mm, 1994 (Colchester, University of Essex, Collection of Latin American Art)

WRITINGS
Some Artists Do, Some Not (Brescia, 1974)

BIBLIOGRAPHY
P. Duarte: *Antonio Dias* (Rio de Janeiro, 1979)
S. Sproccati: *Antonio Dias* (Milan, 1983)
R. Brito: *Antonio Dias* (Rio de Janeiro, 1985)
R. Conduru: '"O país inventado" de Antônio Dias', *Gávea*, viii (1990), pp. 44–59
Re-Aligning Vision: Alternative Currents in South American Drawing (exh. cat., New York, Mus. Barrios; Little Rock, AR A.G.; Austin, U. TX, Huntington A.G.; Caracas, Mus. B.A.; 1997–8)

ROBERTO PONTUAL

Dias, Cícero (*b* Recife, 5 May 1907). Brazilian painter. In 1925 he moved to Rio de Janeiro, where for a short time he studied architecture at the Escola Nacional de Belas Artes. There he came into contact with artists and intellectuals of the modernist movement, including Mário de Andrade, and had his first show in 1927. His preferred medium until the beginning of the 1930s was watercolour; several of his watercolours painted between 1927 and 1930 are in the Instituto de Estudos Brasileiros at the University of São Paulo. At the 1931 National Salon of Fine Arts (Rio de Janeiro)—called the 'revolutionary salon' because of its preponderance of avant-garde artists—he exhibited *I Saw the World: It Began in Recife* (watercolour, 2×12 m; Rio de Janeiro, Mus. N. B.A.), a work that already displayed a lyrical, slightly erotic Surrealism that sought to recapture the memory of his childhood in the north-east of Brazil. He became acquainted with Surrealism at first hand only after settling in Paris in 1937. On his return to Paris at the end of World War II after two years spent in Lisbon, he developed a vividly coloured geometric abstraction, joining the Groupe Espace and taking part in exhibitions at the Galerie Denise René. In 1948 he painted an abstract mural in the Ministry of Finance in Recife. By the time of his 1965 São Paulo Biennial retrospective he had returned to figurative art, to imaginary landscapes and portraits in a vehemently regional tropical style. Later figurative works include a series of paintings on the life of *Brother Caneca* (1983–5; Recife, Casa Cult.).

BIBLIOGRAPHY
G. Freyre: 'Dois modernos pintores do Brasil: Cícero Dias e Francisco Brennand', *Humboldt*, 14 (1966)
P. M. Bardi: *Profile of the New Brazilian Art* (Rio de Janeiro, 1970)
M. R. Batista and Y. S. de Lima: *Coleção Mário de Andrade: Artes plásticas* (São Paulo, 1984)
Un Art autre, un autre art (exh. cat. by D. Abadie, Paris, Artcurial, 1984)
R. Pontual: *Entre dois séculos: Arte brasileira do século XX na Coleção Gilberto Chateaubriand* (Rio de Janeiro, 1987)
L. Olavo Fontes: *Cícero Dias: años 20* (Rio de Janeiro, 1993)
M. Reinaux: *Cícero Dias: O sol e o sonho* (Recife, 1994)

ROBERTO PONTUAL

Díaz, Luis (*b* Guatemala City, 5 Dec 1939). Guatemalan painter, sculptor, printmaker and architect. Although he studied architecture at the Universidad de San Carlos in Guatemala (1959–61), as an artist he was essentially self-taught. One of the most important abstract artists in Guatemala, he worked in a variety of media, favouring new materials and bold geometric forms. As an architect he co-designed two important public buildings in Guatemala City: a library at the Universidad de San Carlos known as the Edificio de Recursos Educativos (1969; with Augusto de León Fajardo), and the Instituto de Fomento

Municipal (1973). He produced a number of murals in Guatemala City: *Genesis* (clay, 5 sq. m) in the residence of the architect Max Holzheu; *Genesis* (1972; Banco Inmobiliario Col.); *Nest of Quetzals* (acrylic, 1974; Inst. Fomento Mun.); *Fissure* (concrete, 9 sq. m, 1975; Casa Salem); *Untitled* (concrete and mirror, 160 sq. m, 1980) at the Cámara Guatemalteca de la Construcción; and *Quetzal* (aluminium, 1.35×7.2 m, 1984; Banco del Quetzal Col.). He exhibited widely as a printmaker, painter and sculptor and established the Galería DS in Guatemala City, one of the first commercial galleries in Guatemala to promote modern art. Examples of his work can be found in the Museo Nacional de Arte Moderno in Guatemala City.

BIBLIOGRAPHY
L. Méndez Dávila: *Arte vanguardia Guatemala* (Guatemala City, 1969)
Luis Díaz (Guatemala City, 1989)
Luis Díaz (Guatemala City, c. 1990)
Luis Díaz: Treintitantos años después, 1964–1994. Retroinstalación (exh. cat., Guatemala City, Gal. Tunel, 1994)
R. Díaz Castillo: *Visión del arte contemporáneo en Guatemala*, ii (Guatemala City, 1995)
Guatemala: Arte contemporaneo (Antigua Guatemala, 1997), pp. 42–52
JORGE LUJÁN-MUÑOZ

Díaz Bencomo, Mario (*b* Pinar del Río, 26 July 1953). Cuban painter, active in the USA. He left Cuba at the age of 14 as a political exile, going first to Spain and then in 1968 to Miami, where he settled. There he became a leading figure in the Cuban–American generation of artists that emerged in Miami during the 1970s (*see* LATIN-AMERICAN ARTISTS OF THE USA, §4). Working in acrylic, he was concerned with the strength of colour and texture; thematically topography and distance are the key elements of his flat, Expressionist abstraction. The influences of Peruvian painter Fernando de Szyszlo and of the Catalan Antoni Tàpies (*b* 1923), as well as of the New York School, are visible in his work. His *Wind Paintings* (e.g. 1986; Miami, FL, Barbara Gilman) address motion and change, themes latent in his work after 1980.

BIBLIOGRAPHY
P. Plagens: 'Report from Florida: Miami Slice', *A. America*, lxxiv/11 (1986), pp. 27–39
Outside Cuba (exh. cat. by I. Fuentes Pérez and others, New Brunswick, NJ, Rutgers U., Zimmerli A. Mus.; New York, Mus. Contemp. Hisp. A.; Oxford, OH, Miami U., A. Mus.; Ponce, Mus. A.; and elsewhere; 1987–9), pp. 254–7
RICARDO PAU-LLOSA

Diaz Morales, Ignacio (*b* Guadalajara, 16 Nov 1905; *d* Guadalajara, 3 Feb 1992). Mexican architect, teacher and urban planner. He studied civil engineering and architecture at the Escuela Libre de Ingenieros, Guadalajara, between 1921 and 1928. From 1927 he was responsible for redesigning and completing the vaults of the Expiatory Temple, Guadalajara, a Gothic Revival building begun in 1897 by Adamo Boari Dandini. In 1936 Diaz Morales began independently to plan the Cruz de Plazas, a group of four open spaces around Guadalajara Cathedral. The plan, which included large fountains, was accepted around 1947 and completed in 1957. In November 1948 Diaz Morales founded the Escuela de Arquitectura of the Universidad de Guadalajara, and in 1950 he travelled to Europe and recruited a group of teachers of architecture and art, including the sculptor Mathias Goeritz. From

1949 he also presided over the technical committee responsible for preserving and restoring the frescoes of José Clemente Orozco in Guadalajara, and in 1959 he was made responsible for the restoration of the Teatro Degollado, Guadalajara. He was Director of the Escuela de Arquitectura until 1960 and taught there until 1963.

BIBLIOGRAPHY
L. Gómez and M. A. Quevedo: 'Testimonios vivos: 20 arquitectos', *Cuad. Arquit. & Conserv. Patrm. A.*, 15–16 (1981), pp. 111–14
F. González Gortázar, ed.: *La arquitectura mexicana del siglo XX* (Mexico City, 1994)
Ignacio Diaz Morales habla de Luis Barragán: Conversación con Fernando González Gortázar (Guadalajara, 1991)
E. Ayala Alonso and J. M. Buendía Júlbez, eds.: *Textos sobre Ignacio Diaz Morales: Del espacio expresivo en la arquitectura* (Mexico City, 1994)
ALBERTO GONZÁLEZ POZO

Dieste, Eladio (*b* Artigas, 1 Dec 1917). Uruguayan engineer. He graduated in 1943 from the University of Montevideo and is the only Uruguayan engineer to have made an impact on the international architectural scene, achieving this although he was trained as a civil engineer. He is associated with the substance known as reinforced ceramic, a material produced by combining brick, Portland cement and iron rods. With Dieste's inventiveness and rigorous application of scientific analysis, this material was used to create frameworks of surprising slenderness and to roof large areas using few supports. As Dieste himself explained, the striking results that can be obtained depend less on calculation than on the creation of an appropriate form capable of combining the material with the physical laws of equilibrium and a wider consciousness of the universe. By using bent surfaces or singly or doubly curved vaulting, Dieste achieved significant results in terms of cost reduction and structural efficiency. His deep religious feelings convinced him that there was a basic coincidence between what is moral and what is economic. It is perhaps because of this belief that a method initially devised to resolve problems arising from the construction of such utilitarian buildings as shopping centres (e.g. in Montevideo, 1983–4), storehouses, silos, aerials and industrial buildings was also used with striking aesthetic effect, for example in the wave-walls of the parish church at Atlántida (from 1957) and the restoration (1967–71) of S Pedro in Durazno. In these works Dieste achieved a sensitive handling of space and an interesting use of lighting at a low height to enhance the plasticity of shape and the texture and chromatic quality of brick, which he used not only as a durable material but also as an expressive element.

BIBLIOGRAPHY
J. P. Bonta: *Eladio Dieste* (Buenos Aires, 1963)
F. Bullrich: *New Directions in Latin American Architecture* (London, 1969), pp. 54–5, 93
D. Bayón and P. Gasparini: *Panorámica de la arquitectura latinoamericana* (Barcelona, 1977), pp. 176–97
Eladio Dieste: La estructura cerámica (Bogotá, 1987)
J. F. Liernur, ed.: *America Latina: Architettura gli ultimi vent'anni* (Milan, 1990)
Arquitectura en Uruguay, 1980–90 (Montevideo, 1992)
MARIANO ARANA

Díez Navarro, Luis (*b* Málaga, c. 1700; *d* Guatemala, c. 1780). Spanish military engineer, active in Mexico and Guatemala. In 1731–2 he arrived in New Spain with a royal commission. By 1733 he was director of works for

the new Real Casa de la Moneda (Royal Mint; 1731–4) in Mexico City. He was involved with the fortifications (1731, 1733, 1738) at Veracruz and worked at the Sanctuary of the Villa de Guadalupe (1737–8), outside Mexico City. Díez Navarro also collaborated on the largest engineering project in New Spain, the draining of the Valle de México (1736–41). In 1740 he designed the church of S Brígida (destr.) in Mexico City, one of the only churches in Spanish America with an oval plan. In Mexico City in 1739 he became Maestro Mayor at the Palacio de los Virreyes and at the Reales Alcázares, as well as in the Cathedral. In 1741 he became Ingeniero Ordinario and shortly after was assigned to the Kingdom of Guatemala. One of his first tasks was to inspect the Caribbean coast, paying particular attention to its defences. He continued to be involved with coastal defences and made the first designs (1743–4) for the fort at Omoa. From 1751 he carried out major modifications to the Real Palacio, Santiago de Guatemala (now Antigua). The two-storey stone arcading along the main square (1760s) is similar to that previously built for the Ayuntamiento in the same square. He also designed the building for the royal Renta de Tabacos (1766–8) and the Casa de Chamorro (1762) in the same city, and probably also made the designs (1765; Seville, Archv Gen. Indias) for the unbuilt Hospicio de S Vicente, El Salvador, which feature an oval chapel similar to that of S Brígida, Mexico City. Following the Guatemala earthquake of 1773, he played a major role in assessing damage and made the first plans for Guatemala City (1776). Despite his age and lack of mobility, he continued to supervise all royal works until 1777.

BIBLIOGRAPHY

D. Angulo Iñiguez: *Planos de monumentos arquitectónicos de América y Filipinas en el Archivo de Indias* (Seville, 1939)

H. Berlin: 'El ingeniero Luis Díez Navarro en México', *An. Soc. Geog. & Hist. Guatemala*, xx (1974), pp. 89–95

JORGE LUJÁN-MUÑOZ

Diomede, Miguel (*b* Buenos Aires, 20 July 1902; *d* Buenos Aires, 15 Oct 1974). Argentine painter. He was self-taught and began painting in 1929, first exhibiting in 1941 and elaborating a personal language in the tradition of Cézanne and Bonnard. In small, intimate paintings he restricted himself to the world of objects, using light to suggest form and to give vibrancy to the rich colouring, and sketchy brushstrokes to insinuate the presence of objects within a solid geometric structure. Although he maintained perceptible outlines in his early works, these later disappeared, allowing the forms to dissolve in a space that becomes the main protagonist, for example in *Oranges* (Buenos Aires, Mus. N. B.A.). Reality becomes transformed into something light and airy, revealing the emptiness within which objects exist, with colour defining imaginary layers of space interwoven into a single atmosphere, as in *Grapes, Fig and Peach* (1945; Buenos Aires, Mus. N. B.A.). As a painter of everyday themes Diomede inquired into the spirit of things. In 1958 he received a bronze medal at the Exposition Universelle in Brussels.

BIBLIOGRAPHY

E. Poggi: *Miguel Diomede* (Buenos Aires, 1953)

M. L. San Martín: *Pintura argentina contemporánea* (Buenos Aires, 1961), p. 104

Miguel Diomede (1902–1974): Exposición retrospectiva (exh. cat., Buenos Aires, Salas N. Cult., 1989)

NELLY PERAZZO

Distéfano, Juan Carlos (*b* Buenos Aires, 1933). Argentine painter and sculptor. He studied at the Escuelas Nacionales de Bellas Artes, Buenos Aires, and in 1960 was awarded the Beca de Italia scholarship. He lived in Barcelona from 1977 to 1979, when he returned to Buenos Aires. After some noteworthy work as a graphic designer, Distéfano began to investigate new materials for use in making his sculptures. As a draughtsman he had an accurate, almost Renaissance line, which he extended to his explorations of sculpture. This was made possible by his use of polyester, glass fibre, resins and acrylic colours, together with moulds and bleaches, in a complex process. By distancing himself from traditional materials and through his use of vibrant colour, Distéfano achieved unforeseen surface qualities and textures. His works, with their strong plastic content, became visibly dramatic and tensely expressive. His subjects were always tortured human figures who sought to express a monologue in their committed silence. His pictorial sense was always pre-eminent in his skilful conjunction of volume and space.

BIBLIOGRAPHY

E. Pérez: *Distéfano* (Buenos Aires, 1991)

Arte argentino contemporáneo (exh. cat., Buenos Aires, Mus. N. B.A., *c*.1994)

Un altre mirar arte contemporani argentini/Otra mirar arte contemporánea argentino (exh. cat., Barcelona, Generalitat Catalunya, 1997)

OSVALDO SVANASCINI

Dittborn, Eugenio (*b* Santiago, 1943). Chilean painter, printmaker, draughtsman and video artist. He studied at the Escuela de Bellas Artes of the Universidad de Chile in Santiago (1961–5), at the Escuela de Fotomecánica in Madrid (1966), the Hochschule für Bildende Kunst in West Berlin (1967–9) and at the Ecole des Beaux-Arts in Paris.

Dittborn, together with other theorists and artists working in Chile in the 1970s, based his work on critical examination of the marginal position of Chilean art in relation to international developments, adopting to this end practices at odds with Chilean traditions. Rejecting conventional forms of painting as well as the usual methods of producing and presenting prints, he instead favoured photography as a source both of imagery and technique by means of screenprinting. He found his imagery ready-made in the portraits featured in old Chilean criminology magazines; he combined mechanical techniques such as offset lithography and screenprinting with traditional handcrafting methods of embroidery and drawn-threadwork; and in the mid-1980s he even went so far as to produce works on brown wrapping paper (e.g. *To Clothe*, 1986–7; see fig.), which he folded and then distributed through the ordinary post, calling them his own variant of correspondence art. Dittborn used such contrasts within his work to reflect disparate realities, mirroring the social interaction of different levels in society and underlining the racially mixed origins of Latin American practices by exaggerating the clash between domestic crafts and advanced modern technology.

WRITINGS

Pinturas postales (exh. cat. by E. Dittborn and others, Santiago, 1985)

Eugenio Dittborn: *To Clothe*, photo screenprint with China ink, 2.08×1.53 m, 1986–7 (Austin, TX, University of Texas, Jack S. Blanton Museum of Art)

BIBLIOGRAPHY
Eugenio Dittborn (exh. cat., Buenos Aires, Cent. A. & Comunic., 1979)
R. Kay: *Del espacio de acá: La obra de E. Dittborn* (Santiago, 1980)
M. Ivelić and G. Galaz: *Chile: Arte actual* (Santiago, 1988)
G. Brett: *Transcontinental: Nine Latin American Artists* (London, 1989)
Art from Latin America: La cita transcultural (exh. cat., ed. N. Richard and B. Murphy, Sydney, Mus. Contemp. A., 1993)
Remota: Pinturas aeropostales. Airmail paintings: Eugenio Dittborn (exh. cat., New York, New Mus. Contemp. A.; Santiago, Mus. N. B. A., 1997)
MILAN IVELIĆ

Djanira (da Motta e Silva) (*b* Avaré, 1914; *d* Rio de Janeiro, 31 May 1979). Brazilian painter. She spent her childhood and youth in the country in the south of Brazil. On moving to Rio de Janeiro *c.* 1939, she taught herself to paint and in 1940 had five months of informal teaching under Emeric Marcier (*b* 1916) in Rio de Janeiro, always retaining in her work a non-academic spontaneity and freshness. Her development was not, however, that of a naive painter. Her precise, poetic vision of the landscape, ethnic character and working life of Brazil often concentrated on workers such as coffee-pickers, miners, wood-cutters, fishermen, cowherds, weavers and workers in car factories. The Museu Nacional de Belas Artes, Rio de Janeiro, has many of her works: paintings, drawings and engravings from various periods, among them the canvases *The Circus* (1944) and *Mestizo Children* (1952).

BIBLIOGRAPHY
M. Barata and others: *Djanira no acervo do Museu Nacional de Belas Artes* [Djanira in the collection of the National Museum of Fine Art] (Rio de Janeiro, 1985)

R. Sampaio: 'Interiores, figuras e paisagens' [Interiors, figures and landscapes], *Seis décadas de arte moderna na Coleção Roberto Marinho* (Rio de Janeiro, 1985), pp. 260–67
Djanira e a azulejaraia contemporânea, Mus. N. de B. A. (Rio de Janeiro, 1997)
ROBERTO PONTUAL

Dominica. *See under* ANTILLES, LESSER.

Dominican Republic. Country occupying the eastern two-thirds of the Caribbean island of Hispaniola. The western part is occupied by Haiti (see fig. 1). The capital is Santo Domingo, and Spanish is the official language; the population (7.4 million in 1996) is of mixed African, Indian and European descent. It has the highest mountain in the Caribbean, Pico Duarte (3075 metres), but also includes much rich agricultural land with large plantations. Cultivation of sugar-cane began in the 16th century, and its need for a large workforce led to imposition of slavery on the Amerindian population and importation of Africans for forced labour; ratification of the abolition of slavery took place in 1844. Mining of nickel and textile manufacture are also important, although tourism is the main source of foreign exchange.

I. Introduction. II. Cultures. III. Architecture. IV. Painting, graphic arts and sculpture. V. Patronage and collecting. VI. Art institutions.

I. Introduction.

The Dominican Republic is the oldest settlement of European origin in America. After its discovery by Christopher Columbus in 1492 it was named Santo Domingo and became the base from which Spain conquered the New World. It was ruled by France from 1795 to 1808 but reverted to Spanish rule until declaring independence in 1821. It was then invaded and ruled by Haiti from 1822 until 1844, when it again became independent, adopting a constitution and the name Dominican Republic. It was re-annexed by Spain in 1861 and four years later applied unsuccessfully to join the USA, finally settling for independence. Incursions from neighbouring Haiti and economic instability continued; the USA occupied the Republic from 1916 until 1924. Rafael Trujillo became President in 1930 and established a long, ruthless dictatorship until his assassination in 1961. Since 1966 the country has been governed by the Social Christian Reform Party.

BIBLIOGRAPHY
D. Suro: *Arte dominicano* (Santo Domingo, 1969)
F. Moya Pons: *Manual de historia dominicana* (Santiago, 1974)
D. de los Santos and V. Peguero: *Visión general de la historia dominicana* (Santiago, 1977)
T. Mejía-Ricart: *Santo Domingo. Ciudad primada: Sus orígenes y evolución histórica* (Santo Domingo, 1992)
F. Moya Pons: *The Dominican Republic: A National History* (New York, 1995)
JANET HENSHALL MOMSEN

II. Cultures.

1. AMERINDIAN. The first inhabitants of the region came in three waves of emigration from the area of modern Venezuela and Guyana. The first group, the Ciboney, were a pre-agricultural and pre-ceramic people; the second, the Arawaks, were farmers; and the third, the Caribs, were able navigators and warriors. At the time of

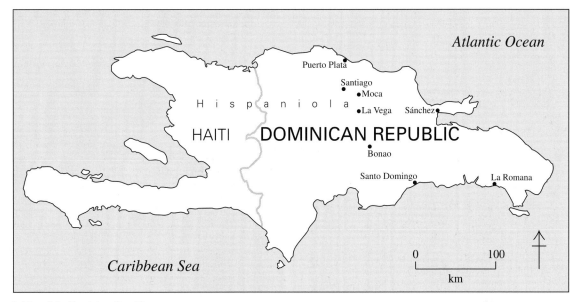

1. Map of the Dominican Republic

the Spaniards' arrival the island was populated by the Tainos ('good men'), an Arawak people who comprised the largest Amerindian group in the Antilles. Besides fishing and hunting, the Tainos based their collective economy on farming, yucca being their main crop. The communal organization was family-orientated. Dwellings (*bohíos*) were built by the men, and the women undertook domestic tasks, including making pottery and basketwork. The children helped the adults, their special assignment being to scare birds from the crops; their paternal grandparents looked after their education. Taino culture was based on a polytheistic and animistic religion. Their beliefs and myths, particularly those concerning creation, reveal a strong bond with nature. Each of the five tribal chiefs (*caciques*) had a guardian divinity, or *zemi*. Officiating

2. Taino Amerindian stone trigonolite decorated with a human face, 180×230 mm, 19th century (Santo Domingo, Museo del Hombre Dominicano)

priests and witch doctors, the shamans or *behiques*, were powerful intermediaries between gods and men. Two great ceremonies were an essential part of religious ritual: the *cohoba*, in which, under the influence of inhaled hallucinogenic powders, chiefs and *behiques* received guiding messages from the *zemi*; and the *areyto*, a didactic but entertaining celebration that included songs, dances and the recitation of historic events. The Tainos' principal game was *batey*, an outdoor ball-game.

Indigenous arts were linked to farming conditions and domestic needs. The Tainos worked with fibres, wood, shell, bone, clay and stone. The most important stone item was the trigonolite, a three-pointed propitiatory idol (see fig. 2), but axes, pestles and animal yokes were also produced. In ceramics there was a variety of forms and decorative motifs, the Chicoid style being the most outstanding. Articles included bowls, pots, saucepans and anthropomorphic or zoomorphic vases, while decoration comprised dotted lines, incisions and modelling. Figuration alternated with geometric abstraction. Similar forms of expression appear in the rock drawings or petroglyphs found in caves, such as the Cuevas de Bonbón. The naturalistic or schematic figures represented humans (more often male than female), animals (mainly birds and fish), or a combination of animal and human features; among the abstract forms, the triangle was predominant.

In spite of the extermination of the Amerindian population through maltreatment, sickness and killing within 50 years of colonization, their cultural legacy is a valuable one. There has been a vigorous development of archaeology and ethno-anthropological research, and there is a growing awareness among the Dominican people of their Amerindian heritage. The influence of Pre-Columbian art has also been significant on such late 20th-century artists as Paul Giudicelli. The commemoration in 1992 of 500 years since Columbus's 'Discovery of America' gave new impulse to Amerinidan studies, literature and visual arts.

BIBLIOGRAPHY
P. Henríquez Ureña: 'Palabras antillanas en el diccionario de la Academia', *Rev. Filol. Esp.*, xxii/2 (1935), pp. 175–86
D. Suro: 'Arte Taino', *Cuad. Hispamer.*, xxxv (1952), pp. 21ff
C. Colón: *Diario de Colón* (Madrid, 1968)
J. Bosch: *De Christobal Colón a Fidel Castro, colección hombres, hechos e ideas* (Madrid, 1970)
J. Arrom: *Mitología y artes prehispánicas de las Antillas* (Mexico City, 1971)
M. Veloz Maggiolo: *Arqueología prehistórica de Santo Domingo* (Singapore, 1972)
F. Maya Pons: *Historia colonial de Santo Domingo* (Santiago, 1977)
D. de los Santos and V. Peguero: *Visión general de la histórica dominicana* (Santiago, 1977)
D. Logan: *Nuevas pictografías en la Isla de Santo Domingo: Las Cuevas de Bonbón* (Santo Domingo, 1978)
C. Magnier: *Santo Domingo* (Montreuil, 1984)
C. Huggins, P. Glinton and B. Smith: *Bahamian Art, 1492–1992* (Nassau, 1992)
L'Art des sculpteurs tainos: Chefs-d'oeuvre des Grandes Antilles précolombiennes (exh. cat., Paris, Petit Pal., 1994)
MARIANNE DE TOLENTINO

2. AFRO-CARIBBEAN. It is difficult to evaluate objectively the importance of the African heritage of the Dominican Republic, and the topic remains the subject of debate between the Hispanophile and the Africanist schools of thought. When Columbus arrived in Santo Domingo, slavery was a practice already known in Spain, but the aim of a massive importation of black slaves to Hispaniola did not exist, for the first of them had already been converted to Catholicism when they were brought over from Spain. The cultivation and processing of sugarcane, however, needed a considerable workforce. The Spanish preferred the more submissive Amerindians, but their rapid extinction led to importation of slaves from West Africa, mainly Dahomey, Bantu and Yoruba, peoples brought in legally and as contraband. In the 17th century the sugar industry and slave trade declined simultaneously. The extreme poverty of the Spanish section of the island, however, mitigated the conditions of slavery: the suffering of both master and slave led to closer inter-racial relationships. By the abolition of slavery in the mid-19th century, mainly African cultural features had become mixed through assimilation with Spanish customs. Maltreatment of the black population also destroyed many of their native practices, so rendering difficult the recognition of the original cultural and ethnic groupings. This applies particularly to magical religious rites, for example the funeral ceremonies that commemorated the first anniversary of a death. Indeed, religious syncretism constitutes one of the main elements of Afro-Caribbean culture, expressed in the practice of Vodoun, a form of worship whose myths, rites and gods fuse elements of African myths and magic with Christian theology. Despite its original links with and similarities to Haitian Vodoun (*see* HAITI, §II, 2), Dominican Vodoun has a separate identity. It attributes supreme authority to God, and there are intermediate divinities, known as *loas*, who have supernatural powers but human tastes, vices and passions. These divinities are divided into four groups: the elements of water, fire, earth and air. The major *loas* include the Barón del Cementerio, Belié Belcán, Candelo, Anaísa and Metré Sillí.

Magic and witchcraft are fundamental, and myths, much less important than rites, are closely linked to the benefits or help that the believer seeks through ceremonial practice. Dominican Vodoun lacks a hierarchical priesthood. The

3. Jorge Severino: *St Marta La Dominadora*, acrylic and oil on canvas, 1.83×1.02 m, 1978 (Santo Domingo, Museo de Arte Moderno); Afro-Caribbean representation of the saint as a *loa*

service is conducted by the witch-doctor, who can be male or female and acts as an intermediary between the divinities and the 'clients'. To transmit petitions he goes into a trance or state of being possessed. Aspects of Catholicism are present in Vodoun, since all practitioners are baptized and claim to be churchgoers. The principal point of contact is in the devotion to saints, for the Afro-Caribbean *loas* have their counterparts in Catholic holy figures (see fig. 3). There is a domestic form of devotion, the *velaciones*, night vigils to saints, consisting of singing, praying or dancing, and their objects of worship are altars, crucifixes, candles and coloured lithographs of saints, sold in the markets.

Musical groups accompany the religious practices and ceremonies; their violent rhythmic body movements, shouts and shrill noises reveal their African origin. The dances, called Holandés, Danois, Fango, Bambula and Jodú, were prohibited in the mid-19th century as obscene and scandalous. A fusion of African and European sources is also present in the national Dominican dance of *merengue*, variants of which exist in Puerto Rico, Cuba and Haiti. African influences also extend to the construction of rural houses, basketry and wooden tools, and even to language: words of African languages, especially Bantu, have entered into the 'creole' Spanish of the country. African motifs and inspiration occur as an important cultural component of contemporary visual arts, becoming increasingly influential with growing Caribbean cultural integration.

BIBLIOGRAPHY

F. Moya Pons: *Manual de historia dominicana* (Santiago, 1974)

H. Tolentino Dipp: *Raza e historia en Santo Domingo* (Santo Domingo, 1974)

C. E. Deive: *Vudu e magia en Santo Domingo* (Santo Domingo, 1979)

F. Lizardo: *Cultura africana en Santo Domingo* (Santo Domingo, 1979)

J. Bosch: *Composición social dominicana* (Santo Domingo, 1986)

F. Franco: *Los negros, los mulatos y la nación dominicana* (Santo Domingo, 1989)

C. Albert: *Mujer y esclavitud en Santo Domingo* (Santo Domingo, 1990)

W. W. Megenney: *África en Santo Domingo: Su herencia lingüística* (Santo Domingo, 1990)

C. Huggins, P. Glinton and B. Smith: *Bahamian Art, 1492–1992* (Nassau, 1992)

MARIANNE DE TOLENTINO

III. Architecture.

The characteristic, popular architecture of the Pre-Columbian region consisted of timber-framed, thatch-roofed houses or *bohíos*. This building type survives in rural areas, and the name has been retained. The arrival of the Spaniards led to the introduction of urban planning. Urban settlements on the island multiplied, and the capital, Santo Domingo, founded in 1496 by Columbus's brother, Bartolomé, was laid out on a rectilinear grid on the west bank of the Ozama River. The earliest colonial monuments in Santo Domingo include the hospital of Nicolas de Ovando (governor, 1502–9), which was in ruins by the late 18th century and partly destroyed in 1929. Its complex plan and elevations are preserved in the Archivo de Indias, Seville. Ovando also commissioned the Torre del Homi-

naje (1503), built by Cristóbal de Tapia, a battlemented structure resembling a medieval keep, commanding the approaches to the Ozama. Work on a new cathedral began in 1521 and was completed in 1538. In 1541 it was dedicated to S María de la Encarnación. It is a sturdy, Gothic cross-vaulted church with lateral chapels and three naves of equal height. The PLATERESQUE STYLE façade has been attributed to the Spanish architect Rodrigo Gil de Liendo and to Luis de Moya, his master builder from 1531 (see fig. 4). A number of Gothic monastic churches with features of MUDÉJAR origin were built in the first half of the 16th century, but all are partly or wholly ruined. Liendo was also largely responsible for the church of S Francisco (1547–69), Santo Domingo, on which the Spanish masons Antón and Alonso Gutiérrez Navarrete probably worked, and which dates from the 1520s. The most important palace was the Alcázar (1510–14) of Almirante Don Diego Colón in Santo Domingo (partly ruined, partly restored). Its unusual plan had two arcaded sides to its square, inner patio and recalls contemporary country mansions in southern Spain. Its design was copied in the Casa de Engombe, Santo Domingo, a little later in the 16th century. By the mid-1530s the Plateresque style was well established, for example the chapel of S Aña (*c.* 1535) in the cathedral.

When the seat of Spanish government in the Caribbean moved to HAVANA in 1552, Hispaniola became depopulated, and little was built for over two centuries: two notable exceptions, both in Santo Domingo, are the Jesuit

4. Cathedral of S María de la Encarnación, Santo Domingo, 1521–38; façade attributed to Rodrigo Gil de Liendo and Luis de Moya

church of La Compañía (1714–40), with a forbidding façade recalling the sobriety of Cuban Baroque, and the church of S Bárbara (begun *c.* 1700), with a heavy rectangular tower that overwhelms the façade, rising to an impressive bell-tower storey. British influence began to replace that of Spain, especially in domestic architecture. These buildings mainly comprised single-storey timber-framed and weatherboarded houses with Georgian-style sash-windows, often set back from the street and incorporating a covered public walkway in the structure. Decorative bracket-inserts at the heads of timber columns were fretted, often imitating *Mudéjar* arch profiles, and fretwork fascias and panels abounded; the style became eclectic as the century progressed and imported cast- and wrought-iron elements such as columns and balustrades increasingly became available. There are notable examples of such buildings at Puerto Plata, Santiago, La Vega, Moca and La Romana; at Sánchez, there is a Victorian Gothic Revival, timber-framed and corrugated iron-clad church (*c.* 1890) with an ogee cupola above a tiny bell-tower. Although some vernacular idioms still persist in rural areas, this style was largely superseded when the USA assumed direct rule. The Americans introduced simple rectilinear buildings in brick and reinforced concrete and brought framed multi-storey buildings to Santo Domingo before the end of the 1920s; later examples of these show touches of Art Deco.

In 1930, at the beginning of the dictatorship of Leónidas Trujillo Molina, a hurricane damaged buildings in Santo Domingo and elsewhere. In the same year Dominican architects trained in Europe and the USA returned home. The most important included Guillermo González and José Antonio Caro Alvarez. González's five-storey apartment building (1937) in the Avenida Pasteur, Santo Domingo, has distinct overtones of Le Corbusier's work and was the first building to show the influence of the European Modern Movement. A number of public buildings were constructed during the Trujillo regime, including university buildings, the Palacio Nacional, Palacio de Bellas Artes and various works for the Feria de la Paz (1955), but real growth took place upon the country's stabilization in the mid-1960s. An international pluralism developed during the 1970s, exemplified by the Museo del Hombre

5. Museo del Hombre Dominicano, Plaza de la Cultura, Santo Domingo, 1972–6, by José Antonio Caro Alvarez, José A. Caro Ginebra and Danilo Caro Ginebra

Dominicano (see fig. 5), Plaza de la Cultura, by Caro Alvarez (with José A. Caro Ginebra Carbonell and Danilo Caro Ginebra) and the Banco Central by Rafael Calventi, both in Santo Domingo. The headquarters of the Asociación de Ahorros y Prestamos (1978) by William Reid Cabral is a square glass building with an external structure derivative of Oscar Niemeyer's Brasília Baroque, while the Galerías Comerciales (1979) by Eduardo Selman is a five-storey neo-Brutalist building. An active group of younger Post-modernist architects included Oscar Imbert, Gustave Moré, Marcelo Albuquerque and, most notably, Plácido Piña. Piña's Banco Hipotecaria Domenicano (1980), Santo Domingo, and Casa Salene ('El Ediculo') at San Pedro Marcoris (1983) are sophisticated examples of an appropriate cultural coding carefully related to form and function. The vast Columbus Lighthouse, completed in 1992 for the 500th anniversary of Columbus's arrival, was designed by the British architect John Lea Gleave, whose design was chosen in an international competition (1928–30) sponsored by the Pan-American Union.

During the 1990s, Santo Domingo and Santiago underwent increased urban development, with the construction of expressways, commercial centres and apartment blocks in imaginative designs; in La Romana, Bavaro, Samana, Las Terrenas and Puerto Plata, beach resorts in Mediterranean and Antillean styles have been developed.

BIBLIOGRAPHY

A. Kelsey: *Program and Rules for the Competition to Select an Architect for the Monumental Lighthouse in the Dominican Republic to the Memory of Christopher Columbus* (Washington, DC, 1928)

D. Angulo Iñiguez, E. Marco Dorta and M. J. Buschiazzo: *Historia del arte hispano-americano*, 3 vols (Barcelona, 1945–56), i, pp. 79–120; iii, pp. 164–5

E. W. Palm: *Arquitectura y arte colonial en Santo Domingo* (Santo Domingo, 1974)

M. Ugarte: *Monumentos coloniales: Colección Museo de las Casas Reales* (San Sebastián, 1978)

Codia, lvi (1978) [special issue marking the Evento Arquitectura]

L. Alemar: *La ciudad de Santo Domingo* (Santo Domingo, 1980)

R. Segre, ed.: *Latin America in its Architecture* (New York, 1981)

R. Calventi: *Arquitectura contemporánea dominicana / Contemporary Dominican Architecture* (Santo Domingo, 1986) [bilingual text]

E. Pérez Hontas Carimos: *Monumentos y sitios del Gran Caribe / Monuments and Sites of the Greater Caribbean* (Santo Domingo, 1989) [bilingual text]

J. F. Liernur: *America latina: Architettura, gli ultimi vent'anni* (Milan, 1990), pp. 102–7

A. Gardinier: 'Bâtiment phare', *D'architectures*, xxiv (1992), p. 36

C. Huggins, P. Glinton and B. Smith: *Bahamian Art, 1492–1992* (Nassau, 1992)

M. E. Monte Urraca: *Memorias de la ciudad de Santo Domingo: Origen, decadencia y rescate de su patrimonio cultural* (Santo Domingo, 1992)

E. E. Crain: *Historic Houses in the Caribbean* (Gainesville, 1994)

E. Pérez Montas: 'La Hispaniola Colombina', *Arquitectura colonial iberoamericana*, ed. G. Gasparini (Caracas, 1997), pp. 17–60

E. Perez Montas: *La Ciudad del Ozama: 500 Años de historia urbana* (Santo Domingo, 1998/*R* 1999)

MARIANNE DE TOLENTINO

IV. Painting, graphic arts and sculpture.

Despite the existence of a sophisticated Amerindian art (*see* §II, 1 above), Dominican art did not begin to develop a national style until after independence. This was strongly influenced by visiting European artists such as Juan Fernández Corredor, who arrived from Madrid in 1883. From this date until 1900 all the main 19th-century European trends—Neo-classicism, Romanticism, Impressionism—mixed and fused to create a Dominican style.

The first large exhibition in Santo Domingo, the Salón Artístico of 1890, comprised landscape and portrait paintings and copies of famous works.

The first Dominican painter, printmaker and caricaturist was Domingo Echavarría (*d* 1849); other pioneers included Abelardo Rodríguez Urbaneta (1870–1933), an outstanding painter, sculptor, photographer and musician. Typical subjects included portraits, landscapes, imaginary historical scenes and patriotic allegories; between 1920 and 1940 figure painting gained popularity. Realism and neo-Impressionism became the dominant trends; abstract art remained unknown. The work of the modern Dominican artists Yoryi Morel (1909–78) and Jaime Colsón (1901–75) exemplifies its two main styles. Morel's work was of a vernacular nature—rustic scenes, fiestas and rituals and tropical bucolic landscapes, orchestrated with impressionistic touches—while Colsón's drew its inspiration from the Ecole de Paris, drawing on Cubism or a Neo-classicism charged with a metaphysical or mythological message. The first important Dominican woman artist was Celeste Woss y Gil (1890–1985), who introduced modernist treatment of the nude to Dominican painting. Another important figure was Darío Suro (*b* 1918).

The 1940s were a decisive decade for Dominican art, owing to an influx of European painters and sculptors fleeing totalitarian regimes. Paradoxically, they were welcomed by the dictator Rafael Trujillo, who wished to cultivate a liberal image. Some of these artists were just passing through; others remained, including the German Georg Hausdorf (1894–1959), the Spanish painters José Vela Zanetti (*b* 1913) and Josep Gausachs (1889–1958) and the Spanish sculptor Manolo Pascual. Deeply moved by a 'new world', these artists gave free rein to their inspiration to create some of their best work. This, and their teaching, made a significant contribution to the development of Dominican art. Gilberto Hernández Ortega, Eligio Pichardo and Paul Giudicelli (see fig. 6) were among the first graduates of the Escuela Nacional de Bellas Artes (see §VI below).

The dominant style in painting during the 1950s and 1960s was Expressionism, sometimes incorporating elements of realism, magic or fantasy. Works were largely figurative, with occasional examples of abstraction; Afro-Caribbean features appeared, while European stylistic influences persisted. Colours were strong, brushstrokes forceful, texture generous and form a controlled baroque. Notable figures of the period included Guillo Pérez, Fernando Peña Defillo, Silvano Lora, Ada Balcácer, Domingo Liz and Mariano Eckert. Dominican sculpture also assumed a national character distinguished by direct carving, predominantly in precious woods, of massive scale in elongated, totemic forms. Outstanding sculptors included Antonio Prats-Véntos, Luichy Martínez-Richiez and Gaspar Mario Cruz. The 1960s were marked by struggles for the restoration of democracy. Nationalist art flourished, characterized by militant and passionate works of figurative Expressionism. Painters included Cándido Bidó, Elsa Núñez, Ramón Oviedo, José Rincón Mora, José Cestero, Asdrúbal Domínguez and Jorge Severino.

During the 1970s the diverse styles that emerged as a result of developing international contacts included Pop art, Photorealism and Surrealism; abstraction continued

6. Paul Giudicelli: *Meditation on the Armour of a Soldier*, mixed media on canvas, 1.50×1.25 m, 1963 (Santo Domingo, Museo de Arte Moderno)

to lag behind. Sculpture did not make great advances; the only noteworthy sculptors were José Ramón Rotellini, Ramiro Matos and Soucy de Pellerano. Printmaking, which had been retarded by an attitude that scorned the multiple original work, was developed by Miki Vicioso, Rosa Tavárez and Carlos Sangiovanni. Although a number of artists left the country, including Vicente Pimentel, Alonso Cuevas, Manuel Montilla and Aurelio Grisanty, others, such as Iván Tovar and Martínez-Richiez, returned. Other artists active at this time included Geo Ripley, heading the avant-garde, Alberto Bass, a Social Realist, Guadalupe, who drew on the essence of Pre-Columbian art and Danicel, who attempted a symbiosis between the history of art and Afro-Caribbean research. The pursuit of form went beyond thematic commitment, and individual values outweighed collective interests. On the theoretical side, art criticism developed.

In the 1980s, parallel to the general population explosion, there was a rise in the number of young artists. Those under the age of 30 favoured abstraction, often mixed with figurative art, neo-Surrealism and neo-Expressionism, and were more interested in working on paper through drawings and prints. Permanent sculpture installations were encouraged. International recognition began to grow for such artists as Radhamés Mejía, Víctor Ulloa, Tony Capellán and Jesús Desangles.

In the 1990s, an informal group including Capellán, Marcos Lora Read, Fernando Varela, Jorge Pineda, Belkis Ramírez, Pascal Maccariello and Paul Recio created works to express an 'arte de ruptura', with intellectual and social

themes, which at the same time preserve harmony of shape, colour and proportion. Important international painters include Ramon Oviedo (*b* 1927). Works on paper were still comparatively unpopular with artists in the 1990s, though the Museum of Drawing, Santo Domingo, opened its doors in 1995. The most vigorous category of works on paper is photography, known especially through the work of Wifredo García (1935–90). Critical images, mostly in colour, identify the Caribbean reality and exhibit up-to-date techniques; outstanding figures include Domingo Batista, Martín López and Pablo Díaz.

BIBLIOGRAPHY

M. Valldeperes: *El arte de nuestro tiempo* (Ciudad Trujillo, 1957)
D. Suro: *Arte dominicano* (Santo Domingo, 1969)
E. Rodriguez Demorizi: *Pintura y escultura en Santo Domingo* (1972)
M. de Tolentino: 'Arte dominicano', *Listín Diario* (1972–90) [regular contributions]
D. de los Santos: *La pintura en la sociedad dominicana* (Santiago, 1978)
J. Miller: *Historia de la pintura dominicana* (Santo Domingo, 1979)
M. de Tolentino: *Pintores dominicanos jóvenes para las Américas* (Santo Domingo, 1986)
——: 'El expresionismo en la pintura dominicana', *100 años de pintura dominicana* (Santo Domingo, 1989)
C. Huggins, P. Glinton and B. Smith: *Bahamian Art, 1492–1992* (Nassau, 1992)
C. Gerón: *Obras maestras de la pintura dominicana/Masterpieces of Dominican Painting, 1843–1993*, 4 vols (n.p., 1994)
——: *Pintores extranjeros y dominicanos/Foreign and Dominican Painters, 1936–1995* (Santo Domingo, 1995)
Dominican Art: Spanish Artists and Modernity, 1920–61 (exh. cat., Santo Domingo, Cent. Cult. Hisp., 1996)
J. Miller: 'Dominican Republic', *Latin American Art in the Twentieth Century*, ed. E. Sullivan (London, 1996), pp. 103–17

MARIANNE DE TOLENTINO

V. Patronage and collecting.

Commissions and money to support the arts became most significant in the second half of the 20th century. In 1942 the national Biennales, held in Santo Domingo, were established and were held regularly until 1960, then resumed in 1972. In the period after 1961 the strength of national art life depended largely on institutional and financial backing by private companies, including events organized by the official cultural sector. This was accompanied by a flourishing of exhibitions. Private enterprise favoured art that contributed to the community and educational work, including support of group and individual exhibitions, publications and publicity. The companies that offered this support included those producing rum, drinks and cigarettes (Brugal, Bermúdez, Barcelo, E. León Jiménes) and several multinationals (the Dominican Telephone Company, Falconbridge). The E. León Jiménes Art Competition was founded in 1964 as a national contest and has promoted young achievements in sculpture, painting and drawing. Banks and financial institutions also offered patronage. The state made tax reductions for patronage in the context of 'aid for institutions with non-profit making aims'.

The Museo de Arte Moderno in Santo Domingo (formerly Galería de Arte Moderno; founded 1976) has the largest collection of art in the country, owing to its official character and its donations. There are, however, a considerable number of institutions and individuals that have systematically acquired paintings and sculptures. These include the Banco Central, the Universidad Autón-oma de Santo Domingo and the *voluntariado* of the Museo de las Casas Reales. Financial institutions have also been noteworthy for the size of their national collections: the Banco Popular, Bancrédito, Nacional de Vivienda and others. In the late 20th century the number of private collectors also increased. The bulk of collections comprised paintings and works of confirmed value, with little interest in works on paper. High, rising prices led to a shift in the social class of collectors, moving from the middle classes and 'intellectuals', who were the first collectors in Santo Domingo, to economically powerful sectors. The most important individual collector, Catalan-born Juan José Bellapart, established the Fundación Bellapart and, in 1999, opened the Museo Bellapart, housing the country's most comprehensive collection of Dominican art up to the 1960s.

An art market as such was non-existent until the mid-20th century but reached its peak during the 1980s when galleries multiplied. Cultural centres and museums also sold art works during temporary exhibitions. The commercial art market was concentrated in Santo Domingo with outlets in tourist centres throughout the country.

BIBLIOGRAPHY

R. Herrera Cabral: 'Protección al arte', *Listín Diario* (25 March 1966)
——: 'Actividades culturales', *Listín Diario* (29 Oct 1966)
D. de los Santos: *La pintura en la sociedad dominicana* (Santiago, 1978)
M. de Tolentino: 'Necesidades del arte y los artistas dominicanos', *Listín Diario* (21 Aug 1978)
A. Schwartz: *Valorización del arte* (Santo Domingo, 1979)
M. de Tolentino: 'Un asunto discutido: El precio de las obras de arte', *Listín Diario* (11–12 July 1980)
Fundación Brugal: *Estatutos* (Santo Domingo, 1987)
M. de Tolentino: 'El estado y la condición del artista', *Listín Diario* (18 Aug 1989)
Reglamento, XIII Concurso E. León Jiménes (Santiago, 1989)
M. Loli de Severino: *La inversión en el arte* (Santo Domingo, 1991)
C. Huggins, P. Glinton and B. Smith: *Bahamian Art, 1492–1992* (Nassau, 1992)
D. de los Santos: *Concurso de arte Eduardo León Jiménes: 25 años de historia* (Santo Domingo, 1993)

MARIANNE DE TOLENTINO

VI. Art institutions.

The Dominican Republic has a surprising number and diversity of art institutions, which are concentrated in Santo Domingo in the cultural Plaza de la Cultura Juan Pablo Duarte complex. The first Museo Nacional was established in 1927 as the repository of objects of varying value, including objets d'art, archaeological and historical items. In 1942 the museum was completely modernized, and the collection was transferred under the supervision of the newly created Dirección General de Bellas Artes. A museum dedicated exclusively to art dates from 1943, when the Galería de Bellas Artes opened. According to the original statute, it was to preserve and exhibit 'works belonging to the government which form the nucleus of the "Museum of Modern Art" which this gallery aspires to become'. It also organized individual and group national and international exhibitions. When the Palacio de Bellas Artes was built in 1956, sculptures, paintings and drawings were transferred there. In 1963 the Galería Nacional de Bellas Artes had nine sumptuous rooms covering two storeys, containing mostly oil paintings by Dominican and exiled European artists. The small collection had its source

in Biennale awards and donations. The first museum guide was published in 1963 by the Director Aida Cartagena Portalatín. In 1976 the collection was transferred to the new Galería de Arte Moderno (now Museo de Arte Moderno), which opened in December in a building of three storeys and a basement designed by José Miniño. Except for one of the rooms, all spaces are open and interlinked, making it a flexible museum space. It includes an auditorium, children's workshop, library and printshop. The predominantly national collection comprises more than 700 sculptures, paintings, drawings, prints and photographs. Outside Santo Domingo there is a museum for the E. León Jiménes Art Collection in Santiago, and a single rural museum in Ríos de Neybo, created by Silvano Lora.

Although the first formal, official, professional art education was offered from 1942 when the Escuela Nacional de Bellas Artes was established in Santo Domingo, drawing and painting were taught in the capital from 1885, including classes by the Spanish painter Juan Fernández Corredor. There is also evidence of a public municipal school of drawing in 1890. In Santo Domingo in 1908 the versatile Abelardo Rodríguez Urbaneta established his Academia de Dibujo, Pintura y Escultura, of which he was director until 1933. Other painters who had their own academies include García Godoy and Yoryi Morel in the provinces and Celeste Woss y Gil in the capital. Immigrant European artists made up an important element of the initial professional body of the Escuela Nacional when it was founded. The first director was the Spanish sculptor Manolo Pascual, and subjects taught included life painting, colour, modelling, perspective, landscape, anatomy, applied arts and prints, and theory and history of fine arts. In three years of study and one postgraduate year the school prepared students for the title of Profesor de Dibujo, the only degree that it awarded. The faculty, mostly graduates of the school, decided to reform the programme in 1978, but this was not realized until 1989. Three years of general study were offered, followed by two years of specialization in painting, sculpture and drawing. At university level, professional technical training was offered at the Universidad Autónoma de Santo Domingo and APEC Escuela de Arte. In 1975 the Colegio Dominicano de Artistas Plásticos opened in Santo Domingo. In the 1990s the Universidad Pedro Henríquez Ureña opened an Escuela de Artes Plásticas with the ultimate aim of awarding the degree of Licentiate in Art. Under the overall direction of the Dirección General de Bellas Artes, five provincial schools offered a basic education but were in financial difficulties in the late 20th century. At this time the Escuela Cándida Bidó in Bonao was created. A branch of the Parsons School of Design, the Escuela de Arte Diseño, established in 1982 in Altos de Chavón, near La Romana, has both a national and international orientation and has become highly respected.

BIBLIOGRAPHY

R. Diaz Niese: 'Un lustro de esfuerzo artístico', *Cuad. Dominicanos Cult.*, xxiii/11 (1945)

A. Cartagena Portalatín: *Galería de Bellas Artes: Catálogo general* (Santo Domingo, 1963)

E. Rodríguez Demorizi: *Pintura y escultura en Santo Domingo* (Santo Domingo, 1972)

M. de Tolentino: 'La Escuela de Bellas Artes se cuestiona', *Listín Diario* (1, 5 and 7 Feb 1981)

D. Henríquez: 'Reseña de la plástica dominicana', *Arte contemporáneo dominicano*, ed. G. Nader (Santo Domingo, 1984)

S. Pérez de Ruiz: *Obras integradas a la Galería de Arte Moderno desde 1978 hasta 1984* (Santo Domingo, 1984)

M. de Tolentino: 'Lo que esperamos de la GAM', *Listín Diario* (18 Dec 1988)

MARIANNE DE TOLENTINO

Dompé, Hernán (*b* Buenos Aires, 24 July 1946). Argentine sculptor. He studied at the Escuela Nacional de Bellas Artes 'Manuel Belgrano' and the Escuela Nacional de Bellas Artes 'Prilidiano Pueyrredon'. Taking as his starting-point forms associated with Inca, Aztec and Maya civilization as experienced in journeys through Peru and Mexico, encompassing nature and architecture as well as pieces made of clay, Dompé treated his sources as catalysts in his pursuit of a regional identity, rather than as models with a supposed universal validity. Synthesizing in this way the values of a humanistic sculpture into a form of modern discourse and using mixed techniques including modelling, he transmuted objective reality into the material presence of marble or sedimentary rock elaborated with the most refined of traditional techniques. Giving preference to symbolic values (e.g. *Totem*, 1970×510×240 mm, 1983; wood and iron version, Buenos Aires, Mus. N. B.A.), Dompé thus stressed a contextual reading of his works that transcends the specific time and place of its production.

BIBLIOGRAPHY

J. Glusberg: *70/80/90* (Buenos Aires, 1996), pp. 71–3

Esculturas (exh. cat. by J. Glusberg, Buenos Aires, Gal. A. Contemp., 1996)

J. López Anaya: *Historia del arte argentino* (Buenos Aires, 1997)

'Recurrencias': *Arte argentino de la generación de los 80* (exh. cat., Caracas, Mus. A. Contemp. Sofía Imber, 1997), p. 374

JORGE GLUSBERG

Downey, Juan (*b* Santiago, 11 May 1940). Chilean painter, printmaker and video artist. He studied architecture at the Universidad Católica de Chile in Santiago and printmaking at Taller 99, a workshop in Santiago run by Nemesio Antúnez, where he explored new technical methods for representing machine imagery and energy. In 1962 he travelled to Spain and then to Paris, where he studied at Stanley William Hayter's Atelier 17.

In the mid-1960s Downey settled in the USA, where he became interested in and made contact with the pioneers of video art, which became his primary medium. Proposing to work directly with energy rather than simply representing it, he presented his first audio-visual installation in 1966, conveying light, sound and energy by means of closed-circuit television. Conceiving of the artist as a cultural communicator and keen to appropriate to his own ends methods of image reproduction derived from advanced technology, he created a series entitled *Video Transamérica*, which he began in 1971 and worked on for nearly 20 years, in order to provide information on indigenous Latin American cultures and to make known their present state. The series includes *Yucatán* (1973) as well as *Yanomami Healing One* and *Yanomami Healing Two* (both 1977), the latter of which document his experiences amongst the Yanomami Indians of southern Venezuela and represent an attempt to get closer to the

roots of Latin America through the study of anthropology and iconography. Subsequent series included *The Thinking Eye*, begun in 1979, a survey of Western culture from the pyramids of Egypt to the skyscrapers of Manhattan from an autobiographical point of view, and *The Looking Glass*, in which he analysed the use of mirrors in masterpieces of painting, in palaces and gardens, in mythology and in daily life. His main concern here was with culture in its socio-political context. Rupturing the conventional narrative form of commercial television, Downey consistently used video to achieve fresh insights.

WRITINGS
with others: *Festival Downey: Video porque TeVe* (Santiago, 1987)

BIBLIOGRAPHY
G. Galaz and M. Ivelić: 'El video arte en Chile', *Rev. Aisthesis*, 19 (1986)

VIDEO RECORDINGS
A. Hoy: *Juan Downey: The Thinking Eye* [videotape, 1987]

MILAN IVELIĆ

Dubugras, Victor (*b* La Flèche, Sarthe, 1868; *d* Rio de Janeiro, 1933). French architect, active in Brazil. He emigrated to Argentina as a child and studied architecture in Buenos Aires; he also trained with the Italian architect Francisco Tamburini (*d* 1892), who created many of the neo-Renaissance buildings in Buenos Aires. He emigrated to Brazil in 1891 and began to practise in São Paulo, assisting Francisco de Paula Ramos de Azevedo and designing some public buildings, such as law courts and schools, in several towns in the interior of Brazil.

In 1894 he was appointed professor of architectural drawing in the newly founded Escola Politécnica, São Paulo. At this time, São Paulo was one of the fastest-growing cities in the world, owing to coffee production and immigration. This industrial growth resulted in the development of a wealthy middle class who were eager to build European-style luxury homes, and it was a very important time for Dubugras. His first designs were influenced by the eclecticism then prevailing in São Paulo, but he moved away from classicism towards more medieval forms, then towards the Art Nouveau style that gave him more freedom of expression. He began to produce highly individual and imaginative solutions that were among the first to treat space as the foremost element in architecture, for example the Villa Uchôa (1903), São Paulo, which was a large splendid house, featuring heraldic ornament although it was modern in its spatial volumes, containing double-height rooms. In 1907 he designed the Mairinque Railway Station, Sorocambo, São Paulo, which can be considered one of the first examples of modern building in Brazil; of particular interest is the way he used reinforced concrete, with ribs expressing the lines of stress in a way that anticipated future developments. In this project he adopted the geometric restraint characteristic of German and Austrian work, although in other projects, such as the Horácio Sabino house (1903; destr. 1952), Avenida Paulista, São Paulo, he continued to use the curving forms of Art Nouveau.

After 1915 Dubugras adopted the neo-colonial style that had recently been introduced in an attempt to express a national cultural identity. Seeking to avoid the grammar and vocabulary of European styles, it drew its inspiration from 18th-century colonial architecture in Brazil, adopting the Baroque ornament in new and modern architectural applications. The main proponent of the new style was Ricardo Severo (1869–1940), a partner of Francisco de Paula Ramos de Azevedo, but Dubugras was celebrated for his richly imaginative solutions, enthusiastically supported by his client, the Prefect of São Paulo, Washington Luiz. His best-known works in the style are found in the complex of buildings along the road linking São Paulo to Santos, the Caminho do Mar, including Pouso Paranapiacaba, Rancho da Maioridade, Padrão do Loreno, Cruzeiro Quinhentista and a small belvedere. After 1925 Dubugras moved to Rio de Janeiro, where he abandoned the neo-colonial style and returned to the approach he had used in the Mairinque project as a point of departure in search of formal purism and rationalism combined, inevitably, with his own personal fantasy.

BIBLIOGRAPHY
C. A. C. Lemos: *Alvenaria burguesa* (São Paulo, 1985)
B. Lima de Toledo: *Victor Dubugras e as atitudes de renovação em seu tempo* (diss., São Paulo, 1985)
A. Fabris, ed.: *Ecletismo na arquitetura brasileira* (São Paulo, 1987) [chap. 4]
Y. Bruand: *Arquitetura contemporânea no Brasil*, i (São Paulo, 1981), p. 33ff

CARLOS A. C. LEMOS

Duclos, Arturo (*b* Santiago, 3 May 1959). Chilean painter and sculptor. He studied art at the Universidad Católica de Chile in Santiago (1977–82) and in 1980 joined Escena de Avanzada, an avante-garde movement comprising a multi-disciplinary group of artists and intellectuals that did not follow the official discourse of Pinochet's dictatorship. The influence of this movement can be seen in Duclo's early installations, which used cast-off materials and found objects. In the mid-1980s Duclos began to paint. Using such untraditional supports such as bath towels, curtains, sleeping bags and corduroy, he brought conceptual art into the Chilean painting tradition. He held his first solo exhibition, La Lección de Anatomia, in the Bucci Gallery, Santiago, in 1985; he was awarded a Guggenheim Fellowship in 1992.

His work is meticulously, neatly and methodically constructed and has a strong graphic presence (e.g. *Bodegon*, 1990; see fig.). Images and texts from a vast archive, collected over many years, are infinitely recombined.

Arturo Duclos: *Bodegon*, oil and enamel on paper, 255×330 mm, 1990 (Colchester, University of Essex, Collection of Latin American Art)

Sources of inspiration include VANITAS still-lifes, Suprematism, Abstract Expressionism, alchemy, Jewish mysticism and Chinese philosophy, among other things. Bones, crosses, stars, hammers and sickles are basic symbols. Duclos's use of these images and signs, making them converge on the canvas to question and subvert their conventional meanings, forces the viewer to reflect on Eastern and Western culture in the widest sense.

BIBLIOGRAPHY
N. Richard: 'Margins and Institutions', *Art & Text*, xxi (1986)
D. Cameron: 'Arturo Duclos', *Flash A.*, clxxxii (1995), p. 100
J. P. Mellado: 'Arturo Duclos: Ornament and Representation', *A. Nexus*, xxi (1996), pp. 87–8
Alchemy and the Work of Arturo Duclos (exh. cat. by M. J. Montalva, Colchester, U. Essex Gal., 1998)

MARÍA JOSÉ MONTALVA

Duffaut, Préfète (*b* Jacmel, 1 Jan 1923). Haitian painter. His imaginative landscapes take as their framework the labyrinth of narrow streets, colourful houses and glimpses of the sea of Jacmel, on Haiti's southern coast. Claiming to have had a vision of the Virgin (or the Vodoun goddess Erzulie) on the Ile de la Gonave, he treated her image repeatedly in his paintings. She appeared, according to him, to exact a promise from him to paint her image on the local church. It was a photograph of this image that brought Duffaut to the attention of the American watercolourist Dewitt Peters (1901–66) and led to his affiliation with the Centre d'Art in Port-au-Prince.

Duffaut remained faithful to the geometricized, even diagrammatic abstraction that he had developed early in his career. His two frescoes in Ste-Trinité Episcopal Cathedral in Port-au-Prince, the *Temptation of Christ* and the *Processional Road* (both 1951), are based upon the same pattern. Using intense, flat colours and clearly delineated shapes, he shunned illusions of volume and depth, rendering the costumes and features of his naive figures as patterns on flat shapes. He showed little concern for relative proportion and rendered architecture without perspective, in a manner curiously resembling a gouache of the *Palace of Sans Souci* (Port-au-Prince, Bib. Haït. F.I.C.) painted by Numa Desroches (1802–80) in the early 19th century. Duffaut's later work tended to slip into mannerisms that were unfortunately adopted by lesser Haitian painters.

BIBLIOGRAPHY
P. Apraxine: *Haitian Painting: The Naive Tradition* (New York, 1973), p. 32
Haitian Art (exh. cat. by U. Stebich, New York, Brooklyn Mus., 1978)
M. P. Lerrebours: *Haïti et ses peintres*, i (Port-au-Prince, 1989), pp. 295–306

DOLORES M. YONKER

Dunkley, John (*b* Savanna-la-Mar, 10 Dec 1891; *d* Kingston, 17 Feb 1947). Jamaican painter and sculptor. Essentially self-taught, he is believed to have been introduced to the rudiments of painting by an amateur painter while living in Panama in the late 1920s. His career, however, began in earnest in Jamaica in the mid-1930s. His painting methods were slow and painstaking, using a variety of unorthodox materials and tools, including house paint and brushes made from the twigs of trees. His mature work (*c.* 1939–47) reveals an individual approach both to subject-matter and to the formal organization of his paintings.

John Dunkley: *Diamond Wedding*, mixed media on canvas, 405×510 mm, 1939 (Kingston, National Gallery)

The majority of these are imagined landscapes, although many were probably based on memories of particular places, especially the Rio Cobre Gorge in St Catherine, Jamaica. The landscapes, with their dark tonalities, fantastic overblown foliage and other much-repeated motifs (never-ending roads, trees with phallic truncated branches, ravines) and their unusual creatures (jerboas, spiders, crabs), are truly disquieting works. In many, this unease is heightened by the anticipation of some terror about to strike; a mongoose lies in wait for an unsuspecting bird; a bird is poised to strike a fish; a jerboa approaches a giant spider's web; a woman fishing is perched perilously close to the edge of a cliff.

Dunkley occasionally ventured into social commentary, as in his *President Roosevelt Gazed at Portland Bight* (1940; Kingston, priv. col.), and in *Shepherd* (*c.* 1944; Kingston, priv. col.), where the political activist Alexander Bustamante is cast in the role of the Good Shepherd, to whom a flock of sheep come. His *Parade with Tramcars* (*c.* 1945; Kingston, Bolivar Gal.) lovingly records the Coke Methodist Church and aspects of city life of the 1930s, while *Diamond Wedding* (1939; see fig.), of an old couple, is full of affectionate humour and quiet dignity. Dunkley was a loner. Although in his lifetime he did contribute works to exhibitions, he refused to be drawn into the fervour of activity surrounding the fledgling Jamaican art movement of the late 1930s and the 1940s. When his talent was recognized, and he was approached to join the art classes organized by the Institute of Jamaica in the 1940s, he declined, stating: 'I see things a little differently'. Although he produced some 30 stone- and wood-carvings, it is on the basis of his 50 known paintings that his reputation as Jamaica's finest 'primitive' artist rests. He left no true followers, but something of his love of the fantastic existed in younger artists such as Carl Abrahams and Colin Garland.

BIBLIOGRAPHY
John Dunkley (exh. cat. by D. Boxer, Kingston, Inst. Jamaica, N.G., 1976)
Jamaican Art, 1922–1982 (exh. cat. by D. Boxer, Washington, DC, Smithsonian Inst.; Kingston, Inst. Jamaica, N.G.; 1983)
V. Poupeye: *Caribbean Art* (London, 1998)

DAVID BOXER

Durán. Spanish family of architects, active in Mexico from 1690 to after 1750. It is assumed that José Durán,

Miguel Custodio Durán and Diego Durán Berruecos were related, although research to date has not produced any firm evidence. José Durán was responsible for the plan of the basilica of Guadalupe, which was built (1695–1709) by Pedro de Arrieta at the foot of the hill of Tepeyac, north of Mexico City. It is longitudinal in plan, with aisles, but centrally organized with a crossing dome equidistant from the sanctuary and the entrance. This dome presides over each elevation, framed by octagonal bell-towers at the corners. A possible stylistic source is the Basílica del Pilar (begun 1681), Saragossa, Spain.

Miguel Custodio Durán is associated with a series of works carried out in Mexico City. The most important of these is the church of S Juan de Dios (1729) on the north side of the Alameda Gardens. The main elevation is dished inwards in the manner of a *nicchione*. Use is also made of the undulating order of pilasters, invented *c.* 1660 by Fray Juan Andres Ricci (1600–81). The church of S Lázaro and the monastery church of Regina (1731) are also attributed to Miguel Custodio Durán.

The church of SS Sebastian y Prisca in Taxco is attributed to Diego Durán Berruecos. Built between 1748 and 1758 at the expense of the silver magnate José de la Borda (1700–78), it represents an early provincial manifestation of the 'Ultra Baroque' (Kubler). The pink stone church dominates the town, which is itself elevated above the Mexico–Acapulco road. This effect is further emphasized by the verticality of the design, which derives from the use of a double square system of proportions, in which the height of the tower is twice the overall width of the façade, and the height of the façade panel is twice its own width. The tower shafts are plain to the height of the nave eaves, save for their circular windows, but above this the belfries are thickly adorned with columns and *estípites*. Paired columns on the main façade are straight at ground-level but twisted at the upper range. The high dome is decorated with polychrome glazed tiles.

BIBLIOGRAPHY

D. A. Iñiguez, E. M. Dorta and M. J. Buschiazzo: *Historia del arte hispanoamericano*, 3 vols (Barcelona, 1945–56)

G. Kubler and M. Soria: *Art and Architecture in Spain and Portugal and their American Dominions, 1500–1800*, Pelican Hist. A. (Harmondsworth, 1959)

M. Toussaint: *Arte colonial en México* (Mexico City, 1962)

E. Vargas Lugo: *La iglesia de Santa Prisca de Taxco* (Mexico City, 1974)

G. Tovar de Teresa: *El barroco en México* (Mexico City, 1981)

R. Gutiérrez: *Arquitectura y urbanismo en Iberoamérica* (Madrid, 1983)

J. Bérchez: *Arquitectura mexicana de los siglos XVII y XVIII* ([Mexico City], 1992), pp. 133–47; 161–73

MARIA CONCEPCIÓN GARCÍA SÁIZ

Dutary, Alberto (*b* Panama City, 3 July 1932; *d* Panama City, 23 March 1998). Panamanian painter and printmaker. He studied at the Escuela Nacional de Artes Plásticas in Panama City and at the Real Academia San Fernando and the Escuela Nacional de Artes Gráficas in Madrid, where he held his first one-man show in 1957 before returning to Panama. Although he was always a figurative painter, in paintings such as *Figures at Twilight* (1960; Washington, DC, A. Mus. Americas; *see* PANAMA, fig. 3) and in his series of over 50 works, *Saints*, in the early 1960s (e.g. *Mocking Saint*, 1962; Panama City, Mus. A. Contemp.), he combined the rich surface textures of Spanish informal abstraction with mysterious ghost figures expressing an Existentialist point of view. In spite of their apparent simplicity, such pictures as *Objects for a Ceremony* (1973) and the *Consumer as Clay* (1968; both Panama City, Mus. A. Contemp.) are full of symbolic and mythic associations as well as social criticism. In Dutary's later works his iconography became less varied, with a preference for tall, ascetic women and female mannequins as virtually interchangeable figures. Dutary's paintings, drawings, pastels and lithographs were exhibited widely in Panama and abroad. He also helped promote the arts in Panama as one of the founders in 1962 of the Instituto Panameño de Arte and through his teaching in schools and at the Universidad de Panamá.

BIBLIOGRAPHY

M. Molleda: 'Arte de América y España', *A. Int.*, vii/6 (1963), p. 45

X. Zavala Cuadro and others: 'Alberto Dutary: Pintor panameño', *Rev. Pensam. Centamer.*, 155 (1977), pp. 1–9

Y. Díaz de Gámez: 'Apuntes sobre el desarrollo de las artes plásticas en Panamá', *Rev. Lotería*, 360 (1986), pp. 123–38 [interview]

MONICA E. KUPFER

Dutch Antilles. *See under* ANTILLES, LESSER.

Dutch Guiana. *See* SURINAM.

E

Echave [Chávez]. Mexican family of painters of Spanish origin. Baltasar de Echave Orio the elder (*b* Zumaya, *c.* 1558; *d* Mexico City, *c.* 1620) arrived in Mexico from Spain *c.* 1580. He worked with his father-in-law, Francisco de Zumaya (also known as Francisco de Ibía and Francisco de Gambo), on the principal retable and the S Miguel retable in Puebla Cathedral in 1590. His most important works date from the first two decades of the 17th century, during which he produced paintings for the retable of the Franciscan church of Santiago de Tlatelolco, Mexico City, of which the *Visitation* (Mexico City, Pin. Virreinal) and *Portiuncula* are certainly by him; the attribution of the *Annunciation* (Mexico City, Pin. Virreinal), *Resurrection* and *Stigmatization of St Francis* (Guadalajara, Mus. Reg. Antropol. & Hist.), originally in the same church, is more cautious. For the church of La Profesa, Mexico City, he executed the *Adoration of the Magi*, *Agony in the Garden*, *Martyrdom of St Aponius* and *Martyrdom of St Pontian* (all Mexico City, Pin. Virreinal). The retables of the churches in Tlalmanalco and Xochimilco are also attributed to him. His mature style, distinguished by its treatment of light and shade, shows evidence of Venetian influence, presumably acquired during his time in Spain.

His son Baltasar de Echave Ibía the younger (*b* Mexico City, 1585; *d* Mexico City, 1650) developed a softer style, as is evident in his surviving works: two paintings of the *Immaculate Conception*, the *Conversation of the Hermit Saints Paul and Anthony*, *St John the Baptist*, *Mary Magdalene*, *St John*, *St Luke*, *St Mark*, *St James of Alcalá* and a *Portrait of a Lady* (all Mexico City, Pin. Virreinal); the *Baptism* (Xochimilco, church); and the *Annunciation*, *Visitation* and *St Francis of Paola* (all Guadalupe, Mus. Basilica). Another son, Manuel de Echave Ibía, is known from only one work, the *Virgin Placing the Chasuble on St Ildefonso* (Churubusco, Mus. Hist.). Baltasar de Echave Rioja (1632–82), grandson of Baltasar de Echave Orio, worked in a style closer to the chiaroscuro introduced into Mexico by Sebastián López de Arteaga, and iconographically the influence on him of Rubensian subjects is of great importance. This can be seen in the large canvases depicting the *Triumph of Religion* and the *Triumph of the Church*, painted for Puebla Cathedral (*in situ*). Also by him are the *Martyrdom of St Pedro Arbues* (1667), the *Entombment* (1668; both Mexico City, Pin. Virreinal), the *Last Supper* and the *Washing of the Feet* (both 1681; Puebla, S Domingo de Izucar).

BIBLIOGRAPHY
M. Toussaint: 'Baltasar de Echave Orio, llamado "el Viejo"', *El arte en México: Pintura colonial*, iii (Mexico City, 1934)
G. Danes: 'Baltasar de Echave Ibia: Some Critical Notes on the Stylistic Character of his Art', *An. Inst. Invest. Estét.*, iii/9 (1942), pp.15–26
D. Angulo Iñguez, E. Marco Dorta and J. Buschiazzo: *Historia del arte hispanoamericano* (Barcelona, 1945–56)
M. Toussaint: 'Pinturas coloniales mexicanas en Davenport', *An. Inst. Invest. Estét.*, xiv (1946), pp. 25–32
G. Kubler and M. S. Soria: *Art and Architecture in Spain and Portugal and their American Dominions, 1500–1800* (London, 1969)
G. Tovar de Teresa: *Pintura y escultura del renacimiento en México* (Mexico City, 1979)
N. Sigaut: 'Una pintura desconocida de Manuel de Echave', *An. Inst. Invest. Estét.*, lv (1986), pp. 85–96
M. Burke: *Pintura y escultura en Nueva España: El barroco* (Mexico City, 1992)
J. G. Victoria: *Un pintor en su tiempo: Baltasar de Echave Orio* (Mexico City, 1994)
R. Ruiz Gomar and others: *Un pintor manierista: Baltasar de Echave Ibia* (Mexico City, 1995)

MARIA CONCEPCIÓN GARCÍA SÁIZ

Echeverría, Enrique (*b* Mexico City, 1923; *d* 1972). Mexican painter. He studied painting and drawing under the Spanish painter Arturo Souto, who had lived in exile in Mexico since 1940 and whose Post-Impressionist style influenced Echeverría's painting for some time. In 1952 Echeverría became associated with the newly founded Galería Prisse in Mexico City, run by artists opposed to nationalist tendencies in Mexican art, through which he befriended José Luis Cuevas, Alberto Gironella and Vlady. Also in 1952 he was awarded a scholarship by the Instituto de Cultura Hispánica, which enabled him to live in Europe for just over one year.

Echeverría began as a figurative painter but developed a form of abstraction concerned with the interrelationship of form and colour, with imagery still discernible. The play between representation and abstraction was particularly evident in works influenced by Nicolas de Staël (1914–55), including a series of *Interior Landscapes* characterized by a restrained use of colour. In later years he used bright, contrasting colours and motifs vaguely reminiscent of those employed by Karel Appel, in dynamic, decorative and exuberant pictures dominated by curves. In spite of his premature death from a kidney infection, he became an important figure of the so-called 'generation of rupture' in Mexico.

BIBLIOGRAPHY
T. del Conde: *Un pintor mexicano y su tiempo: Enrique Echeverría* (Mexico City, 1979)
Homenaje Enrique Echeverría (1923á1972): Exposición antológica (exh. cat., Mexico City, U. Autónoma Met., [1992])

TERESA DEL CONDE

Eckell, Ana (*b* Buenos Aires, 30 Oct 1947). Argentine painter. She studied in Buenos Aires at the Escuela

Nacional de Bellas Artes Manuel Belgrano (1961–4) and at the Escuela Nacional de Bellas Artes Prilidiano Pueyrredón (1965–7). Making reference in her paintings to comic strips, to the work of Otto Dix (1891–1961) and George Grosz (1893–1959) and to the early pictures of Jean Dubuffet (1901–85), to photograms and to the cinema, she combined a variety of images and styles in a single work without establishing a narrative. Superimposing caricatured human and animal forms on to a surface of animated brushstrokes akin to gestural abstraction, she created from these fragments pictures that were like puzzles for the spectator. By such means she created an art endowed both with the humour and playfulness of childhood and with an exasperation and underlying horror (e.g. *Untitled*, 1985; see colour pl. IX, fig. 1).

BIBLIOGRAPHY

J. Glusberg: *Del Pop-art a la Nueva Imagen* (Buenos Aires, 1985), pp. 518–20

Dibujantes argentinos en Alemania (exh. cat., intro. by G. Whitelow, Buenos Aires, Fond. N. A., 1995)

Arte contemporáneo 80/90: Colección Fundación Banco Patricios (Buenos Aires, 1995)

Eckell, García y López Armentía en la XLVII Bienal Internacional de Venezia (exh. cat. by J. L. Borges and others, Buenos Aires, Mus. N. B.A., 1997)

HORACIO SAFONS

Eckhout, Albert (*b* Groningen, *c.* 1610; *d* Groningen, 1666). Dutch painter and draughtsman. Eckhout and Frans Post were the two most important artists who travelled to Brazil in 1637 in the entourage of the newly appointed governor-general, Johan Maurits, Count of Nassau-Siegen (*see* NASSAU-SIEGEN, JOHAN MAURITS OF), on whose initiative Eckhout was assigned to paint people, plants and animals as part of a scientific study of the country. Eckhout's studies are characterized by an objectivity that is sober, direct and without artistic embellishment. In 1644 Johan Maurits, nicknamed 'the Brazilian', returned to the Netherlands where he published the collected scientific material as *Historia naturalis Brasíliae* (1648). He also used this material as a diplomatic tool; in 1654 he presented Frederick III of Denmark with a series of room decorations that Eckhout had partially painted in Brazil between 1641 and 1643. This series comprised nine large portraits of aboriginal Indians, twelve still-lifes with Brazilian fruit and three portraits of Congolese envoys (Copenhagen, Stat. Mus. Kst).

The only painting by Eckhout in a Dutch public collection, *Two Brazilian Turtles* (see colour pl. IX, fig. 2), was probably one of the works of art sold by Johan Maurits in 1652 to Frederick William, the Great Elector. This group included 800 chalk, oil and watercolour drawings of fish, reptiles, birds, insects, mammals, Indians, mulattos, fruits and plants, most of them presumably by Eckhout. They were collected into seven books, the *Libri picturati*, of which four volumes containing 400 oil sketches were entitled *Theatrum rerum naturalium Brasíliae* (Kraków, Jagiellonian U. Lib.). In 1679 Maurits gave Louis XIV of France a present of eight paintings of Indians and animals in imaginary landscapes with still-lifes of Brazilian and African fruits and plants painted by Eckhout after his return to the Netherlands. In 1668 Maximilian van der Gucht of The Hague made a series of tapestries after these paintings for the Great Elector, and a second series, the

'Tenture des Indes', was woven in 1687 by the French firm later known as Manufacture Royale des Gobelins (Paris, Mobilier N.). The paintings are no longer extant, but the cartoons for the tapestries were used until the 18th century. The many surviving tapestry series woven after 'Les anciennes Indes' (e.g. Amsterdam, Rijksmus.; Valletta, Pal. Grand Masters) testify to the popularity of these representations.

At Johan Maurits's recommendation, Eckhout entered the service of John-George I, Prince-Elector of Saxony, in 1653, and he remained in Dresden for the next ten years. His most important commission was for the ceiling decorations in the Hofflössnitz hunting lodge, for which he used his Brazilian studies or drew from memory. During this period he also made a series of large oil paintings of exotic, mainly Asiatic peoples (Schwedt, Schloss). In 1663 he returned to Groningen, where he was awarded citizenship.

BIBLIOGRAPHY

T. Thomsen: *Albert Eckhout* (Copenhagen, 1938)

Soweit der Erdkreis reicht (exh. cat., Cleve, Städt. Mus. Haus Koekkoek, 1979)

Zowijd de wereld strekt (exh. cat., The Hague, Mauritshuis, 1979–80)

C. do Prado Valladeres: *Albert Eckhout: Pintor de Maurício de Nassau no Brasil: 1637–1644* (Rio de Janeiro, 1981)

——: *Albert Eckhout: A presença da Holanda no Brasil, século XVII* (Rio de Janerio, 1989)

Albert Eckhout: Brasil Holandês, 1637–1644 (exh. cat., São Paulo, Mus. N. Dinamarca, 1991)

B. P. J. BROOS

Ecuador, Republic of. South American country. It is in the north-west of the continent and is bordered to the north by Colombia, to the south and east by Peru and to the west by the Pacific Ocean (see fig. 1). It also includes the Galapagos Islands off the Pacific coast. The country

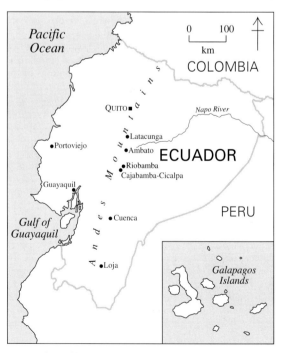

1. Map of Ecuador; those sites with separate entries in this encyclopedia are distinguished by CROSS-REFERENCE TYPE

occupies an area of 270,690 sq. km and has a population of *c.* 12 million (1998), 40% of which is Indian. The capital is Quito, but the largest city is the chief port, Guayaquil. The country is tropical, and regional variations in climate are determined by the Andes mountains, running north to south, which divide Ecuador into three regions: the coastal or ante-Andean region; the mountainous Andean region, a volcanic area containing some highly fertile valleys; and the Oriente region to the east, the principal centre for oil production, which led to a period of rapid economic expansion in the 1970s. Throughout its history the country has been beset by earthquakes. The territory that makes up modern Ecuador was under Spanish colonial rule from 1533 until independence was achieved in 1822. In October 1998, after 51 years of conflict and undeclared wars, a peace agreement was signed between Ecuador and Peru, defining a common border; treaties of commerce, Amazon River navigation and border integration were also agreed.
.

I. Introduction. II. Indigenous culture. III. Architecture. IV. Painting, graphic arts and sculpture. V. Patronage, museums and art libraries. VI. Art education.

I. Introduction.

The Spanish conquest of the territory that now constitutes Ecuador began in 1533, when Sebastián de Benalcázar defeated the Incas to conquer Quito, which he burnt down. The following year, with Diego de Almagro, he founded the new city, with a rigidly hierarchical social framework, in which the Spanish ruled over Indian vassals. Subsequently, Quito and its provinces were incorporated into the Viceroyalty of Peru, established in 1542. In 1563 Quito became the seat of government, the Real Audiencia. Architecture in the 16th and 17th centuries was in the Spanish Baroque style, wth churches, monasteries and convents being built extensively by the evangelizing religious orders. Painting, sculpture and wood-carving served to decorate religious buildings, with a distinct regional style that came to be known as the Quito school.

In the early 19th century continuing Spanish oppression of the mixed-race (mestizo) and Indian populations produced a desire for political, social and economic change and led to the development of pro-independence movements. An unsuccessful proclamation of independence in 1809 was followed in 1820 by a proclamation of autonomy in Guayaquil, and independence was achieved in 1822 with the battle of Pichincha. Quito was then incorporated into the Republic of Gran Colombia, and in 1830, when that federation was dissolved, Ecuador became a separate country.

The arts flourished in the new republic, despite the series of dictatorships that dominated the 19th century. In painting, religious themes were gradually supplemented by portraiture and landscapes, and in architecture Neoclassicism prevailed. Political tensions between liberals and conservatives, however, erupted into revolution in 1895, when the liberal Eloy Alfaro introduced anti-clerical reforms and encouraged economic expansion. During the 20th century civilian governments alternated with military regimes; voting was limited to the literate public until 1979. Economic expansion, including increased agricul-

ture in the coastal region and the export of oil, led to increasing urban populations, and housing and commercial building consequently took place.

BIBLIOGRAPHY
J. M. Vargas: *Historia del arte ecuatoriano* (Quito, 1964)
M. Monteforte: *Los signos del hombre: Plástica y sociedad en el Ecuador* (Cuenca, 1985)
D. Bayón and M. Marx: *South American Colonial Art and Architecture* (New York, 1989), pp. 37–41, 136–40

CONSUELO DE PÓVEDA

II. Indigenous culture.

After the colonizing Spaniards arrived in Ecuador in the early 16th century, chroniclers made frequent positive references regarding the artistic capacity of the area's indigenous peoples and their capability in learning how to handle new instruments and tools and easy assimilation of the new techniques of easel painting and polychrome wooden sculpture. The high quality of the work produced by the Quito school of artists brought the city cultural renown (*see* Quito), and it owes its fame to the work of many indigenous people who learnt the Western techniques of stone masonry to construct churches and civilian buildings and who embellished the surroundings with many works of fine art and craft in a Baroque style. (For further information on indigenous and mestizo artists working in the Western traditions of easel painting and sculpture, *see* §IV below.) A number of indigenous traditions in practice at the time of the Spaniards' arrival persisted into the late 20th century.

There are two specialized centres in Cotopaxi province producing ceramics: Pujili and Victoria. The former produces multicoloured ceramics in a wide variety of popular shapes and nativity scenes of three, five or more pieces. The latter is known for its plates, serving dishes, large earthenware jars and cooking pots, sometimes inscribed upon request. In the provinces of Chimborazo and Cañar, early techniques are used to produce male and female *guagtanas* (concave and convex door knockers) and large vessels for storage of corn, water collection or preparation of corn liquor, as well as small containers for domestic use. Jatumpamba, situated between the provinces of Azuay and Cañar, is famous for production of cooking pots and other containers in a red ware, made from clay taken from the public square, and fired in open ovens that make use of the mountain breezes. In the small town of Cera in Loja a highly polished ware is produced; it is named after its centre of production. The ceramics of Sarayacu in the Amazonian region are also outstanding for their very thin sides, varied zoomorphic designs and forms of pictorial decoration dating back to Pre-Columbian times.

Textile production is the most widely practised of the crafts of the indigenous Ecuadorean peoples. Diverse textiles of various materials, including hemp, reed, horsehair and fibres from local plants, are made, for example for carpets, baskets, mats and sieves, all of which can sometimes be in bright colours. The Otovalan people not only produce and distribute textiles all over Ecuador but also travel to other countries within the Americas and to Europe to sell their baizes, clothing items and other articles in cotton, wool and even synthetic fibres, the designs of which are very old. In the province of Chimborazo the

inhabitants of Guano make the best woollen carpets, with beautiful geometric designs that have been traditional from Pre-Columbian times. The people of Cañar specialize in sashes and hatbands decorated with motifs taken from their famed archaeology. In Azuay the ancient technique of ikat still exists, consisting of knotted threads. A special form of weaving using plaited strips of a vegetable fibre known as 'hat straw' (*Carludovica palmata*) has become world famous. The garment produced, the Panama hat, was produced on a large scale from the mid-19th century until the mid-20th. The hat is still produced in the province of Manabi, from which it originates, but most of all in the provinces of Azuay and Cañar.

With regard to metalwork production, the art of working silver or gold by hand for jewellery has remained the trade of craftsmen, although with modification to designs according to fashion and the demands of the upper classes. Indigenous women still favour traditional forms, including the *tupos* (fastenings for clothes) in the shape of suns. Chordeleg, Cuenca and Saraguru produce the most jewellery. The art of the locksmith, using traditional methods similar to those of the colonials, survives in several cities. The simple, decorative crosses intended for the highest part of a house for protection and those hung in the ritual ceremony known as 'Cruz Compadre' or 'Huasipichana' are also renowned.

Work in wood was not favoured traditionally by the indigenous peoples, although its use began to increase after colonization. In San Antonio in Imbabura, many artists produce carved frames, furniture, sculpture and iconographic works of Christ and the saints, often depicting them with indigenous features. In Quito, Cuenca and some other cities artisan workshops run in the traditional way, with master craftsmen, craftsmen and apprentices produce images of the saints upon commission.

Other indigenous forms of art include the 'bread-dough' sculptures produced in Pichincha and the multi-coloured, highly decorative figures made from *masapán* in the town of Calderon. In Tigua in Cotopaxi naive paintings on animal hide are made and then sold in Quito. Production of musical instruments is also traditional, due to their use by peoples in Pre-Columbian times. In the provinces of Bolívar, Cañar and Azuay rondadors, flutes, ocarinas, mouth-organs, quipas, tambourines, drums, guitars, quenas and pinquillos are made, while in the province of Esmeraldas a typical instrument is the marimba drum, made from palm wood and resonant pipes of thick reeds known as *guaduas*.

BIBLIOGRAPHY

H. Crespo Toral, F. Samaniego Salazar and J. M. Vargas: *Arte ecuatoriano*, 2 vols (Quito and Barcelona, 1976)

C. Malo González: *Expresiones estéticas populares de Cuenca*, 2 vols (Cuenca, 1983)

M. Naranjo V. and others: *La cultura popular en el Ecuador* (Cuenca, 1986–)

J. E. Hudelson: *La cultura quechua de transición* (Quito, 1987)

Ecuador: La tierra y el oro, Ajuntament de Madrid (Madrid, 1992)

C. A. Coba: *Instrumentos musicales populares registrados en el Ecuador* (Quito, 1992)

H. C. Jaramillo: *Inventario de diseños de tejidos indígenas de la provincia de Imbabura* (Quito, 1992)

P. Cuvi: *Crafts of Ecuador* (Quito, 1994); Eng. trans. by M. E. Fleweger

L. Davies and M. Fini: *Arts and Crafts of South America* (Bath, 1994)

JUAN CORDERO IÑIGUEZ

III. Architecture.

1. COLONIAL PERIOD, 1534–1822. In the 17th and 18th centuries earthquakes, volcanic action and fires severely damaged and in some cases destroyed such cities as Riobamba, Ambato, Latacunga, Guayaquil and Portoviejo. Most of Ecuador's colonial architectural heritage is therefore concentrated in QUITO. Almost from its foundation in 1534 the city became a centre for the religious orders, who embarked on an extensive building programme. The Franciscans, who arrived with the conquistadors, were led by the Flemings Jodoco Ricke de Marsalaer (*d c.* 1574) and Pedro Gosseal ('Pedro el Pintor') and the Castilian Pedro de Rodeñas. They founded an extensive monastery (begun 1530s), more broadly European in character than elsewhere in Latin America and typifying the *quiteño* manner that came to be identified with the city. The fabric of the great MUDÉJAR-panelled, single-naved church of S Francisco, with its octagonal dome on squinches at the crossing, was completed by 1581. The Indian masons Jorge de la Cruz Mitima and his son Francisco Morocho worked on the fabric for 20 years. The late Renaissance façade has Baroque elements in its paired columns, and there is also evidence for the influence of Flemish Mannerism. The decoration of the church is characteristic of the Quito school; richly gilded high-relief panels touched with carmine—by that time part of the *quiteño* tradition—later replaced the *Mudéjar* panelling destroyed in the earthquake of 1755.

Quito Cathedral was built between 1562 and 1565. The three-naved church is divided by stone Gothic arches on square piers and has a *Mudéjar*-panelled roof. The comparatively simple Renaissance lateral elevation on the south side of the Plaza Mayor is in a style still popular in Andalusia at that time, and, although there have been additions, much of the original fabric remains. The Dominicans were allocated land as early as 1541, and the Augustinians arrived in Quito in 1565. After early attempts at building, both orders seem to have commissioned the Spanish architect FRANCISCO BECERRA in 1581. S Domingo was completed in 1623 (cloister 1640); the single-aisled church has a wealth of *Mudéjar* panelling. The adjoining Rosary Chapel, built over an archway across the adjacent street and with two cupolas, dates from the 1730s. The church of S Agustín (completed 1617) has a uniquely patterned rib-vaulted choir derived from the Gothic tradition. Its well-known Sala Capitular dates from the mid-18th century.

The Jesuit church of La Compañia—three-aisled, cruciform, with a dome at the crossing—was begun in 1606 by Ayerdi de Madrigal and Gil de Madrigal and continued after 1634 by the Italian Marco Guerra, who completed the body of the church by 1649. The guild of the Cofradía del Santísimo then commissioned the Franciscan architect Antonio Rodríguez to provide plans for the Sagrario (1669–1706), adjoining the cathedral. Rodríguez also built the Santuaria de Guápulo (1693), near Quito, with an elegant transitional late Renaissance façade rising to a white, three-bell *espadaña* (bell chamber).

Both *Mudéjar* and European Baroque influences are apparent in the few significant provincial buildings remaining from the 17th and 18th centuries. The cathedral

of Riobamba (now restored) has a delicately decorated planar façade, divided only by slender pilasters barely raised above the surface; consoles support a simple three-bell *espadaña*. In Cuenca the convent church of Las Monjas has an unbroken rectangular façade with only a balustrade at first-floor level and a two-storey *espadaña*; a lateral portal has bold pilasters with *Mudéjar* surface decoration and an entablature using unusual half-pediments, also found in house portals in Cuenca.

At the beginning of the 18th century José Jaime Ortiz rebuilt the Quito church of La Merced (1701–37), which has been destroyed repeatedly in the previous century, creating a modest but notable domed Baroque church and preserving some earlier elements. The façade of La Compañía, however, is wholly 18th century, in a CHURRIGUERESQUE style with free-standing spiralling solomonic columns on the lower range. It was begun (1722) by the German Leonard Deubler and completed (1765) by Venancio Gandolfi. The chapel of the Bethlemite Hospital, completed in 1779, has a remarkable stone portal of archaizing classical design with *Mudéjar* decoration.

BIBLIOGRAPHY

J. G. Navarro: *La iglesia de la Compañía de Jesús en Quito* (Madrid, 1930)

B. Gento Sanz: *Historia de la obra constructiva de San Francisco* (Quito, 1942)

J. G. Navarro: *Religious Architecture in Quito* (New York, 1945)

D. Angulo Iñiguez, E. Marco Dorta and M. J. Buschiazzo: *Historia del arte hispano-americano*, 3 vols (Barcelona, 1945–56), i, pp. 594–620

P. Kelemen: *Baroque and Rococo in Latin America* (New York, 1951), pp. 41–2, 159–64

R. Gutiérrez, ed.: *Barroco iberoamericano* (Barcelona and Madrid, 1997)

A. Ortiz Crespo: 'La arquitectura colonial en el Audiencia de Quito', *Arquitectura colonial iberoamericana*, ed. G. Gasparini (Caracas, 1997), pp. 253–86

RICARDO DESCALZI

2. AFTER 1822. After independence there were few developments in architecture before the secession of the Republic of Ecuador from Gran Colombia in 1830. A Neo-classical style was subsequently adopted for the civil building programme in Quito, where new European influences were comparatively quickly absorbed. The work of Thomas Reed (1810–78), a Danish architect of British extraction, is especially notable. Reed designed the Penal Panóptico (penitentiary) in Quito on a cruciform plan and began (c. 1850) repairs and modifications to the Palacio de Gobierno (over the original Real Audiencia), work that continued to the end of the 19th century and in which other architects, including Juan Pablo Sanz, were involved. Filling the west side of the Plaza Grande, it was completed as a horizontal three-storey composition with a colonnaded gallery above a sturdy stone ground-floor and pedimented end-pavilions.

Rebuilding and restoration after earthquakes, as well as a number of new commissions, ensured that church building continued in the 19th century. The Recoleta de la Merced at El Tejar, high above Quito, was rebuilt in 1832. A simple stone building, it is notable for the unusual cloisters, the double-rhythm upper floor of which has a scalloped wall between the columns in counterpoint with the arches. The theocratic policy of the dictator Gabriel García Moreno, active between 1860 and 1875, provided a sympathetic environment for church building and restoration in the third quarter of the century. Juan Pablo

Sanz, working in a modified Neo-classical manner, was responsible in Quito for the chapel (1860) of the Colegio Jesuita, the south and east cloisters (1866) of S Domingo (where he also rebuilt the church tower after the earthquake of 1868) and the church of S Barbara (1870s). The latter is unusual in Latin America in having a Greek-cross plan and a distinctive timber-lined iron cupola. Sanz showed little inhibition about changing the character of the buildings he was commissioned to restore, a tendency best exemplified perhaps by the conflation of references in his late 19th-century reconstruction of Guayaquil Cathedral (see fig. 2): neo-Byzantine cupolas crown towers that are spectacularly high for such a seismically unstable region. Also notable is the *fin-de-siècle* cathedral of Cuenca (begun 1882; unfinished) by the German architect Juan Stiehle, with its rich array of Carrara marbles.

Developments in the centre of Quito after the turn of the century included the Palacio Arzobispal (1906), completing the north side of the Plaza Grande, one of a number of buildings showing the influence of French academic classicism. Others included the Banco Central de Ecuador and the Círculo Militar (both 1920s). The Teatro Bolivar (1930s) shows continued *Mudéjar* influence in its façade, while in the Casa de la Cultura (1947), of mixed *Mudéjar*, Art Deco and Modernist extraction, José María Vargas and Rodrigo Pallares continued the Latin American tradition of 'plastic integration', or collaboration between architects and fine artists.

Quito experienced rural–urban migration in the 1940s, and a major earthquake in 1949 added to the need to

2. Juan Pablo Sanz: Guayaquil Cathedral, late 19th century

concentrate on housing; nevertheless in the 1950s and 1960s there was a growth also in commercial development in the typical International Style buildings of such architects as Sixto Durán Ballén and Jaime Dávalos, trained in the USA. Among a number of public buildings erected by the municipality of Quito, the work of Diego Banderas Vela (*b* 1936) and Juan Espinosa Páez (*b* 1937) is notable: their Palacio Municipal (completed 1975; for illustration *see* QUITO), which occupies the east side of the Plaza Grande, is a modest building conscious of its context, although without direct historicist influence. Three storeys of simple rectilinear composition sit comfortably under a flat-pitched tiled roof alongside its distinguished neighbours. The housing effort following fires at Guayaquil was characterized by the rapid construction between 1981 and 1982 of 10,000 basic but carefully sited brick and block dwellings beside the Banco Ecuatoriano de Vivienda. A serious earthquake in 1987, however, again raised the problems of reconstruction and rebuilding.

BIBLIOGRAPHY

J. E. Hardoy and others: *El centro histórico de Quito: Introducción al problema de su preservación y desarrollo* (Quito, 1984)

'Ecuador: Municipalidad de Quito', *Summa*, cxxxii (1986), pp. 44–9

L. Castedo: *Historia del arte ibero-americano*, ii (Madrid, 1988), pp. 30–31, 205–07

I. del Pino: 'La época republicana en Quito', *Arquit. & Urb.*, ix/2 (1988), pp. 58–61

RICARDO DESCALZI

IV. Painting, graphic arts and sculpture.

1. COLONIAL PERIOD, 1534–1822. As elsewhere in Latin America, the art produced in Ecuador during the colonial period had a predominantly religious function and was principally destined for churches and other religious buildings. It consisted mainly of paintings and sculpture; although European engravings were imported and used by artists as models, the graphic arts were practised little during the colonial period.

An important painter in the early part of the colonial period was Pedro Bedón (1556–1621), a Dominican friar from Quito, also active in Colombia, who founded the Cofradía del Rosario, a guild in which Indian and mestizo painters worked and which played an important part in the development of the distinctive painting style that came to be associated with the Quito school. This was characterized by its lavish treatment of religious themes, the figures displaying dramatic, realistic expressions of either extreme suffering or ecstasy. The same characteristics can be found in the sculpture associated with the school, notable also for the rigid appearance of the usually gilded figures and their vivid, highly coloured decoration. Among Bedón's most important pupils were Tomás del Castillo and Adrian Sánchez Galque, whose *Mulattoes of Esmeraldas* (see fig. 3) is one of the earliest surviving Spanish colonial paintings. In the 16th century the first collage-type paintings were also created in Quito. These were paintings in which the figures appeared dressed in fabric sewn into the canvas (e.g. the *Death of the Virgin*, Quito, Mus. Franciscano). Notable among wood-carvers in the 16th century were Diego de Robles, whose work included the *Baptism* on the high altar of the church of S Francisco, Quito, and Francisco Benítez, who executed the reliefs on the panels of the choir and balcony in the same church. Perhaps the most important sculptor around this time was Luis de Rivera, who in 1599 executed the catafalque for the death of Philip II, King of Spain.

In the 17th century notable painters included the Panamanian Jesuit Hernando de la Cruz (1591–1646) and his pupil Miguel de Santiago (1626–1706), who was known for the skilled composition of his paintings, his use of colour and the atmosphere of the landscape elements in

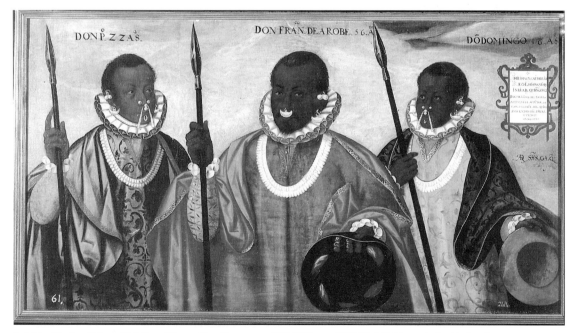

3. Adrian Sánchez Galque: *Mulattoes of Esmeraldas*, oil on canvas, 920×1750 mm, 1599 (Madrid, Museo de América)

his work. He decorated the cloister of S Agustín, Quito, with the *Life of St Augustine*; he also executed *The Rule*, a vast painting (8×6 m), also known as 'The Thousand Faces', in the presbytery. Santiago's relative and follower Javier Gorívar (1665–1740) painted the *Kings of Judah* in the church of S Domingo, Quito. Father Carlos was a significant 17th-century sculptor, producing among other things floats for Holy Week processions. José Olmos, nicknamed 'Pampite', produced dramatic sculptures of Christ as well as paintings (e.g. *Christ in Agony*, Quito, S Roque).

Casimiro Albán, Antonio Albán and Nicolás Albán were among the artists who produced coloured drawings of the *Flora of Bogotá* for the Colombian Expedición Botánica (1784–1817), led by José Celestino Muntis. The illustrations from this nationalistic scientific expedition are held in the Jardín Botánico, Madrid. Leading painters of the 18th century included Bernardo Rodríguez (*fl* 1775–1803) and his relative and pupil MANUEL SAMANIEGO Y JARAMILLO, renowned for his highly developed realism and atmospheric landscapes. His religious works included the *Assumption of the Virgin* (Quito Cathedral). Together with Rodríguez he executed scenes from the *Life of Christ* in Quito Cathedral. During the same period the accomplished wood-carver and painter BERNARDO DE LEGARDA created the finely composed *Virgin of the Apocalypse* or the *Winged Virgin of Quito* (Quito, S Francisco); Legarda's work was held in many Quitan churches. His Indian pupil Manuel Chili, known as CASPICARA, produced outstanding sculptures of religious figures, in which detailed attention to anatomy and expression was coupled with a Baroque treatment of drapery. In such group scenes as *Assumption of the Virgin* (Quito, S Francisco), the figures were arranged in a painterly manner. Towards the end of the 18th century, as pro-independence sentiments began to emerge, Baroque and Rococo styles came to be associated negatively with colonialism, and during the wars of independence (1800–22) a new genre developed in the depiction of patriotic struggle and heroism, as in the anonymous *Execution of the Heroine Rosa Zarate and of Nicolás de la Peña (in Tumaco)* (1812; Quito, Mus. A. Mod.).

BIBLIOGRAPHY
H. Crespo Toral, F. Samaniego Salazar and J. M. Vargas: *Arte ecuatoriano*, 2 vols (Quito and Barcelona, 1976)
J. G. Navarro: *La pintura en el Ecuador del siglo XVI al XIX* (Quito, 1991)
Barroco de la Nueva Granada: Colonial Art from Colombia and Ecuador (exh. cat., New York, Americas Soc. A. G., 1992)
X. Escudero de Terán: *América y España en la escultura colonial quiteña* (Quito, 1992)
A. Kennedy Troya: 'La escultura en el virreinato de Nueva Granada y la Audiencia de Quito', *Pintura y escultura y artes útiles en Iberoamérica, 1500–1825*, ed. R. Gutiérrez (Madrid, 1995), pp. 235–55
R. Gutiérrez, ed.: *Barroco iberoamericano* (Barcelona and Madrid, 1997)
J. Martínez Borrero and others: *De lo divino y lo profano: Arte cuencano de los siglos XVIII y XIX* (Cuenca, 1997)

RICARDO DESCALZI

2. AFTER 1822. Ecuador's achievement of independence in 1822 had profound cultural as well as historical and political consequences. In painting the most important of these was the demise of religious art, as new models for the development of the arts were set by European Romanticism and Realism. With the formation of the Republic in 1830 the new art began to flourish in the form of portraiture, landscape and *costumbrista* painting, documenting regional customs and people. A significant role in the introduction of these new styles and genres was played by European travellers, scientists and artists, who helped arouse among local artists an interest in nature and in the surrounding social and human environment.

During the 19th century the conservative mentality of the land-owning aristocracy, who retained political power, was gradually obliged to yield to the new ideas of the rising middle class and liberal intellectuals. One of the artists who strove hardest for artistic and social change was JUAN AGUSTÍN GUERRERO, who advocated seeking inspiration from nature in pursuit of an original, national art. The first major portrait painter was Antonio Salas (1780–1860), founder of a long dynasty of painters and creator of numerous portraits of the heroes of independence. Landscape painters concentrated on local themes, and prominent figures included RAFAEL TROYA, who produced realistic works painted *en plein air*. The *costumbrista* painting of JOAQUÍN PINTO, with its nationalist ideals, contributed to his status as a leading 19th-century artist; he produced scientifically precise illustration work, while continuing to undertake religious commissions. Sculpture during the 19th century showed little development from the colonial period and remained primarily religious in theme and ornate in style. There were no significant sculptors working in bronze or marble, so that the images of liberators and public figures that began to decorate Quito had to be commissioned from Europe.

The incorporation of modern art trends in Ecuador stemmed from the work of several European teachers, who from 1912 rejuvenated teaching at the Escuela de Bellas Artes, Quito, belatedly introducing Impressionism into painting and secular sculpture. The Italian sculptor Luigi Cassadio, for example, influenced such sculptors as Jaime Andrade Moscoso. In the 1930s a period of reflection began on questions of national identity and on the influence of the avant-garde. The social failure of the liberal revolution of 1895, the reception accorded to socialist ideas and the example of the Mexican muralists also helped to reorientate painting towards social criticism, expressed notably in the Indigenism movement, initiated by CAMILO EGAS, which sought to focus on the social situation of the country's Indian population. Its main exponents were Eduardo Kingman, who portrayed the oppression of the indigenous people of Ecuador, and OSWALDO GUAYASAMÍN, who treated similar themes in a style influenced by Expressionism and Cubism. Guayasamín produced both murals and paintings, the former inspired by Mexican muralism (see fig. 4).

In the 1940s and 1950s two painters trained in Europe, MANUEL RENDÓN SEMINARIO and ARECELI GILBERT, introduced abstract art to Ecuador. This was followed in the 1960s by a movement reacting against Indigenism and combining international idioms with a symbolism derived from Pre-Columbian cultures. The outstanding exponents of this style were ENRIQUE TÁBARA, an anti-traditionalist who developed a surrealistic symbolism, Aníbal Villacis (*b* 1927), who used Indian sign systems combined with colonial art motifs, and Estuardo Maldonado (*b* 1930), who used geometric and archaeological symbols in his

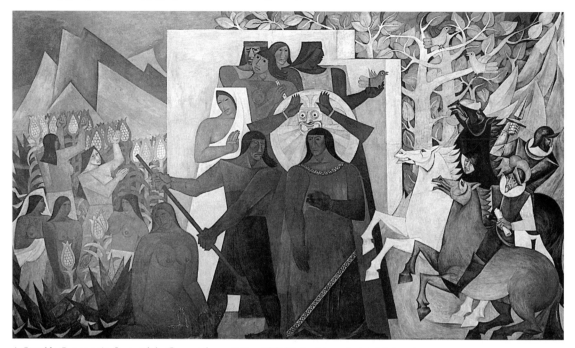

4. Oswaldo Guayasamín: *Incas and the Conquest*, fresco, 6×9 m, 1948 (Quito, Museo de Arte Moderno)

paintings and kinetic sculptures. Another avenue of approach, anthropological in content and anti-traditional in stance and which made use of collage, was pursued by OSWALDO VITERI and Mario Solís (*b* 1940), whose rigorously composed work focused on the use of texture. As in Europe, an anti-establishment mood prevailed at the end of the 1960s. RAMIRO JÁCOME, José Unda (*b* 1948), WASHINGTON IZA and Nelson Román (*b* 1945) founded the group Los Cuatro Mosqueteros, which formed its own 'anti-salon' in Guayaquil in 1968, in opposition to the official salon.

The oil boom of the 1970s and the consequent modernization of the country were reflected in art through the adoption of urban themes and of the latest international contemporary trends. Ramiro Jácome, for example, treated aspects of city life in an ironic neo-figurative style, while MAURICIO BUENO developed post-modern, conceptualist ideas using technological elements in his multi-media work. Another consequence of the short-lived oil boom was the appearance of a neo-nationalist trend, which took three forms: the first, that of authentic naive art, practised by Quechua Indian painters; the second, a primitivist genre led by GONZALO ENDARA CROW, portraying village scenes with magic realism; and the third, a pseudo-mythical style led by Nelson Román.

Sculpture was less widely practised than painting. The most prolific and stylistically diverse sculptor was JAIME ANDRADE, who created mosaic murals in stone, wood and iron. In the 1980s a revival in sculpture produced two notable 'organicist' sculptors working in marble, Jesús Cobo (*b* 1953) and José Antonio Cauja (*b* 1953), and one 'brutalist' working in wood, stone and ceramics, Gabriel García (*b* 1952).

Graphic art, first introduced through engravings imported from Europe during colonial times, was practised during the 19th century but began to develop in the 20th century, notably in the area of lithography. Significant graphic artists included the wood-engraver and muralist Galo Galecio (*b* 1908) and NICOLÁS SVISTOONOFF, an etcher and painter. Also notable are the drawings of Miguel Varea (*b* 1948).

BIBLIOGRAPHY

D. Bayón, ed.: *Arte moderno en América latina* (Madrid, 1985)
G. Rubiano Caballero: *La escultura en América latina (siglo XX)* (Bogotá, 1986)
D. Bayón: *Historia del arte hispanoamericano, siglos XIX y XX*, iii (Madrid, 1988)
El siglo XX de las artes visuales en Ecuador (exh. cat. by H. Rodríguez Castelo, Guayaquil, Mus. A. Banco Cent., 1988)
L. Oña: *Las artes plásticas del Ecuador en el siglo XX*, xliii of *Ecuador: Historia de la República*, ed. A. Pareja (Quito, 1990)
L. Oña: 'Artes plásticas en Ecuador', *Voces de Ultramar: Arte en América Latina: 1910–1960* (exh. cat., Madrid, Casa América; Las Palmas de Gran Canaria, Cent. Atlántic. A. Mod.; 1992), pp. 57–62
Iza, Jácome, Román, Unda: Los cuatro mosqueteros (exh. cat. by H. Rodríguez and R. Jácome Durango, Quito, Fund. Cult. Exedra, 1993)
L. Oña: 'Ecuador', *Latin American Art in the Twentieth Century*, ed. E. Sullivan (London, 1996), pp. 180–89

LENIN OÑA

V. Patronage, museums and art libraries.

The evangelizing missions of the Spanish religious orders led quickly to the construction of churches and other religious buildings in Ecuador. In response to the need to decorate these, numerous workshops appeared throughout Quito, where master craftsmen were aided by skilled artisans and apprentices. Many workshops located near monasteries established regular working relationships with various orders. Such patronage also occurred in other towns: in El Tejar, for example, the order of Nuestra Señora de la Merced patronized José Cortés.

Pedro Bedón (1556–1621), the first significant artist in Quito, grouped mestizo and Indian painters into the Cofradía del Rosario, an artistic guild, and helped them with the creation and sale of their paintings. In some instances paintings were used by artists as payment in kind: Miguel de Santiago (1626–1706), for example, left many paintings in the lower cloister of the monastery of S Agustín, Quito, where he was protected by the monks for a number of years from imprisonment for an act of disrespect to the authorities. Church patronage continued throughout the 18th century, with such artists as Bernardo Rodríguez (*fl* 1775–1803) and Manuel Samaniego y Jaramillo being attached to Quito Cathedral.

In the 19th century, commissions for paintings celebrating the achievement of independence were given to, among others, Antonio Salas (1790–1860), to whom a portrait of *Simón Bolívar* (1829; Oswaldo Viteri priv. col.) is attributed. The need for new civil buildings in the early years after independence also led to a number of commissions in the field of architecture, especially in Quito (*see* §III, 2 above). In the 20th century the state was responsible for numerous artistic commissions, including those for the sculptural mural *Quito* (1976–7) at the Municipio de Quito, by Jaime Andrade, and others by Humberto Moré in a number of parks in Quito. Moré was also commissioned to produce a sculptural mural for the company Mutualista Previsión y Seguridad, Quito. Notable private collectors in the 20th century included the poet Alfredo Gangotena, who collected modern realist works.

Few museums in Ecuador pre-date the 20th century, although the Universidad Central del Ecuador, founded in Quito in 1769, had its own museum, and in Guayaquil the Museo Municipal was opened in 1862 with a collection that eventually included colonial and modern painting as well as numismatics. The first major museum founded in the 20th century was the Museo de Arte Colonial (est. 1914) in Quito, with a collection that spanned the colonial period. In 1930 the Museo de Arte e Historia de la Ciudad was founded, also in Quito, with a collection of painting and sculpture and documents relating to the city's past. Religious museums operating in the capital in the late 20th century included those of the Franciscan and Dominican monasteries and the museum of the Jesuits.

Between 1920 and 1940 a number of local museums sprang up in response to important archaeological discoveries. Other important museums outside Quito at the end of the 20th century included the Museo de Artesanías, the Museo Municipal and the Museo del Monasterio de la Concepción, all in Cuenca; the museum of the order of La Concepción in Riobamba, established on the initiative of Ricardo Descalzi and rich in colonial gold- and silverwork; and the Centro Cultural in Guayaquil, which has collections of colonial and modern painting and sculpture. A number of provincial capitals also have regional museums, often with collections of Pre-Columbian pottery. The small town of Cajabamba-Cicalpa has a museum with a collection of exquisitely cut stones from the sites of ruined monasteries at the original city of Riobamba, destroyed by an earthquake in 1797. Another important development in the 20th century was the establishment of museums by private institutions such as banks, either in their local branch offices or as separate entities. The Museo

Antropológico y Pinacoteca del Banco Central del Ecuador, founded in 1974 in Guayaquil, for example, houses a collection of archaeological items and contemporary Latin American art.

Art libraries in Ecuador include the Biblioteca de la Casa de la Cultura Ecuatoriana and the Biblioteca de Arte de la Fundación Guayasamín, both in Quito. An important photographic collection is held at the Departmento de Investigaciones Históricas of the Banco Central del Ecuador, also in Quito.

BIBLIOGRAPHY
J. G. Navarro: *Guía artística de Quito* (Quito, 1961)
H. Crespo Toral, F. Samaniego Salazar and J. M. Vargas: *Arte ecuatoriano*, 2 vols (Quito and Barcelona, 1976)
RICARDO DESCALZI

VI. Art education.

Painting, drawing, sculpture and crafts were first taught immediately after the conquest to Indians in the Colegio de S Juan (later the Colegio S Andrés) in Quito, run from 1535 by the Franciscan Pedro Gosseal ('Pedro el Pintor'). Young artists were also trained in the workshops of individual artists and subsequently joined painting and sculpture guilds, such as the Cofradía del Rosario, Quito, run by the Dominican friar Pedro Bedón (1556–1621). A further two monastic schools were established in the 18th century.

Religious teaching institutions continued to exist during the 19th century, and several secular establishments were also founded. The first was initiated by the French artist Ernst Charton and was followed in 1852 by the Escuela Democrática Miguel de Santiago, Quito, where exhibitions were held. The Escuela de Bellas Artes was established by the state in Quito in 1872; the painter Luis Cadena was its first Director. The school closed, however, in 1875 and did not reopen until 1904.

In 1902 the Escuela de Pintura was founded in Cuenca. Increased concern with art education also led to teaching from secondary-school level through to university. There were several university-level institutions dedicated to fine art by the late 20th century, including the Academia de Bellas Artes 'Remigio Crespo Toral' in Cuenca. Faculties of fine arts also existed in a number of universities, such as the Universidad Central de Ecuador, Quito.

Design was first taught at specialist institutions from the early 1970s, and by the late 20th century there were seven design training centres, including the school of design and decoration at the Universidad Laica 'Vicente Rocafuerte' de Guayaquil. By the same period universities throughout the country were offering architectural courses, such as that at the Universidad Técnica Particular de Loja.

BIBLIOGRAPHY
E. Ayala Mora, ed.: *Nueva historia del Ecuador*, ix (Quito, 1988)
A. Kennedy: 'Del taller a la academia: Educación artística en el siglo XIX en Ecuador', *Procesos*, ii (1992)
LENIN OÑA

Egas, Camilo (*b* Quito, 1889; *d* New York, 18 Sept 1962). Ecuadorean painter and teacher, active in the USA. He studied at the Escuela de Bellas Artes, Quito (1904–11), and received a government grant to study at the Regia Scuola di Belle Arti in Rome (1911–14) and at the

Academia de San Fernando in Madrid in 1920. His ideology and aesthetic of this period relate him to Spanish *modernismo*. The more monumental style used in *Procession* (1922; Quito, Mus. Camilo Egas Banco Cent.) marks a transition before his years in Paris. In 1923 he attended the Académie Colarrosi, exhibiting between 1924 and 1925 at the Salon des Indépendants and at the Salon d'Automne. He returned to Ecuador between 1925 and 1927 and played a pivotal role in forming the Indigenist movement. The theme of the Indian in his work was related to the rise of Socialism, national indigenous movements and the constitution of Marxist parties in Latin America. He founded Ecuador's first art periodical, *Helice*, in 1926. In 1927 he settled in New York and consecutively assimilated various styles: firstly social realism (e.g. *Street 14*, 1937; Quito, Mus. A. Mod.); then Surrealism, neo-Cubism and finally Abstract Expressionism. In the 1930s, his work included two murals, *Harvesting Food in Ecuador: No Profit Motif in Any Face or Figure* and *Harvesting Food in North America* (New York, New Sch. Soc. Res.). He taught from 1932 and was the first director of art of the New School for Social Research, New York. The Museo Camilo Egas in Quito was inaugurated in 1981 with a permanent exhibition of his work, now closed. The collection belongs to the Banco Central del Ecuador, and some pieces are exhibited at the Museo Nacional del Banco Central, Quito.

BIBLIOGRAPHY

Historia del Arte Ecuatoriano, 4 (Quito, 1977), pp. 44–52
Camilo Egas (exh. cat., Quito, Mus. Camilo Egas Banco Cent., 1978)
M. Monteforte: *Los Signos del hombre* (Quito, 1985), pp. 251–2
M. Trinidad Pérez: *The Indian in the 1920s Painting of the Ecuadorian Painter Camilo Egas* (MA thesis, Austin, U. TX, 1987)
T. Pérez: 'La apropiación de lo indígena popular en el arte ecuatoriano del primer cuarto de siglo: Camilo Egas (1915–1923)', *Artes académicas y populares del Ecuador*, ed. A. Kennedy (Quito, 1995), pp. 143–74

ALEXANDRA KENNEDY

Egenau, Juan (*b* Santiago, 24 Feb 1927; *d* Santiago, 22 April 1987). Chilean sculptor. He studied architecture at the Universidad Católica de Chile in Santiago (1947–8) before transferring to the Escuela de Bellas Artes at the Universidad de Chile, also in Santiago, where he studied painting, drawing and printmaking from 1949 to 1952. In 1959 he obtained a scholarship to study goldwork at the Scuola Porta Romana in Florence. In 1962 he took a course in casting at the Escuela de Artes Aplicadas at the Universidad de Chile, at the same time producing ceramics, enamels and sculptures. While studying casting on a Fulbright scholarship in 1968 at the Rhode Island School of Design in Providence, RI, he developed a technique of modelling for sand-casting in aluminium, which he used exclusively in his later work. From 1956 until his death he was professor of fine arts at the Universidad de Chile.

Egenau experimented with a spontaneous manner in his early work, first in bronze and later in aluminium, observing natural shapes and their interrelationships as a paradigm of order and harmony. Through these concerns he became interested in transcending history and in tracing human experience back to its mythic origins: in his *Ancestors* series, which he began in *c*. 1966, such as *Monumental Ancestor* (1969; Santiago, Pontificia U. Católica), he externalized his investigation into origins by presenting them, in the manner of genetic coding, as the first models of psychic structures and human behaviour.

In the early 1970s Egenau examined the human reliance on modern technology on the basis of its utility, efficiency and scientific principles. Directing his attention to technical instruments, he sought to analyse their purpose and mode of operation, adopting the schematic language of his source material but suspending or neutralizing its function. In other works he took the human figure as his subject-matter, initially suggesting its presence by means of very simple archaic forms and later in the form of classically structured torsos made of aluminium. The optimistic tone of these works was tempered by intimations of insecurity, aggression and destruction, which he conveyed by protecting them with a hermetic metal armour-plating, as in *My Conquered Love* (1978; Santiago, Mus. N. B.A.). In the mid-1980s he produced his *Black Series* of sculptures, in which he concealed the shiny metal surface in black paint, extending his longstanding interest in mysterious origins and ambiguous meaning.

BIBLIOGRAPHY

Egenau Juan: La alquimia de la materia (exh. cat., essay by M. Ivelić; Santiago, Gal. Epoca, 1986)
Egenau Juan: De metal y de fuego (exh. cat., essay by M. Ivelić; Santiago, Inst. Cult. Las Condes, 1988)

MILAN IVELIĆ

Egerton, Daniel Thomas (*b* England, 1797; *d* Tacubaya, Mexico City, 27 April 1842). English painter, draughtsman and engraver, active in Mexico. He exhibited with the Royal Society of British Artists, of which he was a founder-member, between 1824 and 1829. Inspired by the writings of Alexander Humboldt, he travelled to Mexico in 1830 and from 1831 made a series of sketches of landscapes including views of mines, ranches and cities. Twenty-five oil paintings and more than a hundred watercolours and drawings in red chalk date from this period. On his return to England, his pictures were made into prints to form an album of colour lithographs. As the record of a travelling artist, the album contributed to a fashionable genre of the period. Egerton's work depicted an abundant natural world and prosperous towns, with each urban or rural landscape inhabited by people dressed in traditional costume, who are generally positioned in the foreground and surrounded by typical local vegetation (e.g. *View of the Valley of Mexico* (1837; Mexico City, Dept. Distr. Fed.). In 1841 Egerton returned to Mexico with his wife and settled in the capital. They were both murdered in 1842.

PRINTS

Views of Mexico (London, 1840)

BIBLIOGRAPHY

E. Gutiérrez and T. Gutiérrez: *Daniel Thomas Egerton* (Mexico City, n.d.)
M. Kiek, ed.: *Egerton en México, 1830–1842* (Mexico, 1976)
F. Ramírez: 'La visión europea de la América tropical: Los artistas viajeros', *Hist. A. Mex.*, 67–9 (1982)
Art in Latin America: The Modern Era, 1820–1980 (exh. cat. by D. Ades and others, London, Hayward Gal., 1989), pp. 41–61
F. Anders and others: *European Traveller-Artists in Nineteenth-century Mexico* (Mexico City, 1996)

ELOÍSA URIBE

Ehrenberg, Felipe (*b* Mexico City, 27 June 1943). Mexican painter, printmaker, performance artist, writer, teacher and publisher. He qualified as a printmaker at a very early

age, then as a painter and engraver under the tutelage of several masters, among whom the most influential on his life was José Chávez Morado. Although he at first worked with traditional media, he possessed a constantly innovative and critical attitude and experimented with performances, installations, happenings, correspondence and media art, as well as writing, lecturing and publishing on such themes as artistic experimentation, cultural promotion, professional management for artists, collective mural painting and the publishing process. From 1968 to 1972 Ehrenberg lived in England where, with the architect Martha Hellion and the critic and historian David Mayor, he founded the Beau Geste Press/Libro Acción Libre in Devon, to propagate the work of artists involved with the Fluxus movement of the 1970s. He was also instrumental in the rise of many artistic groups, workshops and small publishing houses, such as Grupo H$_2$O/Talleres de Comunicación, in which tutors gave workshops on editorial work and collective mural painting. He was involved in numerous collective mural projects in Mexico.

BIBLIOGRAPHY
R. Tibol: *Gráfica y neográfica* (Mexico City, 1987)
J. A. Manrique: *Artistas en divergencia* (Mexico City, 1988)
C. Monsiváis: *Entrada libre* (Mexico City, 1988)
N. García Canclini: *Culturas híbridas* (Mexico City, 1990)
Felipe Ehrenberg: Pretérito imperfecto (exh. cat., Mexico City, Mus. A. Carrillo Gil, *c*.1993)
Manifiesta: Muestra de instalaciones y performance de Felipe Ehrenberg, Helen Escobedo, Marcos Kurtycz (exh. cat., Mexico City, Cent. Cult. S Teresa, 1993)
JULIETA ORTIZ GAITÁN

Eleta, Sandra (*b* Panama City, 4 Sept 1942). Panamanian photographer. She studied art history at Finch College, New York (1961–4), and in the following three years painted in Spain. In 1972–3 she was Instructor of Photography at the Universidad de San José, Costa Rica, and from 1974 worked as a freelance photographer in Panama. Her photographs were not merely reportage, although they provide a documentary record of daily life in Panama, but also give a vivid picture of the character of the Panamanians. This is particularly marked in her photographic study of three peasant women from the Tonosi Valley, and in her series on the village and people of Portobelo.

PHOTOGRAPHIC PUBLICATIONS
Portobelo (Buenos Aires, 1981)

BIBLIOGRAPHY
Contemp. Phots
M. C. Orive and others: *Sandra Eleta: Portobello, fotografía de Panamá* (Buenos Aires, 1991)
A. Hopkinson, ed.: *Desires and Disguises: Five Latin American Photographers* (London, 1992), pp. 17–28
ERIKA BILLETER

El Salvador, Republic of [Sp. *República de El Salvador*]. Central American country. It is bordered to the north and east by Honduras, to the south-east by the Gulf of Fonseca, to the south by the Pacific Ocean and to the west by Guatemala (see fig. 1). It covers an area of 21,200 sq. km and has a population of over five million; *c.* one million live in the capital, San Salvador, which is located in the central southern region of the country. The territory is subdivided politically into 14 departments. El Salvador gained independence from Spanish colonization in 1821. This article covers the art and architecture produced since colonial times.

1. ARCHITECTURE. The Spanish colonial conquest and rule began with the discovery of El Salvador by Andrés Niño in 1522. Within the Viceroyalty of Guatemala, El

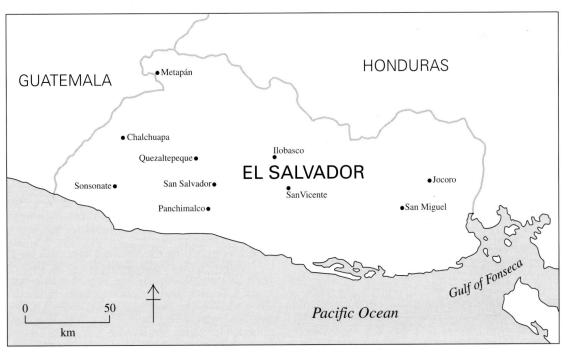

1. Map of El Salvador

Salvador was of immense value for its agricultural wealth. In the struggle for independence in Central America, San Salvador was the first city to rebel, and the country played a leading role in Central American integration, with the establishment in 1951 of the Organización de Estados de Centro América (ODECA), the headquarters of which were in San Salvador. The capital was founded in 1525 by Pedro de Alvarado near a volcano. The early adobe and thatch settlement was destroyed by an earthquake in 1575 and reconstructed on its present site in the second half of the 17th century. When Antigua was destroyed in 1773 San Salvador became the largest city in Central America, and in 1786 it became the seat of an Intendancy within the Audiencia of Guatemala. Further earthquakes in 1789, 1854 and 1873 wiped out virtually all of the capital's colonial architecture, including the cathedral and town hall; little remains from the 16th and 17th centuries, although a few buildings survive from the 18th. One of the most significant is the massively constructed church del Pilar (1762–9) at San Vicente, whose nave arcades and barrel-vaulted roof have survived successive tremors. A unique pentagonal arch over its entrance doorway and a single octagonal opening above it enhance the impression of strength, though the highly original façade with its bolster (*almobadillado*) pilasters is reminiscent of architecture in Antigua. The church at Metapán (1743) has nave walls strengthened by pilasters and centrally placed columns, suggesting Mexican influence. Also of interest are the parish churches around San Salvador with roofs framed and decorated in *Mudéjar* style. Santa Cruz in Panchimalco (see fig. 2), 15 km south of the capital, is perhaps the best known. Rebuilt and enlarged in the mid-18th century, it has fine carved and painted column-brackets, cross-ties and rafters and unusual octagonal framing to the roof of the main chapel reminiscent of Los Dolores (1732), Tegucigalpa, Honduras. A low and wide entrance archway is the only opening in a sturdy façade that emphasizes the

2. El Salvador, Panchimalco, Santa Cruz, main façade, mid-18th century

horizontal and rises to a voluted third storey whose modest termination reflects the suggestion of towers at either end. Other examples are the nunnery churches of S Sebastián (*c.* 1880) and Santiago, now in the San Salvador suburbs of the same name, and at Jocoro in the east, where a scalloped pediment is enlivened with stucco Baroque reliefs.

In a plan of 1788 for the Casa Reales (Seville, Archv Gen. Indias), Pedro Guerrero aimed to bring together in a single block of domestic scale all the administrative sections for the new intendancy, contained within a square of the San Salvador city grid. Uniform, arcaded, single-storey façades to the surrounding streets gave access through decorated portals via common vestibules to the house for the Intendente, the Cajas Reales, Renta de Tabaco and Aduana. 18th-century urban houses survive in San Miguel and elsewhere. Towards the end of the 19th century the city became dominated by structures of timber and stamped metal sheeting, a fine example of which is the Candelaria church, San Salvador (completed 1891). Neo-classical design continued into the 20th century even after the introduction of reinforced concrete and steel-framed structures in such buildings as the Teatro Nacional (1930).

Increased American influence brought a period of progress and development in the 1950s and the introduction of the International Style. Housing the increasingly numerous landless poor brought the introduction of suburban and rural rehousing under such agencies as the Fundación Salvadoreña de Desarrollo y Vivienda Mínima (FUNDASAL). The earthquake of 1986 destroyed many urban buildings of the 1950s and 1960s, even though they were intended to be earthquake-resistant.

2. PAINTING, SCULPTURE AND OTHER ARTS. Among the indigenous population, various arts and crafts continued to be practised following colonization. Prominent among these was pottery, which had a strong tradition influenced by Mexican ware but with distinctive linear and geometric patterns. Basketry, matmaking and weaving were also practised. Painting and sculpture were practised only by the Spanish colonizers, as were decorative arts such as leatherwork, gold- and silversmithing and cabinet-making. Traditional items continued to be manufactured in the late 20th century at a number of sites, including Ilobasco, where erotic miniatures of painted clay were made in pottery workshops using modern designs, and Quezaltepeque, which produced crockery.

As in other Latin American countries, colonial painting and sculpture in El Salvador had a strong religious content, through the influence of Spain, and many leading painters were also prominent sculptors. Unfortunately, natural disasters have destroyed much of what existed. Works of the highest quality were commissioned from the capital of the Viceroyalty, Guatemala, whose school of painting rivalled those of Mexico and Peru. In both churches and private collections there are paintings from the Spanish period executed by Guatemalans. Outstanding among these are the altarpieces of several colonial churches, such as that of the church of Sonsonate, executed in 1582 by Quirio Cataño (1550–1622) and Antonio Rodas, and that of Panchimalco. Painting was almost entirely anonymous

and eclectic, while candid and naive in style. The artists, often monks or people of mixed race, showed the latent influence of native motifs and elements of the natural environment in repeated patterns and elaborate foliage. Much of the decorative work on sculptures was executed by anonymous local craftsmen. The influence of indigenous skills in sculpture also led to the use of such materials as corn and bone, in addition to cedar and mahogany. Imagery was simplistic but vigorous, and the style echoed the elaborate realism of European Baroque sculpture.

Silvestre Antonio García (*d* 1807) carved the renowned image of Christ, *Salvator mundi* (1777), that is housed in San Salvador's cathedral (begun 1950s; designed by José María Durán). Francisco W. Cisneros (1823–78) reached prominence following independence, but few of his works remain in El Salvador, as he settled abroad. Pascasio González (1848–1917) was a sculptor, architect, painter and quilter; in collaboration with his former pupil Marcelín Carballo (1874–1949) he painted images in the capital's cathedral. The real initiator of a post-Independence artistic style was the painter and sculptor Carlos Alberto Imery (1879–1949), a student of Carballo, who studied in Rome, France and Spain before returning in 1912 to found the Escuela Nacional de Artes Gráficas in San Salvador, which produced many successful artists. In 1936 the Spanish master Valero Lecha (1894–1976) founded another academy of painting, from which many successful artists emerged to promote modernism in El Salvador. Other leading painters included Mauricio Aguilar (1919–78), whose *Pear* (1973; see 1985 exh. cat., p. 161) is typical of his expression of the effect of light on natural objects, and Benjamín Cañas (1933–89), whose interest in the absurd is shown in the series *Kafka: Letters to Milena* (1976; see 1985 exh. cat., p. 163).

The most prominent 20th-century sculptor was Valentín Estrada (1902–84). While displaying an academic realism in portraits and idealized monuments (e.g. portrait of the hunting Indian *Atlacatl*, 1924–5; see Mariño Sánchez and others, fig. 78), he also adapted the formal vocabulary of ancient native traditions in such works as the open-air sculpture *Shiutetl, God of Fire* (1955; San Salvador, Planes de Renderos). The Spanish artist Benjamín Saúl (1924–80) settled in El Salvador in 1964. His contorted and playful female nudes (e.g. *Woman Lying Down*, 1968; San Salvador, Edificio de la Centroamericana priv. col.) had a lasting influence on his pupils, who included Dagoberto Reyes, Mauricio Jiménez Larios, Osmín Muñoz, Carlos Velis, Alberto Ríos Blanco, René Ocón and Andrés Castillo, and with whom he formed the short-lived sculpture cooperative Grupo UQUXKAH for the purpose of executing the abstract work *Monument to the Sea* (bronze, 1971; San Salvador, 25 Avenida Norte). The metal sculptures of Rubén Martínez, notably the passion cycle *Via Crucis* (1980; San Salvador, Iglesia del Rosario) brought him considerable acclaim.

3. PATRONAGE, MUSEUMS AND ART EDUCATION. The Museo Nacional David J. Guzmán in San Salvador was founded in 1883 and houses archaeological, ethnological and historic collections. Artistic institutions promoting the plastic arts include the Asociación de Artistas Plásticas de El Salvador, the Asociación Salvadoreña de Trabaja-

dores del Arte y la Cultura and the Unión General de Autores y Artistas Salvadoreños. Non-profit-making private institutions exist to support the arts, such as the Patronato Pro-Patrimonio Cultural y Asociación del Patrimonio Cultural de Santa Ana, which supports government efforts in the preservation of and research into the national heritage. The Patronato Pro-Cultura fosters the plastic arts, music and dance, and the Patrimonio Pro-Arte is dedicated to music and the theatre. The Universidad Dr José Matías Delgado in San Salvador was founded in 1977 and has departments of fine and applied arts. The Consejo Nacional para la Cultura y el Arte (CONCULTURA) was created in 1991 by the Ministry of Education with the aim of contributing to the investigation, preservation, patronage, advancement and dissemination of culture and the arts.

BIBLIOGRAPHY
A. Guerra Triqueiros: 'The Colonial Churches of El Salvador', *Bull. Pan Amer. Un.*, lxxii (1938), pp. 271–9
Ars, 1 (1951) [issue on El Salvador]
D. Angulo Iñíguez: *Historia del arte hispanoamericana*, iii (Barcelona, 1956), pp. 62–74
J. Sanz y Díaz: 'Pintores salvadoreños contemporáneos', *Ars*, 8 (1957), pp. 53–69
O. M. Monedero: *Historia de la arquitectura contemporánea en El Salvador* (San Salvador, 1970)
J. Casin de Montes: 'Arte colonial de El Salvador: Criterios de valorización estética', *Estud. Centamer.*, xxviii (1973), pp. 243–5
C. Mariño Sánchez and others: *Desarrollo de la escultura en El Salvador* (San Salvador, 1974)
Selections from the Permanent Collection (exh. cat. by J. C. Baena Soares, R. Novey and M. Traba, Washington, DC, Mus. Mod. A. Latin America, 1985)
J. R. Cea: *De la pintura en El Salvador* (San Salvador, 1986)
J. A. Fernández: *El Salvador: La huella colonial* (San Salvador, 1996)
M. Kupfer: 'Central America', *Latin American Art in the Twentieth Century*, ed. E. Sullivan (London, 1996), pp. 51–79

CLAUDIA ALLWOOD DE MATA

Endara Crow, Gonzalo (*b* Quito, 1936; *d* Quito, 14 April 1996). Ecuadorean painter and sculptor. He studied at the Faculty of Arts of the Universidad Central in Quito (1971) and then taught at the Escuela de Bellas Artes de Loja. In 1977 he gave up teaching to concentrate on his career as an artist. He was a proponent of the naive style of fantastic realism, which corresponded in Latin American visual art to magic realism in literature and constituted a typically Latin American expression of the paradoxes of everyday reality. In his studies of the life of the mestizo population of the Andean world, Endara Crow chose themes based on people's daily lives, depicting, for example, horses pulling bells up the sides of mountains and animals and birds peering out from the upper floors of picturesque provincial houses, in images bordering on magic and the bizarre. In his painting Endara Crow worked mostly in acrylic. He also created colourful sculptural monuments and murals. His work was exhibited internationally, and he was awarded many prizes, including the Swiss International Naive Painting prize in 1982 and an award at the 1st Bienal de La Habana, Cuba, in 1984. He was a member of the Henri Rousseau group.

BIBLIOGRAPHY
H. Rodríguez Castelo: 'Gonzalo Endara Crow', *Rev. Diners*, 15 (1983), pp. 44–8
Gonzalo Endara Crow (exh. cat., Quito, La Manzana Verde, 1984)

C. Suárez: *Endara Crow* (Quito, 1986)
H. Rodríguez Castelo and others: *Gonzalo Endara Crow* (Quito, 1990)

CECILIA SUÁREZ

Ender, Thomas (*b* Vienna, 3 Nov 1793; *d* Vienna, 28 Sept 1875). Austrian painter active in Brazil. He studied at the Akademie der Bildenden Künste in Vienna, where from the start he was interested in recording landscape, especially in watercolour. As a protégé of Chancellor Metternich he was appointed artist to the Austrian scientific mission that left for Brazil in 1817 accompanying Dona Leopoldine, the Archduchess of Austria and the Imperial Brazilian princess. During his ten-month stay in Brazil, spent mainly in Rio de Janeiro, São Paulo and in trips between the two cities, he depicted landscapes, people, architecture, everyday implements and the flora and fauna of the region in nearly 800 watercolours and drawings (Vienna, Bib. Akad. Bild. Kst.). Careful detail outweighs the intrusion of a certain exoticism in these works, as can be seen, for example, in *Guanabara Bay* (1817; São Paulo, Mus. A.). On his return to Austria, and after a sightseeing and study trip through Italy, he became professor of landscape painting in the Akademie der Bildenden Künste in Vienna between 1836 and 1851.

BIBLIOGRAPHY
J. F. de Almeida Prado: *Thomas Ender: Pintor austriaco na corte de D. João VI* (São Paulo, 1955)
G. Ferrez: *O velho Rio de Janeiro através das gravuras de Thomas Ender* (São Paulo, 1957)
——: *O Brasil de Thomas Ender* (Rio de Janeiro, 1976)
G. Kaiser and R. Wagner: *Thomas Ender, Brasilien-Expedition, 1817: Aquarelle aus den Kupferstichkabinett der Akademie der Bildenden Künste Wien* (Washington, DC, Lib. Congr., 1993)

ROBERTO PONTUAL

Enríquez, Carlos (*b* Zulueta, nr Remedios, 3 Aug 1900; *d* Havana, 2 May 1957). Cuban painter. He studied painting in secondary school in Cuba and then for a short time in 1924 at the Pennsylvania Academy of Fine Arts in Philadelphia. In the USA he met and married the American painter Alice Neel; they were divorced some years later. Upon his return to Cuba in 1925 he continued painting on his own and became involved with the group of avant-garde painters and writers seeking to break with the Academy. Enríquez's unconventional, erotic drawings and paintings focused on subjects such as a nude woman on a horse (pen and ink drawing, 1930; Miami, FL, Cub. Mus. A. & Cult.). They shocked even the most open-minded and were withdrawn from various exhibitions in the late 1920s. From 1930 to 1933 Enríquez lived in Spain and France, where he became interested in Surrealism. His first individual exhibition took place at the Lyceum in Havana in 1934, soon after his return to Cuba, but it was closed almost immediately because of its scandalous content.

In paintings such as *Horsewoman* (1932; Havana, Mus. N. B.A.), contact with Surrealism led Enríquez to depict disembodied forms, X-ray images of body parts and scenes of violence and sexuality in veil-like areas of tan, white and green. After 1934 he dealt increasingly with Cuban rural folklore and myths in such paintings as the *Abduction of the Mulattas* (1938) and the *King of the Cuban Fields* (1934; both Havana, Mus. N. B.A.). Enríquez used the term 'romancero guajiro', which can be translated as 'the romantic spirit of the Cuban peasant', to describe his interest in folklore. This preoccupation with Cuban themes can also be found in Enríquez's novel *Tilín García* (Havana, 1939) and other writings by him. The 1940s and 1950s were a period of great productivity, characterized by female nudes in which tones of green predominate.

BIBLIOGRAPHY
A. de Juan: 'Carlos Enríquez en Cuba', *Pintura cubana: Temas y variaciones* (Havana, 1978, 2/Mexico City, 1980), pp. 71–4
Carlos Enríquez (exh. cat., Havana, Mus. N. B.A., 1979)
Carlos Enríquez (exh. cat., ed. C. Luis; Miami, FL, Cub. Mus. A. & Cult., 1986)
J. Martínez: *Cuban Art and National Identity: The Vanguardian Painters, 1925–50* (Gainesville, 1994)
N. G. Menocal: 'An Overriding Passion: The Quest for a National Identity in Painting', *J. Dec. & Propaganda A.*xxii (1996), pp. 187–219

GIULIO V. BLANC

Escalante, Constantino (*b* Mexico City, 1836; *d* Mexico City, 1868). Mexican illustrator and printmaker. Although a portrait by him of his music teacher Pedro Picasso was accepted into the Academy's exhibition of 1855, his work as an illustrator did not take an academic route. He became involved with liberal politics at the close of the Guerra de los Tres Años in 1861 and was the first caricaturist on the bi-weekly review *La Orquesta*, which was founded in that year. Escalante worked for the magazine until his death in 1868, producing 514 lithographs that provide a detailed vision of Mexico's history through his critical eyes; he dealt most frequently with foreign invasions and the relationship between the Church and state. Working largely for an illiterate public, he used his caricatures to draw attention to some of the problems that oppressed his fellow countrymen. He also produced independent albums of lithographs such as National glories (*Glorias nacionales*), which was sponsored by Vicente Riva Palacio (1832–96), the director of *La Orquesta*. He died in a streetcar accident at the age of only 32.

WRITINGS
Glorias nacionales (Mexico City, 1863, rev. 1867)

BIBLIOGRAPHY
R. Carrasco Puente: *La caricatura en México* (Mexico City, 1953), pp. 37–8, 63–7
E. Acevedo: *Constantino Escalante en el periódico 'La Orquesta'* (diss., Mexico City, U. Iberoamer., 1975)
E. Acevedo: *Constantino Escalante: Un mirada irónica* (Mexico City, 1996)

ESTHER ACEVEDO

Escobar, Marisol. *See* MARISOL.

Escobedo, Helen (*b* Mexico City, 28 July 1934). Mexican sculptor and museum administrator. She studied in 1950–51 at Mexico City College (now Universidad de las Américas), where she was introduced to sculpture by the renowned abstract artist, Germán Cueto. Awarded a travelling scholarship to the Royal College of Art, London (1951–4), Escobedo met luminaries of European sculpture, including Henry Moore, Jacob Epstein and Ossip Zadkine, who profoundly influenced her sense of organic integrity in form and material. It became clear to her that sculpture as museum piece or domestic ornament did not fulfil her objectives. During the 1960s and early 1970s Escobedo created works on a monumental scale and

became well known for such ambitious urban sculptures as *Signals* (painted aluminium, h. 15 m, 1971), sited at Auckland Harbour, New Zealand, and *Doors to the Wind* (painted reinforced concrete, h. 17 m, 1968) at Anillo Periférico and Calzada del Hueso on the Olympic Friendship Route, Mexico. From the 1980s she directed her work towards ecological and humanitarian issues. A number of site-specific installations and performances explored the theme of the densely populated metropolis of Mexico City. While conscious of the social meaning of art, her approach was abstract and conceptual rather than overtly realist. She used natural materials, such as interwoven branches and grass, or the detritus of urban life. As a cultural promoter, she held such positions as director (1958–82) of the museum of the Universidad Nacional Autónoma de México, and director (1983–5) of the Museo de Arte Moderno, Mexico City.

BIBLIOGRAPHY

C. Gorostiza: *Escultura mexicana contemporánea* (Mexico City, 1960)
R. Eder: *Helen Escobedo* (Mexico City, 1982)
Helen Escobedo: Lawn Figures (exh. cat., Oxford, MOMA, 1992)
Manifiesta muestra de instalaciones y performance de Felipe Ahrenberg, Helen Escobedo, Marcos Kurtycz (Mexico City, 1993)
G. Schmilchuk: 'Escultura arquitectónica, monumental y ambiental', *México en el mundo de las colecciones de arte*, vi (Mexico City, 1994), pp. 117–239

RITA EDER

Escoffery, Gloria (*b* Gayle, St Mary, Jamaica, 22 Dec 1923). Jamaican painter and writer. She studied at McGill University, Montreal, and the Slade School of Fine Art, London. She began painting in the 1940s and is best known for her depictions of life in rural Jamaica. Other works have surreal imagery and often include art historical and literary references. Typically, even her genre scenes have surreal overtones: slightly distorted figures appear alienated and isolated and are placed in desolate settings. In many works she combined figurative elements with abstract geometrical elements such as patterned borders or geometrically structured backgrounds. A fine colourist, she worked in oil and acrylic as well as watercolour and gouache. One of her masterworks is the five-panel *Mirage* (1987; Kingston, N.G.). She was perhaps Jamaica's most important art critic and for many years wrote for *Jamaica Journal*.

BIBLIOGRAPHY

D. Boxer and V. Poupeye: *Modern Jamaican Art* (Kingston, 1998)

VEERLE POUPEYE

Escuelas de Pintura al Aire Libre. Open-air painting schools developed in Mexico as artistic teaching projects for broad sections of the population during the period of the Revolution (1910–17). The first phase of their existence took place under Victoriano Huerta's government (1913–14), and their structure was established under the government of Alvaro Obregón (1920–24). Alfredo Ramos Martínez was the project's main promoter, supported by civil servants, intellectuals and artists. The precepts by which art was to be taught were based on those of John Dewey's Action School in the USA; children and adolescents, farmers and factory workers were to meet and develop their own ideas with sincerity and simplicity, taking as their model the Barbizon school of landscape painting, with its devotion to contact with untamed nature.

The first of the *escuelas*, situated at Santa Anita Ixtapalapa on the outskirts of Mexico City, was named Barbizon. Impressionism, a great deal of naive art and a certain involuntary expressionism were all blended together in the works of the students, who needed no formal qualifications to enter the schools. David Alfaro Siqueiros was among them. The project was extended to Chimalistac and moved on in 1921 to Coyoacán, where an attempt was made to involve native Mexicans and mestizos in order to encourage the production of a uniquely Mexican art. Under the government of Plutarco Elías Calles (1924–8), the open-air painting schools system was expanded to include branches in Xochimilco, Tlálpan and Guadalupe Hidalgo. This expansion, which reached the states of Michoacán and Puebla in the 1930s, was due to the enormous need for expression that arises in periods of transition and social upheaval, when a society's cultural traditions are under attack. In 1932 the schools' name was changed to Escuelas Libres de Pintura; entry requirements were also changed. In 1935 government subsidies, already reduced, finally ceased, and the schools went into decline. The Tasco school, under the Japanese director Tamiji Kitagawa (1894–1990), was the last to disappear in 1937, having survived for two years on local resources. Several thousand students attended the open-air painting schools, and their works were exhibited in Berlin, Paris and Madrid in 1926 with great success. During their rise to fame, the schools were enthusiastically supported by Diego Rivera, Alfonso Reyes (1889–1959), Pierre Janet (1859–1947), Eugenio d'Ors and Dewey; during their decline, they were criticized by Siqueiros and Rufino Tamayo.

BIBLIOGRAPHY

R. Martínez and others: *Monografía de las Escuelas de Pintura al Aire Libre* (Mexico City, 1926)
Homenaje al movimiento de Escuelas de Pintura al Aire Libre (exh. cat. by S. Pandolfi and others, Mexico City, Inst. N. B.A., 1981)
Escuelas de Pintura al Aire Libre y Centros Populares de Pintura (exh. cat., Mexico City, Inst. N. B.A., 1987)
S. Pandolfi: 'The Mexican Open-Air Painting Schools Movement (1913–1935)', *Images of Mexico: The Contribution of Mexico to 20th Century Art* (exh. cat., ed. E. Billeter, Frankfurt am Main, Schirn Ksthalle; and elsewhere, 1988), pp. 123–8

RAQUEL TIBOL

Escurialene style. *See* ESTILO DESORNAMENTADO.

Espínola Gómez, Manuel (*b* Solís de Mataojo, Lavalleja, 5 July 1921). Uruguayan painter. Having shown an early talent as a portrait painter, he was encouraged by the Uruguayan composer and violinist Eduardo Fabini, who posed for him several times, to study formally. With Fabini's help he obtained a scholarship to study, briefly, at the Círculo de Bellas Artes of Montevideo under the Uruguayan master Guillermo Laborde (1886–1940) and later under José Cúneo. In 1946 he won second prize at the Salón Nacional de Bellas Artes in Montevideo, and in 1948, together with Washington Barcala, Luis Solari and Juan Ventayol (1911–71), he founded the Grupo Carlos Federico Sáez, which had a dynamic effect on local art circles. Espínola Gómez was much affected by his visit to the São Paulo Biennale in 1953, where he saw Pablo Picasso's *Guernica* (1937) and tapestries by Henri-Georges Adam (1904–67), and by his first trip to Europe in 1957.

The range of his subject-matter, as indicated by major paintings such as *Fat Man* (1960; Montevideo, Mus. N. A. Visuales), *Portrait of a Tall Man* (1947; see 1980 exh. cat., pl. 5) and *Most Serene Landscape with Head* (1975; see 1980 exh. cat., pl. 53), indicates a strong attachment to the human figure and landscape. He created unreal landscapes with crystallized figures tempered by real light. He was awarded major prizes at the Salón Nacional de Artes Plásticas in Montevideo in 1961 and 1962.

BIBLIOGRAPHY

Retrospectiva Espínola Gómez 1980 (exh. cat., Montevideo, Gal. Latina, 1980)

Arte contemporáneo en el Uruguay (exh. cat., ed. A. Kalenberg; Montevideo, Mus. N. A. Plást. & Visuales, 1982), pp. 35–6

A. Kalenberg: 'El transrealismo: La paralogía de Espínola Gómez', *A. Colombia*, 30 (1986), pp. 28–31

UABC (exh. cat., ed. W. Beeren; Amsterdam, Stedel. Mus., 1989), pp. 30–31

J. Abbondanza: *Manuel Espínola Gómez* (Montevideo, 1991)

ANGEL KALENBERG

Espinoza, Eugenio (*b* San Juan de los Morros, 29 Nov 1950). Venezuelan sculptor. He studied at the Escuela de Artes Plásticas 'Cristóbal Rojas' and at the Instituto de Diseño Neumann, both in Caracas (1968–71). From 1977 to 1980 he lived in New York, where he studied at the Pratt Institute and at the School of Visual Arts. Espinoza began exhibiting in 1969, participating in the Salón Arturo Michelena de Valencia, Venezuela. From then on he showed his work in one-man and group shows in Venezuela and abroad. The net, represented with canvas stretched to different tensions, was a constant theme of Espinoza's work. In 1985 he represented Venezuela in the São Paulo Biennale in Brazil.

BIBLIOGRAPHY

F. Paz Castillo and P. Rojas Guardia: *Diccionario de las artes plásticas en Venezuela* (Caracas, 1973)

M. Hernandez Serrano, ed.: *Diccionario de las artes visuales en Venezuela*, 2 vols (Caracas, 1982)

La rama florecida: Escencia y misterio de la naturaleza: Obras recientes de Manuel Espinoza (exh. cat., Caracas, Mus. A. Contemp., 1986)

CCS-10. Arte venezolano actual (exh. cat., Caracas, Gal. A. N., 1993)

Eugenio Espinoza: Línea Blanca (exh. cat. by E. Sierra, Caracas, Mus. A. Visuales Alejandro Otero, 1995)

ELIDA SALAZAR

Espinoza, Manuel (*b* San José de Guaribe, nr Zaraza, 1 Jan 1937). Venezuelan painter and engraver. He studied in Venezuela at the Escuela de Artes Plásticas 'Arturo Michelena' in Valencia (1953) and at the Escuela de Artes Plásticas 'Cristóbal Rojas' in Caracas (1955–7). From 1958 to 1966 he participated in national paint salons, exhibiting work that focused on the aesthetic interpretation of indigenous nature. In 1962 Espinoza represented Venezuela at the Venice Biennale. Two years later he was nominated Director of the Círculo del Pez Dorado in Caracas, a competition group that sought to promote art and culture in Venezuela. From 1976 he was involved in creating the Galería de Arte Nacional, also in Caracas, which he directed for eight years. Also in 1976 he helped establish in Caracas the Centro de Enseñanza Gráfica (CEGRA) and the Taller de Artes Gráficas (TAGA). In 1980 he was awarded the Premio Nacional de Artes Plásticas.

BIBLIOGRAPHY

F. Paz Castillo and P. Rojas Guardia: *Diccionario de las artes plásticas en Venezuela* (Caracas, 1973), p. 89

ELIDA SALAZAR

Espinoza Dueñas, Francisco (*b* Lima, 1926). Peruvian painter, printmaker and ceramicist, active in Europe. He studied at the Escuela Nacional de Bellas Artes in Lima until 1953 and then began to exhibit paintings, prints, murals and ceramics on an annual basis in Lima. He continued his studies in Spain in 1956, and from then on remained in Europe, mainly in Paris and Madrid. In Paris he became an assistant at the printmakers' workshop at the Ecole Nationale Supérieure des Beaux-Arts. Following a period in Cuba where he worked at the Taller de Grabado de Cubanacán, Espinoza Dueñas returned to France to study ceramics at Sèvres, executing sculptural, symbolic works reminiscent of Pre-Columbian Peruvian ceramics. His paintings, which are expressionistic in style, are colourful, energetic and full of symbolism (e.g. *Pampa Road*, 1955; Lima, Mus. A.)

BIBLIOGRAPHY

J. A. de Lavalle and W. Lang: *Pintura contemporánea II: 1920–1960*, Col. A. & Tesoros Perú (Lima, 1976), pp. 158–9

W. IAIN MACKAY

Estilo desornamentado [Sp.: 'stripped or unornamented style']. Term used to describe a phase in Spanish architecture in the 16th century and the early 17th, which developed in reaction to the excessive decoration of the PLATERESQUE STYLE. Emphasis was placed on the correct use of Classical orders, the composition of masses, walls and spaces and contemporary Italian practice. *Estilo desornamentado* owed much to the influence of Italian and Portuguese military engineers and to the anti-decorative functionalism of the first Jesuits. Starting in the 1540s, it reached its summit with Juan de Herrera's work (1563–84) at the Escorial, spreading thereafter throughout almost all of Spain (except Andalusia) and differing from the Portuguese *Estilo chão* ('plain style') in that it enjoyed less freedom from academic rules and the styles derived from Italy. Only in the 1990s was the term applied to Latin American architecture.

The term was apparently in use in Spain in the later 19th century; it was subsequently applied by C. Justi (1908) to describe the monastery of the Escorial and was taken up by G. Kubler. It was coined to replace the various terms—Herreran, Escurialense, Viñolesco, Tridentine and Mannerism—used by Spanish architectural historians to describe the Escorial and its sequels. Its use has been limited to English and American historians, although J. B. Bury declared himself radically opposed to it (1986). Spanish writers have preferred to use the term 'classicism' to describe this last phase of 16th-century architecture in Spain, keeping the phrase *estilo desornamentado* to designate Renaissance detailing before the construction of the Escorial, where decoration (known as Plateresque) using candelabra and grotesques was abandoned. This detailing is then contrasted with that of the Renaissance buildings that employed such ranges of decoration and were dubbed *ornamentado* ('ornamental').

The tendency to reject the practice of superimposing such decoration on Renaissance structures, leaving the

Classical orders as the only decorative element in this type of architecture, seems to have been encouraged by the publication in 1537 and 1540 of books II and IV of Sebastiano Serlio's *Regole generali di architettura sopra le cinque maniere degli edifici* (Venice, 1537–51) and their translation into Spanish by Francisco de Villalpando (1552). Architects from the 1540s, such as Alonso de Covarrubias and Luis de Vega, or Diego de Siloé later on, tried to forgo the use of superficial decoration and limit themselves to employing the orders, together with rustication, as the sole characteristics of a style of architecture that they claimed was 'Roman' or 'ancient'. During the same period, architects such as Rodrigo Gil de Honañón, working in a Gothic Survival tradition, tried to divest their Gothic structures of any kind of ornament, including the orders, as they considered decoration to be superfluous and prized the structural design ('the plan') above any type of additional element ('art'). The same literary sources were extremely influential in Latin America, not only in Mexico but also in Peru and in Ecuador (e.g. the façade of the monastery of S. Francisco, Quito).

Although this state of affairs did not apply uniformly, an important departure in Spanish architecture clearly occurred towards 1560, centred on the court of Philip II. The arrival of Juan Bautista de Toledo from Naples and the brief presence of Francesco Paciotto (1562) signified a renewal of Italian models (the last Spaniards to come from Italy, such as Diego de Siloé or Pedro Machuca, had returned *c.* 1520). In an attempt to apply the principles of Vitruvius and the 16th-century theory of Classical orders correctly, stress was laid on architecture composed of well-proportioned masses, walls and spaces. There was wide use of Italian forms (not excluding, however, contributions from Flanders), where surfaces were articulated by using Classical orders or linear ensembles of very simple geometric figures, thereby producing a gradual simplification of the orders that reduced them often to a minimum, giving rise to the expression 'reductive classicism'.

The most direct disciples of Herrera's school—Juan de Valencia and Francisco de Mora—continued to work in the style established by Herrera at the monastery of the Escorial. Within court circles in Madrid, the Carmelite Fray Alberto de la Madre de Dios (*fl* 1610) and Juan Gómez de Mora also continued the style until the mid-17th century. An important centre for the style was also formed in Toledo by other disciples or assistants of Herrera, such as Diego de Alcántara (*d* 1587), Nicolás de Vergara and Juan Bautista Monegro and their respective followers. Herrera's plans for Valladolid Cathedral (1580) gave rise to another centre in that city, whose chief representatives, Juan de Ribero Rada (*d* 1600), Juan de Nates (*fl* 1620) and Diego and Francisco de Praves (1586–?1637), transmitted its characteristics to the architecture of old Castile, León, Asturias, Cantabria, the Basque country and, through Salamanca, to Galicia. Herrera's influence, through both his own designs and those of certain disciples, reached regions such as Valencia and soon touched Andalusia and even Aragon. Here, as in Catalonia, architecture developed characteristics similar to those encouraged by the court, thus promoting exceptional stylistic consistency throughout Spain. Herrera's influence in Latin America has been poorly understood, despite his

evident impact on buildings such as the cathedrals of Mexico City and Puebla and in the work of architects such as Juan Gómez de Trasmonte.

Despite some local opposition and divergences around 1600 and 1620, the style, with its geometrical characteristics and stress on mathematical elements, prevailed throughout the 17th century. From the 1640s, however, the notion of enriching buildings began slowly to be accepted via a new wave of decorative art, which nevertheless respected the composition of the structures and the treatment of the orders.

BIBLIOGRAPHY

J. de Castilho: *Lisboa antiga: O bairro alto* (Lisbon, 1879, 3/1954–62)
C. Justi: *Miscellaneen aus drei Jahrhunderten spanischen Kunstlebens*, 2 vols (Berlin, 1908)
J. de Contreras: *Historia del arte hispánico*, i (Barcelona and Buenos Aires, 1945)
G. Kubler and M. Soria: *Art and Architecture in Spain, Portugal and their American Dominions*, Pelican Hist. A. (Harmondsworth, 1959)
——: *Portuguese Plain Architecture, between Spices and Diamonds, 1521–1706* (Middletown, CN, 1972)
A. Bustamante García: *La arquitectura clasicista del foco vallisoletano: 1561–1640* (Valladolid, 1983)
G. Kubler: *Mexican Architecture of the Sixteenth Century* (New Haven, 1948, rev. 1972; Sp. trans., Mexico City, 1983)
F. Marías: *La arquitectura del renacimiento en Toledo: 1541–1631*, 4 vols (Toledo and Madrid, 1983–6)
J. Rivera Blanco: *Juan Bautista de Toledo y Felipe II: La implantación del clasicismo en España* (Valladolid, 1984)
S. Sebastián López, J. de Mesa Figueroa and T. Gisbert de Mesa: *Arte iberoamericano desde la Colonización a la Independencia* (Madrid, 1985)
C. Wilkinson: 'Planning a Style for the Escorial: An Architectural Treatise for Philip of Spain', *J. Soc. Archit. Hist.*, xliv (1985), pp. 37–47
El Escorial en la Biblioteca Nacional (exh. cat., Madrid, Bib. N., 1985)
J. B. Bury: 'Juan de Herrera and the Escorial', *A. Hist.*, ix/4 (1986), pp. 428–49
Herrera y el clasicismo (exh. cat., Valladolid, Pal. Santa Cruz, 1986)
F. Marías: *El largo siglo XVI: Los usos artísticos del renacimiento español*, (Madrid, 1989)
V. Fraser: *The Architecture of Conquest: Building in the Viceroyalty of Peru, 1535–1635* (Cambridge, 1990)
J. Bérchez: *Arquitectura mexicana de los siglos XVII y XVIII* (Mexico City, 1992)
M. Sartor: *Arquitectura y urbanismo en Nueva España: Siglo XVI* (Mexico City, 1992)

FERNANDO MARÍAS

Estípite. Column or pilaster that tapers towards its base, often overlaid by a sequence of geometric solids that obscure the basic structure; it is characteristic of the CHURRIGUERESQUE style used in 17th- and 18th-century Spanish and Latin American architecture.

☐

Estrada, José María (*b* Guadalajara, Mexico, *c.* 1800; *d* Guadalajara, *c.* 1860). Mexican painter. He was a pupil of José María Uriarte, the director of the Academia de Guadalajara, but his links with academic painting seem to have been only rudimentary, since his work was in a more popular spirit related to naive art. He was a fine portraitist, generally showing his sitters in three-quarter view, turned towards the left and with their hands usually holding some object. He rendered their expression gracefully and sometimes humorously, with a fresh naturalism; he treated the background in a very sober way, in marked contrast to his obvious delight in detail in painting the figure. In his portrait of *Matilde Gutiérrez* (1838; see fig.), for example, greys, blacks and whites are used to underline the warmth of the child's flesh, her small body glimpsed through the

José Maria Estrada: *Matilde Gutiérrez*, oil on canvas, 980×728 mm, 1838 (Mexico City, Museo Nacional de Arte)

delicate fabrics of her clothes; her lips and eyes are shaded in such a way as to contribute to her sweet expression. One of her hands holds a richly dressed doll, while the other seems to be calling a dog towards her. Another notable work is the portrait of *Miguel Arochi y Baeza* (*c.* 1840; Mexico City, Mus. N. A.), in which the young man's elegance is emphasized by his erect posture and by the tall hat emphasizing his slimness. The buttons, the folds of his cravat, the flowers in his buttonhole and the watch chain hanging from his pocket provide an opportunity for the painter to show his command of detail.

BIBLIOGRAPHY

R. Montenegro: *Pintura mexicana, 1830–1860* (Mexico City, 1933)
J. Fernández: *Arte mexicano de sus orígenes a nuestros días* (Mexico City, 1958)
——: *El arte del siglo XIX en México* (Mexico City, 1983)

MARGARITA GONZÁLEZ ARREDONDO

Estridentismo. Mexican group of writers and artists, active between 1921 and 1927. The group's members included Silvestre Revueltas (1899–1940), Fermín Revueltas, Leopoldo Méndez, Ramón Alva de la Canal and Germán Cueto, and the writers Arqeles Vela and Germán List Arzubide, with Diego Rivera and Jean Charlot as sympathizers. All were keen to stress the importance of cosmopolitanism. They followed Futurism in a complete rejection of academicism and Symbolism in the arts, although no limits were imposed on what should replace these, and their ideal of making art public and accessible corresponded with that of the mural movement in Mexico. This aim at a cultural revival was initially expressed through a manifesto published in the first issue of the periodical *Actual*, written by the poet Manuel Maples Arce, who initiated the trend. The manifesto included a directory of avant-garde artists and writers of all contemporary styles, probably compiled with the help of Rivera and Charlot, who had recently returned from Paris. It called on Mexican intellectuals to unite and form a society of artists, claiming 'the need to bear witness to the vertiginous transformation of the world'. Maples Arce recommended rapid action and total subversion as an immediate strategy, and looked to the USSR for ideological inspiration. Taking an iconoclastic attitude, he condemned religiosity and patriotism. The generally incoherent and aggressive manifesto borrowed from Marinetti's Futurist manifestos and Spanish Ultraist ideas. The group's ideas were further propagated by the periodicals *Irradiador* (1924) and *Horizonte* (1926–7), the latter being published by their own publishing house, Ediciones Estridentistas. Public meetings and casual exhibitions at the Café de Nadie, Mexico City, were also held.

WRITINGS

M. Maples Arce: 'Hoja de vanguardia comprimido estridentista', *Actual*, 1 (1921)
G. List Arzubide: *El movimiento estridentista* (Mexico City, 1926)

BIBLIOGRAPHY

L. M. Schneider: *El Estridentismo: Una literatura de la estrategia* (Mexico City, 1970/*R* 1997)
S. Fauchereau: 'The Stridentists', *Artforum*, xxiv (Feb 1986), pp. 84–9
Art in Latin America: The Modern Era, 1820–1980 (exh. cat. by D. Ades and others, London, Hayward Gal., 1989), pp. 131–2, 306–9 [contains reprint of manifesto]
L. Schneider: *Estridentismo o una literatura de la estrategia* (Mexico City, 1997)

ELISA GARCÍA BARRAGÁN

F

Fabrés, Antonio (*b* Barcelona, 27 June 1854; *d* Rome, 23 Jan 1938). Catalan painter, sculptor and teacher, active also in Mexico. He was the son of the draughtsman Cayetano Fabrés. He studied at the Academia Provincial de Bellas Artes in Lonja (1867–75) and in the studio of the sculptor Andrés Aleu y Teixidor. With his sculpture in plaster the *Dead Abel* (1875; Barcelona, Real Acad. Cat. B.A. San Jordi), he won a scholarship to study in Rome. There he was attracted to the work of the sculptor Vincenzo Gemito (1852–1929) and at the same time to the paintings of Mariano José Bernardo Fortuny y Marsal (1838–74); eventually he abandoned sculpture to devote himself completely to painting. He worked in a similar Orientalist genre, inspired by North African subject-matter, in paintings such as the *Warrior's Repose* (1878), the *Sultan's Present* (1877–8; both Barcelona, Mus. A. Mod.), and *On the Sultan's Order* (*c.* 1902; Mexico City, Mus. N. A.). His painting of musketeers, *The Drunkards* (1896; Mexico City, Mus. N. A.), a subject also popularized by Jean-Louis Meissonier, displays a compositional virtuosity in keeping with the academic realism of the time. When in 1895 he showed the *Offering to the Virgin Mary* at the Paris Salon, he had a magnifying glass placed beside the painting so that the viewer might observe the minute details.

In 1892 Fabrés settled in Paris, where he showed regularly at the Salon and submitted work to international competitions. His Paris dealer was Goupil. In 1900 Jesús F. Contreras invited Fabrés to Mexico City to run the department at the Escuela Nacional de Bellas Artes; he acquiesced and moved to Mexico in 1902. The Mexican government acquired *The Drunkards* and commissioned a painting on the subject of local history to decorate a room in the Palacio Nacional, Mexico City (*in situ*), entitled *Hidalgo after the Victory of Monte de las Cruces* (*c.* 1903–4). He also designed the arms room (destr., see Moreno, pp. 61–5) of the president's private residence. In Mexico, Fabrés abandoned exotic themes in favour of realistic depictions of the daily milieu. His principal formative influence on his students, among whom were Diego Rivera, Saturnino Herrán and José Clemente Orozco, was to develop an interest in the life of ordinary people. In 1907 Fabrés left Mexico to settle once more in Rome.

WRITINGS
'Verdades', *An. Inst. Invest. Estét.*, lvi (1986), pp. 173–204

BIBLIOGRAPHY
S. Moreno: *El pintor Antonio Fabrés* (Mexico City, 1981)

FAUSTO RAMÍREZ

Facio, Sara (*b* Buenos Aires, 18 April 1932). Argentine photographer and publisher. She trained as a painter at the Escuela Nacional de Bellas Artes, Buenos Aires (1947–53), and took up photography only in the late 1950s. She studied in Buenos Aires first in the studio of Luis d'Amico and then in 1960 under Annemarie Heinrich. In 1960 she opened a studio in Buenos Aires with the Argentine photographer Alicia d'Amico (*b* 1933). She contributed to *La Nación* and *Autoclub*, and in 1973, together with María Cristina Orive, she co-founded La Azotea, a publishing house specializing in Latin American photography. She was primarily a documentary photographer, whose reputation did not depend on the recording of sensational events. Her photographs were realistic portrayals of the Argentine way of life; they were taken using natural light and were not modified in the laboratory.

PHOTOGRAPHIC PUBLICATIONS
Buenos Aires, Buenos Aires (Buenos Aires, 1968)
Retratos y autorretratos (Buenos Aires, 1973)
Seven Voices (New York, 1973)
Geografía de Pablo Neruda (Buenos Aires, 1974)
Humanario (Buenos Aires, 1976)
with M. C. Orive: *Actos de fe en Guatemala* (Buenos Aires, 1980)
with Alicia d'Amico: *25 años de fotografía* (Buenos Aires, 1985)
Retratos, 1960–1992 (Buenos Aires, 1992)

WRITINGS
'Fotografía Argentina, 1920–1950', *Historia general de arte en la Argentina*, vii (Buenos Aires, 1995)
La fotografía en la Argentina desde 1840 a nuestros días (Buenos Aires, 1995)

BIBLIOGRAPHY
E. Billeter: *Fotografie Lateinamerika* (Zurich and Berne, 1981)
J. Potenze: *Sara Facio* (Buenos Aires, 1982)
A. Hopkinson, ed.: *Desires and Disguises: Five Latin American Photographers* (London, 1992), pp. 53–64

ERIKA BILLETER

Falla, Julián (*b* Guatemala City, 4 Sept 1787; *d* Guatemala City, 22 March 1867). Guatemalan painter and printmaker. He was a pupil of the Guatemalan painter Juan José Rosales (1751–1816) and of Pedro Garci-Aguirre. He studied in the Escuela de Dibujo of the Sociedad de Amigos del País in Guatemala City, and he later taught there for more than 45 years; his role in training many artists was perhaps his greatest contribution. One of the first etchers and lithographers in Guatemala, in 1834 he was in charge of the lithographic reproduction of views of the indigenous ruins of Iximché and Utatlán published as illustrations (each 115×175 mm) in the *Atlas geográfico del Estado de Guatemala* (1835).

In 1835 Falla and other artists were commissioned to produce a collection of model drawings for the Academia de Estudios. In the same year he received a Guatemalan government award for one of his etchings and a commission for a portrait of General Francisco Morazán, the president of the Federation of Central America. Most of his pictures, almost all of them portraits, have been lost, but the quality of his brushwork and Neo-classical style can be appreciated in his portrait of *Canon José María Castilla* (oil on canvas, 612×501 mm, 1845; Guatemala City, Acad. Geog. & Hist.).

BIBLIOGRAPHY
R. Toledo P.: 'Julián Falla (1787–1867), maestro e impulsor de la pintura en Guatemala', *El Imparcial* (21 March 1967)
E. I. Núñez de Rodas: *El grabado en Guatemala* (Guatemala City, 1970), pp. 77–8
M. Rubio Sánchez: 'El pintor Julián Falla', *An. Acad. Geog. & Hist. Guatemala*, lvi (1992), pp. 361–5
JORGE LUJÁN-MUÑOZ

Fazzolari, Fernando (*b* Buenos Aires, 28 Sept 1949). Argentine painter and stage designer. After a series of pictures featuring hallucinatory images of disembodied mouths and orifices, bodies and pits, he began to treat circus scenes, exploiting their symbolic suggestiveness by representing candles, ladders, insects and animals of arbitrary size alongside ambiguous human forms. Falling somewhere between the merry and the tragic, they have a theatrical aspect consonant with his experience as a stage designer. Combining a lively, almost festive palette with thick paint, sometimes violently applied, Fazzolari emerged in the 1980s as one of the leading Neo-Expressionist painters in Argentina.

BIBLIOGRAPHY
Fernando Fazzolari (exh. cat., intro. H. Safons; Buenos Aires, A. Nue., 1983)
J. Glusberg: *Del Pop-art a la Nueva Imagen* (Buenos Aires, 1985), pp. 520–22
Arte contemporáneo 80/90: Colección Fundación Banco Patricios (Buenos Aires, 1995)
HORACIO SAFONS

Felguérez, Manuel (*b* Hacienda de Valparaíso, Zacatecas, 12 Dec 1928). Mexican painter and sculptor. He grew up in Zacatecas and achieved recognition as a sculptor in Mexico City *c.* 1953, after briefly attending courses there at the Escuela Nacional de Pintura y Escultura 'La Esmeralda'. He worked as a ceramicist and travelled throughout Mexico to study the country's archaeology, art, geography, customs and traditions. After studying medicine briefly at the Universidad Nacional Autónoma de México in Mexico City, he decided to devote himself to art, travelling for the first time to Europe in 1947 in order to visit museums, churches and monasteries. On his return to Mexico he obtained a scholarship from the French government, which allowed him to study in Paris for two years. There he met Brancusi, frequently visiting his studio, but he was especially close to Ossip Zadkine.

Felguérez returned definitively to Mexico in 1956, teaching sculpture in Mexico City at the Escuela de Arte y Diseño of the Universidad Iberoamericana and later at the Universidad Nacional Autónoma de México. Together with his first wife, Lilia Carrillo, whom he married in 1960, he initiated the Ruptura movement, which (as its name

Manuel Felguérez: *Three Circular Sections*, painted metal, 305×401×128 mm, 1976 (Austin, TX, University of Texas, Jack S. Blanton Museum of Art)

suggests) consciously broke with the selfconsciously Mexican identity pursued by other painters. In 1958 his first important one-man exhibition of painting and sculpture in Mexico was held at the Galería Antonio Souza in Mexico City, a meeting-place for dissident artists. While he established a reputation (both as a painter and sculptor) as perhaps the strictest exponent of geometric abstraction in Mexico, he also made daring excursions into other styles, although he continued to incorporate geometric elements (e.g. *Three Circular Sections*, 1976, see fig.; see also colour pl. X, fig. 1). After 1979, in particular, he emphasized painterly qualities of colour, touch and surface texture, for example in *Light Path* (oil on canvas, 1.15×1.35 m, 1987; see D. Bayón and R. Pontual, *La Peinture de l'Amérique latine au XXe siècle*, Paris, 1990, p. 97). He is also credited with the first abstract mural, painted in earth and tar in the Diana cinema in Mexico City, and with initiating a new phase of mural painting in Mexico. He was influential in many ways on the public sphere of Mexican cultural life: he was active as a polemicist, lecturer and theoretician, instigating changes in the course of study at the Escuela Nacional de Artes Plásticas; he frequently served on exhibition juries and planned and promoted a free forum for exhibitions and discussions, the Salón Independiente, which was in operation between 1968 and 1971; and in 1975 he was the first Mexican artist to win one of the grand prizes at the São Paulo Biennale.

WRITINGS
El espacio múltiple (Mexico City, 1978)
La máquina estética (Mexico City, 1983)
BIBLIOGRAPHY
Manuel Felguérez: El espacio múltiple (exh. cat., intro. O. Paz; Mexico City, Mus. A. Mod., 1973)

J. A. Manrique and others: *El geometrismo mexicano* (Mexico City, 1977)
Manuel Felguérez: Muestra antológica (exh. cat., essays T. del Conde and L. M. Schneider; Mexico City, Inst. N. B.A., 1987)
J. García Ponce: *Manuel Felguérez* (Mexico City, 1992)
F. González Gortázar, ed.: *La arquitectura mexicana del siglo XX* (Mexico City, 1994)
J. Villoro: *Manuel Felguérez: El límite de una secuencia* (Mexico City, 1997)

TERESA DEL CONDE

Fernández, Agustín (*b* Havana, 16 April 1928). Cuban painter. He studied at the Academia de S Alejandro in Havana from 1946 to 1950 and the Art Students League, New York, in 1949. He had his first one-man exhibition at the Lyceum in Havana in 1951. In 1959 he left Cuba for Paris, from where he moved to San Juan, Puerto Rico, in 1968 before settling in New York in 1972 as a political exile.

During the 1950s Fernández painted luminous pictures that combine still-life elements with landscapes, as in *Landscape and Still-life* (1956; see colour pl. X, fig. 2). In such works he made elements of the still-life dissolve into the distant landscape forms in order to coalesce the expansiveness of landscape with the still-life interplay of form and light. In the 1960s he developed his mature style, characterized by images of body parts and armour on large canvases painted in earth tones, greys, and black and white. Like his Brazilian contemporary Antonio Henrique Amaral, he explored unflinchingly the interrelationship of sexuality and aggression without sensationalism or vulgarity, as in *The Large Skin* (1964; see fig.), in which the multiplication of breasts and blades is used to explore how violence and eroticism parallel each other in affirming and subverting the integrity of the self. Fernández's work is formal and lyrical, almost metaphysical, rather than cathartically expressionist.

BIBLIOGRAPHY
R. C. Kenedy: *Agustín Fernández* (New York, 1973)
Outside Cuba/Fuera de Cuba (exh. cat. by I. Fuentes-Pérez, G. Cruz-Taura and R. Pau-Llosa, New Brunswick, NJ, Rutgers U., Zimmerli A. Mus.; New York, Mus. Contemp. Hisp. A.; Oxford, OH, Miami U., A. Mus.; and elsewhere; 1987–9)
Agustín Fernández: A Retrospective (exh. cat., Miami, FL, A. Mus., 1992)

RICARDO PAU-LLOSA

Fernández Ledesma, Gabriel (*b* Aguascalientes, 30 May 1900; *d* Mexico City, 26 Aug 1984). Mexican painter, printmaker, writer and ceramicist. He enrolled at the Escuela Nacional de Bellas Artes, Mexico City, in 1917 and soon became active in the post-revolutionary nationalist cultural movement, attempting to recuperate folk-art motifs and techniques. In 1920 he designed a ceramic frieze for the Colegio Máximo de San Pedro y San Pablo, Mexico City. He edited the influential art magazine *Forma* (1926–8) and was involved in creating the Escuela Libre de Escultura y Talla Directa, Mexico City, the ¡30–30! group (which promoted the democratization and de-academization of the arts), and the Centros Populares de Pintura, which offered art education to people in industrial areas, encouraging the representation of their surroundings without academic constraints. In the 1930s he directed an exhibition space funded by the Ministerio de Educación Pública, for which, with Roberto Montenegro and Francisco Díaz de León, he designed posters and catalogues noted for their innovative typography. Fernández Ledesma also produced prints inspired by popular graphics and figurative paintings influenced by Picasso and by Pittura Metafisica; he also wrote several books on popular traditions and stage and costume designs.

BIBLIOGRAPHY
Exposición homenaje a Gabriel Fernández Ledesma (exh. cat., Aguascalientes, Mus. Aguascalientes, 1981)
Gabriel Fernández Ledesma: Artista y promotor cultural (exh. cat., Mexico City, Mus. Pal. B.A., 1982)
J. Alanís: *Gabriel Fernández Ledesma* (Mexico City, 1985)
B. Valdivia: *El eco de la imagen: Vanguardia y tradición en Gabriel Fernández Ledesma* (Aguascalientes, 1992)

KAREN CORDERO REIMAN

Fernández Muro, José Antonio (*b* Madrid, 1920). Argentine painter of Spanish birth. He moved to Argentina in 1938, studying under the Spanish Catalan painter Vicente Puig (1882–1965) and holding his first one-man exhibition in 1944. In 1952 he joined the ARTISTAS MODERNOS DE LA ARGENTINA. He took Constructivism as his starting-point, preserving its rigour and severity but moving towards a lyrical and highly personal form of abstraction. In the late 1950s he began to create rhythmic patterns of circles on geometric shapes by means of perforated sheets of metallic foil, an impressed effect which he was the first to use in Argentina, for example in *Penetrating Black* (1962; see fig.).

Fernández Muro moved to New York in 1962 and from 1969 divided his time between Madrid and Paris. From *c.* 1970 he made reliefs in which he displayed an inexhaustible imagination, consistently offering the observer a renewed vision of geometry through a sensitivity towards materials,

Agustín Fernández: *The Large Skin*, oil on canvas, 2.72×1.96 m, 1964 (Detroit, MI, Detroit Institute of Arts)

José Antonio Fernández Muro: *Penetrating Black*, bubbled foil paper and oil on canvas, 1.27×1.27 m, 1962 (Washington, DC, Art Museum of the Americas)

a refined elaboration of texture and an incomparable assurance in composition. He won many awards for his work, including the Guggenheim International Prize in New York in 1960.

BIBLIOGRAPHY
A. Pellegrini: *Panorama de la pintura argentina* (Buenos Aires, 1967), pp. 61, 69–70
Fernández Muro (exh. cat., preface L. Castedo; Madrid, Mus. A. Contemp., 1985)
NELLY PERAZZO

Ferrari, Juan Manuel (*b* Montevideo, 21 May 1874; *d* Buenos Aires, 31 Oct 1916). Uruguayan sculptor. He received his first sculptural lessons at the workshop of his father, the Italian sculptor Juan Ferrari (1836–1918), followed by a brief period at the Escuela Nacional de Bellas Artes in Buenos Aires in 1888. From 1890 he studied in Rome under Ettore Ferrari (1845–1929) and Ercole Rosa, winning first prize for sculpture in 1892. On returning to Montevideo in 1897 he established a workshop as well as a course in visual arts at the University of Uruguay. By the time he moved to Buenos Aires in 1910, his reputation as a sculptor specializing in monumental work was firmly established in Uruguay and Argentina.

While still living abroad Ferrari created sculptures of the human figure influenced by Auguste Rodin's use of voids and striking contrasts of light, such as *Prometheus Chained* (1893; Montevideo, Av. Agraciada). On his return to Latin America he made numerous full-length figures on a small scale such as *The San Román Café Owner* (1896) and *Diógenes Héquet* (*c.* 1896; both Montevideo, Mus. N.A. Plást.), busts and monumental works such as *Monument to General San Martín's Liberation Army* (1914; Mendoza, Argentina, Cerro de la Gloria) and the monument to General Juan Antonio Lavalleja, *Carbine on his Back and Sabre in Hand* (1902; Minas, Plaza Mayor). In 1915 he completed a life-size memorial sculpture dedicated to Arturo Santa-Anna (Montevideo, Buceo cemetery), in which he masterfully summarized his development.

UNPUBLISHED SOURCES
Montevideo, Mus. N. A. Visuales [B. Parallada: *Monografía sobre Juan Manuel Ferrari*]
BIBLIOGRAPHY
J. P. Argul: *Las artes plásticas del Uruguay* (Montevideo, 1966); rev. as *Proceso de las artes plásticas del Uruguay* (Montevideo, 1975)
ANGEL KALENBERG

Ferreira, Jesús Reyes. *See* REYES FERREIRA, JESÚS.

Ferrer (Garcia), Rafael (Pablo Ramón) (*b* Santurce, Puerto Rico, 1933). Puerto Rican painter, sculptor and installation artist. In 1952 he entered Syracuse University, NY, to study for a liberal arts degree and there began to paint, influenced by the Cubist works of Picasso and Braque. After only 18 months he went to the Universidad de Puerto Rico, where he studied painting under the French Surrealist painter Eugenio Granell (*b* 1912). Through Granell, Ferrer became acquainted with Dada and Surrealism and in 1953 was introduced by him to André Breton (1898–1966) and Wilfredo Lam, and to the writer Benjamin Peret in Paris. After three months in Paris he went to New York, where he worked as a drummer while continuing to paint. He returned to Puerto Rico in 1960 and the following year had a controversial two-man show with the Puerto Rican painter Rafael 'Chafo' Villamil at the museum of the Universidad de Puerto Rico, near Mayaguez. By this time he had abandoned painting in favour of sculpting in wood, steel and other materials.

In 1966 Ferrer moved to Philadelphia and soon met Robert Morris, Richard Serra and the American sculptor Italo Scanga (*b* 1932). In December 1968 he made several *Leaf Pieces*, consisting simply of piles of leaves, in various New York galleries, including the Leo Castelli Gallery (see 1973 exh. cat., p. 10). The following year he produced his *Hay, Grease, Steel* and *Ice Pieces* (see 1971 exh. cat.) for the *Anti-Illusion/Procedures/Materials* show at the Whitney Museum of American Art in New York. These ephemeral works caused him to be associated with the Process art movement, a label he later rejected. In 1972 he mounted an exhibition at the Pasadena Art Museum, CA, which included the work *Madagascar*, the first of several that referred to specific geographical locations. Later installations, under titles such as *Celebes, Patagonia, Sudan*, were made from various materials and objects, including animal skins, kayaks and explorers' equipment. The *Deseo* show at the Contemporary Arts Center, Cincinnati, OH (1973), included works of this type (see 1973 exh. cat.). After 1978 Ferrer abandoned installations and returned to painting.

BIBLIOGRAPHY
Rafael Ferrer: Enclosures (exh. cat. by S. Prokopoff, Philadelphia, U. PA., Inst. Contemp. A., 1971)
Deseo: An Adventure, Rafael Ferrer (exh. cat. by C. Ratcliff, Cincinnati, Contemp. A. Cent., 1973)
North, East, West, South and Middle: An Exhibition of Contemporary American Drawing by Rafael Ferrer (exh. cat., Philadelphia, PA, Moore Coll. A. & Des., 1975)
Rafael Ferrer (exh. cat. by S. Prokopoff, Boston, ICA, 1978)
Rafael Ferrer: Impassioned Rhythms (exh. cat., Austin, TX, Laguna Gloria A. Mus. and elsewhere, 1982) □

Ferrez, Marc (*b* Rio de Janeiro, 1843; *d* Rio de Janeiro, 1923). Brazilian photographer. He trained as a photographer with Franz Keller (1835–90), from Mannheim in

Marc Ferrez: *View of Rio de Janeiro with Corcorada and Sugarloaf*, albument print, *c*. 1875 (Rio de Janeiro, Instituto Moreira Salles Collection)

Germany, and worked as a photographer in Rio de Janeiro, before joining the photographic firm of Leuzinger. In 1865 he opened his own studio. He specialized in photographs of landscapes and shipping, as in *View of Rio de Janeiro with Corcorada and Sugarloaf* (*c*. 1875; see fig.), but was also one of the first photographers of the Indian population of the Amazon region. In 1876 he exhibited his material—which was also of ethnological interest—at the *Exhibition of the Century* in Philadelphia, PA, winning the gold medal. In 1904, at the World's Fair in St Louis, MO, he was the only photographer to win a gold medal. In 1907 he opened the first picture-house in Rio de Janeiro and concentrated his attention on the new technical possibilities.

BIBLIOGRAPHY

E. Billeter: *Fotografie Lateinamerika* (Zurich and Berne, 1981)

R. Fabian and H. C. Adam: *Frühe Reisen mit der Kamera* (Hamburg, 1981), pp. 133–62

O. do Rio Amigo: *Fotógrafo Marc Ferrez: Paisagens e tipos humanos de Rio de Janeiro, 1865–1918* (São Paulo, 1984)

G. Ferrez: *A fotografia no Brasil: 1840–1900* (Rio de Janeiro, 2/1985); Eng. trans. by S. de Sá Rego (Albuquerque, 1990)

——: *O rio antiguo do fotógrafo Marc Ferrez* (São Paulo, 3/1989)

——: *Um passeio à Petrópolis en companhia do fotógrafo Marc Ferrez* (Rio de Janeiro, 1993)

P. Vasquez: 'Marc Ferrez: A Master of Brazilian Photography', *J. Dec. & Propaganda A.*, xxi (1995), pp. 26–41

ERIKA BILLETER

Fierro, Pancho [Francisco] (*b* Lima, 1810; *d* Lima, 28 July 1879). Peruvian painter. A mulatto (of mixed parentage),

he was self-taught and was probably illiterate; his paintings remained unsigned, and their titles were possibly added later. He became the leading *costumbrista* artist in Peru, with watercolours that recorded the people and events of the transitional phase between the colonial and Republican periods, although the fact that he portrayed not only established types and traditions but also figures from the early modern era set him apart from other *costumbrista* artists. His works were usually characterized by their gentle caricature, and it has been suggested that some paintings were influenced by the works of Goya. His technique involved laying down a basic pencil sketch, which was then built up with a series of brightly coloured washes; the drawing often lacked proportion, perspective and shape, although outlines were usually eloquent and lively. The figure depicted was identifiable by the inclusion of details indicating his trade or status (e.g. *Friar Tomato*, n.d.; Lima, Mus. A.). Fierro's prolific output amounted to *c*. 1200 watercolours, *c*. 238 of which were owned by the contemporaneous Peruvian *costumbrista* writer Ricardo Palma (collection acquired in 1954 by the Municipalidad de Lima Metropolitana). The largest collection outside Peru is probably the 78 watercolours (St Petersburg, Mus. Ethnog.) bought by Leopold Schrenk, a Russian scientist sent by Tsar Nicholas I to Peru in 1854. There are also numerous small collections of his work, mainly in Europe, Fierro exerted considerable influence both during his career and into the 20th century, when such leading

Indigenist artists as José Sabogal took an interest in his work.

BIBLIOGRAPHY

J. Sabogal: *Pancho Fierro* (Lima, 1945)
J. A. de Lavalle and W. Lang: *Pintura contemporánea I: 1820–1920*, Col. A & Tesoros Perú (Lima, 1975), pp. 32–7
Exposición de acuarelas Pancho Fierro (exh. cat., Lima, Mun. Lima Met., 1986)
T. Muñoz-Najar: 'Pancho en Rusia', *Caretas* [Lima] (1994), pp. 54–6
R. Cantuarias Acosta: *Pancho Fierro* (Lima, 1995)

W. IAIN MACKAY

Figari, Pedro (*b* Montevideo, 29 June 1861; *d* Montevideo, 24 July 1938). Uruguayan painter, writer, lawyer and politician. He showed artistic inclinations from childhood but completed a degree in law in 1886; his appointment as a defence counsel for the poor brought him into contact with social issues that later informed his art. In the same year he studied briefly with the academy-trained Italian painter Godofredo Sommavilla (1850–1944), married and left for Europe, where he came into contact with Post-Impressionism. On his return to Uruguay he became actively involved in journalism, law and politics as well as fostering the creation of the Escuela de Bellas Artes. During the course of his life he published a number of books that reflected his broad interests in art, art education and legal matters. He was a member of the Uruguayan Parliament, president of the Ateneo of Montevideo (1901) and director of the Escuela Nacional de Artes y Oficios (1915).

In 1921 Figari moved to Buenos Aires in order to devote himself completely to painting. Working in oil on cardboard he created figurative compositions as arrangements of colour, reconstructing rather than documenting the Uruguayan scene; the geography, gaucho life, the celebrations, symbolic rituals and carnivals of the local black community. He continued to expand on this subject-matter while living in Paris from 1925 to 1933 in works painted from memory, which gained him broader recognition as a painter. Works such as *Call to Prayer* (1922), *Burial* (*c.* 1924; Montevideo, Mus. N.A. Visuales) and *Creole Dance* (*c.* 1925; New York, MOMA; *see* URUGUAY, fig. 3) both typify his work at its best. In 1930 he was awarded the Grand Prize in the *Exposición del centenario* in Montevideo and the Gold Medal at the Seville Ibero-American Exposition, and on his return to Uruguay in 1933 he was appointed artistic adviser to the Ministry of Public Education.

WRITINGS

El crimen de la calle Chaná (Montevideo, 1896)
Plan general de la organización de la enseñanza industrial (Montevideo, 1917)
Arte, estética, ideal (Paris, 1920)
El arquitecto (Paris, 1928)
Historia Kiria (Paris, 1930)

BIBLIOGRAPHY

J. L. Borges: *Figari* (Buenos Aires, 1930)
L. V. Anastasia, A. Kalenberg and J. M. Sanguinetti: *El caso Almeida* (Montevideo, 1976)
A. Kalenberg: 'Pedro Figari: El escenario americano', *América: Mirada interior* (exh. cat., Bogotá, Bib. Luis-Angel Arango, 1985)
Seis maestros de la pintura uruguaya (exh. cat., ed. A. Kalenberg; Buenos Aires, Mus. N. B.A., 1987), pp. 57–82
K. Grant: 'The Candombe Paintings', *Lat. Amer. A.*, iii/2 (1991), pp. 21–4
Pedro Figari (1861–1938) (exh. cat., Paris, Pav. A., 1992)
G. Peluffo Linari: *Historia de la pintura uruguaya: De Blanes a Figari* (Montevideo, 1993)
I. Pini: 'Pedro Figari: The Search for Roots', *A. Nexus*, xviii (1995), pp. 64–8
R. Pereda: *Pedro Figari* (Montevideo, 1995)
Figari de luz de luna (exh. cat., Montevideo, Gal. Sur, 1996)

ANGEL KALENBERG

Figueroa, Pedro José (*b* Bogotá, after *c.* 1750; *d* Bogotá, 1838). Colombian painter. Like the painters who had worked in the region during the colonial period, he specialized in portraits and religious paintings and displayed a preference for a frontal treatment of the human figure and for heavy draperies as backdrops. Nevertheless, his work was distinguished by indications of atmosphere, customs and politics, which established the terms for the development of painting in Colombia during the 19th century. The portraits he painted after 1812 of the national hero, *Simón Bolívar* (e.g. Bogotá, Mus. N.), combined the solemnity and showiness of his attire with an understated and almost naive manner. His most important religious work, the *Trinity* (Bogotá Cathedral), is characterized by a pictorial economy and delicacy.

Figueroa's importance as the outstanding transitional figure between Colombia's colonial and republican periods can be measured by the influence that he exercised through his studio, where the most important Colombian painters of the 19th century received their artistic education. His sons Miguel Figueroa, Celestino Figueroa and José Santos Figueroa, as well as Luis García Hevia and José Manuel Groot, were among his pupils.

BIBLIOGRAPHY

G. Giraldo Jaramillo: *La miniatura, la pintura y el grabado en Colombia* (Bogotá, 1980), pp. 44, 53–4, 59, 96, 163–4, 178, 181, 267, 291, 349
E. Barney Cabrera: *Historia del arte colombiano*, ix (Bogotá, 1983)

EDUARDO SERRANO

Filgueiras Lima, João (*b* Rio de Janeiro, 10 Jan 1932). Brazilian architect. He graduated in architecture from the Federal University of Rio de Janeiro (1955) and worked in various offices, including the Retirement and Pensions Institute for Bankers in Rio de Janeiro (1952–8 and 1961–2). He then worked with Oscar Niemeyer on several projects in Brasília (1962–70) including the Faculty of Science (1963), University of Brasília, and Ministry of Defence (1970). Filgueiras Lima became one of the most sculpturally expressive architects in Brazil, but his work was also characterized by a commitment to the use of advanced industrial technology, particularly prefabrication, which he studied on a visit to the USSR, Poland and East Germany (1963). Major projects using structural prefabricated reinforced concrete include the Administrative Centre of Bahia (1973), Salvador, comprising several long, low-rise buildings curving round the contours, elevated on columns and designed as a series of modular boxes to allow for infinite extension. In the Central Administration of Bahia (CAB) chapel (1974), his curved plan was roofed by prefabricated concrete columns with flared tops, arranged in a dramatic, ascending helicoidal form. In the Hospital for Locomotive Disorders (1976), Brasília, he used precast Vierendeel girders with octagonal cut-outs to enclose and support the wards; these were stacked like boxes in a staggered form to provide terraces. Later

projects included the medium- and maximum-security prisons (1986) in Rio de Janeiro. He also used lightweight, prefabricated, reinforced concrete for basic sanitation, in schools and health clinics, for passenger shelters, city furniture and small bridges. In 1978, based on the principles of this work, the Prefecture of Salvador set up a factory producing lightweight prefabricated sections to provide sanitation in the city's shanty towns; a similar organization was set up in Rio de Janeiro in 1984.

WRITINGS

Escola transitória (Brasília, 1984)
Fábrica de escolas (Rio de Janeiro, 1984)

BIBLIOGRAPHY

'João Filgueiras Lima, arquiteto', *Módulo*, 57 (1980), pp. 78–93
'Modern Brazilian Architecture', *Process: Archit.*, 17 (1980), pp. 98–111
 [special issue]

REGINA MARIA PROSPERI MEYER

Fini, Leonor (*b* Buenos Aires, 30 Aug 1908; *d* Paris, 18 Jan 1996). French painter, stage designer and illustrator of Argentine birth. She grew up in Trieste, Italy. Her first contact with art was through visits to European museums and in her uncle's large library, where she gleaned her earliest knowledge of artists such as the Pre-Raphaelites, Aubrey Beardsley and Gustav Klimt. She had no formal training as an artist. Her first one-woman exhibition took place in Paris in 1935 and resulted in friendships with Paul Eluard, Max Ernst, René Magritte and Victor Brauner, bringing her into close contact with the Surrealists; her sense of independence and her dislike of the Surrealists' authoritarian attitudes kept her, however, from officially joining the movement. Nevertheless her works of the late 1930s and 1940s reflect her interest in Surrealist ideas. She also participated in the major international exhibitions organized by the group.

Fini's almost mystical appreciation for the latent energy residing in rotting vegetation and her interest in nature's cycles of generation and decay can be seen in works such as *Os Ilyaque* (*c.* 1948; ex-West Dean House, W. Sussex; see Chadwick, no. 152) and *Sphinx regina* (1946; priv. col., see Chadwick, no. 154), which also reveal the influence of German Romantic and Symbolist painters. Her works are meticulously painted, their surfaces built with layers of small and carefully modulated brushstrokes. From the 1960s her work displayed a consistent set of obsessional, recurring themes: provocative nymphets, languid nudes and the ubiquitous sphinx-like cats that mediate between the human and the bestial. The elaborate rituals and mysterious sexual dramas first evident in Fini's work of the late 1930s continued to play a dominant role.

Fini's work for the theatre included costumes and sets for George Balanchine's *The Crystal Palace* (1945), Racine's *Bérénice* for Jean-Louis Barrault (1955), a production of Wagner's *Tannhäuser* at the Paris Opéra (1963) and Jean Genet's *Le Balcon* (1969). Among her numerous illustrations are drawings for editions of *Juliette* (Rome, 1944) by the Marquis de Sade, *Aurélia* (Monaco, 1960) by Nerval, *Les Fleurs du mal* (Paris, 1964) by Baudelaire and *Romeo and Juliet* (Nice, 1979) by Shakespeare.

BIBLIOGRAPHY

A. Moravia and others: *Leonor Fini* (Rome, 1945)
M. Brion: *Léonor Fini et son oeuvre* (Paris, 1955)
X. Gauthier: *Léonor Fini* (Paris, 1973)
W. Chadwick: *Women Artists and the Surrealist Movement* (London, 1985)
Léonor Fini (exh. cat., Paris, Pal. Luxembourg, 1986)
J. Godard: *Leonor Fini, ou, Les métamorphoses d'une oeuvre* (Paris, 1991)
W. Sauré: *Leonor Fini: Kunsthaus Dr. Hans Hartl* (Munich, *c.*1993)
Léonor Fini (Paris, 1997)

WHITNEY CHADWICK

Folk architecture. *See* VERNACULAR ARCHITECTURE.

Gonzalo Fonseca: *Granary III*, red travertine, 203×540×501 mm, 1971 (Austin, TX, University of Texas, Jack S. Blanton Museum of Art)

Fonseca, Gonzalo (*b* Montevideo, 2 July 1922; *d* Seravezza, Italy, 10 June 1997). Uruguayan painter and sculptor. He studied from 1942 under Joaquín Torres García and was one of the original members in 1944 of the TALLER TORRES GARCÍA, in whose mixed exhibitions he took part. In his sculptures and paintings alike he searched for a structured fixing of a recognizable motif, which he conceived as a kind of naturalism. From 1964 he concentrated solely on sculpture; one of his best-known sculptures is a concrete *Tower* (h. *c.* 13 m; Mexico City, Ruta de la Solidaridad) for the 1968 Olympic Games in Mexico City. He spent much of his career in the USA and was the creator of the first sidewalk sculpture in New York city: an unpolished marble column, *Votive Column* (1970) on East 70th Street, between Park Avenue and Madison Avenue. In 1990 he represented Uruguay at the Venice Biennale. Another work from this period is *Granary III* (1971; see fig.), a small piece in red travertine.

BIBLIOGRAPHY

J. P. Argul: *Las artes plásticas del Uruguay* (Montevideo, 1966); rev. as *Proceso de las artes plásticas del Uruguay* (Montevideo, 1975)

Uruguay: Gonzalo Fonseca (exh. cat. by A. Kalenberg, Montevideo, Mus. N. A. Plást., 1990)

Gonzalo Fonseca: Recent Works (exh. cat., ed. Karl Katz; New York, Jew. Mus., 1971)

M. V. Manley: 'Gonzalo Fonseca', *Lat. Amer. A.*, ii/2 (1990), pp. 24–8

Gonzalo Fonseca: XLIV Bienale di Venezia (Montevideo, 1990)

ANGEL KALENBERG

Fonseca e Silva, Valentim da [Valentim, Mestre] (*b* Brazil, *c.* 1750; *d* Rio de Janeiro, 1813). Brazilian sculptor and wood-carver. His earliest surviving works, mainly commissioned from religious fraternities and all located in Rio de Janeiro, date from the late 1770s. His surviving work, typical of the transition from Baroque-Rococo to Neo-classicism, includes the carving on the main altar of the noviciate chapel of the church of Carmo and the altar of the church of S Francisco de Paula; the statues of *St John the Evangelist* and *St Matthew* (both Rio de Janeiro, Mus. Hist. N.); the two monumental candelabra in the monastery of S Bento; and the fountains das Marrecas, das Saracuras and do Lapidário in city squares. His most important work was the large-scale sculptural project that he planned for the Passeio Público in Rio de Janeiro, consisting of terraces with benches tiled with *azulejos* (glazed tiles), pavilions decorated by the painter Leandro Joaquim (1738–98), waterfalls, four flights of steps, statues of *Apollo*, *Diana*, *Jupiter* and *Mercury*, and an entrance gate with bas-reliefs and two pyramids or obelisks (1783). The whole scheme, of which much remains, constitutes a pioneering attempt to improve the conditions of life and leisure in that city.

BIBLIOGRAPHY

M. A. Porto Alegre: 'Iconografia brasileira', *Rev. Inst. Hist. & Geog. Bras.*, xix (1856)

N. Batista: 'Mestre Valentim', *Rev. SPAHN*, iv (1940)

ROBERTO PONTUAL

Fontana, Lucio (*b* Rosario, Santa Fé, 19 Feb 1899; *d* Comabbio, nr Varese, 7 Sept 1968). Italian painter, sculptor and theorist of Argentine birth. He moved with his family to Milan in 1905 but followed his father back to Buenos Aires in 1922 and there established his own sculpture studio in 1924. On settling again in Milan he trained from 1928 to 1930 at the Accademia di Brera, where he was taught by the sculptor Adolfo Wildt (1868–1931); Wildt's devotion to the solemn and monumental plasticity of the Novecento Italiano group epitomized the qualities against which Fontana was to react in his own work. Fontana's sculpture *The Harpooner* (gilded plaster, h. 1.73 m, 1934; Milan, Renzo Zavanella priv. col., see 1987 exh. cat., p. 118) is typical of his work of this period, with a dynamic nervousness in the thin shape of the weapon poised to deliver a final blow and in the coarse and formless plinth. Soon afterwards, together with other northern Italian artists such as Fausto Melotti (1901–86), Fontana abandoned any lingering Novecento elements in favour of a strict and coherent form of abstraction. In 1934 he became a member of Abstraction–Création and went on to take part in the Corrente group's exhibitions.

In his early abstractions Fontana took a middle course between painting and sculpture by producing plaster reliefs and free-standing but essentially planar works in plaster or iron, for example *Abstract Sculpture* (iron, h. 625 mm, 1934; Turin, Gal. Civ. A. Mod.), in which a meandering but generally straight-edged line of metal describes a single plane. Fontana at this time used both flat, geometrically regular shapes and organic biomorphic forms with undulating contours suggestive of enlarged cells. There are other ambiguities and apparent inconsistencies in his work of the late 1930s: alongside his search for a geometric perfection he also produced an extensive group of ceramics in which figures or objects are suggested in a fragmented and violently disturbed form that draws attention to the manipulation of the clay by his hand, and especially by his thumb. In works such as *Horses* (1938; Duisburg, Lehmbruck-Mus.), some of which he produced in 1937 at the Sèvres factory in Paris, Fontana displayed his sympathy with the Neo-Expressionist currents that were emerging in the major cities of Italy as a reaction against the retrospective spirit of the Novecento.

During World War II Fontana returned to Argentina, where in 1946 he founded the Academia Altamira with the artists Jorge Romero Brest and Jorge Larco; together they collaborated on the *Manifiesto blanco* (Buenos Aires, 1946). In this text, which Fontana did not sign but to which he actively contributed, he began to formulate the theories that he was to expand as SPAZIALISMO, or Spatialism, in five manifestos from 1947 to 1952. He opted decisively for abstraction but hinted also at the need to take account of new techniques made possible by scientific progress. This text therefore marked the end for him not only of figurative art but also of a static, classical style of abstraction. He also questioned the traditional reliance in Western art on a flat support such as canvas or paper, proposing instead that the time had come for artists to work in three or rather four physical dimensions, since time also had to be added to the equation, in order to disturb the entire environment with their interventions.

Following his return to Italy in 1948 Fontana exhibited his first *Spatial Environment* (1949; Milan, Gal. Naviglio), which prefigured later international developments such as environmental art, performance art, land art and Arte Povera. This first temporary installation by Fontana consisted of a giant amoeba-like shape suspended in the void in a darkened room and bombarded by neon light, a

1. Lucio Fontana: *Spatial Concept*, oil on canvas with glass, 850×1250 mm, 1955 (Milan, Civico Museo d'Arte Contemporanea)

material which was to be taken up by other artists in the 1960s. By their nature such works had an ephemeral life, but they were reconstructed for later exhibitions on the basis of documentary evidence provided by Fontana's drawings, by photographs and by first-hand accounts. Fontana's concern with environments led him also to collaborate in the early 1950s with the architect Luciano Baldessari (1896–1982) on the design of several exhibition pavilions.

Fontana's concept of Spazialismo, as formulated in the texts that he published on his return to Italy, was based on the principle that in our age matter should be transformed into energy in order to invade space in a dynamic form. He applied these theories to a feverish, violent, subversive and radical production in which he synthesized the various elements of his art. He devised the generic title *Concetto spaziale* ('spatial concept') for these works and used it for almost all his later paintings. These can be divided into broad categories: the *Buchi* ('holes'), beginning in 1949, and the *Tagli* ('slashes'), which he instituted in the mid-1950s. In both types of painting Fontana assaulted the heretofore sacrosanct surface of the canvas, either by making holes in it or by slashing it with sharp linear cuts.

The *Buchi*, such as *Spatial Concept* (oil on paper mounted on canvas, 790×790 mm, 1952; Paris, Pompidou), continue to exploit the beauty of chance and accident seen earlier in Fontana's ceramics, and in this sense they bear comparison with other developments of the period such as *Art informel*, Tachism, Abstract Expressionism and action painting. In some works Fontana violated the surface not only by piercing it but by sticking irregularly shaped objects, such as bits of coloured glass, on the canvas in random configurations, as in *Spatial Concept* (1955; see fig. 1). The *Tagli*, such as *Spatial Concept—Expectations* (1959; Paris, Mus. A. Mod. Ville Paris), are clearer and more concise in form, but they are also generally asymmetrically and casually arranged. However many cuts are made into the canvas, the surface as a whole remains intact and two-dimensional, and, for all their apparent violence, these pictures continue to be displayed as conventional easel paintings. They form an important part of Fontana's contribution to Continuità, which the artist joined in 1961.

Fontana applied similar techniques to sculptures such as *Spatial Concept* (painted iron, diam. 3 m, 1952; Turin, Gal. Civ. A. Mod.). The most successful of these works are those in which the incisions are made into a lumpy surface that retains the delightfully irregular and unpredictable character of soft organic materials such as wax or chalk even when cast in bronze. Other sculptures are more decisively three-dimensional, as in the case of imperfect and randomly shaped spheres such as *Nature* (1959–60; Otterlo, Rijksmus Kröller-Müller), in which visible gashes suggest sexual orifices or eruptions of volcanic activity. In sculptures of this type Fontana not only completely freed himself from the tyranny of two dimensions but created a balance between the idea and its physical manifestation. Among Fontana's last works are a series of *Teatrini* ('puppet theatres'; see fig. 2), in which he returned to an essentially flat idiom by using backcloths enclosed within wings resembling a frame; the reference to theatre emphasizes the act of looking, while in the foreground a series of irregular spheres or oscillating, wavy silhouettes creates a lively shadow play. He was awarded the Grand Prize for Painting at the Venice Biennale of 1966.

2. Lucio Fontana: *Teatrini*, pen and ink, 310×210 mm, 1965 (Paris, Centre Georges Pompidou)

WRITINGS
Primo manifesto dello spazialismo (Milan, 1947)
Secondo manifesto dello spazialismo (Milan, 1948)
Manifesto tecnico dello spazialismo (Milan, 1951)

BIBLIOGRAPHY
T. Sauvage: *Pittura italiana del dopoguerra* (Milan, 1957)
G. P. Giani: *Lucio Fontana* (Venice, 1958)
E. Crispolti: 'Carriera barocca di Fontana', *Il Verri*, iii/3 (1959), pp. 101–8
M. Tapié: *Devenir de Fontana* (Turin, 1961)

F. De Bartolomeis: *Segno antidisegno di Lucio Fontana* (Turin, 1967)

G. Ballo: *Fontana: Idea per un ritratto* (Turin, 1970)

Lucio Fontana: Concetti spaziali (Turin, 1970)

E. Crispolti: *Omaggio a Fontana* (Rome, 1971)

P. Fossati: *L'immagine sospesa* (Turin, 1971), pp. 168–78

G. Manganelli: *L'ironia teologica di Fontana* (Milan, 1978)

G. Ballo: *Lucio Fontana* (Rimini, 1982)

E. Crispolti: *Fontana: Catalogo generale*, 2 vols (Milan, 1986) [cat. rais.]

Lucio Fontana (exh. cat. by B. Blistène and others, Paris, Pompidou, 1987)

Lucio Fontana (exh. cat. by B. Blistène and others, Amsterdam, Stedel. Mus.; London, Whitechapel A.G.; 1988)

Lucio Fontana, 1899–1968 (exh. cat., Barcelona, Fund. Caixa Pensions, 1988)

G. Joppolo: *Lucio Fontana: "Qui sait comment est Dieu?" Biographie (1899–1968)* (Marseille, c.1992)

J. De Sanna: *Lucio Fontana: Materia, spazio, concetto* (Milan, c.1993)

P. Campiglio: *Lucio Fontana: La scultura architettonica negli anni trenta* (Nuoro, 1995)

Lucio Fontana e Milano (exh. cat., Milan, Mus. Permanente, 1996)

RENATO BARILLI

Forner, Raquel (*b* Buenos Aires, 22 April 1902; *d* Buenos Aires, 10 June 1988). Argentine painter. She completed her studies at the Academia Nacional de Bellas Artes in Buenos Aires in 1923 and from 1929 to 1931 received tuition in Paris from Othon Friesz (1879–1949). In her choice of subject-matter she revealed a consistent concern with humanity and with the events of her time. During the Spanish Civil War (1936–9) she began to paint pictures in a powerful and dramatic style, inspired by the tragedies that have laid humanity waste, and often working in series, as in *The Drama* (1940–46; e.g. Buenos Aires, Mus. N. B.A.) and the closely related *See No Evil, Hear No Evil, Speak No Evil* (1939; Buenos Aires, Mus. Mun. A. Plást. Sívori), *The Rocks* (1947), *The Farce* (1948), *The Banners* (1952) and *Apocalypse* (1954); in the last of these, charred tree trunks, architecture in ruins and fantastic beings bear witness to a civilization in agony.

In 1958 Forner began work on *Space Series* and related pictures such as *Battle of Astral Beings II* (1961; Washington, DC, Kennedy Cent. Perf. A.) and the *Return of the Astronaut* (1969; see colour pl. XI, fig. 1), in which she related, with great imagination, the adventures and misadventures of a humanity hurled into the cosmic abyss. Her colours became vibrant and the surfaces of her paintings densely populated with interlaced figures undergoing metamorphosis at fantastic speed. The mythology created by Forner on the theme of humanity in space, both in these paintings and in several portfolios of lithographs, points towards the future and to hope for the moral improvement of humanity.

BIBLIOGRAPHY

Raquel Forner (exh. cat., essay P. Restany; Paris, UNESCO, 1977)

G. Whitelow: *Raquel Forner* (Buenos Aires, 1980)

Raquel Forner: Retrospectiva (exh. cat., Buenos Aires, Mus. N. B. A., 1983)

Raquel Forner: Series espaciales, 1957–1988, Fundación Banco Patricios (Buenos Aires, 1993)

Latin American Woman Artists, 1915–1995 (exh. cat. by E. Biller and others, Milwaukee, WI, A. Mus. 1995)

NELLY PERAZZO

Fragelli, Marcelo (Aciolly) (*b* Rio de Janeiro, 6 Oct 1928). Brazilian architect. He graduated in architecture from the Federal University of Rio de Janeiro in 1952 and went to work for M. M. M. Roberto, one of the early Modernist practices. Roberto was then attempting to develop structures that transcended the static forms of early functionalism but in a different direction from the sculptural forms of Oscar Niemeyer's experiments in Pampulha (1942–4). Fragelli assimilated these ideas but, when he formed his own practice in São Paulo (1961), he retained an individual approach to design; he also remained apart from the Brutalist style of João B. Vilanova Artigas that dominated São Paulo at that time. Fragelli's work was characterized by his skilful use of such materials as reinforced concrete, brick, timber and glass both in their natural state and in combination with each other, and by the delicate detail of his finishes; his buildings include houses for Tasso Fragoso Pires (1959), Rio de Janeiro, and Ernesto d'Orsi (1972), São Paulo. His best-known works include several stations on the northern section of the São Paulo Metro, especially those that are elevated and integrated with the structures of the supporting bridges, for example the Ponte Pequeña Metro Station (1973), where he also used cantilevered staircases. He also designed many residential, office and industrial buildings, including Edifício Converbrás (1980), Rio de Janeiro, and he received several awards, including two honourable mentions in the 8th São Paulo Biennale (1963).

BIBLIOGRAPHY

'Modern Brazilian Architecture', *Process: Archit.*, 17 (1980), pp. 64–70 [special issue]

A. Xavier, C. Lemos and E. Corona: *Arquitetura moderna paulistana* (São Paulo, 1983)

A. Xavier, A. Britto and A. L. Nobre: *Arquitetura moderna no Rio de Janeiro* (São Paulo, 1991)

CARLOS A. C. LEMOS

Franco, Siron (*b* Goiás Velho, Goiás, 25 July 1947). Brazilian painter. Born to a poor family, he was largely self-taught, although he joined on an informal basis the Estudio Ao Ar Livre (Open-air Studio), established in Goiânia by two local painters, D. J. Oliveira and Cleber Gouvea. Initially Franco worked as a portraitist to make money, also receiving a few minor graphic design commissions. After a number of exhibitions he was awarded the first Global Spring Salon Travel Prize (1973), which led to a six-month period in Mexico. This was followed by the prestigious 24th Rio de Janeiro Salon of Modern Art (Museu Nacional de Belas Artes) Travel Prize. Franco chose to spend the two-year award in Madrid, from 1976 to 1978. In 1979 he collaborated with the actor/director Odilion Carmargo on the urban project *Veracidade* ('Truthfulness'). Between 1985 and 1987 he worked as art director with the Brazilian film director Washington Novaes on a number of documentary films: *Xingú* (winner of the gold medal at the World Wide Television Festival, 1985), *Pantanal* (1986), and *Kuarup adeus ao Chefe Mal Kuawa* ('Farewell Malakuawa Chief'; 1987). Franco's concern with the less privileged members of Brazilian society, the environment and the indigenous population reflect his own origins and interest in political and social issues. In 1987 he produced the *Cesium* series, following the radiation disaster in Goiâna. Traces of *Cesium* as well as the series *Furs* (1983–90) survive in *Memoria* (1990; see fig.). There is a striking metallic element to the work, which infuses the canvas with a new dynamism that allows the animal forms to dominate the subtle and intriguing background, forming an unexpected dialogue with the spectator. In 1992 Franco was commissioned by the Brazilian

Siron Franco: *Memoria*, mixed media on canvas, 1.80×1.91 m, 1990 (Colchester, University of Essex, Collection of Latin American Art)

Indian Community to create a monument. More recent works include an installation, *Radiografía brasiliera* ('Brazilian X-ray'), created in 1996 as a reaction to the massacre of members of the Moviemento Sem Terra (The Landless Movement), and *Marcas ne tela* ('Marks on the Canvas', 1.90×7.20 m, 1994; Monterrey, Mus. A. Contemp.).

BIBLIOGRAPHY

Art of the Fantastic: Latin America, 1920–1987 (exh. cat. by H. T. Day and H. Sturges; Indianapolis, IN, Mus. A., 1987)

R. M. Leite: 'Siron Franco', *Latin American Art*, iv (1992), pp. 37–9

D. Ades: *Figures and Likenesses: Siron Franco – Paintings 1968–95* (Rio de Janeiro, 1996)

ADRIAN LOCKE

Frasconi, Antonio (*b* Buenos Aires, 28 April 1919). Uruguayan printmaker and illustrator of Argentine birth. The son of Italian parents who settled in Montevideo when he was two weeks old, he first exhibited drawings in 1939 at the Ateneo in Montevideo and studied printmaking with various artists, while also working as a political caricaturist in the weekly publications *Marcha* and *La Línea Maginot*. His diverse influences included German Expressionism, José Guadalupe Posada, the Taller de Gráfica Popular and woodcuts by Japanese artists such as Katsushika Hokusai and Kitagawa Utamaro.

Frasconi visited the USA in 1945 on a grant from the Art Students League, New York, and later taught extensively at the New School in New York. His illustrated edition of *Twelve Fables of Aesop* (New York, 1954), published by MOMA, was chosen as one of the 50 Books of the Year by the Institute of Graphic Arts, and in 1960 he won the Grand Prize at the Venice Film Festival for his film *The Neighbouring Shore*, based on more than 100 woodcuts. His work as a printmaker encompassed political themes, as in the series *Those who Have Disappeared* (see 1987 exh. cat.), as well as portraits of jazz musicians such as *Duke Ellington* (1976), *Bessie Smith* and *Charles Mingus* (1973), and of the American 19th-century poet *Walt Whitman* (1981; see 1985 exh. cat.). In 1969 he was named a National Academician by the New York Academy of Design.

BIBLIOGRAPHY

N. Hentoff and C. Parkhurst: *Frasconi—Against the Grain* (New York and London, 1974)

Antonio Frasconi: Un clásico de la xilografía (exh. cat., ed. A. Kalenberg; Montevideo, Mus. N.A. Plást., 1985)

Involvement: The Graphic Art of Antonio Frasconi (exh. cat., ed. E. A. Tonelli, Los Angeles, UCLA, Wight A. Gal.; New York, Mus. Contemp. Hisp. A.; 1987–8), pp. 46–7

The Books of Antonio Frasconi: A Selection, 1945–1995 (exh. cat., ed. A. Lierner; New York, Grolier Club, 1996)

ANGEL KALENBERG

French Antilles. *See under* ANTILLES, LESSER.

French Guiana [Guyana; Fr. La Guyane]. French department on the north-east coast of South America. It is bordered by Surinam to the west and by Brazil to the south and east (see fig. 1). The capital city, Cayenne, is located on a small estuary island and is occupied by two-thirds of the total population of *c*. 100,000. The department occupies *c*. 90,000 sq. km. The interior is almost entirely covered by Amazonian forest, bordered and traversed by rivers and empty of people. The swamp forest and the plains towards the coast are relatively densely populated. The first French settlement was established in the region in 1604; despite the greed of the various European powers in the 16th and 17th centuries, French Guiana remained a French colony until 1946, when it became an overseas department.

I. Introduction. II. Architecture. III. Traditional and other arts. IV. Art life and institutions.

I. Introduction.

In the 16th century there were over 30 ethnic groups of *c*. 30,000 people in total, spread out between the Mana and

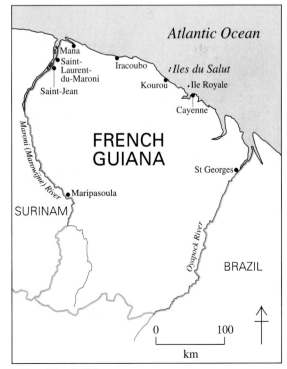

1. Map of French Guiana

Maroni rivers. The economy, established at the time of colonization, rested on the trade in African slaves. However, removed from main trade currents, the region remained underpopulated. Economic activity was based on the cultivation, using servile labour, of plantations of sugar cane, annatto, indigo, cotton and spices. In 1676 Cayenne was occupied by the Dutch for one year, and the Portuguese later occupied the city from 1808 to 1817. In 1982 French Guiana became a completely separate region governed by two local assemblies. Conceived primarily as a logistical support for the French Antilles, French Guiana has only rarely been considered for its intrinsic interest, and different French governments have always hesitated between developing the region for general habitation or just exploiting its natural resources; by the late 20th century French Guiana remained an underdeveloped country.

The extensive variety of ethnic groups is the result of successive immigrant waves of varying origins. The predominant groups are Asians and African-European mulattos; there remain, in reduced numbers, the original Amerindian inhabitants, as well as European settlers and blacks descended from African slaves who escaped from Surinam. Creole society serves as the region's administrative and political pillar, although in the 20th century there was a greater involvement of tribal Amerindians and people of African descent in this area. Additional groups included French convicts sent to Devil's Island and other penal colonies, and gold prospectors who came in the mid-19th century.

II. Architecture.

With its grid layout, the city of Cayenne is typical of 18th-century colonial towns, which were built on flat ground. The centre is occupied by administrative offices and businesses. The urban network, proposed in a fully preserved layout drawn up by Etienne François de Turgot, Governor of Guiana, in 1764, was executed between 1821 and 1842. The Place des Palmistes, graced by royal palm trees, is surrounded by traditional colonial buildings that have been restored. The colonizers, wishing to protect themselves from foreign incursions and from the hostilities of the Caribbean Indians, built such forts as Cépérou fort (*c.* 1679) in Cayenne. Its upper parts preserve some of the old layout, and its enclosing wall shows former ramparts. To the south of Cayenne is the brick Diamant fort (1848), comprising a battery, vaulted barracks and triangular courtyard; restoration, begun in 1985, has saved the fort from the encroaching tropical vegetation. Soldiers and sailors played a role in the stylistic development of domestic architecture. Navy carpenters from the French provinces taught their techniques, and a craftsmen's guild was formed. Some models of European houses and churches were copied and adapted to the climatic conditions, but frequent fires, coupled with the use of poor materials, have meant that there are no significant remains of these buildings. Dutch and French influences were allied with local Guianese techniques in improvements made to the homes of wealthy city dwellers. Creole houses (see fig. 2), built in the early 19th century, are interesting

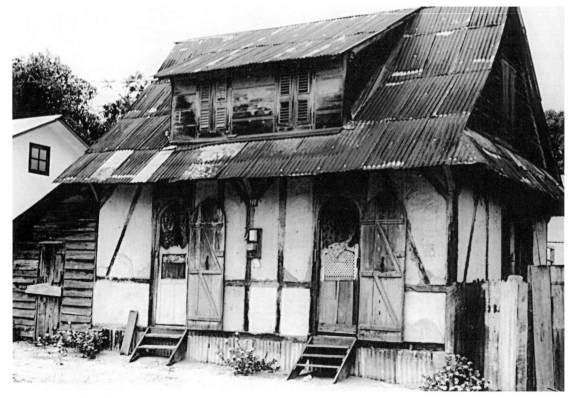

2. Creole house, Mana, French Guiana

for their adaptation to the climate, using vast roof spaces, high ceilings and openings to ensure passive air circulation. Often two storeys high, the houses were sometimes surrounded by canopies with balconies on the main façade; the steeply sloping roofs had large overhangs. Particular care was taken with houses, mainly for rich merchants, built between the late 1880s and the 1930s, using brackets of wrought or cast iron and iron guard rails and floors. Examples are found in the Bar des Palmistes and Rue Mollé, Cayenne. For country houses, which were to proliferate after the abolition of slavery, plaited wood, knotted in an earthen mortar, and laths and planks were used. Gardens were planted around the houses.

Of all the convict prison sites, only those of Saint-Laurent-du-Maroni, Saint-Jean and the Iles du Salut, off the coast of Kourou, still preserve some of the elements of the prison and its organization. This architecture reveals a surprising unity considering that it was created by many unpaid labourers. The quarters for the administrators and directors were given a degree of comfort: the building complexes were surrounded by low brick walls, wide passageways isolated the living quarters, and finally the washrooms and kitchens were linked by covered galleries. The Saint-Laurent buildings were subsequently used as offices for the administration of the sub-prefecture. The hospital and town hall have retained their uses, as have many of the buildings occupied by civil servants. Conservation and renovation projects were under way in the 1990s, when some buildings were classified as historic monuments, such as the church of Iracoubo (1887–97).

III. Traditional and other arts.

From both Western and creole points of view it is possible to make fairly arbitrary distinctions in French Guianese artistic production between the fields of arts and crafts, the latter being confined more (although not exclusively) to the tribal population. In the late 20th century there were only six Amerind peoples (c. 3200 individuals) in French Guiana, belonging to different linguisto-cultural groups. The Galibi (or Kalina), Wayana, Palikur, Arawak, Wayampi and Emerillon are the outcome of a complex dynamic in which the Amerinds were either in opposition to or took part in the formation of the colony, although the polarization of French Guiana by gold and convicts hardly affected them. These societies have maintained contact with each other through commercial, festive or matrimonial exchanges. Their artistic creation is closely linked to the value attached to material objects and group activities, essentially revolving around feasts and dances. The forest environment, hunting and fishing are the principal inspirations for creation and imagery. Boat-building has a strong tradition, and vessels are typically brightly painted. Body art includes extensive face and body painting and tattooing. Feathers are used for headdresses and general adornment (see fig. 3), with live birds often being plucked and injected with pigment to produce new coloured feathers. Beads are made from shells, glass, seeds and stones for use in necklaces and armlets that portray animal forms or that are arranged in geometric patterns. Basketwork is traditionally practised by men, and animal or geometric images are made either by weaving

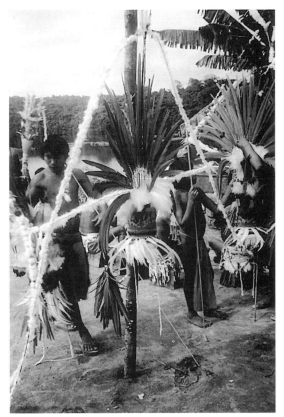

3. Wayana festive headdresses, Twenké, French Guiana, 1984

different materials or by using coloured elements. Pottery is also made, but with the exception of the red, white and black ware made for sale to tourists by the Arawak, its decoration is not of particular interest. Diversity of artistic creation increased when these societies came into contact with the West. In 1967 the French administration proposed French citizenship, and therefore French rights, to the Amerinds and to the population of African descent, in an effort to regulate through assimilation the problem of their identity. Between 1967 and 1969, c. 65% of the six ethnic groups of Amerinds became French, but the groups were not all in contact with the West to the same degree; the Galibi and Palikur were used to contact with Europeans through temporary work on the coast, but the Wayampi and Wayana in the interior were ill-prepared for the dependence that would follow.

Groups of people of African descent began to escape from coastal plantations in the latter part of the 17th century, moving inland, while others started to settle on the banks of the Maroni River from the late 18th century. They adopted many traits of the way of life and techniques of their Amerindian neighbours, in particular boat-building. The Aluku, who number c. 3000, are French citizens and are integrated into the dominant economic and political system; the Samaraka (also c. 3000 in number) settled on the coast at Kourou and Saint-Laurent and work seasonally, selling sculpted images to tourists. The Aluku and Ndjuka groups provided transport for miners during the goldrush in the late 19th century, which allowed them

to introduce many changes into their way of life. The history of the art of these peoples is remarkable for the ease with which ideas and shapes moved from one region and from one medium to another. Wood-carving and sculpture, often bearing painted decorations, carving on gourds, patchwork and embroidered clothing have been the traditional artistic activities. The style of Aluku arte-facts, as well as those of other groups of African descent, developed in the context of cultural exchanges based on rituals and marriage between groups. Among the artefacts some relatively constant traits can be seen: notions of colour contrast, syncopated symmetry and curvilinear script, based on globally African concepts but related principally to West African tribal art.

Innovation and invention are visible where Amerind and European contributions mix, ensuring that black Guianese art possesses constantly changing qualities, adapted to new forms and techniques. The result is a synthesis that bears witness to the Afro-American cultural process. Decorative sculpture and painted wood-carving started to develop from the latter part of the 19th century and blossomed and evolved over the following century. Until the late 20th century all Aluku men carved and sculpted objects, principally utilitarian, which they offered to their wives or girlfriends. These objects were character-ized by skilled low-relief work and frequently by sexual imagery personal to the couple. However, the wealth of artistic production is now mainly to be seen only in museums and private collections, and despite the various attempts to safeguard the artistic traditions, the quality of the artefacts has declined. Since the division of the Aluku's Inini territory into three parts in 1968 and the regionali-zation of 1982, deep social and cultural changes have taken place, such as the dispersal of clans, growing monetariza-tion and lower levels of artistic activity. Living areas, painted decoration, furniture and everyday utensils have taken on a Western appearance; the painting formerly associated with carving ceased to be practised by all but a handful of individuals. Gourds, traditionally decorated by women, have been practically abandoned in favour of plastic and glass crockery; the few remaining gourds are kept for funerary purposes or for sale to tourists. The same applies to hand-sewn and embroidered patchwork clothes, which have been replaced by ready-made garments generally bought through catalogues. The social role of *objets d'art* as spousal gifts has almost disappeared. Only boat-building continues to thrive. Music remains the most significant marker of ethnic identity, with drums still being made for community rituals and festivals.

The influence of the Amerinds and groups of African descent on creole society was largely material. It was among the Guianese creoles that the first qualified crafts-men in jewellery were recruited; French businessmen and entrepreneurs were to introduce to the colony a taste for adornments and jewels that the creole élite adopted at the end of the 19th century. Jewellery became a symbol of the wealth acquired in gold nuggets, and gold had a monetary value until the eve of World War II. Following the influx of migrants from the Antilles in the late 19th century and early 20th, Guianese jewels were often inspired by Antilles models, such as convicts' chains and choker necklaces. It was, however, principally the Chinese, acting as interme-diary merchants at the gold-prospecting sites, who inspired a style favouring gold of different colours and the mixture of gold and precious stones. A later foreign group that established itself in French Guiana was the Hmong community from Laos, who arrived from 1977. They achieved successful economic integration largely through the agricultural sector, but their traditional craftwork of embroidered wall hangings with cloth appliqué work, produced mainly by women, was sold at markets close to their villages.

The convict population included a number of artists: François Lagrange painted the chapel of the Ile Royale (1938–41) in oil and produced works on canvas after he was freed. His portraits and scenes from a convict's life and of Guianese people brought him a degree of renown, and although the chapel painting has deteriorated consid-erably, some of his canvases have been preserved in Cayenne. In the early 20th century the former convict Pierre Huguet painted scenes in the church of Iracoubo (1887–97), which connect episodes from the New Testa-ment to friezes and decorative motifs of mock marble and sky, sometimes executed in stencil. Huguet's work is reminiscent of popular paintings that are naive in style. Some Galibi artists, including Fritz St Jura, Thérèse Josselin, Mayipulo and Kiliman, became integrated into contemporary society by painting scenes of traditional life in a naive style on canvases and by selling stools in animal forms. It is among the youngest generation of French Guianese, born to immigrant parents, that one can see a real emergence of Western-style plastic arts. John Lie A Fo (*b* 1945), a Surinam artist who settled in French Guiana, had exhibitions in the Caribbean, Venezuela and the Netherlands. His expressionistic style of painting incor-porates *figuration libre* (abstracted figuration) and elements of graffiti. José Legrand (*b* 1947), one of the founders of the Formsens arts centre, exhibited in Paris and introduced innovative practices into French Guiana, such as works on urban sites and displays concerned with the problems of the colonized creole. The work of Roseman Robinot (*b* 1944), Frank Doriac, Raymond Désiré and Thierry Tian Sio Po (*b* 1964) expresses their Guianese identity while also revealing connections to international art.

IV. Art life and institutions.

The Musée de Cayenne, which houses natural history and ethnographic exhibits, was established in 1901. In late 20th-century French Guiana the need began to be felt to rediscover cultural and historic reference points, searching for identity by making overtures to indigenous people rather than to European traditions. From 1986 the Wayana association, Caway, ensured that Amerindian artefacts, intended largely for sale to tourists, displayed the same qualities as in the past. An association to preserve the national artistic heritage of the Alukus, called Mi Wani Sabi ('I want to know'), was founded in 1989 to supervise the continuation of ancestral forms; that same year it organized the exhibition *Regards sur l'art Boni aujourd'hui*. In addition to organizing exhibitions, the association republished old works and created a documentary archive. There is, however, an undercurrent of assimilation into creole society. A planned regional museum would offer

the chance not only to preserve old artefacts still available from indigenous peoples but also to reflect the recognition of Guianese creoles.

Two artists' associations, the Association des Artistes de Guyane (ADAG, founded 1979) and Association des Artistes Peintres (AAP, founded 1980), concentrate on the avant-garde and are represented by students whose work developed in Europe, the Antilles and North America. In 1979 the first group exhibition of young painters living in French Guiana was held. In 1983 the AAP, and in particular José Legrand, created Formsens, which was until 1988 an exhibition space, meeting place, loan library and video library. In 1984 an exhibition of contemporary European artists was organized (see 1984 exh. cat.). On the whole, Guianese artists have been frustrated by the absence of a structure for exhibiting and by the difficulty of establishing a market for local art. Between 1985 and 1987, some 15 exhibitions took place in Cayenne, in hotels, office buildings and restaurants.

In 1989 the dozen or so artists grouped around Serge Goudin-Thebia, a Guianese living in Martinique, founded an association called Mitaraka. In its manifesto the group stated its commitment to 'revealing the specific forms of the relationship between art and the sacred and between the sacred and art, through flora and fauna, manners and customs, and the mythology of the creole and traditional cultures of French Guiana'. Mitaraka also published a periodical by the same name; the first issue (Feb 1992) included poetry, art criticism and interviews with local painters. Although Mitaraka seemed innovative in its inclusion of members from beyond French Guiana, notably the Antilles and Venezuela, non-creole artists have had to adopt creole and generally Western techniques to express their Guianese identity; only when assimilated into the prevailing creole ambience are non-creoles able to give voice. In the late 20th century a dialectic existed between an imitative tradition and the search for an artistic expression of Guianese identity, and this represented more than a simple split between learned and popular art. Questions of identity and the questioning of ties with France have turned the plastic arts and literature of French Guiana into a forum for collective commitment to those forgotten by history, whose voice has not been heard.

BIBLIOGRAPHY

J. Hurault: *Africains de Guyane* (Paris, 1970)
P. Grenand and F. Grenand: 'Les Amérindiens de Guyane Française aujourd'hui: Eléments de compréhension', *J. Soc. Américanistes*, lxvi (1979), pp. 361–82
S. Price and R. Price: *Afro-American Arts of the Suriname Rain Forest* (Berkeley, 1980)
Du réel à l'imaginaire (exh. cat., Cayenne, Hôtel de la Préfecture, 1984)
K. M. Bilby: *The Remaking of the Aluku: Culture, Politics, and Maroon Ethnicity in French South America* (diss., Baltimore, MD, Johns Hopkins U., 1989)
Regards sur l'art Boni aujourd'hui (exh. cat. by M.-P. Jean Louis and S. Anelli, Cayenne, Cons. Reg. Guyane, 1989)
'Des Blancs et des Indiens', *Phréat., Lang. & Création*, liii (1990), pp. 9–17
D. Bégot: 'Le Système des beaux arts dans le monde créole', *La Grande Encyclopédie de la Caraïbe*, x (Guadeloupe, 1990), pp. 26–47
M.-J. Jolivet: 'Entre autochtones et immigrants: Diversité et logique des positions créoles guyanaises', *Etud. Créoles*, xiii/2 (1990), pp. 11–32
J.-P. Klingelhofer, ed.: *Culture, Artisanat Wayana*, Caway Association (Cayenne, 1990)
'Les lianes d'Ariane', *Phréat., Lang. & Création*, liii (1990), esp. pp. 9–17, 47–60, 94–100 [special issue on French Guiana]

'Cultures de la Guyane et des Caraïbes: Arts de la terre, poétique du monde', *Mitaraka* i (1992) [whole issue]

MICHÈLE-BAJ STROBEL

Frias da Mesquita, Francisco de (*b* 1578; *d* after 1645). Portuguese military engineer, active in Brazil. From 1598 onwards he was in receipt of a royal pension as the pupil of his relative Nicolau de Frias. As a Master Engineer in Brazil between 1603 and 1635, he played an important role in setting an architectural style for the colony; numerous civil and ecclesiastical buildings were made his responsibility. He played an important part in the dissemination of the Mannerist architecture of the period. Working during the Spanish domination over Portugal (1580–1640), he had the opportunity to execute projects by Tiburzio Spannochi, architect to Phillip II, such as the Forte da Lage (1606) in Recife and the Forte do Mar (1609–12) in Salvador, Bahia. In 1614 he planned and began the construction of his principal work, the Forte dos Reis Magos, in Natal, Rio Grande do Norte. In the same year he took part in the reconquest of Maranhão, where he planned the Forte de Quaxenduba in São Luis. In 1617 he travelled south to build the Fortaleza de São Mateus in Cabo Frio; in the same year he planned the Mosteiro dos Benetinos in Rio de Janeiro. As a soldier, he took part in the expulsion of the Dutch from Salvador (1624–5), constructing fortifications during this war. He is last recorded in 1645 as an elderly, retired man, living in Portugal.

BIBLIOGRAPHY

J. Gomes de Brito: 'Convento das flamengas em Alcântara e os arquitectos Frias', *Rev. Arqueol.* [Lisbon], ii (1888)
C. Silva-Nigra: 'Francisco de Frias de Mesquita, engenheiro-mor do Brasil', *Rev. SPAHN*, ix (1945), pp. 9–84
A. de Carvalho: *D. João V e a arte do seu tempo*, ii (Lisbon, 1962), pp. 49–50, 140–41
V. Serrão: *Bol. Cult. Assembl. Distr. Lisboa*, cxxxiii (1977), p. 42; cxxxvi (1980), p. 4

CARLOS A. C. LEMOS

Friedeberg, Pedro (*b* Florence, 11 Jan 1937). Mexican painter. The son of German Jewish parents, he arrived in Mexico at the age of three. Having shown an early inclination for drawing and reading, he studied architecture at the Universidad Iberoamericana, where he was profoundly influenced by the teaching of Mathías Goeritz. Although his paintings, filled to overflowing with surprise, were sometimes described as examples of Surrealism or fantastic realism, they are not easily definable in terms of conventional categories. He used architectural drawing as the medium through which he created unusual compositions in series such as *Pure and Impure Architecture*; *Animals, People, Idiots, Philosophers*; *Sublime Perspectives*; and *Unclassifiable Lucubrations*. Friedeberg also designed furniture and useless objects, admitting that his artistic activity was rooted in boredom. This sense of irony and surfeit imparted to his pictures, through the hallucinatory repetition of elements, an asphyxiating formal disorder.

BIBLIOGRAPHY

I. Rodríguez Prampolini: *Pedro Friedeberg* (Mexico City, 1973)
Pedro Friedeberg: Clepsidra y Babilómetro (Mexico City, Mus. A. Mod; Coahuila, Mus. Bib. Pape, 1986)

JULIETA ORTIZ GAITÁN

Fuente, Enrique Yañez de la. *See* YAÑEZ, ENRIQUE.

G

Gahona, Gabriel Vicente. *See* PICHETA.

Galán, Julio (*b* Múzquiz, 1958). Mexican painter. Galán moved with his family to Monterrey in 1970 and after studying architecture there in 1978–82 became a full-time artist. Following a trip to New York in 1984, during which he met Andy Warhol, Galán subsequently spent part of each year in the USA. Known for his figurative paintings with collages and added objects, Galán is one of a generation of Mexican artists including Nahum B. Zenil (*b* 1947), German Venegas (*b* 1959), Alejandro Colunga (*b* 1948) and Roberto Marquez (*b* 1959), whose works are pervaded by a strong sense of the fantastic. Galán's varied sources include Surrealist painting, small painted Mexican votive images and *retablos* (nativity scenes). Like Rocío Maldonado, Galán plays with religious images, subverting them in compositions in which the artist often features as the principal character. Galán may appear as an adult or child or as a female character in a variety of guises. In *Muchacha triste porque se va de México* (1988; Rotterdam, Mus. Boymans-van Beuningen) Galán appears as a young woman sad to leave her homeland. The homoerotic element present in Galán's paintings is fundamental to the artists' questioning of traditional views in Mexico. Like the Neo-Mexicanismo movement, Galán challenges established beliefs and conventions through his painted narratives of overlapping metaphoric images. While Galán's work is rooted in Mexican culture, the success enjoyed by the artist among the New York avant-grade during the 1980s is evident in his reference to American photographs, postcards and Hollywood cinema.

BIBLIOGRAPHY

'Julio Galán: Retrospective Exhibition', *Latin Amer. A.* vi/1 (1994), pp. 58–9

E. J. Sullivan, ed.: *Latin American Art in the Twentieth Century* (London, 1996)

J. HARWOOD

Galeotti Torres, Rodolfo (*b* Quetzaltenango, 4 March 1912; *d* Guatemala City, 22 May 1988). Guatemalan sculptor. He began his career as an apprentice to his father, Antonio Galeotti, a sculptor and marble-worker from Tuscany. When he finished his secondary education in Quetzaltenango he went to Italy, where from 1930 to 1933 he studied drawing, modelling and sculpture in marble at the Accademia di Belle Arti e Liceo Artistico in Carrara. On his return to Guatemala he made an *Obelisk to Victory* (h. 19 m, 1934–5; Quetzaltenango) and worked on the sculptural decoration in hammered cement of the Palacio de la Unión (known as the 'Maya Palace', 1940) in San Marcos and on the Palacio Nacional (1940–43) in Guatemala City.

Galeotti Torres twice won first prize in the Concurso Nacional de Escultura Rafael Yela Günther, and in 1945 he was commissioned to produce a monument to the *Revolution of 1944* (hammered cement, h. 2 m; Guatemala City, Escuela Federación Pamplona). This was followed in 1946 by a one-man show that was a resounding success. During these years he developed his particular style of vigorous figures under the influence of contemporary Mexican sculptors. Among his outstanding works are *Three Moments in Engineering* (relief, 1959), for the School of Engineering at the Ciudad Universitaria in Guatemala City; *Tecún Umán* (1968; Quetzaltenango); and busts of diverse distinguished personages from Guatemalan history, such as *Bernal Díaz del Castillo*, *Rafael Landívar*, the doctors *Rodolfo Robles* and *Juan J. Ortega*, the musician *Rafael Alvarez* (composer of the national anthem), *Marshal J. V. Zavala* and the writer *Carlos Wyld Ospina*. In the last years of his life he made two large pieces of sculpture sited in Guatemala City: *Ball Player* (1984; Banco Indust. Col.) and *Pope John Paul II* (1986; Guatemala City, Avenida Las Americas).

BIBLIOGRAPHY

J. A. de Rodríguez, ed.: *Arte contemporáneo occidente–Guatemala* (Guatemala City, 1966), pp. 53–5

C. C. Haeussler: *Diccionario general de Guatemala* (Guatemala City, 1983), pp. 668–9

E. Illescas de Gereda: 'Notas sobre Galeotti Torres', *Banca Cent.*, xxiv (Jan-March 1995), pp. 17–32

L. Méndez D'Avila: *Visión del arte contemporáneo en Guatemala*, i (Guatemala City, 1995)

JORGE LUJÁN-MUÑOZ

Gálvez. Guatemalan family of sculptors. Antonio Joseph de Gálvez was a master carpenter and mason. Few of his works are known. In 1720 he contracted with S Francisco, Santiago de Guatemala (now Antigua), to make the *monumento* (altar) used on Maundy Thursdays. He was in charge of the rebuilding of the monastic hospital of S Pedro in Santiago de Guatemala. His son Francisco Javier de Gálvez was also a master carver, whose surviving works show high ability. In 1747 Francisco Javier contracted to make the retable of the *Crucifixion* (untraced) in the Capilla de Los Reyes in Santiago de Guatemala Cathedral. In 1758 he was commissioned by the church of La Merced in Santiago de Guatemala to make two retables (Guatemala City, La Merced), one of *Jesus of Nazareth* and the other

of *Our Lady of Slavery*. He also worked in the Real Palacio in the 1760s under the direction of Luis Díez Navarro. Francisco Javier's brother, Vicente de Gálvez (*d* 1780), was also a master carver. He directed the erection of the temporary catafalques for the funeral ceremonies of Ferdinand VI (1760) and Isabella Farnese (1767) and probably also made others. Vicente moved to Tegucigalpa, Honduras, where he made the high altar of the parish church, and at his death he was working on the statues of *El Señor Crucificado de las Animas* and *St Joseph* and the gilding of the pulpit. Both Francisco Javier and Vicente can be considered among the principal exponents of Spanish American Baroque in Guatemala. They developed new forms of columns and pilasters and at the same time extended the decorative repertory of altarpieces and occasional architecture.

BIBLIOGRAPHY
H. Berlin: *Historia de la imaginería colonial en Guatemala* (Guatemala City, 1952)
H. Berlin and J. Luján-Muñoz: *Los túmulos funerarios en Guatemala* (Guatemala City, 1983)

JORGE LUJÁN-MUÑOZ

Gálvez Suárez, Alfredo (*b* Cobán Alta Verapaz, 28 July 1899; *d* Guatemala City, 14 Dec 1946). Guatemalan painter. He was a pupil of Justo de Gandarias (1848–1933), a Spanish artist residing in Guatemala, and of Agustín Iriarte (1876–1962); in spite of this training he is often considered self-taught because he did not attend the Escuela Nacional de Bellas Artes. When his reputation was already established, he was awarded a grant by the Mexican government in 1923, which made it possible for him to study recent artistic developments there at close hand and thus to complete his training.

Gálvez Suárez divided his time between his own art and his work (between 1928 and 1939) as a draughtsman in a print shop and lithographer's workshop. He was especially effective in tempera and watercolour, as attested by such works as *Women Weavers of Atitlán* (tempera, *c.* 1936) and *Decorator of Masks, Chichicastenango* (watercolour, 1938; both Guatemala City, Mus. N.A. Mod.). His most important works, however, were paintings on a mural-like scale executed in tempera on fibreglass and cardboard panels for the main staircases in the south façade of the Palacio Nacional in Guatemala City (1940–43). These include *The Conflict* (4.56×19.56 m), a major scene representing the struggle between the Indians and the Spaniards following the Conquest; two minor scenes, *Don Quixote* (4.52×3.26 m) and *The Message* (4.52×3.38 m, a reference to *Popol Vuh*), symbolizing the Spanish and Mayan–Quiche languages respectively by way of literature; and three panels showing the evolution of a national identity, including *Blood, Technique and Spirit* (4.27×17.26 m), which moves from the pre-Hispanic period to the 20th century. Gálvez Suárez also executed other large-scale paintings that were later destroyed, for example in the Guatemala pavilion at the Golden Gate International Exhibition (San Francisco, CA, 1933) and *The Four Continents* (*c.* 1944; Guatemala City, San Carlos Gran Hotel). He taught at the Academia Nacional de Bellas Artes in Guatemala City from 1940, and in 1945 he was visiting professor of drawing and painting at the University of New Mexico in Albuquerque.

BIBLIOGRAPHY
M. Alvarado and R. Galeotti: *Indice de pintura y escultura* (Guatemala City, 1946)
I. L. de Luján and L. Luján Muñoz: *Alfredo Gálvez Suárez (1899–1946)* (Guatemala City, 1989)
L. Méndez de Penedo: 'Alfredo Gálvez Suárez', *Banca Cent.*, xviii (July–Sep 1993), pp. 75–87
L. Méndez D'Avila: *Visión del arte contemporáneo en Guatemala*, i (Guatemala City, 1995)

JORGE LUJÁN-MUÑOZ

Gamarra, José (*b* Tacuarembó, 12 Feb 1934). Uruguayan painter and printmaker. He studied from 1952 to 1959 at the Escuela Nacional de Bellas Artes in Montevideo under the painter Vicente Martín (1911–98), supplementing his education with training as a printmaker in Rio de Janeiro in 1959 under Johnny Friedlaender and Iberé Camargo. He exhibited widely after settling in France in 1963, winning a major prize at the Paris Biennale in 1963 and taking part in the Venice Biennale in 1964. A work from this period is *Untitled* (mixed media on burlap, 1964; see

José Gamarra: *Untitled*, mixed media on burlap, 1.05×1.06 m, 1964 (Austin, TX, University of Texas, Jack S. Blanton Museum of Art)

fig.). In his early works Gamarra often favoured archaic 'magical' signs, as in *Painting* (see Argul, pl. 63), in which spiky linear forms are displayed in relief on a textured surface; other works, such as *Painting* (1962; see Argul, pl. 65), are indicative of the more openly mythical side of his early painting. His later paintings, some of which are dependent on photography (see exh. cat., pls 167, 168), often treat specifically Latin American subjects, in the context of their historical origins, seen with a critical eye.

BIBLIOGRAPHY
J. P. Argul: *Las artes plásticas del Uruguay* (Montevideo, 1966); rev. as *Proceso de las artes plásticas del Uruguay* (Montevideo, 1975)
Art of the Fantastic: Latin America, 1920–1987 (exh. cat., ed. H. T. Day and H. Sturges; Indianapolis, Mus. A., 1987), pp. 166–9, 246–7
José Gamarra (exh. cat., Paris, Gal. Albert Loeb, 1992)
L. Pérez Oramas: 'José Gamarra: Después del Edén', *A. Nexus*, viii (1993), pp. 92–4

ANGEL KALENBERG

Gandolfi, José Maria (*b* São Paulo, 1933). Brazilian architect. He graduated from the Faculty of Architecture

of Mackenzie University, São Paulo (1958), and established an office in Curitiba in 1961, when he was appointed Professor of Architectural Composition at the Federal University of Paraná. Working in association with others, he won a series of important public competitions including a club (1962; with Luiz Forte Netto) at Campo Santa Monica, near Curitiba; the Municipal Theatre (1966; with Roberto Luiz Gandolfi and L. F. Dunin) at Campinas, São Paulo; and the Petrobrás Headquarters (1968; with Roberto Luiz Gandolfi, Luiz Forte Netto, J. Sanchotene, A. Assad and V. de Castro) in Rio de Janeiro, which concealed its gigantic size in a composition of mass and space created by hanging gardens. He and his brother, Roberto Luiz Gandolfi (*b* 1936), then won competitions for the offices of the Banco do Brasil (1970) in Caxias do Sul and the Instituto Brasileiro do Café headquarters (1976) in Paranaguá. They went into practice together, and the reputation gained from the competition entries led to an impressive number of contracts for both public and private works; the partnership became one of the best known in Brazil. Gandolfi helped form the Directorate of Urban Development in Curitiba in 1971, becoming Director of Parks and Open Spaces; in four years he expanded the city's green areas from 0.5 sq. m to 12.5 sq. m per head, giving Curitiba an unequalled quality of environment. Later concern for the integration of buildings and landscape was revealed in designs for two branches of Citicorp Bank, one in Porto Alegre (1980) and the other at Curitiba (1984) in which internal gardens and a series of terraces continue the open space in front of the building towards the central atrium.

BIBLIOGRAPHY

'Master Plan: State of Paraná Coast', *Acrópole*, 341 (1967), pp. 22–5
'Petrobrás Headquarters', *Constr. São Paulo*, 1250 (1972), pp. 6–12
'Citibank Headquarters in Curitiba and Porto Alegre', *Projeto*, 82 (1985), pp. 80–89

PAULO J. V. BRUNA

Garavito, Humberto (*b* Quetzaltenango, 26 Jan 1897; *d* Guatemala City, 1 June 1970). Guatemalan painter, collector and writer. He began his artistic studies in Quetzaltenango, where he was fortunate to come into contact with the Spanish painter Jaime Sabartés (1881–1968) and Carlos Mérida, with whom he became friends. He continued his studies in Guatemala City and then in Mexico City at the Real Academia de San Carlos, where his fellow students included Rufino Tamayo, Roberto Montenegro and Miguel Covarrubias. He returned briefly to Guatemala only to leave for Europe. He studied in Madrid at the Academia de Bellas Artes de San Fernando and from 1924 to 1925 lived in Paris. He returned to Guatemala City in 1927 and in 1928 became director of the Academia de Bellas Artes. By then he had developed a style derived from French Impressionism, although he gradually moved towards a more naturalistic style, perhaps in response to the taste of his clients.

Garavito generally painted in oils on a medium or small scale, concentrating on the beautiful Guatemalan landscape, of which he can in a sense be considered the 'discoverer'. His preferred subjects were the mountains, volcanoes and lakes of the Guatemalan high plateau, and he was the first to incorporate in his works the Indians in their brightly coloured clothes. He was the central figure

and teacher of a group of figurative painters and painters working in a naturalistic style, such as Antonio Tejeda Fonseca (1908–66), Valentín Abascal (1909–81), Hilary Arathoon (1909–81), Miguel Angel Ríos (*b* 1914) and José Luis Alvarez (*b* 1917), and his influence on young painters continued even after his death. As a collector and art historian he was responsible for the revaluation of Francisco Cabrera.

WRITINGS

Francisco Cabrera: Miniaturista guatemalteco (Guatemala City, 1945)

BIBLIOGRAPHY

Humberto Garavito, pintor de Guatemala (exh. cat. by I. L. de Luján and L. Luján-Muñoz, Guatemala City, Gal. Dzunún, 1981)
L. Méndez D'Avila: *Visión del arte contemporáneo en Guatemala*, i (Guatemala City, 1995)

JORGE LUJÁN-MUÑOZ

Garay (Caicedo), Epifanio (*b* Bogotá, 1849; *d* Bogotá, 1903). Colombian painter and singer. He studied at the Académie Julian in Paris, where he began his career as a painter of religious subjects and scenes of local customs and manners. Later he devoted himself to portraiture, earning a reputation as its greatest exponent in Colombia and establishing a workshop. His work in this genre was not only constant and prolific but also represented a considerable achievement through his ability both to capture the sitter's likeness and to convey a sense of his or her personality.

Garay's parallel career as an opera singer, which enabled him to travel extensively, helped him acquire the sophistication and worldly air visible in his work. He exhibited his paintings in Paris with some success. His association with opera led him to use props, accessories and costumes in his paintings, as if he were choosing these elements to enhance the beauty, courage, spiritual qualities or dignity of the sitter. Garay's realistic and detailed rendering of women's accessories and clothing, and of objects such as books, pens and walking sticks in his portraits of men, contributes to the solemn attraction of his work.

BIBLIOGRAPHY

Epifanio Garay: Iniciación de una guía de arte Colombiano (exh. cat. by F. A. Cano, Bogotá, Acad. N. B.A., 1934)
Garay (exh. cat. by N. Haime, Bogotá, Mus. N., 1979)

EDUARDO SERRANO

García, Domingo (*b* Coamo, 1932). Puerto Rican painter and printmaker. He studied painting at the School of the Art Institute of Chicago, the National Academy of Design in New York and with William Locke in London. In 1959 he founded the Campeche Workshop and Gallery in San Juan, where for nine years he taught painting, drawing and screenprinting. In the 1950s, when Puerto Rican painting was dominated by social realism, he was rare in developing an expressionist style with the aim of expressing a subjective reality. In both paintings and screenprints he used figurative subject-matter as a point of departure for the exploration and communication of his psychological and emotional state, with portraits and especially self-portraits playing a constant and significant role.

Primarily a portraitist, García also painted urban landscapes and abstract themes. Although he consistently used intense colour and gestural brushwork in his work, his production can be divided into several stylistic phases:

gestural expressionist depictions of landscape and figures (1957–68); portraits and cityscapes in a style related to hard-edge and colour field painting (1965–75); and from 1976 a return to imaginative, expressionistic modes of painting, this time characterized by a more sombre palette dominated by blacks. In some works, particularly in his poster designs, he manifested a concern with the social and political reality of Puerto Rico, and in 1986 he embarked on an ambitious project aimed at representing the conflict of Puerto Rican history through monumental iconic portraits of key figures of the island's past.

BIBLIOGRAPHY
Personajes del recuerdo: Recent Works by Domingo García (exh. cat. by L. S. Sims, New York, Mus. Barrio, 1979)
Domingo García: Cuatro décadas de pintura (exh. cat. by L. Homar, J. A. Pérez Ruiz and L. S. Sims, San Juan, Inst. Cult. Puertorriqueña, 1987)
Domingo García: Recent Work (exh. cat. by E. García Gutiérrez and M. C. Ramírez, San Juan, Park Gal., 1988)
MARI CARMEN RAMÍREZ

García, Gay (Enrique) (*b* Santiago de Cuba, 15 Jan 1928). Cuban sculptor, painter, printmaker and tapestry maker. He graduated from the Academia de S Alejandro in Havana in 1955 and went to Mexico, where he studied with David Alfaro Siqueiros in Mexico City. In 1962 he travelled to Italy on a Unesco scholarship. As a political exile from Cuba he lived for several years in Europe, the USA and Puerto Rico before settling in Miami in 1978. He worked in bronze and steel, realized murals, drawings, lithographs and tapestries. His tapestries echo the concern with gestural brushwork and grainy texture evident in his drawings and lithographs. His painting and sculpture were initially influenced by Abstract Expressionism, but as a sculptor working in bronze and steel, his affinities were with Arnaldo Pomodoro (*b* 1926). García's originality lay in the tensions he created between smooth and coarse textures, and between geometric and asymmetrical forms as a means of suggesting metaphors within an essentially abstract formal language. For example, in *Icarus* (1984; Coral Gables, FL, priv. col., see 1987 exh. cat., p. 143) he transposed the frailty attributed to Icarus's wings on to the torso and his strength on to the wings.

BIBLIOGRAPHY
M. V. Adell, ed.: *Pintores cubanos* (Havana, 1962)
R. Pau-Llosa: 'Gay García: La escultura de la acción', *Vanidades*, xxv/2 (1985), pp. 12–13
Outside Cuba/Fuera de Cuba (exh. cat., New Brunswick, NJ, Rutgers U., Zimmerli A. Mus., 1987)
RICARDO PAU-LLOSA

García, Romualdo (*b* Guanajuato, 1852; *d* Guanajuato, 1930). Mexican photographer. In 1887 he opened a photographic studio, at a time when Guanajuato, a mining town, was experiencing an unprecedented economic boom that made it one of Mexico's most important commercial centres. He became the town's most popular society photographer, recording the aristocracy in their fashionable European clothes, as well as the priesthood, the agricultural labourers and the miners.

Stylistically and technically traditional, García took all his photographs in the studio, always in front of the same props and in the same lighting conditions. He did not present detail, or suggest internal emotion. His subjects either stood or sat, and always appeared full-figure; they knew that they were appearing in a photograph, and looked appropriately static.

BIBLIOGRAPHY
C. Canales: *Romualdo García: Un fotografo, una ciudad, una época* (Guanajuato, 1980)
E. Billeter: *Fotografie Lateinamerika* (Zurich and Berne, 1981)
Images of Mexico: The Contribution of Mexico to 20th Century Art (exh. cat., ed. E. Billeter; Frankfurt am Main, Schirn Ksthalle; Dallas, TX, Mus. A.; 1987–8), pp. 377–9
C. Canales and E. Poniatowski: *Romualdo García: Retratos* (Guanajuato, 2/1990)
Romualdo García (exh. cat. by E. Poniatowski, Monterrey, Mus. A. Contemp., 1993)
ERIKA BILLETER

García, Víctor Manuel. *See* VÍCTOR MANUEL.

García Guerrero, Luis (*b* Guanajuato, 18 Nov 1921). Mexican painter. He practised as a lawyer in Mexico City before enrolling in 1949 at the Escuela Nacional de Artes Plásticas, Mexico City, and the Escuela de Pintura Escultura y Grabado 'La Esmeralda', also in Mexico City. His landscapes, usually in small format, were strongly influenced by Cézanne and depicted in detail the countryside around Guanajuato and Mexico City (*The Three Kingdoms of Nature*, oil on wood, 1982; Mexico City, Gal. A. Mex.). He also produced still-lifes, which were realistic and characterized by a uniform, warm light; they reveal great simplicity, precision and delicacy. In his portraits Guerrero often painted workmen and farm labourers, and he emphasized the expression of the eyes. He exhibited throughout Mexico, and frequently at the Galería de Arte Mexicano, Mexico City.

BIBLIOGRAPHY
M. Traba: *La zona del silencio: Ricardo Martínez, Gunther Gerzso, Luis García Guerrero* (Mexico City, c. 1975)
L. Cardoza y Aragón: *Luis García Guerrero* (Mexico City, 1982)
S. Pitol: *Luis García Guerrero* (Guanajuato, 1993)
ELISA GARCÍA BARRAGÁN

Garci-Aguirre, Pedro (*b* Cádiz, ?1750; *d* Guatemala City, 15 Sept 1809). Spanish engraver and architect, active in Guatemala. He studied in Cádiz around 1760, and in 1773 he moved to Madrid, where he was probably taught by the noted engraver Tomás Francisco Prieto (1726–82). In 1778 he was appointed assistant engraver of the Real Casa de Moneda in Guatemala, where he arrived the next year. Following the death of the principal engraver, he was confirmed in this post in 1783 and held it until his death. Besides his work as engraver of coin dies and medal stamps, Garci-Aguirre made numerous fine copperplate engravings for books (e.g. P. Ximena: *Reales Exequias por el Señor Don Carlos III*, Guatemala City, 1790) and other publications. In Guatemala he revived the art of engraving, working in the Neo-classical style, which he was one of the first to introduce to the country. He soon became involved with architectural works in connection with the building of the new capital of Guatemala City, first in the Real Casa de Moneda and then on other royal projects. From 1783, together with Santiago Marquí, he was responsible for the construction of the cathedral in Guatemala City. He was mainly associated with the Dominican Order, for which he worked at their sugar mill in San Jerónimo (Verapaz) and built their large vaulted church

and monastery in Guatemala City (both completed 1809). Though building had already begun, his design for the church of the convent of S Clara in Guatemala City was not approved by the Real Academia de S Fernando in Madrid since it was considered to be in bad taste. He took part in the initial stages of the construction of the great churches of S Francisco and La Recolección (1780–1808), both in Guatemala City. In 1795 his design for an Academia de Bellas Artes was not accepted by the Crown. As a member of the Sociedad de Amigos del País of Guatemala, he was responsible for establishing the first Escuela de Dibujo in Guatemala and was the first director from March 1797. When the Sociedad de Amigos was closed by royal decree in 1800, the school continued under his direction until his death. In this school leading Guatemalan artists such as José Casildo España (1798–1848) and the miniaturist Francisco Cabrera were trained.

BIBLIOGRAPHY

M. C. Amerlinck y Assereto: 'Pedro Garci-Aguirre, la iglesia de Santa Clara en la Nueva Guatemala y la Academia de San Fernando de Madrid', *Archv Esp. A.*, cxciii (1976), pp. 41–57

R. Toledo Palomo: *Las artes y las ideas de arte durante la independencia, 1794–1821* (Guatemala City, 1977)

J. Luján-Muñoz: 'Pedro Garci-Aguirre, arquitecto neo-clásico de Guatemala', *Bol. Cent. Invest. Hist. & Estét. U. Caracas*, xxiii (1978), pp. 74–109

R. Gutiérrez, ed.: *Pintura, escultura y artes útiles en Iberoamérica, 1500–1825* (Madrid, 1995)

JORGE LUJÁN-MUÑOZ

García Joya, Mario. *See* MAYITO.

García Mesa, José (*b* Cochabamba, 1846; *d* La Paz, 1911). Bolivian painter. In 1864 he went to Europe to study painting. He remained there for some years, visiting Rome and working in Paris, where he had a studio. On his return to Bolivia, he worked for a time and then returned to Europe. In 1880 he offered his services as portrait painter to the newspaper *El Comercio* in La Paz, stating that he had founded an academy of drawing and painting in the Instituto Nacional de Ciencias y Letras. At this time he painted murals with religious themes for Cochabamba Cathedral. In 1882 the Musée du Louvre in Paris bought one of his paintings. In 1889 he took part in the Exposition Universelle in Paris and in the Salon d'Artistes Libres, where he obtained an honourable mention for his painting *Lake Titicaca*. His style was academic, with rigid figures in grandiose poses, painted in a limited range of cool colours. He frequently made use of photography to treat urban topics. While in Paris he painted large views of the principal cities of Bolivia, based on photographs, for example *The City of Sucre* (1889; Sucre, City Hall) and *Cochabamba Main Square* (1889; Cochabamba, City Hall). His later paintings include *The Execution of Murillo* (1905; La Paz, Mus. Casa Murillo). Several of his landscapes and seascapes, painted in France, are in the Real Museo Charcas, Universidad Mayor, Sucre.

BIBLIOGRAPHY

M. Chacón Torres: *Pintores del siglo XIX* (La Paz, 1963)

P. Querejazu: *La pintura boliviana del siglo XX* (Milan, 1989)

PEDRO QUEREJAZU

García Ponce, Fernando (*b* Mérida, Yucatán, 1933; *d* Mexico City, 11 July 1987). Mexican painter and draughtsman. He studied architecture at the Universidad Nacional Autónoma de México in Mexico City, at the same time taking private painting lessons from the Spanish painter Enrique Climent (1897–1980). Like the majority of artists of his generation, he made study trips to Europe and shared the general desire to practise a cosmopolitan art without nationalistic traits. His early works showed the impact of his architectural training and of the Cubism of Braque and Gris, but he later abandoned all traces of figuration in favour of an abstract style that focused attention on the process by which the painting was constructed. His prolific production, which consisted not only of paintings but also of collages and prints, showed a variety of influences during and after the 1960s, including *Art informel*, matter painting (especially from Catalonia), the austerity of Minimalism but above all the assemblages of Kurt Schwitters (1887–1948), within compositions clearly structured by orthogonals criss-crossed by diagonal elements and aggressive fissures. His brother Juan García Ponce (*b* 1932) was a noted writer and the leading critic of the so-called 'generation of rupture' artists in Mexico.

BIBLIOGRAPHY

Fernando García Ponce (exh. cat., intro. M. L. Borrás; Mexico City, Mus. A. Mod., 1978)

El mundo plástico de Fernando García Ponce (exh. cat., essay R. Eder; Monterrey, Mus. Reg. Nue. León, 1982)

M. L. Borrás: *Fernando Gracía Ponce* (Mexico City, 1992)

Fernando García Ponce (1933–1987): Pinturas, collages y gráficas (exh. cat. by J. García Ponce, Mexico City, Mus. Pal. B.A., 1997)

TERESA DEL CONDE

Garland, Colin (*b* Sydney, 1935). Jamaican painter of Australian birth. He studied painting first at the National School of Art, Sydney (1953–5) and later at the Central School of Art and Design, London (1959), before emigrating to Jamaica in 1962. He arrived in the island a very competent painter, with the rudiments of his style in place. Inspired essentially by Surrealism and Magic Realism, he also studied the work of various artists who have exhibited a taste for the fantastic, such as Botticelli, Bosch, Giuseppe Arcimboldo and Richard Dadd. He also benefited from his knowledge of the art of John Dunkley and some of the Haitian primitives. Jamaica and Haiti were his principal sources of inspiration. The land and sea, the flora, the birds, fish and the people of varied types and exotic costumes all feature in his surreal juxtapositions. The paintings are hard to decipher, and indeed, Garland claimed that they are not meant to be unravelled like puzzles but simply viewed as exotic fantasias. However, paintings such as *End of an Empire* (1971; artist's col.) and *In the Beautiful Caribbean* (1974; Kingston, N.G.) demonstrate his interest in constructing a more coherent iconography. He was also a sensitive portraitist, illustrator and stage designer, although his excursions into these areas were rare.

BIBLIOGRAPHY

P. Archer-Straw and K. Robinson: *Jamaican Art* (Kingston, 1990)

V. Poupeye: *Caribbean Art* (London, 1998)

DAVID BOXER

Gasparini, Paolo (*b* Gorizia, 1934). Venezuelan photographer of Italian birth. He moved to Venezuela in 1954, working as a photographer of architecture. At the same

time he depicted the landscape and the life of the Venezuelan countryside. He was invited to participate in the Fourth Photographic Show in Spilimbergo, Italy, where he won a silver medal. He settled for four years in Cuba, where he worked at the Consejo Nacional de Cultura. His work, based on neo-realism, was influenced by that of Paul Strand (1890–1976), and he was particularly interested in photographing aspects of the social structure. He returned to Venezuela in 1967 and took part in the Venezuelan Pavilion at Expo 67 in Montreal. He was a founder-member of the Consejo Latinoamericano de Fotografía. Examples of his photography are in the Museum of Modern Art, New York, in the International Museum of Photography at George Eastman House, Rochester, NY, and in the Bibliothèque Nationale in Paris.

PHOTOGRAPHIC PUBLICATIONS
Retromundo (1987)

BIBLIOGRAPHY
Sammy Cucher: Dystopia/Paolo Gasparini: La pasión sacrificada, 2 vols (exh. cat., Caracas, Mus. A. Visuales Alejandro Otero, 1995)

CRUZ BARCELÓ CEDEÑO

Gasperini, Gian Carlo. *See under* CROCE, AFLALO AND GASPERINI.

Gedovius, Germán (*b* Mexico City, 1 May 1867; *d* Mexico City, 16 Mar 1937). Mexican painter and teacher. He studied at the Kunstakademie in Munich from 1884 to 1892. After producing a series of portraits in the manner of Old Masters, such as *Self-portrait in the Style of Rembrandt* (San Luis Potosí, Casa Cult.), a particularly outstanding example, he showed the influence of late 19th-century German Symbolism in paintings such as *Fantasy Palette* (1893; Mexico City, Carolina Reinking priv. col., see 1984 exh. cat., p. 35). There are Symbolist overtones, too, in some of the many portraits painted on his return to Mexico, such as *Dolores Gedovius* (1898; San Luis Potosí, Casa Cult.).

Gedovius was one of the principal proponents of a type of painting evoking the age of the Viceroys from a modern point of view. Among his favourite subjects were the interiors of old convents, usually deserted (e.g. *Sacristy at Tepotzotlán*, 1906; Saltillo, Ateneo Fuente); contemporary figures dressed in the costumes of New Spain, such as the portrait of *Luis Quintanilla* (1901; Guadalajara, Mus. Reg. Antropol. & Hist.); and flower studies depicting traditional Talavera flower vases. He also painted works with allegorical overtones such as *Baroque Nude* (*c.* 1920; Mexico City, Mus. N. A.), in which a figure is surrounded by fragments of retables; the combination here of a religious atmosphere with eroticism bears comparison with the work of decadent poets.

Like Saturnino Herrán, Gedovius painted popular types and customs with the aim of expressing what was then called the 'soul of the nation'. Stylistically his work encompassed elements of the neo-Baroque and of Post-Impressionism. He exercised considerable influence as a teacher of colouring and composition at the Escuela Nacional de Bellas Artes in Mexico City in the first decades of the century.

BIBLIOGRAPHY
Germán Gedovius, 1867–1937 (exh. cat., essay F. Ramírez, Mexico City, Mus. N. A., 1984)

FAUSTO RAMÍREZ

Gego [Goldschmidt, Gertrudis] (*b* Hamburg, 1 Aug 1912; *d* Caracas 17 Sept 1994). Venezuelan architect, sculptor, draughtsman and printmaker of German birth. She studied architecture at the Technische Hochschule in Stuttgart until 1938; one of her principal teachers was Paul Bonatz. The following year she travelled to Venezuela, where she combined her artistic career as a sculptor, draughtsman and engraver with teaching work. In 1952 she adopted Venezuelan nationality. She later began experimenting with the conversion of planes into three-dimensional forms (e.g. *Esfera*, 1959; see colour pl. XI, fig. 2), exploring the media of drawing, watercolour, engraving, collage and sculpture and integrating them into architectural spaces in defiance of artistic conventions. A pioneering example of her integration of art and architecture was her design (1962) for the headquarters of the Banco Industrial de Venezuela in Caracas, which comprised a 10-m tower of interlocking aluminium and steel tubes. Later works that explored the form of the web included *Trunk No. 6* (wire, 1976; artists col., see exh. cat., p. 114). She participated in numerous one-woman and group shows in Venezuela and other countries, and in 1980 she was awarded the Premio Nacional de Artes Plásticas in Venezuela. She executed over 850 sculptures, 600 drawings and 60 engravings during her career.

UNPUBLISHED SOURCES
Caracas, Fond. Gal. A. N., Archvs [File G-9]

BIBLIOGRAPHY
M. F. Palacios: 'Conversación con Gego', *Ideas*, 3 (1972), pp. 23–7
Gego (exh. cat. by H. Ossott, Caracas, Mus. A. Contemp., 1977)
J. Calzadilla: *El artista en su taller* (Caracas, 1979)
De Venezuela: Treinta años de arte contempóraneo (1960–1990)/From Venezuela: Thirty Years of Contemporary Art (1960–1990) (exh. cat. by R. de Montero Castro, Seville, Pab. A., 1992)

GUSTAVO NAVARRO-CASTRO

George, Milton (*b* Asia, Manchester, Jamaica, 23 July 1939). Jamaican painter. He attended the Jamaica School of Art in Kingston part-time, although he was essentially self-taught. He started exhibiting in the late 1960s and he was a major exponent of the expressionist trend in Jamaican art. His central theme was the absurdity of the human condition, as seen from a personal, highly subjec-

Milton George: *Fourteen Pages from my Diary* (detail), oil pastel on paper, 310×385 mm, 1983 (Kingston, National Gallery)

tive perspective. While his early work is characterized by a gentle melancholy, his mature work has satirical, albeit anguished overtones. The human figure is central to most of his paintings and is usually subjected to caricatural distortion, although on occasion he also experimented with full abstraction. His major subjects were the self, the artist and the art world, the individual versus society, the man–woman relationship. Occasionally he also commented on political issues. Most of his works include self images, in the form of direct self-portraits or projections into other personae such as the Christ figure. Among his major works is a 14-panel work, *Fourteen Pages from my Diary* (1983; see fig.), which presents a pitilessly funny analysis of the artist's relationship with women. He worked mainly in oils and oil pastel on canvas and paper. Often described as 'a painter's painter', his paintings illustrate a sensuous delight in the act of painting itself. A daring colourist, he had an acute sense for the emotional impact of colour, and some of his most dramatic paintings verge on the monochromatic and minimalist (e.g. *Judgement*, 1987; Kingston, priv. col.).

BIBLIOGRAPHY

G. Escoffery: 'The Intimate World of Milton George', *Jamaica J.*, xix/2 (1986), p. 28

New World Imagery: Contemporary Jamaican Art (exh. cat., London, Hayward Gal., 1995)

D. Boxer and V. Poupeye: *Modern Jamaican Art* (Kingston, 1998)

V. Poupeye: *Caribbean Art* (London, 1998)

VEERLE POUPEYE

Gerstein, Noemí (*b* Buenos Aires, 10 Nov 1908; *d* Buenos Aires, 30 Nov 1993). Argentine sculptor. She began her studies in 1934 under the Argentine sculptor Alfredo Bigatti (1898–1964), and in 1950–51 she studied in Paris under Ossip Zadkine (1890–1967) with a French government grant. After working in a conventional figurative style she gradually assimilated the language of the avant-garde, for example in an extraordinary series of *Maternities* (1952–6; *Mother and Son*, version, iron and bronze, h. 350 mm, 1953), in which forms are defined by rhythmic relationships between hollows and volumes. In 1953 she won first prize in the international section of a London-based competition for a monument to the *Unknown Political Prisoner*, representing the theme with an abstract work (version, steel and bronze, 450 mm, 1953; Buenos Aires, Acad. N. B.A.). This was followed by an expressive symbolic marble carving entitled *The Scream* (1956; Buenos Aires, Mus. N. B.A.).

In the late 1950s Gerstein began to use iron and other metals soldered together into exaggerated vertical shapes. These were followed by works made of soldered bronze tubes, sometimes on a monumental scale, for example *Young Girl* (1959; see fig.) and the aggressive *Samurai* (1959; Buenos Aires, Mus. N. B.A.). One such work was awarded a prize in 1962 at the international sculpture competition run by the Instituto Torcuato Di Tella in Buenos Aires. In 1964 Gerstein began using metal fragments or industrial elements placed on a background of sheet metal to create landscapes or humorous scenes, and she also produced doors, iron gates and fountains. From the 1970s she deployed polished bronze hemispheres in different combinations: closed or open, grouped rigidly together or loosely arranged.

Noemí Gerstein: *Young Girl*, bronze, h. 654 mm, 1959 (New York, Museum of Modern Art)

BIBLIOGRAPHY

E. Rodríguez: *Noemí Gerstein* (Buenos Aires, 1955)

O. Svanascini: *Noemí Gerstein* (Buenos Aires, 1962)

J. López Anaya: *Historia del arte argentino* (Buenos Aires, 1997)

NELLY PERAZZO

Gerzso, Gunther (*b* Mexico City, 17 June 1915). Mexican painter and printmaker. He was sent by his parents to Cleveland, OH, to study stage design. On his return to Mexico in 1935 he joined the national film industry and worked for years on a large number of films. Soon afterwards he began to concentrate on painting; he had Julio Castellanos and Juan O'Gorman as mentors but was essentially self-taught. He was particularly influenced by Wolfgang Paalen and other Surrealist artists who arrived in Mexico during World War II. The impact of Surrealism was evident in the paintings shown at his first exhibition in 1950, by turns dramatic, witty and erotic. His feeling for colour was already much in evidence.

Still following Paalen's example, though without imitating him, in the mid-1950s Gerzso moved towards abstraction, basing his first such paintings on prehispanic architecture, as in *Landscape at Papantla* (1955; Mexico City, Mus. A. Carrillo Gil). Even after 1960, when he began to concentrate on subtle relationships of colour within a geometric structure, he continued to hint at sensory and even erotic responses. While linear elements dominate the compositions of his mature and meticulously

executed paintings and screenprints (e.g. *House of Tonatiuh*, 1978; see colour pl. XI, fig. 3), even in these works colour alludes to hidden levels of experience.

BIBLIOGRAPHY
L. Cardoza y Aragón: *Gunther Gerzso* (Mexico City, 1972)
O. Paz and J. Golding: *Gerzso* (Neuchâtel, 1983)
R. Eder: *Gunther Gerzso: El esplendor de la muralla* (Mexico City, 1994)
D. Ashton: *Gunther Gerzso* (Beverly Hills and Mexico City, 1995)
XAVIER MOYSSÉN

Gilbert, Araceli (*b* Guayaquil, 13 May 1914). Ecuadorean painter. She studied in Santiago, Chile, at the Escuela de Bellas Artes (1936–9) and at the Escuela de Bellas Artes in Guayaquil, Ecuador (1942–3). Between 1944 and 1946 she studied with the French Purist Amédée Ozenfant (1886–1966) in New York. During this period her work changed considerably, with flatter forms organized in synthetic, chromatic planes (e.g. *Composition with Masks*, 1947; Quito, priv. col.). Her contact (1950–52) as a studio assistant with Jean Dewasne (*b* 1921) and Edgar Pillet (*b* 1912), co-directors of the Atelier d'Art Abstrait in Paris, was decisive, as was her involvement with Auguste Herbin (1882–1960). In her one-woman show in 1953 at the Galerie Arnaud in Paris, she presented mature work: the violent colours on large surfaces were sensual and balanced by their rational abstraction; she adopted the square patterns of Mondrian with no restriction on the use of colour. From 1955, however, when she exhibited at the Museo Nacional de Arte Colonial in Quito, Ecuador, her work became abstract in the tradition of *Art informel*, breaking with rigid geometry, incorporating organic elements and creating illusions of volume within carefully controlled movement (e.g. *Variations in Red*, 1955; Guayaquil, priv. col.); with works such as this she pioneered the style of *Art informel* in Ecuador, breaking the dependence on Indigenism that had been so dominant. In the 1960s the spaces in her works became larger, and the geometric treatment became more complex, as in *Requiem for Sidney Beche* (1965; Guayaquil, priv. col.). In the following decade she incorporated more rectilinear elements while maintaining the strength of her tropical colours.

BIBLIOGRAPHY
Abstract Currents in Ecuadorian Art (exh. cat. by J. Barnitz, New York, Cent. Inter-Amer. Relations, 1977), pp. 15-19
J. Barnitz: *Latin American Artists in the US before 1950* (New York, 1981)
L. Oña: *Arte de Araceli* (Quito, 1995)
E. Sullivan, ed.: *Latin American Art in the Twentieth Century* (London, 1996), p. 186
ALEXANDRA KENNEDY

Giorgi, Bruno (*b* Mococa, São Paulo, 6 Aug 1905). Brazilian sculptor of Italian descent. In 1911 he moved from São Paulo to Rome, where he began studying sculpture from 1920 to 1922. He moved to Paris in 1935 to complete his studies under Aristide Maillol (1861–1944) and at the Académie de la Grande Chaumière. Returning to Brazil in 1939, he lived first in São Paulo and from 1942 in Rio de Janeiro, where he worked with the architect Oscar Niemeyer, producing the granite monument to *Youth* (1946) for the outdoor garden of the Ministry of Education in Rio de Janeiro. In the 1960s he again collaborated with Niemeyer and produced several sculptures for the new city of Brasília, including the bronze *Two*

Warriors (1961) in the Praça dos Três Poderes and the marble *Meteor* (1965) for the Ministry of Foreign Affairs in the Palácio dos Arcos (*see* BRAZIL, fig. 10). He was named best national sculptor in the 1953 São Paulo Biennial. His work constantly oscillated between the figurative stylization of his women, warriors and musicians and an abstract reductionism influenced by the organic qualities of Barbara Hepworth's work and to a slight extent by Baroque sensuality. The Museu Manchete (Rio de Janeiro) houses several of his marble sculptures and his bronze *Chimera* (1966).

BIBLIOGRAPHY
P. M. Bardi: *Profile of the New Brazilian Art* (Rio de Janeiro, 1970)
F. Aquino: *Museu Manchete* (Rio de Janeiro, 1982)
W. Zanini, ed.: *História geral da arte no Brasil*, ii (São Paulo, 1983)
Bruno Giorgi (exh. cat. by J. Klintowitz, Rio de Janeiro, Gal. Skulp., 1985)
ROBERTO PONTUAL

Gironella, Alberto (*b* Mexico City, 26 Sept 1929). Mexican painter. He was self-taught as a painter but well versed in philosophy, literature and 20th-century avant-garde art. Like other young Mexican painters in the 1950s, he sought to break with local traditions, basing his art instead on Spanish Baroque painting and on the work of Francisco de Goya. His favourite themes were love and death, time, bullfighting, eroticism and painting itself, as in *The Glutton* (1958; Washington, DC, A. Mus. Americas), an image of a seated skeleton with overtones of the court portraits of Diego Velázquez. In the 1960s and 1970s he produced an important series about queens, for example *Queen Riqui* (Mexico City, Mus. A. Mod.), in which the figure undergoes various metamorphoses. *The Burial of Zapata* and *Other Burials* (both 1972; Mexico City, Pal. B.A.) were part of a politically and artistically controversial exhibition; these were followed by a series on Baroque themes, for example *The Gentleman's Dream* (1977; Mexico City, Fund. Cult. Televisiva), demonstrating his preoccupation with eroticism and the passage of time.

BIBLIOGRAPHY
R. Eder: *Gironella* (Mexico City, 1981)
M. Martínez Lambarry: *Tradición y ruptura en la pintura de Alberto Gironella* (diss., Mexico City, U. N. Autónoma, 1988)
Alberto Gironella: Tren de vida (exh. cat., Guanajuato, Mus. Granaditas, 1990)
V. Fraser: 'Surrealising the Baroque: Mexico's Spanish Heritage and the Work of Alberto Gironella', *Oxford A. J.*, xiv/1 (1991), pp. 34–43
Café con Gironella leche de Alberto Gironella (exh. cat., Mexico City, Casa Lamm Cent. Cult., 1997)
MARGARITA MARTÍNEZ LAMBARRY

Goeldi, Oswaldo (*b* Rio de Janeiro, 31 Oct 1895; *d* Rio de Janeiro, 15 Feb 1961). Brazilian draughtsman and printmaker. In 1901 he returned to Switzerland with his father, the Swiss naturalist Emil Goeldi, founder of the ethnological Museu Paraense Emilio Goeldi in Belém do Pará. In 1917 he enrolled in the Ecole des Arts Décoratifs in Geneva and in Berne discovered the drawings of Alfred Kubin (1877–1959), whom he met in Germany in 1930–31 and whose essentially critical, imaginative Expressionism had a marked influence on the evolution of his work. He settled in Rio de Janeiro in 1919 and in 1921 held a much admired exhibition, which led to his participation in the 1922 Semana de Arte Moderna in São Paulo with a group of drawings. One of Latin America's most important

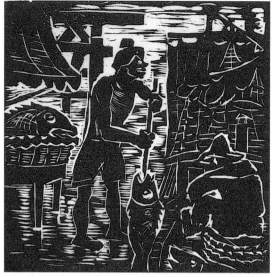

Oswaldo Goeldi: *Untitled*, woodcut, 200×240 mm (Colchester, University of Essex, Collection of Latin American Art)

printmakers, he took up printmaking in 1924, particularly favouring woodcuts, and he illustrated numerous books, reviews and literary supplements, especially after the success of his illustrations for Raul Bopp's poem *Cobra Norato* (Rio de Janeiro, 1937). His illustrations for the Brazilian translation of Dostoyevsky's novels, for example *The Idiot* (Rio de Janeiro, 1944), are exceptional in their technique and their poignancy. His independent work concentrated on a melancholic and dramatic treatment of humble people such as fishermen (see fig.), bohemians and drunks, expressing disenchantment, solitude and silence with a grave lyric quality, as in his woodcut of an old man, *Old Age* (Rio de Janeiro, Bib. N.). In 1960 he won the engraving prize at the Bienal Interamericana in Mexico.

BIBLIOGRAPHY
A. Machado: *Goeldi* (Rio de Janeiro, 1955)
J. R. Teixeira Leite: *A gravura brasileira contemporânea* (Rio de Janeiro, 1965)
J. M. dos Reis Júnior: *Goeldi* (Rio de Janeiro, 1966)
O. da Silva: *A arte maior da gravura* (Rio de Janeiro, 1976)
C. Zílio and others: *Oswaldo Goeldi* (Rio de Janeiro, 1981)
R. Pontual: *Entre dois séculos: Arte brasileira do século XX na Coleção Gilberto Chateaubriand* (Rio de Janeiro, 1987)
P. Venancio Filho: 'Goeldi: Um expressionista na trópicos', *Novos Estudos*, xl (1994), pp. 117–24
Oswaldo Goeldi: Um auto-retrato. Exposiçao comemorativa do centenário de nascimiento (1895–1961) (exh. cat., Rio de Janeiro, Cent. Cult. Banco Brasil, 1995)
S. Cabo Geraldo: *Goeldi: Modernidade extraviada* (Rio de Janeiro, 1995)
J. de Mindlin: 'Illustrated Books and Periodicals in Brazil, 1875–1945', *J. Dec. & Propaganda A.*, xxi (1995), p. 76
ROBERTO PONTUAL

Goeritz, Mathias (*b* Danzig, Germany [now Gdańsk, Poland], 4 April 1915; *d* Mexico City, 4 Aug 1990). German painter, sculptor and teacher, active in Mexico. He studied philosophy and art history in Berlin at Friedrich-Wilhelms Universität, also attending some courses in fine arts and taking his doctorate in 1940. In 1940 he emigrated to Spanish Morocco, where he worked as a teacher until 1944. He returned to Europe at the end of World War II

in 1945, settling in Spain, first in Granada, then in Madrid and finally in Santillana, near Santander. There he devoted himself to painting, meeting avant-garde artists and in 1948 helping to found the Escuela de Altamira, which represented a call to artistic rebellion and propounded absolute creative freedom.

In 1949 Goeritz settled in Mexico and became professor of visual education and drawing at the Escuela de Arquitectura of the Universidad de Guadalajara, on the invitation of the school's director, Ignacio Díaz Morales (1905–92). He taught in Guadalajara until 1954, his natural restlessness finding an outlet in opening galleries and promoting a series of innovative cultural activities as well as in producing his own work. Of singular importance was his creation of a museum in Mexico City, the Museo Experimental El Eco, which operated from 1951 to 1953 and had both a national and an international impact. A sculpture made by him for the museum, *Snake* (1953; Mexico City, Mus. A. Mod.), prefigured Minimalism, and the manifesto published on the museum's inauguration, *Arquitectura emocional*, had repercussions in the work of architects such as Luis Barragán, who adopted the term to define his own work.

On moving to Mexico City in 1954, Goeritz continued to teach and entered a richly productive period, particularly with his sculpture. He produced a series of *Heads* made from gourds or cast in bronze, and public sculptures such as *The Animal of the Pedregal* (1954) for the Jardines del Pedregal de San Angel in Mexico City. He also worked productively in collaboration with a number of architects, especially Barragán, with whom he created a monumental sculpture, *The Towers of Satélite*, for the Ciudad Satélite in Mexico state in 1957. During the same period he produced a series of massive and roughly finished sculptures in wood, such as *Moses* (1956; see colour pl. XII), which were deeply expressive.

Goeritz became severely depressed by the death of his wife, the photographer Marianne Goeritz (1910–58), and his work became bitter, aggressive and hard. In 1958–9 he made the first of a series of mural-sized objects called *Messages* (e.g. 1968; Mexico City, Hotel Camino Real) from metal sheets and nails, and he turned towards spirituality by designing liturgical objects and decorations, in particular the stained-glass windows of Cuernavaca Cathedral (1961). From this period comes his *Mexican Pyramids* (1959; see fig.).

In 1961 Goeritz participated at the Galería Antonio Souza in a group exhibition, *Los hartos*, for which he published another manifesto. Other participants included José Luis Cuevas and Pedro Friedeberg, with whom he was instrumental in establishing abstraction and other modern trends in Mexico. His early enthusiasm returned, and he carried out a great number of works, including easel paintings, prints and sculptures. His outstanding sculptures of this period include the *Mixcoac Pyramid* (1969) at the Unidad Habitacional Lomas de Plateros in Mexico City and his collaboration with Helen Escobedo, Manuel Felguérez, Hersúa, Sebastián and Federico Silva on the Espacio Escultórico (1979; Mexico City, U. N. Autónoma), a large outdoor sculptural complex at the Ciudad Universitaria on the outskirts of Mexico City.

Mathias Goeritz: *Mexican Pyramids*, 1959 (Paris, Centre Georges Pompidou)

Through his foreign contacts Goeritz was able to help commission sculptures in Mexico by well-known foreign artists, for example a series of 18 works known as *La ruta de la amistad* (1968) in Mexico City, as well as to execute works of his own abroad, notably at the Alejandro and Lilly Saltiel community centre in Jerusalem (1975–80). He was also instrumental in encouraging and promoting other artists both through his teaching (as in the case of Sebastián) and through his friendship with other artists. His rebellious nature and vigorous promotion of the avant-garde made him a leading figure in the development of modern art in Mexico. He also made regular contributions to the monthly 'Sección de arte' in the periodical *Arquitectura/México* from 1959 to 1978.

WRITINGS
Arquitectura emocional (exh. cat., Mexico City, Mus. A. Mod., 1984)

BIBLIOGRAPHY
O. Zuñiga: *Mathias Goeritz* (Mexico City, 1963)
X. Moyssén: 'Los mayores: Mérida, Gerszo, Goeritz', *El geometrismo mexicano* (Mexico City, 1977), pp. 51–75
F. Morais: *Mathias Goeritz* (Mexico City, 1982)
F. González Gortázar, ed.: *La arquitectura Mexicana del siglo XX* (Mexico City, 1994)
I. Rodriguez and F. Asta, eds: *Los ecos de Mathias Goeritz: Ensayos y testimonios* (Mexico City, 1997)
Los ecos de Mathias Goeritz (exh. cat., Mexico City, Antiguo Colegio de San Ildefonso, 1997)
G. Schmilchuk: 'Escultura arquitectónica, monumental y ambiental', *México en el mundo de las colecciones de arte*, vi (Mexico City, 1994), pp. 177–239
L Kassner: *Mathias Goeritz, 1915–1990: Una biografía y obra*, 2 vols (Mexico City, 1998)
LOUISE NOELLE

Goitia, Francisco (*b* Fresnillo, Zacatecas, 1882; *d* Xochimilco, nr Mexico City, 1960). Mexican painter. He began his studies in 1896 at the Academia de San Carlos in Mexico City. In 1904 he left for Barcelona and then for Italy, returning in 1912 to Mexico, where he resumed painting. From 1918 to 1925 he did field work with the anthropologist Manuel Gamio at Teotihuacán and Xochimilco. His early paintings included *The Witch* (1916), in the 'Tremendista' style of exaggerated Symbolist-influenced realism, *Dance of the Revolution* (1916), a very early treatment of this subject-matter, and *The Hanged Man* (1917; all Zacatecas, Mus. Goitia), all revealing his taste for sombre and even grotesque themes. In *Father Jesus* (1927; Mexico City, Mus. N. A.), generally considered his best painting, two women are shown keeping vigil over a dead man; its graphic force and dramatic quality give it particular distinction in the history of early 20th-century Mexican art. In *Santa Monica Landscape* (1945; Mexico City, Mus. N. A.) the grandeur of the landscape is heightened by the simplicity of treatment. In other landscapes and in self-portraits, however, Goitia reverted to a more traditional type of painting.

BIBLIOGRAPHY
J. Fernández: *Arte moderno y contemporáneo de México* (Mexico City, 1952)
J. A. Manrique: 'Tres astros solitarios: Atl, Goitia, Reyes Ferreira', *Historia del arte mexicano*, ed. J. A. Manrique, xiv (Mexico City, 1982), pp. 2128–32
J. Farías Galindo: *Goitia: Biografía* (Zacatecas, 2/1990)
JORGE ALBERTO MANRIQUE

Goldschmidt, Gertrudis. *See* GEGO.

Gómez, Pedro Nel. *See* NEL GÓMEZ, PEDRO.

González. Mexican family of painters. During the second half of the 17th century and the first half of the 18th a pictorial technique was developed in Mexico, known generically as *enconchado* (shellwork), in which parts of the ground of the picture were painted with paints made up with fragments of mother-of-pearl, giving a shine to the transparencies and glazes. Although several painters used this technique, its main exponents were Juan González and Miguel González (*b* 1664), who signed the majority of the known works, though their exact family relationship is not known. The earliest extant work by Juan González is the *Adoration of the Shepherds* (1662; Washington, DC, Smithsonian Inst.). Other paintings include a series dedicated to the *Life of St Ignatius Loyola* (1697; Mexico, priv. col.) and a series of 24 panels of the *Conquest of Mexico* (1698; Madrid, Mus. América), signed by both Miguel and Juan. The subject of this latter group was one of the most often repeated by the exponents of *enconchado*. In 1699 Juan received a commission for two groups of 13 or 14 pictures (untraced). His last known signed work is a painting of *St Michael* (1717). Miguel González was a son of Tomás González and painted the *Virgin of Guadalupe* (Madrid, Mus. América; see colour pl. XIII) in 1697. His signature also appears on another series of the *Conquest of Mexico* (Buenos Aires, Mus. N. B.A.), as well as on 12 panels devoted to the *Allegories of the Creed* (Tepotzotlán, Mus. N. Virreinato; Mexico City, Banco N. de México).

BIBLIOGRAPHY
J. de Santiago Silva: *Algunas consideraciones sobre las pinturas enconchadas* (Mexico City, 1976)
M. Dujovne: *La conquista de México y Miguel González* (Buenos Aires, 1977)

M. C. García Sáiz: *Los enconchados*, ii of *La Pintura colonial en el Museo de América* (Madrid, 1980)

M. Dujovne: *Las pinturas con incrustaciones de nácar* (Mexico City, 1984)

G. Tovar de Teresa: 'Documentos sobre enconchados y la familia mexicana de los González', *Cuad. A. Colón.*, 1 (1986), pp. 97–103

MARIA CONCEPCIÓN GARCÍA SÁIZ

González, Carlos (*b* Melo, Cerro Largo, 1 Dec 1905; *d* Montevideo, 30 April 1993). Uruguayan printmaker and painter. He studied with Andrés Etchebarne Bidart (1889–1931) and produced only 32 prints—24 woodcuts, 1 etching and 7 monotypes—which nevertheless exerted an immense influence on printmaking in Uruguay. He made very small editions of his woodcuts, altering the block after each impression so that each print was unique. Admired by his fellow artists for his technical innovations, he also developed a great popular following for his treatment of local stories and images, as in *Death of Martín Aquino* (1943), *Horse Breaking* (1938), *Branding* (1938), *Shed* (1938) and *Races* (1938), and of familiar legends, as in *Werewolf* (1944), and *Popular Story* (1942; all Montevideo, Mus. N.A. Plást.). With Luis Mazzey he worked on murals such as *Work at ANCAP* (1947) in the ANCAP Building in Montevideo, and the *History of Commerce in Uruguay* (1950), at the Centro de Vendedores de Plaza y Viajantes, Montevideo. He exhibited frequently in Uruguay at the Salón Municipal and the Salón Nacional, winning Gold Medals in 1943 and 1944, and was recognized as a major Latin American printmaker in exhibitions held in New York in 1945 and in Paris in 1949.

BIBLIOGRAPHY

J. P. Argul: *Las artes plásticas del Uruguay* (Montevideo, 1966); rev. as *Proceso de las artes plásticas del Uruguay* (Montevideo, 1975)

A. Kalenberg: 'Carlos González o la invención del grabado uruguayo', *Imágenes*, iii (1980)

Carlos González (exh. cat., ed. A. Haber; Montevideo, Centro de Exposiciones, Palacio Municipal, 1988)

ANGEL KALENBERG

Gonzalez, Christopher (*b* Kingston, 1943). Jamaican sculptor. He graduated from the Jamaica School of Art in 1963, subsequently studying at the California College of Arts and Crafts, Oakland, CA. From his earliest days as a sculptor he was influenced by the symbolism of Edna Manley. His *Man Arisen* (1966; Kingston, N.G.) is a direct descendant of Manley's *Negro Aroused* (1935; Kingston, N.G.). The early symbolist works of Picasso seem to have been a major influence as well, resulting in the typical emaciated Gonzalez figure of the 1960s and 1970s. His first major commission, a standing Christ for the Holy Cross Catholic Church in Kingston (1968), was rejected, possibly as much for its haunting expressionism as for its suggestion of nudity. This intense expressionism continues in two bronze reliefs representing the *Birth and Unity of the Nation*, commissioned for the tomb of the former Prime Minister Norman Manley (1975). Considered the most vivid image-maker of his generation of sculptors, Gonzalez was the logical choice for the important commission of a monument to Jamaica's cultural hero, the Rastafarian reggae star, *Bob Marley* (see fig.). Completed in 1983, it draws heavily on popular and Rastafarian imagery and shows the hero like a massive tree with roots reaching into the ground, his locks like sinuous branches and his face agonized, with mouth open in prophetic song.

Christopher Gonzalez: *Bob Marley*, bronze, h. 2.17 m, 1983 (Kingston, National Gallery)

Controversial from the first viewing, the monument was rejected. Deposited in the National Gallery of Jamaica in Kingston, it is now a major attraction there.

BIBLIOGRAPHY

P. Archer-Straw and K. Robinson: *Jamaican Art* (Kingston, 1990), pp. 60–61, 83–4, 162

D. Boxer and V. Poupeye: *Modern Jamaican Art* (Kingston, 1998)

DAVID BOXER

González, Juan (*b* Camaguey, 12 Jan 1945; *d* Miami, FL, 24 Dec 1993). Cuban painter and draughtsman, active in the USA. He studied at the University of Miami, from 1965 to 1972. He painted haunting dreamscapes and works full of oneiric imagery. In *Nativity* (watercolour, 1979; Eisenstein priv. col., see 1992 exh. cat., p. 9) he drew upon the motif of the theatre to highlight and delight in the ironies of representation. His drawings are subtle and enigmatic. Works by González are in a number of collections, including the Hirshhorn Museum and Sculpture Garden, Washington, DC (e.g. *Pop Goes the Piper*, 1970; see fig.); the Carnegie Museum of Art, Pittsburgh (*see* LATIN AMERICAN ARTISTS OF THE USA, fig. 4); and the

Juan González: *Pop Goes the Piper*, paper on plexiglass, 927×762 mm, 1970 (Washington, DC, Hirshhorn Museum and Sculpture Garden)

Indianapolis Museum of Art. As well as in one-man shows, his work has been exhibited in group exhibitions, including *Outside Cuba/Fuera de Cuba*, a show of Cuban emigré art produced since 1960, organized by Rutgers University in 1987.

BIBLIOGRAPHY

Juan González (exh. cat., Miami, Dade Community Coll., Wolfson Campus Gal., 1981)

R. H. Cohen: 'The Art of Juan González', *A. Mag.*, 57 (1983), pp. 118–21

Juan González: A Twentieth-century Baroque Painter (exh. cat., Dallas, TX, S. Methodist U., Meadows Mus. & Gal., 1992)

I. McManus: *Dreamscapes: The Work of Juan González* (New York, c.1994)

RICARDO PAU-LLOSA

González, Juan Francisco (*b* Valparaíso, 1854; *d* Santiago, 1933). Chilean painter. On the recommendation of Pedro Lira he studied at the Academia de Bellas Artes in Santiago under the painters Ernesto Kirchbach (1832–80) and Juan Mochi (1831–92), also following a humanities course at the Instituto Nacional, where his fellow students included the painters Onofre Jarpa (1849–1940) and Alfredo Valenzuela Puelma (1856–1909). He made several trips to Europe, first in 1887, again in 1895–6 and finally in 1905, during which he befriended Joaquín Sorolla y Bastida. In 1897, together with Valenzuela Puelma and Alfredo Helsby, he founded the Exposiciones Municipales at Valparaíso, which rivalled in importance the annual Salón Oficial in Santiago. At the Salón Oficial in Santiago of 1898 he was awarded the Premio de Honor.

González was an extremely prolific artist, producing thousands of paintings during his long career, and his works express the restlessness, nervous energy and spontaneous joy of life that characterized his temperament. A sensual painter of great vitality, he based his pictorial theory on the first and most immediate impressions suggested to him by his subject-matter. Moving steadily towards an ever greater freedom of expression, he was greatly affected by the different cities and towns in which he lived: the port of Valparaíso, then Limache and various hamlets in the interior region of Aconcagua, later Melipilla and finally the capital, Santiago. The particularity of his views of different cities is evident in works such as *Seascape (Valparaíso*; oil on wood, 345×745 mm), *View of La Serena* (oil on canvas, 365×500 mm), *Races in Viña del Mar* (1890s) and *Panorama of Santiago* (all Santiago, Mus. N. B.A.). Although he usually observed the whole of his subject when painting such landscapes, in his still-lifes of fruits and especially of flowers (e.g. *Roses*, oil on canvas, 436×500 mm, Santiago, Mus. N. B.A.) he tended to treat the images with a spectacular intensity in bright colours, outlining their forms in a vivid light against a mysteriously shadowed background.

There were three distinct periods in González's painting. At first he worked in a technique still bound to academic principles; his preferred subject-matter at this time included landscapes of Valparaíso Bay, of the rocky coastline and of farms. In his second phase his colours became rich and radiant, while his vision was simplified and his treatment of forms became more unified. Finally, in works such as *De la Vega Stage-coach* (oil on canvas, 320×420 mm; Santiago, Mus. N. B.A.) he achieved a freedom and synthesis of form and colour, a skilful handling of tone and an orchestration of the brushwork for dramatic effect. He revealed himself as a master of sensitivity and lyrical feeling but also made use of chance and improvisation; rather than planning his paintings in drawings or oil sketches, he preferred to confront his subject directly and to respond to his own accumulated experiences. This way of working helped make González one of the strongest and most original of Chilean painters.

From 1908 to 1920 González was an influential teacher at the Escuela de Bellas Artes in Santiago. In 1918 he was co-founder with the painters Pedro Reszka (1872–1960) and Judith Alpi of the Sociedad Nacional de Bellas Artes.

WRITINGS

La enseñanza del dibujo (Santiago, 1906)

BIBLIOGRAPHY

A. Bulmes: *Juan Francisco González* (Santiago, 1933)

R. Zegers de la Fuente: *Juan Francisco González, el hombre y el artista* (Santiago, 1953)

Exposición retrospectiva del pintor Juan Francisco González (exh. cat., Santiago, Mus. N. B.A., 1953)

Juan Francisco González, 1853–1933 (exh. cat., intro. R. Abarca Valenzuela; Santiago, Mus. N. B.A., 1976)

E. Pereira Salas: *Estudios sobre la historia del arte en Chile republicano* (Santiago, 1992)

CARLOS LASTARRIA HERMOSILLA

González, Manuel de la Cruz (*b* San José, 16 April 1909; *d* San José, 1986). Costa Rican painter, draughtsman and writer. A self-taught artist, in 1934 he joined the Círculo de Amigos del Arte founded in 1928 by Teodorico Quirós and Max Jiménez, collaborating with Quirós on a mural in encaustic for the group's meeting-place, Las Arcadas in San José. In 1946–7 he founded the Teatro Experimental. He started teaching in the fine arts faculty of the Universidad de Costa Rica in San José, but in 1949 he left the country for political reasons and went to Havana. During this period he started a series of nudes and pictures of Cuban peasant girls (*goajiras*; e.g. *Goajira*, 1954; artist's col., see Ulloa Barrenechea, p. 106) in Indian ink with a scraping or *sgraffito* technique, in which the forms were simplified and stylized. The influence of Wifredo Lam is evident in these works.

In 1952 González went to Venezuela, where his painting was influenced by the geometric abstraction followed by the group Los Disidentes (e.g. *Space-Colour*; artist's col., see Ulloa Barrenechea, p. 108). His work lost all figurative reference, becoming purely abstract. He executed the *Spatial-mural* between 1959 and 1960 (San José, Banco Anglo Costarricense). González was a member of Grupo Ocho (1961–4), which aimed to stimulate artistic creativity through the organization of exhibitions and contacts with the international art world. The group also rejected notions of 'classical' beauty. There followed for González a period of obsessive experimentation with composition and drawing that lasted until 1971, and which can be followed in his notebooks (San José, Mus. Banco Cent.). Only a few of these ideas were transferred to canvas, using a lacquer technique. These works were not understood by Costa Ricans, still unaccustomed to avant-garde ideas, and González abandoned abstract art and returned to painting local scenes.

UNPUBLISHED SOURCES
San José, Mus. Banco Cent. [notebooks]

WRITINGS
Poemas gráficos (San José, 1976)

BIBLIOGRAPHY
E. Prieto: 'Manuel de la Cruz González: Pintor Costarricense', *Repert. Amer.*, xxii (Oct 1940)

R. Ulloa Barrenechea: *Pintores de Costa Rica* (San José, 1975), pp. 104–11

Kunst aus Costa Rica: Die expressionistischen tendenzen (exh. cat., Hannover, Sprengel Mus., 1992)

JOSÉ MIGUEL ROJAS

González, Pedro Angel (*b* Santa Ana del Norte, Nueva Esparta, 9 Sept 1901; *d* Caracas, 11 March 1981). Venezuelan painter and engraver. He studied at the Academia de Bellas Artes, Caracas (1916–22). In 1921 he became associated with members of the Círculo de Bellas Artes whose non-academic attitude towards painting he supported. He went on to become a pioneer of engraving in Venezuela, organizing the Taller de Artes Gráficas in 1936 at the behest of the directorate of the Escuela de Artes Plásticas y Aplicadas de Caracas. His paintings depicted the valley of Caracas in the style of Manuel Cabré, recording changes in the city and its surroundings (e.g. *El Avila Seen from Sabana Grande*, 1946; Caracas, Gal. A. N.). In 1942 he was awarded the national painting prize.

WRITINGS
Pedro Angel González habla de sí mismo (Caracas, 1981)

BIBLIOGRAPHY
P. Erminy and J. Calzadilla: *El paisaje como tema en la pintura venezolana* (Caracas, 1975)

J. Calzadilla: *Pedro Angel González* (Caracas, *c*.1996)

YASMINY PÉREZ SILVA

González Bogen, Carlos (*b* Upata, 6 June 1920; *d* Caracas, 1992). Venezuelan sculptor and painter. He studied at the Escuela de Artes Plásticas y Aplicadas in Caracas (1943–8) and was initially a painter. After winning the Premio Nacional de Artes Plásticas in the Salón Oficial Anual de Arte Venezolano in 1948, he spent four years in Paris, where he was a leading member (1950–57) of Los Disidentes, a group of Venezuelans who criticized the cultural institutions in their country and supported the development of geometric abstraction there. González Bogen's work moved progressively from abstraction to figurative forms until he began to sculpt, a discipline he considered a true integration of the arts. On returning to Caracas, he joined the Cuatro Muros movement, by which artists from different disciplines brought new artistic solutions to the Venezuelan cultural panorama, including the integration of mural painting and architecture.

BIBLIOGRAPHY
F. Paz Castillo and P. Rojas Guardia: *Diccionario de las artes plásticas en Venezuela* (Caracas, 1973); rev. as *Diccionario de las artes visuales en Venezuela* (Caracas, 1985), p. 158

ELIDA SALAZAR

González de León, Teodoro (*b* Mexico City, 29 May 1926). Mexican architect. He studied at the Escuela de Arquitectura at the Universidad Nacional Autónoma de México, where he won a scholarship that enabled him to live in Paris (1948–9) and work in the studio of Le Corbusier, whose influence was crucial for his future development. Another important early influence was his work with such outstanding Mexican architects as Carlos Obregón Santacilia and Mario Pani. He then established himself in professional practice in partnership with Armando Franco (*b* 1925), concentrating mainly on construction techniques that made use of prefabricated elements (e.g. Casa Catán, Mexico City, 1951; destr.). He also demonstrated his interest in urban planning with several studies for cities and rural areas in Mexico. Later, such works as the Escuela de Derecho (1966) at the Universidad de Tamaulipas, Tampico, marked González de León's belief that the possibilities of the International Style had been exhausted, but still influenced by Le Corbusier, he adopted a new formal and functional position. Such elements as the Mediterranean patio began to appear in his work, along with a tendency towards massive linearity and the judicious use of concrete. His approach to the 20th century's most characteristic material was original: he used an aggregate made from stones hammered to reveal the grain, which showed their natural colour against the

drab grey of the concrete. This became an unmistakable trademark of his work.

In 1968 González de León began a period of collaboration with ABRAHAM ZABLUDOVSKY, although the two architects managed to retain a substantial degree of autonomy. Their first collaborative projects focused on solutions to Mexico's chronic housing shortage and included the Mixcoac-Lomas de Plateros housing complex (1971), the La Patera housing development (1973) and the Ex-hacienda de Enmedio (1976), all in Mexico City. It was in their designs for public buildings, however, that the two architects were able to develop their individual plastic language, creating a sense of permanence by their use of such traditional elements as the cloister and portico, the limited use of sheltered windows and, especially, by their handling of large asymmetrical volumes in exposed, impeccably finished concrete and in their sensitivity to context. The first work of this kind produced by the partnership was the Delegación Cuauhtémoc (1972–3; in collaboration with Luis Antonio Zapiain (*b* 1942) and Jaime Ortiz Monasterio (*b* 1928)) in Mexico City. This was followed in 1975 by the completion of three important projects: the headquarters of INFONAVIT (Instituto del Fondo de la Vivienda para los Trabajadores) and the new building of the Colegio de México, both in Mexico City, and the Mexican Embassy in Brasília, Brazil, in collaboration with Francisco J. Serrano. The partnership was also responsible for the Museo Rufino Tamayo (1981) in the Parque Chapultepec, sensitively integrated with the surrounding trees, and the Universidad Pedagógica (1983) in the rocky area of El Ajusco.

González de León continued to demonstrate a distinctive personal style, however, producing works that were responsive to particular requirements and were carried out to a high standard, with a consistent stylistic approach. His unfailing creativity was also evident in buildings where he had greater freedom of expression. Among his mature works were such civic projects as the Parque Tomás Garrido Canabal (1985), the Centro Administrativo (1986–7) and the Biblioteca del Estado (1987–8), all in Villahermosa, Tabasco, and all designed in collaboration with Francisco Serrano. The partnership with Zabludovsky continued to develop, meanwhile, in such projects as the building of several banks in Mexico City and the restoration of the National Auditorium (1989–91). In collaboration with Francisco J. Serrano and Carlos Tejeda (*b* 1948), he designed the Palacio de Justicia Federal (1987–92), an impressive building aligned on either side of a pedestrian walkway more than 200 m long. He also began to produce independent work, such as museum buildings for the archaeological site at Tajín, Veracruz (1991–2), the Rufino Tamayo Plaza (1990–91) and the office building for the Fondo de Cultura Económica (1990–92; both in Mexico City); the latter is unusual in rising to 10 floors but incorporating curved façades. The Conservatorio Nacional de Música (Mexico City), notable for its bold volumes and curvilinear façades, and the Mexican showroom of the British Museum (London; see fig.) were inaugurated in 1994.

WRITINGS
Retrato de arquitecto con ciudad (Mexico City, 1996)

Teodoro González de León: *Mexican Gallery*, British Museum, London, 1994

BIBLIOGRAPHY
Contemp. Architects
Teodoro González de León y Abraham Zabludovsky: Ocho conjuntos de habitación (Mexico City, 1976)
P. Heyer: *Mexican Architecture: The Work of Abraham Zabludovsky and Teodoro González de León* (New York, 1978)
J. Glusberg: 'Teodoro González de León', *Seis arquitectos mexicanos* (Buenos Aires, 1984)
L. Noelle: 'Teodoro González de León', *Arquitectos contemporáneos de México* (Mexico City, 1988)
Teodoro González de León: La voluntad del creador (Bogota, 1994) [contribs by L. Noelle and W. Y. R. Curtis]
M. A. Roca, ed.: *The Architecture of Latin America* (London, 1995), pp. 96–101
Ensamblajes y excavaciones: La obra de Teodoro González de León, 1968–1996 (exh. cat. by A. Rossi and others, Mexico City, Mus. Rufino Tamayo, 1996)

LOUISE NOELLE

González Gortázar, Fernando (*b* Mexico City, 19 Oct 1942). Mexican architect and sculptor. He studied architecture from 1959 to 1966 at the Universidad de Guadalajara, where he also attended Olivier Seguin's sculpture studio. He worked at first in Guadalajara, where his *Large Gate* (1969) in the Jardines Alcalde, which gives symbolic access to a new urban development, is made up of concrete prisms. The *Fountain of Sister Water* (1970), Colonia Chapalita, is an experiment in Brutalism, with rough surfaces of exposed concrete, while the structure (1972) at the entrance to the Parque González Gallo deploys bold projecting forms contrasting with the neighbouring trees. In 1972–3 he designed the *Tower of Cubes*, Plaza Vallarta, Guadalajara, and the *Large Spike*, Calzada de Tlalpan, Mexico City, both vertical monuments constructed from prefabricated concrete prisms. He next exploited the expanses of urban squares, breaking up the flatness of

their surfaces, for example with inserted bodies of water and irregularly placed cube-shaped 'islands' in the Plaza de la Unidad Administrativa (1973), Guadalajara, or with diagonal terraces and concrete prisms in the Plaza del Federalismo (1975), Guadalajara. In 1986 he went to Spain, where among other works he built the Fountain of Stairs (1987), Fuenlabrada, Madrid, and *the Tree* (1995) in El Escorial. He participated in several collective exhibitions in Mexico, Spain, Belgium, Italy and Japan, and a retrospective exhibition of his work was held in the Museo Rufino Tamayo, Mexico City, in 1999. In 1989 he was awarded the Henry Moore Prize at the Hakone Open-Air Museum and the Utsukushi-ga-hara Open-Air Museum in Japan. With Mathias Goeritz and Sebastián, he is one of the most prominent exponents of geometricism in Mexican urban art. His mature architectural work also shows a rich sculptural quality, as in his underground tram station, Juarez2 (1992) and the Public Security Center (1993), both in Guadalajara, or in the Museo del Pueblo Maya (1993), Dzibilchaltún, Yucatan.

WRITINGS
ed.: *La arquitectura Mexicana del siglo XX* (Mexico City, 1994)

BIBLIOGRAPHY
J. A. Manrique: 'Los geometristas mexicanos en su circunstancia', *El geometrismo mexicano* (Mexico City, 1977), pp. 77–115
R. Tibol: *Fernando González Gortázar* (Mexico City, 1977)
G. Schmilchuk: 'Escultura arquitectónica, monumental y ambiental', *México en la mundo de las colecciones de arte*, vi (Mexico City, 1994), pp. 177–239
M. Larrosa: *Fernando González Gortázar* (Mexico City, 1998)
ALBERTO GONZÁLEZ POZO

González-Goyri, Roberto (*b* Guatemala City, 20 Nov 1924). Guatemalan sculptor and painter. He studied at the Escuela de Bellas Artes in Guatemala City (1938–45) and from 1942 to 1945 worked on the stained-glass windows at the Palacio Nacional. In 1948 he won a grant that enabled him to study in New York, at the Art Students League and at the Sculpture Center, until 1951. On his return from the USA he concentrated on sculpture until 1973, working particularly closely with Guatemalan architects in the 1950s on large reliefs in exposed cast concrete, mainly for government buildings in Guatemala City. The outstanding examples of these reliefs in Guatemala City, characterized by simple lines and an epic scale, are *Guatemalan Nationality* (3×40 m, 1959) for the Seguro Social building; *Culture and Economy* (14×7.5 m, 1963–4) for the Crédito Hipotecario building; *Economy and Culture* (40×21 m, 1964; Banco de Guatemala); and *The Quetzal and the Golden Eagle* (8×4 m, 1973; Inst. Guat. Amer.). He also produced a free-standing monument to the national hero, *Tecún Umán* (hammered concrete, h. 7.5 m, 1963; Guatemala City), and small sculptures such as *Wolf's Head* (bronze), which was awarded a prize in Guatemala and was acquired in 1957 by the Museum of Modern Art in New York. He served briefly as director of the Escuela de Artes Plásticas in Guatemala City (1957–8).

From 1974 González Goyri devoted himself more to painting, partly because of the limitations imposed on him as a sculptor in working to commission. His technical mastery and superb use of colour, demonstrating an original application of elements from the work of Rufino Tamayo and Carlos Mérida, earned him a serious reputa-

tion in Guatemala and several national and international prizes. Among his important later works are a mural (mosaic, 4.80×17.80 m, 1998) on the Rey-Rosa Building, Guatemala City, and an iron sculpture (h. 5 m, 1998) at the Corporación de Occidente, also Guatemala City.

BIBLIOGRAPHY
M. Aragón de Martínez: *La pintura de Roberto González-Goyri* (Guatemala City, 1985)
Pinturas recientes de Roberto González-Goyri (exh. cat., Guatemala City, Patrn. B.A., 1987)
J. Gómez-Sicre: 'La creación artística de Roberto González-Goyri', *Rev. Pensam. Centroamer.*, 206 (1990), pp. 25–6
El diálogo eterno del Maestro González-Goyri (exh. cat. by J. H. Rodas Estrada, Guatemala City, Fundación Paiz, 1994)
L. Méndez D'Avila: *Visión del arte contemporáneo en Guatemala*, i (Guatemala City, 1995)
Guatemala: Arte contemporáneo (Antigua Guatemala, 1997), pp. 17–20
F. Albizúrez Palma, L. A. Arango and R. Martínez: 'Homenaje a Roberto González-Goyri', *Banca Cent.*, xxxv (Jan–March 1998), pp. 37–56
JORGE LUJÁN-MUÑOZ

González Rul, Manuel (*b* Querétaro, 1 Aug 1923; *d* Mexico City, 8 Nov 1985). Mexican architect and teacher. He studied at the Escuela Nacional de Arquitectura in the Universidad Nacional Autónoma de México, Mexico City, graduating in 1949. In the early period of his career he built private residences with impressive formal qualities, combining a concern for technical innovation with a search for original forms, including the Casa Dubernard in Coyoacán and the Casa D'Avila in Mexico City (both 1949). Nevertheless, his best-known achievements are public buildings of very diverse types. The Díaz Ordaz Gymnasium (1968), Magdalena Mixhuca, Mexico City, exemplifies symbolic architecture: its exterior elevation forms the initial 'M' of Mexico. Its three-dimensional rooftops act as roofs and walls simultaneously, achieving overall an arresting formal unity. In 1975–6 González Rul designed (with Agustín Hernández) the Heroico Colegio Militar, Mexico City. This is a vast and ambitious work, its main theme being a reference to Mexican cultural roots. It contains huge squares reminiscent of the open spaces of Pre-Columbian architecture. In contrast, González Rul's pursuit of abstract architectural form is exemplified by the Sociedad de Escritores building (1978–9) and the headquarters of the Colegio de Arquitectos (1981–3), both in Mexico City. The great visual impact of these buildings made them both landmarks. From 1957 González Rul taught at the Universidad Nacional Autónoma de México, Mexico City.

BIBLIOGRAPHY
I. Maya Gómez and J. Torres Palacios, eds: *Manuel González Rul* (Mexico City, 1984)
LOURDES CRUZ

Gordon, Arturo (*b* Valparaíso, 7 Aug 1883; *d* Valparaíso, 27 Oct 1944). Chilean painter. He entered the Academia de Bellas Artes in Santiago in 1903, studying drawing under Cosme San Martín and painting under Pedro Lira, Juan Francisco González and later with the Spanish painter Fernando Alvarez de Sotomayor (1875–1960). Under the influence of Alvarez de Sotomayor and especially of González, Gordon and other like-minded Chilean painters such as Pedro Luna and Agustín Abarca (1882–1953), who became known as the Generación del Trece, began to free themselves from the academic naturalism that

dominated Chilean art at that time. Gordon was one of the most prominent members of the group because of the innovations that he introduced in his treatment of light, which he regarded as an independent element in its own right, and his use of bright colours. The partial disintegration of forms in his pictures, his use of coloured shadows and his emphasis on the luminosity of atmosphere link his work to French Impressionism. His choice of subject-matter was also novel in Chilean painting, since he addressed himself not only to landscapes but also to the activities of the poor and deprived, painting scenes of everyday life and religious subjects as well as festivals and popular dances, as in *Evening Party* (Santiago, Mus. N. B.A.).

Gordon also produced some murals, notably a series for the Biblioteca Nacional in Santiago in 1926, and in 1928 he travelled to Seville with another Chilean painter, Laureano Guevara, to decorate the Chilean pavilion at the Exposición Internacional taking place there. From 1936 to 1944 he taught painting at the Escuela de Bellas Artes in Viña del Mar.

BIBLIOGRAPHY
Arturo Gordon y su obra (exh. cat. by A. Romera and R. Bindis, Santiago, Sala Capilla, 1974)

<div align="right">MILAN IVELIĆ</div>

Gortázar, Fernando González. *See* GONZÁLEZ GORTÁZAR, FERNANDO.

Gottardi (Folin), Roberto (*b* Venice, 30 Jan 1927). Italian architect, stage designer and teacher, active in Cuba. He graduated from the Istituto Superiore d'Architettura in Venice in 1952, where he was a pupil of Carlo Scarpa (1906–78), Franco Albini (1905–77) and Luigi Piccinato (*b* 1899). He began his professional career in BBPR Architectural Studio in Milan. In 1957 he went to Venezuela to work in a local studio and in 1960 was invited to join a Cuban programme. Thereafter he trained architectural students in the problems of creativity and plasticity as professor of Basic Design of the Faculty of Architecture in Havana. In 1961 he took part with Ricardo Porro and Vittorio Garatti in designing the Escuelas Nacionales de Arte at Cubanacán, Havana, his particular role being the designing of the Escuela de Artes Dramáticas. In this building he combined the compact volumetric tradition of brick walls and the irregular urban spaces of medieval Italian cities with the internal courtyards of Spanish colonial tradition. The work was broken off in 1965 but the project was resumed in 1980, when he combined High Tech components with pre-existing elements. In the Menocal Command Post in the province of Havana (1967) he adapted prefabricated structural elements to form an organic-looking structure that develops down from the top of a hill. His later stage designs introduced a meaningful connection between architecture, painting and scenic arts in Cuban culture. Examples include *Girón* (1981) and *Dédalo* (1989), designed for the Conjunto de Danza Contemporánea de Cuba.

BIBLIOGRAPHY
H. Consuegra: 'Las escuelas nacionales de arte', *Arquitectura/Cuba*, 335 (1965), pp. 14–25
R. Segre: *Cuba: Architettura della rivoluzione* (Padua, 1970)
G. Fiorese: *Architettura e istruzione a Cuba* (Milan, 1980)
R. Segre: *Arquitectura y urbanismo de la revolución cubana* (Havana, 1989)
J. A. Loomis: *Revolution of Forms: Cuba's Forgotten Art Schools* (New York, 1998)

<div align="right">ROBERTO SEGRE</div>

Gourd. Large and diverse group of plants of the Cucurbitaceae family, related to pumpkins and squash. Gourds occur in a wide variety of sizes, shapes and colours. Although grown for their ornamental fruit, the hand-shelled varieties of gourds are often used for bottles, drinking cups, musical instruments etc. Their hard rind provides an ideal surface for decoration.

Gourds are available throughout the Americas and were domesticated *c.* 11,000 BC in Mesoamerica and by *c.* 7500 BC in the Andes. By Pre-Ceramic phase VI (*c.* 2500 BC–*c.* 1800 BC), gourds were being decorated at the north coast site of Huaca Prieta, Peru, by incising and, to a limited extent, excising designs depicting highly geometricized feline, avian and reptilian motifs (see fig. 1). Gourds continued in use into ceramic-using periods and have been found at Ancón, Paracas, Nazca and numerous later sites. They were decorated by means of incision, excision and burning (possibly done using acids to create various colours in the decorated areas), painting, dyeing and inlaying with mother-of-pearl, shells and hardstones. Designs range from simple geometrical feline figures, birds or fish, in both positive and negative styles, to complicated, stylized, incised figures.

New uses and shapes were developed in the Colonial and Republican periods, particularly in southern highland Peru and northern Argentina and Uruguay, and development continues in the central highlands of Peru (see fig. 2). Small gourds were decorated and trimmed with silver lips and legs, a tradition that is continued in Argentina, Uruguay, Paraguay and southern Brazil, where the vessels are used for drinking *mati*, a tea made from the leaves of the holly tree. In Peru, small gourds are used as receptacles for lime, employed as a catalyst when chewing coca leaves; similar gourds are used by the Kogi of Colombia. The artists of Mayocc and Cochas Grande, Peru, produce finely incised gourds with narrative decorations. Designs from Cochas Grande tend to be less detailed and are filled in with colours burnt on using various plant dyes. There are also important gourd decorating traditions in Mexico (e.g. lacquered gourds from Olinalá) and painted gourds from Petare, Miranda, Venezuela. From the late 1970s, probably in response to increasing tourism, new art forms and styles

1. Carved gourd from Huaca Prieta, Peru, Pre-Ceramic period, before *c.* 1950 BC; reconstruction drawing (after Bird)

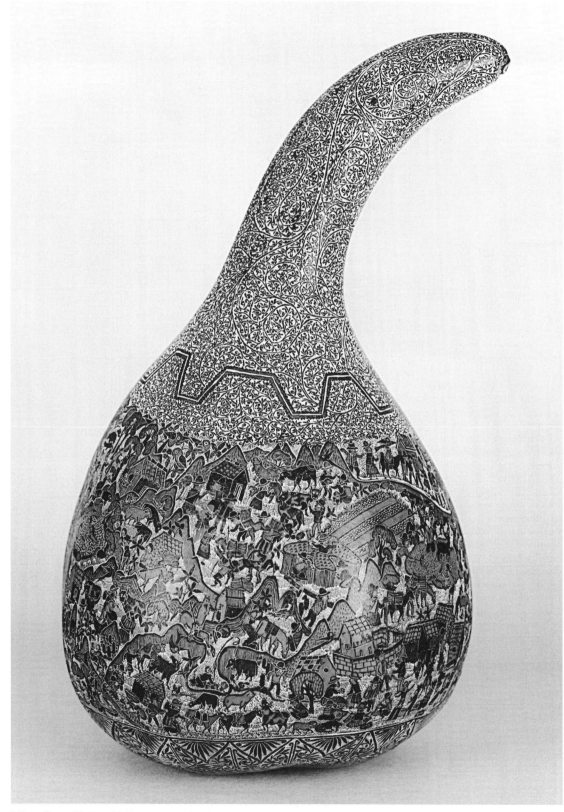

2.'Carved' gourd by David Saldaña García and his brother, 370×240 mm, from Cochas Chico, Peru, c. 1992 (London, British Museum)

developed, such as gourds containing *retablos* (nativity scenes), scenes with figures and shops, or gourds dyed a single colour and incised with extremely fine lines.

Collections of Pre-Columbian and contemporary carved gourds are located in the Museo de la Cultura, the Museo de la Nación, the Museo Nacional de Antropología y Arqueología, the Colección Luza, all in Lima, and the Museo Nacional de Antropología, Mexico City, as well as in the British Museum, London.

BIBLIOGRAPHY

J. B. Bird: 'Pre-ceramic Art from Huaca Prieta, Chicama Valley', *Ñawpa Pacha*, i (1963), pp. 29–34; also in *Peruvian Archaeology: Selected Readings*, ed. J. H. Rowe and D. Menzel (Palo Alto, 1978), pp. 62–71
J.-C. Spahni: *Mates decorados del Perú* (Lima, 1969)
V. Toneyama: *The Popular Arts of Mexico* (New York, 1974)
E. Menzie: *Hand-carved and Decorated Gourds of Peru* (Santa Monica, 1976)
C. Sayer: *Crafts of Mexico* (London, 1977), pp. 60–75, 88–91

W. IAIN MACKAY

Goyri, Roberto González. *See* GONZÁLEZ GOYRI, ROBERTO.

Grajeda Mena, Guillermo (*b* Guatemala City, 1 Oct 1918; *d* Guatemala City, 5 June 1995). Guatemalan sculptor, painter, draughtsman, printmaker and teacher. He studied at the Academia Nacional de Bellas Artes (1936–40) and at the Escuela de Artes Aplicadas in Santiago, Chile (1945–8), where he specialized in direct carving in hard stone and in bronze casting. From 1949 to 1962 he was professor of sculpture at the Escuela Nacional de Artes Plásticas, and from 1948 to 1986 he organized exhibitions at the Instituto de Antropología e Historia, both in Guatemala City.

Grajeda Mena's work is distinguished by its forceful draughtsmanship and strong expressive sense. His outstanding sculptures include *Maternity* (450×410×320 mm, 1947), directly carved in volcanic stone, *Archaic Christ* (wood, h 2.85 m, 1953–4; both Guatemala City, Mus. N. A. Mod.) and *The Conquest* (reinforced concrete relief, 6×10 m; Guatemala City, Pal. Mun.). As a painter he was noted for his colour sense and enthusiasm for experimenting with new materials. His most important murals include *Olmec Culture* (1972; Escuintla, Mus. Democ.) and *National History* (1981; Guatemala City, Acad. Geog. & Hist.). He also made a reputation as a caricaturist.

BIBLIOGRAPHY

Guillermo Grajeda Mena, datos biográficos (Guatemala City, 1975)
Exposición retrospectiva Guillermo Grajeda Mena (exh. cat., Guatemala City, 1986) [retrospective]
Guillermo Grajeda Mena (exh. cat., Guatemala City, Fundación Paiz, 1995)

JORGE LUJÁN-MUÑOZ

Gramcko, Elsa (*b* Puerto Cabello, 9 April 1925). Venezuelan painter and sculptor. She was essentially self-taught. Gramcko first exhibited geometrically abstract works, continuing to work in this style until the mid-1950s, when she turned to *Art informel* interpretations based on the exploration of different materials. She represented Venezuela in the fifth São Paulo Biennale in Brazil in 1959 and in the Venice Biennale in 1964. In 1968 she was awarded the Premio Nacional de Escultura at the 29th Salón Oficial Anual de Arte Venezolano. From then on she took part in numerous one-woman and group exhibitions at a national level. Her work is held in various collections throughout the Americas.

BIBLIOGRAPHY

Gramcko (exh. cat., Washington, DC, Pan Amer. Un., 1959)
M. Hernández Serrano, ed.: *Diccionario de artes visuales en Venezuela*, 2 vols (Caracas, 1982)
Elsa Gramcko, una alquimista de nuestro tiempo: Muestra antológica, 1957–1978 (exh. cat. by E. Schon, Caracas, Gal. A. N., 1997)

ELIDA SALAZAR

Grandjean de Montigny, Auguste-Henri-Victor (*b* Paris, 15 July 1776; *d* Rio de Janeiro, 1 March 1850). French architect and urban planner, active in Brazil. He studied at the Ecole des Beaux-Arts in Paris with Charles Percier and Pierre Fontaine and won the Prix de Rome in 1799 with a scheme for a necropolis. In 1801 he moved to Italy to complete his studies at the French Academy of Fine Arts in Rome. There he restored (1803) the early imperial tomb of *Caecilia Metella* on the Via Appia and laid out the gardens of the Villa Medici, which was acquired by the French government in 1804. He travelled throughout Italy, studying, sketching and executing various designs, among them one for a theatre at Naples. In conjunction with Auguste Famin (1776–1859) he wrote *L'Architecture de la Toscane* (1815), which was widely read at the time by architects in search of details of early Renaissance buildings. In 1810 he was summoned by Jerome Bonaparte, King of Westphalia (*reg* 1807–13), to work on projects in Kassel. Notable among these are the salons of Simon Louis Du Ry's Schloss Wilhelmshöhe, the monument to Napoleon I in Opera Square, a triumphal arch and the design of the royal palace of Bellevue, which he did not complete because of the fall from power of Jerome Bonaparte in 1813.

Grandjean returned to Paris, where he was invited by Joachim Le Breton to join the French artistic mission that was to offer its services at the Portuguese court in Brazil. The mission, which made a profound impression on the arts in Brazil, was composed of the painters JEAN-BAPTISTE DEBRET and NICOLAS-ANTOINE TAUNAY, the printmaker Charles-Simon Pradier (1786–1848), the sculptor Auguste-Marie Taunay (1768–1824), the engineer François Ovide and the secretary of the mission, Pierre Dillon. The artistic mission arrived in Rio de Janeiro in March 1816, with, among other items, a collection of 54 paintings that Le Breton had purchased in France. These formed the original nucleus of the Museu Nacional de Belas Artes. During the first few years the artists of the mission encountered great difficulties of adaptation and of gaining a sympathetic audience for teaching. The death of Le Breton in 1819 represented a severe setback for the mission and its position at the Portuguese court. Pradier and Nicolas-Antoine Taunay returned to Paris, while Auguste-Marie Taunay died in Rio in 1824. Debret and Grandjean were thus left with the responsibility for the training of local artists, although the situation improved with the arrival of the brothers Marc Ferrez (1788–1850) and Zephirin Ferrez (1797–1851) as assistants in sculpture and printmaking. The creation in 1820 of the Royal Academy of Design, Painting, Sculpture and Architecture did not have great impetus, however, because of the return to Portugal the following year of King John VI and his

Auguste-Henri-Victor Grandjean de Montigny: Museum of the Pontificia Universidade Católica, Rio de Janeiro, c. 1826

court. In 1826 it became the Academy of Fine Arts and was installed in an Empire-style building designed by Grandjean de Montigny, who succeeded Henrique José da Silva (1772–1834) as acting director in 1834. Among the more significant pupils in his architecture classes were Manuel de Araujo Porto Alegre (1806–79), Joaquín Bethencourt da Silva, Jacinto Rebelo and Antonio Baptista de Rocha.

Among Grandjean de Montigny's other projects in Brazil were official commissions for the Royal School of Arts and Trades, the adaptation of the Seminary of San Joaquín as the Colegio Pedro II (1838) and, most notably, the Merchants' Exchange (1819–20), Custom House (1820), the church of Maceio (1838), the Senado Palace (1848) and Imperial Palace (1848). He also designed many ephemeral works for the royal court in Brazil: triumphal arches, catafalques, funeral pyres, obelisks and decorations. Most of his work, however, was for private patrons, for example the fine Plaza de Comercio (1820) and many residences, such as the House of Souza e Meneses and those at 22, Rua Catete and 81, Dutra. His own residence in the district of Gavea in Rio de Janeiro (c. 1826; now the Museum of the Pontificia Universidade Católica; see fig.) is striking for the way it sits in the landscape, a success repeated in the Casa de Campo at Catumbi.

Grandjean de Montigny was also active as an urban planner, advising on the layout of new streets, boulevards and squares and submitting designs for a water-supply system for gardens. The popularization of the Neo-classical style, which characterized Brazilian architecture in the second half of the 19th century, owed much to his designs and built works. The transition from popular Baroque, which had achieved its greatest successes in Minas Gerais and Bahia, to a more strictly classical style would not have been possible without the transformation of official taste by the French art mission and particularly the work of Grandjean de Montigny.

WRITINGS

Recueil des plus beaux tombeaux executés en Italie pendant les XVe et XVIe siècles (Paris, 1813)
L'Architecture de la Toscane (Paris, 1815)

BIBLIOGRAPHY
A. Morales de los Rios: *Grandjean de Montigny e a evolucão da arte brasileira* (Rio de Janeiro, 1941)
A. A. de Taunay: *A missão artistica de 1816* (Rio de Janeiro, 1956)
I. Arestizabal and others: *Uma cidade en questão. Grandjean de Montigny e o Rio de Janeiro* (Rio de Janeiro, 1979)
J. G. Vieira: 'Taunay, Debret e Grandjean de Montigny', *Aspectos da arte Brasiliera* (Rio de Janeiro, 1980)
Q. Campofiorito: *A Missao artística francesa e seus discipulos, 1816–1840* (Rio de Janeiro, 1983)
A. Sousa: *Arquitectura neoclássica brasileira: Um reexame* (São Paulo, 1994)
RAMÓN GUTIÉRREZ

Grau, Enrique (*b* Cartagena, 1920). Colombian painter, sculptor, printmaker, film maker and stage designer. He studied at the Art Students League in New York from 1941 to 1943 and subsequently visited Italy, where he studied fresco and etching techniques before settling again in Colombia. Consistently devoted to the human form, he initially depicted figures with angular heads and striped

Enrique Grau: *Boy with Umbrella*, oil on canvas, 1.02×1.12 m, 1964 (Washington, DC, Art Museum of the Americas)

tunics in a strong light, with symbolic objects such as eggs, masks or cages.

In such later paintings as *Boy with Umbrella* (1964; see fig.) Grau's figures were transformed into plump, fleshy and voluptuous beings, richly arrayed with lace, feathers, hats and fans, like characters taken from the theatre or from popular turn-of-the-century postcards. His scenes were gradually filled with anecdotal details and numerous objects, including cupboards, easels, boxes, masks and flowers, through which he suggested emotionally charged atmospheres. Grau also produced murals, prints, stage sets, films and especially sculptures. The first of these were assemblages of antique and industrial objects, but he subsequently made cast-bronze sculptures that convey a sensuousness, mystery and nostalgia similar to that evoked by his paintings.

WRITINGS
El pequeño viaje del Barón von Humboldt (Bogotá, 1977)

BIBLIOGRAPHY
Cien años de arte colombiano (exh. cat. by E. Serrano, Bogotá, Mus. A. Mod., 1985)
G. Rubiano: *Enrique Grau: Esculturas* (exh. cat., Bogotá, Gal. Fernando Quintana, 1994)
Enrique Grau, [Bogotá] (1995)

EDUARDO SERRANO

Grau, Ricardo (*b* Bordeaux, 13 Sept 1907; *d* Lima, 4 June 1970). Peruvian painter, teacher and photographer of French birth. He studied at the Escuela Nacional de Bellas Artes, Lima, under José Sabogal from 1920 before attending the Académie Royale des Beaux-Arts, Brussels, in 1924. In 1925 he left to study under Fernand Léger, André Lhôte and Othon Friesz, among others, and he took part in various salons in Paris during the 1930s. His work at this time was influenced particularly by that of Cézanne, Matisse and Braque. In 1937 Grau returned to Peru, becoming one of the first representatives in Latin America of modern European painting, which stood in contrast with the Indigenist style then prevalent in Peru. Grau taught at the Universidad Nacional Mayor de San Marcos in Lima (1942) and was Director of the Escuela Nacional de Bellas Artes from 1945 to 1949. During this period his palette brightened, and by the 1950s he was showing considerable interest in Surrealism and in the art of such Pre-Columbian cultures as the Nazca and Chimú and particularly the Vicús (of which he had a substantial collection of artefacts). He returned to abstract art in the 1960s, using colour as an independent means of expression. In 1967, however, he took up photography (largely due to failing eyesight and adverse reactions to the chemicals in paints) and was successful notably for his portraiture.

BIBLIOGRAPHY
J. A. de Lavalle and W. Lang: *Pintura contemporánea, II: 1920–1960*, Col. A. & Tesoros Perú (Lima, 1976), pp. 78–85
Eduardo Moll: *Ricardo Grau, 1907–1970* (Lima, 1989)

W. IAIN MACKAY

Greco, Alberto (*b* Buenos Aires, 14 Jan 1915; *d* Barcelona, 14 Oct 1965). Argentine painter, sculptor, performance artist, conceptual artist, poet and illustrator. After studying in Buenos Aires at the Escuela Nacional de Bellas Artes and with Cecilia Marcovich and Tomás Maldonado, he quickly established a reputation for his scandalous views, attracting extreme disapproval and equally strong support. After delivering a lecture at the Juan Cristóbal bookshop, Buenos Aires, entitled 'Alberto Greco y los pájaros' he was briefly imprisoned for his 'Communism and subversive acts'. On his release in the same year he travelled to Paris on a French government grant, selling drawings and watercolours in the cafés and studying painting with Fernand Léger (1881–1955) and printmaking with Johnny Friedlaender (*b* 1912). Between 1956 and 1958 he lived in São Paulo, where he became aware of *Art informel*; he painted in this style in the late 1950s and early 1960s (Glusberg, pp. 284–5).

As early as 1959, when he had returned from São Paulo to Buenos Aires, Greco had expressed his corrosive vision of society through the form of his work. In his shows he exhibited tree trunks and rags for cleaning window gratings or floors. He moved again to Paris in 1961 and in March 1962 inaugurated an art form that he called 'Living Art', exhibiting white mice in a glass box with a black background. He explained that: 'Living Art seeks out the object, but once the object is found it leaves it in its place, it does not transform it, does not improve on it, does not take it into an art gallery' (quoted in Glusberg, p. 286). His sculptural installations and live events, like those of Yves Klein (1928–62), whom he admired, contained elements that could be labelled retrospectively as conceptual art and performance art. He discovered his characters in the street, drawing chalk circles around them and adding his signature; he published recipes for Informalist cuisine in the supplement to the Buenos Aires newspaper *La Nación*; and in the centre of Buenos Aires he displayed posters announcing 'Greco, qué grande sos' ('Greco, how great you are!'). Greco turned against painting on the grounds that it had lost the eternity to which he aspired, claiming that the medium had completed its cycle with Klein's blue monochrome paintings. He committed suicide with barbiturates in a room in Spain bursting with sanitary appliances. On his left hand he wrote 'Fin' ('the end'). As death

approached, he noted down his final sensations in scrawled handwriting.

BIBLIOGRAPHY

H. Safons: 'Del pañal a la cruz', *Periscopio*, 50 (1970), pp. 56–8
Alberto Greco a cinco años de su muerte (exh. cat. by L. F. Noé, Buenos Aires, Gal. Carmen Waugh, 1970)
J. Glusberg: *Del Pop-art a la Nueva Imagen* (Buenos Aires, 1985), pp. 283–8
Alberto Greco: Un extravío de tres décadas (exh. cat., Buenos Aires, Cent. Cult. Borges, 1996)
J. López Anaya: *Historia del arte argentino* (Buenos Aires, 1997), pp. 231–8

HORACIO SAFONS

Greenwood, John (*b* Boston, MA, 7 Dec 1727; *d* Margate, Kent, 16 Sept 1792). English painter, engraver and auctioneer of American birth. In 1742 he was apprenticed to the Boston engraver Thomas Johnston, though he abandoned engraving for painting. In 1752 he went to Paramaribo, Surinam, where in the space of five years he painted 113 portraits, which he recorded along with numerous other events and observations in a notebook. While there he painted his best-known work, *Sea Captains Carousing in Surinam* (*c.* 1752–8; see fig.). It is the only tavern scene conversation piece painted in colonial America and was most likely inspired by a print of William Hogarth's *Midnight Modern Conversation* (New Haven, CT, Yale Cent. Brit. A). Greenwood remained in Surinam until May 1758, when he departed for Amsterdam, where he helped reopen the Amsterdam Art Academy, returned to engraving and produced numerous mezzotints. He had moved to London by 1763 and became one of the city's most prominent auctioneers, though his connoisseurship was rudimentary: Titian's *Death of Actaeon* (*c.* 1559; London, N.G.) passed unrecognized through his hands.

BIBLIOGRAPHY

F. Weitenkampf: 'John Greenwood: An American-born Artist in Eighteenth-century Europe', *Bull. NY Pub. Lib.*, xxxi (1927), pp. 623–34 [cat. of his prts]
John Greenwood in America, 1745–1752 (exh. cat. by A. Burroughs, Andover, MA, Phillips Acad., Addison Gal., 1943)

RICHARD H. SAUNDERS

Grenada [Grenadine Islands]. *See under* ANTILLES, LESSER.

Grilo, Sarah (*b* Buenos Aires, 1920). Argentine painter. She studied painting in Buenos Aires under the Spanish Catalan painter Vicente Puig until 1943 and lived in Spain and France from 1948 to 1950, when she returned to Buenos Aires. She was a founder-member of the Grupo de Artistas Modernos de la Argentina in 1952 and in 1957 went on a study trip to Europe and the USA with her husband, the painter José Antonio Fernández Muro. Having worked briefly in a figurative idiom she adopted a lyrical style of abstraction, characterized by refined colour harmonies and thick impasto, that was in marked contrast to the Constructivist tendencies then prevalent in Argentina. Emphasizing emotive over rational qualities, she combined highly tactile surfaces with more ambiguously defined areas.

In 1962 Grilo again left Argentina, funded by a Guggenheim Fellowship, and settled in New York, where she began using letters and numbers reminiscent of the graffiti on city walls (e.g. *X on the Street 13*, 1964; see fig.); these suggestive signs of contemporary urban life were superimposed over pale, delicate colours in horizontal rhythms or tightly interwoven into structures that sometimes covered the entire surface. After 1970 Grilo divided her time between Madrid and Paris.

BIBLIOGRAPHY

D. Bayón: *Aventura plástica de Hispano América* (Mexico City, 1974), p. 151
Sarah Grilo (exh. cat., intro. D. Bayón; Madrid, Mus. A. Contemp., 1985)
R. Brughetti: *Nueva historia del la pintura y escultura en la Argentina* (Buenos Aires, 1991)
Six Latin American Women Artists (exh. cat., Lewisburg, PA, Bucknell U., 1992)
Latin American Women Artists, 1915á1995 (exh. cat. by G. Biller and others, Milwaukee, WI, A. Mus., 1995)

NELLY PERAZZO

Grimm, (Johann) Georg (*b* Immenstadt, 1846; *d* Palermo, 24 Dec 1887). German painter and teacher, active

John Greenwood: *Sea Captains Carousing in Surinam*, oil on bedticking, 951×1910 mm, *c.* 1752–8 (St Louis, MO, Art Museum)

Sarah Grilo: *X on the Street 13*, mixed media on canvas, 1.01×1.02 m, *c.* 1964 (Austin, TX, University of Texas, Jack S. Blanton Museum of Art)

in Brazil. He entered the Akademie der Bildenden Künste in Munich in 1868 but interrupted his studies in 1870 to fight in the Franco-Prussian War. After travelling through Italy, Greece, Turkey, the Near East and North Africa, he left for Brazil from Lisbon, probably in 1878. He settled in Rio de Janeiro but also went to other parts of the country. The paintings resulting from these travels were exhibited in 1882 by the Sociedade Propagadora das Belas Artes in Rio de Janeiro. His work was well-received as an antidote to the lifeless conventionalism of Brazilian painting at the time, and he was invited by the Academia Imperial das Belas Artes to teach landscape painting. Although he was at the Academia only until 1884, he completely transformed its teaching methods by introducing *plein-air* painting. His best-known pupils were Gio-

vanni Battista Castagneto and Antonio Parreiras. Suffering from tuberculosis, he left Brazil in the middle of 1887. *Rock of the Good Voyage* (1887; Niterói, Mus. Parreiras) typifies his landscapes, vibrating with their own light and combining realist precision with exotic fantasy.

BIBLIOGRAPHY
L. Gonzaga Duque: *A arte brasileira* (Rio de Janeiro, 1888)
A. Morales de los Rios Filho: *O ensino artístico* (Rio de Janeiro, 1942)
C. R. M. Levy: *O grupo Grimm: Paisagismo brasileiro no século XIX* (Rio de Janeiro, 1982)
M. E. Peixoto: *Pintores Alemães no Brasil durante o século XIX* (Rio de Janeiro, 1989)

ROBERTO PONTUAL

Grippo, Víctor (*b* Junín, Buenos Aires, 10 May 1936). Argentine sculptor. After studying chemistry and drawing

at the Universidad Nacional de La Plata, he applied his scientific background from the early 1970s to a series of works entitled *Analogy*, in which he established correlations between scientific experiments and the poetry of artistic discourse. Concerned with emulating the processes of nature, he presented sculptural installations in the form of controlled investigations, for example using copper and zinc electrodes to measure the energy of potatoes as a means of demonstrating the parallel between the transformations in the tuber and the process of human perception. In another series, entitled *Crafts* (1976; see Glusberg, p. 171), he presented tools used for manual activities as a way of defending human dignity in an age in which any form of manual ability is considered archaic. Such themes were in line with those of the Grupo CAYC, of which he was a founder-member.

BIBLIOGRAPHY

J. Glusberg: *Del Pop-art a la Nueva Imagen* (Buenos Aires, 1985), pp. 167–76
G. Brett: *Transcontinental: Nine Latin American Artists* (London, 1989)
M. Pacheco: 'Víctor Grippo: A Warm Conceptualist', *Art from Argentina, 1920–1994* (exh. cat. by D. Elliott and others, Oxford, MOMA, 1994), pp. 100–105
Un altre mirar arte contemporani argentini/Otra mirar arte contemporáneo argentino (exh. cat., Barcelona, Generalitat Catalunya, 1997)

JORGE GLUSBERG

Grupo CAYC. Argentine group of artists. It was founded in Buenos Aires in 1971 as the Grupo de los Trece by the critic Jorge Glusberg (*b* 1938) and renamed Grupo CAYC because of its close association with the Centro de Arte y Comunicación. The group held its first public show in 1972 in the exhibition *Hacia un perfil del arte latino americano* at the third Bienal Coltejer, Medellín, Colombia. The group's chief members were Jacques Bedel, Luis Benedit, Jorge Glusberg, Víctor Grippo, the sculptor Leopoldo Maler (*b* 1937), the sculptor Alfredo Portillos (*b* 1928) and Clorindo Testa. Treating the visual aspect of works of art as just one element in order to demonstrate the complexity and richness of the creative process, they took a wide view of Latin American culture that spanned the cosmogony of Pre-Columbian societies to the technological and scientific concepts of the late 20th century. In 1977 they won the Gran Premio Itamaraty at the 14th São Paulo Biennale with their collective work *Signs of Artificial Eco-systems*.

BIBLIOGRAPHY

J. Glusberg: *El Grupo CAYC* (Buenos Aires, 1979)
H. Safons: *A Sense for History: CAYC Group* (Buenos Aires, 1980)
J. Glusberg: *Del Pop-art a la Nueva Imagen* (Buenos Aires, 1985), pp. 127–32, 483–8
CAYC Group [Jacques Bedel, Luis Benedit, Jorge Glusberg, Víctor Grippo, Alfredo Portillos, Corindo Testa]: Striped House Museum of Art, Tokyo (exh. cat., Buenos Aires, Cent. A. & Comunic., [1993])
N. García Canclini: 'Modernity after Postmodernity', *Beyond the Fantastic: Contemporary Art Criticism from Latin America*, ed. G. Mosquera (London, 1995)

HORACIO SAFONS

Guadalajara. City in Mexico. It is the capital of the state of Jalisco, in western Mexico, *c.* 200 km from the Pacific coast. A point of convergence of transport routes, which has helped the development of its industry, commerce and agricultural production, it has a population of *c.* 1.6 million. It was founded on its present site in the Valley of Atemajac in 1542, and in 1560 it was declared capital of the kingdom of Nueva Galicia, entailing the transfer of the tribunal and royal treasury from Compostela (now Tepic). When New Spain was divided into 12 *intendencias*, the city became the capital of the *intendencia* of Guadalajara, which comprised the present state of Jalisco, part of Aguascalientes and Zacatecas.

Guadalajara contains notable examples of all the artistic and architectural styles imported from Europe by the Spanish colonists, from the Gothic to Neo-classicism. The Cathedral (1561–1618) was planned as a basilica and begun by Martín Casillas. It is the only one in Mexico to have an interior in the Gothic style. It contains oil paintings by such renowned artists as José de Alcibar and Miguel Cabrera, and, in the sacristy, there is a painting attributed to Bartolomé Esteban Murillo and a large canvas by Cristobal de Villalpando. Other religious edifices of note are the former monastery of S Monica, which has a magnificent Baroque façade with solomonic columns (1773), the church of S Francisco (16th century; altered in the 17th), a Baroque work of fine quality, and the Capilla de Nuestra Señora de Aránzazu, a Churrigueresque construction that retains its original altarpieces.

The 18th-century Palacio de Gobierno has an austere Baroque façade, while the wall paintings in its main stairwell, representing *Hidalgo and National Independence*, were executed in 1937 by José Clemente Orozco and are among his greatest works (*see* OROZCO, JOSÉ CLEMENTE, fig. 2). The Neo-classical Teatro Degollado (mid-19th century; see fig.), by José Jacobo Gálvez, is fronted by a portico with 16 Corinthian columns in imitation of the Pantheon in Rome. The auditorium is semicircular, and the dome is decorated with a painting based on Canto IV of Dante's *Divina Commedia*.

The Neo-classical Hospicio Cabañas (1805; now Instituto Cultural Cabañas) on Plaza Tapatía was built by José Gutiérrez to a design by Manuel Tolsá. Its chapel contains murals (1938–9) by José Clemente Orozco depicting the conquest of Mexico, with the extraordinary *Man of Fire* in the dome. Orozco's colours are vibrant and his painting shows his mastery of perspective.

Guadalajara, Teatro Degollado by José Jacobo Gálvez, mid-19th century

The bandstand in Plaze de Armas, cast in Paris in the early 20th century, is a magnificent example of Art Nouveau. Notable modern buildings in the city include the series of houses (1927) by Luis Barrágan, the IBM building (1975) by Ricardo Legorreta and the Banco Refaccionario de Jalisco (1973) and the Archivo del Estado de Jalisco (1989), both by ALEJANDRO ZOHN. The Museo de Arqueología del Occidente de México (1960) houses pre-Columbian artefacts, including anthropomorphic receptacles and figurines.

BIBLIOGRAPHY
B. Luis Pérez: *Guadalajara de Indias* (Guadalajara, 1932)
J. Cornejo Franco: *Guadalajara colonial* (Guadalajara, 1939)
A. Chávez Hayhoe: *Guadalajara en el siglo XVI*, 2 vols (Guadalajara, 1991)
H. A. Martínez González: *La catedral de Guadalajara* (Guadalajara, 1992)
S. LETICIA TALAVERA, P. MARTANO MONTERROSA

Guadeloupe. *See under* ANTILLES, LESSER.

Guatemala, Republic of. Central American country. It is bordered on the north and west by Mexico, on the northeast by Belize and on the south-east by El Salvador and Honduras; the Pacific Ocean forms a coastline 250 km long to the south-west and the Caribbean Sea a shorter coast to the north-east (see fig. 1). The capital is GUATEMALA CITY (formerly Nueva Guatemala or Guatemala de la Asunción), although before its foundation in 1776 the capital was Santiago de Guatemala (founded 1527), which, following a landslide in 1541, was relocated (1543) several kilometres away on the site of present-day ANTIGUA. Despite the country's relatively small size, it can be divided into three distinct geographical areas: the lowlands in the north (comprising about a third of the country's territory); the central, mountainous highlands; and the southern coastal plain. The lowlands contain notable classic Maya archaeological sites. The highlands include two more or less parallel mountain ranges: to the north the Sierra de Los Cuchumatanes and to the south the Sierra Madre. A chain of *c.* 30 volcanoes runs across the latter, some still active. The southern part of the country is subject to earthquakes, which have influenced its architecture (*see* §III below). The abundant stone in Guatemala is not of a quality sufficient for building, although in the late 20th century marble was found in the middle valley of the River Motagua. There is a good supply of clay, which is used for domestic utensils, brick and tile. The highlands are abundant in conifers and the lowlands in precious woods, such as mahogany, which have been used for building and for furniture.

I. Introduction. II. Indigenous culture. III. Architecture. IV. Painting, graphic arts and sculpture. V. Textiles. VI. Gold and silver. VII. Ceramics. VIII. Furniture. IX. Patronage, collecting and dealing. X. Museums, art libraries and photographic collections. XI. Art education.

I. Introduction.

The region was part of the Maya civilization until the Spanish conquest (1524–35). Under the Spanish it formed part of the Kingdom of Guatemala or Audencia de Guatemala, which included the modern Mexican state of Chiapas, together with the territories now occupied by Costa Rica, Nicaragua, El Salvador and Honduras. The economy was largely based on agriculture, with limited mining resources. The population included Spanish, mestizo (mixed race), black, and indigenous Indian people, this last group forming the majority. Independence was achieved in 1821 without great military campaigns. From 1823 to 1838 the former colonial region (without Chiapas) operated as the Federación de Centro América and then separated definitively into the five Central American Republics. Guatemalan independence was formally declared in 1847. The 19th century was marked by long-term administrations, first a conservative, pro-Catholic one (1838–71), then for the rest of the century a liberal, progressive and anti-clerical regime. Until 1944 the government was dominated by the heirs of liberalism, with continued anti-clericalism and restrictions on democracy. From 1945, with varying success, efforts were made to modernize the country and to make it more democratic. Under populist governments (1945–54) a new, democratic constitution was introduced, together with legislation affecting the distribution of land and working conditions. Thereafter these efforts were compromised by periods of great violence, including guerrilla and counter-guerrilla warfare; which ended in 1996 with the signing of a peace accord. In the late 20th century the country underwent a difficult period in pursuit of socio-economic development in the face of an enormous demographic growth, from an estimated 2.7 million in 1950 to *c.* 9.5 million in 1995. There was also a significant growth in Protestantism, and Guatemala became the Latin American country with the largest proportion (30%) of non-Catholics in its population.

BIBLIOGRAPHY
E. Chinchilla Aguilar: *Historia del arte en Guatemala: Arquitectura, pintura y escultura* (Guatemala City, 1963, rev. 1965)
H. Berlin: 'Artistas y artesanos coloniales de Guatemala: Notas para un catálogo', *Cuad. Antropol.*, v (1965), pp. 5–35
J. Alonso de Rodríguez, ed.: *Arte contemporáneo Occidente Guatemala* (Guatemala City, 1966)
L. Luján Muñoz: *Síntesis de la arquitectura en Guatemala* (Guatemala City, 1968, rev. 1972)
P. Gerhard: 'Colonial New Spain, 1519–1786: Historical Notes on the Evolution of Minor Political Jurisdictions, XVI. Guatemala', *Hb. Mid. Amer. Ind.*, xii, pt 1 (1972), pp. 129–32
M. J. MacLeod: *Spanish Central America: A Socioeconomic History, 1520–1720* (Berkeley and Los Angeles, CA, 1973)
J. A. Móbil: *Historia del arte guatemalteco* (Guatemala City, 1974/*R* 1977)
J. Alonso de Rodríguez: *Plateros y batihojas* (1981), ii of *El arte de la platería en la Capitanía General de Guatemala* (Guatemala City, 1980–81) [specialist discussion of silverwork]
Historia general de Guatemala, 6 vols (1993–9)
A. M. Urruela de Quezada, ed.: *El tesoro de La Merced* (Guatemala City, 1997)
J. Luján-Muñoz: *Breve historia contemporánea de Guatemala* (Mexico City, 1998)
JORGE LUJÁN-MUÑOZ

II. Indigenous culture.

About 42% of Guatemala's inhabitants are Indian descendants of the builders of the Maya civilization, which was at its peak *c.* AD 250–*c.* 900. When the Spanish arrived, the Maya civilisation was already in decline, though many indigenous traditions survived. Despite suffering through the import of diseases during the 16th and 17th centuries, the indigenous population grew again slowly following independence. By the late 20th century there was an increase in the number of Indians entering non-agricultural

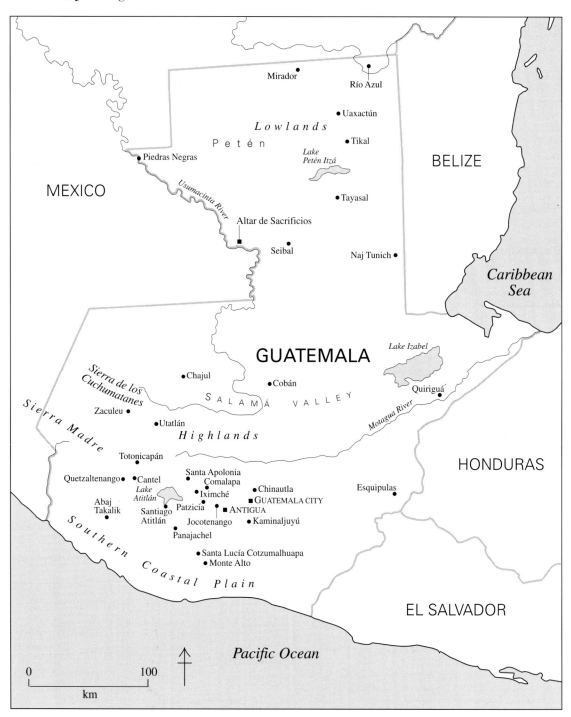

1. Map of Guatemala; those areas with separate entries in this encyclopedia are distinguished by CROSS-REFERENCE TYPE

occupations and the emergence of an Indian intellectual sector, with massive migration to cities.

In the first recognizable period of indigenous artistic production following the Spanish conquest (c. 1524–c. 1600), the long Maya pictorial tradition came close to a dramatic termination, with the population being forced into *reducciones* (settlements) for easier religious and tax control. The Catholic Church's zeal for massive indoctrination into the new faith led to a systematic destruction of pagan sculptural and architectural works, murals, codices and pictorial books. Ancient cities that had been abandoned began to decay, and palaces and temples were robbed of their valuable art objects. Art in the pre-conquest Maya tradition continued only in remote places away from

the Spanish. Notable examples of this include the large pictorial polychromatic wall paintings in some huts in Chajul in the department of Quiche.

By the second period (c. 1600–c. 1773) the Indians had been christianized, resettled and protected by laws that diminished abuse and interference from the Spaniards. A new form of community organization developed around a patron saint that first complemented but later obliterated Pre-Columbian organizations. The *cofradías*, hierarchically organized religious associations, paralleled and complemented the political–administrative organization. Their devoted members clothed and decorated the saints' images and celebrated their holy days with processions and theatrical dances, for which they produced elaborate masks representing animals, Spaniards or other themes and other paraphernalia. Women's artistic contributions were considerable, since the decorations for these festivities depended heavily on textile-making and sewing, although women did not participate in dancing or other public representations. Indian men could engage in the making of religious ornamentation as carpenters, sculptors and painters, but fine imagery and painting were usually executed by licensed members of the trade unions of European origin. Earthquakes have destroyed most of the evidence of native contributions. However, the Indian influence in the Baroque church of S Andres Semetabaj with its superb polychrome façade is one of the best surviving examples.

After c. 1773 there was a consolidation of the Indian *municipio* (county), a social organization that developed from the *reducciones*, the protected and secluded *pueblos de Indios* and the parochial administration. The Indian *municipio* gradually acquired the characteristics of a little government. It gave the individual a self-identity, which had to be expressed by symbols easily recognizable by other Indians as well as by the rest of the population. Dress became in this way a very important and distinctive feature of each *municipio* (*see also* §V below). While differences in dress had been promoted by the Spaniards for easy identification, its cultural and socio-psychological relevance grew as the *municipio* developed as the first and often the only fatherland for its people. Dress was simple and of the dull colour of unpainted native fibres during the previous centuries. Increasing availability of new materials and vividly coloured threads coincided with the growing importance of the *municipio*. This was crucial for artistic development, because it made possible the casting of old mythological–religious themes and old and new designs into a semi-pictorial utilitarian art. At this late point in history the painting abilities of Pre-Columbian times were transferred from stone to cloth and dress, and from the hands of men to women.

However, after 1944 there was a progressive deterioration of the Indian *municipio* as a self-contained entity and a growing consciousness of national identity. The loosening of the *municipio* organization had a greater liberating effect on men. In 1930 Andres Curuchich (*b* 1891), an Indian from the town of Comalapa in the central highlands, rose to international fame by initiating a pictorial Primitivist tradition, which attracted many followers. Two aspects of this tradition are particularly interesting: for the first time in centuries the work was individually conceived, yet the painter used traditional themes, such as the landscape around the village, its streets, groups of people in the *municipio*'s costume, festivities or other collective social affairs, without emphasizing individual features. The artist had, therefore, become sufficiently free from *municipio* tradition, which blurred individuality, to be able to objectivize its powerful binding force. Improvements in communication made it possible for *Ladinos* (non-Indians) to settle in increasing numbers among Indians. The *Ladinos* brought new technology, information, forms of production and commercial activity. The national revolution and the changes it brought allowed the Indians to participate in the national political life and establish the basis for a significant improvement of their education and the expansion of a national network of telecommunications and transportation. Most men adopted European dress, and women, more traditionally bound and less educated, used dress from other *municipios* as well as from their own, following fashion and personal taste rather than tradition.

BIBLIOGRAPHY
C. A. Smith, ed.: *Guatemalan Indians and the State, 1540–1988* (Austin, TX, 1990)

A. MÉNDEZ-DOMÍNGUEZ

III. Architecture.

1. 1524–1821. 2. After 1821.

1. 1524–1821. A cathedral was completed in the first capital of Santiago de Guatemala by 1539 but lost when the settlement was carried away in a landslide in 1541. The wattle and adobe structures of early colonial buildings had roofs supported on timber and covered in thatch or palm leaves. Traditional skills in burnished plasterwork were applied to the stucco surfacing of the retable façades of numerous Catholic churches. Though often reinforced with brick or stone, the rubble structures were unfortunately too fragile to withstand earthquakes, and little has survived from the 16th and 17th centuries. Stucco surfaces and thatched roofs could be quickly restored as the occasion arose, however, and designers soon began to adapt practice to local conditions. The unique transition of Spanish styles was superimposed on the simple local techniques of building. In the mid-16th century, for example, there were still references to the Romanesque, as in the cloisters of the church of S Cristóbal Totonicapán; Gothic details can be found alongside early Renaissance forms, often with Plateresque surface treatment and *Mudéjar* elements in both interior and exterior design. In spite of frequent rebuilding, the standard Spanish grid plan, centred on a main square, has survived in the towns and cities of the earthquake zone as elsewhere. Antigua is said to have been laid out by an architect of Italian origin, Juan Bautista Antonelli the elder (*see* ANTONELLI), on a grand scale with fountains supplied from nearby mineral springs.

A characteristic example of mid-17th-century buildings for the religious orders in the capital was the church of the Hospital de S Pedro Apóstol (1645–65), begun by Juan Pasqual (1628–c. 1660) and continued by Joseph de Porres (*see* PORRES), the Guatemalan architect who dominated the last third of the 17th century. He built the first vaulted church in Guatemala (1666–9). During the 17th century there was also a zeal for renovation and replacement of

earlier, less substantial buildings. Brickwork replaced adobe, naves were wider and higher, and façades more imposing in scale. The cathedral of Santiago de Guatemala (now Antigua) was rebuilt as a vaulted three-naved church with a dome at the crossing (1666–80). Joseph de Porres worked on it from 1670 until its completion (damaged in earthquake, 1717; restored by Diego de Porres, 1721; severely damaged and abandoned, 1773). Only the bases of the towers remain, but the classically composed Renaissance façade, said to be based on a model by Sebastiano Serlio, also displays a certain Baroque exuberance in the multiplicity of niches between each of four pairs of coupled giant order columns, which rise through two storeys and continue above the entablature to enclose a boldly voluted top storey. Joseph de Porres, appointed Arquitecto Mayor by the city fathers in 1687, moved slowly away from classical models towards early Baroque forms: features such as salomonic columns appear only in later buildings such as the church of S Francisco (completed 1698), Antigua, on which Ramón de Autillo had worked in the 1670s. Porres was also responsible for the church of Belén (1678), the church and monastery of S Teresa (1683–7) and the church of La Compañía de Jesús (1698), all in Antigua. The church of La Merced (1650–90; rebuilt 1750s), Antigua, is perhaps the most characteristic example of the city's architecture. Parts of the rubble walls of this three-naved, vaulted and domed church are 3 m thick and survived well in the earthquake of 1773. Sturdy columns with Baroque spiral decoration to the lower (Tuscan) order frame the niches of a two-storey classical façade. The third (octagonal) storeys of the massive towers show examples of the new bolster (*almobadillado*) pilasters, and the second-storey pilasters simulate inverted lyres. The invention of new forms of pilaster was one of the hallmarks of 17th–18th-century Guatemalan architecture. The bolster pilasters of El Calvario (1655; destr. 1717; reconstructed 1720), Antigua, were among the first. Other buildings in Antigua of that period that incorporated pilasters were S Clara, Santa Cruz, San José, S Rosa de Lima and S Ana. The range came to include inverted urns and back-to-back volutes among other decorative forms.

The individual development of Baroque is associated with Diego de Porres in the first half of the 18th century and José Manuel RamÍrez (*see* RAMÍREZ, (1)) in the second. The former became Arquitecto Mayor on his father Joseph's death, and he was himself succeeded in the post by Ramírez in 1743. In 1717, the year of a major earthquake, Porres completed one of the largest convents in Santiago de Guatemala, the Colegio de Cristo Crucificado or La Recolección, begun by his father in 1693. He was appointed also to assess the damage in the city and to repair many of the buildings, including the cathedral. Important commissions over the succeeding decades included the oratory of S Felipe Neri (1720–30), the Real Casa de Moneda (1734–8), and convents and churches for the Capuchins (1731–6), all in Antigua. His work culminated in the largest building of 18th-century Guatemala, the sanctuary at Esquipulas, in the east near the borders with El Salvador and Honduras (see fig. 2). Like Guadalupe in Mexico and Copacabana in Bolivia, Esquipulas was probably a popular place of pilgrimage before the Spanish arrival. A small church was built there to house the *Christ*

2. Sanctuary at Esquipulas, probably by Diego de Porres, completed 1759

of Esquipulas (1595) by Quirio Cataño (*fl* 1594–1617), and it was the growing popularity of the pilgrimage to Esquipulas that necessitated so vast a building in so remote a place. Completed (1759) by Diego's son Felipe, who supervised the work after 1740, the church is raised on a mighty podium with a squat four-storey tower at each of its four corners and has a narrow three-storey façade, the cornices of which are out of line with those on the towers. A flat dome, finials at each level of the towers and a large multi-foil arch above the portal are expressions of continuing Mudéjar influence. MUDÉJAR influence is also apparent in the work of José Manuel Ramírez in the new building for the Universidad de S Carlos (licensed to grant degrees, 1676), previously housed in the Dominican college of St Thomas Aquinas. The new buildings (1763–73), adjacent to the Seminario Tridentino (*c.* 1758; designed by Ramírez), were restored in the late 19th century. Other mid-18th-century civil buildings in Antigua include the Real Cabildo (1740–43) and the later Real Palacio (1758–68), probably the work of the military engineer Luis Díez Navarro, who came to Guatemala from Mexico in 1741. The buildings face each other across the Plaza Mayor. Both reflect the style adopted for government buildings in the Spanish colonies: both have two-storey arcades facing the square. The former is constructed in stone and has a sober air; an Italianate cupola was added to the tower in the 19th century. Private dwellings in Antigua include the well-known Casa de los Leones (architect unknown), with its massive stone portal flanked by salomonic columns and high-relief rampant lions, and the Casa de Chamorro (1762; also by Díez Navarro), a more typical urban Baroque house with an arcaded patio.

Of the many churches of this period in Antigua, El Carmen (1728; rebuilt after 1717 earthquake; now in ruins) is unusual for the in-depth arrangement of many columns on both storeys of the façade and the Plateresque patterning around the portal and on upper-storey columns; the Hermitage church of Santa Cruz (rebuilt 1731–45) has 18th-century overall stucco decoration but combines a

Renaissance style with Baroque features such as the bolster pilasters of the upper storey. An interesting example near Antigua is the church at Jocotenango, which has a two-storey, classically arranged façade with a polygonal window flanked by bolster pilasters above the portal; elsewhere coupled salomonic columns frame the niches. The church was designed by Bernardo Ramírez (see RAMÍREZ, (2)), son of José Manuel, and was in the process of construction at the time of the severe earthquake of 1773.

Guatemala City was begun in 1776, and the Neo-classical style was introduced almost immediately by the Spanish architect Marcos Ibáñez (assisted by Antonio Bernasconi) in the design for the new cathedral. The execution of the work was taken over by PEDRO GARCI-AGUIRRE in 1802 and Santiago Marquí after 1805, and the cathedral (though uncompleted) was dedicated on 16 January 1813. However, Neo-classicism was slow to displace the local Baroque. Political unrest and economic difficulties slowed down the process of building a new city for over 30,000 displaced inhabitants of Antigua. Many buildings remained unfinished when Guatemala achieved independence in 1821.

2. AFTER 1821. The development of Guatemala City, the capital of the new independent Republic of Central America, and later of the Republic of Guatemala, was considerably delayed by political events in the 1830s and 1840s. Neo-classical buildings such as the cathedral and the church of S Francisco, however, were finally completed in the 1850s, the latter already beginning to show the influence of European academic classicism in its vast Corinthian portico. Few new buildings were begun during this period, though the Teatro Nacional, by Miguel Rivera-Maestre, begun in the 1830s, was completed in 1859 in modified form by an immigrant architect of German origin, José Beckers, in the classical style with a Tuscan order supporting a pediment on the main façade. Other important buildings in Guatemala City in the 1860s were the Mercado Central and the headquarters of the Sociedad Económica de Guatemala, both by Julián Rivera.

When a new liberal regime acceded to power in 1871, it expropriated monasteries and put them to use as offices and schools, thus reducing the need for new buildings. Coffee was the main export crop, and new building was focused on roads and railways with their associated stations. The west of the country in particular benefited from the coffee industry: in Quetzaltenango the surge of construction of both public and private buildings was notable. There was a vigorously classical trend in designs based on Jacopo Vignola's treatise *Regola delli cinque ordini d'architettura* (Rome, 1562), using cut stones from nearby quarries and stonecutters brought over from Italy: outstanding examples were the Palacio Municipal, the Pasaje Henríquez, the Banco de Occidente and theatres in both Quetzaltenango and nearby Totonicapán. In the last decade of the century, building in Guatemala City included the Registro de la Propiedad Inmueble, and as a result of the international fair held in 1897, a new boulevard, Avenida de la Reforma, was opened up and pavilions were built with roofs of imported steel and glass. The city was embellished in French taste—even sculptures imported from Europe were erected. Development continued beyond the turn of the century, after Quetzaltenango was partially destroyed by earthquakes in 1902.

The first two decades of the 20th century began and drew to an end with major earthquakes in 1901–2 and 1917–18. Schools and hospitals were built after the first but did not survive the second. More characteristic of the presidency (1898–1920) of Manuel Estrada Cabrera perhaps were the temples of Minerva, ostensibly built to honour the 'studious youth' of the country, and in which were held politically orientated fiestas to the goddess of learning and the arts. That in the capital (1901; destr. 1953), in the form of a Greco-Roman temple, boasted high-relief decoration by the Venezuelan sculptor Santiago González (d 1909), who was brought over expressly from Paris. After the presidency of Estrada Cabrera, there was a tendency to distance new designs from both the colonial tradition and the dominant classicism of the 19th century. In the decade of democratic government that followed, a number of astylar buildings emulated contemporary European rationalist trends: these included buildings for the Facultad de Medicina, the Corte Suprema de Justicia and the Facultad de Farmacía in Guatemala City and the Edificio Rivera in Quetzaltenango. During the government of Jorge Ubico (1931–44) there was a Spanish colonial revival. Important buildings of the period were the Central de Correos (1938), the Legislative Palace (1939), the Edifico de Sanidad Pública (1940), theTerminal Aérea and the Policía Nacional both (1941), and the Palacio Nacional (1943).

Thereafter, Guatemalan architecture gradually returned to Modernist lines. The so-called Olympic City (1950), a highly successful sports facility built in a ravine area, was a landmark in the urban development of the capital. In the 1950s and 1960s there followed a number of interesting buildings that subscribed to an experimental movement to integrate painting, sculpture and other art forms such as mosaics with architecture. Among these were the Palacio Municipal (1958), the Seguro Social building (1959), the Banco de Guatemala (1964) and the new Terminal Aérea (1969), all in Guatemala City. The Crédito Hipotecario Nacional (1964) and the Biblioteca Nacional (1965) are especially notable for concrete relief sculptures by the Guatemalan artist–engineer EFRAÍN RECINOS. His Gran Teatro (completed 1978) best demonstrates his originality and vigour in bringing together architecture and the other arts. Situated on a hilltop site in the middle of the city, it is conceived as a large-scale sculptural work in its own right, employing very original forms and decorated externally with mosaic.

The threat of earthquakes became less significant as anti-seismic building techniques in steel and reinforced concrete developed. Among the varied buildings using these new structural methods is the Hospital Nacional (1979) of Puerto Barrios, serving a rural area in Guatemala. Consisting of 142 factory-built, steel-framed modules, it was designed by Mariani Associates of Washington, DC, and Robert Ziegelman of Birmingham, MI; the units were shipped from the USA ready for crane-assembly into a two- and three-storey 200-bed general hospital, the cold-rolled steel modules of which can readily articulate one with the other under seismic action. The urban Banco de Occidente (1980) by Skidmore, Owings & Merrill (see fig.

3. Skidmore, Owings & Merrill: Banco de Occidente, Guatemala City, 1980

3) is a simple three-storey rectilinear exposed reinforced concrete office building, its face set back from a sturdy street grid-façade reminiscent of Aldo Rossi's Gallaretese 2, Milan. A galleried patio, here rethought as an enclosed atrium, is part of the strategy of a building requiring no energy inputs for full operation in a city under reconstruction. Both buildings exemplify the significance of building regulations enacted to limit building heights, as well as a determination in both public and private sectors to make a virtue out of the necessity of appropriate technology against recurrent earthquakes.

BIBLIOGRAPHY

V. M. Díaz: *Las bellas artes en Guatemala* (Guatemala City, 1934)
P. Kelemen: 'Some Church Façades of Colonial Guatemala', *Gaz. B.-A.*, n. s. 5, xxvi/924 (1944), pp. 113–26
Catálogo del Museo Colonial de Antigua, Guatemala, Instituto de Antropología e Historia (Guatemala City, 1950)
P. Kelemen: *Baroque and Rococo in Latin America* (New York, 1951), pp. 39–40, 122–9, 133
D. Angulo Iñiguez, E. Marco Dorta and M. J. Buschiazzo: *Historia del arte hispano-americano*, 3 vols (Barcelona, 1945–56), iii (1956), pp. 1–17
E. Chinchilla Aguilar: *Historia del arte en Guatemala: Arquitectura, pintura y escultura* (Guatemala City, 1963, rev. 1965)
S. D. Markman: *Colonial Architecture of Antigua Guatemala* (Philadelphia, 1966)
V. L. Annis: *La arquitectura de Antigua Guatemala, 1543–1773* (Guatemala City, 1968)
L. Luján Muñoz: *Síntesis de la arquitectura en Guatemala* (Guatemala City, 1969)
B. Gauria: 'Prefabricated Modules Speed Hospital Construction', *Archit. Rec.*, clxv/4 (1979), pp. 141–3
Escultura 80: Certamen Centroamericano de Escultura 1980 y Valoración retrospectiva de escultura y relieve integrados a la arquitectura guatemalteca de 1950 a 1980 (Guatemala City, 1980)
'Banco de Occidente: SOM, Chicago', *Space Des.*, 221 (Feb 1983), pp. 52–3
T. Frisch: 'Reconstruction in Guatemala', *Archithèse*, xiv/5 (1984), pp. 10–12
Historica general de Guatemala, 6 vols (1993–9)
E. Tejeira Davis: 'El neocolonial en Centroamérica', *Arquitectura neocolonial: América Latina, Caribe, Estados Unidos*, ed. A. Amaral (São Paulo, 1994), pp. 113–28
J. Luján-Muñoz: 'La arquitectura y la albañilería en la ciudad de Guatemala a finales del siglo XVIII', *Rev. U. Valle Guatemala*, vi (Dec 1996), pp. 12–24
E. Aguirre Cantero: *Espacios y volúmenes: Arquitectura contemporánea de Guatemala* (Guatemala City, 1997)
J. Luján Muñoz: 'Guatemala: Arquitectura colonial del reino de Guatemala', *Arquitectura colonial iberoamericana*, ed. G. Gasparini (Caracas, 1997), pp. 145–78

JORGE LUJÁN-MUÑOZ

IV. Painting, graphic arts and sculpture.

1. 1524–1821. 2. After 1821.

1. 1524–1821. The numerous churches built in the 16th century for both the Spanish and indigenous communities in Guatemala created an overwhelming demand for religious works of art executed in the approved manner.

The first works arrived with the Spanish, who brought with them small-scale religious paintings and sculptures. They were followed by artists of mediocre ability who came over from Spain. In the principal Guatemalan cities these artists and artisans reproduced the guild organization of the Spanish mainland, especially of Castile and Andalusia, where most originated. Gradually the membership of these changed from being composed of artists of Spanish origin to include artists of mestizo, indigenous or African descent, no doubt the result of the continuing shortage of skilled artists and the indifference manifested by the Spanish for manual work, when more prestigious posts in colonial society were available to them. By 1600 Indian artists were also beginning to recover a sense of purpose after the systematic disparagement of their art by Roman Catholic missionaries (*see also* §II above).

The arts that thrived best were painting and sculpture, which were in continuous demand. Every new church required several altars and retables, each of which was adorned with paintings and sculptures. In an environment of mass production, only a few painters and sculptors maintained high standards. Of these, one of the earliest known painters was Pedro de Liendo y Salazar (*fl* 1615–26), active in Santiago de Guatemala (now Antigua). Other painters included Francisco Montúfar (*fl* 1611–50) and, later in the century, members of the de Merlo family, and Blas de Mesa (*fl* late 17th century), who worked in the Comayagua region of Honduras. Guatemalan painters generally followed Spanish and European trends, which they absorbed through engravings, books or through Mexican painters such as CRISTÓBAL DE VILLALPANDO, who painted a cycle of the *Life of St Francis* for the Franciscan convent at Santiago de Guatemala (1691; now at Antigua, Mus. Colon.). Although there was some wall painting in the 16th century, this soon diminished, and works were done in oils on canvas or, less frequently, on panel or copper. Guatemalan sculptors received more attention, examples of their work being exported to Mexico and even Spain. These were religious effigies carved from wood and elaborately covered with gold (*dorado*) and colours to produce a vivid effect of reality, including the prized *encarnado* (Sp. flesh-colour); comparatively few sculptures were of plaster or stone. Among the recorded names of sculptors are Juan de Aguirre (*fl* mid-16th century); Quirio Cataño (*fl* 1594–1617), whose *Christ of Esquipulas* (1594–5; Esquipulas Church) is a celebrated example; Pedro de Brizuela (*fl* 1600); and later Alonso de la Paz (*fl* mid-17th century) and MATEO DE ZÚÑIGA. Painters, sculptors, carpenters (*ensambladores*) and decorators (*estofadores*) collaborated on the production of retables, for which Guatemala was a regional centre throughout the colonial period (*see* RETABLE, §1). Among the leading 18th-century practitioners were members of the GÁLVEZ family.

The centre of artistic life in Guatemala was initially at Santiago de Guatemala (now ANTIGUA) and then, after the capital's transfer, at Nueva Guatemala (now GUATEMALA CITY). All the important art commissions were executed by artists from the capital, either in the city itself or at the place where the work was to be installed. In the last quarter of the 18th century, the impact of Neo-classicism led to important changes in artistic production,

especially in the capital. In painting there was a certain amount of secularization, which took the form of portraiture, particularly miniatures. In sculpture new materials were tried, but the lack of known marble deposits in the country until the 1950s—discovered at Zacapa in the Motagua Valley—prevented the disappearance of the popular polychromed wood sculpture. In the late 18th century and early 19th the quality of execution improved due to new art teaching (*see* §XI below).

The development of the graphic arts in Guatemala was comparatively slow, since printing presses were established only in 1660. The first prints were exclusively woodcuts, then around the beginning of the 18th century artists began engraving on copper; it was not until *c.* 1800 that etchings and aquatints were introduced. The subjects were mainly religious and published in the form of prayers, books containing prayers for novenas, and pious prints, for which plates were made locally, although they were also imported. Another important source of commissions were books commemorating royal funeral rites, for which large engravings were required to reproduce the catafalque made for the occasion. The development of engraving was also associated with the engravers of the Real Casa de Moneda, founded in Santiago de Guatemala in 1733, who also executed printing commissions and taught. This was especially true in the last part of the colonial period, when they excelled in engraving on copper (*see* GARCI-AGUIRRE, PEDRO). The capital was the main source of prints for the whole kingdom, since, for most of the colonial period, it had the only printing presses in the region.

2. AFTER 1821. Guatemala's independence had little direct effect on artistic activity, although the socio-political instability of the following decades meant that there were few commissions. Secularization continued, resulting in a slow decrease in the importance of religious art. Moreover, at times (1829–38; after 1871) the Roman Catholic Church was persecuted, thus ceasing to be the main patron of the arts. Attempts to institutionalize art education in schools or academies failed, and the guild-based training system of apprentice, artisan and master craftsman continued. There was little significant improvement in artistic standards in the course of the 19th century. Practice remained more or less at a competent level, concentrated in the capital. Unlike other Latin-American countries, where foreign artists were encouraged to settle and domestic artists helped to study abroad, Guatemala remained largely isolated. Nevertheless, direct artistic dependence on Spain was broken as influences were received from other European countries, especially France and Britain. With the diminishing role of the Church, the only remaining opportunities left to painters were portraits of politicians and the bourgeoisie. Guatemala's only outstanding 19th-century artist, the miniaturist and engraver FRANCISCO CABRERA, worked in this field, producing intense portraits of exquisite Neo-classical sensibility. Although he had pupils, none managed to equal his achievement. In sculpture the religious image in polychromed wood was dislodged from its dominant role only slowly, secular sculpture in marble and bronze being introduced only in the last quarter of the 19th century. Etching and lithogra-

phy were practised for the first time in this period, notably in the work of Julián Falla.

When the government of José María Reina Barrios (President, 1892–8) initiated a French-influenced plan for Guatemala City, which included the placing of several bronze monuments on newly made boulevards, foreign sculptors were invited to contribute. Together with earlier arrivals, these formed a largely Italian community and included Andrea Galeotti, Giovanni Esposito, Francesco Durini, Achille Borghi, Adriatico Froli, Desiderio Scotti and Carlo Nicoli; as well as the Spaniards Justo de Gandarias (1848–1933) and Tomás Mur. Notable examples of their work include bronze statues of Cristóbal Colón (1896) and *Fray Bartolomé de las Casas* (1897; Guatemala City) by Mur and of *Miguel García Granados* (1897; Guatemala City, Boulevard 30 de Junio) by Durini. Stylistically they are representative of late 19th-century academic sculpture. Engraving was usually associated with the mint, where the work of the Swiss-born Johann Baptist Frener (1821–98) was outstanding, particularly as a teacher. He also designed coinage and a series of medals commemorating presidents of the Republic. The government of Manuel Estrada Cabrera (President, 1898–1920) continued the policies of its predecessors on a reduced scale. The arrival from Paris of the Venezuelan sculptor Santiago González (d 1909) was important in introducing Impressionism and subsequent developments to Guatemala. He was initially commissioned to carve reliefs for the Templo de Minerva (1901; destr. 1953) and the Teatro Nacional (c. 1830–59), both in Guatemala City. His real accomplishment, however, was in the training of Guatemalan artists and encouraging them to study abroad, which ended the country's artistic isolation. The Spanish painter Jaime Sabartés y Gual also lived in Guatemala (1904–28) and was similarly influential. Consequently the painters Agustín Iriarte (1876–1962), Carlos Valenti (1884–1910) and CARLOS MÉRIDA went overseas, as did the sculptor Rafael Rodríguez Padilla (1890–1929). Later, in the 1920s, the painters HUMBERTO GARAVITO and ALFREDO GÁLVEZ SUÁREZ and the sculptor RAFAEL YELA GÜNTHER also studied abroad.

For the rest of the period artistic activity remained at a standstill in Guatemala, although in 1920 the Escuela de Artes Plásticas, Guatemala City, was established under the direction of Rodríguez Padilla. With no art market, galleries or regular source of commissions, artists had to engage in public or private teaching or resign themselves to living modestly. Governments barely concerned themselves with supporting the arts. Those artists who remained out of the country continued their development in milieus more attuned to internationally recognized movements, for example Carlos Mérida in Mexico, while those who did return tended to focus their activities on provincial themes, either in Impressionist-style landscapes (Garavito) or scenes of Indian life (Gálvez Suárez). The culture of the indigenous people was also expressed in the Primitivist paintings of Andrés Curruchic (1891–1969; see §II above). These marked part of the movement for a rediscovery of national identity.

Optimism rose with the change of administration in 1944–5, on the presumption that a democratic government would be favourable to art. A process of artistic modern-

ization began, as European movements of the last few decades, none of which had been adopted by local artists, started to be discussed and supported. Government support began in 1945, and gradually public taste broadened. Realism, dominated by landscape art, was replaced, at first timidly, by other trends more directly related to Latin-American art, especially Mexican, and to those of the USA and Europe. Again some artists went abroad on fellowships: GUILLERMO GRAJEDA MENA and DAGOBERTO VÁSQUEZ to Chile; ROBERTO OSSAYE and ROBERTO GONZÁLEZ GOYRI to the USA; and Adalberto de León (1919–57) to France. Both democratic governments (1945–51; 1951–4) sought, for the first time in Guatemalan history, to mobilize art for their cause, not always with positive results. In the process of political polarization, which culminated with the counter-revolution in 1954, some artists played an outstanding role, both in groups and individually. Nevertheless, in spite of the triumph then of anti-democratic forces, there was no return to the previous situation in the arts. Development, increasingly linked to international movements, continued, in particular towards a 'Guatemalan' style inspired by Pre-Columbian and vernacular arts.

Between 1955 and 1980 there were very interesting experiments in the integration of the fine arts with architecture. Several young architects called on sculptors and painters to decorate their buildings (see also §III, 2 above). Sculptors executed works of large dimensions, generally in concrete. During the 1960s the first commercial art galleries appeared in Guatemala City, and there was an economic upgrading of works of art and institutions that supported the arts. The number and quality of artists increased, as did the prices fetched by works of art; the latter made it possible for the first time in many decades for artists to live exclusively on the proceeds of their profession.

From the 1960s Guatemala experienced varied, even conflicting, currents of artistic style. Although predominantly expressionistic, there were also examples of abstract painting (see DÍAZ, LUIS) and realism, especially the landscape-orientated type. Of ever-growing importance was a 'school' of indigenous painters practising naive art in various communities in the western part of the country, especially Comalapa, Patzicía and Santiago Atitlán. Professional artists also played an important role in protests against the repression and violence that afflicted Guatemala after 1965. Enhanced confidence among artists led to the formation, in the mid-1960s, of the group Vértebra, comprising the painters ELMAR ROJAS, MARCO AUGUSTO QUIROA and ROBERTO CABRERA, whose work is characterized by a figurative expressionism with deliberately disconcerting overtones (see fig. 4). In spite of the fact that painting was the most popular art form, there were interesting developments in sculpture, although commissions were scarce, and many sculptors took up painting (e.g. Grajeda Mena, Vásquez and González-Goyri). The talents of the few artists of high quality in the graphic arts were not fully exploited. Generally, art with aspirations to the experimental and to novelty became more evident, with limited public and private support. Having shaken off its isolation and modernized the tastes of educated

4. Elmar Rojas: *Drowned Physiognomy of Reality*, oil on hardboard, 1220×980 mm, 1970 (Washington, DC, Art Museum of the Americas)

Guatemalans, art in Guatemala has risen above socio-political difficulties to reflect international movements. At the same time influences of the rich popular artistic tradition have emerged, both native and non-native.

BIBLIOGRAPHY

V. M. Díaz: *Las bellas artes en Guatemala* (Guatemala City, 1934)
G. Valenzuela: *La imprenta en Guatemala* (Guatemala City, 1934)
S. Toscano: 'La escultura colonial en Guatemala', *An. Inst. Invest. Estét.*, ii/5 (1940), pp. 45–53
C. A. Ward: 'The Guatemalan Art Renaissance', *Bull. Pan Amer. Un.*, lxxv (1941), pp. 282–90
E. Fernando Granell: *Arte y artistas en Guatemala* (Guatemala City, 1949)
H. Berlin: *Historia de la imaginería colonial en Guatemala* (Guatemala City, 1952)
J. L. Cifuentes: *Pintores y escultores guatemaltecos* (Guatemala City, 1956)
L. Méndez Dávila: *Art in Latin America Today: Guatemala* (Washington, DC, 1966)
——: *Arte de vanguardia: Guatemala* (Guatemala City, 1969)
E. I. Núñez de Rodas: *El grabado en Guatemala* (Guatemala City, 1970)
G. Grajeda Mena: *Los Cristos tratados por los escultores de Guatemala* (Guatemala City, 1972)
El grabado guatemalteco, Dirección General de Cultura y Bellas Artes y Estudio-Taller Cabrera (Guatemala City, 1973)
L. Luján-Muñoz: 'Notas sobre la pintura mural en Guatemala', *Antropol. & Hist. Guatemala*, ii (1980), pp. 197–213
J. B. Juárez: *Pintura viva de Guatemala* (Guatemala City, 1984)
B. La Duke: *Compañeras: Women, Art and Social Change in Latin America* (San Francisco, 1985), pp. 47–52
I. Lorenzana de Luján and L. Luján-Muñoz: 'Apuntes sobre la pintura popular en Guatemala', *La pintura popular en Guatemala* (exh. cat., Guatemala City, Programa Cult. Paiz, 1987), pp. 1–11
L. Castedo: *Precolombino: El arte colonial*, i of *Historia del arte iberoamericano* (Madrid, 1988), pp. 271–6
Galería Guatemala: Muestra de pintura del siglo XX (Guatemala City, 1990)
J. H. Rodas Estrada, ed.: *Pintura y escultura hispánica en Guatemala* (Guatemala City, 1992)
L. Luján-Muñoz and M. Alvarez Arévalo: *Imágenes de Oro* (Guatemala City, 1993)
Historica general de Guatemala, 6 vols (1993–9)
R. Díaz Castillo: 'En torno a las ideas estéticas durante muestra Revolución de Octubre', *Polémica*, ii (1994), pp. 36–40
B. Rodríguez: *Arte centroamericano: Una aproximación* (Caracas, 1994)
R. Gutiérrez, ed.: *Pintura, escultura y artes útiles en Iberoamérica, 1500–1825* (Madrid, 1995)
Visión del arte contemporáneo de Guatemala, 3 vols (Guatemala City, 1995–6)
M. Kupfer: 'Central America', *Latin American Art in the Twentieth Century*, ed. E. Sullivan (London, 1996), pp. 51–79
Texoche madera de dios: Imaginería colonial Guatemalteca (exh. cat., ed. I. Paiz de Serra; Mexico City, Mus. Franz Mayer, 1997)

JORGE LUJÁN-MUÑOZ

V. Textiles.

On the arrival of the Spanish conquistadores in Guatemala in 1524, the Highland Maya possessed a textile tradition similar to that of other ethnic groups in Mesoamerica. This tradition comprised a technology based on cotton and agave fibres, natural dyes (e.g. indigo and purple) and hand-weaving on a backstrap loom. In addition to brocade (supplementary weft weaving), the decorative techniques included embroidery, featherwork and printing with ceramic or wooden stamps. Weaving was a woman's craft. Textiles were used for family clothing, as an exchange medium and for the payment of taxes to the rulers.

The Spaniards introduced European textile technology, which included new materials and instruments such as wool, silk, carding-boards, the spinning-wheel and the treadle loom. In the largest urban centres of the Audiencia de Guatemala, notably Santiago de los Caballeros (now Antigua), Quetzaltenango, Ciudad Real and San Salvador (now in El Salvador), treadle-loom weaving was practised through the guild system. This European system of production operated until the end of the Colonial period (1524–1821), when economic liberalism replaced the mercantilism that protected the guilds. In the 'Indian towns', the settlements set up by the colonizers to control the Maya population, weaving in the pre-Hispanic tradition produced cotton textiles for family clothing (*see also* §II above), exchange and the payment of taxes to the colonial authorities. In some of these towns treadle looms were introduced to manufacture cloth for local and regional consumption.

Guild weaving was affected by the earthquake of 1773, which destroyed the city of Santiago, and by economic changes that put an end to the guilds. Despite these transformations urban treadle-loom weaving survived in Guatemala City, Antigua and Quetzaltenango during the 19th century and the beginning of the 20th. With competition from factories producing cotton yarn and cloth, such as that founded in Cantel in 1876, treadle-loom weaving in these cities began to die out. However, it continued to be important in several Maya communities (see fig. 5), and after World War II tourist demand for Maya textiles increased treadle-loom production in their workshops.

The advent of synthetic dyes during the second half of the 19th century and the establishment of textile factories affected the materials used in Maya weaving on both backstrap and treadle looms. By the mid-20th century synthetic dyes had replaced natural ones, and factory-spun cotton thread had, with some exceptions, replaced hand-spun thread. Imported rayon and fine cotton yarns rivalled

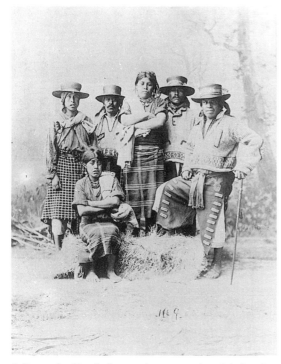

5. Guatemalan Maya Indians wearing cotton and wool clothes, from a late 19th-century photograph (Cambridge, MA, Harvard University, Peabody Museum); blouses woven on backstrap looms, skirts and jackets on treadle looms

silk as the most prestigious materials for brocade and embroidery. Acrylic thread was introduced in the 1960s, and in the following decades it largely displaced cotton and rayon. This was due, among other factors, to the political and economic crises that afflicted the country, especially the Maya population. The designs of contemporary Maya ethnographic textiles reflect Guatemalan history. Some geometric motifs are pre-Hispanic; other motifs, introduced during the Colonial period, are related to the Spanish and Arabic repertories. The most modern brocaded designs, representing flowers, fruit and birds, have been copied from cross-stitch magazines.

BIBLIOGRAPHY

C. M. Pancake: *The Costumes of Rural Guatemala* (Guatemala City, 1976)
M. Anderson: *Guatemalan Textiles Today* (New York, 1978)
M. B. Schevill: *Evolution in Textile Design from the Highlands of Guatemala* (Berkeley, 1985)
O. Arriola de Geng: *Los tejedores en Guatemala y la influencia española en el traje indígena* (Guatemala City, 1991)
L. Asturias de Barrios and D. Fernández García, eds: *La indumentaria y el tejido mayas a través del tiempo* (Guatemala City, 1992)
M. B. Schevill: *Maya Textiles of Guatemala: The Gustavus A. Eisen Collection, 1902* (Austin, 1993)
C. Hendrickson: *Weaving Identities: Construction of Dress and Self in a Highland Guatemala Town* (Austin, 1995)
M. B. Schevill: *The Maya Textile Tradition* (New York, 1997)

LINDA ASTURIAS DE BARRIOS

VI. Gold and silver.

Documentary sources show that there were workers in precious metals in the settlement of Santiago de los Caballeros (now Antigua) from its foundation in 1524, while an attempt was made to regulate their activities as early as 1540. Antonio de Rodas, described as '*maestro platero, pintor y escultur*', and Juan de Salazar, a Sevillian first recorded in 1604 who served as an assaymaster, were prolific craftsmen, but, as a result of the disastrous earthquake of 1773, virtually no pieces survive from the 16th and 17th centuries. A rare survival, the silver antependium of the church of Jerez de la Frontera in Spain, made in Guatemala in 1730 by Manuel Quesada (*fl* 1721–48), is in the typical Baroque style.

The establishment of the new capital, Guatemala City, after the earthquake of 1773 and the building of new churches there resulted in numerous ecclesiastical commissions for Guatemalan silversmiths, who were more adept than their South American counterparts at assimilating Rococo decorative elements into their work (see fig. 6). The silver tabernacle of the church of S Augustín Acasaguastlán successfully incorporates rocaille motifs and foliate scrolls into a Baroque form; similarly, the antependium of S Antonio, Retalhuleu, is decorated with distinctive heavy gadrooning, which, like cast and applied stylized leaves, is a constant feature of Guatemalan silver dating from the last quarter of the 18th century. Ornament consisting of grapes and European flowers was preferred to the more exotic, native vegetal motifs employed by South American silversmiths.

The work of Miguel Guerra (*fl* 1774–1802), a prolific maker of domestic articles, shows a decided French influence, for example in his use of moulded borders and cast, applied decoration. Fine engraving of foliage and animals appears on many of his trays and dishes. Cast cagework formed of rocaille motifs and foliate scrolls superimposed over plain forms was popular and was used for such domestic items as table braziers, as well as ecclesiastical silver, for example a ciborium by Patricio Girón (Guatemala City, Nuestra Señora de las Mercedes). Typical Guatemalan silver items from the end of the 18th century include signs, usually embossed with the figure of a saint, that were made for the *cofradías* (exclusively male religious organizations) and large, two-handled bowls with lobed decoration and handles elaborately cast as foliage or crowned lions that were popular for domestic use. One of the few surviving Neo-classical works is the great tabernacle in the sanctuary of Guatemala Cathedral, formed of four Ionic columns and executed in 1813 by Francisco Alvarez (*fl* 1785–1813). A *quinto* (tax) mark of a closed crown appears on some pieces from the 18th century, often in conjunction with a maker's mark and a town mark depicting either St James over the mountains of Guatemala (for Antigua, the former capital), the initials SS flanking a mountain (for San Salvador) or a bird (possibly for Quetzaltenango).

BIBLIOGRAPHY

H. H. Samayoa Guevara: 'El gremio de plateros de la ciudad de Guatemala y sus ordenanzas (1524–1821)', *Antropol. & Hist. Guatemala*, ix/1 (Jan 1957), pp. 16–24
Platería de Guatemala (exh. cat., Antigua, Mus. Colon., 1975)
J. Alonso de Rodríguez: *El arte de la platería en la Capitanía General de Guatemala* (Guatemala, 1981)
L. Luján-Muñoz and M. Alvarez Arévalo: *Imágenes de oro* (Guatemala City, 1993)
Historica generale de Guatemala, 6 vols (1993–9)
C. Esteras Martín: *La platería en el Reino de Guatemala, siglos XVI–XIX* (Guatemala City, 1994)

CHRISTOPHER HARTOP

water), *apastes* (earthenware tubs for corn), *comales* (flat clay dishes for making tortillas), *batidores* and *jarros* (pots and jars for drinking coffee and chocolate) and *ollas* (pots or saucepans). A reddish clay is used, which can be buffed, burnished or painted with black-and-white designs. Small pottery figures of humans and animals are made in the town of Rabinal (Baja Verapaz) and decorated with aniline paint. The ceramics inspired by the Spanish wares and made since the Conquest were produced on a potter's wheel and fired in a kiln. Most notable in this range are the maiolica wares, which in the late 20th century were manufactured only in the town of Antigua, although until the beginning of the 20th century they were also made in Guatemala City. A glazed pottery that is not maiolica is made in San Miguel Totonicapán and Jalapa. Common wares include tablewares, kitchen wares, flowerpots, gargoyles and glazed tiles. In Antigua, fruit-shaped money-boxes and shepherd figures for Nativity scenes are also made.

BIBLIOGRAPHY

L. Luján Muñoz: *Historia de la mayólica en Guatemala* (Guatemala City, 1975)

R. E. Reina and R. M. Hill: *The Traditional Pottery of Guatemala* (Austin, 1978)

I. Morales Hidalgo: *Cerámica tradicional del Oriente de Guatemala* (Guatemala City, 1980)

C. A. Lara Figueroa: *Síntesis histórica de las cerámicas populares de Guatemala* (Guatemala City, 1981)

Historica generale de Guatemala, 6 vols (1993–9)

JORGE LUJÁN-MUÑOZ

VIII. Furniture.

In the majority of regional towns simple, traditional Spanish-style furniture is produced for local consumption. The furniture industry, which began early in the Colonial period, is mainly concentrated in Guatemala City, where pieces in wood, metal and other materials are produced. In some cases traditional Spanish or other European designs are imitated; in others modern international designs, especially those of Scandinavia, are copied. Another important centre of production is Totonicapán, where chairs, tables, cupboards, sideboards and chests of pine, in some cases painted with aniline, are made; only recently has carved cedar furniture begun to be produced. In San Juan Ostuncalco (Quetzaltenango) furniture in pine and knotted maguey is produced, while in Antigua large numbers of pieces of furniture carved from cedar, mahogany and other woods are manufactured by craftsmen such as Joaquín Gaytán and Florencio Ruíz. The quality of Guatemalan cabinetwork has improved in the late 20th century, and some pieces are now exported.

BIBLIOGRAPHY

I. de Santos: *Artesanías de Guatemala* (Guatemala City, 1971)

A. Ortiz Domingo: *Artesanías de madera en Totonicapán* (Guatemala City, 1986)

JORGE LUJÁN-MUÑOZ

IX. Patronage, collecting and dealing.

During the colonial period the Roman Catholic Church was by far the largest patron of art in Guatemala. It was followed in size by the colonial administration, which employed artists either through agencies, such as the Real Casa de Moneda, or in such projects as the building (after

6. Silver and mahogany *Virgin and Child*, h. 400 mm (with pedestal), figure from Guatemala City, 18th century; pedestal from Santiago de Guatemala, 19th century (private collection)

VII. Ceramics.

There are two clearly distinguishable ceramic traditions in Guatemala: the indigenous and the Spanish. The former derives from Pre-Columbian, utilitarian ceramics; wares are created manually and 'baked' by covering them with burning straw. There are many centres of production, among the most notable being Chinautla, Santa Apolonia, San Luis Jilotepeque and San Cristóbal Totonicapán. The most common items are *tinajas* (large earthenware jars for

1776) of Guatemala City, the new capital. Private patrons began to make an impact only at the turn of the 18th century, for example commissioning portrait miniatures. A flow of mainly religious art continued in and out of Guatemala throughout the period. Destinations included other parts of the kingdom of Guatemala, New Spain (now Mexico) and Spain itself, where Guatemalan religious statues were highly appreciated. From the existence from the 16th century of collections of Pre-Columbian objects in Europe, a modest trade in these must also be supposed. During the 19th century the role of the Church as the main patron declined, virtually ending with the anti-clerical laws passed in 1871. The state assumed this role, which reached a highpoint in the late 19th century and the early 20th in connection with the embellishment of cities. Private patronage tended to focus on works of art imported from France, Britain or, in the case of marble statues for cemeteries, from Italy. This trend declined in the 20th century, but mediocre genre paintings, still-lifes and landscapes continued to be imported from Europe for the homes of the Guatemalan bourgeoisie.

Generally during the 20th century there has been a growth in patronage of the arts in Guatemala. The state, through the Ministry of Culture and Sports (before 1986 through the Ministry of Education), provided artists with tuition that was either free or greatly reduced. Some artists were given positions in teaching and administration in the public sector, while others sporadically received fellowships for study abroad. The ministry also organized competitions, prizes, exhibitions and publications. From c. 1970 private patronage began to take shape. This was initially in the form of foreign corporate support (e.g. Esso Central America) and later by domestic firms, both sources of funding occasionally sponsoring valuable competitions. The first permanent organization in this field was the Patronato de Bellas Artes (founded 1971), which has sponsored exhibitions and publications. In 1978 the Programa Permanente de Cultura was established by Organización Paiz, an important commercial group, which began with a biennial exhibition of contemporary fine arts that became the most important show in the country and, arguably, in Central America. As the result of the Biennale, a collection gradually took shape, forming the basis of the Museo de Arte Contemporáneo. In 1983 the Organización para las Artes Francisco Marroquín was founded. Affiliated with the university of the same name, it has organized exhibitions, courses and performances. In the mid-20th century a valuable role was played by the foreign cultural institutes in Guatemala City, notably those of France, the USA, Italy, former West Germany and Spain, which organized exhibitions, courses and travel fellowships. Later their importance was reduced, but they have continued to function as exhibition venues for Guatemalan and other artists.

A market in contemporary art developed in Guatemala from the 1960s, with commercial galleries opening in Guatemala City. Guatemala has not played any significant role in the international art market, except in the case of antiquities. Since these are prohibited by law from leaving the country, illegal dealing occurs. The greatest demand, especially from museums and collectors in Europe and the USA, is for Pre-Columbian items (jade and ceramics), which has encouraged unauthorized excavations, especially at Maya sites in Petén. The number of Maya items appearing in foreign auctions also rose in the late 20th century, a significant proportion believed to have been plundered from sites in Guatemala. The illegal export of items from the colonial period, such as paintings, sculpture, engravings and gold and silver work, also increased.

ROSSINA CAZALI, JORGE LUJÁN-MUÑOZ

X. Museums, art libraries and photographic collections.

Short-lived attempts were made to found the first museums at the end of the colonial period and the beginning of independence. It was not until the 1930s, however, that museums existed with any degree of continuity, most being state institutions. The Museo Nacional de Arqueología y Etnología, Guatemala City, established in 1931, has a copious collection of Pre-Columbian, especially Maya, objects. The Museo Nacional de Historia, Guatemala City, with displays of 18th- and 19th-century religious art and a collection of prints, was established in 1976, when the former Museo Nacional de Historia y Bellas Artes (founded 1934) was divided into two separate institutions. At the same time the Museo Nacional de Arte Moderno, Guatemala City, was created, with a collection of late 19th-century and 20th-century painting, sculpture and graphic arts, including an important collection of paintings of the first period of Carlos Mérida. The Museo Nacional de Artes e Industrias Populares, Guatemala City, was founded in 1959 in a private residence that unfortunately lacked adequate facilities; it also has a specialized library.

Museums in Antigua include the Museo Colonial (founded 1936) and the Museo de Santiago (founded 1957). The former is located in a building once used by the University of S Carlos. It has the best public collection of colonial paintings in Guatemala, including works by Tomás de Merlo and Cristóbal de Villalpando, as well as religious statues and fragments of retables. The Museo de Santiago, occupying a part of the town hall, has some colonial silverwork, pottery and other crafts, as well as paintings and religious items. The Museo del Libro Antiguo, Antigua, was founded in 1960 on the occasion of the tricentenary of the arrival of the printing press in Antigua, then the capital of the kingdom of Guatemala. It exhibits books, pamphlets and leaflets from the colonial period and has a library of antiquarian books. Also run by the state are regional archaeological museums, located at important sites. Among these are the Museo Arqueológico-Sylvanus G. Morley, in Tikal Park, Petén; Museo Arqueológico de Zaculeu, near Huehuetenango; and Iximché, in Tecpán Guatemala. State museums are generally modest institutions with few activities, due to their limited resources. Most lack restoration workshops, and they are not yet up to date with modern museographic trends, in either the presentation of their objects or their relations with the visiting public.

There are also several important private museums. The first, the Museo Ixchel del Traje Indígena, Guatemala City, was founded in 1977 and is devoted to the collection, preservation, exhibition and investigation of textiles and native costumes of Guatemala. Besides a collection of c.

5000 items, it has an extensive specialized library. There is also the Museo Popol Vuh, Universidad Francisco Marroquín, Guatemala City, with Pre-Columbian items, especially pottery, and religious statues from the colonial period. Both museums operate in the sphere of activities of the privately run Francisco Marroquín University and have their own education, publication and research programmes. The Museo de Arte Contemporáneo was founded in 1989 by the Programa Permanente de Cultura de la Organización Paiz, in Guatemala City, making use of the collection of the Paiz Biennale. It has organized exhibitions of national and foreign artists, lectures and short courses.

In the provinces there are also private and municipal museums, among them the Museo de la Democracia, Escuintla, founded in 1966, devoted to the Olmec culture; the Museo Regional Verapacense in Cobán and the museum at San Pedro Carchá, both in Alta Verapaz, with archaeological and ethnic materials of the area; the Museo Municipal at Amatitlán, with archaeological objects drawn from Lake Amatitlán and environs; and the Museo Regional in Chichicastenango, with objects found in the province of that name. The Catholic Church also plays an important role in the conservation of collections and objects from the colonial period. In the Archbishop's Palace next to Guatemala City Cathedral is the Museo Cafarnaum, containing historical documents as well as paintings, objects and religious statues of different epochs. The Museo Fray Francisco Vázquez, attached to the church of S Francisco, Guatemala City, has a small collection of statues and furniture of the 18th and 19th centuries.

In both state and private museums and other institutions specialized libraries of modest proportions have been taking shape. The Instituto de Antropología e Historia, Guatemala City, has a centralized library that includes Pre-Columbian, colonial and modern art. The Academia de Geografía e Historia, Guatemala City, has a library with material on art history, as does the Centro de Investigaciones Regionales de Mesoamérica (CIRMA) in Antigua. The former has organized an archive of photographs into a genuine collection, with emphasis on national historical themes, while the latter has the only well-organized photographic collection in Guatemala, with photographs dating from 1880 and works by the photographers Juan J. Yas, Domingo Noriega, A. G. Valdeavellano and others. Founded in the 1980s, it has gradually developed its collection.

BIBLIOGRAPHY
L. Luján Muñoz: *Guía de los museos de Guatemala* (Guatemala City, 1971)
——: 'Museums in Latin America: Guatemala', *Museum* [Paris], xxv (1973), pp. 187–9
——: *El primer Museo Nacional de Guatemala, 1866–81* (Guatemala City, 1979)
ROSSINA CAZALI

XI. Art education.

For most of the colonial period, art education in Guatemala was in the hands of the guilds, which faithfully reproduced European patterns of organization. The Real Casa de Moneda, after its foundation in 1733, played a leading role until the late 19th century in training artists and employing them, mainly in engraving. The first attempt to establish formal art education in Guatemala occurred in 1795, when the newly founded Real Sociedad Económica de Amigos del País de Guatemala asked King Charles IV of Spain (*reg* 1788–1808) to establish an Academia de Bellas Artes in Guatemala. When this proposal was unsuccessful, the Sociedad Económica itself founded an Escuela de Dibujo, in Guatemala City in 1797, under the direction of PEDRO GARCÍ-AGUIRRE, a senior engraver at the Casa de Moneda and original instigator of the plan for an Academia de Bellas Artes. The Escuela de Dibujo offered courses in sculpture and painting, as well as draughtsmanship and engraving, and continued a precarious existence well into the 19th century. There was little advance in art education in the 19th century apart from isolated efforts, such as an attempt in 1834 to establish a collection of graphic and sculptural reproductions for teaching purposes. Hence, much of the art training of the second half of the 19th century and the first two decades of the 20th was carried on in short-lived private schools. Among these, that of the Venezuelan sculptor Santiago González (*d* 1909), active in Guatemala between 1901 and 1909, is particularly noteworthy. In 1920 the government-sponsored Academia de Bellas Artes was finally founded in Guatemala City. Despite changes of curriculum and, in 1947, a change of name to Escuela Nacional de Artes Plásticas, it has been in continuous existence since as the main art training centre in Guatemala.

In the second half of the 20th century other developments in art education were largely tied to the universities. In the 1940s courses were added to the curriculum of the Universidad Popular in drawing, painting and sculpture, all at an intermediate, non-professional level. The first school of architecture in Guatemala was established at the University of S Carlos de Guatemala, Guatemala City, in 1960. Towards the end of the 1970s, schools of architecture also opened in three private universities. In 1969 for the first time studies in the fine arts were established at university level in the Escuela de Arte, University of S Carlos, which later offered both Bachelor and Master of Arts courses in restoration, museum administration and the teaching of art in schools. The Rafael Landívar University (founded in 1961) and Mariano Gálvez de Guatemala University (founded in 1966) both instituted teacher-training courses in fine arts and graphic design, while the Instituto Femenino de Estudios Superiores (IFES) included courses in art education and fashion design.

BIBLIOGRAPHY
E. I. Núñez de Rodas: *Reseña histórica de la Escuela de Artes Plásticas* (Guatemala City, 1970)
Museo de Arte Colonial Antigua Guatemala (Antigua, 1986)
ROSSINA CAZALI, JORGE LUJÁN-MUÑOZ

Guatemala City [formerly Guatemala de la Asunción]. Capital of Guatemala. It is situated 1492 m above sea-level in a broad, elongated valley running from north to south. It was founded on 2 January 1776 following the transfer of the capital from Antigua (*see* ANTIGUA (i)), which had been largely destroyed by an earthquake in 1773. The problems of housing *c.* 30,000 inhabitants were compounded by an ensuing economic recession, which

slowed the construction process. The grid-plan urban design of Antigua was reproduced (although with broader streets), orientated to the cardinal points and focusing on a central main square. The major buildings were not generally completed until the mid-19th century. Those in the main square include the cathedral; its Neo-classical design was drawn up by the Spanish architect Marcos Ibáñez with the help of Antonio Bernasconi, although the building's execution was taken over by Bernasconi, José de Sierra and PEDRO GARCÍ-AGUIRRE from 1783 and Santiago Marqui from 1803 to c. 1835. It was dedicated in an incomplete state in 1813 and eventually finished in 1865. The church of S Francisco, completed in 1851, showed the influence of European academic classicism.

The city underwent expansion towards the end of the 19th century, notably to the south (1896–7), with the opening up of the Avenida de la Reforma and the grounds of an international fair. By c. 1900 the city had a population of 100,000. Artistic activity in the city was stimulated by the establishment in 1920 of the government-funded Academia de Bellas Artes (later Escuela Nacional de Artes Plásticas), which quickly became the focal point of art education in Guatemala. Developments in architecture mid-century were demonstrated by the Palacio Nacional (1939–43), designed by Rafael Pérez de León (1896–1958) to simulate a Spanish Renaissance-style stone construction, and the so-called 'Centro Cívico', with the Palacio Municipal (1958), the Seguro Social building (1959) and the Banco de Guatemala (1964); the last three all showed the attempt to integrate the visual arts with architecture. The Teatro Nacional (completed 1978) by EFRAÍN RECINOS is possibly the most original and successful 20th-century building in the city, having been conceived effectively as a large-scale sculptural work on its hilltop site in the city centre.

Repeated earthquakes throughout the 20th century (notably in 1917–18 and 1976) led to the destruction of many buildings, and in general the fear of earthquakes has caused few tall buildings to be put up, although anti-seismic techniques using steel and reinforced concrete have improved safety.

The population of Guatemala City had reached 2 million in 1990, and the cultural life of the city was enriched by the fine arts and architectural courses at the Universidad de S Carlos and other universities and by various museums and art galleries, as well as by an active art market.

BIBLIOGRAPHY
L. Luján Muñoz: *Síntesis de la arquitectura en Guatemala* (Guatemala City, 2/1969)
R. Aycinena E.: 'Algunas consideraciones sobre el valle de La Ermita y la fundación de la ciudad de Guatemala y su desarrollo', *An. Acad. Geog. & Hist. Guatemala*, lxi (1987), pp. 245–80
G. Gellert: *Ciudad de Guatemala: Dos estudios sobre su evolución urbana* (Guatemala City, 1992)
Historica generale de Guatemala, 6 vols (1993–9)
H. Gaitán: *Centro histórico de la ciudad de Guatemala* (Guatemala City, [1995])
JORGE LUJÁN-MUÑOZ

Guayasamín, Oswaldo (*b* Quito, 1919; *d* 10 March 1999). Ecuadorean painter. He studied at the Escuela de Bellas Artes in Quito. He worked first in an Indigenist style: influenced by Mexican muralism, he painted village scenes, notably in the fresco *The Incas and the Conquest* (1948; Quito, Mus. A. Mod.; *see* ECUADOR, fig. 4) and in the series of 100 paintings *Road of Sorrow* (Quito, Mus. Fond. Guayasamín), exhibited for the first time in 1952. He adopted a more universal approach in *Age of Anger* (Quito, Mus. Fond. Guayasamín), first exhibited in 1966, in which he depicted the disasters of World War II in 220 paintings.

Guayasamín's work is characterized by geometric composition, fine draughtsmanship, thick lines and vigorous brushwork; his central theme was the human condition afflicted by the evils of war and injustice. He also painted portraits, still-lifes, landscapes and nudes. Guayasamín exhibited internationally and was also patron of the Fundación Guayasamín in Quito.

BIBLIOGRAPHY
J. Camón Asnar: *Guayasamín* (Barcelona, 1973)
J. Lassaigne: *Oswaldo Guayasamín* (Barcelona, 1977)
Guayasamín, el mundo: Colección Línea Aerea Nacional, Chile (exh. cat., Santiago and elsewhere, 1990)
Guayasamín (exh. cat., Mendoza, Mus. Fader; Buenos Aires, Salas N. Cult.; 1993)
CECILIA SUÁREZ

Guedes, Joaquim (*b* São Paulo, 18 June 1932). Brazilian architect, urban planner, teacher and writer. He graduated in architecture from the University of São Paulo (1954) and went into private practice (1955). Rejecting prevailing trends and influences, Guedes engaged in a constant search for new technical solutions, regarding each project as an opportunity to experiment with new ideas. His architecture can be divided into three groups: the first is characterized by the importance of structure as a means of defining space and volume, as in the church of Vila Madalena (1955) and the Cunha Lima House (1958), São Paulo; the industrial school (1966) at Campinas and one of his own houses (1973), São Paulo. The latter (see fig.), set below street level, has a modular, rectangular plan with roof and floor planes in exposed reinforced concrete, supported on four columns; thin concrete overhangs protect the glazed wall at first floor level, which slides back to turn the living room into a terrace. The second group exhibits a greater complexity of form in which the structure no longer determines the spatial result; examples include the forum of Itapira (1959), the Institute of Mathematics (1965) and the Pereira House (1968), all in São Paulo; the central library of Bahia (1968), Salvador, and the Dourado House (1974), São Paulo.

Joaquim Guedes: Guedes House, São Paulo, 1973

In the third group a concern for designing in accordance with Brazilian conditions, both environmental and economic, is evident, using simpler construction methods and incorporating traditional architectural elements to modify the climate. Examples include the Landi House (1967), Butantan, São Paulo, a basic, functional design using corrugated asbestos, brick and concrete, and his designs for houses in the new town of Caraíba (1976–80), incorporating internal patios and constructed of local clay bricks for thermal insulation. Some buildings combine several of these themes, though in a more compact and simple form, for example the Toledo House (1963), Piracicaba, São Paulo, a brick and concrete design reminiscent of Le Corbusier's Maisons Jaoul (1951–5), Paris, and the Beer House (1976), São Paulo, a severe composition in brick. Guedes's equally important activities as an urban planner began in 1957 when he took part in the national competition for the master-plan for the new national capital, Brasília. He went on to produce urban plans for São Paulo (1967), Campinas (1969), Porto Velho (1971), the new towns of Carajás and Marabá (1972), Piracicaba (1974), Campo Grande (1985) and Moji Guaçu (1971 and 1987), among others. He received particular recognition for his skill in the complex planning of new towns, his best-known works in this field being plans for the cities of Caraíba (1976–80), Bahia and Barcarena (1979–82), Amazonia. For Caraíba, located in a semi-arid area and planned to house a population of 13,000 workers from the copper mines, Guedes carried out extremely thorough analyses that included not only the eco-geological systems of the region, urban hierarchy and future use of the town but also social organizations and local building materials and techniques. Inspired by the local tradition of grid-like village patterns, with plazas as focus points, his plan avoided social stratification by mixing dwelling types and creating spaces for future growth, both of individual houses and of the city. The orientation of the streets and houses, the architectural design and the construction methods were all planned to combat the harsh climatic conditions. His success as an urban planner resulted in Guedes being the only Brazilian invited to take part in the 1986 competition for the replanning of 70 ha of Bicocca Park in Milan, Italy, sponsored by Pirelli and the Prefecture of Milan. Guedes was also an influential teacher, encouraging philosophical reflection and technical innovation; he became Professor of Planning in the Faculty of Architecture and Urban Planning at the University of São Paulo in 1969, and he also taught at the Ecole d'Architecture de Strasbourg, France.

WRITINGS

'The Private House in Brazilian Tradition and the Problem of the New Generation', *Global Interiors*, 2 (1972)
'Obras y proyectos del studio de J. Guedes e Associados', *Rev. Summa*, 6 (1979)
'Caraíba New Town and Other Works', *Spazio & Soc.* (July 1979)

BIBLIOGRAPHY

P. M. Bardi: *Profile of New Brazilian Art* (São Paulo, 1969)
F. Bullrich: *New Directions in Latin American Architecture* (London and New York, 1969)
D. Bayón and P. Gasparini: *Panorámica de la arquitectura latino-americana* (Barcelona, 1977; Eng. trans., New York, 1979)
'Modern Brazilian Architecture', *Process: Archit.*, 17 (1980), pp. 71–81 [special issue]

REGINA MARIA PROSPERI MEYER

Guerra, Gabriel (*b* Unión de San Antonio, near Guadalajara, Jalisco, 1847; *d* Mexico City, 3 Nov 1893). Mexican sculptor. He entered the Escuela Nacional de Bellas Artes in Mexico City in 1873, with Miguel Noreña as his sculpture instructor. His outstanding student works include *Fisher Boy, Cupid Deceived*, also known as *Nymph and Cupid* (1877; see fig.), a sculptural group on the theme of the punishment of Cupid, and *Charity* (clay, 1881), a small sentimental group redeemed by the realistic observation of the protagonist and the use of modern dress; all three in Mexico City, Mus. N.A. The subject-matter of these academic works indicates the markedly secular tendency that took hold in the 1870s, replacing the Biblical iconography preponderant around the middle of the century; this development paralleled the coming to power of the liberals after the defeat of the conservative party. Moreover, the delicate sensuality and attenuated neo-Rococo style of *Cupid Deceived* is an important link in the transition to the frank eroticism of turn-of-century modernism.

Guerra profited from the incipient, but already growing patronage of monumental sculpture. He created the *Torture of Cuauhtémoc* (plaster, exh. 1886; Mexico City, Mus. Ciudad), one of a group of great bronze reliefs made for the base of the monument to *Cuauhtémoc* designed in 1877 by the civil engineer Francisco M. Jiménez (*d* 1884). As a totality this monument, to which other sculptors also contributed between 1884 and 1887, was one of the most successful examples in Mexico of the revival of pre-Hispanic styles.

Guerra's most notable monumental work was a statue of *Gen. Carlos Pacheco* (plaster, exh. 1892; Mexico City, Mus. N.A.; bronze, 1894; Cuernavaca) commissioned by the state of Morelos. Although the posthumously cast bronze did not capture its full vigour, it achieves both

Gabriel Guerra: *Cupid Deceived (Nymph and Cupid)*, plaster, 1685×770×800 mm, 1877 (Mexico City, Museo Nacional de Arte)

grandeur and realism in depicting the figure of a man who had lost his left arm and leg in the struggle against the empire of Maximilian. Both iconographically and stylistically, Guerra's work helped prepare the way for other Mexican sculptors working at the end of the 19th century.

BIBLIOGRAPHY
Gabriel Guerra (1847–1893): Una voluntad escultórica (exh. cat. by M. Díaz, Mexico City, Mus. N.A., 1986)

FAUSTO RAMÍREZ

Guerrero, Juan Agustín (*b* ?Quito, 1818; *d* ?Quito, 1880). Ecuadorean painter and musician. He was involved in the foundation of the Escuela Miguel de Santiago in Quito in 1849 (transformed in 1852 into the Escuela Democratica Miguel de Santiago), and he won third prize for his painting *Modesty* (Quito, Mus. Fund. Hallo) when the school held the first public art exhibition in Ecuador. He criticized the dependence of Ecuadorean art on Spanish and other European models, and he fought for the liberation of oppressed social classes and particularly of the indigenous people, as well as for individual creativity and the autonomy of the artist from the ecclesiastical powers that remained dominant in Ecuador at that time. Stylistically, Guerrero represented the transition from Quito's colonial Baroque style to Romanticism. He introduced watercolour painting into Ecuador and used the medium to illustrate, criticize and satirize leading figures of time. His album of drawings and watercolours of landscapes, personalities and customs of the period (*c.* 1860–70; Quito, Mus. Fund. Hallo) constitutes an important document: the portrayal of regional customs and people (*Costumbrismo*) occurred rather late in Ecuador and was a product of the contact between Ecuadorean intellectuals and foreign travellers and scientists interested in the ethnography of indigenous groups in the mountains and jungle.

BIBLIOGRAPHY
J. Castro y Velázquez: *La colección Castro: Evaluación histórico-etnográfica de una serie de pintura costumbrista ecuatoriana del siglo XIX* (MA thesis, Bonn, Rhein. Friedrich-Wilhelms-U., 1976)
W. Hallo: *Imágenes del Ecuador del siglo XIX: Juan Agustín Guerrero (1818–1880)* (Quito and Madrid, 1981)
J. Castro y Velázquez: 'Pintura costumbrista ecuatoriana del siglo XIX', *Cuad. Cult. Pop.*, xvi (1990)
J. G. Navarro: *La pintura en el Ecuador del siglo XVI al XIX* (Quito, 1991), pp. 179–80

ALEXANDRA KENNEDY

Guerrero, Xavier (*b* San Pedro de las Colonias, Coahuila, 3 Dec 1896; *d* Mexico City, 29 June 1974). Mexican painter, draughtsman and engraver. He was taught the basics of painting by his father, a painter and decorator, and the outstanding characteristic of his stylized realism was its decorative beauty. At the age of 16 Guerrero began to work as a house and church decorator in Guadalajara; there he joined the Centro Bohemio, an avant-garde group led by the painter and politician José Guadalupe Zuno (1891–1980), whose house Guerrero decorated in 1925. He was DIEGO RIVERA's assistant from 1922 to 1924 and joined the Mexican Communist Party with Rivera in 1922. Both became members of its executive committee, Rivera in 1923, Guerrero in 1925, when with DAVID ALFARO SIQUEIROS they founded the periodical *El machete* as the organ of the Sindicato de Obreros Técnicos, Pintores y Escultores. Guerrero had a relationship with Tina Modotti

from 1924 until 1928, when he left for Moscow to study at the Leninist School, a centre for political instruction, until 1932. He had one-man exhibitions at M. Knoedler & Co. in New York (1943) and at the Museo de Arte Moderno in Mexico City (1972). Some of his major works, such as *Self-portrait* (1947), *Man Making Paper* and *Landscape with Shacks*, are in the Instituto Nacional de Bellas Artes in Mexico City.

BIBLIOGRAPHY
J. Charlot: *The Mexican Mural Renaissance* (New Haven and London, 1963), pp. 241–51, 257–9, 269–79, *passim*
M. Constantine: *Tina Modotti: A Fragile Life* (New York, 1975, rev. 1983), pp. 64, 66, 82, *passim*
Xavier Guerrero y su obra (exh. cat., Mexico City, Mus. A. Mod., 1978)

RAQUEL TIBOL

Guerrero Galván, Jesús (*b* Tonila, Jalisco, 1 June 1910; *d* Cuernavaca, 11 May 1973). Mexican painter. He moved in the 1930s to Mexico City, where he became involved with the muralist movement, avoiding socio-political, folkloric and historical subjects in favour of poetic metaphor, as in *Fertility* (1931), painted in the former church of S Tomás in Guadalajara. Although he continued to paint murals, such as *Earth* (1958; Guadalajara, Mus. A. Mod.), his lyrical sensitivity was most suited to easel paintings, especially portraits and studies of women and children. His figures are shown in a dreamlike state, absorbed in daily tasks or surrounded by symbols, as in *Woman with Birds* (1956; Mexico City, Mus. A. Mod.), in which a woman in profile is shown surrounded by hens and doves against the luminosity of the sky.

BIBLIOGRAPHY
Jesús Guerrero Galván (exh. cat., Mexico City, Pal. B.A., 1952)
Visión poética de un gran pintor, Jesús Guerrero Galván (exh. cat., Mexico City, Mus. A. Mod., 1977)
Jesús Guerrero Galván (1910–1973): De personas y personajes (exh. cat. by O. Debroise and L. Lozano, Mexico City, Mus. A. Mod., 1994)

MARGARITA GONZÁLEZ ARREDONDO

Guerrero y Torres, Francisco Antonio de (*b* Villa de Guadalupe [now Guadalupe], *c.* 1727; *d* Mexico City, 1792). Mexican architect. He is first documented as carrying out various repairs and inspecting the work of others in Guadalupe. By 1767 he had been appointed Maestro de Arquitectura by the municipality of Mexico City. Between 1770 and 1774, as Maestro Mayor, he worked in Mexico City on the estate of the Marqués of Oaxaca, the royal palace, the cathedral and the Inquisition Tribunal, the Santo Tribunal de la Fe. His most important ecclesiastical commission was the Capilla del Pocito (1779–91) in Guadalupe. Its unconventional plan is derived from Sebastiano Serlio's interpretation of a Roman temple, with an oval central space (rather than Serlio's circular chamber) surrounded by rectangular chapels and an octagonal sacristy; the building is approached by a small circular vestibule. The exterior shows this juxtaposition of spaces thanks to a large central dome with smaller domes set over the vestibule and the sacristy. The traditional polychromy of Mexican Baroque architecture is achieved here, as in his other work, through the use of white Chiluca stone, red *tezontle* and Puebla glazed tiles, with the tiles covering the lanterns and parapets as well as the domes. In Mexico City he worked on numerous churches and convents,

carrying out both renovations and new commissions. Among the latter is the church of La Enseñanza (1772–8), which has a rectangular plan; its aisleless nave is chamfered at the angles and divided into three sections by means of different roof heights.

In secular architecture Guerrero y Torres won great prestige with his numerous commissions from the nobility of Mexico for their private residences in Mexico City. In 1769 he began the house of the Marqués de Xaral de Berrio (now the Palacio Iturbide). The four-storey façade stresses its verticality by the use of a giant order of pilasters on the lower two floors, while a minor order flanks all the fenestration. The house (1769) he built for the Marqués de San Mateo de Valparaíso (now the Banco Nacional de México) has a courtyard where huge intersecting arches frame the corners and windows display concave sills. In 1778 Guerrero y Torres was working on the palace for the Condes de Santiago de Calimaya. In his domestic as in his ecclesiastical work, he used polychrome materials, reserving white stone to emphasize doorways, windows and ornamental features, such as the gargoyles in the form of cannon, which were intended as allusions to the posts of governor and captain-general that several of his patrons had held.

BIBLIOGRAPHY

A. Iñiguez, D.-M. Dorta and J. E. y Buschiazzo: *Historia del arte hispanoamericano*, 3 vols (Barcelona, 1945–56)

H. Berlin: 'Three Master Architects in New Spain', *Hisp. Amer. Hist. Rev.*, xxvii (1947)

G. N. Patton: *Antonio Guerrero y Torres and the Baroque Architecture of Mexico City in the Eighteenth Century* (Ann Arbor, 1958)

M. Toussaint: *Arte colonial en México* (Mexico City, 1962)

G. Gasparini: *América, barroco y arquitectura* (Caracas, 1972)

G. Tovar de Teresa: *El barroco en México* (Mexico City, 1981)

G. Loera Fernández: 'Francisco Antonio Guerrero y Torres: Arquitecto y empresario del siglo XVIII', *Bol. Mnmts Hist.*, 8 (1982), pp. 61–84

R. Gutiérrez: *Arquitectura y urbanismo en Iberoamérica* (Madrid, 1983)

G. Tovar y Tovar: *Gerónimo de Balbás en la catedral de México* (Mexico City, 1990)

J. Bérchez: *Arquitectura mexicana de los siglos XVII y XVIII* ([Mexico City], 1992), pp. 275–85

MARIA CONCEPCIÓN GARCÍA SÁIZ

Guevara Moreno, Luis (*b* Valencia, 21 June 1926). Venezuelan painter and engraver. He studied at the Escuela de Artes Plásticas, Caracas, subsequently becoming an illustrator and cartoonist on various publications in Caracas. He went to Paris in 1949, where he attended André Lhote's studio and later the Atelier d'Art Abstrait, when it was directed by Jean Dewasne (*b* 1921). In Paris he took part in the activities of the groups Los Disidentes and Madi. His work in this period was clearly Constructivist, and it attracted considerable critical attention in Paris. In 1954 he returned to figurative painting, partly with political motives and partly in response to the figurative and abstract–lyrical European trends of the time. His work was subsequently influenced by critical realism. Guevara Moreno represented Venezuela in the biennales of São Paulo and Venice and was awarded several important national prizes, including the National Award for Painting and the National Award for Drawing and Graphic Arts.

BIBLIOGRAPHY

F. Paz Castillo and P. Rojas Guardia, eds: *Diccionario de las artes visuales en Venezuela*, ii (Caracas, 1982), p. 113

C. Barceló: *De la abstracción a la figuración: El cambio de tendencia en cuatro pintores venezolanos* (diss., Caracas, U. Cent. de Venezuela, 1988)

CRUZ BARCELÓ CEDEÑO

Guggiari, Hermann (*b* Asunción, 1924). Paraguayan sculptor. He studied sculpture under Vicente Pollarollo in Asunción and from 1943 at the Escuela Superior de Bellas Artes Ernesto de la Cárcova in Buenos Aires. In the late 1940s and early 1950s, he dealt with local political and social themes, but his style became progressively simplified and centred on the significant properties of materials and the sculptural possibilities of form, until he reached a strongly expressive abstraction that confirmed him as the central figure of modern sculpture in Paraguay. His principal materials were iron and steel, which were torn apart in dramatic gestures to suggest that man's existence is a search for liberty. This poetic of breaking and rending was a constant element in Guggiari's work throughout his career. It appears, for example, in *Christ* (steel, h. 4 m, 1969; Asunción, Santa Cruz) and in *Kansas* (1980; see fig.).

BIBLIOGRAPHY

Guggiari, Blinder, Colombino (exh. cat. by L. Abramo, Asunción, Misión Cult. Bras., 1969)

T. Escobar: *Una interpretación de las artes visuales en el Paraguay* (Asunción, 1984)

TICIO ESCOBAR

Guiana, British. *See* GUYANA.

Guignard, Alberto da Veiga (*b* Nova Friburgo, 25 Feb 1896; *d* Belo Horizonte, 25 June 1962). Brazilian painter, draughtsman and teacher. As an adolescent he lived in Switzerland, France and Germany. He studied at the Akademie der Bildenden Künste in Munich from 1916 and completed his studies informally in Florence between 1925 and 1928, visiting museums. Throughout this period he absorbed a wide variety of influences, including Neue Sachlichkeit, Expressionism and Surrealism. He returned to Brazil in 1929, settling initially in Rio de Janeiro and expressing his enthusiasm for Brazil in a personal language derived from European modernism, for example in the *Newlyweds* (1937; Rio de Janeiro, Fund. Ottoni de Castro Maya). In 1944 he was invited to Belo Horizonte by the city's Prefect, Juscelino Kubitschek (later President of Brazil), to teach an open drawing course. His long teaching career had a profound influence on more than one generation of artists in Minas Gerais. His work was deeply affected by the mountainous landscape of the interior of this state, with its gentle slopes and vast misty panoramas reflected in works such as the *Landscape in Ouro Preto* (1950; São Paulo, Mus. A.). His spontaneous, lively powers of observation were likewise applied to his many portraits and still-lifes, for example the *Twin Sisters* (1940; Rio de Janeiro, Pal. Cult.). He also explored religious themes, as in the painting of *St Sebastian* (1960; Rio de Janeiro, Banco do Estado) and especially the figure of the suffering Christ.

BIBLIOGRAPHY

M. Leão: *Guignard* (São Paulo, 1963)

R. M. F. de Andrade: *Guignard* (Rio de Janeiro, 1967)

Guignard (exh. cat. by F. Morais, São Paulo, Cent. A. Novo Mundo, 1974)

F. Morais: *Alberto da Veiga Guignard* (Rio de Janeiro, 1979)

C. Zílio, ed.: *A modernidade em Guignard* (Rio de Janeiro, 1979)

R. Pontual: *Entre dois séculos: Arte brasileira do século XX na Coleção Gilberto Chateaubriand* (Rio de Janeiro, 1987)

Guignard, uma seleção da obra do artista (exh. cat., São Paulo, Mus. Segall, 1992)

R. Naves: 'O Brasil no ar: Guignard', *A forma difícil: Ensaios sobre arte Brasileira* (São Paulo, 1996), pp. 131–78

ROBERTO PONTUAL

Hermann Guggiari: *Kansas*, iron and limestone with welded steel plate, 1980 (Hays, KS, Fort Hays State University)

Guillén, Asilia (*b* Granada, Nicaragua, 1887; *d* Granada, 1964). Nicaraguan painter and embroiderer. Born to a prominent family in the old city of Granada, she was given a patrician education that emphasized embroidery and music as the arts proper to her station. For several decades she practised embroidery, gradually replacing the traditional formal elements and conventional subjects such as decorative floral motifs with landscapes and scenes from Nicaraguan history conveyed in a broad range of colour.

The growing national fame of Guillén's embroidery led her to take up oil painting in 1951 at the suggestion of a friend, the poet Enrique Fernández Morales. She studied under Rodrigo Peñalba at the Escuela Nacional de Bellas Artes in Managua but quickly arrived at a distinctive style of naive art by transposing the style and subject-matter of her embroidery to brightly coloured and richly detailed oil paintings that won the admiration of leading literary figures such as Ernesto Cardenal and Pablo Antonio Cuadra, for example *Rafaela Herrera Defends the Castle Against the Pirates* (1962; see colour pl. XIV, fig. 1). Typical of her mixture of fact and fantasy, of epic vision and modest scale, is *Heroes and Artists Come to the Pan-American Union to be Consecrated* (1962; Washington, DC, A. Mus. Americas; *see* NICARAGUA, fig. 3), painted to commemorate her successful exhibition of 1962 at the gallery of the

Pan American Union in Washington, DC. Her art was a significant precedent for the Solentiname primitivist painting, which flourished in Nicaragua after the Sandinista Revolution in 1979.

BIBLIOGRAPHY
E. Fernández Morales: 'Doña Asilia, pintora primitivista', *Pez & Serpiente*, 2 (Aug 1961), pp. 89–95
J. Gómez-Sicre: 'Embroidery in Oils: Asilia Guillén of Nicaragua', *Américas*, xiv/10 (1962), pp. 17–20
J. Valle-Castillo: 'El inventario del paraíso: Los primitivistas de Nicaragua', *Nicaráuac*, 12 (April 1986), pp. 161–75

DAVID CRAVEN

Günther, Rafael Yela. *See* YELA GÜNTHER, RAFAEL.

Gurría, Angela (*b* Mexico City, 24 March 1929). Mexican sculptor. She received some useful tuition from Germán Cueto but was otherwise self-taught, specializing in monumental works that explore volume and space and that exist somewhere between the real world and a language of abstract forms derived from it. Her materials for such works included concrete, as in *Station One* (1968) on the Ruta de la Amistad in Mexico City, and wrought iron, as in *The Papaloapán River* (1970; Mexico City, Mus. A. Mod.). She also produced works as integral to architectural settings, for example *Homage to the Ceiba Tree* (1977) for

the Hotel Presidente Chapultepec in Mexico City. The sometimes sombre nature of her work came to the fore in a one-woman exhibition held in 1983 on the subject of death.

BIBLIOGRAPHY

L. Kassner: *Diccionario de escultura mexicana del siglo XX* (Mexico City, 1983), pp. 158–9

X. Moyssén: 'Angela Gurría', *Doce expresiones plásticas de hoy* (Mexico City, 1988)

Angela Gurría: Obra reciente (exh. cat., Mexico City, Gal. Avril, 1995)

XAVIER MOYSSÉN

Gutiérrez, Felipe S(antiago) (*b* Texcoco, nr Mexico City, 20 May 1824; *d* Texcoco, 4 April 1904). Mexican painter and writer. He entered the Academia de San Carlos in Mexico City in 1836, studying under Miguel Mata (1814–76) and subsequently with Pelegrín Clavé; the preponderance of biblical themes in his student production can be attributed to the emphasis on such subject-matter both in Clavé's work and among the conservative group that dominated the Academia in the mid-19th century. Gutiérrez's ideological sympathies with the liberal faction, however, soon led him to produce paintings such as the *Judgement of Brutus* (1857; Mexico City, Mus. N.A.), republican in theme and markedly influenced in style by David, although falling far short of the latter's technical perfection.

Unlike most of his fellow students at the Academia, Gutiérrez did not begin to teach until after he had completed many years of travelling; from 1862 he lived in various cities in Mexico, then in San Francisco, Paris, Rome, Madrid, New York and finally in Bogotá, where he achieved considerable renown as a teacher of painting. While travelling he supported himself by painting portraits, for example the particularly outstanding one of *Señora Sánchez Solís* (Toluca, Mus. B.A.), the wife of his patron Felipe Sánchez Solís, a Mexican lawyer and liberal intellectual for whom he also painted an interesting regional scene with autobiographical overtones, the *Indian Boy's Farewell* (1876; see 1990/91 exh. cat., p. 514). In Europe he embraced the contemporary revaluation of Spanish Baroque painting, later making it known in Mexico through works such as *St Bartholomew* and *St Jerome* (both exh. 1886; Mexico City, Mus. N.A.), directly influenced by Jusepe de Ribera. The rich blending of colours and boldness of execution of his works of this period, for example the *Andean Huntress* (exh. 1891; see fig.), also suggest affinities with Spanish artists such as Eduardo Rosales Martínes (1836–73) and Mariano Fortuny y Marsal (1838–74), both of whom had become his friends in Rome, and also with the work of Courbet; while in Europe he appears to have met Courbet's champion, Jules-Antoine Castagnary (1830–88). Gutiérrez also wrote some art criticism, including articles on exhibitions held in 1875, 1877 and 1881 at the Escuela Nacional de Bellas Artes. He also published a long and interesting account of his travels and a treatise on drawing and painting.

WRITINGS

Viaje de F.S.G. por México, los Estados Unidos, Europa y Sudamérica, 2 vols (Mexico City, 1882–3)

Tratado de dibujo y pintura (Colima, 1864/*R* Mexico City, 1895)

BIBLIOGRAPHY

I. Rodríguez Prampolini, ed.: *La crítica de arte en México en el siglo XIX* (Mexico City, 1964), ii, pp. 366–82, 417–37; iii, pp. 81–125

J. M. Caballero-Barnard: 'Felipe S. Gutiérrez, pintor de Academia', *A. México*, 171 (1973) [whole issue]

Mexico: Splendors of Thirty Centuries (exh. cat., New York, MOMA, 1990–91), pp. 513–14

Felipe S. Gutiérrez: *Andean Huntress*, oil on canvas, 1.00 x 1.62 m, exhibited 1891 (Mexico City, Museo Nacional de Arte)

E. Garrido and others: *Felipe Santiago Gutiérrez: Pasión y destino* (Toluca, 1993)

<div style="text-align:right">FAUSTO RAMÍREZ</div>

Gutiérrez, Rodrigo (*b* San Luis Potosí, 1848; *d* Mexico City, 1903). Mexican painter. He studied at the Academia de San Carlos in Mexico City (1865–71) and was an outstanding pupil of the painter Pelegrín Clavé. He was considered one of the finest portrait painters of his time, but like the rest of his fellow pupils Gutiérrez also practised history painting. One of his most remarkable group portraits was a key work in the development of national subject-matter in Mexican painting, *The Tlaxcala Senate* (oil on canvas, 1874; Mexico City, Mus. N.A.). This is a large canvas with many almost life-size figures, and, unlike other paintings of Mexican subjects, it shows well executed realism in the treatment of the individual figures despite the classicizing style of the poses and composition. Gutiérrez taught painting at the Instituto de Zacatecas, Mexico City, but his career ended abruptly in 1884, when he suffered brain damage in a fall from his horse.

<div style="text-align:center">BIBLIOGRAPHY</div>

J. Fernández: *El arte del siglo XIX en México* (Mexico City, 1967, rev. 1983), pp. 64, 112

F. Ramírez: 'Arte del siglo XIX en la ciudad de México', *Historia del arte mexicano* (Madrid, 1982), p. 50

<div style="text-align:right">ESPERANZA GARRIDO</div>

Gutiérrez Alarcón, Sérvulo (*b* Ica, 1914; *d* Lima, 21 July 1961). Peruvian painter, potter and sculptor. He had little formal education, but after training as a boxer in Lima he settled in Buenos Aires, where his interest in pottery led him to set up a workshop for the conservation of Pre-Columbian pottery and for the manufacture of pottery in the style of this period. He learnt to sculpt and studied painting under Emilio Pettoruti (1892–1971). In 1938 he went to Paris, where he studied the work of the French masters and relaxed his style, rejecting academic canons. Returning to Peru in 1942, he adopted a rather Expressionist style of painting, with clear lines, suggestive of sculpted forms. He avoided the other avant-garde European styles of the period, opting for a while for elements of the Indigenist style (*see* PERU, §IV, 2). Under Pettoruti he developed a great interest in sculpture. His activity in this field was limited to a few works, culminating in 1942 when he won first prize in a competition for his sculpture *Amazonía* (1942). He went on to develop a rather violent approach, including scoring paint to heighten textural qualities and using bold strokes of red, blue, green and black, and by the early 1950s his painting was truly Expressionist, as in *Don Juan* (1952; Lima, Mus. Banco Cent. Reserva). After the mid-1950s, his painting tended towards mystical themes, such as *St Rosa de Lima* (*c.* 1960–61), and became increasingly aggressive and violent, somewhat reminiscent of Fauvism.

<div style="text-align:center">BIBLIOGRAPHY</div>

J. Villacorta Paredes: *Pintores peruanos de la República* (Lima, 1971), pp. 99–101

J. A. de Lavalle and W. Lang: *Pintura contemporánea: Segunda parte, 1920–1960*; Arte y tesoros del Perú (Lima, 1976), pp. 126–35

Homenaje a Sérvulo (exh. cat., Lima, Inst. Peru. Admin. Empresas, 1985)

G. Banks: 'Authenticity and Restoration in the American Collections at the Manchester Museum', *Bull. Mus. Royaux A. and Hist.*, lxiii (1992), pp. 145–54

<div style="text-align:right">W. IAIN MACKAY</div>

Guyana, Cooperative Republic of [formerly British Guiana]. Country in South America. It is bordered by Venezuela on the west, Brazil on the south, Surinam on the east and the Atlantic Ocean on the north (see fig. 1). It includes the counties of Demerara, Essequibo and Berbice; the capital is Georgetown in Demerara. Its terrain consists of a highly cultivated coastal region, an interior of rainforest, and open savannah in the south-west. Initially colonized by the Dutch in the early 17th century, it came under British rule in the early 18th, gaining independence in 1966.

I. Introduction. II. Indigenous culture. III. Architecture. IV. Painting, graphic arts and sculpture. V. Patronage and institutions.

I. Introduction.

The Dutch began to settle Guyana in 1616, and in 1621 the Dutch Chartered West India Company was given a monopoly in trade with the region. Failed attempts to settle the Pomeroon River were made by English colonists in 1639 and 1642. However, the Dutch created three colonies along the Essequibo, Demerara and Berbice rivers, trading with the various tribal groups, in particular the Caribs. The settlers also cultivated sugar cane from the end of the 17th century, which led to the organized importation of African slaves. Following a slave insurrection in 1763, the British conquered the three Dutch colonies in 1781, founding Georgetown (originally Fort St

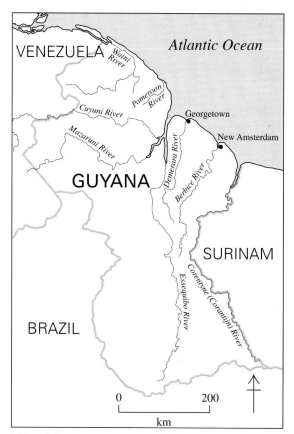

1. Map of Guyana

George) at the mouth of the Demerara River. After brief occupations by the French (1782) and the Dutch (1784), the territory, reconquered by the British in 1796, was ceded to Britain in 1803. This cession was formally confirmed by the Treaty of Paris in 1814, and in 1831 the three colonies were united as the colony of British Guiana. British rule resulted in considerable civic building, but during the 19th century fine art was limited to a few depictions of local life by visitors and amateurs (*see* §§III and IV below).

Initially, British occupation led to a steep acceleration in imports of slaves and new capital. Then the slave trade was abolished in 1807, and evangelization among the slaves began in 1808. In the two decades following emancipation (1838), communities of freed slaves purchased sugar estates in the coastal region. This so-called Village Movement preserved areas of traditional Afro-Guyanese culture during a period of traumatic social change and mass influx of immigrants of different racial and linguistic affiliations. In the 80 years after emancipation, imported and indentured labour came to work in the European-owned sugar plantations, primarily from India, China and Madeira. During the final two decades of the 19th century a severe recession in the sugar industry led to the amalgamation of some estates and diversification of the economy. Through the Reform Movement, the rising creole middle class began to challenge the constitutional power of the planters. The late 19th and early 20th centuries were also marked by the emergence of Afro-Guyanese art and architecture. Mass political action finally culminated in independence in 1966. In the 1970s the government of Forbes Burnham attempted to reorganize the economy along socialist lines.

BIBLIOGRAPHY
P. M. Netscher: *Gescheideinis van de koloniën Essequebo, Demerary en Berbice, van de vestiging der Nederlanders aldaar tot op onzen tijd* [History of the colonies Essequibo, Demerary and Berbice from the Dutch establishment to the present day] (The Hague, 1888)
V. T. Daly: *A Short History of the Guyanese People* (London, 1980)
F. Chambers: *Guyana* (Oxford and Santa Barbara, CA, 1989)

DENIS WILLIAMS

II. Indigenous culture.

The indigenous population comprises a number of ethnic groups: *c.* 6300 Arawak (Lokono), *c.* 5200 Warao, *c.* 4500 Karinya (Carib), *c.* 4200 Kapon (Akawaio), *c.* 5000 Kapon (Patamona), and *c.* 500 Pemon (Arekuna), all occupying the north-west and the coastal region between the Demerara and Corentyne rivers. The south is occupied by *c.* 7800 Carib-speaking Makusi, *c.* 5600 Wapisiana and *c.* 200 Waiwai. The economy of all the groups is based primarily on manioc horticulture, supplemented by hunting and fishing. Manioc-based subsistence has guaranteed the survival of key traditional arts and industries, notably architecture, ceramics, basketry, featherwork, beadwork and weaving. The raw materials employed in the manufacture of all artefacts originally came mainly from the forests. Many materials were seasonal, for example the seeds of the crab-nut tree, used for body paint. Particular inorganic raw materials, such as pottery clay, tempering materials used in pottery manufacture such as sand, decomposed granite, mica etc, or a particular kind of stone suitable for

the manufacture of grater chips, may be rare or unobtainable in a given area, and this placed specific values on the associated products.

Trade, based on the barter of such artefacts as Karinya pottery, Wapisiana cotton hammocks or Warao canoes and fibre hammocks, survived into the middle of the 20th century. Two ceramic traditions, both originating from the north-west, have characterized the indigenous groups, other styles of pottery in the south being of only local importance. The pottery tradition from the north-west known as the Mabaruma style is characterized by incision, punctation and low- and high-relief modelling. Red painting or white slip is occasionally used. Certain of its decorative motifs are specifically associated with rituals appertaining to manioc processing. Brewing manioc beer required chewing quantities of cassava bread by way of promoting fermentation. The process was thought to be facilitated by magical observances involving mouth and tongue tattooing. The representative pottery decoration features a two- or three-dimensional human head with a characteristically distended mouth representing the chewing process, which served to induce potency in the drink. Belief in the efficacy of these magical practices in due course crossed tribal frontiers, generating new motifs in incised and painted pottery decoration. The other tradition is represented by Karinya pottery, which survives to the present on the Pomeroon River. The inception of this polychrome Horizon style of the Karinya Caribs of the Moruka and Pomeroon rivers has been dated to *c.* 200 BC, though it may have existed there much earlier. Decoration is by red or black geometric bands on a white slip, sometimes embellished with serial dots.

Surviving forms of basketware include the remarkable tubular manioc press, whose constricting action is believed to have derived from the ingesting motions of the anaconda snake. A miniature version is used for extracting oil from the crab-nut seed. Basketry fish-traps are still made by the Akawaio (see fig. 2). Basketry is also combined with featherwork to produce the magnificent feather crowns still used by the Waiwai, but which until the mid-20th century constituted distinguishing insignia among many of the other tribal groups. Made of parrot and macaw feathers, they were used on ceremonial or festive occasions in combination with a wide range of other decorations fashioned from such materials as seeds, bone, teeth, insect cocoons and beetles' wings. Feather ornaments are woven into the hair of Waiwai males, and feathers are also used to adorn such simple manufactured objects as cosmetic boxes, combs, fans and bone flutes. The ornate women's bead apron, originally made up from chains of grass or other seeds attached to a square of bark cloth, was later manufactured from European trade beads. Fabrics are woven with fibres from such plants as silk grass, moriche or other palm leaves. The Warao hammocks are of a sturdy rope made from moriche fibre. The finest specimens exhibit the texture of silk. Cotton thread spun on the traditional spindle-whorl is woven into baby slings, calf-bands and hammocks. They are usually characterized by a total absence of decoration.

Indigenous architectural traditions are continued by the peoples in the hinterland of the tropical forests, who build large, circular dwellings that symbolize aspects of their

2. Akawaio Indian basketwork fish-trap, liana in wrapped twining, 255×970 mm, collected in Guyana c. 1951 (Oxford, Oxfort University, Pitt Rivers Museum)

cosmological beliefs. Successive horizontal planes in the cone-shaped dwellings of the Warao and Waiwai serve to conceptualize specific areas of the universe. In the Waiwai buildings, apertures in the roof represent passageways to the cosmos. Around the central pole that supports the structure is a sacred space, the various Waiwai households being distributed around its periphery. The positions of the rafters and intermediate purlins also coincide with specific cosmological spaces. Such dwellings continue in use among the Waiwai and, until the early 20th century, were also characteristic of the Wapisiana, Makusi and Arecuna. The dwellings of certain coastal groups were of wattle and daub on square plans, roofed with dhalebana (*geonoma*) palm leaves.

BIBLIOGRAPHY

E. Im Thurn: *Among the Indians of Guiana* (London, 1883/R 1967), p. 269

W. Roth: *An Introductory Study of the Arts, Crafts and Customs of the Guiana Indians* (Washington, DC, 1924)

J. Ford: 'Los pueblos indígenas de Guyana', *América Indíg.*, xlviii/2 (1988), pp. 323–52

DENIS WILLIAMS

III. Architecture.

Transient European trading posts in the 16th century preceded the establishment by the Dutch West India Company of the first permanent settlement at Kijkoveral (1616–21), a small island at the confluence of the Cuyuni and Mazaruni rivers near present-day Bartica. The early Dutch settlements were protected by fortresses such as Fort Nassau on the Berbice River, founded in 1627 and rebuilt in brick during the 1720s (mostly destr.; see Hartsinck, pp. 284 and 299). The moated brick Fort Zeelandia on the Essequibo, designed by the Dutch governor Laurens Storm van 's Gravesande (1704–75), was built in 1744 on the site of earlier timber forts (1687 and 1739) and is relatively well preserved. The British conquest and foundation of Georgetown in 1781 led to a growth in civil architecture. The first building to use classical orders was an armoury in Georgetown (probably before 1800; destr.; anon. drawing, London, PRO). From 1808 London Missionary Society churches were built for the slaves. Both the churches and town houses were built in clapboarding imported from the USA, but most did not survive major fires in the 19th century. The unremarkable steepled Gothic Revival Presbyterian church of St Andrew (consecrated 1818), Stabroek, was built by Joseph Hadfield (fl 1818–34), as was the neighbouring brick and stucco Neo-classical parliament building (1829–34), with a central dome and Doric columns. The timber Smith Congregational Church (1841), still well preserved in Brickdam, Georgetown's oldest street, is also in the Gothic Revival style.

Labour shortages, particularly after the emancipation of the slaves, affected the quality of such buildings as the Seaman's Hospital (1838), the timber and metal railway station (1848), and the governor's residence, State House (1854), all in Georgetown. However, the development of infrastructure included a stuccoed brick prison (1841) at

the penal settlement on the Mazaruni River. With an increased flow of immigrants and better economic conditions in the 1860s and 1870s, the quality of buildings improved, for example in the Renaissance-style church of the Sacred Heart (1861), Georgetown, built for Portuguese indentured immigrants from Madeira by the Italian Jesuit priest Benedict Schembri (*fl* 1860–75) and later much extended by Father Joseph Baldini (*d* 1883), also Italian. In 1881 Stabroek Market, an important iron building incorporating Tudor and Gothic motifs, was built by the American railway engineer Nathaniel Kay (1831–1902). Civic architecture in Georgetown flourished in the last two decades of the century, for example the Victoria Law Courts (1884) by Baron Hora Siccama (1842–1921), a civil engineer, the timber Gothic Revival City Hall of 1888 by the Jesuit priest Ignatius Scoles (1839–96) and, in the same style, the neighbouring City Engineer's Office (*c.* 1890), also by Scoles. A Magistrates Court (1890) was built by the Colonial Civil Engineer's Office. St George's Cathedral (1889–92), one of the world's tallest timber buildings (43.5 m), is reputedly by Reginald Blomfield (1856–1942). The indentured Muslims and Hindus on the sugar plantations built mosques and sivalas in traditional forms, first in wattle and daub and then in permanent materials. Towards the end of the century, as the older generation died out, such 'India style' buildings came under the influence of the creole style developed by such Afro-Guyanese architects as James Sharples (1845–1913). This style was characterized by houses with steeply pitched roofs, raised on platforms above the swampy ground, with fretted bargeboards, decorative cast-iron balcony rails and jalousies. The use of platforms probably originated on sugar plantations as early as the 1830s. It was later extended to grand town houses and the cottages of the rising creole middle class. Traditional Western styles were practised by Leonard Stokes (1858–1925), who was chosen to design the Gothic and Romanesque-style Roman Catholic cathedral of the Immaculate Conception, Georgetown (1914–25; see fig. 3).

Little of the European Modern Movement reached Georgetown until rebuilding after a major fire in 1945. Because there were few locally based practices, until the late 1960s most major commissions went to expatriate British architects: for example, the University of Guyana (completed 1963), a tasteful series of lightweight framed buildings, was designed by the British architect Frank Mowbray Rutter (1911–89). In 1966 George Henry (*b* 1930), a Guyanese who had worked in Britain and Pakistan, started what is now the largest local practice with such Brutalist buildings as those for the National Insurance Scheme in Georgetown (1967) and New Amsterdam (1968). Another Guyanese, Norris Mitchell (*b* 1938), designed the colourful National Cultural Centre (1976), Georgetown. In 1984 Albert Rodrigues (*b* 1941), the local head of the major Caribbean practice Gillespie & Steel, went into partnership with Michael Cox (*b* 1945): both produced distinguished houses in the mid-1970s.

BIBLIOGRAPHY

J. J. Hartsinck: *Beschryving van Guiana of de wilde kunst in Zuid America* [Description from Guyana of the wild art in South America] (Amsterdam, 1770)

'Ignatius Scoles: Obituary', *Lett. & Not.: Inter. J. Eng. Prov. SJ*, xxxiii (1895–6), pp. 551–61

A. Leechman: 'Notes on Ancient Sites and Historical Monuments Now Existing in the Colony of British Guiana', *Official Gaz.* (12 July 1913), pp. 1–14

A. Crossthwaite: 'Trollope's Prepossessing City: Architecture of Georgetown, Guyana', *Country Life*, cxliii (28 March 1968), pp. 718–20

R. Westmaas: 'Building under our Sun: An Essay on the Development of Guyanese Architecture', *Cooperative Republic of Guyana, 1970*, ed. L. Searwar (Georgetown, 1970), pp. 129–58

'Wooden Wonder: Wooden Cathedral in Georgetown, Guyana', *Architects' J.*, clxxxii/28 (1985), pp. 16–17

L. Bosman: 'Een onbekend ontwerp van Abraham van der Hart: Het gouvernementsgebouw in Demerary' [An unknown design by Abraham van der Hart: The government building in Demerary], *Kon. Ned. Oudhdknd. Bond: Bull.*, xc/4 (1991), pp. 135–9

DENIS WILLIAMS

IV. Painting, graphic arts and sculpture.

A few map-illustrations and sketches in travel records are all that survive of the period before 1800. It is unlikely that painting or sculpture were practised by the Dutch. After the colonies were reoccupied by the British in 1796, officers and amateurs began almost at once to produce records of local scenery and events. The earliest recorded watercolour sketches, those of Lt Staunton St Clair (*fl* 1806–8), were executed during the first decade of the 19th century. The 1820s and 1830s were marked by the work of Joshua Bryant (*fl* 1810–36), whose watercolours of official ceremonies and public buildings suggest that he may have been an official colonial artist. The painter Charles Bentley (1805/6–54), official artist to the expedition of Robert Hermann Schomburgk in Guiana and the Orinoco (1835–9), was the first to record scenes of Amerindian life in the interior, for example lithographs published in Schomburgk's *Twelve Views of the Interior of British Guiana* (1841). A contemporary, William Hedges (*fl* 1831–6), carefully executed several local landscapes in oil. The official artist to Schomburgk's second expedition (1841–3) was Edward Alfred Goodall (1819–1908), son of Turner's engraver, Edward Goodall. Working in the English topographical tradition, he executed watercolours of Georgetown and particularly of Kingston, as well as hundreds of ethnographical, topographical and botanical sketches (Berlin, Botan. Mus., and London, BL, Add. MSS 16936–9). A few mainly architectural pictures were executed by Goodall's predecessor on the Schomburgk ex-

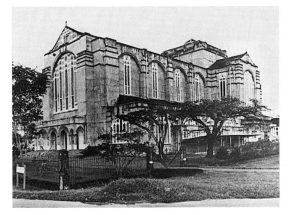

3. Leonard Stokes: Roman Catholic cathedral of the Immaculate Conception, Georgetown, Guyana, 1914–25

pedition, W. L. Walton (*fl* 1840; London, BL, Add. MSS 66939, nos 55–7). Photographs of undistinguished 19th-century paintings and a few originals from 1836 to 1882 have survived in the University of Guyana Caribbean Research Library in Georgetown: pictorial journalism included genre scenes submitted to the *Illustrated London News* (31 March and 28 April 1888) by M. Prior and A. Forestier; the drawings in the collection include one attributed to a Chinese immigrant working in 1886 and a portrait copy of the black Haitian general Toussaint L'Ouverture, probably by a creole.

In the first half of the 20th century the first native Guyanese artist, Samuel Horace Broodhagen (1883–1950), a portrait sculptor, also produced some landscapes in oil. In 1931 the first exhibition of art in Georgetown was organized by a group of expatriate amateur painters who, in 1929, had formed the Arts and Crafts Society as a popular movement for stimulating the visual arts. Like the more economically orientated Self-Help Movement, it had a far-reaching influence. It served as the model for the Guyanese Art Group, founded in 1944 by a handful of native-born artists led by the watercolourist Guy Sharples (1906–56), son of the architect James Sharples (1845–1913). The Guyanese Art Group's exhibition became an annual national event.

Other important figures included Edward Rupert Burrowes (1903–66), born in Barbados and a tailor by trade, and his pioneering associate Hubert Moshett (*b* 1901), a sign-painter. Burrowes's pedantic work was inspired by late Victorian painting. He was most important as a teacher (*see* §V below), notably of such painters as Stanley Greaves (*b* 1934), Donald Locke (*b* 1930), and Emerson Samuels (*b* 1928) who also became involved in art education. During the 1940s and 1950s a small group of Guyanese painters attracted recognition in metropolitan centres: they included Denis Williams (*b* 1923), who came to the notice of Wyndham Lewis in the early 1950s, Frank Bowling (*b* 1936), now represented in the Tate Gallery, London, and Aubrey Williams (1926–90), who worked in an Abstract Expressionist style characterized by a tropical intensity of colour somewhat reminiscent of the later palette of Paul Gauguin. However, these artists had only partial success in creating an identifiable national form of art. The period was marked by the emergence of the painter Marjorie Broodhagen (*b* 1912).

Other artists, for example from Arawak and Makusi backgrounds, introduced elements of traditional arts and industries into contemporary art. The superimposed circular planes of traditional architecture were employed by the terracotta muralist Stephanie Correia (*b* 1930) in low reliefs articulated by such materials as feathers, seeds, shell, bone and fibre. Paintings of the Arawak artist George Simon (*b* 1947) translated the reticulations of thatching into serial units of light. Less ambitiously, the Makusi artist Guy Marco (b 1961) translated basketry weave into colour patterns. Forest woods were carefully selected by Oswald Hussein (*b* 1954) for sculpture inspired by Arawak myth. Dudley Charles (*b* 1945), Donald Locke, Andrew Lyght and Ronald Savory (*b* 1933) all incorporated Amerindian petroglyph motifs (timehri) in their early paintings.

During the early 1970s, Expressionova was founded by a group of radical artists and writers, some still at school, in order to create a national artistic idiom. Its name came from the title of a contemporary literary journal edited by the writer Noel Williams. The catalogue cover of the short-lived movement's only exhibition, *Expressionova 1974*, held in Georgetown, consisted of a concrete poem by Terrence Roberts (*b* 1949) in the shape of the national flag of Guyana. Members included Roberts, the founder, Keith Khan (*b* 1949), and Carl Martin (*b* 1951). Their surrealistic art received little popular attention. Images drawn from the Guyanese landscape were juxtaposed with such universally known 'cultural sites' as the Taj Mahal in Agra. References to English poetry added to the works' ambiguity. Examples of Expressionova in the National Art Collection include the *Birth of Roraima* by Roberts and *Cloves* and *The Jungle* by Martin.

Important sculpture and painting was produced by the naive artist Philip Moore (*b* 1921). Born into the Jordanites, a syncretic religious movement, Moore drew upon Afro-Guyanese history and forms (see fig. 4). His 5 m-high bronze memorial to *Cuffy*, the leader of the Slave Revolution of 1763 on the Berbice River, cast by the British Morris Singer Foundry, was installed in Georgetown in 1975. The sculptor Ivor Thom (*b* 1954) produced two bronze high reliefs (1986) on a heroic scale for the Burnham mausoleum in Georgetown, and a figurative bronze memorial (1.8×3.0 m) to the slave martyr *Damon* (1988) in Essequibo (both cast by the local firm BACIF). The Rastafarian musician and patron of the arts Compton ('Camo') Williams (*b* 1949) displayed his collection of painting and sculpture in his private Roots and Culture Gallery to serve as a focus for a new generation of woodcarvers led by Gary Thomas (*b* 1954). Outstanding were Omowale Lumumba (*b* 1952) and Ernest Van Dyke (*b* 1951). These artists expressed an unstudied Afro-Guyanese aesthetic drawn from the spirituality of their people, which was diametrically opposed to the intellectual concerns or 'book art' of Expressionova or the expatriate Guyanese artists.

BIBLIOGRAPHY
'A Newcomer from Guiana', *Time* (18 Dec 1950), p. 33
E. Goodall: 'The Diary of Edward Goodall, esq., during his Sojourn in Georgetown from 28 July to 11 September 1841', *J. Brit. Guiana Mus. & Zoo*, 35 (1962), pp. 39–53
W. Lewis: 'A Negro Artist', *The Listener* (7 Dec 1950), pp. 423–4
Guyana: Colonial Art to Revolutionary Art, 1966–1976 (Georgetown, *c.* 1976)

DENIS WILLIAMS

V. Patronage and institutions.

From *c.* 1620 to *c.* 1790 significant patronage of architecture and the decorative arts was concentrated in the Dutch fortresses. Shortly after the British took final control in 1796, the official posts of Colonial Artist and Colonial Architect were instituted. During the 19th century the British continued to develop civic architecture, although largely ignoring the fine arts (*see* §III above). From the first decade of the 19th century, the different religious groups, in particular the Roman Catholic Church, commissioned buildings, while neglecting painting and sculpture. The mercantile classes became significant patrons of architects, painters and draughtsmen during the second half of the 19th century, in particular in the town houses of absentee landlords. However, following the severe

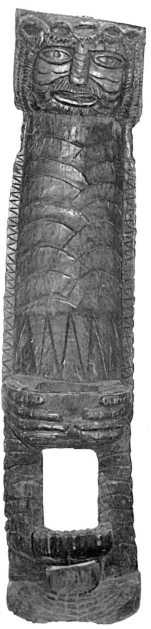

4. Philip Moore: *Stool of Resistance*, painted wood, h. 2.15 m, 1978 (Georgetown, National Art Collection)

recession in the sugar industry in the late 19th century, the demand for domestic architecture passed to the rising creole middle class.

Art education remained restricted until the late 1920s, when certain expatriate amateurs volunteered as art teachers in their own homes. In 1931 the first exhibition of art in Georgetown was organized by the Arts and Crafts Society (*see* §IV above). With the continuing growth of the creole middle class, some Guyanese artists started working in advertising and sign-painting. Afro-Guyanese art was encouraged by the development in the 1930s and 1940s of a cultural identity among the middle class, inspired

by international movements or associations such as the League of Coloured Peoples. From 1945 to 1956 the Working People's Art Class transmitted traditional Western artistic practices to a wider public. It was founded by the painter and sculptor Edward Rupert Burrowes and funded by businesses and institutions, including the British Council. Drawing and painting were taught solely by Burrowes in whatever building could be made available and to whoever attended. The Working People's Art Class democratized the art scene. It was not until 1975 that the Burrowes School of Art, Georgetown, only the second in the British Caribbean, was founded by the government. The University of Guyana has a small faculty of architecture. From the 1970s the newly independent state emerged as the most important patron of both art and architecture.

BIBLIOGRAPHY
A. J. Seymour: *Cultural Policy in Guyana*, UNESCO (Paris, 1977)
D. Williams: *From the National Collection, Guyana* ([Georgetown], 1987)
DENIS WILLIAMS

Guyane, La. *See* FRENCH GUIANA.

Guzmán, Alberto (*b* Talera, 4 Sept 1927). Peruvian sculptor. He studied at the Escuela Nacional Superior de Bellas Artes in Lima, graduating in 1958 with a gold medal. In 1959 he won the Premio Nacional de Escultura and settled in Paris. His sculptures, based on articulated structures, are made of bronze, stainless steel, wire and marble. In the late 1960s the aggressively spiky forms of his early Parisian works became enclosed in hemispherical forms, given a contrastingly high polish, as in *Large White Tension* (welded steel, 2.20×1.25 m, 1968; Paris, Mus. N.A. Mod.).

BIBLIOGRAPHY
J. M. Ugarte Eléspuru: *Pintura y escultura en el Perú contemporáneo* (Lima, 1970)
Exposition Guzmán (exh. cat. by J. Lassaigne, Paris, Mus. Bourdelle, 1972–3)
LUIS ENRIQUE TORD

Guzmán de Rojas, Cecilio (*b* Potosí, 1899; *d* La Paz, 1950). Bolivian painter. He studied painting in Potosí under Avelino Nogales. In 1920 he left for Spain, where he studied at the Escuela de Bellas Artes de San Fernando in Madrid, in the studio of Julio Romero de Torres (1880–1930); later he also studied at the Ecole des Beaux-Arts in Paris. He remained in Europe until 1929, travelling through several countries and living in Paris and Rome. Although he initially had a provincial mentality, he benefited from his exposure to European artistic trends, and his work began to show the influence of Art Nouveau and Art Deco. On his return to Bolivia he settled in La Paz. There he became Director of the Escuela de Bellas Artes and Director General of the Fine Arts in the Ministry of Education, where he propagated a style and concept of native art that he called 'Indo-American'. In 1945 he was in London, with a grant from the British Council to study restoration. Following this visit abroad he developed what he called the 'coagulatory' technique of painting, based on formulas developed from ancient treatises on painting.

As a painter his output was prolific and can be divided into several phases. The first of these began in Madrid, with such works as the *Triumph of Nature* (1928; La Paz,

Mus. N. A.), executed with the technique of *calidadismo*. A second phase depicted the drama of soldiers during the Chaco War (1932–5), in an expressionistic style, as in *T. B. Can Be Evacuated* (1934; La Paz, Mus. N. A.). A third stage centred around the human figure, as in *Aymara Christ* (1939; La Paz, priv. col.) and numerous portraits. From 1940 he produced a large series of landscapes of Machu-Picchu and Lake Titicaca, and from 1947 until his death he worked on the coagulatory technique, both in landscapes and in semi-abstract works such as *Profundity* (1948; La Paz, priv. col.). As a restorer of paintings, Guzmán de Rojas was the discoverer of Bolivian colonial art, particularly of the Baroque painter Melchor Perez de Holguín. He founded the first Pinacoteca Nacional in La Paz, now known as the Museo Nacional de Arte, and assembled the first collection of colonial paintings in the Museo Nacional de la Casa de Moneda in Potosí.

BIBLIOGRAPHY

Art of Latin America since Independence (exh. cat., New Haven, Yale U. A.G.; Austin, U. TX, A. Mus.; 1966)

L. Castedo: *Historia del arte ibero-americano*, ii (Madrid, 1988)

P. Querejazu: *La pintura boliviana del siglo XX* (Milan, 1989)

Entre el pasado y el presente: Tendencias nacionalistas en el arte boliviano, 1925–1950 (exh. cat., Washington, DC, Int.-Amer. Dev. Bank, 1996)

PEDRO QUEREJAZU

H

Habana, La. *See* HAVANA.

Haiti, Republic of. Country in the Caribbean. Occupying 26,000 sq. km of the western part of the island of Hispaniola (see fig. 1), it is volcanic in origin and mountainous. Intense cultivation of mountain slopes has caused severe erosion, and despite attempts at reforestation, Haiti is virtually barren of forest cover. The principal agricultural regions are the lowlands of the northern plain, the central plateau, the valley of the Artibonite River and the Cul de Sac plain in the south. Over 100 rivers and streams flow from mountain headlands into the Atlantic to the north, the Gulf of La Gonâve to the west and the Caribbean Sea to the south. The largest cities are the capital of Port-au-Prince and Cap-Haïtien in the north. The majority of Haitians speak French Creole and practise the religion of Vodoun.

I. Introduction. II. Cultures. III. Architecture. IV. Painting, sculpture and other arts. V. Patronage and art institutions.

I. Introduction.

Christopher Columbus landed on Hispaniola in 1492, making it a Spanish colony. In 1664 Louis XIV placed the territory of Haiti under the control of the French West India Company, and renamed Saint-Domingue, it was ceded to France in 1697 by the Treaty of Rijswijk; Spain retained control over Santo Domingo (now the DOMINICAN REPUBLIC) in the east of the island. French hegemony over Saint-Domingue created a wealthy colony with a productive plantation economy built on the labours of African slaves, the Amerindian population having proved too recalcitrant and too physically frail for the gruelling work and maltreatment meted out by their Spanish overlords. Ironically, a Dominican priest, Bartolomé de Las Casas, appalled at the dreadful toll suffered by the Amerindians, suggested the importation of African labour. As a result, Africans arrived in ever-increasing numbers from the beginning of the 16th century until the Haitian Revolution of 1791, led by Toussaint L'Ouverture. Slaves were briefly freed following the French Revolution (1789–99), but slavery was subsequently reimposed, and it was not until independence was declared in 1804 that they were finally emancipated. Despite the country's small size, the nature of its terrain has produced a rich variety of regional differences. The north has tended to retain more vestiges of its colonial past.

1. Map of Haiti

Since it became the first independent republic in the Caribbean, Haiti has suffered a troubled history, particularly in the 20th century. Between 1915 and 1934 the country was occupied by the USA, and in 1950, following a military coup, Dr François 'Papa Doc' Duvalier became president, marking the beginning of a period of dictatorship that lasted until 1991. After another brief period of military rule, Jean-Bertrand Aristide was re-installed as president in 1994.

BIBLIOGRAPHY

J.-B. du Tertre: *Histoire générale des Antilles habitées par les Français* (Paris, 1667)

Le R. Père Labat: *Nouveau voyage aux îles de l'Amérique*, 8 vols (Paris, 1742)

L. E. Moreau de Saint-Méry: *Description topographique, physique, civile, politique et historique de la partie française de l'Ile de Saint-Domingue*, 2 vols (Philadelphia, 1797)

T. Madiou: *Histoire d'Haïti*, 4 vols (Port-au-Prince, 1848–1922)

H. Courlander: *The Drum and the Hoe: Life and Lore of the Haitian People* (Berkeley, 1960)

C. L. R. James: *The Black Jacobins* (New York, 1963)

U. Stebich, ed.: *Haitian Art* (New York, 1978; Ger. trans., 1979)

J. Dayan: *Haiti: History and the Gods* (Berkeley, c.1995)

DOLORES M. YONKER

II. Cultures.

1. AMERINDIAN. The earliest migrants to arrive in the Caribbean were the Amerindians known as Ciboneys. They came from either Venezuela, Yucatán or Florida, or perhaps from all three regions. Motifs carved on their hemispherical stone vessels, axes and other objects resemble those found on stone bowls and early pottery from Florida, particularly in the striations incised on the rims of pots. Forms of flint implements, however, suggest Cuban connections. The finely polished petalloid celts are found throughout the Caribbean, and they appear with clay griddles that coincide with the development of agriculture. When Columbus landed on the north shore of Haiti, most of the inhabitants were Arawak-speaking Tainos, who are believed to have emigrated from the Amazon Basin. Sometimes they are also referred to as 'Ceramic Indians' from the red slip-painted pottery that they produced. They decorated the handles of their vessels with modelled zoomorphic and anthropomorphic figures, probably of religious significance. On his second voyage Columbus brought the Spanish priest Ramón Pané to make a record of the island's culture. Pané noted that these saucer-eyed creatures with relief appliqués represented deities, or *zemis*. *Zemis* were also carved in wood, stone, bone and shell. They presumably served also as amulets or small, personal altars; funeral remains were also packed into baskets elaborated with figures of *zemis*. Such objects were sometimes preserved in caves, which evidently served as shrines; petroglyphs and paintings of *zemis* have also been found in caves. Pané explained the *zemis* as intermediaries to the all-powerful deity. Columbus recorded in his diary that Taino chiefs (*caciques*) had small houses reserved as *zemi* shrines where ceremonies were led by priests in narcotics-induced trances.

Few objects carved in wood have survived, but these exhibit a high level of skill and aesthetic sensibility. The largest, taken from the Ile de La Gonâve, is a squatting figure carved from a hollowed tree trunk, which may have served as the body of a drum. Several examples of *dujos* (squat, four-legged stools with curved seats carved with

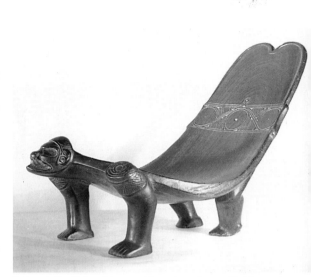

2. Amerindian Taino *dujo*, carved 'gayac' wood seat with inlays and engraving, 780 x 420 x 303 mm, *c.* 1490 (Paris, Musée de l'Homme)

an animal or human head at the front) are preserved in the Museo del Hombre Domeniciano (formerly the Museo Nacional), Santo Domingo; the Heye Foundation, Museum of the American Indian, New York; the British Museum, London; and the Musée de l'Homme, Paris. One has its gold inlay intact, a rare surviving example of Taino goldwork (see fig. 2). A terracotta vessel in the form of a head, with characteristic discoid eyes (Paris, Mus. de l'Homme), was used to hold *cohoba*, the narcotic powder inhaled through tubes to induce trance during religious ceremonies. One curious and common form is the trigonolite, a triangular stone carving that often bears rudimentary human features, the function of which is unknown but could relate to the custom recorded by Columbus's son that each *cacique* had three ritual stones for use in ceremonies for fertility or rain.

Columbus instituted a scheme called *repartimientos* or *encomienda*: a system of distributing land to European settlers that included the Amerindians living there. Within decades of European arrival on Hispaniola the Amerindian population was virtually annihilated, but *encomienda* survived and continued as the foundation of the subsequent plantation economy. The influence of Arawak dwelling-types can be seen in the palisaded walls, porches and lashing building techniques still used in some areas of Haiti.

BIBLIOGRAPHY

I. Rouse: *Prehistory in Haiti* (New Haven, 1939)

E. Mangones and L. Maximilien: *L'Art pré-colombien d'Haïti* (Port-au-Prince, 1941)

F. G. Rainey: *Excavations in the Fort Liberté Region, Haiti* (New Haven, 1941)

M. Aubourg: *Haïti préhistorique* (Port-au-Prince, 1951)

H. J. Braunholtz: 'The Oldman Collection: Aztec Gong and Ancient Arawak Stool', *BM Q.*, xvi/2 (1951), pp. 54–5

I. Rouse: 'Areas and Periods of Culture in the Greater Antilles', *SW J. Anthropol.*, vii (1951), pp. 248–65

——: 'Prehistory of the West Indies', *Science*, i (1964), pp. 419–513

J. E. Cruxent and I. Rouse: 'Early Man in the West Indies', *Sci. Amer.* (Nov 1969), pp. 42–69

M. V. Maggiolo: *Arqueología prehistórica de Santo Domingo* (Singapore, 1972)

I. Rouse: 'Roots: Pre-Columbian', *Haitian Art*, ed. U. Stebich (New York, 1978), pp. 22–5

W. Hodges: 'L'Art rupestre précolombien en Haïti', *Conjonction*, cxliii (1979), pp. 5–38

C. P. Charles, ed.: *Christophe Colomb, les Indiens et leurs survivances en Haïti: Etudes historiques, linguistiques, sociologiques réunies, présentées* (Port au Prince, 1992)

DOLORES M. YONKER

2. AFRO-CARIBBEAN. After the annihilation of the Amerindians it became imperative for the Spanish to find an alternative source of labour to support their evolving colonial regime. Bartolomé de Las Casas's proposal to import Africans, since he believed them more resistant to the tropical climate and more accustomed to fieldwork, was attractive to the Spanish government. Their concurrent incursions into Mesoamerica had absorbed much of their resources, and the prospect of a productive and relatively docile colony was a welcome one. Nicholas de Ovando, the first Governor of Haiti, ordered the importation of the first Africans; by 1520 they constituted almost all of the labour force. By 1521 the Spanish interest in their Caribbean colonies waned, after they had achieved the conquest of Mexico and tapped the gold reserves of South America. The population dwindled and the northern coast fell prey to French and English pirates.

By the 17th century the population of Saint-Domingue was estimated at 6000 adult white and mulatto males and *c.* 50,000 black slaves. By 1775 the slave population had increased to *c.* 250,000, and whites and mulattos numbered *c.* 30,000. These statistics do not, however, include the 'maroons', escapees from slavery or servitude who sought and maintained asylum in isolated mountain valleys, building their own society based on African rather than European models. Although they periodically raided plantations, the maroons were of only peripheral concern until the years preceding the Revolution. Maroon chiefs formed warrior bands in the mountains and established contact with counterparts in the plantations and towns. The revolutionaries considered themselves as Africans, enlisting the aid of spiritual entities derived primarily from the cultures of Dahomey and the lower Congo Basin. The complex of beliefs, customs and ethical standards that united them was called Vodoun, a term deriving from the Fon language of Dahomey, as does much of the terminology and practice of Vodoun (*see also* AFRICAN DIASPORA),

The 18th century was a crucial period in the development of Haitian culture. A rapidly increasing demand for fieldworkers for sugar and indigo plantations coincided with an influx of Congolese immigrants. Afro-Caribbeans of Dahomean origin tended to look down on the more recent, Congolese arrivals, referring to them as *bossale*, a term used in Vodoun to designate an uncontrolled and often violent possession of the spirit. Vodoun is the religion practised by the majority of Haitian people. An essential objective is the invocation of the *loas* (spirits), which constitute a pantheon of 401, all facets of an all-powerful deity referred to as the 'Bon Met' (Fr. Creole: 'Good Master'). During the ritual these spirits are believed to 'mount' their 'horses', that is possess the devotees. The *loas* are divided into groups or 'nations', two of which are dominant: the Rada *loas*, believed wise and essentially beneficent, are named after Alladah, a Dahomean town; the Petro *loas* have linguistic and symbolic connections to

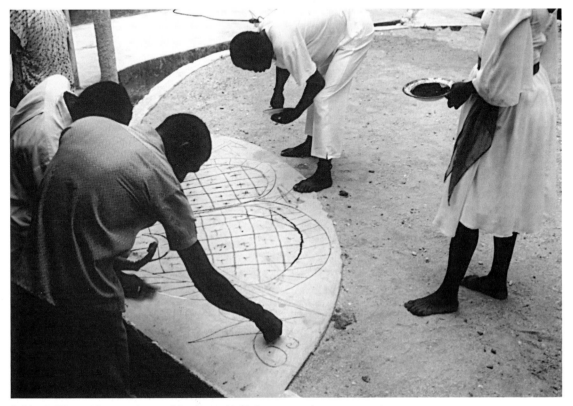

3. Afro-Caribbean *vèvè*, geometric ground drawing used in Vodoun ceremonies

the Republic of Congo and to Angola. The Rada spirits reside over such domestic rites of passage as marriage, initiation and naming; the Petro *loas* are spoken of as tough and fiery, ready to meet the demands of a devotee given the appropriate remuneration. The pantheon of Vodoun reflects sources of other African peoples' migrations: Mande, Bamana, Yoruba, Ewe, Igbo and Akan.

The influence of Africa survives in Haiti in manufacturing techniques, cooperative labour and the construction and design of dwellings in *lakous* (traditional compounds). Such social institutions as the decision-making hierarchy, polygamy, kinship ties and obligations, veneration of ancestors and child-naming have African prototypes. As in some traditional African societies, women play the crucial role in commercial transactions. Certain assumptions are held in common with African ones, including the accessibility to divinity by means of mediating spirits in anthropomorphic form. Music and dance are central to any gathering in Haiti, and both are heavily influenced by Africa in the instruments, dances, songs and ritual objects used, for example the iron standards (*asens*), deriving from Dahomey, and the power objects (*paquets Congo*). Creolized with sequins, ribbons and feathers, these resemble the *minkisi* medicine bundles of the Congo and Zaïre. The tradition of linked terracotta bowls honouring twins is found in various African societies, especially the Fon and Bamana.

Before most ceremonies, geometric ground drawings (*vèvès*) are executed in flour, brick dust, ashes or coloured powders (see fig. 3). Sifted skilfully on to the earth floor of the temple (*houmfort*) by a priest or priestess, they are intended to invite spirits to attend the ceremony and possess their devotees. Each *loa* has a particular *vèvè*, and the complete ensemble of hundreds of drawings constitutes a symbolic set. Similar drawings are made in Angola, Zambia, Zaïre and Nigeria; some authorities have suggested Amerindian prototypes. The emblems and the ceremonies have appeared in the paintings of Haitians who are also adepts (*see* §IV below). The influence of Vodoun on arts also applies to such colourful ritual objects as the sequinned flags emblazoned with sacred *vèvès*, shrine objects, sacred wall paintings and regalia. The complex symbolism used in the service of the *loas* directs the use of certain colours, musical rhythms, dance movements, odours and tastes. The ceremonies are multi-sensory in their appeal.

BIBLIOGRAPHY

J. Price-Mars: *Ainsi parle l'oncle* (Paris, 1928; Eng. trans., Washington, DC, 1983)
M. Herskovits: *Life in a Haitian Valley* (New York, 1937)
H. Courlander: *Haiti Singing* (Chapel Hill, 1939)
L. Maximilien: *Le Vodou haïtien: Rite Radas-Canzo* (Port-au-Prince, 1945)
M. Deren: *Divine Horsemen: The Living Gods of Haiti* (New York, 1953)
M. Rigaud: *La Tradition voudoo et le voudoo haïtien* (Paris, 1953)
A. Métraux: *Le Vaudou haïtien* (Paris, 1958; Eng. trans., London, 1959 and New York, 1972)
H. Courlander: *The Drum and the Hoe: Life and Lore of the Haitian People* (Berkeley, 1960)
R. Bastide: *Les Amériques noires* (Paris, 1967; Eng. trans. as *African Civilizations in the New World*, London, 1971)
J. B. Romain: *Africanisme haïtien: Compilations et notes* (Port-au-Prince, 1978)
R. F. Thompson: *Flash of the Spirit: African and Afro-American Art and Philosophy* (New York, 1983)
Sacred Arts of Haitian Vodou (exh. cat., Los Angeles, CA, Fowler Mus. Cult. Hist., 1995)
L. M. Martínez Montiel, ed.: *Presencia africana en el Caribe* (Mexico City, 1995)

DOLORES M. YONKER

III. Architecture.

Indigenous architectural forms were a composite of available materials and technologies suitable to the climate and life values of the populace. Several types were published by Gonzalez de Oviedo in 1526 (see bibliography). An early type, the caney, was hexagonal in plan with a single door: cane strips or twigs were lashed to heavy corner posts, often trunks of the royal palm; the roof was steeply pitched for drainage. The more common rectangular-plan form with a verandah-like porch, a single doorway and several small windows was probably based on Yoruban prototypes. Like its modern successor, it was thatched with palm leaves or guinea grass, the wattled walls filled with mud, then plastered. It was grouped with storehouses, cookhouses and a community vodoun temple (*houmfort*) in a compound (*lakou*) that stems from African models. Adapted to the Spanish urban grid, this house type, timber-framed, extended three or four rooms deep. High ceilings and heavily shuttered doors and windows with iron fittings reflected a colonial influence. The verandah, providing cool shelter and allowing for social interaction, also evolved in the West Indies.

Columbus ordered earthwork fortifications at once for Hispaniola's vulnerable north coast. Sizeable coastal cities were subsequently protected with more durable fortifications. Typical of the coastal forts was St Louis, constructed in an irregular pentagonal plan around an open court, with five bastions at the corners. It provided a model for subsequent constructions. France was forced to fortify 40 more sites, using designs inspired by Sébastien Leprestre de Vauban (1633–1707), which abandoned easily targeted high walls and towers for a more expansive series of earthen walls surfaced with heavy masonry, taking advantage of topographical features.

Henri Christophe's Citadelle de la Ferrière (inaugurated 1816) remains the ultimate example of West Indian military architecture. Covering one hectare atop a mountain, it is a four-sided fort with a prowlike bastion soaring *c.* 15 m above ground. Below it, the Palais de Sans Souci (*c.* 1813; designed by an English officer, Ferrière) is an imposing three-storey Neo-classical edifice (see fig. 4). The pedimented façade is approached by a monumental double stairway. A remarkable water-system supplied the buildings and irrigated the elegant gardens and its fountains.

In the 18th century the designs of residential buildings were based largely on English Georgian traditions. English pattern books provided examples of classically symmetrical façades, with pediments and engaged pilasters that were adapted to urban as well as plantation houses. The shops and town houses in Jacmel and Cap-Haïtien typify the more modest urban structures. Heavy, masonry ground floors with doors opening on to the street support lighter and often overhanging second storeys, with decorated balconies of iron or turned wood. Exuberantly scrolled ironwork was imported from France and Germany and inspired iron markets to be set up in the major town centres.

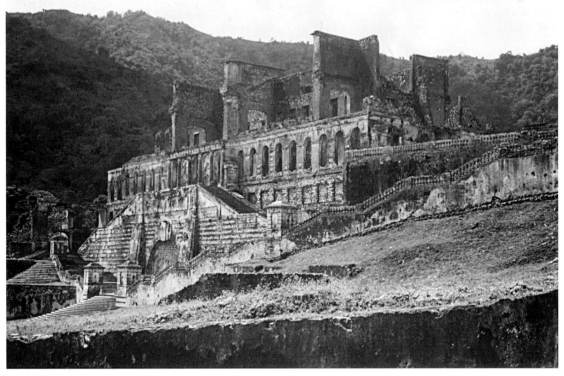

4. Palais de Sans Souci, Milot, *c.* 1813

Few examples of early churches remain. The Old Cathedral, Port-au-Prince, a timbered barrel-vaulted, slate-roofed, five-aisle example, was built in 1720 and was under restoration until destroyed in 1991. The Baroque pedimented façade, with a central tower flanked by curved volutes, was typical. In the 19th century the simple townhouse form in Port-au-Prince exploded in a riot of fanciful towers, fretwork and ornamental colonnades. The development of machines capable of producing decorative multiples challenged Haitian creativity and produced the 'gingerbread' house style. Like the popular louvres and jalousies, fretwork was not only decorative but provided natural ventilation from the prevailing trade winds.

The surviving public buildings in Port-au-Prince exemplify variety and eclecticism. The Roman Catholic cathedral (completed 1915), a confection of pink and white stone, is a Romanesque Revival building. The glistening white Palais National (1918) on the Champ de Mars was designed and built by Georges Baussan during the American occupation (1915–34). ALBERT MANGONES and Robert Baussan (*b* 1937), as well as the younger Pierre-Richard Villedrouin, have contributed to the development of modernism in Port-au-Prince with blocks of flats, office buildings and restaurants. The Musée du Panthéon National Haïtien on the central Champ de Mars owes its blue-tiled conical roof fantasies to the French architect Alexandre Guichard.

UNPUBLISHED SOURCES

Port-au-Prince, Inst. Sauvegarde Patrm. N. [various documents]
D. Didier, D. Elie and P. E. Lubin: *Evolution du système de défense en Haïti* (1983)

BIBLIOGRAPHY

G. F. de Oviedo: *Natural History of the West Indies* (originally pubd Toledo, 1526; Eng. trans., Chapel Hill, NC, 1959)
A. A. Phillips: *Gingerbread Houses: Haiti's Endangered Species* (Port-au-Prince, 1975)
The Afro-American Tradition in Decorative Arts (exh. cat. by J. Vlach, Cleveland, OH, Mus. A., 1978), pp. 122–38
P. Gosner: *Caribbean Georgian: The Great and Small Houses of the West Indies* (Washington, DC, 1982)
E. E. Crain: *Historic Houses in the Caribbean* (Gainesville, 1994)
P. Gosner: *Caribbean Baroque: Historic Architecture of the Spanish Antilles* (Pueblo, CO, 1996)

DOLORES M. YONKER

IV. Painting, sculpture and other arts.

Wealthy colonials were eager consumers of art from abroad: the construction and furnishing of plantation houses and town houses created a demand for luxury items and decorative objects. Foreign artists satisfied most of the demand for portraiture; furniture, ceramics, glassware, jewellery and textiles were imported from France and elsewhere. The Revolution, which terminated slavery, and French hegemony marked the founding of a black republic. The history of Haitian painting and sculpture is documented principally from that time. Henri Christophe, crowned King in 1811, set out to build a monarchy modelled on that of England: the creation and appreciation of art was to be the province of royalty. Christophe's portrait was painted by the English painter Richard Evans (1784–1871), whom Christophe had invited to Haiti to begin a programme of art education (*see* §V below). Christophe's pose and the setting are derived from English historical portrait tradition. One of Evans's students,

Numa Desroches (?1802–?1880), painted naive but informative renderings of Christophe's Palais de Sans Souci at Milot.

Until well into the 20th century, painting was dominated by European styles, mainly French and English Romanticism and French and Italian Baroque. Alexandre Pétion, President of the southern Haitian Republic (1807–19), was determinedly Francophile, patronizing such French painters as J. Barincou, who arrived in Haiti in 1816 and was listed in the Philadelphia City Directory in 1839. His paintings of generals adorned the Palais National. Thimoleon Dejoie (?1800–65) received commissions from President Boyer (1818–43) for historic paintings celebrating his rule: one of his most notable works represented Boyer entering Cap-Haïtien with his generals. Little more than the names of two sculptors important at the time are documented: the quality of Jayme Guilliod's (1800–70) work can be estimated in a drawing for a figure of Toussaint L'Ouverture in chains, which dates from 1851. Louis Edmond Laforesterie (1837–94), who was also noted for heroic portraits, had studied in Paris and later returned there when political turmoil threatened his livelihood. It was the Emperor Faustin Soulouque who appointed and titled the court painter Baron Colbert de Lochard (1804–74). Seven of his religious paintings (1851–3) hung in the Old Cathedral in Port-au-Prince. For Lochard and others the French portrait painter Hyacinthe Rigaud (1659–1743) was a model. By the late 19th century the popularity of the new medium of photography had reduced the market for painted portraits, but historic subjects were still depicted. Edouard Goldman (1870–1930) won a medal at the Exposition Universelle in Brussels (1910) for his interpretation of the *Discovery of America*. Unfortunately the destruction of the Palais National in 1912 destroyed the entire national collection of paintings, including the historical series.

Until the advent in the 1920s of the Indigenist movement, which stimulated a new interest in Haitian culture, Haiti's art was based upon academic models; talented students were sent to Paris for instruction in drawing and painting. However, the literary movements of 1890 and 1915 paved the way to a genuinely Haitian art. The excesses of the first years of the American occupation prompted Goldman in 1920 to paint the *caco* (rebel) chief Charlemagne Perrault crucified. The same subject was to be taken up again by the Cap-Haïtien painter PHILOMÉ OBIN, whose aim was to be the creator of a visual history of his country. In 1944 he sent the representation of Roosevelt's lifting of the American occupation to the newly opened Centre d'Art in Port-au-Prince. At this time a flowering of Haitian arts began. Three generations of artists have emerged from the Centre, including Petion Savain (1906–73) and his pupils George Remponeau (*b* 1916) and Maurice Borno (1917–55). Some, such as Luce Turnier (*b* 1924), ANTONIO JOSEPH and Jacques Enguerrand Gourgue (*b* 1930), work in international styles; others known as 'primitives' were essentially self-taught; including Obin, CASTERA BAZILE, WILSON BIGAUD and RIGAUD BENOIT (see fig. 5). The latter were the principal artists selected to contribute murals (executed in tempera) to the project at Sainte Trinité Cathedral in Port-au-Prince. Artists who are also priests of Vodoun, such as HECTOR HYPPOLITE, ANDRÉ PIERRE and LaFortune Félix, and those who claim to be only observers, such as Benoit, Bigaud and GÉRARD VALCIN, have depicted the dramatic ceremonies of their religion, representing *loas* in imaginative forms.

Sculptors in Haiti have developed a unique medium using scrap metal to cut and pound into figure compositions. Oil-drums have also been transformed into decorative, lacelike representations of everyday scenes, Vodoun archetypes or mythical images of African origin. The drums are processed into flat plates, with designs traced in chalk and then cut out with hammer and chisel, and finished by polishing. Artists working with this form include GEORGE LIAUTAUD, Serge Jolimeau (*b* 1952), Murat Brierre (1938–92) and Gary Darius. Several artists have produced notable wood-carvings, but threats of terrible retribution during the centuries of colonial domination effectively stifled the African legacy of carved masks and figures. Other sculptors have produced brightly painted papier-mâché works, including figures with a carnivalesque gaiety.

The collaboration after *c*. 1944 between fine artists and craftsworkers is exemplified by painted screens and room dividers, the results of a successful union between the local popular painters and cabinetmakers. Most are mass-produced, but some are painted by such artists as Fernand Pierre, Adam Leontus (*b* 1923) and Ghandi Daniel. They depict brilliantly coloured scenes of enchanted landscapes or jungles with fantastic flora and fauna. Wooden storage boxes of various sizes, painted with similar decoration, have become popular with tourists and collectors. Artists who have painted these include Bernard Touissant, Vierge Pierre (*b* 1945) and Jackson Charlot. The painted decoration on 'tap-taps', small open buses used for public transport in Port-au-Prince, includes religious subjects and colourful animals and flowers. Vodoun flags and ritual paraphernalia are also mass-produced for the tourist market, for example painted calabashes or gourds, intended as offerings to *loas*. André Pierre has elevated this medium to an art form. Pottery, weaving and basketwork are also produced by skilled Haitian artists.

BIBLIOGRAPHY

L. E. Moreau de Saint Méry: *Description topographique, physique, civile, politique et historique de la partie française de l'Ile de Saint-Domingue*, 2 vols (Philadelphia, 1797)
P. Thoby-Marcelin: *Art in Latin America Today: Haiti* (Washington, DC, 1959)
Artists of the Western Hemisphere: Art of Haiti and Jamaica (New York, 1968)
S. Williams: *Voodoo and the Art of Haiti* (1969)
P. Apraxine: *Haitian Painting: The Naïve Tradition* (New York, 1973)
S. Rodman: *The Miracle of Haitian Art* (New York, 1973)
J.-M. Drot: *Journal de voyage chez les peintres du voudou* (Geneva, 1974)
E. I. Christensen: *The Art of Haiti* (New York, 1975)
L. G. Hoffman: *Haitian Art: The Legend and Legacy of the Naïve Tradition* (Iowa, 1975)
U. Stebich: *Haitian Art* (New York, 1978; Ger. trans., 1979)
J. Anquetil: *Haïti, l'artisanat créateur* (Paris, 1982)
M.-J. Nadal and G. Bloncourt: *La Peinture haïtienne: Haïtian Arts* (Paris, 1986)
S. Pataki: *Haitian Painting: Art and Kitsch* (Chicago, 1986)
Haïti: Art naïf, art vaudou (Paris, 1988)
S. Rodman: *Where Art Is Joy: The First Forty Years* (New York, 1988)
M. P. Lerrebours: *Haïti et ses peintres*, 2 vols (Port-au-Prince, 1989)
A. Fourbet: *Voodoo Blacksmiths* (New York, 1990)
Black Ancestral Legacy (Dallas, TX, Mus. A., 1990), pp. 87–96

5. Rigaud Benoit: *Baptism of the Assotor Drum*, oil on hardboard, 584×737 mm, *c.* 1950 (Mrs Angela Gross private collection, New Jersey)

Déita: *Objets au quotidien: Art et culture populaire en Haïti* ([Haiti], 1993)
A. Gerald and others: *50 Années de peinture en Haïti, 1930–1980, I: 1930–1959* (Port-au-Prince, 1995)
Sacred Arts of Haitian Vodou (exh. cat., ed. D. J. Cosentino; Los Angeles, CA, Fowler Mus. Cult. Hist., 1995)
V. Poupeye: *Caribbean Art* (London, 1998)

DOLORES M. YONKER, EVA PATAKI

V. Patronage and art institutions.

An infrastructure to provide opportunities for training and sale did not develop beyond the rudimentary stage until the second half of the 20th century. During the colonial period the taste of wealthy planters for luxuries and decorative objects created a market for these arts, but most of it was probably from abroad. Fire, pillage and earthquakes have destroyed the evidence to support this belief, however. Foreign artists also often served as teachers. The Church, usually a source of dependable patronage, was entirely absent from Haiti during the 19th century until the Concordat of 1860, which strengthened the bond between Rome and the Haitian government and church. Some political leaders believed that the presence of art and artists was essential as an index of civilization. Henri Christophe summoned the English artist Richard Evans (1784–1871) to establish an academy of painting and drawing at the Palais de Sans Souci, Milot, and to plan for including painting and drawing in the schools. At the same time, in southern Haiti from 1807 to 1818, Alexandre Pétion authorized the purchase of French works more in keeping with his Francophile taste, and he encouraged French painters, particularly J. Barincou, to establish an art school in Port-au-Prince; he also ordered that the visual arts be included in the school curriculum. Most commissions to Haitian artists were for portraits, although there were a few of historic themes and fewer still of landscapes. From time to time such Haitian painters as Baron Colbert de Lochard (1804–74), appointed court painter to Emperor Faustin Soulouque (*reg* 1849–59), created grand historic tableaux for public edification. Unfortunately, public buildings were often the victim of the most violent eruptions; when they were destroyed, works of art inside also suffered the same fate.

Developments in the 20th century included the foundation of the Académie de Peinture et de Dessin in 1915 by Archibald Lochard (1837–1923) and Normil Charles (who also opened the Académie de Peinture et Sculpture after 1927). There is little evidence of the existence of an art museum in Haiti previous to the museum attached to the Bureau of Ethnology, founded in 1941 by Jacques Romain (1907–44), Haitian ethnologist, poet, novelist, journalist and diplomat. In 1944 the Centre d'Art was established in Port-au-Prince, offering both exhibition

facilities and classes. By 1947 it had mounted 40 exhibitions of pictorial art and one of sculpture, two exhibitions in Cap-Haïtien, one in the USA and one in Paris. A branch of the centre, planned as only the first of five in smaller towns in the country, was opened in 1945 under the directorship of the painter Philomé Obin. In 1958 the Ecole des Beaux Arts was set up in Port-au-Prince. In 1962 the Musée d'Art Haïtien opened under the patronage of the Episcopal College St Pierre. Together the Centre and the museum have organized Haitian representation in European and American museums and galleries. A government-supported Institut National de la Culture et des Arts Haïtiens in Port-au-Prince opened in 1983 with an exhibition of the first generation of Haitian naive artists. Ironically, the support for production of works representing Haitian themes came largely from the USA and Europe: important collections include the Richard and Anna Flagg Collection at the Milwaukee Art Museum, WI; the Davenport Municipal Art Gallery, IA; and the Astrid and Halvor Jaeger private collection in Neu-Ulm, Germany. The Musée d'Art Haïtien in Port-au-Prince retains a foundation collection, as formed by its late Director, PIERRE MONOSIET.

DOLORES M. YONKER

Hastings, Rafael (Eduardo Indacochea) (*b* Lima, 27 March 1945). Peruvian painter and sculptor. He studied at the Pontificia Universidad Católica de Lima, the Université Catholique de Louvain, the Université Libre in Brussels, the Royal College of Art in London and the Ecole du Louvre in Paris. Concerning himself primarily with the figure and with the destiny of the human race, he combined a firm and suggestive draughtsmanship with a balanced use of colour, later favouring intimate, dreamlike atmospheres that are sometimes disquieting or suggestive of profound solitude.

BIBLIOGRAPHY
C. Arambulo: *Rafael Hastings: Dibujos, 1964é1994* (Lima, 1995)
LUIS ENRIQUE TORD

Havana [La Habana]. Capital of Cuba. The city of San Cristóbal de La Habana was established three times between 1514 and 1519: first, on the south coast of Cuba at the mouth of the River Onicaxinal; second, on the north coast, on the banks of the River Casiguaguas (now the Almendares); and finally on the bay that sheltered the port of Carenas. It was founded in honour of the saint and the Indian chief Habaguanex. Its key position in the Caribbean made it the main city of the Spanish Antilles. In 1552 it became the capital, and in 1592 Philip II granted it the status of city. In 1610 its population rose to 10,000. Its grid plan was irregular, and its first streets, which ran parallel to the coast, were winding. In contrast to the monocentric urban development of cities in Latin American colonies, in Havana the activities of the community took place in different areas, giving rise to a polycentric plan that persisted throughout the city's history. Religious activities centred on the cathedral square; political, administrative and military activities on the Plaza de Armas; foreign commerce on the Plaza de S Francisco; and domestic trade on the Plaza Nueva (now Plaza Vieja). Government buildings and the mansions of the wealthiest families were situated around these squares. Until the 19th century the city was enclosed by walls and fortifications. It was protected by the latter until 1762, when the English fleet captured the castle of Los Tres Reyes del Morro. The population had been rising since the beginning of the plantation economy: in 1750 the city had 50,000 inhabitants; by 1827 there were 100,000. As the area within the walls proved to be too cramped, new settlements arose outside them; at the same time the Arsenal was constructed, the shipyard that produced some of the largest ships of the Spanish fleet. In 1837 the city was linked to the hinterland by rail.

Between 1834 and 1838 two basic axes of urban development were decided on, as well as the site for the future political, administrative and cultural centre: the Paseo del Prado and the Paseo de Isabel II (now Parque Central) and, perpendicularly, the Calzada de la Reina and the Paseo Militar (or Paseo Carlos III). Havana's compact growth was on the coastal plateau, with a system of roads dominated by parallel colonnaded avenues: Galiano, Belascoain and Infanta. The demolition of the city walls in 1863 released a central space, of which the upper middle class and the Government took advantage to build public edifices and Neo-classical mansions. In the second half of the 19th century the bourgeois suburbs of El Cerro and El Vedado arose, with their sumptuous mansions.

After the birth of the Republic (1902), Havana assumed a new dimension as a metropolis, expanding to incorporate the surrounding towns of Guanabacoa and Marianao. Social boundaries also appeared: to the west, along the coast, the upper middle class; to the south, the lower middle class; and at the back of the bay, the working class. In 1925 President Gerardo Machado invited the French landscape architect and urban planner J. C. N. Forestier (1861–1930) to draw up an overall plan of Havana, based on the type popularized by Baron Georges-Eugène Haussmann (1809–91). Although it was never realized, it emphasized some public areas and attributed particular value to the sea-front esplanade, the Malecón (see fig.), as well as the Parque de la Fraternidad, Paseo del Prado, Avenida del Puerto and Avenida de los Presidentes. It also proposed a 'green' area via the Almendares River, culminating in the Gran Parque Metropolitano.

In the 1950s the population of Havana exceeded one million. Without strict urban planning, the city grew in disorderly fashion out towards the suburbs, leaving large open spaces as a result of land speculation. The introduction of several rapid-transit avenues (Vía Blanca, 41 and 51, Acosta and S Catalina) proved insufficient to recover the lost environmental cohesion. In 1956 the Town Planning Associates group (Paul Lester Wiener, Josep Lluís Sert and Paul Schulz) drew up a new plan for Havana in accord with the guidelines of the CIAM's Charte d'Athènes. In contrast to the 'office-city' of Forestier, they designed a 'leisure-city', planned to facilitate American tourism. New landmarks, hotels and luxury tower blocks arose. New emphasis was given to the symbolic significance of the civic square conceived by Forestier. The building of the bay tunnel made possible a new expansion zone, East Havana, near the new Presidential Palace, connected to the beaches frequented by the moneyed classes. Plans for the historic centre that would have

Havana, view of the city with the Malecón in the foreground

permanently destroyed any continuity in the urban fabric were also envisaged but never realized.

The Cuban Revolution (1959) brought fundamental changes, including a social redistribution of urban space that transformed land use. Population movement was reduced and growth restricted; only in 1990 did the city's population reach two million. Workers' housing developments were constructed at Habana del Este, Alamar, San Agustín and Atta Habana. The road system was enhanced by construction of ring-roads, and a large green area comprising the Parque Lenin, the Jardín Botánico and the Parque Zoológico Nacional was created. UNESCO's designation of Havana as a cultural heritage site in 1982 meant that the historic centre underwent an important rescue and restoration operation.

See also CUBA, §III.

BIBLIOGRAPHY

Directorio crítico de La Habana (Havana, 1883)
P. Martínez Inclán: *La Habana actual* (Havana, 1925)
I. A. Wright: *Historia documentada de San Cristóbal de la Habana en el siglo XVI*, 2 vols (Havana, 1927)
E. Roig de Leuchsenring: *La Habana, apuntes históricos*, 3 vols (Havana, 1963)
J.-P. Garnier: *Une Ville, une révolution: La Havane* (Paris, 1973)
R. Segre and others: *Transformación urbana en Cuba: La Habana* (Barcelona, 1974)
J. Rallo and R. Segre: *Introducción histórica a las estructuras territoriales y urbanas de Cuba, 1519–1959* (Havana, 1978)
G. Eguren: *La fidelísima Habana* (Havana, 1986)
A. Núñez Jiménez and C. Venegas Fornias: *La Habana* (Madrid, 1986)
E. Leal Spengler: *La Habana, ciudad antigua* (Havana, 1988)
Estrategia, Grupo de Desarrollo Integral de la Capital (Havana, 1988)
F. Chateloin: *La Habana de Tacón* (Havana, 1989)
G. Mosquera: *Contemporary Art from Havana* (London, 1989)
C. Venegas Fornias: *La urbanización de las murallas: Dependencia y modernidad* (Havana, 1990)
M. E. Martin Zequiera and E. L. Rodríguez Fernández: *Guía de arquitectura: La Habana colonial (1519–1898)* (Havana and Seville, 1993)
N. Stout and J. Rigan: *Havana/La Habana* (New York, 1994)
J. Dec. & Propaganda A., xxii (1996) [issue dedicated to Cuba]
R. Carley: *Cuba: 400 Years of Architectural Heritage* (New York, 1997)
R. Segre, M. Coyula and J. Scarpaci: *Havana: Two Faces of the Antillean Metropolis* (Chichester, NY, 1997)

ROBERTO SEGRE

Heep, (Adolf) Franz (*b* Fechbach, Silesia, 24 July 1902; *d* Paris, 4 March 1978). Brazilian architect of Silesian birth. He studied architecture in Germany at the Kunstschule, Frankfurt am Main, where he met Adolf Meyer (1881–1929) and became his assistant in Frankfurt until Meyer's death. He then moved to Paris and worked for Le Corbusier. In 1932 he set up an office with Jean Ginsberg (1905–83), designing blocks of flats that successfully adapted the design principles of Le Corbusier's villas to the typology of the infill building, and he became well known in the Paris region. He left Paris during World War II and moved to Brazil, where he settled in São Paulo, at

first working in engineering and construction offices and then establishing his own architectural office in 1950. He became a naturalized citizen in 1952 and obtained official recognition as an architect in 1959. Since 1870 the city of São Paulo had shown a marked preference for foreign architects; Heep therefore found himself in a favourable environment and was able to make a considerable mark on the city centre with his buildings. His work was characterized by rigorous technical design in construction, specifications and finishes, and by careful planning; it was strongly influenced by Le Corbusier but also by German design of the 1920s and by innovative design in Brazil. Important examples in São Paulo include the Itália building (1956–9), an office building designed as a triangular tower with curved corners, covered with *brise-soleil*, that was the tallest structure in Brazil; the Lausanne (1953–8) and Lugano-Locarno (1962) buildings, blocks of apartments; and the church of S Domingos, designed in 1952, attached to the Dominican convent and parish headquarters at Perdizes, on which he worked for 14 years and which he considered to be his finest work. He taught at the Mackenzie School of Architecture, São Paulo, and also worked for the United Nations (1965–8) as a member of the Architecture Council for Latin American countries.

BIBLIOGRAPHY

C. A. C. Lemos: *Arquitetura brasileira* (São Paulo, 1979)
Y. Bruand: *Arquitetura contemporânea no Brasil* (São Paulo, 1981)
W. Zanini, ed.: *Historia geral da arte no Brasil* (São Paulo, 1983)
C. Gati: 'Perfil de Arquiteto: Franz Heep', *Projeto*, 97 (1987), pp. 97–104

JULIO ROBERTO KATINSKY

Helsby (Hazel), Alfredo (*b* 1862; *d* 1933). Chilean painter. He studied painting under Alfredo Valenzuela Puelma (1856–1909) *c*. 1885, and under Juan Francisco González, before travelling in 1907 on a government grant to Europe, where he exhibited at the Salon de la Société des Artistes Français in Paris and at the Royal Academy of Arts in London. While in Europe he became acquainted with contemporary artistic tendencies and with the work of earlier artists, notably Turner, whose physical representation of light-filled, wet atmosphere he emulated. Helsby, who was attracted from an early age to landscape painting, superimposed the most delicate hallucinations on visions of reality; in paintings such as *Rainbow over the Canals of Chiloé* (Santiago, Mus. N. B.A.) he pulverized the plasticity of his forms with a puzzling technique that transformed them into a diaphanous surface of air, light and reflections. Such interests affected also his outdoor figure scenes, such as *Paseo Atkinson* (Valparaíso, Mus. Mun. B.A.), which were essentially naturalistic in approach.

One constant factor in Helsby's mature painting was his handling of the material properties of his paints. He used a palette knife to work on dense multi-coloured paint, creating suggestive textural effects. Through a skilful use of smudging and the density of his surfaces he represented plants and earth in harmony with translucent shadows and the vibrant transparency of distant elements and skies. His colour schemes often consist of a single dominant hue together with shades of the same colour. He also painted portraits, for example of *Juan Mochi* (see Galaz and Ivelić, p. 144). The artist signed himself either as Alfredo Helsby or Helsby Hazel; he is usually referred to as Alfredo Helsby Hazel.

BIBLIOGRAPHY

G. Galaz and M. Ivelić: *La pintura en Chile desde la colonia hasta 1981* (Santiago, 1981), pp. 125–6, 128–9, 144–53, 179, 187
Alfredo Helsby (exh. cat. by F. de la Lastra, Santiago, 1983)
Alfredo Helsby (exh. cat. by C. Lastarria, Valparaíso, 1984)

CARLOS LASTARRIA HERMOSILLA

Hernández (Navarro), Agustín (*b* Mexico City, 29 Feb 1924). Mexican architect. He graduated in architecture from the Universidad Nacional Autónoma de México and was admitted to the profession in 1954. His early work, mostly in the area of housing, consisted of simple, functional buildings in which he gradually espoused a more innovative sculptural expression based on a rigorous but varied geometric style. The Escuela de Ballet Folklórico (1968), Mexico City, was the first of a series of richly plastic works inspired by Mexico's Pre-Columbian heritage, in which autochthonous features are treated in a wholly contemporary manner. There followed a series of houses in Mexico City in which Hernández experimented with various geometrical modules: the hexagon was the basis for the Casa Silva (1969), the circle for the Casa Alvárez (1971), and the triangle for the Casa Amalia Hernández (also 1971). In 1971 Hernández was also commissioned to design the Heroico Colegio Militar at Tlalpan, a monumental complex of buildings to the south of Mexico City (completed 1976; in collaboration with Manuel González Rul). The school's design recalls Pre-Columbian ceremonial sites and forms, with some of the individual units having sloping walls that accentuate the reclamation of cultural roots. Similar forms appear in a contemporary hospital (1974–6) for the Instituto Mexicano del Seguro Social, Mexico City, which again demonstrates the architect's sculptural and formal interests.

Among Hernández's most imaginative works, however, is his own highly innovative studio (1976) at Bosques de las Lomas, Mexico City, which is notable both for its construction techniques and for its formal and functional approach. Analogous to a tree, the studio's slender central unit or 'trunk' rises from a steeply wooded hillside and is crowned by four interlocking pyramidal forms, two under tension and two under compression. Hernández returned to curvilinear geometries for the Casa Neckelmann (1979) and Casa Betech (1981): the design of the former, partially subterranean, is of distinctive mollusc-shell form, a spiriform volumetric progression derived from the golden section. A more abstruse form, producing a remarkable array of interior spaces on two main levels and an even more remarkable external shape, was used in his next non-residential building, the Centro de Meditación (1984–6) at Cuernavaca, Morelos. The principal forms here are derived from the *mandala* of Hinduism and comprise an imaginative interplay of open cylindrical spaces interposed within essentially rectangular units.

Later works by Hernández use complex solid geometries and display structural virtuosity, as in one of the most remarkable of late 20th-century houses, the Casa en el Aire (1988–91), in Bosques de las Lomas, Mexico City. Here two closely spaced rectilinear concrete pylons, both pierced by huge circular voids, rise from a steep slope. A rhombic-section steel-framed element, comprising the living accommodation, rests on the hilltop at one end and penetrates the two circular voids of the pylons to different

depths at the other. Hernández's main building material was concrete, and all his constructions are notable for the high quality of their finish and their imaginative functional solutions. His work also always had an element of innovation, however, since he regarded creativity as being inextricably linked to the originality and uniqueness of each project. Moreover, his deep understanding of structural geometry, which allowed him to create surprising shapes and spaces, was always complemented by consultation with specialist engineers, and this enabled him to construct some of the most controversial buildings in modern Mexican architecture.

WRITINGS
Gravedad, geometria y simbolismo (Mexico City, 1989)

BIBLIOGRAPHY
'Análisis de la actividad arquitectónica de Agustín Hernández', *Constr. Mex.*, 9 (1978), pp. 6–16
L. Noelle: *Agustín Hernández: Arquitectura y pensamiento* (Mexico City, 1982)
C. Bürkle: 'An Architect for Mexico', *Conn. A.*, 27 (1982), pp. 62–7
J. Glusberg: 'Agustín Hernández', *Seis arquitectos mexicanos* (Buenos Aires, 1984)
L. Noelle: 'Agustín Hernández', *Arquitectos contemporáneos de México* (Mexico City, 1988)
P. Quintero, ed.: *Modernidad en la arquitectura mexicana* (Mexico City, 1990), pp. 161–200
L. Noelle: *Agustín Hernández* (Barcelona and Mexico City, 1995)
Augustín Hernández, arquitecto (Mexico City, 1998)

LOUISE NOELLE

Hernández [Morrillo], Daniel (*b* ?Hurpay, Huancavelica, 1 Aug 1856; *d* Lima, 23 Oct 1932). Peruvian painter and draughtsman. In 1860 he was brought to Lima and at an early age displayed considerable artistic talent. In 1870 he started studying with the Italian painter Leonardo Barbieri, and in 1875 he went to Europe to study under Lorenzo Valle, having won a scholarship from the Peruvian government. In Paris he met Ignacio Merino, who recommended that he study in Rome. He spent ten years in Italy absorbing the aesthetics of Classical art then returned to Paris, where he met Mariano Fortuny y Marsal, Francisco Pradilla, Armando Villegas and others. He took part in numerous exhibitions, particularly Artistes Français, where he was commended in 1890; he won the gold medal at the Exposition Universelle in 1900, and in 1901 he was awarded the Legion d'Honneur. From 1912 he spent some time in Montevideo and Buenos Aires, returning to Europe *c.* 1914. In 1917 he settled in Lima and in 1919 set up the Escuela Nacional de Bellas Artes at the invitation of President José Pardo, continuing as its Director until his death. His works include watercolours, drawings and murals, and his themes range from seascapes, landscapes, still-lifes and historical paintings to portraits. He is perhaps best known for his *Reclining Women* series, typical of which is *The Idle Lady (La Perezosa)* (1906; see colour pl. XIV, fig. 2). His portraits included *D. Nicolás de Piérola* (1889; Lima, Mus. N. Hist.) and *Sra Mesones* (1883; Lima, Pin. Mun.). His work has been criticized for portraying a slightly idealized, superficial world; he was concerned 'with the strength of the lines, sincerity of vision' and with 'avoiding frivolous preoccupation with superfluous details' (Villacorta Paredes).

BIBLIOGRAPHY
J. Villacorta Paredes: *Pintores peruanos de la República* (Lima, 1971), pp. 34–5

J. A. de Lavalle and W. Lang: *Pintura contemporánea, I: 1820–1920*, Col. A. & Tesoros Perú (Lima, 1975), pp. 116–27
C. Zúñiga Segura: *Daniel Hernández: Imagen y presencia* (Lima, 1989)

W. IAIN MACKAY

Hernández, Santiago (*b* Mexico City, 1833; *d* Mexico City, 1908). Mexican illustrator and lithographer. He studied at the Escuela Militar de Ingenieros, Mexico City. When the school was reorganized following the American invasion of 1847, he was commissioned to execute portraits of the *Child Heroes*. During the French intervention he founded a number of political newspapers, including *El espectro*, *El perico* and *Palo de ciego*, for which he executed caricatures and lithographs. Persecution forced him into hiding, but he re-emerged in 1865 as interpreter and chief draughtsman to the Comisión Científica del Imperio. Following the death in 1868 of Constantino Escalante, Hernández became the caricaturist for the periodical *La orquesta*; he also produced lithographs for *El artista* (e.g. *The Rattle*; see Fernández, fig. 227). He collaborated with Hesiquio Iriarte on, among other things, illustrations for *El libro rojo* (1870), a novel by Vicente Riva Palacio, director of *La orquesta*. At the time of his death Hernández was producing caricatures for *El hijo del ahuizote*.

BIBLIOGRAPHY
J. Fernández: *Arte moderno y contemporáneo de México* (Mexico City, 1952, R/1983)
R. Alvárez: *Enciclopedia de México* (Mexico City, 1966)
C. Díaz y de Ovando: 'El grabado comercial en la segunda mitad del siglo XIX', *Hist. A. Mex.*, 85–6 (1982)

ELOÍSA URIBE

Hernández Cruz, Luis (*b* San Juan, 1936). Puerto Rican painter, printmaker, sculptor and draughtsman. He studied painting at the University of Puerto Rico, receiving his BA in 1958, and completed his MA at the American University in Washington, DC, in 1959. From the 1960s he was one of the most consistent advocates of abstract painting in Puerto Rico, and in 1977 he co-founded Frente with artists Lope Max Díaz, Antonio Navia and Paul Camacho, with the aim of bringing together abstract and experimental painters and of renewing artistic institutions in Puerto Rico. Hernández Cruz was also a founder-member and President of the Congress of Abstract Artists that took place in Puerto Rico in 1984.

In his paintings Hernández Cruz used landscape and figures as points of reference for a symbolic language of abstract and organic forms. The lyrical, evocative qualities of colour and the material, rhythmic qualities of textual surfaces were fundamental in the evolution of his abstract vocabulary. During the 1960s he explored intense colour under the influence of Fernando de Szyszlo and Rufino Tamayo before turning to more structural concerns that he explored also in constructions and totem-like sculptures. In the 1970s he was concerned primarily with the organization of forms in space, but he later returned to the human figure in a dynamic neo-expressionist style of heavy impasto and vibrant colours.

BIBLIOGRAPHY
Luis Hernández Cruz: Pinturas y grabados (exh. cat. by M. Traba, San Juan, Inst. Cult. Puertorriqueña, 1972)
Luis Hernández Cruz: Obra reciente: Pinturas (exh. cat. by M. de Tolentino, Ponce, Mus. A., 1984)

Luis Hernández Cruz: Pinturas y dibujos (exh. cat. by M. Benítez, San Juan, Inst. Cult. Puertorriqueña, Arsenal Puntilla, 1985)

M. de Tolentino: *Luis Hernández Cruz: Tiempos y formas de un itinerario artístico* (San Juan, 1989)

MARI CARMEN RAMÍREZ

Herrán, Saturnino (*b* Aguascalientes, 9 July 1887; *d* Mexico City, 8 Oct 1918). Mexican painter and teacher. After moving to Mexico City he entered the Escuela Nacional de Bellas Artes in 1904, studying drawing under Antonio Fabrés and painting under Germán Gedovius; he in turn taught there from 1910 until his premature death. His first paintings took as their subjects allegories of nature (e.g. *Flora*, 1910; Mexico City, Sergio Zaldívar priv. col., see Ramírez, 1989, pl. 3), local mythology (e.g. *The Legend of the Volcanoes*, 1910; Saltillo, Ateneo Fuente) and scenes of work that were either optimistic in tone (e.g. *Labour*, 1908; Aguascalientes, Mus. Aguascalientes), conceived as allegories (e.g. two decorative panels for the Escuela de Artes y Oficios, 1910–11; Mexico City, Inst. Poli. N.) or imbued with social criticism through an emphasis on the oppression and misery of the workers, as in *Glass Grinder*, *Pot Sellers* (both 1909; Aguascalientes, Mus. Aguascalientes).

Herrán used very free brushwork to capture the vibration of light and to create a blurred effect for his backgrounds, but he outlined his figures with clearly marked contours. Among the diverse influences on his early paintings were the work of Frank Brangwyn, Joaquín Sorolla y Bastida and Ignacio Zuloaga. In 1912 he began to stress local colour in his decadent, *fin-de-siècle* subject-matter by setting his scenes against colonial Mexican architecture: in *Blind Men* (1914; Aguascalientes, Mus. Aguascalientes), for instance, the despairing figures seem crushed beneath the weight of the cupola of the church of Loreto, while the tragic agony of the old man in *The Last Song* (1914; Aguascalientes, Mus. Aguascalientes) is given shelter by the façade of the Sagrario Metropolitano. The refinement of Herrán's draughtsmanship and use of colour balances the naturalistic imagery in these works combining drawing with watercolour, a technique adapted from Spanish painters such as Néstor de la Torre.

From *c.* 1913 Herrán transcended the late 19th-century zeal for recording picturesque local customs by charging his representations with symbolic significance, and in so doing he became one of the principal exponents of the nationalist modernism that came to dominate Mexican art until the mid-1920s. In one of his most representative paintings, *The Offering* (1913; Mexico City, Mus. N. A.), he treated the theme of the three ages of man, while in paintings such as *El jarabe* and *La tehuana* (both 1914; Aguascalientes, Mus. Aguascalientes) the *fin-de-siècle* motif of the femme fatale was tinged with surprising vernacular suggestions.

From *c.* 1915 Herrán made a significant contribution to the iconic expression of the 'nation's soul', a task that was considered fundamental by the members of his generation. Herrán felt that Mexican identity was singled out and defined by the fact that it was of mixed race, and he devoted his most important late works to expressing this sense of national identity, exalting the spiritual beauty of the native people of Mexico in exquisite drawings of

Indians whose languid silhouettes stand out against freely-interpreted backgrounds of Pre-Columbian sculpture. He celebrated Mexico's Spanish roots in the series *Las criollas*, culminating in two allegorical oil paintings, *The Shawl* (1916) and *Criolla with Mantilla* (1917–18; both Aguascalientes, Mus. Aguascalientes), which depict a number of female nudes half-covered by the typical garments indicated by the titles and surrounded by emblematic fruits, with the Baroque profiles of the Sagrario and Mexico City Cathedral rising up in the background.

From late 1914 until his sudden death from a gastric infection in 1918, Herrán worked on *Our Gods* (see exh. cat., pp. 40–41), a mural frieze in triptych form for the Teatro Nacional (now the Teatro de Bellas Artes), which was then under construction in Mexico City. Although he completed only one of the lateral panels, representing the native worshippers (Mexico City, Alicia G. de Herrán priv. col.), the project survives in three watercolour drawings (Aguascalientes, Mus. Aguascalientes). The lateral wings were to represent a double procession of Indians and Spaniards coming to pay tribute to the syncretic deity of the central panel, in which the images of Christ and Coatlicue coalesce in a vivid expression of his theme concerning the mixture of the two races.

BIBLIOGRAPHY

M. Toussaint: *Saturnino Herrán y su obra* (Mexico City, 1920)

L. Garrido: *Saturnino Herrán* (Mexico City, 1971)

F. Ramírez: *Saturnino Herrán* (Mexico City, 1976)

Saturnino Herrán, 1887–1987 (exh. cat., essay F. Ramírez; Mexico City, Inst. N. B.A., 1987)

F. Ramírez and others: *Jornadas de homenaje a Saturnino Herrán* (Mexico City, 1989)

M. Toussaint: *Saturnino Herrán y su obra* (Mexico City, 2/1990)

V. Muñoz: *Herrán Saturnino: La pasión y el principio* (Mexico City, 1994)

FAUSTO RAMÍREZ

Herrerabarría, Adriano (*b* Santiago, Veraguas, 28 Dec 1928). Panamanian painter and teacher. He completed his studies in art and education in 1955 in Mexico City at the Academia San Carlos and at the Escuela Normal Superior. In Panama, Herrerabarría was for many years a teacher and, later, Director of the Escuela Nacional de Artes Plásticas (former Academia, then Escuela, Nacional de Pintura). His early paintings reflect the influence of social realism and of the Mexican muralists. In later works, such as *Earth of Races* (1981, Panama City, artist's col., see Wolfschoon, p. 264), a dramatic image of faces trapped in a web of biomorphic shapes, political, social and racial issues are intertwined with mystical and Existentialist themes and organic forms derived from Surrealism.

BIBLIOGRAPHY

R. Miró: 'Cuatro artistas panameños contemporáneos', *Ocho expresiones artísticas* (exh. cat., Panama City, Cent. Convenciones Atlapa, 1981)

E. Wolfschoon: *Las manifestaciones artísticas en Panamá* (Panama City, 1983)

Herrerabarría: Desfase (exh. cat. by E. Wolfschoon and others, Panama City, Mus. A. Contemp., 1997)

MONICA E. KUPFER

Herrera Toro, Antonio (*b* Valencia, 16 Jan 1857; *d* Caracas, 26 June 1914). Venezuelan painter and writer. He studied in Caracas under Martín Tovar y Tovar, José Manuel Maucó and Miguel Navarro y Cañizares, before being awarded a government fellowship in 1875 to study

in Europe. He went to Paris and two years later to Rome, where he was taught by Modesto Faustini (1839–91), Cesare Maccari and Francesco Santoro (*b* 1844). He returned to Venezuela in 1880. From 1882 he taught at the Academia de Bellas Artes in Caracas and distinguished himself as a portrait painter and as a painter of historical scenes in an academic style: among his best-known works are *Fire Started by Ricaurte in San Mateo* (1883) and *Self-portrait, Standing* (1895; both Caracas, Gal. A. N.). He also completed the decoration of Caracas Cathedral in 1883 and of the soffit of the Municipal Theatre of Valencia in 1892. That year he also founded the humorous publication *El Granuja*, and from 1909 to 1912 he was Director of the Academia de Bellas Artes.

WRITINGS
Manchas artísticas y literarias (1898)

BIBLIOGRAPHY
J. Calzadilla: *Antonio Herrera Toro* (Madrid, n.d.)
A. Boulton: *Historia de la pintura en Venezuela*, ii (Caracas, 1972)
Antonio Herrera Toro, 1857–1914: Final de un siglo (exh. cat. by F. da Antonio and others, Caracas, Gal. A. N., 1995)
MARÍA ANTONIA GONZÁLEZ-ARNAL

Herreran style. *See* ESTILO DESORNAMENTADO.

Herrería, Julián de la [Cervera, Andrés Campos] (*b* Asunción, 1888; *d* Valencia, Spain, 1937). Paraguayan painter, engraver and ceramicist. He studied at the Real Academia de Bellas Artes de San Fernando, Madrid, and spent six years studying in Paris in private studios. His first exhibition, in Asunción in 1920, marked a turning-point in the history of Paraguayan art. He showed oil paintings inspired principally by Cézanne and the Fauvists, and the arbitrary colours and heavy impasto of his stylized landscapes introduced local artists to the innovations of Impressionism and Post-Impressionism previously unknown in Paraguay; as a result, other painters began to use them in their work. In his engraving, Herrería used a simplified line based on flat contrasts of colour. From 1922 he began to work in ceramics, developing themes derived from Pre-Columbian Latin-American traditions and scenes of daily rural life in Paraguay. His plates and small sculptures had designs influenced by Art Deco. The series of motifs used in his ceramics show a deep understanding of Paraguayan humour and popular art and give a vivid portrait of everyday life that transcends the merely picturesque.

BIBLIOGRAPHY
M. A. Fernández: *Art in Latin America Today: Paraguay* (Washington, DC, 1969)
J. Plá: *El espíritu del fuego: Biografía de Julián de la Herrería* (Asunción, 1977)
T. Escobar: *Una interpretación de las artes visuales en el Paraguay* (Asunción, 1984)
TICIO ESCOBAR

Hidalga (y Musitu), Lorenzo de la (*b* Alava, Spain, 1810; *d* Mexico City, 1872). Spanish architect, painter and teacher, active in Mexico. He graduated as an architect from the Real Academia de Bellas Artes de S Fernando, Madrid, but also worked in painting, sculpture and pastel miniatures. In 1836 he worked in Paris under Henri Labrouste (1801–75), and in 1838 he went to Mexico City, where he opened a school of drawing. As one of the

outstanding architects in Mexico at the time, he was made an *académico de mérito* of the Academia de S Carlos and its director of architecture. His chief work was the Teatro de Santa Anna (1842–4; later Teatro Nacional; destr. 1901), Mexico City, a Neo-classical building that was for a long time the most costly in the city. The principal façade had a portico with four large Corinthian columns rising through two storeys. He also rebuilt the dome (1845–8) of the side chapel of the church of S Teresa la Antigua, Mexico City. His solution was a Neo-classical dome supported by a double drum, producing interesting light effects in the interior. The windows of the upper drum, concealed by an incomplete vault rising from the lower one, illuminate paintings around the bottom of the dome. Few of his other works have survived.

BIBLIOGRAPHY
E. García Barragán: 'Lorenzo de la Hidalga', *Del Arte: Homenaje a Justino Fernández* (Mexico City, 1977)
J. Urquiaga and V. Jiménez: 'Antecedentes: El antiguo teatro nacional', *La construcción del Palacio de Bellas Artes* (Mexico City, 1984)
MÓNICA MARTÍ COTARELO

Hippolite, Hector. *See* HYPPOLITE, HECTOR.

Hispaniola. Caribbean island lying between Puerto Rico and Cuba. Christopher Columbus arrived on the island in 1492 and named it the Isla Española. It is divided into two countries: HAITI in the west and the DOMINICAN REPUBLIC in the east. □

Hispano-American artists. *See* LATIN AMERICAN ARTISTS OF THE USA.

Hlito (Oliveri), Alfredo (*b* Buenos Aires, 4 May 1923; *d* 1993). Argentine painter. He studied at the Escuela Nacional de Bellas Artes in Buenos Aires from 1938 to 1942 and in 1945 was a founder-member of the ASOCIACIÓN ARTE CONCRETO INVENCIÓN. He played a leading role in the development of abstract art in Argentina during the 1940s and 1950s. From 1945 he worked in a Constructivist style that took as its starting-point the notion of a line fracturing the plane in the work of Joaquín Torres García; by the early 1950s this was elaborated into compositions of pure geometrical forms. From 1954 to 1962 he explored effects of vibrating colour, first using discernible forms conveyed in a pointillist technique and then by juxtaposing lightly applied flat brushstrokes in diluted colours to create a shimmering veil-like surface (e.g. *Espectro No. 4*; see colour pl. XV, fig. 1).

While living in Mexico from 1963 to 1973, Hlito developed a vocabulary of rhythmic, fundamentally organic forms using curved lines; these led to acrylic paintings in a vertical format in which vibrant atmospheres, interpenetrated by dynamic planes, generated monumental spaces of glittering colour. In 1976 he returned to earlier experiments but with a greater expressive force. In 1985 he was awarded the Premio Di Tella. He exhibited at the Salon des Réalités Nouvelles in Paris (1948), at the São Paulo Biennale (1954, 1975), at the Venice Biennale (1956) and at the second Exposition de l'Art Concret (Zurich, Ksthalle, 1960).

BIBLIOGRAPHY

R. Brill: *Hlito* (Buenos Aires, 1981)
Alfredo Hlito: Obra pictórica, 1945–1985 (exh. cat. by M. Nanni, Buenos Aires, Mus. N. B.A., 1987)

HORACIO SAFONS

Holguín, Melchor Pérez de (*b* Cochabamba, *c.* 1665; *d* Potosí, *c.* 1730). Bolivian painter. In 1693 he was working in Potosí, Bolivia, the Spanish empire's largest city and most important centre of mining. He was highly esteemed and developed a characteristic style that emphasizes the facial features. His images of saints, mystics and ascetics reflect the religious ideals of the Hispano-American Baroque. He signed many of his paintings and portrayed himself in some of them, for example the *Last Judgement* (1708; Potosí, S Lorenzo).

In his early works he depicted ascetic saints famed for their acts of charity, such as *Fray Pedro de Alcántara* and *St Juan de Dios* (both La Paz, Mus. N. A.), using grey tones. At the end of the 17th century he incorporated a wider range of colours into his paintings and began to work on a larger scale, as in the *Last Judgement*, which includes scenes of the *Glory* and *Hell*. This theme became popular throughout the Viceroyalty, with compositions of this type appearing in rural highland churches, such as those at Carabuco and Casquiaviri. Holguín later began his series of *Evangelists* (Potosí, Convent of S Francisco). Among the best are the half-length *St Matthew* (Potosí, Mus. N. Casa Moneda), the series (1724) after engravings by Marten de Vos and those in the Museo Nacional, La Paz. His most famous painting, the *Entry into Potosí of the Viceroy Diego Morcillo* (1716; Madrid, Mus. América), shows a good example of the sumptuous Baroque festivals held by the imperial city. Late works depict the infancy of Christ, such as in the *Rest on the Flight into Egypt* (*c.* 1715; La Paz, Mus. N. A.). Holguín's work was extremely influential; his paintings were copied in the 19th century, and in documents he is sometimes described as 'Brocha de Oro'. Among his disciples were Gaspar Miguel de Berrío (*b* Potosí, 1706) and two later painters only known as Ecoz and Carabel.

BIBLIOGRAPHY

J. de Mesa and T. Gisbert: *Holguín y la pintura virreinal en Bolivia* (La Paz, 1977)
J. Bernales Ballesteros: *Historia del arte hispano-americano, siglos XVI al XVIII* (Madrid, 1987)
L. Castedo: *Historia del arte ibero-americano* (Madrid, 1988)
D. Bayon: *Historia del arte sudamericano* (Barcelona, 1989)
Potosí: Colonial Treasures and the Bolivian City of Silver (exh. cat., New York, Americas Soc. A. Gal., 1997)
R. Gutiérrez, ed.: *Pintura, escultura y artes útiles en Iberoamérica, 1500–1825* (Madrid, 1995)

TERESA GISBERT

Homar, Lorenzo (*b* San Juan, 1913). Puerto Rican printmaker, painter, illustrator and teacher. He grew up in New York City and from 1937 to 1942 studied there at the Art Students League and at Pratt Institute before doing four years' military service. After World War II, he returned to New York as a designer for Cartier, the jewellers where he had been apprenticed as a student, and studied at the Art School of the Brooklyn Museum, where he met Max Beckman and Rufino Tamayo. In 1950 he returned to Puerto Rico, where he was the principal founding member of the Centro de Arte Puertorriqueño and joined the staff of the Division of Community Education, becoming its Graphic Arts Director in 1951

Homar is credited as the artist most responsible for promoting printmaking in Puerto Rico. He trained other important artists, such as Antonio Martorell, José Rosa and Myrna Báez, and ran workshops at Cali in Colombia and in Havana, Cuba, helping to extend his influence further afield in Latin America. While serving as director of the graphic workshop of the Instituto de Cultura Puertorriqueña, the most important in Puerto Rico, from 1957 to 1970, he produced more than 500 posters and several portfolios of screenprints, such as *Casals Portfolio* (1970), which were admired for their distinctive style and sophisticated technique. As many as 30 to 40 manual runs were used in the making of each poster, which were characterized also by an expressive use of typography and textures.

Screenprinted posters, woodcuts, engravings, political cartoons, book illustrations, logos and stage designs all feature in Homar's prolific production. From 1964 to 1972 he produced a series of monumental woodcuts in which he combined political or poetic texts with highly evocative images and expressive rhythmic incisions. Assimilating aspects of American Realism and German Expressionism, he also continued producing paintings on social realist themes rendered in a neat, meticulous style that suggests a printmaker's rigour and precision.

BIBLIOGRAPHY

Exposición retrospectiva de la obra de Lorenzo Homar (exh. cat. by R. Arbona, M. Benítez and M. C. Ramírez, Ponce, Mus. A., 1978)
Puerto Rican Painting: Between Past and Present (exh. cat. by M. C. Ramírez, Washington, DC, Mus. Mod. A. Latin America, 1987)

MARI CARMEN RAMÍREZ

Honduras, Republic of. Central American country. It is bordered by Guatemala and El Salvador to the west and south-west and by Nicaragua to the south-east. Honduras has a 640-km coastline on the Caribbean Sea in the north and a narrow access to the Pacific through the Gulf of Fonseca in the south (see fig. 1). It is the second largest republic in Central America, its area of *c.* 112,100 sq. km dominated by mountainous terrain, with narrow coastal lowlands. Because of its elevation, much of the country has a moderate tropical climate, and the vegetation ranges from pine, oak and broadleaf monsoon forests in the temperate highlands to dense mangrove thickets, open savannah and vast tropical rain-forests in the humid coastal lowlands. Communications are relatively undeveloped, particularly in the east, and the population is mainly rural, about 70% living in the mountain valleys, where Comayagua, the former capital, and TEGUCIGALPA, the present capital, are also located. Honduras was colonized by Spain after 1502, becoming independent in 1821 and an autonomous state in 1838. About 90% of its people are now mestizo (of mixed European and Indian descent).

I. Introduction. II. Architecture. III. Painting, graphic arts and sculpture. IV. Patronage and institutions.

I. Introduction.

In 1502, during Christopher Columbus's fourth and final voyage to the Americas, Europeans saw for the first time

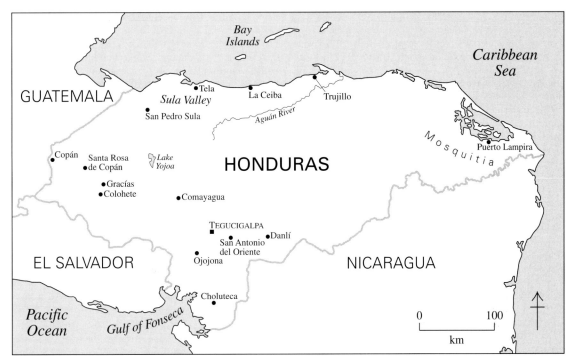

1. Map of Honduras; TEGUCIGALPA has a separate entry in this encyclopedia

the islands and north coast of what became the Republic of Honduras. At the moment of contact with Europeans, most of Honduras was inhabited by Lenca peoples (in south-west, central and east-central regions), Tolpan/Jicaque (north-central), Chorotegas (south) and intrusive Nahua groups (north-west and north-east) from central Mesoamerica, who arrived during the last centuries preceding contact. The wealth of the complex socio-political organization of these indigenous Honduran domains was based on the enormous agricultural potential of their fertile coastal valleys and well-irrigated highland basins, as well as far-reaching trade networks. For example, during Christopher Columbus's exploration of the Bay Islands (Islas de la Bahía) off the north coast of Honduras he captured a large trading canoe carrying commercial products that included cacao, cotton cloth and copper axes; when he made his first landfall on the American continent at the bay of Trujillo, some of the people he found there were dressed in cotton garments, while others were tattooed or painted or armed with flint-edged and flint-pointed weapons. In the Mosquitia region, along the coast east of Trujillo, on the other hand, the indigenous peoples were linked to Intermediate Area (Macro-Chibchan) cultures; they were semi-nomads who kept seasonal plantations of manioc and other root crops but also depended heavily on hunting and foraging for subsistence.

In 1516 a chain of slaving ships from the Antilles began to sweep the Bay Islands and adjacent Honduran mainland, beginning the process of destruction of the indigenous population that was accelerated by Spanish exploration and conquest between 1524 and 1540. During that period the indigenous populations in the areas of highest concentration—the Sula, Naco and Aguan Valleys—were hunted

down to provide forced labour for the colonists in such places as Peru, their villages and plantations destroyed. This destruction reached its peak in the subsequent onslaught of European diseases. Girolamo Benzoni, an Italian traveller who passed through Honduras in 1540, calculated that the indigenous population had declined by almost 90% as a result of the wars of conquest, disease and slavery. Modern researchers agree that an estimated indigenous population of 1,200,000 in Honduras at the moment of European contact is realistic. This total was never again approached, even though some recovery took place, beginning in the 18th century. By then the population of Honduras was predominantly mestizo (of mixed Indian and European descent), and this trend was never reversed. At the end of the 20th century indigenous groups in Honduras comprised just 5% of the total population of *c*. 5 million.

Throughout the colonial period, Honduras formed part of the Spanish captaincy-general of Guatemala. Early Spanish settlements included Trujillo on the north coast, the original capital, and San Pedro Sula. Other towns were founded in southern and western areas occupied before the conquest, including Comayagua, which became the capital in 1573, Gracías and Choluteca. In all these centres the Roman Catholic Church and missions were the principal artistic patrons during the colonial period. The Spanish economy in the Honduran colony was initially based on cacao, sarsaparilla and silver, later including gold, cattle and indigo, and Tegucigalpa was founded *c*. 1578 as a result of the discovery and mining of silver in the region.

Traditional methods of conquest were not successful in the tropical rain-forests of the Mosquitia, and the western limits of this barrier became the frontier of Spanish

colonization. In a subsequent attempt to break that barrier, the 16th-century colonial policy of conquest gave way to one of evangelism and recolonization of the indigenous groups in *reducciones* (missionary settlements). The territory of the Tolpan/Jicaque peoples was also included in the sphere of missionary activity. Ultimately, however, the mission-orientated recolonization of the largely itinerant populations had little success. By the middle of the 17th century the indigenous populations on the north-east and north-west coasts had disappeared or migrated inland. The few that remained on the Bay Islands were removed to the mainland as a guarantee against their voluntary or forced support of the pirates and privateers who swept the Caribbean. Pirate attacks in the 17th and 18th centuries led to the construction of some impressive coastal fortifications on the north coast of Honduras by the Spanish, but the depopulation of the Bay Islands allowed them to become periodic refuges and refitting ports for the Dutch, English and French until well into the 18th century. English influence in the region ultimately led to their control of the Bay Islands and the north-eastern Mosquitia region (Mosquito Coast), which lasted until 1859. In 1795-6 the English deported to the Bay Islands a contingent of several thousand belligerent Black Caribs (of mixed Carib Indian and African descent) from St Vincent Island in the eastern Caribbean. From here the Black Caribs passed almost immediately to the mainland and in a short time became, together with the Miskito, one of the predominant ethnic groups along the Caribbean coast. The Garífuna peoples of Honduras are direct descendants of the Black Caribs.

After declaring independence from Spain in 1821, Honduras joined other former colonies in the Central American Federation in an attempt by Francisco Morazán to form a united Central America; however, this was dissolved in 1838, and Honduras became an autonomous state, its politics subsequently dominated by instability. Independence did not bring advantages for the native populations. The reigning government policy included the forced integration of indigenous groups into the mestizo community, a policy accompanied by systematic discrimination against traditional lifestyles and culture. For example, in the middle of the 19th century the Tolpan/Jicaque peoples were obliged to provide manpower for sarsaparilla plantations, and the extreme abuses to which they were subjected forced a number of them to seek refuge in the north-central highlands. That refuge, La Montaña de la Flor, remains the home for *c*. 600 descendants of those who fled, and they are the only Tolpan/Jicaque who still speak their native language. The Miskito and Garífuna in the Mosquitia region are the two most numerous ethnic communities in Honduras that preserve not only their language but also maintain strong cultural roots. Small populations of the Pech/Paya and Tawahka/Sumu also survive in the Mosquitia, although both groups are threatened by the uncontrolled penetration of landless peasants from the central and southern highlands of Honduras into the tropical rain-forest.

Independence resulted in some urban expansion and improvement, particularly in Comayagua and Tegucigalpa, which became the capital in 1880. A major economic stimulus was provided to the north coast by timber exploitation and the establishment of extensive banana plantations in the late 19th century and early 20th, particularly by companies from the USA that ultimately monopolized banana production, converting Honduras into the world's largest exporter of bananas until the 1950s. This resulted in the construction of transportation networks, port facilities and new urban centres in the north. Political instability continued, however, with civil wars in 1924 and 1932. After World War II, workers' strikes in the banana plantations led to the liberal agrarian and labour reforms of the government (1957–63) of Ramon Villeda Morales, but these were followed by the coup d'état of General Oswaldo López Orellano and 17 years of almost continual military government. In the 1980s elected governments re-established democracy in Honduras, and in the 1990s new attempts were initiated to encourage regional economic cooperation.

BIBLIOGRAPHY

R. Chamberlain: *The Conquest and Colonization of Honduras* (Washington, DC, 1953)
C. L. Johannessen: *Savannas of Interior Honduras* (Berkeley and Los Angeles, 1963)
G. Lara-Pinto: *Beiträge zur indianischen Ethnographie von Honduras in der 1. Hälfte des 16. Jahrhunderts unter besonderer Berücksichtigung des historischen Demographie* (Hamburg, 1980)
J. Arancibia: *¿Honduras: Un estado nacional?* (Tegucigalpa, 1984)
A. Constenla: *Las Lenguas del Area Intermedia: Introducción a su estudio areal* (San José, Costa Rica, 1991)
T. L. Merrill, ed.: *Honduras: A Country Guide* (Washington, DC, 3/1995)

GLORIA LARA-PINTO

II. Architecture.

1. 1502–1838. The first substantial colonial buildings in Honduras were constructed in Trujillo, which was formally founded as the capital of the new colony in 1524. A cathedral was completed there before 1539 and a Franciscan convent established in 1582, but here, as elsewhere in the region, earthquakes and the fragility of materials and construction resulted in the destruction of many colonial buildings of the 16th and 17th centuries, which were designed and built mostly by architects and master-builders from Guatemala and Spain. Under repeated attacks from the sea, Trujillo was abandoned in 1643 and not re-populated until the end of the 18th century. In 1573 the capital was moved to Comayagua, founded in 1537 but sacked by Indians, then re-established with city status in 1557 as a centre of silver mining; its growth was assured by its strategic location midway between the Caribbean and the Pacific. The simple rectangular church of La Merced (under construction by 1611) served as the cathedral until the early 18th century. It was designed with a single-storey, undivided stucco façade and exemplified the 'Seismic Baroque' style, characterized by thick walls, small window openings and low towers. The present cathedral of Comayagua dates from the first quarter of the 18th century. It has a barrel-vaulted nave and side aisles culminating in a squat main dome and side domes, faced externally with local green and yellow ceramic tiles. An imposing, if simple, four-storey façade is divided into four vertical bays by single engaged columns. The church of La Caridad (1730), Comayagua, like La Merced, has a simple single-storey façade, with a crenellated gable over S-shaped cornices. Unfortunately, its

character was submerged under unsympathetic 20th-century restoration.

Tegucigalpa was also founded as a mining settlement in 1578. The parish church of S Miguel de Tegucigalpa (1756–82; now the cathedral), although rectangular, has side chapels adjacent to the apse, giving a cruciform effect; it is domed and has a single barrel-vaulted nave. An inscription on the façade (see fig. 2) dates that part of the building to 1765 and names the architect as Gregorio Nancianceno Quiróz. The influence of buildings in Antigua, Guatemala, is evident in the characteristic bolster pilasters applied to the two-storey façade. The cathedral was carefully restored after earthquake damage in 1809 and 1899. Although of earlier foundation (1732), the church of Los Dolores, Tegucigalpa, which has unusually slender towers for the earthquake zone, was not finished until 1815 (restored 1910). Here the front surfaces of the bolster pilasters are flat. Inside, the church has a timber ceiling influenced by the MUDÉJAR style.

Other notable churches in Honduras include those at Gracías, La Jigua and Colohete, all in the province of Lempira in the west of the country. The stucco façade of S Manuel de Colohete (mid-18th century), for example, is covered with a network of decoration in low relief; the nave and aisles are divided by massive timber columns, bracketed to simulate *Mudéjar* arches. Typical of the mining villages around Tegucigalpa is San Antonio del Oriente, with simple single-storey houses with red-tiled roofs, and a church dedicated to La Merced (early 18th century); this boasts a single-storey façade with an undulating gable crowned with maiolica urns. A few examples of military architecture remain, such as the Fortress of San Fernando de Omoa (1759–79), the most massive Spanish fortress in Central America, built in defence against the pirates. There are also remains of Baroque civil architecture in the ruins of the Caxa Real (1739–41; designed by Don Balta Zar de Maradiaga) at Comayagua and the aqueduct at Danlí (late 18th century). Before the end of the 18th century, somewhat later than in other areas of Latin America, the Baroque style began to give way to Neo-classicism in a form imported from Spain but inspired by French architecture: a rare example in Honduras is the early 19th-century church at Danlí.

2. AFTER 1838. The demand for urban growth created by independence was less insistent in Honduras than elsewhere, owing to the agricultural base of its economy, as well as political instability. Ecclesiastical patronage also declined, and although Neo-classicism remained an influence, building activity in the 19th century concentrated largely on residential work in a colonial vernacular tradition. In 1880, however, the transfer of the capital to Tegucigalpa stimulated new development. The strongest architectural influence at the time was the work of Georges-Eugène Haussmann in Paris, but a wide range of other stylistic models from Europe was also adopted and the influence of the USA increased, especially after the 1870s, when the banana industry began to be developed. The influence of the Beaux-Arts style is apparent in such buildings as the Palacio del Distrito Central, the building of the Financiera (late 19th century; destr. 1978), both in Tegucigalpa, and the classical portals of the Cementerio (1884) at Comayagüela, the sister city of Tegucigalpa. Eclecticism in Honduran architecture continued well into the 1920s. As well as revivals of the French and Italian Renaissance, there was also evidence of the influence of the Romanesque Revival after H. H. Richardson (1838–86), for example the Casa Vieja (1890s), and the Gothic Revival, for example the Casa Presidencial (1919), both in Tegucigalpa. The latter also expresses elements derived from the *Mudéjar* tradition, as does the Templo Masónico in San Pedro Sula.

As American companies expanded the fruit industry, towns on the north coast, including San Pedro Sula and the ports of La Ceiba, Tela and Trujillo, reflected the eclectic tastes of such American architects as Richard Morris Hunt (1827–95; e.g. the Club Social del Banco Sogerín, San Pedro Sula); moreover, components imported from New Orleans were used in the construction of railway stations, warehouses and public buildings in the area. Art Nouveau appeared in the second decade of the 20th century in, for example, the Casa de los Muñecos (1920), Comayagüela, and in a number of buildings in San Pedro Sula and Tegucigalpa. However, acceptance of the European Modern Movement was delayed by a nostalgic return in the 1920s to colonial models involving such

2. Tegucigalpa Cathedral, façade by Gregorio Nancianceno Quiróz, 1765

Mediterranean features as overhanging roofs, intricately fashioned grilles, balconies and ornamental oriel windows (e.g. the Municipalidad in La Ceiba and such houses as the Casa Cordova, 1938, in San Pedro Sula). Art Deco was also introduced in the 1920s, lasting until the 1940s (e.g. the Casa Castro, 1927–30, San Pedro Sula; by R. Bermudez). The International Style became predominant in public and commercial buildings constructed after 1935; notable examples include the Ministerio de Hacienda (1940), the Banco Central de Honduras and the Palacio Legislativo (both 1950), all in Tegucigalpa, and the Instituto Hibueras and Banco Nacional de Fomento (1950), Comayagüela. Domestic architecture was distinguished by the bungalows built by American fruit companies along the whole of the north coast after the 1920s; these were directly inspired by the California Bungalow style, and their broad eaves and spacious verandahs and porches were well suited to the informal lifestyle and tropical climate of Honduras. Architects active in the second half of the 20th century include Fernando Martínez, Leo García and Francisco Rodríguez, all of whom were influenced by international developments, particularly those originating in European countries and the USA, including Postmodernism.

BIBLIOGRAPHY

F. Lunardi: *El Tengaux y la primera iglesia catedral de Comayagua* (Tegucigalpa, 1946)
P. Kelemen: *Baroque and Rococo in Latin America* (New York, 1951), pp. 45–6, 127–32
D. Angulo Iñiguez and others: *Historia del arte hispanoamericano*, iii (Barcelona, 1956), pp. 51–60
F. Lacouture, F. Flores and R. Soto: *Edificios y monumentos históricos de Tegucigalpa y Comayagüela* (Tegucigalpa, 1977)
R. Agurcia and R. Soto: 'La casa de Don Calecho: Un ejemplo de la arquitectura vernácula en Honduras', *Yaxkin*, vii/1 (1984), p. 47
B. Dohle: *Visión de la arquitectura en Honduras según arquitectos hondureños* (San Pedro Sula, 1986)
R. Soto: 'El patrimonio cultural de Honduras', *Prisma*, ii/10 (1987), p. 20
R. C. Mejía Chacón and R. M. Ordóñez Ferrera: *Estudio preliminar para la preservación y desarrollo del casco histórico de Trujillo* (diss., Tegucigalpa, U. N. Auton. Honduras, 1989)
M. F. Martínez Castillo: *Cuatro centros de arte colonial provinciano hispano criollo en Honduras* (Tegucigalpa, 1992)

ROLANDO SOTO

III. Painting, graphic arts and sculpture.

1. 1502–1838. Early colonial art in Honduras was dominated by religious painting and sculpture, which was intended to help the religious conversion of the indigenous population in addition to its use by the Spanish. At first many works were imported from Spain; particularly significant were the sculptures brought from Seville in the 17th century to the cathedral in Comayagua, then the capital city, for example the retable of the main altar (*in situ*), which contained a Crucifix commissioned by Philip IV, King of Spain, in 1620 and executed by Andrés de Ocampo. Other polychromed figures in the niches of the retable and elsewhere in the cathedral are attributed to Francisco de Ocampo (*d* 1639), the nephew of Andrés, and show the influence of Juan Martínez Montañés. The remains of a Crucifix originally sent to Trujillo (now in the monastery of S Francisco, Guatemala City) may be by Montañés himself. Other works were imported from Guatemala and Mexico, to which the Spanish Crown sent many artists. Guatemalan artists also worked in Honduras,

for example the sculptor Vicente Javier (*fl* 1748–80), who arrived in Honduras *c.* 1761 and worked in a late Rococo style (e.g. the exceptionally fine main altar of Tegucigalpa Cathedral). MESTIZO decoration, in which Baroque and indigenous artistic forms were combined, was executed by the Guatemalan sculptor Vicente de la Parra (e.g. the altar of *The Rosary* in Comayagua Cathedral, 1708). Guatemalan painters working in Honduras included Blas de Mesa (1740–76), who was active in the region of Comayagua at the end of the 17th century.

In the middle of the 18th century several Honduran painters gained prominence, for example Zepeda (e.g. *St Michael the Archangel*, Comayagua, S Francisco); Cubas, who worked in Tegucigalpa Cathedral; and Dardón and Antonio de Alvarez, who produced eight scenes from the *Life of the Virgin* (*c.* 1669) in Comayagua Cathedral, influenced by Francisco de Zurbarán. Perhaps the most outstanding painter of the colonial period was José Miguel Gómez (1712–1806), who was also influenced by Zurbarán. A mestizo born in Comayagua, he studied in Antigua, Guatemala. He was discovered in the middle of the century by Bishop Don Diego Rodríguez de Rivas, who commissioned from him many religious paintings now in Comayagua Cathedral. Gómez also supervised the decoration of S Miguel, Tegucigalpa (now the cathedral), and produced paintings for the hermitage dedicated to the Virgin in Suyapa (e.g. *Jesus of Nazareth*, *c.* 1777; *in situ*). His last known work, the *Divine Shepherdess* (Señora F. de Quiñonez priv. col.), was signed in 1805. Gómez also produced portraits, a kind of painting that became more popular in the first decade of the 19th century. Other portraits painted towards the end of the 18th century included works by Valladares (e.g. *Bishop José de Palencia*, 1773; Comayagua, Mus. A. Relig.).

2. AFTER 1838. Political instability in the middle of the 19th century led to a decline in the production of painting, sculpture and work in gold and silver, materials that became scarce at that time. The popularity of painting also suffered from the spread of photography and lithography in Honduras, and religious commissions became particularly rare. Nevertheless, the colonial style of painting lingered into the middle of the century in the work of Toribio Torres from Comayagua. He painted religious subjects, including commissions by Bishop Compoy (e.g. a series of portraits now in the chapter room of Comayagua Cathedral); he also produced several family portraits, a genre that remained popular until the end of the 19th century. Ecclesiastical patronage also extended to Toribio Pérez (e.g. the portrait of *Monseñor Cristóbal de Pedraza*, 1850; Comayagua, Mus. A. Relig.).

In the 19th century, however, secular commissions became more important than religious ones. This trend, together with the loosening of links with Spain, opened Honduran painting to French influences, particularly history paintings and heroic portraiture of the Napoleonic era, although Honduran examples of this style were largely unremarkable. Sculpture in this period was dominated by Europeans working in Honduras, such as the Frenchman Leopoldo Morice (e.g. the equestrian statue of *General Francisco Morazán*, 1882; Tegucigalpa, Parque Central), and by the import of European works, especially from

Italy. It was not until the second and third decades of the 20th century that Honduran painting and sculpture revived, led by a generation of artists who lived and studied in Spain, Italy and France. These included the sculptor Samuel Salgado, who trained in Italy, and the painter Pablo Zelaya Sierra (1896–1933). Zelaya Sierra left Honduras in 1916 and studied in Costa Rica and Madrid, where he was heavily influenced by his teacher, the Cubist Daniel Vázquez Díaz. Zelaya Sierra's works were marked by the separation of line and colour as independent elements of the picture. On his return to Honduras in 1932 he reflected the civil war of that time in the painting *Brother against Brother* or *Destruction* (Tegucigalpa, Mus. Banco Atlántida). His work, collected in the Museo Pablo Zelaya Sierra in Ojojona and in the Banco Central de Honduras in Tegucigalpa, was very influential.

Other artists of this generation who studied in Europe produced naturalistic paintings inspired by Impressionism. They included Confucio Montes de Oca (1896–1925), a painter of luxuriant, colourful landscapes, and Carlos Zúñiga Figueroa (1892–1964), who specialized in private and public portraiture; both artists were also inspired by 17th-century Spanish painting, especially that of Diego Velázquez. Maximiliano Euceda (1891–1986) was influenced by such contemporary Spanish artists as Joaquín Sorolla y Bastida (1863–1923) and produced landscapes and portraits with a fine sense of detail. Like Figueroa, he painted posthumous portraits of heroes of the struggle for independence, for example the portrait of *General Fran-cisco Morazán* in the Palacio del Distrito Central in Tegucigalpa.

With the foundation of the Escuela Nacional de Bellas Artes (ENBA) in 1940 (*see* §IV below), the visual arts gained new prominence in the cultural life of Honduras. The director, Arturo López Rodezno (*b* 1906), was an accomplished oil painter, watercolourist, draughtsman, engraver and ceramicist. He also introduced murals to Honduras, for example those in the ENBA (1942–6) inspired by Maya art, and he collaborated with Miguel Angel Ruiz (*b* 1928), who brought Mexican influences to Honduran mural painting as a result of a stay in Mexico between 1948 and 1953, when he worked with Juan O'Gorman and Diego Rivera. A later example of Ruiz's murals is the one painted in 1981 for the Banco Atlántida, Tegucigalpa, where a fine collection of late 20th-century Honduran paintings is also held (*see* §IV below). Dante Lazarroni Andino (*b* 1929) was also influenced by the expressionistic aspects of Mexican social realism. The foundation of the ENBA gave, in addition, a stimulus to Honduran sculpture, particularly through the work of Alfonso Henríquez and Arturo Guillen, as well as such later sculptors as Mario Zamora (e.g. statues, Tegucigalpa, Palacio Legislativo, ground floor, 1958–60), Obed Valladares and Julio Navarro.

Another influence on Honduran artists of the 1940s and 1950s was Surrealism: for example, Moisés Becerra (*b* 1926) painted highly coloured surreal representations of Honduran life, which he also depicted in his illustrations

3. José Antonio Velásquez: *San Antonio del Oriente*, oil on canvas, 660×940 mm, 1957 (Washington, DC, Art Museum of the Americas)

and engravings. Ricardo Aguilar (1915–51) moved from Impressionism to a Surrealist style marked by planar modelling and an esoteric symbolism. Many Honduran artists, however, persisted with a naturalistic style, for example the painter Alvaro Canales (1922–83) and the sculptor–painters Mario Castillo (*b* 1932), who painted colourful, impressionistic landscapes, and Roberto M. Sánchez (*b* 1915). As well as depicting landscapes and folkloric themes, Sánchez also continued the tradition of painting images of the heroes of independence. Another painter of rural Honduras was the amateur primitive artist José Antonio Velásquez (1903–83), whose work was widely exhibited from the 1950s (see fig. 3). His work can be compared with the naive paintings of Teresita Fortín (1896–1982), which were based on personal memories (e.g. the *Story of My Life*, 1978). Other notable artists of the period included Horacio Reina, a portrait painter and commercial artist, and Manuel López Callejas, whose activities ranged from architectural design to drawing cartoons and designing stamps.

BIBLIOGRAPHY

L. Mariñas Otero: *La pintura en Honduras* (Tegucigalpa, 1959, rev. 1977)
——: 'La escultura en Honduras', *Cuad. Hispamer.*, xlii/125 (1960), pp. 215–23
M. F. Martínez Castillo: *La escultura en Honduras* (Tegucigalpa, 1961)
El arte contemporáneo en Honduras (Tegucigalpa, 1968)
B. la Duke: *Compañeras: Women, Art and Social Change in Latin America* (San Francisco, 1985), pp. 53–6
R. Becerra and E. López: *La pintura en Honduras* (Tegucigalpa, 1989)
R. Fiallos: *Datos históricos sobre la plástica hondureña* (Tegucigalpa, 1989)
L. Becerra and J. Evaristo López Rojas: *Honduras: Visión panorámica de su pintura* (Tegucigalpa, 1994)
M. Kupfer: 'Central America', *Latin American Art in the Twentieth Century*, ed. E. Sullivan (London, 1996), pp. 51–79

ROLANDO SOTO

IV. Patronage and institutions.

Artistic and architectural patronage in Honduras during the Spanish colonial period was dominated almost exclusively by the Roman Catholic Church, although the Spanish Crown also played a role by sending both artists and works of art to such colonies as Honduras (*see* §III, 1 above), and the local civil and military authorities commissioned important buildings (*see* §II, 1 above). After independence in the 19th century the role of the Church declined, and patronage began to pass to the state. Official commissions celebrated independence itself, and private individuals began to commission portraits. In general, however, artistic patronage and production declined during the 19th century, largely as a result of political instability that continued into the 20th century. Although the first important institutions in Honduras were established at this time—the Biblioteca Nacional and Archivo Nacional were both founded in Tegucigalpa in 1880—Honduran artists still had to go abroad to other countries in Latin America or to Europe to receive training and patronage (*see* §III, 2 above).

This situation improved with the establishment of the Escuela Nacional de Bellas Artes in Tegucigalpa in 1940, incorporating the earlier Escuela de Artes y Oficios, founded in Comayagüela in the late 19th century. It was directed by the engineer, painter and ceramicist Arturo López Rodezno (*b* 1906), himself trained at the Escuela

Libre de Pintura y Escultura in Havana and at the Académie Julian in Paris. Other teachers included the painters Maximiliano Euceda (1891–1986), Roberto M. Sánchez (*b* 1915) and Ricardo Aguilar, and the sculptor Samuel Salgado. This period was also marked by the first collective exhibitions of Honduran art, in Tegucigalpa and at the Bienal Hispanoamericana de Arte in Madrid (both 1951), and many Honduran artists became well known in the USA: for example, José Antonio Velásquez (1903–83) was discovered by the American Doris Stone and exhibited in 1953 and 1954 in Washington, DC, at the Organization of American States, and Manuel López Callejas drew cartoons for the *Washington Post*. Collecting also became more general in Honduras itself: in the 1980s the commercial popularity of such graphic arts as lithography spread to painting, which could be acquired in shopping precincts as well as commercial art galleries.

Another important feature of the 20th century in Honduras was the growth of museums, particularly those concerned with Honduran archaeology, many of which came to be administered by the Instituto Hondureño de Antropología e Historia (IHAH), an autonomous body within the Ministry of Culture that was also given responsibility for national monuments and archaeological sites. The first of these museums, the Museo Nacional, was established in Tegucigalpa in 1932 and reinstituted there by the IHAH in 1976 in a palatial Neo-classical building that was once the residence of a president of Honduras, Julio Lozano Díaz. Its exhibitions cover a number of areas, including natural history, ethnology, cultural history, technology and art, but they emphasize Honduran archaeology. The Galería Nacional de Arte is housed in the former Mercedario convent (built 1654), and the Museo Histórico de la República is in another former presidential palace; both were opened in Tegucigalpa in 1993–4. Discoveries from the Maya ruins of Copán are displayed in the Museo Regional de Arqueología in Copán Ruinas, founded in 1940 by Dr Gustav Stronsvick and remodelled between 1984 and 1985 under the archaeologist Ricardo Agurcia (*b* 1950). Museums in the former capital, Comayagua, include the Museo Arqueología y Histórico de Comayagua, established by Colonel Gregorio F. Sanabria in 1949 to conserve and display the cultural heritage of the valley of Comayagua, particularly its archaeological remains; and the Museo de Arte Religioso, established by Monsignor Bernardino Mazzarella (1904–79) in the 1970s to exhibit liturgical objects and religious art from the region and administered by the local episcopate. Important municipal museums include the Museo del Cabildo in Danlí, founded by the engineer Gonzalo Lobo Sevilla (*b* 1920) in 1975, and the Museo de San Pedro, Cortés. Other significant historical and archaeological collections are found in private museums such as the Museo Histórico in Trujillo (belonging to Rufino Galán and opened in the 1970s); the Museo del Banco Atlántida in Tegucigalpa (founded 1988), which also has a complete gallery of paintings; and the Museo de Roatán (founded 1991) in the Bay Islands. The Museo Nacional de Historia Colonial was opened in 1990 at the colonial fortress of San Fernando de Omoa and is devoted to the history of the site.

BIBLIOGRAPHY
Escuela nacional de bellas artes, 1940–48, Ministerio de Educación (Tegucigalpa)
R. Soto: *Banco Atlántida en la historia de la pintura en Honduras* (Tegucigalpa, 1988)
El Banco Atlántida en la historia de la pintura hondureña (exh. cat., Tegucigalpa, Mus. Banco Atlántida, 1991)
 ROLANDO SOTO

Huie, Albert (*b* Falmouth, Trelawny, 31 Dec 1920). Jamaican painter. He came to the attention of the Institute of Jamaica in the late 1930s, when he also received his early training from the Armenian artist Koren der Harootian (1909–91). He was assistant to Edna Manley during her art classes at the Junior Centre, Kingston, in the early 1940s. He went on to study at the Ontario College of Art, Toronto, and at the Camberwell School of Arts and Crafts, London. He was founding tutor in painting at the Jamaica School of Art and Crafts, Kingston, in 1950. Huie is best known as a landscape and genre painter. More effectively than any other Jamaican artist he captured the shimmering, atmospheric quality of the Jamaican landscape and the rhythm of life in the rural areas. Some of his works have socio-political overtones and express nationalist sentiments and his sympathy for the working class. He also made his mark as a portrait painter; his earliest major works are portraits, among them a portrait of *Edna Manley* (1940; see fig.). His earliest works have a naive quality, while his mature work shows a strong Post-Impressionist influence. His style changed very little after the early 1940s, though in the 1960s he concentrated on the nude figure. While he usually painted in oil, his acrylic paintings are characterized by a more muted palette and a flatter design.

BIBLIOGRAPHY
P. Archer Straw and K. Robinson: *Jamaican Art* (Kingston, 1990), pp. 7, 9–10, 24–8, 162–3

Albert Huie: *Edna Manley*, oil on canvas, 865×210 mm, 1940 (Kingston, National Gallery)

D. Boxer and V. Poupeye: *Modern Jamaican Art* (Kingston, 1998)
V. Poupeye: *Caribbean Art* (London, 1998)
 VEERLE POUPEYE

Humareda, Víctor (*b* Lampa, nr Juliaca, 6 March 1920; *d* 23 Nov 1986). Peruvian painter and draughtsman. He moved in 1938 to Lima, where he studied at the Escuela Nacional Superior de Bellas Artes under José Sabogal, Julia Codesido (*b* 1892) and Ricardo Grau. In 1947 he travelled to Buenos Aires, where he completed his studies at the Escuela Superior de Bellas Artes Ernesto de la Cárcova. He worked in a dramatic Expressionist style, using strong, rich colours to express his particular vision of Lima as seen from the point of view of a poor immigrant from the provinces. He was only remotely involved with commercial galleries, and his work was full of the isolation, melancholy and darkness of his life. Humareda evolved a sombre, realistic vision of the old streets of the capital and of the misery of the poor bullfighters and prostitutes, the Quixotes of his imagination. His drawings, characterized by precise and economical marks, constitute further evidence of his remarkable psychological insights.

BIBLIOGRAPHY
E. Moll: *Victor Humareda, 1920–1986* (Lima, 1987)
E. Sánchez Hernani: *Victor Humareda: Imagen de un hombre* (Lima, *c*.1989)
J. A. Bravo: 'Humareda o el tacto de la neblina', *El Comercio* (28 November 1993), p. 14
 LUIS ENRIQUE TORD

Humboldt, (Friedrich Heinrich) Alexander von , Baron (*b* Berlin, 14 September 1769; *d* Berlin, 6 May 1859). German explorer, diplomat and natural scientist. He was born to a wealthy, aristocratic Prussian family: his father was a military officer and his mother a French Huguenot. Initially taught by private tutors, he attended the universities of Frankfurt-an-der-Oder and Göttingern before enrolling in the Freiburg Mining Academy in 1791. Humboldt was appointed assessor to the Smelting Department in Berlin in 1792, before becoming Director General of Mines in Franconia. In 1796, on receipt of a substantial inheritance, he dedicated his life to pursuing his interests in the natural world, a passion brought about by a friendship with the naturalist Georg Forster (1754–94), who had sailed on Captain Cook's second journey around the world.

Humboldt spent two years in Paris searching unsuccessfully for a position with various scientific expeditions, which were being disrupted by the Napoleonic Wars. He then petitioned Charles IV of Spain for permission (hitherto restricted to Spanish officials and members of the Roman Catholic mission) to travel to Spanish America. The Spanish crown, mindful of Humboldt's mining expertise and desperate for new forms of income from its American dominions, authorized Humboldt to mount a self-funded expedition along with French botanist Aimé Bonpland (1773–1858). Armed with the latest French technological equipment and fuelled by liberal European Enlightenment thought, they arrived in South America in 1799 and spent the next five years gathering a vast amount of data from the viceroyalties of Nueva Granada, Peru and Nueva España, and the Caribbean island of Cuba, although they were denied access to Brazil. The expedition travelled extensively, covering nearly 10,000 km, and

devoted itself to collecting scientific and ethnographic material. Much of the information they brought back, such as colour reproductions of Mexican codices and drawings of Aztec and Inca cultures, was the first such accurate material of its kind to be seen in Europe. While in Nueva Granada they made contact with the celebrated Expedición Botánica de Nueva Granada, commissioned in 1784 under the Spanish botanist José Celestino Mutis (1732–1808).

On his return to Europe in 1804, Humboldt settled in Paris. Between 1804 and 1827 he produced various written accounts of the expedition, including the celebrated *Voyage de Humboldt et de Bonpland aux régions équinoxiales du nouveau continent* (1805–34), *Essai politique sur le royaume de la Nouvelle-Espagne* (1811), and *Personal Narrative of Travels to the Equinoctial Regions of the New Continent, 1799–1804* (1814–29). Humboldt was hailed by liberator Simón Bolivar (1783–1830), and influenced a generation of scientists including JOHANN MORITZ RUGENDAS and Charles Darwin (1809–82).

By 1827 Humboldt had spent most of his inheritance and was forced to return to Germany, where he served as a diplomat before entering the court of Frederick William III, King of Prussia (*reg* 1797–1840), as tutor to the Crown Prince in Berlin. In 1829 he accepted an invitation from the Russian Tsar Nicholas I to carry out an extensive expedition in Russia which took him to Central Asia. On his return Humboldt spent the next 25 years in Berlin working on *Kosmos* (1845–62), a hugely ambitious scientific work, which he never completed.

BIBLIOGRAPHY

S. L. Catlin: 'Traveller-Reporter Artists and the Empirical Tradition in Post-Independence Latin America', *Art in Latin America: The Modern Era, 1820–1980*, ed. D. Ades (New Haven, 1989), pp. 41–61

J. Cameron: *Kingdom of the Sun God: A History of the Andes and their People* (London, 1990)

D. Brading: *The First America: The Spanish Monarchy, Creole Patriots, and the Liberal State, 1492–1867* (Cambridge, 1991)

ADRIAN LOCKE

Hung, Francisco (*b* Canton, 16 June 1937). Venezuelan painter of Chinese birth. In 1956 he entered the Escuela de Artes Plásticas 'Julio Arraga' in Maracaibo, and in 1958 he travelled to Paris to study at the Ecole Supérieure des Beaux-Arts. He returned to Venezuela in 1962 and held his first one-man show in 1963 at the Museo de Bellas Artes, Caracas. During the 1960s he was associated with *Art informel*. His fundamentally gestural painting comprises an intensely personal calligraphy, in which Asian and American influences are blended. His murals and large-format works executed between 1964 and 1965 earned him the Venezuelan Premio Nacional de Pintura, and he was a joint representative of Venezuela in the seventh Bienale de São Paulo.

BIBLIOGRAPHY

F. Paz Castillo and P. Rojas Guardia: *Diccionario de las artes plásticas en Venezuela* (Caracas, 1973), p. 121

Tiempo de Hung (exh. cat., Porlamar, Mus. Francisco Narváez, 1989)

De Venezuela: Treinta años de arte contemporáneo (1960–1990)/From Venezuela: Thirty Years of Contemporary Art (1960–1990) (exh. cat. by R. de Montero Castro, Seville, Pab. A., 1992)

Based on information supplied by LELIA DELGADO

Hunza. *See* TUNJA.

Hurtado, Angel (*b* El Tocuyo, 27 Oct 1927). Venezuelan painter and film maker. He studied at the Escuela de Artes Plásticas y Aplicadas in Caracas (1944–8) and then went to Paris, where he studied art history and film at the Sorbonne (1954–9). He returned to Caracas, where he taught film journalism at the Universidad Central de Venezuela, Caracas, and directed the cinema department of Televisora Nacional. Hurtado's painting during this period was articulated around the dynamic interplay of dark bands; his series *Signs of the Zodiac* won him the Venezuelan Premio Nacional de Pintura in 1961. Again in France he worked for television, and in 1970 he moved to Washington, DC, to become head of the film section at the Department of Cultural Affairs of the Organisation for American States, making documentaries on various artists. In later paintings, such as *The Clarity That Never Ceased* (1986; Caracas, Mus. A. Contemp.), he used thinly worked veils of colour.

BIBLIOGRAPHY

R. Delgado: *Angel Hurtado* (Caracas, 1970)

Angel Hurtado: Paisajes interiores y divertimientos (exh. cat., ed. S. Imber; Caracas, Mus. A. Contemp., 1990)

M. de la Vega: *Angel Hurtado* (Caracas, *c*.1994)

11 artistas venezolanos representados por Galería Freites (exh. cat., Caracas, Gal. Freites, 1994)

Based on information supplied by LELIA DELGADO

Hyde, Eugene (*b* Portland, 25 Jan 1931; *d* St Catherine, 15 June 1980). Jamaican painter. In 1953 he left Jamaica to study advertising design at the Art Center School in Los Angeles. In 1955, however, he moved to the Los Angeles County Art Institute, where he studied painting and graphic art for five years; he returned to Jamaica in the early 1960s and continued to work in advertising while painting and exhibiting regularly. In the 1960s and 1970s, along with Karl Parboosingh, he became a major force in the development of abstract art in Jamaica, and in 1970 he established in Kingston the John Peartree Gallery, which for ten years was to be the principal venue for exhibitions of abstract and modernist art in Jamaica. Hyde's own art ranged from an Expressionism influenced by the American painter Rice Lebrun (*b* 1900) in California in the late 1950s, to a more abstract vision developed in Jamaica in the 1960s and 1970s, where the Abstract Expressionist style of New York provided the technical basis for extended series devoted principally to dance, the female nude and Jamaican flora. After 1975 his figurative Expressionism resurfaced, but with added psychological dimensions inspired by artists such as Francis Bacon. He began to depict the social outcasts, the homeless and the deranged who roamed the streets of Kingston, whom he called the 'casualties'. For Hyde, this would be the fate of all Jamaicans if the march towards Communism in Jamaica was not halted. In painting after painting he denounced his country's government.

BIBLIOGRAPHY

Eugene Hyde, 1931–1980, A Retrospective (exh. cat. by R. Smith McRea, Kingston, Inst. Jamaica, N.G., 1984)

DAVID BOXER

Hyppolite [Hippolite], **Hector** (*b* Saint-Marc, 15 Sept 1894; *d* Port-au-Prince, 9 June 1948). Haitian painter. The

250 works produced by him during the last two-and-a-half years of his life dominate the extraordinary achievements of the so-called Haitian primitives. Like his father and grandfather he was a priest of Vodoun. He also worked as a shoemaker and housepainter, and it was interest in some painted doors in a bar in Monrouis, near Saint-Marc, that led him to paint pictures. Hyppolite created his own myth and lived it. His claim to have spent five years in Africa is dubious, but it is certain that he was outside Haiti from 1915 to 1920, perhaps cutting cane in Cuba. Most of his life was lived in penury. The Haitian critic and poet Philippe Thoby-Marcelin brought him to Port-au-Prince in 1945. In the following year André Breton (1896–1966) bought his paintings and arranged an exhibition of his work at UNESCO in Paris, writing that Hyppolite's fresh and powerful imagery could reinvigorate European art (Breton). His subjects invite interpretation on many levels. His principal subject, with whom he contracted a spiritual marriage, was woman, in the form of Erzulie the temptress, the queen or the sea goddess. Figures, landscapes and other objects are represented almost summarily in his pictures; he placed little value on perfecting techniques, applying the paint rapidly with chicken feathers and his fingers. In his last year the darker side of magical Vodoun appeared in his pictures.

BIBLIOGRAPHY

S. Rodman: *The Miracle of Haitian Art* (New York, 1974), pp. 24–35

Haitian Art (exh. cat. by U. Stebich, New York, Brooklyn Mus., 1978)

A. Breton: 'Hector Hyppolite', *Kunst aus Haiti* (Berlin, 1979), pp. 218–20

S. Rodman: *Where Art is Joy* (New York, 1988), pp. 47–55

M. P. Lerrebours: *Haïti et ses peintres*, i (Port-au-Prince, 1989), pp. 309–16

DOLORES M. YONKER

I

Ibarra, José de (*b* Guadalajara, 1688; *d* Mexico, 1756). Mexican painter. His earliest known work belongs to the 1720s, after which time he produced numerous religious paintings, including a series of panels devoted to female figures in the Gospels such as the *Woman Taken in Adultery*, the *Samaritan Woman* and *Mary Magdalene in Simon's House* (all Mexico City, Pin. Virreinal). Other works include *St Anthony*, the *Dream of St Joseph*, a *Pietà*, the *Coronation of St Rosa* and the *Betrothal of the Virgin* (all Mexico City Cathedral), as well as numerous works in various provincial Mexican churches and museums, such as *Christ Among the Doctors*, the *Death of the Virgin*, the *Assumption of the Virgin*, the *Immaculate Conception*, the *Flagellation* and *St Joseph with Two Benefactors* (all Zacatecas, Mus. Guadalupe). In the cathedral of Puebla are his *Betrothal of the Virgin*, the *Assumption of the Virgin*, *St Michael* and *St Joseph*, and in Querétaro are his *Trinity*, *Circumcision*, *Ecce homo* and *Triumph of the Faith* (Querétaro, Mus. Reg.). Ibarra also painted numerous official portraits, including many of Spanish viceroys, most of which are in the Museo Nacional de Historia del Castillo de Chapultepec, Mexico City. His work is characterized by its rejection of the previous generation's excesses of colour and by its careful draughtsmanship. In 1754 he became president of the newly founded but short-lived Academy of Painting in Mexico.

BIBLIOGRAPHY
M. Toussaint: *Pintura colonial en México* (Mexico City, 1965)
M. C. García Sáiz: 'Aportaciones a la obra de José de Ibarra', *Archv A. Valenc.* (1978)
X. Moyssen: 'El testamento de José de Ibarra', *Bol. Mnmts Hist.*, vi (1981)
S. Sebastian, J. de Mesa and T. Gisbert: *Arte iberoamericano desde la colonización a la independencia* (Madrid, 1985)
M. Burke: *Pintura y escultura en Nueva España: El barroco* (Mexico City, 1992)

MARIA CONCEPCIÓN GARCÍA SÁIZ

Ijjasz de Murcia, Emese. *See under* ALVAREZ IJJASZ MURCIA.

Imana, Gil (*b* Sucre, 1933). Bolivian painter, sculptor and teacher. From the age of 13 he studied at the Academia de Bellas Artes and in the workshop of Juan Rimsa in Sucre. An extremely active painter, Imana had 58 one-man shows and numerous collective exhibitions after 1950 in cities in Bolivia, Latin America, Europe and the Middle East. He was a member of the artists' group Generación del 52, and in Sucre he was also the founder of the Anteo group of poets, writers and artists. His left-wing ideology linked him to the National Revolution of 1952, within the group of so-called 'social' painters. His subject-matter of social protest centred around the human figure, in particular woman, singly or in groups, with a slight landscape element, and frequently taking the theme of motherhood. He not only painted in oil and acrylic on canvas but also executed frescoes or acrylic murals, such as *The Telephone Company* (1956; Sucre) and *Medicine* (1983; La Paz, Medic. Coll.), and others in Lima and Callao, Peru. In addition, he was a draughtsman and produced graphic work and occasionally sculpture, such as *Crucifix* (1977; La Paz, priv. col.). Imana was the director of the schools of fine art in Sucre and La Paz, as well as a professor in Mérida, Venezuela. He was married to Inés Córdoba, a Bolivian ceramicist and textile artist.

BIBLIOGRAPHY
Art of Latin America since Independence (exh. cat., New Haven, Yale U. A.G.; Austin, U. TX, A. Mus.; 1966)
L. Castedo: *Historia del arte Ibero-americano*, ii (Madrid, 1988)
P. Querejazu: *La pintura boliviana del siglo XX* (Milan, 1989)
Exposición boliviana actualidad en pintura (exh. cat., Madrid, Casa Amer., 1995)
Arcángels actuales de Bolivia (exh. cat., London, Mall Gals, 1996)

PEDRO QUEREJAZU

Inca, Juan Tomás Tuyru Tupac. *See* TUYRU TUPAC INCA, JUAN TOMÁS.

Iommi, Ennio (*b* Rosario, 20 March 1926). Argentine sculptor. His father was a sculptor, and Iommi studied in his father's workshop and attended metalwork courses. He was a founder-member of the ASOCIACIÓN ARTE CONCRETO INVENCIÓN and is one of the most representative Constructivist sculptors in Argentina. In 1954 he created *Continual Forms* (white concrete, 2.0×0.8×1.2 m), a sculpture for a house in La Plata designed by Le Corbusier. His highly formal work was characterized at first by an economy of means, rigorous logic and dynamic rhythms and tensions, with an intelligible and rational structure of form that was optimistic in tone. It was with such works that he won a gold medal in Brussels at the Exposition Universelle et Internationale in 1958, took part in the exhibition *Concret Art* at the Kunsthaus, Zurich, in 1958, and participated *hors concours* in the São Paulo Biennale in 1961 and Venice Biennale in 1964.

Iommi completely changed direction in 1977, using coarse elements and distressed materials without aestheticizing them in any way. While he had always been interested in the relationship between the artist and society,

he now categorically rejected consumerism and saw technology as a negative force that contributed to contemporary anxieties. He continued to exhibit internationally and in 1981 erected *Spatial Construction* (stainless steel, 4.0×1.2×0.7 m) in the Plaza Argentina in Brasília.

BIBLIOGRAPHY

C. Córdova Iturburu: *80 años de pintura argentina* (Buenos Aires, 1978), pp. 145–7

N. Perazzo: *El arte concreto en la Argentina* (Buenos Aires, 1983), pp. 159–64

Enio Iommi (exh. cat., Buenos Aires, Gal. Julia Lublin, 1989)

No perder la memoria: Enio Iommi esculturas, 1979–1992 (exh. cat, Buenos Aires, Fund. Banco Patricios, 1992)

Espacio como forma: Enio Iommi (exh. cat., Buenos Aires, Gal. Ruth Benzacar, 1997)

NELLY PERAZZO

Irarrázabal, Mario (*b* Santiago, 1940). Chilean sculptor. He studied philosophy and art from 1960 to 1964 at the University of Notre Dame, IN, and theology at the Università Gregoriana Pontificia in Rome from 1965 to 1967. In 1968 he continued his studies under the German sculptor Otto Waldemar. He first exhibited his work in Chile in 1970, consistently using the human figure to express injustice, loneliness, helplessness, sorrow and torture, as in *Judgement* (1978; Valparaíso, Mus. Mun. B.A.). Favouring a directness of expression in his bronzes, for which he used the lost-wax process, he sought to leave visible traces of textures and of the marks made in manipulating the material. He used the nudity of the human body, sometimes lacerated or with exaggerated proportions—the torso is sometimes unduly large in relation to the arms and legs—to emphasize its vulnerability and helplessness, reinforcing this impression by his choice of postures. Whether prone, reclining, seated or standing, the figure is always characterized by the determined way in which the head is held, which completes the expressive effect.

During the 1970s Irarrázabal was unable to work on a monumental scale because of the high cost of casting in bronze. In the 1980s, however, he discovered the possibilities of cement, which he used for commissioned works in Chile and other countries, for example *Monumental Hand* (1982) in Punta del Este, Uruguay, *Monumental Finger* (1987) at the International Sculpture Park in Nairobi, and *Human Group* (1985) at the Galerías Nacionales in Santiago. Irarrázabal's implicit criticism of aspects of human behaviour took on particular poignancy after the installation of a military government of Chile in 1973 when, in order to escape official censorship, he turned to a more conceptual mode.

BIBLIOGRAPHY

M. Ivelić: *La escultura chilena* (Santiago, 1978)

Mario Irarrázabal: Esculturas megalíticas (exh. cat., essay M. Ivelić; Santiago, Inst. Cult. Las Condes, 1985)

M. Ivelić and G. Galaz: *Chile: Arte actual* (Santiago, 1988)

MILAN IVELIĆ

Iriarte, Hesiquio (*b* Mexico City, ?1820; *d* Mexico City, ?1897). Mexican illustrator and printmaker. He probably began his career in 1847 in the workshop of the Murguía publishing house. In 1854, in collaboration with Andrés Campillo, he created an outstanding series of illustrations for the book *Los mexicanos pintados por sí mismos*, in which he portrayed character types (e.g. *Great Poet*, lithograph) in the manner of Honoré Daumier. In 1855 he founded the firm Litografía de Iriarte y Compañía. The following year he published portraits of famous personalities in the weekly review *El Panorama*. He was a co-founder in 1861 of the political fortnightly *La Orquesta*, on which he worked for more than ten years as an illustrator and eventually as a caricaturist and as editor. Iriarte continued to contribute to a number of periodicals, including *El Renacimiento*, and his firm also published the weekly *San Baltazar* (1869–70). He collaborated with Santiago Hernández on numerous illustrations for, among others, Vicente Riva Palacio's book *El libro rojo*. Iriarte went into partnership *c.* 1892 with the typographer Francisco Díaz de León to address the demands of new techniques in commercial lithography, and soon after to produce publications illustrated with photogravures.

PRINTS

Los mexicanos pintados por sí mismos (Mexico City, 1854)

V. Riva Palacio: *El libro rojo* (Mexico, 1870)

BIBLIOGRAPHY

M. León Portilla, ed.: 'Hesiquio Iriarte', *Diccionario Porrúa de historia, biografía y geografía de Mexico*, ii (Mexico City, 1964, 5/1986), p. 1536

C. Díaz y de Ovando: 'El grabado comercial en la segunda mitad del siglo XIX', *Hist. A. Mex.*, ed. J. Salvat and J. L. Rosas, xii (Mexico City, 1986), pp. 1708–25

AÍDA SIERRA TORRES

Iturbide, Graciela (*b* Mexico City, 16 May 1942). Mexican photographer and film maker. Iturbide trained at the Centro Universitario de Estudios Cinematográficos in Mexico City (1969–72), where she studied photography as well as film making. During this period she became assistant to one of her teachers, the celebrated Mexican photographer MANUEL, ALVAREZ BRAVO. From Alvarez Bravo, Iturbide gained a very Mexican sense of the poetry in life, which she attempted to capture in her work. From the 1970s Iturbide worked as a freelance photographer for the Instituto Nacional Indigenista, the Secretaria de Comunicaciones and numerous magazines in Mexico City. Projects included a photo-essay on the Seri Indian community (1981) with text by the anthropologist Luis Barjau, and another in the early 1990s on the community of Juchitán, in the Isthmus of Tehuantepec. The latter, with the support of the Mexican artist Francisco Toledo, aimed to recapture the community's Zapotec culture and return it to the people. In an attempt to grasp the poetry that surrounded her, Iturbide focused on the human element, whether present or merely suggested. In *Manos poderosas* (1988, Mexico City, Gal. A. Contemp.), the faces of an old woman and young girl stare at the camera, obscured by two carved wooden hands that appear to grab the viewer. This picture is an example of Iturbide's desire to record the feelings of her subjects by capturing, via the camera, the moment when their gaze coincides with hers.

PHOTOGRAPHIC PRINTS

Los que Viven en la Arena (Mexico City, 1981)

Images of the Spirit (Philadelphia, 1998)

BIBLIOGRAPHY

Hecho en Latinoamerica (exh. cat. by R. Tibol, Mexico City, Mus. A. Mod., 1978)

'Con guantes de seda: Entrevista con Graciela Iturbide', *Casa Américas* (1990), pp. 88–99

La Mujer en México/Women in Mexico (exh. cat. by E. J. Sullivan and L. Nochlin, New York, N. Acad. Des.; Mexico City, Cent. Cult. A. Contemp.; Monterrey, Mus., 1990–91)

J. HARWOOD

Iturria, Ignacio (*b* Montevideo, 1949). Uruguayan painter. He began painting at the age of 15 during a period of isolation resulting from an asthma condition. In 1976 Iturria moved with his family to Spain, starting off in Barcelona before settling in Cadaqués. He began exhibiting in Spain and South America in the 1980s, returning in 1986 to Montevideo where, influenced by his travels, he began to look inwards. Iturria's earlier open and light-filled pictures of Cadaqués contrast with later works that, although they appear to be restricted in their palette to black, white and brown, do in fact contain a variety of colours. Using oil and acrylic on canvas, Iturria manipulated these colours to bring otherwise sombre compositions to life. Within these compositions, familiar objects such as old furniture become a stage or theatre for Iturria's reflections on the past and present, scale, and changes in time and space. The meditative state within which Iturria often worked allowed him to produce such whimsical images as that in which a cupboard is transformed into an appartment block or, as in *Presente y pasado* (1991, Caracas, Mus. B.A.), where a sofa becomes the landscape over which a plane flies and a tiny figure rides on horseback. Not knowing whether such elements are toys or real, the viewer is led into a world of ambiguity in which the artist questions what it means to be human, often with a particular focus on family life.

BIBLIOGRAPHY

'Ignacio Iturria', *A. Nexus* (1993), vii, pp. 88–90

'The End of Solitude: Young Artists on the Rise', *ARTnews* (Oct 1990), pp. 138–43

J. HARWOOD

Ivaldi [Ivaldy], **Humberto** (*b* Panama City, 24 Dec 1909; *d* Panama City, 10 March 1947). Panamanian painter and teacher. He studied under Roberto Lewis and in 1930 won a scholarship to the Academia de San Fernando in Madrid, where he spent five years. On his return to Panama, Ivaldi taught at the Escuela Nacional de Pintura, later becoming its director, a post he held until his death. His academic background was apparent in the careful and detailed rendering of his traditional still-lifes and many portraits, for example *Mitzi Arias de Saint Malo* (*c.* 1947; Panama City, Guillermo Saint Malo priv. col., see Wolfschoon, p. 444). His particular contribution within a Post-Impressionist idiom was most evident in genre paintings and in landscapes, such as *Wind on the Hill* (1945; Panama City, Jorge Angelini priv. col., see Wolfschoon, p. 443), which were often characterized by dynamic diagonal compositions, free brushwork and great sensitivity to the atmospheric quality of colours.

BIBLIOGRAPHY

H. Calamari: 'Breves apuntaciones sobre la obra de Humberto Ivaldi', *Supl. Lit. Panamá América* (23 March 1947), centrefold

R. Miró: 'Lewis, Amador, Ivaldi', *Rev. Lotería*, 219 (1974), pp. 72–80

E. Wolfschoon: *Las manifestaciones artísticas en Panamá* (Panama City, 1983)

MONICA E. KUPFER

Ixtolinque, Pedro Patiño. *See* PATIÑO IXTOLINQUE, PEDRO.

Iza, Washington (*b* Quito, 1947). Ecuadorean painter and engraver. He studied at the fine arts faculty of the Universidad Central de Quito. Together with José Unda (*b* 1948), Ramiro Jácome and Nelson Román (*b* 1945) he was a member of the group Los Cuatro Mosqueteros, which set up its own 'anti-Salon' in Guayaquil (1968) in opposition to the official Salon. In the early 1970s he exhibited work in a geometric style influenced by Op art, but he later revolutionized Ecuadorean art through the coarse realism and critical attitude of his more figurative work. His ironic aesthetic of ugliness dwelt principally on the human figure; although he was at first preoccupied with solitude and helplessness, in his later work he moved towards a magical neo-figurative style, as in *The Bath* (1982; Horacio Soler priv. col.). As a result of his involvement with the research group Piru, Iza was influenced by Pre-Columbian art in his choice of colours and motifs, and this led to a period of fantastic realism, sustained by superb draughtsmanship. The influence of José Luis Cuevas was also important for Iza, above all in his response to his environment in a country where ugliness was inextricably linked to modernization.

BIBLIOGRAPHY

H. Rodríguez Castelo: 'Iza', *Rev. Diners*, 24 (1984), pp. 42–5

H. Rodríguez Castelo and R. Jácome Durango: *Iza, Jácome, Román, Unda* (Quito, 1993)

CECILIA SUÁREZ

Izaguirre, Leandro (*b* Mexico City, 1867; *d* Mexico City, 1941). Mexican painter, illustrator and teacher. He entered the Academia de San Carlos in Mexico City in 1884. After studying with Santiago Rebull and José Salomé Pina, he soon devoted himself to the painting of historical subjects favoured by liberal critics in an attempt to create a Mexican school of painting, as in *Columbus at Rábida* and the *Founding of Tenochtitlán* (both Mexico City, Mus. Pal. B.A.). The highest recognition he received was for a painting of great breadth and aspiration, for which he was awarded a medal when it was exhibited in Philadelphia in 1893: the *Torture of Cuauhtémoc* (1892; Mexico City, Mus. Pal. B.A.) in which, with a sort of academic realism, the dignity of the last Aztec emperor is portrayed in a sordid setting, contrasted with the suffering of the king of Tlacopan and the cold indifference of the conquistadors. He was a professor at the Academia, had work commissioned in Europe (1904–6) and worked as an illustrator for the magazine *Mundo ilustrado*.

BIBLIOGRAPHY

J. Fernández: *Arte moderno y contemporáneo de México* (Mexico City, 1952)

B. Espejo: *Historia de la pintura mexicana*, iii (Mexico City, 1989)

JORGE ALBERTO MANRIQUE

Izcue, Elena (*b* Lima, 1889; *d* Lima, 1970). Peruvian designer, painter and teacher. She taught drawing in local schools before entering the Escuela Nacional de Bellas Artes in Lima in 1919. Inspired by Peru's indigenous heritage and the love of her country, Izcue often depicted Indian and Inca themes in her paintings (e.g. *Untitled*, 1924; Lima, Palacio de Gobierno). With her twin sister Victoria, she created the 'Incaic decorative art' style of interior design in the early 1920s. She illustrated the children's book *Manco Capac: Leyenda nacional* (1923; see colour pl. XVI, fig. 1) at the request of Rafael Larco

Herrera. He covered the publication costs of Izcue's *El arte peruano en la escuela* (Paris, 1926), which showed children how indigenous motifs could be used to decorate various handicrafts (see fig.). After graduating in 1926, Izcue received a grant to travel to Paris, where she attended the Académie de la Grande Chaumière and studied with Fernand Léger and Marcel Gromaire. To finance living in Paris, she produced Peruvian-influenced fashion accessories, and in 1929 Jean Charles Worth asked her to join the Maison Worth as a designer. She worked for Worth for ten years, during which time she and her sister staged an exhibition in New York (1935) and helped to decorate the interiors of the Peruvian pavilions in the Paris (1937) and New York (1939) World Fairs. On her return to Lima, Izcue resumed her earlier interests in art education and proposed various projects for state-funded institutions specializing in decorative and graphic arts.

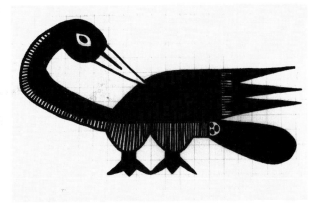

Elena Izcue: illustration from *El arte peruano en las escuela* (Paris, 1926), fol. 1

BIBLIOGRAPHY

J. Otero: 'Apuntaciones de arte: Elena and Victoria Izcue', *Variedades*, 823 (1923), pp. 3509–14
R. Larco Herrera: 'Dos artistas Peruanos en Paris', *Variedades*, 1073 (1928)
P. A. Means: 'Elena and Victoria Izcue and their Art', *Pan Amer. Bull.*, lxx (1936), pp. 248–53
P. Antrobus: *Peruvian Art of the Patria Nueva, 1919–1930* (diss., U. Essex, 1997)

PAULINE ANTROBUS

Izquierdo, María (*b* San Juan de los Lagos, Jalisco, 30 Oct ?1906; *d* Mexico City, 3 Dec 1955). Mexican painter and printmaker. She moved to Mexico City to study at the Academia de San Carlos and soon afterwards briefly shared a studio with Rufino Tamayo, who influenced her artistic development and taught her how to use gouache and watercolour. She exhibited in New York in 1929 and later made woodcuts with the Liga de Escritores y Artistas Revolucionarios, an association founded in 1934. In her paintings Izquierdo embraced popular traditions both in her masterly use of colour and in her tendency towards a naive or primitive style (e.g. *Family Portrait*, 1940 ; see colour pl. XVI, fig. 2). Her work has a provincial flavour, reflected in her favourite subjects: still-lifes, cupboards, altars, fruit, horses, portraits and the circus, for which she felt a special attraction.

BIBLIOGRAPHY

H. García Rivas: *Pintores mexicanos* (Mexico City, 1965), pp. 220–21
M. Helm: *Modern Mexican Painters* (New York, 1974), pp. 117, 140, 142–6, 148
O. Debroise: *Figuras en el trópico: Plástica mexicana, 1920–1940* (Barcelona, 1984), pp. 153–66
María Izquierdo, 1902–1995 (exh. cat., Chicago, IL, Mex. F. A. Cent. Mus. *c*. 1996
The True Poetry: The Art of María Izquierdo (exh. cat., ed. E. Ferrer, New York, Americas Soc. A. Gal., 1997)

LEONOR MORALES

J

Jácome, Ramiro (*b* Quito, 10 Sept 1948). Ecuadorean painter, draughtsman and printmaker. He was self-taught. Working in the neo-figurative style that revitalized Ecuadorean art in the 1970s, he was a member with José Unda (*b* 1948), Washington Iza and Nelson Román (*b* 1945) of the Los Cuatro Mosqueteros group, which was opposed to the art promoted by the official Salon. The members of the group formed their own 'anti-Salon' in Guayaquil in 1968. Jácome's incisive and ironic drawing style fed on ugliness, the grotesque and the horrific. He experimented with colour, space and line, as well as with abstraction, incorporating indigenous chromatics and magical elements. His desire to demythologize the history of America led him to paint the series *El camino de El Dorado* to illustrate a compilation of poetic texts published in 1979. This was followed in 1991 by the series *500 Years* on the theme of the discovery of America and another on *Famous and Anonymous Characters of Quito*. He also criticized urban life, as in *Megapopolis* (1990; artist's col.). He used various materials, including acrylic, oil and ink on canvas and wood, and worked with engraving and screenprinting. Jácome's work was widely exhibited, and he took part in the Venice Biennale (1990); he was also awarded numerous prizes, including first prize at the Salón Nacional Mariano Aguilera in Quito (1980).

WRITINGS
El camino de El Dorado (Quito, 1979)

BIBLIOGRAPHY
J. Icaza: *Huasipungo* [illus. by Jácome] (Quito, n.d.)
Algo sobre Jácome (exh. cat., Quito, Mus. Camilo Egas Banco Cent., 1983)
H. Rodríguez Castelo: 'Ramiro Jácome', *Rev. Diners*, 18 (1983), pp. 36–40
Iza, Jácome, Román, Unda (exh. cat. by H. Rodríguez Castelo and R. Jácome Durango, Quito, Fund. Cult. Exedra, 1993)
CECILIA SUÁREZ

Jaimes Sánchez, Humberto (*b* San Cristóbal, 25 June 1930). Venezuelan painter and printmaker. He studied at the Escuela de Artes Plásticas y Aplicadas de Caracas (1947–50) and was a member of the Taller Libre de Arte in 1949. Jaimes Sánchez lived in Europe from 1954 to 1957, studying architecture at the Ecole des Beaux-Arts, Paris (1955–6). His painting initially drew its inspiration from American archaeology, but in 1956 he executed his first lyrical abstract works. Later he executed his so-called 'psychological paintings'; the exploration of colour and material characterized all his work. He was a member of the Informalistas group between 1960 and 1962. In 1961 he began printmaking, joining the group of engravers El Taller in 1962. In the same year he won the Premio Nacional de Pintura at the Venezuelan Salón Oficial for *Fragments of Earth* (1961; Caracas, Gal. A. N.). He was also a member of Presencia 70 (1970–71).

BIBLIOGRAPHY
R. Delgado: *Humberto Jaimes Sánchez* (Caracas, 1969)
A. Boulton: *Historia de la pintura en Venezuela: Epoca contemporánea*, iii (Caracas, 1972)
Humberto Jaimes Sánchez: Tierras psicológicas—Exposición antológica (exh. cat. by J. Calzadilla, Caracas, Gal. A. N., 1980)
MARÍA ANTONIA GONZÁLEZ-ARNAL

Jamaica. Island country in the Caribbean. The third largest island among the Greater Antilles, it lies 144 km south of Cuba and covers an area of 11,425 sq. km (see fig. 1). It is a lush island traversed by a mountain range, and it includes an area of unusual limestone formations, the Cockpit Country. The population in 1996 was *c.* 2.6 million.

I. Introduction. II. Cultures. III. Architecture. IV. Painting, graphic arts and sculpture. V. Interior decoration and furniture. VI. Ceramics. VII. Metalwork. VIII. Patronage. IX. Collecting and dealing. X. Museums. XI. Art education.

I. Introduction.

When Columbus arrived in Jamaica in 1494 it was inhabited by Arawak-speaking Taino Amerindians. Juan de Esquivel conquered the island in 1509, and by 1513 the first Africans were present as personal servants of the Spanish settlers. Within decades the indigenous population had died out through war and European disease. They were replaced by West Africans bought to work as slaves on sugar plantations. In 1655 an English expeditionary force landed and captured Spanish Town, which had been the capital since 1635. The Spanish released the slaves to hinder English occupation and abandoned the island after about five years. Many of the slaves fled into the interior Cockpit Country, where they and their descendants became known as Maroons and waged war against the new colonists until 1739, when a peace treaty was negotiated, which granted 1500 acres and certain rights to the Maroons. Port Royal, near Kingston, a base for the buccaneer Henry Morgan, was destroyed in an earthquake in 1692. There was a further wave of slave importation from the late 17th century. Many Kikong- and Yoruba-speaking peoples arrived, particularly in the 1770s. The slaves were emancipated in 1838, when most of them left the plantations to settle in the mountains. From 1840 to 1865, 8000

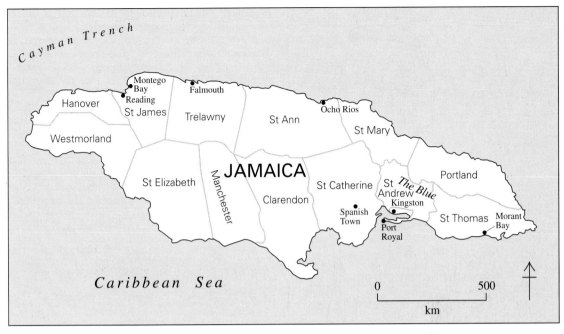

1. Map of Jamaica

West Africans arrived to work as waged labourers on the plantations. Kingston became the capital in 1870. In 1958 Jamaica joined the Federation of the West Indies but withdrew in 1961 and gained independence within the Commonwealth in 1962. There was a high rate of emigration from the mid-20th century, but at the end of the 20th century the natural annual increase in population was *c*. 1.5%. Approximately 90% of the population is of West African descent; the remainder includes people of Chinese, East Indian and European origin. Maroon settlements still exist at St Mary, Portland and St Elizabeth. Sugar remains the main export crop, although in 1995 alumina accounted for 44% of merchandise exports, while bananas, coffee, cocoa, citrus, tobacco, spices and illegal ganja (marijuana) are also grown. Jamaica's official second foreign exchange earner is tourism.

BIBLIOGRAPHY

C. V. Black: *History of Jamaica* (London, 1958, 2/1983)

Jamaica J., i– (1967–)

F. E. Hurwitz and S. J. Hurwitz: *Jamaica: A Historical Portrait* (New York, 1971)

M. Binney, J. Harris and K. Martin: *Jamaica's Heritage* (Kingston, 1991)

JANET HENSHALL MOMSEN

II. Cultures.

1. Amerindian. 2. Afro-Caribbean.

1. AMERINDIAN. The language and culture of Jamaica's first inhabitants, the Taino Amerindians, were similar to those of the indigenous peoples of Hispaniola, Puerto Rico and eastern Cuba (*see also* CARIBBEAN ISLANDS, §II, 1). Archaeological remains include rather crude pottery decorated with red or black paint and geometric designs incised on the borders of the vessels. These correspond to what archaeologists of the Antilles consider sub-Taino styles of pottery. This evidence sug-

gests that the first inhabitants of the islands arrived towards the 12th century, possibly from Hispaniola. Ethno-historical references to their culture are scant, since chroniclers of the Spanish Conquest focused on Hispaniola. In a letter to the Catholic kings, discovered in the late 20th century, Columbus described aspects of the aboriginal art while informing of the arrival of a large canoe with a Jamaican *cacique* (Sp.: Indian chief), his family and servants. He drew attention to the fine and elaborate ornaments and paraphernalia of the individuals: the canoe was decorated with painted designs; the men wore colourful red-and-white feather head ornaments; one had a banner-like woven-cotton cloth; another carried a wooden trumpet carved with bird motifs; over his chest the *cacique* bore a large stone-bead necklace with a gold ornament in the form of an 'iris flower' and 'on his head a garland of small white stone beads with a few hanging over his forehead, while from his ears hung two large gold tablets with strings of marble beads and even though naked, he wore a belt of small stone beads'.

The best examples of the Amerindian art of Jamaica are three idols (AD1000–1500; London, BM) carved from Guaiacum-wood, discovered in 1797 in a cave in Carpenters Mountains, Parish of Vere. The bird-headed idol (h. 880 mm) has conch-shell incrustation for teeth in its beaklike mouth. Its tubular body has extended upper appendages that simulate arms or perhaps wings. The legs have carved bands under the knees, like the cotton ones commonly used by the Tainos. The second (see fig. 2), an anthropomorphic, armless idol (h. 1.03 m), has legs stretched wide apart. Its gaping mouth reveals conch-shell teeth. This idol has representations of the cotton leggings and also the round ear-plugs used by the Tainos. The third idol (h. 390 mm), representing the upper torso of a human figure, carries on its head a round dish or canopy, which

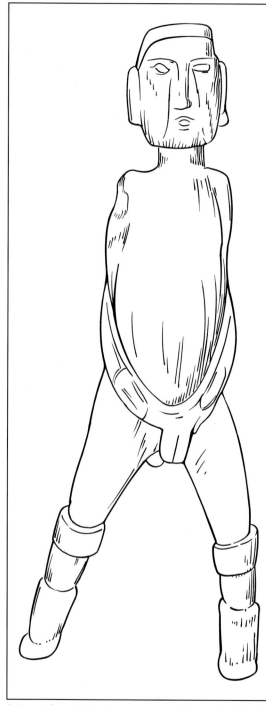

2. Amerindian idol, Guaiacum wood, h. 1.03 m, AD 1000–1500, from Carpenters Mountains, Parish of Vere, Jamaica, found 1797 (London, British Museum)

was used to deposit the hallucinogenic *cohoba* powder or snuff, used by the Taino shamans in their rituals. Under the eyes, vertical grooves that possibly contained shell incrustations may represent tears. In 1983 Lee reported the discovery in St Ann of a gold-leaf disc (16×21 mm; now in Kingston, Inst. Jamaica), probably used as an ornament. The use of stone by Amerindians in Jamaica was limited to celts, mortars and rather simple corporal ornaments. Other examples of the Amerindian art of Jamaica include pictographs. These were discovered at Mountain River Cave in St Catherine. They are painted with a black pigment, possibly a type of bituminous material (Watson). The 148 identifiable pictographs are mostly of animals, such as iguanas, turtles, birds and frogs. Some anthropomorphic figures as well as some abstract pictographs were also uncovered. There is also evidence of a few petroglyphs. Ethno-historical sources reveal that Jamaican Amerindians played *batey*, the ceremonial ball-game of the Tainos, using a rubber ball. By the late 20th century, however, no special monolith-lined court, such as those of Puerto Rico and Hispaniola, had been found.

BIBLIOGRAPHY
T. A. Joyce: *Central American and West Indian Archaeology* (London, 1916)
S. Loven: *Origins of the Tainan Culture of the West Indies* (Göteborg, 1935)
J. W. Lee: 'A Pre-Columbian Gold Artifact from Jamaica', *Proceedings of the 10th Congress for the Study of Pre-Columbian Cultures of the Lesser Antilles: Montreal, 1985*, pp. 343–5
K. Watson: 'Amerindian Cave Art in Jamaica', *Jamaica J.*, xxi/1 (1988)
I. Rouse: *The Tainos: Rise and Fall of the People who Greeted Columbus* (New Haven, 1992)

RICARDO E. ALEGRÍA, MELA PONS-ALEGRÍA

2. AFRO-CARIBBEAN. The Africans imported as slaves, came from many peoples of West Africa, the majority being Asante from the Gold Coast and Yoruba and Ibo of southern Nigeria. Smaller numbers of Kongo and Mandingo were also prominent, particularly among the later Free Africans. Despite the island's slave laws and Christianity, which together exerted control over a people already stripped of virtually all possessions, many slaves secretly and surreptitiously continued to practise their traditions, particularly in music, dance, beliefs, language and other customs. The Maroons (from the Spanish *cimarron*, 'wild and untamed'), for example, who had formed from bands of escaped slaves, communicated by means of talking drums and their *abeng*, a cow-horn bugle used also as a musical instrument and for ceremonial occasions. Their secret language contained many Akan words. African culture can still be observed within the modern Maroon, Kumina and Nago communities in Jamaica (*see also* AFRICAN DIASPORA). Following independence the rise of nationalism led to a re-examination and renewed appreciation of Afro-Jamaican cultural expression. The African Caribbean Institute at the Institute of Jamaica in Kingston was established in 1972 as the principal cultural agency for the study and dissemination of research on Africa and its heritage in the Caribbean.

Although Christianity is the dominant religion on the island, a number of African religious beliefs and cults have been practised. Obeah, for example, was brought to the Caribbean by the Asante and flourished for over 300 years. In 1772 the historian Edward Long wrote disparagingly of the practice: 'Some of these execrable wretches in Jamaica introduced what they called the "myal dance" and established a kind of society into which they initiated all they could. The lure hung out was that every Negro initiated into the myal society would be invulnerable to the white man; and, although they might appear to be

slain, the obeahman could, at his pleasure, restore the body to life.' In response to the threat to the planters' authority, the government's suppression of the cult in an effort to control the black population ensured its entrenched secrecy within Jamaican society. It is therefore difficult to estimate the extent to which it has been practised, although it became less popular over time. Practitioners, both men and women, may be associated with one of two forms of Obeah, or a combination of both. Some Obeahmen or -women have balm yards (herb gardens) and use local roots, herbs and other natural substances, such as earth, blood, bones, feathers and ashes, in established forms clearly related to African antecedents. Others are associated with religious cults, claiming to be able to control spirits to do their bidding. Obeah can, however, be worked for any number of reasons.

Kumina (or Cumina) is regarded as the most African of the Jamaican religious cults and is believed either to have been brought with the Free Africans between the 1840s and 1860s or to have received new stimulation from their arrival. Many of the Free Africans settled in St Thomas, where the cult has remained strongest. Kumina groups were also formed in Portland, St Catherine, Kingston and other areas. Extensive research has revealed a Bantu, and more specifically a Kongo ancestry for this cult. Kumina ritual is largely conducted in Kikongo, the language of the Kongo peoples, and the name Kumina itself is a Kikongo word meaning to act or move rhythmically. Kumina people also refer to themselves by the Bantu term Bongo. The ceremonies of Kumina, a cult of ancestor worship, are performed for such specific reasons as births, deaths, weddings, wakes, entombments and thanksgiving. Kumina comprises both rites of incorporation and rites of passage. Singing, dancing and drumming are the three key elements of Kumina ceremonies. The goat-skin-covered hollow drums, played only by men, include the large *kimbanda* or *kbandu* and the smaller *kyas* or *cass*. Their importance lies in their hypnotic rhythms, through which control is exercised over certain spirits. Both men and women may become leaders following a long apprenticeship. They then hold the pre-eminent position within the group, since they control such spirits as the sky gods, earthbound gods and ancestral zombies.

Myalism, another Jamaican possession–healing cult, was probably first associated with Obeah, in that its potions and trances were employed to counteract the influences of the latter. Myal men are also bush-healers, using herbs for healing and protection; they also became associated with 'shadow catching', capturing and controlling 'duppies' (ghosts of dead people). The traditional dance of *gombay* is considered a Myal dance. Myalism reached its zenith between Emancipation and the 'Great Revival', an orgy of religious conversion in 1860–61. Thereafter, Myalism appears to have disappeared, and many of its elements were absorbed into Revivalism, another spirit cult, which gained great impetus at this time, developing from a synthesis of African religious beliefs and Christianity. This cult is celebrated in several forms, the two major ones being Revival Zion (or Zion) and Pocomania (now more commonly known as Puk Kumina). The state of possession or 'getting into the spirit', a notable feature of services, is induced through a ritual that includes music and songs

borrowed from orthodox religion, but uniquely performed accompanied by drumming, dancing, clapping, groaning and the chanting of prayers. One of the best-known contemporary leaders is Revival Shepherd Mallica 'Kapo' Reynolds, whose fame derives primarily from his reputation as an acclaimed Intuitive artist (*see* §IV below). Early Revivalist meetings were held in consecrated areas called the 'seal ground' or 'mission ground', part of the leader's yard, where a temporary booth was erected. In the late 20th century some bands (or groups) began to construct more permanent churches. Revivalism has been important in preserving traditional Jamaican folk culture and has inspired the development of various Jamaican art forms.

The origins of Rastafarianism remain obscure, but it came to national attention in the 1930s. The inspiration of Marcus Garvey's Universal Negro Improvement Association and his teachings on the pre-eminence of black culture and the need for self-improvement and self-reliance of Africans aroused a black consciousness and pride. Rastafarianism emerged from this movement, against the backdrop of organized labour and political groups. Its principal icon and eventual Messiah was Haile Selassie (1891–1975), who became Emperor of Abyssinia (now Ethiopia) in 1930. The identifying symbol of the lion, with the red, green and gold Ethiopian flag flying, is another reference to Selassie's title as the Lion of Judah. The movement's two fundamental doctrines are that Haile Selassie was the black reincarnation of Christ and that repatriation to Africa assured the redemption of black people in their spiritual home. Thus Rastafarianism came to reflect the national search for a cultural identity that absorbed Jamaica at this time and beyond independence. Rastafarians differentiate themselves from 'Babylon' (or mainstream society) in such aspects of everyday life as speech, dress, behaviour and diet. While an adherent must retain his beard (a symbol of his pact with Jah or Jehovah) and his Bible as his source of knowledge and wisdom, a more extremist group called 'locksmen' popularized long, uncombed hair or dreadlocks in emulation of the lion's mane, which has now become an identifiable trademark of all cult members. The use of marijuana or 'ganja' as a biblical herb is associated with the cult's meditative nature, through which wisdom and communication with God can be achieved. Rastafarianism's close identification with the performing and visual arts has given the cult visibility at an international level, especially in popular music. The paintings of Albert Artwell (*b* 1942) are defined by his personal revelation of Rastafari, and other artists have begun to employ the trappings and idioms of Rastafarianism to create a new iconography.

A fusion of European, African and Creole cultures can be seen in Jonkonnu (or John Canoe), a traditional feature of Jamaican Christmas celebrations involving bands of costumed masqueraders roaming the streets of towns and villages (*see also* CARNIVAL). The practice appears to have started early in Jamaican history, among the slave population, and was widely popularized by the late 18th century. It was initially suppressed by the government, who feared that such gatherings might encourage rebellion and covert communication via drums and conch-shells among the blacks. The masquerade includes music, dance, pantomime and drama. The word Jonkonnu itself may be linked to

the Ewe terms *dzono* or *dzonko*, and *kunu* or *nu*, meaning deadly sorcerer or sorcerer man respectively. This reinforces hypotheses that Jonkonnu originated from West African secret societies such as the Poro and Egungun, especially since all the players are masked men. The earliest forms and characters of the masquerade were closely associated with secrecy and magic, and such early characters as Cow Head, Horse Head, Jack in the Green and Pitchy Patchy bear a strong resemblance to West African parallels. The 19th-century artist Isaac Mendes Belisario (?1795–1849) documented Jonkonnu characters in a print series in the 1830s (see fig. 3).

Among the crafts brought to Jamaica from Africa is basketry. Local materials are used, including bamboo, wiss or withe, thatch palm, sisal or jippa jappa. Some forms of basket betray their African origin. The Jamaican bankra, for example, a rectangular travelling basket with handles and a cover, is clearly derived from the bonkara of Ghana, which has a similar function of transportation of goods and food to market. Jamaica's traditional coarse earthenware, such as *yabbahs* and monkey jars (see fig. 7 below), have distinctive African features (*see* §VI below). Archaeological research at Morant Bay in St Thomas has provided evidence of the technological skills of the early Maroons, who produced ironwork for domestic use and weapons. African sources have been identified in the motifs used in the grillwork and fretwork designs that decorated older buildings, for example patterns of the *adinkra* cloths of the Asante of Ghana (Bryan; *see* §IV below).

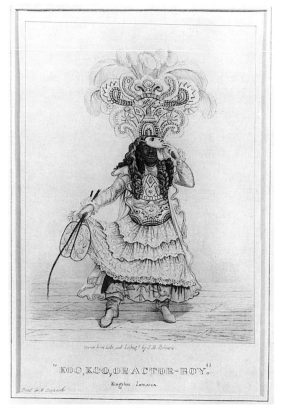

3. Isaac Mendes Belisario: *Koo Koo or Actor-boy*, character from the Jonkonnu masquerade, lithograph, 399×495 mm, 1837 (St Michael, Barbados Museum)

During the 1850s the Rev. James Phillippo recorded the continuity of a wood-carving tradition, noting, 'Fifteen or twenty years ago in a Negro burying ground, at no great distance from the author's residence in Spanish Town, there was scarcely a grave that did not exhibit from two to four rudely carved images.' Such funerary statuary may reflect a continuity with the burial traditions of the Akan peoples of West Africa. The Jamaican traditional walking-stick is still subconsciously associated with the symbol of an Obeahman's power. More recently the artists David Miller and his son (of the same name) reinterpreted West African imagery and form: David Miller jr, for example, has re-examined the African physiognomy in his wooden sculpture.

BIBLIOGRAPHY
J. H. Bell: *Obeah: Witchcraft in the West Indies* (1889/*R* 1970)
O. Senior: *A–Z of Jamaican Heritage* (1983, 2/1988)
R. F. Thompson: *Flash of the Spirit: African and Afro-American Art and Philosophy* (New York, 1983)
V. Poupeye-Rammelaere: 'The Rainbow Valley: The Life and Work of Brother Everald Brown', *Jamaica J.*, xxi/2 (1988), pp. 2–14
C. Goucher: 'John Reeder's Foundry: A Study of 18th Century African–Caribbean Technology', *Jamaica J.*, xxiii/1 (1989), pp. 39–43
D. Armstrong: 'Recovering an Early 18th-Century Afro-Jamaican Community: Archaeology of the Slave Village at Seville, Jamaica', *Proceedings of the 13th International Congress for Caribbean Archaeology: Curaçao, 1990*, pp. 344–62
V. Poupeye-Rammelaere: 'The Iconography of Marcus Garvey: Part 2', *Jamaica J.*, xxiv/2 (1992), pp. 24–33
L. M. Martínez Montiel, ed.: *Presencia africana en el Caribe* (Mexico City, 1995)

ALISSANDRA CUMMINS

III. Architecture.

The first Spanish colonists settled at Sevilla La Nueva (now New Seville; mostly destr.). The earliest Spanish domestic buildings were simple timber-framed, palm-thatched, square or oblong huts based on Amerindian designs (reconstruction of Amerindian hut in St Catherine, Arawak Ind. Mus.). Manufacture of local clay bricks and roof tiles is recorded as early as 1527. The island's first governor, Juan de Esquivel, erected a two-storey fortified dwelling of cut stone, with external walls over 1.20 m thick, on 2.40 m-wide foundations. The settlement was soon abandoned in favour of Villa de la Vega (now Spanish Town), which comprised 400 to 500 buildings laid out on the characteristic Spanish grid plan with a central square. In the 17th century, houses were generally small with high timber walls raised on a masonry base and roofed with locally manufactured clay tiles. Little survives from over 150 years of Spanish colonization.

When the English captured Jamaica in 1655 Spanish Town was mostly destroyed, and the building materials were reused. During visits in 1687 the physician and botanist Hans Sloane (1660–1753), who later wrote the comprehensive, two-volume *Natural History of Jamaica* (1707 and 1725), described Jamaican houses as being bungalows of timber and plaster with shuttered windows and inner courtyards in the Spanish mode. More important buildings were constructed in masonry, for example the cathedral of St James (begun 1655) on the site of an early 16th-century Franciscan chapel. The development of sugar cultivation gave rise to the construction of houses such as Drax Hall (1690), facing the sea on the St Ann coast, a broad-roofed masonry and timber-boarded house. Several

4. Courthouse, Falmouth, 1815, restored 1926

of the plantation houses were fortified against raids, such as that by the French in 1694. Stokes Hall (*c.* 1710), St Thomas, and Colbeck Castle (*c.* 1748), St Catherine (both ruined), are examples: they have massive corner towers and loopholes for cross-fire defence.

Port Royal had developed to serve the sugar trade during the 17th century and boasted masonry buildings up to four storeys high before it was destroyed by an earthquake in 1692. Kingston was founded in 1693. Houses there were built lower and wider, with verandahs, arcades and sash windows in the emerging Jamaican Georgian style. Surviving examples in this style include the town houses at Falmouth and the government buildings at Spanish Town. In Spanish Town elaborate public buildings were built around the main square. These included the House of Assembly (1762) on the east side, with a ground-floor arcade and deep colonnaded verandah facing the square, and on the west King's House (1762), a splendid H-shaped building in the Georgian style, built under the direction of Henry Craskell (*fl* 1760s), the government engineer; after a fire (1925) it was restored around the remaining façade. Both buildings are in brick with stone dressings. Nineteenth-century plantation houses include Rose Hall (rest. 1969), St James; Marlborough, Manchester; and Bellevue, St Andrew (all *c.* 1770–80). Built in ashlar masonry, with regularly spaced sash windows with and without jalousies, they show increasingly Neo-classical features, such as the tetrastyle portico at Marlborough.

Falmouth, a port founded on the north coast at the end of the 18th century, remains the most complete Jamaican colonial urban environment. Most of the buildings were constructed in the early 19th century. While some brick houses with their small entrance porches exhibit the influence of the Queen Anne style, Barrett House (1799), with its colonnaded verandah on the street front supporting an enclosed, boarded upper storey, is more typically Caribbean Georgian in style. Other notable buildings in Falmouth include the school (1815; formerly the barracks), the elegant classical Courthouse (see fig. 4) and the Caribbean Georgian church (1795).

When plantation society declined following Emancipation, few new mansions were built. The basic characteristics of Jamaican architecture remained unchanged, however, until well into the 19th century. Devon House (1881), Kingston, successfully adapted the English Neo-classical style with a pilastered façade complemented by a colonnaded verandah. Vernacular architecture developed along similar lines to the chattel house found elsewhere in the Caribbean. Many of these small timber houses are concentrated in the Falmouth area. They retain the Georgian sense of proportion in a symmetrical façade with a central door and a window on either side. Front porches are often trimmed with white-painted 'gingerbread' fretwork, echoed by railings and white-painted roof crests. The side windows are often protected by wooden 'coolers' or awnings.

Little construction took place during the first decades of the 20th century following the degeneration of the

sugar industry, which was compounded by the worldwide depression. It was only during the post-World War II period with the beginning of the tourist industry that architectural activity again increased. Many of the new buildings constructed from the 1950s were holiday homes, such as Ocean View, Reading, which incorporated the ruins of an old stone warehouse with jalousied windows to create a simple bungalow, and Casa del Sol, Reading, a low-lying villa with jalousied windows and doors opening on to a wide, covered terrace. In the 1980s local artists and architects were involved in a lively debate concerning their collaboration to enhance the Jamaican lifestyle: the architect Patrick Stranigar's designs for the Jamaican Conference Centre (1985), Kingston, involved experimentation with traditional materials to produce such elements as acoustic baskets, wicker ceiling tiles and macramé sound baffles as part of his search for a Jamaican architectural iconography.

BIBLIOGRAPHY

T. A. L. Concannon: 'Houses of Jamaica', *Jamaica J.*, i/1 (1967), pp. 35–9

Buildings in Jamaica, Jamaica Information Service (Kingston, 1970)

V. Radcliffe: *The Caribbean Heritage* (New York, 1976)

D. Buisseret: *Historic Architecture of the Caribbean* (London, 1980)

P. Grosner: *Caribbean Georgian: The Great and Small Houses of the West Indies* (Washington, DC, 1982)

S. Slezin and others: *Caribbean Style* (London and New York, 1985)

P. Stranigar: 'Art in Architecture', *A. Jamaica*, iv/2 (1985), pp. 24–35

M. Holden: 'Acoustics: Handcrafted in Jamaica—Jamaica Conference Centre', *Archit. Rec.*, clxxiv/12 (1986), pp. 134–7

E. E. Crain: *Historic Houses in the Caribbean* (Gainesville, 1994)

ALISSANDRA CUMMINS

IV. Painting, graphic arts and sculpture.

Little remains on the island of the material culture of Jamaica's Amerindian population (*see* §II, 1 above), while the Spaniards themselves left little of artistic merit. The most important remains are the New Seville Carvings (Kingston, N.G.; see fig. 6 below), a group of architectural friezes and ornaments carved by European craftsmen in local limestone and probably intended to adorn the Governor's residence in the former capital of Sevilla La Nueva (now New Seville). In contrast, the English colonizers left a rich heritage of 18th- and 19th-century art. Of particular interest is the monument in Portland stone (1784–6) to *Admiral Rodney* by the English sculptor John Bacon the elder (1740–99) in the main square in Spanish Town. The nearby cathedral and other churches on the island boast some fine examples of Neo-classical funerary sculpture by Bacon, John Flaxman (1755–1826) and others. The important paintings of the period were produced by itinerant artists, such as the Englishman George Robertson (1748–88), who drew and painted in Jamaica and on his return to England published six aquatints of Jamaican landscapes. James Hakewill (1778–1843) produced a collection of 21 aquatint views published in 1825, while Joseph Bartholomew Kidd (*d* 1889) published 50 hand-coloured lithographs, including *Views of Jamaica*. Of particular interest is Isaac Mendes Belisario (?1795–1849), who settled in Jamaica in 1835; he produced portraits of prominent citizens, some fine landscapes and several topical lithographs chronicling important national events (see also fig. 3 above). During the 19th century several

American painters arrived in Jamaica, notably Ralph Albert Blakelock, Frederick Edwin Church and Martin Johnson Heade, all of whom painted fine Jamaican landscapes.

A truly Jamaican art, however, did not begin to develop until the early 20th century. What is commonly called the Jamaican Art Movement is usually considered to have begun in 1922, the year that the young EDNA MANLEY, who was born and had studied in England, arrived in Jamaica, where her mother had been born. Manley immediately identified with Jamaica and in the 1920s and 1930s produced an impressive body of heroic carvings, notably a series that monumentalized Jamaican womanhood. Beginning with the carving *Negro Aroused* (1935; see fig. 5), her work was given a political edge as she became intimately involved with the developing nationalist political movement spearheaded by her husband, Norman Manley. Other artists emerged during the late 1930s, notably ALBERT HUIE and ALVIN MARRIOTT, who were either directly inspired by Manley's work or encouraged by her active efforts to forge a truly Jamaican art.

A watershed year in Jamaica's political development, 1938 was also important to the development of Jamaican art: the first All Island Exhibition of Art and Craft was staged, with great success. By 1940 the Institute of Jamaica in Kingston (est. 1876), prompted by the fervour of this burgeoning art movement, established classes. Manley was one of the prime movers behind this initiative and was among the early tutors. Through these classes, several new artists came to the fore, including RALPH CAMPBELL,

5. Edna Manley: *Negro Aroused*, mahogany, h. 635 mm, 1935 (Kingston, National Gallery)

DAVID POTTINGER and Henry Daley (1918–50). Although instructed in essentially European naturalistic and Post-Impressionist styles, these artists were inculcated with the nationalist ethos and the need for the development of an indigenous iconography. By 1950 the classes were institutionalized into the Jamaica School of Art and Craft. Several important artists also developed outside the Manley orbit and the institute. They included GLORIA ESCOFFERY, CARL ABRAHAMS, RONALD MOODY, NAMBA ROY and the first of Jamaica's Intuitive painters, JOHN DUNKLEY, a unique visionary.

The 1960s and 1970s were periods of both entrenchment of traditional values and of marked experimentation. While BARRINGTON WATSON developed a figurative style rooted in 19th-century academicism, KARL PARBOOSINGH and EUGENE HYDE drew on more recent styles, in particular a figurative expressionism and Abstract Expressionism. This latter 'American import' (as it was viewed, suspiciously, by some) also found favour with Milton Harley (b 1936) and KOFI KAYIGA. Other 20th-century movements were also belatedly established at this time. Surrealism, for example, found a ready breeding-ground in the work of painter COLIN GARLAND and of sculptor Winston Patrick (b 1946), whose biomorphic forms later gave way to illusionistic abstractions in wood. Hope Brooks, another abstractionist, developed a highly personal style, which relies on subtle textural effects within limited All-over painted canvases. DAVID BOXER also utilized marked textural effects but to different ends. Espousing what were termed New Imagist ideas, born of an investigation of such European figurative artists as Francis Bacon (1909–92) and Jean Dubuffet (1901–85), Boxer created icons of a doomed post-nuclear civilization. After the outstanding example of Dunkley, several Intuitive artists of undeniable talent surfaced, principally the true *naïfs* Gaston Tabois (b 1931) and SIDNEY MCLAREN, and three highly inventive artists steeped in local folklore and traditions, whose works at times moved into mysterious mystical realms: KAPO (Mallica Reynolds), EVERALD BROWN and Albert Artwell (b 1942).

In the late 1970s MILTON GEORGE, a fine colourist inspired by Matisse and Parboosingh, emerged as a major painter; during the 1980s his work took on a marked satirical edge as more weighty subjects entered his repertory. Also during the 1980s a wave of younger artists came to prominence, many of them graduates of the Jamaica School of Art. Especially notable was a loosely defined neo-expressionist group who drew heavily on the New Imagist trends of Boxer and the more recent developments of Milton George. The finest of these include Robert Cookhorne (b 1960). A more abstract approach combined with textural interests also characterized the work of many young female graduates of the Jamaica School of Art, for example Margaret Chen, who returned to Jamaica after spending nearly a decade studying in Canada. Several important Intuitive artists also came to attention in the 1980s, notably William Joseph (b 1919), with his elemental 'Neo-African' carvings, and Leonard Daley (b c. 1930), whose paintings are filled with wildly expressionistic grotesques.

BIBLIOGRAPHY

The Intuitive Eye (exh. cat., intro. D. Boxer; Kingston, N.G., 1979)
P. Beshoff: 'Namba Roy: Maroon Artist and Writer', *Jamaica J.*, xvi/3 (1983), pp. 34–8
P. Bryan: 'Towards an African Aesthetic in Jamaican Intuitive Art', *A. Jamaica*, iii/3–4 (1985), pp. 2–11
P. Archer Straw and K. Robinson: *Jamaican Art* (Kingston, 1990)
D. Boxer: *Edna Manley: Sculptor* (Kingston, 1990)
New World Imagery: Contemporary Jamaican Art (exh. cat., London, Hayward Gal., 1995)
D. Boxer and V. Poupeye: *Modern Jamaican Art* (Kingston, 1998)
V. Poupeye: *Caribbean Art* (London, 1998)

DAVID BOXER

V. Interior decoration and furniture.

In Jamaica, as elsewhere in the Caribbean, the simple huts built by the first Spanish colonists in the early 16th century had little decoration and few furnishings. The inner walls of these timber buildings were plastered with mud, the floor covered with lime concrete. Little remains of the basic furnishings constructed to traditional Spanish designs. The Spaniards were, however, quick to adapt the woven cotton hammocks of the Amerindians to their own use. The New Seville Carvings (see fig. 6), doorjambs associated with the Governor's Mansion in Sevilla la Nueva (now New Seville), are redolent of an Italianate or Spanish Renaissance grotesque style, with confronting foliate scrolls and local bird motifs. These carvings remain the only known examples of such decoration of the period, as

6. New Seville Carvings, doorjamb, limestone, h. 1.37 m, c. 1530 (Kingston, National Gallery)

interior decoration was clearly limited in less exalted households.

The migration of planters from the Lesser Antilles, and particularly Barbados, during the second half of the 17th century almost certainly influenced early interior decoration and furniture design in Jamaica. Jamaican inventories for these early plantation houses (the 'Great Houses') suggest generally smaller buildings than those in Barbados during the same period. The interior rooms probably included a large hall, one or more parlours, a dining-room, several service rooms and the master's chamber on the ground floor. The remaining chambers, rarely more than three in number, were situated upstairs, while the kitchen was generally in a separate building behind the house. Dunn suggested that the best rooms in the house might have been wainscoted, painted or covered with hangings. As with English houses of the same period, the hall remained the centre of activity. Accounts for Bybrook Plantation include the purchase of some dozen cane chairs for the Great House. By the end of the 17th century, however, absentee landlords began to return to London, and the impetus for creative design in furnishing and decorating the Great Houses became more or less stagnant, despite the accumulated wealth of the plantocracy.

Inventories dating from 1674 to 1701 record the presence of skilled and semi-skilled workers in Port Royal, including cabinetmakers, glaziers, carpenters and joiners. The wealthiest sugar planters also built town houses in Port Royal, often larger and more elaborately furnished than the plantation houses. John Taylor recorded (1688) that 'the merchants and Gentry live here to the hight [sic] of splendor in full ease and plenty'. An inventory for the six-room house of the Port Royal shoemaker John Waller listed three beds, a hammock, ten chairs, four stools, four tables, one desk, four chests, two carpets used to cover the tables, two pictures and two mirrors. Inventories of more wealthy households include cabinets inlaid with ivory and tortoiseshell, floral satin chairs, two harpsichords, looking-glasses, oil paintings and framed maps. The hall was often furnished with 50 to 60 chairs and several tables. Few surviving houses, however, predate the 19th century, and none has completely original furnishings to indicate how the interiors were arranged.

While evidence exists of a thriving local furniture industry, the record books of Waring & Gillow Ltd of England record an increasing export trade to the Caribbean during the 18th century, and by 1770 the Jamaican trade exceeded that of any other island. The large range of mahogany items in demand between 1745 and 1785 included billiard and backgammon tables, Pembroke tables, Windsor chairs, pier tables, bed pillars carved in the 'Gothic stile', wardrobes and close stool chairs. Two cases of paper hangings listed such patterns as 'Border No. 1: Black and white on stone; Border No. 17: Sprig on straw, Bengall and sprig on blue, and stripe green on crimson'. In most cases, however, the furniture was sent speculatively, with only a few pieces sent in response to a specific order. By the end of the 18th century the growing number of absentee landlords and the decline in the sugar industry resulted in the virtual disappearance of this prosperous trade with Jamaica.

The interior of the Great House at Good Hope (c. 1755) possesses some fine Neo-classical woodwork. Bryan Castle (c. 1750) is noted for its interior staircase, fine woodwork and classical doorframes executed in stucco. Old King's House (1762; destr. 1925), Spanish Town, impressed observers with its classical proportions and huge reception hall (h. 9.75 m). It was lavishly decorated with a gallery to the west, and archaeological evidence has revealed fragments of painted wall plaster decorated with a black-and-white geometric stencil design consisting of a trellis motif and a lineal dot design. Edward Long, describing the ballroom in 1774, stated that:

> the great saloon . . . is well proportioned; being seventy-three by thirty feet and the height about thirty-two: from the ceiling, which is coved, hung two brass gilt lustres. A screen of seven large Doric pillars, divides the room from an upper and lower gallery of communication, which range the whole length on the West side, and the upper is secured with an elegant entrelas of figured iron work. The East [side] . . . is finished with Doric pilasters; upon each of which are brass girandoles double-gilt.

During the 19th century the pre-eminence of the merchant class led to the development of elegant households and country seats. In 1825 James Hakewill described the interior of Rose-Hall (c. 1770), St James, noting that on the left of the entrance hall:

> is the eating-room, and on the right the drawing room, behind which are other apartments for domestic use. The right wing, fitted up with great elegance, and enriched with painting and gilding, was the private apartment . . . and the left wing is occupied as servants' apartments and offices. The principal staircase, into the body of the house, is a specimen of joinery in mahogany and other costly woods seldom excelled, and leads to a suite of chambers in the upper storey.

The naturalist Philip Gosse's description (1844–5) of Phoenix Park offers a vivid account of a typical building:

> Jamaican houses are commonly built on one principle . . . the furnished part of the house is all on the same level . . . a visitor [enters through] the front door, [into] a spacious hall, in the form of a cross, extending the whole length and breadth of the house. This large hall is the characteristic of all Jamaican houses, it forms the principal sitting room . . . the two square areas formed by one side of the cross are filled by bedrooms; but with these exceptions the whole of the sides and ends of the hall are either occupied by windows, or open, and furnished with jalousies . . . this large and cool apartment is furnished with sofas, ottomans, tables, chairs etc, not differing from ours; but there is no fireplace, nor any carpet. Instead of the latter the floor is made of the most beautiful of the native woods, in the selection of which much taste is often displayed, as also in arrangement, so that the various colours of the wood may harmonize or contrast well with each other. Mahogany, green-heart, breadnut and blood-heart are among the trees whose timber is employed for floors.

Devon House, Kingston, built by George Stiebel in 1881, was refurbished in the 1960s in the style of a late 19th-century Great House. The furnishings are of both European and Caribbean manufacture. The ballroom has round low-relief cherub decorations in the plasterwork ceiling, and a rare Meissen porcelain chandelier hangs in

one of the bedrooms. In the dining-room, two ornately carved sideboards and two cellarettes are typical of 19th-century mahogany West Indian pieces. The dining table and chairs are 20th-century reproductions of Chippendale geometric pattern pieces originally owned by a Jamaican family. Government House, Kingston, was described by James Froude in 1888 as having:

> long airy darkened galleries, and into these the sitting rooms open, which are of course still darker with a subdued green light ... the floors are black, smooth, and polished, with loose mats for carpets. All the arrangements are made to shut out heat and light. The galleries have sofas to lounge on.

During the early 1870s T. N. Aguilar established Aguilar's Furnishing Warehouse in Kingston, importing heavy horse-hair Victorian furniture from the United Kingdom and offering a cabinetmaking service that had developed by the 1930s into one of the most successful furnishing businesses in Jamaica. Similar concerns, such as Fenton's Cabinet Establishment (est. 1919) and the Jamaica Furniture Co. Ltd, (est. 1928) also flourished during the 1930s, employing local craftsmen to produce furniture in cedar, pine and mahogany. This furniture was much influenced by the severe simplicity of contemporary British Art Deco design. Master craftsmen such as Thomas Theophilus Jackson (1888–1983), originally apprenticed to the Scottish firm of Kearn Brothers, continued to command a faithful following until well into the 1960s. His Neo-Victorian, intricately carved mahogany furniture was extremely popular. John Dunkley, as well as producing highly individual paintings and carvings, also decorated furniture in brilliant enamel colours with representations of flowers, leaves and fruit. The first interior design business in Jamaica was also established in the 1930s, when Cayman Islander Burnett Webster (1909–92) began to design contemporary furniture and interiors. Much influenced by European Art Deco, his designs show close affinities with the work of sculptor Edna Manley and artist Koren Der Harootian (*b* 1909), with whom he exhibited during this period. Webster's Decorator's Store (1933–9), which received attention abroad, carried his line of finely crafted furniture designs, often carved and detailed by the young sculptor Alvin Marriott. From the mid-20th century the furnishing of Jamaican interiors has generally been the result of the successful marketing of items of European and American manufacture, although a small minority continue to support the efforts of Jamaican artists and fine craftsmen. Things Jamaican, established in the early 1980s by a government agency formed to stimulate the development of craftsmanship, remains a popular source for reproductions of Jamaican antiques. The Life of Jamaica Building (1983), Kingston, has contributed to the prestige of Jamaican design. The interior, designed by Hester Rousseau, employs natural local materials and Jamaican craftsmanship. The sisal wall hanging with copper accents, the abstract mahogany wall sculpture, and the mahogany and brass boardroom door were all created by the Jamaican sculptor Winston Patrick (*b* 1946).

BIBLIOGRAPHY
B. Edwards: *History, Civil and Commercial, of the British Colonies in the West Indies*, 2 vols (London, 1793)

P. H. Gosse: *A Naturalist's Sojourn in Jamaica* (London, 1851)
C. S. Cotter: 'Discovery of the Spanish Carvings', *Jam. Hist. Rev.*, iii (1948), pp. 227–33
W. A. Roberts: *Old King's House, Spanish Town* (Kingston, 1959)
K. E. Ingram: 'The West Indian Trade of an English Furniture Firm in the 18th Century', *Jam. Hist. Rev.*, iii/3 (1962), pp. 22–37
J. Richards: 'The Chandeliers from Old King's House, Spanish Town', *Jamaica J.*, i/1 (1967)
R. S. Dunn: *Sugar and Slaves: The Rise of the Planter Class in the English West Indies, 1624–1713* (Chapel Hill, 1972)
The Formative Years: Art in Jamaica, 1922–1940 (exh. cat. by D. Boxer, Kingston, N.G., 1978)
Devon House: Guide to the Collection (Kingston, 1984)
N. James: 'T. T. Jackson: A Tribute to One of Jamaica's Master Craftsmen', *A. Jamaica*, iii/1–2 (1984)
S. Dello Strologo: 'Devon House: The House of Dreams', *Jamaica J.*, xvii/2 (1984), pp. 33–40
'Corporate Collection', *A. Jamaica*, iv/1–2 (1985)

ALISSANDRA CUMMINS

VI. Ceramics.

Excavations in the late 20th century at the Old King's House, Spanish Town, revealed a large collection of ceramics, including 16th- and 17th-century Spanish maiolica, Delftware and ceramics from the Wedgwood factory in England, as well as quantities of Chinese porcelain. Excavations in the 17th-century town of Port Royal also uncovered numerous sherds of large water-jars. These jars may possibly have been manufactured locally and have salt-glazed interiors, unglazed exteriors with white-painted rims, and with striped and ladder designs on the body and handles of some wares. Excavations at Spanish Town also revealed evidence of a ceramic folk tradition dating primarily from the 18th century, when the majority of African slaves arrived in the island. These vessels were clearly influenced by West African ceramic traditions, primarily Akan in origin. The number of handmade pots found in dated sites are convincing evidence of the evolution of an indigenous ceramic tradition, which blended European and possibly Arawak influences with African features and forms to produce an identifiable Afro-Jamaican ware by the second half of the 18th century.

Mathewson suggested that two distinct types of earthenware were produced concurrently for both the European and African communities. The vessels for the European market were flat-bottomed, often lead glazed, with strap handles. Pots of African derivation were more often hemispherical with a round base, and unglazed tureens, carafes, saucers and cooking-pots were among the wares produced. Simple, decorative designs were sometimes incised on the surface of these vessels, and one earthenware bowl exhibits pseudomorphs of rivets imitating contemporary European metal cooking-pots. Of more interest, however, are the isolated geometric motifs, which may represent a type of maker's mark, evidence, perhaps, of even greater specialization than has so far been documented. The Afro-Jamaican ceramic tradition continued throughout the 19th century and remains well established in the 20th. Most Jamaican kitchens still contain a monkey jar (see fig. 7) and a *yabbah*. Ma Lou [pseud. of Louisa Jones] (1916–92) was the best-known modern producer of traditional hand-coiled pottery; her cooking-pots, coal stoves and *yabbahs* are highly regarded in Jamaica. During the 1920s Cecil Baugh (*b* 1908) worked in the traditional hand-coiled technique. In 1936, in association

7. Earthenware monkey jar by Cecil Baugh, h. 355 mm, 1984 (Kingston, National Gallery)

with Wilfred Lord, he formed the Cornwall Clay Works in Montego Bay, which operated until 1941. He continued to experiment with new glazes, forms and designs during the 1940s. In 1948 Baugh received a British Council scholarship for his first formal training with Bernard Leach at St Ives in Cornwall, England. Following his return to Jamaica in 1950, he became Ceramics Tutor at the newly formed Jamaica School of Art and Craft in Kingston, a position he held for 24 years. Recognized as the pioneer of modern ceramics on the island, Baugh was the recipient of many national awards. His work was a major influence on most of the major contemporary ceramicists, including Gene Pearson (*b* 1946), Jean Taylor-Bushay (*b* 1948), Norma Rodney Harrack (*b* 1947), Donald Johnson (*b* 1948) and Bella Johnson, the Clonmell Potters, Philip Bryan and David Dunn (*b* 1954). Walford Campbell is a young artist who has gained prominence in the last decades of the 20th century. With Marguerite Stanigar and Margaret McGluie, who have opted for a Post-Modernist approach, they represent an exciting new direction in Jamaican ceramics.

BIBLIOGRAPHY

R. D. Mathewson: 'Jamaican Ceramics', *Jamaica J.*, vi/2 (1972), pp. 54–6
P. Cumper: 'Cecil Baugh, Master Potter', *Jamaica J.*, ix/2–3 (1975), pp. 18–27
N. Harrack: 'Ceramics in Jamaica: An Overview', *A. Jamaica*, iii/1–2 (1984), pp. 8–11
C. Baugh and L. Tanna: *Baugh: Jamaica's Master Potter* (Kingston, 1986)
Jamaica J., xxiv/1 (1991), pp. 23–31

ALISSANDRA CUMMINS

VII. Metalwork.

There is little evidence of sources of precious and base metals in Jamaica. Black asserted, however, that

at the time of the discovery the Indians in the Greater Antilles were found to possess some gold in the form of ornaments. Most of this appears to have been produced in Haiti and Puerto Rico, finding its way to the other islands in the course of trade. Jamaica had very little gold and such as there was the Indians collected by a simple method [from the river].

The earliest Spanish settlers adopted similar methods in their mining operations on the banks of the Rio Minho, near the Longville Estate at Clarendon. Within a few years of their arrival the Spaniards had also assiduously collected by exchange much Arawak gold and many ornaments.

Metals necessary for the consolidation of settlement were imported into the island from the 16th century, to be worked by the skilled craftsmen who settled for that purpose. After the English took control of the island in 1655, Jamaica provided a strategic base from which to launch attacks on the Spanish Empire. Much of the wealth of the island was acquired as a result of buccaneering activities that were eventually based at Port Royal. Henry Morgan's raids on Porto Bello, Panama, in 1667, and Panama City in 1671 were two such exercises. The latter raid on the royal houses, the Governor's Palace, the Law Courts and the Treasury, filled with gold and silver from Peru, netted the buccaneers over 750,000 pieces of eight and brought extraordinary wealth into Jamaica. It found a ready market among the thriving community at Port Royal. Over the next few decades the city rapidly developed as the trading centre and chief market of the island. Francis Hanson offered a contemporary description of the city at its zenith in 1682:

Port Royal, being as it were the Store or Treasury of the West Indies, is always like a continual Mart or Fair where all sorts of choice Merchandizes are daily imported, not only to furnish the island, but vast quantities are thence again transported to supply the Spaniards, Indians, and other nations, who in exchange return us bars and cakes of Gold, wedges and pigs of Silver, Pistoles, Pieces of Eight and several other Coyns of both Mettles, with store of wrought Plate, Jewels, rich Pearl Necklaces, and of Pearl unsorted or undrill'd several Bushels; besides which, we are furnished with the purest and most fine sorts of Dust Gold from Guiney. . .some of which our Goldsmiths there work up, who being yet few grow very wealthy, for almost every House hath a rich Cupboard of Plate, which they carelessly expose.

Excavations of the sunken Port Royal site have also revealed the existence of quantities of pewter artefacts (Kingston, N.G.), evidence of the skilled pewterers who supplied the burgeoning population. Jamaican inventories of the 17th and 18th centuries confirm the extensive use of pewter plates, flatware, candlesticks and bowls in the majority of households. By the late 17th century a number of large firms were engaged in the importation of silverware and bullion.

Another art form that emerged during the late 17th century was that of etched and inlaid tortoiseshell cases and boxes for wigs and combs. Examples in the Cunda collection (Kingston, N.G.) are richly decorated with floral designs reminiscent of English crewel-work of the period. Reputedly inspired by the patronage of Lady Lynch, the Governor's wife, this work seems to have been produced mainly at Port Royal. At least two distinct styles have been

identified, using such motifs as local trees and Amerindian and armorial designs, which can be seen in finely engraved silver mounts. Only one craftsman, Paul Bennett, has been positively identified, being the only maker of combs listed among the Port Royal craftsmen in 1763.

Despite conditions or war and serious internal problems in the early 18th century, the beginning of prosperity in Jamaica and the rise in power and wealth of the Creole proprietors occurred during this period. Also at this time Kingston developed, as did the lavish lifestyle of the privileged, supported by the development of the sugar industry. Wealthy planters, for example Samuel Long and the Governor, Sir Thomas Lynch, lived ostentatiously. Lynch's silver service consisted of some 42 dishes and plates, 44 spoons and forks, and an assortment of candlesticks, basins, condiment pots and beakers, and was valued at £361.

In 1760 the young English coppersmith John Reeder arrived in Jamaica in the company of a local property owner, who encouaged him to start his own foundry operations. By 1772 Reeder had prospered sufficiently to acquire land in St Thomas-in-the-East for the purpose of erecting mills 'with a waterwork for the smelting and other manufactures of iron and other metals'. Various descriptions confirm that the foundry worked both iron and non-ferrous metals, including copper, brass and lead, producing items that ranged from iron boilers and rollers to lead bullets, brass howitzers, mortars and petards, and providing the general outfitting for British warships and other vessels. Skilled foundry-workers included English craftsmen as well as African–Jamaicans. Reeder surmised that 'Africans were perfect in every branch of the iron manufacture so far as it relates to casting and turning. . .and in wrought iron'. Its success was short-lived, however, as by 1782 the Governor-General ordered that the foundry be dismantled in the face of a threatened invasion of the island. By this period a hallmark representing a crocodile's head had been established for Jamaica. A cruet with three vase-shaped castors (c. 1750; Kingston, Devon House) by Charles Allan bears this mark. While it is clear that, stylistically, metalworkers followed trends established in England, there is some evidence to suggest that silversmiths in Jamaica adopted local motifs in their work. J. Ewan (fl early 1800s) is known to have used a breadfruit motif on flatware of that period.

During the first decades of the 20th century some large firms, for example L. A. Henriques and Swiss Stores, continued to employ qualified craftsmen to produce small items and jewellery, but the majority of their stock was imported from Europe. During the 1930s C. A. Scott, a lumber and hardware merchant, established an ironworks at Montego Bay that produced domestic and industrial iron, brass and other metals. The emphasis, however, remained largely on imports. The establishment of the Jamaica School of Art in 1950, however, did much to foster a renewal of interest in local design. Along with tutoring and designing at the jewellery workshop at the Polio Rehabilitation Center, the Edinburgh-trained silversmith Pat Byer acted by 1968 as external examiner for jewellery at the School of Art. For two periods in the 1970s she was also tutor in jewellery at the school. Through these activities, and with the establishment of her studio

8. Pat Byer: *Jamaica Box*, sterling silver studded with jadeite, agate, carnelian and amethyst, 355×317 mm, 1983 (British Royal Collection)

in the early 1960s, Byer played a significant part in the development of metalworking in the island. In 1984 her presentation piece to Queen Elizabeth II (see fig. 8) re-established Jamaica's hallmark of a crocodile. The Jamaica School of Art, now the Edna Manley School for the Visual Arts, continues to play an influential role under the leadership of the master goldsmith Garth Sanguinetti, who was trained by the Gorman company in the USA. Some of the school's more recent and active graduates include Ralf Bender, Hugh Bromfield, Paul Henriques, Philip Cadien, Georgia Brown and Jasmine Girvon.

BIBLIOGRAPHY

C. V. Black: *History of Jamaica* (London, 1958, 2/1983)
I. Baxter: *The Arts of an Island* (Metuchen, 1970)
R. F. Marx: *Report on Silver and Pewter Recovered from the Sunken City of Port Royal, Jamaica* (Kingston, 1971)
R. S. Dunn: *Sugar and Slaves: The Rise of the Planter Class in the English West Indies, 1624–1713* (Chapel Hill, 1972)
C. Goucher: 'John Reeder's Foundry: A Study of 18th-century African–Caribbean Technology', *Jamaica J.*, xxiii/1 (1989), pp. 39–43
ALISSANDRA CUMMINS

VIII. Patronage.

In the 18th and 19th centuries rich landowners sought the service of artists to paint portraits and to document the picturesque 'views' on their plantations. In the 1770s, for example, the English artists George Robertson (1748–88) and Phillip Wickstead (fl 1763–86) were brought to the island in the employ of the wealthy English landowner William Beckford. The colonial government also commissioned British sculptors to execute monuments, such as John Bacon the elder's monument to *Admiral Rodney* (1784–6), commemorating his victory in the Battle of the Saints, and Edward Hodges Baily's monument to *Sir Charles Metcalf*, Governor of Jamaica from 1839 to 1842. In the 20th century the Church was an important patron of contemporary artists, beginning with Edna Manley's *Crucifix* (1950) for All Saints Anglican Church in Kingston. Several works by Manley, Alvin Marriott, Osmond Wat-

son, Karl Parboosingh and Christopher Gonzalez, among others, may be found in churches, principally in Kingston.

Direct state patronage increased dramatically following independence (1962) and the consequent desire adequately to portray the new heroes of Jamaica and to commemorate their deeds. The most important works include the statues of *Sir Alexander Bustamante* (1972) and of *Norman Manley* (1971) in the Parade Square, Kingston, the *Garvey* statue in St Anns Bay, the *Bob Marley* statue (1985) in Kingston and the *Don Quarrie* statue at the National Stadium, all by Alvin Marriott; the *Sam Sharpe* monument by Kay Sullivan (*b* 1944) in Montego Bay; the *Paul Bogle* statue (1965) in Morant Bay by Manley; and the panels on the tomb of *Norman Manley* (1975) at the National Heroes Park, Kingston, by Christopher Gonzalez. By the late 20th century patronage was private, corporate and institutional.

IX. Collecting and dealing.

Until 1974, when the National Gallery was established, public collecting of Jamaican art was restricted to the activities of the Institute of Jamaica in Kingston. In 1974 the Institute's collection of 20th-century works was transferred to the National Gallery, while 18th- and 19th-century works were transferred to the National Library. The National Gallery's collection has since grown dramatically; by the mid-1990s it housed over one thousand works. Apart from its principal collection of Jamaican art, it has a small international collection, which includes mainly 20th-century Caribbean, British and American works. With the acquisition of Edna Manley's *Land* in 1948, the University of the West Indies in Kingston began a programme of collecting; it has proved, however, to be erratic, as have the collecting habits of many of the corporations that boast collections.

The principal private collector of the 1960s and 1970s was A. D. Scott, who acquired hundreds of works that virtually define the backbone of mainstream art of the period. In 1990 Scott donated 40 key works to the National Gallery. During the 1980s there was a marked increase in the number of private collectors, including Wallace Campbell. Through both local and international purchases, Campbell amassed not only a major Jamaican collection, but also an important Caribbean group, principally of Haitian and Cuban paintings.

Privately owned galleries are responsible for most sales of artwork in Jamaica. In general they exhibit a cross-section of artists of various styles and reputation with little specialization. Harmony Hall in Ocho Rios, however, demonstrated an allegiance to the Intuitives, while Frame Centre Gallery in Kingston has tended to concentrate on essentially modernist artists, for example Kofi Kayiga and Milton George.

DAVID BOXER

X. Museums.

The National Gallery of Jamaica in Kingston was founded in 1974 as a division of the Institute of Jamaica. Some 380 modern Jamaican works were then transferred from the Institute, including Edna Manley's *Negro Aroused* (1935; see fig. 5 above), the first modern Jamaican work to be acquired by the Institute (1937). In 1979 the National Gallery curated the landmark exhibition *Intuitive Eye*, bringing together the works of such Jamaican artists working outside the mainstream as Everald Brown and Kapo. Since 1974 the size of the permanent collection has more than quadrupled. The Gallery's policy is to spend its small acquisitions budget only on Jamaican art. Acquisitions are supplemented by loans and donations from artists, collectors, public institutions and corporations. About a quarter of the collection is on permanent display in an installation that focuses on the development of modern Jamaican art. This includes such specialized galleries as the Larry Wirth Collection of work by Kapo, and the A. D. Scott Collection of modern Jamaican art. There is also a display of pre-20th-century Jamaican art and a small international collection. New galleries that are planned are the Edna Manley Memorial Gallery and others for ceramics and photography. The gallery presents an average of four to five exhibitions each year and offers educational services. Originally located in Devon House, Kingston, the National Gallery moved in 1982 to the Roy West Building, a modern building that is rented by the government. Plans exist for a new National Gallery building on King's House lands, not far from its original location at Devon House. In St Catherine, the Arawak Indian Museum includes a reconstruction of a typical pre-conquest Caribbean dwelling.

BIBLIOGRAPHY
'The National Gallery of Jamaica', *Jamaica J.*, xvi/4 (1983), pp. 29–36
G. Milton: *Museums in Jamica* ([Jamaica], n.d.)

XI. Art education.

In the 1940s art classes were held at the Junior Centre of the Institute of Jamaica. In 1950 the Jamaica School of Art was founded, largely through the efforts of artist Edna Manley and Institute of Jamaica officials Philip Sherlock and Robert Verity. The school has fostered both the fine arts and design. Originally small and rather informal, it has grown into a fully accredited tertiary-level institution, with a total student population of *c*. 500. The majority are Jamaican, but the school also attracts foreign students, mainly from the English-speaking Caribbean. In 1976 the School became a part of the Cultural Training Centre campus, located in the New Kingston area, together with the schools of dance, drama and music. In 1987 the School was renamed the Edna Manley School for the Visual Arts. In 1995 the Cultural Training Centre became autonomous, separating from the Institute of Jamaica and operating directly under the Ministry of Education and Culture. It was renamed the Edna Manley College of the Visual and Performing Arts, and its art school became the School of Visual Arts.

BIBLIOGRAPHY
Forty Years: Edna Manley School for the Visual Arts, 2 vols (exh. cat. by V. Poupeye-Rammelaere, Kingston, N.G. and Edna Manley Sch. Visual A., 1990)

VEERLE POUPEYE

Jara, José (*b* Tecamachalco, nr Puebla, 1867; *d* Morelia, 1939). Mexican painter and teacher. In his early years as a student at the Escuela Nacional de Bellas Artes he produced history paintings on indigenous themes, as was then the custom. His *Foundation of Mexico City* (1884; see

José Jara: *Foundation of Mexico City*, oil on canvas, 1.42×1.96 m, 1884 (Mexico City, Museo Nacional de Arte)

fig.), for which he won first prize when it was exhibited at the Escuela in 1889, is subdued in colouring and painted in a meticulously detailed style; its almost photographic appearance presaged the move towards naturalism that dominated Mexican art in the 1890s. Jara also applied himself to regional folkloric painting, whose development was already being fostered in the Escuela Nacional de Bellas Artes. His *Funeral Wake* (Mexico City, Mus. N.A.), awarded a bronze medal when exhibited under the title *Burial of an Indian Man* in 1889 at the Exposition Universelle in Paris, treated a popular theme in an uplifting way thanks to its generous format and classic pyramidal composition. Jara continued portraying popular customs after moving in the 1890s to Morelia, where he taught drawing and painting at the local Escuela de Bellas Artes.

After considerably lightening his palette in the late 1890s, Jara began to concentrate more on landscapes, favouring intimate and unassuming rural scenes. Although small in scale, these pictures (e.g. Guadalajara, Xavier Torres Ladrón de Guevara priv. col.) have an intense luminosity and a rich texture that vigorously evoke the purely material beauty of the objects depicted, in a style more akin to that of Courbet and his followers than to that of the Impressionists.

BIBLIOGRAPHY
José Jara (1867–1939) (exh. cat., essays A. L. Roura and A. Castellanos, Mexico City, Mus. N.A., 1984)

FAUSTO RAMÍREZ

Jaramillo, Manuel Samaniego y. *See* SAMANIEGO Y JARAMILLO, MANUEL.

Jesuit Order [Society of Jesus]. Order of secular clergy recognized by Pope Paul III in 1540. Of all the new orders of secular clergy founded in the Counter-Reformation period (16th and 17th centuries), the Jesuits were to become the most numerous and influential. At first regarded with suspicion by the papacy, they gradually came to be recognized as the most powerful force in the Roman Catholic recovery. The canonization in 1622 of two of the original Jesuits, Ignatius Loyola and Francis Xavier, marked the complete acceptance of the order into the ranks of Catholic orthodoxy.

1. Introduction. 2. Iconography. 3. Latin American missions.

1. INTRODUCTION. In 1528 Ignatius Loyola, after making a pilgrimage to Jerusalem, began a seven-year period of study in Paris. While there he gathered around him a group of six friends who were to form the nucleus of the new order, and in 1534 they took the vows of poverty and chastity, promising to go as pilgrims to Jerusalem, or, failing that, to offer their services to the Pope. In 1537, after a period in Venice hoping to embark for Jerusalem, the friends, now nine in number, moved to Rome. In 1540 they decided to form a new order, which was recognized by Pope Paul III that year.

Like the Theatines and the Oratorians, also founded in the 16th century, the Jesuits are secular clergy, neither cloistered nor bound by the recitation of regular offices. They wear no special dress but instead adopt the normal priest's clothing of whichever region they inhabit. They are not obliged to undergo any penances or fasts that would undermine their fitness to serve the Catholic cause. They are not allowed to own personal property or hold ecclesiastical benefices, living instead on alms and benefactions. According to the constitution drawn up by St Ignatius, a Jesuit has to take the usual three monastic vows of poverty, chastity and obedience. In addition he must take a fourth vow of obedience to the papacy, promising to go wherever the Pope should choose to send him. It was this fourth vow that gave the order its flexibility and extended its influence across the globe. A bull of 1540 restricted its number to 60, but this limit was relaxed four years later, and from this time onwards the numbers grew rapidly: at the death of St Ignatius in 1556 there were 938 Jesuits, by 1626 the number had grown to 15,544, and in 1749 there were 22,589 members, about half of them fully qualified priests.

The training of a Jesuit priest is a long and intensive process. The vows are taken after a two-year spell as a novice. There follows a further period of about 12 years of study and practical experience, although this depends on the individual's previous educational level. Priests are ordained a year before the end of their training. Education was from the start one of the principal roles of the Jesuit Order, with the added advantage that by educating the sons of the privileged classes, for instance at the Collegio dei Nobili in Turin, they could hope to attract the interest of future wealthy benefactors. The schools, colleges and universities run by the Jesuits throughout the world insist on the highest intellectual standards. The highly centralized Jesuit organization is headed by a General, elected for life, to whom the 'provinces' into which the order is divided report. Jesuit houses, or 'colleges', are governed by a Superior, who can hold office for a maximum of six years.

The success of Jesuit missionary work was enhanced by the Jesuit practice of studying the languages and cultures of the countries in which the priests worked. This undoubtedly contributed to the success of Jesuit missions, which was particularly outstanding in India, East Asia and Latin America (*see* §3 below). In North America the adventurous mission work of French Jesuits among Canadian Indians was recorded in their dispatches, later published as the *Jesuit Relations*. The intellectual rigour of the Jesuit Order also equipped them to further the Catholic cause in the Protestant areas of northern Europe. However, their rigid conservatism during the Enlightenment led to their increasing unpopularity, even in Catholic countries, and the order was eventually suppressed in 1773. Its educational role continued in some areas, and in 1814 its restoration allowed Jesuit activities to resume world-wide.

2. ICONOGRAPHY. Although practice of St Ignatius's *Spiritual Exercises* (composed 1521–35; published 1548), a guide to meditation on biblical themes such as the mysteries of the life of Christ, requires the imagination to recreate scenes in the mind's eye, their author was fully aware of the value of religious images in stimulating prayer. Juan de Valdés Leal's painting *A Jesuit Conversion* (*c.* 1660; York, C.A.G.) shows a young man meditating over an open book in front of a picture of the *Crucifixion*, encouraged by an unseen angel behind him. Recognizing the value of sacred images not only as aids to prayer but also as agents of propaganda, the Jesuits evolved a remarkably coherent repertory of religious subject-matter. Unique to the Jesuit Order was the emphasis placed on the name of Jesus. Il Gesù in Rome was the first church named after Jesus (its full dedication is to God, the name of Jesus and the Virgin), and in the *Triumph of the Name of Jesus* on the vault there, frescoed by Giovanni Battista Gaulli in 1676–9, the letters IHS (the abbreviation of the Greek form of the name of Jesus commonly found in paintings) glow in the centre of the heavens beneath the dove of the Holy Spirit (see fig.). On the high altarpiece of the Jesuit church in Bamberg, the Jesuit artist Andrea Pozzo depicted *Heaven, Earth and Hell Worshipping the Name of Jesus* (1700–01; *in situ*). A much more easily illustrated subject was the occasion on which Christ was given the name Jesus, namely the Circumcision. This became a popular Jesuit theme, as it was also the first occasion on which Christ shed blood. The high altar of Il Gesù in Rome is dedicated to the Circumcision, a 19th-century version having replaced Girolamo Muziano's original altarpiece (commissioned 1587), and in 1605 Rubens painted a *Circumcision* for the high altarpiece of the Jesuit church of S Ambrogio, Genoa (*in situ*).

Before Ignatius Loyola and Francis Xavier were canonized in 1622, there were no Jesuit saints. Guercino's beautiful altarpiece of *St Gregory the Great with St Ignatius and St Francis Xavier* (London, D. Mahon priv. col., see L. Salerno: *I dipinti del Guercino* (Rome, 1988), no. 112) must commemorate their canonization by Pope Gregory XV, but Rubens anticipated their recognition when, *c.* 1617–18, he painted his two huge canvases (now in Vienna, Ksthist. Mus.) for the high altar of the Jesuit church in Antwerp, one showing the *Miracles of St Ignatius* and the other the *Miracles of St Francis Xavier*, each to be hung for half the year. In both altarpieces the saints stand triumphantly aloft, casting out devils and healing the sick from the crowds around them. St Ignatius is usually depicted as a balding, dark-haired, bearded figure in black Jesuit robes. In 1609 the *Vita beati Ignatii Loiolae* was published in Rome to celebrate his beatification, with engraved illustrations for which Rubens contributed drawings, and in 1685–8 and 1697–1701 Pozzo executed frescoes showing scenes from the *Life of St Ignatius* in the choir of the church of S Ignazio, Rome (*in situ*). On the vault of the same church, in 1691–4, Pozzo painted his huge fresco, in remarkable *di sotto in sù* illusionistic perspective, of the *Glory of St Ignatius* (*in situ*), a spectacular apotheosis scene signifying the worldwide victory of the Catholic Church. The life of St Francis Xavier provided an opportunity to introduce exotic local colour. The most popular subject was Francis's lonely death on an island off China, which in Carlo Maratti's version, painted for Il Gesù in Rome in 1676, led to the surprising inclusion of figures in feathered headdresses. At about the same time Gaulli was painting an altarpiece of the same subject for S Andrea al Quirinale, the church of the Jesuit novices in

Giovanni Battista Gaulli: *Triumph of the Name of Jesus* (1678–9), fresco, Il Gesù, Rome

Rome, providing a simpler and perhaps more poignant version showing the saint alone on his bed of straw, clutching his crucifix and accompanied only by angels. A more restrained approach can be seen in Poussin's formally composed altarpiece illustrating a *Miracle of St Francis Xavier* (Paris, Louvre) for the church of the Jesuit Noviciate in Paris, commissioned in 1641.

St Ignatius and St Francis Xavier were still the only Jesuits to have been canonized when Alessandro Algardi executed his relief of *St Ignatius and the Early Saints of the Jesuit Order*, commissioned in 1629 for the bronze urn to contain the ashes of St Ignatius in Il Gesù in Rome. Among those included in the relief were St Ignatius and his successor as General, Francis Borgia, who was to be canonized in 1670, as well as several missionaries and Stanislas Kostka (1550–68), a young Pole who became a Jesuit novice in Rome but died there at the age of only 18; he was canonized in 1726. A marble statue by Pierre Legros (1629–1714) in Kostka's cell in the noviciate at S Andrea al Quirinale movingly portrays him lying on his deathbed (1702–3; *in situ*). From the start the Jesuits glorified Christian martyrdom, thus encouraging those embarking on dangerous missions. In the later 16th century the Society acquired the Early Christian church of S Stefano Rotondo as the German–Hungarian Jesuit college and decorated its walls with lurid scenes of martyrdom by Cristoforo Roncalli. An illustrated guide to Christian iconography, *Evangelicae historiae imagines* (Antwerp, 1593) by the Jesuit father J. Nadal, shows how Flemish realism could be used to make scenes of suffering more vivid. Those martyrs who were also effective apostles were given particular emphasis in Jesuit imagery: the two chapels nearest the entrance to Il Gesù in Rome are dedicated to St Andrew, St Peter and St Paul.

The Jesuits' promotion of all those aspects of Catholic doctrine that were rejected by Protestants also led to the great popularity of angels, scenes from the life of the Virgin, representations of the Eucharist or, more symbolically, the Passion and depictions of Heaven, Hell and Purgatory. In the original iconography of Il Gesù, the two transepts were dedicated to the Crucifixion and the Resurrection, while the chapels on either side of the choir were dedicated to the Virgin and St Francis of Assisi (in honour of Francis Xavier and Francis Borgia; neither of them at that time canonized). As an agent of the Catholic and papal cause, Jesuit art also directly promoted the stamping out of heresy. Legros provided an unusually literal representation in the small cherub energetically tearing up a huge and presumably heretical book in his marble group *Religion Overthrowing Heresy*, on the right side of the monumental altar of S Ignazio in Il Gesù. On the left side is a glorification of Jesuit mission work by another French sculptor, Jean Théodon (1645–1713), representing *Faith Crushing Idolatry* (marble; 1695–9).

Indeed, apart from the celebration of the name of Jesus and the commemoration of their own saints and martyrs, the Jesuits played a central role in formulating a more general Counter-Reformation iconography, applicable to any branch of the Catholic Church. The techniques of perspective and illusion pioneered in Jesuit drama were applied, too, to their more permanent religious art, and while the role of the Jesuits in promoting the richness and theatricality generally associated with the Baroque style is not easy to define, the fact that they acknowledged the persuasive value of religious images from the outset helped to steer Counter-Reformation art away from austerity and towards more emotional modes of expression. On the other hand, some early Jesuits were suspicious of decorative richness for its own sake, even in churches, and Bernini's extravagant set-piece for the Jesuits, S Andrea al Quirinale in Rome, was created over a century after the founding of the order, by which time the Baroque style was already established in Catholic art in Rome and beyond.

3. LATIN AMERICAN MISSIONS. The first Jesuits arrived in Brazil in 1549 and in Peru in 1568; further groups followed to other parts of South and Central America and to Mexico during the 1570s. They strove initially to establish power bases in colonial cities, and where possible built their churches and seminaries in a central location. All architectural plans had to be sent to Rome (in duplicate, by separate routes) for approval; nevertheless, the type of site and other local conditions ensured great architectural variety throughout Latin America. Plots were often sought that would allow for the construction of, for example, another courtyard for the college (e.g. S Ildefonso; now the Escuela Nacional Preparatoria, Mexico City; completed 1749). Another common feature of Jesuit missions was the system of *reducciones*, settlements for converted Indians built around Jesuit colleges. Aside from providing agricultural self-sufficiency, the involvement of Indians in workshops resulted in their (usually anonymous) contribution, alongside their Jesuit masters, to the construction of churches and their fittings, as well as to the painting and sculpture housed in them.

Although Jesuit churches had no standard overall plan, several are reminiscent of the general scheme of Il Gesù, in Rome, with implied side aisles created by interconnecting lateral chapels. These included the collegiate church at Bahia (completed 1672; now the cathedral), begun by Francisco Días (1538–1623). Some are firmly single-nave, as in SS Pedro y Pablo (c. 1580), Mexico City, while others break the simplicity of the single-nave format with shallow lateral chapels, as at La Compañía, Cuzco (1651–68). The design of Jesuit church façades was very varied: the upwardly arching façade of La Compañía (1668–70) in Cuzco, attributed to Juan Bautista Egidiano, pre-dates equivalent Baroque development in Italy and was re-worked elsewhere in Peru, not only on Jesuit churches. La Compañía was also innovative in having the first Latin-cross ground-plan; it was also vaulted in brick rather than timber. Further south and in Brazil the tendency was for sober, predominantly horizontal designs (*see* BRAZIL, §IV, 1), while in Mexico the exuberant façade of the mission church of S Martín Tepotzotlán (c. 1760) is one of the first examples of the use of the distinctively Mexican *estípite* form of column outside Mexico City. S Martín is also remarkable for its vertical application of Mexican Baroque, integrating the decoration of the façade with the tower; the heavily ornamented interior exemplifies the Jesuits' enthusiasm for richly carved and gilded retables.

In their first rural missions, in Juli in southern Peru, the Jesuits built in the style of their predecessors, the Dominicans: vast single-nave churches with simple, classicizing portals in brick or stone. In more famous missions in Paraguay, Argentina and Bolivia, broad, triple-aisled basilicas with wooden roofs were built; in Paraguay stone walls and piers supported timber roofs, whereas in Bolivia the wooden churches were often described in early documents as being built from the roof down: a framework of tree-trunk pillars would support the roof during its construction, while the adobe walls were added later. Another distinctive feature of many mission churches was the extension of the eaves to create a portico on every side of the building.

Many of the Jesuit artists and architects who worked on the churches and seminaries in Latin America remain anonymous, but the names of some of these figures are known. These include Bartolomé Cardenosa and the Belgian Father Lemer, who worked at the Compañia (c. 1645/54–71) in Córdoba; Johann Kraus, responsible for the church of S Ignacio (1712–34) in Buenos Aires; Diego López de Arbaiza, who built La Compañía (1576–1603) in Mexico City; Marco Guerra, who completed La Compañía (begun 1606 by Ayerdi de Madrigal and Gil de Madrigal) in Quito; GIOVANNI BATTISTA PRIMOLI, who worked in Paraguay and Argentina, frequently with ANDREA BIANCHI; and the painter BERNARDO BITTI, who was active in Peru and Bolivia between 1575 and 1610 and whose works include the *Adoration of the Shepherds* (c. 1590) in Sucre Cathedral. The Jesuits were eventually expelled from Brazil in 1759 and from all Spanish territories in 1767, but they left a considerable cultural legacy.

BIBLIOGRAPHY

L. Costa: 'A arquitetura dos Jesuítas no Brasil', in *Rev. SPAHN*, 5 (1941), pp. 9–100
M. J. Buschiazzo: 'La arquitectura en madera de las misiones del Paraguay, Chiquitos, Mojos y Maynas', *Latin American Art and the Baroque Period in Europe: Studies in Western Art, Acts of the 20th International Congress of the History of Art: New Jersey, 1963*, iii, pp. 173–90
R. Vargas Ugarte: *Los Jesuitas del Perú y el arte* (Lima, 1963)
T. Gisbert and J. de Mesa: 'Planos de iglesias jesuíticas en el virreinato peruano', *Archv Esp. A.*, clxxiii (1971), pp. 65–101
S. Orienti and A. Terruzi: *Le 'reducciones' gesuitiche nel Paraguay tra il XVII e il XVIII secolo* (Florence, 1982)
M. Díaz: *Arquitectura en el desierto: Misiones jesuitas en Baja California* (Mexico City, 1986)
J. L. Aguilar Marco and others: *Misiones en la península de Baja California* (Mexico City, 1991)
V. Fraser: 'Architecture and Ambition: The Case of the Jesuits in the Viceroyalty of Peru', *Hist. Workshop J.*, xxxiv (1992), pp. 17–32
F. J. Reiter: *They Built Utopia: The Jesuit Missions in Paraguay, 1610–1768* (Potomac, MD, c.1995)

VALERIE FRASER

Jiménez, Edith (*b* Asunción, 1921; *d* Asunción, 14 May 1993). Paraguayan painter and engraver. She studied under Jaime Bestard and Lívio Abramo in Asunción and from 1958 in São Paulo, Brazil. Her paintings of the 1950s were Cubist-inspired landscapes and still-lifes in oils. In the late 1950s she began to transpose her schematized pictorial style into wood-engraving; in the early 1960s her engravings were increasingly based on the simple play of black and white and textures, and she then passed through a phase of abstraction related to *Art informel* finally to reach a purified but effectively suggestive abstraction based on

Edith Jiménez: *Untitled*, wood engraving, 327×477 mm (Colchester, University of Essex, Collection of Latin American Art)

organic forms. Her engravings of this period show her skill in synthesis and her capacity for expression: large shapes are realized straightforwardly in black and white but are animated by an intense inner energy. In the 1970s she embarked on a new technique based on multiple impressions and the use of colour: large masses of strong shades and contrasting tones were superimposed and juxtaposed to provoke special chromatic tensions (e.g. *Untitled*; see fig.). This series of engravings, entitled *Puzzle*, won a prize at the São Paulo Biennale in 1955 and is on permanent display in the collection of the Senate in Brasília.

BIBLIOGRAPHY

O. Blinder and others: *Arte actual en el Paraguay* (Asunción, 1983)
T. Escobar: *Una interpretación de las artes visuales en el Paraguay* (Asunción, 1984)

TICIO ESCOBAR

Jiménez, Max (*b* San José, 16 April 1900; *d* Buenos Aires, 3 May 1947). Costa Rican painter, sculptor, engraver and writer. After spending two years in London, in 1922 Jiménez moved to Paris, where he dedicated himself to sculpture, drawing and painting. He came into contact with leading Spanish literary figures, and he discovered the African-influenced work of Picasso and Modigliani, as well as that of the Paris-based Brazilian painter Tarsila. These influences led to the monumentality and Afro-Caribbean elements present in Jiménez's painting and sculpture, in which traditional concepts of beauty were disregarded and the subjects painted in an exuberant manner (e.g. *Ileana*; see Ulloa Barrenechea, p. 231). In 1925 he returned to Costa Rica, but the lack of galleries or museums and of artistic activity (other than academic) frustrated Jiménez. Having been exposed in Paris to trends far in advance of Costa Rican art and feeling that his avant-garde ideas were not understood, he temporarily ceased to produce art.

In 1928 Jiménez returned to Europe; his collection of poems, *Gleba*, was published in Paris, and he wrote articles

for the Salones Anuales de Artes Plásticas in San José. Also in 1928, he founded the Círculo de Amigos del Arte, an exhibiting society, with Teodorico Quirós. In Spain the following year he met such writers as Ramón del Valle Inclán. From 1928 to 1937 he wrote poems and short stories, which were published in Spain, Chile and Cuba, and he contributed to the Costa Rican periodical *Repertorio americano*. In 1934 he took up wood engraving and illustrated his own articles. He continued making sculptures (e.g. *Red Head*, 1935; San José, Mus. N. Costa Rica), and in 1938 he returned to painting and held one-man shows in Paris (1939), New York (1940 and 1941) and Havana (1942–3). In 1945 he returned to Costa Rica and exhibited at the Galería L'Atelier. Still dissatisfied with Costa Rica, he went to Chile (1946) and Argentina (1947), where an emotional crisis led to his death. His artistic legacy was to open the way to greater expressionism in the painting and sculpture of Costa Rica.

BIBLIOGRAPHY
J. A. Losada: 'La pintura de Max Jiménez', *Norte*, lxxxxi (Feb 1942)
F. Amighetti: 'La pintura de Max Jiménez', *Rev. A. & Let.*, i/4 (1966)
R. Ulloa Barrenechea: *Pintores de Costa Rica* (San José, 1975), pp. 98–103
JOSÉ MIGUEL ROJAS

Johan Maurits, Count of Nassau-Siegen. *See* NASSAU-SIEGEN, JOHAN MAURITS OF.

Jordán, Armando (*b* Coroico, nr La Paz, 1893; *d* Santa Cruz, 1982). Bolivian painter and teacher. The son of a cartographer, in 1903 he moved with his family to Santa Cruz, where he was taught to draw by his father; as a painter he was self-taught. Jordán was an art teacher in several public schools in Santa Cruz between 1915 and 1933. Between 1930 and 1965 he concentrated on drawings and paintings, among them small watercolours, illustrations and coats of arms. His most important work consists of a group of oil paintings (1940–65) that portray with ingenious humour the daily events, fiestas, fashions and customs of the life of Santa Cruz. For this reason his work has great documentary value. He made frequent use of photography to develop his subject-matter and also had his own paintings photographed: he then retouched the photographs with oil paint. He believed this technique, which he called oil-photos (*fotóleos*), was a new contribution to the field of art. He exhibited his paintings for the first time in La Paz in 1971. His best-known works include *The Festival of the Cross* (1950) and *No More Dolts* (1965), in which he impishly, but with great critical acumen, developed themes full of characters portraying his friends and other figures of the day. In 1983 a large retrospective of his work was held in the Museo Nacional de Arte in La Paz.

BIBLIOGRAPHY
P. Querejazu: *La pintura Boliviana del siglo XX* (Milan, 1989)
PEDRO QUEREJAZU

Joseph, Antonio (*b* Baharona, Dominican Republic, 4 Dec 1921). Haitian painter. Of Haitian parentage, he fled on foot to escape the Dominican Republic during the 1938 massacre of Haitians. He selected tailoring as a means to make a living in Port-au-Prince. He was the first to accept an invitation from the American watercolourist

Dewitt Peters (1901–66) to join the Centre d'Art in Port-au-Prince, remaining there as painter and teacher. He studied watercolour with Peters and in 1953 was the first Haitian to win a Guggenheim Fellowship for a year's study in New York; he won a second in 1957. He accompanied Peters to the USA and Europe in 1960 and from 1961 to 1963 lived in the USA, which he continued to visit thereafter. From the first he was considered outstanding among the modernists affiliated to the Centre d'Art.

Joseph amassed an admirable body of work. Peters cited him as a 'brilliant watercolourist' and praised his murals on the walls of the Hotel Ibo Lélé in Port-au-Prince in a speech of 1952. Joseph was fully versed in the academic aspects of painting, in perspective and in colour theory, and he was a superb draughtsman. His work evolved from an expressionistic naturalism to a colourful abstraction. Although he continued to paint and draw from nature, he interpreted his observations with smooth brushwork and closely related, subtle colours suggesting a misty atmosphere, with depth suggested by superposed planes. A subtle symbolism characterized his later pictures, in which figures and objects hint at unexpected relationships of scale and space. Despite his long stays abroad, his feet remained firmly planted in Haiti, from which he drew his subject-matter.

BIBLIOGRAPHY
M.-J. Nadal and G. Bloncourt: *La Peinture haïtienne* (Paris, 1986), p. 52
M. P. Lerrebours: *Haïti et ses peintres*, i (Port-au-Prince, 1989), pp. 393–4

Joseph, Jasmin (*b* Grande Rivière du-Nord, nr Cap-Haïtien, 23 Oct 1923). Haitian sculptor and painter. He began his career as a sculptor, modelling figures in clay while working at a brick factory in Port-au-Prince. In 1948 thirty of these were seen by the American sculptor Jason Seley, who had come from New York to Haiti to work with the American watercolourist Dewitt Peters (1901–66), on a visit to the brick factory to have some of his own pieces fired. The most striking figures were of animals. Seley encouraged Joseph to develop his talent and invited him to the Centre d'Art in Port-au-Prince. Plans were under way for a series of murals at Ste-Trinité Episcopal Cathedral in Port-au-Prince, and Seley suggested that Joseph make a terracotta screen, with sculpted openwork blocks. In addition Joseph produced terracotta *Stations of the Cross* for Ste-Trinité. Upset because his works were being copied while awaiting firing at the brick factory, Joseph turned to painting, favouring muted colours applied in a thin layer to hardboard panels. At about the same time he converted from Vodoun to Protestantism and became a lay priest. Vodoun scenes in his early work were replaced by Christian ones in later compositions, but he continued to represent animals with a wry humour and a not too subtle satire on human foibles. His use of animal tales to point a moral relates to traditions of Haitian folklore. In his later works he featured polar bears and apes interacting in amusing situations.

BIBLIOGRAPHY
S. Rodman: *Where Art Is Joy* (New York, 1988), pp. 123–4
M. P. Lerrebours: *Haïti et ses peintres*, i (Port-au-Prince, 1989), pp. 67–70
DOLORES M. YONKER

Juarez [Xuarez]. Mexican family of painters. Luis Juarez (*b c.* 1585; *d* Mexico City, *c.* 1638) painted in the Mannerist

style of the Spanish painters settled in Mexico, such as Baltasar de Echave Orio and Alonso Vázquez, although his figures are softer than those of his teachers. He began working in the first decade of the 17th century. His signed *St Teresa* (Guadalajara, Mus. Guadalajara) dates from that time and his *St Anthony of Padua* and the *Ascension* (both Querétaro, Mus. Reg.) from 1610. In 1611 he was commissioned to make the triumphal arch for the reception of the Viceroy of New Spain, Fray García Guerra. During the 1620s he painted the retables in the church of Jesús María, Mexico City, and in S Agustín, Puebla. The finest of his numerous religious works are the *Annunciation*, the *Agony in the Garden*, the *Visitation*, the *Archangel Michael* and *St Raphael* (all Mexico City, Pin. Virreinal); the *Mystic Marriage of St Catherine* (see fig.) and the *Virgin Bestowing the Chasuble on St Ildefonso* (both Mexico City, Mus. N. A.); and the *Education of the Virgin* and the *Ascension* (both Querétaro, Mus. Reg.).

Luis's son José Juarez (*b* Mexico City, 1619; *d* Mexico City, 1662) was influenced by the Spanish painters Francisco de Zurbarán and his pupil SEBASTIAN LÓPEZ DE ARTEAGA, who settled in New Spain in 1640. José's models were often drawn from the paintings of Rubens, popularized by engravings. Among his most important works are the *Holy Family* (Puebla, Mus. Colegio B.A.); *SS Justus and Pastor* and *Porciuncula* (both Mexico City, Pin. Virreinal); and the *Martyrdom of St Lawrence* (Mexico City, U. N. Autónoma, Escuela N. A. Plast.). José's daughter Antonia Juarez married the painter Antonio Rodríguez. The works of their two sons represent a transitional style between the 17th and 18th centuries and helped establish the supremacy of draughtsmanship following a period when the importance of colour had been made fashionable by Cristóbal de Villalpando and Juan Correa. Already a master painter in 1688, Nicolás Rodríguez Juarez (*b* Mexico City, 1667; *d* 1734) produced some of his most interesting works at the end of the 17th century. These include the *Prophet Isaiah* (Mexico City, La Profesa) and the portrait of the *Marqués de Santa Cruz as a Child* (Mexico City, Pin. Virreinal). In 1713 he painted the *Flight into Egypt* (Colorado Springs, CO, F.A. Cent.) and *St Mary Magdalene* (Mexico City, Pin. Virreinal) as well as works for Mexico City Cathedral. His output was extensive, and his style was influenced by the work of his father, as was that of Juan Rodríguez Juarez (*b* Mexico City, 1675; *d* Mexico City, 1728). Juan's later paintings, however, executed in the early 18th century, are far more rigidly formulaic than the work of his early years. His paintings for Mexico City Cathedral include the *Assumption of the Virgin* and the *Adoration of the Magi* in the retable of the high altar.

Luis Juarez: *Mystic Marriage of St Catherine*, oil on canvas, 2.03 x 1.23 m (Mexico City, Museo Nacional de Arte)

BIBLIOGRAPHY

D. Angulo, E. Marco Dorta and J. Buschiazzo: *Historia del arte hispanoamericano* (Barcelona, 1945–56)
M. Toussaint: *Pintura colonial en México* (Mexico City, 1965)
F. de la Maza: 'La pintura colonial mexicana del siglo XVII', *Pintura mexicana, siglos XVI–XVII: Colecciones particulares* (Mexico City, 1966)
G. Kubler and M. S. Soria: *Art and Architecture in Spain and Portugal and their American Dominions, 1500–1800* (Harmondsworth, 1969)
X. Moyssen: 'Una interesante pintura de Luis Xuarez', *Bol. INAH*, xxx (1972)
G. Tovar de Teresa: *Pintura y escultura del renacimiento en México* (Mexico City, 1979)
J. R. Ruiz Gomar: *El pintor Luis Xuarez: Su vida y su obra* (Mexico City, 1987)
R. Ruiz Gomar: 'El San Cristóbal de Nicolás Rodríguez Juárez en Guadalupe, Zacatecas', *Homenaje a Federico Sescosse* (Zacatecas, 1990), pp. 81–7
M. Burke: *Pintura y escultura en Nueva España: El Barroco* (Mexico City, 1992)

MARIA CONCEPCIÓN GARCÍA SÁIZ

K

Kahlo (y Calderón), (Magdalena Carmen) Frida (*b* Mexico City, 6 July 1907; *d* Mexico City, 13 July 1954). Mexican painter. She began to paint while recovering in bed from a bus accident in 1925 that left her seriously disabled. Although she made a partial recovery she was never able to bear a child, and she underwent some 32 operations before her death in 1954. Her life's work of *c.* 200 paintings, mostly self-portraits, deals directly with her battle to survive. They are a kind of exorcism by which she projected her anguish on to another Frida, in order to separate herself from pain and at the same time confirm her hold on reality. Her international reputation dates from the 1970s; her work has a particular following among Latin Americans living in the USA.

Small scale, fantasy and a primitivistic style help to distance the viewer from the horrific subject-matter of such paintings as *Henry Ford Hospital* (1932; Mexico City, Mrs D. Olmedo priv. col., see fig.), in which she depicts herself haemorrhaging after a miscarriage, but her vulnerability and sorrow are laid bare. Her first *Self-portrait* (1926; Mexico City, A. Gomez Arias priv. col., see Herrera, 1983, pl. I), painted one year after her accident, shows a

Frida Kahlo: *Henry Ford Hospital*, oil on sheet metal, 1932 (Mexico City, Mrs D. Olmedo private collection)

melancholy girl with long aristocratic hands and neck depicted in a style that reveals her early love for Italian Renaissance art and especially for Botticelli.

Kahlo's art was greatly affected by the enthusiasm and support of Diego Rivera, to whom she showed her work in 1929 and to whom she was married in the same year. She shared his Communism and began to espouse his belief in *Mexicanidad*, a passionate identification with indigenous roots that inspired many Mexican painters of the post-revolutionary years. In Kahlo's second *Self-portrait* (oil on masonite, 1929; Mexico City, Mrs D. Olmedo priv. col., see Herrera, 1983, pl. II), she no longer wears a luxurious European-style dress, but a cheap Mexican blouse, Pre-Columbian beads and Colonial-period earrings. In subsequent years she drew on Mexican popular art as her chief source, attracted by its fantasy, naivety, and fascination with violence and death. Kahlo was described as a self-invented Surrealist by André Breton in his 1938 introduction for the brochure of the first of three Kahlo exhibitions held during her lifetime, but her fantasy was too intimately tied to the concrete realities of her own existence to qualify as Surrealist. She denied the appropriateness of the term, contending that she painted not dreams but her own reality.

The vicissitudes of Kahlo's marriage are recorded in many of her paintings. In *Frida and Diego Rivera* (1931; see colour pl. XVII) he is presented as the great maestro while she, dressed as usual in a long-skirted Mexican costume, is her husband's adoring wife and perfect foil. Even at this early date there are hints that Rivera was unpossessable; later portraits show Kahlo's increasing desire to bind herself to her philandering spouse. *The Two Fridas* (1939; Mexico City, Mus. A. Mod.), in which her heart is extracted and her identity split, conveys her desperation and loneliness at the time of their divorce in 1939; they remarried in 1940.

Kahlo's health deteriorated rapidly in her last years, as attested by *Self-portrait with the Portrait of Dr Farill* (1951; see Herrera, 1983, pl. XXXIV). This depiction of herself sitting bolt upright in a wheelchair, painted after spending a year in hospital undergoing a series of spinal operations, was conceived as a kind of secular ex-voto and given to the doctor whom she has represented as the agent of her salvation.

In 1953 Kahlo's right leg was amputated at the knee because of gangrene. She turned to drugs and alcohol to relieve her suffering and to Communism for spiritual solace. Several late paintings, such as *Marxism Heals the Sick* (Mexico City, Mus. Kahlo), show Marx and Stalin as gods; they are painted in a loosely brushed style, her earlier miniaturist precision having been sacrificed to drug addiction. Her last work, a still-life of a watermelon entitled *Long Live Life* (1954; Mexico City, Mus. Kahlo), is both a salute to life and an acknowledgement of death's imminence. Eight days before she died, almost certainly by suicide, she wrote her name, the date and the place of execution on the melon's red pulp, along with the title ('VIVA LA VIDA') in large capital letters.

For another illustration of Kahlo's work *see* MEXICO, fig. 12.

BIBLIOGRAPHY

T. del Conde: *Vida de Frida Kahlo* (Mexico City, 1976)
R. Tibol: *Frida Kahlo: Crónica, testimonios y aproximaciones* (Mexico City, 1977)
H. Herrera: *Frida Kahlo: Her Life, Her Art* (diss., New York, City U., 1981)
Frida Kahlo and Tina Modotti (exh. cat. by L. Mulvey and others, London, Whitechapel A.G., 1982)
H. Herrera: *Frida: A Biography of Frida Kahlo* (New York, 1983)
M. Drucker: *Frida Kahlo: Torment and Triumph in her Life and Art* (New York, 1991)
H. Herrera: *Frida Kahlo: The Paintings* (London, 1991)
T. del Conde: *Frida Kahlo: La pintura y el mito* (Mexico City, 1992)
C. Fuentes: *The Diary of Frida Kahlo: An Intimate Self-Portrait* (New York, c.1995) [intro.]
Frida Kahlo, Diego Rivera and Mexican Modernism (exh. cat., San Francisco, CA, MOMA, 1996)
Tarsila do Amaral, Frida Kahlo and Amelia Peláez (exh. cat. by L. Montreal Agusí and others, Barcelona, Cent. Cult. Fund. Caixa Pensions, 1997)
M. A. Lindauer: *Devouring Frida: The Art History and Popular Celebrity of Frida Kahlo* (Middleton, CT, 1998)

For further bibliography *see* RIVERA, DIEGO.

HAYDEN HERRERA

Kapo [Reynolds, Mallica] (*b* Bynloss, St Catherine, 1911; *d* Kingston, 1989). Jamaican painter and sculptor. He painted his first important painting, a *Black Christ Seated by the Sea of Galilee*, in 1947. It is moving in its directness and its economy of means, but he soon abandoned painting for wood sculpture and between 1948 and 1969 produced a remarkable output that was unmatched by most Caribbean carvers. The inspiration for many of these carvings came out of Revivalism, and the works are imbued with its rhythms and intense emotionalism; as the flamboyant Revivalist Shepherd and Patriarch Bishop of St Michael's Revival Tabernacle, Kapo had absorbed the spectacle and ritual of this hybrid Afro-Christian religion. His other carvings are simple portraits that are attempts to iconicize and particularize, and to draw on Jamaican history and the

Kapo: *Dark Madonna*, oil on hardboard, 670 × 610 mm, 1978 (Amsterdam, Stedelijk Museum)

rich folklore of the people, such as his sculpture of the national hero *Paul Bogle*, holding aloft a stone as he leads his revolution.

Kapo began to paint again in the early 1960s, and as his powers as a carver declined so his abilities as a painter increased, and for the 20 or so remaining years of his life he produced a body of paintings that is matched only by that of John Dunkley, Jamaica's other leading 'primitive' artist. Kapo is best known for his paintings of the Jamaican landscape, particularly the lush hills of St Catherine, dotted with red-roofed huts and groves of exotic fruit trees, but it is in his figurative works that his unrivalled sense of invention is given full rein. Many of the best paintings, such as his *Be Still, There she Go Satan* and *Revivalist Going to Heaven*, all in the Larry Wirth Collection of Kapo at the National Gallery of Jamaica in Kingston, show some of the colourful, or at times mystical, aspects of Revivalist practices. In *There she Go Satan*, it is Kapo himself who is depicted doing battle with the agents of the devil.

Kapo also attempted traditional Christian themes, such as the Crucifixion in *Crucifix* (1967; Kingston, priv. col.), the Madonna and Child in *Dark Madonna* (1978; see fig.) and the Nativity in *Silent Night* (1979; Kingston, Inst. Jamaica, N.G.). These were painted with such directness and innocence that the Italian primitives are immediately recalled. He painted portraits too, again of an uncompromising simplicity and purity. His portrait of the beautiful young *Elena Ball*, also known as *Laura* (1970; Kingston, priv. col.), is deservedly recognized as one of his finest works.

BIBLIOGRAPHY

Kapo: The Larry Wirth Collection (exh. cat. by S. Rodman and others, Kingston, Inst. Jamaica, N.G., 1982)

Jamaican Art 1922–1982 (exh. cat. by D. Boxer, Washington, DC, Smithsonian Inst.; Kingston, Inst. Jamaica, N.G.; 1983)

D. Boxer and V. Poupeye: *Modern Jamaican Art* (Kingston, 1998)

DAVID BOXER

Kaspé, Vladimir (*b* Harbin, Manchuria [now China], 3 May 1910; *d* Mexico City, 7 Oct 1996). Mexican architect, teacher and writer, of Russian descent. In 1926 he settled in Paris, where between 1929 and 1935 he studied at the Ecole des Beaux-Arts under Georges Gromort. He moved to Mexico in 1942, where he combined editorial work on the periodical *Arquitectura México*, run by Mario Pani, with his first commissions in Mexico City, among them the 'Albert Einstein' Secondary School (1949), with walls of exposed brick. Other examples of his educational architecture, notable for their formal austerity, include the Liceo Franco-Mexicano (1950) and the Facultad de Economía (1953; with J. Hanhausen), Ciudad Universitaria, both in Mexico City. From the 1950s to the 1970s Kaspé continued building in Mexico City; outstanding examples of his work are the Centro Deportivo Israelita (1950–62), Periférico Norte; the Laboratorios Roussel (1961), Avenida Universidad y M. A. Quevedo; and the offices of Supermercados S. A. (1962), Calzada Vallejo. Between 1945 and 1975 he also built more than 30 houses in Mexico City. He was an outstanding teacher of the theory and analysis of architecture at the Universidad Nacional de México (1943–73) and at other universities in Mexico City.

WRITINGS

Arquitectura como un todo (Mexico City, 1986)

BIBLIOGRAPHY

P. Quintero, ed.: *Modernidad en la arquitectura mexicana* (Mexico City, 1990), pp. 201–29

ALBERTO GONZÁLEZ POZO

Kofi Kayiga: *Untitled (Apartheid)*, oil on plywood, 1220×510 mm, 1978 (Kingston, National Gallery)

Kayiga, Kofi [Wilkins, Ricardo] (*b* Kingston, Dec 1943). Jamaican painter and teacher. He studied at the Jamaica School of Art, Kingston, and the Royal College of Art, London, and started exhibiting in the 1960s. In the early 1970s he lectured at Makerere University, Kampala, Uganda. He headed the painting department at the Jamaica School of Art from 1973 to 1981, subsequently moving to Boston, MA, where he lectured at the Massachusetts College of Art. His work showed an emotional and spiritual response to his experience as a black man in a post-colonial New World environment and his allegiance to Africa as his ancestral homeland. Most of his paintings and works on paper are abstract or semi-abstract with a strong emphasis on colour, pattern and rhythm, for example *Untitled (Apartheid)* (1978; see fig.). They represent a synthesis of North American Abstract Expressionism and the artist's African–American cultural and philosophical heritage. His paintings have a spontaneous, discordant and moody quality reminiscent of jazz music, another New World art form.

BIBLIOGRAPHY
D. Boxer and V. Poupeye: *Modern Jamaican Art* (Kingston, 1998)
VEERLE POUPEYE

Kemble, Kenneth (*b* Buenos Aires, 10 July 1923). Argentine painter, critic and teacher. He studied in Paris under André Lhôte (1885–1962), the French painter Georges Dayez (*b* 1907) and Ossip Zadkine (1890–1967). In the mid- to late 1950s, after his return to Argentina, he investigated collage, contributed to the development of *Art informel* and experimented with assemblage and gestural and calligraphic abstraction. He played a leading part in helping to extend the boundaries of art beyond the conventions of traditional media in the early 1960s, for example by his participation in an exhibition, *Arte destructivo* (1961), at the Galería Lirolay, Buenos Aires, at which he showed burnt, broken and half-destroyed objects. A supreme formalist, Kemble arrived at an exultant and evocative abstraction simulating the characteristics of collage in *trompe l'oeil*. He also taught and wrote art criticism, and he lived for periods in Los Angeles and Boston.

WRITINGS
'Autocolonización cultural: La crisis de nuestra crítica de arte', *Pluma & Pincel*, 9 (1976), pp. 1–4
BIBLIOGRAPHY
J. López Anaya: *Kemble* (Buenos Aires, 1981)
J. López Anaya: *Historia del arte argentino* (Buenos Aires, 1997)
HORACIO SAFONS

Kingman, Eduardo (*b* Loja, 3 Feb 1913; *d* Quito, 27 Nov 1997). Ecuadorean painter and teacher. He studied at the Escuela de Bellas Artes in Quito, where he later taught. In 1945 he helped found the Casa de la Cultura Ecuatoriana in Quito and was actively involved in its promotion of Ecuadorean art. He was also appointed director of the Museo Nacional de Arte Colonial in Quito in 1948. His work was in a figurative, social realist style, and he portrayed people oppressed by exploitation and misery, attacking the traditional aesthetic of the academies and schools that came to dominate artistic taste in Ecuador in the late 19th century and early 20th. He was influenced by Mexican mural painting, admiring its qualities of denunciation and tenderness and its colour. His best-known work is *Camillas* (1941; Quito, Mus. A. Mod.), in which he vigorously expressed the pain of the indigenous people, who carry heavy loads on their backs from the coast to the mountains to satisfy the demands of their masters. A constant feature of his work is the expressiveness of hands and faces, created by strong lines. Kingman's work has been exhibited internationally, and he won first prize at the Salón Nacional Mariano Aguilera in Quito in 1935 and 1959.

BIBLIOGRAPHY
Eduardo Kingman: Entre la fuerza y la ternura (exh. cat., Quito, Cancillería Ecuador, 1985)
C. Suárez: *Kingman* (Quito, 1986)
L. Oña: *Eduardo Kingman: Retratos del artista* (Quito, 1994)
CECILIA SUÁREZ

Konstantinovsky, Wladimir. *See* ACOSTA, WLADIMIRO.

Korda (Díaz Gutiérrez), Alberto (*b* Havana, 1928). Cuban photographer. He began his career as a photojournalist, documenting the Cuban revolution (1956–9) on behalf of his friend Fidel Castro. He produced some memorable and popular images, such as *Guerrillero*, a portrait of Ché Guevara. On later journeys through South America, following Castro and his staff, he produced important photo-reportages, such as *Fidel Returns to the Sierra*, *Seven Days in Santiago de Cuba with Fidel* and *Fidel Looks for a Shark*, all of which appeared in the newspaper *Revolución*. He took part in a number of international exhibitions and is regarded as one of the most gifted Cuban documentary photographers.

BIBLIOGRAPHY
E. Billeter: *Fotografie Lateinamerika von 1860 bis heute* (Zurich and Berne, 1981)
—:*Canto a la realidad: Fotografía Latinoamericana, 1860–1993* (Barcelona and Berne, 1993–4) [Sp. and Ger. Text]
ERIKA BILLETER

Košice, Gyula [Fallik, Fernando] (*b* Košice, Czechoslovakia [now Slovak Republic], 1924). Argentine sculptor, theorist and poet of Slovak birth. A resident of Argentina from 1928, he studied at the Escuela Nacional de Bellas Artes 'Manuel Belgrano' in Buenos Aires, and in 1944 he collaborated with Joaquín Torres García and the Argentine poet Edgar Bayley (1919–90) on the magazine *Arturo* (one issue only), which proposed geometric abstraction for the first time in Argentina. He was also a leading figure of ARTE MADÍ, together with Carmelo Arden Quin (*b* 1913). During this period he produced his first articulated mobiles (e.g. *Royi*, 1944; see Glusberg, p. 73), which involved the active participation of the spectator, and early examples of sculptures made of neon (e.g. *Madí Aluminium Structure No. 3*, 1946; *see* ARGENTINA, fig. 6). Like his colleagues in Arte Madí, he proposed the radical autonomy of the art object, and in his later work he explored the possibilities of a diverse range of materials, including even water in his *Hydrosculptures* (see fig.). He won the Torcuato di Tella International Prize in 1962.

Gyula Košice: *Hidroluz*, plexiglass, light, motor and water in wooden case, 1207×511×248 mm, *c.* 1975 (Austin, TX, University of Texas, Jack S. Blanton Museum of Art)

WRITINGS
with E. Bayley: *Invención 1* (Buenos Aires, 1945)
——: *Invención 2* (Buenos Aires, 1945)
Antología Madí (Buenos Aires, 1955)
Arte Madí (Buenos Aires, 1982)
Arte y filosofía porveninista (Buenos Aires, 1996)

BIBLIOGRAPHY
J. B. Rivera: *Madí y la vanguardia argentina* (Buenos Aires, 1976)
C. Córdova Iturburu: *80 años de pintura argentina* (Buenos Aires, 1978), pp. 145–7, 157–9, 218
J. Glusberg: *Del Pop-art a la Nueva Imagen* (Buenos Aires, 1985), pp. 71–2
R. Squirru and others: *Kosice* (Buenos Aires, 1990)

Kosice, obras 1944/1990 (exh. cat., Buenos Aires, Mus. N. B. A., 1991)
G. Pérez-Barreiro: 'The Negation of All Melancholy: Arte Madí/Concreto-Invención, 1944–1950', *Art from Argentina, 1920–1994* (exh. cat. by D. Elliott and others, Oxford, MOMA, 1994), pp. 54–65

For further bibliography *see* ARTE MADÍ.

JORGE GLUSBERG

Kozel, Ana (*b* Bernal, Buenos Aires, 16 Sept 1937). Argentine painter, draughtsman and printmaker. She studied painting under Pedro Domínguez Neyra (1894–1970) and Raquel Forner and printmaking under Alfredo de Vicenzo (*b* 1921). Taking geometric abstraction as her starting-point, she first produced paintings that played flatness against a dynamic tension, such as *Eternal Moment* (1974; Buenos Aires, Mus. A. Mod.). After visiting the National Air and Space Museum in Washington, DC, in 1969, she began to present the geometric elements in circular rhythms as if floating or whirling in space. *Light Series IV* (1979; see fig.) is typical of the way in which she

Ana Kozel: *Light Series IV*, acrylic on canvas, 991 x 991 mm, 1979 (Washington, DC, National Air and Space Museum)

alluded in her later work to energy and light, time and movement in an infinite universe.

BIBLIOGRAPHY
R. Squirru: *49 artistas de América* (Buenos Aires, 1984), p. 80
V. Gould Stoddart: 'Spatial Abstractions', *Américas*, xxxviii/1 (Feb 1986)
Ana Kozel: El cosmos (exh. cat. by G. Whitelow, Buenos Aires, Gal. Van Riel, 1997)

NELLY PERAZZO

Krajcberg, Frans (*b* Kozienice, 12 April 1921). Brazilian sculptor, printmaker, painter and photographer of Polish birth. He left Poland in 1943 to study in Minsk and Leningrad (now St Petersburg), followed by further study with Willi Baumeister in Stuttgart (1945–7). In 1948 he moved to Brazil, living in São Paulo and later in Paraná (1952–6) and Rio de Janeiro (1956–8). The Paraná jungle aroused an interest in nature that was first expressed in paintings and drawings of vegetable forms. After leaving Brazil for Ibiza (1963) he made reliefs in earth and stones, using nature as a raw material rather than merely as a

subject. His subsequent engraved reliefs of leaves or sand furrows, and wooden sculptures of the Bahian coast mangrove trees or the Amazonian jungle, were as much an ecological as an aesthetic statement. He frequently used photography to draw attention to such issues as the scorched Brazilian forests, for example in his book *Natura* (Rio de Janeiro, 1987; text by A. Houaiss, P. Restany and J. M. Filho). From 1958 he divided his time between Brazil and France.

BIBLIOGRAPHY

Frans Krajcberg (exh. cat. by P. Restany, Paris, Cent. N. A. Contemp., 1975)
S. Leirner: 'Frans Krajcberg', *Visão da terra* (exh. cat., Rio de Janeiro, Mus. A. Mod., 1977), pp. 58–69
R. Pontual: 'Comment Frans Krajcberg relève l'empreinte de la terre', *A. Press*, 73 (1983), pp. 26–7

ROBERTO PONTUAL

Kubotta (Carbajal), Arturo (*b* Lima, 1932). Peruvian painter. He was born to a Japanese father and a Peruvian mother, and the influence of the former came to have some bearing on his art. He studied at the Escuela Nacional de Bellas Artes in Lima until 1960, and from 1962 to 1964 he attended the School of the Art Institute of Chicago, where he studied graphic art; he went on to study design in Rio de Janeiro. His painting style developed from realism towards abstraction, and it is characterized by a variety of textures, subtle colours and the suggestion of vast spaces (e.g. *Endlessly Spacious*, 1962; see fig.); his later works include references to Surrealism.

BIBLIOGRAPHY

J. Villacorta Paredes: *Pintores peruanos de la República* (Lima, 1971), pp. 125–6

Arturo Kubotta: *Endlessly Spacious*, oil on canvas, 762 x 813 mm, 1962 (Washington, DC, Art Museum of the Americas)

J. A. de Lavalle and W. Lang: *Pintura contemporánea II: 1920–1960*, Col. A. & Tesoros Perú (Lima, 1976), pp. 170–73

W. IAIN MACKAY

Kuitca, Guillermo (David) (*b* Buenos Aires, 22 Jan 1961). Argentine painter and theatre director. He began painting as a child and held his first one-man show at the age of 13 at the Galería Lirolay, Buenos Aires. In 1978 he won first prize in drawing in the Salon of the Sociedad Hebraica Argentina. He travelled to Europe in 1980,

Guillermo Kuitca: *Gentle Sea*, acrylic on canvas, 1.8 x 2.8 m, 1987 (Amsterdam, Stedelijk Museum)

where he met the choreographer Pina Bausch. In 1982 he won the Grand Prix in the Arché Biennale at the Museo Nacional de Bellas Artes in Buenos Aires. At that time he established his mature style, which contained numerous references to literature, theatre and scenography. Combinations of visual signs within expansive pictorial spaces, supplemented in meaning by the titles (e.g. *Nobody Forgets Anything*, 1982; artist's col., see 1991–2 exh. cat.), reflect the dramatic tone of his work as an experimental theatre director. The scenes and plastic elements, such as beds, introduced in the late 1980s were polyfunctional. They allowed Kuitca to raise personal biography to the level of collective statement, as found in his images based on his grandparents' emigration to Argentina (e.g. *Gentle Sea*, 1987; see fig.). In 1987 he began to include in his paintings city maps and plans of a four-room apartment, which extended the parallels between private and collective. The creation of an irrational perspective, the explicit or concealed presence of sex and the successive montages of planes and characters make Kuitca's painting a visual opera with wide repercussions.

BIBLIOGRAPHY

F. Lebenglik: *Guillermo David Kuitca: Obras, 1982–1988* (Buenos Aires, 1989)

Guillermo Kuitca (exh. cat. by L. Zelevansky, New York, MOMA; Newport Beach, CA, Harbor A. Mus.; Washington, DC, Corcoran Gal. A.; Houston, TX, Contemp. A. Mus.; 1991–2)

E. Shaw: 'Guillermo Kuitca: Mapping the Interstates of the Mind', *Art from Argentina, 1920–1994* (exh. cat. by D. Elliott and others, Oxford, MOMA, 1994), pp. 124–9

Un libro sobre Guillermo Kuitca (Valencia, 1993)

Guillermo Kuitca (exh. cat., Monterrey, Gal. Ramis Barquet, 1995)

HORACIO SAFONS

L

Laguna, Juanito. *See under* BERNI, ANTONIO.

Lam, Wifredo (*b* Sagua la Grande, 8 Dec 1902; *d* Paris, 11 Sept 1982). Cuban painter, draughtsman and sculptor. He was brought up as a Roman Catholic but was also introduced at an early age to African superstitions and witchcraft. In 1916 he moved to Havana, where he began to make studies of the tropical plants in the Botanical Gardens while studying law at the insistence of his family. He studied painting at the Escuela de Bellas Artes from 1918 to 1923 but disliked the academic teaching and preferred to paint out of doors, in the streets. He left for Spain in autumn 1923, remaining there until 1938. In the mornings he attended the studio of the reactionary painter Fernando Alvarez de Sotomayor, curator of the Prado, who was also the teacher of Salvador Dalí, but in the evenings he worked in the studio where the young non-conformist painters gathered. He was fascinated by the paintings of Hieronymus Bosch and Pieter Bruegel I in the Prado and by the Museo Arqueológico Nacional; it was during this period that he also became aware of the work of Paul Cézanne and Paul Gauguin. His early pictures were in the modern Spanish realist tradition (e.g. *Landscape of Las Ventas*, 1926–7; Buenos Aires, priv. col., see Fouchet, 1984, p. 20), but they gradually became much more simplified and decorative.

Lam left Spain for Paris in 1938 after fighting in the Spanish Civil War on the Republican side and taking part in the defence of Madrid. With a letter of introduction from the sculptor Manolo, whom he had met in 1937, he met Picasso, who became a friend and an enthusiastic supporter of his work, and who introduced him to Joan Miró, Fernand Léger, Daniel-Henry Kahnweiler and others. During this period he worked mainly in gouache, producing stylized, hieratic figures influenced by Picasso and by African sculpture, as in *Mother and Child* (gouache, 1050×750 mm, 1939; New York, MOMA). Lam became associated with the Surrealists after meeting André Breton in 1939. In 1940 he fled to Marseille to escape the German invasion and rejoined other Surrealists sheltering there, including Max Ernst and Victor Brauner. In the following year he left for Martinique with André Breton and Claude Lévi-Strauss, among many others, and seven months later again reached Cuba.

Greatly moved, after such a long absence, by the plight of the black population, Lam set out to express their spirit and religious beliefs in a style initially influenced both by Picasso and Ernst and by African sculpture. His first major work of this new type was *The Jungle* (1942–4; see fig.), in which four grotesque figures with terrifying masklike heads are half-engulfed by the vegetation of the tropical rainforest. In 1946 he spent four months with Breton in Haiti, where he extended his knowledge of African divinities and magic rituals by attending some Voodoun ceremonies that greatly interested him. In subsequent pictures, such as *The Wedding* (1947; see colour pl. XVIII, fig. 1), mysterious totem-like personages, often part animal and part human, express an atmosphere of violence and witchcraft; their linear metamorphic forms, seen against monochrome backgrounds, are sometimes in vigorous movement.

Lam returned to Paris in 1946 by way of New York (where he met Marcel Duchamp, Arshile Gorky and Roberto Matta) and settled in Paris in 1952 after dividing his time between Cuba, New York and Paris. In later paintings such as the *Merchant of Dreams* (1962; see colour pl. XVIII, fig. 2) he remained faithful to his early imagery while seeking an ever greater simplification of form and richness of colour. He continued to travel extensively and from 1960 made regular visits to Albisola Mare, near Savona, Italy, where he was encouraged by Asger Jorn to

Wifredo Lam: *The Jungle*, oil on paper, 2.40×2.28 m, 1942–4 (New York, Museum of Modern Art)

make a number of ceramics (see Fouchet, 1984, pls 160–63). These in turn led him in his last years to model sculptures in the round, for casting in metal, of personages similar to those in his paintings.

BIBLIOGRAPHY

F. Ortiz: *Wifredo Lam y su obra vista a través de significados críticos* (Havana, 1950)
M. Leiris: *Wifredo Lam* (Milan, 1970)
A. Jouffroy: *Lam* (Paris, 1972)
P. Soupault: *Wifredo Lam: Dessins* (Paris, 1975)
M.-P. Fouchet: *Wifredo Lam* (Paris, 1976)
L. Curzi: *Wifredo Lam* (Bologna, 1978)
Exposición antológica 'homenaje a Wifredo Lam', 1902–1982 (exh. cat. by J. Allyón, Madrid, Mus. A. Contemp., 1982)
S. G. Daniel: *The Early Works of Wifredo Lam, 1941–1945* (diss., College Park, U. MD, 1983)
M.-P. Fouchet: *Wifredo Lam* (Paris, 1984)
Wilfredo Lam (exh. cat., Madrid, Mus. N. Cent. A. Reina Sofía, 1992)
Wilfredo Lam: A Retrospective of Works on Paper (exh. cat. by C. Merewether and others, New York, Americas Soc. A. Gal., 1992)
Four Crosscurrents of Modernism: Latin American Pioneers. Diego Rivera, Joaquín Torres-García, Wilfredo Lam, Matta (exh. cat. by V. Fletcher and others, Washington, DC, Hirshhorn, 1992)
Wilfredo Lam: Pasión y magia sobre papel (exh. cat., Santiago, Mus. N. B.A., 1995)
Wilfredo Lam: Catalogue Raisonné of the Painted Work. I: 1923–1960 (Paris, 1996)

RONALD ALLEY

Landaluze, Víctor Patricio de (*b* Bilbao, 1827; *d* Guanabacoa, Cuba, 1889). Cuban painter and cartoonist of Spanish birth. He was in Cuba by 1862 and perhaps as early as 1850. He was loyal to Spanish rule, ridiculing separatist causes as a caricaturist for the official press. Landaluze was also the first painter to describe everyday life in Cuba, albeit in a simplistic and folklorical vein. He revelled in stock characters: the black slave girl trying on her mistress's hat, the dandy, the aloof aristocrats observing the buffooneries of carnival dancers in *Epiphany in Havana* (Havana, Mus. N. B.A.). Though not sentimental, Landaluze was a shallow observer of culture and politics. The spirit of the cartoonist never abandoned him at the easel.

BIBLIOGRAPHY

J. Mañach: La pintura en Cuba desde sus orígenes hasta 1900', *Las bellas artes en Cuba*, xviii of *La evolución de la cultura cubana (1608–1927)*, ed. J. M. Carbonell y Rivero (Havana, 1928), pp. 225–66
M. Lascana Abella: 'Víctor Patricio de Landaluze', *Arquitectura* [Havana], 94–5 (1941), pp. 162–8

RICARDO PAU-LLOSA

Landesio, Eugenio (*b* Venária Reale, 27 Jan 1809; *d* Rome, 29 Jan 1879). Italian painter, printmaker, teacher and writer, active in Mexico. He was a pupil of the Hungarian painter Károly Markó (1791–1860) and studied at the Accademia Nazionale di San Luca in Rome. There he met the Spanish Catalan painter Pelegrín Clavé, who in 1854 proposed to the governing body of the Academia de las Nobles Artes de San Carlos in Mexico that Landesio be engaged as professor for the perspective and landscape class, recommending him for his skill as a painter, engraver, lithographer and restorer. His work, which was influenced in particular by the landscapes of Jean-Baptiste-Camille Corot, was already known at the academy, since five of his paintings had been shown in the exhibitions of 1853 and 1854 and had subsequently been bought for the academy's collection (e.g. *View of Rome*, 1853; Mexico City, Pal. B.A.). Once in Mexico, Landesio taught the students to work from nature and concentrated on perfecting their drawing before allowing them to use colour. His pupils included José María Velasco and José Jiménez Aranda. From Landesio they learnt the intricacies of landscape painting, perspective and the ways of using light to create the atmosphere of a landscape. The colouring in Landesio's own work became enriched under the influence of the Mexican landscape (see, for example, colour pl. XVIII, fig. 3). He wrote two treatises, *Cimientos del artista dibujante y pintor* (1866) and *La pintura general o de paisaje y la perspectiva en la Academia Nacional de San Carlos* (1867). In 1877 he left Mexico.

WRITINGS

Cimientos del artista dibujante y pintor: Compendio de perspectivas lineal y aérea, sombras, espejo y refracción con las nociones necesarias de geometría (1866)
La pintura general o de paisaje y la perspectiva en la Academia Nacional de San Carlos (1867)

BIBLIOGRAPHY

E. Báez Macías: 'Eugenio Landesio y la enseñanza de la pintura de paisaje', *Hist. A. Mex.*, lxxiii (1982), pp. 48–57
F. Ramírez: 'La pintura de paisaje en las concepciones y en las enseñanzas de Eugenio Landesio, *Mem.*, iv (1992)
E. García Barragán: 'El arte académico en el extranjero', *México en el mundo de las colecciones de arte*, v (Mexico City, 1994), pp. 191–238

ELOÍSA URIBE

Landi, Antonio Giuseppe [Antonio José] (*b* Bologna, *bapt* July 1713; *d* Belém, 1791). Italian architect and draughtsman, active in Brazil. While still a pupil of Ferdinando Galli-Bibiena (1657–1743) in Bologna, he began to introduce into his projects the classicizing Palladian revival ideas that mark his later work. In 1753 he went to Brazil to take part in the work of demarcating the Portuguese–Spanish frontier set out in the Treaty of Madrid (1750). On completing this work in the Amazon Basin he moved to Belém, where he married and went on to become a royal architect. His designs were documented with illustrations in the album of Alexandre Rodrigues Ferreira's scientific expedition of the late 1780s (Rio de Janeiro, Bib. N.), which facilitated the restoration in the late 20th century of Landi's most important works. These included the vast palace for the governors of Pará in Belém, designed in 1771, for which Landi's own designs have also survived (Lisbon, Bib. N. Col. Pombalina, no. 740; see fig.). This building, despite its austere Pombaline style and the column-base ornamentation tending towards the Baroque, may, in the light of its volumetry, be considered one of the precursors of Neo-classicism in northern Brazil. Landi specialized in religious architecture, redesigning interiors, producing new retables and decorative paintings for existing churches, as well as renovating their façades. Notable examples include the chapel of João Batista (1777), with an octagonal plan and a Palladian façade; the parish church of Santana (consecrated 1782), also classical in spirit, with a dome; and Nossa Senhora das Mercês (1777), which is more Rococo in style. Landi was also an artist and illustrated the flora and fauna of Pará. A volume of these drawings is held in the municipal library of Porto.

BIBLIOGRAPHY

G. Bazin: *L'Architecture religieuse baroque au Brésil* (Paris, 1956), pp. 159–63

Frontaria interior do páteo pela parte da varanda do Palácio

Frontaria principal do Palácio

Antonio Giuseppe Landi: design (1771) for the Palace of the Governors of Pará, Belám, Brazil (Lisbon, Biblioteca Nacional)

A. R. Ferreira: *Viagem filosófica pelas capitanias do Grão-Pará, Rio Negro, Mato Grosso e Cuiabá, 1783–1792* (Rio de Janeiro, 1971)

A. Meira Filho: *O bi-secular palácio de Landi* (Belem, 1973)

——: *Nova contribuição ao estudo de Landi* (Belem, 1974)

G. Roversi, ed.: *Edifici Bolgnesi del cinque–seicento delineati e incisi da Giuseppe Antonio Landi* (Bologna, 1981)

D. Mello jr: 'Barroquismos do arquiteto António José Landi', *Barroco*, xii (Belo Horizonte, 1983), pp. 99–112

CARLOS A. C. LEMOS

Lang, Carlos Alvarado. *See* ALVARADO LANG, CARLOS.

La Paz. Administrative capital of Bolivia, located in the east of the country, with a population in the late 20th century of 5.2 million. It was founded in 1548 by Alonso de Mendoza to celebrate the peace that followed a factional Spanish war and to establish a centre midway along the route between Cuzco and the mining centres to the south of the high Andean plateau. During the colonial period the city was an important commercial and industrial centre. Works of art began to be imported from Spain immediately after the foundation of the city, and they served as models for indigenous artists (e.g. the Mannerist sculpture of the *Virgin of La Paz*, 1550; La Paz Cathedral). In the early 17th century Gregorio Gamarra was among the painters active in the city, executing the *Epiphany* (1607; La Paz, Mus. N.A.) for the Franciscan monastery, and during the 17th century La Paz became a centre for the regional Lake Titicaca school, with its Baroque painting style characterized by large opulent compositions. In the 18th century, examples of MESTIZO Baroque architecture, influenced by indigenous styles and techniques, began to appear in such churches as S Francisco (1744–84) and S Domingo, which served as the city's cathedral until the 19th century. Such fine examples of domestic architecture as the Casa Villaverde (*c.* 1755) also date from the 18th century, although there was little significant civic architecture during this period. Towards the end of the 18th century Neo-classicism began to supersede the Baroque as the dominant artistic style, although such painters as Diego del Carpio, active in La Paz at this time, continued to include Baroque and Rococo elements. In 1830 the Universidad Mayor de S Andrés was founded, and shortly afterwards the cathedral was begun by Fray MANUEL DE SANAHUJA, in a Neo-classical style but still with Baroque features. Bolivia's first school of architecture was established in La Paz in 1832 by Philippe Bertrés and José Núñez del Prado, who also continued to work on the cathedral.

In 1899 La Paz displaced Sucre as the seat of government, and by 1900 ANTONIO CAMPONOVO had been appointed to complete the cathedral (see fig.), remaining faithful to the spirit of Sanahuja's original design. Camponovo was also responsible for the Palacio Legislativo (1900–08) in an academic style. During the 20th century the city underwent urban and cultural renewal, and rural-urban migration led to an expansion of the city limits and the eventual formation of the separate town of El Alto. There was also considerable architectural innovation. For example, Arturo Posnansky's design for his own house, following Pre-Columbian styles, indicated the beginnings of a search for a national architectural style, while prefab-

La Paz Cathedral by Fray Manuel de Sanahuja, Antonio Camponovo and others, *c.* 1830–1905

ricated iron buildings, such as the Aduana Nacional (1915–20; imported from Philadelphia, PA), began to appear. French academicism continued to influence other architects, however, most notably Adán Sánchez, who built the Palacio de Justicia (1919), and EMILIO VILLANUEVA, who built the Hospital General (*c.* 1930) and the Alcadía Municipal. Villanueva showed a more eclectic approach in other buildings, however, such as his work on the Universidad Boliviana Mayor de S Andrés (1940–48). In the fine arts, the foundation in 1926 of the Academia de Bellas Artes stimulated activity in sculpture through the work of such artists as MARINA NÚÑEZ DEL PRADO, who trained there and produced works influenced by Indigenist styles before moving into abstraction. The first exhibition of abstract art in La Paz was held in 1956, but in the period that followed there was a renewal of interest in traditional genres, such as landscape, and in folk art. A significant monument from 1960 was the monument to the National Revolution by Hugo Almaraz, while in the architecture of the 1970s a more organic, contextual approach began to appear, for example in the work of JUAN CARLOS CALDERÓN (e.g. the HANSA headquarters building, 1975) and Marco Quiroga (e.g. Casa Kyllman). A late Brutalist style was adopted in the Casa Buitrago (1982) by Gustavo Medeiros (*see* BOLIVIA, fig. 4). The nine museums in La Paz include the Museo Nacional de Arte housed in the 18th-century Baroque palace of the Condes de Arana, and with a collection of colonial and local modern art; the Museo 'Casa de Murillo', which houses folk and colonial art as well as furniture and costumes; and the Museo del Tambo Quirquincho. There are also several galleries and private art collections.

See also BOLIVIA, especially §§II and III.

BIBLIOGRAPHY
A. Camponoro: *La catedral de La Paz* (La Paz, 1900)
J. de Mesa, A. Crespo and M. Baptista: *La ciudad de La Paz* (La Paz, 1989)
R. Barragán: *Espacio urbano y dinámica étnica: La Paz en el siglo XIX* (La Paz, 1990)

LAURA ESCOBARI, PEDRO QUEREJAZU

Laplante, Eduardo (*b* Cuba, 1818; *d* Cuba, after 1860). Cuban lithographer and painter. Cuba's mid-19th-century boom in printmaking was due to the packaging and advertising needs of its tobacco industry. Laplante was the finest Cuban lithographer of the period, collaborating often with Luis Barañano (*fl* 1856), Federico Mialhe (1825–89) and other artists, and realizing the 38 lithographs that illustrate Justo Cantero's *Vistas de los principales ingenios de Cuba* (1857). Laplante's detailed depictions of rural life in Cuba, particularly the sugar plantation, are invaluable windows into the period, as are paintings such as *Trinidad, General View from the Loma de la Vigía* (1852; Havana, Mus. N. B.A.).

BIBLIOGRAPHY
M. de Castro: *El arte en Cuba* (Miami, 1970), p. 38

RICARDO PAU-LLOSA

La Plata. *See* SUCRE.

Larraín García-Moreno, Sergio (*b* Santiago, 1905). Chilean architect, collector and teacher. His family, in which he was the youngest of 14 children, moved from Chile to Europe in 1919 in anticipation of Chilean political and social unrest. He had no formal training but learnt much from travelling around Europe, attending some private classes and being in the company of adults. He knew the

works of Proust, Apollinaire, Gide and Picasso, and became interested in the arts and avant-garde thought, familiarizing himself with the Bauhaus, Gropius, Le Corbusier and others. He decided to become an architect, and on returning to Chile studied architecture at the Universidad Católica de Valparaíso (qualified 1928), where teaching still followed Beaux-Arts methods. His first work was done in the practice of his cousin Jorge Arteaga, who passed on a commission to design the Edificio Oberpaur, Santiago (1929), reputedly the first work of contemporary architecture in Chile. The six-storey department store and office space was influenced by Erich Mendelsohn's expressionistic style. Characterized by its continuous 'wraparound' windows, the Oberpaur building was also the first in Chile to have escalators. In 1931 Larraín began to teach at the Universidad Católica, where he founded the schools of Art and Design and set in motion radical changes. With Arteaga he designed the Edificio S Lucia (1932) and Edificio Kappes (1934), both in Santiago. After 1944 he worked professionally in association with Emile Duhard, and later with Ignacio Covarrubias and Jorge Swimburn, a collaboration that resulted in such outstanding works as the Torres de Miramar in Viña de Mar (1973–5) and the Edificio Dos Caracoles (1976) in Providencia. A tireless collector, Larraín donated his valuable collection of pre-Hispanic antiquities to the state and founded a museum

of Pre-Columbian art. His diverse career also embraced being a diplomat and a member of the British Intelligence service. After retiring from professional life, he stated of himself, 'I am far from everything, but separated from nothing.'

BIBLIOGRAPHY

H. Eliash and M. Moreno: *Arquitectura y modernidad en Chile, 1925–1965* (Santiago, 1989)

C. Boza Díaz, ed.: *Sergio Larrain GM: La vanguardia como propósito* (Bogotá, 1990)

RAMÓN MÉNDEZ ALFONSO

Larraz, Julio (*b* Havana, 12 March 1944). Cuban painter, active in the USA. He moved to the USA in 1961 and in 1967 started to paint, settling in Grandview, NY, in 1972. From 1968 to 1970 he attended the informal workshops of Burt Silverman (*b* 1928), David Levine (*b* 1926) and Aaron Schickler. During the late 1970s and early 1980s he concentrated on realist still-lifes that exploit the symbolic attributes of fruits, kettles, vegetables, flowers, bells, seashells and other objects (e.g. *Casabas under Cover*, 1979; see fig.), often represented at an angle on tables that function as prosceniums and bathed in a gauzy light surrounded by darkness. In *Edge of the Storm* (1981; artist's col., see 1981 exh. cat., p. 7) a basket of fruit and a kettle can be seen as a distant ship in the rain or as a linen cloth

Julio Larraz: *Casabas under Cover*, oil on canvas, 1.21×1.52 m, 1979 (Austin, TX, University of Texas, Jack S. Blanton Museum of Art)

dangling from a clothesline, a typical example of his use of metaphorical multiple readings.

BIBLIOGRAPHY
Realism and Latin American Painting: The 70's (exh. cat. by L. Alloway, New York, Cent. Inter-Amer. Relations, 1980)
Julio Larraz (exh. cat., Fort Worth, TX, Hall Gals, 1981)
C. Betti and T. Teel: *Drawing: A Contemporary Approach* (New York, 1986)
Julio Larraz (exh. cat. by J. L. Cassullo, Bogotá, Mus. A. Mod., 1986)
Outside Cuba/Fuera de Cuba (exh. cat., New Brunswick, NJ, Rutgers U., Zimmerli A. Mus., 1987)
E. J. Sullivan: *Julio Larraz* (New York, 1989)
Julio Larraz (exh. cat., Bogotá, Alonso A., 1995)
K. K. Kozik: 'Julio Larraz'. *A. Nexus*, xvi (1995), pp. 48–55
Julio Larraz: The Planets (Dallas, *c.* 1996)

RICARDO PAU-LLOSA

Lasansky, Mauricio (*b* Buenos Aires, 12 Oct 1914). American printmaker and teacher of Argentine birth. He began studying painting, sculpture and printmaking at the age of 19 at the Escuela Superior de Bellas Artes in Buenos Aires, and from 1935 he devoted himself primarily to printmaking. From the beginning, for example in the drypoint *Head* (1939; Buenos Aires, Mus. Mun. A. Plást. Sívori), his work was characterized by its variety of expression and by its concern with the human figure, often at critical moments such as birth or death or in the throes of love. On being awarded a Guggenheim Fellowship to travel to the USA in 1943 he spent a year at the Metro-politan Museum in New York studying their collection of contemporary and Old Master prints. On the renewal of his grant he worked at S. W. Hayter's Atelier 17, devoting himself above all to improving his technique in intaglio printing.

Lasansky played an active role in the revaluation of printmaking as a creative rather than reproductive process, and he learnt from both the Renaissance tradition and from Picasso's habit of working directly on the plate rather than from preparatory studies. In 1945 he was appointed lecturer in printmaking at the University of Iowa in Iowa City, where he sought to perpetuate the tradition of the Renaissance workshop; he continued teaching at the university, which awarded him an honorary doctorate in 1959, until the early 1970s. He settled permanently in Iowa City and became an American citizen. In his later work he demonstrated his command of a wide variety of printmaking techniques and of subject-matter ranging from social comment to more cosmic imagery, sometimes verging on abstraction; his consistent devotion to humanist themes remained much in evidence in his later work, as in the etching *Kaddish* (1975; see fig.), one of a series concerned with the Holocaust.

BIBLIOGRAPHY
Lasansky: Twenty-four Years of Printmaking (exh. cat., intro. L. Longman, Iowa City, U. IA Mus. A, 1957)
Lasansky: Printmaker (exh. cat., intro. A. Lester, Iowa City, U. IA Mus. A, 1975)

NELLY PERAZZO

La Serena. Chilean city. It is located *c.* 475 km north of Santiago, on a sloping site 2 km from the Pacific coast. Founded in 1544, its growth was slow, with the population rising from *c.* 6000 in 1800 to 16,000 in 1900 and to just over 100,000 by the early 1990s. Silver and copper mines in its hinterland gave it a certain prosperity in the 19th century, but this diminished after 1900. In 1948 President Gabriel González Videla (1898–1980), himself a native of the town, initiated his Plan Serena, an ambitious scheme of urban renewal, involving an extensive remodelling of the modest city centre. Many buildings (especially those around the main square, but also the railway station) were reconstructed *c.* 1950 in imitation colonial style, good examples being the Intendencia, the Municipalidad, the post office, the law courts and the charming Museo Arqueológico. Other improvements included an ornamental avenue through the south of the city, a section of it lined with reproductions of classical statues, known to the more irreverent inhabitants as the *avenida de los piluchos* ('the nudes' avenue'). The French urban planner Gaston Bardet helped to prepare the Plan Serena; two Chileans, Guillermo Ulriksen and Oscar Prager, exercised overall architectural supervision; a Spanish architect, José Manuel González Valcárcel, advised on detailing. Whatever reservations may be harboured by purists about the role of imitation and pastiche in architecture, the plan turned La Serena into the most agreeable of Chile's provincial towns. A statue of González Videla now stands in the main square.

BIBLIOGRAPHY
H. Eliash and M. Moreno: *Arquitectura y modernidad en Chile, 1925–1965* (Santiago, 1989)
V. Llamarzares: *La Serena* (Madrid, [1991])

SIMON COLLIER

Mauricio Lasansky: *Kaddish*, colour etching, 1070×660 mm, 1975 (Washington, DC, Art Museum of the Americas)

Laso, Francisco (de la Vega de los Ríos) (*b* Yagua, Huari, Tacna, 8 May 1823; *d* San Mateo, Lima Province, 14 May 1869). Peruvian painter and photographer. He commenced his studies under the Ecuadorean artist Javier Cortés (*d* after 1841) and then at the Academia Nacional de Dibujo y Pintura in Lima. In 1842 he went to Paris to study under Paul Delaroche (1797–1856) at the Ecole des Beaux-Arts. He toured Spain and Italy, visiting Venice, where he was able to study Renaissance works. Upon his return to Peru in 1849 he travelled round the southern highlands of Puno and Cuzco, which were to influence his future work.

In 1852 he was given a scholarship and returned to Paris to study under Charles Gleyre (1806–74), witnessing Gleyre's fashionable blend of the romantic and the classical. At this time he also started to develop an interest in portraying the indigenous Peruvian world. In 1855 he exhibited *Mountain Dweller* (*c.* 1855) at the first Exposition Universelle in Paris. Eventually his financial support from Peru was exhausted, and in 1856 he returned there and painted various paintings of a religious nature, including *The Concert* (1856; Lima, Pin. Mun.). He married in Lima in 1858 and returned to Europe in 1863 to tour Spain, Italy and France. Once back in Peru he entered politics. His painting displays academic excellence, with highly skilful compositions. His palette was restrained—a range of browns, greys, pinks and blues—and the mood somewhat melancholic. It is particularly paintings such as *Dweller in the Cordillera*; 1855; Lima, Pin. Mun.; *see* PERU, fig. 7), showing an Indian wearing indigenous costume and carrying a traditional *Moche* pot, that reveal him as a precursor of the Indigenist movement in Peru. He also took an interest in photography (examples Lima, Mus. A.), using photographs in his paintings.

BIBLIOGRAPHY

J. M. Ugarte Eléspuru: *Ignacio Merino y Francisco Laso* (Lima, 1968)
J. A. de Lavalle and W. Lang: *Pintura contemporánea: Primera parte, 1820–1920*, Arte y tesoros del Perú (Lima, 1975), pp. 70–87
G. Buntinx: 'Del "Habitante de las cordilleras" al "Indio alfarero"', *Márgenes*, vi, 10/11 (1994), pp. 9–92
N. Majluf: *The Creation of the Indian in Nineteenth Century Peru: The Paintings of Francisco Laso (1823–1864)* (diss., Austin, U. TX, 1995)

W. IAIN MACKAY

Latin American artists of the USA. Term used to describe artists of Latin American origin who are either permanently settled in the USA, regarding it as their home, or who are temporarily resident there but maintain primary identification with their native countries. Of those permanently settled, three groups in particular have established distinct artistic identities: the Chicanos (or Mexican Americans), the Puerto Ricans and the Cubans.

1. Introduction. 2. Chicano. 3. Puerto Rican. 4. Cuban.

1. INTRODUCTION. The oldest and largest Latin American population in the USA is formed by Mexican Americans (Chicanos), whose ancestral presence pre-dates the 19th-century absorption of Mexican national territory. Later migrants arrived during the Mexican Revolution (1910–20) or came as part of an imported labour force for many decades. By the end of the 20th century the political border between the USA and Mexico, despite immigration restrictions, remained very fluid, and many Mexican Americans lived in both countries. Chicanos are found largely in the Southwest and Midwest of the USA, but scattered populations exist throughout the country. Puerto Ricans have a similar history: their native island became a colony of the USA after the Spanish–American War in 1898. Puerto Ricans migrated to the East Coast (and Midwest) of the USA from the 1940s, maintaining close ties to the island, motivated by choice, nostalgia and the ease of travel. Like Chicanos, mainland Puerto Ricans (who in New York often called themselves Nuyoricans) have been an exploited labour force, whose subsidiary position has been maintained through systematic discrimination and socio-political disadvantage. In the mid-1960s both Chicanos and Puerto Ricans participated in the rebellious militant actions for empowerment that characterized that decade, and their cultural activities in the USA derived largely from that stance. By contrast, Cuban populations, arriving later and settling mainly on the East Coast, were overwhelmingly composed of political exiles fleeing from their country in the aftermath of the Cuban revolution; unlike the other two groups, they were welcomed and supported by the US government. By and large, the Cubans did not or could not visit their homeland. The first wave of Cuban immigrants was largely 'white' and fairly affluent, from the middle and upper classes, and they established a political and financial base of considerable strength in Florida. The second large wave (made up of *marielitos*, brought to the USA in the Mariel boatlift of 1980) included Cubans of obvious African descent, with fewer financial resources and skills (though some trained artists were among them), who settled in many parts of the USA. There were also refugees (including artists) who had participated to varying degrees in revolutionary Cuban society but had become disaffected for sundry reasons. Some of these would have preferred to maintain links with Cuba, had this been possible. Art education for the largely working-class Chicanos and Puerto Ricans of the USA was obtained with difficulty from government institutions as a result of militant demands made during the 1960s and 1970s, and through the establishment of alternative art structures. Exiled Cubans, however, were often first trained in Cuba, subsequently attending art academies in the USA.

BIBLIOGRAPHY

Hispanic Art in the United States: Thirty Contemporary Painters and Sculptors (exh. cat. by J. Beardsley, J. Livingston and O. Paz, Houston, Mus. F.A., 1987)
S. M. Goldman: 'The Manifested Destinies of Chicano, Puerto Rican and Cuban Artists in the United States', *Dimensions of the Americas: Art and Social Change in Latin America and the United States* (Chicago, 1994)

SHIFRA M. GOLDMAN

2. CHICANO. Despite the presence since the 19th century of significant numbers of Mexicans in the USA, Chicano art, as a broad movement with shared ideas and aspirations and addressing issues important to Mexican communities throughout the country, did not emerge until the 1960s. Its roots lay in the Chicano political movement, an alliance of disenfranchised farmers, workers and students. The adoption by young Mexicans of the label Chicano, initially a pejorative term, was a means of identifying their militant nationalist and neo-indigenist

stance. Chicano artists, although sharing a nationally disseminated iconography, did not develop a unified, identifiable style, but a bicultural one that fused US and Mexican sources. Their Mexican heritage is evident in the use of Pre-Columbian design elements, brilliant colour, expressionist forms and a predominantly figurative approach. Mexican mural painting strongly influenced Chicano murals, such as the *Great Wall of Los Angeles*, also known as the *Tujunga Wash Mural* (1976–83), by Judy Baca (*b* 1946) at Tujunga Wash, North Hollywood, CA; the *Torch of Quetzalcóatl* (1988–9) by Leo Tanguma (*b* 1941) in Denver, CO; and *Chicano Moratorium* (1974–9) by Willie Herrón (*b* 1951) and Gronk (*b* 1954) at the Estrada Courts Housing Project in Los Angeles. Mexican and Cuban post-revolutionary prints were crucial to Chicano printmaking style and techniques, while an expressionist and monumental approach in sculpture is evident, for example in *Man on Fire* (1969; see fig. 1) by Luis Jiménez (*b* 1940).

There was also a strong regionalist element in much Chicano art, which combined vernacular forms, styles and techniques with its other sources and was often in opposition to the mainstream art establishment. In Texas and other Southwest locations, for example, folk Catholicism and older forms of ritual arts contributed to Chicano art with the making of altars, masks, images of pre-Catholic healers, contemporary icons to the Virgin of Guadalupe (the patron saint of Mexico), and scenes of local village life and traditional family structures and rites. In New Mexico and southern Colorado, artists drew on a long heritage of artisanship, turning to adobe house construction, traditional handwoven blankets and textiles, and wood-carvings of sacred figures, for example *Reredos*

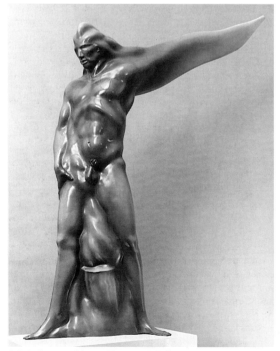

1. Luis Jiménez: *Man on Fire*, moulded fibreglass with epoxy, h. 2.69 m, 1969 (Washington, DC, National Museum of American Art)

(1986; artist's col., see 1987 exh. cat., p. 245) by Luis Tapia (*b* 1950); these were often syncretized with contemporary forms. Urban dwellers customized cars as well as executing graffiti art, while women used distinctive cosmetics and fashion accessories, vernacular expressions that were translated into fine art forms. Some Chicano artists, influenced by farmworker organization campaigns in California and Texas, developed the specialized imagery of labour culture, and alliances were also made with Native Americans, whose cultural forms were thereby linked with those of Pre-Columbian peoples. Such political issues as opposition to the Vietnam War (1965–75), demands for civil rights, political representation, and access to higher education and social services also appeared in Chicano iconography.

During the 1960s and early 1970s Chicano art was characterized by the use of public art forms such as outdoor and indoor murals; posters, primarily screenprints, such as Rupert Garcia's *Maguey of Life* (1974; see *Rupert Garcia*, 1990 exh. cat., p. 51); and public ceremonials. In the period from 1975 the approach of many Chicano artists was transformed by altered socio-political priorities and funding patterns. Another factor was the gradual acceptance into society of artists who had previously been ignored or rejected. Chicano artists concentrated increasingly on producing works for galleries (non-profit-making and commercial), museums and collectors, and there was, therefore, a new interest in drawings, easel paintings, sculpture, photography, installations and more complex print techniques such as lithography and intaglio. Women artists also became a distinct artistic force in the late 1970s, introducing new motifs and concepts. Hitherto, women had been outnumbered and had experienced difficulty being accepted, especially for such physically demanding projects as street mural painting. One notable mural, however, is that painted by Patricia Rodríguez (*b* 1944), Irene Pérez (*b* 1950), Consuelo Méndez Castillo (*b* 1952) and Graciela Carrillo de López (*b* 1949): *Latin America* (1974; San Francisco, CA, Mission Model Cities Building, destr.; see Barnett, 1984, pp. 137–8).

The widespread network of non-profit-making, community-orientated galleries (e.g. San Francisco, CA, Gal. de la Raza) and cultural centres that sustained the Chicano art movement and related it to its public audience during the 1970s survived thereafter, but in many cases it changed its focus from mural and poster art (with the collective attitudes and working methods associated with these forms) and community instructional programmes to gallery space for both professional and aspiring artists (e.g. San Francisco, CA, Mex. Mus., and Chicago, IL, Mex. F. A. Cent. Mus.). In addition, a distinct trend towards institutionalization became apparent, characterized by increased professionalization, the appointment of advisory boards and the stabilization of funding sources through private as well as corporate and government contributions. The mainstreaming of a select stratum of Chicano artists began to some extent to dissipate the sense of collectivity and mutual support that characterized the earlier periods, although many Chicano artists redirected themselves toward alliances with Latin America and other Third World peoples and artists. Nevertheless, a greater degree of individualism and competitiveness became noticeable as

PLATE I

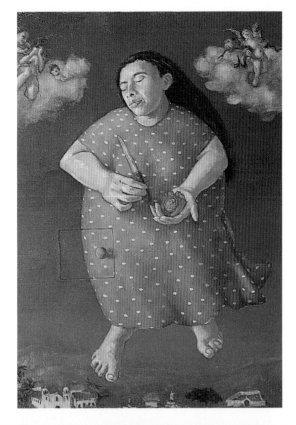

1. Brooke Alfaro: *Virgin of All Secrets*, oil on canvas, 864x813 mm, 1986 (Washington, DC, Art Museum of the Americas)

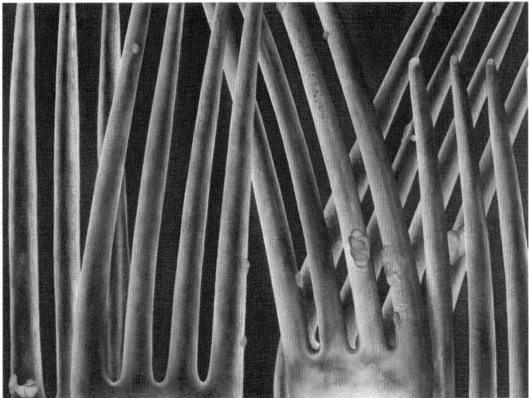

2. Antonio Henrique Amaral: *Battlefield 31*, oil on canvas, 915x1220 mm, 1974 (Austin, TX, University of Texas, Jack S. Blanton Museum of Art)

PLATE II

2. Cundo Bermúdez: *The Balcony*, oil on canvas, 737x587 mm, 1941 (New York, Museum of Modern Art)

1. Nemesio Antúnez: *Black Stadium*, oil on canvas, 1.46x1.14 m, 1977 (Austin, TX, University of Texas, Jack S. Blanton Museum of Art)

3. Juan Manuel Blanes: *The Paraguayan in her Desolate Motherland*, oil on canvas, 1000x800 mm, 1879–80 (Montevideo, Museo Nacional de Artes Visuales)

PLATE III

1. Fernando Botero: *Mona Lisa, Age Twelve*, oil and tempera on canvas, 2.11x1.95 m, 1961 (New York, Museum of Modern Art)

2. Fernando Botero: *Presidential Family*, oil on canvas, 2.03x1.96 m, 1967 (New York, Museum of Modern Art)

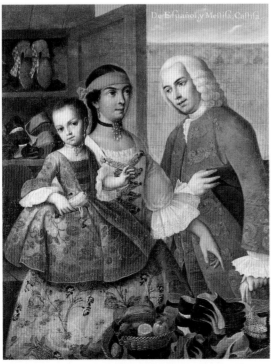

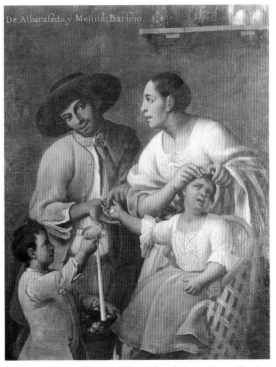

3. Miguel Cabrera: *2. From Spaniard and Mestiza, Castiza,* oil on canvas, 1.32x1.01 m, 1763 (Madrid, Museo de América)

4. Miguel Cabrera: *12. From Albarazado and Mestizo Woman, Barcino,* oil on canvas, 1.32x1.01 m, 1763 (Madrid, Museo de América)

PLATE IV

1. Coqui Calderón: *Tribute to the Letter A, No.2*, acrylic on canvas, 1.02x1.02 m, 1976 (Washington, DC, Art Museum of the Americas)

2. Alejandro Canales: *Communication Past and Present* (1984-6), mural in acrylic, 30x14 m, Telcor Building, Managua

3. Alejandro Canales: *Homage to Wonan: The Literacy Crusade* (detail; 1980, dest. 1990), mural in acrylic, 4x22 m, Valesquez Park, Managua

PLATE V

1. Ernesto de la Cárcova: *Without Bread and without Work*, oil on canvas, 1.26x2.16 m, 1893 (Buenos Aires, Museo Nacional de Bellas Artes)

2. Enrique Careaga: *Spatial-Temporal Spheres BS 7523*, acrylic on canvas, 1.2x1.2 m, 1975 (Washington, DC, Art Museum of the Americas)

3. Mario Carreño: *Cuba Libre*, gouache on paper, 394x350 mm, 1945 (Washington, DC, National Museum of American Art)

PLATE VI

1. Teófilo Castillo: *Funeral of Santa Rosa* (detail), oil on canvas, 900x2040 mm, 1918 (Lima, Museo de Arte)

2. Emiliano di Cavalcanti: *Five Girls from Guaratinguetá*, oil on canvas, 910x710 mm, 1930 (São Paulo, Museu de Arte de São Paulo Assis Châteaubriand)

PLATE VII

1. Pedro Coronel: *Repose*, acrylic with gauze on canvas, 2.03x2.03 m,
1965 (Austin, TX, University of Texas, Jack S. Blanton Museum of
Art)

2. Luis Cruz Azaceta: *A Question of Colour*,
acrylic on canvas, 3.05x3.66 m, 1989
(Houston, TX, Museum of Fine Arts)

PLATE VIII

1. Carlos Cruz-Diez: *Physichromie No.394*, wood, plastic and metal, 1212x622x63 mm, 1968 (Austin, TX, University of Texas, Jack S. Blanton Museum of Art)

2. Germán Cueto: *La Tehuana*, bronze, aluminium and copper, 1090x405x325 mm (Mexico City, Museo de Arte Moderno)

PLATE IX

1. Ana Eckell: *Untitled*, acrylic on canvas, 1000x930 mm, 1985
(Colchester, University of Essex, Collection of Latin American Art)

2. Albert Eckhout: *Two Brazilian Turtles*, paper on panel, 305x510 mm (The Hague, Mauritshuis)

PLATE X

1. Manuel Felguérez: *Origen de la reducción*, enamel on canvas, 813x813 mm, 1975 (Austin, TX, University of Texas, Jack S. Blanton Museum of Art)

2. Agustín Fernández: *Landscape and Still-life*, oil on canvas, 1.22x1.40 m, 1956 (New York, Museum of Modern Art)

PLATE XI

1. Raquel Forner: *Return of the Astronaut*, oil on canvas, 1.94x1.29 m, 1969 (Washington, DC, National Air and Space Museum)

2. Gego: *Esfera*, painted brass and steel, diam. 557 mm, 1959 (New York, Museum of Modern Art)

3. Gunther Gerzso: *House of Tataniuh*, silkscreen, 582x429 mm, 1978 (Washington, DC, Art Museum of the Americas)

PLATE XII

1. Mathias Goeritz: *Moses*, wood and iron, 730x230x210 mm, 1956 (Jerusalem, Israel Museum)

PLATE XIII

1. Miguel González: *Virgin of Guadalupe*, oil on panel, 740x570 mm, 1697 (Madrid, Museo de América)

PLATE XIV

1. Asilia Guillén: *Rafaela Herrera Defends the Castle against the Pirates*, oil on canvas, 635x965 mm, 1962 (Washington, DC, Art Museum of the Americas)

2. Daniel Hernández: *The Idle Lady* (*La Perezosa*), oil on canvas, 690x1050 mm, 1906 (Lima, Museo de Arte)

PLATE XV

1. Alfredo Hlito : *Espectro No. IV*, oil on canvas, 997x813 mm, 1960
(Austin, TX, University of Texas, Jack S. Blanton Museum of Art)

2. Winslow Homer: *Under the Coco Palm*, watercolour over graphite on paper, 380x538 mm, 1898 (Cambridge, MA, Fogg Art Museum)

PLATE XVI

1. Elena Izcue: illustration from A. Gamarra: *Manco Capac: Leyenda nacional* (Lima, 1923)

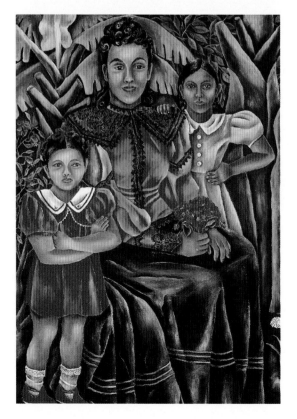

2. Maria Izquirierdo: *Family Portrait*, oil on plywood, 1398x998 mm, 1940 (Mexico City, Museo Nacional de Arte)

PLATE XVII

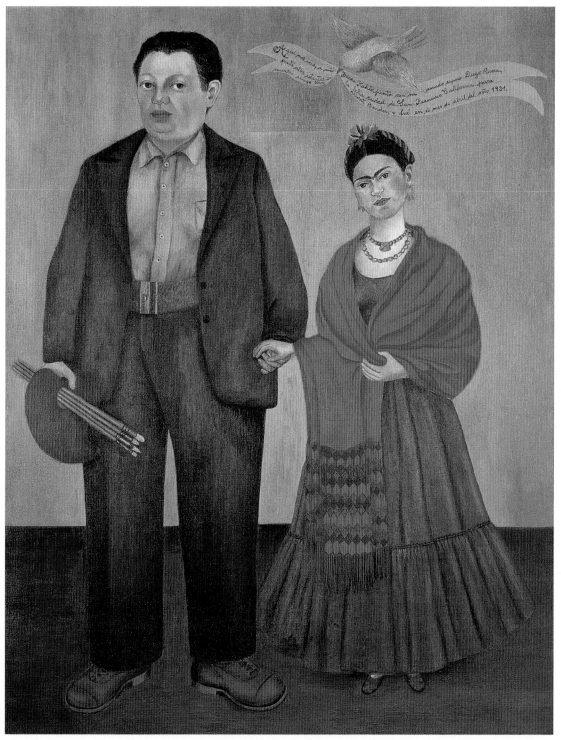

1. Frida Kahlo: *Frida and Diego Rivera*, oil on canvas, 1000x787 mm, 1931 (San Francisco, CA, Museum of Modern Art)

PLATE XVIII

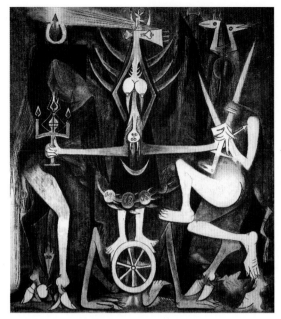

1. Wifredo Lam: *The Wedding*, oil on canvas, 2.15x1.97 m, 1947 (Berlin, Staatliche Museen Preussischer Kulturbesitz)

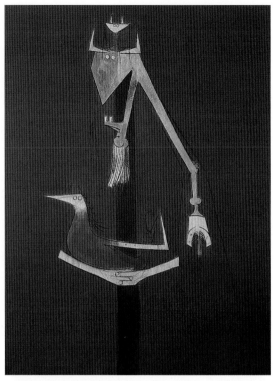

2. Wifredo Lam: *Merchant of Dreams*, oil on canvas, 1300x980 mm, 1962 (Eindhoven, Stedelijk Van Abbemuseum)

3. Eugenio Landesio: *Mexican Landscape*, oil on canvas, 450x630 mm, 1857 (Paris, Musée du Louvre)

PLATE XIX

1. Luis Lopez Loza: *Figures Overwhelming a Blue Sky*, oil on canvas, 1.64x1.54 m, 1975 (Austin, TX, University of Texas, Jack S. Blanton Museum of Art)

2. Eduardo MacEntyre: *Red, Orange and Black*, oil on canvas, 1.64x1.50 m, 1965 (New York, Museum of Modern Art)

3. Antonio Maia: *The Heroes*, oil on canvas, 1030x1030 mm, 1973 (Toronto, Art Gallery of Ontario)

PLATE XX

1. Maruja Mallo: *Song of the Ears of Corn*, oil on canvas, 1.20x2.34 m, 1939 (Madrid, Museo Español de Arte Contemporáneo)

2. Maria Martorell: *Ekho A*, oil on canvas, 1.60x2.2 m, 1968 (Buenos Aires, Museo de Arte Moderno)

PLATE XXI

1. Roberto Matta: *Listen to the Living*, oil on canvas, 749x949 mm, 1941 (New York, Museum of Modern Art)

2. Santos Medina: *Revolutionary Unity of Indo-Americans*, oil and mixed media on canvas, 610x1341 mm, 1982 (Managua, Museo Julio Cortázar del Arte Moderno de América Latina)

PLATE XXII

1. Carlos Mérida: *Plastic Invention on the Theme of Love*, gouache and watercolour over graphite on paper, 750×550 mm, 1939 (Chicago, IL, Art Institute of Chicago)

2. Façade of the church of S Francisco Acatepec, with polychrome glazed tiles in the Poblano style, Puebla, Mexico, 18th century

3. Armando Morales: *Seated Woman*, oil on canvas, 914×914 mm, 1971 (Managua, Banco Central de Nicaragua)

PLATE XXIII

1. Luis Felipe Noé: *Closed for Sorcery*, oil and collage on canvas, 1.99x2.49 m, 1963 (Austin, TX, University of Texas, Jack S. Blanton Museum of Art)

2. Alejandro Obregón: *Cattle Crossing the Magdalena*, oil on canvas, 1.64x1.31 m, 1955 (Houston, TX, Museum of Fine Arts)

3. Miguel Ocampo: *Untitled,* 77/9, acrylic and airbrush on canvas, 1.46x1.27 m, 1977 (Washington, DC, Art Museum of the Americas)

PLATE XXIV

1. Juan O'Gorman: *Mexico City*, tempera on masonite, 660x1220 mm, 1947 (Mexico City, Museo de Arte Moderno)

2. Pablo O'Higgins: *The Market*, colour lithograph, 305x330 mm, 1940 (Washington, DC, Art Museum of the Americas)

3. Gustavo Ojeda: *Downtown Evening*, mixed media on handmade paper, 1015x991 mm, 1986 (Washington, DC, National Museum of American Art)

PLATE XXV

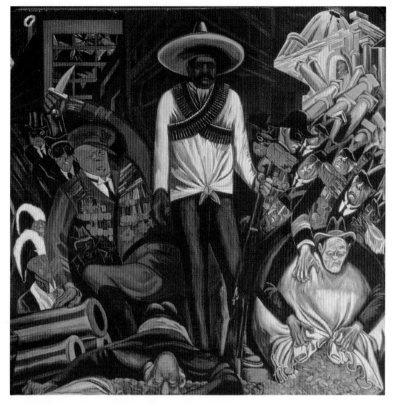

1. José Clemente Orozco: *Hispano-American* (detail; 1932–4), fresco, Dartmouth College, Hanover, NH

2. José Clemente Orozco: *Dive Bomber and Tank* (1940), fresco, 2.75x5.50 m, Museum of Modern Art, New York

PLATE XXVI

1. Alejandro Otero: *Colourythm 1*, enamel on plywood, 2001x482 mm, 1955 (New York, Museum of Modern Art)

PLATE XXVII

1. Amelia Peláez: *Still Life in Red*, oil on canvas, 693x851 mm, 1938 (New York, Museum of Modern Art)

2. Rodrigo Penalba: *Untitled*, oil on cardboard, 400x495 mm, 1944–5 (Washington, DC, Art Museum of the Americas)

PLATE XXVIII

1. Inca noble's tunic (*quompi*), tapestry weave, camelid fibre weft and cotton warp, 915x770 mm, possibly from the south coast of Peru, late 15th century or early 16th (Washington, DC, Dumbarton Oaks Research Library and Collections)

PLATE XXIX

1. Peruvian tapestry with Inca-style designs and European motifs, wool, 2.3x2.1 m, *c.* 17th century (London, British Museum)

PLATE XXX

1. Peruvian armchair, mahogany, 1130x650x460 mm, late 19th century (Leeds, Temple Newsam House)

2. Manuel Piqueras Cotolí: façade of the Peruvian Pavillion, Seville, 1929

PLATE XXXI

1. Rogelio Polesello: *Side A*, oil on canvas, 2.60x1.95 m, 1965 (New York, Solomon R. Guggenheim Museum)

2. Frans Post: *Brazilian Landscape*, oil on panel, 610x915 mm, 1650 (New York, Metropolitan Museum of Art)

PLATE XXXII

1. Omar Rayo: *Trapped*, acrylic on canvas, 660x660 mm, 1960–67
(Washington, DC, Art Museum of the Americas)

2. Vincente do Rego Monteiro: *The Hunt*, oil on canvas, 2.02x2.59 m, 1923 (Paris, Centre Georges Pompidou)

PLATE XXXIII

1. Diego Rivera: *Symbolic Landscape*, oil on canvas, 1.21x1.52 m, 1940 (San Francisco, Museum of Modern Art)

2. Ofelia Rodríguez: *Landscape with Red Live Tree*, mixed media on canvas, 1.7x2.1 m, 1990 (Colchester, University of Essex, Collection of Latin American Art)

PLATE XXXIV

1. Diego Rivera: *Pan American Unity* (1940), fresco, 6.71x21.3 m, City College, San Francisco, CA

2. Antonio Ruiz: *Nouveau Riche,* oil on canvas, 321x422 mm, 1941 (New York, Museum of Modern Art)

PLATE XXXV

2. José Sabogal: *Indian Mayor of Chincheros, Varayoc*, oil on canvas, 1.7x1.05 m, 1925 (Lima, Museo de Arte)

PLATE XXXVI

1. David Alfaro Siqueiros: *Collective Suicide*, enamel on wood with applied sections, 1.24x1.82 m, 1936 (New York, Museum of Modern Art)

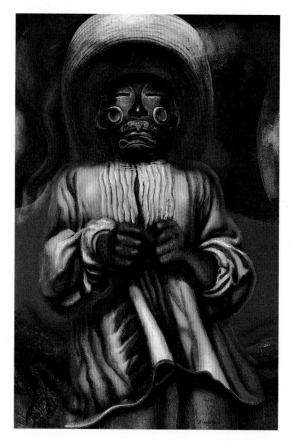

2. David Alfaro Siqueiros: *Ethnographia*, enamel on composition board, 1220x820 mm, 1939 (New York, Museum of Modern Art)

PLATE XXXVII

1. Juan Soriano: *Untitled*, pen and ink, 240x310 mm, 1953 (Colchester, University of Essex, Collection of Latin American Art)

2. Fernando de Szyszlo: *Cajamarca*, oil on canvas, 1270x915 mm, 1959 (Washington, DC, Art Museum of the Americas)

PLATE XXXVIII

1. Rufino Tamayo: *Animals*, oil on canvas, 765x1016 mm, 1941 (New York, Museum of Modern Art)

2. Rufino Tamayo: *Cow Swatting Flies*, oil on canvas, 787x991 mm, 1951 (Austin, TX, University of Texas, Ransome Humanities Research Center)

PLATE XXXIX

1. Joaquín Torres García: *Untitled*, gouache on cardboard mounted on wood, 810x430 mm, 1938 (Buffalo, NY, Albright-Knox Art Gallery)

2. Rafael Troya: *Expedition Camp in the Crater of the Guaga Pichincha Volcano*, oil on canvas, 560x890 mm, 1871 (Mannheim, Reiss-Museum)

PLATE XL

1. José Maria Velasco: *The Valley of Mexico from the Low Ridge of Tacubaya*, oil on canvas, 470x625 mm, 1894 (Mexico City, Museo Nacional de Artes)

2. Armando Villegas: *Electric Panorama*, oil on canvas, 1.10x1.27 m, 1958 (Washington, DC, Art Museum of the Americas)

Chicano artists were assimilated into the commercial art market.

Very few Chicanos, however, entered the costly and highly commercialized field of architecture, and of those that did, most integrated into existing firms without much impact (with a few notable exceptions) on innovative design. Most successful in maintaining a distinct Southwest idiom was the New Mexican contractor Anita Rodríguez (*b* 1941), who made a profession of constructing house extensions with traditional adobe and Indo-Hispanic plastering techniques, combined with the latest technology.

BIBLIOGRAPHY

J. Quirarte: *Mexican American Artists* (Austin, 1973)

Chicana Voices & Visions: A National Exhibit of Women Artists (exh. cat. by S. M. Goldman, Venice, CA, Soc. & Pub. A. Resource Cent., 1983)

A. W. Barnett: *Community Murals: The People's Art* (Philadelphia, 1984)

S. M. Goldman: 'A Public Voice: Fifteen Years of Chicano Posters', *A. J.* [New York], xlix/1 (1984), pp. 50–57

S. M. Goldman and T. Ybarra-Frausto: *Arte Chicano: A Comprehensive, Annotated Bibliography of Chicano Art, 1965–1981* (Berkeley, 1985)

S. M. Goldman: 'Chicano Art of the Southwest in the Eighties', *Made in Aztlán*, ed. P. Brookman and G. Gómez-Peña (San Diego, 1986)

Hispanic Art in the United States: Thirty Contemporary Painters and Sculptors (exh. cat. by J. Beardsley, J. Livingston and O. Paz, Houston, TX, Mus. F.A., 1987)

Rupert Garcia: Prints and Posters, 1969–1990 / Grabados y afiches, 1967–1990 (exh. cat. by R. Garcia, San Francisco, CA, F.A. Museums, 1990)

CARA, Chicano Art Resistance and Affirmation (exh. cat., ed. R. Griswold del Castillo, T. McKenna and Y. Yarbro-Bejarano; Los Angeles, UCLA, Wight A.G., 1990)

E. Sperling Cockcroft and H. Barnet Sánchez, eds.: *Signs from the Heart: California Chicano Murals* (Venice, CA, 1993)

R. J. Dunitz: *Street Gallery: Guide to 1000 Los Angeles Murals*, 2 vols (Los Angeles, 1993)

S. Gorodezky: *Arte Chicano, como cultura de protesta* (Mexico City, 1993)

S. M. Goldman: 'Hidden Histories: The Chicano Experience', *Redefining American History Painting*, ed. P. M. Burnham and L. H. Grese (Cambridge, MA, 1995)

SHIFRA M. GOLDMAN

3. PUERTO RICAN. During the 1930s, after a decade of devastating poverty in Puerto Rico, a small group of artists emigrated from the island to the USA, encouraged by government fellowships to study abroad. The group included Felix Bonilla Norat, Rufino Silva, JULIO ROSADO DEL VALLE, Luis Quero Chiesa, Esteban Soriano and Antonio Richardson; the last three participated in New York in a sign-painting workshop for the government-sponsored Works Progress Administration. After World War II there was mass migration from Puerto Rico into the USA, in addition to which the Puerto Rican government continued to sponsor study fellowships for artists, many of whom settled in New York. During the 1940s and 1950s Olga Albizu studied with Hans Hofmann, while Eloy Blanco (*b* 1933), LORENZO HOMAR, José Antonio Torres Martinó and RAFAEL TUFIÑO attended the Art School of the Brooklyn Museum, where RUFINO TAMAYO taught. Other major Puerto Rican artists who trained in New York at this time included Epifanio Irizarry, Felix Bonilla Norat, Augusto Marín (*b* 1921), José Melendez Contreras, Osiris Delgado, Jesus Oliver and CARLOS RAQUEL RIVERA, while Julio Rosado del Valle became a fellow at the New School for Social Research. Meanwhile, self-taught artists such as Juan De Prey, Johnny Vazquez and Millito Lopez were painting urban murals in which they developed a popular iconography based on nostalgic memories of Puerto Rico.

Around this time there was also a surge of nationalist spirit within Puerto Rico, and the inspiration that this provided extended to artists who had earlier left the island. Some of those who had trained in the USA, such as Tufiño, Homar and Rivera, became active in founding workshops and exhibition spaces in Puerto Rico, and in 1953 Amalia Guerrero founded the Friends of Puerto Rico, a workshop and exhibition space in New York that for two decades functioned as a key support for Puerto Ricans who wanted to pursue a career in the arts. The nationalistic ethos of the 1950s also influenced the aesthetic vocabulary of Puerto Rican artists in New York, with such major figures as Tufiño and Carlos Osorio dividing their time between their native and their adopted countries and becoming involved in teaching in cultural institutions and community workshops. Puerto Rican artists increasingly sought to retain a nationalist spirit while participating fully in the broader aesthetic dialogue of contemporary art in the USA. This led in the late 1960s and the 1970s to interaction and solidarity between Puerto Ricans and other artists and movements, with some Puerto Ricans, such as Ralph Montañez Ortiz and RAFAEL FERRER, attaining international fame.

For the large majority of Puerto Rican artists, however, the ability to exhibit and to interact with other artists was sustained by art centres generated within their own communities. The Friends of Puerto Rico continued to be the key centre for Puerto Rican art in New York, with Juan Maldonado, Victor Linares (*b* 1929), Rafael Tufiño, Carlos Osorio, Domingo Lopez, DOMINGO GARCÍA, Rafael Colón Morales (*b* 1942) and Carlos Irizarry all either studying or teaching there in the 1960s. In 1969 a group of Puerto Rican artists and educators (including Marta Vega, Ralph Montañez Ortiz and Hiram Maristany) founded the Museo del Barrio in the Spanish-speaking section of East Harlem, seeking to make visible the contribution of Puerto Ricans and other Latin Americans to the cultural life of the USA. In 1970 another group of artists, including Marcos Dimas, Adrián García, Manuel Otero, Carlos Osorio, Martin Rubio, Armando Soto and, later, Rafael Tufiño and Nitza Tufino (*b* 1949), founded the Taller Boricua in East Harlem. Originally, the Taller's historical and iconographic inspiration was provided by the rediscovery of the Pre-Columbian Taino ancestry, but subsequently the Taller became a centre for community art education and a prominent advocate of artists' social needs, such as housing. Other artists associated at various times with the Taller included Rafael Colón Morales, Nestor Otero, Jorge Soto (*b* 1947), Diógenes Ballester (*b* 1956), Miriam Hernandez, Elaine Soto and Fernando Salicrup (*b* 1946). In 1973 Charles Biasiny-Rivera, with other Latin American photographers, founded En Foco, an organization dedicated to exploring the unique iconography of Latin American photography, and in 1975 Jack Agueros and Nilda Peraza founded the Cayman Gallery (later renamed the Museum of Contemporary Hispanic Art) in the SoHo district of New York.

Such groups and institutions helped to promulgate the belief, central to Latin American art, in art as a tool for change, with a social as well as an aesthetic meaning. They

2. Juan Sánchez: *Bleeding Reality: As We Are*, oil, laser print and mixed media on canvas, 1.18×2.76 m, 1988 (New York, Museo del Barrio)

also reinforced other tenets: the notion of the artist as cultural activist; the preference for collaborative modes of working through workshops, mural painting and community festivals; the belief in forms of artistic expression with wide dissemination, such as printmaking; and the willingness to forge alliances with political groups. For example, in 1968 several Puerto Rican artists, including Ralph Montañez Ortiz, Marcos Dimas, Armando Soto, Martin Rubio and Adrián García, joined the Art Workers' Coalition, a broad-ranging group of artist–activists who staged protests at major museums to force them to respond to the needs of contemporary artists. Other artists joined more radical political groups, such as the Puerto Rican Young Lords Party, organized in solidarity with the radical African American organization the Black Panthers. The cultural activism of the late 1960s and early 1970s, in which Puerto Rican artists demanded an equal cultural voice and place and an end to marginalization, exclusion and racial prejudice, was of course part of a broader civil-rights movement then shaking North American society. By the late 1970s Puerto Ricans had joined African Americans throughout the USA and Chicanos on the West Coast in solidarity with their demands for social equality and justice.

In the 1980s the Post-modern disposition to question all hierarchies and accepted canons of art enabled Latin Americans to reach a wider, more sympathetic audience, leading to a surge of interest in Latin American art. In this context many Latin American artists were faced with the challenge of retaining their unique cultural identity while also developing a viable, creative relationship with contemporary American culture. Puerto Rican artists met this challenge in visual languages of varied styles and strategies. Some, such as Juan Sánchez, Martin Gutierrez, Robert Coane and Michael Lebrón (*b* 1954), chose a directly political language to monitor current events or redefine their past, in works such as *Bleeding Reality: As We Are* (1988; see fig. 2). Others, such as Arnaldo Roche Rabell (*b* 1955), Jorge Rodriguez, Marcos Dimas, Miriam Hernandez, Elaine Soto and Rico Espinet, treated spiritual or otherworldly dimensions, albeit in radically different styles. Others again, such as Pepón Osorio, used languages related

to popular art to comment on contemporary culture, while Edgar Franceschi, Tony Bechara (*b* 1942) and Bob Rivera explored modes of contemporary abstraction. The more pluralist context of the 1980s also allowed Puerto Rican artists for the first time to meet other Latin Americans and exchange their vastly different experiences of the USA. This dialogue helped to strengthen the sense of a Latin American identity and brought increased recognition from the broader artistic community. It also led to the establishment of crucial ties with other ethnic groups, such as African Americans and Asian Americans, engaged in similar explorations within their own communities.

BIBLIOGRAPHY
The Art Heritage of Puerto Rico: Precolumbian to Present (exh. cat. by R. Alegria and others, New York, Met. and Mus. Barrio, 1974)
P. L. Wilson Cryer: *Puerto Rican Art in New York: The Aesthetic Analysis of Eleven Painters and their Work* (diss., New York U., 1984)
M. Benitez: 'The Special Case of Puerto Rico', *The Latin American Spirit: Art and Artists in the United States, 1920–1970* (exh. cat., New York, Bronx Mus. A., 1989)
S. Torruella Leval: 'Identity and Freedom: A Challenge for the 90s', *The Decade Show: Frameworks of Identity in the 1980s* (exh. cat., New York, New Mus. Contemp. A.; Mus. Contemp. Hisp. A.; and Studio Mus. Harlem; 1990)
Latin American Artists of the Twentieth Century (exh. cat. by W. Rasmussen, F. Bercht and E. Ferrer, New York, MOMA, 1993)
SUSANA TORRUELLA LEVAL

4. CUBAN. Prior to the régime of Fidel Castro in Cuba, which began in 1959, a few Cuban modernists, including Wifredo Lam and Carmen Herrera (*b* 1915), spent periods of time in the USA. Cubism, Surrealism and Constructivism had been the principal influences on Cuban art up to this point, although the Cuban and Afro-Cuban cultures did have some influence (e.g. Lam's *The Jungle*, 1942–4; *see* LAM, WIFREDO, for illustration). After 1959, 10% of the Cuban population moved to various North American cities, principally to Miami, which, with the largest Cuban population outside Havana, played host to the only Cuban society with a democratic and international cultural life. This vibrant cross-section of Cuban society began to pass its heritage to new generations and to interact with North American trends.

The first generation of Cuban artists to establish themselves in the USA in the 1960s continued to work with the

elements of a national cultural identity that they found in the work of such artists as Lam, Amelia Peláez del Casal, Mario Carreño and René Portocarrero. This consisted of a coalescence of geometric and dream imagery, an interest in transformations and juxtapositions, a preoccupation with violence and the infinite, and a forging of visual metaphors. In Miami, for example, RAFAEL SORIANO painted fusions of figures and landscapes (e.g. *Furrows of Light*, 1980; Coral Gables, FL, U. Miami, Lowe A. Mus.), while JOSÉ MIJARES painted anatomical fantasies and surrealistic works (e.g. *High Priestesses of Illusion*, 1971; New York, Cintas Found.), and the sculptor GAY GARCÍA used metal works to address the themes of violence and ecstasy in abstract terms (e.g. *Icarus*, 1984; Coral Gables, FL, priv. col.). Cuban artists of the same generation based in New York included AGUSTÍN FERNÁNDEZ, a painter of metaphors of Eros and violence (e.g. *Large Skin*, 1964; Detroit, MI, Inst. A.), and EMILIO SÁNCHEZ, who painted architectural images of the Caribbean and Manhattan (e.g. *Shutters*, 1986; Miami, FL, Maria Gutierrez F.A.). The following generation produced a number of outstanding artists, including the photographer Tony Mendoza (*b* 1941) and the neo-expressionist painter LUIS CRUZ AZACETA

(e.g. *The Journey*, 1986; artist's col.; see 1987–8 exh. cat., p. 197). JULIO LARRAZ produced allegorical still-lifes (e.g. *Edge of the Storm*, 1981; artist's col.; see 1987–8 exh. cat.). JUAN GONZÁLEZ explored issues of realism (e.g. *Untitled*, 1981; see fig. 3). The uninhabited environments depicted by HUMBERTO CALZADA (see fig. 4) fuse architectural geometry, memory and dream. PAUL SIERRA produced dreamscapes in a style reminiscent of Magic Realism, and the sculptor MARÍA BRITO expressed dream images in *Next Room (Homage to R. B.;* 1986; see 1987–9 exh. cat.).

The younger generation of Cuban artists in the USA in the late 20th century comprised two groups. Members of the first group received most of their education in the USA. They include the abstract painter MARIO DÍAZ BENCOMO, the realist painter Miguel Padura (*b* 1957), and the photographers Mario Algaze (*b* 1947) and María Martínez Cañas (*b* 1960). The work of these artists reflects a creative absorption of European, Latin and North American aesthetics after the 1960s. Díaz Bencomo's work, for example, shows the influence of the Peruvian painter Fernando de Szyszlo as well as that of the Catalan Antoni Tàpies and the New York School, while Padura's work has affinities with that of the Chilean Claudio Bravo.

3. Juan González: *Untitled*, tempera, gold leaf and oil on masonite, 152×178 mm, 1981 (Pittsburgh, PA, Carnegie Museum of Art)

4. Humberto Calzada: *Years of Judgement, Years of Vision, Years of Discourse*, acrylic on canvas, triptych, 1×3 m, 1990 (Miami Beach, FL, Bass Museum of Art)

The second group of younger artists was made up of those artists brought from Cuba in the Mariel boatlift of April 1980 (the *marielitos*). They include Gilberto Ruiz (*b* 1950), who moved to New York in 1987 and whose work combines oneiric and expressionist styles, and the Miami-based painter Carlos Alfonzo (1950–91), who drew on Afro-Cuban animism and the linear patterning of Wilfredo Lam and Amelia Peláez (del Casal) to produce labyrinths in which life and death symbols are locked in combat. At this time Miami continued to provide a focus for the nationwide Cuban-American community with the aid of many exhibitions of Cuban and Latin American art.

BIBLIOGRAPHY
The Miami Generation: Nine Cuban-American Artists (exh. cat., intro. by G. V. Blanc; Miami, FL, Cub. Mus. A. & Cult., 1983)
Art of the Fantastic: Latin America, 1920–1987 (exh. cat. by R. Yassin, E. Lucie-Smith, H. T. Day and others, Indianapolis, IN, Mus. A.; Flushing, NY, Queen's Mus.; Miami, FL, Cent. F.A.; Mexico City, Cent. Cult. A. Contemp.; 1987–8)
Outside Cuba (exh. cat. by I. Fuentes Pérez, G. Cruz Taura, R. Pau-Llosa and others, New Brunswick, NJ, Rutgers U., Zimmerli A. Mus.; New York, Mus. Contemp. Hisp. A.; Oxford, OH, Miami U., A. Mus.; and elsewhere; 1987–9)
J. Gómez Sicre: *Art of Cuba in Exile* (Miami, 1988)
¡Mira! Canadian Club Hispanic Art Tour (exh. cat. by R. Pau-Llosa, S. Torruella Leval and I. Lockpez, Dallas, TX, S. Methodist U., Meadows Mus. & Gal.; and elsewhere; 1988–9)
A. Portes and A. Stepick: *City on the Edge: The Transformation of Miami* (Berkeley, Los Angeles and London, 1993)
RICARDO PAU-LLOSA

Lazo, Agustín (*b* Mexico City, 26 Aug 1896; *d* Mexico City, 28 Jan 1971). Mexican painter, stage designer, illustrator and writer. He studied in Mexico City at the Escuela al Aire Libre de Coyoacán and at the Escuela Nacional de Artes Plásticas, before living in Paris from 1922 to 1930, where he trained as a stage designer from 1928 to 1930 in the studio of Charles Dullin. In Paris he attended the Académie de la Grande Chaumière and became aware of Surrealism; he was one of the first artists to introduce the style to Mexico. In his characteristic small-scale oil paintings, such as *Children with Cage* (Mexico City, Mus. N. A.), in which two girls are silhouetted in front of a curtain, he combined neo-Impressionist brushwork and a highly theatrical handling of light with absurd elements. He abandoned his career as a painter at an early age, concentrating in the 1930s and 1940s on designing for the stage as well as making his name as a critic and playwright.

BIBLIOGRAPHY
C. Mérida: *Modern Mexican Artists* (Mexico City, 1937)
Agustín Lazo (exh. cat., Mexico City, Mus. N. A., 1982)
Siete pintores de la escuela mexicana (exh. cat., Mexico City, Pal. B.A., 1984)
L. M. Lozano and others: *A colección. Andrés Blastein: Pintura moderna de México* (Mexico City, 1997), pp. 106, 112, 154
MARGARITA GONZÁLEZ ARREDONDO

Leal, Fernando (*b* Mexico City, 26 Feb 1896; *d* Mexico City, 7 Oct 1964). Mexican painter, printmaker and critic. He was educated at the Escuela al Aire Libre de Santa Anita, Ixtapalapa, and at the Escuela al Aire Libre de Coyoacán. Leal worked in several media, including engraving, lithography and various painting techniques; he also wrote art criticism. The field in which he produced his most successful work was, however, mural painting. He belonged to the first generation of Mexican muralists, those called on by José Vasconcelos to decorate the public buildings in post-revolutionary Mexico. Leal was notable for his sense of colour, his skilful use of mural painting techniques and for the early use he made of popular Mexican subjects, particularly in his first mural the *Dancers of Chalma* (1922–3; Mexico City, Escuela N. Prep.). Other important murals followed, including the *Scale of Life* (1927, Mexico City, Ministry of Public Health; destr.), *Bolívarian Epic* (1930; Mexico City, Escuela N. Prep.), *Enchained Neptune* (1935, Panama City, N. Inst.; destr.) and *The Appearances of Our Lady of Guadalupe* (1949; Mexico City, Capilla Tepeyac). Leal applied himself to murals in fresco and encaustic, executed in rich, transparent colours, subtly gradated and free from heavy chiaroscuro. His synthesis of shapes in the style of Saturnino Herrán and his avoidance of allegory or symbolism placed his mural work within the context of the Mexican realist school of painting.

WRITINGS
El derecho a la cultura (Mexico City, 1952)
El arte y los monstruos (Mexico City, 1990)

BIBLIOGRAPHY
L. Islas García: *Las pinturas guadalupanas de Fernando Leal* (Mexico City, 1950)
——: *Fernando Leal* (Mexico City, 1951)
J. Fernández: *La pintura moderna mexicana* (Mexico, 1964)
JULIETA ORTIZ GAITÁN

Lecce, Matteo da. *See* PÉREZ DE ALESIO, MATEO.

Lecuona, Juan (*b* Buenos Aires, 30 July 1956). Argentine painter. The geometric tension in his paintings reveals the forms that make up each structure, mobilizes them and tests their limits, but without breaking them. While operating with a perspective on abstraction, he retained simple elements (a course derived from informalism) and synthesized the principles of Neo-Geo (the new geometry). This is a type of dialectic—theoretical and practical—of forms retrieved from the past, involving a rationalistic proposal executed with a careful technique. It is a deconstruction, a self-referential vision of existence and matter, expressed in images, that no other form would be capable of communicating.

BIBLIOGRAPHY
Deconstrucción en la pintura (exh. cat. by J. Glusberg, Rio de Janeiro, Mus. A. Mod., 1988), p. 4
Juan Lecuona (exh. cat., Caracas, Cent. A. Eur.-Amer., 1995)
'*Recurrencias': Arte Argentino de la Generación de los 80* (exh. cat., Caracas, Mus. A. Contemp. Sofia Imber, 1997)
I Bienal interparlamentaris de pintura del Mercosur: Selección de representantes argentinos (exh. cat., Buenos Aires, Cent. Cult. Borges, 1997)
JORGE GLUSBERG

Lee, Wesley Duke (*b* São Paulo, 21 Dec 1931). Brazilian painter and draughtsman. In the 1950s he studied painting and printmaking in São Paulo, New York and Paris. His early work was influenced by Dada, especially Duchamp, and by Pop art, for example *The [red-light] District: Rosario Did Not Go Away. Why?* (1964; Nagaoka, Contemp. A. Mus.). At the João Sebastião Bar in São Paulo in 1963 he staged the first happening in Brazil. He was an influential promoter of new trends in São Paulo, especially in the 1960s and 1970s, for example through his creation of the Rex Gallery and the newspaper *Rex Time* in 1966–7. His espousal of mixed media led him to carry out a series of proposals for the synthesis of the arts from 1964 to 1968; the installation *Helicóptero*, a circular structure 4 m in diameter, painted on both sides and containing electrical components (1967; São Paulo, Mus. A. Assis Châteaubriand), was exhibited at the opening of the National Museum of Modern Art in Tokyo in 1969. He explored the aesthetic possibilities offered by new technology with characteristic irony and satire.

BIBLIOGRAPHY
Report on the Art and Technology Program (exh. cat. by M. Tuchman, Los Angeles, CA, Co. Mus. A., 1970)
C. Teixeira da Costa: *Wesley Duke Lee* (Rio de Janeiro, 1980)
A. Amaral: *Arte e meio artístico—entre a feijoada e o x-burguer* [Art and artistic milieu—between the bean stew and the x-burger] (São Paulo, 1983), pp. 249–53
Retrospectiva Wesley Duke Lee (exh. cat., São Paulo, Mus. A. Assis Châteaubriand; Rio de Janeiro, Cent. Cult. Banco Brasil; [1992])
ROBERTO PONTUAL

Leeward Islands. *See under* ANTILLES, LESSER.

Legarda, Bernardo de (*b* Quito, ?end of the 17th century; *d* Quito, 31 May 1773). Ecuadorian wood-carver and painter. He was a pupil of José Olmos, and he set up his workshop in Quito facing the Franciscan monastery for which he worked. A versatile artist, he was also active as a gold- and silversmith, printer and gunsmith. In 1736 Legarda carved his masterful *Virgin of the Apocalypse* or *Winged Virgin of Quito* (Quito, S Francisco), which was inspired by a painting by Miguel de Santiago. Legarda's fine work reflects the mystical fervour of the legend it depicts. The twisting figure of the Virgin, trampling the head of a dragon underfoot, is balanced by her outspread arms and wings. Her face reflects the beauty of the mestiza, the mixed-race woman of Quito. Elsewhere in Quito, Legarda carved the Baroque altarpieces for the church of La Merced, the hospital and the churches of the Carmen Moderno and Cantuña, as well as the *Crucifixion* in this last church. In 1745 he gilded the high altar of the Jesuit church and decorated the dome of the Sagrario in Quito. His paintings include the *Nativity*, the *Adoration of the Magi*, the *Virgin of Sorrows* and the *Massacre of the Innocents*.

RICARDO DESCALZI

Legorreta, Ricardo (*b* Mexico City, 7 May 1931). Mexican architect and furniture designer, active also in the USA. He graduated from the Escuela Nacional de Arquitectura, Universidad Nacional Autónoma de México, Mexico City, in 1953. He began as a draughtsman in the studio of José Villagrán García, the leader of Mexican Functionalism, becoming his partner between 1955 and 1960. During this period he was a follower of the International Style, as seen in the Hotel María Isabel (1961–2; with Villagrán García and Juan Sordo Madaleno), Mexico City. In 1960 he set up in partnership with Noé Castro (*b* 1929) and Carlos Vargas (*b* 1938), specializing in the design of factories and office buildings, the most notable project of this period being the office building for Celanese Mexicana (1966–8; with Roberto Jean) in Mexico City, with its prismatic outline and technical brio in the use of the hanging structure. In the late 1960s, influenced by LUIS BARRAGÁN and MATHIAS GOERITZ and his own strong sense of Mexican identity, Legorreta embraced 'emotional architecture' (*see* MEXICO, §III, 2), which he developed into an important trend in late 20th-century Mexican architecture. His experience and technical mastery enabled him to combine functional solutions with variations on characteristic Mexican forms. This approach was applied to all types of buildings, including large-scale and complex projects. The first example was the Hotel Camino Real (1968) in Mexico City, where the idea of the tall building was replaced with a linear concept; in later examples, such as the Camino Real hotels in Cancún (1975) and Ixtapa (1981), the relationship of the buildings to their natural environment is stressed.

Legorreta was also active in the area of industrial architecture, designing such buildings as the IBM factory (1975), Guadalajara, and the Renault Engines factory (1983), Gómez Palacio, and in the design of bank buildings, for example the city-centre offices of the Banco de México (1982–5), Mexico City. He designed the Museo de Arte Contemporaneo, Monterrey, in 1991, one of Mexico's most lavish constructions, and in 1992 the new Cathedral in Managua, Nicaragua, with its multi-domed roof. His private houses, for example the weekend house (1973) in Valle de Bravo, Mexico State, express vernacular influences more intensely, the whole being skilfully adapted to its surroundings, while his interior designs reflect his experience of creating furniture and accessories. Generally they follow a balance between austerity and opulence, using

natural materials such as clay, wood and textiles, with decorations drawn from popular crafts.

Legorreta opened an office in the USA in 1985, designing the Westlake Park development (1985, with Mitchel/Giurgola) in Dallas, TX, as well as several buildings there for IBM. Since then, his many commissions have included private houses, the Children's Discovery Museum (1991) in San José, CA, the renewal of Pershing Square (1994) in Los Angeles, CA, and libraries in Monterrey and San Antonio, in Mexico.

WRITINGS

Muros de México (Mexico City, 1978)

BIBLIOGRAPHY

L. Noelle: *Ricardo Legorreta: Tradición y Modernidad* (Mexico City, 1989)
W. Attoe: *The Architecture of Ricardo Legorreta* (Austin, 1990)
F. González Gortázar, ed.: *La arquitectura mexicana del siglo XX* (Mexico City, 1994)
M. A. Roca, ed.: *The Architecture of Latin America* (London, 1995)
J. V. Mutlow, ed.: *The Architecture of Ricardo Legorreta* (London, 1997)

LOUISE NOELLE

Leirner, Jac(queline) (*b* São Paulo, 1961). Brazilian printmaker and conceptual artist. She was introduced to contemporary art and artists from an early age by her collector parents, Fulvia and Adolfo Leirner. She went on to study art at the College of Fine Arts, Fundação Armando Alvares Penteado, São Paulo, between 1979 and 1984, and at the Licenciatura in 1984; she returned to teach at the Fundação from 1987 to 1989. From the 1980s Leirner made sculptures and installations using such products of modern life as devalued bank notes, airline tickets, cigarette packages and shopping bags. This involved a process by which these mundane items are removed from circulation and placed into the art world, often in a conscious inversion of the work of the Brazilian conceptualist CILDO MEIRELES. To this end Leirner remade Meireles's *Zero Cruzeiro* (1978) and the work of another Brazilian artist, *Dinheiro para treinmento* ('Money for training'; 1977) by Waltercio Caldas (*b* 1946). Leirner carefully collected and categorized objects of no apparent value before submitting them to a process of reconstruction and presentation that distanced them from their basic function; the serial arrangements of the same or similar items imbues them with

Jac Leirner: *O Livro (Do Cem)*, screenprint, 647×241 mm, 1987 (Colchester, University of Essex, Collection of Latin American Art)

a hitherto unrecognised value She was also influenced by Minimalism and Arte Povera. In 1990 Leirner was a Visiting Fellow at Oxford University as a guest of the British Council, and Artist in Residence at the Museum of Modern Art, Oxford. In 1991 she was Artist in Residence at the Walker Art Centre in Minneapolis, MN. An example of her printwork is *O Livro (Do Cem)* (1987; see fig.).

BIBLIOGRAPHY

Transcontinental: An investigation of Reality (exh. cat. by G. Brett, Birmingham, Ikon Gal., and Manchester, Cornerhouse, 1990)
Ultramodern: The Art of Contemporary Brazil (exh. cat., ed. A. A. Amaral and P. Herkenhoff, Washington, DC, N. Mus. Women A.,1993)
L. Laguado: 'Jac Leirner', *A. Nexus*, xiii (1994), pp. 40–43

ADRIAN LOCKE

León, Fidelio Ponce de. *See* PONCE DE LEÓN, FIDELIO.

León, Teodoro González de. *See* GONZÁLEZ DE LEÓN, TEODORO.

Le Parc, Julio (*b* Mendoza, 23 Sept 1928). Argentine kinetic artist. He was one of the most active members of the large group of South American artists who established themselves in Paris in the 1950s and played a major role in the launching of Kinetic art in Europe in the next decade. He studied under Lucio Fontana at the Escuela Superior de Bellas Artes in Buenos Aires between 1942 and 1954, before going to Paris in 1958. There he visited Victor Vasarely's studio and met the gallery owner Denise René, who had already established herself as the leading Parisian sponsor of geometrical and kinetic art. In 1960 Le Parc joined 11 other artists, including Francisco Sobrino and his Argentine colleagues Hugo Demarco (*b* 1932) and Horacio García Rossi (*b* 1929), in founding the Groupe de Recherche d'Art Visuel. His reputation was founded on the theoretical stringency and active exhibiting policy of this group, but in 1966 he was awarded the Grand Prix for painting at the Venice Biennale. Ironically this acclaim was offered to a member of a group anxious to repudiate the notion of the celebrated individual artist.

Le Parc had begun working on two-dimensional compositions in colour and black and white as early as 1953, while he was still an art teacher in Buenos Aires. From 1960, however, he began to develop a series of distinctive works that made use of 'skimming' light: these objects, usually constructed with a lateral source of white light which was reflected and broken up by polished metal surfaces, combined a high degree of intensity with a subtle expression of continuous movement (e.g. *Light-continuum*, 1962; see fig.). At the *Kunst–Licht–Kunst* exhibition at the Stedelijk Van Abbemuseum, Eindhoven, in 1966, as at the Venice Biennale of the same year, Le Parc's individuality was rightly remarked on. Despite his commitment to the joint programme of the Groupe de Recherche d'Art Visuel, he was unable to resist the commercial and institutional pressures that singled him out from his colleagues.

BIBLIOGRAPHY

F. Popper: 'Le Parc and the Group Problem', *Form*, 2 (1966), pp. 5–9
——: *Origins and Development of Kinetic Art* (London, 1968)
Soto, Vasarely, Le Parc (exh. cat., Dublin, Hendriks Gal.; Belfast, Ulster Mus.; 1968)
E. Maurizi: *Le Parc: La modulazione della luce* (Macerata, 1980) [pubd at time of exhibition in Macerata, Pin. & Mus. Com.]
J. López Anaya: *Historia del arte argentino* (Buenos Aires, 1997)

Julio Le Parc: *Light-continuum*, wood, stainless steel, motor and light, 1710×1200×300 mm, 1962 (Paris, Galerie Denise René)

M. del Mar Lozano Bartolozzi: 'Entrevista con Julio Le Parc', *Con Eñe* (Feb 1997), pp. 31–5
STEPHEN BANN

Lerner, Jaime (*b* Curitiba, 17 Dec 1937). Brazilian urban planner and teacher. He graduated as an engineer (1960) and an architect (1964) from the Federal University of Paraná, Curitiba, and then developed an active career as an urban planner. He was Prefect of Curitiba in 1971–5, 1979–83 and from 1989, during which time a profound physical, cultural, economic and social transformation of the city was achieved. By giving priority to traffic problems, health and sanitation, leisure and industrialization, Lerner made Curitiba (pop. 1.5 million) a model of urban planning. His approach to planning was essentially humanist, concentrating on the need for citizens to identify with their urban environment through the development of cultural activities, to build at a human scale, to use infrastructure and service networks more efficiently, including the conservation and re-use of old buildings, and to mix functions, social classes and age groups. He also concentrated on the need for better management by the administrators of the city. Lerner subsequently prepared urban plans for most of the principal cities of Brazil including Recife (1975), Salvador (1976), Goiânia (1975), Campo Grande (1977), Aracajú (1976), João Pessoa (1978), Niterói (1978) and São Paulo (1975), as well as for Caracas, Venezuela (1975), and San Juan, Puerto Rico (1987). In 1983–6 he was Consultant to the State Government and Prefecture of Rio de Janeiro in implementing the programme Rio Ano 2000, starting with the improvement of mass transport and the revitalization of the historic centre of the old capital of the republic. Lerner taught urban and regional planning at the Federal University of Paraná and was a visiting professor at the University of California, Berkeley; he also acted as urban planning consultant to the United Nations and was appointed to the United Nations Environment Council in 1990.

WRITINGS
Londrina: A situação 66 (1966)
A cidade: Cenário do encontro (1977)
The City and Scala: One Turn Less of the Screw (1982)

BIBLIOGRAPHY
Brasil Post (30 June 1991)
J. Maier jr: *Time* (14 Oct 1991), p. 44
M. Margolis: *Newsweek* (14 Oct 1991)
REGINA MARIA PROSPERI MEYER

Leufert, Gerd (*b* Klaipeda, 9 June 1914). Venezuelan graphic designer, printmaker, painter, museum curator and teacher of Lithuanian birth. He studied at the High School of Design in Hannover, at the School of Arts and Crafts in Mainz and at the Akademie der Bildenden Künste in Munich. He moved to Venezuela in 1951. In 1957 he was art director of the magazine *El Farol*, and in the following year he taught composition in the Faculty of Architecture and City Planning in the Universidad Central de Venezuela, Caracas, and graphic design in the Escuela de Artes Visuales 'Cristóbal Rojas', Caracas, becoming director of its graphic arts department. He also taught graphic design in the USA at the University of Iowa, Iowa City, and at the Pratt Institute, New York. On his return to Caracas in 1959, he became a curator at the Museo de Bellas Artes and artistic director of its magazine *Visual*. With M. F. Nedo, Leufert did much to revive the graphic arts in Venezuela, producing a series of prints in collaboration with Nedo and Alvaro Sotillo as a symbol of this revival. Leufert's best-known work includes *Marks*, a fusion of writing and graphic design, and *Funeral Songs*, monochrome works of heroic proportions in which sculpture, painting and graphic design are blended.

BIBLIOGRAPHY
A. Armas Alfonzo: *Diseño gráfico en Venezuela* (Caracas, 1985)
Gerd Leufert, crónica apócrifa: Ensamblajes fotográficos (exh. cat. by V. de Stefano, Caracas, Cent. Cult, Consolidado, 1992)
Espacios imaginarios y reales: Tintas de Gerd Leufert (exh. cat., Caracas, Mus. B.A., 1994)
ANA TAPIAS

Levi, Rino (*b* São Paulo, 31 Dec 1901; *d* São Paulo, 29 Sept 1965). Brazilian architect and teacher. He studied at the Academy of Fine Arts in Milan (1921–2) and the School of Architecture, Rome (Dip. Arch., 1926). In 1927 he established his own office in São Paulo, at that time still a provincial city with hardly more than a million inhabitants. His first projects show a variety of influences, including Italian Rationalism and Art Deco, but he then designed the first modern block of flats in São Paulo, the Columbus Building, completed in 1932. His design had a considerable impact on the still largely horizontal urban landscape and contrasted strongly with the eclecticism of most of the larger houses in the city, winning him an immediate reputation as a modernist architect. Another important work of the 1930s was the design of a large new cinema for São Paulo. Opened in 1936, the UFA Palace, with 3100 seats, was an entirely new concept in cinema design: it had no boxes, but the whole audience was seated in the great auditorium and balcony in perfect viewing and acoustic conditions. The work received enormous critical and public acclaim and won him commissions for further cinemas including the Ipiranga (1919 seats) in São Paulo, designed in 1941. This was a more complex project incorporating the 200-room Hotel Excelsior on the narrow site; the result was an outstanding synthesis of technology, function and aesthetics.

At the end of World War II Brazil entered a phase of intense industrialization and rapid urbanization. These were very productive years for Levi, whose practice extended to include as partners Roberto Cerqueira Cesar (*b* 1917) in 1941 and Luiz Roberto Carvalho Franco (*b* 1926) in 1951 and undertook a series of large-scale buildings. The first stemmed from a prize-winning project for the University of São Paulo Maternity Hospital in 1945. Despite being unexecuted, the design impressed technical experts by the clarity with which the various functions were integrated. It led to Levi's association with a group of doctors who were interested in the rationalization of hospital design and administration, and to a series of important designs for hospitals: the Central Cancer Hospital (1947), the Children's Hospital for the Pro-Infancia Crusade (1950) and the Albert Einstein General Hospital (1958), all in São Paulo. All of these hospitals were planned as a group of separate but interlinked buildings accommodating different activities, and they all provided highly practical solutions to technical and functional problems. In 1959 Levi's office won a contract from the Venezuelan government to advise local architects on a national network of 17 hospitals, many of which were subsequently built.

In 1957 Levi and his team received third prize for their competition entry for the new federal capital, Brasília, which was a radical proposal based on a limited number of very high density blocks. Although the design would have been impossible to achieve with the technology available in Brazil at the time, it remained a topic of discussion and argument. Levi's last major work, and his largest, was the Civic Centre of Santo André, won in competition in 1965. Comprising three different buildings, a Town Hall, Council Chamber and Cultural Centre planned around a pedestrian walkway, the design had an exposed concrete structure, with a grid reinforced by *brise-soleils*, and distinguishes between the functions of each building as Levi had done in his hospital designs. The centre was subsequently completed with gardens and works of art by ROBERTO BURLE MARX.

Levi made an important contribution to the introduction of modern architecture to Brazil, not only through his buildings but also in his teaching roles at the University of São Paulo (1954–9) and the University of Caracas (1959), and through his professional activities as founder and President of the Institute of Architects of Brazil and member of CIAM. After his death, on completion of the Civic Centre project, his practice continued and developed, remaining one of the most important in Brazil. Working under the name Rino Levi Architects Associates, and including Paulo J. V. Bruna (*b* 1941) as a partner from 1971, it carried out a long series of important industrial and educational buildings in the 1970s and 1980s.

BIBLIOGRAPHY

'L'Architecture est un art et une science', *Archit. Aujourd'hui*, 27 (1949), p. 50
H. R. Hitchcock: *Latin American Architecture since 1945* (New York, 1955)
H. E. Mindlin: *Modern Architecture in Brazil* (Rio de Janeiro, 1956)
'Hospital in São Paulo, Brazil', *Archit. Rev.* [London], cxxvi/751 (1959), pp. 109–12
'Rapporto Brasile', *Zodiac*, 6 (1960), pp. 84–95
Rino Levi, intro. R. Burle Marx and N. Goulart (Milan, 1974)
P. M. Bardi: *Lembrança de la Corbusier: Atenas, Italia, Brasil* (São Paulo, 1984)

PAULO J. V. BRUNA

Lewis, Roberto (Gerónimo) (*b* Panama City, 30 Sept 1874; *d* Panama City, 22 Sept 1949). Panamanian painter and teacher. He studied painting in Paris at the Académie des Beaux-Arts and in the studio of Léon Bonnat, combining the influence of academic and Post-Impressionist art. On his return to Panama in 1912 he was commissioned to paint the interiors of several new public buildings, among them the Teatro Nacional and the Palacio de Gobierno, which he decorated in the official Neo-classical style. He was an accomplished portraitist and numbered among his sitters many political figures, including numerous Panamanian governors and all the presidents of Panama from 1904 to 1948 (Panama City, Pal. Presidencial).

Lewis was a pioneer of modern art in his country. While his official portraits were academic in style, his landscapes were painted with a Post-Impressionist spontaneity. His murals *Tamarinds of Taboga* (1936; Panama City, Pal. Presidencial), which are among his best-known works, depict bucolic scenes that combine allegory and Classical and symbolist elements with the lively brushwork, bright colours and luminosity of late 19th-century European *plein-air* painting. Lewis was also a dedicated teacher, and as founder (1913) and first director (1913–38) of the Academia Nacional de Pintura (now Escuela Nacional de Artes Plásticas) in Panama City he was responsible for training an entire generation of Panamanian artists.

BIBLIOGRAPHY

R. Miró: 'Lewis, Amador, Ivaldi', *Rev. Lotería*, 219 (1974), pp. 72–80
Exposición Maestros-maestros (exh. cat. by P. Prados, Panama City, U. Panamá, 1987), pp. 15–17
M. Lewis: 'Roberto Lewis: Sus años en Francia', *La Prensa (Epocas)*, v/11 (Nov. 1990), p. 2

MONICA E. KUPFER

Liautaud, Georges (*b* Croix des Bouquets, nr Port-au-Prince, 1899; *d* 1991). Haitian sculptor. He lived all his life in the dusty crossroads village where he was born. He was discovered in 1955 by the American watercolourist Dewitt Peters (1901–66) and Antonio Joseph, who had noticed some unusual forged iron crosses in the town cemetery. Inquiring about the maker of these unique crosses, they were directed to a local blacksmith's shop. Liautaud had worked as a mechanic on the sugar railroad. He explained the crosses as belonging to the graves of Vodounists and offered to make some for his visitors. It was the beginning of a long personal career as well as an entire genre of cut and forged metal sculpture in Haiti. He began to include representational elements in his work, cutting forms out of old oil drums or scrap with a hand chisel or hacksaw, as in *Crucifixion* (1959; see fig.). The technique demanded physical force and produced a roughly contoured shape whose edges were then filed and smoothed. Liautaud also forged elements, heating and hammering the metal to the desired shape; some details were rounded by hammering over forms or bent so that they extended into space. He often took the *loa* (spirits) of Vodoun as his subjects, transforming them into personal metaphors suggesting the darker side of Vodoun. His figures have attenuated

Georges Liautaud: *Crucifixion*, cut and forged oil drum metal, 1170×760×230 mm, 1959 (Washington, DC, Art Museum of the Americas)

and often contorted limbs. Crosses symbolic of Legba (spirit guardian of the crossroads) or of Baron Samedi (lord of the cemetery and the realm of the dead) recur in his work. La Sirène, the mermaid, was his favourite subject, which he loved to adorn with trinkets to accent her sensuality.

BIBLIOGRAPHY
S. Rodman: *Where Art is Joy* (New York, 1988), pp. 123–38
Haïti: Art naïf—art vaudou (exh. cat., Paris, Grand Pal., 1988)
Black Art: Ancestral Legacy (exh. cat., Dallas, TX, Mus. A., 1989)

DOLORES M. YONKER

Lima. Capital of Peru and of the department of Lima. It is located in the Rímac, Chillón and Lurín valleys, with a metropolitan population of *c*. 6,884,000 (1996). It was a Pre-Hispanic regional capital, and then capital of the Viceroyalty of Peru, which included all Spanish territory in South America. Its Pacific port, Callao, is *c*. 6 km to the west.

1. Pre-Columbian. 2. Colonial. 3. Republican.

1. PRE-COLUMBIAN. The first settlements were established in the Pre-Ceramic period (before *c*. 1800 BC) in three valleys. There are a number of later Pre-Ceramic sites near the modern city, for example El Paraíso, Tablada de Lurín, Chilca and Asia. Communities grew, and by the Pre-Ceramic period VI (*c*. 2500–*c*. 1800 BC) there were sizeable ceremonial centres with accompanying settlements (e.g. El Paraíso). Settlements were later founded further inland, usually near or in the watershed of the River Rímac. At Garagay there are exceptional examples of wall painting (*c*. 1200 BC) at the U-shaped temple. Anthropomorphic heads and monstrous figures with feline attributes are depicted in glowing red, pink, blue, purple and yellow on a high-relief frieze modelled in clay. During the Early Intermediate period (*c*. 200 BC–*c*. AD 600) the population probably expanded throughout all three valleys. A series of elegant smaller pyramids and platform mounds were built, mainly in the Rímac Valley, using adobe bricks that are much smaller than those used earlier or later. The Playa Grande (or Interlocking) style was used for wall paintings, pottery and textiles (e.g. fragments, Lima, Mus. Arqueol. & Etnol.); its characteristics include smaller angular interlocking units portraying polychrome geometricized snakes, double- and multiple-headed snakes, fish, cats and birds, usually in yellow, black, cream, brown, purple, orange and red.

With population expansion came changes in architecture and art, including the Maranga (or Proto-Lima) style. A new, black pottery and the use of geometric designs in white on a red or orange background were introduced. Architecture was still based on the stepped pyramid. About AD 700 the area was affected by a series of developments in southern Peru, particularly at such sites as the administrative and ceremonial centre of Pachacamac, for which the people of the Huari culture were probably responsible. Settlements used variations of grid plans increasingly, as at Cajamarquilla. Pottery and textiles also became more formalized, featuring geometric polychrome anthropomorphic figures influenced by Tiahuanaco art. After the decline of the Huari empire *c*. AD 800 a series of small city states developed *c*. AD 1200, of which Ichma or Ichmay is probably the best documented. Located within Lima, and in the Chillón, Canta and Chancay valleys, they were often based around fortified hill-forts within rectangular walls and include sites such as Rupac, Chiprac, Cantamarca and Socos. Nevertheless, under Inca Yupanqui (*reg c*. 1471–93) the Incas conquered much of the coast and built Tambo Inga, Mateo Salado, Avillay, Paramonga and Huarco.

2. COLONIAL. On 1 February 1533 Europeans arrived in the Rímac Valley. Francisco Pizarro knew he would need towns on the Pacific coast of Peru, and Lima and its port, Callao, were established in January 1535. The symbolic foundation stones of the future cathedral were laid, and the central square was marked out; the blocks (*cuadras* or *manzanas*) forming the grid plan extended from it. Each was split into four plots (*solares*) on which individuals were encouraged to build, preferably using 'noble' materials, such as stone. Suitable stone was not readily available, however, nor was it an appropriate building material for an earthquake-sensitive region; therefore such traditional materials as adobe, *quincha* (clay or plaster wattle) and cane were preferred. The materials were also suitable for the dry climate. Consequently, buildings appeared to have a strength and monumentality, particularly where stone portals were incorporated. The National University of S Marcos was founded in 1551. Earthquakes in 1656, 1687

and particularly 1746 severely damaged the city, which nevertheless grew; by 1786 it had 350 streets and 8222 houses. Diego Maroto surveyed Lima after the earthquake of 1687. Such anti-seismic measures as the use of light building materials were applied to a variety of buildings within the Cercado, or walled area. From 1586 the Viceroy, Conde del Villar, forced the original inhabitants to move to satellite settlements outside the Cercado. The Puente de Piedra (1610), which spans the Rímac, is a rare, early stone structure; it was built under Viceroy Juan de Mendoza y Luna, Marqués de Montesclaros.

Architecture in Lima generally reflected European developments, though with a delay of c. 10 to 20 years. Some of these developments subsequently flowed from the capital to the provinces, creating greater anachronisms. During the early colonial period until the 17th century, architecture was Gothic or Renaissance in style. Expressions of the Plateresque (e.g. S Marcelo) were short-lived. Baroque architecture is well represented; the forms of Rococo dominated, largely due to Viceroy José Antonio Manso de Velasco's enthusiastic rebuilding of the city after the devastating earthquake of 1746. Neo-classicism was fashionable at the end of the 18th century and remained so until c. 1821. Lima's colonial architecture reflected its status as the political and administrative centre of the Viceroyalty of Peru. The city had a thriving import–export trade directly with Spain, and building materials were imported, for example wood from Costa Rica, stone from Panama (as in the case of La Merced, which incorporates soft pink granite brought as ballast from Panama), and ironwork, glazed tiles (*azulejos*), glass and textiles (e.g. brocade) from Spain.

Surviving colonial ecclesiastical architecture in Lima includes the cathedral (begun 1598) by FRANCISCO BECERRA (*see* PERU, §III, 1 and fig. 4); S Pedro, or La Compañía (1568; rebuilt 1624–38); the Baroque churches of La Merced (1541–2; altered 1607–15; rest. 1746) and S Agustín (1574–c. 1637; rest.); S Domingo (1540–52), with its Rococo-cum-Neo-classical façade; and S Francisco, which has a church, cloister and catacombs (1657–74; partially rebuilt 1995) by CONSTANTINO DE VASCONCELOS. MATEO PÉREZ DE ALESIO executed a variety of commissions in Lima's churches. In the 18th century Spanish tradition began to give way to French and Austrian architecture, as at Las Nazarenas (1766–71; rebuilt 1835) and Los Huérfanos (completed 1758–66). The smaller churches of Jesús Maria (1722), S Sebastian, La Magdalena Vieja (1557; rebuilt 1931), Trinitarias (inaugurated 1722), S Carlos (in Cocharcas), S Rosa de las Monjas (1704–8), Santiago de Surco, and S Teresa (rebuilt after 1746; destr. 1946) preserve in varying degrees a somewhat formulaic Baroque. Some of the city's churches are richly furnished (*see* PERU, §IV, 1).

Lima's gradual expansion caused the destruction of much colonial domestic and administrative architecture, including the city fortifications. The grid plan and a few domestic structures survive, however: for example the Palacio de Torre Tagle (completed 1735; now part of the Ministerio de Relaciones Exteriores), with its distinctive Moorish and *Mudéjar* elements (see fig. 1); the portal of the Casa de Pilatos (1590); the wooden balconies on buildings near S Domingo; the Casa de Rada; the Quinta

Presa (1766–7; rest.; now Museo del Virreinato); the Casa de Aliaga, built on a Pre-Columbian shrine in the city centre; the Casa de Oquendo (or Osambela, completed 1803–05); and the Casa de Osma. While residential architecture did not follow a set formula or style, houses were typically of one storey with large bay windows and decorative wrought-iron grilles; two-storey dwellings usually had flat roofs, wooden balconies and a two-colonnaded inner patio.

In the final years of the colonial period a number of schools and higher-education centres were established, including a school of art, the Seminario de S Toribio, S Tomás, with its magnificent circular cloister (c. 1750), and the Court of the Inquisition (c. 1569 or 1578; now Museo del Tribunal de la Santa Inquisición y del Congreso). French-influenced gardens and pedestrian areas, such as the Alameda de los Descalzos (c. 1609; embellished by President Ramón Castilla in 1856 with English wrought iron and 12 Carrara marble statues brought from Italy) and the Paseo de Aguas (begun 1770; after the Roman Piazza Navona), were inspired by Viceroy MANUEL AMAT.

All that survives of the city's defensive walls (1685; destr. 1869) is a section at the Cuartel de S Catalina. At Callao is the Real Felipe Fort (1747–74; rest. 1925; now Museo Histórico Militar), a substantial stone fortification estimated to contain several million egg whites in its mortar; it was built to defend the port and city after the attacks of Francis Drake and Thomas Cavendish and the five-month blockade (1624) by Jakob Clerk (known as

1. Lima, façade of the Palacio de Torre Tagle, completed 1735, now part of the Ministerio de Asuntos Exteriores

L'Hermite), and to replace earlier structures destroyed in the earthquake of 1746.

3. REPUBLICAN. The Proclamation of Independence (28 July 1821) by José de San Martín in Lima heralded many architectural changes; the rejection of some Hispanic traditions led to the destruction and replacement of colonial structures with buildings initially based on French and Italian models. Locally developed architecture, suited to the environment, was phased out because it was considered Spanish and unrepublican; at first, it was not understood that colonial architecture was not purely Spanish, but rather a distinctly Peruvian manifestation of Peninsular traditions. In some ways, however, most noticeably in domestic architecture, there was little perceptible change for a considerable period.

The rejection of the colonial past was expressed in the adornment of façades with such mixed Neo-classical elements as Ionic columns with Doric capitals, and cornices with Ionic and Corinthian features. The change was thus confined to exteriors and did not affect interior planning. The inner patio system, balconies with Classical detailing, and the large main portal remained in use. Lima's population in 1821 was 64,000; the city could not sustain major architectural projects. The innovative Lima Penitenciaría was built, however, employing panoptic radial design; it was designed by Maximiliano Mimey and built by Mariano Felipe Paz-Soldán y Ureta (1821–86) in stone, brick and quincha. Administrative and commercial buildings were erected for overseas companies. New materials (e.g. cast iron and glass) and methods of construction were used, as at the Palacio de la Exposición (1875; now Museo de Arte) built by Antonio Leonard and Manuel Anastasio Fuentes (1820–89). The Puente de Hierro (now Puente Balta) and a series of ornamental and functional piers were put up on the coast.

The development of railways under José Balta (President, 1868–72) indirectly affected architecture in Lima, its suburbs and further afield, as people went to the provinces and came from industrialized nations, bringing with them the latest European architectural and engineering techniques. For example, the Hospital Dos de Mayo (1868–75; now Museo Hospital Dos de Mayo; partly rebuilt) by Mateo Graziani has radial colonnaded (Doric) galleries around a central octagonal garden of Italian inspiration. The growth of trade that followed the Dreyfuss Contract (1869) concerning the sale of guano to Europe financed the transformation of such areas as Callao.

Fashionable French academic Neo-classicism was promoted by the architects who came from France and Italy. There were several art schools in Lima with a series of distinguished directors (see PERU, §IV, 2). Urban planning regained its early colonial importance and was applied in such areas as Rímac and the Barrios Altos. Parks and squares, for example the Plaza Bolívar with the equestrian monument to *Simón Bolívar* (1859) by Adamo Tadolini (1788–1868), were laid out by such planners as Jacob Wrey Mould (1825–86). After 1870 a moderate, Italian Neo-classicism was widely applied and adapted to local needs. The Chilean invasion (1881) halted many building projects, which remained in abeyance well into the early 20th century.

The period immediately after the War of the Pacific (1879–83) has been seen as eclectic and characterized by mediocre architectural projects that debased the remnants of Neo-classicism through over-use and an uncomfortable combination with Art Nouveau. Around the Plaza Dos de Mayo (1866; remodelled 1920s) and the circular Plaza Bolognesi long, wide avenues recalling Parisian boulevards were laid out, flanked by buildings of the *petit-hôtel* type. On the outskirts of Lima, at Miraflores and Chosica, the first Mock Tudor English houses were built. Traditional architecture had been almost totally abandoned. Such public buildings as the Casa de Correos (1895), built during the government of Nicolás de Piérola, were typically large, spacious and strong, and could be adapted to a variety of uses.

After 1914 new materials and building techniques, together with increasingly accessible information on architectural trends, became available. A school of architecture was established in Lima, and an interest rekindled in establishing a suitable, identifiably Peruvian architecture. Early experimental styles included some absurd interpretations of earlier forms, for example the replication of adobe walls in brick and concrete and an injudicious overuse of colonial elements. The concurrent influence of international Modernism is evident in a number of houses, schools and hospitals, such as the Hospital del Obrero (1938), built during the presidency of Oscar R. Benavides Larrea. The Paseo de la República (1935; now Vía Expresa or Zanjón), linking central Lima and Miraflores, was planned and built by Ricardo Malachowski the elder; it is now flanked by late 20th-century buildings.

In the 1930s a Peruvian Colonial Revival style arose, particularly evident in the early work of Rafael Marquina y Bueno (1884–1964), Malachowski the elder and Claudio Sahut. They also explored technological developments in such materials as glass, aluminium and plastics. Their earlier work is represented by the Palacio Arzobispal (1916–24), the Palacio de Gobierno (1921–38; see fig. 2), the Club Nacional, the Banco Italiano (now Banco di Crédito), the Hotel Bolívar (1924), Plaza S Martín and the Avenida Nicolás de Piérola (or Colmena), as well as numerous houses. The Palacio Arzobispal (completed 1924) has been considered by some as excessively florid, tasteless and anachronistic, a criticism that may also be levelled at the numerous exaggerated Colonial Revival-style houses. By contrast, in the 1920s sporadic attempts were made to impose an Inca-derived style, as in the Museo Nacional de la Cultura Peruana (founded 1945; formerly the Museo Víctor Larco Herrera, founded 1919; see PERU, §X). This style did not find acceptance, being ill-suited to coastal flat-roofed buildings, and only such individual elements as polygonal-stone or modelled wall cladding were retained on some residential buildings. As with other art forms, a division emerged between the nationalist Hispanists or Traditionalists and the socialist Indigenists, the latter aligning themselves with the socially responsive theories of Le Corbusier, Mies van der Rohe, Frank Lloyd Wright and Walter Gropius.

The Agrupación Espacio was established in 1947 to provide a platform for the discussion of issues raised by Manuel Piqueras Cotolí and subsequently explored by such eminent architects as Benavides, Emilio Harth-Terré

2. Lima, façade of the Palacio de Gobierno, 1921–38

(1899–1983) and José Alvarez Calderón. Harth-Terré and his group were instrumental in creating and promoting the Escuela Nacional de Ingeniería, the Sociedad de Arquitectos (founded 1937), and the Consejo Nacional para la Restauración y Conservación de Monumentos Históricos (*see* PERU, §III, 2). Despite strenuous efforts by such individuals as Bruno Roselli to preserve colonial and early republican buildings in Lima, numerous *casonas* (mansions) were demolished in favour of new road schemes and building projects. However, in 1991, through negotiations carried out by Patronato di Lima with UNESCO, the city was declared a World Heritage site.

Fernando Belaúnde Terry (*b* 1912) explored the use of shapes, blocks and masses at Limatambo Airport (1945–8) and later at Jorge Chávez Airport (1965). Luis Miró Quesada Garland (*b* 1915) designed such experimental housing developments as the Residencial Palomino, and Henri Ciriani designed the Residencial S Felipe, which provides low-cost housing for a high-density population, similar to social housing schemes in Cuba. Functionalist architecture is found in various housing areas, ministries (e.g. Ministry of Work, Ministry of Education and Ministry of Public Health) and hospitals (e.g. Hospital del Empleado, 1950–56).

In the 1950s and 1960s a massive, largely undocumented building boom on the outskirts of the city took place initially at El Agustino and Comas. Such areas, known as *barriadas* or *pueblos jóvenes*, developed at an unprecedented, unpredictable rate, sometimes unplanned. By the late 20th century around 2,600,000 people are estimated to occupy these areas, where architecture ranges from the rudimentary but progressive (e.g. at Villa El Salvador, pop. *c.* 320,000) to the substantial (e.g. at S Martín de Porres). Housing needs have led to the emergence of self-made architects, surveyors and engineers, who combine native forms, modern technology and materials.

Examples of buildings from the 1970s and 1980s include the Centro Cívico y Comercial (1971) by Córdoba, Crousse, José García Bryce, Málaga, Núñez, Páez, Ortiz and others. With its volumetric masses of grey cement and stressed concrete, it refers to Pre-Columbian traditions of walled compounds of the North Coast. Adjacent is the Sheraton Hotel (*c.* 1970) by Ricardo Malachowski the younger, who also built the Hospital de la Fuerza Aérea del Perú. Both buildings are 15–20 storeys high and are substantial structures of reinforced concrete, aluminium and glass, set on wide, horizontal platforms. Some buildings combine glass with vast expanses of concrete or curtain walls, for instance Miguel Rodrigo's Banco Central Hipotecario del Perú (1977) and housing developments (1971–2) in Callao. In the 1980s the search for indigenous roots was temporarily abandoned in favour of the use of tinted glass, coloured tiling and various textures, for example in the Banco Continental (1983) and the Centro Comercial Camino Real. In the 1990s, the US embassy building was designed with references to Pre-Columbian motifs, in particular ancient textile patterns.

BIBLIOGRAPHY

H. Velarde: *Arquitectura peruana* (Mexico City, 1946)
J. Jijón y Caamaño: *Maranga: Contribución al conocimiento de los aborígenes del Rímac* (Quito, 1949)
H. E. Wethey: *Colonial Architecture and Sculpture in Peru* (Cambridge, MA, 1949)
P. Keleman: *Baroque and Rococo in Latin America* (New York, 1951)
A. Kroeber: 'Proto Lima: A Middle Period Culture of Peru', *Fieldiana Anthropol.*, xliv (1954) [whole issue]
F. Engel: 'A Preceramic Settlement on the Central Coast of Peru: Asia, Unit 1', *Trans. Amer. Philos. Soc.*, liii/3 (1963) [whole issue]
E. Tabío: *Excavaciones en la costa central del Perú (1955–1958)* (Havana, 1965)
J. M. Ugarte Elespurú: *Lima y lo limeño* (Lima, 1966)
H. Velarde: *Itinerarios de Lima: Guía de monumentos y lugares históricos* (Lima [1971]); Eng. trans. as *Guide to Lima: Historical Monuments and Sites* (Lima, 1972)
R. Ramírez Villar: *San Francisco de Lima* (Lima, 1974)

E. Harth-Terré: *Perú: Monumentos históricos y arqueológicos* (Mexico City, 1975)

R. Ravines and W. H. Isbell: 'Garagay: Sitio ceremonial temprano en el Valle de Lima', *Rev. Mus. N.*, xli (1975), pp. 253–75

M. Rostworowski de Diez Canseco: *Señoríos indígenas de Lima y Canta* (Lima, 1978)

P. Lloyd: *The 'Young Towns' of Lima: Aspects of Urbanization in Peru* (Cambridge, 1980)

S. A. Calvo: *Lima prehispánica* (Lima, 1984)

Inventario de monumentos arqueológicos del Perú, Lima metropolitana (Lima, 1985)

J. B. Ballesteros: *Historia del arte hispanoamericano: Siglos XVI a XVIII*, ii (Madrid, 1987)

L. Castedo: *Historia del arte iberoamericano*, ii (Madrid, 1988), pp. 31–4, 208–14

V. Fraser: *The Architecture of Conquest: Building in the Viceroyalty of Peru, 1535–1635* (Cambridge, 1990)

A. Castrillón Vizcarra: 'Escultura monumental y funeraria en Lima', *Escultura en el Perú*, Banco de Crédito del Perú (Lima, 1991), pp. 324–85

M. Ibáñez Sánchez: 'Problemas de geografía urbana en Lima metropolitana al año 2010', *Bol. Lima*, xiii (1991), pp. 65–90

J. Gunther Döering and G. Lohmann Villena: *Lima* (Madrid, 1992)

R. Ravines: 'La conservación y restauración de edificios históricos en los centros urbanos', *Bol. Lima*, xiv (1992), pp. 15–18

P. Belaunde: 'Perú: Mito, esperanza y realidad en la búsqueda de raíces nacionales', *Arquitectura neocolonial: América Latina, Caribe, Estados Unidos*, ed. A. Amaral (São Paulo, 1994), pp. 79–94

N. Majluf: *Escultura y espacio público: Lima, 1850–1879* (Lima, 1994)

M. Cubillas Soriano: *Lima: Monumento histórico* (Lima, 1996)

H. Rodríguez Camilloni: 'Forma y espacio en la arquitectura del virreinato del Perú durante los siglos XVII y XVIII', *Arquitectura colonial iberoamericana*, ed. G. Gasparini (Caracas, 1997), pp. 287–318

Gran enciclopedia del Perú (Barcelona, 1998), pp. 632–735

W. IAIN MACKAY

Lima, João Filgueiras. *See* FILGUEIRAS LIMA, JOÃO.

Lima, Victor Meirelles de. *See* MEIRELLES DE LIMA, VICTOR.

Lima Corrêa, Attilio. *See* CORRÊA LIMA, ATTILIO.

Linati (de Prevost), Claudio (*b* Parma, 1790; *d* Tampico, 11 Dec 1832). Italian lithographer, active in Mexico. In 1809 he completed his studies in Paris, but after returning to Italy he was sentenced to death in 1824 for revolutionary activities. He went to Mexico with his colleague Gaspar Franchini in 1825, apparently attracted by the idea of putting his revolutionary ideas into practice. He took a lithographic press with him and set up the first lithographic workshop in Mexico City. In addition to teaching, he printed a weekly periodical, *El Iris*, from February to August 1826, featuring lithographs of fashion models and portraits of such heroes of Mexican independence as Miguel Hidalgo y Costilla. Under this innocent guise, that of printers of a publication intended for women, he and his collaborators gave expression to political comment that led to the periodical's closure, and in September 1826 he was forced to leave Mexico. In 1828 in Brussels he published *Costumes civils, militaires et religieux du Mexique*, one of the first albums to depict various Mexicans in costume.

PRINTS
Costumes civils, militaires et religieux du Mexique (Brussels, 1828)

BIBLIOGRAPHY
L. M. Schneider, ed.: *'El Iris': Periódico crítico literario por Linati, Galli y Heredia: Primera revista literaria del México independiente*, intro. by C. Ruiz Castañeda, 2 vols (Mexico City, 1826/R 1986)

J. Fernández: *Claudio Linati: Trajes civiles, militares y religiosos de México*, intro. by M. Toussaint (Mexico City, 1956)

MÓNICA MARTÍ COTARELO

Lira, Pedro (*b* Santiago, 2 March 1845; *d* Santiago, 20 April 1912). Chilean painter, writer and teacher. He began his studies in 1862 at the Academia de Pintura in Santiago, simultaneously studying law at the Universidad de Chile in Santiago but abandoning that profession after qualifying in 1867. His solid intellectual grounding, his social standing and his strong personality enabled him both to organize art exhibitions and to write about art in newspapers and magazines. With government support he initiated plans to establish a venue for permanent exhibitions in Santiago, the Edificio El Partenón in the Quinta Normal district, which opened in 1886. He also taught and from 1892 to 1907 served as director of the Academia de Bellas Artes in Santiago.

Up to the time of his first trip to Europe in 1873, Lira worked in a Neo-classical style influenced by the work of Raymond Monvoisin (1809–70), the most important French painter to have reached Chile during the 19th century. Living in Paris until 1882, apart from a brief visit home, he borrowed elements from Neo-classicism, Romanticism and Realism but was particularly sympathetic to the academic style favoured in the official salons, demonstrating his technical facility for accurate portrayals in works such as *Philip II and the Grand Inquisitor* (1880; Santiago, Mus. N. B.A.). Lira remained an eclectic painter after his return to Chile in 1882, both in historical works such as *The Foundation of Santiago* (1883; Santiago, Congr. N.) and in works on Realist or Romantic themes, as in *The Letter* (Santiago, Mus. N. B.A.).

Lira also painted portraits and landscapes, finding in the latter subject the stimulus for his most important and individual works after 1900. In paintings such as *In the Quinta Normal* (1908; Santiago, Mus. N. B.A.) he began to dissolve forms, using more spontaneous brushwork, and above all to emphasize the pictorial qualities of his subject-matter.

WRITINGS
Diccionario biográfico de pintores (Santiago, 1902)

BIBLIOGRAPHY
Pedro Lira y su obra (exh. cat. by A. Romera, Santiago, 1974)

MILAN IVELIĆ

Lisboa. Portuguese family of artists, active in Brazil. The architect (1) Manoel Francisco Lisboa often appears in the history of Brazilian art only as the father of (2) Antônio Francisco Lisboa. He was, however, the leading architect in the gold-mining province of Minas Gerais in the mid-18th century and was responsible for most of the secular and ecclesiastical buildings that give Ouro Prêto (formerly Vila Rica) its present individual appearance. His brother, the carpenter and master mason Antônio Francisco Pombal (*fl* 1720–45), probably accompanied him on his emigration to Brazil *c.* 1720. Although there are few documentary references to Pombal, he won fame for his decoration (1736–45) of the nave of the parish church of Pilar in Vila Rica. In a move that was revolutionary for the time, he transformed the traditional rectangular interior of the church into a ten-sided polygon. The architect and

sculptor (2) Antônio Francisco Lisboa was the leading Brazilian artist of the colonial period. He became highly influential for the ingenious and original way in which he developed the Rococo religious style that reached Brazil in the mid-18th century.

BIBLIOGRAPHY
J. Martins: *Dicionário de artistas e artífices dos séculos XVIII e XIX em Minas Gerais*, ii (Rio de Janeiro, 1974)

MYRIAM A. RIBEIRO DE OLIVEIRA

(1) Manoel Francisco Lisboa (*b* Lisbon; *fl c.* 1720; *d* Vila Rica [now Ouro Prêto], Brazil, before 8 Aug 1767). Architect. Probably together with his brother, Antônio Francisco Pombal, he was in the first wave of Portuguese artists to emigrate to Brazil, attracted by the exceptional working conditions offered by the gold-mining region, where from the second decade of the 18th century economic prosperity and population growth led to intensive construction work. He is documented continuously from 1721, when his name first appears in connection with the payment of the 'royal fifths' (*reais quintos*; taxes related to mining), until his death.

Lisboa's first major commission was in 1727, when he planned and directed the building of one of the most important churches in Vila Rica: Nossa Senhora da Conceição, the parish church of Antônio Dias (completed 1742), with its altars and impressive arches designed according to the precepts of Jacopo Vignola. Lisboa also gave practical lessons in architecture and between 1729 and 1759 combined this with his appointment as assessor of his profession (*juíz de ofício*), in which capacity he had

Manoel Francisco Lisboa: S Efigênia, Ouro Prêto, Brazil, 1743–9

to examine and issue licences to practise; all this activity suggests a professional prestige that was rare among contemporary artists. In addition, he frequently provided valuations, giving expert technical and artistic opinion of the work of other artists. In 1753 he was appointed Master of the Royal Works and Appraiser of the Royal Property and in that year was sent by the governor to the city of Mariana in the gold-mining province to prepare an estimate for the building of the episcopal palace. In 1760 he provided estimates and laid down conditions of tender for improvements to Mariana Cathedral.

Lisboa was responsible for other principal buildings that today dominate Ouro Prêto, such as the Casa dos Contos (1734), Governor's Palace (1741–53), S Efigênia (1743–9; see fig.) and various chapels, bridges and fountains. He was equally significant as a teacher, helping to train the first generation of Brazilian-born architects and masons, who in the second half of the 18th century were fundamental to the development of a regional style independent of the Portuguese motherland.

BIBLIOGRAPHY
J. Martins: 'Subsídios para a biografia de Manoel Francisco Lisboa', *Rev. SPAHN*, 4 (1940), pp. 121–53
A. J. R. Russell-Wood: *Manuel Francisco Lisboa* (Belo Horizonte, 1968)

MYRIAM A. RIBEIRO DE OLIVEIRA

(2) Antônio Francisco Lisboa [pseud. O Aleijadinho] (*b* Vila Rica [now Ouro Prêto], Minas Gerais, *c.* 1738; *d* Vila Rica, 18 Nov 1814). Architect and sculptor, son of (1) Manoel Francisco Lisboa. An illegitimate son by an African slave, he had a training that was essentially practical, acquired in association with his father and such other artists as the draughtsman João Gomes Batista (*d* 1788), a former official of the Casa da Moeda in Lisbon, who was appointed in 1751 to the Casa de Fundicão in Vila Rica. Lisboa never left Brazil and, as far as is known, visited the capital Rio de Janeiro only once or twice. His knowledge of contemporary European styles and particularly of elaborate Rococo forms came from ornamental engravings and publications of architectural theory. His sculpture and decorative work shows the influence of southern German prints, particularly those by the Klauber brothers, who were active in Augsburg in the mid-18th century and specialized in religious subjects. From 1777 Aleijadinho was stricken by an unidentified disease that led to a progressive deformation of his limbs, including the loss of some of his fingers and toes, hence his nickname 'O Aleijadinho', the little cripple. Nevertheless, he continued to work until the end of his life, and it is remarkable that the greater part of his documented work dates from after the onset of the disease. He died in great poverty and physical suffering, never having accumulated wealth or achieved social prominence commensurate with his talent.

Aleijadinho's extensive work as an architect and sculptor is entirely confined to the province of Minas Gerais in cities such as Ouro Prêto, São João del Rei and Sabará, which were prosperous centres in the 18th century. Other centres of Minas Gerais, such as Mariana, Santa Rita Durão, Catas Altas, Caeté and Tiradentes, contain works that he designed or executed. Individual statues are in Brazilian museums (Ouro Prêto, Mus. Inconfidência; São

Antônio Francisco Lisboa: sculpture complex for the atrium and great staircase of the pilgrimage sanctuary of Bom Jesus de Matozinhos, Congonhas do Campo, 1800–05

Paulo, Mus. A. Sacra), religious and civic institutions and in private collections.

Aleijadinho's first important commission was probably to design S Francisco de Assis (1766–94), Ouro Prêto, a church for the Ordem Terceira de S Francisco. This is the outstanding example of his highly original architectural style in which, in the ground-plan, sections of curved lines are combined harmoniously as contrasting elements with straight lines. Essentially, this is a compromise between a rectangular Portuguese plan in the Mannerist tradition and a curvilinear plan after Francesco Borromini. Also for S Francisco he designed and carved an extensive series of works, including two pulpits (1771–2), ornamentation of the cupola over the chancel (1773–4), sculpted reliefs on the portal (begun 1774), the lavatorium in the sacristy (1777–9) and the principal retable (1778–94). His splendid decoration of the chancel is considered the finest example of Rococo decoration in Portuguese Brazil.

The principal retable of S Francisco is typical of Aleijadinho's novel altar designs, which had a great influence in the region. The main characteristic is the simplification of the structure, which is stripped of such ornamentation as the canopies and entablatures usual in Portuguese and Brazilian altars at this date and decorated with only a central composition, on which all attention is concentrated. In those retables carved by the artist himself, such as that at S Francisco, this central feature expands into a majestic sculptural representation of the Trinity above the Immaculate Conception in a lozenge-shaped composition, the effect of which owes much to his outstanding skill as a sculptor. In almost all of his altars, pulpits and fountains the remarkable figurative reliefs of

subjects from both the Old and New Testaments have certain medieval traits (Bazin, 1963), such as the Gothic formalism of the figures and the composition of the scenes, which are depicted without regard for perspective.

At the same time as his work at S Francisco, Ouro Prêto, Aleijadinho carried out the external and internal decoration of the churches of the Ordem Terceira do Carmo at Ouro Prêto (portal, sacristy lavatorium and retables of the nave, 1771–1809) and at Sabará (portal, pulpits, choir, nave balustrade and statues of St Simão Stock and St John of the Cross, 1771–82). In 1774 he designed S Francisco de Assis, São João del Rei, another church for the Ordem Terceira de S Francisco, which was intended to rival that at Ouro Prêto. Considerably modified in execution, this plan, of which the drawing for the façade exists (Ouro Prêto, Mus. Inconfidência), represents an important development in the adoption of German Rococo forms, principally in the design of the lateral towers. His other works in this church are the sculpted reliefs of the portal and some of the retables (dates uncertain; see RETABLE, fig. 2).

The most effective and surprising elements in Aleijadinho's work as an architect are in his façades. The design of the cylindrical towers with their bulbous crowns (as at S Francisco de Assis, Ouro Prêto) are almost without precedent in contemporary European architecture, and the decorative stone reliefs at the centres display, out of doors, all the complexity and delicacy of Rococo motifs previously confined to internal church decoration. Although all these forms, with the exception of the cylindrical towers, can be related to prototypes in Portuguese art, Aleijadinho's use of them, as well as the graceful and

harmonious way he created new combinations, is totally original. His adoption and popularization of the local steatite or soapstone, which is easy to carve, enabled lace-work effects that are impossible with any other kind of stone.

The finest example of Aleijadinho's work as a sculptor is the exceptional ensemble of the pilgrimage church of Bom Jesus de Matozinhos, Congonhas do Campo. The Brazilian version of the Italian *sacro monte*, it has important Portuguese precedents, including the stairways at Lamego (1750–60) and Bom Jesus (1781–1811), Braga. Using assistants from his workshop who are named in receipts (and whose participation can be recognized on stylistic grounds), between 1796 and 1799 Aleijadinho carried out the first part of the commission, consisting of 64 life-size wooden statues for the chapels of the Passos (episodes of the Passion), or via Sacra, in front of the church, arranged in 7 groups: the *Last Supper, Agony in the Garden, Betrayal, Flagellation, Crowning with Thorns, Road to Calvary* and *Crucifixion*. Between 1800 and 1805 he carved 12 monumental statues of Old Testament prophets for the atrium of the church and the great staircase leading up to it (see fig.). The ensemble of statues is best viewed from one place, but as the worshipper climbs the stairway and sees them from different angles they are so disposed in different groupings that, in the best medieval tradition, he participates in a deeply expressive staging of the sacred drama. Starting from the prophets, whose predictions prefigured the Redemption, the pilgrim passes all the stages of the Passion of Christ, who is represented in seven magnificent images that synthesize all the nuances of human suffering. In these figures Aleijadinho, in final expression of the Baroque, transcended the stylistic models of his time and breathed new spiritual life into religious sculpture at a moment when in European art in the Age of Enlightenment, the emphasis was predominantly secular.

BIBLIOGRAPHY

J. Bury: 'The Twelve Prophets at Congonhas do Campo', *The Month*, ii/3 (Sept 1949), pp. 152–71
——: 'The Little Cripple', *World Rev.*, n. s., 25 (March 1951), pp. 29–37
——: '"Estilo" Aleijadinho and the Churches of 18th-century Brazil', *Archit. Rev.* [London], cxi (1952), pp. 93–100
——: The "Borrominesque" Churches of Colonial Brazil', *A. Bull.*, xxxvii/1 (1955), pp. 26–53
G. Bazin: *L'Architecture religieuse baroque au Brésil*, 2 vols (Paris, 1956–8) [catalogue raisonné]
R. J. F. Brêtas: 'Traços biográficos relativos ao finado Antônio Francisco Lisboa', *Correio Oficial Minas*, 169–70 (1958) [basic biography]
G. Bazin: *Aleijadinho et la sculpture baroque au Brésil* (Paris, 1963)
R. C. Smith: *Congonhas do Campo* (Rio de Janeiro, 1973) [in Port. & Eng.]
S. de Vasconcellos: *Vida e obra de Antônio Francisco Lisboa, o Aleijadinho* (São Paulo, 1979)
M. A. Ribeiro de Oliveira: *O Santuário de Congonhas e a arte do Aleijadinho* (Belo Horizonte, 1981) [in Port., Fr. & Eng.]
F. Jorge: *O Aleijadinho: Sua vida, sua obra, seu gênio* (São Paulo, 1984)
M. A. Ribeiro de Oliveira: *Passos da Paixão: Antônio Francisco Lisboa, o Aleijadinho* (Rio de Janeiro, 1984) [in Port. & Eng.]
——: *Aleijadinho: Passos y profetas* (Belo Horizonte, 1985)
J. Bury: *Arquitetura e arte no Brasil colonial* (São Paulo, 1991)
R. Gutiérrez, ed.: *Pintura, escultura y artes útiles en Iberoamérica, 1500–1825* (Madrid, 1995)
T. Costa Tribe:' The Mulatto as Artist and Image in Colonial Brazil', *Oxford A. J.*, xix/1 (1996), pp. 67–79

MYRIAM A. RIBEIRO DE OLIVEIRA

López, Cándido (*b* Buenos Aires, 29 Aug 1840; *d* 31 Dec 1902). Argentine painter. He is thought to have studied under the Italian painters Gaetano Descalzi and Baldassare Verazzi (1819–86). Joining an infantry battalion in San Nicolás de los Arroyos when the Triple Alliance of Argentina, Uruguay and Brazil declared war on Paraguay, he subsequently made the war the main theme of his art. While in the army he made many descriptive drawings and accumulated facts and details that guaranteed the fidelity of his retrospective rendering of events. His right wrist was shattered in the battle of Curupaytí in 1866, and when he returned to Buenos Aires he underwent two amputations and was thereafter restricted to the use of his left hand. From his sketches he produced a series of oil paintings that constitute an extraordinary historical record, moving in its sincerity.

López's characteristic pictures, such as *Landing of the Argentine Army in front of the Trenches of Curuzu* (1891), one of 29 paintings by him housed at the Museo Histórico Nacional in Buenos Aires, are executed in an unusual oblong format in a proportion of one to three, which allowed him to convey the expansiveness of the Argentine landscape. His figures are small, disproportionate to their surroundings and painted in minute detail; his colours are pure, flat and thinly applied; and the uniform and intense lighting gives the scenes an air of unreality accentuated by the simultaneity of the actions and a descriptive power that transforms them into poetic metaphor. In spite of the plethora of figures inhabiting his paintings, the action appears to have been frozen and the events framed in absolute immobility.

BIBLIOGRAPHY

J. L. Pagano: *El arte de los argentinos* (Buenos Aires, 1937), pp. 67–8
Cándido López (exh. cat. by M. Gil Solá and M. Dujovne, Buenos Aires, Mus. N. B.A., 1971)
H. Safons: 'El manco de Curupaytí', *Primera Plana*, 452 (1971), pp. 48–9
J. E. Payró: *23 pintores de la Argentina, 1810–1900* (Buenos Aires, 1973), pp. 9, 48–9
J. Glusberg and P. Lóizaga: *Fragments and Details: A Photographic Search for New Semantics: Cándido López* ([Buenos Aires, 1993])
J. López Anaya: *Historia del arte argentino* (Buenos Aires, 1997)

HORACIO SAFONS

López, Nacho [Ignacio] (*b* Tampico, 19 Nov 1923; *d* Mexico City, 24 Oct 1986). Mexican photographer. He studied at the Instituto de Artes y Ciencias Cinematográficas, Mexico City, and with Manuel Alvarez Bravo. He developed a reputation as an outstanding photojournalist, and he used his politically combative vision to record social contradictions and conflicts in Mexico City. The photo-essays he published in *Hoy, Mañana*, and *Siempre!* during the 1950s were among the most critical of the period; notable among them are 'Prison of Dreams' (*Mañana*, 25 Nov 1950) and 'Once We Were Human Beings' (*Siempre!*, 19 June 1954). López was also a news cameraman and made documentary films.

WRITINGS

Yo, el ciudadano (Mexico City, 1984)

BIBLIOGRAPHY

J. Mraz: 'From Positivism to Populism: Towards a History of Mexican Photojournalism', *Afterimage* (Jan 1991)
——: *Nacho López y el fotoperiodismo mexicano durante los años cincuenta* (Mexico City 1996)
Nacho López: Antología de fetiches (exh. cat., Xalapa, Gal. Estado; Veracruz, Inst. Cult.; 1996)

PATRICIA MASSE

López de Arteaga, Sebastian (*b* Seville, 1610; *d* Mexico City, 1652). Spanish painter. A pupil of Zurbarán, in 1640

he settled in Mexico, where he went as part of the retinue of the Viceroy, the Marqués de Villena. Although López de Arteaga produced only a limited amount of work in Mexico, he influenced local painters and was probably mainly responsible for introducing the tenebrist style from Seville. His paintings in Mexico include a *Crucifixion*, an *Incredulity of Thomas*, a *Betrothal of the Virgin*, another *Crucifixion* (1643) and a *Stigmatization of St Francis* (1650; all Mexico City, Pin. Virreinal).

BIBLIOGRAPHY
G. Kubler and M. S. Soria: *Art and Architecture in Spain and Portugal and their American Dominions, 1500–1800*, Pelican Hist. A. (Harmondsworth, 1959)
M. Toussaint: *Pintura colonial en México* (Mexico City, 1965)
J. Fernandez: *Arte mexicano de sus orígenes a nuestros días* (Mexico City, 1968)
E. Marco Dorta: *Arte en América y Filipinas*, A. Hisp., xxi (Madrid, 1973)
X. Moyssen: 'Sebastián de Arteaga', *An. Inst. Invest. Estét.*, xv/59 (1988), pp. 17–34
R. Gutiérrez, ed.: *Pintura, escultura y artes útiles en Iberoamérica, 1500–1825* (Madrid, 1995)
 MARIA CONCEPCIÓN GARCÍA SÁIZ

López Loza, Luis (*b* Mexico City, 1939). Mexican painter, printmaker and sculptor. He studied in Mexico City at the Escuela de Pintura y Escultura 'La Esmeralda' and the Centro Superior de Artes Aplicadas before moving for several years to New York, where he studied at the Pratt Graphic Center. From the end of the 1950s he exhibited in Mexico alongside other young artists whose rebellious stance led them to be referred to as the 'generación de ruptura'. López Loza developed his personal abstract style from the mid-1960s, after his return to Mexico, using decorative devices based on sharply defined formal structures, either in serial form within an enclosed space, as in *Metamorphosis of a Shoe* (1969; Monterrey, Nue. Léon Grupo Indust. ALFA), or distributed in syncopated rhythms (e.g. *Figures Overwhelming a Blue Sky*, 1975; see colour pl. XIX, fig. 1). In the 1980s he began also to produce sculptures carved in wood or stone.

BIBLIOGRAPHY
T. del Conde and others: *Doce expresiones plásticas de hoy* (Mexico City, 1988)
Ruptura (Mexico City, 1988)
 JORGE ALBERTO MANRIQUE

López Méndez, Luis Alfredo (*b* Caracas, 23 Nov 1901). Venezuelan painter. In 1912 he began studying at the Academia de Bellas Artes, Caracas, under Pedro Zerpa and Cirilo Almeida Crespo, among others. He became dedicated to landscape painting and received lessons from Samys Mützner and Emilio Boggio. In 1919 López Méndez travelled to Puerto Rico for political reasons; from there he went to Mexico, the USA, Cuba and finally Europe, returning to Venezuela in 1936 where he held important posts in artistic and political fields. In his work he depicted the valley of Caracas, El Avila mountain, the eastern Venezuelan beaches and exotic women (e.g. *Nude*, 1941; Caracas, Gal. A. N.). His work reflected the artistic concerns of the generation of the reformist, anti-academic movement the Círculo de Bellas Artes and of the school of Caracas. In 1943 he was awarded the national painting prize.

WRITINGS
Círculo de Bellas Artes (Caracas, 1969)

BIBLIOGRAPHY
J. Denis: *La obra de Luis Alfredo López Méndez* (Caracas, 1980)
 YASMINY PÉREZ SILVA

Lovera, Juan (*b* Caracas, 11 July 1776; *d* Caracas, 20 Jan 1841). Venezuelan painter and teacher. He studied under the Dominicans at the convent of S Jacinto in Caracas and with the painter Antonio José Landaeta, following in the traditions of the colonial period. Lovera particularly favoured portraiture, and he nearly always portrayed men with the trappings of their social class, looking ahead with the body at an angle to the right. In 1814 he followed Simón Bolívar to the east and may have stayed in Cumaná, from where he is thought to have travelled to the Antilles. In 1820 he was again in Caracas, where he painted *Divine Shepherdess* (Caracas, Gal. A. N.). In 1824 he became associated with Colonel Francisco Avendaño, who had installed the first lithographic press in La Guaira, which was later moved to Lovera's workshop in Caracas. He began teaching in 1821, and in 1832 taught at the Academia de Dibujo in the Escuela de Primeras Letras in Caracas. His later works included *Don Marcos Borges Receiving the Academic Proposals of his Son Nicanor* (1838; Caracas, Gal. A. N.) and paintings of such historical events as *Rebellion of 19 April 1810* (1835; Caracas, Col. Concejo Mun.) and *Signing of the Act of Independence on 5 July 1811* (1838; Caracas, Col. Concejo Mun.).

BIBLIOGRAPHY
A. Boulton: *Historia de la pintura en Venezuela: Época nacional*, ii (Caracas, 1968/R 1973)
C. Duarte: *Juan Lovera, el pintor de los próceres* (Caracas, 1985)
 MARÍA ANTONIA GONZÁLEZ-ARNAL

Loza, Luis López. *See* LÓPEZ LOZA, LUIS.

Lucena, Víctor (*b* Caracas, 16 June 1948). Venezuelan painter, installation artist and printmaker. He studied fine art at the Escuela de Artes Plásticas y Aplicadas 'Cristóbal Rojas' in Caracas. From 1970 Lucena lived in Milan and took part in salons and biennial exhibitions in Europe. In 1980 he held his first one-man show in Venezuela at the Museo de Arte Contemporáneo in Caracas. His work includes a series of experiments involving the spectator, whereby environments were created aimed at demonstrating the falsehood of daily visual appearances, simultaneously using both real and illusory weights, masses, colours and temperatures. He also distinguished himself with the quality of his graphic design for a series of books for the Fundación Boulton in Caracas.

BIBLIOGRAPHY
Proposiciones de Víctor Lucena, 1969–1980 (exh. cat. by A. Boulton, Caracas, Mus. A. Contemp., 1980)
 Based on information supplied by LELIA DELGADO

Lunar, Emerio (Darío) (*b* Cabimas, 27 Jan 1940; *d* Cabimas, 22 Nov 1990). Venezuelan painter. He was self-taught and is best known for his depiction of female figures and his architectural landscapes, which showed his appreciation of Renaissance art. Characteristic of his painting was the portrayal of solitary figures in a posed, wild-eyed attitude, enveloped in unreal surroundings and in wide spaces containing solid architectural structures, as in *Mona Lisa* (1970; Caracas, Gal. A. N.). The volume of

the figures was achieved with a flattening effect that gave the work an archaic character. Among his most important paintings are *Sadness* (1970; Maracaibo, priv. col.) and *Woman in Green* (1975; Caracas, Mus. A. Contemp.).

BIBLIOGRAPHY

J. Calzadilla: *Emerio Darío Lunar* (Maracaibo, 1979)

Emerio Darío Lunar (exh. cat., Coro, Mus. Dioc. Monseñor Guillermo Castillo, 1991)

MARÍA ANTONIA GONZÁLEZ-ARNAL

M

Manabu Mabe: *Agony*, oil on canvas, 1.89×1.89 m, 1963 (Washington, DC, Art Museum of the Americas)

Mabe, Manabu (*b* Kumamoto 1924). Brazilian painter of Japanese birth. At the age of ten he was taken by his family to Brazil, where he first worked in the coffee plantations in the interior of São Paulo State. After moving to the state capital he painted his first pictures *c.* 1945. Initially, he painted still-lifes and landscapes influenced by Braque and Picasso, such as *Still-life* (1952; Rio de Janeiro, Mus. N. B.A.), but he developed a calligraphic abstraction of compact brushstrokes, abrupt lines and dramatic bursts of paint generally against monochrome backgrounds. Even at his most abstract he continued to use referential titles alluding to the real world and to human emotions, as in *Agony* (1963; see fig.).

BIBLIOGRAPHY
F. Aquino: *Museu Manchete* (Rio de Janeiro, 1982), pp. 22–9
J. Maurício: 'Abstração' [Abstraction], *Seis décadas de arte moderna na Coleção Roberto Marinho* [Six decades of modern art in the Roberto Marinho Collection] (Rio de Janeiro, 1985), pp. 350–61
M. Mabe and others: *Vida e obra* [Life and work] (São Paulo, 1986)

ROBERTO PONTUAL

Macció, Rómulo (*b* Buenos Aires, 29 April 1931). Argentine painter. He was self-taught and showed Surrealist-influenced pictures at his first one-man exhibition in 1956. After a brief period of lyrical abstraction, he returned to figurative references within an essentially Abstract Expressionist style under the influence of Willem de Kooning. After 1961, when he, Ernesto Deira, Luis Felipe Noé and Jorge de la Vega held an exhibition, *Otra figuración*, at the Galería Peuser, Buenos Aires, he adopted a more monumental style concerned with gesture and expression in works such as *Living a Little Every Day* (1963; Buenos Aires, Mus. N. B.A.), often using innovative supports and submerging the human figure in a virtually abstract setting; in these works he favoured violent colours and graphic devices borrowed from the mass media, reflecting his own experience in the advertising business (e.g. *Inside and Outside*, 1965; see fig.). From 1977 Macció no longer treated figures in a fragmented form, picturing them instead like distorted shapes in an early stage of development. From 1982 he turned his attention to archetypes painted in a wild Neo-Expressionist style, using humour and fantasy to create a disconcerting world.

He received various important awards, including the Primer Premio Internacional of the Instituto de Artes Visuales Torcuato Di Tella in Buenos Aires (1963) and

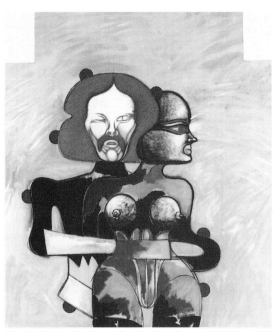

Rómulo Macció: *Inside and Outside*, oil on linen, 1.62×1.29 m, 1965 (Austin, TX, University of Texas, Jack S. Blanton Museum of Art)

the Guggenheim International Prize in New York (1964). He also showed in the Argentine pavilion at the Venice Biennale in 1968.

BIBLIOGRAPHY

A. Pellegrini: *Panorama de la pintura argentina contemporánea* (Buenos Aires, 1967)

Rómulo Macció (exh. cat., preface J. Lassaigne; Milan, Gal. Incisione, 1974)

Diera, Macció, Noé, de la Vega: 1961 Neo Figuración 1991 (Buenos Aires, 1991)

Rómulo Macció: Pnturas de contaminación y olvido (exh. cat. intro. C. Magrini, Buenos Aires, Fund. Proa, 1997)

J. López Anaya: *Historia del arte argentino* (Buenos Aires, 1997)

Re-Aligning Vision: Alternative Currents in South American Drawing (exh. cat., New York, Mus. Barrio; Little Rock, AR A.G.; Austin, U. TX, Huntington A.G.; and Caracas, Mus. B.A.; 1997–8)

NELLY PERAZZO

MacEntyre, Eduardo (*b* Buenos Aires, 20 Feb 1929). Argentine painter. After studying technical drawing, he decided in the late 1940s to become an artist. After producing detailed drawings influenced by Dürer and still-lifes reminiscent of Jean-Siméon Chardin (1699–1779) and Francisco de Zurbarán (1598–1664), in the early 1950s he turned his attention to the work of Seurat and Cézanne and then to Cubism. He came to prominence, however, as one of the principal practitioners of a form of geometric abstraction called ARTE GENERATIVO in the late 1950s, basing his work on the articulation of an extremely simple basic element: a curved line. Believing the circumference of a circle to be the purest means of expressing movement, he favoured regular and symmetrical patterns of development in paintings such as *Red, Orange and Black* (1965; see colour pl. XIX, fig. 2) and explored the rhythmic possibilities of curved lines in impeccably executed paintings that suggest the perfection of geometry, such as *Variable Polyptych II* (1973–5; Washington, DC, Kennedy Cent. Perf. A.).

BIBLIOGRAPHY

O. Haedo: *MacEntyre* (Buenos Aires, 1980)

R. Squirru: *Eduardo MacEntyre* (Buenos Aires, 1981)

NELLY PERAZZO

McLaren, Sidney (*b* St Thomas, 1895; *d* St Thomas, 1979). Jamaican painter. A farmer for most of his life, he did not begin painting until he was nearly 70 years old. A series of successes in local exhibitions in his home town, Morant Bay, prompted him in 1970 to submit works to the Self-Taught Artist Exhibition, at the Institute of Jamaica in Kingston, where he won the first prize, and with it national fame and the affectionate nickname 'The Grandpa Moses of Jamaica'. With the exception of a few portraits, occasional religious paintings, a series of horses on the race-track and one of dancers in the ballroom, the vast majority of his works are intricate depictions of the architecture and teeming streets of Kingston and other Jamaican towns. A keen sense of humour and love of anecdote, coupled with his cartoon-like drawing, bright colours and the wonderful (if accidental) spatial ambiguities of his 'self-taught' method, cause his works to exude a sense of *joie de vivre* that is unmatched in Jamaican art.

DAVID BOXER

Magalhães, Mário Vieira de. *See* PORTO, SEVERIANO.

Maia, Antônio (*b* Carmópolis, 9 Oct 1928). Brazilian painter. He began painting while still living in his native state of Sergipe in north-eastern Brazil and was deeply affected by his native region. After moving to Rio de Janeiro in 1955 he briefly adopted an abstract style, but in 1963 he returned to images of everyday life and popular religion in the north-east. He particularly favoured symbolically charged images of wooden ex-votos (arms, legs, hands, hearts and especially heads) depicted with a technical virtuosity that deliberately eschewed primitivism (*Walkers*, 1968; Curitiba, Mus. A. Contemp.). Visits to the United States in 1968 and to Europe (1969–72, staying longest in Barcelona) widened his contact with international art but did not draw him away from his own Brazilian subjects. In 1974 the Art Gallery of Ontario in Toronto acquired a series of paintings by him (e.g. *The Heroes*, 1973; see colour pl. XIX, fig. 3).

BIBLIOGRAPHY

C. Valladares: *Riscadores de Milagres* [Sketchers of miracles] (Rio de Janeiro, 1969)

W. Ayala: *A criação plástica em questão* [The plastic arts under debate] (Petrópolis, 1970)

O. de Araújo: 'Antônio Maia', *Visão da terra* (exh. cat., Rio de Janeiro, Mus. A. Mod., 1977), pp. 22–33

M. Machado da Silva: *Ex-votos e orantes no Brasil* [Ex-votos and orants in Brazil] (Rio de Janeiro, 1981)

ROBERTO PONTUAL

Maldonado, Rocío (*b* Tepic, 1951). Mexican painter and draughtsman. She studied drawing as a child before attending the National School of Painting, Sculpture and Engraving in Mexico City (1977–80); in 1979 she studied printmaking under Octavio Bajonero. Following a study trip to New York, Washington, Philadelphia and Boston in 1981, Maldonado continued her training in the workshops of Luis Nishizawa in Mexico City, and Gilberto Aceves Navarro at the School of Plastic Arts, National Autonomous University of Mexico. Maldonado is a key figure in the group of figurative artists that constitute the Neo-mexicanismo movement, members of which draw heavily on iconographic elements of Catholicism, Mexican history and art history, as well as popular culture, employing them in a critical way. Better known for her acrylic paintings than her drawings, during the 1980s Maldonado used puppet-like dolls of Mexico's popular artistic tradition as recurrent symbols that challenge conventional representations of women and comments on the way they are used and abused, as in *Las dos hermanas, virgen de barro* (1986; Rivendell Col. Bard Coll., Annandale-on-Hudson, NY). Later she began to use female religious figures and the bleeding heart, a symbol common to native Mexican and Catholic tradition. In the combining of elements from all aspects of Mexican tradition and the embellishment of the canvas with collage and objects that often overspill the frame, Maldonado's work has been called surreal.

BIBLIOGRAPHY

E. J. Sullivan, ed.: *Latin American Art in the Twentieth Century* (London, 1996)

17 Artistas de hoy en México (exh. cat. by L. R. Vera, Mexico City, Mus. Rufino Tamayo, 1985)

Rocío Maldonado (exh. cat. by Rebeca Maldonado, Mexico City, Gal. OMR, 1996)

J. HARWOOD

Maldonado, Tomás (*b* Buenos Aires, 24 April 1922). Argentine painter, graphic designer, teacher and theorist.

He studied at the Academia Nacional de Bellas Artes in Buenos Aires from 1938. In 1944 he was a co-founder of the Argentine avant-garde review *Arturo*, which was concerned with both art and literature and led to the formation in 1945 of the ASOCIACIÓN ARTE CONCRETO INVENCIÓN, of which he was also one of the main instigators. In 1948 he travelled to Europe, where he came into contact with Max Bill (1908–94) and other Swiss Constructivists, whose example inspired him both as a painter and as a theorist on his return to Argentina. *Blue with Structure* (1950, Buenos Aires, Mus. A. Mod.) and *Una forma y series* (1950; see fig.) are typical of a rigorous type of painting with which he became identified. He stressed the application of such ideas, moreover, not only

to art but also to social and political concerns, seeking nothing less than the transformation of the physical environment in which we live. Such convictions gave coherence to all his activities from that time on, including his co-founding in 1951 of *Nueva Visión*, a review of visual culture, and his membership from 1952 of the ARTISTAS MODERNOS DE LA ARGENTINA.

In 1954 Maldonado left Argentina on Max Bill's invitation to teach at the Hochschule für Gestattung in Ulm, of which he became Rector from 1964 to 1966. Thereafter he lived and worked in Europe, apart from a spell of teaching at Princeton University's School of Architecture (1968–70). In 1971 he became professor of environmental planning at Bologna University, and in 1977 editor of the Italian magazine *Casabella*, through which he continued to promote his concept of culture as a totality, rejecting the notion of art, design and architecture as separate categories. He carried out research on education, semiology, the philosophy of language and applied experimental psychology.

WRITINGS
Avanguardia e razionalità (Turin, 1974)

BIBLIOGRAPHY
N. Perazzo: *El arte concreto en la Argentina* (Buenos Aires, 1983), pp. 143–7
T. Maldonado: *Il futuro della modernitá* (Milan, 1987)
J. López Anaya: *Historia del arte argentino* (Buenos Aires, 1997)

NELLY PERAZZO

Mallo, Maruja (*b* Vivero, nr Lugo, 6 Jan 1902; *d* Madrid, 6 Feb 1995). Spanish painter, active also in Argentina. She studied painting at the Escuela de Bellas Artes, Madrid (1926). After a journey to the Canary Islands in 1927, her work was presented to the public by José Ortega y Gasset and his *Revista de Occidente*. Her first exhibition firmly established her among the avant-garde. Through a grant from the Junta para Ampliación de Estudios she travelled to Paris in 1932, where she came into contact with the Surrealists. She exhibited at the Galerie Pierre in 1933 and met André Breton and Picasso. On her return to Spain she worked at the Escuela de Cerámica designing plates. In 1937 she settled in Argentina, giving lectures there and in Montevideo, Chile and Bolivia. She exhibited in various Latin-American countries and in New York. She renewed contact with Spain in 1948 but did not return there permanently until 1965. She was awarded the gold medal for fine arts from the Ministry of Culture in 1982 and from the city of Madrid in 1990.

Mallo's work can be divided into different stages. The first began in 1928 with *Fairs* and *Prints*; the former show strong colouring, and the latter rigorous geometry. They communicate the painter's love of popular fiestas, but are not without some satire. The early *Prints* were followed by *cinemáticas* and *románticas*, which reconciled several aspects of the painter's creative spirit. She soon turned her attention towards a darker, more painful world. This was her period of depicting detritus, skeletons and refuse, for example the series *Sewers and Belfries*, perhaps considered the height of her Surrealist work and the reason for Breton's admiration (*Scarecrow*, 1932; Breton priv. col., see Gómez de la Serna, pl. xvi). On her return to Spain in the 1930s, with Benjamin Palencia and others she became an

Tómas Maldonado: *Una forma y series*, oil on canvas, 1500×700 mm, 1950 (Buenos Aires, Museo de Arte Moderno)

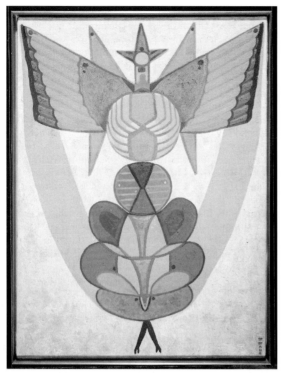

Maruja Mallo: *Airugu*, oil on canvas, 530×400 mm, 1979 (Madrid, Museo Nacional Centro de Arte Reina Sofía)

BIBLIOGRAPHY
R. Gómez de la Serna: *Maruja Mallo* (Buenos Aires, 1942) [incl. essay by Mallo: 'Proceso histórico de la forma en las artes plásticas']
J. Cassou: *Maruja Mallo: Arquitecturas* (Madrid, 1949)
C. de la Gandara: *Maruja Mallo* (Madrid, 1978)
Maruja Mallo (exh. cat., ed. F. Rivas and J. Pérez de Ayala; Madrid, 1992)
Maruja Mallo (exh. cat., Santiago de Compostela, Cent. Galego A. Contemp., 1993)
JUAN PÉREZ DE AYALA

Manaure, Mateo (*b* Uracoa, Monagas, 18 Oct 1926). Venezuelan painter and graphic designer. He studied painting at the Escuela de Artes Plásticas in Caracas (1942–6). At the age of 21 he won the highest award for national painters and went to France. He was a member of the Venezuelan group in Paris, Los Disidentes, who opposed traditional Venezuelan landscape painting. At this time he produced works of an abstract–lyrical tendency, which he varied so that they approached geometric abstraction. In 1952 he returned to Caracas, where, between 1953 and 1955, he executed a series of murals for the university campus. In 1957, with the sculptor Carlos González Bogen (*b* 1920), he founded in Caracas the Cuatro Muros gallery, with the purpose of propagating abstract art in Venezuela. Manaure was also one of the pioneers of graphic design in Venezuela. In 1958–67 he returned to easel painting, with works whose lyrical figuration and subjective landscapes border on the oneiric. Subsequently his art began to show the influence of Constructivism (e.g. *Polychromed Columns*, 1976; Caracas, Mus. A. Contemp.). This continued to rival his earlier lyricism as the dominant element in his work.

BIBLIOGRAPHY
Diccionario de las artes visuales en Venezuela, i (Caracas, 1973), p. 143
C. Barceló: *De la abstracción a la figuración: El cambio de tendencia en cuatro pintores venezolanos* (diss., Caracas, U. Central de Venezuela, 1988)
Mateo Manaure (exh. cat., Caracas, Gal. Durban/César Segnini, 1994)
CRUZ BARCELÓ CEDEÑO

Manes, Pablo Curatella. *See* CURATELLA MANES, PABLO.

Mange, Ernest (Robert de Carvalho) (*b* São Paulo, 28 Dec 1922). Brazilian engineer, architect, urban planner and teacher. He graduated in civil engineering from the Polytechnic School of the University of São Paulo in 1945, and in 1947–48 he worked with Le Corbusier in Paris. In 1955 he became an associate of Ariaki Kato (*b* 1931) in PLANEMAK (Planejamento de Edifícios e Cidades Ltda), a partnership that specialized in a variety of design and engineering projects such as hydroelectric, mining and railway installations, the underground railway in São Paulo, industrial and administrative buildings. The construction of large-scale hydroelectric installations in sparsely populated areas of the interior involved the creation of new towns such as those planned by Mange along the Paraná River: Jupiá (1961–70) with 15,000 inhabitants, Ilha Solteira (1966–74) with 45,000 inhabitants, Itaipú (1976–8) and Porto Primavera (1978) with 24,000 inhabitants; the Tocantins River: Tucuruvi (1975–9); and the Jamari River: Samuel (1981–3). Some of these townships were temporary camps, but the permanent work was very extensive and demonstrated the importance of thoughtful planning in the transfer of thousands of workers and their families from one region to another with the minimum of disruption. Other projects undertaken by Mange, all solidly

important member of the Escuela de Vallecas, in which the artists spent time in discussion, organizing outings into the countryside and observing nature. During this period she executed her purest and most geometric paintings: *Rural Constructions* (1934; priv. col., see Gómez de la Serna, pl. xx); *Country Buildings* (1934; priv. col., see Gómez de la Serna, pl. xxi); her scenery for the opera *Clavileño*, based on an episode in *Don Quijote*; and her ceramic designs. Land, ears of corn and rural life, allied with her love for geometric form, came together in *Surprise of Wheat* (1936; priv. col., see Gómez de la Serna, pl. xxxiii). This began her *pintura del trabajo*, an affectionate approach to social consciousness through the female form: harvesting in *Song of the Ears of Corn* (1929; see colour pl. XX, fig. 1) and fishing in *The Sea's Message* (1937; priv. col., see Gómez de la Serna, pl. xxxviii). The same theme continued in *Supremacy of the Races*, a series of flatly painted portraits of women with huge features emphasizing different racial characteristics.

Mallo's meeting with Chilean poet Pablo Neruda and her visit to Easter Island inform her *naturalezas vivas* (the opposite of *naturalezas muertas*, or still-lifes), with shells, roses, starfish, algae and jellyfish painted in a Surreal, geometric world. These paintings mark the beginning of her last creative phase, a journey towards the heavens, and her world began to be peopled by strange beings, as in the series *Dwellings in the Void*, for example *Airagu* (1979; see fig.).

WRITINGS
Lo popular en la plástica española a través de mi obra (Buenos Aires, 1937)
'El Surrealismo a través de mi obra', *El Surrealismo* (Madrid, 1983)

planned and appropriately detailed, included various technical schools for the Serviço Nacional de Aprendizagem Industrial (1952–6), the elegantly sited Banco América do Sul (1965), Avenida Brigadeiro Luis Antonio, São Paulo, the Municipal Building (1970) at Cubatão, with its excellent system of ventilation and protection from the sun, and the Ciba Geigy Laboratories (1974–6), with 40,000 sq. m of floor space. Later projects involved mine construction and the industrial processing of rare minerals in Amazonia. Mange received a PhD and became a Professor at the University of São Paulo in 1963.

BIBLIOGRAPHY
'Escola de Engenharia de São Carlos', *Habitat*, vi/33 (1956), pp. 44–9
'Usina Limoeiro, Rio Pardo, Esì de Sao Paulo Realização da Companhia Hidroeléctrica do Rio Pardo', *Habitat*, vi/35 (1956), pp. 56–60
'Planejamenio em Urubupunga, E. R. Carvalho Mange, Engenheiro, Ariaki Kato, Arqiuteto', *Acrópole*, 289 (1962), pp. 1–11

PAULO J. V. BRUNA

Mangones, Albert (*b* Port-au-Prince, 26 March 1917). Haitian architect and sculptor. He studied from 1939 to 1942 at the College of Architecture, Cornell University, Ithaca, NY, where he was awarded the Sand Goldwin Medal. His early works, such as the Théâtre de Verdure (1949), the Cité Militaire (1956–7), a social urban development for the military, and the Régie du Tabac (1958), an industrial complex, all in Port-au-Prince, are characterized by simple geometrical lines and large openings in order to integrate the structure with the environment. The materials used include cement blocks, bricks and cobblestones. He was influenced by Le Corbusier, Frank Lloyd Wright and the latter's pupil Henry Klumb (*b* 1905). He also built many villas, notably the Sheila Burns Villa (1956), Diquini, and his own residence (1966), Martissant, as well as the Villa Créole Hotel, Pétion Ville, and the Habitation Leclerc Hotel (1974), Port-au-Prince. Mangones's statue of *St Domingue Marron* (bronze, 1968) and his design for its site in the Place du Marron Inconnu, Port-au-Prince, established his international reputation. The statue, representing a kneeling slave blowing the conch of freedom, illustrated a postage stamp commemorating the United Nations Universal Declaration of Human Rights (1989). After 1978 he undertook the preservation of the historic site combining the Citadelle La Ferrière, the Palace of Sans-Souci and the site of Ramiers in the north of Haiti. In 1979 he was appointed Director of the Institut de Sauvegarde du Patrimonie National (ISPAN), Haiti.

BIBLIOGRAPHY
B. Raymond: 'Haitian Hideaway: Architect Albert Mangones', *Interiors*, cxxxiii/8 (1974), pp. 98–105
E. I. Christensen: *The Art of Haiti* (New York, 1975), pp. 50, 69–70

BENJIE THÉARD

Manley, Edna (*b* Bournemouth, 1 March 1900; *d* Kingston, 10 Feb 1987). Jamaican sculptor of English birth. The daughter of an English cleric and his Jamaican wife, she studied sculpture in London at the Regent Street Polytechnic, the Royal Academy Schools and St Martin's School of Art. In 1921 she married her Jamaican cousin Norman Manley, and in 1922 she travelled with him to Jamaica. Her work in Jamaica in the 1920s and early 1930s strongly reflected the current Vorticist and Neo-classical trends in British sculpture. The influence of Frank Dobson

and Jacob Epstein is particularly marked. Her subject-matter, however, revealed a strong identification with Jamaica and its people. Throughout this period her work was exhibited in England, where she was associated with the London Group, to which she was admitted in 1930. Her work in the late 1930s became increasingly political, reflecting the social upheavals of the time and her husband's involvement with the establishment of a viable political framework for his country. Indeed, with their powerful, insistent rhythms, and the essential leitmotifs of the head straining upwards towards a vision or downwards in suppressed anger, works such as *Negro Aroused* (1935; *see* JAMAICA, fig. 5), *The Prophet* (1936; Kingston, N.G.), *Pocomania* (1936; Kingston, priv. col.) and *Tomorrow* (1939, Wales, priv. col.) have become virtual icons of that period of Jamaican history, a period when black Jamaicans were indeed aroused, demanding a new and just social order.

In the 1940s Manley retreated into a private, Blakean world and produced a series of carvings marked by their extreme subjectivity and almost painterly approach to form and surface. *Horse of the Morning* (1943; Kingston, N.G.) and *Land* (1945; Kingston, U. W. Indies) are key works of the period. The 1950s and 1960s was a period during which teaching duties, political activity and her role

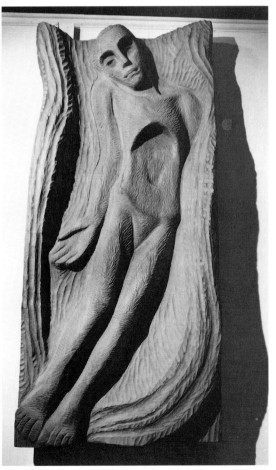

Edna Manley: *Journey*, mahogany, h. 1.55 m, 1973 (Kingston, National Gallery)

as wife of the Premier of Jamaica (1955–62) clearly affected her work. It was notable for major commissions like the *Crucifix* (1950) for All Saints Church, Kingston, *He Cometh Forth* (1962), an allegory celebrating Jamaican independence, for the Sheraton Hotel, Kingston, and the monument to the national hero *Paul Bogle* (1965) for Morant Bay, Jamaica. After her husband's death in 1969, Manley created a last series of wood carvings, attempting to deal with his death and her own grief. *The Angel* (1970; Kingston, parish church), *Mountain Women* (1970; Philadelphia, PA, priv. col.) and *Journey* (1973; see fig.) are key examples. Her subsequent works, modelled and cast in various materials, reflect a variety of concerns. Chief among these is *The Ancestor* (1978), a symbolic self-portrait in which the artist has become the ancestral spirit that nourishes successive generations. In 1985 she stopped sculpting altogether and turned to painting.

WRITINGS
R. Manley, ed.: *Edna Manley, The Diaries* (Kingston, 1990)

BIBLIOGRAPHY
W. Brown: *Edna Manley: The Private Years, 1900–1938* (London, 1975)
D. Boxer: *Edna Manley: Sculptor* (Kingston, 1990)
P. Cresswell: 'Edna Manley, Sculptor: A National Treasure', *Third Text*, xiv (1991), pp. 79–84
D. Boxer and V. Poupeye: *Modern Jamaican Art* (Kingston, 1998)
V. Poupeye: *Caribbean Art* (London, 1998)

DAVID BOXER

Manzo (y Jaramillo), José (María) (*b* Puebla, 1789; *d* Puebla, 1860). Mexican architect, sculptor, painter, lithographer and teacher. He was the leading figure in Puebla in the fields of architecture, sculpture, painting and drawing during the early 19th century. He was director of the Academia de Dibujo in Puebla from its foundation in 1814 and the first recipient of a scholarship from the academy, which allowed him to go to Paris (1824–7), where he studied architecture, drawing and lithography. He also visited museums, factories and prisons, intending to introduce French developments and systems into Puebla. On his return to Mexico he devoted himself to intense public activity, architectural reform, painting, lithography and teaching, and experiments in industrialized production. Among his most important sculptural works is the completion (1819) of the *ciprés* (altarpiece with baldacchino) for Puebla Cathedral, which had been left unfinished on the death of Manuel Tolsá. It combines a high altar, a sepulchral monument and a sanctuary of the Virgin, and it is one of the most spectacular examples of Mexican Neo-classicism. From 1829 Manzo worked on restructuring the interior of the cathedral with the aim of achieving a Neo-classical stylistic unity. Besides a number of oils and drawings, he left a book of notes and watercolours that he made during his European travels.

BIBLIOGRAPHY
I. Katzman: *Arquitectura del siglo XIX en México* (Mexico City, 1973)
A. Alcocer: *La arquitectura de la ciudad de Guanajuato en el siglo XIX* (Mexico, 1988)

MÓNICA MARTÍ COTARELO

Mariano [Rodríguez, Mariano] (*b* Havana, 1912; *d* Havana, 26 May 1990). Cuban painter. He studied briefly in 1936 in Mexico under Manuel Rodríguez Lozano and took part in the 'Modern Cuban painters' exhibition at the Museum of Modern Art, New York, in 1944. He made his name in the 1940s with bold paintings of fighting cocks (e.g. *Cockfight*, 1942; see *MOMA Bull.*, 1944, p. 11), but these were followed by three decades of less vital work. From 1960 he specialized in landscapes and flora, for example *From the Mountains to the Plain* (1963; Havana, Mus. N. B.A.).

BIBLIOGRAPHY
A. H. Barr, jr: 'Modern Cuban Painters', *MOMA Bull.*, xi/5 (1944), pp. 2–14
Pintores y guerrillas: El deber de todo revolucionario es hacer la Revolución (exh. cat., Havana, Casa Américas, 1967)
N. G. Menocal: 'An Overriding Passion: The Quest for a National Identitiy in Painting', *J. Dec & Propaganda A.*, xxii (1996), pp. 187–217

RICARDO PAU-LLOSA

Mariscal. Mexican family of architects. Nicolás Mariscal (*b* Mexico City, 10 Sept 1875; *d* Mexico City, 13 April 1964) and his brother Federico Mariscal (*b* Querétaro, 1881; *d* Mexico City, 19 Aug 1969) both received a Neo-classical architectural education at the Academia Nacional de Bellas Artes in Mexico City, graduating in 1899 and 1903 respectively. Despite this traditional background they showed themselves predisposed to change, especially with respect to a national architecture. Both later became professors at the Escuela Nacional de Arquitectura, Mexico City, of which Federico was also director between 1935 and 1938. Nicolás Mariscal is particularly notable for his militancy on behalf of his profession in Mexico, which he defended against the privileges of the engineers. This activity culminated in 1919 with the creation of the Sociedad de Arquitectos Mexicanos. From 1899 to 1911 he published the prestigious magazine *El Arte y la Ciencia*. In this and in his *Teoría de la arquitectura* (1903) he was able to express innovative ideas. His works include the monument (1923) to *Cristo Rey* (Christ the King), a pilgrimage chapel topped with a statue designed by Fidias Elizondo (1881–1979), on Cerro del Cubilete, Guanajuato, and some houses in the capital.

Federico Mariscal designed a number of important buildings in Mexico City. Examples include the Inspección de Policía building (1906), in a neo-Gothic style; two identical banks (1909; with Nicolás Mariscal); the Esperanza Iris Theatre (1917), with its neo-Baroque tendencies; and the Tostado Ateliers (1923) of neo-colonial inspiration. Between 1930 and 1934 he completed the Palacio de Bellas Artes (begun 1904 by Adamo Boari; see MEXICO, fig. 5), with an Art Deco interior of Maya inspiration. This capacity for innovation can be seen further when, in 1950, working in partnership with his sons Enrique Mariscal (1918–72) and Alonso Mariscal (1914–58), he built the Registro Público de la Propiedad, Mexico City, in a strictly Modernist style. At the beginning of the century Federico Mariscal was a strong proponent of Mexico's national architecture. On the one hand, he issued various publications to draw attention to the architectural heritage of the country, both pre-Hispanic and colonial (*La patria y la arquitectura nacional*, (Mexico City, 1915), and *Estudio arquitectónico de las ruinas Mayas*, (Mexico City, 1928)). On the other hand, he was militantly involved in the Ateneo de la Juventud, proposing the creation of a neo-colonial architecture as an adequate expression of national architecture at the time, a proposal that had the support of many of his colleagues.

BIBLIOGRAPHY

A. & Cienc. (1899–1911)

I. Katzman: *La arquitectura del siglo XIX en México* (Mexico City, 1973)

L. Noelle and D. Schavelzon: 'Un monumento efímero de Federico Mariscal', *An. Inst. Invest. Estét.*, 55 (1986), pp. 161–9

X. Moyssén with A. Boari and F. Mariscal: *Palacio de Bellas Artes, México* (Mexico City and Milan, 1993)

LOUISE NOELLE

Marisol (Escobar) (*b* Paris, 22 May 1930). French sculptor of Venezuelan descent. After studying painting at the Ecole des Beaux-Arts, Paris (1949) and then at the Art Students League (1950) and the Hans Hofmann School (1951–4) in New York, she developed an interest in Mexican, Pre-Columbian and American folk art and turned her attention to sculpture. In her early work she fashioned small, animated figurines out of bronze, terracotta and wood, often placing these pieces in compartmentalized, glass-fronted boxes, for example *Printer's Box* (1958; Mr and Mrs Edwin A. Bergman priv. col., see 1966 exh. cat., no. 4). In 1961 she began to incorporate drawing, painting, and *objets trouvés* into complex, life-size figure arrangements. Cast fragments of her own body and images of her face frequently appear in her works from this decade, many of which address the position of women in modern society. *Women and Dog* (1964; New York, Whitney) depicts a group of fashionable middle-class housewives parading in public wearing blank, masklike expressions; other works depict farm women and socialites in similarly constrained poses.

Marisol's images of contemporary culture, at once deadpan and satirical in tone, were produced in the context of Pop art; the personal, enigmatic, often primitive elements of her work, however, set it apart from the mainstream of the movement. In the early 1970s she carved small, exotic fishes out of mahogany, with her own face on their polished, colourful bodies, and produced a series of prints and drawings with erotic, often violent overtones, such as *Double Flower* (coloured pencils and crayon, 1973; see 1975 exh. cat., no. 1). In the 1980s she returned to large-scale figural assemblages, creating a series of portrait 'homages' to well-known contemporary artists and personalities.

BIBLIOGRAPHY

Marisol (exh. cat., Chicago, IL, A. Club, 1966)

Marisol (exh. cat., ed. L. Shulman; Worcester, MA, A. Mus., 1971)

Marisol: Prints, 1961–73 (exh. cat., ed. J. Loring; New York, Cult. Cent., 1973)

C. Nemser: 'Marisol', *Art Talk: Conversations with 12 Women Artists* (New York, 1975), pp. 179–200

New Drawings and Wall Sculptures by Marisol (exh. cat., New York, Sidney Janis Gal., 1975)

NANCY RING

Maroto, Fray Diego (*b* 1617; *d* Lima, 1696). Peruvian architect. He was a friar of the Dominican order in Lima and one of the most active architects in Peru during the second half of the 17th century. His earliest known work was a new plan (1643) for the cathedral at Trujillo, on the north coast. However, all his known works from 1659 were in Lima: that year he signed a contract to repair the water system in the main cloister of the convent of Nuestra Señora de la Concepción, and in 1663 the Sagrario was begun to his designs on the Plaza de Armas. Following the earthquake of 1678, Maroto took charge of the reconstruction of the transept of S Domingo and designed a new dome using *quincha*, a light construction of plastered reeds on a timber frame, an anti-seismic system first used in Peru in 1657 by Constantino de Vasconcelos. Maroto also rebuilt (1678–81) the second-storey arcades of the main cloister of the Dominican monastery in Lima to a design inspired by Vasconcelos's main cloister at S Francisco (1669–74), where oval lunettes alternate with arcaded openings. Between 1685 and 1687 he was Master of the Works in Lima and *alarife*, Surveyor and Inspector of Public Works. After the earthquake of 1687, with the *alarifes* Pedro Fernández de Valdez and Manuel de Escobar, he surveyed the damage to the cathedral and other major buildings, and his detailed report survives.

WRITINGS

Declaración de Fr. Diego Maroto, Maestro de Reales Fábricas (1687, Lima, Archv Gen. N.); transcribed in 'El terremoto del año 1687', ed. D. Angulo in *Rev. Archv N. Perú*, xii/2 (1939), pp. 131–7

BIBLIOGRAPHY

E. Harth-Terré: *Artífices en el virreinato del Perú* (Lima, 1945), pp. 202, 210, 220

J. Bernales Ballesteros: 'Apuntes para la historia de El Sagrario de la catedral de Lima', *Mercurio Perú*, 455 (1965), pp. 159–73

A. San Cristóbal: *Fray Diego Maroto Alarife de Lima, 1617–1696* (Lima, 1996)

HUMBERTO RODRÍGUEZ-CAMILLONI

Marriott, Alvin (*b* St Andrew, 29 Dec 1902; *d* 20 Sept 1992). Jamaican sculptor. He was initially self-taught, but later attended the Camberwell School of Arts and Crafts, London. He worked as a furniture-carver in the 1930s for the Jamaican Art Deco furniture designer Burnett Webster (1909–92). His own work of this period was influenced by Art Deco and by Edna Manley. Gradually it became more academic, and he became Jamaica's most popular monumental sculptor. Among his best-known works are monuments in Kingston to Jamaica's national heroes, including Norman Manley (1971) and Alexander Bustamante (1972), as well as to the reggae singer Bob Marley (1985). He worked in various materials, including bronze, but was at his best as a wood-carver. His outstanding achievement is the carved ceiling decoration and lectern of the university chapel, University of the West Indies, Mona, Jamaica.

BIBLIOGRAPHY

D. Boxer and V. Poupeye: *Modern Jamaican Art* (Kingston, 1998)

V. Poupeye: *Caribbean Art* (London, 1998)

VEERLE POUPEYE

Martínez, Alfredo Ramos. *See* RAMOS MARTÍNEZ, ALFREDO.

Martínez, Oliverio (*b* Piedras Negras, 1901; *d* Mexico City, 21 Jan 1938). Mexican sculptor. He studied at the Academia de San Carlos, Mexico City (1928–30), under the sculptor José María Fernández Urbina (1898–1975). He was one of the pioneers of innovative trends in 20th-century Mexican sculpture and maintained links with the Mexican muralists, with whom he shared an exalted nationalism and a taste for monumental forms, celebrating the heroes of the Mexican Revolution in, for example, his monument to *Zapata* (1932) in the main square of Cuahutla, Mexico. In 1933 Martínez won a competition to execute four sculptural groups for the monument to

the *Revolution* (1933) for the Palacio Legislativo, Mexico City. Carlos Obregón Santacilia designed the structure of the central cupola and arches of the building, and Martínez intended to place three energetic and geometrically solemn figures on the upper part of each of the four corners. Although the Palacio Legislativo was never built, the monument was completed in 1933 and built on the foundations intended for it. These stone sculptures, each 11.5 m high, depicted *Independence, Reform*, the *Publication of the Agrarian Laws of the Revolution* and the *Publication of the Labour Laws of the Revolution*.

BIBLIOGRAPHY

M. Monteforte Toledo: *Las piedras vivas* (Mexico City, 1965), pp. 202–3, 205

E. O'Gorman and others: *Cuarenta siglos de plástica mexicana*, 3 vols (Mexico City, 1971)

Fuerza y volumen: El lenguaje escultórico de Oliverio Martínez (1901–1938) (exh. cat., Mexico City, Mus. N. A., 1996)

ESPERANZA GARRIDO

Martínez de Arrona, Juan (*b* Vergara, 1562; *d* Lima, 1635). Spanish architect and sculptor active in Peru. He was trained as a sculptor by Cristóbal Velázquez (*d* 1616), a Mannerist of the school of Alonso Berruguete. He arrived in Lima *c.* 1599 and carved the life-sized reliefs of *Christ and the Apostolate* (1608) in cedar above the chests in the sacristy of the cathedral. They are imposing but do not strive for realism, betraying the influence of the Antique, particularly in the disposition and layout of the channelled folds and drapery and through references to Renaissance classicism. In 1614 he was appointed *maestro mayor* of Lima Cathedral, a post which he retained until his death. He is also known to have worked on the stone façade of S Lázaro. Following the earthquakes of 1606 and 1609, various architects were consulted on how to re-roof the cathedral. Wooden vaults were rejected, and Martínez de Arrona proposed Gothic ribbed vaults, executed in brick. This proposal was followed, and the church was completed by 1622; the towers were installed in 1624, when work was also carried out on the portals and choir-stalls. Francisco Becerra's plan was retained, although the Gothic vaults and Ionic columns were altered slightly. They were eventually replaced by an identical structure in wood and plaster following the 1746 earthquake. Seven of the cathedrals' portals were designed by Martínez de Arrona in 1626, combining Baroque with Classical elements through the use of Corinthian columns. The niches and ornamentation were more strongly related to Baroque fashions, and this is particularly the case with the main entrance, with its abrupt changes in the niches between contours, planes and broken pediments.

BIBLIOGRAPHY

H. E. Wethey: *Colonial Architecture and Sculpture in Peru* (Cambridge, MA, 1949)

G. Kubler and M. Soria: *Art and Architecture in Spain and Portugal and their American Dominions 1500 to 1800* (Harmondsworth, 1959), pp. 130–31

E. Harth-Terré: *Perú: Monumentos hispánicos y arqueológicos* (Mexico City, 1975), p. 40

J. B. Ballesteros: *Arte hispanoamericano de los siglos XVI a XVIII*, ii (Madrid, 1987), pp. 254–5, 306

V. Fraser: *The Architecture of Conquest: Building in the Viceroyalty of Peru, 1535–1635* (London, 1990), p. 106

W. IAIN MACKAY

Martínez de Hoyos, Ricardo (*b* Mexico City, 28 Oct 1918; *d* 1983). Mexican painter. He came from a family of artists and was self-taught. He initially concentrated on landscapes and metaphysical themes, as in *The Astronomer* (1944; priv. col., see Bonifaz Nuño, fig. 5). However, the figure of the Indian was a constant element in his production of large-format paintings. Indigenous male and female figures are set dramatically against dark backgrounds; their semi-illuminated bodies are emphasized by the use of a single pure colour, such as blue, red or orange (e.g. *The Sorcerer*, 1971; Mexico City, Mus. A. Mod.). These colossal images draw their inspiration from Pre-Columbian hieratic sculpture, and their highly individual use of colour and fine draughtsmanship distinguish Martínez from his contemporaries.

BIBLIOGRAPHY

R. Bonifaz Nuño: *Ricardo Martínez* (Mexico City, 1965, rev. 1994)

L. Cardoza y Aragón: *Ricardo Martínez: Una selección de su obra* (Mexico City, 1981)

XAVIER MOYSSÉN

Martínez de Oviedo, Diego (*b* Cuzco; *fl* 1664–80). Peruvian architect and sculptor. He was the son of the architect Sebastián Martínez (*d c.* 1660), from whom he received his training. After his native city was destroyed in the earthquake of 1650, he rebuilt the façade and towers (which he may also have designed) of the Jesuit church of La Compañía, one of the finest in Peru, in 1664–8. His carving of the façade in the form of a retable in stone shows similarities to his work in wood for the retables inside this church. Martínez de Oviedo's remarkable achievement as an architect and sculptor is seen in his designs for the cedarwood retable, pulpit and façades of S Teresa, Cuzco, completed in 1676. Other works in Cuzco are in the churches of S Domingo (choir screen, 1665), S Sebastián near Cuzco (principal retable, 1679) and the Cathedral (side altar, 1667). His work in the cloister of the monastery of La Merced, Cuzco, on which he collaborated with his father in 1663, resembles a wood-carving carried out in stone. Together with Francisco Chávez y Arellano, Juan Tomás Tuyru Tupac Inca and Martín de Torres, Martínez de Oviedo was responsible for the artistic renewal in Cuzco, prompted by Archbishop Mallinedo (*d* 1699), in the last third of the 17th century.

BIBLIOGRAPHY

H. Wethey: *Art and Architecture in Peru* (Cambridge, 1949)

J. Cornejo Bouroncle: *Derroteros del arte cusqueño* (Cuzco, 1956)

E. Marco Dorta: *La arquitectura barroca en el Perú* (Madrid, 1957)

R. Gutiérrez: *Arquitectura Virreinal del Cusco y su región* (Cuzco, 1987)

J. Bernales Ballesteros and others: *Escultura en el Perú* (Lima, 1991)

RAMÓN GUTIÉRREZ

Martínez Gutierrez, Juan (*b* Bilbao, 1901; *d* Chile, 1976). Chilean architect and teacher of Spanish birth. He moved to Chile as a child and studied architecture at the Universidad de Chile in Santiago from 1917 to 1922. In 1927 he won the first architectural competition to be organized in Chile, for the Chilean Pavilion at the Exposición Ibero-Americana 1929. He visited Europe in 1928–31 and absorbed the influence of Rationalism, the Bauhaus and other modern developments. In 1931 he became Profesor de Taller (workshop teacher) at the Escuela de Arquitectura of the Universidad de Chile. He became its director

in 1932 and reformed the teaching programme. In 1936 he won a competition for the Escuela de Derecho building (completed 1938) in the Universidad de Chile. Equal to the best architecture of its time worldwide, the building is Rationalist with expressionistic elements in the main curved façade and well-articulated south elevation. After such projects as the Escuela Militar in Santiago (1943), which is an early example of exposed concrete on exterior and interior walls, he designed the Unión Española de Seguros building (1948), which anticipated some of the Gropius/TAC schemes in Boston and also incorporates local material, such as copper, in the façades. Martínez——who was an excellent watercolourist—paved the way for the transformation of architectural teaching in Chile. In 1969 he was awarded the Premio Nacional de Arquitectura and in 1975 became Emeritus Professor of the Universidad de Chile. He stressed the principal that good architecture is the result of conscientious study of its 'function', although his best works in fact transcend this view.

BIBLIOGRAPHY
H. Eliash and M. Moreno: *Arquitectura y modernidad en Chile, 1925–1965* (Santiago, 1989)
RAMÓN ALFONSO MÉNDEZ

Martínez Pedro, Luis (*b* Havana, 1910). Cuban painter. He studied architecture at the University of Havana (1930) before moving to the USA in 1931, where he studied at the Arts and Crafts Club, New York (1932). He returned to Cuba in 1933. The most individual of Cuba's Constructivist painters, he is best known for *Territorial Waters*, a series that reached its climax in the early 1960s and that used geometric forms to describe the wave patterns of water (e.g. *Territorial Waters 5*, 1962; Havana, Mus. N. B.A.). Although such a referential use of hard-edge forms was common among Latin American artists, Martínez Pedro's interest in water as subject-matter is surprisingly rare. By the early 1970s he began to concentrate on enlarged images of tropical flora in a style derivative of Pop art, for example *Coral-tree Flower* (1975; Havana, Mus. N. B.A.).

BIBLIOGRAPHY
A. H. Barr, jr: 'Modern Cuban Painters', *MOMA Bull.*, xi/5 (1944), pp. 2–14
J. Gómez-Sicre: *Pintura cubana de hoy* (Havana, 1944)
RICARDO PAU-LLOSA

Martinique. See *under* ANTILLES, LESSER.

Martorell, Antonio (*b* Santurce, nr Bilbao, 1939). Puerto Rican printmaker, painter, draughtsman, illustrator and performance artist of Spanish birth. He studied in Spain in 1961–2 under Julio Martín Caro and with Lorenzo Homar at the graphic arts workshop of the Instituto de Cultura Puertorriqueña (1962–5). He inherited a social and political commitment from Puerto Rican artists working in the 1950s, but introduced wit and irony to his satirical treatment of political themes in prints, posters and illustrations. From the late 1960s, for instance, he produced portfolios of woodcuts in which he combined texts and images as a way of commenting on social and political events.

Martorell founded the Taller Alacrán in 1968 with the aim of mass-producing art at affordable prices. In the 1970s he began to experiment with innovative printmaking techniques, for example in a series of cut-out works influenced by Pop art, in which he played on stereotypes of authoritarianism in Latin America. In subsequent prints he explored the painterly qualities of woodcuts on a monumental scale. From the late 1970s, however, he was increasingly concerned with innovative live performances that combined printmaking and painting with the movement of actors. From 1978 to 1984 he lived in Mexico City, where he taught printmaking and drawing at the Escuela Nacional de Bellas Artes. He was appointed artist-in-residence at the Universidad de Puerto Rico in Cayey in 1986.

BIBLIOGRAPHY
M. Traba: 'Los Salmos de Martorell', *Rev. Inst. Cult. Puertorriqueña* (July–Sept 1972), pp. 5–9
Antonio Martorell: Obra gráfica, 1963–1986 (exh. cat. by A. Díaz-Royo, N. Rivera and J. A. Torres Martinó, San Juan, Inst. Cult. Puertorriqueña, 1986)
MARI CARMEN RAMÍREZ

Martorell, María (*b* Salta, 18 Jan 1909). Argentine painter. She studied in her home province under Ernesto Scotti (1900–57), painting at that time in a figurative style. Her first journey to Europe in 1952 led her to subject landscape to a geometric treatment and to elaborate more purely abstract forms. While living in Paris in 1955, for example, she made works out of coloured paper suggestive of her experience of the Metro system. Soon after her return to Argentina in 1957 her work became completely geometrical, showing the influence of the work and theories of such 20th-century artists as László Moholy-Nagy, Josef Albers, Max Bill, Georges Vantongerloo and Friedrich Vordemberge-Gildewart. Polygonal shapes predominated in the dynamic spiralling compositions that she produced in 1959–60, while colour became the most important element of the pictures she made in 1961 in New York.

As in the paintings of Robert Delaunay, colour determines outline, space and volume in Martorell's work. These create precise and clearly defined dynamic rhythms that transform the composition as a whole into a kind of sign. Curves echo or approach each other, sometimes multiplied in parallel patterns; they ascend in graceful verticals or take on a more horizontal emphasis, stopping just before the edge of the canvas or taking unexpected turns above or below, with bands of different widths contrasting dynamically with each other. *Ekho A* (1968; see colour pl. XX, fig. 2), an oil painting in diptych form, and *Ekho C* (1968; both Buenos Aires, Mus. A. Mod.), a triptych painted in acrylic, exemplify this period of her development. The objective relationships within a limited space that she conveyed in her first geometric works gave way to a sense of infinite space undulating in unison with the serene forms represented. Like Paul Klee and Max Bill, she based her systematical explorations of form on the analogy of musical variations, and in the 1960s she created environments using panels in which coloured bands imposed a dynamic rhythm. The logic of form and colour in Martorell's work testifies to the determining presence of a harmonious balance of rationality and sensitivity.

BIBLIOGRAPHY
Marisol (exh. cat., New York, Sidney Janis Gal., 1984)
María Martorell y la pintura (exh. cat. by N. Perazzo, Buenos Aires, Gal. A. Centoira, 1985)
N. Grove: *Magical Mixtures: Marisol Portrait Sculpture* (exh. cat., Washington, DC, N.P.G., 1991)

NELLY PERAZZO

Mateo, Julio (*b* Havana, 16 April 1951). Cuban painter and printmaker, active in the USA. He arrived in the USA in 1960 and grew up in Philadelphia, PA. He obtained his BFA from the University of Florida, Gainesville, in 1973 and his MFA from the University of South Florida, Tampa, in 1978. He came from an artistic family, and in his work he drew successfully on his dual Latin- and North-American legacies. From North America he derived his cultivation of constructed and flat, painted surfaces, a legacy of Abstract Expressionism and Minimalism. From Latin America he derived a love of signs and a preoccupation with the functions of language, pioneered by Joaquín Torres García. Mateo's abstractions, for example *Untitled* (1986; see 1987–8 exh. cat., p. 11), are in his words about the '"grammar" of rhythm and process' in the plastic sense, and how 'the limitations of a physical space can determine structure and form'.

BIBLIOGRAPHY
J. Milani: 'Julio Mateo/Printmaker, Sculptor', *Floridian Mag.* (1 Aug 1982), pp. 8–10
R. Hagenberg and others, eds.: *Eastvillage 85* (New York, 1985)
Abstract Visions (exh. cat., New York, Mus. Contemp. Hisp. A., 1987–8), p. 11

RICARDO PAU-LLOSA

Matta (Echaurren), Roberto (Antonio Sebastián) (*b* Santiago, 11 Nov 1911). Chilean painter, printmaker and draughtsman. He was educated at the Sacré Coeur Jesuit College and at the Catholic University of Santiago, where he studied architecture (1929–31). In 1933 he went to Europe and worked in Le Corbusier's atelier in Paris. At the end of 1934 Matta visited Spain, where he met the poet and playwright Federico García Lorca (1898–1936), and Salvador Dalí. The following year he went to Scandinavia (where he met the architect Alvar Aalto) and to Russia, where he worked on housing design projects. He was in London for a short period in 1936 and worked with Walter Gropius and László Moholy-Nagy. Employment with the architects of the Spanish Republican pavilion at the Paris International Exhibition (1937) brought him into close contact with Picasso's *Guernica* (1937; Madrid, Prado), which greatly impressed him. Another important influence at this time was Marcel Duchamp, whose work he first saw in 1936 and whom he met shortly afterwards.

At this time Matta made only drawings, for example *Inside Drive* (1939; see 1984 exh. cat., p. 10). Their vitality and freshness brought his work to the attention of the Surrealists, and André Breton invited him to take part in the Exposition Internationale du Surréalisme (1938). At the suggestion of his friend the painter Gordon Onslow Ford (*b* 1912), he began to paint. On the outbreak of World War II Matta went to New York. He spoke fluent English and made contact with American contemporaries such as Jackson Pollock, Arshile Gorky and Mark Rothko. In summer 1941 Matta travelled with Robert Motherwell to Mexico, where he was deeply impressed by the dramatic landscape and the work of the Mexican mural painters David Siqueiros, Diego Rivera and José Clemente Orozco.

Matta's first exhibition, at the Pierre Matisse Gallery in New York (1942), was praised by Breton as one of the high points of the Surrealist vision; the originality of works such as *Listen to Living* (1941; see colour pl. XXI, fig. 1) made a powerful impact on the American Abstract Expressionists. In 1944 he painted *Vertigo of Eros*, one of the first of his works to have a pun in the title (*Le Vertige d'Eros/Le Vert Tige des roses*); it was immediately acquired by the Museum of Modern Art, New York (see fig.). Influenced by *Guernica* and the works of the Mexican mural painters, he began to paint on a far larger scale than his American contemporaries, who later followed his example and began to produce the monumental works for which they are known.

After his initial success in New York, Matta began to attract the disapproval of powerful American critics such as Clement Greenberg, who objected to the figurative elements in Matta's painting, and of the Surrealists, who considered that his work no longer adhered to their tenets. In 1947 Matta had his first exhibition in Paris at the Galerie René Drouin. He returned to Europe in 1948 when the beginning of cold war politics made life increasingly difficult in the USA for an artist with Matta's strongly held political views. In the same year he was expelled by Breton from the Surrealist group. He lived in Rome, London and Paris but travelled widely outside Europe. He returned briefly to Chile during the period of the Allende government and later divided his time between Paris and Tarquinia in Italy.

Matta's influences include the work of Picasso, Duchamp and Kandinsky, but also such diverse sources as architectural and engineering drawings, science fiction illustrations and films, comic books and graffiti. As a result his painting became epic in scale and subject-matter, as in *Coigitum* (4.12×10.36 m, 1972–3; see 1977 exh. cat.). Retaining his strong political commitment (he was particularly active in denouncing the Pinochet regime in Chile and the US involvement in Latin American politics), Matta often exhibited in factories and in the public buildings of

Robert Matta: *Le Vertige d'Eros/Le Vert Tige des roses*, oil on canvas, 1.96×2.52 m, 1944 (New York, Museum of Modern Art)

left-wing municipalities rather than in art galleries. He also produced numerous prints, including his series of etchings *Hom'mère* (1970), an autobiographical exercise, and many drawings. The subject-matter was often political or based on literary sources, including Arthur Rimbaud, Antonin Artaud, Rabelais and Shakespeare. *The Banquet* (1982, pastel on paper; see 1984 exh. cat., cover) is part of the *Storming the Tempest* series of large pastels, whose theme is the conquest of the New World by the Old, or the exploitation of the Third World by the First.

BIBLIOGRAPHY

A. Breton: *Le Surréalisme et la peinture* (Paris, 1928, rev. 1965; Eng. trans., London and New York, 1972), pp. 82, 146, 149, 182–94

A. Jouffroy: *Une Révolution du regard* (Paris, 1965)

Matta: Coïgitum (exh. cat., London, Hayward Gal., 1977)

G. Ferrari: *Matta: Index dell'opera grafica dal 1969 al 1980* (Viterbo, 1980)

Roberto Matta: Paintings and Drawings, 1971–1979 (exh. cat. by P. Selz and J.-M. Tasende, La Jolla, CA, Tasende Gal., 1980)

Matta, the Logic of Hallucination (exh. cat. by R. Malbert and P. Overy, ACGB, 1984)

Matta (exh. cat. by A. Sayas and C. Schweisguth, Paris, Pompidou, 1985)

Four Crosscurrents of Modernism. Four Latin American Pioneers: Diego Rivera, Joaquín Torres-García, Wifredo Lam, Matta (exh. cat. by V. Fletcher and others, Washington, DC, Hirshhorn, 1992)

Matta hoy, Galería Artespacio, (Santiago, 1996)

Matta: Paradise Now (exh. cat., New York, Maxwell Davidson Gal., 1997)

PAUL OVERY

Matte, Rebeca (*b* 1875; *d* 1929). Chilean sculptor. After studying at the Academia de Bellas Artes in Santiago she lived for many years in Europe, going to Paris in 1900 where she studied under Denys Puech and Paul Dubois at the Académie Julian. She also studied with Giulio Monteverde in Rome, finally settling in a Renaissance mansion in Florence. Working in marble and bronze, she concentrated on the human figure, seeking to represent volume in a rigidly formal manner yet consistently conveying an emotional charge.

Matte formed part of a generation that assimilated academic canons of monumentality in the Greek tradition. Her subject-matter consisted of biographical, historical, allegorical or mythological events. She also produced public monuments, including some government commissions in Chile (e.g. the monument *Héroes de la concepción* at the Parque Cementerio General in Santiago; marble, 2.5×3.0 m, 1920) and one for the Vredespaleis in The Hague (*Grupo la guerra*; marble, 2.0×1.5 m). She was given a teaching post at the Accademia di Belle Arti in 1918, and on her death the Italian government requested one of her marble works for the Palazzo Pitti in Florence.

BIBLIOGRAPHY

M. Ivelić: *La escultura chilena* (Santiago, 1979), pp. 12–15

V. Carvacho Herrera: *Historia de la escultura chilena* (Santiago, 1983), pp. 207–11

CARLOS LASTARRIA HERMOSILLA

Mayito [García Joya, Mario] (*b* Santa María del Rosario, 28 July 1938). Cuban photographer. He studied fine arts at the Escuela Superior de Arte San Alejandro, Havana (1955–7), and subsequently studied at the Cuban Institute of Film Art and Industry (1963–4), where he was Director of Photography in 1961–8. He worked for several advertising agencies in Havana (1957–8), and in 1959 he was one of the founder-members of the photographic team on the newspaper *Revolución*. As an important photo-

graphic reporter, he not only worked in Cuba but also made a moving report on Nicaragua. His name was further enhanced by his work on films such as Tomás Gutiérrez Alea's *La última cena* (1975) and Miguel Latín's *El recurso del método* (1977) and by one-man exhibitions such as *Cuba Va!* at the Museo Nacional de Bellas Artes in Havana (1970). He has also carried out research into the history of Cuban photography.

BIBLIOGRAPHY

E. Billeter: *Fotografie Lateinamerika* (Zurich and Berne, 1981)

——: *Canto a la realidad: fotografía Latinoamericana, 1860–1993* (Barcelona and Berne, 1993–4) [Sp. and Ger. text]

ERIKA BILLETER

Medeiros (Anaya), Gustavo (*b* Cochabamba,16 Dec 1939). Bolivian architect and painter. He graduated from the Facultad de Arquitectura, Universidad Nacional de Córdoba, Argentina, in 1964 and taught in the architectural departments of the Universidad de Cochabamba (1964–9) and the Universidad de La Paz (1974–8). The most widely known architect of the 1970s and 1980s in Bolivia, Medeiros came to notice with his own late Modernist house, on 21st Street in the Calacoto zone of La Paz, in 1970. In the same year he began his major work, the Ciudad Universitaria de Oruro, in collaboration with Franklin Anaya (*b* 1924). On the highland to the northwest of Potosí and Sucre on an open site in view of the town of Oruro, he began to work out his ideas for an architecture that is authentic in its cultural and physical context. The buildings are mainly in exposed board-marked concrete and brickwork, and the design relies largely on standard single-storey units, square in plan, with tiled pitched roofs. One of the later buildings however, the Escuela de Metalurgia (1981), is contained in two linked, single-storey buildings, with pitched roofs spanning the long dimension of their rectangular plan forms. High and deep concrete-framed window embrasures, whose forms suggest Pre-Columbian inspiration, alternate with slender brick panels, the whole contributing to a rather unusual late Brutalist expression. His work in La Paz includes an urban development plan (1975–7), in collaboration with Teresa Gisbert, which proposes preservation and rehabilitation of the historic centre of the city, and private houses such as the Casa Buitrago (1982), a unique Post-modernist solution closely in context with its setting against the mountainside (*see* BOLIVIA, fig. 4). He regarded painting as parenthetic to his architecture but exhibited in America, Europe and Asia. He drew his initial inspiration from Pre-Columbian textiles and, at a later stage, portrayed rural groups, represented in the form of indigenous amulets.

WRITINGS

'Inovación y adaptación', *Summa*, 232 (1986), p. 34

BIBLIOGRAPHY

'Université Technique d'Oruro, Bolivie', *Archit. Aujourd'hui*, 173 (1974), pp. lv–lvii

'Casa en La Paz', *Summa*, 230 (1986), pp. 66–8

'Ciudad Universitaria de Oruro: Facultad de Ingeniería, Bolivia', *Summa*, 232 (1986), pp. 34–9

G. M. Anaya: *Una visión pictórica del ámbito andino* (exh. cat. by I. Rith-Magni, La Paz, Cent. Estud. & Proy. Nueva Visión, 1990)

TERESA GISBERT

Medellín. City located in a mountainous area in the northwest of Colombia. In the late 20th century it had a

population of c. 1.6 million. It grew from the hamlet of San Lorenzo de Aburrá (founded in 1616), in the mining province of Antioquia, and was a small town by 1674, with a merchant class that controlled the growing gold production. The only significant remaining colonial building is the church of the Veracruz (1791–1802) by José Ortiz (1761–1837), with a typical ornamented Baroque façade and triple bell-chamber (espadaña). New industries emerged after independence (1819),, and there was increased construction, with the traditional brick continuing to be a popular material. New buildings included the Metropolitan cathedral of Villanueva (1889–1931), a vast brick edifice by the French architect Charles Carré (1863–1923), who was responsible for the first stage of construction, and the Italian Giovanni Buscaglione (1874–1941), who was responsible for the second stage of construction and designed altars and pulpits (1919–31). Notable 20th-century buildings include the Art Nouveau Teatro Junín–Europa Hotel complex (1924; destr. 1967), Villanueva, by the Belgian architect Agustin Goovaertz, one of the most innovative and advanced buildings of its time in Colombia. The Facultad de Minas (1940–44) by PEDRO NEL GÓMEZ had nationalist murals (also by Nel Gómez) inspired by Mexican muralism. Although skyscrapers such as the Torres Coltejar (1968–70) by the firm of Esguerra, Sáenz, Urdaneta and Samper (Rafael Esguerra García (b 1931), Alvaro Sáenz Camacho (b 1925), Rafael Urdaneta Holguín (b 1928) and Germán Samper Genneco (b 1924)) began to appear, brick was still used in such buildings as the imposing Teatro Metropolitano (1985–7) by Oscar Mesa Rodríguez (b 1950). The city's museums include the Museo de Antioquia, with works by Fernando Botero, the Museo de Arte Moderno and the Museo Etnológico Miguel Angel Builes.

BIBLIOGRAPHY
A. Rueda Meléndez: Medellín, Patrimonio Representativo (Medellín, 1978)
N. Tobón Botero: Arquitectura de la colonización antioqueña, 3 vols (Bogotá, 1985–7)
G. Vires Mejía: Inventario del Patrimonio Cultural de Antioquia (Medellín, 1988)

FERNANDO CARRASCO ZALDÚA

Médici, Eduardo (b Buenos Aires, 15 Dec 1949). Argentine painter. He studied drawing and painting under Anselmo Piccoli (1915–93) and obtained a degree in psychology. His work occupies a transitional position between Neo-Expressionism and painting with a more symbolic emphasis and is characterized by an abstraction full of semiotic nuances. The lyricism of such works as Buenos Aires Is a Fiesta (1984; see Glusberg, 1985, p. 525) has a rhythmic, measured structure. It depicts coloured areas that revolve around a more densely coloured nucleus, the expanding universe, as it were. Portrayal of movement is constant in the works of the 1980s, some of which also depict bodies whose contours merge into the harmonic fabric of the painting. In subsequent works Médici used a more clearly semiotic approach, combining anthropomorphic figures with numbers, letters, lines, crosses, spirals and various designs suggestive of animals or other forms.

BIBLIOGRAPHY
J. Glusberg: Del Pop-art a la nueva imagen (Buenos Aires, 1985); Eng. trans., abridged as Art in Argentina (Milan, 1986), pp. 121, 130–31

Eduardo Médici: Entre mí y mí, Der Brücke Ediciones (Buenos Aires, 1996)
E. Olivares: 'Eduardo Médici: Identidad y diferencia, Galería der Brücke', A. & Ant., A. Cono Sur, x/27 (1996), pp. 54–7
N. Perazzo: 'Eduardo Médici or the Passion of the Body', A. Nexus, xxvi (1997), pp. 58–61

JORGE GLUSBERG

Medoro, Angelino (b Italy, c. 1567; d Spain, c. 1631). Italian painter and draughtsman, active in South America. After a brief stay in Seville, he arrived in South America in 1587, working particularly in Tunja and Bogotá (Colombia), Quito (Ecuador) and Lima (Peru). He returned to Spain some time after 1624. Medoro worked in the Mannerist style of Vasari and Francesco Salviati, and he was an important influence on the developing South American schools. His known work comprises a series dedicated to the Passion in the chapel of los Mancipe, Tunja Cathedral, a Virgin of Antigua in the Dominican church and a Flagellatio in the Franciscan monastery, both in Tunja. Other works include a Virgin of the Rosary (with four saints) in the convent of S Clara, Quito; St Bonaventura and the Entry into Jerusalem in the monastery of S Francisco, Lima; two paintings of the Crucifixion, one of St Diego of Alcalá and one of St Anthony of Padua (all Lima, church of los Descalzos); St Rose of Lima; in the sanctuary of S Rosa, Lima; a painting of Christ with Franciscan Saints in S Marcelo, Lima; and a Crucifixion in the Franciscan monastery of Potosí. There are two drawings dating from his time in Spain in the Alcubierre collection in Madrid.

BIBLIOGRAPHY
M. S. Soria: La pintura del siglo XVI en Sudamérica (Buenos Aires, 1956)
J. Mesa and T. Gisbert: 'El pintor Angelino Medoro y su obra en Sudamérica', An. Inst. A. Amer. & Invest. Estét., xviii (1967), pp. 23–47
——: 'Dos dibujos inéditos de Medoro en Madrid', A. & Arqueol. (1969)
Salazar: 'Nueva obra de Angelino Medoro en Lima', A. & Arqueol. (1969)
J. Mesa and T. Gisbert: La pintura cuzqueña (Lima, 1983)
R. Gutiérrez, ed.: Pintura, escultura y artes útiles en Iberoamérica, 1500–1825 (Madrid, 1995)

MARIA CONCEPCIÓN GARCÍA SÁIZ

Meireles, Cildo (b Rio de Janeiro, 1948). Brazilian printmaker and conceptual artist. He began working with art at age 15, eventually studying at the Escola Nacional de Belas Artes and at the engraving workshop of the Escola do Museu de Arte Moderna, both in Rio de Janeiro. His work is influenced by the Neo-Concrete movement, firmly rooted in Brazil's social and political reality. Since the 1960s, Meireles's work has addressed political, social and environmental issues, often under conditions of strict state censorship. Meireles produced two works in the 1970s that circumvented these restrictions. Insertions into Ideological Circuits 1: Coca-Cola Project (Inserções em circuitos ideológicos 1: Projeto Coca Cola; 1970) and Insertions into Ideological Circuits 2: Banknotes Project (Incerções em circuitos ideológicos 2: Projeto dinheiro; 1970) removed everyday objects of mass circulation out of their institutional setting; these objects were then modified through the addition of political statements before being reintroduced into general distribution. On the other hand, his 1973 installation, The Sermon on the Mount: Fiat Lux, fell victim to the political situation and was only publicly exhibited in 1979. Between

Cildo Meireles: *Zero Dollar*, screenprint, 70×150 mm, 1984 (Colchester, Essex University, Collection of Latin American Art)

1971 and 1973 Meireles lived in New York. He was co-founder of the alternative art journals *Malasartes* (with fellow Brazilian artists Waltércio Caldas Júnior (*b* 1946), Tunga and José Resende (*b* 1945)), and, in 1980, *A parte de fogo* with Tunga. In 1978 Meireles painted *Zero Cruziero*, a political commentary on the impact of inflation on the purchasing power of the Brazilian currency. This was followed in 1978 by *Zero Centavo*, in 1984 by *Zero Dollar* (see fig.) and in 1990 by *Zero Cent*. *Zero Dollar* presented the US dollar, economically dominant throughout the region, as having unchanging monetary value but no cultural worth. Meireles also collaborated on the independent films *Desvio para o vermelho* ('Red Shift'; 1984), directed by Tuca Morales, and *Le faux mounaieur* ('The Counterfeiter'; 1984), directed by Frederic Lafomt. His later large-scale installations, *Olvido* ('Oblivion') and *Missão/Missões: como construir catedrais* ('Mission/Missions: How to Build Cathedrals'; 1987), are highly polemic comments on the historical and continuing plight of Brazil's indigenous cultures and environmental destruction.

BIBLIOGRAPHY
Transcontinental: An Investigation of Reality (exh. cat. by G. Brett, Birmingham, Ikon Gal., and Manchester, Cornerhouse, 1990)
L. Weschler: 'Cildo Meireles: Cries from the Wilderness' *ARTnews*, lxxxix (1990), pp. 95–8
M. Amor: 'Cildo Meireles' *A. Nexus*, xxiv (1997), pp. 98–9
Cildo Meireles (exh. cat., Boston, MA, ICA, 1997)
Re-Aligning Vision: Alternative Currents in South American Drawing (exh. cat., New York, Mus. Barrio; Little Rock, AR, A. Cent.; Austin, U. TX, Huntingdon A.G.; and Caracas, Mus. B.A.; 1997–8)
ADRIAN LOCKE

Meirelles de Lima, Victor (*b* Desterro [now Florianópolis], 18 Aug 1832; *d* Rio de Janeiro, 22 Feb 1903). Brazilian painter. He entered the Academia Imperial das Belas Artes in Rio de Janeiro in 1847 as a student of history painting. In 1852 he was awarded a trip to Europe, which took him in 1853 to Rome, where he studied with Tommaso Minardi and Nicolao Couronni. He settled in Florence, where his hard work persuaded the Brazilian government to extend his stay. Some of his major works, such as the *First Mass in Brazil* (1860; Rio de Janeiro,

Mus. N. B.A.), were painted during this period. On his return to Brazil in 1861 he was made professor of history painting at the Academia Imperial. Together with Pedro Américo de Melo he is considered the greatest exponent of history painting in Brazil, combining a Neo-classical precision with an intense Romantic atmosphere in works such as the *Oath of Princess Isabel* (1875; Petrópolis, Mus. Imp.), the *Battle of Guararapes* (1879; Rio de Janeiro, Mus. N. B.A.) and the *Naval Combat at Riachuelo* (1882; Rio de Janeiro, Mus. Hist. N.). He also painted portraits and some indigenous subjects, as in *Moema* (1866; São Paulo, Mus. A.). Among his rare landscapes was a very detailed circular view of Rio de Janeiro (115 m, destr.), which he first exhibited in Brussels in 1888 on a rotating cylinder that permitted the viewer to stand still as the images went by in front of him. Only six preparatory studies of this work are extant (Rio de Janeiro, Mus. N. B.A.), although he also published *Panorama de la ville de Rio de Janeiro* (Brussels, 1888).

Pontual
BIBLIOGRAPHY
J. M. dos Reis Júnior: *História da pintura no Brasil* (São Paulo, 1944)
E. R. Peixoto: *Victor Meirelles no Museu Nacional de Belas Artes* (Rio de Janeiro, 1970)
A. P. Rosa and others: *Victor Meirelles de Lima* (Rio de Janeiro, 1982)
ROBERTO PONTUAL

Mello, Heitor de (*b* Rio de Janeiro, 1876; *d* Rio de Janeiro, 15 Aug 1920). Brazilian architect. He trained as an architect at the Escola Nacional de Belas Artes, Rio de Janeiro, and in 1898 he founded an office that became Rio de Janeiro's first large planning and construction organization. This was a period of large-scale building in Rio: Mello built several warehouses (1902) in the new port; a commercial building (1905) in Swiss-German style, on the Avenida Central (now the Rio Branco); and the Renaissance-style Eduardo Teiler residence (1905) on Avenida Beira-Mar. Following the successful Exposition Universelle in Paris (1900), Rio de Janeiro adopted the Beaux-Arts style for its own national exhibition in 1908; Mello won the grand prize for his pavilion designs, but he was not asked to

direct the building works. Thereafter he adopted versions of Beaux-Arts styles for all his large-scale public and private commissions in Rio, including the police station and barracks, the Jockey Club (1912) and Municipal Council, the central hospital and the Derby Club (1914); he also designed the post office in Belo Horizonte, Minas Gerais.

In Niterói he built the State Government Legislative Assembly, the Palace of Justice and a teacher training college, all in Greek Revival style. His plans for private houses, of which there are about 50, include some in the Vienna Secession style, some Tudor- and Swiss-style bungalows, and mansions in various classical styles. He was also one of the first to adopt the neo-colonial style, favoured by the Traditionalist Movement, that was introduced during the mid-1910s in an attempt to express a national cultural identity; he designed some houses, school buildings and two hotels (unexecuted) in this new style. Following his death, his office continued to operate under his name, directed by Archimedes Memória (1893–1960) and Francisque Cuchet, and some later works were built to Mello's design, for example the Chamber of Deputies (1921). Memória also took over the Chair of Architectural Composition in the Escola Nacional de Belas Artes, which Mello had held since 1912.

BIBLIOGRAPHY
'Homenagem a Heitor de Mello', *Arquit. Brasil*, i/1 (1921), pp. 29–30
P. F. Santos: *Quatro séculos de arquitetura* (Barra do Piraí, 1977)

SYLVIA FICHER

Melo, Pedro Américo de. *See* AMÉRICO DE MELO, PEDRO.

Mendes da Rocha, Paulo (Archias) (*b* Vitória, Espirito Santo, 25 Oct 1928). Brazilian architect. He graduated in architecture in 1954 from Mackenzie University, São Paulo, one of a new generation of professionals from the newly created, autonomous architecture faculties that replaced the specialist courses in engineering schools. He entered private practice in São Paulo in 1955, and in 1957 he won a competition for the Paulistano Athletics Club, São Paulo. His design incorporated an ingenious structural system and a dramatic trussed roof; it also won a prize at the 1961 Biennale in São Paulo. In 1961 he was invited by João B. Vilanova Artigas, one of the runners-up in the competition for the athletics club, to lecture at the Faculty of Architecture and Urbanism at the University of São Paulo; he was dismissed by the military government in 1969 because of his political views. His architecture was increasingly influenced by Brutalism; the influence of Artigas was particularly evident in his early designs, although he also admired Oscar Niemeyer and Affonso Eduardo Reidy. His affinity with Artigas can be seen in his ability to create imaginative and unexpected spatial solutions from architectural briefs. Other buildings resulting from prizewinning competition entries include the Jockey Club (1963), Goiânia, and the Brazilian Pavilion (1970; with Flavio Motta, Julio Katinsky and Ruy Ohtake) at Expo' 70 in Osaka, Japan, and in 1971 he was placed in the international competition for the design of the Centre Georges Pompidou, Paris. During the 1960s and 1970s, frequently working with others, he completed several

schools and housing estates, office buildings such as the Municipal Insurance Headquarters (1975) in the new administrative centre of São Paulo, cultural buildings such as the Museu de Arte Contemporânea (1975; with Jorge Wilheim) at the University of São Paulo, and university buildings such as those (1977) at Rondonôpolis, Mato Grosso.

BIBLIOGRAPHY
F. Motta, ed.: 'Obra do arquiteto Paulo A. Mendes da Rocha'. *Acrópole*, 343 (Aug–Sept 1967), p. 17 [special issue]
'Museu de Arte Contemporânea, Universidade de São Paulo', *Módulo*, 42 (1976), pp. 60–67
Y. Bruand: *Arquitetura contemporânea no Brasil* (São Paulo, 1981)
S. Silva Telles, ed.: *Inventario de l'obra publicada de Pablo Mendes da Rocha*, 3 vols (Campinas, 1989/91)
J. M. Montaner and M. I. Villace, intro.: *Mendes da Rocha* (Barcelona, 1996)

CARLOS A. C. LEMOS

Méndez, Leopoldo (*b* Mexico City, 30 June 1902; *d* Mexico City, 8 Feb 1969). Mexican painter, printmaker, illustrator and draughtsman. He studied in Mexico City at the Academia de San Carlos (1917–19) and at the Escuela de Pintura al Aire Libre de Chimalistac (1920–22). During the 1920s he was associated with ESTRIDENTISMO, and from 1925 to 1928 he worked as an illustrator for magazines such as *Horizonte* and *Norte de Veracruz*. After exhibiting his work for the first time in the USA in 1930 he held several exhibitions abroad, and in 1939 he received a grant from the Guggenheim Foundation in New York.

Méndez was co-founder in 1934 of the Liga de Escritores y Artistas Revolucionarios, which operated until 1937. On its dissolution he and two other printmakers from the group founded the TALLER DE GRÁFICA POPULAR, whose plastic arts section he headed and which he directed until 1952. As an ideologically committed member of the Mexican Communist Party, he produced outstanding prints in a social realist style, which reflect the problems of social struggle and reveal him as the heir to José Guadalupe Posada. Some of his prints were woodcuts and linocuts, made for films during the 'golden age' of Mexican cinema, such as *Río escondido* (1947), *Pueblerina* (1948), *El rebozo de Soledad* (1949) and *Memorias de un mexicano* (1950). He also published various books, winning a prize for the best illustrated book with *Incidentes melódicos del mundo irracional* (Mexico City, 1946) by Juan de la Cabada. In addition, he produced mural and other large-scale works, sometimes in collaboration with other artists, such as *Playing with Lights* (12 sq. m, 1949), engraved on 12 sheets of transparent plastic and housed in the former Nacional Financiera building in Mexico City. Méndez taught drawing and printmaking, and in 1946 he received the Primer Premio de Grabado de México.

BIBLIOGRAPHY
Leopoldo Méndez (1902–1969) (exh. cat., ed. Inba; Mexico City, Pal. B.A., 1970)
Leopoldo Méndez: Artista de un pueblo en lucha (exh. cat., ed. Ceestem; Mexico City, Cent. Estud. Econ. & Soc. Tercer Mundo, 1981)
R. Carrillo Azpeitia: *Leopoldo Méndez* (Mexico City, 1984)
F. Reyes Palma: *Leopoldo Méndez: El oficio de grabar* (Mexico City, 1994)

LEONOR MORALES

Mendieta, Ana (*b* Havana, 18 Nov 1948; *d* New York, 8 Sept 1985). American sculptor, performance artist, video artist and painter of Cuban birth. From the age of 13,

when she was sent to the USA from Cuba by her parents, she lived in orphanages and foster homes in Iowa. Her sense of exile and the separation from her family proved strong motivating forces on her later work. After completing an MA in painting at the University of Iowa in 1972, she entered the university's new Multimedia and Video Art programme, in which she was free to experiment and develop a unique formal language, gaining an MFA in 1977.

In the 1970s Mendieta began to create 'earth-body sculptures' outdoors in Iowa, using the primal materials of blood, earth, fire and water, having first executed performances that she documented in photographs or black-and-white films. In the *Silueta* series she traced or sculpted the image of her body on the ground, using ignited gunpowder, leaves, grass, mud, stones, other natural elements or cloth. She visited Mexico in 1971 (and again in 1973, 1974, 1976 and 1978) and Cuba in 1980 and 1981, thus re-establishing her connections with Latin America and stimulating her interest in the Afro-Caribbean Santería religion. Her *Rupestrian Sculptures*, carved in the rocks at the Escaleras de Jaruco in Cuba, refer to primitive goddess images.

Mendieta married Carl André in 1975 and lived from 1978 in New York. In 1983 she went to Rome on an American Academy Fellowship. There she created her first permanent objects in a studio setting. She extended and refined the principles of her early work in floor sculptures representing generalized female shapes, delicate and elegant drawings on leaves and bark paper, and large-scale sculptures in which her characteristic abstracted female silhouettes were burnt into tree trunks. Her feelings of alienation, which resulted not only from her exile but from her sense of being marginalized as a Latin American woman, were channelled into powerful, magical and poetic work. André was charged with her murder but acquitted.

BIBLIOGRAPHY

Ana Mendieta: A Retrospective (exh. cat., ed. P. Barreras del Río and J. Perreault; New York, New Mus. Contemp. A., 1987)
J. Tully: 'André Acquitted', *New A. Examiner*, 15 (April 1988), pp. 22–4
A. S. Wooster: 'Ana Mendieta: Themes of Death and Resurrection', *High Performance*, 11 (Spring/Summer 1988), pp. 80–83
M. J. Jacob: *Ana Mendieta: The 'Silueta' Series, 1973–1980* (New York, Gal. Lelong, 1991)
Ana Mendieta: A Book of Works (Miami Beach, 1993)
Ana Mendieta (exh. cat., Santiago de Compostela, Cent. Galego A. Contemp., 1996)
J. Blocker: *Where is Ana Mendieta? Identity, Performativity, and Exile* (Durham, NC, 1999)

SUSAN S. WEININGER

Mercado, Antonio Rivas. *See* RIVAS MERCADO, ANTONIO.

Mercado, Melchor María (*b* La Plata [now Sucre], 1816; *d* Sucre, 1871). Bolivian painter, photographer, museum founder, scientist and soldier. He was self-taught as a painter and established a reputation through his work in various techniques. His major work was an album (1841–60; Sucre, Bib. & Archv N.) composed of 116 watercolours of ordinary people, native and mestizo, fauna, flora, landscapes and nature scenes of various regions of Bolivia. His work is spontaneous and naive, painted with an almost dry brush. The importance of his work lies principally in

his realistic approach to his country and its natural environment. He also painted academic portraits, such as *Casimiro Olañeta* (1857; La Paz, priv. col.), and he established (*c.* 1845) the first Bolivian museum of cultural, mineral, plant and animal specimens (dispersed after 1871). He took up photography towards the end of his life.

BIBLIOGRAPHY

M. Chacón Torres: *Pintores del siglo XIX*, Bib. A. & Cult. Boliv.: A. & Artistas (La Paz, 1963)
L. Castedo: *Siglo XIX, siglo XX* (Madrid, 1988), ii of *Historia del arte ibero-americano*
P. Querejazu: *La pintura boliviana del siglo XX* (Milan, 1989)
G. Mendoza: *Vocación de arte y drama histórico nacional en Bolivia. El pintor Melchor María Mercado (1816–1871): Un precursor* (La Paz, 1991)

PEDRO QUEREJAZU

Merian, Maria Sibylla (*b* Frankfurt am Main, 2 April 1647; *d* Amsterdam, 13 Jan 1717). German painter and engraver, active in Surinam and the Netherlands. After the death of her father, the Swiss engraver and publisher Matthäus Merian (1593–1650), her mother married in 1651 the flower still-life painter Jacob Marell, who became Maria Sibylla's teacher. On 16 May 1665 she married Johann Andreas Graff, another pupil of her stepfather. She thenceforth specialized in illustrations of flowers, fruit and, especially, grubs, flies, gnats and spiders. In 1670 the family moved to Nuremberg. In 1675 Sandrart referred to her in the *Teutsche Academie*, reporting that she painted on cloth (i.e. silk, satin). With Graff, she produced a book of flowers, the first part appearing in 1675; a second edition, enlarged by parts 2 and 3 ,came out in 1680, entitled *Florum fasciculi tres*. It included 36 engravings intended to serve as patterns for embroidery. Only five copies of this book have survived, including a single first edition in the Stadt– und Universitätsbibliothek, Berne (others, Dresden, Sächs. Landesbib., and Inst. Dkmlpf.; Mainz, Stadt-& Ubib.; London, V&A). This was followed by *Der Raupen wunderbare Verwandlung und sonderbare Blumennahrung* (i, Nuremburg, 1679; ii, Frankfurt, 1683), 'in which, by a new invention, the origins, food and metamorphoses of caterpillars, grubs, butterflies, moths, flies and other such creatures . . .are diligently examined, briefly described and painted from life, engraved in copper and published by the author'. The work went into five editions, including those of 1713 and 1714 in Dutch; a third volume was posthumously published (with vols 1 and 2), *c.* 1718, by her daughter Dorothea. Each of its 50 engravings is minutely rendered by Maria Sibylla from her own observations.

In 1681 Maria Sibylla's stepfather Marell died, and after separating from her husband she returned to her mother in Frankfurt. In 1685 she moved with her mother and daughters to Waltha in West Friesland, where she joined a Labadist community. In 1686 Graff tried to persuade his wife to return; when she did not comply he sought legal divorce. In 1690, after her mother's death, Maria Sibylla took her two daughters to Amsterdam, where she soon achieved success as a flower and animal painter. In 1699 she travelled with her younger daughter, Johanna Helena, to Surinam. After a time she fell seriously ill, returning home early (1701) with copious notes, paintings on parchment, dried plants and animals preserved in alcohol. In 1705, after lengthy preparation, her work on

Maria Sibylla Merian: *Pomegranate*, 730×503 mm, hand-coloured engraving; from her *Metamorphosis insectorum Surinamensium* (Amsterdam, 1705), pl. 9 (Nuremberg, Germanisches Nationalmuseum)

Surinamese insects, *Metamorphosis insectorum Surinamensium*, was published in Amsterdam (later edns; *see* SURINAM, fig. 3); most of the copies are hand-coloured. This is the first scientific work to be produced on Surinam. Despite a few biological errors, the illustrations (see fig.) are convincing, especially in their rendering of the full brilliance of the tropical colours. Apart from tranquil studies of nature, there are pictures showing its ferocity, such as the sheet depicting a spider eating a humming-bird.

For her flower paintings Maria Sibylla favoured water-colours applied to parchment, which brought out the natural and fresh qualities of her subjects (examples in Basle, Kstmus.; Berlin, Kupferstichkab.; Darmstadt, Hess. Landesmus.; London, BM; Nuremberg, Ger. Nmus.; Vienna, Albertina; Windsor Castle, Berks, Royal Col.). She engraved her copperplates herself, using a line-and-point technique as well as a crayon style. The sheets coming from the press were run through again with a second plate, producing transfer prints that were lighter and more delicate, and then hand-coloured. Merian's illustrations of flora and fauna not only demonstrate her mastery as a painter and engraver, but express a concern for botany uncommon in a woman of the late 17th century. In Amsterdam she was in close touch with scientists; this intrepid scholar and artist, who paid scant heed to the conventions of her time, is also recognized as a founder of entomology.

WRITINGS
Metamorphosis insectorum Surinamensium (Amsterdam, 1705); facsimile with comm. by E. Rücker and W. T. Stearn, 2 vols (London, 1982)

BIBLIOGRAPHY
Maria Sibylla Merian: Leben und Werk, 1647–1717 (exh. cat., ed. M. Phister Burkhalter; Basle, 1980)

Das verborgene Museum (exh. cat., Berlin, Akad. Kst., 1987), i, pp. 91–3
W. Hoerner: *Der Schmetterling: Metamorphose und Urbild: Eine naturkundliche studie mit einer Lebensbeschreibung und Bildern aus dem werk der Maria Sibylla Merian* (Stuttgart, c.1991)
N. Zemon Davis: *Women on the Margins: Three Seventeenth-century Lives* (Cambridge, MA, 1995)

C. HÖPER

Mérida. Mexican city, capital of the state of Yucatán, at the north-western tip of the Yucatán peninsula, with a population of *c.* 700,000. The city's situation on a limestone platform in the 'sisal region' has favoured its rapid development. Mérida was founded in 1542 by Francisco de Montejo II on the site of the earlier Mayan city of T'Ho, which was demolished by colonizing Spaniards to make way for Spanish constructions. The cathedral of S Ildefonso, begun in 1562 when Fray Diego del Toral was bishop, is the earliest cathedral in Mexico; it was completed in 1598 by Juan Miguel de Agüero (*fl* 1574–1613), who travelled from Spain specially for the purpose. The Renaissance façade is composed of five sections, surmounted by slender towers (*see* YUCATECO). Little of the original interior survives, as the church was burnt down in 1915 during the Mexican Revolution (1910–20). Nevertheless, it contains the statue known as *Christ of the Blisters*, formerly in the church of Ichmul, where another fire produced the blistering on the figure of Christ. The Convento de Monjas Concepcionistas, founded in 1589 for the daughters of conquistadors, retains the church of Nuestra Señora de la Consolación, with its magnificent low choir and, on the exterior, a belvedere that offers a splendid view of the city. The 17th-century conventual church of La Mejorada has one of the finest façades in the city. Among other notable churches is that of S Cristóbal (18th century), with its unusual flared portal.

One of the most significant examples of secular architecture in Mérida is the Casa Montejo, the house of the city's founder. Built in the mid-16th century, only the façade of the original building survives; but it is one of the most important Plateresque secular works in Mexico: it has an abundance of low relief and, in the centre, the coat of arms of the Montejo family, flanked by two halberdiers stepping on the heads of indigenous people. The Palacio de Gobierno (1892) was built on the site of the old Casas Reales; on the walls of the staircase are three murals (completed 1978) by Fernando Castro Pacheco, representing Mayan cosmology, the symbolism of the four cardinal points and the creation of Man. In the Salón de la Historia other works by Castro Pacheco illustrate the evolution of Yucatán. Paseo Montejo, a bustling avenue shaded by tamarind trees, is the commercial zone of Mérida and the location of the Museo de Antropología in the Italianate Palacio Cantón; the museum contains Mayan and other archaeological artefacts. There is an active craft industry in Mérida, producing artefacts made from wood and sisal as well as textiles.

BIBLIOGRAPHY
G. Ferrer de Mendiolea: *Nuestra ciudad Mérida de Yucatán* (Mérida, 1938)
J. Fernández: *Catálogo de construcciones religiosas, Yucatán*, 2 vols (Mexico City, 1945)
R. Aguilar and J. Stella: *Mérida colonial: Su historia y sus monumentos* (Mexico City, 1971)
C. Rasmussen: *Mérida en la época colonial y del oro verde* (exh. cat., Yucatán, U. Autónoma, 1994)

S. LETICIA TALAVERA, P. MARTANO MONTERROSA

Mérida, Carlos (*b* Guatemala City, 2 Dec 1891; *d* Mexico City, 21 Dec 1985). Guatemalan painter and printmaker. He came to painting through music, when incipient deafness made him exchange his piano for paintbrushes. His attendance at meetings organized by the Spanish Catalan painter Jaime Sabartés (1881–1968) proved decisive, for they brought him into contact with the paintings of Picasso; in 1912 he travelled to Paris, armed with a letter of introduction from Sabartés to Picasso. In Paris he frequented the studios of Amedeo Modigliani, Kees van Dongen and Hermengildo Anglada Camarassa and learnt about the artistic avant-garde. He also visited other European cultural centres.

On his return to Guatemala, Mérida, together with Rafael Yela Gunther, began to revalue indigenous art not for its folkloric aspects but for its essential local values prior to the Spanish conquest. At exhibitions held in Guatemala in 1919 and in Mexico in 1920, Mérida showed works such as *Profile* (1920; priv. col., see Nelken, illus. 2), in which he began to establish the distinctive characteristics of his later work: a search for geometric abstraction based implicitly on Mayan plastic arts; the use of intense flat colour, precisely delineated and clearly influenced by autochthonous art; static designs deriving from his European apprenticeship; elegance and good taste; and an emphasis on the human figure.

In the early 1920s Mérida settled permanently in Mexico, although he always retained his Guatemalan nationality. The Mexican muralist movement was just beginning when he arrived, and he collaborated with Diego Rivera on his first mural work. His withdrawal from political concerns and from official art, however, distanced him from the movement, and in the 1940s he emerged instead as a member of the avant-garde in conscious opposition to Mexican muralism. On his return to Mexico after another stay in Paris in 1927, during which he had got to know Picasso, Vasily Kandinsky, Joan Miró, Paul Klee and Joaquín Torres García, he explored Surrealism, geometric abstraction and Torres García's Universal Constructivism. His work oscillated thereafter between Surrealism and abstraction, emphasizing his qualities as a draughtsman and colourist and making use of innovative materials and techniques. The influence of Surrealism is particularly evident in a portfolio of screenprints, *Estampas del Popol-Vuh* (Mexico City, 1943), and in oil paintings such as *Ubiquitous Fascination* (1940; New Haven, CT, Yale U. A.G.) and *Self-portrait* (1948; Luna Arroyo priv. col., see Luján, p. 245).

Little by little, abstraction and especially geometric abstraction began to predominate in Mérida's work, particularly after 1950, and it was to this style, with variations, that he remained committed until his death. In these pure geometric works straight lines cross each other and precisely delineate areas illuminated with clear vibrant colours, with a sense of rhythm and proportion that convey the artist's close affinities with music, dance and architecture. The subjects that inspired him were of local origin, in particular pre-Hispanic texts and codices. There are many fine examples from this period of both his prints and paintings. Many of them make use of diverse materials and techniques, including bark and parchment, sometimes painted with vinyl (e.g. *Architectures*, 1956; Houston, TX,

Carlos Mérida: *The Three Maids*, casein on paper, 502×393 mm, 1956 (Houston, TX, Museum of Fine Arts)

Mus. F.A.), casein (e.g. *The Three Maids*; see fig.) or even screenprinted.

Having reached maturity as an artist and found his own style, Mérida returned during this period to mural painting, but in his own way and as part of a movement concerned with the integration of the plastic arts. Like others aligned with this movement, he collaborated closely with architects in placing and carrying out his murals. His abstract style was suited to contemporary architecture because of the simplicity of its lines and because of his use of such architectural materials as stone, concrete and mosaic. The best of the considerable number of murals he carried out using a great variety of techniques, about 20 in Mexico and 10 in Guatemala, are those on which he collaborated with Mario Pani, because of the harmonious coordination of the mural with its architectural context. In his most successful work, the *Unidad Habitacional Benito Juárez* (1952; Mexico City, destr. 1985 earthquake), Mérida used polychrome concrete as his basic material for the panels and outside staircases, taking his inspiration from pre-Hispanic codices. Although many of his murals were later destroyed, they nevertheless account for much of Mérida's high reputation in Latin America.

For an example of Mérida's works *see* colour pl. XXII, fig. 1.

WRITINGS
Modern Mexican Artists (Mexico City, 1937)

BIBLIOGRAPHY
L. Cardoza y Aragón: *Carlos Mérida* (Madrid, 1927)
M. Nelken: *Carlos Mérida* (Mexico City, 1961)
El diseño, la composición y la integración plástica de Carlos Mérida (exh. cat., Mexico City, U.N. Autónoma, 1962)
X. Moyssén: 'Los mayores: Mérida, Gerszo, Goeritz', *El geometrismo mexicano* (Mexico City, 1977), pp. 51–75

M. de la Torre, ed.: *Carlos Mérida en sus 90 años* (Mexico City, 1981)

L. Luján: *Carlos Mérida* (Guatemala City, 1985)

L. Noelle: 'Los murales de Carlos Mérida', *An. Inst. Invest. Estét.*, xv (1987), pp. 125–43

J. B. Juárez: *Carlos Mérida en el centenario de su nacimiento, 1891–1991* (Guatemala City, 1992)

Homenaje nacional a Carlos Mérida: Americanismo y abstracción (Mexico City, 1992)

E. Espinosa Campos: *Carlos Mérida: Un artista integral* (Mexico City, 1997)

LOUISE NOELLE

Merino, Ignacio (*b* Piura, 30 Jan 1817; *d* Paris, 17 Feb 1876). Peruvian painter and teacher. He had a cosmopolitan existence as a child, living first in Paris, where he worked in the studios of Raymond Monvoisin (1794–1870) and Paul Delaroche (1797–1856) after completing his schooling, and later in Italy and Spain. He returned to Peru at the age of 21, later becoming a drawing teacher at the Convictorio de San Carlos and the assistant director (and eventually director) of the Academia de Dibujo y Pintura, both in Lima. During his second trip to Europe, he visited Spain, the Netherlands, Italy and France, finally settling in Paris.

In his paintings Merino demonstrated a taste for literary and historical subjects, fed by his knowledge of Spanish, English and French literature, which he combined in his early works with the influence of Ingres and later with that of Velázquez, Ribera and Rembrandt. Later in his career he also executed numerous portraits and self-portraits. His more important works include *Columbus before the University of Salamanca* (Lima, Mun. Lima Met.), the *Hand of Carlos V*, *Hamlet*, *Lima Woman in Doorway* and *Reading 'Don Quixote'*, all in collections in Lima.

BIBLIOGRAPHY

T. Núñez Ureta: *Pintura peruana contemporánea: Primera parte, 1820–1920* (Lima, 1975)

L. E. Tord: 'Historia de las artes plásticas en el Perú', *Historia del Perú*, ix (Lima, 1980)

LUIS ENRIQUE TORD

Merlo, Tomás de (*b* Santiago de Guatemala [now Antigua], 15 July 1694; *d* Santiago de Guatemala, 15 Dec 1739). Guatemalan painter. A son of the master painter Tomás de la Vega Merlo (*b c.* 1659; *d* 26 April 1749), he was the most important Guatemalan painter of his generation and the one by whom there are the most identified works. In 1730 he married Lucía de Gálvez, daughter of the master craftsman Antonio Joseph de Gálvez. In 1737 he began a series of eleven paintings of the *Passion* for the church of the Calvario (six, *in situ*; five, Antigua, Mus. Colon.). Two were finished by an unnamed pupil in 1740, and the general quality of the series is not high, perhaps because of poor retouching. In his painting of *St Ignatius of Loyola* (Antigua, Mus. Colon.), which is probably based on an engraving, the saint is depicted preaching, against a graceful background of angels in the upper part. In the Capuchin church in Guatemala City is his *Virgen del Pilar* (1736–8), popularly known as *Nuestra Señora de las Monjitas*, which depicts the six founder nuns of the church kneeling in the lower part of the work. Executed in a style typical of the Baroque, the more skilful upper part shows the Virgin being carried by angels. There are two known works by Merlo's brother, Pedro Francisco de Merlo (1698–1780), a less celebrated painter, in S Pedro Almolonga, Quetzal-tenago, each depicting four scenes from the *Life of the Apostle St Peter*.

BIBLIOGRAPHY

H. Berlin: 'El pintor Tomás de Merlo', *Antropol. & Hist. Guatemala*, v/1 (1953), pp. 53–8

E. Núñez: 'Pintura del período colonial, Pedro Francisco de Merlo', *Antropol. & Hist. Guatemala*, 2nd ser., v (1983), pp. 89–99

JORGE LUJÁN-MUÑOZ

Messil, Gabriel (*b* Buenos Aires, 26 Feb 1934; *d* Buenos Aires, 22 Dec 1986). Argentine painter and sculptor. He studied at the Escuela Superior de Bellas Artes in Buenos Aires, leaving in 1963, and in 1967 travelled on a French government scholarship to Paris, where he became associated with the group around Julio Le Parc. He participated in the Paris Biennale in 1970 before returning in 1974 to Buenos Aires. Around the time of his move to France he changed from a figurative style combining expressionist and geometric elements to a more Minimalist style combining painting and sculpture in open, continuous forms made of polychromed wood, canvas and plaster. Shortly afterwards he began to paint again on a conventional canvas support, depicting figures with such ambiguity and dynamism that one's reading shifts constantly from that of the flat surface to the three-dimensional rendering of the image; the psychological and perceptual intensity of these works goes hand-in-hand with the reliance on black and other sombre colours. From the mid-1980s Messil further emphasized the role of irrational elements at the expense of the formal geometric structure of his pictures in order to increase their sensory impact.

BIBLIOGRAPHY

A. Haber: *Arte argentino contemporáneo* (Madrid, 1979), pp. 194–6

F. Fevre: *Gabriel Messil* (Buenos Aires, 1981)

Homenaje a Gabriel Messil, 1934–1986 (exh. cat., Buenos Aires, Fund. S Telmo, 1990)

J. López Anaya: *Historia del arte argentino* (Buenos Aires, 1997)

NELLY PERAZZO

Mestizo [Sp.: 'mixed' or 'hybrid'] **(Baroque)**. Term first used by in its art-historical sense Angel Guido (1925) to describe the fusion of Baroque architecture with indigenous art forms in South America and especially the Altiplano or highlands of Bolivia and Peru from the mid-17th century to the late 18th. Mestizo is characterized by massive Baroque structure with finely dressed stone detailing in exuberant flat patterns reminiscent of embroidery or wood-carving. Motifs incorporating indigenous fruits and animals were used on portals, retables and decorative friezes; mythological characters play indigenous musical instruments; and Pre-Columbian decorative details help to fill every available space with dense ornamentation.

The most notable examples of the Mestizo style are to be found in the central Andes, at Arequipa in Peru and Potosí in Bolivia. In the region of Arequipa the use of a porous volcanic rock gave rise to a school of plane-surface carving that tended to stress chiaroscuro. The whole façade of the Jesuit church of La Compañía (1698) at Arequipa is carved in a foliated relief that invades the entablatures of the ground- and first-floor orders and fills the tympanum of the pediment (for further discussion and illustration *see* AREQUIPA). The same wealth of surface decoration, but in a finish more akin to wood-carving than

embroidery, may be seen at the church of S Lorenzo (1728–44), Potosí (*see* BOLIVIA, fig. 3). Spiral columns flanking the doorway are transformed in the upper portions of their shafts into caryatids with arms akimbo. The whole composition is substantially repeated on a smaller scale in an overdoor feature, where the columns are flanked by two mermaids playing the *charango*, a stringed instrument.

Efforts were made by the monastic orders in Latin America to eradicate pagan religions, but native workmanship was encouraged in church building since it was thought that the use of indigenous techniques and motifs would help spread Christianity. In addition to formal architecture, the Mestizo style also found expression in ephemeral structures such as triumphal arches, crosses, catafalques, street altars, reviewing platforms and other items that reinforced the importance of processional routes through towns. The Mestizo style eventually gave way before the rise of Neo-classicism and the control of the academies, although Mestizo portals and other features continued to appear in otherwise classicizing designs well into the 19th century, and artwork intimately related to Mestizo was still being recreated in indigenous and peasant communities at the end of the 20th century.

BIBLIOGRAPHY

A. Guido: *Fusión hispanoindígena en la arquitectura colonial* (Rosario, 1925)
A. Neumeyer: 'The Indian Contribution to Architectural Decoration in Spanish Colonial America', *A. Bull.*, xxx (1948), pp. 104–21
H. E. Wethey: *Colonial Architecture and Sculpture in Peru* (Cambridge, MA, 1949)
P. Kelemen: *Baroque and Rococo in Latin America* (New York, 1951)
H. E. Wethey: 'Hispanic Colonial Architecture in Bolivia', *Gaz. B.-A.*, n. s., xxxix (1952), pp. 47–60
P. Kelemen: 'El barroco americano y la semántica de importación', *An. Inst. A. Amer. & Invest. Estét.*, xix (1966), pp. 39–44
S. Sitwell: *Southern Baroque Revisited* (London, 1967)
G. Gasparini: 'La arquitectura colonial como producto de la interacción de grupos', *Bol. Cent. Invest. Hist. & Estét. Caracas*, xii (1969), pp. 18–31
R. Gutiérrez: *Arquitectura colonial: Teoría y praxis* (Resistencia, 1979)
——: *Arquitectura y urbanismo en Iberoamérica* (Madrid, 1983)
T. Gisbert and J. de Mesa: *Arquitectura andina, 1530–1830* (La Paz, 1997)

RAMÓN GUTIÉRREZ

Mexico, United States of [Estados Unidos Mexicanos]. North American country. Situated at the southern tip of the continent between the Gulf of Mexico and the Pacific Ocean, it is bordered by the USA to the north and Guatemala and Belize to the south-east. It is the third largest country in Latin America (area *c.* 1,972,500 sq. km) and is shaped somewhat like a funnel, wide along the USA border and narrowing towards the south-east (see fig. 1); the Isthmus of Tehuantepec, the narrowest point just west of the Yucatán Peninsula, is a low-lying, tropical north–south corridor generally considered to mark the geological division between the continents of North and South America. Physically Mexico is dominated by mountain ranges, which mostly run parallel to the coastline. The northern ranges enclose high central plateaux occupying nearly 50% of Mexico's total area; they comprise arid northern plains and the better irrigated, central Anahuac Plateau, which is the most densely populated region. The Transverse Volcanic Range, which crosses the centre of the country and has several active volcanoes over 4500 m in height, encloses a number of high-altitude valleys and

basins originally filled with lakes; these include the Valley of Mexico, site of the capital, Mexico City. Mexico is divided by the Tropic of Cancer; it has a temperate climate in the high plateaux and a hot, tropical climate in the narrow coastal plains and Yucatán Peninsula. Previously the site of several sophisticated indigenous cultures, notably the Olmec, Maya, Teotihuacán, Zapotec, Mixtec, Toltec and Aztec, the territory of Mexico was colonized by Spain after 1519. It became independent in 1821 and a republic in 1824. The majority of the population is mestizo (of mixed European and Indian descent).

I. Introduction. II. Indigenous culture. III. Architecture. IV. Painting, graphic arts and sculpture. V. Interior decoration and furniture. VI. Ceramics and glass. VII. Gold, silver and jewellery. VIII. Textiles. IX. Patronage, collecting and dealing. X. Museums. XI. Art education. XII. Art libraries and photographic collections.

I. Introduction.

The Spanish conquest of Mexico began with a series of conquistador expeditions from Cuba, the first reaching the Yucatán Peninsula in 1517. The Aztecs had extended their domination over most of the region by then, and the third expedition under Hernán Cortés had the help of various disaffected Indian groups in mounting its attack on the Aztec heartland. After founding the settlement of Veracruz (1519), Cortés made for the Aztec capital, Tenochtitlán (now MEXICO CITY), and finally conquered and destroyed the city in 1521. Conquistadors rapidly moved into other areas, founding such towns as PUEBLA (1530), QUERÉTARO (1531), OAXACA (1532) and MÉRIDA (1542), in some cases rebuilding over conquered settlements. The territory thus colonized was quickly consolidated by the Spanish crown as the Viceroyalty of New Spain. The first Viceroy, Antonio de Mendoza, took office in 1535, and the Spanish religious orders, particularly the Franciscans, the Augustinians and the Dominicans, were extremely successful in converting the indigenous Indians to Christianity, with missions and convents dominating the countryside.

As the great wealth of the country, based principally on silver mining, began to be exploited, large ranches were established to support the mining centres and produce such goods as sugar-cane, cotton, silk and indigo. Mining stimulated the development of such towns as Taxco (1524–80), Guanajuato (1557), ZACATECAS (1546–88) and San Luis Potosí (1592); Mexico City, the administrative centre rebuilt by the Spanish, had a university (founded 1551), schools, palaces and a royal court (Audiencia). During the 17th century the borders were extended north to California and Texas, and after a period of decline following over-exploitation of the land and the indigenous population, the economy revived in the late 17th century and the 18th. New mining towns were founded, for example Chihuahua (1718). GUADALAJARA, founded in the 1540s, became a centre of wealth and industry; Veracruz dominated European trade; Acapulco was the port through which Spain traded with China via its colony in the Philippines. Mexico achieved exceptional splendour in the arts, and the wealth of the ruling classes, the nobility and the clergy was notorious.

At the end of the 18th century the liberal ideas of the European Enlightenment reached the colony, stirring

1. Map of Mexico; those sites with separate entries in this encyclopedia are distinguished by CROSS-REFERENCE TYPE

national consciousness and arousing discontent in the mestizos. The Napoleonic invasion of Spain served as the impulse for a series of independence movements. The first (1810–15) was led initially by Miguel Hidalgo and then by José María Morelos, both priests, who called for an independent state with important changes. They were defeated by the Spanish colonial officials, who then entered into a revolt against Spain and, led by Agustín de Iturbide, declared independence in 1821. Iturbide was proclaimed emperor in 1822 but was overthrown in 1824 when a republic was set up. Then began a difficult period in which the country was unable to consolidate a stable government. Its problems were exacerbated by the war with the USA (1846–8), when Mexico lost half its territory. The war ruined the Mexican economy, and a series of struggles between liberals and conservatives led to armed intervention by France in 1862 and the establishment of the Austrian Archduke Maximilian as emperor in 1864. Three years later the forces of Benito Juárez recovered power and began a series of liberal reforms.

In 1876 General Porfirio Díaz assumed power and held it for nearly 35 years, ushering in a period of order and economic growth supported by foreign investment. Nevertheless, his long dictatorship and lack of democratic reform resulted in the Mexican Revolution of 1910 and a series of uprisings lasting over ten years. A new constitution (1917) embodied principles of social and land reforms, and after 1921 a series of presidents serving for six-year terms sought to re-establish political order and economic and cultural development; power was retained by the Partido Revolucionario Institucional. In the 1950s and 1960s Mexican governments placed a heavy emphasis on industrial growth, particularly in the central region, Mexico City, MONTERREY (founded 1596) and Guadalajara, which created an imbalance in the distribution of wealth and population as well as environmental and fiscal problems. Economic growth was stimulated by the discovery of large new oil and gas reserves in the mid-1970s.

BIBLIOGRAPHY

D. Angulo Iñiguez, E. Marco Dorta and M. J. Buschiazzo: *Historia del arte hispano-americano*, 3 vols (Barcelona, 1945–56)
P. Rojas, ed.: *Historia general del arte mexicano*, 4 vols (Mexico City, 1964–6)
40 siglos de arte mexicano, 4 vols (Mexico City, 1969)
J. Fernández: *Arte mexicano: De sus orígenes a nuestros días* (Mexico City, 1958; Eng. trans., Chicago, 1969)
——: *Estética del arte mexicano* (Mexico City, 1972)
Historia general de México, 4 vols (Mexico City, 1976)
Historia del arte mexicano, 12 vols (Mexico City, 1982)
México: Splendors of Thirty Centuries (exh. cat., ed. K. Howard; New York, MOMA, 1990)

LOUISE NOELLE

II. Indigenous culture.

The Spanish conquest of Mexico and the introduction of Christianity during the 16th century resulted in profound changes to the economic and social traditions of the indigenous peoples and undermined their entire cultural identity. Most of their architecture, sculpture, paintings and codices were destroyed, and they were forced to adapt to Spanish civilization. There was some initial resistance to this process, especially from the numerous priests of the Pre-Columbian religions who had received a long and rigorous education in traditional Indian *Calmécac* schools; these were responsible not only for propagating the religious doctrines and rites but also for the artistic training of the young, since art was profoundly linked to religion, and images were considered sacred. In addition, some of those who had formerly been nobles preserved and communicated a great deal of information about their history and culture, and continued for a time to paint codices. Attempts to resist Christianity met with little success, however, as the Spanish missionaries began to educate the Indian children, who soon became efficient assistants in the spread of Christianity and also undertook artistic work in the convents (*see* §§III, 1(i) and IV, 1(i) below).

The officially promoted evangelization of the Indians resulted in the deepest changes to their culture. In their own communities and in the Spanish urban settlements, Indians became members of Christian brotherhoods and participated in civic and religious duties. In the absence of sufficient numbers of Spanish workmen, the missionaries also drew on the Indians' sophisticated building skills—evident in the Pre-Columbian architecture that survived the wars of conquest—to construct their convents. The Franciscans took full advantage of this experience to build their convents in Mexico City, Texcoco, Tlaxcala, Huejotzingo and Cuernavaca—centres that were all chosen because of their great urban and artistic development before the conquest; in many cases, stones from Pre-Columbian buildings and even some idols were used as foundation-stones for Christian churches or occasionally in the construction of external walls. Churches were also frequently built on earlier temple sites; for example, the church of S Maria de los Remedios was built on the great pyramid of Cholula in the 16th century.

The Indians adapted quickly to the European style under tutelage from the missionaries (*see* §XI below), but in their techniques and use of materials they gave a particular character to their work that was sometimes later referred to as *tequitqui* or Indo-Christian art, with elements comparable to the Mestizo style in Peru and Bolivia. This can be seen most obviously in the continuing use of Pre-Columbian iconography in sculpture and painting: in the former it occurred as much in ornamental work as it did in religious image-making; for example, timid displays of Pre-Columbian symbols were sculpted either in isolation or among other decorative elements on doorways, arches and pilasters. In painting, it occurred in the huge wall-painting programmes in the convents that were erected in the second half of the 16th century. Pre-Columbian symbols are less numerous in painting than in sculpture, either because painter-priests, who alone knew the iconography, intervened only rarely in their execution or because they were eliminated upon their discovery by the monks.

Examples of motifs reminiscent of Pre-Columbian religious ideas that were sculpted in the colonial period include the scrolls that, when placed between the lips of figures, represented speech or song. Coils formed by one or more circles (*chalchihuites*), alone or accompanied by other elements, indicated preciousness or a complex religious concept. Rabbits, lizards, serpents and other creatures, especially eagles, also appear, symbolizing diverse religious ideas; for example, the motifs on the carved

shield on the baptismal font in the Franciscan convent at Acatzingo (see fig. 2) include eagle and tiger claws, as well as a heart pierced by an arrow and, in the centre, reeds. At other times the eagle motif appears either alone or with other symbols representing the god Huitzilopochtli, or with prickly-pear fruit and leaves as the symbol of Tenochtitlán, the Aztec capital. Vegetal motifs also appear, combined with European flora, making it difficult to determine whether they constitute an indigenous motif. This is the case, for example, with the four-petalled flower, which for the Indians was one of the hieroglyphs representing *Nahui Ollin*, the period in which the Indians lived and in which they believed the earth would be destroyed by earthquakes. The same concept was represented by four dots placed at equal distances from a fifth, central one, although this symbol was also used to represent the four corners of the universe and its centre, the earth (*Tlaltícpac*).

Indian artistic traditions are also evident in the decorative carving of some of the stone 16th-century churchyard crosses, as at the church of Santiago, Atzacoalco, and in silverwork (*see* §VII below). In general, however, indigenous arts and techniques declined in the 16th century. Images of saints were made from a paste of corn stalks similar to papier-mâché, and feather mosaics persisted for a few decades after the conquest, as did the production of traditional codices, but these arts had died out by the early 17th century. As gold and silver were exhausted by the ever-increasing demands by the Spanish rulers for tribute, so the increasingly impoverished Indian artists abandoned making objects from precious metals. The Indians in Azcapotzalco, for example, which had been a major centre for silverwork, began using bronze. Indigenous participation in the religious works of the missionaries and church declined in the 17th century as the process of evangelization was completed, and the Indians' artistic production was limited to popular architecture, sculpture and the

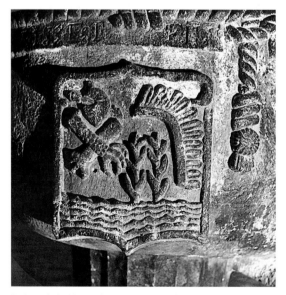

2. Carved shield on a baptismal font, mid-16th century, Franciscan convent, Acatzingo, Puebla, Mexico

creation of altarpieces in rural villages. Within the traditional communities that survived, the production of crafts continued, mainly weaving and clothing (*see* §VIII and fig. 17 below), furniture, ceramics (of which the major centres were Huitzilopochco, Azcapotzalco, Xochimilco and Cuauhitlan) and items for ceremonial or festive use. By this time the indigenous population had dramatically declined due to exploitation and disease; after Mexican independence, their communal property structures were dismantled, and Indians continued to swell the impoverished peasant class. All these factors contributed to the dismembering of the indigenous communities and traditional culture. Despite the loss of some of the traditional artistic techniques, iconography and symbolism, however, certain religious traditions and customs persist in some centres of indigenous population, proving the strength of their ancestral origins.

BIBLIOGRAPHY

J. Moreno Villa: *La escultura colonial mexicana* (Mexico City, 1942)
G. Kubler: *Mexican Architecture of the Sixteenth Century* (New Haven, CT, and London, 1948)
Métodos y resultados de la política indigenista en México (Mexico City, 1954)
R. Ricard: *La conquista espiritual de México* (Mexico City, 1955)
C. Gibson: *The Aztecs under Spanish Rule: A History of the Indians of the Valley of Mexico, 1519–1810* (Stanford, CA, 1964)
C. Reyes-Valerio: *El arte indocristiano: Escultura del siglo XVI en México* (Mexico City, 1978)
J. Cesar and O. Negrete: *La antropología mexicana* (Mexico City, 1981)
J. Lockhart: *The Nahuas after the Conquest: A Social and Cultural History of the Indians of Central Mexico, Sixteenth through Eighteenth Centuries* (Stanford, CA, 1992)
M. Porter Weaver: *The Aztecs, Maya, and their Predecessors* (San Diego, 3/1993)

CONSTANTINO REYES-VALERIO,
CARLOS MARTÍNEZ MARÍN

III. Architecture.

1. 1519–c. 1870. 2. After c. 1870.

1. 1519–c. 1870.

(i) Colonial and Renaissance, 1519–c. 1670. (ii) Baroque, Churrigueresque and Neo-classicism, c. 1670–c. 1870.

(i) Colonial and Renaissance, 1521–c. 1670. During the first part of the colonial period, architecture and urban planning in Mexico were characterized by influences from all the cultures that met in the region. The first Spanish cities, for example, were based on Mexica- or Tenocha-Aztec urban design, as seen in the capital, Mexico City, rebuilt as the seat of the Viceroyalty of New Spain. There the rectilinear Aztec urban plan of Tenochtitlán, with large open spaces for community activities, was retained for the new colonial city, its principal lines radiating from a vast central square in which the Templo Mayor had stood (*see* MEXICO CITY, §§I and II). Indigenous traditions were also reflected in the missions and also in the convents built by the mendicant orders, which dominated building activity in the 16th century. These complexes, for which the missionaries relied heavily on Indian labour (*see* §II above), drew on existing indigenous spatial arrangements for open-air ritual and ceremony: the climate and the size of the congregations determined that the services were conducted from an open chapel facing a spacious walled courtyard or atrium. This was sometimes arcaded to allow for various communal activities, usually with a wide multi-arched entrance portico and often with small, open chapels

(*capillas posas*) at each corner. To these elementary enclosures were added subsidiary chapels, cloisters, a church and school. It is now known that the defensive appearance that characterizes the mid-16th-century convent enclosures did not derive from any military purpose, and that their austere masses, related to determinedly high nave-vaulting, arose from lack of sophistication on the part of the missionary designers, while the *almenas* (battlemented parapets), in a wide variety of shapes and suggesting Islamic origins, were decorative.

The Franciscan Order was the first to undertake a systematic convent building programme, working from 1524 in the Valley of Mexico and in areas south and west of Mexico City. Among the most prominent of their foundations are those of Huejotzingo (1540s) and Tepeaca (1543–80), both of which have churches with crenellated façades, rib-vaulted, aisleless naves and polygonal apses. The church of S Miguel in Huejotzingo has Plateresque decoration (*see* PLATERESQUE STYLE) framed in the characteristic Franciscan rope motif later found in a variety of buildings in Latin America. The Franciscans were also active in Yucatán, where the tropical conditions led to an interesting synthesis of colonial and indigenous styles, notably in the *ramada* chapels, which had no side walls and used branches of trees and foliage to give protection overhead from the sun (*see* YUCATECO).

The Dominicans, who arrived in Mexico in 1526, were active in Mexico City and to the south-east, in the region of Oaxaca. Their foundations included Oaxaca itself (begun 1575), Tlacolula (1580) and Yanhuitlán, the earliest (1550–80; Kubler, 1948) and probably the finest, which has a massively buttressed, high-waisted church with a single low tower because of the region's susceptibility to earthquakes. In Mexico City the church of S Domingo was already in a state of disrepair by 1552; FRANCISCO BECERRA is associated with its renovation between 1573 and 1575.

The Augustinians, who arrived in the 1530s, were allocated sites to the north and west of Mexico City and constructed a remarkable series of convents, of which more than 20 survive to demonstrate the Order's predilection for Plateresque façades. The most notable Augustinian convents include those of Acolman (1541–87), in the State of México; Actopan (begun 1546) and Ixmiquilpan (founded 1550), in the region of Hidalgo; others in the more mountainous region to the north-west and Yecapixtla (begun between 1535 and 1540) in Morelos and Cuitzeo (1548–56) in Michoacán. All of these have heavily buttressed 'fortress' churches with *almenas* and shallow-pitched roofs. The churches of S Miguel, Ixmiquilpan, and S Miguel, Actopan, both by Fray Andrés de Mata (*d* 1574), who was assisted at Actopan by Fray Martín de Asebeido, have single massive towers. At S Pablo de Yuririapundaro another single massive tower and heavily buttressed chevet give an impression of immense strength that contrasts with the delicate decoration of the Plateresque façade. Designed for Fray Diego de Chávez (*c.* 1513–72) by Pedro de Toro (*fl c.* 1560), the church has chapels on either side of the chancel, giving an impression of a cruciform plan.

Only three cathedrals were completed in the 16th century: in Mexico City (1525–32; destr.), Oaxaca (begun 1544; rebuilt 1733) and Mérida (1562–98). The first of these was flat-roofed, with a *Mudéjar* timber structure, and the windows of the classical portal contained *encerados* (waxed cloth or paper, later with paintings). Oaxaca and MÉRIDA have hall-church sections. The cathedral of S Ildefonso, Mérida, has an austere Renaissance façade, with a magnificent recessed arch and two elegant towers (one from 1713); its coffered dome (1586–98) is inscribed to its Maestro Mayor Juan Miguel de Agüero (*fl* 1574–1613). The projected cathedral of S Salvador (1541–68), Pátzcuaro, commissioned by Bishop Vasco de Quiroga (1479–1565), was planned with five separately enclosed naves focusing on a spacious polygonal chancel. Begun by indigenous Tarascan craftsmen, from 1552 the building was under the direction of the Spanish master Hernando Toribio de Alcaraz (*b c.* 1522; *d* after 1572), but it was abandoned soon after Quiroga's death, with little completed. The second, Metropolitan, cathedral of Mexico City (see fig. 3), begun in 1563, may have been based on Jaén Cathedral in Spain, although the similarity is not close. The European type of foundations were inadequate and had to be rejected in favour of indigenous technology using friction piles and a continuous layer of masonry. In 1584 CLAUDIO DE ARCINIEGA was appointed to complete the work. He adopted a basilican section, with double clerestory arrangements, and, after his death in 1593, Agüero continued the work. It was dedicated in 1656, but the interior was not completed until 1667 and the towers only in 1813. The cathedral of Puebla (from 1575; for illustration *see* PUEBLA) is the smaller sister cathedral to the second cathedral in Mexico City. Francisco Becerra claimed to have worked on it as Maestro Mayor from 1575–80. Both buildings show the influence of the classical Renaissance style of the Spanish architect Juan de Herrera, although the cathedral in Mexico City has early Churrigueresque elements (*see* §(ii) below), while in the 1640s the dome at Puebla was sheathed in luminous local glazed tiles (*azulejos*) by the Aragonese architect-priest Mosén Pedro García Ferrer (1583–1660). Late decorative additions included star windows, finials and voluted buttresses. In the 17th century the cathedral of GUADALAJARA was also completed (1618), the only one in Mexico with an interior with Gothic-like elements, and work was begun in 1660 on a new cathedral in Morelia.

Another phase of religious building activity followed the initial period of evangelization: the construction of nunnery chapels in the early 17th century, which was significant in introducing early Baroque features into Mexico, for example at S Clara (begun 1605), Querétaro, and S Jerónimo (1623), Mexico City. That of Jesús María, Mexico City, begun in 1597 by Pedro Briceño and completed in 1621, is characteristic in its flowing decoration, while the nunnery church of La Concepción (1655), Mexico City, directed by Diego de los Santos y Avila (*fl* 1695–1716), has perhaps the earliest example in the country of the polygonal arch.

Few examples of 16th-century secular architecture remain: the castle–palace of Hernán Cortés in Cuernavaca, the Casa de Montejo, Mérida, and the Casa de Andrés de Tobilla, San Cristobal de las Casas, have all been considerably altered. The two-storey Casa de Montejo in Mérida was built partly of Maya stone by an Indian mason to a Spanish design, and it has a decorated portal of mixed

Plateresque, Gothic and *Mudéjar* origin. Schools and colleges were also built by the missionaries, especially the Jesuits, who founded the colleges of SS Pedro y Pablo (1572) and S Ildefonso (1592) in Mexico City, Espíritu Santo (1578) in Puebla, S Nicolás (1578) in Morelia, S Tomás (1591) in Guadalajara and S Martín (1606; now the Museo Nacional del Virreinato) in Tepotzotlán, the church of which has one of the finest Churrigueresque façades (1760–62) in Mexico. Other religious societies devoted to the care of the sick built many hospitals in the main cities.

As the indigenous population declined in the 17th century, so the influence of indigenous traditions in architecture and urban planning declined, and, although cathedrals were established in the traditional open plazas of the cities, important new buildings were built on the perimeter, in European fashion. The use of open chapels and walled atria for communal activities, which were deeply embedded in Central American tradition, lost its importance in the cities and was gradually abandoned, although in more remote areas it persisted. The centres of colonial cities were largely given over to artisans' workshops, grouped together in streets; on the outskirts were the bakeries, abattoirs, tanneries, lime-kilns and other activities proscribed from the centre by regulations governing the diffusion of smells, noise and unpleasant waste materials.

(ii) Baroque, Churrigueresque and Neo-classicism, c. 1670–c. 1870. Towards the end of the 17th century a more homogeneous and prosperous society began to evolve in Mexico, and with it came the development of Mexican Baroque architecture. Generally, however, the tendency towards circular and elliptical plans popular in European Baroque was resisted in favour of straight walls and parallel surfaces. The straight streets and wide squares of the towns lent themselves to the planning of visual focuses and effects of perspective as a logical development, for example in the convent of Las Rosas and the college of S Francisco Xavier (both in Morelia) or the church of S Rosa, Querétaro. Local factors, including a love of ornament, also determined the strong colours and decorated surfaces typical of Mexican Baroque. The bright red *tezontle* stone was used for the main body of many important buildings, while the contrasting yellowish white of *chiluca* stone was used for dressings in Mexico City and in the north and west. In Puebla, painted plasterwork (*yeserías*) and ornate red brickwork achieved particular distinction, as did the extensive use of colourful glazed tiles to decorate external surfaces (for description and illustration *see* POBLANO and colour pl. XXII, fig. 2).

The prosperity of the period was manifested in the building of several important parish churches and their subsequent elevation to the status of cathedrals. Notable examples include the cathedral of San Luis Potosí (1703–c. 1730), an example of the early 'solomonic' style, using carved spiral or 'solomonic' columns, which first appeared in S Teresa la Antigua, Mexico City, and characterized the early Baroque period in Mexico. Carved spiral columns also decorate the façades of the cathedrals of Durango (1695–1765), Aguascalientes (1704–38) and Chihuahua (1725–58), where plain walls contrast sharply with the heavily ornamented portals and upper towers. One of the most representative buildings of the period, however, is the Basilica at Guadalupe, built between 1695 and 1709 to celebrate the miraculous appearance of the Virgin to the Indian Juan Diego. It was built by PEDRO DE ARRIETA to plans by José Durán (*see* DURÁN), and it is characteristic in its angularity and use of such forms as polygonal arches, octagonal lunettes and corner towers. Arrieta also collaborated on the Jesuit church of La Profesa (1714–20), Mexico City, which exemplifies the Mexican Baroque urge to cover façades with flowing foliage reliefs; this tendency

3. Mexico City, Plaza de la Constitución: (left) Metropolitan Cathedral by Claudio de Arciniega, Juan Miguel de Agüero and others, 1563–1813; (right) Sagrario Chapel by Lorenzo Rodríguez, 1749–68

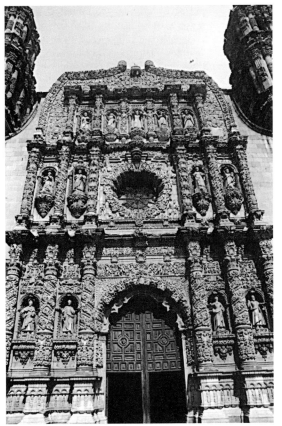

4. Domingo Ximénez Hernández (attrib.): Zacatecas Cathedral, upper façade, 1729–52

culminated in the almost totally encrusted upper façade of the cathedral of ZACATECAS (1729–52; see fig. 4), probably by Domingo Ximénez Hernández. Arrieta's contemporary, Miguel Custodio Durán (*see* DURÁN), worked in a similar style in Mexico City, using solomonic columns in his best-known building, the church of S Juan de Dios (1729).

The early Baroque in Mexico was followed by a style usually described as CHURRIGUERESQUE, although it is sometimes also called the Ultra Baroque. If the early Baroque was characterized by the use of solomonic columns, the Churrigueresque is largely associated with the *estípite* motif, designed by the Spaniard José Benito de Churriguera, although the style that came to prevail in Mexico had few similarities to his work. A vertical element of square cross-section and tapering downwards, the *estípite* was one of the few motifs to be adopted from the European Baroque, and its introduction is usually attributed to JERÓNIMO DE BALBÁS in his design for the retable (1718–37) of the chapel of the Kings in Mexico City's Metropolitan Cathedral. Its early use has also been noted, however, in the portal (1712–18) of the Jesuit college of S Ildefonso (Kubler, 1948), while its use in the finial elements and main portal of the cathedral in Morelia, by Vicente Barroso de la Escayola (*d* 1695), is cited by Marco Dorta (1973).

By about the middle of the 18th century the use of the *estípite* in civil and religious buildings had achieved not only a richness and variety beyond that achieved in Spain, but also a national aesthetic that overrode regional differences. Notable civil buildings to employ the *estípite* include the Ayuntiamento (1720–24) and Aduana (1731), Mexico City, while the first truly Churrigueresque church was SS Prisca y Sebastián (1748–58), Taxco, by José Cayetano de Sigüenza y Góngora (1714–78). Here twin towers soar two storeys above the retable façade, and balustraded, segmentally arched nave bays reach upwards to a dome of blue and yellow tiles. The outstanding example of the style, however, is the Sagrario Chapel (1749–68; see fig. 3 above) of the Metropolitan Cathedral in Mexico City. Designed by LORENZO RODRÍGUEZ on a centralized cruciform plan, the two façades are merged by the masterly use of diagonally arranged planes and the interplay of *estípites*. Other notable Churrigueresque religious buildings are the elegant brick and stucco sanctuary of Ocotlán (*c.* 1750), Tlaxcala, and the church of La Valenciana (1765–88), Guanajuato. The latter, and the church of SS Prisca y Sebastián, are also both further examples of churches financed by prosperous mine-owners.

Houses for the wealthy in Mexico City also incorporated changing architectural styles around the middle of the 18th century: a notable example is Lorenzo Rodríguez's house (1764; with Antonio Rodríguez de Soria (*fl* 1650–86)) for the Conde de San Bartolomé de Xala, which introduced new pilaster arrangements. Another house in Mexico City, designed in 1769 by FRANCISCO ANTONIO DE GUERRERO Y TORRES for the Condesa San Mateo Valparaiso (now a branch of the Banco de México), showed an attempt to simplify the existing complexities of style, and Guerrero's principal work, the Pocito Chapel (1779–91), Guadalupe, its centralized plan crowned with tiled domes, has a classicizing façade that heralds the Neo-classical.

Around the end of the 18th century new architectural criteria were being promoted by authorities and scholars, and the founding of the Colegio de Minas (1792) and the Real Academia de las Nobles Artes de San Carlos (1783; *see* §XI below) led to the emergence of a Neo-classicism based on European models. The style is visible in the ogee tower cupolas (1793) by José Damián Ortiz de Castro (1750–93) in the cathedral in Mexico City, and the church of Carmen de Celaya (1802–7), Guanajuato, by FRANCISCO EDUARDO TRESGUERRAS. Other notable Neo-classical buildings include the Loreto Church (1816) and the residence of the Marqués del Apartado (1810) in Mexico City, by Manuel Tolsá, the Hospicio Cabañas (1805) in Guadalajara, the Alhóndiga de Granaditas (1809) in Guanajuato and the convent of S José (1812) in Orizaba. In addition to Ortiz de Castro and Tresguerras, architects associated with Neo-classicism in Mexico include Miguel Costanzó (1741–1810) in Mexico City and JOSÉ MANZO in Puebla. The most important exponent of the style, however, is MANUEL TOLSÁ, who was head of sculpture at the Academia but who was also active as an architect and whose most notable building was the Palacio de Minería (1797–1813; *see* MEXICO CITY, fig. 2).

Following the struggle for independence, the Academia de San Carlos remained closed, with a consequent interruption not only of the teaching of architecture but also of public building, which virtually ceased. It was not until more settled conditions prevailed in 1843 that the govern-

ment of Antonio López de Santa Ana reopened the school, although architectural teaching was not resumed until 1856. Foreign teachers began to be hired, the most notable being the Italian Javier Cavallari (1810–79), who reorganized architectural studies at the Academia in 1857, combining artistic and scientific approaches and promoting an eclectic, historicist approach.

Much of the building of the first decades after independence continued, however, to be influenced by Neo-classicism. In Mexico City, for example, LORENZO DE LA HIDALGA, who settled there in 1838, was responsible for the Teatro de Santa Ana (1842–4; later the Teatro Nacional; destr. 1901) and the Mercado El Volador (*c.* 1852). Also active in the capital were Ramón Rodríguez Arangoiti (1830–84) and the brothers Juan Agea (1825–?1896) and Ramón Agea (1828–?1892), who all returned to work in Mexico after completing their training in Europe and were active during the brief reign (1864–7) of the Habsburg Emperor Maximilian. In the provinces a number of master builders were active, for example Juan Sanabria (*fl c.* 1831), who was responsible for the Caja de Agua (1831), San Luis Potosí; though lacking academic training, such builders had a thorough knowledge of construction techniques and were able to draw their inspiration from the increasingly available European treatises and manuals.

BIBLIOGRAPHY

Three Centuries of Mexican Colonial Architecture (New York, 1933)
D. Angulo Iñiguez, E. Marco Dorta and M. J. Buschiazzo: *Historia del arte hispano-americano*, 3 vols (Barcelona, 1945–56), i, pp. 121–478; ii, pp. 2–42, 480–820
G. Kubler: *Mexican Architecture of the 16th Century*, 2 vols (New Haven, CT, 1948)
M. Toussaint: *Arte colonial en México* (Mexico City, 1948)
G. Kubler and M. Soria: *Art and Architecture in Spain and Portugal and their American Dominions, 1500–1800*, Pelican Hist. A. (Harmondsworth, 1959), pp. 69–82
J. McAndrew: *Open Air Churches of Sixteenth Century Mexico* (Cambridge, 1965)
L. Castedo: *A History of Latin American Art and Architecture* (London, 1969), pp. 104–11, 116–32
E. Marco Dorta: *Arte en América y Filipinas*, A. Hisp., xxi (Madrid, 1973), pp. 127–49
S. D. Markman: *Architecture and Urbanisation in Colonial Chiapas* (Philadelphia, 1984)
E. Wilder Weismann and J. Hancock Sandoval: *Art and Time in Mexico: From the Conquest to the Revolution* (New York, 1985)
R. W. Morse: 'Urban Development', *Colonial Spanish America*, ed. L. Bethell (Cambridge, 1987), pp. 165–202
C. Chanfón: *Historia: Temas escogidos* (Mexico City, 1990)
L. Icaza: *Arquitectura civil en la Nueva España* (Mexico City, 1990)
J. Garciá Lascurain, C. Chanfón Olmos and M. Ponce Zavala: *Il barocco del Messico*, i of Corpus Barocco (Milan, 1991–)
M. Sartor: *Arquitectura y urbanismo en Nueva España, siglo XVI* (Mexico, 1992)
R. J. Mullen: *The Architecture and Sculpture of Oaxaca, 1530s–1980s* (Tempe, 1995)
J. B. Artigas: *Chiapas monumental (veintinueve monografías)* (Granada, 1997)
——: 'La arquitectura virreinal mexicana', *Arquitectura colonial iberoamericana*, ed. G. Gasparini (Caracas, 1997)
R. Gutiérrez, ed.: *Barroco iberoamericana* (Barcelona and Madrid, 1997)
R. J. Mullen: *Architecture and its Sculpture in Viceregal Mexico* (Austin, 1997)

CARLOS CHANFÓN OLMOS

2. AFTER *c.* 1870.

(i) Eclecticism, *c.* 1870–*c.* 1910. (ii) Modernism, *c.* 1910–68. (iii) 1968 and after.

(i) Eclecticism, c. *1870*–c. *1910.* The accession to the presidency of Porfirio Díaz in 1876 brought a period of

national reorganization and economic growth to Mexico, with a significant increase in public building. The railway systems were modernized and enlarged, with new stations being opened, and new factories and manufacturing centres were built. Central and local government buildings and civic amenities appeared in towns. These included markets (such as La Victoria in Puebla, by Julio Sarasibar, or the Hidalgo in Guanajuato, by Ernesto Brunel), hospitals (such as the Maternidad Tamariz, Puebla, by Eduardo Tamariz (1844–86)) and theatres. In some of these works the influence of Neo-classicism continued to be visible: for example in the Teatro Juárez (1892–1903), Guanajuato, by ANTONIO RIVAS MERCADO, with its classical hexastyle portico and life-size statuary on each pedestal of the balustrade, or the Teatro de la Paz (1889–94), San Luis Potosí, by JOSÉ NORIEGA. The façades of the Penitenciaria, Mexico City, by Antonio Torres Torija (1840–1922) from a modified earlier design by Lorenzo de la Hidalga, are also academic in style, although the building itself has an innovative, functional plan, based on the panoptic theories of Jeremy Bentham. In general, however, Beaux-Arts academicism was predominant, and numerous architects came from Europe to Mexico to work both as professionals and as teachers.

In the early 20th century numerous commercial and residential buildings were constructed in the persisting Beaux-Arts style by such architects as Emilio Dondé (1849–1906), while the brothers Nicolás Mariscal and Federico Mariscal (*see* MARISCAL) built in a variety of styles in Mexico City. Several major projects were also initiated to commemorate the approaching centenary of independence. These included the Teatro Nacional (1904–34; now the Palacio de Bellas Artes; see fig. 5), and the Edificio Central de Correos (1902–7), both in Mexico City, by ADAMO BOARI, and the Secretaría de Comunicaciones (1904–11), also in the capital, by SILVIO CONTRI, which later housed the Museo Nacional de Arte. Both Boari and Contri were Italians who had worked in the USA, and the Correos Central exemplifies the eclecticism of the age: four-storey, stone-faced street elevations deriving from Venetian Gothic are topped with *almenas* (battlemented parapets), and the building is entered by a polygonal-headed portal. The monument to *Independence* (completed 1910), however, was built by the Mexican Rivas Mercado, with sculptures by Enrique Alciati. Similar trends were evident in the provinces; REFUGIO REYES, for example, built some important works in Aguascalientes in eclectic styles, notably his domed church of S Antonio (1908).

(ii) Modernism, c. *1910–68.* The Mexican Revolution virtually paralysed the country for ten years, and it was followed by a strong desire for change and modernism, imbued with a profound nationalism. In the field of architecture, desire for change had already been expressed in the magazine *El arte y la ciencia*, founded by Nicolás Mariscal and published in Mexico City between 1899 and 1911. The lectures of Jesús T. Acevedo (1882–1918) at the Ateneo de la Juventud also argued for new attitudes to architecture and a reappraisal of the country's cultural heritage. The formation in 1919 of the Sociedad de Arquitectos Mexicanos strengthened the position of those architects arguing for a change of direction away from

5. Adamo Boari: Palacio de Bellas Artes (formerly Teatro Nacional), Mexico City, 1904–34

academic eclecticism and towards a national and more forward-looking architecture. At the same time the revolutionary movement presented the first post-revolution governments with an urgent architectural agenda in the areas of housing, schools and health. The architect most closely associated with this new direction was JOSÉ VILLAGRÁN, who by 1925 was building the Instituto de Higiene y Granja Sanitaria at Popotla, Mexico City. Completed in 1927, this is a 'white' building, with similarities to some of the works of the early Modern Movement in Europe. It was followed in 1929–36 by the Hospital para Tuberculosos at Huipulco, a suburb of Mexico City, which is innovative not only in its pavilion planning, with open patient verandahs carried on exposed concrete frames, but also in its sparse, uncompromising appearance. These buildings, together with his work from 1926 as Professor of Theory at the Escuela Nacional de Arquitectura, in which he advocated the principles of the useful, the logical, the aesthetic and the social, established Villagrán as one of the most significant and influential figures in Mexican Modernism.

Other architects associated with the socially orientated architecture of the decade after the Revolution include ENRIQUE YÁÑEZ, who designed numerous hospitals, and CARLOS OBREGÓN SANTACILIA, among whose most important works is the Secretaría de Salubridad y Assistencia (1929) in Mexico City, built in an Art Deco style; this style remained popular in the 1930s for major public buildings such as the interiors of Boari's Palacio de Bellas Artes, completed by Federico Mariscal in 1930–34, and several significant buildings by JUAN SEGURA and FRANCISCO J. SERRANO. Obregón was also active in the educational

field, subscribing to the traditional incremental approach in his neo-colonial Escuela Benito Juárez (1925), also in Mexico City. Probably the most significant contribution in this area was made, however, by JUAN O'GORMAN, whose early works in residential architecture, such as the Casa Diego Rivera (1929–30) or his own house (1931–2), both in San Angel, Mexico City, have undoubted affinities with the work of Le Corbusier. Appointed to design a series of schools in 1933, O'Gorman followed a radical line based on functional criteria to ensure the rapid production of inexpensive, standardized buildings that were later adopted by the Comité Administrador del Programa Federal de Construcción de Escuelas and applied to schools throughout the country. His major work of this period, however, is perhaps the Escuela Técnica (1932–4), Mexico City, which was functionally innovative and had affinities in its expression of structure and movement with the work of the Bauhaus. Another work that helped to lay the basis for a functional response to the demands of education was the Centro Escolar Revolución (1934) by Antonio Muñoz García (1896–1965).

In the 1930s there were also the first serious attempts to address the urgent need for low-cost housing. In this area the work of Juan Legarreta (1902–34), who won a competition in 1932 to design a Worker's House and went on to build several housing complexes, is particularly important and again has similarities with the work of the European Modern Movement. Other architects involved in designing low-cost housing include Enrique Yáñez and ENRIQUE DEL MORAL, as well as Alvaro Aburto (1905–76), who worked in rural housing. With a period of stability following the election in 1946 of Miguel Alemán as

President, the first adequate solution was also offered to the urgent need for housing in metropolitan areas with high densities of population. MARIO PANI, who had experience of building private blocks of flats in the mid-1940s, was perhaps the most important architect in this area; he proposed high-rise housing blocks, which were called *multifamiliar* (multi-family) units and which were planned with ample landscape areas and other amenities. The Miguel Alemán housing complex (1949–50) in Mexico City, which consisted of 13-storey blocks providing over 1000 dwellings, is one of Pani's major works and a model of its kind.

The 1940s were also notable for an increasing commitment by Pani and others to the 'plastic integration' movement, in which painters and sculptors collaborated with architects to produce some striking works (see §IV, 2(iv)(a) below). Among the first buildings to result from such a collaboration were the Sindicato Mexicano de Electricistas (1940), on which Enrique Yáñez worked with David Alfaro Siqueiros, and the Escuela Nacional de Maestros (1945–7), on which Pani worked with José Clemente Orozco and Luis Ortiz Monasterio. 'Plastic integration' was also one of the major themes in the design of the Ciudad Universitaria (1948–52). Built on the lava fields of the Pedregal area on what was then the southern edge of Mexico City, the complex was intended to reunite the dispersed parts of the university in a single location and involved more than 60 architects, as well as such artists as Diego Rivera, Siqueiros, Francisco Eppens (*b* 1913), José Chávez Morado and the Colombian-born Rodrigo Arenas Betancourt (*b* 1919). The overall plan was conceived by Pani and Enrique del Moral, who were also responsible, with SALVADOR ORTEGA FLORES, for the 14-storey Rectoría (1951–2) on the highest point of the campus. The exterior of the Rectoría is decorated with murals by Siqueiros, but it is perhaps the stone walls of the 'Frontones' (1952) by ALBERTO T. ARAI, reminiscent of Pre-Columbian pyramid profiles, and Juan O'Gorman's Biblioteca Central (1948–50) with Gustavo Saavedra and Juan Martínez de Velazco (*b* 1924) that best represent the integration of the plastic arts and architecture with the essence of an indigenous culture: the central block of the latter is decorated with O'Gorman's characteristic reliefs and stone mosaics (for illustration *see* O'GORMAN, JUAN). The structural virtuosity of the cosmic ray laboratory (1951) by FÉLIX CANDELA exhibits an interesting solution, while the Estado Olímpico (1950–52), by AUGUSTO PÉREZ PALACIO (with Jorge Bravo (*b* 1922) and Raul Salinas (*b* 1920), with polychrome stone reliefs by Diego Rivera, reflects the pre-Hispanic theme.

The International Style embraced by AUGUSTO H. ALVAREZ and JUAN SORDO MADALENO gained numerous disciples, meanwhile, as the mastery of reinforced concrete led, in Mexico as elsewhere, to numerous works characterized by the lightly framed glass membranes of curtain-wall cladding. Notable examples include the strip-windowed Registro Publico de la Propriedad (1950–52) by Federico Mariscal, the L-shaped Secretaría de Trabajo y Prevision Social (1954) by PEDRO RAMÍREZ VÁZQUEZ and Rafael Mijares (*b* 1922), the Edificio Cremi (1958) by Ricardo de Robina (*b* 1919) and the elegant glass-fronted Pasaje Jacaranda shop (1956), Calle Londres

by TORRES & VELÁZQUEZ, all in Mexico City; the most spectacular work in this genre at the time was the 43-storey, glass-clad Torre Latino Americana (1957) and the Jaysour Building (1962–4) by Alvarez. Other architects producing similar works included Héctor Mestre (*b* 1909), Francisco Artigas and Reinaldo Pérez Rayón (*b* 1918), all active in Mexico City. Dramatic structural solutions also continued to interest ENRIQUE DE LA MORA and, in particular, Félix Candela, for example in the latter's shell-vaulted church of the Virgin of the Miraculous Medal (1955; for illustration *see* CANDELA, FÉLIX, fig. 1), Mexico City, and other avant-garde structures that developed a lyrical form of Modernism, avoiding the prismatic rigidity of international architecture through their imagination and creativity. This interest endured into the 1960s in such works as the Museo Nacional de Antropología (1964; see fig. 6), Mexico City, by Ramírez Vázquez, Rafael Mijares and Jorge Campuzano. Here a monumental umbrella, cantilevered from a single support, covers most of a spacious central patio.

A third major strand in the architecture of the post-war period in Mexico was formed by a group of architects anxious to preserve the diverse national heritage. Of these 'regionalists' it is LUIS BARRAGÁN whose work is most significant, and those who worked with him, for example MAX CETTO. Persistently pursuing beauty and the recovery of local traditions, Barragán used such natural materials as wood, clay and textiles, and vibrant colours and textures combined with light and water to achieve an integrated effect. After a period of building influenced by Le Corbusier, he began work in an innovative direction with his own house (1947) in Tacubaya, where the massive walls counterpoint the small asymmetric openings, reminiscent of vernacular examples. The sculptor Mathías Goeritz wrote the manifesto *Arquitectura emocional* on the occasion of the opening in 1953 of the Museo Experimental 'El Eco', and Barragán adopted Goeritz's title to refer to his own work. They worked together on a group of function-less sculptural towers, 30 to 50 m high, at the entrance to the Ciudad Satélite (1957), a residential area planned by Mario Pani to accommodate 200,000 inhabitants 15 km from the centre of Mexico City. Some of Barragán's most notable projects, however, are primarily concerned with the enhancement and definition of the landscape, as in his

6. Pedro Ramírez Vázquez, with Rafael Mijares and Jorge Campuzano: Museo Nacional de Antropología, Mexico City, 1964

master-plan and gardens at Jardines del Pedregal de San Angel (1945–52), next to the university, or the master-plan and fountains at Las Arboledas residential development (1961).

(iii) 1968 and after. Following social unrest in 1968, there was a desire on the part of the government to create a greater number of buildings in response to social needs, but there was also a desire on the part of many architects to contribute a new vision of the role of architecture. This led to three main trends within Mexican architecture, in addition to the more internationalist works that continued to be produced by such architects as Augusto Alvarez and Juan José Díaz Infante (*b* 1936). The first of these is marked by the use of geometric forms to produce bold structural compositions and is sometimes referred to as 'sculptural architecture'. Perhaps the most important representatives of the style are AUGUSTÍN HERNÁNDEZ, who introduced a more complex geometric vision in his own studio (1971) and MANUEL GONZÁLEZ RUL, whose Gymnasium Gustavo Díaz Ordaz (1968), Mexico City, is a spectacularly innovative solution in which roof slabs lean together. Hernández and González Rul collaborated on the design of the Heroico Colegio Militar (1976), Tlapán, which combines geometric innovation with axial planning on a grand scale and building forms reminiscent of Pre-Columbian models. Alejandro Caso (*b* 1926) and Margarita Caso (*b* 1930) also produced Pre-Columbian-inspired work, such as the impressive Instituto Nacional de Estadística, Geografía e Informática (1989) in Aguascalientes.

A second, functionalist approach used exposed concrete as a means of expression while recalling such traditional architectural elements as the portico and the courtyard. The inaugurators of this style were TEODORO GONZÁLEZ DE LEÓN and ABRAHAM ZABLUDOVSKY, who created the Colegio de México (1974–5; see fig. 7) and the Universidad Pedagógica (1983), but others working in a similar vein include DAVID MUÑOZ SUÁREZ, Francisco Serrano, Gustavo Eichermann (*b* 1935), Gonzalo Gómez Palacio (*b* 1944) and ALEJANDRO ZOHN. A third style is represented

by RICARDO LEGORRETA, who continued to produce 'emotional architecture', applying Barragán's premises—originally intended for a domestic scale—to enormous and complex buildings, such as the Hotel Camino Real (1968), Mexico City, and the serene IBM factory (1975) in Guadalajara. Other architects whose work has an affinity with that of Barragán and Legorreta include Antonio Attolini Lack (*b* 1931), Andrés Casillas (*b* 1937) and Carlos Mijares (*b* 1930), who built some exceptional churches. Following the establishment of these three broad stylistic groupings in the late 1960s and 1970s, however, a younger generation of architects began to attract attention.

Many of these styles continued into the 1980s: such architects as Díaz Infante and Alvarez continued to produce standard glass towers, such as the former's Bolsa de Valores (1990) and the latter's Edificio Parque Reforma (1983), Mexico City. Augustín Hernández's geometric approach developed into a more complex virtuosity with such features as the circular cutaways of the Centro de Meditación (1986) at Cuernavaca and the Casa en el Aire (1988), Bosque de las Lomas, Mexico City. Younger architects working in a similar style included Oscar Bulnes Valero (*b* 1944) and the other members of the Grupo 103: Fernando López Martínez (*b* 1960) and Bernardo Lira Gómez (*b* 1949). Among the group's most notable works is the new addition to the Instituto Tecnológico de Monterrey (1988) in Nuevo León. Of those working in a functionalist idiom, Zohn developed an architecture of surface texture in such buildings as the formally thrusting Archivos del Estado de Jalisco (1989) in Guadalajara, its windowless surfaces finished entirely in lined hammered concrete, as Orso Núñez with Arcadio Artiz used it at the Centro Cultural Universitario (1976–80). Serrano and Rafael Mijares, meanwhile, adopted brickwork as the dominant medium in the buildings, galleries and patios (1984–7) of the Universidad Iberoamericana outside Mexico City. The partnership of Abraham Zabludovsky and González de León was responsible for three banks in Mexico City. González de León also worked with Serrano on a park (1985) in Villahermosa, Tabasco, and the Palacio de Justicia Federal (1992) in Mexico City; and Abraham Zabludovsky on four theatres (1990–92) in the central part of the country.

Ricardo Legorreta's work continued in the 1980s with the screens, patios and pools of another Hotel Camino Real (1981) at Ixtapa, Guerrero, the Museo Marco (1991), Monterrey, the Children's Discovery Museum, San José, CA (1991), and the cathedral of Managua (1993), Nicaragua. Attolini Lack's similar interests are evident in various residences and a factory in Mexico City, where he created an atmosphere of ascetism with spatial richness. This last tendency has become the more dominant, even fashionable; but certain architects can be considered true exponents of regionalism. One such is Enrique Murillo (*b* 1933), who managed to integrate into the Veracruz environment such works as the Central de Autobuses de Jalapa (1989); Juan Palomar (*b* 1956) worked in a similar way in Guadalajara, as did Ricardo Padilla (*b* 1956) and Jorge Estévez (*b* 1955) with a series of houses in the city of Monterrey inspired by the vernacular architecture of the north-east. Among those who produced holiday homes in the tropical areas are Diego Villaseñor (*b* 1944), José Iturbe (*b* 1946), Javier

7. Abraham Zabludovsky and Teodoro González de León: Colegio de México, Mexico City, 1974–5

Sordo (*b* 1956) and Manuel Mestre (*b* 1954), young designers who adapted such local ideas as *palapas* (palm roofs). Finally, in the sphere of urbanism of the type promoted by Luis Barragán, notable figures include FERNANDO GONZÁLEZ GORTÁZAR, with his series of fountains in Guadalajara, and Mario Schjetnan Garduño (*b* 1945), head of the Grupo de Diseño Urbano, who proposed such works as the Parque Tezozómoc (1982) and the Parque Ecológico de Xochimilco (1993).

Notable examples of the formal trend inspired by the Pre-Columbian past include the Universidad de Mayab (1982) in Mérida, Yucatán, planned by Augusto Quijano (*b* 1955) and Alejandro Domínguez (*b* 1956); Eduardo Reyna Medina from Aguascalientes, and the group comprising Jorge Ballina (*b* 1939), José Creixell (*b* 1937) and Fernando Rovalo (*b* 1940), who produced works such as the Universidad Iberoamericana (1988) in Torreón, subscribe to an integral functionalism. Younger generations have been particularly successful in the international avant-garde trends of the late 20th century such as Post-modernism or Deconstruction. Such is the case with the practices of Luis Sánchez (*b* 1944) and Félix Sánchez (*b* 1944) or of Nuño-MacGregor-de Buen, who have offered solutions to housing and transport problems. The workshops TEN and TAX, led by Enrique Norten (*b* 1954) and Alberto Kalach (*b* 1960), have taken a more provocative stance.

The richness and variety of late 20th-century Mexican architecture shows that its practitioners responded to the most important needs of the country and its inhabitants, at the same time searching for suitable technical and aesthetic solutions. In this manner, by using their creativity to maximum effect and by taking into account the cultural and material conditions, they opened the doors to a promising future.

BIBLIOGRAPHY

E. Born: *The New Architecture in Mexico* (New York, 1937)
I. E. Myers: *Mexico's Modern Architecture* (New York, 1952)
C. Obregón Santacilia: *50 años de arquitectura en México* (Mexico City, 1952)
J. Villagrán García: *Panorama de 50 años de arquitectura en México* (Mexico City, 1952)
M. Cetto: *Modern Architecture in Mexico* (New York, 1961)
I. Katzman: *La arquitectura contemporánea mexicana* (Mexico City, 1963)
C. Bamford Smith: *Builders in the Sun: Five Mexican Architects* (New York, 1967)
I. Katzman: *La arquitectura del siglo XIX en México* (Mexico City, 1973)
'Modern Mexican Architecture', *Process Archit.*, 39 (1983) [whole issue]
L. Noelle: *Arquitectos contemporáneos de México* (Mexico City, 1989)
A. Toca Fernández, ed.: *Arquitectura contemporánea en México* (Mexico City, 1989)
E. Yáñez: *Del Funcionalismo al Post-Racionalismo: Ensayo sobre la arquitectura contemporánea mexicana* (Mexico City, 1990)
L. Noelle: *Catálogo guía de arquitectura contemporánea mexicana* (Mexico City, 1993, rev. 1999)
F. González Gortázar, ed.: *La arquitectura mexicana del siglo XX* (Mexico City, 1994)
J. A. Manrique: 'México se quiere otra vez barroco', *Arquitectura neocolonial: América Latina, Caribe, Estados Unidos*, ed. A. Amaral (São Paulo, 1994), pp. 35–46
R. Vargas Salguero: *Afirmación del nacionalismo y la modernidad* (1998), ii/3 of *Historia de la arquitectura y el urbanismo* (Mexico City)

LOUISE NOELLE

IV. Painting, graphic arts and sculpture.

1. 1519–*c*. 1830. 2. After *c*. 1830.

1. 1519–*c*. 1830.

(i) Early colonial, Mannerism and Baroque, 1519–*c*. 1780. (ii) Neo-classicism, *c*. 1780–*c*. 1830.

(i) Early colonial, Mannerism and Baroque, 1519–c. 1780. After the arrival of the first Franciscan missionaries in Mexico in the 1520s, there was an immediate demand for painters and sculptors to decorate the churches and convents erected under their prolific building programme. In the absence of a significant number of European artists, indigenous Indian craftsmen, under the tuition of such missionaries as Fray Pedro de Gante (*see* §XI below) proved remarkably skilful at adapting to the new artistic demands, although indigenous motifs continued to appear in their work, giving it a distinctive character known as *tequitqui* (*see* §II above). Until the middle of the 16th century the only alternative to the works of these indigenous artists was the import of works from Europe, but by 1556 sufficient numbers of European artists had arrived in the colony to form the Guild of Painters and Gilders, partly to protect themselves against exploitation from their ecclesiastical patrons and partly to fend off competition from Indian artists. Other craft guilds, including the Guild of Carpenters, Woodcutters, Joiners and Viol-makers, were established soon after, and as these guilds began to train apprentices in their studios they laid the basis of a stylistic identity distinct from European models. In painting and sculpture, however, which both remained predominantly religious in character throughout the colonial period, similar stylistic divisions into Mannerist, Baroque and Neo-classical periods can be made, even if these periods in Mexican art do not follow exactly the same chronology as in European art. Printmaking remained relatively unsophisticated, however, although the name of one 16th-century printmaker, Fray Diego de Valadés (1533–82), is known, as well as those of a few later exponents. Again the subject-matter consisted largely of religious allegories and devotional images, but it also included coats of arms, maps, portraits, or simple vignettes, usually in the form of small prints inserted in books or more elaborate title-pages and loose prints, engraved on woodblocks or metal sheets.

Although the arrival of the Spanish led to the mutation of traditional indigenous techniques and to such innovations as SUGAR SCULPTURE, probably in the second half of the 16th century, the most significant art form in the colonial period was the RETABLE, on which painters, sculptors, carvers, gilders and joiners collaborated to produce lavish gilded ensembles incorporating paintings on canvas, relief panels and life-size polychrome statues of saints. Most retable workshops were based in Mexico City, at least until the late 18th century, from where completed works would be transported to the provinces, although sometimes a team would be sent out to construct a retable *in situ*. The workshops are relatively well documented, mainly through contracts for work, but as these were signed only by the major artist in the workshop, the names of only a few artists are known; examples include Sebastián de Ocampo, responsible for the retable of the King and Queen in the cathedral in Mexico City, Isidoro Vicente de Balbás, who designed the altarpieces in the church of SS Prisca y Sebastián, the parish church of Taxco, and Pedro Requena, who was responsible with the Flemish painter SIMÓN PEREINS for the retable of the

church of the Franciscan convent at Huejotzingo (see fig. 8). Pereins, who arrived in New Spain in 1566, was one of the most notable painters in the Mannerist style that dominated until the middle of the 17th century, in which both the elegant, idealistic influence of the Italian tradition and the delight in details of the Flemish school are evident. Outstanding among his known contemporaries are ANDRÉS DE LA CONCHA, Baltasar de Echave Orio (*see* ECHAVE) and Luis Juárez (*see* JUÁREZ).

During the Baroque period, from about the middle of the 17th century, sculpture continued to be the dominant art form, with retables characterized by their incorporation of carved spiral 'solomonic' columns rather than by the Plateresque decoration that had characterized the Mannerist period. The carvers and joiners who were responsible for the construction of these retables were also responsible for furnishing the chapels of private individuals with free-standing wooden images and for such other works as the carving of choir-stalls. Notable artists of this period include Salvador de Ocampo (*fl* 1696–1722), who executed the choir-stalls in the convent of San Agustín, and Juan de Rojas, who carved those in Mexico City's Metropolitan Cathedral. During this period, although Indian artists continued to be officially excluded from the

rank of Master, such sculptors as Salvador de Ocampo were taking on registered Indian apprentices, and at least one eminent 17th-century Indian sculptor is documented: Tómas Juárez, responsible for the retable of the Augustinian church in Mexico City.

The painting of the early Baroque period, covering practically the whole of the second half of the 17th century, is characterized by the incorporation of the austere realism of the Spanish school, reinforced by a taste for contrasts in light and the forceful depiction of volumes and clothing, in the manner of Zurbarán, whose work, with that of Ribera and Rubens, became known through the importation of reproductive engravings. Its most notable exponents were SEBASTIÁN LÓPEZ DE ARTEAGA, José Juárez (*see* JUÁREZ) and Pedro Ramirez (*fl* 1633–78). The second phase of the Baroque, covering the transition from the 17th to the 18th centuries, was a brilliant, ostentatious period characterized by paintings that are vibrant in form, with vivid colours and loose brushwork, echoing the splendour and exuberance of the architecture and retables of the period. The outstanding artists of this time, such as CRISTOBAL DE VILLALPANDO and JUAN CORREA, sacrificed correctness of form for a greater expressiveness.

In the 18th century a new form of sculpture was introduced, in which only the heads and the hands were carved and the remainder were simple dummy figures; in the quest for greater realism, wigs, glass eyes and natural teeth began to be used in figure sculpture. The Churrigueresque architectural style is also visible in, for example, the construction between 1718 and 1737 of the retable of the chapel of the Kings in the cathedral of Mexico City by Jerónimo de Balbás (*see* §III, 1(ii) above). In painting the late Baroque period was marked by the development of a softer and more sentimental style, which, because of its greater delicacy and emotionalism, has been interpreted as a response to the art of Murillo. This style, whose early exponents included Nicolás Rodríguez Juárez and Juan Rodríguez Juárez (*see* JUÁREZ), flourished until the last third of the 18th century, when it began to lose ground to the energetic thrust of Neo-classical court painting. The outstanding painters of this period include JOSÉ DE IBARRA, MIGUEL CABRERA, Francisco Antonio Vallejo (*fl* 1752–84) and José de Alcíbar (1730–1810).

Although painting during the late Baroque period remained predominantly religious in character, there are significant examples of portraiture, and although only isolated works or simple references survive, it seems that still-life was practised, for example by Antonio Pérez de Aguilar (e.g. *Still Life*, n.d.; priv. col.), as well as landscape painting and representations of historical, mythological and folk themes. Although such compositional considerations as the use of diagonal axes are visible in Baroque painting, both to articulate the figures or elements that compose the scenes and to endow these with an element of dynamism, nevertheless it is impossible to claim that painting in Mexico at this time shows dynamic movement or broad perspective. In the peaceful postures of the figures there is reserve and elegance but little anatomical exactness and an over-reliance on archetypes.

ROGELIO RUIZ GOMAR

8. Pedro Requena, Simón Pereins and assistants: main retable, gilded wood, *c.* 1586, church of the Franciscan convent, Huejotzingo, Mexico

(ii) Neo-classicism, c. 1780–c. 1830. The founding in 1783 of the Academia de las Nobles Artes de S Carlos in Mexico City symbolized the demise of the Baroque in Mexico and its official supersession by Neo-classicism; it also heralded the disappearance of the guilds and a consequent restructuring of the system of artistic production. As the endorsement of an academic training became essential to secure patronage, the Academia became an official arbiter of taste and regulator of artistic production, particularly in Mexico City, although artists trained in the guilds continued for many years to work alongside those who had received an academic education. The works of the former usually appeared more old-fashioned as well as exhibiting 'errors' of draughtsmanship and perspective for which they were later highly esteemed when an anti-academic mood became dominant in the 1920s. The Academia's influence was not confined to Mexico City, however, since the academic community in the capital also set the stylistic parameters that were eventually followed in provincial centres of production, especially those in which local academies were established under the direction of artists trained at the Academia. In Puebla, for example, where the local academy maintained cordial relations with the Academia in Mexico City, the transition from Baroque to Neo-classicism was consolidated by the baldacchino of the cathedral (1797–1819) by MANUEL TOLSÁ, director of sculpture at the Academia de San Carlos. This work is a fine example of the abandonment of the traditional retable, made of gilded wood with statues of decorated, polychromed wood, in favour of an altar of stone, brick and stucco, with statues in bronze, stone or wood that imitated 'refined' materials, in accordance with Neo-classical taste.

Although religious iconography continued to play a leading role due to the dominant influence of the Roman Catholic Church in Mexican life, a secularizing tendency was immediately apparent in the early Neo-classical period. One of the outstanding examples of sculpture in this period, for example, is the monumental bronze equestrian statue of *Charles IV* (1796–1803; see fig. 9) by Tolsá, beside the Museo Nacional de Arte in Mexico City. Mythological themes abounded in academic drawings, while scientific and archaeological drawings were cultivated by such artists as Atanasio Echevarría and José Luciano Castañeda, who had trained at the Academia de S Carlos and also been involved with the expeditions organized by the Spanish Bourbon monarchy to record the natural resources and cultural wealth of Hispanic America. By the end of the 18th century there were also a number of well-known Indian sculptors, including PEDRO PATIÑO IXTOLINQUE and Santiago Cristóbal Sandoval, who worked on the sculptures for the tower of the cathedral of Mexico City. In the graphic arts, among those who trained at the Academia de S Carlos under the Sevillean José Joaquín Fabregat (1748–1807), historical and allegorical topics were also predominant, but popular printmaking continued for many years simply to respond to demands for the representation of devout images. In painting, the outstanding figure of the Neo-classical period was RAFAEL XIMENO Y PLANES, who was Director General of the Academia and who created the prototype of the modern portrait, without identifying inscriptions or heraldic signs and concentrating entirely on re-creating the

9. Manuel Tolsá: *Charles IV*, bronze, 1796–1803, Plaza Manuel Tolsá, Mexico City

model, as in his portrait of *Manuel Tolsá* (*c.* 1795; Mexico City, La Profesa). Ximeno's pupils, however, and provincial artists had to submit to tradition and their clients' demands, and the use of inscriptions, which detracted from the illusory effect and bestowed a certain archaic air, continued in their portraits for several decades.

The founding of the Academia de S Carlos and the adoption of Neo-classicism were partly inspired by the same Enlightenment ideas that provided the stimulus for the political emancipation of Mexico in 1821, and for the first few years after independence Neo-classical ideals continued to provide the models for the design of the first allegories of the new nation and the portraits of its first rulers (e.g. the anonymous portrait of the *Liberator Agustín de Iturbide*, 1822; Mexico City, Mus. N. A.).

FAUSTO RAMÍREZ

BIBLIOGRAPHY
J. Morena Villa: *La escultura colonial mexicana* (Mexico City, 1942)
M. Romero de Torreros: *Grabados y grabadores en la Nueva España* (Mexico City, 1948)
M. Toussaint: *Arte colonial en México* (Mexico City, 1949, rev. 1961; Eng. trans., Austin, TX, 1967)
E. Wilder Weismann: *Mexico in Sculpture, 1521–1821* (Cambridge, MA, 1950)
P. Kelemen: *Baroque and Rococo in Latin America* (New York, 1951)
F. Cal'i: *The Art of the Conquistadors* (London, 1961)
M. Toussaint: *Pintura colonial en México* (Mexico City, 1965)
Y. Bottineau: *Ibero-American Baroque* (London, 1971)
G. Tovar de Teresa: *Pintura y escultura del renacimiento en México* (Mexico City, 1979)
E. Wilder Weismann and J. Hancock Sandoval: *Art and Time in Mexico: From the Conquest to the Revolution* (New York, 1985)

M. Burke: *Arte Novohispano. Pintura y escultura en Nueva España: El barroco* (Mexico City, 1992)

G. Tovar y Teresa: *Pintura y escultura en Nuevo España, 1557–1640* (Mexico City, 1992)

Arte y mística del barroco (exh. cat., Colegio S Ildefonso, Mexico City, Antigua, 1994)

R. Gutiérrez, ed.: *Pintura, escultura y artes útiles en Iberoamérica, 1500–1825* (Madrid, 1995)

Converging Cultures: Art and Identity in Spanish America (exh. cat., New York, Brooklyn Mus., 1996)

G. Tovar de Teresa, ed.: *Repertory of Artists in Mexico*, 3 vols (Mexico, 1997)

ROGELIO RUIZ GOMAR

2. AFTER c. 1830.

(i) Romanticism, *c.* 1830–*c.* 1870. (ii) Realism and political art, *c.* 1870–*c.* 1895. (iii) Modernism, *c.* 1895–1920. (iv) Mexican Renaissance, 1920–*c.* 1950. (v) *c.* 1950 and after.

(i) Romanticism, c. *1830*–c. *1870.* Almost immediately after Mexican independence, two versions of romanticism arose. One was a form of nationalist romanticism, which concentrated on the depiction of regional subjects, landscapes and local people and customs in contrast to the universalizing, timeless pretensions of Neo-classicism. A major centre for this regionalist painting was Puebla, where AGUSTÍN ARRIETA, who had trained at the local academy, was active, and in the 1830s paintings of urban scenes by such artists as JOSÉ MANZO and José María Fernández were in great demand in Puebla. Regional themes and character types, as well as urban and rural landscapes, were subjects freely treated in painting and lithography—introduced into Mexico by the Italian Claudio Linati in 1825—by DANIEL THOMAS EGERTON and other 'travelling artists' who, with the opening of the borders after independence, flocked to Mexico between 1820 and 1850. Linati's prints, like those of Karl Nebel (?1800–65) and FREDERICK CATHERWOOD, though directed principally at a European audience, at the same time encouraged local ventures by commercial engravers. In the lithographs printed in workshops set up in the 1830s and 1840s by French and domestic entrepreneurs, there were evident borrowings from the albums of the 'travelling artists'. Mexican lithography reached its maturity with such collections as *Los mexicanos pintados por sí mismos* (1854–5; engravings by HESIQUIO IRIARTE) and *México y sus alrededores* (1855; lithographs by CASIMIRO CASTRO and others).

A different form of romanticism developed in the capital, however, where, amid a period of political instability, the Academia de S Carlos was reorganized in 1843. In 1846 PELEGRÍN CLAVÉ and MANUEL VILAR arrived from Europe to take over the teaching of painting and sculpture, respectively. They succeeded in training a substantial group of students who were stylistically affiliated to the Nazarenes and *Purismo*, perhaps the style most suited to the expressive requirements of the conservative Catholic group that dominated the Academia until 1867. Although the iconography of Clavé's school did not avoid mythological and secular subjects, the Old and New Testaments were its principal source of inspiration. Artists used biblical stories of family dissent and the battles of the Jewish people to reflect, with varying degrees of deliberateness, contemporary political and ideological clashes, as in such paintings as the *Hebrews in Babylonian*

Captivity (1857; Mexico City, Pal. B.A.) by Joaquin Ramírez (*d* 1886). There was no desire among painters to treat contemporary themes directly, however, or to treat national historical themes. In contrast, in sculpture Vilar portrayed figures of national history and heroes of Pre-Columbian antiquity and national independence (e.g. *Motecuhzuma II*, 1850; Mexico City, Mus. N.A.). Landscape painting was comparatively neglected at the Academia until the arrival in 1856 of the Italian EUGENIO LANDESIO; his most notable pupils included Luis Coto (1830–91) and José María Velasco (*see* §(ii) below).

(ii) Realism and political art, c. *1870*–c. *1895.* The period of peace and prosperity that accompanied the 35-year presidency of Porfirio Díaz acted as an effective force of cohesion for the national consciousness and led to a new interest in archaeology and Mexican history. In the fine arts the secularizing trends of the republican system and positivism ended the primacy of biblical iconography and replaced it with subjects from European or Mexican history. The portrayal of episodes from Pre-Columbian history and from the Spanish conquest became especially popular from *c.* 1870, for example in the work of FÉLIX PARRA (see fig. 10). The idealism of the school of Clavé, which can still be detected in such paintings as the *Discovery of Pulque* (1869; Mexico City, Pal. B.A.) by José María Obregón (1832–1902), gradually gave way to the increasingly realistic portrayal of native types, for example in the *Tlaxcala Senate* (1874; Mexico City, Mus. N.A.) by RODRIGO GUTIÉRREZ; this tendency culminated in a sort of quasi-photographic naturalism exemplified by the *Founding of Mexico City* (1889; Mexico City, Mus. N.A.) by JOSÉ JARA. Landscape painting also developed from the romanticism of Landesio (e.g. the *Valley of Mexico*, n.d.; Mexico City, Mus. N.A.) to the quasi-scientific objectivism demonstrated by José María Velasco in his treatment of the same subject (for illustrations *see* VELASCO, JOSÉ MARÍA, and colour pl. XL, fig. 1). Through the influence of realism (encouraged by the popularity of photography), the use of identifying inscriptions was abandoned even in provincial portraits, and the close examination of faces and personalities was intensified, as in the penetrating portraits of HERMENEGILDO BUSTOS (e.g. *Doña Severa Morán de Quintana*, 1894; Mexico City, Pal. B.A.). Moreover, a new interest in domestic issues led to a greater treatment of regional topics, even within the Academia itself, renamed the Escuela Nacional de Bellas Artes in 1867. Political stability and economic prosperity led also to a flourishing of monumental sculpture. Both in the capital and the provinces statues were erected to the heroes of independence and reform, and even to inspirational native historical figures, as in the monument to *Cuauhtémoc* (1878) by MIGUEL NOREÑA in the Paseo de la Reforma, Mexico City, a balanced synthesis of idealistic conception and realistic detail.

In academic etchings, after 1879 a new importance was attached to original compositions. The most important graphic work in this period, however, was in political etchings and popular prints. Outstanding were the political caricatures in such polemical periodicals as *La orquesta* and *El hijo de Ahuizote*, which contained work by CONSTANTINO ESCALANTE and SANTIAGO HERNÁNDEZ.

10. Félix Parra: *Episodes of the Conquest*, oil on canvas, 683×1095 mm, 1877 (Mexico City, Museo Nacional de Arte)

Opposition to the government of Porfirio Díaz later inspired such caricaturists as Daniel Cabrera (1858–1914) and Jesús Martínez Carrión (1860–1906). At the same time the subject-matter of the popular print broadened considerably: to illustrate posters and pamphlets discussing the most important or sensational events of the day and addressed to a largely uneducated mass audience, such publishers as Antonio Vanegas Arroyo contracted the services of Manuel Manilla (1830–95) and JOSÉ GUADALUPE POSADA, the most notable popular engravers in the 19th century in Mexico.

(iii) Modernism, c. 1895–1920. By the end of the 19th century a growing scepticism towards science and the search for a faith that would replace lost religious beliefs led to the adoption by several artists and intellectuals of many of the attitudes of the Aesthetic Movement in Europe as they struggled to penetrate beneath surface reality in a manner similar to that of the Symbolists. Seeking to achieve a subjective and lyrical art but unable to find adequate models to express their new concept of reality in local tradition, they increasingly turned to European art for models. In Mexico, therefore, the advent of modernism represented a deliberate, violent break with the art of the immediate past.

The first signs of a change in style and attitude became evident *c.* 1895 in sculpture. The allegorical, sensual, female nudes of JESÚS F. CONTRERAS, filled with anguish and suggesting complex states of mind, were treated in an impressionistic manner similar to that of Rodin (e.g. *Malgré tout*, 1898; Mexico City, Mus. N.A.). Other young sculptors followed and continued to work in this style until *c.* 1920.

Meanwhile, in painting and the graphic arts JULIO RUELAS, who studied in Germany, popularized the taste for the new stylistic trends among such young artists as ROBERTO MONTENEGRO and Angel Zárraga (1886–1946) through his illustrations (1898–1911) in the *Revista moderna*. Other painters, such as GERMÁN GEDOVIUS, who also studied in Germany, and Alberto Fuster (1870–1922), explored other forms of Symbolism, although in an eclectic manner they also absorbed the chromatic and compositional lessons of Impressionism and Post-Impressionism. The presence of these artists as teachers in the Escuela Nacional de Bellas Artes helped the rapid institutionalization of stylistic change, which was consolidated by the following generation.

Another particularly strong influence on young artists was DR ATL, through both his synthesizing vision of the Mexican landscape and his anarchistic social ideas. Atl's search for new forms of expression in the local landscape and Gedovius's exploration of surviving elements of the culture of the Viceroyalty, together with the insistence of ANTONIO FABRÉS on the portrayal of ordinary people by the students, laid the basis for the start *c.* 1910 of the second phase of modernism. This was an attempt to draw on Symbolism and Post-Impressionism to express what these artists called 'the national soul'. The 'cosmopolitan' iconography of the first phase of modernism, incorporating such elements as the *femme fatale*, the struggle between the sexes and an obsession with death and the macabre, was transformed into recognizably national themes, while retaining their Symbolist, intimist and spiritual significance. It was SATURNINO HERRÁN who most eloquently expressed these aesthetic ideals in such works as *La tehuana*

(1914; Aguascalientes, Mus. Aguascalientes). This modernist nationalism, which has affinities with other forms of Symbolist regionalism (such as the work of Ignacio Zuloaga y Zabaleta and other Spanish artists popular in Mexico at that time), reached its climax in the second decade of the 20th century, coinciding with the profound emotional and cultural upheaval caused by the Mexican Revolution. While a few artists sought to go beyond the movement's stylistic horizon, their work had no effect on Mexican art at the time. However, JOSÉ CLEMENTE OROZCO was already starting his experiments in expressionistic deformation, and DIEGO RIVERA and Angel Zárraga (1886–1946), who spent the tumultuous years of the Revolution in Europe, had a substantial Cubist phase between 1913 and 1918, with Rivera producing such works as *Zapatista Landscape (The Guerrilla*; 1915; Mexico City, Mus. N.A.).

(iv) Mexican Renaissance, 1920–c. 1950. Artistic expression after the Mexican Revolution was strongly influenced by political and social revolutionary ideals, including a strong nationalist consciousness. This coincided with the assimilation of the formal lessons propounded by the European avant-garde movements of the preceding decades and resulted in what is known as the Mexican Renaissance. During this period artists were concerned with the restatement of surface in pictorial space, achieved either through the stressing of the decorative or expressive value of line and colour or through the analytical dismantling and geometric reordering of forms, following Cézanne and the Cubists. In very few works was there a desire to suggest mobility and simultaneity in the manner of the Futurists. Another overwhelming influence was the desire to draw inspiration from 'primitive' art (which for the Mexicans often meant Pre-Columbian culture) and from the spontaneity of native and mestizo folk arts and crafts. Possibly as a result of these influences, Mexican art between 1920 and the end of the 1950s remained predominantly figurative, with very few artists experimenting with abstraction.

(a) Mural painting. Another major influence of the post-revolutionary period was the public, socializing role and the need to address a vast but uneducated audience that the most important artists assigned to their work, while on an intellectual level a statement made in the journal *El machete* in December 1923 by the signatories to the Manifesto of the Union of Technical Workers, Painters and Sculptors, who included Rivera, Orozco and DAVID ALFARO SIQUEIROS, rejected the limited private consumption of art. For these artists monumental painting on the walls of public buildings epitomized public art, and they received official support for their artistic beliefs from José Vasconcelos, the Minister for Education in the government (1920–24) of Alvaro Obregón. As part of an ambitious cultural plan, Vasconcelos urged expatriate Mexican artists to return and collaborate on his programme for the mural decoration of public buildings. Although from the outset, then, Mexican muralism was inextricably linked to the official requirements of the post-revolutionary government, the artists involved were eager to express their own ideas. Many of them were highly political (some

were affiliated to the incipient Mexican Communist Party) and saw art as an instrument of social and cultural revolution and a means of influencing the public life of the country. Apart from Orozco, Rivera and Siqueiros, other artists of what became known as the Mexican school included FERNANDO LEAL, Fermín Revueltas (b 1903), RAMÓN ALVA DE LA CANAL and ROBERTO MONTENEGRO (for illustration *see* MURAL).

For as long as these artists maintained a dialectical relationship with officialdom the mural movement remained alive; when it became a submissive mouthpiece of the state, however, it degenerated into neo-academic rhetoric. During Vasconcelos's term as Secretary for Education, there were experiments with various themes and techniques. The greatest activity was concentrated on educational institutions, such as the Escuela Nacional Preparatoria, on which Orozco and Rivera worked, and the former convent of SS Pedro y Pablo, Mexico City, the cradle of Mexican muralism. Historical and allegorical themes, frequently echoing religious iconography, then gave way to the monumental celebration of 'the work and days' of the Mexican people, the theme of Rivera's murals (1923–8) in the Ministry of Public Education. Stylistic influences ranged from Renaissance mosaics and Florentine murals to modern Synthetism and post-Cubist spatial organization, but also included Pre-Columbian and colonial influences. From 1925 to 1933 the muralists met with hostility from the right-wing government of Plutarco Elías Calles and his immediate successors, and only a few remained active. One of these was Rivera, who around this time created some of his greatest works, such as the murals (1926–7) in the former Jesuit chapel and administration building of the Esculea Nacional de Agricultura (now the Universidad Autónoma) at Chapingo (*see* RIVERA, DIEGO, fig. 2) and the central staircase (1930) of the Palácio Nacional. Others, including Orozco, decided to leave the country, while others again, such as Siqueiros, applied themselves completely to trade-union battles.

From the mid-1930s there was a new rapprochement between artists and government in response to the rise of Fascism in Europe, and, during the government (1934–40) of Lázaro Cardenas, the mural movement was rejuvenated, with commissions for the decoration of markets, union headquarters, state schools and other public spaces. The radical, anti-Fascist, anti-clerical and anti-imperialistic iconography that developed continued to prevail until the end of World War II, when new patrons arose for what was by that time recognized nationally and internationally as an exciting and distinctive form of artistic expression. Commissions followed for the decoration of banks, office buildings, factories, hotels and luxury restaurants, as well as for union buildings (*see* SIQUEIROS, DAVID ALFARO, fig. 2) and for municipal government buildings (*see* OROZCO, JOSÉ CLEMENTE, fig. 2). One of the most interesting later projects was the exterior decoration of some of the buildings of the new university campus in Mexico City built in 1948–52, which posed a double challenge: resistance to the elements and integration with the architecture in accordance with the aims of the 'plastic integration' movement (*see* §III, 2 above). While this led to some interesting works by such artists as JOSÉ CHÁVEZ MORADO and Juan O'Gorman, such as the latter's use of mosaic in

his design for the library of the Ciudad Universitaria (1948–50; for illustration *see* O'GORMAN, JUAN), muralism was soon to become a spent force.

(b) Graphic arts. The graphic arts in this period followed a more or less parallel course to that of muralism. In 1921 JEAN CHARLOT arrived in Mexico from France, fully versed in modern wood-engraving techniques. He also admired late medieval woodcuts as well as popular Japanese prints, and he was one of the first to 'rediscover' Posada's graphic work. By 1922 Charlot, Fernando Leal and Gabriel Fernández Ledesma (*b* 1900) were carving with the grain (*bois au fil*) on woodblocks, producing unprepossessing, deliberately coarse figures on backgrounds lined with deeply marked indentations and using brutal contrasts between black and white. This woodcutting technique became widespread in the following years. It was encouraged in open-air schools of painting (*see* ESCUELAS DE PINTURA AL AIRE LIBRE) and in the popular centres of painting that were opened in the mid-1920s in districts of Mexico City to provide art education for young workers, seeking to preserve and cultivate a deliberate simplicity in the works produced there. The same technique was adopted for political illustrations published in opposition newspapers such as *El machete* and in posters and leaflets, such as those published in 1928 by the !30-30¡ group, to which many of the muralists belonged. The search for low-cost materials also led to the use of linocut engraving. Many of the same artists also produced prints in a style influenced by Cubism and Futurism to illustrate

11. Alberto Beltrán: *Song of the Miners Parade*, linocut, 362×285 mm (Austin, TX, University of Texas, Jack S. Blanton Museum of Art)

books and journals by the ESTRIDENTISMO group of avant-garde artists and poets. Other influences on the graphic arts in the 1920s and 1930s included the posters and typographical compositions of the Soviet Constructivists and, as early as the 1930s, photomontage, which was almost always used for purposes of social criticism. Lithography and metal and wood engraving, which lent themselves to a fine, nuanced treatment of line and colour as opposed to the rustic conciseness of the woodcut, were also given a new lease of life around the mid-1920s by the work of some young graduates of the Escuela Nacional de Bellas Artes, such as Emilio Amero (*b* 1910) and CARLOS ALVARADO LANG, and by some of the muralists, such as Orozco and Siqueiros.

The intensive politicization of the 1930s and consequent use of graphic art as an ideological weapon, together with the desire to investigate collectively the techniques of graphic arts, led to the founding in 1937 of the TALLER DE GRÁFICA POPULAR by a group of artists led by LEOPOLDO MÉNDEZ and PABLO O'HIGGINS. In the following 20 years they produced an enormous quantity of leaflets, posters, books and portfolios of prints, often of great dramatic force, such as *Song of the Miners' Parade* (linocut, n.d.; see fig. 11) by ALBERTO BELTRÁN.

(c) Easel painting. Although easel painting was rejected by the muralists in their manifesto in 1923, many artists continued to use the medium for formal experimentation, for intimist introspection or to depict everyday life, while it enabled the muralists to make copies or small-scale variations of their monumental compositions. In particular, easel painting was a more suitable medium for those artists whose work was essentially lyrical rather than epic and for those who did not share the muralists' radical political ideas, such as MANUEL RODRÍGUEZ LOZANO, JULIO CASTELLANOS, Abraham Angel, AGUSTÍN LAZO, ANTONIO RUIZ, MARÍA IZQUIERDO and RUFINO TAMAYO. For these artists there was no conflict between the desire to express nationalist subjects profoundly and intensely and the assimilation of the most creative developments in European art between the wars. The refined lyricism of these artists constitutes a sort of neo-Symbolism, invested with a renewed formal language derived from the European avant-garde and from a re-evaluation of aspects of Mexico's indigenous art traditions. In this reappraisal the fantastic was an important element. As Fascism advanced, and as the world of the muralists and their associates became more enclosed, many Mexican artists felt drawn to introspection, for example FRIDA KAHLO in such works as *My Grandparents, My Parents and I (Family Tree*; see fig. 12), and this led to some of the clearest expressions of Surrealism in Mexican art. In January 1940 the Exposición Internacional del Surrealismo opened in the Galería de Arte Mexicano, Mexico City, inspired by André Breton, who had visited Mexico in 1938 and met Rivera and Kahlo as well as Leon Trotsky, who had taken refuge in Coyoacán. The exhibition was organized by WOLFGANG PAALEN and the Peruvian César Moro and included, alongside the work of internationally known artists, a number of Mexican paintings and the work of an exceptional photographer, MANUEL ALVAREZ BRAVO. The growth of Surrealism in Mexico was given impetus

12. Frida Kahlo: *My Grandparents, My Parents and I (Family Tree)*, oil and tempera on metal panel, 307×345 mm, 1936 (New York, Museum of Modern Art)

by the arrival of some European artists connected with the movement, such as Paalen, LEONORA CARRINGTON, Alice Rahon (1916–87) and REMEDIOS VARO, who were fleeing from Fascism and the war. Meanwhile CARLOS MÉRIDA, working in isolation, explored both abstract forms of expression and elementary figurative styles, with occasional suggestions of Surrealist influences, for example in *Plastic Invention on the Theme of Love* (1939; see colour pl. XXII, fig. 1).

(d) Sculpture. There was comparatively little significant development in sculpture during this period, despite the patronage offered by the state from the 1920s, beginning with the decoration of the Ministry of Public Education by IGNACIO ASÚNSOLO and Manuel Centurión (1883–1952). One reason for this was the absence of a charismatic leader among sculptors. In the 1920s such French neo-classical sculptors as Aristide Maillol (1861–1944), Charles Despiau (1874–1946) and Emile-Antoine Bourdelle (1861–1929) began to replace Rodin as the major influence for Mexican sculptors, for example in the works of

Asúnsolo, Centurión and Fidias Elizondo (*b* 1909). This led to younger artists, trained in Europe under José de Creeft, realizing the importance of the European reappraisal of direct carving. Such sculptors as Guillermo Ruiz (*b* 1896) and Carlos Bracho (1899–1966) explored Pre-Columbian sculpture and sought to make it the basis on which to create an authentically Mexican style. On his return from Europe, Ruiz founded in 1927 the Escuela de Talla Directa y Escultura in a working-class area of Mexico City, seeking to incorporate into its teaching the carving techniques of the stonecutters and to investigate the possibilities of direct carving, in a response to the demotic and the spontaneous. The most representative of the sculptors inspired by tradition and producing work with a strongly artisan flavour was Mardonio Magaña (1866–1947). GERMÁN CUETO was the only Mexican sculptor familiar with the work of Brancusi, Jacques Lipchitz and Julio González and the only sculptor to experiment during this period with abstraction. Given the dominance of different versions of realism, however, the isolation in which he worked is not surprising.

FAUSTO RAMÍREZ

(v) c. *1950 and after.* In the 1950s Mexican art changed direction again, as such artists as JOSÉ LUIS CUEVAS, ALBERTO GIRONELLA, Vlady (*b* 1920), MANUEL FELGUÉREZ and Vicente Rojo, who had spent some of their formative years studying in Europe or the USA, became increasingly impatient with the dogmatism of the Taller de Gráfica Popular and with the muralists and the supremacy of their didactic–figurative rhetoric. Seeking to break with the immediate artistic past and sparing from their disdain only such independently minded figures as Tamayo, Mérida and Orozco, these younger artists applied themselves to experimenting with contemporary aesthetic ideas and with avant-garde developments, such as abstraction, which had been neglected during the 1920s. The value of Germán Cueto's experimental attitude began to be recognized, and MATHÍAS GOERITZ prefigured Minimalism in such sculptures as *Snake* (1953; Mexico City, Mus. A. Mod.). Mexican cultural policy, under the government of Miguel Alemán, without denigrating the achievements of the Mexican Renaissance, gradually began to promote more subjective, existentialist artistic trends, better suited to the government's modernizing, internationalist pretensions. This new direction was epitomized by the official recognition of the value of such artists as Tamayo, who had opposed the politicization of art, and by the transformation of muralism into a straightforward figurative synthesis, close to geometric abstraction, for example in the work of Carlos Mérida, who covered Mario Pani's housing units with concrete mosaics. Although younger artists were obliged to establish their reputations without help from official recognition, they managed, largely through self-promotion (*see* §IX below), gradually to acquire prestige and legitimacy, both nationally and internationally, finally triumphing over the established order in the major exhibition *Confrontation 66*.

In 1968, however, the government of Gustavo Días Ordaz brutally suppressed the expressions of social discontent, to which a new generation of art students had given voice in a short period of anonymous, fiery and sharply political artistic production. This led indirectly to the rise of a number of heterogeneous associations of artists and theoreticians known collectively as 'the groups'. These associations, which included the Suma group and the Pentagon Process, were inspired by social concerns and the rise of international conceptual art, and they produced work that was clearly urban and populist in content and approach, using such innovative forms as installations, performance art and happenings. Their work, which was often ephemeral, sought to involve social groups normally untouched by aesthetic developments through artistic activities intended to arouse people's political consciousness and increase their aesthetic perception of everyday urban life. In the more conventional art forms, many artists in the 1960s and 1970s were interested in geometric art and in Minimalism. These influences extended not only to painting and printmaking but also to monumental urban sculpture, as in such works as *La ruta de la amistad* (the 'Road to friendship'), a collaborative sculptural project in Mexico City of 1968, and the Centro del Espacio Escultórico building (1979–80) at the Universidad Nacional Autónoma de México. In these monumental sculptural works the artists responsible sought to

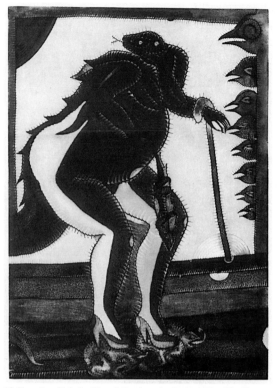

13. Francisco Toledo: *Four Prints from the Guchachi Portfolio (Iguana)*, etching and aquatint with printed colours, 759×562 mm, 1976 (Austin, TX, University of Texas, Jack S. Blanton Museum of Art)

make the urban landscape more human, taking the work of Goeritz as their inspiration.

Around the end of the 1970s and throughout the 1980s there was a revival of painting and sculpture in more traditional formats better suited to a commercial environment. These showed numerous diverse stylistic tendencies, ranging from different types of abstraction to a hyper-realistic figurative style. Although these can be seen to constitute part of a wider renewal of interest in figurative art, some aspects of conceptual art remained important. One of the most important artists of this period was FRANCISCO TOLEDO, a Zapotec Indian who drew heavily on the fauna and mythology of the Oaxaca region for inspiration, for example in his *Four Prints from the Guchachi Portfolio (Iguana)* (1976; see fig. 13). In the mid-1980s a movement known as Neo-Mexicanism arose, which, in a manner similar to other versions of Post-modernism, delighted in allusion and pastiche, integrating elements of the nationalist, popular iconography of the 1920s into a more personal and less political style. The most notable artist associated with the movement, which enjoyed great commercial and critical success both nationally and internationally, was Nahum B. Zenil (*b* 1947), whose images were highly modern and at the same time deeply rooted in national traditions.

See also LATIN AMERICAN ARTISTS OF THE USA.

FAUSTO RAMÍREZ, with KAREN CORDERO REIMAN

BIBLIOGRAPHY

J. Fernández: *Arte moderno y contemporáneo de México* (Mexico City, 1952)

Mexican Art (exh. cat., by F. Gamboa and S. Linné, London, Tate, 1953)

B. Myers: *Mexican Painting in our Time* (New York, 1956)

J. Charlot: *Mexican Art and the Academy of San Carlos, 1785–1915* (Austin, TX, 1962)

——: *The Mexican Mural Renaissance* (New Haven and London, 1963)

E. Edwards: *The Painted Walls of Mexico* (Austin, TX, 1966)

A. Rodríguez: *A History of Mexican Mural Painting* (New York and London, 1969)

S. F. Goldman: *Contemporary Mexican Artists in a Time of Change* (Austin and London, 1977)

——: *Contemporary Mexican Painting in a Time of Change* (Austin, 1981/ R Albuquerque, 1995)

H. Covantes: *El grabado mexicano en el siglo XX, 1922–1981* (Mexico City, 1982)

Wand Bild Mexico (exh. cat., ed. H. Kurnitzky and B. Beck; W. Berlin, Staatl. Museen Preuss. Kultbes., 1982)

J. Fernández: *El arte del siglo XIX en México* (Mexico City, 1983)

I. Rodríguez Prampolini: *El surrealismo y el arte fantástico de México* (México City, 1983)

E. Acevedo and others: *Guía de murales del centro histórico de la ciudad de México* (Mexico City, 1984)

F. Ramírez: *La plástica del siglo de la independencia* (Mexico City, 1985)

Surrealistas en México (exh. cat., Mexico City, Mus. N.A., 1986)

E. Uribe and others: *Y todo por una nación: Historia social de la producción plástica de la ciudad de México, 1780–1910* (Mexico City, 1987)

Ruptura, 1952–65 (exh. cat. by F. Ramírez and others, Mexico City, Mus. A. Carrillo Gil, 1988)

Art in Latin America: The Modern Era, 1820–1980 (exh. cat. by D. Ades, London; S. Bank Cent.; and elsewhere; 1989)

La escuela mexicana de escultura: Maestros fundadores (exh. cat. by A. Arteaga and others, Mexico City, Pal. B.A., 1990)

1910: El arte en un año decisivo: La exposición de artistas mexicanos (exh. cat. by F. Ramírez and others, Mexico City, Mus. N. A., 1991)

Modernidad y modernización en el arte mexicano, 1920–1950 (exh. cat. by O. Debroise and others, Mexico City, Mus. N. A., 1991)

R. Eder: 'La pintura Mexicana entre 1910 y 1960: Lo épico, lo popular y lo íntimo', *Voces de Ultramar: Arte en América Latina, 1910–1960* (exh. cat., Madrid, Casa América; Las Palmas de Gran Canaria, Cent. Atlántic. A. Mod., 1992), pp. 63–70

M. L. Sabau García, ed.: *México en el mundo de las colecciones de arte*, vols v–vii (n.p., 1994)

T. del Conde: 'Mexico', *Latin American Art in the Twentieth Century*, ed. E. Sullivan (London, 1996), pp. 17–49

D. Rochfort: *Mexican Muralists: Orozco, Rivera and Siqueiros* (London, 1997)

G. Tovar de Teresa, ed.: *Repertory of Artists in Mexico*, 3 vols (Mexico City, 1997)

FAUSTO RAMÍREZ

V. Interior decoration and furniture.

European-style furniture was introduced into Mexico by the Spanish in the 16th century. Inventories of the period record items that were in common use in the first houses in the colony, including inlaid, folding, X-frame chairs, 'friary' chairs, trestle tables, beds with carved posts, writing desks, chests, footstools, Flemish tapestries and *guadame-cies* (tooled leather hangings) from Córdoba. In 1568 carpenters' ordinances were established, and in the 17th and 18th centuries Mexican furniture achieved its most distinctive character, marked by massive dimensions and colonial rusticity, combined with vigorous workmanship and exuberant decoration. The furniture trade spread to several centres, each of which developed its own speciality. Michoacán lacquerwork exploited techniques of Pre-Columbian origin; Campeche used tortoiseshell; Puebla was known for wood inlay in the Moorish style; and Oaxaca produced poker-work on trunks and credenzas. Religious furniture was very important and was always in harmony with the architecture of the place of worship for which it was destined. Typical of Mexican Baroque were 'friary' chairs with fantastic carvings on the legs and rails (see fig.

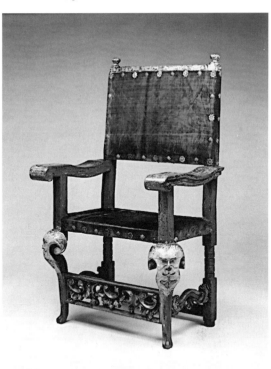

14. 'Friary' chair, wood and velvet, w. 770 mm, 18th century (Mexico City, Museo Franz Mayer)

14), monumental vestry cabinets and huge polygonal or circular sacristy tables with profusely carved frames and inlaid tops.

The aristocratic mansions of the colonial period in Mexico consisted of two storeys, with the rooms ranged round a central patio, similar to houses in Andalusia. Inside, the ceilings were usually of cedar beams, the floors were red brick with alternating glazed tiles, and the walls were covered with red damask or hand-painted Chinese wallpaper. The most elegant furniture was to be found in the drawing-room: folding screens decorated on both sides with scenes of the Spanish conquest, allegories or popular festivals, or lacquered in the oriental style; chairs with graceful curves inspired by European designs; corner commodes and console tables with scrolling cabriole legs; mirrors with silvered frames; writing desks inlaid in the *Mudéjar* style; and cupboards decorated with floral carvings, chequerboard or polychromatic ornament. In 1783 the Academia de las Nobles Artes de S Carlos was founded in Mexico City, and from then on fashionable furniture conformed to the Neo-classical ideals of elegance, restraint and formality. The proportions were lighter, and the exuberant carvings and Moorish-style inlaid work were replaced by delicate marquetry in tropical woods. The main centre of furniture production at this time was Puebla.

The 19th century was dominated by a sequence of styles derived from European furniture. Neo-classicism was followed by the Empire style and then historical eclecticism. Between 1930 and 1955 functional furniture was in favour, while at the same time elaborately carved neo-colonial furniture enjoyed a revival. At the end of the 20th

century a highly purified Mexican style prevailed, related to the monastic spirit of the architecture of Luis Barragán (*see* §III, 2(i) above). This was characterized by large, severe pieces of furniture in white cedar, combined with loom fabrics and popular crafts.

BIBLIOGRAPHY

M. Romero de Terreros: *Las artes industriales en la Nueva España* (Mexico City, 1923)
A. Carrillo y Gariel: *Evolución del mueble en México* (Mexico City, 1957)
T. Castelló Iturbide and M. Martínez del Río de Redo: *Biombos mexicanos* [Mexican folding screens] (Mexico City, 1970)
A. Aguilera, E. Vargas Lugo and others: *El mueble mexicano* (Mexico City, 1985)
R. López Guzmán and others: *Arquitectura y carpintería Mudéjar en Nueva España* (Mexico City, 1992)
M. Angeles Albert: 'Artes decorativas en el Virreinato de Nueva España', *Pintura e escultura y artes útiles en Iberoamérica, 1500–1825* (Madrid, 1996), pp. 315–33

LEONOR CORTINA DE PINTADO

VI. Ceramics and glass.

Although there was a flourishing pottery industry in Pre-Columbian Mexico, the potter's wheel and glazes were unknown. These were introduced by Spanish craftsmen from Talavera de la Reina, Seville and Cadiz, who began manufacturing tin-glazed earthenwares in Puebla between 1550 and 1570. Because of the rapid increase in the number of workshops, the first ordinances for potters were passed in 1653, and these regulated the industry until 1820. Pueblan wares—popularly known as Talavera de Puebla—were produced in three classes: fine, common and yellow, for use in convents and by wealthy Mexicans of European descent. The 'fine' pieces are large and thickly made and painted with dark blue foliage, birds and animals. The pigment was applied thickly so that it stands slightly in relief. On early wares decoration adhered closely to the lacey designs and chinoiseries painted on wares from Talavera de la Reina. The most original of later Pueblan wares were those that were inspired by East Asian porcelain imported into Mexico by the Spanish via the Philippines (see fig. 15).

During the 17th century the ceramics industry was so successful that Puebla became the main centre of pottery production in the Americas. Its products were exported to the far corners of Mexico as well as such other South American countries as Cuba, Venezuela and Peru. The production of tin-glazed tiles for decorative, architectural purposes was also very successful (*see* POBLANO). By the end of the 18th century the prominence of blue-and-white wares had diminished, and rich, polychrome wares became increasingly popular, while Baroque exuberance was replaced by the more measured Neo-classical decorative style.

The War of Independence (1810–21) and the importation of European wares in the 19th century forced many Pueblan potteries to close. Production was thus considerably reduced and wares became more rustic and were decorated with popular motifs. In 1803 Miguel Hidalgo, one of the leaders of the Mexican independence movement, had established the production of tin-glazed earthenware in the town of Dolores Hidalgo, and from about 1850 the manufacture of this type of ware also spread to other areas. In the late 20th century it was still manufac-

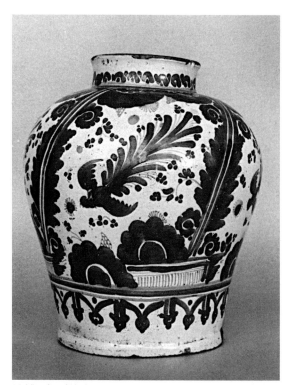

15. Tin-glazed earthenware jar with blue decoration, h. 340 mm, from Puebla, *c.* 1750 (Mexico City, Museo Nacional de Historia, Castillo de Chapultepec)

tured in Puebla, Guanajuato, Guadalajara and Dolores Hidalgo using traditional methods. The tin-glazed tiles made in Dolores Hidalgo were particularly well known. In addition to the factories producing tin-glazed wares in the centre and south of the country, families of potters continued to work their kilns using Pre-Columbian craft methods. The glass industry in Mexico was also started in Puebla, in 1542. Useful and decorative objects were supplied to markets throughout Mexico and to the cities of Central and South America. In 1785 the importation of glass from the factory of La Granja de San Ildefonso, near Segovia in Spain, influenced Mexican production and the style known as *pepita*, so called because it employed a decorative method based on almond-shaped designs, was created (e.g. *pepita* work with floral motifs by Frasco de Vidrio; Mexico City, Mus. Franz Mayer). During the 19th century, craftsmen from Puebla established workshops for the production of blown glass in Mexico City and Guadalajara, which still continued in the late 20th century, producing a great variety of items in bright, vivid colours. In 1909 the mass production of glass was started in Monterrey. In the late 20th century artistic glass and household items were made for both the export and domestic market.

BIBLIOGRAPHY

E. A. Barber: *The Maiolica of Mexico* (Philadelphia, 1908)
E. A. Cervantes: *Loza blanca y azulejo de Puebla*, 2 vols (Mexico City, 1939)
J. R. Alvárez: *Vidrio soplado* (Mexico City, 1969)
T. Castelló and M. Martínez del Rio: *Cristal de granja en México* (Mexico City, 1971)
L. Cortina, ed.: 'La talavera de Puebla', *A. México*, iii (1989) [whole issue]

L. Cortina: 'La loza mexicana del siglo XIX en los museos de los Estados Unidos', *México en el mundo de las colecciones de arte*, v (Mexico City, 1994), pp. 81–119
Vidrio en México (exh. cat. by M. A. Fernández, Mexico City, Cent. A. Vitro, 1990)

LEONOR CORTINA DE PINTADO

VII. Gold, silver and jewellery.

Spanish silversmiths, mostly from Seville, who arrived in Mexico at the beginning of the colonial period found indigenous craftsmen whose skills in casting, for example, were superior to their own. In the 16th century the building of churches and missions and the increasingly wealthy conquistadors created considerable demand for gold and silver objects. At this time it proved difficult to collect the *quinto* (royal tax of one-fifth), payable when silver was refined, fashioned or exported, and in 1526 a royal decree forbade silversmiths from working in Mexico because some had been defrauding the Crown. Such decrees were, however, largely ignored, and a silversmiths' guild was in existence when, in 1522, the viceregal council appointed assay-masters in Mexico City. In 1554 Bartolomé de Medina arrived in Veracruz; he had developed the process of using mercury to refine silver, first employed at the mines of Pachuca.

Surviving 16th-century works, many of them in Spanish churches that received them as votive offerings from successful conquistadors, have vigorous decoration in the Renaissance style, well illustrated by a silver-gilt and rock-crystal crucifix in the church of S Maria in Fregenal de la Sierra, Spain. Other pieces show the successful combination of European features with elements derived from indigenous culture, for example a silver-gilt and rock-crystal reliquary cross (*c.* 1575–8; Mexico City, priv. col., see 1989 exh. cat., no. 16), which has a rock-crystal skull, undoubtedly Aztec in origin, set into the base. Similarly, Indian carved box-wood miniature groups were incorporated into gold and rock-crystal pendants and, in a chalice of *c.* 1575 (Los Angeles, CA, Co. Mus. A.; see fig. 16), are set against multi-coloured feathers and incorporated into the stem. The great reliquary of SS Peter and Paul (*c.* 1580; Tepotzotlán, Mus. N. Virreinato) shows the creativity of Mexican silversmiths at this date. Although the form has a severely plain outline, the Mannerist decoration includes fruit and foliage interspersed with figures. A few domestic pieces survive from the 16th century, including a circular brazier (*c.* 1560; Madrid, Inst. Valencia Don Juan) with classical heads amid exotic, Indian-inspired foliage.

Juan de Padilla (*fl* 1622–72) was the most important Mexican exponent of the Mannerist style in the 17th century: the monstrance that he made in 1634 for the church of Castromocho, his birthplace in Spain, has enamel bosses in the *estilo desornamentado* typical of Hispanic silver of the period, but the expressive cherub heads are unmistakably Mexican. By 1671 there were 75 silversmiths' workshops in Mexico City, all employing considerable numbers of Indian craftsmen. In addition, there was a large colony of Chinese goldsmiths in the city, probably selling East Asian work, as well as making jewellery and filigree work. The most important piece of the 18th century was undoubtedly the great architectonic canopy (destr. 19th century), known as the *cípres*, in the

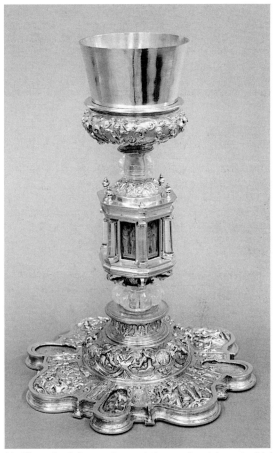

16. Silver-gilt chalice, rock crystal, boxwood and humming-bird feathers, h. 330 mm, from Mexico City, *c.* 1575 (Los Angeles, CA, County Museum of Art)

cathedral in Mexico City, designed in 1740–41 by Jerónimo de Balbás of Seville (*fl* 1718–41).

Baroque motifs were used in Mexican silver by the second decade of the 18th century, for example in two silver-gilt trays (1712 and 1714) in the church of Comillas, Spain. The magnificent silver-gilt monstrance (1724) attributed to José de Aguilar of Puebla (*fl* 1554–60) in the church of Salvatierra de los Barros, Spain, with a stem in the form of a figure of the Virgin of Guadalupe and an elaborately decorated base, is similar to others attributed to the workshops at Puebla de los Angeles, Spain. The antependium (*c.* 1750), with continuous patterns of exotic foliage, of Saltillo Cathedral, probably made in the town, shows the Mexican Baroque style at its zenith, while a silver-gilt chalice (1760s) in the Basilica de Guadalupe, Mexico City, has a stem formed of an *estípite*, a form of richly ornamented column popular in the Baroque architecture of the period (*see* §III, 1 above). By the mid-18th century domestic silver, especially ewers, basins and candlesticks, had become common. The *mancerina* (holder for a porcelain or glass chocolate-cup) appears to be a Mexican invention and was named after one of the viceroys.

The sudden introduction of Neo-classicism can be seen by comparing the rocaille motifs and asymmetry of the

antependium in the church of Nochistlán, Zacatecas, made by Cabrero in 1770 (*fl* 1770–77), with the stark classicism of that made *c.* 1800 for the church of S José Tlaxcala, Tlaxcala. The somewhat ponderous classicism of Mexican silver continued virtually to the end of the 19th century, when increasing mechanization and lack of ecclesiastical commissions resulted in a decline in silversmithing. The craft enjoyed a brief revival, however, in the mid-20th century, largely through the work of William Spratling (*fl* 1931–67), an American working in Taxco.

From 1522 an assay-master's mark was officially required on silverware, and in 1638 makers' marks were made obligatory, although many unmarked pieces survive. The *quinto* mark for Mexico City was a head above the initial M between the Pillars of Hercules, replaced at the end of the 18th century with a simple crowned M. Variations of the former mark are known, with the M replaced with a Z (possibly for Zacatecas), a D, an IV or an O.

BIBLIOGRAPHY

L. Anderson: *The Art of the Silversmith in Mexico* (New York, 1941, 2/1975)
A. Valle-Arizpe: *Notas de platería* (Mexico City, 1941, 2/1961)
C. Esteras Martín: *Platería hispanoamericana: Siglos XVI–XIX* (Badajoz, 1984)
——: *Orfebrería hispanoamericana: Siglos XVI–XIX* (Madrid, 1986)
E. del Hoyo: *Plateros, plata y alhajas en Zacatecas* (Zacatecas, 1986)
El arte de la platería mexicana: 500 años (exh. cat., ed. L. García-Noriega y Nieto; Mexico City, Cent. Cult. A. Contemp., 1989)
S. Cederwall and others: *Spratling Silver* (San Francisco, 1990)
C. Esteras Martín: *Platería del Museo Franz Meyer* (Mexico City, 1992)
——: *Marcas de platería hispanoamerica, siglos XVI–XX* (Madrid, 1992)
Mexicaans Zilver (exh. cat. by C. Bargelli and others, Ghent, Mus. Sierkst., 1993)

CHRISTOPHER HARTOP

VIII. Textiles.

Cotton continued to be the staple material of rural Mexican textiles after colonization, whereas by the late 20th century agave fibre was used only in bags and sacks. Sheep were introduced from Spain in 1526, and thereafter woollen cloth was used by both those of Spanish descent and the indigenous people. In 1530 flax was brought from Europe, and in 1537 silkworm breeding began, mainly in Oaxaca, where it flourished in the 16th and 17th centuries. In 1676, however, the Spanish Government, fearful of competition, forbade the growth of flax and ordered the eradication of the silk industry's white mulberry trees. Textile production increased after the introduction by the Spanish of the spinning-wheel and the treadle loom. The latter was operated by men, whose output surpassed that of native women using the manually operated backstrap loom. Guilds were established, and in 1577 the first ordinances, which controlled textile production in Mexico until independence, were put into force. Commercial textile production increased steadily throughout the 19th and 20th centuries until it became one of the most important industries in Mexico.

In the colonial period a wide variety of vegetable and animal colourants was used, the most popular being indigo, cochineal and shellfish purple (obtained from *Purpura patula pansa*, a species of sea snail). However, chemical dyes became available soon after their first manufacture, and by the late 20th century they had virtually supplanted natural dyes. Similarly, synthetic fibres became widespread in the second half of the 20th century.

Despite the development of extensive industrial production, indigenous textile traditions persist. A wide range of techniques is used: in weaving, brocading and weft-loop patterning; in embroidery, satin, running and cross stitches and draw-thread work. Twining, netting and plangi, a form of tie-dyeing, are also employed. Many of the designs are Pre-Columbian, including the tree of life, the plumed serpent and the jaguar claw, and the richly decorated native dress is still worn, with its fringed belts and embroidered blouses, *huipil* tunics (see fig. 17) and women's *quechquemitl* capes. Two garments in particular have survived from the colonial period: the *rebozo* (stole) and the serape. The *rebozo*, a narrow rectangular cloth with fringes at both ends, was a woman's garment of mestizo origin. In the 17th and 18th centuries *rebozos* were made of silk interwoven with silver and gold thread and embroidered with traditional and regional motifs. No more than 20 examples survive from that period (e.g. W. Sussex, Parham House). *Rebozos* continue to be woven in many places in Mexico. The most abundant and high-quality production is in Tenancingo, where very fine *rebozos* are produced on treadle looms, and in Santa María del Río, where ikat-dyed silk *rebozos* must pass through a ring as proof of their sheerness. Some weavers employ traditional designs, including the snakeskin or the key or stepped-fret pattern, the giver of life.

The serape is the man's garment common to rural Mexico. It is usually made of wool and consists of two large, rectangular pieces of cloth stitched together with an opening in the middle for the head. The motifs are largely those that the Spaniards borrowed from the Muslims, often various combinations of geometric shapes around a central diamond. The rural workshops in Texcoco and

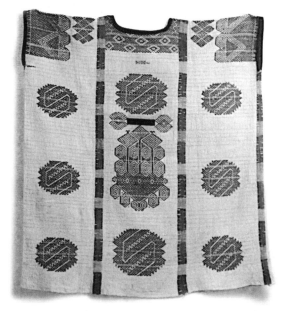

17. *Huipil* tunic, handwoven with gauze technique and a traditional plumed serpent motif embroidered from the back with running stitches, from Ojitlán, Oaxaca, 1958 (private collection)

Chiconcuac, established in the 16th century, are still in existence, and there are factories in Santa Ana Chautempan, Querétaro, Puebla and especially in Saltillo.

BIBLIOGRAPHY

J. Bazant: 'Evolution of the Textile Industry in Puebla, 1544–1845', *Comp. Stud. Soc. & Hist.*, vii/1 (1964), pp. 56–70

T. Castelló Yturbide and C. Mapelli Mozzi: *El traje indígena en México*, 2 vols (Mexico City, 1964, 2/1968)

C. Sayer: *Mexican Costume* (London, 1985); rev. as *Mexican Textiles* (London, 1990)

J. Rivero Quijano: *La revolución industrial en México y la industria textil* (Mexico City, 1990)

R. D. Lechuga: *El traje de los indígenas de México* (Mexico City, 1992)

M. Turok: 'Dechados y textiles mexicanos en museos extranjeros', *México en el mundo de las colecciones de arte*, v (Mexico City, 1994), pp. 121–41

A. México, xxxv (1996) [issue devoted to textiles of Oaxaca]

CARLOTTA MAPELLI MOZZI

IX. Patronage, collecting and dealing.

The first collectors of Mexican art were the conquistadors themselves, led by Hernán Cortés, and the missionaries who undertook the evangelization of the country. They had little appreciation of the artistic significance of the feathered objects and small pottery figures or pieces of sculpture they encountered, but they recognized the need to preserve them as historical testimony to a civilization so different from their own. In 1519, before the conquest had been completed, Cortés sent the first shipment of artefacts to the Spanish King Charles I. These were exhibited in Spain and Brussels, where Albrecht Dürer saw them, commenting that he had 'never seen anything that so delighted the heart' and that he had been 'amazed by the subtle inventiveness' of the indigenous craftsmen. Particularly attractive to the conquistadors was the work in precious metals, which they were able to acquire by taking advantage of imperial tribute procedures. In addition to such tributes as crops and firewood, some craftsmen were required to pay tributes to their new rulers in the products of their work, or in what they could produce in a given period of time. The historic sense of some of these first Europeans thus led to the collection and preservation of invaluable examples of Pre-Columbian art.

The demise of the tribute system around the middle of the 16th century was partly due to the influence of the missionaries, who also introduced Church patronage. Such humanist-influenced figures as Fray Juan de Zumárraga and Bishop Vasco de Quiroga (1479–1565) were responsible for founding schools, hospitals and a university in Mexico City, as well as religious buildings, most notably convents. The creation of such schools of art as that of S José de los Naturales, Mexico City (*see* §XI below), provided the indigenous population with European models through imported prints, especially wood-engravings in books, and as the missionary–patrons commissioned works from trained artists, the principal collections of early colonial art began to be assembled in the churches and convents of the religious orders.

At the end of the 16th century the first newly rich private patrons appeared, financing the building of churches and convents and their decoration. More sophisticated European prints, for example of works by Rubens and Murillo, began to be imported in the late 17th century, and in the 18th century the first private collectors arose among the descendants of European nobility and the enlightened clergy, many of whom taught at the Real y Pontificia Universidad de México. Private patrons also helped introduce new architectural developments in the 18th century. Notable examples are the churches of SS Prisca y Sebastián (1748–58), Taxco, and La Valenciana (1765–88), Guanajuato. Similarly, many prosperous mine-owners and aristocrats, such as the Conde de San Bartolomé de Xala and the Marqués de San Mateo de Valparaíso, helped consolidate changing architectural styles at about this time in the houses built for them (*see* §III, 1(ii) above).

In the early 19th century wealthy aristocratic families collected European and Mexican paintings, especially depictions of religious themes, portraits, still-lifes and genre paintings, which were highly prized. After independence a few collections changed hands, but a more significant shift in the ownership of works of art came with the disentailment of the property of the clergy in 1856, when the treasures of the churches became nominally part of the cultural property of the nation.

The Mexican Revolution in the early 20th century was followed by the formulation of an official government policy of artistic patronage, for which the Minister of Education, José Vasconcelos, was mainly responsible. This led to the vast programme of mural painting that dominated Mexican art in the 1920s, 1930s and 1940s, although many of the artists involved took the opportunities offered as a chance to criticize government social policy (*see* §IV, 2(iv) above). At the same time some of the most important private collections of modern Mexican art began to be formed, with such collectors as Marte R. Gómez, Alvar Carrillo Gil and Gutiérrez Roldán collecting easel paintings by José Clemente Orozco, Diego Rivera, Frida Kahlo David Alfaro Siqueiros and other painters of the Mexican Renaissance. Subsequently some of these collections came to form part of the collections of national museums through their acquisition by the Instituto Nacional de Bellas Artes, which was established in 1947 by the government to promote the arts. In the 1950s a number of artists, rebelling against the official system of patronage, began to show their work in private, often transient, galleries. Later, through biennial exhibitions and salons organized by the Instituto and through competitions sponsored by such international bodies as the Organization of American States and such private multinational corporations as Esso, this younger generation acquired international recognition, but collectors continued to concentrate on assembling representative works by particular members of the Mexican school. There was also particular interest in the works of Rufino Tamayo and Francisco Toledo. Some notable modern artists also formed important collections: for example, Diego Rivera collected Pre-Columbian art and in 1942 began to build the pyramid-shaped Museo Diego Rivera de Anahuacalli in Mexico City as a studio and private museum. Pedro Coronel collected works of African art and Japanese prints; these formed the basis of a museum located in the former Jesuit monastery of S Luis Gonzaga in Zacatecas. His brother Rafael Coronel meanwhile assembled a remarkable collection of masks from every region of Mexico (*see* CORONEL).

Many important private collections are located in regional centres such as Oaxaca and Monterrey, where

financiers helped establish public museums and formed significant private collections. In Guadalajara the Instituto Nacional de Antropología e Historia formed a collection of works by 20th-century artists, most notably paintings by artists belonging to the 'Círculo Bohemio', while in Puebla José Luis Bello collected mainly 19th-century items but also Pueblan and European furniture and *objets d'art* from all periods as well as paintings by regional artists, most notably Agustín Arrieta. The privately owned Museo Amparo is also situated in Puebla.

One of the most important private collectors of the 20th century in Mexico was Franz Mayer, who was born in Mannheim and moved to Mexico in 1905, where he was successful as a financier during the economic boom of the last years of the government of Porfirio Díaz. While also active as a photographer, Mayer was primarily interested in collecting Mexican paintings and decorative art objects. He was particularly impressed by a visit to the Frick Collection in New York and decided to establish his own collection in a house that was not only equipped to contain the assembled works but was also given the necessary funds to ensure the continued preservation and augmentation of the collection and its research. Each room in the house, which now forms the Museo Franz Mayer in Mexico City, is given over to a particular art form, such as Puebla pottery, silverware or painted screens and tapestries.

There are few notable private collections of late 20th-century art in Mexico, despite its diversity, energy and international critical success. Important exceptions, however, are the collections of S. Autrey, M. Moreno and R. Ovalle in Mexico City, and of D. Sada, N. García, S. Zambrano and L. Zambrano in Monterrey, who have assembled works by many of the artists who sought to break with the nationalist and socialist sentiments of the Mexican school.

BIBLIOGRAPHY

L. Pérez de Salazar: *La pintura mexicana en colecciones particulares* (Mexico City, 1966)
J. A. Manrique: 'El manierismo en Nueva España: Letras y artes', *An. Inst. Invest. Estét.*, 45 (1976)
J. A. Manrique and T. del Conde: *Una mujer en el arte mexicano: Memorias de Inés Amor* (Mexico City, 1987)
'Museo Franz Mayer', *A. México*, iv (1989)
Pintura mexicana y española de los siglos XVI al XVII (Mexico City, 1991)
T. del Conde and others: *La pintura de México contemporáneo en sus museos* (Mexico City, 1991)
M. Schneider Enríquez: 'Sergio Autrey: Patron Saint of Mexico', *ArtNews*, xciv (1995), pp. 111–2
A colección. Andrés Blastein: Pintura moderna de México (exh. cat. by L. M. Lozano and others, Pontevedra, Mus. Pontevedra, 1997)

TERESA DEL CONDE

X. Museums.

During the first two centuries of Spanish colonization, some mendicant priests sought to establish a record of Mexico's cultural heritage in its broadest sense by reproducing manuscripts and establishing a record of the indigenous flora and fauna. However, no representative record of the indigenous Indian cultures was compiled, despite early proposals. For example, Francisco de Toledo, Viceroy of Peru from 1569 to 1581, suggested that the collection of King Philip II should include items of interest from New Spain for the 'amusement and wonder of any prince who should visit Your Majesty's court'. During the 18th century the European fashion for small private museums containing items of mainly scientific interest rapidly took root in New Spain. For example, between 1779 and 1783 the Catalan military engineer Miguel Constanzó (1741–1810) began negotiations for the enlargement of the Mexico City mint, which included a collection of medals, prints, busts and other items, to accommodate 'eighty drawings of ancient bas-reliefs, twelve plaster heads and busts, six small statues and the complete collection of the sulphur coins of Greece and Rome'. This formed the basis of the collection of the Academia de S Carlos, which was founded in 1783. The first museum of natural history, the predecessor of the modern Museo Nacional, was established at about the same time. Although largely of scientific interest, it did contain some Pre-Columbian artefacts.

After the short-lived rule of Agustín de Iturbide, who ordered the establishment in 1822 of a conservatory of antiques in the university in Mexico City, the first President of the Mexican Republic, José Guadalupe Victoria, issued a decree on 18 March 1825 creating the Museo Nacional. Provincial museums sprang up throughout the 19th century, some of them becoming celebrated for their perseverance and resilience, such as the Museo Michoacáno. In 1853 Melchor Ocampo tried unsuccessfully to pass a decree providing for the establishment of the museum in Michoacán, but it was not until 1886 that the decree was legally approved and the museum established in the Colegio de S Nicolás de Hidalgo before moving in 1916 to its present site. A similar situation existed in the state of Yucatán, when in 1869 the museum of Yucatán was founded from the collections of the private museum of the Camacho Fathers, set up in the middle of the 19th century in Campeche.

By the end of the 19th century many more museums had been established, including scientific and military museums, and they were followed between 1903 and 1923 by the Museo Regional de Oaxaca (1903); the Museo Arqueológico (before 1910) in Teotihuacán; and the Museo Regional de Antropología e Historia (1918) in Guadalajara. By 1923 others were in operation, though not legally constituted until some time afterwards. These included museums in Guadalupe, Guanajuato, Zacatecas and Veracruz; the Museo Histórico Churubusco; the Museo Colonial de Acolmán (in the convent of S Agustín); the Museo de Arte Colonial in the former Jesuit college of S Martín, Tepotzotlán; the Museo Industrial de Puebla; the Museo Regional de Querétaro (in the monastery of S Francisco) and the Museo Regional de Cuernavaca (in the Palacio de Cortés). In the case of the monasteries, most were converted entirely into art galleries open to the public. This fact, however, points to a shift in emphasis towards the arts. Whereas most of the museums founded between 1869 and 1918 were devoted to the sciences, almost all of those established between 1918 and 1923 concentrated on the arts, in response to a wider need to consolidate a national consciousness. The Museo Nacional de Historia, which moved to the Castillo de Chapultepec, Mexico City, in the 1940s, has a collection on Mexican cultural history.

Following the short-lived Museo Experimental 'El Eco', designed by Luis Barragán and Mathías Goeritz, which opened in 1953, a second important period of museum development began in the early 1960s, when the complex of new museums in Chapultepec Park, Mexico City, was built by PEDRO RAMÍREZ VÁZQUEZ; these include the Museo Nacional de Antropología (see fig. 6 above) and the Museo de Arte Moderno (both 1964); the latter houses the most important collection of modern Mexican painting and sculpture. The whole complex, executed between 1963 and 1965, became a landmark in Mexican museum design, while the work of MIGUEL COVARRUBIAS, Fernando Gamboa (1900–90), Carlos Pellicer (1897–1977), Daniel Rubín de la Borbolla (1907–90) and others gave international prestige to Mexican museum architecture. Another renowned initiative was the creation of the Museo Nacional del Virreinato in the former Jesuit church of S Francisco Xavier in Tepotzotlán.

After 1980 numerous important museums were established, both in the capital and in the provinces. These include the Museo Nacional de Arte, Mexico City, which occupies a building constructed between 1904 and 1911 by SILVIO CONTRI for the Secretaría de Communicaciones. Museum design in this period became an increasingly important area for such architects as TEODORO GONZÁLEZ DE LEÓN and ABRAHAM ZABLUDOVSKY, who built the Museo Rufino Tamayo (1981), Mexico City; Fernando Garza Treviño, who was responsible for the Centro Cultural Alfa (1980) in Monterrey; and RICARDO LEGORRETA, who designed the Museo de Arte Contemporáneo in the 1980s, also in Monterrey, one of the most lavish buildings in Mexico. Juan Sordo Madaleno's designs for the Press Centre for the organizing committee of the 1986 Football World Cup in Mexico City included its transformation into the Centro Cultural de Arte Contemporáneo, while in Jalapa, Veracruz, the firm of Edward Durrell built the Museo Arqueológico (1986), one of the museums most celebrated internationally, and in 1988 the Museo de Tuxtla Gutiérrez in Chiapas was built. A particularly important collection is held in the Instituto de Artes Gráficas de Oaxaca, donated by Francisco Toledo, who also founded the Museo de la Gráfica. The continuing interest in contemporary art was also demonstrated by the opening in 1992 of the Museo del Arte Contemporáneo in Oaxaca.

See also §IX above.

BIBLIOGRAPHY
J. Montes de Oca: *Los museos en la república mexicana* (Mexico City, 1923)
L. Castillo Ledón: *El Museo Nacional de Arqueología, Historia y Etnografía, 1825–1925* (Mexico City, 1925)
G. de la Torre and others: *Historia de los museos de la secretaría de educación pública, ciudad de México* (Mexico City, 1980)
Teatros y museos (Mexico City, 1982)
M. A. Fernández: *Historia de los museos en México* (Mexico City, 1988)
Mem., iv (1991–2), v (1993–4) [issues dedicated to the Museo Nacional de Arte, Mexico City]
A. Henestrosa and others: *Tesoros del Museo Nacional de Historia en el Castillo de Chapultepec* (Mexico City, 1994)
J. A. Manrique and others: *El hombre y su entorno: Presencias en la plástica mexicana del siglo XX: El coleccionismo institucional* (Mexico City, 1994)
Una ventana al arte mexicana de cuatro siglos (exh. cat. by J. Cuadriello and others, Mexico City, Mus. N. A., 1994)
Los museos del INBA en la ciudad de Mexico, CD-ROM (1995) [entries on 10,000 objects from the 11 museums that constitute the Instituto de Bellas Artes]
F. Palma Flores: *Museos de la ciudad de México: Guía ilustrada* (Mexico City, 1996)
C. Vázquez Lovera: *Museo Nacional de Historia en voz de sus directores* (Mexico City, 1997)

AGUSTÍN ARTEAGA

XI. Art education.

In the first decades of the colonial period, when there were very few trained European artists in Mexico, it was the Franciscan missionaries who undertook the task of supervising building works and training the indigenous Indian craftsmen to produce decorative works for churches and convents. The first teaching of Western art was given by Fray Pedro de Gante in the chapel of San José de los Naturales in Mexico City, where European forms of representation and Christian iconography were studied. Although the Indian craftsmen were quick to absorb these lessons, in some cases Pre-Columbian techniques and symbols survived and were applied to the new subject-matter (*see* §II above). From the middle of the 16th century, guilds were set up and training took the form of an apprenticeship within the workshop of a master affiliated to one of the various craft guilds. Although guild regulations apparently excluded Indians from becoming masters, many European artists appear to have taken them on as apprentices, and there are instances of Indian and mestizo craftsmen having their own workshops. Until the 18th century most retables were produced in workshops in Mexico City, from where works for provincial churches were transported and installed, and the retable in this way played an important role in the diffusion of new styles and techniques (*see* §IV, 1(i) above). Throughout the colonial period, imported reproductive prints of the works of major European artists such as Rubens, and in particular of such Spanish artists as Zurbarán and Ribera, were also vital in providing models.

Around the middle of the 18th century the first painting academy was founded in Mexico City by a group of artists around MIGUEL CABRERA, with JOSÉ DE IBARRA as its president, but it was very short-lived. In 1783, however, the Academia de las Nobles Artes de S Carlos de la Nueva España was founded in the capital, heralding the demise of the Baroque and its supersession by the new Neoclassical ideas. This was followed by the establishment of local academies in such provincial centres as Guadalajara (1817), where José Manuel Uriarte was the first Director, and Puebla, where the academy developed out of a school of design founded in 1812 and where local guild-trained artists worked as teachers. An academic education gradually became essential to secure commissions, and although guild-trained artists continued for many years to work alongside academically trained artists, their work was seen as antiquated and crude.

Following Mexican independence the Academia de S Carlos was closed until 1843, when it was reorganized after new funding was secured by President Santa Anna, leading to the arrival of such new teachers as Pelegrín Clavé, Manuel Vilar and Eugenio Landesio from Europe (*see* §IV, 2(i) above). Under their influence the Academia became a powerful, essentially conservative force, but in 1867 it was reorganized and renamed the Escuela Nacional de Bellas Artes. Around the middle of the century it

became common for artists trained at the Academia to travel to Europe to complete their studies, first to Rome then, later, to Germany and France, in particular Paris. Julio Ruelas and Germán Gedovius, for example, studied in Germany and later helped to spread new ideas in Mexico. In the first decade of the 20th century Spain joined Paris as the most attractive destinations for the study of the European avant-garde by such Mexican artists as Angel Zárraga (1886–1946), Roberto Montenegro and Diego Rivera, who was strongly influenced by Cubism.

Within Mexico, however, the prevailing academicism of the Escuela Nacional de Bellas Artes retained a dominant and stifling influence on the education of aspiring artists until the second decade of the 20th century, when a strike by a group of students including José Clemente Orozco led to the dismissal of its director. After the Revolution the Escuela was again renamed, becoming the Academia Nacional de Bellas Artes. More fundamentally, however, the muralists, led by Orozco, Rivera and David Alfaro Siqueiros, wanted to revolutionize the entire artistic establishment, which they characterized as 'bourgeois', and this aim, allied to a desire to reappraise and reanimate popular art and its links with Pre-Columbian traditions, led to the establishment (with government encouragement) of the ESCUELAS DE PINTURA AL AIRE LIBRE, offshoots of the Academia; this step sought to develop the artistic potential of young, untrained artists in a non-academic manner. The drawing method taught by Adolfo Best Maugard (1891–1965), for example, sought to retain the essential features of Pre-Columbian and folk art. The Escuela de Talla Directa y Escultura, founded in a working-class suburb of Mexico City by Guillermo Ruiz (*b* 1896) in 1927, similarly aimed to encourage a spontaneous popular art. In 1935 the study of art history and art criticism was institutionalized by the establishment within the Universidad Nacional Autónoma de México of the Instituto de Investigaciones Estéticas. After World War II the wide dissemination of educational institutions through Mexico led to a greater and wider understanding of art history, of developments in art outside Mexico and, in particular, to a greater understanding of Mexican art within an international context, but formal academic education continually had to compete with the pursuit of innovative values.

BIBLIOGRAPHY

J. Charlot: *Mexican Art and the Academy of San Carlos, 1785–1915* (Austin, TX, 1962)

R.-J. Clot: *La educación artística* (Barcelona, 1968)

E. Baez Macias: *Fundación e historia de la Academia de San Carlos* (Mexico City, 1974)

Las academias de arte. VII coloquio internacional en Guanajuato: Mexico City, 1985, Estudios de arte y de estética

F. Ramírez: *Crónica de las artes plásticas en los años de López Velarde, 1914–1921*, Cuadernos de historia del arte (Mexico City, 1990)

T. del Conde and others: *La pintura del México contemporáneo en sus museos* (Mexico City, 1991)

ENRIQUE FRANCO CALVO

XII. Art libraries and photographic collections.

Despite the country's long tradition of artistic production and art historical studies, there are few specialist art history archives and libraries in Mexico. The Universidad Nacional Autónoma de México, Mexico City, contains in its various departments the most specialized bibliographical resources. The most important library is that of the Instituto de Investigaciones Estéticas, which holds just over 15,000 volumes on Mexican and international art. This is followed in importance by the libraries of the faculty of architecture and the Escuela Nacional de Artes Plásticas, both specializing in architecture, and by the library of the Academia de San Carlos, which is part of the Escuela Nacional de Artes Plásticas and which holds books from the 18th and 19th centuries and earlier.

The Biblioteca Nacional, the Colegio de México and the Universidad Iberoamericana, all in Mexico City, have general art historical bibliographic material in their libraries. The Biblioteca Nacional has an outstanding collection of documentation belonging to the former convents, among which are thought to be the as yet unclassified treatises on architecture and poetics brought to Mexico during the viceroyalty and in the early years after independence. The Instituto Nacional de Bellas Artes has bibliographical resources in its departments, while the Museo de Arte Moderno and Museo Nacional de Arte both have small libraries containing general works on the history of art (all in Mexico City).

The most important specialized photographical archives again belong to the Universidad Nacional Autónoma de México. The Instituto de Investigaciones Estéticas has a rich holding specializing in colour transparencies and black-and-white negatives of Mexican art of different periods, as well as of international and contemporary Latin American art. It also has black-and-white photographs of colonial art taken by Guillermo Kahlo (1872–1941) and Luis Marquéz during the first half of the 20th century. The second most important collection belongs to the faculty of architecture, the slide library of which specializes in Mexican and international architecture and art. The Instituto Nacional de Antropología e Historia in Mexico City also has a rich holding of photographs of Mexican art, and its transparencies and black-and-white photographs of such artistic monuments as houses from the old quarter of Mexico City, archaeological sites and colonial churches from all over the country can be consulted at the institute's offices in the former convent of Culhuacán. The institute's regional centre in Pachuca has other photographic records by Guillermo Kahlo of colonial artistic monuments, complementing the holdings of the Instituto de Investigaciones Estéticas. The Hugo Breheme and Felipe Teixidor Collections are also rich in images of destroyed or untraced artistic monuments. The Archivo General de la Nación holds several million images in its audiovisual information department. Outstanding among these are over 3000 photographs taken at the beginning of the century by the Australian Charles B. Waite, including numerous views of plazas, churches, railway stations and other public buildings in the major towns.

BIBLIOGRAPHY

E. Barberena: *Un análisis de la información del arte latinoamericano contemporáneo* (diss., Mexico City, U. Autónoma Met., 1987)

M. Davidson and others: *Picture Collections: Mexico* (London, 1988)

AURELIO DE LOS REYES

Mexico City [Sp. México]. Capital city of Mexico. Located in the high-altitude Valley of Mexico in the central southern

part of the country, the city (metropolitan population *c.* 22 million) was originally the site of Tenochtitlán, the capital of the Aztec empire, which was destroyed by Spanish conquistadors in 1521; large-scale remains of the principal temple at the centre of the Aztec city were excavated only after 1978. Rebuilt by the Spanish as the capital of the Viceroyalty of New Spain, the city flourished as a centre of colonial art and architecture from the 16th century to the early 19th, and it subsequently remained at the forefront of important innovations in the arts, particularly in the 20th century.

I. Tenochtitlán. II. Later history and urban development. III. Art life and organization.

I. Tenochtitlán.

The city was founded *c.* 1325 by the Mexica people—one of several Aztec groups—in the Valley of Mexico, built on an island of *c.* 10 sq. km near the western edge of Lake Texcoco. A rectilinear urban plan was developed, with large open spaces for communal activities; at its centre was a huge ceremonial precinct containing the most important pyramidal temple, the Templo Mayor (Great Temple) (see fig. 1) during the following two centuries of Aztec expansion, when Tenochtitlán became the imperial capital, the structure was enlarged and rebuilt many times. Tenochtitlán flourished for nearly 200 years, its inhabitants

increasing to *c.* 340,000 before 1519, making it one of the most heavily populated cities in the world. In that year the Spanish conquistadors arrived, led by Hernán Cortés; the final battle for the city in 1521 reduced it to ruins, and the stones of its temples and other buildings were used to create a new colonial city.

Early archaeological finds from Tenochtitlán were recorded in 1790, but until 1978 most knowledge of Aztec architecture came from sites outside the Aztec capital. Limited excavations in the city were undertaken in 1900, 1913–14 (when the south-west corner of the Templo Mayor was discovered), 1933 and 1948, but most finds came to light during the construction of the city's underground subway system in the 1960s (1b). The discovery of the stone sculpture of the moon goddess *Coyolxauhqui* and the subsequent Proyecto Templo Mayor (1978–82), when the main temple of Tenochtitlán was excavated, transformed archaeological knowledge of the Aztecs by offering an unprecedented view of remains at the very centre of the city.

BIBLIOGRAPHY

J. Soustelle: *La Vie quotidienne des Aztèques à la veille de la conquête espagnole* (Paris, 1955; Eng. trans., London, 1961)

M. León-Portilla: *Mexico-Tenochtitlán: Su espacio y tiempo sagrados* (Mexico City, 1978)

F. F. Berdan: *The Aztecs of Central Mexico: An Imperial Society* (New York, 1982)

E. Matos Moctezuma: 'The Grand Temple of Tenochtitlán', *Sci. Amer.*, ccli/2 (1984), pp. 80–89

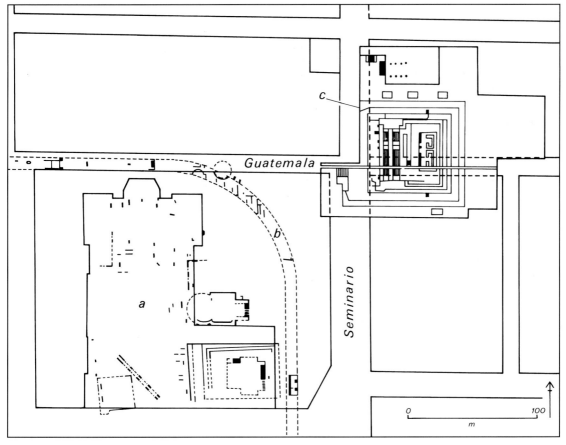

1. Tenochtitlán, plan showing site of Templo Mayor: (a) cathedral; (b) line of subway excavations during the 1960s; (c) Templo Mayor

J. Broda, D. Carrasco and E. Matos Moctezuma: *The Great Temple of Tenochtitlán: Center and Periphery in the Aztec World* (Berkeley and London, 1987)
E. Matos Moctezuma: *The Great Temple of the Aztecs: Treasures of Tenochtitlán* (London, 1988)
C. Chanfón Olmos: 'Tenochtitlán, la capital Mexica', *Cuad. Urbismo*, 1 (1990), pp. 5–18

ELIZABETH BAQUEDANO, EDUARDO MATOS
MOCTEZUMA

II. Later history and urban development.

1. 1521–1821. 2. 1822–1920. 3. After 1920.

1. 1521–1821. The new city that was built on the ruins of Tenochtitlán became the capital of the Viceroyalty of New Spain, its population greatly reduced to about 30,000. Within a few years the city became known as México-Tenochtitlán, but by the middle of the 16th century it was being called México, in memory of the Mexica people who had founded Tenochtitlán. Although the buildings of the great Aztec capital had been destroyed, this allowed for the combination of indigenous and European elements in the creation of the new city. Numerous authors have commented on the influence of Italian Renaissance urban design on the planning of Mexico City. Later investigations, however, tend to highlight the value of indigenous Mesoamerican antecedents; these received little attention before the late 20th century, probably because of the lack of information resulting from the systematic destruction of indigenous documents in the 16th century. The peoples of Mesoamerica, owing to the benign climate, had created an outdoor way of life supported by a system of ceremonies that affected all aspects of daily life; this was reflected in the planning of urban spaces with large public squares and wide, straight roads planned in a rectilinear grid. Such qualities were well expressed—albeit with a very medieval conception—in the so-called Plano de Cortés (Nuremberg, 1524), a report made by Hernán Cortés to the King of Spain. The straight roads and many of the large squares of Tenochtitlán were preserved in the new city, for which plans were drawn up by Alonso García Bravo. The reconstruction work used stone from the ruined Aztec monuments in addition to wood, stone and bricks transported from local villages across the lake and through the canals.

Among the earliest buildings of the new city were fortresses based on European models, but architectural activity in the 16th century was dominated by domestic and religious construction. As the seat of viceregal power, Mexico City was also the operational base for the evangelization campaigns; thus the type of mendicant convent that was widely adopted in Mexico by the Franciscans, Augustinians and Dominicans, characterized by walled courtyards or atria and open chapels (*capillas posas*), was first built in the capital. The religious orders, especially the Jesuits, also built schools and colleges, including SS Pedro y Pablo (1572) and S Ildefonso (1592). The first cathedral was built in 1525–32 (destr.); the second, the Metropolitan Cathedral of Mexico City (begun 1563; *see* MEXICO, fig. 3) was built in the Plaza Mayor (now Plaza de la Constitución) in the centre of the city, near the site where the Aztec Templo Mayor was later discovered (see fig. 1 above). It was based on Jaén Cathedral in Spain, and construction was continued under CLAUDIO DE ARCINIEGA and Juan Miguel de Agüero (*fl* 1574–1613); the cathedral was dedicated in 1656, although the towers were completed only in 1813 (see also fig. 3 below). On another side of the square is the National Palace, the original building of which was a gift to Cortés from the King of Spain; it was rebuilt at the end of the 17th century and enlarged in the 1920s. The city's development in the early 17th century was portrayed in a beautiful plan (1628) made by Juan Gómez de Trasmonte, Maestro Mayor at the cathedral.

During the three centuries of the Viceroyalty, the Church remained the principal patron of architects working in Mexico City, among whom in the 18th century were PEDRO DE ARRIETA and Miguel Custodio Durán (*see* DURÁN): they introduced the ornate carving and solomonic columns of the Mexican Baroque (e.g the Jesuit church of La Profesa, 1714–20, by Arrieta, and S Juan de Dios, 1729, by Durán). Such changes to the external appearance of the buildings were all that was necessary to turn Mexico City into a Baroque city: the wide, straight streets of its urban layout were inherently suited to the planning of Baroque scenographic perspectives and focus on architectural ornament. At the same time, building activity became more diverse as a result of the economic success of trade and mining. In the centre of the city, around the Plaza Mayor (Plaza de la Constitución; see fig. 3 below), elegant town mansions in the latest styles were built from the last quarter of the 17th century for prosperous merchants and miners, many of whom had bought noble titles from the king and formed the local aristocracy. Examples include the house (1764) for the Conde de San Bartolomé de Xala by LORENZO RODRÍGUEZ and the house (1769) for the Marqués de San Mateo de Valparaíso by FRANCISCO ANTONIO DE GUERRERO Y TORRES. Notable 18th-century civic buildings include the Ayuntamiento (1720–24) and Aduana (1731), which employed the *estípite* (a vertical element tapering downwards), a characteristic feature of the Churrigueresque style, which is more importantly exemplified in Lorenzo Rodríguez's Sagrario Chapel (1749–68) at the Metropolitan Cathedral (*see* MEXICO, fig. 3).

Throughout the 18th century the increasing wealth of the city and patronage of the Church allowed the artisans' workshops to flourish, with silversmiths, engravers, organ-builders, lute-makers, blacksmiths, choral-book illuminators, gilders and embroiderers manufacturing the objects needed for worship. These artisans and artists occupied the area between the aristocratic nucleus of the city and the poorer periphery, where the labourers lived; their workshops, although modest, were well built, while the labourers occupied isolated adobe houses in the indigenous style, generally with open spaces for keeping animals and growing vegetables. A new type of middle-class dwelling also appeared in the 18th century: the *casa de vecindad*, a complex of dwellings giving on to a common patio. The lake on the western side of the city dried up during the 18th century, and Mexico City ceased to be an island. It therefore became necessary to police the access of merchandise arriving by land, and for this purpose gatehouses were built on the Peralvillo, Tlatelolco, Nonoalco, San Cosme, La Piedad, San Antonio Abad and San Lázaro access roads.

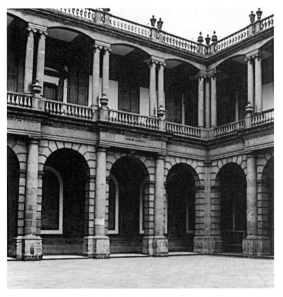

2. Mexico City, courtyard of the Real Seminario de Minería (now Palacio de Minería), by Manuel Tolsá, 1797–1813

In the 1780s the new ideas of the Enlightenment began to arrive in Mexico, and the Academia de las Nobles Artes de S Carlos was founded in Mexico City in 1783 (*see* §III, 1 below). The new ideas gave rise to an awareness of the importance of functionality and order in the city, which can be seen in the work of two viceroys: Antonio María de Bucareli y Urzúa, Viceroy from 1771 to 1779, who created the Paseo Bucareli; and Juan Vicente de Güemes Pacheco, Conde de Revillagigedo, Viceroy from 1791 to 1794, who, despite failing to complete his plan to rejuvenate the city, levelled and paved the streets, numbered the houses, introduced street-lighting and renovated the old aqueducts and drainage systems. Among the principal Neo-classical buildings erected in Mexico City at this time are the Real Seminario de Minería building (1797–1813; now Palacio de Minería; see fig. 2); the church of Nuestra Señora de Loreto (1816); and the palatial residence (1810) of the Marqués del Apartado, all by MANUEL TOLSÁ.

2. 1822–1920. Following independence from Spain in 1821, Mexico City entered a period of change by which it lost its former viceregal appearance. Although the population more than doubled during the 19th century, growing from about 150,000 in 1822 to 350,000 in 1900, its boundaries remained roughly the same until the mid-1860s. The leading architect in the city in the mid-19th century was LORENZO DE LA HIDALGA, who was responsible for the Neo-classical dome (1845–58) of the side chapel of S Teresa la Antigua and the Teatro de S Anna (1844; later the Teatro Nacional), which was destroyed in 1901 to open up the Avenida Cinco de Mayo. The construction of theatres and bars encouraged the extension of street-lighting, which was progressively modernized during the century: the 1200 oil lampposts installed by Viceroy Revillagigedo in the 1790s were replaced by turpentine lanterns in 1835 and by hydrogen lamps in 1869; electric lighting was introduced in 1880. Further

modernization of the city's services included new drainage systems and stone pavements in 1851 and the installation of underground lead water-pipes in 1857 instead of the old aqueducts. Urban improvements included the construction in 1847 of the tree-lined Paseo de las Cadenas, an unusually wide promenade in front of the cathedral in the Plaza de la Constitución, which had a spacious, ordered appearance (see fig. 3). The reform laws, which suppressed convents and monasteries from 1857, removed the last traces of the viceregal regime from the city, and of the former religious institutions only the churches were retained, with some exceptions: the Augustinian church, for example, was turned into a library. At the same time, new streets were opened to break up the old estates, which were put up for sale.

Advances in communication and urban transport in Mexico City were made in the mid-19th century, including the first telegraph line (1852), which linked it with the port of Veracruz; the first railway (1857), which linked the city centre with the sanctuary of La Villa de Guadalupe; and the first public omnibus routes (1863). The physical expansion of the city also began in the 1860s. The Habsburg emperor Maximilian ordered the construction of the Avenida del Imperio (now Paseo de la Reforma), a wide boulevard that joined the city centre with the imperial residence at the Castillo de Chapultepec (now housing the Museo Nacional de Historia) on the south-west fringe; this work was carried out by Juan Agea (1825–?1896) and Ramón Agea (1828–?1892), who had trained in Europe. After 1877, elegant houses in eclectic styles were built along the boulevard, which became a popular residential quarter for members of the local governing aristocracy during the long administration (1877–80; 1884–1911) of President Porfirio Díaz. To one side of it lay the new urban district known as the Colonia de los Arquitectos, conceived by the Spanish architect Francisco Somera (?1830–89) and inhabited by teachers and students of architecture; many houses were built there by prominent members of the profession. This began the Mexican custom of referring to new urban subdivisions as *colonias*: several more were built in Mexico City, including the *colonias* Del Rastro (1889), La Candelaria (1891), Peralvillo (1899) and Romero Rubio (1907) for low-cost housing; the *colonias* San Rafael (1881), Morelos (1886) and Del Valle y Escandon (1909) for middle-class housing of one or two storeys with a small patio; and the *colonias* Roma and La Condesa (1902), Juárez (1906) and Cuauhtémoc (1904) for elegant, upper-class housing in Beaux-Arts and eclectic styles, including Swiss chalets and Italian villas.

The new upper-middle class that emerged during the presidency of Porfirio Díaz promoted the construction of new commercial and cultural institutions in Mexico City, including such large shops as the Palacio del Hierro, Fábricas Universales, Ciudad de México, Fábricas de Francia and the Gran Sedería. Several historic buildings were occupied by the new institutions and schools; for example, the former Palacio de la Inquisición was occupied by the school of medicine; the former convent of the Encarnación by the school of jurisprudence; and the former convent of S Lorenzo by the school of arts and crafts. Several monuments were also raised, especially in the Paseo de la Reforma, including one to *Columbus*

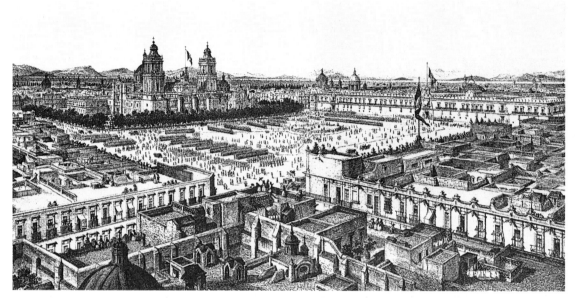

3. Mexico City, view of the Plaza de la Constitución, *c.* 1856; lithograph by Casimiro Castro

(erected 1877), originally conceived in 1865 by Ramón Rodríguez Arangoiti (1830–82), executed in France by Charles Cordier (1827–1905) and sent to Mexico for local assembly; the monument to *Cuauhtémoc*, designed (1877) in a style known as 'neo-Aztec eclectic' by Francisco Jiménez (?1845–83) with sculpture by Miguel Noreña and GABRIEL GUERRA; and the Independence Column (1899–1910) by ANTONIO RIVAS MERCADO (sculpture by Enrique Alciati). In the early years of the 20th century several major building projects were initiated with the help of such European architects as SILVIO CONTRI, ADAMO BOARI and Henri-Jean-Emile Bénard (*b* 1844). Contri built the Palacio de Comunicaciones y Obras Públicas (1904–11; later housing the Museo Nacional de Arte), and Boari designed the eclectic Edificio Central de Correos (1902–7) and the new Teatro Nacional (1904–34; later the Palacio de Bellas Artes; *see* MEXICO, fig. 5). Bénard was responsible for the Palacio Legislativo (designed 1903–4; begun 1910), work on which was abandoned after the fall of President Díaz in 1912 during the Mexican Revolution (1910–20). The metal structure of its great central dome was converted (1933–8) into a monument dedicated to that conflict in accordance with an idea promoted by Carlos Obregón Santacilia.

3. AFTER 1920. Development in Mexico City was halted during the Revolution, but once peace was restored an increase in population was stimulated by renewed investment and the return of many who had fled the conflict. By 1930 the city's population was more than one million, and it continued to grow rapidly, particularly after 1950. The need for a planning body to regulate growth became evident in 1933, when the first planning and zoning laws for the city were drawn up. Between 1920 and 1940 the social democratic ideals that emerged from the Revolution filled the city with schools, hospitals, sports complexes and low-cost housing projects, and with these buildings the Modern Movement in architecture was introduced by such architects as JOSÉ VILLAGRÁN, ENRIQUE YÁÑEZ, Juan Legorreta (1902–34) and JUAN O'GORMAN, whose Escuela Técnica (1932–4) displayed affinities with the work of contemporary European architects. Many of the new public buildings were painted with murals in a programme initiated by the Education Minister José Vasconcelos (*see* §III, 2 and fig. 4 below; *see also* MEXICO, §IV, 2(iv)(a)). Public works interrupted during the Revolution were also resumed, including the Teatro Nacional, completed in 1934 by Federico Mariscal. In addition, the increase in traffic led to the first scheme (1930; unexecuted) for an underground transport system, proposed by the military engineer Miguel Rebollar (1868–1962).

After 1940, in the aftermath of the Spanish Civil War (1936–9) and with the outbreak of World War II, thousands of foreign refugees arrived in Mexico City, and it began to acquire the image of a great cosmopolitan city. The urgent need for housing was addressed by such architects as MARIO PANI, who built more than 1000 dwellings in one complex of 13-storey housing blocks (1947–50) for the Unidad Habitacional Presidente Alemán. Among the most influential projects of the post-war period was the construction of the Ciudad Universitaria (1948–52) in the south of the city, built on the principles of the 'plastic integration' movement with the collaboration of more than 60 architects led by Pani and ENRIQUE DEL MORAL and such artists as Diego Rivera and David Alfaro Siqueiros (for illustration of the library *see* O'GORMAN, JUAN). The International Style of corporate architecture

was also introduced in the 1950s, for example in the Torre Latino Americano (1957) by AUGUSTO H. ALVAREZ, which was made possible only by the new technology of control piles invented by the Mexican engineer Manuel González Flores to resist seismic activity. Elegant new residential districts were developed, including the Jardines del Pedregal, where LUIS BARRAGÁN produced beautiful houses and gardens (1950) reflecting the landscape.

As the population of Mexico City began to increase dramatically, growing from c. 3 million in 1950 to more than 9 million in 1970 and c. 22 million in the mid-1990s, urban development became less ordered. Several access routes into and around the city were established, including the Tlalpan and Miguel Alemán viaducts (the former comprising the old Mexica road from Iztapalapa to Tenochtitlán), then inner and outer ring roads and axis roads; and an underground railway system was built, the first lines being opened in 1969–70. Public transport, however, continued to be a major problem facing the city in the late 20th century, as well as atmospheric pollution, an endemic housing shortage and inadequate public services. Architectural developments in the city in the last decades of the 20th century included innovative structural designs, as seen in the Museo Nacional de Antropología (1964; see MEXICO, fig. 6) by PEDRO RAMÍREZ VÁZQUEZ, one of several museums in Chapultepec Park, and the work of FÉLIX CANDELA, while a more functionalist approach incorporating traditional materials and elements was seen, for example, in the Colegio de México (1974–5; see MEXICO, fig. 7) by TEODORO GONZÁLEZ DE LEÓN and ABRAHAM ZABLUDOVSKY.

BIBLIOGRAPHY

M. Rivera Cambas: *México pintoresco, artístico y monumental* (Mexico City, 1883)
J. Galindo y Villa: *Historia sumaria de la ciudad de México* (Mexico City, 1925)
F. de la Maza: *La ciudad de México en el siglo XVII* (Mexico City, 1968)
H. Beacham: *The Architecture of Mexico* (New York, 1969)
A. García Cubas: *El libro de mis recuerdos* (Mexico City, 1969)
L. Unikel, C. R. Crescenscio and G. Garza: *El desarrollo urbano de México* (Mexico City, 1976)
La ciudad de México: Breve evaluación de su crecimiento (Mexico City, 1978)
M. E. Negrete and H. Salazar: 'Zonas metropolitanas en México, 1980', *Estud. Demog. & Urb.*, i/1 (1986)
R. W. Morse: 'Urban Development', *Colonial Spanish America*, ed. L. Bethell (Cambridge, 1987), pp. 165–202
S. Linné: *El valle y la ciudad de México en 1550* (Mexico City, 1988)
Atlas de la ciudad de México (Mexico City, 1988)
Il barocco del Messico, intro. by C. Chanfón Olmos (Milan, 1991)
G. Tovar de Teresa: *La ciudad de los palacios: Crónica de un patrimonio perdido*, 2 vols (Mexico City, 1992)
L. Noelle: *Guía de arquitectura contemporánea de la ciudad de México* (Mexico City, 1993)

CARLOS CHANFÓN OLMOS

III. Art life and organization.

1. 1521–1821. In the early years of the colonial period there was a dearth of trained European artists in Mexico, and it was therefore considered important to teach Indian craftsmen the rudiments of European systems of representation, a task largely undertaken by Franciscan missionaries. In the early part of the century most works executed by Indians took the form of tributes exacted by their colonial masters, but in the mid-16th century a guild system was established, and civil or religious patrons subsequently paid workshops for their commissions. Often these patrons were private individuals, who would select the artists that were to participate. The chapel of S José de los Naturales played an important role in the city's art life during this period. It was here that the training of indigenous craftsmen was first undertaken (see MEXICO, §XI), and it was here that (from 1552) all works created by them had to be assessed, according to a decree by the Viceroy, Luis de Velasco. Perhaps the most important figures in the city's architectural life in the 16th century were the Maestros Mayores, each with a distinct area of responsibility: one oversaw the general development of the city, for example, while others took care of specific projects, such as the Palacio Real or the Palacio de la Inquisición.

In 1566 SIMÓN PEREINS, the first European-trained painter to settle in Mexico, arrived in the city, and in the last decades of the 16th century he was followed by other artists, who introduced Mannerism and together constituted a circle of refined artists that received the support of viceroys and the ecclesiastical and civil councils. By the early 17th century the art workshops of Mexico City were renowned and highly productive. Artists continued to come from Europe to work in the city, but their numbers diminished, allowing local styles to develop with independence and continuity. The stylistic transition to Baroque, for example, was a natural development from local forms of Mannerism, although European models did provide points of reference. By this time Indians and mulattos were joining the guilds; some even came later to hold important positions within them. JUAN CORREA, for example, had his own workshop, which produced works for churches throughout the whole territory of Nueva España and into North America; some of its works were even imported into Spain.

One of the most celebrated painters in the city in the mid-18th century was Correa's student MIGUEL CABRERA, who with a group of other painters formed Mexico's first academy. Although this was short-lived, it did help to provide the initiative for the foundation in 1783 of the Academia de las Nobles Artes de S Carlos. This was a highly significant event not just for the art life of the city: the academy was the first of its kind to be established in the Americas, and its galleries constituted the first public art museum in the New World. More importantly, perhaps, to the educated élite of Mexican society, the Academia represented a new 'modern' stylistic approach. The dominance of the Baroque was challenged, and, partly through the influence of the Academia, Neo-classicism had been established as the prevailing style by the time the War of Independence ended in 1821.

2. AFTER 1821. After independence and the brief empire (1822–3) of Agustín de Iturbide, Mexico underwent a period of political instability, which was reflected by artistic developments—or the lack of them—in the capital. Whereas the first two decades of the 19th century had been characterized by intense building activity, there was little new construction in the decades that followed. Classes at the Academia were suspended until 1843, and no new works were added to its collection. Church and state had by this time both ceased to be great patrons, and

private patrons were cautious about investing in art. There was, however, discussion of artistic subjects in the press, which played a prominent role for the first time: notable reviews of the time included *El pensador mexicano* and the weekly *El iris*. The latter was set up in February 1826 by the Italian CLAUDIO LINATI, who had opened the first lithographic workshop in Mexico City; the political comment implicit in the caricatures printed by Linati led, however, to the swift closure of *El iris* in October of the same year.

Many of the artists active in the city in the period immediately after independence continued to adhere to a Neo-classical approach, but there were also some European artists active in Mexico who depicted the city and its customs in a romantic vein. Artistic links with Europe were strengthened after 1843, when the Academia was reopened and new teachers, such as the Catalans PELEGRÍN CLAVÉ and MANUEL VILAR and the Italian EUGENIO LANDESIO, were brought over. The Academia began holding annual exhibitions, and these helped to foster the first important critical debates between conservatives, such as Clavé, and liberals, who included JUAN CORDERO and Santiago Gutiérrez and who advocated a nationalist and romantic treatment of Mexican history, landscapes and customs. Such artists as the landscape painter JOSÉ MARÍA VELASCO rose to prominence in the mid-19th century, but the city remained the centre of a desultory art market,

and it was only at the end of the century, under the dictatorship of Porfirio Díaz, that public and private commissions became plentiful.

At the end of the 19th century new ideas about the arts received the support of such modernist reviews as the periodicals *Savia moderna* and *Revista moderna*. Two schools of thought in particular came to prominence in Mexico City: one advocated a form of internationalism and sought to identify with European movements, while the other supported a 'Mexicanism' that sought to give modern representations of traditional Mexican subjects. The two approaches were not necessarily mutually exclusive: the painter SATURNINO HERRÁN, for example, drew inspiration from European symbolism while incorporating into his works urban Mexican types, customs and landscapes. In the early 20th century, avant-garde ideas were also introduced from Europe by such artists as DIEGO RIVERA. The chance to implement these new ideas on a large scale came during the presidency (1921–4) of Alvaro Obregón (the first stable government after the Mexican Revolution). In 1921 the Education Minister José Vasconcelos invited artists to decorate the walls of public buildings, thus initiating the era of Mexican muralism (*see also* MEXICO, §IV, 2(iv)(a), and MURAL). Rivera returned from Paris to take part in the project, while other participating artists included DR ATL, RAMÓN ALVA DE LA CANAL, ROBERTO MONTENEGRO, JEAN CHARLOT, FERNANDO

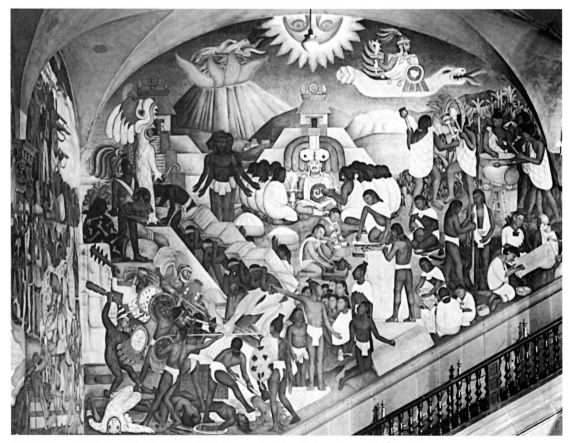

4. Diego Rivera: *Life in Pre-Columbian Mexico* (1929–32), mural painting on the staircase wall of the Palacio Nacional, Mexico City

LEAL, JOSÉ CLEMENTE OROZCO and DAVID ALFARO SIQUEIROS. The first mural to be completed, Rivera's *Creation* (1922–3; Mexico City, Escuela N. Prep.), provoked violent controversy and was derided by those who maintained conservative attitudes to art. As the programme continued, there were also disagreements between the muralists themselves, and the debates were eagerly followed in the press by the public. Despite the fact that the artists involved in the scheme were generally further left, politically speaking, than the government that sponsored them, there was a close relationship between the two groups. Indeed the government was eager to continue to be associated with the murals in the light of the warm reception given to them by Mexican and American art critics.

The 1920s was a decade in which many artistic associations and groupings were founded. In 1922, for example, the leading figures in the mural movement formed the Sindicato de Obreros Técnicos, Pintores y Escultores, which published its manifesto, advocating a public mural art, in the journal *El machete* the following year. At the same time the avant-garde literary and artistic group ESTRIDENTISMO worked to reject academicism and Symbolism in favour of the more forward-looking European movement Futurism. At the end of the 1920s another intellectual group, Contemporáneos, supported such artists as RUFINO TAMAYO and MANUEL RODRÍGUEZ LOZANO, who did not sympathize with the nationalistic slant of the muralists. More generally, however, there was an interest in a reassessment of Pre-Columbian culture (see fig. 4), to which the government again gave its support through the establishment of such non-academic institutions as the Escuelas de Pintura al Aire Libre (*see* MEXICO, §XI).

In the decades that followed, three major institutions were established in Mexico City: the Instituto de Investigaciones Estéticas and the Galería de Arte Mexicano (both 1935) and the Instituto Nacional de Bellas Artes (1947). These reflected to some degree the extent to which the advancement of art had become a government responsibility in the absence of a strong art market; this situation meant that experimentation with new styles was largely left to individual initiatives, however, and received little public financial support. The art life of the city was rejuvenated to some extent in the period after World War II, as many foreign artists and critics settled there, and as the USA replaced Europe as the predominant source of new artistic ideas. In the mid-1950s MANUEL FELGUÉREZ and his wife, Lilia Carrillo, founded Ruptura, a group linked to international movements and opposed to the mural tradition. In 1964 the Museo de Arte Moderno was established in Chapultepec Park, but it was not until 1969 that the Museo began to accept and promote the new artistic approaches adopted by such artists as ALBERTO GIRONELLA, JUAN SORIANO, PEDRO CORONEL, GUNTHER GERZSO and VICENTE ROJO. Numerous other museums were also founded in Mexico City in the 1960s, but the tendency towards the end of the 20th century was for private, rather than state promotion of the arts, a trend reflected in the establishment in the 1980s of such institutions as the Museo Rufino Tamayo and the Centro Cultural de Arte Contemporáneo.

See also MEXICO, §§IX and X.

BIBLIOGRAPHY

G. García Maroto: *Acción plástica popular: Educación y aprendizaje a escala nacional* (Mexico City, 1945)
M. Toussaint: *Arte colonial en México* (Mexico City, 1948, 2/1982)
J. Fernández: *Arte moderno y contemporáneo de México* (Mexico City, 1952)
A. Luna Arroyo: *Panorama de las artes plásticas mexicanas, 1910–1960: Una interpretación social* (Mexico City, 1962)
P. Rojas: *Historia general del arte mexicano: Época colonial* (Mexico City, 1962)
D. Rivera: *Arte y política*, ed. R. Tibol (Mexico City, 1979)
J. A. Manrique, ed.: *Arte mexicano* (Mexico City, 1982)
J. A. Manrique and others: *Modernidad y modernización en el arte mexicano, 1920–1960* (Mexico City, 1991)

JORGE ALBERTO MANRIQUE

Meyer, Pedro (*b* Madrid, 6 Oct 1935). Mexican photographer of Spanish birth. He became a Mexican citizen in 1942 but was educated in the USA, where he trained as an administrator at the Babson Institute, Boston, MA. He was self-taught as a photographer, and after his return to Mexico in 1956 he enthusiastically promoted photography through the Grupo Arte Fotográfico, which he founded in 1963, and the Consejo Mexicano de Fotografía, which he also founded and whose president he became in 1977. His photography was inspired by a deep humanism, both in his keen observation of social structures and in the reliance on shock and irony in his pictorial documentaries, as is evident in his scenes of Nicaragua. An exhibition of his work, *Los otros y nosotros*, held in Mexico City in 1986, caused an international stir.

PHOTOGRAPHIC PUBLICATIONS
Pedro Meyer (Mexico City, 1986)

BIBLIOGRAPHY
Retrospectiva de Pedro Meyer (exh. cat. by C. Monsiváis, Mexico City, 1973)
Los otros y nosotros (exh. cat. by V. Lenero, Mexico City, Mus. A. Mod., 1986)
I. Rodríguez Prampolini: 'Masters of Mexican Photography', *Lat. Amer. A.*, ii/4 (1990), pp. 61–5
Pedro Meyer: Fotografía para recordar, Voyager, CD-ROM (Los Angeles, 1993)
J. Lierner: 'Pedro Meyer', *Lat. Amer. A.*, v/4 (1994), pp. 65–6
J. Fontcuberta, intro.: *Pedro Meyer: Verdades y ficciones/Truth and Fictions: A Journey from Documentary to Digital Photography* (New York, c.1995)

ERIKA BILLETER

Michel, Alfonso (*b* Colima, 1906; *d* Mexico City, 1957). Mexican painter. After living for more or less extensive periods in San Francisco, Florence and Paris, he returned in 1930 to Mexico, where he painted at the University of Guadalajara with Jesús Guerrero Galván. Subsequently he settled permanently in Mexico City. Of the Mexican artists working in the 1930s and 1940s he is perhaps the one who most distanced himself from the rigidity imposed by the notion of a Mexican school, his sojourns abroad having undoubtedly introduced him to ideas from the European avant-garde. He was particularly influenced by the Synthetic Cubism of Braque and Picasso in his handling of figures, as in *Horse* and *Still-life with Landscape* (both Colima, Mus. Cult. Occident.), which he enriched with a very personal and sensual use of colour.

BIBLIOGRAPHY
B. Espejo: *Historia de la pintura mexicana*, iii (Mexico City, 1989)
J. A. Manrique: 'Contracorriente pictórica: Una generación intermedia', *El arte mexicano*, xv (Mexico City, 1989)
Alfonso Michel (1897–1957) (exh. cat., Mexico City, Mus. A. Mod., 1991)
O. Debroise: *Alfonso Michel, el desconocido* (Mexico City, 1992)

Alfonso Michel: Patrimonio artístico de Colima, Instituto Colimense de Cultura/Consejo Nacional para la Cultura y las Artes (Mexico City, 1995)

<div style="text-align: right;">JORGE ALBERTO MANRIQUE</div>

Michel, Jorge (*b* Buenos Aires, 24 Dec 1925; *d* 1991). Argentine sculptor. He was initially drawn to literature, then worked in advertising before finally turning to sculpture as a form through which he could weave together his life and his work. Self-taught, favouring monumental shapes endowed with internal tension and natural rhythms, he often combined elements carved in wood, marble or granite with other materials such as bronze, wrought iron and stainless steel, for example in *Untitled* (1.2×0.6 m; Buenos Aires, Sheraton Hotel). He chose to remain in Argentina partly because of the importance that he attached to materials, especially the granite and hard woods that he was able to obtain there. He usually conceived of his works in homogeneous groupings, sometimes forming a continuity as in *They are Leaning* (white stone from Córdoba, 5×0.5 m, 7 pieces) or a harmony as in *Couple* (bronze on granite base; both Nelly Perazzo priv. col., see Moet, p. 1), sometimes scattering shapes around a central form. At once modern and archaic in their effect, his sculptures convey ancient truths through an apparently timeless language of tangible forms.

BIBLIOGRAPHY

C. Espartaco: *El estupor del arte* (Buenos Aires, 1984), pp. 133–4
D. G. Moet: 'Entrevista a Jorge Michel', *Rev. Cult.*, iii/15 (1986), pp. 1, 22

<div style="text-align: right;">NELLY PERAZZO</div>

Michelena, Arturo (*b* Valencia, 16 June 1863; *d* Caracas, 29 July 1898). Venezuelan painter, draughtsman and illustrator. He executed his first drawings in 1869. In 1874 he met the writer Francisco de Sales Pérez, for whom he illustrated the book *Costumbres venezolanas* (1877). In 1879 he founded a school of painting with his father, the painter Juan Antonio Michelena, at his home in Valencia. From then on he began to receive drawing and painting commissions. His vast output was academic in character and varied in subject. An excellent draughtsman, he was awarded second prize at the Exposición Nacional in Caracas in 1883. He travelled to Paris in 1885 on a government scholarship and studied at the Académie Julian under Jean-Paul Laurens. The accolades he received in France included a medal at the Exposition Universelle in Paris (1889) for the painting *Charlotte Corday* (Caracas, Gal. A. N.). Michelena returned to Venezuela in 1889 to public acclaim but returned to Paris in 1890 and illustrated a luxury edition of Victor Hugo's *Hernani*. In 1892 he settled definitively in Venezuela. He began the project of decorating the Miraflores Palace in Caracas in 1896 and exhibited *Miranda in La Carraca* (1896; Caracas, Gal. A. N.; *see* VENEZUELA, fig. 7) in the exhibition commemorating the 80th anniversary of the death of the liberation fighter Francisco de Miranda.

BIBLIOGRAPHY

J. Rohl: *Arturo Michelena, 1863–1898* (Caracas, 1966)
C. Goslinga: *Estudio biográfico y crítico de Arturo Michelena* (Maracaibo, 1967)
J. Calzadilla: *Arturo Michelena* (Caracas, 1973)
R. J. Lovera De-Sola: 'El mundo en que vivió Arturo Michelena', *Bol. Acad. N. Hist.*, lxxviii/309 (1995), pp. 146–55

Arturo Michelena en los teques: Exposición de obras de arte, mobiliario, documentos y fotografías originales del artista, en las Colecciones de la Fundación Museo Arturo Michelena de Caracas (exh. cat., Caracas, Mus. Arturo Michelena)

<div style="text-align: right;">MARÍA ANTONIA GONZÁLEZ-ARNAL</div>

Migliorisi, Ricardo (*b* Asunción, 6 Jan 1948). Paraguayan painter. He studied in the studio of the painter Cira Moscarda but was basically self-taught and gained his formative experience in various Latin American countries working as a designer of theatre costumes and scenery. His early work, biting and irreverent in style, and with psychedelic and Pop art elements, created a considerable stir in Paraguay's artistic community. Much of this work was in the form of drawings and paintings, but he also devised environments, happenings, audio-visual experiences and montages (see Escobar, 1984, pp. 172, 194). His subject-matter comprised unrealistic hybrid characters, animals and objects from Classical mythology, popular Latin American subjects, kitsch opera, circus and cabaret, television and gossip columns, portrayed in a style linked to Latin American Magic Realism and to expressionist caricature. Humour, eroticism and the absurd animate his work, giving it a flavour of hallucination and nightmare.

BIBLIOGRAPHY

O. Blinder and others: *Arte actual del Paraguay* (Asunción, 1983), pp. 47, 48, 49, 162, 173, 174, 192
T. Escobar: *Una interpretación de las artes visuales en el Paraguay*, ii (Asunción, 1984)
T. Escobar: *Migliorisi, los retratos del sueño* (Asunción, 1986)

<div style="text-align: right;">TICIO ESCOBAR</div>

Mijares, José (Maria) (*b* Havana, 23 June 1922). Cuban painter, active in the USA. He was a graduate of the Academia de San Alejandro in Havana (1938–45), where he taught from 1960 to 1961. He fled from Cuba in 1968 and settled in Miami, FL, where his studio became a focal point of cultural life for other exiled Cuban intellectuals. He was already a principal artist in Cuba, and his work was seen in expatriate circles as a continuity of the Cuban vision, particularly during the 1970s. In his paintings, Constructivism and biomorphic Surrealism are fused with baroque elements derived from colonial Caribbean design in a mixture of influences that also preoccupied many other Cuban artists between 1940 and 1970, including Amelia Peláez del Casal, Cundo Bermúdez, Mario Carreño, René Portocarrero and Jorge Camacho. Mijares's 'organic abstractions' of the 1970s and 1980s are reminiscent of similar work by Wifredo Lam and Yves Tanguy, and he retained his fascination of the 1950s for geometric forms and his dependency on line to represent form, as in *High Priestesses of Illusion* (1971; New York, Cintas Found.). The intense blues and greens of the paintings that he called *vitrales* allude to colonial stained-glass windows. He participated in the biennials at São Paulo in 1953 and Venice in 1956, as well as in numerous group exhibitions in Latin America, Europe and Japan.

BIBLIOGRAPHY

F. Baeza and others: *Mijares* (Miami, 1971)
Outside Cuba/Fuera de Cuba (exh. cat. by I. Fuentes-Pérez, G. Cruz-Taura and R. Paù-Llosa, New Brunswick, NJ, Rutgers U., Zimmerli A. Mus.; New York, Mus. Contemp. Hisp. A.; Oxford, OH, Miami U., A. Mus.; and elsewhere; 1987–9), pp. 156–61

The World of José Mijares (exh. cat., ed. R. J. Caruso; Coral Gables, FL, Marpad A. Gal., *c*.1992); Eng. trans. by J. R. Yobst

RICARDO PAU-LLOSA

Milián, Raúl (*b* Havana, 1914; *d* Havana, 1984). Cuban painter. He was a member of the Grupo de los Once, which introduced Abstract Expressionism into Cuba without great success, although he is difficult to categorize in any one school. He had no formal training and worked entirely in small formats with ink and watercolour, producing haunting images of flowers (e.g. *Sunflower*, 1961; Havana, Mus. N. B.A.) and figures as well as purely abstract work (e.g. *Abstraction*, 1959; Havana, Mus. N. Cuba). His dark palette enabled him to have a subtle control of colour and transparency. His first solo exhibition in Havana was not until 1953. A silver medallist at the third São Paulo Biennial, works by Milán are held by the Museo Nacional de Bellas Artes, Havana; the Museum of Modern Art, New York; and the Milwaukee Art Museum.

BIBLIOGRAPHY
Enciclopedia de Cuba (Madrid, 1975), vii, pp. 200–02

RICARDO PAU-LLOSA

Millan, Carlos B(arjas) (*b* São Paulo, 29 Aug 1927; *d* 5 Dec 1964). Brazilian architect and teacher. He graduated from the School of Architecture at Mackenzie University, São Paulo, in 1951 and in the same year won the student prize at the first Biennale in São Paulo. His early work showed the influence of Marcel Breuer's and Walter Gropius's work in New England; like almost all his generation of architects in Brazil, he was also influenced by Rino Levi and Oswaldo Arthur Bratke. This phase of his work culminated in the O. Fujiwara house (1954), which shows a complete mastery of construction techniques in stone and wood, while also revealing the limitations of the craftsmanship available to him. His preoccupation with the social and economic development of Brazil led him then to change direction: by rationalizing construction methods and using prefabricated components, he sought a compromise between technological development and the unskilled labour that is abundant in Brazilian cities. An important work of this more mature phase is the R. Millan house (1960), Rua Alberto Faria, São Paulo, which received an honourable mention in the 6th Biennale in São Paulo and is often studied by students for its regular structure, exposed prefabricated concrete elements and a central two-storey hall integrating internal and external spaces. Of the same period are some single-storey blocks of flats on pilotis, such as the N. Oliveira house (1960) and his own house (designed 1963; unexecuted), both in São Paulo. Other important works include his designs for the Faculty of Philosophy, Letters and Human Sciences (1961–2) at the University of São Paulo, the church of N S Aparecida (1962) at São Caetano do Sul, São Paulo, and the prizewinning competition entry for the 4th Zone Air Barracks (1963) at São Paulo. He taught at the Mackenzie University from 1957 and the University of São Paulo from 1958.

BIBLIOGRAPHY
'Sede Social do Jockey Club de São Paulo', *Acrópole*, 259 (1960), pp. 159–65

'Carlos Millan', *Acrópole*, 317 (1965), pp. 21–44; 332 (1966), pp. 19-42 [special feature]

PAULO J. V. BRUNA

Mindlin, Henrique E(phim) (*b* São Paulo, 1 Feb 1911; *d* Rio de Janeiro, 6 July 1971). Brazilian architect, writer and teacher. He was the son of Russian immigrants and grew up in an artistic environment. He graduated in 1932 as an engineer–architect from the Mackenzie School of Engineering, São Paulo, and went into practice in São Paulo, carrying out some Modernist work. In 1942 he moved to Rio de Janeiro, where he came into contact with the architects who had been influenced by Le Corbusier, including Lúcio Costa, Oscar Niemeyer, Alfonso Eduardo Reidy and Jorge Moreira; like them, Mindlin became involved with the development of a Brazilian version of Le Corbusier's rationalist Modernism. His first project in Rio was a prizewinning design for the new Ministry of Foreign Affairs (1942; unexecuted) at Itamaraty; thereafter he won several prizes, becoming well known for his participation in competitions and exhibitions. In 1943–4 he studied architecture and construction projects in the USA. He then embarked on a prolific career, designing houses, blocks of flats, offices, industrial buildings, hotels and shops. His domestic work was highly creative, often using butterfly roofs, sunscreens and naturally finished wall planes, and his commercial work incorporated the latest technology, for example the Avenida Central Building (1956), Rio, which was the first steel-framed skyscraper in Brazil. From 1955 to 1966 he also worked in partnership with Giancarlo Palanti (1906–77), producing buildings such as the headquarters of the Bank of London & South America (1957), São Paulo, with a curtain-wall construction, and undertaking the urban development of the Tróia Peninsula, Setúbal, Portugal, where he also had an office (1965–7). In his later work he developed the use of exposed concrete in the Brutalist style, for example the Guanabara State Bank Headquarters (1963), Rio de Janeiro, and for the IBM Factory (1969), São Paulo, he used a space frame structure. Mindlin was also an important writer and critic, contributing numerous articles to journals such as *Acrópole* and producing an important record of early Brazilian Modernism in his book (1956); he was also a spokesman for modern Brazilian architecture at international congresses. He was Professor at the Faculty of Architecture, Federal University of Rio de Janeiro (1968–71), and he also taught in the USA and England.

WRITINGS
Modern Architecture in Brazil (Amsterdam and Rio de Janeiro, 1956)

BIBLIOGRAPHY
H. R. Hitchcock: *Latin American Architecture since 1945* (New York, 1955)
C. B. Yoshida: *Henrique Ephim Mindlin* (São Paulo, 1973)
Y. Bruand: *Arquitetura contemporânea no Brazil* (São Paulo, 1981)

CARLOS A. C. LEMOS

Minujín, Marta (*b* Buenos Aires, 30 Jan 1943). Argentine performance artist and sculptor. After completing her studies in Buenos Aires at the Escuela Nacional de Bellas Artes Manuel Belgrano, the Escuela Nacional Prilidiano Pueyrredón and the Escuela Nacional Ernesto de la Cárcova, she moved in 1960 to Paris on a scholarship from the Fondo Nacional de las Artes. There she became

involved with the presentation of happenings at the Galerie Raymond Cordier and in the Impasse Roussin. On her return to Argentina in 1964 she continued this activity in Buenos Aires and Montevideo and became associated with Argentine Pop artists; later that year she was awarded first prize by the Instituto Torcuato Di Tella in Buenos Aires for a series of strangely shaped and violently coloured hanging cushions. She presented two further installations at the same venue in 1965, one involving audience participation (with members of the public receiving blows or confronting unusual situations) and the other including live animals. In 1966 she collaborated with Allan Kaprow in New York and Wolf Vostell in Berlin on a project involving the mass-media forms of cinema, photography, television, radio, telephone and telegrams.

Minujín settled in New York in 1967 on being awarded a Guggenheim scholarship. There she created a *Menu–Phone*, which produced different sensory effects in the spectator according to the number dialled and which led on to other works combining modern technology and audience participation over the next four years. As a brief respite from these activities she exhibited erotic paintings and drawings in 1973 before returning to complex projects such as *Communicating with the Earth* (1976; Buenos Aires, Cent. A. & Comunic.), which sought to establish a communication network among Latin American artists. From the late 1970s she also created objects such as the *Cheese Venus* (1981; Buenos Aires, Knoll Argentina), a replica of the Venus de Milo made of iron covered with pieces of cheese, as a way of provoking reflection on the value of monuments and of permitting festive participation in a visual and gastronomic spectacle. These were followed by a series of replicas of Classical Greek sculptures, sometimes fragmented or with displaced elements presented to the spectator as a dynamic image.

BIBLIOGRAPHY

J. Glusberg: *Del Pop-art a la Nueva Imagen* (Buenos Aires, 1985), pp. 321–56

R. Squires: 'Eat Me, Read Me, Burn Me: The Ephemeral Art of Marta Minujín', *Performance*, lxiv (1991), pp. 18–27

M. Minujín: *Representaciones tridimensionales* (Buenos Aires, 1993)

J. Glusberg: 'Marta Minujín: Time and Space in her Work', *Art from Argentina, 1920–1994* (exh. cat. by D. Elliot and others, Oxford, MOMA, 1994), pp. 84–9

NELLY PERAZZO

Modotti, Tina [Assunta Adelaide Luigia] (*b* Udine, 16 Aug 1896; *d* Mexico City, 6 Jan 1942). Italian photographer, active in Mexico. She emigrated to the USA in 1918 and met Edward Weston in 1921, moving with him to Mexico City in 1923. There he taught her photography. Modotti's early platinum prints were close-up photographs of still-lifes such as wine glasses, folds of fabric or flowers, as in *Calla Lilies* (*c.* 1927; see Constantine, p. 98). She also made prints of finely composed architectural spaces. By 1927, when she joined the Communist Party, she was starting to incorporate more overt social content in her work. She also gave up making expensive and time-consuming platinum prints in favour of silver gelatin prints.

Modotti photographed political events, for example *Diego Rivera Addressing a Meeting of the International Red Aid, Mexico* (*c.* 1928; see Constantine, p. 117), as well as bullfights and the circus; she focused on the proud faces and hands of mothers, children, artisans and labourers. She was deported from Mexico for her political activities in 1929; during the next decade she dedicated herself to revolutionary and anti-fascist activities in Russia and Spain and took few photographs. In 1939 she returned to Mexico City. Although Modotti photographed from 1923–32, her work is relatively scarce. There is a large collection at MOMA, New York.

BIBLIOGRAPHY

M. Constantine: *Tina Modotti: A Fragile Life* (New York, 1975, rev. 1983, 2/1993)

A. Conger: 'Tina Modotti and Edward Weston: A Re-evaluation of their Photography', *EW: 100, Centennial Essays in Honor of Edward Weston* (Carmel, 1986), pp. 62–79

A. Stark: 'The Letters from Tina Modotti to Edward Weston', *The Archive*, 22 (1986), pp. 3–81

C. Barckhausen: *Auf den Spuren von Tina Modotti* (Cologne, 1988)

M. Hooks: *Tina Modotti: Photographer and Revolutionary* (London, 1993)

M. Figarella Mota: *Edward Weston y Tina Modotti en México: Su inserción dentro de las estrategias estéticas del arte post-revolucionario* (diss., Mexico City, U. N. Autónoma, 1995)

S. M. Lowe: *Tina Modotti: Photographs* (New York, 1995)

Tina Modotti (exh. cat. by P. Cacucci, Mexico City, Pal. Iturbide, 1995); Eng. trans. by M. de Corral

Tina Modotti: Una vita nella storia (Udine, 1995)

A. Cupullo: *Tina Modotti: Semilla profunda* (Havana, 1996)

Dear Vocio: Photographs by Tina Modotti (exh. cat. by P. Albers, San Diego, U. CA, U. A. Gall., 1997)

E. Poniatowski: *Tinisima: A Novel* (New York, 1997)

AMY RULE

Mola. Term for a colourful appliqué blouse worn by Kuna Indian women on the mainland and San Blas Islands of Panama and in the Darien region of north-western Colombia. *Mola* is the Kuna word for cloth, but it also applies to the woman's blouse and the front and back panels from which it is made. *Mola* blouses first appeared in the second half of the 19th century. Although made from European trade cloth, they were an indigenous development, and their complex patterns relate to earlier body paint designs.

Mola panels are hand-stitched, using cutwork and appliqué techniques. Two or more layers of different-coloured fabric are used. Each layer is cut to the shape of the design and stitched to the layer beneath, so that motifs may be outlined in a number of colours. Embroidery is sometimes added to the top layer. The stitching is ex-

Mola blouse, cotton, Kuna Indian, from Panama, 1922 (Oxford, Oxford University, Pitt Rivers Museum)

tremely fine, and no fabric is wasted. The front and back panels of a blouse are usually similar, but never the same. Design subjects include mythological patterns, birds, animals, plants, people and scenes from daily life. Advertisements, magazines, political posters and biblical themes often provide inspiration. The finished front and back panels are made up with a yoke and sleeves of plain or printed fabric (see fig.).

The *mola* blouse is worn with a printed cotton skirt, a red and yellow printed headscarf, a gold nose-ring and other jewellery of gold, beads, coins, seeds and shells. Nearly all Kuna women continue to wear this costume proudly as a symbol of their identity. However, while women have traditionally made *mola*s for their own use, they have also responded to the demands of tourism by selling blouses and panels to visitors. Thus, the *mola* has become a significant part of the Kuna economy, and standards of workmanship remain high.

BIBLIOGRAPHY
A. Parker and A. Neal: *Molas: Folk Art of the Kuna Indian* (Barre, MA, 1977)
M. L. Salvador: *Yer Dailege! Kuna Women's Art* (Albuquerque, 1978)
H. Puls: *Textiles of the Kuna Indians of Panama* (Princes Risborough, 1988)
LINDA MOWAT

Monasterio, Luis Ortiz. *See* ORTIZ MONASTERIO, LUIS.

Monasterios, Rafael (*b* Barquisimeto, 22 Nov 1884; *d* Barquisimeto, 2 Nov 1961). Venezuelan painter and teacher. He studied under Antonio Herrera Toro at the Academia de Bellas Artes, Caracas (1903–10). Monasterios travelled to Barcelona, Spain, in 1911 to further his studies and entered the Escuela de Artes y Oficios La Lonja. With the outbreak of World War I, he returned to Venezuela and lived in Barquisimeto. Three years later he moved to Caracas and dedicated himself to teaching drawing and painting and to mural painting. In 1919 he met the Russian painter Nicolas Ferdinandov, with whom he travelled around the island of Margarita. On returning to Caracas he held an exhibition with Armando Reverón at the Escuela de Música y Declamación de la Academia de Bellas Artes, in which he showed works executed in Margarita. Between 1930 and 1955 he alternated his painting with teaching in Caracas, Maracaibo and Barquisimeto. A landscape painter, Monasterios was concerned with capturing the light and colour of various Venezuelan regions (e.g. *Caricuao Turret*, 1930; Caracas, Gal. A. N.). In 1941 he was awarded the Premio Nacional de Pintura. Although he was not an original member of the Círculo de Bellas Artes, his resolutely innovative character drew him towards the intellectual and artistic group, and while with them he executed some outstanding work.

BIBLIOGRAPHY
A. Boulton: *La obra de Rafael Monasterios* (Caracas, 1969)
P. Erminy and J. Calzadilla: *El paisaje como tema en la pintura venezolana* (Caracas, 1975)
R. Esteva-Grillet: *Rafael Monasterios, un artista de su tiempo* (Caracas, 1988)
Donación Miguel Otero Silva: Arte venezolano en las colecciones de la Galería de Arte Nacional y el Museo de Anzoátegui, Fundación Galería de Arte Nacional (Caracas, 1993), pp. 37–8
YASMINY PÉREZ SILVA

Monosiet, Pierre (*b* Port-au-Prince, 21 April 1922; *d* Port-au-Prince, Dec 1983). Haitian painter and museum director. He began his career as an artist in 1949 by joining the Centre d'Art in Port-au-Prince, remaining there for 23 years, having studied under the Haitian painters Maurice Borno (1917–55), Lucien Price (1915–63) and George Remponneau (*b* 1916). His preferred medium was watercolour. His first one-man exhibition took place at the Centre d'Art in 1952. Noticed as a young man of talent, he was awarded a three-month scholarship that enabled him to visit museums in American cities in 1952. On his return he was made assistant to the American watercolourist Dewitt Peters (1901–66), who ran the Centre d'Art. In 1961 he resigned in order to spend a year in Germany, where he informed himself about all aspects of museum management. The next few years were difficult ones. He went to the Virgin Islands and worked at a variety of jobs unrelated to museum work, all the while teaching himself about conservation and preservation of art and the functioning of museums. On Peters's death Monosiet was called back as consultant for the planning of the Musée d'Art Haïtien in Port-au-Prince, of which he was appointed the first Director in 1972, a post he held until his death. He was always deeply committed to the work of Haitian naive artists, rather than to that of the modernists who found more favour with the Haitian public; the recognition accorded to these artists abroad confirmed his own choices and his conviction that naive painting had its own recognizable and distinct tradition.

BIBLIOGRAPHY
E. I. Christensen: *The Art of Haïti* (New York, 1975)
Haitian Art: The Legend and Legacy of the Naïve Tradition (exh. cat. by L. G. Hoffman, Davenport, IA, Mun. A.G., 1985)
DOLORES M. YONKER

Monsanto, Antonio Edmundo (*b* Caracas, 10 Sept 1890; *d* Caracas, 16 April 1948). Venezuelan painter and art historian. He studied at the Academia de Bellas Artes, Caracas (1904–9), under Emilio Mauri (1855–1908) and Antonio Herrera Toro. In 1912 with Leoncio Martínez, Manuel Cabré and other artists, he co-founded the anti-academic group Círculo de Bellas Artes in Caracas. Between 1916 and 1919 he came into contact with the traveller-artists Samys Mützner, Nicolas Ferdinandov and Emilio Boggio; Mützner in particular offered helpful advice. In 1920, when Monsanto had established himself as a painter through his technical skill and clarity of concept (e.g. *Seascape*, 1920; Caracas, Gal. A.N.), he began to feel dissatisfied with his work and to call himself a 'former painter'. He retired from painting, failing to develop work that had shown much promise, and between 1921 and 1928 he dedicated himself to enhancing his knowledge of art history. He also undertook the restoration of works of art, thereby maintaining his connection with painting. In 1936 he was appointed Director of the Academia de Bellas Artes, Caracas, in that same year renamed the Escuela de Artes Plásticas y Aplicadas, and from then on he dedicated himself completely to teaching, which is where his most important contribution lay.

BIBLIOGRAPHY
L. A. López Méndez: *Círculo de Bellas Artes* (Caracas, 1969)
F. Paz-Castillo: *Entre pintores y escritores* (Caracas, 1970)
P. Erminy and J. Calzadilla: *El paisaje como tema en la pintura venezolana* (Caracàs, 1975)

Cabré y Monsanto: Hacia la reinvención del paisaje, Galeria de Arte Nacional (Caracas, [1990])

YASMINY PÉREZ SILVA

Monteiro, Vicente do Rego. *See* REGO MONTEIRO, VICENTE DO.

Montenegro (Nervo), Roberto (*b* Guadalajara, 19 Feb 1887; *d* Mexico City, 13 Oct 1968). Mexican painter, printmaker, illustrator and stage designer. In 1903 he began studying painting in Guadalajara under Félix Bernardelli, an Italian who had established a school of painting and music there, and he produced his first illustrations for *Revista moderna*, a magazine that promoted the Latin American modernist movement and for which his cousin, the poet Amado Nervo, wrote. In 1905 he enrolled at the Escuela Nacional de Arte in Mexico City, where Diego Rivera was also studying, and won a grant to study in Europe. After two years in Madrid, Montenegro moved in 1907 to Paris, where he continued his studies and had his first contact with Cubism, meeting Picasso, Braque and Gris.

After a short stay in Mexico, Montenegro returned to Paris. At the outbreak of World War I he moved to Barcelona and from there to Mallorca, where he lived as a fisherman for the next four years. During his stay in Europe he assimilated various influences, in particular from Symbolism, from Art Nouveau (especially Aubrey Beardsley) and from William Blake.

On his return to Mexico, Montenegro worked closely with José Vasconcelos, Secretary of State for Public Education during the presidency of Alvaro Obregón in the early 1920s, faithfully following his innovative ideas on murals and accompanying him on journeys in Mexico and abroad. He was put in charge of the Departamento de Artes Plásticas in 1921 and was invited by Vasconcelos to 'decorate' the walls of the former convent, the Colegio Máximo de S Pedro y S Pablo in Mexico City. The first of these works, executed in 1922, consisted of the mural *Tree of Life* (for illustration *see* MURAL), relating the origin and destiny of man, and two designs for richly ornamented stained-glass windows influenced by popular art: *Guadalajara Tap-dance* and *The Parakeet-seller*. They were followed by two further murals in the same building: the *Festival of the Holy Cross* (1923–4), representing the popular festival of 3 May celebrated by bricklayers and stonemasons, and *Resurrection* (1931–3), with a geometric composition bearing a slight Cubist influence. Further murals followed, including *Spanish America* (1924; Mexico City, Bib. Ibero-Amer. & B.A.), an allegory of the historical and spiritual union of Latin America in the form of a map, and *The Story*, also known as *Aladdin's Lamp* (1926; Mexico City, Cent. Escolar Benito Juárez), a formally designed painting with Oriental figures similar in style to a mural made for Vasconcelos's private offices.

Although Montenegro claimed to be a 'subrealist' rather than a Surrealist, in his easel paintings he mixed reality and fantasy; two such works, which fall well within the bounds of Surrealism, were shown in 1940 at the International Exhibition of Surrealism held at the Galería de Arte Mexicano in Mexico City. In his later work Montenegro evolved an abstract style, although he never lost his interest in popular, pre-Hispanic and colonial art. He was also a fine portrait painter, and from the 1940s to the 1960s he produced a splendid series of self-portraits in which he is shown reflected in a convex mirror, thus combining elements of Mannerism and popular art. He illustrated books, made incursions into stage design, working for both the ballet and the theatre, and in 1934 created the Museo de Arte Popular in the recently inaugurated Palacio de Bellas Artes in Mexico City, becoming its first director.

WRITINGS
Planos en el tiempo (Mexico City, 1962) [autobiography]

BIBLIOGRAPHY
J. Fernández: *Roberto Montenegro* (Mexico City, 1962)
I. Rodríguez Prampolini: *El surrealismo y el arte fantástico de México* (Mexico City, 1969)
E. Acevedo and others: *Guía de murales del centro histórico de la Ciudad de México* (Mexico City, 1984)
Roberto Montenegro, 1887–1968 (exh. cat., Mexico City, Mus. N.A., 1984)
L. Morales: *Las artes plásticas en México de 1920 a 1950* (Madrid, 1986)
J. Ortiz Gaitán: *Entre dos mundos: Los murales de Roberto Montenegro* (Mexico City, 1994)
F. Ramírez: 'Los murales de Roberto Montenegro en el antiguo casino Mallorquín de Palma de Mallorca (1919)', *México en el mundo de las colecciones de arte*, v (Mexico City, 1994), pp. 302–7

LEONOR MORALES

Montero, Luis (*b* Piura, 27 Oct 1827; *d* El Callao, 22 March 1869). Peruvian painter. He studied at the Academia de Dibujo y Pintura in Lima under Ignacio Merino. He won a Peruvian government travel grant to study in Europe and spent some time in Italy, where he entered the Accademia di Belle Arti in Florence. In 1851 he returned to Peru, where he replaced Merino as director of the Academia de Dibujo y Pintura. The State gave him another grant, which enabled him to live in Italy from 1852 to 1855 and to travel to Paris. From 1856 to 1859 he lived in Havana, Cuba, where he married. He returned to Peru before living again from 1861 to 1868 in Italy, where he painted the *Funeral of Atahualpa* (3.5×4.3 m, 1867; Lima, Mus. A.), a solemn and grandiloquent history painting, which he exhibited with great success in Brazil, Argentina and Chile; it was purchased by the Peruvian government and reproduced on the 500 Sol banknote. He was awarded the Medalla de Oro del Congreso and a pension for life.

BIBLIOGRAPHY
T. Núñez Ureta: *Pintura contemporánea peruana: Primera parte, 1820–1920* (Lima, 1975)
L. E. Tord: 'Historia de las artes plásticas en el Perú', *Historia del Perú*, ix (Lima, 1980)

LUIS ENRIQUE TORD

Monterrey [formerly Nuestra Señora de Monterrey]. Mexican city and capital of the state of Nuevo León. Situated in the north-east of the country, it is Mexico's third largest city, with a population of *c.* 2.5 million. Various attempts at colonization by the Spanish during the 16th century culminated in the founding in 1596 of Nuestra Señora de Monterrey by Diego de Montemayor. The limited economic interest that the area offered the Spanish, its northern location, the bellicosity of the local indigenous people and the belated establishment and Christianization of the settlement all explain the small number of architectural examples dating from the colonial period. The only significant works that remain are the former hacienda of S Pedro (1660) and the chapel of the

former Palacio de Nuestra Señora de Guadalupe (1787; now Museo Regional El Obispado). The first signs of a regional architecture came after Mexican independence was achieved in 1821. The new rail connection between Monterrey and Mexico City, opened in 1887, fostered industrial development. Notable constructions from this period include the first buildings for the Cervecería Cuauhtémoc (1871; now Museo de Monterrey); those of the iron and steel foundry (1900); and the Vidriera Monterrey (1909). Also significant were the Palacio de Gobierno (1895), the Banco Mercantil (1900) and the Arco de la Independencia Nacional (1910) by A. Gilles, all examples of Neo-classical architecture.

Monterrey finally experienced a cultural boom in the 1970s. In 1974 the Centro de Arte Vitro was founded, followed in 1976 by the Casa de la Cultura de Nuevo León. In 1977 the Museo de Monterrey was established in the old brewery, and the following year the Centro Cultural Alfa was built by Fernando Garza Treviño, later incorporating the stained-glass window *The Universe* (1988) by Rufino Tamayo. Various monumental sculptural works were also erected, including *Homage to the Sun* (h. 27 m, 1979) by Tamayo, works by Manuel Felguérez (1981) and Luis Barragán (1983), and the *Gate of Monterrey* (1985) and *The Irises* (1989) by Enrique Carbajal Sebastián. Revolutionary urban design came to Monterrey in 1985 with the creation of the Gran Plaza, perhaps the largest in the world, by Oscar Bulnes and Benjamín Félix. Bulnes was also responsible for designing the Teatro de la Ciudad, the new Palacio Legislativo, the administrative tower of the Gobierno Estatal building and the INFONAVIT building, all built around the square. He also designed the Centro de Tecnología Avanzada (1989) at the Instituto Tecnológico de Monterrey, an apt symbol of the new era of prosperity being experienced by the city. Other products of this prosperity include the ambitious Parque Fundidora by Eduardo Terraza and the new Museo de Arte Contemporáneo (1991), the work of Ricardo Legorreta.

BIBLIOGRAPHY

I. Cavazos: *Diccionario biográfico de Nuevo León* (Monterrey, 1984)
R. Mendirichaga: *Los cuatro tiempos de un pueblo* (Monterrey, 1985)
I. Cavazos: *Síntesis histórica del estado de Nuevo León* (Monterrey, 1988)
X. Moyssén: *Catorce artistas contemporáneos de Monterrey* (Monterrey, 1991)
B. Béatrice: *Monterrey y sus alrededores* (Mexico City, 1992)

XAVIER MOYSSÉN

Montevideo [San Felipe y Santiago de Montevideo]. Capital of Uruguay. This port city is situated on the north bank of the Río de la Plata estuary, its population of *c.* 1.3 million spread over an area of 400 sq. km. sq. It was founded by the Spanish on a narrow peninsula in 1724 as San Felipe y Santiago de Montevideo, a modest settlement and stronghold to restrict the advance of Portuguese Brazil. Though not rich in natural resources, the region had abundant wild cattle that had bred in the 17th century. The earliest urban layout of Montevideo (Ciudad Vieja, 1724–1830), which was in the usual grid-plan form of Hispano-American towns, has been fundamentally preserved, although apart from the Cerro Fortress (1801–9) designed by the Colonel of the Royal Body of Engineers, José del Pozo y Marqui (1751–1814), only a few traces of its notable military constructions remain (e.g. Puerta

Ciudadela, 1741, by Diego Cardoso). The city also lacks any outstanding examples of early colonial buildings. None pre-dates the last decades of the 18th century, by which time Baroque buildings had been almost entirely superseded by the severe academic Neo-classicism of the Cabildo (1804–11), designed by TOMAS TORIBIO, or had been replaced, as with the Matriz church (1792; later Cathedral), the exterior of which was eventually executed in an Italianate Neo-classical style. A Pompeian design was adopted in the ground-plan of one- and two-storey houses, with rooms distributed around two central patios. From the mid-18th century, flat or terraced roofs, reflecting Andalusian influence, began to replace sloping roofs; the balcony also appeared, persisting in Montevidean architecture until the mid-20th century.

Following independence, in 1830 Montevideo became the Uruguayan capital, and its city walls were destroyed. Under the spur of increased European (principally Italian) immigration a new city was designed, also with a grid-plan layout, next to the earlier one. Growth continued with settlements along the routes that linked the city to the surrounding areas, and these too generally followed the grid-plan. Builders created a standard house-style that still respected the Pompeian ground-plan but not its dimensions: house fronts became narrower (10–12 m), while depth was maintained (at 50 m). Rooms were constructed along one side only, the height of the roof was raised (5–6 m), and the semicircular arch was substituted by the pointed arch. Façades were faced with Florentine ashlar and incorporated dressed-stone window frames and carved wooden doors. Interiors were enriched with marble, stucco and ceramic tiles. Representative of standardized houses were those in the Rens districts in the north and south of the city, developed by the financier Emilio Rens *c.* 1890. Until well into the 20th century the standard ground-plan predominated in housing, acquiring eclectic, historicist features at times, including Palladian columns, *Mudéjar* and Gothic window frames and the latest innovations of Art Nouveau. Public buildings, such as tram and railway stations, factories, markets and shops, were often outstanding examples of eclecticism. The Italian engineer Luis Andreoni (1853–1936) was responsible for a number of notable buildings, including the Central Railway Station (1897).

Although Art Nouveau flourished in the early 20th century in such buildings as the house (1922) built by Juan Antonio Ruis (1893–1974) for himself, Italianate Neo-classicism persisted in the renowned Palacio Legislativo (1925) built in marble by the Italian Gaetano Moretti. From the 1930s the combined influences of Art Deco, the Bauhaus, Frank Lloyd Wright and Le Corbusier transformed architecture in Montevideo (see fig.), notably in the work of JULIO VILAMAJÓ (e.g. Facultad de Ingeniería, 1937–8, Universidad de Montevideo). Further expansion also took place along the banks of the Río de la Plata, and curtain-wall buildings appeared here (for housing) and in the city (e.g. the Notariado building, 1962–7, by Studio Cinco). The dominant influence of Le Corbusier and Modernism gradually gave way, however, to buildings that expressed greater variety of form and colour, and the city remained broadly characterized by low-level construction (and unabated expansion). Its atmosphere is further en-

Montevideo, view of the skyline from the north-west, showing (centre) the Banco de la República (1938), by Giovanni Veltoni (1880–1942) and Raúl Lerena Acevedo (1888–1971), and (foreground) the Aduana (1920s) by Jorge Herron (1897–1969)

hanced by a profusion of tree-lined avenues and by its coastal avenue, the Rambla.

As with architecture, the visual arts were unremarkable in Montevideo before the 19th century, when Neo-classicism was the dominant style. Two of the most notable figures active in the city between the late 19th century and mid-20th were PEDRO FIGARI (*see* URUGUAY, fig. 3) and JOAQUÍN TORRES GARCÍA, who introduced Neo-plasti-cism and Constructivism from Europe. The cultural life of the city is enhanced by various museums, the most notable being the Museo Nacional de Artes Plásticas, which has extensive collections of Uruguayan and European art.

For further discussion of the art and architecture of Montevideo *see* URUGUAY.

BIBLIOGRAPHY
J. Giuria: *La arquitectura en el Uruguay*, ii (Montevideo, 1955)
A. González and others: *Iconografía de Montevideo*, Consejo Departamental de Montevideo (Montevideo, 1955)
J. Abella Trías: *Montevideo, la ciudad en que vivimos* (Montevideo, 1960)
C. Altezor and others: *Historia urbanística y edilicia de la ciudad de Montevideo* (Montevideo, 1971)
M. Canessa de Sanguinetti: *La ciudad vieja de Montevideo* (Montevideo, 1976)
J. P. Margenat: *Arquitectura art deco en Montevideo (1925–1950): Cuando no todas las catedrales eran blancas* (Montevideo, 1994)
M. Arano and L. Garabelli: *Arquitectura renovadora en Montevideo, 1915–1940: Reflexiones sobre un período fecundo de la arquitectura en el Uruguay* (Montevideo, 1995)
Guía arquitectónica y urbanista de Montevideo (Montevideo, 2/1996)
MARTA CANESSA DE SANGUINETTI

Montiel, Ramona. *See under* BERNI, ANTONIO.

Montserrat. *See under* ANTILLES, LESSER.

Monzo, Osvaldo (*b* Buenos Aires, 3 July 1950). Argentine painter. He was self-taught and came to prominence in the early 1980s as part of a current of Neo-expressionism and New Image painting that related to international developments emanating from Europe and the USA. He favoured schematic images presented as signs, their flat-ness counteracted only by the sensations of space induced by his use of colour and texture. He often incorporated written inscriptions into his pictures, as in a series entitled *Little Red Riding Hood and the Wolf*, in which he included quotations from the writings of Sigmund Freud to suggest the figures' subconscious desires.

BIBLIOGRAPHY
J. Glusberg: *Del Pop-art a la Nueva Imagen* (Buenos Aires, 1985), pp. 512–14
HORACIO SAFONS

Moody, Ronald (*b* Kingston, 12 Aug 1900; *d* London, 6 Feb 1984). British sculptor and writer of Jamaican birth. Born into a prominent professional family, he arrived in England in 1923, reluctantly to study dentistry. Alongside his studies he read voraciously in the metaphysics of India and China, which had a lasting influence on his thinking. A chance encounter with the Egyptian sculpture at the British Museum, London, so profoundly affected him with their 'tremendous inner force [and] irresistible movement in stillness' that Moody decided to become a sculptor. Self-taught, by the time he qualified in dentistry in 1930 he was already proficient. His first work in wood, *Wohin*

(1934; Sacramento, CA, Adolf Loeb priv. co.), followed by *Johanaan* (1935; see fig.), began a period of intense creativity that resulted in his moving to Paris in 1938, where two richly productive years brought growing recognition. Moody was forced to flee the city in 1940, two days before it fell to the Germans, abandoning his sculptures. (These pieces were retrieved after the war, along with twelve sculptures that had been sent to the US in 1938 for exhibitions at the Baltimore Museum of Art and elsewhere.) After escaping over the Pyrenees into Spain, Moody arrived back in England in October 1941. Moody's experiences in France and the dropping of the atomic bomb on Hiroshima deeply affected him, and much of his subsequent work concerned the dichotomy between man's potential for self-destruction and for spiritual evolution. *Three Heads* (wood, 1946), the only modern piece in Jawajarlal Nehru's collection of classical Buddhist figures, was the first of many symbolic sculptures that mirrored his growing alarm; the extent of his despair was given form in *Time Hiroshima* (wood, 1977; Vienna, Kurt Oberhuber priv. col.)

Ronald Moody: *Johanaan*, elm, h. 1.57 m, 1936 (London, Tate Gallery)

Following his 1946 one-man show at the Arcade Gallery, London, which included his portrait head *Harold Moody* (plaster, 1946; London N. P. G.), Moody contracted tuberculosis, which limited his ability to work and forced him to cancel exhibitions. While convalescing he scripted a series of radio talks on the history of art and wrote short stories. He continued to write articles and reviews until the late 1970s.

In the late 1950s Moody began experimenting with concrete, stimulated by the new techniques it demanded and the textural effects he was able to achieve; *The Mother* (1958; see CARIBBEAN ISLANDS, fig. 5) is his best known work in this medium. He abandoned concrete a few years later, when he was commissioned to sculpt *Savacou* (cast aluminium, h. 2.13 m, 1964), the 'proud, invincible' symbolic bird based on the form of a parrot, which stands on the campus of the University of the West Indies, Kingston. He then began exploring the textural potential of metallic resins in various works, including portraits.

Although wary of political or social activism, Moody became involved with the Société Africaine de Culture in Paris and served on the London Committee for the Second Conference of Negro Writers and Artists (Rome, 1959). In 1967 he became a member of the Caribbean Artists Movement, actively participating in their many exhibitions and symposia, and he served as chairman of the UK Visual Arts Sub-Committee for the Festival of Art and Culture '77 in Lagos, Nigeria. He served on the Council of the Society of Portraits Sculptors in London and in 1977 was awarded the Musgrave Gold Medal, Jamaica's most prestigious cultural award; the following year he received the Jamaica Institute Centenary Medal for contributions to art.

BIBLIOGRAPHY

M. Seton: 'Prophet of Man's Hope', *The Studio* (June, 1950)

C. Moody: 'Ronald Moody: A Man True to his Vision', *Third Text* (Autumn/Winter, 1989), p. 5

J. Ströter-Bender: *Zeitgenössische Kunst der* Dritten Welt (Cologne, 1991), p. 41

A. Walmsley: *The Caribbean Artists Movement 1966–1972: A Literary and Cultural History* (London, 1992)

V. Poupeye: *St James Guide to Black Artists* (New York, 1997)

Rhapsody in Black: Art of the Harlem Renaissance (exh. cat. by R. Powell and D. A. Bailey, London, S. Bank Cent., 1997), pp. 15, 26, 163

J. Wilson: 'Surfing the "Black" Diasporic Web: Postcolonial British Art and the Decolonisation of the US Visual Culture', *Transforming the Crown: African, Asian and Caribbean Artists in Britain, 1966–1996* (exh. cat., New York, Caribbean Cult. Cent., 1998), pp. 69–76

CYNTHIA MOODY

Mora (y Palomar), Enrique de la (*b* Guadalajara, 16 June 1907; *d* Mexico City, 9 May 1978). Mexican architect. He graduated from the Universidad Nacional Autónoma de México in 1930 and then began working with José Villagrán. Here, from the late 1930s he experimented with shell structures as a means of transcending the straight lines and right-angles that dominated the architecture of the time. While such contemporaries as Carlos Obregón Santacilia and Enrique Yáñez at times shared this approach, de la Mora was exceptional in the persistence of his commitment to it. Such works as the church of the Purísima (1947), Monterrey, were among the very earliest shell concrete churches. All four arms of a conventional cruciform plan are formed in parabolic vaults that spring from ground level, as are four chapels of lower section on

each side of the nave. The external surfaces of the vaults are completely smooth and contrast markedly with a free-standing brick campanile of simple tapered form.

In the early 1950s de la Mora became involved with the social building programme of the time: examples of his work from this period include the Guardería Infantil (1952) for the Secretaría de Comunicaciones and the Facultad de Filosofía (1953–4) in the Ciudad Universitaria, both in Mexico City. These were followed by a series of outstanding churches, designed in collaboration with FÉLIX CANDELA. S Antonio de las Huertas (1956), Mexico City, was the first of a number with centralized plans, made possible by the revision of the liturgy, and was an early example of the development of reinforced concrete shells with free edges. The chapel of Nuestra Señora de la Soledad (1956–8), Mexico City, is a minor masterpiece in which de la Mora (with Candela and Fernando López Carmona) took advantage of the compositional richness of a rhomboid plan, covered it with a single hyperbolic paraboloid shell (hypar) and set it astride massive rubble walls that dip to form a great curving crescent-shaped stained-glass window behind the altar. The chapel of S Vicente de Paul (1958–62), Coyoacán, Mexico City, and the almost contemporary chapel of S José Obrero (1957–62), Monterrey, are less impressive but still structurally adventurous in their treatment of the double curved vault, allowing de la Mora to create an architectural language quite different from that of the International Style.

De la Mora also undertook a number of public and commercial buildings, such as the Bolsa Mexicana (1956) and the headquarters building for the Compañia de Seguros Monterrey (1960–62; with Alberto González Pozo), both in Mexico City. The former boasts a trading floor spanned by hypar cross-vaults designed by Candela, while in the latter, two 30-m high concrete columns rise to support a massive longitudinal beam that is used to anchor 15 double cantilevers on each side; the floor slabs are suspended from the latter, leaving most of the site area free at ground level. There were some later churches, for example the Santuario de Guadalupe (1965), Madrid, Spain, and Santa Cruz (1967) at San Luis Potosí, but de la Mora probably never surpassed the mastery of the Soledad.

BIBLIOGRAPHY

M. L. Cetto: *Modern Architecture in Mexico* (Stuttgart, 1961), pp. 36–40, 50–51, 72–3, 123–5, 138

F. Bullrich: *New Directions in Latin American Architecture* (London, 1969), pp. 54–62

A. G. Pozo: *Enrique de la Mora: Vida y obra* (Mexico City, 1981)

F. González Gortázar, ed.: *La arquitectura mexicana del siglo XX* (Mexico City, 1994)

RAMÓN VARGAS

Moral, Enrique del (*b* Irapuato, Guanajuato, 20 Jan 1906; *d* Mexico City, 11 June 1987). Mexican architect and teacher. He graduated in 1928 from the Escuela de Arquitectura at the Universidad Nacional Autónoma de México, where he belonged to the first generation of students under José Villagrán. Through his studies and through working in Villagrán's practice, del Moral encountered Functionalism, but in his subsequent works he tried to produce designs that were in keeping with both Mexican traditions and his own personal aesthetic ideals, transcending radical functionalism and seeking an approach that

was sensitive to physical, socio-economic and cultural factors.

Del Moral's first works were carried out in collaboration with Marcial Gutiérrez Camarena (1902–54). These were almost exclusively private houses of an elemental simplicity and imbued with the spirit of Le Corbusier. Typical of this period are ten houses for workers, built in Irapuato, Guanajuato, in 1936, which show the influence of the International Style. He continued to work in this idiom into the 1940s, for example in several apartment buildings in the Cuauhtémoc area of Mexico City, such as those in Plaza Melchor Ocampo (1940–42). At the same time, however, he was beginning to develop a new form of expression. In his designs for private houses such as that of the de Yturbe family in San Angel (1946) and his own house in Tacubaya (1949), he adopted a more openly emotional and regionalist approach, producing works that have affinities with the distinctive works of Luis Barragán. His movement in this direction was curtailed, however, by the commencement of an intermittent partnership with MARIO PANI, whose strong personality and commitment to a modified version of the International Style led del Moral to pursue a different approach. The principal works carried out in collaboration with Pani were the master plan and the Rectoría (1951–2) in the Ciudad Universitaria of the Universidad Nacional Autónoma de México (with mural decoration by David Alfaro Siqueiros), the Secretaría de Recursos Hidráulicos (1950–53), situated in the Paseo de la Reforma, a series of houses, hotels and the airport (1954–5) in Acapulco, Guerrero.

Del Moral also produced a number of important public buildings, beginning with the Casacuarán Primary School (1946), Guanajuato. This was followed in the 1950s by the Mercado de la Merced (1956–7) in Mexico City, in which he found a hygienic, economical solution for the retailing of perishable goods, without abandoning his aesthetic ideals. In the 1960s he was responsible for the Procuraduría General de Justicia (1959–69) and the Tesorería del Distrito Federal (1962–3; both destr. in the 1985 earthquake) in Mexico City. Del Moral also established a reputation as the designer of numerous hospitals throughout the country, remarkable for the skill and care with which he allowed for clinical requirements while providing works well suited to their urban context. Perhaps the most representative are the Clínica hospital (1966–8) for the Instituto Mexicano de Seguro Social in Ciudad Obregón, Sonora, and the hospital in Cuautla, Morelos (1967). Del Moral was a professor of architecture in the Universidad de México from 1934 to 1950 and received numerous awards, including the Premio Nacional de Artes in 1978.

WRITINGS

El hombre y la arquitectura: Ensayos y testimonios (Mexico City, 1983)

BIBLIOGRAPHY

Contemp. Architects

'Enrique del Moral', *Arquit. México*, 100 (1968), pp. 42–7

'Enrique del Moral', *Testimonios vivos: 20 arquitectos* (Mexico City, 1981)

S. Pinoncelly: *La obra de Enrique del Moral* (Mexico City, 1983)

L. Noelle: 'Enrique del Moral', *Arquitectos contemporáneos de México* (Mexico City, 1988)

P. Quintero, ed.: *Modernidad en la arquitectura mexicana* (Mexico City, 1990), pp. 91–120

F. González Gortázar, ed.: *La arquitectura mexicana del siglo XX* (Mexico City, 1994)

W. J. R. Curtis: '"The General and the Local": Enrique del Moral's Own House, Calle Francisco Ramírez 5, Mexico City, 1948', *Modernity and the Architecture of Mexico*, ed. E. R. Burian (Austin, TX, 1997), pp. 115–26

L. Noelle: *Enrique del Moral: Un arquitecto comprometido con México* (Mexico City, 1998)

<div align="right">LOUISE NOELLE</div>

Morales, Armando (*b* Granada, Nicaragua, 15 Jan 1927). Nicaraguan painter and printmaker. He studied at the Escuela Nacional de Bellas Artes, Managua, from 1941 to 1945 and from 1948 to 1953 and at the Pratt Graphic Art Center, New York, from 1960 to 1964. He exhibited extensively internationally from 1953 and in 1957 made his first visit to New York on a Guggenheim Fellowship. His first paintings treated local landscapes, still-lifes and genre scenes in a realistic vein, but the work for which he is best known constitutes two distinct phases. From the mid-1950s until the late 1960s, in *Art informel* works such as *Dead Guerilla* (Ramón Osuna priv. col.) and *Ferry Boat* (1964; Managua, Banco Cent. de Nicaragua), he combined figurative elements with broad abstract forms related to the work of Robert Motherwell, sombre colours and a thick impasto influenced by the work of Antoni Tàpies. In the early 1970s Morales turned to a distinctive figurative style of Magic Realism in works such as *Seated Woman*

(1971; see colour pl. XXII, fig. 3), based to some extent on the Pittura Metafisica of Giorgio de Chirico but with a subtle tonal modulation of his own (e.g. *Nude, Horse, Incinerator*, 1974; *see* fig.). From 1982 he made his main home in Paris, where he served in the revolutionary government of Nicaragua as a representative to UNESCO. He resigned his post in 1990, when the Sandinistas lost the national elections, and established a new studio in London. In 1993 a portfolio of lithographs, the *Saga of Sandino*, were featured in an exhibition at the Museo Rufino Tamayo, Mexico City. Among his more important oil paintings from the 1990s are the magical realist portraits of *Gabriel García Márquez* (1993; Gabriel García Márquez priv. col.) and *Carlos Fuentes* (1994; Carlos Fuentes priv. col.)

<div align="center">BIBLIOGRAPHY</div>

G. Compton: 'A Word with Armando Morales', *Américas*, ix/6 (1957), p. 17

Pintura contemporánea de Nicaragua: Segundo aniversario del triunfo de la Revolución Popular Sandinista (exh. cat., Mexico City, Inst. N. B.A., 1981)

C. Martínez Rivas: 'Morales—una observación y cuatro preguntas', *Nicaráuac* 10 (Aug 1984), pp. 175–8

Pintura contemporánea de Nicaragua, Unión Nacional de Artistas Plásticos (Managua, 1986), pp. 42–5

Armando Morales: Recent Paintings (exh. cat. by D. Ashton, New York, Claude Bernard Gal., 1987)

Armando Morales: *Nude, Horse, Incinerator*, oil on canvas, 1.30×1.62 m, 1974 (Austin, TX, University of Texas, Jack S. Blanton Museum of Art)

Armando Morales: Pintura (exh. cat., Mexico City, Mus. Rufino Tamayo, 1990)

L. Kassner: *Armando Morales* (Italy [Américo de Arte Editores], 1995)

M. D. G. Torres: *La modernidad en la pintura nicaragüense* (Managua, 1995), pp. 41–53

Armando Morales: Peintures (exh. cat., Paris, Claude Bernard Gal., 1997)

DAVID CRAVEN

Morales, Ignacio Diaz. *See* DIAZ MORALES, IGNACIO.

Morales de los Ríos (y García Pimentel), Adolfo (*b* Seville, 10 March 1858; *d* Rio de Janeiro, 3 Sept 1928). Spanish architect, writer and teacher, active in Brazil. He was educated by the Jesuits at Puerto de Santa María and the Real Seminario de Nobles, Vergara. After an original preference for studying engineering in Madrid, he attended the Ecole d'Architecture in Paris from 1877 to 1882. His teachers included Jules Merindole (*d* 1888) and Genepin, through whom he met Viollet-le-Duc. After finishing his studies he returned to Spain and took part in numerous competitions: for the Casino at San Sebastián, the Mercado Central, Valencia, the Banco de España, Madrid, the Gran Teatro, Cadiz, and others. He also became active in politics, in the Reformista party, but was unsuccessful as a candidate and left for South America in 1889, settling permanently in Brazil. Based in Rio de Janeiro, he established an architectural career and became one of the more prominent exponents there of late 19th-century eclecticism. He typically worked on large, monumental projects, with spacious ground-plans and façades divided (in the French style) by projecting bays. Outstanding among these are the Escola (now Museu) Nacional de Belas Artes (1908) and the Tribunal Supremo, both in Rio, as well as hotels, mausolea and numerous temporary exhibition spaces. He also designed several houses in the neo-*Mudéjar* style, for example the building that is now the Instituto des Pesquisas Oswaldo Cruz, on the outskirts of Rio. His other activities included painting and sculpture, and he wrote on a variety of subjects. He held the chair of stereotomy at the Escola Nacional de Belas Artes, Rio de Janeiro, where he also taught composition and the history of architecture.

BIBLIOGRAPHY

A. Morales de los Ríos: *Figura, vida e obra de Adolfo Morales de los Ríos* (Rio de Janeiro, 1959)

A. Villar: 'Modernismo en Cádiz', *Archv Hispal.* (1973)

ALBERTO VILLAR MOVELLÁN

Mora Noli, José Guillermo (*b* Panama City, 24 Dec 1923; *d* Panama City, 4 Jan 1981). Panamanian sculptor and printmaker. He trained under the painters Humberto Ivaldi and Carlos Villalaz (1900–66). He held his first important one-man show in Panama in 1944 and left soon after to study at the Art Institute of Chicago and at the Art Students League in New York. He spent the rest of his life in Panama, where he taught art and produced numerous sculptures and murals for public buildings. Mora Noli invented *Cilindrismo*, which was a theory of Constructivist sculpture. He was the first Panamanian to create monumental sculptures, for example the statue to the heroine *Rufina Alfaro* (granite, 1947; Los Santos, Parque 10 de noviembre); because of his concern with historical and nationalist themes he also received numerous commissions for busts of illustrious Panamanian

figures. In sculptures such as *Choco Indian* (mahogany, 1945; Panama City, Mus. Antropol. Reina Torres Araúz) he favoured rough surfaces rather than a polished finish in order to emphasize form and an expressive content.

BIBLIOGRAPHY

Encuentro de Escultura (exh. cat., ed. M. E. Kupfer; Panama City, Mus. A. Contemp., 1978), pp. 40–41

MONICA E. KUPFER

Moreira, Jorge (Machado) (*b* Paris, 23 Feb 1904; *d* 1992). Brazilian architect and teacher. He graduated in 1932 from the Escola Nacional de Belas Artes, Rio de Janeiro, where he participated in the reforms (1930–31) of Lúcio Costa when Modernist teachers including Gregori Warchavchik were introduced. He then worked for a construction company in Rio and designed some houses and blocks of flats. In 1936 he entered private practice and joined the team that developed the design for the Ministry of Education and Health (1936–45; now the Palácio da Cultura; *see* BRAZIL, fig. 5) in Rio with Le Corbusier; led by Lúcio Costa, it also included Carlos Leão (1906–82), Affonso Eduardo Reidy, Ernani Vasconcelos (1912–87) and Oscar Niemeyer. This building introduced Le Corbusier's rationalist principles of Modernism to Brazil, influencing the work of all its young architects thereafter. Moreira, however, was the only one who did not subsequently move away from Le Corbusier's original postulates, becoming perhaps their most representative exponent in Brazil. He continued to use simple, prismatic shapes, never accepting the free structural forms developed by Oscar Niemeyer at Pampulha (1942–4), and he advised his students to avoid originality for its own sake as this would lead to unfortunate results for the less experienced.

From 1949 to 1962 Moreira was involved principally with work for the Cidade Universitária in Rio de Janeiro; completed buildings include the engineering school, medical centre, child care institute and architecture school. All the buildings have a common identity in their clarity of form, use of similar materials, simple rectangular and transverse blocks, pilotis, open screens or *brise-soleil* and high-quality execution, often including glazed tile mosaics, yet each is differently designed according to its different functions. The latter two buildings won first prize at the São Paulo Biennale (1953 and 1957 respectively), and the group won a gold medal at the Exposition Universelle (1958) in Brussels. Two projects in Rio de Janeiro for the financier Antonio Ceppas, a block of flats (1952) with its façades articulated by lattice grilles and movable louvres for ventilation, and a house (1958), also show Moreira's attachment to rationalist principles, used with a strong artistic imagination and attention to detail to produce works of great architectural merit.

BIBLIOGRAPHY

H. R. Hitchcock: *Latin American Architecture since 1945* (New York, 1955)

H. E. Mindlin: *Modern Architecture in Brazil* (Amsterdam and Rio de Janeiro, 1956)

Y. Bruand: *Arquitetura contemporânea no Brasil* (São Paulo, 1981)

A. Xavier, A. Britto and A. L. Nobre: *Arquitetura moderna no Rio de Janeiro* (São Paulo, 1991)

CARLOS A. C. LEMOS

Morel, Carlos (*b* Buenos Aires, 12 Feb 1813; *d* Quilmes, nr Buenos Aires, 10 Sept 1894). Argentine painter and lithographer. He studied drawing with Josef Guth at the University of Buenos Aires from 1827 to 1830. He was the first Argentine artist to complete his training within the country and is considered the earliest to have produced noteworthy work. He began as a miniaturist, painting portraits in collaboration with another Argentine painter, Fernando García del Molino (1813–99), including a portrait of the married couple *Juan Manuel de Rosas and Encarnación Ezcurra* (1836; García Lawson col.) and one of *Encarnación Ezcurra* (1839; Buenos Aires, Mus. Hist. N.). In 1841 he published eight lithographs depicting regional customs and manners as part of a large series printed by the firm Ibarra. In 1842 he travelled to Rio de Janeiro; on his return in 1844 his album *Usos y costumbres del Río de la Plata*, including prints such as *Washerwomen* and *Army Parade*, was published by the Litografía de las Artes, the lithographic workshop of Luis Aldao in Buenos Aires. The prints were later widely reproduced in publications about Argentina during that period. Among Morel's oil paintings, *Cavalry Battle during the Regime of Rosas* and *Charge of the Cavalry Division of the Federal Army*, together with the watercolour *Gaucho Cavalry* (all 1839–40; Buenos Aires, Mus. N. B.A.), testify to his ability as both a history painter and a painter of local customs; his genuine sympathy for such themes is expressed by his lively brushwork and dynamic compositions. The cruel persecution of Morel's family by the dictator Juan Manuel de Rosas probably contributed to the artist's mental instability, leading to his almost total seclusion during the last 50 years of his life. This factor, together with the disappearance of much of his work (documented by the painter and historian Alfredo González Garaño (1886–1969) and the historian and art critic Alejo González Garaño (1877–1946)), led to his later neglect, although his reputation has since been rehabilitated.

BIBLIOGRAPHY

Carlos Morel (exh. cat. by A. González Garaño, Buenos Aires, Asoc. Amigos A., 1933)
J. L. Pagano: *El arte de los argentinos*, i (Buenos Aires, 1937)
A. Matienzo: *Carlos Morel: Precursor del arte argentino* (Buenos Aires, 1959)
A. L. Ribera: 'La pintura', *Historia general del arte en la Argentina*, iii (1984), pp. 111–347

NELLY PERAZZO

Mori, Camilo (*b* Valparaíso, 24 Sept 1896; *d* Santiago, 7 Dec 1973). Chilean painter. He studied from 1914 at the Escuela de Bellas Artes in Santiago, where he was taught by Juan Francisco González and others, and in 1920 he made his first trip to Europe, meeting Juan Gris and exhibiting at the Salon d'Automne in Paris. In 1928 he was sent to Paris as one of a group of the 26 best students from the Escuela de Bellas Artes; he remained there until 1931, when he returned to Chile.

Mori was one of the instigators of the Grupo Montparnasse, the Chilean group of painters formed in 1923 with Luis Vargas Rosas (1898–1977), who gave the group its name, and Henriette Petit (1894–1983). Influenced above all by Cézanne, they aimed to break with a traditional approach to representational painting and looked to contemporary French painting for support, taking as their name a district of Paris associated with avant-garde art.

Their formation was marked by an exhibition organized by Vargas Rosas at the Rivas y Calvo auction house in Santiago; works by Vargas Rosas, Petit, Julio Ortiz de Zárate (1887–1946) and José Perotti were included. A second exhibition, *Salón de Junio*, was held at the same venue in June 1925, with Mori and Manuel Ortiz de Zárate (1887–1946) also participating; on this occasion they strengthened their links with Europe by including works by painters such as Picasso, Gris, Léger, Jacques Lipchitz and Louis Marcoussis.

Mori's early influences included not only Cézanne but also the work of Cubists, notably Braque and Picasso, for example in *L'Intransigeant* (1929; see Galaz and Ivelič, p. 213), a table-top still-life with a newspaper, fish and fruit. His figure paintings, such as *Boxer* (1923; see Galaz and Ivelič, p. 209), with a massive figure dominating an interior space, or the later portrait of his wife, *Maruja Vargas* (1943; see Galaz and Ivelič, p. 213), are more traditional in technique, the latter work resembling late 19th-century French naturalism. At the Salón Oficial in Santiago in 1928, a polemical exhibition for which he acted as commissioner, he exhibited *Traveller* (Santiago, Mus. N. B.A.), sombre in colouring and melancholic in mood.

In 1938 Mori travelled to New York to decorate the Chilean pavilion for the World's Fair held there in that year. Remaining in the USA until 1940, during this period he came under the influence of Pittura Metafisica. During his long life, however, he experimented with such a variety of styles that many other developments in 20th-century art, including Constructivism and Surrealism, were also reflected in his work. For example, *Interior* (1951; see exh. cat.), a formalized and decorative still-life of bottles and jugs viewed in silhouette, suggests an awareness of Purism, although by the 1960s, for example in *Valparaíso* (740×1000 mm, 1962; see exh. cat.), he was working in a style close to *Art informel*.

BIBLIOGRAPHY

Retrospectiva Camilo Mori: Su vida y su obra (exh. cat. by R. Bindis, Santiago, Mus. N. B.A., 1974)
G. Galaz and M. Ivelič: *La pintura en Chile desde la colonia hasta 1981* (Santiago, 1981), pp. 204, 209, 211–13, 255

CARLOS LASTARRIA HERMOSILLA

Mudéjar. Spanish term used to describe the architecture and art of Islamic inspiration produced in the areas of the Iberian peninsula reconquered by Christians between 1085, when Alfonso VI of Castile-León (*reg* 1072–1109) seized Toledo from the Muslims, and the 16th century; the style travelled to the New World with the Spanish colonizers. The Castilian word derives from the Arabic *mudajjan* ('permitted to remain'), and it was initially thought that *Mudéjar* art was produced only by Muslims for Christian masters, but the term has come to be applied to a broader range of works produced by Muslims, Christians and Jews for Christian and Jewish patrons. The distinctive and eclectic style of *Mudéjar* brick, stucco and timber architecture developed in many regions of Spain throughout the long Spanish Middle Ages. *Mudéjar* buildings are related to contemporary Islamic buildings in appearance and techniques of construction and decoration, but their structure is closer to Romanesque and Gothic architecture.

Mudéjar art lasted for so many centuries because the Islamic art from which it drew its inspiration was itself deeply rooted in the Iberian peninsula. The Christian monarchs, the Church and the populace admired mosques, palaces and mansions in the reconquered cities: mosques were consecrated and adapted to Christian worship without major architectural change, while palaces became the residences of kings and aristocrats. New buildings, including churches, archiepiscopal palaces and even synagogues, were decorated in stucco carved with arabesques and geometric patterns and inscribed with Latin or Hebrew phrases juxtaposed to such Arabic ones as 'happiness and prosperity' or the name Muhammad. Palaces were adorned with horseshoe arches, trefoil arches of exquisite design, gardens with two water channels crossing at the centre, wide porticoed patios with a large central cistern, comfortable baths and central throne-rooms. This nucleus was decorated with fine ribbed cupolas, multicoloured carved stucco, niches or cupboards for glazed ceramic jars, and with *Muqarnas* and arabesques. Gradually this Islamic style of decoration gave way to a more naturalistic style inspired by Gothic art of the 13th and 14th centuries. Multicoloured glazed tiles, which were already used on the exterior of the brick towers of Toledo and Aragón, adorned the floors and walls of many palaces and private houses.

Mudéjar religious architecture developed in Toledo after the conquest of the city in 1085, when it became the residence of the kings of Castile and the ecclesiastical centre of Spain. Brick and stone masonry between brick courses became popular, along with horseshoe and trefoil arches and façades similar to those found on mosques. In Old Castile and León, *Mudéjar* architecture appeared during the reign of Alfonso VIII (*reg* 1158–1214). In 1187 he founded the monastery of Las Huelgas and an adjoining palace; these were decorated in the purest Almohad style by master builders from Toledo and Seville. The Capilla de la Asunción, for example, has rich stucco of lambrequin arches supporting ribbed and *muqarnas* domes; the stucco-covered pointed barrel vaults over the cloister of S Fernando (13th century) were decorated with a textile-like pattern of roundels enclosing birds and other animals.

After the conquest of Córdoba in 1236, the famed vaults with interlaced ribs at the Great Mosque provided inspiration for vaults in churches in Toledo, Soria, Navarra and Saragossa, as well as at the hospital of San Blas, near Oloron, and Havarrens in southern France. With the conquest of Seville by Fernando III (*reg* 1217–52) in 1248, Christians had access to the great monuments of Almohad Andalucía, and *Mudéjar* architecture in this region retained a greater Islamic element. The Alhambra, the greatest monument of the Nasrids (*reg* 1230–1492), was an inexhaustible source of exotic artistry that *Mudéjar* master builders adapted for new construction in Toledo and Aragón. Following the example of his friend and ally the Nasrid sultan Muhammad V (*reg* 1354–91 with interruption), Peter the Cruel (*reg* 1350–69) had magnificent throne-rooms built in the midst of his gardens. The finest of his palaces was the Alcázar of Seville; its splendid Salón de Embajadores (see fig.) is one of the finest examples of the *Mudéjar* style.

In Aragón during the 13th and 14th centuries, *Mudéjar* churches were built in brick with variegated exterior

Mudéjar architecture of the Salón de Embajadores, the Alcázar, Seville, Spain, mid-14th century

decoration, revealing that medieval Aragonese builders owed much to Andalusian models, such as the Giralda at Seville. The style came to an end in Spain with the majestic towers of S María at Calatayud (15th century) and the Torre Nueva at Saragossa (16th century; destr. 1892), a 55.6 m clock-tower built by Christian master builders together with one Jewish and two Muslim master builders. At the beginning of the 15th century, *Mudéjar* architecture began to blend first into Late Gothic and then into the first manifestations of Renaissance or PLATERESQUE styles associated with Queen Isabella I of Castile and León and Cardinal Francisco Jiménez de Cisneros.

BIBLIOGRAPHY

D. Angulo Iñiguez: *Arquitectura mudéjar sevillana de los siglos XII, XIII, XIV y XV* (Seville, 1932)
L. Torres Balbas: *Arte almohade, arte nazarí, arte mudéjar*, A. Hisp., iv (Madrid, 1949)
F. Chueca Goitia: *Historia de la arquitectura española: Edad antigua y edad media* (Madrid, 1965)
J. Dodds: 'The Mudejar Tradition in Architecture', *The Legacy of Muslim Spain*, ed. S. K. Jayyusi (Leiden, 1992), pp. 592–7
V. B. Mann, T. F. Glick and J. D. Dodds, eds: *Convivencia: Jews, Muslims, and Christians in Medieval Spain* (New York, 1992)

BASILIO PAVÓN MALDONADO

Mudéjar revival. Term used to describe a style of architecture and the decorative arts employed by some artists in Spain and its colonies in the 19th century. It was based on the medieval work of Spanish *mudajjan*, an Arabic word denoting Muslims living under Christian rule (*see also* MUDÉJAR), and was particularly prevalent in such centres as Burgos, Seville and Toledo (e.g. Toledo Railway Station), which were rich in important examples of Islamic

architecture. Nationalism during this period, however, led to the style being used in other cities throughout the Iberian peninsula and in the Spanish colonies (e.g. masonic temple, San Pedro Sula, Honduras).

☐

Muñoz, Fray Vicente (*b* Seville, 1699; *d* ?Buenos Aires, 1784). Spanish architect, active in Argentina. In 1741 he joined the Franciscan Order in Buenos Aires. When he took his vows it was noted that he was a 'mason–architect', and he worked in this capacity in Buenos Aires, Córdoba and Salta. From 1730 he designed the vaulting for S Francisco, Buenos Aires, following the plans of the original architect Andrea Bianchi, who had begun it *c.* 1724. The dome (1752) of Córdoba Cathedral is attributed to Muñoz. As has been noted, it is a majestic cupola reminiscent of those of Toro Cathedral in Spain or the Old Cathedral in Salamanca (Spain). Its corner turrets are designed in the Romanesque style, although its skilful interplay of curves and counter-curves, onion-shaped crown and base strengthened by a balustered ring are derived from Piedmontese Baroque (Gallardo). In 1754 Muñoz was involved in the construction of S Roque Chapel, Buenos Aires, designed by Antonio Massella, and in 1758 he drew up the design for, and was the builder of S Francisco (destr.), Salta, a forerunner of the present cathedral (1858–82) by Giovanni Soldati. S Francisco had a dome similar to that of Córdoba Cathedral.

BIBLIOGRAPHY
G. Furlong: *Arquitectos argentinos durante la dominación hispánica* (1946)
R. Gallardo: *Las iglesias antiguas de Córdoba* (1990)
JOSÉ MARÍA PEÑA

Muñoz Suárez, David (*b* San Miguel de Allende, Guanajuato, 28 Dec 1924). Mexican architect, urban planner and teacher. At first he worked, like his father, as a mason, before studying architecture (1946–8) at the Universidad Nacional Autónoma de México, Mexico City, where he later taught (1955–80). He planned the Ciudad Sahagún industrial and housing complex (1961) in the state of Hidalgo, based on the urban planning ideas of Carlos Lazo, who was influenced by Ludwig Hilbersheimer. He also designed the new headquarters of the Lotería Nacional (1970; with R. Torres and S. Santacruz), Mexico City, a high triangular prism of steel and glass quite different from his other work. Between 1976 and 1981 he planned the interdisciplinary unit of the Instituto Politécnico Nacional, Iztacalco, Mexico City, and two schools, each for *c.* 18,000 students, at the Universidad Autónoma Metropolitana, Mexico City, on the Azcapotzalco and Xochimilco campuses. He also designed the Palacio de Gobierno (1979) in Tuxtla Gutiérrez. Evident in these is his preference for horizontal masses and the placing of passageways around interior courtyards. Muñoz Suárez also worked with Pedro Ramírez Vázquez and Jorge Campuzano on the new Palacio Legislativo (1982), Mexico City, and on five missionary buildings (1985) in Dodoma, Tanzania. The Seguros Azteca Building (1987), Xochimilco, Mexico City, has a façade formed of a remarkable articulation of expanses of blank concrete.

WRITINGS
'Otras búsquedas contemporáneas', *Cuad. Arquit. Mesoamer.*, ix (1987), p. 92
ALBERTO GONZÁLEZ POZO

Mural. Painting applied to an exterior or interior wall surface, especially in a public building or space. During the 19th century a growing sense of national identity in many countries, especially in Europe, and the emergence of new patrons, both private and public, stimulated a revival in didactic and historical mural painting that was closely linked with revivalist movements in architecture. The mural subsequently became a significant art form throughout the modern Western world, where its potential accessibility for a large viewing public and, in some cases, its ability to stimulate public response led to its use in the promotion of a variety of social and political causes.

During the late 19th century, mural painting in Mexico spread from its colonial role in church decoration and began to be used for secular decorations endorsing the positivist ideology that dominated education and political thought. Such murals as Juan Cordero's *Triumph of Science and Labour over Envy and Ignorance* (1874; Mexico City, Escuela N. Prep.; destr.) were painted in educational institutions and state buildings. After the Mexican Revolution (1910–20), the Secretary of State for Education (1921–4), José Vasconcelos (1882–1959), allocated a substantial budget for the decoration of public buildings with murals, demonstrating his belief in the edifying function of art. ROBERTO MONTENEGRO, DIEGO RIVERA and DAVID ALFARO SIQUEIROS were among those who received the first major mural commissions; they had spent time in Spain during the early 1900s and were familiar with *modernista* mural decorations in Barcelona. The influence of these is evident in the first large-scale mural commission, in which Montenegro, Jorge Enciso, Xavier Guerrero and Gabriel Fernández decorated (1921–2) the former church of SS Pedro y Pablo in Mexico City. The artists depicted motifs drawn from regional craftworks, and Montenegro painted *Tree of Life* in tempera on the main wall, using Symbolist imagery heavily influenced by *modernista* paintings (see fig.). Similar influences are evident in Diego Rivera's *Creation* (encaustic and gold leaf, 1922–3; Mexico City, Anfiteatro Bolívar, Escuela N. Prep.), while a series

Mural by Roberto Montenegro: *Tree of Life* (1922), tempera, former church of SS Pedro y Pablo, Mexico City

of frescoes by JOSÉ CLEMENTE OROZCO were expression-istic in style and treated esoteric themes (e.g. *Struggle of Man against Nature*, 1923; Mexico City, Escuela N. Prep.; destr.).

The influence of *modernismo* declined as nationalist themes became prominent; several mural artists sought to develop nationalist styles based on images and forms from Pre-Columbian and indigenous popular art, as in JEAN CHARLOT's *Conquest of Tenochtitlán* (fresco, 1922–3; Mexico City, Escuela N. Prep., stairway) and FERNANDO LEAL's *Festival at Chalma* (fresco, 1922–3; Mexico City, Escuela N. Prep., stairway). At the same time a more militant tendency was also discernible: many leading mural artists, notably Rivera and Siqueiros, had joined the Mexican Communist Party and in 1922 had helped form the Sindicato de Obreros Técnicos, Pintores y Escultores. The Sindicato issued a manifesto in its periodical, *El Machete*, stating that mural painting should be Socialist in orientation, both in terms of imagery and in methods of execution. Rivera's murals in the Ministry of Education building, Mexico City, started in 1923 on three storeys of the two main courtyards, initially depicted peasant life but gradually became more militant, showing images of work and of the Revolution. Orozco also painted images of the Revolution at the Escuela Nacional Preparatoria; his first version of the *Revolutionary Trinity* (1923–4) was destroyed by hostile students, but he replaced it in 1926–7. Orozco became increasingly overt in his criticism of the exploitation of the working classes, and the left-wing orientation of the muralists' work led to hostility from the government between 1925 and 1933. Consequently, activity in this area was greatly reduced.

A revival in commissions for murals in schools, union buildings and open public areas in the mid-1930s was the result of a united response of the government and artists to the rise of Fascism in Europe. The political emphasis of the murals from this period lessened, however, in the late 1940s, when commissions came from many private institutions as well as for government buildings (for illustration *see* OROZCO, JOSÉ CLEMENTE). Such artists as Rufino Tamayo and JUAN O'GORMAN were less overtly political than Orozco, Rivera or Siqueiros had been, and their murals often reflected a more decorative, folkloric approach. Particularly striking is O'Gorman's mosaic decoration *Historical Representation of Culture* (1948–50), created around the exterior walls of the central library at the Ciudad Universitaria, Mexico City. O'Gorman's use of mosaic was typical of a move towards using different materials and a more technical approach. Siqueiros had encouraged experimentation in the USA in the early 1930s with such approaches and techniques as the use of nitrocellulose pyroxaline paint, photographic projection, airbrushes, curvilinear perspective and collective work. His innovations were demonstrated in *For a Complete Social Security for all Mexicans* (1954; Mexico City, Hospital de la Raza).

The impact of Mexican muralism was felt throughout Latin America in the post-war period. In Argentina, since 1971, more than 400 murals have been painted in schools, regional museums and union buildings by such groups as La Pena in Mar del Plata and Greda in Buenos Aires. A significant example is the mural by Rodolfo Campondonica (*b* 1938) on the history of Argentina, the *Path of Humanity* (1973–80), at the municipal palace at Trenque Lauquen. Against the backdrop of radical political events, many mural artists in Latin America also took to painting on walls in the streets. This occurred in Chile during the government of President Allende (1970–73), when mural artists formed themselves into brigades to protest at military interventionism. Also in the 1970s the Colectivo Acciones de Arte (CADA) was set up in Chile with the aim of producing art collectively in public spaces. In Nicaragua, where the influence of Mexican mural painting was felt most strongly following the Sandinista revolution (1979), such mural painters as Alejandro Canales turned to political and revolutionary themes, as in his vast mural *Communication Past and Present* (30×14 m) on the Telcor Building, Managua (for illustration *see* colour pl. IV, fig. 2). The example of Mexico also inspired the Anteo group in Bolivia to create murals on public, university and school buildings, which took a Marxist stance and idealized Pre-Columbian Bolivia. The group's members included Gil Imaná, Solón Romero (*b* 1925) and Lorgio Vaca (*b* 1930).

See also MEXICO, §IV, 2(iv)(a).

BIBLIOGRAPHY

A. Brenner: *Idols behind Altars* (Boston, 1929, rev. 1970)
B. Myers: *Mexican Painting in our Time* (New York, 1956)
J. Charlot: *The Mexican Mural Renaissance, 1920–1925* (New Haven, 1963)
L. Cardoza y Aragón: *México: Pintura de hoy* (Mexico City, 1966)
E. Edwards: *Painted Walls of Mexico from Pre-Historic Times until Today* (Austin, TX, and London, 1966), pp. 166–276
A. Rodríguez: *A History of Mexican Mural Painting* (New York and London, 1969)
J. Franco: *The Modern Culture of Latin America* (London, 1970)
O. Suárez: *Inventario del muralismo mexicano* (Mexico City, 1972)
F. Chatel and others: *L'Art public: Peintures murales contemporaines, peintures populaires traditionnelles* (Paris, 1981)
Comm. Murals Mag. (1981–7)
J. Fernández: *El arte del siglo XIX en México* (Mexico City, 1983)
N. Coleby: 'La construcción de una estética: El Ateneo de la Juventud, Vasconcelos y la primera etapa de la pintura mural postrevolucionaria, 1921–24' (MA thesis, Mexico City, U. N. Autónoma, 1986)
Art in Latin America: The Modern Era, 1820–1980 (exh. cat. by D. Ades and others, London, Hayward Gal., 1989), pp. 151–79, 323–4
D. Rochfort: *Mexican Muralists: Orozco, Rivera, Siqueiros* (London, 1993)

NICOLA COLEBY, DESMOND ROCHFORT

Murillo, Gerardo. *See* ATL, DR.

Muro, José Antonio Fernández. *See* FERNÁNDEZ MURO, JOSÉ ANTONIO.

N

Narváez, Francisco (*b* Porlamar, 4 Oct 1905; *d* Caracas, 7 July 1982). Venezuelan sculptor, painter and teacher. He studied at the Academia de Bellas Artes, Caracas, from 1922 to 1927. In 1928 he had his first one-man show in the Club Venezuela, Caracas, after which he went to Paris, where he studied at the Académie Julian and in the studio of the French sculptor Paul Landowski (1875–1961). He also met François Pompon and studied the work of Rodin, Aristide Maillol, Emile-Antoine Bourdelle, Mateo Hernández, Charles Despiau and Pablo Gargallo. On his return to Caracas in 1931, Narváez set up a workshop, which was active until 1943. Between 1936 and 1956 he taught at the Escuela de Artes Plásticas y Aplicadas in Caracas, for the last three years as its director. From 1938 he produced decorative work for various architectural projects in Caracas under the direction of Carlos Raúl Villanueva, notably on the reliefs for the façades of the Museo de Ciencias Naturales (*Man* and *Woman*) and the Galería de Arte Nacional, the Toninas Fountain (mythological figures; artificial stone) and on murals (*in situ*, except for n. 42 (destr.)) at the Ciudad Universitaria. He was awarded the Official Prize for Sculpture in 1940 for *Decorative Figure* (mahogany, 790×300×300 mm; Caracas, Gal. A. N.), a work that shows his progression from the stylization of Art Deco to a Creole-inspired phase. In 1948 he won the National Prize for Painting. In his later work he abandoned figuration for an interest in abstraction based on textured volumes (e.g. *3 Volumes*, bronze, 1.36×0.82×0.73 m, 1981; Caracas, Mus. A. Contemp.).

BIBLIOGRAPHY

F. Paz Castillo and R. Rojas Guardia, eds: *Diccionario de las artes visuales en Venezuela*, i (Caracas, 1973), pp. 171–3

R. Pineda: *Francisco Narváez: El maestrazo* (Caracas, 1976)

Francisco Narváez: Hitos de una trayectoria (exh. cat., Ciudad Guayana, Sala Sidor A., 1993)

El proceso creativo en Narváez visto a través de la obra en custodia (Caracas, 1997)

ANA TAPIAS

Nassau-Siegen, Count **Johan Maurits of** (*b* Dillenburg, 1604; *d* 1679). Dutch patron. He was the youngest son of an impoverished branch of the Nassau family. In 1620 he joined the Dutch army led by his cousin, Prince Maurice of Orange. Johan Maurits's career progressed rapidly, and in 1636 he became Governor of the Dutch colony in north-east Brazil. He remained a skilful soldier all his life and as late as 1672 served as field-marshal in the army of the Stadholder William III of Orange.

Johan Maurits governed Dutch Brazil for seven years as an enlightened monarch (*see* BRAZIL, §§I and IV, 1(i)), devoting himself with much enthusiasm to the building of towns and fortifications. As Governor he built himself a palace, as well as a country house surrounded by extensive gardens. The most important aspect, however, of his Brazilian period was the scientific work carried out by people he had invited at his own expense, among them Georg Marggraf, a natural scientist and cartographer, Willem Piso, a doctor, and the artists FRANS POST and ALBERT ECKHOUT, who, with almost naive precision, carefully recorded the landscape, the native population and the country's flora and fauna in hundreds of drawings, gouaches and paintings: the *Theatrum rerum naturalium Brasíliae* (Kraków, Jagiellonian U. Lib.) comprises nearly 1500 oil sketches by Post and Eckhout. The result of their efforts was the monumental *Historia naturalis Brasíliae* (1648), a pioneering publication owing to the systematic approach underlying the research; the publication remained the standard work on Brazilian natural history until the 19th century.

Johan Maurits's Brazilian adventure was not long-lived: his employers, the West India Company, regarded him as too independent and not sufficiently interested in profits. In 1643 he resigned as Governor and returned to the Netherlands, taking with him an extensive collection from which he later made important donations to Elector Frederick William of Brandenburg (1652; a donation that was, in fact, more like a sale); to Frederick III, King of Denmark (1654); and to Louis XIV, King of France (1679). This explains the presence of a series of portraits of Brazilians (e.g. *Negro Woman and Child*, 1641; Copenhagen, Stat. Mus. Kst) and a few still-lifes by Albert Eckhout in Copenhagen. Another series of paintings by Eckhout, given to Louis XIV, became the model on which two of the most popular sets of Gobelins tapestries, *Les Anciennes Indes* and *Les Nouvelles Indes*, were based.

BIBLIOGRAPHY

T. Thomsen: *Albert Eckhout: Ein niederländischer Maler und sein Gönner Moritz der Brasilianer* (Copenhagen, 1938)

E. van den Boogaart, ed.: *Johan Maurits van Nassau-Siegen, 1604–1679: A Humanist Prince in Europe and Brazil* (The Hague, 1979)

Johan Maurits van Nassau-Siegen, 1604–1679 (exh. cat., The Hague, Mauritshuis, 1979)

Soweit der Erdkreis reicht: Johann Moritz von Nassau-Siegen, 1604–1679 (exh. cat., Cleve, Stadt. Mus. Haus Koekkoek, 1979)

B. BRENNINKMEYER-DE ROOIJ

Navarro, Luis Díez. *See* DÍEZ NAVARRO, LUIS.

Negret (Dueñas), Edgar (Luis) (*b* Popayán, 1920). Colombian sculptor. He studied at the Escuela de Bellas

Artes in Cali (1938–43), with Jorge Oteiza in Popayán (1944–6) and at the Clay Club Sculpture Center in New York (1948–50). He began exhibiting his work during the 1940s, when it still showed traces of academicism and the influence of Rodin. He began to experiment with a variety of materials, including plaster, ceramics, iron and steel, and to investigate the possibility of developing an abstract sculptural language while maintaining clear links with reality. Such is the case with *Glass with a Flower* (steel, 350×200×200 mm, 1949; Popayán, Mus. Negret), in which the object identified by the title is 'drawn' in space as a metal line. After living in Paris (1950–52), then in Spain and from 1955 to 1963 in New York, he finally settled on aluminium as the most appropriate sculptural material. At first he cut out shapes from aluminium sheets, assembling them as interlocked forms in a single plane, as in *Equinox* (wood and polychromed aluminium, 1000×700×200 mm, 1957; Popayán, Mus. Negret). Soon he moved from such wall-hanging reliefs to free-standing sculptures made from modular elements; although these works are self-sufficient as abstract sculptures, they maintained links with identifiable subject-matter through the clues provided by their titles, such as *Kachina* (polychromed aluminium, 1300×220×220 mm, 1957; Popayán, Mus. Negret).

Negret made acute reference in his sculpture to both technology and nature, using a strict and measured sense of order. By painting the aluminium in red, blue, white or matt black, he toned down its metallic quality and gave the sculptures an illusion of lightness, so that they sometimes seem about to rise from the ground. The elements are fastened down, however, with clearly visible screws that draw attention to their structure and to the processes and tools used in their fabrication, as in *Coupling* (painted aluminium, 600×900×700 mm, 1972; Popayán, Mus. Negret), one of a later group of sculptures in which he curved the aluminium sheets into arched forms. Another example of a similar work is *Bridge* (1972; see fig.). Negret's sculptures, among the most innovative in post-war Latin American art, could be described as hybrids of natural forms and machinery, conveying the artist's view of existence as based at once on nature and on technology as a human product. The Museo Negret was established in Popayán in 1986 by the Colombian government as a permanent collection surveying Negret's development as a sculptor.

WRITINGS

Negret: Ultima década 1980–90/Regreso al padre Inca (Caracas, 1990)

BIBLIOGRAPHY

Negret: Las etapas creativas (exh. cat. by G. Carbonell, Bogotá, Fond. Cult. Cafetero, 1976)

Edgar Negret (exh. cat., intro. A. Caicedo; Madrid, Mus. A. Contemp., 1983) [retro.]

J. H. Aguilar: 'Negret: La cultura del aislamiento', *Arte* [Bogotá], ii/3 (1987), pp. 40–53

Edgar Negret: De la máquina al mito, 1957–1991 (exh. cat. by J. M. Salvador, Monterrey, Mus.; Mexico City, Mus. Rufino Tamayo; 1991)

C. Jiménez: 'The Enthusiasm of Edgar Negret', *Third Text*, xxx (1995), pp. 85–91

EDUARDO SERRANO

Nel Gómez, Pedro (*b* Anori, Antioquia, 1899; *d* Medellín, 1984). Colombian painter, watercolourist, draughtsman, sculptor and printmaker. He studied engineering and architecture, both of which later influenced the conception of space in his paintings. From 1925 he travelled around Europe, settling until 1931 in Florence, where he was influenced in his choice of medium and style by Renaissance frescoes. The ascendancy at that time of the Mexican muralist movement (*see* MEXICO, §IV, 2(iv)(a)) also affected his decision to work on a large scale and to concentrate on subjects related to Colombian traditions. The murals that he produced on public buildings on his return to Colombia represented aspects of the daily life of his fellow countrymen.

In spite of the fact that there was a general move in Latin American painting to affirm national cultural values, Nel Gómez, because of his links with Mexican muralism, was criticized in some quarters for not giving priority to pictorial values. Nevertheless as a teacher he exerted a considerable influence on the nationalist spirit of younger artists such as Carlos Correa and Débora Arango. He also produced oil paintings, sculptures, drawings, prints and especially watercolours; these generally depicted still-lifes, landscapes and nudes, executed in bright colours and powerful brushstrokes.

BIBLIOGRAPHY

C. Jiménez Gómez: *Pedro Nel Gómez* (Bogotá, 1981)

Cien años de arte colombiano (exh. cat. by E. Serrano, Bogotá, Mus. A. Mod., 1985)

Edgar Negret: *Bridge*, painted aluminium, 595×2750×735 mm, 1972 (Austin, TX, University of Texas, Jack S. Blanton Museum of Art)

L. Oberndorfer: *Pedro Nel Gómez, pintor, escultor y amante: Una crónica*, 2 vols (Medellín, 1991)

EDUARDO SERRANO

Neofiguración. Paraguayan movement, active in the second half of the 1960s. It developed in Asunción as the Paraguayan equivalent of the Nueva Figuración movement in Argentina. However, it formulated its own guidelines and aims, and had a considerable influence on later developments in the visual arts in Paraguay. It represented an approach to figurative art halfway between *Art informel* and Expressionism, between a preoccupation with the physical material of the painting and the intention of distorting the figure. It was used by a group of Paraguayan artists to loosen the rigid pictorial image that had become accepted in the 1950s and to assimilate aspects of historical experience that had not until then played a part in artistic development. Social criticism was approached from two different angles within Neofiguración. The first, represented primarily by CARLOS COLOMBINO and OLGA BLINDER, had a sense of drama and a strong political message; the second, represented by William Riquelme (*b* 1944) and RICARDO MIGLIORISI, had a more satirical perspective and a playful and irresponsible spirit that to some extent was characteristic of the time.

See also PARAGUAY, §IV, 2.

BIBLIOGRAPHY
M. A. Fernández: *Art in Latin America Today: Paraguay* (Washington, DC, 1969)
O. Blinder and others: *Art actual en el Paraguay* (Asunción, 1983)
T. Escobar: *Una interpretación de las artes visuales en el Paraguay* (Asunción, 1984)
Deira, Macció, Noé, de la Vega: 1961 Neo Figuración 1991 (exh. cat., Buenos Aires, 1991)
J. Barnitz: 'New Figuration, Pop and Assemblage in the 1960s and 1970s', *Latin American Artists of the Twentieth Century* (exh. cat., ed. W. Rasmussen; New York, MOMA, 1993), pp. 122–33

TICIO ESCOBAR

Nervo, Roberto Montenegro. *See* MONTENEGRO, ROBERTO.

Nery, Ismael (*b* Belém do Pará, 9 Oct 1900; *d* Rio de Janeiro, 6 April 1934). Brazilian draughtsman and painter. He went to Rio de Janeiro in 1909 and enrolled in the Escola Nacional de Belas Artes in 1915. In 1920 he made his first trip to Europe, completing his studies at the Académie Julian in Paris. On his return to Brazil in 1921 he worked as a technical draughtsman in the Patrimônio Nacional architecture and topography section of the Treasury. In 1922 he married Adalgisa Noel Ferreira, who was to become known as the poet and novelist Adalgisa Nery. On his second trip to Europe between 1927 and 1928 he discovered the work of the Surrealists and of Chagall. Nery was already steeped in his own Thomist-based philosophical-religious doctrine, which his close friend the poet Murilo Mendes called *essencialismo*. He used that and Surrealist themes such as dream and nightmare, spirit and flesh to create an artistic vocabulary that he expressed in painting, poetry and, more freely, in drawing. His images centre on the human body, especially that of the artist himself (e.g. *Self-portrait*, U. São Paulo, Inst. Estud. Bras.), in an obsessive play of masks and mirrors, revealing a search for identity. Recurrent themes in works such as *Standing Figure* (*c.* 1927–8; U. São Paulo, Mus. A. Contemp.) are a fusion of I and the Other, the attraction of the Double, a joining of masculine and feminine, and Adam and Eve united in love and death. He also painted portraits such as that of *Adalgisa* (Campos do Jordão, Pal. Boa Vista). He died from tuberculosis and received recognition only with the 1966 retrospective organized by the Petite Galerie, Rio de Janeiro.

BIBLIOGRAPHY
M. de Andrade: 'Ismael Nery', *Diário nacional* [São Paulo] (10 April 1928)
M. Mendes: 'Recordação de Ismael Nery', *O estado de São Paulo* (1 July 1948–22 Jan 1949) [series of articles]
A. Nery: *A imaginária* (Rio de Janeiro, 1959)
Ismael Nery (exh. cat., intro. A. Bento; Rio de Janeiro, Petite Gal., 1966)
A. Bento: *Ismael Nery* (São Paulo, 1973)
J. Klintowitz: *Mestres do desenho brasileiro* (São Paulo, 1983)
Ismael Nery: 50 anos depois (exh. cat., ed. A. Amaral; U. São Paulo, Mus. A. Contemp., 1984)

ROBERTO PONTUAL

Netherlands Antilles. *See under* ANTILLES, LESSER.

Nevis. *See under* ANTILLES, LESSER.

Nicaragua, Republic of. Central American country. It is bordered on the north by Honduras, to the south by Costa Rica, to the east by the Atlantic Ocean and to the west by the Pacific Ocean (see fig. 1). It occupies an area of 130,000 sq. km, and the population in the late 20th century was 3,700,000. The capital and largest city, Managua, has a population of *c.* 700,000, and other important cities are León (once the capital), Granada, Chinandega, Bluefields and Matagalpa. Nicaragua has a varied and rich geography and one of the most intense and dramatic histories of oppression and resistance of all Latin America. The territory is crossed by the mountain ranges of Los Marribios and the Escudo Oriental; between them are situated the lakes of Cocibolca (Lake Nicaragua) and Xolotlán (Lake Managua), and there are numerous rivers flowing into the Atlantic and the Pacific. Based on its climatic and economic characteristics, the country is divided into three

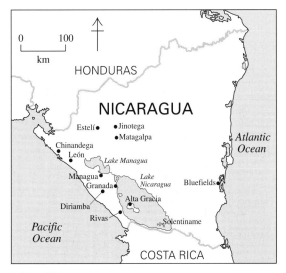

1. Map of Nicaragua

regions: the Pacific, the mountainous centre and the Caribbean Plains.

I. Introduction.

In 1502 Christopher Columbus, on his fourth and last voyage, became the first European to reach Nicaragua. The bloody conquest of the area, which became part of the Audiencia de Guatemala, began in 1523, and until 1531 there was a period of exploitation and extermination of the indigenous people and their culture: by 1540 their numbers had been reduced from *c.* 900,000 to *c.* 40,000. A result of this crusade was a static and underdeveloped colonial economy. During the 17th century the English, French and Dutch variously attacked the territory, managing to destroy the cities of Matagalpa, Granada and León; pirates, too, frequently wrought havoc, and volcanoes and earthquakes also took their toll on colonial art and architecture. The English presence in the Atlantic region continued throughout the 18th century, and after independence was proclaimed in 1821 the period of crisis and anarchy that followed was promoted by English and North American interest in a possible inter-oceanic route. Following brief membership, together with other former members of the Audiencia de Guatemala (Costa Rica, El Salvador and Honduras), of the Federación de América Central, Nicaragua finally became an independent country in 1838. In 1856 an anti-imperialist war was waged against William Walker, an American lawyer-journalist who set himself up as president in that year; after Walker's capture and execution a year later, a period of relative peace and stability was enjoyed. The newly built Managua became the capital in 1858. In 1880 Nicaragua joined the world market through the production of coffee. In 1893 José Santos Zelaya established a liberal bourgeois dictatorship, but this was cut short in 1910 by a North American-backed insurrection. From 1912 North American military intervention occurred repeatedly in support of the Conservative party, but Augusto César Sandino struggled against this and expelled the Americans in 1933. After Sandino's assassination, Anastasio Somoza García seized power; the bloody dictatorship of the Somoza family continued after his death (1956) until 1979, when, following civil war, it was overthrown by the Frente Sandinista de Liberación Nacional. State patronage under the Somozas was minimal, but in the decade of the Sandinista revolution rapid changes in social, political and economic structures occurred, and artistic activity supported by the state flourished. In 1990 the Sandinistas were defeated when Violeta Barrios de Chamorro was elected president, and state patronage once again dwindled.

BIBLIOGRAPHY

V. Gesualdo: 'Nicaragua', *Enciclopedia del arte en América* (Buenos Aires, 1969), pp. 231–5

E. La Orden Miracle: *Catálogo provincial del patrimonio histórico-artístico de Nicaragua* (Managua, 1971)

J. E. Arellano: *Aportes a la historia del arte en Nicaragua* (Managua, 1977); rev. as *Historia de la pintura Nicargüense* (Managua, 1994)

T. L. Merrill, ed.: *Nicaragua: A Country Study* (Washington, DC, 3/1994)

RAÚL QUINTANILLA ARMIJO,
LUIS MORALES ALONSO

II. Architecture.

The architecture of the colonial period was first seen in the cities of León and Granada (founded in 1524 by Francisco Fernández de Córdoba). León Vieja, of which only ruined defences survive, was founded on Lake Managua but had to be abandoned owing to earthquake and flooding; a new capital, León, was then founded in 1610 on the site of the Indian town Subtiaba (later the Leonese suburb of Subtiava). The massive, crude architecture seen in the ruins of León Vieja was a notable prototype for the first Spanish urbanizations carried out in America before the introduction of the Leyes de India. Little remains of the early architecture of colonial Nicaragua; it was influenced mainly by Spanish Baroque, which observed Gothic (Isabelline), Renaissance Plateresque and *Mudéjar* features, derived from the architecture of the Capitanía General, or Audiencia, of Guatemala. There were also touches of Herreresque severity. More memorable was the so-called 'earthquake Baroque' architecture of the late 17th century and the 18th, often with *Mudéjar* elements. Indeed, Nicaraguan colonial architecture was one of the most important examples of Central American Baroque; this was exemplified in ecclesiastical buildings. Nicaraguan churches were mainly rural and had three aisles and a simple roof with two slopes, to which with time were added a porch and a tower. Most notable is S Juan Bautista (1694–1705) in Subtiaba, with triple engaged columns on the façade. The façade of La Recolección (late 18th century) in León has spiralling decoration on many columns and evidence of *estípite* pilasters, while the churches of S Francisco (late 18th century) and La Merced (*c.* 1782; restored 1862) in Granada show a classicizing tendency. Civil architecture of the period is exemplified by the extraordinary Baroque portal known as the Puerta de Los Leones (1809) in Granada, originally part of the house (destr.) of Diego de Montiel, in which twin archaicizing engaged columns either side of a *Mudéjar* ogee arch support reclining lions. Military architecture of the 17th and 18th centuries is represented principally by the castles of the Inmaculada Concepción and of S Carlos, located in outlets of the San Juan River; both are of polygonal structure with corner bastions.

In the latter part of the 18th century, Neo-classicism began to appear, although it remained fused with Baroque. León Cathedral (1747–1824), built by the Guatemalan architect Diego Joseph de Porres (plan dated 1767; Seville, Archv Gen. Indias), has a Neo-classical façade (mainly 19th century), although the five-aisled interior and the apse portal are Baroque. The principal work of colonial architecture and art in Nicaragua, it was the last Spanish cathedral on the continent, and the largest in Central America; consecrated in 1780, it was dedicated as the Basílica de la Asunción in 1860. Other Neo-classical churches include Nuestra Señora de la Concepción del Viejo, Chinandega, with its elevated atrium and perimeter wall of Baroque curves and pinnacles, and the church of La Merced (1685; reconstructed 1723 and 1821) in León.

For some time, the architecture of the Republican period continued the evolution of the colonial era: Baroque elements can be seen, for example in the parish church of Rivas (reconstructed *c.* 1867) and the Teatro Municipal (*c.*

2. Managua Cathedral, Nicaragua, early 1930s

1903) in León. Neo-classicism acquired new momentum in civil architecture towards the end of the 19th century, especially with the advent of the liberal government (1893–1910) of José Santos Zelaya. The Mercados Municipales of Managua and Granada (1892), the Puerta del Cementerio in Rivas and the Parque Central in Managua are all Neo-classical, and the style continued well into the 20th century in the public buildings on the Plaza de la República, including the Ayuntamiento (1927), the Palacio Nacional and the cathedral (both early 1930s; see fig. 2). In the 1930s an eclectic style emerged in the reconstructions following the earthquake of 1931, mixing Baroque, Moorish and Neo-classical elements. Examples include the Palacio Departamental in León (1934), the Mercado Central in Managua (1934) and the Palacio de Casa Presidencial, Managua; the Palacio de Comunicaciones (1936) in Managua was in Art Deco style.

In the 1950s and 1960s the effects of modernization could be seen in the use of both new construction materials and rationalist design. The first International Style highrise buildings were erected, including the Banco de América and the Banco Central de Nicaragua, the pseudo-pyramidal Hotel Intercontinental and the Teatro Nacional de Rubén Darío, all in Managua. In 1972 an earthquake devastated the capital, and internal conflicts later in the decade restricted development; what reconstruction there was was unremarkable architecturally. Rehousing schemes in the 1980s included that on the island of Felice Peña (1984) in the Solentiname archipelago by the Italian Guido Lagana (b 1947), and a major undertaking in Managua was the construction of the new cathedral (1992), with its unique multi-domed roof, by the Mexican architect Ricardo Legorreta.

BIBLIOGRAPHY

S. Salvatierra: 'La catedral de León', *Contribución a la historia centroamericana*, ii (Managua, 1939), pp. 77–86
P. Kelemen: *Baroque and Rococo in Latin America* (New York, 1951)
D. Angulo Iñíguez: *Historia del arte hispanoamericano*, iii (Barcelona, 1956), pp. 74–90
M. González Galván: *Arquitectura colonial de Nicaragua* (Managua, 1970)
P. García: *Acerca de la arquitectura y la realidad nicaragüense* (Managua, 1982)
'Nature and Culture in a Project for Solentiname', *Domus*, 666 (Nov 1985), pp. 28–31
E. F. Figueroa: 'Managua: Una herencia del pasado neocolonial', *Arquit. & Urb.*, viii/3 (1987), pp. 3–12; ix/1 (1988), pp. 38–42
'Legorreta's Cathedral for Managua', *Archit. Rec.*, clxxix/12 (1991), p. 13

RAÚL QUINTANILLA ARMIJO
(bibliography with DAVID CRAVEN)

III. Painting, graphic arts and sculpture.

With the foundation in 1524 of the cities of León and Granada, colonial art began to be produced in the province of Nicaragua. It was strictly religious and was linked to the evangelizing process that accompanied the conquest. The small artistic output of Gothic, Plateresque, Herreresque and Baroque influences that survived the natural and human calamities of the 16th to 18th centuries can be categorized in two groups: works executed by artists from Spain, Mexico, Guatemala and Quito, consisting of religious images and paintings and the engravings of the first chroniclers who visited the province from 1528, such as Fernández de Oviedo; and works produced by anonymous indigenous artists and artisans. Working under adverse circumstances, the latter group created so-called Mestizo art, which was best exemplified in the sculpture and silverwork of the 17th and 18th centuries. Baroque in style, it displayed disparate themes and motifs from Central European conceptions and was of mediocre quality; based on Spanish models it was anachronistic, not only with respect to the art of Spain but also to Guatemala itself, for even when Neo-classicism was thriving in the Audiencia de Guatemala in the 18th century, Baroque prevailed in the province of Nicaragua.

Nicaraguan art continued to be largely influenced by colonial Spanish models even after independence, and the art of the 19th century was therefore predominantly religious. The only real innovation was the secular portrait, a consequence of the emerging bourgeois class. The frugality and tranquillity of such paintings was in marked contrast to the volcanic political situation created by the oligarchic conflicts of the period. The first significant artists in modern Nicaraguan art were Julio y Toribio Jerez (*fl* 1850), Adolfo León Caldera (*fl* 1864–74) and the Colombian painter Santiago Paramo (*fl* 1871–80); artists of average talent, they worked under adverse political and social circumstances. In the early 20th century the leading figure was the painter Juan Bautista Cuadra (1877–1952), and other artists active during the period included Antonio Sarria de Masaya and the sculptor Jorge Navas from Granada. Alejandro Alonso Rochi (1898–1973), a traditional painter of flowers and landscapes, and the sculptor Roberto de la Selva were the first artists to achieve success outside Nicaragua. Other notable artists included the painters Pedro Ortiz de Masaya, Rubén Cuadra de León and Ernesto Brown, founder (1937) of the Círculo de Bellas Artes.

In 1939 the sculptor Genaro Amador Lira (b 1910) founded the Escuela Nacional de Bellas Artes in Managua, and out of this, with the help of the outstanding teaching

3. Asilia Guillén: *Heroes and Artists Come to the Pan-American Union to Be Consecrated*, oil on canvas-covered board, 510×608 mm, 1962 (Washington, DC, Art Museum of the Americas)

of the school's director RODRIGO PEÑALBA, modern art was born in Nicaragua. From 1954 the painter ARMANDO MORALES began to achieve an international reputation as the leading exponent of Nicaraguan painting, with his mixture of abstract and figurative elements. His contemporaries included the sculptors Fernando Saravia (*b* 1922), Edith Gron (1917–67) and the naïve painter and embroiderer ASILIA GUILLÉN, whose work (see fig. 3) prefigured the primitivist painting popular during the 1970s and 1980s.

In the 1960s the Praxis group (1963–72) caused the first great ethical-aesthetic split in Nicaraguan art. The members of the group created a school of abstract painting with roots in the Nicaraguan landscape, and they were actively involved in denouncing the social and political problems created by the Somoza dictatorship. The school of primitive painting in the Solentiname archipelago (*see* SOLENTINAME PRIMITIVIST PAINTING) was active from 1968, when the painter Roger Pérez de la Roche (*b* 1949) first visited the archipelago; however, the efforts of the small farming community that Pérez inspired to paint were thwarted when the Somoza dictatorship destroyed all their work in the late 1970s. Under the Sandinista government in the 1980s, the community again began to play an active

role in the art life of the country. The commercialization of art began during the 1970s with the emergence of various galleries, but in 1978 artists and gallery owners protested against the oppression of the Somoza dictatorship by ceasing all cultural activity. Following the Sandinista revolution in 1979, Nicaraguan art was revitalized and enriched. The Unión Nacional de Artistas Plásticos, founded in 1980, encouraged mural painting and graphic art, as well as promoting and exhibiting nationally and internationally a wide range of Nicaraguan art.

In 1990–91 an artists' collective called Artefactoria was founded under the leadership of Raúl Quintanilla, Teresa Codina, Juan Bautista, David Occón, Patricia Belli and Aparicio Arthola, with a few others. The most notable art movement in contemporary Central American art, this group produced a series of exhibitions, artist performances, public lectures and debates. It also founded in 1991 the most provocative and significant art publication in contemporary Central America, the journal *Artefacto*; this periodical remains the last word in modern Nicaraguan art.

BIBLIOGRAPHY
J. E. Arellano: *Pintura y escultura en Nicaragua* (Managua, 1970)
G. Chase: *Contemporary Art in Latin America* (New York, 1970), pp. 54–7

M. Traba: 'Mirar en Nicaragua', *Pez & Serpiente*, 25 (Winter 1981), pp. 27–86

J. P. Weber: 'Sandinista Arts', *New A. Examiner*, xiii/2 (Oct 1985), pp. 42–4

J. Valle-Castillo: 'Las primitivas de Nicaragua o el inventario del paraíso', *Nicaráuac*, 12 (April 1986), pp. 161–84

Retrospectiva de la pintura nicaragüense, 1700–1950 (exh. cat. by J. E. Arellano, Managua, Teat. N. Rubén Darío, 1991)

D. Kunzle: *A Survey of Nicaraguan Mural Painting*, intro. by R. Quintanilla (Berkeley, 1993)

J. E. Arellano: *Historia de la pintura nicaragüense* (Managua, rev. 5/1994)

D. Kunzle: *The Murals of Revolutionary Nicaragua, 1979–1992* (Berkeley, 1995)

M. D. Torres: *La modernidad en la pintura nicaragüense, 1948–1990* (Managua, 1995)

M. Kupfer: 'Central America', *Latin American Art in the Twentieth Century*, ed. E. Sullivan (London, 1996), pp. 51–79

D. Rochfort: 'International Relations of a National Struggle: The Murals of the Nicaraguan Revolution', *Oxford A. J.*, xx/2 (1997), pp. 80–81

RAÚL QUINTANILLA ARMIJO
(bibliography with DAVID CRAVEN)

IV. Ceramics.

Several types of polychrome ware from the west coast were produced by Nicaraguan indigenous peoples. Nicaragua Ware, Nandiame Ware, Luna Ware and Managua Ware in a variety of shapes, from bowls without legs to bulbous, tripod-supported vessels, often featured delicately incised and carefully modelled details with painted motifs of geometric forms, whether animal or human, in colours ranging from cream, yellow-brown and light orange to red, black and sepia (see fig. 4). This tradition hardly survived between the Spaniards' arrival and 1979. With the new cultural policies instituted in the 1980s, a process of reclamation of the production of ceramics began. Aside from such professional artists as the sculptor Fernando Saravia (*b* 1922) and the painter Santos Medina, who drew upon Pre-Columbian motifs and techniques for their own ceramics, a large school of ceramicists re-emerged through the network of Centros Populares de Cultura from 1980 to 1990. In 1982 Father Ernesto Cardenal, the Minister of Culture, noted that in San Juan de Oriente, traditionally a potters' village, replicas of Pre-Columbian ceramics or new creations inspired by ancient art were being produced; in Matagalpa and Jinotega a very delicate black pottery was made, the clay blackened with pinewood smoke.

4. Luna Ware bowl, h. 190 mm, from Alta Gracia (Cambridge, MA, Harvard University, Peabody Museum)

After 1990, official support ceased for the two major organizations to which ceramicists belonged, the Diriangen National Artisans Union (UNADI) and the National Organization for Medium and Small-scale Industry (CONAPI). Nonetheless, both groups promoted a new revitalization of ceramic production and other artisanal products through national conferences as well as national competitions. As the President of UNADI Jorge Luis Cornejo stated in late 1991, 'There is a kind of rebirth of crafts, but from below, motivated by the crafts people ourselves.' One of the most famous ceramicists in Nicaragua in the late 20th century was Robert Potosme (*b* 1966), the founder of the Quetzalcóatl crafts cooperative in San Juan de Oriente, whose work was inspired by the ceramics of his ancestors.

BIBLIOGRAPHY

S. K. Lothrop: *Pottery of Costa Rica and Nicaragua*, 2 vols (New York, 1926)

P. Rosset and J. Vandermeer, eds: *Nicaragua: Unfinished Revolution* (New York, 1986), pp. 412–13

G. Fernández Ampié: 'We Were Nagrandanos, Nahualt, Chorotegas', *Barricada Int.*, ix, 343 (Nov 1991), pp. 46–7

DAVID CRAVEN

V. Gold, silver and jewellery.

Sixteenth-century silversmiths were active in the Audiencia de Guatemala, including the settlement at León, but virtually no work made in León before the 18th century has survived. It is likely that important commissions were given to silversmiths in Santiago de los Caballeros de Guatemala, for example the three ewers ordered from Antonio de Castro (*fl* 1721–50) for the Colegio de S Ramón in León. Domestic silver made in León from the 18th century can be identified in some cases by the mark of crossed swords, often stamped in conjunction with the *quinto* (tax) mark of a crown. Bold gadrooning and stylized flowerheads, both typically Baroque, continued to be used in the 19th century on trays, boxes and silver-mounted gourd-cups. Silver ex-votos (*milagros*) exist in large numbers but are never marked. Silver and gold folk jewellery, often with filigree decoration or mounted coins, is a continuing tradition, while among the indigenous peoples silver coins mounted as necklaces or elaborate breastplates were still worn in the late 20th century.

BIBLIOGRAPHY

J. Alonso de Rodríguez: *El arte de la platería en la capitanía general de Guatemala* (Guatemala City, 1981)

CHRISTOPHER HARTOP

VI. Patronage.

Prior to the early 20th century, patronage was largely in the hands of the Catholic Church. Government patronage was negligible until the early 20th century, although in 1879 President Joaquín Závala established the Biblioteca Nacional and the Escuela de Artes y Oficios, and in 1896 President José Santos Zelaya founded the Museo Nacional. Among the few public commissions available were those given to the sculptor Edith Gron (1917–67), who executed a marble bust (1960) of the celebrated Nicaraguan poet *Rubén Darío* for the Banco Central de Nicaragua, Managua. More indicative of government patronage during the Somoza family's dictatorship (1933–79) was adaptation of

a large-scale bronze equestrian statue in Managua of *Benito Mussolini* to represent *Anastasio Somoza*; the original statue was made in Italy and was simply refitted with a new portrait. The nature of this official patronage during the 1930s was captured in the title of a poem (1954) by Ernesto Cardenal (*b* 1925): 'Somoza Unveils Somoza's Statue of Somoza in the Somoza Stadium'. From the early 1950s an indigenous school of mural painting gradually emerged through a modest series of commissions from the Catholic Church and the private sector, which included Rodrigo Peñalba's murals (early 1950s) of the *Life of St Sebastian* for the parish church of Diriamba; the murals (1974) of Leoncio Sáenz (*b* 1935) about indigenous culture for La Colonia supermarket, Managua (both Managua, Cent. Conven. Olaf Palme); and César Caraca's mural (1970) for the Instituto Maestro Gabriel, Jiloa. In general, however, the lack of private and state patronage, coupled with the repressive political climate in which artists worked, led to the formation of two important support groups: the avant-garde Praxis group (1963–72), which maintained a cooperative exhibition space, and the painting workshop in the Solentiname parish commune (1968–77), which was ultimately suppressed by Somoza.

After the revolution (1979), official patronage was dramatically redefined and greatly extended. Not only did the new government establish networks such as the Centros Populares de Cultura for promoting broad public engagement with artistic production, but it also embarked on an ambitious, creative and flexible policy of patronage that was responsible for a virtual renaissance in Nicaraguan art. Its achievements included the revitalization of mural painting, the acquisition (in consultation with members of the Unión de Artistas Visuales) of numerous paintings and prints for government buildings around the country and the establishment of a national network of galleries, museums and other exhibition spaces for artisans as well as artists. Throughout the 1980s Nicaragua was a leading country for mural painting, as demonstrated by the widely acclaimed murals in Velásquez Park, Managua, by Alejandro Canales (*Homage to Women: The Literacy Crusade*, 1980), Leonel Cerrato (*The Reunion*) and Julie Aquirre (*Nicaraguan Landscape*), and on the exterior of the Telcor building (*Communication Past and Present*, 1984) by Canales (for illustration of Canales's works, see colour pl. IV, figs. 2 and 3). Scores of foreign painters were also commissioned to execute murals, such as those by Sergio Michilini and a team of Nicaraguan artists in the parish church of S María de los Angeles in the Barrio Riguero, Managua. Significantly, this extensive government patronage did not result in any one 'official style' but rather in the use of a wide variety of styles, techniques and themes. Nor were living leaders of the Frente Sandinista portrayed in public murals (until the 1990 elections, when electoral billboards were painted). The result of this patronage was an innovative form of 'socialist pluralism' that notably socialized artistic production throughout the country.

Following the electoral victory of the Unión Nacional de Opositores in 1990, however, government patronage (except in such cities as León and Estelí, where the Sandinistas won local elections) virtually disappeared, in favour of 'privatization', while government censorship of art (which had ended in 1979) returned, at least on an intermittent basis. International condemnation, for example, greeted the destruction in November 1990 by the mayor of Managua Arnoldo Alemán of the murals in Velásquez Park, and his painting over of the impressive 100-m mural along the Avenida Bolívar, Managua, the *Dream of Bolivar: History of Latin America* (1985), by the Chilean artist Víctor Canifrú. The few exhibitions sponsored by the UNO were held at the Banco Nicaragüense de Industria y Comercio, Managua, and tended to focus on earlier phases of Nicaraguan art rather than on contemporary developments.

Among the most important art patrons of the 1990s was Teresa Codina, a Spanish national but longtime resident of Nicaragua. Her financial support for the vanguard and neo-Dadaist collective of artists called Artefactoría, with its signal art journal *Artefacto* (from 1991), helped to fund the most dynamic force in contemporary Nicaraguan art not only in Managua but outside the capital city as well. Artefactoría staged controversial performance pieces by such artists as Juan Bautista and sponsored installation pieces by such leading Nicaraguan artists as Raúl Quintanilla, Patricia Bell and Aparicio Arthola, among others. For this reason, Managua was the most significant site for contemporary artists and art movements at the end of the century, despite the dire economic circumstances that daily confront individual artists in a country where in 1998 there was over 60% unemployment.

BIBLIOGRAPHY

'Edith Gron', *Enciclopedia del arte en América*, iv (Buenos Aires, 1969)
D. Zamora, ed.: *Hacia una política cultural de la Revolución Popular Sandinista* (Managua, 1982)
M. Randall: 'Breves notas sobre la cultura nicaragüense en la revolución', *Envío*, 8 (May 1983), pp. 1–5
P. Zwerling and C. Martin, eds: *Nicaragua: A New Kind of Revolution* (Westport, 1985), pp. 38–46
D. Craven: 'The State of Cultural Democracy in Cuba and Nicaragua', *Lat. Amer. Persp.*, xvii/3 (1990), pp. 100–119
R. Quintanilla: 'Otra vez la reafirmación del status quo y nada más', *Nuevo Amanecer Cult.* (23 Nov 1991), pp. 4–5

DAVID CRAVEN

VII. Collecting and dealing.

There was little or no collecting or dealing in Nicaragua before the 20th century. When the Nicaraguan artists Rodrigo Peñalba and Armando Morales first started gaining international fame in the 1950s, there were no true commercial galleries in Nicaragua. A turning-point occurred in 1963 with the establishment by the avant-garde Praxis group of the cooperative Galería Praxis in Managua, which lasted until its destruction by earthquake in 1972. The group and the international attention that it gained stimulated collecting and dealing in the country, and in 1974 several private, commercial galleries emerged in Managua showing contemporary art. These included Expo la Prensa, Cueva del Arte, Contemporánea, Ciac, Creativa, Plural de Bellas Artes, Culturama, La Cascada and Taqüe (the last showing the work of several former Praxis members, including Orlando Sobalvarro (*b* 1943), Leoncio Sáenz (*b* 1935) and Roger Pérez de la Roche (*b* 1949)). Unfortunately this upsurge in galleries was funded by the siphoning off of money sent by international relief agencies after the earthquake of 1972 by the social élite surrounding

the Somozas. Thus, while the general population of Managua was left in a desperate situation, the art market developed after 1972 in considerable part as a way of providing decoration for new homes in Managua's affluent neighbourhoods. Nor did the economic position or social status of professional artists notably improve, owing to the high percentage taken by galleries on each sale.

After the revolution (1979), all these private galleries closed and the commercial dealers relocated to Miami, FL; by the late 1980s, only three new private galleries had opened in Managua. It was in this void that the Unión Nacional de Artistas Plásticas, a member of the Asociación Sandinista de Trabajadores de la Cultura (ASTC), and the Ministry of Culture set up a series of artist-administered galleries to exhibit and sell contemporary art. Those under the auspices of the Ministry included the Galería Xavier Kantón in the Escuela Nacional de Artes Visuales in Managua, the Galería Ricardo Aviles inside the main building of the Ministry of Culture in Managua and the Galería Molejón in the Huembes market in Managua, as well as the 28 additional gallery spaces in each of the Centros Populares de Cultura located throughout the country. Furthermore, the Ministry established five large commercial exhibition spaces for artisanal and craft products in Monimbó, Masaya, Managua and Niquinohomo. Three major cooperative galleries were also run by the artists' union: the Galería Fernando Gordillo on the grounds of the ASTC, the Galería Praxis and the Galería Pepitos, all in Managua. With the electoral victory of the Unión Nacional de Opositores in 1990 almost all the government-funded galleries fell into disuse or were closed, except in León and Estelí, where the Sandinistas won; two of the union-run galleries remained open. In place of these public spaces, five commercial galleries were opened. Among the major private art collections in Nicaragua three are notable: those of the novelist Sergio Ramírez (Vice-President, 1979–90), Roberto Parrales (UNO's ambassador to the UK in the 1990s) and Father Miguel D'Escoto (Secretary of State, 1979–90).

BIBLIOGRAPHY
Pintura contemporánea de Nicaragua (exh. cat., essay M. Aróstequi; Mexico City, Inst. N. B.A., 1981), pp. 8–13
B. LaDuke: 'Six Nicaraguan Painters', *A. & Artists*, xii/8 (1983), pp. 9–13

DAVID CRAVEN

VIII. Museums.

Before 1979 Nicaragua had no public museum of fine art. Even the two pre-existing museums that housed important Pre-Columbian art collections—the Museo de Antropología in Managua, with its collection of Nicoya ceramics, Nandiame Ware and Luna Ware, and the Museo Juigalpa in Chontales, housing monumental sculpture—were in a state of disrepair until refurbishment and reorganization by the Sandinistas during the early 1980s. In 1987 the revolutionary government (with financial backing from the Swedish government) opened the Museo de Antropología for Pre-Columbian art in Granada to house a collection of large basalt statues (AD 800–1200) from the Zapatera Island archaeological sites. Several other public museums were opened in the 1980s, including the Museo de la Historia de la Revolución, Managua, containing

pieces of the bronze equestrian statue of *Somoza* that was dismantled in 1979. In addition, the Ministry of Culture displayed both the national collection of paintings and that of the Unión de Artistas Visuales in public buildings such as the Centro de Convenciones Olaf Palme in Managua and in such new exhibition spaces as the Museo Las Ruinas in Managua.

A major museum development in Nicaragua occurred in 1982 when almost all the major contemporary artists in Latin America, including Wifredo Lam, Roberto Matta, Oswaldo Guayasamín, José Gamarra, Julio Le Parc and Jesús Soto, donated examples of their work to the Frente Sandinista and to the Nicaraguan people as a show of international solidarity in the face of growing intervention by the USA in the internal affairs of the country. This collection of almost 400 paintings and prints was subsequently combined with the artists' union's own important collection, which featured several masterpieces of contemporary Nicaraguan art by such artists as Armando Morales and Santos Medina (see colour pl. XXI, fig. 2). Nicaragua thus went from having no museums of modern art to having perhaps the best in Central America and one of the finest collections in the world of 20th-century Latin American art. Originally on display in the Teatro Nacional de Rubén Darío in Managua and known as the Museo del Arte de las Américas, the museum then moved to a neo-colonial building near the Plaza de la Revolución in Managua and was renamed the Museo 'Julio Cortázar' del Arte Moderno de América Latina. As the property of the Frente Sandinista and the artists' union, it ceased to be administered by the Nicaraguan government, although it remained open to the public. After 1990 the UNO government radically cut back spending on the arts, but the various public museums remained open nevertheless, as did the last-mentioned. In 1998, the Nicaraguan government assumed responsibility for the Julio Cortázar Museum of Latin American Art and its collection. Plans to protect and better display these art works were also announced, as the collection was made a public one through an agreement between the Sandinista National Liberation Front (FSLN) and the government.

BIBLIOGRAPHY
D. Craven: *The New Concept of Art and Popular Culture in Nicaragua since the Revolution in 1979* (Lewiston, NY, 1989)
R. Quintanilla: 'Suspended Dialogue: Contemporary Art in Nicaragua', *Third Text*, xxiv (1993), pp. 25–34

DAVID CRAVEN

IX. Art education.

Art education originally took the form of craft workshops where woodwork and painting were taught (17th century). In 1881 Tomás Ayón founded the Ateneo in León where the first classes in aesthetics, recital and oratory were given. In the 20th century activity was considerably increased, and in 1937 the painter Ernesto Brown formed the Círculo de Bellas Artes, on the concept of which the Escuela Nacional de Bellas Artes, founded in 1939 by Genaro Amador Lira (*b* 1910), was based. The painter Rodrigo Peñalba became the Director in 1947, and Fernando Saravia (*b* 1922) was responsible for the sculpture workshop; during Peñalba's tenure, which lasted until 1972, the core of contemporary Nicaraguan art was

produced. Other initiatives of the period included the art school of the Universidad Nacional Autónoma de Nicaragua in Managua and those set up by the sculptor Pedro Vargas in Granada and by the painter Rubén Cuadra in León. In the 1960s Roger Pérez de la Roche (*b* 1949) went to Solentiname and taught art to a group of rural workers, who developed a vigorous school of primitive painting. Following their victory in 1979, the Frente Sandinista set up a national network of Centros Populares de Cultura, and the Dirección de Enseñanza Artística was created, with schools of fine art, dance, music and theatre, based in Managua. Further achievements included the creation of the arts course at the Universidad Centroamericana in Managua, a sculpture project at San Juan de Limay and the efforts by the different artists' unions in the Asociación Sandinista de Trabajadores de la Cultura. In 1990, however, the public programmes were suspended and the Dirección de Artes Plásticas at the Instituto de Cultura was created, based in Managua, to which the schools of art were assigned.

BIBLIOGRAPHY

T. Walker, ed.: *Nicaragua in Revolution* (New York, 1982), pp. 214–58
C. Vilas: *Perfiles de la Revolución Sandinista* (Mexico City, 1984), chap. 6
D. Craven: 'Art in Contemporary Nicaragua', *Oxford A. J.*, xi/1 (Summer 1988), pp. 51–63

RAÚL QUINTANILLA ARMIJO
(bibliography with DAVID CRAVEN)

X. Art libraries.

The only public art library and archive to pre-date the Sandinista revolution of 1979 was at the Banco Central de Nicaragua in Managua, which, aside from containing a collection of Nicaraguan paintings, also published an important series of art historical monographs and bibliographies about Nicaragua through the *Boletín Nicaragüense de bibliografía y documentación*. Some art historical studies are housed in the Biblioteca Nacional in Managua, as well as in the general libraries of the Universidad Nacional in León, the Universidad Centroamericana in Managua and the Universidad Nacional Autónoma de Nicaragua, also in Managua. Art historical literature relating to the post-revolutionary period was contained in an important collection in the Instituto 'Boanerges Cerrato' de Estudios en la Historia del Arte, which was founded by Raúl Quintanilla and was located in the Museo 'Julio Cortázar' del Arte Moderno de América Latina in Managua. The collection includes the papers of the Unión de Artistas Visuales, as well as other period publications and documents, such as the collected cultural supplements for the three leading Nicaraguan newspapers from 1979: *La prensa literaria* (of *La prensa*), *Ventana* (of *Barricada*) and *El nuevo amanecer* (of *El nuevo diario*). Aside from the collection of Quintanilla, the most important documents are in personal archives, the most noteworthy of which are those of Father Ernesto Cardenal (*b* 1925), Rosario Murillo (*b* 1951), Sergio Ramírez (*b* 1942), Miguel D'Escoto, Leoncio Sáenz (*b* 1935) and Orlando Sobalvarro (*b* 1943). A limited number of books and documents about art history can also be found in the government-run Instituto Nacional de Cultura, Managua, which from 1990 was directed by Gladys Ramírez de Espinosa.

BIBLIOGRAPHY

Bol. Nicar. Bibliog. & Doc. (1974–8), nos 1–21

DAVID CRAVEN

Niemeyer (Soares Filho), Oscar (*b* Rio de Janeiro, 15 Dec 1907). Brazilian architect. An internationally acclaimed doyen of the Modern Movement, he developed an intensely expressive and often controversial style in his large volume of executed work that was extremely influential in Latin America, particularly in Brazil, in the three decades from 1935. He employed an often exuberant aesthetic formalism, and his lyrical use of reinforced concrete was rivalled only by the later work of Le Corbusier.

1. Education and early work, to *c*. 1940. 2. Pampulha to Caracas, 1940–55. 3. Brasília, 1956–64. 4. International and late work, after 1964.

1. EDUCATION AND EARLY WORK, TO *C*. 1940. He studied architecture at the Escola Nacional de Belas Artes, Rio de Janeiro (1929–34), where he was influenced by the Modernist teaching introduced by LÚCIO COSTA during his reforms in 1930–31. After graduating, Niemeyer worked in the studio of Costa and Carlos Azevedo Leão (1906–71) and later, for a short period, in the Serviço do Patrimônio Histórico e Artístico Nacional (SPHAN), also with Costa; the latter's sensitivity to Brazilian context and culture, which led him to admire the work of Le Corbusier rather than the European Functionalists, was an early influence on Niemeyer. In 1936 Niemeyer joined the team assembled by Costa to design the Ministry of Education and Health (1937–43; now the Palácio da Cultura; *see* BRAZIL, fig. 5). The team included Affonso Eduardo Reidy, Jorge Moreira, Leão and Hernani Mendes de Vasconcelos, who were all at the Escola Nacional de Belas Artes during Costa's reforms and were among those whose work was praised by Frank Lloyd Wright when he attended the first Salão de Arquitetura Tropical (1933) in Rio. As a member of this team Niemeyer came under the direct influence of Le Corbusier, who spent a month in Rio in 1936 as consultant on the project. Niemeyer was responsible for many of the design details of this highly influential building, and he subsequently took over leadership of the team (1939), but the Ministry building was built largely to Le Corbusier's design and bears all the hallmarks of his hand: pilotis, *brises-soleil* in the form of horizontal louvres on the exposed façade, and sculptural rooftop elements—features so well suited to the Brazilian culture and climate that they were widely adopted thereafter. Although this influence is clearly evident in Niemeyer's later work, it is his own daring originality and imagination, often portrayed in rapid, graphic sketches reminiscent of Le Corbusier's, that characterize his most memorable buildings.

Niemeyer's first independent work was the Obra do Berço day nursery and maternity clinic (1937), Rio de Janeiro, a simple, rectilinear, four-storey building in white stucco, where movable vertical louvres were used for the first time in Brazil, on the three upper floors of its exposed north façade. In 1938 Niemeyer was invited by Costa to participate in the design of the Brazilian Pavilion (1939; *see* BRAZIL, fig. 6) at the World's Fair, New York, a commission won by Costa in competition. Niemeyer developed the design with Paul Lester Wiener (1895–1967) as executive architect in New York, and in this work he first demonstrated his mastery of curvilinear form and

fluid handling of interior space. The building was of great importance in providing a showcase to bring Brazilian architecture to international attention: one result was the exhibition *Brazil Builds* (1942) held at MOMA, New York. Another work by Niemeyer during this period was the Grand Hotel (1940) situated above the 18th-century Portuguese colonial Baroque town of Ouro Prêto. A simple two-storey building with a mono-pitched, tiled roof and covered, trellised balconies at second-floor level, it retains some of the influences of Costa's early colonial traditionalism, and, although uncompromisingly modern in feeling, it is a shining example of integrated, contextual design. His own modest house (1942) at Gavea, Rio de Janeiro, is in similar vein: two stuccoed storeys raised on circular columns present a red pitched roof and verandah to the magnificent view across the Lagoa Rodrigo de Freitas.

2. PAMPULHA TO CARACAS, 1940–55. In 1940 Niemeyer was commissioned by Juscelino Kubitschek, then Prefect of Belo Horizonte, the state capital of Minas Gerais, to design a series of buildings around an artificial lake at Pampulha, a suburb of the city. These buildings (1942–7), which included a church dedicated to St Francis of Assisi, a casino, restaurant, dance hall and yacht club, brought him international fame. The church is roofed by asymmetrical concrete-shell barrel vaults, four of which frame an end wall covered by an *azulejo* panel by Cândido Portinari (see fig. 1). With its slender tower that tapers towards its base like a chair-leg, this building is one of the most reproduced images of 20th-century architecture. The fluid, curving shapes of the casino (now an art gallery) and restaurant, and the gently rising butterfly roofs of the yacht club, were all examples of Niemeyer's growing vocabulary of free forms, echoed in the landscaping by ROBERTO BURLE MARX. The originality of Niemeyer's approach, utilizing the potential of reinforced concrete to produce

the sculptural forms of his design, contrasted sharply with the strict rationalism of the European Functionalists in the 1930s and their concern for industrialized production techniques. His attitude to the use of technology led to a structural inventiveness that increasingly reached outside the range of calculation techniques then current, drawing upon the skills and resources of the structural engineers and others with whom he worked, including Emilio Baungart, Joaquim Cardoso and, later, Riccardo Morandi and Pier Luigi Nervi.

Niemeyer produced a number of other buildings and projects during the 1940s that all incorporated innovative spatial and technological design. They included the elegant Ribeiro das Lages water-tower; the Kubitschek house (1943) at Pampulha; the Fluminense yacht club (1945; unexecuted) planned for Botafogo beach, Rio de Janeiro, where a long, gently curved catenary roof anchored to an extensive terrace was proposed; the innovative, multi-storey Boa Vista Bank (1946), also in Rio; the Burton Tremayne House (1949), Santa Barbara, CA; and the Hotel Regente (1949) on the Leblon beach at Gavea, with a spectacular landscape as a backdrop. The end of the decade was marked by his appointment to the team of architects selected to design the United Nations building (1947–52) in New York, under the directorship of Wallace K. Harrison, where he worked closely with Le Corbusier.

A series of buildings completed in 1950 reflects Niemeyer's continued emphasis on the aesthetics of form as the basis of design. The Peixe-Duchen biscuit factory (with Helio Uchôa) and the Montreal office building, both in São Paulo, mark the progression of his mastery of the curved form, which was further exercised in the S-shaped plan of the multi-storey COPAN Building, São Paulo. The 4th Centennial Exhibition buildings (1951–5; with Uchôa, Zenon Lotufo and Eduardo Kneese de Mello) at Ibirapuera Park, São Paulo, are linked by a great curvilinear covered way of amorphous plan, an extended version of

1. Oscar Niemeyer: St Francis of Assisi, Pampulha, Belo Horizonte, Minas Gerais, 1942–7; *azulejo* panel by Candido Portinari

2. Oscar Niemeyer: Congresso Nacional, Brasília, 1958–60

the approach to the Pampulha restaurant. This period culminated in his own house (1951–3) situated on a steep slope overlooking the sea at Canoas, Rio de Janeiro: the irregular curves of its raised podium and roof slabs, which encompass the gardens and swimming pool as part of the living area, echo the curving walls of the house. Here his approach signalled a move away from the sculptural virtuosity associated with the lyrical use of concrete and rational planning, towards the generation of pure architectural form. This position was confirmed in the extraordinary design (1955; unexecuted) for the Museo de Arte Contemporáneo, Caracas: an inverted pyramid seemingly balanced on the edge of a cliff. His design for a block of flats in the *Siedlung* in Berlin, *Interbau Hansaviertel* (1957–61), in which such architects as Alvar Aalto and Arne Jacobsen participated, also dates from 1955. Other activities during this period included his founding of the architectural review *Módulo* (1954), which he edited until 1964; it reappeared in 1974 and continued in publication until 1987.

3. BRASÍLIA, 1956–64. When Kubitschek became President of Brazil in 1956, he initiated a competition for the master-planning of a new federal capital on a site 1000 km north and west of Rio de Janeiro. The competition was won by Costa with a simple manifesto and urban plan based on two axes in the form of a cross (for illustration *see* COSTA, LÚCIO). Major public buildings were located at the head of the monumental, longitudinal axis, and residential accommodation was planned along the two curved arms of the horizontal traffic axis, with commercial and

amenity buildings in the remaining sectors (for further discussion of urbanism *see* BRASÍLIA). Niemeyer was at once appointed Chief Architect of the government corporation established to construct the new city, a post he retained throughout the first five heroic years of design and construction, drawing only a civil servant's salary. During this time he and Costa worked a logistic miracle: when the new city was inaugurated in 1960, many of the government offices, the Congresso Nacional, a hotel, theatre and the beginnings of a university and housing for government officials were already completed.

In his elegant and original designs for the main public buildings of Brasília, Niemeyer produced a grand-scale architectural expression of Costa's lucid urban plan, with five identical ten-storey ministerial blocks marching up each side of the Esplanada dos Ministérios to the Congresso Nacional at the apex of the Praça dos Três Poderes, flanked by the Supreme Court and presidential offices. Nothing can be added or taken away from the conceptual whole of Niemeyer's design, which here gives formalism an urban as well as an architectural mode. In the Congresso Nacional complex (1958–60; see fig. 2), the shallow convex and concave domes of the Senate Chamber and House of Representatives are separated by a pair of slender, high-rise slabs behind them, housing the Secretariat; the composition forms a sculptural whole set within the bowl of the surrounding hills. Subsequently, *c.* 1985–6, Niemeyer designed and added movable *brises-soleil* to the curtain walling of the Secretariat buildings. Other buildings include the Brasília Palace Hotel, a very long, three-storey block raised on circular pilotis, which faces the artificial lake.

The nearby Palácio da Alvorada, the presidential residence, has glazed walls screened by a roof overhang supported on rows of highly original, reversed arches, which provide another well-known image of Brazilian architecture; this deep verandah and the small chapel are features reminiscent of 18th-century colonial buildings.

In 1960 Niemeyer was appointed Professor in the Faculty of Architecture and Urban Planning at the University of Brasília. A number of buildings to his design continued to be constructed in the new capital, such as the stadium (1961) and the Palácio dos Arcos (1965; for illustration *see* BURLE MARX, ROBERTO), but he returned to private practice in Rio de Janeiro in 1961. Disagreement with the military dictatorship that came to power in 1964 caused him to resign his chair, and he worked in virtual exile for a number of years in Israel, Lebanon, Algeria, France and Italy.

4. INTERNATIONAL AND LATE WORK, AFTER 1964. Niemeyer's work abroad began with a master-plan (1964) for Haifa University in Israel. In the later 1960s a special decree by the French president, Charles de Gaulle, permitted him to practise in France, where he produced a curved design for a headquarters building (1967–80; with Paul Chemetov and Jean Deroche) for the French Communist Party in Paris; an office building with a sculptural auditorium (1972) in Bobigny, also in Paris; a cultural centre (1972) in Le Havre; and urban-development plans for Grasse (1966) and Dieppe (1972; both with Marc Emery). His best-known urban plan, however, is that for Algiers (1968), an imaginative formulation of the notion of controlled growth by separate urban nuclei of about 500,000 inhabitants each, connected by efficient transport systems: this was a scheme reminiscent of the solution to the problem of housing the families of the workers who built Brasília (whose cause Niemeyer repeatedly pleaded), and the rural migrants it attracted, in a series of satellite settlements around the capital.

Niemeyer worked in Algeria throughout the 1970s, designing an extensive range of buildings (1969–72) for the University of Constantine, in which the emphasis on form referred to the work of Le Corbusier, although without the planning rationale and rarely with concern for the hot, arid site conditions, and he continued into the 1980s with a plan for the business centre of the city of Algiers and its zoological gardens. The most notable European designs of this period are the Mondadori Building (1968), Milan, and the FATA building in Turin, designed in 1977 with the engineer Riccardo Morandi. The elegant arches of the Mondadori design echo the design of the Palácio dos Arcos and are not only expressive in themselves but also encapsulate the very function of the building.

Niemeyer continued to design and build in Brazil after 1967, returning there in 1974. Some of his later buildings in Brasília, such as the Ministry of Defence (1968), continued the Mondadori trend. The jewel-like cathedral (des. 1958; completed 1986–7) in Brasília, however, is different and suggests a return to earlier models. Despite its comparatively small size, it punctuates the middle distance of the main vista from all directions. Based on a circular plan, it has a tent-like, inward-sloping structure that opens out gently towards the sky at high level; the spaces between the concrete structural members are filled with glass (for illustration *see* BRASÍLIA). The influence of this modest man on the generation of Brazilian architects who qualified just before and just after World War II was seminal, and it remained considerable elsewhere in the world throughout the 1950s and 1960s. He was much honoured worldwide and received the Pritzker Prize for architecture in 1988.

WRITINGS
Minha experiência em Brasília (Rio de Janeiro, 1961)
A forma na arquitetura (Rio de Janeiro and Milan, 1978)
Meu sosia e eu (Rio de Janeiro, 1992) [with Eng. text]
Conversa de arquiteto (Rio de Janeiro, 1993)

BIBLIOGRAPHY
P. L. Goodwin and G. E. Kidder Smith: *Brazil Builds: Architecture New and Old, 1652–1942* (New York, 1943)
Pampulha, intro. P. L. Goodwin (Rio de Janeiro, 1944) [text in Eng. and Port.]
S. Papadaki: *The Work of Oscar Niemeyer* (New York, 1950)
H. E. Mindlin: *Modern Architecture in Brazil* (Rio de Janeiro and Amsterdam, 1956)
S. Papadaki: *Oscar Niemeyer* (New York, 1960)
E. N. Bacon: *Design of Cities* (London, 1967; rev. 1975), pp. 237–41
R. Spade: *Oscar Niemeyer* (London, 1971)
N. Evenson: *Two Brazilian Capitals: Architecture and Urbanism in Rio de Janeiro and Brasília* (New Haven, CT, 1973)
E. Mocchetti, ed.: *Oscar Niemeyer* (Milan, 1975)
N. W. Sodre: *Oscar Niemeyer* (Rio de Janeiro, 1978)
C. Hornig: *Oscar Niemeyer: Bauten und Projekte* (Munich, 1981)
A. Fils, ed.: *Oscar Niemeyer: Selbstdarstellung, Kritiken, Oeuvre* (Munsterschwarzach, 1982)
E. D. Harris: *Le Corbusier and the Headquarters of the Brazilian Ministry of Education and Health, 1936–1945* (diss., U. Chicago, IL, 1984)
H. Penteado, ed.: *Oscar Niemeyer* (São Paulo, 1985)
G. Luigi: *Oscar Niemeyer: Une esthétique de la fluidité* (Marseille, 1987)
L. Puppi: *Guida a Niemeyer* (Milan, 1987)
J. Katinsky: 'Brasilia em tres tempos', *Arquitetura de Oscar Niemeyer na capital* (Rio de Janeiro, 1991) [Port. and Eng. text]
M. A. Pereira: *Architecture, Text and Context: The Discourse of Oscar Niemeyer* (Ph.D. diss., U. Sheffield, 1993)
M. M. Dos Santos Camisassa: *Modern Architecture and the Modernist Movement in Brazil during the 1920s and 1930s* (diss., Colchester, U. Essex, 1994)
D. K. Underwood: *Oscar Niemeyer and the Architecture of Brazil* (New York, 1994)
C. Borges Lemos: 'The Modernization of Brazilian Urban Space as a Political Symbol of the Republic', *J. Dec. & Propaganda A.*, xxi (1995), pp. 219–37
J. Petit: *Niemeyer, poète d'architecture* (Paris, 1995)
L. Puppi: *Oscar Niemeyer* (Rome, 1996)
M. Sá Corrêa: *Oscar Niemeyer: Ribeiro de Almeida Soares* (Rio de Janeiro, 1996)

JULIO ROBERTO KATINSKY

Niño, Carmelo (*b* Maracaibo, 31 Aug 1951). Venezuelan painter. He studied at the Escuela de Arte 'Neptalí Rincón' in Maracaibo from 1967 to 1970. In his work he used elements derived from Surrealism to create portraits containing imaginary landscapes and figures, as in the *Blue Bird* (1977; priv. col., see 1977 exh. cat., fig. 30). He won a number of important national awards, including first prize in the National Salon of Young Artists (1975) and first honorary mention in painting in the First National Biennale of Young Artists (1981) at the Museo de Arte Contemporáneo de Caracas. Niño also represented Venezuela in the São Paulo Biennale of 1982, in the 12th Biennale at the Musée National d'Art Moderne in Paris, and in the 42nd Venice Biennale (1986).

BIBLIOGRAPHY

Carmelo Niño (exh. cat. by J. Calzadilla, R. Montero Castro and S. Antillano, Caracas, Gal. A. N., 1977)

Los espacios sublimados (exh. cat., Caracas, Cent. A. Euro-Amer.)

ANA TAPIAS

Nishizawa, Luis (*b* Cuautitlán, Jalisco, 2 Feb 1918). Mexican painter, draughtsman and sculptor. Although identified with the Mexican school of painting, he was also greatly influenced by oriental art—his father was Japanese and his mother Mexican—especially in his landscapes and in ink drawings in the traditional manner of Japanese artists. He experimented with diverse techniques of painting and had notable success working with high-temperature colour ceramics, for example in *A Song to Life* (1969), a mural in Celaya, Guajanuato. As a sculptor he produced stone-carvings again evocative of oriental art as well as five monumental stone sculptures incorporated into the landscape (Toluca, Mus. A. Mod. Cent. Cult. Mex.).

BIBLIOGRAPHY

R. Tibol: *Luis Nishizawa: Realismo, expresionismo, abstracción* (Mexico City, 1984)

X. Moyssén and others: *Nishizawa* (Mexico City, 1990)

XAVIER MOYSSÉN

Noé, Luis Felipe (*b* Buenos Aires, 26 May 1933). Argentine painter and theorist. He studied under Horacio Butler and in the early 1960s developed a figurative style of painting based on chaos as an organizing principle (e.g. *Corral of Witches*, 1963; see colour pl. XXIII, fig. 1). Such works were shown in 1961, alongside paintings by Rómulo Macció, Ernesto Deira and Jorge de la Vega, in an exhibition entitled *Otra figuración* (Buenos Aires, Gal. Peuser), which proved a milestone in the renewal of painting in Argentina through its combination of Neo-Expressionist style, unconventional procedures and mixed media techniques, all of which helped turn the human figure into a bold, rebellious image.

Guggenheim fellowships awarded to Noé in 1965 and 1966 enabled him to travel to the USA, where his interest in chaos (glorified in the publication of his text *Antiestética* in 1965) reached a climax when he hurled a large number of his works into the Hudson River. After this he virtually abandoned painting for a decade, although he produced experimental works, generically referred to as *created environments*, using mirrors. On his return to painting in 1975 he produced a series of landscapes, such as *Storm* (1982; see Glusberg, p. 358), in which the conflict and drama of life and nature burst forth in an explosion of splendid and overwhelming colours and forms. Noé was also influential as a theorist and teacher.

WRITINGS

Antiestética (Buenos Aires, 1965)

Una sociedad colonial avanzada (Buenos Aires, 1971)

'Nueve reflexiones acerca de la pintura como lenguaje', *Artinf*, vii/42 (1983)

BIBLIOGRAPHY

J. Glusberg: *Del Pop-art a la nueva imagen* (Buenos Aires, 1985), pp. 357–60

M. Casanegra: *El color y las artes plásticas: Luis Felipe Noé* (Buenos Aires, 1988)

M. Rojas-Miguel: 'Noé y la transvanguardia o tras la vanguardia de Noé', *A. Colombia*, xxxviii (1988), pp. 64–8

Deira, Macció, Noé, de la Vega: 1961 Neo Figuración 1991 (Buenos Aires, 1991)

Luis Felipe Noé: Pinturas 60–95 en el Museo del Palacio de Bellas Artes (exh. cat. by A. Arteaga and others, Mexico City, Mus. Pal. B.A., 1996)

J. López Anaya: *Historia del arte argentino* (Buenos Aires, 1997)

Un altre mirar arte contemporani argentini/Otra mirar arte contemporánea argentino (exh. cat., Barcelona, Generalitat Catalunya, 1997)

Re-Aligning Vision: Alternative Currents in South American Drawing (exh. cat., New York, Mus. Barrios; Little Rock, AR A.G.; Austin, U. TX, Huntington A.G.; and Caracas, Mus. B.A.; 1997–8)

JORGE GLUSBERG

Nogales, Avelino (*b* Potosí, *c.* 1870; *d* Cochabamba, 1949). Bolivian painter, sculptor and teacher. He studied fine arts in Buenos Aires (where he was awarded two gold medals by the Academia de Bellas Artes) and later in France. On his return Nogales taught painting in Potosí and between 1905 and 1920 directed a painting workshop in Cochabamba. He painted portraits of the personages of his time, including *President Bautista Saavedra*, and the mining industrialist *Simón I. Patiño and his Wife* (U. Oruro, Mus. Casa Cult.). He was also a landscape painter and creator of the Cochabamban landscape school. His style was marked by firm brushstrokes and a controlled palette, rich in textures, always maintaining a realistic character. He used colour freshly and generously and introduced the first signs of Impressionism. His major landscapes are in the Nogales family collection. He also painted historic scenes and Bolivian allegories, such as *Murillo's Dream* (1909; La Paz, Mus. Casa Murillo), and sculpted a large equestrian statue of *Bolívar* (1912; Cochabamba, Casa Cult.). Nogales's pupils included Cecilio Guzmán de Rojas.

BIBLIOGRAPHY

P. Querejazu: *La pintura boliviana del siglo XX* (Milan, 1989)

PEDRO QUEREJAZU

Noguera, Pedro (de) (*b* Barcelona, *c.* 1590; *d* Lima, 1655–6). Spanish sculptor and architect, active in Peru. He was trained in Seville in the circle of Juan Martínez Montañés and had attained the status of master before emigrating in 1619 to Lima, the vice-regal capital of Peru. In 1623 he won the prestigious contract for the choir-stalls of Lima Cathedral. These occupied him for more than 20 years and constitute his major surviving work. A single tier of seats is set under a deep, crested canopy, and each seat back, framed by Corinthian columns and a broken, curved pediment, is carved with the figure of a saint or a Church father. There are no direct precedents for Noguera's style: the energy of these figures is closer in spirit to Alonso Berruguete's choir-stalls (1540s) in Toledo Cathedral than to contemporary work in either Peru or Spain. The overall design was soon copied elsewhere: the stalls in S Francisco in Cuzco, for example, adhere to a very similar format but lack Noguera's variety. Noguera was appointed Maestro Mayor of Lima Cathedral in 1638 and continued work on the construction of the lower storey of the main façade, begun in 1626 by his predecessor, Juan Martínez de Arrona. He was probably responsible for the way in which the central niche breaks through the entablature, a motif absent in Arrona's original design. His other works include retables for churches in Lima and elsewhere, ceremonial catafalques for members of the Spanish royal family and the bronze fountain in the main square of Lima (1650).

BIBLIOGRAPHY

H. Wethey: *Colonial Architecture and Sculpture in Peru* (Cambridge, MA, 1949, rev. 2/1971)

E. Marco Dorta: *Fuentes para la historia del arte hispanoamericano: Estudios y documentos*, 2 vols (Seville, 1960)
E. Harth-terré: *Escultores españoles en el virreinato del Perú* (Lima, 1977)
J. Bernales Ballesteros: *Escultura en el Perú* (Lima, 1991)

VALERIE FRASER

Noreña, Miguel (*b* Mexico City, 1843; *d* Mexico City, 1894). Mexican sculptor and teacher. He studied in the studio of Manual Vilar, who recommended that he should enrol in the sculpture class at the Academia de San Carlos in Mexico City. There his training comprised copying plaster casts of ancient Greek sculptures. Noreña exhibited for the first time in 1856 as Vilar's pupil; his simple study of feet and hands was praised by the critics for being 'modelled with intelligence'. His first important work outside the Academia was a sculpture of *Don Vicente Guerrero* (1865), cast in bronze 18 years later and erected in the Plaza de San Fernando, Mexico City (*in situ*). In 1869 he rejected the offer of the directorship of sculpture at the Escuela Nacional de Bellas Artes in Mexico City, undertaking instead a study trip to Europe. On his return to Mexico in 1873 he accepted the post and went on to train young sculptors, including Jesús F. Contreras and Gabriel Guerra. Noreña became widely known as a sculptor of public statues, most notably the Cuauhtémoc monument (bronze, 1878; Mexico City, Paseo de la Reforma) and *Juárez Seated* (1891; Mexico City, Recinto Homenaje Don Benito Juárez), which was cast in bronze from cannons.

BIBLIOGRAPHY
I. Paz: *México actual: Galería de contemporáneos* (Mexico City, 1898)
A. Casado Navarro: 'La escultura durante el Porfiriato', *Hist. A. Mex.*, lxxx (1982), pp. 182–200
E. Uribe: 'Más allá de lo que el ojo ve: Sobre el relieve de Fray Bartolomé de las Casas por Miguel Noreña', *Mem. Mus. N. A.*, iii (1991), pp. 5–25

ELOÍSA URIBE

Noriega, José (*b* 1826; *d* Guanajuato, 1895). Mexican architect. After studying architecture at the Academia de San Carlos, Mexico City, he travelled in Europe in 1867–9. On his return to Mexico he worked as an architect in Guanajuato, and from 1882 he was state engineer of Zacatecas. He designed many types of building, from public squares to residences, churches, schools and prisons, but his most notable designs are three large European-influenced theatres in the interior of Mexico: the Teatro Doblado (1867–80) in León, the Teatro Morelos (1882–5) in Aguascalientes and the Teatro de la Paz (1889–94) in San Luis Potosí. The latter is considered to be the finest Neo-classical theatre to have been built in Mexico during the dictatorship (1877–1911) of Porfirio Díaz. The façades of all three are of local stone, and they have porticos with columns of a colossal order, crowned with large pediments. In 1873 he also began the Teatro Juárez, Guanajuato, which was altered and completed in 1903 by Antonio Rivas Mercado, with a classical exterior and a Moorish interior. Noriega was also engaged on various engineering projects (1873) connected with preventing the flooding to which Guanajuato was prone.

BIBLIOGRAPHY
I. Katzman: *Arquitectura del siglo XIX en México* (Mexico City, 1973)
A. Alcocer: *La arquitectura de la ciudad de Guanajuato en el siglo XIX* (Mexico City, 1988)

MÓNICA MARTÍ COTARELO

Núñez del Prado, Marina (*b* La Paz, 1910; *d* 9 Sep 1995). Bolivian sculptor and teacher. She studied at the Academia de Bellas Artes of La Paz from 1927 to 1929 and was professor of sculpture there between 1930 and 1938. Núñez del Prado had her first exhibition in 1930. Her sculpture originated within the movement of 'native' realism then in force. From 1950 she began to stylize her art and to adopt a totally modern, international expression, finally achieving a style that was almost totally abstract. She worked with a great variety of materials, with an early preference for precious Amazonian tropical woods, and later for stone, especially granite, andesite, basalt, onyx and marble. In the later stages of her career in particular, she also frequently used bronze. She drew very little, instead making small clay models that were then developed into large plaster figures before being transferred to other materials. Núñez del Prado's subject-matter always focused on the human figure, especially the female form. In her early years she concentrated on figural groups, both with musical and dance themes, as in *Guacatocoris* (1948; La Paz, Mus. N. A.), and with themes of social protest and dissent. From the 1950s she focused her attention again on the female figure, as Madonna (see fig.), as a woman walking in the wind on the high plateau, as an Andean divinity on earth, and as Venus (e.g. 1958; La Paz, Mus. N. A.; *see* BOLIVIA, fig. 7). She also became interested in the animals of the Andes, such as the puma and the bull, but especially the condor, and she tried to incorporate a landscape element in her sculpture. In 1988 she executed the bronze *Andean Women in Flight* (1988; Seoul, Olymp. Village, Sculp. Gdn).

WRITINGS
Eternidad en los Andes (La Paz, 1972)

Marina Núñez del Prado: *Mother and Child*, white onyx, 425×337×254 mm, 1967 (Washington, DC, National Museum of Women in Arts)

BIBLIOGRAPHY

G. Francovich: *Los mitos profundos de Bolivia* (La Paz, 1980)

L. Castedo: *Historia del arte Ibero-Americano*, ii (Madrid, 1988)

P. Querejazu: *La pintura Boliviana del siglo XX* (Milan, 1989)

Art in the Iberoamerican Embassies, Art Museum of the Americas, OAS (Washington, DC, 1991)

J. Falcón and others: *Homenaje a Marina Núñez del Prado* (Lima, 1995)

Latin American Women Artists, 1915–1995 (exh. cat. by G. Biller and others, Milwaukee, WI, A. Mus., 1995)

PEDRO QUEREJAZU

Nuñez Soler, Ignacio (*b* Asunción, 31 July 1891; *d* Asunción, 1983). Paraguayan painter. He was self-taught as a painter and began to work towards the end of the 1920s in a naturalistic style, which by the 1950s gradually became more individual. Traditionally considered a naive painter, in reality his apparently straightforward style had a complexity difficult to classify stylistically; his formal and technical resources were very varied. He painted with small rapid flecks, emphasizing contours with thick lines; his figures were modelled and painted flat, using methods similar to those of Pop art, and he employed the imagery of the mass media, 19th-century allegories and various forms of Latin-American kitsch. His oil paintings constitute a minutely detailed narrative document of the character of the old city of Asunción in the first half of the 20th century.

BIBLIOGRAPHY

O. Blinder and others: *Arte actual en el Paraguay* (Asunción, 1983), pp. 50, 99, 174

T. Escobar: *Una interpretación de las artes visuales en el Paraguay*, ii (Asunción, 1984) pp. 115, 164, 196–200, 275, 307–10

TICIO ESCOBAR

Núñez Ureta, Teodoro (*b* Arequipa, 1912; *d* 1988). Peruvian painter, teacher, printmaker and writer. He studied until 1935 at the Universidad Nacional de S Agustín, Arequipa, where he continued to teach history of art and aesthetics until 1950, although he was awarded a Guggenheim Fellowship to study in the USA between 1943 and 1945; as an artist he was self-taught. He later settled in Lima, where he executed a number of large murals (e.g. *Construction of Peru*, 6×16 m, 1954; Lima, Min. Econ. & Finanzas). In these and in watercolour paintings he combined social realism with a degree of caricature reminiscent of the work of PANCHO FIERRO. In 1954 Núñez Ureta was awarded the Premio Nacional de Pintura, and from 1973 to 1976 he was Director of the Escuela Nacional de Bellas Artes in Lima. His written works include a number of books on Peruvian art.

PRINTS

La vida de la gente (Lima, 1982)

BIBLIOGRAPHY

J. Villacorta Paredes: *Pintores peruanos de la República* (Lima, 1971), p. 91

J. A. de Lavalle and W. Lang: *Pintura contemporánea, II: 1920–1960*, Col. A. & Tesoros Perú (Lima, 1976), pp. 104–7

L. E. Tord: *Núñez Ureta pintura mural* (Lima, 1989)

'Hablar del maestro Teodoro Núñez Ureta', *Bellas A.* (1993), pp. 56–9

W. IAIN MACKAY

O

Oaxaca [formerly Antequera]. Mexican city, capital of the state of Oaxaca. It has a population of *c.* 180,000 and is situated *c.* 480 km south-east of Mexico City on the rivers Atoyac and Donaji in the high-lying valley of Oaxaca. Oaxaca has impressive colonial architecture and is close to important Pre-Columbian sites, such as Monte Albán, the ancient Zapotec capital on an artificially flattened mountain 10 km south-west of the centre of Oaxaca, and Mitla, a Zapotec and Mixtec city in the eastern arm of the Oaxaca Valley. The area has been inhabited since at least 9000 BC, and an Aztec military colony is thought to have been established at the site of Oaxaca in 1485. In the 1520s the settlement was captured by the Spanish, who made it a frontier fortress. Under the name Antequera it received a civic charter in 1532. The Dominicans were active there from 1575. The town is built to a characteristic grid plan; in 1782 it became the metropolis of the Oaxacan region and expanded as a result of its increasing prosperity.

The cathedral (begun 1544; rebuilt 1733) has a Baroque façade embellished with reliefs and statues. The church of S Domingo (*c.* 1660) was part of a large Dominican monastery, some of the buildings of which now house the Museo Regional, with its important collection of Pre-Columbian finds from Monte Albán. The church is a massive structure with Mestizo Baroque polychrome stuccowork throughout the interior (*see* MESTIZO). The church of Nuestra Señora de la Soledad (1682–90) has an ornate Baroque façade with numerous reliefs. Other notable churches include S Felipe and S Augustin (both 18th century). The Palacio del Gobierno is a 19th-century Neoclassical building.

Some of the notable artists to emerge in Oaxaca in modern times include RUFINO TAMAYO, FRANCISCO TOLDEO and Rodolfo Morales (*b* 1925). Rufino Tamayo developed a fine collection of Pre-Columbian ceramics and sculptures, which he donated to the city of Oaxaca (Mus. A. Prehispánico). The most notable contemporary crafts in the region are carved and painted animals of wood, ceramic figurines, black pottery and elaborately embroidered dresses.

BIBLIOGRAPHY
M. Toussaint: *Arte colonial en México* (Mexico City, 1948, 4/1983; Eng. trans. of 1st edn, Austin, TX, 1967)
A. Cortes: *Arquitectura colonial del Estado de Oaxaca*, i (Mexico City, 1966)
J. Paddock, ed.: *Ancient Oaxaca* (Stanford, 1966)
P. Keleman: *Folk Baroque in Mexico* (Orlando, 1974)
R. Muller: *Dominican Architecture in Sixteenth-century Oaxaca* (Phoenix, 1975)
El paisaje religioso de México: Los conventos del siglo XVI (Mexico City, 1975)
J. H. Alvarez: *Santo Domingo de Oaxaca* (Mexico City, 1977)
El paisaje churrigueresco de México (Mexico City, 1977)
G. Tovar de Teresa: *Pintura y escultura del renacimiento en México* (Mexico City, 1979)
R. Carrillo Azpeitia: *El arte barroco en México desde sus inicios, hasta el esplendor de los siglos XVII y XVIII* (Mexico City, 1982)
E. Wilder Weismann and J. Hancock Sandoval: *Art and Time in Mexico* (New York, 1985)
R. J. Mullen: *The Architecture and Sculpture of Oaxaca, 1530s–1980s* (Tempe, AZ, 1995)
Oaxaca en el camino, Instituto Oaxaqueño de las Culturas (Oaxaca, 1996)
M. Dalton Palomo and V. Loera y Chávez, eds: *Historia del arte de Oaxaca*, 3 vols, (Oaxaca, 1997)
Oaxaca: La ciudad y los valles centrales/ The City and the Central Valleys, Gobierno del Estado (Oaxaca, 1997)

CAREY ROTE

Obin, Philomé (*b* Bas Limbé, nr Cap-Haïtien, 20 July 1891; *d* Cap-Haïtien, 8 June 1986). Haitian painter. He played an important role in the development of art in Haiti. He was one of the first applicants to the Centre d'Art in Port-au-Prince, to which in 1944 he posted a curious painting (untraced) in homage to President Roosevelt of the USA as he lifted the hated Marine Occupation a decade earlier. The American watercolourist Dewitt Peters (1901–66), who ran the Centre d'Art, bought the work and sent him an encouraging letter. Obin responded at once, announcing his ambition to become the historian of his country in paint. He was soon salaried by the Centre d'Art to develop a Cap-Haïtien branch. In 1951 he travelled to Port-au-Prince to paint two important themes for the Sainte-Trinité Episcopal Cathedral: a *Crucifixion* on the central wall of the apse and a *Last Supper* at the side; Christ on the cross is shown surrounded by people of the Cape dressed to attend Sunday services, oblivious to the tragedy before them.

Obin always included an abundance of genre detail. His *Funeral of Charlemagne Peralt* (1946; destr.) was crowded with figures, each handled separately. Emphasizing clarity of communication, he often included written captions on his paintings and influenced other painters of the Cap-Haïtien school to emphasize drawing over colour and to maintain a rigid frontality in their figures. Utterly opposed to Vodoun, he was an ascetic, moralistic and committed Protestant, who prayed and sang hymns as he painted.

BIBLIOGRAPHY
Haitian Art (exh. cat. by U. Stebich, New York, Brooklyn Mus., 1978)
S. Rodman: *Where Art Is Joy* (New York, 1988)
M. P. Lerrebours: *Haïti et ses peintres*, i (Port-au-Prince, 1989)

DOLORES M. YONKER

Obregón, Alejandro (*b* Barcelona, 1920). Colombian painter, printmaker, draughtsman and sculptor of Spanish birth. After studying in Spain, France and at the Boston Museum of Fine Arts (1937–41), he began his career in Colombia in the mid-1940s with paintings in a naturalistic style. He soon developed a more expressionist idiom based to some degree also on Cubism in its reconstruction of multiple fragmented figures. Gradually extending his range of colour and defining his motifs as signs and symbols of his culture, he favoured images such as mangrove swamps, volcanoes, condors, bulls and gannets. Much of the expressive power of his work was based on striking contrasts, for example between energetic brushwork and fine detail, between mysterious glazes and imposing figures, or between muted grey areas and areas of bright contrasting colours. Direct references to reality co-exist with allusions to magic, enigmas and fantasy. In 1956 he won the Gulf–Caribbean Art Prize for *Cattle Crossing the Magdalena* (1955; see colour pl. XXIII, fig. 2).

Obregón also made forays into political subject-matter as in *The Wake* (1956; Washington, DC, A. Mus. Americas; *see* COLOMBIA, fig. 6), a picture inspired by the massacre of students during the dictatorship of General Gustavo Rojas Pimilla from 1953 to 1957. He also adapted the principles of his paintings to prints, of which he produced a considerable number, as well as drawings and sculptures. Emotiveness and imagination remained the driving forces behind his work.

BIBLIOGRAPHY
J. G. Cobo Borda: *Obregón* (Bogotá, 1985)
Alejandro Obregón, pintor colombiano (exh. cat. by G. García Márquez and others, Bogotá, Mus. N., 1985)
P. Obregón: *¿Obregón. Fue siempre un genio?: ¿Siempre fue un genio?* (Bogotá, 1994)
E. Samper Pizano and others: *Alejandro Obregón* (Bogota, 1996)
S. Benko: 'Roberto Obregón: The Reckoning of an Unveiled Rose', *A. Nexus*, xxviii (1998), pp. 60–65

EDUARDO SERRANO

Obregón, Roberto (*b* Barranquilla, 1946). Venezuelan painter and photographer of Columbian birth. He studied at the Escuela de Artes Plásticas Julio Arraga, Maracaibo. He had his first one-man show in the Centro de Bellas Artes in Maracaibo (1964) and his second at Galería 22 in Caracas (1967). Obregón began working when official support in Venezuela for kinetic art was at its height. He thus seemed an isolated figure as he sought to make a symbolic, conceptual rediscovery of the Venezuelan landscape through two series of photographs tracing the ridge of El Avila Hill, Caracas, from dawn to dusk. In 1978 the Sala Mendoza mounted his exhibition *El agua como cielo*, and in the early 1980s the Museo de Bellas Artes in Caracas mounted *Veinte disecciones*. This exhibition, and another organized in 1988 by the Galería Sotavento, Caracas, was based on Obregón's studies of the rose, which included watercolours and collages, as well as large-scale works on black linoleum in the style of negatives, all depicting the petals of a rose movingly but simply and without colour.

BIBLIOGRAPHY
La década prodigiosa: Los 80. panorama de las artes visuales en Venezuela (exh. cat. by L. A. Duque, Caracas, Gal. A.N., 1990), p. 200
S. Benko: 'Roberto Oregón: The Reckoning of an Unveiled Rose', *A. Nexus*, xxviii (1998), pp. 60–5

ANA TAPIAS

Obregón Santacilia, Carlos (*b* Mexico City, 5 Nov 1896; *d* Mexico City, 24 Sept 1961). Mexican architect and writer. He graduated from the Escuela Nacional de Arquitectura, Mexico City, in 1924, then set up his own practice in Mexico City. His early works mainly reflect the academic style in which he was trained, although they include buildings in the nationalist 'neo-colonial' style. Among these are the Mexican Pavilion (1922; destr., see de Garay, p. 26) at the Exposição Internacional do Centenario do Brasil (1922–3), Rio de Janeiro, and the Benito Juárez School (1925), Mexico City. His first attempts at progressive architecture were in the Art Deco style, notably the Secretaría de Salubridad y Asistencia (1929), Mexico City, which includes murals and stained-glass windows by Diego Rivera. Another important Art Deco work is the monument to the *Revolution* (1938), Mexico City, which makes use of the iron structure of the unfinished Palacio Legislativo of Emile Bernard and includes sculptures by Oliverio Martínez. From the 1940s his work moved towards the International Style, for example the completion of the Hotel del Prado (1946; destr., see de Garay, p. 78), Mexico City, including a mural by Rivera, and the office building of the Instituto Mexicano del Seguro Social (1950), Mexico City, which is decorated with sculptures and a mural by Jorge González Camarena.

WRITINGS
Cincuenta años de arquitectura mexicana (Mexico City, 1952)

BIBLIOGRAPHY
G. de Garay: *La obra de Carlos Obregón Santacilia* (Mexico City, 1979)
F. González Gortázar, ed.: *La arquitectura Mexicana del siglo XX* (Mexico City, 1994)
M. Tenorio-Trillo: *Mexico at the World's Fairs: Crafting a Modern Nation* (Berkeley, 1996)
C. G. Mijares Bracho: 'The Architecture of Carlos Obregón Santacilia', *Modernity and the Architecture of Mexico*, ed. E. R. Burian (Austin, TX, 1997), pp. 151–62

LOUISE NOELLE

Ocampo, Miguel (*b* Buenos Aires, 29 Nov 1922). Argentine painter and diplomat. Although trained as an architect, he began painting while living in Paris as a diplomat from 1948 to 1950, taking a particular interest in the structural methods of Cubism, the colour sense of Pierre Bonnard

Miguel Ocampo: *Ambiguous Neighbourhoods*, acrylic on canvas, 1.27×1.52 m, 1975 (Austin, TX, University of Texas, Jack S. Blanton Museum of Art)

and the subtlety of Paul Klee's paintings; his concern with light also emerged at this time. On his return to Buenos Aires in 1950 he generally used geometric motifs in his paintings, creating dynamic compositions from the tensions and rhythms produced by scattered squares, triangles and, above all, circles. In 1952 he helped found the ARTISTAS MODERNOS DE LA ARGENTINA.

Ocampo returned to Europe as a diplomat in 1956, living in Rome until 1959 and in Paris from 1961 to 1966. Although he softened the geometrical severity of his work, he continued to employ a meticulous technique, using a form of pointillism to render evanescent forms and a diffuse atmosphere. He concentrated his attention on the relationship between large and small forms, leading to their fusion with the background into single planes of colour, with the smaller elements gathered together or expanded in freely rendered rhythms so as to occupy the whole surface. He continued to use these dynamic patterns of coloured shapes, but after 1966 he introduced sinuous curves; while these sometimes suggested hillocks and ridges of landscapes or the rounded contours of the female body, the allusions in works such as *Green Vibration* (1968) and *Untitled* (1977; both Buenos Aires, Mus. A. Mod.) are so subtle that the pictures appear essentially abstract. In his later works he continued to explore evanescent changes of tone, textural variations and a lyrical sensibility for the poetry of colour and light, as in *Untitled 77/9* (1977; see colour pl. XXIII, fig. 3) and *Ambiguous Neighbourhoods* (1975; see fig.). After living in New York from 1969 to 1978—on a diplomatic posting from 1969 to 1974—Ocampo returned to Argentina, settling in La Cumbre, Córdoba.

BIBLIOGRAPHY
Miguel Ocampo (exh. cat. by M. Mujica Laínez, Buenos Aires, Fund. Lorenzutti, 1968)
R. Squirru: *Ocampo* (Buenos Aires, 1986)

NELLY PERAZZO

Ocaranza, Manuel (Egidio) (*b* Uruapan, 31 July 1841; *d* Mexico City, 2 June 1882). Mexican painter. He studied at the Academia de San Carlos in Mexico City from 1861 to 1874 and completed his training in Europe, where he came into contact with modern French art. On returning to Mexico in April 1876 he turned increasingly to *costumbrismo* for his subject-matter, and found ready buyers among the liberal middle class of the restored Republic, which was losing interest in the Nazarene religious paintings circulated in Mexico by Pelegrín Clavé. Ocaranza's themes often had a sentimental, moralizing or allegorical flavour: in *Faded Flower* (exh. 1869; *see* fig.) he alluded to lost innocence, while in other works he censured drunkenness or glorified the educational role of a mother imparting Christian virtue to her children.

Occasionally Ocaranza gave visual form to a phrase or idea in a literal manner, with an ironic and deflating effect: in *Love's Tricks* (exh. 1871; Morelia, Mus. Reg. Michoacano) Cupid is shown poisoning a flower destined for an unsuspecting lover, while in *Mistake* (exh. 1881; Morelia, Casa Cult.) a hummingbird mistakes the lips of a sleeping girl for a flower. Even the occasional triviality of Ocaranza's subject-matter came as a welcome relief from the solemnity of the prevalent academicism, accounting for

Manuel Ocaranza: *Faded Flower*, oil on canvas, 1.69×1.18 m, exhibited 1869 (Mexico City, Museo Nacional de Arte)

the favour his paintings enjoyed, especially with liberal critics of the day.

BIBLIOGRAPHY
F. Hurtado Mendoza and others: *Manuel Ocaranza y sus críticos* (Morelia, 1987) [only monograph on Ocaranza, but seriously flawed, confusing him with architect Manuel María Ocaranza (*d c.* 1865)]

FAUSTO RAMÍREZ

O'Gorman, Juan (*b* Mexico City, 6 July 1905; *d* Mexico City, 18 Jan 1982). Mexican architect, painter and teacher. He studied architecture at the Universidad Nacional de México and qualified as an architect in December 1935. Among his teachers were José Villagrán and Guillermo Zárraga, the latter of whom in particular exerted a powerful rationalist influence on O'Gorman's early development. This influence was further strengthened in 1924, when O'Gorman discovered the writings of Le Corbusier. His subsequent membership of the Communist Party cemented his adherence to a functionalist aesthetic and resulted in designs for a number of houses executed in an austere, almost featureless style that nevertheless remained faithful to Le Corbusier's ideas on plasticity. These included the Casa Cecil O'Gorman (1929), the Casa y Estudio Diego Rivera y Frida Kahlo, built for the artists in 1930–32; and his own house (1931–2), all in the residential district of San Angel in Mexico City.

The innovative approach taken in these works provoked considerable adverse comment, but it impressed Narciso Bassols, Minister of Education, who appointed O'Gorman Chief Architect to his department. Within a year (1933–4) O'Gorman had renovated 33 schools and built another

20, almost all of them in or near the capital. He standardized planning by using a single classroom module and abandoned the traditional cloister plan. These ideas culminated in the Escuela Técnica (1932–4), with classrooms at the front and workshops at the rear; here, and in his other buildings of this period, O'Gorman used exposed concrete facings and easily maintained materials in a design notable for its simplicity and directness. After completing a further number of houses in Mexico City and the building for the Sindicato de Cinematografistas (1934), inspired by ideas derived from Le Corbusier's *L'Esprit nouveau*, O'Gorman withdrew from architectural practice, mainly for ideological reasons. His social beliefs made him reluctant to use his professional skill to earn money, but he continued to teach at the anti-academic Escuela Superior de Ingenieros y Arquitectos at the Instituto Nacional Politécnico in Mexico City, of which he was founder. In this capacity he pronounced himself emphatically against conventional aesthetics and in favour of a socially orientated rationalism.

In 1948 O'Gorman returned to architectural practice to build, in collaboration with Gustavo Saavedra and Juan Martínez de Velazco, the celebrated library of the Universidad Nacional Autónoma de México in Mexico City. Although it is basically a rectilinear, functionalist building, it is covered almost completely in reliefs and polychrome stone mosaics. The blank walls of the stack-block in particular afforded a great opportunity to extend muralism to exterior surfaces (see fig.). The library brought O'Gorman international recognition and came to symbolize the integration of the plastic arts with architecture. It was only later, however, in his own house (1953–6; destr. 1970) in Pedregal de San Jerónimo, that O'Gorman found a truly innovative style. Here, in an organic, oneiric design he used a series of natural caves, which he covered with a profusion of mosaics and reliefs. Among the numerous influences were the organicism of Frank Lloyd Wright, the interest in place of Max Cetto and the sculptural mosaics of Diego Rivera.

As a painter, O'Gorman received his initial tuition from his father, Cecil O'Gorman (1874–1943), a perfectionist whose technical concerns are evident in his son's work. Later, O'Gorman was also taught by such artists as Joaquín Clausell, Antonio Ruiz, Ramón Alva de la Canal and, in particular, Diego Rivera and Frida Kahlo, who became his close friends and frequent collaborators. He produced both murals and easel paintings, tending in the former towards meticulous historical narratives, in which descriptive details took on a unique importance and in which Rivera's influence was obvious. The first mural, carried out in tempera and masonite and intended for Mexico City's first airport (1937–8), demonstrates his control of composition and technique. It is a triptych, of which the side panels (entitled *Religious Myths* and *Pagan Myths*) have been destroyed. The central panel, depicting *Man's Conquest of the Air*, survives in the modern airport and is a diligent tribute to human endeavour. Other murals by O'Gorman include the *Retable of Independence* (1960–61) and the *Retable of the Revolution* (1968–9; both Mexico City, Mus. N. Hist.) and *Credit Transforms Mexico* (1965; Mexico City, Banco Int.). In addition to these painted murals, however, he also experimented (together with

Juan O'Gorman: library exterior with wall mosaics, Universidad Nacional Autónoma de México, Ciudad Universitaria, Mexico City, 1948–50

Rivera) with the use of polychrome mosaics in mural decoration, most notably in the library at the Universidad Nacional Autónoma but also at the Secretaria de Comunicaciones y Obras Públicas (1953), where he again treated themes from Mexican history.

Outstanding among O'Gorman's smaller-scale works, in which his skill as a draughtsman is evident, are his many paintings in tempera on masonite, a technique perfected by him. His subjects included a number of landscapes, into which he often introduced details from popular tradition, such as inscriptions or imaginary figures. Notable examples include *Mexico City* (1947; see colour pl. XXIV, fig. 1), an extraordinarily detailed picture of urban life. He also painted several meticulously executed portraits, outstanding among which is his *Self-portrait* (1950; Mexico City, Mus. A. Mod.), notable for the multiple vision of the artist that it presents. Lastly, he executed a number of

fantastic works (often comprising imaginary landscapes) in which he produced dream images or crushing criticisms of the capitalist system (e.g. *Money and Power: Our 'Marvellous' Civilization*, 1976; Mexico City, Acad. A.). In these the combination of visual richness and the roughness of the elements suggest a complex psychology, the study of which would undoubtedly lead to a greater understanding of the artist's other works.

WRITINGS

La palabra de Juan O'Gorman (Mexico City, 1983)

BIBLIOGRAPHY

C. Bamford Smith: 'Juan O'Gorman', *Builders in the Sun: Five Mexican Architects* (New York, 1967)
'Juan O'Gorman', *Arquit. México*, 100 (1968), pp. 48–55
A. Luna Arroyo: *Juan O'Gorman* (Mexico City, 1973)
I. Rodríguez Prampolini: *Juan O'Gorman: Arquitecto y pintor* (Mexico City, 1982)
Homenaje a Juan O'Gorman (exh. cat., Mexico City, Pal. Medic., 1983)
L. Noelle: 'Juan O'Gorman', *Arquitectos contemporáneos de México* (Mexico City, 1988)
F. González Gortázar, ed.: *La arquitectura Mexicana del siglo XX* (Mexico City, 1994)
E. R. Burian: 'The Architecture of Juan O'Gorman', *Modernity and the Architecture of Mexico* (Austin, 1997), pp. 127–50

LOUISE NOELLE

O'Higgins, Pablo [Paul] (*b* Salt Lake City, 1 March 1904; *d* Mexico City, 1983). American painter and printmaker, active in Mexico. In 1922 he abandoned his music studies to study painting at the School of Fine Arts in San Diego, CA. His admiration for the Mexican muralists took him to Mexico, where he worked (1924–8) as an assistant to Diego Rivera and learnt the techniques of fresco painting. His commitment to the Mexican tradition of Socialist art led to an official invitation to Moscow in 1928. In 1933 he helped found La Liga de Escritores y Artistas Revolucionarios (LEAR). Although clearly influenced by Rivera's work, O'Higgins developed a more starkly realist style of mural painting. His monumental figures of peasants and labourers set in scenes of revolutionary struggle filled the picture space with overlapping, angular forms, as in his anti-Fascist mural *Workers Struggle Against Those Who Exploit Them* (1933–5), one of a series executed in collaboration with other LEAR members, for Abelardo Rodríguez market place (1934–6), Mexico City. As a founder-member of the TALLER DE GRÁFICA POPULAR (formed 1937), he also produced posters and prints (e.g. *The Market*, 1940; see colour pl. XXIV, fig. 2). O'Higgins also painted portraits and studies of desert plants (e.g. *Preparing the Land*, 1975; Magda and Luis Muñoz Castellanos priv. col., see Poniatowska, p. 114).

BIBLIOGRAPHY

A. Rodríguez: *A History of Mexican Mural Painting* (London, 1969)
E. Poniatowska and G. Bosques: *Pablo O'Higgins* (Mexico City, 1984)
Exposición homenaje, Pablo O'Higgins, artista nacional (1904–1983): Mural, apuntes, óleos, acuarelas, dibujos, estampas (exh. cat., Mexico City, Mus. N. B.A., 1985)
Art in Latin America: The Modern Era, 1820–1980 (exh. cat. by D. Ades and others, London, Hayward Gal., 1989), pp. 181–4
L. Uranga López: *El tema campesina en la pintura de Pablo O'Higgins* (Chapingo, 1987)
T. del Conde and others: *Pablo O'Higgins: Un hombre de siglo XX* ([Mexico City], 1992)
Pablo O'Higgins: Un compromiso plástico (exh. cat., Xochimilco, Mus. Dolores Olmedo Patiño, 1995)

□

Oiticica, Hélio (*b* Rio de Janeiro, June 1937; *d* Rio de Janeiro, 22 March 1980). Brazilian painter and performance artist. In 1954 he began studies with Ivan Serpa at the Museu de Arte Moderna in Rio de Janeiro. He immediately devoted himself to a geometric vocabulary and joined the new Frente group (1954–6) and later the Neo-Concrete movement (1959–61). From 1964 to 1969 he made environmental, participatory events—among them *Parangolé* (1964), *Tropicália* (1967) and *Apocalipopótesis* (1968)—either in art centres or in the street. He was one of the leading exhibitors in the exhibition *Nova objetividade brasileira* (Rio de Janeiro, 1967), which reactivated the country's avant-garde. In 1969 he exhibited an installation at the Whitechapel Art Gallery, London, and the following year his work was included in the show *Information* (New York, MOMA). A Guggenheim Fellowship took him in 1970 to New York, where he lived until 1978. During that period he prepared various multi-media projects in the form of texts, performances, films and environmental events. The 25 successive years of his *Metaschemes, Bilaterals, Spatial Reliefs, Nuclei, Penetrables, Meteors, Parangolés*, installations, sensory and conceptual projects from 1954 onwards showed a clear transition from modern to post-modern and represent his most finished achievements. Working with oppositions such as balance/effusion, contemplation/celebration and visual art/body art, he retained a radical stance. In 1981 in Rio de Janeiro his family created the H. O. Project, intended to care for, preserve, analyse and disseminate the work that he left.

WRITINGS

Aspiro ao grande labirinto (Rio de Janeiro, 1986) [posth. col. of writings]

BIBLIOGRAPHY

Nove objetividade brasileira (exh. cat., preface H. Oiticica; Rio de Janeiro, Mus. A. Mod., 1967)
Hélio Oiticica (exh. cat. by G. Brett and others, London, Whitechapel A.G., 1969)
A. Amaral, ed.: *Projeto construtivo brasileiro na arte, 1950–1952* [The Brazilian Constructivist movement in art, 1950–1952] (São Paulo, 1977)
R. Brito: *Neoconcretismo: Vértice e ruptura do projeto construtivo brasileiro* [Neoconcrete art: climax and breaking point of the Brazilian Constructivist movement] (Rio de Janeiro, 1985)
G. Brett: 'Hélio Oiticica: Reverie and Revolt', *A. America*, i (1989), pp. 111–21
L. Figueiredo: 'The Other Malady', *Third Text*, xxviii/xxix (1994), pp. 105–16
S. Salomao: 'Homage', *Third Text*, xxviii/xxix (1994), pp. 129–34
S. Salzstein: 'Hélio Oticica: Autonomy and the Limits of Subjectivity', *Third Text*, xxviii/xxix (1994), pp. 117–28
C. Stellweg: 'Oiticica', *A. Nexus*, xii (1994), pp. 91–5
P. C. Terra Cabo: *Resignifying Modernity: Clark, Oiticica and Categories of the Modern in Brazil* (diss., Colchester, U. Essex, 1996)

ROBERTO PONTUAL

Ojeda, Gustavo (*b* Havana, 8 Sept 1958; *d* New York, 23 Aug 1989). Cuban painter, active in the USA. He arrived in the USA in 1967, where he resided except for a brief period in Spain from 1980 to 1981. He studied at the Parsons School of Design, New York (1975–9). As a leading Cuban–American painter, he was known for his unsentimental treatment of urban themes and landscapes. He controlled the density of paint and the opacity of light through a wide range of moods: from aggression and fear, to celebration of the fast tempos of city streets, as in *Intersection* (1985; New York, David Beitzel Gal., see

1987–9 exh. cat., p. 319). Almost invariably his scenes are uninhabited. In this focus on atmosphere, light and space (e.g. *Downtown Evening*, 1986; see colour pl. XXIV, fig. 3) Ojeda's work was comparable to that of his compatriots Emilio Sánchez and Humberto Calzada. It was also influenced by the painters of the Ashcan school and the Latin–American Luminists. Among the most important group shows in which Ojeda participated were: *An International Survey of Recent Painting and Sculpture* held at MOMA, New York (1984) and *Outside Cuba/Fuera de Cuba*, a survey of Cuban émigré art since 1960, shown at Rutgers University, New Brunswick, NJ (1987).

BIBLIOGRAPHY

G. Henry: 'Gustavo Ojeda at Beitzel', *A. America*, lxxv (Oct 1987), pp. 183–4
Outside Cuba/Fuera de Cuba (exh. cat. by I. Fuentes-Perez, G. Cruz-Taura and R. Pau-Llosa, New Brunswick, NJ, Rutgers U., Zimmerli A. Mus.; New York, Mus. Contemp. Hisp. A.; Oxford, OH, Miami U., A. Mus.; and elsewhere; 1987–9), pp. 316–19

RICARDO PAU-LLOSA

Olaguíbel, Juan (*b* Guanajuato, Mexico, 1896; *d* Mexico City, 1976). Mexican sculptor and teacher. He entered the Academia de San Carlos in Mexico City in 1912 and was taught by Arnulfo Domínguez Bello. He abandoned his studies two years later to join the faction led by the landowner Venustiano Carranza in the Mexican Revolution, during which time he executed political caricatures in sculpture. He completed his studies in the USA as a pupil of Gutzon Barglum and on his return to Mexico frequented the studios of Ignacio Asúnsolo and José María Fernández Urbina (1898–1975). He established a reputation for his work as a teacher at the central office of the drawing department of the Instituto Nacional de Bellas Artes in Mexico City. From 1940 Olaguíbel executed a large number of civic sculptures. In the monument to *Pípila* (stone; Guanajuato, Mexico), he conformed closely to the prevalent ideas of monumentality and used dense, rotund forms. However, in his *Oil Source* (bronze and stone, 1952) and in his *Diana the Huntress* (1942), both on the Paseo de la Reforma in Mexico City, Olaguíbel's style, although still monumental, was more naturalistic.

BIBLIOGRAPHY

M. Monteforte Toledo: *Las piedras vivas* (Mexico City, 1965, rev. 1979), pp. 163, 201, 228
L. Kassner: *Diccionario de escultura mexicana del siglo XX* (Mexico City, 1983), pp. 247–8

ESPERANZA GARRIDO

Olinda. Brazilian city in Pernambuco state. Built 6 km north of Recife in north-eastern Brazil, the city (population *c.* 380,000) was state capital until 1827 and contains exceptional architecture of the 16th–18th centuries. Olinda was founded in 1536, and its sugar plantations and factories subsequently brought enormous prosperity and attracted foreign envy: the Dutch invaded the region in 1630, and Olinda was almost completely destroyed by fire. Most of the present city dates from the end of the 17th century and the 18th. There are outstanding religious buildings such as the church of Nossa Senhora das Graças (1584) by Francisco Dias (1538–1623), which is the sole surviving example of 16th-century Jesuit building in Brazil. The convent of S Francisco (1585; rebuilt 1686) received many

additional embellishments throughout the 18th century, including the great stairway leading to the dormitory, the cloister decorated with Portuguese *azulejos* (glazed tiles) depicting the *Life of St Francis*, and paintings on the ceiling of the nave, in the chapter house and sacristy. The monastery and church of S Bento (completed 1599; rebuilt second half of the 17th century) has a particularly fine high altar of 1655 (interior decoration remodelled after 1750). The church and convent of Nossa Senhora do Carmo, fully active at the beginning of the 17th century and restored in the 18th, are also notable. In the 1960s the city became a centre of art and crafts: painters, engravers and sculptors occupied the tall houses with their heavy doors and their stucco walls painted in various colours in traditional fashion. The city thus became one of the principal centres of the so-called Pernambuco school, exemplified in the work of such artists as José Claudio da Silva, João Câmara Filho (*b* 1944), Gilvan Samico (*b* 1928) and Guita Charifker (*b* 1936). Museums include the Museu de Arte Sacra in the former episcopal palace and the Museu de Arte Contemporânea Pernambuco.

BIBLIOGRAPHY

G. Bazin: *L'Architecture religieuse baroque au Brésil* (Paris, 1956)
J. M. dos Santos Simões: *Azulejaria portuguesa no Brasil, 1500–1822* (Lisbon, 1965)
A. C. da Silva Teles: *Atlas dos monumentos históricos e artísticos do Brasil* (Rio de Janeiro, 1975)
C. P. Valladares: *Nordeste histórico e monumental*, 3 vols (Rio de Janeiro, 1983)
F. Lucarelli: *Ouro Preto e Olinda* (Naples, 1985)
E. Arlégo: Olinda, patrimônio natural e cultural de humanidade (Recife, 1990)

ROBERTO PONTUAL

Oller (y Cestero), Francisco (*b* Bayamón, 17 June 1833; *d* Cataño, 17 May 1917). Puerto Rican painter. He studied from 1851 to 1853 at the Real Academia de Bellas Artes de San Fernando in Madrid under Federico de Madrazo y Küntz and in Paris from 1858 to 1863 under Thomas Couture and Charles Gleyre at the Ecole Impériale et Spéciale de Dessin and at the Académie Suisse. There he met Camille Pissarro, Paul Cézanne and Armand Guillaumin, who together with Couture and the work of Courbet influenced his work towards Realism and Impressionism. His masterpiece *The Wake* (1893; Río Piedras, U. Puerto Rico, Mus. Antropol., Hist. & A.), with its penetrating insights into 19th-century Puerto Rican rural society, is a monumental tribute to the artistic tenets championed by Courbet.

Oller, however, cannot be characterized exclusively as a Realist or Impressionist. In the course of his prolific career he produced portraits, landscapes and still-lifes, adapting his style to the subject. In the *Ponce Silk-Cotton Tree* (1887–8; Ponce, Mus. A.), for instance, he adapted the luminous colour, loose brushstrokes and chromatic richness of Impressionism to a local motif. Oller abandoned Impressionism when he settled permanently again in Puerto Rico in 1884, turning to portraits and still-lifes rendered in a more sombre palette inspired by Courbet. In his later years he sought to create specifically Puerto Rican art, which accounts for his retrospective association with 19th-century Puerto Rican nationalism. Oller's training and exposure to modern European art made him an influential figure in Puerto Rico as both artist and teacher.

He was responsible for the establishment of the Free Academy of Drawing and Painting in Puerto Rico in 1868, and in 1872 he was appointed *pintor de cámara* by King Amadeus of Spain. He also wrote a manual on drawing and painting from nature, first published in 1869.

BIBLIOGRAPHY

O. Delgado Mercado: *Francisco Oller y Cestero (1833–1917): Pintor de Puerto Rico* (San Juan, 1983)

Francisco Oller: Un realista del Impresionismo (exh. cat. by A. Boime and others, Ponce, Mus. A., 1983)

Campeche, Oller, Rod[243]n: Tres siglos de pintura puertorrique[241]a/ Campeche, Oller, Rod[243]n: Three Centuries of Puerto Rican Painting (exh. cat. by Francisco J. Barrenechea and others, New York, Sotheby's; Seville, Univl Exh., Puerto Rican N. Pav.; 1992)

MARI CARMEN RAMÍREZ

Opazo, Rodolfo (*b* Santiago, 1935). Chilean painter. He studied briefly at the Escuela de Bellas Artes of the Universidad de Chile in Santiago and became convinced of his vocation as a painter after visiting Italy in 1957. His early work was influenced by Roberto Matta and another Chilean painter, Enrique Zañartu (*b* 1921), and in terms of attitude he derived much from Surrealism, thinking of the creation of art as a mystical act through which lost levels of reality can be recovered. Valuing pictorial symbols for their vagueness and imprecision, in his pictures he uprooted figures and objects from their accustomed context and reinterpreted Greek mythology, the symbolism of Hieronymus Bosch and the prophetic force of William Blake. To similar ends he used ghostly white shapes, unidentified but placed in limitless spaces or enclosed in boxes as if awaiting transformation, as in *Daybreak* (1972; Santiago, Mus. N. B.A.).

In the late 1970s, realizing that there was a conflict between the limits of ordinary existence and the transcendence that he was seeking, he abandoned mythical sources and replaced the vaguely defined human forms with more aggressive figures identified by their actions and clothing. He particularly favoured sportsmen such as tennis players, swimmers, motorcyclists and rugby players, symbols of the cult of mass success created by the communications media.

BIBLIOGRAPHY

M. Ivelić and G. Galaz: *La pintura en Chile* (Santiago, 1981)

——: *Chile: Arte actual* (Santiago, 1988)

Opazo: Pinturas, 1958–1996 (ex.h. cat. by M. Ivelic and others, Santiago, Tomás Andreu G. A., 1996)

MILAN IVELIĆ

Ordóñez, David (*b* Guatemala City, 4 March 1951). Guatemalan painter, sculptor and designer. He trained first as an architect from 1969 to 1972 at the Escuela Técnica Superior de Arquitectura of the Universidad Complutense in Madrid. In 1972 he attended the Real Academia de Bellas Artes de San Fernando in Madrid, where he studied mural painting and ceramics. On his return to Guatemala in 1972 he continued his architectural studies at the Universidad de San Carlos in Guatemala City from 1973 to 1974 and also became interested in the ethnological study of the Indians of the country, especially in their textiles.

In his paintings Ordóñez combined acrylic paint, sometimes with textured surfaces or luminous varnishes, with superimpositions of fine lines, vivid colour and screen-printing. Executed in editions of 12, each with individual finishing touches, they portray such subjects as the natives of Guatemala and landscapes. He also made sculptures, especially in clay, designed clothing and served as consultant to the Museo Ixchel del Traje Indígena in Guatemala City.

BIBLIOGRAPHY

David Ordóñez (exh. cat., Guatemala City, Gal. Dzunún, 1987)

JORGE LUJÁN-MUÑOZ

Orellana, Francisco Chávez y. *See* CHÁVEZ Y ARELLANO, FRANCISCO.

Orive, María Cristina (*b* Antigua, 1931). Guatemalan photographer, active in France and Argentina. Trained as a journalist, she was a correspondent for the newspaper *El Imparcial* in Paris, and from 1961 to 1969 she was Latin America correspondent for the Office de Radiodiffusion-Télévision Française, Paris. After 1965 she was employed as a photojournalist. In 1973, together with Sara Facio, she founded the publishing firm La Azotea, which was based in Buenos Aires and which dealt above all with the publication of Latin American photographs. Her book *Actos de fe en Guatemala*, compiled with Facio, is an important document of the presence of indigenous traditions in Guatemala.

PHOTOGRAPHIC PUBLICATIONS

with S. Facio: *Actos de fe en Guatemala* (Buenos Aires, 1980)

BIBLIOGRAPHY

A. Hopkinson, ed.: *Desires and Disguises: Five Latin American Photographers* (London, 1992), pp. 41–52

ERIKA BILLETER

Orlando, Felipe (*b* Tenosique, Tabasco, 1911). Cuban painter, teacher and writer, active in Mexico. He lived in Cuba from 1914 to 1946, and then in New York before settling in Mexico City in 1951. Orlando exhibited widely in the USA and Europe. In his semi-abstract figures, still-lifes and landscapes, texture was an important element. In this aspect he was clearly influenced by the work of Rufino Tamayo and Jean Dubuffet. He also wrote fiction and lectured on the Cuban philosopher and political theorist José Martí, as well as on art, ecology and Afro-Cuban culture.

BIBLIOGRAPHY

Felipe Orlando (exh. cat. by J. E. Pacheco, F. Orlando and R. Franquelo, Mexico City, U. N. Autónoma, 1981)

RICARDO PAU-LLOSA

Oropesa. *See* COCHABAMBA.

Orozco, José Clemente (*b* Ciudad Guzmán, Jalisco, 23 Nov 1883; *d* Mexico City, 7 Sept 1949). Mexican painter and draughtsman. He was one of the three most important Mexican mural painters, and his expressionist style has been particularly influential among younger generations of international mural artists. He also produced a large body of caricatures and drawings, as well as easel works.

1. Life and work. 2. Style and imagery.

1. LIFE AND WORK. Orozco was born into a middle-class family, and his early education was not centred on art. He was awakened to it as a student in Mexico City

during the early 1890s, when he encountered José Guadalupe Posada and his popular satirical prints. Orozco studied architecture at evening classes in the Academia de S Carlos, but from 1897 to 1904 he trained as an agronomist and cartographer. He lost his left hand and his hearing and sight were impaired in an explosion during his early adolescence; the resentments and realism caused by physical handicaps affected both his political and artistic thinking.

He entered the Academia formally in 1906 and was subjected to its rigid, old-fashioned programme. This was ameliorated by the influence of the proto-Surrealist symbolism of the painting of one of his tutors, Julio Ruelas, and by the presence of Dr Atl (Geraldo Murillo). The latter saw the art of the past as something to emulate rather than copy and favoured the expressive anatomy of Michelangelo's paintings over academic verisimilitude. Both tutors contributed significantly towards the development of Orozco's taste in subject-matter and style.

During the Revolution, Orozco backed the constitutionalist Carranza government. These were difficult years for him: in 1911 his father died, and at the same time the students at the Academia went on strike in protest against the outdated teaching methods employed there. In 1914 Orozco fled with Dr Atl to Orizaba, Veracruz, where he remained until 1915 and drew cartoons for the political newspaper *La Vanguardia*. Throughout this period, fascinated with that tragic licentiousness bred by war and death's familiarity, he produced a large number of studies of schoolgirls and prostitutes, as well as political caricatures. These he showed unsuccessfully in Mexico City in 1916 at the Librería Biblos. The next year he left for the United States, where on arrival Customs officers confiscated most of his drawings as indecent. After a discouraging and unprofitable stay in San Francisco and New York, he returned to Mexico City in 1919 and in 1923 married Margarita Valladares, by whom he had three children.

In the same year José Vasconcelos, the Minister of Education between 1921 and 1924 under President Obregón, invited Orozco to work in the Escuela Nacional Preparatoria in Mexico City with Diego Rivera, David Alfaro Siqueiros and other members of the fledgling mural movement. In 1924, political protestors damaged Orozco's murals, and he was prevented from working there. In 1925 he painted the privately commissioned mural *Omniscience* at Mexico City's Casa de los Azulejos, and early in 1926 he painted another fresco on the theme of *Social Revolution* at the industrial school in Orizaba, Veracruz. Later that year he returned to the Escuela Nacional Preparatoria and

1. José Clemente Orozco: *Prometheus* (1930), fresco, Pomona College, Claremont, CA

revised and completed his murals. Of the 20 or so panels he painted there, the most notable date from 1926, when he had perfected his large-scale drawing and fresco technique. These include *The Trench*, the *Friar and the Indian* and *The Strike*, the last of which incorporates the head of Christ from the earlier mural that it replaced, *Christ Destroying his Cross* (1924).

In 1927 Cristeros led a revolt against the anticlerical policies of the Calles government. Orozco went to the United States, where he remained until 1934. In New York he met Alma Reed, a writer and art dealer who became his patron and promoted his work for the rest of her life. She arranged exhibitions for him and opened her own gallery, Delphic Studios, in 1930 with a show of his easel paintings and gouaches. She also introduced Orozco to the Ashram, a salon led by Eva Sikelianos, who was devoted to the cultures of ancient Greece and modern India. At the Ashram he came to see the Mexican Revolution in more universal terms, through contact with the ideas behind Gandhi's resistance movement in India, and learnt to apply Guy Hambidge's system of 'dynamic symmetry' (a variation on the golden section) to his work; he also participated in readings of the Greek tragedies. All these factors influenced his subsequent murals.

In 1930 Orozco was commissioned to paint a mural by Pomona College in Claremont, CA. Strongly affected by the *Prometheus* of Aeschylus, he chose the theme of the god's altruistic self-sacrifice for mankind in stealing fire from Zeus (see fig. 1). He painted this mural early in the year, then returned to New York, where Alma Reed had arranged a commission for him at the New School for Social Research (where the American muralist Thomas Hart Benton was already painting). For this, the least expressive of his murals, he chose themes related to the political aspirations of the Ashram and composed images that contrasted revolution and human brotherhood. Orozco based the compositions on the principles of dynamic symmetry, which tended to diminish the fervour of the images.

In 1932 he was invited to paint a mural (see colour pl. XXV, fig. 1) in the Baker Library at Dartmouth College in Hanover, NH. This is his largest work in the United States and depicts the evolution of civilization in the Americas. It is painted on the walls of a long reading-room, and assimilates rather than imposes the structures of dynamic symmetry. Beginning on an end wall with images of primordial migration and human sacrifice, it recounts the myth of Quetzalcóatl, the Pre-Columbian god, the brutalities of the Spanish conquest and modern revolution, and the ironies of modern education. The mural concludes at the far end of the room with pendant panels depicting the human sacrifice brought about by war and a wrathful Christ cutting down his cross, which symbolizes the 'migration of the spirit' in the modern world.

Returning to Mexico City in 1934, Orozco painted the mural *Catharsis* in the Palacio de Bellas Artes. In 1936, at the invitation of the Governor of Jalisco, he moved to Guadalajara to undertake three series of murals, which are considered to be his masterpieces. That year he painted *Creative Man* and the *People and its False Leaders* on the stage-walls and dome of the assembly hall of the University of Guadalajara. Between 1937 and 1938 he filled the great

2. José Clemente Orozco: *Hidalgo and National Independence* (1937–8), fresco, Government Palace, Guadalajara

stair-well of the city's Government Palace with his *Hidalgo and National Independence* (see fig. 2). Lastly, in the vast Hospicio Cabañas, he covered the wall niches, vaults and dome of the former church with images of Mexico before and after the conquest, symbolizing the aspirations of humankind with his *Man of Fire* in the canopy of the dome. These murals display his vigorous style and iconography more forcefully than any of his other works.

In 1940, in sharp contrast to the explosive scale and vivid colours of Guadalajara, he painted a series of essentially black-and-white murals depicting revolutionary scenes on the lateral walls of the Gabino Ortíz Library in Jiquilpan, Jalisco. The scenes culminate in an *Allegory of Mexico* painted in colour on the back wall. Later that year he went to New York, where he painted *Dive Bomber and Tank* (see colour pl. XXV, fig. 2) in the Museum of Modern Art. In 1941 he completed a series of murals in the Supreme Court of Justice in Mexico City and between 1942 and 1944 began a series in the church of the Hospital de Jesús in Mexico City, on the theme of the Apocalypse, which remained unfinished. In 1947 he was given a retrospective exhibition in the Palacio de Bellas Artes, and from 1947 to 1948 he painted the abstract *National Allegory* on an exterior wall of the national school for teachers in Mexico City. During the last two years of his life he painted the frescoes *Benito Juárez* and the *Church and the Imperialists* for Chapultepec Castle in Mexico City and *Hildalgo and the Great Mexican Revolutionary Legislation* for the chamber of deputies of the state of Jalisco in Guadalajara.

2. STYLE AND IMAGERY. With artists of genius, the style sometimes seems to be the opposite of the personality; with talents there is a closer compensatory match. Thus Diego Rivera's childlike flamboyance contrasts with his work's mature coherence, whereas the reckless rhetoric of David Alfano Siqueiros is constant both in life and in art. Orozco, a genius equal to Rivera but physically handicapped, personally retiring, decorous and ironic, painted with the vehemence of one too long held back. He was denied formal studies until the age of 24 and only travelled to Europe for three months in 1932. He struggled with little encouragement for more than half his life, discovering the roots of his art introspectively rather than in historical events or the art of others. Orozco's themes are centred on the stark human suffering and social chaos induced by the idealist's relentlessness. He was apolitical, obsessed with the ironies of that human comedy the events of the Revolution had spread before him, and personally identified with the victim; the radical realism of his work dramatizes only the details of atrocity and triumph while avoiding grandiose, abstract commentaries on human destiny. The power of his work derives from the scale on which he marshalled such detail. In this respect Orozco was the most original of the three main Mexican mural painters—the others being Siqueiros and Rivera—in dealing with the exigencies of architecture; he exploited its human scale in order to dramatize his motifs. This was accomplished by creating dynamic tensions between the architectural elements and the image, systematically excluding recessional space to emphasize the wall plane and contrasting small and large figures to establish hierarchies symbolizing their relative importance.

These formal elements are to be found from the very first major murals. In *Prometheus* (see fig. 1 above) the chaotic masses react to the gigantic god's theft of fire in an essentially undefined space. Similarly at the New School and Dartmouth College, and in the *Catharsis* fresco, although painted on long, unarticulated walls, the imagery constantly presses against the top and bottom edges, the major figures overwhelm the minor ones, and the imagery extends laterally and frontally but seldom into space. Thus, the viewer is bluntly confronted with the subject.

Nowhere in Orozco's murals are these methods brought to such perfection as in his great stairway fresco at Guadalajara's Government Palace. Ascending to the first landing one is confronted by an essentially black-and-white tumult of pierced and mutilated victims, one of which, with a handless arm ineffectually fending off a foot crushing its neck, is Orozco's self-portrait. Above, and against a background of red flags and flame, a gigantic image of the Jesuit priest Miguel Hidalgo gradually appears across the ceiling of the stair-well (see fig. 2). Hidalgo led the 1810 revolt against Spanish rule and is portrayed with raised fist, sweeping a firebrand across the scene of carnage. The side walls of the two flights of steps ascending to the arches of the second level reveal scenes condemning the alliance of the clergy with the military and satirizing the ambitions of Fascism. Painted across and effectively masking the vaulting of the space, these dynamic images, set against a background of fire and smoke, completely arrest the spectator's vision. The titanic scale of the figure of Hidalgo, looming on the ceiling, rivals the effect of a Pantocrator dominating the apse of a Byzantine basilica. Yet here there is no distance from the image, as there is with the *Prometheus* or the *Man of Fire* in the dome of the Hospicio Cabañas. It bears down with all the grim realism of a revolutionary artist's expressive righteousness, allowing the viewer to escape neither anguish nor commitment.

WRITINGS

An Autobiography (Austin, 1962)
The Artist in New York: Letters to Jean Charlot and Unpublished Writings, 1925–29 (Austin, 1974)

BIBLIOGRAPHY

A. Reed: *Orozco* (New York, 1956; Span. trans., Mexico City, 1983)
D. Scott: 'Orozco's *Prometheus*', *Coll. A. J.*, i/17 (1957), pp. 2–18
Exposición nacional de homenaje a José Clemente Orozco con motivo del XXX aniversario de su fallecimiento (exh. cat., Mexico City, Pal. B.A., 1979)
Orozco! (exh. cat., ed. D. Elliott; Oxford, MOMA, 1980)
T. del Conde: *J. C. Orozco: Antología crítica* (Mexico City, 1982)
T. del Conde and others: *Orozco: Una relectura* (Mexico City, 1983)
L. P. Hurlburt: *The Mexican Muralists in the United States* (Albuquerque, 1989)
D. Rochfort: *Mexican Muralists: Orozco, Rivera and Siqueiros* (London, 1997)
R. González Mello: *José Clemente Orozco: La pintura mural Mexicana* (Mexico City, 1997)

FRANCIS V. O'CONNOR

Orozco Romero, Carlos (*b* Guadalajara, 3 Sept 1898; *d* Mexico City, 29 March 1984). Mexican painter and teacher. He studied painting in Guadalajara, and in 1914 he settled briefly in Mexico City before going on in the same year to Europe. He studied in Madrid and Paris until 1921 and developed an interest in avant-garde art. On his return in 1928 he began a long career as a painter and teacher. His paintings, in which his skilful draughtsmanship was evident, helped revive interest in the popular arts of the Jalisco region through his depictions of masks and the pottery of Tonalá. Classical and expressionistic influences fluctuated, with cool shades of blue, grey and green predominating. His Expressionism bordered on Surrealism in paintings of lonely women tormented by neuroses (e.g. *On the Balcony*, 1950; Mexico City, Mus. A. Mod.), and there are Cubist elements in his *Self-portrait* (1956; priv. col., see Nelcen, fig. 86). Orozco Romero also painted highly original landscapes (e.g. *Mountains of Jalisco*, 1981; Mexico City, Acad. A.).

BIBLIOGRAPHY

M. Nelken and others: *Carlos Orozco Romero* (Mexico City, 1959, rev. 1994)
A. de Neuvillate: *Carlos Orozco Romero* (Mexico City, 1973)
Propuestas y variaciones (exh. cat., Mexico City, Mus. Pal. B.A., 1996)

XAVIER MOYSSÉN

Ortega Flores, Salvador (*b* Mexico City, 22 March 1920; *d* Mexico City, 16 Dec 1972). Mexican architect, urban planner and teacher. He trained at the Escuela Nacional de Arquitectura in the Universidad Nacional Autónoma de México, Mexico City. He worked largely in the public domain, where he held important posts, especially in the area of urban planning. As a representative of the General Administration of Public Works in the Federal District of Mexico he played an important role in the building of the underground railway system. In 1950 he formed a partnership with MARIO PANI, with whom he collaborated on various projects, including the administration building of the Ciudad Universitaria (1951–2), Mexico City, on which

Enrique del Moral also collaborated. The building incorporated into the façades murals by David Alfaro Siqueiros, reflecting the contemporary trend for the 'plastic integration' of architecture and the other fine arts in Mexico.

In the field of residential architecture his collaborations with Pani include three housing developments in Mexico City: the Centro Urbano Presidente Alemán (1950), the Centro Urbano Presidente Juárez (1952; partly destr. 1985) and the Unidad Habitacional Santa Fé (1955–6). These developments sought to provide for the growth of densely populated inner-city areas by incorporating landscaped areas, recreation facilities and all amenities. He also made notable studies and designs for housing developments in Azcapotzalco, Ixtacalco, and Culhuacán, in the Federal District of Mexico. Ortega Flores was a professor of architecture at the Universidad Nacional Autónoma de México, Mexico City, from 1944 to 1956. He also taught at the Instituto Technológico, Monterrey, and the Universidad de Guadalajara, Guadalajara.

BIBLIOGRAPHY

M. Larrosa: *Mario Pani, arquitecto de su época* (Mexico City, 1985)

F. González Gortázar, ed.: *La arquitectura mexicana del siglo XX* (Mexico City, 1994)

LOURDES CRUZ

Ortiz Monasterio, Luis (*b* Mexico City, 23 Aug 1906; *d* Mexico City, 16 Feb 1990). Mexican sculptor and teacher. He studied at the Escuela Nacional de Bellas Artes (1921–4) under Ignacio Asúnsolo. He visited California between 1924 and 1926, where he encountered contemporary trends. On returning to Mexico in 1931 he was appointed to teach 'talla directa', sculpting directly in stone, at the Escuela Nacional de Artes Plásticas, continuing until 1962. His creative ability and originality are best seen in his more personal creations. In the 1930s he produced sensual stone sculptures (e.g. *Victory*, 1935; Mexico City, Pérez Amor priv. col.); by 1943 he was incorporating colour into his designs. He produced a number of polychromed terracotta sculptures, including *Motherhood* (1949; Mexico City, Luna Arroyo priv. col.). He also executed some important public monuments, including the fountain of *Nezahualcoyotl* (1956) in Chapultepec, Mexico City; the sculptures (1962) in the Unidad Habitacional Independencia, Mexico City; and sculptures (1963) in the National Medical Centre, Mexico City, in which he dealt with historical themes. Ortiz Monasterio maintained a constant interest in using diverse materials and in pursuing new forms of expression; he expressed nationalist sentiments through his use of Pre-Columbian sources. In the 1960s he preferred polychromed concrete and bronze in his personal work and adopted an almost abstract geometric approach.

BIBLIOGRAPHY

L. Islas García: *El escultor Luis Ortiz Monasterio* (Mexico City, 1964)

Luis Ortiz Monasterio, escultura, Academia de Artes (Mexico City, 1970)

LOUISE NOELLE

Ossaye, Roberto (*b* Guatemala City, 11 Jan 1927; *d* Guatemala City, 8 June 1954). Guatemalan painter. He trained at the Academia de Bellas Artes in Guatemala City from 1941 to 1946 and began painting portraits, in which his talent was already evident, as well as a number of murals with robust figures influenced by contemporary Mexican art and especially Diego Rivera, for example

Working in the Field (1948; Guatemala City, Dir. Gen. Cult. & B.A.). His work, at this time still uncertain and very much at a formative stage, underwent a transformation on his move in 1948 to New York on a Guatemalan government grant. Making his home there for three years, he came in direct contact with new artistic trends and rapidly began the search for his own formal language. At first one can discern the influence, for example in *The Aunts* and *Children* (both *c.* 1947; both Guatemala City, Mus. N. A. Mod.), of Carlos Mérida, whom Ossaye had met before leaving Guatemala during a brief visit Mérida had made there, as well as that of David Alfaro Siqueiros and Rufino Tamayo. In the USA, Ossaye continued to develop quickly, using colourful and expressive forms full of movement and tension. He employed a wide variety of media, including watercolour, casein paint, encaustic, gouache, oil, pyroxylin, tempera and dyes. On his premature death at the age of 27 it was already clear that he was one of the most exciting Guatemalan painters of his generation. His last works were powerful and original, showing different aspects of life, as in *Girl and Eclipse* (1950), or reflecting the tragedy and pain of his young wife's native country, the Dominican Republic, for example in *Calvary* (1953; both Guatemala City, Mus. N. A. Mod.).

BIBLIOGRAPHY

Roberto Ossaye (exh. cat., Guatemala City, U. S Carlos, 1955)

E. de Aparicio: 'El arte Guatemalteco en el Museo de Arte Moderno de Nueva York: I. Roberto Ossaye', *Salón 13* i/1 (1960), pp. 24–32

Roberto Ossaye (exh. cat., intro. V. Vázquez; Guatemala City, Mus. N. A. Mod., 1984)

R. González-Goyri: 'Recuerdo y devoción de Roberto Ossaye', *An. Acad. Geog. & Hist. Guatemala*, ixvi (1992), pp. 249–60

L. Méndez d'Avila: *Visión del arte contemporáneo en Guatemala*, i (Guatemala City, 1995)

L. Méndez de Penedo: 'Roberto Ossaye', *Banca Cent.*, xvi (1993), pp. 78–90

JORGE LUJÁN-MUÑOZ

Otero, Alejandro (*b* El Manteco, 7 March 1921; *d* Caracas, 13 July 1990). Venezuelan painter and sculptor. He began studying at the Escuela de Artes Plásticas y Aplicadas, Caracas, in 1939 and in the following year won a prize in the First Venezuelan Official Art Salon. In 1945 he went to New York and to Washington, DC, where he exhibited figurative works at the Pan American Union. He moved to Paris in 1948, and by 1949 he had completed his series of *Coffee Pots* (e.g. *Blue Coffee Pot*, 1947; Caracas, Gal. A. N.), which marked his transition to a gestural abstraction controlled by linear elements. He was a founder-member of the Los Disidentes group. In Paris he became interested in geometric abstraction, concerned with the optical effects of squares and grids, as in *Colourhythm 1* (1955; see colour pl. XXVI). This interest dominated his work throughout the 1950s and is reflected in his project to integrate his murals with Carlos Raúl Villanueva's architecture (1952) in the Engineering Faculty of the Ciudad Universitaria, Caracas. In 1958 Otero was awarded the National Prize for Painting in the Official Salon, and in 1959 he represented Venezuela in the Biennale of São Paulo, receiving an honourable mention. In the 1960s he abandoned painting in order to work on a larger scale in his 'civic sculptures', such as *Delta Solar* (Washington, DC, N. Air & Space Mus.; see fig.). He also produced collages of *objets*

Alejandro Otero: *Delta Solar*, stainless steel and mixed media, 1.52×2.24 m (pool), 1960s (Washington, DC, National Air and Space Museum)

trouvés, as in *Page Picture No. 1* (paper on wood, 1964; priv. col., see Boulton, 1966, fig. 33).

WRITINGS
Memoria crítica (Caracas, 1993)

BIBLIOGRAPHY
A. Boulton: *Alejandro Otero* (Caracas, 1966)
——: *Historia de la pintura en Venezuela*, iii (Caracas, 1972)
M. E. Ramos: 'Alejandro Otero: Las estructuras de la realidad', *A. Nexus*, ii (1991), pp. 97–9
A. Boulton: *Alejandro Otero* (Caracas, 1994)
Alejandro Otero: Esculturas virtuales: Líneas de luz (exh. cat., Caracas, Mus. A. Visuales Alejandro Otero, 1994)
Tres maestros del abstracionismo y la proyección internacional (exh. cat. by G. Rubiano, Caracas, Gal. A. N., 1994)
MELANÍA MONTEVERDE-PENSÓ

Ouro Prêto [formerly Vila Rica]. Brazilian city in Minas Gerais state. Built on a hill 1000 m above sea-level, *c.* 300 km north of Rio de Janeiro and *c.* 350 km from the Atlantic Ocean, the city (population *c.* 68,000) was the principal gold-producing centre of Brazil in the 18th century and is renowned for its outstanding colonial architecture. It was renamed Ouro Prêto in 1823, was the capital of Minas Gerais state until 1897 and was listed as a World Heritage site by UNESCO in the late 20th century. The site of Ouro Prêto was settled *c.* 1690 after the discovery of gold. The rapid expansion of gold-mining accompanied the growth of the town throughout the 18th century, and it became one of the largest cities in Brazil and a focus for artistic activity in all fields. The population subsequently decreased when local gold deposits were exhausted.

The harmony of its architecture and urban plan is outstanding, with administrative and religious buildings, churches, fountains and other public monuments, as well as some beautiful houses. The principal buildings date from the mid-18th century and include the Palácio dos Governadores, an immense building that now houses the School of Mines and the Mineralogical Museum; and the Casa de Câmara (now the Museu da Inconfidência), designed in 1745 by the military engineer José Fernandes Pinto Alpoim (1700–70) and built in 1784. The Casa dos Contos (1787), built by the collector of taxes João Rodrigues de Macedo, was at the time the most important private house in the city; it is now the Museu da Moeda (mint and numismatic museum) and the Centro de Estudos do Ciclo do Ouro. The 12 churches that marked the growth of the city are magnificent examples of Brazilian late Baroque and Rococo (e.g. for illustration *see* LISBOA, (1)). Outstanding is S Francisco de Assis da Penitência (1766–94), designed and decorated by Antônio Francisco Lisboa, known as Aleijadinho; its features include the decoration of the façade, the retable of the high altar and

the carving of the pulpit (*see* LISBOA, (2)). The *Glorification of the Virgin* on the nave ceiling by MANOEL DA COSTA ATAÍDE is painted in illusionistic architectural perspective (1801–10; *see* BRAZIL, fig. 8). The church of Nossa Senhora do Pilar (1731–3) by Pedro Gomes Chaves has a carved retable by Francisco Xavier de Brito (*d* 1751) and fine side altars in carved gilt wood. Nossa Senhora do Rosário dos Pretos (1725–85; completed by José Pereira Arouca) has a unique oval plan that makes it one of the most original churches in the country (*see* BRAZIL, §IV, 1(i) and fig. 4).

BIBLIOGRAPHY

G. Bazin: *L'Architecture religieuse baroque au Brésil* (Paris, 1956)

M. Bandeira: *Guia de Ouro Prêto* (Rio de Janeiro, 1963)

G. Bazin: *Aleijadinho et la sculpture baroque au Brésil* (Paris, 1963)

L. G. Machado: *O barroco mineiro* (São Paulo, 1973)

S. Vasconcelos: *Vila Rica: Formação e desenvolvimento* (São Paulo, 1977)

D. Bayón and M. Marx: *L'Art colonial sud-américain* (Paris, 1990)

P. de la Riesta: 'Arquitectura Lusobrasileña', *Arquitectura colonial iberoamericana*, ed. G. Gasparini (Caracas, 1997), pp. 493–552

ROBERTO PONTUAL

Oviedo, Diego Martínez de. *See* MARTÍNEZ DE OVIEDO, DIEGO.

P

Paalen, Wolfgang (*b* Vienna, 1905 or 1907; *d* Mexico City, 1959). Austrian painter and writer, active in Mexico. Self-taught, he travelled widely through Europe from 1920, painting in France, Italy, Germany, Switzerland, Greece and Czechoslovakia. He became a member of Abstraction–Création in 1934 and was involved with the Surindépendants in Paris from 1932 to 1935, but from 1935 he was associated primarily with Surrealism. He is generally credited with inventing the Surrealist technique of *fumage*, by which he drew on the canvas with the random and evanescent patterns of smoke from candles, as in *Fumage* (oil and smoke on canvas, 910×600 mm, 1937; Tepoztlán, Morelos, Isabel Marín de Paalen priv. col.; see Morales, pl. I, opp. p. 14). He also produced sculptures made from *objets trouvés*, such as an encrusted umbrella entitled *Articulated Cloud* (1938; Stockholm, Mod. Mus.).

At the beginning of World War II Paalen moved to Mexico with his wife, the French Surrealist poet Alice Rahon Paalen, settling there permanently and becoming friends with Diego Rivera and Miguel Covarrubias. He travelled in the Pacific Northwest and became one of the first artists to explore and discuss the native art of this region at the San Francisco Museum of Modern Art and other major centres. He maintained contact with Max Ernst, Joan Miró and Alberto Giacometti, and in 1942 he founded an international art magazine, *DYN*, whose six issues he edited until its dissolution in 1944. His writings in *DYN* demonstrated that he was a brilliant thinker interested in the creative process and in the overlap between science (especially contemporary developments in physics) and ethnology. Although in 1940 he organized the Exposición Internacional del Surrealismo at the Galería de Arte Mexicano in Mexico City, which included a group of extraordinary Surrealist objects by Victor Brauner, Kurt Seligmann and Paalen himself, after settling in Mexico he pursued a more independent path arising from a profound commitment to art as a process of spiritual transformation. The change is evident as early as *The Messenger* (1941; London, Tate; see fig.), a painting depicting a figure that floats in an agitated but indeterminate space. His works of the 1950s, such as *Dawn* (1958; Mexico City, Mus. Carollo Gil), came close in appearance to European Tachism, but in their emphasis on visionary qualities and mental states they were still firmly linked to the aspirations of the Surrealists.

In retrospect, Paalen's contribution to painting is limited to a degree by his use of such idiosyncratic methods of creation as *fumage* as well as by the hermetic quality of his imagery, and his writings failed to reach a wide audience. His ethnographic researches into the Pre-Columbian cultures of Mexico and into the Haida Indians of the Northwest Coast, however, were significant in synthesizing the principles of archaic art that he attempted to employ in his own work. They suggest, moreover, a deeper synthesis of anthropology and ethnology with Surrealist art than has been recognized by conventional art history.

BIBLIOGRAPHY

DYN, 1–6 (1942–4) [ed. by W. Paalen]
G. Regler: *Wolfgang Paalen* (New York, 1946)
Homenaje a Wolfgang Paalen el precursor (exh. cat., Mexico City, Mus. A. Mod., 1967)
Wolfgang Paalen, preface J. Pierre (Paris, 1980)
L. Morales: *Wolfgang Paalen: Introductor de la pintura surrealista en México* (Mexico City, 1984)
Wolfgang Paalen: Retrospectiva (exh. cat., Mexico City, Mus. A. Carrillo Gil, 1994)
L. Morales: *Wolfgang Paalen: Humo sobre tela* (Mexico City, 1997)

CELIA RABINOVITCH

Pacheco, Ana-Maria (*b* Goias, 17 April 1943). Brazilian sculptor, printmaker and teacher, active in England. She studied sculpture and music at the University of Goias (1960–64) and the University of Brazil, Rio de Janeiro (1965). Through a British Council scholarship she went to England (1973), where she settled, later being appointed as Head of Fine Art at Norwich School of Art, Norfolk (1985–9). For her work she drew upon diverse sources: memories of the landscape of her childhood; the troubled and fantastic visions of Spanish art and literature, of Goya, Picasso and Federico García Lorca. She explored themes of performance and masquerade in sculptural settings of life-size mannequins. Her polychromed-wood carvings, notably *The Banquet* (1985; artist's col., see Brighton, pl. 23) and *Man and his Sheep* (base, Jura marble, 1989; artist's col.; exh. 1995, Plymouth, City Mus. & A.G., see Brighton, pl. 1), place subjects in claustrophobic situations of entrapment and interrogation. It is perhaps in her extensive series of drypoint etchings, realized with consummate technical mastery, that Pacheco found her most complete expression, as in *Rehersal 7* (1990; see fig.); another example is the playful charade of *A Little Spell in Six Lessons* (dry point, 1988–9; boxed sets, boxes painted by artist, Norwich, Castle Mus.; Preston, Harris Mus. & A.G., see Brighton, pls 49–60). Pacheco was also influential as

Wolfgang Paalen: *The Messenger*, oil on canvas, 1988×768 mm, 1941 (London, Tate Gallery)

an educator, advancing art as the product of extremes of experience, encountering and sharing the effects of continuous challenge.

Ana-Maria Pacheco: *Rehersal 7*, etching, 188×165 mm, 1990 (Colchester, University of Essex, Collection of Latin American Art)

BIBLIOGRAPHY
F. Carey: 'The Prints of Ana-Maria Pacheco', *Prt Q.*, v (1988), p. 3
A. Brighton: *Ana-Maria Pacheco* (Sevenoaks, 1989)
Ana-Maria Pacheco. Twenty Years of Printmaking: New Work to Commemorate Twenty Years of Printmaking (Sevenoaks, 1994)
In illo tempore (exh. cat. by P. Hills, Sevenoaks, Pratt Contemp. A., Gal., 1994)

☐

Pacheco [née Dietrich], **María Luisa (Mariaca)** (*b* La Paz, 1919; *d* New York, 1982). Bolivian painter, also active in the USA. She studied art with her father, Julio Mariaca Pando, an architect, and at the Academia de Bellas Artes in La Paz, under Cecilio Guzmán de Rojas and Jorge de la Reza. Between 1948 and 1950 she worked on the newspaper *La Razón* as an illustrator and taught at the Real Academia de Bellas Artes. Between 1950 and 1952 Pacheco studied in Spain under Daniel Vázquez Díaz and at the Escuela de Bellas Artes de San Fernando in Madrid. On her return from Spain she worked in La Paz until 1956, at which time she separated from her husband, Victor Pacheco, and moved with her two children to New York, where she settled. She was awarded three Guggenheim Fellowships. Her painting began within the framework of native realism but towards the end of the 1940s began incorporating other strains. After she settled in New York her paintings became totally abstract and expressive, influenced by *Art informel*. In the late 1970s colour, often in natural earthy shades but highlighted by white, became very important in her work, and she took as inspiration the mountains and light of the Andes. Pacheco frequently made use of such materials as wood and cloth, incorporating them into paintings, collages and drawings, giving her works relief effects. Among her best works are *Untitled* (1966; see fig.), *Glacier* (1978; La Paz, Mus. N. A.) and *Laja* (1980; La Paz, Banco Cent.).

Maria Luisa Pacheco: *Untitled*, oil and wood on canvas, 965×1015 mm, 1966 (Austin, TX, University of Texas, Jack S. Blanton Museum of Art)

BIBLIOGRAPHY
Tribute to María Luisa Pacheco of Bolivia, 1919–1982 (exh. cat., Washington, DC, Mus. Mod. A. Latin America, 1986)
P. Querejazu: *La pintura boliviana del siglo XX* (Milan, 1989)
María Luisa Pacheco, pintora de los Andes (exh. cat., La Paz, Mus. N. A., 1993)
Latin American Women Artists, 1915–1995 (exh. cat. by G. Biller and others, Milwaukee, WI, A. Mus., 1995)

PEDRO QUEREJAZU

Paillet, Fernando (*b* Esperanza, 1880; *d* Esperanza, 1967). Argentine photographer. For 50 years he ran his own photographic studio in his home town, using this base to document the different social classes of his time. In his systematic record of Argentine crafts he showed his ability to achieve surprising effects using only the available natural light in the dark workshops. His photographs remain of interest not just because of the changing ways of life that they record but also because of the visual subtleties resulting from the play of natural light and spatial perspective.

BIBLIOGRAPHY
E. Billeter: *Fotografie Lateinamerika* (Zurich and Berne, 1981)
S. Facio: *La fotografía en la Argentina desde 1840 a nuestros días* (Buenos Aires, 1995)

ERIKA BILLETER

Palacios, Alirio (*b* Tucupita, 1 Dec 1938). Venezuelan painter and printmaker. He first studied at the Escuela de Artes Plásticas 'Cristóbal Rojas', Caracas (1954–9). Between 1962 and 1965 he studied engraving in China; this period was of fundamental importance for perfecting his engraving techniques and for developing the use of black and white that is so characteristic of his work. Late in 1968 he travelled to Poland to study at Warsaw University, returning in 1976 to Venezuela, where he was awarded the national prize for plastic arts in 1978. Work by Palacios from this period can be seen in the Galería de Arte Nacional, Caracas, for example *Diágolo Interior de la Famile Hereje* (ink, crayon and charcoal on paper, 1981) and *Diálogo Horizontal y la Fauna Mayor* (ink, crayon and charcoal on paper, 1981). From 1986 he lived in New York. His large-scale figurative work deals constantly with recreating the world of his childhood through a personal mythology, using oneiric images and creatures.

UNPUBLISHED SOURCES
Caracas, Gal. A. N., Archvs [File P-7 (1,2)]

BIBLIOGRAPHY
A. Kohler: 'Alirio Palacios', *Armitano A.*, 9 (Oct 1984), pp. 49–60
A. Romero: *Manchas de asombro: Alirio Palacios* (Caracas, 1984)
11 artistas venezolanos representados por Galería Freites (exh. cat., Caracas, Gal. Freites, 1994)

GUSTAVO NAVARRO-CASTRO

Palacios, Luisa (*b* Caracas, 10 May 1923; *d* Caracas, Sept 1990). Venezuelan painter and printmaker. She studied at the Escuela de Artes Plásticas y Aplicadas, Caracas. Initially she specialized in pottery and enamelling, but in the 1960s her workshop became an important centre for such printmakers as Gerd Leufert, Gego, Miguel Arroyo and Alejandro Otero. Palacios experimented at the workshop in the use of varnishes, dyes and burins, in order to consolidate her technical knowledge of etching, aquatint and mezzotint. Her printmaking work evolved from abstraction to the figurative, while in painting she concentrated on the study of colour, especially in her landscapes, and on movement, as in the series depicting boxers. Among her awards were those of the Nacional de Artes Plásticas and the Nacional de Dibujo y Grabado. In 1975 she was president of the board of directors of CEGRA (Centro de Enseñanza Gráfica), and a year later she was a founder-member of the Taller de Artistas Gráficos.

BIBLIOGRAPHY
Luisa Palacios: Maestra de tintas (exh. cat. by R. Romero, Caracas, Gal. A. N., 1991)
Luisa Palacios, el taller y la invención del Taga, Biblioteca Nacional de Venezuela (Caracas, 1994)

ANA TAPIAS

Panama, Republic of [Panamá.] Country in Central America. The most southerly state of Central America, it is bordered by Costa Rica to the west and Colombia to the east (see fig. 1). It is only 60 km across at its narrowest point, between the Caribbean Sea to the north and the Pacific Ocean to the south. The two seas are connected by the Panama Canal, which runs for 80 km across the country. The land is dominated by a central mountainous spine, although the remaining land is generally low, with broad valleys that are more developed on the Pacific side, while on the Caribbean side pockets of jungle are interspersed with banana plantations. In the late 20th century the population was *c.* 2,300,000, more than 80% of whom lived on the Pacific side. The capital, Panama City, has a population of *c.* 1 million (including its suburbs) and is located at the Pacific entrance to the Panama Canal; other cities include Colón, La Chorrera, Chitré, Santiago, David and Puerto Armuelles. The country is divided administratively into five regions and nine provinces.

I. Introduction. II. Architecture. III. Painting, graphic arts and sculpture. IV. Patronage and institutions.

I. Introduction.

The modern history of Panama began with the arrival there in 1501 of the Spaniard Rodrigo de Bastidas. This

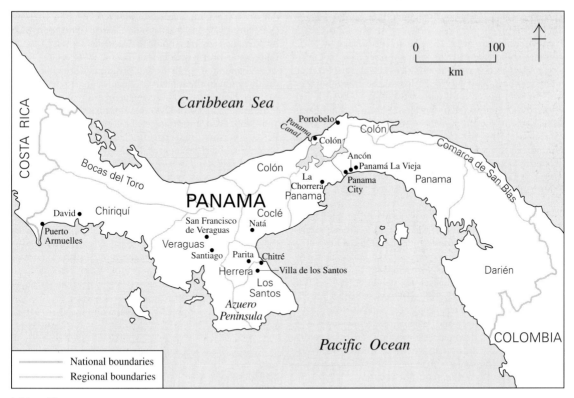

1. Map of Panama

was followed in 1513 by the discovery of the Pacific Ocean on the Panama coast by Vasco Núñez de Balboa. It was from Panama that the conquest of the Inca empire, and part of Central America, was organized. Throughout colonial rule the territory defended the Spanish empire from attack and assisted with transportation between the two oceans. The population grew from 25,000 in 1600 to almost 100,000 in 1800 and comprised a mixture of indigenous people and descendants of African slaves, with a minority of Spanish origin. In 1821 Panama gained independence from Spain and joined the Republic of Gran Colombia. Between 1850 and 1855 the first transcontinental railway in the world was built between Panama City and Colón on the Caribbean, and in 1880 the Panama Canal was begun by Ferdinand de Lesseps; its construction (completed 1914) attracted large numbers of workers from Europe, the USA and the Antilles, and in 1900 the population of the region exceeded 300,000. Panama finally separated from Colombia in 1903, creating the Republic of Panama under protection from the USA; a subsequent treaty granted the USA power to complete construction of the Panama Canal and to control it indefinitely. During the 20th century the country's population increased eightfold, and Panama reaffirmed its principal historic activity of providing international and commercial services. In 1977 the Torrijos–Carter treaties returned to Panama its sovereignty over the Canal Zone from 1979. The military invasion by the USA in December 1989, however, once again placed the country under American protection. This lasted until 1 September 1994, when a new government was installed as a result of free elections, thus reassuring

other countries of Panama's democratic course and enabling it to be fully reincorporated into the international community. On 31 December 1999 the Panama Canal was returned once again to Panama.

BIBLIOGRAPHY

G. Mack: *The Land Divided: A History of the Panama Canal and Other Isthmian Projects* (New York, 1944)

M. P. Duval: *Cadiz to Cathay: The Story of the Long Diplomatic Struggle for the Panama Canal* (Stanford, CA, 1947)

E. Castillero Reyes: *Historia de Panamá* (Panama City, 1962)

A. Castillero Calvo: *Estructuras sociales y económicas de Veragua desde sus orígenes históricos: Siglos XVI y XVII* (Panama City, 1967)

A. Figueroa Navarro: *Dominio y sociedad en el Panamá colombiano, 1821–1903* (Panama City, 1978)

O. Jaén Suárez: *La población del Istmo de Panamá del siglo XVI al siglo XX* (Panama City, 2/1978; 3, Madrid/1998)

C. A. Araúz and P. Pizzurno Gelos: *El Panamá hispano, 1501–1821* (Panama City, 1991)

M. del Carmen Mena García: *La ciudad en un cruce de caminos: Panamá y sus oríenes urbanos* (Seville, 1992)

P. Pizzurno Gelós and C. Andrés Araúz: *Estudios sobre el Panamá replublicano (1903–1989)* (Colombia, [Manfer S.A.], 1996)

OMAR JAÉN

II. Architecture.

1. 1501–1903. Although Spanish settlement in Panama began as early as 1503, colonial architecture was slow to develop. The country's unhealthy climate, transient population and lack of access to building materials were clearly reflected in its early architecture, which for most of the colonial period remained simple and provincial. Early architectural production was centred in the early settlement at Panamá la Vieja, which was founded by Pedrarias Dávila

(Pedro Arias de Ávila) in 1519, but which is now ruined. In 1619 work began on a cathedral in the city, with a massive look-out tower. Despite an earthquake in 1621, this was completed in 1626, with a timber nave, columns and a *Mudéjar* roof; only the stone tower and some external walls, however, have survived. Most of the other churches built in the early colonial period also had *Mudéjar* timber roofs, usually supported by wooden columns (vaulting was little known); façade designs were usually derived from European Mannerist treatises. The church of Nuestra Señora de la Concepción is among the best-preserved from this period. Most domestic architecture of the period was also built of timber, but some civil buildings were built in stone, such as the Casas Reales, a 16th-century Plateresque building (destr.).

In 1671 Panamá la Vieja was destroyed by Sir Henry Morgan, and the settlement was moved to a new, extensively fortified site (the modern Panama City) 8 km to the south-west. The transfer involved carrying stone from the old site for the façades of such churches as La Merced (begun 1680). A new cathedral was also built (1690–1796; see fig. 2), an aisled church with side chapels mostly designed by the military engineer Nicolás Rodríguez. Cruciform nave piers and transverse arches support a timber roof, and a Baroque façade extends the entire width of the nave between massive three-storey towers of whitewashed brickwork with octagonal pyramid spires, a feature later copied throughout the isthmus. Also significant are the single-towered church of S Ana, which has a façade of unusual curvilinear outline dating from 1775, and the Jesuit college (completed 1741; mostly destr. 1781), which has a monumental, 55-m long façade with a loggia on the ground-floor. In the provinces, however, the church at Natá has a fine Baroque façade, strongly influenced by that of the cathedral in Panama City, with a single tower dating from the late 18th century.

The military architecture of the period up to the end of the 18th century is epitomized by the development of Portobelo. The town was founded in 1597, and the first defences, including two tall castles with massive bastions (S Felipe, 1597, and Santiago de Gloria, 1600), were built by the Italian engineer Bautista Antonelli (*see* ANTONELLI). Later, after British attacks in 1739 and 1744, these castles were abandoned, and stronger positions were built under the direction of the military engineers Ignacio de Sala and Manuel Hernández. These included the fortresses of S Jerónimo, Santiago and S Fernando, all built between 1751 and 1760. Also important is the town's brick and stone Royal Treasury: first constructed in 1630–38, it was remodelled by Hernández in 1760–66, its façade reflecting the academic standards of mid-18th-century Spain.

In the 19th century the importance of Panama as a link between South America and the north led to the construction of a railway across the isthmus and to the foundation of the city of Colón on the Caribbean coast. Buildings to serve a transient population grew rapidly, exemplified by the Grand Hotel (1875) and the Central Hotel (1884), both in Panama City, but there was also a notable expansion of domestic architecture, which remained traditional in plan but employed such new materials as concrete and cast iron.

BIBLIOGRAPHY
J. B. Sosa: *Panamá la Vieja* (Panama City, 1919)
S. Gutiérrez: *Arquitectura panameña: Descripción e historia* (Panama City, 1966)
A. Castillero Calvo: 'Portobelo: Apuntes para un libro en preparación', *Rev. Patrm. Hist.*, ü/1 (1978), pp. 135–200
S. Gutiérrez: *Arquitectura actual de Panamá, 1930–1980* (Panama City, 1980)
——: *Arquitectura de la época del canal, 1880–1914* (Panama City, 1980)
O. Velarde: *El arte religioso colonial en Panamá* (Panama City, 1990)
M. L. Vidal Fraitts: *La catedral de Panamá* (Buenos Aires, 3/1992)
E. Tejeira Davis: 'La arquitectura colonial en Panamá', *Arquitectura colonial iberoamericana*, ed. G. Gasparini (Caracas, 1997), pp. 179–92
EDUARDO TEJEIRA-DAVIS

2. AFTER 1903. Independence from Colombia (1903) and the construction of the Panama Canal (finished in 1914) brought numerous foreign architects and craftsmen to Panama City and Colón. As well as military installations, building in the Canal Zone (under American jurisdiction) included housing on Garden City principles and public buildings in an academicist style: examples of the latter include the Palacio Nacional (1910) and the Teatro Nacional (1905–8) in Panama City, by the Italian architect Genaro Ruggieri; the Canal Administration building (1913–15) at Ancón by the American architect Austin W. Lord; and the Hospital S Tomás (1920–24) by the American James C. Wright, also in Panama City. There was also a boom in domestic architecture, with ornate town houses being built in the centres and Caribbean-style houses with fretted barge-boards and verandah-rails in the suburbs. A grander example was set by President Belisario Porras's residence (1922) at La Esposición, Panama City, by the Peruvian Leonardo Villanueva, which, with its neo-Plateresque elements, helped to popularize the Spanish colonial style. The railway also continued to develop: for example, a new two-storey brick station replaced the old timber station at Colón in 1911.

The influence of the Modern Movement was evident in the work of Panama's first local school of architecture (founded 1943) at the Universidad de Panamá in Panama City, originally as part of the Department of Engineering,

2. Panama City, Cathedral by Nicolás Rodríguez and others, 1690–1796

which then became the Department of Engineering and Architecture. The School of Architecture became independent in 1962. It was initially led by Guillermo de Roux (*b* 1916) and Ricardo Bermúdez (*b* 1914), both graduates of American universities. Their work was particularly influenced by contemporary Brazilian work; examples include such buildings as the Universidad de Panamá (begun 1947), which included the celebrated Escuela de Administración y Comercio (1949–53) with its butterfly and shell roofs and *azulejo* (glazed tile) decoration; the Caja de Ahorros (1948–9); and the Urraca apartment building, all in Panama City. Many International Style buildings followed, the pattern set by Ed Stone's El Panamá Hotel (1950), a long, ten-storey slab block with shaded balconies at all levels; this style persisted until the 1980s, when some outwardly Post-modern Florida-inspired experiments appeared in Panama City.

BIBLIOGRAPHY

J. B. Sosa: *Panamá la Vieja* (Panama City, 1919)
H.-R. Hitchcock: *Latin American Architecture since 1945* (New York, 1955)
S. Gutiérrez: *Arquitectura panameña: Descripción e historia* (Panama City, 1966)
A. Castillero Calvo: 'Portobelo: Apuntes para un libro en preparación', *Rev. Patrm. Hist.*, ii/1 (1978), pp. 135–200
S. Gutiérrez: *Arquitectura actual de Panamá, 1930–1980* (Panama City, 1980)
——: *Arquitectura de la época del canal, 1880–1914* (Panama City, 1980)
E. Tejeira-Davis: *Roots of Modern Latin American Architecture: The Hispano-Caribbean Region* (diss., U. Heidelberg, 1987)
O. Velarde: *El arte religioso colonial en Panamá* (Panama City, 1990)
M. L. Vidal Fraitts: *La catedral de Panamá* (Buenos Aires, 3/1992)
E. Tejeira Davis: 'El neocolonial en Centroamerica', *Arquitectura neocolonia: América Latina, Caribe, Estados Unidos*, ed. A. Amaral (São Paulo, 1994), pp. 113–28

EDUARDO TEJEIRA-DAVIS

III. Painting, graphic arts and sculpture.

1. 1501–1903. Soon after colonization, Spanish workshops (and later those in Panama, Ecuador and Peru), began supplying paintings and sculpture for the decoration of Panama's churches and convents in accordance with their evangelizing mission. The statues of the *Immaculate Conception* and *St Joseph* in the church at Parita demonstrate the influence of Seville and of Juan Martínez Montañés in particular in colonial Panamanian sculpture of the 17th century. In general, however, the aesthetic achievements of colonial art in Panama were unexceptional, and work was usually carried out anonymously; in addition, suitable materials were not widely available. Notable examples of religious image-making and painting from the 18th century include respectively the *Immaculate Conception* in the church at San Carlos and the *Holy Trinity* in the church at Natá. A Liman wood-carver who set up in Panama City during the first half of that century created the main altarpiece of the church of S José. Most other altarpieces also date from that century. While some show the influence of Seville and Lima, in others Baroque and Rococo are the dominant styles. Those in the churches at Natá, Parita, Villa de los Santos and San Francisco de Veraguas contain the most important sculptures and paintings of popular Panamanian Baroque.

After independence from Spain was achieved in 1821, numerous foreign artists arrived in Panama to draw and paint its landscapes and to portray its people. The drawings, which were often reproduced as lithographs and wood-engravings when these artists returned home, are more historical iconography than works of art, but some of those by such figures as Charles Parsons (1821–1910), Bayard Taylor (1825–78) and Fessenden Natt Otis (1825–1900) are outstanding. In the 19th century, José Anselmo Yáñez (*b* 1860) from Quito was active as a portrait painter, and the German Charles Christian Nahl (1818–78) and the French artists Ernest Charton (1815–77) and William Leblanc (1822–1903) produced notable landscapes. Towards the end of the century the American Norton Bush (1834–94), the Colombian Epifanio Garay and the Ecuadorian Carlos Endara Andrade (1865–1954) were also active in Panama and with their predecessors helped to engender enthusiasm for painting through the country.

BIBLIOGRAPHY

H. Scenone: *Introducción al arte religioso de Panamá* (Panama City, n.d.)
J. de Arango and O. A. Velarde: 'El istmo, a través de la expresión artística de extranjeros y nacionales, durante el siglo XIX', *Patrim. Hist.*, ii/2 (1979), pp. 139–54
O. A. Velarde: *El arte religioso colonial en Panamá* (Panama City, 1990)
M. Kupfer: 'Central America', *Latin American Art in the Twentieth Century*, ed. E. Sullivan (London, 1996), pp. 51–79

OSCAR A. VELARDE

2. AFTER 1903. Following independence from Colombia in 1903, the most notable artists in the new Republic of Panama were MANUEL E. AMADOR, ROBERTO LEWIS and his student HUMBERTO IVALDI. Painters of official portraits, still-lifes and the local landscape, they produced art that combined traditional French academic training with the innovations of late 19th- and early 20th-century European modernism. As directors of Panama's first art school, the Academia Nacional de Pintura in Panama City (founded by Lewis, 1913; from *c.* 1939 to 1952 the Escuela Nacional de Pintura; from 1952 the Escuela Nacional de Artes Plásticas), Lewis, and later the more modern Ivaldi, were responsible for educating Panama's next generation of painters, which included JUAN MANUEL CEDEÑO, ALFREDO SINCLAIR, EUDORO SILVERA, Ciro Oduber (*b* 1921), the muralist Juan Bautista Jeanine (1922–82) and ISAAC LEONARDO BENÍTEZ. From the 1940s these artists worked in a variety of styles ranging from realism to Expressionism and abstraction, often choosing nationalist themes.

It was not until the 1950s, however, that artists in Panama caught up with the international avant-garde. Most of the artists of this generation studied abroad and on their return introduced the formal and aesthetic innovations of contemporary movements. Sinclair had furthered his studies in Argentina, and TRIXIE BRICEÑO, who came from England, had absorbed the principles of geometric abstraction in Brazil; MANUEL CHONG NETO and the Expressionist ADRIANO HERRERABARRÍA had experience of social realism in Mexico; the prolific artist and teacher GUILLERMO TRUJILLO and ALBERTO DUTARY, who later became associated with the broader Latin American neo-figurative trend, were initially influenced by the abstract values of *Art informel* in Spain (e.g. Dutary's *Figures at Twilight*, 1960; see fig. 3). These artists took an active interest in exhibiting abroad and participating in international competitions, and they also introduced

3. Alberto Dutary: *Figures at Twilight*, oil and collage on canvas, 1.0×1.2 m, 1960 (Washington, DC, Art Museum of the Americas)

to Panama new technical expertise, prompting a phase of exploration with collage and other new media as well as engendering a lasting interest in watercolour painting.

After 1960 the founding of the Instituto Panameño de Arte (*see* §IV below) and the sponsorship of art competitions by American corporations provided a powerful stimulus to local art and brought to public attention such new figures as the abstract and semi-abstract artists COQUI CALDERÓN, ANTONIO ALVARADO and Teresa Icaza (*b* 1940). In the 1970s the establishment of the first art galleries made accessible the work of such new painters as Aguilar Ponce (*b* 1943), TABO TORAL and Antonio Madrid (*b* 1949), as well as the conceptual artist Emilio Torres (*b* 1944). There was also increased activity in the graphic arts. In 1973 Guillermo Trujillo and the Colombian printmaker Alicia Viteri (*b* 1946) were responsible for establishing Panama's first etching workshop at the Universidad de Panamá, and they later founded the Taller de Gráfica Panarte. Nevertheless, the most celebrated Panamanian printmaker, JULIO ZACHRISSON developed his career in Spain. Sculpture has enjoyed limited popularity in Panama. Notable early sculptors included Guillermo Mora Noli (1923–81), CARLOS ABOLEDA and MARIO CALVIT, but their limited production reflected a relative lack of interest in sculpture on the part of the Panamanian art institutions and patrons. Several younger sculptors have come to the fore, however, including the innovative Susie Arias (*b* 1953) and the glass artist Isabel de Obaldía (*b* 1957).

The 1980s were characterized by a stronger art market and the development of private and corporate art collections. Thematically the human condition became the focus of Panamanian art, and a return to figuration in styles ranging from Magic Realism to Neo-Expressionism was evident in the work of such painters as Amalia Tapia (*b* 1947), BROOKE ALFARO, David Solís (*b* 1953), Raúl Vásquez (*b* 1954) and Olga Sinclair (*b* 1957), among others. The US invasion of Panama in 1989 marked the beginning of a new period of democracy. Older artists continued to develop their careers as younger figures joined the cultural scene. However, towards the end of the 20th century Panamanian artists, with only a few

exceptions, remained relatively isolated from the international avant-garde, seemingly uninfluenced by such trends as Arte Povera, performance art, conceptual art and land art. This reflected a general tendency on the part of Panamanian artists to use more traditional media to explore the problems of national identity, as well as social and political issues. These in turn were reflected in images drawn from Panama's rich Pre-Columbian mythology and Spanish heritage, its religious and racial combinations, and its lush and tropical landscape.

BIBLIOGRAPHY

E. Wolfschoon: *Las manifestaciones artísticas en Panamá* (Panama City, 1983)

M. Pascual, ed.: *Tiempo y color: 16 pintores de Panamá* (Caracas, 1991)

M. Kupfer: 'Central America', *Latin American Art in the Twentieth Century*, ed. E. J. Sullivan (London, 1996)

Crosscurrents: Contemporary Painting from Panama, 1968–98 (exh. cat. by M. Kupfer and E. Sullivan, New York, Americas Soc. A.G., 1998)

MONICA E. KUPFER

IV. Patronage and institutions.

During the colonial period, patronage of the arts in Panama followed the pattern that was common throughout Latin America, with funding provided by religious brotherhoods (*cofradías*) and private citizens. In the 17th century, for example, Pedro de Alarcón, a wealthy local merchant, substantially financed the building (1619–26) of the cathedral in Panamá la Vieja (*see* §II, 1 above), and donations from Bishop Cristóbal Martínez de Salas (1626–40), Alonso de Mesa and his wife Beatriz Montero permitted the otherwise penniless Jesuits to build their church of the Compañia de Jésus (1608; destr.; rebuilt 1621); the Cofradía de las Ánimas, one of the wealthiest brotherhoods, had a lavish chapel in the cathedral at Panamá la Vieja, and its altarpiece was a large painting of the *Last Judgement* (destr.) that had been commissioned in Peru. A more humanistic form of patronage developed in the 18th century, exemplified by Francisco Javier de Luna Victoria, Bishop of Panama City from 1751 to 1759. He endowed the Jesuit College, the first institution of higher education on the isthmus (completed in *c*. 1741; largely destr. 1781), and gave substantial donations for building the new cathedral and the parish church at Natá (*c*. 1750–*c*. 1805; *see also* §II, 1 above).

As in other Latin American countries, the tribulations suffered by the Church in the 19th century in the wake of Liberal Reform dealt a severe blow to traditional forms of art patronage. A renewed interest in the fine arts was stimulated by the building of the Panama Canal (begun 1880), which encouraged international contacts and foreign immigration, notably bringing about a sustained French presence. From the 1870s there was a degree of official sponsorship of such prominent artists as the Colombian Epifanio Garay, who first arrived in Panama in 1873 and painted leading politicians and public figures, and ROBERTO LEWIS, who after independence from Colombia in 1903 decorated the interiors of many of the country's most important public buildings (e.g. the Palacio de Gobierno, Panama City, 1912). Such sponsorship, however, ebbed in the course of time.

Art institutions took a very long time to develop in Panama. Formal education in the fine arts began in Panama City with the foundation in 1912 by Roberto Lewis of the

Escuela Nacional de Pintura (later the Escuela Nacional de Artes Plásticas). The first permanent public museum, the Museo Nacional, which opened in 1939, originally dealt only marginally with art, and until the 1950s artists had great difficulty in presenting their work to the public, since there were no local art galleries or exhibitions of any consequence. The first major art exhibition was held in 1953 to celebrate the 50th anniversary of Panama's independence from Colombia and was sponsored by the government. In the late 1950s the Museo Nacional also began exhibiting and collecting contemporary Panamanian art. The privately funded Instituto Panameño de Arte, established in 1962 by ALBERTO DUTARY and others, was, however, the first important art institute dedicated expressly to patronage of the arts. The first significant art competitions took place in the 1960s and were sponsored by international corporations such as Esso (1965) and Xerox (1969–78).

In the 1970s there was a marked improvement in the development of art institutions. Most important was the founding of the Instituto Nacional de Cultura y Deportes (INCUDE) in 1970, superseded by the Instituto Nacional de Deportes and by the Instituto Nacional de Cultura (INAC) in 1974, which in turn opened several museums, notably the Museo de Arte Religioso Colonial (1974) and the Museo Antropológico Reina Torres de Araúz (1976), both in Panama City; the Instituto Nacional de Cultura also operates several fine arts schools throughout the country, and from 1981 it organized an annual painting competition. Also in 1981 the Instituto Panameño de Arte opened the Museo de Arte Contemporáneo in Panama City with a permanent collection of modern Latin American paintings; other private art galleries were established from the late 1970s. Educational facilities were further improved when the department of architecture at the Universidad de Panamá, Panama City, opened a school of fine arts in 1988.

BIBLIOGRAPHY
J. Requejo y Salcedo: 'Relación histórica y geográfica de la provincia de Panamá', *Relaciones históricas y geográficas de América Central*, ed. M. Serrano y Sanz (Madrid, 1908), pp. 1–136
Panamá: Cincuenta años de república (Panama City, 1953)
E. Wolfschoon: *Las manifestaciones artísticas en Panamá* (Panama City, 1983)
EDUARDO TEJEIRA-DAVIS

Pancetti, José Gianini [Giuseppe Giovanni] (*b* Campinas, 18 June 1902; *d* Rio de Janeiro, 10 Feb 1958). Brazilian painter. The son of Italian immigrants, he was taken back to Italy in 1913 by an uncle. He joined the Italian merchant navy in 1919 but the following year disembarked again in Brazil, in Santos. From 1922 to 1942 he served in the Brazilian navy. His first attempts at painting date from 1925. Although completely self-taught, in 1933 he tried to learn something about the craft by joining the Bernardelli group; active from 1931 to 1942, this group of young artists, predominantly painters, met in Rio de Janeiro to exchange ideas about their work and techniques. A notable example of Pancetti's early work is *Workshops* (1940; Rio de Janeiro, Mus. N. B.A.), depicting shipyards in Angra dos Reis. He won a foreign travel award from the Salão Nacional de Belas Artes (Rio de Janeiro) of 1941 but unable to take it up because of World War II and his

already failing health. In 1950 he settled in Bahia, travelling from there to other parts of Brazil. His favoured subjects were landscapes and especially seascapes of Rio de Janeiro, Angra dos Reis, Itanhaem and Salvador (e.g. *Seascape*, 1945; Rio de Janeiro, Mus. N. B.A.), but he also painted portraits and self-portraits. His tendency to reduce and simplify, together with a powerfully suggestive use of colour, reflected a balance between geometrical structure and spontaneity.

BIBLIOGRAPHY
José Gianini Pancetti (exh. cat. by O. Tavares, Rio de Janeiro, Mus. A. Mod., 1955)
M. Lima: *Pancetti* (Rio de Janeiro, 1960)
O. Tavares and C. P. Valladares: *Pancetti: Pinturas* (Rio de Janeiro, 1965)
R. Navarra: *Jornal de arte* (Campina Grande, 1966)
J. R. Teixeira Leite: *Pancetti: Pintor marinheiro* (Rio de Janeiro, 1979)
R. Pontual: *Entre dois séculos: Arte brasileira do século XX na Coleção Gilberto Chateaubriand* (Rio de Janeiro, 1987)
ROBERTO PONTUAL

Pani, Mario (*b* Mexico City, 29 March 1911; *d* Mexico City, 23 Feb 1993). Mexican architect and urban planner. He studied architecture at the Ecole Nationale Supérieure des Beaux-Arts in Paris, graduating in 1934 (his degree was validated by the Universidad Nacional de México in October of the same year). He returned to Mexico at a time of rapid national development and soon earnt recognition for the quality and originality of his designs. The innovative approach that was already evident in his early works remained a feature of his work throughout his subsequent career, although it was at times necessarily diluted to some extent by the requirements of working in a large practice and in numerous professional partnerships. Outstanding among his early works was the Hotel Reforma (1936) in Mexico City, the first modern hotel in the country, which was followed in the 1940s by a series of houses and apartment buildings in Mexico City, including those at Río Balsas 36 (1944), Avenida Juárez 88 (1945) and Paseo de la Reforma 334 (1946, destr.). These were notable for their height and for the split-level planning that Pani adopted. Contemporary with these were the Escuela Nacional de Maestros (1945–7), a pioneering example of the integration of the plastic arts, executed in collaboration with the sculptor Luis Ortiz Monasterio and the painter José Clemente Orozco, and the Conservatorio Nacional de Música (1946), both in Mexico City.

Pani's work in housing continued with the Unidad Habitacional Presidente Alemán (1947–50), south of Mexico City, one of his most important works. This was the first Mexican housing development where he was able to draw on the works of the European architects he had studied in his youth, while modifying their ideas to meet Mexico's urgent social requirements. He erected more than a thousand split-level apartments in six twelve-storey blocks, with schools, shops and other amenities grouped so as to permit large landscaped areas. The success of this complex was repeated in other developments such as the Unidad Habitacional President Juárez (1951–2; partially destr. 1985), carried out in collaboration with SALVADOR ORTEGA FLORES and with exterior coloured concrete or cement decoration by Carlos Mérida; and the Ciudad Habitacional Nonoalco Tlatelolco (1964–6), comprising 12,000 dwellings in over 100 buildings. The scale of the last project was perhaps excessive.

Pani also executed a number of important works in partnership with ENRIQUE DEL MORAL. These included preparing the outstanding and exemplary master-plan for the Ciudad Universitaria (completed 1952; *see* MEXICO, §III, 2) and such buildings as the Secretaría de Recursos Hidráulicos (1950–53), the Rectoría (1951–2) of the Universidad Nacional de México and Acapulco Airport (1954–5). As chairman of the Taller de Urbanismo (*c.* 1950–70) Pani was also able to become involved in the production of schemes for urban development, and he produced a large number of regional plans, such as those for Yucatán (1951), Acapulco (1952), Ciudad Satélite (1954), near Mexico City, and Ciudad Juárez (1963), Chihuahua. He also founded the periodical *Arquitectura* (later *Arquitectura/México*), which provided a critical forum for Mexican architects from 1938 to 1979.

WRITINGS
Los multifamiliares de pensiones (Mexico City, 1953)

BIBLIOGRAPHY
Contemp. Architects
Arquit. México, 67 (1959) [whole issue]
C. Bamford Smith: 'Mario Pani', *Builders in the Sun: Five Mexican Architects* (New York, 1967)
M. Larrosa: *Mario Pani: Arquitecto de su época* (Mexico City, 1985)
L. Noelle: 'Mario Pani', *Arquitectos contemporáneos de México* (Mexico City, 1988)
T. González de León and others: *Homenaje al arquitecto Mario Pani (1911–1993)* (Mexico City, 1993)
F. González Gortázar, ed.: *La arquitectura mexicana del siglo XX* (Mexico City, 1994)
L. Noelle: 'The Architecture and Urbanism of Mario Pani: Creativity and Compromise', *Modernity and the Architecture of Mexico*, ed. E. R. Burian (Austin, 1997), pp. 177–90

LOUISE NOELLE

Panunzi, Benito (*b* Italy, 1835; *d* Italy, after 1870). Italian photographer, active in Argentina. An avid traveller, he visited India and China before opening a studio in Buenos Aires, Argentina, where he worked from 1865 to 1870. He was among the first photographers to discover the beauty of the Argentine Pampa and to make portraits of its picturesque Gauchos. Through his photographic books, which were available on a subscription basis, the Pampa was opened up for tourists. In 1870 he returned to Italy.

BIBLIOGRAPHY
E. Billeter: *Fotografie Lateinamerika* (Zurich and Berne, 1981)

ERIKA BILLETER

Paolera, Carlos Maria della. *See* DELLA PAOLERA, CARLOS MARIA.

Paraguay, Republic of [República del Paraguay]. South American country. It is crossed by the Tropic of Capricorn and the middle meridian of South America and separated from its neighbours by rivers (the Paraná, the Paraguay, the Pilcomayo and the Apa): Paraguay means 'a place of a great river' in the Guaraní Indian language. The landlocked country is bordered by Bolivia on the north, Brazil on the north-east and Argentina on the south-east, south and west (see fig. 1). With a total area of some 406,753 sq. km, it has an estimated population of 4,200,000. The capital is Asunción, with other principal cities being Ciudad del Este (formerly Puerto Presidente Stroessner), Coronel Oviedo, Encarnación, Villarrica and Concepción. Most of the

1. Map of Paraguay

population is of mestizo (mixed Spanish and Guaraní Indian) ancestry. The country welcomed some Spanish and Italian immigrants in the early 20th century and also has peoples from Brazil, Germany and East Asia. The indigenous population of around 60,000 comprises 17 ethnic groups. The River Paraguay divides the country into two distinct large regions: the fertile eastern region, a densely populated zone cut across by tributaries of the Paraguay and the Paraná rivers; and the arid western or Gran Chaco region, with an extremely low density of population. The terrain as a whole consists mostly of marshy plains, meadows, woods and forests, although it has suffered from deforestation. National exports include soya, cotton, timber and cattle.

I. Introduction. II. Indigenous culture. III. Architecture. IV. Painting, graphic arts, sculpture and pottery. V. Textiles. VI. Patronage, collecting and dealing. VII. Museums. VIII. Art education.

I. Introduction.

Before the Spaniards arrived, the country's indigenous population was mainly Guaraní Indians. After the foundation of Asunción (1537) Paraguay became administratively dependent on the viceroyalty of Peru. After the conquering of indigenous peoples, an intense process of cross-breeding took place, resulting in the present mestizo population. In 1585 the Jesuits arrived and established the *reducciones* (missionary settlements). Entrusted by Philip II with the administration of the region of the Paraná and Uruguay rivers, between 1610 and 1767 they succeeded in relocating the Guaraní populations in theocratic collectives under the direction of Jesuit priests. During this period art and architecture were created in the *reducciones* in the style known as Hispano–Guaraní Baroque. The 'Jesuit Republic' retained its economic independence through cultivation of the *mate* plant and cattle raising. It also maintained

political autonomy in the face of armed aggression by Spanish *encomenderos* (colonists granted Indian labourers by royal decree), creoles and Portuguese slave-hunters. The 'Jesuit Republic' reached its social and economic climax in the mid-18th century, with 38 towns and more than 160,000 inhabitants. However, it aroused fierce opposition, and the Jesuits were finally expelled in 1767. In 1776 Paraguay became administratively part of the viceroyalty of Río de la Plata.

In 1811 independence was proclaimed; in 1814 the dictatorship of José Gaspar Rodríguez de Francia began, which lasted until 1840. Under the leadership of Carlos Antonio López from 1844 to 1862, the country was opened up to foreign commerce, and in collaboration with English technicians, work was begun on the country's infrastructure. In 1862 López's son, Francisco Solano López, assumed power and attempted to open up Paraguayan art to European academic influences. However, the War of the Triple Alliance (1864–70) against Brazil, Argentina and Uruguay destroyed the country's economy, left barely 220,000 inhabitants and severely restricted artistic production. The country entered into a relatively liberal phase with the founding of political parties around the mid-1880s; at this time land was privatized, and Anglo-Argentine and Italian capital funded the development of crafts and agricultural exports. In 1904 the 'Colorados' were driven from power by a 'liberal' party revolution, and Paraguay entered a period of instability until 1924. From 1932 to 1935 Paraguay was at war with Bolivia over the possession of the Chaco territory, which was presumed to be rich in oil. From 1936 there was an almost unbroken succession of military governments. In 1954 General Alfredo Stroessner began a military dictatorship lasting 35 years. During this period the country's infrastructure was developed further. An economic crisis that began in 1983, together with political disorder, led to a coup d'état in 1989. The new government initiated a transition to democracy, with the return of exiles, the restoration of civil liberties and the implementation of free elections.

BIBLIOGRAPHY

J. F. Pérez Acosta: *Núcleos culturales del Paraguay contemporáneo* (Buenos Aires, 1959)

J. Plá: *Apuntes para una historia de la cultura paraguaya* (Asunción, 1967)

M. A. Fernández: *Paraguay*, Art in Latin America Today (Washington, DC, 1969)

V. Díaz Pérez: *De arte* (Palma de Mallorca, 1982)

L. Castedo: *Historia del arte iberoamericano*, 2 vols (Madrid, 1988), i, pp. 356–8; ii, pp. 51–3, 273–5

C. J. Ardissone: *Reflexiones sobre el Paraguay* (Asuncion, 1994)

R. Medina: *Apuntes sobre la historia del Paraguay colonial* ([Asuncion], 1996)

MILDA RIVAROLA

II. Indigenous culture.

Before the Spanish arrived in Paraguay, the production of art was based on the distinct cultures of hunter-gatherers and of farmers. The hunter-gatherers in the western or Gran Chaco region had a more dynamic artistic culture than the conservative agricultural Guaraní in the eastern region. This distinction remained after Spanish colonization. The Chaco Indians maintained a greater independence from the Spanish, who mostly settled in the Guaraní *encomiendas*, where Spanish men took Indian wives and adopted Indian customs and even language. Guaraní art also survived to a limited extent. However, the rapidly increasing mestizo population developed new forms of art dominated by Catholicism (*see* §IV, 1 below). By the late 18th century the Indian population had been drastically reduced. Nonetheless, by the late 20th century the surviving peoples were still producing traditional forms of art. Although the Guaraní and Chaco Indians were distinct cultures, their art did have common characteristics. In general, they used austere, schematic styles with a tendency to abstraction. Images are sober and usually geometric in design, except in the case of personal adornment, which was usually lavish and highly colourful. The art of the indigenous groups also shared certain determining factors: for example the rituals of the fiesta, which acted as a focus for artistic production, demanded such forms of indigenous art as body decoration among the Chaco inhabitants and the art of featherwork among the Guaraní and Chaco. The art forms produced were also determined by material necessity: for example, basket-weaving among the Guaraní and the weaving of bromelia fibre (*caraguatá*) from the bromelia plant by the Chaco. These basic art forms contained the essential stylistic characteristics of each culture's art. They were the models for the styles of other kinds of art less fundamental to the society, which generally were more open to the influences of the other cultures that entered Paraguay.

By the late 20th century certain kinds of indigenous art remained remarkably similar to the pre-colonial forms, for example the basket-weaving of the Guaraní, especially the Mbyá. In the *ayaká*, the typical basket form, the Guaraní continued to employ their traditional geometric decorations based on the braiding of bright and dark fibres. This produced chequered designs that offered an enormous variety of possible combinations. The Chaco peoples continued to practise the weaving of bromelia fibre for large bags used by women in harvesting and small bags and large nets used by men in hunting and fishing. The Chamacocos also made ritual clothing and masks from woven materials. The decoration of the bromelia-fibre bags using vegetable dyes was always geometric and included motifs inspired by animal and plant forms. The art of featherwork also continued to a limited extent, according to three clearly defined systems: the Guaraní created featherwork for religious ritual, based on red, yellow and black feathers of tropical birds; the Zamucos (Ayoresi and Chamacocos) constructed exuberant ensembles of feathers of different varieties and colours for their rituals and festivals, although the practice has survived with only the Chamacocos. The ornamental patterns of the other Chaco ethnic groups were based on the white colours of the heron and ostrich, and on wide red strips of dyed wool used to support the feathers. Some ethnic groups still continued to use the traditional models in their collective dances in the late 20th century.

Following the Spanish conquest certain art forms declined or were lost, including the once famous ceramics of the Guaraní. Body decoration with pictures and tattooing, once one of the most widely developed indigenous art forms, also declined. Such decorations were intimately involved with political, social, magic–therapeutic functions and rituals, and acted as marks of tribal identity. This form

of expression lost its original force, and by the end of the 20th century it was practised lavishly by only the Tomárahos (a Chamacoco group). In many other cases the ethnic groups that continued to exercise control over their own culture managed to adapt their artistic forms to the new materials and other conditions imposed by Spanish colonization, while maintaining their basic stylistic qualities. For example, after the introduction of sheep wool and the loom, the Chaco Indians began to replace the use of animal hides for their long coats with woollen fabrics. These coats, as well as ponchos, sashes, bags and underlayers of headbands and crowns of feathers, became widespread among the different Chaco groups. Woollen fabrics were decorated with schematic and geometric designs similar to those used in bromelia-fibre fabrics. The Guaraní continued to use cotton as the basic material of certain fabrics.

The art of beading is another technique that uses materials introduced since colonization, but which has come to represent one of the most characteristic expressions of certain Chaco ethnic groups. The use of small glass beads (*mostacillas*) made possible the development of a new ornamental system based on original tribal designs. Richly embroidered on fine networks of bromelia fibre and strips of red wool, the beads re-create ancient tribal patterns using new colours and textures. Beadwork is practised in necklaces, ornamental chains, headbands and earrings on ritual occasions or as a simple means of personal ornamentation.

In the 20th century, indigenous groups developed new artistic styles in both traditional and Western art forms. For example, the Chaco Indians became the only indigenous populations in Paraguay to continue to produce different pieces of pottery destined for community use and for sale. From the beginning of the 20th century these ceramics incorporated an interesting figurative tendency, producing anthropomorphic and zoomorphic items not traditionally associated with the Chaco technique. Woodcarving was a technique unknown to the Indian population before colonization, but under colonial influence various groups began to carve essentially zoomorphic figures. By the late 20th century the Aché, the Chamacocos, the Manjui, the Lenguas, the Mbyá and especially the Chiripá developed a practice that has attained a notable level of originality and formal assurance (see fig. 2). These pieces are sold for use as seats, amulets and toys. The Chiriganos carve masks used for religious rituals.

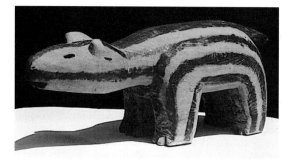

2. Chiripá (Guaraní Indian) wood sculpture, 250×650 mm, 20th century (Asunción, Paraguay, Museo de Arte Indígena)

BIBLIOGRAPHY

A. Métraux: 'The Guaraní', *Handbook of South American Indians*, ed. J. H. Steward, iii (Washington, DC, 1948), pp. 69–74
J. Plá: 'La cerámica popular paraguaya', *Supl. Antropol.*, xi (1976), pp. 7–28
——: *Las artesanías en el Paraguay* (Asunción, 1982)
L. S. Rios: *Situación de la vivienda popular en el Paraguay* (Asunción, 1982)
S. Branislava: *Artesanía indígena: Ensayo analítico* (Asuncion, 1986)

TICIO ESCOBAR

III. Architecture.

1. 1537–*c.* 1811. 2. After *c.* 1811.

1. 1537–*c.* 1811. Asunción (Ciudad de Nuestra Señora de la Asunción) was founded by Juan Salazar y Espinosa in 1537. The survivors of an abandoned settlement at Buenos Aires came to Asunción in 1541, and the town became the administrative centre of a large region lying between the River Paraguay and the Río de la Plata. Its buildings were made from such ephemeral materials as wood and straw, used by the semi-nomadic local Indians (the Carios, a branch of the Guaraní). After their destruction by fire in 1543, the buildings were reconstructed by government order in less combustible adobe and palm-leaf thatch. Asunción remained the principal seat of Spanish power in the region until 1580, when the more conveniently located Buenos Aires was refounded. Sited on a hill on the east side of a bay in the River Paraguay just below the confluence with the Pilcomaya River, Asunción was atypical in its development. The topography militated against regularity in the arrangement of buildings, and the city was not laid out on the standard Spanish grid-iron plan. Growth was spontaneous for *c.* 300 years until 1821, when a grid plan was imposed. It resulted in the destruction of virtually all of Asunción's Spanish colonial architecture, knowledge of which, therefore, is almost wholly dependent on documentary evidence. The bishopric of Asunción was created in 1544 and the first primitive cathedral built in the same year and rebuilt in 1556. The Creole governor in the late 16th century and the early 17th, Hernandarias de Saavedra, commissioned work on a new cathedral in 1603 (completed 1630): records suggest it was the most sumptuous and elegant timber building of its time. Saavedra was also responsible for the building of the town hall and prison (both 1604) in Asunción, by royal command, after the city had failed to make provision for them in its planning after the fire. The cathedral was replaced later for a growing congregation by a larger church with three naves, built under the direction of Pedro Domínguez de Obelar and inaugurated in 1689. This was an adobe building that soon deteriorated, and early in the 18th century the church of La Encarnación was used as the cathedral.

Typical 17th-century city dwellings, planned around inner patios in the Spanish tradition, had adobe walls and roofs tiled over palm leaves on bamboo rafters secured with leather thongs. Along the line of the street the eaves were supported on sturdy columns, and walls were set back under the roof to provide protection from the weather, creating a social space between the public street and the private house for informal meeting. A row of contiguous houses provided a continuous shaded and sheltered walkway or gallery for pedestrians, usually a step

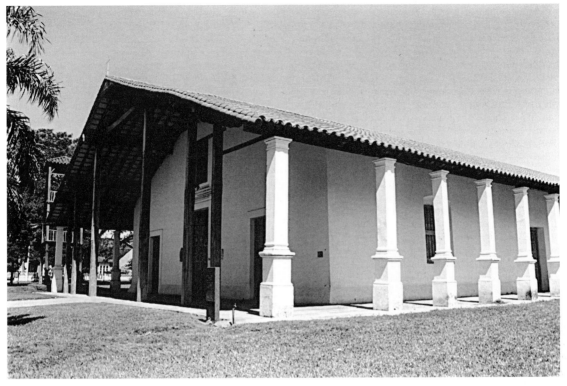

3. Yaguarón, Franciscan mission church, 1670–1720

or two above street level as in the house on the Calle del Coronel Diaz or the Casa Iturburu, both in Asunción. The former has closely spaced hexagonal columns separating the gallery from the street and segmentally arched, iron-grilled windows open on to the gallery.

For nearly two centuries the development outside Asunción was closely bound up with the spread of the Jesuit system of *reducciones* around Jesuit colleges with workshops, hospitals and mission churches. Missions were established from the mid-16th century, and the *reducción* system, based on agricultural self-sufficiency, was set up by Padre Lorenzana in 1607. By the mid-17th century there were over 30 of them administered by a Padre Superior from the Jesuit headquarters at Candelaria (now Argentina), under the Colegio de Buenos Aires. Most of the missions were in the southern half of what is now the eastern region of Paraguay, between Asunción and the Paraná River, though only a few, such as Villarrica (Santiago de Villa Rica, 1570), San Cosmé (San Cosmé y Damián, 1625) and San Ignacio (San Ignacio Guazú, 1684) survived as modern towns: the churches of others survived, though often ruined. It is recorded that a Padre José Cataldino (*d* 1693) built the first mission church of San Ignacio (destr. early 20th century), *c.* 50 km north of the Paraná River. Square timber columns supported the arcades of a three-naved church. The heads of the arches reached almost to the purlins directly supporting a closely spaced bamboo rafter grid, in the panels of which were the remnants of some 1600 paintings by indigenous artists. The partly stone church (ruined) of San Cosmé on the Paraná in the extreme south-east is said to have been like

that of San Ignacio Miní across the river in Argentina, with *Mudéjar* timber brackets carrying the overhanging roof and a finely wrought local interpretation of a Baroque stone portal.

The Franciscans also constructed churches at this time: some of these survived in colonial towns founded in the 17th century, including Luque (1646), Capiatá (1640), Piribebuy (1641), Yaguarón (1670) and Itapé (1680). One of the best preserved is a typical rectangular three-naved Franciscan church at Capiatá (begun *c.* 1650). As well as the rows of columns dividing the interior space into three areas, there are other columns set into the adobe inner walls. There is also an ellipsoidal barrel vault over the sanctuary that culminates in a carved and painted retable in the style known as Guaraní Baroque. Another well-preserved Franciscan church in Paraguay is the mission church at Yaguarón (1670–1720), about 50 km south-east of the capital (see fig. 3). The adobe walls (including the gables) are set well back from the edges of the shallow-pitched tiled roof, the eaves and verges of which are supported on simple columns, providing a gallery around the church. The church is similar to that at Capiatá, although with a wider section. It is also rectangular and three-naved, with rows of free-standing columns immediately inside the walls. All the columns inside the church directly support massive timber purlins with *Mudéjar* characteristics.

In the 18th century the Jesuits continued to build fine churches, such as the church of Jesús (ruined) in the extreme south-east of the country, attributed to Padre Antonio de Ribera (*b* 1717). This was still incomplete

when the Jesuits were expelled from the Spanish American colonies in 1767 and their missions taken over by the Franciscans: its stone façade has three portals with finely cut voussoirs in the arches with strong *Mudéjar* influence in their trilobate form. The church at the nearby mission of La Trinidad (ruined) has a Greek cross plan and was approached from a podium adjacent to a large cloister with powerful stone arcading. The church had all the benefits of the recent availability of cement in the stone barrel vaults and cupola, and demonstrates well the interpretation of the style of the High Renaissance by indigenous craftsmen. The mission was begun in 1706 and is the work of several architects, in particular the Milanese Jesuit GIOVANNI BATTISTA PRIMOLI. He worked on a number of Jesuit mission churches from 1730 but died in 1747, before the transepts of La Trinidad were complete.

After 1765, Paraguay's international trade was opened up, and new Spanish colonists brought with them the more sophisticated architectural ideas of Neo-classicism. Houses took on a more definitely Hispanic appearance, with decorated brick façades on the building line and distinctive portals, reflecting the taste of the cities of the Río de la Plata. A Spanish engineer, Julio de César, was the builder of the late 18th-century church of La Compañía, Asunción, a typical single-naved Jesuit church on a Latin cross plan. It had a cupola at the crossing similar to that of the Jesuit church of S Francisco, Santa Fé, Argentina, though here the cupola was lower (without a drum). De César was also responsible for the façade of a new stone cathedral (1780–91) that was replaced by the present building in the 19th century (*see* §2 below).

2. AFTER *c.* 1811. After Paraguay became independent, the dictatorship (1814–40) of José Gaspar Rodríguez de Francia excluded foreign architectural styles and permitted only utilitarian building such as terraced houses, simple detached dwellings with pitched roofs and public buildings constructed from poor materials. He imposed on the capital a rectilinear grid plan that led to the demolition of much of the city's colonial architecture. However, under the leadership of Carlos Antonio López (1844–62), Paraguayan architecture flourished. He used European technicians, mostly English, to develop the country's infrastructure. The railway station (1854–61), attributed to the British architect Edward Taylor (1801–69), who went to Buenos Aires in the 1820s, is a Neo-classical building related to its surroundings by colonnaded pavement galleries along the two long sides of the main station building in an elegant Ionic order. It also has prominent high-roofed Gothic Revival towers. The city's main axis links it with the port, market and customs house near the port facilities on the River Paraguay and communicates with the principal squares around which national and civic buildings are built. The customs house (mid-1850s) is the work of the Italian architect Alejandro Ravizza.

During this period the late 18th-century cathedral was replaced by a building attributed to Ravizza. It is a three-naved church with twin towers and a three-storey façade rising to a segmentally pedimented top storey (*espadaña*). The austerity of earlier Paraguayan architecture is reflected here in the sober stone arcading of the nave and the absence of decoration on the façade, although there is a fine carved retable. Another church of the period is that of La Santísima Trinidad consecrated in 1854 in Asunción. It has a single tower and a façade that is undivided vertically. A high ground-storey with five arched entrances and three shallow storeys above it build up to a graceful voluted pediment. Near the cathedral on the old Plaza de Armas, the 17th-century town hall was also rebuilt as a characteristic two-storey Spanish municipal building in the Neo-classical style with arcades on both floors overlooking the street.

Ravizza designed other buildings, including the Teatro de la Opera (begun *c.* 1860; uncompleted), based on the design of an 18th-century Italian lyric theatre. Only the heroically scaled entrance portico, the central portion of which takes the form of a triumphal arch, survives. The Club Nacional (*c.* 1860), influenced by Renaissance Revival examples in London, became the model for other buildings designed around an internal courtyard with arcaded galleries on each storey. After visiting Europe, the President's son, Francisco Solano López, advocated a new 'official taste', realized in residences for the López family: the most important of these was his own, also designed by Ravizza. Built on an important riverside site, it later became the Palacio de Gobierno. It is a U-shaped Neo-classical building with two-storey projecting wings embracing the open patio facing the city, but with three storeys where the ground falls away to the River Paraguay. A double arcade surrounds the open space, and a central portico with a giant order is complemented by a carriage-porch with a classical colonnade. Ravizza's Palacio de Congreso (begun mid-1850s; now the Ministerio de Interior) on the Plaza Constitución is another elegant Neo-classical stone building, with two-storey arcaded galleries, a central pediment and balustrade. One of Ravizza's finest works is the oratory of Nuestra Señora de la Asunción (begun 1854; work suspended 1864; completed 1936), now the Pantéon Nacional de los Héroes (see fig. 4). On a Greek-cross plan, it has a hexastyle Corinthian portico and a Baroque dome carried on a tall drum. It may have been modelled on the church by Filippo Juvarra at the Superga Monastery (1717–31) near Turin, Ravizza's birthplace.

During Francisco Solano López's presidency (1862–70) development continued, including the construction of other López houses. For example, Venancio López's house has ground- and first-floor colonnaded storeys progressively set back from the street to a simple attic: the galleries were Italianate versions of a traditional Paraguayan motif. Ravizza's two-storey house for Benigno López has a tripartite Neo-classical façade with Tuscan columns at the lower level and shallow Composite pilasters above, as has his elegant town house for Mme Lynch, with its graceful patio arcades (now the Faculty of Law at the university). However, with the War of the Triple Alliance (1864–70) much of the building initiated by López was left uncompleted. Architectural recovery after the war was slow, but it was aided by an influx of immigrants up to the early 1900s, including Italian master builders who brought the current academic monumental style: for example, La Encarnación (1893) by the Milanese Juan Colombo, a vast three-naved church with side chapels and a semicircular apse.

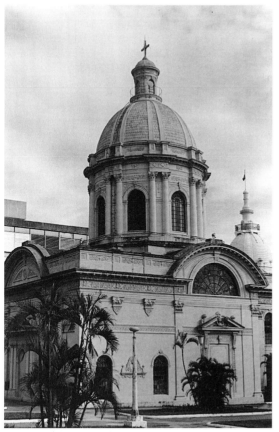

4. Alejandro Ravizza: oratory of Nuestra Señora de la Asunción (now the Pantéon Nacional de los Héroes), Asunción, 1854–1936

Turn-of-the-century buildings in Paraguay, as in Argentina, were often of an indigenous Creole type known as *chorizo* (sausage): they were built on newly divided lots in ring-shaped blocks with a lateral gallery and were embellished with Art Nouveau and later Art Deco decoration. In the suburbs these houses often had front gardens, sometimes with latticed walls, as intermediate spaces between street and house. The grander suburban brick villas had one or two storeys around an inner courtyard. They were Italianate, with steps at the front, columns and arcaded galleries: the roofs were made from various materials finished with metallic ornamental borders. The one or two storeys of city-centre blocks also reflected the prevailing eclecticism: they ranged from the nostalgia of Spanish colonial styles with a gallery or a flat roof to higher Italianate academic façades, though often with elaborate metal grilles to windows and balconies.

These attitudes continued into the 1920s and 1930s in the work of such architects as Miguel Angel Alfaro, trained in Italy, whose work from 1924 to 1927 included houses, funerary monuments and designs for public buildings; Las Escalinatas, Asunción, provided views of the river from a formal Italianate public stairway. The Catalan Enrique Clari designed *c*. 50 buildings in Asunción in this period, in both traditional Paraguayan and international styles, for example the Italianate Cervecería Paraguaya, the Fotográfico Fratta and Casa Pedro Duarte, all with Art Nouveau

decoration. The Casa Masi (now Hotel Hispania), inspired by Catalan *modernisme*, is perhaps his best-known urban building; his suburban Villa Vargas (destr. 1980s) was a jewel of Art Deco design. Several Paraguayan architects educated abroad returned in the later 1930s to introduce the concepts of the Modern Movement. Among the first astylar buildings were Roger Ayala's Ministry of Health, Canesse's Ministry of Public Works, Lido Bar, Hotel Ambassador and various houses, and commercial buildings for Urrutia Ugarte and for Marsal Hnos by Natalio Bareira, all in Asunción. Designers in Argentina also produced work in Asunción; examples include the work of Homero Duarte, among the earliest modernist architecture in Paraguay (e.g. the Banco Central de Paraguay and the Parfina building); José Luis Escobar (e.g. the Social Security building); and Tomás Romero Pereira, who studied in Buenos Aires and at the Ecole des Beaux-Arts in Paris (e.g. the headquarters of the Asociación Nacional Republicana and the Seminario Metropolitano, a simple brick building around a central patio). In the ensuing decade and a half, foreign development loans produced the first International Style buildings with a sobriety dictated by limited resources. In the 1950s the Brazilians Siever and Morales won an international competition to build the Hotel Guaraní in Asunción. With increasing prosperity, major infrastructural development began in the 1950s. Unrelated Modernist buildings were also produced by such local architects as López, Peyrat, Pindu and Puentes.

By the late 1960s Carlos Colombino had built houses reminiscent of traditional adobe buildings (e.g. Casas Loma Cabará and Paco, both 1966, and the Casa Mulder, 1968; all Asunción) in collaboration with his wife, Beatriz Chase. Traditional Paraguayan architecture also influenced the work of such architects as Luis Alberto Boh (*b* 1952) and Pablo Ruggero, and in the 1980s Silvio Feliciangeli (*b* 1943). Educated in Chile, Feliciangeli tried to combine the social and climatic benefits of traditional Paraguayan urban housing with contemporary technology, using local materials, for example at the estate Terrazas de Villa Marra (1982) in Asunción, three-storey high-density housing that exploits modern brickwork and provides roof-garden and terrace space at each level.

BIBLIOGRAPHY

J. Giuria: *La arquitectura en el Paraguay* (Buenos Aires, 1950)

H. Busaniche: *La arquitectura en las misiones jesuíticas guaraníes* (Santa Fé, 1955)

D. Angulo Iñiguez and others: *Historia del arte hispano-americano*, iii (Barcelona, 1956), pp. 665–707

R. Gutiérrez: 'Las casas de los gobernadores en el Paraguay', *An. Inst. A. Amer. & Invest. Estét.*, 24 (1971), pp. 42–58

E. Marco Dorta: *Arte en América y Filipinas*, A. Hisp., xxi (Madrid, 1973), pp. 37–9, 389–95

R. Gutiérrez: *Evolución urbanística y arquitectónica del Paraguay, 1537–1911* (Corrientes, 1974)

J. Plá: *El barocco hispano-guaraní* (Asunción, 1975)

D. Bayon and P. Gasparini: *The Changing Shape of Latin American Architecture* (Chichester and New York, 1979), pp. 155–69

C. Naspi: *Pueblo de guaraníes en las selvas rioplatenses: Una visita a las ruinas jesuíticas* (Asunción, 1981)

C. J. McNaspy: *Lost Cities of Paraguay: Art and Architecture of the Jesuit Reductions, 1607–1767* (Chicago, 1982)

S. Feliciangeli: 'Paraguay: El contexto, la region y la arquitectura', *Summa*, 232 (Sept 1986), pp. 50–53

M. Causarano and B. Chase: *Asunción: Análisis histórico ambiental de su imagen urbana* (Asunción, 1987)

R. Gutiérrez, ed.: *Barroco iberoamericano* (Barcelona and Madrid, 1997)
C. E. Ratto: 'Paraguay: Los pueblos misioneros de la antigua provincia jesuita', *Arquitectura colonial iberoamericana*, ed. G. Gasparini (Caracas, 1997), pp. 355–92

BEATRIZ CHASE

IV. Painting, graphic arts, sculpture and pottery.

1. 1537–*c.* 1811. 2. After *c.* 1811.

1. 1537–*c.* 1811. After the Spanish conquest of Paraguay, distinctive forms of art developed among the mestizo population. This mestizo art is distinguishable from the art of the surviving indigenous cultures (*see* §II above) and can be divided into two kinds: popular rural art and the art produced in Jesuit and Franciscan missions. Paradoxically, popular sculpture became widespread even though the indigenous population was originally unfamiliar with this art form. The sculpture included figurative work in ceramics and wood that contrasted with the austere abstraction of most indigenous art: through contact with Spanish representational art, Paraguayan artists started to produce bold new forms without sacrificing the sober indigenous temperament inherited by the mestizo. The work in ceramics continued to some extent the traditional designs of indigenous pottery but also introduced imaginative figurative forms both in the surface decoration and in the shapes of the objects, for example anthropomorphic pitchers, large fish-shaped bottles and earthenware jugs in the form of birds and especially armadillos. Much later appeared little sculptured figures (especially in Itá), probably connected to the Christmas manger.

Religious wood-carving was based on *santería* (the making of images of saints for popular worship). This became a popular rural practice, the expression of a folk religion, with no concern for official ecclesiastical symbols. Such carving ignored the style of the Baroque religious sculpture that had originally inspired it. It rejected naturalistic proportions in favour of schematic, ordered planes that recorded with simplicity the traditions and symbols of mestizo life.

The work of artists of Guaraní Indian origin in the Jesuit and Franciscan missions during the 17th and 18th centuries is commonly called Hispano-Guaraní Baroque. In its imitation of European Baroque art and its frequent disconnection with indigenous experience, it often lacks originality, expressiveness and conviction. The artists were required rigidly to copy artistic models designed for catechism or indoctrination with little freedom of personal expression. This missionary art produced in particular a vast amount of sculpture. At the mission of La Trinidad (begun 1706; ruined), many stone carvings were executed, for example friezes of angels playing such musical instruments as the Paraguayan harp (*in situ*). The references to features of local life also included the carvings of Paraguayan flora in the doorways between the sanctuary and sacristies in the church. There was also considerable polychrome figure sculpture (e.g. the *Holy Trinity*; Trinidad, Paraguay, Mus. Mis.); missionary artists produced multi-figure compositions of polychrome wood statues (e.g. *Nativity*; Santa María, Paraguay, Mus. Mis.). They also carved with varying degrees of sophistication such saints as the patron of Spain, St James the elder (e.g. *St James Conquering the Moors*; Santiago, Paraguay, Mus. Mis.), and

the founder of the Jesuits, St Ignatius Loyola (e.g. San Ignacio Guazú, Mus. Mis.). Painting was often combined with sculpture, as in the main altar retable at Santiago (Santiago, Paraguay, Mus. Mis.). Relatively little painting has survived on panel or in fresco, though one example is the fragmentary frescoes in the chapel of Our Lady of Loreto at the mission of Santa Rosa, which originally included skilful depictions of angels and an *Annunciation*. A considerable amount of derivative graphic art was also produced (e.g. illustrations for the book *De la diferencia entre lo temporal y lo eterno*, published in Santa Maria in 1705).

However, indigenous characteristics did appear in missionary art, since there were few Jesuit teachers, not all of whom had talent or an artistic education. Moreover, there were a limited number of original works that could be used as models and a lack of the materials necessary for a good imitation. Finally, the Jesuits could not overlook the typical way in which the Indians interpreted alien forms. This element of personal expression can be noted in the persistence of such native visual categories as schematism, symmetry and a linear tendency, which in the best works offset Baroque exuberance with a native sense of moderation and austerity (see fig. 5). The Franciscans also produced notable art in their missions and churches during the 17th and 18th centuries, for example the finely carved Baroque timber high altar and confessionary at the church at Yaguarón (1670–1720). After the expulsion of the Jesuits (1767), much of their art vanished with the missions themselves. However, many of the carvers formerly employed by the Jesuits spread throughout rural Paraguay, increasing the practice of *santería*.

2. AFTER *c.* 1811. After Paraguay gained independence from Spain, José Gaspar Rodríguez de Francia (dictator, 1814–40) isolated his country from the rest of the world and ignored the arts. Popular art, however, continued as it had during the colonial period. From 1844 to 1870 the governments of Carlos Antonio López and Francisco Solano López attempted to promote the arts. Through the contacts of Francisco Solano López with the European courts in the 1850s, in particular, Paraguayan art began to become dependent on academic 19th-century European models. The López family's artistic programme involved importing foreign artists and sending young Paraguayan artists to Europe. This produced in sculpture lifeless official monuments and in painting a belated Neo-classical portraiture led by Aurelio García, Francisco Solano López's court painter.

During the War of the Triple Alliance (1864–70) such newspapers as *El cabichuí* and *El sentinela*, published during the conflict, were illustrated with wood-engravings. These highly significant pictures showed a simple, clean-cut, highly expressive graphic style that was both dramatic and humorous. The extermination of almost the entire adult male population during the war had a catastrophic effect on Paraguayan art: only a few forms of popular art, generally those entrusted to women, such as ceramics, managed to survive. Until the first decades of the 20th century, Paraguayan art relied heavily on that of the basin of the Río de La Plata, which transmitted first Italian and then French influences. This was initially limited to aca-

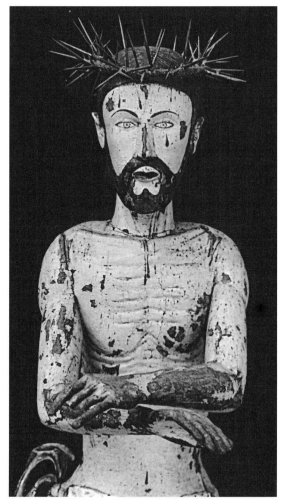

5. Missionary (Hispano-Guaraní Baroque) sculpture of *Christ on the Column*, wood, h. 1.3 m, 18th century (Asunción, Paraguay, Museo del Barro)

demic naturalism, for example in the work of such sculptors as Almeida Pollarollo and Vicente Pollarollo (1903–58) in the early 20th century. Direct contacts with European artists led to new developments: for example the arrival of such Italian professors as Hector da Ponte (1879–1956), who co-founded the Instituto Paraguayo in 1898 (*see* §VIII below) and organized the first Salon de Bellas Artes in 1899. Paraguayan artists won scholarships to study in Rome, Spain and France, including Juan A. Samudio (1879–1935), Pablo Alborno (1852–1958), Carlos Colombo (1878–1960) and Modesto Delgado Rodas (1886–1963). From the 1910s such students as Samudio brought back elements of French Impressionism, while continuing to paint generally in a 19th-century academic style. These developments were encouraged by contacts with Buenos Aires. No definable movement was created in the graphic arts, although the period of c. 1910–c. 1920 produced a certain amount of printmaking.

From the 1920s Post-Impressionism gradually influenced Paraguayan art. Around 1920 JULIÁN DE LA HERRERÍA, who had trained in Madrid, began to paint in a style influenced by Cézanne and by the Fauvists, who were also a great influence on the landscapes of Samudio (e.g. *Landscape*, 1924; O. Blinder priv. col., see Blinder and others, p. 65). During the following two decades the foundations were laid of an artistic renaissance. JAIME BESTARD, trained in Paris, and Polish-born WOLF BANDUREK developed a more systematic use of Post-Impressionist forms and colours: Bestard's work was characterized by solidity of form, while Bandurek produced expressive depictions of Paraguayan history, wars and social injustice. These various concerns influenced such artists as Ofelia Echagüe Vera, who arrived in Asunción from Buenos Aires in 1946. Theoretical foundations for these new developments were given c. 1950 by João Rossi (*b* 1923), a Brazilian artist and art teacher.

In 1954 the Arte Nuevo group, founded by Josefina Plá (*b* 1909), Lilí del Mónico (*b* 1910), OLGA BLINDER and José Laterza Parodi (1915–81), organized the Primera Semana de Arte Moderna, which challenged the conservatism of Paraguayan art. Inspired by the examples of other Latin American avant-garde movements, many other artists participated in varying degrees in the Arte Nuevo Group, for example EDITH JIMÉNEZ, the painter and engraver Leonor Cecotto (1920–81) and HERMANN GUGGIARI. The artists of this period sought to relate contemporary artistic forms to particular Paraguayan social and historical circumstances. Although much of the new art of the 1950s was figurative (e.g. del Mónico's *Faces*, 1954; Asunción, Mus. Parag. A. Contemp.), it was influenced by unnaturalistic styles such as Cubism and Expressionism, as well as Art Deco, Mexican murals and various elements of American culture. From the end of the 1950s artists also began to experiment with abstract painting. This eclectic art was not always capable of synthesizing convincingly its diverse elements but, the artists made progress towards the creation of individual means of expression.

In 1956 LÍVIO ABRAMO moved to Paraguay from Brazil. As well as training almost an entire generation of printmakers (*see* §VIII below), he led a renaissance in Paraguayan graphic art with his own work characterized by geometrization of space: prints were also produced at this time by such artists as Josefina Plá. The avant-garde developments of the period also entered the field of sculpture, which had had a precarious history in Paraguay as a result of unfavourable economic conditions and a lack of teaching centres. As early as the 1950s Josefina Plá and Laterza Parodi produced anti-naturalistic ceramic sculpture. Subsequently, Laterza Parodi made wood-carvings of simplified native themes or abstract forms.

In the 1960s the supremacy of the USA in Latin America encouraged a cult of modernity. Paraguayan art was still strongly influenced by art in Buenos Aires, though Brazilian art and, in particular, the São Paulo Biennales became predominant at this time. In 1964 the group Los Novísimos was founded by José A. Pratt (*b* 1943), ENRIQUE CAREAGA, William Riquelme (*b* 1944) and Angel Yegros (*b* 1943). The group attempted to renew Paraguayan art, destroying its international isolation and confronting the older generations. Such artists as Careaga used modern styles and techniques in abstract art, derived from, for example, Op art and Constructivism, and others partici-

pated in new forms of figurative art. The group presented in more radical form tendencies already present in the work of artists on the fringe of the group.

In the second half of the decade there evolved in Asunción the movement known as NEOFIGURACIÓN, which was preoccupied with political and social criticism. In this movement CARLOS COLOMBINO addressed the human rights violations of Paraguayan and other Latin American dictators, while OLGA BLINDER combined formal structure with lyrical expressionism and social awareness. Colombino also developed the technique of *xylopintura*, in which he used wood-engraving tools to cut into plywood that was then stained with paint. William Riquelme, Bernardo Krasniansky (*b* 1951) and RICARDO MIGLIORISI, who were also associated with Neofiguración, concentrated on satirical and humorous images. Migliorisi in particular employed absurd eclectic imagery related to Pop and psychedelic art in paintings, environments, happenings, audio-visual work and montages. This period was in general characterized by experimentation with new art forms such as happenings.

Abstract painting continued to be produced by such artists as Edith Jiménez, Carlos Colombino, Michel Burt (*b* 1931) and Laura Márquez (*b* 1929). Alberto Miltos, Fernando Grillon and Hugo González Frutos also produced abstract art based on a study of texture and material. In the 1960s expressive abstraction also characterized graphic art by Jiménez and Colombino: as well as using abstracted vegetable forms, Colombino created dramatic figurative graphic art, as did Blinder. Leonor Cecotto (1920–81) and Lotte Schultz (*b* 1925) sought new meanings through special arrangements of figurative forms, for example *Aquatic* (1960; Asunción, Mus. Parag. A. Contemp.) by Schultz. In the late 1960s Fernando Grillon's work showed the influence of Expressionist caricature. Popular forms and themes also influenced the wood-engraving of Jacinto Rivero (*b* 1932) and Miguela Rivera. At the end of the decade Ricardo Yustman (*b* 1942) and later Jenaro Pindú (*b* 1946) initiated a fantastic, expressionistic style of drawing.

The 1970s was characterized by the consolidation and synthesis of the various developments of the preceding decade. While drawing had from the late 1950s become an independent art form in Paraguay, it was not until the 1970s that it developed into a mature technique. After the initial work of Yustman and Pindú, it became more rigorous intellectually, practised by such artists as Luis Alberto Boh (*b* 1952), Miguel Heyn (*b* 1950), Mabel Valdovinos, Ricardo Migliorisi, Selmo Martínez (*b* 1949) and Bernardo Krasniansky. Drawing was also taken up by young artists who arose around the end of the 1970s, such as Julio González, Lucio Aquino (*b* 1953), Luis Cogliolo (*b* 1957), Gabriel Brizuela (*b* 1957), Pedro Florentín Demestri, Félix Toranzos and Nicodemus Espinoza. In the 1970s new techniques of printmaking were developed: Osvaldo Salerno (*b* 1952) started making impressions from real objects, Blinder produced engravings from zincograph blocks, and Jiménez and Colombino made large woodengravings that superimposed contrasting colours and tones so as to introduce a new concept of graphic space.

Around the middle of the decade painting, which had to some extent declined in the previous ten years, regained its former importance. In particular, the movement known as RE-FIGURACIÓN created a new form of figurative art concerned with the nature of pictorial signs, as can be seen in the work of such artists as Miguel Heyn, Mabel Arcondo (1940–76), Osvaldo Salerno, Bernardo Krasniansky, Luis Alberto Boh and SUSANA ROMERO. Re-figuración also influenced Colombino and Blinder, who, together with Enrique Careaga and Leonor Cecotto, IGNACIO NUÑEZ SOLER and Pedro di Lascio (*d* 1978), continued in the direction of a direct, spontaneous type of painting.

Colombino also executed important sculpture and continued his use of *xylopintura* (see fig. 6) into the 1980s. Another important sculptor was Hugo Pistilli, who created schematic linear figures in wrought iron, often based on allegorical motifs. The most significant modern Paraguayan sculptor was Guggiari, who worked with various materials in an abstract style designed to express dramatic themes of laceration and rupture, for example *Kansas* (iron and stone, 1980; for illustrations *see* GUGGIARI, HERMANN). The 1980s was also marked by significant paintings such as the threatening expressionistic polyptychs of Susana Romero. In general, Paraguayan artists of the 1980s and 1990s faced the challenge of expressing contemporary experiences with the artistic styles developed over the preceding three decades.

BIBLIOGRAPHY

P. Albarno: *Arte jesuítico de las misiones hispano-guaraní* (Asunción, 1941)
J. Báez: *Artes y artistas paraguayos: Período renacentista* (Asunción, 1941)
E. Lunte and F. A. Plattner: 'Kunst im "Jesuitenstaat" von Paraguay', *Das Münster*, xii (1959), pp. 407–14
M. A. Fernández: 'L'Art moderne au Paraguay', *Cuad. Amer.*, xxi/1 (1962), pp. 91–103
J. Plá: *El grabado en el Paraguay* (Asunción, 1963)
——: *Arte moderno del Paraguay: Nuestra retrospectiva* (Asunción, 1964)

6. Carlos Colombino: *Paraguay* series, plywood stained with oil, 1.6×1.2 m, 1989 (Asunción, Museo Paraguayo de Arte Contemporáneo)

——: 'Las artes plásticas en el Paraguay', *An. Inst. A. Amer. & Invest. Estét.*, 19 (1966)

P. Gamarra Doldan: 'Le Surréalisme au Paraguay', *Europe*, (1968), pp. 454–7

M. A. Fernández: *Paraguay*, Art in Latin America Today (Washington, DC, 1969)

R. Gutiérrez and E. J. Maeder: 'La imaginería jesuítica en las misiones del Paraguay', *An. Inst. A. Amer. & Invest. Estét.*, 23 (1970), pp. 90–114

J. Plá: *Treinta y tres nombres en las artes plásticas paraguayas* (Asunción, 1973)

T. Escobar: *Una interprección de las artes visuales en el Paraguay*, 2 vols (Asunción, 1982–4)

O. Blinder and others: *Arte actual en el Paraguay* (Asunción, 1983)

T. Escobar: 'Tres artistas y un panorama', *Voces de Ultramar: Arte en América Latina, 1910–1960* (exh. cat., Madrid, Casa América; Las Palmas de Gran Canaria, Cent. Atlántic. A. Mod., 1992), pp. 71–2

El Paraguay en sus artes plásticas: Washington, DC, 1994

Baroque de Paraguay (exh. cat. by P. Sollers and others, Paris, Mus.-Gal. Seita, c.1995)

T. Escobar: 'Paraguay', *Latin American Art in the Twentieth Century*, ed. E. Sullivan (London, 1996), pp. 249–59

G. Teléz Castañeda: *Popayan, Colombia: Guía ciudad histórico* (Bogotá, 1996)

TICIO ESCOBAR

V. Textiles.

Textile production in Paraguay reflects two main influences, those of the indigenous cultures and the Spanish. The Guaraní Indians were the most important indigenous peoples, and during Spanish colonization they demonstrated their ability to work with cotton. The people of the Gran Chaco region, on the other hand, adopted wool for their fabrics, under the influence of pre-Hispanic Andean traditions. The production of textiles can be divided into three groups based on the materials used: cotton, plant fibres and wool (*see also* §II above).

Where cotton is used, there are three distinct types of fabric produced: *ñandutí, yu* and *aópói*. The fabric *ñandutí* (spider's web), an embroidered decoration developed from the Spanish version of cutwork, has a very fine drawn-thread work ground, worked with a needle into a spider's web, and incorporates a decorative pattern that corresponds to the so-called 'Salamanca Suns', a motif that was also common in Tenerife. The embroidered shirts produced in Huelva reflect the Hispano-Moresque influence. The development of *ñandutí* is associated with liturgical vestments and is linked to work produced in the Jesuit *reducciones* that became popular in the 18th century. The decoration also reflects rural traditions and customs, and the iconography consists of flora (climbing plants, ferns and flowers), fauna (aquatic birds, parrots, spiders, ostriches, sheep, oxen etc), domestic motifs (family altars, crosses, loaves, bread ovens, small baskets and patterns derived from filigree jewellery) and mythological scenes. The centre of production of *ñandutí* work is the town of Itauguá. *Yu* (a type of filet lace) is made with a thickly plied thread. The decorative designs are large in scale, with plant and animal themes dominating. Originally used for religious vestments, *yu* has become popular for tablecloths, curtains and quilts. It continues to be produced in Yatayty, Altos, Ipacaraí and Carapeguá. The fabric known as *aópói* combines embroidery and hemstitching on a simple woollen foundation cloth. During the 19th century, when Paraguay was closed to the outside world, textile production became consolidated, and *aópói* was used extensively in the regions for shirts and blouses. The centre of production for *aópói* is Yatayty.

Indigenous weavers use thread obtained from such plant fibres as the palm, coconut and rushes, and in particular *caraguatá* fibre from species of bromelia. Durable, resistant nets made of *caraguatá* are produced by the Zamucos, Matacos and Mashcos peoples of the Gran Chaco region. Bags, shirts and hammocks are made of interlaced thread, several strands twisted together and then dyed with plant or mineral dyes in colours ranging from red to black, used against a neutral background. The geometric designs are of stylized native animals and plants.

Although Europeans introduced sheep in the 17th century, the use of wool was most common in the 19th century. Thick ponchos, blankets, sashes, carpets and articles for the horseman are produced in the regions of Carapeguá, Piribebuy, Pirayú and the department of Misiones. Andean traditions are noticeable. The typical Paraguayan hammock uses a combination of all the above textiles; the cotton mesh, generally embroidered, is of Spanish origin, and the fringes and tassels derive from Hispano-Moresque traditions. The Museo Etnográfico 'Andrés Barbero', Asunción, has an important collection of Paraguayan textiles.

BIBLIOGRAPHY

P. Pastells: *Historia de la compañía de Jesús en la provincia del Paraguay*, 3 vols (Madrid, 1942–9)

B. Susik: *Artesanía indígena: Ensayo analítico* (Asunción, 1986)

Paraguay: El ñandutí (exh. cat. by J. Plá and G. Gonzalez, Asunción, Mus. Parag. A. Contemp., 1989)

RUTH CORCUERA

VI. Patronage, collecting and dealing.

During the colonial period there was little patronage either from individuals or from the government. The most important work was done for the Church, in particular the Jesuit and Franciscan missions (*see* §§III, 1, and IV, 1, above). Under the leadership of Carlos Antonio López and Francisco Solano López there was considerable building sponsored by the state, in particular in Asunción (*see* §III, 2, above). The leaders also patronized the fine arts, commissioning portraits and monuments. The War of the Triple Alliance (1864–70) stopped such activity for the rest of the 19th century. In the 20th century artistic patronage revived, together with the foundation of important collections. One of the greatest collectors was Juan Silvano Godoy (1850–1926), whose collection of foreign art was the basis of the Museo Nacional de Bellas Artes in Asunción (*see* §VII below). However, a market for Paraguayan art was slow to develop. In the early 20th century only the Gimnasio Paraguayo, the Ateneo Paraguayo and the Instituto Paraguayo provided exhibition space in Asunción for the most outstanding artists of Paraguay. Until the 1950s sporadic exhibitions of Paraguayan art were also held in the cultural centres of embassies (e.g. the Instituto Paraguay–Brasil, the Centro Cultural Paraguayo–Americano, the Misión Cultural Brasileña, the Casa Argentina and the Centro Cultural Juan de Salazar of the Spanish embassy). In the 1950s commercial galleries opened in Asunción, for example the art gallery Bohème (1955) and in the 1960s the short-lived ILARI, Muá, Tayi and Atlántica galleries. Arte-Sanos operated continuously from 1974; its

director, Ticio Escobar, became the chief critic of Paraguayan art. In the 1970s the Galería Latinoamericana, Sepia and Casa Taller galleries were established, although none of them achieved much permanence. The galleries Arte-Sanos, Fábrica, Bel-Marco, Malingue, Nuevo Espacio and Pequeña Galería survived into the 1990s, dealing in paintings, graphic arts, items of carving and small sculptures. The art market outside of Asunción remained virtually non-existent. Despite the growth of galleries, no dealers specialized in Paraguayan painting. International sales of the work of some local artists were achieved through one-man or collective shows by these artists in Latin American or European capitals, or in personal deals: Pablo Alborno (1852–1958), Jaime Bestard, Juan A. Samudio (1879–1935), Ignacio Nuñez Soler, Carlos Colombino, Enrique Careaga and Ricardo Migliorisi all achieved international status and comparatively high prices.

Important collectors were also active towards the end of the 20th century; for example, Carlos Colombino collected Jesuit wood-carvings of the 17th and 19th centuries, local gold- and silverwork, Pre-Columbian ceramics, and modern and contemporary Paraguayan and Latin American paintings and popular crafts. Other important private collections of Jesuit items included that of Dr Edgar L. Insfrán (1920–91), who also possessed a large library and archives of historical Paraguayan documents. Such objects were generally little appreciated locally and of relatively low value and so were exported in large quantities. Even after the 1970s, when the value of Jesuit works increased, interest in Guaraní Baroque wood-carving remained quite limited. Paintings by Paraguayan and other Latin American artists were acquired by various collectors, including Osvaldo Salerno (b 1952).

BIBLIOGRAPHY

T. Escobar: *Una interpreción de las artes visuales in el Paraguay*, 2 vols (Asunción, 1982–4)

O. Blinder and others: *Arte actual en el Paraguay* (Asunción, 1983)

MILDA RIVAROLA

VII. Museums.

At the end of the 19th century the Biblioteca Americana y Museo de Bellas Artes was established in Asunción around the collection of the Paraguayan politician, essayist and historian Juan Silvano Godoy (1850–1926). He had acquired works of art during political exile in Buenos Aires (1880–1900) and in trips to Europe (1880–81). He was appointed Director-General of national libraries, museums and archives in 1902, having published in 1901 his views on the form that a historical museum of fine arts and antiquities should take. In 1909 his museum opened to the public as the Museo Nacional de Bellas Artes, although it was still privately owned. Among the works acquired and later donated by Godoy are paintings by Rusiñol, Murillo and Tintoretto. In 1939 the collection became state-owned and in 1969 moved to another site in Asunción.

In 1929 the Museo Etnográfico y de Historia Natural was opened in Asunción. Now called the Museo Etnográfico 'Andrés Barbero', it was sponsored by the Fundación La Piedad of the Barbero family. It was endowed with important Paraguayan archaeological and ethno-

graphic collections, as well as a library, photographs and documents; it also published ethnographical literature. In 1938 the Museo de Cerámica y Bellas Artes 'Julián de la Herrería' was founded in Asunción, containing in particular ceramics by JULIÁN DE LA HERRERÍA. In 1949 the colonial religious sculpture collected by Juan Sinforiano Bogarín (1863–1949) was installed in the Seminario Metropolitano. Subsequently the collection was transferred to a site at the side of Asunción Cathedral, as the Museo 'Monseñor Juan Sinforiano Bogarín'. In 1968 the Museo San Rafael opened in Itauguá, a town founded by Franciscan missionaries. The museum has *c.* 100 polychrome wood sculptures and other items of religious art, regional pottery, colonial furniture and *ñandutí* lace. In 1978 the Museo del Tesoro de la Catedral was founded in Asunción Cathedral to house religious fine and applied art.

In 1972 two artists, Carlos Colombino and Olga Blinder, under the auspices of the Universidad Católica 'Nuestra Señora de la Asunción' in Asunción, organized a 'Circulating Collection' of 42 (later 65) Paraguayan and Latin American drawings and engravings under Blinder's direction. This was intended to foster the graphic arts through exhibitions in educational centres throughout the country. In 1976 the 'Permanent Collection', which includes paintings, sculpture and ceramics, was organized under the direction of Colombino. Both collections constitute the Museo Paraguayo de Arte Contemporáneo with 500 works. This is part of the Centro de Artes Visuales, to which was added in 1980 the Museo del Barro, directed by the artist Osvaldo Salerno (b 1952). It contains *c.* 500 items of regional pottery, as well as Jesuit and popular wood-carving and gold- and silverwork. The Museo de Arte Indígena also started to be organized as a part of the centre under the direction of Ticio Escobar. The centre is a privately sponsored organization under the directorship of Colombino, whose own collections formed an important part of its holdings, together with donations or exchanges of the work of Paraguayan, Latin American and other artists. The centre exemplifies how the organization of art museums continued to be in the hands of artists and a few associates. The Paraguayan painters represented included Ignacio Nuñez Soler, Blinder, Colombino, Edith Jiménez, Enrique Careaga, Ricardo Migliorisi and others. The centre also holds special exhibitions.

Museums of religious art were founded in the 1970s in the former Jesuit missions, for example the Museo de San Ignacio Guazú (1978), the Museo de Santa María de las Misiones, the Museo de San Cosme y Damián, the Museo de Santiago, the Museo de Trinidad and the Museo de Jesús. They are particularly notable for their altarpieces and polychrome wood figure sculpture. There is also a museum of religious art next to the sacristy of the Franciscan mission church at Yaguarón, the Museo de Yaguarón. In 1980 a Museo de Arte Sacro was opened in Concepción.

Other museums include the Museo Etnográfico Guido Boggiani in San Lorenzo (1988), which contains native funeral urns and other archaeological objects. Subsequently, the Fundación Manzana de la Rivera was established (1992) in order to restore 18th- and 19th-century constructions and to create a municipal cultural centre in the old part of Asunción.

BIBLIOGRAPHY

C. R. Centurion: *Historia de la cultura paraguaya* (Asunción, 1961)
J. Plá: *Apuntes para una historia de la cultura paraguaya* (Asunción, 1967)
——: *Historia y catálogo del Museo de bellas artes* (Asunción, 1970, rev. 1975)
C. A. Pussineri: *Museos y colecciones del Paraguay* (Asunción, 1980)

OLGA BLINDER

VIII. Art education.

The Jesuit and Franciscan missionaries who arrived at the beginning of the 17th century ran workshops training the indigenous population to produce religious art (*see* §IV, 1, above). After the expulsion of the Jesuits (1767), the artists that they had trained continued to pass on their knowledge. However, the López family, who ruled Paraguay during the third quarter of the 19th century, imported foreign artists and sent Paraguayan artists abroad to learn European academic techniques (*see* §IV, 2, above). In 1898 two Italian painters set up the Instituto Paraguayo, an academy of painting, in Asunción, then the only intellectual centre in Paraguay. One of these painters, Guido Boggiani (1861–1901), who was also an ethnologist, was killed soon after by Chaco Indians. The other founder, Hector da Ponte (1879–1956), became a teacher in secondary schools in Asunción. In 1933 the Instituto and the Gimnasio Paraguayo combined to form the Ateneo Paraguayo, in which painting was taught first by the painter Juan A. Samudio (1879–1935), then by Jaime Bestard and later, up to 1954, by the painter Ofelia Echagüe Vera (*d* 1980s), who had received her training in Buenos Aires. In the 1950s in Asunción various informal courses were established, including a course on modern art at the YMCA (1950–54), given by the Brazilian painter João Rossi (*b* 1923); a painting workshop at the Centro Cultural Paraguay–Americano (1954–6) led by Olga Blinder; and the 'Julián de la Herrería' wood-engraving workshop founded by Livio Abramo in 1956. In 1957 a faculty of architecture was established in the Universidad Nacional de Asunción, and Roberto Holden Jara (1900–84) founded the academic Escuela de Bellas Artes, which trained art teachers. Nevertheless, the majority of successful artists continued to receive their training in private institutions and independent studios, such as that run in Asunción by Cira Moscarda from 1956 to 1975.

In 1959 the Escolinha de Arte was established in Asunción, introducing methods of 'Education through Art'. As an extension of the Escolinha the Taller de Arte Moderno opened in the Centro de Estudios Brasileros with a course in the history of art in 1969. In 1978 the Instituto para el Desarrollo Armónico de la Personalidad (IDAP), Ascunción, began a variety of programmes, including the Taller de Expresión Infantil (TEI), directed by María Victoria Heisecke (*b* 1946), which introduced techniques of creative expression as a complement to formal education. The IDAP also operated art workshops, led by Olga Blinder, on three levels; this paved the way for the Instituto Superior de Arte, of university status, offering courses in art theory, art education, art history and workshops in various branches of the visual arts; the Institute opened in March 1996, and its first graduates emerged in December 1999. From 1984 to 1990 a workshop in painting was run in the Museo Paraguayo de Arte Contemporáneo in Asunción.

BIBLIOGRAPHY

C. R. Centurion: *Historia de la cultura paraguaya* (Asunción, 1961)
J. Plá: 'Las artes plásticas en el Paraguay', *An. Inst. A. Amer. & Invest. Estét.*, 19 (1966)
T. Escobar: *Una interpretación de las artes visuales en el Paraguay*, 2 vols (Asunción, 1982–4)
O. Blinder and others: *Arte actual en el Paraguay* (Asunción, 1983, rev. 1997)

OLGA BLINDER

Paramaribo [Parmirbo; Permeribo; Pirmeribo; Pumerbo]. Capital of Surinam. Its name, spelled in various ways in early sources, is probably derived from that of the native village called Parmarbo or Parmurbo on the original site. Situated on the west bank of the Surinam River, the town started as a trading post, fortified with palisades, first established in 1613 by the French and extended and built up by the English *c.* 1640. The oldest monument is Fort Zeelandia, originally built by the French in 1640 and finally rebuilt by the Dutch in 1744. The town grew rapidly after 1667, when Surinam was taken by Abraham Crijnssen and became a Dutch possession. Houses were built, first along the Gravenstraat and later on Waterkant and Keizerstraat. Paramaribo replaced Torarica as the capital, with the arrival of Cornelis van Aerssen van Sommelsdijk in 1683. Van Aerssen van Sommelsdijk had a number of drainage canals dug (e.g. the Sommelsdijkse kreek, Limesgracht and Picorniekkreek). In the early 18th century Klipstenenstraat and Knuffelsgracht formed the town's western boundary. Around the 1750s the town covered the area bounded by Gravenstraat, Stoelmanstraat, Steenbakkersgracht and Waterkant. From 1791 the suburb of Combé was laid out to the north-east. Notable 18th-century buildings include the Presidential Palace, formerly the Governor's Residence (1730; extended in the 19th century; *see* SURINAM, fig. 2). Following fires in 1821 and 1832, notable Neo-classical buildings were constructed (*see* SURINAM, §IV), though certain churches (e.g. the cathedral of SS Peter and Paul, 1885) were influenced by the Gothic Revival and Romanesque Revival. In the early 20th century the city grew mainly to the north and south-west with parcelling out of plantations around the town.

BIBLIOGRAPHY

H. D. Benjamins and J. F. Snelleman, eds: *Encyclopedie van Nederlandsch West-Indië* (The Hague, 1914–17/*R* Amsterdam, 1981)
C. F. A. Bruijning and J. Voorhoeve, eds: *Encyclopedie van Suriname* (Amsterdam and Brussels, 1977)
Y. Attema: *Monumentengids van Paramaribo* (Zutphen, *c.* 1981) [historic buildings]

GLORIA C. LEURS

Parboosingh, Karl (*b* St Mary, 1923; *d* Kingston, 1975). Jamaican painter. He studied painting at the Art Students League, New York, at the Ecole des Beaux-Arts, Paris, and at the Instituto Nacional de Bellas Artes in Mexico. He returned to Jamaica in 1953, where he quickly established himself as a major avant-garde figure, challenging the sedate homespun realism of Jamaican artists such as Albert Huie and David Pottinger with vivid Expressionistic canvases. He was influenced by many types of Expressionism, from Rouault's cloisonnisme, the German Expressionism of Emil Nolde and Ernst Ludwig Kirchner, through the Mexican muralists (he claimed to have studied with David Alfaro Siqueiros), to Jackson Pollock and the Abstract Expressionists. His finest works, such as *Jamaican*

Gothic (*c.* 1968; Kingston, N.G.), reveal him applying his modernist approaches to traditional Jamaican subject-matter. In the late 1960s he produced a monumental series of paintings, based on the life of Christ, which met with some success. The best known of these is *Sermon on the Mount* (*c.* 1969; Kingston, N.G.). A few years before his death he became attracted to Rastafarian culture, and inspired in part by photographs of Rastafarians at worship and sacramentally using ganja (marijuana), he embarked on what is generally considered his finest series: sympathetic, richly coloured 'portraits' of Rastafarians in ceremonial dress and smoking ganja, as in *Ras Smoke I* (1974; Kingston, N.G.).

BIBLIOGRAPHY
P. Archer-Straw and K. Robinson: *Jamaican Art* (Kingston, 1990)
DAVID BOXER

Pardo, Mercedes (*b* Caracas, 20 July 1921). Venezuelan painter and printmaker. She studied at the Academia de Bellas Artes, Caracas (1934), at the Escuela de Artes Plásticas y Aplicadas de Caracas (1941–4), and at the Academia de Bellas Artes de Santiago de Chile (1945). Pardo held her first one-woman show in Santiago in 1947. In 1948 she travelled to Paris, where she studied at the Ecole du Louvre and assisted at the studio of André Lhote. She made her first collages and abstract works between 1950 and 1951; a phase of abstract lyricism in her work was followed by *Art informel* between 1956 and 1961. Again in Paris in 1960, she successively explored the use of watercolour and enamel on metal, printmaking (1961–3), and collage on wood (1964–6). In 1969 she executed her first screenprints and returned to Caracas. From the late 1960s she worked in a geometric abstract style, experimenting constantly with colour (e.g. *Shadows and Penumbra*, 1976; Caracas, Gal. A. N.).

BIBLIOGRAPHY
B. Rodríguez: *Pintura abstracta en Venezuela, 1945–1965* (Caracas, 1980), pp. 67–73
G. Carnevali: *Mercedes Pardo: Moradas del color* (Caracas, 1991)
De Venezuela: Treinta años de arte contemporáneo (1960–1990)/From Venezuela: Thirty Years of Contemporary Art (1960–1990) (exh. cat. by R. de Montero Castro, Seville, Pab. A., 1992)
MARÍA ANTONIA GONZÁLEZ-ARNAL

Parra, Félix (*b* Morelia, Michoacán, 1845; *d* Mexico City, 1919). Mexican painter, draughtsman and teacher. He studied drawing and painting from 1861 at the Colegio de San Nicolás in Morelia and from 1864 at the Academia de San Carlos in Mexico City under teachers trained for the most part by Pelegrín Clavé. The subject-matter of the paintings exhibited by him in the 1870s reflected changes both in academic practice and in critical expectations: a charming nude, *The Hunter* (exh. 1871; Morelia, Mus. Reg. Michoacáno), was followed by *Galileo at the School of Padua Demonstrating the New Astronomical Theories* (exh. 1873; Mexico, Mus. N.A.), a historical set-piece and one of his best pictures, and the *Cholula Massacre* (exh. 1877; Mexico, Mus. N.A.), in which he documented an incident of appalling genocide described in *Brevísima Relación de la Destrucción de las Indias* (1552) by the Spanish missionary Fray Bartolomé de las Casas, whom he portrayed in a painting exhibited in 1875. Awarded a scholarship on the basis of the *Cholula Massacre*, Parra lived in France and

Italy for four years. He returned to Mexico City in 1882 to teach decoration at the Escuela Nacional de Artes. From 1909 to 1915 he was also employed as a draughtsman, especially as a watercolourist, at the Museo Nacional de Arqueología, also in Mexico City.

See also MEXICO, fig. 10.

BIBLIOGRAPHY
J. Fernández: *El arte del siglo XIX en México* (Mexico City, 1967), pp. 112, 140, 181, 203, 209
F. Ramírez: *La plástica del siglo de la independencia* (Mexico City, 1985), p. 87
Félix Parra, un artista del siglo XIX: Dibujos inéditos (Toluca, 1996)
ESTHER ACEVEDO

Parreiras, Antonio (Diogo da Silva) (*b* Niterói, 21 Jan 1860; *d* Niterói, 17 Oct 1937). Brazilian painter. He studied briefly at the Academia Imperial das Belas Artes in Rio de Janeiro until 1884, but then became a protégé of Georg Grimm. Under Grimm's influence he shunned academic traditions of landscape painting in favour of direct observation of nature, free brushstrokes and luminosity. From 1888 to 1890 he studied in Venice, under Filippo Carcano. Encouraged by Victor Meirelles de Lima, in the early 1900s he began a series of pictures treating episodes from Brazilian history, such as the *Conquest of the Amazons*, painted during a stay in Paris (1906–7; Belém, Brazil, Pal. Gov. Estado Pará). He returned permanently to Brazil in 1914 but continued to visit Europe, exhibiting at the Petit Palais in Paris in 1919. In 1929 he received a gold medal in the Exposición Internacional in Seville. Although history and genre painting constitute a large proportion of his output, he expressed himself best in his landscapes, which have a romantic flavour decidedly nationalistic in character, for example *Restinga in March* (1933; São Paulo, Mus. A.). The Museu Antonio Parreiras in Niterói holds many of his works.

WRITINGS
História de um pintor (Niterói, 1926)

BIBLIOGRAPHY
C. R. M. Levy: *Antonio Parreiras* (Rio de Janeiro, 1981)
Q. Campofiorito: *História da pintura brasileira no século XIX* (Rio de Janeiro, 1983)

For further bibliography *see* GRIMM, GEORG.
ROBERTO PONTUAL

Paternosto, César (*b* La Plata, 1931). Argentine painter. He studied art and philosophy at the Escuela de Bellas Artes and the Instituto de Filosofía, Universidad Nacional de la Plata (1957–61), the institute from which he received a law degree in 1958. In 1961 he became a member of the abstract painters group, Grupo SI, along with the Italian-born painter Antonio Trotta (*b* 1937), and Argentine artists Héctor José Cartier (*b* 1907), and Alejandro Puente. Paternosto's early work was concerned with abstraction, within which he utilized shaped canvases and serial formats. In 1967 he moved to New York, where he was awarded a Guggenheim Fellowship for painting in 1972, leading to a period of travel in Europe. Paternosto became increasingly interested in the textural quality of canvas, mixing powdered marble with acrylic paint and focusing on contrasts of monochromatic tones. In 1977 Paternosto visited northern Argentina, Bolivia and Peru, a trip which was to have a profound affect on his future

work. As a result of his travels he became increasingly interested in the use of geometric abstraction in the art and architecture of Andean pre-Columbian cultures (e.g. *Trille II*, acrylic on canvas, 1.67x 1.67 m, 1980; Austin, U. TX, Jack S. Blanton Mus. A.). Subsequent return visits to the Andes in 1979 and 1980 and to southern Mexico in 1986 culminated in the publication of *Piedra abstracta, la escultura inca: una visión contemporánea* (Buenos Aires, 1989). From 1981 Paternosto lectured widely in the United States on the links between contemporary and pre-Columbian art and produced the video work *Andean Symbols/ Contemporary Reflections* (1984). In 1990 he was awarded a grant by the Pollack-Krasner Foundation, followed in 1991 by another from the Adolph and Ester Gottlieb Foundation.

WRITINGS
Piedra abstracta, la escultura inca: una visión contemporánea (Buenos Aires, 1989)
The Stone in the Thread: Andean Roots of Abstract Art (Austin, 1996)

BIBLIOGRAPHY
M. C. Ramírez, ed.: *El Taller Torres-García: The School of the South and its Legacy* (Austin, 1992)
A. Medina: 'César Paternosto', *A. Nexus* xix (1996), pp. 52–5
ADRIAN LOCKE

Patiño Ixtolinque, Pedro (*b* San Pedro Ecatzingo, 31 May 1774; *d* Mexico City, 1834). Mexican sculptor. He was admitted to the Real Academia de San Carlos at the age of ten. He later studied with Manuel Tolsá, working with him on religious commissions for several churches in Mexico City. Despite this relationship, Patiño Ixtolinque's religious sculpture remains linked to the more Baroque stylistic forms of the colonial period. By 1817 his style had evolved, and he adhered to Neo-classical canons in his reliefs, such as the *Proclamation of King Wamba* (Mexico City, Mus. N. A.), for which he was awarded the title of Académico de Mérito. Notable among his civic sculptures are two allegories, *America* and *Liberty* (Mexico City, Mus. S Carlos), carved for the unexecuted funerary monument to José María Morelos y Pavón. In 1826, as Director of the Real Academia de San Carlos, he suggested the introduction of study programmes at the Ecole Polytechnique in Paris, but the proposal was unimplemented.

BIBLIOGRAPHY
J. R. Ruiz Gomar: 'La escultura académica hasta la consumación de la Independencia', *Hist. A. Mex.*, 64–5 (1982), pp. 77–89
E. Fuentes Rojas: *El desnudo en el siglo XIX: Dibujos de Pedro Patiño Ixtolinque* (Mexico City, 1986)
ELOÍSA URIBE

Payssé-Reyes, Mario (*b* Montevideo, 5 March 1913; *d* Montevideo, 13 Jan 1988). Uruguayan architect and teacher. After completing his architectural education at the University of Montevideo (1937), he took part in several architectural competitions, winning numerous awards. At the same time he worked as an occasional collaborator of Julio Vilamajó, the outstanding figure in modern Uruguayan architecture, with whom he had studied and for whom he had a profound admiration. He also greatly admired the important Uruguayan painter Joaquín Torres García, and as a result of his contacts with Torres García and the latter's followers, Payssé-Reyes acquired a solid conception of structure, a strict sense of proportion and an interest in the inherent qualities of commonplace

materials. After establishing his own practice in 1943, he made frequent use of rough, exposed brickwork in his buildings. In addition, inspired by the Constructivist painting promoted by Torres García, he often incorporated the applied arts in his work, for example at the Seminario Arquidiocesano (1954–8) of Toledo and his own house (1954–5), Carrasco, Montevideo. The latter provides a clear demonstration of his principles, including a concern that architecture should be compatible with its environmental and cultural context and that design should be supported by constructional logic and a corresponding economy of means. His interest in contextual design is particularly apparent in the Banco de Previsión Social de Montevideo building (1957–72), Montevideo, where there was a clear relationship between the building and its urban setting. Later works included the Uruguayan Embassy (1978–81), Buenos Aires. Payssé-Reyes was an influential teacher at the University of Montevideo, where he taught from 1943; in 1975 he became director of the Escuela de Arquitectura there.

BIBLIOGRAPHY
Macmillan Enc. Architects
'Mario Payssé-Reyes', *Arquitectura* [Montevideo] (Dec 1959) [special issue]
F. H. de Ferrabosco, ed.: *Mario Payssé, 1937–1967* (Montevideo, 1969)
F. Bullrich: *New Directions in Latin-American Architecture* (New York, 1969)
MARIANO ARANA

Paz, Alonso de la (*b c.* 1630; *d c.* 1690). Guatemalan sculptor. He was a contemporary of Mateo Zúñiga and like him was a leading exponent of polychrome sculpture in 17th-century Santiago de Guatemala (now Antigua). He worked *en blanco*, leaving the painting to a master painter. In the 1660s Paz is documented as a master specializing in the carving of wooden religious images. He appears to have worked only in Santiago de Guatemala, where he made statues both for altarpieces and for use in procession. In commissions for altarpieces he often collaborated with the joiner Agustín Núñez and was responsible for all the sculpture. It is known that Paz was commissioned to make a *Virgin* (*c.* 1660–63; venerated in Paz's lifetime, now untraced) by the Blessed Brother Pedro and a statue of *St Joseph* in the church of S José, Guatemala City. Other works attributed to him are based on tradition. Perhaps the best known are two statues of Jesus of Nazareth, popular devotional images since the 17th century. The first, made for Santa Cruz in Antigua, is in the church of La Merced in Antigua; and the second, *Jesus of the Miracles*, is in the church of Santa José in Guatemala City.

BIBLIOGRAPHY
H. Berlin: *Historia de la imaginería colonial en Guatemala* (Guatemala City, 1952)
M. Alvarez Arévalo: *Reseña histórica de las imágenes procesionales de la ciudad de Guatemala* (Guatemala City, 1987)
JORGE LUJÁN-MUÑOZ

Peláez (del Casal), Amelia (*b* Yaguajuay, nr Placetas, 5 Jan 1896; *d* Havana, 8 April 1968). Cuban painter, ceramicist and illustrator. She studied under Leopoldo Romañach (1862–1951) at the Academia de S Alejandro in Havana, where she was influenced by Impressionism. She graduated in 1924 and lived in Paris from 1927 to 1933, studying at the Académie de la Grande Chaumière, the Ecole Nationale Supérieure des Beaux-Arts and the Ecole

du Louvre. She also studied composition and colour with the Russian Constructivist and stage designer Alexandra Exter. She held an individual exhibition at the Galerie Zak in Paris in 1933 and in 1934 returned to Cuba.

Peláez applied her Parisian experiences, particularly of Cubism and of her apprenticeship to Exter, to a personal style based on the forms and colours of the luxuriant tropical vegetation and the Baroque colonial architecture of Cuba. Like Víctor Manuel, she combined modernism with native elements in a style at once Cuban and cosmopolitan in paintings such as *Still-life in Red* (1938; see colour pl. XXVII, fig. 1).

Peláez developed her mature style during the late 1930s and early 1940s while living and working in her family home in the Vibora suburb of Havana. During the 1950s she was a pioneering ceramicist in Cuba (*see* CUBA, fig. 7). She created several important murals in Havana in this period, including an untitled ceramic mural in the Tribunal de Cuentas (1953). She also illustrated Léon-Paul Fargue's *Sept poèmes* (1933; unpubd), Luis Amado Blanco's *Poema desesperado* (1937) and other publications.

BIBLIOGRAPHY

O. Hurtado and others: *Pintores cubanos* (Havana, 1962)
Amelia Peláez (exh. cat. by J. Rigol, Havana, Mus. N. B.A., 1968)
Amelia Peláez (exh. cat., ed. G. Blanc; Miami, FL, Cub. Mus. A. & Cult., 1988)
Amelia Peláez: Exposition retrospectiva, 1924–1967 (ext. cat., Bogotá, Bib. Luis-Angel Arango, 1992)
Four Cuban Modernists: Mario Carreño, Amelia Peláez, Fidelio Ponce, René Portocarrero (exh. cat., Coral Gables, FL, Javier Lumbreras F.A., 1993)
J. A. Martinez: *Cuban Art and National Identity: The Vanguardia Painters, 1925–1950* (Gainesville, FL, 1994)
J. A. Molina: 'Estrada Palma 261: Still Life with Dream about Amelia Peláez', *J. Dec. & Propaganda A.*, xxii (1996), pp. 220–39
Tarsila do Amaral, Frida Kahlo and Amelia Peláez (exh. cat. by L. Montreal Agusí and others, Barcelona, Cent. Fund. Caixa Pensions, 1997)

GIULIO V. BLANC

Peláez, Antonio (*b* Llanes, Asturias, 1921). Spanish painter, active in Mexico. He left Spain during the Civil War in 1936 and settled in Mexico, completing his training under José Moreno Villa and Frida Kahlo at the Escuela Nacional de Pintura y Escultura 'La Esmeralda' in Mexico City. His early work, consisting particularly of portraits and figurative drawings, was featured in his first exhibition, which took place in 1951 with Kahlo's encouragement. His preference for elongated figures in misty and magical settings increasingly gave way to a greater simplification and abstraction. From time to time he returned to figurative work, especially to portraiture, but his art was fundamentally structured by its austere abstract quality, characterized by an interaction of geometrical and graphic elements with richly varied textures and lyrical colours.

BIBLIOGRAPHY

J. Fernández: *El universo poético de Antonio Peláez* (Mexico City, 1959)
J. A. Manrique: *La pintura de Antonio Peláez* (Jalapa, 1960)
M. Nelken: *La evolución de Antonio Peláez* (Mexico City, 1960)
A. de Neuvillate: *Antonio Peláez* (Mexico City, 1974)
O. Paz, intro.: *Antonio Peláez, pintor* (Mexico City, 1975)

JULIETA ORTIZ GAITÁN

Pellegrini, Carlos Enrique (*b* Chambéry, Savoie, 28 July 1800; *d* Buenos Aires, 12 Oct 1875). Argentine painter, draughtsman, lithographer and engineer of French birth. His father was Italian and his mother French. He received a diploma in engineering in Paris in 1825, and in 1827 he was contracted as a hydraulic engineer by Juan Larrea, the Argentine chargé d'affaires in Paris, on behalf of Bernardino Rivadavia, the first Argentine president (1826–7). Pellegrini sailed to Montevideo, Uruguay, in January 1828 but was unable to disembark in Buenos Aires because the port was blockaded by the Brazilian fleet. He remained in Montevideo, where he was hired to design fortifications for the city and its surrounding areas. When he finally reached Buenos Aires in November 1828, political events prevented him from executing the project for which he had been contracted. In letters to his brother and friends in France he included watercolour views of Buenos Aires, in which he graphically and unselfconsciously documented a period of Argentinian life distinct from that previously illustrated by Emeric Essex Vidal (1791–1861). He went on to produce paintings of the four sides of the Plaza de la Victoria, of the cathedral, the old and new poultry markets, meat and fish salthouses, slaughterhouses, churches, street scenes with popular characters, watersellers, soldiers, policemen, travelling salesmen and elegant men and women, documenting architectural and urban themes, as in the *Great Arch of the Poultry Market and Temple of S Francisco* (watercolour, 215×170 mm, 1829; Buenos Aires, Mus. N. B.A.).

As a guest at society parties and soirées in Buenos Aires, Pellegrini began in the 1830s to depict such social gatherings. It was his skill as a portrait painter, however, that opened all doors to him, transforming him into a fashionable artist and enabling him to associate with literary and political figures, to become rich and to render homage to the beauty of important female figures of the period, for example *Juana Rodríguez de Carranza* (watercolour, 1831; Buenos Aires, Mus. N. B.A.). Although Pellegrini's paintings, pastels and miniatures were less skilful than his drawings and watercolours, his lithographs are noteworthy. In 1831 he prepared the *Tableau pittoresque de Buenos Ayres*, an album of lithographs dedicated to the British chargé d'affaires in Buenos Aires, Sir Woodbine Parish. Published in London in 1852 as *Buenos Ayres and the Provinces of the Río de la Plata*, a new edition was brought out in 1958 by Librería L'Amateur, Buenos Aires. In 1841 Pellegrini published there an album of 20 lithographs entitled *Recuerdos del Río de la Plata*. Among his many other activities he founded the *Revista del Plata* in 1853, designed projects for public works, ports, waterways, rivers and lighting systems, and studied cattle and agricultural problems. He was a co-founder of the Instituto Geográfico e Histórico del Río de la Plata, and in 1857 he designed and constructed the original Teatro Colón building using remarkably advanced technical innovations.

BIBLIOGRAPHY

A. González Garaño: *C. H. Pellegrini: Su obra, su vida, su tiempo* (Buenos Aires, 1946)
A. de Paula and R. Gutiérrez: *La encrucijada de la arquitectura argentina: Santiago Evans, Carlos Enrique Pellegrini* (Resistencia, 1974)
A. L. Ribera: *La pintura* (Buenos Aires, 1984), iii of *Historia general del arte en la Argentina*, ed. Academia Nacional de Bellas Artes, pp. 168–75
J. López Anaya: *Historia del arte Argentino* (Buenos Aires, 1997)

NELLY PERAZZO

Pellón, Gina (*b* Havana, 1926). Cuban painter. She settled in Paris as a political exile in 1959, combining in her

paintings the strong chromaticism of the Cobra painters with the calligraphic, automatic brushwork associated with Abstract Expressionism. She concentrated on the female figure, often shown singing, dancing or in some dramatic pose, for example *She Has Left the Page* (1986; see 1986 exh. cat., p. 2).

BIBLIOGRAPHY

Gina Pellón (exh. cat., Paris, Gal. Vanuxem, 1986)

Outside Cuba/Fuera de Cuba (exh. cat., New Brunswick, NJ, Rutgers U., Zimmerli A. Mus., 1987)

RICARDO PAU-LLOSA

Peluffo, Marta (*b* Buenos Aires, 11 Feb 1931; *d* Buenos Aires, 29 Dec 1979). Argentine painter. She studied at the Escuela Superior de Bellas Artes in Buenos Aires and at the Escuela de Bellas Artes in La Plata, exhibiting her abstract paintings from 1952 and with the group Siete Pintores Abstractos from 1957; she also joined the group Phases in 1958, taking part in their exhibitions in Japan and at the Museo de Arte Moderno in Montevideo, Uruguay. Her early paintings, already very assured in technique and exquisite in their sensitive colouring, consisted of delicately harmonized, subtly vibrating and transparent planes in clearly defined geometric shapes.

In the late 1950s Peluffo worked briefly in a style influenced by *Art informel*. These works, such as *Painting* (1959–60; La Plata, Mus. Prov. B.A.), were painted in a thick impasto and with a harmonious sense of colour. Later she turned to a figurative idiom that contained such elements of Pop art as the appropriation of mass-media resources (see fig.). She used this style in portraits of popular figures in Argentina and in numerous self-por-

Marta Peluffo: *Untitled*, acrylic on canvas, 1150×883 mm (Austin, TX, University of Texas, Jack S. Blanton Museum of Art)

traits. Paintings such as *Claudia Sánchez and Nono Pugliese* (1969; Buenos Aires, Mus. A. Mod.) are characterized by sketchy contours and bright, attractive colours.

BIBLIOGRAPHY

A. Pellegrini: *Panorama de la pintura argentina contemporánea* (Buenos Aires, 1967), pp. 81–125

C. Córdova Iturburu: *80 años de pintura argentina* (Buenos Aires, 1978), pp. 148, 150, 165, 171, 176, 218, 219

J. López Anaya: *Historia del arte argentino* (Buenos Aires, 1997)

NELLY PERAZZO

Penalba, Alicia (*b* San Pedro, Buenos Aires, 9 Aug 1913). French sculptor, tapestry designer and weaver of Argentine birth. After studying drawing and painting in Buenos Aires, Penalba received a scholarship from the French government in 1948. In Paris she enrolled at the Ecole Nationale Supérieure des Beaux-Arts in printmaking but began to concentrate exclusively on sculpture after entering the studio of Ossip Zadkine (1890–1967) in 1950. Committed to abstraction from 1951, Penalba exhibited with other young, non-objective sculptors such as Etienne-Martin (*b* 1913) and Etienne Hajdu, with whom she shared a preference for organic form. Her sculpture of the 1950s was chiefly of vertical orientation, composed of modular forms arranged around a central axis in a totemic or columnar manner, as in *Middle Totem* (1954; Rio de Janeiro, Mus. A. Mod.). Despite its organic allusions, Penalba denied any direct reference to plant, rock or animal prototypes, insisting that her work was motivated by a desire to 'spiritualize the symbols of eroticism, the source of all creation' (1964 exh. cat., p. 51). This exploration of procreation was exhausted by the 1960s, when she turned to forms with a curved or horizontal orientation, evident in *Great Winged Creature* (1963; see fig.), where thrusting triangular shapes jut from a curved spine, suggesting the skeleton of a dinosaur or a bird in flight. Clay is Penalba's medium of choice, and although her work is cast in metal, concrete or polyester, the textural quality of the original material is maintained. A commitment to monumental public sculpture has remained a constant throughout her career, apparent in the domineering bronze *Grand Double* (h. 8.5 m, 1971) for the MGIC Plaza in Milwaukee, WI, and the environmental *Winged Field* (1963), composed of over a dozen concrete biomorphic forms scattered between the buildings of the School of Economic and Social Studies at St Gallen, Switzerland. Similar to this last in the use of unattached forms are Penalba's large-scale wall reliefs. Other projects from the 1960s to the 1980s include fountains, designs for Sèvres vases, tapestries, collages and lithographs.

BIBLIOGRAPHY

Alicia Penalba (exh. cat. by M. Seuphor, New York, Otto Gerson Gal., 1960)

Alicia Penalba (exh. cat. by P. Waldberg, Leverkusen, Schloss Morsbroich, 1964)

Penalba (exh. cat. by A. B. Joffroy, J. Goldstein and D. Chevalier, Paris, Mus. A. Mod. Ville Paris, 1977)

T. Alva Negri: *Alicia Penalba: O de la cadencia musical en la escultura* (Buenos Aires, 1986)

A. Collazo: 'Alicia Penalba and Marta Minujín', *A. Nexus*, xii (1994), pp. 110–11

Latin American Women Artists, 1915–1995 (exh. cat. by G. Biller and others, Milwaukee, WI, A. Mus., 1995)

J. López Anaya: *Historia del arte argentino* (Buenos Aires, 1997)

ELISABETH ROARK

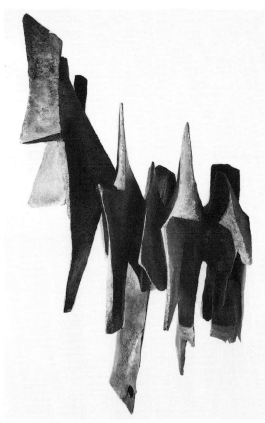

Alicia Penalba: *Great Winged Creature*, bronze, 1.05×1.95 m, 1963 (Pittsburgh, PA, Carnegie Museum of Art)

Peñalba, Rodrigo (*b* Léon, 1908; *d* Managua, 1979). Nicaraguan painter and teacher. He studied from 1926 to 1941 at the Art Institute of Chicago, the Academia de Bellas Artes de S Carlos in Mexico City, the Real Academia de S Fernando in Madrid and the Accademia di Belle Arti in Rome. He remained in Italy after completing his studies, exhibiting in New York and Washington, DC, before returning in 1947 to Nicaragua. There he was named director of the Escuela Nacional de Bellas Artes in Managua, an institution that he helped to revitalize. Known more as an inspirational teacher than as an innovative artist in his own right, Peñalba initially worked in an academic figurative style, for example in his murals of the early 1950s on the theme of St Sebastian for the parish church of Diriamba; he also produced highly emotional figure studies, sometimes on a very small scale, as in *Untitled* (1944–5; see colour pl. XXVII, fig. 2). In the late 1950s he adopted a far more experimental style in oil paintings that made overt reference to Expressionism and to the work of El Greco and José Clemente Orozco; his wholehearted embrace of modernism in the arts led to his being considered the pioneer of modern Nicaraguan painting. In 1963 a group of his former students formed PRAXIS, the first avant-garde movement in the country's history.

BIBLIOGRAPHY

P. Antonio Cuadra: 'Nicaragua's New Artists', *Américas*, vi/2 (1954), pp. 16–19

Rodrigo Peñalba (exh. cat. by J. Gómez-Sicre, Managua, Gal. Praxis, 1966)

Retrospective Peñalba: El maestro indiscutible (exh. cat., Managua, Gal. Casa Ferrando Gordillo, 1986)

M. D. G. Torres: *La modernidad en la pintura nicaragüense, 1948–1990* (Managua, 1995), pp. 26–39

DAVID CRAVEN

Perceptismo. Argentine movement initiated in Buenos Aires in 1947 under the leadership of the painter Raúl Lozza (*b* 1911) and the theoreticians Rembrandt Lozza (1915–90) and Abraham Haber (1924–86). It was announced in 1948 by an exhibition and manifesto. Like the ASOCIACIÓN ARTE CONCRETO INVENCIÓN, from whose internal disagreements the movement emerged, it was concerned with the promotion of Constructivism in Argentina. The theories they promulgated were also conveyed through a magazine, *Perceptismo: Teórico y polémico*, published from 1950 to 1953. One of their primary concerns was with the relationship between the quantity (in terms of surface area) and quality of flat colour; they conceived of the surface as a field against which to arrange shapes whose only justification lay in their interrelationships. In rejecting the supposed conflict between pictorial or fictitious space and the physical space in which we move, they proposed that both were equivalent in value. Lozza's use of enamel on wood to create surfaces as polished and perfect as lacquer typified the technical perfection sought by these painters as a means of suppressing any trace of subjectivity that would otherwise distract the observer from the physical presence of the work, as, for example, in *Painting from the Perceptist Period: No. 184* (1984; Buenos Aires, Mus. Mun. A. Plást. Sívori).

BIBLIOGRAPHY

C. Córdova Iturburn: *80 años de pintura argentina* (Buenos Aires, 1978), p. 147

N. Perazzo: *El arte concreto en la Argentina* (Buenos Aires, 1983), pp. 109–20

NELLY PERAZZO

Pereins [Pereyns], **Simón** (*b* Antwerp, *c*. 1540; *d* Puebla, Mexico, 1589). Flemish painter, active in Spain and Mexico. After a short stay in Portugal around 1558, he moved to Spain, living in Toledo and Madrid until 1566 when he went to Mexico as part of the retinue of the Viceroy, Gastón de Peralta, Marqués de Falces. Pereins painted in a late Mannerist style, and his work executed in Mexico is exclusively religious, although it is recorded that he had previously produced portraits. Around 1579 he painted 12 panels (untraced) with biblical subjects for the sacristy of the church of the convent of S Domingo, Mexico City. In 1585 he painted six panels for the main retable of the old cathedral of Mexico City, and the following year, in collaboration with Andrés de la Concha, he produced the paintings for the retable of the Franciscan church at Huejotzingo, Puebla, the subjects of which were *Mary Magdalene*, *St Mary of Egypt*, the *Adoration of the Shepherds*, the *Adoration of the Magi*, the *Circumcision*, the *Presentation in the Temple*, the *Flagellation*, *Christ Carrying the Cross*, the *Resurrection* and the *Ascension* (see MEXICO, fig. 8). Pereins also painted a retable (untraced) for the Franciscan church of Cuernavaca, as well as a *St Christopher* and the *Madonna of Mercy* for the cathedral of Mexico City (*in situ*).

BIBLIOGRAPHY

M. Toussaint: 'Proceso y denuncias contra Simón Pereyns en la inquisición de México', *An. Inst. Invest. Estét.*, ii, suppl. (1938)

E. E. Ríos: 'Una obra ignorada de Simón Pereins', *An. Inst. Invest. Estét.*, ix (1942)

M. Romero de Terreros: 'Dos obras de Simón Pereyns', *Continente*, iii (1944)

H. Berlin: 'The High Altar of Huexotzingo', *The Americas* (Washington, DC, 1958)

S. Sebastian: 'Nuevo grabado en la obra de Pereyns', *An. Inst. Invest. Estét.*, xxxv (1966)

X. Moyssen: 'Las pinturas perdidas de la catedral de México', *An. Inst. Invest. Estét.*, xxxix (1970)

G. Tovar de Teresa: *Pintura y escultura del renacimiento en México* (Mexico City, 1979)

J. G. Victoria: 'U pintor flamenco en Nueva España: Simon Pereyns', *An. Inst. Invest. Estét.*, xiv/55 (1986), pp. 69–83

MARIA CONCEPCIÓN GARCÍA SÁIZ

Pérez, Régulo (*b* Caicara, nr San Fernando de Apure, 19 Dec 1929). Venezuelan painter. Also known simply as Régulo, he studied at the Escuela de Artes Plásticas y Aplicadas, Caracas (1945–7). He was a member of the Taller Libre de Arte until 1952 and was also actively involved with the groups Los Disidentes (1950), the Pez Dorado (1962–3) and Presencia 70 (1970–72). In 1951 he travelled to Europe, where he stayed for six years. Between 1958 and 1959 he was Director of the Escuela de Artes at the Universidad de los Andes, Mérida, and from 1959 he was Deputy Director of the Escuela de Artes Plásticas 'Cristóbal Rojas' in Caracas. His painting, which was characterized by his empathy for the humble and the dispossessed, earned him the Premio Nacional de Pintura at the Salón Oficial de Arte Venezolano in 1987. He also contributed caricatures to various publications.

WRITINGS

Régulo Pérez: *Orinoco, irónico y onírico* (Caracas, 1992)

BIBLIOGRAPHY

Régulo: Retratos (exh. cat. by M. L. Cárdenas, Caracas, Mus. A. Contemp., 1983)

De Venezuela: Treinta años de arte contemporáneo (1960–1990)/From Venezuela: Thirty Years of Contemporary Art (1960–1990) (exh. cat. by R. de Montero Castro, Seville, Pab. A., 1992)

based on information supplied by LELIA DELGADO

Pérez Barradas, Rafael. *See* BARRADAS, RAFAEL.

Pérez de Alesio, Mateo [Lecce, Matteo da] (*b* Alesio, *c.* 1545–50; *d* Lima, ?1616). Italian painter, active also in Peru. He is documented in Rome from 1568, where he worked with Federico Zuccaro. His works include frescoes in the Villa d'Este in Tivoli and the Villa Mondragone in Frascati. He also painted an altarpiece for S Caterina della Rota in Rome. His most important work is the fresco depicting the *Dispute over the Body of Moses* that he painted *c.* 1574 in the Sistine Chapel (Rome, Vatican) replacing a fresco by Luca Signorelli. He belonged to the Accademia di S Luca. His frescoes in the oratory of S Lucia del Gonfalone in Rome were executed *c.* 1575. In 1576 he travelled to Malta to paint the 13 frescoes (*in situ*) in the main hall of the Palace of the Grand Masters, Valletta. About 1582 he returned to Rome, where he executed frescoes in the apse of S Eligio degli Orefici. He then went to Seville, where he came into contact with Francisco Pacheco and his circle and became known as painter to the Pope and a disciple of Michelangelo. He was commissioned to paint the *St Christopher* in the cathedral and other more minor works. In 1589 he went to Lima, apparently in the retinue of the Viceroy García Hurtado de Mendoza. He arrived at the city with numerous engravings, including works by Dürer, and was extremely active, particularly in the field of wall painting. He painted a *St Christopher* (untraced) for the cathedral and canvases for the cloister of S Domingo, which were hung next to the paintings that Pacheco had sent to this convent from Seville. He also executed a portrait of the *Conquistador Jerónimo de Aliaga*. The wall painting in the cloister of S Francisco is attributed to him, as is that of the Villegas Chapel in the church of La Merced. Pérez de Alesio worked with the painter Pedro Pablo Morón, whom he had met in Naples and who accompanied him until his death. He was one of the most famous Italian painters who went to the Americas. His son Adrian, who was a painter and a poet, the Augustinian friar Francisco Bejarano and Domingo Gil were all his disciples.

BIBLIOGRAPHY

Thieme–Becker

H. Schenone: 'Una pintura en Lima atribuida a Pérez de Alesio', *An. Inst. A. Amer. & Invest. Estét.* (1963)

J. Gere and P. Pouncey: *Italian Drawings in the Department of Prints and Drawings in the British Museum: Artists Working in Rome, c. 1550 to c. 1640* (London, 1983), pp. 125–6

G. Briganti, ed.: *La pittura in Italia: Il cinquecento* (Milan, 1987, rev. 1988, pp. 453, 766)

S. Sebastián López, J. de Mesa Figueroa and T. Gisbert de Mesa: *Summa artis: Historia general del arte la desde colonización a la Independencia (primera parte)*, xxviii (Madrid, 4/1992)

R. Gutiérrez, ed.: *Pintura y escultura y artes útiles en Iberoamérica, 1500–1825* (Madrid, 1995)

TERESA GISBERT

Pérez Palacio, Augusto (*b* Mexico City, 5 Feb 1909). Mexican architect and teacher. He graduated from the Escuela Nacional de Arquitectura, Mexico City, in 1933, having visited several countries in Europe. He supervised the construction of the Hotel del Prado (1939; destr. 1985), Mexico City, and constructed some factories both in Mexico City and the provinces, among them the Fibracel Factory (1948), Ciudad de Valles. His best-known work is the Olympic Stadium (1950; with Raúl Salinas Moro, Jorge Bravo Jiménez (*b* 1922) and Diego Rivera), Ciudad Universitaria, Mexico City. The outer facing of volcanic rock and its unusual shape, based on a system of embankments, result in a building exceptionally adapted to its context in the Pedregal district. Pérez Palacio also designed the Secretaría de Comunicaciones y Obras Públicas complex (1953; with Raúl Cacho (*b* 1912); partly destr. 1985), Mexico City. This is an important example of 'plastic integration', or collaboration between architecture and the fine arts, being richly covered with mosaics in stone by Juan O'Gorman and José Chávez Morado. He was a professor of architecture in the Instituto Politécnico Nacional, Mexico City, from 1934 to 1938, and also taught at the Universidad Nacional Autónoma de México, Mexico City, from 1939 until the 1950s.

BIBLIOGRAPHY

L. de Cervantes: *De crónica arquitectónica: Prehispánica, colonial, contemporánea* (Mexico, 1952)

A. P. Palacio, R. S. Moro and J. B. Jiménez: 'Estadio olímpico', *Arquit. México*, viii/39 (1952), pp. 324–9

F. González Gortázar, ed.: *La arquitectura mexicana del siglo XX* (Mexico City 1994)

K. Kalach: 'Architecture and Place: The Stadium of the University City', *Modernity and the Architecture of Mexico*, ed. E.R. Burian (Austin, TX, 1997), pp. 107–14

LOURDES CRUZ

Perinetti, José Cúneo. *See* CÚNEO, JOSÉ.

Periodical. Magazine or other publication (not usually including general newspapers) that appears at more or less regular intervals. Periodical publications on art in Latin America can be divided into two main categories: the historical and the avant-garde. The former category is dominated by the official publications of academic institutions, museums and libraries; these tend to be relatively substantial, often well-illustrated annual publications, which survive changes of editorship. In contrast, Latin American avant-garde periodicals are, by their very nature, much more ephemeral: often dependent on the enthusiasm of one individual, such publications express the aspirations of the moment and disappear as those aspirations change. Latin America has strong traditions in both categories, with Mexico, Brazil and Argentina heading the lists in both quality and quantity. The *Anales del Instituto de Investigaciones Estéticas* (Mexico City, 1937–) and the *Anales del Instituto de Arte Americano e Investigaciones Estéticas* (Buenos Aires, 1948–) both contain carefully researched and well-illustrated articles that cover both the art and, more especially, the architecture of the whole of Latin America, with interest concentrating on the 16th to 19th centuries. In Venezuela the *Boletín del Centro de Investigaciones Históricas y Estéticas* (Caracas, 1964–86) is similar in scope and quality, although concerned largely with architecture. More usually, such periodicals reflect the inevitable nationalism of their parent institutions, so that the *Revista del Museo Nacional* (Lima, 1932–) focuses on Peruvian art and the *Boletim do Museu Nacional de Belas Artes* (Rio de Janeiro, 1982–) on Brazilian art. *Arte en Colombia* (Bogotá, 1944–), the title of the publication of the Museu de Arte in Colombia, declares this explicitly. The lavishly illustrated *Artes de Mexico*, later *Artes de Mexico y del mundo* (Mexico City, 1953–), the thematic issues of which range from cartoons and photography to Aztec pyramid design, is exceptional in being independently produced.

It is less easy to generalize about the second category, those periodicals that deal with contemporary and avant-garde issues. Although often cheaply produced, short-lived and with small circulations, some of these publications are crucial to an understanding of particular debates within 20th-century art in Latin America. In the 1920s important manifestos were published in *Klaxon* (São Paulo, 1922–3), *Revista de antropofagia* (São Paulo, 1928), *Martín Fierro* (Buenos Aires) and *Amauta* (Lima, 1926–30), none of which survived for more than a few issues. The first and only issue of the Mexican *Revista actual* (Mexico City, 1921) was produced as a manifesto in poster form. In Latin America the arts are typically seen as an integral part of a much broader intellectual context. Many of the avant-garde periodicals just mentioned did not deal exclusively with art but included topics of a more general cultural and political nature. Conversely, much interesting material on art and architecture in Latin America is found in journals that are predominantly literary or historical in orientation. Thus the *Historia y cultura* (Lima, 1967–) includes good material on art, while *Cultura* (Quito, 1978–), produced (and heavily subsidized by) the Banco Central de Ecuador, includes studies of Ecuadorean art

and architecture, as well as literary criticism, historical studies, transcribed documents and poetry. The Cuban *Casa de las Américas* (Havana, 1959–) includes articles on art and architecture, politics, history and literature. Much of this material is, however, available only in the country concerned. The best journal on art currently being produced in Latin America is *Art Nexus* (1991–) from Colombia.

VALERIE FRASER

Peru, Republic of [República del Perú]. South American country, It is situated on the Pacific western seaboard and covers an area of 1,285,216 sq. km, bordered by Ecuador, Colombia, Brazil, Bolivia and Chile. The capital is LIMA, and CUZCO, Trujillo, Chimbote, CAJAMARCA and AREQUIPA are major cities (see fig. 1). The Spaniard Francisco Pizarro arrived in Peru in 1532, and the country declared independence from Spain in 1821, achieving full independence in 1824. Peru is divided by the mountain ranges of the Andes into three distinct geographical areas: desert coast punctuated by fertile valleys, rugged mountainous regions and the vast jungle region. The population of *c.*24 million (1996 estimate) is predominantly Indian (Quechua, Aymara and various Amazonian groups) and mestizo, and the original Inca language of Quechua is spoken by *c.* 27% as the second official language, Spanish being the first; Aymara is also spoken by some, mainly in the southern Andes, around Lake Titicaca. The legal existence of Indian communities was recognized in the constitution only after 1920, however.

I. Introduction. II. Indigenous culture. III. Architecture. IV. Painting, graphic arts and sculpture. V. Metalwork. VI. Textiles. VII. Ceramics. VIII. Furniture. IX. Patronage and collecting. X. Museums. XI. Art education. XII. Art libraries and photographic collections.

I. Introduction.

When the Spaniards arrived at Cajamarca (1532), civil and military hostilities had already taken place among various nobles in the Inca Empire. The soldiers captured Atahualpa and then moved on south to Cuzco, which they sacked. Manco Inca escaped, however, and set up a separate Inca state at Vilcabamba on the eastern slopes of the southern Andes, which was not taken by the Spanish until 1572. Most of the huge empire was affected by the Spanish presence within a short time of the conquest. The Spaniards recognized the sophisticated skills of the indigenous peoples and took advantage of them, developing schools of painting and training architects, stone sculptors, silver- and goldsmiths and other craftsmen for their own purposes. They also practised the system of control known as *reducciones*, which forced the indigenous peoples into specific settlements, and adapted the Inca draft labour system.

In 1535 Lima was founded on the Pacific coast. It was the administrative capital for the Viceroyalty of Peru, which encompassed the whole of non-Caribbean Spanish South America for 250 years; not until the 18th century was the Viceroyalty of Perus split up into Peru and New Granada (1717) and Rio de la Plata (1776). Since most trade passed through Lima, it was an extremely wealthy city, particularly at the height of silver mining in the highland regions, though the great earthquake of 1746 is

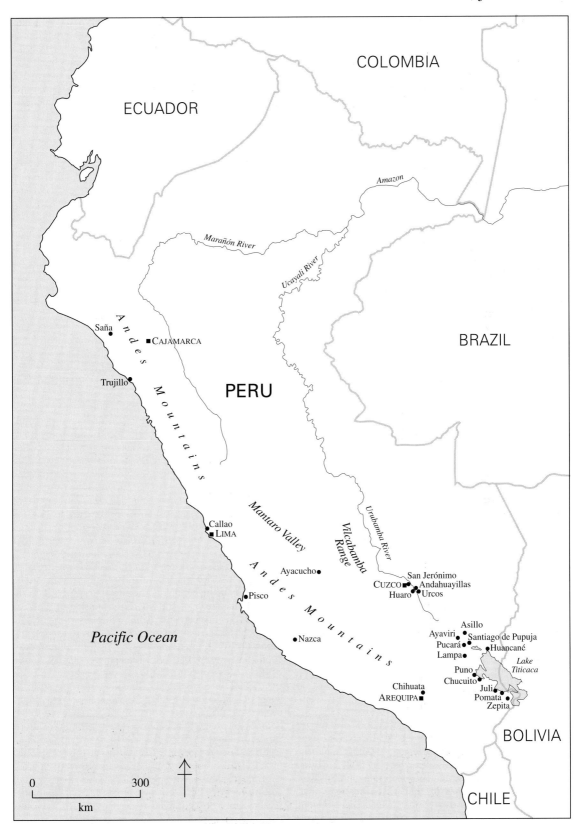

1. Map of Peru; those sites with separate entries in this encyclopedia are distinguished by CROSS-REFERENCE TYPE

regarded as the turning-point for Lima. Unsuccessful uprisings of the Indian population took place in 1781–2 and in 1814. During the 17th and 18th centuries Inca dynastic portraits were painted and owned by both the native Peruvians and the Spaniards and were used as indications of status, but after the first insurrection the Spanish Crown prohibited paintings of the Inca dynasty and banned the wearing of Inca costume and the Quechua language. Independence from Spain was proclaimed on 28 July 1821 and achieved fully by 1824, marking the beginning of the Republican era. Perus embarked on a temporary confederation with Bolivia in 1836–9, and was briefly at war with Spain in 1866; several years later both Bolivia and Peru were defeated by Chile in the War of the Pacific (1879–83), Peru losing much of its southernmost territory and being left almost bankrupt.

The first civilian government in Peru was in office from 1872 under the presidency of Manuel Pardo. In the early decades of the 20th century Augusto Bernardo Leguía y Salcedo served as civilian president (1908–12) and then virtual dictator (1919–30). During this period there was an export boom (rubber, sugar, wool, cotton, oil, silver and copper) that resulted in a major takeover of key sectors of the economy by foreign companies, particularly North American. The second half of the century was dominated by the military, either by their intervention in appointing presidents or by rule of junta. There was an increase in migration to Lima from the 1960s, which was compounded by the effects of terrorism. In 1980 a civilian government took over, but the country was dogged by economic problems and the activities of the guerrilla groups of Sendero Luminoso and Túpac Amaru. In 1990, with popular support, Alberto Fujimoro was elected president. In spite of international criticism of some of his policies he managed to stabilize inflation, curtail Sendero's activities by capturing its leader and end a long-running territorial dispute with Ecuador in 1998.

BIBLIOGRAPHY

H. E. Wethey: *Colonial Architecture and Sculpture in Peru* (Cambridge, MA, 1949/*R* Connecticut, 1971)
H. Velarde: *Arte y arquitectura* (Lima, 1966)
J. Basadre: *Historia de la República del Perú* (Lima, 1969)
J. M. Ugarte Eléspuru: *Pintura y escultura en el Perú contemporáneo* (Lima, 1970)
J. Sabogal: *Del arte en el Perú y otros ensayos* (Lima, 1975)
J. P. Vidal: *Perú: Una nueva geografía* (Lima, 1975)
D. P. Werlich: *Peru: A Short History* (London, 1978)
F. G. Y. Pease: *Del Tawantinsuyo a la historia del Perú* (Lima, 1989)
M. E. Moseley: *The Incas and their Ancestors* (London, 1992)
W. Goodhart: *Peru: Restructuring for Growth* (London, 1994)
N. Davies: *The Ancient Kingdoms of Peru* (London, 1997)
Gran enciclopedia del Perú (Barcelona, 1998)

W. IAIN MACKAY

II. Indigenous culture.

Andean culture was characterized by a richness and variety of styles. In the late 15th century the Inca based their artistic activities on ancient traditions, while adapting them to an essentially functional spirit typical of all their works. Despite the simplicity of their technology they were capable of achieving a high level of artistic creativity; once they had achieved their own particular style, they spread it throughout their empire. When the Spanish tried to impose on the indigenous societies the models of Western culture, above all new Christian religious beliefs through a long and difficult process of evangelization, the continuity of traditional culture, including forms of plastic expression, seemed threatened. These forms of expression were imbued with ritual and symbolic aspects that governed all the activities of daily life, and they gave special significance to the use of objects, ranging from the purely functional to those that had a clear ceremonial use. Despite the missionaries' fear that such objects were 'idolatrous', the continuation of these art forms and the technology used in making them could not be eradicated. Furthermore, the Spanish frequently resorted to indigenous labour for the provision of a wide variety of everyday objects, to which the indigenous artisans applied traditional technology and their creative sensibility, adapting these to the design of new forms and sometimes new materials.

A dual process therefore began of acculturation in forms of plastic expression, as much in functional objects as in the creation of works of art. On the one hand the indigenous people transformed the items of foreign design and function, treating them with the technology and decoration of their own tradition; on the other hand they themselves adapted new motifs and technology in the manufacture of their own pieces, both those of utilitarian function and those for ceremonial purposes. The result was a mestizo and original art. The maturing of this new form, however, was a long and complex process, for although the demands of the colonizers seemed to have forced the indigenous artist and artisan to comply with the new customs and to accept new beliefs, latent resistance to this imposition was maintained throughout the colonial period. Albeit in a less subtle form, even the official academic art that was introduced, first through imported works of art and later through the presence of European artists, was brilliantly developed by indigenous and mestizo practitioners. The so-called CUZCO SCHOOL of painting, which included Diego Quispe Tito as well as an abundance of anonymous artists, exemplifies the capacity for the transformation of subjects and symbols.

This process of transformation perhaps has its most precocious and rich expression in the *queros* (see fig. 2), ceremonial vessels from the Inca period, whose origins lie in the Tiahuanacota tradition and which continued to be used until the beginning of the Republican period (from 1824). They are made of wood, the outside of which is decorated by incision and painting that, from the time of the Spaniards' arrival, began to incorporate a new iconography; this was more descriptive and realist than the linear, geometric style of the Pre-Columbian period. The scenes depicted are of ancient myths or wars, set in a border on the upper part of the vessel. The lower part began to be decorated with floral motifs at the beginning of the colonial period, and the two were sometimes separated by another section, on which there continued to be geometric motifs, similar to the designs on the textiles of ancient Peruvian cultures. Their use and manufacture began to be prohibited because of their ceremonial character and their use in non-Christian rituals. Nevertheless, they did not disappear and constituted what has been considered an 'art of resistance'. In the late 20th century they were still used for ritual purposes in communities of the high plateau regions where animals are grazed (Flores Ochoa, p. 31).

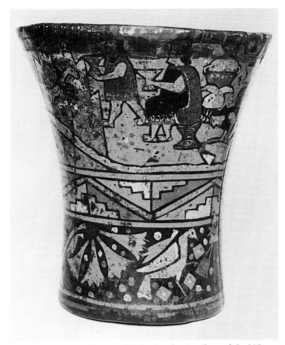

2. Ceremonial vessel (*quero*), incised and painted wood, h. 215 mm, diam. 200 mm at mouth, 130 mm at base, from Cuzco, 18th century (Madrid, Museo de América)

The portable retable, originally known as the 'S Marcos', was also made of wood and was richly polychromed. The art form was inspired by the medieval triptychs introduced to Peru by the Spanish, and portable retables began to be made by the indigenous population in the area around Huamanga (now Ayacucho) in central Peru. Huamanga was one of the most important cities in the Viceroyalty of Peru, and it was the centre of an active internal commercial network; numerous Spanish workshops and textile mills were established there, and the Indians and mestizos learnt the techniques for making religious images, going on to apply them in a very original and free form in their own creations. The 'S Marcos' was the most characteristic example of the blending of two cultures. It was used in the celebratory feasts when branding or marking the herds of cattle, as offerings to the Wamami, the gods who protected the flocks of llamas and alpacas. In peasant communities it retained its original magic-religious function into the late 20th century. Although the structure of a small retable with two doors and two storeys or levels remained unchanged, the iconographic themes used on it have varied since the 1940s. The Huamangan artisan Joaquín López Antay was an original creator of the new retables: on the upper section religious scenes are depicted, and on the lower, popular scenes and scenes from peasant life, in which human figures (Indian and mestizo) and animals are painted in a harmonious range of colours.

The same magical-religious significance is possessed by the small crosses and small figure sculptures of saints, known as *santolines*. The crosses, which vary in size between 200 and 500 mm, are for domestic use and have in their centre the face of Christ modelled from a plaster paste. In the 1990s the colonial techniques and procedures,

using a combination of maguey-wood, stucco and glued-on fabrics to support rich polychrome decoration, survived in workshops in Cuzco that specialize in small-scale religious images. The workshop of Hilario Mendivil began a tradition for a very particular version of viceregal art, using the lightest materials (paper, glue and anilines) to create a repertory of religious themes in a unique style, characterized in particular by long, stylized necks in representations of the Virgin Mary.

The subtle transformation of Pre-Columbian ceremonial objects into magical peasant objects is exemplified by the ancient *conopas* in the form of a llama, which, during the colonial period, came to adopt the form of a bull; the bull was introduced by the Spanish, and its strength and wild appearance inspired fascination in the indigenous Andeans, who assimilated it into their symbolic world, considering it an offering worthy of their gods of the mountains. The *toros de Pucará* pieces made in Santiago de Pupuja in Puno have become emblems of Peruvian indigenous art. The progression of its forms can be detected in the length of the animal's legs, and each piece can thus be placed in its chronological position through the transformation that took place (Statsny, p. 60). The same type of ritual protection is offered by original items of pottery of later popular roots, small churches modelled from clay, with crude and ingenuous designs and with very clearly defined regional styles, which are placed on the roofs of peasant houses throughout the southern mountains of Peru in a ceremony that completes the construction of the dwelling. These objects reproduce the prototype viceregal religious architecture; in the more modern versions that cater for demand from tourists they are being made from rusted, painted copper. One type of small ceramic sculpture, inspired by traditional themes of music and dance, represents the most substantial change of style among the mountain potters: these are expressionistic representations of figures with the distorted gestures and postures of musicians and ballet-dancers; the most notable producers of these included Eladio Orco Azapa, José Mérida and Paulino Mamani.

A traditional manifestation of indigenous art with Pre-Hispanic roots that goes back to pre-ceramic times is the engraved *mate*. The name derives from the Quechuan *mati*, the name for the gourd from which it is made. Once dried and cleaned out, it is decorated using linear or pointed incisions and fine cuts made with a burin-type tool, removing the thin film that covers the fruit. The cuts are coloured with a piece of burning wood and stand out against the light background of the surface. Afterwards they are covered with a layer of transparent coloured varnish. The technique of pyro-engraving used in the 20th century was the same as that used in antiquity, but the indigenous people soon adopted decoration with floral motifs and human figures to replace the geometric designs. They also gave a utilitarian function to the decorated gourds, which had been of a ceremonial nature. The compositions of the designs are very complex, detailed and small, because they represent *costumbrista* scenes (showing typical customs) with many figures on a very small surface. This art form developed in the Mantaro Valley, although its use extended throughout the Sierra and along the coast, especially from the 18th century. In

metalwork the sumptuous domestic silverware of the wealthy classes of the Viceroyalty gave way in the 19th century to smaller pieces, to which the filigree technique, which flourished in numerous provincial workshops, was applied (see §V below). The techniques of embossing and engraving continued to be used in the lavish decoration of saddlery and harnesses; the stirrups were the most decorated part, in particular the type used by ladies, which were in the form of delicate slippers. In the rural environment of the southern Andes the most popular object is the *tupu*, a brooch or pin for fastening women's clothes, the designs on which date back to Inca tradition, although floral and zoomorphic motifs have been incorporated. Bronze is used as a substitute for silver in the manufacture of sumptuous examples that preserve the same beauty and elegance as the originals. Silver also served the indigenous population during the colonial period as a material for ceremonial objects in the form of little bowls known as *cochas*, which were used for drinking in a ritual manner. The figure of the bull, engraved in the bottom or else taking the form of a small sculpture fastened to a stem in the centre of the object, is associated with the symbolic character found in portable retables and *conopas*.

BIBLIOGRAPHY

F. Statsny: *Las artes populares en el Perú* (Edubanco and Madrid, 1981)
M. C. Bravo: *El tiempo de los Incas* (Madrid, 1985)
L. C. Velarde and M. R. Dall'Orso: 'Promoción de artesanía de los Andes', *Promoción de la artesanía y pequeña industria en el Perú*, ed. J. Portocarreno Maisch (Lima, 1987), pp. 254–88
J. A. Flores Ochoa: *El Cuzco: Resistencia y continuidad* (Cuzco, 1990)
M. del Carmen de la Fuente and others: *Artesanía peruana: Orígenes y evolución* (Lima, 1992)
H. Urbano, ed.: *Mito y simbolismo en los andes: La figura y la palabra* (Cuzco, 1993)
L. Davies and M. Fini: *Arts and Crafts of South America* (Bath, 1994)
L. Millones: *El rostro de la fe: Doce ensayos sobre religiosidad andina* (Seville, 1997)

MARÍA CONCEPCIÓN BRAVO

III. Architecture.

1. 1532–1822. 2. After 1822.

1. 1532–1822.

(i) Gothic and Renaissance to early Baroque, 1532–1650. According to tradition, Francisco Pizarro (one of the first Spaniards in Peru) himself laid the foundation for the first primitive adobe church (dedicated 1540) of the new capital, LIMA, but few such buildings have survived. Notable examples of contemporary churches in Ayacucho (formerly Huamanga) include S Cristóbal (begun 1540), La Merced (mid-1540s; façade destr. 1940) and the early nunnery church of S Clara (1568), which has a timber *Mudéjar alfarje* roof. In the Titicaca region there are early Dominican churches such as S Pedro Mártir (*c.* 1560; later accorded cathedral status), with rare extant Gothic arches, and S Juan Bautista (*c.* 1590), both in Juli, and La Asunción (begun 1590), Chucuito. Only documentary evidence exists for 16th-century churches at AREQUIPA (e.g. Villa Hermosa de la Asunción, founded 1540), but nearer to Cuzco are the parish churches at San Jerónimo (1572) and Urcos, both with arcaded narthex and balcony. Sadly, many of these churches, including 80% in the Cuzco area, are largely abandoned.

The basilican plan had already been introduced into Lima, for example in S Domingo (1540–52) by Jerónimo Delgado, first Maestro Mayor of Lima (from 1547). When the bishopric was established (1543), a single-nave cathedral was built (1551) with a timber *Mudéjar* interlace ceiling. When Lima became an archdiocese, a more ambitious church still was commissioned from Alonso Beltrán. When progress failed to be made, however, the Spanish architect FRANCISCO BECERRA was called to the capital (in 1582) by the viceroy Martín Enríquez de Almansa (*d* 1583). In 1584 Becerra was appointed Maestro Mayor for the cathedral, the viceroy's palace and the Real Felipe Fort (completed 1774; now Mus. Hist. Mil. Perú) at Callao and at the same time also designed the cathedral at Cuzco (see below). It was not until 1598, however, that work began on Becerra's hall-church, which, with its pointed nave arches and undecorated groin-vaults in stone, was the earliest fully vaulted building in Peru. It was inaugurated in 1604 when only half finished but was severely damaged by earthquakes in 1606 and 1609. Specific Spanish sources include the scheme (also used by Becerra for Cuzco), which refers to Jaén Cathedral, while the internal use of entablature blocks refers to Granada; the latter became the norm in the Viceroyalty for the next two centuries. In spite of subsequent rebuilding after earthquakes—for example, a new nave was completed in 1622 by Juan Martínez de Arrona—Lima Cathedral retains the Herreresque character of its original design (see fig. 3).

Work began on Cuzco Cathedral in 1560 under the supervision of the Basque architect JUAN MIGUEL DE VERAMENDI. Although he was immediately succeeded in 1561 by Juan Correa, and despite the fact that after a gap of 40 years Bartolomé Carrión was appointed (1603–7) to execute Becerra's proposals, the outer walls remained unfinished in 1644 when a new bishop, Juan Alonso de Orcón, came to office. Under de Orcón and his canon Diego Arias de la Cerda, the cathedral was completed in only ten years (1654; towers completed 1658, consecrated 1668), having suffered little in the major earthquake of 1650. The Maestro Mayor in the later period was Miguel Gutiérrez Sencio (first appointed 1617), perhaps succeeded after 1649 by Francisco Chávez y Arellano. The powerful, wide, low, five-part andesite façade has a true Renaissance nobility; the main portal of the retable façade is said to mark the arrival of the full Baroque in Peru. A few examples of late 16th-century domestic architecture survive in Cuzco: the two-storey Casa del Almirante and the Casa de los Cuatro Bustos (now Libertador-Marriott Hotel) have distinctive Renaissance portals. In spite of Cuzco's temperate climate, both houses have patios with spacious arcades carried on the stone Doric columns of archaicizing design, which became common throughout the city.

In Lima the single-nave La Merced (1541–2), the second church of S Francisco (1556–61), S Agustín (begun 1574; restored) and the church and gate-house (1582–6) of S Domingo all had *Mudéjar* timber ceilings, none of which survived the second wave of development of the monasteries in the second half of the 17th century. Also in Lima, the first Jesuit church of S Pedro (La Compañía; begun 1568), which also had a timber ceiling, was replaced by a basilican church with brick, Gothic rib vaults (1624–38),

3. Francisco Becerra: Lima Cathedral, interior, begun 1598; nave rebuilt, completed 1622

under the direction of Fray Martín Aizpitarte (d 1637). In Cuzco the only 16th-century monastic buildings to survive were the main cloisters of S Francisco (1550s; now the oldest colonial building in the city) and the contemporary lower cloister of S Domingo. Both have Renaissance brick arcades with *Mudéjar alfiz* mouldings in the spandrels. Although work in Ayacucho, such as the Jesuit college (founded 1605), La Compañía (begun c. 1615) and the adjacent S Loreto, continued until almost the end of the century, all retained bold Renaissance features, including pedimented portals surrounded by rusticated ashlar blocks with lozenge-shaped projections, similar to those used at CAJAMARCA nearly a century later.

Other important Renaissance monuments include the ruined monastery churches of S Francisco (1617–19) and S Agustín (1620s) in the now largely abandoned desert city of Saña, near Chiclayo in the far north-west; the rib-vaulted S Agustín is similar to Nuestra Señora in nearby Guadalupe, and all were the work of the mulatto architect Blas de Orellano. A little further south in Trujillo, almost all the brick and stucco architecture had to be rebuilt after an earthquake in 1619. Trujillo Cathedral (1647–66; damaged 1759, restored in 1781 by Cristóbal de Vargas) remains substantially as designed in 1643 by Fray DIEGO MAROTO, a Dominican architect from Lima, but reflects the Herreresque classicism of Cuzco.

(ii) Baroque, Rococo, the Mestizo manner and Neo-classicism, 1650–1822. In the mid-17th century, earthquakes in Lima (1656) and Cuzco (1650) marked the beginnings of the solemn Baroque style of central Peru. The third church of S Francisco, Cuzco (begun 1645; completed 1652), has a lateral portal of tentative Baroque character, whereas S Catalina (rebuilt) and a new Carmelite nunnery church, S Teresa (1670s), both in Cuzco, showed little sign of change. At S Domingo (1681; built on the site of the Inca Temple of the Sun), Cuzco, the solomonic columns of the later

tower (1729–31) are incongruous in the context of a still severe Renaissance façade. A similar tendency is seen in civil and domestic buildings in Cuzco, for example in the arcaded walkways of the Plaza de Armas (partially rebuilt after 1650) or the patios of houses dating from the second half of the 17th century, such as the Casa Peralta and the Casa Garcilaso de la Vega. Confirmation of the Baroque came with the rapid reconstruction (1651–68) of La Compañía, Cuzco, widely attributed to the Flemish Jesuit Fray Juan Bautista Egidiano (1596–1675) and one of the most unified monuments of Spanish colonial architecture. The bracketed and balustraded nave cornice is repeated on the twin-towered façade below belfry level and rises uninterrupted over the trilobate pediment that crowns a three-storey Baroque retable façade; the church was also innovative in having a Latin-cross ground-plan and being vaulted in brick rather than timber. A bold bracketed cornice also figures in the famed Baroque cloister of La Merced (completed 1669), Cuzco, with its heavily rusticated piers and delicately carved detached columns supported on pedestals.

Rebuilding projects in Lima after 1656 included the church and cloisters of S Francisco and the cloister of S Agustín. The former, designed by the Portuguese architect CONSTANTINO DE VASCONCELOS and completed (1674) by his assistant Manuel de Escobar (1639–93) and Fray Carlos de la Concepción, is one of the most memorable images of the Limenian (*limeño*) Baroque style. Seemingly massive rusticated *quincha* (clay or plaster wattle) towers enclose a slender Cuzquenian (*cuzqueño*) retable façade. In the upper range of the cloisters oval lunettes alternate with arches of smaller span, a pattern repeated in rebuilding the main cloister of S Agustín (1684). The transept of S Domingo, Lima, was rebuilt under a contract dated 1683; the dome is said to be by Diego Maroto. This round of building, some of which may post-date the earthquake of 1687, included the replacement of the *Mudéjar* nave ceiling

with a *quincha* Gothic rib vault. Numerous churches of the last quarter of the century were built under the patronage of the wealthy Don Manuel de Mollinedo y Angulo, Bishop of Cuzco from 1673 to 1699. They include the parish church of San Sebastián (1664–78), near Cuzco, by the Indian architect Manuel de Sahuaraura, and S Pedro (begun 1688) and El Belén (1696–8), both in Cuzco, the former by and the second attributed to JUAN TOMÁS TUYRU TUPAC INCA. Single-nave parish churches in the Cuzco province built during the Mollinedo period include those of Lampa (1678–85) with its freestanding Cuzquenian tower, Ayaviri (*c.* 1677–96), Asillo (1678–96) and S Martín (1696), Vilque.

Ayacucho is notable for the presence of a number of interesting examples of church architecture. The cathedral was completed in 1662–72 with a wide five-part, twin-towered façade, while the monastery of S Domingo (rebuilt early 17th century by Fray Bartolomé Martínez and Fray Gaspar de la Fuente, and again in 1715) retains an arcaded narthex with gallery above, comparable with that of the parish church at San Jerónimo (1572). The Carmelite church of S Teresa (1683–1703) is a high barrel-vaulted church of great distinction, with twin high-waisted towers in the Limenian manner common to other contemporary churches in the town such as S Francisco de Paula (1713) and Buena Muerte (1720–26). The towers (mid-18th century) of La Compañía, Ayacucho, have bands of stylized floral motifs of mestizo character. Exceptions to the gravitas of the central Andean Baroque are, however, rare; one example is at Cuzco, where there is planiform sculptured decoration in the interior of El Triunfo, the chapel on the south-east side of the cathedral (rebuilt 1729-32 by Fray Miguel de los Angeles Menchaca), and there are solomonic columns on the exterior of the chapel of the Sagrada Familia (1723–35) on the north-west side. In Lima the façades of La Merced (1697–1704) and S Agustín (1720) are both decorated in a Churrigueresque manner with spiral columns.

Other significant developments in Lima included wider and lower churches, such as S Rosa de las Monjas (1704–8) and Jesús María (1722). Towers were lower, segmental gables approached the semicircular, and single arched portals were simple and even severe. In the mid-century the opportunity to respond to the Rococo tastes of the Bourbon monarchy was afforded following a severe earthquake in Lima in 1746. The chapel of S Tomás (*c.* 1750; now a school) has the only circular cloister in Latin America; the church of Los Huérfanos (Corazón de Jesús), Lima (completed 1758–66 and probably by Cristóbal de Vargas), has an oval nave with Rococo detailing. The façade of S Teresa (rebuilt after 1746; vault fell 1940, destr. 1946), also in Lima, was the finest example of the Rococo in Peru. In the late 20th century the best remaining was the small Carmelite nunnery church of Las Nazarenas (El Cristo de los Milagros; 1766–71; rebuilt after a fire, 1835), Lima, by the viceroy MANUEL AMAT. The church of S Carlos (1758–66; nave vault reconstructed after 1940; now Panteón de los Próceres), Lima, is exactly contemporary with Los Huérfanos and may be by the same architect. The tower of S Domingo, Lima, also damaged in 1746, was rebuilt (1774–5; attrib. Manuel Amat) with considerable Rococo influence in the details (damaged

1940; restored 1942–4; see fig. 4). On the other hand, Lima Cathedral along with its Sagrario Chapel (1663–84) by Fray Diego Maroto, also severely damaged, was faithfully reconstructed (1755) by the Bohemian Jesuit architect Juan de Rher (1691–1756) using timber and stucco for all but the main portal, which was rebuilt with the original stones (towers and cupolas by Pedro Antonio de Molina, 1794).

As with the churches, little civil architecture in Lima escaped the devastation of 1746. Surviving architecture included a few arches of the pavement arcades on the east side of the Plaza Mayor (1699) and a number of stone portals and balconies. Among the most significant buildings of the 18th century was the Palacio Torre Tagle (completed 1735; now part of Ministerio de Asuntos Exteriores; *see* LIMA, fig. 1). The stone portal is an example of the final exaggerations of the Limenian Baroque and is flanked on both sides by enclosed timber *miradores* on carved timber brackets. The Quinta de Presa (1766–7; now Museo del Virreinato), once a villa retreat with a water garden, situated across the Rimac from the old city, is another building traditionally attributed to Viceroy Amat.

A type of planiform decorative carving using mainly European motifs developed at Cajamarca and may have influenced such metropolitan buildings as La Merced and S Agustín, Lima. Cajamarca Cathedral (1682–1762; façade unfinished; accorded cathedral status 1908) follows the basilican scheme of the Lima–Cuzco axis. The columns of the extensively carved three-storey façade (without towers) have a deeply incised pattern of chevrons in the lower part and are solomonic above. Also in Cajamarca, S Francisco (S Antonio de Padua), begun in 1699 by Matías Pérez Palomino and still under construction in 1737 by José Manuel and Francisco Tapia (incongruous additions to towers in 1941 and 1960s), was a near copy of the cathedral; El Belén (also begun 1699; mainly built 1724–44) also has fine planiform sculptured decoration. All three, including the cathedral, have plain surfaces studded with the evenly spaced rows of lozenge-shaped projections that became one of the hallmarks of the Cajamarca style.

Adobe and *quincha* churches between Lima and Arequipa include La Compañía (rebuilt after the 1687 earthquake; completed 1723) at Pisco and S José (1740–44; ruined) and S Javier (first quarter of 18th century; ruined), both in Nazca. All have retable façades enclosed by twin towers with low two-storey Limenian belfries. The decoration of S Javier is influenced by Arequipa, where, in the mid-17th century, the upland stone-carving style known as MESTIZO Baroque seems to have arisen. It consisted of surface planiform carving using both European and indigenous motifs on Baroque forms and spread across the Collao to Lake Titicaca and southward to the cities of Upper Peru (*see* BOLIVIA, §II, 1(ii)(b)); variants also arose in, for example, Cajamarca and Cuzco. In Arequipa and its immediate environs the carving is incised into white *sillar* (a local porous volanic stone), leaving a perceptible recessed background often painted to set off the lacelike, forward surfaces of the patterns, themselves sometimes painted white. Across the Collao this manner was combined in varying degrees with the undercut (wood-carving)

4. Francisco Becerra: Lima Cathedral, main façade, begun 1598; rebuilt 1755 and towers added 1794

technique more typical of Upper Peru (now Bolivia), which relies on shadow for definition.

Few colonial buildings in AREQUIPA survived an exceptionally severe earthquake in 1868, and the great Gothic-vaulted cathedral (completed 1656) by Juan de Aldana had already succumbed to fire in 1844; it was largely rebuilt in the 19th century (*see* §2 below). The most important survivor in the Mestizo manner is La Compañía (the third Jesuit church and its adjacent courtyards, 1650–98; present tower 1919; for illustration *see* AREQUIPA), parts of which were built by Simón de Barrientos (contract dated 1654). S Domingo (1677–80; nave remodelled 1784; vaults rebuilt 1873; restored after earthquake damage in 1958 and 1960) contains the earliest dated example of mature Mestizo Baroque carving (1677), which, externally, is mainly confined to the lateral portal, the raised sculpted tympanum of which set an important precedent for portals in the city. The early 18th-century façade of S Agustín is one of the finest examples of the style: the non-figural decoration of the soffit of the ribbed dome of the octagonal sacristy recalls the *Mudéjar* and Plateresque elements in the origins of the style. The colour-washed, windowless walls of the convent of S Catalina (rebuilt 1662; restored 1758 and 1874) in Arequipa, on the other hand, have a simplicity that is unique in the city; the convent boasts the only colonial tower to survive the 1868 tremors.

The Arequipa style (*arequipeño*) also found expression in a number of village churches around the city, including S Miguel (*c.* 1719–30) by Pérez del Cuadro (dome 1782 by Carlos Aranchi) at Caima, the design of which was copied for S Juan Bautista (1750; partly ruined), Yanahuara, and the contemporary Espíritu Santo, Chihuata, with its unique sculpted dome. The best known Arequipa-style domestic portals are those of the Casa Ugarteche (patio 1738) and the Casa del Moral (mid-18th century). The decorated high tympanum persisted to the end of the century, although the style of the reliefs moved towards the Rococo as, for example, in the Casa de Moneda (1794), Arequipa. The combined style of the Collao culminated in the church of Santiago, Pomata, built in pink-tinged stone in the first quarter of the 18th century. Later examples include, at Juli, S Pedro Mártir (rebuilt by the Jesuits in the early 18th century), Santa Cruz (*c.* 1750) and the portals of such 18th-century residential buildings as the Casa Zavala; in the vicinity of Pucará, the parish church of Santiago de Pupuja (1767); and at Zepita, the church of S Pedro (1765–88). At Puno (formerly San Carlos de Puno, founded as a mining town in 1669) the principal church, dated by Bayón (Bayón and Marx) to 1797 and attributed to Simón de Asto, was raised to cathedral status in 1861. The forms of the façade derive from La Compañía in Cuzco, and the general fabric of the church from Lampa and Ayaviri.

The impact of Neo-classical influence in Peru was perhaps lessened by the fundamental sobriety of much of the existing architecture. The main exponent of Neo-classicism in the first two decades of the 19th century was the Basque architect Matías Maestro (1766–1836), who emigrated to Lima in 1793. He executed viceregal commissions in Lima for the Colegio de Medicina de S Fernando (1810; destr.; known from a contemporary lithograph) and the Cementerio General, which boasted an octagonal domed chapel. Maestro is perhaps best known for his alterations to churches, in which numerous 17th- and 18th-century church furnishings were destroyed and replaced with others of Neo-classical design; he also made more far-reaching changes, such as those to S Pedro (La Compañía), Lima, in 1800–10, where the style of nave and transept was changed and the vault was enclosed in cloth, painted to simulate Neo-classical coffering. The Portada de las Maravillas (1818), Maestro's Doric triumphal arch of stucco and imitation marble in the city walls of Lima, marked for Wethey (1949) 'the passing of Hispanic colonial architecture'.

BIBLIOGRAPHY

E. Harth-Terré: *Artífices en el virreinato del Perú* (Lima, 1945)
D. Angulo Iñiguez, E. Marco Dorta and M. J. Buschiazzo: *Historia del arte hispanoamericano*, 3 vols (Barcelona, 1945–56)
M. Toussaint: *Arte mudéjar en América* (Mexico City, 1946), pp. 81–90
H. Velarde: *Arquitectura peruana* (Mexico City, 1946)
H. E. Wethey: *Colonial Architecture and Sculpture in Peru* (Cambridge, MA, 1949/*R* Connecticut, 1971)
P. Kelemen: *Baroque and Rococo in Latin America* (New York, 1951), pp. 151–96
G. Kubler and M. Soria: *Art and Architecture in Spain and Portugal and their American Dominions, 1500 to 1800* (Harmondsworth, 1959), pp. 86–98
M. J. Buschiazzo: *Historia de la arquitectura colonial en Iberoamérica* (Buenos Aires, 1961)
E. Harth-Terré: 'La obra de Francisco Becerra en las catedrales de Lima y Cuzco', *An. Inst. A. Amer. & Invest. Estét.*, xiv (Buenos Aires, 1961), pp. 18–57
H. Velarde: *Arte y arquitectura* (Lima, 1966)
J. Bernales Ballesteros: *Lima: La ciudad y sus monumentos* (Seville, 1972)
J. García Bryce: *Del barroco al neoclasicismo: Matías Maestro* (Lima, 1972)
E. Harth-Terré: *Perú: Monumentos históricos y arqueológicos* (Mexico City, 1975)
L. Castedo: *The Cuzco Circle* (New York, 1976)
S. C. Agurto: *Lima prehispánica* (Lima, 1984)
J. Bernales Ballesteros: *Historia del arte hispanoamericano*, ii (Madrid, 1987)
C. Walton: *The City of Kings: A Guide to Lima* (Lima, 1987)
L. Castedo: *Historia del arte iberoamericano*, 2 vols (Madrid, 1988)
D. Bayón and M. Marx: *A History of South American Colonial Art and Architecture* (New York, 1989), pp. 42–65, 140–65
V. Fraser: *The Architecture of Conquest: Building in the Viceroyalty of Peru, 1535–1635* (Cambridge, 1990)
R. Gutiérrez, ed.: *Barroco iberoamericano* (Barcelona and Madrid, 1997)
H. Rodríguez Camilloni: 'Forma y espacio en la arquitectura del virreinato del Perú durante los siglos XVII y XVIII', *Arquitectura colonial iberoamericana*, ed. G. Gasparini (Caracas, 1997), pp. 287–318

W. IAIN MACKAY

2. AFTER 1822. Following independence from Spain, the need to improve Peru's infrastructure meant that emphasis shifted to the building of functional and industrial structures. The influence of Neo-classicism persisted in the early years of the Republic, its simpler forms replacing the stylized decoration of the Baroque and Rococo. The period was also characterized by a conscious rejection of the Spanish models of traditional colonial architecture, while France and Italy became the principal sources for military and governmental structures alike. La Penitenciaría in Lima is an early example, based on the popular panopticon or radial plan. The first major Republican building in Peru, it was designed by Maximiliano Mimey; its lower floor was in masonry, and the second floor was built using the flexible and earthquake-resistant *quincha* (*see also* §III, 1, above). Meanwhile Arequipa Cathedral was rebuilt by Lucas Poblete between 1834 and 1847, having succumbed to successive earthquakes and finally a fire. The seven-part Neo-Renaissance façade, divided by numerous pairs of Ionic columns in two ranges, fills one whole side of the Plaza de Armas, the remaining sides of which are formed by covered arcades. Although colonial traditions in residential architecture were rejected for façades, the layout of buildings remained largely unchanged. The traditional mansion or house in Lima, with its painted wooden balconies, remained as popular as ever, as did the entrance flanked by barred windows (in some cases also bays), often incorporating wrought-iron-work. (Indeed the development of the balcony in itself provides much material for study in Lima, Chorrillos, Barranco, Arequipa, Cuzco, Callao and Trujillo.)

The political instability and economic weakness that had marked the early years of the Republic gave way mid-century to increased foreign investment and the exploitation of Peru's resources, such as nitrate and guano. Loans and the new wealth resulted in increased infrastructural development, with the construction of railways and their associated facilities, and from the early 1860s iron components were imported for use in many buildings, including railway stations. President José Balta (in office 1868–72) initiated a programme of public works, but the lack of adequate architectural training meant that the major architects were either Italian or French, and they thus continued to refer back to the prevalent styles of their own countries. The Hospital Dos de Mayo (1868–75; now Museo del Hospital Dos de Mayo) in Lima, backed by Balta, was designed by the Italian Mateo Graziani. It consists of four Neo-classical pavilions radiating from a central octagonal garden; the impact of the design, with its galleries with Doric peristyles, has been lessened by many subsequent alterations. Various designs from the period are attributed to Gustave Eiffel, including that for the Palacio de la Exposición (1869–72; now Museo de Arte), Lima, built for the Exposición Internacional of 1872 by Antonio Leonardi and Manuel Anastasio Fuentes (1820–89). While the building was conservative in layout and decoration, of particular value was the maximization of light and interior space using supporting iron columns.

A hiatus in the building trade brought about by the War of the Pacific (1879–83) was followed by a resurgence of interest in academic classical architecture (e.g. the Casa de Correos, Lima, built *c.* 1895 under Nicolás de Piérola, President 1896–1900), and this was combined in the early 20th century with an eclectic range of styles, including Art Nouveau. Parisian-style boulevards were constructed, and bungalows, mock-Tudor buildings and Italianate mansions were erected. Economic growth and social development following World War I was reflected in architecture and urban planning; cities began to spread, and hospitals, schools and major government buildings were erected. Colonial Revival architecture also began to emerge, based

initially on the work of the Peruvian architect Rafael Marquina y Bueno (1884–1964), who was responsible for the Hotel Bolívar and the complex around Plaza S Martín, and later on that of the foreign architects Ricardo Malachowski the elder and Claudio Sahut. In 1916 the Palacio Arzobispal adjoining Lima Cathedral was rebuilt in this style (see fig. 5); while some considered the style rather tasteless and anachronistic, it nevertheless persisted until well after World War II and must be recognized as a response by architects to a call for a national style and a search for architectural roots.

Another group of architects rejected outright the colonial Hispanic heritage by opting for the functionalist designs that could be achieved using new materials, such as reinforced concrete. Amid these conflicting trends the Agrupación Espacio was founded in 1947, expressing allegiance to the work of Le Corbusier, Walter Gropius, Adolf Loos, Ludwig Mies van der Rohe and Frank Lloyd Wright. Its members included Luis Miró Quesada Garland (b 1915) and Mario Bianco (b 1903). A demand for centres of training for architects was supported by such figures as Augusto Benavides, Emilio Harth-Terré (1899–1983) and José Alvarez Calderón, designer of the building for the Compañía Peruana de Teléfonos, Avenida de la Colmena, Lima. In 1947 the Palacio de Justicia was built, modelled on the Palace of Justice in Brussels. In 1952–4 Bianco designed a building for the new Escuela Nacional de Ingeniería, which included a faculty of architecture of

5. Palacio Arzobispal, Plaza de Armas, Lima, rebuilt 1916

which he was head. The building was of simple design, comprising three storeys of reinforced concrete with an exposed grid of almost Rationalist purity. The Sociedad de Arquitectos (founded 1937), the Consejo Nacional para la Restauración y Conservación de Monumentos Históricos and the journal *El arquitecto peruano* were also established during this period, and they provided a new forum for debate for the profession.

Housing developments in the mid-1940s and 1950s began to cope with the needs created by demographic change, and the Corporación Nacional de Vivienda commissioned various schemes, including the Unidad Vecinal Matute (1952), Lima, designed by Santiago Agurto Calvo (b 1921). Like other Unidades Vecinales it has a straightforward open layout consisting of three- and four-storey blocks of flats, alternating with open areas and groups of one- or two-storey houses. Another such complex, the Unidad Vecinal No. 3, was designed by Fernando Belaúnde Terry (b 1912), President of Peru (1963–8 and 1980–85) and founder of the journal *El arquitecto peruano*. An increasing tendency towards building taller residential and commercial structures was reflected early on by the curtainwalled Radio El Sol Building (1953–4) in Lima by Luis Miró Quesada Garland. Other technical innovations were the use of iron and concrete combined with cladding and such materials as aluminium and glass panels. Residential architecture in the 1970s was profoundly influenced by Frank Lloyd Wright's dynamic horizontal lines, and it made use of local materials such as stone and unfaced brick in combination with glass.

Some Brutalist buildings refer in their aesthetic to the use of adobe and *quincha* in Pre-Columbian Inca constructions, distributing light and air amid the concrete compounds in a manner that reflects Pre-Columbian planning. One such example is the Centro Cívico y Comercial (1971) in central Lima, a collaborative design project involving ten architects and comprising a shopping precinct, theatre, hotel and office tower-block. The shapes and volumetric constructions are striking and strong, but a grim sense of foreboding is evoked by the grey unfinished appearance of the concrete textured surfaces. The use of austere unclad and unfaced textured concrete was prevalent in the 1970s, particularly along the Paseo de la República, Lima's urban express route (or El Zanjón). On either side of this main artery through the city a series of new buildings was erected at key points, many by the architects of the Agrupación Espacio and many in a Neo-Brutalist vein. Foreign investment, mainly North American and Chilean, has brought about the construction of shopping malls and commercial centres. In some cases substantial concrete constructions with curtain walls were combined with colourful decoration, as in the Centro Camino Real in the San Isidro district of Lima by Miguel Rodrigo Mazuré.

One of the most notable developments in Peruvian architecture in the late 20th century arose in response to the growth of slums on the edges of the major cities. The residents of these *pueblos jóvenes* (or *barriadas*) have been encouraged, with official assistance in land acquisition and the provision of infrastructure, to adopt self-help solutions to improve their accommodation. The innate abilities of individual residents have been fostered in projects that in some respects present parallels with Pre-Columbian archi-

tecture and urban-planning traditions. Meanwhile, in private housing developments, there emerged in the 1970s a trend for using simple colour-washed stucco that refers to adobe and *quincha* building techniques and to early Modernist styles. Early examples include the low-rise Viviendas Banco Central de Reserva (1970) in the Lima suburb of Surco, designed by Jaime Persivale Serrano, Eduardo Pomareda Elías and Manuel Villarán Freyre. An influential figure in residential architecture was Juvenal Baracco (*b* 1940), whose works include the Marrou-Yori beach houses (1985) at Playa La Barca, Lurín, Lima, which combine elemental forms with vernacular timber-construction techniques.

BIBLIOGRAPHY

H. Velarde: *Arquitectura peruana* (Mexico City, 1946), pp. 161–72

H.-R. Hitchcock: *Latin American Architecture since 1945* (New York, 1955), pp. 49, 53, 132–3, 195, 197

E. Miranda Iturrino, ed.: *La arquitectura peruana a través de los siglos* (Lima, 1964)

F. Bullrich: *New Directions in Latin American Architecture* (London, 1969), pp. 13–14, 43–4

D. Bayón and P. Gasparini: *Panorámica de la arquitectura latinoamericana* (Barcelona, 1977; Eng. trans., Chichester, 1979), pp. 171–90

P. Lloyd: *The 'Young Towns' of Lima: Aspects of Urbanization in Peru* (Cambridge, 1980)

L. Castedo: *Historia del arte iberoamericano*, ii (Madrid, 1988), pp. 31–4, 208–14

P. Belaunde: 'Perú: Mito, esperanza y realidad en la búsqueda de raíces nacionales', *Arquitectura neocolonial: América Latina, Caribe, Estados Unidos*, ed. A. Amaral (São Paulo, 1994), pp. 79–94

M. A. Roca, ed.: *The Architecture of Latin America* (London, 1995)

A. Zapata: *El joven Belaunde: Historia de la Revista 'El arquitecto peruano', 1947–1964* (Lima, 1995)

W. IAIN MACKAY

IV. Painting, graphic arts and sculpture.

1. 1532–1822. 2. After 1822.

1. 1532–1822. The widespread construction of churches and religious institutions during the 16th and 17th centuries determined the nature of artistic production in Peru during that period. Most religious imagery was imported until *c.* 1580, when European painters, woodcarvers and gilders, assisted by indigenous craftsmen, took a more dominant role in fulfilling the demand for retables, pulpits, paintings, crucifixes and other religious statuary. The Jesuits, in particular, notably after the arrival in Peru in 1575 of the Italian BERNARDO BITTI, made an important contribution to the visual arts. Bitti, the most influential exponent of Mannerism, worked in LIMA, Ayacucho, Juli and Cuzco, as well as in Upper Peru (now Bolivia). Other European artists in Lima around this time included the Andalusian Pedro de Vargas (*b* 1533), who worked with Bitti on retables for La Compañía in Lima, and the two Italian painters MATEO PÉREZ DE ALESIO and ANGELINO MEDORO, who founded a successful workshop after his arrival in 1600. Medoro, Pérez de Alesio and Bitti played an active part in the development of wall painting. Pérez de Alesio executed a number of wall paintings in Lima, including scenes from the *Lives of SS Dominic and Thomas* in S Domingo (after 1589), while Bitti decorated the chapel of Nuestra Señora de Loreto (Capilla de los indios) in La Compañía in Cuzco in 1580, both of which suffered damage in the earthquakes of 1746 and 1650 respectively. The oldest extant examples are those by an anonymous artist in the church of S Jerónimo on the outskirts of Cuzco. They date from *c.* 1572 and consist of a frieze composed of Renaissance motifs, which includes grotesques, cherubs and heraldic emblems. The Jesuits also perfected the indigenous tradition of using agave to produce religious statuary.

The first printing press was established in Lima in 1584, and by 1613 engravings had replaced woodcuts as the means of illustration. Engravings, especially those of Flemish origin from the Amberes school, were a recurrent source of reference, becoming more so in the 17th century, notably in Cuzco. One of the most fascinating examples of the influence of engravings as well as the innovation of the artist, however, was the illustrated chronicle written in the form of a letter to the Spanish monarch entitled *Primer nueva crónica y buen gobierno* (*c.* 1580–1613) by the native Peruvian Felipe Guaman Poma de Ayala. Guaman Poma used European pictorial conventions dating back to the medieval period within an Andean perspective to recount the abuses committed by the Spanish and to request immediate reform.

In the 17th century, artistic expression in Lima continued to follow European developments. Works from the Seville school, including those by the sculptor Juan Martínez Montañés (e.g. the crucifix within the retable of 1607–12 dedicated to *St John the Baptist* in Lima Cathedral) and the painters Murillo and Zurbarán (e.g. the series of *Apostles, c.* 1639, for S Francisco, Lima, and some paintings attributed to Zurbarán in the convent of S Catalina Arequipa), were imported through the Casa de Contratación in Seville and were indicative of the break with Mannerism and the growing preference for greater naturalism. In the Lima school this transition towards the Baroque was visible in the sculpture of Diego Martínez de Oviedo and in the work of the Andalusians Alonso de Mena and Juan Martínez de Arrona. The choir-stalls in Lima Cathedral designed by the Catalan PEDRO DE NOGUERA in 1623, incorporating Renaissance ornament with animated figurative carving, constituted one of the finest examples of the early Baroque style and established the precedent for other series in Lima (e.g. in La Merced and S Agustín), as well as in Trujillo Cathedral and S Francisco in Cuzco. Important changes also occurred during the first part of the century in retable design, which became essentially architectonic and served as the architectural frame for religious statues. In painting, such artists as the Flemish Jesuit Diego de la Puente (1586–1663), inspired by the tenebrism of Rubens and Zurbarán, used colour to give a more emphatic sense of volume. Like Bitti, he worked in many Jesuit colleges, including that in Cuzco, where he painted the scene of the *Transfiguration* for the main altar.

Throughout the Andes wall painting became an established tradition within church decoration during the 17th century, but the best examples were concentrated in the region around Cuzco (*see* CUZCO SCHOOL). Between 1603 and 1607 Diego Cusi Guzmán decorated the church at Chinchero with images of the *Twelve Apostles* and scenes from both the birth and coronation of the Virgin, and later he worked in the church at Urcos. The programme of murals (1618–26) at Andahuaylillas by Angelino Medoro's assistant Luis de Riaño (*b* 1596), one of the most important artists of the Cuzco school, conveyed a clear

didacticism in two scenes flanking the entrance, which represented the path to glory and the path to hell. Commissioned by the humanist Juan Pérez de Bocanegra, the programme also included the sacrament of baptism written in five languages around the baptistery door. Wall paintings later in the century resembled tapestries, in that the subject was often overwhelmed by an emphasis on decorative detail. In 1996 the church of Rapaz, with important, well-preserved and colourful wall paintings dating from 1739, 1761 and 1773, was declared a UNESCO World Heritage Site.

Significant changes in artistic production took place in the 17th century as indigenous painters and craftsmen began to gain their independence from European masters c. 1616, and artists ceased to travel extensively within the viceroyalty after 1630. Consequently, regional schools, the most important of which centred on Cuzco, became increasingly defined. Sculpture tended to emphasize emotion, and such themes as martyrdom and the Passion became preferred subjects. In comparison with artists working in the European classical tradition, indigenous artists did not idealize human anatomy. In painting, Bitti's influence was evident in work by two artists who worked for the Franciscans in Cuzco: Gregorio Gamarra (fl 1601–42), whose image of St Francis's Vision of the Cross in the convent of La Recoleta was based on an engraving by Raphael Sadeler; and the Cuzquenian Lázaro Pardo de Lagos, the last of the Mannerist painters, best known for his depiction of the Franciscan Martyrs in Japan (c. 1630), also in La Recoleta.

The devastation caused by the earthquake in 1650 stimulated a period of great artistic activity in Cuzco. Within 10 to 20 years many churches and cloisters had been built or rebuilt and were ready to be decorated. From 1660 painting from the Cuzco school was recognizable by the use of gold-brocade surface decoration on drapery and the inclusion of birds and flowers within the backgrounds. This sense of exotic ornamentation was paralleled in Mestizo Baroque architecture in the southern Andean region (see §III, 1(ii) above). A crucial figure within the efflorescence of the Cuzco school was Bishop Manuel de Mollinedo y Angulo (d 1699), who arrived in Cuzco in 1673. Mollinedo brought a number of paintings from Spain and promoted the dissemination of the Baroque style within the Cuzco region, insisting that every church should contain a series of paintings depicting the history of its titular saint. Several artists of the Cuzco school received commissions from Mollinedo, notably DIEGO QUISPE TITO, Basilio de Santa Cruz Pumacallao, who decorated the transept of Cuzco Cathedral with images of local saints (1690–99), and JUAN TOMÁS TUYRU TUPAC INCA, sculptor of the venerated Virgin of the Almudena (1686) in the Almudena Church, Cuzco, and to whom the exquisitely carved pulpit in S Blas, Cuzco, is also attributed. Quispe Tito, the foremost painter of this period, produced a series of 12 canvases entitled Signs of the Zodiac for Cuzco Cathedral in 1681, portraying parables of the life of Christ structured within the pagan context of the zodiac. Derived from Netherlandish prints, the paintings owed much to the Flemish landscape tradition.

During the late 17th century the Cuzco school developed a marked aesthetic independence, although works

still generally remained anonymous. This evolution included paintings of the Holy Trinity represented by three identical figures of Christ, hieratic images of the Virgin and series of archangels dressed in outlandish military attire and often holding guns. Members of the Inca nobility were featured in paintings of religious processions (e.g. in Cuzco, Mus. Virreinato), as well as in individual portraits; gold-brocade surface decoration remained a constant feature, as did garlands of flowers. By the 18th century Cuzco had become a commercial centre with large workshops run by such artists as MARCOS ZAPATA and Mauricio García Delgado, supplying merchants with large quantities of paintings.

In 18th-century Lima the Baroque conception of the representation of death was epitomized in the Allegory of Death (Convento de S Agustín), a sinuous skeletal figure carved by the mestizo sculptor Baltazar Gavilán (see fig.

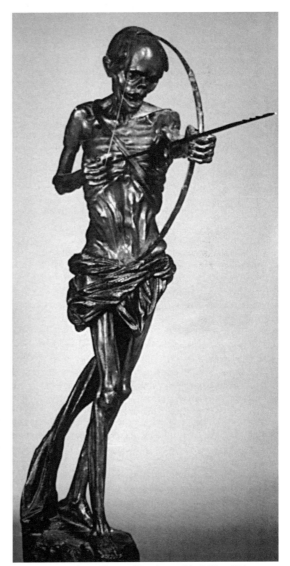

6. Baltazar Gavilán: Allegory of Death, wood, h. 1.95 m, 18th century (Lima, Convent of S Agustín)

6). During the 18th century a prolific increase in secular art also occurred. Several series of portraits of the Inca dynasty were produced from 1717 until the 19th century, and these sometimes also included Spanish monarchs and viceroys. From *c.* 1750 the importance given to Classical education led to artists receiving commissions for mythological subjects. Scientific expeditions, such as those of Condamine in 1735 and Alejandro Malaspina later in the century, also contributed to the development of Peruvian art, documenting local customs and introducing academicism. In 1791 the Spanish painter José del Pozo, the official artist on the Malaspina expedition, was named Director of the Academia de Pintura y Dibujo, Lima, founded by Viceroy Abascal. In contrast to the academicism promoted by Pozo, Tadeo Escalante's ambitious programme of wall paintings (1802) in the church of S Juan, Huara, depicting figures and scenes from both the Old and New Testaments, was evidence of the continued strength and individualism of the Cuzco school.

BIBLIOGRAPHY

H. E. Wethey: *Colonial Architecture and Sculpture in Peru* (Cambridge, MA, 1949/*R* Connecticut, 1971)

J. Howland Rowe: 'Colonial Portraits of Inca Nobles', *The Civilizations of Ancient America. Selected Papers of the XXIXth Congress of Americanists: New York, 1967*, pp. 258–79

P. Kelemen: *Art of the Americas: Ancient and Hispanic* (New York, 1969)

T. Gisbert: *Iconografía y mitos indígenas en el arte* (La Paz, 1980)

F. Stastny: *El manierismo en la pintura colonial* (Lima, 1981)

I. de Mesa and T. Gisbert: *Historia de la pintura cuzqueña*, 2 vols (Lima, 1982)

J. Bernales Ballesteros: *Historia del arte hispanoamericano*, ii (Madrid, 1987)

J. A. Legaz: *Pintura en el Virreinato del Perú* (Lima, 1989)

S. Sebastián: *El barroco iberoamericano: Mensaje iconográfico* (Madrid, 1990)

J. A. de Lavalle: *La escultura del Perú*, Col, A, & Tesoros Perú (Lima, 1991)

R. Mujica Pinilla: *Angeles apócrifos en la América virreinial* (Lima, 1992)

G. Palmer and D. Pierce: *Cambios: The Spirit of Transformation in Spanish Colonial Art* (Albuquerque, 1992)

T. Cummins: 'La representación en el siglo XVI: La imagen colonial del Inca', *Mito y simbolismo en los andes: La figura y la palabra*, ed. H. Urbano (Cuzco, 1993), pp. 87–136

P. Macera: *La pintura mural andina, siglos XVI–XIX* (Lima, 1993)

R. Gutiérrez, ed.: *Pintura, escultura y artes útiles en Iberoamérica, 1500–1825* (Madrid, 1995)

P. Macera: *Murales de Rapaz* (Lima, 1995)

L. E. Wuffarden: *La procesión del Corpus Domini en el Cuzco* (Seville, 1996)

R. Gutiérrez, ed.: *Barroco Iberoamericano* (Barcelona and Madrid, 1997)

PAULINE ANTROBUS, with W. IAIN MACKAY

2. AFTER 1822.

(i) 1822–*c.* 1922. (ii) *c.* 1922–*c.* 1950. (iii) After *c.* 1950.

(i) 1822–c. *1922.* After Independence the State succeeded the Church as the principal patron of artistic production in Peru, instigating a transition from religious to secular imagery (*see also* §IX below). Integral to this development within the visual arts was the demand for portraits of the heroes of the Independence movement. The foremost artist of this genre was JOSÉ GIL DE CASTRO, an active participant in the fight for Independence, who later became the First Painter to the Peruvian Government (e.g. portrait of the *Martyr Olaya*, 1823; Lima, Mus. N. Hist.). In comparison to this celebratory and essentially nationalistic genre, painters—often amateurs or traveller–scientists, mostly from Europe—began to depict Peru's diverse topography and its people. From the mid–1830s the

French artist and diplomat LÉONCE ANGRAND produced numerous watercolours of Lima and southern Peru during his travels (two albums, Paris, Bib. N.). In 1842 the German draughtsman and painter JOHANN MORITZ RUGENDAS visited Peru during his many years in Mexico and South America and produced numerous works that brought him considerable commercial success in Europe. An exception to the predominance of European activity was the self-taught mulatto artist from Lima PANCHO FIERRO, whose watercolours and drawings record (often satirically) aspects of daily life in Lima usually in the *costumbrista* tradition (e.g. *The Lamplighter*, Lima, Mus. Banco Central de Reserva).

From the mid-19th century European influence increased significantly as Peru's leading artists adopted the academicists' preference for portraiture and history painting. The State promoted the development of Neo-classicism by awarding Peruvian artists grants to travel to Europe, in particular to Italy and France. This sometimes resulted in a synthesis that combined European theory with New World-related subject-matter, as seen in history paintings by IGNACIO MERINO (e.g. *Columbus before the University of Salamanca*; Lima, Mun. Lima Met.) and LUIS MONTERO (e.g. *Funeral of Atahualpa*, 1867; Lima, Mus. A.). Academicist influence in Peru was ensured by Merino's appointment as Director of the Academia de Pintura y Dibujo in Lima, a post that Montero also held. FRANCISCO LASO was alone in his rejection of this archaizing trend. He was recognizably the first Peruvian artist to seek and find inspiration in the contemporary Andean world, albeit one that he coloured with the Romanticism of the period, for example in *Dweller in the Cordillera* (1855; Lima, Mun. Lima Met.; see fig. 7). Photography was becoming popular at this time; Francisco Laso was one of the first Peruvia artists to understand and put it to good use in his paintings. In sculpture the number of commissions given to Italian artists, such as Vincenzo Gajassi and more importantly Adamo Tadolini (1788–1868), an assistant to Canova, ensured the prevalence of classicist influence in terms of interpretation as well as in the choice of historical and allegorical subjects (e.g. Tadolini's monument to *Simón Bolívar*, 1859; Lima, Plaza del Congreso). In 1868 work began on the *Monument to the 2nd of May* (Lima, Plaza Dos de Mayo) by French architect E. Guillaume and sculptor L. Cugnot, commemorating the Peruvian victory in the battle against Spain two years earlier; the evocation of patriotic feeling in the work was of paramount importance.

Many of the artists given grants to travel to Europe never returned. Consequently between 1890 and 1910 there was an almost complete absence of professional painters in Peru. The first two decades of the 20th century represented a transitional period, as painting moved from academicism to a realism that focused on portraying the Andean world and Peru's racially mixed population. TEÓFILO CASTILLO contributed significantly to the development of artistic activity, establishing a tradition of art criticism as well as founding his own academy (1905) and proposing the idea of a national school of fine arts in Lima. He painted heavily romanticized landscapes (e.g. *View of Huascarán*, 1881; Lima, Mus. Banco Central de Reserva) and impressionistic evocations of Lima during

7. Francisco Laso: *Dweller in the Cordillera*, oil on canvas, 1.35×0.86 m, 1855 (Lima, Municipalidad de Lima Metropolitana)

the Viceregency (e.g. *Funeral of St Rosa of Lima*, 1918; Lima, Mus. A.). Classicist influence, however, continued into the 1920s, as can be seen in Juan Lepiani's visualizations of the earlier War of the Pacific (1879–83), and more importantly in female nudes and portraits by DANIEL HERNÁNDEZ (e.g. *Reclining Woman*, 1910; Lima, Mus. A.).

After living in Europe for 40 years, Hernández returned to Lima at the request of President José Pardo and became the first Director of the Escuela Nacional de Bellas Artes founded in 1919. The school's foundation coincided with the first year in office of President Leguía, who recognized the social mission that art could fulfil and considered the school as a cradle of nationalist expression. Also in 1919 was the first exhibition of the work of JOSÉ SABOGAL at the Casa Brandes in Lima, an event that would be immensely influential on the future direction of artistic production in Peru. The exhibition contained paintings of Cuzco, thus offering many natives of Lima their first glimpse of life outside the hispanicized capital; Andean life in the former Inca capital was depicted in such works as *First Mass* (1919; Lima, Mus. A.).

(ii) c. 1922–c. 1950. In 1920 Sabogal was appointed as a teacher at the Escuela Nacional de Bellas Artes, succeeding

Hernández as Director in 1932. He urged students to disregard earlier European models, encouraging them to look at and discover their own country. Under his tutelage the *indigenista* school evolved from the mid-1920s, composed of students Camilo Blas (1903–85), Julia Codesido (1892–1971), Carmen Saco (1882–1948), Teresa Carvallo (*b* 1903), Cota Carvallo (1915–80) and ENRIQUE CAMINO BRENT, among others. Sabogal also wrote a number of pamphlets on Andean art and its traditions. For the next 20 years, until Sabogal's forced resignation in 1943, the Indigenist movement dominated Peruvian painting not least because all the above-named artists were to teach at the Escuela Nacional de Bellas Artes; Carmen Saco was notable for being Peru's first successful woman sculptor. Sabogal was also to have great influence on the evolution of graphic art through his recognition of wood-engraving as a versatile and expressive means of representation. During the 1920s many of Peru's leading artists did not strictly belong to the Indigenist group, however, for example JORGE VINATEA REINOSO, a former pupil of Hernández and later a teacher at the Escuela Nacional de Bellas Artes. While Vinatea Reinoso's subject-matter was local, his work revealed the influence of Hernández (e.g. *Horsedealer at Amancaes*; Lima, Mus. A.). ELENA IZCUE, who became a specialist in textile design derived from Pre-Columbian motifs, and Alejandro González Trujillo (Apurímac) were artists with strong compositional skills who remained on the margins of the Indigenist group but who contributed to the growth of graphic arts in Peru.

A number of notable artists worked outside Lima. MARIO URTEAGA ALVARADO, an untrained painter from Cajamarca, was recognizably the most successful artist of this period in capturing an authentic sense of the social reality of the Andean world. Unlike the Indigenists, he recorded such incidents as street fights, crime and drunken Indians returning from fiestas (e.g. in *The Rustler*, 1939; Lima, Mus. Banco Central de Reserva). Francisco González Gamarra (1890–1971) from Cuzco expressed a strong sense of identity with the city's Inca past, evidenced by his reference to the Inca in several of his works (e.g. the *Foundation of Lima*, 1944; Lima, Bib. N.). Another accomplished painter from Cuzco, Felipe Cossío del Pomar (1888–1981), was inspired by both the Pre-Columbian cultures of southern Peru and the Andean present (e.g. *Indian With a Pre-Hispanic Sculpture*; Lima, Mus. A.).

A revival in commissions for secular sculpture from the 1920s was facilitated by the Escuela de Artes y Oficios, which was founded in the 19th century, closed during the War of the Pacific and reinaugurated in 1905, but its potential was restricted by a lack of government support. Sculpture retained its classicist dimension, fulfilling the ideology of the State, until the 1950s, and during the 1920s and 1930s artists were dependent on state commissions for monuments to commemorate Republican heroes, for example the statue of *Admiral Henry Du Petit Thouars* (1924; Lima, Avenida Petit Thouars) by Artemio Ocaña. Works were also donated by foreign governments with trading interests in Peru (e.g. monument to *Manco Cápac* by David Lozano, gift of Japanese government, 1926; Lima, Plaza Manco Cápac). The break with realist sculpture occurred in 1937 with the monument to the aviator *Jorge Chávez Dartnell* (h. 18.2 m; Lima, Plaza Jorge Chávez) by

the Italian Eugenio Baroni (1880–1935). The body of the monument was constructed in marble in the form of a steep pyramid, with bronze reliefs depicting the ascent and fall of Icarus on each side. An Indigenist movement in sculpture corresponding to that in painting failed to materialize. The only two sculptures in Lima that wholly evoked the spirit of Indigenism were *Work* (or *Indian with a Pair of Yoked Oxen*, 1937) by Ismael Pozo (1898–1959) and *The Llamas* (1935; both Lima, Paseo de la República) by Agustín Rivera. Benjamín Mendizábal and Romano Espinoza Cáceda (1898–1957), on the other hand, showed a preference for classical depictions of Inca culture, with works that at times transformed Indians into Greek gods.

Indigenism imposed restrictions on artists both in terms of subject-matter and through its rejection of contemporary movements in modern European art. The first public protest at this was in 1937, when the group Los Independientes held their first exhibition in Lima. Headed by RICARDO GRAU, who had just arrived from Paris and who brought with him the ideas of the Fauves, the group included as principal members SABINO SPRINGUETT, CARLOS QUISPEZ ASÍN, JUAN MANUEL UGARTE ELÉSPURU, Federico Reinoso (*b* 1912) and MACEDONIO DE LA TORRE. The group shunned the sentimentalism of Sabogal and advocated a freedom of expression that did not, however, exclude Peruvian themes (e.g. Springuett's *Coastal Scene*, 1955; Lima, Mus. A.). Two crucial developments in art education at this time ensured that future students would be better informed of contemporary movements in European art: the foundation by the Austrian Expressionist Adolf Winternitz (1906–93) of the Escuela de Artes Plásticas (now the Facultad de Arte) at the Pontificia Universidad Católica del Perú in Lima in 1939; and the appointment of Grau as the Director of the Escuela Nacional de Bellas Artes in 1943. These events were instrumental in the demise of Indigenist art as a coherent and dominant movement. By the 1940s artists were torn between modernist trends and the portrayal of Peruvian themes expressive of their cultural heritage. *The Andes* (1942; L. D'Onofrio col.) by SÉRVULO GUTIÉRREZ ALARCÓN represented a synthesis of the two opposed currents, the monolithic female personifying the magnitude of the mountain range or the spinal cord of Andean civilization.

(iii) After c. 1950. The emphasis placed in the 1940s on formal values of art by both Grau and Winternitz resulted in the rejection of realism at the end of the decade by FERNANDO DE SZYSZLO and Jorge Eduardo Eielson (*b* 1923). Szyszlo's exhibition in 1951 at the Colegio de Arquitectos, Lima, signified a turning-point in Peruvian painting. A student of Winternitz, Szyszlo developed a style of abstraction that was distinctly Peruvian, employing Pre-Columbian myths and references to the Inca and pre-Inca past as the basis of his compositions, which were given titles in Quechua. Another pioneer of abstraction was Alberto Dávila (1912–88), who rejected literary and folkloric content and explored the spatial relationship between the tonality of colour and geometric forms (e.g. *Still-life*, 1959; Lima, Banco de Crédito del Perú). Emilio Rodríguez Larraín (*b* 1927) was also at the nucleus of the evolution of Peruvian Abstract Expressionism. After an

exhibition of abstract art in 1958, Grau and Springuett joined the growing number of progressive artists, but it was SÉRVULO GUTIÉRREZ ALARCÓN who became the major figure in the evolution of contemporary art. The formation of the Instituto de Arte Contemporáneo (IAC) in Lima in the mid-1950s helped to create a market that in turn stimulated artistic activity. Szyszlo took an active part in this process and set up the group Espacio to promote contemporary art through the IAC. These initiatives managed to increase the number of exhibitions held in Lima after 1955, especially those of Peruvian art.

Figurative painting continued in the social realism of ALFREDO RUIZ ROSAS; in the sombre images of poverty and of such popular themes as cockfights by VÍCTOR HUMAREDA; and in the state-commissioned murals of TEODORO NÚÑEZ URETA (e.g. *Construction of Peru*, 1954; Lima, Min. Econ. & Finanzas). Springuett and Carlos Quispez Asín also executed murals, the formalism of which was derived from European Cubism. In the 1960s a new generation of artists experimented with geometric abstraction, which stemmed from a shared interest in international Constructivism. The formation of the Grupo Arte Nuevo attempted to unite these different currents of abstraction; members included Luis Arías Vera (*b* 1932), Teresa Burga (*b* 1939) and José Tang (*b* 1941). Other key artists at this time included Jorge Piqueras (*b* 1925), Miguel Angel Cuadros (*b* 1928), Gastón Gerraud (*b* 1935) and JOSÉ MILNER CAJAHUARINGA; Inca and pre-Inca motifs were commonly used, notably in paintings by Cajahuaringa, which evoked Inca architecture through their geometric forms.

The work of Joaquín Roca Rey (*b* 1923) during the mid-1950s represented the beginning of modernism in sculpture. As a teacher he had considerable influence on later generations of sculptors through his emphasis on and interest in the international scene. He had a keen understanding of volumetric form, and his works have been described as existing somewhere between those of Hans Arp and Henry Moore (e.g. *Angel of Judgement*, with Szyszlo, 1957; see fig. 8). During the 1960s different personal styles developed. While *Stele in Homage to Vallejo* (1961; Lima, Plazuela de S Agustín) by the Spanish Basque Jorge Oteiza signified the first abstract work, Cristina Gálvez (*b* 1919) worked with different media, including wood and leather, to make religious images that evoked the work of Alberto Giacometti. ALBERTO GUZMÁN and Fabián Sánchez produced works in metal, the former experimenting with articulated geometric forms, while the latter invented hybrid creatures using parts of old machines. Víctor Delfín (*b* 1927) attempted to reconcile modernist trends and Pre-Columbian traditions in his work.

The 1970s were marked by the emergence of nationalism and an indigenist renaissance in the visual arts by artists who had trained with Sabogal's group at the Escuela Nacional de Bellas Artes in the early 1940s and some independent sculptors from Spain. The emphasis on Andean figures and regional landscapes was renewed, and the main protagonists of this revival were Pedro Azabeche Bustamante (*b* 1918), Gamaniel Palomino, Jorge Segura (*b* 1918), Andrés Zevallos and Aguiles Rallí (*b* 1920) (e.g. *Street in Rímac*, 1968; Lima, Mus. A.). The award of the

8. Fernando de Szyszlo and Joaquín Roca Rey: *Angel of Judgement* (detail, h. *c.* 3.75 m), marble and bronze, h. *c.* 5.40 m, 1957 (Lima, Cementerio El Angel)

Premio Nacional de Arte in 1976 to retable-maker Joaquín López Antay heightened the debate between the universalists and the localists and, in particular, revealed the strength of feeling about the issue of cultural identity.

In contrast to this realist trend, artists during the 1970s began to experiment with Surrealism and hyperrealism, as in the case of CARLOS REVILLA and GERARDO CHÁVEZ, whose tortured part-human, part-animal figures resemble those of the Chilean artist Roberto Matta. Herman Braun (*b* 1933) explored hyperrealism, while TILSA TSCHUSIYA, whose works of the 1960s had indicated Cubist influence (e.g. *Cemetery*, 1960; Lima, Mus. A.), created her own distinctive pictorial language, inventing mythological subjects that sometimes embodied symbolic references to the Andean landscape and its Inca past. The diversity of styles initiated from the 1950s continued into the late 20th century. A number of major monuments and sculptures were commissioned in the 1960s and 1970s by the revolutionary government to commemorate such individuals as Túpac Amaru and to celebrate the 150th anniversary of Peru's independence (1971). Gomez Uroya, a Spanish sculptor, was commissioned to work on several major projects. The series of collages based on James Joyce's *Ulysses* by Emilio Rodríguez Larraín, the explosive, vividly coloured images of Miguel Angel Cuadros (*b* 1928) and the five *Eunuchs of War* by José Tola (*b* 1943), the canvases of which took on the shape of the strange zoomorphic forms in the paintings, have all emphasized the richness of technique and aesthetic independence of the late 1980s.

Meanwhile an exhibition in 1988 entitled *Andean Presence in Peruvian Painting*, organized by the Consejo Nacional de Ciencia y Tecnología and featuring the work of ten artists from different regions of Peru, testified to the continuing influence of the Indigenists as well as to the Peruvian artists' constant search for their roots. Although of Spanish forebears, Luis Palao Berastein is one of the most accomplished of those who continue to work in an Indigenist vein, often alluding to the work of Francisco Laso. In the 1990s Eduardo Tokeshi, after years of developing his own distinctive style, turned for inspiration to the Andean tradition of painting on boards as exemplified by the 'Tablas de Sarhua' in S Juan de Sarhua, Ayacucho, resulting in such works as *Paisajes de Pie* (exh. Lima, Luis Miró Quesada Garland Gal., 1994; Paris, Maison de l'UNESCO, 1995).

BIBLIOGRAPHY

Art in Latin America since Independence (exh. cat. by S. Loomis Catlin and T. Greider, New Haven, CT, Yale U. A.G.; Austin, U. TX, A. Mus.; 1966)
J. M. Ugarte Eléspuru: *Pintura y escultura en el Perú contemporáneo* (Lima, 1970)
J. Sabogal: *Del arte en el Perú y ottres ensayos* (Lima, 1975)
J. A. de Lavalle and W. Lang: *Pintura contemporánea*, 2 vols, Colección arte y tesoros del Perú (Lima, 1975–6)
M. Lauer: 'Artes visuales en el Perú, 1920–1980', *Arte moderno en América Latina*, ed. D. Bayón (Madrid, 1985), pp. 245–57
D. Bayón: *Historia del arte hispanoamericano*, ii (Madrid, 1988)
Andean Presence in Peruvian Painting, Consejo Nacional de Ciencia y Tecnología (Lima, 1988)
Art in Latin America: The Modern Era, 1820–1980 (exh. cat. by D. Ades and others, London, Hayward Gal., 1989)
J. Torres Bohl: 'Pintura contemporánea', *Kantú Rev. A.*, 8 (July 1990), p. 14
J. Bernales Ballesteros, ed.: *La escultura del Perú*, Colección arte y tesoros del Perú (Lima, 1991)
G. Tello Garust: *Pinturas y pintores del Perú* (Lima, 1992)
P. Macera: *La pintura mural andina, siglos XVI–XIX* (Lima, 1993)
N. Majluf: *The Creation of the Indian in Nineteenth Century Peru: The Paintings of Francisco Laso (1923–1864)* (diss., Austin, U. TX, 1995)
——: 'Peru', *Latin American Art in the Twentieth Century*, ed. E. Sullivan (London, 1996), pp. 191–9
P. Antrobus: *Peruvian Art of the Patria Nueva, 1919–1930* (diss., Colchester, U. Essex, 1997)

PAULINE ANTROBUS, with W. IAIN MACKAY

V. Metalwork.

The Spaniards were astonished at the technical skill of the Indian metalworkers, particularly in casting and probably also in respect to their plating and alloying abilities. The resulting style of works, usually produced by Indian artisans under the supervision of a Spanish silversmith, is referred to as the Mestizo style, often a curious mixture of European and native motifs. Spanish silversmiths were allowed to travel to Peru as early as 1533, and ordinances regulating their trade in Lima were passed in 1612, 1716 and 1735. The great mineral wealth of the Andes passed, for the most part, through Lima on its way to Europe, making the city a highly important centre of gold- and silversmithing. In 1681 the new viceroy, the Duque de la Palata, entered Lima walking on a path of silver bars. The Herrera style, with its emphasis on line and plain surfaces, with silver or silver-gilt heightened by enamel bosses, was imported from Spain at the beginning of the 17th century and was produced concurrently with the Mestizo style (*see* CHURRIGUERESQUE). Large numbers of monstrances in

the Herrera style were produced in Lima workshops throughout the 17th century and were to be found in locations ranging from Colombia to southern Chile and even as far afield as Spain, sent as the gifts of grateful colonists. The tradition of encrusting monstrances with precious stones was not carried to the same extremes as it was in Colombia (*see* COLOMBIA, §V), but one example in the Iglesia del Prado, Lima, when appraised in 1756, was set with 300 emeralds and 700 diamonds. Typical examples are the monstrance in the characteristic Herrera style in the Convento de S Clara, Cuzco, dating from the second half of the 17th century, and the more exuberant example in Ayacucho Cathedral, of *c.* 1740.

Printed Renaissance and Mannerist designs are known to have circulated in Peru, and the Baroque use of dynamic relief and restless movement lent itself well to the additional Indian-inspired naturalism. Oriental influences from imported metalwork and ceramics brought across the Pacific by the Manila galleons were also significant, resulting in distinctly Peruvian designs of continuous trailing foliage and scrolls, often incorporating a tulip-like native flower known as the *cantuta* (see fig. 9). The Baroque style continued in Peruvian silver until the early 19th century, and although the rocaille was introduced at the end of the 18th century, the asymmetry of the Rococo had no place in Peruvian silver, where the forms remained the same and the decoration is continuous yet compartmentalized. Altar fronts and tabernacles were particularly suited to Baroque relief decoration and were often adorned with candle sconces, vases and mirrors. Typically Peruvian is the method of construction of these objects; they are formed of a series of plaques riveted together on a wooden frame. These altar fronts tended to be more extravagant when produced inland; the celebrated example dating from the early 18th century in S Teresa, Cuzco, should be

compared with the more restrained decoration of the altar front of approximately the same date in the cathedral in Ayacucho. Also typically Peruvian are the elaborately decorated tear-shaped plaques intended to be placed behind altar candles for added illumination (e.g. Buenos Aires, Mus. A. Blanco). Other church furnishings made in silver were lanterns, crowns and various fittings for devotional statues, altar cruets and flower vases. The latter were often adorned with delicate filigree work, produced by Ayacucho craftsmen influenced by immigrant Asian craftsmen.

The wealth of silverware in colonial houses was remarked upon by contemporary writers. Dishes, platters, spoons and forks were all made in solid silver, but the lack of any widespread system of official marks makes stylistic identification of such utilitarian objects difficult. Large silver cloak pins (*tupus*), an Indian form, were still worn by Andean women in the 1990s. Silver for the horse and rider was embellished by elaborate cast and chased decoration, but these objects never assumed the same importance as they did in provinces further south. Typically Peruvian are the incense burners in the forms of perforated bowls fixed to a circular dish, traditionally carried by women accompanying the Corpus Christi procession. By the beginning of the 19th century many took the form of llamas, deer and other animals. Filigree examples in the form of turkeys are also known (Lima, priv. col.). Zoomorphic forms were also used for *paves*, or kettles, used to heat water for the herbal infusion, *mate*. Peruvian *mate* cups are often made from polished gourds with applied silver or gold mounts and accompanied by a silver *bombilla*, a perforated drinking straw. Silver mounts also adorn a number of wooden shell-shaped boxes (*coqueras*), often decorated with Baroque and Rococo scrolls, which were evidently used for drying coca leaves. A few examples are known in solid silver, including a severe Neo-classical example dating from the early 19th century with applied gold floral swags (Buenos Aires, Mus. A. Blanco). The Neo-classical style came late to Peruvian silver and can be seen in the large numbers of plain candlesticks with beaded and gadrooned borders and vase-shaped stems. Nationalism was expressed from *c.* 1820 by the addition of coats of arms and libertarian symbols to traditional forms.

BIBLIOGRAPHY
R. d'Harcourt: *L'Argenterie péruvienne à l'époque coloniale* (Paris, 1930)
A. Taullard: *Platería sudamericana* (Buenos Aires, 1941)
F. Muthmann: *L'Argenterie hispano-américaine à l'époque coloniale* (Geneva, 1950)
J. A. de Lavalle and W. Lang: *Platería virreynal* (Lima, 1974)
A. L. Ribera and H. H. Schenone: *Platería sudamericana de los siglos XVII–XX* (Munich, 1981)
C. Esteras Martín: *Platería del Perú virreinal, 1535–1825* (La Paz and Madrid, 1992)
J. A. del B. Duthurburu: *Peruvian Silverwork: The Enrico Poli Collection* (Lima, 1996)
Converging Cultures: Art and Identity in Spanish America (exh. cat., New York, Brooklyn Mus., 1996)
P. Carcedo and others: *The Silver and Silversmiths of Peru* (Lima, 1997)
C. Esteras Martín: *Platería de Perú Virreinal, 1535–1825* (Madrid and Lima, 1997)
R. Gutiérrez, ed.: *Barroco iberoamericano* (Barcelona and Madrid, 1997)
CHRISTOPHER HARTOP

9. Festival hat, repoussé silver plaques on velvet, glass beads and wire, h. 127 mm, diam. 337 mm, 18th century (New York, The Brooklyn Museum)

VI. Textiles.

Peru has arguably the finest textile tradition in South America. In the 16th century the Spanish took advantage

of the highly advanced textile skills that already existed to introduce the treadle loom and set up workshops (*obrajes*) in order to meet their need for cloth. The first workshops were established in the 1540s, and within 25 years they had become so productive that exports from Spain were severely affected. Cotton and the wool of the local cameloids were traditionally used, but to these the Spanish added sheep's wool, linen, metal thread and silk, the last obtained from China via Manila. Cuzco was the chief centre of production until the 18th century, but workshops were in operation elsewhere, including at Huancané, near Lake Titicaca, where the Dominican priests had the charge of a thousand weavers.

The tapestry technique was used to produce clothing for high-ranking Indians, as well as hangings for use in religious ceremonies and colonial homes. The former included shirts, ponchos (see colour pl. XXVIII) and women's mantles (*lliellas*). Such items as these show Pre-Columbian designs of strips of spaced pyramids, rhombuses and zigzags with Christian elements and motifs drawn from the natural environment. A characteristic example (Boston, MA, Mus. F.A.; see fig. 10) has an 'open' composition without central motifs and limiting borders. Other similar mantles are in the collections of the Cooper-Hewitt Museum, New York; the Museum of the American Indian, Heye Foundation, New York; the Textile Museum, Washington, DC; and the Stadtmuseum, Munich.

Tapestry hangings were generally bordered and centralized in the European manner, but like the garments they show a combination of foreign and native influences. One example with four skeletons may commemorate the death in 1621 of Pope Paul V and Philip III of Spain (Washington, DC, Textile Mus.); others carry heraldic devices (see colour pl. XXIX). Motifs were taken from a wide variety of sources, including Flemish tapestries, Spanish and Middle Eastern carpets and European silks, and one particular group of the late 17th century and the early 18th is based on Chinese woven silks and *kossu* mandarin squares (e.g. Boston, MA, Mus. F.A.). At the same time, the native tradition persisted in the colours, the bird and animal forms and the lively drawing. The technique also continued the Pre-Columbian practice: the tapestries are reversible and the shapes interlocked together, not separated by slits in the European manner. Some of the tapestries may have been used as floor rugs, but pile rugs were also made from the 17th century.

Other Pre-Columbian techniques persist in Peru. Warp ikat, for example, which was used in the 18th and 19th centuries to make the indigo cotton shawls of Cajamarca, is still employed in Cuzco, but using wool instead of cotton, to make ponchos and other garments. Painted cloth of great dimensions continued into the viceregal period (e.g. cloth with the *Crucifixion* and scenes from the *Passion*, from the Jesuit missions in north-east Peru, late 18th century or 19th; Washington, DC, Textile Mus.) and is still made by the Shipibo Indians.

Embroidery was never as important as weaving, although Western techniques and designs were introduced by the Spanish to work vestments for the Catholic Church. Wool embroidery was sometimes used on Indian dress, as on the gala costumes of the Mantaro Valley. As fine weaving has declined the use of embroidery has spread, and machine embroidery is sometimes used on garments that were formerly woven, for example shawls. Knitting on two or more needles was introduced by the Spanish and taken up for the production of such garments as the caps with ear flaps worn by men on the high plateau near Lake Titicaca. It is used to make tourist goods, including caps, socks, mittens and even ponchos in the soft colours of the revived vegetable dyes.

BIBLIOGRAPHY

N. H. Zimmern: 'The Tapestries of Colonial Peru', *Brooklyn Mus. J.* (1943–4), pp. 27–52

S. Cammann: 'Chinese Influence in Colonial Peruvian Tapestries', *Textile Mus. J.*, i/3 (1964), pp. 21–34

A. S. Cavallo: *Tapestries of Europe and of Colonial Peru in the Museum of Fine Arts, Boston*, 2 vols (Boston, 1967)

P. Kelemen: 'Lenten Curtains from Colonial Peru', *Textile Mus. J.*, iii/1 (1970), pp. 4–14

A. Bonnet-Correa, ed.: *Historia de las artes aplicadas e industriales en España* (Madrid, 1987)

T. Gisbert, S. Arze and M. Cajías: *Arte textil y mundo andino* (La Paz, 1987)

R. Apesteguía: 'Textilería de transición (1532–1650)', *Arte textil del Perú* (Lima, 1988)

J. Feltham: *Peruvian Textiles* (Aylesbury, 1989)

R. Stone-Miller: *To Weave for the Sun: Ancient Andean Textiles in the Museum of Fine Arts, Boston* (Boston, 1992/R London, 1994)

J. J. Durkin: *Peruvian Colonial Textiles: Their Construction, Iconography and Social Significance* (diss., Colchester, U. Essex, 1997)

Traditional Textiles of the Andes: Life and Cloth in the Highlands: The Jeffrey Appleby Collection of Andean Textiles (exh. cat., ed. L. A. Meisch; San Francisco, CA, de Young Mem. Mus., 1997)

RUTH CORCUERA

VII. Ceramics.

Evidence and documentation for colonial ceramics in Peru is scarce. It is known, however, that some diagnostic Chimú and Inca shapes continued to be used during post-Conquest times. Glazes and in particular lead glazes, often of a type of greenish-yellow streaked with brown, and dark-green glazes similar to those used in Islamic Spain (and other parts of Europe) were introduced by the Spanish. The introduction of the potter's wheel was important in some areas, as it enabled the mass production of some wares. Under the Spanish a series of new ceramic

10. Woman's mantle with siren figures, wool and some metal-wrapped threads in interlocked tapestry with eccentric wefts, weft floats and overstitching, 955×1275 mm, 16th–17th centuries (Boston, MA, Museum of Fine Arts)

shapes was introduced; they were largely utilitarian, such as vessels made for transporting or storing wine, as well as globular amphorae with restricted necks known as *pipas* or *chombos*, for olives, olive oil and water; these were sometimes glazed.

In terms of finer wares during the early years of the colony, only small quantities of European maiolica, mainly from Spain but also from Italy, were imported into Peru. As trade and sea routes across the Pacific via the Philippines were explored, Chinese wares eventually became available. While Pre-Columbian Peru had had a strong tradition of ceramics manufacture, the Spanish failed to stimulate this resource, with the exception of such vessels as the *peruleras* made in Ica and Canas and the *búcaros* of Chile, which were exported to Spain in the 1680s. Consequently, the potting traditions died out in many regions, and a large proportion of the maiolicas and ceramics used in Peru were imported from Mexico or from East Asia.

Little is known about colonial potters with the exception of Pedro Sánchez and Mateo Atiquipa of Vitor (*fl* 1569); it is highly probable that the different religious orders promoted pottery. In the highlands and on the north coast, potters continued manufacturing functional wares much as they were to do into the late 20th century. Tin-glazed ceramics were also made in Peru at an early stage and continued to be manufactured from the 17th century, during which time there were *pintadores de azulejos* in Lima, of which Juan del Corral (*fl* 1640s) became one of the most famous. Tiles made in Lima are thought to be based on Sevillian versions, with an abundant use of birds and flowers. The field of traditional wares continued to expand, a practice maintained, sometimes somewhat artificially, into the 20th century by the tourist trade. Around Cuzco old potting traditions were revived in the 19th century, including traditional wares decorated with Inca motifs. South of Cuzco there are a number of small towns specializing in specific functional forms and *toritos de Pucará* (little bulls). In Quinua there was a strong potting tradition, where bulls, miniature churches, groups of musicians and *chunchos* (jungle people) made to be placed on rooftops as a symbol of protection and for decoration were manufactured; these are exported worldwide and are extremely popular. In the northern highlands, particularly in Cajamarca, new styles are being developed, in which ceramics are overlaid with highly coloured prints and glazes, with floral designs and scenes from the Andean world.

Ceramic traditions in jungle regions were and remain largely unaffected by Inca and Spanish influences. Omagua, Cocama, Shipibo and Conibo ceramics were attractive, polychromed and rather fragile, often decorated with black geometric and linear patterns on a white ground and coated with resins, and were manufactured by women. In the area around Moyobamba, Tarapoto and Lamas and in the Amazonas region, the basic water-carrier form persists but incorporates non-indigenous floral patterns executed with a vari-coloured slip.

On the coast, and in particular the north coast, ceramics are normally functional in nature, largely lacking decoration, with the notable exception of the developments in the 20th century in the Morropé, Simbilá and Chulucanas regions, where largely non-functional, high-quality bur-

nished ceramics incorporating traditional figures and animals of the region are produced. *Huacos* in the style of Pre-Columbian ceramics (mainly Nazca, Moche and Chimú) were produced by many craftsmen and for a variety of purposes, as in the case of the artist Sérvulo Gutiérrez Alarcón and the contemporary wares of commercial manufacturers. Los Reyes Pottery, from Lima, often incorporates Pre-Columbian designs or paintings based on colonial scenes or pictures by the German traveller and artist JOHANN MORITZ RUGENDAS.

BIBLIOGRAPHY

G. Litto: *South American Folk Pottery* (New York, 1976)
R. Ravines and others: *Tecnología andina* (Lima, 1978), pp. 399–466
K. Deagan: *Artifacts of the Spanish Colonies of Florida and the Caribbean, 1500–1800*, i (Washington, DC, 1987)
R. Ravines and Fernando Villiger: *La cerámica tradicional del Perú* (Lima, 1989)
M. del Carmen de la Fuente and others: *Artesanía peruana: Orígenes y evolución* (Lima, 1992)

W. IAIN MACKAY

VIII. Furniture.

Following the Spanish conquest of Peru by Pizarro in 1532, many household furnishings were imported from the homeland, but the settlers soon became self-sufficient and developed a highly distinctive style, in which European traditions mingled with aboriginal decorative elements. Craftsmen excelled in exuberant carving and turned ornaments, and many spectacular Baroque choir-stalls (monastery of S Francisco, Lima), armoires (Palace of the Almirante, Cuzco), settle benches (S Domingo, Cuzco), organ cases, pulpits and confessionals (Ayacucho) were commissioned. Two very typical items that proliferated in the 17th century were multi-drawered cabinets raised on trestle stands with drop-leaf fronts (*vargueño*), and those without fall-fronts (*papelera*); the interiors were generally lavishly carved or richly inlaid with ivory, tortoise-shell and ebony. The use of elaborate wrought-iron lock plates, hasps, hinges, drawer-pulls and other robust hardware is a striking feature of many of these pieces. A sturdy rectangular-framed Italianate type of chair was popular, with back-post finials, simple armrests, chip-carved decoration and elaborately tooled leather back and seat panels fixed by large, ornamental nails (e.g. at Leeds, Temple Newsam House). This was the most characteristic pattern of chair. Leather trunks were also highly prized. Embossed and sometimes painted leather was a Spanish speciality. The craftsmen of Cuzco in southern Peru, centre of the old Inca civilization, excelled in festive carving, displaying the vitality of folk art. The double-headed Habsburg eagle is often featured, and boarded chests frequently have revealed dovetails, the end grain surface enriched with rosettes, while others have special 'stepped profile' dovetails (e.g. at Leeds, Temple Newsam House; see fig. 11). Another interesting technical feature is the use of open-wedged tenon joints to unite chair frames.

The high point of Peruvian domestic colonial furniture was probably reached in the 18th century. During the 19th century patrons and tradesmen turned more to Europe for inspiration, and many ostentatiously splendid suites of furniture in Empire and historical revival styles were made. The most important Peruvian timbers employed by

11. Peruvian carved Chest, (shown open and closed), incense cedar, 440×810×460 mm, early 18th century (Leeds, Temple Newsam House)

furniture-makers were cedar, aguana, walnut, centrolobian, cocobola and parana pine. The most extensive holding of Peruvian furniture in an English public collection is at Temple Newsam House, Leeds (for an example of a 19th-century armchair, see colour pl. XXX, fig. 1); the Hispanic Society of America in New York owned several pieces, and there are, of course, examples in Spanish and Peruvian museums, including the Museo de Arte, Lima.

BIBLIOGRAPHY

G. H. Burr: *Hispanic Furniture* (New York, 1941), pp. 99–113, 206–8
J. de Contreras: *Historia del arte hispánico*, iv (Barcelona, 1945), pp. 291–323, 553–92
M. Toussaint: *Arte mudéjar en América* (Mexico City, 1946), pp. 81–90
H. Wethey: *Colonial Architecture and Sculpture in Peru* (Cambridge, MA, 1949/*R* Connecticut, 1971)
P. Kelemen: *Baroque and Rococo in Latin America*, 2 vols (New York, 1951)
——: *Art of the Americas: Ancient and Hispanic* (New York, 1969)
E. Harth-Terré: *Perú: Monumentos históricos y arqueológicos* (Mexico City, 1975)
T. Gisbert: *Iconografía y mitos indígenas en el arte* (La Paz, 1980)
J. A. de Lavalle and W. Lang, eds: *Arte popular: La talla popular en piedra de Huamanga; Arte y tesoros del Perú* (Lima, 1980)
Converging Cultures: Art and Identity in Spanish America (exh. cat., New York, Brooklyn Mus., 1996)

W. IAIN MACKAY

IX. Patronage and collecting.

During the colonial period patronage was inextricably linked to the Church, which either commissioned works or was the recipient of them. Upholding European tradition, the portrait of the donor was sometimes included in paintings. This was particularly evident in Cuzco, where the Inca nobility and chiefs had maintained a strong sense of identity and high social standing. In the series of canvases depicting the Corpus Christi procession (before 1700; Cuzco, Mus. A. Relig.) and the series of 15 pictures in the church of El Triunfo (1732–3) in Cuzco, a number of *caciques* are depicted, dressed in extravagant costume and wearing the Inca insignia of royalty. As did the viceroys and other civic dignitaries, these descendants of the Incas also commissioned portraits, which emphasized their status by giving prominence to their coat of arms (*see* CUZCO SCHOOL).

After Independence the state succeeded the Church in its role as patron, resulting in the secularization of art, which initially commemorated the heroes of Independence (*see* §IV, 2 above). The increased national consciousness aroused interest in Peru's Pre-Columbian history, and individuals and museums, notably from the USA and Europe, began collecting artefacts; indeed, looting of archaeological sites eventually became so widespread that legislation was introduced and is continually updated to deal with the problem. Throughout the 19th century Peru's leading artists received government grants to travel to Europe, and it was only with the founding in Lima of the Escuela Nacional de Bellas Artes in 1919 that a Peruvian school evolved (*see also* §XI below). State patronage was also evident from the 1920s at the Escuela de Artes y Oficios, which received commissions for civic monuments that reinforced government ideology. During the 1920s and 1930s foreign governments also sponsored works by Peruvian sculptors: these included the monument to *Manco Cápac* (1926; Lima, Plaza Manco Cápac) from the Japanese government.

State patronage did not extend beyond commissions for civic projects. This gap was to be filled by businesses and various organizations, including those representing foreign governments. In 1941 the International Petroleum Company organized the exhibition *Motivos de Talara*, to which Mario Urteaga and Enrique Camino Brent, among others, contributed. Given the absence of galleries, such cultural institutions as the Sociedad Filarmónica and Sociedad Bach, together with local businesses (for example the Aéro Club and Empresas Eléctricas), supported the arts by providing valuable exhibition space. In the 1940s the anti-Fascist organization Asociación Nacional de Escritores y Artistas (ANEA) and the Instituto Cultural Peruano Norteamericano (ICPNA; founded 1938) also contributed to establishing a regular programme of exhibitions. With the opening in 1941 of Lima's first commercial gallery, Francisco Moncloa's Galería de Lima, exhibitions were accorded new status. The gallery also inaugurated the first national art prize, the Premio Manuel Moncloa y Ordóñez. In 1952 Luis Felipe Tello opened the Galería y Biblioteca San Marcos, Lima, and he can be considered one of the first genuine patrons, sponsoring many artists, including Víctor Humareda.

This increased commercialization, which also gave birth to the first semi-professional collectors, was further promoted by the formation of the Instituto de Arte Contemporáneo (IAC) in the mid-1950s, which established the

necessary commercial framework for later eclectic collectors of the 1960s. It replaced the Galería de Lima, and it was financed by large businesses and private investment. The Institute's first president was the collector Manuel Mujica Gallo. State sponsorship around the mid-1950s was manifest in the murals commissioned for a number of government buildings, notably the Ministerio de Economía y Finanzas and the former Ministerio de Educación, where Sabino Springuett, Teodoro Núñez Ureta and Camino Brent all produced works (*see also* §IV, 2(iii) above).

The role of local businesses, the banking community and foreign government councils grew from the 1960s. Especially important was the foundation of the Patronato de las Artes, composed of wealthy financiers, who created the Museo de Arte in Lima in 1961. In 1963 the Banco Wiese established the annual Premio Augusto N. Wiese; in the following year the Instituto Cultural Peruano Norteamericano initiated an annual prize for the Salón Nacional de Grabado, and in 1966 Adela Investment awarded prize-winning students at the Escuela Nacional de Bellas Artes with grants to travel abroad. The pattern of patronage begun in the 1960s continued into the late 20th century. Foreign organizations (e.g. British Council, Instituto Cultural Peruano Norteamericano, Centro Cultural Peruano Japonés, Alliance Française, Goethe Institut) established galleries, and with such large industries as Petro Perú they devised exhibitions and in some cases awarded prizes. This was also true of Peru's leading banks in the 1980s and 1990s, the Banco Continental, the Banco de Crédito del Perú, the Banco Central de Reserva del Perú and the Banco Wiese, which have their own collections and galleries and which finance publications on Peru's artistic heritage. The Banco de Crédito also established an ongoing conservation programme. During the 1980s state patronage decreased, and the little government support that existed was channelled through the Instituto Nacional de Cultura and the Consejo Nacional de Ciencias y Tecnología. The private sector still continued to make significant contributions. In 1992 the Museo de Arte opened a new gallery for contemporary art, and the Banco Wiese (Fundación Augusto N. Wiese) inaugurated the purpose-built Sala de Cultura del Banco Wiese in Miraflores, Lima, with a permanent exhibition of the material from El Brujo, a Pre-Columbian (Moche) site near Trujillo. From 1996 Telefónica del Perú began sponsoring major exhibitions.

BIBLIOGRAPHY

J. M. Ugarte Eléspuru: *Pintura y escultura en el Perú contemporáneo* (Lima, 1970)

E. Gálvez: 'Nuestro impulso para el arte en Lima', *Copé*, ix/21 (1978), pp. 22–7

T. Gisbert: 'Los curacas del Collao y la conformación de la cultura mestiza andina', *500 años de mestizaje en los Andes*, ed. H. Tomoeda and L. Millones (Lima, 1992), pp. 75–120

Premio Augusto N. Wiese: Egresados de la Escuela Nacional de Bellas Artes, 1963–1993 (exh. cat., Lima, Gal. Wiese, 1993)

Pinacoteca del Banco Central de Reserva del Perú, Banco Central de Reserva del Perú (Lima, 1997)

Primer concurso de artes plásticas 'Patronato de Telefónica', Telefónica del Perú (Lima, 1997)

PAULINE ANTROBUS, with W. IAIN MACKAY

X. Museums.

A government decree of 2 April 1822 established plans to found a national museum that would house artefacts from Pre-Columbian cultures, and the Museo Nacional in Lima was inaugurated in 1826. Originally located in the former foreign office and directed by Eduardo Rivero Uztáriz (1798–1857), by 1840 the museum had been transferred to two rooms in the Biblioteca Nacional del Perú in Lima. Similar developments occurred in Cuzco, where in 1848 Prefect José Miguel Medina opened a library and museum in the old hospital of S Andrés. Important developments in Peruvian archaeology motivated the government to sponsor a series of explorations by the Italian naturalist Antonio Raimondi, and in 1866 the government purchased his collection of Pre-Columbian and post-colonization artefacts to establish the Museo Raimondi, later absorbed by the Universidad de S Marcos, Lima. In December 1871 the Sociedad de Bellas Artes was created to administer the Palacio de la Exposición, which became the new home for the Museo Nacional's collection. The government's inability to construct a coherent plan for a national museum was compounded by the Chilean occupation of Lima (1881–4) during the War of the Pacific. The Palacio de la Exposición was ransacked and its holdings taken to the Museo Nacional in Santiago. Although the Chilean occupation led several private collectors to sell to overseas museums, particularly in Berlin, Munich and North America, in 1882 José Lucas Caparó founded a museum in the old house of the Marqués de Valle Umbroso in Cuzco. The collection included a number of 18th-century paintings of the Inca dynasty. Around the same time a fellow Cuzquenian, Vidal Olivera y Vidal, opened another museum in his home in Calle Hatunrumiyoc (closed *c.* 1920). The next stage in the development of a national museum took place with the foundation, again in the Palacio de la Exposición, of the Museo de Historia Nacional (1905–35). Under the directorship of the German archaeologist Max Uhle (1856–1944) and José Augusto de Izcue, the museum functioned under the auspices of the Instituto Histórico del Perú. It housed the Galería Municipal de Pinturas, which contained works by such figures as Ignacio Merino and Luis Montero.

The desire to create a sense of a national culture intensified as plans were made to celebrate the first centenary of Independence in the 1920s. In 1919 three museums were founded: the Museo de Arqueología at the Universidad de S Marcos, Lima, which received the holdings of the Museo Raimondi; the museum at the Universidad de Cuzco, which purchased Caparó's collection; and the Museo Víctor Larco Herrera in Lima. Various foreign governments participated in the centennial celebrations by presenting monuments or works of sculpture to the Peruvian people (*see* §IV, 2 above). The contribution of the Italian government included the Galería (now Museo) de Arte Italiano (inaugurated 1922), designed by Gaetano Moretti, complete with 180 works (sculptures, paintings and engravings). In 1924 a second purpose-built museum to house the Víctor Larco Herrera collection was completed (now the Museo de la Cultura Peruana); in contrast to the classicism of the Galería de Arte, the new Museo de Arqueología Peruana was influenced by Indigenist ideology, and Tiahuanaco influence is evident within its architectural style and decoration. The museum was directed by the eminent archaeologist Julio C. Tello (1890–1947), who built up the collection, which in turn would

later form the basis of the Museo Nacional de la Cultura Peruana. During the presidency of Sánchez Cerro (1930–33) the museum system was restructured, and the Museo de Arqueología was renamed the Museo Nacional (1930–45). Under the careful directorship of Luis E. Valcárcel (1891–1987), departments of history and anthropology were created, as well as three institutes, one of which was dedicated to Peruvian art. In 1945 further restructuring resulted in four categories of museums, including the Museo Nacional de Artes, under which were listed museums of religious art (cloister of S Francisco), the Museo de Bellas Artes (Colegio de S Pablo) and the Museo de Arte Italiano, all in Lima.

Regional museums began to develop in the 1940s. In Cuzco the university museum merged with the Instituto de Arqueología in 1941 to form one of the most important collections of archaeological material in southern Peru. Also in Cuzco, the Museo de Arqueología at the Universidad Nacional de S Antonio Abad opened in 1948, while the Museo Regional at Ica, which houses a good collection of textiles from both the Paracas and Inca periods, was founded in 1947. Outside Lima most regional museums developed in relation to the vicinity of archaeological sites. Three exceptions are those dedicated to the colonial period and associated with the Instituto Nacional de Cultura, namely the Museo de Arte Colonial at the convent of S Francisco, Cajamarca, and the Museo de Arte Religioso and the Museo Histórico Regional, both Cuzco, which initially received funding from UNESCO. Regional universities, such as the Universidad Nacional de S Agustín in Arequipa and the Universidad Nacional de la Libertad in Trujillo, also have museums.

The Museo de Arte (founded 1961) provides an overall view of artistic production in Peru, exhibiting artefacts from Pre-Columbian cultures to modern times, including a large collection of works from the colonial and republican periods. A similar policy has also operated at the Museo del Banco Central de Reserva del Perú, Lima, which exhibits a comprehensive collection of Pre-Columbian ceramics and gold objects, as well as 19th- and 20th-century paintings. Private collectors in Lima have also made their acquisitions accessible to the public in purpose-built museums, the most important figures being Miguel Mujica Gallo (b 1910; Museo de Oro, founded 1960, now Museo de Oro del Perú y Armas del Mundo), Rafael Larco Hoyle (Museo Rafael Larco Hoyle; Pre-Columbian ceramics) and Yoshitaro Amano (1910–83; Museo Arqueológico Amano; Pre-Columbian textiles). The Pontificia Universidad Católica del Perú has also established a museum, the Museo de Arte Popular, which comprises Rosa Alarco's collection of popular art and archaeological material from excavations made by J. Ramos de Cox and Mercedes Cárdenas.

In 1974 the government insisted that all Peru's collections should be registered, but by the mid-1980s a number of museums still had not done so. From 1977 the Museo de Arte Popular del Instituto Americano de Arte in Cuzco, with financial assistance from UNESCO and the Instituto Nacional de la Cultura, Lima, devised a course of 'Introduction into Museology', which included conservation techniques, but scant government support continued to stunt the development of museums. In the 1980s the plan

proposed by the former president and architect Fernando Belaúnde Terry (President, 1963–8 and 1980–85) for a purpose-built museum constructed on the site of the Pre-Columbian shrine at Maranga was rejected. The resulting compromise was the use of the redundant Ministry of Fisheries at San Borja (Lima) to house the new Museo de la Nación, which in the 1990s developed an active cultural programme. In 1992 the Sala de Cultura del Banco Wiese was established to house a display from the Moche site of Huaca del Buyo and exhibits silverwork and finds from various excavations. In August 1994 Electrolima founded a museum of electricity. Sponsorship in the 1990s came from such institutions as National Geographic Magazine, and revenue was generated by exhibitions of Peruvian material abroad.

BIBLIOGRAPHY
J. C. Tello and T. Mejía Xesspe: *Historia de los museos nacionales del Perú, 1822–1946* (Lima, 1967)
J. Matos Mar, J. Deustua C. Rénique and J. Rénique, eds: *Luis E. Valcárcel: Memorias* (Lima, 1981)
A. Castrillón Vizcarra: *Museo peruano: Utopía y realidad* (Lima, 1986)
V. Jackson, ed.: *Art Museums of the World*, 2 vols (Westport, CT, 1987), pp. 827–34
R. Ravines: *Los museos del Perú: Breve historia y guía* (Lima, 1989)
F. Kauffman Doig and others: *Museo de Arte de Lima: 100 obras maestras* (Lima, 1992)
Museo Municipal de arte contemporáneo: Catálogo (Cuzco, Mus. Mun. A. Contemp., cat. by M. Soto Sayhua,1995)
K. Berrin, ed.: *The Spirit of Ancient Peru: Treasures from the Museo Arqueológico Rafael Larco Herrera* (London, 1997)
Pinacoteca del Banco Central de Reserva del Perú, Banco Central de Reserva del Perú (Lima, 1997)

PAULINE ANTROBUS, with W. IAIN MACKAY

XI. Art education.

During the 16th century, art education in Peru was determined by European cultural values and traditions. In Lima, indigenous craftsmen were trained in the workshops of European masters, and these workshops were regulated by guilds, the first for masons and carpenters being established in 1549. Outside Lima the responsibility for education often fell to members of religious orders. This dependence decreased dramatically in the 17th century with the development of regional schools in Cajamarca, Trujillo, Ayacucho, Arequipa and in particular Cuzco, where in 1684 Indian artists left the formerly racially mixed guild (see also CUZCO SCHOOL). By 1829 the Spanish guild in Cuzco had ceased to exist. In 1791 the Spanish painter José del Pozo founded the Escuela de Dibujo. In the early 19th century the Academia de Dibujo y Pintura was established by the state. Its first director was the Ecuadorean painter Javier Cortés, who was succeeded by Ignacio Merino (1850) and Luis Montero. However, after Independence (1824) the majority of artists went to Europe to study. Attempts to check this exodus, such as President Manuel Pardo's foundation of the Sociedad de Bellas Artes in 1872, the foundation of the private Academia Concha (c.1893–4), Lima, by Adelina Astete de Concha and Teófilo Castillo's opening of an academy of painting at La Quinta Heeren, Lima, in 1905, did not succeed.

In 1919 the foundation (supported by Castillo) of the Escuela Nacional de Bellas Artes (ENBA) in Lima initiated the search for a national style of art under the direction of DANIEL HERNÁNDEZ. Although the Escuela Nacional

was based on European practice and theory, under José Sabogal's tutelage an Indigenist school developed that rejected European movements in favour of a re-evaluation of Peru's indigenous heritage (*see also* §IV, 2(ii) above). In Cuzco, Angel Vega Henríquez (1870–1923) had created the Academia de Bellas Artes (organized by the Centro Nacional de Arte y Historia) by 1923 and founded the Academia de Pintura y Dibujo in 1927, which was followed by the foundation of the Centro Qosqo de Arte Nativo in 1931. Art education in Peru continued to be introspective until the late 1930s, and it was only with the creation of the Escuela de Artes Plásticas in 1939, a private institution founded by the Austrian Adolf Winternitz (1906–93) at the Pontificia Universidad Católica del Perú, Lima, together with the appointment of RICARDO GRAU as Director of the Escuela Nacional de Bellas Artes in 1943, that interest in contemporary European and American art was generated. Regional schools such as the Escuela Regional de Bellas Artes 'Diego Quispe Tito' in Cuzco, founded in 1942, and that in Trujillo founded by Pedro Azabache Bustamante in 1962 have ensured that higher art education is available nationwide.

By the 1990s the importance of Peru's artistic heritage continued to be promoted through the Proyecto Regional del Patrimonio Cultural/UNESCO, the Taller de Investigaciones Estéticas en el Diseño Andino Contemporáneo (TIEDAC), as well as by such institutions as the Instituto Nacional de Cultura, Lima, the Museo de Arte, Lima, foreign councils such as the British Council and Goethe Institut, petroleum and mining companies, and the banking community. The impulse given to the graphic arts by the Indigenists also remained a feature of design courses within art schools and in modern specialist schools, notably the Instituto Toulouse-Lautrec (Instituto Superior de Comunicación y Diseño), Miraflores, Lima, which offers courses in interior design and photography. Owing to constant economic problems the advancement of art education in Peru continued to rely largely on private enterprise, for example the International Petroleum Company. The Museo de Arte, Lima, devised a wide range of courses for children and adults, while in 1992 the Escuela de Bellas Artes Corriente Alternativa opened in Miraflores, Lima, and in 1993 Allpamérica (centre for the study of ceramics) established Lima's first ceramics studio and gallery. Architecture is or has been taught at several institutions in Peru; the Universidad Nacional de Ingenieros was possibly the first to do so and has a Faculty of Architecture.

BIBLIOGRAPHY

L. Miró Quesada Garland: 'La enseñanza de la arquitectura en el Perú', *La arquitectura peruana a través de los siglos*, ed. E. Miranda Iturrino (Lima, 1964), pp. 86–8

P. Gjurinovic Canevaro: 'Nuestro patrimonio cultural y su enseñanza escolar', *Ens. Hist.*, 11–12 (1983), pp. 7–9

PAULINE ANTROBUS, with W. IAIN MACKAY

XII. Art libraries and photographic collections.

The Biblioteca Nacional was founded in Lima by General San Martín and inaugurated shortly after Independence was first proclaimed in 1821. Although it possesses a comprehensive collection of art books, this is integral to the main catalogue and does not constitute a separate resource. The library's photographic collection consists of 10,000 plates (5000 not classified) dating from the 19th and 20th centuries and includes a large number of portraits and views by the French photographer EUGENIO COURRET. The archives of the daily newspaper *El Comercio* also date back to the 19th century. The foundation in 1919 of the Escuela Nacional de Bellas Artes in Lima resulted in the first specialist art library, which has in excess of 4500 volumes. Regional art schools, such as the Instituto Superior de Arte 'Carlos Baca Flor' in Arequipa and the Escuela Regional de Bellas Artes 'Diego Quispe Tito' in Cuzco, as well as the Pontificia Universidad Católica in Lima, also have resource centres.

A number of institutions in Lima contain important photographic collections of socio-historical interest. These include the Instituto Raúl Porras Barrenchea, which houses Fernando Garreaud Ferrier's album *Peru 1900*, comprising 600 plates, and the Museo Nacional de Historia, which has works by Courret, Garreaud and others. Another major resource for the works of these photographers, together with those of Adolfo Dubreuil, is the archive curated by Jorge Rengifo and Antonio Rengifo, originally curated by their father Carlos Rengifo, who worked for the Courret studio. Several collections in Lima are associated with archaeological excavations, for example the Julio Tello archive at the Universidad Nacional Mayor de S Marcos, donated by Tello's family, which includes plate-glass negatives depicting sites at Paracas, Chavín de Huantar and Sechín. The Instituto Nacional de Cultura in Lima has also benefited from donated collections, namely those of works by Rómulo Sessarego as well as Abraham Guillén's entire output of 17,000 negatives. In Arequipa the archive of the Vargas brothers documents a chapter in the history of 20th-century southern Andean photography between 1910 and 1930.

The restoration and organization during the 1970s of the more than 14,000 plate-glass negatives that make up the MARTÍN CHAMBI archive in Cuzco, and the subsequent recognition of this photographer, stimulated interest in Peruvian photography. From the late 1980s the Fototeca Andina at the Centro de Estudios Regionales Andinos Bartolomé de las Casas in Cuzco began collating material from other Cuzquenian photographers. The Talleres de Fotografía Social (TAFOS) also began to provide a valuable documentary source on aspects of daily life in different Peruvian communities, ranging from the Andean villages to the shanty towns (or *pueblos jóvenes*) on the outskirts of Lima. The Instituto Audio Visual Inka was also in Cuzco and operated from the home of the photographic historian Adelma Benavente; she later moved to Arequipa. Its collection includes a number of plates by the photographer Juan Manuel Figueroa Aznar, who worked in the city between 1909 and 1940, as well as by Miguel Chani among others. Prolonged economic crisis in the late 20th century, however, had disastrous effects on the development of cultural institutions, and it was some time before the Museo de Arte in Lima was able to establish the capital's second art library; the museum also houses Courret's photographic record of the Exposición Nacional held in Lima in 1872.

BIBLIOGRAPHY

K. McElroy: 'The Daguerrean Era in Peru, 1839–1859', *Hist. Phot.*, iii/2 (1979), pp. 111–23

F. Castro Ramírez: *Martín Chambi: De Coaza al MOMA* (Lima, 1989)

L. Martínez Valenzuela: *Machu Cusco: Las primeras fotografías* (Lima, 1990)

F. Castro Ramírez: 'Los Hnos Vargas de Arequipa', *Kantú Rev. A.*, 9 (Aug. 1991), pp. 41–5

¡Viva el Perú, Carajo! (exh. cat., London, Photographers' Gal., 1991)

El mundo de Figueroa Aznar (exh. cat., Cuzco, 1993)

R. Samarez Argumedo: *El Cusco monumental: Fotografías de Martín Chambi, 1920–1950* (exh. cat., Lima, Banco Continental, 1995)

Peruvian Photography: Images from the Southern Andes, 1900–1945 (exh. cat., ed. P. Antrobus, Colchester, U. Essex, U. Gal., 1996)

PAULINE ANTROBUS, with W. IAIN MACKAY

Petrés, Fray Domingo de [Buix, José Domingo] (*b* Petrés, Valencia, 9 June 1759; *d* 1811). Spanish architect and Capuchin monk, active in Colombia. He trained with his father, the stonemason Domingo Buix. Joining the Capuchin Order in 1780, he was sent to Murcia, where he studied at an art school directed by Francisco Salzillo y Alcarez. In 1792 he was posted to Santa Fe de Bogotá, Colombia, where he took over and concluded the work on the hospice of S José and quickly achieved a well-deserved renown in the viceroyalty of New Granada. He provided designs for S Domingo, Bogota (1794), and the basilica of the Virgin of Chiquinquirá (1796–1823), where his use of an ambulatory recalls the work of Diego de Siloé at Granada. He designed Bogota observatory (1802) and the cathedral of Zipaquirá (1805), 40 km north of the capital, but his masterpiece is Bogotá Cathedral (1806–14), which he rebuilt in the Neo-classical style. Petrés also undertook civil engineering work, such as the conduits and basin for the fountain of S Victoriano, and several bridges, including that of El Topo at Tunja (1802).

BIBLIOGRAPHY

E. de Valencia: *Fray Domingo de Petrés* (Bogota, 1930)

C. Ortega Ricaurte: *Diccionario de artistas en Colombia* (Bogota, 1965)

C. Arbelaez Camacho: 'Una obra poco conocida del arquitecto Fray Domingo de Petrés: La catedral de Zipaquirá', *An. Inst. A. Amer. & Invest. Estét.*, xxi (1968)

A. Bonet Correa: 'Tratados de arquitectura y el arte en Colombia: Fray Domingo de Petrés', *Archv Esp. A.* (1971), pp. 126–36

R. Gutiérrez and others: *Fray Domingo Petrés* (Bogotá, 1999)

R. Gutiérrez, R. Vallín and V. Perfetti: *Fray Domingo Petrés y sy obra arquitectónica en Colombia* (Bogotá, 1999)

RAMÓN GUTIÉRREZ

Petrópolis. Brazilian city in Rio de Janeiro state. Built in the hills, 68 km north of Rio, Petrópolis (population *c.* 285,000) was the summer retreat of the imperial court and later the state capital (1894–1902), and it has some fine 19th-century architecture. The site on which it rose was part of Córrego Seco, the vast estate acquired by Emperor Peter I (*reg* 1822–31) in the 1820s. In 1828 Julius Friedrich Köller (1804–47), a German military engineer, rented the imperial property with the idea of transforming it into a farming community for European immigrants. He drew up the first plan for the city and began the construction of the Palácio Imperial (now the Museu Imperial), begun in 1845 by Köller and continued, after his death, by José Maria Jacinto Rebelo (1821–71) among others. The town's proximity to Rio and its healthy mountain climate contributed to its popularity as the official summer centre of Brazilian heads of state until the inauguration of Brasília in 1960. This popularity affected the layout and architecture of the city, with tree-lined avenues and some magnificent buildings, most of which were built during the second half of the 19th century. The Neo-classical Museu Imperial houses a fine collection of paintings, drawings, sculpture and furniture of the imperial period, as well as the crown jewels of Brazil; it also contains a wealth of historical documents, some of which relate to the foundation and development of the city. Other interesting buildings are the Palácio de Cristal (1879), the former imperial ballroom now used as an exhibition centre; the Grão-Pará (1859–61) and Itaboraí palaces, formerly residences of imperial dignitaries; the Gothic Revival cathedral, completed in 1925, which contains the tomb of the last emperor, Peter II (*reg* 1831–89), and the empress Teresa Cristina; and the summer home of the Brazilian inventor Alberto Santos-Dumont, made into a commemorative museum in 1958.

BIBLIOGRAPHY

A. Sodré: *Museu Imperial* (Rio de Janeiro, 1950)

M. Barata: *A arquitetura brasileira nos séculos XIX e XX* (Rio de Janeiro, 1954)

G. Ferrez: *Iconografia petropolitana, 1800–1890* (Petrópolis, 1955)

F. Camargo e Almeida: *Guia dos museus do Brasil* (Rio de Janeiro, 1972)

F. de Vasconcellos: *Três ensais sobre Petrópolis* (Petrópolis, 1984)

T. de Oliveira Casadei: *Petrópolis: Relatos históricos* ([Petrópolis], 1991)

G. Ferrez: Um passeio à Petrópolis em companhia do fotógrafo Marc Ferrez (Rio de Janerio, 1993)

ROBERTO PONTUAL

Pettoruti, Emilio (*b* La Plata, 1 Oct 1892; *d* Paris, 16 Oct 1971). Argentine painter and museum director. He began to paint at the age of 14 and in 1911 travelled to Italy on a state scholarship. He studied in Florence with Giovanni Giacometti and in 1913 settled in Milan, later engaging in discussions about Futurism with Carlo Carrà, Filippo Tommaso Marinetti and Alberto Sartoris. His paintings, however, showed very little influence from Futurism, owing more to Synthetic Cubism. In 1923 he exhibited 35 works at the Sturm-Galerie in Berlin. He met Juan Gris in Paris in 1924, just before returning to Buenos Aires, where his first exhibition produced such violent reactions that his paintings—the first Cubist works seen there—had to be protected by glass from being spat on.

Works painted by Pettoruti after his return to Argentina continued to show his mastery of a late Cubist style; *The Quintet* (1927; San Francisco, CA, MOMA), for instance, is reminiscent both of the work of Gris and of Picasso's *Three Musicians* (1921; New York, MOMA). His concern, however, with classical rules of form led him away from a strict application of Cubist fragmentation, whether in more conventional works such as the series of Italian landscapes that he exhibited in October 1925 or in extraordinarily polished pictures that are virtually abstract.

Pettoruti was slow in gaining recognition in Argentina, but he eventually became an establishment figure thanks to the encouragement he received from abroad, such as his participation in the First Guggenheim International in 1957 as the representative of South America. He was Director of the Museo Municipal de Bellas Artes in La Plata from 1930 to 1947. While brilliantly crafted, his later works (e.g. *Argentinian Sun*, 1941; Buenos Aires, Mus. N. B.A.; *see* ARGENTINA, fig. 5) were regarded by some critics as little more than academic formal exercises lacking in the creative and combative spirit of his youthful essays in Cubism. Having suffered such incomprehension towards his work in the 1920s, in the 1960s he in turn showed little

sympathy for young artists attempting to break new ground. While he continued to be respected for his early introduction of Cubism to Argentina, by the end of his life he was considered by some to have failed to live up to his promise and to have benefited from a high reputation that outstripped the achievements of his career as a whole.

BIBLIOGRAPHY

O. de Allende: *Emilio Pettoruti* (Buenos Aires, 1946)
J. Bay: *Emilio Pettoruti* (Buenos Aires, 1951)
A. Sartoris: *Pettoruti* (Madrid, 1952)
C. Córdova Iturburu: *Pettoruti* (Buenos Aires, 1963)
——: *Pettoruti* (Buenos Aires, 1981)
S. Verdi Webster: 'Emilio Pettoruti: Musicians and Harlequins', *Lat. Amer. A.*, iii/1 (1991), pp. 18–22
Emilio Pettoruti: 1995 (exh. cat., Buenos Aires, Salas N. Exp. Palais Glace and elsewhere, 1995)
J. López Anaya: *Historia del arte argentino* (Buenos Aires, 1997)

HORACIO SAFONS

Pezerat, Pierre Joseph (*b* Paris, 9 Feb 1801; *d* Lisbon, 1 May 1872). French architect and engineer, active in Portugal and Brazil. He qualified as an engineer at the Ecole Polytechnique and then studied at the Académie de l'Architecture, both in Paris. In 1825 he entered into a contract with the government of Brazil to study hydraulic construction in England for a year, during which time he was introduced to Isambard Kingdom Brunel. He then went to Brazil and worked on assignments in Rio de Janeiro as engineer captain; he was also appointed private architect to Emperor Peter I (*reg* 1822–31). Among the projects he worked on in Rio were the Palácio de São Cristóvão in Quinta da Boa Vista park (1827 and after; now the Museu Nacional), the Academia Militar (later the Escola de Engenharia) and several houses, including that of the Emperor's favourite, the Marquesa de Santos. Following the Emperor's abdication Pezerat entered the service of the French government in Algeria and in 1838–9 was chief engineer of the province of Oran. In 1840 he settled in Lisbon and supervised the construction of the Escola Politécnica (1843–78) on the site of the Colégio dos Nobres, a former Jesuit college dissolved in 1837.

In 1852, after a competition, Pezerat was appointed engineer and architect to the Lisbon municipality, and in the same year he became a professor of design at the Escola Politécnica, Lisbon. He designed many important works in Lisbon from 1850, during a period of political stability and industrial growth in Portugal. These included additional design and construction of the Escola Politécnica; the city abattoir (1863) on a site on the edge of Lisbon; and the S Paulo baths (1850), which were intended to provide the citizens of Lisbon with modern sanitary facilities. He designed these works in an academic Neoclassical style that was commonly used for public architecture in much of Europe at that time.

UNPUBLISHED SOURCES

Lisbon, Câmara Mun. Arquiv. Repartição Téc. [MSS, 1852–72]
Lisbon, Bib. & Arquiv. Hist. Min. Obras. Púb., [MSS, 1853; 1864]

WRITINGS

Mémoire sur les études d'améliorations et embellissements de Lisbonne (Lisbon, 1865)

BIBLIOGRAPHY

J.-A. França: *A arte em Portugal no século XIX*, i (Lisbon 1966)
——: 'Pierre Joseph Pezerat (1801–1872): Le Dernier Architecte néoclassique à Lisbonne', *Bull. Soc. Hist. A. Fr.*, (1979), pp. 225–35

RAQUEL HENRIQUES DA SILVA

Philippe-Auguste, Salnave (*b* Saint-Marc, 27 Jan 1908; *d* Port-au-Prince, 2 June 1989). Haitian painter. He found his artistic vocation late in life, abandoning his career as a lawyer at the age of 51 to paint full-time. He developed a style reminiscent of that of Henri Rousseau, whose work he clearly admired, producing often wildly inventive pictures such as jungle scenes populated by African animals deriving more from his imagination than from reality. His images include fearful hybrid creatures from Haitian folklore shown stalking the jungle, as well as carnival scenes and pictures of market-places.

Using brilliant colours arranged as flat, clearly defined curvilinear shapes, he allowed no atmosphere to dull the chromatic intensity of this natural paradise, with value contrasts enlivening the surface but permitting only a limited illusion of three dimensions. His thoughtful and systematic working methods involved the transfer of an initial pencil drawing on transparent paper to hardboard; this enabled him to keep a record of the composition and to apply the same basic design to successive works, varying only some sections.

BIBLIOGRAPHY

M.-J. Nadal and G. Bloncourt: *La Peinture haïtienne* (Paris, 1986)
M. P. Lerrebours: *Haïti et ses peintres*, i (Port-au-Prince, 1989)

DOLORES M. YONKER

Picheta [Gahona, Gabriel Vicente] (*b* Mérida, 5 April 1828; *d* Mérida, 1 March 1899). Mexican engraver. In 1846 he went to study painting in Europe, where he almost certainly encountered the widely published lithographs of Gustave Doré (1852–83), Honoré Daumier (1808–79) and Paul Gavarni (1804–66), which probably inspired his own work. On returning from Europe he founded, with some friends in Mérida, the periodical *Don Bullebulle* (1847), which satirized with grace and irony social customs, politics and contemporary fashion. During its year-long life he illustrated the periodical with a total of 86 wood-engravings that he signed with the pseudonym Picheta. He achieved a sharpness of line that emphasized his draughtsmanship (e.g. *The Clerk*, 1847; Mexico City, Mus. N. Est.). When *Don Bullebulle*'s critical attitude forced the periodical to close, Picheta's artistic career came to an end. Nevertheless, his work is greatly admired for its historical significance, especially in view of the lack of successful wood-engravers in Mexico during the 19th century.

BIBLIOGRAPHY

J. Orosa Díaz: *Picheta* (Mérida, 1948)
J. Fernández: *El arte del siglo XIX en México* (Mexico City, 1983)
Art in Latin America: The Modern Era, 1820–1980 (exh. cat. by D. Ades and others, London, Hayward Gal., 1989), pp. 112–14

MÓNICA MARTÍ COTARELO

Pierre, André (*b* Port-au-Prince, 29 July 1914). Haitian painter. A farmer as well as a houngan (Vodoun priest) in Croix-des-Missions, just outside Port-au-Prince, he began painting images of the loas (spirits) on the walls of shrines and on ritual objects. The American film maker Maya Deren persuaded him to transfer those images to panels and to join the Centre d'Art in Port-au-Prince in 1949. Seeing no contradiction between the obligations of the priesthood and his work as an artist, he lived and worked in a tiny earth-floored hut adjacent to his temple. As a houngan, his first obligation was to represent the loas

whom he served, clothing them in fancy dress resembling costumes of the 18th century. Although illiterate, he was in command of an abundance of Vodoun and Biblical lore and worked from dreams and meditation, believing that he received direct inspiration from his spirits; his loas were African in origin but totally Creolized. Explaining Christian legends in Vodoun terms, he saw the flood, for example, as the result of a pact between Damballah (the serpentine deity from Dahomey) and God, and the rainbows that appeared after the Flood as the paired rainbow pythons descending from Africa. Pierre humanized the loas, representing them with appropriate attributes, costumes and gestures. He used oil paints, brushing in a solid background of colour over which he painted generalized flat shapes completed with a lacy white linear pattern resembling those drawn in flour on the ground in Vodoun ceremonies.

BIBLIOGRAPHY
S. Williams: *Voodoo and the Art of Haiti* (Nottingham, 1969)
J.-M. Drot: *Journal de voyage chez les peintres du Vaudou* (Geneva, 1974)
Haitian Art (exh. cat. by U. Stebich, New York, Brooklyn Mus., 1978)
G. Mosquera: 'Pierre André', *Ante América* (exh. cat. by G. Mosquera and others, Bogotá, Bib. Luis-Angel Arango, 1992), pp. 149–54

DOLORES M. YONKER

Pierri, Duilio (*b* Buenos Aires, 1954). Argentine painter. He studied at the Escuelas Nacionales de Bellas Artes in Buenos Aries. He was awarded the Beca de Francia scholarship in 1975 and lived in New York from 1980 until 1984, when he returned to Buenos Aires. After 1984 he was awarded numerous prizes for painting and held many one-man exhibitions in the USA, Mexico, Spain, Italy, Finland and Peru. By 1993 Pierri had painted some 20 murals, distinguished by his saturation of the planes and contrived superimpositions. In his use of colour he was influenced by Expressionism, although he made use of Neo-expressionist, Surrealist and Pop art ingredients. His works present him as a narrator, a witness to interiors and exteriors where stories unfold; these sometimes appear banal but can be incisive and at times biting. He also employed the absurd, contriving to create reality through the play of the unreal. His interiors, for example, showed figures enclosed by buildings, or insect–creatures on the edges of mystery, or a memory of his surroundings that was amplified and developed in relation to the aggressive events of daily life. He was a gifted colourist with a spontaneous line and an acid humour that was neither moralistic nor condemnatory.

OSVALDO SVANASCINI

Pina, José Salomé (*b* Mexico City, 1830; *d* Mexico City, 1909). Mexican painter. A grant awarded to him in 1854 enabled him to study in Paris, where he joined Charles Gleyre's studio and painted two works, *Abraham and Isaac* and *Dante and Virgil* (both 1856; Mexico City, Mus. N.A.), which he sent to Mexico City to be exhibited at the Academy. He also showed at the Paris Salon in 1859, receiving an honourable mention. In 1860 he settled in Rome, where in 1865 he was commissioned to produce a painting commemorating the visit of the Archduke Maximilian, Emperor of Mexico (*reg* 1864–7), and his wife Carlota Amalia to Pius IX. Although the painting was never completed, there are two surviving sketches (e.g. *Meeting of Pius IX and Maximilian*, 1865–6; Mexico City,

Mus. N. Hist.) that suggest that he worked from photographs and conformed to the fashion for depicting historical events as scenes from everyday life. Although on his return to Mexico in 1869 Pina was made professor of painting at the Academy in Mexico City, by the time of his death his work had lost credibility among the students, who felt a growing dissatisfaction with the values imposed by religious painting.

BIBLIOGRAPHY
J. Fernández: *El arte del siglo XIX en México* (Mexico City, 1967), pp. 46, 54, 60, 75, 79, 80, 98, 112–15, 139, 143–4, 170
F. Ramírez: *La plástica del siglo de la independencia* (Mexico City, 1985), p. 67

ESTHER ACEVEDO

Pinto, Joaquín (*b* Quito, 18 Aug 1842; *d* Quito, 24 June 1906). Ecuadorean painter, illustrator, draughtsman, engraver and teacher. He attended the first Escuela de Bellas Artes in Quito (1872–5) and was one of the most prolific and versatile Romantic artists in 19th-century Ecuador, working in several genres. His portraits of important figures included that of the historian *Federico González Suárez* (1883; Quito, Mus. A. Mod.). He illustrated González Suárez's archaeological work *Estudio histórico sobre los Cañaris* (Quito, 1878) among others, and contributed illustrations of snails and molluscs for the French naturalist Auguste Cousin's *Faune malacologique de la République de l'Equateur* (*c*. 1893–7; Quito, Archv Nat. Hist. Banco Cent. del Ecuador). In connection with the nationalist movement, Pinto tirelessly explored 'costumbrista' and indigenist themes in dozens of drawings, watercolours and engravings, many of them inspired by *Cantares del pueblo ecuatoriano* (1892) by the Romantic poet Juan León Mera. He painted such landscapes as *El Chimborazo* (1901; Quito, Mus. Mun. Alberto Mena Caamaño) and detailed the local flora and fauna with great precision (e.g. *Tarqui*, 1902; Quito, Mus. A. Mod.). Pinto's important religious commissions included those for the order of Nuestra Señora de la Merced in Quito and Cuenca. He directed the Escuela de Pintura in Cuenca (1903) and taught at the Escuela de Bellas Artes in Quito (1904).

BIBLIOGRAPHY
J. M. Vargas: *Los pintores quiteños del siglo XIX* (Quito, 1971), pp. 32–63
Joaquín Pinto: Exposición antológica (exh. cat., Quito, Banco Cent. del Ecuador, 1983)
Joaquín Pinto, Pintores ecuatorianos (Quito, 1984)
J. G. Navarro: *La pintura en el Ecuador del siglo XVI al XIX* (Quito, 1991), pp. 208–11
A. Kennedy: 'Artistas y científicos: Naturaleza independiente en el siglo XIX en Ecuador (Rafael Troya y Joaquín Pinto)', *Estud. A. & Estética*, xxxvii (1994), pp. 223–41

ALEXANDRA KENNEDY

Pintura al Aire Libre, Escuelas de. *See* ESCUELAS DE PINTURA AL AIRE LIBRE.

Piqueras Cotolí, Manuel (*b* Lucena, Andalusia, 1886; *d* Lima, 26 June 1937). Spanish sculptor and architect, active in Peru. After an eight year apprenticeship in Madrid with the sculptor Miguel Fábregas Blay, he travelled to Rome in 1913 and a year later was awarded a scholarship for the Academia de España. He was officially appointed professor of sculpture at the newly opened Escuela Nacional de Bellas Artes in Lima on 1 June 1919. Piqueras was instrumental in the plans for modernizing Lima drawn up

Manuel Piqueras Cotolí: Sala de Recepciones, Palacio de Gobierno, Lima, 1924 (destroyed)

by President Augusto B. Leguia (1919–30). He designed plans for the urbanization of the suburb of San Isidro and the remodelling of Plaza San Martin, designed the chapel dedicated to Francisco Pizarro in the cathedral and sculpted the figures adorning the conquistador's tomb (1929).

Piqueras was responsible for creating the neo-Peruano architectural language, a re-working of the mestizo style of colonial architecture. By incorporating Pre-Columbian architectural elements and indigenous motifs within a European framework, he believed that the neo-Peruano style represented the 'biological psychology' of the emerging Peruvian nation. Three state commissions enabled Piqueras to explore the potential of his eclectic neo-Peruano vocabulary: the façade of the Escuela Nacional de Bellas Artes, Lima (1919–24); the Sala de Recepciones in the Palacio de Gobierno in Lima (1924; destr.; see fig.) and the Peruvian pavilion in the Exposición Ibero-Americana in Seville (1929; see colour pl. XXX, fig. 2). His project for a heavily influenced Tiahuanaco/Inca design for a basilica dedicated to Santa Rosa in Lima was not realized.

WRITINGS

'Algo sobre el ensayo de estilo neo-peruano en arquitectura', *Huaca*, iii (n.d.), pp. 61–2

BIBLIOGRAPHY

Don Quijote (C. Solari): 'Notas de arte. La obra de Piqueras Cotolí en Lima', *Mundial*, ccclxxii (1927)

P. Antrobus: *Peruvian Art of the Patria Nueva, 1919–1930* (diss., Colchester, U. Essex, 1997)

PAULINE ANTROBUS

Planas, Juan Batlle. *See* BATLLE PLANAS, JUAN.

Planes, Rafael Ximeno y. *See* XIMENO Y PLANES, RAFAEL.

Plateresque style [Sp. *plateresco*, from *platero*, 'silversmith']. Term used to describe the elaborately decorated Late Gothic and early Renaissance architecture of 16th-century Spain and Latin America, especially Mexico. Its characteristically florid decoration employs motifs derived from Gothic, Italian Renaissance and Islamic sources and tends to mask the structure it adorns. The term is also applied, more generally, to the decorative arts of the same period. The comparison between sculpture and architectural decoration and gold- or silverwork in terms of style and skill was commonplace in Spanish literature in the 16th and 17th centuries, including art criticism (from Cristóbal de Villalón in 1539 to Lope de Vega). Contemporary authors did not distinguish between architectural decoration and embroidery or filigree work; there is no reference to specific decorative motifs, only to general forms of handicraft. The term was apparently first used in an anonymous drawing (*c.* 1580) for the decoration of a frieze in the chapter house of Seville Cathedral. The term *targatas platerescas* ('plateresque tablets') appears to describe a decorative motif coming from international Mannerist repertories, used by architectural and sculptural decorators or silversmiths, and bears no relation to the decoration typical of early 16th-century Spanish architecture—the candelabra and grotesques—to which it later referred almost exclusively.

The term Plateresque was linked to the Italian style of decoration by Diego Ortiz de Zúñiga (1677), who described the town hall and the Royal Chapel of the cathedral in Seville as 'all covered with excellently drawn foliage and fanciful decorations that the artisans call Plateresque'. Ortiz de Zúñiga criticized such fantasies for violating the rules of ancient Roman architecture; thereafter the term is

used to describe the highly decorative works of architecture of the first half of the 16th century.

Although the term was also employed during the 18th century to describe any capricious and irrational type of decoration freely applied to architecture, the critic Antonio Ponz used Plateresque style to refer specifically to the middle phase of 16th-century Spanish architecture, between the Gothic style and the revival of Greco-Roman architecture. In 1804 J. A. Ceán Bermúdez continued this line of thought, locating Plateresque architecture between Gothic and Greco-Roman. The style, he claimed, marked 'the commencement of the restoration of the Greco-Roman style, poor in its organization, prodigal in its ornaments and lacking elegance as a whole'. It retained Gothic decoration with a characteristic use of foliage and figures, because both patrons and artisans were used to the 'superfluity and trifling nature of Gothic ornament'. According to Ceán Bermúdez, this type of architecture began with Enrique Egas (?1470–1534), Alonso de Covarrubias (1488–1570), Diego de Siloé (c. 1490–1563), Felipe Vigarny (c. 1475–1542), Juan de Badajoz the younger (c. 1498–c. 1560) and Diego de Riaño (d 1534). From the early 19th century the basic characteristics attributed to the Plateresque style remained constant, with few variations. José Caveda (1849) described it as a mixed style, combining Gothic, Muslim and Classical elements, and praised its distinctive national character.

In the 20th century architectural historians attempted a wide range of definitions, with Bevan (1939) making the pertinent suggestion that Plateresque is 'not so much a type of ornament as a taste for ornament'. Marías (1983–6), reviewing 16th-century literature on art and departing from Bury (1976), sought to relinquish criteria based on decoration in his attempt to characterize the architecture of the period using architectural terms; thus, he distinguished between buildings that are Gothic in technique, structure and volumetry to which Plateresque decoration had been added, and buildings where, beneath a similar type of ornamentation, there exist structures, styles, wall arrangements and a volumetry that were derived from ancient or Italian Renaissance architecture. As contrasted with Plateresque Gothic architecture, it is therefore possible to speak of an ornamented Renaissance style, as opposed to the ESTILO DESORNAMENTADO or stripped style of the second half of the 16th century.

Spanish architecture between 1490 and 1570 can be divided into several currents. The first is marked by the survival and evolution of a Gothic style that rejects any kind of decorative innovation, represented by such schemes as those for the cathedrals of Salamanca and Segovia, designed in the second and third decades of the 16th century and still under construction in the early 17th century. The second current is characterized by a surviving Gothic style that retains the profuse decoration of the Flamboyant style, incorporating ornament from France and Italy and using the orders as mere elements of decoration. Only Corinthian or composite pilasters are used, with no interest in correct morphology or proportion, their shafts covered in reliefs; unorthodox baluster columns are also featured, and entablatures are converted into a series of strips decorated with grotesques. Here the compositions will admit new motifs, which are included in Gothic structures, especially doorways and windows, with the orders lacking any architectural value or impact. This current of Gothic survival, with added Plateresque decoration, features in Diego de Sagredo's treatise of 1526, *Medidas del romano*; it contains precepts by Vitruvius and Leon Battista Alberti, applied to a superficial, decorative concept of the Classical orders, but advocates the use of correct morphology and proportions for the columns and places particular stress on the possibility of their being decorated. Such architects as Lorenzo Vázquez de Segovia (c. 1450–before 1550), Enrique Egas, Diego de Riaño, Juan de Alava (c. 1480–1537) and Francisco de Colonia (1511–42) designed in this style, and such buildings as the Hospital de Santa Cruz in Toledo, with its façade by Antón Egas, Enrique Egas and Alonso de Covarrubias, the Universidad de Salamanca or the Portada de la Pellejería in Burgos Cathedral are among the earliest examples. There are many examples of the style in Mexico, less so in civil architecture (e.g. Casa del Adelantado Montejo, Mérida, 1549) than among religious buildings, as demonstrated by numerous monasteries from Huejotzingo (c. 1550) to Yiririapúndaro (c. 1560) or Cuitzeo (c. 1570).

The third current—represented by Diego de Siloé, Pedro Machuca, Alonso de Covarrubias and Luis de Vega, among others, together with their schemes built from about 1520—was marked by a more accurate use of the orders, compositions influenced by ancient architecture and styles emanating from Italy, although ornamentation was not abandoned when the character of the buildings required it. Ornamentation was suppressed, especially after Sebastiano Serlio's books were published in Spanish in 1552, easing the transition towards the stripped style of the last decades of the 16th century.

BIBLIOGRAPHY

D de Sagredo: *Medidas del romano* (Toledo, 1526, 4/1549, rev. Murcia, 1986)
C. de Villalón: *Ingeniosa comparación entre lo antiguo y lo presente* (Valladolid, 1539, rev. Madrid, 2/1898)
D. Ortiz de Zúñiga: *Anales eclesiásticos y civiles de la ciudad de Sevilla* (Madrid, 1677)
A. Ponz: *Viaje de España*, 18 vols (Madrid, 1772–94, rev. 1947)
J. A. Ceán Bermúdez: *Descripción artística de la catedral de Sevilla* (Seville, 1804/R 1981)
J. Caveda: *Ensayo histórico sobre los diversos géneros de arquitectura empleados en España desde la dominación romana hasta nuestros días* (Madrid, 1849)
J. de Contreras: *Historia del arte hispánico*, i (Barcelona and Buenos Aires, 1945)
B. Bevan: *History of Spanish Architecture* (New York and London, 1939)
J. Camón: *La arquitectura plateresca*, 2 vols (Madrid, 1945)
G. Kubler: *Mexican Architecture of the Sixteenth Century* (New Haven, 1948, rev. 1972; Sp. trans., Mexico City, 1983)
M. Toussaint: *Arte colonial en México* (Mexico City, 1948; Eng. trans., Austin, 1964)
F. Chueca Goitia: *Arquitectura del siglo XVI*, A. Hisp., xi (Madrid, 1953)
E. E. Rosenthal: 'The Image of Roman Architecture in Renaissance Spain', *Gaz. B.-A.*, 6th ser., lii (1958), pp. 329–46
J. Camón Aznar: *La arquitectura y la orfebrería españolas del siglo XVI*, Summa A., xvii (Madrid, 1959, 3/1970)
G. Kubler and M. Soria: *Art and Architecture in Spain and Portugal and their American Dominions*, Pelican Hist. A. (Harmondsworth, 1959)
S. Sebastián: 'La decoración llamada plateresca en el mundo hispánico', *Bol. Cent. Invest. Hist. & Estét. U. Caracas*, vi (1966), pp. 42–85
J. B. Bury: 'The Stylistic Term "Plateresque"', *J. Warb. & Court. Inst.*, xxxix (1976), pp. 199–230
A. Cloulas: 'Origines et évolution du terme "plateresco": A propos d'un article de J. B. Bury', *Mél. Casa Velázquez*, xvi (1980), pp. 151–61
S. Sebastián: *Arquitectura: El renacimiento* (Madrid, 1980), iii of *Historia del arte hispánico*

R. Gutiérrez: *Arquitectura y urbanismo en Iberoamérica* (Madrid, 1983)

F. Marías: *La arquitectura del renacimiento en Toledo (1541–1631)*, 4 vols (Toledo and Madrid, 1983–6)

S. Sebastián López, J. de Mesa Figueroa and T. Gisbert de Mesa: *Arte iberoamericano desde la Colonización a la Independencia* (Madrid, 1985)

F. Marías: *El largo siglo XVI: Los usos artísticos del renacimiento español* (Madrid, 1989)

V. Nieto and others: *Arquitectura del renacimiento en España, 1488–1599* (Madrid, 1989)

V. Fraser: *The Architecture of Conquest: Building in the Viceroyalty of Peru, 1535–1635* (Cambridge, 1990)

M. Sartor: *Arquitectura y urbanismo en Nueva España: Siglo XVI* (Mexico City, 1992)

J. Early: The Colonial Architecture of Mexico (Albuquerque, 1994)

R. J. Mullen: *Architecture and its Sculpture in Viceregal Mexico* (Austin, 1997)

FERNANDO MARÍAS

Poblano. Term used to describe an exuberant architectural and sculptural style that developed in and around the city of Puebla, Mexico, in the 18th century. It is characterized by Baroque elements used in combination with ornate stucco, geometrically patterned red brickwork and poly-chrome glazed tiles (Sp. *azulejos*), which were produced by flourishing local industries. The style developed in parallel with the growth of the city itself. As Puebla became wealthier and more important in the 17th century, increasing numbers of workshops were set up by ceramicists, many of them from Spain; Spanish artistic trends became more important, and these workshops came to exert a great deal of influence on the development of art in the city and surrounding villages. At the same time the growing wealth of the city financed the construction of religious and secular buildings that reveal their patrons' and owners' desire for luxury and display. Heavily ornamented mansions, as well as convents and churches designed in opulent styles reflecting the donations of affluent local merchants, farmers and factory owners, all contributed to the evolution of an architecture rich in colour and imagination.

An important contributory factor to the development of the Poblano style was the Spanish taste for coloured ceramics and plasterwork, and for the type of brick often used in those parts of Spain dominated by Islamic influences. The use of glazed tiles and plaster arabesques, first seen in the 17th century in the interior vaults of such churches in Puebla as La Concordia and S Inés, continued in the dome of the church of S Cristóbal and reached a peak in the Rosario Chapel of S Domingo, which was decorated between 1650 and 1690 with gilt and poly-chrome Baroque plasterwork featuring plant, animal and figural motifs. The Renaissance scrolls in the interior of the Rosario Chapel were remodelled in the Baroque style, while the painted saints and polychrome statues, designed within a framework of complex symbolism exalting the Virgin, are surrounded by a welter of stucco and plaster Moresque tracery, as well as by a profusion of glazed tiles.

During the 18th century, however, the fashion for polychrome brickwork, geometric shapes and glazed tiles, often set in panels with images of saints, spread to the exterior of houses and churches in Puebla, reflecting the economic strength of the city; and this combination of materials, used together with stucco, created the Poblano style that came to characterize the city. Bricks and tiles were employed to form intricate geometric patterns or panels in harmonious, decorative compositions; friezes were executed in plaster, while the balcony supports, door- and window-frames and the cresting of houses and churches were made from a strikingly white mix of lime and sand; decoration was created according to the caprice of sculptor and architect, who gave free rein to their imaginations and combined elements in new ways but always retaining a sense of harmony and the framework of the Baroque. Outstanding examples of religious buildings in Puebla with towers, domes or façades designed in the Poblano style include S José (1595; altered 1628); the Carmelite church (18th century), Guadalupe; and the churches of S Marcos, S Francisco (1667) and S Catalina. The so-called Casa del Alfeñique (*c.* 1790; now Puebla, Mus. Reg. & Cer.) is a masterpiece of secular Poblano architecture, as are the Casa del Canónigo Peláez and the Casa de los Muñecos.

It was natural that the influence of such an attractive style of architecture should extend to the surrounding area, as can be seen, for example, in Atlixco and at the Santuario de Ocotlán in Tlaxcala; in the *camarín* (small chapel behind and above the high altar) of the latter the religious ecstasy of the sculptor overflowed into fantasy. Also notable is the façade of the little church of S María Tonantzintla (*c.* 1700), outstanding above all for the interior of the nave and the dome, the Poblano decoration of which exceeds the Rosario Chapel in richness and polychromy, if not in quality. The masterpiece of glazed-tile work in the Poblano style, however, is the 18th-century church in the village of S Francisco Acatepec, where the Baroque façade is completely encased in multicoloured polychrome tiles (see colour pl. XXII, fig. 2). The influence of the style declined with the advent of new architectural ideas introduced with European Neo-classicism at the end of the 18th century.

A comparable tendency to develop a distinctive Hispano-American form of Baroque may be seen in the Mestizo style of the highland provinces of Peru and Bolivia.

BIBLIOGRAPHY

D. Angulo Iñiguez, E. Marco Dorta and M. J. Buschiazzo: *Historia del arte hispano-americano*, ii (Barcelona, 1948)

P. Kelemen: *Baroque and Rococo in Latin America* (New York, 1951)

S. Sebastián López, José de Mesa Figueroa and T. Gisbert de Mesa: *Arte iberoamericano desde la colonización a la independencia*, Summa A., xxviii and xxix (Madrid, 1981 and 1985)

L. Velázquez Thierry: *El azulejo y su aplicación en la arquitectura poblana* (Puebla, 1992)

CONSTANTINO REYES-VALERIO

Pol, Santiago (*b* Cardereu, nr Barcelona, 19 Jan 1946). Venezuelan graphic designer of Spanish birth. He moved to Venezuela in 1954, where he studied at the Escuela de Artes Plásticas, Caracas. In 1960 he went to Paris, where he continued his studies at the Ecole Nationale Supérieure des Beaux-Arts. In 1965 he started working as a graphic designer. He developed a surrealistic style, influenced by the work of Magritte and Dalí, based on photography of previously modelled or built three-dimensional figures. His posters received awards in Warsaw, Havana, Leipzig and Mexico. In 1990 he became a professor in the Escuela de Artes of the Universidad Central de Venezuela in Caracas.

CRUZ BARCELÓ CEDEÑO

Poleo, Héctor (*b* Caracas, 20 July 1918; *d* Caracas, 26 May 1989). Venezuelan painter. He studied painting at the Academia de Bellas Artes, Caracas, from 1930 to 1938. In 1938 he went to Mexico City on a scholarship to study at the Academia San Carlos. After returning to Venezuela in 1941 he painted *The Three Commissaires* (1942; Caracas, Gal. A. N.), a work of social realism that won him the John Boulton Prize in the Fourth National Salon of Venezuelan Art in 1943. In 1949 he adapted his exacting realism for a surrealist period, and in the following year he was awarded a Guggenheim Fellowship to study in Europe. Poleo returned to Caracas in 1950 and, while retaining the realism of his portraiture, he began to simplify the backgrounds of his works and introduce abstract elements (e.g. *Maternity*, 1952–3; priv. col., see exh. cat., p. 53). These concerns were also evident in his mural for the campus of the Universidad Central de Venezuela in Caracas (1954). In 1958 he settled in Paris. During the 1950s he produced neo-plastic figurative paintings, and in the 1960s he turned to a softly worked and evocative neo-Symbolism in such pieces as *The Arid Sky* (1964; Caracas, Gal. A. N.). Some of these works come close to abstraction, although in the 1980s a schematic realism re-emerged in such paintings as *The Flowers of Night in the Memory* (1982; priv. col., see exh. cat., p. 101).

BIBLIOGRAPHY
S. Noriega: *La pintura de Héctor Poleo* (Mérida, 1983)
G. Morales: *Héctor Poleo o la ecología de la muerte* (Caracas, 1984)
Poleo (exh. cat. by A. Boulton, Caracas, Mus. A. Contemp., 1986)
G. Diel: *Poleo* ([Caracas], [1989]; Eng. trans by B. Rodríguez
Héctor Poleo: Exposición itinerante (exh. cat., Caracas, Gal. A. N., *c*.1992)
MELANÍA MONTEVERDE-PENSÓ

Polesello, Rogelio (*b* Buenos Aires, 26 July 1939). Argentine painter and sculptor. He completed his training as a teacher of printmaking, drawing and illustration in 1958 in Buenos Aires, where he continued to live and work. He demonstrated a precocious talent and held his first one-man exhibition in Argentina in 1959, followed at the age of 22 by a one-man exhibition at the Pan American Union in Washington, DC, that presaged his considerable international success. His concern with the problems of visual dynamics suggested a sympathy with Constructivism and with the work of kinetic artists, although he never used actual movement.

During the 1960s Polesello's paintings were of two types. At first he superimposed paint applied by rubbing, dripping or with a palette knife on to structured and compartmented compositions. Later he used an airbrush to create distinct layers of colour over regular grids of different sizes or on top of curved decorative shapes, as in *Side A* (1965; see colour pl. XXXI, fig. 1). The expressiveness of these works was dependent on the tension created by the relationships of similar or contrasting colours or by the play of light, the most important element in his interrelated paintings and sculptures. His visual explorations grew ever more subtle, as he had an apparently inexhaustible capacity for variations on a single theme. In sculptures carved from plastic, including monumental totems, geometrical forms or suspended plaques with sunken circles in them (e.g. *Concave–Convex Lens*, 1973; Caracas, Mus. A. Contemp.), he broke up multiplied

images, made the light vibrate and changed normal perceptions of space to create rich sensory experiences.

BIBLIOGRAPHY
R. M. Crossa: *Rogelio Polesello* (Madrid, 1979)
R. Pau-Llosa: *Polesello* (Buenos Aires, 1984)
Rogelio Polesello: Progresiones (exh. cat. by P. O'Donnell and others, Buenos Aires, Salas N. Cult., 1995)
Rogelio Polesello (exh. cat. by F. Lebenglik, Buenos Aires, Ruth Benzacar Gal. A., 1996)
J. López Anaya: *Historia del arte argentino* (Buenos Aires, 1997)
NELLY PERAZZO

Pombal, Antônio Francisco. *See under* LISBOA.

Ponce de León, Fidelio (*b* Camagüey, 1895; *d* Havana, 1949). Cuban painter and draughtsman. He studied briefly at the Academia de S Alejandro in Havana under Leopoldo Romañach (1862–1951) and became a notable figure in Cuba's first generation of modernists, who broke with the 19th-century academic style during the 1920s in a search for a national identity. His monochromatic paintings, dominated by white and ochre, are the least Cuban in subject-matter of the work produced by this generation, although ironically he was the only one who never left Cuba.

Ponce de León worked primarily in oil on canvas but also made pencil drawings and pastels. He led a bohemian life racked by alcoholism and poverty, dying of tuberculosis. His principal subject-matter was the figure, but he painted some landscapes bordering on pure abstraction, for example *Fish and Landscape* (Havana, Mus. N. B.A.). His paintings are melancholic, as, for example, the figure painting *Tuberculosis* (1934; Havana, Mus. N. B.A.), and embody a Cuban fatalism, which is often eclipsed by the sensuous clichés of the tropics. Ponce de León was the founder of Expressionism in Cuba, a tradition that includes Antonia Eiriz (*b* 1929), Fernando Luis (1932–83), Luis Cruz-Azaceta and Paul Sierra.

BIBLIOGRAPHY
A. H. Barr, jr: 'Modern Cuban painters', *MOMA Bull.*, xi/5 (1944), pp. 2–14
J. Sánchez: *Fidelio Ponce* (Havana, 1985)
Four Cuban Modernists: Mario Carreño, Amelia Peláez, Fidelio Ponce, René Portocarrero (exh. cat., Coral Gables, FL, Javier Lumbreras F.A., 1993)
Fidelio Ponce de León (1895–1949) (exh. cat., Havana, Mus. N. B.A., 1995)
N. G. Menocal: 'An Overriding Passion: The Quest for a National Identity in Painting', *J. Dec. & Propaganda A.*, xxii (1996), pp. 187–219
RICARDO PAU-LLOSA

Popayán. Colombian city and capital of the department of Cauca. It had a population of *c*. 250,000 in the late 20th century. Popayán was founded in 1536, and it developed a prosperous economy from gold- and silver-mining and from agriculture, which in colonial times were supported by slave labour. After an earthquake in 1736 the city was rebuilt in a uniform style using brick and influenced by the architecture of nearby Quito; the only building surviving from the 16th or 17th centuries is the church of La Ermita (1612). The principal churches were rebuilt with some concern for the Classical orders. The Jesuit Simón Schenherr (1700–73) designed the churches of La Encarnación and S José (1750s), using the standard Jesuit plan with a single nave and side chapels and providing the brick

façade with decoration deriving from the Ionic order to emphasize the portal; this is also the case with S Domingo, rebuilt in 1750 by Gregorio Causí (*b* 1696). The Spaniard Antonio García (1730–98) redesigned and rebuilt S Francisco between 1755 and 1795 in a pure Corinthian order, giving the Baroque three-storey façade a more refined and monumental appearance. The pulpit stairway, attributed to Sebastián Usina is particularly notable: the church's high altar and tower were built much later (1903). The 18th-century churches were filled with Baroque altars and retables decorated with carved, gilded wood, mostly made by craftsmen from Quito. The large family houses built in the 19th century were influenced by academic Neoclassicism, with some doorways decorated in brick, as at the Casa de los Arroyo (*c.* 1804), designed by Marcelino Pérez de Arroyo (1764–1833); patios had classical arcades and pilasters, and friezes and mouldings in brick replaced formerly modest eaves. After the earthquake of 1885, most churches were again rebuilt with alterations; another devastating earthquake in 1983 necessitated further restoration of the city centre.

There are a number of museums in Popayán, including the Museo de Arte Colonial e Historia 'Casa Mosquera', housed in the Universidad del Cauca, the Museo Negret, dedicated to the work of EDGAR NEGRET, and the Museo Arquidiocesano de Arte Religioso. The University also has a fine arts department, within which there is a school of applied arts.

BIBLIOGRAPHY

G. Arboleda: *Diccionario biográfico y genealógico del antiguo departamento del Cauca*, i (Popayán, 1962)

S. Sebastián López: 'Popayán: Arquitectura de piedra pensativa', *El Tiempo* (June 1964), p. 3b

——: *Arquitectura colonial en Popayán y Valle del Cauca* (Cali, 1965)

G. Teléz Castañeda: *Popaya, Colombia: Guía ciudad histórica* (Bogotá, 1996)

J. Velasco Mosquera: *Consideraciones sobre la arquitectura en Popayán* (in preparation)

FERNANDO CARRASCO ZALDÚA

Porres. Guatemalan family of architects. They were active in the 17th and 18th centuries and dominated the architecture of the whole of Central America for a century. José de Porres (*b* Santiago de Guatemala [now Antigua], 1635; *d* Santiago de Guatemala, 17 May 1703) was of mestizo and mulatto origin. He carried out his first works under the master builder Juan Pasqual, a mulatto, from whom he took over (1666) the construction of the church of the Hospital de S Pedro Apóstol, the first vaulted church in the city (completed 1669). He then became assistant architect on the new cathedral, a completely vaulted building, assuming charge from *c.* mid-1670 to its completion in 1686. A triumphal-arch system articulates the façade (for illustration *see* ANTIGUA (i)). His final works were the Belén church (completed 1678), the church and monastery of S Teresa (1683–7), churches for the Jesuit order (completed 1698) and of S Francisco (*c.* 1698). At the time of his death he was working on the church and monastery of La Recolección, begun two years earlier. In these last two buildings he introduced the solomonic order to Guatemalan architecture. He was made the first *maestro mayor* of architecture for Santiago de Guatemala, appointed by the town council in 1687. Although at the beginning of his career he was illiterate, he not only learnt to read but also demonstrated a good knowledge of the works of Sebastiano Serlio and Jacopo Vignola. His works reveal a certain stylistic backwardness, still moving between Classicism, Italian Mannerism and Early Baroque.

His son Diego de Porres (*b* Santiago de Guatemala, 19 Nov 1677; *d* Santiago de Guatemala, 25 July 1741), who likewise spent his entire life in Santiago de Guatemala, began working with his father while still a child. He succeeded him in the year of his death as *maestro mayor* and as director of the construction of La Recolección (completed 1717). After the earthquakes of 1717, he was designated to assess the damage and was made responsible for repairing the main buildings, including the cathedral (1718–21). His principal works were the oratory of S Felipe Neri (1720–30), the Hospital de S Alejo (1722), the church and convent of S Clara (1730–34), the Palacio Real and the Real Casa de la Moneda (1734–8). In addition, the church and monastery of Concepción, Ciudad Vieja (1718–40), the church and convent of the Capuchin nuns (1731–6) and the fountain in the Plaza Mayor (1738–9), based on the Fountain of Neptune in Bologna by Giambologna, are also his works. He was also an expert in hydraulics and in his capacity as Fontanero Mayor (from 1728) made water available to several towns, built the bridge of San Lorenzo el Tejar (1715) and repaired the bridge over the Los Esclavos River (1728). He was probably the designer of the enormous sanctuary at Esquipulas, using a plan inspired by Valladolid Cathedral (*see* GUATEMALA, fig. 2). Like his father, he was familiar with the treatise literature; the influence of the Spanish edition of Serlio is clear. It contained an engraving of a chimney, which gave him the design for an *estípite*, which he used profusely in various church façades, making it the sign-manual of Late Baroque in Guatemala. It is significant that he chose as his device (one that he incorporated into his designs, and in some of his constructions) that of the Platin-Moretus, printers of Antwerp (Belgium). He was for 40 years the chief civil and religious architect of the whole Central American area.

Two sons continued in his profession: Felipe de Porres (*b* Santiago de Guatemala, ?1705; *d* Esquipulas, 10 Nov 1759) served his apprenticeship with his father, collaborating with him on several works. He was responsible for completing (1740–59) the vast church of Esquipulas, the largest in Guatemala during the colonial period and probably designed by his father. Diego José de Porres (*b* Santiago de Guatemala, 11 June 1707; *d* León, Nicaragua, after 1767) also trained and worked with his father. In 1747 he left for Nicaragua to take charge of work on León Cathedral and later of the archbishop's palace and the seminary. He may have been involved with other buildings there, but this remains to be established. Manuel de Porres was possibly the son of Felipe. In 1790 he completed the church of Chiquimula, near Esquipulas, in which he made use of the Serlian *estípite*.

BIBLIOGRAPHY

H. Berlin: *Historia de la imaginería colonial en Guatemala* (Guatemala, 1952)

J. Luján-Muñoz: 'Sebastiano Serlio, Martín de Andújar y Joseph de Porres y las catedrales de Santiago de Guatemala y Ciudad Real de Chiapas', *An. Soc. Geog. & Hist. Guatemala*, l (1977), pp. 35–60

L. Luján-Muñoz: *El Arquitecto Mayor Diego de Porres, 1677–1741* (Guatemala, 1982)

JORGE LUJÁN-MUÑOZ

Porro (Hidalgo), Ricardo (*b* Camagüey, 3 Nov 1925). Cuban architect, active in France. He studied at the School of Architecture in Havana. While designing the Escuela de Artes Plásticas he established a synthesis between colonial traditions (interior galleries and courtyards) and references to the African heritage; in the Escuela de Danza Moderna tropical motifs lighten the monumental concrete structure. His work is marked by a strong romantic content and a use of symbols with erotic and anthropomorphic references. Elements present in his first residences in Havana reach their maturity in the Escuelas Nacionales de Arte (1961–5) in Cubanacán, Havana. The plastic tension of supports appears in the design of the Hotel Euro-Kursaal (1965) in San Sebastián. Because of his political views against the Revolution, Porro left Cuba in 1965 and settled in Paris. In his European works and projects he emphasized the expressive drama of plastic forms, giving them highly sculptural qualities, seen for example in his plans for the Palace of Air and Space (1967; unexecuted), Paris. The contrasting relationship between structure and volume is clearly represented in the Centro de Arte (1976) of Vaduz, Lichtenstein, and contrasts of space and light characterized by structural plasticity are apparent in the Ecole Elsa Triolet (1990) in Saint-Denis, Paris.

BIBLIOGRAPHY
H. Consuegra: 'Las escuelas nacionales de arte', *Arquitectura/Cuba*, 334 (1965), pp. 14–25
J. Rykwert: 'L'opera di Ricardo Porro', *Controspazio*, 3 (1970), pp. 4–15
P. Goulet: 'Défense et illustration du romantisme: Trois soirées avec Ricardo Porro', *Archit. Aujourd'hui*, 224 (1982), pp. 1–7
'Mit Ricardo Porro', *Umriss*, 3–4 (1985), pp. 21–30
R. Segre: *Arquitectura y urbanismo de la revolución cubana* (Havana, 1989)
R. Carley: *Cuba: 400 Years of Architectural Heritage* (New York, 1997)
J. A. Loomis: *Revolution of Forms: Cuba's Forgotten Art Schools* (New York, 1998)
ROBERTO SEGRE

Portinari, Cândido (*b* Brodósqui, Brazil, 30 Dec 1903; *d* Rio de Janeiro, 6 Feb 1962). Brazilian painter. The son of Italian immigrants, he recognized his vocation as a painter from an early age and in 1918 moved to Rio de Janeiro to enrol in the Escola Nacional de Belas Artes. From 1928 to 1931 he lived in Europe, mainly in Paris, on a foreign travel award from the Salão Nacional de Belas Artes (Rio de Janeiro). Canvases painted on his return to Rio de Janeiro, such as *Coffee* (1935; Rio de Janeiro, Mus. N. B.A.; *see* BRAZIL, fig. 9), which won a prize at the Carnegie International in Pittsburgh, PA, in 1935, revealed the influence of the Mexican muralists. In 1936 Portinari began to work on a series of commissioned murals on historical and social themes, central works of Brazilian modernism, notably for the Ministério da Educação e Saúde in Rio de Janeiro (1936–44), the Brazilian pavilion (1939) at the New York World Fair, the Library of Congress (1942) in Washington, DC, the church (1944–6) in Pampulha, near Belo Horizonte (*see* NIEMEYER, OSCAR, fig. 1), Cataguases School (*Tiradentes* panel, 1949; now São Paulo, Pal. Bandeirantes) and the headquarters (1953–7) of the United Nations in New York.

During the 1940s Portinari also worked on a series of Expressionist pictures, *Emigrants*, which drew attention to the poverty and social injustice in northeast Brazil, for example *Migrants from the Northeast*, *Dead Child* and

Burial in the Hammock (all 1944; São Paulo, Mus. A. Mod.). In both his murals and easel paintings he combined realism, Expressionism and a Surrealist lyricism born of a nostalgia for his childhood in the countryside, never losing sight of the Brazilian land and people. In 1979 the Projeto Portinari was founded in Rio de Janeiro to catalogue, study and disseminate his work.

BIBLIOGRAPHY
A. Callado: *Retrato de Portinari* (Rio de Janeiro, 1956)
M. Andrade: 'Candido Portinari', *O baile das quatro artes* (São Paulo, 1963), pp. 121–34
M. Filho: *A infância de Portinari* (Rio de Janeiro, 1966)
C. P. Valladares and F. Aquino: *Portinari* (São Paulo, 1968)
W. Zanini, ed.: *História geral da arte no Brasil*, ii (São Paulo, 1983)
A. Amaral: *Arte para quê?: A preocupação social na arte brasileira, 1930–1970* (São Paulo, 1984)
R. S. G. Lanzelotte and others: 'The Portinari Project: Science and Art Team up Together to Help Cultural Projects', *Proceedings of the Second International Conference on Hypermedia and Interactivity in Museums: Cambridge, 1993*
A. Fabris: *Candido Portinari* (São Paulo, 1996)
A. Callardo: *Candido Portinari* (Buenos Aires, 1997)
Candido Portinari: The Complete Works (Rio de Janeiro, in preparation) [cat. rais.]
ROBERTO PONTUAL

Porto, Severiano (Mário Vieira de Magalhães) (*b* Uberlândia, 1930). Brazilian architect. He graduated from the National School of Architecture in Rio de Janeiro in 1954 and then began to practise in Manaus; he also established an office in Rio de Janeiro, directed by Mário Emilio Ribeiro, to organize details for which there were no facilities in Manaus. To design, construct and supervise building work in the interior of the Amazon region is extremely difficult: only bricks and newly felled green timber from the forest are available there; all other materials have to be transported by boat from Manaus, which may take months. In these conditions Porto achieved a style of architecture of great strength and originality, adapted to the region through careful study of the indigenous inhabitants, climatic conditions and the appropriate use of local technology and materials. Of the buildings he constructed in the middle of the forest, perhaps the best known is the small tourist hotel (1979–83) on the island of Silves, which was awarded a prize by the Institute of Architects of Rio de Janeiro. Built entirely in the local hardwoods and roofed with rough wood chips, its circular form is an interpretation of the indigenous Indian hut. In earlier, conventional projects in Manaus, such as the offices of the Superintendência da Zona Franca (1967), the use of reinforced concrete is adapted to the hot, damp climate: large truncated pyramids 15 m square allow hot air to escape naturally by the roof. At the University of the Amazons (1973) in Manaus, where the buildings were placed at the highest point of the site to catch the prevailing winds, an insulating double-roof structure allows the free circulation of hot air. In other works he used vaulted roofs with reinforced ceramic, such as the School of Music at Fortaleza and the Legislative Assembly building at Porto Velho. His work received international recognition with an award at the Biennale at Buenos Aires in 1985.

WRITINGS
'Centro di Protezione Ambientale in Amazzonia', *Spazio & Soc.*, 56 (1991), pp. 34–41

BIBLIOGRAPHY
'Architecture in the Amazon', *ABA*, 1 (1967–8), pp. 80–125
'Severiano Porto', *Cj Arquitetura*, 20 (1978), pp. 21–47
R. Verde Sein: 'Severiano Porto', *Projeto*, 83 (1986), pp. 43–86 [special
 feature]
PAULO J. V. BRUNA

Portocarrero, René (*b* Havana, 24 Feb 1912; *d* Havana,
7 April 1985). Cuban painter, ceramicist and illustrator.
Although he attended some classes at the Academia de S
Alejandro in Havana, he taught himself to paint by studying
the work of a number of artists, especially Picasso, without
allowing these influences to dominate his own strong
personality. Like many of his Cuban contemporaries he
portrayed local scenes in combination with cosmopolitan
elements. Portocarrero's earliest important paintings, the
interiors of the old Havana Cerro quarter, were painted in
the 1940s. In colourful, baroque still-lifes and in interiors
with figures such as *Interior* (1943; Havana, Mus. N. B.A.),
the *horror vacui* of Cuban colonial architecture and interior
decoration is exploited to the fullest. During the late 1940s
and early 1950s Portocarrero produced abstract and semi-
abstract paintings that stressed colour and geometry. He
also produced a series of pen-and-ink drawings entitled
Masks depicting, for example, a couple in formal dress
(Havana, Mus. N. B.A.). Other series from the 1950s,
1960s and 1970s include cityscapes, cathedrals, Afro-
Cuban deities, women and the carnival. All these series
are characterized by strong colour, a love of the fantastic,
and complex lines and forms, as seen in *Cathedral in
Yellow* (1961; Havana, Mus. N. B.A.), in which a multitude
of architectural features are depicted in contrasting colours
creating a dense surface pattern. Portocarrero also worked
with ceramics during the 1950s, creating a ceramic mural
of female figures and floral motifs for the Palacio de la
Revolución, Havana, in 1968. He illustrated the books of
a number of Cuban authors, including José Lezama Lima's
Paradiso (Mexico City, 1968).

BIBLIOGRAPHY
A. Barr: 'Modern Cuban Painters', *MOMA Bull.*, xi (1944), pp. 1–14
O. Hurtado and others: *Pintores cubanos* (Havana, 1962)
René Portocarrero (exh. cat. by D. Hernández Gil and M. Arjona, Madrid,
 Mus. A. Contemp., 1984–5)
Wifredo Lam and his Contemporaries (exh. cat. by G. Blanc, J. Herzberg
 and L. Sims, New York, Studio Museum in Harlem, 1992)
*Four Cuban Modernists: Mario Carreño, Amelia Peláez, Fidelio Ponce, René
 Portocarrero* (exh. cat., Coral Gables, FL, Javier Lumbreras F. A., 1993)
N. G. Menocal: 'An Overriding Passion: The Quest for a National Identity
 in Painting', *J. Dec. & Propaganda A.*, xxii (1996), pp. 187–219
G. Mosquera: 'René Portocarrero', *A. Nexus*, xix (1996), pp. 76–81
GIULIO V. BLANC

Posada, José Guadalupe (*b* Aguascalientes, 2 Feb 1851;
d Mexico City, 20 Jan 1913). Mexican printmaker and
draughtsman. He showed an aptitude for drawing as a
child and briefly attended the Academia de Aguascalientes,
where he was taught by Antonio Varela. Afterwards he
studied lithography in the workshop of José Trinidad
Pedroza and began to attract attention with his critical
illustrations for Pedroza's periodical *El Jicote*. Local polit-
ical hostility forced both men to move, however, and in
1872 they went to León, Guanajuato, where Posada began
wood-engraving. In 1884 he taught lithography at a local
secondary school. Following the severe floods of 1888 he
moved to Mexico City, where the following year he began

to work as a draughtsman at Antonio Vanegas Arroyo's
printing house and started to move away from lithography
towards cheaper printmaking on zinc, wood and type
metal (see fig. 1).

Posada and Vanegas propagated news items on printed
flyers, illustrated by Posada as *corridos gráficos* in order to
communicate with a largely illiterate public. Posada also
illustrated sensational stories in Vanegas's regular *Ejem-
plos*, using the figure of the devil to represent the tempta-
tion to commit serious crimes, and he drew scenes from
daily life, such as festivities, brawls and traditional customs,
as well as popular character types and portraits of such
heroes as Emiliano Zapata and depictions of dramatic
religious scenes (e.g. *Universal Final Judgement*, 1899; see
Wollen, 1989–90 exh. cat. p. 73). Posada also contributed
to many periodicals, including *El Centavo perdido*, *El
Teatro*, Vanegas's *La Gaceta callejera* (e.g. *Great Pantheon
of Lovers*, n.d.; Mexico City, Mus. N. A.), *El San Lunes*
and *El Hijo del ahuizote*. The political and social stance of
these periodicals, however, led to repeated brief periods
of imprisonment of both men.

Posada's fictional character Don Chepito was one
means to convey social criticism, but he is perhaps best
known for his costumed skeleton characters or *calaveras*.
He used these as a vehicle for political and social satire, as
in *Calavera of the Cyclists* (1889–95; see fig. 2), in which
he criticized what he saw as an obsession with progress.

1. José Guadalupe Posada: *Galeria del Teatro Infantil La Almoneda
del Diablo*, printed booklet, 150×100 mm (Colchester, University of
Essex, Collection of Latin American Art)

2. José Guadalupe Posada: *Calavera of the Cyclists*, engraving, 140×260 mm, 1889–95 (New York, Museum of Modern Art)

The clergy, revolutionaries and Mexican pastimes also came under attack. These *calavera* engravings epitomize Posada's originality and characterization, and they anticipate Mexican mural painting of the 1920s and 1930s. They were skilfully executed, with eloquent use of black and white as well as middle tones; proportion and disproportion were more effectively used in his work on zinc, wood and type metal than in his lithographs.

WRITINGS
El novio de la muerte (Mexico City, 1996)

BIBLIOGRAPHY
Posada: Printmaker to the Mexican People (exh. cat. by F. Gamboa, Chicago, IL, A. Inst., 1944)
José Guadalupe Posada: 50 aniversario de su muerte (exh. cat. by P. Westheim, J. Fernández and J. J. Rodríguez, Mexico City, Mus. A. Mod., 1963)
J. Charlot: *Posada's Dance of Death* (New York, 1964)
Art in Latin America: The Modern Era, 1820–1980 (exh. cat. by D. Ades and others, London, Hayward Gal., 1989), pp. 111–23
Posada, Messenger of Mortality (exh. cat. by P. Wollen, Oxford, MOMA, and elsewhere, 1989–90)
T. Gretton: 'Posada's Prints as Photomechanical Artefacts', *Prt Q.*, ix/4 (Dec 1992), pp. 335–56
R. González Mello: 'Posada y sus coleccionistas extranjeros', *México en el mundo de las colecciones de arte*, v (Mexico City, 1994), pp. 312–73
——: 'Posada and the 'Popular': Commodities and Social Constructs in Mexico before the Revolution', *Oxford A. J.*, xvii/2 (1994), pp. 32–47
J. Gómez Serrano: *José Guadalupe Posada: Testigo y crítico de su tiempo. Aguascalientes* (Aguascalientes, [1995])
Posada y la prensa ilustrada: Signos de modernización y resistencia (exh. cat. by C. Monsiváis and others, Mexico City, Mus. N. A., 1996)
P. Frank: *Posada's Broadsheets: Mexica Popular Imagery, 1890–1910* (Albuquerque, 1998)

ELISA GARCÍA BARRAGÁN

Post, Frans (Jansz.) (*b* Haarlem *c.* 1612; *bur* Haarlem, 17 Feb 1680). Dutch painter and draughtsman, active in Brazil. He was one of the first trained European landscape artists to paint in the New World. His paintings and drawings without exception depict Brazilian scenery with exotic buildings, plants, animals and natives. He probably received his early training from his father, Jan Jansz. Post (*d* 1614), a stained-glass painter, and was also influenced by the early landscapes of his brother, Pieter Post (*b* Haarlem, *bapt* 1 May 1608; *d* The Hague, ?2 May 1669), an architect, although no works exist from this period. When Johan Maurits, Count of Nassau-Siegen (*see* NASSAU-SIEGEN, JOHAN MAURITS OF) went to Brazil as Governor General of the Dutch colony in the north-east in October 1636, Frans Post, together with ALBERT ECKHOUT, was among the artists and scientists on board to record various aspects of Brazilian life, landscape, fauna and flora (*see* BRAZIL, §V, 1). His earliest painting, of the *Island of Itamaracá* (Amsterdam, Rijksmus., on loan to The Hague, Mauritshuis; see fig.), north-east of Recife in Brazil, bears the date '1637 1/3' and thus must have been executed shortly after his arrival in Brazil. It is one of a group of only seven known paintings made in the New World by Post. All of them were painted between 1637 and 1640, and all are very closely related stylistically. They stand out by virtue of their directness and simplicity of vision. Though somewhat naive, they brilliantly capture the local atmosphere; moreover, they are of great topographical significance. Four other canvases of this group are in the Musée du Louvre, Paris, and probably formed part of a collection of more than 30 paintings by Post presented by Johan Maurits to Louis XIV of France in 1679. Remarkably, no paintings done during the last four years of his Brazilian sojourn seem to have been preserved. Post must also have made many drawings and sketches on the spot; however, surviving works on paper from his Brazilian period are even fewer in number than the paintings. They are characterized by the same originality and simplicity; a sketchbook containing 19 views made by Post on the voyage and during their arrival in Brazil in

Frans Post: *Island of Itamaracá*, oil on canvas, 635×895 mm, 1637 (Amsterdam, Rijksmuseum, on loan to The Hague, Mauritshuis)

January 1637 is in the Nederlands Scheepvaartmuseum, Amsterdam.

Post returned to the Netherlands in 1644, probably shortly before the Count. He settled in Haarlem, where he is mentioned first in September 1644, and spent the rest of his career producing imaginary Brazilian landscapes. He entered the Guild of St Luke, Haarlem, in 1646, serving as an officer in 1656–7 and 1658. In 1650 he married the daughter of a schoolmaster, Jannetje Bogaert (*d* 1664) in Zandvoort. Using the drawings he had made in Brazil, Post produced a large number of Brazilian landscape paintings. Those that date from the years immediately following his homecoming still exude some of the same originality and primitive atmosphere as the earlier works. His only known biblical scene, the *Sacrifice of Manoah* (1648; Rotterdam, Boymans–van Beuningen) also has a Brazilian setting (the figures are by another hand). One of his most successful compositions of that period is the *River Landscape* (1650; see colour pl. XXXI, fig. 2). Probably under the influence of the many Haarlem landscapists, Post's technique improved over the years; although the influence of his brother Pieter Post and of Cornelis Vroom can be detected in many of his paintings, Frans Post never abandoned his personal style.

Post's visual memory of the Brazilian countryside seems to have diminished towards the mid-1650s. In most of his paintings after that date an increasingly decorative tendency prevails. Often carefully rendered Brazilian plants and animals form part of a conspicuously heavy repoussoir.

In addition, the subtle colours of his earlier work were gradually replaced by a more saturated and brighter palette, resulting in a less convincing rendering of the Brazilian scenery. Yet, in spite of being more conventional, several of his later landscapes are still admirable examples of his artistry. Particularly impressive is the *Ruins of Olinda Cathedral* (1662; Amsterdam, Rijksmus.). The impact of the large canvas is further enhanced by the 17th-century frame, richly carved with exotic plants and fruits, which may have been part of the original commission and was perhaps designed by Post himself.

Post produced few drawings after his return to the Netherlands, the majority being designs for C. Barlaeus's *Rerum per octennium in Brasília gestarum historia* (Amsterdam, 1647); this important book is an extremely informative document describing not only Johan Maurits's reign in Brazil but also the country and its inhabitants. Post apparently gave up painting and drawing after 1669, as no dated works of the 1670s are known. His portrait was painted by his fellow-artist Frans Hals.

BIBLIOGRAPHY
A. Bredius: *Künstler-Inventare*, 6 vols (The Hague, 1915–22) v, pp. 1691–1718
J. de Sousa-Leão: *Frans Post* (Rio de Janeiro, 1937)
R. Smith: 'The Brazilian Landscapes of Frans Post', *A. Q.* [Detroit], i (1938), pp. 238–67
J. G. van Gelder: 'Post en van den Eeckhout: Schilders in Brazilië', *Beeld. Kst*, xxvi (1940), pp. 65–72
Maurits de Braziliaan (exh. cat. by A. B. de Vries, J. de Sousa-Leão and W. Y. van Balen, The Hague, Mauritshuis, 1953), pp. 38–47, 58–9
A. Guimarães de Segadas Machado: 'Na Holanda, com Frans Post', *Rev. Inst. Hist. & Geog. Bras.*, ccxxxv (1957), pp. 85–295

E. Larsen: *Frans Post: Interprète du Brésil* (Amsterdam, 1962)

Os pintores de Mauricio de Nassau (exh. cat. by J. de Sousa-Leão, Rio de Janeiro, Mus. A. Mod., 1968), pp. 24–67

L. Reviglio: 'Frans Post, o primeiro paisagista do Brasil', *Rev. Inst. Estud. Bras.*, xiii (1972), pp. 7–33

J. de Sousa-Leão, *Frans Post, 1612–1680* (Amsterdam, 1973)

Zo wijd de wereld strekt (exh. cat., ed. E. van Boogaart and F. J. Duparc; The Hague, Mauritshuis, 1979)

R. Joppien: 'The Dutch Vision of Brazil: Johan Maurits and his Artists', *Johan Maurits van Nassau-Siegen, 1604–1679: A Humanist Prince in Europe and Brazil: Essays on the Occasion of the Tercentenary of his Death*, ed. E. van den Boogaart (The Hague, 1979)

P. J. P. Whitehead and M. Boeseman: *A Portrait of Dutch 17th–century Brazil* (Amsterdam, Oxford and New York, 1989)

Frans Post, 1612–1680 (exh. cat. by T. Kellein and U.-B. Frei, Basle, Ksthalle; Tübingen, Ksthalle; 1990)

FREDERIK J. DUPARC

Potosí. Bolivian city in the country's central-southern area, with a population in the late 20th century of *c.* 100,000. According to legend, the Incas were forbidden by 'a thunderous voice' to exploit the silver lodes in the nearby Cerro Rico hill and thereafter called the place Potosí ('noise'). When the Spanish conquistadors discovered the silver, they established a mining camp (1542) at the foot of the hill, 4000 m above sea level. Potosí was officially founded and its plan laid down by Viceroy Francisco de Toledo in 1572. Exploitation of the silver called for ever increasing numbers of *mitavos* (Indians subjected to forced labour), and they converged upon Potosí from every part of the subcontinent that was subject to the *encomienda* system (whereby Indian workers, and sometimes their land, were assigned to Spaniards).

By 1600, with 160,000 inhabitants, it was the most highly populated city in the Americas and fourth in the world after Paris, London and Naples. It was also among the most opulent. The art of Potosí was dominated for most of the 17th century by Spanish realist models. In sculpture the works of Gaspar de la Cueva, from Seville, and of another Spaniard, Luis de Espíndola, were particularly important in introducing Spanish influence. In painting, the characteristic Spanish use of tenebrism is evident; perhaps the most important painter active in Potosí during this period was Francisco de Herrera Velarde (*fl* 1650–70). Potosí also has one of the few examples of civil architecture from the early colonial period, the Casa Vicaria (1615). The city's multi-ethnic population ensured, however, that this direct Spanish influence began to give way in the second half of the 17th century to a MESTIZO Baroque style, modified by indigenous traditions and influences. For example, the European 17th-century Baroque was treated with uninhibited invention in such churches as S Teresa (1685) and La Compañía (1700–07) with its flying bell chamber (*espadaña*), the work of the Indian Sebastián de la Cruz. The numerous churches and monastic establishments built during this period culminated in the celebrated but anonymous S Lorenzo (1728–44), its portal decoration under the great enclosing archivolt being one of the finest examples of Mestizo Baroque (*see* BOLIVIA, fig. 3). In painting the Mestizo Baroque is represented most notably by Luis Niño (*fl c.* 1720; *see* BOLIVIA, fig. 5) and Gaspar Miguel de Berrio (1706–62), who painted a notable view of the city in 1758

View of Potosí by Gaspar Miguel de Berrio, 1758 (Sucre, Universidad Mayor, Real y Pontificia de San Francisco Xavier de Chuquisaca, Museo Charcas)

(U. Sucre, Mus. Charcas; see fig.). The city's wealth ensured that architectural achievement was carried through into civil as well as religious buildings. The Casa de Moneda, set up when the city was founded and rebuilt between 1759 and 1772 by Salvador Villa and Luis Cabello, is one of the finest examples of colonial civil building in Latin America. Nearby, Cajas Reales faces on to the Plaza 10 de Noviembre, the city's principal square, as does the convent of S Teresa (now the Museo del Convento de S Teresa). The fine mansions of Potosí's merchant classes had portals covered with every conceivable Mestizo planiform decoration, and iron-grilled upper windows gave on to the streets of the old city; concealed in their patios were fine Baroque arcades and galleries in both timber and stone, as in the Casa del Corregidor, dating from the last quarter of the 18th century.

The city's cathedral (also facing the Plaza 10 de Noviembre), designed by the Franciscan FRAY MANUEL DE SANAHUJA, was completed in 1838; although Sanahuja is normally associated with Neo-classicism, the cathedral retains much of the Baroque and even a touch of Rococo in the line of the gable. By this time, however, in spite of some diversification to other metal ores, falling silver prices and overworked lodes had caused the population to decline dramatically, and it was not until the turn of the century that rising tin prices again improved the city's fortunes. In the first half of the 20th century many Baroque buildings were renovated in the Neo-classical and other styles, although the cathedral continued to dominate the city, and after the left-wing revolution of 1952 there was rapid urban development in an international modernist style. In the fine arts an interest in Indigenism, promoted most notably by CECILIO GUZMAN DE ROJAS, was coupled with a reawakening of interest in Baroque art on the part of collectors. Art education was boosted with the opening of the Academia Man Césped in 1939, which later became the Escuela de Artes Plásticas and which was eventually incorporated into the Universidad Autónoma Tomás Frías. A number of museums also opened, including the Museo Nacional de la Casa de Moneda (est. 1942), with numismatics and coin-making equipment, and the Museo del Convento S Francisco (est. 1979), with a collection of colonial and modern art.

See also BOLIVIA, §V.

BIBLIOGRAPHY
'Potosí', *Monografía de Bolivia*, i (La Paz, 1975), pp. 208–391
J. de Mesa and T. Gisbert: *Monumentos de Bolivia* (La Paz, 1978)
M. Baptista and others: *Potosí: Patrimonio cultural de la humanidad* (La Paz, 1988)
T. Gisbert and L. Prado, eds: *Potosí: Catalogación de su patrimonio urbano y arquitectónico* (La Paz, 1990)
W. Mendieta Pacheco: *El descubrimiento de América y Potosí* (Potosí, 1992)
Potosí: Colonial Treasures and the Bolivian City of Silver (exh. cat., New York, Americas Soc. A.G., 1997)
LAURA ESCOBARI, PEDRO QUEREJAZU

Pottinger, David (*b* Kingston, 11 Sept 1911). Jamaican painter. He attended art classes at the Junior Centre of the Institute of Jamaica during the 1940s and later studied at the Jamaica School of Art and Crafts. He started exhibiting regularly in the 1940s. He is best known for his haunting, expressionist depictions of life in the ghetto areas of downtown Kingston, where he lived and worked. An example is *Nine Night* (*c.* 1945; Kingston, N.G.), which depicts a nocturnal funeral ritual associated with Revivalism, an indigenous Afro-Christian cult. Over the years his subject-matter and style changed very little. His palette tended to be sombre and verged on the monochromatic, although in later work he started using brighter, more contrasting colours. While his work is always representational, he omitted details such as facial features. On occasion he experimented with a modernist elongation of the human figure.

BIBLIOGRAPHY
D. Boxer and V. Poupeye: *Modern Jamaican Art* (Kingston, 1998)
V. Poupeye: *Caribbean Art* (London, 1998)
VEERLE POUPEYE

Prado, Marina Núñez del. *See* NÚÑEZ DEL PRADO, MARINA.

Praxis. Nicaraguan group of painters and sculptors based in Managua and active from 1963 to 1972. It was centred on an art gallery of the same name that served not only as a cooperative studio and exhibition space for avant-garde art but also as a focal point for Nicaragua's intelligentsia. The inaugural exhibition in 1963 consisted of 37 abstract or semi-abstract oil paintings by 15 artists, most of whom were former students of RODRIGO PEÑALBA at the Escuela Nacional de Bellas Artes in Managua. Among them were Alejandro Aróstegui (*b* 1935), Arnoldo Guillén (*b* 1941), Omar De León (*b* 1929), César Izquierdo (*b* 1937), Genaro Lugo (*b* 1946), Efrén Medina (*b* 1949), Roger Pérez de la Roche (*b* 1949), Leoncio Sáenz (*b* 1936), Orlando Sobalvarro (*b* 1943), Luis Urbina Rivas (*b* 1937) and Leonel Vanegas (*b* 1942).

As the first avant-garde visual arts movement in Nicaragua, Praxis was founded with the express intention of assimilating elements from Western modernism while also arriving at a distinctive national vocabulary of form. The exclusive emphasis on formal experimentation that initially characterized work by group members was soon balanced by a commitment to the vanguard politics of the Sandinista Front and to an examination of the relationship between art and society. These concerns were promoted in two publications (1963 and 1964) bearing the group's name. They allied themselves both to Matter painting in Spain, which was identified with opposition to the Fascist government of General Franco, and to the artistic traditions of pre-colonial Nicaragua that were largely ignored if not suppressed in the period of General Somoza's dictatorship. Lugo's *Head of a Bird* (1964; Managua, Banco Cent. Nicaragua) is typical in its heavily impastoed surface, sombre colours and organic imagery.

BIBLIOGRAPHY
J. E. Arellano: *Tres apéndices más a la obra pintura y escultura en Nicaragua* (Managua, 1978), pp. 55–65
Pintura contemporánea de Nicaragua: Segundo aniversario del triunfo de la Revolución Popular Sandinista (exh. cat., Mexico City, Inst. N. B.A., 1981)
R. Murillo: 'Arnoldo Guillén, Orlando Sobalvarro, Santos Medina y Leonel Vanegas', *Ventana* (3 July 1982), pp. 2–7
B. LaDuke: 'Six Nicaraguan Painters', *A. & Artists*, xii/8 (July 1983), pp. 9–13
Pintura contemporánea de Nicaragua, Unión Nacional de Artistas Plásticas (Managua, 1986), pp. 7–9
D. Craven: *The New Concept of Art and Popular Culture in Nicaragua since the Revolution in 1979* (Lewiston, NY, 1989), pp. 20–23

A. Aróstegui and others: *Maestros del Grupo Praxis: Primera generación* (Managua, 1991)

M. D. G. Torres: *La modernidad en la pintura nicaragüense* (Managua, 1995), pp. 55–91

<div align="right">DAVID CRAVEN</div>

Prebisch, Alberto (Horacio) (*b* Tucumán, 1 Feb 1899; *d* Buenos Aires, 3 June 1970). Argentine architect and writer. He graduated in architecture from the Universidad de Buenos Aires in 1921 and then undertook postgraduate studies in Europe and the USA. Back in Buenos Aires in 1924, he won the competition for the Cuidad Azucarera in the province of Tucumán. He joined the editorial group of the avant-garde review *Martín Fierro*, which supported modern art and architecture against contemporary academicism, and he wrote on architecture for a number of periodicals and newspapers, including Victoria Ocampo's literary magazine *Sur*. Prebisch was one of the pioneers of the Modern Movement in Latin America, producing characteristically astylar buildings such as an apartment building (1928) in the Avenida Cramer, the Casa Luis María Campos (1930; destr.) and Cine Gran Rex (1937), all in Buenos Aires; the latter, with giant, two-storey 'ladder' windows in a flat, massive façade, is typical of cinemas built all over the Western world in the 1930s. His obelisk (1936) at the junction of Avenida 9 Julio, Avenida Corrientes and Avenida Diagonal Norte, Buenos Aires, became a symbol of the city. His extensive oeuvre included cinemas throughout Argentina, from the Plaza (1944) in Tucumán to the Atlas (1966) in Buenos Aires; the Banco do Brasil (1959), Societe Generale Headquarters (1963) and many other office buildings in Buenos Aires; numerous private houses; and public buildings such as the Civic Centre (1954), Barrio Parque 'El Trébol' in Buenos Aires province. He was Dean of the Faculty of Architecture and Urbanism at the Universidad de Buenos Aires from 1968 to 1970.

BIBLIOGRAPHY

F. Bullrich: *New Directions in Latin American Architecture* (London, 1969), pp. 19ff

M. Waisman: 'Documentos', *Summa* [Buenos Aires] (1978)

J. Cacciatore: 'Alberto Prebisch', *Summa* [Benos Aires], 189 (July 1983), pp. 16–19

S. Borghini, H. Salama and J. Solsona: *1930–1950: Arquitectura moderna en Buenos Aires* (Buenos Aires, 1987), pp. 90–99

A. Toca, ed.: *Nueva arquitectura en América Latina: Presente y futuro* (Mexico City, 1990), pp. 247–62

F. Grementieri: 'Alberto Prebisch', *Consejo profesional de arquitectura y urbanismo* [Buenos Aires], 3 (Oct 1994), pp. 18–25.

<div align="right">LUDOVICO C. KOPPMANN</div>

Primoli, Giovanni Battista (*b* Milan, 10 Oct 1673; *d* Mision de Candelaria, 15 Sept 1747). Italian architect, active in South America. He practised as an architect before entering the Jesuit Order. In 1717 he travelled to Rio de la Plata with ANDREA BIANCHI, and they collaborated successfully on works of major regional importance. In these Bianchi acted primarily as a designer, while Primoli completed many of the buildings planned by his colleague. Primoli alternated his work between Buenos Aires and Córdoba, and in 1719 he built projects of his own design for the town council of Buenos Aires. From 1720 to 1729 he was established in Córdoba, working on the Colegio Máximo of the university with Bianchi and starting the construction of the Convictorio and the Casa de Ejercicios.

After briefly returning to Buenos Aires to work on the Colegio de S Ignacio, in 1730 Primoli toured the Jesuit missions to the Guaraní Indians. He began by working on a project for the church (1730) in the village of La Cruz in the province of Corriente and continued with buildings at Concepción (1732), Misiones, both in Argentina. With S Miguel (1733–5, 1737–40; partially ruined), Rio Grande do Sul in Brazil and La Trinidad (1740–6; ruined) in south Paraguay, these constitute his most notable achievements. The establishment of lime-burning plants enabled the techniques of church building to evolve so that timber roof structures were progressively replaced by stone vaults and cupolas, as in La Trinidad. Renaissance and Mannerist influences are apparent in the façade of S Miguel, and the ornamental quality of these schemes shows how native craftsmen freely interpreted European styles. In the early 1950s a museum was built next to S Miguel to display the wooden and stone carvings found inside.

BIBLIOGRAPHY

G. Furlong: *Los Jesuitas y la cultura rioplatense* (Montevideo, 1933)

M. J. Buschiazzo: *Estancias jesuíticas* (Buenos Aires, 1969)

R. Gutiérrez: *San Miguel en misiones*, Documentos de Arquitectura Nacional y Americana, xiv (Resistencia, 1982)

B. Sustersic and E. Auletta: *La Polemica sobre la iglesia de la Santísima Trinidad del Paraná y los Padres 'adversos' a su construcción* (Buenos Aires, 1996)

<div align="right">RÁMON GUTIÉRREZ</div>

Prior, Alfredo (*b* Buenos Aires, 2 May 1952). Argentine painter. His production is multi-faceted, although his point of departure was in conceptual art. Such paintings as *King Kong* (1984; see Glusberg, 1986, p. 122) at first seem merely decorative—series of arabesques and squares with similar motifs and colours—but closer inspection reveals that they are a distinct expression of the new figuration. There is no repetition in the series of contiguous figures, they are traces of a creative process that subverts established canons and gives rise to new images. Prior develops his motifs with complete freedom, demonstrating that unexpected juxtapositions can transform a series of informal marks into an ideological structure. His images of buildings, some recognizable, show that the new figuration does not preclude historical references: in fact the creative process is related to traditional motifs, especially Aztec. Prior's works are linked to a strong indigenous Latin American tradition, although he employs the international language of contemporary art. In 1986 he was awarded the Premio al Artista Joven del Año by the Argentinian section of the Association Internationale des Critiques d'Art.

BIBLIOGRAPHY

J. Glusberg: *Del Pop-art a la nueva imagen* (Buenos Aires, 1985)

——: *Art in Argentina* (Milan, 1986), pp. 122, 129–30 [Eng. text]

L. Thonis: 'Prior, o la escultura del color', *Artinf*, xxi/97 (1997)

S. Ambrosini: 'Alfredo Prior', *Artinf*, xxii/100 (1998)

Alfredo Prior en el Museo Nacional de Bellas Artes (exh. cat. by J. Glusberg, Buenos Aires, Mus. N. B.A., 1998)

<div align="right">JORGE GLUSBERG</div>

Puebla. Mexican city in the state and valley of the same name. It is situated on the south-western slope of La Malinche volcano, 2162 m above sea-level, and it lies at the foot of the Loreto and Guadalupe hills by the River Atoyac. It has a population of *c*. 1 million. Puebla's colonial architecture is among the most magnificent in Mexico.

The city's textile industry is also of national significance: the *rebozos* (Sp.: 'stoles') and serapes produced there are famous. Among its regional industries are the famous Tecali alabaster objects and Talavera pottery (*see* MEXICO, §IV and fig. 15). The city was founded in 1530 on a site known as Cuetlacoapa by Toribio de Benavente, better known as Father Motolinia, and was called Puebla de los Angeles. Built to a grid plan, the city developed rapidly, and by the 18th century Puebla was known for the fine quality of its flour, produced by hundreds of mills along the Atoyac, which was exported to the Antilles and Central America. In the 19th century JOSÉ MANZO and AGUSTÍN ARRIETA were active in the city.

In the main square, the Plaza de la Constitución, which is thickly planted with trees, is the S Miguel Fountain (18th century). The cathedral shows the style of Juan de Herrera (see fig.) and is one of the most beautiful in the country. FRANCISCO BECERRA, who was active on a number of Puebla's churches, worked on the cathedral. Construction began in 1575, and it was completed in the 18th century under Bishop Juan de Palafox y Mendoza. Especially noteworthy are the altarpiece and baldacchino (1797–1818) by Manuel Tolsá and José Manzo, the Capilla de los Reyes, and the sacristy, with 17th-century paintings. The church of S Domingo (1611) houses the Rosario Chapel, which was opened on 16 April 1690; it is notable for its decoration in the POBLANO style. La Soledad Church has two fine Baroque retables in the transept and 18th-century paintings in the sacristy. The Carmelite church has a glazed-tile (*azulejos*) façade. Inside, a notable Baroque oval side chapel houses paintings dedicated to St Theresa of Avila and other Carmelite saints. At S Francisco there is a striking contrast between the stone and the glazed tiles

that cover the façade (see colour pl. XXII, fig. 2). Inside there are ribbed vaults and, in the vestry, paintings by Cristóbal de Talavera (*fl* 18th century).

Outstanding secular architecture includes the Casa del Déan (16th century), which contains interesting Renaissance wall paintings (16th century). In one room are depicted the *Twelve Sibyls* and in another themes inspired by the *Trionfi* of Petrarch. No less interesting is the Casa del que mató al animal. Its fine façade has an unusual, medieval air and is decorated by two reliefs that show figures restraining on a chain two ferocious mastiffs devouring kids. The Casa de los Muñecos has a façade of brick, mortar and glazed tiles. Its name derives from a series of unidentified figures that may depict the *Labours of Hercules*. The Teatro Principal (1550) is famous as the first in America to have been built in horseshoe form.

Puebla has numerous museums, including the Biblioteca Palafoxiana, which has 40,000 books and some European and Latin American incunabula, stacked on Baroque bookshelves carved in 1773. The Museo de las Artesanías, or Museo de Arte Popular Poblano, in the cloister of the former monastery of S Rosa, contains select items of craftwork. The Museo de Arte Religioso, located in the former convent of S Mónica, contains easel paintings from the 17th to 19th centuries, in addition to antique furniture and books. The Museo de Arte 'José Luis Bello y González' and the Museo Bello have both European and Latin American items, including paintings, furniture, sculpture, ivory pieces and glass objects.

BIBLIOGRAPHY
M. Toussaint: *La catedral y las iglesias de Puebla* (Mexico City, 1954)
G. Hubler and M. Soria: *Art and Architecture in Spain and Portugal and their American Dominions, 1500 to 1800*, Pelican Hist. A. (Harmondsworth, 1959)
F. Pérez Salazar: *Historia de la pintura en Puebla* (Mexico City, 1963)
F. J. Cabrera: *Puebla y los poblanos* (Mexico City, 1987)
P. Mariano Monterrosa and S. Leticia Talavera: *Catálogo nacional de monumentos históricos muebles catedral de Puebla*, 2 vols (Puebla, 1988)
——: *Catálogo nacional de bienes muebles del ex-convento de la Santa Mónica de la ciudad de Puebla* (Puebla, 1991)
R. Loreto López: *La ciudad de Puebla* (Puebla, 1994)

S. LETICIA TALAVERA, P. MARTANO MONTERROSA

Puente, Alejandro (*b* La Plata, nr Buenos Aires, 1 May 1933). Argentine painter. In 1960 he joined Grupo Sí, which was moving towards a new form of abstract art that culminated in the use of the shaped canvas. By 1965 Puente was painting in a form of hard-edge abstraction. In 1967 he won a Guggenheim Fellowship and went to New York; he returned to Buenos Aires in 1971. In his painting he used geometrical motifs drawn from Pre-Columbian cultures, recycling the forms to integrate regional and universal elements in a Constructivist spirit. In 1985 he became a member of the Academia Nacional de Bellas Artes. He won a number of prizes, including the Premio Fundación Gutemberg. Works by Puente are in the USA in the collections of the Center for Inter-American Relations, the Chase Manhattan Bank and the Archer Huntington Art Gallery (all New York City); in Asunción, Paraguay, in the Museo de Bellas Artes de Asunción; and in Buenos Aires in the Museo de Arte Contemporáneo.

BIBLIOGRAPHY
J. Romero Brest: *El arte en la Argentina: Últimas décadas* (Buenos Aires 1969) p. 84

Puebla Cathedral, façade, from 1575

J. Glusberg: *Del Pop-art a la nueva imagen* (Buenos Aires, 1985)
——: *Art in Argentina* (Milan, 1986)
Alejandro Puente (exh. cat., Buenos Aires, Gal. Ruth Benzacar, 1993)
J. López Anaya: *Historia del arte argentino* (Buenos Aires, 1997), pp. 314–17, 370–71
'Arco '97: El envío Argentino del FNA', *Cultura* (Buenos Aires, 1997), pp. 19, 21, 32–3

JORGE GLUSBERG

Puerto Rico. Country in the northern Caribbean Sea, east of the Dominican Republic and west of the Virgin Islands. As well as the main island, it includes the smaller islands of Culebra and Vieques (see fig. 1). The capital is San Juan, and the country's population is *c.* 3.5 million (1990). It was a Spanish settlement (called Porto Rico) from 1508, but in 1898 it came under the control of the USA.

I. Introduction. II. Cultures. III. Architecture. IV. Painting, graphic arts and sculpture. V. Decorative arts. VI. Patronage and art institutions.

I. Introduction.

The island was originally settled by Archaic Amerindian peoples from South America (*see* §II, 1 below). Columbus visited the island on his second voyage (1493), naming it San Juan Bautista. It was renamed Porto Rico (Sp.: Rich Port) by Juan Ponce de León, who founded the first town, Caparra (1508); the towns of Santa María de Guadianilla and San Germán followed. In 1515 sugar cane became the major crop, and African slaves were imported to provide labour. The indigenous population rapidly declined and towards the end of the 16th century was almost extinct. Continuous attacks, by local Indians as well as by the English (1595, 1598, 1797) and Dutch (1625), prompted the construction of forts. By the 17th century, defensive walls were completed, and several towns had been established (*see* §III below). The mountain region developed with coffee production (1736), and commerce flourished. Emancipation of the slave population took place in 1873.

Following invasion by the USA (1898), Spain ceded Porto Rico; the American military government was abolished in 1900. In this period coffee plantations almost disappeared, as American sugar companies expanded production on the island. The Jones Law of 1917 granted all Porto Ricans US citizenship and a governor appointed by the American President. In 1932 an Act of Congress changed the country's name to Puerto Rico. The first Puerto Rican governor was appointed in 1946, and the first governor to be elected by the people, Luís Muñoz Marín, was inaugurated in 1948. The Commonwealth of Puerto Rico was established in 1952. Periodic plebiscites (most recently in 1967, 1993 and 1998) have reaffirmed Puerto Rico's status as a US commonwealth, as opposed to an independent country or 51st state.

BIBLIOGRAPHY
M. T. Babín: *Panorama de la cultura puertorriqueña* (New York, 1958)
A. de Hostos: *Diccionario histórico, bibliográfico comentado de Puerto Rico* (San Juan, 1976)
A. Morales Carrión and others: *Puerto Rico: A Political and Cultural History* (New York, 1983)
G. Crescioni: *Breve historia de la cultura puertorriqueña* (Madrid, 1987)
G. R. Cabrera: *Puerto Rico y su historia íntima, 1500–1996* (San Juan, c.1997)
T. Monge: *Puerto Rico* (New Haven, CT, 1997)

MYRNA E. RODRIGUEZ

II. Cultures.

1. AMERINDIAN. The first inhabitants of Puerto Rico were the Archaic Amerindians, who also populated the other islands of the Greater Antilles. Their only art manifestations were very simple shell and stone beads, used as body ornament. The next inhabitants (*c.* 300 BC–*c.* AD 600) were Saladoid Amerindians from South America, who had already occupied Trinidad and Tobago and the Lesser Antilles. The Saladoids had a centuries-old ceramic tradition, characterized by a fine, well-fired pottery, decorated with geometric and figurative white-on-red designs (occasionally with a third colour) and elaborate polychrome designs. In Puerto Rico its early manifestation was in the Hacienda Grande culture (400 BC–AD 400), characterized by effigy bowls. Besides the use of paint, the Saladoids also decorated their pottery with small, modelled

1. Map of Puerto Rico

zoomorphic and anthropomorphic figures projecting from borders and handles. Fine incisions of cross-hatched lines, sometimes filled with white or red pigment, also characterized the earliest ceramic decorations. During this period stone was used mostly in the elaboration of fine rectangular plano-convex celts and amulets. Such semi-precious stones as amethyst, cornelian, jadeite and quartz, as well as mother-of-pearl and conch-shell, were used as ornaments, mostly in the elaboration of beads for necklaces and for amulets.

From AD 400 to AD 600, during the later Cuevas manifestation of Saladoid culture in Puerto Rico, there is evidence of a decline in the fine pottery production and other artistic expressions of Hacienda Grande culture, including the use of semi-precious stones for ornament. By AD 600 a new cultural manifestation of the Ostionoid or Sub-Taino Amerindians of Puerto Rico is evident. In artistic terms the Ostionoid culture in Puerto Rico represents a period of decadence, particularly in pottery and body ornament. Most of the pottery no longer has ornamentation, but Ostionoid design is sometimes composed of wide, simple, incised designs with modelled figures representing bat heads. Borders are sometimes painted red. During the Ostionoid culture stone-carving was prominent, and three-pointed stone idols (or *cemís*) common to Puerto Rican Amerindians are characteristic, though very simple and limited to the triangular shape.

By AD 1000 the Tainan culture flourished. The Tainos produced what was possibly the highest expression of culture in the Caribbean, although their pottery, though richer than the Ostionoid, never reached the quality and artistic expression of the early Saladoids. Their vessels, sometimes polished and decorated with incised geometric designs of line, circle and dot motifs, were occasionally decorated with red or black painted bands. Handles of modelled heads and straps were also common. Shell- and wood-carving reached its climax in Taino art. Elaborate examples of three-pointed stones were carved from marble, granite, serpentine and other hard island stones and then highly polished. The front projection of the idol was modelled into a human or animal face, while the rear projection represented, in incised or carved form, the legs of froglike creatures. In some the central cone-form represents an animal or human head, from which arms extend towards the front where they hold another carved head. Occasionally eye and mouth openings were enriched with gold leaf, conch-shell or bone inlays.

Ceremonial stools carved in stone or wood (*dujos*) represent some of the most sacred and valuable Taino art objects. They were highly polished and sometimes enriched with incised designs and gold or shell inlays. The most characteristic item of Puerto Rican art is the monolithic stone ceremonial belt (see fig. 2), often referred to as a stone collar for its similarity in shape to a horse collar. These belts, of which *c.* 200 are known, represent the highest technical achievement of stone-carving in the area. They are elliptical in shape, and their widths vary in diameter, from 40 to 90 mm. They are associated with the ceremonial rubber-ball game practised by the Tainos. There are numerous examples of the ballcourt in Puerto Rico, for example at Caguanas, Utuado, where it is surrounded by rows of large monoliths with elaborately

2. Puerto Rican monolithic stone ceremonial belt or collar, longest diam. 457 mm, *c.* AD 1000 (New York, American Museum of Natural History); drawing

carved petroglyphs; they were used for ceremonial purposes and for games.

Many objects of artistic value were associated with the ceremony in which hallucinogenic *cohoba* (*Anadenanthera peregrina*) was inhaled, including beautifully carved wooden rattles, bone and clay inhalers and vomiting sticks. Although the Tainos did not practise the art of smelting, they used to pound gold nuggets, found in river beds, into sheets, from which they cut elaborate ornaments and discs used for jewellery and inlay. They produced many small ornaments—ear- and lip-plugs, necklaces and small amulets shaped as animal or human figures, made from clay or carved in stone, bone or conch shell. Although the Tainos died out after the arrival of the Spaniards in Puerto Rico, many elements of their culture survive, for example such craft techniques as the weaving of hammocks and baskets and the manufacture of gourd rattles.

BIBLIOGRAPHY
J. Fewkes: *The Aborigines of Puerto Rico*, 25th Annu. Rep. Bureau Ethnol. (Washington, DC, 1907)
M. Pons-Alegría: 'Taino Indian Art', *Archaeology*, xxxiii/4 (July/Aug 1980), pp. 8–15
I. Rouse: *The Tainos: Rise and Fall of the People who Greeted Columbus* (New Haven, 1992)
L'Art des sculpteurs taïnos: Chefs-d'oeuvre des Grandes Antilles précolombiennes (exh. cat., ed. J. Kerchache; Paris, Petit Pal., 1994)
RICARDO E. ALEGRÍA, MELA PONS-ALEGRÍA

2. AFRO-CARIBBEAN. African slaves were imported to Puerto Rico as early as 1519, bringing with them beliefs, customs and arts that subsequently enriched the native Puerto Rican cultures. After various attempts to abolish slavery, such as the Moret Law of 1870, which granted liberty to those slaves born after 1868, slavery ended in 1873. By then, interracial marriages (forbidden by the Catholic Church) had resulted in a mulatto population, and the African cultural presence was strongly felt. New festivals and 'spiritism' or spiritual cults developed with the interaction of Catholicism and African religious forces, resulting in unique and powerful imagery such as the costumes and masks made of coconut fibre (e.g. of the character of Vejigante) employed at the Feast of Santiago Apóstol in Loíza Aldea, a predominantly black community on the northern coast; these are also made from papier mâché and wiremesh for festivals in other towns. Popular imagery enhanced the characters of the Melchior, the 'black king' of the Magi, and San Martín de Porres, a black saint. Hand-carved wooden figures of such characters, made by humble craftsmen, were adored in cult ceremonies. In the mainstream of art production Afro-Caribbean artists have been successful (*see* §IV below), but in general

an ethnic cultural distinction is not made, and the artists consider themselves primarily Puerto Rican.

BIBLIOGRAPHY

O. Delgado: *Historia de la pintura en Puerto Rico*, viii of *La gran enciclopedia de Puerto Rico*, ed. V. Báez (Madrid, 1976)

J. Sued Badillo and A. López Cantos: *Puerto Rico negro* (Río Piedras, 1986)

La tercera raíz: Presencia africana en Puerto Rico (exh. cat., Puerto Rico, Arsenal de la Puntilla; Mexico City; 1992)

L. M. Martínez Montiel, ed.: *Presencia africana en el Caribe* (Mexico City, 1995)

MYRNA E. RODRIGUEZ

III. Architecture.

Although Columbus visited Puerto Rico on his second voyage of 1493, serious attempts at settlement did not begin until 1508, when Caparra, the first capital, was founded to the south of the islet today occupied by San Juan, the second capital. The first peasant dwellings, *jíbaros*, developed from the Amerindian *bohíos*, dwellings on a circular plan, and *caneyes*, of rectangular plan, built from timber and palm-thatched. After European colonization the island became a strategic and military centre at one of the northern exits of the Caribbean Sea towards the Atlantic and Europe. The continuous attacks both by Indians from the small islands to the east and south and by local Indians necessitated the construction in the 16th century of numerous defensive structures and walls to protect the major urban settlements: the most notable is the great Castillo de S Felipe de El Morro (begun 1591), an imposing fortification in the north of the city of San Juan (see fig. 3). The building was originally designed by Juan de Tejada, an architect of civic buildings, and the military engineer Bautista Antonelli (*see* ANTONELLI), an expert in fortifications with very considerable experience gained in Flanders, who also executed works in Portobelo in Panama and Cartagena de Indias in Colombia. This important fortification, which eventually included a citadel, three small forts and two fortresses as part of the vast defensive complex, protected the islet of San Juan on the Atlantic side from attacks by pirates and by the indigenous population. In the south the Castillo de S Cristóbal was planned to protect the Plaza de San Juan from attacks by land and was built in the 18th century. Such defensive work required the construction of a system of walls, which, together with the castles, resulted in a first-rate protective

3. Juan de Tejada and Bautista Antonelli: Castillo de S Felipe de El Morro, San Juan, Puerto Rico, begun 1591

chain between 1663 and *c.* 1750. The works were executed by the Governor Enrique de Sotomayor, Field Marshal Alejandro O'Reilly and the military engineer Tomás O'Daly.

The colonial urbanization of Puerto Rico followed the 'Leyes de Indias' based on the colonization ordinances (1573) of Philip II, King of Spain. San Germán (founded 1512), San Coamo (founded 1579) and San Felipe de Arecibo (founded 1616) were among the original settlements where the colonial urban legislation was implemented, based on grid plans with orientated parallel streets and a central square with its principal church and Cabildo. During the 17th and 18th centuries Puerto Rico's main purpose remained strategic, so there was very little development in civic and religious architecture. In the largest cities the most interesting civic architecture is in stone and recalls that of southern Spain, in particular of Cadiz and Seville. Outstanding religious architecture is represented by the simple cathedral of San Juan (begun 1528), first built in a Late Gothic style but restored (1801–6) in a late Neo-classical style by Spanish architect Luis de Huertas (1765–1815) and Spanish engineer Tomás Alberto Sedeño (*b* 1750). Other examples include the churches of Coamo (1650; rebuilt 1750; simple Rococo façade restored 1849) and of San Germán, and the hermitage of Porta Coeli in San Germán. Equally important is the Dominican convent of S Tomás Aquino (begun 1523) in Old San Juan, with its church dedicated to S José (begun 1532), which is the last example of Late Gothic architecture in stone in Puerto Rico, as can be seen in the church's restored apse (1769–74). The church has been attributed to Diego de Arroyo of Seville. In 1605 the first Cabildo was built in the Plaza de San Juan; it was rebuilt in 1714 by Juan de Rivera and reconstructed and enlarged (1757–8) with a steeply pitched roof and balcony along its full length under overhanging eaves.

In the 19th century, historic architecture was most fully developed, characterized by the Spanish Isabelline style, particularly in civil and religious architecture. A notable example is the Neo-classical Real Intendencia (1850), designed by Juan Manuel Lambera. At the end of the 19th century in the villages in the interior of the island there developed an architecture that displayed Victorian influences from the Greater Caribbean, particularly in residential and vernacular architecture. During the same period in cities such as Ponce and San Juan, influences of Catalan and Italianate colourful late Neo-classicism appeared, which merged into a *fin-de-siècle* Art Nouveau, unique within the Antilles. In the 20th century the change of sovereignty and the administrative presence of the USA had a significant effect. Many schools and public and administrative buildings were designed by North American architects brought over by the new colonizers, including Adrian C. Finlayson, who was Architect to the Puerto Rico Ministry of the Interior before World War I. The new Capitolio, which dates to the 1920s, was built to the design of the American Frank E. Perkins and was influenced by the Capitol in Washington, DC. Some hospitals and education centres are representative of the style of architecture then prevalent in Florida and California.

A shift towards modernism took place with the arrival in Puerto Rico of the Czech architect Antonín Nechodoma

(1887–1928), who had established himself in the USA and who was active as an architect from 1913 up to his accidental death in 1928. He designed numerous residential works, for example the Eduardo Georgetti House (1923), Santurce, most of which were executed for wealthy clients and bear great similarities to the prairie houses of Frank Lloyd Wright. Henry Klumb (1905–84), a North American architect of German birth, contributed considerably to architectural development in Puerto Rico from 1943; he executed many International Style buildings, including those for the Universidad de Puerto Rico, Río Piedras (1950s), as well as for the pharmaceutical industry, and also produced residential and religious architecture (e.g. church of Beato Martín de Porres, 1950, Cataño, nr San Juan). The Puerto Rican architects Osvaldo Toro (*b* 1914) and Miguel Ferrer (*b* 1915) were the local pioneers of the new architecture of Puerto Rico. Their notable works include various luxury hotels, among them the Caribe Hilton (1947–9), the Corte Suprema de Justicia (1958), and residences (e.g. Teodoro Moscoso House, 1950, Santurce) and other important buildings.

BIBLIOGRAPHY

S. Baxter: 'Recent Civic Architecture in Puerto Rico', *Archit. Rec.*, xlix/2 (1920), pp. 136–68

D. Angulo Iñiguez, E. Marco Dorta and M. J. Buschiazzo: *Historia del arte hispano-americano*, i (Barcelona, 1945), pp. 118–20, 501–4

E. Barañano: *Una ciudad—un pueblo* (1954)

'Henry Klumb Finds an Architecture for Puerto Rico', *Archit. Forum*, ci (July 1954), pp. 122–7

H. -R. Hitchcock: *Latin American Architecture since 1945* (New York, 1955), pp. 58–9, 70–71, 120–21, 203

Urb., Rev. Puertorriqueña Arquit., 1–56 (1962–73)

M. J. Buschiazzo: *Estudio sobre monumentos históricos de Puerto Rico* (1965)

J. A. Fernández: *Architecture in Puerto Rico* (New York, 1965)

R. E. Alegría: *Descubrimiento, conquista y colonización de Puerto Rico*, Colección de Estudios Puertorriqueños (San Juan, 1969)

V. Báez, ed.: *La gran enciclopedia de Puerto Rico*, ix (Madrid, 1976)

M. de los Angeles Castro: *Arquitectura en San Juan de Puerto Rico (Siglo XIX)* (Río Piedras, 1980) [incl. brief chapters on 16th–18th centuries]

T. S. Marvel and M. L. Moreno: *La arquitectura de templos parroquiales de Puerto Rico* (Río Piedras, 1984)

L. Castedo: *Historio del arte ibero-americano*, 2 vols (Madrid, 1988), i, pp. 212–13, ii, p. 25

J. Rigau: *Turn of the Century Architecture in the Spanish Caribbean, 1890–1930* (New York, 1992)

E. E. Crain: *Historic Houses in the Caribbean* (Gainesville,1994)

P. Gosner: *Caribbean Baroque: Historic Architecture of the Spanish Antilles* (Pueblo, CO, 1996)

A. Sepúlveda: 'Puerto Rico: Arquitectura durante el período colonial español', *Arquitectura colonial iberoamericana*, ed. G. Gasparini (Caracas, 1997), pp. 85–104

EFRAIN E. PÉREZ CHANIS

IV. Painting, graphic arts and sculpture.

The oldest paintings produced in Puerto Rico after colonization are anonymous works dating to the 17th century, produced in San Juan and San Germán, the latter the native town of Manuel García, the first painter of whom anything is known. José de Rivafrecha y Campeche (1751–1809), Puerto Rico's first major painter, was a mulatto, born of a Spanish mother (from the Canary Islands) and a slave father who bought his own freedom with his artisanship. Campeche was an excellent painter of religious subjects, especially *Virgins*, miniatures and portraits, receiving commissions from Spanish governors; in only a few paintings did he represent African subjects. In his depictions in Rococo style he was influenced by the prestigious Spanish court painter Luis Paret y Alcázar (1746–79), exiled to the island from 1775 to 1778. Campeche's oldest brothers, Manuel and Ignacio, were also painters. Silvestre Andino (*fl* until 1827) produced religious paintings. Ramón Atiles y Pérez (1804–75) was a notable painter of portraits and skilful miniatures and the major artist of the mid-19th century. Juan Cletos Noa was the teacher of master painter FRANCISCO OLLER. His daughters Magdalena, Amalia and Asunción Cletos Noa, active by the beginning of the 19th century, are the first known women artists in Puerto Rico.

Oller, considered Puerto Rico's most important painter, worked with the Impressionist painters in Paris (1858–63) and painted in two styles, Realism and Impressionism, producing portraits, self-portraits, landscapes and still-lifes. He was an abolitionist, and in his paintings and drawings he denounced the punishment of slaves and depicted them with respect and dignity, for example in *The Wake* (1893; Río Piedras, U. Puerto Rico, Mus. Antropol., Hist. & A.) and in the *School of Maestro Cordero*. His disciples, such as Manuel Jordán (1853–1919), Miguel Pou Becerra (1880–1968), Oscar Cólon Delgado (1889–1968) and Juan Rosado (1891–1962), included Black figures in their landscapes and portraits, although the imagery in some works disguised prejudice and stereotype. Oller's style was the basis for a regional school of painting at the beginning of the 20th century. Artists painted landscapes, still-lifes, local scenes and common people as a cultural defence against the strong influence of the USA following the invasion of 1898. The period of the military government and the World Wars was not conducive to art production. Artists had to practise other professions and skills to survive: Ramón Frade, for example, was a telegraph operator, while Rosado was a commercial painter; Frade glorified the image of the *jíbaro* (compatriot). Other notable painters of these decades were Pou Becerra, from Ponce, who specialized in genre scenes of ordinary people, Cólon Delgado, López de Victoria, Julio Martínez, Luisina Ordóñez and María Cadilla de Martínez. Fernando Díaz MacKenna also deserves special mention for his dedication as a teacher.

Spanish painters who came to the island during the Spanish Civil War (1936–9) were influential in many ways. Alejandro Sánchez-Felipe had arrived by the 1930s; his followers included Rafael Palacios, Narciso Dobal, Ordoñez, Augusto Marín and Fran Cervoni Gely. Cristóbal Ruíz and Eugenio Fernández Granell brought new styles, and Carlos Marichal helped to develop graphic arts, especially woodcut, which by the late 20th century was favoured by many artists. Arnaldo Maas brought a stained-glass tradition, while Guillermo Sureda introduced new techniques in watercolour. Angel Botello Barros worked in painting and lithography. By the mid-20th century, subject-matter was mainly rooted in social problems, as in the paintings of Luis Quero Chiesa and Palacios. Artists who were active at this time include Felix Bonilla Norat, Julio Acuña, Bartolomé Mayol, Jorge Rechany, Epifanio Irizarry, José A. Torres Martinó and María Luisa Penne de Castillo. While JULIO ROSADO DEL VALLE and Olga Albizu were producing pioneering works of abstraction, Osiris Delgado and Samuel Sánchez painted in a naturalistic style.

In the 1950s the components of a national culture were integrated within a powerful imagery, which appeared in prints, drawings and paintings. With the creation of the Division of Community Education by the Puerto Rican government, many artists were employed to produce illustrations and designs for books and films intended to educate people in such areas as health and well-being. RAFAEL TUFIÑO, Lorenzo Homar, CARLOS RAQUEL RIVERA, José Meléndez Contreras and Antonio Maldonado and others created an imagery based on cultural traits, which included those inherited from Africa. The painters Bonilla, Osiris Delgado, Irizarry and Marin, and the sculptors Tomás Batista and Rafael López del Campo also incorporated these ethnic elements into a national culture within their art.

Great achievements in printmaking have been made in Puerto Rico, due mostly to the San Juan Biennial of Latin American and Caribbean Graphics, which has been held since the 1970s. Puerto Ricans who have achieved international recognition as printmakers include Homar, Tufiño, Rivera and Maldonado, and the younger generation of Martín García, Luis Alonso, Nelson Sambolín and Haydée Landing. Sambolín, Jésus Cardona, Dennis Mario Rivera, Consuelo Gotay and Martín García stressed ethnic identity in their works. García won a major prize at the tenth San Juan Biennial of Latin American and Caribbean Graphics with a large-scale woodcut depicting his pregnant wife. A leading exponent of a 'naive' style was Manuel Hernández Acevedo (1922–85). By the 1960s other important artists included MYRNA BÁEZ, Francisco Rodón and José Alicea, who worked in naturalistic styles, and LUIS HERNÁNDEZ CRUZ, Noemí Ruíz and Roberto Alberty, who followed abstract tendencies.

Pioneers of modernism in sculpture include Alberto Vadi (1912–89), Gabriel Vicente-Maura (d 1992) and Luisas Géigel de Gandía. The Spaniard Francisco Vázquez, better known as Compostela, taught such important sculptors as López del Campo, Batista and Andrés Sierra. George Warrock, an American university professor, worked in wood. José Buscaglia, Batista, López del Campo and Ana M. Basso made monuments in bronze. Such sculptors as Pablo Rubio (see fig. 4), Carmen Inés Blondet and María Elena Perales, who worked in metal, participated in international events, such as the First International Symposium of Sculpture in Santo Domingo. From the 1970s many artists working in ceramics won international recognition. New styles developed by using clay with other materials, such as wood, metal and stone, in sculptures, installations and wall pieces, as well as in traditional vessel forms. Ana Delia Rivera, Susana Espinosa, Sylvia Blanco and Jaime Suárez in particular achieved high standards with this material.

BIBLIOGRAPHY
E. Colón Martínez: *Indice bibliográfico arte* (San Juan, 1910–20)
O. Delgado: *Sinopsis histórica de las artes plásticas en Puerto Rico* (San Juan, 1957)
Grabados puertorriqueños, intro. L. Homar (San Juan, 1958)
Dos siglos de pintura puertorriqueña (exh. cat., San Juan, Inst. Cult. Puertorriqueña, 1965)
Pintores contemporáneos puertorriqueños (San Juan, 1969)
M. Traba: *Propuesta polémica sobre el arte puertorriqueño* (Río Piedras, 1971)
The Art Heritage of Puerto Rico, Pre-Columbian to the Present (exh. cat., Río Piedras, U. Puerto Rico, 1973)

4. Pablo Rubio: *Passage of the Wind*, stainless steel with rotating disc, h. 16.45 m, Parque Central, San Juan, Puerto Rico

O. Delgado: *Artes plásticas*, viii of *La gran enciclopedia de Puerto Rico*, ed. V. Báez (Madrid, 1976)
Muestra de pintura y escultura puertorriqueña (exh. cat., San Juan, Inst. Cult. Puertorriqueña, 1977)
Veinticinco años de gráfica puertorriqueña (exh. cat., San Juan, Inst. Cult. Puertorriqueña, 1977)
P. Bloch: *Painting and Sculpture of the Puerto Ricans* (New York, 1978)
Escultura en barro de Puerto Rico (exh. cat., text by R. Alegría and M. Benítez; Springfield, MA, Mus. F.A., 1980)
O. Delgado: *Francisco Oller y Cestero, pintor de Puerto Rico* (San Juan, 1983)
M. Pérez Lizano: *Arte contemporáneo de Puerto Rico* (Bayamón, 1983)
Women Artists from Puerto Rico (exh. cat., New York, Cayman Gal., 1983)
M. E. Somoza: *Graphic Arts in Puerto Rico from 1945 to 1970: An Historical Perspective and Aesthetic Analysis of Selected Prints* (diss., New York U., 1984)
Arte contemporáneo de Puerto Rico (exh. cat., text by M. Rodríguez; San Juan, Inter-Amer. U. Puerto Rico, 1984)
La xilografía en Puerto Rico, 1950–1986 (exh. cat., Río Piedras, Puerto Rico U. A. Mus., 1986)
Mujeres artistas de Puerto Rico (exh. cat., San Juan, Mus. B.A., 1986)
Veinticinco años de pintura puertorriqueña (exh. cat., Ponce, Mus. A.; San Juan, Mus. B.A.; 1986)
Puerto Rican Painting: Between Past and Present (exh. cat., Río Piedras, Puerto Rico U. A. Mus., 1987–8)
O. R. Campeche: *Three Centuries of Puerto Rican Painting* (San Juan, 1992)
O. Delgado Mercado: *Historia general de las artes plásticas en Puerto Rico* (San Juan, 1994)
E. García-Gutiérrez: 'Puerto Rico', *Latin American Art in the Twentieth Century*, ed. E. Sullivan (London, 1996), pp. 119–35
V. Poupeye: *Caribbean Art* (London, 1998)

MYRNA E. RODRIGUEZ

V. Decorative arts.

A variety of decorative arts was produced in Puerto Rico before the arrival of the Spanish (*see* §II, 1 above). The

first decorations and furniture for churches were brought directly from Spain, but local craftsmen soon learnt Spanish techniques and adapted European styles. By the 18th century there were many local artisans producing work in metals and wood for churches and convents. The Spanish also brought over traditional hand-made laces, like the *mundillo*, treasured for use on altars and costumes for special occasions (e.g. baptisms and weddings) and still in demand in the late 20th century. They introduced a need for cult objects, such as images of saints, which in turn developed into one of the most popular art forms. As early as the 17th century local craftsmen created a naive imagery worked in a rustic manner, the significance of which within traditional Puerto Rican culture has been recognized only in the late 20th century. By the 1950s the carving of wooden saints had almost died out and such craftsmen as Zoilo Cajigas scarcely made a living. Nevertheless, at the end of the 20th century there were still some *santeros* (carvers of wooden saints), for example Celestino Avilés, who had individual styles yet used the traditional imagery. The Afro-Caribbean population, who settled mostly in the coastal regions, created exciting costumes and masks (*see* §II, 2 above).

Musical string instruments, such as the *cuatro*, a local creation rather than an adaptation, are designed and hand made in Puerto Rico. Annual contests sponsored by the Instituto de Cultura Puertorriqueña stress perfection in form, technique and resonance as well as originality and exquisite surface decoration; prized instruments are valued not only for their beauty but also for the quality of their sound. A more rustic instrument, the *guiro*, is made from a local tree. Its popularity as both an instrument and as decorative object, especially at Christmas, provides a living for many craftsmen.

Pottery has a long history of production in Puerto Rico. Towards the end of the 20th century it achieved international recognition, following the creation of Grupo Manos in 1977 and Casa Candina in 1980 by well-known artists Jaime Suárez and Susana Espinosa. Suárez, Espinosa, Ana Delia Rivera and Sylvia Blano won major prizes at biennales in Faenza, Italy, and exhibited their art in many countries. The Bienal de la Cerámica Contemporánea Puertorriqueña, sponsored by Casa Candina, attracts professionals and young artists. Ceramicists produce a variety of work, ranging from sculptural pieces, such as the large-scale works of Lorraine de Castro and Toni Hambleton, to fine decorative objects, such as the exquisite vessels of Bernardo Hogan, Hiram Poupart and Roxanna Jordán, boxes by Mari Gamundi, or the body ornaments of John Balossi.

Local appreciation for native crafts was developed by Ricardo Alegría, the first executive director of the Instituto de Cultura Puertorriqueña, and former director of the Walter Murray Chiesa Popular Arts Program. Craftsmen may sell work at annual fairs in Barranquitas (July) and the Bacardí at Cataño (December) and may receive help from the Commonwealth's Administración de Fomento Económico. In 1994 there were over 1000 craftsmen registered at both government agencies, as well as in the association Hermandad de Artesanos. Natural materials used by craftsmen in Puerto Rico include sea shells, fish spines and bones, coconuts, seeds, leather, bamboo, clay and stone. The objects for which they are used include traditional masks, basketry, pottery, macramé and jewellery.

BIBLIOGRAPHY
M. T. Babín: *Panorama de la cultura puertorriqueña* (San Juan, 1958)
The Art Heritage of Puerto Rico: Pre-Columbian to the Present (exh. cat., Río Piedras, U. Puerto Rico, 1973)
V. Báez, ed.: *La gran enciclopedia de Puerto Rico*, viii (Madrid, 1976)
Grupo Manos (exh. cat., Río Piedras, Puerto Rico U. A. Mus., 1979)
Escultura en barro de Puerto Rico (exh. cat. by R. Alegría and M. Benítez, Springfield, MA, Mus. F.A., 1980)
Expresiones en barro (exh. cat., Ponce, Mus. A., 1981) [exh. of sculpture by the Grupo Manos]
L. A. Obanlatte Baik and Y. M. Narganes Storde: *Vieques-Puerto Rico: Asiento de una nueva cultura aborigen antillana* (Dominican Republic, 1983)
Barro y fuego: Cerámica puertorriqueña actual (exh. cat., San Juan, Inst. Cult. Puertorriqueña, 1986)
P. Cruz de Salgado: *Guía completa para hacer collares y otros adornos de semillas* (San Juan, 1989)
Registro oficial de artesanos de Puerto Rico (San Juan, 1993)
L'Art des sculpteurs taínos: Chefs-d'oeuvre des Grandes Antilles précolombiennes (exh. cat., ed. J. Kerchache, Paris, Petit Pal., 1994)
MYRNA E. RODRIGUEZ

VI. Patronage and art institutions.

At the end of the 20th century Puerto Rican arts were dependent more on private financial assistance than on government patronage. A number of private companies supported art events and possessed important collections of art, including Puerto Rican and international financial bodies such as the Banco Popular de Puerto Rico. The international sculpture garden at the botanical gardens of the Universidad de Puerto Rico, Río Piedras, was entirely funded by private companies, for example the Mármoles Vasallo in Ponce. Financial assistance for both individuals and groups of artists was available from the Instituto de Cultura Puertorriqueña, the Fundación Puertorriqueña de los Humanidades and Fondo Nacional para las Artes. Funds were also received from the Fundación de Puerto Rico and Fundación Carvajal and directly from the USA from the National Endowments for the Arts or the National Endowment for the Humanities. Through the Puerto Rican Congress the government provided funds for specific projects to the Instituto de Cultura Puertorriqueña and such other cultural institutions as the Ateneo Puertorriqueña, the Arts Students League of Old San Juan, the Museo de Arte in Ponce, the Casa Candina and the Museum of Contemporary Puerto Rican Art.

In the 1990s a number of individuals possessed collections of works by European and American artists, as well as Puerto Rican art, in some cases including popular arts—a notable example being Teodoro Vidal's collection of carved wooden saints. Collectors included José E. Arrarás, Ricardo Alegría, Graciani-Marchand, B. Gamundi and Luis A. Ferré. In addition, a number of private galleries have promoted and sold contemporary art, among them the Galería Botello in San Juan; the Palomas, Coabey, Corinne Timsitt, Leonora Vega and Luiggi Marrozzini galleries in Old San Juan; the Galería Ridel in Río Piedras; the Ruby Gallery in Santurce; and María Rechanys, Rojo y Negro and Raíces galleries in Hato Rey. Artists were also able to exhibit their work at colleges, universities and cultural centres throughout Puerto Rico.

The Instituto de Arte Puertorriqueña (housed in the 18th-century Hospital de Beneficencia) administrates various museums throughout the country. It also has a magnificent collection of Puerto Rican art, which is exhibited at the 16th-century Dominican convent. Other museums, such as the 17th-century Arsenal de La Puntilla and Museo del Grabado Latinoamericano, hold temporary exhibitions. The Pre-Columbian Taino parks at Caguana in Utuado and Tibes in Ponce are considered 'open' museums, as are the Spanish forts, which also belong to the institute, including the fort at the island of Vieques, San Jerónimo in San Juan and El Cañuelo in the Isla de Cabras. The most significant forts, such as the San Felipe de El Morro and Castillo de San Cristóbal, are administered by the United States Park Service.

The largest and most comprehensive museum in Puerto Rico is the Museo de Arte in Ponce (est. 1965), which houses the collection of the Ferre family. It includes paintings by such European masters as Rubens and Velázquez, as well as Latin American modern art. The most important Puerto Rican painters are also represented (e.g. José de Rivafrecha y Campeche and Francisco Oller). The Universidad de Puerto Rico in Río Piedras also houses a museum of art and anthropology with a valuable collection of Pre-Columbian artefacts, as well as Puerto Rican and European paintings, sculptures and graphic works. The Ateneo Puertorriqueño has a magnificent collection of Puerto Rican paintings (including works by Campeche and Oller).

The Museo de Las Américas, housed in a 19th-century building in Ballajá, Old San Juan, was inaugurated in 1992 and has art and craft work from various countries. By the 1990s the Museum of Contemporary Puerto Rican Art at the Sacred Heart University in Santurce had begun a significant collection. Other notable museums around the country that have important educational roles include the Museo de Arte e Historia de San Juan, the Museo Oller in Bayamón, the Museo Frade in Cayey, and the Casa Roig in Humaco.

By the 1990s art education in Puerto Rico had increased in quantity and quality and covered a large population through the work of elementary and secondary teachers employed by the Department of Education and by private schools. Degrees in art and art education were also available, for example at the Universidad de Puerto Rico in Río Piedras, which also has a school of architecture. The only educational institution fully dedicated to art is the government-sponsored Escuela de Artes Plásticas in San Juan. Since the 19th century, artists have also offered private tutoring in drawing and painting and held classes in cultural centres. The Arts Students League in Old San Juan and the Casa Candina in Santurce both offered courses for adults and children.

Prilidiano Pueyrredón: *Woman Surprised in her Bath*, oil on canvas, 1.01×1.26 m, 1865 (Buenos Aires, Museo Nacional de Bellas Artes)

BIBLIOGRAPHY

Colección de arte latinoamericano/Latin American Art Collection, Ponce, Mus. A. cat. (Ponce, *c*.1994)

Catálogo de las obras de arte en la colección del Ateneo Puertorriqueño (San Juan, 1996)

MYRNA E. RODRIGUEZ

Pueyrredón, Prilidiano (*b* Buenos Aires, 24 Jan 1823; *d* 3 Nov 1870). Argentine painter, architect and engineer. He was the son of General Juan Martín de Pueyrredón, who was briefly Director of the United Provinces of Río de la Plata. The notes and watercolour sketches made by him from 1835 to 1841, when he lived with his parents in Spain and Italy, already testify to his interest in art. From 1841 to 1846 he lived in Brazil and, after a brief return visit to Argentina in 1844, he set off again for Paris, where he graduated as an engineer, settling again in his native country in 1849.

Pueyrredón was active primarily as a painter. He produced psychologically penetrating portraits as well as nudes, mostly destroyed or repainted, expressive of his free and unconventional spirit. Pueyrredón lived an intense and passionate life in an aura of exciting, almost sinful, mystery. In the villa of San Isidro he took refuge with curvaceous Rubensian models, whom he painted in the nude to the indignation and astonishment of the bour-geoisie of Buenos Aires (e.g. *Woman Surprised in her Bath*; see fig.). Pueyrredón was a masterful interpreter of that society, whose attributes were family cohesion and a romantic ardour: bourgeois protocol combined with stimulation of the senses. His extant production comprises approximately 160 oil paintings and 50 watercolours and drawings, including landscapes and street scenes as well as portraits and nudes. His most important works as an architect and engineer are the Presidential residence, Olivos, Buenos Aires, designed in 1851, the renovation (1856–7) of the Pirámide de Mayo, Buenos Aires, and the swing bridge over the Riachuelo River, Avellaneda, Buenos Aires.

BIBLIOGRAPHY

A. D'Onofrio: *La época y el arte de Prilidiano Pueyrredón* (Buenos Aires, 1944)

J. E. Payró: *23 pintores de la Argentina (1810–1900)* (Buenos Aires, 1962), p. 40

H. Safons: 'Prilidiano: Hombre y estilo', *Primera plana*, 399 (1970), pp. 54–5

Prilidiano Pueyrredón (1823–1870) (exh. cat. by M. de Estrada and B. del Carril, San Isidro, Mus. Gen. Pueyrredón, 1970)

J. L. Pagano: *El arte de los argentinos* (Buenos Aires, 1981), pp. 52–3

N. Deffebach: 'Prilidiano Pueyrredón', *Lat. Amer. A.*, iv/1 (1992), pp. 33–5

J. López Anaya: *Historia del arte argentino* (Buenos Aires, 1997), pp. 33–6

HORACIO SAFONS

Q

Querétaro. Mexican city and capital of the state of the same name. It has a population of *c.* 300,000. Querétaro was an Otomí settlement, but, after being conquered by Spain *c.* 1531, it became one of the principal cities of New Spain. Querétaro has always been the commercial centre of one of the most productive agricultural regions in central Mexico, and it preserves its original colonial plan and many colonial buildings, especially from the 17th and 18th centuries.

The Franciscan Convento de la Cruz on the Sangremal Hill, site of a legendary apparition that marked the initial evangelization of the Otomí Native Americans of the region, became in 1683 the first Colegio Apostólico de Propaganda Fide in the New World, sending missionaries to Central America and California. It is still a popular pilgrimage site. The church of S Francisco on the main square was built by Francisco Bayas Delgado in the mid-17th century; its choir-stalls were completed in 1796 by FRANCISCO EDUARDO TRESGUERRAS. The original monastery next door houses the Museo Regional. Bayas Delgado was also responsible after 1662 for completing construction of the Baroque church of S Clara (begun 1605) and the Guadalupe Church (La Congregación) between 1674 and 1680. The churches of S Domingo, S Antonio and La Compañía (now Santiago) can also be dated to the last decades of the 17th century. All these churches have a single nave with a dome at the crossing; especially notable are the tall tower of S Domingo and the Jesuit cloister (now occupied by the Universidad Autónoma de Querétaro).

Between 1731 and 1745 the church of S Agustín and its cloister, decorated with striking stone sculpture, were built; the former monastery of S Agustín (also 18th century) houses the Museo de Arte. Also of note is the conventual church of S Rosa de Viterbo, completed by 1752, with its spacious cloister and tall dome supported by an extraordinary pair of buttresses. The interior conserves all but one of its 18th-century retables, as well as the pulpit and the organ made by Mariano Ignacio de las Casas, while the sacristy still contains many of its original furnishings. De las Casas was responsible for one of the most interesting interiors in the city, the Capilla del Rosario next to S Domingo, designed *c.* 1759. Two other notable interiors are that of the Carmen Church with its wall niches, built by Juan Manuel Villagómez by 1759, and the centrally planned sacristy of S Antonio. Querétaro was probably an important centre for wood sculpture during the colonial period, as witness the *retablos* of S Rose de Viterbo and of S Clara.

Querétaro conserves many examples of 18th-century civil architecture, among them the Casas Reales and the Casa del Diezmo. The grand aqueduct, which was built in 1726 and is *c.* 8 km long, feeds the Neptune Fountain (des. 1797; constr. 1802–7) by Francisco Eduardo Tresguerras, next to the convent church of S Clara, the interior of which was remodelled (1802–7) by Tresguerras. Querétaro Cathedral was built as the church of S Felipe Neri between 1786 and 1804 and is an important example of Mexican Neo-classicism. Other notable Neo-classical structures are the Carmelite convent and church of S Teresa (1807), by Tresguerras, and the Teatro de la República.

BIBLIOGRAPHY

M. Septién: *Historia de Querétaro* (Querétaro, 1966–7)
D. Wright and others: *Querétaro, ciudad barroca* (Querétaro, 1988)
G. Boils Morales: *Arquitectura y sociedad en Querétaro siglo XVIII* (Querétaro, 1994)

CLARA BARGELLINI

Quilici, Pancho [Francisco] (*b* Caracas, 16 April 1954). Venezuelan printmaker and draughtsman, active in France. He graduated in graphic design from the Instituto de Diseño Neumann-Ince, Caracas, in 1978 and studied lithography (1978–9) at the Centro de Enseñanza Gráfica (CEGRA), Caracas. In 1981 he moved to Paris. His work offers a fantastic vision of impossible architecture: oneiric cities are described through a delirious geometry, and within them are combined instruments of astronomy and alchemy, archaeological visions and futuristic technology, and maps and plans as objects of historical and scientific description. Examples of his work include *My Refuge* (1987), *The Planet Looks at Itself* (1991) and *Venezuela: New Cartographies and Cosmogonies* (1992). In three consecutive years he was awarded at the Salón Michelena, Ateneo de Valencia, the Bernardo Rubinstein prize (1978), second prize for drawing from the Instituto Nacional de Hipódromos (1979) and an engraving prize from the daily paper *El Carabobeño* (1980). He also won the Fundarte prize in the first Biennale (1982) of drawing and engraving at the Galería de Arte Nacional, Caracas. In 1982 he represented Venezuela in the Paris Biennale at the Centre Georges Pompidou.

BIBLIOGRAPHY

Pancho Quilici (exh. cat., Caracas, Gal. Minotauro, 1980)
De Venezuela: Treinta años de arte contemporáneo (1960–1990)/From Venezuela: Thirty Years of Contemporary Art (1960–1990) (exh. cat. by R. de Montero Castro, Seville, Pab. A., 1992)

Based on information supplied by LELIA DELGADO

Quintana (Simonetti), Antonio (Luis) (*b* Havana, 18 April 1919; *d* 1993). Cuban architect. He belongs to the generation of professional architects who introduced the Modern Movement into Cuba in the 1940s. He began his professional career with Leonardo Morales (1887–1965) and then assimilated contemporary formal and spatial codes with Emilio del Junco, Miguel Gastón and Martin Domínguez. He was influenced by Le Corbusier in terms of his structural expression and in the use of *brise-soleil* and by Oscar Niemeyer in the relationship between architecture and nature and the freedom and plastic qualities of hanging forms. Characteristic examples are the models of collective housing and the office building of the 1950s in Havana: an apartment block at the street corner 23 y 26 (1952), the Retiro Odontológico (1953) and the Seguro Médico (1955).

Quintana is one of the architects of international standing who did not emigrate from Cuba following the Revolution of the 1950s. From 1959 he focused his attention on landscaping and on ways of achieving lighter volumes and integration with nature using structural solutions of advanced technology. The principal works of this period include an experimental 17-storey residential tower (1968) on the Malecón in Havana; Lenin Park (1970; working with a design team); Hotel de los Cosmonautas (1972) in Varadero; Palacio de las Convenciones (1977) in Cubanacán; sports buildings for the Panamerican Games of 1991 in Havana; and the Heredia Theatre (1991) in Santiago de Cuba.

BIBLIOGRAPHY
'Cuba', *Archit. Aujourd'hui*, 140 (1968), pp. 76–87
R. Segre: *Cuba, l'architettura della rivoluzione* (Padua, 1970)
——: 'Im Auftrag der Revolution: Die Architektur des kubanischen Architekten Antonio Quintana', *Umriss*, 3–4 (1985), pp. 11–19
——: *Arquitectura y urbanismo de la revolución cubana* (Havana, 1989)
R. Carley: *Cuba: 400 Years of Architectural Heritage* (New York, 1997)
ROBERTO SEGRE

Quintero, José Antonio (*b* Caracas, 9 Aug 1946). Venezuelan painter and printmaker. He studied at the Escuela de Artes Plásticas 'Cristóbal Rojas', Caracas (1960–64), and at the Instituto de Diseño Gráfico and the Centro Gráfico del INCIBA, both in Caracas (1964–8). He also worked in the studios of Luisa Palacios and Luis Chacón (*b* 1927). From 1963 he exhibited in both national and international drawing and print exhibitions, notably at the Latin American Bienale at the Universidad Central de Venezuela, Caracas (1967). In the early 1970s his work distinguished itself from the styles then dominating Venezuelan art by its revaluation of the traditional pictorial themes of landscape and figurative representation that had been almost abandoned. He used simplified forms and images full of vigour and dazzling colours. Three of his works—*Nocturnal* (1973), *View of Ávila from Sugar Avenue* (1977) and *Hills, Trees and the Dawn in the Valleys of Aragua* (1980; all oil on canvas)—are held by the Galería de Arte Nacional, Caracas.

UNPUBLISHED SOURCES
Caracas, Fond. Gal. A. N., Archvs [File Q-3]

BIBLIOGRAPHY
J. Calzadilla: 'Los nacidos después de 1940', *A. Quin.*, 25 (1973), pp. 4–5
R. Montero Castro: 'Vigencia del paisajismo venezolano', *Tiempo Real*, 5 (1976), pp. 72–80
GUSTAVO NAVARRO-CASTRO

Quiroa, Marco Augusto (*b* Chicacao, Suchitepéquez, 7 May 1937). Guatemalan painter, sculptor, illustrator and writer. He studied at the Escuela Nacional de Artes Plásticas in Guatemala City between 1953 and 1960 and was inspired by his rural, working-class background to depict the themes, forms and colour of the life of the Guatemalan common people. In the mid-1960s, together with Roberto Cabrera and Elmar Rojas, he founded the Vértebra group. His paintings, mainly in oils, tended towards the flashy and to experimentation with varied textures. Subsequently he showed a preference for bright, dazzling colours based on the designs of Guatemalan fabrics. Ironic and highly expressive, his form of realism became increasingly simple and effective, while continuing to stress its origins in popular culture. *Bird of Powder* (1961), *The Jet* (1963) and *Rebel Angel* (1967; all Guatemala City, Dir. Gen. Cult. & B. A.) are typical of his style. He has also worked successfully on book illustrations and excelled as a short story writer, with several literary prizes to his credit.

WRITINGS
'Perrajes', *Rev. Alero*, iii/4 (1974), pp. 40–50

BIBLIOGRAPHY
L. Méndez Dávila: *La pintura de Marco Augusto Quiroa: Sublimación brillante de lo popular* (Guatemala City, 1967)
R. Díaz Castillo: *Visión del arte contemporáneo en Guatemala*, ii (Guatemala City, 1995)
Guatemala: Arte contemporáneo (Antigua, Guatemala, 1997), pp. 33–6
JORGE LUJÁN-MUÑOZ

Quirós, Teodorico (*b* San José, 1897; *d* San José, 1977). Costa Rican painter and engineer. He received a formal training at the Escuela Nacional de Bellas Artes in San José. From 1916 to 1919 he studied architectural engineering in the USA at the Massachusetts Institute of Technology in Cambridge; his work in this field includes the neo-Gothic S Isidoro of Coronado, Costa Rica. After returning to Costa Rica in 1920 he painted with a strong emphasis on colour; his subjects were mainly rural scenes following the academic, mannerist (*costumbrista*) style introduced by the Spaniard Tomás Povedano in the early 20th century and were typical of the work of members of the exhibiting society, the Círculo de Amigos del Arte, which Quirós founded with Max Jiménez in 1928. Quirós was involved in organizing the group's exhibitions between 1928 and 1937, which stimulated artistic activity at a national level. He also collaborated with Manuel de la Cruz González on a mural for the group's meeting-place, Las Arcadas, in San José. His paintings of the 1930s and 1940s were clearly structured, both compositionally and in the impasto and synthetic application of colour (e.g. *Red Door*, 1945).

As Dean of the fine arts faculty of the Universidad de Costa Rica in San José (1942–5) Quirós set painting standards by which to judge and revive the methods of the former Escuela Nacional de Bellas Artes. From the late 1950s his concept of landscape moved from being rational and schematic to possessing an increasing pictorial richness, as in *Street in Santo Domingo* (1956), which opened the way to a more expressionistic art: shading and looser brushwork gave way to a dramatic style, surprising for its human proportions.

BIBLIOGRAPHY
R. Ulloa Barrenechea: *Pintores de Costa Rica* (San José, 1975), pp. 70–76
JOSÉ MIGUEL ROJAS

Quispe Tito, Diego (*b* Cuzco, 1611; *d* Cuzco, 1681). Peruvian painter. He came from a noble Inca family and worked throughout his life in the district of San Sebastián, where his house still shows his coat of arms painted on the door.

His earliest signed work is an *Immaculate Conception* (1627; Lima, priv. col.), with gilding in the manner of that by native Americans of the CUZCO SCHOOL of painting. Nevertheless, the elongated forms reveal Quispe Tito's knowledge of Mannerist painting. The Italian Jesuit Bernardo Bitti is recorded as active in Cuzco, where his works would certainly have been seen by Quispe Tito; and while young, Quispe Tito would have known Luis de Riaño (1596–1667), a painter from Lima who had been trained in the workshop of another Italian, Angelino Medoro, who worked in Peru. Quispe Tito was also influenced by Flemish engravings. Even so, his paintings achieve a personal style in the use of gilding and spacious landscapes filled with birds and angels. The paintings that make up his series *St John the Baptist* (Cuzco, S Sebastian), signed in 1663, although based on engravings by Johannes Stradanus (1523–1605) and Cornelis Galle (1576–1650), were transformed by his own personal vision. In 1667 he painted several scenes from the *Life of Christ* (Potosí, Mus. N. Casa Moneda), which were sent to Potosí. Quispe Tito's best known work is the series of *Signs of the Zodiac* in Cuzco Cathedral, dated 1681. This consists of copies of a series of engravings by Jan Sadeler (1550–1600) and Adrian Collaert (1560–1618), which were designed to encourage the popular worship of the miracles of Christ in place of the stars; each sign of the Zodiac corresponds to one of the parables of Christ. The engravings were commissioned specifically to be sent to Peru, where the worship of the sun, the moon and the stars was still clandestinely practised.

BIBLIOGRAPHY
F. C. del Pomar: *Pintura colonial (escuela cuzqueña)* (Cuzco, 1928)
G. Kubler and M. Soría: *Art and Architecture in Spain and Portugal and their American Dominions, 1500–1800* (Harmondsworth, 1959)
J. Mesa and T. Gisbert: *Historia de la pintura cuzqueña* (Lima, 1972)
E. Marco Dorta: *Arte en América y Filipinas* (Madrid, 1973)
El zodíaco en el Perú: Los Bassano (s.xvi–s.xvii), Diego Quispe Tito (s.xvii) (exh. cat. by J. M. Ugarte Eléspuru and L. E. Tord, Lima, Casa Osambela, 1987)
TERESA GISBERT

Quispez Asín, Carlos (*b* Lima, 15 April 1900; *d* Lima, 1 April 1983). Peruvian painter and teacher. He studied in Lima at the Academia Concha from 1915 to 1917 and later at the Escuela Nacional Superior de Bellas Artes under Daniel Hernández. In 1921 he travelled to Spain, where he enrolled at the Real Academia de Bellas Artes de San Fernando in Madrid under the Spanish painter Cecilio Plá (*b* 1860).

Quispez Asín returned in the 1930s to Lima, where he developed a style of painting characterized by linear and gracefully expressive drawing and by a delicate handling of oil paint comparable to watercolour in texture and tonality. He also executed murals with reminiscences of Piero della Francesca and Paolo Uccello both in California,

where he lived for some years, and in Lima at the Cámara de Diputados, the Ministerio de Salud Pública and the Universidad Nacional de Ingeniería. He won a number of honours, beginning with the Primer Premio de Pintura de Viña del Mar in Chile (1937) and the Medalla de Oro de la Municipalidad de Lima (1940). From 1943 to 1969 he taught at the Escuela de Bellas Artes in Lima.

BIBLIOGRAPHY
E. Moll: *Carlos Quispez Asín* (Lima, 1988)
LUIS ENRIQUE TORD

Quito. Capital city of Ecuador. It is situated almost on the equator at the northern end of the Andean plateau at an elevation of 3000 m, and had a population in the late 20th century of *c.* 700,000. Its name derives from the indigenous (pre-Inca) tribe in the region, the Quitus. After the execution of the last Inca king, Atahualpa, the city was founded in 1534 by Diego de Almagro. Sebastián de Benalcázar laid out the town of San Francisco de Quito in 1535 at the foot of the volcano Pichincha on a square grid plan, despite the irregularity of the terrain. In 1563 it became the seat of government, the Real Audiencia de Quito, under the viceroyalty of Peru, which was included in the viceroyalty of Nueva Granada in 1717.

Franciscan friars went to Quito with the Spanish conquistadors and, led by the Flemings Jodoco Ricke de Marsalaer (*d c.* 1574), Pedro Gosseal ('Pedro el Pintor') and the Castilian Pedro de Rodeñas, founded the monastery. In the 1530s Gosseal was already teaching the arts to the Indians at the Colegio de S Andrés (originally the Colegio de S Juan) within the monastery walls. The school received the royal warrant in 1555 and helped establish Quito as a centre of the arts. The Franciscans pioneered a broad European style in architecture, combining in their early buildings a blend of early Renaissance with Gothic and *Mudéjar* elements, at first overlaid with a Flemish Mannerism. This was seen, for example, in the great church of S Francisco (completed 1581; see ECUADOR, §III, 1). The three-naved cathedral, with its *Mudéjar*-panelled roof, was constructed between 1562 and 1565 and was inaugurated in 1572. Church-building programmes were also actively carried out by the Dominicans, Augustinians and Jesuits, who all arrived in the 16th century. They were responsible respectively for the churches of S Domingo (1623; cloister completed 1640), S Agustín (1617) and La Compañía (1606–49).

Throughout the colonial period the Quito school of painting and sculpture, with its roots in the Colegio de S Andrés, flourished, the style associated with it being characterized by a dramatic Baroque treatment of religious themes, in which the subjects are typically portrayed in states of extreme emotion. Repeated earthquakes throughout the same period meant that architectural activity was dominated by constant rebuilding. For example, the domed Baroque church of La Merced was rebuilt between 1701 and 1737 by José Jaime Ortiz.

Rebuilding activities continued throughout the 19th century, while notable new civil buildings built after independence include the Penal Panóptico (penitentiary) designed by Thomas Reed (1810–78). The Escuela de Bellas Artes was founded in 1872; European-trained artists taught there, and in the 20th century artists in Quito

Quito, Palacio Municipal, by Diego Banderas Vela and Juan Espinosa Páez, completed 1975

experimented with avant-garde European styles as well as developing local styles and movements, such as Indigenism, begun by CAMILO EGAS in the 1920s. Migration into Quito in the mid-20th century created a need for housing projects, and commercial buildings in the International Style also appeared in the 1950s and 1960s. The Palacio Municipal (1975; see fig.), produced by Diego Banderas Vela (*b* 1936) and Juan Espinosa Páez (*b* 1937), is a notable public building. The city's museums include the Museo de Arte Colonial (est. 1914) and the Museo de Arte e Historia de la Ciudad (est. 1930), which has a collection of paintings and sculpture as well as documents relating to the history of the city.

BIBLIOGRAPHY
J. G. Navarro: *Religious Architecture in Quito* (New York, 1945)
——: *El arte en la provincia de Quito* (Mexico City, 1960)
J. M. Vargas: *Los pintores quiteños del siglo XIX* (Quito, 1971)
Imagen de la ciudad: Quito, testimonio fotográfico, 1860–1930 (exh. cat., Quito, Banco Cent. del Ecuador, 1978)
X. Escudero de Terán: *América y España en la escultura colonial quiteña* (Quito, 1992)
R. Adoum and others: *Panorama urbano y cultural de Quito* (Quito, 1994)
N. Gómez: *Pasado y presente de la ciudad de Quito* (Quito, 1995)
A. Kennedy Troya: 'La escultura en el virreinato de Nueva Granada y la audiencia de Quito', *Pintura y escultura y artes útiles en Iberoamérica, 1500–1825*, ed. R. Gutiérrez (Madrid, 1995), pp. 235–55
A. Ortiz Crespo: 'La arquitectura colonial en el Audiencia de Quito', *Arquitectura colonial iberoamericana*, ed. G. Gasparini (Caracas, 1997), pp. 253–86

RICARDO DESCALZI

R

Ramírez. Guatemalan family of architects.

(1) José Manuel Ramírez (*b* Santiago de Guatemala [now Antigua], 15 March 1703; *d* Santiago de Guatemala, *c.* 1780). He was the son of the architect Sebastián Ramírez (*b* 25 Jan 1681), under whom he must have begun his career. José Manuel became prominent after the death (*d* 1741) of Diego de Porres, whom he replaced in 1743 as Arquitecto Mayor of Santiago de Guatemala (today Antigua). Among his works in Antigua are the plant and casemate of the Fábrica de la Pólvora (1730s), the Seminario Tridentino (*c.* 1758) and the Universidad de S Carlos (1763–73; now Museo Colonial); these last two incorporate cloisters of mixed arches, the first with columns and the second with pilasters. In the 1770s José Manuel handed over his works to his son (2) Bernardo Ramírez.

(2) Bernardo Ramírez (*b* Santiago de Guatemala [now Antigua], 20 Aug 1741; *d* Guatemala City, after 1817). Son of (1) José Manuel Ramírez. He was assistant to his father, collaborating with him on the Seminario Tridentino (*c.* 1758) and the Universidad de S Carlos (1763–73; now Museo Colonial), Antigua. He replaced his father as Arquitecto Mayor of Antigua in 1770, a position he held until after 1790, in what became New Guatemala (Guatemala City). In the earthquakes of 1773 his two important works in progress were slightly damaged: the Casa del Sacristán Mayor (in the cathedral) and the church in Jocotenango, which remained unfinished. In the new capital of Guatemala City he contributed to the construction of the royal buildings and mapped the towns on the outskirts of the capital. In addition, he designed and constructed the monasteries (*c.* 1776–80) of S Catalina, S Rosa and Capuchinas, in Guatemala City, and participated in the building of the convent and church of La Recolección in Guatemala City. His brother Juan Ramírez also worked on the Seminario Tridentino and the Universidad. Possibly Juan Ramírez died young or left the city, since there is no record of him after the 1760s.

BIBLIOGRAPHY

F. X. de Mencos: 'Arquitectos de la época colonial en Guatemala', *Anu. Estud. Amer.*, vii (1950), pp. 163–209

H. Berlin: 'Artistas y artesanos coloniales de Guatemala', *Cuad. Antropol.*, v (1965), pp. 5–35

S. D. Markman: *Colonial Architecture of Antigua Guatemala* (Philadelphia, 1966)

J. Luján-Muñoz: 'Estratificación social y prejuicios a finales del siglo XVIII: Un ejemplo de diferentes actitudes en Guatemala y en España', *Memorias del Segundo Encuentro Nacional de Historiadores: Guatemala City, 1995*, pp. 177–89

——: 'La arquitectura y la albañilería en la ciudad de Guatemala a finales del siglo XVIII', *Rev. U. Valle Guatemala*, vi (1996), pp. 12–24

JORGE LUJÁN-MUÑOZ

Ramírez Amaya, Arnoldo (*b* Guatemala City, 26 Nov 1944). Guatemalan draughtsman, painter, sculptor and printmaker. After studying at the Escuela Nacional de Artes Plásticas in Guatemala City from 1960 to 1964, he attended the Escuela de Arquitectura of the Universidad de San Carlos in Guatemala and in 1976 trained in graphic design at the Universidad Autónoma in Mexico City. He came to prominence as a draughtsman, concentrating on the harsh social and political situation in Guatemala, and published collections of images such as *El cantar del tecolote* (Guatemala City, 1970), *Sobre la libertad, el dictador y sus perros fieles* (Mexico City, 1976) and *Música para embrujaditos* (Guatemala City, 1986).

Ramírez Amaya also produced paintings, sculptures and prints, in which he combined social criticism with an expressive and ironic depiction of misfortune in strange and often grotesque creatures. In general his work exudes existential anguish and demonstrates a desire for improving the quality of life. His painting *Xocomil* (Guatemala City, Mus. A. Contemp.) won first prize at the second Bienal de Arte Paiz in Guatemala City in 1980.

BIBLIOGRAPHY

L. Méndez Dávila: *Arte vanguardia Guatemala* (Guatemala City, 1969)

J. B. Juárez: *Pintura viva de Guatemala* (Guatemala City, 1984), pp. 35–56

Visión del arte contemporáneo en Guatemala, iii (Guatemala City, 1996)

JORGE LUJÁN-MUÑOZ

Ramírez Vázquez, Pedro (*b* Mexico City, 16 April 1919). Mexican architect and designer. He studied at the Escuela Nacional de Arquitectura, Mexico City, where he received his degree in 1943. At the start of his career Mexico was undergoing a period of economic consolidation, while in architecture the International Style was dominant. One of Ramírez Vázquez's first projects was the design of a basic classroom and teacher housing unit for rural communities. Between 1944 and 1964, 35,000 prefabricated frames were produced, using industrialized building techniques, although care was taken to integrate the buildings into the context of the communities they served by using local materials to finish the construction. The design won the Grand Prix of the Milan Triennale in 1960.

From the early 1950s Ramírez Vázquez produced a number of important buildings in collaboration with such

architects as Rafael Mijares (*b* 1924) and Jorge Campuzano (*b* 1931). An outstanding early work was the Secretaría de Trabajo y Previsión Social (1954; destr. 1985) in Mexico City, which was followed in 1957 by the design of 15 market halls, and in 1960 by the Instituto Nacional de Protección a la Infancia, all in Mexico City. That year he came to international recognition with his design for the Mexican Pavilion for the World Fair in Brussels. Other exhibition buildings followed, including the Galería de Historia Mexicana (1960) and the Museo de Arte Moderno (1964), both in Mexico City, while in the state of Chihuahua he built the Museo de Ciudad Juárez (1962); he was also responsible for exhibition buildings in Seattle and New York in 1962 and 1965 respectively. His crowning achievement in this field of activity, however, was the Museo Nacional de Antropología (1964; *see* MEXICO, fig. 6), Mexico City, which combined an international approach with the pursuit of Mexico's cultural roots. An important element in the latter concern was his collaboration with such artists as José Chávez Morado, whose sculpted reliefs on the shaft of the monumental reinforced-concrete umbrella covering the entrance patio contribute to the dramatic effect of the enclosure.

From the mid-1960s Ramírez Vázquez built a number of government buildings. These included the Secretaría de Relaciones Exteriores (1965), the Secretaría de Asentamientos Humanos y Obras Públicas (1976) and the Congreso de la Unión (1981), all prestigious projects in Mexico City, as well as the Japanese Embassy (1975), also in the capital, designed in collaboration with Kenzō Tange (*b* 1913) and Manuel Rosen (*b* 1926). During this period he also designed two other important buildings in Mexico City that relate to two of the principal interests of the Mexican people—the Aztec Football Stadium (1965) and the basilica of Nuestra Señora de Guadalupe (1975, with Gabriel Chávez de la Mora (*b* 1929), José Luis Benlliure (1928–93) and Alejandro Schoenhofer (*b* 1936))—and was president (1966–70) of the organizing committee for the XIX Olympic Games. From 1977–82 he was Minister of Housing and Public Works. He continued, however, to produce designs for exhibition spaces, and some of his most important later works were in this sphere, including the Centro Cultural de Tijuana (1982) in Baja California, the Musée Olympique (1989; finished 1994) in Geneva, Switzerland, and the Mexican Pavilion for the World Fair in 1992 in Seville. He continued to demonstrate his versatility, though, with such projects as the urban plan for Dodoma, Tanzania, executed in 1985 with David Muñóz Suárez and again revealing his preference for collaborative projects. The same versatility was also evident in his involvement for many years in both industrial and graphic design.

WRITINGS
Ramírez Vázquez en la arquitectura (Mexico City, 1989)

BIBLIOGRAPHY
Pedro Ramírez Vázquez: Un arquitecto mexicano (Stuttgart, 1979)
Pedro Ramírez Vázquez (Mexico City, 1989)
P. Quintero, ed.: *Modernidad en la arquitectura mexicana* (Mexico City, 1990), pp. 521–60
F. González Gortázar, ed.: *La arquitectura mexicana del siglo XX* (Mexico City, 1994)
G. Schmilchuk: 'Escultura arquitectónica, monumental y ambiental', *México en el mundo de las colecciones de arte*, vi (Mexico City, 1994), pp. 177–239
J. A. Aguilar Narváez: *Ramírez Vásquez en el urbanismo* (Mexico City, 1995)
R. Vargas Salguero: *Pabellones y museos de Pedro Ramírez Vásquez* (Mexico City, 1995)

LOUISE NOELLE

Ramos, Nelson (*b* Dolores, 19 Dec 1932). Uruguayan painter. He entered the Escuela Nacional de Bellas Artes in Montevideo in 1951, and in 1959 he won a grant to study at the Museu de Arte Moderna in São Paulo under Iberê Camargo and Johnny Friedlaender; he devoted himself to textile design and worked as an illustrator for two newspapers, *O Estado de São Paulo* and *Diario de São Paulo*. In 1963 he continued his studies in Italy, France and Spain on a grant from the Uruguayan government. From 1963 to 1967 he did drawings that are Surrealist in genesis and atmosphere. His 'environments' and 'objects' (1967–9), painted in black and divided in two by a thick white vertical line, an important theme of his work, were presented at the São Paulo Biennale. From 1969 he made 'white paintings', planes of white paint on white painted backgrounds, divided by white vertical lines (e.g. *Vertical with Red*, 1972; see fig.). Later he rejected the conventional

Nelson Ramos: *Vertical with Red*, oil on canvas, 800×1000 mm, 1972 (Austin, TX, University of Texas, Jack S. Blanton Museum of Art)

supports used in painting and instead made reversible bottomless boxes that were carefully crafted and painted by hand. Another series, more dramatic in tone, was *Kites*. His best-known series include *Reversibles* and *Dislocations*. In a series produced from 1996, Ramos borrows the forms of familiar objects and reconstructs them, perhaps in the utopian hope of reconciling our practical and poetic impulses, by making the user of functional objects indiscernible from the spectator of a work of art. An example of his work, *Vault Light*, 1986, is in the Central Bank of Uruguay, Montevideo.

BIBLIOGRAPHY
F. García Esteban: *Artes plásticas del Uruguay del siglo XX* (Montevideo, 1968)
A. Kalenberg: *Nelson Ramos: Blanco, negro. negro blanco. blanco, blanco* (Montevideo, 1974)
Nelson Ramos y Centro de Expresión Artística (exh. cat., ed. J. Helft, Buenos Aires, Fund. S Telmo, 1992)

ANGEL KALENBERG

Ramos de Azevedo, Francisco de Paula. *See* AZEVEDO, FRANCISCO DE PAULA RAMOS DE.

Ramos Martínez, Alfredo (*b* Monterrey, 13 Nov 1871; *d* Los Angeles, CA, 8 Nov 1946). Mexican painter, teacher and draughtsman. He studied at the Escuela Nacional de Bellas Artes and travelled to Europe *c.* 1900, returning to Mexico in 1909. He was twice Director of the Escuela Nacional de Bellas Artes (1913–14 and 1920–28) and founded the Escuela de Pintura al Aire Libre, an alternative to traditional academic pedagogy, which first functioned in the village of Santa Anita (1913–14). Initially Neo-Impressionist in orientation, the school reopened and expanded to include various semi-rural locations in the 1920s and 1930s, with a new Indigenous focus. Ramos Martínez's work was initially distinguished by a skilled use of pastel, with which he produced Gauguin-inspired Breton scenes, conservative, elegant, society portraits (notably idealized portraits of women) and flower studies. Only when he went to the USA in 1929 did an openly Mexican style appear in his painting and drawing, in scenes of indigenous figures in rural settings.

BIBLIOGRAPHY

M. Sodi de Ramos Martínez: *Alfredo Ramos Martínez* (Los Angeles, 1949)
G. R. Small: *Ramos Martínez: His Life and Art* (Westlake Village, 1975)
Alfredo Ramos Martínez (1871–1946): Una visión retrospectiva (exh. cat. by R. Favela and others, Mexico City, Mus. N.A., 1992)
A. Luna Arroyo: *Ramos Martínez* (Mexico City, 1994)
Un homenaje a Alfredo Ramos Martínez (1871–1946) (exh. cat. by X. Moyssén and others, Monterrey, Mus. A. Contemp., 1996)

KAREN CORDERO REIMAN

Rearte, Armando (*b* General Roca, Río Negro, 1946). Argentine painter. He began to paint at the age of 19, exhibiting for the first time at the Premio Ver y Estimar exhibition in Buenos Aires in 1966. After living from 1967 to 1969 in Paris, where he participated in the student demonstrations of the period, he abandoned painting until his return to Argentina ten years later. Motivated by a sense of desperation arising both from his loss of faith in painting and by the repressive political climate in which his country had become engulfed, he created an aura of catastrophe in his paintings through the use of dynamic and monumental fragments, sombre colours, dense surfaces and aggressive brushwork. His work was recognized in Argentina as an important contribution to the emergence in the 1980s of Neo-Expressionism and New Image painting.

BIBLIOGRAPHY

J. Glusberg: *Del Pop-art a la Nueva Imagen* (Buenos Aires, 1985), pp. 513–14

HORACIO SAFONS

Rebouças, Diógenes (*b* Tartaruga, Bahia, 7 May 1914; *d* Salvador, Bahia, Dec 1995). Brazilian urban planner, architect and teacher. He qualified in 1933 as an agronomic engineer from the Escola Agrícola da Bahia, Salvador, and in 1938 as a teacher of painting and drawing from the Escola de Belas Artes da Bahia, Salvador. From 1937 he began to work on residential projects in Salvador that pioneered modern architecture there (e.g. the Mirador Sampaio house, 1937, which shows a strong influence of Frank Lloyd Wright in its low volume, tiled roof, stone pillars and lack of decoration; and the Adelaide Ribeiro house, 1938, inspired by European Modernism), and in 1943 he started planning the Fonte Nova football stadium, modifying his design under guidance from Lúcio Costa,

Oscar Niemeyer and Affonso Eduardo Reidy. In 1943 he was one of the founders of the Escritório do Plano de Urbanismo da Cidade de Salvador (EPUCS) and was responsible for drawing up a plan of the town, for the geomorphological interpretation of its site and for directing studies on sanitation, soil use and architectural conservation. When EPUCS was incorporated into the Prefecture in 1947, Rebouças remained as director until 1951, involved in shaping the Salvador building code; he also designed the Hotel da Bahia (1949–51; with Paulo Antunes Ribeiro), a long, rectangular block of rooms above two floors of public rooms that curve out beyond the plan in an exuberant manner, and the Carneiro Ribeiro school, containing murals by Caribé (*b* 1911), Mario Cravo (*b* 1923), Genner Augusto (*b* 1924) and Maria Célia Amado. In 1948–9 he also worked on the Avenida do Vale (now the Centenário), Salvador's first urban motorway, which he routed to avoid damage to the historic parts of the city.

In 1950 Rebouças graduated as an architect from the Escola de Belas Artes, Salvador; in 1951 he began his teaching career and opened his own office, which became a training ground for young architects in the city. His most important works include the Cidade de Salvador building (1955–6); the Larbrás building (1957); the Bahia maritime station (1958–9); Banco do Estado da Bahia (1960); and the Telebahia building (1967–8). In 1974, for the Federal University of Bahia, he designed the building for the Faculty of Architecture and Town Planning, which he helped to found towards the end of the 1950s. It comprises three buildings linked by low steps and is located on the top of a hill, with a magnificent view of the sea; it is characterized by heavy structural elements and raw concrete. After his retirement from the faculty in 1984 he became a consultant with Construtora Odebrecht and the Fundação Pró-Memória.

WRITINGS

Salvador da Bahia de Todos os Santos no século XIX (Salvador, 1977, rev. 1985)

BIBLIOGRAPHY

H. E. Mindlin: *Modern Architecture in Brazil* (Amsterdam and Rio de Janeiro, 1956) [also pubd in Fr.]

SYLVIA FICHER

Rebull, Santiago (*b* Mexico City, 1829; *d* Mexico City, 1902). Mexican painter and teacher. He enrolled at the Academia de San Carlos in Mexico City at the age of 18, studying under Pelegrín Clavé, and in 1852 won a travelling scholarship to Europe for his *Death of Abel* (Mexico City, Mus. N.A.). On completing seven years of study at the Accademia di San Luca in Rome, he returned to Mexico City, where he was appointed to teach life drawing at the Academia de San Carlos.

In 1865 Rebull was commissioned to paint the portraits of *Maximilian, Emperor of Mexico* (*reg* 1864–7), and his wife *Carlota Amalia*. The Emperor's portrait, which has been kept in the Castillo de Miramar, earned him the Order of Guadalupe, but the Emperor's wife was displeased with her portrait and had the canvas suppressed. Nevertheless, Maximilian then commissioned from Rebull a series of portraits of national heroes, bringing together for the first time in Mexican art historical characters from opposing parties. At the end of his life, his paintings on more religious subjects were criticized by liberal critics

such as Felipe López López and Ignacio M. Altamirano. The *Death of Marat* (Mexico City, Mus. N.A.), a small-scale but powerful history painting exhibited at the Academy in 1875, is generally considered Rebull's outstanding work, demonstrating his command of European models.

BIBLIOGRAPHY

N. Leonardini: *El pintor Santiago Rebull, su vida y su obra, 1829–1902* (Mexico City, 1983)
F. Ramírez: *La plástica del siglo de la Independencia* (Mexico City, 1985), p. 86

ESTHER ACEVEDO

Recife. Brazilian city, capital of the state of Pernambuco. Built on the Atlantic coast in north-eastern Brazil, the city (population *c.* 1.3 million) contains several important Baroque churches. Its early development, in an area inhabited by Europeans from 1534, was linked with that of its neighbour, OLINDA, for which Recife acted as a sea port. The connection was broken in 1630 by the invasion of the Dutch, who virtually destroyed Olinda and developed the town of Mauritzstadt on the island of Santo António at Recife, with a rational urban plan unknown in Brazil at the time. The Dutch also left a rich pictorial record of the town in the work of such artists as FRANS POST and ALBERT ECKHOUT (*see also* NASSAU-SIEGEN, JOHAN MAURITS OF). When the Dutch were driven out in 1654, Recife continued to grow and became one of Brazil's major commercial centres in the second half of the 19th century as well as the cultural centre of north-eastern Brazil. Its most splendid buildings date from the 17th and 18th centuries and provide a catalogue of Baroque forms. The church of the Third Order of S Francisco da Penitência has an interior (completed 1724) rich in paintings, *azulejos* (glazed tiles) and carved gilt woodwork. The convent of S Antonio in its magnificent Golden Chapel (1697) has Portuguese and Dutch glazed tiles. Nossa Senhora da Conceição dos Militares (mid-18th century) has a large mural (1781) of the *Battle of Guararapes* and also houses the Museu de Arte Sacra. S Pedro dos Clérigos (1731–82) contains fine wood-carvings and a *trompe l'oeil* ceiling painted by João de Deus Sepúlveda. Examples of late Neo-classical architecture include the Teatro S Isabel (*c.* 1845) by Louis Vauthier (1815–1901); the former prison (1847; now the Casa da Cultura do Recife) and the Ginásio Pernambucano (1855), both by José Mamede Alves Ferreira. The Museu do Estado de Pernambuco is devoted to the history of the region.

BIBLIOGRAPHY

G. Freyre: *Guia prático, histórico e sentimental da história do Recife* (Rio de Janeiro, 1961)
J. M. dos Santos Simões: *Azulejaria portuguesa no Brasil, 1500–1822* (Lisbon, 1965)
J. R. Teixeira Leite: *A pintura no Brasil holandés* (Rio de Janeiro, 1968)
G. Ferrez: *O álbum de Luís Schlappriz: Memória de Pernambuco, 1863* (Recife, 1981)
C. P. Valladares: *Nordeste histórico e monumental*, 3 vols (Rio de Janeiro, 1983)
E. V. da Oliveira: *Casas eguias do Porto e sobrados do Recife* (Recife, 1986)
H. van Nederveen Meerkerk: *Recife: The Rise of a Seventeenth-century Trade City from a Cultural-Historical Perspective* (Assen, 1989)

ROBERTO PONTUAL

Recinos, Efraín, jr (*b* Quetzaltenango, 15 May 1932). Guatemalan painter, sculptor and architect. He studied in Guatemala City at the Escuela Nacional de Artes Plásticas and at the Universidad de San Carlos, from which he graduated as a civil engineer. As a painter and sculptor he revealed a childlike imagination in strange works that could be described as abstract Surrealist in their cumulative effect of shapes, textures and muted colours. His great formal originality is evident in sculptures such as *Música Grande* (wood construction, *c.* 1968; Guatemala City, Mus. N. A. Mod.). From 1955 he also worked within the movement for the integration of the plastic arts with architecture that was taking place in Guatemala. His outstanding works from this period, all in Guatemala City, include a fountain in the Parque de la Industria (1960), bold in its play of form and volume, and the reliefs in exposed concrete cast *in situ* for the central building of Crédito Hipotecario (14×7.5 m, 1963–4) and for the Biblioteca Nacional (1965).

Recinos's most ambitious work was the Centro Cultural in Guatemala City, created in two stages. Around 1960 he designed an open-air theatre, adapted from the remains of a 19th-century fort to the natural conditions of the site. Later he designed the Gran Teatro, this time working from the foundations of a previous plan. In this building, completed in 1978, he was able to develop all the ideas that he had touched on in the open-air theatre, conceiving architecture as if it were a sculpture to be modelled and incorporating colour into it to create an integrated artistic whole. The result, which dominates the whole of one sector of Guatemala City from its hillside site, is an extraordinary synthesis of architecture and sculpture containing no traditional architectural features. In 1981 it was awarded a prize for the 'highest achievement in the integration of the plastic arts' in Guatemala between 1950 and 1980.

BIBLIOGRAPHY

L. Méndez Dávila: *Arte vanguardia Guatemala* (Guatemala City, 1969), p. vii
Escultura y relieve integrados a la arquitectura de la ciudad de Guatemala, 1950–1980 (exh. cat., Guatemala City, 1980), pp. 2, 19–20
Efraín Recinos y su obra: Exposición homenaje (exh. cat. by A. M. Rodas, Guatemala City, Fund. Paiz, 1991)
R. Díaz Castillo: *Visión del arte contemporáneo en Guatemala*, ii (Guatemala City, 1995)
L. A. Arango: 'Efraín Recinos', *Banca Cent.*, xxviii (1996), pp. 111–20
Guatemala: Arte contemporáneo (Antigua, Guatemala,1997), pp. 25–8

JORGE LUJÁN-MUÑOZ

Re-figuración. Paraguayan art movement active in the 1970s. It produced a form of figurative art based on the exploration of the nature of pictorial signs, yet also with a strong expressive quality. The movement investigated the mechanism of representation and the relationship between reality and image, without abandoning the vital dramatic sense that marks the best figurative work in Paraguay. It was related to the wider development of the visual arts in Paraguay in the 1970s (*see* PARAGUAY, §IV, 2), which was characterized by a reflective mood connected with the prevalence of conceptual art. The most representative artists of Re-figuración were Osvaldo Salerno (*b* 1952), Bernardo Krasniansky (*b* 1951) and Luis Alberto Boh (*b* 1952), but the movement also had a considerable effect on the work of such other artists as Carlos Colombino, Olga Blinder, Susana Romero and a whole generation of young artists working at that time.

BIBLIOGRAPHY
O. Blinder and others: *Arte actual en el Paraguay* (Asunción, 1983)
T. Escobar: *Una interpretación de las artes visuales en el Paraguay* (Asunción, 1984)

TICIO ESCOBAR

Rego Monteiro, Vicente do (*b* Recife, 19 Dec 1899; *d* Recife, 5 June 1970). Brazilian painter, poet and publisher. He became interested in painting while living in Paris between 1911 and 1914. On his return to Brazil he lived first in Rio de Janeiro and then, from 1918 onwards, in Recife. There he prepared a series of watercolours on indigenous themes, such as the *Birth of Mani* (1921; U. São Paulo, Mus. A. Contemp.), which were exhibited in Rio de Janeiro and São Paulo in 1920–21. In 1922 he took part in the SEMANA DE ARTE MODERNA in São Paulo and returned to Europe, establishing a studio in Paris, where he illustrated P. L. Duchartre's *Légendes, croyances, et talismans des indiens de l'Amazonie* (Paris, 1923). From 1922 to 1957 he alternated his residency between Paris and Brazil. In 1930 he and the French poet and critic Géo-Charles (1892–1963) organized the first comprehensive exhibition in Brazil of artists from the Ecole de Paris, which was seen in Recife, Rio de Janeiro and São Paulo. His painting encompassed portraits, still-lifes, allegories, some abstract compositions, scenes of work such as *The Pavers* (1924; Liège, Pal. Congr.), scenes of sport, for example *The Boxers* (1927; Grenoble, Mus. Peint. & Sculp.) and *The Hunt* (1923; see colour pl.XXXII, fig. 2), and especially episodes from the Bible such as the *Adoration of the Magi* (1925; Rio de Janeiro, Col. Gilberto Chateaubriand), all of which combine a sense of sculptural volume derived from ancient Latin American images with Art Deco stylization. Among his influences were Futurism, Cubism, Purism and the geometric Symbolism of the sculptor Ivan Meštrović (1883–1962).

After 1927 Rego Monteiro painted less intensely, and in later life he devoted much of his energies to poetry. From 1946 to 1956 he published the work of French poets through his Paris-based company, La Presse à Bras, and in 1960 he won the Guillaume Apollinaire prize for his own poems, *Broussais: La Charité* (Recife, 1957). He settled permanently in Brazil in 1957 to lecture on painting in Recife and Brasília.

BIBLIOGRAPHY
W. Ayala: *A criação plástica em questão* (Petrópolis, 1970)
Vicente do Rego Monteiro (exh. cat., ed. W. Zanini; U. São Paulo, Mus. A. Contemp., 1971)
Léger et l'esprit moderne (exh. cat. by M. O. Briot and others, Paris, Mus. A. Mod. Ville Paris, 1982)
R. Pontual: *Entre dois séculos: Arte brasileira do século XX na Coleção Gilberto Chateaubriand* (Rio de Janeiro, 1987)
W. Zanini: 'Rego Monteiro e a Escola de Paris', *Rev. Gal.*, xv (1989), pp. 116–19
G. Freire and others: *Vicente do Rego Monteiro, pintor e poeta* (Rio de Janeiro, 1994)

ROBERTO PONTUAL

Régulo. *See* PÉREZ, RÉGULO.

Reidy, Affonso Eduardo (*b* Paris, 26 Oct 1909; *d* Rio de Janeiro, 10 Aug 1964). Brazilian architect and teacher, of French birth. He graduated in architecture in 1930 from the Escola Nacional de Belas Artes, Rio de Janeiro. From 1929 to 1930, while still a student, he worked as assistant to Donat-Alfred Agache, who was drawing up the masterplan for Rio de Janeiro, then the capital of Brazil. After graduating, Reidy joined the public works department of the Prefecture of the Federal District in Rio, where he met Carmen Portinho (*b* 1906), the third woman to graduate in civil engineering in Brazil and one of the first in the world; she became his closest collaborator and worked on many aspects of his projects. Reidy was directly involved with the development of modern architecture in Brazil. In 1931 he was appointed assistant to Gregori Warchavchik, pioneer of modernism in Brazil, when Warchavchik became Professor of Architectural Composition at the Escola Nacional de Belas Artes during Lúcio Costa's directorship and reforms (1930–31) introducing modernist teachers. Reidy continued to teach there and became Professor of Design (1937) and Professor of Urban Planning (1954).

Reidy worked almost entirely in the public sector. His work can be divided into two periods, the first beginning in 1930 with his plans for public buildings in the Prefecture, where his composition of articulated blocks on rigidly orthogonal axes reveals the influence of the Soviet Constructivists. An example of the innovative spatial planning characteristic of his work is the design, won in competition, for the Albergue da Boa Vontade (1931; with Gerson Pompeu Pinheiro (1910–84)), a hostel for the homeless, which consists of a two-storey building built around a courtyard, with two wings bridging across at the upper level. The second period of Reidy's career began when he became a member of the team that developed the design for the Ministry of Education and Health (1936–45; now the Palácio da Cultura; *see* BRAZIL, fig. 5) in Rio with Le Corbusier. Led by Lúcio Costa, the team also included Oscar Niemeyer, Carlos Leão (1906–83), Ernani Vasconcelos (1909–88) and Jorge Moreira. Le Corbusier's urban-planning principles strongly influenced Reidy's work thereafter.

One of Reidy's best-known projects is the residential complex for civil servants, Prefeito Mendes de Moraes (1947–52), Pedregulho, Rio de Janeiro (see fig.); two duplex blocks, a primary school with glazed tile mosaic, a clinic, laundry, shops and other community facilities were planned on the flat part of the site, and a striking five-storey serpentine block of 272 flats was set on the sloping hillside, entered at mid-level from the hill and freely curving around the contours. Other major planning projects included the redevelopment plans for the centre of Rio de Janeiro and for a new civic centre on the Santo Antonio Hill (both 1948); the latter incorporated historic structures and open space and was partially realized in later years. For another urban-planning project, Aterro Glória (1956–62), Flamengo, Rio de Janeiro, a large area of open space located at a traffic axis in the city and built on a partial embankment of Guanabara Bay, Reidy designed the elegantly curved Paulo Bittencourt footbridge in pre-stressed concrete, the park furniture, children's theatres, bandstands and petrol stations. The landscaping was by ROBERTO BURLE MARX. These projects show how his urban-planning ideas combined the design of buildings and the open spaces around them with a meticulous study of the services required, including traffic networks. Reidy was also influenced by the work of Josep Lluís Sert in Spain before the Civil War, as can be seen in the arrange-

Affonso Eduardo Reidy: Pedregulho Housing Development, Rio de Janeiro, 1947

ment and proportioning of the façades at Pedregulho, and by the structural innovation of OSCAR NIEMEYER in his buildings at Pampulha (1942–4); an interest in the industrialization of such traditional architectural elements as open trelliswork is also evident, a trend already adopted by Luís Nunes (1908–37) and Lúcio Costa.

Later works include the Experimental College Brazil–Paraguay (1952), Asunción, and the Museu de Arte Moderna do Rio de Janeiro (1953–9), one of Reidy's most important works and a synthesis of his architectural and planning ideas. The design comprised two buildings planned around a courtyard: a 250-m exhibition building on two storeys above an open-plan ground floor, suspended from trapezoidal portal frames, and a separate office, theatre, restaurant and amenity building with curved forms. The structure of the former appears as rows of concrete ribs supporting the roof and enclosing the glassed-in exhibition area. The building, reconstructed after a fire in 1978, illustrates the spatial and structural innovation typical of Reidy's work. Above all, he developed solutions that were particularly appropriate to their context, appearing to be logical yet organic, and his buildings influenced many architects in Latin America, including João B. Vilanova Artigas in Brazil and Carlos Raul Villanueva in Venezuela, notably in his work at the University of Caracas.

BIBLIOGRAPHY
Brazil Builds: Architecture New and Old, 1652–1942 (exh. cat. by P. Goodwin, New York, MOMA, 1943)
H. E. Mindlin: *Modern Architecture in Brazil* (Amsterdam and Rio de Janeiro, 1956) [also pubd in Fr. and Ger.]
K. Franck: *The Works of Affonso Eduardo Reidy* (Stuttgart and London, 1960)
Y. Bruand: *Arquitetura contemporânea no Brasil* (São Paulo, 1981)
W. Zanini, ed.: *História geral da arte no Brasil* (São Paulo, 1983)
E. D. Harris: *Le Corbusier and the Headquarters of the Brazilian Ministry of Education and Health, 1936–1945* (diss., U. Chicago, IL, 1984)
Affonso Eduardo Reidy (exh. cat., Rio de Janeiro, Pont. U. Católica, 1985)
M. Ceniquel: *Affonso Eduardo Reidy. Ordem, lugar e sentido: Uma visão arquitectônica da centralidade urbana do Rio de Janeiro* (Ph.D. diss., U. São Paulo, 1996)

JULIO ROBERTO KATINSKY

Renart, Emilio (*b* Mendoza, 4 Feb 1925; *d* Buenos Aires, 1991). Argentine painter, sculptor and teacher. He studied at the Escuela Nacional de Bellas Artes in Buenos Aires and started painting around 1945. From the beginning he concerned himself both with aesthetic issues, which he regarded as subjective, and with working methods, which he considered objective, going so far as to invent his own tools (such as small rollers, which he used instead of brushes). From 1958 to 1960 he exhibited paintings and drawings in the style of *Art informel*, followed by collages in 1961. Seeking to fuse painting and sculpture into a single unit, an idea that he proposed as 'Integralism', he produced works entitled *Biocosmos*; these were fabricated from combinations of metal, canvas, paint, plaster, sand, cement, polyester resin, fibreglass and light fittings, and made reference to animal, vegetable and mineral life.

Renart stopped painting from 1969 to 1976 to devote himself to teaching; the team-teaching projects devised by him were adopted by the official education system. His later art included images of the human figure, masklike sculptures that delve into the relationship between the conscious and the unconscious, and *Multi-images* made from refuse in which he recycled his creative investigations.

BIBLIOGRAPHY
P. Harari: *Renart* (Buenos Aires, 1981)
J. Glusberg: *Del Pop-art a la nueva imagen* (Buenos Aires, 1985), pp. 391–8

JORGE GLUSBERG

Renau, Josep (*b* Valencia, 17 May 1907; *d* E. Berlin, 11 Oct 1982). Spanish photomontagist and printmaker, active

in Mexico and Germany. He studied painting at the Escuela de Bellas Artes de San Carlos in Valencia (1919–26), subsequently becoming a graphic designer and photomontagist (1928–39) in Valencia, Madrid and Barcelona. In his printmaking, which was influenced by John Heartfield and by Socialist Realism, he showed a strong commitment to the Republican cause and a talent for satire, often expressed through the use of colourful popular imagery. When the Spanish Civil War ended in 1939 he went into exile in Mexico, where he executed a series of photomontages entitled *The American Way of Life* (1949–66), in which he denounced American imperialism and capitalism. In 1958 he moved permanently to East Berlin, where he executed the series *Fata Morgana U.S.A.*

PHOTOGRAPHIC PUBLICATIONS
Fata Morgana U.S.A. (1967)
The American Way of Life (Barcelona, 1977)

BIBLIOGRAPHY
C. Naggar: 'The Photomontages of Josep Renau', *Artforum*, xvii (1979), pp. 32–6
Idas y caos: Aspectos de las vanguardias fotograficas en España (exh. cat., J. Fontcuberta; Madrid, Salas Picasso; New York, Int. Cent. Phot.; 1984–6)
J. Fontcuberto, ed.: *Josep Renau* (Mexico City, 1985)

MARTA GILI

Rendón Seminario, Manuel (*b* Paris, 2 Dec 1894; *d* Portugal, 3 Jan 1982). Ecuadorean painter of French birth. He studied at the Académie de la Grande Chaumière, Paris, and from 1917 he exhibited in Paris at the Salon des Indépendants and at the Café de la Rotonde. In 1920 he went for the first time to Ecuador, his parents' country, where the colours and rhythms of the tropics made a great impression on him. He exhibited for the first time in Quito in 1943, and in 1945 he took part in the first Salón Nacional de Bellas Artes; further international exhibitions culminated in his award of first prize at the second Bienal Hispanoamericana (1954) in Havana. Rendón introduced abstraction into Ecuadorean painting. He experimented with different avant-garde styles, notably Neo-realism, but sought images of religious origin. His work is characterized by a mastery of the curved line and a vibrant, sensuous luminosity of colour that recalls stained glass, for example *Death of a Young Girl* (1970; Guayaquil, Col. Gilbert-Febres Cordero).

BIBLIOGRAPHY
Manuel Rendón (exh. cat., Madrid, Ateneo, 1965)
M. de Icaza Gómez: *Manuel Rendón* (Guayaquil, 1981)
J. Castro y Velázquez: *Manuel Rendón Seminario (1894–1980): Catálogo razonado* (Guayaquil, 1995)

CECILIA SUÁREZ

Renzi, Juan Pablo (*b* Casilda, Santa Fé, 21 June 1940; *d* 1992). Argentine painter, draughtsman and graphic designer. He studied drawing and painting in Santa Fé with the Argentine painters Gustavo Cochet (1894–1979) and Juan Grela (*b* 1914) and began exhibiting his work in 1963. Until 1966 he was aligned with the work of Argentine painters grouped together under the label of Nueva Figuración (Luis Felipe Noé, Ernesto Deira, Jorge de la Vega and Romulo Macció), combining figurative references with freer elements derived from Abstract Expressionism. During the next couple of years he worked simultaneously in two very different ways. In one group of works he adopted a rational style that had the formal simplicity of Minimalism and the emphasis on the transcendence of ideas over matter characteristic of conceptual art. One such work, *Water in Every Part of the World* (exh. Buenos Aires, Mus. A. Mod., 1967; see 1984 exh. cat., p. 13), consisted of 50 one-litre bottles filled with water, each bearing a label indicating its source of origin; the authenticity of the New York water was confirmed by Sol LeWitt, one of his collaborators on the project. During this same period, however, Renzi worked with other artists from the town of Rosario on *Tucumán arde*, a multi-media event encompassing images, sounds and movement; in seeking an alternative to institutionalized culture their aims were as much political as aesthetic.

From 1968 until his move to Buenos Aires in 1975 Renzi virtually abandoned his work as an artist, rejecting the traditional channels of aesthetic production as inadequate at a time of national crisis. When he returned to painting, in works such as *Mise en scène* (oil on canvas; 1978–9; New York, Chase Manhattan Bank A. Col.), he employed an impersonal Photorealist style and created a dialogue between the image, the title, other texts and references to other artists. In the 1980s, in works such as *Mountain Still-life* (enamel and oil on canvas, 1986; Rio de Janeiro, Mus. A. Mod.), he returned to a more spontaneous and dynamic style closer to Abstract Expressionism, sometimes making recourse to methods of automatism. While the variety and sudden shifts of Renzi's development may seem bewildering—taking in forms of realism and Minimalism, conceptual art and political subject-matter, installations and neo-expressionism—they are linked by his urge to explore every available form and medium through which to communicate his ideas to his audience.

BIBLIOGRAPHY
B. Oldenburg: 'El camino de Renzi', *Arte Argentino Contemporáneo* (Madrid, 1979)
J. Glusberg: 'La Nueva Imagen en Latinoamérica', *Transavangarde International* (Milan, 1982)
Catálogo retrospectiva de Pablo Renzi: Obras de 1963 a 1984 (exh. cat., Buenos Aires, Mus. N. B.A., 1984)
J. Glusberg: *Del Pop-art a la nueva imagen* (Buenos Aires, 1985), pp. 399–402
J. López Anaya: *Historia del arte argentino* (Buenos Aires, 1997)

NELLY PERAZZO

Retable [Lat. *retrotabulum*: 'behind the altar'; Port. *retábulo*; Sp. *retablo*]. Image-bearing structure positioned behind the altar. In its broadest sense the term is interchangeable with altarpiece, but it is used in this article to denote the type of altarpiece produced in Spain, Portugal and their colonies in the New World. Such retables are architectonic in form, usually of carved and polychrome wood (although sometimes made in other materials such as silver, alabaster and enamel), framing paintings, sculptures, reliefs and reliquaries grouped in horizontal tiers or vertical bands; a tabernacle (or monstrance) might be incorporated signifying the eucharistic function of retable and altar. This format became increasingly complex during the Baroque period, reaching vast proportions and dominating the architecture of the east end of a church.

BIBLIOGRAPHY
J. R. Buendía: 'Sobre los orígenes estructurales del retablo', *Rev. U. Complutense*, xxii/87 (1973), pp. 17–40
J. J. Martín González: *El retablo barroco en España* (Madrid, 1993)

1. Spanish colonies. 2. Portuguese colonies.

1. SPANISH COLONIES. The styles of retables in the New World during the Spanish colonial period (1521–1821) frequently reflect an intermingling of native and European sources.

Very few colonial retables from Guatemala have survived. The colonial capital, Santiago de los Caballeros de Guatemala (now Antigua), was devastated by an earthquake in 1773, and ruined churches are almost the only vestiges of the colonial era. The best impression of Guatemalan retables is provided by the retable-façades of these churches, which were treated in a manner similar to the interior retables; indeed, many of the architects who worked in the city in the 17th century were also retable builders (*ensembladores*) and excelled at ornate sculptural decoration. Rococo altars, for example the twin transept altars of La Merced in Santiago de Guatemala commissioned in 1758 from Francisco Javier de Gálvez, show some unique features, such as elaborate orders with putti heads and rocaille ornament. The closest comparison is the decoration of the altars from Querétaro in Mexico, with their use of *estípite* baluster columns. Guatemala exported sculpture to southern Mexico and Central America, and its retable makers were commissioned to design altars in other countries. Vicente de la Parra (*c.* 1667–after 1708), for example, designed the altar of the Rosary in Comayagua Cathedral, Honduras, in 1708; it has bright, polychrome reliefs in a folk style. Vicente de Gálvez travelled to Honduras around 1761 and carved the principal altar of Tegucigalpa Cathedral in a dynamic, graceful late Rococo style.

In Colombia, the master of the main retable (1622–33) of S Francisco in Santa Fe de Bogotá incorporated native flora and fauna in exuberant narrative compositions with repetitive patterns, variety and movement, all accentuated by the strong contrast between low and high relief. The main altar (1635–40) of S Ignacio, Bogotá, was designed by the Italian Jesuit Mateo Luisinich (*fl* 1635–40) and is elaborately decorated in black, red and gold. The Loreto Altar (1720), also in S Ignacio, Bogotá, is characteristic of a new style of Colombian retable, which displays columns covered with deeply undercut figures and ornaments, and this feature was developed further in other Colombian churches. In Quito, Ecuador, retable-making flourished from 1600 to the end of the colonial period. The altars, primarily created by Indian or mestizo artists, are painted in brilliant red, contrasting with shimmering gold leaf heavily applied to the wooden surfaces. The side altar (*c.* 1730) of the chapel of the Santisimo and the main retable (*c.* 1700) in the church of La Compañía (see fig. 1) are examples of this profusely ornamented style.

In Peru the two main cultural centres during the colonial period were Lima, which was strongly influenced by Europe, attracting many Spanish and Italian artists, and Cuzco, which retained an Indian tradition, evident in the more native style of its altarpieces. In Lima many altars were imported from Spain, although most of these have been lost or destroyed. Juan Martínez Montañés (*c.* 1568–1649) and his workshop, for instance, sent altars to Lima from 1590 to 1648. One by Martínez Montañés, dedicated to St John the Baptist (1607 and 1622) in the convent of

1. Main retable (*c.* 1700), church of La Compañía, Quito, Ecuador

the Concepción in Lima, contains fine relief carvings. Most existing altars in Lima and Cuzco date from after the earthquake of 1650. Cuzco was rebuilt immediately thereafter, and numerous altars were constructed in a style characterized by a greater sense of spatial movement, for example the Soledad Altar (*c.* 1660) of La Merced. A type of altar that is unique to Cuzco is covered entirely with mirrors, as found in the main retable (*c.* 1660) of S Clara. The principal altar of S Pedro, ordered by Lorenzo de Vega in 1720, is a gigantic three-storey structure with a division of niches between the paintings and the statues, a typical arrangement in Cuzco.

BIBLIOGRAPHY
P. Kelmen: *Baroque and Rococo in Latin America*, 2 vols (New York, 1951/*R* 1967)
J. M. Vargas: *Arte religioso ecuatoriano* (Quito, 1956)
G. Kubler and M. Soria: *Art and Architecture in Spain and Portugal and their American Dominions, 1500–1800* (Baltimore and Harmondsworth, 1959)
J. G. Navarro: *El arte en la provincia de Quito* (Mexico City, 1960)
S. D. Markman: *Colonial Architecture of Antigua Guatemala* (Philadelphia, 1966)
E. Harth-Terre: *Peru, monumentos históricos y arqueológicos* (Mexico City, 1975)
T. Gisbert: *Iconografía y mitos indigenas en el arte* (La Paz, 1980)
J. Mesa and T. Gisbert: *Historia de la pintura cuzqueña* (Lima, 1982)
CAREY ROTE

2. PORTUGUESE COLONIES. One of the most original and vigorous elements to develop in Portuguese retables was their ornamentation with elaborately carved and gilded

wood (*talha*). This became the most prominent feature of retables in the Baroque style, and in this form they represented a powerful expression of the principles of the Catholic Counter-Reformation: the Church appreciated the attraction of their expressive vocabulary to the faithful, who were thereby drawn to the sacred theatre of the church. Combined with music, incense, processions, sculpture and rich vestments, the retable contributed to the creation of an atmosphere of sanctity.

The models of *talha* used by artists in Portugal were transplanted to her overseas possessions and assumed Oriental characteristics in Goa, Daman, Diu and Macao, or retained a more European emphasis in Brazil. The symbiosis of Portuguese and Indian elements is seen in the high altars of Rachol Seminary (early 17th century), near Margao, S Catarina Cathedral in Old Goa and Daman Cathedral, where the Portuguese composition is combined with strongly Indian motifs at the top of the structure. The monumental Mannerist high altar in Goa Cathedral is arranged in three tiers with fine carved reliefs of the *Life of St Catherine*. From the mid-17th century the retables in Portuguese Indian churches, although derived from the National style, differ in the treatment of the structural elements and in the free interpretation of decorative motifs by local artists. In the 18th century retables lacked the originality and vigour that had previously been characteristic.

It was in Brazil, however, that *talha* was most successfully adopted, particularly with the introduction of gilded *talha* from the end of the 17th century. In the Rococo period, beginning in the 1770s, retables in Brazil acquired profoundly original features with regional variations. In the north-east, especially in Pernambuco, Rococo is marked by a peculiar spiralling treatment exemplified in the attics of the retables in the church of the Misericórdia in Olinda, while the high altar (1780–83) of S Bento is comparable to the fine example in S Martinho at Tibães, Portugal. Rococo reached its highest point in the region of Minas Gerais, especially in the work of Antônio Francisco Lisboa (O Aleijadinho; *see* LISBOA, (2)). His architectural and sculptural works and his profoundly individual treatment of *talha* are found in some of the most important churches of the period, for example Nossa Senhora do Carmo and S Francisco de Assis in Ouro Preto and S Francisco de Assis in São João del Rei (see fig. 2). His best work is in the apsidal chapel of S Francisco in Ouro Preto, which culminates in the retable (1778–94) with its sculptural group of the *Trinity* and the *Virgin* in the centre.

2. Retable (*c.* 1789) by Antônio Francisco Lisboa, S Francisco de Assis, São João del Rei, Brazil

BIBLIOGRAPHY

G. Kubler and M. Soria: *Art and Architecture in Spain and Portugal and their American Dominions, 1500–1800* (Baltimore and Harmondsworth, 1959), pp. 192–3
R. C. Smith: *A talha em Portugal* (Lisbon, 1962)
M. M. de Cagigal e Silva: *A arte indo-portuguesa* (Lisbon, 1966)
C. de Azevedo: *A arte de Goa, Damão e Diu* (Lisbon, 1970)
R. C. Smith: 'The Arts in Brazil: I. Baroque Architecture', *Portugal and Brazil: An Introduction*, ed. H. V. Livermore (Oxford, 1970), pp. 349–84
V. Serrão: *O maneirismo*, Hist. A. Portugal., vii (Lisbon, 1986)
N. M. Ferreira-Alves: *A arte da talha no Porto na epoca barroca: Artistas e clientela, materiais e técnica*, Documentos e memórias para a história do Porto, xlvii (Oporto, 1989)
——: 'Talha', *Dicionário da arte barroca em Portugal* (Lisbon, 1989), pp. 466–70
M. A. R. de Oliveira: 'Barroco no Brasil' and 'Antônio Francisco Lisboa', *Dicionário da arte barroca em Portugal* (Lisbon, 1989), pp. 99–104, 261–2
N. M. Ferreira-Alves: *A Talha do Porto: Do maneirismo ao rococó* (Oporto, 1991)

NATÁLIA MARINHO FERREIRA-ALVES

Reverón, Armando (*b* Caracas, 10 May 1889; *d* Caracas, 18 Sept 1954). Venezuelan painter. He studied under Antonio Herrera Toro at the Academia de Bellas Artes, Caracas (1908–11). In 1911 Reverón obtained a scholarship from the Municipality of Caracas and went to Spain, where he studied at the Escola de Arts i Oficis La Lonja in Barcelona (1911–12) and at the Real Academia de Bellas Artes de San Fernando, Madrid (1912–13). After a brief journey to Caracas he returned to Europe and spent six months in Paris. The three main phases of Reverón's work began with the so-called Blue Period (1912–14), in which blue tones were predominant (e.g. *Enrique Planchärt,*

1912; Caracas, Col. Banco Cent. Venezuela); his landscapes were characterized by a dense and luminous impasto, and his female figures were swathed in a sensual, mysterious atmosphere reminiscent of Goya's *majas* and of the work of Ignacio Zuloaga (1870–1945). In 1915 Reverón returned to Caracas to escape World War I and settled down there. Between 1915 and 1919 he participated in the activities of the anti-academic group Círculo de Bellas Artes and became acquainted with the traveller-artists Samys Mützner, Emilio Boggio and Nicolas Ferdinandov, all of whom, particularly Ferdinandov, influenced him. He moved permanently *c.* 1921 to the coastal town of Macuto, where previously he had met Juanita, his model and companion.

The White Period (1924–34) is generally considered to include the artist's most significant work. He limited his palette exclusively to the use of white to capture the effects of light, using only the canvas for colour and texture; he suggested rather than described the subject, and the images appear to be reverse silhouettes, like photographic negatives. He created his own materials during this period, including coloured earths and his own implements, such as parasols, paintbrushes and palettes. In the Sepia Period (from 1935) sepia tones predominated, with large formats and a combination of techniques: tempera, oil and gouache on paper pasted on card. The work had a notably Expressionist character (e.g. *Self-Portrait with Dolls*, 1949; Caracas, Gal. A. N.).

Reverón is considered to have been one of the most important Venezuelan artists. The originality of his work and way of life aroused great interest among not only art historians and critics but also photographers and film makers. His work was characterized by a profound exploration of the blurred effects of tropical light on such subjects as Caracas and its surroundings; marine landscapes of coconut palms, *uvero* trees, broad beaches and port scenes; female figures (live models and cloth dolls); and portraits, particularly self-portraits. From 1933 his work was exhibited in numerous international one-man shows, and he won important awards, notably in the Venezuelan Pavilion at the Exposition Internationale in Paris in 1937; he was awarded the Premio Nacional de Pintura in Caracas in 1953.

BIBLIOGRAPHY
A. Boulton: *Obra de Armando Reverón* (Caracas, 1966)
J. Calzadilla: *Armando Reverón* (Caracas, 1979)
J. Liscano: *Testimonios sobre artes plásticas* (Caracas, 1981)
J. Balza: *Análogo simultáneo* (Caracas, 1983)
M. Picón Salas: *Las formas y las visiones* (Caracas, 1984)
A. Salcedo-Miliani: *Armando Reverón y su obra* (Barcelona, 1987)
Armando Reverón: Exposición iconográfica documental en el centenario de su nacimiento (exh. cat., Caracas, Gal. A. N., 1991)
M. Picón Salas and others: *Armando Reverón: Una luz como para magos*, i (Caracas, 1992)
M. G. Arroyo and others: *Armando Reverón (1889–1954): Exposición antológica* (Madrid, Mus. N. Cent. A. Reina Sofía, 1992)
Armando Reverón: Luz y cálida: Sombra del Caribe. Exposición itinerante (exh. cat. by A. Boulton and others, Caracas, Fund. Mus. Armando Reverón and elsewhere, 1996–7)

YASMINY PÉREZ SILVA

Revilla, Carlos (*b* Arequipa, 19 Aug 1940). Peruvian painter and printmaker. He studied in the Netherlands and produced fantastic Surrealist-influenced pictures, in which he made reference to Flemish and Italian painting of the Renaissance. In a number of his dreamlike paintings figures appear to have emerged from a great box of robot toys, contributing to the painting's disconcertingly cold atmosphere.

BIBLIOGRAPHY
Carlos Revilla: Retrospectiva, 1955–1996 (exh. cat. by J. Villacorta, Lima, Mus. A., 1996)

LUIS ENRIQUE TORD

Revueltas, Fermín (*b* Santiago Papasquiaro, Durango, 7 July 1902; *d* Mexico City, 9 Sept 1935). Mexican painter. He studied architecture in Chicago before enrolling at the Art Institute of Chicago, where he studied painting until 1919, returning to Mexico in 1920. Within the Mexican post-revolutionary avant-garde, his work was distinguished by a clear awareness of the formal and colouristic concerns of Fauvism, Cubism and Constructivism. In the 1920s he participated in *Estridentismo* and in the Escuelas de Pintura al Aire Libre as a student and teacher. He was also active in the early stages of the mural movement, painting the *Allegory of the Virgin of Guadalupe* (1922–3) at the Escuela Nacional Preparatoria, Mexico City, and he was a member of the left-wing Sindicato de Obreros Técnicos, Pintores y Escultores, as well as of the anti-academic ¡30–30! group, the Cultural Missions and the Communist party. Revueltas also produced prints and designs for stage sets and stained-glass windows.

BIBLIOGRAPHY
Fermín Revueltas: Colores, trazos y proyectos (exh. cat., Mexico City, Gal. O'Gorman, Cent. Cult. U., 1983)
J. Alanís: *Fermín Revueltas* (Mexico City, 1984)
Fermín Revueltas (1902–1935): Muestra antológica (exh. cat., Mexico City, Mus. A. Mod., 1993)

KAREN CORDERO REIMAN

Reyes, Refugio (José) (*b* Sauceda, Zacatecas, 2 Sept 1862; *d* Aguascalientes, 1945). Mexican architect and sculptor. He was self-taught and studied engravings, photographs and the treatises of Vitruvius and Jacopo Vignola. His artistic production was consequently highly original and fitted into the pattern of contemporary eclecticism and Mexican neo-Baroque. In 1876–81 he worked on the railways of Zacatecas, where he learnt to calculate the resistance of materials and came to appreciate the architectural potential of iron. His interest in traditional Mexican architecture, its conservation and interpretation, is evident in his design (1919), which was only partly constructed, for the completion of the 18th-century façade and the towers of the sanctuary of Guadalupe in Aguascalientes. This harmonizes successfully with the building as a whole and the imaginative qualities of Mexican Baroque. The church of San Antonio (1908) in Aguascalientes exemplifies Reyes's spontaneously eclectic architecture. The dome of the crossing is the most complex feature, where Reyes achieved a disconcerting feeling of weightlessness. It has a double circular drum, with the lower part, of smaller diameter, composed solely of a triple row of supporting Doric columns. He had a considerable practice in Aguascalientes, where he built the Banco Nacional de México (1905), hotels and numerous houses. Among Reyes's notable sculptural works is the stone figure of Cuahtemoc (1893), the last Aztec emperor, which

served as a crest on the facade of a house facing the Jesuit church in Zacatecas.

BIBLIOGRAPHY

I. Katzman: *Arquitectura del siglo XIX en México* (Mexico City, 1973)
V. M. Villegas: *Arquitectura de Refugio Reyes* (Mexico City, 1974)
J. L. García Ruvalcaba: 'Refugio Reyes', *A. México*, xxvi (1994), pp. 43–7

MÓNICA MARTÍ COTARELO

Reyes Ferreira, Jesús [Chucho] (*b* Guadalajara, 10 Oct 1882; *d* Mexico City, 5 Aug 1977). Mexican painter, sculptor and collector. He led a very curious life, surrounded by the antiques that he collected. In Guadalajara and later in Mexico City he produced what he called his 'smeared papers': sheets of India paper painted with washes of brilliantly coloured aniline dyes that he prepared himself, with the occasional addition of silver or gilt. Horses and cockerels were his favourite subjects, but he also painted exhausted girls, bleeding Christs, angels, demons and angel–demons, skulls, clowns, prostitutes, circus performers, monks, doves and flowers. His painting has a very particular charm, inspired by popular and colonial art, the aesthetic value of which he was instrumental in promoting. Though influenced by Georges Rouault and by Marc Chagall (whom he met in Mexico in 1942), he was one of the most original figures in 20th-century Mexican art.

BIBLIOGRAPHY

L. S. de Kassner: *Jesús Reyes Ferreira: Su universo pictórico* (Mexico City, 1978)

LEONOR MORALES

Reynolds, Mallica. *See* KAPO.

Ribeiro, Paulo Antunes. *See* ANTUNES RIBEIRO, PAULO.

Riganelli, Agustín (*b* Buenos Aires, 19 May 1890; *d* Buenos Aires, 4 Nov 1949). Argentine sculptor, draughtsman and printmaker. The son of humble Italian immigrants, he worked as a labourer in a carpentry workshop before finding his vocation as a sculptor. He achieved recognition as one of the most important early 20th-century sculptors in Argentina only late in life, finally being awarded all the national and provincial prizes. His work encompasses monuments such as that dedicated to *Those who Fell on 6 September* (stone, 1933), Plaza Intendente, Alvear, Buenos Aires, and a memorial to *Dr Luis Güemes* (bronze, 1935) near the Faculty of Economics, Calle Córdoba, Buenos Aires; more intimate portrait sculpture and maternity groups; and decorative carvings unique in Argentina for their links with Art Deco.

Riganelli's monumental sculptures were admired for their rigorous forms, their severe modelling and their expressive concision, but his most notable achievements were his portrait sculptures of prominent social, artistic and intellectual figures and his heads of children. These include portraits of the Argentine sculptor *Guillermo Facio Hebequer* (plaster, 1916) and of the writer *Ricardo Güiraldes* (wood, 1928), and character studies such as *Child Watching* (wood, 1917), *Jaqueline* (wood, 1924) and *Yankee Boy* (wood, 1927), in which an economical use of materials, combined with an unadorned and sensitive modelling, produced a classical serenity and perfection. He maintained his working-class links in his choice of subject-matter, for example in the series *Working-class Mothers* and in the representation of a construction worker entitled *Skyscraper Man* (1929), in which he stated unequivocally his deep solidarity with other human beings. The most representative collection of his work, including most of the examples cited here, is housed in the Museo Municipal de Artes Plásticas Eduardo Sívori in Buenos Aires. He also produced drawings, monotypes and prints of great interest.

BIBLIOGRAPHY

J. L. Pagano: *Agustín Riganelli* (Buenos Aires, 1943)
H. J. Gaglianone, ed.: *Obras maestras del patrimonio*, Buenos Aires, Mus. Mun. A. Plást. Sívori cat. (Buenos Aires, 1984)
M. Pacheco: 'An Approach to Social Realism in Argentine Art, 1875–1945', *J. Dec. & Propaganda A.*, xviii (1992), pp. 122–53
J. López Anaya: *Historia del arte argentino* (Buenos Aires, 1997)

NELLY PERAZZO

Rimsa, Juan (*b* Lithuania, *c.* 1900; *d* Santa Monica, CA, 1975). Lithuanian painter and teacher, active in Bolivia. He arrived in Bolivia in 1937, settling in Sucre and teaching there at the Academia de Bellas Artes for three years, after which he opened a Taller Superior de Pintura. In 1945 he moved to Potosí, where he also did some teaching, and in 1947 to La Paz. He left Bolivia in 1950 to live in Mexico, and after a few years there he settled in Santa Monica, CA. Rimsa brought to Bolivia the Expressionism that was an important style in northern European art at that time. Fascinated by the light, the native people and the earthy energy of Bolivia, he adapted his figurative paintings to develop a passionate expressionism, using intense colours with strong brushstrokes, frequently outlined in dark colours to achieve dramatic effects unusual in Bolivia at that period. His paintings, crowded by their subject-matter, have a characteristic rhythm and expressive movement, as in *Man in Yellow* (1938; U. Sucre, Mus. Charcas) and *The Founding of La Paz* (1948; La Paz, Alcaldía Mun.). A retrospective of his work was held in the Alcaldía in La Paz in 1975.

BIBLIOGRAPHY

P. Querejazu: *La pintura boliviana del siglo XX* (Milan, 1989)
Entre el pasado y el presente: Tendencias nacionalistas en el arte boliviano, 1925 a 1950 (exh. cat., Washington, DC, Inter-Amer. Dev. Bank, 1996)

PEDRO QUEREJAZU

Rio de Janeiro. Brazilian city, capital of the state of Rio de Janeiro. It is situated on the western shores of Guanabara Bay, a protected harbour at the centre of the continent's east coast, and is surrounded by steep, dramatic hills, including the famous Sugarloaf Mountain (Pão de Açúcar; for illustration *see* FERREZ, MARC). The city (population *c.* 5.5 million) was the capital of Brazil from 1763 to 1960 and retains much of its colonial and 19th-century architectural heritage. It was founded in 1565 by the Portuguese military commander Estácio de Sá, who established a fortified town on the Castelo Hill. Its economic growth was centred on trade through its port, initially in sugar and timber and later in gold from the mining regions of Minas Gerais. Important colonial ecclesiastical buildings, many built by the religious orders that came to undertake missionary work, include S Bento Monastery (1633–41): the interior of its church is covered with magnificent Baroque gilt wood-carving executed in the 17th and 18th centuries by Frei Domingos da Concei-

ção (1643–1718), Simão da Cunha and Inácio Ferreira Pinto; it also contains paintings (1669–90) by Frei Ricardo do Pilar (*d* 1700). The church of S António Convent (1608–15) contains paintings and *azulejos* (glazed tiles). The church of the Third Order of S Francisco da Penitência (begun second half of the 17th century) has fine gilt wood-carvings, and the nave ceiling was painted in 1733–43 by Caetano da Costa Coelho, the first example in Brazil of illusionistic architectural painting. On an elevated site facing the bay is the polygonal Nossa Senhora da Glória do Outeiro (1717–39), the interior of which is covered with Portuguese *azulejos* depicting scenes from the *Song of Songs* (1735–45).

The French invaded and occupied Rio in 1710–11, but the city quickly recovered and began to improve its buildings and amenities, especially under the governorship (1733–63) of Gomes Freire de Andrade. He constructed the Casa dos Governadores (1743), designed by the military engineer José Fernandes Pinto Alpoim (1700–70), which later became the Paço Imperial (now a cultural and exhibition centre). He also restored (1750) the Carioca aqueduct (1723), a fine, monumental work (l. 270 m) with two superimposed tiers of arches; trams now pass over it on their way to the picturesque Santa Teresa district on a steep hillside, which has many fine colonial houses. The first timid reforms in urban planning came in the viceregal period (1763–1808), when the population reached 50,000. The creation of the Passeio Público (1779–83), under the viceroyship of Luís Vasconcelos e Souza, opened out a vast area with gardens adorned with pavilions, sculptures and fountains; the sculptor VALENTIM DA FONSECA E SILVA was one of the main contributors to this pioneering piece of urban planning. He also executed the portals and retables of the new Carmo Convent Church (1770). Artistic activity increased in the city, especially with the development of the 'Fluminense' school of painting, which included Leandro Joaquim (1738–98), Manuel da Cunha (1737–1809), José Leandro de Carvalho and Raimundo da Costa e Silva.

In 1808 the Portuguese royal family moved to Brazil, and Rio was transformed into the seat of monarchy. Among many other embellishments, it acquired botanical gardens, a public library and a new royal theatre; and, with the arrival of the officially invited French artistic mission in 1816, a plan was inaugurated for the development of fine arts in the country. The Academia Imperial das Belas Artes (1826) was founded under the aegis of the artist JEAN-BAPTISTE DEBRET, and local architecture was influenced by the introduction of Neo-classicism, led until 1850 by AUGUSTE-HENRI-VICTOR GRANDJEAN DE MONTIGNY. Architecture moved forward in the spirit of Neo-classicism, with some hints of eclecticism, until the end of the 19th century, as exemplified by the Palácio de São Cristóvão (since 1892 the Museum Nacional) in Quinta da Boa Vista park, on which work lasted from 1809 to 1860, with participation by PIERRE JOSEPH PEZERAT in 1827; the Santa Casa de Misericórdia (1840–52) and Pedro II (1842–52) hospitals, to the design of which a number of architects contributed; and the Palácio do Itamarati (1851–4; completed by José Maria Jacinto Rebelo (1821–71)). Artistic activity in Rio was especially stimulated under Peter II (*reg* 1831–89), an eminent patron

who instigated annual exhibitions of painting, sculpture and architecture at the Academia Imperial with prizes that enabled artists to continue their studies in Europe. The first art galleries appeared at the end of the 19th century, and passed with some difficulty from the official to the private sector. Throughout the 19th century art life in Rio was enriched by numerous painters, draughtsmen and engravers from abroad, particularly by Richard Bate (1775–1856), William Burchell (1781–1863), Henry Chamberlain (1796–1844), THOMAS ENDER, JOHANN MORITZ RUGENDAS and NICOLAS-ANTOINE TAUNAY (see fig.).

The proclamation of the Republic in 1889 gave a new impulse to the development of culture and urban planning in Rio. Francisco Pereira Passos, who was Prefect in 1902–6, made the most of the natural charm of the great urban agglomeration between the mountains and the sea, creating the Avenida Rio Branco with its ornate public buildings in 1903–6. The most influential building for modern Brazilian architecture was the Ministry of Education and Health (1937–45; now the Palácio da Cultura; *see* BRAZIL, §IV, 2(ii) and fig. 5). Le Corbusier was consultant on the project when he visited Brazil in 1936; it was executed by a team of architects led by LÚCIO COSTA and, from 1939, by OSCAR NIEMEYER. In the same period several museums were built, notably the Museu Nacional de Belas Artes (1937), Brazil's principal gallery, and the Museu de Arte Moderna (founded 1948); since 1958 the latter has occupied a building designed by AFFONSO EDUARDO REIDY and rebuilt after a fire in 1978 that destroyed almost all its Brazilian and international contents. Other museums in Rio include the Museu Histórico Nacional (formerly Arsenal de Guerra; begun 1762), which contains historical and art treasures of the colonial and imperial past; the Museu da República (formerly Palácio do Catete; 1858–67; designed by Carl Friedrich Gustav Waehneldt); and the two museums of the Fundação Raymundo Ottoni de Castro Maya: Museu de Tijuca, devoted to colonial Brazilian art, and the Museu da Chácara do Céu (designed by Wladimir Alves de Souza), in a building by Oscar Niemeyer in the Santa Teresa district, housing art.

The transfer of the national capital to Brasília in 1960 deprived Rio of its importance as the administrative centre, but the city remained culturally and artistically important; its art schools, museums, galleries and private collections, such as those of Gilberto Chateaubriand (*b* 1925), Roberto Marinho and João Leão Sattamini (*b* 1940), ensure that Rio remains, with São Paulo, at the centre of artistic activity. Perhaps because of its position open to the sea, it has always been ready to accept adventurous idioms and pioneering models, as for example the Neo-Concrete movement in which Lygia Clark and Hélio Oiticica were outstanding in the 1950s and 1960s.

See also BRAZIL, especially §§I, IV and V.

BIBLIOGRAPHY

L. Edmundo: *O Rio de Janeiro no tempo dos vice-reis* (Rio de Janeiro, 1932)
——: *A corte de D. João no Rio de Janeiro*, 3 vols (Rio de Janeiro, 1939–40)
G. Cruls: *A aparência do Rio de Janeiro, notícia histórica e descritiva da cidade* (Rio de Janeiro, 1949)
G. Ferrez: *A mui leal e heróica cidade de São Sebastião do Rio de Janeiro* (Rio de Janeiro, 1965)
——: *Aquarelas de Richard Bate: O Rio de Janeiro de 1808 a 1848* (Rio de Janeiro, 1965)

Nicolas-Antoine Taunay: *S António Hill*, oil on canvas, 450×560 mm, 1816 (Rio de Janeiro, Museu Nacional de Belas Artes)

C. P. Valladares: *Análise iconográfica do barroco e neoclássico remanescentes no Rio de Janeiro*, 2 vols (Rio de Janeiro, 1978)
G. R. del Brenna: *O Rio de Janeiro de Pereira Passos* (Rio de Janeiro, 1985)
A. Mafra de Souza, ed.: *O Museu Nacional de Belas Artes* (Rio de Janeiro, 1985)
P. Berger: *Pinturas y pintores: Rio antigo* (Rio de Janeiro, 1990)
A. Xavier and others: *Arquitectura moderna no Rio de Janeiro* (Rio de Janeiro, 1991)
R. Sisson: 'Rio de Janeiro, 1875–1945: The Shaping of a New Urban Order', *J. Dec. & Propaganda A.*, xxi (1995), pp. 138–55
ROBERTO PONTUAL

Ríos, Rodríguez de los. *See* SANTIAGO, Marqueses de.

Rivas, Bárbaro (*b* Petare, 4 Dec 1893; *d* Petare, 12 March 1967). Venezuelan painter. He was a self-taught artist, whose subject-matter was largely inspired by biblical themes. His first work was a mural, *Jesus Preaching in Jerusalem* (1923; destr.), painted on the outside of his house in the Caruto district of Petare. He painted his first canvases in 1926, including *The Flock* (priv. col., see exh. cat., p. 48), and *Baruta Landscape* (priv. col., see exh. cat., p. 52), the first of a series of naively painted topographical landscapes that took three decades to complete. There was then an 11-year break in his artistic activity, during which time he worked on the railway in Aragua. In 1937 he lost his job, which led to a nervous breakdown. After his recovery he painted the *Chocolate Factory* (1937; priv. col., see exh. cat., p. 45). In 1953 he began painting works inspired by the townscapes of his past, such as *Little Square in Petare in 1910* (1953; Caracas, Gal. A. N.) and the *Caruto District in 1925* (1955; priv. col., see exh. cat., p. 13), in which spaces and objects are observed from different angles, giving a multifocal effect. He became particularly well known for the 34 self-portraits that he painted between 1954 and 1966. These are notable for their plastic quality and for their iconographic invention. The most common setting is that of the painter beside a religious image, as in *Self-portrait with St Barbara* (*c.* 1956; priv. col., see exh. cat., p. 30), or surrounded by his own private world, as in the *Painter's House* (1956; Caracas, Gal. A. N.). His works of the 1960s were more various in their viewpoints and richer in colouring and brushwork (e.g. *The Cemetery*, 1965; priv. col., see exh. cat., p. 19).

BIBLIOGRAPHY
A. Boulton: *Historia de la pintura en Venezuela*, iii (Caracas, 1972)
F. Da Antonio: *El arte ingenuo en Venezuela* (Caracas, 1974)
Bárbaro Rivas: La intuición pictórica (exh. cat. by A. Boulton, Caracas, Mus. A. Contemp., 1984)
Bárbaro Rivas: Imágenes y revelaciones. Exposición homenaje en el centenario de su nacimiento, 1893 a 1993 (exh. cat., Caracas, Gal. A. N., *c.*1993)
Bárbaros Rivas: Imágenes y revelaciones. Exposición itinerante (exh. cat. by M. Ziegler and others, Caracas, Gal. A. N., 1995)
ANA TAPIAS

Rivas, Humberto (*b* Buenos Aires, 14 July 1937). Argentine photographer, active in Spain. In Buenos Aires he belonged to the circle of the photographer Sameer Nakarius, who founded the Forum Group in the 1950s. From 1959 to 1970 he was head of the photography department at the Instituto Torcuato di Tella in Buenos Aires, and he worked in Barcelona in 1976–7. His style, which matured particularly after his move to Europe in the mid-1970s, combines the inquisitive nature of documentary photography with the rigorous methodology of conceptual art. His most interesting work includes a series of photographs of unoccupied hotel rooms, taken over a period of years around the world, which in spite of their apparent emptiness reveal much about human behaviour.

PHOTOGRAPHIC PUBLICATIONS
Fotografías, 1978–1990 (Barcelona, 1992)

BIBLIOGRAPHY
E. Billeter: *Fotografie Lateinamerika* (Zurich and Berne, 1981)
J. C. Castaño and others: *Humberto Rivas: Fotografías, 1978–1990* (Barcelona, 1991)
S. Facio: *La fotografía en la Argentina desde 1840 a nuestro días* (Buenos Aires, 1995)
ERIKA BILLETER

Rivas Mercado, Antonio (*b* Tepic, 26 Feb 1853; *d* Mexico City, 3 Jan 1927). Mexican architect, restorer and teacher. After studying at the Ecole des Beaux-Arts, Paris, he returned to Mexico in 1879 to practise as an architect–engineer and teach in the Escuela de Ingeniería and the Escuela de Arquitectura, Mexico City. As an architect his most notable project is the monument to *Independence* (1890–1910) on the Paseo de la Reforma, Mexico City, on which he collaborated with the sculptor Enrique Alciati. The slender column rises from a carefully worked base that includes sculptures of historical figures associated with the independence movement, topped by a gilded statue of a winged victory. The Teatro Juárez (1892–1903), Guanajuato, which has a Neo-classical exterior and a neo-Moorish interior, is a competently executed example of his eclecticism. Rivas Mercado also designed domestic buildings, including his own house (1898), Calle de Héroes, which has been poorly preserved, and that of the Macías family (1904; now Museo de Cera), Calle de Londres 6, both in Mexico City. His restorations of historic haciendas include those of Tecajete (1884) in Hidalgo State, and of Chapingo (1900) in Mexico State. His numerous unexecuted projects include a design for the Palacio Legislativo, Mexico City. He was Director from 1903 to 1912 of the Escuela de Bellas Artes de México, Mexico City, where he instituted new methods of study and design.

BIBLIOGRAPHY
J. Cuadriello: 'El historicismo y la renovación de las tipologías arquitectónicas', *Historia del arte mexicano* (Mexico City, 1982)
E. Olivares: *La Obra arquitectónica de Antonio Rivas Mercado* (diss., Mexico City, U. Iberoamer., 1986)
M. Olivares Correa: *Primer director de la Escuela de Arquitectura del siglo XX: Antonio Rivas Mercado* (Mexico City, 1996)
LOUISE NOELLE

Rivera, Carlos Raquel (*b* Yauco, nr Ponce, 1923). Puerto Rican painter and printmaker. He trained at the Edna Coll Academy in San Juan (1947–9) and under Reginald Marsh and Jon Corbino (*b* 1905) at the Art Students League in New York (1950). On his return to Puerto Rico in 1950 he joined the sign and lettering workshop of Juan Rosado, where he met Rafael Tufiño, José A. Torres Martinó and Antonio Maldonado, who like him became members of the Centro de Arte Puertorriqueño.

Finding the subject-matter for his socially committed art in the conditions of life in Puerto Rico, Rivera levelled criticism against oppressive institutions, individuals and the class structure in linocuts such as *Massacre at Ponce* (1956) and *Colonial Elections* (1959, Río Piedras, U. Puerto Rico, Mus. Antropol., Hist. & A.). His virtuoso handling of strong contrasts of black and white recall Mexican printmaking traditions, particularly the work of Leopoldo Méndez and of the Taller de Gráfica Popular. In his paintings he reflected the difficulty and complexity of life in Puerto Rico through allegory, satire and symbolism, creating a sense of expectancy and mystery in nightmarish visions populated by strange insects and animals surrounded by exuberant tropical vegetation. His work, while frequently labelled Surrealist, bore only a superficial resemblance to that movement, with the emphasis placed instead on the evocative quality of the imagery conveyed in an impeccable technique.

BIBLIOGRAPHY
Con Su Permiso . . . Carlos Raquel Rivera (exh. cat. by M. Benítez, J. A. Corretjer and M. E. Somoza, New York, Mus. Barrio, 1980)
Cabal Encomienda: Exposición retrospectiva de Carlos Raquel Rivera (exh. cat., Río Piedras, U. Puerto Rico, Mus. Antropol., Hist. & A., 1984)
MARI CARMEN RAMÍREZ

Rivera (y Barrientos Acosta y Rodríguez), Diego (María Concepción Juan Nepomuceno Estanislao de la) (*b* Guanajuato, 13 Dec 1886; *d* Mexico City, 24 Nov 1957). Mexican painter and draughtsman. He was one of the most important figures in the Mexican mural movement and won international acclaim for his vast public wall paintings, in which he created a new iconography based on socialist ideas and exalted the indigenous and popular heritage in Mexican culture. He also executed large quantities of easel paintings and graphic work.

1. Life and work. 2. Style and iconography.

1. LIFE AND WORK. Rivera's artistic precocity was recognized by his parents, both of whom were teachers. He was drawing at two, taking art courses at nine and enrolled at the Academia de S Carlos in Mexico City at eleven. There the quality of his work, especially his landscape painting, earned him a scholarship at fifteen and a government pension at eighteen. At nineteen he was awarded a travel grant to Europe, and in 1907 he went to Spain, settling in Paris two years later. In November 1910 he returned to Mexico for an exhibition of his work at the Academia, which was part of the Mexican Centennial of Independence celebrations. The Mexican Revolution began the day the exhibition opened, and Rivera returned to Paris early in 1911, remaining there until 1919.

Rivera developed into an accomplished painter during his years in Paris, dextrously exploring both traditional and avant-garde styles. Works such as the *Old Ones* (1912; Mexico City, Dolores Olmedo priv. col., see 1986–8 exh. cat., p. 36) reflect the influence of El Greco and Rivera's contact with Spanish modernist circles, while his portrait of the Mexican painter *Adolfo Best Maugard* (1913; Mexico

City, Mus. N.A.) displays the direct influence of Robert Delaunay's Orphism. *Two Women* (1914; Little Rock, AR A. Cent.) shows Rivera's mastery of the Analytical Cubism of Albert Gleizes, and the *Zapatista Landscape (The Guerrilla)* (1915; Mexico City, Mus. N.A.) echoes the Synthetic Cubism of Picasso and Juan Gris. Rivera made numerous exploratory drawings for these and other paintings. During his later years in Paris he drew a series of pencil portraits in the style of Ingres, of which the finest are the portrait of *Angeline Beloff* (1917; New York, MOMA), his mistress for most of his European stay, and the portrait of *Jean Cocteau* (1918; Austin, U. TX, Ransom Humanities Res. Cent.). By 1917 Rivera had met the art historian Elie Faure, who directed his interest away from the extremes of modernism towards early Italian Renaissance painting. He also stimulated Rivera's interest in the work of Cézanne, whose influence can be seen in the composition and brushwork of his portrait of *Elie Faure* (1918; Paris, priv. col., see Wolfe, pl. 43).

By 1918 Rivera was becoming increasingly pressed by both personal and political matters. His relationship with Angeline Beloff was foundering, and their son died of influenza. In 1919 his daughter Marika was born of a liaison with Marevna Vorobyov-Stebelska. At the same time, he was being urged to return to Mexico to participate through his work in the Revolution. David Alfaro Siqueiros visited him in 1919 in connection with this, and both he and Faure discussed the role of the mural as a proletarian art form. In 1920 José Vasconcelos, later Secretary of Education under President Obregón (1921–4), urged Rivera to go to Italy to study Renaissance murals. Rivera spent over a year there, studying some of the greatest wall paintings in Italy.

Rivera returned to Mexico in 1921 just as Vasconcelos was beginning to consolidate his programme of mural painting in Mexico City (*see* MEXICO, §IV, 2(iv)(a)). He began an intensive study of indigenous art and folk culture in Mexico, travelling to the Yucatán late in the year and to Tehuantepec the next. He later became an avid collector of Pre-Columbian and folk art and made use of their motifs in his murals. In 1922 he began his first government-sponsored mural, the *Creation*, in the Escuela Nacional Preparatoria in Mexico City. By this time a large number of artists had been assembled by Vasconcelos to paint murals, and in the autumn, led by Siqueiros, they formed the Sindicato de Obreros Técnicos, Pintores y Escultores. Rivera also joined the Mexican Communist Party, with which he had a stormy relationship for the rest of his life. In 1922 he married Guadalupe Marín, by whom he had two daughters.

Over the next 15 years Rivera painted a large number of murals. In 1923 he began work with a team of artists on the walls of the two three-storey patios of the new Secretariat of Education building in Mexico City. He soon assumed sole responsibility for the entire project, creating over a hundred fresco panels by 1928, covering over 1585 sq. m. Of these, *The Mine* and *Embrace and Peasants* (both 1923), in the Court of Labour, combine the stylistic influence of Giotto with Mexican folk themes, while one of the last, the *Distributing Arms* panel (1928), which displays all the characteristics of his mature mural style, introduces the great series known as the *Corrida* [or *Ballad*] *of the Proletarian Revolution*, on the third storey of the buildings surrounding the Court of Fiestas. Late in 1924 Rivera also undertook a series of murals in the administration building and in the laicized chapel of the Escuela

1. Diego Rivera: *Detroit Industry* (1932–3), fresco, north wall of garden court, Detroit Institute of Arts, Detroit

2. Diego Rivera: overview of murals showing the *Liberated Earth with Natural Forces Controlled by Man* (1927), fresco, 6.92×5.98 m, on the east wall, chapel of the Universidad Autónoma, Chapingo, Mexico

Nacional de Agricultura (now the Universidad Autónoma) at Chapingo in the state of Mexico, which he completed in 1927. That year his marriage to Guadalupe Marín collapsed after the birth of their second daughter. In the autumn he travelled to the Soviet Union, staying there until May 1928 when he returned to Mexico and completed his Secretariat murals.

There were numerous changes in Rivera's life during 1929. He became Director of the Academia de S Carlos and began the *History of Mexico* mural on the main stairway of the Palacio Nacional in Mexico City. In August he married the artist Frida Kahlo, with whom he had a tempestuous relationship until her death in 1954. The Communist Party was outlawed in Mexico in 1929, and he was expelled from it because of Trotskyite sympathies. The US ambassador Dwight D. Morrow commissioned him to paint a mural on the *History of Cuernavaca and Morelos* at the palace of Cortés in Cuernavaca, Morelos, which he finished late in 1930. By this time he had been forced to resign as director of the Academia by the right-wing Calles government, and he accepted an invitation to paint a mural in San Francisco, CA, which provided an opportunity to escape a difficult situation.

Between 1930 and 1934 Rivera painted five murals in the USA. The first two were his *Allegory of California* for the Luncheon Club of the Pacific Stock Exchange in San Francisco and the *Making of a Fresco, Showing the Building of a City* in the San Francisco Art Institute, both painted in 1931. His *Detroit Industry* frescoes in the garden court of the Detroit Institute of Arts, painted in 1932–3, constitute his most important mural cycle outside Mexico (see fig. 1). In 1933 he began *Man at the Crossroads* for the Radio Corporation of America (RCA) building in the Rockefeller Center, New York. He was prevented from finishing the mural because it contained a portrait of Lenin, and it was destroyed early the next year. Having been deprived of several anticipated commissions by this scandal, Rivera painted a series of 21 overtly political panels called *Portrait of America* for the anti-Stalinist New Workers' School in New York. Only eight panels survive in various locations (see 1986–8 exh. cat., p. 301).

Returning to Mexico City, Rivera painted a revised version of his RCA mural, entitled *Man, Controller of the Universe* (1934), in the Palacio de Bellas Artes. In 1935 he completed his murals on the stairs of the Palacio Nacional (for example *see* MEXICO CITY, fig. 5), and the following year he painted a series of four panels for the Hotel Reforma in Mexico City entitled *Burlesque of Mexican Folklore and Politics* (Mexico City, Pal. B.A.). From 1937 to 1942 he received no mural commissions in Mexico and

devoted himself mainly to easel painting and portraiture. During this period he was host to the exiled Leon Trotsky, who stayed for some time with Rivera and Frida Kahlo at their home in Coyoacán, Mexico City. In 1940 he painted a huge mural on the theme of *Pan-American Unity* for the Golden Gate International Exposition in San Francisco (6.71×21.3 m; see colour pls XXXIV–XXXV, fig. 1).

In 1942 Rivera began the construction of the pyramid-shaped 'Anahuacalli' near Coyoacán, as a residence and private museum for his collection of Pre-Columbian art. He was involved with this structure, which became known as his 'pyramid', for the rest of his life. In his last years he created a number of murals in Mexico City for public and private buildings. Of these the most notable are the series of frescoes entitled *From the Pre-Hispanic Civilization to the Conquest* (1945–51), painted on the walls of the colonnade that surrounds the main courtyard of the Palacio Nacional, and his *Dream of a Sunday Afternoon in the Alameda Park* (1947–8) for the Hotel del Prado. In 1953 he designed his last mural, the mosaic *Popular History of Mexico*, for the façade of the Teatro de los Insurgentes, Mexico City. After the death of Frida Kahlo he married his dealer, Emma Hurtado, in 1955 and travelled to Moscow that year for the treatment of cancer, which proved ineffective.

Although Rivera's fame stemmed from his murals, much of his wealth was generated by his portraiture, particularly after the late 1930s when his mural commissions temporarily ceased. Many of his portraits were of female celebrities or wealthy society women, for instance *Adalgisa Nery* (1945; R. & D. Mareyna priv. col., see 1986–8 exh. cat., p. 201). The gestures and facial features of the sitters are often exaggerated, both in these highly stylized portraits and in Rivera's many depictions of Mexican children dating from the same period, for example *Irene Estrella* (1946; Exeter, NH, Lamont Gal.). In the 1940s Rivera also painted several easel works with Surrealist overtones, possibly due to the influence of Frida Kahlo, for instance *Symbolic Landscape* (1940; see colour pl. XXXIII, fig. 1). The painting depicts twisted and distorted tree forms and was exhibited in the Exposición Internacional del Surrealismo held at the Galería de Arte Mexicano in Mexico City in 1940.

2. STYLE AND ICONOGRAPHY. One of Rivera's most complex and successful mural cycles was painted in the former Jesuit chapel in Chapingo, which served as the auditorium of the Escuela Nacional de Agricultura (now the Universidad Autónoma; see fig. 2). The artist devised a programme of 41 fresco panels in which socialist revolution parallels the evolution of nature. The two themes mirror each other along the opposite walls of the chapel, and the images use symbolism drawn from Christian and Aztec cultures, allegorical female figures derived from academic art and modernist montage techniques. If one examines only the principal panels, the programme painted along the southern, windowed, wall begins in the narthex with a depiction of the *Blood of the Revolutionary Martyrs Fertilizing the Earth*. Proceeding eastward down the nave are four allegorical scenes, *Subterranean Forces*, *Germination*, *Maturation* and *The Abundant Earth*, tracing the development of natural growth from seed to flowering

plant. Along the opposite wall and corresponding conceptually to these five panels are the *Birth of Class Consciousness* in the narthex, *Formation of Revolutionary Leadership*, *Underground Organization of the Agrarian Movement*, *Continuous Renewal of Class Struggle* and the *Triumph of the Revolution*. The two series culminate in the image painted on the eastern wall, depicting the *Liberated Earth and Natural Forces Controlled by Man*. The scene is centred around the huge figure of a reclining female nude, representing the fertile earth, and the circular shape formed by a windmill's blades, which is open to interpretations as wide-ranging as a Christian monstrance and the ceremonial Aztec calendar stone.

This imposing east wall at Chapingo is also typical of Rivera's mature style. It had worldwide influence on public mural painting and especially on artists employed by the New Deal's Treasury Department and WPA art programmes during the 1930s in the USA. A number of traits characteristic of this style can be seen in the *Liberated Earth*. A Cubist compositional structure suspends the pictorial complex between a clearly defined foreground and a background formed by a continuous sky. The sky also forms the background of the ceiling panels, in which male figures holding revolutionary symbols are depicted from below. Through the sky, the ceiling panels and the image on the east wall become united within the architectural frame, which Rivera always respected. The wall plane is maintained in the *Liberated Earth* by the use of a relatively high horizon. The unification of that wall plane is achieved by means of a geometric system loosely based on the golden section; at Chapingo this can be seen in the main panel in the proportionate square and rectangle delimited by the windmill and extended above by the woman's gesture. The geometrical grid is countered by movement within it, as in this image by the gestures of the various figures. Rivera used simple, bold modelling in his murals, derived from the example of Giotto's frescoes and from the demands of mural scale and the fresco technique. The murals show a basic palette of earth colours and black, set off with carefully placed bright colours. Figures are placed one behind the other on a series of overlapping planes that recede from the front to the back of the composition, and heads are massed in a similar arrangement, best seen in the nave panels at Chapingo. At least one deep recessional space is usually incorporated into Rivera's mature murals; on the east wall at Chapingo, for example, this consists of the central cultivated field. Rivera frequently attempted to relate the content of his murals to the external world by some system of symbolism based on the physical orientation of the murals; at Chapingo this was achieved by painting corresponding panels along the opposite walls of the nave and by using the east wall as the source of generative light.

Although Rivera created a vast number of easel works, drawings and prints, which made his fortune as his fame increased, his renown was based on his murals. These displayed a sensibility that was radically different from that of his colleagues in the Mexican mural movement, for he possessed none of Orozco's introversion and lacked Siqueiros's political passion. He was an extrovert with a prodigious facility for painting that stemmed not only from his cosmopolitan training but also from his intellec-

tual openness to mathematics and science as well as the humanities. He was also capable of conceiving art in the context of its historical potential, rather than as a purely personal statement or as a political weapon. Whereas his two colleagues had immediate experience of the human cost of the Revolution, Rivera never experienced the fighting directly, returning to Mexico only when the conflict had abated. For Rivera, injustice was abstract, not concrete; he was therefore not as extreme in his politics and personal opinions as were his colleagues. Although he had a lifelong sympathy with Marxist ideals, he was not psychologically committed to the Communist Party's shifting line, especially when it interfered with art. This led to his exploitation by capitalist interests during the early 1930s. Rivera's art, however, transcends such issues, through his remarkable idiosyncratic fusion of Renaissance, academic, modernist and indigenous Mexican techniques, styles and motifs, and his creation from them of a humanistically and aesthetically responsible socialist iconography.

WRITINGS

R. Tibol, ed.: *Arte y política* (Mexico City, 1979)

BIBLIOGRAPHY

G. March: *Diego Rivera: My Art, My Life* (New York, 1960)
B. D. Wolfe: *The Fabulous Life of Diego Rivera* (New York, 1963)
S. L. Catlin: 'Political Iconography in the Diego Rivera Frescoes at Cuernavaca, Mexico', *Art and Architecture in the Service of Politics*, ed. H. A. Millon and L. Nochlin (Cambridge, MA, 1978), pp. 439–49
H. Herrera: *Frida: A Biography of Frida Kahlo* (New York, 1983) [contains much new material on Rivera]
Diego Rivera: The Cubist Years (exh. cat. by R. Favela, Phoenix, AZ, A. Mus., 1984)
Diego Rivera: A Retrospective (exh. cat., ed. L. Downs and E. Sharp; Detroit, MI, Inst. A.; Mexico City, Pal. B.A.; Madrid, Cent. Reina Sofía; London, Hayward Gal.; 1986–8) [with detailed chronology, census of murals with colour repro., representative selection of easel work, mural studies and dwgs, and extensive bibliog.]
L. P. Hurlburt: *The Mexican Muralists in the United States* (Albuquerque, 1989)
Diego Rivera: Los frescos en la Secretaría de Educación Pública, intro. by L. Cardoza y Aragón (Mexico City, 1994)
A. W. Lee: 'Diego Rivera's "The Making of a Fresco and its San Francisco Public"', *Oxford A. J.*, xix/2 (1996), pp. 72–82
Frida Kahlo, Diego Rivera and Mexican Modernism (exh. cat., San Francisco, CA, MOMA, 1996)
D. Craven: *Diego Rivera as Epic Modernist* (New York, 1997)
G. Rivera Marín: *Diego el rojo* (Mexico City, 1997)
D. Rochfort: *Mexican Muralists: Orozco, River and Siqueiros* (London, 1997)
P. Marnham: *Dreaming with this Eyes Open: A Life of Diego Rivera* (London, 1998)
Diego Rivera: Art and Revolution (exh. cat. by W. Robinson, A. Arteaga and L.-M. Lozano, Cleveland, OH, Mus. A.; Los Angeles, CA, Co. Mus. A.; Houston, TX, Mus. F.A.; and Mexico City, Mus. A. Mod.; 1999–2000

FRANCIS V. O'CONNOR

Roberto, M. M. M. Brazilian architectural partnership. It was formed by three brothers, Marcelo Roberto (*b* Rio de Janeiro, 30 May 1908; *d* Rio de Janeiro, 17 July 1964), Mílton Roberto (*b* Rio de Janeiro, 30 March 1914; *d* Rio de Janeiro, 11 July 1953) and Maurício Roberto (*b* Rio de Janeiro, 20 Feb 1921; *d* Rio de Janeiro, 3 Nov 1997). All three studied architecture at the Escola Nacional de Belas Artes, Rio de Janeiro, where Lúcio Costa's reforms of 1930–31 introduced Modernist teachers, such as Gregori Warchavchik, and the principles of avant-garde European architecture, including Functionalism and the Rationalist ideas of Le Corbusier.

Marcelo Roberto graduated in 1930, and in 1931, after a study trip to Europe, he opened an office as M. Roberto; his design for the Xavier House, shown at the first Salão de Arquitetura Tropical, in 1933, revealed his Modernist approach. In 1934 Mílton Roberto graduated and joined the office, which then became M. M. Roberto. Two projects that are important landmarks of modern architecture in Brazil immediately resulted from this partnership: the headquarters (1936–8) of the Brazilian Press Association (ABI) and the Santos Dumont Airport (1937–44), both in Rio; both won in open competition. The ABI building (see fig.), which was designed before Le Corbusier's second visit to Brazil (1936) to work on the Ministry of Education and Health (now the Palácio de Cultura) with Lúcio Costa, already incorporated many features of his approach, including pilotis on the ground-floor, open-plan floors, fixed *brises-soleil* made of vertical blades of precast reinforced concrete set in horizontal bands, and a roof garden landscaped by Roberto Burle Marx. The development of the Santos Dumont Airport was less fortunate, and the original design was extensively modified before completion. The single long, low building that was constructed nevertheless incorporates similar elements; two storeys of offices are elevated above a ground-floor concourse on six rows of pilotis that provide a characteristic fluidity between interior and exterior space, with the glass wall of the concourse providing uninterrupted views through the building to the airport tarmac.

M. M. Roberto: ABI building, 1936, Rio de Janeiro

The third brother, Maurício Roberto, who graduated in 1944, joined the office in 1941; it then became M. M. M. Roberto. Its first work was the headquarters of the Brazilian Reinsurance Institute (1941–4), Rio de Janeiro, a further example of the diffusion of the vocabulary of Le Corbusier, who was rapidly becoming the dominant influence in modern Brazilian architecture. The free-standing building, which incorporated open space under the ground-floor pilotis and a curved concrete staircase as a sculptural element, was listed as one of the best designs in the world in 1945. The Robertos won the same international success with their recreational centre (1944; in Rio de Janeiro) for employees of the Brazilian Reinsurance Institute, which revealed the tendency in Brazil at that time for elements of neo-colonial architecture, such as tiled roofs, overhanging eaves and verandahs, to be fitted into the modern vocabulary as a means of localizing the international idiom.

Towards the end of the 1940s and in the early 1950s, the work of the Robertos became increasingly influenced by Oscar Niemeyer's sculptural version of Le Corbusier's architectural vocabulary. In their plan for the Serviço Nacional da Indústria (SENAI) technical school (1948–53), Niterói, the model followed was Niemeyer's Pampulha Yacht Club (1942–4), Belo Horizonte, while the Monteiro Coimbra house (1952), Rio de Janeiro, echoed the projecting canopies that Niemeyer had used in the dance hall (1944) at Pampulha. At the same time they pursued developments of their own aimed at breaking up the façades of large buildings with a dynamic sculptural treatment; in the Seguradoras building (1949), Rio de Janeiro, one façade was glazed while the other incorporated movable external blinds, a variation of the brise-soleil. Between the two façades and joining them, the corner of the building was a sinuously curved wall with mosaics, emphasizing the formal effect of the whole. Other examples of this approach include the Marquês de Herval office building (1952) and the Finusa and Dona Fátima buildings (1953–4); the movable blinds on the angled façade of the former produced an extremely lively effect.

These were the last works carried out with the participation of Mílton Roberto; after he died, the Robertos' work lost much of its originality. However, the practice began to dedicate itself more systematically to urban design, producing tourist plans for Grumarí (1952–5), for the region of Cabo Frio and Búzios (1955–8), and a plan for the expansion of Tunis (1957), Tunisia. When the national competition for the master plan for the new federal capital, Brasília, was held in 1957, the Robertos had the best-equipped office in Rio de Janeiro to undertake urban planning work; while their entry came third, their technical report was considered to be the most complete in the competition.

The Alberchiero residential complex (1962–4), Arenzano, Italy, was the last major project in which Marcelo Roberto participated. After his death the office became M. Roberto Architects, operating under the direction of Maurício Roberto and, after 1965, his son, Márcio Roberto (b 25 Nov 1945), who, following family tradition, began to work before graduation (1968). It continued to undertake major projects, including the Convention Centre (1975), Salvador, the Brazilian Academy of Letters (1975),

the Rio de Janeiro Exchange (1985), and the renewal of the A Noite skyscraper (1998), all in Rio de Janeiro. Among its urban planning projects, the firm carried out improvements in several *favelas* (shanty towns), including the Alagados, Salvador (1975), and the Cagi, Rio de Janeiro (1976); during the 1990s it was in charge of the improvement of the *favelas* Serrinha, Grota, Parada de Lucas and Vigário Geral, prefecture of Rio .

BIBLIOGRAPHY

G. Ferraz: 'Individualidades na história da atual arquitetura no Brasil: M. M. M. Roberto', *Habitat*, 31 (1956), pp. 49–66

H. E. Mindlin: *Modern Architecture in Brazil* (Amsterdam and Rio de Janeiro, 1956)

G. Veronesi: 'Marcelo e Maurício Roberto: Scioltezza e libertà', *Zodiac*, 6 (1960), pp. 108–17

P. F. Santos: 'Marcelo Roberto', *Arquitetura* [Brasil], no. 36, pp. 4–13; no. 38, pp. 8–18

SYLVIA FICHER

Robirosa, Josefina (*b* Buenos Aires, 26 May 1932). Argentine painter and draughtsman. After studying under Héctor Basaldúa from 1950 to 1953, she painted abstract pictures, first of interlaced lines and from the late 1950s of transparent planes. Shortly afterwards she became part of a group practising *Art informel* associated with the magazine *Boa*, which had emerged from another group, International Phases; at that time her work was characterized by its subtle and sensitive graphic character.

From 1966 to 1976 Robirosa painted pictures that combined elements of Op art and figuration, using parallel bands of colour that crossed the canvas in undulating rhythms. The figures in these works look contained and imprisoned by a surface that seems to tighten and grow concave, so that they are harmoniously unified by lines and colours in accordance with purely plastic principles, as in *Strangers II* (1969; see fig.). Shortly afterwards her figures took on a greater resolution and a more dramatic quality, becoming independent of their setting and consequently permitting the appearance of a semi-fantastic landscape of stones, sea and clouds. By 1978, by which time Robirosa was working as much on drawings as on paintings, her imagery was dominated by a lyrical vision of landscape, often starting from a view of woods seen from above and with an implicit opposition between nature and culture, for example *Landscape* (1980; Buenos Aires, Mus. N. B.A.). From 1982 she moved further

Josefina Robirosa: *Strangers II*, oil on canvas, 1.5×1.5 m, 1969 (Buffalo, NY, Albright-Knox Gallery)

towards abstraction, using freer brushwork and simplifying the references to landscape in order to arrive at a more essential image. She also carried out designs for tapestries and in 1985 produced a mural for the Argentine metro station in Paris.

BIBLIOGRAPHY

A. Pellegrini: *Panorama de la pintura argentina contemporánea* (Buenos Aires, 1967), p. 97

C. Córdoba Iturburu: *80 años de pintura argentina* (Buenos Aires, 1978), p. 141

P. Lóizaga: 'Josefina Robirosa: Una voz sin dependencias', *A. Ant. A. Cono Sur*, x/27 (1996), pp. 58–61

Josefina Robirosa (exh. cat. by M. Casanegra, Buenos Aires, Gal. Bonino, 1997)

NELLY PERAZZO

Roda, Cristóbal de (*b* Italy, 1561; *d* Cartagena de Indias, 25 April 1631). Italian engineer, active in Spain and South America. He was the nephew of Juan Bautista Antonelli, whom he accompanied to Portugal during Philip II's military campaigns from 1580 (*see* ANTONELLI). Roda assisted Antonelli on an ambitious scheme to make the River Tagus navigable and transform the inner river basin for the benefit of Spanish commerce, and succeeded his uncle after the latter's death in 1588. Roda was sent to Havana, Cuba, in 1593 to replace another uncle, Bautista Antonelli, who had been working on the city's extensive fortifications. Roda worked there for many years, especially on the fortresses of La Punta and El Morro, either side of the narrow harbour entrance, where he exploited the locations and put into practice the most modern theories of bastioned fortification. In 1608 he went to Cartagena de Indias in Colombia to continue building the fortifications designed by Tiburzio Spannochi (1541–1606) and in Panama carried out a survey of the defensive systems at Portobelo, Chagres and Panama. He was also connected with work at Fort Salinas de Araya, Venezuela. The S Angel bastion and S Matías fort at Cartagena de Indias were rebuilt in 1618 after a hurricane. In 1627 he made a wooden maquette of the defences, which was sent to Philip IV with details of all the works undertaken. By his death Roda had completed the fortifications at Havana and Cartagena, the two most important defensive systems in Spanish America, employing the most modern theories and making a significant contribution to military architecture.

BIBLIOGRAPHY

I. Wright: *Historia de San Cristobal de la Habana en el siglo XVI* (Havana, 1927)

D. Angulo Iñiguez: *Bautista Antonelli y las fortificaciones americanas del siglo XVI* (Madrid, 1942)

J. Weiss: *La arquitectura colonial cubana siglos XVI y XVII* (Havana, 1972)

R. Gutiérrez and C. Esteras: *Territorio y fortificación* (Madrid, 1991)

RAMÓN GUTIÉRREZ

Rodrigues, Glauco (*b* Bajé, Brazil, 6 March 1929). Brazilian draughtsman, engraver and painter. At the Engraving Club in Porto Alegre between 1950 and 1955 he developed a form of drawing and engraving that realistically recorded human types and daily life in the country. From 1958 to 1962 he worked in Rio de Janeiro as a graphic artist and illustrator. After spending three years in Rome he concentrated on painting abstracted still-lifes of attenuated objects against areas of intense colour. Before returning to Rio de Janeiro in 1966 he devoted himself again to the human figure, this time under the influence of Pop art. His later Brazilian paintings took photography as a starting-point for critical observations of Brazil in colourful montages of facts, fantasies and commonplaces about the country's history. His tendency was to work in series, as with *Terra Brasilis* (1970), *Letter from Pero Vaz de Caminha* (1971; part, Rio de Janeiro, Col. Gilberto Chateaubriand), *Legend of Coati-Puru* (1977; artist's col.) and *In the Land of Carnival* (1982). An important group of his works is in the Coleção Gilberto Chateaubriand, Rio de Janeiro.

BIBLIOGRAPHY

R. Pontual: 'Glauco Rodrigues', *Visão da terra* [Vision of the earth] (exh. cat., Rio de Janeiro, Mus. A. Mod., 1977), pp. 82–93

——: *Entre dois séculos—Arte brasileira do século XX na Coleção Gilberto Chateaubriand* [Between two centuries—20th century Brazilian art in the Gilberto Chateaubriand Collection] (Rio de Janeiro, 1987), pp. 133–7, 357–63, 564

L. Veríssimo: *Glauco Rodrigues* (Rio de Janeiro, 1989)

ROBERTO PONTUAL

Rodríguez, Alirio (*b* El Callao, 4 April 1934). Venezuelan painter and teacher. He studied at the Escuela de Artes Plásticas, Caracas (1947–50), and at the Istituto di Arte in Rome (1958–61). In the early 1960s he became a professor at the Escuela de Artes Visuales 'Cristóbal Rojas' and at the Instituto Pedagógico in Caracas. He was awarded the National Prize for Painting in 1969 for *Towards Another Galaxy* (Caracas, Gal. A. N.). In 1976 he represented Venezuela in the 37th Venice Biennale. By this stage he had established his characteristic combination of simply delineated perspectival spaces inhabited by isolated figures,

Alirio Rodríguez: *Vestige 59: Homage to Dante*, acrylic on canvas, 1160×890 mm, 1977–8 (Paris, Centre Georges Pompidou)

fluently painted, and usually shown in contorted activities in which speed is implied by the elision of forms (e.g. *Vestige 59: Homage to Dante*, 1977–8; see fig.).

BIBLIOGRAPHY

Alirio Rodríguez: Nueva humanidad/Nouvelle Humanité: Exposition anthologique, 1969–1986 (exh. cat. by J. M. Salvador, Brussels, Musées Royaux B.-A.; Caracas, Mus. B.A.; 1987)
Alirio Rodríguez: Parábola del hombre (exh. cat. by B. Duncan and A. Boulton, Caracas, Mus. A. Contemp.)
C. Silva: *Alirio Rodríguez: Humano Humanitas* (exh. cat., Caracas, Gal. Durban/César Segnini, 1994)

MELANÍA MONTEVERDE-PENSÓ

Rodríguez, Juan Luis (*b* San José, 24 Nov 1934). Costa Rican painter, sculptor and engraver. He studied at the Casa del Artista, San José (1955–8). In his early one-man shows between 1957 and 1959 his painting was expressionistic, and his landscapes and self-portraits were of an intimate nature. In 1959 he won a scholarship to study engraving at the Ecole des Beaux-Arts in Paris. The following year he helped organize the first open-air exhibition in the Parque Central, which aimed to bring fine arts and literature to a wider public. From 1961 he began exhibiting internationally in one-man and group shows. He showed the sculpture *The Combat* at the sixth Paris Biennale in 1969. His use here and elsewhere of *objets trouvés* made Rodríguez a pioneer in Costa Rican experimental sculpture, paving the way for the installations of Otto Apuy in the 1970s and of Rafael Ottón Solís in the 1980s. He continued his studies in engraving at the Vrije Akademie in The Hague (1962–3). In 1965–6 he executed five murals in France, using mosaic and various kinds of stone, including marble.

On returning to Costa Rica in 1972 Rodríguez provided the pilot scheme for a metal-engraving workshop at the fine arts faculty of the Universidad de Costa Rica, which was adopted the following year. This led to the foundation in 1977 of an engraving studio at the Universidad Nacional de Heredia. Rodríguez was one of the first Costa Rican artists to use metal as a medium for engraving. He experimented among other things with the effect of acid on zinc and copper plates, as in *Sun Trilogy* (1965; see Ulloa Barrenechea, p. 168). In his printmaking he worked without preparing the material; the resulting effects of the action of time on the engravings resemble fragments of rock or of trees. He continued to experiment with murals, using either mosaic or different woods, and these experiments extended to his assemblages, generally small-scale works, in which the surface was used to mount *objets trouvés* (e.g. *Window*, mixed media, 1972; artist's col., see Ulloa Barrenechea, p. 167). The influence of the primitive and spontaneous art of Jean Dubuffet (1901–85) is reflected in Rodríguez's use of materials.

BIBLIOGRAPHY

R. Ulloa Barrenechea: *Pintores de Costa Rica* (San José, 1975), pp. 164–8
I. Alvarado Venegas: *Juan Luis Rodríguez Sibaja: El combate retrospectiva* (San José, 1995)

JOSÉ MIGUEL ROJAS

Rodríguez, Lorenzo (*b* Cádiz, 1704; *d* Mexico, 1774). Spanish architect, active in Mexico. In his earlier career he had served as Maestro Mayor at Cádiz Cathedral, but he moved to Mexico around 1731, where he initially worked at the Mint. He came under the influence of Jerónimo de Balbás, whose use of the *estípite* in Mexico Cathedral attracted his admiration. Rodríguez's most important work was the Sagrario Chapel at the Metropolitan Cathedral in Mexico City (*see* MEXICO, fig. 3), for which he presented a plan in 1749. The two south and east façades of the chapel (which adjoins the cathedral) are conceived as stonework retables bounded by two side buttresses, framed in their turn by stretches of plain *tezontle* walling that dip down under a series of moulded copings to corner entrances. The retable panels comprise two superimposed rows of *estípites* in two planes, the rear set articulated by niches that house statues. The centralized plan of the church is in the form of a Greek cross, the interior elevations repeating those of the adjacent cathedral.

Rodríguez's scheme was favoured over another, more traditional one presented by Iniesta Bejarano and signified official acceptance for the *estípite*, which was used thereafter (particularly by Rodríguez) in the interior and exterior decoration of numerous buildings. Various buildings in and around Mexico City that make exuberant use of the *estípite* on their façades have been attributed to Rodríguez, but only the chapel of Balbanera evinces any sign of his subtle manipulation of this feature. Rodríguez also built some important residences for the local nobility. The most outstanding example is the house of the Conde de S Bartolomé de Xala in Mexico City, which has a ground floor, a mezzanine and an upper floor, on which he placed a chapel and the main rooms of the house. The innovative character of Rodríguez's architecture from the beginning of his stay in Mexico initially met with opposition from the more traditional architects, but as his style became accepted, he was appointed Maestro Mayor of the works on the Palacio Real, the cathedral and for the Inquisition. At the same time he became a guild inspector, carrying out numerous inspections and valuations. The influence of Rodríguez's style was extensive and spread, via Guanajuato, as far afield as Texas. It was eventually superseded by that introduced by Francisco Antonio de Guerrero y Torres.

BIBLIOGRAPHY

M. Romero de Terreros: 'La carta de examen de Lorenzo Rodríguez', *An. Inst. Invest. Estét.*, xv (1948), pp. 105–8
D. Angulo Iñiguez, E. M. Dorta and M. J. Buschiazzo: *Historia del arte hispanoamericano*, ii (Barcelona, 1950), pp. 559–62
M. Toussaint: *Arte colonial en México* (Mexico City, 1962)
M. Collier: 'New Documents on Lorenzo Rodríguez and his Style', *Latin American Art and the Baroque Period in Europe: Studies in Western Art: Acts of the Twentieth International Congress of the History of Art: Princeton, NJ, 1963*, iii, pp. 203–18
G. Gasparini: *América, barroco y arquitectura* (Caracas, 1972)
G. Tovar de Teresa: *El barroco en México* (Mexico City, 1981)
R. Gutiérrez: *Arquitectura y urbanismo en Iberoamérica* (Madrid, 1983)
G. Tovar y Tovar: *Gerónimo de Balbás en la catedral de México* (Mexico City, 1990)

MARIA CONCEPCIÓN GARCÍA SÁIZ

Rodríguez, Mariano. *See* MARIANO.

Rodríguez, Melitón (*b* Medellín, 1875; *d* Medellín, 1923). Colombian photographer. In 1892, aged 17, he set up his own photographic studio. He taught himself photography from books, because the town (which was accessible only by mule) had not yet produced a photographer who could have taken him as an apprentice. Medellín, which he never

left, was the source of his inspiration. He photographed the town and the people, creating a unique document of a provincial town in South America in the late 19th century and early 20th. His photographs combined the close observation of documentary reportage with a poetic atmosphere. In 1895 he published his best-known photograph, a portrait of a cobbler on a street in Medellín.

Rodríguez lived almost completely cut off from the world, but he had his materials sent to him from Paris by Lumière and Guilleminaut, and he was aware of contemporary trends in photography, particularly pictorial photography, by which he was evidently influenced. Each of his photographs underlines the picturesque qualities of his native town. Because electric light was not available in Medellín until 1912, he processed his glass negatives in sunlight. Rodríguez was an enthusiastic archivist. His entire photo archive, scrupulously documented and containing thousands of 30×40 mm glass-plates, survives in Medellín.

BIBLIOGRAPHY
E. Billeter: *Fotografie Lateinamerika* (Zurich and Berne, 1981)
F. Escobar: *Melitón Rodríguez: Fotografías* (Bogotá, 1985)
J. A. Rodríguez and others: *Melitón Rodríguez, fotógrafo: Mementos, espacios y personajes, Medellín, 1892–1922* (Medellin, 1995)
W. Watriss and L. Parkinson Zamora, eds: *Images and Memory: Photography from Latin America, 1866–1994* (Austin, TX, 1998)
ERIKA BILLETER

Rodríguez, Ofelia (*b* Barranquilla). Colombian painter and conceptual artist. Rodríguez trained in the Escuela de Bellas Artes at the Universidad de los Andes in Bogotá from 1964 to 1969. Between 1970 and 1972 she gained an M.F.A. from Yale University, where she studied painting under Al Held and Lester Johnson. Although her early training was informed by Pop art, Rodríguez's use of semi-abstract forms and bold contrasting colours, inspired by Colombia's natural environment, has often resulted in her work being stereotyped as 'tropical'. The fantastic landscapes produced by the combining of these painted elements with added objects such as photographs or plastic toys have earned her a reputation as a Surrealist. Within these imaginary landscapes mundane objects become magical, while the titles of such compositions hint at their deeper conceptual meaning. In recent years, such additions have figured more prominently in Rodríguez's canvases, as in *Landscape with Red Live Tree* (1990; see colour pl. XXXIII, fig. 2), where the centre of the work is occupied by a small cupboard containing a photograph of Frida Kahlo and Diego Rivera, watched over by a plastic toucan's beak. These objects also relate to the artist's parallel production of Magic Boxes, small, brightly painted montages that recall the popular art of Colombia in their use of colour. Both interior and exterior surfaces are adorned with an assortment of everyday objects through which these boxes emerge as both dreamlike worlds and reflections on the complexity of modern Latin American life.

BIBLIOGRAPHY
Arte colombiano en el siglo XX, viii (Bogotá, 1987), p. 1879
Hunting in Time: Six Columbian Artists (exh. cat. by E. Lucie-Smith, London, Gimpel Fils, 1991)
'Ofelia Rodríguez', *Art Nexus* (1994), xi, pp. 128–31
Ofelia Rodríguez (exh. cat. by E. Lucie-Smith and A. Sanchez, Monterrey, Gal. Ramis Barquet, 1994)
J. HARWOOD

Rodríguez Juarez [Xuarez]**, Juan.** *See under* JUAREZ.

Rodríguez Juarez [Xuarez]**, Nicolás.** *See under* JUAREZ.

Rodríguez Lozano, Manuel (*b* Mexico City, 4 Dec 1897; *d* Mexico City, 10 July 1971). Mexican painter, teacher and writer. At the age of 14 he settled in Paris. On returning to Mexico in 1921 he began working on mural compositions and easel paintings. He was a member of the intellectual group Los Contemporáneos, and with Antonieta Rivas Mercado he set up *Ulises*, the first experimental theatre in Mexico. He was Director of the Escuela Nacional de Artes Plásticas, Mexico City, from 1936 to 1940. His oil paintings included a number of portraits as well as the 'monumental' series of large nudes, reminiscent of Picasso's classical period (e.g. *The Colossus*, 1936; Mexico City, Mus. A. Mod.), and the paintings of the 'white period', when white predominated in scenes of village women abandoned by their men, who had gone to fight in the Revolution (e.g. *The Farewell*, 1946; priv. col.). Rodríguez Lozano's frescoes included *Piety in the Desert* (1941; Mexico City, Pal. B.A.). His antipathy to the muralists of the Revolution made him a controversial figure in Mexican painting.

WRITINGS
Pensamiento y pintura (Mexico City, 1960)

BIBLIOGRAPHY
J. Bergamín: *Rodríguez Lozano* (Mexico City, 1942)
B. Taracena: *Rodríguez Lozano* (Mexico City, 1971)
B. Zamorano Navarro: *Manuel Rodríguez Lozano: Una revisión Finisecular* (Mexico City, 1998)
XAVIER MOYSSÉN

Rodríguez Luna, Antonio (*b* Montoro, Córdoba, 1910; *d* 1985). Spanish painter and teacher, active in Mexico. A political exile from the Spanish Civil War, in 1939 he settled in Mexico where he was to become important not only as a painter but also as a teacher. His work was pervaded by the shattering experience of exile. Despite this, he was quick to assimilate his new surroundings and almost immediately published a series of drawings, *Dance of the Concheros* (1939, Mexico City, Colegio México), inspired by a dance from San Miguel de Allende. He also worked with David Alfaro Siqueiros on the murals (1939) from the Sindicato de Electricistas at their union building, Mexico City. After a brief stay in the USA on a Guggenheim Foundation grant (1941–3), he returned to Mexico and worked on his *Exodus* series of paintings (1943–50s), the subject of which, like his later painting *Masquerades for a Tyrant* (1963; Mexico City, Mus. A. Mod.), is a protest against the political situation in Spain. On his return from the USA he was invited to teach at the Escuela Nacional de Artes Plásticas in Mexico City. In the 1950s his painting underwent a great change, with neo-Expressionist brushstrokes giving way to an economy of line and form that brought his figuration closer to a geometric and schematized idiom. In his work in the 1960s and 1970s his characters became rigid, confined in geometrical and linear forms. His subject-matter included animals, still-lifes that are empty of superfluous elements and the recurrent judges, cripples, tyrants and pariahs.

BIBLIOGRAPHY

J. Rejano: *Antonio Rodríguez Luna* (Mexico City, 1971)

J. Rejano: *Antonio Rodríguez Luna* (Cordoba, 1984)

G. Ordiales, ed.: *Rodríguez Luna* ([Mexico], *c*.1995)

JULIETA ORTIZ GAITÁN

Rodríguez Padilla, Rafael (*b* Guatemala City, 23 Jan 1890; *d* Guatemala City, 24 Jan 1929). Guatemalan painter, sculptor and printmaker. After studying in Guatemala under the Venezuelan sculptor Santiago González (1850–?1909) he went to Spain, where he was a pupil of the stage designer Luis Muriel. Shortly after returning to Guatemala in 1915 he painted *Self-portrait* (Guatemala City, Mus. N. A. Mod.). He took part in several group exhibitions, winning a national first prize in 1920 and the first prize for painting in the Exposición Centroamericana held in 1921 on the centenary of independence. Works painted by him during the 1920s, such as *Nude* (*c*. 1920), *Portrait of the Artist's Mother* (*c*. 1922) and *Tamales* (*c*. 1922, all Guatemala City, Mus. N. A. Mod.), all reveal the influence of Impressionism. He also produced two portraits of the Spanish Catalan painter Jaime Sabartés (1881–1968), who lived in Guatemala from 1904 to 1927 and became a close friend: one etching and one oil painting (Rodríguez Padilla family priv. col., on loan to Guatemala City, Mus. N. A. Mod.).

As a sculptor Rodríguez Padilla executed various monuments in Guatemala City, including an equestrian statue of a former President, *General J. M. Reina Barrios* (1921), and a statue of *Dr Lorenzo Montúfar R.* (1923), both in bronze and on the Avenida de la Reforma. He also produced a portrait bust of another former president, *J. M. Orellana* (1926), displayed in the foyer of the Banco de Guatemala. He was one of the founders of the Academia Nacional de Bellas Artes in Guatemala City and served as its director from 1920 to 1928. He died by his own hand.

BIBLIOGRAPHY

O. González Goyri: 'Rafael Rodríguez Padilla', *Salón 13*, iii/1 (1962), pp. 55–65

J. A. de Rodríguez: *Arte contemporáneo Occidente–Guatemala* (Guatemala City, 1966), p. 53

G. Grajeda Mena: 'Rafael Rodríguez Padilla, 1890–1929', *A. Plást.*, vi (1973), pp. 19–23

C. C. Haeussler: *Diccionario general de Guatemala* (Guatemala City, 1983), pp. 1397–8

Rafael Rodríguez Padilla (exh. cat. by F. Morales Santos and others, Guatemala City, Fundación Paiz, 1995)

JORGE LUJÁN-MUÑOZ

Rojas (Luna y Saldaña), Bernardo de (*b* Potosí, 1693; *fl c.* 1725). Bolivian architect. He followed a military career, but he was also known as a master architect. He constructed several churches in Bolivia and in 1725 returned to Potosí, where he undertook the construction of Belén Hospital and its church, which has a vaulted nave and transept. The splendid doorway, the work of indigenous sculptors, is in some ways similar to the doorway of the church at Pomata, Peru, on the shores of Lake Titicaca. Both were influenced by Mestizo Baroque, with Pre-Columbian elements in their decoration, for example sun and moon motifs. Also in 1725, the priest Antonio de Molina commissioned him to execute the new church of S Bernardo, Potosí, with a vaulted nave and transept, and he is credited with the design of the church of S Benito,

Potosí, which was the parish church of the Indians who were forced to work in the silver mines of Potosí. It has an interesting structure covered by 11 hemispherical domes.

BIBLIOGRAPHY

B. Arzans de Orsua y Vela: *Historia de la villa imperial de Potosí*, ed. G. Mendoza and L. Hanke, 3 vols (Providence, 1965) [written in 1637]

J. Mesa and T. Gisbert: *Monumentos de Bolivia* (Mexico City, 1970/*R* La Paz, 1977)

M. Chacon: *Arte virreinal en Potosí* (Seville, 1976)

TERESA GISBERT

Rojas, Cecilio Guzmán de. *See* GUZMÁN DE ROJAS, CECILIO.

Rojas, Cristóbal (*b* Cúa, nr Caracas, ?1859; *d* Caracas, 8 Nov 1890). Venezuelan painter. He settled in Caracas in 1878, alternating his work in a tobacco factory with copying and colouring photographic portraits. Rojas studied at the Academia de Bellas Artes, Caracas. In 1881 he worked as an assistant to the painter Antonio Herrera Toro on the decoration of Caracas Cathedral. In the Exposición Nacional (1883) he was awarded a silver medal for his only historical work, *Death of Girardot in Bárbula* (Caracas, Gal. A. N.). In the same year, with a government scholarship, he left for France; he registered at the Académie Julian and exhibited regularly at the Salon of the Société des Artistes Français between 1885 and 1890, receiving an award in 1886 for *Misery* (Caracas, Gal. A. N.). Rojas excelled in the academic techniques of his figure studies. Inspired by the Dutch tradition, he also painted several still-lifes, such as *Still-life with Pheasant* (*c*. 1884; Caracas, Gal. A. N.), as well as a small number of landscapes in an academic naturalist vein. In 1890 he was awarded a medal in the third class for *Purgatory* (Caracas Cathedral) at the Salon.

BIBLIOGRAPHY

A. Junyent: *Cristóbal Rojas, 1858–1890* (Caracas, 1958)

A. Otero: 'Cristóbal Rojas, un pintor esencialmente dotado', *El Farol*, 180 (1959), pp. 2–7

J. Calzadilla: *Cristóbal Rojas y su obra* (Caracas, 1976)

Cristóbal Rojas, un siglo después (exh. cat., Caracas, Gal. A. N., 1990)

A. Junyent and others: *Cristóbal Rojas: Un pintor venezolano* (Los Teques, 1991)

MARÍA ANTONIA GONZÁLEZ-ARNAL

Rojas, Elmar (René) (*b* Sumpango, Sacatepéquez, 1 Dec 1937). Guatemalan painter. He studied in Guatemala City at the Escuela Nacional de Artes Plásticas and at the Universidad de San Carlos, where he graduated as an architect. Active primarily as a painter, in the mid-1960s, together with Marco Augusto Quiroa and Roberto Cabrera, he founded the group Vértebra, which was of great importance in Guatemala. He worked mostly in watercolours and oils in a style at once vigorous and very delicate, with a fine sense of colour, touching on important contemporary events in Guatemala in series such as the *Executed Men* (1969), *For the Death of Adolfo Mijangos* (1971), dedicated to a Guatemalan politician assassinated in 1970, and *The Scarecrows* (1983–4).

Rojas was politically active and served as Minister of Culture in Guatemala from 1986 to 1987. He received many distinctions, including first prize at the Bienal de Panamá (1982) and the Gran Premio Cristóbal Colón de Pintura Iberoamericana (Madrid, 1984). In the late 1980s

he was commissioned to paint a mural for the Organization of American States in Washington, DC.

For an example of Rojas's work *see* GUATEMALA, fig. 4.

BIBLIOGRAPHY
J. Alonso de Rodríguez: *Oleos de Elmar Rojas A.* (Guatemala City, 1962)
L. Méndez D'Avila: *Arte vanguardia Guatemala* (Guatemala City, 1969), p. vii
Elmar Rojas: Pasteles y pinturas (exh. cat., Santiago, Gal. A. Actual, 1984)
L. Méndez D'Avila: *Elmar Rojas* (Caracas, 1993)
R. Díaz Castillo: *Visión del arte contemporáneo en Guatemala*, ii (Guatemala City, 1995)
Elmar Rojas (exh. cat., Miami, Elite F. A., 1995)
Visión de la plástica de Elmar Rojas (exh. cat. by L. Mendez d'Avila, Guatemala City, Fundación Paiz, 1995)
Guatemala: Arte contemporáneo (Antigua, 1997), pp. 37–40
JORGE LUJÁN-MUÑOZ

Rojo (Almazán), Vicente (*b* Barcelona, 1932). Mexican painter, draughtsman and sculptor of Spanish birth. He spent his professional life in Mexico, studying briefly at the Escuela de Pintura y Escultura 'La Esmeralda' in Mexico City in 1950 and from 1953 to 1955 in the studio of the Mexican painter Antonio Souto. His early collaboration with the Mexican painter and draughtsman Miguel Prieto (1907–56) was also decisive for his initial development.

After holding his first one-man show in 1958, Rojo became associated with other young artists who in the 1960s revitalized Mexican art by making a break with its traditions. He worked as an abstract painter almost from the beginning, generally exploring themes in extended series (e.g. *Augury*, 1958–64) until he had exhausted their formal possibilities. His *Signs*, which consist of 'soft' geometrical works with highly textured surfaces, were succeeded by *Homages*, in which he approached the spirit of Pop art, and the *Negations* series (see fig.), in which a large T shape in a square enclosure is subjected to an immense number of internal variations. His longest series, *Rain over Mexico*, all in a square format with uniform

Vicente Rojo: *Negation 34*, acrylic on canvas, 1.11×1.10 m, 1973 (Austin, TX, University of Texas, Jack S. Blanton Museum of Art)

diagonals presented in a great variety of ways, was completed in 1989. In the 1980s he also made ceramics and sculptures while remaining an influential draughtsman. A more recent series, from the 1990s and including painting and sculpture, is called *Pyramids*. He exhibited in 1997 at the Reina Sofía Museum in Madrid and in 1998 was elected a member of the Colegio Nacional in Mexico City.

BIBLIOGRAPHY
J. García Ponce: *Vicente Rojo* (Mexico City, 1971)
J. A. Manrique and others: *El geometrismo mexicano* (Mexico City, 1977)
J. A. Manrique: 'El geometrismo', *El arte mexicano*, xvi (Mexico City, 1982)
Rojo Vicente: Retrospectiva (exh. cat., Puebla, Mus. Amparo, 1993)
Rojo Vicente: Escenarios, 1989–1994. Pintura y escultura (Mexico City, Mus. José Luis Cuevas, 1994)
Rojo Vicente: Una revisión (exh. cat. by L. Driben, Mexico City, Mus. A. Mod., 1996)
Rojo Vicente: Obra gráfica (exh. cat., Madrid, Mus. Casa Moneda, 1996)
JORGE ALBERTO MANRIQUE

Román (Rojas), Samuel (*b* Rancagua, 8 Dec 1907; *d* Santiago, 1990). Chilean sculptor. He entered the Escuela de Bellas Artes in 1924 and studied under the Chilean sculptor Virginio Arias (1855–1941). From 1928 to 1949 he taught sculpture at the Escuela de Artes Aplicadas in Santiago. In 1937 he was awarded a scholarship to study in Europe; after his return to Santiago he founded the Escuela de Canteros in 1943.

Román was a prolific artist who continued to work until 1990. He sought particularly to free sculpture from the burden of literary content, proposing instead a clear and precise meaning without ambiguity or equivocation. In commissioned works such as the monument to *The Educationalists Isabel Lebrun de Pinochet and Antonia Tarragó González* (granite, h. 4 m, 1940; Santiago, Avenida Bernardo O'Higgins) he resisted the temptation of a facile symbolic treatment of educational activity; instead he simplified the forms and purged them of any accessory, so that meaning emerged from the mass itself, from the force and presence of the block of granite. Román's other official works included a monument to *President Balmaceda* (granite and bronze; Santiago, Parque Inglaterra) and marble busts of a number of Chilean presidents (O'Higgins, Aníbal Pinto, Errázuriz, Santa María, Balmaceda and Aguirre Cerda) for the Galería de los Presidentes in the Palacio de la Moneda in Santiago.

Román also produced smaller sculptures (e.g. Santiago, Mus. N. B.A.; Viña del Mar, Mus. Mun. B.A.), in which a greater creative freedom is apparent. His favoured materials for these were terracotta and bronze, the plasticity of which allowed him to develop a contrast between hollows and mass. In 1964 he was awarded the Premio Nacional de Arte.

BIBLIOGRAPHY
M. Ivelič: *La escultura chilena* (Santiago, 1979), pp. 24–7
Diccionario biográfico de Chile (Santiago, rev. 18/1984–6), p. 989
R. Bindis: *Un homenaje al arte de Samuel Román* (Santiago, 1991)
CARLOS LASTARRIA HERMOSILLA

Romero, Susana (*b* Buenos Aires, 10 Feb 1938). Paraguayan painter of Argentine birth. She studied at the Instituto Fernando Fader in Buenos Aires but lived and worked in Paraguay after 1968. During the 1960s her work was confined to drawing; her first portraits and landscapes

showed a preoccupation with man, his destiny and his ambience in linear images enriched with expressionist and fantastic elements. From the early 1970s her work became strong in its use of colour, with large brushstrokes. In the late 1970s she adopted a conceptualist approach: the use of portraits by Hans Memling and other artists led her to consider the nature of the pictorial sign and the mechanism of visual metaphor. The large polyptychs of the mid-1980s show human figures confronted with menacing landscapes and dark horizons; these mark a return to the expressionism and the thematic content of her earlier work.

BIBLIOGRAPHY

O. Blinder and others: *Arte actual en el Paraguay* (Asunción, 1983), pp. 174–93
T. Escobar: *Una interpretación de las artes visuales en el Paraguay*, ii (Asunción, 1984), pp. 259, 261, 273, 290–91, 306, 341
C. Bach: 'On the Edge of Reality', *Américas*, xlvi/3 (1994), pp. 50–51

TICIO ESCOBAR

Rosado del Valle, Julio (*b* Cataño, nr San Juan, 1922). Puerto Rican painter, draughtsman and sculptor. He trained initially in Puerto Rico under the Spanish painter Cristóbal Ruiz and after moving to New York in 1946 continued his studies at the New School for Social Research under Mario Carreño and Camilo Egas. From 1947 to 1949 he studied in Florence and travelled extensively throughout Europe, and on his return to Puerto Rico in 1949 he joined the Division of Community Education as an illustrator and poster designer. He was awarded a Guggenheim Fellowship in 1957 and served as artist-in-residence at the Universidad de Puerto Rico from 1954 to 1982.

Rosado del Valle was one of the first Puerto Rican artists to achieve international recognition. His figurative paintings and drawings of the 1950s, influenced by Picasso and Rufino Tamayo, were characterized by broken planes and colouristic luminosity. In the 1960s he produced richly textured, subtly coloured abstract pictures before returning in the 1970s to figurative subject-matter of a different kind: while maintaining his concern for refined colour, rich impastos and surface textures and rhythms he took inspiration from natural organic forms, especially from insects and snails. Working in a wide range of media and styles, including an expressive realism, organic abstraction and figuration, from the early 1980s he focused his attention on his own psychology with expressionist self-portraits playing a prominent role.

BIBLIOGRAPHY

Julio Rosado del Valle: Exposición retrospectiva, 1946–1977 (exh. cat. by E. Alvarez, San Juan, Inst. Cult. Puertorriqueña, 1977)
Puerto Rican Painting: Between Past and Present (exh. cat. by M. C. Ramírez, Washington, DC, Mus. Mod. A. Latin America, 1987)

MARI CARMEN RAMÍREZ

Roy, Namba [Atkins, Roy] (*b* Accompong, St Elizabeth, 1910; *d* London, June 1961). Jamaican sculptor, painter and writer. He was instructed in carving by his father, who was the storyteller of the Maroon village of Accompong. The traditions of the Maroons and his intense religious beliefs were his major sources of inspiration. He is best known for his sensitive ivory carvings of biblical subjects, which are related in style and symbolism to Congolese art. Apart from ivory, he used any material available to him,

including artificial resins and scrap wood. As a painter, he worked mainly in gouache. While his finest works are in private collections, the National Gallery of Jamaica in Kingston owns one major sculpture, *Accompong Madonna* (*c*. 1958), which was donated by the people of Accompong. Roy also received recognition for his literary work, chiefly the novel *Black Albino* (London, 1961). He spent most of his adult life in London.

BIBLIOGRAPHY

D. Boxer and V. Poupeye: *Modern Jamaican Art* (Kingston, 1998)
V. Poupeye: *Caribbean Art* (London, 1998)

VEERLE POUPEYE

Ruchti, Jacob (Mauricio) (*b* Zurich, 27 June 1917; *d* São Paulo, 1 April 1974). Brazilian architect, interior designer and teacher of Swiss birth. His family moved from their native Switzerland to Brazil when his father, the architect Frederico Ruchti, received a commission from the Klabin family. Jacob studied architecture (1935–40) at the School of Engineering at Mackenzie University, São Paulo, where he resisted the prescribed Neo-classical aesthetic and rebelliously encouraged his fellow students to share his interest in modern architecture. His interest in Constructivism inspired some of his design projects and was expressed in an article for *Clima* (1941). After graduation he worked for a time with his father, designing houses similar in concept to the Usonian houses of Frank Lloyd Wright. In 1946 he was one of the team responsible for designing the headquarters of the Instituto de Arquitetos de São Paulo. In 1951, with Pietro Maria Bardi (*b* 1900), he set up the first school of design in Brazil, the Instituto de Arte Contemporânea of the Museu de Arte, São Paulo, at which he was Professor of Composition; the following year, in association with other architects, including Carlos Millan, he opened Branco & Preto, the first shop for modern furniture in São Paulo. In these years he also helped organize the first and second Bienal de São Paulo and in 1953 was chief architect to the Comissão do IV Centenário de São Paulo, as such responsible for the interior design in the pavilions and marquee. From 1956 he returned to teaching and held the chair of Decorative Composition in the Faculty of Architecture and Town Planning at the University of São Paulo. Ruchti was the first architect trained in São Paulo to devote himself systematically to interior design, which he was always careful to distinguish from interior decoration. He stressed that the role of the interior designer is architectural, involving the structuring of space on the basis of function. His various interior design commissions included designing the Duraplac Gallery (1968) in São Paulo as a sculptural and coloured space specifically intended for the exhibition of sheet metal.

WRITINGS

'Construtivismo', *Clima*, 4 (São Paulo, 1941), pp. 95–101
'Instituto de Arte Contemporânea', *Habitat*, 3 (São Paulo, 1951), pp. 62–5

BIBLIOGRAPHY

P. M. Bardi: 'Gropius, a arte funcional', *Folha de São Paulo* (1984), p. 39
L. Rainer: 'Manipulação e pré-figuração', *Arquit. & Urb. São Paulo*, 12 (1987), pp. 44–6

MARLENE MILAN ACAYABA

Ruelas, Julio (*b* Zacatecas, 21 June 1870; *d* Paris, 16 Sept 1907). Mexican painter, draughtsman and printmaker. He

lived in Mexico City from 1876, later attending the Colegio Militar and the Escuela de Bellas Artes there before leaving for Karlsruhe, Germany, around 1892. There he came into contact with Romanticism and *Jugendstil*, both of which had a great influence on his drawings and prints, the most important part of his work. He studied under the academic painter Meyerbeer and seems to have been particularly attracted by the work of Arnold Böcklin (1827–1901).

Ruelas returned in 1895 to Mexico, where he met a group of intellectuals who three years later founded the *Revista Moderna*, including the writers Jesús E. Valenzuela, José Juan Tablada, Jesús Urueta and Juan Sánchez Azcona, and the painters Germán Gedovius, Roberto Montenegro and Leandro Izaguirre. Ruelas collaborated on several issues of the magazine, the voice of the Latin American modernist movement, from 1899, with reproductions of drawings, vignettes and occasionally of his oil paintings, such as *Jesús Luján Entering the Revista Moderna* (1904; Archivaldo Burns priv. col., see del Conde, p. 43). He produced the major part of his work while living in Mexico. After moving to Paris, where he spent the last years of his life, he learnt how to etch and continued sending prints and drawings to the *Revista Moderna*. Ruelas's subject-matter usually hinged on suffering and death, although in some works the *femme fatale* appears as a symbol of destruction. His ability to conjure a fantastic, macabre and romantic world led to his being considered a forerunner of Surrealism in Mexico.

BIBLIOGRAPHY

Exposición homenaje Julio Ruelas (exh. cat., Mexico City, Pal. B.A., 1965)

J. J. Crespo de la Serna: *Julio Ruelas en la vida y en la muerte* (Mexico City, 1968)

T. del Conde: *Julio Ruelas* (Mexico City, 1976)

M. Rodríguez: *Julio Ruelas: Una obra en el límite del hastío* (Mexico City, 1997)

LEONOR MORALES

Rugendas, Johann Moritz (*b* Augsburg, 29 March 1802; *d* Weilheim, 29 May 1858). German painter and draughtsman, active in South America. He studied first with his father, the engraver Johann Lorenz Rugendas II (1775–1826), and in 1817 went on to further study under Lorenzo Quaglio at the Akademie der Bildenden Künste in Munich. He travelled to Brazil in 1821 as draughtsman with the Russian diplomat Baron de Langsdorff's scientific expedition. However, instead of remaining with the expedition for the whole trip, he preferred to discover on his own the different Brazilian provinces, recording types, costumes and landscapes in Romantic visions full of contrasts, action and exoticism. On his return to Europe in 1825 he brought with him an extraordinarily rich collection of drawings, some hundred of which were reproduced as lithographs and published in Paris by Godefroy Engelmann as *Voyage pittoresque au Brésil* (1827–35) with a text by Colbery in French and German. Encouraged by the German scientist and explorer Alexander von Humboldt, Rugendas left for Latin America again in 1831, living until 1845 in Mexico and Chile with shorter stays in Argentina, Peru, Bolivia and Uruguay. In each of these countries he made numerous paintings and drawings which, like his Brazilian collection, are now dispersed in museums and private collections throughout Europe and Latin America. He returned to Bavaria, where nearly 3000 drawings and

paintings were acquired by the local government, but he then went back to live in Brazil between 1845 and 1846. He took part in exhibitions in Rio de Janeiro and painted the portrait of *Peter II* (1846; Petrópolis, Mus. Imperial) and other members of the Brazilian imperial family (Rio de Janeiro, Mus. N. B.A. and Petrópolis, Mus. Imperial). The interest aroused by his work led to the re-use in 1830 of some of the plates from *Voyage pittoresque au Brésil* as a panorama sold commercially as wallpaper by the Zuber company of Rixheim in Alsace. Decoration inspired by his scenes of the Brazilian jungle was also used on several pieces of a porcelain dinner-service commissioned by Louis-Philippe, King of France, from the Sèvres factory.

BIBLIOGRAPHY

Art of Latin America since Independence (exh. cat. by S. L. Catlin and T. Grieder, New Haven, CT, Yale U., A.G.; Austin, U. TX, Huntington A.G.; San Francisco, CA, Mus. A.; La Jolla, CA, Mus. A.; 1966)

H. G. Mathias: *Rugendas e a viagem pitoresca através do Brasil* (Rio de Janeiro, 1968)

R. Berman: *The Forgotten Journey: Georg Heinrich Langsdorff and the Russian Imperial Scientific Expedition to Brazil 1821–1829* (Amsterdam, 1971)

N. Carneiro: *Rugendas no Brasil* (Rio de Janeiro, 1979)

P. Dierner: *Rugendas: Imágenes de México* (exh. cat., Mexico City, Chapultepec Gal., 1994)

——: 'Rugendas y sus compañeros de viajes', *A. México*, xxxi (1996), pp. 26–39

ROBERTO PONTUAL

Ruiz, Antonio [el Corzo] (*b* Texcoco, nr Mexico City, 2 Sept 1897; *d* Mexico City, 9 Oct 1964). Mexican painter and stage designer. He studied at the Escuela Nacional de Bellas Artes in Mexico City and later designed sets for the cinema, first in Hollywood, CA (1926–9), and later in Mexico, where he also worked as a stage designer, particularly for children's theatre. At the International Surrealist Exhibition held at the Galería de Arte Mexicano, Mexico City, in 1940 (organized by Wolfgang Paalen, André Breton and the Peruvian poet César Moro (1906–78)) he showed *Leader Making a Speech* (1939; Dallas, TX, Stanley Marcus priv. col., see Debroise, 1987, p. 43), in which a small man standing on an enormous chair addresses an audience made up of pumpkins. Although Ruiz was not prolific, his small paintings were imbued with a strong sense of humour and a rich sense of colour, tending towards the popular style of religious ex-votos (e.g. *New Rich*, 1941; see colour pl. XXXIV, fig. 2). He also produced two murals in Mexico and (in collaboration with Miguel Covarrubias) four in San Francisco, CA. In 1942 he was named director of the Escuela de Pintura y Escultura la Esmeralda, a post he occupied for 16 years.

BIBLIOGRAPHY

O. Debroise: *Figuras en el trópico: Plástica mexicana, 1920–1940* (Barcelona, 1984)

L. Morales: *Wolfgang Paalen: Introductor de la pintura surrealista en México* (Mexico City, 1984)

O. Debroise: *Antonio Ruiz, el corcito* (Mexico City, 1987)

Antonio Ruiz: 'El corcito' (exh. cat. by L. Barrios and F. Paniagua, Toluca, Inst. Mex. Cult., 1994)

LEONOR MORALES

Ruiz Rosas, Alfredo (*b* Lima, April 1926). Peruvian painter, active in France. He failed to complete his studies at the Escuela Nacional de Bellas Artes in Lima and went to Europe, where in 1951 he attended the Instituto de Cultura Hispánica, Madrid. He returned frequently to Peru

to exhibit his work, notably representing his country at the São Paulo Biennale of 1961. He settled permanently in Paris in 1965. His work is most notable for its social realism, often expressed through geometric forms and containing elements of Expressionism (e.g. *Plough*, 1955; priv. col.; see de Lavalle and Lang, p. 156). He also executed brightly coloured still-lifes and went on to concentrate increasingly on portraiture, while retaining his interest in social themes.

BIBLIOGRAPHY

J. A. de Lavalle and W. Lang: *Pintura contemporánea, II: 1920–1960*, Co. A. & Tesoro Perú (Lima, 1975), p. 156

Seymur: 'El retorno de Alfredo Ruiz Rosas', *El Comercio* (16 March 1980), pp. 22–3

J. Bernuy: 'La gramática del color', *El Comercio* (29 September 1991), p. 22

W. IAIN MACKAY

Rybak, Taty (*b* Buenos Aires, 18 July 1943). Argentine sculptor. She studied painting under Horacio Butler and sculpture under the Argentine sculptor Leo Vinci. She travelled to Africa, where she became closely involved with sculpture workshops in Zimbabwe, Tanzania and among the Dogon people in Mali, and to India, where she visited the workshop at Mahabalipuram. Using thin metal wires to define form and creating an animated dialogue from the contrast between positive and negative spaces, she created sculptures suspended in the air, fixed to a wall or placed upright without base, in each case combining a directness of method with conceptual complexity. In spite of the severe limitations of her chosen material, which enabled her to create apparently weightless sculptures with subtle outlines, the very rigour imposed by the wire allowed her to give free rein to fantasy and gracefulness without falling into mere decorativeness.

Rybak constantly explored new ideas, adding to her initial repertory of themes of maternity and human couples works based on mythical forms rooted in the unconscious and others concerning the individual's integration in society, as in *Woman Prisoner* (1980; see fig.). Later in the 1980s she produced concise and highly expressive sculptures in which she continued to explore existentialist themes.

BIBLIOGRAPHY

Taty Rybak from Argentina (exh. cat., intro. J. Gómez Sicre; Washington, DC, Mus. Mod. A. Latin America, 1981)

Taty Rybak: Sculptures (exh. cat., intro. N. Perazzo; Paris, Cent. Cult. Arg., 1983)

NELLY PERAZZO

Taty Rybak: *Woman Prisoner*, painted metal, 594×1168×254 mm, 1980 (Washington, DC, Art Museum of the Americas)

S

Sabogal (Diéguez), José (*b* Cajabamba, Cajamarca, 19 March 1888; *d* Lima, 15 Dec 1956). Peruvian painter, printmaker and teacher. From 1908 he visited Europe (Italy in particular) and North Africa before studying at the Academia Nacional de Bellas Artes, Buenos Aires, from 1910. From 1913 to 1918 he taught art in Jujuy. He returned briefly to Buenos Aires before spending six months in Cuzco, where he became committed to portraying scenes of Cuzco and her inhabitants and thus pioneered Indigenism. The works from this period were exhibited in 1919 at the Casa Brandes, Lima, where they caused a considerable stir. In 1920 he began teaching at the Escuela Nacional de Bellas Artes, Lima, becoming Director in 1932; his 'resignation' in 1943 was the result of the government's gratuitous appointments of staff without consultation.

A short visit to Mexico in 1922 and contacts with Diego Rivera, José Clemente Orozco and David Alfaro Siqueiros engendered in Sabogal that determination to promote Peruvian art internationally. He was involved with José Carlos Meriátequi's review, *Amauta* (1926–30), which gave him a political framework in which to interact with other Latin American countries. After leaving the Escuela Nacional de Bellas Artes, he formed with Luis E. Valcárcel (*b* 1891) the Instituto Libre de Arte Peruano at the Museo Nacional de la Cultura Peruana, where he and other Indigenists studied and promoted traditional and modern Peruvian art. Sabogal's work was characterized by brightly coloured, static figures and shapes representing Andean landscapes and people (e.g. *Indian Mayor of Chincheros, Varayoc*, 1925; see colour pl. XXV, fig. 2). Throughout his career Sabogal also produced lithographs, woodcuts (e.g. *Huanca Indian*, 1930; see fig.), book illustrations and a number of murals.

WRITINGS
Mates burilados: Arte vernacular peruano (Buenos Aires, 1945)
Pancho Fierro (Lima, 1945)
El toro en las artes populares del Perú (Lima, 1949)
El kero (Lima, 1952)
Del arte en el Perú y otros ensayos (Lima, 1975)

BIBLIOGRAPHY
J. A. de Lavalle and W. Lang: *Pintura contemporánea, II: 1920–1960*, Col. A. & Tesoro Perú (Lima, 1976), pp. 24–33
Sabogal (exh. cat. by L. E. Tord, Cuzco, Mus. Hist. Reg. and elsewhere, 1982)
J. Torres Bohl: *Apuntes sobre José Sabogal: Vida y obra* (Lima, 1989)
A. Zevallos: *Tres pintores cajamarquinos: Mario Urteaga, José Sabogal, Camillo Blas* (Cajamarca, 1991)
M. Lauer: 'La pintura indigenista peruana: Una visión de los años noventa', *Voces de Ultramar: Arte en América Latina, 1910–1960* (exh. cat.,

José Sabogal: *Huanca Indian*, woodcut, 330×265 mm, 1930 (Washington, DC, Art Museum of the Americas)

Madrid, Casa América: Las Palmas de Gran Canaria, Cent. Atlántic A. Mod., 1992), pp. 73–9
E. Lucie-Smith: *Latin American Art of the 20th Century* (London, 1993), pp. 76–7
W. IAIN MACKAY, with PAULINE ANTROBUS

Sáez, Carlos Federico (*b* Mercedes, 14 Nov 1878; *d* Montevideo, 4 Jan 1901). Uruguayan painter and draughtsman. He came from a highly cultured family and drew and painted from childhood; portraits and copies in oil made before the age of 12 survive. At the age of 13 he moved with his family to Montevideo, where he was taught painting at the Escuela de Arte by Juan Franzi. On the recommendation of Juan Manuel Blanes he was sent to Europe, entering the Accademia Nazionale di San Luca in Rome at the age of 15. There, after frequenting the workshops of the Spanish painters Marcelino Santa María y Sedano (*b* 1866) and Francisco Pradilla y Ortiz, he came into contact with Antonio Mancini (1852–1930) and Francesco Paolo Michetti (1851–1929) and through them

with the Macchiaioli, whose dynamic brushwork he adapted to his own paintings, especially to his portraits. Using rapid brushstrokes and heavy impasto, in paintings such as *Portrait of a Young Man* (*c.* 1899; Montevideo, Mus. N. A. Visuales) and *Ciocciaro Head* (1897; Montevideo, Mus. N. A. Visuales), he combined these methods with a variety of techniques, including splashing and scraping. He was particularly attracted to ways of representing the texture of cloth. He returned to Montevideo gravely ill, the result of his fast-paced and extravagant way of living, and in 1900 won first prize in a poster contest organized by the Ateneo under the direction of Pedro Figari for the Montevideo Carnaval. He died shortly afterwards, aged only 22.

BIBLIOGRAPHY
J. P. Argul: *Las artes plásticas del Uruguay* (Montevideo, 1966); rev. as *Proceso de las artes plásticas del Uruguay* (Montevideo, 1975)
Seis maestros de la pintura uruguaya (exh. cat., ed. A. Kalenberg; Buenos Aires, Mus. N. B.A., 1985), pp. 43–56
R. Pereda: *Sáez* (Montevideo, 1986)

ANGEL KALENBERG

Saintes Islands. *See under* ANTILLES, LESSER.

St Kitts. *See under* ANTILLES, LESSER.

St Lucia. *See under* ANTILLES, LESSER.

St Martin. *See under* ANTILLES, LESSER.

St Vincent. *See under* ANTILLES, LESSER.

Sakai, Kazuya (*b* Buenos Aires, 1 Oct 1927). Argentine painter, graphic designer, teacher and critic. After studying in Japan from 1935 to 1951 he returned to Argentina, remaining there until his move to New York in 1963. His paintings from 1952 were in the style of *Art informel*, with a calligraphic emphasis demonstrating his sympathy with

Kazuya Sakai: *Daughters of Kilimanjaro III (Miles Davis)*, acrylic on canvas, 2×2 m, 1976 (Austin, TX, University of Texas, Jack S. Blanton Museum of Art)

oriental art, but around 1960 he moved towards a more gestural abstraction in works such as *Painting No. 20* (1961; Buenos Aires, Mus. A. Mod.), using thicker paint and more subdued colours.

In 1964 Sakai began to use more geometric shapes in his pictures, and he continued to do so on moving in 1965 to Mexico, where he remained until 1977. His example opened the way to geometric abstraction in Mexico, where there was no real tradition of such work. In 1976, shortly before returning to New York, he began a series of paintings using the formal repetition of parallel undulating lines of strongly contrasting colour (e.g. *Daughters of Kilimanjaro III (Miles Davis)*, 1976; see fig.). From 1986 he began to accumulate on one canvas apparently irreconcilable systems, bringing together illusionistic spaces, flat or modelled colours, free brushstrokes and geometric lines into an expressive, geometric kaleidoscope that nonetheless possesses unity and harmony. In addition to his work as a painter, he taught at universities in Argentina, Mexico and the USA, worked as a graphic designer and attended international conferences as an orientalist and art critic.

BIBLIOGRAPHY
D. Bayón: *Aventura plástica en Hispanoamérica* (Mexico City, 1974), pp. 154–5
Pinturas: Ondulaciones cromáticas y simultáneas (exh. cat., intro. J. Acha; Mexico City, Mus. A. Mod., 1976)

NELLY PERAZZO

Salas, Rafael (*b* Quito, 1824; *d* Quito, 24 March 1906). Ecuadorean painter and teacher. He was the eldest son of the artist Antonio Salas (1780–1860), in whose workshop he was trained together with his 16 brothers and sisters who, like him, dedicated themselves to art and formed the so-called 'Salas dynasty'. He is notable as the first major Ecuadorean landscape painter and inspired such artists as Rafael Troya. He is best known for creating the painting that presided over the official consecration of Ecuador in 1874, *El Corazón de Jesús* (*c.* 1874), the iconography of which was widely propagated. Despite Ecuador's transition from colonialism to modernity, Salas continued to treat religious themes, such as *Mary Magdalene* (1892; Quito, Mus. Jijón y Caamaño), and portraits (e.g. *Simón Bolívar*; Quito, Mus. A. Mod.), yet he also tried to depict scenes from nature with his romantic Andean landscapes, such as *Cotopaxi* (1889; Quito, Banco Cent. del Ecuador). Salas also taught landscape painting at the Escuela de Bellas Artes in Quito from 1904 until his death.

BIBLIOGRAPHY
J. M. Vargas: *Los pintores quiteños del siglo XIX* (Quito, 1971), pp. 20–23
X. Escudero de Terán: *Los Salas: Una dinastía de pintores* (exh. cat., Quito, Banco Andes, 1989)
J. G. Navarro: *La pintura en el Ecuador del XVI al XIX* (Quito, 1991), pp. 204–6
C. Hartup: *Artists and the New Nation: Academic Painting in Quito during the Presidency of Gabriel García Moreno (1861–1875)* (MA thesis, Austin, U. Texas, 1997)

ALEXANDRA KENNEDY

Salcedo, Bernardo (*b* Bogotá, 12 Aug 1941). Colombian sculptor, collagist and conceptual artist. He studied architecture at the Universidad Nacional de Colombia in Bogotá from 1959 to 1965 and began at this time to make collages influenced by Pop art. In 1966 he made the first of his

Boxes, painted in strong flat colours, often red or yellow, to which he affixed industrial elements such as telephone handsets. Soon afterwards he began to make only white boxes, using the colour to complement the mystery of the objects they contained, such as the heads, arms and legs of dolls, machine parts, wooden eggs and domestic objects; the penetrating humour and arbitrariness with which he juxtaposed such things recalled the spirit of Dada.

In the 1970s Salcedo became involved for a time with conceptual art in mordantly critical and irreverent works, such as *The National Coat of Arms* (1973; Bogotá, Mus. A. Mod.). He subsequently returned, however, to sculptural objects, bringing together two or more previously unconnected elements into an unsuspected poetic unity when assembled. These in turn gave way to works concerned with the representation of water, for example a group of saw-blades aligned in wavelike patterns or rectangles of glass arranged to resemble rain. Some of these included human figures, bringing to bear a sense of solitude and anxiety that added to their poetry and suggestiveness.

BIBLIOGRAPHY

E. Serrano: *Un lustro visual* (Bogotá, 1976)
Cien años de arte colombiano (exh. cat. by E. Serrano, Bogotá, Mus. A. Mod., 1985)
Bernardo Salcedo, Fundaçao de São Paulo (São Paulo, 1994)
Bernardo Salcedo (exh. cat., Bogatá, Gal. Garcés Velázquez, 1994)

EDUARDO SERRANO

Salgado, Sebastião (*b* Aimorés, Minas Gerais, 8 Feb 1944). Brazilian photographer. He first trained as an economist at universities in Brazil and the USA (1964–8). While studying for a doctorate in agricultural economics at the University of Paris (1969–71), Salgado started to take photographs. Working as an economist for the London-based International Coffee Organization (1971–3), he visited Africa for the first time. He then moved to Paris and began to work as a photojournalist through the photographic agencies Sygma (1974) and Gamma (1975–9), travelling extensively in Africa, Europe and Latin America. In 1979 he joined Magnum and continued to photograph throughout the world but left the agency in 1994 to work independently. Salgado's major achievement was a series of lengthy documentary projects in the developing nations: refugees and famine in Africa, the plight of peasants in South America and the decline of heavy industries around the world. His photographs were in the tradition of 'concerned photography' and were strong compositions in a vivid style, often alluding to biblical iconography. They were widely published and exhibited and brought him international recognition and numerous photojournalistic awards.

PHOTOGRAPHIC PUBLICATIONS

Other Americas, intro. A. Riding (New York and Paris, 1986)
Sahel: L'Homme en détresse, intro. J. Lacouture, text by X. Emmanuelli (Paris, 1986)
An Uncertain Grace, essay by F. Ritchin (London and Paris, 1990)
Workers: An Archaeology of the Industrial Age, intro. S. Salgado and E. Nepomuceno (London and Paris, 1993)
Terra: Struggle of the Landless, intro. J. Saramago (London, 1997)

NICK CHURCHILL

Salinas (González-Mendive), Fernando (*b* Havana, 19 Dec 1930; *d* 1992). Cuban architect. After graduating in architecture in 1957, he studied at the Rensselaer Polytechnic Institute in Troy, New York. He worked in the offices of Philip Johnson and Mies van der Rohe, and was attracted to the work of Frank Lloyd Wright. On his return to Cuba, he maintained a firm contact with the Italian Franco Albini. In his first private residences such as the Casa del Puente (1958; with Raúl González Romero) in Miramar, he made use of organic ornamentation and natural materials such as wood. This approach, which began in 1959, involved the use of prefabricated building elements whose forms allowed for a balance between large-scale projects and individualized artistic creations. This principle is evident in the offices of EMA (1962) in Havana and the urban development of Manicaragua (1963) in Las Villas. The participation of the occupants and the principle of progressive housing were part of the experimental module Multiflex (1969; destr.), Havana, which received an award in the 9th UIA Congress in Buenos Aires but was not put into use. The Cuban Embassy building (1977) in Mexico City expresses the integration of plastic arts and symbolizes a visual image of contemporary Cuban culture. Salinas's writings laid down a dictum for architecture in developing countries.

WRITINGS

with R. Segre: *La progettazione ambientale nell'era della industrializzazione* (Palermo, 1979)
De la arquitectura y el urbanismo a la cultura ambiental (Guayaquil, 1988)

BIBLIOGRAPHY

F. Bullrich: *New Directions in Latin American Architecture* (New York, 1968)
R. Segre: *Cuba, l'architettura della rivoluzione* (Padua, 1970)
D. Bayón and P. Gasparini: *Panorámica de la arquitectura latinoamericana* (Barcelona, 1977)
R. Segre: *Arquitectura y urbanismo de la revolución cubana* (Havana, 1989)
E. Ayala Alonso, ed.: *Renando Salinas: El compromiso de la arquitectura* (Mexico City, 1992)
C. Véjar Pérez-Rubio: *Y el perro ladra y la luna enfría, Fernando Salinas: Diseño, ambiente y esperanza* (Mexico City, 1994)

ROBERTO SEGRE

Salvador [Bahia]. Brazilian city, capital of the state of Bahia. Built on a peninsula at the entrance to the Baia de Todos os Santos on the north-east coast of Brazil, the city (population *c.* 2 million) was the first Portuguese settlement in the country and its capital until 1763; the historic city centre has some of the finest colonial Baroque architecture in Brazil. Salvador was settled by the Portuguese in 1549 and became wealthy through the development of sugar, hemp and tobacco production, for which large numbers of African slaves were brought to the region, imparting a distinctive character to the city's artistic culture. Between 1650 and 1750 numerous convents, churches, palaces and private houses were built, usually at the top of the hills of the Upper City, where Salvador was founded. Some 70 churches survive from that period, including S Francisco de Assis (1686–1708), with an interior of carved gilt woodwork; the adjoining Franciscan convent, with Portuguese *azulejos* (glazed tiles) in the cloister illustrating maxims from Horace; the church of the Third Order of S Francisco (begun 1702), with a façade of carved white stone and statues of saints of the Order in the chapter house; the cathedral, formerly the Jesuit church, begun by Francisco Dias (1538–1623), completed 1672, with walls covered with coloured marble and *azulejos*, gilded altars

and a painted ceiling in the sacristy; and the monastery church of S Bento (rebuilt after 1624), containing image-reliquaries in polychrome terracotta by Frei Agostinho da Piedade (*fl* mid-17th century). In the Lower City is the monumental Nossa Senhora da Conceição da Praia, designed in 1736 by Manuel Cardoso de Saldanha and built of stone from Portugal; it contains an early example of Brazilian illusionistic perspective painting on the ceiling of the nave (1773) by José Joaquim da Rocha (1737–1807). The Pelourinho district of the city has a picturesque collection of colonial architecture. Other notable buildings include the fort of Monte Serrat to the north (1583; rebuilt 1724); the former convent of S Teresa (1686; now the Museu de Arte Sacra); the Solar de Unhão (late 17th century), a combined residential and administrative building for a sugar estate (now the Museu de Arte Moderna da Bahia); and the mid-19th-century Museu da Fundação Carlos Costa Pinto. Important modern buildings in Salvador include the Central Administration of Bahia (CAB) Chapel by JOÃO FILGUEIRAS LIMA (*see* BRAZIL, fig. 7).

BIBLIOGRAPHY
E. C. Falcão: *Relíquias da Bahia* (São Paulo, 1941)
M. Barata: *Azulejos no Brasil* (Rio de Janeiro, 1955)
G. Bazin: *L'Architecture religieuse baroque au Brésil* (Paris, 1956)
G. Ferrez: *As cidades do Salvador e do Rio de Janeiro no século XVIII* (Rio de Janeiro, 1963)
C. P. Valladares: *Aspectos da arte religiosa no Brasil* (Rio de Janeiro, 1981)
——: *Nordeste histórico e monumental*, 3 vols (Rio de Janeiro, 1982–3)
C. Ott: *Historia das artes plasticas na Bahia (1550–1900)*, 3 vols (Salvador, 1991–3)
P. de la Riesta: 'Arquitectura Lusobrasileña', *Arquitectura colonial iberoamericana*, ed. G. Gasparini (Caracas, 1997), pp. 493–552
ROBERTO PONTUAL

Samaniego y Jaramillo, Manuel (*b* San Blas, Quito, *c.* 1767; *d* Quito, 1824). Ecuadorian painter. He was a pupil of his relative Bernardo Rodríguez, with whom he painted the frescoes depicting scenes of the *Life of Christ* on the tympanum of the central nave of Quito Cathedral. He subsequently painted the large canvas of the *Death of the Virgin* in the canons' choir of the same cathedral. Other religious paintings include the *Nativity*, the *Adoration of the Magi* and the *Last Supper*. His favourite themes, such as the Immaculate Conception, are depicted with the Holy Trinity and in settings full of cherubs and little angels. Samaniego y Jaramillo's style is characterized by his use of shades of blue, which give a feeling of transparency to his passages of landscape as well as a sense of harmony and serenity to the paintings as a whole. These effects are, however, subordinated to the realism of his scenes and to the careful depiction of the figures. He also painted miniatures in oil and portraits of leading contemporary figures.

RICARDO DESCALZI

Sanahuja, Fray Manuel de (*d* La Paz, 1834). Catalan architect, active in Bolivia. He was a Franciscan friar and the leading architect in Bolivia between 1800 and 1830 (*see* BOLIVIA, §II, 2(i)). In 1808 he was called to Potosí to design the cathedral in a predominantly Neo-classical style coexisting with reminiscences of the Baroque. There were brief interruptions in its construction, and it was not finished until 1838. In Potosí he also redesigned the church of S Domingo. He interrupted his work there to execute the principal altar (1820) of the church of La Merced, Cuzco, and a new retable (1830) for the church of La Merced, La Paz. Shortly after he commenced work on a new cathedral for La Paz (for illustration *see* LA PAZ), although only the ground storey was completed before his death; the works were continued by the French engineer Philippe Bertrès and completed in the early 20th century by Antonio Camponovo, who largely followed Sanahuja's design. The cathedrals at Potosí and La Paz were both made from carved stone and display an excellent sense of style.

BIBLIOGRAPHY
H. E. Wethey: *Arquitectura virreinal en Bolivia* (La Paz, 1960)
M. Chacon: *Arte virreinal en Potosí* (Seville, 1973)
T. Gisbert and J. de Mesa: *Monumentos de Bolivia* (La Paz, 1977)
TERESA GISBERT

Sánchez, Edgar (*b* Aguada Grande, 28 Sept 1940). Venezuelan painter. He studied at the Escuela de Artes Plásticas, Barquisimeto, before studying architecture at the Universidad Central de Venezuela, Caracas (1960–66), and printmaking in a printmaking workshop in New York (1970–72). His work, figurative in style, began with drawings of enlarged faces and skin, then ventured into colour and finally into painting that incorporated representations of other parts of the human body, as in *Skin and Landscape #20* (1976; Caracas, Gal. A. N.). In 1988 he had a one-man show at the Galerie du Dragon in Paris.

BIBLIOGRAPHY
Edgar Sánchez: Serigrafías y dibujos (exh. cat. by M. Traba and R. Guevara, Caracas, Gal. A. N., 1978)
Edgar Sánchez: Obra nueva (exh. cat. by R. Guevara, Caracas, Estud. Actual, 1979)
De Venezuela: Treinta años de arte contemporáneo (1960–1990)/From Venezuela: Thirty Years of Contemporary Art (1960–1990), (exh. cat. by R. de Montero Castro, Seville, Pab. A., 1992)
11 artistas venezolanos representados por Galería Freites (exh. cat., Caracas, Gal. Freites, 1994)
MELANÍA MONTEVERDE-PENSÓ

Sánchez, Emilio (*b* Havana, 10 June 1921). Cuban painter and printmaker, active in the USA. From 1944 to 1948 he studied at the Art Students League in New York, and he settled permanently in the city in 1952. Although his chief subject-matter was the Caribbean house, empty of people, with an emphasis on the geometric, luminous values of sun and shadow on shutters, verandahs and courtyards (see fig.), he also depicted New York cityscapes, still-lifes and other themes. A typical work of this period is *Shutters* (1986; Miami, FL, Maria Gutierrez F.A., see 1987–9 exh. cat., p. 175). As a realist painter, his elimination of ancillary elements produced a dreamlike effect, as if the buildings he represented existed only in memory and not in the immanent world. The link between dream, memory and place is a metaphor upon which many speculations about the nature of consciousness have been elaborated in Latin-American art and literature. Sánchez's predecessors in this respect include Amelia Peláez del Casal and Mario Carreño, as well as De Chirico. Among the younger Cubans influenced by the potency of this kind of imagery were María Brito Avellana, Humberto Calzada, Juan González, Julio Larraz and Gustavo Ojeda. Sánchez's solo exhibition at the ACA Gallery in Manhattan in 1985 focused on paintings with a New York theme. He participated in

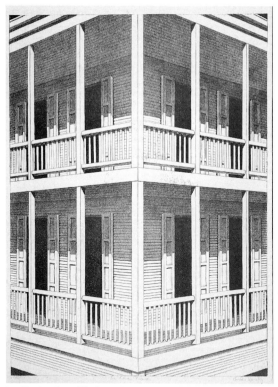

Emilio Sánchez: *The New House*, lithograph, 808×584 mm, 1970 (Washington, DC, National Museum of American Art)

Outside Cuba/Fuera de Cuba, a survey of Cuban émigré art from 1960, held at Rutgers University, New Brunswick, NJ (1987), and in the *Latin American Presence in the United States* exhibition at the Bronx Museum, New York (1988).

BIBLIOGRAPHY
Emilio Sánchez: Recent Works (exh. cat. by R. Pau-Llosa, Fort Lauderdale, FL, Mus. A., 1985)
G. V. Blanc: 'Arquitecto de luces y sombras', *Américas*, xxxviii/3 (May–June 1986), pp. 44–9
Outside Cuba/Fuera de Cuba (exh. cat. by I. Fuentes-Pérez, G. Cruz-Taura and R. Pau-Llosa, New Brunswick, NJ, Rutgers U., Zimmerli A. Mus.; New York, Mus. Contemp. Hisp. A.; Oxford, OH, Miami U., A. Mus.; and elsewhere; 1987–9), pp. 174–9
RICARDO PAU-LLOSA

Sánchez, Juan Félix (*b* San Rafael de Mucuchíes, nr Mérida, 16 May 1900; *d* San Rafael de Mucuchíes, 18 April 1997). Venezuelan sculptor, furniture designer, weaver and architect. He was self-taught as an artist. In 1935 he carved a sculptural group representing *Christ, the Virgin and Mary Magdalene* (untraced). In 1943 Sánchez moved to El Potrero, and in 1946 he constructed the only loom in Venezuela with three heddles. In 1952 he began the construction of the Complejo de El Tisure, near Mérida, an artistic and religious centre located in an immense isolated valley. His most representative works are housed there, including the sculptural group *Calvary*. Between 1960 and 1964 he executed some of his most original pieces of weaving and furniture. His first one-man show was held in 1982 at the Museo de Arte Contemporáneo, Caracas.

See also under VENEZUELA, §II.

BIBLIOGRAPHY
Juan Félix Sánchez, Grupo Cinco (Madrid, 1982)
Lo espiritual en el arte: Juan Félix Sánchez (exh. cat., Caracas, Mus. A. Contemp., 1982)
E. Planchart Licea: *Juan Félix Sánchez: El gigante del Tisure* (Caracas, 1992)
MARÍA ANTONIA GONZÁLEZ-ARNAL

San Miguel [Segura de la Ancuña], Fray **Andrés de** (*b* Medina Sidonia, 1577; *d* Mexico, 1652). Spanish architect and writer, active in Mexico. After a first visit to America in 1593, when he was shipwrecked, he returned there permanently in 1596, entering the Order of Discalced Carmelites in Mexico City (1600). From 1606 he was occupied with the construction and repair of many buildings belonging to the Order. Between 1606 and 1611 he supervised the building, to his own design, of S Desierto de Cuajimalpa, Puebla, a timber-roofed oratory surrounded by six hermit cells (destr.). In 1608 he continued work on the Carmelite convent in Mexico City, begun in 1602 to the plans of Alonso Pérez de Casatañeda (*fl c.* 1573). In 1615 he began the convent of S Angel, Mexico City, which was mostly completed in the following year, although the barrel-vaulted church was not built until 1622–4. Between 1618 and 1629 he worked in the Carmelite convents of Querétaro, Celaya (destr.) and Valladolid (destr.), and others have been attributed to him in Puebla and Atlixco (Puebla). He inspected the drainage of Mexico City (1631 and 1642) and built the bridge over the River Lerma (1650). Around 1630 he began a series of writings on architecture (Austin, U. TX System Libs) in which he reveals a familiarity with the work of Vitruvius, Alberti and Jacopo Vignola. The text and architectural drawings are arranged under different themes: the Temple of Solomon, a subject of much interest to contemporary Spanish scholars, for example Juan Bautista Villapando and Pablo de Céspedes; the temples of Peru; the rules for building Carmelite churches; architecture and mathematics; information on the drainage of a city; and treatises on water, aqueducts and pumps. In his hydrological writings he refers to Pliny, Herodotus and Columela; 20 folios on joinery are of particular interest.

BIBLIOGRAPHY
M. Toussaint: 'Fray Andrés de San Miguel: Arquitecto de la Nueva España', *An. Inst. Invest. Estét.*, 13 (1945), pp. 5–14
D. Angulo and others: *Historia del arte hispanoamericano*, 3 vols (Barcelona, 1945–56)
M. Toussaint: *El arte mudéjar en América* (Mexico City, 1946)
A. Bonet Correa: 'Las iglesias y los conventos de los Carmelitas en México y Fray Andrés de San Miguel', *Archv Esp. A.*, xxxvii/145–8 (1964), pp. 36–47
E. Báez Macías: *Obras de Fray Andrés de San Miguel* (Mexico City, 1969) [transcribes his writings on archit.]
R. Gutiérrez: *Arquitectura y urbanismo en Iberoamérica* (Madrid, 1983)
E. Nuere: *La carpintería de lazo: Lectura dibujada del manuscrito de Fray Andrés de San Miguel* (Malaga, 1990)
I. Bengoechea Izaguirre: *El gaditano Fray Andrés de San Miguel, arquitecto de la Nueva España: Discurso de recepción como Académico de Número...* (Cádiz, 1992)
MARIA CONCEPCIÓN GARCÍA SÁIZ

Santacilia, Carlos Obregón. *See* OBREGÓN SANTACILIA, CARLOS.

Santa Fe de Bogotá. *See* BOGOTÁ, SANTA FE DE.

Santa Fe school. *See under* BOGOTÁ, SANTE FE DE.

Santa María, Andrés de (*b* Bogotá, 1860; *d* Brussels, 1945). Colombian painter and teacher. His family moved to Europe in 1862, and he spent his childhood in London, Brussels and Paris, where he studied at the Ecole des Beaux-Arts and took part in numerous Salons, winning some prizes and honourable mentions. His work of this period could be described as a form of social realism. He returned in 1893 to Bogotá, where he did valuable work as a teacher and revolutionized the art world with his Impressionist-influenced art, which caused considerable and passionate controversy. He executed numerous portraits and landscapes along these lines, giving visual expression to his emotions on rediscovering the light and exuberance of the tropics. These helped to establish him as one of the first and most influential artists to introduce modernism to Latin America. Later Santa María placed more emphasis on the materiality of his paintings, using intense colours to help convey an impression of space and solid forms in still-lifes, religious paintings and portraits. His use of a rich and juicy impasto led his work to be compared by some critics to that of Adolphe Monticelli (1824–86). He returned permanently to Europe in 1911, settling in Brussels and devoting himself to a solitary life as a painter until his rediscovery in his old age by critics and a few young artists; major retrospectives of his work were then held in Brussels and London.

BIBLIOGRAPHY
A. Ridder: *Andrés de Santa María* (Brussels, 1937)
E. Serrano: *Andrés de Santa María* (Bogotá, 1978)
E. Serrano: *Andrés de Santa María, pintor colombiano de resonancia universal* (Bogotá, Mus. A. Mod., 1988)
Andrés de Santa María: Nuevos testimonios, nueva visión: Obras de las colecciones de Bélgica (exh. cat., Bogotá, Bib. Luis-Angel Arango, [1989])
EDUARDO SERRANO

Santa María del Puerto Príncipe. *See* CAMAGÜEY.

Santiago (de Chile) [formerly Santiago del Nuevo Extremo]. Capital of Chile. The country's largest city, it is located at the northern end of the Chilean central valley. To the east, the great crest of the Andes mountain range (the Cordillera) forms a magnificent backdrop to the city, while the much lower coastal range to the west separates Santiago from the Pacific Ocean. The Mapocho River, which is prone to severe flooding, runs through the city. Santiago was founded in 1541 (as Santiago del Nuevo Extremo) at the foot of the Cerro Santa Lucía by the Spanish *conquistador* Pedro de Valdivia. Sacked by Indians in 1542, the city soon recovered. It was the first Chilean capital, the seat of a bishopric from 1561 and of a Real Audiencia (appeal court and administrative tribunal) from 1609. In May 1647 it experienced the worst of its many earthquakes, and many buildings were destroyed. The poverty of the colony also meant that the city's growth was slow. Limited improvement occurred towards the end of colonial times, with the construction (1765) of an 11-arched stone bridge across the Mapocho (destr. 1889), and a range of government buildings on one side of the main plaza, as well as the austere Neo-classical Real Casa de la Moneda (known as 'La Moneda'); designed by JOAQUÍN TOESCA Y RICCI, it was finished in 1805 and used as the

presidential palace from 1846 (*see* CHILE, fig. 2). In 1800, however, as Chile approached independence from Spain (1818), Santiago's population was no more than 30,000; it had 2000 houses (mostly one-storey and of adobe construction) and 180 blocks; only a few streets were paved; and its churches were less ostentatious than those of the Spanish empire's viceregal capitals.

After Independence, with the coming of new wealth, Santiago began to lose its colonial look, with more streets being paved and later with the introduction of gas-lighting and horse-drawn trams (1857). The rich families of the country's governing class built themselves European-style mansions. The city's main avenue, the Alameda de las Delicias—a sheep-track in colonial times—was tranformed into a handsome tree-lined boulevard by Bernardo O'Higgins (Supreme Director, 1818–22), and urban improvements made during the vigorous reforming intendancy of Benjamín Vicuña Mackenna (1831–86), whose impact on Santiago was second to none, gave the capital new avenues and transformed the hitherto unsightly Cerro Santa Lucía into a delightful urban folly with new paths, sculptures and trees. Public buildings of note dating from this period include the new Congreso Nacional (completed 1876) and the Teatro Municipal (1853; altered) both by the French architect Claude-François Brunet Debaines (1788–1855), a key figure in the city's growth, and succeeded in his post as *arquitecto de gobierno* by Lucien Ambrose Hénault (1790–1880). Their work was ably complemented by that of such Chileans as FERMÍN VIVACETA RUPIO, whose achievements included the main building of the Universidad de Chile (*c.* 1865; see fig.) and the tower surmounting S Francisco, the city's oldest church (begun in 1572). The next era of distinguished public architecture in Santiago was from 1900 to 1925. The city's historic core was embellished with two stylish railway terminals (1900 and 1913), the Palacio de Bellas Artes (1910; by Emile Jecquier), the Club de la Unión (1925) and the ornate Biblioteca Nacional (1925). Redolent of the styles of Europe's Belle Epoque, these buildings contrast strongly with the rather drab office-blocks of the Barrio Cívico, constructed in the 1930s in a substantial remodelling of the streets around La Moneda.

Santiago's demographics altered drastically in the course of the 20th century, with the population rising from 300,000 in 1900 to 4 million by the early 1990s, at which point nearly one third of all Chileans were living in the capital. Physically, too, the city expanded well beyond the historic core and its limited 19th-century accretions—partly in line with the notable urban plan submitted in 1930 by the Austrian Karl Brunner. Increasingly after the 1920s the wealthier classes relocated to the fast-growing eastern suburbs—now collectively termed the *barrio alto*—which spread inexorably towards the Cordillera, finally reaching it by the 1980s; apartment blocks were built extensively in the area, and several shopping malls were constructed. More modest districts developed on the north side of the Mapocho, while the south became a predominantly working-class redoubt. After 1950 large shanty-towns (originally nicknamed *callampas* or mushrooms) grew up on the fringes of Santiago, although their extent was reduced by a series of low-cost housing schemes from the 1960s. Mounting problems of traffic congestion were

Santiago, façade of the main building of the Universidad de Chile, by Fermín Vivaceta Rupio, c. 1865

partly alleviated by the building of an underground railway, whose first section opened in 1975. Deregulation of the bus system, however, one of the free-market policies adopted by the Augusto Pinochet dictatorship (1973–90), added to pollution and contributed to Santiago's horrendous air pollution, among the worst in the western hemisphere.

The first major educational and cultural institutions in Santiago were founded in the 19th century. The Escuela de Arquitectura was founded in 1849 by Brunet Debaines. The Academia de Pintura (later the Escuela Nacional de Bellas Artes) was also established in 1849 under the Italian painter Alessandro Cicarelli (1811–79). The Museo Nacional de Bellas Artes, housed since 1910 in the Palacio de Bellas Artes, has an exceptional collection of Chilean painting from the mid-19th century onwards. Two associated museums in the same building are the Museo de Arte Popular Americano and the Museo de Arte Contemporáneo. The Museo de Arte Colonial de San Francisco, mostly containing religious art and located beside the church of S Francisco, was opened in the 1970s.

BIBLIOGRAPHY

R. León Echaiz: *Historia de Santiago*, 2 vols (Santiago, 1975)
Guía de la arquitectura en Santiago (Santiago, 1976)
P. Gross, A. de Ramón and E. Vial: *Imagen ambiental de Santiago, 1880–1930* (Santiago, 1984)
M. Laborde: *Santiago: Lugares con historia* (Santiago de Chile, 1990)
F. J. Pizarro Gómez: 'Arquitectura colonial chilena', *Arquitectura colonial iberoamericana*, ed. G. Gasparini (Caracas, 1997), pp. 443–62

SIMON COLLIER

Santo Domingo. Capital of the DOMINICAN REPUBLIC, founded by Christopher Columbus's brother Bartolomé in 1496. It was also the Spanish colonial name for the country.

□

São Paulo. Brazilian city, capital of the state of São Paulo. Built on an elevated site *c.* 90 km inland from the Atlantic coast and about 350 km south-west of Rio de Janeiro, São Paulo (metropolitan population *c.* 9.6 million) is the largest city in South America and the industrial centre of Brazil; it contains numerous examples of influential 20th-century architecture. The city was founded in 1554, when the Jesuits built a college there, and it developed slowly over three centuries as a centre for the religious indoctrination of the Indians and the organization of expeditions to the interior. At the beginning of the 19th century it had only 10,000 inhabitants. A first impulse to progress came in 1850 with the wealth produced by the coffee industry; the subsequent construction of a pioneering industrial estate at the beginning of the 20th century transformed the city into the major economic centre of the country, stimulating large-scale immigration, particularly from Italy and Japan. Architecture and urban planning, which had remained almost stagnant from the earliest times, were modernized with great rapidity. Art Nouveau was introduced by the Swedish architect Carl Eckman (1866–1940), who designed the Vila Penteado (1902), and the French architect VICTOR DUBUGRAS, who designed the Mairinque Railway Station (1907) and luxurious residences, most of which were later demolished. The eclecticism prevailing at the turn of the century is particularly apparent in the work of FRANCISCO DE PAULA RAMOS DE AZEVEDO, notably the Teatro Municipal (1903–11). The opening of Avenida Paulista in 1891 provided a new residential axis for the wealthy élite; garden suburbs on the English model were also initiated, pioneering the concept in Brazil.

In the 1920s São Paulo became the centre of Brazilian Modernism, given public expression by the SEMANA DE ARTE MODERNA in 1922, which brought together poets, painters, sculptors, architects and musicians. Modern architecture was introduced by the Russian-born architect GREGORI WARCHAVCHIK, who set up his office in São Paulo in 1927 and produced the Modernistic House (1927–30) in the Vila Mariana district. Le Corbusier's lectures in the city in 1929 stimulated new ideas that came to fruition in succeeding years. RINO LEVI designed the Columbus building (1932), the first modern block of flats in São Paulo. The São Paulo 'school' of Structuralists was led by João B. Vilanova Artigas, who taught at the Faculty of Architecture and Urban Planning at the University of São Paulo from the 1940s and designed its new building in 1961 (for further discussion and illustration *see* ARTIGAS, JOÃO B. VILANOVA). Many of the finest private houses in the city were built by OSWALDO ARTHUR BRATKE in the 1950s. From this period the city's art schools, exhibitions, museums and galleries gave it a leading role in contemporary art, shared only by Rio de Janeiro. It has some of the principal museums of Brazil: the Museu de Arte Sacra (in an 18th-century convent), the Pinacoteca do Estado, the Museu de Arte de São Paulo (1958; by LINA BARDI; see fig.), the Museu de Arte Moderna, the Museu de

São Paulo, Museu de Arte de São Paulo by Lina Bardi, 1958

Arqueologia e Etnologia and the Museu de Arte Contemporânea (1975; by Carlo Mendes da Rocha and Jorge Wilheim). The last two museums belong to the University of São Paulo, which also houses in its Instituto de Estudos Brasileiros the collection of 20th-century Brazilian art acquired by the writer Mário de Andrade (1893–1945). In 1951 the city held its first Bienial Internacional de Artes Plásticas, which is still held in a building (1951–4) designed by Oscar Niemeyer in Ibirapuera Park. A striking contrast to the predominant cosmopolitanism and modernity is the traditional decoration of the populous Japanese quarter.

BIBLIOGRAPHY

L. Saia: *Arquitetura paulista* (São Paulo, 1960)
G. Ferraz: *Warchavchik e a introdução da nova arquitetura no Brasil* (São Paulo, 1965)
A. Amaral: *As artes plásticas na Semana de 22* (São Paulo, 1970)
——: *A hispanidade em São Paulo* (São Paulo, 1981)
A. de Oliveira Godinho, ed.: *O Museu de Arte Sacra de São Paulo* (São Paulo, 1983)
W. Zanini, ed.: *História geral da arte no Brasil*, 2 vols (São Paulo, 1983)

ROBERTO PONTUAL

Sapaca, Marcos. *See* ZAPATA, MARCOS.

Schmid, Martin (*b* Baar region, Switzerland, 26 Sept 1694; *d* March 1772). Swiss architect and musician, active in Bolivia. He entered the Jesuit Order and in 1730 was sent to join the Jesuit missions to the indigenous Chiquito peoples of eastern Bolivia, in the Chaco rainforests bordering Brazil and Paraguay. In 1731 he organized the craft workshops in the mission of S Javier and began the construction of the church there. Like all the churches in that region, it is a timber structure with a rectangular ground-plan and a pitched roof. The plan is organized on the basis of five rows of timber columns, with the three central rows dividing the internal space into two aisles and the outer rows defining the enclosing walls and supporting the widely overhanging eaves. These churches were based on ancient Greek models and were adapted to the humid climate and forested nature of the region. Schmid also constructed the churches at S Rafael (1749–53) and Concepción (1768), and he was responsible for the retable in the church at S Miguel. His decorative style was derived from the Bavarian Baroque and Rococo. Schmid was forced to leave South America when the Jesuits were expelled in 1767.

BIBLIOGRAPHY

Fernandez: *Relación historial de las misiones de indios chiquitos* (Madrid, 1726)
M. Buschiazzo: 'La arquitectura de las misiones de Moxos y Chiquitos', *Sudamerika*, iii (1953)
F. A. Plattner: *Deutsche Meister des Barock in Südamerika* (Freiburg im Breisgau, 1960) p. 62
J. Mesa and T. Gilbert: *Monumentos de Bolivia* (Mexico City, 1970/*R* La Paz, 1977)
W. Hoffmann: *Vida y obra de Martin Schmid S.J. (1694–1772): Misionero suizo entro los Chiquitanos: Músico artesano, arquitecto y escultor* (Buenos Aires, *c*.1991)
Martin Schmid (1694–1772): Missonar, Musiker, Architekt: Ein Jesuit aus der Schweiz bei den Chiquitano-Indianern in Bolivien/Las misiones Jesuíticas de Bolivia: Martin Schmid (1694–1772): Misionero, músico y arquitecto entre los chiquitanos (exh. cat., Lucerne, Hist. Mus.; Santa Cruz, Bolivia, Fund. Sui. Cult.; 1994)

TERESA GISBERT

Schulz Solari, Oscar Agustín Alejandro. *See* XUL SOLAR.

Scliar, Carlos (*b* Santa Maria do Rio Grande do Sul, 21 June 1920). Brazilian draughtsman, engraver and painter. At the age of 15 he began publishing illustrations in the newspapers of his native state. In 1940 he went to live in São Paulo, where he began his career as a painter. He joined the Família Artística Paulista (a group founded in 1937, typical of the second phase of Brazilian Modernism) and allowed his work to be influenced by a vivid, socially committed Expressionism, often using drawing and engraving. Between 1944 and 1945 he fought in Italy as a soldier in the Brazilian Expeditionary Force and produced rapid but undramatic drawings of the war. During a subsequent stay in Paris from 1947 to 1950 he developed his characteristic style under the influence of late Cubism and afterwards of Giorgio Morandi. On his return to Brazil, from 1950 to 1956 he helped to create the local Engraving Club in Porto Alegre; in its artistic aims and political stance he promoted a polemical form of realism devoted to landscape, human types and scenes of the still rural south. He returned to painting only on settling in Rio de Janeiro in 1956, capturing the rituals of everyday life in still-lifes, landscapes, seascapes and portraits. The Museu Manchete, Rio de Janeiro, owns his polyptych *Ouro Preto*, a 180° vision of that historic city in Minas Gerais. The most important of his works can be found in the Coleção Gilberto Chateaubriand in Rio de Janeiro (e.g. *Self-portrait*, 1948).

BIBLIOGRAPHY

J. Amado and J. Cardozo: *Naturezas mortas* [Still-lifes] (Rio de Janeiro, 1963)

R. Braga: *Caderno de guerra de Carlos Scliar* [Carlos Scliar's wartime sketchbook] (Rio de Janeiro, 1969)

R. Pontual: *Carlos Scliar—O real em reflexo e transfiguração* [Carlos Scliar—reality reflected and transfigured] (Rio de Janeiro, 1970)

R. Pontual and others: *Carlos Scliar* (São Paulo, 1983)

Scliar: A persistência da paisagem: Uma aventura moderna no Brasil (exh. cat., Rio de Janeiro, Mus. A. Mod., 1991)

ROBERTO PONTUAL

Sebastián(, Enrique Carbajal) (*b* Chihuahua, 1947). Mexican sculptor. He began his studies in 1965 at the Escuela Nacional de Artes Plásticas in Mexico City and later benefited from the teaching and influence of Mathías Goeritz. Together with Goeritz, Geles Cabrera, Juan Luis Díaz and Angela Gurría he became part of the Gocadiguse group, which specialized in urban art and executed works in Villahermosa in 1974. Participating in the Salón Independiente from 1969, he consistently explored the plastic possibilities of geometry, which led him in turn to a mathematical study of crystals that enlivened his production. In his small-scale works, some of them capable of movement, he explored with supreme confidence and surprising inventiveness the development of geometrical forms in space, limiting himself to straight lines and to solids with coloured flat surfaces. He worked with iron and reinforced concrete and also with paper and silver.

Sebastián was one of a number of Mexican artists involved in a broad movement of art in an urban context. He produced large-scale works for open-air locations throughout Mexico, especially in Mexico City and Monterrey, and abroad. Together with Goeritz, Manuel Felguérez, Helen Escobedo, Federico Silva and Hersúa he helped realize the Espacio Escultórico (1979; Mexico City, U. N. Autónoma), a large outdoor sculptural complex at the Ciudad Universitaria on the outskirts of Mexico City.

BIBLIOGRAPHY

T. del Conde: 'Las nuevas generaciones de geometristas mexicanos', *El geometrismo mexicano*, ed. J. A. Manrique and others (Mexico City, 1977)

I. Rodríguez Prampolini: *Sebastián: Un ensayo de arte contemporáneo* (Mexico City, 1981)

JORGE ALBERTO MANRIQUE

Segall, Lasar (*b* Vilna [now Vilnius], 7 July 1890; *d* São Paulo, 2 Aug 1957). Lithuanian painter and printmaker, active in Brazil. In 1906 he enrolled in the Berlin Akademie, where he was a student of Lovis Corinth and Max Liebermann. He took part in the Berlin Freie Sezession in 1909 and in 1910 held a one-man show of Expressionist paintings at the Galerie Gurlitt in Dresden. In 1912 he went to Brazil, introducing Expressionist paintings to the country for the first time when he exhibited his work in Rio de Janeiro and in the interior of São Paulo state during 1913. From 1914 to 1923 he lived in Dresden, where he participated in Expressionist exhibitions and published a book of five etchings, *Souvenirs of Vilna* (Dresden, 1919). In 1923 he returned to Brazil to marry and settle in São Paulo, where his activities included the founding of the Sociedade Pro-Arte Moderna in 1932.

Segall adapted his Expressionist style to Brazilian subjects and colour schemes in paintings such as *Brazilian Landscape* (1925; São Paulo, Mus. Segall) and *Banana Plantation* (1927; see fig.). In the 1930s he turned to more sombre subjects, such as the wanderings of the Jewish people, racial and religious discrimination, poverty and human suffering, for example in the paintings *Pogrom* (1936) and *Immigrant Ship* (1939–41; both São Paulo, Mus. Segall) and in the series of wood-engravings about prostitution produced between 1936 and 1944 for the album *Mangrove* (Rio de Janeiro, 1944; São Paulo, Mus. Segall). He was a productive printmaker from 1919, favouring etching, wood-engraving and lithography. His late work

Lasar Segall: *Banana Plantation*, oil on canvas, 870×1270 mm, 1927 (São Paulo, Pinacoteca do Estado de São Paulo)

was characterized by a more lyrical, peaceful vision of the world in geometrically structured landscapes that verge on the abstract, for example *Sunlit Forest* (1955; São Paulo, priv. col., see Bardi, p. 165).

BIBLIOGRAPHY

P. M. Bardi: *Lasar Segall* (Milan, 1959)
P. M. de Almeida: *De Anita ao Museu* (São Paulo, 1961)
J. R. Teixeira Leite: *A gravura brasileira contemporânea* (Rio de Janeiro, 1965)
Lasar Segall (exh. cat. by F. Gullar and others, Rio de Janeiro, Mus. A. Mod., 1967–8)
W. Zanini, ed.: *História geral da arte no Brasil*, ii (São Paulo, 1983)
R. Pontual: *Entre dois séculos: Arte brasileira do século XX na coleção Gilberto Chateaubriand* (Rio de Janeiro, 1987)
Lasar Segall e o Rio de Janeiro (exh. cat. by F. Morais and A. M. Machado, Rio de Janeiro, Mus. A. Mod., 1991)
C. Mattos: *Lasar Segall* (São Paulo, 1997)
R. Naves: 'Expressão e compaixão nos desenhos de Segall', *A forma difícil: Ensaios sobre arte brasileira* (São Paulo, 2/1997), pp. 197–224

ROBERTO PONTUAL

Seguí, Antonio H. (*b* Córdoba, 11 Jan 1934). Argentine painter and printmaker. Although he began to study law in 1950, he soon abandoned it for painting, which he studied while travelling in France and Spain in 1951–2. In 1957, the year of his first one-man show at the Galeria Paideia, Córdoba, he moved to Mexico, where he lived until 1961. He settled in Paris in 1963. In the early 1960s he produced paintings of Expressionist origin (e.g. *Napoléon*, 1963; see fig.), their heavy impasto soon developing into a very personal form of *Art informel* presaging the theatrical devices of his later work. Although these estab-

lished his reputation in Europe, in 1966–8 he took up a bright, flat style related to Pop art, as in *Roberto Climbing a Staircase* (1966; see 1969 exh. cat., p. 13). This gave rise to painted assemblages with cartoon-like figures and settings cut out of wood, as in *The Sea* (1966; priv. col., see 1969 exh. cat., p. 28). This personal response to Pop art was superseded by a postcard realism with which he reworked images by Winslow Homer for his first one-man show in New York, at the Lefebre Gallery in 1972. A period of dry Surrealistic images followed, owing an explicit debt to Magritte (e.g. *Triptych*, 1977; see 1978 exh. cat.), before a more intimate style surfaced in his graffiti interventions on Rembrandt's *Anatomy Lesson of Dr Tulp*. These works, such as *After Alexandre* (1978; see 1985 exh. cat., p. 41), followed Seguí's own experience of surgery after a leg injury.

In the late 1970s Seguí embarked on the Nueva Figuración that became characteristic of his work, presenting geometric, quadrangular, normally empty interiors, or else exteriors that are opaque in content but coloured in texture. He enclosed the human figures in cubes that give the impression of a melancholy theatrical montage. His imaginative vision is best seen in works completed between 1976 and 1980, including *Blind Men in the Garden* (1979; Paris, Pompidou). For nine years he was officially forbidden to return to Argentina because of his critical stance towards the military regime. After the free elections of 1984 he returned and represented Argentina officially at the Venice Biennale in that year with a series of paintings in which he analyzed his varied ways of looking, for example in *Nervous Little Town* (1984; see 1985 exh. cat., p. 78).

BIBLIOGRAPHY

Antonio Seguí (exh. cat. by B. Krimmel, Darmstadt, Ksthalle, 1969)
Seguí (exh. cat., Caracas, Mus. B.A., 1978)
Seguí (exh. cat., New York, Lefebre Gal., 1979)
Seguí (exh. cat., Aix-en-Provence Cathedral, Cloître St Louis, 1985) [incl. interview with H. Le Chénier]
J. Glusberg: 'Antonio Seguí', *Lat. Amer. A.*, iv/1, (1992), pp. 77–9
Antonio Seguí: Hombre de ciudades (exh. cat. by A. M. Escallón and others, Washington, DC, A. Mus. Americas; Mexico City, Mus. Rufino Tamayo; 1996–7)
J. López Anaya: *Historia del arte argentino* (Buenos Aires, 1997)

JORGE GLUSBERG

Segura, Juán (*b* Mexico City, 23 June 1898). Mexican architect. He was one of a number of Mexican architects working in the wake of the Revolution who dismissed the tenets of classicism and instead strove for an architectural form that would embody simultaneously a national and modern idiom. Segura introduced innovative interiors and spatial arrangements to numerous houses and various commercial and recreational buildings in Mexico City, for example the remarkable Ermita building (1929). The broken outlines and mosaic or plasterwork *sgraffito* of the façades display his personal interpretation of the Baroque style and could even be described as Post-modern.

BIBLIOGRAPHY

I. Katzman: *Arquitectura contemporánea mexicana* (Mexico City, 1963)
L. G. Alicia and G. S. Tomas, eds: *Análisis celular: Edificio Ermita* (Mexico City, 1984)
A. Toca Fernández: *Orígenes de la arquitectura moderna en México: Juán Segura* (Mexico City, 1984)
E. X. de Anda: *Evolución de la arquitectura de México* (Mexico City, 1987)

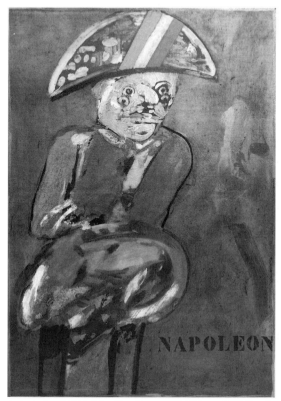

Antonio Seguí: *Napoleón*, oil on linen, 1289×976 mm, 1963 (Austin, TX, University of Texas, Jack S. Blanton Museum of Art)

P. Quintero, ed.: *Modernidad en la arquitectura mexicana* (Mexico City, 1990), pp. 589–621

F. González Gortázar, ed.: *La arquitectura mexicana del siglo XX* (Mexico City, 1994)

A. Toca Fernández: 'Juan Segura: The Origins if Modern Architecture in Mexico', *Modernity and the Architecture of Mexico* ed. E. R. Burian (Austin, 1997), pp. 163–76

RAMÓN VARGAS

Segura de la Ancuña, Andrés de. *See* SAN MIGUEL, Fray andrés de.

Semana de Arte Moderna. Series of events held at the Teatro Municipal in São Paulo from 11 to 18 February 1922, which marked the arrival of modernism in Brazil. The year 1922 was the centenary of Brazilian independence and a time of economic prosperity centred in São Paulo. The Semana marked the cultural emergence of a Brazilian bourgeoisie, with financial support from enlightened businessmen and politicians such as Paulo Prado, Oscar Rodrigues Alves and Alberto Penteado. The antecedents of the Semana date back to a startling exhibition of works by the São Paulo painter Anita Malfatti (1896–1964), held in São Paulo in December 1917. She had studied in Berlin and New York between 1914 and 1916, and her paintings were practically the first examples of Expressionism to be seen in Brazil, provoking the initial break with weak academic traditions inherited from the 19th century. Inspired by the polemical slogans if not by the art of Marinetti's Futurism, the scandalous Semana of 1922 permitted the lukewarm provincial and academic traditions in Brazilian art to be openly challenged. The Semana consisted of concerts, including pieces written and conducted by the composer Heitor Villa-Lobos; the reading of texts and poems by writers such as Mário de Andrade, Ronald de Carvalho, Oswald de Andrade, Guilherme de Almeida and Merotti del Picchia; and an exhibition of paintings, drawings, sculptures and architectural projects by 15 artists including Anita Malfatti, EMILIANO DI CAVALCANTI (the leading light in its organization), Victor Brecheret, Antonio García Moya (1891–1956) and Georg Przyrembel (1885–1956). The inaugural lecture, 'A emoção estética na arte moderna', was given by Graça Aranha, a writer, diplomat and member of the Brazilian Academy of Letters who had direct contact with Europe and with the new movements in international art, especially the *esprit nouveau*. Underlying the introduction of modernist ideas to Brazil through the Semana's events was a desire to create a modernism that would be rooted in Brazilian soil.

This introduction of modernism gained further impetus later in the decade through the activities of the poet and critic Oswald de Andrade and the painter TARSILA, both from São Paulo. These activities reached a climax in Oswald's *Manifesto antropófago* (São Paulo, 1928), inspired by Tarsila's recently finished painting *Abaporu* (Ind.: 'cannibal'; São Paulo, Dantas de Souza Forbes priv. col., see Bardi, p. 201). Both represented an earthy primitivism and a cosmopolitan Surrealism that provided the materials for building further on the influential events of the Semana.

BIBLIOGRAPHY

E. Di Cavalcanti: *O testamento da alvorada*, i of *Viagem di minha vida* (Rio de Janeiro, 1955)

M. S. Brito: *Antecedentes da Semana de Arte Moderna*, i of *História do modernismo brasileiro* (Rio de Janeiro, 1964)

A. Amaral: *Artes plásticas na Semana de 22* (São Paulo, 1970)

M. R. Batista and others: *Brasil: 1o tempo modernista, 1917–1929* (São Paulo, 1972)

A. Avila: *O modernismo* (São Paulo, 1975)

P. M. Bardi: *História de arte brasileira* (São Paulo, 1975)

A. Amaral, ed.: *Arte y arquitectura del modernismo brasileño* (Caracas, 1978)

P. Rivas, ed.: 'Le Modernisme brésilien', *Europe* (1979) [special issue]

R. Pontual: *Entre dois séculos: Arte brasileira do século XX na Coleção Gilberto Chateaubriand* (Rio de Janeiro, 1987)

A. Amaral: *Arts in the Week of '22* (São Paulo, 1992)

——: 'Stages in the Formation of Brazil's Cultural Profile', *J. Dec. & Propaganda A.*, xxi (1995), pp. 9–25

ROBERTO PONTUAL

Seoane, Luis (*b* Buenos Aires, 1 June 1910; *d* La Coruña, Spain, 5 April 1979). Argentine painter and poster designer. He moved with his family in 1916 to Galicia and later to La Coruña, where he attended primary school, and then to Santiago de Compostela, where he undertook his initial studies and held his first exhibition in 1929. His first works, stimulated by Galician Romanesque art and in part also by German Expressionism, depicted figures from Galician folklore. In 1936 he returned to Argentina, where he dedicated himself to journalism and painting. Following a trip to Europe in 1949, during which he met with Picasso in Paris and Henry Moore in London, from 1951 to 1954 he subjected his work to successive simplifications through which he arrived at an almost abstract language, using outlines to enclose planes of pure colour. From 1954 Seoane gradually disassociated the linear elements from the colour, a process that culminated in works such as *Circus Figure* (1959; Buenos Aires, Mus. Mun. A. Plást. Sívori), in which the decisive role is played by line. In 1952 he designed the first abstract posters in Argentina for a commercial company; he also painted numerous murals in Buenos Aires and designed tapestries in Santiago de Compostela. As a painter he favoured still-lifes, figures and popular themes, as in *Marisqueras 1 (Women Selling Shellfish)* (1969; see fig.).

BIBLIOGRAPHY

R. Squirri: *Seoane: Estudio crítico–biográfico* (Buenos Aires, 1976)

T. Alva Negri: *Luís Seoane* (Buenos Aires, 1981)

X. Cid Cabido: *Seoane (1910–1979): Unha fotobiografía* (Vigo, Galicia, 1994)

H. González Fernández: *Luís Seoane* (Vigo, Galicia, 1994)

NELLY PERAZZO

Luis Seoane: *Marisqueras 1#*(*Women Selling Shellfish*), oil on canvas, 1.14×1.46 m, 1969 (Buenos Aires, Museo de Arte Moderno)

Serpa, Ivan (Ferreira) (*b* Rio de Janeiro, 1923; *d* Rio de Janeiro, 1973). Brazilian painter, draughtsman and teacher. While studying engraving in 1946 with the Austrian Axel Leskoschek (*b* 1889) in Rio de Janeiro he worked in a figurative style but soon became one of the pioneers of concrete art in Brazil. In 1951 he was named best young national painter at the first São Paulo Biennale for his geometric constructions such as *Formas* (1951; U. São Paulo, Mus. A. Contemp.). He was the founder and prime mover of the Frente group of geometric artists in Rio de Janeiro. A trip to Italy and Spain awarded to him by the Salão Nacional de Arte Moderna, Rio de Janeiro, in 1957 led him first to a freer abstraction and subsequently to a type of *Art informel* that developed on his return to Brazil into an expressive and referential style similar to Cobra. His *Animals* and *Darkness* series of paintings and drawings (1963–6), such as *Marisqueras I* (1964; U. São Paulo, Mus. A. Contemp.; see fig.), are images of pain and aggression that transform human beings into monsters. His subsequent pen-and-ink drawings subject the female form to an obsessive and clinical eroticism (e.g. *Women and Animals*, 1966; Rio de Janeiro, Col. Gilberto Chateaubriand), but from 1968 until the end of his life he concentrated on precise, almost mathematical construction of pictorial space in vivid colours comparable to Op art and the work of Josef Albers (e.g. *Geomantica*, 1972; São Paulo, Julio Bogoricin priv. col.). He worked, especially in the Museo de Arte Moderna in Rio de Janeiro, as a teacher of art to children and adults, exerting a strong influence over a whole generation of young artists. The same museum organized a posthumous retrospective in 1974.

BIBLIOGRAPHY
M. Pedrosa and I. Serpa: *Crescimento e Criação* [Growth and creation] (Rio de Janeiro, 1954) [Serpa's teaching philosophy]
F. Morais: 'Ivan Serpa e seu comércio de espacialidade poética' [Ivan Serpa and his use of poetic space], *GAM*, 6 (1967), pp. 33–6
R. Pontual: 'Unidade e multiplicidade—O universo de Ivan Serpa' [Unity and multiplicity—the universe of Ivan Serpa], *GAM*, 18 (1969), pp. 20–23
A. Amaral, ed.: *Projeto construtivo brasileiro na arte, 1950–1962* [The Brazilian Constructivist movement in art, 1950–1962] (São Paulo, 1977), pp. 172–5

Ivan Serpa: *Marisqueras I*, oil on canvas, 1.00×1.15 m, 1964 (São Paulo, Universidade de São Paulo, Museu de Arte Contemporânea)

Expressionismo no Brasil: Heranças e afinidades [Expressionism in Brazil: legacies and affinities] (exh. cat. by S. T. Barros and I. Mesquita, São Paulo, 18th Biennale, 1985), pp. 37, 39, 47, 112, 122
Ivan Serpa: Retrospectiva, 1947–1973 (exh. cat. by R. Roels jr, Rio de Janeiro, Cent. Cult. Brasil, 1993)
H. M. Dias Ferreira: *Ivan Serpa: O 'expressionista concreta'* (Rio de Janeiro, 1996)

ROBERTO PONTUAL

Serrano, Francisco J. (*b* Mexico City, 12 March 1900; *d* Mexico City, 3 Dec 1982). Mexican architect. He studied at the Universidad Nacional Autónoma de México (1924–5) and was one of several architects in the 1930s and early 1940s who introduced to Mexico a style of predominantly geometric, zigzagging architectural designs, and the use of mosaics and metals to achieve a characteristic polychromy and shine. This formal language was most successful in private commissions and was later promulgated in the exhibition of decorative arts that took place in Paris in 1952. Some of Serrano's residential apartment buildings, such as the Martí (1931), Querétaro 109 (1935) and the Cine Teresa (1931) in Mexico City are considered prototypes of Mexican Art Deco. On the other hand, the Basurto Building (1940–44) displays Serrano's compositional freedom, his imaginative approach to space that was unrestricted by the sharply rectilinear lines of the style.

BIBLIOGRAPHY
M. L. Cetto: *Modern Architecture in Mexico* (Stuttgart, 1961)
I. Katzman: *Arquitectura contemporánea mexicana* (Mexico City, 1963)
X. Esqueda: *Una puerta al Art-Deco* (Mexico City, 1980)
F. González Gortázar, ed.: *La arquitectura mexicana del siglo XX* (Mexico City, 1994)
L. Cruz González Franco: *Francisco J. Serrano, ingeniero civil y arquitecto* (Mexico City, 1998)

RAMÓN VARGAS

Shinki Huamán, Venancio (*b* Barranca, nr Paramonga, 1 April 1932). Peruvian painter. He was born to a Japanese father and a Peruvian mother. He attended the Escuela Nacional de Bellas Artes in Lima, where he was taught by, among others, Sabino Springuett, Ricardo Grau and Juan Manuel Ugarte Eléspuru. His work was inspired partly by travels through Ecuador, Mexico and Peru, but in its symbolism it also reflected his admiration for the works of Bosch, El Greco, Klee and Miró; with its subtle range of tones and textures and its undefined forms it also expressed elements of his Japanese heritage. In the 1960s Shinki Huamán began to explore further the use of tone as a means of conveying space, while figurative elements reflected the Surrealist interest in the subconscious (e.g. *Night, Day and You*, 1968; Lima, Banco de Crédito del Perú).

BIBLIOGRAPHY
J. Villacorta Paredes: *Pintores peruanos de la República* (Lima, 1971), pp. 122–4
J. A. de Lavalle and W. Lang: *Pintura contemporánea, II: 1920–1960*, Col. A. & Tesoro Perú (Lima, 1976), pp. 174–7

W. IAIN MACKAY

Sibellino, Antonio (*b* Buenos Aires, 7 June 1891; *d* Buenos Aires, 18 July 1960). Argentine sculptor and painter. He studied first under the Spanish sculptor Torcuato Tasso y Nadal (1855–1935) and the Argentine sculptor Arturo Dresco (1875–1961) and then at the Academia Nacional de Bellas Artes in Buenos Aires. A scholarship awarded to him by the Argentine government

Antonio Sibellino: *Woman with Handkerchief*, terracotta, 850×400×560 mm, 1946 (Buenos Aires, Museo Nacional de Bellas Artes)

spaces became radiant and expansive. Interested in dream images and paradoxes, he evoked different pictorial planes in his painting *Two Rooms* (1986; Chicago, IL, Gwenda Jay Gal., see 1987–9 exh. cat., p. 284), turning the depicted spaces into stagelike arenas where props, backdrops and real objects possess the same ontological status. With these devices he affirmed the illusive quality of pictorial space and the charm of theatrical forms of representation, which link him to such Latin American artists as Mario Carreño and Fernando Botero, who also used metaphors of theatre to expand the power of their images; Sierra's sense of colour and texture, however, are indisputably North American. He participated in such major group exhibitions as: *Hispanic Art in the United States*, organized by the Corcoran Gallery of Art, Washington, DC, and the Houston Museum of Art (1987); and a survey of Cuban émigré art from 1960, *Outside Cuba/Fuera de Cuba*, organized by Rutgers University, New Brunswick, NJ (1987).

BIBLIOGRAPHY
Hispanic Art in the United States: Thirty Contemporary Painters & Sculptors (exh. cat. by J. Beardsley and J. Livingston, Washington, DC, Corcoran Gal. A.; Houston, TX, Mus. F.A.; 1987)
Outside Cuba/Fuera de Cuba (exh. cat. by I. Fuentes-Perez, G. Cruz-Taura and R. Pau-Llosa, New Brunswick, ME, Rutgers U., Zimmerli A. Mus.; New York, Mus. Contemp. Hisp. A.; Oxford, OH, Miami U., A. Mus.; and others; 1987–9), p. 284

RICARDO PAU-LLOSA

in 1909 enabled him to travel through France, England, Belgium, Switzerland and Spain; he studied at the Accademia Albertina di Belle Arti in Turin and in 1911 installed himself in a studio in Paris, returning to Argentina in 1913. He returned to France on a second scholarship, exposing himself to the influence of Symbolism and Cubism, but was repatriated in 1915.

In the 1920s Sibellino was one of the first sculptors in Latin America to use abstract forms (e.g. *Composition of Forms: Twilight*, bronze, 1×0.54 m, 1926; San Salvador, Dir. Cult. & Turismo). In works such as the carving *Love* (terracotta, 750×750 mm, 1927; La Plata, Mus. Prov. B.A.) he combined the influence of Rodin and Emile-Antoine Bourdelle with that of Cézanne, representing form by means of intersecting planes. Between 1938 and 1944 he abandoned this tendency to abstraction in favour of a more expressionist style applied to subject-matter drawn from the Spanish Civil War, as in *Woman with Handkerchief* (1946; see fig.). He worked slowly, completing few sculptures but gradually achieving a great economy of means. He spent the last years of his life painting portraits and still-lifes, which he called *Pittura Metafisica*.

BIBLIOGRAPHY
J. E. Payró: 'Escultura moderna: Curatella Manes y Sibellino', *Ars*, xii/61 (1963)
A. O. Nessi: *Sibellino* (Buenos Aires, 1981)
J. López Anaya: *Historia del arte argentino* (Buenos Aires, 1997)

NELLY PERAZZO

Sierra, Paul (*b* Havana, 30 July 1944). Cuban painter, active in the USA. He settled in Chicago in 1961 and studied at the Art Institute of Chicago from 1963 to 1966. His work from the 1970s showed his fascination with body language. The figures in these paintings mimic the mannerisms of early cinema, but by 1980 Sierra had shifted his attention to a kind of magical realism. His colours and

Sigala, José (*b* Barquisimeto, 1940; *d* Barquisimeto, 26 July 1995). Venezuelan photographer and teacher. He first studied architecture, ceramics and jewellery, but in 1963 turned to the study of photography in Philadelphia with Murry Weiss and Sol Libsohn, returning to Venezuela in 1964 where he taught and led workshops in photography at the Instituto de Diseño, Caracas, and at the Consejo Nacional de la Cultura, Caracas. Sigala worked as a photographer for the Museo de Arte Contemporáneo in Caracas and for the newspaper *El nacional* and its magazine *Pandora*. He coordinated the photography for the newspaper *El informador* in Barquisimeto. Sigala concentrated on photographing people, as in *Vicky* (1964; Caracas, Mus. B.A.) and the series of 13 photographs of *María Antonieta Cámpoli* (1974; Caracas, Mus. A. Contemp. Sofía Imber). In 1990 he was awarded the Premio Nacional de Fotografía.

BIBLIOGRAPHY
M. T. Boulton: *Anotaciones sobre la fotografía venezolana contemporánea* (Caracas, 1990)

MARÍA ANTONIA GONZÁLEZ-ARNAL

Silva, Carlos (*b* Buenos Aires, 1930; *d* Buenos Aires, 14 June 1987). Argentine painter. He studied briefly under Vicente Puig but was essentially self-taught, forming the theoretical basis of his work from the writings of Kandinsky, Mondrian, Max Bill and Tomás Maldonado. His preference for simple geometric shapes also owed something to the theories of the French mathematician Jules Henri Poincaré, whose ideas about the reduction of natural forms to geometric ones had earlier helped set the terms for Cubism. Using a rectilinear grid as a framework for marks of different colour, he was able to create strong suggestions of movement.

Silva based his evocative schemes on mathematical principles, in later works relying on the relationship

between sets of three and square roots as a way of varying the rhythm of the grid. In works such as *Exult* and *Vivaldi* (1964; both Buenos Aires, Mus. A. Mod.) he used a great variety of circular and oval dots to create a sense of expansion outwards from the centre to the periphery. After 1970 his grids were no longer dictated by mathematical calculations, instead breaking free from such principles in order to relay more forcefully the expressive possibilities of a geometrical language rooted in his own sensibility. He also designed textiles and worked as a graphic designer.

BIBLIOGRAPHY

J. Romero Brest: *El arte en la Argentina* (Buenos Aires, 1968), p. 60
J. Sapollnik and N. Wicnudel: *Carlos Silva* (Buenos Aires, 1981)
Carlos Silva (exh. cat., Buenos Aires, Fund. San Telmo, 1991)
J. López Anaya: *Historia del arte argentino* (Buenos Aires, 1997)

NELLY PERAZZO

Silva, Federico (*b* Mexico City, 16 Sept 1923). Mexican painter and sculptor. Although he was essentially self-taught, he worked as an assistant to David Alfaro Siqueiros from 1945 and was decisively influenced by him in his early work with regard to both style and subject-matter. Silva's mural *Technology in the Service of Peace* (1953; Mexico City, Escuela Sup. Arquit. Pol.) is an outstanding example from those years, in which his work was imbued with a realism and a profound commitment to socialism.

In 1968, after a period of analysis and introspection during which he almost abandoned painting altogether, Silva returned to art through kinetics, light and abstraction. He held three exhibitions in which he revealed himself to be an innovative artist able to master new technology: *Arte cinético* (Mexico City, Mus. A. Mod., 1969), *Lumínica no. 2 y laser* (Mexico City, Pal. B.A., 1972) and *Objetos del sol y otras energías libres* (Mexico City, Pal. B.A., 1976). The creation of electro-mechanical objects to produce effects of movement or light introduced him to sculpture, of which there are fine examples of different types in the grounds of the Universidad Nacional Autónoma de México in Mexico City: *Bird C* (1976), a steel mobile; *Autonomy* (1979), made from triangular modules; the environmental work *Espacio escultorico* (1979), on which he collaborated with Mathias Goeritz and other artists; and *Snakes of the Pedregal* (1986), a monumental work in stone and concrete. He also produced large-scale easel paintings and the murals *Story of a Mathematical Space* (1979; Mexico City, U. N. Autónoma, Facultad de Ingeniería), which makes superb use both of colour and of a rigorously geometric abstraction, and *La Cueva de Huites*, painted on a large manmade tunnel.

WRITINGS

Objetos del sol y otras energías libres (exh. cat., Mexico City, Pal. B.A., 1976)
La escultura y otros menesteres (Mexico City, 1987)
'Crónica', *La Cueva de Huites, una pintura rupestre al norte de Sinaloa*, by A. de Luna, X. Moyssén and others (Mexico City, 1998)

BIBLIOGRAPHY

Federico Silva (Mexico City, 1979)
L. Noelle: *Génesis de un mural* (Mexico City, 1981)
R. Bonifaz Nuño: *Un arte intemporal de Federico Silva* (Mexico City, 1993)
Silva Federico: Nuestra Batalla. Obra monumental: Escultura y pintura (exh. cat., Mexico City, Mus. Pal. B.A., 1996)

LOUISE NOELLE

Silva, Valentim da Fonseca e. *See* FONSECA E SILVA, VALENTIM DA.

Silvera, Eudoro (*b* David, Chiriquí, 7 May 1917). Panamanian painter and musician. He studied under Roberto Lewis at the Escuela Nacional de Pintura in Panama City in the 1930s and from 1942 to 1950 at the Juilliard School of Music and the Cooper Union in New York. He held his first one-man exhibition in 1947 in New York, but he was most active in the 1950s and 1960s, winning an Honourable Mention at the São Paulo Bienal in 1957. Silvera had a preference in his paintings for local subject-matter, including religious customs, dancers, musicians, tropical fruit and fish, and in works such as *Untitled* (1954; Panama City, C. M. Gasteazoro priv. col., see Wolfschoon), featuring a guitarist, he explored symbolism and dramatic impact by means of elongated figures and stylized shapes influenced by Cubism. His wide stylistic range encompassed expressionism to semi-abstraction, and he also made caricatures.

BIBLIOGRAPHY

R. Miró: 'Eudoro Silvera', *La República: Supl. Dominical* [Panama City] (19 Aug 1979), p. 1G
R. Oviero: 'Silvera vuelve a exponer después de seis años', *La Prensa* [Panama City] (26 May 1983), p. 4B
E. Wolfschoon: *Las manifestaciones artísticas en Panamá* (Panama City, 1983, p. 180)

MONICA E. KUPFER

Simone, Alfredo de. *See* DE SIMONE, ALFREDO.

Sinclair (Ballesteros), Alfredo (*b* Panama City, 8 Dec 1915). Panamanian painter. He studied under Humberto Ivaldi in Panama and at the Escuela Superior de Bellas Artes Ernesto de la Cárcova in Buenos Aires, where he was first exposed to abstract art and international trends. During the 1940s and 1950s he experimented with academic, Cubist and Abstract Expressionist styles, before defining a semi-abstract approach emphasizing colour and light. He made numerous collages, such as *Fish* (1968; Panama City, Mus. A. Contemp.), in which he sometimes incorporated fragments of coloured glass, a reference to his earlier occupation as a maker of neon signs. In the 1970s the figurative references in Sinclair's paintings were reduced to small, virginal faces among abstract shapes; some works, such as the small colour studies called *Stains* (e.g. *Mancha*, 1971; Panama City, Mus. A. Contemp.), are completely abstract. Another series, *Movements of a River* (e.g. 1981; Panama City, Mus. A. Contemp.), consists of simplified and monumental forms of luminous colour with soft, dark contours and a stained-glass quality that is typical of Sinclair's lyrical abstraction. A smooth and glossy surface and bright, translucent colours contribute to a mystical and contemplative effect in keeping with Sinclair's religious nature.

BIBLIOGRAPHY

Alfredo Sinclair: Imágenes (exh. cat. by H. Venegas, Ponce, Mus. A., 1985); rev. as *Alfredo Sinclair: Referencias* (exh. cat. by M. E. Kupfer, Panama City, Mus. A. Contemp., 1986)
Alfredo Sinclair: El camino de un maestro (exh. cat., Panama City, Mus. A. Contemp., 1991)
Crosscurrents: Contemporary Painting from Panama, 1968–98 (exh. cat. by M. Kupfer and E. Sullivan, New York, Americas Soc. A.G., 1998)

MONICA E. KUPFER

Siqueiros, David Alfaro (*b* Santa Rosalía de Camargo, 29 Dec 1896; *d* Cuernavaca, 6 Jan 1975). Mexican painter. From the start of his career he alternated between political

and artistic activity. His radical approach to art and his creation of new mural techniques made him one of the most influential figures on younger generations of international mural artists.

1. Life and work. 2. Working methods and technique.

1. LIFE AND WORK. He enrolled in architecture, painting and drawing classes at the Academia de S Carlos in Mexico City in 1911 and spent his first year there participating in a student strike organized to protest against outdated teaching methods. He studied *plein-air* painting at the new Santa Anita school, and he became involved in the students' political conspiracy against the Mexican dictator Victoriano Huerta (1913). The following year, as the Revolution continued, he joined the constitutionalist army of President Carranza, rising to a position on its general staff. His interest in art continued throughout the Revolution; a member of the Congreso de Soldados-Artistas in Guadalajara, in 1919 he was sent to Paris (where he first met Diego Rivera) by the government, both as a military attaché and as an artist on a scholarship. After prolonging his stay in Europe, Siqueiros returned to Mexico from Italy in 1922 at the invitation of José Vasconcelos, Secretary of Education (1921–4) in the new government of President Obregón. In Mexico City he joined in the educational and cultural programme established by Vasconcelos, for which Rivera was already painting a mural in the Escuela Nacional Preparatoria there (*see* MEXICO, §IV, 2(iv)(a)). In response to the new artistic and ideological opportunity made possible by Vasconcelos's ambitious painting programme, he helped to unionize the new mural movement under what came to be known as the Síndicato de Obreros Técnicos, Pintores y Escultores and became the editor of its news-sheet, *El Machete*. In 1923 he was elected to the executive committee of the Mexican Communist Party along with Rivera. For a while the artists' union in effect ran the Party, with *El Machete* becoming the official voice of Communism in Mexico.

Siqueiros wrote the union's manifesto, published in *El Machete* in 1924. In it he declared that easel painting was egotistic, over-intellectualized, élitist and insufficiently ideological to instruct the masses; in contrast to this, murals were not private property and reached a wider public. Further, artists must take the side, and the role, of workers, labour in teams to avoid bourgeois individualism, unionize themselves to protect the interests of their craft, and strive to create a proletarian art that would revolutionize the world. Although these ideals influenced the mural movement at its start, they were eventually perpetuated only by Siqueiros.

Between 1922 and 1924 Siqueiros painted a series of murals in the Escuela Nacional Preparatoria and assisted in the painting of another series in the former chapel of the University of Guadalajara in the state of Jalisco. The quality of his work at this time, however, cannot be compared with that of Rivera and José Clemente Orozco. In 1925 he gave up painting entirely, and for the next five years he devoted himself to Communist Party affairs and to the organization of labour unions. In 1930–31 he was imprisoned under a right-wing regime for his political

activities and later confined to the city of Taxco in the state of Guerrero. There he took up painting again and began a series of technical experiments. He was exiled in 1932 and went to Los Angeles, CA, where he painted several murals, the most notable being *Tropical America* for the Plaza Art Center. Threatened with deportation, he travelled in South America during 1933, painting experimental murals and vociferously proselytizing for a revolutionary art and social order in Uruguay, where he was imprisoned, and in Argentina, from which he was expelled.

From Argentina he went to New York, where he had his first solo show in the USA at Alma Reed's Delphic Studios early in 1934. Later in the year he returned to Mexico. At this time Siqueiros, an ardent Stalinist and advocate of industrial techniques in art, began to attack Rivera for his Trotskyism and interest in indigenous Mexico, setting off a vehement public debate between the two artists, which lasted until 1935. In 1936 Siqueiros returned to New York, where he participated in the first American Artists' Congress. He also established the Siqueiros Experimental Workshop, attracting a 'team' of young artists, many of whom were employed by the new Works Progress Administration's Federal Art Project. Siqueiros encouraged them to explore the use of synthetic paints, new techniques, such as the airbrush, and photography and film in the creation of both serious paintings and political floats and banners. He also produced several easel works at this time, of which the most famous are *Collective Suicide* (1936; see colour pl. XXXVI, fig. 1) and *Echo of a Scream* (1937; see fig. 1).

In 1937 Siqueiros joined the Spanish Republican Army and fought in the Spanish Civil War, returning to Mexico

1. David Alfaro Siqueiros: *Echo of a Scream*, enamel on panel, 1219×914 mm, 1937 (New York, Museum of Modern Art)

2. David Alfaro Siqueiros: *Portrait of the Bourgeoisie* (1939, originally titled *Portrait of Fascism*), mural using industrial enamel and spray-gun, on the stairwell of the Electricians' Union building, Mexico City

City two years later. In addition to easel works, for example *Ethnographia* (see colour pl. XXXVI, fig. 2), he painted one of his most important murals, *Portrait of Fascism* (now entitled *Portrait of the Bourgeoisie* ; see fig. 2), for the Electricians' Union building in the capital. In May 1940 he led an attempt to murder Leon Trotsky in his home in Mexico City. He was later acquitted and took refuge in Chile, where he was confined in the city of Chillán from 1941 to 1942. In 1943, after travelling extensively through Latin America, he painted several murals in Havana, Cuba, returning to Mexico in 1945.

During the years following World War II and throughout the 1950s Siqueiros concentrated more on his art. He painted several of his best-known murals in the Palacio de Bellas Artes in Mexico City on the themes of liberty and the Spanish Conquest and others in various government buildings in the capital. He continued to experiment with new techniques, of which the most innovative was *escultopintura* or the combination of sculpture and painting in his murals. In 1960, however, he again became embroiled in political controversy; he was arrested and later sentenced to eight years in prison. In 1964 he was pardoned. He immediately undertook to finish the projects he had begun before his arrest, such as his mural *From Porfirianism to the Revolution* in Chapultepec Castle, Mexico City. The following year he was privately commissioned to create a vast mural for a hotel complex in Cuernavaca in the state of Morelos. The original project was modified and transformed into the Poliforum Siqueiros (completed 1969) at

the Hotel de México in Mexico City. The Poliforum houses the mural relief *The March of Humanity in Latin America*, a work of stupefying visual rhetoric that nevertheless sums up Siqueiros's lasting ambitions for the mural. It also served to train an international group of young mural painters, many of whom went on to organize teams of artists to work as community muralists in the ghettos of the USA, Latin America and Europe during the late 1960s and after.

2. WORKING METHODS AND TECHNIQUE. While Siqueiros's rhetorical murals are closer to Orozco's expressionism than to the cerebral craft of Rivera, his reliance on blatant agitprop to convey his messages deprives his murals of a more human dimension. The images in them of the crucified worker, the lynched peasant, the machine of capitalism, the crying child, the rampant horse of the revolution and the massed, serried heads set against swags of red lack the links with tradition, the stylistic circumspection and the personal vision that are present in the work of his colleagues. The universality of their work contrasts with Siqueiros's robust but fatally tendentious talent. His most important contribution to wall painting was to make direct use of the mural's public nature to emphasize its social function. Whereas Rivera used architecture as a frame and Orozco treated it as a foil, Siqueiros employed it as the fulcrum of both style and message. If art was for the people, then it must involve them in its imagery physically and psychologically, as well as visually.

The Poliforum Siqueiros, an elliptical building the size of a football field, completely covered inside and out, ceiling and roof, with murals and *escultopintura*, was the culmination of nearly 40 years of research and experimentation. This began in Argentina in 1933 with his mural *Plastic Exercise*. Painted on the curved walls and floor of a tunnel-shaped bar in a private residence outside Buenos Aires, it became the prototype of the environmental form and technical methods favoured by Siqueiros during the rest of his career. First he organized a team of artists to work under his direction, the work being, at least in theory, a collective rather than an individual enterprise. He developed methods of analysing the viewpoints from which people would see his work by means of photography and film and then designed the mural in order to obtain maximum visual impact. Perhaps most importantly, he rejected the slow technique of fresco painting, which had been revived by his colleagues in the mural movement in keeping with Renaissance and Mexican traditions. Instead, he employed a method of direct painting, using quick-drying industrial enamels with spray-guns on cement.

These were the methods disseminated among the New York artists working in his Experimental Workshop in 1936–7. (The evidence suggests that Jackson Pollock first encountered the aleatory application of 'duco' enamel in Siqueiros's workshop.) Siqueiros again practised these techniques in 1939 while painting his mural for the stairwell of the Electricians' Union building. Here he deliberately ignored the cubic structure of the space, creating a continuous series of images across the walls and ceiling. He effectively masked the corners with the sweep of a dynamic composition that had been carefully calculated by studying the viewpoints of people circulating on the stairs.

Siqueiros used these techniques with many variations in almost all his subsequent murals, always seeking to envelop the viewer in an integrated painted environment. In 1948–9 he created another prototype of the Poliforum in the mural entitled *Monument to General Ignacio Allende* at the Escuela de Bellas Artes in San Miguel de Allende in the state of Guanajuato. The unfinished mural was begun on the ten walls, arches and ceilings of four domed bays with a programme that reaches from the past to the future in terms of a progression from figurative to abstract compositions.

By the 1950s Siqueiros had begun to experiment with *escultopintura*, most notably in the exterior cement relief covered with mosaics entitled *The People to the University and the University to the People* at the University City in Mexico City. In all of these efforts, which culminated in the Poliforum Siqueiros, his primary concern was the social accessibility and political purity of his imagery. Unlike his colleagues, whose work and political beliefs became less radical as they grew older, he never lost his faith in a revolutionary art and, as the youngest, lived to inspire a new generation of artist–activists. He ended his career as the most influential, if not the most accomplished, member of the Mexican mural movement, unflagging in his conviction that art is a weapon in the struggle for social justice, and that an artist must live, as well as depict, his beliefs.

WRITINGS

El Machete, vii (June 1924) [manifesto of the Sindicato de Obreros Técnicos, Pintores y Escultores, ed. Siqueiros]
Art and Revolution (London, 1975) [anthol. of writings dated 1921–60]
Me llamaban el Coronelazo (Mexico City, 1977) [autobiographical writings]

BIBLIOGRAPHY

M. Rogovin: 'The March of Humanity: An Expression in Public Art', *Alumni Bull.*, 26 (1969), pp. 19–29 [mem. of a team member who worked on the Poliforum Siqueiros]
R. Tibol: *David Alfaro Siqueiros: Un mexicano y su obra* (Mexico City, 1969)
S. M. Goldman: 'Siqueiros and Three Early Murals in Los Angeles', *A. J.* [New York], xxxiv/33 (1974), pp. 321–7
L. P. Hurlburt: 'The Siqueiros Experimental Workshop: New York, 1936', *A. J.* [New York], xxxvi/35 (1976), pp. 237–46
J. Renau: 'Mi experiencia con Siqueiros', *Rev. B.A.* (Jan/Feb 1976), pp. 2–25
L. P. Hurlburt: 'David Alfaro Siqueiros' *Portrait of the Bourgeoisie*, *Artforum*, xv/6 (1977), pp. 39–45
D. Rochfort: *The Development of a Revolutionary Public Mural Art in the Work of David Alfaro Siqueiros, 1896–1975* (diss., London, Royal Coll. A., 1986)
L. P. Hurlburt: *The Mexican Muralists in the United States* (Albuquerque, 1989)
X. Moysén: *David Alfaro Siqueiros: Pintura de caballete* (Mexico City, 1994)
P. Stein: *Siqueiros: His Life and Works* (New York, 1994)
Siqueiros/Pollock, Pollock/Siqueiros (exh. cat. by J. Harten, Düsseldorf, Ksthalle, c.1995)
M. González Cruz Manjárrez: *La polémica Siqueiros-Rivera: Planteamientos estético-políticos, 1934–1935* (Mexico City, 1996)
David Alfaro Siqueiros: Portrait of a Decade, 1930–1940 (exh. cat., Mexico City, Mus. N. A.; London, Whitechapel A.G.; 1996–7)
D. Rochfort: *Mexican Muralists: Orozco, Rivera and Siqueiros* (London, 1997)
Iconografía de David Alfaro Siqueiros (exh. cat., Mexico City, Inst. N. B.A., 1997)

FRANCIS V. O'CONNOR

Sívori, Eduardo (*b* Buenos Aires, 13 Oct 1847; *d* Buenos Aires, 5 June 1918). Argentine painter. After travelling in Europe he returned to Buenos Aires in 1873, greatly impressed by Corot's work. He studied at the Escuela Estímulo de Bellas Artes in Buenos Aires under the Italian-born Argentine painters Francisco Romero (1840–1906) and José Aguyari (1843–85) before returning in 1882 to Europe, where he studied at the Académie Colarossi in Paris and produced paintings influenced by Jean-Paul Laurens. Among the paintings exhibited by him at the Salon in Paris from 1886 to 1891 was *The Maid Getting Up* (exh. 1887; Buenos Aires, Mus. N. B.A.), which by virtue of its subject-matter and naturalistic style was considered so revolutionary in Buenos Aires that it could be exhibited there only privately at the time.

Sívori was one of the first painters in Argentina to begin to free himself from the constraints of Italian and Spanish realism. In his later pictures on domestic themes, and in landscapes such as *The Marsh* (1902; Buenos Aires, Mus. N. B.A.) and *Ranch with Ombú Tree* (Buenos Aires, Mus. A. Blanco), he adopted more fluid brushwork and increasingly bright colours. Like the Impressionists, whose paintings he had seen in Paris, he began to paint in the countryside itself rather than in the studio, capturing effects of light in an understated way. While incorporating some elements from Impressionism into his work, including a rather timid adoption of the principles of complementary contrasts of colours, he remained devoted to a recognizably Argentine subject-matter.

BIBLIOGRAPHY
C. Córdoba Iturburu: *La pintura argentina del siglo veinte* (Buenos Aires, 1958), pp. 32–3, 124–5
J. E. Payró: *La pintura* (Buenos Aires, 1988), vi of *Historia general del arte en la Argentina*, Academia Nacional de Bellas Artes (1982–8), pp. 159–62

NELLY PERAZZO

Sojo, Felipe (*b* ?Mexico City, 1833; *d* Mexico City, 5 July 1869). Mexican sculptor. He was an outstanding pupil of Manuel Vilar at the Academia de S Carlos, Mexico City, which he entered in 1845. His important student work included the sculpture *Mercury Putting Argos to Sleep* (1854; Mexico City, Mus. N. A.), in which the figure of the god had obvious affinities to the *Mercury* of Bertel Thorvaldsen (1818; Copenhagen, Thorvaldsens Mus.), and the relief, *Descent from the Cross* (1855; Mexico City, Mus. N. A.), an ambitious composition in which the actions of a group of people are skilfully interwoven. Both works reveal the purist direction of the academy's teaching. On the death of Vilar, Sojo was appointed director of the sculpture department (1860), a position he occupied until 1868. He was one of the artists favoured under the liberal cultural policies adopted by Maximilian, Emperor of Mexico (*reg* 1864–7). His best-known work is a pair of marble busts of the *Emperor* and his wife, *Empress Charlotte* (versions in Mexico City, Mus. N. A. and Mus. N. Hist.).

BIBLIOGRAPHY
S. Moreno: 'Un siglo olvidado de escultura mexicana', *A. México*, cxxxiii (1970), pp. 10–12, 54–6

FAUSTO RAMÍREZ

Solar, Xul. *See* XUL SOLAR.

Solari, Luis (*b* Fray Bentos, 17 Oct 1918; *d* Montevideo, 13 Oct 1993). Uruguayan printmaker and painter. He moved to Montevideo in 1934 to study drawing and painting at the Círculo de Bellas Artes until 1937 under Guillermo Laborde (1886–1940). He pursued his particular interest in etching in 1952 during a three-month course at the Ecole Nationale Supérieure des Beaux-Arts in Paris under Edouard Goerg (1893–1968), and from 1967 to 1969 he took advanced courses at the Pratt Graphic Center and the New York Graphic Workshop under the Brazilian Roberto De Lamonica (*b* 1933) and the Uruguayan Luis Camnitzer (*b* 1937). His most notable works, including mezzotints and acrylic paintings, for example *Painting and Collage* (see Argul, 1966, pl. 64), are of clumsy and animal-like masked figures whose costumes reveal rather than conceal their true identity. The humanist conception carries vestiges both of the medieval period and of the colonial legacy. Among Solari's many prizes and distinctions were first prizes for drawing at the Salón Nacional de Bellas Artes in Montevideo in 1955 and 1964, the first prize for painting there in 1965 and the gold medal for printmaking at the first Bienal de Artes Gráficas in Cali, Colombia, in 1977. In 1989 the Museo Solari opened in the city of Fray Bentos showing his works and promoting fine arts in the region.

BIBLIOGRAPHY
J. P. Argul: *Las artes plásticas del Uruguay* (Montevideo, 1966); rev. as *Proceso de las artes plásticas del Uruguay* (Montevideo, 1975)
A. Kalenberg: 'Solari, el pueblo, el mundo', *Eco* (Dec 1974)
Arte contemporáneo en el Uruguay (exh. cat., ed. A. Kalenberg; Montevideo, Mus. N. A. Plást., 1982)

Luis Solari: Una visión retrospectiva, 1948–1988 (exh. cat., Montevideo, Mus. Mun. Blanes, 1989)

ANGEL KALENBERG

Solentiname primitivist painting. Style of painting practised from 1968 by a Nicaraguan group of rural labourers on the island of Mancarrón in the Solentiname archipelago of Lagos de Nicaragua. The style took its name from the parish in which it arose with the encouragement of Padre Ernesto Cardenal (*b* 1925), a priest, poet and man of letters who in 1979 became the Minister of Culture in Nicaragua. This community of 1000 impoverished labourers was established in 1965 around the basic precepts of liberation theology, with its emphasis on social justice and communal sharing being predicated on a type of Christian Socialism. Motivated by these egalitarian ideals and a deep involvement with the arts, Cardenal invited the painter Roger Pérez de la Rocha (*b* 1949) to Solentiname to introduce the populace to the fine arts.

Pérez de la Roche's arrival in 1968 stimulated a general interest in oil painting, so that within a few years a high percentage of the population in Solentiname, including entire families such as the Aranas, the Guevaras and the Silvas, had become part of a distinctive new school of naive or primitivist painting that had recourse to imagery from popular art forms such as weaving and painted gourds. Solentiname paintings, such as Alejandro Guevara's *Lagos de Nicaragua* (*c*. 1980; see Cardenal, 1980, p. 29), generally depict local landscapes accented by various aspects of daily life: workers in the fields, well-known sites, leisurely interchange in villages and glimpses of the animal kingdom. Some works feature biblical episodes interpreted according to liberation theology, as in Gloria Guevara's *Crucifixion* (*c*. 1979; see Valle-Castillo, p. 184), which depicts Christ neither as a transcendental entity nor as a superhuman historical force but as an ordinary labourer.

By means of overlapping forms, even lighting and a non-hierarchical disposition of figures in relation to each other and to nature, Solentiname primitivist paintings do not so much depict the life of the area's rural inhabitants as evoke an almost tactile sense of the material fabric of the place and of its social relations. Following the involvement of several labourers from Solentiname in an uprising against General Somoza in 1977, the dictator ordered the complete destruction of the parish, including all its artworks and its library. The suppression of this art continued until the overthrow of Somoza by revolutionary forces in 1979, at which time it began again to occupy an important place in national cultural developments. During the decade of Sandinista leadership in Nicaragua (1979–90), the earlier artistic achievement of Solentiname served as an important model for the art programs and cultural policies instituted by Ernesto Cardenal and the FSLN, the Sandinista National Liberation Front.

BIBLIOGRAPHY
E. Cardenal: 'Lo que fue Solentiname', *Casa Américas*, 108 (1978), pp. 158–60
——: *Tocar el cielo* (Managua, 1980)
I. Rodríguez Prampolini: 'Ante una exposición de Solentiname', *Casa Américas*, 118 (1980), pp. 114–15
E. Cardenal: *Nostalgia del futuro* (Managua, 1982)

J. Valle-Castillo: 'Los primitivistas de Nicaragua', *Nicaráuac*, vi/12 (1986), pp. 161–85
D. Craven: *The New Concept and Popular Culture in Nicaragua since the Revolution in 1979* (Lewiston, 1989), pp. 15–20

DAVID CRAVEN

Soler, Ignacio Nuñez. *See* NUÑEZ SOLER, IGNACIO.

Solón Romero, Walter (*b* Sucre, 1925). Bolivian painter, printmaker and draughtsman. He studied fine arts in La Paz, Sucre and Santiago, Chile, and graphic arts in Rio de Janeiro. He worked principally in Sucre and La Paz, although he travelled widely and exhibited his art in one-man shows, group exhibitions and biennales in Latin America, Europe, Africa and Asia. He was a founder-member of the group Anteo in Sucre and a member of the painters' group 'Generación del 52'. His most important works were murals, which were inspired by Mexican examples. These include *Jaime Zudañes and the May Revolution* (1952), *Mariano Moreno and the Doctors of Charcas* (1952; U. Sucre), *Message to the Teachers of the Future* (1953; Sucre, Escuela N. Maestros), and *Portrait of a Town* (1983; La Paz, U. Hall). Romero's subject-matter was social dissent and protest against political injustice. He made use of historical allegory in a pedagogical way, both in his paintings and in his many engravings and illustrations, notably in the series *Don Quixote and the Dogs*. He also worked a great deal on tapestries, seeking to restore importance to a medium that in pre-Hispanic times was considered one of the highest forms of plastic cultural expression.

BIBLIOGRAPHY
P. Querejazu: *La pintura boliviana del siglo XX* (Milan, 1989)

PEDRO QUEREJAZU

Sordo Madaleno, Juan (*b* Mexico City, 28 Oct 1916; *d* 13 March 1985). Mexican architect and urban planner. He graduated from the Escuela de Arquitectura, Universidad Nacional de México, Mexico City, in 1939. His buildings are notable for the variety of both type and style, reflecting his eclectic and well-informed approach to contemporary trends in architecture. Notable examples of Sordo Madaleno's work in the International Style are his own house (1952), modified with personal touches, the Cine París (1954), with its surprising structure and composition, and the Seguros Anáhuac Building (1958; all Mexico City). He significantly influenced the design of hotels in Mexico by introducing new concepts to meet the demands of tourism and was also among the first to introduce into Mexico a new type of large-scale commercial centre, such as the Plaza Satélite (1971), Mexico City. His ability to produce works to suit a particular function is demonstrated by the Merck Sharp & Dohme Laboratories (1960) and his last major project, the Centro Operativo Bancomer (1978; both Mexico City).

BIBLIOGRAPHY
M. L. Cetto: *Moderne Architektur in Mexico* (Stuttgart, 1960; Eng. trans., New York, 1961)
'Juan Sordo Madaleno: Su obra', *Arquit. & Soc.*, xxxviii (1986), pp. 5–38
L. Noelle: *Arquitectos contemporáneos de México* (Mexico City, 1988)
F. González Gortázar, ed.: *La arquitectura Mexicana del siglo XX* (Mexico City, 1994)

XAVIER MOYSSÉN

Soriano, Juan (*b* Guadalajara, 18 Aug 1920). Mexican painter, draughtsman and sculptor. He was something of a prodigy by the age of 14 and held his first one-man exhibition in Guadalajara shortly before moving to Mexico City in 1935. Essentially self-taught, he worked first as a portraitist of the cultural élite, producing commissioned portraits of such well-known figures as Xavier Villurrutia, Gabriel Orendain, Rafael Solana, Luis G. Basurto and Diego de Mesa; two paintings of María Asúnsolo are particularly outstanding. Until 1954, when he travelled to Europe with Diego de Mesa, he painted a wide range of subjects, including landscapes and theatrical and magical pictures of Baroque archangels holding flaming swords, processions and boys and girls in ambiguous situations. The most evident stylistic influences on these works are from Jesús Guerrero Galván, Federico Cantú and Julio Castellanos. The impression conveyed is of mythological characters set against mountainous, arid or richly vegetated landscapes (e.g. *Untitled*, 1953; see colour pl. XXXVII, fig.1).

Soriano made frequent visits to Europe, living for a time in Rome and later settling in Paris. From 1954 to 1974 he painted in a semi-abstract style in works such as *Apollo and the Muses, Eyes and Radiant Fish* (1957–8; Mexico, Jorge López Páez priv. col.) and a series of portraits of *Lupe Marín* (1960; Mexico City, Gal. Ponce), which combine an identifiably Mexican spirit with a Mediterranean sense of light. He later turned to a figurative style, dominated by relationships of light and colour in place of the finely drawn outline by which he had previously enclosed the volumes.

Soriano also executed ceramic and bronze sculptures, including a monumental *Bull* installed on the banks of the Río Grijalba, marking the entrance to the Parque Garrido Canábal in Villahermosa, Tabasco. In 1987 he was awarded the Premio Jalisco and the Premio Nacional de Arte, the most prestigious prize for artistic achievement in Mexico.

BIBLIOGRAPHY
J. Fernández and D. de Mesa: *Juan Soriano* (Mexico City, 1976)
T. del Conde: *Juan Soriano* (Mexico City, 1984)
M. Teresa Marquez: *Autorretrato de Juan Soriano* (Mexico City, 1987)
C. Monsiváis and others: *Juan Soriano: Retratos y esculturas* (Mexico City, 1991)
Juan Soriano: Retrospectiva, 1937–1997 (exh. cat., Madrid, Mus. N. Cent. A. Reina Sofia, 1997)

TERESA DEL CONDE

Soriano, Rafael (*b* Cidra, Matanzas, 23 Nov 1920). Cuban painter, printmaker and teacher, active in the USA. He graduated from the Academia de S Alejandro in Havana in 1942 and from that year until his departure from Cuba for Miami, FL, in 1962, he taught at the Escuela de Artes Plásticas in Matanzas. From 1950 to 1964 he painted geometric abstractions, a popular form among Latin American artists of his generation, for example *Tension* (1964; Miami, FL, priv. col., see 1987 exh. cat., p. 191). By 1970, however, he had developed a luminist style of painting under the influence of Roberto Matta, exploring the unconscious not through Surrealist dream imagery but by means of light as a symbol of creative energy and thought. For Soriano, light revealed the inner spaces of solids, as in the terrain in *Furrows of Light* (1980; Miami, FL, Lowe A. Mus.), or the head in *Mercator's Dream* (1981;

Miami, FL, priv. col., see Pau-Llosa, 1987, p. 102). His first one-man exhibition was at the Lyceum in Havana in 1947, and he held an important exhibition at the Zea Museum in Medellín, Colombia, in 1981.

BIBLIOGRAPHY
J. Gómez-Sicre: 'The Subjective Painting of Rafael Soriano', *Latin Amer. Times*, ii/19 (1980), p. 30
R. Pau-Llosa: 'In Light's Dominion: The Art of Rafael Soriano', *Carib. Rev.*, xi/3 (1982), pp. 38–9
——: 'Painters of Time', *A. Int.*, n.s. i/1 (1987), pp. 100–04
Outside Cuba/Fuera de Cuba (exh. cat., New Brunswick, NJ, Rutgers U., Zimmerli A. Mus., 1987)
R. Pau-Llosa: 'The Oasis of the Infinite: Rafael Soriano and Enrique Castro-Cid', *Drawing*, xii (1991), pp. 97–101
RICARDO PAU-LLOSA

Sosa, Antonieta (*b* New York, 1 March 1940). Venezuelan conceptual and performance artist. She studied psychology at the Universidad Central de Venezuela, Caracas, and sat in on classes at the Escuela de Artes Plásticas Cristóbal Rojas (now the Escuela de Artes Visuales Cristóbal Rojas) in Caracas, at which she later taught (1983–94). In 1962–6 she studied art at the University of California, Los Angeles (UCLA), graduating with a degree in Plastic Arts (1966). Sosa returned to Venezuela in 1966 and combined her work with investigations into the expressive possibilities of the body. She was a founder-member of the dance group Contradanza (1973–6) and performed in *Las cosas que nos pasan* in Caracas. From 1970 she was highly active as a teacher of expression through movement and the plastic arts. In her work (examples in Caracas, Mus. B.A. and Ciudad Bolívar, Mus.) she reflected upon the surface and space and on the body as an instrument for the comprehension of such space. Sosa also used the chair as a structure from which to ponder the world, space and the role of the spectator.

Based on information supplied by LELIA DELGADO

Sotillo, Alvaro (*b* Caracas, 13 Nov 1946). Venezuelan graphic designer. He studied in Caracas at the Escuela de Artes Plásticas Cristóbal Rojas and at the Instituto de Diseño of the Fundación Neumann-Ince. As a designer he worked on books, magazines, catalogues and posters, as well as designing and executing prints, and he received numerous national and international awards. Among these was the Premio Letra de Oro in 1985 in the exhibition *Los libros más bellos del mundo* for *La emblemática de Gerd Leufert* (1972–85). Other works that received awards are *La gran sabana*, *El llano* (Caracas, 1977) and *Diccionario historia de Venezuela*.

BIBLIOGRAPHY
A. Armas Alfonzo: *Diseño gráfico en Venezuela* (Caracas, 1985)
ANA TAPIAS

Soto, Jesús (Rafael) (*b* Ciudad Bolívar, 5 July 1923). Venezuelan painter, sculptor and kinetic artist. He studied at the Escuela de Artes Plásticas in Caracas from 1942 to 1947, and from 1947 to 1950 he was director of the Escuela de Bellas Artes in Maracaibo. At first he painted principally under the influence of Cézanne and Cubism and to a lesser extent under that of Mondrian and the Soviet Constructivists, whose work he knew from reproductions. In 1950 he settled in Paris, where he began producing abstract paintings composed of serialized and geometric forms that suggested effects of motion. These revealed Soto's affinities with other artists later associated with Op art. His first kinetic work, *Spiral* (1955; priv. col., see Joray and Soto, p. 57), consisted of two overlapping perspex sheets, each painted with a spiral to produce an apparently vibrating image. The exhibition *Le Mouvement* at the Galerie Denise René, Paris, in 1955, at which *Spiral* was shown along with works by Victor Vasarely, Yaacov Agam, Jean Tinguely, Pol Bury and others, marked the official birth of Kinetic art.

Soto favoured industrial and modern synthetic materials such as perspex, nylon, steel, thin metal rods and industrial paint in the series of works incorporating real and apparent movement that he began in 1955. In the early 1960s he explored the textures of *objets trouvés*, including old wood, discarded and rusty wire and unravelled rope, in such works as *Old Timber* (1960; untraced, see Joray and Soto, p. 93). His kinetic works created oppositions between static and dynamic elements so as to invite the spectator's active participation both visually and intellectually. His *Penetrables* of the 1960s took this involvement one step further by inviting the spectator into a transparent, fluid and moving mass of suspended nylon threads. The transparent perspex *Cube with Ambiguous Space*, which he exhibited at the Stedelijk Museum, Amsterdam, in 1968 (see Joray and Soto, pp. 220–26), deliberately dislocated the spectator's ability to distinguish between solid objects and open space, between reality and illusion. This was followed in 1969 by two murals executed for the UNESCO buildings in Paris.

Soto pursued his investigation of brain and eye in the 1970s in such works as *Suspended Apparent Volume* (1976; see fig.), a monumental assemblage of aluminium tubes painted yellow and white and suspended from the ceiling so as to form part of the architecture. Other works of this period that reveal Soto's interest in the relation between architecture and sculpture include monumental environmental installations intended to occupy space in an urban setting, such as the *Monument to the Nationalization of Steel*

Jesús Soto: *Suspended Apparent Volume*, painted aluminium tubes, 30.5×18.3×24.4 m, 1976 (Toronto, Royal Bank of Canada)

(180×120 m), commissioned in 1975 by the Venezuelan President Carlos Andrés Pérez for Ciudad Guayana. In his kinetic works of the 1980s, such as the *Ambivalences* series, Soto introduced a variety of colours (in contrast to the deliberately restricted colour range that had dominated his early works) arranged almost arbitrarily to create an impression of vibrating movements and a destabilized physical structure (e.g. *Ambivalence on a Rhombus*, 1981; priv. col., see Joray and Soto, p. 136). Other important works of the 1980s include the large kinetic sculpture (1983) at the Chacaito metro station at Caracas; the ceiling (1983) of the Teresa Carreño Theatre, Caracas; and *Nylon Cube* (1983), a cube formed of nylon threads that disappears, reappears and becomes transparent in front of the spectator, demonstrating Soto's interest in the apparent conversion of physical matter into energy.

BIBLIOGRAPHY
Soto (exh. cat. by G. Brett, New York, Marlborough–Gerson Gal., 1969)
A. Boulton: *Soto* (Caracas, 1973)
B. Rodríguez: *La pintura abstracta en Venezuela, 1945–1965* (Caracas, 1980)
J. Balza: *Jesús Soto, el niño* (Caracas, 1981)
R. Guevara: *Ver todos los días* (Caracas, 1981)
M. Joray and J. R. Soto: *Soto* (Neuchâtel, 1984)
Jesús Soto: La física, lo inmaterial (exh. cat., Caracas, Mus. B.A., 1993)
Tres maestros de abstraccionismo y la proyección internacional (exh. cat., by G. Rubiano, Caracas, Gal. A. N., 1994)
23a Bienal internacional São Paulo, Fundação Bienal de São Paulo (Sao Paulo, 1996)
BÉLGICA RODRÍGUEZ

Spazialismo [It.: 'spatialism']. Italian art movement founded by LUCIO FONTANA *c.* 1947 in Milan. The theory of Spazialismo was anticipated in the *Manifiesto blanco* (Buenos Aires, 1946), which was produced by Fontana and colleagues during his time in Argentina during World War II. Subsequently six manifestoes were produced (1947–52), including a *Manifesto tecnico dello spazialismo* (Milan, 1951). Fontana and his associates felt that the time had come to move away from the flat surface and illusory space of the canvas and towards an art that was a synthesis of colour, sound, movement, time and space: an art, moreover, that took account of new techniques made possible by scientific progress (e.g. television, neon lighting). In keeping with this regard for scientific discovery was Fontana's proposal that matter should be transformed into energy and invade space in dynamic form. This view resulted in various temporary constructions (e.g. *Spatial Environment*, Milan, Gal. Naviglio, 1949), which anticipated such developments as environmental and performance art. Fontana's attempts to get away from the flat surface of canvas led to paintings in which the canvas was pierced by holes or slashes, sometimes made more three-dimensional by the application of objects or materials, such as coloured glass, as in his *Spatial Concept* of 1955 (Milan, Civ. Mus. A. Contemp.; *see* FONTANA, LUCIO, fig. 1).

BIBLIOGRAPHY
M. Tapié: *Devenir de Fontana* (Turin, 1965)
Luciano Fontana, 1899–1968 (exh. cat., Barcelona, Cent. Cult. Fund. Caixa Pensions, 1988)
Luciano Fontana: Paintings (exh. cat., Cologne, Gal. Karsten Greve, 1988)
Fontana e lo Spazialismo (exh. cat., Osaka, Kodama Gal., 1988)
D. Marangon: *Spazialismo: Protagonisti, idee, iniziative* ([Italy], 1993)
Spazialismo: Arte astratta. Venezia 1950–1960 (exh. cat., Vicenza, Cent. Int. Stud. Archit. Palladio, 1996)

Spilimbergo, Lino Eneas (*b* Buenos Aires, 12 Aug 1896; *d* Unquillo, Córdoba, 17 March 1964). Argentine painter and draughtsman. After studying at the Academia Nacional de Bellas Artes in Buenos Aires, he worked in Italy and France from 1925 to 1928. While in Italy he became interested in the work of Giovanni Bellini, in the treatment of the figure in the paintings of Piero della Francesca, and in the concise and dramatic conception of Giotto's art. Seeking an objective approach, Spilimbergo created monumental forms that look almost petrified in their sculptural contours and that are subject to the rational control of the underlying geometric structures, independent of the image represented. In characteristic paintings such as *Figures* (Buenos Aires, Mus. N. B.A.), one of several completed between 1931 and 1940, he conveyed a psychological penetration married to the formal values of a carefully articulated, balanced composition, animated by linear arabesques and arriving at an image at once naturalistic in treatment and hieratic in feeling.

BIBLIOGRAPHY
L. Hurtado: *Lino Spilimbergo* (Buenos Aires, 1941)
E. Azcoaga: *Lino Eneas Spilimbergo* (Buenos Aires, 1963)
J. López Anaya: *Spilimbergo* (Buenos Aires, 1980)
J. López Anaya: *Historia del arte argentino* (Buenos Aires, 1997)
HORACIO SAFONS

Springuett, Sabino (*b* Parinacocha, Ayacucho, 12 July 1913). Peruvian painter and teacher. He studied at the Escuela Nacional Superior de Bellas Artes in Lima under Daniel Hernández, Jorge Vinatea Reinoso and José Sabogal, graduating in 1934. Even in his earliest work he showed a special interest in the vernacular, although he maintained a certain distance from the emphasis on indigenous subject-matter shown in the work of Sabogal. A skilful painter with a fresh and graceful use of colour, he had a preference for the deserted landscape of the Peruvian coast and for images related to those seen in the high-quality crafts of his native province, although he also produced some abstract paintings characterized by strong contrasts. In addition he executed a number of murals: in Lima for the Universidad Nacional de Ingeniería, the Ministry of Public Health and the Eternit factory, and also in Miraflores. From 1943 to 1974 Springuett taught at the Escuela de Bellas Artes.

See also PERU, §IV, 2.

BIBLIOGRAPHY
J. M. Ugarte Eléspuru: *Pintura y escultura en el Perú contemporáneo* (Lima, 1970)
L. E. Tord: 'Historia de las artes plásticas en el Perú', *Historia del Perú*, ix (Lima, 1980), pp. 169–360
LUIS ENRIQUE TORD

Stern, Grete (*b* Elberfeld [now Wuppertal-Elberfeld], 9 May 1904). German photographer and designer, active in Argentina. After studying (1923–5) graphic design at the Technische Hochschule, Stuttgart, she became active in advertising and layout design. Around 1927 she met the Bauhaus photographer Walter Peterhans (1897–1960). While studying with him in 1927–8 and completing his Bauhaus course in 1930, her work was informed by Surrealism and Constructivism and by what László Moholy-Nagy called the 'new vision' or the problems of an increasingly urban, mechanical age. In 1929 Grete Stern

established a studio in Berlin called Foto Ringl + Pit (Ringle + Pit), with fellow photographer Ellen Auerbach (*b* 1906). It was active mainly between 1929 and 1933 and became noted for its innovative advertising work. In 1933 Stern fled Germany and opened a studio in London, where she was active until 1937. Her production during these years is marked by her portraits of *Bertolt Brecht* and *Helene Weigel* and original works for Shell UK Ltd and the Kynch Press. Around 1936 she married the Argentine photographer Horacio Coppola, with whom she opened a studio in Buenos Aires. After World War II she was chiefly interested in architectural and documentary photography, earning a number of important commissions in Argentina. She is perhaps best known for her work of this period for the Argentine architect Amancio Williams and for the Municipal Architects Office of Buenos Aires. Stern's work later diversified as she became official photographer for the Department of Correspondence of the Museo Nacional de Bellas Artes, Buenos Aires (1956–70). She received important documentary commissions, photographing aboriginal cultures in Resistencia (1956) and the native cultures of Chaco (1959–60) and Chaco Norteño (1964). In 1982 she received the Konex prize for her lifetime achievement in photography.

PHOTOGRAPHIC PUBLICATIONS
Begegnungen mit Menschen, Bauhaus-Archiv (Berlin, 1975)
Fotografía en la Argentina, 1937–1981 (Buenos Aires, 1988)

BIBLIOGRAPHY
M. Lavin: 'Ringle + Pit: The Representation of Women in German Advertising, 1929–33', *Prt Colr Newslett.*, xvi/3 (1985), pp. 89–93
Grete Stern: Obra fotográfica en la Argentina (exh. cat., Buenos Aires, Fond. N. A., 1995)
W. Watriss and L. Parkinson Zamora, eds: *Image and Memory: Photography from Latin America, 1866–1994* (Austin, 1998)
JAMES CRUMP

Suárez, Alfredo Gálvez. *See* GÁLVEZ SUÁREZ, ALFREDO.

Suárez, David Muñoz. *See* MUÑOZ SUÁREZ, DAVID.

Suárez, José (*b* Allariz, nr Orense, 1902; *d* La Guardia, nr Pontevedra, 5 Jan 1974). Spanish photographer, active in Argentina. He studied law at the Universidad de Salamanca, where he became interested in photography. He was employed by the film company CIFESA, directing numerous documentaries on the customs and traditions of Galicia. At the end of the Spanish Civil War (1939) he went into exile in Argentina, where he continued to work as director of photography on various films and as a contributor of both articles and photographs to such newspapers as *La Nación* and *La Prensa*. The core of his work, which is full of humanism and tenderness, is centred on the themes of customs and ways of life: fishing scenes, women working, and celebrations and festivities, not only in his native Galicia but also in Argentina, Uruguay and Japan, in whose theatre and performing arts he was extremely interested.

PHOTOGRAPHIC PUBLICATIONS
Galicia, terra, mar e xentes (Pontevedra, 1981)

BIBLIOGRAPHY
Idas y caos: Aspectos de las vanguardias fotográficas en España, 1920–1945 (exh. cat. by J. Fontcuberta, Madrid, Salas Picasso, 1984; Eng. trans., New York, Int. Cent. Phot., 1986)
MARTA GILI

Suárez, Pablo (*b* Buenos Aires, 1937). Argentine painter. Born to a wealthy, aristocratic family, he grew up on a large *estancia* where a combination of the vast landscape and the authoritarian regime of his family was to have a profound influence on his future work. Suárez began studies in agronomy at the Universidad de Buenos Aires only to abandon them in 1959. He was a principle protagonist of the 1960s movement Contexto artístico. During a period of extreme state censorship Suárez was politically active, participatiang in an anti-Vietnam exhibition. In 1968, in protest of the banning of a work by Roberto Plate (*b* 1940), he was one of the artists exhibiting at *Experiencias '68* to remove their work and publicly destroy it. This act led to the formation of the direct political action group of artists, Tucumán Arde, of which Suárez was a member. Influenced by Pop, Realism and Surrealism, and with a fascination for the erotic (an art form with which he has been involved since age 13), Suárez was noted for unmasking social reality in a period dominated by cultural industry. His work is always critical, operating on a centre-periphery while he himself always observed from the margins, whether it be from a social, individual, political or sexual viewpoint. This corrupted visualization of observed and recorded reality through the utilization of crude, kitsch and prototypical iconography, dominates his work. His use of satire, with a cynical quality, presents the viewer with a provovative and often irreverent view of society. *Sin título* (*Untitled*; oil on canvas, 2.36×1.77 m; Buenos Aires, Mus. N. B.A.) is a typical work, filled with confident brushstrokes and the use of strong colour. The painting is clearly designed both to repulse and to intrigue the spectator with its erotic undertones and bold, kitsch style.

BIBLIOGRAPHY
J. Glusberg, F. Jarauta and J. López Anaya: *Arte argentino contemporáneo*, Buenos Aires, Mus. N. B.A. cat. (Buenos Aires, 1994)
L. Roberts: 'Pablo Suárez: A Portrait of Resistance', *Art from Argentina, 1920–94* (exh. cat. by D. Elliot; Oxford, MOMA, 1994), pp. 106–13
J. López Anaya: *Historia del arte argentino* (Buenos Aires, 1997)
ADRIAN LOCKE

Sucre [formerly La Plata]. City in Bolivia. Located in the Andes Mountains in the central-southern region of the country, it was the first Spanish settlement in the territory that now constitutes Bolivia, founded in 1540 by Pedro Anzures as La Plata; before the conquest it had been occupied by Yampara Indians, who called it Chuquisaca. From 1563 the city was the seat of the judicial and administrative authority of the Audiencia de Charcas. Its social structure during the colonial period was rigidly hierarchical, with Spaniards and creoles being dominant over African slaves and those of mixed race (mestizos). The city was laid out following the traditional Spanish grid plan, and the cathedral was begun by Juan Miguel de Veramendi in 1552, although it was not completed until 1712, to a design by José González Merguelte. Churches completed during the early part of the colonial period include S Francisco (1581–1619) by Martín de Oviedo, following Andalusian styles. The churches of La Merced and S Miguel are notable for their *Mudéjar* panelling, dating from the late 16th century or early 17th, while an important early civic building was the Casa de Moneda (1592). By 1600 the Plaza Mayor had been built, surrounded by tall

and low buildings with balconies, and this and the Plaza de Mercaderes helped establish La Plata as a flourishing market town.

As elsewhere in Bolivia during the early colonial period, the city developed its own characteristic school of painting and sculpture, European influences being modified by local techniques and traditions; the use of pasteboard made of agave fibre, for example, was characteristic of the sculpture workshops of La Plata. The Universidad Boliviana Mayor, Real y Pontificia de San Francisco Xavier was established in 1624 on the site of the Jesuit Colegio de Santiago, a school for Indians. Its two-storey cloister, with Ionic and Doric orders, dates from 1697, and *Mudéjar* influence is clear in its spandrel panels. In the 17th century some notable monastery churches were also built in an exuberant Baroque style, the most important of these being S Theresa (1665), by Pedro de Peñaloza, and S Clara (1639). Throughout the colonial period the city's churches were richly decorated with paintings and retables; examples of the former include Antonio Bermejo's *Magdalene*, dating from the 17th century, in the church of S Theresa, while the church of S Miguel is noted for its *Calvary* retable (*c.* 1765). Although Baroque elements persisted in architecture into the 19th century, the church of S Felipe Neri (late 18th century) marked the transition to Neo-classicism, and at the end of the 18th century a Neo-classical style of painting, although still incorporating Baroque and Rococo elements, also began to appear in the works of such painters as Oquendo.

After the founding of the independent republic of Bolivia in 1825, the city's name was changed to Sucre. Neo-classical buildings continued to appear until mid-century (e.g. the Capilla Redonda, 1850), although immediately after independence the city went into economic decline until the late 19th century, when new mining companies brought economic prosperity. This stimulated urban renewal and the introduction of new academic and eclectic styles. In the 1880s and 1890s numerous country houses (*quintas*) were built in the valleys surrounding the city, in an academic style and with landscaping modelled on French gardens. The Palacio de la Glorieta (1900), on the outskirts of the city, designed by Antonio Camponovo, is perhaps the most significant example of eclecticism in Bolivia, combining 14 styles in its structure.

The most important development in the arts in Sucre during the 20th century was the founding in 1950 of the group Anteo, comprising artists, writers and intellectuals, notably GIL IMANA. The group sought to defend the position of the working classes and Indians, and its members felt an affinity with the work of the Mexican muralists, seeing mural painting as a means of expressing Marxist ideology. Cultural life in the city was also supported by the establishment of a number of museums, including the Museo Charcas (est. 1939), with the widest collection in Bolivia of art from the Renaissance period onwards; the Casa de la Libertad, founded in 1925 under sponsorship from the Banco Central de Bolivia; and the Museo Catedralicio (est. 1962), financed by the Church and which houses a collection of religious art.

See also BOLIVIA, §§II and III.

BIBLIOGRAPHY

G. Mendoza and M. Céspedes: *Chuquisaca y Potosí*, Monografía de Bolivia, iv (La Paz, 1975)

J. de Mesa and T. Gisbert: *Monumentos de Bolivia* (La Paz, 1978)

J. de Mesa and T. Gisbert: *Sucre: Bolivia* (Bogata, 1992)

LAURA ESCOBARI

Sugar sculpture. Type of sculpture made with melted sugar. It is confined to Mexico, and its origins are uncertain, although it seems likely that it developed in imitation of the Pre-Columbian custom of creating images with *tzoalli* dough (a Náhuatl term for maize and amaranth seeds kneaded with honey), as described in detail by 16th-century Spanish chroniclers. The latter tradition has survived to the late 20th century alongside sugar sculpture. Aztec deity images were made of clay, stone, wood or *tzoalli* dough, and less frequently of gold, silver or jade. The last three, more expensive materials, were used for temple images, but *tzoalli* images were also 'sacred', in that pieces were broken off and eaten, perhaps as if they represented the flesh of the gods. The 16th-century chronicler Diego Durán described how birds were made with such dough, with wings, feathers and other details attached to them and painted, techniques also used by modern sugar sculptors.

Sugar was introduced into the Americas by the Spaniards in the mid-16th century, and the creation of sugar sculpture probably began soon thereafter. Today, sugar skulls (see fig.) seem to be the most important form produced, especially for the celebration of the Day of the Dead (1 November). In some regions, such as Toluca (*c.* 50 km west of Mexico City), where sugar sculpture is highly important, preparations for the festival begin from mid-October. This celebration, the Feria del Alfeñique, includes a sugar fair that lasts until the festival of the Day of the Dead.

Sugar sculpture is made from a basic mixture of sugar and water. Decoration is added using a piping paste of icing sugar and egg whites, with added colouring, some

Sugar sculpture, skull made of sugar paste and paper, h. *c.* 254 mm, from Michoacán, Mexico, 1986 (Fort Worth, TX, Modern Art Museum)

hues comprising a combination of four or five colours. Some examples from Metepec in Toluca have additional decorations, such as hats, diadems or flowers; all the different stages of such individual sculptures are finished by hand. Sugar skulls (sometimes chocolate) are mass-produced in various sizes using moulds of two or three sections, with a range of facial expressions: cheerful or sad-looking skulls, skulls with flattened features, prominent cheekbones, gaping jaws and many others. Some are inspired by the images of Hollywood stars of the 1930s; others seem to be copies of Aztec stone skulls, sometimes with the addition of feathers and ear plugs, also made of sugar paste. Some skulls are decorated with eyelashes of metallic paper. One common trait in all sugar skulls is the inscription of Christian names on the forehead. Painted decorations use vegetable dyes, as the skulls are meant to be eaten as sweets and are often filled with aniseed liquid. Besides skulls, miniature coffins, complete with a skeleton inside, animals (particularly sheep) and different parts of the body are also made of sugar paste.

There are two main groups of sugar sculptors: those who specialize in the mass production of sugar skulls, and those who produce other forms in sugar or who specialize in marzipan or what is known in Mexico as *dulce de pepita*. Among marzipan figures, hands are common, including hands holding bouquets. Sugar sculpture has become a tourist attraction, and with this popularity it has also become more common to produce a wider repertory of figures, including musical instruments, flowers and other forms, as well as human beings and animals; the trade in sugar figures seems to be mostly in the hands of nuns. Despite innovations, traditional iconography remains intimately related to the death imagery associated with the Day of the Dead celebrations.

BIBLIOGRAPHY
D. Durán: *Historia de las Indias de Nueva España y Islas de Tierra Firme* (MS, Madrid, Bib. N., *c.* 1581); ed. J. F. Ramírez (Mexico City, 1967–80); Eng. trans., ed. F. Horcasitas and D. Heyden as *Book of the Gods and Rites* and *The Ancient Calendar* (Norman, 1971, 3/1977)
N. Gutiérrez Solana: 'Materiales utilizados en las imagenes mexicanas (de acuerdo con Sahagún y sus indormantes)', *An. Inst. Invest. Estét.*, xlvii (1977), pp. 11–21
E. Cortés and others: *Los Días de Muertos: Una costumbre mexicana* (Mexico City, 1986)
Lebende Tote: Totenkult in Mexico (exh. cat., ed. H. Ganslmayr; Bremen, Übersee-Mus., 1986)
C. Sayer: *Arts and Crafts of Mexico* (London, 1990)
The Skeleton at the Feast: The Day of the Dead in Mexico (exh. cat. by E. Carmichael and others, London, Mus. Mankind, 1991–2)

ELIZABETH BAQUEDANO

Surinam, Republic of [Suriname; formerly Dutch Guiana]. Country situated on the northern Atlantic coast of South America. The capital is Paramaribo. The Corantijn River to the west forms the boundary with Guyana; the Marowijne River to the east is the boundary with French Guiana; the Toemakhoemak Mountains in the south border on to Brazil (see fig. 1). Savannah forms the heart of the country. The population was *c.* 400,000 in the early 1990s and is ethnically diverse owing to large-scale immigration, first of African slaves for Dutch plantations in the 17th–18th centuries and then, from the second half of the 19th century, of Asian workers. Indigenous Amerindians form a minority group.

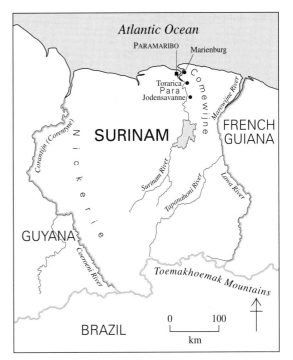

1. Map of Surinam; the site PARAMARIBO has a separate entry in this encyclopedia

I. Introduction. II. Indigenous culture. III. Afro-American culture. IV. Architecture. V. Painting, graphic arts and sculpture. VI. Decorative arts. VII. Patronage and institutions.

I. Introduction.

During the first half of the 17th century the region was colonized as part of Guiana by the Dutch, English and French. In 1651 Torarica was established as the capital of a growing Dutch colony. A plantation area for sugar, coffee and coca was significantly extended under the governor Cornelis van Aerssen van Sommelsdijk (1637–88). There was an annual importation of 4000 slaves from Africa; after 1753 this number doubled. By the late 18th century, of a population of 50,000 over 90% were slaves, and the number of plantations was more than 500. A stock exchange crisis in Amsterdam in 1773 put the plantations in the control of their creditors, who installed administrators; mismanagement caused a rapid decline. A period of English control (1804–16) paved the way to the dismantling of the slave trade, and emancipation was finally proclaimed in 1863. The colony obtained a measure of autonomy in 1866. Meanwhile, the number of plantations had declined to under 200; thus the Chinese (from 1853), Indians (from 1873) and Javanese (from 1890) were brought in to strengthen the plantation workforce. Balata and gold mining also became important activities in the 20th century. The statute of 1954 signalled the end of the colonial period. Paramaribo became the capital in 1974. The final break with the Netherlands came on 25 November 1975 with the proclamation of Surinam's independence. The country experienced a military coup in 1980, free elections in 1987, and a second military intervention in 1990; in 1991 it became again a parliamentary democracy.

GLORIA C. LEURS

II. Indigenous culture.

The indigenous population is divided into five groups: Arawak, Carib, Trió, Wayana and Akuriyo. In the late 20th century they numbered an estimated 11,000, a very small minority of Surinam's total population of c. 400,000. Surinam was first inhabited c. 15,000 BC, and an agricultural economy was established c. 4000 BC, with bitter cassava (manioc) becoming the staple crop. European colonization, beginning in the 16th century, is one explanation for the indigenous groups' migration south from the coast to the interior. In the late 20th century they lived in the eastern coastal area on the banks of the Lawa, Tapanahoni and Coeroeni rivers. After the 1970s there was a little urban migration, and from 1986 many of the indigenous population left their homes as a result of the civil war.

Arawak and Carib houses typically have a square plan, with a pitched roof made of leaves, reaching down to the ground and supported by posts. The orientation of the ridge of the roof takes account of the direction of rain from the north-east trade winds. Arawak huts differ slightly from those of the Caribs, in that the outside walls are finished with wattle. The floors are made of compressed earth. Wayana houses are round, with domed roofs. There is no division between sleeping and living space. The huts are furnished with hammocks and wooden benches shaped like crocodiles and tigers. The men plait manioc-presses, sieves, carrying-baskets and bags out of the split bark of the warimbo (*Ischnosiphon gracilis*), the fibre of Maritius palm leaves and lianas. Painted red or black, the plaited decorative patterns include meanders, triangles, squares and parallel lines, and sometimes also human figures. Men's loincloths (*kamisa*) are made of cotton and fastened with a string made of lianas or cotton strips. Women's loincloths, which cover only the front, are often worn as a hip cloth fastened on one side. Carib and Arawak women wear a covering cloth (*saja*) fastened at the shoulder. Red and blue are the principal colours of clothing: sometimes the cloths are given long fringes of white cotton. Carib men and women also wear leg bands: the women's are made of cotton, the men's of pips, seeds and animals' teeth, which are also used to make necklaces. The body is painted with red and black paint. The Trió and Wayana also wear rings of feathers on their heads. Contacts with Western culture are responsible for the disappearance of traditional dress, which in the late 20th century was worn only on special occasions.

Earthenware is made by the women in the traditional way by coiling. Decoration, on the inner and outer surfaces, is partly applied before firing and varies from parallel curving and angular lines and stripes to cross shapes in brown–red and black. Sometimes sprigged decoration is applied, shaped like frogs, snakes and men's faces. The clay is dried using the burnt bark of the kwepi tree and fired in an open-air wood fire. Pots are made for practical use and as decorative pieces in animal-shapes and vases, mainly for tourism. By the late 20th century only the Carib, Wayana and Trió still made earthenware, some for their own use, some for sale. The best-known Carib pots are their storage jars (*prapi* and *samaku*), drinking bowls (*sabera*) and waterjugs (*watrakan*). Industrially manufac-

tured products have mostly replaced earthenware in the households of the indigenous groups.

BIBLIOGRAPHY
H. D. Benjamins and J. F. Snelleman, eds: *Encyclopedie van Nederlandsch West-Indië* (The Hague, 1914–17/*R* Amsterdam, 1981)
C. F. A. Bruijning and J. Voorhoeve, eds: *Encyclopedie van Suriname* (Amsterdam and Brussels, 1977)

GLORIA C. LEURS

III. Afro-American culture.

From the mid-17th century, slaves of African origin escaped from the plantations and formed communities in central and east Surinam. They are called 'Bush Negroes' or sometimes also 'Bush Creoles'. The descendants of the original communities are the Saramaccaners, Aucaners, Aluku, Matuariërs or Matawi, Paramaccaners and Kwinti: the first two are the largest groups, each numbering c. 20,000. Cultural differences arise only in language, dress and specific customs. The people live mainly by farming and fishing. In the late 20th century many 'Bush Negroes' who worked in forestry and mining were government employees or employed by private companies. Arguably, the 'Bush Negroes' of Surinam survive as the only Afro-Americans who have preserved their original culture. A pattern of migration to Paramaribo was, however, prompted when, between 1960 and 1965, a hydro-electric power station was built in central Surinam. From 1986 the civil war caused many 'Bush Negroes' to leave their original homes. A significant proportion fled to French Guiana or settled in Paramaribo.

The 'Bush Negroes' developed wood-carving, calabash-work and textiles to a high level. The objects were originally made as gifts for loved ones but came to be produced mostly for the tourist market, so that their social significance altered. Wood-carving is done by men, who produce a large range of objects, including paddles, benches, combs, peanut-grinding boards, winnowing trays, mortars and food-stirrers. Panels of carved wood are also attached to the walls of houses. According to Price and Price, wood-carving began to develop in the first half of the 19th century. They define four styles between 1870 and 1980, based on decorative patterns: Style I (1870–1900), Style II (1870–1930), Style III (1905–80) and Style IV (1945–80). Hurault, however, defines three stylistic periods, overlapping only slightly: archaic (1830–70), classical (1860–1920) and modern (from 1920). There are several views about the symbolic meanings of the carvings: Price and Price detect an iconography, while both Hurault and Muntslag differ. Regional differences are perceptible. In the 20th century in the east the 'Bush Negroes' applied commercial paint to the carvings.

Calabashes are worked by both men and women. After the flesh has been removed with pieces of glass, the women decorate the inner surface, while the men work on the outside, using the same tools as for wood-carving: the knife, compasses and chisel. The designs are complex and show similarities with the patterns carved on wood. The 'Bush Negroes' apparently learnt calabash-work from the indigenous population, who no longer practise this art form. From the second half of the 19th century they developed their own characteristic styles.

Weaving has not developed in the material culture of the 'Bush Negroes', but other forms of textiles have been produced. Price and Price have defined five overlapping styles: the early embroidery style (1850–1930) with compositions of curvilinear patterns; the late embroidery style (1895–1980), characterized by purely linear shapes; the 'bits-and-pieces compositions' (1890–1945), typically working squares, rectangles and triangles in a 'patchwork' technique, the main colours being red, white and blue; the 'narrow-strip compositions' (1910–70), in which long strips of striped material are sewn together; and lastly an embroidery style from 1960, in which cross-stitches are applied in symmetrical compositions. From the second half of the 20th century a form of textile art, called 'decorative sewing' by Price and Price, has been produced, consisting of embroidery and patchwork, using industrial cotton.

Scholars differ over the question of whether the Afro-American culture of the 'Bush Negroes' is a continuation of African culture or a unique development. Dark, Kahn and Herskovits are among those who espouse the first theory. However, Price and Price propose that there is 'continuity in change' and that the legacy of African culture has been mixed with new influences from South America. Elements of African culture are still observable among the Creoles, the descendants of slaves brought from Africa who did not form a breakaway community but remained on the plantations. They were freed when slavery was abolished in 1863. These African elements are principally found not in material expressions, which have been strongly influenced by Western culture, but in the language, song and dance of the working class of this group.

BIBLIOGRAPHY

M. J. Herskovits: 'Bush Negro Art', *Illus. A.*, v (Oct 1930), pp. 25–37; repr. in *The New World Negro*, ed. F. S. Herskovits (Bloomington, 1966), pp. 157–67

M. J. Herskovits and F. S. Herskovits: *Suriname Folk-Lore*, Columbia University Contributions to Anthropology, xxvii (New York, 1936)

P. J. C. Dark: *Bush Negro Art: An African Art in the Americas* (London, 1954)

M. C. Khan: 'Little Africa in America: The Bush Negroes', *Américas*, vi/10 (1954), pp. 6–8, 41–3

F. H. J. Muntslag: *Tembe: Surinaamse houtsnijkunst* [Tembe: Surinam wood-carving] (Amsterdam, 1966)

J. Hurault: *Africains de Guyane: La Vie matérielle et l'art de noirs réfugiés de Guyane* (Paris and The Hague, 1970)

S. Price and R. Price: *Afro-American Arts of the Suriname Rain Forest* (Berkeley, 1980)

L. M. Martínez Montiel, ed.: *Presencia africana en el Caribe* (Mexico City, 1995)

GLORIA C. LEURS

IV. Architecture.

According to descriptions, in Surinam's first capital, Torarica (founded between 1651 and 1667), there were *c.* 100 houses and a church. The town, of which nothing remains, has not yet been studied. At Casipoora Creek, opposite Torarica, a wooden synagogue (destr.) was built in 1651–2 by Jewish settlers. Portuguese Jews settled in Jodensavanne, where between 1600 and 1664 a village was laid out with 80–90 houses and a synagogue (1685; destr.). It was a rectangular (*c.* 13×29 m), two-storey building of brick. The shorter west and east sides had high projecting gables. This structure included a triangular roof space, which was accessible from the long wall. The oldest monument is Fort Zeelandia in Paramaribo, a pentagonal stone structure with bastions, situated on a bend in the

2. Presidential Palace, Paramaribo, Surinam, 1730, extended 19th century

Surinam River. Originally it was a wooden fort built by the French in 1640 and fortified by the English in 1650; it was rebuilt by the Dutch governor Laurens Storm van 's-Gravesande in 1744.

Most of Surinam's buildings, both during the colonial period and after, were framed and clad in the abundant local timbers, although coniferous wood from Europe was also used. Ballast bricks and later those produced by small local kilns were used for some public buildings and more generally for foundations. Colonial houses are typically two-storey on a rectangular plan, with symmetrical façades. The front and back walls each have a monumental double door with pilasters and a carved fanlight, incorporating the owner's initials or made of small glass panes. From the 18th century there were shuttered windows, and later sash windows were also introduced. The roofs were pitched or mansard, with attics, and made of wood (prohibited in the 19th century because of the fire risk), pantiles and slates. External walls were painted white, doors and windows bright green and the brick foundations red. The best houses had interior panelling. During the 18th century the influences of the Louis XIV, Louis XV and Louis XVI styles appeared, mainly in cast-iron railings for balconies and staircases. German influence in the 19th century is shown in attics with three or four windows, including a semicircular window at the top. The oldest examples of surviving colonial architecture are in Paramaribo, including the Presidential Palace, formerly the Governor's Residence (see fig. 2), and the Bishop's House (before 1750), built entirely of brick. Historic architecture is also found in Nickerie, Para and Comewijne. Most of Paramaribo's existing colonial buildings date from the 19th century, as more than five hundred older properties were lost in fires in 1821 and 1832. Reconstruction adopted the Neo-classical style then prevalent in Europe, which is seen in Doric, Ionic and Corinthian porticos, and in balconies supported by columns; examples include the Ne Ve Shalom synagogue (1842) and the Ministry of Finance (1841). Romanesque Revival and Gothic Revival influences appeared in a few churches, for example the cathedral of SS Peter and Paul (1885). In the early 20th century influences from Art Nouveau, Art Deco and the Amsterdam school appeared to a limited degree.

Traditional construction continued until World War II, after which the use of concrete predominated. Between the 1940s and 1960s the building style was determined by such Dutch architects as J. Nagel, F. E. Mathijsen, M. J. Bijkerk and J. Wiegerinck, whose lean-to roofs were adopted on a large scale. From the 1960s local architects, of whom Harold van Ommeren, Willy Relyveld, Roy Emanuels and Arie Verkuyl are examples, were trained in the Netherlands and returned to develop an original architecture that took account of local climate and context. Lucien Lafour and Rikkert Wijk (who later practised in Amsterdam) produced buildings in this genre using appropriate timber technology, for example the Health Centre, Marienburg. An entirely separate development was the construction of mosques and Hindu temples, where Eastern forms were adopted.

BIBLIOGRAPHY

J. L. Volders: *Bouwkunst in Suriname: Driehonderd jaren nationale architectuur* (Hilversum, 1966)

C. L. Temminck Groll, ed.: *De architektuur van Suriname, 1667–1930* (Zutphen, 1973)

A. van Eyck: 'Tropical Lafour', *Archit. Rev.* [London], clxxvi/1052 (1984), pp. 62–7

——: 'Construire nel Suriname' *Spazio & Soc.*, xiv/56 (1991), pp. 42–51

GLORIA C. LEURS

V. Painting, graphic arts and sculpture.

The oldest depictions of Surinam are lithographs, illustrating such descriptions of the colony as that of Herlein (*Beschryvinge van de volk-plantige Zuriname* [Description of the settlements of Surinam], Leeuwarden, 1718) and published in the Netherlands; the means for making lithographs in Surinam did not exist until *c.* 1850. During the 17th, 18th and 19th centuries, mainly landscapes were produced, generally in pencil, chalk and watercolour; painting was practised on a limited scale. Most of the artists were European amateurs, either settlers or travellers, such as the German MARIA SIBYLLA MERIAN, who from 1699 to 1701 made drawings of insects and plants (see fig. 3). Drawings and paintings were commissioned by the plantation owner Jonas Witsen from Amsterdam from the Dutch painter Dirk Valkenburg (1675–1721), who travelled in Surinam from 1707 to 1709. Other drawings were produced by the Dutchman J. Carpentier Alting (*fl c.* 1791) and the Scot John Gabriel Stedman (1744–97), a mercenary who published an illustrated account of his travels in 1796. Drawings and a number of paintings by anonymous artists are also known from the 18th century.

A larger number of 19th-century artists is known; for example, during the first half of the century Gerrit Schouten (*b* 1780), who was born in Surinam, painted still-lifes and watercolours of local fruits but was better known

3. Maria Sibylla Merian: illustration from the album *Metamorphosis insectorum Surinamensium* (Amsterdam, 1705)

for his topographical panoramas. Certain visitors to Surinam published lithographs in books or albums: they included the artist Pierre-Jacques Benoit (1782–1854) and the planter Theodore Bray (1818–87), both from Belgium. Bray's album, published in 1868, contained 25 often satirical lithographs, produced in Paramaribo by Petit, probably the first lithographic press in Surinam. Between 1860 and 1862 the Dutch naval officer G. W. M. Voorduin (1830–1910) published an album that included eight watercolours. Landscape watercolours by the Dutch planter and merchant Nicolaas Box (1785–1864) exist in the Surinam Museum in Paramaribo, while the Tropenmuseum in Amsterdam has a sketchbook by J. F. A. Cateau van Roosvelt (1823–91). An artist called Lovera (presumably the Venezuelan painter Pedro Lovera) visited Surinam in 1885, and the French 'Peintre de l'état' Paul Merwart (1855–1902) was there in 1900; a portrait by Lovera and market scenes by Merwart are known.

During the second half of the 19th century Surinam artists offered to train pupils in their studios. Possibly the first artist to do so (in 1879) was Salomon del Castilho, mainly known for his pastel portraits; his example was followed by George Rustwijk (1862–1914) and M. C. Robles in 1892 and 1895 respectively. During this period portraits and still-lifes were introduced. Painting attracted increasing attention. European styles of the late 19th and early 20th centuries, including Impressionism, can be seen in the work of such artists as Alphonse Faverey (1900–79), who first made portraits and townscapes in watercolour, pastel and oils in 1919. Sculpture was not made in the 18th and 19th centuries, as far as is known; the statues that decorated plantation gardens were probably from Italy. However, from c. 1920 sculpture was produced by J. E. Mezas, who made portraits in wood. The most important artists of the first half of the 20th century, though, were Wim Bos Verschuur and John Pandelis, who depicted town views, portraits and landscapes in oils, chalk and pastel.

After World War II, Surinam artists trained in the Netherlands introduced various degrees of abstraction, as in the sculpture *Alonso de Ojeda* (1963) by Erwin de Vries (b 1929), an internationally renowned sculptor and painter. However, the great majority of artists practised figurative art. Important artists from Surinam settled permanently in the Netherlands. Although painting was the principal art form, graphic art was stimulated by Jules Chin A Foeng (1944–83) and René Tosari (b 1948). The leading artists from 1960 included Nola Hatterman (1899–1984), Rudi Getrouw (b 1928), Ruben Karsters (b 1941), Soeki Irodikromo (b 1945) and Stuart Robles de Medina (b 1930). After 1980 a younger generation of painters came to the fore, the most important being George Ramjiawansingh (b 1954) and Rinaldo Klas (b 1954). De Vries and Robles de Medina accounted for new developments in sculpture, using such materials as wood, bronze, aluminium and cast concrete.

BIBLIOGRAPHY

H. D. Benjamins and J. F. Snelleman, eds: *Encyclopedie van Nederlandsch West-Indië* (The Hague, 1914–17/R Amsterdam, 1981)

G. Leurs: *De Sticusa-kollektie van moderne Surinaamse beeldende kunst* (diss., U. Amsterdam, 1980)

——: 'De ontwikkeling van de beeldende kunst in Suriname', *Catalogus Nationale Kunstbeurs* (exh. cat., Paramaribo, 1988), pp. 9–10

Twintig jaar beeldende kunst in Suriname, 1975–95 (exh. cat., Paramaribo, Stichting Surinaams Mus.; Amsterdam, Kon. Inst. Tropen; Rotterdam, Mus. Vlkenknd.; 1995)

GLORIA C. LEURS

VI. Decorative arts.

Furniture and jewellery are the only decorative arts that have developed to a significant degree in Surinam. Prevailing European styles of furniture, chiefly 18th-century, were followed in the colony from the outset and were produced locally as well as being imported. The Rococo, Queen Anne and Art Deco styles were particularly popular. Typical Surinam pieces made in these styles were the Rococo vitrine-cupboard, topped with asymmetrical wood-carving, and the sideboard, a local adaptation of the European buffet. Art Deco marquetry was often applied to the backrests of chairs and to cupboard doors. Tropical hardwoods, chiefly mahogany and cedar, were used, with little or no veneer. The influence of European styles continued for a long time: Rococo furniture was made until the end of the 19th century, and the Art Deco style was employed until the 1950s. Smaller wooden objects such as jewel cases and serving trays with intarsia were also produced. Most of the craftsmen remained anonymous until the end of the 19th century and the beginning of the 20th, when such figures as J. N. Rijssel, Henry A. Venoaks, Henry Macintosch and André R. de Vries were active.

Local production of jewellery probably started during the 18th century, and from the end of the 19th century it was produced mainly by Chinese craftsmen. A typical Surinam piece is the *boeien*—a ring of gold or silver, with open arms that close over each other usually with rosebuds or snake heads on the ends. Other pieces use such local materials as gold and silver in combination with the black tufted feather of the powisi (*Crax alector*), the white stone found in the head of the koobi fish (*Plagoscion surinamensis*), beads of garnet, red coral, bauxite stones, cowrie shells and the stones of various fruits, including the Muceena family. Filigree is often used on earrings, pendants and brooches.

BIBLIOGRAPHY

A. F. Lammens: *Bijdragen tot de kennis van de kolonie Suriname: Dat gedeelte van Guiana hetwelk bij tractaat ten jare 1815 aan het Koninkrijk Holland is verbleven, tijdvak 1816 tot 1822* [Contributions to the general knowledge of the colony of Suriname: the part of Guiana which, at the treaty of 1815, has remained part of the Kingdom of Holland, period 1816–1822], ed. G. A. de Bruijne, Bijdragen tot de Sociale Geografie en Planologie, 3 (Amsterdam, 1982)

J. G. Stedman: *Narrative of a Five Years Expedition against the Revolted Negroes of Surinam*, ed. R. Price and S. Price (London and Baltimore, 1988)

GLORIA C. LEURS

VII. Patronage and institutions.

Although some of the governors were influential in establishing literature and science associations in the colony's early history, no attention was paid to the visual arts. In 1865 the gift of a collection of stuffed animals to the colony by J. M. Janssen Eijken Sluijters made it necessary to establish a museum. The Koloniaal Museum, founded in 1867, was housed in the Koloniale Bibliotheek until its closure in 1908, due to neglect; the collection of

mainly botanical and zoological objects and minerals was transferred to the Schoolmuseum. The first art exhibition was probably in 1876, organized together with a show of agriculture, livestock and industry; the visual arts were not significantly promoted until the early 20th century, when a branch of the Dutch association Arti et Amicitiae was opened in the colony *c.* 1900. Its activities included annual lotteries of reproductions of works by Dutch artists. From 1934 the Surinaamse Kunstkring organized exhibitions of local and foreign artists' work.

Although in the second half of the 19th century, artists offered training in their studios, institutions for art education were not founded until much later. One of the first was the CCS-school voor Beeldende Kunsten (established 1953). In 1962 a training course was set up for drawing teachers, and in 1966 the Surinaamse Akademie voor Beeldende Kunsten opened. This was followed in 1967 by the Nationale Instituut voor Kunst en Kultur, and in 1971 a start was made on creating the Nieuwe School voor Beeldende Kunsten. Some of these initiatives were backed by the Stichting voor Culturele Samenwerking met Suriname en de Nederlandse Antillen (STICUSA), which provided financial support, as well as Dutch teachers. In the 1990s the Akademie voor Beeldende Kunsten, set up by the government in 1981, was the only organization of its kind still functioning.

From the 1970s the buying and collecting of modern art from Surinam increased, both by private individuals and businesses, mainly banks; the Ministry of Education and Development adopted a systematic collecting policy from 1980, acquiring the most extensive collection. Exhibiting opportunities were notably increased by the foundation of the Nationale Kunstbeurs, which enabled young and established artists to show new work each year. The Surinaams Museum was opened in 1952: although its collections are principally ethnographical, historical and natural historical, it also has a small collection of 19th- and 20th-century art. The museum was moved in 1972 to the restored 17th-century Fort Zeelandia in Paramaribo, but ten years later it was forced to leave the fort, which reverted to its original function after a coup. From 1989 the Stichting Initiatiefgroep Bouw Nieuw Museum tried to bring about the construction of a new national museum, as well as ensuring that sufficient attention was paid to the visual arts.

GLORIA C. LEURS

Svistoonoff, Nicolás (*b* Shanghai, 15 Feb 1945). Ecuadorean painter, draughtsman and engraver of Russian origin. He arrived in Ecuador in 1953, moved to Guayaquil in 1960 and studied at the Escuela de Bellas Artes there. He went on to study at the Real Academia de Bellas Artes de S Fernando, Madrid. He initially worked in an Expressionist style but soon moved to Tachism; thereafter he began to explore the language of the absurd and worked in the style of Neofiguración as well as his interpretation of Spatialisme. After a period in Spain he settled in Quito and produced engravings. He was awarded first prize in the Bienal de Grabado Iberoamericano in Montevideo (1983) and was also successful at the 8th Bienal del Grabado Latinoamericano in San Juan, Puerto Rico. He encouraged the medium of engraving in Ecuador from

the workshop that he directed in the Casa de la Cultura Ecuatoriana.

The key elements in Svistoonoff's work are powerful use of colour and light and the treatment of space and texture. He criticized the changes that modern life produced, expressing this in his works by the use of images of cement blocks to replace forests in a solitude peopled by thousands of anonymous men (e.g. *Building under Construction*, 1976; Quito, artist's col.). In the 1980s he developed another central symbol of spears placed in different positions within an abstract space, and his specific historical references gave way to universal themes. By the late 1980s his work had become even more abstract.

CECILIA SUÁREZ

Szyszlo (Valdelomar), Fernando de (*b* Barranco, Lima, 5 July 1925). Peruvian painter and teacher. He was born to a Polish father and a Peruvian mother. He studied architecture before transferring in 1944 to the Escuela de Artes Plásticas at the Pontificia Universidad Católica del Perú in Lima, where he was taught by Adolf Winternitz (*b* 1906), under whom he developed a vigorous and poetic abstract style. In 1948 he went to Paris, holding his first exhibition there the following year. He spent the next few years in Paris and Florence, absorbing the influence of Leonardo and Rembrandt, as well as that of Picasso and other leading 20th-century artists, and developing a style that combined abstraction with Pre-Columbian themes and forms expressed in bright colours. In 1951 Szyszlo returned to Lima, where his abstract style was something of a novelty.

Following the establishment in the mid-1950s of the Instituto de Arte Contemporáneo in Lima, he formed the group Espacio to help promote contemporary art, attempting to encourage links between the universal approach of abstract art and the national Indigenist style. He expressed this synthesis in such paintings as *Cajamarca* (1959; see colour pl. XXXVII, fig. 2), while in others he used Quechuan titles to affirm his cultural heritage (e.g. *Puriq Runa (IX)*, 1976; see fig.).

Fernando de Szyszlo also collaborated with other artists, notably with the sculptor Joaquín Roca Rey (*b* 1923) in *Angel of Judgement* (bronze and marble, h. *c.* 3.75 m, 1957; Lima, El Angel Cemetery; *see* PERU, fig. 8). Szyszlo achieved an international reputation, with exhibitions worldwide and visiting professorships in several North American universities, and his work was enormously influential on 20th-century Peruvian art. A major retrospective of his work was held in 1976 at the exhibition hall of Petroperú, Lima.

WRITINGS

Miradas furtivas: Antología de textos (Lima, 1996)

BIBLIOGRAPHY

J. Villacorta Paredes: *Pintores peruanos de la República* (Lima, 1971), pp. 106–9

J. A. de Lavalle and W. Lang: *Pintura contemporánea, II: 1920–1960*, Col. A. & Tesoro Perú (Lima, 1976), pp. 150–55

V. Fraser and O. Baddeley: *Drawing the Line: Art and Cultural Identity in Contemporary Latin America* (London, 1989), pp. 36–8

R. Pau-Llosa and J. Alanis: *Fernando de Szyszlo* (Bogotá and New York, 1991)

Fernando de Szyszlo: Las puertas de la noche (exh. cat., Bogotá, Gal. Alfred Wild, 1992)
Szyszlo (exh. cat., London Durini Gal., 1994)

Fernando Szyszlo (exh. cat., Miami, FL, Durban Seguini Gal., 1995)
Szyszlo in Labyrinth/Szyszlo en su laberinto (exh. cat., Washington, DC, A. Mus. Americas, 1996)

W. IAIN MACKAY

Fernando de Szyszlo: *Puriq Runa (IX)*, acrylic and modelling paste on canvas, 815×1003 mm, 1976 (Austin, TX, University of Texas, Jack S. Blanton Museum of Art)

T

Tábara, Enrique (*b* Guayaquil, 1930). Ecuadorean painter. He studied at the Escuela de Bellas Artes in Guayaquil. In 1955 he received a grant to go to Spain, and he lived in Barcelona until 1964. He first used Expressionism as a reaction against indigenism; Tábara's work was central to the Latin American movement, which began to abandon social realism in the 1950s. In his early work he painted characters on the margins of society in a hard and grotesque manner. From 1953 he started to experiment with abstraction, and in the 1960s he constructed a language of magical and mythical connotations derived from Pre-Columbian calligraphy (e.g. *Region of the Shiris*, 1967; see fig.). His work from this period is rich in texture, combining elements glued to the canvas, serial calligraphy and telluric forms. In 1969 he began to search for new signs, notably feet and legs (his *pata-pata* motif), and from 1985 he revitalized his use of colour and added leafy vegetation to the feet and legs in his quest to create morphologies compatible with the mythical culture of American man. Tábara exhibited worldwide to great critical acclaim.

BIBLIOGRAPHY
H. Rodríguez Castelo: 'Tábara', *Rev. Diners*, 5 (1981), pp. 32–40
L. Oña: 'Enrique Tábara', *Rev. Diners*, 89 (1989), pp. 42–6
C. A. Areán: *Tábara* (Bogotá, 1990)

CECILIA SUÁREZ

Enrique Tábara: *Region of the Shiris*, oil on canvas, 1.1×1.1 m, 1967 (Austin, TX, University of Texas, Jack S. Blanton Museum of Art)

Taller de Gráfica Popular. Printmaking workshop in Mexico City. It was founded in 1937 by the Mexican printmakers Leopoldo Méndez, Pablo O'Higgins and Luis Arenal on the dissolution of the plastic arts section of the Liga de Escritores y Artistas Revolucionarios, which had operated from 1934. Méndez was its first director, holding that position until 1952. A number of other artists joined this original core, including Raúl Anguiano, Alfredo Zalce, Jean Charlot, Alberto Beltrán (*see* MEXICO, fig. 11) and Mariana Yampolsky.

Adopting a form of social realism in response to the conditions under the government of General Lázaro Cárdenas (1934–40), the workshop's members, who worked as a collective and most of whom belonged to the Mexican Communist Party, maintained a resolutely political stance. In addition to woodcuts and linocuts they produced posters, pamphlets and magazine illustrations in support of trade unions or denouncing Fascism. Among the foreigners who collaborated with the Taller was Hannes Meyer, who directed their publishing house, La Estampa Mexicana, while living in Mexico City from 1939 to 1949. Their most important publications included *Estampas de la Revolución mexicana*, Juan de la Cabada's *Incidentes melódicos del mundo irracional* (1946), illustrated by Méndez, and *El sombrerón* by Bernardo Ortiz. The Taller de Gráfica Popular established an international reputation through its many exhibitions abroad and through the establishment of associated workshops elsewhere in Mexico (in Uruapan and Pátzcuaro), in the USA (New York and San Francisco), Brazil and Italy.

BIBLIOGRAPHY
M. C. García Hallat: *Ubicación social y artística del Taller de Gráfica Popular* (MA thesis, Mexico City, U. Iberoamer., 1970)
J. Gutiérrez, N. Leonardini and J. Stoopen: 'La época de oro del grabado en México', *Hist. A. Mex.*, 101 (1982)
El Taller de Gráfica Popular: Sus findatores (Guadalajara, 1989)
D. Ades: *Art in Latin America: The Modern Era, 1820–1980* (London, 1989), pp. 181–94
Green, J. R.: 'Taller de Gráfica Popular', *Lat. Amer. A. Mag.*, iv/2–3 (1992), pp. 65–7; 85–7
El Taller de Gráfica Popular en México, 1937–1977 (exh. cat. by H. Prignitz, Mexico City, Inst. N. B.A., 1992)
A. A. Casas: 'Graphic Design in Mexico: A Critical History', *Print* (Jan/Feb 1997), pp. 98–104
D. Craven and K. S. Howe: *A Partisan Press with Revolutionary Intent: The Work and Legacy of TGP* (in preparation)

LEONOR MORALES

Taller Torres García [Torres García Studio]. Uruguayan group founded in Montevideo in 1944 by JOAQUÍN

TORRES GARCÍA. It was conceived by the artist as part of an exhaustive programme of art education initiated by him on his return to Uruguay in 1934 after living in Europe for 43 years. The group, which organized mixed exhibitions and published its own official magazine, *Removedor*, until it disbanded in 1963, included among its members Torres García's sons Augusto Torres (1913–92) and Horacio Torres (1924–76), along with Julio Alpuy (*b* 1919), José Gurvich (1927–74), Francisco Matto (1911–95), Gonzalo Fonseca and Manuel Pailós (*b* 1918). Guided by their direct contact with Torres García, who directed them more in terms of ideas than of techniques, they were instrumental in establishing abstract art and modernism in Uruguay. As the membership included not only other artists but also sympathetic intellectuals such as the poet Esther de Cáceres, the psychiatrist Alfredo Cáceres and the writer Juan Carlos Onetti, their influence stretched beyond the visual arts to the cultural life of the country in general.

<div align="center">WRITINGS</div>

Removedor, 1–28 (1944–63)

<div align="center">BIBLIOGRAPHY</div>

J. P. Argul: *Las artes plásticas del Uruguay* (Montevideo, 1966); rev. as *Proceso de las artes plásticas del Uruguay* (Montevideo, 1975)
F. García Esteban: *Artes plásticas del Uruguay del siglo XX* (Montevideo, 1968)
La escuela del Sur (exh. cat., ed. M. C. Ramirez; Madrid, Mus. N. Cent. A. Reina Sofía, 1991)
C. A. Petrella: *La propuesta educativa del Taller Torres García, 1942–1949* (Montevideo, 1995)

<div align="right">ANGEL KALENBERG</div>

Tamayo, Rufino (*b* Oaxaca, 29 Aug 1899; *d* 24 June 1991). Mexican painter, printmaker, sculptor and collector. He is one of a select group of Mexican painters who attained international reputations in the 20th century, in his case sustained over a long and varied career. Opposed to the ideological current represented by Diego Rivera, David Alfaro Siqueiros and José Clemente Orozco, he eschewed ephemeral political messages in favour of purely pictorial and aesthetic questions. He came from a region in Mexico noted for its traditions and indigenous groups, its Pre-Columbian art and highly-coloured popular art, all of which influenced his work as early as *Woman in Grey* (1931; Mexico City, Mus. A. Mod.), a primitivistic image of a female nude. Throughout his life he collected more than 1000 Pre-Columbian ceramics and sculptures, donating them in 1974 to the people of Oaxaca as the Museo de Arte Prehispánico.

On the death of his parents in 1911, Tamayo settled in Mexico City to live with his aunt. He attended the Escuela Nacional de Bellas Artes from 1917 to 1921 but was essentially self-taught. From 1936 he lived intermittently in New York, where he came into contact with the art of Matisse, Braque and Picasso, which influenced his development. In 1938 he began teaching at the Dalton School, New York, generally spending his winters there and summers in Mexico City; in 1949 he made his first visit to Europe, where he subsequently established a considerable reputation through numerous exhibitions.

Tamayo's skill and sensibility as a draughtsman were fundamental to his art. As a painter he was an accomplished and inventive technician and an outstanding colourist, notably in easel paintings but also in murals. Linear contours, flat areas of colour and a highly formalized surface design of interlocking shapes characterize Tamayo's early work, such as *Women of Tehuantepec* (1939; Buffalo, NY, Albright–Knox A.G.), a depiction of the inhabitants of Oaxaca and characteristic of his recurring concern for Mexican types and costumes. His use of brilliant colour as a constructive element, together with a growing softness of forms and delicate but richly-brushed surfaces, increasingly defined his style, as can be seen by comparing two of his many animal pictures: *Animals* (1941; see colour pl. XXVIII, fig. 1), a stylized depiction of two ferocious-looking dogs howling at the moon and guarding their bones, and *Cow Swatting Flies* (1951; see colour pl. XXVIII, fig. 2), a gently humorous and light-filled painting. A similar development can be traced between the *Flute Player* (1944; New York, IBM Corp.) and *Man with Guitar* (see fig. 1).

Tamayo's later paintings demonstrate little stylistic development but evince an ever-growing technical refinement and originality in the use of colour. Among the best-known of his varied subjects are still-lifes, such as those featuring great slices of watermelon, for example *Melon Slices* (1950; New York, MOMA), and often penetrating portraits, such as *Olga* (1964; Mexico City, Mus. A. Contemp. Int. Rufino Tamayo) or the study of the painter *Jean Dubuffet* (1972; Mexico City, Mus. A. Contemp. Int. Rufino Tamayo), with whose taste for primitive imagery

1. Rufino Tamayo: *Man with Guitar*, oil on canvas, 1.95×1.30 m, 1950 (Paris, Centre Georges Pompidou)

and textured surfaces Tamayo's work has much in common. Tamayo also produced pictures in which a refined sensualism is conveyed through warm colours modified by different intentions. Allusions to love are sometimes subtle, as in *Woman and Bird* (1944; Cleveland, OH, Mus. A.; see fig. 2), and sometimes blatant, as in *Nude in White* (1943; Oslo, Kstnernes Hus). Another of Tamayo's preoccupations, both in his canvases and in some murals, was Man's place in the universe. *Man before the Infinite* (1950; Brussels, Mus. A. Mod.), in which a stylized figure gazes at a distant constellation of stars, *Celestial Bodies* (1946; Milan, Gal. A. Mod.) and the mural *Total Eclipse* (acrylic on canvas, 1976; Monterrey, Nue. León Grupo Indust. ALFA), a return to a subject treated 30 years earlier (*Total Eclipse*, 1946; Cambridge, MA, Fogg), all bear witness to his continuous interest in the theme.

Tamayo's work as a muralist was independent of the politically-inspired movement represented by Rivera, Orozco and Siqueiros, and he preferred to paint on enormous stretched canvases. He produced his first mural in fresco, *Music*, inspired by folk music, for the Music Conservatory in Mexico City (1933; now Ministerio del Patrimonio Nacional). Only once did he make a political statement, in the mural *Revolution* (1938; Mexico City, Mus. N. Cult.). He defined his aesthetic beliefs in *Nature and the Artist, the Work of Art and the Observer* (2.95×13.28 m, 1943; Northampton, MA, Smith Coll. Mus. A.) and carried out a considerable number of highly decorative works in which he expressed his thoughts on the history of Mexico, for example in the important mural *Birth of our Nationality* (1952; Mexico City, Pal. B.A.). He interpreted the ancient culture and religious myths of the Mexican Indians in various ways: *Day and Night* (vinyl on

masonite, 1954; Mexico City, Sanborn's Casa Azulejos) and *Duality* (vinyl on canvas, 1963–4; Mexico City, Mus. N. Antropol.). Abroad he carried out murals with themes taken from history or Classical mythology, such as the first version of *America* (vinyl on canvas, 1955; Houston, TX, N Bank). He made two versions of *Prometheus* (both vinyl on canvas, 1957, Río Piedras, U. Puerto Rico; and 1958, Paris, UNESCO).

Tamayo was also important as a printmaker, beginning in the 1920s with woodcuts, such as the Expressionist-influenced *Virgin of Guadalupe* (1930; New Haven, CT, Yale U. A.G.). In the late 1950s he began to produce colour lithographs, such as the portfolio entitled *Apocalypse de St Jean* (1959) and *Man with Sombrero* (1964), using the medium to create an equivalent to the lyrical colour and sensuous surfaces of his paintings. From the mid-1970s, in prints such as *Personage, Moon and Star* (1975; see 1976 exh. cat., no. 87), he devised innovative mixed technique procedures that exploited a remarkable range of textural effects. Tamayo also worked as a sculptor, modelling in clay, casting pieces in bronze and designing monumental iron sculptures such as *Homage to the Sun* (h. 27 m, 1979; Monterrey, Nue. León, Alcaldía), *Germ* (h. 15 m, 1980; Mexico City, U. N. Autónoma) and *Conquest of Space* (1983; San Francisco, CA, Int. Airport), all of which give ample proof of his creativity.

WRITINGS
Textos de Rufino Tamayo (Mexico City, 1987)

BIBLIOGRAPHY
R. Goldwater: *Rufino Tamayo* (New York, 1947)
V. Alba: *Coloquios de Coyoacán con Rufino Tamayo* (Mexico City, 1956)
P. Westheim: *Tamayo* (Mexico City, 1957)
O. Paz: *Tamayo en la pintura mexicana* (Mexico City, 1959)
E. Genauer: *Tamayo* (New York, 1975)
Rufino Tamayo (exh. cat. by J. García Ponce and M. Koike, Tokyo, N. Mus. Mod. A., 1976)
Rufino Tamayo: Fifty Years of his Painting (exh. cat. by J. B. Lynch jr, Washington, DC, Phillips Col., 1978)
Rufino Tamayo: Myth and Magic (exh. cat. by O. Paz, New York, Guggenheim, 1979)
X. Moyssén: *Rufino Tamayo* (Mexico City, 1980)
O. Paz and J. Lassaigne: *Rufino Tamayo* (Barcelona, 1982)
Rufino Tamayo: 70 años de creación (exh. cat., Mexico City, Pal. B.A., 1987)
Sculptures and Mixographs by Rufino Tamayo (exh. cat. by E. Sullivan, Chicago, IL, Mex. F.A. Cent. Mus., 1990–91)
J. A. Manrique and others: *Rufino Tamayo: Imagen y obra escogida* (Mexico City, 1991)
O. Paz and J. Lassaigne: *Rufino Tamayo* (Barcelona, 1994)
J. C. Pereda and M. Sánchez Fuentes: *Los murales de Tamayo* (Mexico City, 1995)
Rufino Tamayo: Del reflejo al sue[241]o, 1920–1950 (exh. cat. by R. Tibol, Mexico City, Cent. Cult. A. Contemp., 1995)
Tactar. Tamayo. Obra gráfica (exh. cat., Caracas, Mus. B.A., 1995)

XAVIER MOYSSÉN

2. Rufino Tamayo: *Woman and Bird*, oil on canvas, 1065×860 mm, 1944 (Cleveland, OH, Cleveland Museum of Art)

Tarsila [Amaral, Tarsila do] (*b* Capivari, 1 Sept 1886; *d* São Paulo, 17 Jan 1973). Brazilian painter. She spent her childhood on farms in the interior of São Paulo State, attended school in Barcelona and later trained privately in São Paulo under the painter Pedro Alexandrino Borges (1864–1942). From 1920 to 1923 she attended the Académie Julian in Paris and studied with Emile Renard (1850–1930), André Lhôte (1885–1962), Albert Gleizes (1881–1953) and Fernand Léger (1881–1955). While briefly in São Paulo from June to December in 1922 she formed the Grupo dos Cinco with the painter Anita

Malfatti (1896–1964) and the writers Menotti del Picchia, Mário de Andrade and Oswald de Andrade, to the last of whom she was married at the time. Her close links to the local modernist movement are evident in the fusion of Brazilianism and internationalism of *The Negress* (1923; U. São Paulo, Mus. A. Contemp.; see fig. 1), painted in Paris.

In 1924 she travelled through the old gold-rush towns of Minas Gerais with Mario de Andrade, Oswald de Andrade, other modernist companions and the French poet Blaise Cendrars, whose book *Feuilles de route I: Le Formose* (Paris, 1914) she illustrated. This journey led to her Pau-Brasil (Brazilwood) phase of paintings, with Brazilian themes characterized by geometrically stylized depictions of natural shapes, landscapes and city scenes all in bright colours, as in *Estrada de Ferro Central do Brasil* (1924; U. São Paulo, Mus. A. Contemp.; see fig. 2). In 1926 Tarsila visited the Middle East and exhibited for the first time in the Galerie Percier in Paris, exhibiting there again in 1928. The earthy Surrealist archaism of her recently finished painting *Abaporu* ('Cannibal'; São Paulo, Dantas de Souza Forbes priv. col., see P. M. Bardi, *Historia da Arte Brasileira*, São Paulo, 1975, p. 201) inspired Oswald de Andrade to elaborate and publish his *Manifesto antropófago* (São Paulo, 1928; *see* SEMANA DE ARTE MODERNA). During another stay in Europe she exhibited in Moscow in 1931 where her *Fisherman* (1925; St Petersburg, Hermitage) was acquired by the state. In the 1930s she moved away from that mixture of primitivism, construction and Surrealism towards social themes in paintings such as *Workers* (1933; Campos do Jordão, Pal. Boa Vista). It was only a passing phase, however, and from 1939 onwards she returned to the simple lyricism inspired by popular art, for instance in *St Ipatinga of Segredo* (1941; São Paulo,

2. Tarsila: *Central Brazilian Railway*, oil on canvas, 1.42×1.27 m, 1924 (São Paulo, Universidade de São Paulo, Museu de Arte Contemporânea)

Pal. Governo Estado). Later works include the religiously inspired *Procession of the Sacrament* (1954; São Paulo, Bienal).

Tarsila's fusion of such apparently disparate elements as the Russian pre-Revolutionary avant-garde, the magical tropical world of Henri Rousseau, the precise rules of the *esprit nouveau* and the inexhaustible symbolism of Surrealism all formed part of her revelation of a complex Brazil, at once traditional and contemporary.

BIBLIOGRAPHY

S. Milliet: *Tarsila* (São Paulo, 1953)
Tarsila (exh. cat., ed. A. Amaral; Rio de Janeiro, Mus. A. Mod.; U. São Paulo, Mus. A. Contemp.; 1969)
A. Amaral: *Tarsila: Sua vida e seu tempo*, 2 vols (São Paulo, 1975)
R. Pontual: *Cinco mestres brasileiros: Pintores construtivistas* (Rio de Janeiro, 1977)
——: *Entre dois séculos: Arte brasileira do século XX na Coleção Gilberto Chateaubriand* (Rio de Janeiro, 1987)
Art of the Fantastic: Latin America, 1920–1987 (exh. cat. by H. T. Day and H. Sturges, Indianapolis, IN, Mus. A., 1987)
M. G. de Silva Lima: *From Pau-Brasil to Antropofágia: The Paintings of Tarsila do Amaral* (diss., Albuquerque, U. NM, 1988)
G. Ferreira and I. de Araújo: 'De Tarsila a Lygia Clark: Influence de Fernand Léger et d'Andre Lhote', *Cah. Brésil Contemp.*, xii (1990), pp. 125–37
A. Amaral: 'Tarsila: Modernidade entre a racionalidade e o onírico', *Vozes*, lxxxvii/4 (1993), pp. 53–9
F. Bercht: 'Tarsila de Amaral', *Latin American Women Artists of the Twentieth Century* (exh. cat., New York, MOMA, 1993), pp. 52–9
Tarsila Amaral, Frida Kahlo and Amelia Peláez (exh. cat. by L. Montreal Agusí and others, Barcelona, Cent. Cult. Fund. Caixa Pensions, 1997)

ROBERTO PONTUAL

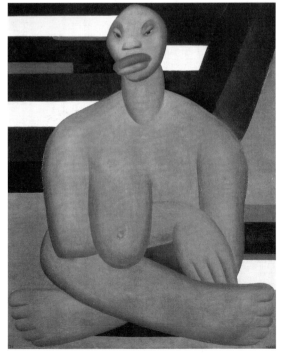

1. Tarsila: *The Negress*, oil on canvas, 1000×813 mm, 1923 (São Paulo, Universidade de São Paulo, Museu de Arte Contemporânea)

Taunay, Nicolas-Antoine (*b* Paris, 11 Feb 1755; *d* Paris, 20 March 1830). French painter. The son of a painter-enameller at the Sèvres factory, Taunay began his promising career aged thirteen in the studio of Nicolas-Bernard Lépicié. He later studied with Nicolas-Guy Brenet and

Francesco Casanova before moving to Rome to study at the Academie de France in 1784. In 1795 Taunay was named a founding member of the Institut de France, where he taught watercolour. Patronized by Empress Josephine, when Napoleon fell Taunay accepted Joaquim Lebreton's offer to travel to Brazil in 1816 as part of a French Artistic Mission to 'refine' creole culture. The mission, gathered at the request of King John VI, who had moved his court from Portugal to Rio de Janeiro in 1806, included naturalists, architects and artists. With Jean-Baptiste Debret and Auguste-Marie Taunay (1768–1824), his sculptor brother, Taunay helped found the Real Academia de Belas Artes do Rio de Janeiro in 1820, where he taught painting. During Taunay's five-year stay in Brazil, he lived in Cascatinha da Tijuca, immersed in the tropical landscape to which he showed great sensitivity in works such as *Santo António Hill* (1816; Rio de Janeiro, Mus. N. B.A.; for illustration *see* RIO DE JANEIRO). His greatest talent lay in genre and portrait painting; his portrait of John VI, King of Portugal (*reg* 1816–26) is one example of one of several works painted in Brazil. Taunay returned to Paris in 1821, leaving his son Félix Emilio Taunay (1795–1881) to teach landscape painting in Rio. Taunay exhibited eleven of his Brazilian works in the 1822 Salon de Paris and was made a member of the Légion d'honneur in 1824.

BIBLIOGRAPHY
A. D. Taunay: *Nicolas-Antoine Taunay: Documentos sobre sua vida e sua obra* (Rio de Janeiro, 1916)
——: *A Missão Artística Francesa de 1816* (Rio de Janeiro, 1956)
Enciclopedia del arte en América ([Buenos Aires], 1968)
J. HARWOOD

Tegucigalpa. Capital of Honduras. The city is on a plateau 975 m above sea-level, which is surrounded by mountains and has two rivers flowing through it, the Rio Grande (or Rio Choluteca) and the Rio Chiquito. Unlike other cities founded by the Spaniards in the region, it developed due to rich silver deposits that extended into the surrounding hills. It was initially known as the Real de Minas de San Miguel de Tegucigalpa, and the first references to its silver mines date from 1578 and 1579; the municipality of Tegucigalpa was officially created in June 1579. The town grew rapidly as settlers arrived to work in the mines. In 1587 construction began on the Real Caja de Rescates (now the Tipografía Nacional), which was responsible for the supply of mercury and the collection of the 'quinto real' tax. In 1594 official recommendations advocated use of strong and durable materials for new buildings, suggesting that earlier constructions were of perishable materials. By the early 17th century the church of the Immaculate Conception (alterations 18th–20th centuries; now in Comayagüela), and the Franciscan convent (begun *c.* 1590, rebuilt 20th century; now Departamente de Historia Militar de las Fuerzas Armadas) had been built, and the town was spreading west from the Plaza Principal, the Barrio and the hermitage church of El Calvario (end 18th century). Later extensions were the Barrio Abajo, the Barrio la Fuente and the Barrio de La Joya (now La Hoya). The church and convent of Nuestra Señora de la Merced Redención de Cautivos were built in 1654. Important buildings constructed in the 18th century include the church of Los Dolores (begun 1732; interior

altered 1910) and the parish church of S Miguel de Tegucigalpa (1756–82; now the cathedral; *see* HONDURAS, fig. 2). Tegucigalpa was an independent city from 1762 until 1821, when it was joined by a bridge to Comayagüela, an Indian town that until 1820 had its own council and local territory. In 1849 the administration was established in Tegucigalpa, and in 1880 the capital was officially moved to the city from Comayagua, 70 km to the northwest.

At the end of the 19th century a series of public buildings and recreational spaces were constructed and laid out, including the Cementerio General (from 1879), the Hospital General de la República (begun 1880 by Francisco Planas Zúñiga; additions 1933; now Palacio de los Ministerios; conversion by Alessandro Arrighi, 1993), and the Medical School (1883; now the Post Office). The Casa del Gobierno (or Casa Presidencial, 1919; now Museo Histórico de la República) by Auguste Bressani was inaugurated in 1921, as was the Teatro Nacional Manuel Bonilla (1905–15) by Cristobal Prats. Other projects of the late 19th century and the 20th include the Parque Dionisio Herrera (1942), the Escuela de Artes y Oficios (inaugurated 1890; now the Ministerio de Educación Pública), the Hospital S Felipe (1919–24), the Parque Valle, the Parque la Leona and the Palacio de Comunicaciones (1947; now Hondutel offices). In the late 1980s the new Galería Nacional de Arte was established in the former convent of Nuestra Señora de la Merced Redención de Cautivos.

In the 1930s and 1940s many streets were converted into pedestrian areas paved with concrete flagstones. The city's later extensions in all directions led to the construction of new *barrios* and three additional bridges linking Tegucigalpa and Comayagüela. In the 1960s 'Colonias', housing units set up with assistance from the USA under the Alliance for Progress programme, were built. Later, new housing estates were constructed in the suburbs and were linked to the main part of the city by boulevards, ring-roads and avenues containing shops, restaurants and bars. Due to an influx of people from the countryside in search of better prospects of employment, shanty towns began to appear on the hills around the city.

See also HONDURAS, §II, 1 and 2.

BIBLIOGRAPHY
W. V. Wells: *Explorations and Adventures in Honduras, 1857* (New York, 1857; Sp. trans., Tegucigalpa, 1960, San José, 2/1978) [incl. early description of Tegucigalpa]
R. E. Duron: *La provincia de Tegucigalpa (Bajo el Gobierno de Mallol, 1817–1821)* (Tegucigalpa, 1978)
M. Aguilar: *Tegucigalpa, apuntes de Manuel Aguilar* (Tegucigalpa, 1991)
L. López Nol and P. Graco Pérez: *Diseños decorativos en la arquitectura de Tegucigalpa* (in preparation)
ROLANDO SOTO

Testa, Clorindo (*b* Naples, 10 Dec 1923). Argentine architect and painter of Italian birth. He came to Argentina in 1924 and subsequently graduated in architecture from the University of Buenos Aires (1948). After working with the team developing a master-plan for Buenos Aires, he went to Italy to paint (1949–51) on a scholarship from the University of Buenos Aires. His stay there was probably instrumental in the development of his approach to the designing of 'architectural spacescape promenades'. He

1. Clorindo Testa with SEPRA: Banco de Londres y América del Sur (now Banca Hipotecario), Buenos Aires, 1959–66

then returned to Buenos Aires to begin his architectural career. Working with different partners on nearly every project, Testa became known as Argentina's most important designer in the 1960s and 1970s. He was a specialist in competition entries and won more than 20 first prizes for projects covering health, housing, education, commercial and other fields. A characteristic of his work, deriving from his early experience in urban planning and design, is

2. Clorindo Testa: *Untitled*, oil and graphite on canvas, 1.3×1.3 m, 1965 (Austin, TX, University of Texas, Jack S. Blanton Museum of Art)

the way each building is considered not in isolation but as an element in the urban environment, implying a design approach based on topology rather than Euclidean geometry. This can be seen, for example, in his early design for the Cámara Argentina de la Construcción (1952; with Dabinovic, Gaido and Rossi), Buenos Aires, or his plans for the development of Catalinas Norte (1959–60), Buenos Aires. In the latter project he proposed continuous multi-level podia and bridges to relate the cluster of towers within the city, but these elements were not included in the final design.

Testa's major works include the Provincial Government House, Civic Centre and bus terminal (1955–63; with Dabinovic, Gaido and Rossi), Santa Rosa, La Pampa; the Biblioteca Nacional (begun in 1962; with A. Cazzaniga de Bullrich and F. Bullrich), Buenos Aires, a raw-concrete, sculptural building raised on huge columns; and the headquarters of the Banco de Londres y América del Sur (now Banco Hipotecario;1959–66; with SEPRA; see fig. 1), which is considered to be one of the most important buildings in Buenos Aires and one that clearly reveals Testa's mastery of form and spatial manipulation. Its floors are cantilevered out into a large, open interior space, creating a dramatic yet functional design that is executed with great technical skill. It responds to its urban setting by the creation of a huge, carved-out corner entrance that forms a link between building and street; the glazed walls are enclosed and screened by a sculptural, grille-like concrete perimeter structure, revitalizing the streetscape, establishing a strong formal identity and providing a formal brutalist identity in contrast with the refined interior.

This building is also a good example of the other principal characteristics of Testa's work: his sensitivity to seen or imagined form, resulting in a physical pleasure in the act of drawing or painting; his ability to synthesize form and function, and to translate a complete design concept into expressive drawings; and his capacity to find new solutions to intricate technical problems. Other important buildings include the Naval Hospital (1970–82; with Lacarra and Genond), Parque Centenario, and the Buenos Aires Cultural Centre (1972–9; with Bedel and Benedit), Junín Street, in Buenos Aires; the Presidente Plaza hospital (1976), La Rioja; a government hospital (1979) in the Côte d'Ivoire, Africa, where a number of difficult environmental conditions had to be met in the design; the 'La Perla' resort (1885), Mar del Plata; and the Recoleta Cultural Centre (1990) and the Hebraica building (1994) in Buenos Aires.

Testa continued to paint throughout his architectural career, and his work showed a versatile evolution in a human, often humorous vein, in accordance with his philosophical preoccupations. His works ranged from pen-and-ink sketches (1950) carried out in Europe, to impressionistic fantasies in oil on canvas (1952); murals (1966) at the Provincial Government House, Santa Rosa; aerosol-paint 'thesis' presentations on cardboard (1970); some dark works in oil and graphite (see fig. 2); the *Peste* series in pen and ink (1978); the *Adam and Eve* series in aerosol and wax pencil (1981; e.g. Buenos Aires, Col. Chase Manhattan Bank, N.A.; Buenos Aires, ELFF Col.; Buenos Aires, Gal. Ruth Benzacar); and graphic sculptures as townscape happenings. His work has been exhibited in

Argentina (e.g. at the Museo de Arte Moderno, Buenos Aires, 1994) and at international exhibitions.

WRITINGS

with J. Glusberg: *Hacia una arquitectura topológica* (Buenos Aires, 1977)

BIBLIOGRAPHY

F. Bullrich: *Arquitectura argentina contemporánea* (Buenos Aires, 1963)
D. Bayón and P. Gasparini: *Panorámica de la arquitectura latino-americana* (Barcelona, 1977; Eng. trans., New York, 1979)
M. Waisman: *Documentos para una historia de la arquitectura argentina* (Buenos Aires, 1978)
J. Glusberg: *Clorindo Testa: Pintor y arquitecto* (Buenos Aires, 1983)
'Clorindo Testa', *Summa*, 183–4 (1983), pp. 1–142
Y. Futagawa, ed.: 'SEPRA y Clorindo Testa: Banco de Londres y América del Sur', *Global Archit.*, 65 (1984) [whole issue]
Revista 3 de teoría, história y crítica de la arquitectura (Nov-Dec 1993) [issue dedicated to Testa]
'Clorindo Testa y una nueva obra en Buenos Aires', *Revista* (16 May 1994)
Clorindo Testa: Exposición retrospectiva (exh. cat., Buenos Aires, Mus. A. Mod., 1994)
J. López Anaya: *Historia del arte argentino* (Buenos Aires, 1997)
M. A. Roca, ed.: *The Architecture of Latin America* (London, 1995)

LUDOVICO C. KOPPMANN

Tito, Diego Quispe. *See* QUISPE TITO, DIEGO.

Tobago. *See under* TRINIDAD AND TOBAGO.

Tobón Mejía, Marco (*b* Santa Rosa de Osos, nr Medellín, 1876; *d* Paris, 1933). Colombian sculptor, draughtsman, painter and medallist. He studied with Francisco Antonio Cano and co-founded with him the review *Lectura y Arte*, in which he published illustrations and vignettes influenced by the motifs and sinuous style of Art Nouveau. In 1905 he left for Havana, where his talent was more fully recognized. Cuban patronage enabled him to travel to Paris, where he executed delicate life-size marble statues that blend classicism and sensuality, such as *Poetry* and *Silence* (both *c.* 1914; Bogotá, Mus. N.), which are notable for their harmony and ambitious scale.

Tobón Mejía's most personal and interesting works, however, were reliefs in bronze and other alloys in which he gave free rein to his talents as a designer, to his admiration for the subjectivity of the Symbolists and especially to his own imagination and fantasy. In works such as *First Waves* (1915; Bogotá, Mus. A. Mod.), in which a young woman prepares to enter the sea, or *Female Vampire* (*c.* 1910; Bogotá, Mus. N.), he demonstrated a strong inclination towards the supernatural and the mysterious. He also worked, though more sporadically, as a draughtsman and painter, and his production as a medallist was recognized as the first of its kind in Colombia. His work established new standards of quality in Colombian sculpture, introducing a graceful and modern stylization far from the academic Realism that had hitherto predominated.

BIBLIOGRAPHY

Cien años de arte colombiano (exh. cat. by E. Serrano, Bogotá, Mus. A. Mod., 1985)
Marco Tobón Mejía (exh. cat. by M. Acevedo, Bogotá, Mus. A. Mod., 1986)
J. Cárdenas: *Vida y obra de Marco Tobón Mejía* (Medellin, 1987)

EDUARDO SERRANO

Toesca y Ricci, Joaquín (*b* Rome, *c.* 1740; *d* Santiago de Chile, 1799). Italian architect, active in Chile. He began his career in the office of Francesco Sabbatini (1721–97), who at that time was working for the Spanish authorities in Naples. In 1759 Charles IV of Naples assumed the Spanish throne as Charles III (*reg* 1759–88) and took Sabbatini to Madrid as architect to the Crown, together with his best assistants, including Toesca. Toesca's career in Madrid was pursued under Sabbatini's shadow, but he came into his own when he was seconded to Chile in 1778 to rebuild Santiago Cathedral, burnt down in 1769. Reusing the existing foundations, Toesca produced a Neo-classical design, now obscured by late 19th-century additions. His major work was the mint in Santiago, the Real Casa de Moneda (*see* CHILE, fig. 2), now the executive residence. The plan is laid out around several courtyards behind a Neo-classical elevation that features a three-storey central block in three bays flanked by two-storey wings. The central block is articulated below by four sets of coupled columns of a giant order, to which coupled pilasters correspond on the third floor. In lieu of columns, the six-bay wings are marked off by clustered pilasters and surmounted by a heavy balustrade. The composition recalls Luigi Vanvitelli's backdrop to the Piazza Dante, which was going up in Naples while Toesca was working on Sabbatini's schemes there.

Other projects of Toesca's include the rebuilding of the earthquake-damaged church of La Merced (completed 1795) and the design of the hospital of S Juan de Dios. He was also responsible for the embankment of the River Mapocho, and designed a number of parish churches. In the last two years of his life he taught architecture at the Academia de S Luis in Santiago. The influence of his executed work and that of his collaborators and students was far-reaching in Chile.

BIBLIOGRAPHY

R. Toro: 'Toesca, ensayo sobre su vida y su obra', *Bol. Acad. Chil. Hist.* ii/3 (1934)
A. Benavides Rodríguez: *Le arquitectura en el virreinato del Perú y en la capitanía general de Chile* (Santiago, 1941, 2/1961; rev. by J. Benavides Courtois, 3/1988), pp. 252–62
E. Pereira Salas: *Historia del arte en el reino de Chile* (Santiago, 1965)
G. Guarda Geywitz: 'El triunfo del neoclasicismo en el reino de Chile', *Bol. Cent. Invest. Hist. & Estét. Caracas*, viii (1967)
I. Cádiz Avila: *La pequeña Quintrala de Joaquín Toesca* (Concepción, Chile, 1993)

RAMÓN ALFONSO MÉNDEZ

Toledo, Francisco (*b* Juchitán, Oaxaca, 17 July 1940). Mexican painter, sculptor, textile designer, printmaker and collector. He grew up in an area that was rich in legends, rites and beliefs springing from a strong rural tradition predating the Spanish conquest of Mexico. He began to draw and paint at a very early age, studying first in Oaxaca, where he produced linocuts in the graphic workshop run by Arturo García Bustos (*b* 1926). In 1957 he moved to Mexico City to attend the Escuela de Diseño y Artesanía of the Instituto Nacional de Bellas Artes. After holding his first one-man shows of gouaches and prints in 1959 in Fort Worth, TX, and Mexico City, he moved in 1960 to Paris, where until 1963 he studied printmaking under Stanley William Hayter. While continuing to work within western traditions, he became interested in the art of oriental cultures and in ancient Mexican art, especially in those forms that were not officially sanctioned. In his attitude towards the sustaining inspiration of traditions he was particularly close to Paul Klee.

Francisco Toledo: *Shoe and Toads*, acrylic on paper on masonite, 560×750 mm, 1972 (Austin, University of Texas, Jack S. Blanton Museum of Art)

Toledo left France for Mexico in 1965 only to return in 1968, finally settling again in Oaxaca in the following year. He worked in a wide variety of media, including painting, drawing, printmaking, sculpture, tapestry and ceramics, often enriching one technique with discoveries made in another. While his formal vocabulary evolved in response to the demands of each medium, with the forms often based on his appreciation of abstract art, he added consistently to a richly varied iconography of fantastic primordial visions (e.g. *Shoe and Toads*, 1972; see fig.). His work was particularly close in spirit to that of Latin American writers such as Gabriel García Marquéz, Juan Rulfo and Jorge Luis Borges, whose *Manual de zoología fantástica* (Mexico City, 1984) he illustrated. Evoking primordial visions underlying everyday events so ordinary as to pass unnoticed, Toledo's motifs included the imprint of a crab on wet sand, iguana, a woman's large backside, the fur of a cat, the outline of a bat or the scales of an iguana, as in the etchings and aquatints of the *Guchachi Portfolio (Iguana)* (1976; Austin, U. TX, Huntington A.G.; see MEXICO, fig. 13). Generally he re-used such images so as to build on their metaphorical meanings, with their identities and interrelationships often clarified by their decorative function.

Although painting and printmaking remained the most important media for Toledo, in the 1980s he also produced polychromed wax sculptures with erotic overtones, such as *Bull Woman*, also known as *Pasifae* (1987; priv. col.), and true fresco paintings on transportable frames. From 1975 to 1983 Toledo lived successively in New York, Oaxaca and Mexico City, finally settling in Paris until 1987, when he returned to Mexico. At that time he began to amass a collection of prints by artists from all over the world as the basis for the Instituto de Artes Gráficas de Oaxaca in his former house, which he donated to the state. In addition to housing this permanent collection, the museum was intended as a venue for touring exhibitions organized in collaboration with the Museo Nacional de la Estampa in Mexico City.

BIBLIOGRAPHY

L. Cardoza y Aragón: *Toledo: Pintura y cerámica* (Mexico City, 1972)

M. Traba: *Los signos de la vida: José Luis Cuevas, Francisco Toledo* (Mexico City, 1976)

T. del Conde: *Francisco Toledo* (Mexico City, 1981)

C. Monsiváis: *Lo que el viento a Juárez* (Mexico City, 1986)

T. del Conde: 'Franciso Toledo', *A. Nexus*, ii (1991), pp. 48–52

Francisco Toledo: Retrospective of Graphic Works (exh. cat. by T. del Conde, Chicago, Mex. F.A. Cent. Mus., 1998) [Eng. and Sp.]

Francisco Toledo: Paintings and Gouaches (New York, 1996)

Francisco Toledo (exh. cat. by E. Billeter, Mexico City, Gal. Avril, 1997)

Francisco Toledo: Zoologie Fantastique (exh. cat. by C. Monsiváis, Paris, Cent. Cult. Ambassade Mex., 1997)

TERESA DEL CONDE

Tolsá, Manuel (*b* Enguera, Valencia, 1757; *d* Mexico City, 24 Dec 1816). Spanish architect, sculptor and teacher,

active in Mexico. He studied at the Real Academia de Bellas Artes de S Carlos, Valencia, at a time when Baroque forms were being rejected in Spain and Neo-classicism was being promoted. He was apprenticed to the sculptor José Puchol Rubio (*d* 1797), who also taught him extensively about architecture. In 1780 Tolsá moved to Madrid, where he studied under Juan Pascual de Mena and at the Real Academia de Bellas-Artes de S Fernando, where his subjects included painting. There he also designed several reliefs, including the *Entry of the Catholic Kings into Granada* (1784; Madrid, Real Acad. S Fernando). He was selected as an academician in 1789.

Following the endorsement of Juan Adán and Manuel Francisco Alvarez de la Peña, in 1790 Tolsá succeeded José Arias (*c.* 1743–88) as director of sculpture at the Real Academia de S Carlos de la Nueva España in Mexico City. He took with him a collection of plaster casts for sculptures, many books and 154 quintals (7 tonnes) of plaster for the Academia. He arrived in 1791 and set about repairing the statues that had been broken during the voyage. He gave classes on stucco ornament and decorative work in wood and stone and encouraged a change of taste away from the prevailing Baroque style. He also started a ceramics class and prepared the tiles for the convent of Churubusco.

From 1793, when Tolsá was appointed Director de las Obras at Mexico Cathedral, he began to concentrate on architecture, while occasionally undertaking sculptural commissions. In 1796, for example, he was commissioned to design the model for the bronze equestrian statue of *Charles IV* (erected 1803), popularly known as 'El Caballito', which stands beside the Museo Nacional de Arte, Mexico City (*see* MEXICO, fig. 9). The Real Seminario de Minería (1797–1813; now the Palacio de Minería; *see* MEXICO CITY, fig. 3), covering an area of almost 7500 sq. m and built around seven courtyards, is one of his finest architectural works. It is classical in style yet closely integrated with the surrounding contemporary architecture in Mexico City in a way that shows the direct dissemination of form and content to actual buildings at a time when academic architectural studies were important.

Tolsá's contribution to the completion of the cupola (1809) of Mexico Cathedral was paralleled by his replacement of the old Baroque retables by Neo-classical designs. He also made a number of designs in a transitional style, such as the unexecuted design (1808) for a church dedicated to Nuestra Señora de Loreto in Mexico City, and a plan (1797; Seville, Archv Gen. Indias) for the Carmelite convent in Querétaro, which was completed (1807) by Francisco Eduardo Tresguerras. His other projects included the Mexico City cemetery (1808) and a plan for a scale model of such an amenity after a royal decree required its provision in Spanish colonial cities. In 1810 he was appointed director of architecture at the Academia shortly after the death of Antonio González Velázquez the younger (*b* 1750), though he obtained his credentials as an architect only in 1813. His architectural skills are apparent in the residences he built for the Marqués del Apartado (1795) and in the Palacio de Buenavista (1795). His most important late sculptural works were the altar (begun 1799) of S Domingo, Mexico City, and the altarpiece with a baldacchino (1797–1818) for Puebla Cathedral.

BIBLIOGRAPHY

M. Toussaint: *La catedral y el sagrario de México* (Mexico City, 1917)
A. Encontria: *Breve estudio de la obra y personalidad del escultor y arquitecto don Manuel Tolsá* (Mexico City, 1929)
D. Angulo Iñiguez: *Arquitectura neoclásica en México* (Madrid, 1958)
S. F. Pinoncelly: *Manuel Tolsá, arquitecto y escultor* (Mexico City, 1969)
S. Pinoncelly: *Manuel Tolsá: Artífice de México* (Mexico City, 1974)
A. Gómez Ferrer: *Una lección neoclássica: La arquitectura de Manuel Tolsá en la Nueva España* (Valencia, 1986)
El Palacio de Minería, Sociedad de Ex-alumnos de la Facultad de Ingeniería de la Universidad Nacional Autónoma de México (Mexico City, 1988)
J. Berchéz and others: *Tolsá, Gimeno, Fabregat: Trayectoria artísta en Espagña, siglo XVIII* (Valencia, 1989)

RAMÓN GUTIÉRREZ

Toral, Mario (*b* Santiago, 12 Feb 1934). Chilean painter, printmaker and illustrator. He studied under the painter Agustín Calvo (*b* 1878) and then at the Escuela de Bellas Artes in Montevideo, Uruguay, and under Henri-Georges Adam in Paris. While living in Paris from 1950 to 1962 he familiarized himself with techniques of drawing and printmaking. On his return to Chile in 1962 he taught at the Escuela de Arte of the Universidad Católica in Santiago, but he later devoted himself exclusively to his art.

Toral worked first as a printmaker in the late 1950s and early 1960s, and he also received commissions to illustrate volumes of poetry by Pablo Neruda. By the end of the 1960s, however, he worked primarily as a painter. In his *Totem* series initiated in 1967, for example, he depicted human faces as if imprisoned in enormous blocks, introducing a vein of fantasy that became characteristic of his art (e.g. *Faces Number 9*, 1973; see fig.). A favourite theme was the conflict between the material and the spiritual, as in his series *Captives of Stone* (1976–7; see Galaz and Ivelič, p. 291), in which figures seem to be swallowed up by matter, suggesting a transformation from one state to another. Although there are links with Surrealism in Toral's work, his cultivation of mysterious moods and an almost evanescent line, together with the fleshy eroticism of his

Mario Toral: *Faces Number 9*, oil and acrylic on canvas, 1.52×1.53 m, 1973 (Austin, TX, University of Texas, Jack S. Blanton Museum of Art)

figures, are too personal to be aligned with a single movement.

BIBLIOGRAPHY

Mario Toral: Gravuras, desenhos, ilustrações (exh. cat., Rio de Janeiro, Mus. A. Mod., 1964) [leaflet]

G. Galaz and M. Ivelič: *La pintura en Chile desde la colonia hasta 1981* (Valparaíso, 1981), pp. 291–2, 294, 318, 337

Exposición de obras de Mario Toral (exh. cat., intro. L. Castedo; Santiago, Inst. Cult. Las Condes, 1984)

CARLOS LASTARRIA HERMOSILLA

Toral, Tabo [Octavio] (*b* Boquete, Chiriquí, 29 Aug 1950). Panamanian painter. He studied at the Maryland Institute College of Art in Baltimore in 1969 and at the Nova Scotia College of Art in Halifax from 1969 to 1971 before completing his education from 1971 to 1976 at the Escuela de Comunicación Social of the Universidad de Panamá. His first works were delicate and anecdotal drawings and etchings of mysterious, fairy-tale characters in fanciful surroundings. From the late 1970s he produced brightly coloured abstract paintings with gridlike substructures based on esoteric geometric relationships and inspired by Eastern philosophies; they were usually titled after the date on which they were finished, for example *1–3–1981* (Panama City, Mus. A. Contemp.). Toral moved to the USA in the early 1980s, where he changed to a figurative, neo-expressionist style and produced murals of semi-mechanical figures influenced by graffiti art. After returning to Panama in 1994, Toral explored new territory by combining the abstract geometric style of his earlier works with figurative elements, often human figures such as aborigines or bound women.

BIBLIOGRAPHY

Tabo Toral: Oleos, 1981 (exh. cat. by C. Alemán and M. E. Kupfer, Panama City, Gal. Arteconsult, 1981)

Tabo Toral, Panama (exh. cat. by E. Camargo and J. Gómez Sicre, Washington, DC, Mus. Mod. A. Latin America, 1983)

Tabo Toral: Inclinaciones (exh. cat., Panama City, Arteconsult, 1997)

Crosscurrents: Contemporary Painting from Panama, 1968–98 (exh. cat. by M. Kupfer and E. Sullivan, New York, Americas Soc. A.G., 1998)

MONICA E. KUPFER

Toribio, Tomás (*b* Villa de Porcuna, Spain, 1756; *d* Montevideo, 23 June 1810). Spanish architect, active in Uruguay. After graduating from the Academia de San Fernando in Madrid, he became a key figure in the colonial architecture of Uruguay, where he introduced Spanish Neo-classical academicism, with some elements of transitional Mannerism. The Cabildo (des. 1804, under constr. 1804–69, Montevideo, his own house (1804) in Montevideo and the parish church (1808) at Colonia del Sacramento are his major works and constitute one of the most significant legacies of colonial architecture. The architecture is sober and austere in its orderly treatment of space and subtle ornamentation of façades. The Cabildo, which was the seat of city government as well as jail and courthouse (now the Museo y Archivo Histórico Municipal), has an area of 2000 sq. m. It is a bold, vigorous building, square in plan and with a simple internal layout based on a series of rooms built around large open patios, vaulted galleries and a monumental central staircase. The façade includes rectangular, flat-arched windows, sober moulding and a rhythmic distribution of pilasters and granite columns. The Doric order is used at first-floor level, and

Ionic at the second. Toribio's house makes excellent use of a narrow plot. The ground-floor is a covered passageway; the upper floor is divided into two sections separated by a hall. The severe façade features a large central balcony with a wrought-iron balustrade. The church at Colonia del Sacramento was damaged by lightning in 1823 and rebuilt in two phases (1836–41 and 1865–8). Despite some modifications, it clearly reflects the sober character of Toribio's original scheme. In the early 19th century Toribio also worked on the Cathedral (1790–1804) in Montevideo.

BIBLIOGRAPHY

C. Pérez Montero: *El Cabildo de Montevideo: El arquitecto, el terreno, el edificio* (Montevideo, 1950)

J. Giuria: *La arquitectura en el Uruguay*, i (Montevideo, 1955)

A. Lucchini: *Ideas y formas en la arquitectura nacional*, Nuestra Tierra, xi (Montevideo, 1969)

J. C. Gaeta, ed.: *Guía de la Ciudad Vieja, Montevideo: Guías el arqa de arquitectura* (Montevideo, 1994)

Guía arquitectónica y urbanística de Montevideo (Montevideo, 1996)

ALICIA HABER

Toro, Antonio Herrera. *See* HERRERA TORO, ANTONIO.

Toro, Luis Felipe [Torito]. (*b* Caracas, 1879; *d* 1955). Venezuelan photographer. He photographed the most important political events in Venezuela in the first half of the 20th century. Toro's work appeared in such major newspapers and publications of the period as *El nuevo diario*, *El cojo ilustrado* and *Billiken*. Aside from his official photography, he was an alert observer of changes in the city of Caracas, and was an exceptional portrait photographer. Much of his work is housed in the Consejo Municipal de Caracas.

BIBLIOGRAPHY

J. Dorronsoro, ed.: *Luis Felipe Toro (c.1881–1955)* (Caracas, 1987)

Based on information supplied by LELIA DELGADO

Torre, Macedonio de la (*b* Trujillo, 27 Jan 1893; *d* 13 May 1981). Peruvian painter. He travelled abroad while still very young, visiting Bolivia and Argentina and frequenting the group of artists led by Luis Quinquela Martín in Buenos Aires. On his return to Peru he held his first exhibitions in Arica in 1917 and in Trujillo in 1918. His work matured in France, Belgium, Germany and Italy, and he exhibited in Paris at the Salon d'Automne in 1928 and the Salon des Indépendants from 1927 to 1930. Together with other members of the group Los Independientes, led by Ricardo Grau, he brought Fauvism and abstract art to Peru in the late 1930s, opening the way to modernism, but his influence was considerably limited by the prevalence at that time of the movement concerned with indigenous subject-matter led by José Sabogal. Torre's expressive strength, original personality and versatility led him to depict diverse subjects, including landscapes, gardens painted in an Impressionist style, portraits, still-lifes and vivid multicoloured compositions that he called 'jungles' because they suggested landscapes dense with plant life. His most important works are to be found in private collections in Lima.

BIBLIOGRAPHY

L. E. Tord: 'Historia de las artes plásticas en el Perú', *Historia del Perú*, ix (Lima, 1980), pp. 169–360

J. M. Ugarte Eléspuru: 'Nuestros grandes maestros: Macedonio de la Torre', *Kantú, Rev. A.*, iii (1987), pp. 7–12

LUIS ENRIQUE TORD

Torres, Francisco Antonio de Guerrero y. *See* GUERRERO Y TORRES, FRANCISCO ANTONIO DE.

Torres, Martín de (*b* Fuente del Maestro, Extremadura; *fl* 1631; *d* ?Cuzco, 1664 or 1680). Spanish sculptor and architect, active in Peru. He influenced generations of indigenous sculptors in the Cuzco region, where he was resident from about the 1630s until 1664 and where he introduced and developed the PLATERESQUE STYLE. Some of his carved retables are known only from documentation, as is the case with the principal altar (1631; destr. 19th century) at La Merced, Cuzco. Other works in Cuzco include the principal retables in Cuzco Cathedral, executed (1637–?1646) in collaboration with Juan Rodríguez Samanez (*fl* 1626–56), in the monastery of S Clara (1636) and in the monastery of S Agustín (1639; all destr.). He also worked with Rodríguez Samanez on the principal retables for the Monasterio de Nuestra Señora de los Remedios (destr. 1650) and for the Hospital de Españoles de S Juan de Dios in 1637, both in Cuzco. He is best known for the two *ambónes* (1656) in Cuzco Cathedral, pulpits placed either side of the high altar; which complement the building's mid-17th-century architecture. They are decorated with paired columns, flanking niches with angular and squared tops, pediments with volutes crowned by a cartouche, and with five carved Apostles on each pulpit. In 1651, following the 1650 Cuzco earthquake, he was contracted as architect to work on the main entrance to the church of La Merced, Cuzco, This was completed in 1669, with the exception of the tower, which was finished in 1675 possibly by Torres himself.

BIBLIOGRAPHY
H. E. Wethey: *Colonial Architecture and Sculpture in Peru* (Cambridge, MA, 1949), pp. 198, 203, 214, 296
E. Harth-Terré: *Perú: Monumentos históricos y arqueológicos* (Mexico City, 1975), pp. 31, 61–2, 130–31
J. de Mesa and T. Gisbert: *Historia de la pintura cuzqueña*, i (Lima, 1982)
J. B. Ballesteros: *Historia del arte hispanoamericano in siglos XVI–XVIII*, ii (Madrid, 1987), pp. 258–62

□

Torres García, Joaquín (*b* Montevideo, 28 July 1874; *d* Montevideo, 8 Aug 1949). Uruguayan painter, teacher and theorist, active also in Spain and France. His father was a Catalan emigrant from Mataró and his mother was Uruguayan. Financial problems forced the family to return to Catalonia in 1891, and he entered the Escuela de Artes y Oficios in Mataró. In 1892 he went to Barcelona, where he attended the Academia Baixas and became involved in the Cercle Artistic, also working as an illustrator for magazines and participating in various exhibitions. In 1903–4 he collaborated with Antoni Gaudí on the Templo Expiatorio de la Sagrada Familia (begun 1882) in Barcelona and on renovating the stained glass in the cathedral of Palma de Mallorca. In 1905, through the works he exhibited at the Sala Parés, his talent as a muralist was recognized by Eugenio d'Ors (1881–1954). He became involved in teaching and met Manolita Piña, whom he married in 1909. In 1910 he provided decorations for the Uruguayan pavilion at the Exposition Universelle et Inter-

nationale in Brussels. In 1911 he was commissioned to paint frescoes in the Salón de Sant Jordi in the Palau de la Generalitat, Barcelona (*in situ*), a task that took four years and gave rise to considerable controversy.

Having isolated himself in Tarrasa, Torres García began to paint local scenes and landscapes, as in *Street Scene* (1916; priv. col., see Jardí, p. 93). His desire to convey the dynamism of street life is apparent in a series of works exhibited in 1917 at the Dalmau Galeries, Barcelona, for example *The Fair* (1917; priv. col., see Jardí, p. 95). At this time he met the Uruguayan painter Rafael Barradas, who was also working with urban themes. In June 1917 *Un enemic del poble*, a magazine founded by the Catalan poet Joan Salvat Papasseit, published an untitled drawing by Torres García that depicts the hubbub of Barcelona life (priv. col., see Jardí, p. 102). The picture is divided into squares, an early indication of his approach to spatial organization that led to his Constructivist period a decade later.

As an extension of his teaching endeavours, Torres García began making wooden toys. In 1920 he moved to New York, where he also designed toys, that were manufactured in Fiesole and Livorno after he returned to Europe in 1922. In 1924 he moved to Villefranche-sur-Mer in France, and two years later settled in Paris. In 1928 he submitted works to the Salon d'Automne, but they were rejected. Jean Hélion (1904–87), also rejected, organized a successful show that November: entitled *Cinq peintres refusés par le jury du Salon d'Automne*, it was held at the Galerie Marck. Torres García's stay in Paris brought him into contact with Mondrian, an encounter that proved decisive. In late 1929 he and Mondrian were among the founders of Cercle et Carré, whose single group exhibition, incorporating works by 46 essentially Constructivist artists, took place in April 1930 at Galerie 23 in Paris; he left the group in July 1930 after disagreements with his colleague Michel Seuphor (*b* 1901). A call from friends in the newly formed Spanish Republic led him to move to Madrid in 1932. He held exhibitions at the Museo de Arte Moderno and the Sociedad de Artistas Ibéricos, organized the Grupo de Arte Constructivo, which exhibited at the Salón de Otoño in 1933, gave lectures and returned to teaching. He also established the compartmentalizing linear grid that would become his most familiar compositional device. Yet the period was discouraging for him, and in April 1934 he decided to return to Uruguay after a 43-year absence.

In Uruguay, Torres García set out on a formidable educational undertaking: he gave 600 lectures and organized 24 exhibitions of his work. In 1935 he founded the Asociación de Arte Constructivo and from 1936 to 1943 he published *Círculo y cuadrado* (10 numbers), which was modelled on a short-lived periodical of Cercle et Carré. It was followed in 1944 by *Removedor* (26 issues), the official publication of his workshop, the TALLER TORRES GARCÍA. Torres García introduced Cubism, Neo-plasticism and Constructivism to Uruguay. In his own work after his return he often achieved a balance between nature and reason, through a combination of Constructivist elements and signs referring to nature (see fig.). Although conveyed frontally, his motifs have an inner three-dimensionality, as in *Untitled* (1938; see colour pl. XXIX, fig. 1). These

Joaquín Torres García: *Universal Art*, oil on canvas, 1060×750 mm, 1943 (Montevideo, Museo Nacional de Artes Plásticas y Visuales)

R. Pereda: *Torres García* (Montevideo, 1991)
Torres García (exh. cat., ed. T. Llorens; Madrid, Mus. N. Cent. A. Reina Sofía, 1991)
Joaquín Torres García: Construcciones en madera y oleos (exh. cat., Punta del Este, Gal. Sur, 1993)
F. Bazzano Nelson: 'Joaquín Torres García and the Tradition of Constructive Art', *Latin American Artists of the Twentieth Century* (exh. cat., ed. W. Rasmussen, New York, MOMA, 1993), pp. 72–85
G. Peluffo: 'Torres García in Montevideo', *A. Nexus*, xxii (1996), pp. 72–7
El Universalismo Construcivo y la Escuela del Sur (exh. cat., Washington, DC, A. Mus. Americas, 1996)

ANGEL KALENBERG

Torres García Studio. *See* TALLER TORRES GARCÍA.

Torres & Velázquez. Mexican architectural partnership formed in 1953 by Ramón Torres (*b* Pachuca, Hidalgo, 22 Nov 1924) and Héctor Velázquez (*b* Mexico City, 25 Dec 1923). Both partners studied at the Escuela Nacional de Arquitectura at the Universidad Nacional Autónoma de México, graduating in November 1949. They both then spent a period studying abroad before establishing themselves in private practice. Their first works as a partnership were in the International Style, making free use of glass and metal but nevertheless achieving high-quality, attractive structures, such as a house (1959; in collaboration with Victor de la Lama) in Cuernavaca, Morelos, and the Centro Comercial Jacaranda (1956) in Mexico City, in which the various shop units shared a glass façade. The Lotería Nacional tower (1969–71), however, designed in collaboration with David Muñoz Suárez and 102 m high, marked the end of this stylistic period; built on a slender isosceles triangle plan, its foundations made innovative use of cryogenic construction techniques.

In many of their other works Torres & Velázquez were by this time adopting a style more obviously responsive to the Mexican environment. They executed a number of buildings faced with rough textures and using warm colours, in which the wall space predominated over window openings, and they also started to introduce more welcoming interiors. Their designs from the 1960s included several private houses, as well as the Conjunto Habitacional S Juan de Aragón (1964–6), with 10,000 dwellings, and the Unidad Habitacional Villa Olímpica, in collaboration with Agustín Hernández, Manuel González Rul and Carlos Ortega, for the Olympic Games of 1968 in Mexico City. The design of their housing projects (1986; in brick) in Villahermosa Tabasco, for over 1000 apartments, reflects their concern with climate, including thorough ventilation and areas of shade. They also executed the Natural History Museum there in 1987.

BIBLIOGRAPHY
L. Noelle: 'Retrospectiva de la obra de Ramón Torres', *Arquit. México*, 117 (1978), pp. 16–36
——: 'Ramón Torres', *Arquitectos contemporáneos de México* (Mexico City, 1988)
——: 'Héctor Velázquez', *Arquitectos contemporáneos de México* (Mexico City, 1988)
F. González Gortázar, ed.: *La arquitectura mexicana del siglo XX* (Mexico City, 1994)

LOUISE NOELLE

structures, and the reduced signs they contain, echo the work of indigenous South American cultures, such as the walls of the Pre-Columbian Incan fortress of Sacsahuaman. In 1938 Torres García finished his *Cosmic Monument* (Montevideo, Mus. N. A. Plást.), a wall of granite blocks inscribed with figurative and emblematic signs, and in collaboration with his followers painted the 27 murals at the Colonia Saint Bois sanatorium in Lezica, near Montevideo; 20 of the murals are extant, depicting a variety of themes. In 1944 he published the most extensive of his books, *Universalismo constructivo*, in which he summed up his ideas about plastic art. His followers include his two sons, Augusto Torres (1913–92) and Horacio Torres (1924–76), as well as Julio Alpuy (*b* 1919), Gonzalo Fonseca (1922–97), Manuel Pailós (*b* 1918), José Gurvich (1927–74) and Francisco Matto (1911–96).

WRITINGS
Historia de mi vida (Montevideo, 1934)
Metafísica de la prehistoria indoamericana (Montevideo, 1935)
La tradición del hombre abstracto (Montevideo, 1938)
Universalismo constructivo (Buenos Aires, 1944)
Lo aparente y lo concreto en el arte (Montevideo, 1947)
La recuperación del objeto (Montevideo, 1952)

BIBLIOGRAPHY
J. P. Argul: *Joaquín Torres García* (Buenos Aires, 1966)
J. Torres García (exh. cat., ed. D. Robbins; Providence, RI Sch. Des., Mus. A.; Ottawa, N.G.; New York, Guggenheim; 1970)
E. Jardí: *Torres García* (Barcelona, 1973; Eng. trans., New York, 1973)
Torres-García: Grid–Pattern–Sign: Paris–Montevideo, 1924–1944 (exh.cat. by M. Rowell, London, Hayward Gal.; Barcelona, Fund. Miró; Düsseldorf, Städt. Ksthalle; 1985–6)
A. Kalenberg: *Arte uruguayo y otros* (Montevideo, 1990), pp. 69–92

Tovar y Tovar, Martín (*b* Caracas, 10 Feb 1827; *d* Caracas, 17 Dec 1902). Venezuelan painter. He studied (1839–40) under Antonio José Carranza and in 1841 under

Carmelo Fernández and Celestino Martínez at the Colegio La Paz, Caracas. In 1850 he studied at the Real Academia de S Fernando, Madrid, and from 1851 to 1855 he lived in Paris and was taught by Léon Cogniet (1794–1880) at the Ecole des Beaux-Arts. Although he continued to travel frequently to Europe, he returned to Caracas in 1855, painting some of his best portraits before 1860 (e.g. *Ana Tovar y Tovar de Zuloaga*, 1858; Caracas, Machado Zuloaga estate). In 1859 he gave drawing classes at the Colegio Roscio, Caracas. Tovar y Tovar became associated with José Antonio Salas in 1864, establishing the art photography studio of Tovar y Salas. In 1867 he directed the painting section of the Academia de Bellas Artes. He was the official painter for the government (1870–88) of Antonio Guzmán Blanco, and was commissioned in 1873 to paint a gallery of portraits of leading figures for the Capitolio Nacional, Caracas. In 1883 he was awarded first prize in the Exposición Nacional for *Signing of the Independence Act* (Caracas, Col. Concejo Mun.). He was commissioned by the National Executive in 1884 to execute a number of large historical and allegorical paintings, outstanding among which is the *Battle of Carabobo* (1887; Caracas, Col. Pal. Federal). After 1890 he frequently executed landscapes from sketches (e.g. *Macuto Landscape, c.* 1890; Caracas, Gal. A.N.).

BIBLIOGRAPHY

E. Planchart: *Don Martín Tovar y Tovar, 1828–1902* (Caracas, 1952)
A. Boulton: *Historia de la pintura en Venezuela: Epoca nacional*, ii (Caracas, 1968/R 1972)
J. Calzadilla: *Martín Tovar y Tovar* (Caracas, 1977)
Donación Miguel Otero Silva: Arte venezolano en las colecciones de la Galería de Arte Nacional y el Museo de Anzoátegui (Caracas, 1993), pp. 19–20

MARÍA ANTONIA GONZÁLEZ-ARNAL

Tresguerras, Francisco Eduardo (*b* Celaya, 13 Oct 1759; *d* Celaya, 3 Aug 1833). Mexican architect, painter, engraver and sculptor. He studied painting under Miguel Cabrera at the Real Academia de las Nobles Artes de S Carlos in Mexico City but did not graduate. He subsequently took up wood-carving and engraving. He learnt the elements of architecture from the Jesuits, who gave him a copy of the writings of Jacopo Vignola. His architecture exhibits a familiarity with the classic treatises, although he never visited Europe. Tresguerras's first major work (1780s) was the reconstruction in Neo-classical style of the convent church of S Rosa, Querétaro, originally consecrated in 1752. The dome over the crossing is set on a drum articulated by rusticated columns, which flank a series of round-headed openings. He is also credited with remodelling the interior of the convent church of S Clara, Querétaro, and with constructing the Neptune Fountain (1802–7) in the plaza in front of it. The god stands under a triumphal arch, while water pours through the mouth of a fish at his feet. Tresguerras also completed (1807) the Carmelite convent in Querétaro, to the designs of Manuel Tolsá.

Tresguerras's most outstanding work was the church of Carmen de Celaya (1803–7), which displayed an emergent Neo-classicism derived from European models (*see* MEXICO, §III, 1). The nave bays are marked externally by buttresses capped by inverted consoles, with square scrolls adapted from ancient Mexican architecture. The crossing dome has a drum set off by coupled columns, in the manner of St Peter's, Rome, but these features are here continued up the dome's tiled exterior with the slightest inflection. The side portal, abutting the transept, has a dished upper storey that serves as a background to the aedicule housing a statue of the Virgin. The main entrance, at the end of the nave, is surmounted by a tower, the upper storeys of which are articulated with various combinations of classical forms, capped by a conical dome. Tresguerras designed all the *retablos* for the church, carved and painted most of the figure sculpture and executed the frescoes.

The most notable secular building by Tresguerras was the palace he designed (1809) for the Condes de Casa Rul in Guanajuato. It features a colossal order above a plinth storey, with a slightly projecting central range surmounted by a pediment, an uncompromising statement of Tresguerras's adherence to Neo-classicism. Other important works include the Teatro Alarcón (1827) in the town of San Luis Potosí, where he also designed the public water supply system. Tresguerras's works set the standard for progressive 19th-century academic Neo-classicism in Mexico, in contrast with the brilliant period of Mexican popular Baroque. He epitomized a certain group of Latin American architects who, although self-taught, were convinced of their creative potential.

BIBLIOGRAPHY

V. M. Villegas: *Francisco Eduardo Tresguerras, arquitecto de su tiempo* (Mexico City, 1964)
Ocios literários (1972)
R. Gutiérrez: *Arquitectura iberoamericana, 1800–1850* (Resistencia, 1979)
R. Gutiérrez and C. Esteras: *Territorio y fortificación* (Madrid, 1991)
——: *Arquitectura y fortificación: De la ilustración a la independencia americana* (Madrid, 1993)

RAMÓN GUTIÉRREZ

Tridentine style. *See* ESTILO DESORNAMENTADO.

Trinidad and Tobago, Republic of. Caribbean country. It comprises the islands of Trinidad (4828 sq. km) and Tobago (300 sq. km) and lies at the southern tip of the Caribbean archipelago (see fig. 1). Trinidad was colonized from 1532 and was united with Tobago in 1889. The country achieved independence in 1962. The capital is Port of Spain, and the official language is English.

I. Introduction. II. Cultures. III. Architecture. IV. Painting and sculpture. V. Interior decoration and furniture. VI. Ceramics. VII. Patronage and collecting. VIII. Museums. IX. Art education.

I. Introduction.

Unlike many largely volcanic Caribbean islands, Trinidad was until recent geological times a part of the South American mainland and is separated from Venezuela by only 11 km of sea. This island is divided by three mountain ranges running east to west: the Northern Range, a continuation of Venezuela's coastal cordillera; the Central Range, which forms a belt across the middle of the island; and the low hills of the Southern Range. Swamps occur in lowland areas, and tropical rainforest covers much of the island. Tobago lies *c.* 30 km north-east of Trinidad and is dominated by the Main Ridge, running along the northern part of the island. The land flattens out to the lowlands of the south-west.

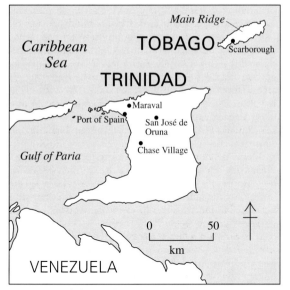

1. Map of Trinidad and Tobago

Prior to Christopher Columbus's arrival in 1498, Trinidad was settled by Amerindian tribes: Caribs and Arawaks. For the next 200 years it remained a colonial backwater, a base for fruitless expeditions in search of El Dorado. Spain, which had colonized Trinidad from 1532, attempted to attract foreign settlers, the Cedula of Population (1783) resulting in an influx of French settlers and their slaves. Under governor Don Chacon, Port of Spain was enlarged, and the population tripled to 18,000. In 1797 a British fleet under Sir Ralph Abercromby forced a Spanish surrender. Trinidad then became an experimental Crown colony with Spanish laws and a French-speaking population, controlled directly from London through a governor. With slave emancipation in 1834, a new labour force was needed for the sugar plantations, a problem solved eventually by importing c. 144,000 Indian indentured labourers between 1845 and 1917. Tobago was fought over and settled by the Dutch, French, Spanish, English, pirates and Latvian Courlanders before it was united with Trinidad, following the collapse of its sugar economy.

After the Depression and the labour unrest of the 1930s, the presence of the USA in Trinidad during World War II revitalized the economy. The most decisive postwar development was the emergence in 1956 of the cohesive People's National Party, led by Dr Eric Williams, which steered Trinidad and Tobago to independence (1962) and then republic status (1973).

BIBLIOGRAPHY
D. Buisseret: *Historic Architecture of the Caribbean* (Port of Spain, 1986)
Caribbean Art Now (exh. cat., London, Commonwealth Inst., 1986)
JERRY BESSON

II. Cultures.

1. Amerindian. 2. Afro-Caribbean.

1. AMERINDIAN. The earliest important art expression of the Amerindians of Trinidad and Tobago is found in the Saladoid, a prehistoric manifestation of the Arawak culture that migrated from Venezuela c. 700–600 BC. The earliest pottery, the Cedrosan and the Palo Seco styles of the Saladoid culture, is characterized by a very fine and thin hard-fired ware, with attractive white-on-red painted designs and thin line incisions filled with a white paste on inverted bell-shaped bowls with flaring rims and D-shaped strap handles. This type of pottery is also characteristic of Pre-Columbian north-eastern Venezuela, the Lesser Antilles and Puerto Rico. Painted decorative motifs consist of straight lines, circles, spirals and other geometric forms applied in ornamental bands on the upper exterior surface. Slip and paints were obtained from mineral oxides, kaolin and occasionally charcoal. The slip-dipped method of painting the entire vessel surface was commonly used. Early Cedros pottery is also characterized by a large percentage of unpainted bowls with cross-hatched, flaring rims, which has come to be considered a diagnostic trait of early Saladoid pottery throughout the region.

A cultural change can be seen in such later pottery styles as the Erin Bay (700–1000 AD) and Bontour (1000–1500 AD). These have less artistic merit while still exhibiting continental influences. Erin Bay style is characterized by lack of painted ornamentation, coarse but polished surfaces, and a profusion of modelled, wide-incised decorated lugs, similar to the Barrancoid pottery style from Venezuela, from which it derives. Bontour style is characterized by the collared *olla* vessels, hardly ornamented except for some incising, appliqué and a few effigy lugs. As is the case throughout the Antilles, these seem to reflect a decline in the use of pottery for ceremonial and religious objects in favour of wood, shell and stone.

Other artistic objects of possible ritual significance, such as polished axes, beads, amulets in the form of bats, birds, frogs or other mythological creatures, were made from mother-of-pearl, shell and polished semi-precious stone. Wood was also used for such ritual objects as snuff-pipes, rattles and masks. Wooden ceremonial four-legged stools (*dujos*), similar to those of the Tainos from the Greater Antilles, have been found in the pitch-lake of Trinidad. By the time of the Spaniards' arrival, the Saladoid culture had disappeared. Chroniclers and travellers noted Nepuyos, Aruacos (Arawaks) and Caribs, whose cultures were comparable with the Arawaks and Caribs of South America. The Amerindian population continued to thrive until around the end of the 18th century, when the plantations developed with the arrival of French creole refugees.

BIBLIOGRAPHY
J. W. Fewkes: *A Prehistoric Island Culture Area of America* (Washington, DC, 1922)
S. Loven: *Origins of the Tainan Culture, West Indies* (Göteborg, 1935)
I. Rouse: 'Prehistory of Trinidad in Relation to Adjacent Areas', *Man*, xlvii (July 1947)
J. Bullbrook: *On the Excavation of a Shell Mound at Palo Seco, Trinidad, B.W.I.*, Yale U., Pubns Anthropol., 50 (New Haven, 1953)
A. Boomert and others: 'Archaeological–Historical Survey of Tobago, W.I.', *J. Soc. Americanistes*, lxxiii (1987)
P. Harris: 'Amerindian Trinidad and Tobago', *Proceedings of the 12th International Congress for Caribbean Archaeology: Montreal, 1988*
RICARDO E. ALEGRÍA, MELA PONS-ALEGRÍA

2. AFRO-CARIBBEAN. Afro-Caribbean culture in Trinidad and Tobago has its origins with the introduction of black slaves and their French owners, whom the Spanish

had invited in the late 18th century to settle and economically develop the two islands. Many slaves were from the Congo region and present-day Nigeria and were Yoruba and Igbo peoples (*see also* AFRICAN DIASPORA). Many Yoruba and other African settlers who were freed at Freetown in Sierra Leone also made their ways to the shores of Trinidad and Tobago; some came as freed Blacks, and some became owners of sugar estates. African religion and its manifestation in music and performance and African medicine provided a foundation for Afro-Caribbean culture in Trinidad and Tobago. Although it is difficult to reconstruct the historical setting of the importation and adaptation of African culture in these islands, it is known that the Orisa cults of the Yoruba had made inroads in the early 19th century. The Yoruba deity of thunder, Shango (Sango in Trinidad and Tobago), was very strong and remains at the heart of the Afro-Caribbean religious experience, in which artistic expression is interwoven. Worship of this deity was strong in both the rural Trinidad and the primary cities, including Port of Spain. Shango yards flourished in the Belmont and Levantile districts in the east of the capital. Healing rites, dancing, music and feasting were among the activities that took place in the yards. While the old form of Shango worship was becoming a memory for the middle-aged generation of the late 20th century, the cult of Sango had become a focus of the so-called Shouter revivalists, a branch of the Baptists. As in West Africa, Shango is associated with wealth and good luck, which has bolstered his attractiveness in Trinidad and Tobago. The African tradition of medicine is referred to in Trinidad and Tobago as Obeah, and it is found throughout the islands. Obeah men and women may be compared to the healer–diviners of the Yoruba known as the *babalawo*, although the practice may comprise Kongo elements. Obeah magic is a carefully guarded secret on both islands. Its efficacy is based on a programme of sacrifices, divination and the making of medicines to aid patients who need help with a particular task or a challenge that concerns the opposite sex. The use of animal sacrifices, bones, stones and other kinds of materials to make power images has its roots in African medical practices.

Music is an important part of African-derived Caribbean traditions, especially use of the primary instruments of the drum and the gong, as well as other percussive instruments used in the arts of masquerade. During the late 19th century and early 20th, percussive bands known as *tamboo bamboo* were the mainstay of carnival music. Each band consisted of several individuals who carried hollowed bamboo stocks that were tuned to a certain pitch. Because these instruments could be turned into weapons when aesthetic rivalries became out of control, they were banned. In their place emerged the biscuit tin, kerosine can and other metal containers (pans), which could be tuned. At the centre of a large steel-band orchestra is the percussive ensemble that keeps the pan artists' melodies and harmonies together. Its primary instrument is the double gong, often in the form of two motor car brake-drums, which maintains the rhythm of the other instruments of the ensemble. The double gong, or *aggogoo* as it is known in Trinidad and West Africa, is also the primary instrument

of ceremonial music on the West African coast among the Yoruba and such people as the Asante of Ghana.

The impact of Yoruba culture in the West Indies, and particularly Trinidad and Tobago, has been well documented (e.g. Bascom; Thompson). It is especially evident at CARNIVAL. After slave emancipation the British sought a new labour source for the sugar and cocoa estates. The indentureship programme in Sierra Leone resulted in *c.* 6000 Yoruba expatriates, who had settled in Freetown, relocating in Port of Spain, primarily in the Belmont area (formerly known as Freetown in honour of the city they had left). Belmont is an active centre for the worship of Shango, as are the northern rural areas. As in Freetown, the Yoruba introduced the *sousou* banking system, known in that African city as *asusu*. Trinidadian *sousou* may have been used to fund the various carnival masquerade groups in the 19th century.

It is difficult to trace the history of specific carnival masking styles, elements and symbols back to Africa. Maureen Warner-Lewis, however, reports that in the early history of Port of Spain the Dahomian Rada peoples all dressed in similar costumes and paraded on carnival day. In Freetown, dressing alike is referred to as *ashoebi* ('we of one dress'). Such dress may be the foundation for the sections of the modern-day large carnival bands in which individuals of each section dress alike to convey a theme or idea about the band. In general, the aesthetic of assemblage that guides carnival masquerades may be traced to early migrations from Africa. This aesthetic of display demands the accumulation of such *objets trouvés* as bones, shells, horns and cloth, to create a powerful object similar to Obeah power objects. As modern materials became available, plastic ornaments and other fancy materials were added to the pool of items from which this aesthetic could be manifested. With the advent of the Black Power movement of the 1970s, many Trinidadian artists began referring to art books as sources for rendering African-style costumes. Thus both history and a new consciousness help explain African and particularly Yoruba-derived masking elements. Mid-19th century eyewitness accounts of masquerade bands indicate the development of an African and European aesthetic:

> Now we observe the Swiss peasant, in holiday trim, accompanied by his fair Dulcima—now companies of Spanish, Italians, and Brazilians glide along in varied steps and graceful dance . . . But what see we now?—goblins and ghosts, fiends, beasts and frightful birds—wild men—wild Indians and wilder Africans. (Wood, p. 152)

This account shows the development of a dual carnival aesthetic, consisting of the 'fancy' aesthetic as embodied by the Dulcima companies and the 'fierce' aesthetic exemplified by the wild Indians, beasts and fiends. In general the fierce aesthetic derived from African traditions of animal mask presentations and the fancy from the European courtly masking tradition representing kings, queens and courtesans. As carnival developed larger and larger spectacles, the number of principal masquerade characters increased. The Indian character, inspired by the indigenous Caribs, appeared in many styles and spread throughout the Caribbean. Fancy kings and queens, devils,

sailors, East Indians, prostitutes, men in women's dress and horse- and cow-head masks were also represented. The important African-derived performer, the Mocu Jumbie or stilt masker, appeared in early carnival in Trinidad and throughout the West Indies. Another masker, Pierrot Grenade, is characterized by his dress of strips of cloth, with bells attached at the ends, and a large heart-shaped breast-plate that was decorated with mirrors and boa. With a wire-screen mask, this Pierrot character protected his carnival territory against other Pierrots by verbal competitions. The strip-style costume, heart-shaped chest ornament and wire-screen mask appear in many other Caribbean festival costumes including a masquerade of St Kitts–Nevis and Jonkonnu of Jamaica (see JAMAICA, §II, 2). These convergences suggest a common Afro-Caribbean history for these and other festivals.

There are a few examples of masquerade for which specific African origins, including the Yoruba, can be traced. There has, however, been much controversy about the sources in the case of the Midnight Robber (see fig. 2). The character may have been inspired by late 19th-century illustrations of outlaws in popular literature or by images of the Mexican bandit that were produced by such artists as Frederic Remington. The People's Cultural Association of Trinidad, in a newsletter (1987) about robber history and Trinidad's politics, traces the character back to the Ogboni society and Adamu Orisa plays of the Yoruba city of Lagos in Nigeria. Certainly the use of skulls, feathers, metal and reflective surfaces in robber costumes

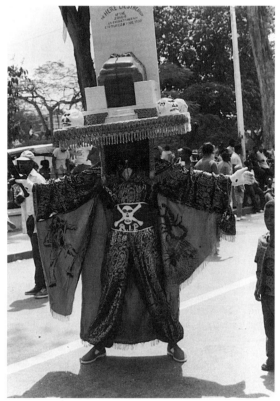

2. Midnight Robber masquerade character with Tombstone Headdress, Trinidad

is paralleled in African costumes and in the practice of Obeah. The fringed hat of the robber, which resembles a fringed platform on which a complex and often tiered superstructure rests, may have its origins in Cross-River costume traditions; such tassel-fringed hats were worn by coastal chiefs of the Niger Delta. Such hats are also found on images that adorn the *nduen fobara* of the Kalabari Ijo, again from the Delta area (see Barley, p. 51). The fringe motif may have been adapted by Kru sailors, then introduced to Freetown and the West Indies. The term *nduen* itself may be the origin of the Trinidadian *dwen* or *duen*, which refers to a class of spirits that is sometimes represented in carnival and that Warner-Lewis suggests is of Efik Ibibio origins. The term *nduen* is also an Ijo term for the dead.

Trinidadians have introduced to carnival Yoruba concepts of spiritual force, which reside in the power of the Orisa, the 401 designated deities. The underlying reason for celebrating with carnival bands is to bring in the new year with a fresh start and to clear away the old afflictions, which include hardship, disease and pain. Wayne Berkeley's Rain Forest masquerade of 1983 included a section called 'Lightning', in which the maskers carried doubled celt (axe) motifs that referred to the god Shango. The Rain Forest band ingeniously transformed the cityscape of Port of Spain into a living rain forest that included sections portraying white and green palms, tropical flowers, hurricanes and the sun (see Nunley and Bettelheim, p. 105). Shango also inspired the designs by Berkeley for the King and Queen sections for the Cocoyea Village band in 1987. The giant robber-shaped king, called Spell of the Cocoyea Broom, was made out of strips of cocoyea palm leaf ribs, which were then dipped in glue and silver glitter. Berkeley explained that the idea for using cocoyea strips came from Shango priests of Trinidad, who dust or clean their altars with a broom made from cocoyea. Thus as the king danced around the Savannah stage, he cleared and purified the Cocoyea Village masquerade band for the new year. Furthermore, in this instance the stage served as the national shrine for the procession of this king, who therefore cleansed the country in its national masquerade festival of 1987.

Since World War II, masquerade bands of Trinidad and Tobago have grown considerably, with some having a membership of 4000 masqueraders. The organization of the bands has become thematic, with issues ranging from the political or ecological to social concerns. The Bailey brothers have been important in the development of masquerade bands. George Bailey (1935–71) and his two brothers, Albert and Alvin, grew up in the multi-ethnic Woodbrook district of Port of Spain. As well as having a curiosity for all cultures of the world, George was profoundly aware of his African heritage. With the English school curriculum, he was also knowledgeable about Greek, Roman and English history, subjects that would play a part in his carnival masquerade. In 1956 he and his brothers produced a masquerade band called Timus Leopard King, which, according to Albert Bailey, was based on research about Africa. George sought to show the variety of African cultures at a time when all Africans were considered black and all the same. He proclaimed the diversity of Africa in a profoundly African manner,

through the performance of masquerade. Combining historical research and African adaptations in Trinidad, which included Obeah, Shango and a fierce style of masking, he further expanded the thematics of Afro-Caribbean culture in its primary form in Trinidad and Tobago: carnival. In 1957 his band produced Back to Africa, which stunned the crowds who saw its procession through the streets of Port of Spain and across the various stages where the formal competitions were held. One section of the band included 70 horsemen mounted on bent-wire horses and dressed in robes similar to the professional cavalries of North Africa and the Sudan; other sections included witch-doctors and juju men, who were dressed in the African fierce style of costume. The last section included kings of Nigeria such as the Obas of Benin and the Alafins of the Yoruba; dressed in rich velvets, brocades and capes, these African kings in royal regalia emphasized the point that other African countries, not just Egypt, had a rich history of civilization and kingship. This newly introduced African monarchy in masquerade paved the way for other bands based on African subject-matter. At the time of Back to Africa other popular band leaders were using themes drawn from Hollywood cinema, creating such masquerades as Quo Vadis and Imperial Rome. Bailey's workshop included many students who have established themselves in London, New York and Toronto. Bailey himself has been credited with raising the art of wire-bending to new levels, using light metal substructures that allowed for the creation of large-scale costumes that could be danced in easily by one person. Since his death, other bands have presented African-based themes, drawing on famous types of African art, such as the Bamana antelope headdresses, Dogon masks, Mossi plank masks and Zulu warrior costume, for their design and production.

BIBLIOGRAPHY

T. Winterbottom: *An Account of the Native Africans in the Neighbourhood of Sierra Leone* (London, 1803, 2/1969)
M. Deren: *Divine Horseman: The Living Gods of Haiti* (New York, 1953)
D. Wood: *Trinidad in Transition* (London, 1968)
W. Bascom: *Shango in the New World* (Austin, 1972)
E. Hill: *Trinidad Carnival: Mandate for a National Theatre* (Austin, 1972)
B. Brereton: 'The Trinidad Carnival, 1870–1900', *Savacou*, xi–xii (Sept 1975), pp. 46–57
M. T. Drewal: 'Projections from the Top in Yoruba Art', *Afr. A.*, xi/1 (1977), pp. 43–9, 91–2
J. Martin: *Krumen down the Coast*, African Studies Working Papers, 64 (Boston, MA, 1982)
R. F. Thompson: *Flash of the Spirit: African and Afro-American Art and Philosophy* (New York, 1983)
F. Lamp: 'Cosmos, Cosmetics, and the Spirit of Bondo', *Afr. A.*, xviii/3 (1985), pp. 28–43, 98–9
S. A. Boone: *Radiance from the Waters: Ideals of Feminine Beauty in Mende Art* (New Haven, 1986)
V. Comma: 'Carnival in London', *Masquerading: The Art of the Notting Hill Gate Carnival* (London, 1986)
J. W. Nunley: *Moving with the Face of the Devil: Art and Politics in Urban West Africa* (Chicago, 1987)
F. E. White: *Sierra Leone's Settler Women Traders, Women of the Afro-European Frontier* (Ann Arbor, 1987)
People's Cult., 4 (Feb 1987)
J. W. Nunley and J. Bettelheim: *Caribbean Festival Arts: Each and Every Bit of Difference* (Seattle, 1988) [pubd on the occasion of an exh., St Louis, A. Mus., 1988]
N. Barley: *Foreheads of the Dead: An Anthropological View of Kalabari Ancestral Screens* (Washington, DC, 1989)
P. Mason: *Bacchanal! The Carnival Culture of Trinidad* (Philadelphia, PA, 1998)

JOHN NUNLEY
(bibliography with MAUREEN WARNER-LEWIS)

III. Architecture.

At the time of the Spaniards' arrival the indigenous architectural form was a palm-thatched shelter (*ajoupa*) supported on undressed timbers divided with walls of clay reinforced by straw. The colonizers made use of local skills, for example in the churches and missions set up in the mid-17th century by evangelizing Catalan Capuchin monks. By 1700 the centre of occupation moved from the first capital of San José de Oruna to Puerta de los Hispanioles (Port of Spain), until then little more than a fortified trading post. The rapid rise in population caused by the arrival of the royalist French creole planters was accompanied by the architectural development of the French creole style in Port of Spain with several streets of timber-sided buildings with shingle roofs. A devastating fire in 1808 razed the city to the ground and inspired the colony's first set of building regulations, making it obligatory to use brick or stone and slate roof-tiles. The early 19th century was a period of stability, during which the Anglican Holy Trinity Cathedral was built (1823), facing Woodford Square, and the earlier timber Roman Catholic cathedral (1787) was replaced with the cathedral of the Immaculate Conception (1816–32) on Independence Square in Port of Spain. Both are by Philip Reinagle, working in the Gothic Revival style. The former, wholly constructed in squared Laventille limestone, has a pinnacled tower with a squat octagonal spire and boasts a hammerbeam roof; the latter, with typical brick quoins to dressed, rubble infilling, is more collegiate in style. Neo-classicism was less evident than Gothic Revival, although a few examples of public buildings included the Court House (1822; destr. 1954), Scarborough, Tobago, by Samuel Hall, which had a pedimented tetrastyle portico, and the General Hospital (1855), Port of Spain, by Lewis Samuel, with windows set in deep reveals giving internal shade and externally an almost layered effect to the elevations.

During the 19th century a number of nationalities and races brought their architectural influences to bear: English, Scottish, French, African, American, Venezuelan, Barbadian and Grenadian. The chattel house-type found throughout the Caribbean islands developed in great numbers, particularly in the suburbs of Belmont, Newtown and Woodbrook, from a small unit to a highly decorative building extended by galleries with high roofs, jalousies and a profusion of fretwork. George Brown (*b* 1852), an architect recently qualified at the University of Glasgow, went to Port of Spain in 1882. He was employed by Turnbull Stewart & Co. and began almost immediately to transform the city. After a fire in 1895 he rebuilt both sides of Frederick Street using masonry cross-walls at right-angles to the street to support a steel structure and slender cast-iron columns, brackets, lantern lights, grilles and balustrading, imported from Glasgow, to give a unique character to his elegant two-storey terraces. Tall cast-iron columns set at the edge of the pavement gave shaded galleried streets (now mostly destr.) and with lacy verandah rails above bestowed a lightness of touch on building façades. Walls were typically of rubble, stuccoed and painted in light colours and trimmed with red brick quoins to arched openings at ground-floor level. The Union Club

(1904), Port of Spain, is an especially well-proportioned surviving three-storey example with open galleries at both upper levels (see fig. 3). Brown was also responsible for some of the many *fin-de-siècle* estate houses and urban mansions. He mixed an uninhibited eclecticism with Arts and Crafts forms already tinged with incipient Art Nouveau, exuberantly decorated: for example, the Queen's Park Hotel (1909), Mille Fleurs and Hayes Court and, strangely out of character, the Romanesque baronial, towered and turreted Archbishop's House. More broadly, as well as dozens of smaller 'gingerbread houses' there are improbable crow-stepped and battlemented mansions such as Killarney (known as Stollmeyers Castle), designed and built by the popular architect–builders Taylor & Gilles, and 12 Queen's Park West (1904), south of the Savannah, by Edward Bowen, where the filigree dormer gable and frilled roofs of the chinoiserie pavilions represent the ultimate achievements of this genre.

In Port of Spain the versatile German architect Daniel Meinerts Hahn completed the free-style museum (1892) and the Italianate Queen's Royal College (1900) and rebuilt Government House (completed 1907; originally the Red House) in a pretentious Second Empire style. A diversity of styles continued in the period leading up to World War II: the Rosary Church by Père Marie Joseph Guillet is a rigid work of Gothic Revival in the style of Pugin; urban buildings included such examples as Bowen's classical store (1923) for C. Lloyd Trestrail on Broadway; the church of the Purification of Our Lady (enlarged and completed 1934), Maraval, is a Romanesque pastiche with a broken curvilinear pedimented gable with Spanish colonial overtones. A local architectural profession developed after 1945, though overseas consultants were employed for some specialized buildings. The local architect W. H. Watkins (later with Watkins, Phillips, Bynoe & Partners) designed an International Style urban block of six storeys (1960) in Port of Spain, a curtain-walled building completely clad in vertical louvres (for some time the city's highest building). John Weeks, then at the Nuffield Foundation Division for Architectural Studies in London, was the designer–consultant of the climate- and context-conscious student halls of residence (1957–60; with Colin Laird) at the Imperial College of Tropical Agriculture, Piarco. With independence and then an oil boom during the 1970s, the importance of the local profession grew. Gillespie & Steel Associates (principal architects John Gillespie (*b* 1925) and Colvin Chen (*b* 1941)) were responsible for such buildings as the Rhand Credit Union Headquarters (1987), Port of Spain, and for Crown Point Airport (1985; with Colin Laird), Tobago.

BIBLIOGRAPHY

J. M. Richards, ed.: *New Buildings in the Commonwealth* (London, 1961), pp. 161–71

D. Buisseret: *Historic Architecture of the Caribbean* (London, 1980)

R. W. A. Osborne: 'A Review of Some of the Factors Affecting Housing in Trinidad and Tobago in the 1980s', *Int. J. Housing Sci. & Applic.*, vi/3 (1982), pp. 241–54

J. N. Lewis, ed.: *Architecture of the Caribbean and its Amerindian Origins in Trinidad* (Washington, DC, 1983)

3. George Brown: Union Club, Port of Spain, Trinidad, 1904

L. E. Mitchell: 'Colonial Style: A Look at the Late 19th Century Town Houses of Port of Spain, Trinidad', *Period Homes*, vii (May 1986), pp. 35–7

E. E. Crain: *Historic Houses in the Caribbean* (Gainesville, 1994)

JOHN NEWEL LEWIS

IV. Painting and sculpture.

The multi-cultural diversity within Trinidad and Tobago has linked the artistic expressions and iconography of not only Africa and Europe but also India, China and the Middle East. In colonial times, imperial social and political systems stunted the growth of an indigenous expression of art, and young West Indian men were educated in Europe. Nevertheless, the first formal emergence of a Trinidadian painter, Michel Jean Cazabon (1813–88), took place in the mid-19th century. Born in Trinidad, the son of Martiniquan 'free coloureds', he studied in Paris under Paul Delaroche and returned to Trinidad *c.* 1850. Closely following the traditions of French landscape painting, he captured the islands and their people in carefully executed watercolours and oils. With the exception of the botanical studies and simple landscapes of Theodora Walter (1889–1959), daughter of a Trinidadian mother and granddaughter of the English watercolourist Theodore Walter, there are few examples of Trinidadian art from the latter part of the 19th century and early part of the 20th. As

West Indian nationalism began to make itself politically vocal in the 1930s, in the arts a growing movement away from a European philosophy was formalized with the emergence of a group that called itself the Society of Trinidad Independents (1929–39). In the work of the Independents can be seen, for the first time, a consciousness of Trinidad's cultural heritage. The influences of Amerindian iconography and the symbols of African Obeah (*see* §II, 2 above) in the work of Hugh Stollmeyer (1913–81) are two such examples. This spirit was further reinforced by the portraits of exotic black figures by Boscoe Holder (*b* 1920) in the late 1930s, and in the early 1940s by the images of the East Indian by M. P. Alladin (1919–80). Around this time, too, there developed a new appreciation for the country's folklore through the illustrations of Alfred Codallo (1915–70).

The late 1940s and 1950s were dominated by the work of Sybil Atteck (1911–75). She studied in Europe and Peru and later in the USA under the German painter Max Beckmann. Her style developed from a European/Amerindian neo-classicism to a more Expressionistic style of painting (see fig. 4). The growing political independence of the 1950s and early 1960s created a frenzy of activity in the arts, and Atteck's style formed the nucleus of Trinidad and Tobago's first recognizable school of painting. Few artists from this period did not experiment with expres-

4. Sybil Atteck: *Steelbandsmen*, oil on canvas, 1949 (Central Bank of Trinidad and Tobago Collection)

sions of national identity, woven into the strongly geometric composition of the Atteck genre. In the 1950s the Trinidad Art Society (inaugurated 1943) conducted courses in sculpture by Sybil Atteck and Carl Broodhagen of Barbados. The medium does not, however, appear to have been taken seriously by many of the artists. Joan St Louis, Pat Chu Foon (*b* 1931) and later Ralph Baney were, perhaps, the exceptions, although Baney's influences were more directly related to his English training. The introduction of monumental sculpture into mainstream art in Trinidad and Tobago was formalized in the work of Chu Foon. He learnt the fundamentals of sculpting while apprenticed to a manufacturer of handmade toys in the late 1940s. Through Atteck and the 'boys behind the bridge' (Ken Morris with his copper reliefs and Rafael Samuel with his naive wood-carvings), he further developed his skills. In 1963 he attended the Universidad de las Américas, Puebla, where he studied Fine Art, and in 1967 the Academia San Carlos, Universidad Nacional de México, where he studied sculpture. In Mexico, Henry Moore's work was the major inspiration at that time, having in turn recognized the influence of Pre-Columbian art, in particular the forms of the Aztecs, in his sculpture. Returning to Trinidad in 1968, Chu Foon executed several public sculptures, including a statue of *Gandhi* (1969), *Spirit of Hope* (1971), *Tribute to the Steelband Movement* (1972) and *Mother and Child* (1980) at the new Mount Hope Hospital. Chu Foon is also recognized for his paintings in which, through abstraction, he depicted the relationship of man's inner space to 'outside universal space'. Alongside the more formal development of a Trinidadian Expressionism was the acceptance of intuitive painting as a valid expression through the work of Leo Basso (1901–82).

Following national independence in 1963, experimentation with a range of ethnic and cultural expressions in the quest for a common identity resulted in artistic eclecticism. Following the international wave of Black consciousness in the 1970s, there emerged an important awareness of Trinidad and Tobago's African heritage, best represented by the work of LeRoy Clarke (*b* 1939). Clarke sought to provide a validity and integrity to the strong religious, cultural and social associations between the Caribbean and Africa. At the same time, the older traditions of landscape painting continued with renewed vigour, as in the watercolours of Jackie Hinkson (*b* 1942). From 1974 Peter Minshall (*b* 1941) developed concepts for carnival by placing the masquerader into highly exaggerated structures. By connecting the feet and arms of the human vehicle to these structures, the movement of the body is echoed by extension, projecting the wearer's energy, to the point where the puppet-structure completely dominates the puppeteer. In combination with the movement of the bodies to the rhythm of the music, enormous dancing mobiles are produced. Such mobiles featured significantly in the opening ceremony of the Barcelona Olympic Games in 1992 and the Atlanta Olympic Games in 1996. Throughout the 1980s the traditional images of Africa, India and Europe continued to provide inspiration for artists, but by the 1990s expressions of anger against historic circumstance were slowly giving way to a new multi-cultural awareness; representations were concerned more with personal, social and environmental statements.

Artists preferred to identify themselves within the mainstream of contemporary international expression, rather than with the old values of national, cultural and ethnic identity.

BIBLIOGRAPHY

G. MacLean: *Cazabon: An Illustrated Biography of Trinidad's Nineteenth Century Painter, Michel Jean Cazabon* (Port of Spain, 1986)

N. Guppy, ed.: *A Painter of Living Flowers: Theodora Walter, 1889–1959* (London, n.d. [1988]) [privately pubd cat. of works]

LeRoy Clarke (exh. cat., ed. G. MacLean; Port of Spain, Aquarela Gals, 1991)

G. MacLean: 'L'Art de Trinite et Tobage: Un Héritage bigarré', *1492/ 1992: Un Nouveau Regard sur les Caraïbes* (exh. cat., ed. P. Bocquet; Courbevoie, 1992), pp. 141–62

——: 'Minshall in Barcelona', *Galerie* [Port of Spain], i/2 (1993), p. 26

——: 'Sybil Atteck', *Galerie* [Port of Spain], i/2 (1993), pp. 28, 325

V. Poupeye: *Caribbean Art* (London, 1998)

GEOFFREY MACLEAN

V. Interior decoration and furniture.

The early Spanish settlers appear to have relied heavily on imported materials from Spain. The system of trading in the New World, regulated from Seville, was monopolistic, limiting the colonists to irregular shipments from Spain. Interior decoration and furniture design were therefore largely influenced by contemporary Spanish trends, while at the same time suffering delays, sometimes of long duration, before new designs appeared locally. During the 17th century the first capital of San José de Oruna consisted of *c.* 30 houses; the interiors of these palm-thatched dwellings were described by a contemporary observer as 'rough and unadorned'. In 1763 the Governor of Grenada observed that the timber in Trinidad was 'the best in this part of the world for shipping: besides vast quantities of curious woods for the inside of houses and cabinets'. In Tobago, the isolated estate houses were typically decorated in the English taste and were furnished with imported furniture of the period. Reproductions of the imported furniture were also produced by skilled slave workers, often under the supervision of an indentured craftsman from the home counties. The diaries (1807–12) of Sir William Young record his investigations into the uses of the native trees found on his estates on the island. Under Young's direction, Matthew Hood, 'a very intelligent timber merchant and master carpenter', identified Baleazar, dockwood, yellow sanders, *bois fidèle*, *santa maria* and dogwood as well-known, fine cabinet woods. Silk cotton, 'soft, white and without knotts, suited for ceilings', and wild tamarind, 'a good wainscot wood', were also identified.

By 1783 the Spanish Government recognized that foreign immigrants would have to be accepted if the island was to be developed as a plantation colony. The subsequent influx of French planters and merchants from Grenada, Martinique, Guadeloupe, St Lucia and Cayenne virtually transformed the country into a French colony, and their arrival towards the end of the 18th century injected new life into the building industry. Almost immediately the French creole style became standard for interior decoration and furniture as French creole culture pervaded every aspect of life on the island. Many of these new settlers were farmers who lived in large timber houses on their estates. The interiors of these usually two-storey dwellings were kept cool and dark by shuttered jalousies

5. Trinidad furniture, showing influence of French colonial style, 19th century

on the windows. Simple decoration, in the form of pierced fretwork panels were installed above doors or along the tops of interior walls to allow greater airflow. Little survives of furnishings from periods earlier than the 19th century.

In the early years of the 19th century furniture was characterized by French-inspired, Empire-style mahogany pieces imported from Martinique. After slave emancipation (1834), skilled craftsmen from the plantations set up small workshops and continued to produce furniture influenced by French-inspired colonial pieces (see fig. 5), although there is little evidence of a furniture-making industry developing in the colony. By 1860, as the colony flourished, the characteristics of the Trinidadian lifestyle changed. Houses were furnished more lavishly. Nogging came into general use, finished with a lime-plaster rendering. Timber room-divisions were often papered, using imported European designs on a hessian ground. Ceilings were higher and were boarded or beaded, usually flat. All rooms opened on to a gallery, and the internal corridors were seldom used. Polished mahogany floors were the norm. Crystal chandeliers might hang from ceilings. Upholstered furniture from England remained a rarity. At the end of the 19th century and the beginning of the 20th there was a significant migration of European merchants to Trinidad. Laird (1954) described their homes as 'vulgarity, gayness, boldness, daring—all mixed with a dash of nostalgia for England, France, Scotland, Spain, Holland, Ireland, Corsica, and yet the houses achieved a very high degree of suitability to the climate'. These styles were

mixed with contemporary creole design and resulted in a rich Victorian style of decoration. The Magnificent Nine houses built near Savannah Park in Port of Spain remain the ultimate examples of this affluent lifestyle. Marble floors, cedar, mahogany and greenheart panelling and staircases, high ceilings and wrought-iron fretwork were features often in evidence. Although in the 1990s local furniture continued to be produced, Trinidad made no claims to a recognizably indigenous style; taste continued to be influenced by imports from Europe and the USA. In the latter part of the 20th century young, foreign-trained artists and craftsmen were producing original furniture designs, although these could not yet be described as uniquely Trinidadian in style.

UNPUBLISHED SOURCES

St Augustine, Trinidad, U. W. Indies, Lib. [diaries of 1807–12 of Sir William Young]

BIBLIOGRAPHY

Mrs Carmichael: *Domestic Manners and Social Conditions of the White, Coloured and Negro Populations of the West Indies*, 2 vols (London, 1833)
C. Laird: 'Trinidad Townhouse or the Rise and Decline of a Domestic Architecture', *Carib. Q.*, (Aug 1954), pp. 188–98
A Magnificent Nine: Historical Facts on Nine Buildings in Trinidad and Tobago (Trinidad, 1976)
J. N. Lewis: *Ajoupa* (Trinidad, *c.* 1980)

ALISSANDRA CUMMINS

VI. Ceramics.

From the earliest settlement of Trinidad by the Spanish colonials, ceramics were probably imported from the Old

World for the colony. As attention shifted to Central and South America, however, major shipping often bypassed this small, unimportant outpost. The colonists therefore had to rely on a growing contraband trade, particularly with the Dutch and English. In addition the indigenous Amerindian population probably supplied the major source of domestic wares produced for both their own and later the Spanish community. Deagan (1987) has suggested that by the mid-17th century Mexican maiolica had spread to the Caribbean region, almost completely replacing ceramics from the Old World. Ceramics from the island of Hispaniola may have been another source of supply. It is more probable, however, that such domestic earthenwares as olive jars, cooking pots and bowls were produced by the settlers, since the island was left to its own devices until the 1780s. Despite the influx of African slaves brought by the French landowners, there is little evidence suggesting the development of a distinct, African-influenced form, as created in neighbouring Barbados and in Jamaica.

Following the slave emancipation (1834) new sources of labour were supplied by black creoles as well as immigrants from Sierre Leone, who probably introduced their traditional forms of pottery-making, including the 'monkey' and other domestic wares. By the 1850s East Indian indentured labourers, primarily from Calcutta, were predominant among the artisans in the colony. By the 1870s the Indians had formed their own permanent settlements and reconstituted many of their traditional social institutions. Samaroo (1984) observed that following their indentureship as agricultural labourers many East Indians took to the occupations sanctioned by their caste position, including the Kumars to pottery. The 1891 census of East-Indian population in Trinidad did not list pottery-making as a recognized occupation, which suggests that ceramic production was a secondary occupation and that items were probably produced primarily for private domestic use.

During the 20th century Trinidadian East Indians, particularly around Chase Village, in the central Chaguanas region (Trinidad), continued to be the primary producers of local pottery. As well as adopting such traditional Afro-Caribbean forms as the 'monkey jar', decorative flower pots and water-jars, these craftsmen produced traditional Indian forms including the *diya*, a small ceramic lamp, the *lota*, a water-jar, and the 'tassa drum'. During the early 1960s Ralph Baney (*b* 1929) was among a small group of Trinidadians awarded British Council scholarships to study at the Brighton College of Art in England; on his return in 1964 Baney, together with his wife Vera Baney, experimented with sculpture and ceramics and pioneered the use of local clays and glazes. Vera produced abstract or totem-like forms. Gloria Harewood (*b* 1927) attended a local training course in ceramics between 1966 and 1968 and then studied under Cecil Baugh at the Jamaica School of Art (1968–70). During the late 1960s and early 1970s she made several visits to Europe and East Asia to observe other ceramic techniques, while continuing to experiment with various clays and glazes, as well as with different forms of ceramic production and kiln construction (see fig. 6). Other contemporary potters included Bunty

6. Gloria Harewood: incised 'calabash' earthenware vase, diam. 230 mm, 1985; terracotta bowl, diam. 300 mm, 1988 (Port of Spain, private collection)

O'Connor (*b* 1951), Derrick Gay, Margaret Della Costa (*b* 1950) and Mrs Aguiton.

BIBLIOGRAPHY
A. Boomert: *Bibliography of Trinidad and Tobago Pottery* (Trinidad, n.d.)
B. Samaroo: 'East Indian Influences in the British Caribbean', *Conference on Migration and Cultural Contact in the Caribbean: Barbados, 1984*, pp. 12–13
K. Deagan: *Artifacts of the Spanish Colonies of Florida and the Caribbean, 1500–1800* (Washington, DC, 1987)
ALISSANDRA CUMMINS

VII. Patronage and collecting.

During colonial times and the 19th century, patronage of art was mainly by the expatriate community: the islands' administrators, planters, wealthy travellers and, to a lesser extent, local plantation owners and merchants. The most important collections of work by Michel Jean Cazabon (1813–88) were commissioned by Lord Harris, then Governor of Trinidad, and two Scottish plantation owners, William Burnley and James Lamont. Expatriate patronage continued to play a large part in the development of the arts, particularly in the 1930s, with support for the Society of Trinidad Independents (STI) and later in the formation of the Trinidad Art Society in 1943. The most important body of work by members of the STI is now in the private collection of the J. B. Fernandes Trust Company, Port of Spain. Until the mid-1950s the novelty of life in the tropics and colonial decadence determined a preference for island art or native portraiture. Although at the end of the 20th century there was still a general preference for decorative work, intellectual independence and a greater understanding of universal trends, through education and travel, encouraged a more informed market.

Around the time of political independence patronage in the arts was encouraged at all levels. Official participation helped to establish several important collections, in particular those of the Central Bank of Trinidad and

Tobago and Trinidad Hilton Hotel, both in Port of Spain. At this time too, several of the Government Ministries and newly formed national corporations purchased art. Since then many of these collections have not been properly maintained, nor have they been augmented by new purchases. In the case of new acquisitions, the choice of material has often been inappropriate. By the 1990s there existed in both the public and private sectors a growing awareness of art acquisition as an alternative to traditional investment. This led to a more adventurous market, but it became apparent that the need to rationalize collections in terms of quality and content would only be understood clearly through education and with a more formal market. Market stability was slowly assisted by a more professional approach to dealing. In addition, despite differences of language, the Caribbean began to recognize a common cultural heritage, and through regular exchanges and greater regional dialogue the market not only opened up for Trinidad and Tobago's artists but also provided a common voice for international appreciation.

For bibliography see §IV above.

GEOFFREY MACLEAN

VIII. Museums.

During the 18th and 19th centuries European interest in tropical archaeology, anthropology and natural history as scientific disciplines served as a catalyst for the formation of the earliest museums in the West Indies. Agricultural, economic and empirical endeavours also led to the development of research collections. At the same time, Victorian philanthropic motives stimulated efforts to educate the newly freed slave population after emancipation. These activities were influential in the establishment of the Victoria Institute in 1887 (later the Royal Victoria Institute, now the National Museum and Art Gallery) in Port of Spain. Built as a memorial for Queen Victoria's Jubilee, it was intended to be a scientific institute with a museum of the colony. The museum began in 1889 with a collection of local fauna presented by the Trinidad Field Naturalists' Club. The Institute opened to the public in September 1892. Examples of local flora, geological and mineral specimens and various archaeological finds were later added, forming the major portion of the collections. Lectures and technical classes in a variety of areas were held, as well as exhibitions of paintings by local artists. Annual horticultural displays were also typical of the period. Plans for an industrial commercial museum and one of hygiene were mooted, but by the 20th century these had not come to fruition. In 1920 the entire structure and contents of the Institute were destroyed by fire, and the following decades were devoted to the reconstruction of the buildings and collections. In 1976–7 a UNESCO consultant mission on the development of museums was undertaken at the request of the government. Also during this period the Museum of Tobago History, Mt Irvine, Tobago, was founded by a private trust, and the Coast Guard Marine Museum, Staubles, Trinidad, was also established (both 1977). A UNESCO-sponsored seminar on 'Concepts of Cultural Heritage and Preservation' and other initiatives led to the establishment of a Museum Task Force in 1980, with a mandate to plan in detail the

setting up of a decentralized museum system for Trinidad and Tobago. The Victoria Institute was renamed the Trinidad National Museum and Art Gallery, reflecting the significant growth of its 20th-century art collection. Permanent exhibits now include representative examples of carnival costume, as well as a major exhibit on the island's important oil and energy industry. It also houses a collection of works by Michel Jean Cazabon (1813–88).

BIBLIOGRAPHY

Proc. Victoria Inst. (1894–1902; 1924–8)
F. A. Bather and T. Sheppard: 'Directory of Museums in the West Indies', The Museums Association Directory of Museums (London, 1934), pp. 59–63
F. de Carmago e Almeida-Moro: Trinidad and Tobago: Development of Museums, UNESCO Technical Report (Paris, 1977)
Concepts of Cultural Heritage and Preservation, Report of UNESCO/Trinidad and Tobago Government (Paris, 1978)
Purpose, Role and Programmes of the Proposed Museum System of Trinidad and Tobago, Museum Task Force (Trinidad, 1980)
J. S. Whiting: Museum Focused Heritage in the English-speaking Caribbean, UNESCO Technical Report (Paris, 1983)
A. Cummins: The History and Development of Museums in the English-speaking Caribbean (diss., U. Leicester, 1989)
A. Cummins: 'The Caribbeanization of the West Indies: The Museum's Role in the Development of National Identity', Museums and the Making of Ourselves, ed. F. Kaplan (Leicester, 1994), pp. 192–221

ALISSANDRA CUMMINS

IX. Art education.

Recognition of fine art as a valid profession has been slow to develop in Trinidad and Tobago. Michel Jean Cazabon (1813–88), who studied at the Académie des Beaux-Arts in Paris, was lucky to be born into a family whose cultural values included a serious appreciation of the arts. He was, however, viewed by the majority of the population as an eccentric. Cazabon taught several students but encouraged a general appreciation of painting rather than helping them to make careers as fine artists. Under the guidance of Amy Leong Pang, the artists grouped themselves into the Society of Trinidad Independents, an informal alliance that can be considered Trinidad's first school of painting. The artists gathered in private homes, painted and discussed the arts and developed their ideas. The Independents also published their own philosophical newspaper, intended for the enlightenment of the conservative attitudes born of a strong religious and colonial heritage. Their ideas, however, were considered outrageous and bohemian, and they survived only until 1939.

From the Independents the Trinidad Art Society was formed in Port of Spain in 1943. The Society's aim was 'to encourage the practice of Fine and Applied Arts and Crafts and to foster their appreciation and practice in Trinidad and Tobago by every possible means such as holding exhibitions, the awarding of scholarships and prizes'. Sybil Atteck (1911–75), a founder-member, introduced a more formal attitude to the study of painting through a strictly academic appreciation. The Art Society sponsored classes in the many aspects of artistic expression by artists such as the French Neo-Impressionist Pierre Lelong and the Barbadian sculptor Carl Broodhagen and exhibited the work of its members every year. These exhibitions were held first at the Royal Victoria Institute but from 1959 at the old Woodbrook Market. Serious criticism was encouraged, the reviews of Derek Walcott

being among the most important commentaries. After political independence scholarships were offered, mainly by the British Council, for artists to study fine art. Most students went to the UK, and for specific training (e.g. ceramics) to continental Europe. Later, scholarships provided by the Ministry of Culture and Commonwealth extended the learning experience to many other countries, including various African nations, Canada, India and the USA. Institutions in Trinidad that offer art education include the John Donaldson Technical Institute (established 1963), which provides courses in graphic and applied arts, and the Creative Arts Centre (established 1986), part of the University of the West Indies, St Augustine. By the 1990s, through government loans and scholarships and because of the limited facilities available locally, students of Fine Art continued to be educated outside Trinidad, although a wish to be philosophically closer to Trinidad and Tobago led many to attend the Edna Manley School of Fine Art in Jamaica and the Ecole Régionale d'Arts Plastiques in Martinique.

For bibliography *see* §IV above.

GEOFFREY MACLEAN

Troya, Rafael (*b* Caranqui-Imbabura, 25 Oct 1845; *d* Ibarra, 15 March 1920). Ecuadorean painter. He was self-taught as an artist. Between 1870 and 1874 he was appointed as the sole illustrator to a team of German scientists, including the naturalist Wilhelm Reiss and the geologist Alfons Stübel, who undertook volcanic surveys in Ecuador. Stübel trained him to make scientific oil paintings of landscapes *in situ*, emphasizing the details of flora and the exact location of mountains and rivers (e.g. *The Cotopaxi, Ecuador*, 1874; see fig.). A few of the 66 works executed during these years are in the Städtische

Reiss-Museum, Mannheim (e. g. *Expedition Camp in the Crater of the Guaga Pichincha Volcano*, 1871; see colour pl. XXXIX, fig. 2). This scientific vision of the Andean landscape, combined with the freedom of the contemporary Romanticism, created a personal style that changed little and made him one of the most important 19th-century landscape painters in Latin America. His scientific paintings served as models for such later works as the *Eastern Mountain Range from Tiopullo* (1874; Quito, Banco Cent. del Ecuador) and the *Deer Hunt* (1918; Guayaquil, Mus. Antropol. & Mus. A. Banco Cent. del Ecuador). Troya executed portraits of notable Ecuadorean society figures, including the politician and historian *Pedro Moncayo Esparza* (before 1904; Ibarra, Bib. Mun.), and continued to receive commissions from the Church (e.g. *Twelve Apostles, c.* 1912; Ibarra, Metropolitana Cathedral).

BIBLIOGRAPHY

J. M. Vargas: *Los pintores quiteños del siglo XIX* (Quito, 1971), pp. 64–7
Historia del arte ecuatoriano, 3 (1977), pp. 187–9, 235–6
A. Kennedy Troya: *El pintor Rafael Troya (1845–1920): Catálogo razonado* (Quito, 1984, rev. 1991)
——: *Rafael Troya (1845–1920): Un paisajista ecuatoriano* (MA thesis, New Orleans, Tulane U. LA, 1984)
——: 'Arte y ciencia: Rafael Troya (1845–1920) y los geólogos alemanes Reiss y Stübel', *Bol. Acad. N. Hist.*, cli–ii (1988), pp. 421–55
——: 'Artistas y científicos: Naturaleza independente en el siglo XIX en Ecuador (Rafael Troya y Joaquín Pinto)', *Estud. A. & Estética*, xxxvii (1994), pp. 223–41
——: *Rafael Troya: El pintor de los Andes Ecuatorianos* (Quito, 1999)

ALEXANDRA KENNEDY

Trujillo, Guillermo (*b* Horconcitos, Chiriquí, 11 Feb 1927). Panamanian painter, ceramicist, printmaker, tapestry designer and landscape architect. He studied both architecture and painting in Panama, holding his first exhibition in 1953; he then continued his studies in Madrid

Rafael Troya: *The Cotopaxi, Ecuador*, oil on canvas, 990×1690 mm, 1874 (Quito, Museo Perez Chiriboya del Banco Central)

Guillermo Trujillo: *Still-Life with Fruit*, 1975 (Washington, DC, Art Museum of the Americas)

(1954–8) at the Real Academia de Bellas Artes de San Fernando, at the Escuela de Cerámica de la Moncloa and at the Escuela Superior de Arquitectura. In 1959 he returned to Panama, where he began a long teaching career at the Universidad de Panamá. In the early 1960s Trujillo painted social satires, such as *The Commissioners* (1964; Panama City, Mus. A. Contemp.) with small monstrous figures in cavernous settings. Later his palette brightened as he turned to new subjects based on nature, including numerous still-lifes and semi-abstract paintings with botanical allusions, for example *Still-life with Fruit* (1975; see fig.).

Always a versatile and prolific artist, in the 1970s and 1980s he based his subjects both on his rich imagination and on his knowledge of Panama's indigenous cultures. He made recurring reference to the patterns of pre-Columbian ceramics, natural and biomorphic forms, mythological and primitive figures, and Indian symbols and ceremonies, all treated as elements of an iconography strongly related to his Panamanian origin. Although generally classified as belonging to the return to figuration among Latin American artists, he ranged stylistically from realism to abstraction.

BIBLIOGRAPHY
I. García Aponte: *Guillermo Trujillo* (Panama City, 1964)
M. E. Kupfer: *A Panamanian Artist, Guillermo Trujillo: The Formative Years* (diss., New Orleans, Tulane U. LA, 1983)
P. L. Prados: 'Guillermo Trujillo's Lost Paradise', *Trujillo* (Caracas, 1990)
Guillermo Trujillo: Retrospectiva (exh. cat., Panama City, Mus. A. Contemp., 1993)
Guillermo Trujillo: Mito y metamorfosis (exh. cat. by R. Tibol and others, Mexico City, Mus. Rufino Tamayo, 1997)
Crosscurrents: Contemporary Painting from Panama, 1968–98 (exh. cat. by M. Kupfer and E. Sullivan, New York, Americas Soc. A.G., 1998)
MONICA E. KUPFER

Tschusiya, Tilsa (*b* Supe, nr Paramonga, 1936; *d* Lima, 23 Sept 1984). Peruvian painter. She studied at the Escuela Nacional Superior de Bellas Artes in Lima, graduating in 1959 with the school's Gold Medal; she had already received second prize in the Salón Municipal in 1957 and represented Peru at the first Biennale des Jeunes in Paris in 1958. Working in a figurative idiom indebted to Surrealism, she created a unique dreamlike universe that made her paintings among the most intense and rich in modern Peruvian art. Although she reached her imagery

through intuition, she arrived at forms connected iconographically both with Andean and oriental traditions. The diaphanous quality of her draughtsmanship and her smooth, finely gradated play of blended colours combined to create an atmosphere in which myths take root, fantastic creatures appear and strange metamorphoses take place, ensuring the originality of her work.

BIBLIOGRAPHY
J. E. Wuffarden: *Tschusiya* (Lima, 1981)
E. Moll: *Tilsa Tschusiya (1929–1984)* (Lima, 1990)
Latin American Women Artists, 1915–1995 (exh. cat by G. Biller and others, Milwaukee, WI, A. Mus., 1995)
LUIS ENRIQUE TORD

Tufiño, Rafael (*b* Brooklyn, NY, 1918). Puerto Rican painter, printmaker and designer of American birth. He moved permanently to Puerto Rico with his Puerto Rican parents in 1936, initially studying under the Spanish painter Alejandro Sánchez Felipe and with Juan Rosado at his sign-painting workshop in San Juan. In the late 1940s he studied painting, printmaking and mural painting at the Academia de San Carlos in Mexico with José Chavez Morado, Antonio Rodríguez Luna and Castro Pacheco. He joined the staff of the Division of Community Education in Puerto Rico as a poster artist and illustrator in 1950, serving as director of the graphic arts workshop of this division from 1957 until 1963. He was awarded a Guggenheim Fellowship in 1966 and the National Award for the Arts in 1985.

Tufiño's early art was influenced by the social realist currents in Puerto Rican art and by the Mexican nationalist artistic movement. Together with Lorenzo Homar and Carlos Raquel Rivera, Tufiño became a leading printmaker, and like them he worked primarily with woodcuts, linocuts and screenprints. While his expressive emphasis on stark contrasts of black and white can be compared with the production of the TALLER DE GRÁFICA POPULAR in Mexico, he favoured a poetic rather than satirical tone and distinguished himself in his screenprints with his masterly exploitation of the painterly potential of the medium.

Tufiño is often described as the painter of the people of Puerto Rico because of his sensitivity in depicting ordinary places and situations. His subject-matter ranged from intimate interiors and portraits of family and friends to landscapes, nudes and representations of Afro-Caribbean 'bomba y plena' musical festivals. His paintings are characterized by a strong line, richness of colour and spontaneity of touch.

BIBLIOGRAPHY
E. Ruiz de la Mata: 'The Art of Tufiño', *San Juan Rev.*, ii/11 (1966), pp. 18–24
Puerto Rican Painting: Between Past and Present (exh. cat. by M. C. Ramírez, Washington, DC, Mus. Mod. A. Latin America, 1987)
L. R. Cancel and others: *The Latin American Spirit: Art and Artists in the United States, 1920–1970* (New York, 1988)
MARI CARMEN RAMÍREZ

Tunga [De Barros Carvalho e Mello Mourão, Antonio José] (*b* Palmares, Pernambuco, 8 Feb 1952). Brazilian conceptual artist. He graduated in architecture from the Universidade Santa Ursula, Rio de Janeiro in 1974. In 1976 he co-founded and edited the alternative art journal *Malasartes*, along with fellow Brazilian artists Cildo Meireles, José Resende (*b* 1945) and Waltercio Caldas (*b* 1946);

Tunga: *Jardin de Mandragoras*, mixed media, 520×200×60 mm, 1992 (Colchester, University of Essex, Collection of Latin American Art)

Meireles and Tunga also founded another art journal together, *A parte do fogo*, in 1980. Tunga produced installation work involving both animate and inanimate objects, and also uses film and video, as in the 1980 *Dois irmões* ('Two Brothers') project and in his collaboration with Arthur Omar, *O nervo de prata* ('The Silver Needle'). Large scale and repetition dominate Tunga's work, which forms an alliance between the natural and the industrial. The result is often the presentation of seemingly desolate industrial landscapes where the initial appearance of sterility is off-set by natural elements that challenge the viewer's perception. The presence of these organic elements gives life to the industrial forms, forcing the viewer to confront the reality of Brazil's struggle to marry industrial development with environmental preservation. Huge plates of steel and magnets merge with what appear to be long, thick plaits of hair, a recurrent theme in his work. This hair is often real, attached to the heads of living people or, as in the 1983 work *Seeding Sirens*, to a mould of his own head that floats, disembodied, in a rock pool. At other times this hair is constructed of entwined snakes, copper wire or lead, or has a comb trapped in its fibres. The scale of a later work, *Jardins de Mondragoras* (1992; see fig.), is unusual, although the themes and materials are typical: a tiny exoskeleton of a frog nestles among an inhospitable array of copper leaf and wire, iron filings and a thermometer, all of which are held in place by powerful magnets that secure the objects to the steel plate base.

WRITINGS
Barroco de Lírios (São Paulo, 1997)

BIBLIOGRAPHY
Tunga (exh. cat., Glasgow, Third Eye Cent., 1990)
Transcontinental: An Investigation of Reality (exh. cat. by G. Brett, Birmingham, Ikon Gal., and Manchester, Cornerhouse, 1990)
ADRIAN LOCKE

Tunja [Hunza]. City in the central region of Colombia. Capital of the department of Boyacá, it is situated at an altitude of 2793 m and had a population in the late 20th century of *c.* 180,000. In Pre-Columbian times it was the site of the Muisca village of Hunza, whose wood and straw houses were decorated with gold rattles and hanging plates on the doors and windows. The area was notable for its production of fine cotton blankets. In 1527 the Spanish conquistadors arrived, and in 1539 Gonzalo Suárez Ren-

dón took possession of the land and drew up a conventional Spanish grid plan for the city. The region attracted many Spaniards, who built their houses of lime and rock with clay roofs and decorated the entrances with escutcheons. Between 1541, when it acquired city status, and 1610 Tunja enjoyed similar status to Bogotá. A wide knowledge of humanistic and classical culture is evident in the ambitious cathedral (begun 1569); with its three naves and stone façade (*see* COLOMBIA, fig. 3) created by Bartolomé Carrión, it is an unusual and outstanding example of Renaissance architecture in Latin America. The same classical interest is evident in the mural paintings of the early 17th century in some houses (*see* COLOMBIA, §IV, 1), but the city's most significant exponent of Renaissance painting was the Italian painter ANGELINO MEDORO, active in Tunja in the late 16th century (e.g. the *Annunciation*, 1588; Tunja, Templo de Santa Clara). The single-nave monastic churches built in the 17th century represented the culmination of Baroque decoration in Latin America, with abundant retables, carved panels and *Mudéjar* panelling on the ceilings, as in the church of S Clara (1613) by Juan Bélmez and Antonio de Alcántara, and the Dominican Capilla del Rosario (1563). Museums in the city include the Museo Eclesiástico Colonial and the Colección de los Padres Dominicanos.

BIBLIOGRAPHY
R. Correa: *Historia de Tunja* (Tunja, 1948)
E. Marco Dorta: *Arquitectura del renacimiento en Tunja* (Bogotá, 1957)
S. Sebastián López: *Album de arte colonial de Tunja* (Tunja, 1963)
P. Vandenbroeck: 'Missionary Iconography on Both Sides of the Atlantic', *America, Bride of the Sun* (Antwerp, 1992), pp. 84–96
G. Mateus Cortés: *Tunja: Guía histórica del arte y la arquitectura* (Bogotá, 1995)
NATALIA VEGA

Tupac Inca, Juan Tomás Tuyru. *See* TUYRU TUPAC INCA, JUAN TOMÁS.

Tuyru Tupac Inca, Juan Tomás (*b* San Sebastián; *d* Cuzco, 1718). Peruvian architect and sculptor. A descendant of the Inca nobility, he was the finest of the indigenous craftsmen who participated in the reconstruction of the old Inca capital, Cuzco, after the earthquake of 1650. He was self-taught as well as being trained in the system of guild artisans and had excellent technical skills, which included gilding and the building of altarpieces. Tuyru Tupac Inca's finest work as an architect is the design of S Pedro, attached to the Hospital de Indias in Cuzco, his plan for which was drawn up in 1688 and is preserved in Spain in the Archivo General de Indias in Seville. In addition he built the tower (1688) of the Recoleta Church, Cuzco, and Belén Church (in construction, 1696) in Cuzco is also attributed to him. Among his finest works as a sculptor are the statue of the *Virgen de La Almudena* (1686) in the Almudena church, Cuzco, a retable (*c.* 1690) in the same church and another in Cuzco Cathedral (1714). In 1679 he carved 26 figures for the principal retable of S Ana, Cuzco, and executed the gilding of this retable and the principal retables of S Sebastián, near Cuzco, and San Juan de Dios, Cuzco. Dating from the 1690s, the designs of the pulpits of the Almudena church, of S Pedro, Cuzco, and Belén are also by him, and the famous carved pulpit

of S Blas, Cuzco, is attributed to him, but without documentary evidence.

BIBLIOGRAPHY

D. Angulo Iñiguez: *Planos de monumentos arquitectónicos de América y Filipinas en el Archivo General de Indias*, 7 vols (Seville, 1933–9)

P. Kelemen: *Baroque and Rococo in Latin America*, 2 vols (New York, 1951)

E. Marco Dorta: 'La influencia indígena en el barroco del Perú', *XXXVI Congreso internacional de Americanistas; Sevilla, 1966*

R. Gutiérrez, ed.: *Pintura, escultura y artes útiles en Iberoamérica* (Madrid, 1996)

——: *L'Arte christiana del Nuovo Mondo: Il Barocco dalle Ande alle Pampas* (Milan, 1997)

RAMÓN GUTIÉRREZ

U

Ugalde, Manuel (*b* Cuenca, *c.* 1805; *d* Cochabamba, Bolivia, after 1888). Ecuadorian painter, active in Bolivia. He arrived in Bolivia a few years after it gained independence in 1825. He worked in Cuzco (Peru), La Paz, Potosí and Sucre and spent the last years of his life in Cochabamba. His painting of the *Valley of Cochabamba* (1830; Cochabamba, City Hall), portraying the valley and the city, ushered in a new era in landscape painting in Bolivia, replacing the imaginary landscapes and conceptual perspective of the painting of the preceding colonial period with a greater concern for accuracy. He also painted portraits of important dignitaries, such as *Marshal Andrés de Santa Cruz* (*c.* 1839; La Paz, priv. col.) and *President Gregorio Pacheco* (1884; La Paz, Bib. Mun.). His painting is academic in style, with grey and unemotional colours.

BIBLIOGRAPHY
M. Chacón Torres: *Pintores del siglo XIX*, Bib. A. & Cult. Boliv.: A. & Artistas (La Paz, 1963)
P. Querejazu: *La pintura boliviana del siglo XX* (Milan, 1989)

PEDRO QUEREJAZU

Ugarte Eléspuru, Juan Manuel (*b* Lima, 11 May 1911). Peruvian painter, sculptor, teacher and critic. His adolescence was spent in Germany and Spain. In 1929 he went to Buenos Aires, studying first (until 1932) at the Escuela Superior Nacional de Artes and then (1933–6) at the Escuela Superior de Bellas Artes 'Ernesto de la Cárcova'. In 1940 he returned to Lima, where he struggled against being absorbed into the Indigenist movement and joined the group Los Independientes, whose members promoted European styles, although not to the exclusion of Peruvian

Mario Urteaga Alvarado: *Burial of an Illustrious Man*, oil on canvas, 584×825 mm, 1934 (New York, Museum of Modern Art)

subject-matter (*see also* PERU, §IV, 2). In 1944 he began teaching at the Escuela Nacional de Bellas Artes, Lima, becoming its Director in 1956. Ugarte Eléspuru's paintings are characterized by rich textures and colours and are often purely abstract (e.g. *Death of Pachacamac the Bull-fighter*, 1961; Lima, Mus. A.), although in such murals as *Urban Education* (5.0×6.0 m, 1956; Lima, Ministerio de Educación) he refers broadly to the strong figures and social comment of Mexican murals by Diego Rivera and others. His sculptures include the bust of *Túpac Amaru* (bronze, 1964; Quito, Plaza de los Próceres). He also wrote a number of books about Peruvian art and architecture and acted as a juror and commissioner for a number of international exhibitions.

WRITINGS

Lima y lo limeño (Lima, 1966)
Ignacio Merino y Francisco Laso (Lima, 1968)
Pintura y escultura en el Perú contemporáneo (Lima, 1970)

BIBLIOGRAPHY

J. Villacorta Paredes: *Pintores peruanos de la República* (Lima, 1971), pp. 85–7
J. A. de Lavalle and W. Lang: *Pintura contemporánea, II: 1920–1960*, Col. A. & Tesoro Perú (Lima, 1976), pp. 100–103
Ugarte Eléspuru: 50 años de obra total, 1931–1981 (exh. cat., Lima, Mus. A., 1981)
Juan Manuel Ugarte Eléspuru: Obra retrospectiva (exh. cat. by P. Gjurinovic Canevaro, Lima, Banco Indust. Perú, 1982)

W. IAIN MACKAY

Upper Peru. *See* BOLIVIA.

Urteaga Alvarado, Mario (Tulio Escipión) (*b* Cajamarca, 1 April 1875; *d* Cajamarca, 12 June 1957). Peruvian painter. Having worked as a journalist, administrator, teacher and farmer, he took up oil painting around the age of 30. Urteaga seems to have been self-taught, using such poor quality materials as old sugar sacks and cheap pigments, as well as making his own brushes. His scenes of the lives of northern Andean Indians are colourful. Their naïve though detailed execution has been described as primitive and unacademic, and has been likened to that of Henri Rousseau. His spontaneity and topicality are reminiscent of the caricatures of PANCHO FIERRO, yet his representation of the indigenous peoples of Peru and their daily life is serious; he was the first painter to portray Indian people without patronizing them, as can be seen in the *Burial of an Illustrious Man* (1934; see fig.) and *Return of the Peasants* (Lima, Mus. A.). A retrospective exhibition of his work was held at the Banco de la Nación, Lima, in 1989.

BIBLIOGRAPHY

J. A. de Lavalle and W. Lang: *Pintura contemporánea: Primera parte, 1820–1920*, Arte y tesoros del Perú (Lima, 1975), pp. 184–95
Mario Urteaga, 1875–1957: Un hombre, un pincel, un mundo (exh. cat., Lima, Banco de la Nación, 1989)
A. Zevallos: *Tres pintores cajamarquinos: Mario Urteaga, José Sabogal, Camilo Blas* (Cajamarca, 1991)

W. IAIN MACKAY

Uruguay, Eastern Republic of [Republica Oriental del Uruguay]. South American country. It is on the east coast of the continent, bounded to the south and east by the estuary of the River Plate and the south Atlantic, to the west by the River Uruguay and Argentina and to the north by Brazil. With an area of *c.* 187,000 sq. km, Uruguay is

1. Map of Uruguay; those sites with separate entries in this encyclopedia are distinguished by CROSS-REFERENCE TYPE

one of the smallest countries in South America, and 87% of its population is urban, over one third living in the capital city, MONTEVIDEO, a port situated on the River Plate (see fig. 1). Through this river and its tributaries, the Uruguay and Paraná rivers, Uruguay is at the entrance to a vast navigable river system, and Montevideo is one of the ports of entry to Argentina, Paraguay, Bolivia and the Brazilian state of Rio Grande do Sul. Physically, the country consists of undulating grass plains on granite, with chains of low hills. The climate is temperate and humid; agriculture and dairy production dominate in the south, but stock-rearing occupies much of the land in the north and centre. Uruguay was colonized by Spain after 1624 and became independent in 1828. About 85% of its population are of European descent.

I. Introduction. II. Indigenous culture. III. Architecture. IV. Painting, graphic arts and sculpture. V. Gold and silver. VI. Textiles. VII. Collections and museums. VIII. Art education. IX. Art libraries and photographic collections.

I. Introduction.

Uruguay was the last area in South America to be colonized by Spain. Juan Díaz de Solís first landed in 1516 during his exploration of the River Plate estuary, and contacts were subsequently made by gauchos who came from Argentina to take charge of increasing herds of cattle introduced by the Spanish. Only in 1624, however, did Spain send missionaries to the territory to begin the conversion of the indigenous population, which was drastically reduced in the colonial period and finally disappeared shortly after independence (*see* §II below). During the 17th century the territory was disputed between the Portuguese in Brazil and the Spanish in Argentina, and this led to the founding of the first settlements of any

size—initially by the Portuguese in 1680 at COLONIA DEL SACRAMENTO across the river from Buenos Aires, and then by Spain, which established a more significant settlement in 1726 at San Felipe y Santiago de Montevideo (now Montevideo). However, the territory, known as the Banda Oriental, was not rich or of great appeal to colonizers and hence in general there was limited development and artistic production during the colonial period. In 1811 José Gervasio Artigas led an independence revolution against Spain, and the territory became part of a federation with the newly independent Argentina until 1821, when it was annexed by Portugal. Only after British intervention in the ensuing conflict over possession of the territory did Uruguay finally achieve its independence in 1828.

In 1830, the date of the first constitution, Uruguay had 74,000 inhabitants, a society with few class distinctions, a rural economy, a land ownership that was not clearly defined and political rivalry between two main factions, the liberal Colorados and the conservative Blancos. These conditions led to many years of political instability and civil strife, with Montevideo under siege from 1843 to 1851, followed by war with Paraguay (1865–70). However, in the last quarter of the 19th century and the first three decades of the 20th the population increased rapidly, helped by a substantial influx of immigrants, particularly from Spain, Italy and France; Europeans accounted for half the population of Montevideo between 1840 and 1890, resulting in the predominance of European influences in the arts, which began to flourish amid improved economic prosperity and urban expansion. This continued during the presidency (1903–29) of José Batlle y Ordóñez, which marked a period of advanced social reform, the development of the consumer goods industry and trade with Europe, stimulating further cultural developments in the country. However, lasting economic depression that began with the financial crisis of 1929 led to renewed political unrest and the breakdown of democratic government, first in 1933 and again in 1973 when a harshly repressive military dictatorship took power and large numbers of Uruguayans left the country. Democracy was restored in 1985.

BIBLIOGRAPHY

W. E. Laroche: *Elementos contributos a la historia del arte en el Uruguay* (Montevideo, 1952)

E. Laroche: *Derrotero para una historia del arte en el Uruguay* (Montevideo, 1961)

W. Reyes Abadie and A. Vázquez Romero: *Crónica general del Uruguay*, 4 vols (Montevideo, 1980–86)

L. Castedo: *Historia del arte iberoamericano*, 2 vols (Madrid, 1988), i, p. 358

M. L. Coolighan and J. J. Arteaga: *Historia del Uruguay desde los orígenes hasta nuestros días* (Montevideo, 1992)

JOSÉ PEDRO BARRÁN

II. Indigenous culture.

At the time of European arrival (1516), three distinct groups of indigenous peoples were living in the territory that became Uruguay. The Guaraní peoples lived on the lower parts of the River Uruguay and on the north shore of the River Plate as far east as the River Santa Lucía, having recently arrived by way of the Paraná River. A characteristic feature of their culture was the practice of secondary burials in large, thick clay pots. After coloniza-

tion they seem to have rapidly disappeared from the region, as chronicles of the 17th century no longer include references to them. The Chanáe peoples lived on the banks and islands of the middle section of the River Uruguay, with a transitional culture partly based on hunting and fishing and partly on an incipient agriculture, possibly borrowed from the Guaraní. They developed a ceremonial form of pottery portraying birds. After colonization they were brought into the first *reducciones* (missionary settlements), but they quickly became integrated with Europeans, and their culture disappeared around the middle of the 18th century.

The Charrúa peoples were the largest group, whose original culture shared elements in common with those of the Chaco, Pampean and Patagonian areas. They were hunter-gatherers who used the bow and arrow and the *boleadora* (hunting sling) and demonstrated great skill in making the tips of arrows and spears; they also mastered the technique of stone polishing, which they applied to making multi-edged maces. Pre-Columbian stone tablets engraved with geometric designs based on the circled cross are attributed to the Charrúa; this device also appears in pictographs made on rocks, especially in the Chamangá and the Pintos River area (Flores), the Mahoma Hills (San José) and the Maestre de Campo (Durazno). They made a rough type of incised or burnished clay utilitarian pottery and practised initiation or funeral ceremonies of a shamanistic type. The culture of the Charrúas underwent rapid, profound transformations through contact with Europeans, from whom they adopted the use of iron tools and weapons, cloth, alcohol, tobacco and *mate* (a tealike plant), all of which they obtained by bartering cowhides. The introduction of the horse increased their mobility and bellicosity, the depredatory features of their economy and probably their numbers. The Spanish waged continual war on them, and although they joined the forces of José Gervasio Artigas during the struggle for independence, they were nearly all massacred in the battle of Salsipuedes (1832) by the forces of the new republic.

BIBLIOGRAPHY

A. Serrano: 'The Charrúa', *Handbook of South American Indians*, ed. J. H. Steward, i (Washington, DC, 1946), pp. 191–6

R. Pi Hugarte: *El Uruguay indígena* (Montevideo, 1969)

E. Acosta y Lara: *La guerra de los Charrúas en la Banda Oriental*, 2 vols (Montevideo, 1989)

L. R. González Rissotto and S. Rodríguez Varese: *Guaraníes y paisanos: Impacto de los indios misioneros en la formación del paisanaje* (Montevideo, 1990)

RENZO PI HUGARTE

III. Architecture.

The first significant European building activity in the Banda Oriental resulted from the dispute between Spain and Portugal over possession of the territory (*see* §I above), which led to the founding of settlements there by both powers. Following the Spanish incursion into Santo Domingo de Soriano (1624), the first urban settlement of any size was established by the Portuguese in 1680 at Colonia del Sacramento. A fortified base facing Buenos Aires across the River Plate, it was typical of other enclaves set up by the Portuguese along the coast of Brazil, with stone and brick fortifications designed by military engineers and simple dwellings of adobe and thatch. Montevideo (for-

merly San Felipe y Santiago de Montevideo), situated on a promontory 250 km to the east of Colonia, was a Spanish settlement established in 1726, in response to the Portuguese initiative, by the Governor of Buenos Aires, Don Bruno Mauricio de Zabala, and its early development was also dominated by the construction of fortifications. Other strongpoints, fortresses and guard-houses were developed along the shores of the River Plate and the north-eastern coastal border with Brazil (e.g. the Fortaleza S Teresa), and the military engineers responsible for this work also designed and constructed civil and religious buildings in the urban settlements. In Montevideo, for example, the church of the Immaculate Conception (now the cathedral) was begun *c.* 1784 by a Portuguese military engineer in the service of Spain, José Custodio de Saa y Faría. A large building with a triple nave, it is planned on the Latin cross with a dome at the crossing. Another engineer, José del Pozo y Marquy, was responsible for the parish church (1792) of San Carlos, near Maldonado—a fortified settlement established by the Spanish in 1757 at the entrance to the estuary of the River Plate—and de Saa also built the simple, Neo-classical church of S Fernando (1796) at Maldonado.

European academic Neo-classicism was introduced by the Spanish architect TOMÁS TORIBIO, who studied in Madrid and arrived in the colony around 1799. He designed the façade of the cathedral in Montevideo, said to be influenced by the Neo-classical façade of Pamplona Cathedral; the towers were completed much later (1858) when the façade was renovated by the Swiss architect Bernardo Poncini (1820–63). Toribio also designed the church at Colonia del Sacramento (1808; reconstructed 1836–41) and the Cabildo (1804–11), Montevideo, a Neo-classical town hall and former prison building that faces the cathedral across the city's oldest square, the Plaza Constitución.

In the years following independence in 1828, official Uruguayan architecture continued to be strongly influenced by Neo-classicism and imperial French architecture in works that sought to symbolize the power of the new state. Despite political instability and civil war (*see* §I above), a series of urban developments was begun in Montevideo, the capital of the republic after 1828; the Plaza Independencia (see fig. 2) was laid out in 1837 by the Italian architect Carlos Zucchi (*d* 1856), who had studied in Paris; he also designed the French Beaux-Arts-style Teatro Solís (1841) in the Plaza Independencia (completed 1856 by Francisco Garmendia). More settled conditions in the last quarter of the 19th century led to more widespread urban expansion, with the adoption of contemporary European artistic trends encouraged by an influx of European immigrants as well as by the need for Uruguayan architects to study abroad. The Italian engineer Luis Andreoni (1853–1936), for example, designed some of Montevideo's best-known public buildings in eclectic styles: the Uruguay Club (1885) in the Plaza Constitución, the Umberto I Hospital (1890) and the central railway station (1897); other eclectic buildings were designed by the Uruguayan engineer Juan Alberto Capurro, who was trained in Italy. The construction of rail links stimulated economic growth and led to a speculative building boom that resulted in some surprisingly high-quality housing

2. Old Government House, Plaza Independencia, Montevideo, by Carlos Zucchi, 1837

complexes, for example the Reus districts in the north and south of the city, developed by the Catalan financier Emilio Reus, and the well-planned communities of one- and two-storey standardized terraced houses built around patios (1890s), whose carefully scaled façades created open-spaced 'corridor' streets that are characteristic of large sectors of Montevideo.

In the early 20th century Art Nouveau took root in Montevideo, as in Buenos Aires, for example in school buildings by the Office of Public Works and in a number of private residences designed by the first graduates from the new school of architecture (*see* §VIII below), including the house built for himself (1921) in Montevideo by Juan Antonio Rius (1893–1974). The celebrations of 1930 were marked by a series of competitions, and these resulted in several buildings reflecting the language of European Rationalism, although tinctured with Art Deco for a period. Among these are the Estadio Centenario (1930), with a soaring Art Deco tower, by Juan Antonio Scasso (1892–1975); the Centro Médico (1932) by Carlos Surraco; and the Palacio Municipal by Mauricio Cravotto (1893–1962), all in Montevideo. Notable public buildings by Rius include the Facultad de Ontología (1932–9) for the Universidad de Montevideo, a three-storey 'white' building in the purist spirit of the Modern Movement. A similar character is found in the Clínica Médica (1930), Montevideo, by Ernesto Leborgne (1906–86). These architects were among the pioneers of Modernism in Uruguay.

One of the most widely acclaimed and influential architects of the 1930s and 1940s—although he was not one of the pioneers—was JULIO VILAMAJÓ. His work ranged from the amalgamation of simplified classical features with a Modernist handling of surfaces and materials (e.g. his own house of 1930) to the highly articulate, reinforced-concrete Facultad de Ingeniería (1937–8), Universidad de Montevideo, reminiscent of work by Auguste and Gustave Perret. In contrast, the buildings of his Villa Serrana (1943–8), a resort centre in the country north of Montevideo, were designed in local stone, timber and thatch in harmony with the environment. Another notable figure was ANTONIO BONET, a Spanish architect who had worked with Le Corbusier; well-known works

include Punta Ballena, near Punta del Este, the Casa Berlingieri (1946), which is reminiscent of Le Corbusier's work of the 1930s, and the restaurant-hotel La Solana del Mar (1947), which suggested a new aesthetic, its long single-storey glass façade open to the beach. Vilamajó's pragmatic, almost astylar approach was adopted by his pupil, MARIO PAYSSÉ-REYES, although in a manner much influenced by the Constructivist painter Joaquín Torres García; this is evident in the structure, proportion and use of such materials as rough, local brickwork in his buildings, for example his own house at Carrasco (1955), Montevideo. ELADIO DIESTE, an engineer who was also a member of Torres García's circle, developed a unique brick and tile technology that resulted in such structural masterpieces as the parish church at Atlántida (1959); its wave-walls and tile-vaulting were repeated in later works (e.g. a shopping centre (1983–4) in Montevideo).

In the 1960s a series of multi-storey curtain-wall buildings was produced (e.g. the Notariado Building (1962–7), Montevideo, by Estudio Cinco), but there was also a renewed interest in Le Corbusier's work after World War II. This appears in later buildings by Payssé-Reyes, for example the Banco de la República (1962), Punta del Este, although it is perhaps most obvious in the work of Nelson Bayardo, whose board-marked concrete Columbarium (1962) at the Cementerio del Norte, Montevideo, provides one of the best-known images of Uruguayan architecture. The increasing pluralism of the decade is particularly evident in buildings at Punta Ballena, for example in the Casa Olle Pérez (1966) by Juan Borthagaray (b 1917), who had worked for Mies van der Rohe, and in the casa-pueblo settlement of artists' houses designed by the Uruguayan sculptor Carlos Páez Villaro, which continued to grow for 30 years after the early 1960s; its forms climbing the rising ground from the sea are suggestive of Gaudí and reveal a growing sense of formal freedom.

A feature of the 1970s was the construction of many new urban residential developments by cooperatives, encouraged by a new housing law (1968). A notable example is the medium-rise housing complex in Montevideo built of brick in north European realist character (1971–5) for the Savings and Loans Cooperative (COVFI) by the Centro Cooperativista Uruguayo. System building techniques were also developed, as seen in the Hospital Policial (1975–83), Montevideo, by the Benech, Marzano, Sprechman and Villaamil partnership. The last decades of the 20th century were characterized by a growing awareness of the need for conservation of Uruguay's architectural heritage; an example of this work is the rehabilitation (1980s) of the Reus terraces, Montevideo, by the Grupo de Estudios Urbano.

BIBLIOGRAPHY
L. E. Azarola Gil: Los orígenes de Montevideo, 1600–1900 (Buenos Aires, 1933)
F. Ferreiro: Orígenes uruguayos (Montevideo, 1937)
C. Pérez Montero: El Cabildo de Montevideo: El arquitecto, el terreno, el edificio (Montevideo, 1950)
J. Giuria: La arquitectura en el Uruguay, 1830–1900 (Montevideo, 1958)
F. Bullrich: New Directions in Latin American Architecture (London, 1969), pp. 14–21, 54–8, 90–92
D. Bayón and P. Gasparini: Panorámica de la arquitectura latino-americana (Barcelona, 1977; Eng. trans., New York, 1979), pp. 191–214
A. Migdal: 'Dossier Uruguay', Spazio & Soc., 35 (1986), pp. 88–125
R. L. Mourelle: 'Viviendas de arquitectos', Arquitectura [Montevideo], 256 (1986), pp. 10–21
J. F. Liernur, ed.: America Latina: Architettura gli ultimi vent'anni (Milan, 1990), pp. 162–79
A. Toca, ed.: Nueva arquitectura en América Latina: Presente y futuro (Mexico City, 1990), pp. 29–41
Arquitectura en Uruguay, 1980–90 (Montevideo, 1992)
C. J. Loustau: 'La arquitectura colonial en la República Oriental del Uruguay', Arquitectura colonial iberoamericana, ed. G. Gasparini (Caracas, 1997), pp. 393–408

MARIANO ARANA, RUBEN GARCÍA MIRANDA

IV. Painting, graphic arts and sculpture.

European artistic production in the territory that became Uruguay, unlike other countries in Latin America, was very limited during the colonial period (see §I above), although minor religious statuary flourished in the churches. The first significant artistic views of life in Uruguay were provided by the travelling chroniclers of the 19th century—scientists and explorers as well as artists—who recorded their findings in drawings and lithographs. Among the most important were the Englishmen Conrad Martens (who accompanied Charles Darwin) and EMERIC ESSEX VIDAL; the German JOHANN MORITZ RUGENDAS; and the Frenchman Alphonse D'Hastrel (1805–70), who was the most significant name for Uruguay. Other European artists who worked or settled in Uruguay included the Spanish calligrapher Juan Manuel Besnes e Irigoyen (1788–1865) and the Italian Cayetano Gallino (1801–84), who produced elegantly drawn portraits. These artists introduced contemporary European styles and movements to Uruguay: the sculpture of José Livi (1820–90), for example, represented European Neoclassicism (e.g. the statue of Liberty, 1866; Montevideo, Plaza Cagancha). European influences continued to dominate Uruguayan art: in addition to large numbers of European immigrants, nearly all Uruguayan artists studied and travelled abroad until the establishment of art schools in the 20th century (see §VIII below).

Uruguayan historical and social iconography began with the work of JUAN MANUEL BLANES, the country's first important native-born artist, who painted historical subjects (e.g. Oath of the Thirty-three Uruguayan Patriots, 1878; Montevideo, Mus. N. A. Visuales), genre scenes, particularly of rural life, and portraits (e.g. Carlota Ferreira, Montevideo, Mus. N. A. Visuales; and an official portrait of General José G. Artigas, Montevideo, Casa Gobierno). His imagery found an echo in the work of his elder son, Juan Luis Blanes (1856–95), and other Uruguayan artists, including Horacio Espondaburu (1855–1902), who painted gaucho themes; Diógenes Hequet (1866–1902), who concentrated on military subjects; and Manuel Larravide (1871–1910), a painter of seascapes. Historical subjects were also used in the monumental work of the first important Uruguayan-born sculptor, JUAN MANUEL FERRARI, who was influenced by Auguste Rodin (e.g. the monument to General San Martin's Liberation Army, 1914; Mendoza, Argentina, Cerro de la Gloria).

The first signs of modernism in Uruguayan painting appeared in the 1890s in the work of such artists as CARLOS FEDERICO SÁEZ and Carlos María Herrera (1875–1914). Sáez was influenced by the Macchiaioli (Italian luminists) and used techniques later associated with Abstract Ex-

pressionism (e.g. *Ciocciaro Head*, 1897; Montevideo, Mus. N. A. Visuales). Herrera, who specialized in pastel, played an important role as an educator and founder of the Círculo de Bellas Artes in 1905 (*see* §VIII below). Impressionism was introduced into Uruguay by PEDRO BLANES VIALE and Milo Beretta (1875–1935). They developed the art of landscape painting, using a luminous palette that owed more to Spanish painters than the Ecole de Paris (e.g. *Palma de Mallorca* by Blanes Viale, 1915; Montevideo, Mus. N. A. Visuales). Immediate followers of this approach included Manuel Rosé (1882–1961) and Carlos Alberto Castellanos (1881–1945), the first maker of tapestry cartoons. The development of Uruguayan imagery is revealed in the work of PEDRO FIGARI, who was influenced by Post-Impressionism and whose paintings portray the lives of blacks and gauchos (see fig. 3). JOSÉ CÚNEO and others followed his example in appropriating and transforming foreign artistic languages by filling them with local content.

Uruguayan printmaking during the early 20th century was marked by the appearance of xylography and the work of Federico Lanau (1891–1929), who did wood-engravings linked to the French school of the 1920s, and Leandro Castellanos Balparda (1894–1957), who worked against the grain and incorporated Latin American motifs, particularly in his later work. CARLOS GONZÁLEZ may perhaps be considered the founder of Uruguayan printmaking in that he reflected the essence of Latin America in a primitive and direct language that showed an affection for rural people. Meanwhile, the sculptor Antonio Pena (1894–1947), a student of Emile-Antoine Bourdelle at the Académie de la Grande Chaumière, Paris, was producing the

last works of Uruguayan historical classicism. Other important sculptors of this generation included the naturalist José Belloni (1882–1965); José Luis Zorrilla de San Martín (1894–1975), whose figures revealed an expressive, Baroque strength; Severino Pose (1894–1964), who was a follower of Anton Hanak in Vienna; and Bernabé Michelena (1888–1963), who produced monumental works—the best known is at Montevideo's Carrasco Airport.

The next generation of painters was more interested in geometrization, in some cases leading to Constructivism. Cubism and Futurism were incorporated obliquely into Uruguayan art through RAFAEL BARRADAS, who lived in Spain for most of his career and produced paintings he called *vibracionismo* because of their shimmering appearance (e.g. *Apartment House*, 1919; Montevideo, Mus. N. A. Visuales). In contrast, Miguel Angel Pareja (1908–84) freed colour from Impressionist naturalism, introducing an abstract conception. By far the most celebrated and influential Uruguayan artist of the late 1930s and 1940s, however, was Joaquín Torres García, who returned to Montevideo from Europe in 1934 at the age of 60. He found a flourishing Uruguay, and there he introduced a radical change to artistic development with a universal type of abstract art. Through his teaching, writing and his studio, the TALLER TORRES GARCÍA, he introduced Cubism, Neo-plasticism and Constructivism as well as his own concept of 'Constructive Universalism', which was highly influential in the creation of a national art (for illustration *see* TORRES GARCÍA, JOAQUÍN). His late works include the *Cosmic Monument* (1938; Montevideo, Mus. N. A. Visuales). His students and followers included his sons, Augusto Torres (1913–92) and Horacio Torres (1924–76),

3. Pedro Figari: *Creole Dance*, oil on cardboard, 521×813 mm, *c.* 1925 (New York, Museum of Modern Art)

and GONZALO FONSECA, who is also a sculptor. Others took his Constructivism a stage further, consolidating non-figurative art. Antonio Llorens (1920–95) and Rhod Roth-fuss (1936–69) were members of the Argentine Arte Madí group, and Rothfuss was also a pioneer of the shaped canvas, theorizing on it as early as 1944. In 1955 José P. Costigliolo (1902–85) and the sculptor María Freire (*b* 1917) organized Uruguay's first non-figurative art exhibition.

Uruguayan sculpture also underwent a radical change in the mid-20th century, and this can be seen in the work of Eduardo Díaz Yepes (1909–79), a naturalized Spaniard, who began with abstraction (e.g. *Womb*, onyx, 1958; São Paulo, Parque de Ibirapuera) and ended with a symbolic interpretation of reality (e.g. monument to *Those Who Died at Sea*, 1958; Montevideo, Plaza Virgilio), which he integrated splendidly into the setting. GERMÁN CABRERA produced abstract works in marble, bronze, porous concrete, scrap iron, ceramics, baked clay and wood. Other abstract sculptors included Salustiano Pintos (1905–75), who used wood and sandstone in serialized totem-pole forms; Octavio Podestá (*b* 1929), who resolved iron figures with a mechanistic approach; Wifredo Díaz Valdéz (*b* 1932), who made cuts in commercial wooden products, destroying their cultural use and identity and thus revealing their organic core; and Hugo Nantes (*b* 1933), who followed Yepes's expressionist vein, creating monsters with mimetic forms made of discarded materials.

Other approaches in painting included ALFREDO DE SIMONE's 'arte matérico', in which he used rhythmic brushstrokes and heavy impasto to communicate the vibrancy of the city's streets and tenements (e.g. *Suburb*, 1941; Montevideo, Mus. N. A. Visuales). WASHINGTON BARCALA and NELSON RAMOS worked with everyday objects and materials, producing what Kalenberg termed an 'Organic Constructivism'. LUIS SOLARI dressed his figures in animal masks, visualizing an indigenous mythology; he also created zoomorphic characters in his drypoint etchings. The work of MANUEL ESPÍNOLA GÓMEZ developed in the same surrealist, dreamlike environment, culminating in *Mid-afternoon Crepe Hangers* (Montevideo, priv. col., for illustration see Kalenberg, p. 177), a funeral symbolizing the end of an era. The Uruguay of the 1960s was not the one encountered by Torres García, and political and economic problems were thereafter reflected in art. Around 1980 JOSÉ GAMARRA began to produce large-format paintings filled with irony and a naive air, addressing the problem of colonialism. The printmaker ANTONIO FRASCONI directly addressed political themes. Carlos Tonelli (*b* 1937) took refuge in a world of symbols consecrated by esoteric tradition, and Clever Lara (*b* 1952) concentrated on a naturalist approach, also inspired by the Taller Torres García. The etchings of Luis Camnitzer (*b* 1937) added a conceptual dimension, provoking an ethical–political reflection linked to the preservation of human rights.

BIBLIOGRAPHY
J. M. Fernández Saldaña: *Pintores y escultores uruguayos* (Montevideo, 1916)
C. S. Vitureira: *Arte simple* (Montevideo, 1937)
J. Romero Brest: *Pintores y grabadores rioplatenses* (Buenos Aires, 1951)
J. P. Argul: *Pintura y escultura del Uruguay: Historia crítica* (Montevideo, 1958)
E. Dieste: *Teseo: Los problemas del arte* (Montevideo, 1964)
F. García Esteban: *Panorama de la pintura uruguaya contemporánea* (Montevideo, 1965)
J. P. Argul: *Las artes plásticas del Uruguay: Desde la época indígena al momento contemporáneo* (Montevideo, 1966); rev. as *Proceso de las artes plásticas del Uruguay* (Montevideo, 1975)
F. García Esteban: *Artes plásticas en el Uruguay en el siglo XX* (Montevideo, 1970)
Arte contemporáneo en el Uruguay (exh. cat., ed. A. Kalenberg; Montevideo, Mus. N. A. Visuales, 1982)
Seis maestros del arte uruguayo (exh. cat., ed. A. Kalenberg; Buenos Aires, Mus. N. B.A.; Montevideo, Mus. N. A. Visuales; 1985–7)
Arte dell'Uruguay nel novecento (exh. cat., Rome, Ist. It.–Lat. Amer., 1988–9)
G. Peluffo: *Historia de la pintura uruguaya* (Montevideo, 1989)
A. Kalenberg: *Arte uruguayo y otros* (Montevideo, 1990)
W. E. Laroche: *Pintores uruguayos en España, 1900–1930* (Montevideo, 1992)
A. Kalenberg: 'Recatado, permeable, individualista: Uruguayo', *Voces de Ultramar: Arte en América Latina, 1910–1960* (exh. cat., Madrid, Casa América; Las Palmas de Gran Canaria, Cent. Atlántic. A. Mod., 1992), pp. 81–4
G. Peluffo Linari: *Historia de la pintura uruguayana: De Blanes a Figari* (Montevideo, 1993)
A. Haber: 'Uruguay', *Latin American Art in the Twentieth Century*, ed. E. Sullivan (London, 1996), pp. 261–81
ANGEL KALENBERG

V. Gold and silver.

No goldwork or silverwork made before the 19th century in the region that is now Uruguay appears to have survived. Before this date, silversmiths no doubt concentrated on producing plain, domestic articles; the more ambitious ecclesiastical commissions were ordered from Peru or Buenos Aires (across the River Plate), such as the elaborate lectern (*c.* 1770; Buenos Aires, priv. col.) made for Montevideo Cathedral. During the 19th century, however, the increase in wealth on account of the cattle industry, combined with growing nationalism, led to a tremendous increase in demand for domestic silver articles, specifically those associated with the infusing and serving of the drink *mate*, and with horse trappings and personal adornments for the gaucho. Silver and even gold *mates* in the form of gourds or sometimes following the shape of chalices were often chased with foliate scrolls and sometimes have stems in the form of birds; they are often accompanied by a *bombilla* or perforated tube. Such European emigré silversmiths as Marcelino Barnech (*fl* 1840–*c.* 1870), Jose Mantegani, Carlos Bellini and Torricella made magnificent silver and even gold horse trappings. Bridles, reins, breast-plates and some saddle girths were mounted in silver and were sometimes made of silver mesh. Personal items for the caudillo and gaucho included spurs, whips and daggers, usually decorated with European-inspired cast or chased foliate scrolls and often incorporating such nationalistic symbols as the 'Cap of Liberty'.

BIBLIOGRAPHY
F. O. Assuncão: *Uruguayan Folk Art* (Montevideo, 1985)
CHRISTOPHER HARTOP

VI. Textiles.

There is little information available concerning early production of textiles in Uruguay. There was no indigenous tradition, and the colonial inheritance was limited, although from the 18th century there was some production of textiles on domestic looms (also called 'creole looms' or

4. High-warp tapestry-weaving at the Gobelins manufactory, Paris; from *L'Encyclopedie Diderot et d'Alembert: Tapissier* (Paris, 1786)

'pre-looms') in rural areas. Still in use, these vary in size and are made from a rough, simple frame of wood. Coarse woollen cloth, pallets and blankets, in whites, ochres and greys and in simple patterns or in stripes were also produced. From the 19th century, particularly in schools run by Spanish nuns, embroidery work was executed for more refined domestic flags and presidential sashes, as well as crocheting, lace cuff edging, macramé and painstakingly executed Hispanic petit point; this tradition, however, is gradually disappearing.

From 1915 textiles were produced in the workshops of the Escuela Nacional de Artes y Oficios, from 1944 in the Universidad del Trabajo del Uruguay (formerly the Escuela Nacional de Artes y Oficios) and from 1960 in the Escuela Nacional de Bellas Artes, all in Montevideo. Although many items continued to be imported, the manufacture of textiles became an important industry in the second half of the 20th century. The most significant output was in wool products, promoted, in the late 20th century, by the Secretariado Uruguayo de la Lana (est. 1968), which has organized the Bienales de Tapiz de Lana since 1978.

An important centre of production is Manos del Uruguay (est. 1968), formed of 18 cooperatives producing carpets, curtains, blankets, cushions and tapestry cloth made of wool and natural native fibres (ramie and thistle) based on models from its own department of design. Stylistically, production has evolved from the use of two or three natural colours to more than 90 different shades and from sheepskin wool to refined wool. Batik and tapestry are also produced. Craftsmen of European ancestry, skilled in traditional techniques, execute crochet and macramé work. Products are exported to the USA and Europe. Throughout Uruguay—particularly in Montevideo— there is a limited industrial production of patterned wool and acrylic fibre carpets, for which many of the designs are imported. The quality of wool carpets is

supervised by the Secretariado Uruguayo de la Lana. As well as cooperatives and industrial production, there is also a small number of independent craftsmen producing wool and batiks.

The production of tapestry has been of great importance from 1960, thanks to the influence of Ernesto Aroztegui (1930–94), both as craftsman and teacher. He encouraged research and, as the result of his involvement in the Taller Montevideano de Tapices (1967), a large, progressive movement in tapestry work developed that emphasized the importance of each stage in the process of tapestry-making. Aroztegui excelled in the high-warp Gobelin technique, so called because the warp is tensioned in a vertical position between two horizontal rollers, supported one above the other in a frame. The bulk of the warp is rolled on to the upper roller, and the ends are attached to the lower roller. As the weaving progresses, the warp is periodically released from the upper roller, and the completed work is rolled on to the lower roller (see fig. 4). He worked in a style that was both symbolic and hyperrealist, often making use of anamorphic images (e.g. *Double Portrait of Sigmund Freud with Cancer of the Lower Left Jaw*; see fig. 5). He ended his teaching career managing a workshop at the Escuela Nacional de Bellas Artes. From 1960 to 1980 most tapestry was of fine-grain high-warp thread. Thereafter all kinds of materials and fibres were incorporated, and experimental, three-dimensional work in the style of nouvelle tapisserie began to be produced. The Centro de Tapicería Uruguaya, an association of

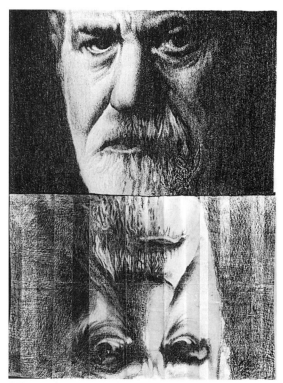

5. Ernesto Aroztegui: *Double Portrait of Sigmund Freud with Cancer of the Lower Left Jaw*, high-warp tapestry, plastic and synthetic with cotton warp and crayon on paper, 240×180 mm (Montevideo, Dr Ricardo Bernadi private collection)

craftsmen established in 1982, which has a membership of 140 tapestry-makers, promotes the production of tapestry in Uruguay.

BIBLIOGRAPHY

A. Martínez Montero and E. Villegas Suárez: *Historia de la Universidad del Trabajo del Uruguay* (Montevideo, 1968)

F. García Esteban: *El arte nuevo* (Montevideo, 1969)

O. Larnaudie: *Artesanía uruguaya* (Montevideo, 1988)

S. Rostagnol: *Las artesanas hablan* (Montevideo, 1988)

Artesanía Uruguaya (exh. cat. by O. Larnaudie, Washington, DC, Uruguayan Embassy, 1991)

A. Haber: 'Manos del Uruguay: Coopératives rurales d'artisanes textiles', *Mains de femmes*, ed. J. Etienne (Paris, 1995)

——: 'Uruguay', *Latin American Art in the Twentieth Century*, ed. E. J. Sullivan (London, 1996; Sp. trans., Madrid, 1997)

O. Larnaudie: 'Tiempos y modos artesanales del Uruguay', *La Bienal del objeto artesanal* (exh. cat., Montevideo, Intendencia Mun., 1997)

A. Haber: 'De la circumspección a la exploración de la intimidad', *Historias de la vida privada en el Uruguay*, ed. J. P. Barrán, G. Caetano and T. Porzecanski (Montevideo, 1998)

ALICIA HABER

VII. Collections and museums.

Uruguay's public collections are primarily devoted to Uruguayan art, with a sprinkling of Latin American and 19th-century European painting. Its private collections, on the other hand, include more examples of European art after the Renaissance. The number of museums in Uruguay grew steadily after the stimulus to the arts provided by the creation of the first formal art schools in the early 20th century (*see* §VIII below). The first museum to be established was the Museo Nacional (1837). Its subsequent reorganization in 1911 resulted in the creation of the Museo Nacional de Bellas Artes, the Museo Nacional de Historia Natural and the Archivo y Museo Histórico Nacional. The first of these became the Museo Nacional de Artes Plásticas, today the Museo Nacional de Artes Visuales, the most important museum of art in Uruguay, which is located in the Parque José E. Rodó in Montevideo. Its complex history was marked by temporary closures, but in 1961 it was permanently reopened, and in 1969 it embarked upon a dynamic policy for the popularization of art, underscored by temporary exhibitions that attracted huge numbers of visitors. The museum underwent a substantial rebuilding programme in 1970, directed by the Argentine architect Clorindo Testa; it was subsequently expanded, tripling the total area of the museum, and in 1986 new, technically advanced galleries and a conference hall were added.

The holdings of the Museo Nacional de Artes Visuales include the most complete and systematic collection of Uruguayan art in existence, with the most important collection of the works of Rafael Barradas and major collections by Juan Manuel Blanes, Carlos Federico Sáez, Pedro Figari, Joaquín Torres García and José Cúneo. Its European collection comprises mostly 19th-century painting, including works by Giovanni Fattori, Mariano Fortuny y Carbó, Joaquín Sorolla y Bastida, Ignacio Zuloaga and Hermenegildo Anglada-Camarasa. Its Latin American collection includes paintings by David Alfaro Siqueiros, Emilio Pettoruti and Jorge de la Vega, and the Cuban painter René Portocarrero (1912–86).

The second most important museum in the country is the Museo Municipal Juan Manuel Blanes, founded in 1928 but not finally opened to the public until 1935. The holdings of the Museo Municipal Juan Manuel Blanes were based on the collection of European paintings and sculptures donated to the Municipality of Montevideo in 1912 by Alejo Rossell y Rius (1848–1919) and his wife, Dolores Pereira. Between 1928 and 1953 the museum's initial core of works was increased by purchases from individuals, by donations and, above all, from the Salón Municipal de Artes Plásticas that began in 1940, bringing a contemporary profile to the works entering the museum's collection. Uruguayan works held by the museum include oils, drawings, sketches and documents of Blanes, and oils and drawings by Figari, Torres García, Cúneo, Sáez, Luis Solari, Pedro Blanes Viale and, in particular, Alfredo De Simone. Also of note are some prints by Carlos González, who donated several works to the museum in 1991.

Other important museums in Uruguay include the Museo Torres García, founded in 1988 by the Fundación Torres García, with a view to bringing together works by the artist that were scattered around the world; the Museo de Arte Americano of Maldonado; the Museo de Historia del Arte y del Arte Precolombino y Colonial of the Municipality of Montevideo; the Museo Solari, opened in Fray Bentos in 1989, including works by Luis Solari and promoting fine arts in the region; the Museo de Bellas Artes y Artes Decorativos of Salto; and the Instituto Histórico y Cultural of San José.

BIBLIOGRAPHY

F. García Esteban: 'Valorización crítica del acervo actual del museo', *Rev. Mus. Juan Manuel Blanes*, i/1 (1958), pp. 18–20

Catálogo descriptivo del Museo Nacional de Bellas Artes (Montevideo, 1966)

Museo Torres García: Acervo de la fundación, Fundación Torres García (Montevideo, 1990)

ANGEL KALENBERG

VIII. Art education.

Applied arts were first taught in Uruguay in the second half of the 19th century, initially in the Talleres de Maestranza and after 1878 in the Escuela Nacional de Artes y Oficios in Montevideo. The Escuela changed radically under the direction of Pedro Figari between 1915 and 1921, when he discarded academicism and created a modern centre of training, in which art and industry were of equal importance, and emphasis was placed on regional art and originality of design. This was the basis on which was founded the Universidad del Trabajo del Uruguay, Montevideo (1942; formerly the Escuela Nacional de Artes y Oficios), where applied arts were taught. Before 1905 professional art education was imparted individually by artists, principally foreign, and most Uruguayan artists travelled to Europe to acquire a complete training. This situation changed in 1905 when the Círculo de Bellas Artes, the first formal institution for art education, was founded. Many of the best-known artists of Uruguay studied and taught there, helping to foster the development of modern art. In 1943 the Escuela Nacional de Bellas Artes was founded; it acquired university status in 1959 and established a new curriculum in 1960. Organized through a series of workshops, its programme involved active teaching, the development of the senses, teamwork, experimentation, spontaneity, empirical learning and integration with the environment.

Private studios and workshops also played an important role in the development of modern Uruguayan art. The most prominent of these, the Asociación de Arte Constructivo and the TALLER TORRES GARCÍA, were founded by JOAQUÍN TORRES GARCÍA in 1935 and 1943. After his death in 1949 his pupils continued teaching his principles of Constructivism. Other important private workshops and training centres included the Club de Grabado, which from 1953 offered instruction in the graphic arts; and the Centro de Diseño Industrial, which established a training programme for designers in 1988.

Formal architectural training began in 1888 in the Facultad de Matemáticas y Ramas Anexas in Montevideo; the Facultad de Arquitectura was subsequently founded in 1915. The tuition of the French architect José P. Carré (1870–1941) was particularly influential between 1906 and 1940. A new curriculum was established in 1952, described as a humanistic technical programme based on the concept of the architect as a technician in the service of society. The course was organized in workshops directed by leading architects, among them Julio Vilamajó, Mauricio Cravotto (1893–1962), Mario Payssé-Reyes and Carlos Gómez Gavazzo (1904–87).

BIBLIOGRAPHY

J. P. Argul: *Educación para la belleza y el arte: Del ejercicio de la crítica de arte* (Montevideo, 1956)
——: *Los artes plásticas del Uruguay: Desde la época indígena al momento contemporáneo* (Montevideo, 1966); rev. as *Proceso de las artes plásticas del Uruguay* (Montevideo, 1975)
A. Martínez Montero and E. Villegas Suárez: *Historia de la universidad del trabajo del Uruguay* (Montevideo, 1968)
Proyección de su experiencia educacional, Escuela Nacional de Bellas Artes (Montevideo, 1986)
R. García Miranda: 'Evolución de los estudios de arquitectura', *El País* (Dec 1988)

ALICIA HABER

IX. Art libraries and photographic collections.

Most of the libraries and slide collections with significant art-historical material are found in Montevideo. The most important are the Biblioteca Nacional del Uruguay, the Biblioteca Municipal del Museo de Historia del Arte and the libraries of the Facultad de Arquitectura at the Universidad de la República, the Museo Nacional de Artes Plásticas, the Universidad Católica and the Escuela Nacional de Bellas Artes. These collections cover international and Uruguayan art history from the prehistoric period to the 20th century. There are 30 other libraries with partial collections. Specialist libraries include those at the Centro de Diseño Industrial (design); the Biblioteca Artigas-Washington (American art); the Biblioteca del Instituto Cultural Anglo-Uruguayo (British art); the French Embassy and Alliance Française (French art); and the Instituto Italiano di Cultura (Italian art). The best libraries for the study of Uruguayan art are those of the Círculo de Bellas Artes, the Museo Nacional de Artes Plásticas and the Biblioteca Nacional. The Comisión Nacional de Bellas Artes has a large collection of catalogues on Uruguayan art, and there is a library devoted to Joaquín Torres García at the Museo Torres García.

The most important slide collections, covering international and Uruguayan art, are those of the Facultad de Arquitectura, the Escuela Nacional de Bellas Artes and the Museo Municipal de Historia del Arte. There are also specialist slide collections in the foreign cultural institutes. The Ministerio de Educación y Cultura has a slide collection of Uruguayan sculpture, and the Intendencia Municipal de Montevideo has an important collection of black-and-white photographs of the history of the city. Due to economic problems, the use of microfilm and computers is restricted to a few private libraries, such as the Biblioteca Artigas-Washington.

ALICIA HABER

V

Valcin, Gérard (*b* Port-au-Prince, 10 July 1927; *d* Port-au-Prince, 15 May 1988). Haitian painter. He came from a poor family and was forced to leave school after only three years. He began to paint after coming into contact with the Centre d'Art in Port-au-Prince and became a full-time artist as soon as he began to earn enough from his pictures to abandon his work as a tile-setter. He joined the Centre d'Art in 1959. He was a fervent adept of Vodoun, from which he took much of his subject-matter. He was attracted by the life of the countryside, usually situating his ceremonial scenes amid lush tropical foliage. Leaves, rows of tilled earth and the movements of water or human figures all conform to simplified motifs arranged in rhythmic repetition. In his pictures the embodied spirits are provided with symbolic dress and attributes; details of costume and draperies are highly stylized, falling into neatly parallel and rhythmic folds, and hands and faces are conventionalized. Using precisely delineated contours and enamel-like surfaces similar to those of the patterned tiles with which he worked in his youth, he arranged figures in circles, squares or horizontal registers across the picture plane; they have little individuation. With their pure colours and stylized but precise rendering, his pictures sometimes resemble the illuminations of medieval manuscripts.

BIBLIOGRAPHY
Haitian Art (exh. cat. by U. Stebich, New York, Brooklyn Mus., 1978)
M. P. Lerrebours: *Haïti et ses peintres*, i (Port-au-Prince, 1989)
DOLORES M. YONKER

Valdés, José Bedia. *See* BEDIA VALDÉS, JOSÉ.

Valdivieso, Raúl (*b* Santiago, 9 Sept 1931). Chilean sculptor. He studied at the Escuela de Bellas Artes in Santiago under the Chilean sculptors Julio Antonio Vásquez (*b* 1900), Lily Garáfulic (*b* 1914) and Marta Colvin. He left Chile in 1958 for Spain, France and Morocco, settling in Spain in 1961 but returning to Chile in 1974 to produce a number of works, including an important commission for the Parque de las Esculturas in Santiago (*Bandaged Torso*; stone, h. 1.62 m, installed 1989), before leaving again for Spain.

Valdivieso worked in bronze and in stone (granite, limestone, diorite and basalt). Much of his work was concerned with natural forms, conveyed with a directness of feeling. Approaching mass through a process of gradual abstraction, Valdivieso sought a balance between the visual and tactile qualities of his materials and the meanings implicit to their forms. He often formulated his sculptures first in easily moulded, ductile materials, which he then translated into the final work. He particularly favoured chrome-plated bronze for its accentuation of the surface with its brilliant finish.

In one of his most characteristic series, *Seeds* (*Emerging Seed*; marble, h. 400 mm, 1985; Santiago, Mus. N. B.A.), Valdivieso simplified natural forms into masses of great formal purity, establishing an intimate dialogue between the material (stone or bronze) and the suggestions of fruit, seeds and doves. In his sculptures of the 1980s he combined such forms with shapes related to sexual organs (*Kiss*; bronze, h. 330 mm, 1982; artist's col.).

BIBLIOGRAPHY
Raúl Valdivieso: Esculturas (exh. cat., Madrid, Gal. Nebli, 1963)
M. Ivelič: *Escultura chilena* (Santiago, 1979), pp. 57–62
W. Sommer: *Plástica chilena* (Santiago, 1985), pp. 64–7
CARLOS LASTARRIA HERMOSILLA

Valentim, Mestre. *See* FONSECA E SILVA, VALENTIM DA.

Valle, Angel Della. *See* DELLA VALLE, ANGEL.

Valle, Julio Rosado del. *See* ROSADO DEL VALLE, JULIO.

Valparaíso. Chilean city. With a population of *c.* 300,000, it is located on the coast *c.* 100 km west of Santiago, for which it served as a port for centuries. The city's shore and hillside areas are connected by tortuous streets and by several funicular railways installed between 1883 and 1914. First reconnoitred by the Spaniard Juan de Saavedra in 1536, Valparaíso was founded in 1544, and it remained a tiny settlement until the commercial expansion of the 19th century. The population rose from *c.* 5000 in 1800 to 100,000 in 1875, and the port assumed a notably cosmopolitan character with the arrival of numerous foreign merchants. The British, in particular, imprinted a characteristic tone on the business district and on the hillside suburb of Cerro Alegre, where English-style villas proliferated (although few survive). A more traditional Chilean atmosphere prevailed in the Almendral district north along the coast. Urban improvements such as street-paving were initiated in the 1850s. Public buildings constructed during these years include the modestly handsome Intendencia (*c.* 1855), the church of La Matriz (1842), the Casa de la Aduana (1855) and a series of plain but imposing public warehouses. Much rebuilding was needed after the savage bombardment of the city by a Spanish naval squadron in

March 1866, but Francisco Echaurren, the city's Intendant from 1870 to 1876, sponsored further improvements.

In August 1906 Valparaíso was almost completely devastated by the worst in a long series of earthquakes, and some 4000 people died. A further economic setback occurred in 1914 with the opening of the Panama Canal, which ended Valparaíso's dominance as a port. From the 1960s its traditional role was also challenged by the new container-port at San Antonio, 110 km to the south. The steady growth of Viña del Mar, the smart and fashionable ocean resort adjoining Valparaíso to the north, lessened the port's attractiveness as a place of residence for the wealthier classes. By the early 1990s Viña del Mar's population was approaching Valparaíso's, and the two cities effectively formed a single conurbation (although Valparaíso retains a more 'popular' and raffish character than its affluent neighbour). In 1990, on a whim of the outgoing dictator Augusto Pinochet (b 1915), Valparaíso was made the seat of the National Congress, for which the most extravagant public building in the city's history was hurriedly erected in the Almendral district (1991). It is perhaps best described as half neo-Babylonian, half Post-modernist. The Museo Municipal de Bellas Artes in the Art Nouveau Palacio Baburizza, Cerro Alegre district, houses a collection of Chilean paintings.

BIBLIOGRAPHY
E. Pereira Salas: *La arquitectura chilena en el siglo XIX* (Santiago, n.d.)
SIMON COLLIER

Varo, Remedios (b Anglés, nr Girona,16 Dec 1908; d Mexico City, 8 Oct 1966). Spanish painter, active in Mexico. She began her studies at the Real Academia de San Fernando in Madrid in 1934 and even in her earliest work showed a tendency to work from the imagination. In 1937, while living in Paris, she married the French poet Benjamin Péret (b 1899) and through him became involved in the activities of the Surrealists. The influence of Surrealism is apparent in early works such as *Vegetal Puppets* (1938; priv. col., see Kaplan, p. 62), in which the elongated floating figures are formed out of wax dripped on to an unprimed wooden surface. After the occupation of France by Germany, Varo and Péret fled in 1942 to Mexico, where many exiled Surrealists, notably Leonora Carrington and Wolfgang Paalen, were already active.

Varo did not begin to paint full-time until 1953, and her most characteristic work dates from this period. She was greatly influenced by André Breton (1896–1966) in her cultivation of dreamlike moods, but she rejected an unswerving reliance on the subconscious in favour of deliberate fantasies. Her painstaking technique suggests a direct debt to medieval art, for example to the Romanesque frescoes of her native Catalonia, especially in the treatment of architectural elements. In typical early works such as *Useless Science or the Alchemist* (1955; priv. col., see Kaplan, p. 126), buildings, objects and clothing take on a life of their own, undergoing a metamorphosis linked to the theme of a spiritual journey; the natural environment, often shown as threatening, is populated with male and female figures who resemble the artist herself. Humorous touches help to dissipate the otherwise solemn mood of these claustrophobic spaces. Another characteristic painting, *Hairy Locomotion* (oil on hardboard, 1960; Mexico

City, Márgara Garza priv. col., see Kaplan, p. 157), exemplifies both the artist's command of line and the unrestrained imagination by which everyday objects and events undergo mutations into unusual things. Three men, identified by the artist as detectives, appear to float within a labyrinthine architecture as they steer their way through corridors on enormous beards that are considerably longer than their bodies. She remained faithful to such dream-like atmospheres and perplexing narratives in the works painted over the last few years of her life.

BIBLIOGRAPHY
O. Paz, R. Callois and J. González: *Remedios Varo* (Mexico City, 1966)
E. Jaguer: *Remedios Varo* (Mexico City, 1980)
Remedios Varo, 1913–1963 (exh. cat., Mexico City, Mus. A. Mod., 1983)
J. A. Kaplan: *Unexpected Journeys: The Art and Life of Remedios Varo* (New York and London, 1988)
R. Ovalle and W. Gruen: *Remedios Varo: Catálogo Razonado* (Mexico City, 1994)
Remedios Varo (1913–1963) (exh. cat. by T. del Conde and F. Serrano, Mexico City, Mus. A. Mod., 1994)
MARGARITA GONZÁLEZ ARREDONDO

Vasconcelos, Constantino de (b Braga; d Lima, 22 Aug 1668). Portuguese architect and engineer, active in Peru. He was educated in the Renaissance humanist tradition, studying philosophy, theology, mathematics, cosmography, perspective and architecture after Vitruvius. Vasconcelos went to the Spanish Viceroyalty of Peru in 1629 with Don Hernando de Vera y Zúñiga, Archbishop of Santo Domingo, who had been transferred to a new seat in Cuzco. To celebrate the arrival of the new archbishop, in 1630 Vasconcelos designed a gold medal, which was sent to Spain. He then worked as an engineer in mines at Oruro, Potosí and Huancavelica. Vasconcelos took part as a cosmographer and military engineer in the 1645 expedition to Valdivia in Chile, where he drew a topographical map of the port and a design for its fortifications. His architectural masterpiece was the church of S Francisco (1657–74), Lima, largely built under the supervision of his assistant Manuel de Escobar (1639–93). Here Vasconcelos employed the anti-seismic *quincha* form of construction, using plastered reeds on a wooden frame, which was adopted in Lima and elsewhere on the Peruvian coast. The façade (begun 1669) features two towers with military rustication, banded at the lower levels, which embrace a *retablo*-type entrance bay, delicately detailed in striking contrast. The cloister elevations use overlapping Serlianas at first-floor level, the side openings partially filled in to display oval apertures.

BIBLIOGRAPHY
M. Suárez de Figueroa: *Templo de N. grande patriarca San Francisco de la provincia de los doce apóstoles del Perú en la ciudad de los reyes* (Lima, 1675)
B. Gento Sanz: *San Francisco de Lima* (Lima, 1945)
G. Lohmann Villena: *Las minas de Huancavelica en los siglos XVI y XVII* (Seville, 1949), pp. 292, 315–36, 338–41, 343–5, 396
D. Angulo Iñiguez and others: *Historia del arte hispanoamericano*, ii (Barcelona, 1950), pp. 136, 142–4
H. Rodríguez-Camilloni: 'El conjuncto monumental de San Francisco de Lima en los siglos XVII y XVIII', *Bol. Cent. Invest. Hist. & Estét. U. Caracas*, (1972), pp. 31–60
——: 'The Retablo-façade as Transparency: A Study of the Frontispiece of San Francisco, Lima', *An. Inst. Invest. Estét.* (1991), pp. 111–22
H. Rodríguez-Camilloni: 'Tradición e innovación en la arquitectura del Virreinato del Perú: Constantino de Vasconcelos y la invención de la arquitectura de quincha en Lima durante el siglo XVII', *Arte, historia e*

identidad en America. XVII Coloquio Internacional de Historia del Arte: Mexico City, 1994, pp. 387–403

HUMBERTO RODRÍGUEZ-CAMILLONI

Vásquez, Dagoberto (*b* Guatemala City, 2 Nov 1922). Guatemalan sculptor and painter. After studying at the Academia de Bellas Artes in Guatemala City (1937–44), he received a grant that enabled him to continue his studies from 1945 to 1949 at the Escuela de Artes Aplicadas of the Universidad de Chile in Santiago, Chile. He was part of a generation of artists who revitalized art in Guatemala after World War II; like Guillermo Grajeda Mena, Roberto González-Goyri and, later, Efraín Recinos, he was associated with the efforts of several architects to integrate the arts in their new buildings.

As both a sculptor and a painter Vásquez maintained a consistent artistic line without obvious changes, achieving a personal synthesis of expressionism and abstraction with a great simplicity of form. His sculptures were made of a variety of materials, including marble, bronze, clay, sheet brass, wood and concrete. Among his most important works, all in Guatemala City, are the *Origins of Life* (7.5×2.5 m, 1951), a mosaic at the Instituto de Nutrición de Centroamérica y Panamá (INCAP); two concrete reliefs cast *in situ*, *Song for Guatemala* (10×6 m, 1957; Guatemala City, Pal. Mun.) and *Economy and Culture* (40×7 m, 1964; Guatemala City, Banco de Guatemala); and bronzes such as *Christ* (h. 1.7 m, 1974) for the Capilla San Ignacio and *Fire* (h. 1.7 m, 1980) for the Organización Eléctrica Guatemalteca.

BIBLIOGRAPHY
Dagoberto Vásquez (exh. cat., Guatemala City, Gal. El Túnel, 1983)
L. Méndez d'Avila: *Visión del arte contemporáneo en Guatemala*, i (Guatemala City, 1995)
Dagoberto Vásquez Castañeda: Una vida en el arte (exh. cat. by R. Cazali, Guatemala City, Fundación Paiz, 1996)
Guatemala: Arte contemporáneo (Antigua, 1997), pp. 13–16
L. Escribá: 'Dagoberto Vásquez Castañeda: Una vida dedicada al arte', *Banca Cent.*, xxxvi (1998), pp. 133–46

JORGE LUJÁN-MUÑOZ

Vásquez Brito, Ramón (*b* Porlamar, 29 Aug 1927). Venezuelan painter and teacher. He studied from 1943 to 1947 at the Escuela de Artes Plásticas in Caracas, where he then taught from 1947 to 1973. His painting, which evolved from Cubism through geometric abstraction to lyrical landscape painting, shows his attraction to coastal light and to open spaces. The colours are limited to shades of blue, green, grey and white. Vásquez Brito represented Venezuela in the 31st Venice Biennale in 1962 and during his career received numerous national awards, including the CONAC Prize at the 11th Biennale of Visual Arts (1983) at the Museo de Arte Contemporáneo de Caracas.

ANA TAPIAS

Vázquez, Pedro Ramírez. *See* RAMÍREZ VÁZQUEZ, PEDRO.

Vega, Eduardo (*b* Cuenca, 13 June 1938). Ecuadorean ceramicist and designer. He studied from 1958 to 1960 at the Real Academia de S Fernando and in the studio of Eduardo Peña in Madrid. He attended the Brixton School of Building, London, from 1960 to 1961 and went on to study ceramics at the Ecole des Beaux-Arts et des Arts Appliqués à l'Industrie in Bourges with Jean Lerat and Jacqueline Lerat between 1967 and 1968. On returning to Cuenca, a region with a strong pottery tradition, he created one of his most outstanding murals, the *Land of El Dorado* (1969; Cuenca, Hotel El Dorado). At the time he was the only artist in the country extensively involved in producing ceramic murals. His large-format works, in terracotta and decorated with slip, emphasize volume by creating sharp contrasts of light and shade. His depiction of tropical abundance and of historical and mythical characters and other stylized local details combine to produce optical labyrinths. By incorporating international styles his works bring together the vocabulary of Pre-Columbian ceramics and 20th-century pottery to create a very personal language. In 1973 Vega set up the ceramics business Artesa in Cuenca, for which he designed hundreds of decorative and utilitarian pieces, that bore the trademark *Vega* and were exported worldwide. Notable later works include *Of the Three Moons* (1985–7; Quito, Banco Ecuatoriano de la Vivienda), *The Totems* (1991, Cuenca, Remigio Crespo and Unidad Nacional), a monumental ensemble of concrete and clay, *Men of Stone* and *Taking the Spirit out of the Earth* (1995, Quito, Pal. Cardondelet).

BIBLIOGRAPHY
M. Monteforte: *Los signos del hombre* (Quito, 1985), pp. 220–21
A. Kennedy: 'Los geográficos murales de Eduardo Vega', *Trama*, 47 (1988), pp. 69–72
J. Dávila: 'Eduardo Vega: El misterio de la arcilla', *Rev. Diners*, 84 (1989), pp. 44–8
A. Kennedy Troya: 'La cerámica artística actual', *Historia de la cerámica en el Ecuador: Síntesis* (Cuenca, 1992), pp. 44–5
——: *E. Vega: Obra mural y escultórica* (Cuenca, 1996)
A. Abad, ed.: *De la inocencia a la libertad: Arte cuencano del s. XX* (Cuenca, 1998), pp. 98, 133

ALEXANDRA KENNEDY

Vega, Jorge de la (*b* Buenos Aires, 27 March 1930; *d* Buenos Aires, 26 Aug 1971). Argentine painter. He studied architecture for six years before devoting himself to painting. His first works were sensitive geometric abstractions. In 1961 he took part in the exhibition *Otra figuración* at the Galería Peuser in Buenos Aires with Ernesto Deira, Rómulo Macció and Luis Felipe Noé, working in a style derived from the CoBrA group; this was a milestone in the renewal of Argentine figurative painting. The Surrealist elements visible in his early work disappeared during the two years (1965–7) that he lived in the USA, first to teach painting at Cornell University in Ithaca, NY, and then on a Fulbright fellowship (for example, *Lapse of Consciousness*, 1965; see fig.). On his return to Argentina he began to paint psychologically penetrating pictures of male and female faces and body parts, such as *Jigsaw Puzzle* (1967; see Glusberg, p. 76), in a bold graphic style reminiscent of poster designs. Capturing expressions full of feeling and emotion but picturing them in a style at once ironic and dramatic, de la Vega wanted his art to be as natural and free from limitations as life itself. During the last years of his life he also wrote and sang popular protest songs.

BIBLIOGRAPHY
C. Córdova Iturburu: *80 años de pintura argentina* (Buenos Aires, 1978), pp. 152, 175–6, 193, 218–19
J. Glusberg: *Del Pop-art a la nueva imagen* (Buenos Aires, 1985), pp. 74–6
M. Casanegra: *Jorge de la Vega* (Buenos Aires, 1990)

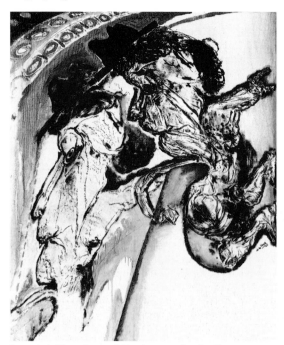

Jorge de la Vega: *Lapse of Consciousness*, oil and collage on canvas, 1.3×1.1 m, 1965 (Austin, TX, University of Texas, Jack S. Blanton Museum of Art)

Diera, Macció, Noé, de la Vega: 1961 Neo Figuración 1991 (exh. cat., Buenos Aires, Cent. Cult. Recoleta, 1991)
Jorge de la Vega: Obras, 1961–1970 (exh. cat. by M. E. Pacheco, Buenos Aires, Cent. Cult. Borges, 1995)
'Arco '97: El envío argentino del FNA', *Cultura* (1997), pp. 15, 29–30 [special edition]
Un altre mirar arte contemporani argentí/Otro mirar arte contemporáneo argentino (exh. cat., Barcelona, Generalitat Catalunya, 1997)
Re-Aligning Vision: Alternative Currents in South American Drawing (exh. cat., New York, Mus. Barrios; Little Rock, AR A.G.; Austin, U. TX, Huntington A.G.; and Caracas, Mus. B.A.; 1997–8)
JORGE GLUSBERG

Veiga Guignard, Alberto da. *See* GUIGNARD, ALBERTO DA VEIGA.

Velamendi, Juan Miguel de. *See* VERAMENDI, JUAN MIGUEL DE.

Velasco, José María (*b* Temascalcingo, 6 July 1840; *d* Mexico City, 27 Aug 1912). Mexican painter and teacher. As a landscape painter he was the most representative figure of Mexican academic painting in the 19th century. He produced a large body of work, in which the main theme was the spectacular natural scenery of his own country, interpreted according to his own singular vision. Stylistic unity and meticulously high standards of production characterize his work.

Velasco was from a small village in the provinces and from a family with no artistic tradition, but he began attending evening drawing classes at the Academia de Bellas Artes de S Carlos in Mexico City in 1858. He worked briefly in the studio of the Catalan painter Pelagrín Clavé but felt unhappy with the style imposed on him and completed his training from 1860 in the studio of Eugenio Landesio. Landesio's method lay in the faithful representation of nature, in careful drawing, in a thorough knowledge of colouring technique and above all in perspective. Velasco assimilated all that Landesio taught him, eventually surpassing him but without losing the classical composition, measured colour, accurate drawing and absence of drama with which his academic training had imbued him: he never painted a storm in his landscapes.

Velasco was objective by temperament, an observer of nature in its most minute details, and it was thus that he painted rocks, foliage, waterfalls and the shapes of clouds. He began teaching at the academy in 1868 but without creating a school of painting, his students imitating him but never surpassing him. His work was removed from that of contemporary European landscape painters, from the naturalism of Gustave Courbet and the symbolism of German artists such as Caspar David Friedrich. Instead he kept to what he had learnt from Landesio.

Velasco's early paintings, such as *Rustic Bridge at San Angel* (1862; Mexico City, Mus. N. A.), centre on landscapes in the vicinity of Mexico City. Landesio's influence is clearly evident in an *Outing in the Surroundings of Mexico City* (1866; Mexico City, Mus. N. A.). In 1874 Velasco and his family settled in Villa Guadalupe, high up on the northern outskirts of Mexico City. The landscape of the Valley of Mexico, seen from a high vantage point and with its grandeur and the special light peculiar to high places, became his main subject. Between 1873 and 1877 he created some of his most important landscapes, capturing for the first time the valley's extraordinary scale. The *Valley of Mexico* (1875; Mexico City, Mus. N. A.; see fig.) reveals his command of perspective, the vastness of the setting emphasized by the insertion of tiny human figures; the transparency of the atmosphere is indicated by the snowy caps of the volcanoes. Another major landscape of this period, entitled simply *Mexico* (1877; Mexico City, Mus. N. A.), is a symbolic work that subtly incorporates the eagle of the national coat of arms.

From the end of the 1870s Velasco broadened the range of themes treated in his paintings. Landscape sometimes served as a pretext for treating history and archaeology, as in *Pyramids at Teotihuacán* (1878; Mexico City, priv. col., see Fernández, 1983, pl. 122) and *Netzahualcoyotl's Bath in Texcoco* (1878; Mexico City, Mus. N. A.). Both the natural sciences and positivism interested Velasco, leading him on occasion to represent foliage and trees with botanical precision, as in the *Bridge at Metlac* (1881; Mexico City, priv. col., see Fernández, 1983, pl. 126). In the large pictures on the theme of evolution that he painted in 1904 for the Instituto Geológico (Mexico City, U.N. Autónoma), he demonstrated his knowledge of the evolution of the species on earth and in water. Such scientific concerns were also manifested in several paintings in which he showed Halley's Comet passing across the Mexican sky in 1910.

Velasco often painted the peaks of volcanoes such as Popocatepetl and Ixtaccihuatl, as well as Citlaltepetl or Pico de Orizaba, which are such salient characteristics of the Mexican landscape; an original view of the first two can be found in *Volcanoes Seen from Atlixco, Puebla* (1887; Mexico City, Banco N. de México). In one version of *Citlaltepetl* (1892; Mexico City, priv. col.) the composition

José María Velasco: *Valley of Mexico*, oil on canvas, 465×620 mm, 1875 (Mexico City, Museo Nacional de Arte)

is divided into two sections: the lower band contains the tropical vegetation of Veracruz, while the upper section represents the volcano amidst the arid landscape and the cold light of the peaks. Velasco painted *Citlaltepetl* again in a curious canvas in which he included a train (1897; Mexico City, Mus. N. A.) as a symbol of progress, which some of his critics had accused him of ignoring.

Velasco visited Paris in 1889 as head of the Mexican mission to the Exposition Universelle, where he exhibited 68 paintings. The influence of the Impressionists can be seen in several small sketches such as *Landscape: Europe* (1889; Mexico City, priv. col., see Fernández, 1983, pl. 138). However, on his return to Mexico after travelling through England, Germany, Italy and Spain, Velasco again centred his work on the Valley of Mexico, now frequently depicting it from a lower viewpoint. *Chimalpa Hacienda* (1893; Mexico City, Mus. N. A.), depicting the distant farm set in a large valley with volcanoes in the background, exemplifies the classical, descriptive style maintained by Velasco until his death, as does his 1894 canvas, *The Valley of Mexico from the Low Ridge of Tacubaya* (1894; see colour pl. XL, fig. 1).

BIBLIOGRAPHY

J. de la Encina: *El paisajista José María Velasco* (Mexico City, 1943)

J. Fernández: *El arte del siglo XIX en México* (Mexico City, 1952, rev. 2/1967/*R* 1983), pp. 85–104

C. Pellicer: *José María Velasco: Pinturas, dibujos, acuarelas* (Mexico City, 1970)

X. Moyssén: *José María Velasco: Un estudio sobre su obra* (Mexico City, 1991)

José María Velasco: Un paisaje de la ciencia en México (exh. cat. by E. Trabulse, Toluca, Inst. Mex., 1992)

M. E. Altamirano Piolle: *Homenaje Nacional: José María Velasco (1840–1912)* (Mexico City, 1993)

Homenaje nacional: José María Velasco (1840–1912), 2 vols (exh. cat. by M. E. Altamirano Piolle, Mexico City, Mus. N. A., 1993)

X. Moyssén: 'Cuadros de José María Velasco en colecciones europeas y norteamericanas', *México en el mundo de las colecciones de arte*, v (Mexico City, 1994), pp. 258–77

M. Tenorio-Trillo: *Mexico at the World's Fairs: Crafting a Modern Nation* (Berkeley and London, 1996)

XAVIER MOYSSÉN

Velázquez, Héctor. *See under* TORRES & VELÁZQUEZ.

Vélez, José Miguel (*b* Cuenca, July 1829; *d* Cuenca, 1 Dec 1892). Ecuadorean sculptor. He received his training in the workshop of the Cuencan painter Eusebio Alarcón (*fl* 1835–64). From a young age he was interested in polychromed wood-carving on religious themes, a medium that was greatly esteemed by the Quito school during the colonial period. Vélez, however, transformed the former Baroque language into Neo-classicism, inspired by imported examples and incorporating the academic teachings brought so late into Ecuador. Especially worthy of mention are his Crucifixes (e.g. *Holy Christ*; church of Señor de las Aguas, Girón, Azuay), as well as his images of the Infant Christ and Calvary, which were sought by collectors, religious communities and museums throughout the country. Together with Gaspar de Sangurima (1787–*fl* 1833), his disciple Daniel Alvarado (*c.* 1867–1953) and other local engravers, Vélez managed to make Cuenca the most important centre of 19th-century sculpture in the country. His portraiture was also significant, and he created a series

of busts of public figures in wood and marble, including that of the celebrated Franciscan journalist *Fray Vicente Solano* (Cuenca, Colegio Semin.).

BIBLIOGRAPHY

F. J. M. Vargas: *El arte religioso en Cuenca* (Quito, 1967)
J. T. León: *Biografías de artistas y artesanos del Azuay* (Cuenca, 1969)
Salvat: *Historia del arte ecuatoriano*, iii (Quito and Barcelona, 1977), pp. 237–9
M. Vintimilla: *Catalogación de la obra escultórica de José Miguel Vélez, artista azuayo tallador de cristos* (BA thesis, U. Estatal de Cuenca, 1998)

ALEXANDRA KENNEDY

Venezuela, Republic of. South American country. It is bordered by the Caribbean Sea to the north, Brazil to the south, Guyana to the east and Colombia to the west (see fig. 1). Its name, meaning 'little Venice', was given to it in 1499 by the Italian explorer Amerigo Vespucci, who compared the indigenous people's dwellings, which were built on water, to those of the Italian city. The country is divided into twenty states, two federal territories, one federal district and the insular territories. The capital is CARACAS (founded 1567). The majority of the country's *c.* 20 million inhabitants live along the coast. More than 60% of the population is of mixed ethnic origin, 20% Caucasian, 9% of African descent and *c.* 2% Amerindian.

The country's topography and location provide it with a variety of climates. The west, lying at the tip of the Andes, has fertile valleys: the two most important Andean cities are Mérida and San Cristóbal. Maracaibo, Venezuela's great oil city to the north, has a hot, dry climate; the other major city on the Venezuelan gulf, Coro, founded in 1528, has a well-preserved historic district. On the central plains large cattle ranches extend along the Apure, Arauca and Capanaparo, and in the south and east are the rainforest, the Amazon and Amacuro territories and the Orinoco River, one of the longest in the world. The north-eastern area of Venezuela has developed a strong tourist industry, centred on Puerto de la Cruz and Barcelona on the Caribbean coast; Barcelona, Cumaná, Clarines and Araya have remained virtually unchanged since Independence (1821) and are renowned for their colonial splendour. The remains of Nueva Cádiz, one of the oldest Spanish settlements on the continent, are preserved at Cubagua island.

I. Introduction. II. Indigenous culture. III. Architecture. IV. Painting, graphic arts and sculpture. V. Gold and silver. VI. Textiles. VII. Patronage, collecting and dealing. VIII. Museums. IX. Art education. X. Art libraries and photographic collections.

I. Introduction.

When Columbus arrived in the area comprising modern Venezuela on his third voyage in 1498, the profuse

1. Map of Venezuela; CARACAS has a separate entry in this encyclopedia

vegetation and immense rivers convinced him he had reached paradise, and so he called the region Isla de Gracia. The following year the Italian explorer Amerigo Vespucci reached the Coquivacoa Gulf (now the Gulf of Maracaibo). During the colonial period the province was administered by the Audiencia of Santo Domingo and the Viceroyalty of Nueva Granada. The settlement of Nueva Cádiz was first established by the Spanish *c.* 1510, and colonization continued in 1514 with a settlement of Dominican friars on the eastern coast of Cumaná, but the major territorial conquests took place on the western coast. From Coro (founded 1528) the Spanish launched their conquest of Venezuela, using Coro and El Tocuyo (founded 1547) as political and administrative centres. The major cities were founded by colonists farming cacao and tobacco using African and indigenous labour, based on the *encomienda* system, whereby Indians were granted as slaves to the conquerors.

The exploitation of minerals and agriculture quickly led to a feudal production system based on export, and during the 17th century the province's expanding economy created a wealthy creole upper class, commonly called 'los grandes cacaos'; with the Church, some of these wealthy figures were patrons of the arts. Prosperity increased further when Venezuela became a Capitanía General in 1777. The economic and political conflicts between the conspicuous colonial class and their Spanish rulers, however, eventually led in 1806 to Venezuela's long and bloody revolutionary war, led by Francisco de Miranda and Simón Bolívar; independence was achieved in 1821, two years after the formation by Bolívar of Gran Colombia, comprising Venezuela, Ecuador and Panama. In 1830 Gran Colombia was divided, and General José Antonio Páez became Venezuela's political and military figurehead. His control profoundly marked the evolution of the country's centralized power structure in the 19th century and early 20th. Political and economic instability followed Páez's defeat in 1846, with the liberals and conservatives vying for power without instigating any substantial reforms.

Antonio Guzmán Blanco led the country through constant political turmoil from 1870 to 1890, but some important social advances were made during this time, and Guzmán was a strong supporter of the arts. It is often said ironically that Venezuela did not enter the 20th century until 1936, following the death (1935) of the dictator Juan Vicente Gómez, but Gómez was succeeded by other equally repressive military governments. Oil meanwhile became the government's largest source of income and significantly improved the country's economy, financing the foundation of artistic institutions but also highlighting the unequal distribution of wealth.

After overthrowing Venezuela's first democratic government (1945–8), in 1948 Marcos Pérez Jiménez took power and curtailed all political freedom. A national uprising in 1958 overthrew Jiménez, and in 1961 Venezuela's first democratic constitution was adopted. In the 1970s and 1980s the international oil crisis benefited Venezuela, but this sudden increase in national wealth created a false illusion of splendour, permitting large-scale construction and investment in heavy industry, social services and education but also encouraging political corruption, which intensified social inequalities. The eco-nomic crisis of the late 1980s led to further social upheaval and to several futile military coups, which threatened South America's oldest and most stable democracy.

BIBLIOGRAPHY

J. F. Acevedo Mijares: *Historia del arte en Venezuela* (Caracas, 1951)
A. Boulton: *Historia de la pintura en Venezuela*, 3 vols (Caracas, 1964–72)
Venezuela, 1498–1810, Sociedad Amigos del Museo de Bellas Artes (Caracas, 1965)
G. Moron: *Historia de Venezuela*, 5 vols (Caracas, 1971)
E. Armitano, ed.: *Diccionario biográfico de las artes plásticas en Venezuela: Siglos XIX y XX* (Caracas, 1973)
J. Calzadilla: *El arte en Venezuela* (Caracas, 1976)
Arte de Venezuela, Consejo Municipal del Distrito Federal (Caracas, 1977)
Diccionario manual de Venezuela: Geográfico histórico y biográfico (Caracas, 1982)
R. J. Velásquez and others: Venezuela moderna medio siglo de historia, 1926–1976 (Caracas, 2/1993)
J. J. Martín Frechilla: *Planes, planos y proyectos para Venezuela, 1908–1958: Apuntes para una historia de la construcción del país* (Caracas, 1994)

MARIO ELOY VALERO

II. Indigenous culture.

When Amerigo Vespucci reached the Coquivacoa Gulf, he marvelled at the skill of the indigenous inhabitants, whose homes, known locally as *palafitos*, were built on water. When the Spaniards arrived, different regions of the country showed diverse stages of cultural development. Most of the flatlands, the rainforest and central mountain range were occupied by Carib peoples; some were nomadic hunters, while others settled in the fertile valleys or beside rivers. Their dwellings were built from compressed mud and reeds with palm roofs, and they produced carved tools and weapons, musical instruments and sophisticated ceramics. In the Andean region most Pre-Columbian peoples were related to the Chibcha nation (one of the major Andean cultures) and were known as Timoto-Cuicas. They had sophisticated agricultural systems and produced a wide range of ceramics, textiles, gold ornaments, religious artefacts and stone or obsidian tools; these peoples made their dwellings from stone, adobe and other local materials.

Indigenous building forms, materials and techniques were adapted by the colonists, who incorporated new architectural elements such as doors, large windows, patios and courtyards into the religious, governmental and private buildings of the 15th and 16th centuries (*see* §III below). Spanish crafts were introduced by the colonists, and their workshops employed indigenous labour for the most rudimentary tasks. In the absence of Spanish labour, mestizos or *pardos libres* (men of mixed racial origin), gradually acquired the full range of skills as carpenters, gilders, metal-casters and painters of religious icons and idols, continuing indigenous craft traditions but adding European techniques and materials to create a unique phenomenon of transculturation. During the first half of the 18th century the mestizo artist Juan Pedro López (1724–87) was an exemplary figure, being a gifted sculptor of religious images as well as an excellent portrait painter.

Important elements of indigenous crafts remain in the contemporary production of textiles in Quibor valley in the state of Lara. These items are a direct legacy of the Arawak peoples who occupied the valley at the time of the Spanish settlers. Hammocks (*chinchorros*) are made principally in Zulia, Apure and Mérida, and different types of basket are produced in the coastal regions, notably by

2. *Cuatro* made by Cruz Quinal of Cumanacoa Sucre State, l. 0.70 m, 1980s (London, Horniman Museum and Library)

handmade, almost exclusively by women, and they are sometimes painted in vibrant colours with abstract designs. A very refined pottery painted with white abstract figures is produced in the states of Lara and Yaracuy in the mid-west of the country by individuals and workshops.

Another strong tradition of contemporary indigenous culture is the production of musical instruments. Influenced by Pre-Columbian, African or Spanish models, craftsmen produce chord instruments such as guitars and *cuatros* (small guitar-like instruments; see fig. 2) in Carora and Barquisimeto in the state of Lara, and in the state of Sucre. In Barlovento in the central region drums are made from hollowed trunks to obtain different tones. Maracas, also Pre-Columbian in origin, are created in various parts of the country.

Traditional dances with Pre-Columbian influences such as the *mare-mare* and the *sebucan* on the eastern coast are still performed, and the feast of Los diablos de Yare, which is African in influence, is celebrated in Miranda: during the feast the frenzied dancers sing while wearing masks representing the Devil. A number of traditional dances and religious festivals such as the Cruz de Mayo in the Caribe region demonstrate the way in which Pre-Columbian and African cults are interwoven with Christian beliefs and iconography.

During the 20th century many artists were strongly influenced by indigenous art forms, including ARMANDO REVERÓN, whose works challenged the traditional separation between academic and non-academic art; naive art, produced by artists who have not had traditional academic training, often used as its subject-matter such popular events as religious celebrations. Indigenous artistic production continued to exist alongside this.

Perhaps the most noteworthy 20th-century indigenous artist was JUAN FÉLIX SÁNCHEZ, whose work encompassed painting, sculpture, architecture, textile design and other forms of arts and crafts. Produced in an isolated site high in the Andes in Mérida, Sánchez's output represents an Andean tradition of self-taught artists whose work defies the boundaries between the utilitarian and the artistic and the sacred and the secular. Near his home he created from 1952 a complex of architecture, sculpture and outdoor furniture using local materials such as stone, gravel and wood arranged on a series of terraces on the mountainside; the whole symbolizes the passion and agony of Christ. Sánchez also used unique three-heddle frames instead of the traditional two-heddle frames for weaving textile designs with abstract patterns in subtle colours, characteristics that relate his work to that of Venezuelan kinetic artists, especially Carlos Cruz-Diez. Despite its variety, Sánchez's work has an integrity binding together his religious and aesthetic ideas, the natural environment in which he lived and his country's history.

BIBLIOGRAPHY

M. Acosta Saignes: *Estudios en antropología, sociología, historia y folklore* (Caracas, 1980)
F. Vegas: *Venezuelan Vernacular* (Princeton, 1985)
G. Gasparini: *Arquitectura popular de Venezuela* (Caracas, 1986)

MARIO ELOY VALERO

III. Architecture.

1. 1514–1821. 2. 1821–*c*. 1900. 3. After *c*. 1900.

1. 1514–1821.

family-run workshops on the island of Margarita, as well as along the eastern coast and in the region of Coro in the west.

Ceramics, both utilitarian and artistic, are made in a number of different styles depending on the region and local influence. In the Andean states the ceramics are still

(i) Religious. It has been estimated that of *c.* 130 extant churches of the colonial period, only 10 originated in the 16th and 17th centuries (Bayón and Marx, p. 32). Although the Gothic style was still prevalent in Spain when that country launched itself into the conquest of the New World, the style failed to put down roots in Venezuela; it is, however, probable that traces of Gothic were evident in the two ephemeral churches of Cubagua and in the earliest stone houses erected by the Spanish. The first churches were built by Dominican and Franciscan missionaries along the coast; indeed, the humble church erected by Fray Francisco de Córdova and Fray Juan Garcés when they arrived in Cumaná in 1514 was perhaps the earliest, but by 1515 nothing remained. In early 1517 another Franciscan expedition arrived, and within a couple of years the missionaries built two churches and two houses and opened schools and a home for indigenous children. This attempt at peaceful colonization (which also provided the first formal education in Venezuela) was cut short by a fire that destroyed the buildings in September 1520, and no new attempt was made for some time. It seems that in 1537 the church of Santiago may have been inaugurated on the desert island of Cubagua, but already by the following year the local inhabitants began to leave the island, and in 1540 the Cabildo and royal officials moved to Cabo de la Vela.

Since barely any trace remains of the earliest Spanish buildings in Venezuela, the origins of religious architecture there must be sought in the contemporary and almost identical cathedrals of Coro and La Asunción on the island of Margarita. These churches established a scheme of construction that underwent few significant variations until well into the 19th century: a rectangular floor-plan was divided into three naves by masonry arcades, usually Tuscan columns with round arches, the spandrel walls of which directly supported the open timber rafters of collar-beam roofs. This system perhaps has its immediate precedent in Tenerife, although the panelled roof is a characteristic variant of the Venezuelan style. Construction of the church of La Asunción (now the cathedral) began in 1570, but by the end of the century only the main chapel (which collapsed in 1667), sacristy and tower had been erected. A double-pitched roof was expressed externally in a simple gable, unadorned but for a portal with a marked Renaissance flavour: a round arch surmounted by a decorated frieze and pediment carried on short columns that rise from the impost of the arch. Work on Coro Cathedral began in 1583 and was completed in 1617; the 'maestro' Francisco Ramirez from Margarita worked on the presbytery and sacristies in 1608–13. The city had been built as an episcopal see in 1531, and the first 11 bishops in Venezuela came from Coro; in 1637 the see was transferred to Caracas. The church's interior has taller columns and five nave-arches, instead of six, in a length equal to that of La Asunción, producing a loftier space, covered with a single-pitched open roof; a simple bell-tower was added by 'maestro' Bartolomé de Naveda in 1630. It has undergone many restorations, the first in 1775 and the latest in 1958.

The monastery of S Francisco was founded in Caracas in 1572; an early adobe church was replaced in 1593 with a more permanent structure designed by Antonio Ruiz Ullán, which was notable for having a plain rear wall and a nave and aisles separated by two series of piers, without arches, that held cross-pieces on their lintels. (The plan is preserved in the Archivo General de Indias, Seville.) Destroyed in the earthquake of 1641, the church was succeeded initially by a more modest one with one aisle and side chapels, but in 1745 Fray Mateo Veloz returned the church to its original three-aisle form. Remodelling in 1887, however, destroyed its unity: the robust pillars were exchanged for lighter ones, the choir was modified, the wooden tribunes were removed, and the *Mudéjar* panelled ceiling was covered by a smooth wooden ceiling; fortunately the original ceiling was uncovered again in 1942.

The first cathedral in Caracas (begun in 1614) was not extant for long, as it was destroyed in the earthquake of 17 June 1641. In the mid-1660s the first steps were taken towards erecting a new larger, five-nave cathedral (by Juan de Medina), the construction of which was to take ten years, although the complementary works continued until 1713. The same constructional method was used: the nave arcades were carried on octagonal columns, and the walls above the arches were pierced with relieving arches to reduce superimposed load. The rendered brick façade (1711–13) has been attributed to Francisco Andrés Meneses (see fig. 3). In 1766 another violent earthquake caused new damage to the stricken cathedral, though mostly to the tower, which had been built in three parts; the earthquake of 1812 left the upper part damaged, and it was then permanently removed, leaving just the lower

3. Francisco Andrés Meneses: façade of Caracas Cathedral, 1711–13

parts. The earthquakes, however, were arguably not the worst affliction suffered by the cathedral, which underwent subsequent remodellings and restorations. In January 1866 work began on reforms that totally altered the floor-plan: the aisles were lengthened to locate the canonical choir behind the main altar, and to this effect the sacristy was demolished, and the precious retable of carved, gilded wood with the tabernacle in silver relief was removed. As part of the remodelling of 1932 the original octagonal stone columns and the open-rafter roof were all concealed. Of particular interest, however, are the chapels on the epistle side: in the chapel of the Most Holy Trinity lie the remains of Simón Bolívar's parents; its ceiling is panelled and coffered, and the whole is beautifully gilded.

The prosperity enjoyed by Venezuela in the 18th century, fuelled by the creation of the Real Compañía Guipuzcoana in Caracas (which in 1728 won the right to monopolize the import of European goods) and the liberal administration of the Bourbons in Spain, was reflected in architecture, and although no monuments of great distinction were built, there was considerable building activity that included many interesting, if comparatively modest, churches. In the valleys around Caracas notable examples included the churches at Petare (Miranda), begun in 1704 but built slowly over more than half a century, and at Turmero (Aragua), under construction in 1781. Both were built to the usual Venezuelan scheme, with three-storey façades divided by pilaster grids characteristic of the simplified rhythmic Venezuelan Baroque. To the west, at El Tocuyo (Lara), founded in 1545, churches had vaulted presbyteries, lateral chapels and domed crossings. Well-known examples included Nuestra Señora de la Concepción (1766), the façade of which replicated that of Caracas Cathedral; S Francisco (after 1776), with domed side chapels; and S Domingo (1766), which had entablature blocks between the columns and arches of the nave arcades, after the contemporary church of La Concepción de la Orotava, Tenerife. Gasparini pointed to the absence of exuberant decoration in 18th-century Venezuelan architecture typical of Latin American Baroque elsewhere. Columns were generally cylindrical and wooden, with a Roman Doric base and Tuscan capital; the solomonic column was little used in Venezuela, and instead the *estípite* was favoured, notably among retable designers. The arch took various forms: the lightly flared semicircular arch is found in Caracas Cathedral and in S Francisco in El Tocuyo; the flat arch, which is neither moulded nor flared, was used in the façades of S Francisco, Guanare, and the parish church of Ospino; and in the last third of the 18th century lobate and mixtilinear arches appeared. In Caracas the churches of Altagracia, Las Mercedes and Santísima Trinidad (now the Pantéon Nacional) suffered severely in the earthqauke of 1812; they were, however, rebuilt later in the century.

(ii) Military and domestic. The broad coastline of Venezuela, constantly exposed to invasion from the Caribbean, had to be protected by military fortifications at strategic points. The ruins of the most important fortress are on the Araya peninsula opposite Cumaná. Work began there in 1622 under Juan Bautista Antonelli the younger (*c.* 1585–1649)

(*see under* ANTONELLI) and was completed around mid-century by the engineer Jerónimo de Soto. The fortress's trapezoid plan is earthquake-resistant, and the whole structure is built from blocks of stone. On the island of Margarita stand the forts of S Carlos Borromeo (1664–84) in Pampatar and of S Rosa in La Asunción. The castle of S Carlos in Maracaibo, protecting access to the lake, was completed in 1682 by Francisco Ricardo and was enlarged and modified in 1784 by the engineer Casimiro Isava. Beside the city of San Tomé de Guayana, but later moved to Angostura, the fort of S Francisco was built in 1678–81 to defend the Orinoco River. Construction of the fort of Puerto Cabello was begun in 1732 principally to protect the interests of the Real Compañía Guipuzcoana; designed by Juan Amador Courten in the shape of a fan open to the sea, it was completed in 1741 by Juan Gayangos.

The origins of the Venezuelan colonial house can be found above all in southern Andalusia, Spain, and perhaps also in the Canary Islands, where climatic conditions are similar. The Andalusian-style patio, suited to the new environment, is found in numerous houses in Venezuela's principal cities and towns. In the early years of colonization, however, indigenous materials and techniques were often used. The most notable colonial houses are to be found in the interior. Generally in Caracas and towns in the interior the houses are of one storey for fear of earthquakes, and the rooms enclose a patio on two or three sides; some houses have more than one internal patio. In the commercial coastal cities such as La Guaira and Puerto Cabello, buildings with two storeys are found; those houses on the coast most worthy of mention include the house of the Real Compañía Guipuzcoana (now the customs house) in La Guaira, which has sturdy Tuscan columns on the ground floor of the patio directly supporting elegant timber balconies above; while in Coro there is an admirable group of colonial houses in Calle Azamora.

2. 1821–*c.* 1900. Following independence (1821) the few civil buildings that the republican government inherited included the houses of the Real Compañía Guipuzcoana in La Guaira and Puerto Cabello. When the religious orders withdrew, numerous convents also passed into government hands, and these were used for various civil and military purposes, such as universities and barracks. A clearly defined architectural profession still did not exist at this point, and nor did it for the duration of the 19th century. The Colegio de Ingenieros was founded in 1861 in Caracas, and the architects' role was filled by engineering graduates such as Olegario Meneses (*c.* 1810–60), who designed the southern part of the Universidad Central de Venezuela (1840s) in Caracas, the first important architectural project in republican Venezuela. The design included a patio open to the street formed by two-storey arcades of Tuscan and Ionic half columns on pilasters. When a cholera epidemic hit Caracas in 1855, Meneses designed the Hijos de Dios cemetery in the north of the city, which conformed with his markedly Neo-classical style. Another engineer active during this period in the field of architecture was Alberto Lutowski (1809–71), who was responsible for the extensive arcaded market in Valencia (1845–8), the first of its type and size in Venezuela, and the S Jacinto

market (1853) in Caracas, which comprised three pavilions, each of three storeys. He also built two churches: that of Nuestra Señora del Rosario in Antímano and the Nuevo Templo de S José in Puerto Cabello; both were built in stone in 1857.

The coming to power in 1870 of Antonio Guzmán Blanco was a mixed blessing for Venezuelan architecture. On the one hand his presidency gave a vigorous boost to construction, while on the other he sanctioned the destruction of a number of notable historic buildings. Luciano Urdaneta (1825–99), the son of the distinguished figure Rafael Urdaneta and a graduate engineer from the Ecole Nationale Supérieure d'Arts et Métiers in Paris, planned the Palacio Legislativo (the first part of the Capitolio) in Caracas in 1872. Despite the fact that the south façade does not reflect the building's true dimensions, the central pediment being no more than a decorative feature over the entrance, the sobriety of the Tuscan columns and the rhythm and proportion of the windows make the building an accomplished example of Neo-classical architecture. The Palacio Federal in Caracas, completed in 1877 in collaboration with Roberto García (1841–1936), is much more Baroque, as much in the tense line of its front, with its Corinthian columns and caryatids (see fig. 4), as in its oval dome; it was here that the ministries and government officials were to be based, and it was the most important building erected under Guzmán Blanco. Throughout the whole ensemble of the Capitolio extensive use is made of columns, railings and iron grilles imported from England. Also by Urdaneta was the design for the Parque de El Calvario (1873) in Caracas.

The most prolific architect employed by Guzmán Blanco was Juan Hurtado Manrique (1837–96), who applied with fluency formal repertoires from different sources. He designed the collegiate Gothic Revival façade of the Universidad (1876), Caracas, in a curious classical arrangement of Gothic elements that included a balustrade with crocketted finials, as well as Gothic-style buildings for the Museo Nacional (*see also* §VIII below) and the Santa Capilla (both 1883); the last, built on the site of the church of S Jacinto (demolished by Guzmán Blanco), is modelled on the 13th-century Sainte-Chapelle in Paris. Indeed, the architectonic quality of the Gothic Revival style generally in Venezuela in the 19th century reflected French models and was formal and structurally modest. Hurtado Manrique achieved better results in the basilica of S Teresa (1876; for illustration *see* CARACAS), the most attractive and monumental of 19th-century Venezuelan churches in terms of both its scale, with its two Neo-classical façades, and its spaciousness, enhanced by multiple cupolas in the side chapels. The Neo-colonial arcades in the patios of the Casa Amarilla de la Cancillería (rebuilt 1891), a two-storey townhouse on the Plaza Bolívar, and the Arco de la Federación, both Caracas, are other derivations from French architecture. Antonio Malaussena (1853–1919), an architect of French origin, designed the column in the Plaza Bolívar commemorating the Battle of Carabobo of 1821; he went on to design the Teatro Municipal (1890), a sumptuous neo-Baroque work for which, despite the reduction in scale, the Opéra in Paris appears to have been the model. Several works from the era of Guzmán Blanco were undertaken under the super-

4. Luciano Urdaneta and Roberto García: entrance façade of the Palacio Federal, the Capitolio, Caracas, completed 1877

vision of the Minister for Public Works, Jesús Múñoz Tebar (1847–1909), who alone was responsible for the Hospital Vargas (1891), an imposing ensemble based on French hospital design, although with an unusual reworking of Gothic forms adapted to the tropical climate.

At the end of the century President Joaquín Crespo built his two residences in Caracas, a villa at Santa Inés and the Palacio de Miraflores. The first, initially Neo-classical but later covered with a form of decoration similar to Art Nouveau that made abundant use of plaster reliefs, wall paintings and different types of glass, was executed under the Spanish Catalan architect Juan Salas, who brought to Caracas a group of craftsmen from Spain, including wood-carvers, carpenters and plasterers. This decorative style was sometimes referred to as the 'crespista style' and was influential on houses in Caracas during that period and into the first years of the 20th century, creating eclectic examples of architecture.

3. AFTER *c.* 1900. Urban dwellings during the 20th century, particularly in Caracas, retained the simplified forms of the colonial house, though reduced to more modest proportions with, at the front, a door and two

windows. The hall and patio were retained, and in the more sumptuous houses these were enclosed by columns; in others fretted wooden screens and stained glass were used. The influence of Dutch architecture, transmitted via the Antilles, can be seen in Maracaibo. Architecture during the régime (1899–1908) of Cipriano Castro was, in its use of a formal vocabulary, a continuation of the 19th century. Its major representative was Alejandro Chataing (1874–1928), who, even in the aftermath of the economic and political crisis of 1902, designed between 1904 and 1912 a large number of public buildings in Caracas; these included the neo-Baroque Teatro Nacional (1904), with coupled columns, a giant Composite order and ornate sculptural groups; the Second Empire-style Palacio de la Gobernación y de Justicia (1905); the Academia Militar (1905), planned around a spacious parade-ground in the Beaux-Arts tradition and raised on a great podium on a hilly site; the Museo Bolivariano (1911); the Archivo General de la Nación (1912); and a number of banks, cinemas and churches in Caracas. In 1904 he also designed Villa Zoila as a residence for the President, and in 1912 he designed the house of the Boulton family; both buildings were in the Paraíso district of Caracas and gave rise there to a new type of dwelling for the capital. Chataing used the widest variety of formal repertories, largely borrowed from French architecture, which included steeply pitched roofs of varied forms covered with flat tiles, with double columns, dressed stone walls and entrance halls sheltered by metal-framed glass roofs; no Venezuelan architect was as prolific, and none used with such freedom all manner of formal themes.

Eclecticism, both successful and unsuccessful stylistically, endured through the 27 years of government by Juan Vicente Gómez (1908–35), both in the construction of private houses in Caracas and in public buildings. Examples of the latter are found throughout Venezuela: the Hotel Jardín (1915) and large hotels designed by Ricardo Razetti (1864–1932) in Maracay; and Palacio de Gobierno at San Cristóbal, together with the annexed houses with their Art Nouveau façades; and in Maracaibo the Egyptian Revival prison (1908) designed by Luis Múñoz Tebar. Simplified industrial forms lent an air of modernism to the salt depositories by Rafael Seijas Cook (1887–1969). The young Spanish Catalan architect Manuel Mujica (1897–1963) who arrived in Caracas in 1927 continued the trend for Neo-colonial architecture in the numerous houses he designed for the first residential suburbs of Caracas. He subsequently changed to a more Modernist style with notable results, including, among others, his own house in Campo Alegre (1936).

The International Style was introduced to Caracas by the French urban planner Maurice Rotival *c.* 1936. Carlos Raúl Villanueva, who had studied at the Ecole des Beaux-Arts and the Institut d'Urbanisme in Paris and was a member of Rotival's team, had designed the Modernist residence of La Florida (1934) in Caracas, despite returning to a form of Neo-classicism for the Museo de Ciencias Naturales and the Museo de Bellas Artes (both begun in 1935), both in Caracas. He returned to Modernism in his design for the Escuela Gran Colombia (1939), Caracas, one of many designs for school buildings backed by the government of Eleazar López Contreras. In 1940 Villan-

ueva redeveloped the residential area of El Silencio in Caracas, marking a new era in Venezuelan architecture with his concept of interconnected residential blocks giving on to a central open area, including an arcaded main plaza. Also from his practice, which was to train the next generation of young architects, were the projects for the Urbanización General Rafael Urdaneta (1943), Maracaibo, the Cerro Piloto (1953) and the imposing residential group 23 de Enero (1955–7), Caracas. In 1944, the practice began the celebrated project for the Ciudad Universitaria, Caracas, freeing itself gradually from its initial classicism to arrive finally at the most accomplished blend of styles in Venezuelan architecture in the Aula Magna (1952; for illustration *see* VILLANUEVA, CARLOS RAÚL) and the central ensemble of the Universidad Central; the buildings and open spaces between were further embellished by the inclusion of works of art by leading international artists such as Henri Laurens (1885–1954) and Fernand Léger (1881–1956).

From the examples set by Manuel Mujica there emerged in parallel a trend that attempted to give value to certain elements of popular Venezuelan architecture, such as tiled roofs, timber structures and whitewashed walls. The principal protagonists of this trend were Tomás José Sanabria (*b* 1922) and Fruto Vivas (*b* 1928), whose series of houses in the environs of Caracas began with his own at Altamira (1954). Between 1952 and 1954, however, the Centro Simón Bolívar was built around the Plaza Bolívar in Caracas by Cipriano Domínguez, and two of the International Style administrative buildings around the square have towers of over 30 storeys; the whole ensemble reflects the influence of Le Corbusier and was to have a considerable effect on future constructions in the capital's centre. New generations of architects went on to erect some notable buildings in Caracas: they included the Banco Central (1959–63) by Tomás José Sanabria; the Edificio Polar (1952–3; with Pacheco Martin Vegas, *b* 1920) and the Banco Metropolitano (1957) by José Miguel Galia (*b* 1919), who also built the Seguros Orinoco building (1976); the building of the Corporación Venezolana de Guayana (1967–70) by Jesús Tenreiro (*b* 1936); the new Ateneo (1974–82) by Gustavo Legorburo (*b* 1930); and the commercial centres by Antonio Pizani (*b* 1937).

One of the most significant buildings of the late 20th century was the Teatro Teresa Carreño (completed 1983) by Carlos Gómez de Llarenas (*b* 1939), in which modern materials such as plastic, aluminium and opaque glass, combined with concrete, were used to notable effect (see fig. 5). Also by Gómez de Llarenas is the Torre Europa, in which dark glass is set against pre-cast cladding. The gigantic residential ensemble of Parque Central (1983), Caracas, by Enrique Sisco (*b* 1940) and Daniel Fernández Shaw (*b* 1939) is an expression of the same tendency, with its 50-storey glass towers. In the sphere of popular housing numerous suburbs were built in the late 20th century, leading to a spectacular growth in the area and increased population of Venezuelan cities. Although the building of housing was anticipated, the cities' infrastructure was not taken into consideration, and retrospective solutions have been sought. The metro system in Caracas was developed in an attempt to solve the problem of transportation from suburban areas. In the interior of the country numerous

5. Carlos Gómez de Llarenas: Teatro Teresa Carreño, Caracas, completed 1983

housing projects were also undertaken, but these are lamentably uniform in design and fail to take into account the climatic and cultural differences of each region.

BIBLIOGRAPHY

D. Angulo Iñiguez, E. Marco Dorta and J. M. Buschiazzo: *Historia del arte hispano-americano*, 3 vols (Barcelona, 1945–56), i, pp. 532–3, 538–9; iii, pp. 165–222

C. R. Villanueva: *La Caracas de ayer y de hoy, su arquitectura colonial y la reurbanización de El Silencio* (Paris, 1950)

G. Gasparini: *La casa colonial venezolana* (Caracas, 1962)

——: *La arquitectura colonial en Venezuela* (Caracas, 1965)

F. Bullrich: *New Directions in Latin American Architecture* (London, 1969), pp. 20–27, 69–83

G. Gasparini: *Restauración de templos coloniales en Venezuela* (Caracas, 1969)

G. Gasparini and J. P. Posani: *Caracas a través de su arquitectura* (Caracas, 1969)

E. Pardo Stolk: *Las casas de los caraqueños* (Caracas, 1969)

G. Gasparini: *Templos coloniales en Venezuela* (Caracas, 1976)

D. Bayón and P. Gasparini: *The Changing Shape of Latin American Architecture* (New York, 1979)

A. Leszek Zawisza: *Anuario de arquitectura, Venezuela 1981* (Caracas, 1981)

——: *Arquitectura y obras públicas en Venezuela, siglo XIX*, 3 vols (Caracas, 1984)

G. Gasparini and L. Margolies: *Arquitectura popular en Venezuela* (Caracas, 1986)

D. Bayón and M. Marx: *A History of South American Colonial Art and Architecture* (New York, 1989), pp. 32–7, 130–36, 364

J. F. Liernur: *America Latina: Architettura, gli ultimi vent'anni* (Milan, 1990), pp. 180–96

C. Caraballo Perichi: 'Venezuela: La arquitectura tras las quimera de la historia', *Arquitectura neocolonial: América Latina, Caribe, Estados Unidos*, ed. A. Amaral (São Paulo, 1994), pp. 129–46

G. Gasparini: 'Venezuela: Sobre arquitectura colonial', *Arquitectura colonial iberamericana*, ed. G. Gasparini (Caracas, 1997), pp. 223–51

R. Gutiérrez, ed.: *Barroco iberoamericano* (Barcelona and Madrid, 1997)

ELIDA SALAZAR

IV. Painting, graphic arts and sculpture.

1. 1514–1821. 2. 1821–*c.* 1900. 3. After *c.* 1900.

1. 1514–1821. The country's geographical location in the north of South America and the fact that its most important towns were almost all built near the coast influenced its artistic development during Spanish rule, as the cities traded principally with the Viceroyalty of Mexico, the islands of Puerto Rico and Cuba, and Spain. The earliest artistic activity took place in the second half of the 16th century, after the establishment of the first towns. Inspired by European examples, local art evolved slowly in parallel with the gradual growth of the cities. From 1637, however, with the transfer of civil and religious authority from Coro to Caracas, there grew an artistic centre that in time became the most important in the country; by the 18th century there were *c.* 130 artists active in Caracas, often working in several genres.

Initially the majority of artists were white, while the remainder were so-called *pardos libres* or mestizos. The white artists of European descent provided instruction based on models from Spain or the Canary Islands, while the second group developed the skills to provide the religious art demanded by the Church and commissioned by some wealthy individuals. In Caracas a close network of artists developed, owing to frequent marriages between members of artistic families, and these close bonds created a continuity of style in their work that survived the progressive succession of Baroque, Rococo and Neo-classical styles.

Unlike other Latin American countries, in Venezuela there were no artists' guilds with fixed sets of rules, so that

many artists—either separately or in groups—practised painting, sculpture, gilding, silver-plating and ornamentation. Artists began their apprenticeships between the ages of eight and twelve in the workshop of a master craftsman, who would teach them the trade in five years (although this could be extended up to eight); the master also undertook to feed and clothe the apprentice and to teach him the Catholic faith. During the 17th century the development of the arts was, however, very limited, owing to the poverty of the people and a series of disasters—plagues and epidemics, earthquakes, pirate raids—that destroyed or severely damaged the towns that were in the process of formation; thus, although several artists achieved some renown, their work has disappeared.

Much more remains, however, of the work of 18th-century artists. Francisco José de Lerma (*fl* 1719–53) was a brilliant painter who displayed a knowledge of European works gained via Flemish, Sevillian or Italian prints; his *Our Lady of Mercy* (Caracas, Mus. A. Colón.) was inspired by an engraving by Gian Marco Cavalli. Certain similarities with the work of the Mexican Juan Correa suggest Lerma may have been familiar with the latter's paintings. In his palette Lerma combined sepias with dark grey, yellow and red, and occasionally emerald green, sky blue and white. His contemporaries, who used a limited range of austere colours, included Fernando Alvarez Carneiro (1696–1744), who is known for his two large paintings of the *Life of St Francis of Assisi* (Caracas, S Francisco); and José Lorenzo Zurita (1695–1753), who produced two portraits of *Don Juan Mijares de Solórzano* and one of *Bishop José Félix Valverde* (Caracas, Mus. A. Colón.). The sculptor Enrique Antonio Hernández Prieto (*fl* 1742–5) carved the clothed statue of *St Peter* in Caracas Cathedral, which is impressive for its vigour and realism.

In the second half of the 18th century there was a change from the rather austere tradition that had dominated since the 17th century: the arrival of several artists from the Canary Islands revived the arts at the same time as prosperity increased. The dominant figure of this period was Juan Pedro López (1724–87), the son of Canary Islanders, a painter, sculptor and gilder who produced an extensive body of work. Judging by his style, López's apprenticeship may well have taken place in the workshop of a fellow Canary Islander who had settled in Caracas, and his work had considerable impact on other artists in the city. The wood-carver and sculptor Domingo Gutiérrez (1709–93) used the Rococo style in the altarpieces and frames he made for López's paintings. The compositions used by López also drew their inspiration from European engravings and reflect his ability as a sculptor. His style is related to that of certain Mexican painters, such as Miguel Cabrera, and his use of colour was, like that of Cabrera, marked predominantly by the yellows, ochres, pinks and blues characteristic of the Rococo style. Outstanding in López's vast production were the *Virgin of the Carmelites Protecting the Carmelite Nuns* (c. 1774; see fig. 6) and the works painted in 1755 for the altarpiece of the main sacristy of Caracas Cathedral, and his sculptures include the *Statue of Faith*, cast in bronze for the cathedral tower in 1769.

Influenced in part by the works of López, but also informed by realist tendencies, a group of *pardos libres*

6. Juan Pedro López: *Virgin of the Carmelites Protecting the Carmelite Nuns*, oil on canvas, 1.47×1.06 m, *c.* 1774 (Caracas, Asociación Venezolana, Amigos del Arte Colonial)

formed what was effectively a school under the guidance of Antonio José Landaeta, but which in the late 18th century fell increasingly under the influence of the Puerto Rican artist José de Campeche y Rivafrecha and the Mexicans José de Páez and José de Alzibar. The intensity of the colours of their paintings gradually diminished, and they became affected and sugary. Although often similar in appearance, the works of the sculptor of religious images José Francisco Rodríguez (1747–1808), known as 'El Tocuyano', included the excellent carved group representing the *Coronation of the Virgin* (Caracas, S Francisco). Other artists active at the end of the 18th century included the portrait painter José Antonio Peñaloza (*fl* 1776–1803), Francisco Contreras (*fl* 1767–1819) and Francisco Lovera (*fl* 1795). Painting also developed to an extent in the cities of El Tocuyo and Mérida, both situated in the west of the country. These centres, much smaller than Caracas, developed special features that distinguished them, although their overall production was generally uniform, characterized by the use of brilliant colours in paintings executed on wood, using a technique based on a mixture of tempera and oil.

An earthquake in 1812, which destroyed the main cities, and the War of Independence that followed, ending in 1821, effectively halted artistic development. Only two painters succeeded in continuing the tradition they had inherited from the Hispanic past: the former student of Antonio José Landaeta, JUAN LOVERA (who became the portrait painter of the national heroes of independence),

and Hilarión Ibarra (*fl* 1798–1854), whose works reveal a naivety and lack of academic knowledge; the sculptor José de la Merced Rada (*fl* 1797–1855) produced religious images that had a certain charm. These artists contributed to the shift that eventually took place towards greater national pride and the celebration of the heroes and battles of the independence movement.

<div align="right">CARLOS F. DUARTE</div>

2. 1821–*c*. 1900. At the time of independence (1821) Venezuela was still fundamentally an agricultural nation, and it was not until the 20th century that the more diverse economy was strong enough to sustain a broad range of artistic institutions. The Republic had been constituted in 1811 but 20 years of wars had paralysed all other activity in the country. Juan Lovera, one of the most significant painters of this transitional phase, created an important body of portraits of the principal leaders of independence; the first lithographic press in Caracas was also housed in his workshop.

In 1835 the Academia de Dibujo y Pintura was founded, the only formal establishment of its kind in Caracas at the time (*see also* §IX below). In 1849 a painting class was begun there, and the name was changed to the Academia de Bellas Artes; the first director was Antonio José

Carranza (1817–93), an accomplished portrait painter. During the same period foreign scientists and artists began to arrive in Venezuela, just as they did in other newly liberated countries in South America, to explore and depict the tropical landscape. One of the first among these 'traveller–reporter' artists was the German painter Ferdinand Bellermann (1814–89), who lived in the country from 1841 to 1844 and travelled through a substantial part of it, making records in pencil and on canvas (e.g. *View of La Guaira*, 1842–6; Caracas, priv. col.). The Englishman Lewis B. Adams (1809–53) was considered the best painter in Caracas, where he died in 1853; a prolific portrait painter, he had a significant influence on the young artists of the period. Other foreign visitors included the Danish artist Fritz Georg Melbye (1826–96) and the young Camille Pissarro (1830–1903), who travelled with him in 1852–4. These two artists assembled an important body of pictures, significant not only for their artistic value but also as a reflection of the social customs of the time and as a record of the environment (e.g. Pissarro's *View of La Guaira*, watercolour, 1851; priv. col.); Melbye remained a further ten years after Pissarro's departure.

During the second half of the 19th century foreign artists and scientists continued to visit the country, but the degree of political stability under the presidency (1870–

7. Arturo Michelena: *Miranda in La Carraca*, oil on canvas, 1896 (Caracas, Galería de Arte Nacional)

90) of Antonio Guzmán Blanco also stimulated artistic activity on the part of native inhabitants. Of particular note was MARTÍN TOVAR Y TOVAR. A pupil of León Cogniet in Paris from 1851 to 1855, he was dedicated principally to portraiture and epic themes. His greatest work was the *Battle of Carabobo*, executed in Paris and first exhibited in Caracas in 1888 and hung in the Salón Elíptico of the Palacio Federal in Caracas; measuring 26×13 m, it is believed to have been the largest picture in Latin America at the time. Tovar also executed the *Signing of the Independence Act* (Caracas, Col. Concejo Mun.), for which he won first prize in the Exposición Nacional in 1883; it was he who initiated the academic style in Venezuela, based principally on the epic theme of the history of the country's independence. ARTURO MICHELENA, at the age of only 16, set up a school of painting with his father Juan Antonio Michelena in Valencia, Venezuela, and went on in 1885 to study painting in Paris in the studio of Jean-Paul Laurens at the Académie Julian. He was awarded the gold medal in the second class of the official Salon in Paris in 1887 for his painting *Sick Child* (untraced; copy in Caracas, Gal. A. N.) when he was only 24; this was quite a distinction, considering not only his youth but also the fact that he was a foreign artist. Further success came in the Exposition Universelle in Paris in 1887, when he entered his painting of *Charlotte Corday* (Caracas, Gal. A.N.) and won a gold medal in the first class. His skill was matched by his thematic versatility. He depicted religious and mythological subjects as well as epic and historical ones (e.g. *Miranda in La Carraca*, 1896; Caracas, Gal. A.N.; see fig. 7).

CRISTÓBAL ROJAS was equally skilful. Like the others, he studied in Paris, in the studio of Jean-Paul Laurens (1838–1921), but his brief career prevented a fuller development. His principal works generally treated the realist themes that were fashionable at the end of the century: scenes of poverty, destitution and death (e.g. *Misery*, 1886; Caracas, Gal. A.N.), but he painted equally magnificent canvases on other themes, including still-lifes, mythological subjects and one historical painting, the *Death of Girardot in Bárbula* (1883; Caracas, Gal. A.N.). In Venezuela, as happened frequently in other Latin American countries, political instability often prevented the harmonious equilibrium that could encourage the arts, and for this reason there are frequent interruptions in the production of some Venezuelan artists. The three figures discussed above, however, demonstrated a degree of artistic accomplishment that had never previously been reached in the country, and their work stimulated a high standard of production in their successors, some of whom went on to achieve international renown.

ALFREDO BOULTON

3. AFTER *c*. 1900. The modern period in Venezuelan painting began with Tito Salas (1888–1974), who studied in Paris from 1905 and who mastered a wide stylistic range, being influenced particularly by Impressionism but also by academic painting. He attended the Académie Julian under Laurens, as well as the Académie des Beaux-Arts under Lucien Simon (1861–1945) and the Académie de la Grande Chaumière, where he encountered the work of the Spaniards Joaquín Sorolla y Bastida (1863–1923)

and Ignacio Zuloaga (1870–1945). At the age of 19 he won a gold medal at the Paris Salon (1907) with the painting of the '*S Genaro*', which was the first demonstration of a new pictorial style in Venezuelan painting. A recurring subject was the leader of the independence movement, Simón Bolívar, and many of Salas's paintings are housed in the Casa Natal del Libertador, Caracas.

Venezuela's proximity to the great sailing routes of the Caribbean and the Atlantic has historically been of great cultural value to the country, making information from Europe speedily available. Indeed, in the first decade of the 20th century the names of Cézanne, Monet and Renoir were already known in Caracas. In 1912 a group of young artists including MANUEL CABRÉ and ANTONIO EDMONDO MONSANTO set up the Círculo de Bellas Artes in Caracas in open rebellion against the academic tradition represented by the Director of the Academia de Bellas Artes, ANTONIO HERRERA TORO, and with a desire to make landscape painting more popular; it is ironic that Herrera Toro had himself studied in Paris, bringing with him a fairly free and well-developed stylistic language that served in the training of the very group that now opposed him, but their dissatisfaction indicated the degree to which Venezuela was receptive to the most up-to-date European trends. This spirit of intellectual renewal affected not only painting but also collecting, generating a higher level of interest in the work of young artists and marking the beginning of an era of greater artistic activity in the visual arts. This was despite the fact that Caracas scarcely had 120,000 inhabitants, and the political and economic situation in the country at large was still rather unstable.

Under the direct influence of French Impressionism, Venezuelan visual arts, led spiritually by the Círculo de Bellas Artes, acquired a new stylistic sense and new subjects, as much in conceptual as in figurative terms. Social and epic themes were replaced initially by landscape painting, which was given a stylistic and colouristic treatment that differed from the sketches of the 19th-century traveller–reporter artists. A particularly influential early figure was EMILIO BOGGIO, who had lived in Paris and was inspired by the Impressionists. ARMANDO REVERÓN developed a supremely advanced technique for depicting the effects of changing light on figurative subjects through a chromatic process, surpassing any realistic representation. This approach was at its most effective during his 'White Period' of the mid-1920s to mid-1930s, when he used only white paint and kept patches of the canvas bare. Other notable figures active during the same period included FEDERICO BRANDT, who studied in Paris and the Netherlands and specialized in Dutch-inspired interior scenes and *bodegones*. LUIS ALFREDO LÓPEZ MÉNDEZ produced landscapes in the tradition of the Círculo de Bellas Artes, while Manuel Cabré was the most distinguished contemporary landscape painter, depicting the mountains of Caracas in a vigorous style and with strong colourist ability. RAFAEL MONASTERIOS was an acutely sensitive and subtle painter in the same tradition, producing such works as *Caricuao Turret* (1930; Caracas, Gal. A.N.); his contributions to the genre earned him the Premio Nacional de Pintura in 1941. Also of note were MARCOS CASTILLO, an accomplished painter of portraits and still-lifes, and the sculptor and painter FRANCISCO

NARVÁEZ, who distinguished himself in both fields by winning national prizes in each.

In 1936 the Academia de Bellas Artes changed its name to the Escuela de Artes Plásticas y Aplicadas; at this point some of the most accomplished artists of the time entered its staff. Not long after, in 1945, a new (but all too short) phase in the political life of Venezuela began, with a three-year period of democracy, during which pedagogic ideas were revised and brought up to date. New wealth from Venezuela's exploitation of its oil altered the fundamental bases of social structures, and this in turn had repercussions on the arts, notably in the creation of institutions and increased financial assistance for students (*see also* §§VII and VIII below). A new group of young artists set off to complete their studies in the USA, Paris, Mexico and Chile, and some of these went on to achieve international renown. Among them HÉCTOR POLEO, the first Venezuelan painter to explore Surrealism, and JACOBO BORGES, whose paintings developed from an early Cubism to an Expressionist style used to convey social criticism, are particularly notable. LUIS GUEVARA MORENO moved from abstraction to figuration in his paintings and engravings, as did OSWALDO VIGAS (see fig. 8), whose paintings, sculptures and pottery were inspired by Pre-Columbian art. MERCEDES PARDO, who studied in Paris and Chile, worked through abstraction and *Art informel* towards geometric abstraction in her paintings and prints. The sculptor MARISOL was born in Paris and studied painting there before changing to sculpture, adopting a Pop art style and using it as a means of expressing the position of women in society.

While others did not study abroad, their work often showed the influence of European or North American styles: RAMÓN VÁSQUEZ BRITO worked initially in a Cubist style before going on to produce landscapes; RÉGULO PÉREZ was particularly influential and over a 20-year period belonged to some of the most significant Venezue-

lan artists' groups, including the avant-garde Taller Libre de Arte (1948–52), whose members were interested in the history and culture of Venezuela, Los Disidentes (who promoted geometric abstraction), Pez Dorado and Presencia 70. The printmaker and painter LUISA PALACIOS was an important figure in the promotion of graphic art through her presidency (1975) of the Centro de Enseñanza Gráfica (CEGRA) and her role in founding the Taller de Artes Gráficas (TAGA, 1976). ALIRIO PALACIOS also pursued graphic art, studying engraving in China, where he was inspired to produce largely black-and-white images; and VÍCTOR LUCENA, in addition to his work as a painter and installation artist, produced notable book designs. The more local genre of naive art was explored by such figures as BÁRBARO RIVAS, a self-taught painter whose works are distinguished by their rich treatment of colour and by their multifocal effect.

Three figures deserve special attention for their innovative contributions to art internationally. JESÚS SOTO was a key figure in the development of kinetic art, having exhibited in Paris in 1955 in the exhibition *Le Mouvement*, in which the art form made its first public appearance; in works based on geometric patterns, Soto explored such factors as the distance that separates the spectator from the object and the vibration that takes place on the surface of the picture when the spectator moves. It was as part of this quest to investigate the importance of space as a conceptual material in the work of art that Soto created the *Penetrables* (e.g. 1968; Berne, Ksthalle), in which the spectator was able to move between suspended nylon threads. Similarly, CARLOS CRUZ-DIEZ explored the reactions of colour to vibration, with optical elements that simultaneously fuse, mix and change, creating, with the movement of the spectator, a range of colours that interweave and disappear and a great mobile space that changes, builds, disappears and becomes real at the moment when the spectator is in front of the work (e.g. his series *Physichromy*, begun 1959).

ALEJANDRO OTERO, another graduate of the Escuela de Artes Plásticas, arrived in Paris in 1946 and, after briefly being influenced by Picasso, achieved such an acute purification of the image that it virtually disappeared, leaving only visual references as an original point of departure. In the mid-1950s he further revised the concepts of form and colour, based on a new visual rhythm, in his *Colourhythms*, in which a group of vertical bands interweave and yet simultaneously maintain visual unity (e.g. *Colourhythm 1*, 1955; see colour pl. XXVI). In later years Otero's work was based on large metallic structures in which the movement within the actual work was the principal function of the structure. Around 1986 he built *Sun Tower*, a 50 m-high structure of steel and rust-proof aluminium, in the large Raúl Leoni reservoir in Guri, a mining region of Venezuela. The structure is composed of two large discs spinning in opposite directions, movements governed by the wind; it constitutes one of the most outstanding symbols of artistic production in contemporary Venezuela.

ALFREDO BOULTON

BIBLIOGRAPHY
J. Semprum: *Estudios críticos* (Caracas, 1938)
J. Nucete Sardi: *Notas sobre la pintura y la escultura en Venezuela* (Caracas, 1940, 3/1957)

8. Oswaldo Vigas: *Imposing Symbol*, oil on canvas, 800×800 mm, 1956 (Washington, DC, Art Museum of the Americas)

Tres siglos de pintura venezolana (exh. cat. by E. Planchart, Caracas, Mus. B.A., 1948)

M. Picón-Salas: *La pintura en Venezuela* (Caracas, 1954)

E. Planchart: *La pintura en Venezuela* (Caracas, 1956)

Veinte años del Salón a través de sus premios (exh. cat., Caracas, Mus. B.A., 1959)

J. Calzadilla: *El abstraccionismo en Venezuela* (Caracas, 1961)

——: *Pintores venezolanos* (Caracas, 1963)

A. Boulton: *Historia de la pintura en Venezuela*, 3 vols (Caracas, 1964–72)

J. Calzadilla: *El arte en Venezuela* (Caracas, 1967)

P. Briceño: *La escultura en Venezuela* (Caracas, 1969)

L. A. López Méndez: *El Círculo de Bellas Artes* (Caracas, 1969)

A. Boulton: *Historia de la pintura en Venezuela*, iii (Caracas, 1972)

C. F. Duarte: 'Historia y origen de varias obras atribuídas a Juan Pedro López', *Bol. Hist. Fund. John Boulton* (1972), no. 30

C. F. Duarte and G. Gasparini: *Arte colonial en Venezuela* (Caracas, 1974)

J. Calzadilla and R. Montero Castro: *Visión de la pintura en Venezuela* (Caracas, 1975)

C. F. Duarte: 'Visión de las artes durante el período colonial', *Bol. Hist. Fund. John Boulton* (1975), no. 39

P. Erminy and J. Calzadilla: *El paisaje como tema en la pintura venezolana* (Caracas, 1975)

J. Calzadilla: *El arte en Venezuela* (Caracas, 1976)

Las artes plásticas en Venezuela, Consejo Nacional de la Cultura (Caracas, 1976)

J. Calzadilla: *Movimientos y vanguardia en el arte contemporáneo en Venezuela* (Caracas, 1978)

C. F. Duarte: *Pintura e iconografía popular de Venezuela* (Caracas, 1978)

——: *Historia de la escultura en Venezuela: Época colonial* (Caracas, 1979)

B. Rodríguez: *Breve historia de la escultura contemporánea en Venezuela* (Caracas, 1979)

Gráfica venezolana: Aguatinta, intaglio, serigrafía, litografía (exh. cat., Caracas, Mus. B.A., 1979)

Arte constructivo venezolano, 1945–1965 (exh. cat., Caracas, Gal. A.N., 1979–80)

A. Boulton: *La pintura en Venezuela* (Caracas, 1987)

Obras de arte de la Ciudad Universitaria de Caracas (Caracas, 1991)

B. Rodríguez: 'Venezuela: Entre lo nacional y lo universal', *Voces de Ultramar: Arte en América Latina, 1910–1960* (exh. cat., Madrid, Casa América; Las Palmas de Gran Canaria, Cent. Atlánt. A. Mod.; 1992), pp. 85–90

De Venezuela: Treinta años de arte comtempóraneo (1960–1990)/From Venezuela: Thirty Years of Contemporary Art (1960–1990) (exh. cat. by R. de Montero Castro, Seville, Pab. A., 1992)

S. Noriega: *Ideas sobre el arte en Venezuela en el siglo XIX* (Mérida, Venezuela, 1993)

Luisa Palacios, el taller y la invención del Taga, Biblioteca Nacional de Venezuela (Caracas, 1994)

A. Kennedy Troya: 'La escultura en el virreinato de Nueva Granada y la Audiencia de Quito', *Pintura y escultura y artes útiles en Iberoamérica, 1500–1825*, ed. R. Gutiérrez (Madrid, 1995), pp. 235–55

R. Carvajal: 'Venezuela', *Latin American Art in the Twentieth Century*, ed. E. Sullivan (London, 1996), pp. 138–57

Taller libre de arte (exh. cat., Caracas, Mus. Jacobo Borges, 1997)

ALFREDO BOULTON, CARLOS F. DUARTE

V. Gold and silver.

As early as 1519, ten silver chalices are recorded as having been supplied to the Venezuelan missions by the Sevillian silversmith Juan de Oñate (1549–1624), but it was not until 1557 that another Sevillian, Cristobal del Espinar, arrived in Venezuela to establish a workshop, probably in the settlement of Coro. A Portuguese silversmith, Francisco de Acosta, was established in Caracas (founded in 1568) by 1572, but unlike in Peru and Mexico, the lack of significant natural resources of precious metals meant that most gold and silver objects were imported. At the end of the 17th century and throughout the 18th, however, there was a great increase in the activity of goldsmiths in Caracas. Juan Picón's great monstrance (1678; Caracas Cathedral), set with numerous gemstones, shows his confident use of the Baroque style. A silver sepulchre by Sebastián de Ochoa Montes (1725–8; Caracas, S Francisco) incorporates some Indian influences, reflecting de Ochoa's mestizo origins; most Venezuelan silverwork, however, is thoroughly Spanish in style. More original is the work of Domingo Vicente Nuñez (1703–65); his monumental tabernacles (e.g. Caracas, S Teresa), which made use of the *estípite* type of column, were extremely influential. The work of Pedro Ignacio Ramos (*fl* 1739–81) represents the mature Venezuelan Baroque style in silver. His antependium of *c.* 1755, now in the church of Nuestra Señora de Altagracia, Caracas, shows his ability to mix Rococo ornament with Baroque forms.

Monstrances encrusted with gemstones, for example that made by an unknown goldsmith for the church of S Lucía, Miranda, in 1761, represent the wealth of mineral resources in Nueva Granada. One made by Francisco de Landaeta (*fl* 1740–1802) for the church of S Francisco, Caracas, is totally Baroque in style, while another, also made by him for Macaray Cathedral at the end of his career, shows confident use of Neo-classical ornament. The work of his contemporary, Pedro Fermín Arias (1753–1814), also shows a gradual transition from Baroque to Neo-classical styles.

With the establishment of a siversmiths' guild in the second half of the 18th century, a system of assaying and hallmarking was used. A small number of pieces from this period are struck with the name of the silversmith, while some are also stamped with CARACAS in a rectangular punch. After independence in 1830 there were few important ecclesiastical commissions, and silversmiths made only such functional domestic objects as salvers, candlesticks, dishes and cups, which are indistinguishable from Spanish examples.

BIBLIOGRAPHY

G. Gasparini and C. F. Duarte: *Los retablos del período colonial en Venezuela* (Caracas, 1971)

C. F. Duarte: *El orfebre Pedro Ignacio Ramos* (Caracas, 1974)

——: *El maestro de oro y plata Francisco de Landaeta* (Caracas, 1977)

——: *El arte de la platería en Venezuela: Período hispánico* (Caracas, 1988)

CHRISTOPHER HARTOP

VI. Textiles.

The manufacture of rugs in Venezuela began at the end of the 16th century. It is known that by *c.* 1605 there were various textile mills operating in the cities of Mérida and Trujillo. Rugs were also made in Barquisimeto and El Tocuyo and, later, in Caracas.

The Spanish constructed cotton mills in the Andean region, as cotton was produced in abundance in Pueblo Llano, San Juan, Lagunillas and El Egido. Blankets and rugs were later made in these mills using wool and hair from the llama. Herds of sheep and llama were very common in the region, especially in the villages along the Valle de las Piedras and in Timotes. The colours white, black and brown were found in their natural state, and additional colours were produced from vegetable dyes. Intense shades of red, blue, yellow and green were used, at times mixed with one another to achieve a larger number of colours.

High-warp, vertical looms were used. In rugs made in Mérida, the warp threads were made up of three thin strands of cotton twisted together. The weft threads were

much thicker, made up of between 12 and 20 strands twisted together to make one thread. This technical detail was peculiar to the weavers in this region, as in other rugs the warp and weft threads were usually of the same thickness. The different-coloured knots that constituted the decoration were inserted into the weave and covered the weft as well as the warp. The type of knot used was a Spanish knot, a simple knot around one thread. For this reason the knots appeared in a zigzag form, and in those designs composed of straight lines they were not easily distinguishable. Depending on the distance between the warp threads, there could be between 4 and 20 knots per square centimetre. The nap was cut over the entire surface after the rug had been finished, in the Spanish fashion.

The designs of the four examples that survive from the vast production at Mérida are loose, abstract compositions of infinite variety (see fig. 9). A link is evident with designs from Cuenca and Alcaraz, which were in turn derived from the Turkish 'garden' rug that had a central area surrounded by a bordered strip with a further outer border. The decorative repertory includes such birds as ducks and herons, as well as various stylized flowers, some of which resembled the *frailejón*, a plant of the Andean plateau. The manufacture of rugs in Mérida, where the most renowned mills were those of the Jesuits, continued until the end of the 19th century. Very little is known of production in Caracas, since all material evidence has disappeared, and the only graphic documents that exist, relating to one item manufactured at the end of the 18th century, give information only on the design and colour; these are derived from the European Neo-classical style and are perhaps inspired by the designs of the Adam brothers in England. From the few written documents that exist, it is known that although there was a preference for the colour green, rugs in a variety of colours were also made. It is thought that rugs continued to be produced in Caracas after the War of Independence.

The manufacture of cloth was an industry that achieved a reasonably high level of development, and it contributed in large part to stimulating the economy in the new cities at the end of the 16th century. A variety of articles was made, for example altarcloths, napkins, towels, sheets, pillow-cases, tablecloths and painting canvases, using the 'linen of the earth' as the fabrics produced were called. From a very early date cotton and linen fabrics were made in Caracas, Chacao, Aragua, El Tocuyo, Mérida and Trujillo. In Caracas, for example, there was 'a mill where linen is woven' that belonged to Francisco de Castillo and was mentioned in his estate inventory of 1621. It is recorded that in 1636 Diego Vásquez Escobedo gave 200 reales to Francisco de Guadalupe to bring him two pieces of 'Aragua linen', indicating that this type of manufacture was in full production and that the name was already known in Caracas. The linen of El Tocuyo also achieved great fame, to the extent that even in the late 20th century certain fabrics produced in some areas of South America are known by the name of that city.

BIBLIOGRAPHY
C. F. Duarte: *Historia de la alfombra en Venezuela* (Caracas, 1979)
——: *Historia del traje durante la época colonial venezolana* (Caracas, 1984)
CARLOS F. DUARTE

VII. Patronage, collecting and dealing.

During the colonial era in Venezuela there was little patronage of the arts other than that offered by the Church. The first collections were created in the mid-17th century and comprised locally produced religious images commissioned by the Church. The artists who produced such works generally remained anonymous and received meagre payment for their work. Some private families supported artists by commissioning paintings for oraria, chapels and church altars. The nobility and upper middle classes also imported images of devotional saints or dedications to the Virgin from New Spain (Mexico) or from Europe, or else commissioned portraits from Spanish painters established in the newly created colonies. The possession of numerous paintings in the houses of land-owners and distinguished figures was a measure of status: the more objects and images there were, the greater one's wealth, standing and religious devotion. This type of collecting therefore fulfilled a function of snobbery, and collectors blindly followed the dictates of fashion without taking account of the aesthetic or historical value of works.

Information on collecting during this period has been gathered largely through the efforts of Alfredo Boulton, who conducted extensive research into the wills of these noblemen and ecclesiastical figures, the first true collectors of art in Venezuela. It is known, for example, that Diego Fernández de Araujo owned a variety of paintings on religious themes, and this type of research has made it possible to assess how limited the knowledge of painting was at the time. Noblemen typically commissioned full-length portraits of themselves and their wives; an inscription at the foot of the work identified the subjects, listing their titles and including a picture of their escutcheon; these works often remained anonymous, however. This

9. Altar rug, cotton and wool, 1.82×1.82 m, from Mérida, 2nd half of the 18th century (Caracas, Asociación Venezolana, Amigos del Arte Colonial Colección; on loan to Caracas, Museo de Arte Colonial de Caracas)

situation continued during the 18th century, as art continued to contribute solely to raising the importance of the Church and indicating the status of the powerful.

The tumultuous events surrounding the achievement of independence in 1821, however, and the rapid changes in society that ensued were to have a profound effect on the tradition of collecting in Venezuela. While the Spanish colonial empire was dismantled and destroyed as fast as possible, art nevertheless constituted an important witness to the political process. Patriotic and allegorical portraits of the life and work of the liberators and paintings commemorating the major battles were commissioned for government palaces, and new academic styles emerged. Some private collections were renewed with commissioned works showing naturalistic details, such as landscapes and family portraits, but collecting generally was still not widespread. In the second half of the 19th century, during the government (1870–90) of General Antonio Guzmán Blanco, the state began to promote the arts actively. By granting protection to the painters Martín Tovar y Tovar, Arturo Michelena and Cristóbal Rojas, the state helped to raise the status and quality of painting in Venezuela. Among others who benefited was Antonio Herrera Toro, who at the end of the century received financial assistance from the government for his studies in France. Tito Salas (1888–1974) was likewise assisted by the government (1899–1908) of Cipriano Castro in his studies in France and Spain.

In the 20th century, landscapes and still-lifes helped establish a realist tradition, which, in its evocations of everyday life, attracted the attention of the potential collector. Arístides Rojas was the first important collector in Venezuela, and the fact that he collected not only antique objects, stylish furniture and works in gold but also works by Venezuelan artists helped raise the status of the latter. Successive dictatorships, however, disrupted the cultural development of the country, and it was only after the death of General Juan Vicente Gómez in 1935 that Venezuela achieved a renaissance of sorts in the field of literature and the arts. The inauguration in Caracas in 1938 of the Museo de Bellas Artes and the building in 1944–5 of the Ciudad Universitaria, also in Caracas and both by Carlos Raúl Villanueva, signified Venezuela's embracing of modernity, underlined by Villanueva's invitation to the most important international artists of the period to create works for the university campus and buildings. In the mid-1940s an important group of pupils from the Escuela de Artes Plásticas y Aplicadas, Caracas, was given grants to study in Chile, Mexico, the USA and France. In 1944 the private sector instituted various painting prizes, and some individuals even contributed towards the cost of European studies for some artists.

The country's intellectual and economic élite began to collect works of international art based on knowledge and historical awareness, rather than in response to fashion. The collection of Cubist works made by Pedro Vallenilla Echeverría was outstanding, containing works by Picasso, Braque, André Lhote, Juan Gris, Robert Delaunay and Auguste Herbin, among others; the dedication of José Luis Plaza's collection to the work of Giorgio Morandi makes it one of the most important in the world; the Boulton collection, begun by Alfredo Boulton's ancestor

Arístides Rojas, contains not only fundamental works of painting but also coins and medals, furniture and porcelain; and the collection of José R. Urbaneja, donated to the Museo de Bellas Artes, contains pieces of china and heraldic porcelain from the 18th century that greatly enriched the heritage of the museum. It was through private collectors that the collections of corporations and financial institutions were started, as wealthy businessmen had greater power to purchase works as well as the facilities to exhibit and preserve them. Examples of such collections include those of the Banco Central de Venezuela, Seguros Carabobo, the Fundación Polar, the Banco Mercantil and the Banco Consolidado.

The fluctuating socio-political and economic situation in Venezuela has affected the quality and quantity of art collections throughout the 20th century. Interest has grown, as much on the part of public institutions as privately, in collecting contemporary Latin American art; this is due largely to the professionalization of the Museo de Bellas Artes as well as to the appearance of new museums, such as the Galería de Arte Nacional (founded in 1975) and the Museo de Arte Contemporáneo de Caracas Sofía Imber (founded 1974), which carry out educational and promotional work. The Federación de Fundaciones Privadas comprises 112 institutions dedicated to helping to cover the costs of studying in various different professional disciplines, including the arts. In the 1990s Venezuelan collectors recognized worldwide included Gustavo and Patricia Cisneros, with their important collection of contemporary Latin American art, and Miguel Angel Capriles, the owner of the most important collection of modern Latin American art in the South American continent.

The first galleries aimed at stimulating and encouraging the commercialization of art in Venezuela appeared mid-century. Small-scale art dealers appeared first, functioning as traders entrusted by collectors to update their old-fashioned collections, and this gave rise to the first commercial galleries established by private foundations and connoisseurs of modern art (e.g. Fundación Eugenio Mendoza, Galería Clara Sujo, Galería Adler-Castillo). In the 1980s a significant number of new galleries began to emerge in major Venezuelan cities, responding to a new interest among young people and the professional middle class. Art auctions were first held in Venezuela on the initiative of the Fundación Eugenio Mendoza, which from the first in 1953, held the only important and respected auctions in the country. Other sporadic auctions are held for charitable or fund-raising purposes, such as that held in 1991 to raise funds for the rebuilding of the Casa Amarilla de la Cancillería.

BIBLIOGRAPHY

A. Rojas: *Obras escogidas de Arístides Rojas* (Paris, 1907)

20 obras de la Colección Pedro Vallenilla Echeverría: Primera exposición de un ciclo dedicado a las colecciones privadas en Venezuela (exh. cat., Caracas, Mus. B.A., 1959)

A. Boulton: *Historia de la pintura en Venezuela*, i (Caracas, 1964)

Donación Miguel Otero Silva: Obras de la colección de pintores venezolanos destinadas al Museo de Bellas Artes de Caracas y al Museo Regional de Barcelona (exh. cat., Caracas, Mus. B.A., 1965)

A. Boulton: *Historia de la pintura en Venezuela*, ii (Caracas, 1968)

G. Gasparini and C. Duarte: *Los retablos del período colonial en Venezuela* (Caracas, 1971)

Los 80: Panorama de las artes visuales en Venezuela (exh. cat., Caracas, Gal. A.N., 1989)

Obras de arte de la Ciudad Universitaria de Caracas, Consejo Nacional de Cultural/Universidad Central de Venezuela (Caracas, 1991)

Donación Miguel Otero Silva: Arte venezolano en las colecciones de la Galería de Arte Nacional y el Museo de Anzoátegui, Fundación Galería de Arte Nacional (Caracas, 1993)

El Cubismo: Tradición y vanguardia: Donación Pedro Vallenilla Echeverría y otras adquisiciones (Caracas, 1993)

Naturalezas muertas en la Colección Galería de Arte Nacional (exh. cat., Caracas, Gal. A. N., 1995)

Una visión del arte venezolano, 1940–1980: Colección Clara Diament Sujo (exh. cat. by C. Diament Sujo and S. Benko, Caracas, Gal. A. N., *c.*1995)

Banco Central de Venezuela: Colección de arte, 1940–1996, Banco Central de Venezuela (Caracas, 1996)

Galería de Arte Nacional: Veinte años por el arte venezolano, 1976–1996 (exh. cat., Caracas, Gal. N. A., 1996)

Museo de arte contemporáneo de Caracas Sofía Imber: Obras de su colección (Caracas, n.d.)

ALFREDO BOULTON, ZULEIVA VIVAS

VIII. Museums.

As in many other Latin American countries, museums in Venezuela did not develop until later in the country's history, partly because of the lack of a substantial middle class with available leisure time and resources to promote the study and cultivation of the fine arts. The oil boom of the 1940s gave rise to an impressive and dramatic growth in the number and comprehensiveness of art museums, the most important of which are in Caracas. The institution with the oldest continuous history is the Museo de Bellas Artes, which forms part of a cultural complex in the heart of the city. It was founded in 1874 as the Museo Nacional, by the culturally minded Antonio Guzmán Blanco (President, 1870–90). The architect Juan Hurtado Manrique (1837–96) designed a Gothic Revival structure for the museum, which was erected and opened in 1875. Like many 19th-century museums, it was a general cultural institution containing not only paintings but also a mineral collection, stuffed birds and handicrafts made by indigenous artists. In 1917 the museum was relocated and its name changed to the Museo de Bellas Artes. It acquired the collection of the Academia de Bellas Artes, which included important works by various colonial and 19th-century Venezuelan artists. Construction of the present building in the Parque los Caobos did not begin until July 1935. Venezuela's most renowned and influential architect of the period, CARLOS RAÚL VILLANUEVA, chose the site and drew up plans for the museum, making the most of the park and its vegetation. Opened in 1938, the new building houses some of the best works by past and present Venezuelan artists as well as works by various foreign artists whose influence had been felt in Venezuela. In 1952 the museum was enlarged in a project again undertaken by Villanueva.

Another major institution in Caracas is the Museo de Arte Contemporáneo, founded in 1974. Its mission was to create and maintain a permanent collection of works by late 20th-century Venezuelan and foreign artists. Built mainly of reinforced concrete, iron and glass, the building was constructed in two stages, with the first storey finished in 1974 and the second in 1982. The museum now consists of five floors, three of which are devoted to exhibition space. The institution's library of *c.* 17,500 volumes is one of the largest fine arts libraries in the country (*see also* §X below). In the selection of works by foreign artists, Sofía Imber de Rangel, former director of the museum, was particularly influential, as she had lived in Europe and had made contact with many of the leading artists of the post-World War II period. The Museo de Arte Colonial, in a late 18th-century house at the Quinta de Anauco, Caracas, is the best example in Venezuela of a museum devoted to the fine and decorative arts of the Spanish colonial period. The institution was founded by Don Juan Javier Mijares de Solorzano. In 1958 the 'Anauco' house was donated to the nation by the Eraso family as a permanent seat of colonial art. The building is typical of a Venezuelan *estancia* and possesses an impressive internal patio. The various corridors are lined with pillars of the Tuscan order supporting a wooden roof; flat plaster ceilings are lined by simple mouldings in accordance with late 18th-century taste.

A number of smaller museums exist that are devoted to the arts and crafts of the colonial period, to the period of the War of Independence (1806–21) or to later in the 19th century. Since Venezuela's national hero and liberator, Simón Bolívar, is still treated with great reverence, it is not surprising that two museums are devoted to him: the Museo Cuadra de Bolívar and the Museo Bolivariano, both in Caracas. The former contains murals by Tito Salas portraying incidents during the revolutionary war, while the latter contains historical paintings and portraits of Bolívar and his contemporaries. One museum of note outside Caracas is the Fundación Museo de Arte Moderno 'Jesús Soto' in Ciudad Bolívar, which is also an international research centre for constructivist, geometric and kinetic art. Three individuals were responsible for championing the idea of the museum: Soto himself, who wanted his native town to have a fine arts centre, the architect Villanueva and the governor of the state. Inaugurated in 1973, the museum manifests the influence and taste of Soto, not only in the various works by him in the collection but also in the paintings and graphic works by other contemporary artists, acquired by Soto when he was in Paris. The museum, containing works by over 200 artists, has six large exhibition halls and an enclosed garden patio.

BIBLIOGRAPHY

Catálogo del Museo de Bellas Artes (Caracas, 1958)

M. G. Arroyo and R. Lozano: *El Museo de Bellas Artes de Caracas y algunas de sus obras* (Caracas, 1978)

C. F. Duarte: *Museo de Arte Colonial de Caracas, 'Quinta de Anauco'* (Caracas, 1979)

H. Lassalle: 'Ciudad Bolívar's Museum of Modern Art: The Soto Foundation Museum', *Museum*, xxxvii/3 (1985), pp. 156–62

J. M. Salvador: 'The Caracas Museum of Contemporary Art', *Museum*, xxxvii/1 (1985), pp. 41–5

——: *Obras ejemplares del Museo de Arte Contemporáneo de Caracas* ([Caracas], 1985)

Galería de Arte Nacional: Veinte años por el arte venezolano, 1976–1996 (exh. cat., Caracas, Gal. N. A., 1996)

ANTHONY PÁEZ MULLAN

IX. Art education.

During the initial stages of the Spanish colonization of Venezuela, art objects were imported from Spain and later from Mexico and Peru, and it was only in the 17th century that Spanish artists came to the colony to aid in the production of religious images. It was thus in a rather

unstructured manner that the teaching of drawing, painting and sculpture to the indigenous people, those of African descent and creoles began; they were also taught European methods of construction by being involved in erecting ecclesiastical buildings. Artists were apprenticed between the ages of eight and twelve in the workshop of a master craftsman and would remain there between five and eight years, learning the master's trade. There was virtually no other artistic education in Venezuela for two centuries, although an informal school was established by Antonio José Landaeta in the late 18th century, and in 1818 an elementary school was established in Caracas by Vicente Méndez; drawing was taught there by the painter Juan Lovera.

It was only with the rise of the Venezuelan republican state in the 1820s that institutionalized, government-backed art education was established. The Sociedad Económica de Amigos del País, created in 1829 by José Antonio Páez to stimulate economic, political, social and cultural development, sanctioned the creation of a drawing school, which, with the name of Academia de Dibujo y Pintura and under the direction of Joaquín Sosa, began functioning in Caracas in 1835. In November 1838, by resolution of the Diputación Provincial de Caracas, the Escuela Normal de Dibujo was established; this opened in 1839 with 39 pupils and was directed by the painter and lithographer Celestino Martínez. In 1849 the Diputación Provincial changed the Academia de Dibujo y Pintura to the Academia de Bellas Artes, and painting and music were added to its teaching; Antonio José Carranza (1817–93) directed the arts department. In 1852 the same Diputación founded the Instituto Provincial de Bellas Artes.

The Academia de Bellas Artes remained in existence for almost a century, led by the most representative artists of the period, who followed the precepts and methodology of European academic institutions. The presidency (1870–90) of Antonio Guzmán Blanco continued to favour the arts and education, and students at the Academia began to benefit from grants enabling them to study in Europe. In its final period the Academia was directed by ANTONIO HERRERA TORO, an austere, conservative man opposed to changes in methods of study. In 1912 a group of rebel students founded an independent workshop in Caracas called the Círculo de Bellas Artes. This action initiated a process of reforms to art education in Venezuela that remains incomplete.

In 1936 the Academia de Bellas Artes was reconstituted as the Escuela de Artes Plásticas y Aplicadas, under the directorship of ANTONIO EDMUNDO MONSANTO, and the period of domination by the Academia was thus ended. In 1949 the school began to call itself the Escuela de Artes Plásticas y Artes Aplicadas Cristóbal Rojas; later it became the Escuela de Artes Plásticas Cristóbal Rojas, and finally the Escuela de Artes Visuales Cristóbal Rojas. In 1958, after the fall of the dictatorship of Marcos Pérez Jiménez, the students and a number of teachers asked the Ministerio de Educación to nominate a commission to reorganize the education system. One of their requests was that professional artistic training should be included in general education; another, that artistic training be divided into basic, intermediate and higher levels. These hopes were finally realized only in 1991, when the Consejo Nacional

de la Cultura supported the Ministerio de Educación in renovating the entire system of art education, creating the Instituto Universitario de Estudios Superiores de Artes Plásticas Armando Reverón, the curriculum of which is based on an integral conception of culture and art. Within the framework of this inter-institutional agreement a new curriculum was approved for the Escuela de Artes Visuales Cristóbal Rojas; this pilot scheme, if successful, was to be applied subsequently to all the other art schools nationally. With regard to graphic arts, the Centro de Enseñanza Gráfica (CEGRA) and the Taller de Artes Gráficas (TAGA) were both established in 1976 by MANUEL ESPINOZA, LUISA PALACIOS and others.

BIBLIOGRAPHY

J. Nucete Sardi: *Notas sobre la pintura y la escultura en Venezuela* (Caracas, 1940, rev. 1950)

R. de la Plaza: *Ensayos sobre el arte en Venezuela* (Caracas, 1977)

A. Madriz: *La enseñanza de la educación artística en Venezuela* (Caracas, 1985)

MANUEL ESPINOZA

X. Art libraries and photographic collections.

Among the most important art libraries in Venezuela is the library of the Museo de Bellas Artes in Caracas, which contains *c.* 6000 volumes on art from the prehistoric period to the present. The museum's research department also has an important journal and slide library, covering art in general but specializing in Latin American and Venezuelan art; this material has been undergoing classification since 1978. The Biblioteca Pública de Arte Sofía Imber, attached to the Museo de Arte Contemporáneo in Caracas, was founded in 1974 and holds *c.* 7500 monographs as well as 10,000 national and foreign exhibition catalogues, 17,000 transparencies, videos and audio-visual material on art from prehistoric times onwards. Also of significance is the Centro de Información y Documentación Nacional de las Artes Plásticas (CINAP), part of the Galería de Arte Nacional in Caracas, created in 1976. Its documentary material includes books and journals on Venezuelan art, and it also has a slide library with black-and-white photographs, transparencies, videos and a 'verbal archive' (comprising artists' interviews recorded on cassettes and in script form). The Biblioteca Carlos Manuel Muller, part of the Museo de Arte Colonial at the Quinta Anauco, Caracas, specializes in colonial (particularly Venezuelan) Latin American art. The architecture faculty of the Universidad Central de Venezuela in Caracas has an important documentation centre containing books and journals on architecture.

Documentary photographic archives on themes related to art can also be found in a number of institutions in Venezuela. The archive of the education ministry's División de Tecnología Educativa possesses 800,000 negatives on political, social and cultural events in Venezuela and has transparencies, videos and 16-mm films on art; it is used essentially as a teaching aid by schools and universities but is also open to the general public. The Archivo Audiovisual de Venezuela, which forms part of the Biblioteca Nacional, holds many 19th- and 20th-century photographic collections as well as an oral history archive and specializes in national history and art. It manages the Exposición Anual de Fotografía Documental, as well as

workshops and seminars, and has an important cartographical and iconographical collection with over 43,000 images. Noteworthy among private collections are the Fundación Boulton in Caracas, with 19th- and 20th-century photographs and documentation, and the collection of Carlos Eduardo Misle, which specializes in 19th-century photographs. Other noteworthy audiovisual institutions include the Museo Audiovisual in Caracas and Artevisión at the Universidad Simón Bolívar, which produces art documentaries for television; various oil companies and banks also have slide libraries and documentary archives and sponsor documentary videos and art books.

BIBLIOGRAPHY

Imágenes de la Venezuela del siglo XX: Fotografías del Archivo Histórico de Miraflores, Caracas (Caracas, 1998)

SUSANA BENKO

Veramendi [Velamendi]**, Juan Miguel de** (*b* Viscaya Prov.; *fl* 1552–72). Spanish architect, active in Peru. He is documented as having worked in the cities of Cuzco and La Plata (now Sucre, Bolivia). In 1559 Veramendi was called upon by the Cabildo authorities of Cuzco Cathedral to supply plans for a new building. He signed the contract on 17 October 1559, agreeing to work as Maestro Mayor on the cathedral for an annual salary of 3000 pesos. Construction started to Veramendi's plans on 11 February 1560 but was never finished, and the scheme was superseded by a new design attributed to Francisco Becerra. Records (Cuzco Cathedral Archives, 'Actas capitulares', i, fol.114*r–v*) also indicate that another architect, Juan Correa, was engaged to work on the original design by Veramendi between 1561 and 1564. Veramendi's other major work was the first cathedral in La Plata, with a rib-vaulted transept and sanctuary, built from 1552 to 1572. In 1583 Francisco de Veramendi, possibly a relative of Juan Miguel, was engaged in the construction of a new chapel in this cathedral.

BIBLIOGRAPHY

R. Vargas Ugarte: *Ensayo de un diccionario de artífices de la América meridional* (Lima, 1947, 2/Burgos, 1968), pp. 107–9

H. E. Wethey: *Colonial Architecture and Sculpture in Peru* (Cambridge, MA, 1949, 2/1969), p. 40

J.M. Covarrubias Pozo: *Cuzco colonial y su arte* (Cuzco, 1958), pp. 13–14

E. Harth-Terré: 'La obra de Francisco Becerra en las catedrales de Lima y Cuzco', *An. Inst. A. Amer. & Inves. Estét.*, xiv (1961), pp. 18–57

HUMBERTO RODRÍGUEZ-CAMILLONI

Vernacular [Folk] **architecture.** Term used to describe informal, usually domestic, architecture that is rooted in local traditions and is generally produced by craftsmen with little or no formal academic training, whose identity is unrecorded. The vernacular architecture of any region may be characterized by the use of a particular material readily available in the area, by the prevalence of a particular building type related to the dominant local economic activities or by the use of a particular style, possibly derived from local materials and techniques.

1. Pre-Columbian and Hispanic models. The vernacular architecture of Central and South America is characterized by an extraordinary variety and morphological richness, reflecting with sensitivity both national and local history and moulded by diverse and subtle ethnic influences as well as by extremely wide-ranging geographical situations. While this variety and richness needs to be borne in mind, since the essence of the vernacular lies in its links with a local community, a distinctive and characteristic general feature of the vernacular architecture of Central and South America is its mixture of surviving indigenous traditions and fundamentally Spanish or Portuguese influences. On a smaller scale and again reflecting local history, there is also evidence in some regions of African and French ethnic influences and of later influences from other western European countries.

Although no examples of vernacular dwellings have survived from the Pre-Columbian period, documentary evidence—above all from Central America—provides information on the building traditions established before the time of the conquest. There exist mural and model representations, manuscript drawings and pictographic records as well as descriptions by the conquistadors and other chroniclers of the 16th century. Ceramic and stone models from Nayarit in Mexico, for example, dating from around the beginning of the Christian era, show rectangular houses, some with a single storey or where the top part of the house has been abated. Their high roofs with large eaves have such long ridges that at each end they bend inwards. Hernán Cortés, in the *Cartas de relación*, mentions dwellings made of straw and built on a masonry platform found in the warmer regions of the Mexican conquered territory. Other chroniclers from the same period write of houses made from sun-dried bricks, lime and stone, the last of these showing remarkable craftsmanship in the cutting and almost invisible joinery of the stone. The typical Aztec dwelling seems to have had very small windows and doors; many of the pictographic records of the ground-plans of dwellings—often including depictions of the area of worship, the barns and wells—provide useful information on domestic customs and family relationships.

With the domination of the Aztecs by the Spaniards and the birth of colonial architecture, there began a process of cultural amalgamation. The indigenous masons, instructed by Spanish masters of works, retained their traditional knowledge while also learning new methods. From 1550, the dwellings of the conquistadors and the conquered were mixed territorially in the ancient urbanization of Tenochtitlán (now Mexico City), and thereafter all the architectural styles subsequently imported from Europe, from the Baroque to Modernism, took on a characteristically Latin American identity. Nevertheless, a vernacular architecture rooted in Pre-Columbian traditions is still produced in remote towns and isolated Indian communities, as in the single-room houses of the Chipaya in the Oruro department of Bolivia (see fig. 1).

A particularly important element in the Iberian influence was the introduction of urbanization. The orders given by Philip II in 1573 for the 'discovery, new population and pacification of the Indies' sought to impose not only a new social organization but also a new spatial structure. A process of architectural as well as religious evangelization ensued, in which the ordered layout dictated by Renaissance urban theory in Europe was imposed throughout the whole newly Hispanic territory; this has survived into the 20th century, with a few exceptions owing to topog-

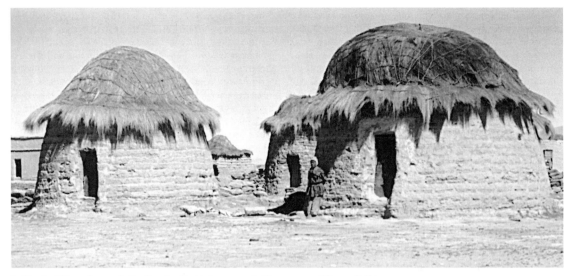

1. Circular Chipaya houses, built of earth with dried grass roofs, Department of Oruro, Bolivia

raphy, throughout the whole of Castilian-speaking Latin America. However, the geometric and orthogonal layout of the towns founded or modified following Philip's decree was not in fact common throughout the Iberian peninsula, and nor was it wholly contradictory to Pre-Columbian traditions in Latin America. For example, while the central square can be traced back to its Mediterranean origins, the size of the examples built in Central and South America dates back to the time of the arrival of the conquistadors, when large public spaces already existed. Indeed, the new model city in the form of a chess board, with straight streets dividing blocks of buildings, with a central square of huge dimensions in which the powers of the Church and the government were united, and without a surrounding wall to impede the outward expansion of the city, can be seen as a new project for a new society, or rather a new world. This new project lent itself for many reasons to a process of architectural syncretism. Moreover, while new sacred buildings, monuments and palaces replaced existing structures, the effect was one of substitution and thus to some extent of continuity, in which the vernacular architecture of ordinary dwelling places was almost unaffected.

2. Calle Hatun Rumyoc, Cuzco, Peru, showing Spanish Colonial additions to Inca masonry (before 1533)

This continuity is particularly evident in some streets in Cuzco, for example, where colonial architects added extra storeys to single-storey buildings of Inca masonry, preserving in some cases the shaded, narrow urban layout (see fig. 2).

2. THE VERNACULAR RESPONSE. Characteristic of the surviving vernacular tradition was a reaction against the straight, wide streets of the new urban layouts. This reaction took the form of shaded, intimate interiors, protected from the new influences, as it were, by the exterior walls and often containing a patio, mirroring the Mediterranean tradition and symbolizing the mixture of cultures. Other characteristics are restricted to particular regions, reflecting the close link between vernacular architecture and the immediate environment. The huge differences in climate that can be found in the vast territory of Latin America, exacerbated by the mountainous landscape, necessarily result in an immense morphological diversity of habitat. This diversity is further reinforced by the use of local materials, again reflecting regional climatic conditions. In the temperate regions, in towns and small cities, rows of terraced houses, usually of one storey, are predominant. Porches are common (despite the apparent reluctance of most housing to face the street), and porticos are often found around the inner patio. A huge variety of columns with their respective bases, shafts and capitals show the local peculiarities of the architecture; examples range from tree trunks joined together by ties to arcades with domes. Where the porch is absent, its place is sometimes taken by a roof with large eaves that protect the pedestrian from the sun as much as from the rain. The porticos that look on to the patios, and which are sometimes repeated at first-floor level to create half-open interior façades, form a corridor off which all the rooms lead and in which most family and social life is led. The patio itself, which is geometric in its layout and sometimes has a central fountain, is inspired much more by the plazas of a town than by a natural garden.

The shaded interiors created by these porticos and porches are frequently roofed with beams and roofing

boards. The windows are very tall, with stone frames or frames in colours different from those of the façade, and are often protected by iron bars on the outside. A great variety of constructive solutions exists for roofs. They may be flat or pitched, and in the late 20th century they were made from straight slabs of concrete, covered with available raw materials, such as mud tiles or straw, according to the climatic conditions. The material used for the walls also depends on local conditions, although adobe is widely used for its thermal qualities as much in cold regions as in warmer ones. It may be smoothly inconspicuous or decoratively ostentatious, sometimes with joints of mud interspersed with stones from the river or ceramic pebbles to ensure that it is not washed away by the rain.

In the warmer and more rural regions detached dwellings are more common, each surrounded by its own small garden. These houses usually have a rectangular ground-plan, the two short sides sometimes being semicircular in shape; very occasionally the dwelling is completely circular (as on the Pacific coast of Mexico, where its origin is in the African Bautu). As is usually the case in the vernacular architecture of almost all of the vast Latin American territory, porticos are again common on either one or both sides of the longest façade, supporting an extension of the roof, or surrounding the whole house. Very occasionally houses can be found with roofs forming large eaves over the walls. Local vegetation, assembled according to varying local techniques, provides the principal building materials in these regions. Walls may be made from vertically arranged tree trunks connected by woven palm, or branches of trees may be laid horizontally and covered with mud mixed with fibres, left as they are or painted with lime; sometimes tree trunks alone may be used, roofed with hay, palm or local plants.

Most of these dwellings comprise a single multi-functional room in which, when the climate permits, the inhabitants sleep in hammocks. The solutions found for ventilation are often ingenious. Where there are no window openings, ventilation is provided by lattices made from adobe in the form of decorative patterns, by little bamboo bars and by woven liana. In certain countries and regions of Latin America the strong colouring of the vernacular architecture is remarkable and quite unlike any European examples. A notable example is a particular dark blue hue found in architectural details in the high plateaux of Mexico and used since Aztec times. Another trait common to this type of dwelling is the central role of the kitchen, in which in certain parts of Mexico the placentas of newly born babies are buried. Indeed, many of the mythical and spiritual aspects of vernacular architecture in Mexico have survived from Pre-Columbian times: the positioning of Mayan houses in the Yucatán peninsula, for example, reflected the community organization and the race of the inhabitants; although deeply affected by the orthogonal pattern imposed by the Spanish, the result was a new and organic architectural mix.

In the late 20th century the vernacular architecture of Latin America was subjected to another form of cultural domination, exercised in the name of modernity. Increasingly, examples of international modernist design took root in the capital cities and expanded towards the cities and towns of the provinces. This architecture, reflecting the modern principles of universality and supposed functionality, was incapable of being integrated into the vernacular context, since its internationalism and its hostility towards the domestic were alien to the very essence of the vernacular. Although ingenious examples of bricolage exist, making use of fragments of modern materials such as plastics and laminates, this creativity is conditioned by poverty and can hardly be classified as vernacular. It is therefore only in minute details, such as the use of particular colours, that the vernacular tradition is visible, or else, paradoxically and with varying degrees of success, in the work of such modern architects as Luis Barragán.

BIBLIOGRAPHY

H. Cortés: *Cartas de relación* (Mexico City, 1969)
Transcripción de las ordenzas de descubrimiento de nueva población y pacificación de las Indias, dadas por Felipe II (Madrid, 1973) [facs.]
F. Vegas: *Venezuelan Vernacular* (Princeton, 1985)
G. Gasparini: *Arquitectura popular de Venezuela* (Caracas, 1986)
F. J. López Morales: *Arquitectura vernácula en México* (Mexico City, 1987)
J. A. Campos: *La arquitectura vernácula en México*, Cuadernos de arquitectura virreinal (Mexico City, 1989)
C. Aubry: *Arquitectura doméstica ecléctica en Argentina y Chile* (in preparation)
R. Trebbi del Trevigiano: *Arquitectura espontánea y vernácula en América Latina: Teoría y forma* ([Valparaiso], c.1985)
I. M. Salinas: *Arquitectura de los grupos étnicos de Honduras* (Tegucigalpa, 1991)
A. Tamez Tejeda: *Arquitectura vernácula mexicana del noreste* (Monterrey, 1993)

ADA DEWES

Victorica, Miguel Carlos (*b* Buenos Aires, 4 Jan 1884; *d* Buenos Aires, 9 Feb 1955). Argentine painter. He studied under the Italian painter Ottorino Pugnaloni and then at the Escuela de la Asociación Estímulo de Bellas Artes in Buenos Aires under Angel Della Valle, Eduardo Sívori,

Miguel Carlos Victorica: *Bohemian Kitchen*, oil on canvas, 1.51×1.18 m, 1941 (Buenos Aires, Museo Nacional de Bellas Artes)

Reinaldo Giudici (1853–1921) and Ernesto de la Cárcova. A travel grant in 1911 enabled him to move to Paris, where he lived for seven years. He studied under Louis Désiré Lucas (*b* 1869), from which one can deduce that his artistic education was above all academic, and he was influenced first by the work of Eugène Carrière (1849–1906) and later by Fauvism.

Victorica returned to Buenos Aires in 1917 and like other painters set up his studio in the Riachuelo district near the harbour. Although he had previously relied on an impasto technique and earth colours, from 1918 he gradually adopted freer and more expressive methods, as in his oil painting *Nude* (1923; Buenos Aires, Mus. N. B.A.). From 1940 the sensitive use of tone and materials became essential characteristics of his painting, as in *Bohemian Kitchen* (1941; Buenos Aires, Mus. N. B.A.; see fig.). His work, in giving predominance to colour in defiance of the constrictions of drawing and contour, prefigured the development in Argentina of a form of gestural abstraction using stains of colour. He worked in both oils and pastels and produced landscapes, portraits, still-lifes and scenes of local customs.

BIBLIOGRAPHY
J. E. Payró: *Veintidós pintores: Facetas del arte argentino* (Buenos Aires, 1944), pp. 75–83 [illus.]
S. Blum: *Victorica* (Buenos Aires, 1980)

NELLY PERAZZO

Víctor Manuel (García) (*b* Havana, Oct 31 1897; *d* Havana, 1 Feb 1969). Cuban painter and teacher. He is generally considered to be the initiator of modernism in Cuba. From 1910 he studied at the Academia de S Alejandro in Havana and taught elementary drawing there until 1925, when he went to Paris. There he formed part of the Latin American artistic and literary Grupo de Montparnasse and abandoned academic painting. On his return to Cuba in 1927 he participated in the Asociación de Pintores y Escultores exhibition in Havana, which marked the official beginning of modern painting in Cuba. As a teacher and avant-garde painter he had a considerable influence on painters of his own and succeeding generations.

Víctor Manuel reconciled Parisian modernism with traditional Cuban themes and elements in order to create works that were at once culturally specific and cosmopolitan. *Tropical Gypsy* (1927; Havana, Mus. N. B.A.) is his best-known painting, referring to Gauguin and modern European art while seeking to portray a national icon, the *guajiro* or peasant. Víctor Manuel remained obsessed with the depiction of this Cuban ideal type throughout his career, and many of his paintings are thus variations on one theme. He also painted bucolic landscapes, romantic couples, portraits and Havana street scenes (e.g. *Street Scene*, 1936; Havana, Mus. N. B.A.). Almost all these works contain idealized images that have a lyrical, dreamlike quality.

BIBLIOGRAPHY
G. Pérez-Cisneros: 'Víctor Manuel y la pintura cubana contemporánea', *U. La Habana*, 1 (1941), pp. 208–30
Víctor Manuel (exh. cat., Havana, Museo N. B.A., 1969)
Origins of Modern Cuban Painting (exh. cat., ed. J. A. Martínez; Miami, FL, Frances Wolfson A.G., 1982)
Víctor Manuel: Un innovador en la pintura cubana (exh. cat., ed. R. Viera; Miami, FL, Cub. Mus. A. & Cult., 1982)

J. A. Martínez: *Cuban Art and National Identity: The Vanguardia Painters, 1927–1950* (Gainesville, 1994)

GIULIO V. BLANC

Vidal, Emeric Essex (*b* Brentford, Middx, 29 March 1791; *d* Brighton, 7 May 1861). English draughtsman and painter, active in Brazil, Uruguay and Argentina. He joined the Royal Navy when he was 15. On his travels to the Baltic region, the Cape of Good Hope, St Helena, the West Indies, North America and South America he was prompted to apply his skill as a draughtsman and watercolourist to the production of local views. While staying in Brazil and Río de la Plata from May 1816 to September 1818, he produced watercolours depicting the exuberant vegetation of Brazilian landscapes and the regions surrounding Montevideo and Buenos Aires. He also recorded numerous views of Buenos Aires, its port and neighbouring villages, and its inhabitants: travelling salesmen, gauchos, soldiers and scenes of peasant customs, including *The Cabildo, Buenos Aires, from under the Arch of the Market Plaza* (Oct 1817). Twenty-five hand-coloured aquatints after his illustrations were published by Rudolf Ackermann in monthly booklets as *Picturesque Illustrations of Buenos Ayres and Montevideo* (London, 1820; copy annotated by Vidal, Buenos Aires, Mus. Mun. A. Plást. Sívori), all depicting outdoor scenes accompanied by Vidal's written commentary. Drawn from nature, they show characteristic scenes and customs of Buenos Aires and also document local dress in faithful detail. Although Vidal protested about the liberties taken by the publisher in the production of the prints in his absence, they give a revealing and almost complete picture of Buenos Aires *c.* 1820. Vidal travelled again to Brazil and Río de la Plata in 1828–9, painting numerous works in Brazil but only one in Montevideo and two in Buenos Aires. His aquatints were used for a long time by publishers to illustrate accounts of travel in those regions.

BIBLIOGRAPHY
A. González Garaño: *Acuarelas inéditas de Vidal: Buenos Aires en 1816, 1817 y 1819* (Buenos Aires, 1931)
Emeric Essex Vidal: Su vida y su obra (exh. cat. by A. González Garaño, Buenos Aires, Asoc. Amigos A., 1933)
Acuarelas inéditas sobre Río de Janeiro (Buenos Aires, 1961) [24 lithographs executed in France]
J. López Anaya: *Historia del arte argentino* (Buenos Aires, 1997)

NELLY PERAZZO

Vidal, Miguel Angel (*b* Buenos Aires, 27 July 1928). Argentine painter and sculptor. Basing his work on the rigorous structural application of the straight line as his basic unit, he was one of the main creators in the late 1950s of a style of painting called ARTE GENERATIVO. Tending to work in series to which he gave titles such as *Dynamic Structures, Displacements, Integrations, Radiations, Fugues* and *Reflections*, he revealed his inexhaustible inventiveness in elaborating his fundamental system, for example in *Homage to Albers* (1965; Buenos Aires, Mus. A. Mod.), in which he acknowledged his debt to a pioneer of geometric abstraction, Josef Albers (1888–1976).

Vidal favoured strong centrifugal and centripetal tensions and often made his lines converge on a point in bundles, generating luminous irradiant foci and superimposed meshes that create fleeting sensations, as in *First*

Miguel Angel Vidal: *First Vision*, oil on canvas, 1098×800 mm, 1968 (New York, Solomon R. Guggenheim Museum)

Vision (1968; New York, Guggenheim; see fig.). By concentrating on the luminous energy of the lines and the poetic suggestiveness of space within a severely restricted geometric vocabulary, he was, by the 1980s, creating work that was almost mystical in tone. He applied these principles not only to paintings but also to sculptures made of plastic and metal, some of them using boxlike forms and systems of modular development.

BIBLIOGRAPHY
C. Córdoba Iturburu: *80 años de pintura argentina* (Buenos Aires, 1978), p. 185
I. Picovano: 'Arte generativo: Eduardo MacEntyre, 1929; Miguel Angel Vidal, 1928', *Arte argentino contemporáneo* (Madrid, 1979), pp. 175–9
J. López Anaya: *Historia del arte argentino* (Buenos Aires, 1997)
NELLY PERAZZO

Vieira de Magalhães, Mário. *See* PORTO, SEVERIANO.

Vigas, Oswaldo (*b* Valencia, Carabobo, 4 Aug 1926). Venezuelan painter, ceramicist and sculptor. He started painting around 1942. His work was initially abstract but it became figurative with surrealistic elements, as in *The Tetragramist* (1943) and *Composition* (1943–4; both artist's col.). He attended the Escuela de Artes Plásticas y Aplicadas in Caracas irregularly from 1948 to 1951. In 1949 he joined the Taller Libre de Arte, an avant-garde group active between 1948 and 1952, which sought to explore Venezuelan historical and cultural roots. His interest in Pre-Columbian Venezuelan cultures influenced his subsequent work. From 1952 to 1964 he lived in Paris, where

he studied at the Ecole des Beaux-Arts and frequented the studio of Marcel Joudon. Later Vigas produced both pottery and sculpture, in addition to paintings.

BIBLIOGRAPHY
G. Diehl: *Oswaldo Vigas* (Caracas, 1990)
Vigas Oswaldo (exh. cat., Caracas, Grupo Li Cent. A., 1997)
ANA TAPIAS

Vigo, Edgardo Antonio (*b* La Plata, 1927). Argentine conceptualist artist. He studied at the Escuela Superior de Bellas Artes of the Universidad Nacional de la Plata before moving to Paris (1953–4), where he befriended the Venezuelan artist Jesús Soto. Until the end of the 1950s Vigo's work centred around heterodox objects, graduating to the construction of his *máquinas inútiles* ('useless objects') by 1957. To this end Vigo has been seen as the precursor of visual poetry and concept art, especially with his *Señalmientos* ('Designations'). Vigo was active in the founding and publication of various art journals, including *W.C.* (which produced five editions); *D.R.K.W. 60* (three editions); *Diagonal cero* in 1964 (28 editions); and *Hexágono* (13 editions). In 1967 he published *Baroque Mathematical Poems* in Paris. In 1969 Vigo organized the Exposición Internacional de Novísima Poesía/69 at the Instituto Torcuato Di Tella of Buenos Aires, a multi-media show involving artists from around the world. In 1970 he participated in the collective exhibition *de la figuración al arte de sistema* at the Centro de Arte y Comunicaciones (CAYC) in the Museo Emilio Caraffa de Córdoba, along with fellow Argentine artists Luis Fernando Benedit (*b* 1937) and Nicolás García Uriburu (*b* 1937). From the 1970s Vigo became integrated into the international art movement *Arte correo*. He went on to found the Museo de la Xilográfia de La Plata. A major retrospective of his work at the Fundación San Telmo took place in 1991, and in 1994 he was selected to represent Argentina at the Internacional Bienal of São Paulo. A typical work is *Poema visual de las Madres de la Plaza de Mayo* (mixed media, 1.40×1.00 m, 1990; artist's col.), a haunting combination of words and objects that refers to Argentina's 'Dirty War' (1976–82). The white cloth, symbolizing the Madres de la Plaza Mayo, hangs like a shroud over shreds of fabric containing the words of a poem in which the seeds of eternal memory of the disappeared are sown.

BIBLIOGRAPHY
De la Figuración al arte de sistemo (exh. cat. by J. Glusberg, Córdoba, Argentina, Mus. Prov. B.A. 'Emilio A. Caraffa', 1970)
J. López Anaya: *Historia del arte argentino* (Buenos Aires, 1997)
1 Bienal de Artes Visuais do Mercosul (exh. cat., Porto Alegre, Fund. Bienal A. Visuais Mercosul, 1997)
ADRIAN LOCKE

Vila Rica. *See* OURO PRÊTO.

Vilamajó, Julio (*b* Montevideo, 1 July 1894; *d* Montevideo, 11 April 1948). Uruguayan architect, teacher and writer. He qualified as an architect in 1915 and two years later began teaching architecture. From 1921 to 1924 he was in Europe on a university scholarship and was exposed to Hispano-Islamic culture. This influenced the houses that he designed between 1925 and 1927 and one that he built for himself in 1930; the latter displays a combination of Modern Movement principles, Florentine Renaissance

architecture (seen in the overall shaping of masses and the decorative treatment of the façades), and Vilamajó's fondness for the Islamic tradition, which is evident in his handling of vegetation, light and water and in the subtle gradation of external spaces.

Despite his receptiveness to a variety of influences, he created some highly original works, notably the annexe to the Americana Café (1914), Montevideo; the Facultad de Ingeniería (begun 1937), Universidad de Montevideo; and the Villa Serrana resort centre (completed 1948), *c.* 140 km north of Montevideo. The geometrical clarity of the Americana Café, the severity of its proportions and the dark grey and sepia tones achieved by Vilamajó's use of ceramic cladding are reminiscent of the work of Joaquín Torres García. The Facultad de Ingeniería surprises by the systematic use of exposed reinforced concrete and the bold treatment of openings, volumes and surfaces. Its most striking feature is the convincing resolution of the problems posed by the site, which was uneven and near a low-density residential area, a public park and the Río de la Plata estuary. Its elevated setting and mass make the work a landmark. At Villa Serrana, Vilamajó planned an irregular distribution of houses and a layout of zigzag roads that follow the contours to preserve the natural features of the area. He formulated guidelines concerning the construction of private houses, which limited the materials used to local stone, wood and brick, to be painted within a fixed range of colours (ochres, browns and reds). The houses had to have sloping, thatched roofs supported on simple structures built using roughly hewn poles of eucalyptus wood. Vilamajó also designed a parador (Ventorrillo de la Buena Vista) and a hotel (Mesón de las Cañas), which were completed soon after his death. Both reveal the freshness and confidence with which he combined foreign influences and specifically local traditions in his use of materials and building techniques.

WRITINGS

'Estudios regionales para Punta del Este', *Diario 'El Día'* (18 Aug 1943)

BIBLIOGRAPHY

'Dibujos de Julio Vilamajó', *Montevideo U. Arquit. Rev.*, vi (1965)
A. Lucchini: *Julio Vilamajó: Su arquitectura* (Montevideo, 1970)
M. Arana: 'Julio Vilamajó ante la arquitectura y el medio', *Nuestra Arquit.*, I (1980), pp. 34–41
M. Arana and L. Garabelli: *Arquitectura renovadora en Montevideo, 1915–1940* (Montevideo, 1991)
C. J. Loustau: *Vida y obra de Julio Vilamajó* (Montevideo, 1994)

MARIANO ARANA

Vilanova, João B. Artigas. *See* ARTIGAS, JOÃO B. VILANOVA.

Vilar, Antonio Ubaldo (*b* La Plata, 16 May 1889; *d* Buenos Aires, 7 April 1966). Argentine engineer and architect. He graduated as a civil engineer from the Universidad de Buenos Aires in 1914 and then worked for an oil company in Patagonia (1918–20) and, throughout the 1920s, as a land surveyor. He helped with the studies for Le Corbusier's master-plan *Les Grands Travaux de Buenos Aires* (1929; unexecuted). Vilar subsequently established a large practice in collaboration with his brother Carlos Vilar, and he was among the early proponents of Rationalism and internationalism in Argentina. His early works include a minimal housing system first used at the former premises of the Hindu Club (1931; destr.) at Don Torcuato in Buenos Aires province; several large blocks of flats, such as those for the Nordiska Kompaniet (1935; altered) and those on the Avenida Libertador (1935), both in Buenos Aires; the Banco Holandés Unido (1935; altered), Buenos Aires; and a series of private houses at San Isidro, the most notable (1938) of which, on the corner of Roque Sáenz Peña and Rivera Indarte, boasts a unique curved façade that echoes Le Corbusier's 'white' period. Vilar also designed the Hospital Policial Bartolomé Churruca (1938–42; with others), Buenos Aires, but he is perhaps most widely known for his work as chief designer for the Automóvil Club Argentina. With a team that included Hector Morixe, Arnoldo Jacobs, Rafael Gimenez and Abelardo José Falamir, Vilar designed the Club's graphics and standard equipment as well as its headquarters building (1940–43) on the Avenida Libertador, Buenos Aires, and out-stations throughout the country. His later buildings tend towards an incipient classicism but are marked by high-quality construction, usually executed in such materials as granite and marble.

BIBLIOGRAPHY

M. Scarone: *Antonio Vilar* (Buenos Aires, 1975)
S. Borghini, H. Salama and J. Solsona: *1930–1950: Arquitectura moderna en Buenos Aires* (Buenos Aires, 1987), pp. 38–42, 46–50, 70–74, 97–107
E. Katzenstein: 'Argentine Architecture of the Thirties', *J. Dec. & Propaganda A.*, xviii (1992), pp. 54–75

LUDOVICO C. KOPPMANN

Vilar, Manuel (*b* Barcelona, 15 Nov 1812; *d* Mexico City, 25 Nov 1860). Catalan sculptor and teacher, active in Mexico. He studied at the Escuela de Nobles Artes in Barcelona under Damián Campeny and from 1834 on a scholarship in Rome under Antonio Solá at the Accademia di S Luca. He also attended the studios of Bertel Thorvaldsen and Pietro Tenerani in Rome. He adhered to the aesthetic doctrines of purism, and professed an admiration for the Italian 'primitives' of the 13th to 15th centuries. In 1846, with his friend Pelegrín Clavé, Vilar accepted the Mexican government's invitation to reorganize the departments of sculpture and painting at the Academia de S Carlos in Mexico City. They restructured the curriculum and between 1849 and 1881 mounted regular art exhibitions, to which teachers, students and artists independent of the academy contributed their works. The interest generated raised art criticism in Mexico to a professional level.

Vilar was an excellent teacher, solicitous of his pupils at a period of economic and political instability hardly favourable to the practice of sculpture. He also acted as an agent, advising the academy about the acquisition of works and securing commissions for his students. His personal output was also prolific, although limited by lack of means. His pieces were moulded in plaster until the end of the 19th century and early 20th, when his reputation ensured that the more monumental works were cast in bronze. For example, his bronze statue of *Christopher Columbus* (1892) stands in the Plaza de Buenavista, Mexico City, while the plaster cast version (1858) is in the collection of the city's Museo Nacional de Arte. A notable work on a religious theme, *St Carlo Borromeo Protecting a Child* (1858; Mexico City, Mus. S Carlos), allegorizes the pater-

nalistic nature of the academy. He also explored themes of national history, in works such as *Moctezuma [Motecuhzuma] II* (1850; Mexico City, Mus. N. A.). He fulfilled various commissions for monuments to *Augustín de Iturbide*, who helped consolidate Mexican independence in 1821.

WRITINGS
S. Moreno, ed.: *Copiador de cartas y diario particular* (Mexico City, 1979)

BIBLIOGRAPHY
S. Moreno: *El escultor Manuel Vilar* (Mexico City, 1969)

FAUSTO RAMÍREZ

Villagrán (García), José (*b* Mexico City, 22 Sept 1901; *d* Mexico City, 10 June 1982). Mexican architect, teacher and theorist. He graduated in 1923 from the Academia de S Carlos, Mexico City. There his teachers, many of whose professional careers had coincided with the dictatorial regime (1876–1910) of General Porfirio Díaz, emphasized the virtues of nationalism and modernity in architecture. At the time of Villagrán's graduation, however, the Mexican Revolution had just ended, and the great transformation of the country's social life was just beginning, in which architecture was to play an important part through the provision of an infrastructure of schools and hospitals as well as low-cost housing. It was in the medical field that Villagrán began his career, designing the Instituto de Higiene y Granja Sanitaria (1925–7) in Mexico City, which in the shape of its isolated pavilions represented a break with the architecture of the past. The hospital was also carefully planned to meet the specific clinical demands of the medical advisers who acted as architectural consultants. The result was a synthesis of the aesthetic and the functional that was emblematic of the 'integralism' of Modernist architecture of the time, of which Villagrán became the undisputed leader.

Villagrán continued to find hospital design a fertile area as his career developed in the 1930s and 1940s. Works from this period include the Hospital para Tuberculosos (1929–36) in Huipulco, a suburb of Mexico City; the Instituto Nacional de Cardiología (1937–44), designed in collaboration with the distinguished cardiologist Ignacio Chávez; the Pabellón de Cirugía (1941); and the Hospital Manuel Gea González (1943–7). In all of these he overcame severe limitations in terms of economic resources to produce works notable for their breadth of outlook. These buildings are also all examples of Villagrán's gradual transition from compositions dominated by rhythm and symmetry to a more harmonious approach, in which the essential element was the asymmetrical combination of volumes and spaces. His projects were not limited to designs for hospitals, however. He designed his own house and the La Palma office building (both 1935), both in Mexico City, and the Escuela de Arquitectura y Museo de Arte (1951; in collaboration with Alfonso Liceaga and Xavier García Lascurain) at the city's Ciudad Universitaria. In the last, carefully proportioned areas of unadorned brickwork alternate with large areas of glazing in metal frames. In the 1950s and 1960s he also collaborated with a number of architects (including Gabriel García del Valle, José Antonio Mendizabal, Ricardo Legorreta and Raúl Gutiérrez) on a number of office buildings (e.g. for the

Ford Motor Company, 1963) and hotels (e.g. Hotel Maria Isabel, early 1960s), all in Mexico City.

Villagrán was perhaps as important for his teaching and theoretical work, however, as for his executed designs. He taught at the Academia de S Carlos from 1923 until 1957, and was a director of the Universidad Nacional Autónoma de México from 1953 to 1970, where he was Professor of Theory of Architecture at the Escuela Nacional de Arquitectura. To all his students (who included Enrique del Moral, Juan O'Gorman and Enrique Yañez) he emphasized the need for 'Mexican solutions to genuinely Mexican problems' and the importance of a complete mastery of construction techniques, since they should plan only what they knew to be practically possible. While the modernity and nationalism extolled by his own teachers had been worthwhile aims, these could, he believed, be achieved only by remaining faithful to national habits and customs. An essential element in his architectural theory, derived from these beliefs, was the idea of 'architectural sincerity', derived from a commitment to national character, modernity, regionalism and beauty.

WRITINGS
Panorama de 50 años de arquitectura mexicana contemporánea (Mexico City, 1950)
Meditaciones ante un crisis formal de la arquitectura (Mexico City, 1962)
Apuntes para un estudio (Monterrey, 1963)
Esencia de lo arquitectónico (Mexico City, 1971)
Integración del valor arquitectónico (Mexico City, 1992)

BIBLIOGRAPHY
A. T. Arai: 'José Villagrán García: Pilar de la arquitectura contemporánea de México', *Arquit. México* (1955)
R. Vargas: *José Villagrán y la escuela mexicana de arquitectura* (Mexico City, 1987)
R. Vargas Salguero: *Teoría de la arquitectura* (Mexico City, 1987)
F. González Gortázar, ed.: *La arquitectura mexicana del siglo XX* (Mexico City, 1994)
E. Burian, ed.: *Modernity and the Architecture of Mexico* (Austin, 1997)

RAMÓN VARGAS

Villalpando, Cristóbal de (*b* Mexico City, *c.* 1644; *d* Mexico City, 1714). Mexican painter. He worked in a decorative Baroque style, based on the primacy of light and colour over accuracy of form. In 1675 he painted the altarpiece of the church of S Rosa de Lima, Huaquechula, Puebla, and subsequently worked until 1681 on the altarpiece of the church of S Rosa de Lima, Azcapotzalco. On several occasions between 1683 and 1686 he produced paintings for Mexico City Cathedral, including the *Apotheosis of St Michael*, the *Woman of the Apocalypse*, the *Church Militant and Triumphant* and the *Triumph of the Eucharist* (all *in situ*). In 1686 he worked on the triumphal arch dedicated to the Conde de la Monclova, Melchor Portocarrero and Lasso de la Vega. This was followed by the *Apotheosis of the Eucharist* in the Cúpula de los Reyes, Puebla Cathedral, and a new version of the *Church Militant and Triumphant* for Guadalajara Cathedral. In 1691 Villalpando painted a series on the *Life of St Francis* for the Franciscan monastery of Antigua, Guatemala, and in 1710 a series on the *Life of St Ignatius Loyola* for the Jesuits at Tepotzotlán. Other works by Villalpando include the *Flagellation*, *St Teresa*, *St John of the Cross*, the *Betrothal of the Virgin*, the *Entombment*, the *Agony in the Garden*, the *Presentation of the Virgin* (Mexico City, Monastery S María de los Angeles), another version of the *Entombment*, the

Annunciation, the *Nativity* and the *Flight into Egypt* (all Mexico City, Pin. Virreinal).

BIBLIOGRAPHY

J. Fernández: 'Composiciones barrocas de pinturas coloniales', *An. Inst. Invest. Estét.*, xxviii (1958)
F. Maza: *Cristóbal de Villalpando* (Mexico City, 1964)
M. Toussaint: *Pintura colonial en México* (Mexico City, 1965)
E. Marco Dorta: *Arte en América y Filipinas*, A. Hisp., xxi (Madrid, 1973)
S. Sebastian, J. de Mesa and T. Gisbert: *Arte iberoamericano desde la colonización a la independencia* (Madrid, 1985)
J. Gutiérrez Haces and others: *Cristóbal Villalpando (c.1649–1714)* (Mexico City, 1997)

MARIA CONCEPCIÓN GARCÍA SÁIZ

Villanueva, Carlos Raúl (*b* Croydon, Surrey, 30 May 1900; *d* Caracas, 16 Aug 1975). Venezuelan architect and teacher, of English birth. His father, Carlos Antonio Villanueva, was a diplomat and author of several history books about South America. His mother, Paulina Astoul de Villanueva, was French and was his link with the culture and life of Europe, where he spent his early life. In 1920 he began to study architecture with Gabriel Héraud at the Ecole des Beaux-Arts, Paris, from which he graduated in 1928; he then went on to study at the Institut d'Urbanisme, University of Paris. In 1929 he returned to Venezuela and settled in CARACAS, where he established his own architectural practice. This long stay in Europe marked his professional and personal life; his subsequent approach to architecture was inspired by his European background, and he even spoke his mother tongue, Spanish, with a strong French accent. At the same time, however, he was deeply interested in both the traditional architecture of Venezuela and its constraints, such as the brilliant light and tropical climate.

From 1929 to 1939 Villanueva was Director of Buildings at the Ministry of Public Works in Caracas. His early works included the bullring (1931) in Maracay, where a traditional arcaded form was expressed with a skeletal concrete structure, and a group of buildings in Caracas begun in 1935: the Museo de Los Caobos (now the Museo de Bellas Artes), the Museo de Bellas Artes and the Museo de Ciencias Naturales. This museum complex is characterized by a series of indoor–outdoor rooms; one of its main features is the way in which it utilizes the strong light contrasts of the climate. Other buildings of this period include the prize-winning Venezuelan Pavilion at the Exposition Internationale des Arts et Techniques dans la Vie Moderne, Paris (1937; with Luis Malaussena), and the Escuela Gran Colombia (1939), Caracas, which reveals the influence of the Paris school of architecture.

In 1940 Villanueva won a competition organized by the Banco Obrero, an institution that provided low-cost housing, for the redevelopment of El Silencio, a working-class quarter in the centre of Caracas. Here he produced a series of buildings linked by a continuous arcade at street-level and grouped around a central plaza, revealing a concern for the quality of the human environment that became characteristic of all his work. He remained consultant architect to the Banco Obrero until 1960. Another low-cost housing project of this period responded to traditional residential patterns: the General Rafael Urdaneta development (1943–4), Maracaibo, a mixture of single-family houses and low-rise blocks of flats, was

Carlos Raúl Villanueva: foyer of Aula Magna (auditorium), Ciudad Universitaria, Caracas, 1952

planned concentrically around urban amenity centres and public spaces, and the buildings made full use of natural ventilation techniques. He developed these principles in several housing projects subsequently built in Caracas, such as the Fransico de Miranda and Coche developments (1946–7); Ciudad Tablitas and El Paraíso (with Carlos Celis Cepero and Manuel Mijares), both begun in 1951; and 23 de Enero (1955–7; with José Manuel Mijares, Carlos Brando and José Hoffman). The last two projects are considered among the best low- to middle-income housing complexes in Venezuela. Set in a hillside landscape, the mixture of low- and high-rise blocks allows much of the natural environment to be retained and makes full use of the cool breezes found above ground-level.

In 1944–5 Villanueva began work on perhaps his best-known project, the Ciudad Universitaria, Caracas (see fig.), producing a master-plan and the first building for the department of medicine. Construction continued on the project until its completion in 1959, with Villanueva designing a large number of separate faculty buildings, auditorium and library. A feature of the exposed concrete structure is the use of precast lattice panels that produce brilliant patterns of sunlight and shade as well as promoting the flow of air. The entire complex is set in landscaped gardens connected by covered walkways and plazas incorporating works of art. The integration of architecture, painting and sculpture in the Ciudad Universitaria is one of its principal characteristics; for Villanueva this symbolized the understanding of common goals as well as the compromise between different modes of expression. He included works by Alexander Calder, Victor Vasarely, Antoine Pevsner, Baltasar Lobo, Hans Arp, Fernand Léger and Henri Laurens, as well as important Venezuelan artists such as Mateo Manaure, Armando Barrios, Oswaldo Vigas, Víctor Valera, Francisco Narváez and Carlos González Bogen. The result is a truly beautiful university campus, with halls and shady plazas strewn with works of art and interspersed with spacious gardens. Another notable building designed by Villanueva at the Ciudad Universitaria is the Olympic stadium (1950–52), an elegant structure of slender concrete columns and cantilevered beams. He became the founding Professor of Architecture at the university in 1944.

Later works by Villanueva include the Fundación La Salle office building (1961–4), Caracas; the Venezuelan Pavilion (1967; with E. Trujillo) for Expo '67 in Montreal, in which he placed a *Penetrable* by the artist Jesús Soto; the Museo Jesús Soto (1970–73) in Ciudad Bolívar; and the new building for the Museo de Bellas Artes (begun 1972), Caracas. He received many national and international honours and awards, including the Premio Nacional de Arquitectura (1963) for his work on the university campus in Caracas. He was a founder and President of the Sociedad de Arquitectos de Venezuela and the Consejo Nacional de Protección de Monumentos Históricos, which reflected his continuing interest in the historical architecture of Venezuela. Villanueva's development of a lyrical and structurally dynamic version of Modernism, adapted to the environment and traditions of Venezuela, had a lasting influence on younger architects of the region.

WRITINGS

La Caracas de ayer y de hoy, su arquitectura colonial y la reurbanización de El Silencio (Paris, 1950)
Caracas en tres tiempos (Caracas, 1966)

BIBLIOGRAPHY

A. Granados Valdés: *Guía obras de arte de la Ciudad Universitaria* (Caracas, n.d.)
A. Bloc: 'Cité Universitaire de Caracas: Essai d'intégration des arts au centre culturel', *Archit. Aujourd'hui*, 55 (1954), pp. 52–61
S. Moholy-Nagy: *Carlos Raúl Villanueva and the Architecture of Venezuela* (New York, 1964)
'Three Cubes of Colour: The Venezuelan Pavilion at Expo '67', *Archit. Forum*, cxxvii/2 (1967), pp. 58–9
F. Bullrich: *New Directions in Latin American Architecture* (London and New York, 1969), pp. 73–82
G. Gasparini and J. P. Posani: *Caracas a través de su arquitectura* (Caracas, 1969)
J. P. Posani and M. Suzuki: *Carlos Raúl Villanueva* (Tokyo, 1970)
D. Bayón and P. Gasparini: *Panorámica de la arquitectura latino-americana* (Barcelona, 1977; Eng. trans., New York, 1979), pp. 214–31
J. P. Posani: *The Architectural Works of Villanueva* (Caracas, 1985)
L. Soffer and A. Grumbach: 'Carlos Raúl Villanueva', *Art d'Amérique Latine, 1911–1968* (exh. cat., Paris, Pompidou, 1992), pp. 456–61
Arquitectura de Carlos Raúl Villanueva (Caracas and Madrid, 1993)

BÉLGICA RODRÍGUEZ

Villanueva, Emilio (*b* La Paz, 28 Nov 1884; *d* La Paz, 14 May 1970). Bolivian engineer, architect, urban planner and writer. He qualified as an engineer in Chile in 1907, pursued an academic career to become Dean of the Faculty of Science and Rector of the Universidad Boliviana Mayor de 'San Andrés', La Paz, and served as Minister for Education after World War I. In 1943 he founded the School of Architecture in the Universidad de La Paz, the first in Bolivia other than the short-lived school begun by Philippe Bertrés and José Núñez del Prado in the 1830s. Brought up in the aura of French academicism, Villanueva produced buildings in the 1920s and 1930s in that style; the Banco Central de Bolivia (1926), La Paz, is an example. Buildings such as his Alcaldía Municipal (1925), La Paz, with its 17th-century French influence, and the Hospital General (1916–25), in the Miraflores district of La Paz, however, show greater eclecticism. Thereafter Villanueva worked towards a national architecture based on the ancient Pre-Columbian culture of Tiahuanaco, of which the monolithic architecture and characteristic sculpture inspired his Stadium in La Paz (1942; destr., see Mesa, pp. 40–41) and influenced the form and structure of his building for the Universidad Boliviana Mayor de 'San Andrés' (1940–8), La Paz. As an urban planner he was responsible for planning Mariscal Santa Cruz (1945), the principal avenue of the city of La Paz along the bed of the River Choqueyapu, and prepared a development plan (1927) for the Miraflores district of the city.

WRITINGS

Urbanismo: Esquema de la evolución urbana en Europa y América (La Paz, 1943)
Urbanística: Práctica y técnica (La Paz, 1967)

BIBLIOGRAPHY

C. Mesa: *Emilio Villanueva: Hacia una arquitectura nacional* (La Paz, 1984)

TERESA GISBERT

Villasana, José María (*b* Veracruz, 1848; *d* Tacubaya, Mexico City, 14 Feb 1904). Mexican illustrator and lithographer. He began his career in 1869, making prints for the weekly *La ilustración potosina* in San Luis Potosí. He collaborated with Alejandro Casarín and Jesús Alamilla on illustrations using engravings coloured with pen for the novel *Ensalada de pollos* by José Tomás de Cuéllar. In these the use of a schematic design accentuated the

appearance of the figures portrayed. He created caricatures (1872–3) for *La orquesta* and other periodicals, but he established his reputation with caricatures (1874–6) of government figures for the weekly *Hijo Ahuizote*. Villasana was a member of the political party of President Porfirio Díaz and in 1880 published ferocious caricatures of Díaz's opponents in *El coyote emplumado*. He was co-publisher in 1883, with Ireneo Paz, of *La patria ilustrada* and in 1888 he founded his own weekly, *México y sus costumbres*; in both periodicals he published his own caricatures of public figures. In 1896 Díaz's government honoured him with a seat in the Chamber of Deputies. His last works were published in *El mundo ilustrado*, on which he collaborated from 1897.

BIBLIOGRAPHY

M. Toussaint: *La litografía en México en el siglo XIX* (Mexico City, 1934)
R. Carrasco: *La caricatura en México* (Mexico City, 1953)
C. Díaz y de Ovando: 'El grabado comercial en la segunda mitad del siglo XIX', *Hist. A. Mex.*, 85–6 (1982)

AÍDA SIERRA TORRES

Villavicencio, Antonio (*b* La Plata [now Sucre], 1822; *d* Sucre, after 1888). Bolivian painter. It is possible he was taught painting by Manuel Ugalde. He went to France to improve his skills, and in 1856 he was in Paris. His known works date from 1844 to 1866. He was active mainly in Sucre, although he also worked in Potosí and La Paz. He painted in various genres, but his work mainly consists of official portraits of presidents and national and regional dignitaries such as *Simon Bolívar* (U. Sucre, Mus. Charcas), *General José Ballivián* (1844; La Paz, Alcaldía) and *Mariano Melgarejo* (1866; Potosí, Mus. N. Casa Moneda). Villavicencio's style was sober and academic, but his portraits, landscapes and allegories have documentary value as a record of painting in the country after the long period of mestizo art.

BIBLIOGRAPHY

M. Chacón Torres: *Pintores del siglo XIX*, Bib. A. & Cult. Boliv.: A. & Artistas (La Paz, 1963)
P. Querejazu: *La pintura boliviana del siglo XX* (Milan, 1989)

PEDRO QUEREJAZU

Villegas, Armando (*b* Pomabamba, Ancash, 1928). Peruvian painter, active in Colombia. He studied at the Escuela Nacional de Bellas Artes in Lima until 1950 and then at the fine arts faculty of the Universidad Nacional de Colombia in Bogotá, where he then settled. His work was initially figurative, but it developed towards a more abstract style (e.g. *Electric Panmorama*, 1958; see colour pl. XL, fig. 2), blending references to Pre-Columbian textile art and colonial art in largely monochromatic, textured paintings. Figurative elements later re-emerged in symbolic, Baroque-inspired compositions that evoke the works of Lucas Cranach, Dürer or Niklaus Deutsch, and in drawings that similarly look to European rather than Andean traditions (e.g. *Knight of the Thistle*, 1978; priv. col.; see Fraser and Baddeley, pl. 14). In the 1980s his work increasingly contained mythological and symbolic elements (e.g. *Masked Nobleman*, 1986; priv. col.; see Fraser and Baddeley, p. 76).

BIBLIOGRAPHY

J. A. de Lavalle and W. Lang: *Pintura contemporánea, II: 1920–1960*, Col. A. & Tesoro Perú (Lima, 1976), pp. 164–7

V. Fraser and O. Baddeley: *Drawing the Line: Art and Cultural Identity in Contemporary Latin America* (London, 1989), pp. 75–6

W. IAIN MACKAY

Vinatea Reinoso, Jorge (*b* Arequipa, 22 April 1900; *d* Arequipa, 15 July 1931). Peruvian painter and illustrator. He first exhibited in Arequipa in 1917 after leaving school, and in 1918 he went to Lima, where he was influenced most notably by the work of the Peruvian painter Daniel Hernández, who from 1919 to 1924 taught him at the Escuela Nacional de Bellas Artes. After working as an art critic for the newspaper *El Comercio* and contributing as a caricaturist to the magazines *Mundial* and *Variedades*, in 1925 he began teaching at the Escuela Nacional. Vinatea Reinoso's caricatures were rarely rebellious or anarchic but reflected the gentle satire typical of the work of PANCHO FIERRO. His painting, which pioneered Peruvian Indigenism, was influenced by the work of the French Impressionists and by the other leading Indigenist painter, JOSÉ SABOGAL, although Vinatea Reinoso used more complex perspectives and structures than many Indigenists. His colours were generally subdued and were applied with fragmentary brushstrokes, giving a somewhat unfinished appearance to his works (e.g. *Church Interior, Cuzco*, 1930; Lima, Mus. Banco Cent. Reserva).

BIBLIOGRAPHY

C. Gálvez: 'Un caricaturista arequipeño', *Fanal*, xxii/81 (1967), pp. 10–13
J. Villacorta Paredes: *Pintores peruanos de la República* (Lima, 1971), pp. 60–69
Jorge Vinatea Reinoso (exh. cat. by J. M. Ugarte Eléspuru, Lima, Mus. A. It., 1980)
L. E. Tord: *Jorge Vinatea Reinoso* (Lima, 1992)
L. E. Wuffarden and N. Majluf: *Jorge Vinatea Reinoso, 1900–1931* (exh. cat., Lima, Mus. N. Lima, 1997)

W. IAIN MACKAY

Viñolesco style. *See* ESTILO DESORNAMENTADO.

Virasoro, Alejandro (*b* Buenos Aires, 1892; *d* Buenos Aires, 1978). Argentine architect. From the age of 15 he attended the school of architecture set up in 1901 by Alejandro Christophersen in the Universidad de Buenos Aires, where his final projects revealed a challenge to prevailing academic attitudes that continued throughout a successful professional career. Virasoro acknowledged the influence upon his work of Léon Bakst's stage designs for the Diaghilev ballet, which visited Buenos Aires after World War I, and of Matila Ghyka's early books on the theories of mathematical proportion: *Esthétique des proportions* (Paris, 1927) and *Le Nombre d'or* (Paris, 1931). In line with the populist reforms of the 1920s, Virasoro adopted high standards of performance and provided good facilities for employees in his design and construction organization, for which he adopted the motto *Viribus Unitis*. Although the change to right-wing government in 1930 caused the collapse of Virasoro's practice, he is regarded as one of the pioneers of the Modern Movement in Latin America and of prefabricated housing in particular. His approach to modernism was through Art Deco, for example in his own house (1925) at calle Agüero, Buenos Aires, and in La Equitativa del Plata (1929), which has been criticized for excessive use of the square in its decoration. Virasoro also built a number of non-rhetorical urban buildings in Buenos Aires, such as the Banco El

Hogar Argentino (1926), calle B. Mitre, and the Casa del Teatro (1927), Avenida Santa Fé. Perhaps most notable, however, were his early contributions to social housing, using prefabricated components to achieve simple geometrical forms, as in La Continental housing development (1929) at Banfield, Buenos Aires Province.

BIBLIOGRAPHY
F. Bullrich: *Arquitectura argentina contemporánea* (Buenos Aires, 1963)
J. M. Peña and J. Martini: *Alejandro Virasoro* (Buenos Aires, 1969)
LUDOVICO C. KOPPMANN

Virgin Islands. *See under* ANTILLES, LESSER.

Visconti, Eliseu (d'Angelo) (*b* Salerno, 30 July 1866; *d* Rio de Janeiro, 15 Oct 1944). Brazilian painter and decorative artist, of Italian birth. He was taken as an infant from Italy to Rio de Janeiro. In 1884 he began studying in Rio de Janeiro at the Academia Imperial das Belas Artes and the Liceu Imperial de Artes e Ofícios under Victor Meirelles de Lima, Henrique Bernardelli (1837–1946) and Rodolfo Amoedo (1857–1941). He was active in efforts to eliminate the academy's rigid academic discipline. He went to Paris in 1892 and attended the Ecole des Beaux-Arts and the Ecole des Arts Décoratifs, where he was taught by Eugène-Samuel Grasset. At the 1900 Exposition Universelle in Paris, Visconti won a silver medal for the paintings *Youth* (1898) and *Dance of the Wood Nymphs* (1899; both Rio de Janeiro, Mus. N. B.A.). Following the Pre-Raphaelites, his main influences were Botticelli and other painters of the Italian Renaissance, but he was also affected by Grasset and Art Nouveau. On his return to Brazil, among the works exhibited in 1901 in Rio de Janeiro were a series of ceramic objects with Brazilian floral motifs and designs for postage stamps. His florid style began to give way to Impressionism in the stage curtain, circular ceiling panel and proscenium frieze he executed for the Rio de Janeiro Teatro Municipal (1906–7; *in situ*). In 1906 he became director of painting at the Escola Nacional de Belas Artes in Rio de Janeiro.

In 1923 Visconti decorated the hall of the Conselho Municipal in Rio de Janeiro (*in situ*), and in 1924 he painted the panel the *Signing of the First Republican Constitution* (*in situ*) for the Palácio Tiradentes, also in Rio. At the end of his life, continuing to paint in an Impressionist style, he carried out a series of joyful family portraits and luminous landscapes of the mountain region of Teresópolis, near Rio.

BIBLIOGRAPHY
Pontual
F. Barata: *Eliseu Visconti e seu tempo* (Rio de Janeiro, 1944)
J. M. dos Reis Júnior: *História da pintura no Brasil* (São Paulo, 1944)
P. M. Bardi: *The Arts in Brazil* (Milan, 1956)
Art of Latin America since Independence (exh. cat. by S. L. Catlin and T. Grieder, New Haven, Yale U. A.G.; Austin, U. TX, Huntington A.G.; San Francisco, Mus. A.; La Jolla, A. Cent.; 1966)
Q. Campofiorito: *História da pintura brasileira no século XIX* (Rio de Janeiro, 1983)
Eliseu Visconti e a arte decorativa (exh. cat. by I. Arestizabal, Rio de Janeiro, Solar Grandjean de Montigny, 1983)
ROBERTO PONTUAL

Vital Brazil, Álvaro (*b* São Paulo, 1 Feb 1909). Brazilian architect. He studied in Rio de Janeiro, graduating as a civil engineer from the Escola Politécnica and as an architect from the Escola Nacional de Belas Artes (1933), where he participated in the reforms of 1931–2 when Lúcio Costa introduced Modernist teachers; this exposed him to the teachings of Le Corbusier and his rationalist approach to Modernism. Until 1936 he worked with Adhemar Marinho (*b* 1911), and they designed the Esther building (1936) in São Paulo, which is considered to be the first free-standing modern building in the city. It was also the first multi-use building in São Paulo, comprising ten floors of shops, offices and flats as well as an underground car park. Conceived in accordance with Le Corbusier's principles, it combined a new structural system of pilotis and open-plan floors with a sculptural sense of the building's volume, its four façades articulated in a manner reminiscent of Art Deco. A member of CIAM, Vital Brazil worked as a Modernist architect for 50 years, particularly in Rio de Janeiro. He adopted an extremely elegant, rational style with great simplicity and clarity of structure, exemplified in the Vital Brazil Institute (1941), Niteroi, a scientific laboratory building named after his father, a famous scientist, which comprised a long, white block raised on pilotis with small windows on the exposed side and full glazing on the other, its crisp appearance expressing the building's use. He won first prize at the first São Paulo Biennale (1951) with his design for the Clemente Faria bank building in Belo Horizonte, a triangular-shaped building with an elegant design incorporating horizontal bands of vertical *brises-soleil* on one façade. His work during the 1960s and 1970s includes the apartment block in Rua Timbiras (1961) and the Banca da Lavoura de Minas Gerais (1963), both in Belo Horizonte; the house in Rua Constantino Menelau, Cabo Frio (1961); and the house for Tiso Vital Brazil, Rua Alves Mota, Guaratinguetá (1972).

WRITINGS
50 anos de arquitetura (São Paulo, 1986)

BIBLIOGRAPHY
H. E. Mindlin: *Modern Architecture in Brazil* (Amsterdam and Rio de Janeiro, 1956)
C. A. C. Lemos: *Arquitetura brasileira* (São Paulo, 1979)
A. Xavier, C. Lemos and E. Corona: *Arquitetura moderna paulistana* (São Paulo, 1983)
P. Nobel: *Alvaro Vital Brazil: 50 años de arquitetura* (São Paulo, 1986)
CARLOS A. C. LEMOS

Viteri, Oswaldo (*b* Ambato, 8 Oct 1931). Ecuadorean painter and draughtsman. He studied architecture at the Universidad Central del Ecuador, Quito. In 1960 he won the Gran Premio at the Salón Mariano Aguilera with *Man, House and Moon* (Quito, Mus. Municipal Alberto Mena Caamaño), with which he expressed an ongoing attempt to come to terms with the past and with the history of South America, as well as a desire to move beyond the anecdotal language of some Ecuadorean art. There followed a brief 'Pre-Columbian' phase, during which he sought mestizo symbols for his painting. By the mid-1960s his work was abstract, and by 1970 he had moved on to assemblage and a rejection of previous pictorial language, producing compositions of rag dolls, old cement bags and the gold borders of ecclesiastical vestments and other elements redolent of Latin America's colonial past. In the 1970s he continued to use rag dolls coupled with other textures, for example in *We Are Wanderers of the Night*

and of Suffering (1979; Quito, artist's col.). Viteri's conceptually based art sought to universalize from a mestizo perspective Andean and characteristic local themes, such as isolation, in a highly contemporary language that helped rejuvenate Ecuadorean art.

BIBLIOGRAPHY

Viteri (exh. cat., Madrid, Club Int. Prensa, 1969)

M. Traba: *Dos décadas vulnerables en las artes plásticas latinoamericanas, 1950–1970* (Mexico City, 1973), p. 43

H. Rodríguez Castelo: 'Viteri', *Rev. Diners*, 14 (1982), pp. 54–8

——: *Viteri* (Bogotá, 1992)

CECILIA SUÁREZ

Vitullo, Sesostris (*b* Buenos Aires, 6 Sept 1899; *d* Paris, 16 May 1953). Argentine sculptor active in France. He studied at the Escuela Nacional de Bellas Artes in Buenos Aires before moving in 1925 to Paris, where he studied under Emile-Antoine Bourdelle. Living a tragic bohemian existence and feeling a strong nostalgia for Latin America, he returned incessantly to the theme of the gaucho, as in *Gaucho in the Bough* (grey granite, 1951; Buenos Aires, Mus. A. Mod.), and sought also to conjure the landscape of Argentina—with its light, its wind and the contours of the Andes—in sculptures such as *Totem Patagonia* (wood, 1951; Buenos Aires, Mus. A. Mod.).

Basing his stark and violently contrasting intersecting planes on a close analysis of natural forms, Vitullo arrived at a symbolic visual language by which the horizontality of the pampa and the verticality of the mountains are equated with masculine and feminine archetypes. He carved a variety of materials, notably oak, marble, granite and other stone.

BIBLIOGRAPHY

Vitullo sculpteur argentin (exh. cat., intro. B. Dorival; Paris, Mus. N. A. Mod., 1952) [45 works, 1940–52]

Vitullo au Musée Bourdelle et dans les grandes collections (exh. cat., intro. M. Dufet; Paris, Mus. Bourdelle, 1981)

I. Pirovano and others: *Sesostris Vitullo: Escultura* (Buenos Aires, 1997)

NELLY PERAZZO

Vivaceta Rupio, Fermín (*b* Santiago, 1829; *d* Valparaíso, 1890). Chilean architect. His father was unknown and his mother a humble laundress who made great efforts in order to educate her son. He began working for a cabinetmaker at the age of 13 and then joined a drawing class for craftsmen at the Instituto Nacional, Santiago. There were few professional architects in Chile at that time, and he was commissioned at the age of 18 to design the Casa de Orates building. Vivaceta Rupio joined the first architecture class of the Frenchman Claude François Brunet-Debaines (1788–1855), who had been contracted by the Chilean government. His fellow pupil Ricardo Brown and he were the first architects to be trained in Chile. As a result of his assiduity and determination, he was selected by Brunet-Debaines to complete outstanding works when the contract expired. Working in the 19th-century Neo-classical tradition, with some gestures towards the neo-Gothic, Vivaceta Rupio rebuilt the towers of several Santiago churches and built several private houses and the church and convent of Carmen Alto. He contributed to repairs to the cathedral of Santiago and collaborated with Brunet-Debaines on plans for the Portal Tagle, Casa McClure and the Iglesia de la Veracruz (1852) and with Lucien Ambrose Hénault (1790–1880) on the

Universidad de Chile (1863; for illustration *see* SANTIAGO), all in Santiago. Deeply concerned for the welfare of labourers and artisans, in 1862 he founded the first mutual benefit society in Chile, the Unión de Artesanos, as well as the Escuela Nocturna de Artesanos, to provide training in the trades and to foster a spirit of fraternity.

BIBLIOGRAPHY

E. Pereira Salas: *La arquitectura chilena en el siglo XIX* (Santiago, n.d.)

R. A. Méndez Brignardello: *La construcción de la arquitectura: Chile, 1500–1970* (Santiago, 1983)

RAMÓN MÉNDEZ ALFONSO

Volpi, Alfredo (*b* Lucca, 14 April 1896; *d* São Paulo, ?30 May 1988). Brazilian painter of Italian birth. He was taken as an infant to São Paulo by his Italian parents and began painting in 1914 after working as a painter-decorator. In the 1930s he was involved in the modernist groups active in São Paulo, including the Família Artística Paulista; he held his first one-man exhibition at the Itá Gallery, São Paulo, in 1944. He became involved in the Concrete art movement in Brazil and took part in Concrete art exhibitions in São Paulo and Rio de Janeiro in 1956 and 1957.

Until the mid-1940s Volpi painted landscapes and figures in a rough, realistic manner, already revealing his strong attraction for the picturesque and popular aspects of his subjects. Between 1945 and 1950 he painted seascapes and groups of houses along the Itanhaem littoral,

Alfredo Volpi: *Night Façade*, tempera on canvas, 1.15×0.73 m, 1955 (Universidade de São Paulo, Museu de Arte Contemporânea)

but after 1950 he established his characteristic vocabulary of soft and sensual brushstrokes and simple, schematized shapes, with a limited range of such motifs as popular façades, church arches, flags, sails and masts; examples include *Night Façade* (1955; U. São Paulo, Mus. A. Contemp.; see fig.). In the 1970s these motifs gradually evolved into abstract geometrical paintings with contrasting ranges of colour, as in *Kinetic Composition* (1970; São Paulo, Mus. A. Mod.). In 1951 he painted a panel for the church of Cristo Operário (São Paulo), which he followed with frescoes for the chapel of Our Lady of Fátima (1958) and for the Palácio dos Arcos (1966) in Brasília.

BIBLIOGRAPHY

J. A. França: 'Volpi', *Aujourd'hui*, 46 (1964)

Alfredo Volpi (exh. cat., ed. A. Amaral; Rio de Janeiro, Mus. A. Mod., 1972)

T. Spanudis: *Volpi* (Rio de Janeiro, 1975)

A. Amaral, ed.: *Projeto construtivo brasileiro na arte, 1950–1962* (São Paulo, 1977)

R. Pontual: *Cinco mestres brasileiros: Pintores construtivistas* (Rio de Janeiro, 1977)

O. T. Araújo: *Dois estudos sobre Volpi* (Rio de Janeiro, 1986)

Volpi: 90 anos (exh. cat. by O. T. Araújo, São Paulo, Mus. A. Mod., 1986)

O. T. de Araújo: *A. Volpi* (São Paulo, 1991)

R. Naves: 'Anonimato e singularidade am Volpi', *A forma difícil: Ensaios sobre arte brasileira*, (São Paulo, 1997), pp. 179–96

ROBERTO PONTUAL

Warchavchik, Gregori (*b* Odessa, 2 April 1896; *d* São Paulo, 27 July 1972). Brazilian architect, writer and teacher of Russian birth. He studied architecture at the University of Odessa and the Scuola Superiore di Architettura, Rome, graduating in 1920, and he worked in Rome for the classicist architect Marcello Piacentini before moving to São Paulo in 1923 and entering private practice. In 1925 he published an article that became a manifesto for modern architecture in Brazil; its emphasis on the industrialization of construction, particularly of standard components for low-cost housing, foreshadowed the theories of CIAM, of which he was a member (1929–42). Warchavchik was responsible for the first modern houses in Brazil; they were functionalist designs and included his own house (1927–8), some low-cost housing (1929) and the 'Modernistic House' (1930), all in São Paulo. The latter, built for exhibition, introduced modern architecture to a wider audience; it was a Cubist design, complete with furniture, lighting and decoration, and it contained works by avant-garde artists such as Anita Malfatti (1896–1964), Victor Brecheret, Emiliano di Cavalcanti, Lasar Segall and Tarsila who had participated in the earlier Semana de Arte Moderna (1922). In 1931 Warchavchik was invited to teach a new course in modern architecture at the Escola Nacional de Belas Artes, Rio de Janeiro, by Lúcio Costa, who had been appointed to direct and reform the teaching there. Although the course was short-lived, it introduced the principles of avant-garde European architecture to a generation of Brazilian architects. He worked in partnership with Costa from 1931 to 1933, and with Oscar Niemeyer in their team they carried out several Functionalist projects, such as the group of low-cost houses (1933) in Gamboa, Rio de Janeiro. In 1939, with João B. Vilanova Artigas, Warchavchik won second prize in a competition for the town hall, São Paulo, his first urban-scale project (unexecuted). After 1940 his work moved away from the purism of his earlier projects and began to incorporate natural materials, as in the Crespi beach house (1943), with painted timber shutters, or the Prado beach house (1946), both in Guarujá. He continued to be a regular contributor to the newspapers of Rio de Janeiro and São Paulo until 1961; these writings and his early work had a profound influence on the development of modern architecture in Brazil.

WRITINGS

'Acerca de arquitetura moderna', *Correio Manhã* (1 Nov 1925)

BIBLIOGRAPHY

A. Sartoris: *Gli elementi dell'architettura funzionale* (Milan, 1931)

G. Ferraz: *Warchavchik e a introdução da nova arquitetura no Brasil, 1925 a 1940* (São Paulo, 1966)

Warchavchik, Pilon, Rino Levi: Três momentos de arquitetura paulista (exh. cat., São Paulo, Mus. Lasar Segall, 1983)

C. Rodríguez dos Santos: 'L'autre phare de Colomb: Origénes de l'architecture moderne au Brésil', *Art d'Amerique Latine, 1911–1968* (exh. cat., Paris, Pompidou, 1992), pp. 116–27

M. M. dos Santos Camisassa: *Modern Architecture and the Modernist Movement in Brazil during the 1920s and 1930s* (diss., Colchester, U. Essex, 1994)

REGINA MARIA PROSPERI MEYER

Watson, Barrington (*b* Lucea, Hanover, Jamaica, 9 Dec 1931). Jamaican painter and dealer. He studied at the Royal College of Art, London, the Rijksacademie, Amsterdam, and elsewhere in Europe. In the early 1960s, together with Karl Parboosingh and Eugene Hyde, he was one of the founding members of the Contemporary Jamaican Artists' Association, which gave impetus to the second generation of the Jamaican Art Movement. His approach was essentially academic and realist, with occasional modernist intrusions. He experimented with abstraction, and in some works he employed a futurist analysis of movement. He is best known for his large-scale, epic depictions of Jamaican life painted in grand academic manner, such as the *Garden Party* (1976; Bank of Jamaica col.), which is a panoramic commentary on the idiosyncrasies of Jamaican society. He was also a popular portrait painter, and his finest portraits, such as the portrait of *Valerie Bloomfield* (1962; see fig.), have an intimate, immediate quality. He was also well known for his nudes and erotic scenes, painted mainly in oil and watercolour. From 1962 to 1967 he was Director of Studies at the Jamaica School of Art, Kingston.

Barrington Watson: *Valerie Bloomfield*, oil on hardboard, 510×710 mm, 1962 (Kingston, National Gallery)

BIBLIOGRAPHY
P. Archer Straw and K. Robinson: *Jamaican Art* (Kingston, 1990), pp. 57, 59, 70–73, 166–7
D. Boxer and V. Poupeye: *Modern Jamaican Art* (Kingston, 1998)
V. Poupeye: *Caribbean Art* (London, 1998)

VEERLE POUPEYE

Watson, Osmond (*b* Kingston, 1934). Jamaican painter. He attended the art classes of the Institute of Jamaica's Junior Centre (1948–52) and then studied at the Jamaica School of Art in Kingston (1952–8). He began to exhibit in Jamaica with some success, but decided to further his studies at St Martin's School of Art in London (1962–5). On his return to Jamaica it was clear that his work had undergone a dramatic transformation, primarily as a result of his visits to the British Museum in London and his encounters there with masterpieces of African art. These may have struck a chord within him, but it was clear in his paintings that Picasso's Cubism provided the conduit for his Africanisms. In his sculpture, particularly his delicately polychromed bas-reliefs, the influence seems to have been more direct: many works seem related to Yoruba carvings in the proportions and massing of the figures. Intensely Jamaican in his subject-matter, he produced in the late 1960s and 1970s an extended series of paintings that drew their imagery from Jamaican Jonkonnu, a Christmas festival where the revellers are costumed and masked (*see* JAMAICA, §II, 2); these paintings are among his best-regarded and most popular works. Later he extended his iconography by delving into Jamaica's pre-colonial past to retrieve symbols and motifs from the lost Arawak culture. In some of these paintings of 'Arawak vibrations', Watson skirted the brink of abstraction. The teachings of the Black Nationalist Marcus Garvey and the philosophy of the Rastafarian movement influenced him tremendously, and he produced some moving images of Rastafarian and other Black subjects. He was also an obsessive painter of self-portraits, in some of which he is to be found in Rastafarian guise, as a revolutionary *Freedom Fighter* or as a Black Christ.

BIBLIOGRAPHY
D. Boxer and V. Poupeye: *Modern Jamaican Art* (Kingston, 1998)
V. Poupeye: *Caribbean Art* (London, 1998)

DAVID BOXER

Wessing, Koen (*b* Amsterdam, 26 Jan 1942). Dutch photographer, active also in South America. He studied at the Rietveld Academy in Amsterdam and then with the Dutch photographer Ata Kando, also working as a freelance press photographer in Amsterdam. From the end of the 1960s he worked as a documentary photographer in the tradition of politically engaged, concerned photography. His early work showed the influence of Ed van der Elsken (1925–90) with its interest in human drama, its use of a direct, lively approach and a dark printing technique; but he soon evolved a personal style, combining these elements with a strong formal approach.

Wessing made his first major photo-reportage in Paris during the student revolts in 1968, publishing it as *Parijs, 1968* (Amsterdam, 1968). From the 1970s he became deeply involved with the political situation of South America, later publishing collections of these images, such as *Chile, September 1973* (Amsterdam, 1974) and *Van*

Chili tot Guatemala: Tien jaar Latijns-America ('From Chile to Guatemala: Ten years in Latin America'; Amsterdam, 1983; Ger. trans., 1983). The most striking aspect of his photography is a sense of danger and aggression achieved through strong pictorial contrasts and symbolic details, seen in *Chile* (1973; see 1978 exh. cat., no. 78), where a man walks down a street apparently oblivious to the phalanx of armed policemen to his right. In the Netherlands, Wessing received various documentary commissions from the Amsterdam Fund for the Arts and in 1976 made a series entitled *Andere culturen in onze cultuur* ('Other cultures within our culture') for the Historical Department of the Rijksmuseum.

BIBLIOGRAPHY
Fotografie in Nederland, 1940–75 (exh. cat., ed. E. Barents; Amsterdam, Stedel. Mus., 1978)
P. Tereehorst: 'Koen Wessing', *Dut. A. & Archit. Today*, xx (1986)
P. Terreehorst and T. de Ruiter: *Koen Wessing* (Amsterdam, 1993)

HRIPSIMÉ VISSER

Wiedemann, Guillermo (*b* Munich, 1905; *d* Key Biscayne, FL, 1969). Colombian painter of German birth. He studied at the Kunstakademie in Munich under the German painter Hugo von Habermann (*b* 1899) and the German painter and printmaker Adolf Schinnerer (1876–1949). He lived in Berlin in 1931–2, coming into contact with Max Liebermann, and in 1933 he exhibited with the Neue Sezession in Munich. He decided to leave Germany for political reasons, particularly after Hitler's persecution of 'degenerate' art, and in 1939 he travelled to Colombia; he acquired Colombian nationality seven years later. He was immediately dazzled by the local population and by tropical plant life, which he began to interpret with an extremely expressive line and bold use of colour.

All vestiges of representation later disappeared from Wiedemann's work, and he devoted himself, particularly in his watercolours, to a lyrical use of colour that led him to pure abstraction. These paintings, in spite of their freedom of expression and colour, were characterized by strong lines and an underlying geometrical emphasis. Afterwards he made collages using humble materials such as wire, string, plaster, cloth and paper, which he transformed into aesthetically unified compositions notable for their rhythmic sequences. Wiedemann's work, particularly because of its poetic, spontaneous and experimental nature, influenced both abstract and figurative art in Colombia.

BIBLIOGRAPHY
M. E. Iriarte: *El arte descubre un mundo: Guillermo Wiedemann* (Bogotá, 1985)
Cien años de arte colombiano (exh. cat. by E. Serrano, Bogotá, Mus. A. Mod., 1985)
El legado de Guillermo Weidemann (exh. cat., Bogotá, Bib. Luis-Angel Arango, 1994)

EDUARDO SERRANO

Wilheim, Jorge (*b* Trieste, 23 April 1928). Brazilian architect and urban planner of Italian birth. He graduated as an architect–planner from Mackenzie University, São Paulo, in 1952 and his early works included the general hospital (1954), Santa Casa, Jaú, a typical International Style design of intercommunicating, long, low blocks, and the urban plan for the new town of Angelica (1956). In 1957 he led a team that took part in the national compe-

tition to develop a master-plan (unexecuted) for the new capital, Brasília, and in 1965 he produced a preliminary urban plan for Curitiba; this was based on his theory of urbanization as a continuous process that made elaboration of a plan in itself less important than the creation of organizations able to implement appropriate measures. This theory was used in all the plans financed by the Ministry of the Interior in the 1960s and 1970s. Other urban plans in which Wilheim was involved include those for Joinville, Santa Catarina, (1965; unexecuted); Osasco, São Paulo (1966); Goiânia (1968); São José dos Campos (1969); and Campinas (1969).

Wilheim also designed a large number of public buildings in collaboration with other architects, for example Anhembi Park (1967–73), São Paulo's main exhibition and convention hall, on 44 ha of land on the banks of the River Tiête; and the Museu de Arte Contemporânea (1975; with Paulo Mendes da Rocha) at the University of São Paulo, a square building with sharply angled walls, raised on columns. In 1981 he won an important competition for the replanning of Vale do Anhangabaú (1991), São Paulo, redesigning the traffic systems beneath an 8-ha pedestrian park incorporating a plaza for cultural events and an open exhibition space, together with bus and metro stations. He played an active role in public life as head of three government offices in São Paulo: the State Secretariat of Economy and Planning (1975–9); the Municipal Secretariat of Planning (1983–5) and, from 1986, the Secretariat of the Environment. He also led EMPLASA (the state agency for metropolitan planning) in the formulation of a new development plan for São Paulo (1992–2000). In 1992 work began on the construction of his new Opera House and Cultural Centre for the Performing Arts, São Paulo.

WRITINGS

São Paulo Metropole 65 (São Paulo, 1965)
O Substantivo e o adjetivo (São Paulo, 1976)
Espaços e palavras (São Paulo, 1985)

BIBLIOGRAPHY

H. E. Mindlin: *Modern Architecture in Brazil* (Amsterdam and Rio de Janeiro, 1956)
'Museu de Arte Contemporânea, Universidade de São Paulo', *Módulo*, 42 (1976), pp. 60–67

REGINA MARIA PROSPERI MEYER

Wilkins, Ricardo. *See* KAYIGA, KOFI.

Williams, Amancio (*b* Buenos Aires, 19 Feb 1913; *d* Buenos Aires, 14 Oct 1989). Argentine architect and urban planner. He was the son of the composer Alberto Williams. He first studied engineering and aviation and became a leading member of the Rationalist Grupo Austral, before graduating as an architect from the University of Buenos Aires in 1941; he then went into practice in Buenos Aires. Williams became well known for his daring design experiments, manipulating space and utilizing technology to the full; they include such projects as 'Dwellings in Space' (1942), International Airport (1945) and 'Hanging Office Building' (1946), all in Buenos Aires; the latter was conceived as four huge concrete columns with beams and upper arcades from which the floors were hung. His built works include the Concert Hall (1942–53), Buenos Aires, and the House over the Brook (1943–5; see fig.), con-

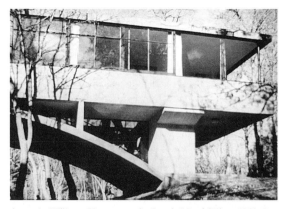

Amancio Williams: House over the Brook, Mar del Plata, 1943–5

structed for his father in Mar del Plata; with the aim of raising the building off the ground but eliminating columns, the structure was designed like a bridge, supported on a parabolic curve.

In 1947 he travelled to Europe and met Le Corbusier, whose work he greatly admired; he published the Charte d'Athènes of CIAM in Buenos Aires, and in 1948 he founded the Architectural Studies Centre there on the French model. He also supervised the building (1949–54) in La Plata of the only house in Latin America designed by Le Corbusier, using ramped first-floor access as a solution to the restricted frontage. Between 1943 and 1958 Williams also prepared regional plans for Patagonia, Buenos Aires, Corrientes and El Tigre; he designed three hospitals in Corrientes (1948–53) and the shell-form Bunge y Born Pavilion (1966), Sociedad Rural Annual Exposition, Buenos Aires. Later, unexecuted projects included some reinforced-concrete, vaulted and shell-roof buildings, the West German Embassy (1968; with Walter Gropius), Buenos Aires, and Antarctic City (1985). Although most of Williams's work remained unexecuted, it achieved great impact both locally and internationally, where it was often exhibited, receiving many honours and awards, and it played an important role in the development of modern architecture in Argentina.

See also under ARGENTINA, §II.

BIBLIOGRAPHY

R. González Capdevila: *Amancio Williams* (Buenos Aires, 1955)
M. Waisman: *Documentos para una historia de la arquitectura argentina* (Buenos Aires, 1978)
J. Silvetti, ed.: *Amancio Williams* (Cambridge, MA, 1987)
Amancio Williams, Archivo Amancio Williams (Buenos Aires, 1990)

LUDOVICO C. KOPPMANN

Windward Islands. *See under* ANTILLES, LESSER.

Women and art history. There is no lack of evidence of women's participation in the history of arts of all forms, cultures and periods, from ancient traditions, such as pottery and carving or silk-weaving and painting in China (*c.* 3000 BC), to the present and numerous forms of artistic expression. Yet traditional art history has kept us in systematic ignorance of the fact that women have always made art. It took the emergence of feminism in the late 20th century to redress the almost complete neglect of

women artists by art history and to undermine the stereotyped views of art made by women.

Little mainstream South and Central American art history has dealt specifically with the role of the woman artist. Individual artists such as the Colombian Beatriz Gonzalez (*b* 1936) or Marisol in Venezuela are dominant figures in their respective contexts. Certain artists, such as the Colombian DÉBORA ARANGO or the Cuban Amelia Peláez (1897–1968), have been re-appraised in light of feminist writings, but the problematic relationship of 'Latin American art' to that of 'international' art (see Richard) has in general taken precedence over discussions of gender divisions. The two issues have merged, however, in one instance. Late 20th-century perceptions of the art of South and Central America have been dominated by the enormous popularity of a woman artist, the Mexican FRIDA KAHLO. Kahlo has become not only the most famous and highly priced 'woman' artist but has also come to represent the perceived characteristics of an art produced outside the mainstream of European and North American culture (Baddeley, 1991).

The elision of these two strands of marginality within contemporary art history, the non-European and the 'feminine', has served to highlight rather than hide the role of the woman artist within Latin America. To some extent the work of the women artists of South and Central America has found a wider international audience than that of many of their male compatriots. In this sense the categorization 'woman artist', despite its intrinsic claims to represent a marginalized culture, is a more empowering category than 'Latin American', which denies an international relevance to the art it describes. Many of the stereotypes of Latin American art—decorative, naive, emotional, exotic—relate to the international stereotypes of femininity so attacked by late 20th-century feminism. Kahlo's reputation by the 1980s had grown from a recognition of these shared characteristics (see 1982 exh. cat.; Herrera, 1983). In addition to this, the traditional divisions between the arts, the high art–low art debate (which assigns a hierarchical value to particular forms of creativity), has great relevance within the context of South and Central America (Baddeley and Fraser, 1989). The culture of this region has been recognized abroad primarily via its popular art, usually anonymously produced manifestations of Latin America's complex racial and cultural mix. As with many popular craft traditions, women have played a key role in initiating and perpetuating these forms of creativity. Within the area of fine art, many of the more renowned female practitioners have manifested an awareness of such popular traditions.

In Mexico, Kahlo is an archetype for such a position, but this is also found in the work of her contemporaries María Izquierdo, Olga Costa, ROCIO MALDONADO and Amalia Mesa-Bains (*b* 1943). The formal languages of all these artists draw heavily on the traditions of popular religious imagery and lay claim to an art of highly charged emotion. The scale and materials of Kahlo's works (e.g. *My Grandparents, My Parents and I (Family Tree), 1936*; see MEXICO, fig. 12) echo the small votive images on tin found in many Mexican churches. Izquierdo's brightly coloured Virgins of Sorrows (e.g. *Altar of Sorrows*, 1943; Mexico City, Gal. A. Mex.) show the same mix of the

aesthetic and the violent intrinsic to the Catholic tradition. These same references are found in the work of Costa (e.g. *The Fruitseller*, 1951; Mexico City, Mus. A. Mod.), with the added claim to the carefree beauty of the Mexican marketplace, with its riot of colour and carefully composed objects and produce. Maldonado and Mesa-Bains have added to this appropriation of the languages of popular art, with its evocation of the 'woman's world' of church and marketplace, a more knowing feminist aesthetic that transfers the traditions of earlier women artists to the large canvases and installations of the late 20th century; this is exemplified by, for example, Maldonado's *The Virgin* (1985; Mexico City, Cent. Cult. A. Contemp.) and Mesa-Bains's installation *Queen of the Waters* (1992) for the Arte America exhibition (Bogotá, Bib. Luis-Angel Arango).

However, the Latin American artist's fascination with the traditions of the popular have not been the only strand of practice to produce important women artists. In Brazil the beginnings of modernist experimentation were dominated by the work of TARSILA and Anita Malfatti (1889–1964). The negative critical response to an exhibition in 1917 of Malfatti's 'fauvist'-style paintings (e.g. the *Yellow Man*, 1915–16; São Paulo, U. São Paulo, Mus. A. Contemp.) made her a figurehead for the Brazilian avant-garde. In 1922 both women participated in the groundbreaking SEMANA DE ARTE MODERNA, which was to be instrumental in introducing the Brazilian art world to the debates of European modernism. In conjunction with the poet Oswald de Andrade, Tarsila transformed the modernist aesthetic into a more specifically Latin American and anti-colonialist movement, outlined in Andrade's *Anthropophagite manifesto* (1928) and made visual in Tarsila's *Anthropophagy* (1929; Fund. José e Paulina Nemirovsky).

The naturalization and reworking of the prevailing international avant-garde aesthetic, initiated by Tarsila, was continued by a younger generation of artists including Iona Saldanha (*b* 1921). In her minimalist sculptures, such as *Bamboo Installation* (1969; artist's col.), she used traditional materials and ritualized compositions to create an art that links the concerns of colour field painting of the 1960s with anthropology. In Bolivia, MARÍA LUISA PACHECO and in Peru, Tilsa Tschusiya also created a visual language that synthesized the specifics of their cultures, as both women and Latin Americans, with the demands of modernity. In both these women's works the purity of painterly abstraction is undermined: in Pacheco's subtle canvases by the fleeting glimmer of an Andean landscape, and more obviously in Tsuchiya's references to Quechua mythology, as in *Machu Picchu* (1974; Lima, priv. col., see Baddeley and Fraser, p. 114).

A harder edged abstraction has been manifested in the work of some women artists, such as Gego and Mercedes Pardo in Venezuela, but probably most notably in the work of the Brazilian Lygia Clark. In 1959 Clark (along with Lygia Pape (*b* 1929)) was one of the founder-members of the Brazilian Neo-Concrete group and through her articulated sculptures (e.g. *Machine Animal* (*Bicho*), 1962; São Paulo, Fulvio and Adolpho Leirner priv. col., see 1989 exh. cat., p. 265) gained an international reputation. Clark's highly cerebral work subverts traditional expectations of the 'irrational' nature of Latin American culture and denies

expectations of a greater physicality and emotion in the work of women artists. The changing expectations of the 1980s and 1990s, in the wake of the Post-modernist rejection of a single monolithic culture, have led to the international recognition of contemporary Latin American art. Within this category the role of the woman artist has been central, an intrinsic part of a wider exploration of cultural identity.

BIBLIOGRAPHY

J. Franco: *Modern Culture of Latin America: Society & the Artist* (Harmondsworth, 1970)

Frida Kahlo & Tina Modotti (exh. cat., London, Whitechapel A.G., 1982)

H. Herrera: *Frida: A Biography of Frida Kahlo* (New York, 1983)

N. Richard: 'Post-Modernism and Perifery', *Third Text*, ii (Winter 1987–8)

J. Franco: *Plotting Women: Gender & Representation in Mexico* (London, 1989)

O. Baddeley and V. Fraser: *Drawing the Line: Art & Cultural Identity in Contemporary Latin America* (London, 1989)

Art in Latin America: The Modern Era, 1820–1980 (exh. cat. by D. Ades and others, London, Hayward Gal., 1989)

La mujer en México/Women in Mexico (exh. cat., New York, N. Acad. Des.; Mexico City, Cent. Cult. A. Contemp.; Monterrey, Mus.; 1990–1)

O. Baddeley: 'Her Dress Hangs Here: De-Frocking the Kahlo Cult', *Oxford A. J.*, xiv/1 (1991)

Six Latin American Women Artists (exh. cat., Lewisburg, PA, Bucknell U., 1992)

E. Lucie-Smith: *Latin American Art of the Twentieth Century* (London, 1993)

Regards de femmes (exh. cat., Liège, Mus. A. Mod., 1993)

Latin American Women Artists, 1915–1995 (exh. cat. by G. Biller and others, Milwaukee, WI, A. Mus., 1995)

Tarsila do Amaral, Frida Kahlo and Amelia Peláez (exh. cat. by L. Montreal Agusí and others, Barcelona, Cent. Cult. Fund. Caixa Pensions, 1997)

M. Agoisín: *A Woman's Gaze: Latin American Women Artists* (New York, c. 1998)

ORIANA BADDELEY

X

Ximeno y Planes, Rafael (*b* Valencia, 1759; *d* Mexico, 1825). Spanish painter, draughtsman and teacher, also active in Mexico. His early years in Valencia were strongly influenced by his uncle, the painter Luis Planes (1742–1821), who taught him drawing and whose work has sometimes been attributed to his nephew and pupil. Ximeno was closely involved in the academic world in which he spent his whole career. He was very young when he attended the Academia de S Carlos in Valencia, where he won prizes in painting in 1773 and in life drawing in 1775. In the same year he left to study at the Academia de S Fernando, Madrid, under Manuel Monfort y Asensi, and eventually, after a failed attempt in 1778, he won a scholarship to study at the Accademia di S Luca, Rome. At these academies he received a training based on the strictest classicism, which he later implanted in Mexico.

In Madrid, Ximeno was attracted to the art of Anton Raphael Mengs, whose works he copied between 1775 and 1778, including the portrait of the *Marquesa de los Llanos* and *Self-portrait* (copies in Valencia, Mus. B.A.) and the *Annunciation* (untraced), copied from Mengs's last work of 1779. Ximeno also copied paintings in the Spanish royal collections, including *SS Peter and Paul* (*c.* 1755; Valencia, Mus. B.A.), after the painting by Guido Reni, and *St Sebastian* (*c.* 1755; Valencia, Mus. B.A.), after the painting by Titian, then in the sacristy of the Escorial. Equally classical in style is the *Meeting Between Two Commanders* (*c.* 1780; Madrid, Real Acad. S Fernando, Mus.) and the *Eternal Father Reprimanding Adam and Eve* (*c.* 1780; Valencia, Mus. B.A.) painted in Rome, where Ximeno was much influenced by the works of Raphael.

In May 1794 Ximeno went to Mexico to direct the teaching of painting at the Real Academia de S Carlos de Nueva España, founded in 1783. There he had the opportunity to guide the academy towards Neo-classicism. He introduced important reforms in teaching methods, among which was the introduction in 1795 of the study of anatomy using live models. He was appointed Director General in 1798 on the death of the engraver Jerónimo Antonio Gil.

Ximeno's religious paintings in Mexico include the great monumental groups in the *Assumption of the Virgin* (1809–10; destr. 1967) for the dome of the metropolitan cathedral, which brought him considerable fame. He depicted the same theme, including the *Coronation of the Virgin* (1812–13), in the chapel of the Palacio de Minería, Mexico City, which is important as the only extant monumental group by Ximeno.

Ximeno's portraits are considered to be his most accomplished works, and their pictorial quality is seen in his portrait of *Jerónimo Antonio Gil* (before 1798; Mexico City, Pin. Virreinal); it is regarded as one of the most important examples of Neo-classical painting during the period of the viceroys. Ximeno's portrait of the Spanish sculptor and architect *Manuel Tolsá* (*c.* 1795; Mexico City, Iglesia de la Profesa) is also very fine. These works express the purest classical style and show the artist's concern with portraying the sitter's character.

Ximeno was an excellent draughtsman and illustrator of books. His drawings (Valencia, Mus. B.A.) include *St Andrew*, *St James* and *St Thomas the Apostle*. A fine group of drawings, *Cuaderno de Viaje* (Mexico City, Soc. Exalumnos Fac. Ingen.), with scenes observed on his journey from Europe to Mexico, was published in 1985.

BIBLIOGRAPHY
D. Angulo Iñiguez: *La Academia de Bellas Artes de Mexico y sus pinturas españolas* (Seville, 1936), p. 45
X. Moyssén: 'Las pinturas perdidas de la catedral de Mexico', *An. Inst. Invest. Estét.*, 39 (1970), pp. 87–112
T. A. Brown: *La Academia de San Carlos de Nueva España de 1792 a 1810* (Mexico City, 1976), p. 33
X. Moyssén: 'Una maqueta de Rafael Ximeno', *An. Inst. Invest. Estét.*, 48 (1978), pp. 67–70
A. Espinós Díaz and C. García Saiz: 'Algunas obras de Rafael Ximeno y Planes anteriores a su llegada a México', *Archv Esp. A.*, 202 (1979), pp. 115–35
X. Moyssén: *El pintor Rafael Ximeno y Planes su libreta de dibujos* (Mexico City, 1985)
Catálogo de la exposición Tolsá, Ximeno, Fabregat: Trayectoria artística en España siglo XVIII (exh. cat. by A. Espinós Díaz and others, Valencia, 1989)
ADELA ESPINÓS DÍAZ

Xuarez. *See* JUAREZ.

Xul Solar [Schulz Solari, Oscar Agustín Alejandro] (*b* San Fernando, 14 Dec 1888; *d* 10 May 1963). Argentine painter. He was self-taught and spent many years of his youth visiting Europe, holding his first exhibition in Milan in 1920. He returned in 1924 to Buenos Aires where, like Emilio Pettoruti and other artists who had also familiarized themselves with new trends in Europe, he became part of the first wave of the avant-garde in Argentina. Undeterred by the hostile reactions aroused by his first exhibitions, he remained resolved to pursue an unconventional approach throughout his life.

Although Xul Solar's work made use of characteristic Surrealist elements such as twinned images, fantastic perspectives and the animation of the inanimate, his forms

are fundamentally abstract and mystical. He thought of his art as a way of revealing the spiritual dimensions of man, and to this end he referred to magic, occult philosophy, astrology and linguistics, bringing together descriptive and invented forms, cabalistic numbers and gestural marks, vanishing points and spatial ruptures into an extravagantly inventive poetic narrative, as in *Saint Dance* (1925; Buenos Aires, Marion and Jorge Helft priv. col., see 1989 exh. cat., p. 142).

Xul Solar's development exemplifies a creative drive towards the expression of an exalted state of awareness, beginning with works produced between 1919 and 1930, characterized by accents of colour within a rarefied light; among these pictures, in which objects appear to materialize within a spatial order that supports them and fixes them in place, are a series of monochromatic works. From 1930 he pursued the esoteric aspects of his art with greater single-mindedness, and after 1960 he gave greater prominence to colour and transformed his images into clearly legible signs on a static support. His pictures are small and are generally painted in watercolour and tempera, as in *Deep Valley* (1944; Buenos Aires, Soc. ALART). His highly original world view and philosophical preoccupations led him to devise, among other inventions indicating the subtlety and complexity of his imagination, a general American language (Neocriollo), a universal language that he called Panlengua, and a game (panjuego) based on chess.

BIBLIOGRAPHY

O. Svanascini: *Xul Solar* (Buenos Aires, 1962)

J. López Anaya: *Xul Solar* (Buenos Aires, 1980)

Art in Latin America: The Modern Era, 1820–1980 (exh. cat. by D. Ades, London, Hayward Gal., 1989), pp. 142–3

M. H. Gradowczyk: *Alejandro Xul Solar* (Buenos Aires, 1994)

Xul Solar: The Architectures (exh. cat., ed. C. Green, London, U. London, Courtauld Inst. Gals, 1994)

B. Sarlo: 'The Case of Xul Solar: Fantastic Invention and Cultural Nationality', *Art from Argentina, 1920–1994* (exh. cat. by D. Elliott and others, Oxford, MOMA, 1994), pp. 34–9

HORACIO SAFONS

Yampolsky, Mariana (*b* Chicago, 6 Sept 1925). Mexican photographer, printmaker and writer of American birth. After studying humanities in Chicago, in 1944 she emigrated to Mexico. From 1945 to 1958 she worked as an engraver in the Taller de Gráfica Popular with Leopoldo Méndez. She was a founder-member in 1951 of the Salón de la Plástica Mexicana. As a photographer she was self-taught; her typical subject-matter was rural Mexico, in particular vernacular architecture and harmonious depictions of sites used for either daily or ceremonial functions. She also photographed Indian or mestizo peasants engaged in domestic activities and celebrations (e.g. *Since You Went Away*, 1980; see fig.), and she published educational and art books.

WRITINGS
La casa que canta: Arquitectura popular mexicana (Mexico City, 1982)
Estancias del olvido (Mexico City, 1987)
La raíz y el camino (Mexico City, 1988)
R. Rendón Garcini: *Haciendo Poblanas* (Mexico City, 1992)
Mazahua (Toluca, 1993)
C. Sayer: *The Traditional Architecture of Mexico* (New York, 1993)

PHOTOGRAPHIC PUBLICATIONS
The Edge of Time: Photographs of Mexico (Austin, 1998)

BIBLIOGRAPHY
S. M. Goldman: 'Six Women Artists of Mexico', *Woman's A. J.*, iii (1982–3), pp. 1–9

Mariana Yampolsky: *Since You Went Away*, photograph, 360×360 mm, 1980 (Colchester, University of Essex, Collection of Latin American Art)

La mujer en México (exh. cat., Mexico City, Cent. Cult. A. Contemp., 1990)
Regards de femmes (exh. cat., Liège, Mus. A. Mod., 1993), pp. 86–9
M. Agosín: 'Los sortilegios de la mirada: La fotografía de Mariana Yampolsky', *Fem*, xviii/136 (1994), pp. 42–5
G. Rábago Palafux: 'Mariana Yampolsky: The Singing Camera', *Voices Mexico*, xxvii (1994), pp. 57–61
Romperlos: Encuentro de fotografía latinoamericana (exh. cat., Caracas, Mus. A. Visuales Alejandro Otero, 1994), pp. 48–51
F. Reyes Palma and N. Schnaith: *Mariana Yampolsky* (Salamanca, 1995)
The Edge of Time: Photographs of Mexico by Mariana Yampolsky (Austin, 1997)
PATRICIA MASSE

Yañez (de la Fuente), Enrique (*b* Mexico City, 17 June 1908; *d* Mexico City, 24 Nov 1990). Mexican architect, writer and theorist. He was a member of the Escuela Mexicana de Arquitectura, a group that from 1925 onwards sought to create an architecture that simultaneously expressed nationalism and modernity. Within this group, which was led by José Villagrán García, Yañez, with Juan O'Gorman and Juan Legorreta, represented the socialist tendency. In 1938, with Alberto T. Arai, Enrique Guerrero, Raúl Cacho, Carlos Leduc and Ricardo Rivas, Yañez formed the Unión de Arquitectos Socialistas, which had a significant influence on Mexican architecture. Their approach was characterized by an emphasis on the utilitarian and social aspects of architecture, for example the reduction of spaces to a bare minimum, and by a rejection of 'bourgeois' aesthetics. Nevertheless, Yañez's own house (1935) and the Sindicato Mexicano de Electricistas Building (1938) have a certain rhythmic plasticity, albeit rationalist and sparse. Later, still in the context of developing a 'nationalist functionalism', Yañez became one of the foremost designers of hospitals in Mexico. He won the competition for the construction of the Instituto Mexicano del Seguro Social's first hospital and designed the most important hospital complex in Mexico, the Centro Médico Nacional (1954–8; destr. 1985), Mexico City. The participation in the latter of the painter José Chávez Morado and the sculptor Francisco Zúñiga, among others, made it a milestone in the movement for the 'plastic integration' of the fine arts in Mexico in the 1950s. Among his many completed projects, other noteworthy hospitals include the Adolfo López Mateos Hospital (1969–70). His published writings recount his professional experiences and discuss architectural theory and history.

WRITINGS
Hospitales de seguridad social (Mexico City, 1973)
Arquitectura: Teoría, diseño, contexto (Mexico City, 1983)
Del Funcionalismo al Post Racionalismo (Mexico City, 1990)

BIBLIOGRAPHY

R. López Rangel: *Enrique Yañez en la cultura arquitectónica mexicana* (Mexico City, 1989)

P. Quintero, ed.: *Modernidad en la arquitectura mexicana* (Mexico City, 1990), pp. 623–68

F. González Gortázar, ed.: *La arquitectura mexicana del siglo XX* (Mexico City, 1994)

RAMÓN VARGAS

Yela Günther, Rafael (*b* Guatemala City, 18 Sept 1888; *d* Guatemala City, 17 April 1942). Guatemalan sculptor. He was first trained by his father, Baldomero Yela Montenegro (1859–1909), who was a sculptor and marble-carver. While still very young he worked with the Venezuelan sculptor Santiago González, a former student of Auguste Rodin, then resident in Guatemala, and with the Italian Antonio Doninelli, who ran a bronze foundry workshop. He was also extremely friendly with the Guatemalan painters Carlos Mérida and Carlos Valenti (1884–1912) and with the Spanish Catalan painter and sculptor Jaime Sabartés (1881–1968), who later became Picasso's secretary. His first important sculptures, both in Guatemala City, were monuments to *J. F. Barrundia* (1905–6) in the General Cemetery and to *Isabel La Católica* (1915).

Around 1921 Yela Günther went to Mexico, where he came into contact with the anthropologist Manuel Gamio, who directed his attention towards Maya and Aztec art. He also had the encouragement of Diego Rivera, who wrote enthusiastically of his work in *El Demócrata* (2 March 1924). One of his most important works of this period, a relief made in 1922 entitled *Triptych of the Race*, for the Museo Arqueológico in Teotihuacán, was demolished in the 1960s. After living in the USA from 1926 to 1930 he returned to Guatemala, settling there permanently, and produced his largest works, combining elements of sculpture and architecture. These include works in Guatemala City, notably a monument to the *Leaders of the Independence* (1934–5) and the mausoleum of the aviator *Jacinto Rodríguez D.* (1932), and in Quetzaltenango a monument to the national hero *Tecún Umán* (a re-creation of a large Maya stele) and a monument to *President Justo Rufino Barrios* (1941) in the main square. His outstanding sculptures on a smaller scale include the *Supreme Sadness of the Defeated Race* (bronze), a bust carved in wood of the jurist *Salvador Falla*, and *Christ* from a plaster of 1936 cast in bronze in 1947 (all Guatemala City, Mus. N. B.A.). Stylistically his works combine elements revealing the influence of Rodin and of Art Deco. He was Director of the Escuela Nacional de Bellas Artes for several years until his death.

BIBLIOGRAPHY

C. C. Haeussler Y.: *Diccionario general de Guatemala* (Guatemala City, 1983), iii, pp. 1660–67

L. Luján Muñoz: *Carlos Mérida, Rafael Yela Günther, Carlos Valenti, Sabartés y la plástica contemporánea de Guatemala* (Guatemala City, 1983)

F. Albizúrez Palma: 'Acercamiento a Yela Günther (1888–1942)', *Banca Cent.*, xxv (1995), pp. 105–20

JORGE LUJÁN-MUÑOZ

Yrarrázaval, Ricardo (*b* Santiago, 1931). Chilean painter. A self-taught painter, in the 1950s and 1960s he based his landscape motifs and colours on the Andes, using very simple forms suggestive of Pre-Columbian textiles in their flat, abstract designs and balanced chromatic effects. It was a question of subjecting archetypal shapes to a subtle

and rational play of colour. While remaining committed to a careful technique in both his oil paintings and pastels, Yrarrázaval fundamentally changed direction in 1973, when he began to represent isolated and suspended figures undergoing gradual deterioration: faceless and with their bodies swollen as if by internal pressure, they appear to have lost their identity, leaving behind only realistically painted shirts, collars and ties. The suggestion is of a collective anonymity, an identity crisis embodied in purely external human gestures revealed through social rituals and through the status and prestige accorded to dress and fashion. Yrarrázaval continued in these works to emphasize the material quality of his paintings and the strong three-dimensional illusion of his forms, relying exclusively on the palette knife to reveal or conceal forms by a meticulous modelling of light and shade.

In the 1980s Yrarrázaval began to combine hand-painted motifs with photographic images, especially Polaroid snapshots and stills obtained from the television screen. He imposed himself on such mechanically produced images in order to achieve perplexing effects, in particular by showing faces out of focus in order, again, to suggest the loss of identity.

BIBLIOGRAPHY

M. Ivelić and G. Galaz: *La pintura en Chile* (Santiago, 1981)

——: *Chile: Arte actual* (Santiago, 1988)

A. Pérez: *La soledad en dos pintores chilenos: Mario Carreño y Ricardo Yrarrázaval* (Santiago, 1992)

MILAN IVELIĆ

Yrurtia, Rogelio (*b* Buenos Aires, 6 Dec 1879; *d* Buenos Aires, 4 March 1950). Argentine sculptor. He enrolled at the Escuela de la Sociedad Estímulo de Bellas Artes, Buenos Aires, in 1898 and soon afterwards joined the studio of the sculptor Lucio Correa Morales (1852–1923). In 1899 he won a scholarship to study in Europe. In Paris he attended the studio of the sculptor Jules-Félix Coutan (1848–1939), at the same time studying drawing at the Académie Colarossi; he made studies of corpses in the morgue and acquired a great mastery of human anatomy. At the Salon in Paris in 1903 he exhibited *The Sinners* (see Prins), a major group of six female figures, influenced by Rodin's *Burghers of Calais* in its rhythmic arabesques, open treatment of line and soft modelling. In 1904 it was shown again at the World's Fair in St Louis, MO, where it was awarded a major prize, but he renounced both the prize and associated commission because of a controversy about his youth.

Yrurtia exhibited for the first time in Buenos Aires, with great success, in 1905. The occasion marked the end of his period of experimentation and the start of his mature production as a sculptor. By 1907 he had received major commissions in Buenos Aires, and this enabled him to return to Paris, where he remained until 1921. Notable among these early commissions in Argentina were a bronze monument to the surgeon *Alejandro Castro* (1904–5; Buenos Aires, Hosp. Clínicas), vigorously modelled in broad planes and precise in its symbolism, and a monument to *Dorrego* (bronze, 1907), commissioned by the Argentine government. The latter work, situated in the small square between Viamonte and Suipacha in Buenos Aires and consisting of an equestrian figure on an archi-

Rogelio Yrurtia: *Hymn to Work*, 14 life-size bronze figures, 2.15×2.60×13.50 m, 1907–9 (Buenos Aires, Plaza Canto al Trabajo)

tectural base flanked by powerful allegorical figures representing Fate and History, was the first of his important sculptural groups. It was followed by the skilfully constructed *Hymn to Work* (1907–9, see fig.), a group of 14 life-size figures in bronze erected in the Plaza Canto al Trabajo, Buenos Aires, in which naked figures, arranged on an open and outward curve, advance in an excited throng that maintains its unity through the continuity of movement. Yrurtia's struggle between Romanticism and Classicism is particularly evident in this work: the naked, ideal, timeless bodies are at the same time anti-classical in their dynamism, curved structure and asymmetry. In his *Cenotaph to Rivadavia* (1916–32; Buenos Aires, Plaza Miserere) Yrurtia subordinated the bronze sculpture to an architectural setting in stone inspired by Art Deco, through which he achieved an austere formal and conceptual simplicity.

On his return to Buenos Aires in 1921, Yrurtia taught for two years at the Escuela Nacional de Bellas Artes. In his sculpture, such as the portraits of family and friends made in the 1940s, he gradually reduced male and female figures to their essential characteristics. His adoption of an extreme economy of means characterized his development of a sculptural style that was modern but that also attempted to free itself of blind repetition of European formulae. On the opening of the Museo Casa de Yrurtia in Buenos Aires in 1949 he was appointed its honorary director.

BIBLIOGRAPHY
Rogelio Yrurtia (exh. cat., preface H. Caillet-Bois; Santa Fé, Argentina, Mus. Prov. B.A., 1938)
E. Prins: *Rogelio Yrurtia* (Buenos Aires, 1941) [Sp., Fr. and Eng. text]
J. Rinaldini: *Rogelio Yrurtia* (Buenos Aires, 1942)
Dibujos de Yrurtia (exh. cat., ed. L. C. Morales; Buenos Aires, Mus. Casa de Yrurtia, 1964)
J. López Anaya: *Historia del arte argentino* (Buenos Aires, 1997)
NELLY PERAZZO

Yucateco. Term used to designate the architecture characteristic of the Yucatán peninsula in south-east Mexico, particularly the religious architecture of the 16th century. A number of factors militated against Spanish settlement in Yucatán in the early 16th century, notably the intense heat, difficulties in irrigating the area, the lack of precious metals and the sparseness of the Indian population, which was mostly Maya. Consequently, the peninsula's social and economic development was very different from that of the more densely populated central plateau, and this was reflected in its architecture, which was of a simpler and more austere character.

Despite the obstacles to settlement, Franciscan missionaries arrived in the Yucatán peninsula in the 1530s and 1540s and began to construct simple buildings to house the monks. In order to accommodate the large congregations of Indians, however, and to protect them from the sun, they built *ramadas*, or large shelters, in the monastery compounds. These were supported by tree trunks, with roofs made from branches, and they had no side walls, thereby allowing the free passage of air. Services were conducted from a small, open-fronted stone chapel or chancel, which was built facing the *ramada*. Such complexes, comprising dormitories, chapel and *ramada*, formed the first Yucatán monasteries. Later, especially in the 17th century, these 'open-air' or 'Indian' chapels formed the basis of the typical Yucatán convent churches, with simple, stone naves replacing the original *ramadas* in front of the chapels.

The monasteries that grew out of these *ramadas* retained their own distinctive features throughout the 17th and 18th centuries, with few of the Romanesque, Gothic, Plateresque, Renaissance or Baroque details that were so sumptuously adopted in the rest of Mexico. Instead, their façades were relatively simple, although one notable distinguishing feature was the development of the front gable-ends to serve as wall belfries to house the bells. The design of the gable-ends was very varied, in some cases their size being increased at the expense of the walls, with the height of the latter being reduced to a minimum. A semicircular,

ribbed vault usually covered the chancel. Other monasteries were later built with great transverse arches that, because of the thickness of the walls, provided space for extra chapels. Another characteristic feature was the construction of large arcades surrounding the atrium, for example in the monastery at Izamal. Despite the poverty of the Yucatán region, 29 Franciscan monasteries were built there, each with its own stylistic identity, although most are simple and austere. They were used not only to teach Christian doctrine but also for the artistic and architectural training of indigenous craftsmen, and one monk, Fray Juan Pérez de Mérida, established a reputation as the builder of the monasteries of Mérida, Maní, Izamal and Sisal de Valladolid, assisted by his Indian apprentices.

The architecture of the 16th-century cathedral of S Ildefonso, Mérida, is also characteristically different from that of the cathedrals in Mexico City, Guadalajara and Puebla, on which work began in the same period. S Ildefonso is a simple, aisled hall church with large columns supporting sail vaults and a dome over the crossing. The vaults and dome are decorated with simple mouldings, as is the rest of the building. The façade of the cathedral is also very simple and austere in its execution, with an almost fortress-like composition of towers and walls in plain ashlar masonry flanking a tall central arch above the main portal, which has small-scale classicist detailing.

The only important work of secular architecture that has survived in Yucatán is the Casa de Montejo (1549), the former residence of the conquistador Francisco de Montejo II, which has an uncharacteristic broad band of Plateresque ornament above the main portal, decorated with an abundance of low relief intended to set off the Montejo coat of arms; this coat of arms is flanked by two large halberdiers, with two figures of Indians at their feet, which stand out from the harmoniously and profusely decorated whole with its medallions and grotesques.

In the 17th and 18th centuries the Baroque influence on architecture in Yucatán was almost negligible. The capriciously designed gable-ends characteristic of the 16th century continued to influence Yucatán architects, who transformed them into wall belfries and sometimes into full-scale bell-towers. A few façades, such as that of the church of the Third Order of the Jesuits (1618) in Mérida, contained a few very simple Baroque elements, and the façade of the 18th-century church of S Cristóbal has a flared portal similar to that in S Juan de Dios in Mexico City, but again the Baroque ornamentation is relatively simple, as are the sparse plant and flower decorations on other churches in Yucatán.

BIBLIOGRAPHY

D. Angulo Iñiguez: *Historia del arte hispanoamericano*, i and ii (Barcelona, 1945)

E. Wilder Weismann and J. Hancock Sandoval: *Art and Time in Mexico: From the Conquest to the Revolution* (New York, 1985), pp. 67–75

CONSTANTINO REYES-VALERIO

Z

Zabludovsky, Abraham (*b* Bialystok, 14 June 1924). Mexican architect of Polish birth. He studied at the Escuela de Arquitectura at the Universidad Nacional Autónoma de México, graduating in 1949. In his early years he produced a large number of outstanding residential buildings and offices in Mexico City, making rigorous use of the International style and demonstrating an impeccable handling of contemporary design, techniques and materials. Also notable from this period was the Centro Cívico Cinco de Mayo (1962), Puebla, on which he collaborated with Guillermo Rossel. In 1968 Zabludovsky began working in collaboration with TEODORO GONZÁLEZ DE LEÓN, although the two architects continued to work on some projects individually and retained their separate stylistic identities. Their collaborative work was remarkable for its quality and maturity, establishing functional and formal solutions that were later widely imitated. Clear examples of their characteristic proposals for constructions of massive, linear volume are the Delegación Cuauhtémoc (1972–3; with Jaime Ortiz Monasterio (*b* 1928) and Luis Antonio Zapiain (*b* 1942)), the headquarters of INFON-AVIT (Instituto del Fondo Nacional de la Vivienda para los Trabajadores, completed 1975) and the new building for the Colegio de México (1974–5; *see* MEXICO, fig. 7), all in Mexico City. Zabludovsky also carried out a number of works individually in the same style. Outstanding among these was the Centro Cultural Emilio O. Rabasa (1983), Tuxtla Gutiérrez, Chiapas, a construction with sculptural aspects that manages faithfully to fulfil the need for both theatricality and diffusion. He also designed two multipurpose auditoriums in Celaya and Dolores Hidalgo, Guanajuato (1990), two theatres in Guanajuato, Guanajuato, and Aguascalientes, Aguascalientes (1991), and a convention centre in Tuxtla Gutiérrez, Chiapas (1994).

BIBLIOGRAPHY

Contemp. Architects

P. Heyer: *Mexican Architecture: The Work of Abraham Zabludovsky and Teodoro González de León* (New York, 1978)

L. Noelle: 'Abraham Zabludovsky', *Arquitectos contemporáneos de México* (Mexico City, 1988)

P. Heyer: *Abraham Zabludovsky, Architect* (New York, 1993; Sp. trans., Mexico City, 1998)

F. González Gortázar, ed.: *La arquitectura mexicana del siglo XX* (Mexico City, 1994)

M. A. Roca, ed.: *The Architecture of Latin America* (London, 1995)

G. de Garay: *Abraham Zabludovsky: Cincuenta años de arquitectura* (exh. cat., Mexico City, Mus. Rufino Tamayo, 1995)

LOUISE NOELLE

Zacatecas. City in Mexico. Capital of the state of the same name in the central highlands of Mexico, it is *c.* 250 km north-east of Guadalajara and has a population of *c.* 150,000. The city was established in 1546 and became the most important silver-mining centre of colonial Mexico. The uneven terrain (it is situated in a ravine) and its initial quick growth resulted in an irregular but picturesque plan. Conservation efforts have preserved the city's colonial scale and many colonial buildings in the local reddish limestone. A late 18th-century chapel dedicated to the Virgin crowns the Cerro de la Bufa, the hill that dominates the city. The cathedral was constructed as the parish church of La Asunción (begun 1612; completed 1752), integrating parts of the chapels of the Miraculous Crucified Christ and of the Virgin to produce a spacious three-aisled church; the architect was probably Miguel Sánchez Pacheco and, at the end, Domingo Ximénez Hernández. In the variety of its elements and the complexity of its iconography (which originally corresponded to the decoration of the main retable inside), the façade is one of the most spectacular of colonial Mexico (*see* MEXICO, fig. 4). Also notable are the side portals; the dome was rebuilt in the mid-19th century. Other noteworthy colonial structures include the 18th-century aqueduct, some houses near the cathedral and the Jesuit church of S Domingo (1746–9). All its retables but one survive, and there are notable wall paintings in the sacristy by Francisco Martinez. The former Jesuit college of S Luis Gonzaga is now the Museo Pedro Coronel. The ruins of S Francisco, with an elaborate sculpted façade (before 1736), are part of a museum containing the collection of the painter Rafael Coronel. The church of S Agustín, best known for the 18th-century relief over the side door, representing the *Conversion of St Augustine*, was also partly ruined but has been restored. A 19th-century covered market also survives, and the Museo Francisco Goitia occupies a notable house that was formerly the Governor's mansion. The church of Nuestra Señora de Guadalupe, in the nearby town of the same name, was built before 1721 and preserves many colonial and 19th-century works of art, including its choir-stalls; the ample monastery houses an important museum of colonial art.

BIBLIOGRAPHY

D. Kuri Breña: *Zacatecas: Civilizadora del norte* (Mexico City, 1944, rev. 1959)

C. Bargellini: *La arquitectura de la plata: Iglesias monumentales del centro-norte de México, 1640–1750* (Madrid, 1990)

E. Rodríguez Flores: *Compendio histórico de Zacatecas* (Zacatecas, 1992)

CLARA BARGELLINI

Zachrisson, Julio (Augusto) (*b* Panama City, 5 Feb 1930). Panamanian printmaker and painter, active in Spain.

Julio Zachrisson: *Death of Chimbombó*, hard and soft ground etching, 492×629 mm, 1963 (New York, Museum of Modern Art)

He studied under Juan Manuel Cedeño at the Escuela Nacional de Pintura in Panama City and from 1953 to 1959 at the Instituto Nacional de Bellas Artes in Mexico City. In 1961 he moved to Madrid, where he began his important work at the Real Academia de Bellas Artes de San Fernando. Zachrisson's etchings, drypoints, lithographs and woodcuts tell stories, mock tradition and criticize society, encompassing subjects as varied as the circus and the myth of Icarus. In works such as the *Death of Chimbombó* (1963; see fig.) he depicts life with humour and satire in a cruel and even tragic vision. His fantastic world is peopled by an entourage of monsters, witches and grotesque figures drawn from Panamanian urban folklore, Spanish literature, classical mythology and personal experiences. Zachrisson's paintings, produced since 1970s, tend to be less detailed than his etchings but are equally biting in their use of irony, sexual explicitness and references to his Panamanian background. Formally, his paintings emphasize colour and design over volume, with flat, intense hues, hard edges and nearly invisible brushstrokes, as in *Cazanga* (1984; Panama City, Mus. A. Contemp.). Zachrisson's work has been widely exhibited, both in Latin America and in Spain, where in 1996 he was awarded the prestigious Goya–Aragón Prize.

BIBLIOGRAPHY

Zachrisson: Obra pictórica (exh. cat., Panama City, Inst. N. Cult., 1978)
Zachrisson: Obra calcográfica (exh. cat., Santander, Mus. Mun. B.A., 1981)
Crosscurrents: Contemporary Painting from Panama, 1968–98 (exh. cat. by M. Kupfer and E. Sullivan, New York, Americas Soc. A.G., 1998)

MONICA E. KUPFER

Zalce, Alfredo (*b* Pátzcuaro, Michoacán, 12 Jan 1908). Mexican painter, printmaker and teacher. He studied in Mexico City at the Academia de San Carlos (1924–9) and at the Escuela de Grabado y Talla Directa. In 1930 he founded the Escuela de Pintura y Escultura in Taxco. He was also a member of the Liga de Escritores y Artistas Revolucionarios and an early member in 1937 of the TALLER DE GRÁFICA POPULAR, taking part in their group exhibitions and publications until 1950. From 1951 he was director of the Escuela de Pintura y Escultura in Morelia, Michoacán. In addition to his career as a teacher he was active politically. He practised primarily as a printmaker with a clear and precise draughtsmanship; he published, for example, a portfolio of eight lithographs, *Estampas de Yucatán* (1945), after travelling through the area for several months. He was also involved with the muralist movement in Mexico, and in 1930, in collaboration with Isabel Villaseñor, he was the first in Mexico to use coloured concrete for murals, in their work on the external walls of the Escuela de Ayotla in Tlaxaca. Among his most notable murals are *Defenders of National Integrity* (fresco and coloured concrete, 1951) and *Brother Alonso of the Order*

of the True Cross (1952; both Morelia, Mus. Reg. Michoacano), in which fragmented figures are reintegrated into a subtle geometry, at once rational and poetic.

BIBLIOGRAPHY

Treinta años de pintura y grabado de Alfredo Zalce (exh. cat., Mexico City, Pal. B.A., 1962)

B. Taracena and others: *Alfredo Zalce, un arte propio* (Mexico City, 1984)

Zalce total (exh. cat. by A. Hijar, Morelia, Mus. A. Contemp. Alfredo Zalce; Mexico City, Inst. N. B.A.; 1995)

MARGARITA GONZÁLEZ ARREDONDO

Zanettini, Siegbert (*b* São Paulo, 1934). Brazilian architect and teacher. He graduated in 1959 from the Faculty of Architecture and Town Planning at the University of São Paulo, where he received a PhD in 1972. He belonged to the third generation of modern architects in Brazil, benefiting from the opportunities presented by rapid industrialization, the founding of Brasília and the intensive urbanization of the cities. In 1964 he became Professor of Planning at the University of São Paulo, and his preoccupation with social concerns was reflected in his approach to planning for housing, education and health in the city's suburbs. From this experience came a variety of experiments with timber, steel, reinforced concrete and techniques that combine industrial components with the abundant unskilled labour available in the large cities. In 1968 he won a competition for the construction of a maternity hospital at Vila Nova Cachoeirinha, on the outskirts of São Paulo, on which he worked for three years with a large interdisciplinary team and with the local population. He also designed a number of primary schools and banks, such as the Banco do Estado de São Paulo (1978) at Alto da Boa Vista, in which he experimented with concrete and steel construction, producing works of great formal and spatial richness. Later works include the Ermelino Matarazzo Municipal Hospital (1985), and the Sports Centre (1986) and TELESP Training Centre (1987) in São Paulo. His importance to modern Brazilian architecture lay in his efforts to reconcile his roles as a highly competent professional and a teacher sensitive to social, economic and technological problems.

BIBLIOGRAPHY

'Siegbert Zanettini', *Acrópole*, 352 (1968), pp. 13–41 [special feature]

'Hospital e Maternidade, Vila Nova Cachoeirinha, São Paulo', *Cj Arquitetura*, 15 (1977), pp. 48–9

Cad. Bras. Arquit., 8 (1981) [issue dedicated to Zanettini]

PAULO J. V. BRUNA

Zapata [Sapaca], **Marcos** (*b* ?1710–20; *d* ?1773). Peruvian painter. He was one of the last artists of the CUZCO SCHOOL, whose members followed and repeated the formulae developed by Diego Quispe Tito. Though not outstandingly original, he is notable for the quantity of his production and commissions: between 1748 and 1764 he painted at least 200 works. His level of output was probably due to his use of numerous apprentices, such as Cipriano Toledo y Gutiérrez (*fl* 1762–73), Ignacio Chacón (*fl* 1763–80) and Antonio Vilca (*fl* 1778–?1803). During the 18th century Zapata and the other members of the Cuzco school started producing works incorporating highly formal, idealized figures based on the engravings that had long been supplied to artists by the religious orders of Cuzco. The indigenous artists consequently lost all contact with the Spanish realist school, a process to which Zapata contributed. However, while using European prints as a guide, in many of his pictures there are various non-European features: elegant creoles, black slaves and such events as the epidemic of 1720 that affected the southern Andes. He is likely to have been influenced by such print series as the *Eulogia Mariana* by C. B. Schaefler (1684–1756), printed by M. Engelbrecht, which he interpreted in the Cuzco tradition, leading to paintings full of anecdotal scenes containing an abundance of trees, vegetation, oversize birds and such strong colours as vermilion and cobalt blue. His first known series of paintings consists of 24 works depicting the *Life of St Francis of Assisi* (1748) for the Capuchin Order in Santiago de Chile, followed by the series of 50 paintings for Cuzco Cathedral in 1755 and that of 73 works, executed *c.* 1762 in collaboration with Toledo y Gutiérrez, for the Jesuits at La Compañía in Cuzco. He is also known to have sent paintings to Humahuaca in Argentina, to Bolivia (then Alto Perú) and to be sold in Lima.

BIBLIOGRAPHY

E. Kuon: *Pintura cuzqueña: Presentación de la obra de Marcos Zapata* (BA thesis, U. Cuzco, 1970)

J. Mesa and T. Gisbert: *Historia de la pintura cuzqueña* (Lima, 1982), pp. 209–20

A. Rojas Abrigo: 'El barroco de Marcos Zapata y su pintura en Chile', *Actas de la primera y segunda jornadas internacionales en torno al barroco europeo y americano: 1981–1983* (Valparaiso, 1985), pp. 135–42

W. IAIN MACKAY

Zohn, Alejandro (*b* Vienna, 8 Aug 1930). Mexican architect of Austrian birth. He studied at the Universidad de Guadalajara, Mexico, graduating as an engineer in 1955 and as an architect in 1963. His abilities as an engineer are reflected in several bold and ingenious structures that derive partly from the precepts of FÉLIX CANDELA. Notable examples are the acoustic shell (1958) in Agua Azul Park, the Libertad Market (1959) and the 'Presidente Adolfo López Mateos' Sports Centre (1962), all in Guadalajara. The market is especially noteworthy for its roof of hyperbolic paraboloids, which allow for wide areas without supports. He also built residential blocks, paying careful attention to details of interior functionality, the durability and maintenance of materials and residents' individuality. The housing complex 'CTM-Atemajac' (1979), Guadalajara, is one of his main achievements in this area, comprising several buildings with brick facing, none more than five storeys. Among his numerous other designs in Guadalajara, the most notable are the Banco Refaccionario de Jalisco (1973), the 'Mulbar' shopping centre and car park and the Archivo del Estado de Jalisco building (1989). The latter is in exposed concrete and has a minimum of openings, giving it the appearance of a sculptured fortress. Zohn's own house (1989), also in the city, is in a more intimate, emotional style and has affinities with the vernacular architecture of the Jalisco area.

WRITINGS

'Arquitectura e identidad (en una perspectiva vista desde México)', *Nueva arquitectura en América Latina: Presente y futuro*, ed. A. Toca (Mexico City, 1990), pp. 263–79

Alejandro Zohn: *Entorno e identidad* (Mexico City, 1997)

BIBLIOGRAPHY

'Alejandro Zohn', *Process: Archit.*, 39 (1983)

L. Noelle: 'Alejandro Zohn', *Arquitectos contemporáneos de México* (Mexico City, 1989)

F. González Gortázar, ed.: *La arquitectura Mexicana del siglo XX* (Mexico City, 1994)
C. González Lobo: *Alejandro Zohn, entorno e identidad* (Mexico City, 1997)
LOUISE NOELLE

Zúñiga, Francisco (*b* San José, 27 Dec 1912). Mexican sculptor, printmaker, draughtsman and teacher of Costa Rican birth. He studied sculpture under his father, Manuel María Zúñiga, in San José, Costa Rica, and after his arrival in Mexico City in 1936 at the Escuela de Talla Directa under the direction of Guillermo Ruíz (1895–1964) and Oliverio Martínez. Martínez, together with the painter Manuel Rodríguez Lozano, helped motivate his monumental concept of form. Other lasting influences came from his encounter with Aztec sculpture and from the work of other sculptors, such as Auguste Rodin, Aristide Maillol and even Henry Moore, whose work, like his, was based primarily on the human body. Throughout his career Zúñiga was especially devoted to the female form, naked or clothed.

The monumental character of Zúñiga's sculpture is evident not only in public commissioned works, such as the stone reliefs of the *Allegory of the Earth and Communications* (1953–4) at the Secretaría de Comunicaciones in Mexico City, but also in sculptures conceived for more private and intimate settings, for example *Seated Woman from Juchitán* (1974; see fig.). In 1959, in works such as *Standing Women* (bronze; Mexico City, Mus. A. Mod.), he moved from the non-academic naturalism of his early style, which was still linked to the 19th century, to a more realistic idiom, taking as his models the indigenous women of south-eastern Mexico, whom he represented standing or seated, singly, in pairs or in a group. They are women with large bodies, both heavily built and scrawny, all seemingly caught in a violent transition from youth to old age. They inhabit a dramatic silence in which there is no communication, and occasionally they appear with the ancestral dignity of their race, as in *Woman from Yalalag* (bronze, 1975; Monclova, Bib. Pape). Only in exceptional cases do men appear. He availed himself of a variety of methods and materials, modelling in clay and plaster and also working in Carrara marble, alabaster and other kinds of stone; his preferred medium was cast bronze.

Drawing served Zúñiga as an essential basis for his sculpture and for his prolific production as a lithographer. His prints, some printed in black and others in colour, presented the same subject-matter as his sculptures, with an equivalent emphasis on the volumetric treatment of female figures. Zúñiga, who as a teacher trained many outstanding Mexican sculptors, became a naturalized Mexican citizen in 1986.

BIBLIOGRAPHY
C. F. Echeverría: *Francisco Zúñiga* (Mexico City, 1980)
J. Brewster: *Zúñiga: The Complete Graphics* (New York, 1985)
M. Parquet: *Zúñiga: Esculturas* (Paris, 1986)
XAVIER MOYSSÉN

Zúñiga, Mateo de (*b c.* 1615; *d* Santiago de Guatemala [now Antigua], ?14 Jan 1687). Guatemalan sculptor. His work as a master sculptor (Maestro) began around 1640 in Santiago de Guatemala (now Antigua). In 1654 he made the famous Baroque processional statue of *Jesús Nazareno* for the church of La Merced (*in situ*), which was finely carved and brought him renown. The tinting and painting of the figure was by Joseph de la Cerda. A statue made for the church of Candelaria, known as *Jesús Nazareno de Candelaria* (now in the church of the Candelaria, Guatemala City) has also been attributed to him, but on insufficient grounds. In 1660, as the leading sculptor in Guatemala, Zúñiga received important commissions that included retables for the convents of La Concepción and of S Catalina. In 1666 he was responsible for the construction of the catafalque for the funerary honours for Philip IV (*d* 1665). In the contract he described himself as Maestro of sculpture and architecture. In 1670 he was commissioned to build two retables for S Domingo and, for the new cathedral, his two most significant works: the principal retable and the retable for the sacristy (destr. 1773). For the work in the cathedral sacristy the contract states that he was also to carve the figures of the *Four Evangelists*, *God the Father*, two scenes of the *Holy Sacrament* and the *Triumph of the Church* and all the ornamental angels as well as those on the columns.

BIBLIOGRAPHY
H. Berlin: *Historia de la imaginería colonial en Guatemala* (Guatemala City, 1952)
M. Alvarez Arévalo: *Breves consideraciones sobre la historia del Jesús de la Merced* (Guatemala City, 1982)
H. Berlin and J. Luján-Muñoz: *Los tumulos funerarios en Guatemala* (Guatemala City, 1983)
JORGE LUJÁN-MUÑOZ

Francisco Zúñiga: *Seated Woman from Zuchitán*, bronze, 1054×899×1128 mm, 1974 (Washington, DC, Hirshhorn Museum and Sculpture Garden)

Black and White Illustration Acknowledgements

We are grateful to those listed below for permission to reproduce copyright illustrative material and to those contributors who supplied photographs or helped us to obtain them. The word 'Photo:' precedes the names of large commercial or archival sources who have provided us with photographs, as well as the names of individual photographers (where known). It has generally not been used before the names of owners of work of art, such as museums and civic bodies. Every effort has been made to contact copyright holders and to credit them appropriately; we apologize to anyone who may have been omitted from the acknowledgements or cited incorrectly. Any error brought to our attention will be corrected in subsequent editions. Where illustrations have been taken from books, publication details are provided in the acknowledgements below.

Line drawings, maps and plans are not included in the list below. All of the maps were produced by Oxford Illustrators Ltd, who were also responsible for some of the line drawings.

Abrahams, Carl National Gallery of Jamaica, Kingston
Abramo, Lívio Collection of Latin American Art, University of Essex, Colchester (Donated by Alex Gama)
Abularach, Rodolf Art Museum of the Americas (OAS), Washington, DC
African diaspora *1* Photo: J.M. Vlach; *2* Department of Library Services, American Museum of Natural History, New York; *3* Fowler Museum of Cultural History, UCLA, Los Angeles, CA
Almeida Júnior, José Ferraz de Pinacoteca do Estado de São Paulo
Alonso, Raúl Bronx Museum of the Arts, New York (Gift of the artist; no. 1987.2)
Alvarez Bravo, Manuel Norton Simon Museum, Pasadena, CA (no. PH.71.43)
Amaral, Antonio Henrique Art Museum of the Americas (OAS), Washington, DC
Anguiano, Raúl Museum of Modern Art, New York (Inter-American Fund)
Antigua (i) Consejo Nacional para la Protección de la Antigua Guatemala, Guatemala City/Photo: Julio Taracena
Antilles, Lesser *1* Trustees of the British Museum, London; *2* Photo: Larsen Collinge International, Bath; *3* Photo: Robert Harding Picture Library, London; *4* Photo: Yellow Poui Art Gallery, St Georges, Grenada; *5* Photo: Alissandra Cummins
Antúnez, Nemesio Jack S. Blanton Museum of Art, University of Texas at Austin, TX (Gift of Barbara Duncan, 1994)/Photo: Rick Hall
Arequipa Photo: Robert Harding Picture Library, London
Argentina *2–3* South American Pictures, Woodbridge, Suffolk/Photo: Tony Morrison; *4* Bibliográfica Omeba, Buenos Aires; *5* Museo Nacional de Bellas Artes, Buenos Aires; *6* Arts Council Collection, London/© Gyula Kosice, Buenos Aires; *7* Museo de Motivos Populares Argentinos, Buenos Aires
Artigas, João B. Vilanova Photo: Julio Roberto Katinsky
Bahamas, the *2* Trustees of the British Museum, London; *3–4* Department of Archives, Nassau; *5* P. Neko Meicholas Jr, Nassau, N.P./© John Beadle, Jackson Burnside III, Stan Burnside, Brent Malone and Antonius Roberts (5 artists of B.-C.A.U.S.E)
Barragán, Luis Photo: Armando Salas-Portugal
Batlle Planas, Juan Coleccion Museo de Arte Moderno de Buenos Aires
Belize *2* Photo: D. Donne Bryant, DDB Stock Photo, Baton Rouge, LA; *3* Belize Arts Council
Belkin, Arnold Jack S. Blanton Museum of Art, University of Texas at Austin, TX (Gift of Mary Brewster McCully, 1974)/Photo: George Holmes
Benedit, Luis Jack S. Blanton Museum of Art, University of Texas at Austin, TX (Gift of Waldo Rasmussen, 1982)/Photo: George Holmes
Berni, Antonio Jack S. Blanton Museum, University of Texas at Austin, TX (Barbara Duncan Fund, 1977)/Photo: George Holmes
Blinder, Olga Collection of Latin American Art, University of Essex, Colchester (Donated by the artist)
Bogotá, Santa Fe de Photo: Valerie Fraser
Bolivia *2* Photo: Ernesto Vargas Perez, La Paz; *3, 5* Museo Nacional de la Casa de Moneda, Potosí, Bolivia; *4* Photo: Gustavo Medeiros Anaya, La Paz; *6* Museo Tambo Quirquincho, La Paz; *7* Museo Nacional de Arte, La Paz; *8* Photo: Ruth Corcuera; *9* Museum der Kulturen, Basel
Bonevardi, Marcelo *1* Solomon R. Guggenheim Museum, New York (Gift of the Dorothy Beskind Foundation, 1973; no. FN. 68.1867); *2* Museo Nacional de Bellas Artes, Buenos Aires
Botero, Fernando Museum Moderner Kunst, Stiftung Ludwig, Vienna
Boxer, David National Gallery of Jamaica, Kingston
Brasília Photo: © Julius Shulman, Hon. AIA, Los Angeles, CA
Brazil *2* Trustees of the British Museum, London; *3* Collection João Marino, São Paulo; *4* Bridgeman Art Library, London; *5, 7* South American Pictures, Woodbridge/Photo: Tony Morrison; *6* Photo: G.E. Kidder Smith, New York; *8* Photo: Antonio Fernando Batista dos Santos; *9* Museu Nacional de Bellas Artes, Rio de Janeiro; *10* Photo: Brazilian Embassy, London; *11* Instituto Lina Bo e P.M. Bardi/Photo: F. Albuquerque; *12* Museu de Arte de São Paulo
Brecheret, Victor Museu de Arte Contemporânea da Universidade de São Paulo
Brizzi, Ary Jack S. Blanton Museum of Art, University of Texas at Austin, TX (Archer M. Huntington Museum Fund, 1970)/Photo: George Holmes
Buenos Aires South American Pictures, Woodbridge, Suffolk/Photo: Tony Morrison
Burle Marx, Roberto Photo: Marcel Gautherot
Burton, Mildred Collection of Latin American Art, University of Essex, Colchester (Donated by Marcos Curi)
Bustos, Hermenegildo Museo de Alhondiga de Granaditas, Guanajuato/Photo: Bridgeman Art Library, London/New York
Butler, Horatio Museo Nacional de Bellas Artes, Buenos Aires
Camargo, Sergio © Tate Gallery, London

Posada, José Guadalupe *1* Collection of Latin American Art, University of Essex, Colchester (Donated by Dr Ele Wake); *2* Museum of Modern Art, New York

Post: (2) Frans Rijksmuseum, Amsterdam

Potosí South American Pictures, Woodbridge, Suffolk/Photo: Tony Morrison

Puebla Photo: Overseas Agenzia Fotografica, Milan

Puerto Rico *2* American Museum of Natural History, New York; *3* Archivo General de Puerto Rico/Photo: US Army; *4* Photo: Myrna E. Rodriquez

Pueyrredón, Prilidiano Museo Nacional de Bellas Artes, Buenos Aires/Photo: Bridgeman Art Library, London/ New York

Quito Museos Municipales, Quito/Photo: Alfonso Ortiz Crespo, 1993

Ramos, Nelson Jack S. Blanton Museum of Art, University of Texas at Austin, TX (Archer M. Huntington Museum Fund, 1974)/Photo: George Holmes

Reidy, Affonso Eduardo Photo: Prof. John Musgrove

Retable *1* South American Pictures, Woodbridge, Suffolk/Photo: Tony Morrison; *2* Art Archive of the Calouste Gulbenkian Foundation, Lisbon (Legacy of Robert C. Smith)

Rio de Janeiro Atman Press Agency, Rio de Janeiro/Photo: Elisa Ramos

Rivera, Diego *1* Detroit Institute of Art, Detroit, MI (Founders Society Purchase, Miscellaneous Memorials Fund)/© DACS, 1999; *2* Detroit Institute of Art, Detroit, MI (Founders Society Purchase, Miscellaneous Memorials Fund)/Photo: Dirk Bakker, 1990/© DACS, 1999

Roberto, M. M. M. Photo: Julio Roberto Katinsky

Robirosa, Josefina Albright-Knox Art Gallery, Buffalo, NY (Gift of Seymour H. Knox, 1970)

Rodríguez, Alirio Centre Georges Pompidou, Paris (Collections Mnam/Cci)

Rojo, Vincente Jack S. Blanton Museum of Art, University of Texas at Austin, TX (Archer M. Huntington Museum Fund, 1974)/Photo: George Holmes

Rybak, Taty Art Museum of the Americas (OAS), Washington, DC

Sabogal, José Art Museum of the Americas (OAS), Washington, DC

Sakai, Kazuya Jack S. Blanton Museum of Art, University of Texas at Austin, TX (Archer M. Huntington Museum Fund, 1977)/Photo: George Holmes

Sánchez, Emilio National Museum of American Art, Washington, DC/Photo: Art Resource, New York

Santiago South American Pictures, Woodbridge, Suffolk/Photo: Peter Francis

São Paulo Museu de Arte de São Paulo

Segall, Lasar Pinacoteca do Estado de São Paulo

Seguí, Antonio H. Jack S. Blanton Museum of Art, University of Texas at Austin, TX (Archer M. Huntington Museum Fund, 1970)/Photo: George Holmes/© DACS, 1999

Seoane, Luis Collecion Museo de Arte Moderno de Buenos Aires/© DACS, 1999

Serpa, Ivan Museu de Arte Contemporânea de São Paulo

Sibellino, Antonio Museo Nacional de Bellas Artes, Buenos Aires

Siqueiros, David Alfaro *1* Museum of Modern Art, New York; *2* Photo: Ramiro Romo

Soto, Jesús Royal Bank of Canada Archives, Toronto/© DACS, 1999

Sugar sculpture Modern Art Museum of Fort Worth (Museum Purchase)

Surinam *2* Photo: D. Donne Bryant, DDB Stock Photo, Baton Rouge, LA; *3* Royal Collection, Windsor Castle/© Her Majesty Queen Elizabeth II

Szyszlo, Fernando de Jack S. Blanton Museum of Art, University of Texas at Austin, TX (Gift of Dr Evelyn Hammond and Bennett Spelce, 1986)/Photo: George Holmes

Tábara, Enrique Jack S. Blanton Museum of Art, University of Texas at Austin, TX (Gift of John and Barbara Duncan, 1971)/Photo: George Holmes

Tamayo, Rufino *1* Centre Georges Pompidou Musée National d'Art Moderne, Paris/© Fundación Olga y Rufino Tamayo, A.C., Mexico City; *2* Cleveland Museum of Art, 1998, Cleveland, OH (Gift of Leonard C. Hanna, Jr; no. 1950.583)/© Fundación Olga y Rufino Tamayo, A.C., Mexico City

Tarsila *1–2* Museu de Arte Contemporânea da Universidade de São Paulo

Testa, Clorindo 1 Photo: Julius Shulman, Hon. AIA, Los Angeles, CA; *2* Jack S. Blanton Museum of Art, University of Texas at Austin, TX (Gift of Barbara Duncan, 1973)/Photo: George Holmes

Toledo, Francisco Jack S. Blanton Museum of Art, University of Texas at Austin, TX (Gift of Barbara Duncan, 1977)/Photo: George Holmes

Toral, Mario Jack S. Blanton Museum of Art, University of Texas at Austin, TX (Gift of Joe Minerals Corporation, 1977)/Photo: George Holmes

Torres García, Joaquín Museo Nacional de Arte Plásticas e Visuales, Montevideo/© ADAGP, Paris and DACS, London, 1999

Trinidad and Tobago *2* Photo: Cristopher Laird; *3* Photo: John Gillispie; *4* Aquarela Galleries, Port of Spain; *5* Photo: Nicholas Guppy, London; *6* Photo: Matthew McHugh

Troya, Rafael Museo Perez Chirboya del Banco Central, Quito/Photo: Bridgeman Art Library, London/New York

Trujillo, Guillermo Art Museum of the Americas (OAS), Washington, DC

Tunga Collection of Latin American Art, University of Essex, Colchester (Donated by Charles Cosac)

Urteaga Alvarado, Mario Museum of Modern Art, New York (Inter-American Fund)

Uruguay *2* South American Pictures, Woodbridge, Suffolk/Photo: Tony Morrison; *3* Museum of Modern Art, New York; *4* British Library, London (no. NL.15.d, pl.IX); *5* Photo: Alicia Haber

Vega, Jorge de la Jack S. Blanton Musueum of Art, University of Texas at Austin, TX (Gift of Barbara Duncan, 1973)/Photo: George Holmes

Velasco, José María Instituto Nacional de Bellas Artes y Literatura, Mexico City

Venezuela *2* Horniman Museum, London; *3–5* South American Pictures, Woodbridge, Suffolk/Photo: Tony Morrison; *6* Asociación Venezolana, Amigos del Arte Colonial Collección, Caracas/Photo: M. Aldaca; *7* Galería de Arte Nacional, Caracas; *8* Art Museum of the Americas (OAS), Washington, DC; *9* Asociación Venezolana, Amigos del Arte Colonial Collección, Caracas

Vernacular architecture South American Pictures, Woodbridge, Suffolk/Photo: Tony Morrison

Victorica, Miguel Carlos Museo Nacional de Bellas Artes, Buenos Aires

Vidal, Miguel Angel Solomon R. Guggenheim Museum, New York (Purchased with funds contributed by Fundacion Neumann, Caracas, Venezuela, 1968; no. 68.1867)

Villanueva, Carlos Raúl South American Pictures, Woodbridge, Suffolk/Photo: Tony Morrison

Volpi, Alfredo Museu de Arte Moderna do São Paulo

Watson, Barrington National Gallery of Jamaica, Kingston

Williams, Amancio Photo: Grete Stern

Yampolsky, Mariana Collection of Latin American Art, University of Essex, Colchester (Donated by the artist)

Yrurtia, Rogelio Archivo Museo Casa Yrurtia, Buenos Aires

Zachrisson, Julio Museum of Modern Art, New York (Inter-American Fund)

Zúñiga, Francisco Hirshhorn Museum and Sculpture Garden, Smithsonian Institution, Washington, DC (Gift of Joseph H. Hirshhorn, May 12, 1976)

Colour Plate Acknowledgments

Cover illustration: Antonio Ruiz: *The New Rich*, oil on canvas, 321x422 mm, 1941 (New York, Museum of Modern Art/ Photo: Museum of Modern Art)

PLATE I.

1. Brooke Alfaro: *Virgin of All Secrets*, oil on canvas, 864x813 mm, 1986 (Washington, DC, Art Museum of the Americas/Photo: Art Museum of the Americas, OAS)

2. Antonio Henrique Amaral: *Battlefield 31*, oil on canvas, 915x1220 mm, 1974 (Austin, University of Texas, Jack S. Blanton Museum of Art/Photo: Jack S. Blanton Museum of Art, Archer M. Huntington Museum Fund, 1975/Photo: Rick Hall)

PLATE II.

1. Nemesio Antúnez: *Black Stadium*, oil on canvas, 1.46x1.14 m, 1977 (Austin, University of Texas, Jack S. Blanton Museum of Art/ Photo: Jack S. Blanton Museum of Art, Gift of Barbara Duncan, 1994/Photo: Rick Hall)

2. Cundo Bermúdez: *The Balcony*, oil on canvas, 737x587 mm, 1941 (New York, Museum of Modern Art/Photo: Museum of Modern Art, Gift of Edgar Kaufmann)

3. Juan Manuel Blanes: *The Paraguayan in her Desolate Motherland*, oil on canvas, 1000x800 mm, 1879–80 (Montevideo, Museo Nacional de Artes Visuales/Photo: Bridgeman Art Library, London/New York)

PLATE III.

1. Fernando Botero: *Mona Lisa, Age Twelve*, oil and tempera on canvas, 2.11x1.95 m, 1961 (New York, Museum of Modern Art/ Photo: Museum of Modern Art, Inter-American Fund)

2. Fernando Botero: *Presidential Family*, oil on canvas, 2.03x1.96 m, 1967 (New York, Museum of Modern Art/Photo: Museum of Modern Art, Gift of Warren D. Benedek)

3. Miguel Cabrera: *2. From Spaniard and Mestiza, Castiza*, oil on canvas, 1.32x1.01 m, 1763 (Madrid, Museo de América/Photo: Museo de América)

4. Miguel Cabrera: *12. From Albarazado and Mestizo Woman, Barcino*, oil on canvas, 1.32x1.01m, 1763 (Madrid, Museo de América/Photo: Museo de América)

PLATE IV.

1. Coqui Calderón: *Tribute to the Letter A, No. 2*, acrylic on canvas, 1.02x1.02 m, 1976 (Washington, DC, Art Museum of the Americas/ Photo: Art Museum of the Americas, OAS)

2. Alejandro Canales: *Communication Past and Present* (1984-5), mural in acrylic, 30 x 14 m, Telcor Building, Managua (Photo: David Craven)

3. Alejandro Canales: *Homage to Woman: The Literacy Crusade* (detail; 1980, dest. 1990), mural in acrylic, 4 x 22 m, Valesquez Park, Managua (Photo: David Craven)

PLATE V

1. Ernesto de la Cárcova: *Without Bread and without Work*, oil on canvas, 1.26x2.16 m, 1893 (Buenos Aires, Museo Nacional de Bellas Artes/Photo: Museo Nacional de Bellas Artes)

2. Enrique Careaga: *Spatial-Temporal Spheres BS 7523*, acrylic on canvas, 1.2x1.2 m, 1975 (Washington, DC, Art Museum of the Americas/Photo: Art Museum of the Americas, OAS)

3. Mario Carreño: *Cuba Libre*, gouache and ink, 394x350 mm, 1945 (Washington, DC, National Museum of American Art, Gift of the Container Corporation of America/Photo: Art Resource, New York)

PLATE VI.

1. Teófilo Castillo: *Funeral of Santa Rosa* (detail), oil on canvas, 900x2040 mm, 1918 (Lima, Museo de Arte/Photo: Pauline Antrobus)

2. Emiliano di Cavalcanti: *Five Girls from Guaratinguetá*, oil on canvas, 910x710 mm, 1930 (São Paulo, Museu de Arte de São Paulo Assis Châteaubriand/Photo: Bridgeman Art Library, London/New York)

PLATE VII.

1. Pedro Coronel: *Repose*, acrylic with gauze on canvas, 2.03x2.03 m, 1965 (Austin, University of Texas, Jack S. Blanton Museum of Art/ Photo: Jack S. Blanton Museum of Art, Gift of Carol and Robert Strauss, 1982/Photo: George Holmes)

2. Luis Cruz Azaceta: *A Question of Colour*, acrylic on canvas, 3.05 x 3.66 m, 1989 (Houston, TX, Museum of Fine Arts/Photo: Museum of Fine Arts, Houston; Museum purchase with funds provided by the National Endowment for the Arts and the Prospero Foundation in honour of Dr Peter C. Marzo and the exhibition Hispanic Art in the United States: 30 Contemporary Painters and Sculptors)

PLATE VIII.

1. Carlos Cruz-Diez: *Physichromie No. 394*, wood, plastic and metal, 1212x622x63 mm, 1968 (Austin, University of Texas, Jack S. Blanton Museum of Art/Photo: Jack S. Blanton Museum of Art, Gift of Irene Shapiro, 1986/Photo: George Holmes/© DACS, 1999)

2. Germán Cueto: *La Tehuana*, bronze, aluminium and copper, 1090x405x325 mm (Mexico City, Museo de Arte Moderno/Photo: Museo de Arte Moderno)

PLATE IX.

1. Ana Eckell: *Untitled*, acrylic on canvas, 1000x930 mm, 1985 (Colchester, University of Essex, Collection of Latin American Art, Donated by the artist/Photo: Ferdy Carabott)

2. Albert Eckhout: *Two Brazilian Turtles*, paper on panel, 305x510 mm (The Hague, Mauritshuis/Photo: Mauritshuis)

PLATE X.

1. Manuel Felguérez: *Origen de la reducción*, enamel on canvas, 813x813 mm, 1975 (Austin, University of Texas, Jack S. Blanton Museum of Art/Photo: Jack S. Blanton Museum of Art, Gift of Carol and Robert Strauss, 1982/Photo: George Holmes)

2. Agustín Fernández: *Landscape and Still-life*, oil on canvas, 1.22x1.40 m 1956 (New York, Museum of Modern Art/Photo: Museum of Modern Art, Inter-American Fund)

PLATE XI.

1. Raquel Forner: *Return of the Astronaut*, oil on canvas, 1.94x1.29 m, 1969 (Washington, DC, National Air and Space Museum/Photo: National Air and Space Museum, Smithsonian Institution)

2. Gego: *Esfera*, painted brass and steel, diam. 557 mm, 1959 (New York, Museum of Modern Art/Photo: Museum of Modern Art, Inter-American Fund)

3. Gunther Gerzso: *House of Tataniuh*, silkscreen, 582x429 mm, 1978 (Washington, DC, Art Museum of the Americas/Photo: Art Museum of the Americas, OAS)

PLATE XII.

1. Mathias Goeritz: *Moses*, wood and iron, 730x230x210 mm, 1956 (Jerusalem, Israel Museum/Photo: Israel Museum)

PLATE XIII.

1. Miguel González: *Virgin of Guadalupe*, oil on panel, 740x570 mm, 1697 (Madrid, Museo de América/Photo: Museo de América)

PLATE XIV.

1. Asilia Guillén: *Rafaela Herrera Defends the Castle against the Pirates*, oil on canvas, 635x965 mm, 1962 (Washington, DC, Art Museum of the Americas/Photo: Art Museum of the Americas, OAS)

2. Daniel Hernández: *The Idle Lady* ('*La Perezosa*'), oil on canvas, 690X1050 mm, 1906 (Lima, Museo de Arte, Donated by the Prado family/Photo: Pauline Antrobus)

PLATE XV.

1. Alfredo Hlito Olivari: *Espectro no. IV*, oil on canvas, 997x813 mm, 1960 (Austin, University of Texas, Jack S. Blanton Museum of Art/Photo: Jack S. Blanton Museum of Art, Gift of Barbara Duncan, 1974/Photo: George Holmes)

2. Winslow Homer: *Under the Coco Palm*, watercolour over graphite on paper, 380x538 mm, 1898 (Cambridge, MA, Fogg Art Museum/Photo: Fogg Art Museum, Louise E. Bettens Fund)

PLATE XVI.

1. Elena Izcue: illustration from A. Gamarra: *Manco Capac: Leyenda nacional* (Lima, 1923/Photo: Pauline Antrobus)

2. María Izquirierdo: *Family Portrait*, oil on plywood, 1398x998 mm, 1940 (Mexico City, Museo Nacional de Arte/Photo: Schalwijk/ Art Resource, New York)

PLATE XVII.

1. Frida Kahlo: *Frida and Diego Rivera*, oil on canvas, 1000x787 mm, 1931 (San Francisco, CA, Museum of Modern Art/Photo: San Francisco Museum of Modern Art, Albert M. Bender Collection, Gift of Albert M. Bender/© DACS, 1999)

PLATE XVIII.

1. Wifredo Lam: *The Wedding*, oil on canvas, 2.15x1.97 m, 1947 (Berlin, Staatliche Museen Preussischer Kulturbesitz/Photo: Bildarchiv Preussischer Kulturbesitz/© DACS, 1999)

2. Wifredo Lam: *Merchant of Dreams*, oil on canvas, 1300x980 mm, 1962 (Eindhoven, Stedelijk Van Abbe Museum/Photo: Stedelijk Van Abbe Museum/© DACS, 1999)

3. Eugenio Landesio: *Mexican Landscape*, oil on canvas, 450x630 mm, 1857 (Paris, Musée du Louvre/Photo: RMN/Photo: Gerard Blot)

PLATE XIX.

1. Luis López Loza: *Figures Overwhelming a Blue Sky*, oil on canvas,1.64x1.54 m, 1975 (Austin, University of Texas, Jack S. Blanton Museum of Art/Photo: Jack S. Blanton Museum of Art, Archer M. Huntington Museum Fund, 1975/Photographer: George Holmes)

2. Eduardo MacEntyre: *Red, Orange and Black*, oil on canvas, 1.64x1.50 m, 1965 (New York, Museum of Modern Art/Photo: Museum of Modern Art, Inter-American Fund)

3. Antonio Maia: *The Heroes*, oil on canvas, 1030x1030 mm, 1973 (Toronto, Art Gallery of Ontario/Photo: Art Gallery of Ontario, Gift of Brascan Ltd, 1976)

PLATE XX.

1. Maruja Mallo: *Song of the Ears of Corn*, oil on canvas, 1.20x2.34 m, 1929 (Madrid, Museo Nacional Centro de Arte Reina Sofia/ Photo: Archivo Fotográfico, Museo Nacional Centro de Arte Reina Sofia)

2. María Martorell: *Ekho A*, oil on canvas, 1.6x2.2 m, 1968 (Buenos Aires, Museo de Arte Moderno/Photo: Coleccion Museo de Arte Moderno de Buenos Aires)

PLATE XXI.

1. Roberto Matta: *Listen to the Living*, oil on canvas, 749x949 mm, 1941 (New York, Museum of Modern Art/Photo: Museum of Modern Art, Inter-American Fund)

2. Santos Medina: *Revolutionary Unity of Indo-Americans*, oil and mixed media on canvas, 610x1341 mm, 1982 (Managua, Museo Julio Cortázar del Arte Moderno de América Latina, now in the National Institute of Culture, Managua/Photo: David Craven)

PLATE XXII.

1. Carlos Mérida: *Plastic Invention on the Theme of Love*, gouache and watercolour over graphite on paper, 750x550 mm, 1939 (Chicago, IL, Art Institute of Chicago/Photo: Art Institute of Chicago, Gift of Katharine Kuh; no. 1955.818)

2. Façade of the church of S Francisco Acatepec, with polychrome glazed tiles in the Poblano style, Puebla, Mexico, 18th century (Photo: South American Pictures, Woodbridge, Suffolk)

3. Armando Morales: *Seated Woman*, oil on canvas, 914x914 mm, 1971 (Managua, Banco Central de Nicaragua/Photo: David Craven/© DACS, 1999)

PLATE XXIII.

1. Luis Felipe Noé: *Closed for Sorcery*, oil and collage on canvas, 1.99x2.49 m, 1963 (Austin, University of Texas, Jack S. Blanton Museum of Art/Photo: Jack S. Blanton Museum of Art, Archer M. Huntington Museum Fund, 1973/Photo: George Holmes)

2. Alejandro Obregón: *Cattle Crossing the Magdalena*, oil on canvas, 1.64x1.31 m, 1955 (Houston, Museum of Fine Arts/Photo: Museum of Fine Arts, Gift of Brown and Root Inc.)

3. Miguel Ocampo: *Untitled, 77/9*, acrylic and airbrush on canvas, 1.46x1.27 m, 1977 (Washington, DC, Art Museum of the Americas/Photo: Art Museum of the Americas, OAS)

PLATE XXIV.

1. Juan O'Gorman: *Mexico City*, tempera on masonite, 660x1220 mm, 1947 (Mexico City, Museo de Arte Moderno/Photo: Museo de Arte Moderno)

2. Pablo O'Higgins: *The Market*, colour lithograph, 305x330 mm, 1940 (Washington, DC, Art Museum of the Americas/Photo: Art Museum of the Americas, OAS)

3. Gustavo Ojeda: *Downtown Evening*, mixed media on handmade paper, 1015x991 mm, 1986 (Washington, DC, National Museum of American Art/Photo: Art Resource, New York)

PLATE XXV

1. José Clemente Orozco: *Dive Bomber and Tank*, fresco, 2.75x5.50 m, 1940 (New York, Museum of Modern Art/Photo: Museum of Modern Art)

2. José Clemente Orozco: *Hispano-American* (detail), fresco, 30.5x30.2 m, 1932–4 (Instituto Nacional de Bellas Artes y Literatura, Mexico City/Photo: Bridgeman Art Library, London/New York)

PLATE XXVI.

1. Alejandro Otero: *Colourrythm 1*, enamel on plywood, 2001x482 mm, 1955 (New York, Museum of Modern Art/Photo: Museum of Modern Art, Inter-American Fund)

PLATE XXVII.

1. Amelia Peláez: *Still Life in Red*, oil on canvas, 693x851 mm, 1938 (New York, Museum of Modern Art/Photo: Museum of Modern Art)

2. Rodrigo Penalba: *Untitled*, oil on cardboard, 400x495 mm, 1944–45 (Washington, DC, Art Museum of the Americas/Photo: Art Museum of the Americas, OAS)

PLATE XXVIII.

1. Peruvian tapestry with Inca-style designs and European motifs, wool, 2.3x2.1 m, *c.* 17th century (London, British Museum/Photo: Trustees of the British Museum)

PLATE XXIX.

1. Inca noble's tunic (*quompi*), tapestry weave, camelid fibre weft and cotton warp, 915x770 mm, possibly from the south coast of Peru, late 15th century or early 16th (Washington, DC, Dumbarton Oaks Research Library and Collections/Photo: Dumbarton Oaks Research Library and Collections)

PLATE XXX.

1. Peruvian armchair, mahogany (*aguano*), 1130x650x460 mm, late 19th century (Leeds, Temple Newsam House/Photo: Temple Newsam House)

2. Manuel Piqueras Cotolí: façade of the Peruvian Pavillion, Seville, 1929 (Photo: Pauline Antrobus)

PLATE XXXI.

1. Rogelio Polesello: *Side A*, oil on canvas, 2.60x1.95 m, 1965 (New York, Solomon R. Guggenheim Museum/Photo: Solomon R. Guggenheim Museum, Purchased with funds contributed by Fundacion Neumann, Caracas, Venezuela, 1966; no. F.N. 66.1824/Photo: David Heald)

2. Frans Post: *Brazilian Landscape*, oil on panel, 610x915 mm, 1650 (New York, Metropolitan Museum of Art/Photo: Metropolitan Museum of Art, Purchased with funds from various donors, 1981; no. 1981.318)

PLATE XXXII.

1. Omar Rayo: *Trapped*, acrylic on canvas, 660x660 mm, 1960–67 (Washington, DC, Art Museum of the Americas/Photo: Art Museum of the Americas)

2. Vincente do Rego Monteiro: *The Hunt*, oil on canvas, 2.02x2.59 m, 1923 (Paris, Centre Georges Pompidou/Photo: Centre Georges Pompidou, Collections Mnam/Cci)

PLATE XXXIII.

1. Diego Rivera: *Symbolic Landscape*, oil on canvas, 1.21x1.52 m, 1940 (San Francisco, Museum of Modern Art/Photo: San Francisco Museum of Modern Art, Gift of friends of Diego Rivera/© DACS, 1999)

2. Ofelia Rodriguez: *Landscape with Red Live Tree*, mixed media on canvas, 1.7x2.1 m, 1990 (Colchester, University of Essex, Collection of Latin American Art, Donated by the artist/Photo: Ferdy Carabott)

PLATE XXXIV.

1. Diego Rivera: *Pan American Unity*, fresco, 6.71x21.3 m, 1940 (San Francisco, City College/Photo: City College of San Francisco, http://www.riveramural.com/© DACS, 1999)

2. Antonio Ruiz: *The New Rich*, oil on canvas, 321x422 mm, 1941 (New York, Museum of Modern Art/Photo: Museum of Modern Art)

PLATE XXXV.

1. José Sabogal: *Indian Mayor of Chincheros, Varayoc*, oil on canvas, 1.7x1.05 m, 1925 (Lima,

Pinacoteca Municipal de Arte/Photo: Pauline Antrobus)

PLATE XXXVI.

1. David Alfaro Siqueiros: *Collective Suicide*, enamel on wood with applied sections, 1.24 x 1.82 m, 1936 (New York, Museum of Modern Art/Photo: Museum of Modern Art, Gift of Dr Gregory Zilboorg)

2. David Alfaro Siqueiros: *Ethnographia*, enamel on composition board, 1220x820 mm, 1939 (New York, Museum of Modern Art/ Photo: Museum of Modern Art, Gift of Abby Aldrich Rockefeller)

PLATE XXXVII.

1. Juan Soriano: *Untitled*, ink on paper, 240x310 mm, 1953 (Colchester, University of Essex, Collection of Latin American Art, Donated by Emma Reyes/Photo: Ferdy Carabott)

2. Fernando de Szyszlo: *Cajamarca*, oil on canvas, 1270x915 mm, 1959 (Washington, DC, Art Museum of the Americas/Photo: Art Museum of the Americas, OAS)

PLATE XXXVIII.

1. Rufino Tamayo: *Cow Swatting Flies*, oil on canvas, 787x991 mm, 1951 (Austin, University of Texas, Art Collection, Harry Ransom Humanities Research Center/Photo: Art Collection, Harry Ransom Humanities Research Center, the Nickolas Muray Collection of Mexican Art/© Fundación Olga y Rufino Tamayo, A.C., Mexico City)

2. Rufino Tamayo: *Animals*, oil on canvas, 765x1016 mm, 1941 (New York, Museum of Modern Art/Photo: Museum of Modern Art, Inter-American Fund/© Fundación Olga y Rufino Tamayo, A.C., Mexico City)

PLATE XXXIX.

1. Joaquín Torres García: *Untitled*, gouache on cardboard mounted on wood, 810x430 mm, 1938 (Buffalo, NY, Albright-Knox Art Gallery/Photo: Albright-Knox Gallery Art Gallery, Gift of the Seymour H. Knox Foundation, Inc., 1967)

2. Rafael Troya: *Expedition Camp in the Crater of the Guaga Pichincha Volcano*, oil on canvas, 560x890 mm, 1871 (Mannheim, Reiss-Museum/Photo: Völkerkundliche Sammlungen im Reiss-Museum Mannheim)

PLATE XL.

1. José María Velasco: *The Valley of Mexico from the Low Ridge of Tacubaya*, oil on canvas, 470x625 mm, 1894 (Mexico City, Museo Nacional de Arte/Photo: Bridgeman Art Library, London/New York)

2. Armando Villegas: *Electric Panorama*, oil on canvas, 1.10x1.27 m, 1958 (Washington, DC, Art Museum of the Americas/Photo: Art Museum of the Americas, OAS)

Appendix A

LIST OF LOCATIONS

Every attempt has been made in compiling this encyclopedia to supply the correct current location of each work of art mentioned, and in general this information appears in abbreviated form in parentheses after the first mention of the work. The following list contains the abbreviations and full forms of the museums, galleries and other institutions that own or display art works or archival material cited in this encyclopedia; the same abbreviations have been used in bibliographies to refer to the venues of exhibitions.

Institutions are listed under their town or city names, which are given in alphabetical order. Under each place name, the abbreviated names of institutions are also listed alphabetically, ignoring spaces, punctuation and accents. Square brackets following an entry contain additional information about that institution, for example its previous name or the fact that it was subsequently closed. Such location names are included even if they are no longer used, as they might be cited in the encyclopedia as the venue of an exhibition held before the change of name or date of closure. The information on this list is the most up-to-date available at the time of publication.

Aachen, Ludwig Forum Int. Kst
 Aachen, Ludwig Forum für Internationale Kunst

Adelaide, A.G. S. Australia
 Adelaide, Art Gallery of South Australia

Aguascalientes, Mus. Aguascalientes
 Aguascalientes, Museo de Aguascalientes

Amsterdam, Kon. Inst. Tropen
 Amsterdam, Koninklijk Instituut voor de Tropen

Amsterdam, Rijksmus.
 Amsterdam, Rijksmuseum [includes Afdeeling Aziatische Kunst; Afdeeling Beeldhouwkunst; Afdeeling Nederlandse Geschiedenis; Afdeeling Schilderijen; Museum von Asiatische Kunst; Rijksmuseum Bibliotheek; Rijksprentenkabinet]

Amsterdam, Stedel. Mus.
 Amsterdam, Stedelijk Museum

Andover, MA, Phillips Acad., Addison Gal.
 Andover, MA, Phillips Academy, Addison Gallery of American Art

Annandale-on-Hudson, NY, Bard Coll., Rivendell Col.
 Annandale-on-Hudson, NY, Bard College, Rivendell Collection

Antequera, Mus. Mun.
 Antequera, Museo Municipal

Antigua, Mus. Colon.
 Antigua, Museo Colonial

Antwerp, Kon. Mus. S. Kst.
 Antwerp, Koninklijk Museum voor Schone Kunsten

Asunción, Mus. Parag. A. Contemp.
 Asunción, Paraguay, Museo Paraguayo de Arte Contemporáneo

Asunción, Paraguay, Mis. Cult. Bras.
 Asunción, Paraguay, Misión Cultural Brasilera

Austin, TX, Laguna Gloria A. Mus.
 Austin, TX, Laguna Gloria Art Museum [Texas Fine Art Association]

Austin, U. TX, A. Mus.
 Austin, TX, University of Texas at Austin, University Art Museum [name changed to Huntington A.G. in 1980]

Austin, U. TX, Huntington A.G.
 Austin, TX, University of Texas at Austin, Archer Museum Huntington Art Gallery [until 1980 called U. TX, A. Mus.]

Austin, U. TX System Libs
 Austin, TX, University of Texas System Libraries

Baltimore, MD, Walters A.G.
 Baltimore, MD, Walters Art Gallery

Barcelona, Cent. Cult. Fund. Caixa Pensions
 Barcelona, Centre Cultural de la Fundació Caixa de Pensions

Barcelona, Fund. Miró
 Barcelona, Fundació Joan Miró

Barcelona, Generalitat Catalunya
 Barcelona, Generalitat de Catalunya

Barcelona, Mus. A. Mod.
 Barcelona, Museu d'Art Modern

Basle, Ksthalle
 Basle, Kunsthalle Basel

Basle, Kstmus.
 Basle, Kunstmuseum [incl. Kupferstichkabinett]

Belém, Brazil, Pal. Gov. Estado Pará
 Belém, Brazil, Palácio de Governo do Estado do Pará

Belfast, Ulster Mus.
 Belfast, Ulster Museum

Belmopan, House Cult.
 Belmopan, House of Culture

Berlin, Akad. Kst.
 Berlin, Akademie der Künste [formed by unification of former Preussische Akademie der Künste & Deutsche Akademie der Künste der DDR]

Berlin, Botan. Mus.
 Berlin, Botanisches Museum

Berlin, Kupferstichkab.
 Berlin, Kupferstichkabinett [formerly at Dahlem, since 1994 at Tiergarten]

Berlin, Staatl. Ksthalle
 Berlin, Staatliche Kunsthalle

Berlin, Staatl. Museen Preuss. Kultbes.
 Berlin, Staatliche Museen Preussischer Kulturbesitz [admins Ägyp. Mus.; Alte N.G.; Altes Mus.; Antikenmus.; Bodemus.; Gal. Romantik; Gemäldegal.; Gipsformerei; Kstbib.; Kupferstichkab.; Mus. Dt. Vlksknd.; Mus. Ind. Kst; Mus. Islam. Kst; Mus. Ostasiat. Kst; Mus. Vlkerknd.; Mus. Vor- & Frühgesch.; Neue N.G.; Pergamonmus.; Schinkelmus.; Schloss Charlottenburg; Schloss Köpenick; Skulpgal.; Staatsbib.; Tiergarten, Kstgewmus.]

Berne, Ksthalle
 Berne, Kunsthalle

Birmingham, Ikon Gal.
 Birmingham, Ikon Gallery

Birmingham, AL, Mus. A.
 Birmingham, AL, Museum of Art

Bogotá, Acad. N. B.A.
 Bogotá, Academia Nacional de Bellas Artes

Bogotá, Alonso A.
 Bogotá, Alonso Arte

Bogotá, Bib. Luis-Angel Arango
 Bogotá, Biblioteca Luis-Angel Arango del Banco de la República

Bogotá, Bib. N. Colombia
 Bogotá, Biblioteca Nacional de Colombia

Bogotá, Fond. Cult. Cafetero
 Bogotá, Fondo Cultural Cafetero

Bogotá, Gal. Alfred Wild
 Bogotá, Galería Alfred Wild

Bogotá, Gal. Fernando Quintana
 Bogotá, Galería Fernando Quintana

Bogotá, Gal. Garcés Velázquez
 Bogotá, Galería Garcés Velázquez

Bogotá, Mus. A. Colon.
 Bogotá, Museo de Arte Colonial

Bogotá, Mus. A. Mod.
 Bogotá, Museo de Arte Moderno

Bogotá, Mus. A. Relig.
Bogotá, Museo de Arte Religioso

Bogotá, Mus. N.
Bogotá, Museo Nacional

Bogotá, Mus. Oro
Bogotá, Museo del Oro [Banco de la República]

Bogotá, Quinta Bolívar
Bogotá, Quinta de Bolívar

Bogotá, U. Andes
Bogotá, Universidad de los Andes

Bonn, Rhein. Friedrich-Wilhelms-U.
Bonn, Rheinische Friedrich-Wilhelms-Universität

Boston, MA, ICA
Boston, MA, Institute of Contemporary Arts

Boston, MA, Mus. F.A.
Boston, MA, Museum of Fine Arts

Bremen, Übersee-Mus.
Bremen, Übersee-Museum

Bridgetown, Queen's Park Gal.
Bridgetown, Queen's Park Gallery [Barbados]

Brussels, Mus. A. Mod.
Brussels, Musée d'Art Moderne

Brussels, Musées Royaux A. & Hist.
Brussels, Musées Royaux d'Art et d'Histoire [Koninklijke Musea voor Kunst en Geschiedenis]

Brussels, Musées Royaux B.-A.
Brussels, Musées Royaux des Beaux-Arts de Belgique/Koninklijke Musea voor Schone Kunsten van België [admins Mus. A. Anc.; Mus. A. Mod.; Mus. Wiertz]

Buenos Aires, Acad. N. B.A.
Buenos Aires, Academia Nacional de Bellas Artes

Buenos Aires, Americas Soc.
Buenos Aires, The Americas Society

Buenos Aires, A. Nue.
Buenos Aires, Arte Nuevo

Buenos Aires, Asoc. Amigos A.
Buenos Aires, Asociación Amigos del Arte

Buenos Aires, Banco Ciudad
Buenos Aires, Banco de la Ciudad de Buenos Aires

Buenos Aires, Bunge & Born Found.
Buenos Aires, Bunge and Born Foundation

Buenos Aires, Cent. A. & Comunic.
Buenos Aires, Centro de Arte y Comunicación [CAYC]

Buenos Aires, Cent. Cult. Borges
Buenos Aires, Centro Culturales Borges

Buenos Aires, Cent. Cult. Recoleta
Buenos Aires, Centro Cultural Recoleta

Buenos Aires, Cent. Mus. Exp. S Martín
Buenos Aires, Centro Municipal de Exposiciones San Martín

Buenos Aires, Col. Chase Manhattan Bank, N.A.
Buenos Aires, Collection of the Chase Manhattan Bank, N.A.

Buenos Aires, Fond. N. A.
Buenos Aires, Fondo Nacional de las Artes

Buenos Aires, Fund. Banco Patricios
Buenos Aires, Fundación Banco Patricios

Buenos Aires, Fund. Lorenzutti
Buenos Aires, Fundación Lorenzutti

Buenos Aires, Fund. Proa
Buenos Aires, Fundación Proa

Buenos Aires, Fund. S Telmo
Buenos Aires, Fundación San Telmo

Buenos Aires, Gal. A. Centoira
Buenos Aires, Galería de Arte Centoira

Buenos Aires, Gal. Bonino
Buenos Aires, Galería Bonino

Buenos Aires, Gal. Carmen Waugh
Buenos Aires, Galería Carmen Waugh

Buenos Aires, Gal. Julia Lublin
Buenos Aires, Galería Julia Lublin

Buenos Aires, Gal. Peuser
Buenos Aires, Galería Peuser

Buenos Aires, Gal. Rubbers
Buenos Aires, Galería Rubbers

Buenos Aires, Gal. Ruth Benzacar
Buenos Aires, Galería Ruth Benzacar

Buenos Aires, Gal. Van Riel
Buenos Aires, Galería Van Riel

Buenos Aires, Hosp. Clínicas
Buenos Aires, Hospital de Clínicas

Buenos Aires, Inst. Fr. Estud. Sup.
Buenos Aires, Instituto Francés de Estudios Superiores [Van Riel]

Buenos Aires, Inst. Torcuato Tella
Buenos Aires, Instituto Torcuato di Tella

Buenos Aires, Mus. A. Blanco
Buenos Aires, Museo de Arte Isaac Fernández Blanco

Buenos Aires, Mus. A. Contemp.
Buenos Aires, Museo de Arte Contemporáneo

Buenos Aires, Mus. A. Mod.
Buenos Aires, Museo de Arte Moderno [de la Ciudad Buenos Aires]

Buenos Aires, Mus. Badii
Buenos Aires, Museo Badii

Buenos Aires, Mus. Casa de Yrurtia
Buenos Aires, Museo Casa de Yrurtia

Buenos Aires, Mus. Hist. N.
Buenos Aires, Museo Histórico Nacional

Buenos Aires, Mus. Hist. N. Cabildo Ciudad
Buenos Aires, Museo Histórico Nacional del Cabildo de la Ciudad de Buenos Aires y de la Revolución de Mayo

Buenos Aires, Mus. N. B.A.
Buenos Aires, Museo Nacional de Bellas Artes

Buenos Aires, Mus. Saavedra
Buenos Aires, Museo Saavedra

Buenos Aires, Primer Mus. Hist. Argentina
Buenos Aires, Primer Museo Argentino de Historia Argentina en la Escuela Primaria

Buenos Aires, Salón Altamira

Buenos Aires, Salas N. Cult.
Buenos Aires, Salas Nacionales de Cultura

Buenos Aires, Salas N. Exp. Palais Glace
Buenos Aires, Salas Nacionales de Exposiciónes, Palais de Glace

Buenos Aires, Sheraton Hotel

Buffalo, NY, Albright–Knox A.G.
Buffalo, NY, Albright–Knox Art Gallery [formerly Albright A.G.]

Cali, Mus. A. Mod. La Tertulia
Cali, Museo de Arte Moderno La Tertulia

Cambridge, MA, Fogg
Cambridge, MA, Fogg Art Museum

Cambridge, MA, Harvard U., Peabody Mus.
Cambridge, MA, Harvard University, Peabody Museum of Archaeology and Ethnology

Campos do Jordão, Pal. Boa Vista
Campos do Jordão, Palácio Boa Vista

Caracas, Cent. A. Eur.-Amer.
Caracas, Centro de Arte Euro-Americano

Caracas, Cent. Cult. Consolidado
Caracas, Centro Cultural Consolidado

Caracas, Col. Banco Cent. Venezuela
Caracas, Colección del Banco Central de Venezuela

Caracas, Col. Concejo Mun.
Caracas, Colección Concejo Municipal

Caracas, Estud. Actual
Caracas, Estudio Actual

Caracas, Fund. Mus. Armando Reverón
Caracas, Fundación Museo Armando Reverón

Caracas, Gal. A. N.
Caracas, Galería de Arte Nacional [incl. Centro de Información Nacional de las Artes Plásticas]

Caracas, Gal. Durban/César Segnini
Caracas, Galería Durban/César Segnini

Caracas, Gal. Freites
Caracas, Galería Freites

Caracas, Gal. Mus.
Caracas, Galería el Museo

Caracas, Grupo Li Cent. A.
Caracas, Grupo Li Centro de Arte

Caracas, Mus. A. Colon.
Caracas, Museo de Arte Colonial

Caracas, Mus. A. Contemp.
Caracas, Museo de Arte Contemporáneo de Caracas

Caracas, Mus. A. Contemp. Sofía Imber
Caracas, Museo de Arte Contemporáneo Sofía Imber

Caracas, Mus. Arturo Michelana
Caracas, Museo Arturo Michelana

Caracas, Mus. A. Visuales Alejandro Otero
Caracas, Museo de Artes Visuales Alejandro Otero

Caracas, Mus. B.A.
Caracas, Museo de Bellas Artes

Caracas, Mus. Jacobo Borges
Caracas, Museo Jacobo Borges

Caracas, Sala Mendoza

Cayenne, Cons. Rég. Guyane
Cayenne, Conseil Régional de Guyane

Chicago, IL, A. Club
Chicago, IL, Arts Club

Chicago, IL, A. Inst.
Chicago, IL, Art Institute of Chicago

Chicago, IL, Gwenda Jay Gal.
Chicago, IL, Gwenda Jay Gallery

Chicago, IL, Mex. F.A. Cent. Mus.
Chicago, IL, Mexican Fine Art Center Museum

Churubusco, Mus. Hist.
Churubusco, Museo Histórico

Ciudad Bolívar, Mus.
Ciudad Bolívar, Museo de Ciudad Bolívar [Casa del Correo del Orinoco]

Ciudad Guayana, Sala Sidor A.
Ciudad Guayana, Sala de Sidor Artes

Cleve, Städt. Mus. Haus Koekkoek
Cleve, Städtisches Museum Haus Koekkoek

Cleveland, OH, Mus. A.
Cleveland, OH, Cleveland Museum of Art

Coahuila, Mus. Bib. Pape
Coahuila, Museo Biblioteca Pape

Cochabamba, Casa Cult.
Cochabamba, Casa de la Cultura

Cochabamba, City Hall

Colchester, U. Essex
Colchester, University of Essex

Colchester, U. Essex, Col. Lat. Amer. A.
Colchester, University of Essex, Collection of
Latin American Art

Colchester, U. Essex, U. Gal.
Colchester, University of Essex, University
Gallery

Cologne, Gal. Karsten Greve
Cologne, Galerie Karsten Greve

Colorado Springs, CO, F.A. Cent.
Colorado Springs, CO, Fine Arts Center

Columbus, GA, Mus.
Columbus, GA, Columbus Museum

Comayagua, Mus. A. Relig.
Comayagua, Museo de Arte Religioso

Copenhagen, Stat. Mus. Kst
Copenhagen, Kongelige Kobberstiksamling,
Statens Museum for Kunst

Copenhagen, Stat. Mus. Kst
Copenhagen, Statens Museum for Kunst

Copenhagen, Thorvaldsens Mus.
Copenhagen, Thorvaldsens Museum

Coral Gables, FL, Elite F.A. José Martínez-Cañas
Coral Gables, FL, Elite Fine Art José
Martínez-Cañas

Coral Gables, FL, Gary Nader F.A.
Coral Gables, FL, Gary Nader Fine Art

Coral Gables, FL, Javier Lumbreras F.A.
Coral Gables, FL, Javier Lumbreras Fine Art

Coral Gables, FL, Marpad A. Gal.
Coral Gables, FL, Marpad Art Gallery

Coral Gables, FL, U. Miami, Lowe A. Mus.
Coral Gables, University of Miami, Lowe Art
Museum

Córdoba, Argentina, Mus. Prov. B.A. 'Emilio A.
Caraffa'
Córdoba, Argentina, Museo Provincial de
Bellas Artes 'Emilio A. Caraffa'

Coro, Mus. Dioc. Monseñor Guillermo Castillo
Coro, Museo Diocesano Monseñor Lucas
Guillermo Castillo

Cortland, SUNY, Dowd F.A. Gal.
Cortland, State University of New York,
Dowd Fine Arts Gallery

Cotovanta, Mus. A. Dec.
Cotovanta, Museo de Artes Decoratives

Cuenca, Colegio Semin.
Cuenca, Ecuador, Colegio Seminario

Curitiba, Mus. A. Contemp.
Curitiba, Museu de Arte Contemporañea

Cuzco Cathedral
Cuzco, Cuzco Cathedral

Cuzco, Mus. A. Relig.
Cuzco, Museo de Arte Religioso

Cuzco, Mus. Hist. Reg.
Cuzco, Museo Histórico Regional

Cuzco, Mus. Mun. A. Contemp.
Cuzco, Museo Municipal de Arte
Conemporáneo

Cuzco, Mus. Virreinato
Cuzco, Museo del Virreinato

Cuzco, U. N. S Antonio Abad
Cuzco, Universidad Nacional de S Antonio
Abad

Dallas, TX, Mus. A.
Dallas, TX, Dallas Museum of Art

Dallas, TX, Mus. F.A.
Dallas, TX, Museum of Fine Arts

Dallas, TX, S. Methodist U., Meadows Mus. &
Gal.
Dallas, TX, Southern Methodist University,
Meadows Museum and Gallery

Darmstadt, Hess. Landesmus.
Darmstadt, Hessisches Landesmuseum

Darmstadt, Ksthalle
Darmstadt, Kunsthalle [Kunstverein
Darmstadt]

Davenport, IA, Mun. A.G.
Davenport, IA, Davenport Municipal Art
Gallery

Detroit, MI, Inst. A.
Detroit, MI, Detroit Institute of Arts

Dresden, Kupferstichkab.
Dresden, Kupferstichkabinett

Dresden, Sächs. Landesbib.
Dresden, Sächsische Landesbibliothek [incl.
Zentrale Fachbibliothek]

Dublin, Hendriks Gal.
Dublin, Hendriks Gallery

Duisburg, Lehmbruck-Mus.
Duisburg, Wilhelm-Lehmbruck-Museum

Durazno, Mus. Mun.
Durazno, Museo Municipal

Düsseldorf, Ksthalle
Düsseldorf, Kunsthalle

Düsseldorf, Städt. Ksthalle
Düsseldorf, Städtische Kunsthalle

Escuintla, Mus. Democ.
Escuintla, Museo de la Democracía

Exeter, NH, Lamont Gal.
Exeter, NH, Lamont Gallery

Fort de France, Carib. A. Cent. (Métiers A.)
Fort de France, Caribbean Art Centre
(Métiers d'Art) [Martinique]

Fort Lauderdale, FL, Mus. A.
Fort Lauderdale, FL, Museum of Art

Frankfurt am Main, Schirn Ksthalle
Frankfurt am Main, Schirn Kunsthalle

Ghent, Mus. Sierkst
Ghent, Museum voor Sierkunst

Glasgow, Third Eye Cent.
Glasgow, Third Eye Centre [Cent. Contemp.
A.]

Grenoble, Mus. Peint. & Sculp.
Grenoble, Musée de Peinture et de Sculpture
[name changed to Mus. Grenoble in 1986]

Guadalajara, Mus. A. Mod.
Guadalajara, Museo de Arte Moderno

Guadalajara, Mus. Guadalajara
Guadalajara, Museo de Guadalajara

Guadalajara, Mus. Reg. Antropol. & Hist.
Guadalajara, Museo Regional de Antropología
e Historia

Guadalupe, Mus. Basilica
Guadalupe, Museo de la Basilica

Guadalupe, Mus. Reg.
Guadalupe, Museo Regional de Guadalupe

Guanajuato, Mus. Granaditas
Guanajuato, Museo de Granaditas

Guatemala City, Acad. Geog. & Hist.
Guatemala City, Academia de Geografía e
Historia

Guatemala City, Banco de Guatemala

Guatemala City, Bib. N.
Guatemala City, Biblioteca Nacional

Guatemala City, Dir. Gen. Cult. & B.A.
Guatemala City, Dirección General de Cultura
y Bellas Artes

Guatemala City, Fund. Paiz
Guatemala City, Fundación Paiz

Guatemala City, Gal. Dzunún
Guatemala City, Galería Dzunún

Guatemala City, Gal. El Túnel
Guatemala City, Galería El Túnel

Guatemala City, Mus. A. Contemp.
Guatemala City, Museo de Arte
Contemporáneo

Guatemala City, Mus. N. A. Mod.
Guatemala City, Museo Nacional de Arte
Moderno

Guatemala City, Pal. Mun.
Guatemala City, Palacio Municipal

Guatemala City, Patrn. B.A.
Guatemala City, Patronato de Bellas Artes

Guatemala City, U. S Carlos
Guatemala City, Universidad de S Carlos

Guayaquil, Mus. Antropol. & Mus. A. Banco
Cent.
Guayaquil, Museo Antropológico y Museo de
Arte del Banco Central del Ecuador

Hamburg, Gal. Levy
Hamburg, Galerie Levy

Hannover, Sprengel Mus.
Hannover, Sprengel Museum [Kunstmuseum
Hannover mit Sammlung Sprengel]

Hartford, CT, Wadsworth Atheneum

Havana, Casa Africa
Havana, Casa de Africa

Havana, Casa Américas
Havana, Casa de las Américas

Havana, Mus. A. Dec.
Havana, Museo de Artes Decorativas

Havana, Mus. N.
Havana, Museo Nacional

Havana, Mus. N. B.A.
Havana, Museo Nacional de Bellas Artes [in
Palacio de Bellas Artes]

Hays, KS, Fort Hays State U.
Hays, KS, Fort Hays State University

Houston, TX, Contemp. A. Mus.
Houston, TX, Contemporary Arts Museum

Houston, TX, Mus. F.A.
Houston, TX, Museum of Fine Arts

Houston, TX, N Bank

Ibarra, Bib. Mun.
Ibarra, Biblioteca Municipal

Indianapolis, IN, Mus. A.
Indianapolis, IN, Museum of Art [incl.
Clowes Fund Collection of Old Master
Paintings]

Iowa City, U. IA Mus A
Iowa City, IA, University of Iowa Museum of
Art

Kingston, Inst. Jamaica, N.G.
Kingston, Institute of Jamaica, National
Gallery

Kingston, Jamaica, U. W. Indies
Kingston, Jamaica, University of the West
Indies

Kingston, N.G.
Kington, National Gallery [delete Inst.
Jamaica]

Kraków, Jagiellonian U. Lib.
Kraków, Jagiellonian University Library

La Jolla, CA, A. Cent.
 La Jolla, Art Center [name changed to Mus. Contemp. A. in 1971]
La Jolla, CA, Tasende Gal.
 La Jolla, Tasende Gallery
La Paz, Alcaldia
La Paz, Banco Hipotecario N.
 La Paz, Banco Hipotecario Nacional
La Paz, Bib. Mun.
 La Paz, Biblioteca Municipal Mariscal Andrés de Santa Cruz
La Paz, Cent. Estud. & Proy. Nueva Visión
 La Paz, Centro de Estudios y Proyectos Nueva Visión
La Paz, Medic. Coll.
 La Paz, Medical College
La Paz, Mus. Casa Murillo
 La Paz, Museo Casa de Murillo
La Paz, Mus. N. A.
 La Paz, Museo Nacional de Arte
La Paz, Mus. Tambo Quirquincho
 La Paz, Museo del Tambo Quirquincho
La Paz, U. Hall
 La Paz, University Hall
La Plata, Mus. Prov. B.A.
 La Plata, Museo Provincial de Bellas Artes
Las Palmas de Gran Canaria, Cent. Atlántic. A. Mod.
 Las Palmas de Gran Canaria, Centro Atlántico de Arte Moderno
Leeds, Temple Newsam House
Leiden, Kon. Inst. Taal-, Land- & Vlkenknd.
 Leiden, Koninklijk Instituut voor Taal-, Land- en Volkenkunde [KITLV]
Leverkusen, Schloss Morsbroich
 Leverkusen, Städtisches Museum Leverkusen [in Schloss Morsbroich]
Lewisburg, PA, Bucknell U.
 Lewisburg, PA, Bucknell University
Liège, Mus. A. Mod.
 Liège, Musée d'Art Moderne
Liège, Pal. Congr.
 Liège, Palais des Congrès
Lima, Archv Gen. N.
 Lima, Archivo General de la Nación
Lima, Banco de Crédito del Perú
Lima, Banco de la Nación
Lima, Banco Indust. Perú
 Lima, Banco Industrial del Perú
Lima, Bib. N.
 Lima, Biblioteca Nacional del Perú
Lima, Casa Osambela
 Lima, Casa de Osambela
Lima, Gal. Wiese
 Lima, Galería Wiese
Lima, Inst. Peru. Admin. Empresas
 Lima, Instituto Peruano de Administración de Empresas
Lima, Min. Econ. & Finanzas
 Lima, Ministerio de Economía y Finanzas
Lima, Mun. Lima Met.
 Lima, Municipalidad de Lima Metropolitana
Lima, Mus. A.
 Lima, Museo de Arte
Lima, Mus. A. It.
 Lima, Museo de Arte Italiano
Lima, Mus. Arqueol. & Etnol.
 Lima, Museo de Arqueología y Etnología de la Universidad Nacional

Lima, Mus. Banco Central de Reserva
 Lima, Museo del Banco Central de Reserva
Lima, Mus. N.
 Lima, Museo de la Nación de Lima
Lima, Mus. N. Hist.
 Lima, Museo Nacional de Historia
Lima, Pin. Mun.
 Lima, Pinacoteca de la Municipalidad de Lima
Lisbon, Bib. N.
 Lisbon, Biblioteca Nacional
Lisbon, Câmara Mun.
 Lisbon, Câmara Municipal
Little Rock, AR A. Cent.
 Little Rock, AR, Arkansas Art Center
London, BL
 London, British Library
London, BM
 London, British Museum
London, Commonwealth Inst.
 London, Commonwealth Institute
London, Durini Gal.
 London, Durini Gallery
London, Gimpel Fils
 London, Gimpel Fils Ltd
London, Hayward Gal.
 London, Hayward Gallery
London, Mall Gals
 London, Mall Galleries
London, N.G.
 London, National Gallery
London, N. Mar. Mus.
 London, National Maritime Museum [Greenwich]
London, Photographers' Gal.
 London, Photographers' Gallery Ltd
London, PRO
 London, Public Record Office and Museum
London, Royal Coll. A.
 London, Royal College of Art
London, S. Bank Cent.
 London, South Bank Centre
London, Serpentine Gal.
 London, Serpentine Gallery
London, Tate
 London, Tate Gallery
London, U. London, Courtauld Inst.
 London, University of London, Courtauld Institute of Art
London, U. London, Courtauld Inst. Gals
 London, University of London, Courtauld Institute Galleries
London, V&A
 London, Victoria and Albert Museum [houses National Art Library]
London, Whitechapel A.G.
 London, Whitechapel Art Gallery
Los Angeles, CA, Co. Mus. A.
 Los Angeles, CA, County Museum of Art [incl. Robert Gore Rifkind Center for German Expressionist Studies]
Los Angeles, CA, Fowler Mus. Cult. Hist.
 Los Angeles, CA, Fowler Museum of Cultural History
Los Angeles, CA, ICA
 Los Angeles, CA, Institute of Contemporary Art
Los Angeles, UCLA
 Los Angeles, University of California

Los Angeles, UCLA, Mus. Cult. Hist.
 Los Angeles, University of California, Museum of Cultural History [name changed to Fowler Mus. Cult. Hist. in 1992]
Los Angeles, UCLA, Wight A.G.
 Los Angeles, University of California, Frederick S. Wight Art Gallery
Lucerne, Hist. Mus.
 Lucerne, Historisches Museum [in Altes Zeughaus]
Luján, Mus. B.A.
 Luján, Museo de Bellas Artes
Macerata, Pin. & Mus. Com.
 Macerata, Pinacoteca e Musei Comunali [Civica Pinacoteca]
Madrid, Ateneo

Madrid, Bib. N.
 Madrid, Biblioteca Nacional [housed with Mus. Arqueol. N.; incl. Sala de la Biblioteca Nacional]
Madrid, Casa América
 Madrid, Casa de América
Madrid, Círc. B.A.
 Madrid, El Círculo de Bellas Artes
Madrid, Club Int. Prensa
 Madrid, Club Internacional de Prensa
Madrid, Gal. Jorge Mara
 Madrid, Galería Jorge Mara
Madrid, Gal. Nebli
 Madrid, Galería Nebli
Madrid, Gal. Vandrés
 Madrid, Galería Vandrés
Madrid, Inst. Valencia Don Juan
 Madrid, Instituto de Valencia de Don Juan
Madrid, Min. Obras Púb. & Urb.
 Madrid, Ministerio de Obras Públicas y Urbanismo
Madrid, Mus. A. Contemp.
 Madrid, Museo Español de Arte Contemporáneo
Madrid, Mus. América
 Madrid, Museo de América
Madrid, Mus. Casa Moneda
 Madrid, Museo Casa Moneda
Madrid, Mus. N. Cent. A. Reina Sofía
 Madrid, Museo Nacional Centro de Arte Reina Sofía
Madrid, Prado
 Madrid, Museo del Prado [Museo Nacional de Pintura y Escultura]
Madrid, Real Acad. S Fernando
 Madrid, Real Academia de Bellas Artes de San Fernando
Madrid, Real Acad. S Fernando, Mus.
 Madrid, Real Academia de Bellas Artes de San Fernando, Museo
Madrid, Salas Picasso
 Madrid, Salas Pablo Ruiz Picasso
Managua, Banco Cent. de Nicaragua
 Managua, Banco Central de Nicaragua
Managua, Cent. Conven. Olaf Palme
 Managua, Centro de Convenciones Olaf Palme
Managua, Gal. Praxis
 Managua, Galería Praxis
Managua, Teat. N. Ruben Dario
 Managua, Teatro Nacional Ruben Dario

Manchester, Cornerhouse

Maracay, Gal. Mun. A.
Maracay, Galería Municipal de Arte

Medellín, Mus. A. Mod.
Medellín, Museo de Arte Moderno

Medellín, Pal. Mun.
Medellín, Palacio Municipal

Melbourne, Gal. E. Hill
Melbourne, Gallery on Eastern Hill

Memphis, TN, Brooks Mus. A.
Memphis, TN, Memphis Brooks Museum of
Art [Brooks Memorial Art Gallery]

Mendoza, Mus. Fader
Mendoza, Museo Fader

Mexico City, Acad. A.
Mexico City, Academia de Artes

Mexico City, Ant. Col. San Ildefonso
Mexico City, Antiguo Colegio de San
Ildefonso

Mexico City, Ant. Colegio San Ildefonso
Mexico City, Antiguo Colegio de San
Ildefonso

Mexico City, Archv. Gen. N.
Mexico City, Archivo General de la Nación

Mexico City, Banco Int.
Mexico City, Banco Internacional

Mexico City, Banco N. de México
Mexico City, Banco Nacional de México

Mexico City, Bib. Ibero-Amer. & B.A.
Mexico City, Biblioteca Ibero-Americana y de
Bellas Artes [in Pal. B.A.]

Mexico City, Capilla Tepeyac
Mexico City, Capilla del Tepeyac

Mexico City, Casa Lamm Cent. Cult.
Mexico City, Casa Lamm Centro de Cultura

Mexico City, Cent. A. Vitro
Mexico City, Centro de Arte Vitro

Mexico City, Cent. Cult. A. Contemp.
Mexico City, Centro Cultural de Arte
Contemporáneo

Mexico City, Cent. Cult. S Teresa
Mexico City, Centro Cultural Santa Teresa

Mexico City, Cent. Escolar Benito Juárez
Mexico City, Centro Escolar Benito Juárez

Mexico City, Cent. Estud. Econ. & Soc. Tercer
Mundo
Mexico City, Centro de Estudios Económicos
y Sociales del Tercer Mundo

Mexico City, Cent. Imagen
Mexico City, Centro de la Imagen

Mexico City, Colegio México
Mexico City, Colegio de México

Mexico City, Dept. Distr. Fed.
Mexico City, Departamento del Distrito
Federal

Mexico City, Escuela N. Prep.
Mexico City, Escuela Nacional Preparatoria

Mexico City, Fomento Cult. Banamex
Mexico City, Fomento Cultural Banamex

Mexico City, Gal. A. Contemp.
Mexico City, Galería de Arte Contemporáneo

Mexico City, Gal. A. Mex.
Mexico City, Galería de Arte Mexicano

Mexico City, Gal. Avril
Mexico City, Galería Avril

Mexico City, Gal. Met.
Mexico City, Galería Metropolitana

Mexico City, Gal. OMR
Mexico City, Galería OMR

Mexico City, Gal. Ponce
Mexico City, Galería Ponce

Mexico City, Gal. Tenatitla
Mexico City, Galería Tenatitla

Mexico City, Inst. N. B.A.
Mexico City, Instituto Nacional de Bellas
Artes

Mexico City, Inst. Poli. N.
Mexico City, Instituto Politécnico Nacional de
Mexico

Mexico City, Mus. A. Carrillo Gil
Mexico City, Museo de Arte Alvar y Carmen
T. Carrillo Gil

Mexico City, Mus. A. Contemp. Int. Rufino
Tamayo
Mexico City, Museo de Arte Contemporáneo
Internacional Rufino Tamayo

Mexico City, Mus. A. Mod.
Mexico City, Museo de Arte Moderno

Mexico City, Mus. A. Sinaloa
Mexico City, Museo de Arte de Sinaloa

Mexico City, Mus. Ciudad
Mexico City, Museo de la Ciudad

Mexico City, Mus. Diego Rivera
Mexico City, Museo Diego Rivera de
Anahuacalli

Mexico City, Mus. Franz Mayer
Mexico City, Museo Franz Mayer

Mexico City, Mus. José Luis Cuevas
Mexico City, Museo José Luis Cuevas

Mexico City, Mus. Kahlo
Mexico City, Museo Frida Kahlo

Mexico City, Mus. N. A.
Mexico City, Museo Nacional de Arte

Mexico City, Mus. N. Antropol.
Mexico City, Museo Nacional de
Antropología

Mexico City, Mus. N. Cult.
Mexico City, Museo Nacional de las Culturas

Mexico City, Mus. N. Est.
Mexico City, Museo Nacional de la Estampa

Mexico City, Mus. N. Hist.
Mexico City, Museo Nacional de Historia,
Castillo de Chapultepec

Mexico City, Mus. Pal. B.A.
Mexico City, Museo del Palacio de Bellas
Artes

Mexico City, Mus. Rufino Tamayo
Mexico City, Museo Rufino Tamayo

Mexico City, Mus. S Carlos
Mexico City, Museo de San Carlos

Mexico City, Pal. B.A.
Mexico City, Palacio de Bellas Artes [houses
Mus. Pal. B.A.]

Mexico City, Pal. Iturbide
Mexico City, Palacio de Iturbide

Mexico City, Pal. Medic.
Mexico City, Palacio de la Medicina

Mexico City, Pin. Virreinal
Mexico City, Pinacoteca Virreinal de San
Diego

Mexico City, Recinto Homenaje Don Benito
Juárez
Mexico City, Recinto de Homenaje a Don
Benito Juárez [in Pal. N.]

Mexico City, Soc. Exalumnos Fac. Ingen.
Mexico City, Sociedad de Exalumnos de la
Facultad de Ingeniería

Mexico City, U. Autónoma Met.
Mexico City, Universidad Autónoma
Metropolitana

Mexico City, U. Iberoamer.
Mexico City, Universidad Iberoamericana

Mexico City, U. N. Autónoma
Mexico City, Universidad Nacional
Autónoma de México

Mexico City, U. N. Autónoma, Escuela N. A.
Plast.
Mexico City, Universidad Nacional
Autónoma de México, Escuela Nacional de
Artes Plasticas

Miami, FL, A. Mus.
Miami, FL, Art Museum

Miami, FL, Barbara Gilman

Miami, FL, Bass Mus. A.
Miami, FL, Bass Museum of Art

Miami, FL, Cent. F.A.
Miami, FL, Center for the Fine Arts

Miami, FL, Cub. Mus. A. & Cult.
Miami, FL, Cuban Museum of Arts and
Culture

Miami, FL, Durban Seguini Gal.
Miami, FL, Durban Seguini Gallery

Miami, FL, Frances Wolfson A.G.
Miami, FL, Frances Wolfson Art Gallery
[Miami-Dade Community College]

Miami, FL, Maria Gutierrez F.A.
Miami, FL, Maria Gutierrez Fine Arts

Milan, Civ. Mus. A. Contemp.
Milan, Civico Museo d'Arte Contemporanea
[in Pal. Reale]

Milan, Gal. A. Mod.
Milan, Galleria d'Arte Moderna

Milan, Gal. Incisione
Milan, Galleria dell'Incisione [Elio Palmisano]

Milan, Gal. Naviglio
Milan, Galleria del Naviglio

Milan, Mus. Permanente
Milan, Museo della Permanente

Milwaukee, WI, A. Cent.
Milwaukee, WI, Art Center [now A. Mus.]

Milwaukee, WI, A. Mus.
Milwaukee, WI, Milwaukee Art Museum
[formerly A. Cent.]

Monclova, Bib. Pape
Monclova, Biblioteca Pape

Monterrey, Gal. Ramis Barquet
Monterrey, Galería Ramis Barquet

Monterrey, Mus.
Monterrey, Museo de Monterrey

Monterrey, Mus. A. Contemp.
Monterrey, Museo de Arte Contemporáneo

Monterrey, Mus. Reg. Nue. León
Monterrey, Museo Regional de Nuevo León
Felipe de J. García Gampuzano

Monterrey, Nue. León, Alcaldia
Monterrey, Nuevo León, Alcaldia

Monterrey, Nue. León Grupo Indust. ALFA
Monterrey, Nuevo León Grupo Industrial
ALFA

Monterrey, Nue. León, Promoc. A.
Monterrey, Nuevo León, Promoción de las
Artes

Monterrey, Pinacoteca Nuevo León
Monterrey, Pinacoteca de Nuevo León

Montevideo, Casa Gobierno
Montevideo, Casa de Gobierno [Offices of
President of Uruguay]

San Francisco, CA, de Young Mem. Mus.
San Francisco, CA, M. H. de Young Memorial Museum

San Francisco, CA, F.A. Museums
San Francisco, Fine Arts Museums of San Francisco [admins Achenbach Found. Graph. A.; de Young Mem. Mus.; Pal. Legion of Honor]

San Francisco, CA, Int. Airport
San Francisco, CA, International Airport

San Francisco, CA, Mex. Mus.
San Francisco, CA, Mexican Museum

San Francisco, CA, MOMA
San Francisco, CA, Museum of Modern Art

San Francisco, CA, Mus. A.
San Francisco, CA, Museum of Art [name changed to MOMA in 1976]

San Ignacio Guazú, Mus. Mis.
San Ignacio Guazú, Museo de Misión

San Isidro, Mus. Gen. Pueyrredón
San Isidro, Museo General Juan Martín de Pueyrredón [Buenos Aires]

San José, Mus. A. Costarricense
San José, Museo de Arte Costarricense

San José, Mus. Banco Cent.
San José, Museos Banco Central

San José, Mus. N. Costa Rica
San José, Museo Nacional de Costa Rica

San Juan, Inst. Cult. Puertorriqueña
San Juan, Instituto de Cultura Puertorriqueña

San Juan, Inst. Cult. Puertorriqueña, Arsenal Puntilla
San Juan, Instituto de Cultura Puertorriqueña, Arsenal de la Puntilla

San Juan, Park Gal.
San Juan, Park Gallery

San Juan, U. Puerto Rico
San Juan, Universidad de Puerto Rico

San Luis Potosí, Casa Cult.
San Luis Potosí, Casa de la Cultura

Santa Cruz, Bolivia, Fund. Sui. Cult.
Santa Cruz, Bolivia, Fundación Suiza por la Cultura

Santa Fé, Argentina, Mus. Prov. B.A.
Santa Fé, Argentina, Museo Provincial de Bellas Artes 'Rosa Galisteo de Rodriguez'

Santa Fe, Granada, Inst. América, Cent. Damián Bayón
Santa Fe, Granada, Instituto América, Centro Damián Bayón

Santa María, Paraguay, Mus. Mis.
Santa María, Paraguay, Museo de Misión

Santander, Mus. Mun. B.A.
Santander, Museo Municipal de Bellas Artes

Santiago, Congr. N.
Santiago, Congreso Nacional

Santiago, Escuela Jard. Parque Cousiño
Santiago, Escuela Jardín del Parque Cousiño

Santiago, Gal. A. Actual
Santiago, Galería Arte Actual

Santiago, Gal. Carmen Waugh
Santiago, Galería Carmen Waugh

Santiago, Gal. Época
Santiago, Galería Época

Santiago, Gal. Imagen
Santiago, Galería Imagen

Santiago, Gal. Praxis
Santiago, Galería Praxis

Santiago, Inst. Cult. Las Condes
Santiago, Instituto Cultural de Las Condes

Santiago, Mus. A. Colon. S Francisco
Santiago, Museo de Arte Colonial de San Francisco

Santiago, Mus. Hist. N.
Santiago, Museo Histórico Nacional [Dirección de Bibliotecas, Archivos y Museos]

Santiago, Mus. N. B.A.
Santiago, Museo Nacional de Bellas Artes [formerly Mus. Pint.]

Santiago, Paraguay, Mus. Mis.
Santiago, Paraguay, Museo de Misión

Santiago, Pontificia U. Católica
Santiago, Pontificia Universidad Católica de Chile

Santiago, Sala Capilla
Santiago, Sala la Capilla [Municipalidad de Santiago]

Santiago, Tomás Andreu Gal. A.
Santiago, Tomás Andreu Galería de Arte

Santiago, Tres Manchas, Exp. Gabinete
Santiago, Tres Manchas, Exposición de Gabinete

Santiago de Compostela, Casa Parra
Santiago de Compostela, Casa de Parra

Santiago de Compostela, Cent. Galego A. Contemp.
Santiago de Compostela, Centro Galego de Arte Contemporánea

Santo Domingo, Cent. Cult. Hisp.
Santo Domingo, Centro Cultural Hispanico

Santo Domingo, Gal.
Santo Domingo, La Galería

Santo Domingo, Gal. A. Mod.
Santo Domingo, Galería de Arte Moderno [now Mus. A. Mod.]

São Paulo, Bienal

São Paulo, Cent. A. Novo Mundo
São Paulo, Centro de Artes Novo Mundo

São Paulo, Cent. Cult.
São Paulo, Centro Cultural

São Paulo, Gal. Raquel Arnaud
São Paulo, Galería Raquel Arnaud

São Paulo, Inst. Moreira Salas
São Paulo, Instituto Moreira Salas

São Paulo, Mus. A. Assis Châteaubriand
São Paulo, Museu de Arte de São Paulo Assis Châteaubriand

São Paulo, Mus. A. Brasileira
São Paulo, Museu de Arte Brasileira

São Paulo, Mus. A. Mod.
São Paulo, Museu de Arte Moderna do São Paulo

São Paulo, Mus. A. Sacra
São Paulo, Museu de Arte Sacra

São Paulo, Mus. Casa Bras.
São Paulo, Museu da Casa Brasileira

São Paulo, Mus. N. Dinamarca
São Paulo, Museo Nacional da Dinamarca e São Paulo

São Paulo, Mus. Segall
São Paulo, Museu Lasar Segall

São Paulo, Paço A.
São Paulo, Paço de Artes

São Paulo, Pal. Bandeirantes
São Paulo, Palácio Bandeirantes

São Paulo, Pin. Estado
São Paulo, Pinacoteca do Estado de São Paulo

São Paulo, U. São Paulo, Mus. A. Contemp.
São Paulo, Universidade de São Paulo, Museu de Arte Contemporânea

Seoul, Olymp. Village, Sculp. Gdn
Seoul, Olympic Village, Sculpture Garden

Sevenoaks, Pratt Contemp. A., Gal.
Sevenoaks, Pratt Contemporary Art, The Gallery

Seville, Archv Gen. Indias
Seville, Archivo General de las Indias

Seville, Pab. A.
Seville, Pabellón de las Artes

Seville, Univl Exh., Puerto Rican N. Pav.
Seville, Universal Exhibition, Puerto Rican National Pavilion

Springfield, MA, Mus. F.A.
Springfield, MA, Museum of Fine Arts

Stockholm, Mod. Mus.
Stockholm, Moderna Museum

Sucre, Bib. & Archv N.
Sucre, Biblioteca y Archivo Nacional

Sucre, City Hall

Sucre, Escuela N. Maestros
Sucre, Escuela Nacional de Maestros

Sucre, Mus. Catedral
Sucre, Museo de la Catedral

Sydney, Mus. Contemp. A.
Sydney, Museum of Contemporary Art [incl. U. Sydney, Power Gal. Contemp. A.]

Tegucigalpa, Mus. Banco Atlántida
Tegucigalpa, Museo del Banco Atlántida

Tegucigalpa, U. N. Autón. Honduras
Tegucigalpa, Universidad Nacional Autónoma de Honduras

Tepotzotlán, Mus. N. Virreinato
Tepotzotlán, Museo Nacional del Virreinato [in former church of S Francisco Xavier]

Tokyo, N. Mus. Mod. A.
Tokyo, National Museum of Modern Art [Metropolitan Museum of Modern Art]

Toluca, Inst. Mex.
Toluca, Instituto Mexiquense

Toluca, Mus. A. Mod. Cent. Cult. Mex.
Toluca, Museo de Arte Moderno del Centro Cultural Mexiquense

Toluca, Mus. B.A.
Toluca, Museo de Bellas Artes

Toronto, Royal Bank of Canada

Trinidad, Paraguay, Mus. Mis.
Trinidad, Paraguay, Museo de Misión

Tübingen, Ksthalle
Tübingen, Kunsthalle Tübingen

Tucson, AZ, Mus. A.
Tucson, AZ, Museum of Art

Turin, Gal. Civ. A. Mod.
Turin, Galleria Civica d'Arte Moderna e Contemporanea

Valencia, Mus. B.A.
Valencia, Museo de Bellas Artes [Museo Provincial de Bellas Artes; Museo de San Pio V]

Valletta, Pal. Grand Masters
Valletta, Palace of the Grand Masters [houses Palace Armoury]

Valparaíso, Mus. Mun. B.A.
Valparaíso, Museo Municipal de Bellas Artes

Venice, CA, Soc. & Pub. A. Resource Cent.
Venice, CA, Social & Public Art Resource Center

Veracruz, Inst. Cult.
Veracruz, Instituto Veracruzano de Cultura

Vicenza, Cent. Int. Stud. Archit. Palladio
Vicenza, Centro Internazionale di Studi di Architettura Andrea Palladio [Domus Comestabilis-Basilica Palladiana]

Vienna, Albertina
Vienna, Graphische Sammlung Albertina

Vienna, Bib. Akad. Bild. Kst.
Vienna, Bibliothek der Akademie der Bildenden Künste

Vienna, Ksthist. Mus.
Vienna, Kunsthistorisches Museum [admins Ephesos Mus.; Ksthist. Mus.; Mus. Vlkerknd.; Nbib.; Neue Gal. Stallburg; Samml. Musikinstr.; Schatzkam.; houses Gemäldegalerie; Neue Hofburg; Kunstkammer; Sammlung für Plastik und Kunstgewerbe]

Viña del Mar, Mus. Mun. B.A.
Viña del Mar, Museo Municipal de Bellas Artes

Washington, DC, A. Mus. Americas
Washington, DC, Art Museum of the Americas [formerly Mus. Mod. A. Latin America]

Washington, DC, Corcoran Gal. A.
Washington, DC, Corcoran Gallery of Art

Washington, DC, Hirshhorn
Washington, DC, Hirshhorn Museum and Sculpture Garden [Smithsonian Inst.]

Washington, DC, Int.-Amer. Dev. Bank
Washington, DC, Inter-American Development Bank

Washington, DC, Kennedy Cent. Perf. A.
Washington, DC, J. F. Kennedy Center for the Performing Arts

Washington, DC, Lib. Congr.
Washington, DC, Library of Congress

Washington, DC, Mus. Mod. A. Latin America
Washington, DC, Museum of Modern Art of Latin America [now A. Mus. Americas; part of Org. Amer. States]

Washington, DC, N. Air & Space Mus.
Washington, DC, National Air and Space Museum [Smithsonian Inst.]

Washington, DC, N.G.A.
Washington, DC, National Gallery of Art

Washington, DC, N. Mus. Women A.
Washington, DC, National Museum of Women in the Arts

Washington, DC, Pan Amer. Un.
Washington, DC, Pan American Union

Washington, DC, Smithsonian Inst.
Washington, DC, Smithsonian Institution [admins Anacostia Neighborhood Mus.; Freer; Hirshhorn; N. Air & Space Mus.; N. Mus. Afr. A.; N. Mus. Amer. A.; N. Mus. Nat. Hist.; N.P.G.; N. Zool. Park; Renwick Gal.; Cooper-Hewit Mus.]

Washington, DC, Smithsonian Inst. Traveling Exh. Serv.
Washington, DC, Smithsonian Institution, Traveling Exhibition Service [S.I.T.E.S.]

Washington, DC, Textile Mus.
Washington, DC, Textile Museum

Wilberforce, OH, N. Afr.-Amer. Mus. Cult. Cent.
Wilberforce, OH, National Afro-American Museum and Cultural Centre

Willemstad, Curaçao Mus.
Willemstad, Curaçao Museum [West Indies]

Winnipeg, A.G.
Winnipeg, Art Gallery

Worcester, MA, A. Mus.
Worcester, MA, Worcester Art Museum

Xalapa, Gal. Estado
Xalapa, Galería del Estado

Xochimilco, Mus. Dolores Olmedo Patiño
Xochimilco, Museo Dolores Olmedo Patiño

York, C.A.G.
York, City Art Gallery [until 1892 called F.A. & Ind. Exh. Bldgs]

Yucatán, U. Autónoma
Yucatán, U. Autónoma

Zacatecas, Mus. Guadalupe
Zacatecas, Museo Guadalupe [Museo de Arte Colonial]

Zurich, Ksthalle
Zurich, Kunsthalle Zürich

Zurich, Ksthaus
Zurich, Kunsthaus Zürich

Appendix B

LIST OF PERIODICAL TITLES

This list contains all of the periodical titles that have been cited in an abbreviated form in italics in the bibliographies of this encyclopedia. For the sake of comprehensiveness, it also includes entries of periodicals that have not been abbreviated, for example where the title consists of only one word or where the title has been transliterated. Abbreviated titles are alphabetized letter by letter, including definite and indefinite articles but ignoring punctuation, bracketed information and the use of ampersands. Roman and arabic numerals are alphabetized as if spelt out (in the appropriate language), as symbols (e.g. A + '⟨A plus⟩'). Additional information is given in square brackets to distinguish two or more identical titles or to cite a periodical's previous name (where such publishing information was known to the editors).

A. America
 Art in America [cont. as *A. America & Elsewhere*; *A. America*]
A. América & Filipinas
 Arte en América y Filipinas
A. & Ant., A. Cono Sur
 Arte e Antigüedades, Arte del Cono Sur
A. & Arqueol.
 Arte e arqueología
A. & Artists
 Art and Artists
 A. & Australia
 Art and Australia
Abitare
A. Bull.
 Art Bulletin
A. & Cienc.
 El arte y la ciencia
A. Colombia
 Arte en Colombia [cont. after 1992 as *A. Nexus*]
Acrópole
Actualidades
A. & Des.
 Art and Design
Afr. A.
 African Arts
Afterimage
A. Hist.
 Art History
A. Int.
 Art International
A. Jamaica
 Arts Jamaica
Alero
Alumni Bull.
 Alumni Bulletin of the Rhode Island School of Design
América Indíg.
 América indígena
Américas
A. México
 Artes de México
An. Acad. Geog. & Hist. Guatemala
 Anales de la Academia de geografía e historia de Guatemala

An. Acad. N. A. & Let.
 Anales de la Academia nacional de artes y letras
An. Carnegie Mus.
 Annals of the Carnegie Museum
A. Nexus
 Art Nexus
An. Inst. A. Amer. & Invest. Estét.
 Anales del Instituto de arte americano e investigaciones estéticas
An. Inst. Invest. Estét.
 Anales del Instituto de investigaciones estéticas
A Noite
An. Soc. Geog. & Hist. Guatemala
 Anales de la Sociedad de geografía y historia de Guatemala
Antropol. & Hist. Guatemala
 Antropología e historia de Guatemala
Anu. Estud. Amer.
 Anuario de estudios americanos
A. Plast.
 Artes Plasticas
Apollo
A. Press
 Art Press
A. Quin.
 Arte quincenal
Archit. Aujourd'hui
 L'Architecture d'aujourd'hui
Architects' J.
 Architects' Journal
Archit. Forum
 Architectural Forum
Archit. Médit.
 Architecture méditerranéenne
Archit. Rec.
 Architectural Record
Archv A. Valenc.
 Archivo de arte valenciano
Archv Esp. A.
 Archivo español de arte [prev. pubd as *Archv Esp. A. & Arqueol.*]
Archv Hispal.
 Archivo hispalense

Armitano A.
 Armitano arte
Arquit. Brasil
 Arquitectura do Brasil
Arquitectura
 ii) [Colegio oficial de arquitectos, Madrid; cont. as *Rev. N. Arquit.*]
Arquit. México
 Arquitectura de México [prev. pubd as *Arquitectura* [Mexico]]
Arquit. & Soc.
 Arquitectura y sociedad
Arquit. & Urb.
 Arquitectura y urbanismo
Arquit. & Urb. São Paulo
 Arquitetura e urbanismo de São Paulo
Ars
Artforum
Artinf
ARTnews
Arturo
Atenea
A. & Text
 Art and Text
Aujourd'hui
 Aujourd'hui: Art et architecture [prev. pubd as *A. Aujourd'hui*]
Autoclub
A. Visual
 Arte visual
Banco Cent.
 Banco Central
Barricada
Barricada Int.
 Barricada internacional
Beeld. Kst
 Beeldende kunst
Belize Today
 Belize Today Magazine
Beliz. Stud.
 Belizean Studies
Bellas A.
 Bellas artes
Billiken
BM Q.
 British Museum Quarterly

Boa
Bol. Acad. Chil. Hist.
 Boletín de la Academia chilena de historia
Bol. Acad. N. Hist.
 Boletín de la Academia nacional de historia
Bol. Archv Gen. Nación
 Boletín del Archivo general de la nación
Bol. Cent. Invest. Hist. & Estét. Caracas
 Boletín del Centro de investigaciones históricas y estéticas de Caracas
Bol. Cult. Assembl. Distr. Lisboa
 Boletim cultural da Assembléia distrital de Lisboa
Bol. Hist. Fund. John Boulton
 Boletín histórico de la Fundación John Boulton
Bol. INAH
 Boletín del Instituto nacional de antropología e historia
Bol. Inst. Invest. Hist. & Estét.
 Boletín del Instituto de investigaciones históricas y estéticas
Bol. Lima
 Boletín de Lima
Bol. Mnmts Hist.
 Boletín de monumentos históricos
Bol. Nicar. Bibliog. & Doc.
 Boletín nicaraguense de bibliografía y documentación
Bol. Real Acad. B. Let.
 Boletín de la Real academia de buenas letras [Seville]
Brooklyn Mus. J.
 Brooklyn Museum Journal
Brukdown
 Brukdown: The Magazine of Belize
Bull. NY Pub. Lib.
 Bulletin of the New York Public Library

Bull. Pan Amer. Un.
 Bulletin of the Pan American
 Union
Bull. Soc. Hist. A. Fr.
 Bulletin de la Société de l'histoire
 de l'art français
Cad. Brasil.
 Cadernos brasileiros
Cah. Brésil Contemp.
 Cahiers du Brésil contemporain
Carib. Q.
 Caribbean Quarterly
Carib. Rev.
 Caribbean Review
Carib. Stud.
 Caribbean Studies
Caricom Persp.
 Caricom Perspective
Casa Américas
 Casa de las Américas
Casabella
Clima
Codia
Coll. A. J.
 College Art Journal [prev. pubd as
 Parnassus; cont. as A.J. [New
 York]]
Colon. Amer. Rev.
 Colonial American Review
Con Eñe
Conn. A.
 Connaissance des arts
Connoisseur
Constr. São Paulo
 Construção São Paulo
Continente
Controspazio
Copé
Cordialidad
Correio Manha
 Correio da manha
Correio Oficial Minas
 Correio oficial de Minas
Corrente
Country Life
Cras
Critique
Cuad. A. Colon.
 Cuadernos de arte colonial
Cuad. Amer.
 Cuadernos americanos
Cuad. Antropol.
 Cuadernos de antropología
Cuad. Arquit. & Conserv. Patrm. A.
 Cuadernos de arquitectura y
 conservación del patrimonio
 artístico
Cuad. Arquit. Mesoamer.
 Cuadernos de arquitectura
 mesoamericana
Cuad. Cult. Pop.
 Cuadernos de cultura popular
Cuad. Dominicanos Cult.
 Cuadernos dominicanos de cultura
Cuad. Hispamer.
 Cuadernos hispanoamericanos
Cuad. U.
 Cuadernos universitarios
Cult. Peru.
 Cultura peruana
Cultura
Das Münster

Dawn
Diario 'El Dia'
Domus
Don Bullebulle
 Don Bullebulle: Periódico
 burlesco y de extravagancias
 redactado por una sociedad de
 bulliciosos
Drawing
Dreamworks
Dut. A. & Archit. Today
 Dutch Art and Architecture Today
DYN
Eco
El Colombiano
El Comercio
El Democrata
El Día
El Granuja
El Heraldo
El Imparcial
El Iris
El Jicote
El Machete
El Mundo
El País
El Panorama
El Renacimiento
Encuadre
Ens. Hist.
 Enseñanza de la historia
Envío
Escena
Estud. A. & Estética
 Estudios de Arte y Estéticas
Estud. Centamer.
 Estudios centroamericanos
Estud. Demog. & Urb.
 Estudios demográficos y urbanos
Ethnographia
Etud. Créoles
 Etudes créoles
Europe
Excelsior
Fanal
Fem
Fieldiana Anthropol.
 Fieldiana Anthropology
FL Anthropol.
 The Florida Anthropologist
Flash A.
 Flash Art (International)
Floridian Mag.
 Floridian Magazine
Forma
GAM
Gávea
Gaz. B.-A.
 Gazette des beaux-arts [suppl. is
 Chron. A.]
Global Archit.
 GA [Global Architecture]
Global Interiors
Habitat
Hb. Mid. Amer. Ind.
 Handbook of Middle American
 Indians
Helice
High Performance
Hijo Ahuizote
 Hijo del Ahuizote

Hisp. Amer. Hist. Rev.
 Hispanic American Historical
 Review
Hist. A. Mex.
 Historia del arte mexicano
Hist. Phot.
 History of Photography
Hist. Workshop J.
 History Workshop Journal
Horizonte
 Horizonte: Revista mensual de
 actividad contemporánea
House & Gdn
 House and Garden
Hueso Húmero
Humboldt
Ideas
Illus. A.
 Illustrated Arts
Il Piccolo
Il Verri
In Situ
 In Situ: The Journal of the Zambia
 Institute of Architects
Interiors
Int. J. Housing Sci. & Applic.
 International Journal for Housing
 Science and its Applications
Int. Studio
 International Studio
Inzyn. & Budownictwo
 Inzynieria i budownictwo
 [Engineering and construction]
Irradiador
Jamaica J.
 Jamaica Journal
J. Brit. Guiana Mus. & Zoo
 Journal of the British Guiana
 Museum and Zoo
J. Comérc.
 Jornal do comércio
J. Dec. & Propaganda A.
 Journal of the Decorative and
 Propaganda Arts
J. Soc. Américanistes
 Journal de la Société des
 américanistes
J. Soc. Archit. Hist.
 Journal of the Society of
 Architectural Historians [prev.
 pubd as J. Amer. Soc. Archit.
 Hist.]
J. Warb. & Court. Inst.
 Journal of the Warburg and
 Courtauld Institutes [prev. pubd as
 J. Warb. Inst.]
Kantú, Rev. A.
 Kantú, revista de arte
La Nación
Landscape
La Orquesta
La Prensa
La Razón
La República: Supl. Dominical
 La República: Suplemento
 dominical
Lat. Amer. A.
 Latin American Art
Lat. Amer. A. Mag.
 Latin American Art Magazine
Lat. Amer. Persp.
 Latin American Perspectives
La Vanguardia

Lett. & Not.: Inter. J. Eng. Prov. SJ
 Letters and Notices: The Internal
 Journal of the English Provinces
 of the Society of Jesus
Listín Diario
Lyra
Man
Manchete
Marcha
Márgenes
Mél. Casa Velázquez
 Mélanges de la Casa Velázquez
Mem.
 Memoria
Mem. Mus. N. A.
 Memoria del Museo Nacional de
 Arte
Minotaure
 Minotaure: Revue artistique et
 littéraire
Mitaraka
Módulo
MOMA Bull.
 Museum of Modern Art Bulletin
 [prev. pubd as Bull. MOMA, NY]
Montevideo U. Arquit. Rev.
 Montevideo Universidad de
 arquitectura revista
Mundial
Mus. Ethnographers Grp Newslett.
 Museum Ethnographers Group
 Newsletter
Nassau Pink
Ñawpa Pacha
New A. Examiner
 New Art Examiner
Newsweek
New Yorker
Nicaráuac
Norte
Novos Estud.
 Novos Estudos
Nuestra Arquit.
 Nuestra arquitectura
Nueva Prov.
 Nueva provincia
Nueva Visión
Nuevo Amanecer Cult.
 Nuevo amanecer cultural
Official Gaz.
 Official Gazette
Orígenes
Oxford A. J.
 Oxford Art Journal
Pan-Amer. Bull.
 Pan-American Bulletin
Performance
Period Homes
Periscopio
Pez & Serpiente
 El pez y la serpiente
Photo-Vision
Phréat., Lang. & Création
 Phréatique, langage et création
Pioneer America
Pluma & Pincel
 Pluma y pincel
Polemica
Primera Plana
 Primera plana
Print
Prints

Appendix C

List of Contributors

Acevedo, Esther
Aguilera, Marta
Alegría, Ricardo E.
Alley, Ronald
Allwood de Mata, Claudia
Antrobus, Pauline
Arana, Mariano
Arciprete de Reyes, Marta
Arteaga, Agustín
Asturias de Barrios, Linda
Baddeley, Oriana
Baixas Figueras, Isabel
Balmaceda, Lissette
Bann, Stephen
Baquedano, Elizabeth
Barcelo Cedeño, Cruz
Bargellini, Clara
Barilli, Renato
Barran, José Pedro
Benko, Susana
Bernal Ponce, Juan
Besson, Jerry
Billeter, Erika
Blanc, Giulio V.
Blinder, Olga
Bosman, Jos
Boulton, Alfredo
Boxer, David
Brenninkmeyer-De Rooij, B.
Broos, B. P. J.
Bruna, Paulo J. V.
Burnside III, Jackson L.
Calvo, Marta
Canessa de Sanguinetti, Marta
Cardet, Ernesto
Carrasco Zaldua, Fernando
Chadwick, Whitney
Chanfón Olmos, Carlos
Chase, Beatriz
Churchill, Nick
Coleby, Nicola
Collier, Simon
Concepción Bravo, María
Conde, Teresa del

Corcuera, Ruth
Cordero Iñiguez, Juan
Cordero Reiman, Karen
Craven, David
Crowley, Daniel J.
Crump, James
Cruz, Lourdes
Cummins, Alissandra
Delgado, Lelia
Descalzi, Ricardo
Dewes, Ada
Duarte, Carlos F.
Duparc, Frederik J.
Eder, Rita
Elliott, David
Escobar, Ticio
Escobari, Laura
Espinós Díaz, Adela
Espinoza, Manuel
Fanning, Irene
Ferreira-Alves, Natália
 Marinho
Ficher, Sylvia
Foss, Paul
Franco Calvo, Enrique
Fraser, Valerie
García Barragan, Elisa
García Sáiz, Maria
 Concepción
Garrido, Esperanza
Gili, Marta
Gisbert, Teresa
Glinton, Patricia
Glusberg, Jorge
Goldman, Shifra M.
González Arredondo,
 Margarita
González Pozo, Alberto
González-Arnal, María
 Antonia
Gray, Jocelyn Fraillon
Gullick, C. J. M. R.
Gutiérrez, Ramon
Gutiérrez, Rebeca
Haber, Alicia

Haraksingh, Kusha
Hartop, Christopher
Harwood, J.
Herrera, Hayden
Höper, C.
Hugarte, Renzo Pi
Ivelić, Milan
Jaén, Omar
Kalenberg, Angel
Katinsky, Julio Roberto
Kennedy, Alexandra
Koppmann, Ludovico C.
Krohn, Lita Hunter
Kupfer, Monica E.
Lara-Pinto, Gloria
Lastarria Hermosilla, Carlos
Lee, Ann McKeighan
Lemos, Carlos A. C.
Leurs, Gloria C.
Lewis, John Newel
Locke, Adrian
Luján-Muñoz, Jorge
Mackay, W. Iain
Maclean, Geoffrey
Manrique, Jorge Alberto
Mapelli Mozzi, Carlotta
Marías, Fernando
Martí Cotarelo, Mónica
Martínez Marín, Carlos
Martinez Lambarry, Margarita
Masse, Patricia
Matos Moctezuma, Eduardo
Méndez, A.
Méndez Brignardello, Ramón
 Alfonso
Milan Acayaba, Marlene
Momsen, Janet Henshall
Montalva, Maria José
Montêquin, François-Auguste
 de
Montero, C. Guillermo
Monterrosa, P. Martano
Monteverde-Penso, Melanía
Moody, Cynthia
Morales Alonso, Luis

Morales, Leonor
Mosquera, Gerardo
Mowat, Linda
Moyssén, Xavier
Navarro-Castro, Gustavo
Noelle, Louise
Nunley, John
O'Connor, Francis V.
Oña, Lenin
Ortiz Avila, Jorge
Ortiz Gaitán, Julieta
Overy, Paul
Paez Mullan, Anthony
Pataki, Eva
Pau-Llosa, Ricardo
Pavon Maldonado, Basilio
Peña, José María
Perazzo, Nelly
Pérez Chanis, Efrain E.
Pérez de Ayala, Juan
Pérez Silva, Yasminy
Pintado, Leonore Cortina de
Pons-Alegría, Mela
Pontual, Roberto
Poppi, Cesare
Poupeye, Veerle
Poveda, Consuelo de
Prosperi Meyer, Regina Maria
Querejazu, Pedro
Quintanilla Armijo, Raul
Rabinovitch, Celia
Rahming, Patrick
Ramírez, Fausto
Ramírez, Mari Carmen
Ramón, Armando de
Reyes, Aurelio de los
Reyes-Valerio, Constantino
Ribeiro de Oliveira, Myriam
 A.
Ring, Nancy
Rivarola, Milda
Roark, Elisabeth
Rochfort, Desmond
Rodríguez, Bélgica

Rodriguez, Myrna E.
Rodríguez-Camilloni,
 Humberto
Rodríguez Ceballos, Alfonso
Rojas, José Miguel
Rote, Carey
Ruiz Gomar, Rogelio
Rule, Amy
Safons, Horacio
Salazar, Elida
Saunders, D. Gail
Saunders, Richard H.
Segre, Roberto
Serrano, Eduardo
Sierra Torres, Aída
Silva, Raquel Henriques da
Soto, Rolando
Starczewski, Jerzy Andrzej
Strobel, Michèle-Baj
Suarez, Cecilia
Svanascini, Osvaldo
Talavera, S. Leticia
Tapias, Ana
Tejeira-Davis, Eduardo
Tesler, Mario
Théard, Benjie
Tibol, Raquel
Tolentino, Marianne de
Tord, Luis Enrique
Torruella Leval, Susana
Troya, Alexandra Kennedy
Uribe, Eloísa
Valero, Mario Eloy
Vaquero, Julieta Zunilda
Vargas, Ramón
Vega, Natalia
Velarde, Oscar A.
Villar Movellán, Alberto
Visser, Hripsimé
Vivas, Zuleiva
Warner-Lewis, Maureen
Weininger, Susan S.
Williams, Denis
Yonker, Dolores M.

INDEX

This index comprises a selective listing of references in the *Encyclopedia of Latin American Art and Caribbean Art*. It has been compiled to be useful and accessible, enabling readers to locate both general and highly specific information quickly and easily. Numbers refer to specific page references. Page numbers in italics refer to illustrations. A first-level illustration reference in a biographical entry (following the person's name rather than a sub-heading) indicates a portrait of the individual. Colour plate references appear as large roman numerals. The index contains cross-references to direct the reader from various spellings of a word or from similar terms.